WORLD ARTISTS

1950–1980

'88

Biographical Dictionaries from The H. W. Wilson Company

American Reformers
Greek and Latin Authors 800 B.C.–A.D. 1000
European Authors 1000–1900
British Authors Before 1800
British Authors of the Nineteenth Century
American Authors 1600–1900
Twentieth Century Authors
Twentieth Century Authors: First Supplement
World Authors 1950–1970
World Authors 1970–1975

The Junior Book of Authors
More Junior Authors
Third Book of Junior Authors
Fourth Book of Junior Authors and Illustrators
Fifth Book of Junior Authors and Illustrators

Great Composers: 1300–1900
Composers Since 1900
Composers Since 1900: First Supplement
Musicians Since 1900
Popular American Composers
Popular American Composers: First Supplement

World Artists 1950–1980

WORLD ARTISTS

1950–1980

An H. W. Wilson Biographical Dictionary

by
CLAUDE MARKS

THE H. W. WILSON COMPANY

NEW YORK

1984

Library of Congress Cataloging in Publication Data

Marks, Claude.
 World artists, 1950-1980.

 Bibliography: p.
 1. Artists—Biography. 2. Art, Modern—20th century.
I. Title.
N6489.M37 1984 709′.2′2 [B] 84-13152
ISBN 0-8242-0707-6

CONTENTS

Artists Included

PREFACE

THE KALEIDOSCOPIC CHARACTER of contemporary art, and the rapidity with which movements have succeeded each other since the end of World War II, make the compilation of a reference work covering this period a challenging task. *World Artists 1950–1980* contains biographies of 312 artists who both worked and were influential during this 30-year period.

While it is tempting in terms of social history to categorize each decade—the conformist '50s, the rebellious '60s, the me-generation '70s, and, possibly, the anxious and uncertain '80s—and while art reflects in some degree the changing patterns and tensions of society, individual artists of stature generate their own momentum, and are inclined to let history, especially art history, take care of itself. In this compendium of world art, it has not been possible to include every artist of significance, but an attempt has been made to select outstanding figures from many countries, representing a wide variety of styles and movements and embracing the long-neglected graphic media as well as painting and sculpture.

The international ascendancy of American art began about 1950, but that occurrence represented a carrying forward of the European modernism that developed uninterrupted from 1880 to 1939. In today's art world New York City occupies a position comparable to that of Paris between the wars, but the presence in the United States in the 1940s of avant-garde artists who had fled Nazi-occupied Europe was crucial in the emergence not only of American action painting but also of a more cosmopolitan outlook in general. In addition to meeting Mondrian, Léger, and Chagall, young American artists were stimulated by contact with such Surrealist luminaries as André Masson, Yves Tanguy, Max Ernst, and Roberto Matta. The showing of their work in 1942 at Peggy Guggenheim's Art of This Century Gallery was soon followed by an exhibit in the same gallery of many of the vanguard American painters—Jackson Pollock, Robert Motherwell, William Baziotes, Mark Rothko, Clyfford Still, Adolph Gottlieb, and David Hare. The 1948 Peggy Guggenheim-sponsored European tour of the new American painting caused a sensation and contributed to the shifting focus of the entire international art scene, as did the subsequent State Department-sponsored tours. Indeed, American abstract expressionism in its boldness and bigness was a reaction against the easel-painting scale and structural disciplines of School of Paris cubism, which in its later phases—though not with such masters as Georges Braque and Nicolas De Staël—often lapsed into mere tasteful, decorative "picture making."

Europe, though exhausted by the war, soon began again to contribute to the

advance of modernism. The figurative tradition there was renewed by Henry Moore, from the older generation of artists, and by a younger group of British sculptors in his wake. In France Alberto Giacometti, Germaine Richier, and Jean Dubuffet, and in England the painter Francis Bacon, created, in their various ways, new existential images of man—ravaged, attenuated, battered or fragmented, reflecting aspects of the harrowing 20th-century experience in Europe that had no real equivalent in America.

Along with historical circumstances, national characteristics have remained a constant factor in art of the late modern period. Even in the realm of the nonobjective there are, despite superficial stylistic affinities, marked contrasts between the gestural panache of Georges Matthieu and the volatile, multilayered calligraphy of Jackson Pollock's dripped abstractions, and between the broad but elegant brushstrokes of Pierre Soulages and the raw, thrusting energy of Franz Kline.

The triumph of American modernism in the 1950s was viewed as a rebellion against the materialism and spiritual complacency of that decade, but even the art scene was conformist in that it was not acceptable to be in the slightest degree representational. It is significant that in the United States the Dutch-born Willem de Kooning, in his extraordinary "Women" canvases, was the only first-generation Abstract Expressionist to tackle the human figure. When de Kooning was told by a leading supporter of the new abstraction that "it is impossible today to paint a face," he replied, "That's right, and it is impossible *not* to." Ultimately everything depends not on schools and movements, however influential and innovative, but on the vision and commitment of the artist.

In the late 1950s there was a reaction against the subjective, painterly, "artist-as-hero" approach of the Abstract Expressionists. That rejection was first expressed in the combine-paintings of Robert Rauschenberg (who said he aimed "to work in the gap between art and life") and the proto-pop imagery of Jasper Johns, with his American flags, targets, and bronze simulated beer cans. This phase has been termed "neo-dada," and, significantly, it owed much to the anti-art gestures and found objects of the veteran iconoclast Marcel Duchamp, who, by the early 1960s, had become a kind of guru to many of the younger artists.

The critic and historian Edward Lucie-Smith observed that much of the art produced since 1945 has been "more notable for taking existing ideas to extremes than for new invention," and, without detracting from the achievements of the artists of this period, it is true that virtually every recent movement had its origins earlier in this century. The Kandinsky of 1910–13, with his lyrical abstractions, can be considered the first action painter, and Hans Hofmann, who came to the United States from Munich in 1932, is now regarded as the doyen of abstract expressionism. Assemblage, the pop art of the 1960s, happenings, and performance art hark back in many ways to dada and surrealism. Junk sculpture and the environmental sculpture of Louise Nevelson were anticipated in the Merz constructions that Kurt Schwitters made in Germany about 1920. Forerunners of op art, kinetic art, and minimalism can be found in the activities of the Bauhaus. Hard-edge geometric abstraction can be traced back to de Stijl in Holland, and Russian constructivist metal sculpture of the 1917–20 revolutionary period had enormous influence on such later sculptors as Alexander Calder, George Rickey, Richard Lippold, and Sue Fuller. However, the work of the Americans

in this field was different from the severe, purposeful constructions of Vladimir Tatlin and Aleksandr Rodchenko, having an airiness, lightness, and technical dexterity which reflected the same American flair for engineering that created the great suspension bridges.

Viewed in relation to the pioneering achievements of the first half of the century, the period covered in this volume can perhaps be termed "manneristic," given the emphasis on style (the how rather than the what), and the carrying of one or another aspect of the visual to its ultimate limits. There are, of course, several factors that make the contemporary art scene very different from that of earlier periods. One is the existence, at least in the West, of a far more accepting—that is, less easily shocked—public. Another is the abundance of galleries and cultural institutions, and a third is the rapidity with which even the most advanced styles are taken up and publicized. Indeed, in the period 1950–1980 the old avant-garde became the establishment, as the doctrines of modernism became the new orthodoxy of major museums and universities, a situation that prompted British sculptor Reg Butler to complain that there was "nothing left to rebel against any more." The rising artists, rebels on their own terms, soon became big business, and by the late 1960s some were already considered "old masters." Moreover, the art market and the gallery system's vast machinery of promotion and speculation acquired an importance they had never previously enjoyed. Pop art, with its apparent accessibility and its strong element of theater, did much to make art "public." Andy Warhol, whose role in the realm of pop is analogous to that of Salvador Dali in the fashionable phase of surrealism, once declared that "everyone can be famous for fifteen minutes"—a wry comment on a society in which instant celebrity can also mean equally rapid obsolescence.

In addition to being a painter, Warhol has been a filmmaker and editor of a "celebrity" magazine. This combining and overlapping of various arts has been a notable feature of the post–World War II era—for instance, Robert Rauschenberg's collaborations with the composer John Cage and the dancer Merce Cunningham, and David Hockney's designs for opera and ballet. A precedent for these joint activities can be found in the Italian Futurists in the years before World War I, and in Serge Diaghilev's Ballets Russes, to which so many artists, including Picasso, Matisse, Braque, and Miró, contributed.

Op art, post-painterly abstraction, minimalism, mixed media, the conceptual art of the 1960s and 1970s in which the idea is more important than the realization, the earth art of Robert Smithson and the "wrappings" of Christo, photorealism (itself a form of abstraction), video art—these and other movements have arisen and often coexisted in the space of just a few years. Having more recently come into use is the elusive term "postmodernism," which would seem to imply a revaluation of values and a borrowing from various pictorial sources. Naturally, some trends will prove more ephemeral than others, but the pluralism of the current art scene, though bewildering, is healthier than the doctrinaire avant-gardism embraced by artists, critics, and museum directors in the 1950s. Today, those knowledgeable in art accept that there is room for an Edward Hopper as well as a Tom Wesselmann or a Jean Tinguely, for the frozen tableaux of a George Segal as well as the abstract lyricism of a Helen Frankenthaler.

One of the notable features of today's art world is the number of women art-

ists, including Bridget Riley, Alice Neel, Sue Fuller, Joan Mitchell, and Louise Bourgeois, among many others. Black artists, or rather fine artists who happen to be black, are also forceful presences. Because of the unique and dramatic nature of the black experience in the United States, what they paint is no less significant than how they paint. Artists of the stature of Jacob Lawrence, Bob Thompson, Romare Bearden, and Benny Andrews have achieved, each in his own way, what Ben Shahn called the "shape of content."

Lawrence and Bearden, like many of the American artists in this volume, managed to survive and continue their work during the Depression years thanks to the Federal Arts Project (FAP), which was established by the Roosevelt Administration in 1935. The FAP embraced abstract artists as well as Social Realists and American Scene painters, and, through its mural program and other diverse cultural activities, it touched the lives of millions of Americans, including those who lived far from urban centers and had never seen an original work of art. Pollock, Lee Krasner, the Soyer brothers, James Brooks, Ilya Bolotowsky, and Alice Neel were among the younger artists associated with the FAP, which was not dismantled until the early 1940s.

Ideally, a reference book such as this should include artists from the Third World, but the cultural situation in those countries is still unclear. Central and South America present no such problem, however, and many outstanding Latin-American artists have long been internationally known. On the other hand, the countries of Asia have their own centuries-old artistic heritage, and the transition to the modern world has not been easy. It is the Japanese who have been the most successful, especially in sculpture, in combining the refinement, sensitivity, and craftsmanship of their native tradition with the bold experimentation of modern movements in the West. In the United States the Japanese-American sculptor Isamu Noguchi has developed a rich and varied abstract idiom while always retaining a link with natural forms. The garden he created in 1956–58 for the UNESCO building in Paris is an example of architectural and environmental sculpture that harmoniously blends East and West.

Besides providing factual information about the lives and works of artists, this volume seeks to highlight the individual contribution of each artist, and deals with such matters as background, working ambiance, and aesthetic belief. Whenever possible, statements by the artists themselves have been included, although many have preferred to let the work speak for itself. When a young man announced to Matisse that he intended to be a painter, Matisse replied, "Then you must cut out your tongue—you will not need it any more!" Paradoxically, Matisse himself could lucidly discuss his work and art in general. The statements provided by artists for this book, whether dealing with their life, their work, or both, are illuminating and often eloquent.

Inevitably the setting of an opening and closing "cut-off" date is arbitrary and has led to the exclusion of such artists as Piet Mondrian (who died in 1944) and Arshile Gorky (who committed suicide in 1948), major influences on the post–World War II generation of painters. On the other hand, Henri Matisse died in 1954, and thus worked for only a few years in the time span of this book, but it would be inconceivable not to have included him. Not only were he and Pablo Picasso *the* giants of the art of this century, but Matisse's supreme mastery of

color and design, including the gouache cutouts of his last years, had a considerable impact on color-field painting and more recent developments. In the case of Picasso there has been a tendency to regard his prolific and varied output from the Second World War's end to his death in 1973 as a virtuoso performance, a series of dazzling variations on themes and styles developed in earlier years. But, as the French critic Georges Ribémont Dessaignes observed, "Nothing that anyone can say about Picasso is correct," for the final Dionysiac explosion of color and imagery and the defiant, seemingly slapdash freedom of his canvases of 1969–73 may well have provided an impetus for the neo-expressionist movement which has emerged in the early 1980s.

I should like to express my thanks for the invaluable assistance of Jeffrey Harrison, Julie Schumacher, Eleanor F. Wedge, and Steven Anzovin in the preparation of this book. Although it has been claimed that we are witnessing the end of the modern era which began over a century ago with Manet, the story of art is never concluded as long as there are men and women with the urge to create, in the words of William Butler Yeats, "Those images that yet/fresh images beget."

Claude Marks
New York, 1984

KEY TO PRONUNCIATION

ā	āle	ō	ōld	ü	Pronounced approximately as ē, with rounded lips: French u, as in *menu* (mə-nü); German ü, as in *grün*	
â	câre	ô	ôrb			
a	add	o	odd			
ä	ärm	oi	oil			
		o͞o	o͞oze			
ē	ēve	o͝o	fo͝ot			
e	end	ou	out			
				ə	the schwa, an unstressed vowel representing the sound that is spelled a as in sofa e as in fitted i as in edible o as in melon u as in circus	
g	go					
ī	īce	*th*	*then*			
i	ill	th	thin			
к	German *ch* as in *ich* (iк)					
		ū	cūbe	zh	azure	
		û	ûrn; French eu, as in *jeu* (zhû), German ö, *oe*, as in *schön* (shûn), *Goethe* (gû′te)	′	= main accent	
N	Not pronounced, but indicates the nasal tone of the preceding vowel, as in the French *bon* (bôN)			″	= secondary accent	
		u	tub			

KEY TO ABBREVIATIONS

Am.	American	inst.	institute	
cntr.	center	instn.	institution	
ca.	circa	MOMA	Museum of Modern Art	
col.	college	NYC	New York City	
gal.	gallery	univ.	university	

ADAMS, ROBERT (October 5, 1917–), British sculptor, is one of the most important members of the post-Henry Moore generation of British sculptors. He was born in Northampton, England, where the elementary school stressed arts and crafts. From 1937 to 1946 he attended evening classes at the Northampton School of Art, while working by day at various firms, including a printing shop, a timber yard, and an agricultural machinery manufacturer. There was no sculpture teacher at the school, but Adams taught himself woodcarving. Until 1955 he worked almost exclusively in wood, but also experimented with stone and various metals; his early mother-and-child groups indicate that he was well-acquainted with the work of Moore and Barbara Hepworth.

Adams's first solo exhibition was held in 1947 at the Gimpel Fils Gallery, London. By then, as Charles S. Spenser noted in *Studio International* (October 1966), the artist's sculptures "were becoming tenuous, exploring space rather than defining form." Dissatisfied with carving, he was already becoming interested in wire construction. During a visit to Paris in the late 1940s he had admired the metal sculptures of Julio González and Picasso. After he accepted a teaching position at the Central School of Arts and Crafts, London, a post he held until 1960, he took up welding. At that time he was the only British sculptor, with the exception of Lynn Chadwick, to be working in welded steel.

In 1949 Adams's work was shown in a solo exhibit in Paris at the Galerie Jeanne Bucher and at the Salon des Réalités Nouvelles. The following year he received his first major sculptural commission, from the King's Heath School in Northampton. His ten-foot-high sculpture commissioned by the Arts Council for the Festival of Britain in 1951 has been described by Spenser as "more like joinery than carving, a kinetic construction clearly influenced by plants." Adams represented Britain in the Venice Biennale of 1952, along with sculptors Kenneth Armitage, Reg Butler, Lynn Chadwick, Bernard Meadows,

ROBERT ADAMS

William Turnbull, Geoffrey Clarke, and Eduardo Paolozzi. This was the second generation's "never-to-be-forgotten début," according to one critic. In these years Adams also was active as a printmaker; in 1950 he won the engraving prize at the São Paulo Bienal.

Although Adams used the title *Figure* for many of his vertical pieces, they actually marked a bold step into abstraction, combining curved forms with sharp points and angles—as in *Figure* (1948) and the ten-foot-high *Apocalyptic Figure* (1951), in ashwood. His weightier works in stone included the squat *Three Stone Forms,* somewhat reminiscent of sculpture stands by Brancusi. The artist's wooden *Divided Pillar* and *Divided Column* (both 1951) resemble stacks of blocks varying in size.

Even after he had begun his series of open steel works, Adams continued to experiment with monumental, blocky forms. *Rectangular Form 3* (1955), for example, is a monolithic work in bronze. But he soon found that the relief was a more articulate genre for this type of composi-

tion, and in 1956 created one of his most successful works, *Architectural Screen* in bronze. He later used a similar idiom for his *Relief in Reinforced Concrete,* completed in 1960 for the New Theater building at Gelsenkirchen, West Germany. The relief, 9 feet high by 75 feet long, is painted white. In *Quadrum* J.P. Hodin wrote: "Its precise geometric forms are like hieroglyphs of an unknown language of beauty." Two years earlier Adams had made another relief, in cement, titled *Descending Forms,* commissioned by the London County Council for the Eltham Green Secondary School in Woolwich. About this time he also designed a sculptured ceiling panel, a wall relief, and six metal screens for the smoking-room of the P and Q ocean liner *Canberra.*

In the mid-1950s Adams began to concentrate on bronze and steel sculptures, incorporating bars cut out of steel plate. Some, including *Long Points* (1956), with its slender crescents, and the two *Climbing Forms* of 1961 seemed to take up where the wooden figures had left off. Others, such as *Movement Through a Curve* (1956) and *Rising Forms* (1960), were more or less horizontal, curvilinear pieces, made by welding flat steel shapes together at various angles. Still another series, called "Screen Forms," dating from the early 1960s, broke up a flat surface into myriad triangular, diamond-shaped, and rectangular facets.

In 1962 Adams was chosen, along with the sculptor Hubert Dalwood and the painter Ceri Richards, to represent Britain at the 31st Venice Biennale. The pieces he showed at the Biennale indicated that rectangles were beginning to play a larger role in his vertical sculptures. The over-six-foot-high *Circular Form and Bar* (1962, bronzed steel) contains one curved form, but two *Barriers* of the following year are each dominated by monolithic vertical rectangles, and contain no curved edges. In *Balanced Forms* (1963) Adams was concerned with rectangles arranged in planar relations to each other, while in the "Web Development" series of 1965 he sought purity of formal relationships using a minimum of shapes. He also turned to a different kind of screen form with his *Rectangles with Holes,* plates welded to stands and perforated with a cutting torch.

Curves reappeared in Adams's work in the late 1960s, but these were created by bending rectangles into curves rather than by cutting out curved shapes. In *Insert* and *Polarity,* both of 1968, and other pieces in this vein, one of the curves was arranged in relation to one or more flat rectangular shapes. The sculptures retained their classical austerity and purity but acquired a new grace. This trend towards elegance and refinement was continued in the 1970s with his series of "Wave Forms." In *Wave Form No. 5* (1973), for example, the curves rise up in a continuous movement from a flat circular plane. His bronze casts, such *Slim Bronze No. 3* (1973), *Double Fin* (1974), *Brown Wings* (1978), and the graceful *Divergence* (1979), also went through a continuous refinement as the sculptor distilled the constructivist elements out of his work while playing polished and matte surfaces against each other.

Robert Adams, a quiet and serious man with dark eyes, a grizzled moustache, and the powerful hands of a welder, is a much respected figure in postwar British art, although less widely known than some of his contemporaries. Critics have found his work difficult to place stylistically, but from the beginning they have acknowledged his eminence as a master craftsman in close touch with his materials. As Charles Spenser wrote in *Studio International* (March 1965): "From the simple relationships of flat steel shapes, virtually without decoration, Adams evolves endless variations. Always controlled and elegant, his imagination works entirely within the limits and character of the material."

Adams has spent much of his career in London, but he and his wife Patricia also own a cottage in Essex. In 1967 he spent two or three weeks sketching intensively in the Essex countryside, and this, according to Ian Mayer of *Sculpture International,* despite the complete lack of figurative associations in Adams's works, has been a powerful source of inspiration. Mayer pointed out that there is much more than mere craftsmanship in Adams's sculpture, and although the influence of nature on his work should not be exaggerated, neither should that influence be ignored. Adams, who distrusts self-consciously intellectual or philosophical statements about art, has said, "I think of my work as inorganic; [but] I don't know . . . I think it has something to do with nature."

EXHIBITIONS INCLUDE: Gimpel Fils Gal., London from 1947; Gal. Jeanne Bucher, Paris 1949; Passedoit Gal., NYC 1950; Victor Waddington Gal., Dublin 1955; Gal. Parnass, Wuppertal, W. Ger. 1957; Bertha Schaefer Gal., NYC 1963; Gimpel & Weitzenhofer Ltd., NYC 1981. GROUP EXHIBITIONS INCLUDE: Salon des Réalités Nouvelles, Paris 1949; São Paulo Bienal 1950; International Open-air Exhibition of Sculpture, Middelheim Park, Antwerp, Belgium 1951; "Artistes Anglais Contemporains," organized by British Council for tour of France, 1952; Venice Biennale 1952, '62; International Exhibition of Sculpture, Mus. Rodin, Paris 1956; "Ten Young British Sculptors," São Paulo Bienal 1957; "14 European Sculptors," Staempfli Gal., NYC 1959; "Recent British Sculpture," organized by British Council for Nat. Gal. of Canada for tour of Ot-

tawa, Montreal, Toronto, and other Canadian cities, 1961; "3 Constructivist Sculptors," Bertha Schaefer Gal., NYC 1961; International Exhibition of Prints, Tokyo 1963; "Trois Artistes Britanniques," Mus. Nat. d'Art Moderne, Paris 1963; Documenta 3, Kassel, W. Ger. 1964; "British Sculpture in the Sixties," Tate Gal., London 1965; Open-air Sculpture Exhibition, Battersea Park, London 1966; "Four British Sculptors," Gimpel & Weitzenhoffer Ltd., NYC 1975.

COLLECTIONS INCLUDE: British Council, London Gal. Nazionale d'Arte Moderno, Rome; MOMA, and New York Public Library, NYC; Albright-Knox Art Gal., Buffalo, N.Y.; Univ. of Michigan, Ann Arbor; Mus. de Bellas Artes, Caracas, Venezuela; Mus. of Modern Art, São Paulo.

ABOUT: "Robert Adams: Recent Sculpture" (cat.), Gimpel Fils Gal., London, 1968; Hodin, J.P. "Trois Artistes Britanniques" (cat.), Mus. Nat. d'Art Moderne, Paris, 1963; Moore, E. (ed.) Contemporary Art 1942–72: Collection of the Albright-Knox Art Gallery, 1972; Read, H. A Concise History of Modern Sculpture, 1964. *Periodicals*—Apollo August 1962; Arts Magazine January 1980; Quadrum 10 (Brussels) 1961; Sculpture International April 1969; Studio International March 1965, October 1966, July–August 1974.

AFRO (AFRO BASALDELLA) (March 4, 1912–September 24, 1976), Italian painter, was a master of lyrical abstraction who played an important role in reviving Italian painting after World War II. He was born Afro Basaldella in Udine, in northeastern Italy. His father and uncle were decorators specializing in the ceilings of Venetian mansions, and his brothers Mirko and Dino Basaldella became sculptors. (The unusual first names Afro and Mirko are traditional ones in the province of Udine.) At the age of eight Afro joined the family business, but he also received artistic training at academies in Florence and Rome, and graduated from the Venice Lyceum in 1931. He had his first show at the Galleria del Milione, Milan, in 1932. He won a competition in 1936 for decorating an opera house in Udine with a huge work painted in the pseudo-primitive manner then in vogue; but Afro's work, in that era of Mussolini fascism, was not considered sufficiently heroic and rhetorical. Despite the protests of the Italian Department of Fine Arts, it was covered with whitewash and is now known only from photographs.

In 1937 Afro was commissioned to decorate the Albergo delle Rose on the island of Rhodes, in the Aegean Sea. In this instance he employed a style inspired by Venetian 17th- and 18th-century decorative painting. Lionello Venturi commented on the "sparkling technique" of those murals. In a sense even his abstract work alway retained a Venetian "painterliness."

AFRO

Until then Afro had worked primarily as a decorator, but in 1937, after a short stay in Paris, he turned to easel painting and settled in Rome. His subjects were mostly still lifes, in which the objects were skillfully arranged, well drawn, and painted with correct tonal values. It was as if, at this early stage, the young artist was proving his technical perfection to himself.

From 1940 to 1944, Afro served with the Italian armed forces but found time to give occasional classes at the Venice Academy and to pursue his painting. In a still life painted in 1941, the treatment of space remained traditional, but the forms were fewer and more simplified, and the effect of light was accorded greater importance. The next stylistic progression in Afro's early work can be seen in *Still Life with Candle* (1942), which looks forward to the artist's later abstractions. The space was brought up to the surface, and the few objects, greatly simplified and painted with sharp contrasts of light and shade, were rendered in a manner recalling fauvism.

Afro's portraiture also evolved in the early years of World War II. *Liliana* (1940) and *Portrait of the Painter Natili* (1941) were painted in an impressionistic manner. In his *Portrait of the Painter Turcato* (1942) the simplification of the form showed that his style was headed toward postimpressionism. By 1944, when he painted the *Portrait of Maria,* Afro's preoccupation with abstract geometrical form was evident; this new concern with formal structure led to a deemphasis on color.

Several paintings with simple figures dating from 1944 reveal uncertainties in Afro's style, as

if he were still searching for his direction; *Woman Reading* is a variant of a Picasso subject. Two still lifes painted in that year, one of which is now in the Venice Gallery of Modern Art, display, to quote Venturi, "a perfect harmony between the abstract and the concrete." Afro clearly felt the influence of Braque.

In the final stages of World War II, Afro worked with the partisan resistance movement in Venice, and for almost two years he ceased painting, apparently because of his experience of the brutality of war. In two still lifes of 1947, real objects were still represented, but the colors were pale, almost pastellike, and the objects dissolved into abstractions. In *Fish* (1947) Afro showed his potential as a colorist in the subtle relationship between the yellow-green background and the light blue-violet-green tones of the table. In 1948 Afro became productive again, and it was then that he finally developed his personal style.

Between 1946 and 1948, a group of Italian artists had formed the Fronte Nuovo delle Arti (New Front for the Arts). These painters worked in a postcubist style which seemed to some to contain the seeds of a new academism. Afro, however, maintained his distance from that influential group, feeling that he was already beyond that stage. In the work he produced in 1948 there was greater clarity than in his earlier paintings. He changed the nature of his subjects, and his color acquired an expressive autonomy; he enriched his effects by using colors applied one on top of the other like glazes. In *Glass Eye* and *Machine*, both in the Grosso Collection, Turin, Italy, there is an element of fantasy, with the patterns in space suggesting magical meanings.

In 1949 Afro began to express motifs and background simultaneously. *Landscape,* painted in that year, represents an imaginary city and there is no distance between subject and background. The harmony of 1948 had disappeared, and from 1951 on his style was more dynamic.

Afro spent eight months in the United States in 1950. In New York he was particularly impressed by the work of Arshile Gorky and Joan Miró. He did not paint any American scenes on the spot; his vision, as Venturi has observed, needed "the intervention of time that favors the transition from the humdrum to the poetic." Back in Rome he painted *New York Landscape* (1951) and *Cowboy* (1952); the latter is in the Lee A. Ault Collection, New Canaan, Connecticut, and has been described as having "a fleeting quality, like the wind." Afro did many landscapes in 1951, using different aspects of natural objects as a means of depicting human emotions. Among the most interesting were the obsessive

Landscape Dedicated to Franz Kafka, and *Underwater Hunt,* representing a dramatic struggle between monsters of the netherworld. There was a certain relaxation in *Autobiography* (1952) with its engaging play of pinks and whites against browns and greens, but in *Fear of the Night* (1952; Albright-Knox Art Gallery, Buffalo, New York) two symbolic figures, male and female, and unidentifiable demonic shapes are depicted.

In 1952 Afro exhibited at the Venice Biennale with a group of painters who called themselves The Italian Eight and were determined to follow their own instincts, independent of theories and programs. Afro's international reputation was growing. He had already exhibited in New York City, and in 1955 he had a very successful show there at the Catherine Viviano Gallery. That same year he was represented in the important "New Decade" exhibition at New York's Museum of Modern Art. In 1956 Afro was awarded first prize for Italian painting by the international jury at the Venice Biennale, although many of the Italian delegates were not in favor of the award.

Afro was especially encouraged by three canvases of 1957, because he felt that in them he had freed himself of representation and had displayed his new strength and joy in painting—*Quiet Stone, Lost Wax,* and *Candlemass*. Despite differences in size, they form a trilogy from the standpoint of color and show the high degree of refinement achieved by Afro in his painting technique. James Johnson Sweeney once applied to Afro a phrase of the Goncourts: "His colors are not the colors of a painter but touches of a poet."

In 1958 Afro and his brother, the sculptor Mirko, were artists-in-residence at Harvard University, Cambridge, Massachusetts. Mirko taught drawing and industrial design, and Afro taught landscape and figure painting. Afro's English was limited, but, as one student observed, he "express[ed] so much with his face." When not teaching, he worked ten hours a day in his studio, and relaxed by firing an air pistol at empty paint cans. In 1958 Afro also taught at Mills College, Oakland, California. While in California he painted a large mural especially for the new UNESCO building in Paris. Venturi described it as "a work carried out in a gentle and reserved way, a testimony of a long civilization."

During the 1960s Afro's paintings became further simplified in line and color. His abstractions lost all reference to specific objects in nature and appeared most often as luminous areas of warm, suffused color, freely brushed on and loosely linked together in an ambiguous space. The col-

ors were usually distributed without violent contrasts and were subtly blended. However, there are dramatic dark accents and a suggestion of movement in *Malalbergo* (1962) and a dynamic calligraphy akin to abstract expressionism in *Untitled* (1964), in which the colors are reduced to seemingly spontaneous black and red strokes on a white ground.

Afro continued to live and work in Rome, and taught at the Rome Academy. He made several designs for the theater, including the sets for the ballet *Portrait of Don Quixote,* presented at the Rome Opera.

By the 1970s Afro had established a worldwide reputation, and his works were shown in the major international museums. He died in Zurich at the age of 64, after a long illness. In his later years he was a distinguished-looking, white-haired man with a natural elegance and great personal charm. Lionello Venturi, who knew Afro well, wrote that in "his attitude towards the world, his first approach seem[ed] timid, but his attitude ultimately [became] decisive and courageous, so that he [allowed] himself to contemplate the world with the same freedom with which he . . . lived in it." Some critics, aware of his family heritage, used the word "decorative" to disparage his painting, but Venturi felt that Afro in his best work had "reached a decorative, structural and expressive unity," and praised his ability to bring three-dimensional patterns to the surface and transmute his emotions into painting.

In 1955 Afro wrote the following statement for the catalog to MOMA's "New Decade" group exhibition: "I often think of myself as a painter who is a story-teller. Were it possible to sum up in a line, or in the luminous quality of a color, my deepest feelings, my memories, my opinions, my intolerances, my mistakes and fears, the mysterious flow of my entire being could spill over into my painting voluntarily, so that the origin of all images would be found to stem from my personal life. For this reason I do not avoid such words as dream, emotion, lyrical feeling, that are nowadays rejected by those who want contemporary painting to express intellectual clarity and awareness of the methods used for producing certain effects." By the late 1950s, when he had abandoned figurative and allusive elements and representative symbols, Afro was intent on making the painting itself "the actual reality of the feeling." He explained: "Painting becomes its own inspiration, the life of feeling, the will power of the intelligence, a moral and imaginary individuality. The picture does not make allusions, but inspires its own being, secret and unforgettable, like everything one has dreamed of having or regretted losing.

"Today I can no longer think of an artist—nor have I ever thought in this way—as a clown or as a magician who performs tricks; I see him rather as a plant that grows spontaneously in its natural element, blending the individual stature of his existence in the light of the whole."

EXHIBITIONS INCLUDE: Gal. del Milione, Milan 1932; Gal. la Cometa, Rome 1936; Gal. la Zecca, Turin, Italy 1939; Gal. Mediterranea, Palermo, Italy 1940; Gal. Sindacalo, Udine, Italy 1944; Gal. del Zodiaco, Rome 1946; Gal. il Camino, Milan 1947; Catherine Viviano Gal., NYC 1950–68; Gal. dell' Obelisco, Rome 1953; Venice Biennale 1956; Mills Col. Art Gal., Oakland, Calif. 1958; Mus. of Santa Barbara, Calif. 1958; Massachusetts Inst. of Technology, Cambridge, Mass. 1960; Gal. de France, Paris 1961; Gal. la Medusa, Rome; Univ. of South Florida, Tampa 1966; Gal. Milhaud, Florence 1968; Nationalgal., Berlin 1969. GROUP EXHIBITIONS INCLUDE: Rome Quadrenniale from 1935; Venice Biennale 1936, '40, '52, '54; "Twentieth Century Italian Art," MOMA, NYC 1949; Sâo Paulo Bienal 1952, '53; "8 Iitalienische Maler," Kestner-Gesellschaft, Hanover, W. Ger. 1953; Documenta 1, 2, and 3, Kassel, W. Ger. 1955, '59, '62; "The New Decade," MOMA, NYC 1955; Pittsburgh International, Carnegie Inst. 1958; International, Solomon R. Guggenheim Mus., NYC 1960; International of Drawing, Darmstadt, W. Ger. 1967.

COLLECTIONS INCLUDE: Gal. Nazionale d'Arte Moderna, Rome; Gal. d'Arte Moderna, and Mus. Civico, Turin, Italy; Gal. Internazionale d'Arte Moderna, Venice; Gal. d'Arte Antica e Moderna, Udine, Italy; Tate Gal., London; Mus. Nat. d'Art Moderne, and UNESCO headquarters, Paris; Staatliche Mus., and Nationalgal., Berlin; MOMA, and Solomon R. Guggenheim Mus., NYC; Albright-Knox Art Gal., Buffalo, N.Y.; Princeton Univ. Art Mus., N.J.; Yale Univ. Art Gal., New Haven, Conn.; Boston Mus. of Fine Arts; Carnegie Inst., Pittsburgh; Barnes Foundation, Merion, Pa.; Baltimore Mus. of Art; Detroit Inst. of Arts; Minneapolis Inst. of Arts; City Art Mus., St. Louis, Mo.; William Rockhill Nelson Gal., Kansas City, Mo.; Los Angeles County Mus.; Montreal Mus. of Fine Arts; Royal Ontario Mus., Toronto; Mus. de Bellas Artes, Caracas, Venezuela; Mus. de Arte Moderna, Rio de Janeiro; Mus. de Arte Moderna, Sâo Paulo.

ABOUT: Bénézit, E. (ed.) Dictionnaire des peintres, sculpteurs et graveurs, 1976; de Libero, L. (ed.) Afro, 1946; Moore, E. (ed.) Contemporary Art 1942–1972: Collection of the Albright-Knox Art Gallery, 1972; Pellegrini, A. New Tendencies in Art, 1966; Ritchie, A.C. "The New Decade" (cat.), MOMA, NYC 1955; Soby, J.T. and others "20th Century Italian Art" (cat.), MOMA NYC, 1949; Venturi, L. Afro, 1954, Italian Painters of Today, 1958. *Periodicals*—Art News February 1950; Life June 9, 1958; L'Unita (Washington, D.C.) September 25, 1976.

***AGAM, YAACOV (YAACOV GIPSTEIN)**
(May 11, 1928–), Israeli painter, is a leading ki-
netic artist. He was born Yaacov Gipstein in
Roshon-le-Zion, one of the first Zionist settle-
ments in Palestine. His father, an Orthodox rab-
bi, was a devoted student of kabbalah, the texts
and traditions of Jewish mysticism. Agam re-
called in an interview with Grace Glueck (*New
York Times,* May 22, 1966): "My father wanted
to send me to a religious school, but there wasn't
one. So I played hooky. It's a good thing, too. I
was thrown back on an inner world. Instead of
school logic I learned to use intuition, reason,
and reflexes." With his father, Agam also studied
kabbalah, which he defines as "the search for the
unknown behind the known," or, put another
way, the search for the spiritual reality behind
appearances. As a boy, he would draw pictures
on sand dunes and watch entranced, as the wind
blew them away.

In 1945 Agam was imprisoned by the British
authorities for two years as a suspected member
of the Zionist underground. In 1947–48 he stud-
ied at the Bezalel School of Arts and Crafts in Je-
rusalem. Unsurprisingly for one immersed in
mystical texts, he also developed an interest in
occultism, chiromancy, and graphology. After
leaving the Bezalel School he traveled to Europe,
and in 1950–51 studied in Zürich with Siegfried
Giedion and Johannes Itten, the theorist of form
and the originator in the early 1920s of the
"preparatory course" at the Bauhaus in Weimar.
Through Itten, Agam absorbed the Bauhaus be-
lief in the efficacy of clean design, hard-edged
geometry, and pure color. In 1951 Agam settled
in Paris, attending the Atelier d'Art Abstrait, be-
coming interested in the modern esoterica of sci-
ence and technology. In turn this led to his
experiments with mechanical and optical move-
ment in art. The artist had no money, and during
his school years, he recalls, he lived on "Salvation
Army soup." A characteristic work of this period
was *Modifiable Rhythm* (1952), a painting in oil
on composition board with pivoting wooden ele-
ments.

Agam's first solo exhibition, totally devoted to
kinetic, movable, and transferable paintings,
opened at the Galerie Craven, Paris, in 1953. In
some works the objects themselves moved; in
others an illusion of movement was created as
viewers changed their positions; others, which he
called "tactiles," required viewers' direct partici-
pation. Years later Agam remarked, "I am very
original, I was the first one who ever let a specta-
tor touch one of my paintings."

In 1956 Agam married a young Israeli, Clila
Lusternik; they have three children. He partici-
pated in the 1955 "Mouvement I" show, the first
group exhibition of the kinetic movement, at the

YAACOV AGAM

Galerie Denise René, Paris. That same year he
made his American debut at the Doris Meltzer
Gallery, New York City. His first solo exhibition
in Israel was at the Tel Aviv Museum in 1958.
Works created in that year included *Four
Themes—Counterpoint,* in oil on wood, and
Spatial Relief, in oil on wood with movable met-
al parts. *Four Themes—Counterpoint* is de-
signed with a corrugated surface that has a
different geometrical image painted on each
side of the corrugations. As the viewer moves
parallel to the painting, and sees different sides
of the corrugations, a theme appears, develops,
is modified, and disappears, giving way to an-
other. By the late 1950s this had become his
"signature" technique.

Agam visited both North and South America,
and in 1961 gave a lecture in Chicago on
"Painting in Four Dimensions." His emphasis
was, and has remained, on movement, the cons-
tant transformation of reality as the work of art
changes its spatial and temporal relationship
with the viewer. As he remarked in an interview
in 1974: "I never make any two-dimensional
paintings—I like to do things that move. Picasso,
Chagall, Vasarely—they're two-dimensional. I
aim for the maximum simplicity and the largest
diversity."

Solo exhibitions in Brussels (1958), London,
New York City and Tel Aviv (1959), and Basel
and Zürich (1962) enhanced Agam's internation-
al reputation. In 1963, at the São Paulo Bienal,
he won the "International Prize for Artistic
Research," an award created especially for him
by the jury. He was represented in a group show
of 26 Israeli painters and sculptors held at the

°ä´ gäm, yä´ kof

Museum of Modern Art, New York City, in 1964. In the same year he was commissioned by the Israeli government to execute a 197-foot mural entitled *Jacob's Ladder* for the National Convention Center in Jerusalem. Soon afterwards he executed a gigantic "space-time" mural for the Israeli ocean liner *Shalom.*

With the advent of op art in the mid-1960s, popularized through the work of Victor Vasarely and Bridget Riley, among others, the allure of producing purely retinal sensations through dazzling color and value contrasts became irresistible to an increasing number of artists. Op art was first presented to the American public on a large scale in the "Responsive Eye" exhibition which opened at MOMA in 1965. One of the most striking works in the show was Agam's giant *Double Metamorphopsis II,* which changed completely depending on whether one stood on its left or on its right. Photographs of these two contrasting aspects were shown with John Canaday's generally favorable review in *The New York Times* (February 28, 1965). The pattern as seen from the extreme right was, to quote Canaday, "a severe diagram of black and white verticals interrupted by small forms." From the left could be seen "a clear pattern of a few brightly colored shapes on a white ground." Canaday noted that such triangular-ridged corrugations were used as far back as the Renaissance, "so that the portrait of one individual could be seen when the surfaces were viewed from the left, and another when they were viewed from the right." Agam, however, had taken what has been essentially a novelty and created, with his active illusions of space, depth, and movement, a meditation on mutability.

When Agam held an exhibition of one hundred metamorphic paintings and objects at the Marlborough-Gerson Galleries, New York City, in 1966, Charlotte Willard (*New York Post,* May 28, 1966) noted the significance of Agam's being the son of a rabbi. "Out of his observations and creative imagination," she wrote, "he seems to have synthesized the scientific concept of reality with the Hebrew idea of Jehovah . . . the nameless, imageless Jehovah, a word that means 'He Is,' or 'Being.'" Agam told Grace Glueck he believed that his work expressed a Jewish concept of reality—the multiplicity of life within the infinity of God. However, Hilton Kramer, in his review of the show in *The New York Times* (May 14, 1966), took a highly skeptical view of Agam's work. He wrote: "One's overall impression is of an artist who has settled on a three-dimensional technical device that cannot begin to compensate him (or the spectator)for a general paucity of pictorial or sculptural invention." Kramer declared that there was "far more picto-

rial intelligence and subtle feeling" in Mondrian's *Broadway Boogie-Woogie* of 1942–43, "than in all Mr. Agam's contrived manipulation of our optical sensibilities."

Agam's obsession with multiplicity extended to other art forms. An orchestral clarinetist from the age of 12, and thoroughly familiar with the laws of harmony, he wrote what he called "trans-forms," music composed of polyphonic elements that could be played in an infinite variety of sequences. He acquired a keyboard instrument for playing "plastic works," and also designed a theater in which events relating to a single action would be played out on multiple stages surrounding the audience.

In 1968 Agam was a guest lecturer at Harvard University, Cambridge, Massachusetts, where he conducted a seminar course in the theory of advanced visual communication. Over the years he has delivered lectures concerning his theories and experiments at many art schools, conventions, and universities.

"The largest painting in the world" was what Agam, with some overstatement, called his gargantuan hexagonal mural completed in 1970 for the new cultural center in Leverkusen, West Germany. *Time* magazine (May 18, 1970) compared it to "a massive, multicolored jewel that only becomes visible from different angles." Painted with the aid of ten assistants on 592 sheets of aluminum, each mounted at a 60-degree angle to the wall, the mural "totally encompasses the center's hexagonal-shaped auditorium in a changing panorama of colors and forms." Many viewers, including the Parisian Op artist Jésus Rafael Soto, were full of admiration, but there was also adverse criticism. Some of the city fathers of Leverkusen complained that the mural's visual movements were distracting to lecturers and entertainers, but Willi Kreiterling, director of the cultural center, insisted that "Agam's murals no more distract than the elaborate decorations in a Baroque church."

Agam himself, then 42 years old, paid tribute to the city's daring in accepting his "living wall," as he called it, his first experiment with a "total environment." He was also gratified that the bitterness between German and Jew had been overcome. "The Germans," he said, "were willing to meet my every technical exigency, going even further perhaps than the Americans and Israelis might have done." *Time* called the mural "a landmark in kinetic painting."

In the 1970s Agam was besieged with major commissions. Since 1966 he had added sculpture to his activities. All his sculptures were based on the principle of the repetition of elementary shapes. They were made of stainless steel and

were mobile, varying in size from miniatures that could be held in the hand to monuments 60 feet tall. In 1971 a 35-foot-tall structure by Agam was installed in front of the Juilliard School of Music at Lincoln Center, New York City. As described by Emily Genauer in the *New York Post* (May 15, 1971), "It rises in a dizzying series of angles of stainless steel which are movable." Genauer, among others, felt that this construction in no way enhanced its architectural setting; she called it "35 feet of conceit. . . . The piece is a tiresome, mechanical, lifeless construction whose zig-zagging rhythms haven't the faintest relationship to any other architectural structure in the vicinity." She compared it unfavorably to Henry Moore's splendid reclining figure in front of the Vivian Beaumont Theater, also at Lincoln Center, an example of a sculpture that can "make its whole vicinity come alive."

Agam's "metamorphic" murals are the most popular of his works. In 1972 he created for the Elysée Palace in Paris a whole "Environmental Salon," with paintings on all the walls, a kinetic ceiling, moving transparent colored doors, and a kinetic tapestry on the floor. He received many honors and had retrospectives in Paris and Amsterdam (1972) and in Düsseldorf (1973). In the new Parisian district of La Défense, at the end of the Champs-Elysées, he created in 1975 a monumental musical fountain of 66 vertical water-spouts shooting up to 30 feet into the air, with fire leaping from the top (an effect achieved by an ignition system running up through the jets of water). He used the silkscreen process in his 30-foot-square mural completed in 1979 for the Eye Foundation Hospital in Birmingham, Alabama; it was called by *Art in America* (May-June, 1979) "the most unique example of serigraphy today."

Yaacov Agam runs a studio in Montparnasse for the production of his lithographs and sculptures, but lives with his family on an estate near the Charles de Gaulle airport. "There's too much distraction in Paris," he explained. "I've moved to the country where people have less access."

Agam has been described as a serious man, "rather roly-poly," according to Jane Perlez of the *New York Post,* with a shaggy, bushlike moustache and a composed, dignified manner. He is by no means reluctant to discuss his work in his heavily accented English. Always fascinated by new forms and new methods of expression, he says he is looking for a "new dimension beyond the visible." He points out that the most important things in man's life are those he cannot see: "God, atoms, electricity, we can't see them." The multiple techniques he uses, incorporating an element of play and often of humor,

are aimed at establishing a direct rapport with viewers and inviting their willing participation. "I like to let people talk to my work. I make it as attractive as I can, so it will draw them like flowers lure butterflies."

He has retained the Jewish concept of God, who he asserted "has no one form, no static image." Of his kinetic art Agam has said, "I tried to give this approach a plastic expression by creating a visual form that doesn't exist. The image appears and disappears, but nothing is retained. . . . I try to transmit the feeling that change is a normal process of living, cause for joy, not discontent. . . . My endeavor has been to create a kind of painting existing not only in space but in the time in which it develops and evolves, thus producing a foreseeable infinity of plastic situations flowing out of one another, whose successive apparitions and disappearances provide ever-renewed revelations."

EXHIBITIONS INCLUDE: Gal. Craven, Paris 1953; Gal. Fuerstenberg, Paris 1954; Doris Meltzer Gal., NYC 1955; Gal. Denise René, Paris from 1956; Gal. Aujourd'hui, Palais des Beaux-Arts, Brussels 1958; Tel Aviv Mus. 1958, 1972–73; Drian Gal., London 1958; Gal. Suzanne Bolling, Zurich 1959, '62; Marlborough-Gerson Gals., NYC 1966; Mus. Nat. d'Art Moderne, Paris 1972; Städtisches Mus., Düsseldorf 1973; Stedelijk Mus., Amsterdam 1972; Gal. Attali, Paris 1974; Birmingham Mus. of Art, Ala. 1976; Mus. de Arte Moderno, Mexico City 1976; Janus Gal., Washington, D.C. 1977; Nahari Gal., New Orleans 1978. GROUP EXHIBITIONS INCLUDE: "Salon des Réalités Nouvelles," Mus. Nat. d'Art Moderne, Paris 1954–56; "Mouvement I," Gal. Denise René, Paris 1955; Pittsburgh International, Carnegie Inst. 1958, '61, '64, '72; Paris Biennale 1959; "Transformable Painting: Painting in Movement," Drian Gal., London 1959; "Bewogen Beweging," Stedelijk Mus., Amsterdam 1961; São Paulo Bienal 1963; "Art Israel," MOMA, NYC 1964; "The Responsive Eye," MOMA, NYC 1965; "Plus by Minus: Today's Half-Century," Albright-Knox Art Gal., Buffalo, N.Y. 1968; "3 Israeli Artists—Agam, Lifshitz, Zaritsky," Whitechapel Art Gal., London 1969; "12 Ans d art contemporain en France," Grand Palais, Paris 1972; "Sculptures in Nature," Gal. Attali, Paris 1976.

COLLECTIONS INCLUDE: Mus. Nat. d'Art Moderne, Paris; Kaiser Wilhelm Mus., Krefeld, W. Ger.; Kunstmus., Düsseldorf; Civic Center, Leverkusen, W. Ger.; MOMA, and Juilliard School, Lincoln Center for the Performing Arts, NYC; Albright-Knox Art Gal., Buffalo, N.Y.; Hirshhorn Mus. and Sculpture Garden, Washington, D.C.; City of St. Louis, Mo.; Nat. Convention Center, Jerusalem.

ABOUT: Agam, Y. and others Sculpture or the Twentieth Century, 1962; Bénézit, E. (ed.) Dictionnaire des peintres, sculpteurs et graveurs, 1976; Current Biography, 1981; Seitz, W.C. "Art Israel: 26 Painters and Sculptors" (cat.), MOMA, NYC, 1964; Seuphor, M. La

Sculpture de ce Siècle, 1959. *Periodicals*—Ariel (Jerusalem) no. 9 1964–65; Art and Artists January 1970; Art d'aujourd'hui (Paris) January 1954; Art in America May–June 1979; Arts December 1974; Aujourd'hui (Paris) March 1958, May 1961; Christian Science Monitor December 21, 1972; Look April 18, 1967; New York Post May 28, 1966, May 15, 1971, July 23, 1971; New York Times February 28, 1965, May 14, 1966, May 22, 1966; Time May 18, 1970.

*ALBERS, JOSEF (March 19, 1888–March 25, 1976), German-American painter, graphic artist, and teacher, was among the first of the Bauhaus teachers to leave Nazi Germany for the United States, where his influence as artist, theorist, and teacher was widespread. Best known for his series of paintings and graphic works entitled "Homage to the Square," begun in 1949, he has been called "the father of Op Art." But this title, though containing an element of truth, is misleading. Albers's concerns were by no means confined to mere optical effects. He was a dedicated painter and a serious craftsman and technician whose work involved, but was not limited to, the exploration of color relationships, usually within a rigid geometrical framework.

Albers was born in the industrial Ruhr district, in Bottrop, Germany, the only child of Lorenz Albers, a house painter, and Magdalena (Schumacher) Albers. Craftsmanship was a tradition on both sides of his Westphalian family—blacksmiths on his mother's side, carpenters and handymen on his father's. From 1902 to 1905 he attended the Preparatory Teachers' Training School in Langenhorst, Westphalia, and in 1908 he received his teaching certificate at the teachers college in Büren. Also in 1908 he began a five-year period of teaching in Bottrop primary schools. He also toured German cities, and in Munich, southern Germany's haven for artists, he first saw the works of Cézanne and Matisse.

In 1913 Albers decided to pursue formal art studies and enrolled at the Royal Art School in Berlin, where he obtained his Qualified Art Teacher certificate in 1915. Between 1916 and 1919, while teaching in public schools, he attended the School of Arts and Crafts (Kunstgewerbuschule) in Essen. During this period he made his first lithographs and blockprints. Many lithographs, *Workers' Houses* (1916) for instance, were influenced by Cézanne and cubism, whereas the blockprints show the influence of expressionism. In 1919–20 Albers studied painting with the noted symbolist and teacher of Klee and Kandinsky, Franz von Stück, at the Academy of Fine Arts in Munich, but he was becoming increasingly bored with the traditional and representational in art.

Photo by Jon Naar

JOSEF ALBERS

Aware of his family's artisan heritage, Albers was ineluctably drawn in 1920 to the Bauhaus, the modernist laboratory-workshop founded in Weimar in 1919 by the architect Walter Gropius. Albers was in complete sympathy with the Bauhaus's attempt to unite the disciplines of architecture, sculpture, and painting and to give the craftsman a status equal to that of the artist by eliminating barriers between the fine and applied arts. He entered the Bauhaus when he was 32, studying with Johannes Itten.

There he eliminated figuration from his work and began to experiment with glass, making glass pictures and designing stained-glass windows. "Equipped with a knapsack and a hammer," Albers recalled, "I scouted the town dump; the bottles I found provided me with all the kinds of glass I needed for making my glass paintings." The first of these works, including *Figure* and *Rhenish Legend,* both of 1921, were freely composed and made up of clear shards. Then, in 1922, Albers organized and reopened the Glass Workshop at the Bauhaus, began to impose more discipline on his own works in glass. Using opaque, sandblasted glass, he created rectangular and square compositions such as *Bundled* (1926) and *Pillars II* (1928). About 1929 he loosened up this rational grid and introduced hard-edged curves into his work, as in *The Impossibles* and *Incorrectly Wound,* both of 1931. Those pieces are composed of imaginary sheets wound into cylinders—his first attempts to deal directly with the principle of visual illusion.

Meanwhile, Albers had begun teaching courses at the Bauhaus in 1923, joining a faculty

°äl´ berz, yō´ sef

that included Paul Klee, Wassily Kandinsky, and László Moholy-Nagy. In 1925, the year of his appointment as professor, he married Anni Fleischmann, a Bauhaus student who had met Albers in the Glass Workshop. She later won renown for her woven tapestries and fabric designs.

In 1925 Albers moved with the Bauhaus to its new location in Dessau, and on to Berlin in 1932. In the intervening years he taught courses in materials, basic design, wallpaper design, furniture design, glass design, and drawing, stressing the points of interrelationship between the fine and applied arts. From 1928 to 1930 Albers was assistant director of the Bauhaus and head of both the furniture and wallpaper workshops. His best-known furniture design that was suitable for mass-production was a chair, made in 1926, which had been called "the first modern chair in bent laminated wood." He was resolutely opposed to all forms of expressionism and emotionalism in art and rejected any clear-cut distinction between art and design.

Following the brief period of residence in Berlin in 1932, the Bauhaus was closed by the Nazis in 1933. Albers, his wife, and the architects Gropius and Mies Van Der Rohe subsequently immigrated to the United States, where they were influential in disseminating the Bauhaus aesthetic, which deeply influenced American art and industrial design.

On the strength of a recommendation from Philip Johnson, then director of the architecture department at the Museum of Modern Art, New York City, in 1933 Albers obtained a teaching position at the small, progressive Black Mountain College in North Carolina. For the next 16 years he gave courses in design which made the college a prominent center for avant-garde theories of art. "Albers," Barbara Rose wrote, "became an important force in American art from the moment he took over the art department at . . . Black Mountain College. . . . Here he raised art instruction to the sophisticated level it had reached at the Bauhaus, stressing the principles of abstract composition and design that were the core of the Bauhaus curriculum."

With his often abrasive personality and overbearing, dogmatic manner, Albers as teacher was respected and feared rather than loved by his students. In a 1969 film, *Homage to the Square*, made by Hans Namuth and Paul Falkenberg, Albers's most famous student, Robert Rauschenberg, recalled: "Albers was a beautiful teacher, but an impossible person. His criticism was so devastating that I couldn't ask for it. But 21 years later, I'm still learning what he taught me."

From 1936 to 1941 Albers also lectured on modern art and design principles at Harvard University. He has his first solo shows in 1936, in Manhattan and Mexico City, and between 1936 and 1941 had numerous showings of his glass pictures, some of which had been done soon after immigrating to North America. In the late 1930s Albers joined the American Abstract Artists, an association which campaigned for the acceptance of native abstract art and sought to make New York City an international center for modernism.

Albers's woodcuts and linoleum cuts of 1933 and 1934, such as *Embraced* (1933) and *Aquarium* (1934), show he had established an equilibrium between freedom and discipline in his art. Soon after arriving in America, Albers did a series of ten gouaches titled "The Treble Clef," in which the line of the clef was free while the enclosed areas were filled in with black, gray, and white. Albers also made several free studies in oil, often experimenting with a loose geometry, as in *The Gate* (1936). This painting is related to the later group of paintings that he generically titled *Homage to the Square*, though *The Gate* in much less rigid in construction.

Albers's graphic works of the early 1940s show a seemingly haphazard, stringlike line, as in *Speed* (1949), but Albers soon turned to the straight horizontal and vertical lines of what he called the "Graphic Techtonics," a series of zinc lithographs. In such works as *Ascension, Seclusion,* and *Sanctuary,* all of 1942, he again dealt with visual illusion, creating a tension between the two-dimensional and the three-dimensional by varying the thickness of the lines in these rectilinear labyrinths. As David Shapiro wrote in an *Art News* article (November 1971) titled "Homage to Albers," "These abstract compositions perform space and volume illusions of multiple images, thereby inducing several interpretations." In Albers's woodcuts of the late '40s, called the "Multiplex Series," white lines on a black field create seemingly impossible volumes, and thus prefigured the "Structural Constellations" of the 1950s. "With many of Albers's 'impossible' designs," Shapiro said, "there is a constant bafflement to the eye that seeks a sensible reading. . . . "

In 1950 Albers left Black Mountain to become hed of the newly established department of design at Yale University, where he taught until 1958. Also in 1950 he executed a brick mural, *America,* for the Gropius-designed Harvard Graduate Center; it resembles his more advanced glass paintings of the late 1920s. Another large-scale work was *White Cross Window* (1954), which he did for the chapel of the Bene-

dictine Abbey of St. John in Collegeville, Minnesota.

Albers's interest shifted from spatial illusion to color illusion in a series of oil paintings, *Variants on a Theme,* begun in 1949. "I am particularly interested in the psychic effect," Albers said, an esthetic experience that is evoked by the interaction of juxtaposed colors. . . . Every perception of color is an illusion. . . . We do not see colors as they really are. In our perception they alter one another. For example, two different colors can look the same or two indentical colors can look different. . . . This 'play' of colors, this change in identity is the object of my concern."

Homage to the Square, begun in 1949 and comprising works done over a period of 25 years, addressed the same aesthetic question but through the utmost simplicity of design. Albers used a structure of three or four colored squares each progressively smaller and superimposed one upon another—squares within squares that, to quote one writer, were of "subtly varied hues within a very narrow range of color." To an extent, techniques of spatial illusion were reintroduced, for not only do the color squares seem to react with and change each other, but some squares appear to recede and others to project toward the viewer, creating an illusion of depth.

Albers preferred the square to other geometric shapes because of its economy of form and because he believed that the square, of all conceivable man-made forms, most completely severed a work of art from nature. "Art should not represent," he asserted, "but present." Accordingly, for his series of squares, Albers applied the paint directly to masonite boards with a palette knife as fast as he could, he said, to avoid infusing "a personal touch."

Inimical as he was to the "personal touch," and just as he had rejected German expressionism in the 1920s, Albers was unsympathetic to the subjectivism of the American Abstract Expressionists of the 1940s and 1950s. He once complained of those painters, "Why do they have to tell everyone what's wrong with their digestion or that they've had a toothache? I don't believe that 'self-expression' is the aim of art. Art is performance, and it's the change of performance, not expression, that excites me."

Albers designed numerous murals, among them one for New York City's Time-Life Building, installed in 1961, and another for the Pan-Am Building, also in Manhattan, in 1963. In his "White Line Series," begun in 1964, he divided the central color area with a white line, thus producing visual ambiguities by contrasting the values of juxtaposed colors. Although these works are widely considered soothing and lyrical, David Shapiro has pointed out that Albers "disdains to consider his paintings as merely meditative."

Albers's influence peaked in the 1960s. His technique of juxtaposing two somewhat similar colors to produce the illusion of a third was taken up in that decade by Op artists. Moreover, the severe geometry of Albers's work, and the square-within-a-square simplicity of his *Homage,* "provided examples of non-allusive, conceptual paintings," as Barbara Rose noted, which guided post-Abstract Expressionist painters. Also influential for the so-called New Abstractionists of the '60s was Albers's book *Interaction of Color* (1963), the product of his lifelong systematic investigation of color phenomena.

Although the squares overshadowed the rest of his work, Albers did not abandon other projects. He continued to do "Structural Constellations," and the somewhat similar "Duo" series, begun in 1958, of inkless intaglio prints. These anticipate his "Embossed Linear Constructions," inkless embossed prints begun in 1969. During the last two decades of his life Albers lectured all over the United States and received many awards and honorary degrees.

Albers's paintings had never before commanded high prices, but in his last years they earned him a substantial income. He and his wife continued to live simply, however. In 1970 they moved from their Cape Cod cottage to a modest, split-level house in the nearby suburb of Orange, Connecticut. Despite his advanced years, Albers continued to work with undiminished vigor until the very end, attributing his creative energy in old age to the fact that he had tried "to remain a student." Neat and methodical, the white-haired Albers in his basement studio (his wife Anni worked upstairs) struck a *New York Times* interviewer as presenting "more the image of a draftsman or engineer than an artist."

In May 1975 the couple celebrated their 50th wedding anniversary. On March 25, 1976, Josef Albers, aged 88, died in his sleep at the Yale-New Haven Hospital.

Though he was indebted to Bauhaus and Constructivist principles, in his series of squares–on–squares Albers was completely original, superseding in some respects the geometric abstractions of Malevich, Mondrian, and van Doesburg. He can be considered a twentieth–century classicist insofar as his static format represented a kind of pure order, an order with ethical as well as aesthetic dimensions. "The reason for aesthetics is ethics, and ethics is its aim," Albers declared—an echo of the utopian vision of the Bauhaus, He added: "When you see how each color helps, hates, penetrates, touches, doesn't—that's parallel to life."

EXHIBITIONS INCLUDE: J.B. Neumann's New Art Circle, NYC 1938, '45, '56; The Artists' Gal., NYC 1938; Mus. of Art, San Francisco 1939–40, '53, '64; Mus. of Art, Baltimore 1942; Egan Gal., NYC 1946, '49, '69; Memphis Academy of Arts, 1947; Sidney Janis Gal., NYC 1949–1970; Yale Univ. Art Gal., New Haven, Conn. 1956; Stedelijk Mus., Amsterdam 1961; MOMA, NYC 1964–67; Gal. Denise René, Paris 1968; Kestner-Gesellschaft, Hanover, W. Ger. 1968, '73; Kunsthalle, Hamburg 1970; Städtische Kunsthalle (retrospective), Düsseldorf 1970; Univ. Art Mus. (retrospective), Princeton, N.J. 1971; Metropolitan Mus. of Art (retrospective), NYC 1971; Heslington Hall, York Univ., England 1973; Busch-Reisinger Mus., Harvard Univ., Cambridge, Mass. 1976. GROUP EXHIBITIONS INCLUDE: "Bauhaus Masters," Kunsthalle, Basel (toured Zürich) 1929; "American Abstract Artists," Riverside Mus., Bronx 1939; "Josef Albers, Hans Arp, Max Brill," Herbert Hermann Gal., Stuttgart 1949; "Contemporary American Painting," Univ. of Illinois, Urbana 1951, '52, '53; "Josef and Anni Albers," Wadsworth Atheneum, Hartford, Conn. 1953; "Cézanne and Structure in Modern Painting," Solomon R. Guggenheim Mus., NYC 1963; "The Responsive Eye," MOMA, NYC 1965; "Two Decades of American Painting," MOMA, NYC (toured Japan, India, Australia) 1967; "Homage to Josef Albers and Michael Rothenstein," Kongresshalle, Berlin, 1969; "Geometric Abstraction 1926–42," Dallas Mus. of Fine Art 1972; "Futurism: A Modern Focus," Solomon R. Guggenheim Mus., NYC 1973.

COLLECTIONS INCLUDE: Metropolitan Mus. of Art, MOMA, Whitney Mus. of Am. Art, and Solomon R. Guggenheim, Mus., NYC; Albright-Knox Art Gallery, Buffalo, N.Y.; Wadsworth Atheneum, Hartford, Conn.; Harvard Univ., and Mass. Inst. of Technology, Cambridge, Mass.; Smith Col., Northampton, Mass.; Bennington Col., Vt.; Carnegie Inst., Pittsburgh; Corcoran Gal. of Art, Hirshhorn Mus. and Sculpture Garden, Washington, D.C.; Mus. of Art, Baltimore; Duke Univ., Durham, N.C.; Chicago Art Inst.; Art Mus., Denver, Colo.; Los Angeles County Mus. of Art; Stedelijk Mus., Amsterdam; Städtische Mus., Leverkusen, W. Ger.; Bauhaus Archive, Darmstadt, W. Ger.

MURAL COMMISSIONS INCLUDE: Harvard Univ., Cambridge, Mass.; Time-Life Building, NYC; Pan-Am. Building, NYC; Inst. of Technology, Rochester, N.Y.; Yale Univ. Art Building, New Haven, Conn.

ABOUT: Albers, J. Poems and Drawings, 1961, Interaction of Color, 1963, Search Versus Research: Three Lectures by Josef Albers at Trinity College, April 1965, 1969; "American Abstract Artists" (cat.), MOMA, NYC, 1946; Bayer H. and others Bauhaus 1919–28, 1938; Current Biography, 1962; Gomringer, E. Josef Albers, 1968; Rose, B. American Art Since 1900, 2d ed. 1975; Spies, W. Josef Albers, 1971; *Periodicals*—Art News November 1959; Arts Magazine June 1959, December 1979; Life March 1956; Los Angeles Museum Art Bulletin No. 1 1962; New York Times March 26, 1976; Werk (Winterthür, Switzerland) April 1958.

ALBRIGHT, IVAN (LE LORRAINE) (February 20, 1897–November 18, 1983), American painter, was by no means a realist in the traditional sense. His work, with its obsessive emphasis on surface detail and its use of warped perspective and multiple angles of light, has sometimes been called hyperrealistic, but that too is an inadequate term. Its closest links are with magic realism, but it is a peculiarly funereal and macabre kind of "magic," a vision of haunting psychological intensity imbued with a morbid sense of the corruption of matter and the decay of age.

Ivan Le Lorraine Albright was born in North Harvey, Illinois, on the outskirts of Chicago, the son of Adam Emory and Clara Emilia (Wilson) Albright. His father, the descendant of a long line of gunsmiths, was a genre painter. He named Ivan Le Lorraine after the 17th-century French painter Claude Lorrain; Ivan's identical twin brother, Malvin, was given the middle name Marr, after Carl von Marr, under whom Adam had studied art in Germany. A younger brother was named Lisle Murillo, after the Spanish artist of that name, and he, too, became a painter.

Ivan and Malvin were taught to draw when they were eight years old. They often posed as ragged, barefoot urchins for their father's sentimental rustic scenes. Partly as a reaction against their father's type of art, the twin brothers took up architecture, which Ivan studied from 1915 to 1916 at Northwestern University and the next year at the University of Illinois. He first showed his work in 1918 at the Chicago Art Institute's annual watercolor exhibition. At the very end of World War I Ivan served as a private in the American Expeditionary Force and was stationed at a base hospital in Nantes, France. His unusual assignment was to paint watercolors of wounds, which he executed with an accuracy that impressed the medical corps. This experience undoubtedly affected his later work, which often seems grotesque in its meticulous examination of flesh. While at the hospital, he also became fascinated by X-ray images, which he said had provided "the best art training I ever had."

After the war Albright studied briefly at the École des Beaux-Arts, Nantes, before returning to the United States. Immediately he began work as an illustrator of brain operations for a surgeon in Oak Park, Illinois, whom he had met in France. In the fall of 1919 he had not yet decided to become a painter and was torn between architecture and chemical engineering. He tried his hand at advertising illustration, but abandoned it as being too commercial. In January 1920 he won a scholarship to the Art Institute of Chicago which was later renewed three times;

© Kennedy Galleries

IVAN ALBRIGHT

the value of the scholarship convinced him that he should at least continue his art training. In 1923 he graduated with honors in life and portrait painting. Albright then spent one semester at the Pennsylvania Academy of Fine Arts (where his father had once studied with Thomas Eakins), and the spring term of 1924 at the National Academy of Design in New York City. Despite this extensive education, which honed his already impressive technical skill, he was little influenced by any of his teachers, and even as a student his individuality was apparent. After receiving an honorable mention in 1926 at the Art Institute's Annual American Exhibition for his painting *Paper Flowers*, he was finally convinced that he should pursue an artistic career.

In 1927 Ivan, Malvin, and their father set up studios in an abandoned Methodist church in Warrenville, Illinois, a small town near Chicago. Malvin, like Ivan, had given up architecture for art. About this time Ivan's idiosyncratic style began to emerge. *The Lineman* (1927) and *The Blacksmith* anticipate his later figures, although there was less preoccupation with detail and virtually no background setting. Soon Albright began to add environments, but despite the increase in detail and their garish colors the pictures still had an air of desolation, which was not allayed by their long, literary titles. *Heavy the Oar to Him Who Is Tired, Heavy the Coat, Heavy the Sea* (1928–29) is considered his outstanding work of the period. His style, exemplified by *Woman* (1928), was described by Daniel Catton Rich as "terrifying in its realism."

Albright's 1930 painting *Into the World There Came a Soul Called Ida* created a furor when it was first exhibited at the Art Institute of Chicago, but nonetheless won him an honorable mention. It showed a flabby, primping prostitute painted in repellent greens and purples with sickly yellowish shadows. Also in 1930 he had his first solo exhibition, at the Walden Book Shop in Chicago.

In 1931, the year of Albright's first solo museum show, at the Art Institute of Chicago, he completed *And God Created Man in His Own Image (Room 203)*, depicting an aging derelict undressing. Later that year he began work on one of his most celebrated paintings, *That Which I Should Have Done I Did Not Do*, also known as *The Door*. In this eight-foot-high canvas, a spectral female hand holding a lace handkerchief rests on the carved molding of a mortuary door. The painting was not completed until 1941, and the following year it won him the Temple Gold Medal at the Pennylvania Academy—in all likelihood awarded to him for his technical mastery rather than for the appeal of his subject, though Albright's already-perfected brand of necrotic sentimentality has its audience. Later in 1942 the same painting won a prize as the best picture in the Artists for Victory exhibition at the Metropolitan Museum of Art, New York City. It is now owned by the Art Institute of Chicago.

Another painting, *The Window*, was begun by Albright in 1941, and worked on intermittently over a 21-year period. Its full title is *Poor Room—There Is No Time, No End, No Today, No Yesterday, No Tomorrow, Only the Forever, and Forever, and Forever Without End*. In this work, which involved Albright's most elaborate studio construction, a broken window of a decrepit brick building becomes a horrifying vortex of objects. By the ingenious manipulation of black window shades, and by shifting the larger items around his studio on wheels, he was able to give each object the kind of light he wanted. Michael Brenson, in Albright's obituary in *The New York Times*, called *The Window* "a concentration of many of [the artist's] ideas," and noted that every object in the work is "so encrusted with realistic detail that the stone and wood seem swollen and almost physical."

Albright won wide public recognition in 1943, after he and his twin brother went to Hollywood to paint a series of portraits depicting the moral and physical degeneration of the title character in the MGM version of Oscar Wilde's *The Picture of Dorian Gray*. The horrendous final portrait, with its incredibly detailed corruption, often brought forth shrieks from the audience. It was rumored that Albright was paid $75,000 for the series, which remained in his possession. He later painted a *Temptation of St. Anthony* for the film *Bel Ami*.

On August 27, 1946, Albright married Jose-
phine Medill Patterson Reeve, daughter of the
founder of the New York *Daily News.* They had
two children, Adam Medill and Blandina Van
Etten. Albright was by this time highly success-
ful, and living in Chicago's fashionable North
Side. Summers spent at the Three Spear Ranch
in Dubois, Wyoming, inspired a series of West-
ern still lifes, including the *Wild Bunch (Hole in
Wall Gang)* of 1950–51. With the advent of the
new American painting of the 1950s, Albright
came to be regarded as a traditionalist, if an odd
one, but he still had his Chicago supporters.
From 1955 to 1957 he painted the *Portrait of
Mary Block,* now in the Art Institute of Chicago.
Jan van der Marck in *Art in America* (Novem-
ber/December 1977) compared the face in this
portrait with its "impassioned paleness" and
"eyes brimful of ominous intent" with faces in
the work of the 16th-century German painter
Hans Balding Grien. Van der Marck wrote that
the Mary Block portrait is "so chillingly ren-
dered and so surreal in its obsessive portrayal of
detail that it makes Dali's *Face of Mae West
Seen as an Interior,* also at the Art Institute, look
playful and contrived."

Pop art's revival of figuration after a decade
of abstract expressionism may have been partly
responsible for a renewed interest in Albright's
work. In any event, his 1964 retrospective at the
Art Institute of Chicago was a major success. The
following year Albright decided to leave Chica-
go, and to move family and studio to Woodstock,
Vermont, where they bought two houses, one for
children, grandchildren, and guests. In the late
1960s he began work on a figure painting called
The Vermonter for which Kenneth Harper At-
wood was the model. He followed his usual prac-
tice of devoting many months exclusively to a
single picture.

The work of Ivan Albright is outside the main-
stream of American painting, and with the possi-
ble exeption of Leon Golub's so-called Chicago
Monster School, has had little or no influence on
other painters. However, one of his most outspo-
ken admirers has been the French painter Jean
Dubuffet, who declared, "Never before has an
assault of such force been given to the rationalis-
tic order." Elsewhere Dubuffet describes Al-
bright's world, with still-life compositions like
The Window in mind, as "a howling tumult,
polycentric of many forms—a Gehenna of forms
entirely delivered to delirium."

In contrast to the macabre character of his
paintings, which have been called "a collective
memento mori," and to the morbidity of his self-
portraits—the night before his death in 1983 he
was working on a portrait of his eyes in order,
his daughter Alice claimed, "to see what death

looked like"—Ivan Albright himself was a brisk
and cheerful man, short, rotund, and balding.
Jan van der Marck wrote of him: "Interviewing
Ivan Albright is as futile as collecting light from
shooting stars. . . . Mock arrogance alternates
with tongue-in-cheek humility in a rambling
monologue running the gamut from self-
deprecating humor to sly assertivenesss." For all
Albright's love of paradox, especially the para-
doxical circularity of life and death, there was
a philosophical basis for his work. He stated, "I
hope to control the observer, . . . to make him
feel tossed around in every direction, to make
him realize that objects are at war. . . . Every-
thing in the canvas is fighting. I want to give a
feeling of frustration." Although Albright admit-
ted that he liked "to see dust move and crawl
over an object like a film," he insisted that he
was no less interested in growth than in death
and dissolution. Despite his meticulous tech-
nique, he aimed far beyond straight representa-
tion and trompe l'oeil effects. "Whenever
possible," he said, "I like to create a feeling of the
unknown."

EXHIBITIONS INCLUDE: Walden Bookshop, Chicago
1930; Art Inst. of Chicago 1931; Touring exhibition of
11 paintings, Washington, D.C., NYC, Boston, Brussels
World's Fair 1946–47; Retrospective, Art Inst. of Chi-
cago, and Whitney Mus. of Am. Art, NYC 1964–65.
GROUP EXHIBITIONS INCLUDE: Art Inst. of Chicago 1918,
'23, '26, '49; Pennsylvania Academy, Philadelphia
1924; "Artists for Victory," Metropolitan Mus. of Art,
NYC 1942; (Joint exhibition with his brother Malvin)
A.A.A. Gal., NYC 1945; Art Inst. of Chicago 1946; Nat.
Academy of Design, NYC 1961; Dunn International
Exhibition, Beaverbrook Art Gal., Fredericton, New
Brunswick, Canada 1963.

COLLECTIONS INCLUDE: Metropolitan Mus. of Art,
MOMA, Whitney Mus. of Am. Art, and Solomon R.
Guggenheim Mus., NYC; Wadsworth Atheneum,
Hartford, Conn.; Nat. Gal. of Fine Arts, and Library
of Congress, Washington, D.C.; Art Inst. of Chicago.

ABOUT: "Ivan Albright" (cat.), Art Institute of Chicago,
1964; Current Biography, 1969; Rose, B. American Art
Since 1900, 2d ed. 1975. *Periodicals*—American Artist
January 1966; American Art Journal May 1976; Art in
America November/December 1977; Art News No-
vember 1964; Magazine of Art February 1943;
Newsweek November 24, 1943; New York Times No-
vember 19, 1983; Time July 6, 1942.

***ALECHINSKY, PIERRE** (October 19,
1927–), Belgian painter and graphic artist, was
born in Brussels, the only child of a Jewish immi-
grant father and a Belgian mother. Both parents
were physicians, and the boy grew up in a culti-

°al˝ ə chin´ skē, pyâr

John Lefebre

PIERRE ALECHINSKY

vated family that loved books, art, and music. Alechinsky was sent to a primary school in Brussels, where he became aware of the fact that he was left-handed. "At that time children were not allowed to be left-handed," he said, "and I was instantly dubbed a dunce." Fortunately, he was helped by certain enlightened teachers "who insisted that I make my left hand serve me totally. . . . The strange thing about my situation [was] that I discovered that my left hand contained what I might call a magic quality." He found that he could write backwards, as well as from left to right, and because he could reverse his images he later became "extremely interested in the art of engraving and lithography, because the finished product is reversed automatically."

During World War II members of Alechinsky's family were imprisoned or deported. His father was dismissed from the hospital in which he worked, and bombing raids on Brussels completely disrupted Alechinsky's life in those years.

With the Liberation in 1944, Alechinsky enrolled in La Cambre, the national college for architecture and decorative arts in Brussels. There he learned to design posters, wrappings, and labels but was mainly interested in the techniques of book design, typography, and engraving processes. He also took courses in book illustration and was soon illustrating publications by leading poets, including Guillaume Apollinaire.

In 1947 Alechinsky traveled in Morocco and Yugoslavia, and that same year he held his first solo exhibition of paintings at the Galerie Lou Cosyn, Brussels. He has described those works as "portraits of girls whom I monstrified." At this time he also met several of the Belgian Surreal-

ists, including René Magritte, Camille Goemans, and André Soures. Later that year, he joined the association Jeune Peinture Belge. The Young Belgian Painters were avant-garde artists influenced by postwar expressionism, and Alechinsky participated in their last exhibition, which was held at the Palais des Beaux-Arts, Brussels.

Alechinsky received his diploma from La Cambre in 1948; soon afterward he married his present wife, Michèle, whom he calls "Micky." Their two sons, Ivan and Nicholas, were born in 1952 and '58 respectively.

Alechinsky visited Paris for the first time in 1948 and took part in an exhibition of the group known as Les Mains Eblouies (Dazzled Hands). In 1948 he met the Belgian poet Christian Dotremont who was organizing the first exhibitiion of the Cobra group, at Les Ateliers du Marais, Paris. The name "Cobra" was an acronym derived from Copenhagen, Brussels, and Amsterdam, inasmuch as the chief members of the group included Asger Jorn, a Dane, the Belgian Dotrement, and the Dutch painters Karel Appel, Corneille, and Constant. Alechinsky was immediately attracted to Cobra, which had been founded in 1948 and which reacted against both communist-approved social realism and constructivist art. In the catalog to his Pittsburgh retrospective in 1977, Alechinsky wrote that Cobra, in addition to a desire for despecialization—painters writing, writers painting—meant "spontaneity: total opposition to the calculations of cold abstraction, the sordid or 'optimistic' speculations of socialist realism, and to all forms of split between free thought and the action of painting freely." At 22, Alechinsky was the youngest Cobra member and perhaps the one most strongly affected by its principles. Notwithstanding his later mythopoeia and phantasmagorical depictions of the strange and fantastic—here the Flemish tradition of Bosch, Brueghel, and Ensor played a role—Alechinsky's work from the moment he joined Cobra celebrated, to quote John Gruen, "a joyousness and positivism of spirit. . . . His paintings and drawings do not scream in horror but squeal in glee: they do not threaten or scare us, but revel in the absurdity of fear."

When the Cobra group disbanded in 1951, Alechinsky left Belgium and settled in Paris. On a grant from the French government he studied engraving at Stanley William Hayter's famous Atelier 17. "To Bill Hayter," he said, "I owe my taste for copper and acid." During this period Alechinsky met Miró, Calder, Giacometti, and other artists and poets living in Paris and participated in many group exhibitions in Belgium, France, Italy, Holland, and the Scandinavian

countries. In 1954 he had his first solo show of paintings in Paris.

More influential than any of the noted artists Alechinsky met at this time was a group of Japanese calligraphers based in Paris. Their work inspired in him a passion for oriental calligraphy, at which he became brilliantly adept. In 1955 he traveled to Japan and held a solo show in Tokyo. In Kyoto and Tokyo he became even more familiar with Japanese calligraphy and made a prize-winning film, *Caligraphie japonaise.* His large oil on canvas, *Seize the Day* (1958; Hirshhorn Museum and Sculpture Garden, Washington, D.C.), shows, despite the rich, heavy impasto, a distinctly Far Eastern influence in the cool, silvery tonalities and the spirited black calligraphic "signs" which animate the entire surface.

In the 20 years after his trip to Japan, Alechinsky produced innumerable works of art in all media, always remaining faithful to the expressionist principles of Cobra. He executed a mural for the Cinemathèque Française, Paris, in 1957, and in 1958 he was appointed to the Board of Directors of the Salon de Mai, a post he held for 12 years. He exhibited in many group shows in Switzerland and, as his international following grew, in the United States and England. In 1959 he was invited to participate in the São Paulo Bienal and the next year he won the Hallmark Prize in New York City for his painting *Hommage à Ensor* (1956). Also in 1960 he represented Belgium at the Venice Biennale. A characteristic painting of the early '60s was his turbulent oil *The Green Being Born* (1960; Musée Royal d'Art Moderne, Brussels). In 1963 Alechinsky further acknowledged his debt to James Ensor, a progenitor of Flemish expressionism and continental surrealism, in his painting *Fête d'Ensor.*

In the 1960s Alechinsky continued to develop Cobra's aesthetic principles of spontaneous paint application, which is akin to action painting in abstract expressionism, and the depiction of disturbing images that arise from the subconscious. A characteristic work is *Greet the North, Greet the South* (1962), in which a mass of indistinct figurative forms—perhaps human, or beast, or fish; the swarming crowd is a familiar Cobra theme—is portrayed. The stylistic affinities with American action painting are striking, but, as Alechinsky has said, "My work, provoked by emotion and spontaneity, will never be abstract. It will always represent man."

In 1965, four years after his first visit to the US, Alechinsky held a solo exhibition at the Jewish Museum, New York City, showing 43 paintings dating from the years 1958–65. John Gruen

of the New York *Herald Tribune* wrote that, despite the macabre aspects of his imagery, "Alechinsky never quite rises to the irony and dark humor that was Ensor's hallmark." Gruen added that the pictures showed "tremendous energy and tremendous skill" but that they were "put to the service of a wonderfully inventive decoration, seldom to an emotionally searing statement."

Also in 1965, while working in the Manhattan studio of Chinese-born artist Walasse Ting, Alechinsky abandoned the use of oils and, painting on a sheet of paper, he began his first picture in acrylic. He explained: "I took this sheet to France. I began to observe it pinned to the wall while sketching row by row on long strips of rice paper. I pinned these around: I had just organized 'Central Park,' my first painting with marginal notes. I fastened everything upon a canvas backing: first superimposition. I was soon going to break myself away from painting in oil." This technique of bordering an expressionist painting with comic-strip panels was continued in works such as *The Voyeur Seen* and *Stars and Disasters.*

Since the mid-'60s Alechinsky has refined his current mode of work in ink and/or acrylics on paper, for which he uses special Japanese brushes. Grace Glueck of *The New York Times* (October 28, 1977) described his working methods: "Standing over a flat surface, he produces a strange and mocking and brilliant graffiti of sinuous lines, fabulous beasts, fluid signs and circles tied together in improbable configurations, the main action commented on in marginal panels that resemble abstract comic strips." In *Le Complexe du sphinx* (1967; Museum of Modern Art, New York City), in acrylic and ink on canvas and Japanese paper, the abstract "comments" occupy the lower register of the picture, the canvas center being filled by ominous and enigmatic forms on a dark ground.

In 1972 Alechinsky again represented Belgium at the Venice Biennale, and in 1977 he became the first winner of the $50,000 Andrew W. Mellon prize for artists. Established by the Carnegie Institute's Museum of Art, Pittsburgh, the prize was presented to him at the October 1977 opening of a show of 137 of his paintings at the museum. The exhibit catalog contained a long, surrealistic tribute by Eugène Ionesco, but an *Art News* critic wrote: "Although Alechinsky is talented, energetic and prolific, his oeuvre was simply not up to this excessiveness. While there were good paintings in the show, they could not offset the artist's repetition of the same basic ideas over and over again."

Grace Glueck described Alechinsky as "a slight fellow, as bearded of face as he is bald of

head," The artist lives with his wife, Micky, in Bougival, a suburb of Paris. "I am completely suburban," Alechinsky admitted. "I stay in a room with four walls and find my pleasure in solitude." Describing a meeting with Alechinsky, John Gruen was struck by "the discrepancy between the man and his work: The man is contained, controlled, reserved—an intellectual. The artist is flamboyant, often outrageous and seemingly anti-intellectual."

Alechinsky said that he paints because it unifies all his senses and puts him in full accord with himself. "I know that if I leave a trace of myself . . . , my pleasure . . . , that is readable to me alone, I'm sure to touch someone else. . . . In my work it is the gesture, the act of painting, that produces the thought. The two can't be separated. Brain and hand act as one."

EXHIBITIONS INCLUDE: Gal. Lou Cosyn, Brussels 1947; Gal. Apollo, Brussels 1948; Gal. Nina Dausset, Paris 1954; Palais des Beaux-Arts, Brussels 1955, '69; Gal. Nabis, Tokyo 1955; Gal. du Dragon, Paris 1956; Inst. of Contemporary Arts, London 1958; Gal. van de Loo, Munich 1961, '75; Carnegie Inst., Pittsburgh 1961, '77; Gal. de France, Paris 1962, '66, '71; Lefebre Gal., NYC from 1962; Stedelijk van Abbe Mus., Eindhoven, Neth. 1963; Arts Club of Chicago 1965; Jewish Mus., NYC 1965; Mus. of Fine Arts, Houston 1967; Venice Biennale 1972; Art Gal. of Ontario, Toronto 1978. GROUP EXHIBITIONS INCLUDE: "Les Mains Eblouies," Gal. Maeght, Paris 1948; "First Exhibition of International Experimental Art CoBrA," Stedelijk Mus., Amsterdam 1949; Gal. Geert van Bruaene, Brussels 1950; Mus. des Beaux-Arts de la Ville de Liège, Belgium 1951; Pittsburgh International 1952–70; São Paulo Bienal 1953, '59; "European Art Today," Minneapolis Inst. of Arts, Minn. 1959; Venice Biennale 1960; Documenta 3, Kassel, W. Ger. 1964; "Painting in France," Nat. Gal., Washington, D.C. 1968; "The Belgian Contribution to Surrealism," Edinburgh Festival 1971; "European Painting in the Seventies," Los Angeles County Mus. 1975.

COLLECTIONS INCLUDE: Mus. Royaux des Beaux-Arts de Belgique, Brussels; Mus. Nat. d'Art Moderne, Paris; Mus. Cantini, Marseille, France; Stedelijk Mus., Amsterdam; Gal. Nazionale d'Arte Moderna, Rome; Peggy Guggenheim Collection, Venice; Mus. der Stadt, Darmstadt, W. Ger.; Israel Mus., Jerusalem; Mus. d'Art Contemporain, Montreal; MOMA, and Solomon R. Guggenheim Mus., NYC; Hirshhorn Mus. and Sculpture Garden, Washington, D.C.; Carnegie Inst., Pittsburgh; Mus. of Fine Arts, Houston; Mus. de Arte Moderna, São Paulo.

ABOUT: Alechinsky, P. Pierre Alechinsky, 1977; Bosquet, A. Alechinsky, 1971; Heusch, Luc de Alechinsky, 1950; Pellegrini, A. New Tendencies in Art, 1966; Putnam, J. Alechinsky, 1967; Rivière, Y. Catalogue raisonné, 1973. Periodicals—Art in America January–February 1978; Art News January 1978; Toronto Globe and Mail March 11, 1978; New York Herald Tribune May 21, 1965; New York Times February 20, 1962, October 28, 1977, November 13, 1977; Time June 25, 1965.

*ANDRE, CARL (September 16, 1935–), American sculptor and painter, has been called the high priest of minimal art and it was he who coined the terms "post-studio" and "post-gallery" art. He was born in Quincy, Massachusetts, the youngest of three children, and an only son. His father's family was of Swedish descent, and his paternal uncles and grandfather were all practical men employed in the shipbuilding and construction industries. Carl's father, a retired marine draftsman, was an accomplished woodworker and an avid reader who encouraged his son's interest in literature. "My father read Keats to me on his knee," Andre said. "My uncle recited Poe to me on the way to work." Some of his earliest memories are of heaps of granite blocks and acres of rusting steel plates waiting for use in the shipyard. (Quincy is a center for the shipbuilding and granite-quarrying industries.)

From 1940 to '50 Andre attended Quincy public schools, and in '51 he entered Phillips Academy, Andover, Massachusetts, where he studied art with Patrick and Maud Morgan. During his two years at Andover he met the future artists Hollis Frampton and Michael Chapman. At the Academy Andre was more interested in sculpture and in handling materials than in painting. He began chiseling into timbers in 1953, after his roommate Hollis Frampton had aroused his interest in the sculpture of Brancusi. About this time Andre also began to write poetry.

In 1953, after leaving Phillips, Andre worked as an office boy for the Boston Gear Works, and the following year he traveled to Europe. In France he visited the Louvre and in England he was taken by a maternal aunt and uncle to see Stonehenge; the influence of those giant boulders can be seen in some of his later constructions, especially his earthworks. In 1955–56 he served in the US Army as an analyst in military intelligence.

Andre moved in 1957 to New York City where he worked for several months as editorial assistant to a book publisher. In New York he met another former Phillips Academy student, Frank Stella, who was then working on his austere "black" paintings; Andre was impressed by their rigor. In Stella's tiny second-story loft in the SoHo district of lower Manhattan Andre, influenced by Constantin Brancusi, began to carve wooden sculpture. Brancusi had shown his sculp-

°äN drā´

ture on pedestals carved and cut by himself; thus the stack of elements almost became part of the sculpture—and Andre adopted this principle of stacking. The largest of Andre's carved sculptures was *Last Ladder* (1959), made from a timber found on a vacant lot and closely related to Brancusi's *Endless Column*. However, in contrast to Brancusi's regular column, Andre cut five notches asymmetrically on one face of the timber, rather than using the timber to articulate form and space. When Stella pointed out that the uncarved face of the upright timber was also sculpture, Andre began to rethink his practice, and moved from an interest in shaping materials to making a structure from materials.

Unable to interest buyers or galleries in his sculpture, and needing to support himself, Andre worked from 1960 to '64 as a freight brakeman and conductor for the Pennsylvania Railroad on its Newark–Jersey City run. This experience led him to develop the concept of sculpture as place rather than form or structure. Moved by the "vast swampy meadows" of New Jersey, he decided his sculpture should be "more like roads than buildings." This idea was to become known as earthworks, or land art. As developed by Andre and other practitioners such as Robert Smithson, earthworks was the making of a natural setting *into* a work of art as opposed to the customary use of an environment as the *site* of an art work. While working on the railroad, Andre also became committed to the use of standardized, interchangeable units—the coupling of freight cars was the procedure that confirmed him in this practice—which culminated in *Lever* (1966), a long row of 139 unconnected bricks.

In New York, in 1959, Andre had used a radial-arm saw to cut two-by-four-inch timbers, mortising them together to make two pyramids, one square, the other triangular. His original *Pyramids* were destroyed sometime between 1960 and '64, when Andre was working on the railroad, but in '64 he was invited by E. C. Goossen to reconstruct one for an exhibition at the Hudson River Museum, Yonkers, New York. Andre remade the square pyramid in four-by-four-inch and named it *Cedar Piece*. In 1964 he was able to begin working on a large scale again. He retained the principle of stacking but soon ceased to build upward, believing that extension across the floor was a more efficient means of controlling space. He carried this horizontal tendency even further in 1965, when he realized, while canoeing, that sculpture should be "as low as water." Andre was also at pains to use materials without transformation, so as to disclose their essential properties—the "leadenness" of lead, for instance. For similar reasons he was to use the

simplest configurations—squares and rectangles—to focus the viewer's attention on the material itself.

In 1965 Andre had his first New York City solo show when the curator Henry Geldzahler invited him to show his work in an exhibit titled "Shape and Sculpture" at the Tibor de Nagy Gallery. The following year, when *Lever* was included in the "Primary Structures" show at the Jewish Museum, New York City, Andre achieved a minor succès de scandale. Andre described his 34½-foot row of unjoined tan firebricks as "Brancusi's *Endless Column* [put] on the ground," but audiences were unprepared for the extreme simplicity of minimal art.

By the mid-'60s minimalism had emerged as an important movement and Andre, along with such Minimalist colleagues as Donald Judd and Robert Morris, was among the first to bring the idea of "less is more" to American sculpture. Whatever Andre's debt to Brancusi, his work contained none of that master's symbolic content. Nor was it related to the suprematism of Malevich or the monochrome paintings of Yves Klein—both of those artists were thought too "spiritual" and metaphysical by the Minimalists, who were concerned only with the "thing-in-itself." Minimalism was also part of the "cool" '60s reaction against the heroic spiritual odyssey undertaken by the Abstract Expressionists of the 1950s. Not surprisingly, the Minimalists were influenced by constructivism. Thus the shapes of Andre's stacks of diverse materials, including magnets, pieces of styrofoam, and bricks, were mathematically predetermined.

For his second solo show at Tibor de Nagy, held in 1966, Andre made a series of eight sculptures, each comprising 120 bluish-white sandlime bricks in two layers. In various combinations the bricks formed eight quite different shapes. Because Andre believed that a work of art exists only when on exhibition, works like "Equivalents" were usually dismantled when not being shown. One of these "Equivalents," as the series was called, was to provoke the Tate Gallery controversy of 1976.

In 1969 Andre was represented in "The Art of the Real," a group show sponsored by New York City's Museum of Modern Art which toured Europe. In 1969 he created *37 Pieces of Work,* a mammoth, 36-by-36-foot "carpet" of 1,296 metal squares forming a checkerboard of unattached zinc, copper, steel, lead, and aluminum sections. This gleaming expanse occupied the surface of the floor in Andre's 1970 retrospective at the Solomon R. Guggenheim Museum, New York City, and was the largest of several metal "carpets" on view in the show. (Visitors were en-

couraged to walk on them.) Also included in the exhibit were earlier "Timber" pieces which rose from the floor, *Lever,* and a dozen framed collages, which were described by Hilton Kramer of *The New York Times* (October 3, 1970) as being "more or less in the manner of concrete poems."

Recognizing the originality of Andre's sculpture, Kramer wrote, "He is doing something, or attempting to do something, that hasn't been done before, at least as sculpture." Peter Schjeldahl, reviewing the retrospective in *The New York Times* (October 18, 1970), wrote that "the presence of '37 Pieces' in Frank Lloyd Wright's fabulous Guggenheim interior [was] more theatrical than that of any other Andre." Schjeldahl admitted that Andre was "not much fun," but added, "Puritanically severe, his work rewards sensitive perusal with some nice surface effects and a certain feeling of unease."

A pioneer of the earthworks movement, Andre designed two sculptures in 1968 specifically for outdoor locations in Aspen, Colorado: *Long Piece Summer* and *Pile of Rocks.*

By the early 1970s some critics wondered whether the reductivism of Andre and other Minimalists, having attained its ad absurdum in conceptual art, had not outlived itself. Despite the critical reaction against minimalism, in the '70s Andre continued to make sculpture on a monumental scale. A large, complex, carefully patterned floor piece, on view in Andre's 1976 show at the John Weber Gallery, SoHo, was described by John Russell of *The New York Times* (January 18, 1976) as "an immensely long, narrow rectangle formed from 576 zinc, magnesium, aluminum, copper, iron and lead plaques." Russell was reminded of Italian Renaissance floorways. The show also included five wooden pieces in Western red cedar, which Russell called "a transposition of Brancusi's sculpture without any of the overtones of myth, totem and taboo which Brancusi made welcome."

Equivalent VIII, one of Andre's sculpture of 1966, consisting of 120 bricks arranged in a rectangular pile, two bricks high, six across and ten lengthwise, was remade for a 1969 exhibition of the touring "Art of the Real" show at the Tate Gallery, London. The brick piece attracted little notice at the time. It had, in fact, been purchased by the Tate in 1972, reportedly for $12,000, and had lain around the gallery for four years without arousing controversy. But a storm broke in 1976 when the *Sunday Times* of London, after combing the Tate's recent catalog, commented in its business news section on what it called Andre's "insouciant masterpiece." The Tate, complained the *Sunday Times,* received

an annual grant of over one million dollars from the British Government, and it was clearly misspending the taxpayers' money. The popular press, including the *Daily Mirror,* followed with a volley of ridicule.

The controversy over the Andre sculpture occurred on the eve of the Tate's bicentennial exhibition of the beloved works of John Constable, and Sir Norman Reid, the Tate's director, reminded his critics that "Constable was violently attacked in his own day." London's art critics, however, did not rush to the Tate's defense; the influential *Times* columnist Bernard Levin agreed with the *Evening Standard* that Andre's work was no more than "a pile of bricks." But in *The New York Times* (February 20, 1976) John Russell seconded the Tate's decision and praised Andre's gift for "specifically American plain statement." If his work had made people wonder whether it was art, that had been true of much good art in the past, Russell said. Robert M. Semple Jr, in an article on the same page of *The New York Times,* noted that one visitor leaving gallery 19 in the Tate, where the bricks were on display, was heard to remark: "I like them. They relax me."

Later in 1976 Andre was involved in a dispute with the Whitney Museum of American Art, New York City. *12th Copper Corner* had been made the year before specifically to be shown in the Whitney's 1976 group exhibition "200 Years of American Sculpture." Visiting the show two days before the opening, Andre was furious at finding his piece in "a totally mutilating installation," and demanded its removal. A few days later he found that the museum had substituted for it a similar piece of his, *29th Copper Cardinal,* which it had recently purchased, but Andre complained that its installation, too, was "absolutely inappropriate." Soon afterward he offered to buy *29th Copper Cardinal* back for $26,000, but later paid a much lower price, declaring that it was no longer art. Weeks later, announcing that the Whitney had "demonstrated ignorance of the nature of my work by its use of it," Andre decided to show both *12th Copper Corner* and *29th Copper Cardinal* on the ground floor of a vacant building at 355 West Broadway in lower Manhattan. The controversy raised the issue of an artist's right to determine the manner in which his work is displayed in a museum or gallery.

In 1977 Andre was commissioned to create a site sculpture on a triangular plot of grass at the intersection of Main and Gold Streets in Hartford, Connecticut. (This was his first permanent commission for a public site sculpture.) Andre produced *Stone Field,* consisting of 36 boulders,

each weighing from 1000 pounds to 11 tons, laid out in eight rows of progressively smaller rocks. Andre was inspired to choose boulders for his arrangement because they were typical of New England's glacier-created landscape. Also, they reminded him not only of the tombstones in the neighboring Center Church graveyard but of Stonehenge.

Many Hartford residents were furious over the sculpture, especially on learning that Andre's fee had been $87,000, and *Stone Field* became a political issue. The cost of the sculpture was absorbed by the Hartford Foundation for Public Giving and the National Endowment for the Arts. *A Village Voice* critic predicted that "the people of Hartford will warm to it," and called *Stone Field* "a civilizing element in urban daily life, as well as an audacious venture in public art." Despite mixed reaction to the work, it has remained in place.

Reviewing a small traveling retrospective of Andre's sculpture, in 1978 Mark Stevens wrote in *Newsweek* that "the sculpture has an ideological swagger that can be misleading. Most of it is pacific in flavor, composed of simple means in a serene order." He noted that there was none of the "metaphysical baggage" of religion or myth that travels with the simple forms of Barnett Newman and Mark Rothko. "Only the work itself is there," Stevens said, "governed by its own internal rules." However, Stevens felt that behind this strict reductivism was "a faith that, in its way, is as naive as any romantic conception of aesthetics: that art, if stripped down to its bones, will reveal something important—an essence."

The accusation of producing boredom in the viewer has been leveled at Andre's work, but the noted critic Barbara Rose, in a defense of minimalism, asserted, "Boring the public is one way of testing its commitment." On the other hand, Hilton Kramer, skeptical of endowing boredom with a moral imperative, wrote in *The New York Times* (May 15, 1977), "Boring work is boring work, even when offered in a series of boring variations." Nevertheless, Kramer expressed admiration for an enormous work by Andre called *The Waves*—four widely spaced rows of vertical members—which was exhibited in 1979 in the old Musée d'Art Moderne on the Avenue Wilson in Paris.

Carl Andre married the former Rosemarie Castro; they are divorced. Andre, who lives in downtown New York, is a striking-looking man, with a round figure, a broad face framed by shoulder-length brown hair thinning at the part, and a chest-length brown beard. He usually wears Farmer Brown overalls and a black fedora.

Although capable of bombastic pronouncements on art, Andre is generally amiable, and he dislikes the controversy his work has aroused. Nor does he view his sculpture as aggressive: "I like . . . art works which sort of ambush you, that in a sense take you by surprise. . . . I don't like art that dominates you." He says of his aesthetic: "My works are not the embodiments of ideas or conceptions. My works are, in the phrase of William Blake, 'lineaments of gratified desire.'"

EXHIBITIONS INCLUDE: Tibor de Nagy Gal., NYC 1965, '66; Dwan Gal., NYC 1967, '69, '71; Konrad Fischer Gal., Dusseldorf 1967, '69, 1971–74; Gemeentemus., Hague 1968; Gian Enzo Sperone, Turin, Italy 1969, '73; Solomon R. Guggenheim Mus., NYC 1970; St. Louis Art Mus., Mo. 1971; John Weber Gal., NYC from 1972; Addison Gal., Andover, Mass. 1973; MOMA, NYC 1973; Kunsthalle, Bern 1975; Cusack Gal., Houston 1975; Whitechapel Art Gal., London 1978; Albright-Knox Art Gal., Buffalo, N.Y. 1978; Univ. Art Mus., Berkeley, Calif. 1979. GROUP EXHIBITIONS INCLUDE: Hudson River Mus., Yonkers, N.Y. 1964; "Primary Structures," Jewish Mus., NYC 1966; "American Sculpture of the 60s," Los Angeles County Mus. of Art 1967; "Minimal Art," Gemeentemus., Hague 1968; Documenta 4, Kassel, W. Ger. 1968; "Art of the Real," MOMA, NYC 1969; "Anti-Illusion," Whitney Mus. of Am. Art, NYC 1969; Tokyo Biennale 1970; "Art vivant aux Etats-Unis," Fondation Maeght, Saint-Paul-de-Vence, France 1970; "Drawing and Diagrams," Rijksmus. Kröller-Müller, Otterlo, Neth. 1972; Whitney Biennial, NYC 1973; "Contemporanea," Rome 1973; "Some Recent American Art," Nat. Gal. of Victoria, Melbourne, Australia 1974; Mus. d'Art Moderne, Paris 1979.

COLLECTIONS INCLUDE: MOMA, NYC; Albright-Knox Art Gal., Buffalo, N.Y.; Walker Art Cntr., Minneapolis; Pasadena Art Mus., Calif.; Tate Gal., London; Stedelijk Mus., Amsterdam; Kunstmus., Basel; Hessisches Landesmus., Darmstadt, W. Ger.; Wallraf-Richartz Mus., Cologne; Staatsgal., Stuttgart, W. Ger.; Nat. Gal. of Canada, Ottowa; Art Gal. of Ontario, Toronto.

ABOUT: Andre, C. Quincy Book, 1973, 144 Blocks and Stones, 1974, Eleven Poems, 1974; "Carl Andre" (cat.), Whitechapel Art Gal., London, 1978; Develing, E. and others, "Carl Andre" (cat.), Gemeentemus., Hague, 1969; Waldman, D. "Carl Andre" (cat.), Solomon R. Guggenheim Mus., NYC, 1970. *Periodicals*—Art in America April 1980; Art Week June 16, 1979; Artforum October 1966, June 1970, March 1978; Arts Magazine May 1974; Los Angeles Times June 3, 1979; New York June 7, 1976; New York Times October 3, 1970, October 18, 1970, January 18, 1976, February 20, 1976, May 15, 1977; March 26, 1978; Newsweek July 31, 1978; Village Voice March 31, 1976, September 19, 1977.

ANDREWS, BENNY (November 13, 1930–), American painter, writes: "One thing I cannot do when it comes to talking about myself or my work as a painter is not mention that I came from the southern part of the United States of America. Not only that, I must go into details about coming from that part of the country in order for me to begin talking about my works. I was born November 13, 1930, to George and Viola Andrews, about three-and-a-half miles outside of Madison, Georgia, a very small town basically supported at that time by cotton farmers in the surrounding area.

"A few years after I was born, my parents moved to a cotton farm and started working as sharecroppers, the lowest form of human work one could ever imagine. On the surface of it, the terms and conditions of sharecropping sound fair. That is, the owner of the property and farm implements furnishes half of what it takes to cultivate and harvest the cotton and the sharecropper furnishes the labor. Well, it doesn't take long for the laborer to realize that he comes out on the short end of the stick.

"So here we were, the poorest and the most disrespected people imaginable, merely eking out a living by working from sunup to sundown, five to six days per week year-round. On top of that the inhumane system of discrimination was one hundred percent in effect, and our lives were just one step removed from physical slavery.

"This was my life until I reached 18 years of age, and like a bat out of hell I ran off to Atlanta, Georgia, again to work in a form of servitude, doing busboy work in segregated restaurants for a meager salary; but at least I'd left the plantations and could walk the streets of Atlanta and day-dream by looking into the windows of clothing stores.

"The above describes the physical existence of me and others like me in those days. The difference for me, and what eventually saved me from the fates of most of my peers, was the fact that at age three I'd been drawing pictures, both from my imagination and from the newspapers and magazines that, fortunately, my parents insisted on buying with the spare change they had. I started to develop my imagination then. I'd dream of faraway places, the ones I'd seen pictures of, and since I couldn't go to them, I started to draw them. Later I painted from my imagination scenes and incidents that I longed to be in. I, and I repeat I, always wanted to be in these scenes, so whatever I did I did from a personal standpoint. In order for these dreams to have any meaning I had to include surroundings and people that I knew, so I made sure that my environment was part of my dreams.

Mary Ellen Andrews

BENNY ANDREWS

"Later, when I was to go to the Art Institute in Chicago (1954–58), where I received a BFA, and after four years of service in the United States Air Force, I found that I was faced with a classic problem which confronts all outsiders in esoteric places like the art school: I had to conform to the whims of the powerful and influential art teachers and paint the fashions of the day—at that time it was de Kooning, Pollock, Rothko, Marca-Relli, and Matta—or be ostracized. I cannot say that I chose to be ostracized, I just could not bring myself to accommodate those people, because I was determined to paint what I wanted to paint, and so I was ostracized.

"I also was determined to remain true to what I felt an artist should be, and that was a human being who happened to paint, sculpt, or etch, never giving up his or her right to remain himself. Needless to say, in the eyes of the school, I was a total failure, and I found that very easy to live with—in fact I gained a certain amount of strength from the academics' utter dislike for what I chose to do, which was natural-looking black and white people from *all* regions of America.

"*I thought* that once I came to New York City (1958) this problem would vanish; well, it didn't. In fact, I've come to learn that man is almost incapable of dealing with himself directly, and I've come to expect resistance to my work as a matter of course. Since then, and there have been a lot of sinces, I've continued to work and develop my point of view and I've gained an understanding from a large number of people outside of the so-called mainstream of art. It is in this area that I derive my strength to continue

as a painter. I find in these less formally art-trained people, there is more honesty and appreciation for what they see; they are not so damned intimidated by what someone else has written about what to expect in a work; they come more innocently to a work of art.

"I need this, because in many ways I'm far from my roots, the place and people that I grew up with, so I need the untutored eyes that these nonformally art-trained people have. Oh, I have an ego, too, and I need to be able to compete with the so-called pros, both critics and practitioners, and I'm happy to say that I do.

"So today I exhibit in all of those prestigious places, and my works are owned and operated by the big collectors and museums, and from a standpoint of cooling other 'mainstream types' from claiming that I cannot compete, well, that kind of exhibiting helps. But when it gets lonesome and quiet in my studio on those long days when there is nothing between me and my canvas but air and my conscious, I must be able to know deep down in my heart that I continue to paint what I feel and want to paint. I must know that when my paintings go up on walls, be they in museums or in neighborhood community centers, that people unencumbered by the latest 'word' on what is and what isn't can look at the work and say, 'Well, he may be crazy, but at least he's trying to say something.' I'll try my hardest to make sure that I'm trying to say something artistic and human."

The black experience in the United States has been so intense that there is little danger of a talented black artist substituting sterile cerebration or stylistic mannerisms for meaningful content. Benny Andrews has evolved a highly personal style to express his deepest feelings about racial conflict and the human condition in general. He is part of the second wave of black artists in America (the first included Romare Bearden and Jacob Lawrence).

He was the second of ten children of sharecroppers, George Cleveland Andrews and Viola (Perryman) Andrews. From 1948 to 1950, he attended Fort Valley State College, and from 1956 to '58 he studied at the University of Chicago. In 1958 Andrews received a Bachelor of Fine Arts degree from the Chicago Art Institute, and moved to New York City.

Between 1960 and 1970 Andrews had numerous solo exhibitions, including 11 at the Paul Kessler Gallery, Provincetown, Massachusetts, and three at the Forum Gallery, New York City (1962, '64, and '66). His subject matter, inspired by memories of growing up in rural Georgia and

by his anger at the materialism and racism of society, was never interpreted in a literal manner, but was expresed through an original use of symbols, selective design, and a forceful isolation of the images in space.

Andrews has experimented with a combination of oil and collage, frequently building out the forms in three dimensions. This method worked most effectively in his painting *The Champion* (1967). According to painter Raphael Soyer, "[*The Champion*] shocked and repelled some of us, but looking at it long, one felt the artist's deep pity for this battered, exploited black pugilist, and his deep-seated anger at a society which is guilty of such cruelty, and finds such cruelty profitable."

In 1965 Andrews received a John Hay Whitney Fellowship which was renewed the following year. Despite his success, he became increasingly disturbed by the inadequate recognition of black artists and black culture generally in leading museums. In the late '60s Andrews was one of the key organizers (and co-chairman, with Cliff Joseph) of the Black Emergency Cultural Coalition. This loose-knit but militant and articulate group of over 150 black artists gained immediate prominence in 1969 by demonstrating against a controversial exhibit, "Harlem on my Mind," at the Metropolitan Museum of Art, New York City. Whatever the intentions of its organizers, the exhibit seemed to Andrews "a continuation of the paternalistic approach" to black culture. Furthermore, no black scholars or historians had asked to help assemble the show.

The coalition's next target was the Whitney Museum of American Art, New York City, when it was discovered that the museum's entire colleciton comprised only ten works by black artists. Later in 1969 the Whitney agreed to hold an exhibition titled "Contemporary Black Artists in America," but the coalition objected to the way it was handled and boycotted the show. Fifteen of the 75 artists scheduled to participate withdrew from the exhibition in sympathy with the boycott, and in April 1971 50 black artists staged a "Rebuttal to the Whitney Museum Exhibition" at the Acts of Art Galleries, Manhattan. In October 1973 Andrews assembled approximately one hundred works by 40 artists in an exhibition called "Blacks: USA: 1973" at the New York Cultural Center. This show, Andrews said, was what should have been mounted at the Whitney. Even if there was "nothing spectacular or trendsetting," it showed "areas open for development and of interest to the black community."

These activities stimulated debate in New York art circles of the question, "Is there such a thing as black art?" Andrews said of himself and

the coalition: "Don't mistake us—we're artists first," and he pointed out that an all-black show would not necessarily reflect the totality of black experience. At pains to avoid accusations that he was a "separatist" in cultural matters, Andrews simply tried to stake a claim for long-neglected black artists.

Ever the committed artist, Benny Andrews has also devoted time to various prison art programs and was an instructor in the SEEK program for disadvantaged students at Queens College, Flushing, New York. Among Andrews's many exhibitions, each of which usually centered on a single theme, was a large show at the Studio Museum, in Harlem, New York City, in 1971, entitled "Symbols." It was described by one critic as Andrews's "exploration of his own past," which was "the past of every country boy—black or poor white—in the land." Andrews's work evoked not only "the acid quality of exploitation, human abuse, and hardship" of the sharecropper system in the South, but also "the love that brought us through those years."

Malcolm Preston, reviewing Andrews's exhibition at the Robley Gallery, Roslyn, Long Island, in December 1971, praised the "strength, urgency, and immediacy" of his style, in which "stark, neo-realist images are often combined with collage." Preston also observed that "several of the paintings have a softer, more lyrical mood than others." This lyricism is particularly noticeable in Andrews's line drawings and mixed-media works on paper, which are delicate and contain elements of fantasy along with a wryly humorous or poignant human content. The drawings on paper are more intimate and personalized than the forceful, emotionally charged "public" utterances of his large canvases.

The tragic killings of inmates and guards at New York's Attica State Prison in 1971 were among the sources of a series of large-scale allegorical paintings and drawings which culminated in the 10-by-28-foot canvas entitled *Trash*. Exhibited along with its many preliminary studies at the A.C.A Gallery, New York City, in 1972, *Trash* was described in the show catalog as "a global comment on the expression of anti-human ideas and the creation of death-dealing instruments throughout the world." Catalog author Edmund B. Gaither went on to describe Andrews's depiction of a kind of train bearing figures and objects symbolizing "false religion plus sexism plus militarism plus false democracy" and "being towed by two human pullers towards a cosmic junkyard."

James R. Mellow, in *The New York Times* (May 5, 1973), called Andrews "an artist for whom ideas rather than formal subtleties pro-

vide the real urgencies of his work." Mellow found Andrews's third large allegorical painting, *Circle*, exhibited along with its related oil-studies and drawings at the A.C.A. Gallery in May 1973, "leaner and more graphic" than *Trash*. He interpreted *Circle* as being about "the vicious circle of white myths about the black man." A key image in the picture was that of a black man "stretched out in crucified form on a rundown bed," with "a slice of watermelon where his heart should be." Meanwhile, a somewhat surreal bird of ill-omen "made of a draped cloth and a stove-pipe" circles above. Mellow felt that the drawing did not always escape the "visual clichés of social-significance painting of the 1930s" and that the use of collage was perhaps too literal, but he added that Andrews "manages to overcome these formal limitations by the sheer force of his convictions." He noted that Andrews's painting "hints at a more complicated, more personal and mysterious imagery" than its content of social commentary might seem to allow.

Andrews visualized these mural-sized paintings as part of an ambitious "Bicentennial Series"—"a dissenting opinion on the Great American Dream," to quote the artist. They were made in sections, so their size would accommodate any gallery. The fourth allegorical picture, *Sexism*, was followed by *War*, exhibited at the A.C.A. Gallery in May 1975. "*War*," said Andrews in an interview in the *Christian Science Monitor*, "deplores the destruction of Vietnam and the horrors of all the wars fought by the United States." Contributing to the urgency of the theme were the artist's childhood memories of newspaper photos of bomb-devastated Europe during World War II, his own Air Force experiences in Korea in the early 1950s, and his reactions to the trauma of Vietnam.

War was the simplest, strongest, and most moving of Andrews's allegorical paintings. On the left, a young black soldier, dead, is sprawled on stark, simply drawn rocks. In the center an immense white space creates a powerful negative shape. On the right stands a grieving woman, gazing up at the empty sky as she leans against a boulder on which she casts an ominous black shadow.

In early 1976 Andrews exhibited, at the Lerner-Heller Gallery, New York City, studies on paper for *Utopia*, his sixth and final work in the Bicentennial Series. This large painting, which measured 10 feet by 20 feet and was conceived on what Andrews called "an optimistic note," was to express the hope "that all Americans can live and work together to make this nation one people." In the studies the symbolism was once

again imaginative and evocative rather than literal: the imagery included strange and exotic plant forms recalling Hieronymous Bosch's *Garden of Earthly Joys.*

Highly articulate as well as artistically productive, Benny Andrews has contributed art criticism to *Encore* magazine and been a guest lecturer at numerous colleges. He is the illustrator of *I Am the Darker Brother: An Anthology of Modern Poems by Negro Americans* (1968) and the author of *Between the Lines: Seventy Drawings and Seven Essays* (1978); a selection from his as-yet-unpublished autobiography, *My First Forty Years,* appeared in a then-new magazine, *Ataraxia* (Spring 1975), in a special issue devoted to the artist.

Andrews and his wife, the former Mary Ellen Jones Smith, a professional photographer whom he married in Chicago on April 3, 1957, live in Westbeth, in downtown Manhattan, where they maintain seperate studios. They have three children, Christopher, Thomas Michael, and Julia Rachael. Andrews has noted, with some humor, that his parents' large family reflects the "whole black spectrum" in politics and skin color. His mother lives in Atlanta but often attends her son's openings in New York. One brother, Raymond, is a writer whose novel *Appalachee Red* (1978) contains illustrations by Benny; another brother is a Black Muslim.

EXHIBITIONS INCLUDE: Paul Kessler Gal., Provincetown, Mass. 1960–70; Forum Gal., NYC 1962, '64, '66; Studio Mus., Harlem, NYC 1971; Robley Gal., Roslyn, L.I. 1971; A.C.A. Gal., NYC 1972–75; Lerner-Heller Gal., NYC 1976.

COLLECTIONS INCLUDE: Detroit Inst. of Arts; MOMA, NYC; Mus. of African Art, Washington, D.C.; Butler Inst. of Am. Art, Youngstown, Ohio; Chrysler Mus., Provincetown, Mass.; Norfolk Mus., Va.; High Mus., Atlanta, Ga.; Bridgeport Mus., Conn.; Stout State Univ., Menomonie, Wisc.; Slater Memorial Mus., Norwich, Conn.; La Jolla Mus., Calif.; Joslyn Art Mus., Omaha, Nebr.; Univ. of Kansas, Lawrence.

ABOUT: Andrews, B. Between the Lines: Seventy Drawings and Seven Essays, 1978; Gaither, E. B. "Benny Andrews" (cat.), A.C.A. Gal., NYC, 1972. *Periodicals*—Ataraxia (Madison, Ga.) Spring 1975; Atlanta Journal-Constitution August 1, 1965; Christian Science Monitor May 6, 1975; New York Post January 8, 1973; New York Times May 15, 1969, January 21, 1970, January 31, 1971, December 16, 1971, May 5, 1973; Oakland Tribune (California) August 30, 1969.

ANUSZKIEWICZ, RICHARD (JOSEPH) (May 23, 1930–), American painter, came into prominence during the op art movement of the early 1960s as a purveyor of dazzling and disorienting coloristic effects. He was born in Erie, Pennsylvania, to Adam Jacob and Victoria Ann (Jankowski) Anuszkiewicz. His parents were immigrants from Poland who met after they had settled in Pennsylvania. His father was employed as a skilled worker in an Erie paper mill. By an earlier marriage of his mother, Richard had a half-sister and four half-brothers, all much older than he.

In a conversation with the art critic Gene Baro, printed in the catalog to the painter's 1975 exhibition at the Andrew Crispo Gallery, New York City, Anuszkiewicz recalled that he "wanted to be an artist from the first." His father brought home from his factory colored papers and pads on which Richard made innumerable drawings. In the parochial grade school to which he was sent, the nuns recognized his talent and allowed him special privileges. As he told John Gruen in an *Art News* (September 1979) interview, "I really had a very happy childhood and never wanted anything. Even though we lived through the Depression, I never felt it. I had companionship, affection—all the good things. . . I think I was born a hard-edge artist, because I would put strong black outlines around even my littlest drawings."

After grade school, Anuszkiewicz attended Cathedral Prep, a Catholic high school. He was unhappy there, and after two months he persuaded his parents to let him transfer to Erie Technical High, a vocational school where his formal artistic training began. His teacher was Joseph Plavcan, a professional painter who gave his students a thorough grounding in the basics of drawing and painting and introduced them to the impressionist and other theories of color. Plavcan was interested in American provincial art, and under his influence Anuszkiewicz painted in watercolors scenes reminiscent of the Ash Can School, social realism, and the work of painters such as Charles Burchfield and Edward Hopper. His earliest pictures were of Erie, his home town; *From My Kitchen Window,* painted in 1945, was his first watercolor. Another townscape of his high school years was *Bonfire* (1946).

In his last year of high school, Anuszkiewicz won a scholarship to the Cleveland Institute of Art, which he entered in 1948 at the age of 18. He claims that the instructors during the five years he spent there had little influence on him, but it was at this time that he was first exposed to real paintings. He saw a Van Gogh exhibition at the Cleveland Museum, and often visited that museum's collection. In his own work he contin-

°ä´´ nōōs´ Kə vich

RICHARD ANUSZKIEWICZ

ued to develop as "a sort of Midwest regional painter," as he told Grace Glueck of *The New York Times* (February 21, 1965). There were still echoes of Burchfield and Hopper in *Negro Wedding* (1949) and *The Bridge* (1950). However, two paintings of 1951, *Six Altar Boys at Sanctus* and *Eight Windows,* already indicated a tendency toward abstraction in the arrangement of forms.

In 1953 Anuszkiewicz was awarded his Bachelor of Fine Arts degree from the Cleveland Institute, and won a Pulitzer Traveling Fellowship which gave him a stipend of $1,500. He could have gone abroad with the money, but decided to stay in America. Not ready for New York, he enrolled in the Yale University School of Art and Architecture to study with Josef Albers, whose explorations of optical phenomena in geometric color configurations made him a forerunner of op art. Although Albers was a formative influence on his work, Anuszkiewicz admitted to Gruen that he was probably Albers's worst student. "The fact is, Albers had a very strong, hard, dogmatic personality. . . . He wasn't willing to compromise his ideas in any way." Albers was a stern taskmaster who would deliberately upset his students in order to make them think, but he had, as Anuszkiewicz admits, "a marvelous eye for the way shape, color, and line interrelated." After being exposed to Albers's theories of color, Anuszkiewicz extrapolated from them for his master's thesis, "A Study in the Creation of Space in Line Drawing." In writing his thesis he was also influenced by Rudolf Arnheim's book *Art and Visual Perception,* and by Albers's discussions of the color of Cézanne and

Paul Klee. Describing his own work during his two years at Yale, Anuszkiewicz recalled: "I was beginning to paint semi-abstractly, although I couldn't really free myself from realism." Taking advantage of Yale's proximity to New York, he visited Manhattan's museums and galleries on weekends, and looked at the Abstract Expressionists, as well as at the later work of Matisse, Picasso, and Stuart Davis.

Although he was already 25, Anuszkiewicz still did not feel ready to move to New York. When he left Yale with an MFA in 1955, he went back to Cleveland, but felt out of place there and unsure of his direction. Deciding that he needed more academic study, he enrolled at Kent State University, Ohio, to work for a BS in education, which he received in 1956. At Kent State he continued to paint, and in 1955 had his first solo show, a the Butler Institute of America Art, Youngstown, Ohio. He had intended to apply what he had learned at Yale to realism, but found that "instead of continuing to paint realistically, I severed it completely and began to paint abstractly—just like that!" While at Yale he had found Albers's ego so strong that, as he admitted to Grace Glueck, "I struggled to preserve what I already had." Now, with Albers no longer a threat, he could do as he pleased, "and what I apparently wanted to do was to go completely abstract." He felt that the complementary use of color that he had studied in Cézanne, Seurat, Klee, the Fauves, Stuart Davis, and Robert and Sonia Delaunay could become a subject matter in its own right.

In 1957 Anuszkiewicz finally moved to New York City, where he worked for a time at the Metropolitan Museum of Art cleaning and restoring architectural models for the newly opened Junior Museum. All the while he continued to paint. His earliest optical paintings—the term did not yet exist—were two-color, or, less frequently, three-color experiments with figure-ground relationships. In *On Blue* and *Green on Red,* both painted in 1957, irregular forms roamed at random over the entire canvas. These and other works of this type were influenced by abstract expressionism, although his painting, as it subsequently developed, was, like op art itself, a reaction against abstract expressionism and the Pollock-de Kooning branch of action painting. In 1958 he took his canvases round to Samuel Kootz, Sidney Janis, Martha Jackson, and other gallery owners who were open to avant-garde painting, but nothing happened.

He decided to make a trip abroad, and in 1958 he and two friends traveled for six months in Europe and North Africa, visiting France, Italy, Spain, and Germany, camping out as often as

possible. Anuszkiewicz was deeply affected by seeing Europe's great architecture and art treasures, including Chartres and Cologne cathedrals and the cave paintings in Spain, finding the experience very different from looking at slides in classrooms.

Upon his return to New York City, Anuszkiewicz found a job with Tiffany and Company, designing miniature silver animals. He stayed with Tiffany a year and a half. At this time he met a young grade school teacher, Elizabeth (Sally) Feeney, whom he married on November 26, 1960. They have three children, Adam, Stephanie, and Christine.

At the age of 30 Anuszkiewicz was still without a gallery, but Karl Lunde, director of The Contemporaries gallery, New York City, happened to see some of his paintings hanging in the office of one of the artist's friends and immediately contacted Anuszkiewicz, offering him a solo show. A typical painting of 1960, *Plus Reversed*, is one of several color-mix pictures in which many shapes, sometimes regular, sometimes irregular, tended to congregate toward the center of a square canvas, producing a dazzling purely "retinal" impact.

The exhibit at The Contemporaries was intended to be a three-week show, but a review by Stuart Preston in *The New York Times* (March 5, 1960) called the work "eye-shattering and difficult to look at." After two weeks there were no sales, and the owner of the gallery told Lunde to take the show down. Lunde stalled; on the Saturday of the second week someone bought a painting. An hour later Alfred H. Barr, director of collections of the Museum of Modern Art, bought one painting for the museum and another for Nelson Rockefeller. In Anuszkiewicz's words, "That did it. Things began moving from then on."

Anuszkiewicz continued his chromatic experiments in 1961. In *Knowledge and Disappearance* he used a pattern of squares and rectangles to produce an illusion of depth, and a pattern of concentrated circular lines in *Water from the Rock* (1961–62) to create the illusion of advancing and receding forms. His second show at The Contemporaries, held in 1961, received the somewhat grudging approval of reviewers. The New York *Herald Tribune* critic wrote, "Few of his designs, which are fascinating superficially, are more than tasteful, semicommercial applications, such as excellent designs for tiles or floor-coverings." In *The New York Times* (April 2, 1961), Stuart Preston observed that Anuszkiewicz's method "could be a tedious optical trick, were it not for this artist's composing patterns of appealing liveliness and variety."

Real success and recognition came after Anuszkiewicz was included in the Museum of Modern Art's "Recent Acquisitions" show of 1963, which led to his being the subject of a major article in *Time* magazine. "When that happened," the artist told John Gruen, "I sold 17 paintings in one month!" By late 1964 he had joined the prestigious Sidney Janis Gallery, and his inclusion in MOMA's seminal group show, "The Responsive Eye," organized by William C. Seitz in 1965, further established him as "one of the New Wizards of Op," to quote *Life* magazine.

From 1963 to 1965 Anuszkiewicz taught at Cooper Union in lower Manhattan. He was artist-in-residence at Dartmouth College in 1967 and visiting artist at the University of Wisconsin, Cornell University, and Kent State University in 1968.

Although op as an art movement proved to be a relatively transient phenomenon, Anuszkiewicz has held fast to his vision, and continues to develop and enrich his work. Beginning with *Unit* in 1966, he painted a series of black and white paintings that used a grid pattern to create spatial illusion. In 1967 he translated his ideas into optical sculpture by producing three-dimensional cubes of enamel on plywood, some of which, including *Convex and Concave: I Dimension* and *Sectional,* he set on a mirrored base. In his color canvases he expanded his palette with a greater variety of warm and cool hues, achieving a greater subtlety of chromatic vibration, as evidenced in the glowing acrylic squares of *Moonbow* (1968), *Orange Delight* (1969), and *Sun Game* (1970). John Canaday, reviewing the artist's 1969 exhibit at the Sidney Janis Gallery in *The New York Times* (April 5, 1969), observed that, because Anuszkiewicz's paintings were "works of art created entirely by calculation" and were "executed with mechanical precision," this contradicted Canaday's own belief that "no painting of real interest can be produced entirely by rule." Canaday was baffled by the fact that despite this contradiction he found the paintings to be "really beautiful."

By the early 1970s op art had had its day, and for some years the artists who had given the movement its initial momentum, including Anuszkiewicz and the British painter Bridget Riley, suffered what some felt to be an undeserved eclipse. Anuszkiewicz, though somewhat bitter at this "betrayal" by American critics, did not abandon his vision or adopt a trendier style. In 1975 he left Janis and moved to the Andrew Crispo Gallery. Commenting on his show of 30 new acrylic paintings held there in 1975, Louis Chapin wrote in *Art News* (May 1975): "Anuszkiewicz now embroiders solid colors with

stripes that change hue fractionally and look like gradations from a slide rule. The effect is to return the eye to the color field and so to deepen and invigorate this field that it seems to be producing light rather than reflecting it." The artist created these pencil-thin stripes by laying drafting tape, which is sold in precise widths, in a diagonal or polar radial pattern over one field of intense color. He then painted one or more additional colors directly over the tape, then stripped the tape away to reveal the first color underneath. The result, especially when Anuszkiewicz used a pattern of "rays," recalling traditional depictions of the sun with emanating lines of warmth, was indeed an image of pulsating, radiant color.

In addition to his canvases, Anuszkiewicz produced many prints and lithographs in the 1960s and '70s. He sometimes applied certain techniques of op art to commercial designs, as were an increasing number of other designers. By the mid '60s he was using polka dots or diverging and converging lines in designs of fur coats, stockings, packages, wall hangings, and rugs. He also designed ceramic-tile coasters, commissioned by *Art in America,* and in 1970 he created *Centum,* a multiple of one hundred porcelain-enamel tiles, for Abrams Original Editions. In the early 1970s he designed exterior murals for a YMCA building in New York City and an office building in New Jersey. In the *Centum* project and the exterior murals, Anuszkiewicz closely supervised the skilled craftsmen whose actually did the work, as he does the assistants who help him on his canvases. He considers his painting to be architectural in technique as well as in structure, since each picture develops from a carefully prepared plan.

Richard Anuszkiewicz, who lives and has his studio in Englewood, New Jersey, has been described by John Gruen as "a tall, heavyset man with short-cropped blond hair and piercing light blue eyes." Gruen added: "A shy demeanor masks drive, ambition, insecurity, and a certain aggresiveness." Karl Lunde, in his comprehensive 1977 study of the artist, noted that "his conversation is highly abstract, and his restlessness and search for variety drive him to pace the floor when he is alone or to jump into his car impulsively and drive for hours." However, "he enjoys all kinds of art and music, people, and experience." He is also an accomplished cook, specializing in salads, and his recipes are included in the *Museum of Modern Art Artists' Cookbook* (1977).

Anuszkiewicz remarked to Gruen in 1979: "I feel that I've made a major contribution to the history of color—not in the sense of Op Art, but as a continuing esthetic idea in art history." He has developed his retinal kineticism beyond the "dazzle" stage of the early '60s to a more luminous and subtly vibrating imagery that has been likened to musical cadence. He told Grace Glueck, "I really love color. I try to manipulate it in schemes that give the viewer a particular feeling of enchantment. If you want to call it emotion, that's fine."

EXHIBITIONS INCLUDE: Butler Inst. of Am. Art, Youngstown, Ohio 1955; The Contemporaries, NYC 1960, '61, '63; Sidney Janis Gal., NYC 1965–75; Cleveland Mus. of Art 1966; Hopkins Art Center, Dartmouth Col., Hanover, N.H. 1967; J. L. Hudson Gal., Detroit 1968, '71; De Cordova and Dana Mus. and Park, Lincoln, Mass. 1972; Andrew Crispo Gal., NYC 1974, '75. GROUP EXHIBITIONS INCLUDE: "Geometric Abstraction in America," Whitney Mus. of Am. Art, NYC 1962; "Americans 1963," MOMA, NYC 1963; "Formalists," Gal. of Modern Art, Washington, D.C. 1963; Annual, Whitney Mus. of Am. Art, NYC 1963–72; Pittsburgh International, Carnegie Inst. 1964, '67, '70; "The Responsive Eye," MOMA, NYC 1965; "Plus by Minus: Today's Half-Century," Albright-Knox Art Gal., Buffalo, N.Y. 1968; Documenta 4, Kassel, W. Ger. 1968; "Exposition-Position," Gal. Denise René, Paris 1969; "The Structure of Color," Whitney Mus. of Am. Art, NYC 1971; Biennale, Corcoran Gal. of Art, Washington, D.C. 1975.

COLLECTIONS INCLUDE: MOMA, NYC; Albright-Knox Art Gal., Buffalo, N.Y.; Newark Mus. Association, N. J.; Rhode Island School of Design, Providence; Yale Univ. Art Gal., New Haven, Conn.; Fogg Art Mus., Harvard Univ., Cambridge, Mass.; Philadelphia Mus. of Art, and Pennsylvania Academy of Fine Arts, Philadelphia; Carnegie Inst., Pittsburgh; Smithsonian Inst., Corcoran Gal. of Art, and Hirshhorn Mus. and Sculpture Garden, Washington, D.C.; Fort Lauderdale Mus. of the Arts, Fla.; City Art Mus., St. Louis, Mo.; Detroit Inst. of Arts, Flint Inst. of Arts, Mich.; San Francisco Mus. of Art.

ABOUT: Arnason, H. H. History of Modern Art, 1968; Baro, G. "Richard Anuszkiewicz" (cat.), Andrew Crispo Gal., NYC, 1975; Barrett, C. Op Art, 1970; Battcock, G. The New Art: A Critical Anthology, 1966; Current Biography, 1978; Elsen, A. E. Purposes of Art, 1967; Geldzahler, H. "New York Painting and Sculpture 1940–1970" (cat.), Metropolitan Mus. of Art, NYC, 1969; Lucie-Smith, E. Late Modern: The Visual Arts Since 1945, 1969; Lunde, K. Anuszkiewicz, 1977; Miller, D. (ed.) "Americans 1963" (cat.), MOMA, NYC, 1963; Parola, R. Optical Art: Theory and Practice, 1969; Seitz, W. H. (ed.) "The Responsive Eye" (cat.), MOMA, NYC, 1965. *Periodicals*—Art in America March 1970, January 1971; Art News May 1975, November 1976, September 1979; Arts December 1963; New York Herald Tribune April 8, 1961; Life December 11, 1964; New York Times March 5, 1960, April 2, 1961, February 21, 1965, April 5, 1969.

*APPEL, KAREL (April 25, 1921–), Dutch painter, was a leader of the influential Cobra group and a pioneer of action painting in post–World War II Europe.

He was born in Amsterdam, the son of a barber, and grew up near the Amsterdam docks. Appel worked in his father's barbershop until the age of 18, when he left home to become an artist. He wandered restlessly, taking to the road for long periods, and at one time found himself among the Belgian miners of the Borinage region, where Van Gogh had once lived.

In 1940 Appel won a scholarship to the Royal Academy of Fine Arts, Amsterdam, where he studied until 1943. He was interested in impressionism. Picasso, the School of Paris, and primitive art, and his early painting showed the influence of Picasso and Matisse. After the liberation of the Netherlands in 1945, Appel, reacting against the isolation and the stifling, oppressive atmosphere of the years of German occupation, discovered Dubuffet and *art brut,* whose raw power and primordial energies freed the artist from the more restrained influence of the School of Paris. He first aroused public interest in 1946, when he exhibited in a show of young painters from the Low Countries at Amsterdam's Stedelijk Museum. Also that year Appel held his first solo show, in Groningen, the Netherlands; his second solo show was at the Guildhall of Amsterdam in 1947, and his third came in 1948 at the Santee Landweer Gallery in the same city.

By the late 1940s there was an active avantgarde movement in Holland. Appel met and exhibited with the Dutch painter Corneille in Amsterdam, and in 1948 was one of the founder of the Experimental Group. These artists, who included Corneille and the Belgian Pierre Alechinsky, were opposed to the geometric and traditional in modern Dutch art as exemplified by Mondrian and de Stijl. Later in 1948, in Paris, they founded the international Cobra group (an acronym formed from Copenhagen, Brussels, and Amsterdam, the native cities of the group's members). Appel's closest colleagues in this group of expressive abstractionists were Corneille, Alechinsky, Constant, and Asger Jorn. The group held exhibitions and published a review, to which Appel often contributed. The painter Constant said in the *Cobra Review:* "Our desire is what makes revolution." In a manifesto published in 1948 in *Reflex,* another avantgarde review, the Dutch painters declared: "A picture is no longer merely a construction of colors and lines, but an animal, a night, a scream, a human being, or all together." The members of Cobra sought absolute spontaneity, and found their inspiration in folk art, in the primitivism of sketches by children, in prehistoric art, and in

KAREL APPEL

the mythopoeic element of old Viking and Eskimo art. Glorifying instinct, they were averse to the so-called cultural, or mannered and rigorously intellectual, approach to art—hence their affinity with action painters of the New York School and their repudiation of constructivism, with its emphasis on Platonic order and beauty. Though hostile to geometric abstraction, Cobra artists were receptive to figuration, which they often included in their spontaneous expressions of subconscious fantasy; for example, several of Appel's painting are noted for the looks of terror on faces which can be made out in the violent swirl of colors.

Appel's work in the late '40s, with its humorous and crude imagery and strongly expressionist tendencies, recalled the *art brut* of Dubuffet. In 1949 he was commissioned to paint a mural for the cafeteria of the Amsterdam city hall. The mural, entitled *Questioning Children,* provoked an uproar and received international publicity when lunching civil servants complained that it upset their digestion and hurled pats of butter at it. The mural was eventually covered over with whitewash by order of the local art commission, despite the loud protests of yonger artists and their supporters. It had, however, impressed influential members of the Dutch art world, who realized that this was the work of a painter to be reckoned with.

The burly, uninhibited Appel enjoyed, and even welcomed, the storm of controversy aroused by his work. He reveled in the role of "barbarian bohemian," a persona that was heightened some years later when a Dutch filmmaker persuaded Appel to throw paint and

°äp´el

grunt, growl, and shriek before a camera stationed behind one of his canvases. The result was a larger-than-life look at the artist in action, and it earned him the nickname "painting beast." However, art connoisseurs and Appel's friends insisted that the flamboyance was only outward, a façade, and that he was, in fact, warm, intelligent, and sensitive.

In 1950 Appel moved permanently to Paris, taking quarters in the rue Santeuil, over a tannery, and living the life of a struggling Left Bank painter. He continued to exhibit with the Cobra group in Paris, and in 1951 took part in the second international Cobra exhibition of experimental art in Liège, Belgium. That same year he was introduced to the avant-garde art critic Michael Tapié, whose articles on Appel helped to win the artist an international reputation. Until then he had been known but not honored by the public in the Netherlands, but his prestige grew after the Palais des Beaux-Arts, Brussels, gave him his first major solo exhibition, in 1953, and especially after he was awarded the UNESCO prize at the Venice Biennale of 1954. This was an eventful year for Appel; Tapié organized a solo exhibition at the Studio Paul Fachetti, Paris, and Martha Jackson mounted his first American solo show in her New York City gallery, one well known for its support of avant-garde art.

As recognition of his art spread, Appel increasingly received mural commissions in Holland. In 1955 he executed in Rotterdam a wall painting on the exterior of an exhibition building designed by the noted architect Bakema. Entitled *The Wall of Energy*, it was painted on brick, extending more than one hundred yards on the facade of the building. In 1956 the Stedelijk Museum, Amsterdam, commissioned a second mural from him (the first had been painted in 1951 for the lobby of the auditorium). In both Stedelijk Museum murals, architectural elements, including doors, ceiling, and balcony, were incorporated into the composition and the overall color scheme. Appel said of his mural painting: "As a specialist in form and color in his own right, the painter should collaborate with the architect in the early stages of design . . . in order to intensify the design of the individual space." Thus, he concluded, "the painter will help to make the structure more dynamic and individual."

Despite these and other successes in his native land. Appel continued to live in Paris, claiming he could not stand Holland for more than two or three days at a time. In the mid-'50s he married a Dutch fashion model named Machteld.

In 1957 Appel made his first visit to the United States and Mexico. He had long been a jazz enthusiast, and while in New York City he painted portraits of Sarah Vaughan and Dizzy Gillespie.

For Appel, painting was a battle, an explosion, an adventure, "a constant struggle with oneself," and he called the style generated by his thick impasto and his feverish attack on the canvas "boff!" Like his fellow Dutchman Willem de Kooning, who had been living in America since 1926, Appel retained figural elements within a generally abstract-expressionist idiom. Years later, reflecting on the evolution of his style and the influence of American culture, he wrote: "First I painted man full of expression. The canvas filled to the edges, thick with paint. Later I discoverd space, spatial dimensions and later the void—the empty space in which I dynamically moved paint, action in space (people-landscapes). Then I worked from wet white as a space-background, the unfinished space which I became familiar with in New York—where one tears down and builds up. In the interim man lives. Now I deal with total space, in which I depict man infused with dramatic power."

There was indeed a change in emphasis from the totemic compression and concentration of *Two Heads* (1953; Guggenheim Museum, New York City) to the free-wheeling energy of such vehement action paintings as *Woman and Birds* and *Beach Life,* both of 1958 (the latter painting is now in the Hirshhorn Museum and Sculpture Garden, Washington, D.C.). The colors are raw, vivid, and applied in heavy, swirling brushstrokes. Appel has always said that he is interested in force, not theories of aesthetics. "My painting tube is like a rocket which describes its own space," he declared in 1975.

In the late 1950s there were further public commissions, including a mural executed in 1958 for the restaurant walls of the UNESCO headquarters building in Paris. Appel was awarded the international prize for painting at the São Paulo Bienal of 1959, and was holding his fifth solo show at the Martha Jackson Gallery when he won the Guggenheim International Award in 1960. At 39 he was the youngest artist ever to have received that prize. The winning picture was a swirling composition in strident reds, yellows, and blues, with the paint laid on so thickly as to be virtually in relief. Its title was *Woman with Ostrich,* although to the untrained eye the subject was not readily discernible.

New York critics often discussed the relationship of Appel's work to American abstract expressionism and action painting. Kenneth B. Sawyer in his catalog introduction to Appel's 1960 exhibit at the Martha Jackson Gallery cal-

led the Dutch painter "the legitimate heir to northern expressionism," but noted that "his conception of painted space has altered subtly since his first visit to the United States in 1957." The English critic Herbert Read observed that Appel had found the world "Van Gogh was seeking, but did not find—the world of abstract expressionism." Read's highly debatable view was contested by Thomas B. Hess, who, indignant at any comparison of Appel with Van Gogh or the American Abstract Expressionists, wrote in Art News (October 1957): "It is certainly not hard to think of a hundred and fifty living artists whose works show a great deal more vitality than Appel's perfunctory gushes. . . . A comparison of this salon art with Van Gogh's emphasizes the level to which modern-art cant has been debased." In France many critics considered Appel "the most brilliant representative" of a deliberately "barbaric" expressionism.

Growing fame and prosperity enabled the artist in 1966 to acquire and renovate a beautiful castle in the village of Molesmes, near Auxerre, some 150 kilometers from Paris. The Château de Molesmes, whose ground included a farm and a chapel, provided Appel and his wife with a welcome retreat where, in its several large studios, he often worked day and night. "Here I am far from rumor mills, the petty jealousies, and can concentrate on work without playing the art game," he said.

However, Appel did not isolate himself from the outside world. During the May 1968 student–worker uprisings in Paris, he joined with other artists in creating original works to help the students raise money to support their rebellion. Appel's contribution was a lithograph showing a blue-eyed student as the victim of police brutality. The caption read: "Dans l'action ils ont montré la source de leur beauté" (In action they showed the source of their beauty). In 1968–69 Appel carried his ideas into the third dimension with a series of very large relief sculptures in painted wood (early in his career he had experimented with painting bundles of wood). These were exhibited in museum in Paris, Brussels, Amsterdam, and Basel. A lively group of works in a similar vein were his so-called "monsters" in relief form, shaped from polyester materials and garishly painted in bright, clashing colors. During a visit to the US in 1971, Appel made a number of large-scale sculptures in polychromed aluminum, and the following year there was a major exhibition of his wood sculptures at the Musée d'Art Contemporain, Montreal. "The use of new materials such a polystyrene allowed him [Appel] more freedom of form," R. W.D. Oxenaar commented in Contemporary Art 1942–72, "but the style of his painting [after

about 1965] became more formalized, with some traces of Pop art."

EXHIBITIONS INCLUDE: Beerenhuis, Groningen, Neth. 1946; Guildhall, Amsterdam 1947; Santee landweer, Amsterdam 1948; Palais des Beaux-Arts, Brussels 1953; Studio Paul Facchetti, Paris 1954; Martha Jackson Gal., NYC from 1954; Gimpel Fils, London 1959–62; West Coast tour organized by Pasadena Art Mus., Calif., and Esther-Robles Gal., Los Angeles 1961–62; Gimpel and Hanover Gal., Zürich 1963–64; Stedelijk Mus., Amsterdam 1965; Centre Nat. d'Art Contemporain, Paris 1968; Gemeente Mus., The Hague 1969; Gal. Schubert, Milan 1971; Mus. d'Art Contemporain, Montreal 1972–73; Aberbach Fine Art, NYC 1975. GROUP EXHIBITIONS INCLUDE: Cobra exhibition Stedelijk Mus., Amsterdam 1949; Salon de Mai, Paris 1949–57; Librairie 73, Paris 1950; Gal. Pierre, Paris 1951; Mus. des Beaux-Arts de la Ville de Liège, Belgium 1951; Pittsburgh International, Carnegie Inst. 1952–67; São Paulo Bienal 1953, '59; Venice Biennale 1954; "Younger European Painters," Solomon R. Guggenheim Mus., NYC 1954; "The New Decade," MOMA, NYC 1955; Documenta 2 and 3, Kassel, W. Ger. 1959, '64; "New Images of Man," MOMA, NYC 1959–60; "New Images of Man," Baltimore Mus. of Art 1959–60; "Dutch Artists of the Twentieth Century." Stedelijk Mus., Amsterdam 1962; "40 Key Artists of the Mid 20th Century," Detroit Inst. of Arts 1965; "Painting and Sculpture Today," Indianapolis Mus. of Art 1970.

COLLECTIONS INCLUDE: Stedelijk Mus., Amsterdam; Boymans-Van Beuningen Mus., Rotterdam; Frans Hals Mus., Haarlem, the Neth.; Koninklijke Mus. voor Schone Kunsten, Antwerp, Belgium; Mus. Royal des Beaux-Arts, Brussels; Mus. des Beaux-Arts, Liège, Belgium; Nat. Mus., Copenhagen; Tate Gal., London; Centre Nat. d'Art Contemporain, Paris; Kunstmus., Zürich; Mus. of Fine Arts, Boston; Albright-Knox Art Gal., Buffalo, N.Y.; Walker Art Center, Minneapolis, Carnegie Inst., Pittsburgh; Solomon R. Guggenheim Mus., and MOMA, NYC; Hirshhorn Mus. and Sculpture Garden, Washington, D. C.; Mus. de Bellas Artes, Caracas.

ABOUT: "Karel Appel" (cat.), Aberbach Fine Art, NYC, 1975; Bellew, P. Karen Appel 1943–1967, 1967; Claus, H. and others Appel, 1962; Current Biography, 1961; Dotremont, C. Appel, 1950; Lucie-Smith, E. Late Modern: The Visual Arts Since 1945, 1974; Moore, E. (ed.) Contemporary Art 1942–72: Collection of the Albright-Knox Art Gallery, 1972; Pellegrini, A. New Tendencies in Art, 1966; Sawyer, K. B. "Karel Appel" (cat.), Martha Jackson Gal., NYC, 1960; Tapié, M. Un Art autre, 1952. Periodicals—Art News October 1957; Holland Herald no. 8 1977; Newsday November 2, 1960; Time December 7, 1959.

ARMITAGE, KENNETH (July 18, 1916–), British sculptor, is, like the two leading British sculptors of the previous generation, Henry Moore and Barbara Hepworth, a native of York-

Jorge Lewinski

KENNETH ARMITAGE

shire. His father had started as an office boy in Bradford and ended up as director of an oil firm in Leeds. His mother was Irish, and Kenneth spent every childhood summer at her country birthplace in County Longford. He recalled: "The contrast between industrial Leeds and rural Lackan, especially over half a century ago, was startling, and the times at Lackan so wildly happy, it has haunted me ever since."

At home and at school Kenneth drew constantly. In practical Yorkshire, art was suspect, especially in the grim 1930s when unemployment was rife, but a sympathetic art teacher persuaded his parents to let him pursue what seemed to them a futile obsession. In 1934, at the age of 18, he went to the Leeds College of Art, where Moore had studied 15 years earlier, then on a scholarship enrolled in 1937 in the Slade School of Fine Arts, London. During his two years at the Slade he began the serious study of sculpture. His first stone carvings were strongly influenced by the Egyptian and Cycladic sculptures he saw in the British Museum; his central theme from the beginning was the human figure. Like Moore he preferred direct carving in stone, although he later worked in clay or plaster to be cast in bronze.

From 1939 to 1946 Armitage served in the British Army, as a trainer in aircraft and tank identification. After the war he decided to give up carving, which he now found "restricted, closed in." He wanted to discover a way of "extending forms," and this led him to the flat, screenlike style which first gained him recognition.

Armitage taught sculpture for ten years (1946–1956) at the Bath Academy of Art in Corsham, Wiltshire. His colleague there was the painter William Scott, who became a close friend. In the '50s there was a strong artistic affinity between their work, especially in their flat, soft, rectangular interpretation of the female torso. Armitage did not begin to exhibit until 1952, when he was 36. This comparatively late start was due partly to the six years spent in the army, partly to modesty. He did not wish his work to appear in public before he felt sure about what he was doing.

The immediate success of his first exhibition at Gimpel Fils, London, in 1952 was well worth waiting for. By that time Armitage's chosen medium was cast bronze. Whatever his earlier indebtedness to Moore, the younger sculptor's originality was at once apparent in such works as *People in a Wind* and *People Going for a Walk* (both 1951), and *Seated Group Listening to Music* (1952). In the catalog to a 1974 Armitage exhibition in Tokyo, Yoshiaki Inui compared Armitage's approach to that of Moore: "The most expressive element in Moore's representative series of works, 'Mother and Child' or 'Reclining Figures,' is their overwhelming sense of volume which gives the impression that the sculpture is rooted in the earth." Inui pointed out that in sharp contrast to Moore's organic mass, "Armitage's essential is structure," which gives order to the entire form. In Armitage's bronze groups of the early '50s "a curtain-like extended plane makes the central part of each structure. Out of the plane, twiggy limbs and small heads thrust out."

There was a refreshing lack of self-consciousness in these bronzes, more than half of which were of two or three figures linked together, a motif he had first introduced in 1949. The others were of single figures of girls. "I like sculpture to look as if it had happened," the artist wrote in 1955, "and to express an idea as simply as possible." Reviewing the Gimpel Fils show of 1952 in *Architectural Review,* Robert Melville wrote that "these free-standing, double-sided reliefs have a charm and loveableness which is rare in modern sculpture," though *Seated Group Listening to Music* possessed a "brooding, calamitous stillness." At the 1952 Venice Biennale, Armitage's work was prominently displayed in "New Aspects of British Sculpture," Britain's contribution to the Biennale. Other sculptors exhibiting were Robert Adams, Lynn Chadwick, Geoffrey Clarke, Bernard Meadows, Henry Moore, Eduardo Paolozzi, and William Turnbull.

Armitage continued to work in a similar vein in 1953, when he made one of the most spirited

of his smaller bronzes, *Children Playing*. Here the irregular, horizontal screen-form uniting the three little figures serves as a counterpoint to their lilting, resilient, up-and-down movement. In the artist's words: "I find most satisfying work which derives from careful study and preparation but which is fashioned in an attitude of pleasure and playfulness"; work "adapted to the idea of the moment, and carried out with the risk and tension of tightrope walking."

From 1953 to 1955 Armitage held a Gregory Fellowship in sculpture from the University of Leeds. His sculpture became more plastic and massive and somewhat less frontal, as in his bronze relief of 1954, *Reclining Figure*, but never deviated much from the horizontal and the vertical because, as he said, "we walk vertically and rest horizontally, and it is not easy to forget North, South, East, West, and up and down."

In 1954 Armitage had his first New York City solo exhibit, at the Bertha Schaefer Gallery. A second show there in 1956 provided the occasion for his first visit to the United States. Reviewing that show at Bertha Schaefer, *Arts* praised Armitage's semiabstract bronze figures, in which "a collective, as yet impersonal, humanity is merged together in one continuous body, from which delicate insect-like limbs and heads protrude like budding spores."

Many of Armitage's bronzes were highly formalized figures of girls resting on their backs, legs up in the air (as in *Roly-Poly*, 1955) or stretched out at right angles to their arms. The most striking of these figures was *Figure Lying on Its Side* of 1957, of which he made several versions. In 1972 Alan Bowness noted the sculptor's "constant emphasis on front and side views, rather than on total three-dimensional realization" in his treatment of the female torso. Bowness suggested that "this may derive unconsciously from his wartime experiences" with the silhouettes used for aircraft and tank identification. "The shape of the tank and its tracks, the thin horizontal line of its guns, all seem somehow reflected in the girls." A parallel can be found in the impact of the mechanized weaponry of World War I on the painting of Fernand Léger in the early 1920s.

Between 1955 and 1957 there was a change of emphasis in Armitage's technique. Plaster replaced clay as modeling material for a group of works which included *The Sentinels* and a model for a war memorial for the town of Krefeld, West Germany. For this monument he won first prize in an international competition held in 1956. Linked figures, such as *Diarchy* and *Triarchy*, produced in 1957, a prolific year for the artist, were more impersonal than his previous work: he was already thinking of projects on a much larger scale. His great success at the 1958 Venice Biennale, where he was represented with William Scott and Stanley William Hayter, made it possible for him to carry out such large-scale works. *Triarchy*, of which the final version, nine feet long, was completed in 1959, was by far the largest sculpture he had made. Bowness described the three linked figures as having "a remoteness, as if representing some ancient authority."

Triarchy marked the beginning of what has been called Armitage's "metaphorical sculpture," a phase which lasted until 1965. During these years the artist achieved a measure of public recognition. A large retrospective in 1959 at the Whitechapel Art Gallery, London, was followed by solo shows in 1960 in Germany and Scandinavia. The spirit of Armitage's 1960s work was very different from the compassionate, often whimsical character of his earlier bronzes; the change seemed to reflect unrest in the sculptor himself. According to Bowness, a new *Figure Lying on Its Back* (1961) displayed "an almost destructive violence in the treatment of the female form." He also described Armitage's series of "Prophets" and "Sybils" (1961–62) and a linked group of three "Guardians" and a "Monitor" (1961) as "rather empty, hollow figures that leave us strangely unmoved." The new figures, all symbols of superior authority, can perhaps be regarded as equivalents to T.S. Eliot's "hollow men."

All these sculptures have strange projecting flanges and funnels. The flanges were inspired, according to Armitage, by "a curious fungus in the form of flat, horizontal shelves growing out in clusters from the tree trunk," which he had seen many years before. He incorporated these forms in *The Sun*, a decorative project commissioned for the Château Mouton Rothschild near Bordeaux, France, on which he worked intermittently from 1961 to 1963. Ideas for this project were reflected in many other sculptures and drawings made at this time.

From 1963 to 1964 Armitage was guest artist in Caracas, Venezuela, a city in which he has many friends and to which he has returned several times. There he produced his series of figures of Pandarus, the unsavory, lascivious go-between in the medieval romance of Troilus and Cressida. "The orifices of the Pandarus figures," writes Bowness, "are ugly, threatening, dark; projecting out of an almost blank and featureless wall." Bowness detected a kind of self-probing anger in these disturbing bronzes.

In 1963 Armitage's work was included in an impressive exhibition in Darmstadt, West Ger-

many, entitled "Zeugnisse der Angst in der modernen Kunst" (Evidences of Anxiety in Modern Art). Anxiety is the animating emotion in much of Armitage's sculpture. Even in the lighthearted early bronzes Yoshiaki Inui perceived "a tragic 'basso continuo' played in a minor key," reflecting a world in which "man has lost his individual identity, and is buried under the wall-like surface"; his humanity is revealed only "by the thin, stiff limbs and tiny, projecting faces." Undoubtedly this tragic quality reached its climax in 1965 in *The Legend of Skadar,* inspired by an old Slavic folk song recorded by Alan Lomax. The song tells the story of a woman, chosen by lot, who was bricked up alive in the wall of a fortress to propitiate the gods who were preventing the building of a city. The man who had devised this barbaric scheme found to his horror that his own wife, who had just given birth, had been selected. A hole was left in the wall exposing her breasts, so that the child could be fed while she was still alive. In Armitage's fourth version of *The Legend of Skadar* the breasts, as one critic observed, "project piteously from the implacable flat surface of the wall, and in the sixth version the breasts have multiplied alarmingly as if to stress the savage eroticism of the story." In contrast to the gruesomeness of this theme, and of *The Forest* (1963), in which arms and legs reach out as if crying for help, at the same time Armitage embarked on a series of delightfully ribald and mischievous black-and-white illustrations for Chaucer's *Reve's Tale,* not yet published.

In the early 1960s Armitage, dissatisfied with bronze, began to experiment with painted surfaces and with wax as a modeling material. The gigantic *Arm* of 1967 was cast in fiberglass and polyester. *Arm,* a great, heavy, out-thrust fist over 12 feet long, bursts out of a square frame and is supported on a prop. It recalls the massive fragment, now in the British Museum, of a colossal statue of Rameses II, a piece that Armitage had long admired. *Arm* was made in Berlin, where Armitage was a guest artist from 1967 to 1969. When shown at the First International Exhibition of Modern Sculpture at the Hakone Open Air Museum in Japan in 1969, *Arm* dominated the exhibit.

Armitage was impressed by the precision with which German craftsmen carried out his sculptural ideas, and after his return from Berlin to England in 1969 (he was awarded a CBE that year), his work showed a considerable change. He concentrated on forms in the round, in a series of works in which parts of the human body were united with a table or a chair, and began to use drawing in conjunction with sculpture by mounting silkscreen and photographic images on simple shapes. In *Big Doll* (fiberglass, 1969), ingenuous eyes are drawn in black onto the smooth surface of the ovoid head. The head rests on cupped hands on two forearms—the figure is wittily reduced to these three elements—and the whole is supported by a wooden table. The piece's "relaxed pose and ovoid roundnesses," wrote W. J. Strachan in *Connoisseur* (July 1974), "create a feeling of complacency tinged with apprehension."

After a somewhat uncertain beginning, Armitage's new style, combining sculpture and drawing, asserted itself most effectively in such works as *Folding Screen* (1972), commissioned by Nottingham University. In *Folding Screen,* drawings of walking female nudes were silkscreened in black on four six-foot-high white plywood panels. Cutout arms and legs projected from the flat surfaces. Photographs taken during its display in 1973 in the Nottingham University Library convey the communication between the figures on the screen and the movement of the students passing by.

In other works of the same period, three-dimensional figures were set on bases in front of white background panels enlivened by a motif silkscreened in black (as in *Figures and Clouds,* 1972). In contrast to the solemnity of Armitage's "metaphorical" pieces of the 1960s, there is in these "sculpture-paintings" a very personal warmth and playfulness. The figures, though doll-like, have an appealing gamine quality. The small ensemble *Bernadette Going to Wales* (1972), in wood and plaster, is a lively example. Armitage also produced disturbing figures in three dimensions with a hollowed-out area where the head and face should be—"a clear, disillusioned image," to quote Inui, "of a hollow man maintaining only his surface."

Although government commissions for monumental sculpture are comparatively rare in Britain, Armitage was selected by the Department of the Environment to create a colossal piece for the Royal Marines training center in Lympstone, Devon. Consisting of two arms bent at right angles with clenched fists, *Both Arms* was hardly one of his most moving and intimate works; the real core of his sculpture, wrote Alan Bowness, resides in Armitage's "warm interest in people" and his "amused tolerance of the oddities and quirks of human behaviors."

In 1972–73 the British Arts Council organized a major retrospective of Armitage's work which toured several cities in England and Wales. In July 1974 seven sculptures in bronze or painted aluminium were shown along with a large group of etchings and drawings at the Kasahara Gallery in Osaka, Japan. Drawings have always

been important to him, he has said, not so much as preliminary studies for sculpture but as "a parallel, equal and continuous activity." The boldly summarized, dynamic forms of his lively "urchin" nudes, rendered in strong, black strokes, are like a running commentary on his work. A review in *Studio International* of Armitage's drawings at the Hester van Royen Gallery, London, praised their "humor and technical invention," and called them "a worthy counterpart to his best sculptural achievement."

Another recent project involved cooperation with the architects and designers of the New City developed by the Milton Keynes Development Corporation. The city includes the first permanent sculpture park in Britain, and a piece by Armitage was the first to be installed. *Kenneth Armitage*, a film, was produced and directed for the BBC by John Read in 1960.

Armitage was married in 1940 to Joan Augusta Munro Moore. They have been separated for many years; there are no children. The artist lives and works in a large studio in Avonmore Road, off the Kensington High Street. As with most sculptors, studio space is always in short supply as works accumulate in the rooms and in the small garden. A genial, exuberant man of robust build, Armitage has an unruly shock of gray hair and what has been described as a "lusty laugh." His warm, outgoing personality well matches the humanism of his work. Admitting that the minimal sculpture of some of his contemporaries "cleansed" the contemporary art scene, he nonetheless feels that figurative art poses more complex challenges. "For me to do nonobjective sculpture," he once said, "is like an escape." Even when his figures are highly abstract, he has managed, in the words of one critic, "to encapsulate human observation" within the context of his forms.

Armitage is reluctant to talk about himself or his work, leaving that task to critics. His achievement was eloquently summarized by Alan Bowness: "Kenneth Armitage's sculpture is about people. How a gesture will reveal an emotion. How people appear to us, how they react to our presence, how we can lose contact with them altogether. The sculpture may be playful in feeling; it may be painful. We may smile or turn away, almost in embarrassment. There is always a basic humanity, a concern for people on a very direct and forthright level that distinguishes Armitage's work from that of most sculptors today."

EXHIBITIONS INCLUDE: Gimpel Fils, London 1952, '57; Bertha Schaefer, NYC 1954, '56; Paul Rosenberg, NYC 1958, '62; Whitechapel Art Gal., London 1959; Kestner-Gesellschaft, Hanover, W. Ger. 1960; Marl-

borough Fine Art, London 1962, '65; Nottingham Univ. Library, England 1973; Hester van Royen Gal., London 1974; Kasahara Gal., Osaka, Japan 1974. GROUP EXHIBITIONS INCLUDE: Venice Biennale 1952, '58; Documenta 1, 2, and 3, Kassel, W. Ger. 1954, '59, '64; "The New Decade," MOMA, NYC 1955; "New Images of Man," MOMA, NYC 1959; Tokyo Biennale 1963; "Zeugnisse der Angst in der modernen Kunst," Darmstadt, W. Ger. 1963; "The English Eye," Marlborough-Gerson, NYC 1965; "British Sculpture in the Sixties," Tate Gal., London 1965; Sculpture International, Solomon R. Guggenheim Mus., NYC 1967; International Exhibition of Modern Sculpture, Hakone Open Air Mus., Japan 1969, '71; "24 English Sculptors," Burlington House, London 1971; Holland Park, London 1975.

ABOUT: Bowness, A. "Kenneth Armitage" (cat.), British Arts Council, London, 1972; Inui, Y. "Kenneth Armitage" (cat.), Kasahara Gal., Osaka, Japan, 1974; Lynton, N. Art in Progress, 1962; Penrose, R. Artists of Our Time, Kenneth Armitage, 1960; Spencer, C. Kenneth Armitage, 1973. *Periodicals*—Architectural Review March 1953; Art Digest March 15, 1954; Arts May 1956; Connoisseur July 1974; New York Herald Tribune April 1, 1956; Studio International July/August 1974.

***ARP, JEAN** (September 16, 1887–June 7, 1966), French sculptor, painter, graphic artist, and writer, was one of the most original and versatile artists of the modern movement in this century. His novel and boldy organic forms in various media have had an immense influence on the modern movement.

He was born Hans Arp in Strasbourg, in Alsace, which at that time belonged to Germany. His father, Pierre-Guillaume Arp, of Danish descent and a native of Schleswig-Holstein, operated a cigar and cigarette factory. His mother, Josephine (Koeberlé) Arp, was French. He had one brother, François. Hans grew up speaking three languages, German, French, and the Alsatian dialect, but, as for many Alsatians, the sympathies of his family were with France. Later, when asked by the American painter George L. K. Morris about his introduction to art, Arp recalled that in early childhood he drew with colored pencils, "in a huge book that looked like an accounting ledger," pictures of "unknown dream places." Years later, in one of his poems, he wrote, "It was in dreams that I learned how to write, and it was only much later that I laboriously learned how to read."

Despite young Arp's precocity, at school in Strasbourg he was a daydreamer, the "dream captain" of his later book of verse, *The Dream Captain's Log Book* (1965), who usually seemed to be "somewhere else," as he put it. But the fig-

°ärp, zhäN

JEAN ARP

ures on the facade of Strasbourg's Gothic cathedral awakened his interest in sculpture, and his literary gifts were displayed early on. He wrote his first poems in Alsatian, and one of them was published in 1902, when Arp was 15, by a teacher who had been charmed by the freshness of his sensibility and by the artless spontaneity of his use of language. Two years later Hans was to have published a collection of poems (written in German) title *Logbuch* (Logbook), but an editor lost the manuscript. However, also in 1904, *Das Neue Magazin,* a literary review edited by René Schickele, published three of his poems.

From 1904 to 1905 Arp studied drawing at the School of Arts and Crafts in Strasbourg, while also taking private instruction with Georges Ritlang. He felt no artistic conflict between the differing mediums of poetry and plastic art, as he felt no split allegiance between the cultures of France and Germany which had shaped him. From 1905 to 1907 Arp studied at the Weimar School of Art, where his principal teacher was Ludwig von Hofmann, and, having always dreamed of living in Paris, where he had first been exposed to modern art on a visit in 1904, he went there in 1908 and briefly studied at the Académie Julien. In 1909, when competition from the German Tobacco Agency forced Arp's father to close his factory, Hans moved with his family to Weggis, on the shores of Lake Lucerne in Switzerland.

Arp had found the art training he received in the academies stifling, and in the several years he worked in Weggis, in relative isolation, he produced abstract painting. Years later he wrote of this period: "All problems of art interested

me, and I did my best to get hold of every single book on modern art. But since I didn't have the knack of assimilating the experiences of other artists, I laboriously sought my own means of expression in my solitude at Weggis. It was there in 1910 or 1911 that I discovered on my own what is now known as abstract art."

In 1909 Arp had met Paul Klee in Weggis, and during his three years there he founded, with a group of Swiss painters which included Wilhelm Gimmi and Oskar Lüthy, Der Moderner Bund. Arp participated in Der Moderner Bund 's first exhibition, at Lucerne in 1911. Also that year, he visited Munich and met Kandinsky, whose abstract paintings confirmed Arp in the course he had been pursuing independently. Arp later wrote that Kandinsky and Daniel Rossiné "were the first people to understand and encourage my work." Kandinsky invited Arp to join the expressionist *Blaue Reiter* group, and in 1912 he showed in the second *Blaue Reiter* exhibition in Munich. In 1913 he was represented in the first Salon d'Automne, which was organized by Herworth Walden for the avant-garde Galerie Der Sturm in Berlin.

On August 1, 1914 Arp boarded the last train from Strasbourg to France, and upon arriving in Paris learned that war had been declared. He moved into the rue Gabrielle and Max Jacob introduced him to Picasso; soon afterwards Arp met Modigliani, Maillol, Apollinaire, and Bonnard and became friendly with Robert and Sonia Delaunay and other Montmartre and Montparnasse artists. But, lacking money and finding that his French-German binationality did him little good in a time of war between France and Germany, he returned to neutral Switzerland. In 1915 Arp settled in Zürich, but the German authorities tried to repatriate him to serve as a soldier. Arp cleverly escaped that fate by contacting the local German Consulate and convincing them, through strange behavior and outlandish answers to their questions, that he was insane.

In November 1915 Arp's abstract works, consisting of collages and wall tapestries, were exhibited at Zürich's Galerie Tanner. The geometric austerity and abstract spirituality of these works is regarded by some critics as a search for a universal language, a balm for strife and discord. At this time he met Sophie Taeuber, a gifted artist who was to marry Arp in 1921 and become his close collaborator.

After the Galerie Tanner show Arp moved from paintings with rectilinear designs to abstract collages which were composed, Arp said, according to the laws of "chance—rudimentary, irrational, mutilated"—and incorporated mate-

rials that were "found, broken." This sudden change in style anticipated the emergence of the dada movement, of which Arp was a founder, along with Tristan Tzara, Marcel Janco, Hugo Ball (who had invited Arp to Zürich), and Richard Hülsenbeck, in February 1916 at Zürich's Cabaret Voltaire, where that brilliant international group of poets and artists regularly assembled. Their inconoclastic attitudes—antimilitaristic, antinationalistic, antiaesthetic, and bitingly satirical—were in part a reaction to the horror of World War I, the dreariness of bourgeois social conventions, and their boredom, not only with traditional art but with such modern styles as cubism. The Dudaists delighted, it has been said, in "inventing ways of giving the bourgeoisie insomnia," though Arp, unlike such colleagues as Tzara, was more interested in developing new forms of artistic expression than in simply flouting social conventions. Years later Arp remarked, "We weren't really bad, we were just very turbulent."

In 1916, in addition to taking part in the deliberately "outrageous" dadaist performances in the Cabaret Voltaire and writing for the *Dada* review, Arp contributed woodcut illustrations to Hülsenbeck's *Phantastische Gebete* (Fantastic Prayers). In 1916–17 he made his first polychrome wood reliefs, including the wittily titled *Madame Torso with Wavy Hat,* and *Forest* (Collection of Roland Penrose, London). As Herbert Read has pointed out, "A painted wood relief by Arp is no longer sculpture or painting. It is an *object d'art,* but in a sense not always implied by that phrase. . . . " Arp subsequently executed woodcuts for Tristan Tzara's *25 Poèmes* (1918) and his *Cinéma calendrier du coeur abstrait* (1920). Though he had published illustrations in a 1914 edition of the Bhagavad-Gita that had figurative elements, the illustrations of this period were entirely abstract. In 1917 and 1918 Arp contributed sketches entitled *Automatic Drawings* to dadaist periodicals, and in 1918, in collaboration with Sophie Taeuber, he created large abstract collages with geometric, rectilinear forms which had been cut out by a book trimming device. Also during this period Arp experimented with drawings and sculptures in wood relief that were arranged according to "the Law of Chance"; chance, Arp said, "embraces all laws and . . . can only be experienced through complete direction to the unconscious."

After World War I, when Arp moved to Cologne in 1919, he found that dadaism had spread to Germany. From 1919 to 1920 he was active with the dadaist group in Cologne, which included Max Ernst and Johannes Baargeld; they published two dadaist periodicals and, in April 1920, took part in the most "scandalous" of all dada exhibitions, held at Brauhaus Winter in Cologne. The show, which was entered through a men's urinal, opened with a young girl in a first communion dress reciting obscene verse. The ensuing uproar led to the exhibition's closing by the police. Also in 1920, Arp published his first collection of poetry; it was written in German.

That same year Arp and Ernst worked together on a series of photo collages entitled "Fatagaga," an acronym for *fabrication de tableaux garantis gazométriques.* One of Arp's collages of 1920, *According to the Laws of Chance,* was made from scraps of paper that had fallen to the floor and were arranged in the pattern they had assumed. Also that year Arp was represented in the International Dada Exhibition in Berlin; at this time he met the avant-garde Russian artist El Lissitzky, with whom he later published *The Isms of Art* (1925), and the radical German Abstractionist and collagist, Kurt Schwitters, who called his version of dada "Merzism." Arp was to work with Schwitters on the review *Merz* in 1923. Arp's most original works in the early 1920s were his painted bas-reliefs in wood, including *Bird in an Aquarium* (ca. 1920) and *Mountain, Table, Anchors, Navel* (1925).

By 1924, the year André Breton issued his "Surrealist Manifesto"," Parisian dadaism had been superseded by surrealism. Arp soon joined the movement and took part in the first surrealist exhibition, at Paris Galerie Pierre in November 1925.

In 1926 he and his wife (now Sophie Taeuber-Arp) settled at Meudon, near Paris, and Arp "Gallicized" his given name to Jean. For the next few years Arp and his wife worked closely with the de Stijl artists Theo van Doesburg and Piet Mondrian. Arp continued his association with the Surrealist, who rejected geometric art, despite his participation in 1930 in the Constructivist group "Cercle et Carré (Circle and Square) and his involvement in 1931 with the Abstraction-Création group, an international association of sculptors and painters dedicated to geometric abstraction. Arp saw no contradiction in working in disparate styles, in part because he believed that all art springs as spontaneously from the artists as fruits from a tree.

Arp's earliest free-standing sculptures, in bronze, stone, or plaster, date from the period 1931–32. He called these ovoid biomorphic shapes "concretions,"or concrete art, to stress the fact that his sculptures, with their organic forms, "fit naturally into nature." In *On My Way* (1948) Arp wrote: "We want to create as the plant creates its fruit, and not re-create. . . . As there is not the slightest trace of abstraction in this art, we call it concrete art."

Arp's biomorphic sculptural style produced work that, Marcel Duchamp said, resembled "how the body would have looked had it been redesigned." In *Torso* (1931) a human figure seems to be in the process of taking shape, as if the sculptor had captured the movement just before the shape achieved a concrete form. The influence of surrealism is evident in the sexual symbolism of many of Arp's sculptures in the round, and the surrealist fascination with metamorphosis is present in such bronzes as *Shell and Head* (in the late Peggy Guggenheim's Venice Collection) and *Human Concretion,* both of 1933. Arp's work has been compared to that of Brancusi, especially in the simple beauty of its craftsmanship. Arp's sculptures are distinguished by their extreme simplicity of shape and color (he used no more than three lines). Accordingly, he was one of the few artists to have gained the approval of the Minimalists of the 1960s.

After the Nazi invasion of France in 1940, Arp fled with Sophie to the Midi, and in 1941 they settled in Grasse, which was in the Unoccupied Zone. There he and his wife collaborated with Sonia Delaunay and Alberto and Susi Magnelli on a series of abstract lithographs. The Arps traveled to Zürich in November 1942; two months later, on January 13, 1943, Sophie Taueber-Arp died in an accident near Zürich. For months Arp was unable to work. A Roman Catholic, he considered taking religious orders, but was finally persuaded by friends to resume his art. However, it was not until his return to Meudon, in 1946, that he again took up sculpture.

In 1948 a New York publisher brought out Arp's *On My Way: Poetry and Essays, 1912–47,* and Arp visited the United States for the first time in 1949. He returned in 1950 when he received a commission from Harvard University, Cambridge, Massachusetts, for a large wood relief in the Graduate Center, one of his best-known monumentally scaled sculptures. He traveled to Greece and Italy in 1952 and published *Dreams and Projects.* Two years later he won the Grand Prize for Sculpture at the Venice Biennale. Major exhibitions of his work were held in Bern (1956), Basel (1950), and at New York City's Museum of Modern Art (1958). He executed a monumental sculpture, in cement and metal, in Caracas, Venezuela, in 1956, and a large copper relief for the UNESCO building in Paris the following year.

Arp visited Mexico in 1958, and Egypt, Jordan, and Israel in 1960. In Brussels, in 1959, he married Marguerite Hagenbach, and the following year in Paris he was made a Chevalier de la Légion d'Honneur.

Many critics see in Arp's work the purity and harmony of Greek sculpture. Reviewing Arp's 1954 show of sculpture at the Curt Valentin Gallery, in New York City, Howard Devree wrote in *The New York Times* (March 7, 1954): "Arp's marbles and bronzes have a sensuous quality, such that they fairly invite the hand to follow the eye along the curves and rhythms of his beautifully finished pieces. . . . "

Arp's last years were divided between his home in Locarno, Switzerland, with his second wife, and the house in Meudon that had been designed by Sophie Taeuber-Arp. He died in Locarno at the age of 78.

Jean Arp was five-feet seven-inches tall, with blue eyes and close-cropped gray hair. Alexander Liberman, who photographed Arp in his long, narrow studio in Meudon in 1959, noted in his book, *The Artist in His Studio,* that "behind his deceptive scholarly calm lurked a wit destructive yet essentially kind. A quick shy smile broke the Olympian mask to reveal for an instant that the most serious creative act can have its roots in humor and a sense of play."

Jean Arp was as adroit with words as with the invention of new shapes. He declared in his essay on concrete art in *On My Way*: " . . . Concrete art aims to transform the world; it aims to make existence more bearable; it aims to save man from the most dangerous folly, vanity; it aims to simplify man's life; it aims to identify him with nature; . . . where concrete art enters, melancholy departs, dragging with it its gray suitcases full of black sighs."

EXHIBITIONS INCLUDE: Gal. Tanner, Zürich 1915; Gal. Goemans, Paris 1929; Buchholz Gal., NYC 1949; Curt Valentin Gal., NYC 1949, '54; Gal. del Naviglio, Milan 1957; MOMA, NYC 1958; Gal. d'Art Moderne, Basel 1958, '62; Gal. Denise René, Paris 1959, '60; Stedelijk Mus., Amsterdam 1959; Mus. Nat. d'Art Moderne, Paris 1962; Everett Ellin Gal., NYC 1963; Solomon R. Guggenheim Mus., NYC 1969, '72; Metropolitan Mus. of Art, NYC 1972; "Arp on Paper," MOMA, NYC 1976. GROUP EXHIBITIONS INCLUDE: Moderner Bund, Hôtel du Lac, Lucerne, Switzerland 1911; Moderner Bund, Zürich 1912; Der Blaue Reiter, Gal. Neue Kunst, Munich 1912; Erster Deutscher Herbstsalon, Gal. der Sturm, Berlin 1913; Gal. Tanner, Zürich 1915; International Dada Exhibition, Berlin 1920; Erste International Dada-Messe, Brauhaus Winter, Cologne 1920; Salon Dada, Gal. Montaigne, Paris 1922; First Surrealist Exhibition, Gal. Pierre, Paris 1925; "Cercle et Carré," Gal. 23, Paris 1930–31; Gal. Abstraction-Création, Paris 1933; "Cubism and Abstract Art," MOMA, NYC 1936; "Fantastic Art, Dada, Surrealism," MOMA, NYC 1936–37; "Arp—Sophie Taeuber-Arp," Sidney Janis Gal., NYC 1950; "Arp—Sophie Taeuber-Arp," Gal. Denise René, Paris 1950; "Arp—Sophie Taeuber-Arp," Kestner Gesellschaft, Hanover, W. Ger. 1950; Venice Biennale 1954;

"Schwitters, Arp," Kunsthalle, Bern 1956; "The Art of Assemblage," MOMA, NYC 1961; "Jean Arp—Sophie Taeuber-Arp," Gal. Denise René, Paris 1962; "Arp, Calder, Marini," Gal. d'Art Moderne, Basel 1963; "Arp, Sonia Delaunay, Poliakoff," Mus. Rath, Geneva, Switzerland 1964; "Futurism: A Modern Focus," Solomon R. Guggenheim Mus., NYC 1973; "Pioneers of Modern Sculpture," Hayward Gal., London 1973.

COLLECTIONS INCLUDE: Metropolitan Mus. of Art, MOMA, and Solomon R. Guggenheim Mus., NYC; Albright-Knox Art Gal., Buffalo, N.Y.; Munson-Williams-Proctor Inst., Utica, N.Y.; Graduate Center, Harvard Univ., Cambridge, Mass.; Philadelphia Mus. of Art; Hirshhorn Mus. and Sculpture Garden, Washington, D.C.; Des Moines Art Center, Iowa; Inst. of Arts, Detroit; Mus. of Fine Arts, Dallas; Tate Gal., London; Mus. Nat. d'Art Moderne, Paris; Mus. des Beaux-Arts, Strasbourg, France; Kunstmus., Bern; Kunstmus., Basel; Kunsthaus, Zürich; Rijksmus. Kröller-Müller, Otterlo, Neth.; Peggy Guggenheim Collection, Venice; Moderna Mus., Stockholm.

ABOUT: Arp, J. Die Wolkenpuppe, 1920, Der Pyramidenrock, 1924, (and others) Die Kunst-Ismen, 1925, Konfigurationen, 1930, Des Taches dans le vide, 1937, Rire de coquille, 1944, Le Siège de l'air: Poèmes 1915–1945, 1946, On My Way—Poetry and Essays 1912–1947, 1948, Auch das ist nur eine Wolke. Aus den Jahren 1920–1950, 1951, Auf einem Bein, 1955, Zweiklang—Sophie Taeuber-Arp, 1960, Gesammelte Gedichte, Band I, Gedichte 1903–1939, 1963, The Dream Captain's Log Book, 1965, Jours Effeuillés: Poémes, essais, souvenirs 1920–1965, 1966; Bénézit, E. (ed.) Dictionnaire des peintres, sculpteurs et graveurs, 1976; Breton, A. Le Surréalisme et la peinture, 1928; Cathelin, J. Arp, 1959; Current Biography, 1954; Giedion-Welcker, C. and others Jean Arp, 1957; Jean, M. (ed.) Arp on Arp: Poems, Essays, Memories, 1972; Jianu, L. Jean Arp, 1973; Liberman, A. The Artist in His Studio, 1960; Motherwell, R. (ed.) The Dada Painters and Poets, 1951; Read, H. A Concise History of Modern Sculpture, 1964, Arp, 1968; Schmidt, G. Sophie Taeuber-Arp, 1948; Seuphor, M. L'Art abstrait, ses origines, ses premiers maîtres, 1949, Arcadie d'Arp, 1950. Periodicals—Art News January 1949; New York Times March 7, 1954, May 26, 1972, July 23, 1976, December 23, 1977, December 12, 1982; Newsweek July 26, 1976; Quadrum II (Brussels) 1961.

AVERY, MILTON (CLARK) (March 7, 1885–January 3, 1965), American painter, was exceptional among American painters in having grasped, and translated into his own idiom, Matisse's direct use of color and treatment of the figure and landscape in terms of flat patterns and rhythmic contours. Avery's subtle and personal style of decorative color painting was in marked contrast to mainstream American art of the 1940s, when, as the art historian Barbara Rose has observed, "most painting took on the pallid chalkiness of tempera or the lurid rotogra-

Grace Borgenicht Gallery, NYC

MILTON AVERY

vure tonalities of commercial illustration." As a master of color and simplified form, Avery had a marked influence on the post–World War II generation of avant-garde American painters.

Milton Clark Avery was born in the village of Sand Bank, in upstate New York, the son of Russell Eugene Avery, a tanner, and the former Esther March. He was the youngest of four children. In 1898 Avery's family moved to Wilson Station, Connecticut, near East Hartford. At the age of 16 Avery went to work as a factory hand at the Hartford Machine and Screw Company. He worked for various factories in the area over the next few years, but about 1910 he applied for a lettering class at the Connecticut Art Students League. The class, however, was soon discontinued, and instead he entered a sketching-from-life class. Encouraged by his instructor, Charles Noel Flagg, he realized that he wanted to become a painter, and by 1911 he was listed as an artist in the Hartford City Directories.

Largely self-taught, Avery would paint from nature by day, starting in at dawn in the Hartford meadows after an eight-hour night shift in a typewriter factory. (Avery continued to work at these jobs because by 1915, due to a series of deaths in his family, he was the only adult male in a household of 11.) Although his work was not accepted in local exhibitions, the rejections did not rob him of two qualities he retained throughout his life—his naive outlook and his sense of humor.

While working the night shift at the Travelers Insurance Companies, Avery began taking classes at the School of the Art Society of Hartford,

where he received top honors in life drawing and portrait painting. In 1920 he spent the summer in Gloucester, Massachusetts, in order to paint from nature. As Hilton Kramer observed in an important article on the artist in *The New York Times Magazine* (August 29, 1982), "This eventually set a work pattern that Avery would follow for the next four decades: He garnered his impressions of nature in summer landscapes—first in Gloucester, then in Vermont, Quebec's Gaspé Peninsula, California, Maine, Cape Cod and other locales—by means of drawings and watercolors, and spent his winters making paintings based on these studies."

In 1924, in Gloucester, Avery met the Brooklyn-born commercial artist and illustrator Sally Michel; he moved to New York City in 1925 to be with her, and they were married on May 1, 1926. Meeting Michel was, as Kramer said, "the turning point of [Avery's] life." Working as a freelance illustrator, she freed Avery from the burden of ever having to hold a job, and his artistic independence as well was sustained by her moral support.

The move to Manhattan introduced Avery to European modernism, especially the work of Matisse, and consequently he remade his art. In Avery's first solo show, held at the old Opportunity Gallery, New York City, in 1928, his work, described by one critic as resembling that of "certain Europeans," consisted of long, narrow figures painted in a somber key, casting shadows and slightly modeled, but the main emphasis was on expression. The eminent artist Max Weber predicted that Avery would "go far."

In the next few years Avery's work began to be shown and he won two awards, the Atheneum Prize of the Connecticut Academy of Fine Arts (1929) and the Logan Prize for International Water Color at the Art Institute of Chicago (1930). During the Depression years, Avery was one of the many artists supported by the New Deal's Works Progress Administration. This and the money Sally earned enabled the Averys to devote their entire lives to art. "Rising at 6 in the morning," wrote Barbara Haskell, "they would often draw or paint straight through until dinner." Their daughter March was born in 1932, and was soon to become a favorite subject of Avery's paintings.

Avery, accompanied by his wife and a group of young avant-garde artists that included Mark Rothko and Adolph Gottlieb—both of whom always admired and lavishly praised his work—made frequent field trips in these years to Gloucester, to Vermont, and to the Gaspé Peninsula. The group also drew from models during weekly meetings in Avery's studio. Gottlieb later recalled: "Avery was a wonderful draftsman. His figures were more literal than they would appear later in the paintings which developed out of the sketches." Even though Avery always remained a figurative painter, the meetings and discussions in his studio with Rothko, Gottlieb, and other young painters helped to lay the basis for a specifically American form of abstract art.

Avery's own paintings were moving in the direction of what Sheldon Cheney has called "creative simplification." Influenced by Matisse, his colors brightened and he flattened spaces and simplified shapes, without a loss of tonal emphasis. By 1932 Avery's work was being regularly exhibited in New York City, but among the critics only Henry McBride of the New York *Sun* supported the increasingly modern direction his art was taking.

Seashores, with or without figures, were Avery's favorite landscape motifs. A typical early example is *Cutting Fish* (1933; Whitney Museum of American Art, New York City). His daughter March posed for the charming, rather Matissean *Interior with Figure* (1938; Hirshhorn Museum and Sculpture Garden, Washington, D. C.). After 1940 Avery's now frequently exhibited work won him wide recognition and critical appreciation in the US.

Color was becoming a dominant interest in Avery's canvases, and a critic from *Art News* (December 15, 1942) commented, "Color is the real soul of his painting, color as finely balanced as Braque's and often as inventive and as unorthodox as Matisse—tart, unexpected combinations." As the use of bold, close-valued color became Avery's central concern, he took the crucial step of virtually eliminating anecdotal or narrative detail from his work, allowing color to function independently of subject matter. Another important development of the later 1940s came when Avery began to thin his pigments to the consistency of watercolor. This, as Kramer pointed out, let the "color lay on the canvas surface more as a transparent veil than as an independent substance." This effect anticipated the abstract, color-field painting of the 1950s and '60s, but in Avery's case "it was a pure achievement of the painter's eye rather than the result of some theory or program," to quote Kramer.

Avery's pictures, though, were hard to sell because the taste of most American collectors at this time was conservative, and Avery was an "in-between" artist, neither radically avant-garde (he was almost totally uninfluenced by cubism) nor fashionably academic. Nevertheless, he steadfastly pursued his own independent course.

An exhibit titled "My Daughter March" consisted of paintings of Avery's daughter made over the years since 1932; it was held at the Durand-Ruel Galleries, New York City, in 1947. One of the interiors for which March had posed was *Morning Call* (1946; Hirshhorn Museum and Sculpture Garden), a highly stylized painting, abstracted into patterns of flat shapes and simplified forms, but with an intimate charm typical of Avery's work. This quality of intimacy has caused Avery to be likened to Vuillard, especially when working in a lower register. When Avery's colors were brighter there was greater affinity to Matisse.

In 1949 Avery won First Prize, National Water Color, at the Baltimore Museum of Art, and an important retrospective of his work was presented there in 1952. In the catalog to this exhibition, Frederick S. Wright noted that in Avery's painting there "is something not . . . widely present in our time: acceptance of the human condition and peace of mind. . . . " Wright described Avery as "a lyric poet . . . in the New England tradition," as well as a "humorist," and praised the "lyric ease" with which he painted.

A fine graphics artist, Avery in 1950 made a portfolio of drypoints, *Laurels–No.4,* for the Laurel Gallery, New York City, which was printed by S. W. Hayter at the Atelier 17 in Paris. Avery himself did not visit Europe for the first time until 1952, and despite some traveling in his later years his paintings, as one writer pointed out, were "effectively stay-at-home art—not in some absurd folksy way, but because with great economy of means he was able to paint the New England ocean-scape for which he had particular affection, and the glittering echoes of the summers he spent in Provincetown, Massachusetts."

Reviewing Avery's show of November 1957 at the Grace Borgenicht Gallery, New York City, Clement Greenberg commented in an important *Arts* magazine article (December 1957) that the landscapes painted in Provincetown in the summer of that year "attest to a new and more magnificent flowering of his art." Greenberg added: "There is no glamor about Avery's art: it is daring, but not emphatic or spectacular in its daring." The show included an unusually monumental canvas *Poetry Reading* (48 inches by 60 inches), but Greenberg felt that Avery was "at his highest and broadest and strongest in his landscapes and seascapes." One of these 1957 seascapes, the disarmingly simple yet subtle and delicate *Sandbar and Boats,* in which the water is painted in soft, yellowish tonalities, is now in the Hirshhorn Museum and Sculpture Garden. An earlier work, *Green Sea* of 1954, is in the Metropolitan Museum of Art, New York City.

In 1958 Avery obtained Second Prize at the Boston Arts Festival, and the following year won the Money Award at the "Art USA" show in New York City. In 1960 he was given a retrospective exhibition, which opened at the Whitney Museum and traveled for two years. Despite these shows, the years 1950–60 had not been kind to Avery. One year he made only $50 from sales of his work. More important, with the ascendancy of abstract expressionism, representational painting of any kind—even Avery's radiant, near-abstract version—was in disfavor among leading critics and curators. Avery had produced his greatest masterpieces in the 1950s, but even the 1960 Whitney retrospective failed to win him the acclaim that was his due.

Milton Avery died in New York City on January 3, 1965. He was a quiet, gentle, soft-spoken man, five feet seven inches tall, with blue eyes and gray hair that had once been brown. His favorite recreations were reading, playing pool, and watching television. His daughter March is now a talented artist in her own right. Avery was a prolific painter up to the very end. When his close friend Mark Rothko pointed out to him that if he painted fewer pictures he could charge higher prices, Avery replied with astonishment: "But what would I do the rest of the time?" He always preserved a refreshing simplicity of outlook, and he never lost the humorously disarming quality that distinguished him as an artist and as a human being.

In the fall of 1982, more than 17 years after the artist's death, the Whitney mounted a giant Avery retrospective which earned him recognition as an American master. Marks Stevens of *Newsweek* (October 4, 1982) praised him as "perhaps the greatest [colorist] this country has produced," and noted that "Avery is probably the critical link between Matisse and certain abstract-expressionist and color-field painting of the 1950s and 1960s." Discussing why recognition of Avery's achievement was so late in coming, Kramer wrote: "It could not quite be fitted into any of the handy categories by which contemporary art tends to be judged. It belonged to no 'school,' it generated no controversy and the artist who created it was definitely not 'a personality.' It was therefore assumed—mistakenly—to be not of major importance. . . . To me, [Avery] is a painter who continues to grow in stature with each passing year."

EXHIBITIONS INCLUDE: Opportunity Gal., NYC 1928; Gal. 144, NYC 1932; Valentine Gal., NYC 1935, '36, '38, '41; Phillips Memorial Gal., Washington, D.C. 1943, '44, '52; Paul Rosenberg & Co., NYC 1943–47, '50; Durand-Ruel Gal., NYC 1945–49; Art Mus., Portland, Oreg. 1947; Grace Borgenicht Gal., NYC from

1951; Mus. of Art, Baltimore (toured U.S.) 1952; Am. Federation of Arts tour 1959–60; Whitney Mus. of Am. Art, NYC (toured U.S.) 1960; Waddington Gal., London 1962, '65, '66, '74; MOMA, NYC (memorial exhibit which toured U.S.) 1965–66; Sheldon Memorial Art Gal., Univ. of Nebraska, Lincoln 1965; Collection of Fine Arts, Smithsonian Inst., Washington, D.C. (toured U.S.) 1969–70; Corcoran Gal. of Art, Washington, D.C. 1972–73; William Benton Mus. of Art, Univ. of Connecticut, Storrs 1976; "Milton Avery," Whitney Mus. of Am. Art, NYC 1982. GROUP EXHIBITIONS INCLUDE: Wadsworth Atheneum, Hartford, Conn. 1930, '31; Carnegie International, Pittsburgh 1944; Pennsylvania Academy of Fine Arts, Philadelphia 1945; "Milestones of American Painting in Our Century," Inst. of Contemporary Art, Boston 1949; "Contemporary American Painting and Sculpture," Univ. of Illinois, Urbana 1955; "The Museum and Its Friends," Whitney Mus. of Am. Art, NYC 1958; "Landscapes, Interior and Exterior," Mus. of Art, Cleveland 1975; "Seascape: Avery and the European Masters," Grace Borgenicht Gal., NYC 1976; "Milton Avery and His Friends," Grace Borgenicht Gal., NYC 1978.

COLLECTIONS INCLUDE: Metropolitan Mus. of Art, MOMA, and Whitney Mus., of Am. Art, NYC; Brooklyn Mus., N.Y.; Newark Mus., N.J.; Albright-Knox Art Gal., Buffalo, N.Y.; Wadsworth Atheneum, Hartford, Conn.; Yale Univ., New Haven, Conn.; Brandeis Univ., Waltham, Mass.; Smith College, Northampton, Mass.; Pennsylvania Academy of Fine Arts, Philadelphia; Phillips Gal., Hirshhorn Mus. and Sculpture Garden, and Smithsonian Inst., Washington, D.C.; Mus. of Art, Baltimore; Butler Art Inst., Youngstown, Ohio; Walker Art Center, and Univ. of Minnesota, Minneapolis; Witte Memorial Mus., San Antonio; Honolulu Academy of Arts, Hawaii; Tel Aviv Mus.

ABOUT: Breskin, A.D. Milton Avery, 1969; "Contemporary American Painting and Sculpture" (cats.), Univ. of Illinois, Urbana, 1951, 1952, 1955; Current Biography, 1958; Eliot, A. Three Hundred Years of American Painting, 1957; Goodrich, L. and Baur, J. I.H. American Art of Our Century, 1961; Greenberg, C. Art and Culture, 1961; Haskell, B. Milton Avery, 1982; Kramer, H. Milton Avery: Paintings 1930–1960, 1962; Rose, B. American Art Since 1900, 2d ed. 1975. Periodicals—Art Digest December 1, 1952; Art in America February 1978; Art International (Lugano) February 1978; Art News no. 61 1942, December 1952, no. 55 1956, April 1978; Arts Magazine December 1957; Newsweek October 4, 1982; New Yorker April 3, 1978; New York Times January 4, 1965, January 31, 1976; New York Times Magazine August 29, 1982; Time September 27, 1982; Village Voice October 12, 1982.

BACON, FRANCIS (October 28, 1910–), British painter, is famous for his strange, obsessive art which has given a new dimension to modern figurative painting. He was born in

FRANCIS BACON

Dublin of English parents. His father was a horse trainer. Bacon quit school early, and at age 16 left Ireland for a life of "drifting." He worked in an office in London and then traveled to Berlin at the peak of the Weimar Republic. "It was really harsh," Bacon recalled. "I saw something much more violent than Christopher Isherwood. His is a gentleman's version of what I saw."

In 1927 Bacon was living in Paris and occasionally working in interior deoration. He saw a Picasso exhibition and "was so fascinated I said, 'Why shouldn't I try and paint?'" He never went to art school and began to make drawings and watercolors. "I don't believe you can be taught technique," he said. "It comes from your own nervous system."

Returning to London in 1928, Bacon earned a modest living as a furniture designer and interior decorator. He began painting in oils in late 1929, and the following year he held a joint exhibition in his studio with the Australian painter Roy de Maistre. He showed furniture—"extremely bad copies of Le Corbusier"—as well as gouaches and oils. Studio magazine published a double-page spread on Bacon's studio titled, "The 1930 Look in British Decoration."

In 1931 Bacon moved to the Fulham Road in Chelsea, where he devoted more time to painting and maintained himself by odd jobs unconnected to art. His first important paintings came in 1933, three somewhat abstract works called "Crucifixions." One was reproduced in Herbert Read's Art Now, and a second purchased by the well-known collector Sir Michael Sadler. That same year Bacon took part in two group exhibitions at the Mayor Gallery, London.

His style grew surrealistic, though his entry to the 1936 International Surrealist Exhibition in London was rejected as "insufficiently surrealist." His 1934 solo show at the Transition Gallery, London, met with little success, and, discouraged by these experiences, Bacon began to gamble. He exhibited three works, including *Figures in the Garden,* in "Young British Painters," a group show at Agnew's in 1937, but he painted little in the next few years.

In 1942 Bacon was declared unfit for the army because of his asthmatic condition, an affliction since childhood, and he worked instead as an air-raid warden in a civil defense unit. During the war years Bacon destroyed nearly all his earlier work—approximately 700 paintings according to one estimate—and only about ten canvases remain from the period 1929–44.

For the most part Bacon was an unknown until 1946, when he painted the first picture he ever really liked. He had intended to do a bird alighting on a field, but the finished painting was centered around an ominous umbrella. Titled *Painting, 1946,* it was sold to a dealer for $400 and now hangs in the Museum of Modern Art, New York City. This was the beginning of a weird chimerical imagery "for which no parallels can be found in the art of the present or the past," according to James Thrall Soby.

From 1946 to 1950 Bacon lived mainly in Monte Carlo under the constant temptation of the roulette tables. He also became friendly with painter Graham Sutherland, who lived nearby in Menton and with whom he had previously exhibited in group shows in London. There was some reciprocal influence in their work.

Bacon was almost 40 before he had his first major solo show, an exhibit at the Hanover Gallery which got a mixed reception from critics. Also in 1949, he painted a series of "Heads" and the first of his notorious "Screaming Popes." These paintings, first exhibited in 1951 at Bacon's third show at the Hanover Gallery, are variations on Velásquez's renowned *Portrait of Innocent X* in Rome's Doria-Pamphili Gallery. A critic wrote that "under Bacon's hand, Velásquez's Pope Innocent X—quiet, cool, self-assured—seems literally to have been shocked into a disintegrating movement. His mouth opens in a blurred scream which could be expressive of anything from the hilarity of a sadist to the imbecility of a victim of complicated tortures." Bacon's popes are not clad in the sumptuous red of Velásquez's Innocent X but in a lurid purple. The figures appear caged in plate glass and to inhabit a dark, silent world of terror. The scream was influenced, according to Bacon's own statement, by the screaming nurse in the Odessa steps sequence in Eisenstein's *Potemkin,* as well as by exquisite color illustrations in an old book on diseases of the mouth that the artist had seen in Paris.

More than ten screaming popes were painted, and one of the strongest dates from 1953. Critics stressed the horror and violence in Bacon's pictures, but he himself feels a kinship with the old master tradition of *la belle peinture,* Velásquez and Rembrandt being his favorites among earlier artists. "I wanted to make the scream into something which would have the intensity and beauty of a Monet sunset," Bacon said of his "Pope" pictures. Henry Geldzahler has pointed out, in reference to Bacon's "rawness of subject matter," that "it is just this tension between new content and traditional means of portrayal that makes Bacon's work so fresh and masterful."

From 1950 on, Bacon lived in London, often changing studios, but he traveled widely. In 1950, and again in 1952, he visited South Africa. At his 1953 Hanover Gallery exhibition he showed landscapes inspired by Africa and the south of France. For his African animals motifs Bacon used photographs as well as memory. A photograph of an elephant became for him "a trigger—a release action. It releases one's sensibility and one's psyche, and all kinds of images crowd into you from seeing this particular image." Especially striking were the paintings of lean, hungry dogs in the burning African sun, images of isolation that he intensified with stark color and the schematic suggestion of vast, empty spaces.

In October 1953 Bacon had his first solo show in the United States, at Durlacher Brothers in New York City. In addition to the Pope series it included *Study for Portrait, Sphinx (I and II).* The exhibit was well received, and there was a realization that Bacon's art, however idiosyncratic, was also the product of a European generation that had experienced firsthand the full horrors of war—a phenomenon for which there was no real American equivalent.

Bacon's first portrait of Lucian Freud, an almost equally obsessive painter, dates from 1951. Since then portraits of his friends have provided a major theme, though they are not so much portraits as expressionistic renderings of the "otherness," as a disciple of Sartre might put it, of others. Working directly on the unprimed canvas, and turning accidents of paint to his advantage, he tries to go beyond likeness. "I have always hoped to make portraits which went far away from the person in front of me, but that I could bring back in a nonillustrational way to his real appearance." Hair and foreheads are fairly specific, but the nose, eyes, and mouth are usual-

ly blurred and twisted, and the lower part of the face, to quote Geldzahler, "is most often elided in quick motion, explosion or disintegration." "If they were not my friends, I could not do such violence to them," Bacon told John Russell. His numerous self-portraits, often done in series of three, comprise mangled forms unified by deft and painterly handling. He is haunted by the idea of decomposition, and has quoted Jean Cocteau: "When you shave everyday in the mirror you watch death at work."

Bacon's international reputation increased in 1954 when he was selected, along with Ben Nicholson and Lucian Freud, to represent Great Britain at the Venice Biennale. He took the opportunity to visit Italy, but did not attend the Biennale. In the summer of 1956 Bacon traveled to Tangier to see his friend Peter Lacey, and he returned there frequently over the next three years.

In 1957 Bacon began a series of "Studies for Portrait of Van Gogh." They were brightly colored and the landscape was stressed more than usual, but the image was still one of isolation and obsession. Even in this series Bacon introduced on the horizon a suggestion of an architectural structure of wirelike lines, one of his favorite devices, which serves to enclose the scene and has both compositional and psychological significance.

Exhibitions of Bacon's work throughout Europe and in America in the following years included a retrospective at the Tate Gallery in 1962, and a 64-canvas show at the Solomon R. Guggenheim Museum, New York City, in 1963. This was at the height of the popularity of pop art and of hard-edge abstraction, and Hilton Kramer later claimed that Bacon's exhibition "left no discernible trace on American painting." He was attacked mainly by two groups of critics: those who found his inspiration "sick" and those who considered it no longer possible for the human figure to be portrayed explicitly. However, with the revival of figural paintingin the US and Europe in the early 1980s Bacon has enjoyed something of a vogue. Bacon himself even contends that his work is "hated in America," but the statement is exaggerated. In fact his painting has widely interested the American public.

Bacon has said that he conceives of his pictures in threes, and since 1962 many of his works have been large-scale triptychs. The first of these, *Three Studies for a Crucifixion* (1962), was inspired, he said, by the "wormlike" movement of Cimabue's *Christ on the Cross*. In 1966 one of his triptychs, exhibited in Pittsburgh, was awarded the Carnegie International Painting Prize.

Some of the most challenging canvases in the immense Bacon retrospective which opened at the Grand Palais, Paris, in October 1971, were the "Studies for Bullfight" (1969), with large, flat areas of brilliant orange in the background. This same color was used in the triptych *Three Studies from the Human Body* of 1970. Part of a circular ground area created the arena for the violent struggle of man and bull, and a more arbitrary circular platform defined the space for the various studies of Bacon's companion and model George Dyer. Interior architecture was kept to a minimum, but familiar objects such as wall switches, hanging light bulbs, beds that sometimes suggested operating tables, and chairs and mirrors provided a schematic setting for contorted single figures or tangled homosexual couplings. The tubular structures that often enclose the figures and help to delimit the space come, Bacon explained, "from my own metal furniture [designed in the '40s], but fundamentally they are an attempt to lift the image outside its natural environment."

George Dyer committed suicide in a Paris hotel room in October 1971, just as Bacon was about to attend the opening of his Grand Palais retrospective. This gruesome event provided the theme of the most sensational triptychs in the impressive Bacon show that filled three large galleries at the Metropolitan Museum of Art, New York City, in 1975. *Triptych, May–June 1973* reads from right to left, with the agonized figure of George Dyer vomiting in a sink, then lurching across the bathroom "casting a melodramatic shadow on the floor," to quote *Time* magazine, and in the left-hand panel dying, hunched on a toilet, "a deliquescent knot of white flesh." The familiar Bacon accessory, a bare light bulb, hangs from the ceiling in the central panel: it is vaguely associated in Bacon's mind with the suspended egg in Piero della Francesca's *Brera Madonna* in Milan. The show was curated by Henry Geldzahler to cover the years 1968–1974, and in several of the exhibited works, including *Portrait of a Man Walking Down Steps* (1972), the idea of motion and speed is part of the imagery. An important influence on Bacon was that of the stop-motion experiments of the late-19th-century English photographer Eadweard Muybridge, especially "Men in Motion," his studies of wrestlers.

There was widespread interest in the Metropolitan show, but the reviews were mixed. *Newsweek* wrote that "His subjects are as ugly as ever. His means are not." But Robert Hughes in *Time* felt that Bacon's work had "gained immeasurably in its scope of color and plasticity of drawing," and declared that "no other living artist can paint flesh at this pitch of intensity . . .

or with this command over pigment." However, Hilton Kramer of *The New York Times* (March 30, 1975) found Bacon's traditional bravura of the paint handling "egregiously ersatz, an attempt at instant old master effects that ends in being little more than a form of theatrical illustration." Thomas B. Hess in *New York* magazine was even more caustic. While acknowledging that the press and public were intrigued and titillated by "the glittering, tawdry and fusty anecdotes that have become part of Francis Bacon's peculiar litany." and while not denying the "rare, creepy sensibility" in his work, Hess felt that "Bacon has become a virtuoso of his own eccentric manners." The overall impact of the show, he added, was that of "an assembly-line geared to produce crack-ups. It's not Van Gogh's desperate frenzy that ruffles these surfaces. It's the vivid, exsanguinated reverie of Gustave Moreau."

Certainly there is a hint of fin-de-siècle perversity in Bacon's remark, "In all the motor accidents I've seen, people strewn across the road, the first thing you think of is the strange beauty—the vision of it, before you think of trying to do anything. It's to do with the unusualness of it." In defense of Bacon's vision Edward Lucie-Smith observed that "Bacon's consistent, narrow art represents at least one of the positions that it is possible to take up, vis-a-vis mid-twentieth century experience." Bacon's abject and distorted figures, children of an epoch that has seen civilized nations take up genocide as an official policy of state, cower in glaringly lit rooms to show "man stripped of his few remaining pretensions."

Francis Bacon lives and works in London. He was 65 at the time of his visit to New York for the Metropolitan show, but looked a boyish 50. He was described in *The New York Times* (March 16, 1975) as having "close-cropped gray hair, a trim physique, and a pear-shaped face that seems assembled of disparate elements." His appearance was brilliantly captured in a portrait painted in 1952 by his friend Lucian Freud that is now in the Tate Gallery. Bacon's private life has been compared to that of Jean Genet and Tennessee Williams, much of it spent in the homosexual subcultures of London and the French Riviera. In either environment he can indulge his passion for gambling.

In London Bacon works from eight or nine in the morning to about three in the afternoon in his cluttered, messy studio, which he calls "gilded squalor." The floor of the skylit room is littered with piles of notebooks, paper, crumpled photographs, movie stills, books, cardboard boxes, paint tubes, rags, and brushes in jars. Out of this overwhelming clutter canvases rise, propped against the walls. He prefers to work directly on the unprimed canvas, and only a few of Bacon's drawings have ever been seen. After work he goes to the less fashionable pubs of Soho or to a small and shabby after-hours Soho club with slot machines, and telephones for bookies. He usually wears form-fitting blue jeans, a bulky sweater, and a black leather wind-breaker.

Always articulate, Bacon has said that, not withstanding the morbidity that defines his public image, he remains exhilarated by three things:" When a painting, however despairing, comes right. When I meet someone I get on well with. And when I have a marvelous win." In a more serious vein he has said: "I would like one day to trap a moment of life in its full violence, its full beauty. That would be the ultimate painting."

EXHIBITIONS INCLUDE: Transition Gal., London 1934; Hanover Gal., London 1949–59; Durlacher Brothers, NYC 1953; Beaux-Arts Gal., NYC 1953; Inst. of Contemporary Art, London 1955; Gal. Rive Droite, Paris 1957; Gal. d'Arte Galatea, Turin, Italy 1958; L'Obelisco, Rome 1958; Richard Feigen Gal., Chicago 1959; Marlborough Fine Arts, London from 1960; Tate Gal., London 1962; Solomon R. Guggenheim Mus., NYC 1963; Gal. Maeght, Paris 1966; Grand Palais, Paris 1971–72; "Recent Paintings 1968–1974," Metropolitan Mus. of Art, NYC 1975. GROUP EXHIBITIONS INCLUDE: Mayor Gal., London 1933; "Young British Painters," Agnew's London 1937; Lefevre Gal., London 1945, '46; Pittsburgh International, Carnegie Inst. 1950, '58, '66; Inst. of Contemporary Art, London 1952; Venice Biennale 1954; MOMA, NYC 1955; "Three Masters of Modern British Painting," traveling exhibition organized by Arts Council, 1958; Salon de Mai, Paris 1960, '61; Documenta 3, Kassel, W. Ger. 1964; "British Painting 1945–1970," arranged by British Council in cities in Norway and Poland, 1972; "Four Contemporary Masters—Giacometti, Dubuffet, de Kooning, Bacon," Mus. de Bellas Artes, Caracas, Venezuela 1973; "Eight Figurative Painters," Yale Cntr. for British Art, New Haven, Conn. 1981.

COLLECTIONS INCLUDE: Tate Gal., London; Mus. of Art, Birmingham, England; Metropolitan Mus. of Art, MOMA, and Solomon R. Guggenheim Mus., NYC; Hirshhorn Mus. and Sculpture Garden, Washington, D.C.; Yale Univ. Art Gal., New Haven, Conn.; Albright-Knox Art Gal., Buffalo, N.Y.; Chicago Art Inst.; Detroit Inst. of Arts; Nat. Gal. of Canada, Ottawa.

ABOUT: "Francis Bacon" (cat.), Grand Palais, Paris, 1971; Geldzahler, H. "Francis Bacon: Recent Paintings 1968–1974" (cat.), Metropolitan Mus. of Art, NYC, 1965; Kramer, H. The Age of the Avant-Garde: An Art Chronicle of 1956–1972, 1974; Lucie-Smith, E. Late Modern: The Visual Arts Since 1945, 1969; Rothenstein, J. and others Francis Bacon: Catalogue Raisonné, 1964; Russell, J. Francis Bacon, 1971; Sylvester, D. In-

terviews with Francis Bacon, 1975; Trucchi, L. Francis Bacon, 1975. *Periodicals*—Architectural Review August 1962; Art News February 1947, December 1968; Arts September 1957; Horizon December 1949–January 1950; Magazine of Art (Washington, D.C.) January 1952; New York April 21, 1975; New York Post March 20, 1975; New York Times October 20, 1963, March 16, 1975, March 30, 1975, August 26, 1976; The New Yorker May 12, 1975; Saturday Review November 7, 1953; Time April 7, 1975.

Renato Bencini Fotografo

ENRICO BAJ

***BAJ, ENRICO** (October 31, 1924–), Italian painter and graphic artist, is best known for his satirical mixed-media portraits and witty collages. He has links with surrealism on the one hand and with Jean Dubuffet and *art brut* on the other; more recently he has incorporated elements of pop art into his work. His inventiveness has made him difficult for critics to categorize, and he is constantly experimenting with new techniques and combinations of techniques.

A native of Milan, where he still lives, Baj began to paint regularly in the late 1930s. Between 1937 and 1939 he studied law in Milan and obtained his diploma, then in 1945 enrolled in the Brera Academy of Art, where he studied until 1948. In contrast to the sterile neoclassicism that had been favored under Mussolini's fascist regime before the war, the teachers at the Brera Academy emphasized the work of Picasso, but Baj was also drawn to Matisse. Other influences were those of the automatic drawing technique of the Surrealists and the gestural, all-over approach of Jackson Pollock.

Baj began to paint seriously on his own in 1950, and in 1951 he had his first solo show, at the Galleria San Fedele, Milan. Also in 1951, he and Sergio Dangelo founded the Nuclear Art Movement. In their manifesto, published in Brussels in 1952, they rejected the entire previous avant-garde, and deplored "the domination of the right angle, the gear, the machine, and all forms of cold and geometric abstraction." They also rejected surrealism and the influence of the dream world, and declared that "nuclear disintegration" was *the* leitmotif of this century. In 1953 Baj and Asger Jorn, one of the founders of the Cobra group, launched an "International Movement for an Imaginist Bauhaus," at the Hochschule für Gestaltung (Design College) which had been founded by Max Bill in Ulm a short time before. Jan van der Marck wrote, "With Jorn, Baj shared an interest in images and symbols that emerge from visual chaos." This concern led to the predominance of figuration in his art after the mid-1950s.

In 1954 Jorn and Baj organized the International Ceramics meeting at Albisola, Italy, and

contributed to the first issue of the review *Phases*. At this time Baj first became interested in introducing new materials into his work. He made collages and assemblages in Milan from 1956, the year he founded the magazine *Il gesto*, together with Dangelo and Edouard Jaquer. From 1955 on he participated in all the exhibitions at the Phases movement in Paris, and in the mid-1950s he also contributed to such avant-garde periodicals as *Boa* (Buenos Aires), *Edda* (Brussels), *Direzioni* (Milan), and *Bokubi* (Tokyo). In 1957, the year of his first solo show in London, he published the manifesto "Contro lo Stile" (Against Style), which was signed by Yves Klein and Dangelo, among many others. His first solo exhibition in Paris was at the Galerie Daniel Cordier in 1958. The last issue of the magazine *Il gesto*, published in 1959, was dedicated to "interplanetary art."

In his early works Baj was influenced by Dubuffet and *art brut*. In his "nuclear" period he was fascinated by science fiction and the fantastic illustrations to be found in pulp magazines, and produced such extraplanetary fantasies as *Arrival of the Martians*. In 1956 he turned to collage, and by the late 1950s he was introducing a wide range of materials into his works. He came to believe that "painting means to paint with something, with colors naturally, but also with objects," and that "everything can be used to make a picture." He used clock faces, protest buttons, rope, broken mirrors, felt, and miscellaneous objects and materials found in attics and elsewhere. The element of humor and satire is important in Baj's work, and the list of things he incorporated in his compositions includes, he

claimed, memories and feelings. "Modern technology has given me epoxy glue, that portentous paste that can stick anything onto anything, even memories, even dust, even honors and dishonors."

In 1959 Baj was associated with the Nouveau Réaliste group in Milan, and did a series of "Invasions" in which he superimposed creatures he called "Ultra-bodies" onto ready-made scenes of Switzerland. Many Italians have claimed Baj as the real father of Pop Art, although, as Lucy R. Lippard has pointed out, "his ferocious men inhabit the world of science fiction, not the down-to-earth realism of Pop Art." In the early 1960s Baj used pieces from an erector set in some of his works to mock the use of machinery and technology in art.

Baj was included in the exhibition "Art of Assemblage" at the Museum of Modern Art, New York City, in 1961. He visited New York for the show, and met another irreverent spirit, Marcel Duchamp. In Paris later that year he met André Breton, who invited him to participate in subsequent surrealist exhibitions, and who introduced him to many poets. In the catalog to Baj's 1971 exhibition of the Museum of Contemporary Art, Chicago, Jan van der Marck wrote, "If we accept Surrealism not merely as a movement but as a state of mind, then Baj is its perfect embodiment." Baj was also interested in "pataphysics," the name coined around the turn of the century by the absurdist playwright Alfred Jarry to describe the imaginary, irrational science that governs exceptions. In 1963 Baj and the French novelist Raymond Queneau founded the Institute of Pataphysics in Milan. From 1963 to 1966 Baj lived and worked in Max Ernst's studio in Paris.

Reviewing Baj's exhibition in February 1963 at the Cordier and Ekstrom Gallery, New York City, Dorothy Adlow wrote in the *Christian Science Monitor* (February 1, 1963) that his work "adds perhaps another ingredient of weirdness and oddity to the much-burdened technique of collage." Several of Baj's "Generals" (a series) were displayed in the show. These were satirically humorous figures, painted, to quote Adlow, "with heavy childish outlines, blaring and acid hues, and an assortment of ribbons, medals, [and] passementerie." The "Generals" are among the artist's best-known works. In *Count Joseph Tyszkiewicz, General of the Lancers* (1965), a political campaign button was used for the eye on the face in profile, and, as usual, real medals, bought at a flea market, were pinned to the puffed-out chest.

In 1964 Baj executed a series of "Abductions" in which he painted the seducers, and hired a sign painter to depict the nudes. In his collage and oil on canvas, *Adam and Eve*, also of 1964, a cartoon deity expels a nude Adam and Eve from the Garden in a parody, in the style of modern pornography, of Masaccio's painting in the Brancacci Chapel in Florence. In the 1960s Baj became more involved in graphics and engraving, often illustrating the works of his poet friends. He also illustrated Lucretius's *De Rerum Natura*.

About 1967 Baj began to parody cubism and other styles of Picasso in a series of works culminating in full-scale remakes of *Les Demoiselles d'Avignon* and *Guernica*, the latter completed in 1969. In Milan in 1969 he continued to concentrate on graphics, and collaborated with numerous magazines, including *Marcatre* and *Flash Art*. He also began to work regularly in plastics. There were other spoofs of well-known works of art; he twice redid Seurat's *Grande Jatte*, first in its original size, and then at twice the size of the original.

In 1969–70 Baj traveled in the United States and Australia. His work received its first real exposure in the US when, in October 1971, he was given a retrospective at Chicago's Museum of Contemporary Art. The exhibit included his *Guernica* parody, and Bill Marvel, writing in the *National Observer*, described two other typically satiric works: "A pincushion graphically suggests the primly pursed mouth of *English Lady*; a glass eye stares disconcertingly from behind a watch crystal in *King and Queen*, and the King's mouth is a telegraph key." Baj satirized the "art and technology" movement in *Mechanical Sculpture*, a lumpy, five-foot-tall creature constructed of erector-set parts.

In the early 1970s, Baj, still in a parodic vein, created a work called *A La Mode de Vasarely* which, although made up of illusionistic op art lines, is nevertheless figurative. In 1978, on the occasion of his retrospective at the Indianapolis Museum of Art, the museum's director, Robert A. Yassini, wrote in the catalog, "Baj's pictures are statements of our times, comments on the history of art, haunting and amusing images and powerful and profound observations about life in the twentieth century."

Enrico Baj has been married twice—to Gigliola Olivieri (1954), with whom he had a daughter, and to Roberta Cerini di Castegnate (1966), with whom he had a daughter and two sons. He has dark eyes, a full face, and a strong nose. His mobile, ironic mouth conveys something of his mocking wit. Having no use for pure abstraction—his work always contains representational elements—Baj has said, "I believe that art, that painting specifically, has a cultural val-

ue and not just an aesthetic one." Jean Petit, in the catalog to a 1974 exhibit of the artist's graphic work in Geneva, wrote, "Baj's lucid little world, with its whimsical characters and its 'commedia dell'arte,' amounts to one great spoof in which all aspects of our universe are examined with a good deal of earnestness." This earnestness is revealed in such works as *Funeral of the Anarchist Pinelli,* and in Baj's statement: "Painting is really not very important when you confront it with the reality of men and the world we live in." Emphasizing that, despite his inventiveness, art for him is more than stylistic exploration, he said in 1971, "I try to make my world have some relation our world."

EXHIBITIONS INCLUDE: Gal. San Fedele, Milan 1951; Gal. l'Asterico, Rome 1954; Kunstkredsen, Copenhagen 1956; Gal. Daniel Cordier, Paris 1958; Gal. One, London 1959; Gal. del Naviglio, Milan 1960; Gal. Raymond Cordier, Paris 1961; Cordier and Ekstrom Gal., NYC 1963; Palazzo Reale, Milan 1964, '74; Gal. Pierre, Stockholm 1965; Arts Club, Chicago 1966; Studio Marconi, Milan from 1967; Gemeentemus. the Hague 1967; Studio Condotti, Rome 1968, '70; Palazzo Grassi, Venice 1971; Mus. of Contemporary Art, Chicago, 1971; Gal. Michaud, Florence 1972; Mus. Boymans-Van Beuningen, Rotterdam 1973, '74; Moderna Mus., Stockholm 1973; Kunsthalle, Düsseldorf 1973, '75; Mus. d'Art et d'Histoire, Cabinet des Estampes, Geneva, Switzerland 1974; Royal Mus., Antwerp, Belgium 1975; Indianapolis Mus. of Art 1978; Dartmouth Col. Art Gal., Hanover, N.H. 1979; Ringling Mus. of Art, Sarasota, Fla. 1980. GROUP EXHIBITIONS INCLUDE: "Baj e Dangelo—pitture nucleari," Gal. San Fedele, Milan 1951; "Mostra del Movimento Nucleare," Gal. San Fedele, Milan 1953; "Peinture Nucléaire," Gal. Saint-Laurent, Brussels 1953; "Arte Nucleare," Sala degli Specchi, Venice 1954; "Phasen," Stedelijk Mus., Amsterdam 1957; "Segno e Materia," Gal. La Medusa, Rome 1958; "Boîte Alerte, Exposition Internationale du Surréalisme," Gal. Daniel Cordier, Paris 1959; "Surrealist Exhibition in the Enchanters' Domain," International Surrealist Exhibition, D'Arcy Gals., NYC 1960; "Art of Assemblage," MOMA, NYC 1961; "New Realism," Sidney Janis Gal., NYC 1962; São Paulo Bienal 1963; Venice Biennale 1964; "Pop Art, Nouveau Réalisme, etc. . . . ," Palais des Beaux-Arts, Brussels 1965; "Recent Italian Painting and Sculpture," Jewish Mus., NYC 1968; "Surrealism?," Moderna Mus., Stockholm 1970; "Métamorphose de l'objet," Palais des Beaux-Arts, Brussels 1971; "Il mito della macchina; escalazione, ironia, crisi," Gal. Blu, Milan 1972; "La ripetizione differente," Studio Marconi, Milan 1975.

COLLECTIONS INCLUDE: Gal. d'Arte Moderna, Milan; Peggy Guggenheim Collection, Venice; Mus. d'Art et Industrie, Saint-Etienne, France; Tate Gal., London; Stedelijk Mus., Amsterdam; Boymans-Van Beuningen Mus., Rotterdam; Mus. d'Art et d'Histoire, Cabinet des Estampes, Geneva, Switzerland; Mus. des XX Jahrhunderts, Vienna; Moderna Mus., Stockholm; Carnegie Inst., Pittsburgh; Nat. Gal. of Art, Washington, D.C.; Cincinnati Mus. of Art; Inst. of Contemporary Art, Chicago; Power Foundation of the Univ. of Sydney, Australia.

ABOUT: Abrams, H. New Art Around the World, 1966; Baj, E. and others Manifeste de la Peinture Nucléaire, 1952, (and others) Contro lo Stile, 1957, (and others) Arte Interplanetaria, 1959; "Enrico Baj" (cat.), Indianapolis Mus. of Art, 1978; Bénézit, E. (ed.) Dictionnaire des peintres, sculpteurs et graveurs, 1976; Crispolti, E. Catálogo generale Bolaffi opere di Baj, 1973; Jacquer, E. Baj, 1956; Jouffroy, A. Baj, 1972; Lippard, L.R. Pop Art, 1966; Pellegrini, A. New Tendencies in Art, 1966; Petit, J. Baj: Catalogue de l'oeuvre et des multiples, 1970, "Enrico Baj" (cat.), Mus. d'Art et d'Histoire, Cabinet des Estampes, Geneva, Switzerland, 1974; Sauvage, T. Arte Nucleare, 1962; van der Marck, J. Baj, 1962, "Baj" (cat.), Mus. of Contemporary Art, Chicago, 1971. *Periodicals*—Christian Science Monitor (Boston) February 1, 1963; Corriere della Sera (Milan) August 1969; Flash Art (Rome) no. 13 1969; Marcatre (Milan) June 1965, June 1966; Multiplicità Internazionale (Stockholm-Zürich) October 1972; National Observer (Washington, D.C.) October 9, 1971.

***BALTHUS (COUNT BALTHASAR KLOSSOWSKI DE ROLA)** (February 29, 1908–), French painter of dreamily mysterious and erotic figures, interiors, and landscapes, belongs to no school or group. He is one of the few non-Pop artists to have made figuration work in an era largely dominated by abstraction.

Balthasar Klossowski was born in Paris to a cultured Polish family whose older members had immigrated to France about the middle of the 19th century. His father, Erich Klossowski, who published a standard monograph on Honoré Daumier in 1908, subsequently abandoned art criticism for painting, producing skillful works in the impressionist manner. Balthus's mother, Baladine, was also a painter. Pierre Bonnard and André Derain were among the distinguished artists who were intimates of the Klossowski household.

Balthus's early childhood was spent in Paris, but during World War I the family moved to Switzerland. Living in what Robert Hughes of *Time* magazine (April 16, 1984) called "genteel poverty," they settled first in Bern, then in Geneva. In the mountains and lakes of Switzerland, Mark Stevens wrote in *Vanity Fair,* Balthus found "something comparable to great oriental painting, which celebrates the harmony and grandeur of such landscapes. He also liked the frescoes of the popular traditional painters in the small churches of the region." In Geneva the poet Rainer Maria Rilke became a close family friend (Baladine was infatuated with him) and

°bäl´ thōos

Courtesy of MOMA, NYC; Photo by James Thrall Soby

BALTHUS

encouraged the boy's precocious artistic talent. Indeed, after the Klossowskis separated, Rilke bacame a surrogate father to Balthasar. At the age of 11 Balthus composed an album of drawings, *Mitsou* (the story of an Angora cat), which was published in 1921 with a preface in French by Rilke.

The cat Mitsou was to make his ghostly appearance in several of Balthus's most important canvases, as one of many obsessive memory-images. In fact, Balthus says that he has never stopped seeing as he did as a child. He inscribed a self-portrait of 1937 "H. M. the King of the Cats," and many of the women in his works have a decidedly feline allure.

In 1924 Balthus and his mother returned to Paris, where he resolved to become a painter and became friendly with André Gide. Although he received useful advice from artist friends, Balthus was largely self-taught as a painter. In fact, he spent three months copying Poussin's *Echo* and *Narcissus* in the Louvre. In 1926 he traveled in Italy where he copied Masaccio's murals in Florence and the great frescoes by Piero della Francesca in the church of San Francesco in Arezzo. The cool color and static, monumental forms of Balthus's *Nude in Front of a Mantel* (1955; Metropolitan Museum of Art, New York City) are strongly reminiscent of Piero.

Balthus told James Thrall Soby in 1956 that it was Bonnard who first taught him what it meant to be an artist. "Bonnard," he said, "showed me there was no need for an aesthetic in the usual sense of the word. He could make art out of central heating—or anything else, for that matter."

But the strongest influence on Balthus was that of the 19th-century Realist master Gustave Courbet. He took to heart Courbet's dictum: "Create a suggestive magic that contains both the object and the subject, the world outside the artist and the artist himself," and Courbet's *Portrait of P. J. Proudhon and His Children* (1865–67), in which the three little girls play and read in the background while the social theorist Proudhon sits meditating on the steps, made a strong impression on Balthus. Like some of Courbet's other works, it evoked in him haunting childhood memories. Other important sources of Balthus's subject matter and style were children's picture books of the late 19th century, especially the illustrations for such horrendous "cautionary tales" as "Little Pauline Burned for Disobedience" from *Struwwelpeter* (Schock-headed Peter) and the Tenniel-illustrated edition of *Alice's Adventures in Wonderland*—quintessentially Victorian images revealing the taboos and terrors of childhood within a setting of stolid bourgeois domesticity.

In 1928 Balthus painted frescoes in the church of Beatenburg, a village in the Bernese Oberland; they were later destroyed in the restoration of the church. In 1929 he did his military service in Morocco, an experience which was later to inspire his curious seminaive picture *Garrison in Morocco* (1933), in which soldiers in absurdly high fezzes attempt to capture a white horse in a barracks-yard.

About 1933 he made a series of brilliant black-and-white illustrations for Emily Bronte's *Wuthering Heights*. (He has read widely in English literature, and says that his grandmother was a Gordon from Scotland, distantly related to Lord Byron. It must be remembered, though, that Balthus has a penchant for myth-making—the title "Comte de Rola" is self-conferred—and, as Robert Hughes has pointed out, the artist's myth about himself is that he is "the painter as romantic hero, a Byronic creature with a secret wound and obscurely exalted origins.") Balthus's ink drawings for *Wuthering Heights*, with their deliberate and powerful awkwardness, are especially vivid when illustrating those early episodes in the novel which convey the malaise and tangled emotions of late childhood growing into adolescence—one of the artist's constant preoccupations. He converted one of the drawings ("Why have you that silly frock on, then?") into a large painting showing himself as Heathcliff watching Cathy dress in her room. Voyeurism, combined with a certain aristocratic detachment, recurs in Balthus's trancelike, enigmatic world.

In 1934 Balthus had his first solo exhibition,

at the Galerie Pierre, Paris. Among the works shown in the exhibit, which was reviewed by the artist's friend, the avant-garde writer Antonin Artaud, was the large canvas *The Street,* begun in 1930 and completed in 1933 (an earlier version was painted in 1927). In this version of a Parisian alley the figures, even when walking, have a rigid, transfixed quality, and the atmosphere is bizarre and claustrophobic. According to Hughes, "Most of the themes of Balthus's mature work are announced in this striking precocious painting: the rigorous yet mysterious space, the haughtily erudite quotations from high art, the choice of sex object, the theatricalization of rape."

The most shockingly "obscene" of the pictures, *The Guitar Lesson* (1934), had to be taken from the wall by gallery director Pierre Loeb, and was only shown to visitors in a private room. In the painting the young woman who is the music teacher treats the body of her pupil, a girl of about 12 stretched across her lap, as a guitar, and tugs at the child's hair, as if meting out punishment. The girl's actual guitar has tumbled on the floor. This painting had been seen only rarely before the Balthus exhibition at the Pierre Matisse Gallery, New York City, in 1977. Thomas B. Hess of *New York* magazine wrote that "the intensity of its image, locked in a classic pictorial structure, suggests the particular quality of Balthus's art." However, Balthus's eroticism, always implicit in his figure compositions, is usually far more subtly and obliquely conveyed. The novelist André Pieyre de Mandiargues, describing the impact on him of Balthus's first solo show in Paris in 1934, claimed that the exhibition heralded the return of an element that had not been seen in French art since Courbet—eroticism (as distinct from sensuality). The critic wrote: "Balthus's humanism is erotic and cruel." Thus, it seemed altogether fitting that in 1935 Balthus should have been commissioned by Artaud, theorist of the "theater of cruelty," to design sets and costumes for Artaud's version of Shelley's *The Cenci,* a lurid drama of incest, revenge, and punishment in late Renaissance Italy.

In *The Children* (1937), Balthus treated what was to be a recurrent theme, little girls, occasionally in the company of a young boy, playing and dreaming in the stillness of a bourgeois living room. There is something ambiguous and innocently perverse about the provocative attitudes of Balthus's nymphets in this and similar paintings, but the mood of vague ennui and incipient sexuality is contained within a tightly controlled formal structure in the monumental tradition of Uccello, Piero della Francesca, and Seurat. Picasso, an admirer of Balthus's work, hung *The Children* in his Vallauris villa (it is now part of

the Picasso bequest in the Louvre). "Balthus is so much better than all those young artists who do nothing but copy me," Picasso once said. "He is a real painter."

Balthus has been condemned for lasciviously exploiting the sexuality of young girls, but his defenders claim that his erotic paintings deal with another subject as well, loss of innocence. And it is, perhaps, Balthus's unique gift that he depicts the imminent victimization of adolescents in such a stately and appealing way that he catches both artist and spectator in a web of complicity. Indeed, as Albert Camus said, Balthus's victims "are significant ones: he shows a knife, but never any blood. . . . He is interested not in crime but in purity. . . . He shows them as being offered up in all the profound innocence of that which is no more."

In 1937–38 Balthus painted a sympathetic but far from joyous portrait of Joan Miró with his little daughter. As Mark Stevens observed, Balthus captured Miró's intensity, but something of that artist's timidity as well. The first Balthus work seen in America was the portrait painted in 1936 of André Derain, who stands, imposing and vaguely sinister with his jowly face, cold eyes, and massive bathrobed body, while an adolescent model, her clothing in disarray, slumps in the background. New York critics were struck by Balthus's muted colors, very different from the bright palette then typical of French modernist painting. This memorable work was shown at the Pierre Matisse Gallery in 1938 and is owned, along with the portrait of Miró, by the Museum of Modern Art, New York City. According to Stevens, these are "great portraits" in a century poor in portraiture.

Balthus married Antoinette de Watteville in 1937. Also in 1937 he painted his largest canvas up to that date, *The Mountain,* in which the craggy setting is an imaginary plateau in the Bernese Oberland. The model for the young blond woman stretching was his wife. The presence of the oddly detached figures, as well as the hallucinatory lighting, make this by far the most compelling of all Balthus's landscapes, which often tend to be rather dry and lifeless. Another exception is the luminous but muted *Cherry Tree* of 1940.

With the onset of war in 1939 he was sent to the front, but ill-health caused him to be demobilized a month later. He spent the last years of World War II with his wife and children in Switzerland, working mainly at Freiburg. In 1943 he exhibited at the Galerie Georges Moos, Geneva.

After the war Balthus painted with renewed dedication. In 1946 he held an important exhibition, his second in Paris, at the Wildenstein Gal-

leries. One of the most striking canvases on view was *The Golden Days* (1944–46), now in the Hirshhorn Museum and Sculpture Garden, Washington, D.C. A young girl reclines in a chaise-longue idly studying her reflection in a hand-mirror; in the background on the right an adolescent boy tends the blazing fire in the fireplace. The painting, in mellow brownish hues, is firmly, even severely, composed, with characteristically erotic undertones.

In 1950 Balthus designed sets and costumes for *Cosí fan Tutte* for the festival at Aix-en-Provence, France. Four years later he transferred his studio from Paris to a Louis XIII manor at Chassy in the Nièvre region of central France. He worked there most of the time, visiting Paris only occasionally. One of his major, mural-sized paintings, *The Bedroom,* was begun in 1952 and completed in 1954. Typically, a nude adolescent girl sprawls in an abandoned pose—her figure, shown in profile, except for her head half-turned towards the viewer, almost repeats the pose of *The Golden Days.* An ogreish and dwarfish girl, clothed, her figure and abnormally large head rendered in the awkward style of the *Struwwelpeter* illustrations, forcefully draws aside the window curtain. The soft sunlight gently and secretively gilds the nude girl's figure. That frequent observer of Balthus's equivocal scenes, the inscrutable cat—the artist's alter ego—watches from a small table on the farther side of the window.

In 1961 André Malraux, de Gaulle's Minister of Culture and a longtime admirer of the artist, named him director of the French Academy in Rome. Balthus was the first major artist to occupy this post since Ingres, over one hundred years before. During his 16-year tenure (he retired in 1977), Balthus directed extensive restorations on the 16th-century interior of the Villa Medici, the French Academy's headquarters, and on its famous gardens. The American painter Raphael Soyer visited Balthus in the Villa Medici in August 1961, and described the elusive artist as a "handsome, artistocratic, thin-blooded man" with a "finely chiseled face" that reminded Soyer of Chopin's.

Biographical details have always been sparse on Balthus, a loner like his friend Giacometti but even more secretive. He resents all intrusions, and when critic John Russell was preparing a catalog about him for the 1968 Balthus retrospective at London's Tate Gallery, he told Russell to "just say that Balthus is a painter about whom nothing is known." He insists that "an artist should remain anonymous," but it would seem that his vision, however transposed, is rooted in personal experience, drawing on the pres-

ent as well as the remembered past. "Some say my paintings are sinister and abnormal," he remarked in 1957. "But I have had the same vision since I was four. Perhaps that is abnormal."

A painstaking craftsman, Balthus works very slowly, producing only about five new canvases a year. He painted several interesting landscapes in Chassy in the late '50s, cool in color, highly textured, and with a Seuratlike stillness. In 1963, in Rome, he began a canvas, *The Turkish Room,* completed in 1966, in which a decorative Orientalism—possibly a distant echo of Ingres—made its appearance. Here the protagonist is a little nude Chinese girl reclining on a sofa in a shuttered room with elaborate patterns on the floor, wall, and furnishings. She holds up a hand mirror. Seeing this painting at the Pierre Matisse Gallery in 1967, Hilton Kramer felt that Balthus, by flattening his space and stressing the decorative element, had given his fantasy an "unexpectedly benign and relaxed" quality, and that this represented "a clear loss." Hughes also sees a decline in Balthus's later work. After 1961, he wrote, "the measured suppleness of Balthus's paint surface . . . began to ossify, acquiring a thick, chalky, fresco-like appearance. It was meant to suggest the warmth and historical patina of old Roman walls, and so it did, but in a merely decorative way."

Nevertheless, about 1967, Balthus, using his young Japanese wife Setsuko as a model, achieved a kind of breakthrough. His studies of Setsuko culminated in two large canvases, completed in 1976 after much reworking: *Japanese Figure with Black Mirror* and *Japanese Figure with Red Table.* They were exhibited for the first time in a condensed and selective Balthus retrospective at the Pierre Matisse Gallery in 1977, the artist's first important showing in that city since the MOMA exhibit of 1956–57. Thomas B. Hess in *New York* magazine remarked on the impact on these paintings of Japanese art, and their "immensely complicated dense surfaces on which light dances as if in a dusty room." For the first time in the artist's work the female figure is mature and pregnant. (Setsuko had two children with Balthus; the first-born died in childhood.) The exhibit also included some exquisite pencil drawings of adolescent nudes, and one of the artist's very rare self-portraits, a study in charcoal executed in 1943.

Fascinating as the decorative trend of the Japanese paintings was, the quintessential Balthus, in somewhat mellowed form, could be found in *Nude in Profile* (1977), a painting filled with the suffused glow of morning light. The outline of the girl's body and her slightly *quattrocento* profile are invested, to quote Hughes, "with a

hushed archaic permanence." The layers and scumbles of paint give her flesh "the porous matte quality of fresco plaster." Mark Stevens in *Newsweek* admired the "troubling malice" of *Katya Reading* (1970–76), another recent canvas.

A major Balthus retrospective was held at the Metropolitan Museum of Art, New York City, in early 1984. Sanford Scwartz, in his *New Yorker* review, commented that "Balthus's work can be stimulating in a group show" but added that his paintings, when seen en masse, "have very little cumulative impact, [and] can make a viewer . . . a bit numb." Schwartz considered that "his most intense and vibrant works" were the illustrations done between 1932 and 1935 for *Wuthering Heights* and that much of his inspiration came from books and reproductions of pictures.

Balthus continues to live and work in virtual seclusion in his chateau in Nièvre. Outwardly the cultivated fastidious aristocrat, the man himself remains mysterious, a maverick among painters. His refined and obsessive eroticism has been called "post-Freudian," but his art, with its constant dialogue with the past, eludes easy categorization. As Hilton Kramer pointed out in *The New York Times*, "There are times when his whole stance as an artist seems a conscious denial of modernity, yet the effect of his art . . . is to encourage a wider definition of what modernity consists of."

EXHIBITIONS INCLUDE: Gal. Pierre, Paris 1934; Pierre Matisse Gal., NYC 1938, '49, '57, '62, '66, '67; Gal. Georges Moos, Geneva, Switzerland 1943; Wildenstein et Cie., Paris 1946; Gal. des Beaux-Arts, Paris 1946, '56; Lefevre Gal., London 1952; MOMA, NYC 1956–57; Mus. Civico di Torino, Italy 1961; Arts Club of Chicago 1964; Mus. des Arts Decoratifs, Paris 1966; Casino Communal, Knokke-le-Zoute, Belgium 1966; Tate Gal., London 1968; Gal. Claude Bernard, Paris 1971, '72; Mus. Cantini, Marseilles, France 1973; "Paintings and Drawings, 1934–1977," Pierre Matisse Gal., NYC 1977; Centre Georges Pompidou (Beaubourg), Paris 1983; "Balthus: A Retrospective," Metropolitan Mus. of Art, NYC 1984. GROUP EXHIBITIONS INCLUDE: "Art in Our Time," MOMA, NYC 1939; "Exposition d'Art Contemporain," Palais des Papes, Avignon, France 1947; American Federation of Arts tour 1962–65 (Paintings from the Joseph H. Hirshhorn Foundation Collection).

COLLECTIONS INCLUDE: MOMA, and Metropolitan Mus. of Art, NYC; Hirshhorn Mus. and Sculpture Garden, Washington, D.C.; Boymans-Van Beuningen Mus., Rotterdam.

ABOUT: Bénézit, E. (ed.) Dictionnaire des peintres, sculpteurs et graveurs, 1976; de Rola, S.K. Balthus, 1983; Leymarie, J. Balthus, 1983; Lucie-Smith, E. Late

Modern: The Visual Arts Since 1945, 1969; "Paintings and Drawings, 1934–1977" (cat.), Pierre Matisse Gal., NYC, 1977. *Periodicals*—Art Digest April 7, 1949; Art News December 2, 1956; Cahiers d'art (Paris) no. 20–21 1946; Guardian October 5, 1968; New York Herald Tribune March 11, 1962; Life January 28, 1957; New Yorker May 7, 1984; New York November 21, 1977; New York Times April 2, 1967; Newsweek December 5, 1977; L'Oeil (Paris) March 1956; Time March 12, 1961, November 28, 1977, April 16, 1984; Vanity Fair February 1984; XXe siècle (Paris) June 1975.

BASKIN, LEONARD (August 15, 1922–), American sculpture, printmaker, and book illustrator, was born in New Brunswick, New Jersey. His father, Samuel Baskin, was a rabbi who had emigrated from Poland around the turn of the century. After settling in the West, first in Salt Lake City and then in Denver, he moved to the East. He married his second wife, May Guss, in Philadelphia in 1918—his first marriage had ended in divorce—and settled with her in New Brunswick, where he had obtained a post as rabbi. Bernard, the eldest of their three children, was born in 1920, Leonard in 1922, and Pearl in 1925.

The family moved to Brooklyn in 1925, and the boys were sent to a yeshiva, where they received a strict religious education. Their father was a Talmudic scholar, and learning was valued in the Baskin home. Education, especially self-education, became for Leonard synonymous with life itself.

At 16 Baskin enrolled in night school at the Educational Alliance, New York City. His teacher, Maurice Glickman, with whom he studied until 1939, became his chief mentor. "The best way to learn about art," Baskin later told his own students, "is to attach yourself to an artist." He was influenced not only by watching Glickman at work as a sculptor, but by his teacher's idealistic socialism.

In 1941, after taking courses at New York University's School of Architecture, Baskin received a scholarship to the Yale University School of Fine Arts, where he studied until 1943, when he was expelled for "incorrigible insubordination." Enlisting in the US Navy, he qualified as a pilot and flew numerous solo missions for the Air Corps. He also served as a gunner in the merchant marine, making several Atlantic crossings before being transferred to a freighter in the Pacific. He wrote poetry, short stories, and a novel in his leisure time and was allowed to set up a small "studio" in the carpenter's shop of a ship he served on in the Pacific. Among the sculptures he carved there was *Torso* (ca. 1943), in wood and 13¼ inches high.

Kennedy Galleries

LEONARD BASKIN

After the war Baskin returned to New York City, where he attended the New School for Social Research on the GI Bill. He married Esther Tane, a friend of his sister's and a psychology student at Brooklyn College, and they moved into a studio apartment at the edge of the East River in Brooklyn. In the postwar years Baskin was as he had been during the Depression, a leftist. His aesthetic and political positions were united in his forcefully muscled *Prometheus,* carved in red oak during his years at the New School. This figure was intended as a metaphor for the worker, but its expressive distortion was as removed from orthodox social realism as it was from abstract expressionism, which was then becoming the dominant style in American art, and to which Baskin was resolutely opposed. According to Irma B. Jaffe, the *Prometheus* is "somewhat confused as sculptural form, yet it has a certain power. . . . " Social message also dominated form in another sculpture executed at this time, *Pelle the Conqueror,* which was influenced by Rodin.

Nevertheless, these were years of intense intellectual growth, and Baskin's promise as a sculptor was confirmed by the Louis Comfort Tiffany Foundation Fellowship he received in 1947, about the time that he began to make woodcuts. In 1948 he became art editor of a Marxist cultural journal, *New Foundations.* Although Baskin relied on orthodox Marxian terms when discussing art, his conception of realism was not of the naturalistically detailed, literally "true-to-life" kind, but was for him a means of expressing the totality—"all of man's existence," he said—and of revealing "the inner workings and meanings of society."

Baskin found his teachers at the New School stimulating and enjoyed his classes in life drawing under Julian Levi. In 1949, the year of his graduation, he briefly abandoned sculpture for printmaking, and showed six prints, including a series entitled "Prophet," in an exhibition at the Philadelphia Art Alliance. He had come to realize that sculpture was far less suited than prints to the preaching of a social message, but was moving away from the propagandistic side of left-wing ideology.

In 1950, at a time when the Abstract Expressionists were advancing radically beyond their cubist and surrealist sources, Baskin left for Europe with his wife. The trip seems to have been decisive in his artistic development, inasmuch as Baskin was to find his place as a sculptor within the older European traditions from which the Abstract Expressionists were cutting themselves off. He spent nine months in Paris, where he enrolled in Ossip Zadkine's studio at the Académie de la Grande Chaumière. He left abruptly after Zadkine, on seeing photographs of Baskin's *Prometheus* and *Pelle the Conqueror,* said, "We'll soon disabuse you of all this Rodin nonsense." Baskin continued, however, to work from time to time in Zadkine's studio, being obligated to do so under the GI Bill. He also spent hours in the Louvre, studying the 6th century B.C. *Hera of Samos* and the great Egyptian and Mesopotamian figures and reliefs. He became interested in the life-size medieval *gisants,* supine stone figures resting on the tombs of monarchs and religious dignitaries, in the cathedrals and churches he visited. (Critics have noted the persistence of death as a theme in Baskin's work.) He was impressed by illustrations in an old journal of the casts of the dead found at Pompeii, casts he eventually saw on his travels. Baskin and his wife also spent two weeks in London, where he was deeply moved by the Egyptian and Mesopotamian collections in the British Museum.

Early in 1951 the Baskins moved to Florence, and Leonard held his first solo exhibition of woodcuts there in April. Typical of his prints at this time was *Son Carrying Father* (1950), which in its stark expressionism recalls Orozco and other Mexican Social Realists. In Florence, Baskin enrolled at the Accademia delle Belle Arti, but found the teaching there sterile. He learned far more from visiting the churches and museums of Florence and other towns in Tuscany, Umbria, and the Latium. In Pisa, he discovered the work of the Italian late-Gothic sculptor Tino di Camaino, whose archaizing quality, hieratic grandeur, and strange, awkward power helped the young artist in his own progress toward self-discovery.

Baskin and his wife returned to New York City in the late spring of 1951. Esther soon enrolled in the doctoral program in psychology at the Clark Institute, Worcester, Massachusetts, and the Baskins moved there later that year. Baskin became an instructor in printmaking at the Worcester Art Museum, and set up his Gehenna Press in his home at 6 Castle Street. In the more than 25 years of its existence, the Gehenna Press produced some one hundred books, many of them illustrated with Baskin's wood engravings. In 1952 he completed his bronze sculpture *Dead Man (1)*, which, in its austere simplicity influenced by the medieval *gisants* and the casts in Pompeii, marked a radical departure from his ideologically motivated sculptures of the '40s. Also in 1952 he sent a group of his woodcuts to William Lieberman, curator of prints and drawings at the Museum of Modern Art, New York City. Lieberman introduced him to Grace Borgenicht, who showed his prints in her gallery, never expecting to sell any, because they were "so stark, so aggressive." But she sold all she had taken, including the powerful *Man of Peace* (1952; MOMA), and for the next 16 years Baskin exhibited regularly at the gallery. In 1953 he was awarded a Guggenheim fellowship for printmaking, and met the Realist painter Ben Shahn, whose work he had long admired.

Although Baskin did not exhibit sculpture between 1952 and 1956, he was working in wood, stone, and clay. His major carving of the early '50s was *Man with Dead Bird* (1954), in walnut, a three-dimensional statement of his *Man of Peace* woodcut. From 1952 to '56 he also continued work on the series of *Dead Men* which he had begun in Paris, exploring variations of poses and shapes while maintaining an overall unity and simplicity of form. In 1953 he began to teach printmaking and sculpture at Smith College, Northampton, Massachusetts, and the following year he received the Ohara Museum Prize from the Japanese National Museum, Tokyo.

The theme of death in Baskin's sculpture is to be found in his works of the mid-'50s that pay homage to artists and poets of the past. His bronze *Head of Blake* (1955) was remarkably faithful to the life-mask taken in 1823 by James S. Deville of the then 65-year-old William Blake. In 1954 Baskin carved a head of the French etcher and lithographer Rodolphe Bresdin. Using a daguerreotype as his model, Baskin carved the head in Brazilian rosewood (wood carving continued at that time to be Baskin's favorite medium). In its contrast of severe and decorated surfaces the Bresdin head was reminiscent of certain Mesopotamian works, such as the so-called *Head of Hammurabi* in the Louvre, or the late Assyrian statue of Assurnasirpal II in the British Museum, London. Baskin paid tribute to a fellow sculptor in his wood carving *Barlach Dead* (1959), one of several portraits he made of the visionary German artist who died in 1938.

The peak of Baskin's stone carving was, perhaps, *The Guardian* (1956), in limestone, a work influenced by Rodin's massive *Monument to Balzac* of 1897, which Baskin knew both in its final form and from Rodin's preparatory studies. As Baskin regarded Rodin's *Balzac* as the "guardian" of the realist tradition and the repudiation of romanticism, he saw his own *Guardian* as the embodiment of his lonely struggle to continue and defend the figurative tradition in American sculpture. In contrast to the proud indomitability of *The Guardian* was the bloated, heavy-jowled *Poet Laureate* (1956), an ironically titled bronze bust of an artist who has betrayed his gift.

Among Baskin's compelling images of death, grief, and suffering were *John Donne in his Winding Cloth,* a bronze of 1955 and an early use of the "wrapped" motif, and the stark woodcut *Hanged Man,* also of 1955. Baskin was to take up the "hanged man" theme over 20 years later, in one of his bronze figures of 1976.

Baskin held his first major solo exhibition at the Boris Mirski Gallery, Boston, in the spring of 1956, and was given his first museum show at the Worcester Art Museum that November. In March 1957 his sculpture received its first showing in New York City, at the Borgenicht Gallery. At a time when abstract expressionism was still strong, Baskin's "figurative, harsh, and unsettling art," to quote Irma B. Jaffe, was not welcome in all quarters. One reviewer commented on the "morbidity" of his sculptures and on their "intractably ugly but solemn reality." However, MOMA, despite its support of New York School modernism, acquired *Man with Dead Bird* and in 1959 included his work in its "New Images of Man" exhibition.

In the mid-'50s Esther Baskin contracted multiple sclerosis, a fatal disease of indeterminate duration. Nevertheless, the couple decided to have a child, and their son, Tobias, was born in 1957. Confined to her bed in the Baskin home at Fort Hill, Northampton, where they had moved in 1955, Esther managed to write two books. In 1964, Lisa Unger, daughter of an architect friend of Baskin's, began studying art with Baskin. Soon the relationship changed, and Lisa moved into the Baskin home, helping in the care of Esther and Tobias. This unorthodox arrangement was accepted by Esther, and in 1967 she and Leonard divorced and he and Lisa married. They continued to live with Esther until her

death in 1970. Lisa and Leonard's son, Hosea, was born in 1969, and Lisa gave birth to their daughter, Lucretia, in 1974.

Baskin had stopped carving in stone in 1958 and his figures in all media had been male, but after marrying Lisa he began sculpturing female figures, including *Phaedra* (1969) and *Lisa,* a bronze relief of 1971. There were also changes in his technique. He had previously cast his bronze sculptures from plaster figures, but he now began to work mostly in clay, aiming at smoother surfaces. He did fewer wood carvings than before but did not stop altogether. Some of his most striking sculptures of the 1960s have been categorized by Irma Jaffe as "figures of evil." These include *Armored Man,* a birchwood of 1962, and the brutal *Figure* (1971) in bronze, a sculptural version of a figure that had appeared earlier, in an ink drawing of 1967 called *Laughing Sheriff,* which had been inspired by the civil rights movement. In many of Baskin's woodcuts, the figure resembles an anatomy chart, showing in detail veins, muscle tissue, and nerves.

Several sculptures of birds done in the late '60s were endowed with an eerie, often sinister quality. Examples are the monolithic bronze *Owl* (1960), one of Baskin's best-known pieces; *Caprice* (1963), also in bronze, in which the strutting bird is the moral equivalent of the arrogantly prideful *Poet Laureate*; and the hybrid bronze *Seated Birdman* (1961), with its suggestion of barbaric cruelty. The standing crow of 1968, *Hood,* is another of his symbols of menace, and the carved eagle of 1963, *Apotheosis,* outstanding in what Baskin calls his "evil ornithology," is to the artist a descendant of the bird of Jupiter and the "double-headed and barbarous" imperial eagle of Rome.

Baskin had treated mythological themes in his *Daedalus* (1967) and in *Phaedra.* The latter was also one of his first "wrapped figures" since *John Donne in his Winding Cloth*; the wrapping was used primarily as an expressive device signifying mourning. After 1970 Baskin's sculpture was less haunted by images of evil, grief, and death. Such works in bronze as *Divinator* (1974), *Prophet: Homage to Rico Lebrun* (1971), and *Isaac* and *Sybil,* both of 1976, seem to express man's potential for heightened spirituality. Groups of two figures, such as *Aeneas Carrying His Father From Burning Troy* (1971), *The Prodigal Son* (1976, the year after Baskin's father's death), and *Ruth and Naomi* (1978), departed from his customary portrayals of men in isolation by conveying a sense of hope and of brotherhood. One major work, *The Altar,* completed in 1977, was carved in laminated wood.

In 1973, when he relinquished his teaching post at Smith, Baskin moved with his family to England, though he maintains a studio and home in Little Deer Island, Maine. Baskin is a pleasant, bearded man, five feet eight inches tall, who, as Jaffe has noted, bears "a physical and expressive resemblance" to "the figures and faces he has made."He himself has remarked, "I fully believe that all my figures are me." Sensitive, complex, a man of many moods, he is patient and thoughtful in discussing his work, but is intolerant of pretense. Although he works largely from imagination, he is firmly opposed to the abstract trends in contemporary art and has remained true to his humanistic beliefs. The Realist painter Raphael Soyer included him in his *Homage to Thomas Eakins,* a group portrait of 1966.

Although Baskin has made free-standing sculpture and bronze reliefs of birds and dogs with symbolic overtones, he believes that "the human figure is the image of all men and of one man. It contains all and can express all." On another occasion he said: "Man must rediscover man, harried and brutalized, distended and eviscerated, but noble withal, rich in intention, puissant in creative spur, and enduring in the posture of love."

EXHIBITIONS INCLUDE: Glickman Studio Gal., NYC 1939; Gal. School of Architecture and Allied Arts, New York Univ. 1940; Gal. "Numero," Florence 1951; Boris Mirski Gal., Boston 1952–69; Grace Borgenicht Gal., NYC 1953–69; Worcester Art Mus., Mass. 1956–57; Boymans-Van Beuningen Mus., Rotterdam 1961; MOMA, NYC 1961–62; Bowdoin Col. Mus. of Art, Brunswick, Maine 1962; Nationalmus., Stockholm 1968; Nat. Collection of Fine Arts, Smithsonian Instn., Washington, D.C. 1970; F.A.R. Gal., NYC 1970; Kennedy Gal., NYC from 1971. GROUP EXHIBITIONS INCLUDE: Philadelphia Art Alliance 1949; "New Images of Man, MOMA, NYC 1959; São Paulo Bienal 1961; Venice Biennale 1968.

COLLECTIONS INCLUDE: MOMA, Whitney Mus. of Am. Art, and New York Public Library, NYC; Brooklyn Mus., N.Y.; Albright-Knox Art Gal., Buffalo, N.Y.; Munson-Williams-Proctor Inst., Utica, N.Y.; Newark Mus., N.J.; Princeton Univ., N.J.; Yale Univ., New Haven, Conn.; Mus. of Fine Arts, Boston; Brandeis Univ., Waltham, Mass.; Harvard Univ.,Cambridge, Mass.; Smith Col., Northampton, Mass.; Worcester Art Mus., Mass.; Pennsylvania Academy of Fine Arts, Philadelphia; Hirshhorn Mus. and Sculpture Garden, and Library of Congress, Washington, D.C.; Art Inst. of Chicago; Detroit Inst. of Arts; City Art Mus. of St. Louis, Mo.; Univ. of Nebraska, Lincoln; Seattle Art Mus., Wash.; Bezalel Nat. Mus., Jerusalem.

ABOUT: Ames, W. and others "Leonard Baskin" (cat.), Bowdoin Col. Mus. of Art, Brunswick, Maine,

1962; Current Biography, 1964; Jaffe, I.B. The Sculpture of Leonard Baskin, 1980; "Leonard Baskin" (cat.), Nat. Collection of Fine Arts, Smithsonian Instn., Washington, D.C., 1970; "Leonard Baskin, The Graphic Work, 1950–1970" (cat.), F.A.R. Gal., NYC, 1970; Sadik, M. (ed.) "Leonard Baskin" (cat.), Kennedy Gals., NYC 1972; Selz, P. (ed.) "New Images of Man" (cat.), MOMA, NYC, 1959; Soyer, R. Diary of an Artist, 1977. *Periodicals*—Art in America February 1956, Summer 1962, November–December 1966; Arts Magazine March 1957, January 1981; Atlantic Monthly April 1961, September 1964; Life January 1964; New Foundations Summer 1948; Show August 1963.

WILLI BAUMEISTER

***BAUMEISTER, WILLI** (January 22, 1889–August 31, 1955), German painter, belonged to the intermediate generation of 20th-century German modernists, but his major works were produced after World War II, when he began to gain wider recognition. Widely exhibited in Europe, his work is little known in the United States.

Baumeister was born in Stuttgart. His forebears were craftsmen and there had been four generations of painters on his mother's side. In 1905 he was apprenticed to a house painter and decorator, and he also enrolled at the Stuttgart Academy of Art, where he studied until 1907 with Robert Poetzelberger. After national service from 1907 to 1908, he resumed the study of art at the Stuttgart Academy with Arthur Igler and, in 1909, with Adolf Hölzel, a noted theorist of color. A fellow student, and eventually a close friend and artistic collaborator, in Hölzel's class was Oskar Schlemmer, who won fame after World War I as painter, sculptor, stage designer, writer, and influential teacher at the Bauhaus.

Baumeister's early work was influenced by Cézanne and the Cubists. In 1911 he visited Paris, and the following year had his first solo exhibition, in Zürich. Between 1912 and 1914 he traveled in Switzerland, Germany, the Netherlands, and France. He was by then acquainted with the progressive art movements in Germany, and, although never associated with the Expressionists, in 1913 he participated in the important first Herbstsalon (Autumn Exhibition), held in Herwarth Walden's avant-garde Berlin gallery, Der Sturm. In 1914 he returned to Paris and there collaborated with Schlemmer and Heinrich Stenner on the design of 12 mural panels for the Werkbund Exhibition in Cologne, the last significant display of modern German architecture and design before the outbreak of World War I. Those murals no longer exist.

Baumeister served with the German Army in 1914. The following year, in Vienna, he met Oskar Kokoschka and the progressive architect Adolf Loos. After the war he often visited Paris, and by 1919 Baumeister was producing austere constructivist paintings based largely on the play of horizontals and verticals. In 1920 he began a series of "Mauerbilder" (Wall Paintings), murals consisting mainly of diagonals, acute angles, and curves that were somewhat similar in design to purist art. An article he wrote in 1922 for the Paris-based journal *L'Esprit nouveau* attracted the attention of the Purists Amédée Ozenfant and Le Corbusier, and of Fernand Léger, who became a lifelong friend. Moreover, Léger's influence can be seen in Baumeister's figural, semiabstract paintings of machinery and of athletes with mechanical movements, a style exemplified by his *Man and Machines* (1925).

In 1926 Baumeister married Margarete Oehm, who was to bear him two daughters, Krista and Felicitas. In 1928 Baumeister was appointed professor of typography and photography at the Städel School of Art in Frankfurt-am-Main, the beginning of a five-year tenure. By the late 1920s he was combining the angularity of purism with the curves of surrealism. In Paris, in 1930, he joined the Circle and Square group and two years later became a member of the influential constructivist Abstraction-Création association. When the Nazis seized power in 1933, Baumeister's works were withdrawn from German museums, some paintings were publicly burned and denounced as "degenerate" art, and he was dismissed from the faculty at Frankfurt and forbidden to exhibit. However, he chose to remain in Germany and, clandestinely, continued to paint, though he worked in almost complete isolation.

°bou´ mīs tə, vē´ lē

In 1937, influenced by Miró and Klee, he began increasingly to use organic, biomorphic forms, most notably in a series of "ideograms," which call to mind prehistoric drawings.

During World War II Baumeister was employed at Dr. Kurt Herbert's paint factory in Wuppertal, where he conducted research into mural techniques and studied color. From 1942 to the war's end he lived in Arach and contributed illustrations to editions of the Bible, Shakespeare's *The Tempest,* and the Sumerian epic *Gilgamesh.* His study of the history of ancient cultures, myths, legends, fables, and prehistoric art led to several important series of paintings. "African Stories" (1942–55), "Perforations," "Paintings with Reliefs," his "Eidos" pictures, and his "African" and "Peruvian" paintings. These works consisted of floating, biomorphic forms, some of which suggest a grotesquely distorted human figure, while others resemble primordial organisms. However, Baumeister was never a pure abstractionist. "Even his most completely nonobjective works," one critic said, "have some relationship to the visible world, and, in this respect, he remained closer to the School of Paris than to the Bauhaus."

In 1946 Baumeister was appointed to a professorship at the Stuttgart Academy of Art, a position he held until his death. His postwar works included two series, "Cyclopean Walls" and "Metaphysical Landscapes," which are ranked among his most original creations. They consisted, to quote Vivien Raynor of *The New York Times,* of "tablet-like images, mysteriously incised with ideographic shapes." Baumeister called these works "undeciphered handwriting." As artistic activity began to revive after the utter sterility of the Nazi years, Baumeister's works were widely exhibited in Germany as well as in France. In 1947 he published *Das Unbekannte in der Kunst* (The Unknown in Art), which had been completed during the war and set forth Baumeister's ideas on the creative process. From his "Metaphysical Landscapes," on which he continued to work until about 1954, Baumeister moved into his final best-known phase, which culminated in the two series "Montaru" (1953–55) and "Monturi" (1953–54). In the "Montaru," heavy floating black forms occupy the middle of a large canvas, whereas in the "Monturi" the floating masses are white on a black ground. These tachiste paintings paralleled developments in American abstract expressionism, although Baumeister was not much influenced by the New York School. His *Am Orontes* (1954) and *Euphor I* and *Two Lanterns,* both of 1955, show the influence of the calligraphy of the Far East in line and image and have affinities with Miró, Klee, and Ernst.

Baumeister was awarded a prize at the São Paulo Bienal in 1951 and had a major retrospective in Stuttgart three years later. Morever, in the early '50s he became a hero to the younger, postwar generation of German painters, both for his art and his courage in attempting to keep alive the spirit of German modernism during the Nazi period. According to Will Grohman, author of *Willi Baumeister: Life and Work,* the artist "always felt he was the link between Picasso and the younger men. . . . "

In addition to his painting, Baumeister worked occasionally as a stage designer. He did the sets for a 1926 production in Stuttgart of Händel's *Ariodante*; other stage designs were done in Darmstadt in 1952–53.

Baumeister died in Stuttgart at the age of 66. His generosity and encouragement was deeply valued by younger artists like Julius Bissier, who, though only four years Baumeister's junior, came to him for advice, and Karl Otto Götz, whose work reflects Baumeister's influence.

The Italian critic Aldo Pellegrini praised Baumeister's personal kind of "poetic abstraction," which he said was based on "free and fluid forms in a pictorial space of very subtle texture." Reviewing an exhibition of the artist's work at the Hutton Gallery in New York City in 1978, Vivien Raynor observed: "Most artists have completed their work by the time they die. But with Baumeister, who was not only delayed by the war but had the misfortune of being on the losing side, there is the feeling that, at 66, he was cut off just as his Indian summer was beginning."

EXHIBITIONS INCLUDE: Neupert Gal., Zürich 1922; Kunstkabinett, Stuttgart, W. Ger. 1923; Gal. of Contemporary Art, Paris 1927; Gal. Alfred Flechtheim, Paris 1929; Gal. Bonaparte, Paris 1930; Scheller Gal., Stuttgart, W. Ger. 1931; Gal. il Milione, Milan 1935; New Theater, Stuttgart, W. Ger. 1945; City Mus., Wuppertal, W. Ger. 1947; Kunstkabinett, Frankfurt, W. Ger. 1948; Gal. Jeanne Bucher, Paris 1949, '54; Otto Stangl Gal., Munich 1951, '56, '60; Hacker Gal, NYC 1952; Württemberg Art Society, Stuttgart, W. Ger. 1954; I. C.A. Gal., London 1956; Kleeman Gal., NYC 1956; Stedelijk Mus., Amsterdam 1956; Studio d'Arte Contemporanea, Rome 1957, '63; Gunther Franke Gal., Munich 1958; Klihm Gal., Munich 1958; Fränkische Gal., Nuremberg, W. Ger. 1960; Lorenzelli Gal., Milan 1963; Staatsgal., Stuttgart, W. Ger. 1969; Gal. Nazionale d'Arte Moderna, Rome 1971; Städelisches Kunstinst., Frankfurt-am-Main, W. Ger. 1972; Hutton Gal., NYC 1978. GROUP EXHIBITIONS INCLUDE: Herbstsalon, Gal. Der Sturm, Berlin 1913; "Hölzel and his Circle," Freiburg 1916, and Frankfurt 1917; "Baumeister: Schlemmer," Schaller Gal., Stuttgart, W. Ger. 1918; "The Art of Today," Artists' Alliance, Paris 1925; Salon des Indépendants, Paris 1927; "Young German Art," Brooklyn Mus. of Art 1927; "Abstract and Surrealist

Painting and Sculpture," Kunsthaus, Zürich 1929; "Living German Art," Kunsthaus, Zürich 1934; "Constructivists," Kunsthaus, Zürich 1937; "Schlemmer: Baumeister: Paintings of the Twenties," Dr. Werner Rusche Gal., Cologne 1948; Pittsburgh International, Carnegie Inst. 1950; São Paulo Bienal 1951; "German Twentieth Century Masterpieces," Kunstmus., Lucerne, Switzerland 1953; "Younger European Painters," Solomon R. Guggenheim Mus., NYC 1954; Documenta 1, Kassel, W. Ger. 1955.

COLLECTIONS INCLUDE: Nationalgal., and Gal. des XX Jahrhunderts, Berlin; Landesgal., Hanover, W. Ger.; Kunstmus., Düsseldorf; Städtische Kunsthalle, Mannheim, W. Ger.; Gal. der Stadt, Stuttgart, W. Ger.; Stedelijk Mus., Amsterdam; Mus. des Beaux-Arts, Grenoble, France; Gal. Nazionale d'Arte Moderna, Rome; MOMA, NYC; Albright-Knox Art Gal., Buffalo, N.Y.; Milwaukee Art Center.

ABOUT: Baumeister, W. Das Unbekannte in der Kunst, 1947; Bénézit, E. (ed.) Dictionnaire des peintres, sculpteurs et graveurs, 1976; Dreier, K. S. Baumeister, 1926; Graff, W. (ed.) Willi Baumeister, 1927; Grohman, W. Willi Baumeister: Life and Work, 1952; Moore, E. (ed.) Contemporary Art 1942–72: Collection of the Albright-Knox Art Gallery, 1972; Pellegrini, A. New Tendencies in Art, 1966; Read, H. A Concise History of Modern Painting, 1959; Schlemmer, T. (ed.) The Letters and Diaries of Oskar Schlemmer, 1972. *Periodicals*—Alumnus (Ann Arbor, Mich.) vol. 62 no. 14 1956; Aujourd'hui (Paris) no. 5 1955; Bauhaus (Pessau) vol. 3 no. 4, 1929; Die Form (Berlin) vol. 1 no. 10 1926; New York Times November 17, 1978; Die Schaffenden (Berlin) vol. 4 no. 4 1923; Schwäbische Thalia (Stuttgart) vol. 8 no. 4 1926; Sélection, Chronique de la vie artistique (Antwerp) no. 11 1931.

***BAZAINE, JEAN** (December 21, 1904–), French painter, is a member of the middle generation, or postwar painters, of the School of Paris. Although he is an influential European Expressive Abstractionist, Bazaine rejects the idea that his work is abstract.

Bazaine was born in Paris. While earning his degree in literature, he studied sculpture under Landowsky at the Ecole des Beaux-Arts, Paris, but in 1924 realized that painting was his true means of expression. From 1930 on he exhibited in group shows with Jean Fautrier, Jean Pougny, Edouard Georg, and Marcel Gromaire; the last mentioned became a close friend. At the time of Bazaine's first solo exhibition at the Galerie Van Leer, Paris, in 1932, he met Pierre Bonnard, who encouraged him. In 1934 Bazaine exhibited his watercolors, a medium which, with drawing and etching, was to play an important role in his development. Even in his most abstract work, the preliminary observation of external reality is an essential element in his formal language. In his

°bä zen´, zhäN

JEAN BAZAINE

painting, Bazaine said, "an essential quality of the object devours the complete object."

In 1936 Bazaine visited Saint-Guénolé, Brittany, for the first time. Inspired throughout his career by the sea and by marine light, especially in northern climes, he was to return there often. A cultivated, reflective man, Bazaine, after 1934, published essays on art and artists in magazines. He was represented in the group show "L'Art indépendant: Maîtres d'aujourd'hui" (Independent Art: Today's Masters) at the Petit Palais in the Paris International Exposition of 1937. He became friendly with the painter Jacques Villon, and in the same year executed his first design for stained glass. Awarded the Prix Blumenthal in 1938, the young painter was still experimenting and absorbing various influences.

During the German occupation, Bazaine, in May 1941, was a principal organizer of an important exhibition at the Galerie Braun, Paris, called "Twenty Young Painters of the French Tradition." Besides Bazaine, the painters Alfred Manessier, Charles Lapicque, Jean Le Moal, and Gustave Singier took part in the show, which defied the Nazi conception of art. It is believed that, although the title was intended to "appease" the Germans, they sanctioned the exhibition as proof of the "degeneracy" of French art. Instead, the show kept alive the spirit of the School of Paris in Vichy France and was to influence French art in the early postwar years.

Interested in religious art, in 1943 Bazaine began designs for three stained glass windows for the church at Assy, France, which he completed in 1950. He participated with other artists in the

"Twenty Young Painters" show, including Maurice Estève and Lapicque, in the Salon d'Automne, Paris, in 1944; to celebrate the Nazi retreat from Paris, the artists dubbed the famous gallery the Salon de la Libération.

In 1945–46 Bazaine was a major influence on the Brussels group Jeune Peinture Belge, an association of expressive abstractionists whose membership included Anne Bonnet, Pol Bury, and Pierre Alechinsky. His wartime writings *Temps présent* and *Esprit poesie '43* were published as articles in reviews, as monographs (*Fernand Léger* [1945]), or in the form of essays, as in his well known *Notes sur la peinture d'aujourd'hui* (1948, Notes on Painting Today). Bazaine's prewar paintings had been in the style of expressive naturalism, and his pictures of 1942 –47 contained descriptive elements based on external appearances and were formalized in the style of French cubism. From 1947 to 1955, in such works as *The Seaport* (1948), *Wind from the Sea* (1949), *Child of the Night* (1949), *La Chairière* (1951, The Glade), and *Low Tide* (1955), he continued to express his response to natural motifs, but his subjects ceased to be recognizable and he transposed his sensations into a more poetic and symbolic idiom, with linear rhythms and rich color harmonies. The structure of his pictures became freer and more dynamic—"as if dashed off with large nervous strokes" Aldo Pellegrini said—than that of other members of the postwar School of Paris.

In *Late Modern* (1969) Edward Lucie-Smith described the dilemma facing Bazaine and other French painters of his generation. Having grown up in the shadow of the great names of the School of Paris—Matisse, Picasso, Braque, Léger—they were, after the repressive and isolated years of the German occupation, attempting to "maintain the impetus of the modernist revolution" and at the same time "maintain the prestige of Paris" as the world art center. Despite the acclaim these painters received in Paris, they were eclipsed internationally by the New York School of Abstract Expressionists. Although the expressive abstraction of the postwar School of Paris, especially the tachist branch to which Bazaine belonged, had affinities with American abstract expressionism, the first generation of New York School painters had been open to all forms of European modernism—German expressionism as well as Picasso—in the 1930s and early '40s. But the even-tempered French cubism practiced by the "generation of 1900" between the wars had been comparatively unaffected by such styles as German expressionism, the Bauhaus, Paul Klee's lyrical abstraction, or by Piet Mondrian and Wassily Kandinsky, both of whom had worked in Paris but were largely ignored.

Bazaine was represented in the Venice Biennale of 1948, where he was to exhibit again in 1952. His first major exhibition was held in Paris in 1949, and in 1950 he received an honorable mention at the Carnegie International, Pittsburgh, where he was thereafter to show regularly. In 1951 he executed his first mosaic for the church at Audincourt, France, and in the same year showed for the first time in the São Paulo Bienal. He visited the United States in 1952 to serve on the jury of the Carnegie International. Travels to Spain in 1953, '54, and '62 inspired several works. His next stained glass commission, windows for the baptistry of the church of Audincourt, was in 1955, and he also designed a *Tree of Life* window for the church of Villiparisis, France, which had been built by the architect Novarina. His large mosaic for the UNESCO building, Paris, was installed in 1960. He has also executed stained glass windows for the apse of the old Gothic church of Saint-Séverin, France.

Bazaine's post-1955 work was enriched by his reading of Marcel Proust and marked by a return to the "informalism" of the late paintings of Claude Monet. The linear and rhythmic structure of his canvases disappeared, and his work became evocations of the world's "environment"—the sea, the sky, the snow, and the wind—with which he had wanted never to lose contact. Bazaine combined bright, at times fauvist color with subtle intimations of atmosphere and shimmering light. *Shadows on the Hill* (1961) and *Light on the Straw* (1972) are characteristic paintings of this phase. *Light on the Straw* was described by Anna and Giorgio Bacchi in the *Christian Science Monitor* (August 28, 1978), as "both poetic and muscial. . . . Dry straw, left by the threshing, glitters in the hot sunshine, emitting golden streaks brilliant as shooting fireworks."

The first Bazaine retrospective was presented by the Kunsthalle, Bern, in 1959 and traveled to the Stedelijk Museums in Eindhoven and Amsterdam. A second retrospective was held in Hanover, Zürich, and Oslo in 1963, and a third was given at the Musée d'Art Moderne, Paris, in 1965. He gave a lecture in 1961 in Moscow on painting and the world of today, which he repeated in Bucharest the following year. He received France's Grand Prix National des Arts in 1964.

Bazaine's versatility and his determination to experiment were evident in his 1967 design of a tapestry for the new Palace of Justice in Lille, France. In the same year the Stedelijk Museum, Amsterdam, presented an exhibition of his gouaches, watercolors, and drawings which traveled to Paris in 1968. The show's catalog con-

tained poems by Bazaine's friends André Frénaud and René Char and a foreword by Jean Tardieu.

Anna and Giorgio Bacchi pointed out that, although Bazaine's pictures are singularly striking as mosaics and stained glass, "he is primarily an easel painter." In his latest pictures, they noted, "things have lost their contours, and become more profoundly a network of equivalences and universal signs." They describe Bazaine himself as resembling "the statues on Chartres Cathedral, slight, sincere, unassuming, but unwavering in his approach to art." He lives quietly at Clamart, a small town near Paris.

Jean Bazaine is acknowledged to be an outstanding theorist, art critic, and writer. His *Exercice de la peinture,* published in Paris in 1973, summarized his ideas on art and encouraged younger painters. He wrote: "Desert of the white canvas! There we, wishing to exist as painters, must at any cost create forms. Will the flotsam of our memories provide sufficient chaos to enable us to construct a world? We make the first step, the initial brush stroke, but undoubtedly it will be our last free act. The entire canvas has been invaded: the white has turned to light, the surface to space. A long unequal combat is joined.

"A second move, a second touch, another space, a different light: already the canvas begins to lead us. Turn by turn we are possessors and possessed. The work advances tentatively, trembling on the brink of disaster. Art thrives on such crises: dissonance opens up horizons.

"It is almost invariably at the end of a long, sterile effort that the power of the artist surges, flashing like an unforeseen flower, refinding the union of night and day, unalterable space, the light behind the shadow.

"Over and above the view, it is to the beating of the heart that the painting accords, and even more from a pulsation that comes from the outside. When these two are in harmony, the painting sings.

"To be of the world for an artist is to let oneself be consumed by, it."

EXHIBITIONS INCLUDE: Gal. Jeanne Castel, Paris 1930–39; Gal. Van Leer, Paris 1932, '34; Gal. Maeght, Paris from 1949; Gal. Blanche, Stockholm 1950, '64, '69; Kunsthalle, Bern 1959; Stedelijk van Abbemus., Eindhoven, Neth. 1959; Stedelijk Mus., Amsterdam 1959, '67; Kestner-Gesellschaft, Hanover, W. Ger.1963; Kunsthaus, Zürich 1963; Kunstnerner Hus, Oslo 1963; Mus. d'Art Moderne, Paris 1965; "Peintures 1942–47," Gal. Louis Carré, Paris 1965; Mus. de Metz, France 1972; Maison de la Culture, Nevers, France 1974; Mus. d'Art Moderne de la Ville de Paris 1975. GROUP EXHIBITIONS INCLUDE: "L'Art indépendant: Maîtres

d'aujourd'hui," Petit Palais, Paris 1937; "Vingt jeunes peintres de tradition Française," Gal. Braun, Paris 1941; "Twenty Young Painters," Salon d'Automne, Paris 1944; "Bazaine, Estève, Lapicque," Gal. Louis Carré, Paris 1945; Venice Biennale 1948, '52; "Advancing French Art," Louis Carré Gal., NYC 1950; Pittsburgh International Exhibition of Painting, Carnegie Inst. 1950; São Paulo Bienal 1951; Documenta 1, Kassel, W. Ger. 1955; Brussels World's Fair 1958.

COLLECTIONS INCLUDE: Mus. d'Art Moderne, Paris; Fondation Maeght, Saint-Paul-de-Vence, France; Stedelijk Mus., Amsterdam; Stedelijk van Abbemus., Eindhoven, Neth.; Mus. Boymans-Van Beuningen, Rotterdam; Wallraf-Richartz Mus., Cologne; Kunstammlung Nordrhein-Westfalen, Düsseldorf; Kunstmus., Winterthür, W. Ger.; Göteborgs Konstmus., Sweden; Sonja Henie–Niels Onstad Foundations, Oslo; MOMA, NYC; Mus. of Art, Pittsburgh.

ABOUT: "Bazaine '53" (cat.), Gal. Maeght, Paris, 1953; Charbonnier, G. Le Monologue du peintre, 1959; Dorival, B. "Jean Bazaine" (cat.), Mus. d'Art Moderne, Paris, 1965; Lucie-Smith, E. Late Modern: The Visual Arts Since 1945, 1969; Maeght, A. Jean Bazaine, 1953; Pellegrini, A. New Tendencies in Art, 1966; Seuphor, M. Dictionnaire de la peinture abstraite, 1957; Tardieu, J. and others "Bazaine" (cat.), Mus. d'Art Moderne de la Ville de Paris, 1975; Ubac, R. Textes de Jean Bazaine, 1970. *Periodicals*— Christian Science Monitor August 28, 1978; Esprit (Paris) June 1950; Formes et couleurs (Paris) no. 6 1943; Nouvelle revue Française (Paris) April 1, 1941.

***BAZIOTES, WILLIAM** (June 11, 1912–June 5, 1963), American painter, was born in Pittsburgh, Pa. to Frank and Stella Baziotes, but was reared in Reading, Pennsylvania, where the family moved in 1913. His first job was on a newspaper, and about 1931–32 he apprenticed at a stained-glass factory, where he was encouraged by fellow workers to pursue his interest in art.

In 1933 Baziotes went to New York City and enrolled at the National Academy of Design, where he studied painting under the Realist Leon Kroll and was graduated in 1936. From 1936 to 1941 Baziotes worked, as did many American artists during the Depression, for the Works Progress Administration (WPA); he taught art for the Federal Arts Project and the easel painting project. In those years, according to Robert Motherwell, social realism dominated the WPA as well as the New York art scene, but Baziotes was influenced by the School of Paris, especially Matisse, Picasso, and Miró. His *Nude,* painted in 1940, shows the influence of Picasso's late cubist style of the mid-1930s.

The 1930s and 1940s was a period of ferment for American artists, the most prominent of

°baz ē ō′ tēz

Peter A. Juley & Son

WILLIAM BAZIOTES

whom lived in New York. Many of those artists continued to work within the realistic traditions of the 19th century, but there was a seminal group of abstractionists who wanted American art to develop along the lines of European modernism. Through his close friend Robert Motherwell, Baziotes was drawn into the circle of younger, radical American artists who were to be known as the Abstract Expressionists. In the early 1940s Baziotes, through his association with expatriate European Surrealists living in the New York City area, was deeply influenced by the surrealist doctrine that abstract painting should draw from and evoke forces hidden within the unconscious. Like Motherwell, he was drawn to the surrealist principle of automatism, a means of using imagery embedded in the subconscious—without interference from the rational intellect. His painting of 1942, *The Butterflies of Leonardo da Vinci,* shows the influence of the Surrealist exponent of automatism, Matta, and his series of drawings and paintings known as "Psychological Morphologies." In 1942 Baziotes exhibited in André Breton's "First Papers of Surrealism" show at the Whitelaw Reid Mansion, New York City.

Baziotes's first solo exhibition was held in 1944 at Peggy Guggenheim's Art of This Century Gallery, in Manhattan, which showed the European Surrealists as well as younger American artists such as Motherwell, Pollock, and Rothko. While Pollock and Motherwell were developing the expressive, gestural style of action painting in the mid-1940s, Baziotes's work of that period emphasized the instinctual, and his experiments with automatic techniques led to the use of bio-

morphic forms. Those free organic shapes, similar to such biological forms as the amoeba, had been developed by Miró and Arp and were later used by the Surrealists (Baziotes had seen Miró's work at a Museum of Modern Art exhibit in 1941); biomorphic forms were, according to Barbara Rose, "a source of inspiration throughout the forties" to the American avant-garde.

Baziotes's biomorphic imagery was often derived from marine forms of life, as in such paintings as *The Pond* (1955), *Moby Dick, Waterform, Waterflower,* and *Aquatic* (1961). He believed that titles should be evocative, even though he might not necessarily begin his canvas with a specific theme in mind. "The subject matter," he said in a statement of 1944, "may be revealed to me in the middle of my work, or I may not recognize it until a long time afterward." Other artists of the New York School, including Adolph Gottlieb, Theodoros Stamos, and Mark Rothko, also created biomorphic forms from marine imagery, but, as critic Lawrence Alloway pointed out, "Baziotes is unique in that the spatial organization of [his compositions] implies a dense medium like water, as well as evoking reminiscences of particular organisms," such as sea anemones, octopus tendrils, or amoebic cells. "Baziotes's works of the 1940s wove together dark Surrealist monsters, Cyclopes, and various rude beasts in a web of black, stolid forms," wrote Kay Larson of *New York* magazine, and Baziotes's paintings were also distinguished by "his smooth brushwork and carefully toned coloring," to quote Sheldon Cheney.

In 1946 Baziotes had his first show at the Kootz Gallery, New York City, and the following year he was awarded the Walter M. Campana Memorial Purchase Prize at the Annual Exhibition of the Chicago Art Institute for his painting *Cyclops.* This work, despite its shapes that were redolent of the human contour and its title's allusion to the beast of classical mythology, was modeled after a rhinoceros which Baziotes had seen in the Bronx Zoo. (The rhino's eye, set low in the head, made him think of the mythical Cyclops.)

In 1948, with Robert Motherwell, Barnett Newman, Mark Rothko, and the sculptor David Hare, Baziotes founded the influential Subjects of the Artist group in Greenwich Village. That association of artists, most of them Village residents, friendly competitors, and denizens of artists' hangouts like the Cedar Bar, grew out of the camaraderie and regular exchange of ideas among the artists of the New York School. This grew into "The Club," which became a rallying point for many of New York's abstractionist

painters. Discussion groups met at the group's headquarters, a Village loft, and Baziotes and other notables of the New York art scene delivered lectures. Those artists rejected representation, but, they maintained, no painting can be without a subject and, in lieu of objective representation, the proper subject of the artist was the act of painting itself. Another, similar group, called the Painters' Club, was formed by William de Kooning in late 1949, but the New York School artists lost interest in such clubs in the mid-1950s, when their avant-garde styles began to be widely accepted by art dealers, critics, the academy, and the major museums and galleries.

Baziotes is known as a first-generation member of the New York School that popularized the style known as abstract expressionism (the second generation emerged after 1956), but his work was not completely abstract. His biomorphic shapes contained figurative elements, and his surrealistic imagery has been compared both to the strange monsters of Karel Appel and the figures of Paul Klee. Baziotes never developed the fluid painterly freedom and direct action-painting techniques of some of his fellow Abstract Expressionists. He worked slowly, laying one color over the other in soft, rather dry scumbles, and as this process continued through the 1950s his output became confined to only a few paintings a year. Moreover, his use of biomorphic imagery is often quite decorative, and his gifts as a subtle colorist are evident in *Congo* (1954; Los Angeles County Museum), whose curvilinear biomorphic forms, which resemble a serpent and a meandering river, were, in the words of Barbara Rose, "flattened out into decorative patterns which float in a watery atmosphere." Other smoothly colored Baziotes works are *Green Night* (1957; Hirshhorn Museum and Sculpture Garden, Washington, D.C.), the mysterious *White Bird* (1957; Albright–Knox Art Gallery, Buffalo, New York), and *Dusk* (1958; Solomon R. Guggenheim Museum, New York City).

In the 1950s and early '60s Baziotes showed regularly at the Kootz Gallery. But because of his limited productivity—he was described by Lawrence Alloway as one who stood "solitary and anxious before the canvas"—and the emergence of new styles (particularly hard-edge painting and pop art) that had no connection to surrealism, Baziotes had become, to quote Kay Larson, "a shadowy entry in the textbooks" by the time of his death in 1963.

Although he had shown with Gottlieb, Motherwell, and Carl Holty at Paris's Galerie Maeght in 1947, Baziotes's works were little known in Europe at the time of abstract expressionism's ascendancy in the United States. But in 1955 he was represented in an important exhibition at the Musée National d'Art Moderne, Paris, titled "50 ans d'art aux Etats-Unis." In 1957 the Contemporary Arts Museum, Houston, mounted an aptly titled show, "The Magical Worlds of Redon, Klee, Baziotes." For the artists for whom surrealism led to abstract expressionism, Baziotes was virtually alone in continuing, on occasion, to depict a surreal fantasy world of protoplasmic forms, which seem to float on the canvas as if suspended in mid-air. Baziotes said of that show, "The emphasis on flora, fauna and beings makes the exhibit a most intriguing and artistic one for it brings forth those strange memories and psychic feelings that mystify and fascinate all of us." All three artists were, in a sense, "poets of the brush," and Baziotes was a great admirer of Baudelaire. He even derived some of the titles for his paintings from Baudelaire's poems.

Despite his indebtedness to surrealism, Baziotes asserted that his work was not done from memory or experience. For Baziotes, one critic observed, "The art of painting was itself the experience embodied in the work and . . . its subject manifested itself only as the picture proceeded. More than most other Abstract Expressionists, he regarded painting as an act of autobiographical improvisation."

William Baziotes died at his New York City home at the age of only 51. Robust and energetic in his youth, the young Baziotes was remembered by Clyfford Still as one who "spoke and walked with an ease and freedom that seemed immune to age." Indeed, in the 1930s a boxer named Bobby Ruttenberg offered to train him as a professional fighter. (Always interested in boxing, Baziotes, in 1960, copied into his notebook a statement by the boxer Gene Tunney which confirmed his own sense of the solitude of the working artist: "If there's any extreme form of individualism, it's ring fighting. You wage your own battle all by yourself. No partners, no comrades in there with you. Like dying, you fight alone.")

The artist's widow, Ethel Baziotes, whom he married in 1941, recalled that in his later years Baziotes would draw in the morning and then paint, but "never before noon." He painted in gloves in order to keep his hands warm, because of a rheumatic condition. A quiet, reflective man, but with a sociable side, he could discuss his early ordeals as a struggling artist with gentle humor, yet he was essentially, as Mrs. Baziotes wrote in a letter to Still in 1970, "a darkling poet."

A memorial exhibition of Baziotes's work was held at the Guggenheim Museum in 1965. In the

show's catalog the artist was quoted as having said, in the mid-1950s, "When I paint, I do not consider myself an abstractionist in the sense that I'm trying to create beautiful forms that fit together like a puzzle. The things in my painting are intended to strike something that is an emotional involvement—that has to do with the human personality and all the mysteries of life, not simply colors or abstract balances. To me it's all reality."

EXHIBITIONS INCLUDE: Art of This Century Gal., NYC 1944; Kootz Gal., NYC 1946–58; Sidney Janis Gal., NYC 1961; "William Baziotes—A Memorial Exhibition," Solomon R. Guggenheim Mus., NYC 1965; "William Baziotes: Late Work 1946–1962," Marlborough Gal., Inc., NYC 1971; Blum Helman Gal., NYC 1984. GROUP EXHIBITIONS INCLUDE: "First Papers of Surrealism," Whitelaw Reid Mansion, NYC 1942; "Introduction à la peinture moderne Américaine," Gal. Maeght, Paris 1947; Annual exhibition, Chicago Art Inst. 1947; Venice Biennale 1948; "Twentieth Century Painters—USA," Metropolitan Mus. of Art, NYC 1950; "15 Americans," MOMA, NYC 1952; "Four Abstract Expressionists," Walker Art Cntr., Minneapolis 1953; São Paulo Bienal 1953–54; "50 ans d'art aux Etats-Unis," Mus. Nat. d'Art Moderne, Paris 1955; "The New Decade," Whitney Mus. of Am. Art, NYC 1955; "The Magical Worlds of Redon, Klee, Baziotes," Contemporary Arts Mus., Houston 1957; Documenta 2, Kassel, W. Ger. 1959; "American Abstract Expressionists and Imagists," Solomon R. Guggenheim Mus., NYC 1961–62; "Vanguard American Painting," European tour organized by Solomon R. Guggenheim Mus., 1961–62; "Four Centuries of American Art," Minneapolis Inst. of Arts 1963–64.

COLLECTIONS INCLUDE: Metropolitan Mus. of Art, MOMA, Whitney Mus. of Am. Art, and Solomon R. Guggenheim Mus., NYC; Albright-Knox Art Gal., Buffalo, N.Y.; Munson-Williams-Proctor Inst., Utica, N.Y.; Vassar Col. Art Gal., Poughkeepsie, N.Y.; Nat. Collection of Fine Arts, and Hirshhorn Mus. and Sculpture Garden, Washington, D.C.; Brandeis Univ., Waltham, Mass.; Harvard Univ., Cambridge, Mass., Smith Col., Northampton, Mass.; Art Inst. of Chicago; Detroit Inst. of Arts; Walker Art Center, and Minneapolis Inst. of Arts, Minneapolis; Washington Univ., St. Louis, Mo.; Baltimore Art Mus.; Seattle Art Mus.; Tel Aviv Mus.

ABOUT: "William Baziotes—a Memorial Exhibition" (cat.), Solomon R. Guggenheim Mus., NYC 1965; "William Baziotes: Late Work 1946–1962" (cat.), Marlborough Gal., Inc., NYC, 1971; Brion, M. and others Art Since 1945, 1958; Cheney, S. The Story of Modern Art, 1958; Freed, E. K. and others "The Magical Worlds of Redon, Klee, Baziotes" (cat.), Contemporary Arts Mus., Houston, 1957; Hess, T. B. Abstract Painting, 1951; Janis, S. Abstract and Surrealist Art in America, 1944; Lucie-Smith, E. Late Modern: The Visual Arts Since 1945, 1969; Moore, E. (ed.) Contemporary Art 1942–1972: Collection of the Albright-Knox Art Gal., 1972; Ragon, M. Peintres Contemporains, 1964;

Rose, B. American Art Since 1900, 2d ed. 1975. Periodicals—Art Digest November 1, 1947, January 15, 1954; Athene (Chicago) Autumn 1947; It Is Autumn 1959; New York March 26, 1984; New York Times June 7, 1963; Perspective No. 2 (Hunter Col., NYC) 1956–57; Possibilities I Winter 1947–48; Time February 20, 1956.

BEARDEN, ROMARE (HOWARD) (September 2, 1914–), American painter, writes: "I was born in Charlotte, North Carolina, in the home of my great-grandfather, H.B. Kennedy, on Graham Street. During May 1976 I returned to Charlotte, but the Kennedy home, and indeed many other buildings nearby, had long been torn down. Charlotte is no longer a sleepy southern town, but now a busy growing metropolis.

"Two memories of my youth in Charlotte remain, therefore they must have some importance for me. My great-grandfather had a large garden, and one summer, I recall I was entranced with a beautiful tan, orange, and brown flower. I learned it was a tiger lily. Each day I would go and look at that flower; but one Sunday I found it gone, with only a green stem trembling in the air like a small garter snake. My great-grandfather saw my concern. He told me that my grandmother had worn it to church. Then he said, 'Don't worry, this is good soil and next year your tiger lily will be back once again.'

"One evening, grandfather took me to the depot. A large crowd was there, so grandfather put me on his shoulder. I saw a box car and in the open door were as many flowers as in our garden. There was a casket with two soldiers on both sides of it. The old lady in the casket, my grandfather told me, was Mrs. Stonewall Jackson. She was born in Charlotte and was brought from Virginia, before burial, for this one evening; she did not, I am told, return the following year.

"My parents moved to New York City when I was three or four years old. We first lived on the west side of 66th Street, I believe, with an aunt of my father's. In those days Harlem had not yet been settled by colored people. When we did finally move to Harlem, there were only about eight blocks along Seventh and Lenox Avenues where black people lived.

"I went to school at P.S. 5 on 141st Street and Edgecombe Avenue. Most of the pupils were Irish, Jewish, and Italian, with only a small percentage of blacks. This changed each year as more blacks moved into the neighborhood.

"At P.S. 5, a number of students, who all wore a kind of blue uniform, were called 'The Home Boys.' That is, they came from the Hebrew Or-

Bill Anderson

ROMARE BEARDEN

phan Home, which was located a bit west of Lewisohn Stadium, where the City College teams played football, baseball, and lacrosse. During the summers, the stadium was used for marvelous symphonic concerts.

"When I finished public school, I went to De Witt Clinton High School in New York City. The school had so many pupils that there were about five annexes in various parts of the city. In the year and a half that I attended Clinton, I never made it to the main building. After that, I decided to stay with my maternal grandmother in Pittsburgh, and I went to Peabody High in East Liberty. Near the end of my high school days I had become a fairly good student. It is interesting, though, that I had very little involvement with art, I mean in light of my present concern.

"In college, I did become interested in cartooning and drew for the humor magazine; also I was the art editor of the New York University *Medley* in my senior year. I received a BS degree from NYU, as I planned to enter medical school. My favorite subject in the sciences was mathematics. Since I had little interest in the other sciences, I finally understood that medicine was not for me.

"There was very little to count, in those Depression years, except the unemployed, and very little need for mathematicians. I went to the Art Students League in the evenings to study with the German master of corrosive satire, George Grosz. Grosz introduced me to the great draftsmen of the past—Dürer, Holbein, and Ingres, in particular. After studying for nearly two years with Grosz, I took a studio at 33 West 125th

Street and tried to paint. My first efforts were done on large sheets of brown paper. I painted my remembrances of the South, and at my retrospective at the Museum of Modern Art, during the spring of 1971, all that I could find of these works were shown in a separate room.

"After World War II, I showed at the G Place Gallery in Washington, D.C., run by the late Caresse Crosby. Soon afterwards, Mr. Samuel Kootz took me into his New York gallery which he had just opened in late 1945, at 15 East 57th Street. I showed fairly regularly with this gallery, until I left for Paris in 1950 to study under the GI Bill at the Sorbonne.

"When I returned in 1952 to New York City, I did not resume creative painting for some time. I had read the *Journals* of Eugène Delacroix, and I was intrigued by the fact that he copied works of old masters almost to the end of his life. So I had a number of photographic enlargements made of paintings by Duccio, Giotto, Veronese, De Hooch, Rembrandt, Manet, and some others, and systematically copied them. I feel, as a result of two or three years of this study, I learned a great deal about the way a painting is put together.

"During 1964, I did a number of small collages of urban and southern scenes, returning, in a way, to my first interest. Although my subject matter derives from the life of my people, at least as I know it, I hope I have found some universal elements to which all persons may relate."

Romare Bearden's intellectual curiosity and the wide range of his artistic interests were already evident during his two years at the Art Students League in New York City (1936–37). In addition to attending George Grosz's evening classes at the League, Bearden studied every Friday with that strange and gifted Russian emigré artist, John Graham, and also took lessons in Oriental brushwork and calligraphy from a Mr. Wu in Chinatown. He became closely associated with the 306 Group, an informal organization of artists living in Harlem, of whom the best known was Jacob Lawrence. Another member of the group, Add Bates, who in 1940 gave Bearden his first solo show, took him downtown to meet Stuart Davis, Paul Burlin, and other prominent artists.

Bearden's early "remembrances of the South" included *The Visitation* (1941), in tempera on composition board, and *Folk Musicians* (ca. 1941–42), in gouache and casein. These early scenes were, to quote Carroll Greene, "stylized

statements of Negro life expressed in simple, colorful forms." Bearden participated in several group exhibitions in Harlem, and one of his paintings was reproduced in *Fortune* magazine in 1942.

During World War II Bearden served with the all-black 372d Infantry Regiment. His bitter awareness of the way the black soldiers were treated at home gave added weight to his statement: "I cannot divorce myself from the inequities that are around me."

However, social-realist propaganda painting was not for him. After the war, Bearden set out to enrich his figurative style by studying cubism, taking from it only what he needed. He was already strongly attracted to collage and montage which later were to become his main means of expression. In the late 1940s Bearden, working mainly in tempera or watercolor, painted semicubist figure compositions with strong black directional lines boldly superimposed on luminous color areas (*From the Iliad,* 1947; *Woman Seated on Rock,* 1948). His work was included in traveling exhibits of American artists sponsored by the State Department and was shown in leading museums in the United States.

When Bearden went to Paris under the GI Bill in 1950 at the age of 36, he had already built a reputation in America. Through letters from his dealer Samuel Kootz and the painter Carl Holty, he met Picasso, Braque, and Léger, and became friendly with Jean Hélion and the sculptor Brancusi. He learned more during his three and a half years in Paris from studying other painters than from painting himself, but whereas before the war he had worked mainly in tempera, he now began to paint in oils, using the medium almost as thinly as watercolor. He was sympathetic to cubism because that movement had drawn part of its inspiration from African sculpture, but his own handling of space was very different.

For some time after Bearden's return to New York City in 1954 he painted only intermittently. He had always felt close to music and turned to songwriting, becoming a member of the American Society of Composers, Authors, and Publishers (ASCAP). He wrote the music for a hit song, "Sea Breeze." In 1957 he married Nanette Rohan, a West Indian who organizes the Chamber Dance Company in New York City.

In 1963, black artists calling themselves the Spiral Group began to meet in Bearden's Harlem studio. They were concerned with their special problems as black artists and the larger struggle for social equality. Bearden's paintings from 1956 to 1961 had been entirely nonobjective, but in 1964 he began a remarkable series of collages based on the black experience, with the overall title "The Prevalence of Ritual," which included *Baptism, Tidings, The Conjur Woman,* and *The Funeral.* Inspired by the techniques of film documentary, Bearden used projected images, abrupt transitions of scale, and fragmented yet haunting cutouts of faces and figures to convey the kaleidoscopic vividness of the world as he saw it. Some of the 1964 collages exhibited in the second of many solo shows at the Cordier & Ekstrom Gallery, New York City, dealt with life in Harlem (*The Street* and *Uptown Looking Downtown*). Others evoked memories of the rural South (*Train Whistle Blues*). Guitar players often appear, and other collages recall the heyday of Harlem jazz in the 1930s (*The Savoy* and *Grand Terrace Ballroom*). Bearden found an analogy to his own vision and technique in the jazz musicians who, as he said, "seemed to distort sound in order to recreate it." His compositions showed great thematic variety and technical inventiveness. One frequent motif was the distant locomotive, recalling de Chirico, but rendered completely in collage.

In the late 1960s and early '70s, Bearden's use of color became richer and his patterns more decorative. In *Blue Interior, Morning* (1968), rectangular shapes serve as a setting for complex, fragmented, ingeniously textured figures. There was an occasional touch of the surreal, a hint of Hieronymus Bosch and Max Ernst in such works as *The Blue Snake* (1971), further evidence of Bearden's wide frame of reference. *Palm Sunday Processional* (1967–68) suggests an Egyptian or Persian relief. He used collage and mixed media in *Flights of Fantasy* (1970), and in other collages he introduced the lively patterns of patchwork quilts. In one *Mother and Child* Bearden used a photograph, slightly retouched, of a Benin ivory mask for the mother's face, and a piece of red-checked gingham for her apron. His colors are often silkscreened on paper.

Despite this eclectic inventiveness, Bearden's work has always sprung primarily "from the need to redefine the image of man in the terms of the black experience I know best." He handles his themes with deep emotion but without sentimentality or social propaganda. He sets out to paint his people "as passionately and dispassionately as Bruegel painted the life of Flemish people in his day." The experience he portrays can be joyous as well as sad—some of his paintings of female bathers in tropical or everyday surroundings have a uniquely sensual exuberance.

Growing public interest in Bearden's work led to commissions for posters, for a mural in Times Square (now removed), and for the covers of *Fortune* (January 1968), *Time* (November

1968), *The New York Times Magazine* (1969), and *TV Guide* (1976). He took part in an international poster exhibition in Warsaw and Sofia, Bulgaria. In January 1977 he designed sets for the Harlem-based Alvin Ailey Dance Company.

Bearden's solo show at the Corcoran Gallery in Washington, D.C., in 1966 was followed in 1971 by a widely acclaimed retrospective exhibit, "Romare Bearden: the Prevalence of Ritual," at the Museum of Modern Art, New York City. Almost all the works were collage paintings. Despite the persistence of certain images in the works exhibited—trains, windows, roosters, the moon, the haunting eyes of his people—Bearden did not regard them as symbols to be interpreted in a literary sense. "Each painting envisions a world complete within itself."

Nonetheless, certain classical myths have always fascinated him. In 1948 he did 16 variations on the *Iliad* and the *Odyssey,* exhibited at the Niveau Gallery, New York City. *Circe Preparing a Banquet for Ulysses* (1968) used black characters in vaguely Greek dress and surroundings. *Hommage à Pinturicchio* (1969) wittily paraphrased the Renaissance master's painting of the returning Ulysses finding Penelope at her loom. Early in 1977 Bearden began a new series freely based on the *Odyssey* and exhibited later that year in the Cordier & Ekstrom Gallery. A traveling retrospective of Bearden's work ended its tour at the Brooklyn Museum of Art in 1981.

Romare Bearden, who lives with his wife Nanette in downtown Manhattan, goes to work every day at his studio in Long Island City, Queens. He and his wife spend part of each year on the Caribbean Island of St. Martin. Bearden is a large, rotund man with a kindly, easy-going manner. In conversation he is soft-spoken and modest and displays a remarkable range of artistic and cultural interests. Bernard S. Meyers, commenting on Bearden's "contribution to the artistic humanism of our time," describes his poetic and dynamic montage paintings as "a series of elegies on the works and days of black America." Carroll Greene called his "Prevalence of Ritual" exhibition "an affirmation, a celebration, a victory of the human spirit over all the forces that would oppress it."

EXHIBITIONS INCLUDE: G. Place Gal., Washington, D.C. 1945; Samuel Kootz Gal., NYC 1945, '46, '47; Niveau Gal., NYC 1948; Barone Gal., NYC 1955; Michel Warren Gal., NYC 1960; Cordier & Ekstrom Gal., NYC from 1961; Corcoran Gal, Washington, D.C. 1966; Carnegie Inst., Pittsburgh 1966; "Romare Bearden: the Prevalence of Ritual," MOMA, NYC 1971; Nat. Collection of Fine Arts, Washington, D.C. 1971; Studio Mus., Harlem, NYC 1972; Brooklyn Mus., N.Y. 1981. GROUP EXHIBITIONS INCLUDE: "New Names in Ameri-

can Art," Baltimore Mus. of Art 1944; "Advancing American Art," Metropolitan Mus. of Art, NYC 1946; "Abstract and Surrealist American Art," Art Inst. of Chicago 1948; "Annual Exhibition of Contemporary American Painting," Whitney Mus. of Am. Art, NYC 1956, 1969–70; "The Portrayal of the Negro in American Painting," Forum Gal., NYC 1967; "30 Contemporary Black Artists," Minneapolis Inst. of Arts 1968; "Afro-American Artists: New York and Boston," Mus. of Contemporary Arts, Boston 1970.

COLLECTIONS INCLUDE: Metropolitan Mus. of Art, MOMA, and Whitney Mus. of Am. Art, NYC; Philadelphia Mus. of Art; Boston Mus.; Princeton Univ. Arts Mus. N.J.; High Mus. of Art, Atlanta; Flint Inst. of Arts, Mich.; St. Louis Mus. of Arts, Mo.

ABOUT: Bearden, R. and others The Painter's Mind: A Study of the Relations of Structure and Space in Painting, 1969; Greene, C. "Romare Bearden: The Prevalence of Ritual" (cat.), MOMA, NYC, 1971; Washington, M.B. The Art of Romare Bearden: The Prevalenace of Ritual, 1974. *Periodicals*—Art Digest October 1, 1945, November 15, 1948; Art News October 1964; Art Now: New York no. 4 1970; Critique November 1946; New York Herald Tribune January 24, 1960; Leonardo (Oxford) January 1969; Metropolitan Museum of Art Bulletin January 1969; New York Times February 22, 1970; New York Times Magazine October 2, 1983; Time October 27, 1967.

BELL, LARRY (December 6, 1939–), American sculptor, was born in Chicago. As a child he moved with his family to California, and from 1953 to 1957 he studied at Birmingham High School in Eureka. Between 1957 and 1959 he took courses with sculptor and Environmental artist Robert Irwin at the Chouinard Art Institute in Los Angeles. Meanwhile he supported himself by a variety of odd jobs, working as a bowling-alley maintenance engineer, truck driver, and picture framer. He started his artistic career as a painter, influenced, like many of his contemporaries, by abstract expressionism; but he soon found that painting evoked in him "a gnawing frustration with two-dimensional form." Several other artists of Bell's generation, notably Don Judd, Robert Morris, and Ronald Bladen, also began as painters, but soon rejected painting on the grounds that it lacked concreteness and actual "presence."

From 1957 to 1965 Bell earned his living as general manager and factotum in a Hollywood salon-cabaret, The Unicorn. In 1962 he traveled to Mexico, and that same year began to incorporate glass into his canvases. He exhibited his new works in his first solo show, held in 1962 at the Ferus Gallery, Los Angeles, where he showed again in 1963 and 1965. He was becoming increasingly concerned with the ephemeral quali-

Tony Vinella

LARRY BELL

ties of light and color. In order to portray them in a Platonically "pure" manner, he began painting glass cubes with abstract designs and geometric cut-outs. He found that the paler his colors, the more easily viewers were able to ignore his cubes as objects, and to enjoy them as vehicles for light. To quote Jan Butterfield of *Art in America* (September–October 1978), "His cubes are highly introspective works in which the viewer finds himself looking down *into* or, paradoxically, *through* an object in order to 'see' it."

Beginning in the mid-1960s Bell, in his quest for ephemeral effects, used glass in a more complex way, challenging even further the traditional concept of the "art object." A characteristic work was *Plated Glass Construction Chrome Bands* (1965), a cube of coated glass plates bound by metal strips. Like his other cubes it both reflects the spectators and allows them to see what lies on the other side. The "art object" was not the cube itself but the fleeting effects of transparency and reflection. In Bell's untitled double box (1964), owned by the Albright-Knox Art Gallery, Buffalo, New York, an enigmatic space and a fully disclosed one are brought together and yet kept in contrast. Bell has always built his own machinery and devised his own techniques—he even adopted certain processes from the aerospace industry, using coated glass to achieve iridescent colorations—but he has never considered highly sophisticated technology as an end in itself: he dismisses it as "just so much voodoo."

Since 1965 Bell has exhibited regularly at the Pace Gallery, New York City. Critics initially

tended to admire his craftsmanship on the one hand, while finding his art detached or, paradoxically, too self-involved. John Canaday, writing in *The New York Times,* (April 29, 1967), noted that the artist's "cool, impersonally designed glass cubes reject the effusive vulgarities of pop art in one form of the just-now-latest mode." Sam Hunter, writing in 1966, commented on "the almost precious refinement of Bell's intimate, alternately opaque and transparent glass cubes."

From the late 1960s, Bell traveled regularly— he visited North Africa, Australia, and Southeast Asia—and taught at a number of universities, including the University of California, Berkeley, and the University of South Florida, Tampa. Bell's first free-standing "walls" were exhibited in a group show, "Los Angeles Six," at the Vancouver Art Gallery, British Columbia in 1968. In the spring of 1970 he took his walls to London as one of three Los Angeles artists exhibiting in the Tate Gallery (the other two were Robert Irwin and Doug Wheeler). The show, described by Marjorie Bruce-Milne in the *Christian Science Monitor* (May 16, 1970) as "one of the most revolutionary art exhibitions so far seen in London," consisted "not of individual paintings and sculptures but of complete environments especially designed for the gallery" and involving "the walls, ceiling, floor space, and particularly the lighting." In *New York* magazine Barbara Rose commented on Bell's change from objects to environments, and observed that he was now exhibiting "complex spatial [works] emphasizing physically disorienting perceptual illusions." Rose described his mirrored-glass wall environments, with their "shimmering surfaces, glossy reflections and fine craft," as "a quintessential distillation of the Los Angeles School." She added that his new works, which could be appreciated "as simple narcissistic toys or the most advanced experiments in perceptual psychology, are the first examples of abstract art that have both popular and specialized appeal."

In 1974 Bell, along with Robert Irwin, Newton Harrison, Joshua Young, Ed Wirtz, and Frank Geary, founded the California-based Don Quixote Collective. Even though over the years his work had followed a course of progressive reduction of its formal means, as had the work of these other artists, especially Irwin, he has never considered himself a Minimalist. As one critic remarked, Bell's concerns are different from those of minimal art in that his works display, along with technical mastery, subtle and complex variations of light and color. It has been said that Bell's objects are "close in spirit to the creations dreamed of by the alchemists"—that is the creation of the ephemeral and the spiritual (the

manifold translucencies and reflectivities of glass and mirrors) from the base (metal and window pane).

By 1976 Bell was involved in a project of monumental proportions, *The Iceberg and Its Shadow,* a sculptural work that fills an entire room. Jan Butterfield described it as "lyrical, illusory, alternately clear and elusive," adding that "its reality is largely the viewer's own." The piece, consisting of 56 huge planes of ⅜-inch glass—some smoky, some clear—rises one hundred inches at its highest points and weighs about 13000 pounds. The clear planes are the iceberg, and the rich, smoky gray ones are the iceberg's shadow. When the piece was shown in 1976 at the Santa Barbara Museum of Art, California, Bell wrote that the title evolved when he "began to think about the idea of the piece being like an iceberg, because there were so many inherent possibilities in the structure and combinations that at any one time you could only be seeing the tip." Bell explored some of the combinations afforded by the placement of the 56 planes as he installed the work in a succession of museums. *Iceberg* was eventually placed on extended loan to the Massachusetts Institute of Technology, Cambridge, with the purpose of rearranging it at regular intervals over three years to show its changing manifestations. In an interview with Jan Butterfield, Bell said that he did not plan ahead of time just how to set up the planes, and that "the decision to put them in one place or another is more or less intuitive and has to do with many changing factors." He felt that "each exhibition has given me a little bit more information, some things I hadn't known about before."

Bell's "Noble Metal Series" was exhibited at the Janus Gallery, Venice, California, in 1979. One part of the work consisted of four four-foot black paper squares hung on a wall. Barry Fahr, writing in *Artweek,* described the squares as having "a little bit of color in the upper left- and lower right-hand corners;" to the left were "tall white rectangles, halved vertically, with faint gray areas." Each sheet of paper had been coated with a subtle shade or shades of metal or mineral—gold, silver, platinum, or lapis lazuli—and changed color as the viewer moved past. Fahr admitted that the colors were clean and elegant, but felt there was "too much sameness" in the show, and that there did not seem to be "an idea or uniqueness to justify the process. . . . Bell lets himself off the hook by finding a suitable format—the 'series'—then not taking the chance of deviating from it." Yet other critics found Bell's pure visual sensualism refreshing—like a dive into clear water.

Larry Bell lives and works in Taos, New Mexico. In 1967 Bell married Gloria Jean Neilsen; they were divorced in 1971. Since 1973 his companion has been Janet Ruth Burns; they have a daughter, Zara Augusta. Youthful and with dark curly hair, Bell talks little about his attitudes and ideas. As he told Butterfield in 1978: "I have never dealt with those things called 'statements.' I don't *know* from 'statements' except in my work." When Bell does talk about his work, it is in a decidedly "cool," offhand manner. Remarking that, regardless of what others might suppose, "I have never thought of myself as being particularly private,"he added: "The things that are relative to the esoteric edge of your life—which have to do with the color and flavor of your work—are not the issue. The color and flavor of your work will be there *irrespective* of whether or not you survive. But if you don't survive, you will not have the joy of dealing with the color and the flavor."

EXHIBITIONS INCLUDE: Pace Gal., NYC 1957–73; Ferus Gal., Los Angeles 1962, '63, '65; Gal. Ileana Sonnabend, Paris 1967; Stedelijk Mus., Amsterdam 1967; Mizuno Gal., Los Angeles 1969, '71; Hayward Gal., London 1971; Pasadena Art Mus., Calif. 1972; Oakland Art Mus., Calif. 1973; Marlborough Gal. D'Arte, Rome 1974, '75; Gal. Il Cavallino, Venice 1974, '75; Fort Worth Art Mus., Tex. 1975; Washington Univ., St. Louis, Mo. 1976; Santa Barbara Mus. of Art, Calif. 1976; Corpus Christi Mus. of Art, Tex. 1976; Massachusetts Inst. of Technology, Cambridge 1977; Janus Gal., Venice, Calif. 1979. GROUP EXHIBITIONS INCLUDE: "War Babies," Huysman Gal., Los Angeles 1961; "California Hard-Edge Paintng," Pavilion Gal., Balboa, Calif. 1964; "Boxes," Dwan Gal., Los Angeles 1964; "The Responsive Eye," MOMA, NYC 1965; São Paulo Bienal 1965; "Contemporary American Sculpture," Whitney Mus. of Am. Art, NYC 1966; "Primary Structures," Jewish Mus., NYC 1966; "The 1960s," MOMA, NYC 1967; Documenta 4, Kassel, W. Ger. 1968; "Los Angeles Six," Vancouver Art Gal., British Columbia 1968; Tate Gal., London 1970; "11 Los Angeles Artists," Hayward Gal., London 1971; "Looking West," Palais des Beaux-Arts, Brussels 1972; "Art in Space," Detroit Inst. of Fine Arts 1973; "Art Now 74," Kennedy Center, Washington, D.C. 1974; "War Resisters League," Heiner Friedrich Gal., NYC 1976.

COLLECTIONS INCLUDE: MOMA, and Whitney Mus. of Am. Art, NYC; Albright-Knox Art Gal., Buffalo, N.Y.; Wadsworth Atheneum, Hartford, Conn.; Massachusetts Inst. of Technology, Cambridge; Art Inst., Chicago; Walker Art Center, Minneapolis; Pasadena Art Mus., Calif.; Country Mus. of Art, Los Angeles; Fort Worth Art Center, Tex.; Tate Gal., London; Stedelijk Mus., Amsterdam; Kaiser Wilhelm Mus., Krefeld, W. Gar.; Art Gal. of New South Wales, Sydney, Australia.

ABOUT: Coplans, J. "Los Angeles Six" (cat.), Vancouver

Art Gal., British Columbia, 1968; Lucie-Smith, E. Late Modern: The Visual Arts Since 1945, 1969; Rose, B. American Art Since 1900, 2d ed. 1975; *Periodicals*—Art and Architecture June 1967; Art and Artists January 1972; Art in America September–October 1978; Art International (Lugano) December 1971, December 1975; Artforum April 1963, January 1964, February 1965, February 1970, October 1972; Artweek December 22, 1979; Christian Science Monitor May 16, 1970; New York January 29, 1973; New York Times April 29, 1967, April 25, 1971; Studio International May 1965; Time February 9, 1968.

BENTON, THOMAS HART (April 15, 1889– January 19, 1975), American painter, was together with John Steuart Curry and Grant Wood, a leader of the popular American Scene School of the 1930s, also known as regionalism. To Benton, American art gained its identity and strength from the rural traditions of the South and Midwest; though not a folk or naive artist himself, his own work drew strongly upon folk portraiture and scene painting.

The vehement anti-European and antimodernist attitudes of Benton, aided and abetted by his friend, critic Thomas Craven, are the more remarkable in view of Benton's brief period of modernist experimentation in Paris between 1915 and 1920. It is also ironic that he should have been the instructor at the Art Students League, New York City, from 1929 to 1931, of Jackson Pollock, the most radical figure in the American breakthrough in painting after World War II.

Thomas Hart Benton was born in Neosho, Missouri, and named after his great-uncle, Senator Thomas Hart Benton of Missouri. His father, Maecenas E. Benton, served in the House of Representatives from 1896 to 1904. In his early 'teens Benton studied at the Corcoran Gallery of Art, Washington, D.C. At the age of 17 he worked as a cartoonist for the *Joplin American* in Joplin, Missouri. After a brief term at the Western Military Academy in Alton, Illinois, he attended school at the Art Institute of Chicago from 1907 to 1908; his teacher was Frederick Oswald.

Benton spent the years 1908–11 in Paris, studying first at the Académie Julian, then at the Académie Colarossi, before abandoning art classes to study on his own. In those years he discovered and was influenced by Cézanne, Matisse, and the Cubists, as well as by the masterpieces in the Louvre. John Thompson taught him the techniques of impressionism. While in Paris, Benton knew the sculptors Jo Davidson and Jacob Epstein, the painters André Lhote, John Marin, and Diego Rivera, and Ger-

THOMAS HART BENTON

trude Stein's brother, Leo. Many of the pictures he had painted in Paris are said to have been lost in a fire.

After returning briefly to Neosho in 1911 and visiting Kansas City, Benton moved in 1912 to New York City, where he stayed until 1918. His first paintings done in New York show influences of Cezánne and Gauguin, but he became increasingly drawn to synchromism, that earliest of American avant-garde movements, founded in Paris in 1912 by Stanton Macdonald-Wright and Morgan Russell. Those who remembered Benton as he was later—a vociferous antimodernist and champion of American populism—were amazed when it was discovered that in 1915–20 Benton had produced a number of small but accomplished paintings in a radical, abstractionist style influenced by synchromism. However, as Hilton Kramer pointed out in *The New York Times* (January 10, 1982), the paintings of those years "are actually closer to Matisse's Fauvism than to anything found in the Synchromist works of Russell and Macdonald-Wright." Benton participated in "The Forum Exhibition of Modern American Painters" held at the Anderson Galleries, New York City, in 1916, and the following year he had two solo exhibitions in Manhattan, one at the Daniel Gallery, the other at the Chelsea Neighborhood Association Gallery. His experiments with abstraction culminated in his 1918 work, *Constructivist Still Life*.

From 1918 to 1919 Benton served as architectural draftsman in the US Navy in Norfolk, Virginia, doing watercolors of navy-life routine—an important step away from modernist

experimentation and towards conventional representational art. In 1919 he returned to New York City and began developing what was to become one of his regular techniques: the making of clay and plaster models in preparation for his paintings. Also in 1919 he began work on his "American Historical Epic," a series of murals based on American history which eventually took nine years to complete.

In 1922 Benton married Rita Piacenza, who had been one of his students at the Chelsea Neighborhood Association. He began teaching at the Art Students League, in 1926; among his pupils were Jackson Pollock and Fairfield Porter.

In the late 1920s he made many long tours in the South and Midwest, and at this time decided that art should be inspired not by ideas but by the environment. Totally rejecting his former modernist tendencies, he reacted against the purely aesthetic approach to art which he believed had infiltrated the United States from Paris. His turn towards realism was accompanied by an assertive, even chauvinistic nationalism, in keeping with his wish to create an American art free of international influences.

One of his main targets was the photographer, exhibitor, and champion of modernism, Alfred Stieglitz. Benton's desire to reach as many Americans as possible led him to mural painting, in his view the most "democratic" form of art. Among his major mural commissions was *America Today,* a series of eight panels begun in 1928 and completed in 1930 for the New School for Social Research, New York City. This was followed by *The Arts of Life in America* five panels completed in 1932 for the library of the Whitney Museum of American Art, and now in the New Britain Museum of American Art in Connecticut. Both series depict phases of the national life of the US. Their most positive quality is the strong concern with the rhythmic composition of the figures. (Some critics claim that this element in Benton's work was reflected in some of the early paintings of Jackson Pollock, despite Pollock's very different orientation.) Sheldon Cheney found the early Benton mural style "overcharged with surface movement." In *The Story of Modern Art,* Cheney observed: "Subject and method were alike melodramatic, and perfectly in line with the ideals of 'pep' and 'snap' set up in boom days." Barbara Rose, referring to Benton's "bulging, muscular figures, drawn from Michelangelo and combined with popular images," added, "If these murals are vulgar in spirit and crude in technique, nonetheless they are bursting with energy." In 1933 Benton's 22-panel *Social History of the State of Indiana* was

exhibited at the Century of Progress International Exhibition in Chicago.

In spite of his constant activity as a muralist in the 1920s and '30s, Benton continued to produce easel paintings. *The Lord is My Shepherd* (1926) is an interior depicting two old people eating, while *Boomtown* (1928) is an outdoor scene full of bustling activity. In *Cotton Loading* (1928) and *Cotton Pickers* (1928–29), the style is looser and more appealing than in many of his other works, although the black farmworkers are depicted in what now seems an insensitive, stereotyped manner, and the slick, rubbery forms are restless rather than plastically expressive. For all their realistic intent, the stylizations in Benton's regionalist scenes often seem mannered and contrived.

During the Depression years, Benton and the other important Regionalists, John Steuart Curry and Grant Wood, found themselves in direct, conflict with the American modernism represented by such artists as Stuart Davis and the architect Frank Lloyd Wright. They also differed in their thinking from the Urban Realists of the 1930s, represented by Edward Hopper, Reginald Marsh, and the Soyer brothers. The Regionalists harked back to a simpler era, subscribing to what Barbara Rose described as "a comfortable collective fantasy of a God-fearing, white-picket-fence America." Hilton Kramer suggested that Benton's violent rejection of modernism may also have been a reaction against his own attachment to Marxist causes in early 1920s.

In his easel painting of 1934, *Jealous Lover of Lone Green Valley,* Benton accentuated the rhythms of the landscape in order to intensify the suspense of the scene. In 1935 he was commissioned to paint murals in the Missouri State Capitol in Jefferson City. He was also offered a position as director of painting and drawing classes at the Kansas City Art Institute. For these two reasons he left New York in 1935 and moved to Kansas City, Missouri. The State Capitol murals, completed in 1936, depicted legendary or fictional Americans—Huckleberry Finn, Frankie and Johnnie, and Jesse James.

In 1937 Benton's first autobiography, *An Artist in America,* was published, and in 1939 his daughter Jessie was born. One easel painting of the late 1930s, *Hollywood* (1937) was a crowded composition recalling the city scenes in his *The Arts of Life* murals of 1932. However, most of his other easel pictures had a Missouri setting. They included *Cradling Wheat* (1938) and *Threshing Wheat* (1939). In *Threshing Wheat,* the forms of the horizon, the clouds, and the dark smoke from the threshing machine partake of the same undulatory rhythm. *Persephone*

(1939), an Americanization of the classical myth, depicted an old farmer spying on a nude woman.

The movie company 20th Century-Fox commissioned Benton in 1939 to do promotional posters for the film of John Steinbeck's novel *The Grapes of Wrath,* and two years later he did lithographs for Jean Renoir's *Swamp Water.* In 1942 his painting *Aaron* was awarded the Carol H. Beck Medal at the 138th annual exhibition at the Pennsylvania Academy of Fine Arts, Philadelphia. Three years later *The Music Lesson* was acclaimed as the most popular painting at the Carnegie Institute's annual show. Benton understood and knew how to tap the nostalgic and naive dreams of even the most sophisticated viewers; without a doubt he was one of modern art's few real Populists.

In the 1940s Benton did a series of gruesome, semisurrealistic paintings depicting the destruction of war. These included *Again Starry Night,* and *The Sowers.* In *The Sowers* a German soldier scatters skulls instead of seeds. But Benton could never look beyond the American scene for long; he also painted such peaceful subjects as *Jessie and Jake* (1942) and the still life *Silver Vase* (1945), and turned to historical and legendary themes in *Custer's Last Stand* (1943) and *Wreck of Ole '97* (mid-1940s). The heavily anecdotal element in Benton's work was apparent in *Photographing the Bull* (1946), and his *Poker Night* (1948) was based on a scene in the film version of Tennessee Williams's *A Streetcar Named Desire.* In *Apple of Discord* (1950) he continued his program of mythicizing rural life by painting Adam and Eve in an American farm setting.

Abstract expressionism's sudden rise to dominance in the 1950s intensified Benton's anti-avant-garde stance. (It did not help that he was being "betrayed" by his own students.) He habitually referred to Picasso as "an example of artistic decadence," and in a 1951 *Saturday Review* article he attacked what he called "all this anarchic idiocy of the current American art scene." Pollock was included in this sweeping indictment.

Benton's own popularity was, initially, not much hurt by abstract expressionism, which was, and remains unpopular outside the urban art centers. In 1954 he completed the mural *Abraham Lincoln* for Lincoln University in Jefferson City, Missouri. Two years later he completed another mural, *Old Kansas City,* for the Kansas City River Club, and in 1957 executed two murals for the power authority of the state of New York at Massena, *Jacques Cartier Discovers the Indians* and *The Seneca Discover the*

French. Another mural, *Father Hennipen at Niagara Falls,* was completed in 1961 for the Niagara Power Authority.

Former President Harry S Truman shared Benton's affection for Missouri—the president's home state—and his dislike of modern art. In 1962 Benton completed the mural *Independence and the Opening of the West* for the Harry S Truman Library in Independence, Missouri. In 1970–71, shortly before Truman's death, Benton completed a portrait of the former president seated in an easy chair surrounded by books.

Benton chose Western locales for many of his paintings of the 1950s and '60s, including *The Shepherder* (1955–60) and *The Trail Riders* (1964–65). In *Lewis and Clark at Eagle Creek* (1966–67) the figures were dwarfed by landscape, as was customary in the paintings of the 19th-century American Romantics. (Benton was well aware of, and often quoted, the styles and devices of earlier American artists.) *Ten Pound Hammer* (1965) was based on the John Henry story, and *Forward Pass* (1971) was a football scene. Benton also had bronzes made of both these works.

Since 1935 Benton lived in his rambling Missouri farm house in Kansas City. He only returned East in the summers, which he spent with his wife at their seaside home on Martha's Vineyard, Massachusetts. His last mural, *Turn of the Century Joplin,* was installed in 1972 in the Municipal Building in Joplin, Missouri. He died of heart disease in a Kansas City hospital at the age of 85, shortly after collapsing in his studio.

Gruff in manner, with rugged furrowed features and grizzled moustache, Benton, in his younger days, prided himself on his ability to use his fists and belonged to the school of thought that held that the American artist had to be a hairy-chested "tough guy," a "real he-man." Even his friend and propagandist Thomas Craven, leading advocate in the 1930s of a politically conservative cultural nationalism, noted that Benton was "ashamed of his innermost feelings." Once having rejected his own early flirtations with modernism, he never departed from his 1934 statement that "a living art, or living arts, rather, are generated by the direct life experiences of their makers within milieus and locales." Elsewhere he wrote: "I have a sort of inner conviction that for all the possible limitations of my mind and the distorting effects of my processes, for all the contradictory struggles and failures I have gone through with, I have come to something that is in the image of America and the American people of my time."

EXHIBITIONS INLCUDE: Daniel Gal., NYC 1917; Chelsea Neighborhood Association Gal., NYC 1917; Ferargil Gal., NYC 1935; The Lakeside Press Gal., Chicago, 1937; Joslyn Art Mus., Omaha, Neb. 1951; New Britain Mus. of Am. Art, Conn. 1954; Mus. of Art, Univ. of Kansas, Lawrence 1958; Indiana Univ. Art Mus., Bloomington 1966; James Graham and Sons, NYC 1968, '70; Rutgers Univ. Art Gal., State Univ. of New Jersey, New Brunswick 1972. GROUP EXHIBITIONS INCLUDE: "The Forum Exhibition of Modern American Painters," Anderson Gal., NYC 1916; Century of Progress, International Exhibition, Chicago 1933; Pennsylvania Academy of Fine Arts Annual, Philadelphia 1942; "Romantic Painting in America," MOMA, NYC 1943; Pittsburgh International, Carnegie Inst. 1945.

COLLECTIONS INCLUDE: Metropolitan Mus. of Art, MOMA, and Whitney Mus. of Am. Art, NYC; Brooklyn Mus., N.Y.; Pennsylvania Academy of Fine Arts, Philadelphia; Hirshhorn Mus. and Sculpture Garden, Washington, D.C.

ABOUT: Baigell, M. Thomas Hart Benton, 1974; Benton, T. H. An Artist in America, 1937; Cheney, S. The Story of Modern Art, 2d ed. 1958; Graven, T. Thomas Hart Benton, 1939; Current Biography, 1940; Eliot, A. Three Hundred Years of American Painting, 1957; "Romantic Painting in America" (cat.), MOMA, NYC, 1943; Rose, B. America Art Since 1900, 2d ed. 1975. *Periodicals*—Arts Magazine June 1981; Magazine of Art May 2, 1939; New York Times December 10, 1972, January 20, 1975, January 10, 1982; Time February 3, 1975.

BERMAN, EUGENE (November 4, 1899–December 14, 1972), Russian-American painter and stage designer, was associated from the late 1920s on with the neoromantic movement. Berman's melancholy paintings of deserted streets and crumbling baroque buildings combine technical mastery with a surreal and dreamlike quality present also in his stage designs.

Eugene Berman was born in St. Petersburg, Russia. He and his elder brother, Leonid (who was also to win renown as a Neoromantic artist), showed an early interest in drawing and painting and were encouraged by their family. In 1906 their father died, and their stepfather sent Eugene to study in Germany, Switzerland, and France. He remained abroad until his return to Russia in 1913. In St. Peterburg Berman studied painting with P.S. Nauman and architecture with S. Grusenberg. The Russian Revolution impelled him and his family to leave Russia in 1918.

After traveling in Finland and England, Berman settled in Paris in 1919 and remained there for 20 years. From 1919 to 1922 he attended the Académie Ranson, Paris, along with his brother and Christian Bérard, and they studied under Maurice Denis and Edouard Vuillard.

Robert Emmett Bright, Roma

EUGENE BERMAN

In 1922 Berman visited Italy and was enchanted by the country and its buildings. About this time he began to paint the subjects for which he is best known—landscapes dominated by architectural ruins and the lonely courtyards of Italian palazzi. From 1923 to 1925 he exhibited in Paris at the Salon d'Automne, and in 1926 he and his brother, along with Bérard and Pavel Tchelitchew, mounted a group exhibition at the Galérie Drouet, Paris. As a result of this exhibit they became known as "Neoromantics." Each was reacting in his own manner against post impressionism, fauvism, cubism, constructivism, and all formally analytic styles. As a group their work reflected the influence of Picasso's Blue Period and also of surrealism, but in a milder, less aggressive and histrionic form than Dali and Ernst. They wished to restore traditional human elements and emotions to art, avoiding distortion of the figure and evoking psychological moods. " . . . They certainly belong to the history of art in our time," wrote Herbert Read. "But not to the history of the style of painting that is specifically 'modern'."

During his annual trips to Italy, Berman made numerous sketches and later used his drawings as aids in the paintings of Italian scenes that he did from memory. He was particularly drawn to Palladian and baroque architecture, and his broken columns and crumbling walls were usually bathed in a late afternoon light. The nostalgic quality of his treatment is suggested by such titles as *Memory of Ischia* and *Memory of Verona*, both of 1931, and *Memory of Chioggia* (1932). The mood of his pictures recalls that of de Chirico's deserted piazzas, and there are also elements

reminiscent of the preromantic images of Piranesi, Francesco Guardi's *Capricci*, (imaginary landscapes or architectural fantasies) and Hubert Robert's paintings of ancient ruins. Berman's figurative style and treatment of space was also influenced by Raphael and the Renaissance masters. One writer described a typical Berman scene, with "isolated, hooded figures like apparitions [that] cast long shadows against a deep landscape." A Renaissance-type perspective is used, but the writer continued, is often "forced" in order to "give impressions of longing and flight, melancholy and nostalgia." This surreal atmosphere is present in such a work as *The Magic Circle, Venice* (1932), which depicts figures reclining in a public square.

In 1932 Berman had his first New York City exhibition, at the Balzac Galleries, where he was to exhibit regularly for the next 15 years. In 1932 he painted *Memory of Saint-Cloud* and did a series on the bridges of Paris. One of his favorite technical devices, so evident in these works, was the use of spatter and washes to suggest the patina of antiquity on his paintings' surfaces.

Berman's work was beginning to sell in part because it appealed to conservative collectors wanting quality paintings less challenging than cubist and nonobjective art. In the early 1930s the artist traveled in Italy, Spain, and France, and by 1934 he had turned to the subject matter of ruins, desolation, debris, and the kind of "picturesque" poverty that is found in 18th-century Venetian painting. *Debris on the Beach* (1934) and *Desolate Landscape* (1936, also called *Wasteland*) are examples of this phase of his work, which culminated in a set of murals done for the home of James Thrall Soby in 1936. Beggar children in tatters were seen through the holes and gaps of peeling, crumbling walls. In a mural executed in 1938, the rags and tatters became trompe l'oeil devices, as if the scenes were painted on rags pinned to the wall. Berman used similar effects in *Lost Children of the Road* and *Trompe L'Oeil*, both of 1938, and throughout his career he signed many of his paintings with a trompe l'oeil device.

Berman's vision and aesthetic had obvious affinities with the theater, and although he was primarily an easel painter, stage design became for him a major creative venture. The Wadsworth Atheneum, in Hartford, Connecticut, owns a model of *Venetian Décor*, a stage setting from 1932, and a sketch for an elaborate baroque set done for the Hartford Festival in 1936. He designed sets and costumes for a 1937 production in Paris of Brecht's *Threepenny Opera*. Though effective, his designs were no doubt less stark and more pictorial than Brecht would have wished.

Berman's reputation as a stage designer was enhanced by his sets and costumes for *Icare,* a ballet in two scenes by Serge Lifar which was presented by the Ballet Russe de Monte Carlo at the Drury Lane Theatre, London, in 1938. Typically Bermanesque in their mixture of fantasy and technical precision were his designs for *Devil's Holiday*, a ballet by Frederick Ashton with music by Vincenzo Tommascini. It was staged by the Ballet Russe de Monte Carlo at the Metropolitan Opera House, New York City, in 1939.

Berman's most important stage designs during these years were for the Anthony Tudor ballet *Romeo and Juliet* at the Metropolitan Opera in 1942, and for the Balanchine ballets *Dances Concertantes* and *Le Bourgeois Gentilhomme*, both given at City Center, New York City, in 1944.

Berman had first visited the United States in 1935, and in 1940 he fled war-torn Europe for the United States. He became a naturalized citizen in 1944. In 1941 he was given a retrospective at the Institute of Modern Art, Boston, and that same year he designed the costumes and the single setting for George Balanchine's ballet *Concerto Barocco*, give at Hunter College by Ballet Caravan, which was headed by Lincoln Kirstein, an admirer of Berman's work. At this time Berman painted elaborate landscapes with exaggerated, manneristic perspective. For example, *View in Perspective of a Perfect Sunset* (1941) depicts a bright orange-colored avenue bordered with columns and obelisks diminishing to a point on the horizon. In this, as in *Flight into Egypt* (1941), the theme of destruction is present, emphasized by the broken columns and the placement of the figures.

In the early 1940s Berman painted groups of surrealistic female figures turned away from the viewer, some with bags over their heads and others swathed in draperies that rendered their bodies formless. Paintings in this vein include *The Muse of the Western World* (1942), *Nike* (1943; Hirshhorn Museum and Sculpture Garden, Washington, D.C.), and *Cassandra* (1942–43). *Proserpina* (1944), a serene view of a woman in profile, is an exception, but in *Proserpina II* (1945–46) Berman returned to surrealistic imagery. Many of Berman's allegorical figure compositions painted between 1942 and 1946 contained fantasy portraits of Ona Munson, whom he married in 1950.

About 1945, the year of his first solo show at the Museum of Modern Art, New York City— the second was in 1947—Berman returned to trompe l'oeil devices. Possibly influenced by the violence and destruction of World War II, he

painted bullet holes and rips and tears in his works. In *Misérére* (1945), the scene of a woman, with a seemingly dead man, in a chamber whose ceiling is crowded with stalactites is made more disturbing by a multitude of bullet holes. There are similar effects in his *Death in Venice* (1945–46), while *The Spring*, painted at the same time and representing a female figure, gives the illusion of being shattered like a window and taped together. A few years later Berman muted this surface destruction with subtle tachiste effects which often resulted in an ambiguity: were the spatters on the surface of the painting or on the objects depicted?

A Guggenheim Fellowship granted in 1947 and renewed in 1949 enabled Berman to travel in Mexico. There, he did works depicting Mexican baroque architecture. The pictures often have a dreamlike atmosphere, as in *The Obelisks* (1949), in which the buildings bend and bulge in a surrealistic undulation. In some works the water spouts on the buildings are transformed into guns. They appear in *The Temple of the Shell* (1947), *The Gate of the City* (1948), and *San Cristobal of Los Niños Perdidos*. There is a bizarreness and an Escher-like quality in *The Pyramids* (1949), in which a multitude of people go in and out of doorways. By this time the figures had become smaller and less significant than in Berman's previous works.

From 1951 to 1957 Berman devoted most of his energies to stage design, primarily for the Metropolitan Opera. The Balanchine ballet *Concerto Barocco* was revived in 1951, and Berman's major opera designs were for *La Forza del Destino* (1952), *Cosí Fan Tutte* (1956), and *Don Giovanni* (1957). Some viewers felt, however, that the ponderousness of the Don Giovanni sets, and Berman's emphasis on the more exaggerated aspects of mannerist and baroque architecture, were at odds with the spirirt of Mozart's music. In 1952 Berman designed the interior for the theater at the Ringling Museum in Sarasota, Florida. Many of the artist's watercolor and ink studies for sets and costumes were exhibited in galleries along with the paintings.

Berman, with his love of color and elegance, rejected the very abstract, cubistic settings of Appih and Gordon Craig, which to him seemed "gloomy, rigid and depressing in their puritanistic primness and intellectual intolerance." This was a narrowly one-sided view, but in keeping with Berman's nostalgia for the past.

In 1957 Berman left the United States and settled in Rome. He collected all types of art, from primitive to modern, and his home became a virtual museum. His paintings in the late 1950s and into the 1960s often feature Roman ruins. *Two Roman Columns and Three More* (1958) depicts monumental columns ravaged by time. One of the columns is broken and topped with grass and other vegetation, and laundry is draped between them. (Indeed, in 17th-century Rome cattle were allowed to graze in the Roman Forum and wash was hung amid the ruins.) A small figure sits on a fallen piece of column in one corner. *The Sarcophagus and the Column* (1958–59) follows a similar formula. Berman's paintings of the Colosseum, Trajan's Column, and ruined amphitheaters convey emptiness and desolation. *The Ruined Temple* (1962) depicts ruins in an eerie mist.

In 1963 Berman returned briefly to New York to design the decor for Verdi's *Otello* at the Metropolitan Opera. In 1965 he went to Egypt, where he painted pyramids, the Sphinx, fallen obelisks and ruins; in most of these works only small, robed figures appeared. In the late 1960s he visited the impressive ruins of Leptis Magna in Tripolitania, Libya which inspired his "Medusa" series, depicting various aspects of the Medusa. In *La Medusa Ferita* (1968) the sculptured head of the wounded Medusa lies in the grass. These later works have the now-familiar tachiste spatterings.

Eugene Berman was given a major retrospective at the American Academy in Rome in 1970. He died in Rome two years later. He was below medium height, and his bald head, round face, and heavy, horn-rimmed glasses gave him an owlish appearance. One critic described Berman as "an offbeat talent, out-of-step with the period of which he lived." His success with the public was largely due to the romantic, nostalgic, and discreetly surreal atmosphere of his works, and he was admired by fellow artists for his technical expertise. "He was not so much a visionary as an artist with a strong sense of passionate imagery," Sheldon Williams wrote in *Contemporary Artists,* "a brilliant illustrator of remote times that perhaps hardly existed."

EXHIBITIONS INCLUDE: Gal. Granoff, Paris 1927; Gal. de l'Etoile, Paris 1928; Balzac Gal., NYC 1932–47; Zwemmer Gal., London 1935; Gal. Montaigne, Paris 1939; Inst. of Modern Art, Boston 1941; Decker and Flynn Gal., Los Angeles 1944; MOMA, NYC 1945, '47; M. Knoedler & Co., NYC 1947–65; Kraushaar Gal., NYC 1948, '49, '54, '60; Hanover Gal., London 1949; Inst. de Arte Moderno, Buenos Aires 1950; Lefevre Gal., London 1960; Phoenix Art Mus., Ariz. 1963; Richard Larcade Gal., NYC 1969–72; La Medusa Gal., Rome 1969; Am. Academy, Rome 1970. GROUP EXHIBITIONS INCLUDE: Salon d'Automne, Paris 1923–25; Gal. Drouet, Paris 1926; Wadsworth Atheneum, Hartford, Conn. 1931; Mus. du Petit Palais, Paris 1934; "Modern Painters and Sculptors as Illustrators," MOMA, NYC 1936; "European Art of This Century," Toledo Mus. of Art,

Ohio 1938; Place Vendôme Gal., Paris 1939; Pittsburgh Annual, Carnegie Inst. 1943–50; Annual, Whitney Mus. of Am. Art, NYC 1945–50, '55; "American Art 1910–1960," Knoedler Gal., NYC 1960.

COLLECTIONS INCLUDE: Metropolitan Mus. of Art, and MOMA, NYC; Wadsworth Atheneum, Hartford, Conn.; Mus of Fine Arts, Boston; Smith Col., Northampton, Mass.; Philadelphia Mus. of Art; Phillips Gal., and Hirshhorn Mus. and Sculpture Garden, Washington, D.C.; Mus. of Art, Cincinnati; Mus. of Art, Baltimore; City Art Mus., St. Louis Mo.; County Mus. of Art, Los Angeles; Mus. of Art, Santa Barbara, Calif.; Brighton Art Gal., England; Mus. d'Art Moderne, Paris; Graphische Sammlung, Albertina, Vienna; Gal. d'Arte Moderna, Venice.

ABOUT: Battersby, M. The Decorative Thirties, 1971; Berman, E. Imaginary Promenades in Italy, 1956; "Eugene Berman" (cat.), Lefevre Gals., London, 1960; Levy, J. Eugene Berman, 1946; Lynes, R. The Graphic Work of Eugene Berman, 1971; P-Orridge, G. and others (eds.) Contemporary Artists, 1977; "The Theatre of Eugene Berman" (cat.), MOMA, NYC, 1947. *Periodicals*—Art Digest November 1, 1943; Arts Magazine April 1969.

ANTONIO BERNI

*BERNI, ANTONIO** (May 14, 1905–), Argentine painter, sculptor, collagist, printmaker, and tapestry designer, has been variously described as a Neorealist and as a painter of socalled abstract realism, but he strongly objects to being included in any specific school. "The strong point of my art has always been the narrative," he wrote, "and all my formal and chromatic changes have been made accordingly, since now, more than ever, I consider that style is not only a way 'of doing' but also a way of thinking and analyzing."

Antonio Berni was born in Rosario de Santa Fe, Argentina, the youngest child of Napoleon Berni, an immigrant tailor from Italy, and his second wife, Margarita Picco, a native of Santa Fe Province. Antonio had an elder brother, whom the father named Victor Hugo Zola Berni, and a sister, Elvira. The artist was named Deliso Antonio, but he never used the first name.

In 1916 Berni began his art education in a stained-glass workshop run by a Catalonian artisan named Buxadero. Meanwhile he studied drawing and painting at the Catalonian Center in Rosario, with two other Catalans, Enrique Munne and Eugenio Fornels. A precocious talent, he was influenced at an early age by the Argentine painter Fader and by the realism and impressionism of the Spanish painter Joaquin Sorolla y Bastida. About 1918, Berni's teacher Fornels helped him organize his first show, when he was still in his early teens. The works, exhibited

in a Rosario gallery which no longer exists, are said to have been landscapes in oil. From 1921 to 1924 Berni abandoned his secondary studies and lived with the peasants of the pampas, painting landscapes of that vast, grassy region.

In 1925, at the age of 21, he was awarded a fellowship from the Jockey Club of Rosario to study painting in Europe. After a year in Madrid he went to Paris, where he lived until 1931, also traveling in Belgium, Holland, and Italy. From 1925 he exhibited regularly in America and Europe; in 1927 some of his European works were shown in Buenos Aires at the Sociedad Amigos del Arte. In Paris Berni studied with André Lhote and, at the Grande Chaumière, with Othon Friesz. In 1928 he came into contact with the Surrealists, making friends with Louis Aragon and, especially, Henri Lefebvre. Although Berni never joined the surrealist movement, it strongly influenced his painting, as well as the photomontages and collages which he began in 1929. Ellen Schwartz wrote in *Art International* (January 1972): "From Surrealism Berni inherited a temporary style, but more importantly it developed his technical proficiency and freed him from the dangers of provincialism and academicism." Also in 1929 Berni married his first wife, Paule Cazenave, a Frenchwoman by whom he had a daughter, Hélène.

After his return to Rosario in 1930, Berni continued to experiment. He soon joined the Mexican David Alfaro Siqueiros in painting a mural, *Plastic Exercize,* in a private home on the outskirts of Buenos Aires. In 1932 he showed the first collection of his surrealist works, including oils, collages, and photomontages. His surrealism

°bâr´ nē, än tō´ nyō

bore a definite Argentine stamp. One critic asserted that the dual influence of surrealism and Mexican mural painting guided Berni's style of the 1930s, while Argentina's repressive conservative regime, mass unemployment, and sluggish economy convinced him of the need for political and cultural confrontation. However, Berni always maintained that Argentine artists could not afford, or be as politically effective with, the direct calls for revolution of the Mexicans. Rejecting both socialist realism and formal art, he founded a group which he called Nuevo Realismo (New Realism). He painted large, murallike canvases, often for labor unions and factories, with the recurring theme of the exploitation of workers. The style of these paintings was an awkward, slightly distorted and highly personal realism. In *New Chicago Athletic Club* (1937) and other works of the 1930s, Berni painted groups of people in a landscape or architectural setting with a depth of perspective that he later discarded.

In 1937 Berni won the first prize for painting at the International Exposition, Paris, and in 1940 he was awarded the first prize at the National Salon, Buenos Aires. From 1935 to 1946 he taught at the National School of Fine Arts, Buenos Aires, and actively exhibited in solo and group shows. He was selected in 1941 by the National Commission of Culture to study pre- and postcolonial American art, and this gave him the opportunity to travel along the Pacific Coast. He won Argentina's Grand National Award for painting in 1943. The following year, Lincoln Kirstein wrote in *The Studio*: "Antonio Berni's large panels of workmen and children remind one at once of North American social realists and the large heads of Siqueiros."

In 1949, together with Juan Carlos Castagnino, Lino Enea Spilimbergo, Demetrio Urruchua, and the Spaniard Colmeiro, Berni founded the Atelier of Mural Art, in the hope of stimulating mural activity in Buenos Aires. He also painted his own independent series, in oil and tempera on canvas, on the people of rural areas, including cotton harvesters and woodcutters, against a background of arid soil or inhospitable forest. In 1950 Berni married his second wife, Nelida Gerino, by whom he had a son, José Antonio.

Although most of Berni's works in the early 1950s were concerned, directly or indirectly, with social problems, some were more decorative and optimistic, foreshadowing his later tapestry designs. One of these was a panel painted for the house of Juan B. Justo of Buenos Aires, and reproduced in *The Studio* in August 1952. It depicts two boys, one naked, the other semi-naked, fording a river on horseback in an uninhabited landscape, and evokes a life free from the pressures of the city.

From 1955 to 1960 Berni exhibited in Paris, Bucharest, Warsaw, Prague, and Moscow. In 1958 he returned to collage and assemblage; he began collecting and using waste and garbage from local shantytowns to piece together the makeshift world of two invented characters who were to play a central and continuing role in his work—Juanito Laguna and Ramona Montiel. Juanito Laguna, as Berni described him, was a boy from Bajo Flores, a tough section of Buenos Aires. "He has nothing, except his capacity to work; cheated and exploited, he builds his miserable refuge, changing wooden cases, useless cans and other rubbish thrown out by the urban bourgeosie to dwellings, furniture and kitchen utensils." Juanito, for Berni, was an artist out of necessity, creating the things he needed out of whatever he found. Berni's style, in the works devoted to Juanito, had expressionistic elements, but was essentially a collage, blending abstraction and figuration, different from his earlier precise realism. Nonetheless, Juanito's world on canvas was real, palpable, and devastatingly accurate. *Juanito Laguna Goes to Conquer the Big City* (1963), for instance, shows the boy walking in piles of debris, culled from real garbage. Berni continued to paint pictures of Juanito throughout the 1960s and well into the '70s. Juanito also starred in a series of prints, on which Berni worked intensively from 1961. At the Venice Biennale of 1962 he was awarded the International Grand Prize for his Juanito drawings and engravings. Many of the prints resemble collages, because they were made by pressing inked found objects to the paper.

Soon after the first appearance of Juanito Laguna, Berni invented his other main character, Ramona Montiel. Ramona, whose story has some parallels with that of Evita Perón, was described by Gilbert Chase as "a girl of the people who has to make her way in the world and is not too particular about how she does it." With her "lace edgings, the showy nylons and the costume jewelry," to quote Berni, Ramona belongs to a more sophisticated world than Juanito. Ramona's life and loves were depicted in a narrative series of prints and collages (1961–64) considered by many to be the artist's most striking and original work. In the print-collage *Ramona Lives Her Live*, her extravagant attire is made up of "discarded furbelows and fripperies," suggesting both La Belle Epoque and the flea market. One writer noted that Ramona has about her a "somewhat old-fashioned Parisian nostalgia." There is a wild, Dubuffet-like grotesquerie in the oil and collage *The Girlfriend of Ramona*

(1962), while some of Ramona's "protectors," as in the print-collages *The Colonel* and *The Admiral,* come close to mechanistic semiabstractions. The more nightmarishly monstrous figures, such as those that the guilt-ridden Ramona sees in the solitude of her room, recall Berni's association with surrealism. But Berni's depiction of the life story of his archetypal characters did not lead to the betrayal of his more general desire for social justice, because, as one critic said, "the spirit of popular passion persists, documenting poverty but now sublimated into artistic forms." Indeed, in what is surely a unique instance of modern art being reabsorbed directly into mass culture, popular tango recordings were made about Juanito Laguna and played on Argentine radio.

In 1963 Berni turned to tapestry and opened a tapestry studio. From 1966 on he exhibited his tapestries in Uruguay and in many cities of Argentina. In the full-size color cartoons, from which the dyers and weavers worked under his direction, he made use of decorative floral patterns, a marked contrast to his earlier depictions of the wretched poor. His tapestry *Bird,* exhibited at the Galleria Rubbers, Buenos Aires, in 1971, is one example.

Berni carried his collages one step further by creating environments as well as sculpture in plaster and other materials. One such environment was *Massacre of the Innocents,* constructed for a 1972 show in Paris. His international renown was growing, particularly in France. In 1967 he had participated in a group exhibition, "La Bande dessinée et la figuration narrative," in Paris, and also mounted major retrospectives in Argentina, the United States, Mexico, and Brazil. A second retrospective was held at the Musée Municipal d'Art Moderne, Paris, in 1971. *The World of Ramona,* a variegated and complex multimedia environment, was constructed at the 1970–71 Buenos Aires Expo.

Despite his forays into other media and his more recent concern with cybernetics, Berni has not abandoned painting and collage. In *Juanito Laguna—Shoe Shine* (1977), the boy wears a real woolen cap. In *Airport* (1977) the "ideal" world of the timetable and of that depicted in an advertisement for underwear is contrasted with the tawdry reality of four people sleeping in chairs below.

Antonio Berni was formerly president of the Argentinian Society of Plastic Artists, and is now a member of the Academy of Design in Florence. He commutes between Buenos Aires and Paris, and is married to his third wife, Silvina Victoria. A sturdily built man, the artist is clean-shaven and wears horn-rimmed spectacles, with sideburns extending from ear to jawline. He has recently expressed his belief in art's "dual functions; as a form and as a significance." Berni consistently avoids both purely formal art and the more banal aspects of social realism while using elements of both. Of this balancing act, Ellen Schwartz wrote: "His remarkable oeuvre demands to be understood as an amalgamation of personal, socio-political, and aesthetic impulses, which have perhaps never before functioned in such perfect harmony."

EXHIBITIONS INCLUDE: Sociedad Amigos del Arte, Buenos Aires 1927, '32; Salon Nancy, Madrid 1928; Amigos del Arte, Montevideo, Uruguay 1938; Gal. Greuze, Paris 1955; Gal. du Passeur, Paris 1963; Mus. of Modern Art, Miami 1963; Mus. de Arte Moderno, Santiago de Chile 1964; Huntington Hartford Gal., NYC 1965; Palacio de Bellas Artes, Mexico City 1967; "La Caverna de Ramona," Gal. Rubbers, Buenos Aires 1967; Mus. de Arte Moderno, Rio de Janeiro 1968; Gal. El Taller, Buenos Aires 1969; Buenos Aires Expo 1970–71; Mus. d'Art Moderne de la Ville de Paris 1970–71; Mus. Muncipal d'Art Moderne, Paris 1971; Gal. Atelier Jacob, Paris 1973; Gal. Rubbers, Buenos Aires 1973, '75; Gal. Renom, Rosario, Argentina 1974; Wells Gal., Ottawa, Canada 1974; Imagen Gal. de Arte, Buenos Aires 1974, '76; Gal. Zanini, Rome 1975; "The Magic of Everyday Life," Bonino Gal., NYC 1977. GROUP EXHIBITIONS INCLUDE: International Exposition, Paris, 1937; Nat. Salon, Buenos Aires 1940; "Homenae a Machado," Maison de la Pensée, Paris 1955; "Art Latino-Américain," Mus. d'Art Moderne, Paris 1962, '65; Venice Biennale 1962; Salon de Mai, Paris 1963; International Biennial of Etchings, Ljubljana, Yugoslavia 1963, '65; International Biennial of Etchings, Tokyo 1964; "El Arte Argentina Hoy," Walker Art Cntr. Minneapolis 1964; "Mythologies Quotidiennes," Mus. d'Art Moderne, Paris 1965; "La Bande dessinée et la figuration narrative," Mus. des Arts Décoratifs, Paris 1967; "Arte y Cibernetica," Gal. Bonino, Buenos Aires 1969; "Arte y Cibernetica," Caracas, Venezuela ca. 1970.

COLLECTIONS INCLUDE: Mus. Nacional de Bellas Artes, and Mus. de Arte Moderno, Buenos Aires; Mus. Nacional de Bellas Artes, Montevideo, Uruguay; MOMA, NYC; Mus. Muncipal, Saint-Denis, France; Mus. des Beaux-Arts, Ostende, Belgium.

ABOUT: Aragon, L. and others Berni, 1971; Bénézit, E. (ed.) Dictionnaire des peintres, sculpteurs et graveurs, 1976; Chase, G. Contemporary Art in Latin America, 1970; Pellegrini, A. New Tendencies in Art, 1966. *Periodicals*—Art International (Lugano) January 1972; Aujourd'hui (Paris) April 1964; Connoisseur May 1975; Domus (Milan) April 1975; Magazine of Art October 1943; Opus International (Paris) May 1971); Studio October 1944, August 1952

*BERTOIA, HARRY (March 10, 1915–November 4, 1978), American sculptor and designer, first achieved public recognition in 1952 for a steel-frame chair he designed for Knoll Associates. Turning to sculpture, and working exclusively in metal stock and plate, he drew upon his industrial design experience in executing large-scale constructions and screens for public buildings, fountains, and plazas. Beginning in the 1960s he devoted much of his time developing unique forms of musical sculpture.

Harry Bertoia was born in San Lorenzo, a village near Udine in northeastern Italy. In 1930, at the age of 15, he came to America with his father, first to Canada, then to Detroit. After several years his father returned to Italy, but Harry remained in Detroit, attending Cass Technical High School, the Art School of the Society of Arts and Crafts (1936), and the Cranbrook Academy of Art in Bloomfield Hills, Michigan, on a scholarship (1937–38). On his application to Cranbrook he described himself as "rather silent, resolute and industrious."

Although he took only painting and drawing classes at Cranbook, he worked in metal on his own. When he graduated in 1938, he was asked to stay in order to start a metal-crafts department, which he headed until 1943. In 1942, he married Brigitta Valentine, with whom he had a son, Val, and two daughters, Mara Lesta and Cecilia.

In the early 1940s Bertoia worked both in graphics and jewelry design. His early woodcuts, such as *Grape Harvest* (1941), were figurative and narrative, but a few years later he was making abstractions by rolling printer's ink onto a table, laying rice paper on top, and then rubbing with a pencil, stylus, or even with his finger. He also developed an unusual monotype technique, using movable plates which added a further element of chance to his designs. His jewelry was composed for the most part of free, organic shapes.

Bertoia's monoprints were included in a Loan Exhibition of nonobjective painting held at the Museum of Non-Objective Art, New York City in 1943. Also in 1943 he moved to Venice, California, to work for the Evans Products Company. Later that year he met furniture-maker Charles Eames and began designing chairs with him for the same company. From 1947 to 1949 he was a graphic designer for the Point Loma Naval Electronics Laboratory in San Diego. His graphics and jewelry were exhibited in three shows in the Karl Nierendorf Gallery, New York City, in 1943, 1945, and 1947. Meanwhile, Bertoia was also active as a sculptor. His sculptures of the late 1940s, already composed of metal

Courtesy of Staempfli Gallery, New York

HARRY BERTOIA

rods and cutout shapes (at that time still an unusual medium), are sparsely constructed compared to his later works.

In 1950, the year he moved to Barto, near Allentown, Pennsylvania, Bertoia designed his own chair, which was made up of a web of metal rods bent to conform to the human body. The chair was put on the market by Knoll Associates in 1952 and has since became a classic. Bertoia designed two other chairs, an ottoman and a bench for Knoll, but by 1953 he was no longer involved in furniture design.

In sculpture, Bertoia had finally found the idiosyncratic relationship between line and form that he had sought in his prints. Metal panels were combined with a network of rods, with negative space playing an important role in the compositions. Bertoia said, "One prevailing characteristic of sculpture is the interplay of void and matter, the void being of equal value to the component material units." Bertoia applied this idea in a series of large commissioned "Sculpture Screens" in buildings and public places around the United States. The first of these, completed in 1953, was for Eero Saarinen's General Motors Technical Center in Warren, Michigan. Bertoia worked closely with Saarinen on this work, which measured 10 feet by 36 feet by 8 inches. The screen's grids were not completely flat, as in a mural, but had a depth which made them more spatially complex.

In 1954 Bertoia worked with the architectural firm of Skidmore, Owings and Merrill to install an even larger sculpture, 16 feet high and 70 feet wide, in the Manufacturers Hanover Trust Com-

°bâr toi´ ya

pany headquarters in Manhattan. It consisted of 800 panels of welded bronze plate, brazed-over with nickel-silver and brass to a complex grid of rods; the piece's hexagonal geometry echoed the shape of a honeycomb. Other screens were made for the Cincinnati Public Library (1954), the Massachusetts Institute of Technology, Cambridge (a reredos, or altar backdrop, for Saarinen's chapel, 1955), the First National Bank of Miami (1956), and the State Department building in Washington, D.C., also in 1956. His imagery, though generally abstract, was drawn from natural sources, particularly the decorative lines of plants. In 1956 the artist was awarded the Craftsmanship Medal by the American Institute of Architects. The following year he made his first trip to Europe since settling in America, and in 1958 he had a sculpture screen in the US pavilion at the Brussels World's Fair.

The network of rods in Bertoia's sculptures became more complex in the early 1960s. *Nova* (1961), which now hangs at Syracuse University, New York, is a nest of fine copper, bronze, and steel rods, with a few rectangles and trapezoids protruding at the ends, as is *Sunburst* (1962), a wall-hanging for the Bankers Trust Building, New York City, *Galaxy* (1964), which hangs from the ceiling of the Golden West Savings and Loan Association in Crystal Valley, California, and *Sunlit Straw* (1964), a brass mural in the Northwestern National Life Insurance Building in Minneapolis. Evidently, the clean, industrial image projected by Bertoia's sculpture was perfectly matched to the sleek new headquarters being raised by these conservative financial institutions. His works can fairly be said to be among the first to belong to that subgenre of public art known as "corporate sculpture."

Another of Bertoia's motifs was the sphere (or hemisphere), first used in a 1956 sculpture resembling a dandelion. In the early 1960s he began making spheres and spheroids of rods projecting from a central core. *Balanced Sphere* (1961), in the Denver Hilton Hotel, and *Fountain Sculpture* (1963) have an elegant, ethereal quality. Some of these pieces hang from the ceiling; others, which resemble bushes, are set on stands and have little budlike metal nodes at the ends of the rods. *Untitled* (1965, Hirshhorn Museum and Sculpture Garden, Washington, D.C.) is made up of stainless steel wires spreading out in a fanlike formation from a concrete base.

In 1967 and 1968 Bertoia made two large fountain sculptures—one for the Philadelphia Civic Center, the other for the Manufacturers and Traders Trust Building in Buffalo, New York—that were very different from any of his previous works. Made of copper rods bent into graceful curves and brazed over with bronze to create a ribbed surface over which water cascades, they resemble gigantic, beautiful flowers.

Paralleling his interest in spatial relationships, Bertoia also became fascinated, in the course of working with thin lengths of rod and hollowed and beaten sheet, with the musical properties of certain varieties and shapes of metal. His first sound sculpture was begun in 1960. Most of these works were masses of rods, bars, and gongs that, when activated by hand or air currents, produced musical sounds much like those of an elaborate wind chime, or a glockenspiel. As early as 1956 he had made a gong for the State Department. One of his sound sculptures, dating from 1967, was a sheaf of fine rods banded together at the base which flared upward in a cone.

Throughout the 1970s Bertoia continued to make what he called "Sonambients" and even made recordings and films of them. In 1971 he received an honorary doctorate from Muhlenberg College, Allentown, Pennsylvania, which also gave him an exhibition in 1975. Films about the artist include *Harry Bertoia's Sculpture* (1965), a Clifford B. West production, and Jeffrey Eger's *Sounding Sculpture by Harry Bertoia.*

In 1978 Bertoia installed a sound sculpture commissioned by the Federal Reserve Bank Building in Richmond, Virginia. In November of that year he died in his 18th-century home in Barto, Pennsylvania, aged 63. He was buried next to his favorite gong behind the barn which had been his studio for nearly 20 years.

EXHIBITIONS INCLUDE: Karl Nierendorf Gal., NYC 1940, '43, '45, '47; Smithsonian Instn., Washington, D.C. 1943; Knoll Associates, NYC 1951; Staempfli Gal., NYC 1959, '63, '68; Fairweather-Hardin Gal., Chicago 1961, '68, '75; Knoll International, Amsterdam 1964; Knoll International, Zürich 1968; K.B. Gal., Oslo 1972, '75; Wadsworth Atheneum, Hartford, Conn. 1974; Art Inst. of Chicago 1975; Muhlenberg Col., Allentown, Pa. 1975. GROUP EXHIBITIONS INCLUDE: Mus. of Non-Objective Art, NYC 1943; "Graphics," San Francisco Mus. of Art 1945; U.S. Pavilion, Brussels World's Fair 1958; London Triennial Exhibition of Sculpture in the Open Air, Battersea Park, London 1963.

COLLECTIONS INCLUDE: MOMA, Whitney Mus. of Am. Art and Solomon R. Guggenheim Mus., NYC; Albright-Knox Art Gal., Buffalo, N.Y.; Munson-Williams-Proctor Inst., Utica, N.Y.; Massachusetts Inst. of Technology, Cambridge; Hirshhorn Mus. and Sculpture Garden, Washington, D.C.; Virginia Mus. of Fine Art, Richmond; Denver Art Mus.

ABOUT: Benthall, J. Science and Technology in Art To-

day, 1972; Davis, D. Art and the Future: A History/ Prophecy of the Collaboration Between Science, Technology and Art, 1973; Nelson, J. K. Harry Bertoia: Sculptor, 1970; Torvey, J. The Technique of Kinetic Art, 1971; Trier, E. Form and Space: Sculpture in the 20th Century, 1968. *Periodicals*—Art International (Lugano) April 1973; Art News March 1976; New York Times November 8, 1978; Village Voice May 3, 1980.

***BEUYS, JOSEPH** (May 12, 1921–), German sculptor, environmental artist, and conceptualist, is the most conspicuous and controversial figure in the contemporary German—and, probably, European—avant-garde. The term "Plastik," often used by Beuys in regard to his work, is not confined to sculpture, one of its common dictionary meanings, but is applied by him to all creative activity and, by extension, to the social totality and, indeed, the whole process of living, of all manner of being and doing. This he also calls the "social sculpture." He is associated with environmental art and the creation of happenings, a trend which can be traced back to Marcel Duchamp and dada, yet Beuys's uniquely German forms of expression are very different from the witty, anarchic iconoclasm of Duchamp or the free-wheeling expansiveness and stylish eclecticism of Robert Rauschenberg. There is in Beuys a deep seriousness of purpose, a polemic aggressiveness, and a craving for absolutes that spring directly from his German background—a frame of reference that embraces not only the drastic wartime and postwar experiences of Germany, but the transcendental, romantic Northern tradition—what Herbert Read has called "the spirit of great forests." Beuys was the first postwar German artist to freely make • use of the Teutonic Mythos tainted by its identification with Nazi ideology, and thus he paved the way for the brooding, myth-imbued neoexpressionist painting of such contemporary Germans as Anselm Kiefer and Georg Baselitz.

Beuys is totally opposed to the "elitist" museum system and of art as a commodity for the wealthy. But few beyond the German intelligentsia and radical left—both products of bourgeois backgrounds—understand or support his difficult, intensely personal art and his anarchic politics. Beuys's personal magnetism, his absolute conviction, have nonetheless helped him acquire real political power such as few artists have wielded.

Joseph Beuys was born in the little town of Cleves in the flat, marshy Brabant country in the northwest corner of Germany, only a mile or two from the Dutch border. (Beuys [rhymes with "voice"] is a Dutch name.) Caroline Tisdall has described the region as "a Celtic and Catholic enclave in a Germanic and Protestant country."

Peggy Jarrell Kaplan

JOSEPH BEUYS

An only child, Beuys was left very much to himself as he grew up in the troubled years of post–World War I Germany. He got his education as much from the landscape and history of Cleves as from formal schooling or conventional family life, and he felt a kinship with the marshy, waterlogged terrain. As a boy he worked a great deal in farmyards, doing "a lot of whitewashing," as he remembers, and seeing to the warmth and comfort of the animals. Wandering by himself in the countryside around Cleves, he liked to envision himself as a shepherd, crook in hand, surrounded by an imaginary herd. He was also a passionate collector of miscellaneous creatures and objects, "from beetles, mice, rats, frogs, fish and flies to old agricultural instruments."

When Hitler came to power in 1933, Beuys was 12 years old. "Everyone went to church," recalled Beuys, "and everyone went to Hitler Youth." It is significant that when the burning of forbidden books took place in the local high school, Beuys reached into the flames to rescue the *Systema Naturae* of Linnaeus. The reasons for its banning by the Nazis remain obscure.

In his adolescence Beuys ran away and joined a traveling circus, becoming a proficient stuntman in the process. In a Germany that under the Nazis was becoming increasingly regimented, the circus stood for a free, nomadic life, celebrating ritual, the interdependence of human beings and animals, and the bringing of wonder and surprise into the lives of the spectators. The roots of Beuys's later practice of "performance art" can be partly traced to this early experience.

At the age of 19, Beuys was conscripted into

°bois

the Luftwaffe. He was trained first as an aircraft radio operator in Posen and Erfurt, and then as a combat pilot at Pardobitz; during missions he was seriously wounded five times. In 1943, when flying a JU-87 over the Crimea as a combat pilot, he was shot down in a snowstorm by Russian flak. Given up for dead by the German search parties, he was found unconscious in the wreckage by Tartar tribesmen who inhabited what was then a no-man's-land between the Russians and the Germans, and favored neither side. "Had it not been for the Tartars," he commented, "I would not be alive today."Their nomadic way of life fascinated Beuys, who had always admired Genghis Khan. When, after several days, and with great difficulty, he recovered consciousness in a German field hospital, he had distinct memories of how the Tartars had "covered my body in fat to help it regenerate warmth, and wrapped it in felt as an insulator to keep the warmth in." Beuys also remembered "voices saying 'Voda' [water], then the felt of their tents, and the dense, pungent smell of cheese, fat, and milk." Fat and felt had saved his life, and many years later he used those materials in his sculpture as emblems of healing.

In 1945, after his fifth serious injury, Beuys received the gold ribbon for the wounded. He was taken prisoner by the British in Cuxhaven, and after his release and demobilization he returned in 1946 to his parents' home in Kleve, near Rindern, which had been bombed. Having experienced the brutality and horror of Nazism and war, Beuys now tried to orient himself to a Germany that was, in John Russell's words, "guilt-ridden, near-paralyzed and largely derelict." Beuys decided to devote himself entirely to artistic interests, studying sculpture along with his private scientific investigations. He came into contact with a group of artists working in Cleves, among whom was the sculptor Walter Brux, who tutored Beuys in the fundamentals of sculpture, and the painter Hans Lamers, who acquainted him with the newest trends in French art. The drawings and watercolors Beuys exhibited in the group's first shows, held in 1946 and 1947, caused some consternation because they were exploratory studies of natural forms rather than works of decorative art.

In 1947, after collaborating on a zoological film with the naturalist Heinz Sielmann, Beuys enrolled at the Düsseldorf Academy of Art. Here he found that concepts of art could be as restrictivce as the rigid, academic application of ideas to natural science. At this time Beuys was drawing copiously—he defined drawing as any kind of relatively small notation on paper—and in 1949 he entered the class of Ewald Matare, a professor of sculpture who had been dismissed by the Nazis as a producer of "degenerate art" in 1933. Matare was known for his emphasis on craft and for his mystical belief in the unity of all creation. One of his sayings was, "Art is a footprint in the sand." He encouraged his pupils to use everyday materials, and this was to influence Beuys in his understanding of aesthetic connections between art and sculpture.

From the very beginning, Beuys was concerned in his sculptures with meaning rather than aesthetic effect. *Head* (1949), in wood, was the basic solid equivalent of the animal skull that recurs later in his work. *Sleds* (also 1949), in bronze, introduced a theme that was to reach full expression in *The Pack* of 1969. *Sleds* consists of two bronze wedges capable of an oblique sliding movement somewhat like that of the steering runners of a large sledge. Since 1948 Beuys, in addition to being inspired by German Romanesque art, had become interested in the alchemist Paracelsus, who defined natural, philosophic man as the microcosmic center of all being, and Beuys's wooden *Crystal* (1949) was a construction motivated by "a basic need to work with mathematical and Platonic orders," to quote the artist.

After World War I, Walter Gropius, founder of the Bauhaus, had had the Utopian vision of a constructive society based on reason, order, and harmony in contrast to the destruction and irrationality of that terrible war. Beuys, in the aftermath of World War II, had an opposite but equally powerful vision: "Chaos," he explained, "can have a healing character. Chaos can be coupled with the idea of open movement which channels the warmth of chaotic energy into order." Before long he was to antagonize not only the right wing, who regarded him as a dangerous subversive and anarchist, but also some of the young left wing who disliked the spiritual, mythological, and irrational content of his work. Beuys declared: "In places like universities, where everyone speaks so rationally, it is necessary that a kind of enchanter should appear"—the enchanter being himself, the artist as shaman. Beuys believed that in education there should be a place not only for magic but for humor as well.

In 1950 Beuys, who has an unflagging interest in literature, philosophy, and the history of ideas, became fascinated by "the Irish mythological element" in the works of James Joyce, and in that writer's "process of expansion" which "is in actuality a spiritual form of movement." Beuys saw Leonardo da Vinci and Galileo as key figures in "the concept of knowledge with which the bourgeoisie made their revolution." He then

went on to analyze Karl Marx, whose positivism he also regarded as bourgeois. Beuys's own concept of a "direct democracy" and of a "social sculpture" still lay in the future, but meanwhile he was bitterly hostile to the dollar-backed materialistic society then emerging in West Germany and which culminated in the economic miracle of the 1950s, and '60s. He saw this kind of rapacious but dynamic civilization as containing the seeds of its own destruction.

In 1951 Beuys left the Academy of Art in Düsseldorf, obtaining a studio in an old wing of a school in the city (the wing has since been torn down) where he worked until 1954. In a group exhibition, "Iron and Steel," sponsored by the Düsseldorf Ironworkers' Union, he exhibited a small *Pietà*, an open-work relief marked by the stylized distortions of Romanesque art. It received a prize through the vote of the sculptor Gerhardt Marcks. Other sculptures created by Beuys in the early 1950s were of a completely different nature. Since 1948 many of his drawings and etchings had been sensitive, archetypical representations of animals—hares, deer, moose, sheep, swans, and bees. Their association with nomadic life as well as the principle of movement were involved—the shepherd image had fascinated Beuys since boyhood. His 1952 etching *Untitled (From the Physiology of Bees)* was related in theme to his sculpture of the same year, in beech wood and wax, *Queen Bee III.*

The physical–organic world of bees was a starting point for Beuys's theory of sculpture. He saw the creation of heat, as well as the building of the honeycomb, "which looks like the negative of a rock crystal," as essentially sculptural processes, and this provided him with one motive for using wax and fat. Despite the difference in style, Beuys saw a relationship between his "Queen Bees" and the traditional medieval iconography of his crosses and *Pieta.* He described his "Queen Bees" as "nothing more than moving crosses," which were, however, "totally organic." Two of the "Queen Bee" pieces are in the Hessisches Landesmuseum, Darmstadt, West Germany. An ink drawing of 1952, *Queen Bee,* was later included in Beuys's enigmatic series "The Secret Block for a Secret Person in Ireland."

The trauma of Germany's recent past found expression in Beuys's work in his symbolic use of wounds. In 1958 a competition for a Holocaust monument was sponsored by the International Auschwitz Committee. Beuys's models and drawings for the competition showed the victims as they were brought directly into Auschwitz on a railway line. Later in 1958 Beuys took all his objects and drawings relating to Auschwitz—including a drawing of a starved and crippled girl, charred remains, lengths of rotting sausage, blocks of fat on electric hot plates, and a mummified rat in a bucket of straw (a savage parody of Christ in the manger)—and arranged them in a glass case in the Ströher Collection in the Hessisches Landesmuseum. For Beuys, "The principle of Auschwitz finds its perpetuation in . . . the delegation of responsibility to groups of specialists and the silence of intellectuals and artists." The struggle against this condition and its causes has been at the root of Beuys's political activism. In protest against a society in which "ability and creativity are burnt out," Beuys as early as 1954 began to think of himself as a magical healer who offered spiritual regeneration.

In 1955 Beuys was cast into a spiritual and physical crisis, from which he only slowly recovered while working on a farm in Kranenburg, in the Netherlands, during the summer of 1957. On September 19, 1959, Beuys married Eva Wurmbach, an art teacher and the daughter of a noted zoologist. They have a daughter, Jessyka.

Beuys's insistence on merging art and life, and his rejection of the standard substances of sculpture, culminated in 1960 in his "Opus": *Bathtub.* This was the metal tub in which he had been bathed as a child, with sculptural additions—sticking plaster, symbolizing physical and psychic wounds, and fat-soaked gauze. The fat inside the tub, Beuys said, stood for "creativity in the anthropological sense, not restricted to artists." The tub was not, as many people thought, a kind of readymade. On the contrary, Beuys maintained, "the stress is on the meaning of the object. It relates to the reality of being born in such an area and in such circumstances. . . . It is the transformation of substance that is my concern in art, rather than the traditional aesthetic understanding of beautiful appearances." (In 1977 *Bathtub* was mistaken for a beer-cooler at a party in the museum where it was stored. Whereas Duchamp, had *Bathtub* been his, would likely have been amused by this inadvertent comedy, Beuys was not. *Bathtub*'s owner sued (even though the piece was not harmed) and was awarded $94,000 damages, a verdict Beuys "happily greeted as a victory over the 'exploitive self-interest' of the beer drinkers," to quote Robert Hughes.)

In 1961 Beuys was appointed professor of sculpture at the Düsseldorf Academy of Art, and settled in that city, where he still has his home and studio. The following year Beuys established, through George Maciunas and Nam June Paik, the Korean performance artist, his first contacts with the international movement, Fluxus. The aims of Fluxus—the flowing, a name inspired by Heraclitus's dictum, "All being is

flux"—were to break down all barriers between art and life, to influence artistic and spiritual development through provocative action, and to create an aesthetic basis for evolutionary change. Fluxus was part of the international trend that produced the happenings of the 1960s and the performance art of the 1970s. Fluxus offered Beuys an opportunity to work out his personal ideas in front of a large audience. Unlike the American happenings, Fluxus events had a more structured, disciplined character, and depended far less on audience participation.

Most of those taking part in Fluxus were musicians—there was a link with the avant-garde composers John Cage and Karlheinz Stockhausen. Beuys has said, "The acoustic element and the sculptural quality of sound have always been essential to me in art." His early "actions" (he prefers the term "action" to "performance") were very much in the nature of a concert. His *Concert for Two Musicians,* at the 1963 "Festum Fluxorum Fluxus" at the Staatliche Kunstakademie, Düsseldorf, lasted for about 20 seconds. Wearing the felt hat which is his trademark, he "wound up a clockwork toy, two drummers, on the piano, and let them play until the clockwork ran down." Less provocative and more ritualistic was *The Chief—Fluxus Chant,* performed first in Copenhagen in 1963, and then in the Galerie René Block, Berlin, on December 1, 1964. The artist lay wrapped in a roll of felt for nine hours (partly an allusion to his wartime experience among the Tartars); a dead hare lay at either end of the roll, and at irregular intervals the artist uttered what he called "a catalogue of leftist sound vocabulary. . . . "The most recurrent sound was deep in the throat and hoarse like the cry of the stag: ö ö." Another Beuys event of 1964, *Kukrei/Akopee-neim/Brown/Cross/Fat Corners/Model Fat Corners,* so infuriated the right wing that one reactionary student punched Beuys so that his nose bled. His work was attacked by the left as lacking in didactic content, although less dogmatic young German radicals tend to view him as a messiah. Beuys's own hope was that "Actions, Happenings and Fluxus will . . . release new impulses which will . . . create better relationships in many areas."

Beuys used chunks of fat, perhaps his favorite substance, in various pieces including *Chair with Fat* (1964). He also stuffed corners of rooms with wedges of the greasy material. In a Paris "action" in 1966, Beuys encased a piano in felt, thwarting its potential for making sound. (This was one of the most striking objects in the large Beuys exhibition in the Solomon R. Guggenheim Museum, New York City, in 1979.) In the course of the 1960s Beuys's "actions" became increasingly bizarre and enigmatic—they included lec-

turing on art to a dead hare (1965), dumping gelatin on his head, and, in 1969, clashing cymbals during his simultaneous solo performance of Goethe's *Iphigenie* and Shakespeare's *Coriolanus,* as a horse munched hay. His ambition throughout was to "release the energies" and the human significance of objects and substances hitherto ignored in art, and to help bring about the true liberation of society.

Beuys's desire for "a genuine democracy" led to his founding of the German Student Party in Düsseldorf in 1967 and the Non-Voting Free Referendum Party for Direct Democracy in 1971. He united the concept of the German Student Party with the so-called "Fluxus Zone West," a reference to "the situation of Western man." Beuys held no public meetings and maintained one tiny office. He used stamps with the names of his organizations on manifestos, political statements, editions, objects, drawings, and books, all part of his intention to integrate every activity within his total concept of "social sculpture."

Beuys's political activism was the object of considerable opposition by professors at the Düsseldorf Academy of Art. He engaged in a political trial of strength with the Ministry of Education over his acceptance of students who had been denied admission to the academy in the winter semester of 1971–72. In 1972 Beuys won a decision in what he called a "boxing match for direct democracy" against a critic of his views. This and various provocative gestures and demonstrations by Beuys and his followers led to his dismissal from the academy, which in turn provoked letters of protest to the Minister of Education from such well-known figures as Allan Kaprow in New York City and the sculptor César in Paris. A hearing before the Düsseldorf court in 1973 led to a decision in Beuys's favor and his dismissal was postponed.

The artist engaged in a second burst of political activity when in 1976 he ran for a seat in the West German Parliament as a non-party candidate—he actually received two percent of the vote. This rose to 3.5 percent in the elections for the European Parliament early in 1979. Beuys considered this "a very good result," which indeed it was, given the oddity of his program and person.

Meanwhile he had had several showings in other countries. In the spring of 1974 an exhibition of "The Secret Block for a Secret Person in Ireland" was held at the Museum of Modern Art in Oxford, England; this was a presentation of 266 drawings and gouaches from the years 1936–1972, and was later shown in Edinburgh, the I.C.A. Gallery in London, Dublin, and at the

Arts Council Gallery in Belfast. On this last occasion Beuys spoke of the hope of founding a free international college for creativity in Ireland. He has always been fascinated by Ireland, with its "boggy" terrain and its "Celtic spirituality." According to Beuys the "Secret Block," also shown at the 1979 Guggenheim retrospective, represents the development of his form of thought as part of a continuing work process. As Caroline Tisdall wrote in the catalog to the 1974 exhibition: "For Beuys, drawing has been a way of thinking, or a thinking form . . . a way to reach areas unattainable through speech or abstract thinking alone."

Beuys again touched on the motif of the herd animal in his ritual "action" of May 1974 in th René Block Gallery, New York City, titled "*I Like America and America Likes Me.*" Cloaked in felt and lying on the floor, he held a weeklong "dialogue" with a coyote in a room in the gallery divided by a grating. For Beuys the small canid represented a romanticized pre-Columbian America, with its savage harmony of man and nature. During a 14-day stay with the photographer Charles Wilp in Africa in January 1975, Beuys stripped himself naked, shaved his head, and painted ritual signs in the sand. For the German authorities, this was the last straw, and the next month the county court in Düsseldorf pronounced his final dismissal as professor at the academy.

Beuys's environment, *Tramway—Tram Stop,* was exhibited in the German pavilion at the Venice Biennale of 1976. It consisted of a central column, about 23 feet high, with a man's head emerging from a dragon's mouth, four cylindrical elements made of iron, a section of tram line, and a bent metal rod. Like all of Beuys's work, it has autobiographical as well as socio-historical significance, and relates to a stopping-place where, as a five-year-old in Cleves, he would get on and off the tram.

Already famous in Europe, Beuys became better known in America through a major exhibition (1979–80) at the Guggenheim Museum. Down the ramp in the Guggenheim were placed 24 "stations." One of the most remarkable was Station 2, called *PtCoFe,* an iron cage made of platinum, a cobalt alloy, and iron. The artist's inscription noted: "The clamp which hangs in this iron cage held in turn from 1948 to 1954 a small head of Mars, from 1954 to 1958 a plaster head of Napoleon, from 1958 to 1963 an amorphous lump of plaster with fat, from 1963 to 1972 a block of copper [etc.]." The end result, in Beuys's view, incorporated a process through time and alluded to different aspects of iron—for instance, Mars represents the warlike nature of

iron, and Napoleon is the personification of that principle. Little of this is evident without the accompanying explanation, doubtful, but Beuys maintains that "the object transmits while the text demonstrates."

The most memorable piece in the Guggenheim show was his "emerging object" called *The Pack,* dating from 1969. From the rear of a battered, grimy Volkswagen bus, with Beuys's name stenciled in small letters on the side, there emerged a pack of 20 survival sledges, each carrying felt, fat, and a flashlight. According to Beuys, "In an emergency the Volkswagen bus is of limited usefulness, and more direct and primitive means must be taken to ensure *survival.* . . . Each sled carries its own survival but the flashlight represents the sense of orientation, the felt is for protection, and fat is food." In this instance, unlike some of the other pieces, the imagery itself is powerful, and needs carry no verbal explanation: one may be reminded of the physical process of giving birth, of an invading army issuing from a landing craft, or the Greeks pouring out of the Trojan horse (except that in *The Pack*) the ostensible purpose is survival, not destruction). Carrie Rickey, writing in the *Village Voice,* found "the camaraderie of the sleds, their jolly militarism, both funny and frightening." None of the objects in the Guggenheim exhibit were in the standard substances of sculpture, and though the many drawings had a searching, sensitive quality, aesthetic pleasure was never the artist's main concern.

There are elements in Beuys's work of happenings, minimal art, conceptual art, and earthworks, yet Beuys himself fits into no artistic category, and he does not even want to be called an artist, at least in the modern sense of the word; he maintains that "everyone is an artist." Beuys wishes instead to be considered an archetype, a spiritual leader, a redeemer. Alastair Mackintosh, recalling the impact made by Beuys's "action" at the Edinburgh College of Art in 1970 on a public not given to welcoming the avant-garde, has written, "Joseph Beuys's greatest work is Joseph Beuys, or rather the presentation of Joseph Beuys." He has certainly established himself, to quote John Russell, as "an absolutely hypnotic performer in monodramas of his own making." Though he prefers to call on older traditions, there is something deeply Christian about his work, and deliberate, Christlike self-sacrifice is the basis of his evident spiritual appeal. Indeed, his cult-hero status among German youth is the Pied Piper product of his "magnetic and benevolent character," to quote Robert Hughes.

In an article titled "The Shaman as Artist" in

The New York Times Magazine, John Russell described Joseph Beuys as "implausibly thin and impossibly tall, hollow of cheek and hollow of eye," and "endowed by nature with a huge arching forehead" and "a look of lasting wonderment." His self-imposed uniform of felt slouch hat, worn, many-pocketed fishing jacket, and simple shirt and pants makes him instantly recognizable. He lives in Düsseldorf, but travels a great deal. Although, according to his associate Caroline Tisdall, he has often been ranked "somewhere between clown and gangster" by ultraconservatives and is always a controversial figure, he is totally serious in his conception of the artist as educator, political philosopher, and shaman. He has declared that "a man's understanding of life should be expansive enough to project beyond his personal problems and hear the Homeric laughter that runs through the whole structure of life." Of his own work he said: "The outward appearance of every object I make is the equivalent of some aspect of inner human life." Beuys wants each of his "environments" to "effect the modern consciousness originally, archtypically and beyond the times. Not lastly it therefore awakens interest and curiosity."

EXHIBITIONS INCLUDE: Kunstmus., Wuppertal, W. Ger. 1952; Kunstmus., Nijmegen, Neth. 1953; Städtische Mus., Kleve, W. Ger. 1961; Städtische Kunstakademie, Düsseldorf 1963, '68; Gal. Schmela, Düsseldorf 1965, '66, '69, '71; Gal. René Block, Berlin 1964, '66, '69, '72; Stedelijk van Abbemus., Eindhoven, Neth. 1968; Kunstmus., Basel 1969; Kunsthalle, Düsseldorf 1970; Edinburgh Col. of Art 1970; Moderna Mus., Stockholm 1971; Staatliche Graphische Sammlung, Munich 1972; Tate Gal., London 1973; Mus. of Modern Art, Oxford, England 1974; Ronald Feldman Gal., NYC from 1974; René Block Gal., NYC 1974; Inst. of Contemporary Arts, London 1975; Kestner-Gesellschaft, Hanover, W. Ger. 1976; Solomon R. Guggenheim Mus., NYC 1979–80. GROUP EXHIBITIONS INCLUDE: "Fluxus," Kunstakademie, Düsseldorf 1953; "Festum Fluxorum Fluxus," Staatliche Kunstakademie, Düsseldorf 1963; Documenta 3, 4, and 5, Kassel, W. Ger. 1964, '68, '72; " . . . and in us . . . below us . . . underneath us," Parnass Gal., Wuppertal, W. Ger. 1965; "Mainstream," Darmstadt, W. Ger. 1967; "Joseph Beuys and Henning Christiansen Concert," Berlin 1969; Venice Biennale 1976; São Paulo Bienal 1979; "Arte Povera et Anti-Form," Centre d'Art Plastiques Contemporains, Bourdeaux, France 1982. collections include: Hessisches Landesmus., Darmstadt, W. Ger; "Zeitgeist," W. Berlin 1982.

ABOUT: Adriani, G. and others Joseph Beuys: Life and Works, 1979; "Joseph Beuys . . . mit Braunkreuz" (cat.), Gal. René Block, Berlin, 1966; Bénézit, E. (ed.) Dictionnaire des peintres, sculpteurs et graveurs, 1976; Cabane, P. and others L'Avant-garde au XXe siècle, 1969; Current Biography, 1981; Henri, A. Environ-

ments and Happenings, 1974; Hughes, R. The Shock of the New, 1981; Tisdall, C. "The Secret Block for a Secret Person in Ireland" (cat.), Mus. of Modern Art, Oxford, England, 1974, Joseph Beuys, 1979. *Periodicals*—Art and Artists November 1971; Art News April 1973, Summer 1974; Artforum December 1969; Avalanche Summer 1972, May/June 1974; Centerfold (Toronto) August-September 1979; Christ und Welt (Düsseldorf) no. 37 1968; New York Post November 3, 1979; New York Times Magazine October 28, 1979; Studio International June 1974; Umbrella (Edinburgh) April 1972; Village Voice November 26, 1979.

BILL, MAX (December 22, 1908–) Swiss sculptor, architect, painter, graphic artist, and industrial designer, is also a teacher and theorist and writer on art, best known for his advocacy of the aesthetic principles of the Bauhaus. He was an early exponent of concrete art, and has pursued geometric tendencies with a purity and logic at once pragmatic and spiritual, elegant and austere.

Max Bill was born in Winterthür, Switzerland. From 1924 to 1927 he studied at the School of Arts and Craft in Zürich, where he specialized in silversmithing. He visited Paris in 1925 to see the International Exposition of Decorative Art, and in 1926 he traveled to Italy.

Inspired by a lecture given by Le Corbusier, Bill decided to study architecture, and from 1927 to 1929 he attended the Bauhaus in Dessau and studied under Albers, Kandinsky, Klee, Moholy-Nagy, and Oskar Schlemmer. As a student there Bill experimented with a variety of materials including paper, which he has continued to use as the basis of many of his sculptural projects. He took workshops in metal, theater, painting, and architecture, and was thoroughly indoctrinated into Bauhaus principles. The idea of a synthesis of all the arts and crafts was crucial to the formation of his outlook, and he has always remained "a man of the Bauhaus."

In 1930 Bill established himself in Zürich as an architect, though he was also active as a painter, sculptor, industrial graphic designer, and publicist. He married Binia Spoerri in 1931, and the following year he joined the Paris-based Abstraction-Création group; he remained a member until 1936. In the '30s he met Jean Arp, Max Ernst, Alberto Giacometti, Piet Mondrian, and the writer Ignazio Silone, with whom he worked on the magazine *Information*; the Belgian abtract sculptor and theorist Georges Vantongerloo also had a strong influence on his art.

Many of Bill's sculptures experiment with the Möbius strip (named after the German mathematician A.F. Möbius) and its endless surface. The first of these works, *Endless Ribbon,* or

Endless Loop (1935), was done in black diorite. These experiments continued until 1953, and most of the later ones are done in polished metal. In these sculptures the movement of the form results from the changing position of the viewer.

In 1936 Bill designed the Swiss pavilion at the Milan Triennale. From 1935 on, he followed the example of de Stijl artist Theo van Doesburg, who advocated concrete art as an alternative to abstract art. Van Doesburg had written: "We call Concrete Art those works of art which originate on the basis of means and laws of their own, without external reliance on natural phenomena or on any transformation of them, in other words without undergoing a process of abstraction. . . Concret Art in its ultimate outcome is the pure expression of harmonic laws and proportions." Bill also followed his former Bauhaus teacher Josef Albers in his approach to art as the antithesis of "self-expression." Both men believed that concepts must be concrete.

In 1937 Bill became a member of Allianz, a group of Swiss artists that embraced both Concrete and Surrealist artists. His sculpture *Construction* in gray granite also dates from that year. Bill spent much of 1938 in Paris working on his book *Le Corbusier and Pierre Jeanneret*, and in the same year completed a series of lithographs titled "Fifteen Variations on a Single Theme." The "theme" is a spiral that progresses from an equilateral triangle to an octagon and shows his interest in mathematical and logical systems. In the late 1930s Bill met Antoine Pevsner and Marcel Duchamp, and in collaboration with Hans Schmidt he designed the exhibit "City Building and National Planning," which was displayed as the Swiss National Exhibition in Zürich in 1939.

In the early 1940s Bill served in the Swiss military, but devoted his free time to art. His painting at that time was based on the straight line and the carefully calculated relationship of geometric planes, and he often used rectangles to study color progressions, as in *Construction with Ten Rectangles* (1940–43). In sculpture he worked with simple shapes, such as the doughnut-shaped rings of *Construction with Ring* (1940–41), in gilded bronze, *Construction with a Ring* (1942–44), in black diorite, and *Construction with and within a Cube* (1944–45), in brass.

In 1944 Bill organized the "Konkrete Kunst" exhibition in Basel. About 1946 he began to tip some of his square canvasses and set them on a point, giving them a diamond shape when mounted. He introduced more nonprimary and pastel colors into his paintings. Again, the compositions remained primarily rectilinear, quite unlike the graceful curves he fashioned in some of his sculpture of the late period, including *Rhythm in Space* (1947–48, in red granite) and his large steel and plaster loop sculpture *Continuity*, erected in Zürich in 1946–47 but destroyed by vandals in 1948.

Bill's belief in art's social function led to his participation in the founding of the Institute for a Progressive Culture in 1947. " . . . The function of works of art is clear and simple," he wrote. "Their utility is a question of their suitability for mental use." What he considered "mentally useful" was the loop, a motif he took up again in the late 1940s with *Endless Loop from a Circular Ring II* (1947–49), and *Surface Limited by One Single Line* (1948). He continued to experiment with the loop motif throughout his career.

In 1949 Bill won the Kandinsky Prize for painting, and in 1951 he was awarded the Grand Prix for sculpture at the São Paulo Bienal. Also in 1951 he designed the Swiss pavilion at the Milan Triennale. In 1950–57 Bill was a cofounder of the Hochschule für Gestaltung in Ulm, southern Germany, a university for visual arts that was created to carry on the Bauhaus tradition. From 1951 to 1956 he served as rector of the college and director of the departments of architecture and product design. During this period he designed the college faculty building and the student dormitories.

Bill received an honorable mention in the 1952 international competition for a "Monument to the Unknown Political Prisoner." Also in 1953 he traveled to Peru and the United States, and later that year to Brazil to serve as a juror for the Grand Prix in architecture at São Paulo. His exhibitions and lectures throughout South America during the 1950s, contributed to the rise of a regional neoconstructivist movement, centered primarily in Argentina.

In 1954 Bill received a gold medal at the Milan Triennale. Later in the decade, after disagreements over artistic and educational policies arose at the college, Bill left Ulm and returned to Zürich. In 1960 he organized the important "Konkrete Kunst" exhibition in Zürich, which summed up 50 years in the development of concrete art. He became chief architect of the section on "Creation and Education" for the Swiss National Exhibition held in Lausanne in 1964, the year in which he was named honorary member of the American Institute of Architects. He visited the United States in 1965 to participate in the International Congress, "Vision 55," at Southern Illinois University.

Among Bill's sculptures of this period was *Family of Five Half Spheres* (1965–66), in black

granite, and the "Condensation" series, including a diagonal canvas, *Condensation from Violet to Yellow*, (1964) typified his painting in the mid-'60s. Another painting based on geometric abstraction is *Field of 32 Parts in 4 Colors* (1965), a square canvas owned by the Albright-Knox Art Gallery, Buffalo, New York. The painting has been described as "a veritable color exercise in trigonometry," in which "no two symmetrically opposed triangles bear the same color, [with] each of the four colors—green, blue, orange, and pink—being used once in each shape." The hard-edged triangles form a central diamond shape, erecting "a visual spaciousness and sense of depth within the otherwise tight surface arrangement," to quote from *Contemporary Art 1942–72*. Also in 1965, Bill designed a theater tent and stage setting for a production of Alfred Jarry's *Ubu Roi*.

Continuing his engineering work, Bill designed the Lavina Tobel Bridge at Tamins, Switzerland, in 1966–67. The following year he built his own house and studio in Zumikon, near Zürich, where he still works. In 1967 he was appointed professor at the School of Fine Arts in Hamburg and was elected to the Swiss parliament.

Bill returned to the loop theme in sculpture in 1968 with his *Double Surface with Six Angles*, in gilded brass, followed in 1971 with a teardrop-shaped piece, also in gilded brass, *Surface in Space with Two Angles*. The loop became more complex with a tall, sinuous work in chromium nickel, *Endless Spiral Surface* (1974).

In the 1970s, Bill continued to travel and lecture throughout Western Europe as well as the United States and Japan. In 1974 he had a traveling exhibition in the US, and in 1976 he had retrospectives in Hamburg, Berlin, and Stuttgart.

Max Bill has been described by Edward Hüttinger as "the embodiment of the thinking artist," and he is highly articulate.

"I am of the opinion that it is possible to develop an art largely on the basis of mathematical thinking," he stated in 1949. However, he qualified this view in the mid–'70s: "Today, I know better . . . mathematics is only one of the methods by which ideas can be transmuted into what I call *concret* art."

There is nothing cold or overly cerebral in his geometric vocabulary of forms. From his Bauhaus days he has retained a cheerful, optimistic, undogmatic attitude towards art, which he maintains, "is just as pluralistic as our society." "It is my opinion," he said, "that art has a unique opportunity to form a counterpoise to the technology-ridden, polluted and commercialized consumer civilization. It can do so with comparatively small material resources but with a correspondingly greater intellectual discipline."

EXHIBITIONS INCLUDE: Atelier des Künstlers, Zürich 1929; Kunstmus., Basel 1939; Gal. d'Art Moderne, Basel 1949; Mus. de Arte Moderna de São Paulo 1950; Ulmer Mus., Ulm, W. Ger. 1956; Helmhaus, Zürich 1957; Gal. Suzanne Bollag, Zürich from 1958; Staempfli Gal., NYC from 1963; Kunsthalle, Bern 1968; Kestner-Gesellschaft, Hanover, W. Ger. 1968; Gal. Denise René, Paris 1969, '71; Centre Nat. d'Art Contemporain, Paris 1969–70; San Francisco Mus. of Art 1970; Marlborough Gal., Zürich 1972; Marlborough Fine Art, London from 1974; Albright-Knox Art Gal., Buffalo, N.Y. 1974; Marlborough Gal., NYC 1975; Gal. Lorenzelli, Milan 1979. GROUP EXHIBITIONS INCLUDE: Bauhaus, Dessau, Ger. 1928; Kunsthalle, Bern 1930; Gal. Abstraction-Création, Paris 1934; Milan Triennale 1936, '54; "Bauhaus 1919–1928," MOMA, NYC 1938; "Konkrete Kunst," Kunsthalle, Basel 1944; "Allianz," Kunsthaus, Zürich 1947; "Albers, Arp, Bill," Gal. Herrmann, Stuttgart, W. Ger. 1948; "Pevsner, Vantongerloo, Bill," Kunsthaus, Zürich 1949; São Paulo Bienal 1951; "Monument to the Unknown Political Prisoner," Inst. of Contemporary Art, London 1952; Middelheim, Antwerp Biennale, Belgium 1955–63; Venice Biennale 1958; "50 ans d'art moderne," Palais des Beaux-Arts, Brussels 1958; "Concrete Art: Fifty Years of Development," Kunsthaus, Zürich 1960; "Max Bill and Le Corbusier," Gal. Amora, Geneva, Switzerland 1968; Kunstmarkt, Cologne 1971; "Zürich Concrete Artists," Bundner Kunstmus., Zürich 1978.

COLLECTIONS INCLUDE: Kunstmus., Basel; Kunstmus., Bern; Kunsthaus, Zürich; Kunstmus., Winterthür, Switzerland; Wilhelm-Lehmbruck Mus., Duisburg, W. Ger.; Niedersächsisches Landesmus., Hanover, W. Ger.; Staatsgal., Stuttgart, W. Ger.; Mus. des XX Jahrhunderts, Vienna; Mus. Royaux des Beaux-Arts de Belgigue, Brussels, Middelheim Park Open-Air Mus., Antwerp, Belgium; Peter Stuyvesant Collection, Amsterdam; Mus. Nat. d'Art Moderne, and Centre Nat. d'Art Contemporain, Paris; Gal. Nazionale d'Arte Moderna, Rome; New York Univ. Art Collection, and Ciba-Geigy Collection, NYC; Albright-Knox Art Gal., Buffalo, N.Y.; Busch-Reisinger Mus., Harvard Univ., Cambridge, Mass.; Hirshhorn Mus. and Sculpture Garden, Washington, D.C.; Art Inst. of Chicago; Inst. of Art, Detroit; County Mus., Los Angeles; Mus. of Fine Arts, and Mus. of Contemporary Art, Montreal; Art Gal. of Ontario, Toronto; Mus. of Modern Art, São Paulo; Mus. of Modern Art, Buenos Aires; Hakone Open-Air Mus., Tokyo; Mus. of Contemporary Art, Nagaoka, Japan.

ABOUT: Bénézit, E. (ed.) Dictionnaire des peintres, sculptures et graveurs, 1976; Hüttinger, E. Max Bill, 1978; Moldonado, T. Max Bill, 1955; Moore, E. (ed.) Contemporary Art 1942–72: Collection of the Albright-Knox Art Gallery, 1972; P-Orridge, G. and others (eds.) Contemporary Artists, 1977; Staber, M. Max Bill, 1964. *Periodicals*—Architectural Design no. 11 1955; Art International (Lugano) no. 3 1963, no. 7

1974, November 1980; XXe siècle (Paris) no. 4 1938; Werk (Winterthür, Switzerland) no. 8 1938, no. 3 1948.

BISHOP, ISABEL (1902–), American painter and etcher, is an Urban Realist whose serious, sensitive, and highly personal style has won the respect of both modernists and traditionalists.

She was born in Cincinnati, Ohio and raised in Detroit. At 16 she came to New York City to study illustration at the School of Applied Design for Women. At the time she resented the drudgery of "drawing, drawing, drawing," but later she was grateful for the discipline. At 17 she started painting at the Art Students League. "I never had any choice after that," she said.

Bishop's teachers at the League in the 1920s were Kenneth Hayes Miller and Guy Pène du Bois, former students of Robert Henri, the guiding spirit of the early 20th-century Ashcan School. Both carried on the tradition of American Scene painting, which emphasized the urban environment. Miller and his most celebrated student, Reginald Marsh, created tableaux of New York pedestrians, a subject that came to dominate Bishop's work. Miller inspired intense loyalty in his students, and Bishop, to quote John Canaday of *The New York Times* (April 8, 1967), "all but genuflects at mention of his name today." She recalled: "Miller was interested in modern art, but led us to traditional sources."

Bishop's first show was hung at the Dudensing Gallery, New York City. About 1930 she moved to the Midtown Galleries, where she has remained.

In 1934 Bishop married Dr. Harold G. Wolff, who became a prominent neurologist. Their son, Remsen, who was born in 1940, became a photographer. In the same year as her marriage, Bishop leased her present studio at the northwest end of Union Square, an area that has provided her over the years with a continuously changing panoroma. She and her husband (he died in 1962), lived in Riverdale, the Bronx, and for more than 40 years she commuted daily to her Manhattan studio.

In the aftermath of the Depression, Union Square was the scene of tumultuous May Day rallies as well as ad hoc soap-box oratories. Bishop's observant eye also noted the lounging hobos—"America's only leisure class, she called them; salesgirls and waitresses hurrying to and from work and eating hot dogs and ice-cream on their luncheon break; bench-sitters; drugstore and soda-fountain patrons; and all manner of pedestrians. Bishop's treatment of these subjects

ISABEL BISHOP

had none of the over-genial picturesqueness of the Ashcan School, and she avoided the sentimental and illustrational handling of the urban scene that marred the work of many Realists of the 1930s. In 1938 she painted a mural that was commissioned by the US Government, for the small town post office of New Lexington, Ohio, but she was not on the WPA art project in the '30s, though she did serve on several juries. Also, her orientation was less political than that of some of her colleagues. She later explained that her main preoccupation is the transformation of a "non-event"—people walking in the street—into a pictorial "event" with its own dignity and mystery that suggests "motion . . . you can feel in your nervous system."

Bishop's rigorous draftsmanship and her deliberateness resulted in an art which critic John Canaday noted was "less connected with an American tradition that adapted Impressionism to the local scene than to the Renaissance tradition whereby the nude became the vessel for the majesty of the human spirit." Bishop's *Nude* (1934; Whitney Museum of American Art, New York City), with its careful, sensitive drawing and its pearly flesh-tones, is typical of her essentially classical approach to the figure.

In 1945 Bishop studied engraving with Stanley William Hayter at the New School for Social Research in New York City. Her etchings have won several awards. Among printmakers of the past she admires Dürer the most, and her favorite artists are those in whom one can see what she calls "the make of the form."

In preparing a picture, Bishop completes hundreds of sketches, worked form life in Union

Square, which she then modifies and reworks into larger, more formal drawings. For years she recruited models from the square, but now relies mainly on students. When a composition with several figures is arranged, Bishop makes an etching of it in her studio. The next step is an etching with aquatint, to establish tonal patterns. Before beginning the painting she often photostats the etching, enlarging it to the scale of the proposed picture, and also un-reversing the design. She prefers to paint in tempera and oil on gessoed board or, less frequently, canvas. This "mixed technique" is closer to the old masters than to impressionist or postimpressionist practice.

In 1946 she was elected Vice-President of the National Institute of Arts and Letters, the first woman officer since the Institute's founding in 1898. In 1947 her etching *Outdoor Lunch Room* won the American Artists Group prize. At this time her painting *Two Girls* was owned by the Metropolitan Museum of Art, New York City, and another was in the collection of the Whitney.

The New York Times found her "worn subway straphangers and shopgirls" exhibited in 1948 to be "stoically inexpressive" and "frighteningly isolated from any sort of human situation." Bishop's figures never communicate with one another, rather, they express her increasing fascination with movement. In the subway, "people are always going or coming [and] there is always movement," she told *Time* magazine in 1960. "The idea of mobility means a potential for change. This I consider characteristic of American life." Despite the images of hurrying, a pervading sense of stillness is possible as the *Time* critic added: "She can give the Union Square station some of the mystery of a cathedral."

In the 1960s Bishop continued to watch the changing scene in Union Square, as anti-war demonstrators assembled and young men burned their draft cards. At the time, she began to experiment with new and more analytical methods. A *New York Times* review of her show at the Midtown Galleries in May 1960 noted that although her motifs remained the same, "they are handled far more broadly now, with suffusions of light that fall into abstract schema." The critic was reminded of Puvis de Chavannes, Seurat, and Vuillard. He felt that her favorite blond tonalities—pale ochers, grays, and pinks—had taken on new depths "as she varies surfaces with rhythmic graining, or scumbling."

In May 1975, Bishop received an honor which many felt was long overdue. At the age of 72, she was given a retrospective of her paintings, draw-

ings, and etchings at the Whitney Museum. Now her pedestrians included students walking to and from their classes, as well as workers and Union Square hobos. Critics focused attention on her most recent paintings and her new treatment of space. Thomas B. Hess in *New York* magazine (May 19, 1975) wrote: "While drawing defines contours, edges constantly are dissolved in semitransparent rectangular planes of close-set dots and hatches." Hess praised Bishop's "labyrinthine working methods" and observed that "the figures seem to walk—to offer a glimpse of movement—through small miracles of pictorial cunning." Any hint of storytelling had disappeared, and "Bishop's thoughtful, serious, inward style could be a paradigm of the postactivist, post-revolutionary, easy-going cool-cat students of the 1970s."

Spry and alert in her 70s, the handsome white-haired Isabel Bishop has "the patrician look of an Eakins portrait," to quote Grace Glueck of *The New York Times* (April 11, 1975). She combines a lively intelligence with modesty, charm, a warm interest in people and events, and an engaging and quizzical sense of humor. Her top-floor studio, from which she still surveys the ebb and flow of Union Square, contains works in progress, items of clothing for ther models, and a large oil sketch for her one mural. The walls are covered with her own drawings and prints and with reproductions of works she admires, including Vermeer's *Lace-Maker* and portraits by Pisanello, Mantegna, Titian, and Rubens.

Though strongly committed to figurative painting, Bishop has always shown great understanding for other forms of expression, and she refuses to accept dogmatic divisions between abstraction and representation. "Abstract painting is apt to be sounder aesthetically, though less communicative," she says. "(So figurative painting is properly challenged by it all the time—it has to be as good."

The lease on Bishop's studio, in which she had worked virtually every day for 44 years, expired in December 1978. She moved to a new studio a block away, but she professed that without her familiar vista of Union Square "part of my life will be over. My world is through my window." She observed with a smile, "I look out of my window and I feel I've eaten."

EXHIBITIONS INCLUDE: Midtown Gal., NYC 1933–75; "Drawings," Nat. Collection of Fine Arts, Smithsonian Inst., Washington, D.C. 1945; Berkshire Mus., Pittsfield, Mass. 1957; "Isabel Bishop Retrospective," Univ. of Arizona Mus. of Art, Tucson 1974; "Isabel Bishop Retrospective," Whitney Mus. of Am. Art, NYC 1975. GROUP EXHIBITIONS INCLUDE: "Second Biennial Exhibition—Part One: Sculpture, Drawings and Prints,"

Whitney Mus. of Am. Art, NYC 1936; "Golden Gate International Exhibition," San Francisco 1939; "American Art Today," New York World's Fair, Flushing Meadow 1940; "Artists for Victory," Metropolitan Mus. of Art, NYC 1942–43; "Painting in the United States, 1947," Carnegie Inst., Pittsburgh 1947; "Judge the Jury—Perry T. Rathbone, Isabel Bishop and Richard Lippold," Virginia Mus. of Fine Arts, Richmond 1960–61; "Contemporaries #1," Gal. of Modern Art, NYC 1965; "1969 Annual Exhibition: Contemporary American Painting," Whitney Mus. of Am. Art, NYC 1969–70.

ABOUT: "Isabel Bishop" (cat.), Univ. of Arizona Mus. of Art, Tucson, 1974; Lunde, K. Isabel Bishop, 1975; Rose, B. American Art Since 1900, 2d ed. 1975. *Periodicals*—Art News November 1951, May 1960, April 1974; Arts Magazine November 1955; Magazine of Art January 1939; New York May 19, 1975; New York Post March 16, 1933; New York Times November 12, 1947, May 5, 1960, April 8, 1967, April 11, 1975, April 12, 1975; New York World-Telegram February 15, 1936, April 29, 1941; May 16, 1960.

Courtesy of Carol Crawford CAPS

NELL BLAINE

BLAINE, NELL (1922–), American painter and graphic artist, writes: "I was born in 1922 in Richmond, Virginia, a city full of pride in its history. My parents were hardworking, middle-class people guided by firm Baptist principles. We lived in a suburb in the north end of town, characterized by homey but rather stiff little houses. The beauty of our street was largely due to the gracefully arching elms which formed a long green tunnel. I gardened as a young child, inheriting a passion for nature from both parents. At two years of age I was given glasses, which were tied on with a ribbon, as I was severely crosseyed and near-sighted. I rushed about ecstatically pointing and exclaiming: 'Water! Tree! Flower! House!' I learned then the value and excitement of seeing.

"Trips were made to Baltimore relatives and to my grandfather's rough cabin on the Mobjack Bay by Model-T and Chesapeake Bay Line. Traveling was high adventure. My mother, Eudora Catherine Garrison, the youngest of six children, had been a dutiful daughter to her remarkable parents, nursing her invalid mother for years until she died. My father, Harry Wellington Blaine, an expert lumber inspector, held the same job for 40 years. He was a stoical, romantic, and literate—though inarticulate—man, brought up in hardship on an isolated Virginia farm. He loved gardening and fussed over his huge, perfect dahlias (the largest blossoms I've ever seen), but he wouldn't exhibit them. In his last years he suffered terrible attacks of cardiac asthma, aggravated by stresses of the Depression.

"Until I was ten, I was constantly sick with children's diseases. Anemic, I was put into a special fresh air class and given sun-lamp treatements. I missed a year at school, but my mother, a former teacher, kept me up with the studies. Mother said I wanted to be an artist at five. I also wanted to be the *best*. I remember actually praying: 'God, please make me the GREATEST!' I was a very unsophisticated teenager but had an unusually clear sense of purpose, though sometimes a wild, uncontrollable ambition and rebelliousness took hold. At 15 I published drawings and essays in the *Richmond Times-Dispatch* and was art editor of the high school magazine and literary editor of the newspaper. I was isolated, intensely shy yet energetic and determined. My father died suddenly when I was 16. Later that year I enrolled in the Richmond School of Art (RPI), an extension of William and Mary College. I dusted easels and answered telephones on a working scholarship. Though my work was academic at first, my teachers were conscientious and gave me an excellent introduction to my life in art. My greatest inspiration and knowledge of painting came when I left Richmond in 1942 and studied with Hans Hofmann in New York. I was 20 and was a monitor and worked at various part-time jobs. In and around the school I met many young artists who were to become friends, and later some were associates in the Jane Street Gallery: Albert Kresch, Louisa Matthiasdottir, Judith Rothschild, Robert de Niro, Virginia Admiral, and Leland Bell. In 1943 I married Robert Bass, a musician and photographer. The marriage lasted six years. Bob and Lee introduced me to jazz, which led to friendships

with Jane and Jack Freilicher and Larry Rivers. At 21, in early 1944, I joined the American Abstract Artists group. I showed in 'The Women' at Peggy Guggenheim's Art of This Century. Clement Greenberg and Peggy's associate, Howard Putzel, encouraged me, and when Putzel opened his 67 Gallery he asked me to join his stable, which included Pollock, Hofmann, Gottlieb, and Seliger. He died just before my scheduled exhibition. Hyde Solomon, my neighbor on 21st Street, asked me to show with the new Jane Street Gallery, the first serious cooperative in New York. I had my first solo show there in 1945. *PM* ran a piece, 'Sherry and Art Down on Jane Street,' and Ad Reinhardt pasted me on the 'pure' branch of his famous tree.

"After Jane Street disbanded in 1949, I worked six months as art director of United Jewish Appeal in order to travel in France and Italy. I learned more about typography and scraped pennies together since no grants materialized. Once in Paris I located a charming apartment and a studio that had been Ezra Pound's. I managed to live, travel, and work for six months on one thousand dollars. The experience hastened the gradual transition away from abstraction towards figuration. Most Jane Street artists were dogmatically abstract in 1945 but by the early '50s had become figurative.

"I returned to New York on the Queen Mary in December 1950 with one dollar in my pocket: it was a very cold pier. The next five years were a continuous struggle economically. During the early 1950s my association with poets John Ashbery, Frank O'Hara, Kenneth Koch, Denise Levertov, and the dancer Midi Garth resulted in several collaborations. The Tibor de Nagy Gallery showed my work and was a supportive center.

"In 1956 I began a long and continuing association with the Poindexter Gallery. I began to live on painting sales. A period of work and travel to Yaddo, MacDowell Colony, and Mexico strengthened my color and the work seemed to 'breathe.'

"In 1959, after a trip through Italy, Egypt, Turkey and Greece, I contracted polio while painting on the Greek island of Mykonos. Almost completely paralyzed, I was flown to New York and lay in an iron lung over five months. Fellow artists, Mrs. Poindexter and friends held a benefit show at Poindexter Gallery, with over 79 artists giving works. After long therapy and many discouraging attempts I returned to painting, but with an adjustment: painting oils with my left hand and drawing with my right. I was assisted by a dedicated nurse-friend who bacame a painter. Although confined to a wheelchair I

could work vigorously and freely. Since 1944 I have had over 35 solo exhibitions, and except for the first months of severe paralysis, I have always painted and drawn in a spirit of grateful satisfaction, ever since my first glasses showed me 'Water! Tree! Flower! House!'"

Nell Blaine is one of the few American painters who, having started as a strongly committed abstractionist—and "very dogmatic about the purity of art," as she once remarked—moved in the early 1950s to a fluid representational style. She has been praised, by Stuart Preston in 1956, for her "pictorial hedonism and her endearingly gay color," but her "sense of organization and . . . way of putting a picture together comes from the abstract days," to use Blaine's words. Even after she abandoned her hard-edge abstractions of the late 1940s, the New York action painting of the early '50s influenced the vigor of her attack on the canvas and her total activation of the surface.

Nell Blaine was stricken with polio in 1959, but after protracted therapeutic treatment she overcame the handicap by learning to paint in oils with her left hand. "[Her] spontaneity and control are so perfectly balanced," Martica Sawin noted in *Arts Magazine*, "that it would be impossible to know from looking at the paintings that Nell Blaine had been told when she contracted polio . . . that she would never be able to paint again."

Her first solo show had been in 1945, in New York City, and, after numerous exhibitions in the 1950s, Blaine received wide critical acclaim in the 1960s and 1970s. For example, a *New York Times* reviewer observed at the time of her 1960 show at the Poindexter Gallery that "the way she builds a picture out of multitudinous, little observed facts recalls the prose style of Virginia Woolf." Another show at that gallery in 1970 elicited praise from James R. Mellow, who, despite misgivings about the loose structure of some of her work, spoke of her feeling for "the poetry of place" and added that her "painting . . . seeks not to prod or shock but to share."

In the summer and fall of 1978, and again in 1979, Nell Blaine made painting trips to the Austrian Tyrol. A group of her Tyrolean landscapes in watercolor and pastel, including *Snow, Acherkogel* (1978), were among the highlights of her show of paintings at the Fischbach Gallery, New York City, in the spring of 1979. Reviewing the exhibit in *New York* magazine (May 7, 1979), John Ashbery sensed that a "joie de vivre" is bound up with a "joie de peindre" in her re-

cent work. Ashbery found the paintings even "more vigorous and wildly chromatic than every before. Yet the stridency is always satisfying to the eye and never seems gratuitous." The critic also praised "the bright, messy still lifes and interiors," among them the oil painting *Red Candle and Four Bouquets* (1978).

According to Blaine, 1979 was "a great year." A watercolor, *Anemones, Red Tablecloth,* and *Window, Riverside Drive* were included in an exhibition of "Artists' Postcards," which had opened in 1978 at New York City's Cooper-Hewitt Museum and subsequently toured several countries. The Metropolitan Museum of Art, New York City, acquired a painting, *Lester Leaps,* which she had done at age 23 and which had been inspired by her favorite jazz musician, Lester Young. The Metropolitan Museum also purchased two drawings she had done in the year 1945. Sue Durden, in an article on Nell Blaine in the *Richmond Times-Dispatch,* called her "the high priestess" of light and color.

In November 1979 Blaine received the First Governor's Award of Virginia for the Arts, in a televised ceremony. Six months later she was awarded an honorary Doctor of Fine Arts degree from the Moore College of Art in Philadelphia; she was the commencement speaker on that occasion. Two group exhibitions in which Nell Blaine participated in 1980 were "The Artist in the Park," at New York City's Hirsch and Adler, in the spring, and "The Fifties: Aspects of Painting in New York," presented at the Hirshhorn Museum and Sculpture Garden, Washington, D.C.

Discussing her *Rocks and Bright Foliage* of 1977, along with paintings by Monet, Pissarro and Childe Hassam, in the *Architectural Digest,* David Bourdon described Blaine as "a masterful contemporary colorist [who] integrates a rhythmic abstract structure into her unbound view of nature to achieve a seasonal landscape bathed with light and dazzling hues." And in an important *Arts Magazine* piece, "Abstract Roots of Contemporary Representation," Martica Sawin asserted that Blaine is "one of the most exciting and masterful colorists that American painting has seen."

In addition to her oils, watercolors, and graphic art, Nell Blaine has executed murals commissioned by the Revlon Company and lithographs for the New York Hilton Hotel. Films about the artist include *Nell Blaine Paintings* (1957) by Ilya Bolotowsky, the noted Geometric Abstractionist painter, and *Nell Blaine Exhibition, Poindexter Gallery,* produced by the Cine Art company and now owned by Vivas Art Films Inc., of New York City. A 1967 taped interview

with Blaine by Dorothy Gees Seckler is owned by Archives of American Art, of the Smithsonian Institution, Washington, D.C.

Blaine shares an apartment in Manhattan, on Riverside Drive, overlooking the Hudson River, with her companion Caroline Harris, who is also a painter. In New York her still-life painting is often done after dark, because as Blaine puts it, she is "a night person." Many of her landscapes are painted in Gloucester, Massachusetts, where she spends six months each year.

EXHIBITIONS INCLUDE: Jane Street Gal., NYC 1945, '48; Virginia Mus. of Fine Arts, Richmond, 1947, '55, '73; Tibor de Nagy Gal., NYC 1953, '54; Poindexter Gal., NYC 1958, '60, '66, '68, '70, '72, '76; "To Nell Blaine," Poindexter Gal., NYC 1959; "Nell Blaine, Works, 1955–73," Picker Gal., Colgate Univ., Hamilton, N.Y. ca. 1975; Fischbach Gal., NYC 1979; Virginia Mus., Inst. of Contemporary Art, Richmond 1979. GROUP EXHIBITIONS INCLUDE: "The Women," Art of This Century Gal., NYC 1945; American Abstract Artists Annuals (at the Riverside Mus. alternate years), 1945–57; American Abstract Artists, Palais des Beaux-Arts de la Ville de Paris 1950; American Abstract Artists, Mus. of Modern Art, Rome ca. 1951; "U.S. Painting: Some Recent Directions," Stable Gal., NYC 1955; "Recent Drawings, U.S.A.," MOMA, NYC 1956; Annual, Whitney Mus. of Am. Art, NYC 1957; "Festival of Two Worlds," Spoleto, Italy 1958; "Hans Hofmann and His Students," circulated by MOMA, NYC 1963; "American Painting," Cincinnati Art Mus. 1966; Nat. Inst. of Arts and Letters, NYC 1967. '70, 74, '75; "Artists' Choice: Figurative Art in New York," Prince Street Gal., NYC 1976; "Artists' Postcards," Cooper-Hewitt Mus., NYC 1978; "Hans Hofmann as Teacher: Drawings by His Students," Metropolitan Mus. of Art, NYC 1979; "Recent Acquisitions," Metropolitan Mus. of Art, NYC 1979; "Originals," Graham Gal., NYC 1980; "The Artist in the Park," Hirsch and Adler, NYC 1980. "The Fifties: Aspects of Painting in New York," Hirshhorn Mus. and Sculpture Garden, Washington, D.C. 1980.

ABOUT: Munro, E. Originals: American Women Artists, 1978. *Periodicals*—American Artist August 1973; Art Digest November 1, 1954; Art News May 1957, December 1959, April 1960, April 1966; Arts Magazine June 1976; New York Herald Tribune September 20, 1953; Iconograph no. 2 1946; New York May 7, 1979; New York Post March 9, 1977; New York Times September 20, 1953, April 29, 1956, October 11, 1970, December 2, 1972; Richmond Times-Dispatch April 22, 1979.

BLAKE, PETER, (THOMAS) (July 25, 1932–), the most famous and productive of the British Pop artists, began to attract attention as a student in the mid-1950s, just before the dawning of the pop movement. His work has a depth and individuality which transcend facile labels,

Jorge Lewinski

PETER BLAKE

and is marked by a visual humor rarely found in American Pop artists.

Peter Thomas Blake was born in Dartford, Kent. He studied at Gravesend Technical College from 1946 to 1949, and at the Gravesend School of Art until 1951. This was followed by a brief period of national service in the Royal Air Force from 1951 to 1953. There was a hint of his future direction when, in 1952, he made a pen-and-ink and watercolor drawing in which, with subtle self-mockery, he depicted himself in his RAF jacket and the trousers of a harlequin.

After his discharge he studied for three years (1953–56) at the Royal College of Art, London, at a time when many of the new British painters were studying there. All of them were fascinated by American movies, advertising, and popular culture, but Blake combined an interest in the imagery of mass culture with a refinement and formal rigor that were closely linked to the painting traditions of the past. Many of his works of the 1950s were of children. He did several versions (including two each in 1954 and 1956) of *Children Reading Comics,* and in 1955 he participated in the *National Observer* exhibition, "Portraits of Children." In other pictures the children wear buttons and badges (among Blake's favorite images), as in *ABC Minors* (1955), a painting whose title comes from a Saturday morning cinema club to which Blake had belonged as a boy. Most of these pictures have a portraitlike quality which captures the personality of the sitters, despite a flat, quasi-naive style.

Blake took part in group exhibitions at the Royal College in 1954 and 1955. In 1956 he won

the Leverhulme Research Award which enabled him to travel abroad; he studied popular art in Holland, Belgium, France, Italy and Spain. However, his primary orientation was toward the United States. In November 1956 Roger Coleman, writing in *Ark* magazine, the journal of the Royal College of Art, called Blake "a romantic naturalist," and noted that "very often Blake's pictures are littered with the small objects of our urban civilization, the things that pass through our hands a dozen times daily, the cigarette packs, the detergent box, sweet wrappings, watch-boxes, bus tickets, and so on; the world of the throw-away object. Blake transforms these things into images of the most compelling sort, so that we look at them a little harder next time, just to see [if] they are as real as he makes them."

The most complex of Blake's paintings of the 1950s is *On the Balcony,* begun in 1955 while he was still a student at the Royal College, and completed in 1957. This meticulous work was one of the earliest in England to use pop imagery. It is crowded with pictures within pictures—reproductions of paintings, photographs, postcards, and magazine covers, many with a balcony motif. The effect is of collage, but in fact the entire surface is hand-painted, even the astonishingly realistic monochrome "photo" of members of the British royal family on the balcony of Buckingham Palace. Many of the images have personal meaning for the artist, including a portrait of John Minton, Blake's tutor, who committed suicide while *On the Balcony* was in progress. The still life in the lower left corner quotes the "Breakfast Table" paintings of John Bratby, then at the height of his fame in England. Above it is a small framed reproduction of Manet's *The Balcony* (1869), held by a boy whose spectacles, in a Hitchcockian touch, reflect the artist himself. This highly original work, blending innovation and tradition, is now in London's Tate Gallery.

Blake also executed a series of paintings of circus signs for sideshow oddities; these included *Loelia, World's Most Tattooed Lady* (1955); *Siriol, She-Devil of Naked Madness* (1955); *Dixie, Darling of the Midway* (1955–58); and *Cherie, Only Bearded Tattooed Lady* (1957). Blake used collage in many of those pictures, as for instance in Loelia's tattoos, and made the signs look old by rubbing out parts and scratching them. There is often, as several critics have observed, a strong nostalgic sentiment in Blake's art.

The circus series harks back to Victorian and Edwardian eccentricities, the period of his parents' youth, but Blake moved on to modern per-

sonalities in such works as *Sammy Davis, Jr.* (1957–60) and *Kim Novak Wall* (1960). The "Walls" of 1960, such as *Early Wall* and *Elvis and Cliff,* are pictures of modern heroes of popular culture above a board presumably for pinning notices. Blake's "Doors," notably *Girlie Door* (1959) and *Sinatra Door* (1960), are actual doors, with photographs pasted to them. Aldo Pellegrini wrote of Blake's *Girlie Door* and similar collage constructions that "all this shoddy dream material is organized with strict neoplastic rigor . . . by means of irreproachable orthogonal divisions which seem to ennoble the poor imagery and make it immediately attractive, full of enchanting suggestions." *Love Wall* (1961) is made up of stills of movie love scenes.

In his *Self-Portrait with Badges* (1961), Blake, now bearded, painted himself as an Elvis Presley fan, his denim jacket decked with badges and buttons (one button reads "Adlai," another "Elvis"); he holds a copy of an Elvis fan magazine. The figure has the pseudo-naive frontality of the figures in *On The Balcony.* The brushstrokes are very free, contrasting with the trompe l'oeil precision of *Toy Shop* (1962). The door on the left side of *Toy Shop* has the punning sign "No bottles, No canvassers," and seems to be a relic from the previous century, but the window on the right is replete with the masks, puzzles, and novelties of modern times. In 1961 Blake began a series of wrestlers, the first being *Brown Adolf Kaiser* (1961–63), and in 1962 he painted the first of his "Pin-up Girl" series.

Blake switched from oil to acrylic about 1963, the year of his marriage to Jann Haworth and his first visit to the US. Between 1960 and 1964 he was an instructor at the St. Martin's School of Art, London, and at the Harrow School of Art, Middlesex. In 1964 he took a teaching post at the Royal College of Art.

Blake combined wrestler and pin-up girl in *Little Lady Luck* (1965). Surrounded with lucky charms, Lady Luck's sexual directness and the multicolored lettering above her head gave the painting, in acrylic and collage on cardboard, the appearance of the flashy scoreboard of a pinball machine. In reference to this and similar pictures Alan Bowness wrote, "With no hint of patronizing, he has taken the visual material familiar to his contemporaries . . . as the raw matter of his art. . . . It is all very direct and straightforward, done with patience and a loving attention to triviality." Other wrestlers include *Les Orchidées noires* (1965), a fictional French female tag team, and *Babe Rainbow* (1967). In the mid-1960s Blake also took an interest in Tarzan, as in *Jane and Areeta* and *Tarzan and his Family at the Roxy Cinema,*

New York (1966). He assembled his *Tarzan Box,* a three-dimensional jungle scene, in 1965. (Blake's first object assemblage had been "*Crazy,*" *said Snow White,* exhibited in 1959.)

Blake did not begin painting in watercolors until 1967, but soon acquired remarkable control over the medium. Several of his watercolors of children, a motif to which he periodically returned, included *Boy Eating a Water Melon* and *Girl in a Poppy Field* (both 1969). In *Girl in a Poppy Field* he made an abstract, experimental beginning which became the girl's overalls. In 1967 he designed the famous cover for the Beatles' album, *Sgt. Pepper's Lonely Hearts Club Band.*

In the 1970s Blake turned from contemporary subjects to illustrations for literary fantasies, including *Alice in Wonderland* and *Through the Looking Glass.* In his illustration "*Well this is grand,*" *said Alice,* "*I never expected I should become a Queen so soon,*" Blake depicted a girl wearing a crown in a field of flowers. This and three other works were made into stained-glass windows for a projected Lewis Carroll library. There was a fey, otherworldly quality in such works of the early '70s as *Death of a Moth* and *A Fairy: Study for Once Upon a Time.* Blake exhibited less frequently in the 1970s, though he continued to paint portraits from time to time, using the title as part of the composition, as in the watercolors *Pretty Boy Michael Angelo* (1972) and *Pretty Penny* (1977) and the oil *Blanche neige and bête noire* (1976–77).

Peter Blake, a robust, stocky, bearded man, lives and works in Willow Bath, England. His house has been described by Edward Lucie-Smith as "crammed with memorabilia—postcards, seaside souvenirs, toys, knickknacks of every sort," out of which the artist distills his "very personal poetry." Although Blake has sometimes called himself a "realist," Lucie-Smith sees his work as "a reversion to the tradition of the Pre-Raphaelites in the middle of the 20th century." But whereas the Pre-Raphaelites yearned for the Middle Ages, Blake looks back with affection and humor to "the popular culture of the 1930s and 1940s"—the Middle Ages of modern art. Lucie-Smith observed, "Unlike other pop painters, Blake is always concerned to be a little out of date."

In 1969, the year of Blake's retrospective at the City Art Gallery, Bristol, Roger Coleman wrote, "I asked Blake what he wanted to do in painting—his answer was, 'to make magic.'"

EXHIBITIONS INCLUDE: Portal Gal., London 1962, '69; Robert Fraser Gal., London 1965, '69; City Art Gal., Bristol, England 1969; Waddington Gal., London 1969, '70; Peter M. David Gal., Minneapolis 1971; Ste-

delijk Mus., Amsterdam 1973; Kunstverein, Hamburg, W. Ger. 1973, '74; Gemeentemus., Arnhem, Neth. 1974; Palais des Beaux-Arts, Brussels 1974; Hayward Gal., London 1974. GROUP EXHIBITIONS INCLUDE: Royal Col. of Art, London 1954, '55; "Five Painters," Inst. of Contemporary Arts, London 1958; "Objects and Sculpture," Inst. of Contemporary Arts, London 1960; "New Reality," Sidney Janis Gal., NYC 1962; Shakespeare Exhibition, Stratford-on-Avon, England 1964; Carnegie Inst. International, Pittsburgh 1964, '67, '68; "Contemporary British Art," Mus. of Modern Art, Tokyo 1970; "British Painting and Sculpture, 1960–70," Nat. Gal. of Art, Washington, D.C. 1970–71; "Earth Images," Scottish Gal. of Modern Art, Edinburgh 1973; Mus. Boynmans-Van Beuningen, Rotterdam 1976.

COLLECTIONS INCLUDE: Tate Gal., London; Trinity Col., Cambridge, England; Carlisle City Gal., England; Hirshhorn Mus. and Sculpture Garden, Washington, D.C.

ABOUT: Compton, M. Pop Art, 1970; Crone, R. (ed.) "Peter Blake" (cat.), Stedelijk Mus., Amsterdam, 1973; Lippard, L. R. Pop Art, 1966; Lucie-Smith, E. Late Modern: The Visual Arts Since 1945, 1969; Melville, R. English Pop Art—Figurative Art Since 1945, 1971; Pellegrini, A. New Tendencies in Art, 1966; "Peter Blake" (cat.), City Art Gal., Bristol, England, 1969; Russell, J. and others Pop Art Redefined, 1969. *Periodicals*—Ark, Journal of the Royal College of Art (London) November 1956; Art and Artists January 1970; (London) Sunday Times Magazine November 1964; Motif (London) no. 10 1962.

***BOLOTOWSKY, ILYA** (July 1, 1907– November 22, 1981), American painter, wrote: "I was born in the Old Russia of the Czars, a Russia which retained many feudal overtones. An émigré during the revolution, I had my schooling in Russian, French, and English, in Russia, Turkey, and the United States.

"As a young boy under Turkish bombardment in the First World War, as an American soldier in the Second, and as a mature adult, artist, and educator, I have seen history being made at an increasingly rapid pace.

"I find my freedom and harmony in the orderliness of neoplasticism, my chosen direction in art.

"I work in the neoplastic style because for me it is the most meaningful and exciting direction in art. Neoplasticism does not keep me away from other disciplines, since I also make experimental films and write avant-garde plays. Neoplasticsm can achieve unequaled tension, equilibrium, and harmony through the relationship of the vertical and horizontal neutral elements. The effect may be likened to epiphany or metanoia. Neoplasticism is neo-Platonic. As a Neoplasticist, I strive after an ideal of harmony

°bōl ō tôf′ skē, il′ yä

O.E. Nelson

ILYA BOLOTOWSKY

(a Platonic idea, an archetype that can have no existence, but has being). No artist can ever completely achieve this ideal in his work. Since an absolute archetype has being, a theoretically absolute artist, having painted one such archetype, would have to give up art. It is fortunate for us, that in our Sisyphean, existential predicament, we can go on painting and striving in our own imperfect ways, thus achieving the only sort of happiness allotted to us.

"Nowadays, when so much art tortures the retina and concentrates on pathological elements, there is an ever greater need for an art that searches for new ways to achieve absolute harmony and equilibrium, for an art that strives for the timelessness of the Platonic ideas."

A pioneer of abstract painting in America in the early 1930s, when social realism was in vogue, Bolotowsky remained faithful to the ideals of neoplasticism long after that style had been superseded by other, less purist types of nonobjective art. When hard-edge abstraction arose in the 1960s, Bolotowsky and other members of the original American Abstract Artists group were rediscovered and reappraised.

Ilya Bolotowsky was born in 1907 in St. Petersburg (now Leningrad), the son of Jules J. and Anastasia (Shapiro) Bolotowsky. At the time of Ilya's birth his father was a law student at the University of St. Petersburg; his mother had been studying for her master's degree at the Bestuzhev University, at that time the only universi-

ty for women in Russia. In 1910 the family moved to Baku in the Caucasus, where the elder Bolotowsky practiced law.

Ilya studied with private tutors instead of attending school. His mother, a self-taught artist, gave him his first instruction in drawing, but as a boy he did not consider becoming a professional artist. "Because of the Russian or Tolstoian influence," he said, "it was felt that you had to do something socially useful. So it was understood that I would be a lawyer."

Bolotowsky took his examinations at the Gymnasium in Baku, but his schooling was interrupted by the Russian Revolution. In the winter of 1919 the Bolshevik forces reached Baku, and the Bolotowsky family, who were supporters of Kerensky, fled to Georgia, then an independent republic. In 1920, faced with the imminent invasion of their new home, they found refuge in Istanbul. There Bolotowsky attended a French school, the Collège Saint-Joseph, where he received instruction in English. The school, where he stayed two years, offered an art class which the young Russian boy thought ridiculous, because the teacher, who did not know how to draw, "made us do geometric shapes free-hand" instead of having the pupils work realistically. Bolotowsky said in an interview during his exhibition at the Solomon R. Guggenheim Museum, New York City, in 1974, "It's funny that years later I became a geometric painter. Maybe this affected me more than I realize."

Meanwhile, his father ran a trading corporation with a partner in Istanbul. Jules Bolotowsky had always intended to go to America, and by 1923 he had made enough money for the journey. In September the family moved to the United States, and six years later Ilya became an American citizen.

Because it was obvious that Bolotowsky's energies were focused on art, he enrolled in 1924 in the National Academy of Design, the one art school in New York that charged only a nominal tuition. (His father was still unenthusiastic about a career in art, preferring that Ilya steer a steadier, more middle-class course.) Ilya found the academy "a very stodgy school" where painters were expected to use "very subdued silvery and brown tones." But it had models, and during the six years he spent there Bolotowsky, although considered a rebel, managed to comply sufficiently with academic requirements to win first prize in a student competition for drawing and painting, as well as a Tiffany Foundation scholarship. He described his painting in those days as "a kind of Academic Impressionism." A self-portrait in pencil dated 1929 shows an intense young man with dark curly hair and a small moustache neatly turning up at the ends.

After leaving the academy in 1930, Bolotowsky got a job designing textiles, and he also helped support himself by teaching in settlement houses. In 1932, having saved enough money and won a small scholarship, he went to Europe for ten months. In Paris, where he stayed only a few weeks, he studied the old masters in the Louvre, and was impressed by the cubism of Picasso and Braque. He spent a lot of time in Italy and also visited Germany and Denmark. In Europe, as he later recalled, he became more of an Expressionist than an Impressionist, but he was influenced less by the Germans than by Chaïm Soutine.

Two years before leaving for Europe, Bolotowsky had seen an exhibition in New York City of modern Russian art which included the Constructivists and the Suprematist Kasimir Malevich. Though keenly interested, Bolotowsky was not yet ready to absorb these ideas. The work of Mondrian, later a major influence on Bolotowsky's aesthetic, was very hard to find in Paris in the early 1930s. Bolotowsky's first view of the revolutionary Dutch abstractionist's rigorously geometric forms was at a showing of the Gallatin Collection in New York in 1933. He also first saw the work of Miró at this time.

After his return from Europe, Bolotowsky, like many of his fellow artists, had to cope with the hard times resulting from the Depression. "It took a certain amount of dedication, or maybe fatalism, to continue painting," he said. He took a job with a textile company, but in 1934, after the company failed, he joined the Works Progress Administration's Federal Arts Project, which initially required him to paint realistic New York scenes. "I did one from a window in the Woolworth Building, another one was of a barber shop, a third of some steel workshop." He obtained a WPA teaching job, then from 1935 to 1941 worked for the WPA mural project, which had been started by the painter Burgoyne Diller, Mondrian's first disciple in the United States. Diller was, in Bolotowsky's words, "totally dedicated to promoting abstract style in murals before abstract art was accepted in the US." Already trying abstraction, Bolotowsky showed some of his sketches to Diller.

In 1936 Bolotowsky designed a mural for the Williamsburg Housing Project in Brooklyn, which was among the very first abstract murals ever commissioned in the United States. The mural no longer exists, but a sketch for it in casein and ink on paper shows a crisp, clean-edged approach to abstract forms, with influences of Miró and the more geometric, post–1914 phase of Wassily Kandinsky.

In the same year, 1936, Bolotowsky helped to

found the American Abstract Artists, along with Diller, other painters on the WPA mural project, and their friends. Charmion Von Wiegand, Balcomb Greene, George L.K. Morris, and Harry Holtzman, the last named a student of Hans Hofmann and an ardent follower of Mondrian, were also members of the group. Bolotowsky was represented for many years in the group's influential annual shows and in 1957–58 served as its president.

His last major undertaking of the 1930s was the abstract mural (10 feet by 16 feet) for the Hall of Medical Science at the New York World's Fair of 1939. The surviving sketches show that, as in the Williamsburg mural, Bolotowsky was combining geometric and biomorphic forms. As distinct from the semiabstraction of Stuart Davis and other American painters influenced by Léger and Picasso, Bolotowsky and his colleagues in American Abstract Artists believed in pure abstraction, "a perfection in structure beyond human bounds." He adopted a more severely angularized idiom in his 50-foot-long mural completed in 1940 for the Hospital for Chronic Diseases on Welfare Island, New York. Under the strong influence of suprematism, all biomorphic elements were excluded. Instead of aiming at flatness, he sought "to create a freer space in a rather depressing room."

Bolotowsky's creative endeavors were interrupted by military service during World War II. A staff sergeant stationed with the US Army Air Corps in Nome, Alaska (1942–45), he made some sensitively realistic ink drawings of soldiers, including one of a wounded pilot, but he felt that the stay in Nome "had no effect on my painting, even though it proved to be very useful to me later in my creative writing." In Alaska he began to collect Northwest Coast Indian and Eskimo art, and also edited a Russian–English military dictionary, for which he was awarded a prize.

After leaving the army and returning to New York City, Bolotowsky took up his painting where he had left it, but from the mid-1940s he began to develop his own version of neoplasticism. Mondrian's stay in New York from 1940 until his death in 1944 had a strong impact on American abstractionists, and Bolotowsky soon adopted the Dutch master's exclusively horizontal-vertical orientation and rectangular color blocks. Unlike Fritz Glarner and some others, however, Bolotowsky never reduced his palette to Mondrian's yellow, red, and blue. He would often assign those colors to large areas, whereas Mondrian preferred white, gray, and black for the larger spaces. Bolotowsky sometimes used lavenders, several shades of the primaries, or subtly muted hues. From 1950 on he rarely felt the need for black lines to separate the color areas.

In 1945 Bolotowsky was invited by A.E. Gallatin to exhibit in "Eight by Eight," a group show of paintings by abstract artists at the Philadelphia Museum of Art. In 1946 he had a solo show at J.B. Neumann's New Art Circle, New York City, and met the noted abstractionist Josef Albers. In 1946, when Albers took a long sabbatical from Black Mountain College in North Carolina, Bolotowsky took his place as head of the art department. He stayed there two years, and found the social life "interesting at first but it got to be a self-centered and closed community, since on the outside it was the old south . . . different from the present day south." Among his students was Kenneth Noland, who was to be prominent in the 1950s and '60s as a leader of the reductive school of painting. "His present style," said Bolotowsky years later, "has nothing to do with what I taught him." In contrast to Albers, known for his ideas of strict discipline in art instruction, Bolotowsky as a teacher at Black Mountain was described as "ebullient, pixyish, shocking—a kind of Peck's bad boy."

Bolotowsky's own painting in the Black Mountain years combined Mondrian-like rectangular grids, and had tilted planes and varied color schemes. *Opalescent* of 1947 and *Arctic Diamond* of 1948 are examples. *Arctic Diamond* was one of the first of his shaped canvases, which became more frequent after the mid-50s. After his return to New York, Bolotowsky found that there was still little demand for neoplastic pictures. In 1948 he took another teaching position as associate professor of art at the University of Wyoming, Laramie, where he remained until 1957; later he said that his long stay in Laramie "may have affected my feeling for space, light and color." There, still experimenting with shaped canvases, he used the rims of old wagon wheels as stretchers for his first tondos. To prevent the composition from "rolling," he used tangential straight lines which counterbalanced the curved format. Glarner, with Bolotowsky the most dedicated of American Neoplasticists, also began using tondos at this time, and hit upon the same compositional technique.

In Wyoming Bolotowsky had a great deal of time for painting, but he also began to make experimental movies, utterly different from his other work, using trick photography and surrealist visual effects. One of these films, *Metanoia*, was awarded first prize at the Midwest Film Festival in Chicago in 1963. The plot was an allegory of his own creation in which the protagonist "sometimes looks like Christ the Martyr or the

Redeemer and at other times the Inquisitor."
This enigmatic Christ figure, sometimes shown
walking on narrow catwalks at great heights, was
both a tortured and a triumphant figure. Bolo-
towsky also made films of artists in their studios,
including Marcel Duchamp, David Smith,
George L.K. Morris, and the Constructivist
Naum Gabo.

In 1957 Bolotowsky went to New Paltz, New
York, as professor of art at the State University
of New York Teachers College, and rented a stu-
dio in town from a woodworker, who supplied
the artist with a wide variety of cubes and col-
umns of wood. Bolotowsky used these to create
his first sculptural pieces, neoplastic columns
painted at first in oil, but then in the crisp,
quick-drying medium of acrylic, which became
his favorite medium for painting on canvas as
well. His triangular and four-sided painted tow-
ers are perhaps his most original contributions to
the language of geometric abstraction—a neo-
plasticism in three dimensions, in the purist spir-
it of the de Stijl sculptor Georges Vantongerloo
but with the added element of color. They have
been compared to abstract totem poles.

His creative activities also extended to the
writing of plays and stories. An absurdist musi-
cal, *The Neurotic Lion*, containing fantasized
reminiscences of Wyoming, and an avant-garde
drama, *Darling, Poor Darling,* were performed
at Finch College, New York, in 1968. *Darling,
Poor Darling* was given four performances at the
Solomon R. Guggenheim Museum in 1974 in
conjunction with a retrospective of his paintings.
As in his films, Bolotowsky was able in his plays
to express emotions, fantasies, and ideas that had
no place in the severely restricted world of neo-
plasticism. A written work of a very different or-
der was a Russian–English art dictionary
compiled by Bolotowsky in 1962.

In 1963 Bolotowsky completed a large mural,
45 feet long and 2 feet high, for the lobby of a
cinema in New York City. The mural's progres-
sion of tonalities from cool to warm in a strictly
geometric idiom suggests the passage of time.
Bolotowsky left New Paltz in 1965 to take a post
as chairman of the art department at Southamp-
ton College, Long Island. He held many other
teaching positions during periods of leave from
Southampton, including adjunct professor at
Hunter College, New York City, and visiting
professor at the University of New Mexico, Al-
buquerque, in 1969. Bolotowsky retired from
teaching in 1974.

Neoplasticism, even during Mondrian's life-
time, had never been a popular style, and the
predominance of abstract expressionism in the
1950s and of pop and op art in the 1960s ac-

counted for the long neglect of Bolotowsky, who
had remained steadfastly loyal, but without sub-
servience, to neoplastic ideals. His previous solo
exhibitions had a mixed reception. The *New
York Times* critic Stuart Preston, reviewing a
show at the Grace Borgenicht Gallery in October
1963, felt that "Bolotowsky's cool art" lacked
"the weightiness of Mondrian's" and that "his
work distinctly pleases without being in any way
stirring." Other critics found his work too
"sweet," tainted by decorativeness. But James R.
Mellow, in his *New York Times* review of a 1972
exhibition, wrote that the artist injected "a new
freshness and vitality" into the "austere and
conceptual" neoplastic style, and demonstrated
"that there is still . . . a good ideal of life left
in the old geometric mode."

Bolotowsky's 1974 retrospective of 91 works at
the Guggenheim was a belated recognition of
the artist's long, concentrated, and dedicated
pursuit of an art of equilibrium, refinement, and
harmony. It was, as Peter Schjeldahl wrote in
The New York Times, "a triumph as much for
a personality as for a talent." In the foreword to
the Guggenheim catalog, Adelyn Breeskin wrote
that the "artist's more recent paintings, with
their jewel-like color, bring to mind the icons of
Bolotowsky's native Russia," and speculated "on
the differences between the impact of Bolo-
towsky's Russian heritage and the Dutch back-
ground of Mondrian." Commenting on the
favorable response to his first major show, Bolo-
towsky said, "I think it's very nice, very enjoy-
able. But when you get to my age, you don't get
so excited."

Ilya Bolotowsky, who died in 1981, lived with
his wife, Meta, whom he married in 1947, in a
spacious studio on the top floor of an office
building in downtown Manhattan. They often
spent the summer months in Sag Harbor, Long
Island. Their son Andrew, a concert flutist, has
composed music for some of his father's plays.
Characteristically, his studio, with its abundance
of shaped canvases, painted wooden columns,
journals, and miscellaneous papers, was remark-
ably well organized. Bolotowsky remained faith-
ful to the Platonic belief in "the creation of an
ideal, balanced harmony. Something that in ac-
tual biological existence is not given to man."

EXHIBITIONS INCLUDE: New Art Circle, NYC 1946, '52;
Rose Fried Gal. (The Pinacoteca), NYC 1947, '49;
Univ. of Wyoming, Laramie 1949; Grace Borgenicht
Gal., NYC 1954, '56, '58, '59, '61, '63, '68, '70, '72, '74;
London Arts Gal. 1971; Solomon R. Guggenheim Mus.,
NYC 1974; Nat. Collection of Fine Arts, Smithsonian
Inst., Washington, D.C. 1975. GROUP EXHIBITIONS IN-
CLUDE: "New Horizons in American Art," MOMA,
NYC 1936; New York World's Fair, NYC 1939;

"American Non-Objectives," Mus. of Non-Objective Painting, NYC 1942–43; "Eight by Eight: American Abstract Painting Since 1940," Philadelphia Mus. of Art 1945; Seattle World's Fair 1963; New York World's Fair, Flushing Meadow 1964; "Plus by Minus: Today's Half-Century," Albright-Knox Art Gal., Buffalo, N.Y. 1968; "The 1930's: Painting and Sculpture in America," Whitney Mus. of Am. Art, NYC 1968; "Post-Mondrian Abstraction in America," Mus. of Contemporary Art, Chicago 1973.

COLLECTIONS INCLUDE: Solomon R. Guggenheim Mus., Whitney Mus. of Am. Art, MOMA, and Metropolitan Mus. of Art, NYC; Brooklyn Mus., N.Y.; Philadelphia Mus. of Art, Gallatin Collection; Duncan Phillips Gal., Nat. Collection of Fine Arts, Smithsonian Inst., and Hirshhorn Mus. and Sculpture Garden, Washington, D.C.; Albright-Knox Art Gal., Buffalo, N.Y.; Cleveland Mus. of Art; Walker Art Cntr., Minneapolis; Yale Univ., New Haven, Conn.; Brandeis Univ., Waltham, Mass.; Mus. d'Art Moderne, Céret, France; Jerusalem Mus., Walter P. Chrysler Collection; Rhode Island School of Design, Providence.

ABOUT: American Abstract Artists The World of Abstract Art, ca. 1957; Breeskin, A.D. "Ilya Bolotowsky" (cat.), Guggenheim Mus., NYC, 1974; Current Biography, 1975; Goodrich, L. and others American Art of Our Century, 1961; Rose, B. American Art Since 1900, 2d ed. 1975; Seuphor, M. Dictionary of Abstract Painting 1957. *Periodicals*—Art d'aujourd'hui (Paris) June 1951; Art News November 1947; Art Now no. 2 1970; New York Herald Tribune October 3, 1963, April 7, 1968, March 12, 1972, October 6, 1974; Newsday September 18, 1974; Réalités nouvelles (Paris) July 1972.

***BONTECOU, LEE** (January 15, 1931–), American sculptor, was born in Providence, Rhode Island. Her father, Russell Bontecou, was in the aluminum canoe business. The family left Rhode Island and Lee's early youth was spent in Bronxville, New York, and Nova Scotia. She attended Bradford Junior College, Haverhill, Massachusetts, and from 1952 to '55 studied with John Havannes and William Zorach at the Art Students League, New York City.

Bontecou began with fantastic animal and bird sculpture, including, in 1956, a bizarre, chunky pterodacty-like creature of plaster and terra cotta. Her early pieces were later cast in bronze. Bontecou still draws birds, animals, and insects.

While in Rome on a Fulbright grant from 1957 to '58, Bontecou also traveled to other Italian cities and to Greece. Her work was included in a group show, "Scultura nella città" (Sculpture in the City), at the Festival of Two Worlds, Spoleto, Italy, in 1958. The same year, she made her first drawings for reliefs, which she was later to construct from canvas, steel, and wire. In 1959

Courtesy of Castelli Gallery, NYC

LEE BONTECOU

she received a Lewis Comfort Tiffany Foundation Fellowship for her bronze sculptures of birds and imaginary animals.

Bontecou's first solo exhibition was held at Gallery G, New York City, in 1959. In *The New York Times* (February 8, 1959) Stuart Preston described her as "an interesting young metal sculptor." Of her bird subjects Preston wrote, "She abstracts from nature in an imposing, formal style of armor-plating which gives them [the bird sculptures] a rigid, rather menacing, prehistoric appearance as well as lending them the ceremonial grace of ancient Chinese bronzes."

Bontecou could have produced her bird sculptures indefinitely; instead she began making abstract canvas and steel constructions. These works, in some of which laundry bags were stretched and sewn over wire armature, combined strength and elegance; they were so rapidly purchased by museums and collectors that she had to stop selling to have time to assemble enough compositions for her first show at the Leo Castelli Gallery, New York City, in the fall of 1960.

One of the first of her more complex relief structures was *Untitled* (1960: Albright-Knox Art Gallery, Buffalo, New York), in which a central black void, created by an oval-shaped opening, projects from a black wooden board on which the entire relief is mounted. From this cavity irregularly shaped strips of canvas are arranged on a rectangular welded steel frame, attached by pieces of copper wire twisted in place and visible on the work's front side. The discarded laundry bags she used were obtained from a steam laundry on the street-level floor below her

°bon´ tee co͞o´´

studio. "I like space that never stops," Bontecou said. "Black is like that. Holes and boxes mean secrets and shelter."

The constructions in her second (1962) show at the Castelli Gallery were described by a *New York Times* (November 25, 1962) critic as "cloth on metal frames riddled with saw teeth; sawed off gun barrels and sinister apertures that look like flame-throwers. . . . Concave and convex, [they bristle] with tiny wire tentacles that add creepily to their air of menace." They were, the writer concluded, "marvels of ingenuity." In the winter of 1962 Bontecou won second prize in the Corcoran Biennial, Washington, D.C., and many of her works were purchased by the Ford Foundation. She declared that she made her sculptures to hang like paintings: "I want to get sculpture off the floor and on the wall."

Not all of Bontecou's works are as menacing as her untitled sculpture of 1961—in which the teeth of two saws lock in a grim bite over the central hole—but most have at least one baffling black hole. To some viewers this gives her work erotic and Freudian significance; others are reminded of science fiction, volcanoes, or post-nuclear-blast craters.

In 1964 Bontecou executed a monumental composition for the New York State Theater in Lincoln Center. This massive three-dimensional structure of curving geometric shapes took her five months to assemble. First she welded pieces of metal to form the sculpture's curving outline and then attached canvas strips to the frame with wire. The bulges in the sculpture resulted from molded fiberglass forms which were covered with stretched canvas or white pigment. Some of the canvas she found in the street and some came from an old fire hose that she cut and then flattened. When the 7-by-20-foot assemblage was completed, she "toned" parts with blown-on soot. The work's only color came from pieces of yellow chamois stretched around the holes. The construction included, along with welded metal rods, the plexiglass turret of a World War II bomber. The work was compared in *Life* magazine to "a complex flying machine that might actually be able to get up off the ground and soar." The reviewer noted that when Bontecou was not welding away at one of her huge assemblages, she made miniature model airplanes in her studio. Although usually chary of titling her works, Bontecou dubbed her Lincoln Center sculpture *1964*.

Bontecou's first Paris exhibition was at the Galerie Ileana Sonnabend in 1965. Reviewing her 1966 Castelli show in the *World Journal Tribune* (October 12, 1966), John Gruen wrote, "Miss Bontecou . . . continues to construct mixed-media sculptures in which masses of billowing, jutting shapes are made to merge, interrelate and converge, finally forming structures that suggest huge spidery objects, as mysterious in content as they are brilliant in execution." Gruen noted a change in Bontecou's approach to color: "In her present show, the artist has moved from the murky brown-black-beige armature-like color sequences to pale blues, reds and yellows that serve to lend her work a new sense of finality. . . . The effect may be less brutal but it is no less arresting."

In the catalog to Bontecou's Paris exhibit at the Sonnabend, Annette Michelson wrote, "This art is neither feminine nor feminist; in its scale, its manner of reconciling contradictions, it achieves that essentially androgynous character which distinguishes the art of her time." In the same catalog Gillo Dorfles, though noting that Bontecou's ferocious work hardly corresponded to the public's notion of a "woman artist," remarked on the "combination of a brilliant, meticulous feminine craftsmanship (in the stitching of the canvas, etc.) with the heavy 'brutalism' of certain kinds of North American architecture."

In 1967 Bontecou abandoned steel, canvas, burlap, and screen wall constructions for strange fish and flower forms in vacuum-formed, free-standing or hanging plastic. Some were over seven feet high and all were at once graceful and menacing. Transparent and made to be suspended from a ceiling, the fish were intended to be seen from all angles. The large, sinister plants looked like carnivores from another planet. These new pieces' surfaces were rich with texture, layering, and what Carter Ratcliff called "biological rhyming" in the catalog to a 1972 Bontecou retrospective at the Museum of Contemporary Art, Chicago. Ratcliff pointed out that the transition to plastic flora and fauna had a continuity that could be traced back through drawings she had made to accompany her earlier, steel and canvas sculptures.

In the 1960s Bontecou maintained a studio in a loft on the fringes of Greenwich Village. By 1970 she had begun producing aquatints and lithographs.

Lee Bontecou now lives and works in Monsey, upstate New York. She is petite and sturdy, with a round, determined face and light hair which she wears in a bob. She enjoys conversation and is not self-absorbed, nor given to compulsively discussing her work and motivations. She rarely titles her sculptures because, "I do not want to tell others what to see or experience in my work."

In a letter of 1960, quoted in the catalog to the "Americans 1963" group show at the

Museum of Modern Art, New York City, Bontecou wrote: "I'm afraid I am rather vague about expressing philosophies of art, and especially about my own work. I can only say that I do not know if what I am doing is art nor do I have any real concern. I just want to do what I believe and what I want to do, and what I must do to get what I want—something that is natural and something that exists in us all.

"My concern is to build things that express our relation to this country—to other countries—to this world—to other worlds—in terms of myself.

"To glimpse some of the fear, hope, ugliness, beauty and mystery that exists in us all and what hangs over all the young people today.

"The individual is welcome to see and feel in them what he wishes in terms of himself."

EXHIBITIONS INCLUDE: Gal. G, NYC 1959; Leo Castelli Gal., NYC 1960, '62, '66, '71; Gal. Ileana Sonnabend, Paris 1965; Mus. Boymans-Van Beuningen, Rotterdam 1968; Städtisches Mus., Leverkusen, W. Ger. 1968; Mus. of Contemporary Art, Chicago 1972; Davidson Art Center, Wesleyan Univ., Middletown, Conn. 1975; Halper Gal., Palm Beach, Fla. 1976; "Lee Bontecou in Retrospect," Hathorne Gal., Skidmore Col., Saratoga Springs, N.Y. 1977. GROUP EXHIBITIONS INCLUDE: "Scultura nella città," Festival of Two Worlds, Spoleto, Italy 1958; "New Media—New Forms I and II," Martha Jackson Gal., NYC 1960; Whitney Mus. of Am. Art, NYC 1960, '62, '66, '68; "The Art of Assemblage," MOMA, NYC 1961; Pittsburgh Intl. 1961, '67, '70; VI São Paulo Bienal 1961; "Art Since 1950," World's Fair, Seattle 1962; "Americans 1963," MOMA, NYC 1963; 28th Biennial Exhibition, Corcoran Gal. of Art, Washington, D.C. 1963; Documenta 3, Kassel, W. Ger. 1964; "Painting and Sculpture of a Decade, 1954–1964," Gulbenkian Foundation, Tate Gal., London 1964; "Flint Invitational," Flint Inst. of Arts, Flint, Mich. 1966; "Sculpture—A Generation of Innovation," Art Inst. of Chicago 1967; "Contemporary Drawing Show," Fort Worth Art Center, Tex. 1969; "L'Art vivant Américain," Maeght Foundation, Saint-Paul-de-Vence, France 1970; "American Drawing 1970–73," Yale Univ. Art Gal., New Haven, Conn. 1973; "Contemporary American Prints," Metropolitan Mus. of Art, NYC 1976; "The Liberation: 14 American Artists," Corcoran Gal. of Art, Washington, D.C.; "Perspective '78; Works by Women," Freedman Gal., Albright Col., Reading, Pa. 1978.

COLLECTIONS INCLUDE: MOMA, Whitney Mus. of Am. Art, Solomon R. Guggenheim Mus., and New York State Theater, Lincoln Center, NYC; Albright-Knox Art Gal., Buffalo, N.Y.; Andrew Dickson White Mus., Cornell Univ., Ithaca, N.Y.; Yale Univ. Art Gal., New Haven, Conn.; Smith Col. Mus., Northampton, Mass.; Carnegie Inst., Mus. of Art, Pittsburgh; Corcoran Gal. of Art, Hirshhorn Mus. and Sculpture Garden, Washington, D.C.; Cleveland Mus. of Art; Walker Art Center, Minneapolis, Minn.; Virginia Mus. of Fine Arts, Richmond, Va.; Dallas Mus. of Fine Arts, Tex.; Houston Fine Arts Mus., Houston, Tex.; Ministry of Cultural

Affairs, Paris; Stedelijk Mus., Amsterdam; Kunstmus., Basel; Moderna Mus., Stockholm.

ABOUT: "Americans 1963" (cat.), MOMA, NYC, 1963; Wescher, H. (ed.) Nouveau dictionnaire de la sculpture moderne, 1970. *Periodicals*—Art International (Lugano) November 1970; Das Kunstwerk (Baden-Baden) Summer 1971; Life April 10, 1964; Look September 27, 1960; New York Times February 8, 1959, November 25, 1962; Providence R.I. Journal June 9, 1963; XXe siècle (Paris) June 1968; Washington Post January 4, 1961; World Journal Tribune October 12, 1966.

***BOTERO, FERNANDO** (April 19, 1932–), Colombian painter and sculptor, creates immediately recognizable, balloonlike human and animal figures—he often applies the same treatment to fruit and other still-life objects—which combine implicit satire with what appears to be a personal obsession.

He was born in Medellin, an industrial center in Colombia. His introduction to the world of art came in the pages of art magazines; reproductions of surrealist paintings, especially those of Magritte, had a great initial influence on him. In 1948 he showed for the first time in a group exhibition in his home town. Botero was 18 when he saw his first original Picasso, at the Bogotá art museum. In 1951 he settled in the capital, where he had his first solo show at the Gallery Leo Matíz. However, his efforts at painting were sporadic, and he had a deep sense of creative inadequacy.

Botero's admiration for Gauguin, as the archetype of the "rootless bohemian" rather than as a painter, contributed to his own eagerness to escape his native Colombia. As a result of a second, more successful solo show in Bogotá in 1952, he earned enough money to finance a trip to Europe. He was further encouraged by winning the second National Prize for Painting in Colombia. He booked a passage to Madrid, where he enrolled at the Academy of San Fernando to study drawing. After working from models and plaster casts, he decided that his real teachers were the masterpieces in the Prado, and he obtained permission to work there.

During his year-long stay in Madrid, Botero developed disciplined work habits and made a series of studies after Velázquez and Goya. From Goya he acquired a critical view of the human comedy, while the meticulously painted, realistic still lifes he produced at this time showed the influence of the early Velázquez. Meanwhile he attempted to earn his living by selling copies of Titian and Tintoretto paintings.

Botero was disappointed on his first visit to

°bō tâ´ rō, fĕr nän´ dō

Hirshhorn Museum; Photo: John Tennant

FERNANDO BOTERO

Paris in 1953 by the 20th-century French painters in the Musée National d'Art Moderne, finding them pale in comparison to the Spanish masters in the Prado. He was far more impressed by the 17th-century French paintings in the Louvre. His interest in Velázquez led him, not forward to Manet, but back to Giotto, Mantegna, Piero della Francesca, and other artists of the early Renaissance.

He acquired first-hand knowledge of Quattrocento painting when journeying through northern Italy to Tuscany in 1954. He especially admired the murals of Piero della Francesca in Arezzo. In Florence he attended the art history lectures of Roberto Longhi and studied the technique of fresco. He once again applied a severe discipline to his own painting, and for 18 months worked like a Renaissance master.

Returning to Bogotá in 1955, Botero held a show of his work at the Biblioteca Nacional, which was a fiasco. He was accused by his friends of being a "museum painter," and he realized that provincial Colombia had finally caught up with developments in contemporary art. Deeply discouraged, he gave up painting for a year.

His interest in painting was rekindled during a visit to Mexico in 1956–57, when he discovered the work of Diego Rivera, José Clemente Orozco, and David Alfaro Siqueiros. These famed Mexican muralists seemed to him to provide a link between the Italian Renaissance and the art of the 20th century. He went in 1957 to Washington, D.C., where he had a solo show sponsored by the Pan-American Union. This exhibit was more successful than his previous shows, although it was roughly handled by the critics, who found his subjects too contrived and their grotesqueness too elegant and self-conscious. The critics compared Botero's approach unfavorably with the drive of the contemporary American action painters who followed de Kooning's lead. However, Botero was already aware of the New York School and admired the monumental scale and free brushwork of de Kooning and Kline. At the same time he kept his distance, realizing that his deepest sympathies were with his native Colombia—its daily life, its religious myths, and its folk art descended from the Indians.

Botero worked in Colombia in 1958–59 and had several solo shows, the most important of which was held at the Biblioteca Nacional in 1959. *The Sisters,* painted in that year, has all his stylistic idiosyncracies. The five sisters, their forms grotesquely inflated like balloons about to burst, pose in their comfortable, stuffy sitting room. Four contented cats, one on the dresser in the background, two on the floor, and one held in the plump arms of one of the younger sisters, complete the scene. The spirit is that of amiable satire rather than sharp social comment. Although Botero adapted what appears to be a naive style, he is not a true, unselfconscious primitive. Klaus Gallwitz has observed: "Just as Picasso made use in Cubism of some formal elements of primitive art, so Botero employs the colonial tradition of South America."

In 1960 Botero moved to New York City, where he won the Guggenheim National Prize for Colombia. The following year the Museum of Modern Art, New York City, purchased his *Mona Lisa at the Age of Twelve* (1959), which created a stir when first exhibited in the museum. He remained in Manhattan for several years, greatly stimulated by the city's environment but always mindful of his Latin-American heritage. *Our Lady of New York* (1966), a fantastically bulbous Madonna, with her child in one hand and an apple in the other—even her crown is like a truncated pumpkin—must have struck some viewers as sacrilegious, but that was not the artist's intention. He felt a kinship with native Colombian art and with the primitive painters of western Europe, and in this picture he used a device he has often repeated—the depiction of himself as a tiny figure carrying palette and brushes.

Also in 1966, Botero had his first solo show in the Staatliche Kunsthalle, Baden-Baden, West Germany. Not surprisingly, his type of inflated grotesquerie was much appreciated in Germany. In 1967 he revisited Italy, and also traveled in Germany, where he studied the work of Al-

brecht Dürer. Several of his paintings of the late 1960s are humorous variations on the themes of well-known pictures of the past. *Self-Portrait with Madame Pompadour* (1969) depicts himself as a diminutive figure next to a full-sized, plump, and simpering Pompadour, in her day a generous patron of the arts. *Le Déjeuner sur l'herbe*, also of 1969, reverses Manet's treatment in that the man is nude and the woman is clothed, although with a generous exposure of thigh. The picnic still life in the foreground is painted with as much gusto as the figures, and a scarlet serpent entwined around a tree-trunk adds an allegorical note. The rhythms are skillfully orchestrated, and the mood is one of humorous sensuality. A bourgeois social milieu is amusingly suggested in *Man Going to His Office* (1969). The surreal impact of this work is enchanced by incongruities of scale. An enormous baby, held by a very small nurse at an upper-story window, waves goodbye to the man of the house, who is dressed in a black business suit. His wife, even more monumental than the baby, waves cheerily from a larger window. The man's head is diminutive compared to his body, while the snowcapped hills in the background on the right are like enormous pears. The painting technique is, as always, meticulous.

From 1973 on, Botero has lived the greater part of the year in Paris, with summers spent in Colombia and frequent visits to New York. He can paint comfortably anywhere except in Colombia, where he feels too close to his subject. Before and after his move to Paris he painted compositions featuring clerics, generals, and politicians. The bloated, overblown bodies and faces in such works as *The President's Family* (1967; MOMA), *Field Marshal* (1970), and especially *Minister of War* and *Military Junta* (both of 1973), could be construed as social satire, although Botero denies any attempt at caricature—he prefers the word "deformation." He claims that his figures are not fat, but on the contrary quite slender. This can hardly be said of his opulent female nudes, including *Rosalba* (1969) and the woman in *Rural Concert* (1972). For all their comicality they have a ripe voluptuousness that appears to spring from the artist's own fantasies. *Homage to Bonnard* (1972) shows a full-figured nude stepping out of a bathtub, a typical Bonnard theme, although the smooth technique is very different, and Botero's tiled bathroom has certain realistic details that the French master would never have included

Botero's continued admiration for Velázquez found expression in *Child from Vallecas* (1971), his own doll-like version of the Spanish painter's portrait of the sad court dwarf Francisco Lezcano. He also painted his own parodies of Rubens's *Self-Portrait with Isabella Brandt,* and of Vigée Lebrun's *Marie Antoinette.*

Still lifes of food have been part of Botero's repertoire, with emphasis on the succulent and volumetric aspect of fruit, cakes, and other edibles. In *Colombian Still Life* of 1969 a minute figure of a little girl holding a Colombian flag stands on top of a luscious chocolate cake. A more disturbing still life, also painted in 1969, is *Butcher's Table,* in which a smiling pig's head among the sausages looks very much alive.

After working for long periods in oils, Botero turns periodically to charcoal drawings or pastels. Since 1975 he has been making sculptures—his bronze *The Big Hand* is owned by the Hirshhorn Museum and Sculpture Garden, Washington, D.C. During 1976–77 he worked almost exclusively on a series of large sculptures, cast in bronze and in polyester resin. Botero's subjects underwent little change when translated into three dimensions. He explained: "I create my subject's somehow visualizing them in my style. I start as a poet, put the colors down on canvas as a painter, but finish my work as a sculptor, taking delight in caressing the forms."

Some critics have felt that while Botero's recent works may have gained in refinement, they have lost some of their earlier aggressiveness, and that there is a danger of their becoming amusing, anecdotal, and formulaic *faux-naïf* genre paintings. At his best, however, Botero has created, in the words of one critic, "a personal, fantasy world of undeniable conviction." He has never lost his Colombian identity, and his early background has continued to inspire much of his imagery. "Latin America," he says, "is one of the few places in the world that can still be transmuted into myth."

In Paris Fernando Botero occupies spacious, well-appointed rooms on the Boulevard du Palais, across from the Sainte-Chapelle. He collects pre-Colombian art and works from the Spanish colonial period, and enjoys fine furniture. Unlike his plump, pneumatic figures, Botero is slender, with dark hair and a short beard. He is a gracious host, receiving his guests, according to Gallwitz, "with the old-fashioned air of a man consciously master of house and hearth." His studio is within walking distance of his home, and the same is true of his residence on Fifth Avenue in New York.

Summing up the theme that runs through all his work, Fernando Botero said: "What is important is finding where the pleasure comes from when we look at painting. For me it is enjoyment of life combined with sensuousness of form. Thus the formal problem is how to create sensuousness through form."

EXHIBITIONS INCLUDE: Gal. Leon Matíz, Bogotá, Colombia, 1951 '52; Biblioteca Nacional, Bogotá, Colombia 1955, '59; Pan-American Union, Washington, D.C. 1957; Gres Gal., Washington, D.C. 1957, '60; The Contemporaries, NYC 1962; Staatliche Kunsthalle, Baden-Baden, W. Ger. 1966, '70; Gal. Buchholz, Munich 1966, '68, '72; Center for Inter-Am. Relations, NYC 1969; Gal. Claude Bernard, Paris 1969, '72; Hanover Gal., London 1970; Marlborough Gal., NYC 1972, '75; Marlborough Gal. d'Arte, Rome 1973; Marlborough Gal., Zürich 1974; Hirshhorn Mus. and Sculpture Garden, Washington, D.C. 1979–80. GROUP EXHIBITIONS INCLUDE: Bienal Hispanoamericano, Barcelona 1955; Venice Biennale 1958; International, Solomon R. Guggenheim Mus., NYC 1958, '60; São Paulo Bienal 1959; Pittsburgh International, Carnegie Inst. 1964, '67; "The Emergent Decade," Andrew Dickson White Mus. of Art, Cornell Univ., Ithaca, N.Y. 1966; "The Emergent Decade," Solomon R. Guggenheim Mus., NYC 1966; "Inflated Images," Circulating Exhibition, MOMA, NYC 1969–70; "12 Artists from Latin America," Ringling Mus. of Art, Sarasota, Fla. 1971.

COLLECTIONS INCLUDE: MOMA, Solomon R. Guggenheim Mus., and New York Univ., NYC; Rhode Island School of Design, Providence; Hirshhorn Mus. and Sculpture Garden, Washington, D.C.; Baltimore Mus. of Art; Milwaukee Art Center; Univ. of Texas, Austin; Mus. de Arte Moderno, Bogotá, Colombia; Mus. de Ponce, Puerto Rico; Mus. de Bellas Artes, Santiago, Dominican Republic; Mus. de Bellas Artes, Caracas, Venezuela; Mus. de Arte Contemporaneo, Madrid; Mus. de Arte Moderno del Vaticano, Rome; Neue Pinakothek, Munich; Kunsthalle, Nuremberg, W. Ger.; Ateneumin Taidemuseo, Helsinki, Finland.

ABOUT: Arciniegas, G. Botero, 1976; Engel, W. Botero, 1952; Gallwitz, K. Botero, 1976; Hunter, S. "Botero" (cat.), Marlborough Gal., NYC, 1975; P-Orridge, G. and others (eds.) Contemporary Artists, 1977. Periodicals—Art and Artists December 1970; Art in America December 1962; Art International (Lugano) December 1974; Arts Magazine April 1972; Goya (Madrid) January 1973; Time no. 27 1966.

*BOURGEOIS, LOUISE (December 25, 1911–), has tapped more directly and more successfully than any other American sculptor the psychosexual sources of the formal imagination. For years her disquieting work was largely ignored by critics and dealers because it touched too nakedly on the violent discord between the sexes, because it was aggressively sexual in content, and simply because it was frank work by a woman, fundamentally divergent from the male-dominated abstract movements of the 1950s and 1960s. In the 1970s, with the resurgence of feminism as a political and intellectual force and the concomitant increased value placed on art made by women, Bourgeois received long-overdue attention; this was capped

© 1978 by Peter Moore

LOUISE BOURGEOIS

by a major retrospective at the Museum of Modern Art, New York City, in 1982. That exhibition demonstrated the importance of her sculpture to the strong work being done in ritual, performance, and environmental art by younger women, many of whom took their cue from her.

Bourgeois was born in Paris, in the Left Bank district of Saint-Germain-des-Près. She grew up in a building next to the Café de Flore (later made famous by Jean-Paul Sartre and Simone de Beauvoir), but much of her childhood was spent in Aubusson and by the River Bièvre near Paris. Her father Louis, whom she described as "quite a charmer," and to whose constant womanizing she later attributed her obsession with imagery of sexual destructiveness, had a decorating business dealing in tapestries. Her mother specialized in restoring the old tapestries that her husband found in the stables and on the walls of decaying country villas. Louise had an older sister, Henriette, and a younger brother, Pierre. At the end of World War I, when there was renewed demand for tapestries as decoration, the Bourgeois family established a thriving business. As Bourgeois remarked to Paul Gardner in Art News (February 1980): "There was never enough money to spoil us. But there was just enough not to talk about it."

At the age of ten she was asked to help restore some 18th-century tapestries. Her first assignment was to draw a foot that had been worn away. She began to make meticulous drawings of feet (years later, in her life-class studies at the Grande Chaumière, the feet would always be forcefully stressed).

Bourgeois attended the Lycée Fénelon, Paris,

°bôr zhwäh´

receiving her baccalaureate in 1932, the year her mother died. (Louise always had difficulties with her self-engrossed father, but had had a close, nurturing relationship with her mother.) The 20-year-old Bourgeois then enrolled at the Sorbonne, where she studied mathematics. As she remarked to Paul Gardner, "Mathematics represented a world of order that I wanted." During her three years at the Sorbonne she had a studio in the rue de Seine.

At various times between 1936 and 1938 Bourgeois took classes at the Ecole du Louvre and the Ecole des Beaux-Arts, but she found her studies at the Académie de la Grande Chaumière in 1937–38 far more rewarding. She particularly enjoyed a sketch class "where you had to produce something in five minutes. After the meaningless discipline of the Ecole, I found this freedom very exciting." At the Grande Chaumière her main teacher was Wierick, but she also studied painting with Yves Brayer. Her fellow students in Brayer's class remember her quiet, with exquisitely chiseled features, and a subtle smile, friendly but somewhat reserved.

Most important to Bourgeois's art education was her brief training with Fernand Léger in 1938. "Léger turned me into a sculptor," she recalled. "It happened this way: one day he took a wood shaving—it was like a lock of hair—and he pinned it up under a shelf, where it fell, freely in space. We were told to make a drawing of it." Bourgeois became interested in the spiral of the shaving, its form and its trembling quality. "I did not want to make a representation of it. I wanted to explore its three-dimensional quality. And so I did. I knew from this exercise that I would be a sculptor, not a painter."

While a student at the Grande Chaumière, Bourgeois would sometimes drop in at a nearby café, the Closerie des Lilacs in Montparnasse. Here André Breton, the high priest of surrealism, held forth to his disciples on poetry, aesthetics, and ethics. The Surrealist group paid no attention to the very young Bourgeois, who, in her turn, maintained a deliberately aloof attitude.

In 1938, the last year of peace in Europe, Bourgeois met a young American art historian, Robert Goldwater, who was completing his Ph. D. thesis on primitivism in modern painting. She told Paul Gardner, "I felt he was someone I could trust." Later in 1938 they were married and settled in the United States.

Shortly after the young couple's move to New York, the Parisian émigrés began to arrive—André Breton, Max Ennst, André Masson, and Marcel Duchamp. Bourgeois, although herself influenced by surrealism, did not welcome their presence. "It was the Left Bank again. . . . They were so lordly and pontifical." In the Goldwaters, crowded home, not only artists but also left-leaning writers were received, including Edmund Wilson, Mary McCarthy, and Dwight Macdonald. The Goldwaters had three small children. Of Bourgeois at this time the art dealer Alan Groh recalled that she "was a fastidious mother and absolutely scrupulous about using any of her husband's connections to further her career." Goldwater later became professor at New York University, director of the Museum of Primitive Art, and one of America's most distinguished art historians.

About 1941 Bourgeois's sculpture took the form of life-sized elongated wooden figures and groupings—described by her as "the people I left behind in Paris." By 1947 she entered what she calls "a period of pregnant women." The reviewer for *Art News* wrote of her 1947 show at the Norlyst Gallery: "Her women emerge from chimneys, or terrified, they watch from their beds as curtains fly from a nightmare window"; Bourgeois had evolved a personal style in "the humanization of Surrealism." The sculpture of 1947 was related to her group of etchings, "He Disappeared into Complete Silence," begun in 1946 and completed in 1947. Each etching was accompanied by a poem written by the artist. In these etchings, and in a balsa-wood sculpture of 1947, *Sleeping Figure,* she used what she described in *Art Journal* (Summer 1976) as "symbolic geometry," which for Bourgeois represented "emotional security." She added: "Geometrical figures, circles, half-circles, points, lines, vectors . . . were my vocabulary and still are today." But there was also a surreal element, with a suggestion of physical presences; her work, whatever the degree of abstraction, has always been related to personal memories and experiences.

Bourgeois describes her work of 1947 as "very elliptical and direct." It was seen by dealer Arthur Drexler, who, captivated by the slender, upright forms in her studio, offered her a show at the Peridot Gallery on 12th Street in Manhattan, in 1949. The exhibit included a seven-foot-high totemic wooden grouping, *The Blind Leading the Blind.* Bourgeois calls this piece "environmental"—in fact the whole Peridot show was conceived as an environment, at that time an entirely new approach. In her words, "The space of the viewer *becomes* the space of the maker." *Sleeping Figure* (paradoxically, a vertical piece), also in the exhibit, was bought in 1949 by Alfred Barr for MOMA; it was recently sold to the Detroit Institute of Arts.

In 1951 Bourgeois began a complex, abstract

piece in painted wood, *One and Others* (1953; Whitney Museum of American Art, New York City). The small scale and what Susi Bloch described as the "closed cluster effect" of this sculpture created for the viewer "a purely illusory dimension of space," and that "distancing" of the object that has been so critical in the development of abstract sculpture.

Bourgeois had two more shows at the Peridot Gallery, in 1950 and 1953; she also exhibited at the Allan Frumkin Gallery, Chicago, also in 1953, and at the White Art Museum at Cornell University, Ithaca, New York, in 1959. Her abstract, totemic style was, despite a superficial resemblance in freedom of form and the violence of its preconscious motivations, essentially independent of the charged emotionalism of early 1950s abstract-expressionist painting. Her independence was even more marked in the 1960s, the decade of reductivism, the hard edge, and other "cool" manifestations. As Carter Ratcliff observed in *Art International* (November/December 1978), Bourgeois "continued as if Minimalism and its offshoots had never appeared." In the late 1960s she produced some hanging pieces which J. Patrice Marandel of *Arts* (October 1978) has described as "looking like some exotic insects' nests." Her disquieting *Knife-Woman* (1969) depicted the seductive body of a woman being slowly turned into an elongated knife.

During the 1960s Bourgeois was in demand as a teacher. She taught at the Great Neck Public Schools, New York, in 1960, at Brooklyn College in 1963 and 1968, and at Pratt Institute in Brooklyn from 1965 to 1967. Since then she has been professor of sculpture at the School of Visual Arts, New York City.

In the 1970s Bourgeois continued to experiment with a variety of materials and forms. The motivation behind her work has remained, in her words, "personal and quasi-erotic," although increasingly she has become involved in feminist and political causes. Her sculpture has often been cited, rather disingenuously, as typical of "woman's art" in its very privacy and sensuality. Over the years she has worked with marble, wood, plaster, bronze, and latex rubber to express, according to Paul Gardner, "the metaphors for her memories of the family and its frequently cruel interrelationships."

After the death in 1974 of her husband, Bourgeois went through a period of withdrawal, living and working in comparative isolation in her studio in the Chelsea section of Manhattan. In 1975 she completed the first of her "Structures"; this was an open-form sculpture composed mainly of cardboard boxes which were slashed in two and then stapled, taped, or screwed to a cardboard or plexiglass tree or sheet, which in turn was supported by a welded steel substructure. The base was a steel chair cut in two. The whole, with the exception of the substructure, was painted in bright reds and greens, but the overall feeling was by no means festive. It was exhibited with four other "Structures" at the Xavier Fourcade Gallery, New York City, in 1978.

The inclusion of Bourgeois's early work in the 1976 Whitney Museum exhibition "200 Years of American Sculpture" effectively drew attention to the importance of her work to the development of modern American sculpture. Two Bourgeois exhibits were held simultaneously in New York City in the fall of 1978. The major new works shown at the Xavier Fourcade Gallery were the "Triangles." Occupying the entire main exhibit space at the Hamilton Gallery of Contemporary Art was a massive piece titled *The Confrontation,* an assemblage in wood and latex. A white oval made of tightly gathered open triangles, graduating in size from about two to seven feet in height, surrounded a low platform covered in blue sheeting on which were two large half circles and one vertical form, flanked by groupings of phallic and breastlike shapes. *The Confrontation* reminded the critic John Russell of human sacrifices, both male and female. Certainly it has the look of a stage set for some menacing sexual ritual. Regarding the erotic imagery in much of her work, Bourgeois has said, "The eroticism was not conscious, but when people talk about it I am not embarrassed."

In late 1982, at the age of 71, the artist was given her first major retrospective, at MOMA. In his *New York Times* review (July 24, 1983), John Russell claimed that this show proved that Bourgeois "has few rivals when it comes to looking into corners of the psyche that are normally kept dark, and she does it with a finality that can leave the observer gasping."

Bourgeois's sculpture, with its frequent suggestions of violence, anxiety, sexuality, and cruelty, reflects her persistent fascination with the surrealist movement that reached its height when she was a teenager in Paris. She once remarked, "I belong to the same generation as Simone de Beauvoir. Not much was forbidden. Nothing was hidden." The artist is a small, intense woman with subtle, delicate features. Despite her long residence in America she retains a typically Parisian worldliness. She can be charming, polite, and courtly, but also, according to Gardner, "unexpectedly abrupt, elusive, willful." Gardner adds that "her moods mask a shyness and a naturally suspicious French nature

about people." She stays most of the year in her Chelsea townhouse, but stores her work in a farmhouse in Connecticut. She told Gardner: "I love the Chelsea area—I walk a lot and it reminds me of the Left Bank, with the open market, the flower stalls, the fur district, the prostitutes. . . . There is safety and danger, passivity and aggression all around." She finds that trips to France depress her, since they evoke too many memories. She is fascinated by "punks," with their cultivation of outrageous fashions, quasi-nihilistic attitudes, and contempt for authority, and has occasionally staged wild "happenings" at her gallery featuring punk models.

She remains very French in her lack of illusions about life and art. She said to Gardner: "I think my world is very *real*. There is isolation and loneliness-and, yes, cruelty. . . . What is important to me is *the recall.* . . . Some artists refer to what happens in the studio as 'inspiration.' I do not. I call it recall. I allow myself a *controlled recall.* . . . When I work, it is a battle. Can I say what I feel, what I recall? The fight is a kind of articulation. When it is successful, I am completely liberated."

EXHIBITIONS INCLUDE: Bertha Schaefer Gal., NYC 1945; Norlyst Gal., NYC 1947; Peridot Gal., NYC 1949, 50, 53; Allan Frumkin Gal., Chicago 1953; White Art Mus., Cornell University, Ithaca, N.Y. 1959; Stable Gal., NYC 1964, '75; Rose Fried Gal., NYC 1964; Greene Street Gal., NYC 1974; Xavier Fourcade Inc., NYC 1978, 79; Hamilton Gal. of Contemporary Art, NYC 1978; "Louise Bourgeois," MOMA, NYC 1982–83. GROUP EXHIBITIONS INCLUDE: Whitney Mus. of Am. Art Annual, NYC 1945 (and regularly until 1968); Salon de la Jeune Sculpture, Paris 1965, 69; International Sculpture Biennale, Carrara, Italy 1969; "The New American Painting and Sculpture," MOMA, NYC 1969; "Sculpture: American Directory 1945–75," Washington, D.C. 1975; "200 Years of American Sculpture," Whitney Mus. of Am. Art, NYC 1976.

COLLECTIONS INCLUDE: MOMA, Whitney Mus. of Am. Art, and New York Univ., NYC; Storm King Art Center, Mountainville, N.Y.; Mus. of the Rhode Island School of Design, Providence; Detroit Inst. of Art, Detroit; Mus. d'Art Moderne, Paris.

ABOUT: Baur, J.I.H. Nature in Abstraction, 1958; "Louise Bourgeois" (cat.), MOMA, NYC, 1982; Current Biography, 1983; Lippard, L. From the Center: Feminist Essays on Women's Art, 1976; Trier, E. Form and Space: Sculpture in the 20th Century, 1968. *Periodicals*—Art in America March/April 1975, May/June 1976, September/October 1977; Art International (Lugano) October 1964, April 1969, Fall 1978; Art Journal Summer 1976, Art News November 1978, February 1980; Arts Magazine June 1976; New York February 11, 1974, November 22, 1982; New York Times October 5, 1979, July 24, 1983; Time November 22, 1982.

***BRANCUSI, CONSTANTIN** (February 19, 1876–May 16, 1957), Rumanian-French sculptor, was a pioneer of abstract art. He abandoned naturalistic representation to capture the essence of objects. His ideal of simplicity was attained in such famous works as his "Bird in Space" series (ca. 1919–25) and *The Beginning of the World* (ca. 1924), an egglike bronze ovoid.

He was born in Hobitza, a village in the province of Gorj, in the foothills of the Transylvanian Alps of Rumania. The son of peasants (though they had small landholdings and were probably less poverty-stricken than the Brancusi mythmakers have claimed), Brancusi had three half-brothers, two brothers, and a sister. Brancusi's peasant roots have been romanticized—his close observation of nature and of the forms of peasant culture is reflected in his sculpture—but in adolescence the harshness of his back-country existence was mitigated only by his attachment to his mother and sister.

Brancusi ran away from home twice before leaving his family for good at the age of 11. Recalling those early days, he told Alexander Liberman, author of *The Artist in His Studio*, that he worked in a cleaning and dyeing shop, where he performed tasks so efficiently that the owner said, "I know something you will not be able to make—a violin." Brancusi then hollowed out wood, boiled it—and, supposedly, discovered the secret of Stradivarius. Upon hearing the violin's beautiful sound, the owner declared, "You must become a sculptor."

In 1894 Brancusi entered the School of Arts and Crafts, Craiova, Rumania, and mastered woodworking, graduating with honors in 1898. He then went to the Bucharest School of Fine Arts, and concluded his three years of study there by making *Antinöus Flayed,* a life-size male anatomical figure which was subsequently used at the Bucharest Medical School. After completing his studies in 1902, Brancusi left Rumania for Paris via Vienna, Munich, and Basel, undertaking much of the journey on foot and working en route. In 1904 he arrived in Paris, where he got a dishwashing job and was employed as a cantor in a Rumanian church. He enrolled in 1905 in the Ecole des Beaux-Arts studio of the sculptor Antonin Mercié and studied there until early 1907. His financial situation was improved by a Rumanian state grant and the patronage of a young Cracovian industrialist, Victor Popp, who admired Brancusi's sculpture. His skill in portraiture also brought a number of commissions his way.

°bran´ kōō zĕ

UPI/BETTMAN ARCHIVE

CONSTANTIN BRANCUSI

In 1906 Brancusi exhibited for the first time, at the Salon d'Automne, Paris. Brancusi was then working in the naturalistic tradition of Auguste Rodin, who praised the young sculptor's work and asked him to become his assistant. Brancusi declined and reportedly commented that nothing can grow in the shadows of great trees. Brancusi's individual style emerged in the "Sleeping Head" series he began in 1906. In 1907 he received a commission for his first major work, a funerary monument he entitled *The Prayer*. The sculptural concept of this piece marked a decisive break with Rodin, especially in the greater concern with overall abstract shape. "Traditionally," Slavka Sverakova said of Brancusi's manner of abstraction in *Makers of Modern Culture* "the space of a sculpture was understood to be underneath, or contained within, its surface. But Brancusi activated the space between the surface and the beholder, making that space subjective, to be experienced and lived through in time." Brancusi, then, arrived at his abstract style by eliminating unnecessary surface detail from his work and by radically stripping down, reducing, and simplifying his shapes.

About 1907 Brancusi moved to a new studio at 54 rue Montparnasse, Paris, and began to associated with Henri Rousseau, Henri Matisse, and Fernand Léger. He visited Bucharest in 1907 and 1909, having on both occasions exhibits in the Rumanian capital, where he showed regularly until 1928. In 1909 Brancusi met Amedeo Modigliani, became his friend, and induced him to take up sculpture. Among the leading artists, writers, poets, and composers Brancusi knew in

Paris were Ezra Pound, Raymond Radiguet, Edgard Varèse, Erik Satie, Guillaume Apollinaire, and the sculptor Julio González. Brancusi was an habitué of the cafés of Montparnasse and he enjoyed traveling. But in contrast to the gregarious side of his nature was a love of solitude and simplicity; there was also a mystical strain which derived in part from his reading of Milarepa, an 11th-century Tibetan monk.

In 1909 Brancusi adopted direct carving and, increasingly influenced by African sculpture, he worked mainly by theme, executing numerous versions of his notable works. One of his 1908 versions of *The Kiss* (ca. 1908–21) served as a gravestone for a friend in the Montparnasse cemetery. The best-known version of *The Kiss,* dating from 1910, established his reputation as a reconciler and combiner of primitive and sophisticated styles. Also in 1910, he met Margaret Pogany, a young Hungarian painter who became his friend and muse. From 1911 to 1931 he excuted many variations of the "Mademoiselle Pogany" theme, using different media. A bronze version of 1913 (Musée d'Art Moderne, Paris), in its semiabstract, slightly mannered stylization, combines art nouveau elements with streamlined forms which looked forward to those of Art Deco. Brancusi's first bird series, titled "Maiastra," the name of a mythical Rumanian bird, was begun in 1912; he developed variations on this theme for the rest of his life.

Brancusi began to achieve international recognition in the years before World War I. One of his "Mademoiselle Pogany" pieces was included in the famous 1913 Armory Shows in New York City, Chicago, and Boston, and in 1914 he exhibited at Alfred Stieglitz's avant-garde gallery at 291 Fifth Avenue, New York City.

In 1916 Rumania entered the war on the side of the Allies, but Brancusi was declared unfit for military service. In that year he carved *Princess,* which, when he exhibited it in Paris in 1920, was scorned as obscene. The phallic motif of that piece recurs in Brancusi's work. His continued interest in African tribal sculpture is evident in the series of woodcarvings he began about 1914, including *Prodigal Son* (1914), *Sorceress* (1916), and *Adam and Eve* (1921). In 1918 he began working on his wooden *Endless Column,* the first, 1920) version of which was 23 feet high and installed in the garden of photographer Edward Steichen's home outside of Paris. In 1937, while executing sculptures for a park in Tirgu Jiu, Rumania, Brancusi was to construct a steel *Endless Column* which was over one hundred feet high. Among his chief sculptures of the 1920s were *Socrates* (1923), *Cock* (1924), and *White Negress*

(1926). *Torso of a Young Man,* in polished bronze and supported on a stone and wood base, also dates from 1924 and is in the Hirshhorn Museum and Sculpture Garden, Washington, D.C. Brancusi made the wooden bases for his compositions and designed his own furniture, clothes, and household utensils as well.

Brancusi first visited the United States in 1926 and, in New York City, met Alfred Stieglitz. From 1926 to '28 he was in litigation with the US Customs Bureau, which, refusing to believe that his *Bird in Space* (1925) sculpture was a work of art, charged him with illegally importing industrial materials. Prominent artists, critics, and art dealers contested the government's ruling, and the matter was settled in the artist's favor in November 1928, when the judge ruled that, although *Bird* bore no resemblance to a living object, it was a work of art "by reason of its symmetrical shape, artistic outlines and beauty of finish." The decision led to legal changes permitting the duty-free importation of abstract art.

In Paris in the early '20s Brancusi associated with such eminent avant-gardists as Jean Cocteau, Erik Satie, Tristan Tzara, Francis Picabia, and Oskar Kokoschka. From 1927 to '28 the young Japanese-American sculptor Isamu Noguchi was his assistant. At this time Brancusi moved to his final studio, at Impasse Ronsin, not far from Montparnasse. In 1924 he produced the first of his "Fish," a series on which he worked until 1930. As quoted in Malvina Hoffman's book *Sculpture Inside and Out,* Brancusi discussed his "Fish": "When you see a fish, you do not think of its scales. You think of its speed, its floating, flashing body seen through the water. . . . If I made fins and eyes and scales, I would arrest its movement and hold you by a pattern or a shape of reality. I want just the flash of its spirit."

In 1937 Brancusi was asked by the Maharajah of Indore, India, to design a *Bird in Space* sculpture for a proposed Temple of Deliverance. Brancusi traveled to Bombay but found that the Maharajah was ill and had canceled the project. Brancusi was, however, enchanted by India, and returned home via Egypt, Holland, and Rumania, where he attended the inauguration of his *Endless Column,* which had been commissioned by the National League of Rumanian Women as a monument to the World War I dead.

Brancusi spent the rest of his life in Paris but made one final trip to the US in 1939. During World War II he worked on only a few motifs, including another version of the *Cock* (1941), in polished bronze, and the *Turtle* (1943), in wood; *Seal* also dates from 1943. The first major monograph on Brancusi, written by V. G. Paleolog,

was published in Bucharest in 1947. After the war he worked tirelessly in his Paris studio and, once famous for his hospitality and culinary skills, led a simple, secluded life in his last years. His international fame was assured, and in 1954 the Arensberg Collection donated 17 Brancusi sculptures to the Philadelphia Museum of Art; the following year he was given a major retrospective at the Guggenheim Museum, New York City. According to Robert Hughes, Brancusi's project was to endow the forms of the nonhuman world "with something of the clarity and finality of law. His style was clear as water. Its concern was the purity of carving. . . . No twentieth-century sculptor has had a more rapturous feeling for surfaces than Brancusi."

Constantin Brancusi died in his studio and was buried in the Montparnasse cemetery. The contents of his immense studio, much photographed during his lifetime, were bequeathed to the Musée National d'Art Moderne, where a reconstruction of the studio was opened to the public in 1962. It is now installed in a special building as part of the Centre Georges Pompidou (Beaubourg), Paris.

Brancusi was a short, robust man, with pale, piercing eyes and a full white beard, which gave him the appearance of a Tolstoyan mystic or seer. He reminded Alexander Liberman of "a Buddhist monk or Merlin the Magician." Brancusi would not let Liberman photograph him, for toward the end of his life he feared that if his picture were taken he would die. Modest and genial, he was also a curious mixture of hedonist and ascetic. In his earlier days Brancusi had been a lover of women, wine, and tobacco, but he rarely discussed his private life, much of which remains a mystery.

Nevertheless, Brancusi spoke with uncommon lucidity about his art. "What is real is not the external form," he said of his aesthetic aims, "but the essence of things . . . it is impossible for anyone to express anything essentially real by imitating its exterior surface." Brancusi expressed his philosophy of life in the maxim "Create like a god, command like a king, work like a slave."

EXHIBITIONS INCLUDE: Alfred Stieglitz's Photo-Secession Gal. ("291"), NYC 1914; Wildenstein and Co., NYC 1926; Brummer Gal., NYC 1926, '33; Solomon R. Guggenheim Mus., NYC 1955, '69; Muzeul de Arta al Academici R.S.R., Bucharest, Rumania 1956–57; Staempfli Gal., NYC 1960; Mus. of Art of the Socialist Republic of Rumania, Bucharest 1970; Gemeentmus., The Hague 1970. GROUP EXHIBITIONS INCLUDE: "Bucharest Artists," Palatui Ateneului, Bucharest, Rumania 1903; XVI Exposition de la Société Nationale des Beaux-Arts, Paris 1906–08; Salon d'Automne, Paris 1906, '07, '09; VI Tinerimea Artisti-

ca, Bucharest, Rumania 1907–1928; Salon des Artistes
Indépendants, Paris 1910–13; Armory Shows, NYC,
Boston, Philadelphia 1913; "Modern French Artists,"
U Praze Moderni Umeni, Prague 1914; Society of In-
dependent Artists Annual, NYC 1917; "Allies of
Sculpture," Ritz-Carlton Hotel, NYC 1917; Société An-
onyme, NYC 1920, '26; Salon des Tuileries, Paris
1926–29, '33; "Abstrakte und Surrealistische Malerei
und Plastik," Kunsthaus, Zürich 1929; "A Century of
Progress," Art Inst. of Chicago 1933; "Cubism and Ab-
stract Art," MOMA, NYC 1936; "International Surre-
alist Exhibition," New Burlington Gals., London 1936;
"Origines et développement de l'art international
indépendant," Mus. du Jeu de Paume, Paris 1937;
"From Rodin to Brancusi," Buchholz Gal., NYC 1941;
"20th Century Art from the Arensberg Collection," Art
Inst. of Chicago 1949; "L'Oeuvre du XXe siècle," Mus.
d'Art Moderne, Paris 1952; "L'Oeuvre du XXe siècle,"
Tate Gal, London 1952; São Paulo Bienal 1953; Trien-
nale, Milan 1957; "Pioneers of Modern Sculpture,"
Hayward Gal, London 1973; "Brancusi and
Mondrian," Sidney Janis Gal., NYC 1982.

COLLECTIONS INCLUDE: Metropolitan Mus. of Art,
MOMA, and Guggenheim Mus., NYC; Albright-Knox
Art Gal., Buffalo, N.Y.; Mus. of Fine Arts, Boston;
Fogg Art Mus., Cambridge, Mass.; Mus. of Art, Phila-
delphia; Nat. Gal. of Art, and Hirshhorn Mus. and
Sculpture Garden, Washington, D.C.; Cleveland Mus.
of Art; Art Inst. of Chicago; Detroit Inst. of Arts; Mus.
of Fine Arts, Houston, Tex.; Portland Art Mus., Ore.;
Mus. Nat. d'Art Moderne, and Centre Georges Pompi-
dou, (Beaubourg) Paris; Tate Gal., London; Peggy
Guggenheim Foundation, Venice; Art Mus. of the So-
cialist Republic of Rumania, Bucharest; Mus. of Art,
Craiova, Rumania.

ABOUT: Burnham, J. Beyond Modern Sculpture, 1968;
Current Biography, 1955; Geist, S. Brancusi: A Study
of the Sculpture, 1968, Brancusi: The Sculpture and
Drawings, 1975; Gredion-Weicker, C. Constantin
Brancusi, 1959; Hoffman, M. Sculpture Inside and
Out, 1939; Hughes, R. The Shock of the New, 1981;
Liberman, A. The Artist in His Studio, 1960; Lynton,
N. The Story of Modern Art, 1981; Paleolog, V. G.
Brancusi, 1947; Read, H. A Concise History of Modern
Sculpture, 1964; Ritchie, A. C. Sculpture of the Twen-
tieth Century, 1952; Spear, A. T. Brancusi's Birds,
1969; Wintle, J. (ed.) Makers of Modern Culture, 1981.
Periodicals—Art Journal no. 1 1965, Fall 1978; Art
News October 1954; Arts July 1923; Cahiers d'art (Par-
is) no. 2 1927.

*BRAQUE, GEORGES (May 13, 1882–
August 31, 1963), French painter, was, in collab-
oration with Pablo Picasso, the originator of cub-
ism, the movement that reshaped 20th-century
art. Though never apotheosized outside of
France as Picasso has been, Braque is one of the
most important painters of all time.

Because Braque's youth was spent in Le Ha-
vre, he is often mistakenly thought of as a native

French Embassy Press & Information Division

GEORGES BRAQUE

of Normandy, but he was born at Argenteuil,
near Paris, in the Seine valley, the "cradle of
impressionism." His father, besides running a
house-painting and commercial decorating busi-
ness, was a Sunday painter who exhibited at the
Salon des Artistes Français. In 1890 the family
settled in Le Havre, a seaport on the English
Channel where Claude Monet had been reared.
It was also the birthplace of the influential Fau-
ve painters Raoul Dufy and Othon Friesz; the
latter was to encourage the young Braque when
he became a painter in Paris. Braque loved the
Channel, and he was to make use of memories
of the sea throughout his career.

At 15 Braque attended evening classes at the
local Ecole des Beaux-Arts, but unlike Picasso he
showed no precocity in drawing or painting. His
father insisted that Georges acquire the family
métier, and in 1899 he was apprenticed to his fa-
ther's decorating business. He also worked for
other Le Havre painter-decorators, whose craft
involved special skills such as imitating various
wood grainings and simulating marble surfaces;
this training helped Braque to achieve technical
mastery and gave him a lifelong respect for, and
understanding of, materials, meticulous crafts-
manship, and decorative effects.

Braque moved to Paris in 1900 and enrolled
in evening art classes at the Cour Municipal des
Bastignolles. Unconvinced that he could become
a professional painter, Braque continued his ap-
prenticeship as a painter-decorator. The few
Braque canvases that survive from this period,
somber in tone and recalling early impression-
ism, show no startling originality.

In October 1902, after completing a short pe-

°bräk, zhôrzh

riod of military service, the 20-year-old Braque rented a room in Montmartre. He enrolled in the Ecole des Beaus-Arts, studying with the academician Léon Bonnat, but stayed only two months. He found the Académie Humbert far more stimulating. There he met painters of his own age or slightly older: Francis Picabia, Marie Laurencin, Dufy, and Friesz, among others. He also visited the Louvre and the Musée du Luxembourg. In the Louvre he was impressed by the dignity and economy of Egyptian and archaic Greek sculpture, by the disciplined classicism of Poussin, and by the gravity, intimacy, and textural richness with which Chardin endowed his still-life objects. Corot was another favorite, especially the figure paintings. Braque never cared for the Italian Renaissance, which he later described as merely "a period of dispersion and grandiloquence."

In 1904 Braque set up a Montmartre studio in the rue d'Orsel and began to paint seriously. That same year, having seen the first of a series of Cézanne exhibitions in Paris he became aware of the importance of the great Post-Impressionist. Cézanne's building of form through color and his search for an "architecture of space" profoundly affected Braque's development. But, unlike Picasso, Braque absorbed new influences very slowly. His artistic liberation began in 1905, when he saw the dazzlingly brilliant fauvist canvases of Matisse and Derain in an exhibition at the Salon d'Automne, Paris. "These two painters," Braque said, "opened the way to me," and for a time the lessons of Cézanne were eclipsed by the fauvist idea of pure color.

In March 1906 Braque showed seven fauvist paintings at Paris's Salon des Indépendants, all of which he later destroyed. Among his surviving fauve canvases are those painted in Antwerp in the summer of 1906, when he shared a studio overlooking the Scheldt with his friend Othon Friesz. Braque considered these views of the Antwerp harbor his first truly creative works. Fresh and colorful as these pictures are, the influence of Gauguin and Cézanne counterbalanced what Braque later described as "the fauve paroxysm." Moreover, his own structural tendencies—identified by Robert Hughes as "Braque's sense of order, *mesure,* and visual propriety"—are already evident. Braque's most inventive fauvist pictures were painted in the autumn and winter of 1906, in the fishing port of L'Estaque, in southern France, which had inspired some of Cézanne's finest landscapes. This was Braque's first visit to the Mediterranean, and *Wharf at L'Estaque* (1906; Musée d'Art Moderne, Paris) shows the impact of the brilliant colors, fierce light, and sharp contours of the Midi.

Braque was, however, becoming disenchanted with fauvism, feeling that Matisse was inimitable, and that, in his words, "it was impossible to make any further progress with the method adopted at that time." Returning to Paris in February 1907, Braque exhibited in the Salon des Indépendants and met Matisse, André Derain, and Maurice de Vlaminck. He spent the summer in La Ciotat and the fall in L'Estaque, and painted *View from the Hôtel Mistral, L'Estaque* (1907) from memory in his studio—a major step for Braque in that he was beginning fully to assimilate the lessons of Cézanne and was to become primarily a studio, rather than an easel-and-landscape, painter. "One day I noticed that I could go on working at my motif no matter what the weather might be," he observed. "I no longer needed the sun, for I took my light everywhere with me." In the *Hôtel Mistral* canvas the forms of nature were flattened and compressed in accordance with the picture plane, and bright fauvist coloring was abandoned for Cézanne-ish blues, greens, and browns.

In Paris, in 1907, Braque met the young dealer Daniel-Henri Kahnweiler, who was Picasso's representative and had recently opened a gallery. Kahnweiler took on Braque's entire work, and he and the poet Guillaume Apollinaire introduced the young artist to Picasso. At Picasso's studio, Braque was astounded, and at first deeply disturbed, by Picasso's revolutionary canvas, the as-yet-unnamed *Demoiselles d'Avignon* (1907). Even Picasso's sophisticated, avant-guard colleagues had been troubled by the painting's violence, and Braque, according to Picasso's mistress, Fernande Olivier, exclaimed, "You paint as if you wanted to force us to eat rope and drink paraffin, instead of our accustomed food."

But for Braque, as for other progressive painters, *Les Demoiselles* was, in its bold rethinking and reworking of natural forms and its primeval intensity, a catalyst. Its broken planes and its disruption of classical proportions obviously influenced Braque's *Grand Nu* (Large Nude), completed early in 1908, although Braque, still under the sway of Cézanne, gave the volumes more weight than Picasso had in *Les Demoiselles,* and his formalizations were free of Picasso's dramatic expressionism. Also, the human figure, so crucial to Picasso, never had the same importance for Braque.

In the landscapes painted on his third visit to L'Estaque, in the spring and summer of 1908, Braque interpreted nature in terms of "cylinders, spheres, and cones," to borrow Cézanne's phrase. *Houses at L'Estaque* (1908; Bern Kunstmuseum) and *Road Near L'Estaque*

(1908; Museum of Modern Art, New York City) are now considered by many art historians to be the first truly cubist paintings. Braque had abandoned sensuous fauve decorativeness; his palette was more subdued, close to that of Cézanne, but the forms were drastically reduced to their essential volumes and planes, and the activation of the rhythms produced a concentrated energy that seemed to pick up where Cézanne had left off. Describing *Houses at L'Estaque,* Robert Hughes said: "Every scrap of detail is edited out of the view. One is left with an arrangement of prisms and triangles, child's-block houses, the scale of which is hard to judge: relative size was one of the first casualties of the Cubist war against perspective." Braque sent seven of his new L'Estaque canvases to the Paris Salon d'Automne competition of 1908, but the jury, of which Matisse was a member, rejected five of them. Accordingly, Braque withdrew all the paintings and exhibited them, along with others, at Kahnweiler's gallery.

In November 1908 the critic Louis Vauxcelles, who had coined the term fauvism, published an article in the magazine *Gil Blas* accusing Braque of reducing everything to "little cubes," and thus gave the incipient movement a name: cubism. By this time Braque and Picasso had become friends. Picasso had been initially irked by Braque's new style, considering it an unethical borrowing, but he soon realized, that he and Braque were developing similar artistic ideas.

While Picasso was painting in Horta de San Juan, Spain, in the early summer of 1909 Braque was in the hill town of La Roche-Guyon, which has been called a "ready-made Cubist landscape." Braque's painting *La Roche-Guyon* was his final homage to Cézanne. Like Picasso, he was now concerned with creating what the Cubists were to call "tactile space," the use of the two-dimensional picture surface as opposed to the illusionistic representation of three-dimensional objects in deep space which had dominated painting since the Renaissance. (Braque had painted in the summer of 1908 his first cubist still life, *Still Life with Musical Instruments,* which eliminated illusionistic perspective to portray what has been described as "a solid wall of musical instruments.")

The canvases of 1908–09 mark the transition from Braque's early cubism to the period of his and Picasso's collaboration which culminated in analytical cubism. After their return to Paris in the fall of 1909, Braque and Picasso, whose Montmartre studios were nearby, began to see each other every day, beginning the partnership in which they were, in Braque's happy phrase, "roped together like mountaineers." Typical of

Braque's analytical cubism is *Violin and Candlestick* (1910), in which the objects are identifiable but fragmented, as if reflected in shattered glass, and color is reduced to a gray-ochre monochrome, as in Picasso's compositions of the same period. "Color would interfere with our conception of space," Braque explained.

In 1910 Picasso and Braque found an ally in Juan Gris, a young Spanish painter. The next year, inspired by, among other works, Picasso's 1910 cubist portrait of Kahnweiler, Braque painted his first figure compositions. Also in 1911 he met the sculptor Henri Laurens, who became a lifelong friend.

By 1911, Picasso and Braque were, in Hughes's words, "painting like Siamese twins." Nevertheless, there were differences in style. In his figurative compositions Picasso always suggested the individual personality, however abstract the form; but the figure in Braque's *Man with Guitar* (1911; MOMA) is impersonal and as vague as the musical instrument; the "man" serves to unify the complex scaffolding of planes and volumes. In another work of 1911, *Le Portuguais,* the product of a summer spent with Picasso at Céret in the Pyrenees, Braque lettered the word "BAL" in the painting's upper-right corner, thus introducing typographical characters to the canvas, an important contribution to cubist technique. The lettering created a teasing spatial ambiguity and also introduced fragments of reality to the discontinuous geometry of the cubist canvas, a motif Apollinaire commented on in a 1913 edition of *Der Sturm.* "Labels, notice, and advertisement," he said, "play a very important aesthetic role in the modern city." The injection of literal, everyday realism in the form of letters and numerals also a prevented analytical cubism from becoming too hermetic and obscure. Another new element of the "real," introduced in Braque's *Homage to Johann Sebastian Bach* (1912), was an area of simulated wood graining in the painting's lower left-hand corner. This trompe l'oeil effect allowed Braque to introduce color, not for descriptive purposes but in a manner independent of specific images.

The second stage of cubism, known as synthetic cubism, began in the winter of 1911, when Picasso pasted a piece of oilcloth (to simulate wallpaper) in the middle of an oval still life framed in rope. In the fall of 1912, after a summer with Picasso in Sorgues, in the Midi, Braque went a step further. Drawing upon his training as painter/ decorator and his instinctive feeling for *la matière,* he pasted strips of colored wallpaper, printed to simulate wall paneling, onto a painted canvas. These 57 "Papiers Collés" (1912–14, Paper Collages), including the lyrical

Valse (Violin), the elegant *Clarinet,* and *Guitar, Jou*—Braque was a music lover and musical motifs predominate in the series—"altered the direction of Cubist painting," according to William C. Agee in his *Criterion* (February 1983) article, "Looking at Braque." After the gray-ochre monochromes of analytical cubism the papiers collés were the means whereby, in Braque's words, "color came into its own." "By their absolute flatness the paper strips . . . purged the last traces of illusionist space that had been at the heart of Western traditon for five hundred years," Agee wrote. "The technique also enabled Braque and Picasso . . . to compose with a new freedom, while at the same time restoring a badly needed clarity to their art, which had become so fragmented by [late] 1911 that it was virtually impossible to decipher. Thus, through the impetus of *papiers collés,* Cubism restructured itself into its Synthetic phase, a style composed of fewer and broader shapes."

Although highly controversial, cubism had won international recognition before World War I, and Braque and Picasso achieved fame among avant-garde artists everywhere. The war, however, dispersed the Cubists. In August 1914 Braque received his call-up notification at Sorgues, where he was staying with Picasso and Derain. Picasso, a neutral because of his Spanish citizenship, accompanied Braque and Derain to the Avignon station. "I never saw them again," Picasso recalled. His statement was not meant literally, but as recognition that thenceforth they were to follow very different paths. The "heroic" days of cubism were over.

In 1915 Braque received a severe head wound at Carency and had to be trepanned. in 1916, after a long convalescence at Sorgues, he was discharged and awarded the Legion of Honor and the Croix de Guerre. When Braque returned to Paris and resumed painting, in 1917, he continued to explore and develop the principles of cubism in still-life paintings. By 1918 he had decided to go no further in the direction of abstraction, and instead began to "put some flesh back on the ambiguous bones of Cubism," to quote Robert Hughes. "In art," Braque declared in 1917, "progress consists not in extension but in the knowledge of its limits."

Braque's works of 1917–19, including the collage *Musical Forms* (1918; Arensberg Collection, Philadelphia Museum of Art), were painted in large flat areas with a quietly elegant palette which was now quite different from that of Picasso. However, there were echoes of Picasso's neoclassicism of the early 1920s in Braque's decorative, yet monumental, paintings of female nudes, often depicted carrying baskets of fruit, as in *Seated Woman with Basket of Fruit* (1926; Chester Dale Collection, New York City).

Braque's vaunted "sensuality of the spirit" animated his small, muted yet sumptuous, still lifes of the 1920s. Those works, of which *Black Rose* (1972) is an exemplar, were painted in his characteristic palette of those years—olive greens, rich browns, dark yellows, white, and black, (the last mentioned was used as a color, not as a shadow). In the still lifes of the '20s and '30s Braque's feeling for the objects was assimilated to his firm, but never rigid, pictorial structure.

In 1924 Braque moved into the house—built for him at 6 rue du Douanier by the eminent architect Auguste Perret—that became his Paris base. In 1928 he began to use lively colors, especially yellow and blue, more liberally and inaugurated the series of monumental vertical compositions known as "Guéridons," in which still-life objects are crowded into the upper-central area of the canvas. In 1929 Braque began spending summer vacations on the Normandy coast, and his series of beach scenes, which he humorously labeled "postcards," derived from those summer excursions.

The linear element in Braque's work became more important after 1930, as did his predilection for the curvilinear rhythms that have affinities with Picasso's baroque style of the early 1930s. An example is *The Clay Pipe* (1931; MOMA). He also executed designs based on ancient Greek mythology in which networks of finely drawn lines were scratched on plaster panels or painted on clay, as in *Europa* (1937).

In 1933, at the Kunsthalle, Basel, Switzerland, Braque has his first major retrospective. In a series of studio interiors of the late '30s, including *Woman with a Mandolin* (1937; MOMA) and *The Painter and His Model* (1939), the human figure reemerged in his work. These paintings are marked by great richness of color and a subtle complexity in the interlocking shapes; the figures, usually female, are, as always in Braque, presences, not distinctive individuals. It is significant that when Picasso, reacting to the spread of fascism and the agony of the Spanish Republic, was painting *Guernica* and other impassioned works, Braque was celebrating the stillness of a studio interior and the familiar intimacy of well-loved objects. In the 1950s Picasso remarked sarcastically to Braque, "Who would have thought that you would become the Vuillard of cubism?"

Braque's sculptures, which he began making in the late 1930s, were never truly three-dimensional, but were meant to be seen in relief. There was a playful treatment of horses, fish,

and birds, and the sculptures reveal his love of archaic Greek and "primitive" figurines as well as his growing interest in rough textures, a quality he was beginning to introduce into his paintings.

Braque remained in Paris throughout World War II. Though outwardly detached from the struggle—most of his paintings of 1940–44 were ostensibly calm interiors and still lifes—he was affected by the somber mood of the city under German occupation. The color black, now used as a shadow, becomes more prominent in Braque's paintings of these years; a stark, claustrophobic feeling is palpable. In *Jug and Skull* (1943) the jug is so thickly encrusted with gravel that it assumes the quality of a relief.

After the war Braque continued to work quietly in Paris and at his studio in Varengeville, Normandy. In his still lifes, such as *The Coffee Mill* (1947), there were flashes of his earlier lyricism, although the tonalities were still muted. Also in 1947 he showed for the first time at the gallery of his new dealer, Aimé Maeght.

"With Matisse and Picasso," Hughes asserted, "Braque was the last great European artist to use his own studio as a subject." According to Hughes, the "image of the studio as a privileged place of transmutation, memory, and contemplation is the key" to Braque's acclaimed series, "Les Ateliers" (1949–54, Studios). Hughes praised those paintings for their "calm transparency and baffling layers of images, their space that keeps opening and shutting like a concertina or a zigzag screen, and their mysterious cutout bird—an emblem of imagination, perhaps, set free in the room."

Images of a bird in flight preoccupied Braque in many of his paintings of the 1950s and early '60s. He used a bird motif in his ceiling decorations of the Salle Henri II in the Louvre (in their startling simplicity those commissioned designs are reminiscent of Matisse's late paper cut-outs). In his last year Braque became interested in Eastern mysticism, particularly Zen Buddhism, whose doctrine that things should be seen not separately but in their unity, or interrelationship, appealed to him. The late bird pictures suggest a quest for the spiritual, the infinite, as if the artist were seeking escape from the confines of the studio. But with Braque even the sky is made as densely tactile as the still-life objects.

Georges Braque died in Paris at the age of 81. His last painting, *The Weeding Machine* (1963), recalled with surprising emotional force his early love of Van Gogh; although its composition is suggestive of *Crows Over the Cornfield,* it lacks that work's tragic, ominous overtones. Instead, there is a sense of fulfillment as the agricultural machinery, its work done, sits idly in the field under the evening sky.

Braque in his later years is described in Alexander Liberman's book, *The Artist in His Studio,* as looking like a much younger man. In his late 70s Braque was still robust and there was "great humanity and penetration in his light brown eyes." In his youth the tall, reserved artist struck Alice B. Toklas as looking like a cowboy; and with his shock of white hair, his rugged but refined features, and his long, sensitive hands, the older Braque, too, cut an impressive figure.

Braque's lifelong companion was his wife, the former Marcelle Lapré, whom he married in 1912. In addition to painting, Braque was commissioned by Sergei Diaghilev to design the décor and costumes for the ballet *Les Fâcheux;* after World War II he contributed designs to Louis Jouvet's Paris production of *Le Tartuffe.* He was the author of numerous articles on art.

Unlike Picasso, with his provocative and often contradictory statements about art, or Matisse, with his calm and lucid comments, Braque was conceptually inclined, and his ideas were frequently expressed in the condensed form of aphorisms. In a 1917 article in the journal *Nord-Sud,* entitled "Pensees et Reflexions sur la Peinture," he wrote: "The goal [in painting] is not to be concerned with the reconstitution of an anecdotal fact, but with the *constitution* of a pictorial fact. . . . The senses deform, the mind forms. . . . Nobility grows out of contained emotion. . . . I like the rule that corrects emotion."

EXHIBITIONS INCLUDE: Gal. Kahnweiler, Paris 1908; Gal. Feldman, Berlin 1914; Gal. de L'Effort Moderne, Paris 1919; Gal. Simon, Paris 1920; Gal. Paul Rosenberg, Paris 1924, '26, '29, '30, 1936–39; Gal. Flechtheim, Berlin 1925; Kunsthalle, Basel 1933; Alex Reid Gal., London 1934, '36; Lefevre Gal., London 1934, '36; Valentine Gal., NYC 1934, '41; Paul Rosenberg & Co., NYC 1942, '46, '48, '52, '55, '64; Gal. Maeght, Paris 1947, '52, '54, '56, '58, '59, '62, '63; MOMA, NYC 1949; Cleveland Mus. of Art, Ohio 1949; Nat. Mus. of Modern Art, Tokyo 1952; Kunsthalle, Bern 1953; Kunsthaus, Zürich, 1953; Inst. of Contemporary Arts, London 1954; Royal Scottish Academy, Edinburgh 1956; Tate Gal., London 1956; Venice Biennale 1958; Mus. du Louvre, Paris 1961; Haus der Kunst, Munich 1963; "Georges Braque, An American Tribute," four-gallery retrospective, NYC 1964; "Braque: The Great Years," Art Inst. of Chicago 1972–73; "Hommage à Georges Braque," Centre Georges Pompidou (Beaubourg) Paris 1982; "Braque: The Papiers Collés," Nat. Gal. of Art, Washington, D.C. 1982; "Georges Braque: The Late Paintings," Fine Art Mus. of San Francisco 1983 Walker Art Center, Minneapolis, 1983, Mus. of Fine Arts, Houston, Tex. 1983; "Georges Braque: The Late Paintings," Phillips Collection, Washington, D.C. 1983. GROUP EXHIBITIONS INCLUDE: Salon des Indépendants, Paris 1906–09; Salon d'Automne, Paris

1907, '20, '22; Moderne Kunst, Kunstkring, Stedelijk Mus., Amsterdam 1911; Sonderbsund, Cologne 1912; Intl. Exhibition of Modern Art (Armory Show), NYC 1913; Alfred Stieglitz's Photo-Secession Gal. "29," NYC 1914; Internationale Kunstausstellung, Kunsthaus, Zürich 1925; "Cubism and Abstract Art," MOMA, NYC 1936; "Les Maitres de l'art indépendant," Petit Palais, Paris 1937; "L'Influence de Cézanne," Gal. de France, Paris 1947; "Georges Braque, Juan Gris, Pablo Picasso," Kunsthalle, Bern 1948; "Les Fauves," MOMA, NYC 1952; São Paulo Bienal, 1953; "Twentieth Century Masters," Marlborough Fine Arts, London 1955; "50 Ans d'art moderne," Palais des Beaux-Arts, Brussels 1958; "Les Sources du XXe Siècle," Mus. d'Art Moderne, Paris 1960; "Le Cubisme," Gal. Beyeler, Basel 1962; "Jean Paulhan et ses Environs," Gal. Krugler, Geneva 1963; "The Essential Cubism: Braque, Picasso and Their Friends, 1907–20," Tate Gal., London 1983.

COLLECTIONS INCLUDE: Mus. Nat. d'Art Moderne, and Centre Georges Pompidou (Beaubourg), Paris; Nouveau Mus. des Beaux-Arts, Le Havre, France; Fondation Maeght, Saint-Paul-de-Vence, France; Stedelijk Mus., Amsterdam; Van Abbemus., Eindhoven, Neth.; Rijksmus. Kröller-Müller, Otterlo, Neth.; Kunsthaus, Zurich; Kunstmus., Basel; Mus. des Beaux-Arts, and Rupf Foundation, Bern; Tate Gal., London; Glasgow City Art Gal. and Mus.; Wallraf-Richartz Mus., Cologne; Kunstsammlung Nordheim-Westfalen, Düsseldorf; Württembergisde Staatsgal., Stuttgart; Moderna Mus., Stockholm; Mus. of Copenhagen; Nat. Gal., Prague; Metropolitan Mus. of Art, MOMA, and Solomon R. Guggenheim Mus., NYC; Brooklyn Mus., NY; Yale Univ. Art Gal., New Haven, Conn.; Philadelphia Mus. of Art; Phillips Collection, and Hirshhorn Mus. and Sculpture Garden, Washington, D.C.; Walter P. Chrysler Jr. Collection, U.S.A.; Art Inst., Chicago; City Mus., St. Louis, Mo.; Nat. Gal. of Canada, Ottawa.

ABOUT: Apollinaire, G. Les Peintres cubistes, 1913; Applebaum, S. (ed.) Georges Braque: Illustrated Notebooks 1917–1955, 1971; Barr, A. "Cubism and Abstract Art" (cat.), MOMA, NYC 1936; Bissière, R. Georges Braque, 1920; "Braque, The Great Years" (cat.), Art Inst. of Chicago, 1972; Charbonier, C. (ed.) Le Monologue du Peintre, 1959; Chipp, H.B. Georges Braque: The Late Paintings 1940–1963, 1982; Cogniat, R. Braque, 1970; Cooper, D. Braque: Paintings 1909–47, 1948; Descargues, P. and others. Tout l'Oeuvre peinte de Braque 1908–1929, 1973; Dielh, G. (ed.) Les Problèmes de la Peinture, 1945; Einstein, C.G. Braque, 1934; Fumet, S. Sculptures de G. Braque, 1951; Gallatin, A.E. Georges Braque, 1943; Giry, M. Fauvism: Origins and Developments, 1982; Heron, P. Braque, 1958; Hofman, W. Georges Braque: His Lithographic Art, 1962; "Hommage à Georges Braque" (cat.), Centre Georges Pompidou (Beaubourg), Paris, 1982; Hope, H.R. Georges Braque, 1949; Hughes, R. The Shock of the New, 1980; Liberman, A. The Artist in His studio, 1960; Monod-Fontaine, I. Braque: The Papiers Collés, 1982; Mullins, E. The Art of Georges Braque, 1968; Paulhan, J. Braque le Patron, 1945; Russell, J. Georges Braque. *Periodicals*—Art News November 1972; Cahiers d'art (Paris) no. 1 1954; Criterion February 1983; New York Times August 1, 1982; Nord-Sud (Paris) no. 10 1917; Nouvelle revue Française (Paris) January 1974; Observer December 1957.

BRATBY, JOHN (July 19, 1928–), British painter, came into prominence in the London art world in the mid-1950s as a leader of the so-called Kitchen-Sinkers. He was born in Wimbledon, Surrey, the son of a wine taster who later worked as a clerk in the offices of Gordon, makers of the popular gin. At school the only subject that interested John was art, and following a short stint in the army he continued his education by entering Kingston Art School, Surrey, in 1949. He failed the intermediate exam in arts and crafts the following year, but he continued to paint on his own, supporting himself by odd jobs in a toy factory, a brewery, and on a Thames-side wharf. He established a painting work pattern that he has followed ever since: painting his immediate surroundings, his room, assortments of domestic objects, and the recurrent motif of sunflowers seen through the window. Bratby failed the intermediate exam once again, and he worked alone for another year.

In 1951 the 23-year-old Bratby applied for admission to the Slade School of Art in London. The school principal, William Coldstream, and painter Claude Rogers were impressed by the sheaf of vigorous, stark, uncompromising and, as they called them, "un-pretty" drawings Bratby had brought with him. They were ready to admit him to the Slade, but Bratby announced that he would prefer attending the Royal College of Art, which he had heard was a better school. Obligingly, Coldstream telephoned Robin Darwin, principal of the Royal College, and recommended that Bratby be admitted. He entered the school in 1951 and remained a student for three years.

In order to save rent and commuting expenses, Bratby moved into unoccupied rooms in the Royal College's vast rambling Victorian building in South Kensington, and he installed a camp bed and a paraffin stove. The room ran alongside the top story of the Victoria and Albert Museum, and, writes one critic in 1961 monograph on Bratby "connoisseurs of things like *netsukes* or knife-handles visiting the museum were often assailed by a strong and inexplicable smell of frying kippers."

Bratby's studio paraphernalia quickly mounted. It included one of the art-school skeletons— Bratby had no interest in anatomy, but he was fascinated by the shapes of the bones—and dust-

JOHN BRATBY

bins, which he enthusiastically painted whole groups of, using thick heavy paint. He later described his use of thick paint as "the natural result of vigour and energy in a painting." Also, he had been generously granted an extra allowance for art materials.

While at the Royal College, Bratby won the Abbey Minor Scholarship, the Italian Government Scholarship, and the R.C.A. Minor Traveling Scholarship. He went to Italy, but as he spoke no Italian, took very little interest in the paintings in museums, and disliked the cooking; the visit was not a success. His vision needed to be constantly nourished by the commonplace and the familiar in austere postwar England.

In 1953 Bratby was introduced to Jean Cooke, an accomplished painter who was supporting herself from her painting and pottery. He proposed marriage within four hours of meeting her, and they were married within a week. Jean Bratby, who appears in many of her husband's canvases of the '50s and '60s, was described in a *Guardian* interview (October 1, 1969) as "very small, rounded and polished like a hazel-nut: long nut-brown hair, child-like in stature and voice." Jean described Bratby's work at the time of their marriage: "He used to rush at paintings. . . . When we first met, his paint seemed very thick because I'd been working with little tiny tubes, I was so poor. He would just put on a whole tube without a second's thought. I thought he was very extravagant." For several years, the Bratbys lived and painted in one room in Fulham, often using their groceries as models.

Bratby had his first solo exhibition in 1954, one year after leaving the Royal College, at the Beaux-Arts Gallery, London. In preparation for this show, Bratby had worked intensely for a year. His work attracted widespread attention, and the show was a succès de scandale. Gallery visitors were confronted with very large canvases of uningratiating subject matter and mounds of thickly piled, slashed-on paint. Some paintings showed the Bratby breakfast table, loaded with Corn Flakes packages, rumpled, soiled napkins, and dirty, empty milk bottles. In all this domestic clutter stood the figure of Jean, distraught, wild-eyed, untidy, and looking years older than her real age. "Bratby could always be relied on to add thirty years to the prettiest young woman," wrote Alan Clutton-Brock. At the time, another critic found the faces "desperately and deliberately ugly." Naturally, attention was paid to two six-and seven-foot high pictures of water-closets. Bratby enjoyed the shock value of this supposedly "unpaintable" subject, but its deeper appeal for him was in the shapes of the bowls, pipes, and cisterns. Some critics found the heavy application of paint to be as tasteful as the subject matter and the color to be harsh and insensitive; others acknowledged that the very crudity and "unsubtlety" of the assault on the canvas was in keeping with a new kind of realism, far removed from the bland, stylish formalism of much English painting of the time. Financially, though, the exhibition was a success, as Bratby sold more than £500 worth of pictures.

The emergence of what was soon called the "Kitchen Sink School," which at the time included Bratby, Jack Smith, Derrick Greaves, and Edward Middleditch, preceded by a few years the appearance of the first of Britain's "Angry Young Men" playwrights, which was John Osborne, whose *Look Back in Anger* was produced in London in 1956. For both painters and writers the new mood was one of disillusionment with the drab provincialism of the postwar English scene and of rebellion against a worn-out "genteel" tradition. Yet, this highly subjective protest was far removed from the social realism of a Renato Guttuso in Italy or of Philip Evergood in the United States. "Kitchen-Sinkers" were more realist than socialist, and Bratby's realism, in particular, contained strong elements of expressionism (Kokoschka was one of the living artists he most admired).

The Bratbys' circumstances considerably improved, and they moved into a large, rambling Victorian house in London's suburban Blackheath district, near Greenwich. It included ample work space for both painters, and an unkempt, overgrown garden, in which Bratby built a small studio. The Bratbys and their three children kept very much to themselves, hardly

ever going out or having people in despite increasing celebrity.

In the mid-1950s Bratby's subject matter and style did not change, but his colors became brighter and more varied. In some of the canvases the face of one of his children peers through tall sunflower stalks. In 1956 he won the Guggenheim award in the British section of the Venice Biennale—he won a second award there in 1959—but his work reached a much wider audience in 1957 when he painted the huge canvases of artist-protagonist Gulley Jimson in the film version of Joyce Cary's novel *The Horse's Mouth,* starring Alec Guinness. Bratby's rough, aggressive, heavily impastoed style made the mural-sized canvases extremely effective on the screen. Although a self-described "hermitlike character," Bratby enjoyed the publicity. "It's illogical and mad," he admitted later, "and springs from God knows where, but when the spotlight's on me, I feel enormously encouraged."

In 1959 Bratby was made an Associate of the Royal Academy, despite his unconventional subject matter and his off-beat manner. He was working at a tremendous pace, and in October of that year he showed 28 new oils at London's Zwemmer Gallery. The art critic for the London *Times* commented that "He can be visually greedy, slightly coarse-grained, literal, shocking in a good-humored, terrier sort of way." It was noted that in addition to Bratby's "usual drab cast of bohemian friends and family" there was a new addition, Brigitte Bardot, based on magazine photographs. *The Guardian* praised the manner in which Bratby's "gluttonous eye devours his surroundings in huge, optical mouthfuls," but the same essay remarked on the artist's Bardot pictures: "He has not yet begun (and perhaps he never will begin) to learn how to brood. Profundity therefore is beyond his present reach."

In March 1960, Bratby published a novel, *Breakdown,* which he also illustrated. Attacked in some quarters for its lurid, sensational subject matter, it nevertheless sold well. The novel's leading character, James Brady, is a successful, happily married painter who is possessed by a savage, futile, and self-destructive urge which lands him in desperate, sometimes ludicrous, situations. The book ends with his death under melodramatic circumstances worthy of a Gothic novel. The public was eager to find autobiographical elements in this very readable novel about an artist's disintegration, perhaps because it seemed to corroborate the myth of the "crazy" artist. And Bratby admitted that "now and again I have drawn incidents from my own experience

and distorted and exaggerated them into pure fiction," but added that if Brady were truly Bratby, "I would indeed be an awful mess." The author even teased the reader by having the real John Bratby discussed by other characters in the novel. (James Brady says that Bratby is a better draftsman than he, but that he [Brady] gets more humanity in his work. Elsewhere it is stated that Bratby and Brady "are both of the same generation" and that both express "the tensions and unrest of our atom-bomb-threatened age.")

November 1961 marked Bratby's first New York City exhibit, at the Bernhardt Crystal Galleries. *The New York Times* noted that "Bratby has moved from the kitchen sink to the studio window and is looking out." In Bratby's earlier work, the *Times* continued, "all objects—stoves and windows and people—were uniformly painted," and in his current canvases "the poetry seems to be fighting its way out through the color, and the years of austerity seem to be passing." The New York *Herald Tribune* wrote that whereas Bratby's newest paintings were "no more conventionally agreeable in approach than the clutter of dirty dishes he used to make his subject, they're more dynamic." The *Tribune* went on to praise the intricate patterning and the lushness of the palette.

In his book, *A Painter's Pilgrimage,* American painter Raphael Soyer describes a visit to Bratby in his Blackheath house in May 1961. Bratby, then 32, was "bearded but very young-looking, his even pale complexion [was] accentuated by red lips [and] small brown eyes behind thick horn-rimmed glasses, [and he had a] high forehead with long, soft dark brown hair." Soyer was reminded of "a character out of Russian literature," and he found something Russian-seeming in Bratby's manner of painting and in some of the faces in his canvases. Soyer had been impressed by Bratby's "vital, free, non-conforming" canvases at the Crystal Galleries, and seeing Bratby work at them he was amazed at the one-painting-a-day speed with which the artist turned out his canvases. "You'll probably change as you go on, in your point of view, your state of mind, in technique," Soyer said. Bratby replied emphatically, "No, I'll always paint like this. I once made an attempt to change, but with unsatisfactory results." When Soyer asked if he could call on him again and sketch him, Bratby replied, "Sure, any time. I always work. I never leave this place. I never go anywhere."

On his second visit five days later, Soyer was "impressed by the amount of Bratby's work, its vigor and vitality, also by its lack of polish and by its repetitiousness." He made two sketches of

Bratby, one of him "sitting on a hand-carved wooden claptrap of an armchair with some of his wild figure paintings behind him." (Both sketches are reproduced in Soyer's book.)

In the 1960s Bratby carried out several large-scale commissions: in 1963 a three-panel mural called *The Feeding of the 5,000* painted for Heythrop Hall in Oxfordshire; a religious mural, *Golgotha,* for St. Martin's Chapel in Lancaster; in 1968 drawings for the *Oxford Illustrated Old Testament;* and in 1969 a 20-by-7-foot mural for the Frankfurt Finance House. His monograph on Sir Stanley Spencer was published in 1969.

Bratby continued to enjoy celebrity status in the '60s, though critical opinion in Britain was less favorable than in the '50s. An emphasis on nonfigurative art made Bratby's expressionist realism seem outmoded to some critics, and he was also criticized by the Marxist writer John Berger, who claimed that Bratby had been spoiled by success in a capitalist society. Moreover, a *Guardian* review of Bratby's retrospective exhibit at the Lane Gallery, Bradford, in January 1966 found Bratby's draftsmanship weak and questioned whether he had ever been a revolutionary painter. The review ended with an ironical prediction that "Sir John Bratby," as President of the august Royal Academy, would address "the glittering throng at the annual dinner."

"I could not go with the tide," Bratby said later, explaining his response to the change from figurative to abstract art in Britain. For years my work was ignored by the art establishment. Perhaps this rejection had a disencouraging effect on me, perhaps not. Certainly it was a difficult period, from 1962 to 1970, though I did many of my best paintings in that period. One series was of "Paintings Within Paintings," and another was of vast works which were the repainting of three panels from a mural called *The Feeding of the 5,000.*"

Bratby was especially embittered in the '60s by what he saw as the new orthodoxy of abstract art, which took hold in British art circles after having been "imported" from New York. So pervasive was the new orthodoxy, Bratby wrote, that "English artists formerly supported by the Arts Council, the critics, and main public galleries were suddenly rejected. One limited concept of what Painting is was replaced by another, the replacement posing as the New Enlightenment in Painting. . . . The all-consuming monster was the art of the Plastic Age and commercial visuals—nonhuman creations with no soul."

Bratby's work done from 1970 to 1976 includes a series of what he calls "Romantic Emotional" works that celebrate the female and another series of portraits of "Individuals" which was exhibited at the National Theatre, London, in spring 1978.

John Bratby, now divorced, continued for several years to live and work in the combined studio and coach-house in Blackheath. The untidy, overgrown garden strewn with fragments of Victorian statuary and ramshackle hand-carved and hand-painted armchairs is in striking contrast to the trim lawns and hedges of the neighboring suburban houses. He has since moved to the south coast of England. Large and small canvases pile up in his several studios. His many portraits include figures from the theater and movie worlds, but it is his self-portraits that make the strongest impression. Vigorously painted flowers have largely replaced dustbins and kitchen faucets as motifs, and Bratby is aware of how horrified his former mentors would have been at this relatively "pretty" subject matter.

Critics have commented on how little Bratby's thickly painted style has developed over the years, in spite of a lightening of the palette and a change of themes. Nevertheless, Bratby has retained the individuality of his best works, and remains, in the words of the London *Times,* "a rare and admirable spirit of independence."

EXHIBITIONS INCLUDE: Beaux-Arts Gal., London 1954, '55, '56, '59; Tartaruga Gal., London 1955; French and Company Gals., NYC 1958; Zwemmer Gal., London 1959, '60, '61, '64, '66, '68; Lane Gal., Bradford, England 1960, '66; Bernhardt Crystal Gals., NYC 1961; Ashgate Gal., Farnham, England 1962, '64; ACA Gal., NYC 1964; Gal. ACA, Rome 1964; Calouste Gulbenkian Gal., People's Theatre, Newcastle-upon-Tyne, England 1965; Vanderbilt Gal., Boston 1965; Thames Gal., London 1966; Gal. 66, London 1966; Laing Art Gal., Newcastle-upon-Tyne, England 1967; Fairfield Hall, Croydon, London 1967, '68; Gray Art Gal., Hartlepool, England 1969; Furneaux Gal., London 1970; South London Art Gal., London 1971; Thackeray Gal., London 1971, '74, '75; Sackville Gal., E. Grinstead, England 1974; City Art Gal., Wakefield, England 1974; The Menories, Colchester, England 1974; Preston Street Gals., Brighton, England 1974; Southwell Brown Gal., London 1975; Nat. Theatre, London 1978. GROUP EXHIBITIONS INCLUDE: Pittsburgh International, Carnegie Inst. 1955, '56, '57; Venice Biennale 1956, '59; "The Seasons," Contemporary Art Society, Tate Gal., London 1956; "Fiftieth Anniversary Exhibition," Tate Gal., London 1960.

COLLECTIONS INCLUDE: Royal Col. of Art, Tate Gal., Contemporary Arts Society, Arts Council of Great Britain, British Council, and Victoria and Albert Mus., London; MOMA, NYC; Detroit Inst. of Arts; Ashmolean Mus., Oxford, England; Walker Art Gal., Liverpool; Nat. Gal. of Canada, Ottawa; Nat. Gal., New South Wales, Australia; Carlisle Art Gal., England; Nat. Gal. of New Zealand, Wellington.

ABOUT: Bratby, J. Stanley Spencer's Early Self-Portrait, 1969; Clutton-Brock, A. John Bratby, 1961; Rothenstein, J. British Art Since 1900, 1962; Soyer, R. A Painter's Pilgrimage, 1962. *Periodicals*—Guardian October 1, 1969.

BROCQUY, LOUIS LE. *See* LE BROCQUY, LOUIS

BROOKS, JAMES (October 18, 1906–),

American painter, is a leading representative of the second wave of Abstract Expressionists. As Sam Hunter observed, "He absorbed the innovations of Pollock and de Kooning into a personal manner, but broadened and smoothed out something of their expressive individuality in a more consonant and representative art of unerring formal harmony."

Brooks was born in St. Louis, Missouri. Although both his parents were southerners, his father's occupation as traveling salesman moved the family from city to city and region to region. They lived in Oklahoma City in 1911, moved to Denver in 1914, and to Dallas in 1916. From 1923 to 1925 Brooks attended Southern Methodist University, Dallas, majoring in art. He went on to study at the Dallas Art Institute before moving to New York City in 1926. There he attended night classes at the Art Students League, studying with Kimon Nicolaides and with Boardman Robinson, the American Scene painter and muralist. To finance these studies he worked as a commercial letterer, most often of advertising displays. He was eager to free himself of provincial attitudes, but at that time there was no coherent body of American art in the modern style to which he could apprentice himself.

During the summer of 1931 Brooks shared a studio in Woodstock, New York, with the painter Bradley Walker Tomlin, who was then a Realist, and did not arrive at abstraction until about 1946. In the years 1931–34 Brooks took many trips in the West and Southwest, making sketches for the paintings and prints he was then doing in the social realist style. Typical of this period are *Oklahoma Barber Shop* (1931) and *Early Morning*. His works were being exhibited in New York and other cities, and in 1936 his lithograph *Copper Mine, Butte* was purchased by the Whitney Museum of American Art, New York City. However, from 1936 to 1942 he virtually gave up easel painting in order to execute murals under the auspices of the Works Progress Administration's (WPA) Federal Arts Project. It was during these years that he met Jackson Pol-

JAMES BROOKS

lock and Philip Guston, who were to become his colleagues in the abstract expressionist movement.

Brooks achieved wide recognition for his WPA murals, which were characterized by realism, an easy mastery of large spaces, and the ability to compose flat color shapes on a monumental scale. In 1938 he completed *The Acquisition of Long Island,* a mural for the Woodside branch of the Queensborough Public Library. Two years later another large mural, *Labor and Leisure,* was completed for the post office of Little Falls, New Jersey. Brooks's career as a muralist culminated in *Flight* (1939–42), executed for the rotunda of the International Marine Terminal of La Guardia Airport in Queens. An impressive monumental work which occupied him exclusively for two-and-a-half years, *Flight* measured 12 feet 3 inches by 235 feet, and blended crisp realism, as in the depiction of such figures as Icarus and Leonardo da Vinci, with cubist elements and the near-abstraction of a cluster of flying machines. Unfortunately, the mural, consisting of several horizontal panels following the curve of the rotunda, was painted over in the mid-1950s by order of the Port Authority of New York, but it was recently restored.

In 1942 Brooks left the WPA project and joined the US Army. He served in the historical division as a combat artist in Egypt and the Near East and spent the last five months of the war in Washington, D.C.

Returning to New York City after his discharge with the rank of technical sergeant, Brooks renewed contact with many of the paint-

ers he had met through the WPA, several of whom, including Pollock, Guston, and Tomlin, were now leading members of the American avant-garde. He also began submitting his own work, which at this time was influenced by the synthetic cubism of Picasso and Braque, for criticism to Wallace Harrison, a well-known teacher whose thorough understanding of cubism Brooks admired. Moreover, he set out to "learn how to paint again," with greater emphasis on the paint surface and an attempt to make "negative intervals" just as real as the images that could be thought of as being representational.

From 1946 to 1948 Brooks taught drawing at Columbia University. In 1947 he also taught at Brooklyn's Pratt Institute and married the painter Charlotte Park. In the late '40s his brand of cubism became looser and more spontaneous. Such works as *Dialogue* and *Number 18,* both of 1947, combine cubist forms with the free brushwork of abstract expressionism.

In 1948 Brooks made a major breakthrough in his development as an abstract painter. He was spending the summer in Maine, doing works on paper which he would then glue to a canvas. But the paint or the glue, or possibly both, seeped through to the reverse side of the canvas, forming unusual, haphazard shapes—and the shapes interested him more than the paintings which had accidentally caused them. For two years he experimented with this automatic method which depended, as Jean Arp might have said, "on the laws of chance." Many of these works resemble the early all-black "drip" paintings of Pollock, with whom Brooks was then spending time in New York and Montauk, Long Island. His influence can also be seen in Brooks's *Number 27* (1950), in which color and line become one, much as they do in Pollock's swirling abstractions. Yet, even if Pollock were the central liberating influence, Brooks's painting differs in feeling from Pollock's. As Irving Sandler has pointed out, "The one [Brooks's style] is measured, nuanced and slow in tempo, the other is paroxysmal, raw, and fast in tempo." Unlike Pollock, Sandler continued, Brooks "worked and reworked his chance shapes, thoughtfully shaping and relating them—somewhat in the spirit of Cubist picture-making."

Brooks had his first solo show in 1950, the year he reached his mature painting style, at the Peridot Gallery, New York City. Although Irving Sandler classifies Brooks as a first-generation Abstract Expressionist, other critics group him with the second wave of action painters who emerged in the mid-1950s.

About 1952 Brooks's color areas became larger, though they still comprised an all-over surface accented with splatters of paint. He sought a balance between spontaneity and control, and this reconciliation is a key element of his unique style. "The conflict between spontaneous and deliberate behavior, a great dualism of modern times," Brooks said in 1953, "is keenly felt by the artist."

About 1953 he abandoned fluid tones—which the critic Dore Ashton said were "of great beauty, . . . marked by their undulant rhythms that, while wholly free of specific reference, seemed to conjure up landscape analogies." *Gant* (1955; Albright-Knox Art Gallery, Buffalo, New York) is an important example of this technique. In the mid-'50s Brooks's all-over method of composition was modified by the introduction of complex organic forms into his work, although frenetic brushstrokes and splatters of paint were retained. About 1955 Brooks began to give his paintings strange names in order to stress the uniqueness of each canvas. Examples of this practice are *Gant, Altoon* (1956), and *Karrig,* also 1956.

In 1958 Brooks was awarded First Prize at an exhibition staged by the Art Institute of Chicago. In the early 1960s he added a sharp, linear calligraphy to his flat, irregular forms, as in *Octon* (1961), *Cooba* (1963), and *Quagett* (1964). Regarding *Cooba,* now in the Albright-Knox Art Gallery, Brooks wrote: "Cooba . . . is in oil, but has characteristics (blotting of areas, washes) that caused me to turn thereafter mostly to acrylic emulsion, a water medium that accomplishes these more readily." In this medium, too, Brooks sought a rapprochement of opposites— the equipoise of closed forms and the open line, and of chance and deliberate manipulation.

In 1963 the Whitney Museum mounted a Brooks retrospective which subsequently traveled throughout the United States. Also in 1963, Brooks was artist-in-residence at the American Academy in Rome; two years later he was visiting artist at the New College, Sarasota, Florida.

About 1966 Brooks, still working in acrylics, began to brighten his palette and give his forms more sharply defined edges, though he managed to retain a sense of compositional "randomness." In the words of Aldo Pellegrini, "A sense of calm, of equilibrium, and a contained lyricism emanate from his pictures." His brushstrokes had become far less turbulent than those of other action painters. *Arrib* and the *Culladon* (which is six feet by seven feet), both of 1967, contain large definite color areas as well as splatters of paint. The trend toward clarity and structural simplicity continued into the 1970s in such works as *Fonteel* (1974) and *Jorah* (1976), in which the large expanse of color create an elegant monu-

mentality of composition. Despite changes in emphasis, Brooks's aesthetic had changed little since the early 1950s. In 1971 he wrote, "I start a canvas with a mindless complication of several colors which I then accept as a separate entity, and on equal terms."

An intense man with rugged, heavily lined features, James Brooks divides his time between New York City and the Springs, East Hampton, Long Island. He believes that, as he said in 1953, "discipline and spontaneity, [which] had seemed so antagonistic, merge as [the painter] engages in a dialogue with his painting." More concerned with formal relationships than with images, Brooks said, "My interest is in this encouragement of the forms that are intent on surfacing, and my function is to act not as a maker but as a discoverer." He regards good painting as "a door opened to man's spirit," and in 1955 Brooks declared, "The painting surface has always been the rendezvous of what the painter knows with the unknown."

EXHIBITIONS INCLUDE: Periodot Gal., NYC 1950; San Francisco Mus. of Art 1963; Whitney Mus. of Am. Art, NYC 1963; Philadelphia Art Alliance 1966; Dallas Mus. of Fine Arts 1972; Finch Col., N.Y. 1975; Martha Jackson Gal., NYC 1975, '76; Lerner-Heller Gal., NYC 1978; Gruenebaum Gal., NYC 1980, '83; "Retrospective," Portland Mus. of Art, Me. 1983. GROUP EXHIBITIONS INCLUDE: Pittsburgh International, Carnegie Inst. 1952, '55, '58; "The Decade," Whitney Mus. of Am. Art, NYC 1955; "12 Americans," MOMA, NYC 1956; São Paulo Bienal 1957; Osaka International, Japan 1958; Art Inst. of Chicago 1958; "The New American Painting," MOMA, NYC 1959; Documenta 2, Kassel, W. Ger. 1961; "Abstract Expressionists and Imagists," Solomon R. Guggenheim Mus., NYC 1961; Pittsburgh International, Carnegie Inst. 1964; "Art of the United States, 1670–1966," Whitney Mus. of Am. Art, NYC 1966; "20th Century Art from the Nelson Rockefeller Collection," MOMA, NYC 1969; "Museum Pieces of the Post-War Era," Solomon R. Guggenheim Mus., NYC 1971; "The Private Collection of Martha Jackson," Albright-Knox Gal., Buffalo, N.Y. 1974; "30 Years of Am. Printmaking," Brooklyn Mus. 1976; "Survey of Modern Am. Art," Solomon R. Guggenheim Mus., NYC 1979; "Am. Painting 1930–1980," Haus der Kunst, Munich 1981; "Abstract Expressionism Lives," Stamford Mus., Conn. 1982; "Images of Texas," Univ. of Texas, Austin 1983.

COLLECTIONS INCLUDE: Metropolitan Mus. of Art, MOMA, Guggenheim Mus., and Whitney Mus. of Am. Art, NYC; Brooklyn Mus, N.Y. Albright-Knox Art Gal., Buffalo, N.Y.; Tate Gal., London.

ABOUT: Abrams, H. New Art Around the World, 1966; Ashton, D. American Art Since 1945, 1982; Cheney, S. The Story of Modern Art, 2d ed. 1958; Flanagan, G. A. Understanding and Enjoying Modern Art, 1962; Hunter, S. James brooks, 1963, American Art of the 20th Century, 1972; Miller, D. C. (ed.) "12 Americans" (cat.), MOMA, NYC, 1956; Moore, E. (ed.) Contemporary Art 1942–72: Collection of the Albright-Knox Art Gallery, 1972; Pellegrini, A. New Tendencies in Art, 1966; Ruepple, M. "James Brooks" (cat.), Dallas Mus. of Fine Arts, 1972; Sandler, I. The New York School 1978. Periodicals—Art in America September 1976, February 1980; Art News February 1963, February 1967, April 1967, December 1972; Arts Magazine September 1978, December 1983; New Yorker March 6, 1971; New York Times November 12, 1972, June 29, 1975, November 30, 1979; Village Voice September 15, 1978.

*BUFFET, BERNARD (July 10, 1928–), French painter, has been called his country's only important contemporary academic artist. Immensely popular with collectors all over the world, Buffet's emaciated figures, drawn with an assured and razor-sharp line, are also readily recognized and accepted by the public, who see them on Christmas and post cards and film posters. "Buffet is in the street," wrote his friend Maurice Druon in the booklength study Bernard Buffet; "his art is popular art." Despite the artist's considerable success, few avant-garde critics take him seriously, citing the lack of inventiveness and unmerciful sentimentality of his later work. For his part, Buffet has repudiated abstraction in any form, calling it "a return to infancy" for "tired intellectuals."

In 1928, Buffet was born to a poor family living near the Place Pigalle, Paris. His father, who ran a small factory, took little interest in him. Expelled from the lycée for his manifest lack of interest in anything but drawing, in 1944 he was accepted into the Ecole des Beaux-Arts, Paris. Buffet's progress was swift; by the time of his first solo show, at a Paris bookstore in 1947, the essential elements of his style and sensibility were formed: the angular drawing of tortured or miserable men and women (many with his own features); the complete dependence on line to define form, with sparse color—grays, off-whites, bleached blues, and blood-reds—applied seemingly as an afterthought; and the canvas scratched as if in despair. Derived on the one hand from German expressionism, and on the other from his personal modification of 19th-century stylizations of Byzantine and medieval religious figures, Buffet's rather grim imagery struck a responsive chord in the dispirited postwar climate of France. Critics have connected Buffet's early successes with the simultaneous flourishing of existentialist philosophy.

As quick as was Buffet's artistic maturation, the growth of his reputation was no less rapid. By the age of 20, he had participated in both the

°bü fä´, ber när´

BERNARD BUFFET

Salon des Indépendants and the Salon d'Automne, won the Prix de la Jeune Peinture, and shared the prestigious Prix de la Critique with Bernard Lorjou. The art world's publicity mills were far less sophisticated in the late 1940s than they would become after the '60s, but Buffet's astonishing rise was aided by a media blitz. In 1958 a major retrospective of his work was held in Paris; Buffet was 30, an exceedingly young age for such an honor. The collector Yasushi Inone inaugurated in 1974 a museum in Mishima, Japan, devoted solely to a collection of the artist's work assembled by a Japanese banker.

The reason for Buffet's popular success can be found, in part, in the subjects he chooses to paint. Each of his yearly shows in Paris is devoted to a single theme. The crucified Christ, quite obviously the symbol of the artist's own tortured individuality, appears constantly in his oeuvre, beginning with the 1946 *Christ* and *Deposition from the Cross* and culminating in the 11-painting series of the Sacré-Coeur in 1967. Even better known are Buffet's sad clowns—*Head of Clown* and *Clown Violinist* (both 1955), for example—which have been widely reproduced and copied. Circus acts and richly dressed matadors comprise other such thematic categories. The artist, a world traveler, has also painted cityscapes of many world capitals, including Paris, New York, Venice, and Pisa, applying the same elongating stylization to buildings as he does to the human figure.

Taken as a whole, Buffet's subjects are not in any way difficult, and it may be for that reason that the public has embraced him in gratitude.

"Buffet has followed none of the tendencies of his time," wrote Druon. "He has not been concerned with researches, with systematic experimentation, and his success provides more material for sociology than his work offers fresh matter for aesthetics. [Buffet] has not sought to breach the rampart of the incommunicable with his brush; he has not run his head against the beyond of things. In the last analysis, Buffet is a classic, almost an academic, the only important academic of our period, who has pursued with a gait all his own the path laid down by Monsieur Ingres and Monsieur Courbet."

Other critics have not been so generous. In an article entitled "The Unstoppable Decline of Bernard Buffet" in *Galerie; Jardin des arts*, A. Bosquet claims that the painter's early still lifes and figures reflected "the poverty and introspection of the postwar world," but since then Buffet has abandoned his graphism, acceded to bourgeois demands for clowns, and become "the most banal academic artist." Writers have also commented ironically on the contrast between Buffet's present affluence and the mannered emaciation of his figures. Buffet replied: "I have known success. It has sometimes been thought exaggerated. The mistake made is imagining that I have, even once, in order to obtain it, consented to betray the truth such as I feel and conceive it."

Buffet's response to abstract art has been equally adamant. "Does a painter know how to draw a hand or a foot? No? Then let him start learning. I refuse to confuse decorators and makers of bathroom mosaics with painters. . . . This kind of painting is based solely on relationships of colors. It turns its back on form. Something in it is missing. I feel that abstract art is a dead end. An effort was made to pass it off as the highest form of intellectual evolution. This is paradoxical, for tired intellectuals actually invented the haughty form. Abstraction is above all a return to infancy, a game played among initiates incapable of carrying the weight of real discipline."

Buffet works constantly, painting for ten hours or more every day in a studio heaped with the detritus of artistic effort—paint tubes, used brushes, broken stretchers, mountains of old rags. Blue-eyed and dark-haired, he lives with his wife Annabel, a model who often poses for him in costume, and his two children in the village of St. Cast, Britanny. He also owns a chateau in Aix-en-Provence and a large apartment/studio in Paris.

EXHIBITIONS INCLUDE: Gal. Les Impressions d'Art, Paris 1947; Thommen Gal., Basel 1950; Kleemann Gal., NYC 1950, '51, '53; Gal. Viscounti, Paris 1952, '53;

Gal. Drouvant-David, Paris 1952, '53, '54; Knoedler Gal., NYC 1952, '56; Los Angeles County Mus. of Art 1954–55; Gal. Motte, Geneva, Switzerland 1956; Gal. David and Garnier, Paris 1957, '58, '59, '60, '61, '62, '63, '64; Gal. Charpentier, Paris 1958; Wally Findlay Gal., NYC 1959, '64, '66, '67; Lefevre Gal., London 1963, '66, '71; Gal. de Arte Laietana, Barcelona, Spain 1974–75; Mus. Bernard Buffet, Mishima, Japan 1974; Gal. Biosca, Madrid 1974; Gal. Sargot-le Carrec, Paris 1976; Gal. Maurice Garnier, Paris 1978; Gal. des Chaudronniers, Geneva, Switzerland 1982. GROUP EXHIBITIONS INCLUDE: Salon des Indépendants, Paris from 1947; Salon d'Automne, Paris from 1947; Salon de Mai, Paris from 1948; Arthur Tooth and Sons, London 1955, '57; Gal. Lefevre, London 1957, '64.

COLLECTIONS INCLUDE: Mus. d'Art Moderne, Paris; Toronto Mus. of Art; Mus. Bernard Buffet, Mishima, Japan; MOMA, NYC.

ABOUT: Druon, M. and others Bernard Buffet, 1966. *Periodicals*—Art in Australia October–December 1974; Art News February 1977; Galerie: Jardin des arts (Paris) April 1975; Print Collector (Italy) December 1978.

Yves Gavaert, Brussels

DANIEL BUREN

BUREN, DANIEL (1938–), French artist, is so resolutely opposed to the "art object as displayed in a museum" and to romantic notions of the "artist as hero" that he refuses to provide any biographical details other than that he was born in Boulogne-Billancourt and that he maintains residences in Paris and Berlin. In 1974, Buren wrote: "My work since 1965 rules out a biography, which . . . would provide information not about the nature of the work, but only about the artist's career and his 'respectability.'" His rejection of the mystification of art has led him to favor neutral, anonymous works and to abhor the personality cult. Indeed, Buren even dislikes being photographed and he creates what he calls "zero-level" art from which the signature of a unique personal style is erased.

Since 1965 Buren's work has been based on variations of one motif: the vertical stripe. He uses striped paper panels—the stripes vary only in color, from green to yellow, blue, red, brown, orange, or gray, and alternate with white bands—which he pastes, like wallpaper, to any available surface, though he prefers to adorn the public thoroughfares of large cities. Sometimes his characteristic striped rectangular panels are on cloth and allowed to hang freely, like a banner; other times the stripes are painted on a wall or other exterior.

Buren was originally a painter, but in the late 1950s and early 1960s he grew dismayed with the almost complete ignorance of new developments in American art that prevailed—and, ac-

cording to him, continues to prevail—at the Paris Ecole des Beaux-Arts and other French art schools. "The students hadn't even heard of Pollock," Buren recalled. About 1965, he chose to work exclusively with the stripe, probably because it is so ordinary a form, everywhere to be seen—on awnings, beach tents, and the like—without suggesting high art. More important, Buren values the stripe because it is "real," devoid of illusion, mystery, and content, which are the characteristics of traditional painterly art that he repudiates.

Buren's work has been linked to the conceptual art movement of the 1960s and 1970s, and his ostensible "anti-art" posture calls to mind the dadaist iconoclasm of Marcel Duchamp. However, Buren has observed that even Duchamp's outrageous found objects—such as the metal bottle rack and the urinal—are now enshrined in museums, a telling example, to Buren as well as radical critics of the so-called tradition of the new, of how avant-garde art has lost its power to shock, has been tamed and institutionalized by the academy and the large museums.

In theory, Buren's concerns are close to those of modern abstract art, but his practice remains outside that tradition. His work is conceptual in that it reflects the shift from the definition of art as an object of aesthetic contemplation and satisfaction to art as an idea or as an emblem of the artistic process. Moreover, Buren's repeated use of the striped format elevates the question of where painting is to go in the postmodern era to the level of coherent "art strategy," to quote the critic Caroline Tisdall.

To imbue the commonplace artifacts of urban

life with his art, Buren has traveled in the cities of many countries and plastered the facades of their buildings with his stripes—and in doing so has had brushes with the law. In various sections of Bern, Switzerland, surreptitiously in the dead of night, he pasted up some of his striped panels, but an order-loving citizen reported him to the police. Buren was arrested and spent several days in jail. In Paris, official permission is nearly always required to put up a poster or sign, but in 1970 Buren foiled the bureaucracy by finding a way to affix a white and orange striped paper panel to corners of the large billboard spaces in the Paris Métro reserved for posters and advertisements. Soon 140 Métro stations had their own Buren. The artist had each panel-adorned wall photographed from the platform opposite, and in 1973 the series of pictures was published in two large volumes, titled *140 Stations du Métro Parisien.*

In late 1970 Buren took his "guerrilla art" to New York City, where his striped panels began to appear unexpectedly in public places—on buildings, walls, and fences as well as on trucks and other nonstationary sites. Buren, who had procured a large list of names of New York art-world doyens, cleverly publicized his heretofore anonymous activities by giving a phone number to call for a recorded message stating where the latest "work" could be seen.

Although many of Buren's striped panels were soon removed, some were still in place in New York as late as 1973. One with green and white stripes was attached to the ground floor of a dingy building's Bleecker Street facade. With its setting an abandoned store, the canvas panel was entirely unremarkable, unless a passerby stopped to look and wonder: Why is it there? The panel was reproduced on the March 1971 cover of *Art News,* and in that photographic context the panel and its urban surroundings formed an effective—if accidental—abstract design. In *The Meanings of Modern Art* (1981) John Russell remarked, "Where in his combine paintings Robert Rauschenberg literally brought the city into art, Daniel Buren takes art into the city, but surreptitiously."

Buren's unorthodox, underground procedures constitute a revolt against the whole art museum and gallery system. In many of his published tracts on art theory, he asserts that the museum reifies art; it confers an aesthetic framework, an economic value, and an alien mystique which Buren deplores because, in his words, it has transformed "the reality of the world into an image of the world, and History into Nature."

Nevertheless, when his work is shown in a museum or a gallery, Buren attempts to transform the building itself—on occasion, its exterior as well as its interior—into a complement of his conceptualist perspective. In so doing, Buren seeks to transcend the "closedness" of museums, a stifling atmosphere, according to Buren, in which an old master, a Mondrian abstraction, and Warhol pop are all reduced to the same status, that of "art objects" on display. For instance, his 1973 exhibit at the John Weber Gallery, New York City, was "extended" by striped panels that Buren strung across the street to the building opposite.

Buren has "opened up" the display space of other museums and galleries as well. The piece he contributed to the 1971 "International Exhibition" at the Solomon R. Guggenheim Museum, New York City, was, unlike most of his displays, a visual confrontation with the space rather than an integration of disparate elements. He felt that the Gugggenheim's spiraling interior diminished whatever was shown inside, and challenged it with a blue-and-white striped banner which he suspended from the skylight. Measuring 66 feet by 32 feet, it occupied nearly the entire height and width of the museum's central well, thus blocking the ramp-to-ramp view of other works, which were meant to be seen from a distance. Because of objections from several of the exhibiting artists whose works were dwarfed by Buren's piece, the banner was withdrawn. Though opposed to its withdrawal, Buren claimed, in true neodadaist fashion, that the ensuing contretemps was also "part of the piece."

For the "Eight Contemporary Artists" exhibit at the Museum of Modern Art, New York City, in 1974, he tried to go beyond the museum's confines by stringing black-and-white striped paper panels, which John Russell called "echo images" of MOMA's Philip Johnson-designed windows, along the corridor and in the garden. Two years later, Buren showed simultaneously in two galleries which are located on different floors of the same building, 420 West Broadway, in lower Manhattan's SoHo section. The upper exhibition space was on the fourth floor, at the John Weber Gallery, the lower was two floors down, at the Leo Castelli Gallery.

Buren designed the show so that the viewer's attention was focused on 420 West Broadway's exterior as well as on both galleries' rooms. He displayed large striped "supergraphics," the top halves of which occupied the fourth floor with the corresponding bottom halves situated downstairs. This strategy made demands on the imagination and memory of the viewer, who had to move about to see the piece in full and even then was forced to complete the image in his or her mind. Buren intended this exhibit to show that

there can be no fixed vantage point from which art "ought" to be seen.

One of Buren's most colorful and visually striking projects, occasioned by a regatta on the Wannsee and sponsored by the Berliner Künstlerprogramm and the Folker Skulima Gallery, took place in Berlin in 1975. He made nine pieces of nylon into sails and fitted them to the masts of nine sailboats which took part in the regatta. The sails were sewn together in alternate bands of white and the colors blue, green, yellow, red, orange, and maroon. The event was almost a "happening" but for the mathematically precise logic with which it was executed.

After the regatta the sails were installed in the gallery of the Berlin Academy of Fine Arts in the order in which the boats finished the race. The spacing of each piece was determined by the length of the wall divided by nine. Titled "Sail/Canvas, Canvas/Sail," the exhibit contrasted the practical function of sails, as in the regatta, with the transformation of the sails into a form of canvas art when displayed in a museum. A booklet commemorating the event was published by the Berlin Künstlerprogramm.

Daniel Buren is a bearded, dark-haired man of medium height; his manner is brisk and pleasant. The unmarried Buren lives in Paris on a small side street, a few blocks south of the Pigalle Métro station, where he occupies two floors of a walk-up apartment building; the living quarters are on the lower floor, the floor above is his studio. Working in an environment that is more like a cluttered office than a studio, Buren manages to find his way amid the seeming disorder of voluminous correspondence, mathematical calculations, and the artist's own manuscripts and publications.

When asked how he makes a living from art that cannot be purchased, Buren explained that museums and galleries engage him to present his displays, which are usually newsworthy. Also, he occasionally designs stripe motifs for the homes of private patrons. Buren believes that he has, in his words, accomplished "a complete rupture with art"; if there is to be an art of the future, he told *The New York Times* (August 11, 1974), it would be "an inquiry—a work of which nothing can be said, except that it is."

EXHIBITIONS INCLUDE: "Peinture affichée—Pitture affisse," Incontri Internazionali d'Arte, Rome 1972; "Part 2," John Weber Gal., NYC April 1973; "Within and Beyond the Frame," John Weber Gal., NYC October 1973; "Transposizione," Gal. Toselli, Milan 1974; "Triptyque," Gal. Rolf Preisig, Basel 1974; "Three Passages," Gal. Grada, Zagreb, Yugoslavia 1974; "Transparency-Opacity," Max Protetch Gal., Washington, D.C. 1974; "Voile/Toile, Toile/Voile," Berliner Künstlerprogramm, Berlin 1975; Simultaneous exhibit, John Weber Gal. and Castelli Gal., NYC 1976; "Three Installations," Gal. Paul Maenz, Cologne 1977; Gal. Yvon Lambert, Paris 1978; Nat. Gal. of Victoria, Melbourne 1979; Stedelijk van Abbemus., Eindhoven, Neth. 1981; Krefeld Mus., W. Ger. 1982. GROUP EXHIBITIONS INCLUDE: Kunstmarkt, Cologne, 1972; Documenta 5, Kassel, W Ger. 1972; "Identification," Hayward Gal., London 1973; "Exposition de peintures réunissant certains peintres qui mettraient la peinture en question," Place Vendôme, Paris 1973; "Political Art," Max Protetch Gal., Washington, D.C.; "Eight Contemporary Artists," MOMA, NYC 1974–75; "12 x 1" Palais des Beaux-Arts, Brussels 1975.

ABOUT: Contemporary Artists, 1983; "Five Texts" (cat.), John Weber Gal., NYC, 1973; Hughes, R. The Shock of the New, 1981; Russell, J. The Meanings of Modern Art, 1981. *Periodicals*—Artforum September 1973; Art News March 1971; New York Times August 11, 1974, October 20, 1974, October 1, 1976; Studio International (London) September-October 1975; Village Voice November 1, 1973.

***BURRI, ALBERTO** (March 12, 1915–), Italian painter, shocked the still classically minded art world in Italy in the early 1950s with his daring use of unconventional materials, but he has since been acclaimed, to quote the *Christian Science Monitor* (July 28, 1972) as "one of the most original interpreters of the vast abstract expressionist current stirred up by World War II."

Burri was born in Città di Castello, a small town in the province of Umbria, in central Italy. His father was a wine merchant, his mother a schoolteacher. Burri showed an early interest in painting, but was trained to be a physician, studying medicine from 1934 to 1940 at the University of Perugia. After receiving his degree, he joined the Italian Army, and served as a doctor in North Africa during World War II. In 1943 he was captured by the British and worked as a prison camp doctor for 18 months, then was transferred to an American prisoner-of-war camp near Hereford, Texas. It was there that, for want of something to do, he began to paint. The dearth of real art materials forced him to find available substitutes. "I painted 12 or 14 hours a day," he recalled. "For canvas I often used sacks from the kitchen. If I ran out of what I needed I used something else. When I used up all my white paint, I used toothpaste." In all likelihood his struggles at that time to obtain art supplies account for his later use of unconventional materials.

After his repatriation in 1945, Burri returned for a short time to his native Umbria, and then moved to Rome, a vital center of artistic and intellectual activity in the postwar years. He aban-

°boō rē´, äl ber´tō

Aurelio Amendola

ALBERTO BURRI

doned medicine in order to follow his painting impulse. He had no formal training, but was determined to become a full-time artist. His cousin, Annibale Bucchi, a violinist and composer, provided him with a place to stay. Burri's painting in the POW camp had been figurative, and for a short time in Rome he explored conventional painting techniques, using oil and tempera. "I began in a traditional, figurative way," he said; "little by little it modified, evolved, changed." In 1947 he had his first solo show, at the Galleria La Margherita, Rome. His first totally abstract works were in 1948, beginning with a small painting called *Nero I.* "Today it may not seem so exceptional," Burri said of it in 1978, but "nobody was doing anything quite like it 30 years ago." For *Nero I* and other works he used ordinary coal tar, sometimes mixed with paint, sometimes in its pure state, calling these works "Catami," after the Italian word for the medium he was using. He soon began to incorporate found materials, such as burlap sacks, paint rags, and discarded fabrics, into his compositions.

About 1950 Burri made his first convex "Gobbo" (Hunchback) paintings, using small tree branches and other materials. He also made what he called "Muffe" (Moulds), paintings from an impasto of pumice and linseed oil. The thickly painted canvases seemed to be sprouting fungus.

In 1949 Burri visited Paris, several European countries, the United States, Mexico, and Japan. He participated in 1951, along with Ettore Colla, Giuseppe Capogrossi, and Mario Ballocco, in the Gruppo Origine in Rome, which believed,

according to Henry Martin of *Art News*, "that pure formalist abstraction was a narrow, simple-minded and decorative victim of the figurativism to which it was an insufficient reaction." "Alberto Burri," Martin continued, "was among the first to discover that freedom from representation and geometry give importance not only to the artist's gesture but to the sheer physicality of his materials, and thus to a kind of autonomous poetry within them." About 1952 Burri began using burlap sacks to create his "Sacchi" (Sacks). These were completely nonobjective works, but their rough, brown surface alluded to the earth. Burri noted: "I have always been interested in making something beautiful from poor materials." In these compositions of sacking, said one critic, "Burri accepted and incorporated any chance effects such as tears, patches or imprinted lettering, redeeming rubbish and transmuting it into a challenge."

Some European critics have seen in Burri's tearing and stitching of the burlap and his frequent use of red paint—his palette is limited almost exclusively to black, white, and red—a connection with the artist's experience as a wartime doctor. Michel Ragon calls Burri's oeuvre an "art of the wound and the scar." But Burri shuns such explanations, saying: "Words are no help to me when I try to speak about my paintings." He has also stated, "I gave to the paintings the name of either the color or the shape because I don't want to make any suggestions in a literary sense."

Burri had a solo show at the Galleria dell'Obelisco, Rome, in 1952. The following year he went to the United States and had his first American exhibition at the Frumkin Gallery, Chicago; the show traveled to the Solomon R. Guggenheim Museum, New York City, and also to Los Angeles and San Francisco. That same year the influential curator and critic James Johnson Sweeney wrote a monograph on the artist. Burri lived in America until 1960, working as an art teacher. He exhibited in Chicago, New York, and Oakland, California, and in 1955 was included in the "New Decade" exhibition at the Museum of Modern Art, New York City, as well as in the São Paulo Bienal and the Carnegie International, Pittsburgh. When some of his works arrived in the US in 1955, they were taxed by the Customs Service, which declared that they were not art but "vegetable matter." Later the decision was reversed in Burri's favor. In 1955 Burri married the American choreographer Minsa Craig.

By the mid-1950s Burri was treating his canvases with fire and smoke, and turning to such materials as burnt cloth, burnt wood, and thin,

rusted iron sheets. He called his fire technique *combustione.* Gerald Nordland, director of the Milwaukee Art Center, wrote of these works: "There is an element in Burri's fire paintings that reaches backward to primordial feelings." Although Burri maintains that "materials are not important, it's the forms that intererst me," his exploration of materials was most influential, and, according to some authorities, inspired such artists as Yves Klein, Conrad Marca-Relli, and Robert Rauschenberg.

In the late 1950s Burri was making his series of "Ferri" (Irons) collages of thin iron sheets welded together. He varied their surfaces by treating them with fire and acid. In 1958 he won the Carnegie International Prize and the following year he participated in Documenta 2 in Kassel, West Germany. He was awarded the International Art Critics Prize at the Venice Biennale of 1959, and had an exhibition the next year at the Martha Jackson Gallery, New York City.

In 1960 Burri returned to Italy with his wife. Since then he has divided his time between Rome, his ancestral home in Città di Castello, and his wife's home in Los Angeles. In the 1960s he developed the "Plastiche" (Plastics), works made from very thin plastic sheet, often burnt, smoked, crumpled, scarred, and blistered. His "Cretti" (Cracks) were invented in the 1970s. In these huge, monochromatic works Burri manipulated the drying process of thickly painted surfaces to create a web of cracks resembling parched earth. James H. Beck of *Arts Magazine* described the "Cretti" as "a new kind of landscape."

Burri had three retrospective exhibitions in the 1970s: the first in 1971 at the Galleria Civica d'Arte Moderna, Turin, the second in 1972 at the Musée National d'Art Moderne, Paris, and the third at the Guggenheim Museum in 1978. Hilton Kramer observed in his review of the Guggenheim show in *The New York Times* (June 23, 1978) that the "sheer materiality of this art," with its use of real textures and surfaces in relief, "was always essential to its impact," but he added "it would be foolish to deny that the passage of time has not had the effect of taming its power." "In spite of the roughness and unartistic quality of the material," Aldo Pellegrini wrote, "Burri's work is without aggressiveness: it has, instead, a lyrical impetus, although this is controlled, ascetic, severe." Some critics have unfavorably compared what they consider Burri's typically European "tasteful sensuousness" with the "raw crudeness" of American abstract expressionism. However, Lavinia Learmont, writing in *Contemporary Artists,* finds "genuine anguish" in Burri's work and sees in his collages of rotting sacks and other scraps of rubbish "visual metaphors of man's self-inflicted wounds." Whatever their final judgment, critics agree that Burri, in the words of Aldo Pellegrini, "has contributed on a large scale to the development of the technique of assemblages that employ discarded and unartistic material."

A Burri museum is being planned in Città di Castello, where the artist now spends most of his time, painting in the nearby mountains. Alberto Burri was described in the *New York Post* as "a short handsome owl with gray hair and black eyebrows." In a recent statement Burri asserted his individuality and his disregard for criticism of his art. "I don't pay much attention to the public. I'm interested in working for myself. I'm driven to painting by the sheer pleasure of it. Art's the most important thing for an artist. You must keep your mind on it constantly—and hit upon the right path."

EXHIBITIONS INCLUDE: Gal. La Margherita, Rome 1947, '48; Gal. dell'Obelisco, Rome 1952, '54, '57; Fondazione Origine, Rome 1953; Frumkin Gal., Chicago 1953, '54; Stable Gal., NYC 1953, '55; Oakland Art Mus., Calif. 1955; Gal. del Cavallino, Venice 1956; Gal. Rive Droite, Paris 1956; Gal. del Naviglio, Milan 1957; Gal. La Bussola, Turin, Italy 1957, '65; Carnegie Inst., Pittsburgh 1957; Albright-Knox Art Gal., Buffalo, N.Y. 1958, '64; Mus. of Art, San Francisco 1958; Palais des Beaux-Arts, Brussels 1959; Martha Jackson Gal., NYC 1960; Hanover Gal., London 1960; Gal. de France, Paris 1961; Marlborough New London Gal., London 1963; Mus. of Fine Arts, Houston 1963; Walker Art Center, Minneapolis 1964; Marlborough-Gerson Gal., NYC 1964; Gal. Civica d'Arte Moderna, Turin, Italy 1971; Mus. Nat. d'Art Moderne, Paris 1972; Solomon R. Guggenheim Mus., NYC 1978; J. Corcoran Gal., Los Angeles 1979; Gal. D'Ascanio, Rome 1979; Instituto Italiano di Cultura, NYC 1980; Gal. L'Isola, Rome 1981. GROUP EXHIBITIONS INCLUDE: "Art Club of Rome," Gal. Nazionale d'Arte Moderna, Rome 1947, '50; "Salon des Réalités Nouvelles," Mus. d'Art Moderne, Paris 1949; "Gruppo Origine," Fondazione Origine, Rome 1951; Venice Biennale 1952, '56, '59, '66, '68; "Younger European Painters," Solomon R. Guggenheim Mus., NYC 1953; Pittsburgh International, Carnegie Inst. 1955, '58; "New Decade," MOMA, NYC 1955; "Painting in Post-War Italy 1945–57," Columbia Univ., NYC 1956; São Paulo Bienal 1955, '59, '65; Documenta 2, Kassel, W. Ger. 1959; "Prizewinners from the Venice Biennale," World House Gal., NYC 1961; "Four Italian Painters," Kestner Gesellschaft, Hanover, W. Ger. 1964; "Contemporary Italian Art," Ulster Mus., Belfast 1967; "New Italian Art 1953–71," Walker Art Gal., Liverpool 1971; "Paris-Paris: Création en France, 1937–57," Centre Georges Pompidou (Beaubourg), Paris 1981.

COLLECTIONS INCLUDE: Gal. Nazionale d'Arte Moderna, Rome; Mus. Nat. d'Art Moderne, Paris; Nat. Gal.,

Berlin; Albright-Knox Art Gal., Buffalo, N.Y.; Carnegie Inst., Pittsburgh.

ABOUT: Bénézit, E. (ed.) Dictionnaire des peintres, sculpteurs et graveurs, 1976; Nordland, G. "Alberto Burri: A Retrospective View 1948–1977" (cat.), Solomon R. Guggenheim Mus., NYC, 1978; Pellegrini, A. New Tendencies in Art, 1966; P-Orridge, G. and others (eds.) Contemporary Artists 1977; Ragon, M. "Alberto Burri" (cat.), Gal. de France, Paris, 1961. *Periodicals*—Art News December 1954, March 1981; Art World Summer 1978; Arts Magazine October 1979; Christian Science Monitor (Boston) July 28, 1972; New York Herald Tribune February 14, 1960; New York Post July 22, 1978; New York Times November 29, 1953, May 29, 1955, September 27, 1959, June 23, 1978.

REG BUTLER

BUTLER, REG(INALD COTTERELL)

(April 13, 1913–), British sculptor, came into prominence in the early 1950s as Britain's most challenging postwar sculptor. He was born in Buntingford, Hertfordshire, the only son of Friedrick William Butler, an Irishman and relative of William Butler Yeats. His mother, the former Edith Barlthrop, was of Anglo-French extraction. At the age of seven Butler was fashioning his first sculptures by melting silver paper in the grate of a stove and running it into molds formed by ashes beneath the bars. While at Hartford Grammar School he painted a striking portrait in oil of an old man.

In 1932 Butler began to train as an architect and in 1937 became an Associate of the Royal Institute of British Architects in London. He married Mary Child the following year, and between 1937 and 1939 he served as a lecturer at the Architectural Association School. Afterward, he spent one year as an engineer, before taking conscientious objector status in 1940 and going to work in a village smithy in Sussex.

During his stay in Sussex in the war years, Butler put up prefabricated huts and mended farm tractors, milling machines, and harvesters. He was haunted by a feeling that farm implements were mysterious archaic presences, and he began to sculpt in forged iron. As yet, architecture remained his chief occupation, and from 1946 to 1950 he served as an editor for architectural journals.

Butler abandoned his career as an architect in 1950, at the age of 36, and became a full-time sculptor. The previous year, he had exhibited his first works in a three-person show at London's Hanover Gallery. The piece that attracted the most attention was Butler's seven-foot-high *Woman*, a skeletal form in forged iron with its center of gravity well off the line of its actual supports. This model, along with *Torso* (ca. 1950; Albright-Knox Gallery, Buffalo, New York), was shown at the Institute of Contemporary Arts' London-Paris exhibition at the New Burlington Galleries in the spring of 1950. Of *Torso*, Butler has written: "Although it is abstracted it is by no means nonfigurative, that is to say, it is a *torso*. Technically it is the first figure in which I used arc-welding as a means of modeling; the forms in iron in previous figures were forged only, not forged-welded-forged."

Butler's work at the New Burlington Galleries exhibit was hailed as "the tragic and humble record of the sensation of growing up." Butler had worked with Henry Moore in the late 1940s, but his early open-iron sculpture represented a distinct change from the "direct carving" aesthetic of Moore and of Barbara Hepworth. Unlike Moore's earthbound figures, *Torso* is, in effect, a drawing in space. As with other early works by Butler, it derives from the iron sculptures of Julio González and Picasso. The close-to-life-sized *Torso*, with its spiky, insectlike forms and staring eyes was a manifestation of postwar surrealist imagery. It confronts the viewer head on and has a strange, disquieting appearance.

In 1950 Butler was appointed Gregory Fellow in sculpture at the University of Leeds for a three-year term. At the Venice Biennale of 1952 he showed *Reclining Figure*, which had been commissioned by the Festival of Britain Committee. This sculpture, now in Scotland's Aberdeen Art Gallery, brought him international attention and is regarded as one of Butler's most important larger achievements.

Butler won the International Sculpture Com-

petition organized in 1953 by the Institute of Contemporary Arts for a piece of sculpture to commemorate or symbolize the theme of the Unknown Political Prisoner. The prizes, totaling $32,000, were made possible by an anonymous donor. More than 3,500 entries from 57 countries competed, and Butler's entry won the $12,670 grand prize. Butler described his model, which was intended to rise to a minimum of one hundred feet when actually built, "as designed to provide interest both as seen from a distance, and close to." He pointed out its three elements: the natural rock foundation that provided a "natural" setting even if the monument were to be erected in the center of a city; the three women in whose minds the unknown prisoner was remembered; and the town, a symbol "which suggests the tyranny of persecution and the capacity of man to rise beyond it." Butler omitted the prisoner himself from the cagelike structure, which *The New York Times* (March 16, 1953) compared to "a battered television aerial."

In those days of the cold war and the aftermath of World War II, much dispute was stirred regarding the possible political motivations of the competition. Butler's winning entry provoked storms of protest, culminating in an act of violence by an outraged Hungarian refugee, Laszlo Szilvassy, who wrenched the sculpture from its stand in London's Tate Gallery and destroyed it. Some sympathy was elicited from the public when they learned that Szilvassy's parents had been murdered by the Nazis, and Butler was eventually able to reconstruct the piece. Members of Parliament signed a motion to defeat a proposal to erect the sculpture on the cliffs of Dover, though a secret ballot taken among visitors to the Tate Gallery exhibition confirmed the judges' original decision and the Museum of Modern Art in New York City bought a small bronze replica of Butler's model; both West Berlin and Amsterdam offered the full-scale monument a permanent home. The incident raised the question, "Is a public art possible in a fragmented world with no universally accepted visual symbols?"

The Oracle, commissioned in 1952 for the entrance hall of the new Hatfield Technical College near London, was another important piece from the early 1950s. Like *Torso,* it is a mixture of closed forms and open armature in forged iron, suggesting a spiky, monstrous insect. Butler said that he had in mind not only the "oracles and sphinxes of antiquity but the earliest flying creatures, the pterodactyls, and the biomorphic aspect of the latest jet aircraft."

In 1954 Butler gave up welded sculpture in favor of cast bronze—more specifically, shell bronze, then a new method of casting which, according to *Art News,* "produces sculpture several times lighter than ordinary bronze." At his solo show at London's Hanover Gallery in spring 1954, no iron sculpture was on view. Metal rods were still used as supports, but the figures were closed forms, cast or wrought directly in bronze. *The Manipulator* (1954; Albright-Knox Art Gallery) is representative of this phase of his work. The emphasis had shifted to mass and surface qualities, and away from the linear and spatial concerns of his earlier compositions.

In the winter of 1955 Butler's work was given its first American solo exhibition at the Curt Valentin Gallery, New York City. His highly praised *Girl with a Vest* was later acquired for the Nelson A. Rockefeller Collection. In this piece the shell bronze was used to depict the taut torso of the girl as she pulls a vest over her head.

Butler began to paint some of his bronze figures so that they no longer resembled the metal, and *Personality Girl,* commissioned by Edward Hulton, founder of Britain's now-defunct weekly, *Picture Post,* was cast in silver. Moreover, Butler's relatively naturalistic figurative sculptures of female nudes made in the years 1955–60 disappointed critics who thought they verged on academism. After 1960, however, Butler showed a complete renewal, which was manifested in small bronzes inspired by primitive, especially African, sculpture. Outstanding works of the early 1960s are *Head of Ara* (1962) and *Towers* (1964).

By 1960 Butler had established a reputation as an influential teacher and theoretician. He had taught sculpture at the Slade School of Fine Art, London, as well as at Leeds University, and in 1962 he published *Creative Development: Five Lectures for Students,* in which he attempted to define the aims of modern art. In these lectures he expressed concern for the "essence" of things, and he stressed the relationship between perception and creation. By all accounts, he was a remarkable teacher.

About 1968 Butler moved from the style inspired by primitive and African sculpture to what at first sight looked like a kind of pop realism. His new sculptures were technically remarkable female nudes cast in bronze, tinted in flesh tones with a form of industrial paint which gave them a velvety, skinlike surface, and posed in odd, erotic positions. John Canaday, reviewing Butler's show at the Pierre Matisse Gallery, New York City, in *The New York Times* (March 31, 1973), wrote that a first impression on entering the gallery was of works of the "waxworks-casting-from-life" school, "but it takes only a minute to recognize that in spite of

real hair, wigs, and realistic glass eyes and hyperexplicit femaleness, these are not realistic sculptures but the wildest, most excessive fantasies." Some critics found the work self-indulgent.

In the manner of Germaine Richier and Giacometti, Butler frequently places his figures of girls in a constructivist framework of metal bars. This kind of setting, as the *Phaidon Dictionary of 20th Century Art* observes, makes the young women appear as victims of oppression, "yet their anxiety and apparent helplessness is offset by a rich sensuality, which has been the hallmark of Butler's latest work."

In recent years Reg Butler has withdrawn from the public art scene in England, rarely exhibiting and never publicly expressing his views. He and his wife Mary still live in Berkhamstead, Hertfordshire, in the modernized wing of an old red-brick mansion which once served Charles II as a shooting-box. Butler's studio is full of equipment of his own making, and contains electric motors, a camera, a lithographic press, welding gear, and a blower for the furnace.

Butler is a tall, wiry man, with a broad forehead and shaggy hair. The diverse forms taken by his sculpture over the years spring in part from an attitude best expressed by Butler in his statement in the catalog to "The New Decade—22 European Painters and Sculptors," exhibition at MOMA in 1955: "Looking for a sculpture is like trying to find the hub of a wheel. Often when one thinks one has found the hub—one is still along a spoke! Often one runs right through the hub and out along another spoke! If you travel outwards along a spoke *away* from the hub you come towards the sterile world of the academic art systems. . . . Art which packs a punch is always near the hub: is a fusion of a multitude of strands."

EXHIBITIONS INCLUDE: Curt Valentin Gal., NYC 1953, '55; Hanover Gal., London 1954, '57, '63; Kunstkring, Rotterdam 1957; Gal. Springer, Berlin 1957; Gal. Alex Vomel, Dusseldorf 1958; Pierre Matisse Gal., NYC 1959; '60, '73; Konstmus. Goteborg, Sweden 1960; Gal. Obelisco, Rome 1961; J.B. Speed Art Mus., Louisville, Ky. 1963; Queens Square Gal., Leeds, England 1964; Welsh Arts Council Gal., Cardiff, Wales 1967. GROUP EXHIBITIONS INCLUDE: Hanover Gal., London 1949; Venice Biennale 1952, '54; "The Unknown Political Prisoner," Inst. of Contemporary Arts, London 1953; "Young British Sculptors," toured USA, Canada, and W. Ger., 1955; "The New Decade—22 European Painters and Sculptors," MOMA, NYC 1955; Pittsburgh International, Carnegie Inst. 1958; Middelheim, Antwerp Biennale, Belgium 1961; "Twelve Views of Mankind," MacRobert Centre Art Gal., Univ. of Stirling, Scotland 1974.

COLLECTIONS INCLUDE: Tate Gal., Arts Council of Great Britain, British Council, and Contemporary Arts Society, London; Whitworth Art Mus., Manchester, England; City Art Gal., Bristol, England; City Art Gal., Leeds, England; Nat. Gal., Edinburgh; Municipal Mus., the Hague; Mus. Civico, Turin, Italy; Gal. d'Arte Moderna, Venice; Konstmus., Goteborg, Sweden; Nat. Gal., Oslo; MOMA, NYC; Brooklyn Mus., N.Y.; Albright-Knox Art Gal., Buffalo, N.Y.; Mus. of Fine Arts, Boston; Smith Col. Mus. of Art, Northampton, Mass.; Carnegie Inst., Pittsburgh, Hirshhorn Mus. and Sculpture Garden, Washington, D.C.; Baltimore Mus.; City Art Mus., St. Louis, Mo.; Univ. of Michigan, Ann Arbor; City Art Gal., Toronto; Nat. Gal. of South Australia, Adelaide.

ABOUT: Butler, R. Creative Development: Five Lectures for Students, 1962; Current Biography, 1956; Hall, D. (ed.) "Twelve Views of Mankind" (cat.), MacRobert Centre Art Gal., Univ. of Stirling, Scotland, 1974; Lucie-Smith, E. Late Modern: The Visual Arts Since 1945, 1969; Read, H. A Concise History of Modern Sculpture, 1964; "Reg Butler" (cat.), Pierre Matisse Gal., NYC, 1962; Ritchie, A.C. (ed.) "The New Decade—22 European Painters and Sculptors" (cat.), MOMA, NYC, 1955; Schwartz, P.W. The Hand and Eye of the Sculptor, 1969. *Periodicals*—Architectural Review February 1953; Art and Artists June 1974; Art News May 1954, February 1955; Life June 1, 1953; New York Times March 16, 1953, January 16, 1955, March 31, 1973; Picture Post April 4, 1953; Time March 23, 1953.

CALDER, ALEXANDER (July 22, 1898–November 11, 1976), American sculptor, illustrator, and engineer, gave a new dimension to modern sculpture with his brilliantly inventive and witty "mobiles" and "stabiles" and was the first 20th-century American artist to win international acclaim.

Calder was born in Lawnton, Pennsylvania (now part of Philadelphia) into a family of artists: his grandfather, Alexander Milne Calder (his statue of William Penn is on top of the Philadelphia City Hall), and his father, Alexander Stirling Calder, were traditional sculptors and his mother, the former Nanette Lederer, was a professional portrait painter.

Calder ("Sandy" to his family and friends) recalled that at the age of five he was making little wood and wire figures, and that at eight he was making jewelry for his sister Peggy's doll out of bits of copper wire found in the streets. In 1906 his family moved west to Arizona to assist his father's recovery from a heart ailment. In 1910, after a stay in Pasadena, California, the family returned east to New York state, but in 1913 moved back to California, where Alexander Stirling Calder was appointed Acting Chief of Sculpture for the 1915 Panama-Pacific Exposi-

© Hans Namuth, NYC

ALEXANDER CALDER

tion, which was held in San Francisco. In each new home, Sandy set up his own workshop, recalling that "mother and father were all for my efforts to build things myself—they approved of the homemade." In San Francisco he was fascinated by the machinery and movement of the gaily painted cable cars.

When in 1915 his family moved again, to New York City, Alexander Calder decided to become an engineer and entered Stevens Institute of Technology in Hoboken, New Jersey. He graduated in 1919 with a degree in mechanical engineering, his senior thesis topic, paradoxically enough, being titled "Stationary Steam Turbines." A fellow student remembers Sandy in his Stevens days as "a very quiet, warm person, physically solid and ready to roughhouse at any moment just for fun."

Calder spent the next few years, without much enthusiasm, in a succession of jobs, including automotive engineer, draftsman, insurance company investigator, and machinery salesman, which took him to various parts of the country. His outlook improved when he returned to New York City in 1922 and attended drawing classes at a public night school. The same year he joined the crew of the passenger ship *H. F. Alexander* on its New York–San Francisco run through the Panama Canal, working in the boiler room.

He began a more serious concentration on art in 1923 with his enrollment in the Art Students League, New York City, where he remained for three years. He studied briefly with Kenneth Hayes Miller, Thomas Hart Benton, and Guy Pène du Bois and for longer periods with those veterans of the Ash Can School, George Luks

and John Sloan. However, the academic approach to art made little impression on him for he was, and always remained, the inventive craftsman.

While still at the League, Calder got his first job as an artist in 1924, free-lancing for the *National Police Gazette* and working at various commercial assignments, for, as he said, "I seemed to have the knack of doing it with a single line." With his *Gazette* pass, he spent two weeks in the spring of 1925 sketching the Ringling Bros. and Barnum and Bailey Circus, with which he became increasingly fascinated. At this time he also created his first wire sculpture, a rooster sundial.

In 1925–26 Calder made some bold and spirited brush-and-ink drawings of animals and birds at the Bronx Park and Central Park zoos. A book, *Animal Sketching,* based on these drawings was published in 1926, and his text contained the following extremely acute observations: "ANIMALS—ACTION. These two words go hand in hand in art. . . . Remember that 'action' in a drawing is not necessarily comparable to physical action," and above all, "Enjoy what you are drawing."

Also in 1926 Calder made his first wood carving, with the amusing title *The Flattest Cat,* and had his first exhibition of oil paintings at the Artists' Gallery, New York City. Calder's early oils, depicting circus and urban subjects, have been called "creditable," but as Jean Lipman has pointed out, "It was not until he began painting in gouache that he found a technique perfectly suited to his high-spirited, rapid, spontaneous expression."

In June 1926 Calder sailed for Europe as a day laborer on a British freighter *Galileo,* visiting London and then Paris, where he took sketching classes at the Grande Chaumière. On his second visit to Paris that year he took a studio room at 22 rue Daguerre and there he made small articulated animals in wood and wire and then the first figures for his miniature *Circus.* A friend visiting his studio suggested that Calder make his objects completely out of wire. "I accepted his suggestion, out of which was born the first Josephine Baker"—the earliest of several wire portraits he made of the famous music-hall star, then the rage of Paris. Some of these "calligraphic sculptural caricatures" were already prototypes of the mobile concept inasmuch as they were designed to be suspended by a thread from the ceiling and quiver at the slightest breeze, "as if a tremor of life ran through them," to quote the artist.

Through the English engraver Stanley William Hayter Calder met the sculptor José de Creeft and other personalities in the Paris art

world. In 1927 Calder began giving performances of his miniature *Circus* for his friends and received enthusiastic reviews from Paris critics; he also exhibited animated toys at the Salon des Humoristes. Nevertheless, he still considered himself a painter.

Calder returned in 1927 to the United States, where the Gould Manufacturing Company wished to market the "action toys" he had begun designing for them. In his room in New York City he gave performances of his *Circus,* and held his first exhibit of wire animals and caricature portraits at the Weyhe Gallery. However, an *Art News* review began, "Of the wire sculpture of Alexander Calder Jr., the best is silence." A group of wire athletes made for an advertising agency earned him a check for the then sizable sum of one thousand dollars.

In Paris in the fall of 1927 Calder resumed his *Circus* performances, which became a leading attraction in intellectual and artistic circles. He met Jules Pascin and Joan Miró; the latter became a lifelong friend and profoundly influenced Calder's work. Pascin wrote a catalog introduction for Calder's first solo show in Paris, at the Galerie Billiet in early 1929. Calder also exhibited wire sculpture and jewelry in Berlin, where a film was made on him as part of a series called "Artists at Work." On the voyage back to New York in June 1929 he met Louisa Cushing James, a grandniece of William and Henry James. Calder fell in love at once, and after an ardent courtship, they were married in Concord, Massachusetts, in January 1931. They later had two daughters, who are now Sandra Davidson and Mary Howar.

In Paris in 1930 Calder's frequent *Circus* performances brought him into contact with Fernand Léger, Frederik Kiesler, and the de Stijl artist Theo van Doesburg. A visit to Piet Mondrian's Paris studio in the fall of 1930 was fundamental to Calder's development. He admired the Dutch painter's austere abstractions but startled Mondrian by saying that he would prefer to see them oscillate. The impact of Mondrian's rectangles and his limited but brilliant palette of the primary colors plus black and white made Calder want to paint and work abstractly, and so he made his first abstract construction, *Une Boule noire, une boule blanche,* incorporating the elements of both motion and sound. He was invited to join the Abstraction-Création group, which included van Doesburg, Jean Arp, Mondrian, Antoine Pevsner, and others.

Fernand Léger wrote the catalog preface for Calder's first exhibition of abstract constructions, shown with drawings and wire portraits at the Galerie Percier, Paris, in 1931. Léger wrote:

"[Calder] is American one hundred per cent." However, Calder had by no means abandoned figurative art. He made the final figures for the *Circus,* began a series of large pen-and-ink circus drawings, and illustrated Aesop's *Fables.* His single-line drawings, like his wire sculptures, were marked by precision, clarity, wit, and elegance.

Calder's first pure "mobiles" date from the winter of 1931, when he began to make abstract sculpture with moving parts, operated by electric motors or hand cranks. The term *mobiles* was coined by Marcel Duchamp when these motorized moving sculptures were exhibited in Paris at the Galerie Vignon in 1932. (Calder owed the term *stabiles* to Jean Arp.) When the mobiles were shown at the Julien Levy Gallery, New York City, later that year, Calder remarked: "Why must art be static? . . . The next step is sculpture in motion." Back in Paris, Calder made a standing mobile in painted sheet metal, wood, and wire, with the engaging title *Calderberry Bush.* Although his mobiles may have analogues in natural forms, Calder pointed out that they were "abstractions which resemble nothing in life except their manner of reacting."

In 1933 Calder met the influential American critic James Johnson Sweeney, who responded enthusiastically to Calder's work. Returning to America, the Calders bought an 18th-century farmhouse in Roxbury, Connecticut. In 1934 Alfred Barr purchased a motorized Calder sculpture, *A Universe,* for the Museum of Modern Art, New York City, and Calder set up his first outdoor mobile, *Steel Fish,* in Roxbury. The Calders decided to settle in the United States, working in Roxbury during the summer and spending each winter in an apartment on Manhattan's Upper East Side. Louisa painted and also wove rugs and other fabrics of Calder's and her own design. They rented small shops nearby—a different one each winter—to use as studios, whitewashing the windows and choosing the west side of the street for the morning sun. Calder had a solo show at the Pierre Matisse Gallery, New York City, where he continued to exhibit until 1943.

Given the kinetic element in Calder's work, it seemed natural for him to design mobiles for the dance, as he did for Martha Graham's ballet *Panorama,* performed at the Bennington School of Dance, Vermont, in the summer of 1935. The set was an arrangement of overhead discs which the dancers pulled by lines attached to their wrists. The following year he designed "plastic interludes"—circles and spirals that "performed" on an empty stage and that set the mood for each movement of Martha Graham's

Horizons, presented in New York City. Calder's first large-scale stabile, *Whale,* was constructed in 1937.

When MOMA moved to its present location on West 53d Street in 1939, the museum commissioned Calder's large mobile, *Lobster Trap and Fish Tail,* for its main stairwell. In 1940 Calder had his first exhibition of jewelry at the Willard Gallery, New York City. His jewelry, made of silver, gold, brass, and occasionally zinc, was never intended to be mass produced, most of it having been made for friends and given to them on special occasions.

During World War II Calder studied civilian camouflage and conducted occupational therapy in veterans' hospitals. He also executed a large, standing mobile, *Red Petals,* for the Arts Club in Chicago. In 1943 MOMA organized Calder's first major museum exhibition. During the show Calder gave *Circus* performances in the museum penthouse, and the exhibition was a popular success. In 1944 Curt Valentin became Calder's dealer and publisher.

In 1945 Calder was working on a long series of mobiles that could be disassembled and mailed in small packets, and Marcel Duchamp suggested that Calder should return with these works to Paris. Calder had his first postwar show in Europe, at the Galerie Louis Carré, Paris, in October 1946, and Matisse was among the show's visitors. Jean-Paul Sartre, who saw affinities between Calder's sculpture and his own existentialist philosophy, wrote the catalog's preface, remarking on the mobiles: "A general destiny of movement is sketched for them, and then they are left to work it out for themselves. . . . A mobile is . . . like the sea, and casts a spell like it; forever rebeginning, forever new." Calder's mobiles were "at once lyrical inventions, technical combinations of an almost mathematical quality, and sensitive symbols of nature." Calder considered Sartre's essay the most perceptive ever written about his work.

Although Calder cared little for surrealism, he was included in the last major group show of the surrealist movement, "Le Surréalisme en 1947," at the Galerie Maeght, Paris. In the next few years the Calders traveled to Brazil, Finland, England, Sweden, and Germany. In 1952 Calder received first prize for sculpture at the Venice Biennale and designed sets for Henri Pichette's play *Nucléa,* produced in Paris by the Théâtre National Populaire.

Calder broke new ground with his acoustic ceiling for the auditorium in University City, Caracas, Venezuela, and his work was in demand in many countries. Calder's fame, however, had not yet brought him financial security.

In 1953 the Calders visited their friend and future son-in-law, Jean Davidson, at his home in Saché, near Tours, France. Davidson urged them to buy François Premier, an ancient house by the river Indre. They bought it, and the Calders thereafter spent part of each year in Saché.

At one of Calder's finest New York City shows, held in 1955, nothing was sold, but the Calders' material circumstances improved rapidly starting in 1958, when Calder began to receive major public commissions. That year Calder completed *Whirling Ear* for the Brussels World's Fair, *Spirale* for the UNESCO building in Paris, and *125* for New York (now Kennedy) International Airport. He won first prize at the Carnegie International Exhibition for his monumental mobile *Pittsburgh,* and by 1960 he was financially independent.

In the late '50s Calder began making large stabiles, which were first exhibited at the Galerie Maeght, Paris, in 1959. He had outgrown his studios and his ability to execute his large-scale works by hand: "In 1958 I had three metal shops working for me, two in Waterbury and one, ten miles away, in Watertown. I got a sense of being a big businessman as I drove from one to another." He also had ideal collaborators in France in the craftsmen of the Etablissements Biémont, an ironworks in Tours.

With boundless energy Calder continued to draw, paint, illustrate books, design tapestries and stage sets, and make toys for his grandchildren. His 1964 retrospective at the Solomon R. Guggenheim Museum, New York City, took on the character of an apotheosis, and Frank Lloyd Wright's building, with its spiral design, was a perfect setting for Calder's airy mobiles, his few large stabiles, and the "many very small objects suitable for children to bat and crush." "To this," Calder remarked, "I attribute my success. My fan mail is enormous—everybody is under six!"

Calder was amused and pleased by all the acclaim, but he never allowed himself to become a cult figure, removed from the real world. On January 2, 1966, he and his wife placed a full-page advertisement in *The New York Times* protesting the Vietnam War, and in 1972 he supported the antiwar presidential campaign of George McGovern with a bold and colorful poster.

There were some who felt that Calder overextended himself in his 70s—a *Time* critic wrote that Calder designs spray-painted on a DC-8 jet for Braniff International Airlines in 1974 "border on triteness"—but the artist could never resist a new challenge. In his last years, Calder's innumerable gouaches and prints, robust and high-spirited at their best, were often "clumsy

and bumptious and little else," according to an *Art News* reviewer. But there was general praise for his monumental stabiles, including *Flamingo,* commissioned in 1974 by the US General Services Administration for Federal Center Plaza in Chicago. To quote a *New York Times* critic, "Sheet metal or steel plate took on the look of gigantic stalking creatures, part insect and part extravagant vegetable" in his stabiles. In the period of *Flamingo,* Calder also made a motorized, brilliantly painted mural, *Universe,* for the Sears Tower, also in Chicago.

In 1975 the Calders visited Israel, where he agreed to design a huge stabile for Jerusalem. However, by the mid-1970s Calder's health was failing, although few realized it because of his activity and general ebullience. His career reached its splendid culmination in the major retrospective of his work that opened at the Whitney Museum of American Art, New York City, on October 14, 1976, and whose title, "Calder's Universe," was drawn from a Calder statement of 1951: "The underlying sense of form in my work has been the System of the Universe, or part thereof. For that is rather a large model to work from." One month after the Whitney's gala opening, while the exhibition was still drawing enthusiastic crowds, Calder died of a heart attack in New York City.

Those who met Alexander Calder in his last years remember him as a round, burly, lumbering, white-haired man, who spoke in a low rumble and had eyes that twinkled mischievously. At work he wore blue jeans and the red shirt which became his trademark. Always the craftsman, he deliberately used the word work instead of art to describe his activity. Generally unassuming, humorous, and full of joie de vivre, Calder could nevertheless be sharp-tongued. He was once commissioned to make a stabile, preferably one suggesting a horse, for a town in Texas. When the Texans remarked that the finished work didn't look like a horse, he replied, "Well, it probably isn't a horse!"

In a commemorative *Art News* article (January 1977), Franz Schulze warned against a facile view of Calder as merely a gruff, "bearishly loveable, winking old grandpa," and reminded readers that Calder's major works were "the products of a great and serious modern artist." Although other, avant-garde critics have belittled Calder's work as "middlebrow," repetitive, and "cute," artists such as Miró, Léger, Arp, and Henry Moore saw Calder from the beginning as a vital and original creator, thoroughly American in his pragmatism and technical ingenuity, yet gifted with an imagination and sense of play that knew no boundaries of age or nationality.

Films about the artist include *Alexander Calder* (1929), directed by Dr. Hans Cürlis and filmed in Berlin by Walter Turck; *Dreams that Money Can Buy* (1948), a surrealist film by Hans Richter (distributed by McGraw-Hill Films); *Works of Calder* (1951), produced and narrated by Burgess Meredith, music by John Cage; *The Great Sail* (1966) by Robert Gardner (distributed by Phoenix Films, New York City), and *Calder, un portrait* (1972), by Charles Chaboud and Daniel Felong (produced by Aimé Maeght, Paris).

EXHIBITIONS INCLUDE: Artists' Gal., NYC 1926; Weyhe Gal., NYC 1928, '29; Gal. Billiet, Paris 1929; Gal. Nierendorf, Berlin 1929; Gal. Percier, Paris 1931; Gal. Vignon, Paris 1932; Julien Levy Gal., NYC 1932; Pierre Matisse Gal., NYC 1934–43; Freddy Mayor Gal., London 1937, '38; George Walter Vincent Smith Art Mus., Springfield, Mass. 1938; Willard Gal., NYC 1940; MOMA, NYC 1943; Buchholz Gal., NYC 1944–55; Gal. Louis Carré, Paris 1946; Inst. of Contemporary Art, Washington, D.C. 1948, '50; Gal. Maeght, Paris 1950–75; Massachusetts Inst. of Technology, Cambridge 1950; Stedelijk Mus., Amsterdam 1951, '60; Mus. de Bellas Artes, Caracas, Venezuela 1955; Perls Gals., NYC 1956–75; Mus. de Arte Moderna, Rio de Janeiro 1959; Tate Gal., London 1962; Solomon R. Guggenheim Mus., NYC 1964–65; Mus. Nat. d'Art Moderne, Paris 1965; Akademie der Künste, Berlin 1967; Fondation Maeght, Saint-Paul-de-Vence, France 1969; "A Salute to Alexander Calder," MOMA, NYC 1969–70; Mus. Toulouse-Lautrec, Albi, France 1971; Haus der Kunst, Munich 1975; "Calder's Universe," Whitney Mus. of Am. Art, NYC 1976–77. GROUP EXHIBITIONS INCLUDE: Salon des Humoristes, Paris 1927; Harvard Society for Contemporary Art, Cambridge, Mass. 1929; "Painting and Sculpture by Living Americans," MOMA, NYC 1930–31; Gal. Peire, Paris 1933; "Modern Painters and Sculptors as Illustrators," MOMA, NYC 1936; "Fantastic Art, Dada and Surrealism," MOMA, NYC 1936; San Francisco Golden Gate International Exhibition 1939; "Artists for Victory," Metropolitan Mus. of Art, NYC 1942; Kunsthalle, Berne 1947; "Le Surréalisme en 1947," Gal. Maeght, Paris 1947; Venice Biennale 1952; "Le Mouvement," Gal. Denise René, Paris 1955; "4 Masters," World House Gals., NYC 1957; "Nature in Abstraction," Whitney Mus. of Am. Art, NYC 1958; "18 Living American Artists," Whitney Mus. of Am. Art, NYC 1959; "Motion in Art," Stedelijk Mus., Amsterdam 1961; "Outdoor Sculpture '66," De Cordova Mus., Lincoln, Mass. 1966; Fête de l'Humanité, Vincennes, France 1969; "La Sculpture en plein air," Palais des Beaux-Arts, Charleroi, France 1973; "Monumenta: Sculpture in Environment," Newport, R.I. 1974.

COLLECTIONS INCLUDE: Metropolitan Mus. of Art, Whitney Mus. of Am. Art, MOMA, and Solomon R. Guggenheim Mus., NYC; Nat. Gal., Smithsonian Inst., and Hirshhorn Mus. and Sculpture Garden, Washington, D.C.; Art Mus., Princeton Univ., N.J.; Wadsworth Atheneum, Hartford, Conn.; Mus. of Fine Arts, Hous-

ton; Los Angeles County Mus.; Mus. Nat. d'Art Moderne, Paris; Fondation Maeght, Saint-Paul-de-Vence, France; Mus. Nat. Fernand Léger, Biot, France; Nationalmus., and Moderna Mus., Stockholm; Wallraf-Richartz Mus., Cologne; Kunsthalle, Berne; Mus. de Bellas Artes, Caracas, Venezuela.

ABOUT: "Alexander Calder" (cat.), Buchholz Gal., NYC, 1947; Arnason, H.H. and others Calder, 1966; Barr, A.H., Jr. Cubism and Abstract Art, 1936; Calder, A. Animal Sketching, 1926, Calder: An Autobiography with Pictures, 1966; Current Biography, 1966; Kuh, K. The Artist's Voice: Talks with Seventeen Artists, 1960; Léger, F. "Alexander Calder" (cat.), Gal. Percier, Paris, 1931; Lipman, J. and others (eds.) Calder's Circus, 1972, Calder's Universe, 1976; Pascin, J. "Alexander Calder" (cat.), Gal. Billiet, Paris, 1929; Read, H. A Concise History of Modern Sculpture, 1964; Rose, B. "A Salute to Alexander Calder" (cat.), MOMA, NYC, 1969; Sartre, J.-P. "Alexander Calder" (cat.), Gal. Louis Carré, Paris, 1946; Sweeney, J.J. "Alexander Calder" (cat.), MOMA, NYC, 1951. *Periodicals*—Art in America Winter 1956–57, October 1964; Art News January 1977; Artforum March 1965; Look December 9, 1958; Museum of Modern Art Bulletin Spring 1951; The New Yorker October 22, 1960; Newsweek November 22, 1976; Time November 20, 1964.

CALLERY, MARY (June 19, 1903–February 12, 1977), American sculptor, is a neglected figure in the development of polychromed direct-metal sculpture. Her work, cast in bronze or welded and forged of steel, forms a bridge between the playful animals and circus figures of the early Calder and the abstract painted assemblages of David Smith. Like Calder, she invested her compositions with a humor and grace sorely lacking in the mainstream of American sculptural innovation.

Born in New York City and raised in Pittsburgh, Callery studied sculpture with Edward McCarten at the Art Students League, New York City, from 1921 to 1925. She lived in Paris from 1930 to 1940, taking private classes with Henri Laurens and the Russian-born sculptor Jacques Loutchansky and meeting Picasso, Matisse, Duchamp, Man Ray, and Calder, who was an especially important early influence. Her own work began rather traditionally: full-bodied women in the Maillol manner, cast in bronze from clay models. She returned to New York City in 1940 (although she maintained a studio in Paris through the 1960s and spent part of each year there), where she had solo shows at the Buchholz Gallery (later the Curt Valentin Gallery) starting in 1944. After a visit to Georgia O'Keeffe's New Mexico studio in 1945, she lived for two years in Montana (1945–47).

By the early 1940s Callery had developed her signature style: lanky figures and animals, gracefully modeled from strips of clay or wax, that the French artist Michel Seuphor called "filiform personages set in a plane or against the void like ideograms of a perfect elegance." Even Picasso showed a sympathetic interest in her sculpture. *Musician* (1942), in which the player is interwoven with a treble-clef that is also his instrument, and *Plant* (1942), really a vegetal human figure, are good examples of her early work in this vein, which was fresh, accessible, undemanding, and popular. Unlike Giacometti's attenuated, anxious figures, her linear acrobats, dancers, birds, dogs, and horses evoke no unease, but rather a sense of pleasure at their calligraphic sinuosity and naturalness of pose. "To be a work of art," she wrote of her sculpture in 1959, "it must have its emotional life. One must like the thing, be attracted to it, or even repulsed. It must work on you. Only then does it become living." Other important works in this style are *Amity* (1946), *The Curve* (1947), *The Seven* (1956), and *The Fables of La Fontaine* (completed 1954), a large white steel construction (9½ feet by 20 feet) on the playground of P.S. 34 on Manhattan's Lower East Side. A masterpiece of economy and spatial draftsmanship, *Fables* captures the innate nature of frog, fox, crow, and human with a handful of steel lines. She also did portrait heads in bronze, terracotta, and marble. "The change from nature to one's own imagination is continually enriching," she said.

At the same time that she was refining her figures and portraits Callery was developing another, more abstract and adventurous, style. In 1943 and again in 1949 she collaborated with Fernand Léger on a series of rough plaster and bronze reliefs (*Constellation* and *Dancers*, both 1943; *Mural Composition*, 1949). Léger painted the backgrounds and, occasionally, with a painter's disregard for sculptural tradition, the sculptures themselves. This must have been a revelation to Callery. At that time even the Constructivists rarely polychromed their work, and certainly not in primary colors; painting bronze was unheard of. Callery began making her own brightly painted iron and steel constructions in 1949, well before David Smith or Anthony Caro; she sought, she said, "contrapuntal harmonies" of color and form, rather than the "internal dissonances" of her work with Léger. These include *Equilibrist* (1949), three balancing figures in white, blue, and yellow; *Tomorrow Is a Mystery* (1949), in white, black, and orange; *Three Birds in Flight* (1953), in painted aluminum for the Aluminum Company of America in New York City; *Libellule* (1954, Dragonfly), a fanciful mothlike construction in white and black; and *Composition with Tendrils* (1957),

one of her most abstract works, in which red and white bars float upward from intertwined coils against an irregular, flat black grid. Most of Callery's polychromed pieces were not shown in the United States until 1979, two years after her death, at the Washburn Gallery, New York City; this may explain why she never received due credit as one of the progenitors of the explosion of color in 1960s sculpture.

By 1960 her sculpture had become almost entirely abstract, although still biomorphic and natural in inspiration. *Composition 2* (1960), has a tail and a plenitude of wiggling tendrils, but *Composition 7* (1960), a basketlike round of steel and brass, has little reference to anything specifically biological. She made her first fountain for the 1958 Brussels World's Fair; arcing streams of water from bronze tubes pushed its large bronze paddle wheels. Forged steel tendrils dominated four smaller fountains that she completed in 1964. Her large (36 feet by 10 feet by 1 foot) brass *Gate* (1963–64), one of her last works, is a densely layered screen of geometric shapes that recalls the mural reliefs of Harry Bertoia and indicates that Callery might have moved toward a more geometric brand of abstraction had she continued work beyond the mid-1960s.

Mary Callery, taught for many years at the experimental Black Mountain College in North Carolina. She died in Paris in 1977.

EXHIBITIONS INCLUDE: Buchholz Gal., NYC 1944; Arts Club of Chicago 1946; Curt Valentin Gal., NYC 1947, '49, '50, '52, '55; Salon du Mai, Paris 1949; Margaret Brown Gal., Boston 1951; Gal. des Cahiers d'Art, Paris 1954; M. Knoedler and Co., NYC 1957, '61, '65; M. Knoedler and Co., Paris 1962; B.C. Holland Gal., NYC 1968; Washburn Gal., NYC 1979. GROUP EXHIBITIONS INCLUDE: Mus of Fine Arts, Houston 1939; City Art Mus., St. Louis, Mo. 1946; Philadelphia Mus. of Art 1949; Mus. Rodin, Paris 1956; Mus. of Fine Arts, Dallas 1958; Brussels World's Fair 1958.

COLLECTIONS INCLUDE: Alcoa Company Collection: Phillips Collection, Washington, D.C.; Cincinnati Mus. of Art; Eastland Shopping Center, Detroit; Wadsworth Atheneum, Hartford, Conn.; Whitney Mus. of Am. Art, MOMA, Lincoln Center, Public School 34, Aluminum Co. of Am., and New York Univ., NYC; Mus. of Art, San Francisco; Toledo Mus. of Art, Ohio; Virginia Mus. of Fine Arts, Richmond; Brooklyn Court House, N.Y.

ABOUT: "Mary Callery, Sculpture" (cat.), M. Knoedler and Co., NYC, 1961; Read, H. A Concise history of Modern Sculpture, 1964; Seuphor, M. Sculpture of this Century, 1960 *Periodicals*—Art News March 1979.

***CAMPIGLI, MASSIMO** (July 4, 1895–May 1971), Italian painter, drew on preclassical and surrealist sources for his primitively stylized yet lyrical portraits of women. Born in Florence, Campigli moved with his family to Milan, where he spent his childhood and much of his later life. Before World War I, he worked as a journalist, meeting among others the Futurist painters. He fought with the Italian Army from 1915, but was taken prisoner in Hungary. After his release he resumed his career as a journalist and was sent to Paris, where he lived for the next 15 years. There, inspired by the work of Picasso and Léger, he began to paint at night while eking out a meager living working for the paper by day. "Cubism had then reached its period of great precision [by] observing a rigid discipline," he explained. "Since my nature inclines toward psychological intimacy, while aspiring at the same time to order and serenity, I somehow felt that my whole life would be given a meaning if I were to devote myself to painting in such a spirit." Although he frequented the artists' cafés of Montparnasse, Campigli's innate shyness prevented him from meeting those older artists whose works he most admired.

Campigli's trip to Rome in 1928 was a major turning point in his career. The Etruscan funerary sculpture on display at the Villa Giulia profoundly affected his painting. Abandoning any pretense of cubistic analysis, as well as conventionally realistic perspective and rendering, he adapted the simplified figurative stylizations of the Etruscans, and eventually their interest in civilized and domestic settings. During a trip later that year to Rumania, he painted his first important work, *The Gypsies* (1928), which depicts three figures posed before a ruined arcade that angles into the distance of a barren, sandy-colored landscape. In the foreground, a large woman in the bare-breasted attire of Minoan Crete carries an amphora. Behind her, a second woman reclines, reading the Tarot, while at a distance a naked man sits on a white horse. Campigli had obviously been looking at symbolist painting and the work of Giorgio de Chirico and the *scuola metafísica*; The Gypsies has the same static air of sexual mystery that can often be found in de Chirico's paintings. However, rather than make use of the conventions of pre-Renaissance Italian painting and 19th-century magazine illustration, as de Chirico did, Campigli reached further back, to preclassical sources, to give these figures a fey, otherwordly, quality. "His women," wrote one critic, "in the form of funeral urns, have somewhat affected graces, wasp-waisted, painted lips, arms like amphora handles." *The Gypsies* contains within it the germ of every minor stylistic variation in Campigli's later work.

°käm pē lē, mä´ sē mō

Istituto Italiano di Cultura, NYC

MASSIMO CAMPIGLI

After his 1929 solo show at the Galerie Jeanne Bucher, Paris, Campigli found himself rescued from destitution. His paintings were decorative and popular, and were sought by museums and collectors as a very palatable brand of antiqued surrealism. He was not, however, a prolific artist, and spent much time scratching out and repainting each work.

Landscape and space had essentially disappeared from his painting by 1930, the year of *Villa Belvedere*. The women in this work, staring from the windows of a completely flat facade, are themselves unmodeled, frontal, stylized, and expressionless; they stare blankly as if from eternity.

In the early 1930s Campigli worked on a number of mural projects with de Chirico and Marco Sironi. After a sojourn in Milan in the mid-'30s, he married the sculptress Giuditta Scalini in Paris; they had a son, Niccolo. He left Paris again for Milan in 1939 and executed a fresco mural for the University of Padua in 1939–40. He stayed in Milan for the duration of World War II, and returned to make the French capital his base of operations about 1949.

Campigli had begun to paint heads and busts of women in the mid-'30s and continued to do so regularly until the end of his career. These works were predominately hieratic and unemotive, like the Egyptian, Cretan, and Etruscan art that inspired them. The artist sometimes arranged his subjects in groups—as in *The Hat* (1940) and the "Bathers" series (1942–44)—and often two women gaze deeply into each other's eyes, as in *The Jewels* (1946), *The Flower* (1947), and *Cat's Cradle* (1947), which all take their

names from an emblematic object Campigli has placed in the picture. A series on weavers— including *Four Weavers* (1950) and *The Weavers* (1954)—may have encouraged him to experiment with more abstract color patterns (as may have a growing interest in preclassical craft decoration). Certainly in his late work Campigli has made his figures so emblematic and impersonal that they function as little more than iconographic compositional elements. At times the figures have shrunken to the size of chess pieces, notably in two paintings called *Maison* (1960–61) and *Ballet* (1967); the game was one of the artist's hobbies.

The French critic André Chastel wrote of the mysteries of Campigli's work in a full-length study, *Les Idoles de Campigli* (1961). "One finds oneself in the paradise of the libido," Chastel said, "in secret communication with the kingdom of the dead." Campigli divided the last 30 years of his life between Paris, Milan, Rome, and St. Tropez, where he died in 1971. He illustrated a number of books, including collections of the poems of Sappho and Paul Verlaine, *The Book of Marco Polo*, and works by André Gide.

EXHIBITIONS INCLUDE: Gal. Bragaglia, Rome 1923; Gal. Jeanne Bucher, Paris 1929, '38; Gal. de Milione, Milan 1931; Julian Levy Gal., NYC 1932, '35, '39; Gal. Barbaroux, Milan 1934, '40, '42; Gal. del Cavallino, Venice 1942, '61; Stedelijk Mus., Amsterdam 1946, '55; Boymans-Van Beuningen Mus., Rotterdam 1947; Gal. L'Obelisco, Rome 1947, '67; Gal. de France, Paris 1949, '51, '53, '61, '65; Hanover Gal., London 1952; Gal. del Naviglio, Milan 1953, '60; Gal. La Hune, Paris 1954, '61; Gemeentemus., The Hague 1955; Kunsthalle, Bern 1955; Gal. Stangl, Munich 1959, '63; Gal. La Bussola, Turin, Italy 1964. GROUP EXHIBITIONS INCLUDE: Venice Biennale 1928, '48; "Campigli: Sironi," Marlborough Fine Arts, London 1957; "Masters of Modern Italian Art," Nat. Mus. of Modern Art, Kyoto, Japan; "Masters of Modern Italian Art," Nat. Mus. of Modern Art, Tokyo ca. 1960.

COLLECTIONS INCLUDE: Gal. d'Arte Moderna, Milan; Gal. Nazionale d'Arte Moderna, Rome; Mus. d'Arte Moderna, Venice; Gal. d'Arte Moderna, Florence; Mus. d'Art Moderne de la Ville, Paris; Mus. des Beaux-Arts, Grenoble, Switzerland; Kunsthaus, Zürich; Mus. Español de Arte Contemporaneo, Madrid; Stedelijk Mus., Amsterdam; Moderna Mus., Stockholm; Nat. Gal., Oslo; Tate Gal., London; Fogg Mus., Harvard Univ., Cambridge, Mass.; Virginia Mus., Richmond; City Art Mus., St. Louis, Mo.; Mus. de Arte Moderna, Rio de Janeiro; Mus. de Arte Contemporanea, São Paulo; Mus. de Bellas Artes, Caracas, Venezuela; Mus. of Modern Art, Tel Aviv; Mus. of Modern Art, Kamakura, Japan.

ABOUT: Brizio, A.M. Ottocento e Novecento, 1962; Cassou, J. Campigli, 1957; Chastel, A. Les Idoles de Campigli, 1961; Courthion, P. Massimo Campigli, 1938;

Franchi, R. Massimo Campigli, 1944; Raynel, M. Campigli, 1949; Russoli, F. Campigli pittori, 1965; Serafino, G. (ed.) Omaggio a Campigli, 1972. *Periodicals*—Lacerba (Florence) July 1914; London Times June 4, 1971.

***CAPOGROSSI, (GUARNA) GIUSEPPE** (March 7, 1900–October 9, 1972), Italian painter, had already won fame in Italy as a figurative painter when, in 1949, he turned to a highly personal abstract idiom. A distinctive symbol or emblem of his own invention appeared in all his works for about 20 years, but with this simple element he achieved an extraordinary variety of plastic means.

Guarna Giuseppe Capogrossi was born in Rome, and pursued classical studies there from 1915 to 1917 at the Instituto Massimiliano. After serving in the Italian Army as a second lieutenant in the mountain regiment at Adanello, he studied law until 1923 at the University of Rome. He received his first instruction in painting from Felice Carena in 1926, and subsequently gave up law for a career in art. Capogrossi spent the years 1927–32 in Paris, developing a style inspired by Cézanne; he lived and worked in seclusion, relatively unaffected by more modern art movements. On his return to Rome in 1932 he founded, with Corrado Cagli and Cavalli, the Gruppo Romano, which reacted against the neoclassical art prevalent under fascism. His own paintings at this time included landscapes, still lifes, and groups of dancers, in a somewhat impressionistic style. *On the Bank of the Tiber* (ca. 1933) depicts three seated figures outdoors, and *Vestibule* (1934) represents a group of nudes in an interior. His townscape of 1936, *Paesaggio,* shows buildings from the vantage of a high window. In *Peasant Woman* (1939) a woman is digging with a shovel, and a dancer is portrayed in *Ballerina* (1942). Capogrossi painted one model almost exclusively until the late 1940s.

He was considered one of Italy's leading painters when, about 1949, he underwent what critics have termed "a crisis." The artist became concerned less with things than with the space around them, and he described this experience as his "rupture with the object." In *Art Digest* (March 1, 1955) Dore Ashton explained this stylistic shift: "Capogrossi, at the time of his crisis, felt a great craving for simplicity. . . . For half a year he painted only in black and white. He invented a simple sign which he then multiplied, forced through a series of metamorphoses." This sign, which came to him in 1950, has been described by one critic as possessing "in addition to an undeniable plastic and compositional effec-

GIUSEPPE CAPOGROSSI

tiveness, a mysterious cryptic character, derived from both magic and science, and evoking ancient symbols drawn from hermetic texts, such as treatises on alchemy."

Capogrossi's "sign," basically a dentate, curved form with a few teeth (usually four), is like a child's rendering of a comb, a rounded letter "E" with an extra tooth. At first these signs were painted swiftly, and made up a kind of unreadable alphabet; in fact they were generally transformations of certain letters, "A's," "M's," and "W's" being special favorites. The sign was not only Capogrossi's personal ideoglyph, but his structural tool, and the diversity he achieved with this simple motif is astonishing. Sometimes, as in *Surface 3* (1951), the signs are arranged in rows like an ancient script. At other times, as in *Surface 9,* they are arranged seemingly at random. In *Surface 16–A* the signs confront each other in horizontal rows as if undergoing mitosis. Capogrossi often placed the signs on colored backgrounds of various types, such as the white and yellow rectangular areas of *Composition* (1952). At other times he painted patches of color between them. In the early 1950s the signs themselves were nearly always black and small. Later, Capogrossi painted both background and signs in color, and made the signs fewer and more monumental. Sometimes the toothed forms create areas of negative space which vie for dominance with the solid shapes. In a 1961 article on Capogrossi in *Quadrum* Léon Kochnitzky wrote, "The movement which animates the signs is always purposeful and calculated, the countersigns playing the role of fugal counterpoint." Many critics have likened Capo-

grossi's works to music and Nello Ponente wrote in *New Art Around the World,* "Capogrossi's experiments with the rhythmic and serial possibilities of painting rival the most advanced music, but he also tests the continuity of space and time." According to Aldo Pellegrini, Capogrossi's works attain "the mobility of a plastic ballet."

In 1951 Capogrossi, together with, among others, Ettori Colla and Alberto Burri, founded the Gruppo Origine, whose program included the rejection of three-dimensional figuration, the purely expressive use of color, and a preference for primitive imagery originating in ancient writing and signs. In 1952 Capogrossi was also associated with the Gruppo Spaziale in Milan, but despite these connections he remained a solitary figure. In 1956 he married Costanza Menney, with whom he had two daughters, Beatrice and Olga; the family lived in both Milan and Rome.

In the 1960s Capogrossi frequently, but not invariably, gave the signs sharper edges. In many of his paintings he deliberately confused background and foreground, sign and countersign in a display of virtuosic formal complexity. Examples are *Surface 537* (1963), *Surface 558* (1965), and *Surface 635* (1967–68). Capogrossi also experimented with painted relief in the 1960s; in *Surface 451* (1962) and *Surface 577* (1966) the raised signs are arranged in regular rows. However, *Surface 517* is mostly open space containing only a few signs, some overlapping. The signs in *Surface 605* (1967) and *Surface 570* are sunken instead of raised.

Capogrossi taught painting at the Liceo Artistico, Rome, from 1946 to 1965, and at the Accademia di Belli Arti, Naples, from 1965 to 1970. In the early 1970s he produced colorful and elegant lithographs called the "Quartz" series, which, like the "Surface" paintings, explored numerous permutations of simple artistic problems. In *Quartz 2* and *Quartz 10,* the background is divided into three vertical bands of color, and the symbols change shades as they pass from one area into another. In *Quartz 8,* the background is orange, and despite the painting's flatness the viewer experiences the optical illusion of "seeing farther" into the white signs to more distant black forms beyond. This is the "transcendent spatial and temporal reality which finds itself refracted on the surface" of which Léon Kochnitzky wrote in his study of the artist.

Since he began to exhibit in 1927, Capogrossi's work was represented in many exhibitions throughout the world. He showed fairly regularly at the Venice Biennale from 1928 on, at the Rome Quadriennale from 1935, at the São Paulo Bienal in 1955 and 1959, and also exhibited at the Carnegie International, Pittsburgh. He received numerous awards, including the Grazzian Prize in Milan in 1953, the Giulio Einaudi Prize at the Venice Biennale of 1954, the Etching Prize at the Venice Biennale in 1959, and the Prize of the Municipality of Venice at the Biennale of 1962. He died in Rome in 1972, aged 72.

Giuseppe Capogrossi had deep-set eyes, an aquiline nose, and a strong facial structure. He was, according to one writer, "a man of wide and discriminating reading, and of mature, fastidious civility in thought, word, and gesture."

In a career extending over a quarter of a century, he managed never to repeat himself. As Sheldon Williams pointed out in *Contemporary Artists,* one could never say, in relation to his work, that "when you have seen one, you have seen them all." Far from imprisoning him, the "sign" gave Capogrossi a freedom of experimentation which led to countless variations. With each painting he presented himself with a new aesthetic problem. In 1955 he stated: "As I work I find enormous problems. Enormous. I make hundreds of bad drawings, but then I find something. These elements I use suffice for me at the moment; there seems to be no end of the problems they bring me."

EXHIBITIONS INCLUDE: Gal. San Marco, Rome 1946; Gal. Il Milione, Milan 1950; Gal. del Cavallino, Venice 1950, '52, '54, '56, '58, '64, '66; Gal. del Naviglio, Milan from 1951; Gal. Rive Gauche, Paris 1956; Inst. of Contemporary Arts, London 1957; Leo Castelli Gal., NYC 1958; Gal. 22, Düsseldorf 1960; Gal. Sistina, São Paulo 1960; Gal. Schmela, Düsseldorf 1963; Tokyo Gal. 1963; Gal. La Medusa, Rome 1964; Gal. Il Segno, Rome 1966; Staatliche Kunsthalle, Baden-Baden, W. Ger. 1967; Mala Gal., Ljubljana, Yugoslavia 1967; Gal. Marlborough, Rome 1969; Gal. Goerge Moos, Geneva, Switzerland 1970; Gal. Bon a Tirei, Milan 1973; Gal. Nazionale di Arte Moderna, Rome 1974. GROUP EXHIBITIONS INCLUDE: Gal. Dinesen, Rome 1927; Venice Biennale 1928, '30, '48, '54, '59, '62; "Capogrossi, Cavalli, Cagli, Sclavi," Gal. Jacques Bonjean, Paris 1933; Quadriennale Nazionale d'Arte, Rome 1935; "Gruppo Origine," Gal. Origine, Rome 1951; "Arte Spaziale," Gal. del Naviglio, Milan 1952; "Mostra dell'Arte Italiana," Kunsthaus, Zürich 1953; "Younger European Painters," Solomon R. Guggenheim Mus., NYC 1953; Biennale of Colored Lithographs, Cincinnati Art Mus. 1954; São Paulo Bienal 1955, '59; "Italienische Malerei Heute," Stadtliche Mus., Leverkusen, W. Ger. 1956; "Between Space and Earth," Marlborough Gal., London 1957; Pittsburgh International, Carnegie Inst. 1958; "Contemporary Italian Art," Illinois Inst. of Technology, Chicago 1960; Biennale Scanavino Joachim Gal., Chicago 1962; "Capogrossi, Sangregorio," Gal. Müller, Stuttgart, W. Ger. 1963; "Guggenheim International Award," Solomon R. Guggenheim Mus., NYC 1964; "Painting and Sculpture of a Decade 1954–64," Tate Gal., London 1964; "Salute to Italy:

100 Years of Italian Art," Wadsworth Atheneum, Hartford, Conn. 1966; "Arte Italiana Contemporanea," Mus. of Modern Art, Tokyo 1967; "Recent Italian Painting and Sculpture," Jewish Mus., NYC 1968; "Contemporary Art: Dialogue Between the East and the West," Mus. of Modern Art, Tokyo 1969; "Dix Maîtres Italiens de la Peinture Contemporaine," Mus. Château, Cagnes-sur-Mer, France 1970; "New Italian Art," Walker Art Gal., Liverpool 1971; "Internationale Kunstmesse," Kunstmus., Basel 1974.

ABOUT: Abrams, H. New Art Around the World, 1966; Argan, G. and others, Capogrossi, 1967; Bénézit, E. (ed.) Dictionnaire des peintres, sculpteurs et graveurs, 1976; Pellegrini, A. New Tendencies in Art, 1966; P-Orridge, G. and others (eds.) Contemporary Artists, 1977; Seuphor, M. Capogrossi, 1954; Tapié, M. Capogrossi, 1962. *Periodicals*—Art Digest March 1, 1955; Art International (Lugano) February–March 1976; Avanti! (Milan) September 1968; Il Corriere della Sera (Milan) October 10, 1972; L'Espresso (Rome) December 1971.

Jorge Lewinski

ANTHONY CARO

***CARO, ANTHONY (ALFRED)** (March 8, 1924–), British sculptor, is considered the most important sculptor in the United Kingdom since Henry Moore. In the 1950s Caro was a competent, minor artist working in Moore's shadow, but in the '60s he pioneered the new abstract sculpture movement in England. His revolutionary nonfigurative works were large-scale and low-lying, making use of the floor in a way that challenged the pedestal tradition in sculpture.

He was born in a suburb of London, the son of Alfred Caro, a well-to-do stockbroker, and Mary Caro. By his own admission "a dreamy kid," Caro decided to become a sculptor while attending the exclusive Charterhouse School. His parents objected to a career in art, so Caro took an engineering degree at Christ's College, Cambridge, in 1944. "I just scraped through," Caro recalled. Caro served in the Fleet Air Arm for the remainder of World War II, but upon returning to civilian life he defied his father and studied art at Regent Street Polytechnic in 1946. The following year he enrolled at the Royal Academy Schools, where he received strict academic training for the next half-decade.

"It wasn't until the end of my time at the Academy that I discovered Henry Moore existed," Caro told Dorothy Gallagher of *The New York Times* (May 18, 1975). "The Academy treated him as a kind of threatening joke." He visited Moore at his home in Much Hadham, Hertfordshire, and asked for a job. Six months later, in 1951, Moore hired him as a part-time assistant. Caro's two-year apprenticeship to Moore "was like opening a whole world," the artist said. " . . . Moore would give me books out of his li-

brary, and they were my first contact with Cubism or Surrealism or anything like that." But if Moore exposed him to modernism, the conservative Royal Academy required him, day in and day out, to work only from the figure.

In 1953 Caro left Moore and took a part-time teaching job at the St. Martin's School of Art, London, where he was to lecture for the next two decades. In his own work Caro concentrated on making large figurative bronzes. He began as an Expressionist, making "many figures, all of clay or plaster, and all of them rather intent on doing something," and using distortion for maximum emotional impact. "For example," he told Gallagher, "I had seen a snapshot of a man lighting a cigarette, and I noticed that everything was in that little space between the match and the cigarette. I made a sculpture of this." In *The New Yorker* (July 7, 1975) Harold Rosenberg described *Man Taking Off his Shirt*, a typical early Caro work, as "a swollen mass of metal with truncated arms and a head the size of a pea."

In 1956 Caro had a solo show at the Galleria del Naviglio, Milan, and his first solo exhibition in London was at Gimpel Fils in 1957. Caro's figurative bronzes of the 1950s were considered a caricature of Moore's figures and one critic, alarmed by the savagery and heavy lumpishness of Caro's sculpture, wrote, "One almost wishes them back into clay."

Caro became dissatisfied with creating "people substitutes" in bronze, and felt that modeling in clay was "lifeless." Caro's breakthrough can be traced to his visit to the United States in 1959. Through discussions with Kenneth Noland, David Smith, Robert Motherwell,

°kä´rō

Helen Frankenthaler, and the critic Clement Greenberg, he was educated in the principles underlying the abstract art movement. He was especially influenced by the sculptor David Smith, who was internationally renowned for his structural arrangements of simple geometrical volumes in welded steel. Now aware of the possibilities of metal assemblage, Caro taught himself how to weld after returning to England. He decided to use prefabricated steel because it was "anonymous, arbitrary, and . . . cheap." More important, he discovered that his avoidance of abstract sculpture—"I thought abstraction was about ideas and not about feelings"—had been based on "quite a misinterpretation of the meaning of abstraction. I didn't have to represent, and I could still put my feelings into it."

The difference between the expressionistic modeling, heavy textures, and bulbous forms of *Woman Waking Up,* a Caro bronze of 1955, and *24 Hours,* the first of his abstract steel sculptures of 1960, is vast. *24 Hours,* a low-lying, free-standing piece consisting of a brown-painted disk, a triangle, and a rectangle, took three months to complete and was followed by *Midday,* another important transitional steel sculpture of 1960. Caro painted these nonfigurative compositions of the 1960s. His sculptures became increasingly asymmetrical, forcing the viewer to move around them, and their basic format was, to quote Rosenberg, "extension along the ground or on table-tops of metal segments of different weights, sizes, shapes, textures, either fastened together or laid in place in relation to the ensemble." Rosenberg noted that, unlike the "piled-up abstract forms of Smith, Caro's chief aesthetic ancestor," Caro's pieces "drift out in sideways movements and backward and forward, like an erratic signature." According to Norbert Lynton, what distinguished Caro's new sculptures from "the abstracted and distorted figuration that dominated British sculpture in the fifties" was "their avoidance of any reference or significance other than that inherent in relationships of colored forms in space. Every sculpture, every part of every sculpture, was to be pure sculpture."

Caro wants his sculpture to be like music, "the expression of feeling in terms of the material," but his work is consonant with the "cool," neutral, and impersonal art of the '60s, as manifested in the paintings of Kenneth Noland, Ellsworth Kelly, and Frank Stella. But Rosenberg pointed out that Caro's sculptures are "for the most part too complex to be assimilated into Minimalism," notwithstanding similarities between Caro's spatial concepts and the color-field painting and "stain" canvases of Helen Frankenthaler and Morris Louis. "I try to open up the material spatially to release the sculpture," Caro explained.

Caro's approach represented a reaction against his immediate predecessors in British sculpture, Reg Butler, Kenneth Armitage, and Lynn Chadwick. Their vaguely figurative iron and bronze forms were expressions of postwar angst, and Caro called their work "bandaged and wounded art." Although his sculpture has a more urban character than Henry Moore's, and his materials are totally different from his mentor's, critics have seen a link with Moore in Caro's linear and horizontal emphases. Edward Lucie-Smith wrote that "from some angles Caro's sprawling sculptures can seem like Moore's giantesses stripped to their skeletons." Unlike Moore, Caro likes his sculpture to be shown indoors. If shown outside, he prefers a structured and enclosed space. "It's time for sculpture to come out of the city square and be less a mock-heroic thing," he declared.

In the academic year 1963–64 and in the spring semester of 1965 Caro taught at Bennington College, Vermont. His important *Titan,* in steel and painted bright blue, was executed in Bennington in 1964. According to Tim Hilton of the *Times Literary Supplement* (June 4, 1982), *Titan* "was sparer and less additive than his English work. This may have accorded with American taste, particularly that of Greenberg and Noland. But it may be that his sculpture changed because of his first real contacts with David Smith." When Caro returned to England, he began to work in series, on Noland's recommendation. In London, between 1965 and '69, Caro entered what Hilton claimed was "his first very great period," beginning with the graceful *Prairie* (1967) and continuing to *Orangerie* (1969). After 1969 Caro's work changed again; he stopped painting his compositions and produced heavier pieces.

Caro exhibited twice at the Venice Biennale, in 1958 and 1966. In the catalog to the Venice Biennale of 1966, D. Thompson said that Caro's sculptures "define a gesture, a mood, an experience, but use their scale and their material presence to make such things as real as a table in a room, and to involve the spectator in a kind of open dialogue within the space they both occupy." Caro showed with Noland and Frank Stella at the Metropolitan Museum of Art, New York City, in 1968, and in 1969 a Caro retrospective was held at the Hayward Gallery, London. Three Caro sculptures in welded steel shown at the André Emmerich Gallery, New York City, in 1970 reminded *New York Times* (May 11, 1975) critic Hilton Kramer "of the large paper cut-out collages of Matisse's old age." The sculp-

tures were *Orangerie,* painted a brownish, earthy red, *Deep North,* painted a deep mossy green, and *Sun Feast,* in dazzling yellow. In late 1972 Caro spent three weeks at the Rigamonte factory in Verduggio, Italy, where he produced some 15 pieces in varnished steel.

The first US retrospective of Caro's work opened at the Museum of Modern Art, New York City, in April 1975 and later went on tour. Some critics, including Robert Hughes of *Time* (May 5, 1975), admired the elegance and buoyancy of Caro's sculptures but felt that he had been "consecrated" rather arbitrarily by MOMA as the legatee of David Smith, as the "English dauphin carrying on a great tradition." Hughes stated that Caro's work lacks "the immense flawed vitality of David Smith's . . . it is an intelligent, distinguished but sometimes only decorative addition to the short history of constructed sculpture." The exhibited works Hilton Kramer preferred were those of the period 1962–70. He thought *Early One Morning* (1962) "possibly the finest thing that Mr. Caro has ever done," a use of the constructivist mode that "evokes something of the scale and multiplicity of incident of a panoramic landscape without actually describing anything. . . . "

Indebted to painting for many of his ideas, Caro welcomed an invitation from London's National Gallery in 1977 to show *Orangerie* in surroundings composed of paintings that he chose from the gallery's permanent collection. Caro's choices were intuitive, but he took form, space, and color into consideration. His selections were interesting. They included a Courbet still life of apples which looked almost sculptural; Cézanne's *Rocky Landscape;* Giovanni Bellini's seraphic *Madonna of the Meadow;* Monet's delighful *Trouville Beach,* with the linear rhythm of the umbrellas silhouetted against the sky; Manet's *Eva Gonzales,* which exemplifies, Caro said, "Manet's clarity of structure combined with looseness of paint"; Titian's *Noli Me Tangere,* in which the figures touch the ground very lightly; and Rembrandt's *Saskia as Flora,* among others. "Painters have influenced me enormously and in a great many ways," Caro explained. "It was better to go to painting than to old sculpture, because painting gave one ideas of what to do but no direct instructions on how to do it." When asked in a 1977 interview conducted by Alistair Smith for London's National Gallery how he felt about his abstract art being seen with old, figurative art, Caro replied, "There is no break in continuity. In every period the artist has to find a way through to a visual truth that works for him in the time he lives, and this may involve radical innovation which is disturbing to contemporary eyes."

Anthony Caro lives and works in Frognal, London, not far from Hampstead Heath. He was married in 1949 to the former Sheila May Girling; they have two sons. Caro was described by Robert Hughes as "a twinkling, compact man with a boxer's fleshy nose and a pepper-and-salt-beard." While working in his studio, the artist listens to music, especially Mozart.

As a teacher at St. Martin's School Caro "led the revolution in modern sculpture that, so remarkably, was effected in a single department in one English art school," to quote Tim Hilton. Philip King, David Annesley, William Tucker, Michael Bolus, and Isaac Witkin were among his students. "I never make models or drawings," Caro answered when asked about recent projects. "There are a lot of different ways I work now, but when I began I'd have a bit of steel and I'd stick it up, maybe put a block of wood under one end, and say, well, it needs something to make it work. So you keep on going until it works. Really, you discover what you've done afterwards. Art's to do with discovery."

EXHIBITIONS INCLUDE: Gal. del Naviglio, Milan 1956; Gimpel Fils, London 1957; Whitechapel Art Gal., London 1963; André Emmerich Gal., NYC from 1964; Washington [D. C.] Gal. of Modern Art 1965; Kasmin Gal., London from 1965; David Mirvish Gal., Toronto from 1966; Rijksmus. Kröller-Müller, Otterlo, Neth. 1967; Hayward Gal., London 1969; MOMA, NYC 1975. GROUP EXHIBITIONS INCLUDE: "New Sculptors and Painter-Sculptors," Inst. of Contemporary Arts, London 1955; Pittsburgh International 1958; Venice Biennale 1958, '66; 5th Middelheim Biennale, Antwerp 1959; La Biennale de Paris 1959; "Sculpture in the Open Air," Battersea Park, London from 1960; "Painting and Sculpture of a Decade 54–64," Tate Gal., London 1964; "Primary Structures," Jewish Mus., NYC 1966; "American Sculpture in the Sixties," Los Angeles County Mus. 1967; Metropolitan Mus. of Art, NYC 1968; "British Painting and Sculpture 1960–1970," Nat. Gal. of Art, Washington, D.C. 1970–71; "Skulpturen der Moderne," Kunsthalle, Tübingen, W. Ger. 1981.

COLLECTIONS INCLUDE: Tate Gal., London; MOMA, NYC; Hirshhorn Mus. and Sculpture Garden, Washington, D.C.; York Univ., Toronto.

ABOUT: "Anthony Caro: An Interview with Alistair Smith" (cat.), Nat. Gal., London, 1977; Current Biography, 1981; Lucie-Smith, E. Late Modern: The Visual Arts Since 1945, 1969; Lynton, N. The Story of Modern Art, 1981; Waldman, D. Anthony Caro, 1982; Whelan, R. and others Anthony Caro, 1974. *Periodicals*—Artforum June 1972; Arts Magazine January 1965; Christian Science Monitor November 20, 1967; Gazette no. 1 1961; Listener September 1, 1955; (London) Times October 4, 1963; Times Literary Supplement June 4, 1982; New York Times July 18, 1971,

May 11, 1975, May 18, 1975, July 21, 1977; New York-
er July 7, 1975; Studio International January 1966;
(London) Sunday Times Magazine June 15, 1969;
Time March 12, 1965, July 22, 1968, May 5, 1975;
Washington Post October 2, 1966.

CÉSAR

***CÉSAR (CÉSAR BALDACCINI)** (January 1,
1921–), French sculptor, was born in Mar-
seilles, with his twin sister, Armandine. His fa-
ther was an Italian cooper of Tuscan origin.
César has declared: "I am profoundly Latin and
I remain very attached to my native origin—all
the more so as there's no difference between a
Marseillais and a Genoese." Indeed, the organiz-
ers of a César retrospective in the Casino at
Knokke, Belgium, hailed him as "the Marseillais
par excellence," even though he had long been
a self-proclaimed "citizen of the world."

The Baldaccini family lived in Belle-de-Mai,
a working class district of Marseilles, and César
left school in 1933 to assist his father, who then
ran a small wine shop. The first sculptor César
ever heard about was Michelangelo, whose name
was known to his parents "because he was a Tus-
can like us." On the advice of a commercial trav-
eler, César's mother enrolled him in 1935 in the
Ecole des Beaux-Arts, Marseilles. After attend-
ing evening classes in drawing, he took the regu-
lar sculpture courses and mastered convential
artistic techniques. One of his teachers, Cornu,
had once prepared stones for Rodin.

The year 1939, when César graduated from
the Beaux-Arts, saw the outbreak of World War
II. For a brief period in 1942 César took part in
outdoor youth programs in stone-yards and con-
struction sites sponsored by the Vichy govern-
ment. Later that year a small scholarship
enabled him to leave for Paris with two friends,
and in 1943 he was admitted to the Ecole des
Beaux-Arts in *la capitale*. During his stay in Paris
he lived in the same house as Alberto Giacomet-
ti, of whom he said: "Giacometti was of Italian
origin like myself, but he was a Swiss-Italian, a
man of mountains. I'm a man of the sea." De-
spite these differences of temperament, César
deeply admired Giacometti's personality, his
dedication to work, his perpetual dissatisfaction
and desire to "begin over again," and the
"presence" emanating from his sculpture.

In 1944, when his money ran out, César re-
turned to Marseilles, but in 1946 he was back in
Paris, and continued to work intermittently at
the Beaux-Arts. His impatience with stone, clay,
and other "classical" materials led him in 1947
to take a course in ceramics in Montpellier. Over
the next two years he experimented with plaster
and iron, and went on to make *repoussé* reliefs
in lead and constructions in wire.

In 1952, working in a small factory building
in Trans, in Provence, and in a garage in
Draguignan, southwest of Grasse, César tried his
hand at welding and discovered the possibilities
of scrap-iron. He recalls that the idea of working
in scrap-iron had first come to him in Paris,
"because I used to see in the rue Bonaparte a
photo of a shepherd by [Pablo] Gargallo" (the
Spaniard who had introduced Picasso to metal
sculpture, and was one of the first sculptors to
work in iron). "I said to myself, 'There's someone
who's avoided the bronze thing'; it's linear with
voids and flat areas. I was against modeling and
slick surfaces." Scrap-metal had the additional
advantage of being inexpensive.

One of César's earliest scrap-metal sculptures
was *The Fish* of 1953–54, nearly ten feet long.
Within the overall fishlike shape the treatment
was spiky and skeletal. In 1954 a group of
César's friends persuaded him to produce
enough pieces for an exhibition. His first solo
show at the Galerie Lucien Durand, Paris, in-
cluded *Cat*, a series of "Marionettes" suspended
by wires within boxlike structures, *Bat*, which
looked like some eerily spectral flying machine,
and the larger-than-life *Seated Nude, Pompeii*,
an image that recalled the petrified bodies un-
earthed at Pompeii, but which was the more dis-
turbing for its scrap-iron composition. The
originality of César's work, along with his flam-
boyant and picaresque personality (which was
already well known in Paris art circles), made
the exhibition a great success. *The Fish* was ac-
quired in 1955 by the Museé National d'Art
Moderne and is now in the Centre Pompidou
(Beaubourg).

°sā zär´.

Some critics saw César as a follower of the sculptor Germaine Richier, who was also from the Midi and whose aggressive and imaginative mutations of the human form often suggested decay and metamorphosis. But, although César felt a kinship with Richier's work, as he did with Giacometti's, he denied any direct influence. "The only person who could have influenced me was Picasso." César admired those Picasso sculptures in which commonplace objects are incorporated into the image and transformed, as in the brilliant *Bull's Head,* assembled by Picasso in the war years from the handlebars and seat of a wrecked bicycle.

From 1954 to 1966 César worked at Villetaneuse, a small factory building in a northern suburb of Paris. In the late '50s he tended increasingly to combine flat surfaces, enlivened by corrugations and other textures, with three-dimensional forms, as in *The Wing* (1955–56), the somewhat humorous *Man of Saint-Denis* (1958), and *Man of Villetaneuse* (1959), all in welded iron. Other sculptures were essentially flat, near-rectangular reliefs, and included *Flat Sculpture* (1958) and *The Little Window* (1959).

In 1956 César met Picasso and was also given a room in the French pavilion at the Venice Biennale. His first solo exhibition outside of France was held at the Hanover Gallery, London, in 1957. The following year he married Rosine, whom he had met seven years earlier. They have a daughter, Anna.

The year 1960 marked a turning point in César's career. He revisited his native Marseilles for the first time in 12 years and began his series of "Compressions dirigées" (controlled compressions). These were objects made with the help of the giant machines used for crushing and baling automobiles and other metal scrap into packages. When César first saw an enormous compressor installed at Gennevilliers, in the Midi, by a French company dealing with the processing of scrap-metal, he knew he had found a new means of expression. Fascinated by the violent and devastating process which nevertheless resulted in a new form (destruction and creation have always been closely linked in his mind), César soon began using the machinery himself. As his skills increased he found he could control exactly the disposition of the various parts and arrive at a composition of very specific forms and colors.

Three of César's "compressed" automobiles were exhibited at the Salon de Mai, Paris, in 1960 and caused a sensation, arousing much controversy. Later that year he held a solo show at the Hanover Gallery, and Pierre Restany, the French critic instrumental in founding the Nouveau Réalistes group, wrote in the catalog, "His oeuvre opens one of the roads to the new realism." Also in 1960, the American John Chamberlain was creating abstract sculptures out of fragments of crushed or wrecked automobiles, but César has pointed out that Chamberlain's works were "assemblages," whereas his own sculptures such as *Dauphine* (a make of car) of 1961 and *Klaxon* of 1962, were truly compressions, dealing directly and aggressively with the material. Although in 1960 César joined Restany's New Realists with the intention of taking a "metaphysical look at technology," he has denied any programmatic or literary intention and objects to being classified either as a New Realist or a Neodadaist. If he uses material from the junkyard, it is not to make a statement about waste and decay in a consumer society, but because he is excited by the physical density of the materials themselves and their transformation. "What interests me are the beauties and possibilities of the materials," he said. "All materials are precious when I talk to them."

In 1961 César visited the United States for his exhibit at the Saidenberg Gallery, New York City. He met Marcel Duchamp and saw a parallel between Duchamp's readymades and his own compressions, but noted that in Duchamp "there's a kind of visual indifference, he rejects shock, whereas with me it's quite the reverse." César's cars crushed into cubes are, as Lucy Lippard has written, "acts of defiance."

In addition to the controversial compressions, César produced several figurative pieces, notably the *Venus of Villetaneuse* (1962) and the *Victory of Villetaneuse* (1965). The titles can be seen as ironic parodies of the Venus of Milo and the Victory of Samothrace, but critics have detected a "nostalgia for antiquity" recurring periodically in César's work. The female torsos were rendered in solid volumes, and the armlessness of the *Venus* and the lack of head and arms in the *Victory,* were in their way a reference to the sculpture of antiquity.

In 1965 César saw a craftsman enlarging a Germaine Richier sculpture by means of a pantograph, an instrument long used by sculptors for reproducing their work on a different scale. César had been invited to participate in an exhibition at the Galerie Claude Bernard, Paris, on the theme of "the hand," and it occurred to him that the pantograph, instead of being used in the traditional way, could be made to enlarge any part of the human anatomy. He asked the man if he could enlarge his (César's) thumb, which, naturally for a sculptor, he considered the most expressive part of the hand. The thumb, enlarged to 16¼ inches and cast in bronze, was ex-

hibited at the Galerie Claude Bernard in 1965; enlarged to over 6 feet and cast in plaster, it was shown at the Salon de Mai in 1966. That same year César took a mold of the breast of a dancer at the Crazy Horse Saloon in Paris and had it cast in stainless steel and in polyester. While never averse to a bit of sensationalist showmanship, César was also quite concerned with the problem of transforming "the real" into an artistic statement. César's last wrought-iron sculpture, an expressive bird piece entitled *La Pacholette*, was completed in 1966.

The next phase of César's sculpture, the series of "expansions," began in 1967 with his discovery of polyurethane. Expanded polyurethane is made by combining two separate chemicals which come in liquid form and which, after mixing, set in about 24 seconds—time enough to manipulate the material and control its shape. The result was what the artist called a "controlled happening," a kind of "action sculpture." A large orange-painted *Expansion* ("40 litres of expansion") was shown in the Salon de Mai in 1967. César recalled, "When I made the large expansion for the Salon de Mai, someone wanted a piece of it, so I cut a piece off and said 'take it!'" César enjoyed this public participation, and his "Expansions" were sometimes done in the form of performances. He would fling a bucket of liquid polyurethane down a grand staircase in some large public building and the surprised viewers would scatter in all directions as the plastic "lava" grew in front of them and assumed its final shape. Some of César's expansions, widely exhibited in Europe and South America, were like elongated horizontal or vertical distortions of the thumb motif, often coated with white lacquer. In another, smaller expansion, solidified liquid appeared to be emerging from an actual aluminum kettle.

One unimpressed voice was that of *New York Times* critic Hilton Kramer, who reviewed César's works at the 1967 São Paulo Bienal (where César had refused one of the lesser awards) and found the "large accumulation of synthetic materials" to have "no discernible form or meaning." He considered César's work "merely a tasteless attempt to catch up on the esthetics of the sixties." But Jasia Reinhardt of *Architectural Design* wrote that César's expansions "are not only original, they are surprising. . . . There is a monumentality about a process during which 2 or 3 gallons of liquid can be transformed into mountains of solidified foam with folds, waves and undulations."

In 1968 one of César's compressions was donated to the Museé National d'Art Moderne, Paris; it is now in the Centre Pompidou (Beau-

bourg). In 1970 choreographer Dick Sanders commissioned a décor consisting of three giant expansions for the Ballet-théâtre Contemporain at the Maison de la Culture in Amiens, France. That year César was also appointed professor of sculpture at the Ecole des Beaux-Arts, Paris, and has taught there ever since.

In 1971 César made his first compressions of jewelry, which produced richer textures than scrap-metal. He also exhibited cooking utensils and other metal objects, flattened, mounted on canvas, and sprinkled with a light dusting of paint. From 1972 to 1973 he made a series of masks, some cast in bronze, some in polyester foam, and using his own features. (He then had a heavy moustache; the beard came later.) The face was "invaded" in different degrees by the modeling substance, suggesting a constant process of transformation and flux, but it was also a way of injecting himself directly into his sculptures. Some critics consider these masks to be his finest sculptures.

A vast César retrospective opened in Geneva in February 1976 and was subsequently shown in Grenoble, at the Knokke Casino in Belgium, in Rotterdam, and finally at the Museé d'Art Moderne de la Ville de Paris.

In 1977 César, working in his studio near the Montparnasse cemetery, completed a series of medium-sized polyurethane expansions. The formations resembled heavy folds of drapery created by streams of molten lava—again the "controlled happenings." The expansions were given a coating of polyester resin and finished off with layers of acrylic lacquer—white, black, or occasionally flesh-pink.

César employs two assistants, and in the office adjoining his studio his long-time agent and secretary, Michel Lefranc, helps to organize exhibitions and other contacts with the outside world. On the walls of the office are sketches by Jean Tinguely, an old friend of César's, and amusing photomontages incorporating César's face or parts of it. César teaches twice a week at Ecole des Beaux-Arts, driving to the school in an old rattletrap of a station wagon which could well end up as a "compression." He is short and stocky with melancholy brown eyes and a shaggy beard.

The idea of "performance," both in his art and his personality, is very much part of his Marseilles heritage. When a number of people are present he tends to clown. "Humor is a means of defense," he said, "a parade. A way of imposing myself. I'm small. . . . The phenomenon of my size conditions my whole life. . . . Chaplin and Picasso are what they are because they're small." Privately he is more serious, even rather wistful,

as when he periodically questions the validity of a life in art. He has been described as "a bright mask of humor over a black mask of anxiety."

Never an intellectual, and sometimes regretting his fragmentary education, César proceeds by impulse and instinct. "I know that I'm always close to the thing I'm seeking and which I don't manage to grasp. The day when I capture that fugitive light it will be death! No one can capture it, but there is always hope."

EXHIBITIONS INCLUDE: Gal. Lucien Durand, Paris 1954; Gal. Rive Droite, Paris 1955; Hanover Gal., London 1957, '60; Gal. Creuzevault, Paris 1957, '70; Gal. Claude Bernard, Paris 1959; Saidenberg Gal., NYC 1961; Gal. Apollinaire, Milan 1961; Mus. Contini, Marseilles, France 1966; Stedelijk Mus., Amsterdam 1966; Wilhelm-Lehmbruck-Mus. der Stadt, Duisberg, W. Ger. 1966; Gal. Schwarz, Milan 1970; Centre Nat. d'Art Contemporain, Paris 1970; Palais des Beaux-Arts, Brussels 1971; Mus. d'Art et d'Histoire, Geneva, Switzerland 1976; Mus. de Peinture et de Sculpture, Grenoble, France 1976; Casino, Knokke, Belgium Mus. Boymans-Van Beuningen, Rotterdam Mus. d'Art Moderne de la Ville de Paris 1977. GROUP EXHIBITIONS INCLUDE: Salon de Mai, Paris from 1955; Venice Biennale 1956; Middelheim Biennale, Antwerp, Belgium 1957; São Paulo Bienal 1957, '67; Pittsburgh International, Carnegie Inst. 1958, '67; Documenta 2, 3, and 4, Kassel, W. Ger. 1959, '64, '68; "New Images of Man," MOMA, NYC 1959; "New Images of Man," Baltimore Mus. of Art 1960; "The Art of Assemblage," MOMA, NYC 1961; Mus. des Arts Décoratifs, Paris 1965; Gal. Claude Bernard, Paris 1965; Tokyo Biennale 1966; International, Solomon R. Guggenheim Mus., NYC 1967–68; ROSC '71, Dublin 1971.

COLLECTIONS INCLUDE: Centre Georges Pompidou (Beaubourg), Paris; Gal. Claude Bernard, and Gal. Henri Creuzevault, Paris; Tate Gal., London; Rijksmus. Kröller-Müller, Otterlo, Neth.; Mus. Cantini, Marseilles, France; Hirshhorn Mus. and Sculpture Garden, Washington, D.C.; Gal. Semiha Huber, Zürich.

ABOUT: Baldwin, J. and others César, Compressions d'or, 1973; Cabanne, P. César par César, 1971; "César" (cat.), Hirshhorn Mus. and Sculpture Garden, Washington, D.C., 1974; "César: Rétrospective des Sculptures" (cat.), Mus. d'Art et d'Histoire, Geneva, Switzerland, 1976; Lippard, L. R. Pop Art, 1966; Lucie-Smith, E. Late Modern: The Visual Arts Since 1945, 1969; Read, H. A Concise History of Modern Sculpture, 1964; Restany, P. "César" (cat.), Hanover Gal., London, 1960, César, 1975; Russell, J. "César" (cat.), Hanover Gal., London, 1957. Periodicals—Architectural Design September 1976; Christian Science Monitor April 1, 1968; Connaissance des arts (Paris) September 1976, December 1976; New York Herald Tribune April 14, 1961; Les Lettres Françaises (Paris) December 30, 1965, January 12, 1972; New York Times October 1, 1967; XXe siècle (Paris) May 1961.

CHADWICK, LYNN (RUSSELL) (November 24, 1914–), British sculptor, first won recognition in the early 1950s as a leader of the generation of semifigurative British sculptors who came after Henry Moore and before Anthony Caro. He was born in London, the son of Verner Russell Chadwick, a justice of the peace, and the former Marjorie Brown Lynn. He came relatively late to sculpture, having originally intended to become an architect. After attending Merchant Taylor's school in London, he worked as an architectural draftsman from 1933 to 1939.

During World War II Chadwick served as a pilot in the Fleet Air Arm, and it has been suggested that his experience as a wartime pilot may have influenced his sculpture, especially in its concern with movement in space. After leaving the service in 1946, he worked for a year as architect and furniture designer with the architect Rodney Thomas. Then, as he put it, he "pulled the ripcord and jumped." He settled in Gloucestershire with his wife, the former Charlotte Anne Secord, whom he had married in 1942, and their young son. He earned his living as a handyman while he made mobiles of wood and string or metal and colored glass, influenced by Alexander Calder and Julio González. Soon he switched to modeling the human figure.

Chadwick was 36 when he had his first solo show, held at Gimpel Fils, London, in 1950. It was so successful that he was commissioned by the British Council to execute three mobiles for the 1951 Festival of Britain in London. His mobile *The Fish Eater* (1950–51), now in the collection of the Arts Council of Great Britain, was typical of his early sculptures. (After 1951 he gradually freed himself from Calder's influence, creating skeletal structures within which spiky, hooklike elements rotated on off-center pivots.) The overall effect suggested aggressive animals, repellent insects, strange and disquieting birds, crustaceans, and other unusual and but menacing creatures. Chadwick also made sculptures consisting of thin metal sheets, used simply or combined with armatures or other materials, as in *The Inner Eye* (1952; Museum of Modern Art, New York City). In this piece a lump of glass is suspended in a vaguely human framework of iron and wire.

Chadwick's work reached an international public when he was among a large group of new British sculptors, including Armitage, Butler, Paolozzi, and Turnbull, who were shown at the Venice Biennale of 1952. In the following year he won an award in the International Sculpture Competition on the theme of "The Unknown Political Prisoner," organized by the Institute for Contemporary Arts, London.

Jorge Lewinski

LYNN CHADWICK

Beginning in 1953 Chadwick developed his own casting technique, which involved the use of reinforcement processes. He first constructed a steel skeleton, which he then covered with a skin of plaster and reinforced with iron filings before casting it in bronze.

The period of Chadwick's greatest acclaim began in the mid-1950s. "The New Decade," a group show held at MOMA in 1955, included his work. The following year he scored a major success when he was awarded the International Sculpture Prize at the Venice Biennale. The sculptures Chadwick exhibited in Venice toured Europe, and Chadwick showed his work in leading museums in Vienna, Munich, Paris, Amsterdam, and Brussels, as well as in London.

Winged Figures (1955), a bronze group now in the Tate Gallery, London, demonstrates a tendency towards less aggressive imagery; the two standing forms were reminiscent of the work of his friend Kenneth Armitage. A mysterious and vaguely ominous feeling pervades *The Watchers* (1960), a 92-inch-high bronze group of three standing figures with spindly legs and highly formalized heads. Even Chadwick's more abstract works always have what Herbert Read called a "vitalist" quality; they convey a sense of organic life, but a life fraught with anxiety. One critic has detected the influence of the spiky, semiabstract images of Graham Sutherland's paintings on the work of both Chadwick and Reg Butler. Another critic, commenting on the "menacing, animalistic forms" of Chadwick's mobiles and other sculptures of the early 1950s and the more recognizable birdlike creatures that followed, remarked that "the bleak despera-

tion of their stance seemed to symbolize the experience of war and its aftermath." Chadwick moved to a more abstract language and more anonymous material (painted iron) in *Winged Figures* (1962), but soon returned to his semifigurative imagery.

In 1962 Chadwick visited Toronto for a month at the invitation of the Ontario College of Art and the Canada Council. The college supplied him with a studio, where sculpture students had the opportunity to see him work on his latest welded metal piece *The Watcher.*

Chadwick had made his name as an exponent of anxiety (Herbert Read, for example, thought his sculpture expressed "the geometry of fear"). The 1960s saw the advent of pop, op, minimalism, conceptual art, and other manifestations of "cool" art. The seemingly impersonal, nonfigurative metal sculptures of such younger sculptors as Anthony Caro and Philip King represented a reaction against the dramatic expressionism of Chadwick and Armitage. Chadwick was even made a Companion of the British Empire in 1964, but his work suffered a period of neglect. It was rarely exhibited in London in the late '60s and early '70s, although he had numerous shows on the Continent.

In 1974 the first London exhibition of Chadwick's sculpture in eight years was held at Marlborough Fine Art. One critic noted that Chadwick had reverted to a degree of naturalism that was effective in the large-scale group *Three Elektras,* but that on the whole "there is a sense of pulling back from a rich idiom instead of pushing it forward." Another reviewer observed that the "dramatic, worrying aspects" of Chadwick's animalistic and birdlike forms of the 1950s and early '60s had been "weakened in the employment of smoother surfaces and less aggressive extensions, and by the evolution of human or animal forms less in conflict with themselves or us." In such bronzes as *Winged Figures* (1976), the writer noted that "stylistic formulas of pyramid shapes or wing-spans have now been reduced to anecdotal, almost sentimental symbols. . . . " Critical response to Chadwick's next London exhibition, at Marlborough Fine Arts in 1978, was mixed. *Three Sitting Watchers* (1975), *Pair of Walking Figures—Jubilee* (1977), and *Cloaked Figure IX* (1978) were singled out by one critic as "outstandingly strong and forceful images" that achieved "a mythic connection which relates classical and modern man. . . . " Another critic called attention to the effective contrast of the static and the dynamic in the juxtaposition of the vertical figures and the swirling folds of cloaks in *Cloaked Couple II* (1977), yet concluded that

the artist's "formalization of the human image only emphasizes the difficulty of achieving a convincing and relevant solution to a perpetual problem." "Abstraction," noted another reviewer, "seems like a decorative adjunct rather than an inherent necessity."

Chadwick's marriage to Charlotte Anne Secord was dissolved, and in 1959 he married Frances Mary Jamieson, who died in 1964 after bearing him two daughters. His present wife is the photographer Eva Reiner; they have one son. The Chadwicks have lived for many years in what has been described as a neo-Gothic castle in Stroud, Gloucestershire, in a secluded valley in the Cotswold Hills.

A sturdy man with strong yet sensitive features, Chadwick has remained stubbornly independent. His statement in the catalog to the 1955 "New Decade" exhibit at MOMA still holds true: "If I look back on my work over a period of years, I can see a development from mobiles and constructions, on to beaten shapes with limbs and connections, to the solid forms on which I'm now working. . . . Most of the time I work in iron. . . . I am pleased if the iron forms I make have a sort of organic reality, as if they were the logical expression of the materials which I use. . . . Apart from these practical considerations I do not analyze my work intellectually. When I start to work, I wait till I feel what I want to do; and I know how I am working by the presence or lack of a rhythmic impulse. I think that to attempt to analyze the ability to draw ideas from their subconscious source would almost certainly interfere with that ability."

EXHIBITIONS INCLUDE: Gimpel Fils, London 1950, '52; Saidenberg Gal., NYC 1957; Gal. Daniel Cordier, Paris 1958; Gal. Daniel Cordier, Frankfurt, W. Ger. 1959; Marlborough New London Gal., London 1961, '66; Knoedler Gals., NYC 1961, '65; Forum Gal., Bristol, England 1963; Gal. Grosshenning, Düsseldorf 1966; Waddington Gal., Montreal 1968, '72; Dorsky Gal., NYC 1969, '71; Gal. Blu, Stockholm 1969; Gal. d'Eendt, Amsterdam 1969, '76; Court Gal., Copenhagen 1969, '75; Gal. Zodiac, Geneva, Switzerland 1971, '72; Gal. Moos, Toronto 1972; Gal. Blu, Milan 1972; Marlborough Fine Art, London 1974, 78; Marlborough Gal., Zürich 1974, 78; Gal. Toninelli, Milan 1975; Gal. Contacto, Caracas, Venezuela 1975, '77. GROUP EXHIBITIONS INCLUDE: Building Trades Exhibition, London 1947; "International Open Air Exhibition of Sculpture," Battersea Park, London 1951; Venice Biennale 1952, '56; "Unknown Political Prisoner," Tate Gal., London 1953; "British Painting and Sculpture," Whitechapel Art Gal., London 1954; "The New Decade," MOMA, NYC 1955; "Lynn Chadwick/ Yvon Hitchens," Mus. Nat. d'Art Moderne, Paris 1957; São Paulo Bienal 1957; Documenta 2, Kassel, W. Ger. 1959; "Armitage, Chadwick," Kestner-Gesellscheft, Hanover, W. Ger. 1960; "British Art Today," San Francisco Mus. of Art 1962; "Painting and Sculpture of a Decade, 1954–64," Tate Gal., London 1964; "Nine British Sculptors," Delhi, India 1965; Expo '67, Montreal 1967; Biennale, Middelheim Park, Antwerp, Belgium 1969; Exposition Internationale, Mus. Rodin, Paris 1971; Stroud Festival, Gloucestershire, England 1976.

COLLECTIONS INCLUDE: Tate Gal., Victoria and Albert Mus., Arts Council of Great Britain, and British Council, London; Birmingham Art Gal., England; Whitworth Art Gal., Manchester, England; Bristol City Art Gal., England; City Mus., Gloucester, England; Nat. Mus. of Wales, Cardiff; Scottish Nat. Gal. of Modern Art, Edinburgh; Mus. Nat. d'Art Moderne, Paris; Mus. Royaux des Beaux-Art, Brussels; Boymans-Van Beuningen Mus., Rotterdam; Kunsthaus, Zürich; Neue Nationalgal., Berlin; Wilhelm-Lehmbruck Mus., Duisberg, W. Ger.; Stadtische Kunsthalle, Recklinghausen, W. Ger.; Kunstmus. Gothenburg, Sweden; Louisiana Mus., Humleback, Denmark; Mus. Civico, Turin, Italy; Mus. d'Arte Moderna, Venice; MOMA, NYC; Albright-Knox Art Gal., Buffalo, N.Y.; Carnegie Inst., Pittsburgh; Art Inst. of Chicago; Los Angeles County Mus. of Art; Nat. Gal. of Canada, Ottawa; Mus. of Fine Art, Montreal; Nat. Gal. of South Australia, Adelaide.

ABOUT: Bowness, A. Lynn Chadwick, 1962; "Lynn Chadwick" (cat.), Marlborough Fine Art, London, 1961; Giedion-Welcker, C. Contemporary Sculpture: An Evolution in Volume and Space, 1956; Hodin, J.P. Lynn Chadwick, 1961; Moore, E. (ed.) Contemporary Art 1942–72: Collection of the Albright-Knox Art Gallery, 1972; "The New Decade" (cat.), MOMA, NYC, 19545; Ramsden, E.H. Sculpture: Themes and Variations, 1953; Read, H. Lynn Chadwick, 1958, A Concise History of Modern Sculpture, 1964; Seuphor, M. The Sculpture of this Century: Present-day Sculpture in Great Britain, 1960. Periodicals—Art International (Lugano) March 1978; Art News October 1976; Art News and Review July 1957; Burlington Magazine (London) April 1978; Christian Science Monitor March 9, 1957; Horizon March 1978; Listener (London) October 1954; L'Oeil (Paris) February 1957; Quadrum (Brussels) November 1956; Toronto Globe and Mail May 21, 1962.

*CHAGALL, MARC (July 7, 1887–), Russian painter, printmaker, and stained-glass artist, is the last survivor of those creative years in Paris before World War I that revolutionized 20th-century art. He was born in the ghetto of the village of Vitebsk, Russia, the oldest of nine children. His father, who changed the family name from Segal to Chagall, made his living by packing herring into barrels. The boy grew up in the harsh but colorful surroundings of the Jewish shtetl that were later to provide abundant imagery for his paintings. In his autobiography, My Life, written as early as 1922, he recalled that "all around us were churches, fences, shops, syna-

°shə gäl´, märk

Agence France Presse, Nice; Photo by Ralph Gatti

MARC CHAGALL

gogues—simple and eternal like the buildings in Giotto frescoes."

Because his parents were devout Chasidic Jews, strictly following the commandment against "graven images," Chagall as a child was not exposed to art. One day he saw a schoolmate copying a magazine drawing and was so impressed that he too began copying illustrations. Encouraged by the praise of his schoolmate for his first efforts, he began to entertain the idea of art as a career. His mother could not conceive of his being a painter, but thought that if her son became a photographer, that would mean "a real job and a house with furniture." He was apprenticed by his parents to a photographer, but found he was soon bored by retouching and similar chores. He persuaded his parents to let him study art, and in 1906 he took private lessons with an academic Vitebsk painter, Jehuda Penn. The following year Chagall entered the Imperial School for the Protection of Arts, St. Petersburg. In Czarist Russia, Jews needed special permits to move to cities, so Chagall had managed to obtain a document identifying him as the official representative of the merchants of Vitebsk.

Chagall spent two years of study, 1907–09, in St. Petersburg, and also, in 1908–09, studied privately with the painter Léon Bakst, who was later to win international fame as a designer for Diaghilev's Ballets Russe. Bakst introduced Chagall to the work of Cézanne, Gauguin, and Van Gogh.

These were years of great poverty for Chagall. He slept in a corner of a workmen's barracks, and for a while he was apprenticed to a sign painter. His first notable work, *The Dead Man,*

painted in 1908 when he was 21, was inspired by a funeral in Vitebsk, a city he often revisited. The painting shows a corpse lying in a street surrounded by candles. Nearby a woman weeps, and a man plays a fiddle on a roof. This latter image, which was to become, as it were, Chagall's emblem, and which, many years later, was to provide the theme of one of the most successful of all Broadway musicals, *Fiddler on the Roof,* had a basis in fact, for Chagall's Uncle Nench played the fiddle on roofs at Jewish village festivals. Chagall's work was also influenced by the mystical icons of the Russian Orthodox church hieratic images of saints that he admired for being "magical and unreal."

In 1910 an art-loving St. Petersburg lawyer and liberal politician, Maxim Vinaver, impressed by Chagall's work, proposed sending him either to Rome or Paris. Chagall chose Paris, and his newfound patron gave him a modest stipend of 125 francs a month. In Paris Chagall settled with other Russian painters in "La Ruche" (The Beehive), near the Vaugirard slaughterhouse near Montparnasse. In the next four years he discovered the work of Bonnard and Matisse and became friendly with the poets Blaise Cendrars, Max Jacob, Guillaume Apollinaire, and André Salmon. He also met La Fresnaye, Robert and Sonia Delaunay, Modigliani, and other painters of the School of Paris.

It was in these years that Chagall developed his personal style and, in the opinion of some critics, produced his finest work, in which the naive vision of Russian folk art was disciplined and enriched by its contact with Parisian cubism and Delaunay's orphism. Chagall's desire to "synthethize" a whole life experience found expression in his large canvas of 1911, *I and the Village,* now in the Museum of Modern Art, New York City. In this painting, images derived from memories of Vitebsk are infused with a strong element of fantasy and the unconscious. As the profiles of the two main characters, a man and a huge cow, confront each other, a peasant woman whirls beneath topsy-turvy roofs, and lower down the artist's hand holds a flowering branch. The simultaneity of image and activity and the abrupt changes of scale would often recur in his work, as in *The Soldier Drinks* (1912–13) where all the elements are disjointed, producing an effect of surprise and defying logic and gravity. The cap of the tipsy Russian soldier floats above his head, while below, in the foreground, tiny figures of the same soldier with a woman on his knee echo the picture's dominant rhythms. The sharp planes reflect the impact of cubism, but the warm vibrant colors, exuberant handling, and poetic evocations of Russian village life are Chagall's alone.

In 1914 Guillaume Apollinaire introduced Chagall to the Berlin critic and promoter Herwarth Walden, editor of the weekly avant-garde magazine *Der Sturm* and director of a Berlin gallery of the same name. Walden organized Chagall's first solo exhibition, consisting of two hundred paintings, which remained in Germany after war was declared. The introduction to the catalog was written by Apollinaire.

Chagall stopped off to see his Berlin exhibition as he was en route to Vitebsk. His childhood sweetheart Bella Rosenfeld, daughter of a Moscow merchant, had written him that she had another suitor. Chagall arrived in Vitebsk shortly before war broke out and married the handsome, dark-haired Bella in 1915. In the same year Chagall was mobilized, but placed in the reserve.

Several of his paintings in the teens expressed his happiness with Bella, including *The Birthday* (1915–23), in which figures of a youth and a girl float in ecstasy, and *Self-Portrait with a Wine Glass* (1917). Outstanding among the canvases done after his return to Russia is *Rabbi of Vitebsk* (1914), controlled in color and design and free from sentimentality. His folkloric, fantastic imagery was at its best in *Over Vitebsk* (1916; MOMA). In this painting cubist structure was already less evident than in his pre–1914 canvases.

For two years Chagall and Bella lived in St. Petersburg and their daughter, Ida, was born in 1915. The Bolsheviks seized power in 1917, and the following year the revolutionary council appointed Chagall cultural commissar for the Vitebsk area. He founded an art school and local museums in Vitebsk, set about reforming the teaching of art, and called upon well-known artists to cooperate in the creation of a new social order. Soon, however, he began to disagree on matters of art and aesthetics with the young Soviet political leaders of the area, who took a dim view, to quote Aline Mosby of *Art News* (Summer 1977), of his "flying green cows and upsidedown girls." Chagall was also opposed to the suprematism of Malevich. The Chagalls finally left Vitebsk under pressure.

In Moscow Chagall was commissioned in 1919 by Alexis Granowsky, director of the Kamerny Jewish Theater, to paint murals for the foyer and to design stage sets. Here, too, Chagall's floating figures, which have been called "semi-surrealist," met with official disapproval. In 1922 Chagall emigrated again, leaving for Berlin. He had already begun his autobiography, *Ma Vie*, and remained in Berlin long enough for Cassirer to publish his first series of engravings illustrating this life story. Chagall then moved to

Paris, where Blaise Candrars introduced him to the dealer Ambroise Vollard, who immediately commissioned Chagall to make engraved illustrations for an edition of Gogol's *Dead Souls*. However, Chagall's 96 *Dead Souls* illustrations, on which he worked until 1927, were not published until 1949.

Chagall had his first retrospective exhibition in 1924, at the Galerie Barbazanges-Hodebert, Paris. During the mid-1920s his style became increasingly romantic and gave form to the fantastic, narrative themes derived from folk memories of his Russian origin, motifs he was to repeat innumerable times for over 50 years. *The Jewish Wedding* (1926; MOMA) is typical of this phase. In 1926 he had his first solo in New York, at the Reinhart Galleries. From 1924 to 1926 the Chagalls spent several months each year in Brittany, Montchauvet, Mourillon, and the Auvergne.

In 1927 Chagall began another Vollard commission, the illustration of the *Fables* of La Fontaine, and completed the one hundred plates for this edition in 1930. The following year he traveled in the Near East, visiting the Holy Land, Syria, and Jerusalem in search of themes and local color for his illustrations of the Old Testament, yet another Vollard commission. Chagall's illustrated Bible was finally published in 1956, 17 years after Vollard's death. Chagall's other book illustrations include those for the *Arabian Nights* (published in 1948), *Daphnis and Chloë* (after a trip to Greece), and Boccaccio's *Decameron*. His autobiography was published in 1931.

By 1933, when he had a large retrospective at the Basel Art Museum, Chagall had become internationally famous. He was extremely disturbed by political developments in Europe in the early 1930s, and his uneasiness was aggravated by a visit to Poland in 1935. The persecution of the Jews in Germany and the growing threat of war led him to paint darkly dramatic religious works, including several *Crucifixions,* in the 1930s. A picture from the same period in his more familiar vein was *Time is a River without Banks* (1930–39).

Chagall was awarded first prize in the 1939 Carnegie International, Pittsburgh, and in 1941, at the invitation of MOMA, he left with his wife for the United States. They arrived on June 23, and settled in New York City, where they associated with Léger, Masson, Mondrian, Breton, and Zadkine, all of whom had fled war-torn Europe. At first Chagall felt rejuvenated by the new environment, and in 1943 he painted *The Juggler,* whose main figure is half bird and half man. Painted in lush colors, the picture is full of sym-

bols of the artist's childhood memories—of circuses, of his house in Vitebsk, of his Uncle Nench playing the fiddle, and of the big clock which hung in the Chagall home. But he also painted tragic themes, as in *Fallen Angel*, in which the world explodes as a fleeing rabbi clutches the Torah and an angel falls from the sky in a wave of blood, and *Obsession* (1943).

Personal tragedy struck Chagall with the death in 1944 of his beloved wife Bella. For several months Chagall refused to paint, but assisted their daughter Ida in her translation of Bella's memoirs of Russia, *Burning Lights*. In 1945 he completed the sets and costumes for Stravinsky's ballet *Firebird* and created other theatrical designs. MOMA gave Chagall a retrospective in 1946, and the following year he returned to Paris, where he had another retrospective, at the Musée National d'Art Moderne. This exhibition traveled to Amsterdam and London.

At the Venice Biennale of 1948, Chagall was awarded the international prize for engraving. He lived for a while in Orgenval and in Saint-Germain-en-Laye, in northern France, but in 1949 he settled near Vence in southern France, where he initially worked mainly in ceramics. That same year he did two murals for the intimate Watergate Theatre, London. His allegorical canvas *The Red Sun* from that period referred once again to Russian-Jewish folkloric fantasy, while evoking the memory of his late wife. In 1952 Chagall married Valentine (Vava) Brodsky, a beautiful, dark-haired, Russian-born divorcée, who had been a hat designer in London.

In the 1950s Chagall visited Israel, Greece, Italy, and London and began an ongoing involvement with a new medium when, in 1957, he collaborated with Charles Marq, master glass painter at the Atelier Simon in Rheims. When the richly colored windows for Metz Cathedral were completed in 1960, Chagall's intense blues and violets, glowing reds, and luminous yellows had given new life to the images of Abraham, Moses, Jacob, and the golden vision of Paradise. Chagall was then commissioned by the architect Joseph Neufeld and the Women's Zionist Organization to design 12 stained-glass windows, symbolizing the 12 tribes of Israel, for the synagogue of the Hadassah Hebrew University Medical Center near Jerusalem. These windows, each with a dominant color and symbolic imagery relating to an individual tribe, were exhibited in Paris and New York before being installed in Israel in 1962.

In 1964 Chagall designed a ceiling for the Paris Opera, followed in 1965 by two large murals for the facade of the Metropolitan Opera, Lincoln Center, New York City. These two paintings were felt by some observers to be facile repetitions of the artist's familiar themes, haphazard in design and overly sweet in color. In 1965–66, also for the Metropolitan Opera, he designed sets for Mozart's *Magic Flute* that have been criticized by some for being gaudy and for overpowering the music and the production. During 1967–68 Chagall designed a triptych of tapestries representing the Creation, the Exodus, and the Entry into Jerusalem. The tapestries were commissioned by André Malraux, the French minister of cultural affairs under President de Gaulle, for presentation to the Israeli parliament.

While Chagall was on a nine-day visit to his native Russia in the early 1960s the Soviets asked him to sign his 1919–20 murals in the Kamerny Theater, and some of his pictures, which had remained hidden in museum storerooms, were taken out for a small exhibition in his honor. He told Aline Mosby in 1977: "Whether my works are still in basement storage there I do not know . . ." He added: "I still have a sister in Leningrad, and many nieces. . . . "

Major Chagall retrospectives took place in Zürich and Cologne in 1967, and an important exhibition at the Pierre Matisse Gallery, New York City, was held in 1968. The Musée National du Passage Biblique Marc Chagall was inaugurated in Nice in 1973, and his windows for Rheims Cathedral were installed the following year.

Since 1949 Chagall and his wife had been living in a house near Vence called Les Collines but finding, after a while, that the 21 steps up to his studio were too much for him, the aging artist ordered a new house built, also near Vence, with an elevator. At the new house, named "La Colline," his wife Vava, he has said, "keeps his life in order," shielding him from visitors. His cluttered studio, according to Mosby, contains "heaps of books, canvases, palettes, photographs of relatives, a Russian samovar," as well as records of Mozart and Bach that he plays while he works.

Marc Chagall is a short, stocky man, with a tanned, weather-beaten face, whose strongly marked features were, to quote Alexander Liberman, who photographed him in 1958, surrounded by thinning, unruly locks of grey hair." At the approach of his 90th birthday in 1977, Chagall seemed, according to Mosby, to be in excellent form, "with the senses of a man decades younger." He is alert and curious about people and places. His ready smile contrasts with the frequent sadness in his eyes, but in his complex nature there is considerable shrewdness and an

awareness of his own "persona." Two or three times a year the Chagalls go to Paris to visit his daughter Ida Meyer and to stay in their 18th-century flat in the Quai d'Anjou.

Critics generally believe that Chagall's most important contribution to modern art was made in Paris in the years immediately before and during World War I, when, to quote Herbert Read; "his particular fantasy seemed to reinforce the quite different fantasy of de Chirico, and together they opened a path into the unconscious where few artists had hitherto ventured." Read qualified this statement, asserting that Chagall "has always kept one foot on the earth that nourished him." Although Chagall's work of the last 50 years enjoys immense popularity, many critics have been disturbed by his constant repetitiousness and by what they consider his overindulgence in whimsical fantasy. The Yale art historian George Heard Hamilton once described Chagall's work as "high-class kitsch, too pretty." However, Picasso admired Chagall's "primordial palette"—Chagall's own phrase—and Francoise Gilot, in *Life with Picasso* (1964), quotes Picasso as saying, "When Matisse dies, Chagall will be the only painter left who understands what color really is. I'm not crazy about those cocks and asses and flying violinists and all the folklore, but his canvases are really painted, not just thrown together."

Chagall's clearest and most direct statement about his art's folk-legend subject matter and supposedly presurrealist character was made in a recorded interview in New York City in 1944. Answering charges that his work was anecdotal and "literary," he declared: "As far as literature goes, I feel myself more 'abstract' than Mondrian and Kandinsky in my use of pictorial elements. . . . What I mean by 'abstract' is something which comes to life spontaneously through a gamut of contrasts, plastic at the same time as psychic, and pervades both the picture and the eye of the spectator with conceptions of new and familiar elements. . . .

" . . . That I made use of cows, milkmaids, roosters, and provincial Russian architecture as my source-forms is because they are part of the environment from which I sprang and which undoubtedly left the deepest impression on my visual memory of any experiences I have known. . . . "

EXHIBITIONS INCLUDE: Gal. der Sturm, Berlin 1914; Gal. Barbazanges-Hodebert, Paris 1924; Reinhart Gals., NYC 1926; Gal. Bernheim-Jeune, Paris 1930; Gal. Le Centaure, Paris 1930; Gal. Flechtheim, Berlin 1930; Stedelijk Mus., Amsterdam 1932, '47, '56; Kunsthalle, Basel 1933, '56; Leicester Gals., London 1935; Palais des Beaux-Arts, Brussels 1938, '57; Pierre Matisse Gal.,

NYC from 1940; MOMA, NYC 1946; Art Inst., Chicago 1946; Mus. Nat. d'Art Moderne, Paris 1947; Tate Gal., London 1948; Gal. Maeght, Paris 1950, '52, '54; Gal. dell'Obelisco, Rome 1952; Kunsthalle, Bern 1956; Bibliotèque Nat., Paris 1957; Haus der Kunst, Munich 1959; Mus. des Arts Décoratifs, Paris 1959, '61; Mus. Masséna, Nice, France 1962; Mus. of Western Art, Tokyo 1963; Municipal Mus., Kyoto, Japan 1963; Mus. des Beaux-Arts, Rouen, France 1963; Israel Mus., Jerusalem 1965; Kunsthaus, Zürich 1967; Kunsthalle, Cologne 1967; Fondation Maeght, Saint-Paul-de-Vence, France 1967; Grand Palais, Paris 1969–70; Los Angeles County Mus. of Art 1973; Solomon R. Guggenheim Mus., NYC 1975; Mus. Nat. du Passage Biblique Marc Chagall, Nice, France 1976; Davlyn Gal., NYC 1978. GROUP EXHIBITIONS INCLUDE: Salon des Indépendants, Paris 1912; Salon d'Automne, Paris 1912; "Year 1915," Salon d'Art de Michailova, Moscow 1915; "Knave of Diamonds," Moscow 1916; "Exhibition of Paintings and Sculptures by Jewish Artists," Gal. Lemercier, Moscow 1917; Pittsburgh International, Carnegie Inst. 1939; Venice Biennale 1948; "Russian Art of the Revolution," Andrew Dickson White Mus. of Art, Ithaca, N.Y. 1970; "Russian Art of the Revolution," Brooklyn Mus., N.Y. 1970; "Russian Avant-Garde," Leonard Hutton Gal., NYC 1971.

COLLECTIONS INCLUDE: MOMA and Solomon R. Guggenheim Mus., NYC; Albright-Knox Art Gal., Buffalo, N.Y.; Wadsworth Atheneum, Hartford, Conn.; Mus. of Art, Philadelphia; Inst. of Arts, Detroit; Los Angeles County Mus.; Art Gal. of Ontario, Toronto; Tate Gal., London; Mus. Nat. d'Art Moderne, Paris; Mus. Nat. and Mus. Nat. du Pessage Biblique Marc Chagall, Nice, France; Mus. des Beaux-Arts, Liege, Belgium; Stedelijk Mus., Amsterdam; Stedelijk van Abbe Mus., Eindhoven, Neth.; Mus. Boymans-Van Beuningen, Rotterdam; Kunstmus., Basel; Kunstmus., Bern; National Gal., Berlin; Wallraf-Richartz Mus., Cologne; Russian Mus., Leningrad; Tretyakov Gal., Moscow; Tel Aviv Mus.; Nat. Gal. of Victoria, Melbourne.

ABOUT: Ayrton, M. Chagall, 1950; Cassou, J. Chagall, 1965; Chagall, M. Marc Chagall: My Life, 1957; Goldwater, R. and others (eds.) Artists on Art, 3d ed. 1958; Haftmann, W. Chagall, 1972; Kloomok, J. Marc Chagall: His Life and Work, 1951; Lassaigne, J. Chagall, 1957; Leymarie, J. The Jerusalem Windows by Marc Chagall, 1962; Maritain, R. Marc Chagall, 1943; Meyer, F. Marc Chagall, l'oeuvre gravée, 1957, Marc Chagall, 1961; Mourlot, F. and others The Lithographs of Chagall, 1969; Raynal, M. (ed.) Histoire de la peinture moderne, De Picasso au Surréalisme, 1950; Read, H. A Concise History of Modern Painting, 1959; Roth, C. (ed.) Jewish Art: An Illustrated History, 1961; Sorlier, C. (ed.) Chagall by Chagall, 1979; Sweeney, J. J. and others "Marc Chagall" (cat.) MOMA, NYC, 1946; Venturi, L. Marc Chagall, 1945. *Periodicals*—Art News Summer 1977; L'Art vivant (Paris) December 1927; Cahiers d'art (Paris) nos.1–4 1935; Le Figaro littéraire (Paris) March 1952; Les Nouvelles litteraires (Paris) April 1932; Paris-Journal May 1924; Partisan Review Winter 1944; XXe siècle (Paris) November 1969.

CHAMBERLAIN, JOHN (ANGUS)

CHAMBERLAIN, JOHN (ANGUS) (April 16, 1927–), American sculptor, was in the late 1950s one of the first artists to translate the energy and spontaneity of the New York School of abstract expressionism into three dimensions. He is best known for the welded metal sculptures he made from parts of wrecked automobiles.

Chamberlain was born in Rochester, Indiana but his youth was spent in Chicago. From 1943 to '46 he served in the US Navy. He began as a painter, but while studying at the Art Institute of Chicago, from 1950 to '52, he realized that sculpture was his main interest. At the museum he was impressed by a David Smith sculpture, one of the early "Agricolas," exhibited in 1952 and by a Giacometti that was set up at the head of the stairs. "There's a larger presence available in a sculpture than there would be in painting, so I made a choice there in terms of the physicality of it," Chamberlain recalled, as quoted in the catalog to his 1971 retrospective at the Guggenheim Museum, New York City.

By 1953 Chamberlain had discarded the traditional sculptural techniques of carving and modeling in favor of welding. His early sculpture, influenced by David Smith, was linear, open, and constructed mainly from iron pipes. He left Chicago in 1954, and in 1955–56 studied and taught at the avant-garde Black Mountain College in North Carolina, where he encountered the work of Franz Kline and other New York School painters. Among the courses offered at Black Mountain was the Bauhaus derived course on materials, which helped to develop Chamberlain's awareness of materials and textures.

Chamberlain moved to New York City in 1956 and took a studio. In those days Chamberlain could not afford expensive materials, and junk metal appealed to him because it was free. He produced his first works using crushed automobile parts in 1957. Chamberlain recalled that he had run out of store-bought materials and "went to Larry Rivers's place [in Southampton, Long Island] and he had some old car parts out there—a '29 Ford. All of a sudden I liked them [car parts] for some reason. Then a couple of months later it occurred to me that there were all of those junkyards out there and it was fantastic—just free material—free material at that time was essential. And here it was, free steel that was already painted. You couldn't beat it with a sledge-hammer."

Among Chamberlain's assemblage sculptures of 1957 were *Projectile D.S.N.Y.* in steel, and *Shortstop*, in welded and painted steel. *Shortstop* is composed of two fenders entwined by a twisted rod. In the same year his first solo show was mounted at the Wells Street Gallery, Chicago.

Francois Meyer, Switzerland; Castelli Gallery

JOHN CHAMBERLAIN

Between 1959 and '63 Chamberlain worked exclusively on assemblages made from the metal of junked cars. Typical works were *Johnny Bird* (1959) and *Hudson* (1960), both in welded and painted steel. Notwithstanding the associations such pieces might hold for viewers, Chamberlain insisted that the sociology of his materials was unimportant to him and that his sculpture is not intended as an ironic statement about mass culture. Though he admits that his sculpture of the '50s was infused with anger, what interested him in the parts of junked cars was their color and abstract formal qualities. Nevertheless, one cannot ignore the wider implications of this fascination with junk metal, which was also to be found in the late '50s and early '60s in the work of Richard Stankiewicz, Jean Tinguely, and Mark di Suvero. These works can be seen as comments on the profligacy of the consumer society, but Chamberlain's intense subjectivism links him to the Abstract Expressionist painters. His work has affinities with the formalistic painterliness and self-referentiality of works by Willem de Kooning, although Chamberlain claims to have been more influenced by Kline.

Chamberlain compositions were included in the touring "Art of Assemblage" exhibition organized by the Museum of Modern Art, New York City, in 1961–62. Chamberlain's temperament was characteristic of the "hot," expressionist modalities of the late '40s and '50s; inevitably, in the "cool" '60s, his career, although not his art, suffered. As Barbara Rose pointed out in *Artforum* (February 1972), he was not attuned to "the highly cerebral, buttoned-down and straightened out '60s, with its preference for the hard

line, both in criticism and in art." The "cool" mode of minimalism was not for Chamberlain. Nonetheless, he was friendly with Don Judd, Minimalist creator of steel boxes, wall modules, and other so-called primary structures; at one time in the '60s Chamberlain made galvanized pieces out of crushed Donald Judd boxes. A wall-piece of 1962, *Dolores James,* was acquired by the Guggenheim Museum.

In the 1960s Chamberlain experimented with different materials and sizes. His largest piece, fifteen by eight by four feet, was executed for the New York World's Fair of 1964. About 1962 he started painting his sculptures because he "felt that the material needed a little help." At various times he used scrap metal, paper bags, polyurethane, and plexiglass. After spending time in Los Angeles, where the modern craft aesthetic was being practiced, Chamberlain produced a series of gleaming chrome and flecked-enamel relief plaques which had the so-called California look. He used auto lacquer on formica in about 50 paintings of 1964–65 with sets of nine small squares on a larger ground. They were named after rock groups; *Shangri-las* (1964) is owned by the artist, *The Rolling Stones* (1965) is in a private collection, and Diana Ross, appropriately, owns *The Supremes.* In these works Chamberlain concentrated more explicitly on color. He would select a geometric shape and build up the surface by spraying as many as 100 coats of automobile lacquer, first on masonite and then on formica, in order to achieve one color.

Chamberlain's crushed aluminum sculptures of 1967–68 extended the range of his work. His preference for fitting or interlocking disparate parts was superseded by a predilection for single units, such as the boxlike structure of galvanized steel he used in *Norma Jean Rising* (1967). By 1970 he was making mineral-coated melted plexiglass sculptures, in which the multiple reflections "create shifting planes out of a fluid space whose organization is ultimately amorphous," as Diane Waldman said in the Guggenheim retrospective catalog. *Dinnebitto, Polacca,* and *Ziki-Dush-Jhini,* all of 1970, are in this vein. Waldman observed that, "although the material is transparent, the structure is no more self-explanatory than his crushed auto sculptures." At this time Chamberlain also made small paper-bag sculptures. His photography is considered highly original, and he has made 16 mm films, including *Wedding Night* (1967), *The Secret Life of Hernando Cortez* (1968), *Wide Point* (1968), and *Thumbsuck* (1971).

One of the most energetic compositions in the large 1979 exhibition at the Whitney Museum of

George Segal's sculptures was the life-size portrait in gleaming silver of John Chamberlain working. Reviewing a 1977 Chamberlain exhibition at the Heiner Friedrich Gallery, New York City, John Russell of *The New York Times* (November 25, 1977) remarked that the artist's new crushed-metal sculptures "make a somewhat mannered and decorative effect. . . . The old raw energy has gone from these sculptures, but by way of compensation they have an autumnal fullness and softness of feeling."

John Chamberlain has a studio on the Bowery, in lower Manhattan. He is restless and leads a nomadic life, having many times crossed and recrossed the American continent. His appearance, stocky, robust, with a moustache and an unruly shock of hair, still suggests the 1950s bohemian. In *Artforum* Phyllis Tuchman noted that his diction and manner are revealing: without intellectual pretensions, he expresses himself in a colorful everyday vernacular. He is intuitive rather than methodical, and earthbound rather than inclined to metaphysical speculation. When asked by Tuchman whether his works of the early '60s were metaphorical, he replied: "No, they're self-portraits. The portraiture had more to do with the balances and rhythms and spaces and areas and attitudes than it had to do with what one looked like. If you look at the sculptures, you can see that most all the sculptures I do, of one kind and another, have certain kinds of balance or rhythm that are characteristic of myself. That's the way I feel about it; other people feel differently and read different things."

EXHIBITIONS INCLUDE: Wells Street Gal., Chicago 1957; Martha Jackson Gal., NYC 1960; Leo Castelli Gal., NYC from 1962; Gal. Ileana Sonnabend, Paris 1964; Dwan Gal., Los Angeles 1966–67; Gal. Rudolf Zwirner, Cologne 1967; Cleveland Mus. of Art 1967; Lo Giudice Gal., Chicago 1970; Solomon R. Guggenheim Mus., NYC 1971; Heiner Friedrich Gal., NYC 1977. GROUP EXHIBITIONS INCLUDE: "Recent Sculpture: USA," MOMA, NYC 1959–60; "Le Nouveau Réalisme," Gal. Rive Droite, Paris 1960; Whitney Annual, NYC 1960–71; São Paulo Bienal 1961; "The Art of Assemblage," MOMA, NYC 1961–62; Pittsburgh Intl. 1961, '67; "Sculpture in the Open Air," Battersea Park, London 1963; Venice Biennale 1964; "Etats-Unis: Sculpteurs du XXe siècle," Mus. Rodin, Paris; "New York Painting and Sculpture: 1940–1970," Metropolitan Mus. of Art, NYC 1969–70; "Art and Technology," Los Angeles County Mus. of Art, 1971; Whitney Biennial, NYC 1973.

COLLECTIONS INCLUDE: MOMA, Whitney Mus. of Am. Art, and Solomon R. Guggenheim Mus., NYC; Albright-Knox Art Gal., Buffalo, N.Y.; Hirshhorn Mus. and Sculpture Garden, Washington, D.C.; William Rockhill Nelson Gal. and Atkins Mus. of Fine Arts,

Kansas City, Mo.; Detroit Inst. of Arts; Los Angeles County Mus. of Art; Pasadena Art Mus., Calif.; Tate Gal., London; Landesmus., Darmstadt, W. Ger.; Gal. Nazionale d'Arte, Rome.

ABOUT: Lippard, L. R. Pop Art, 1966; Read, H. A Concise History of Modern Sculpture, 1964; Rose, B. American Art Since 1900, 2d ed. 1975; Rosenberg, H. Artworks and Packages, 1969; Seuphor, M. The Sculpture of this Century, 1959; Waldman, D. and others "John Chamberlain" (cat.), Guggenheim Mus., NYC, 1971. *Periodicals*—Art International (Lugano) January 1964; Art News April 1969; Artforum February 1967, February 1972; Metro (Venice) May 1961; New York Times January 19, 1962, November 25, 1977; Vogue April 1970.

Courtesy Gallerie Maeght

EDUARDO CHILLIDA

*CHILLIDA, EDUARDO (January 10, 1924–), Spanish sculptor, has gained international prominence with his abstract yet emotionally charged works of wrought iron, wood, and steel.

Chillida was born in San Sebastian, Spain, where he lived with his parents and his two brothers, Gonzalo and Ignacio, in a house next to the Hotel Biarritz, which was managed by his grandparents. The artisan heritage of his native Basque has always influenced Chillida, particularly in his use of heavy metals to create his positively stated forged shapes.

After attending high school in San Sebastian until 1942, Chillida began his studies in architecture at the University of Madrid the following year. He remained at the university until 1946, but soon abandoned the study of architecture for drawing and design, which he took classes in at a private academy, and sculpturing.

In 1948 Chillida moved to Paris and settled in the Spanish House in the Cité Universitaire. His first attempts in sculpture were in stone and plaster, mostly the latter, and in 1948 he completed a terra-cotta sculpture, *Pensadora*. His sculptures from 1948 to 1951 reveal, in the words of the poet Octavio Paz, "a simultaneous attraction for women and the earth." Chillida became friends with the sculptor Pablo Palazuelo, whom he had visited in Madrid and who also came to live at the Cité Universitaire. In 1949 Bernard Dorival, the curator at the Musée d'Art Moderne, Paris invited them to exhibit at the Salon de Mai. Chillida showed his first two works, *Forma* (1948) and *Pensadora*. In *Forma*, modeled in plaster, the headless female form appeared to be "oscillating between the natural and the human worlds," In Paz's words.

Chillida exhibited a second time at the Salon de Mai in 1950. That year he also returned to San Sebastian, where he married Pili Belzunce, of

French Basque origin. The young couple moved to Villaines-sous-Bois, France, and Palazuelo rented a studio next to their apartment. The director of the Galerie Maeght, Paris, chose two of Chillida's plaster sculptures, *Torso* (1950) and *Metamorphosis* (1949), for "Les Mains éblouies" (Dazzled Hands), an exhibition that grouped together 23 young artists representing the first wave of postwar abstraction in France. *Torso* (now in the Fondation Maeght, Saint-Paul-de-Vence, France), a highly simplified, archaizing sculpture, was typical of this transitional phase of Chillida's work, in which he was still searching for his own idiom. *Metamorphosis* (1949), his first abstract sculpture of two curved bodies, has since been destroyed.

In April 1951 Pili and Eduardo returned to San Sebastian for the birth of their first child, a daughter, Guiomar. They settled in Hernani, in the Basque province of Guipuzcoa, in the Villa Allegre.

With the aid of a blacksmith, Chillida, in October 1951, completed his first truly abstract sculpture in iron, *Ilarik*, a kind of funeral stele with simple geometric interlocking forms. Helped by his friend José Cruz Iturbe, he installed his first forge in his home, and from then on iron was the dominant medium in his work. For the next few years, in what he regarded as a period of gestation, he refused to exhibit prematurely, and forged a whole series of objects in rough metal which suggested agricultural implements used to "plow" the heavens—including *Peine del viento I* (1952–53, Wind Comb I) and *Desde dentro* (1953, From Within). These pieces were all in iron, and *Desde dentro* is now in the

°chē lyē´ də, ä dwä´ dō

Solomon R. Guggenheim Museum, New York City. Of the series of sculptures produced between 1952 and 1956 Octavio Paz has noted that the iron was "filed and sharpened into slender jets that curve around or shoot assaultingly into space."

In 1954 the artist was given his first solo exhibition at the Clan Gallery, Madrid, which included 13 sculptures, slate engravings, collages, and drawings. Chillida was then invited to exhibit ten sculptures in the Spanish section of the Milan Triennale, where he won an award. In the same year he received a commission for four doors in iron relief for the Basilica of Aranzazu in the province of Guipuzcoa, and was invited to take part in the 1955 "Eisenplastik" exhibition in the Kunsthalle in Bern. In December 1954 Chillida showed his iron sculpture *Desde dentro* at the "Premier salon de la sculpture abstraite" organized by Denise René in her Paris gallery.

In 1955, at the age of 31, Chillida received an important commission from the city of San Sebastian, a monument to the memory of Sir Alexander Fleming, the discoverer of penicillin. This monument, carved in stone, was unveiled in the Ategoprieta garden in San Sebastian. In the following year Chillida had an important exhibition of 27 of his sculptures at the Galerie Maeght, Paris. Gaston Bachelard wrote a preface for the 1956 catalog titled "Le Cosmos du fer."

Over a period of 12 years, from 1954 to 1966, Chillida completed a series of 17 sculptures called "Yunque de sueños" (Anvil of Dreams). In most of these sculptures, the "anvil" was iron and the base wood. Octavio Paz observed: "At times the relationship between the sculpture and its base is that of the axe and the trunk; at other times of lightning and the tree." In one of Chillida's notebooks he wrote that he had returned to wood "guided only by a scent." Wood was later to assume major importance in his work.

Between 1956 and 1959 Chillida created "Rumor de limites" (Rumor of Limits), a series of seven sculptures, five of iron and two of steel. The transposition of the visual and tactile into the sonorous, a constant theme in Chillida's work, is also indicated by such titles as *Resounding Spaces I* and *Music of the Constellations*, both of 1954, and *Place of Silences* (1958). Other pieces with evocative titles were *In Praise of Fire* (1955), *In Praise of Air* (1956), and three iron sculptures called "Irons of Trembling," made, respectively, in 1955, 1956, and 1957. The title of *Silent Music* (1955), an iron sculpture with forms suggesting both a trident and a fantastic harp, was taken from a poem by the 16th-century Spanish mystic St. John of the Cross.

Twelve sculptures Chillida exhibited in the Spanish pavilion at the Venice Biennale of 1958 won him the International Grand Prize for sculpture. In September of that year he was invited to Chicago to receive an award from the Graham Foundation. During his American visit Chillida met James Johnson Sweeney, then director of the Guggenheim Museum, and the architects Mies van der Rohe, Charles Eames, and Frederic Kiesler. He exhibited at the Pittsburgh Bicentennial International and the Carnegie Institute, which bought *Aizain* (In the Wind), one of his iron sculptures. In 1959 he took part in Documenta 2, Kassel, West Germany. Chillida's drawings of the late 1950s, in ink or litho crayon, were described by a *New York Times* critic (February 16, 1958) as resembling "sensitive oriental calligraphy, seemingly illuminating his iron work only in their adherence to pure form."

On December 13, 1959 Chillida settled with his family in San Sebastian. By then he had five children, Guiomar, Pedro, Ignacio, Carmen, and Suzanna. He began to work in wood, and in 1960 embarked on the series of four major sculptures called "Abesti gogora" (Rough Chant). Chillida constantly sought a balance between his poetic feeling and his respect for the expressive power inherent in the material. Wood enabled him to achieve a more massive, compact organization of space.

The "Asbesti gogora" consisted of great wooden beams coupled and assembled, compact constructions with sudden open spaces. His original *Abesti gogora*, bought by the Museum of Cuenca, Spain, was the starting point for the large *Abesti gogora I*, now in the Museum of Fine Arts in Houston. The fifth version of *Abesti gogora*, a huge sculpture not in wood but in granite, was completed in 1966 and installed in a garden in the Houston Museum.

While continuing to sculpt in wood, in late 1959 Chillida began to work in steel, completing *Rumor de limites IV*. In 1960 he received the Kandinsky Prize, awarded by the artist's wife, Nina Kandinsky, to a young artist. The 23 sculptures he showed at the Galerie Maeght in 1961 were greatly admired by Georges Braque, and each exchanged a work with the other. In 1962 there were concurrent but separate exhibits at the Kunsthalle in Basel by Mark Rothko and Chillida, who showed 32 sculptures.

Chillida made a series of trips in the Mediterranean in 1963. In Greece the light of the white villages inspired his sculptures in alabaster (such as the "Elogio de la luz" [Praise of Light] series of 1965). In Rome he particularly admired the work of the late 19th-century sculptor Medardo Rosso.

In 1964 Chillida was invited a third time to exhibit at the Pittsburgh International, where he received the Carnegie prize for sculpture. That same year he showed two large wood sculptures (*Abesti gogora II* and *Abesti gogora III*) and ten iron sculptures at the Galerie Maeght. In the following year he exhibited for the first time in London, at the McRoberts and Tunnard Gallery, and Roland Penrose wrote the preface to the catalog. Sheldon Williams of *The Guardian* (July 1, 1965) praised Chillida's "intimate understanding of the character of his media," and added: "No ripple of the windblown Atlantic, no tree root nor grained stone escapes him."

In 1966 Chillida exhibited 38 sculptures as well as collages and drawings at the Wilhelm-Lehmbruck Museum, Duisburg, West Germany, and was awarded the first Wilhelm-Lehmbruck prize for sculpture. The same year he received the Nordrheim-Westfalen prize in Düsseldorf. He went to a granite quarry in Budino, Galicia, to sculpt three 60-ton granite stones, *Abesto gogora IV,* for the Houston Museum of Fine Arts, where Chillida's first retrospective in the United States—consisting of 42 sculptures, 23 drawings, 8 collages, and 14 engravings—was held. In 1967 the Houston retrospective traveled to Utica, New York, and the City Art Museum, St. Louis.

The major work in the Chillida exhibit at the Galerie Maeght in 1968 was *Alrededor del vacio IV* (Around the Void IV), in steel. This was accompanied by 14 sculptures in iron, granite, and alabaster. All these works were then shown in a special display at Documenta 4.

Chillida received several retrospectives in European cities in 1969, including Zürich, Basel, Amsterdam, and Munich. That same year Chillida's steel sculpture of 1966, *Peine del viento IV* (Wind Comb IV), was installed in the new UNESCO building in Paris. Martin Heidegger's book *Die Kunst und der Raum* (Art and Space), illustrated with Chillida's litho-collages, was published in 1969 in Switzerland, where Chillida met with the German metaphysician. Chillida has previously illustrated several works, among them André Frénaud's *Le Chemin des devins* (1966) and Max Holzer's *Meditation in Kastilien* (1968).

In 1971 the Thyssen Company, on the occasion of its centennial, offered the city of Düsseldorf a large sculpture by Chillida. The monument was made in the city's steel works under the artist's supervision and placed in front of the new Thyssen building. Chillida's 1972 solo show at the Galleria Iolas Velasco, Madrid, his first in the Spanish capital since 1954, had an extraordinary impact on the Spanish public. He was awarded the Rembrandt Prize in 1975 in San Sebastian, and in the same year created and presented an alabaster sculpture, *Gurutz,* to the church of Santa Maria in his native city. In September 1977 a public square was opened in the city of San Sebastian where three steel sculptures, *Peines del viento* (Wind Combs), were attached to rocks beaten by the sea and high tide. Chillida shared the Andrew W. Mellon Prize with Willem de Kooning for the year 1978, and was provided with a retrospective exhibit at the Carnegie Institute in the fall of 1979. One of his most striking pieces of 1979 was the large steel sculpture *Homage to Calder,* with its powerful, curvilinear rhythms. Chillida, who had met Calder some years before, admired his work and his buoyant spirit.

The Carnegie Institute show traveled in 1980 to the Guggenheim, where it shared space with "New Images from Spain," the American public's first view of post-Franco Spanish art. Chillida, representing an earlier generation, occupied the lower half of the museum. In his *New York Times* review (March 28, 1980), Hilton Kramer particularly admired the open-form steel sculptures of the 1950s and early '60s, "with their airy and elegant calligraphic forms," and regarded them as "among the minor classics of modern sculpture." They are, in fact, Chillida's most admired works. Kramer thought the small scale of these open-form steel sculptures worked to their advantage, whereas the artist's "attempts at more monumental sculpture tend to misfire." For example, Kramer considered *Meeting-Place* (1973–74), a large construction in reinforced concrete, representative of a now over-familiar "kind of academic modernism," but felt that work remaining intimate in scale managed "to sustain an essentially poetic sensibility."

Eduardo Chillida is a handsome, dark-haired man who, despite his celebrity, has preferred to live and work in San Sebastian, away from international centers and with little contact with fellow · artists. Temperamentally very different from the impulsive Catalans Julio González, the great precursor of modern metal sculpture, and Joan Miró, the Basque Chillida, with his roots in Spanish artisanship, is a contemplative artist—"almost ruminative," as one critic wrote. Chillida says that his subject is the relationship between time and space, defined by three-dimensionality. For many years Chillida has been writing a series of notebooks on philosophy, and some of these notebook pages, long unknown to the public, appeared in the catalog to the artist's 1980 Guggenheim retrospective. Among his reflections are the following:

"Do limits for the spirit exist? Thanks to space, limits exist in the physical universe—and I can

be a sculptor. Nothing would be possible without this rumor of limits and the space which allows them. What type of space allows limits in the spiritual world?

"Sculpture should always face and be attentive to everything around it which moves and enlivens it."

EXHIBITIONS INCLUDE: Sala Clan, Madrid 1954; Gal. Maeght, Paris 1956, '61, '64, '66, '68, '70; Kunsthalle, Basel 1962; McRoberts and Tunnard Gal., London 1965; Wilhelm-Lehmbruck Mus.; Duisburg, W. Ger. 1966; Mus. of Fine Arts, Houston 1966; Munson-Williams-Proctor Inst., Utica, N.Y. 1967; City Art Mus., St. Louis, Mo. 1967; Kunsthaus, Zürich 1969; Stedelijk Mus., Amsterdam 1969; Gal. Renée Ziegler, Zürich 1970; "Die Kunst und der Raum" (Martin Heidegger, Chillida), Librairie La Hune, Paris 1970; Sala Gaspar, Barcelona, Spain 1971; "20 años de escultura," Gal. Iolas Velasco, Madrid 1972; Gal. d'Art Moderne, Basel 1974; Gal. Internacional de Arte, Madrid 1975; "Obra grafica completa," Gal. Iolas Velasco, Madrid 1977; Gal. Maeght, Zurich 1978; Carnegie Inst. Mus., of Art, Pittsburgh 1979; Solomon R. Guggenheim Mus., NYC 1980. GROUP EXHIBITIONS INCLUDE: Salon de Mai, Paris 1949, '50; "Les Mains éblouies," Gal. Maeght, Paris 1950; Milan Triennale, 1954; "Premier salon de la sculpture abstraite," Gal. Denise René 1954; "Eisenplastik," Kunsthalle, Bern 1955; Venice Biennale 1958, '62; Pittsburgh International, Carnegie Inst. 1958, '61, '64 '68; Documenta 2, 3, 4, and 6, Kassel, W. Ger. 1959, '64, '68, '77; "New Spanish Painting and Sculpture," MOMA, NYC 1960; "Three Spaniards: Picasso, Miró, Chillida," Mus. of Fine Arts, Houston 1962; "Paintings and Sculpture of a Decade 1954–64," Tate Gal., London 1964; "Dix ans d'Art vivant," Fondation Maeght, Saint-Paul-de-Vence, France 1967; "Sculpture from Twenty Nations," Mus. of Fine Arts, Montreal 1968; "Grafica d'oggi," Mus. d'Arte Moderna, Venice 1972; "Tapies, Chillida," Gal. Laurent, Geneva, Switzerland 1973; "Contemporary Spanish Art," Marlborough Fine Art, Ltd., London 1974; Four Sculptors: Chillida, Gargallo, González, Penalba," Gal. Carmen Martinez, Paris 1976; "Le Livre et l'artiste 1967–1976," Bibliothèque Nat., Paris 1977.

COLLECTIONS INCLUDE: MOMA, and Solomon R. Guggenheim Mus., NYC; Munson-Williams-Proctor Inst., Utica, N.Y.; Mus. of Art, Carnegie Inst., Pittsburgh; Hirshhorn Mus. and Sculpture Garden, Washington, D.C.; Art Inst. of Chicago; Washington Univ. Gal. of Art, St. Louis, Mo.; Mus. of Fine Arts, Houston; Tate Gal., London; UNESCO, Paris; Fondation Marguerite et Aimé Maeght, Saint-Paul-de-Vence, France; Gal. Nazionale d'Arte Moderna Contemporanea, and Mus. Vaticani-Collezione d'arte contemporanea, città del Vaticano, Rome; Mus. Civico, Turin, Italy; Wilhelm-Lehmbruck Mus. der Stadt Duisburg, W. Ger; Staatsgal., Stuttgart, W. Ger.; Kunstmus., Basel; Kunstmus., Berne; Kunsthaus, Zürich; Mus. La Chaux de Fonds, Switzerland; Mus. español de arte contemporaneo, Madrid; Sonja Henies-Niels Onstads Foundation, Hovikodden, Norway.

ABOUT: Bachelard, G. "Eduardo Chillida" (cat.), Gal. Maeght, Paris, 1956; Bénézit, E. (ed.) Dictionnaire des peintres, sculpteurs et graveurs, 1976; Celaya, G. Los Espacios de Chillida, 1974; "Eduardo Chillida" (cat.), Solomon R. Guggenheim Mus., NYC, 1980; Esteban, C. Chillida, 1971; Giedion-Welcker, C. Contemporary Sculpture: An Evolution in Volume and Space, 1961; Meyer, F. "Chillida" (cat.), Kunsthalle, Basel, 1962; Penrose, R. "Eduardo Chillida" (cat.), McRoberts and Tunnard Gal., London, 1965; Seuphor, M. Dictionary of Modern Sculpture, 1959; Sweeney, J.J. "Chillida" (cat.), Mus. of Fine Arts, Houston, 1966. *Periodicals*—ABC (Madrid) May 1965; Christian Science Monitor April 12, 1969; Cimaise (Paris) November/December 1956; Guardian July 1, 1965; New York Times February 16, 1958, October 15, 1966, March 28, 1980; La Table ronde (Paris) November 1950; XXe siècle (Paris) January 1957; Werk (Winterthur, Switzerland) no. 2 1969.

CHIRICO, GIORGIO DE. *See* DE CHIRICO, GIORGIO

CHRISTO (CHRISTO VLADIMIROV JAVACHEFF) (June 13, 1935–), Bulgarian-American sculptor and draftsman, is famous for the use of fabrics to wrap and tie objects, urban buildings, and landscape sites. His spectacular projects are media events which unite conceptual art and earthworks.

He was born Christo Vladimirov Javacheff in Gabrovo, Bulgaria, the middle son of Wladimir Ivan Javacheff, who owned a chemical-manufacturing business, and the former Tzveta Dimitrova, who in her youth had been active in politics. The Javacheffs were one of Bulgaria's socially and intellectually prominent families. Christo's older brother, Anani, is now a theater and film actor in Bulgaria and the Soviet Union; the younger brother, Stephen, is a chemist in Bulgaria. The family business was nationalized when the communists came to power in 1944.

From 1952 to 1956 Christo attended the Fine Arts Academy in Sofia, where he learned to paint in the officially approved socialist realist manner and received an education in the Soviet version of Marxism. In 1956 he went to Prague, Czechoslovakia, to study and work at the avant-garde Burian Theater. The cultural atmosphere of Prague was freer than that of most Eastern European cities, and Christo was introduced to modern art by theatrical director Emil Burian. However, three months after Christo's arrival the Hungarian uprising was suppressed by the Russians, and he fled to the West. For one semester in 1957 he trained at the Fine Arts Academy in Vienna. After a brief stay in Geneva, he arrived in Paris in 1958.

© Wolfgang Volz

CHRISTO

In Paris Christo made friends with the critic Pierre Restany and other members of the Nouveau Réalistes group, who derived from neodadaism their concern with the transformation of everyday objects into art. Although he was included in three of their exhibitions, Christo was not an official member of the group, nor did he sign their "Manifeste du Nouveau Réalisme." He created sculptures, some of which consisted of bottles, tin cans, oil drums, and boxes left unmodified; others were wrapped in cloth and string or painted. His first packages (called "empaquetages") and wrapped objects (called "emballages") were made in 1958. On November 28, 1959, he married Jeanne-Claude de Guillebon, the stepdaughter of a French general. Their son Cyril was born in 1960.

Christo's interest in packaging represented a new concern with the object, as a reaction against abstraction, including the generalized tachiste painting (a style bearing affinities to abstract expressionism) he himself had been practicing. Christo's packaging, in addition to embodying the myth of an affluent, economically expanding, consumer-oriented society, enabled him to draw attention to a commonplace or all-too-familiar object, and to remove it from its usual function. By tightly wrapping such everyday objects as cars and furniture in various materials, Christo made them unrecognizable, imbuing them with an ambiguous and mysterious "presence."

In 1961 Christo made his first project for a packaged public building. It consisted of collaged photographs of a building-sized package, alongside of which stood people and parked cars;

there were detailed written specifications for the wrapping of the building. In the early 1960s Christo made a series of large monuments with barrels, including the now famous *Iron Curtain—Wall of Oil Drums*. Consisting of 204 stacked barrels, four meters high, that temporarily blocked traffic on the rue Visconti in Paris one evening in June 1962, Christo's *Iron Curtain* was a reference to the then one-year-old Berlin Wall. This direct assault on the environment anticipated ideas Christo was to carry further in subsequent years. (Operating on an even larger scale, Christo had, in 1961, created large shrouded hulks in the harbor of Cologne that he called "Dockside Packages." One of these large wrapped packages virtually filled the Galleria Apollinaire in Milan in 1963.)

Other projects of the early 1960s included the wrapping in semi-transparent layers of plastic, polythene, or other materials, and the tying with rope, of motorcycles, bicycles, automobiles, road signs, and even—temporarily—female models. One obvious source of inspiration for the artist was the Surrealist Man Ray's sewing machine tied up in blanket of 1920.

In 1963 Christo began creating a series of "Store Front" showcases with large plate-glass windows, carefully shrouded by cloth or paper, as if the windows were empty or being decorated. This store-front motif was carried further after Christo moved to New York City in 1964. He now made life-size replicas of store fronts with covered up show windows, still with the idea, as Lawrence Alloway pointed out in his book on Christo, of "the shielding of the internal space from the viewer." In *Environments and Happenings*, Adrian Henri observed, "A row of these in a gallery has the same kind of desolate poetry as a painting by Giorgio de Chirico." Gradually the store fronts evolved into long corridors bounded by shrouded windows. Then Christo turned his attention to the interiors of the corridors—large, empty rooms with blank walls and mysterious doors leading nowhere. The culmination of this facet of Christo's work was *Corridor Store Front* of 1968, which comprised an area of 1,500 square feet.

By the mid-1960s Christo's projects were grandiose in scale. According to Restany, "He found his real scale when he came to America. That sense of space and big dimension—it must be the same kind of feeling that the Europeans had when they first landed here in colonial times. It gave Christo a kind of hyper-dimension."

In 1966 he produced his first *Air Package*, for the Stedelijk van Abbemuseum in Eindhoven, Holland. This *Air Package* was a sphere of plas-

tic and rope, 17 feet in diameter, which floated above the museum and surrounding streets, and was secured by cables attached to the ground. Christo also exhibited a wrapped tree in Eindhoven, but even more ambitious was his *5,600 Cubic Meter Package* created for Documenta 4, the international avant-garde art show held in Kassel, West Germany, in 1968. This air package was a column of opaque plastic and rope, 280 feet high and 33 feet in diameter. It was supported by cables anchored in a 900-foot diameter circle of concrete foundations.

In the summer of 1968 Christo packaged a fountain and a medieval tower at the Festival of the Two Worlds in Spoleto, Italy. About the same time he wrapped the Kunsthalle Museum in Bern, Switzerland, and in the winter of 1968 he packaged the Museum of Contemporary Art in Chicago with 62 pieces of brown tarpaulin, secured with two miles of brown rope. At one point Christo had a plan for covering up the Museum of Modern Art in New York City, but this project fell through. However, in 1968 the Museum exhibited the artist's models, drawings, and photographs for the project, which Emily Genauer of *Newsday* called "a set of charming, witty and surprisingly well-crafted toys."

Christo's wrapped packages took on a new dimension at the very end of the 1960s in the form of landscape projects. The most striking of these was *Wrapped Coast—Little Bay—One Million Square Feet,* completed near Sydney, Australia, in 1970. For that project he covered a rocky, mile-long portion of the Australian coastline with a million square feet of erosion-control polythene sheeting and 36 miles of polypropylene rope. The enterprise was completed at an estimated cost of $120,000.

In 1970 Christo accepted the post of artist-in-residence at the Aspen Center of Contemporary Art in Colorado. At that time he was looking for possible sites for landscape projects, and he knew, as his wife Jeanne-Claude pointed out, that "Aspen would be the perfect place from which to travel around." He now had the opportunity of constructing a *Valley Curtain* in Rifle Gap, Colorado, a narrow valley bordered by sheer sandstone cliffs located 70 miles west of Aspen, and a few miles north of the small town of Rifle. The *Valley Curtain* was conceived as a great hawser slung between two mountains 1,250 feet apart, and carrying some 200,000 square feet of nylon polyamide curtain dyed bright orange and weighing four tons. Planning for its construction began in July 1971, but because of massive problems—logistics, weather, opposition by environmentalists, and the drafting of proposals for returning the landscape to

its former condition—the project was not completed until 1972.

To raise the money for *Valley Curtain's* construction—which eventually cost about $850,000—Christo and his wife created the Valley Curtain Corporation, with the artist as sole stockholder. Christo gave to the corporation all his drawings, models, and photo-montages for the project, as well as a number of earlier unsold works. The artworks were then sold by the corporation to the artist's backers in Europe and the United States. When *Valley Curtain* was completed, the corporation was dissolved. Christo has made a practice of paying for his spectacular but commercially valueless enterprises by making drawings and prints—some of them very beautiful—of the projects to be sold via galleries as handmade art objects.

The first curtain installed in Rifle Gap was torn loose by a gust of wind and dashed to pieces against the rocks below. Undaunted, Christo scheduled the laying of a new curtain which was in place by August 10, 1972. On that day reporters, tourists, art critics, a film crew, and the entire population of Rifle Gap were in attendance, and the giant, light-reflecting curtain was dramatically unfurled. It was supposed to hang for a month, but was ripped to shreds by a sandstorm on August 11. The story of the entire project was recorded in a half-hour documentary, *Christo's Valley Curtain* (1974), directed by Albert and David Maysles and Ellen Giffard for Maysles Films.

Christo's next major project was the much-publicized *Running Fence,* the idea for which, a fence running for miles along the coast and into the sea, he had conceived in 1972. As with *Valley Curtain,* Christo and his wife formed a corporation, the Running Fence Corporation, which raised $2,000,000 through the sale of Christo's works, as well as through bank loans and the selling of book and film rights.

Deciding on the California coast for his project, Christo saw *Running Fence* as an 18-foot-high ribbon of white woven nylon fabric that would undulate for $24\frac{1}{2}$ miles along the rolling hills of Marin and Sonoma counties, running across private ranches, farms, roads, beside subdivision homes, through the middle of small towns, and into the Pacific Ocean at Bodega Bay, just north of San Francisco. The permission of 59 landowners and 15 governmental bodies had to be obtained. Ironically, the main opposition came from local artists who organized a committee to stop the project, convinced that it was more of a publicity stunt than a work of art. After innumerable public hearings, conciliatory visits by the artist to residents of the area, a final

clearing by the California Superior Court, and the obtaining of the necessary permits, Christo began work on *Running Fence* in April 1976.

The project, completed in September 1976, stayed up only two weeks but became a major media event. Some art authorities disparaged the fence as a waste of time and resources, but Marina Vaizey praised it in *The New Republic*: "The sculpture itself is a beautiful and amazing thing, a phenomenon that in itself looks quite wonderful, and even more, insinuates itself into the landscape [without interfering with it]. It intensifies the characteristics, physical and emotional, of the way in which we apprehend the meeting points of man and his landscape."

Christo himself sees *Running Fence* and *Valley Curtain* as fostering the interpenetration of "real life" and art in order to heighten insight into both. Indeed, Christo's conception of the creative process is a dialectical one. "The work develops its own dimension," he told *Art News*. "It is always bigger than my imagination alone."

Like *Valley Curtain, Running Fence* was filmed by the Maysles brothers, and was photographed for the 1979 book on Christo published by Harry N. Abrams, Inc.

Another public project, *Wrapped Walkways,* had first been realized as part of the transformation of the Museum Hans Lange in Krefeld, West Germany, in 1971. That setting, however, had proved too confined, too private, and in October 1978 the Contemporary Art Society of the Nelson-Atkins Gallery, Kansas City, Missouri, approached Christo to undertake a similar work in the Jacob L. Loose Memorial Park. Finding the circumstances he had been looking for, the artist covered the park's formal garden walkways, picnic shelters, and jogging paths with 136,268 square feet of light-reflecting, saffron-colored nylon cloth. Begun on October 2, 1978 and successfully completed two days later, *Wrapped Walkways* was taken up, as planned, on the 16th. Jan van der Marck, in an *Art in America* review (January/February 1979), wrote that "what 'Wrapped Walkways' lacked in mythic proportions and remoteness, it more than made up for by being down-to-earth (literally), people-oriented, and formally taunting (predicated on a given but erratic design)." The critic was reminded of the yellow brick road in *The Wizard of Oz*. Like Christo's earlier projects, *Wrapped Walkways* was financed by the artist through the sale of drawings and small-scale collages of both the work-in-progress and the completed project.

Christo's next project, and perhaps his most spectacular, was called *Surrounded Islands* (1983). At a cost of $3.5 million, the artist and

some 430 assistants girdled 11 small islands in Miami's Biscayne Bay for two weeks with "ten floating skirts of bright pink polypropane, 6.5 million square feet of fabric, which fanned out 200 feet from the islands," to quote *Art News*.

Because the Biscayne Bay is a popular public recreation area, *Surrounded Islands* was, as Christo said, his "most urban project." With the pink skirts, the deep blue of sky and water, and the green of the islands, the project was also his most painterly. "This is my *Water Lilies*," Christo declared. *Surrounded Islands* moved Grace Glueck of *The New York Times* to rhapsodize: "Where other artists put nature in a frame, Christo goes boldly to the landscape itself, bringing to it elegant artistic effects that recall our attention to the splendor of the natural environment . . . in the same romantic spirit as the painters of the 19th-century West."

Recent urban projects proposed but as yet unrealized by Christo have included the wrapping of Paris's oldest bridge, the Pont Neuf, and *Wrapped Reichstag,* which he represented in a two-part collage of 1979, composed of fabric, twine, pastel, and part of a map. The Reichstag building, on the border of divided Berlin, had been the seat of Germany's doomed democratic government between the wars and is currently under the jurisdiction of four powers (the US, the USSR, Great Britain, and France). As Jonathan Fineberg pointed out in *Art in America* (December 1979), the Reichstag so symbolizes "some of the most deeply felt issues of German identity" that Christo's project has aroused considerable controversy in Germany. The Bulgarian-born artist has long wanted to execute a project that would, as he said, "physically engage both East and West."

Christo and Jeanne-Claude live in downtown Manhattan, in an old building on the edge of SoHo. Since 1970, she has been president of the CVJ Corporation, which receives all income from her husband's projects. Jeanne-Claude, who was born at the same hour of the same day of the same year as Christo, is in charge of the financial, promotional, administrative, and curatorial aspects of her husband's works in all media.

Christo was described by Calvin Tomkins in 1976 as "a slim, rather frail-looking man with shoulder-length dark hair and a thin, intelligent face that frequently breaks into an engaging smile." Sincerity, courtesy, and sheer persistence have helped Christo win skeptics—public administrators and environmentalists for the most part—over to his projects. Referring to his efforts to launch *Running Fence* and other landscape projects, he said in his heavily accented

English: "When I approach these ranchers or other people I tell them before everything [that] it will be a very beautiful thing."

Fineberg traces Christo's concern with "active social dialogue" to his "socialist education, with its dialectical emphasis and grounding in Russian Constructivist thinking," but the artist's concern for the interpenetration of art and life also owes something to Marcel Duchamp. Referring to Fra Angelico's frescoes, Christo has said: "There was no way to do this art without being a profoundly religious man. To do valid work then, it was necessary to be profoundly religious. . . . We live in an essentially economic, social, and political world. Our society is directed to social concerns of our fellow human beings. . . . That, of course, is the issue of our time, and this is why I think that any art that is less political, less economical, less social today, is simply less contemporary."

EXHIBITIONS INCLUDE: "Stacked Oil Drums," Cologne Harbor 1961; Gal. Haro Lauhus, Cologne 1961; "Iron Curtain—Wall of Oil Drums," rue Visconti, Paris 1962; Gal. Schmela, Düsseldorf 1963, '64; Gal. Apollinaire, Milan 1963; Gal. del Leone, Venice 1963, '64, '68; "Air Package and Wrapped Tree," Stedelijk van Abbemus., Eindhoven, Neth. 1966; Leo Castelli Gal., NYC 1966; Wide White Space Gal., Antwerp 1967, '69; "Packed Fountain and Tower," Spoleto, Italy 1968; John Gibson Gal., NYC 1968, '69; MOMA, NYC 1968; "Packed Museum of Contemporary Art" and "Wrapped Floor," Mus. of Contemporary Art, Chicago 1969; "Wrapped Coast," Little Bay, Sydney, Australia 1969; Max Protetch Gal., Washington, D.C. 1970; "Valley Curtain," Grand Hogback, Rifle, Colo. 1971; Hans Lange Mus., Krefeld, W. Ger. 1971; Stedelijk Museum, Amsterdam 1973; Seriaal Gal., Amsterdam 1973; "The Wall Wrapped," Rome 1974; "Running Fence," Marin and Sonoma Counties, Calif. 1976; "Wrapped Walkways," Jacob L. Loose Memorial Park, Kansas City, Mo. 1978; "Surrounded Islands," Biscayne Bay, Miami 1983. GROUP EXHIBITIONS INCLUDE: "New Realists," Sidney Janis Gal., NYC 1962; "Nieuwe Realisten," Gemeentemus., The Hague 1964; "Eight Sculptors: The Ambiguous Image," Walker Art Center, Minneapolis 1966; "Dada, Surrealism and Their Heritage," MOMA, NYC 1968; Documenta 4, 5, Kassel, W. Ger. 1968, '72; "Pop Art Reassessed," Hayward Gal., London 1969; 10th International Exhibition, Metropolitan Mus. of Art, Tokyo 1970; "Arte Povera/Conceptual Art," Mus. of Modern Art, Turin 1971; "Diagrams and Drawings," Rijksmus. Kröller-Müller, Otterlo, Neth. 1972; "Monumenta," Newport, R.I. 1974.

COLLECTIONS INCLUDE: MOMA, and Whitney Mus. of Am. Art, NYC; Albright-Knox Art Gal., Buffalo, N.Y.; Mus. of Fine Arts, Philadelphia; Mus. of Fine Arts, Houston; Tate Gal., London; Centre National d'Art Contemporain, Paris; Stedelijk Mus., Amsterdam; Boymans-Van Beuningen Mus., Rotterdam; Rijksmus. Kröller-Müller, Otterlo, Neth.; Stedelijk van Abbe-

mus., Eindhoven, Neth.; Kaiser Wilhelm Mus., Krefeld, W. Ger.; Wallraf-Richartz Mus., Cologne; Kunstverein, Stuttgart; Neue Pinakothek, Munich; Kunsthaus, Zürich; Moderna Mus., Stockholm.

ABOUT: Alloway, L. Christo, 1969; Bourdon, D. Christo, 1972, Christo: Valley Curtain, 1973; Christo, Christo: 5600 Cubic Meter Package, 1968, Christo—Wrapped Coast: One Million Square Feet, 1969, Christo—Valley Curtain, 1973; Current Biography, 1977; Goheen, E. R. Christo: Wrapped Walkways, 1979; Henri, A. Total Art: Environments, Happenings, and Performance, 1974; Rosenberg, H. Artworks and Packages, 1969; Tomkins, C. The Scene: Reports on Post-Modern Art, 1976, and Bourdon, D. Christo: Running Fence, 1979. Periodicals—Art in America November/December 1976, January/February 1979, December 1979; Life September 6, 1968; Art News January 1984; New York Times August 18, 1979; Village Voice July 26, 1976.

CLOSE, CHUCK (July 5, 1940–), American painter, is a leading Photo-Realist. He is known for the over-life-size heads he paints as exact imitations of photographs.

He was born Charles Close, an only child, in Monroe, Washington. His father died when Chuck was ten, and Close remembers him as an "incredibly competent" man who "made me things—toys—from scratch, whole bicycles from scratch." His mother's avocations included skiing and competition-class sailing. The encouragement and indulgence of his family made Close "feel special."

After attending Everett Community College, Washington, in 1958–60, Close studied for two years at the University of Washington, Seattle, receiving a BA degree in 1962. Having attended the Yale Summer School of Music and Art, Norfolk, Connecticut, in 1961, he enrolled in Yale University the following year, taking an MFA degree in 1964. At that time, Close said, "The whole art world seemed plugged into New Haven." The dominant influence among students of his generation was abstract expressionism, and Close's earliest paintings were richly colored abstractions with biomorphic imagery.

A Fulbright grant enabled Close to study at the Akademie der Bildenden Künste, Vienna, in 1964–65. After returning to the United States, he became an instructor at the University of Massachusetts, Amherst, a position he held until 1967, when he moved to New York City. There he set up a studio in the area south of Greenwich Village that became known as SoHo when avant-garde artists and dealers began converting 19th-century warehouse lofts into studios and galleries.

Courtesy the Pace Gallery, NYC

CHUCK CLOSE

As a student at Yale, Close had been impressed by the large scale and power of Willem de Kooning's "Woman" canvases of the 1950s. Close had developed a facility for producing works in the painterly manner of abstract expressionism, but he was also affected by the cultural and political movements of the '60s, the period when the rudiments of his own style were developed. But, as Thomas B. Hess observed in *New York* (May 30, 1977) magazine, the motif of an "enlarged mugshot was in Warhol's repertoire by the early 1960's," as were Warhol's over-scale paintings of the Campbell's soup can. Hess also pointed out that Man Ray and Marcel Duchamp had used the airbrush years before and that "paintings with photo-documentation are as old as photography." (Indeed, Delacroix, Corot, and, later, Degas had all used photographs as aids in their painting.) Hilton Kramer of *The New York Times* (April 19, 1981) wrote that "the whole conception of Mr. Close's style owes much to the ethos as well as the esthetics of the Pop movement" and noted that another '60s form, minimal art, also contributed to Close's development.

Nevertheless, Close's giant portrait-head paintings were the result first of shaking off abstract expressionism and then of drawn-out experiments. In an interview with Jerry Tallmer of the *New York Post,* Close recalled: "Twelve years ago I was painting off my raw nerve endings. The color was very loose and open. I would paint in, paint out, change everything, scrape it off, put it back in." But Close became increasingly dissatisfied with the "painterliness" of his work: " . . . That's when I went to black and white, and to the grid . . . with the grid you couldn't change everything, couldn't paint it in and out. It wasn't so much an art decision as a programmed decision. I had always wanted my paintings to be of equal importance all over, and the only way they could be that, was intellectually. An attempt to make every square inch the same."

The first of Close's photograph-derived paintings had been a giant nude begun in 1966 but never completed, largely because of technical problems. On his second attempt to paint that subject, he discarded the brush and used the canvas as a testing ground for spray-guns, sponges, razor blades, and erasers. From then on he abandoned conventional painter's tools in favor of the airbrush. Close successfully applied his new techniques in 1968, when he used a photograph as the basis of a gigantic black-and-white self-portrait. Over the next few years he executed a series of nine-by-seven-foot portraits of himself, his wife, and friends. These were in acrylic on gessoed canvas and based on full-face, passport-like photographs. After overlaying the photograph and the canvas with corresponding grids, Close transmitted the images square by square, using airbrushes which obliterated the canvas and concealed any trace of the artist's hand—what Close termed "art marks." "I'm not really interested in photography," Close told *Contemporary Artists,* "but one thing I like about photographs is the snapshot or mugshot quality of a California driver's license. It's got such an immediacy and a strong reason to exist in terms of nailing down what a certain driver looks like. It doesn't have anything to do with vanity, it doesn't have anything to do with the ego of the sitter, or whatever."

Opposed to romanticization, Close rendered his frontal, virtually expressionless mugshots with cold objectivity—even when he himself was the subject. "I've always felt it necessary to maintain a certain distance from the subject," Close explained. "When I painted myself, I always referred to it as 'him'—I somehow couldn't deal with the fact that it was me, and whether I looked ugly or handsome or whatever."

Close was included in the Whitney Annual, New York City, in 1969, and a typical portrait, *Joe,* dates from that year. The nine-foot-high image of the bland, bespectacled, altogether "ordinary" face of a friend (Joe Zucker) was disturbing: a large close-up, every hair, wrinkle, and pore was pitilessly exposed. Another monumental portrait of 1969 in acrylic on gessoed canvas was *Frank,* now in the Beaubourg, Paris. For these and six other enormous black-and-white head portraits, including *Keith* and *Bob,*

both of 1970, Close chose to photograph personal friends, preferring anonymous subjects to film stars or media celebrities. As Lisa Lyons observed, [He] had no interest in . . . making Pop icons à la Warhol's commissioned superstar portraits." Close refuses to entangle his art in what he derides as the "ego problems" of the famous and well-to-do.

In 1969 Close joined the Bykert Gallery, New York City, where he held his first Manhattan solo show in 1970. In part because Close emerged at a time when such radical nonrepresentational styles as conceptual art and body art were popular, his return to meticulously exact, trompe l'oeil portraiture won widespread attention and critical acclaim—even though in 1971 *The New York Times* pronounced his work "rubbish." European interest in Close led to his participation in Dusseldorf's "Prospect '71" group show and in Documenta 5, Kassel, West Germany, where an entire wing of the exhibition hall was devoted to his paintings.

In 1967 Close had banished color from his work, but in 1970, certain that he could not further refine his black and white technique, he began to search for new methods. Eager to avoid old habits of mixing pigments on a palette, he experimented with a painting technique analogous to the photo-mechanical process whereby color reproductions are printed. He used a color transparency of Kent Floeter, a painter friend from his Yale days, as the basis for his acrylic painting *Kent* (1971; Art Gallery of Ontario, Toronto). Five dye transfer prints made from three continuous time separations of the transparency—in red, blue, and yellow—were used as working drawings for the three studies of *Kent* Close made in the summer of 1970. For the nine-by-seven-foot gessoed *Kent* canvas, the artist used acrylic paints which matched the dyes in hue and intensity. In painting *Kent* and two subsequent portraits, of his father-in-law Nat Rose and the artist Susan Zucker, Close wore a tinted cellophane filter over his glasses, which permitted him to see only the color he was applying. By 1971, when he began the portrait of painter John Roy, he felt confidence in his intuitive judgment of the amount and density of each hue, and discarded the filters. Close admitted that this "long and involved process" can be boring; but compared to the "emotional highs and lows" of his abstract expressionist period, "working is now a much more stable experience." He has likened the making of a continuous tone painting to "building a wall brick by brick."

John (1971–72) was the most complex of Close's four-color paintings of the years 1970–72. The gaze of the enormous bespectacled head never meets that of the viewer. At first glance the image seems photographic, but closer inspection reveals that the full moustache and beard, rendered with sharp clarity in the front, blur at the sides where they meet the shirt collar. The jacket is impressionistically painted and the entire picture demonstrates Close's technical virtuosity. Close wants to foster new ways of seeing, and in *Artforum* he said, "My large scale forces the viewer to focus on one area at a time. In that way he is made aware of the blurred areas that are seen with peripheral vision. Normally we never take those peripheral areas into account. . . . In my work the blurred areas don't come into focus, but they are too large to be ignored."

In 1971 Close began to experiment with watercolor, and the following year *Keith,* his first print, was commissioned. To avoid what he called the "needless repetition of painting issues" he turned to mezzotint, a medium little used after the development of photo-engraving in the 19th- century. *Keith* is 51½ by 42 inches; a grid, etched into the copper plate, is hidden by the dark jacket but is visible across the over-sized face. According to Close, the presence of the grid attests to his analytical approach to realism. Moreover, *Keith* is a black image on a black field, and only after long concentration does the head materialize for the viewer. The gradual emergence of the image was inspired by the near-monochromatic paintings of Ad Reinhardt, the New York School abstractionist admired by Close. Close's friend Keith was also the subject of a "dot drawing," one of a group of such works begun in 1973 and executed with an airbrush.

Close's *Leslie* (1973), a watercolor of his wife, was based on what she considered a "horrible photograph" and is about half the size of his acrylic portraits. The transparency of the medium makes the image appear one with the surface, and Leslie's skin takes on a subtle luminosity. She commented: "Though I find it difficult to confront my own image, I like the painting a lot—I love the colors, the watercolor surface, the clarity."

In 1977 Close joined the Pace Gallery, New York City. Also that year he executed a grisaille self-portrait watercolor which measures 84 by 60 inches and is a tour de force of technique. He has done numerous self-portraits since 1968 as an objective chronicle of the aging process. The earliest of these, in graphite on paper, shows him as a scruffy James Dean-like character, whereas the 1977 grisaille is more sober, depicting a balding man with a neatly trimmed moustache and beard.

In the late '70s Close worked on three-color

continuous-tone acrylic paintings and applied his mechanistic three-color dot technique to pastels. A striking, if unflattering, pastel of *Linda* dates from 1977; she had also been the subject of an acrylic painting of 1976. Mark Greenwald was the subject of a series of "Mark" portraits executed in 1978–79, including a nine-foot-high acrylic painting composed of individual airbrushed dots, *Large Mark/Pastel.* Joan Simon discussed the "Mark" portraits in *Art in America* (February 1980): "The enormously magnified size obviously contributes to the expressive impact of the painted faces. We see every pore, blemish and hair in monstrous proportion." However, in *Vogue* David Bourdon acknowledged the artist's "shrewd calculations and laborious efforts" but found the paintings exhibited in the St. Louis Art Museum in 1980 "oppressively lifeless." "It is even arguable whether they are portraits at all," he added, "since the artist makes no attempt to define the sitter's character." For Bourdon, Close's faces were "mere pretexts for experiments with various types of marking." In his most recent work Close has adopted a more painterly approach, less dependent on the photographic image.

In 1967 Close married Leslie Rose, a horticulturist and landscape architect. Their daughter, Georgia Molly, was born in 1974. From 1967 to '71 Close taught at the School of Visual Arts, New York City, and at New York University from 1970 to '73, when he received a National Endowment for the Arts grant.

Despite the gargantuan size of his paintings, there is nothing alarming about Chuck Close himself, who was described as "the most approachable of men" by John Russell of *The New York Times* (May 6, 1977). He is a large man, and his mobile, bearded face "is so basically convivial as not to lend itself to an intimidating posture." He is a slow, deliberate worker and a large-scale acrylic painting begun in the fall in his SoHo studio is likely to be completed one year later at his summer home in East Hampton, Long Island. In the catalog to the 1980 "Close Portraits" exhibition at the Walker Art Center, Minneapolis, Lisa Lyons wrote, "Close has fused the attitudes of minimalism and realism, and in this unique synthesis, he has radically expanded the concept of portraiture." "I wanted to paint something that people cared about—a face contains very specific information that people can sense is either right or wrong," Close declared. "That keeps me on my toes, keeps me from letting well enough alone, or saying, this is close enough—no pun intended."

EXHIBITIONS INCLUDE: Art Gal., Univ. of Massachusetts, Amherst 1967; Bykert Gal., NYC 1970, '71, '73, '75;

Los Angeles County Mus. of Art 1971; Mus. of Contemporary Art, Chicago 1972; MOMA, Projects Gal., NYC 1973; Akron Art Inst., Ohio 1973; Minneapolis Inst. of Arts, Minn. 1975; San Francisco Mus. of Modern Art 1975; Baltimore Mus. of Art, 1976; Pace Gal., NYC from 1977; Wadsworth Atheneum, Hartford, Conn. 1977–78; Kunstraum, Munich, W. Ger. 1979; St. Louis Art Mus., Mo. 1980; Walker Art Center, Minneapolis, Minn. 1980; Whitney Mus. of Am. Art, NYC 1981. GROUP EXHIBITIONS INCLUDE: "1969 Exhibition of Contemporary American Painting," Whitney Mus. of Am. Art, NYC 1969; "Three Young Americans," Allen Memorial Art Mus., Oberlin Col., Ohio 1970; "22 Realists," Whitney Mus. of Am. Art, NYC 1970; "Prospect '71," Düsseldorf 1971; "Documenta 5," Kassel, W. Ger. 1972; "Hyperréalistes Américains," Gal. des Quatre Mouvements, Paris 1972; "Photo-Realism: the Ludwig Collection," Serpentine Gal., London 1973; "Hyperréalistes Américains/Réalistes Européens," Centre Nat. d'Art Contemporain, Paris 1974; "Three Realists: Close, Estes, Raffael," Worcester Art Mus., Mass. 1974; Tokyo Biennale 1974; "Drawing Now," MOMA, NYC 1976; "Modern Portraits: The Self and Others," organized by Department of Art History at Columbia Univ. for Wildenstein Gal., NYC 1976; "Biennial Exhibition," Whitney Mus., of Am. Art, NYC 1977, '79; "Documenta 6," Kassel, W. Ger. 1977; "American Painting of the 1970's," Albright-Knox Art Gal., Buffalo, N.Y. 1978; "The Grid: Format and Image in 20th Century Art," Pace Gal., NYC 1978; "Printed Art: A View of Two Decades," MOMA, NYC 1980.

COLLECTIONS INCLUDE: MOMA, and Whitney Mus. of Am. Art, NYC; Allen Memorial Art Mus., Oberlin Col., Ohio; Minneapolis Inst. of Arts, and Walker Art Cntr., Minneapolis, Minn.; Ackland Art Mus., Univ. of North Carolina, Chapel Hill; Nat. Mus. of Canada, Ottawa; Art Gal. of Ontario, Toronto; Mus. d'Art Moderne, Centre Georges Pompidou (Beaubourg), Paris; Neue Gal., Stadt Aachen, W. Ger.; Mus. Moderner Kunst, Vienna; Australian Nat. Gal., Canberra.

ABOUT: Battcock, G. (ed.) Super Realism: A Critical Anthology, 1975; Current Biography, 1983; Kulterman, U. New Realism, 1972; Lucie-Smith, E. Super Realism, 1979; Lyons, L. and others (eds.) "Close Portraits" (cat.) Walker Art Center, Minn., 1980; P-Orridge, G. (and others) Contemporary Artists, 1977; Rose, B. American Art Since 1900, 2d ed. 1975. *Periodicals*—Art in America January/February 1970, November/December 1972, January/February 1975, February 1980; Art International (Lugano) September 1971; Art News Summer 1980; Artforum January 1970; Arts Magazine January 1973, June 1974, June 1978; New York May 30, 1977; New York Post October 27, 1979; New York Times May 6, 1977, April 19, 1981; Vogue January 1981.

***CORNEILLE (CORNELIS GUILLAUME VAN BEVERLOO)** (July 3, 1922–), Dutch painter, was a founder of the Cobra movement.

°kôr nä´

John Lefebre

CORNEILLE

Born in Liège, Belgium, of Dutch parents, he studied drawing at the Rijksakademie, Amsterdam, from 1940 to 1943, but was a self-taught painter. In 1946 he had his first solo show in Groningen, The Netherlands, and the next year exhibited with Karel Appel in Amsterdam. Also in 1947 Corneille visited Hungary, staying for several months in Budapest, where a series called "Gardens," which he had painted in that city, was exhibited.

An important year in Corneille's career was 1948: with the artists Appel and Constant, he founded the Dutch Experimental Group and its review *Reflex*, which led later that year to the formation in Brussels the influential Cobra group. Cobra, which was also the title of the review the group published, was formed from the first letters of the names of the home cities of the movement's leaders: Copenhagen, home of the Danish artists Asger Jorn and Karl-Heining Pedersen; Brussels, where the poet Christian Dotremont and the painter Pierre Alechinsky lived; and Amsterdam, where the Dutch contingent of Cobra included Corneille, Appel, and Constant (Constant A. Nieuwenhuis).

Cobra rebelled against the School of Paris—although Cobra leaders like Corneille were to become influential painters in Paris—and rejected cubism and neoplasticism in favor of a gestural painting style which was similar to American action painting. Corneille and his colleagues were also influenced by the surrealist doctrine that images arising from the unconscious are more powerful than those generated by the intellect. The aims of the movement were expressed by Constant: "The Experimental Group takes the position that improvisation is an essential precondition of vital art, and therefore it rejects any a priori principle of composition. Although our work is not abstract, we refuse to accept imitation, in any sense whatsoever, as in conflict with the improvisational character. Our work is thus like a stream that has no beginning and no end, and leads us through every region of the unconscious, ever revealing to us images hitherto unknown."

Corneille participated in the important group show of the Cobra movement in Amsterdam's Stedelijk Museum, in 1949, and also exhibited with Appel and Constant in Paris that year. The Cobra movement became centered in Paris when Corneille and Appel moved there in 1950. Corneille took part in the group show "Les Mains Eblouies" (Dazzled Hands) at Paris's Galerie Maeght in 1950, and showed the following year at the Salon de Mai, Paris, where he has exhibited regularly ever since. Also in 1951, he had solo shows in Amsterdam and Rotterdam. The next year Corneille traveled to Ahaggar, a mountainous region in the central Sahara. Critics have stressed the importance of this journey to the development of Corneille's work. Traveling through the desert his awareness of the shapes and colors of minerals was heightened, and he was inspired to paint such works as *Landscape with Fossils,* the triptych *White Rocks, Burnt Earth,* and *The Forest of Stones.*

In 1953 Corneille took part in another Cobra group show in Paris and had solo exhibitions in Antwerp and Paris. He was also represented in Paris's Salon d'Octobre and in the São Paulo Bienal. Also that year Corneille studied etching in Stanley William Hayter's Atelier 17 in Paris. In 1954 he studied ceramics with Mazzotti in Albisola, Italy, and his paintings were included in the Venice Biennale. In 1955 he produced a series of large drawings in color entitled " . . . And the Country Loses Itself in Infinity." Executed in ink and gouache, some are as large as $29\frac{1}{2}$ by $66\frac{1}{2}$ inches. Inspired, like much of Corneille's work, by bird's-eye views of landscapes and geological strata, the jigsaw-like shapes are reminiscent of the imagery of Jean Dubuffet.

Corneille visited Mallorca in 1954–55, and from the mid-'50s on he took part in numerous group shows. He received an honorable mention at the Carnegie International, Pittsburgh, in 1955, and the next year had solo exhibits at the Stedelijk Museums in Amsterdam and Schiedam, the Netherlands, and at the Palais des Beaux-Arts, Brussels. Also in 1956 he received the Solomon R. Guggenheim Prize of the Netherlands and painted *Souvenir of Amsterdam.* After touring Africa by automobile in 1957–58, Corneille published his travel notes.

Corneille's paintings of 1958, such as *Spanish Town* (Stedelijk Museum, Amsterdam), were transposed landscapes, viewed as if from the air, with vivid color and dense, compact forms. In 1958 he traveled to South America and the Antilles and visited the United States for the first time. He was greatly impressed by New York City, which inspired a group of drawings.

In Paris Corneille and other former members of Cobra (the group had disbanded in 1951) became associated with the Phases movement, whose name was taken from *Phases* art magazine, which had appeared in January 1954. In that year Corneille, Alechinsky, Asger Jorn, and others participated in the first of several group exhibitions entitled "Phases," which traveled to Milan, Mexico, Geneva, Amsterdam, Brussels, Warsaw, Buenos Aires, and Tokyo. Other artists, ones unconnected with Cobra, who were members of the movement included the Italians Giuseppe Capogrossi and Enrico Baj, the Frenchman Pierre Soulages, the Spaniard Antoni Tapiès, and the Swede Öyvind Fahlström. From 1959 to '63, when it dispersed as a movement, Phases bore affinities with surrealism, and its artists were concerned with the painting of the imaginary, a world of pure invention which "has nothing to do with [the] planned and rationalized fantasy" of, say, science fiction, as Aldo Pellegrini observed. Corneille remained, to quote Pellegrini, "a lyricist of painting," combining spontaneity, freedom, and "generous use of color" with an increasingly patterned and controlled design. According to R.W.D. Oxenaar in *Contemporary Art 1942–72*, "His paintings were less gestural and more formally organized than those of the other Cobra painters, although he shared their interest in brilliant color and bold, simple shapes." An example of his work of the early '60s is *Beginning of Summer* (1962; Albright-Knox Art Gallery, Buffalo, New York), which can be interpreted as an aerial view of a stylized landscape, with colors and shapes suggestive of plants and garden paths.

From 1961 to 1966 Corneille summered in Mallorca and Cadaqués on Spain's Costa Brava. Among the many paintings inspired by his time in Spain was the vivid gouache *Catalan Summer* (1965). Oxenaar pointed out that Corneille, unlike Appel, was never drawn to the expressionist side of Cobra, but "always tended more in the Klee–Miró direction." Although Corneille and other Cobra painters had in the late 1940s sought, to quote Lawrence Alloway, "a . . . subject matter which would provide a counterculture to the Mediterranean-derived aesthetics of Parisan formality and learning," in his later years in Paris Corneille became, in Oxenaar's words, "more and more definitely a French painter, without any direct connection with specifically Dutch tradition." Referring to Corneille's "free landscape-like abstractions," Oxenaar declared, "He is Braque to Appel's Picasso."

In 1966 Corneille visited Brazil, and in 1968 he executed mosaics in Vela-Luka, Yugoslavia. He traveled to Mexico in 1970. From the late 1960s Corneille's works became more directly figurative and the color areas increased in size. He used what one critic called "visionary, lyrical imagery" to portray a world of man, animals, and lush vegetation.

In Pollenza, Italy, during the summer of 1973, Corneille and his friend Giorgio Cegna, an editor, began work on a series of plates depicting the adventures of Pinocchio. Corneille felt that previous illustrations of the tale were "bland and mediocre," and that the theme "permitted me, along with my usual vocabulary, to use all sorts of new characters I had never drawn before." He and Cegna produced what he called a "colossal book" that was "completely and expertly handmade in steel . . . with plexiglass pages" and was to be installed permanently in the city park of Milan, as part of the Fifth Milan Triennale. The Pinocchio book drew crowds but was vandalized by students from the Architecture Department of the Milan School of Fine Arts. The book was repaired, transferred to a museum, and shackled with heavy chains to a wall. Frustrated in the dream of setting up books to be admired by "all people in city parks throughout the world," Corneille and Cegna decided to put out a series of serigraphs in black and white that the artist could rework in gouache and colored inks. Twenty-five of these delightfully imaginative gouaches were exhibited at the Lefebre Gallery, in New York City, in October 1975. In the catalog Corneille remarked that he had not reread Collodi's tale, but "preferred conjuring up the images that had been dormant in my memory since childhood," including "the talking cricket," and "the two-headed fire-spewing dragon." His monsters were far more entertaining and whimsical than terrifying.

There was a more sensuous vein of fantasy in another series of colorful gouaches entitled *Italian Summer*, which Corneille produced in the Italian town of Maesta-Urbisaglia. These were exhibited at the Lefebre Gallery in the autumn of 1976. The foreword to the catalog was written by Christian Dotremont, who called Corneille "a winged geologist, a leaping surveyor."

Dotremont described Corneille's art as "a physical sensation, from viewing to living to vision," a vision "that mobilizes the other senses.

The tactile view of the city, of stone, earth, sand, woman, air, water." Dotremont called Corneille's canvases "paintings that are both mobiles and circuses. Paintings that are peasant wedding-beds, rooms with blazing windows." It is an art that provides "a joyous, gay, happy sensation." As Corneille himself wrote in the preface to the catalog of his 1975 "Pinocchio" exhibition in New York City, "Just look, and do not flee enchantment."

Positive and exuberant in his paintings, Corneille in person is quiet and reticent, with the awkward shyness of an adolescent. He was married to a Dutchwoman, but they have been separated for many years. Corneille lives in Paris but spends much of his time in Italy.

EXHIBITIONS INCLUDE: Het Beerenhuis, Groningen, Neth. 1946; "Gardens," Europai Iskola, Budapest 1947; Gal. Birch, Copenhagen 1950; Martinet en Michels, Amsterdam 1951; t'Venster, Rotterdam 1951; Kunstkabinet Horemans, Antwerp 1953; Gal. Colette Allendy, Paris 1953; Palais des Beaux-Arts, Brussels 1956; Stedelijk Mus., Amsterdam 1956, '60, '65, '66; Stedelijk Mus., Schiedam, Neth. 1956; Gal. Le Gendre, Paris 1959; Gemeentemus. the Hague 1961; Brook Street Gal., London 1961; Lefebre Gal., NYC from 1962; Gal. del Naviglio, Milan 1963; Kunsthalle, Düsseldorf 1964; Gal. Stangle, Munich 1969; Gal. Ivan Spece, Ibiza, Spain 1969, '71; Gal. Rive Gauche, Paris 1971; Gal. La Medusa, Rome 1974; Mus. d'Art Moderne, Ghent, Belgium 1974; Mus. de Arte, São Paulo 1975; Gal. Espare, Amsterdam 1975; Mus. of Art, Carnegie Inst., Pittsburgh 1975. GROUP EXHIBITIONS INCLUDE: "Junge Schilders," Stedelijk Mus., Amsterdam 1946; Gal. Colette Allendy, Paris 1949; Gal. Birch, Copenhagen 1949; "Cobra," Stedelijk Mus., Amsterdam 1949; "Experimental Art," Stedelijk Mus., Amsterdam 1950; "Les Mains eblouies," Gal. Maeght, Paris 1950; "5 Peintres Cobra," Gal. Pierre, Paris 1950; Salon de Mai, Paris from 1951; Brooklyn Mus. of Art 1952; São Paulo Bienal 1953, '59; Venice Biennale 1954; Carnegie International, Pittsburgh 1955; Guggenheim International, NYC 1956; World's Fair, Brussels 1958; Documenta 2 and 3, Kassel, W. Ger. 1959, '64; Mus. d'Art Moderne, Paris 1966; "Zacheta," Warsaw 1966; Moderna Gal., Ljubljana, Yugo. 1969; Court Gal., Copenhagen 1970; Studio Erre, Rome 1971; Ibiza Graphic, Spain 1972; "Cobra 1948–78," Statens Mus. for Konst, Copenhagen 1978.

COLLECTIONS INCLUDE: Stedelijk Mus., Amsterdam; Gemeentemus., Hague; Stedelijk Van Abbe Mus., Eindhoven, Neth.; Frans Hals Mus., Haarlem, Neth; Mus. d'Art Moderne, Paris; Solomon R. Guggenheim Mus., NYC; Albright-Knox Art Gal., Buffalo, N.Y.; Mus. of Fine Arts, Houston.

ABOUT: "Italian Summer" (cat.), Lefebre Gal., NYC, 1976; Lambert, J.-C. Corneille, 1960; Laude, A. Corneille le roi—image, 1973;Lucie-Smith, E. Late Modern: The Visual Arts Since 1945, 1969;Maurizi, E. Corneille et la vie, 1973; Moore, E. (ed.) Contemporary Art 1942–1972: Collection of the Albright-Knox Art Gallery, 1972; Pellegrini, A. New Tendencies in Art, 1966; "Pinocchio" (cat.), Lefebre Gal., NYC, 1975; Read, H. A Concise History of Modern Painting, 1959. *Periodicals*—Art News October 1975.

CORNELL, JOSEPH (December 24, 1903–December 29, 1972), American artist, created idiosyncratic collages and assemblages. He associated with Surrealists in the 1930s and 1940s, but his work was poetic and nostalgic in tone. John Russell, writing in *The New York Times* (July 29, 1977), called him "our supreme master of intelligent make-believe."

He was born in Nyack, New York, the son of Joseph I. Cornell, a buyer and designer of textiles for menswear, and Helen Ten Broeck Storms. A sister, Elizabeth, was born in 1905, a second sister, Helen, in 1906, and a brother, Robert, in 1910. After 1910 the elder Joseph Cornell maintained a woodworking shop in the family stable, where he carved boats and made furniture; his wife, an avid reader, wrote movie scenarios as a hobby. Both parents enjoyed acting and music. It was a closely knit family and Cornell had warm and vivid memories of excursions to Coney Island's penny arcades, the water ballets and dance spectacles at New York's Hippodrome, and vaudeville programs at the Palace.

As a boy Cornell loved fairy tales. He also enjoyed reading *The Book of Knowledge* and *St. Nicholas: Scribner's Illustrated Magazine for Girls and Boys.* Both publications featured riddles, games, and such "do-it-yourself" projects as shadow-boxes. Unlike his sister Elizabeth, who studied drawing and painting in 1915 with Edward Hopper, he received no artistic training, but he was a movie enthusiast by 1914; in 1917 he and a friend staged a play in the family stables. The typed tickets for the performance read: "COMBINATION TICKET/ENTITLES BEARER TO: 'The Professional Burglar'/Relic Museum/Candy/Shadow Plays/ . . . "

The artist's early years were saddened by the progressive illness and eventual paralysis of Cornell's brother Robert and his father's death from leukemia in 1917. The family's resources were seriously depleted, but Mrs. Cornell made the best of a difficult situation. In the summer of 1917 she was advised by her late husband's employer to send Joseph to the prestigious Phillips Academy in Andover, Massachusetts. Since she could no longer afford their Nyack home, she moved her family, in the fall of 1918, to rented quarters in Douglaston, Long Island.

Cornell entered Phillips Academy, the oldest preparatory school in America, in September

The Joseph Cornell Study Center, National Museum of Art, Smithsonian Institution

JOSEPH CORNELL

1917. He remained there until June 1921, but did not complete the required courses and was not awarded a diploma. His years at Andover were difficult. A highly sensitive youth prone to nightmares and stomach problems, he had never before been away from his family for any great length of time. Although he loved to read, he did not distinguish himself academically. Moreover, there was no art program at Andover at that time, but while working during the summer of 1919 or 1920 at the Kundardt Textile Mill in Lawrence, Massachusetts, Cornell became interested in the famous glassware produced in the town of Sandwich, Massachusetts, and scoured the area for examples. This was possibly the first indication of his passion for collecting. He also began to illustrate his letters to his family with Mutt and Jeff caricatures. His foraging of parts of New England in search of glass stimulated an interest in the American past.

In 1921 Cornell left Andover for Bayside, New York, where his family had moved in 1919, and took a job at William Whitman Company Inc., a wholesale textile firm. Until 1931 he peddled woolen samples in the business district of lower Manhattan. He was unsuited for the job, but it gave him the opportunity to explore New York City. Memories of windows of caged tropical birds in a pet shop were to inspire his "Aviary" series of the 1940s. He discovered stores between Second and Third Avenues from which he later acquired innumerable records, prints, and photographs, and he nourished his love of collecting in the Oriental stores between 25th and 32nd Streets, buying Japanese prints and the first boxes for his objects. He was espe-

cially fond of the secondhand bookstores extending from the Bowery up Fourth Avenue to Union Square, and in one store, "The Sign of the Sparrow," he made his first literary purchase, a 1913 issue of the Parisian periodical *Musica.*

Cornell's interests soon began to extend into all the arts—music, dance, theater, film, and the visual arts. He and his sisters often attended the Metropolitan Opera and he began to collect librettos and recordings of modern European composers. Although he became versed in theatrical history, he greatly preferred the movies, enthralled by what he later described as "the profound and suggestive power of the silent film to evoke an ideal world of beauty," and Cornell started collecting movie memorabilia.

During the 1920s Cornell was introduced through magazines to modern French painting. In 1926 he attended the memorial exhibition of John Quinn's collection at the Art Center, New York City. His favorite pictures in the show were Seurat's *Le Cirque,* Henri Rousseau's *Sleeping Gypsy,* Picasso's *Mother and Child by the Sea,* and a *Window Still Life* by Derain. He also became aware of 20th-century photography and contemporary American artists, including Charles Demuth and Peter Blume.

Cornell's unhappiness in his job led to his conversion in 1925 to Christian Science. In May 1929 the family settled in a modest white-frame house on Utopia Parkway in Flushing, Queens, where he spent the remainder of his life. The Great Depression caused Cornell to lose his job at Whitman's in 1931, but unemployment gave him more time to explore Manhattan and to visit museums and galleries. In November 1931 he discovered the new Julien Levy Gallery, a center for avant-garde art. Soon after watching Levy unpack surrealist works destined for the exhibition "Newer Superrealism" at the Wadsworth Atheneum in Hartford, Connecticut, Cornell returned to the gallery with several of his own collages. Encouraged by Levy, he participated in the gallery's group show "Surréalisme" in January 1932, the first exhibition in New York to be devoted to the surrealist movement. The 28-year-old Cornell was represented by several collages and one construction, *Glass Bell,* a bell jar under which a Japanese fan and a collage of an eye on a rose rested on a mannequin's hand. His collages were influenced by Max Ernst's celebrated album of juxtaposed engravings *La Femme 100 têtes,* but lacked Ernst's aggressiveness. Cornell's first solo show, held at the Levy Gallery in November 1932, included further studies of the bell jar, mechanical toys modified by collage that Cornell called "*jouets surréalistes*" (surrealistic toys), and the first of his

"shadow-boxes"—small rectangular or round cardboard cases containing loose or mounted engravings, pins, table knives, and other ephemera.

Between 1932 and 1936 Cornell experimented with various kinds of containers for his constructions. *Untitled (Snow Maiden)* (ca. 1933) displayed mounted figurative cutouts under glass inside a paperboard box; *Object Beehive* (1935) combined photomontage with three-dimensional elements in a round pinewood box. *Untitled (Soap Bubble Set)* (1936; Wadsworth Atheneum) was the earliest example of the genre for which Cornell is best known, constructions encased in handmade wooden boxes. The incongruous juxtaposition of objects was directly influenced by surrealism, but Cornell's intention was very different. Far from seeking to shock the spectator in the manner of the Surrealists, as one French critic noted, Cornell communicated the spirit of "a theater of strangeness and also a nostalgia for such late-19th-century curiosities as dioramas and reliquaries." When *Untitled (Soap Bubble Set)* was exhibited in the historic 1936 group show "Fantastic Art, Dada, Surrealism" at the Museum of Modern Art, New York City, Cornell was irritated at being presented as a Surrealist. He wrote to Alfred H. Barr Jr., who organized the exhibition, " . . . I do not share in the subconscious and dream theories of the Surrealists," although he admitted admiring much of their work.

In the 1930s Cornell became increasingly interested in film. In 1933 he wrote the scenario for a never-realized film about a photographer, *Monsieur Phot (Seen Through the Stereoscope)*. That same year he saw the two surrealist films by Buñuel and Dali, *L'Age d'or* and *Le Chien andalou*, when they were screened by the New York Film Society. In 1936 he produced *Rose Hobart*, a free reconstruction of *East of Borneo* (a 1931 jungle "drama" from Universal Pictures) into what has been described as "collage-cinema." Among the more striking sequences were the explosion of a volcano and an eclipse sequence in which the sun falls into a pool. At a showing of *Rose Hobart* at the Julien Levy Gallery in December 1936, an enraged Dali accused Cornell of having stolen ideas that he (Dali) had thought about but never executed. Cornell made more films over the next three decades—including *Bookstalls, By Night with Torch and Spear* (1955), *Aviary* (1955, with Rudy Burkhardt), *Nymphlight* (1957), and, with Larry Jordan, *The Children's Party* and *The Midnight Party* (both 1969)—but his feelings about them were mixed, and in 1968 he said regretfully that "My films never really got off the ground." One film critic has written that "Joseph Cornell's cinema remains the central enigma of his work. His films have a roughness and an insidiousness that the constructions and collages never exhibit."

During the 1940s Cornell continued to construct his small, stagelike boxes, which have been described as "microcosmic universes of poetic associations." His growing repertoire of subjects—now encompassing both high culture and forms of mass entertainment—is indicated by the interpenetration of text and imagery in his essay and photomontage entitled *Enchanted Wanderer: Excerpt from a Journal Album for Hedy Lamarr*, published in the December 1941 issue of *View*. For example, Cornell's love of ballet found expression in such works as *Portrait of Ondine* (ca. 1947–51), a paperboard box containing various paper materials as a tribute to the ballerina Fanny Cerrito, whereas another of his box-constructions was a tribute to Lauren Bacall, one of the artist's favorite screen heroines. Cornell dipped into art history in *The Medici Slot Machine* (1942) with a severe composition of rectangles, the center dominated by a reproduction of a Moroni portrait of a Renaissance prince and the sides filled with allusions to the prince's life.

In the 1940s Cornell became a close friend of the Surrealist Roberto Matta; he also met Robert Motherwell, Max Ernst, and Ernst's wife Dorothea Tanning. He was affiliated with Peggy Guggenheim's Art of this Century Gallery and with the Julien Levy Gallery until they closed, respectively, in 1947 and 1949.

In December 1949 the Egan Gallery, New York City, presented "Aviary by Joseph Cornell," an exhibition based on a series he had been working on since 1946. One critic described these constructions as "mounted cutouts of colorful birds, mirrors, springs, and drawers starkly ordered in luminously painted containers." Thomas B. Hess wrote in *Art News* (January 1950) that the "Aviary" works "have a strict honesty, a concentration of texture and ordering of space, that raise them far above the older velours-lined jobs"—this last a reference to Cornell's previous show at the Hugo Gallery, New York City, largely devoted to the ballet and installed against blue-velvet walls.

By 1951 Cornell had developed health problems, including pressures on his spine and right leg and attacks of migraine, insomnia, and vertigo. He lamented the unavailability of books and other materials in the aftermath of World War II, and was distressed by the demolition of cherished New York landmarks. In the early 1950s his shadow-boxes often transcended the miniature stage-set concept and verged on pure abstraction; some of these pieces were made up of

a white wooden grid of small compartments in which multiple white cubes moved freely. In other boxes he returned to the object, as in those which suggested dovecotes and their bird population. The accidental discovery of damage to a box in his cellar workshop in the early 1950s led to experiments with what Cornell described as "the freer medium of collage and 'painting' (rubbing, scraping, etc.) on flat mounts— masonite and plywood." These methods were used in the series dedicated to Juan Gris (1953–55), in which a cutout cockatoo was one of the elements.

In the fall of 1955 he resumed making independent, two-dimensional collages which differed from his earlier "montages" in being based on colorful clippings from contemporary books, magazines, and commercial art reproductions instead of being derived from turn-of-the-century black-and-white engravings and woodcuts. Cornell continued in this vein into the 1960s, with such collages as *Untitled (Home Poor Heart)* (ca. 1962; MOMA). His sister Elizabeth had also begun making collages, and they often exchanged ideas.

Cornell's reputation grew rapidly in the 1950s. He participated in MOMA's group show of 1952, "Fifteen Americans," and in July 1953 his first solo exhibition in an American museum was held at the Walker Art Center, Minneapolis. "The Art of Assemblage," a traveling exhibition organized by MOMA in 1961–62, was the first attempt to place Cornell's work in a context other than surrealism. By 1961 he was hiring assistants to scout for materials, help with carpentry, and reorganize the storage areas in his Flushing home. The declining health of his mother and brother made it increasingly difficult for him to manage his work and his family responsibilities and inevitably slowed down his production.

In the last decade of his life, from 1962 to 1972, Cornell fluctuated between periods of decreased activity and sporadic bursts of energy. Continuing to make trips, although less regularly than before, to Manhattan, he still found inspiration in Times Square, despite that area's growing tawdriness. What one critic called his "idealized empathy for women" led him to befriend a waitress and struggling actress named Joyce Hunter, whom he had first met in a Sixth Avenue coffee shop in February 1962. Cornell commemorated her in several collages, including *Vue par Tina (Mathematics in Nature)* (1962). His sympathy for her persisted even after she and two friends were arrested in September 1964 for stealing nine boxes from his home. Hunter was murdered in New York in December 1964, and Cornell's sense of loss was profound; in 1965 he requested

Larry Jordan to film scenes in the Flushing graveyard where she had been buried.

Cornell's invalid brother died in 1965, and his mother in 1966. His collage *Time Transfixed* (1965), with its echoes of Magritte, was dedicated to Robert's memory. From the mid-1960s, autobiographical recall predominated in his diaries and artwork. Several collages were based on family photographs and on Robert's drawings.

His first retrospective in American museums were held in 1967, at the Pasadena Museum of Art, California, and at the Solomon R. Guggenheim Museum, New York City. Considerably weakened by surgery in early June 1972, Cornell died at home from heart failure at the age of 69.

In late 1980, MOMA mounted a comprehensive exhibition of Cornell's work, with 200 boxes and 70 collages. Hilton Kramer, reviewing the retrospective in *The New York Times* (November 18, 1980), questioned whether Cornell's "odd and eccentric talent" could sustain a show of such magnitude. "This is an exhibition in which less would definitely have been more," Kramer observed. As art dealer John Bernard Myers wrote in *Art Journal* (Winter 1975/76), Cornell "remained a private person living in his own world"; unable to cope with or understand the present, he had "an obsession with the past." His intriguing, imaginative assemblages satisfied his passion for retrieving history and creating nostalgic evocations. "Shadow-boxes," the artist wrote in 1948, "become poetic theaters or settings wherein are metamorphosed the elements of a childhood pastime."

EXHIBITIONS INCLUDE: Julien Levy Gal., NYC 1932, '39, '40; Wakefield Gal., NYC 1942; Hugo Gal., NYC 1946; Copley Gals., Beverly Hills, Calif. 1948; Egan Gal., NYC 1949, '50, '53; Walker Art Center, Minneapolis 1953, '67; Stable Gal., NYC 1955, '57; New Gal., Bennington, Vt. 1959; Robert Schoelkopf Gal., NYC 1966; Pasadena Mus. of Art, Calif. 1967; Solomon R. Guggenheim Mus., NYC 1967; Brandeis Univ., Waltham, Mass. 1968; Metropolitan Mus. of Art, NYC 1970; Cooper Union, NYC 1972; Queens County Art and Cultural Center, N.Y. 1973; A.C.A. Gals., NYC 1975; MOMA, NYC 1980–81. GROUP EXHIBITIONS INCLUDE: "Surréalisme," Julien Levy Gal., NYC 1932; "Fantastic Art, Dada, Surrealism," MOMA, NYC 1936; "Exposition Internationale du Surréalisme," Gal. des Beaux-Arts, Paris 1938; "Objects by Joseph Cornell, Box-Valise by Marcel Duchamp, Bottles by Lawrence Vail," Art of this Century, NYC 1942; "Abstract and Surrealist Art in the United States," Denver Art Mus. 1944; "Fifteen Americans," MOMA, NYC 1952; Annual, Whitney Mus. of Am. Art, NYC from 1953; Pittsburgh International, Carnegie Inst. 1958; "The Art of Assemblage," MOMA, NYC 1961; "Painting and Sculpture of a Decade 1954–64," Tate Gal., London 1964; "Dada, Surrealism and their Heritage," MOMA, NYC 1968; "New York Painting and Sculpture

1940–1970," Metropolitan Mus. of Art, NYC 1969–70; Documenta 5, Kassel, W. Ger. 1972; "American Art at Mid-Century," Nat. Gal. of Art, Washington, D.C. 1973.

COLLECTIONS INCLUDE: MOMA, and Whitney Mus. of Am. Art, NYC; Albright-Knox Art Gal., Buffalo, N.Y.; Wadsworth Atheneum, Hartford, Conn.; Mus. of Fine Arts, Boston; Hirshhorn Mus. and Sculpture Garden, Washington, D.C.; Allen Memorial Art Gal., Oberlin Col., Ohio; Des Moines Art Center, Iowa; Walters Art Gal., Baltimore; Fort Worth Art Mus., Tex.; Pasadena Mus., Calif.; Nat. Gal. of Canada, Ottawa; Tate Gal., London; Mus. Nat. d'Art Moderne, Paris; Peggy Guggenheim Collection, Venice; Kaiser Wilhelm Mus., Krefeld, W. Ger.; Moderna Mus., Stockholm.

ABOUT: "The Art of Assemblage" (cat.), MOMA, NYC, 1961; Bénézit, E. (ed.) Dictionnaire des peintres, sculpteurs et graveurs, 1976; Jean, M. The History of Surrealist Painting, 1960; "Joseph Cornell" (cat.), A.C.A. Gals., NYC, 1975; Levy, J. (ed.) Surrealism, 1936; McShire, K. (ed.) "Joseph Cornell" (cat.), MOMA, NYC, 1980; O'Doherty, B. American Masters: The Voice and the Myth, 1973; Rosenberg, H. Artworks and Packages, 1969; Waldman, D. Joseph Cornell, 1977. *Periodicals*—Art International (Lugano) no. 10 1959; Art Journal Winter 1975/76; Art News January 1950, December 1957, Summer 1967; Artforum February 1963; Arts Magazine May 1967; Design Quarterly (Minneapolis) no. 30 1954; New York November 24, 1980; New York Times December 31, 1972, July 29, 1977, October 28, 1977, November 18, 1980; View December 1941.

CRAWFORD, RALSTON (September 5, 1906–May 1, 1978), American painter, lithographer, and photographer, was among the Precisionists, or Cubist Realists, of the 1930s who took as their subject the modern industrial landscape. Born in St. Catherines, Ontario, Canada, he moved with his family to Buffalo, New York when he was four years old, at which time he was naturalized. After attending high school in Buffalo, he spent part of 1926 as a sailor on tramp steamers to the Caribbean, Central America, and eventually California. He stayed in Los Angeles, studying at the Otis Art Institute in 1926–27 and working briefly in 1927 in the Walt Disney studio. Later that year he returned east to enroll in the Pennsylvania Academy of Fine Arts, Philadelphia. During his three years in Philadelphia he also studied at the Barnes Foundation in nearby Merion, Pennsylvania, where he was introduced to the work of Matisse and Picasso. He lived and painted in New York from 1930 to 1932, when he was married to Margaret Stone.

In 1932 Crawford went to Paris; he studied at the Académie Colarossi and the Académie

RALSTON CRAWFORD

Scandinave. After traveling to Italy, Spain, and the Balearic Islands in 1933, he returned to the United States to attend Columbia University. His first solo exhibition was held at the Maryland Institute of Art, Baltimore, in 1933. Beginning in 1934, Crawford spent several years painting in Chadds Ford and Exton, Pennsylvania.

Crawford's early paintings, such as *Ninth Avenue Elevated* (1934), *Electrification* (1936, Hirshhorn Museum and Sculpture Garden, Washington, D.C.), and *Worth Steel Plant* (1936), were akin to those of Charles Sheeler, Charles Demuth, and Niles Spencer in their sharp-edged simplification of forms. Broad planes of flat color and crisp shadows defined the essential, geometric shapes of city buildings, storage tanks, water towers, and other elements of the modern industrial environment.

In 1937 Crawford was awarded a Bok Fellowship to study at the Research Studio in Florida. It was at this time that he, like Sheeler and others of the Precisionists, became interested in photography. He took a trip to New Orleans and obtained a special police permit to visit bars usually off-limits to whites, so that he could photograph black jazz musicians.

Crawford moved in 1940 to New York City, which he adopted as his "only home"; except for his many travels and his teaching stints at various colleges and universities, he remained in the city for the rest of his life.

He did his first lithograph, *Overseas Highway*, in 1940. Based on a 1939 painting with the same title, it is a characteristically precisionist image: a bridge that reaches a vanishing point on the horizon. Although Crawford's litho-

graphs are closely related to his paintings (and to his photographs), his graphic works, more abstract but with no loss of precision, display a freedom and spontaneity of line rarely visible in his paintings

Nineteen-forty-two was an important year for Crawford: he married Peggy Frank, was awarded the Metropolitan Museum of Art's Purchase Prize for color lithography, and entered the Army Air Force. As chief of the visual presentation unit of the Western Section of the Army Air Force weather division, he prepared graphic information and weather charts for fliers and other military personnel. In 1945 he was assigned to the China-Burma-India Theater of operations; while in India he photographed the cave temples. At the war's end he was awarded an Army commendation ribbon.

After his discharge in 1946, Crawford was commissioned by *Fortune* magazine to witness and make paintings of Test Able, the detonation of the atomic bomb at Bikini Atoll. The results were brightly colored illustrations that resembled his lithographs; they differed from most of his paintings in their abandonment, for the most part, of clean, sharp edges. Some paintings based on the destructiveness of war, such as *Bomber* (1944), do, however, have this same "shattered" quality.

The general tendency of Crawford's work in the postwar years was towards increasing abstraction. But order, clarity, and simplicity remained characteristics of Crawford's paintings and lithographs, no matter how abstract.

In 1947 Crawford taught at the Honolulu Academy of Arts in Hawaii and in 1948–49 at the Brooklyn Museum Art School. From 1949 to 1950 he was a visiting artist at Louisiana State University, Baton Rouge. At that time, and for the next ten years, he made frequent trips to New Orleans to paint and photograph its jazz world and its cemeteries. In 1950 he went to Mexico to photograph; the following year he returned to Europe to work on lithography in Paris. Back in New York City in 1952, he set up his studio in Madison Square and joined the faculty at the New School for Social Research, a post he held through 1961, with one year's interruption in 1954–55, when he worked in Paris with master printmakers.

The evolution of Crawford's painting can be observed in his treatment of similar subjects over time. In *Public Grain Elevators, New Orleans* (1938), reality is simplified but there is still a sense of perspective in depth. Some of this is lost in *Grain Elevators from the Bridge* (1942), but the elevators and the girders of the bridge are still visible. *Grain Elevators, Minneapolis* (1949)

is completely abstract, and *Grain Elevator* (1951) is almost two-dimensional. On the occasion of a Crawford retrospective at the Century Association, New York City, the artist said, "I don't feel obligated to reveal the forms. They may be totally absent to the viewer of the work, or even to myself, but what is there, however abstract, grows out of something I have seen. I make pictures." Crawford's lithographs, many of them black and white, show a similar tendency. Despite such titles as "Third Avenue Elevated" (a 1951 series) and "Cologne Landscape" (another series, begun in 1951), the subject matter was often lost in pattern. But, as one critic wrote, Crawford was "stimulated by everything with which he has come into contact." This concern with the variety of experience is evident in his admirable photography, which was perhaps his most intimate artistic expression.

In 1958 Crawford had his first retrospective, at the Milwaukee Art Center, and in 1961 he held an exhibition of color lithographs at the Lee Nordness Gallery, New York City. A second retrospective was presented in 1968 at the Creighton University Fine Arts Gallery, Omaha, Nebraska. In 1969 he was one of several artists who participated in a special program sponsored by the United States Department of Interior; his assignment was a rendering of the Grand Coulee Dam in the state of Washington.

His many students and friends have praised Crawford's keen intelligence and the warmth of his personality. He dressed elegantly and was a connoisseur of fine wines. A fan of automobiles and auto racing, he often attended the Indianapolis 500; he admired the skill and courage of the drivers just as he appreciated the daring and artistry of bullfighters.

In his painting and prints, Ralston Crawford sought a balance, a form of expression less cerebral than that of Mondrian and Van Doesburg, but far less impulsive than abstract expressionism. However precise his style and impersonal his subject matter, he never discounted the emotional factor. He declared, "I believe that good paintings are done by and for people who do resort to the use of reason, along with having a concern with their feelings."

Ralston Crawford died in Houston, where he had gone to make arrangements for an exhibition of his work, at the age of 71. He was given a traditional jazz funeral service in New Orleans, the city that had meant so much to him, and was buried there in the St. Louis cemetery.

EXHIBITIONS INCLUDE: Maryland Inst., Baltimore 1934; Boyer Gals., Philadelphia 1937; Boyer Gals., NYC 1939; Flint Inst. of Arts, Mich. 1947; Downtown Gal.,

NYC 1944, '46, '50; Caresse Crosby Gal., Washington, D.C. 1945; Santa Barbara Mus. of Art, Calif. 1946; Milwaukee Art Center 1958; Creighton Univ. Fine Arts Gal., Omaha 1968; New York Century Association, NYC 1969; Lee Nordness Gals., NYC 1969; Contemporary Arts Center, Cincinnati 1971; Zabuskie Gal., NYC 1973; Whitney Mus. of Am. Art, NYC 1973; Robert Miller Gal., NYC 1983. GROUP EXHIBITIONS INCLUDE: "A New Realism," Cincinnati Modern Art Society 1941; "Artists for Victory," Metropolitan Mus. of Art, NYC 1942; "Abstract Painting and Sculpture in America," MOMA, NYC 1951; "The Precisionist View in American Art," Walker Art Center, Minneapolis 1960.

COLLECTIONS INCLUDE: Metropolitan Mus. of Art, MOMA, and Whitney Mus. of Am. Art, NYC; Brooklyn Mus., N.Y.; Albright-Knox Art Gal., Buffalo, N.Y.; Munson-Williams-Proctor Inst., Utica, N.Y.; Fogg Mus. of Art, Cambridge, Mass.; Phillips Gal., and Hirshhorn Mus. and Sculpture Garden, Washington, D.C.; Baltimore Mus. of Art; Cincinnati Art Mus.; Toledo Mus., Ohio; Walker Art Center, Minneapolis; Los Angeles County Mus.; Honolulu Academy of Art.

ABOUT: Agee, W. Ralston Crawford, 1983; Dwight, E. H. "Ralston Crawford" (cat.), Milwaukee Art Center, 1958; Freeman, R. B. Ralston Crawford, 1953, The Lithographs of Ralston Crawford, 1962; Osborne, H. (ed.) The Oxford Companion to Twentieth Century Art, 1981; "The Photography of Ralston Crawford" (cat.), Sheldon Memorial Art Gal., Univ. of Nebraska, Lincoln, 1974; Rose, B. American Art Since 1900, 2d. ed. 1975. *Periodicals*—Art in America October 1955, November 3, 1960; Arts Magazine October 1961; Daily Worker December 12, 1946; New York Times December 7, 1946, October 23, 1955, May 2, 1978; Newsday July 17, 1963.

CREEFT, JOSÉ DE. *See* DE **CREEFT, JOSÉ**

***CREMONINI, LEONARDO (RAFAELLO)** (November 26, 1925–), Italian painter, writes: "I was born in Bologna, Italy, on November 26, 1925. I began to paint very early with the advice and help of my father, Luigi, who was a very good amateur painter.

"I began studying art in Bologna in 1940 in close association with the painter Guglielmo Pizzirani; I completed my artistic studies between 1946 and 1950 at the Brera Academy in Milan.

"An early success in New York City, at the Catherine Viviano Gallery [in 1952] made me a very well-known painter in the United States and an unknown one in Paris, where I had been living without exhibiting between 1951 and 1960.

"From 1951 to the present, the only city where I have had a solid base is Paris. Long work

LEONARDO CREMONINI

periods (nearly always six months) kept me in Forio d'Ischia until 1955. Then, in 1956, Douarnenez in the Finistère [in Brittany], Bertinoro in Romagna (Italy), Panarea (Aeolian Islands) very often, and several times in Procida and Andalusia as well as San Lucas de Barrameda. There were also long journeys in Spain, Ireland, Morocco, Egypt, France, Portugal, the Sahara, Nepal, and Tibet.

"In 1967 I won the only important award for my painting, the first Manotto prize. Besides easel painting, I am intensely involved with engrazing, lithography, and serigraphs in order to give a multiple dimension to my imagery.

"I am passionately interested in vegetation, and I have a tropical garden in Panarea surrounding my studio.

"I have a teen-age son.

"A central problem in my work will always be to give maximum life to the language of a picture beyond its inexorable limits as a commercial object."

———

Leonardo Cremonini's work has been described by the critic Aldo Pellegrini as "Surrealizing neo-figuration." In his paintings of the 1950s angularly distorted human figures were placed in an impersonal landscape setting, sometimes merging with their surroundings. *Women in the Sun* (1954) and *Bathers Amongst the Rocks* (1955–56; Hirshhorn Museum and Sculpture Garden, Washington, D.C.) belong to this earlier period. From 1961 on, the events of the Algerian War made Cremonini increasingly

aware of the struggle of man, not only against an indifferent nature, but against his fellow man. He depicted, to quote Pellegrini, "hallucinatory, desolate beings, seemingly corralled, who sometimes appear to disintegrate, in interiors or in landscapes belonging to no time or place." Even when he represented what appeared to be an everyday interior, as in *Blindman's Buff* (1963–64), there were disturbing, nightmarish elements. In this canvas a distraught, blindfolded figure is reflected in a large oval mirror facing the viewer, while blurred and decomposing human forms, somewhat reminiscent of Francis Bacon, seem to melt into the living room, where only the furniture remains solid. (The mirror is a recurring symbol in Cremonini's paintings.)

Critics have noted that the climate of estrangement, desolation, and incongruity in Cremonini's work, the heritage of surrealism, is made up for by rich and luminous color and great refinement of handling. Because Cremonini has taken the human condition and the troubled soul of modern man as his subject matter, leading modern writers have discussed his work. These include Alberto Moravia, in the catalog to a 1972 Cremonini exhibit at the Galleria Gabbiano, Rome; Stephen Spender, in the catalog to an exhibit at London's Hanover Gallery in 1955; and Michel Butor, in the catalog to a show at the Palais des Beaux-Arts, Brussels, in 1969.

EXHIBITIONS INCLUDE: Centre d'Art Italien, Paris 1951; Catherine Viviano Gal., NYC 1952, '54, '57, '62; Hanover Gal., London 1955; Gal. del Milione, Milan 1960; Gal. du Dragon, Paris from 1960; Gal. Galatea, Turin 1963; Palais des Beaux-Arts, Brussels 1969; Kunsthalle, Basel 1969; Retrospective, Mus. Civico, Bologna (and tour) 1969–70; Kunsthalle, Darmstadt, 1970; Gal. Gabbiano, Rome 1972. GROUP EXHIBITIONS INCLUDE: Carnegie International, Pittsburgh 1952, '55, '58, '64; "Modern Italian Art," Tate Gal., London 1956; Salon de Mai, Paris 1958, '65, '68; "20th Century Italian Art from American Collections," Palazzo Reale, Milan, and Gal. Nazionale d'Arte Moderna, Rome 1960; "The Stanley J. Seeger Jr. Collection," Art Mus., Princeton Univ., N.J. 1961; Venice Biennale 1964, '66; "Signed, Protest, Manifest," Städtische Kunsthalle, Recklinghausen, W. Ger. 1965; "Quadriennale Nazionale d'Arte, Rome 1966; "Visage humain dans l'art contemporain, " Mus. Rath, Geneva 1967; "L'Art vivant," Fondation Maeght, Saint-Paul-de-Vence, France 1968.

COLLECTIONS INCLUDE: MOMA, NYC; Brooklyn Mus., N.Y. Albright-Knox Art Gal., Buffalo, N.Y.; Detroit Inst. of Arts; Carnegie Inst. Mus., Pittsburgh; City Art Center, St. Louis; Colo. Springs Fine Arts Center; Hirshhorn Mus. and Sculpture Garden, Washington, D. C.; Mus. Nat. d' Art Moderne, and Mus. d'Art Moderne de la Ville, Paris; Gal. d'Arte Moderna, Bologna; Gal. d'Arte Moderna, Milan; Inst. di Storia dell'Arte.

Pisa; Gal. d' Arte Moderna, San Marino, Italy; Mus. d'Art Moderne, Algiers: Nat. Mus., Jerusalem.

ABOUT: Bénézit, E. Dictionnaire des peintres, sculpteurs et graveurs, 1976; Pellegrini, A. New Tendencies in Art, 1966. *Periodicals*—Art International (Lugano) February 1975; Arts Magazine February 1957; Gazette des Beaux Arts (Paris) October 1983.

***DALI, SALVADOR (DOMENECH FELIPE JACINTO)** (March 11, 1904–), Spanish painter, has been one of the most famous and controversial of 20th-century artists. Although synonymous in the public mind with surrealism, Dali was excommunicated from the movement by André Breton, the "pope" of surrealism, in the late 1930s. Moreover, in the last four-and-a-half decades his work, though technically as accomplished as ever and containing various surrealist devices, has had none of the hallucinatory impact, obsessive fantasy, and power to shock of his early paintings. Over the years, showmanship, commercialism, and a genius for public relations have replaced imagination in Dali's art.

Salvador Felipe Jacinto Dali was born in Figueras, in the Gerona province of Upper Catalonia in northeastern Spain, the son of Salvador and Felipa Dome (Domenech) Dali. His talent for drawing, apparent at an early age, was encouraged by his father, a notary, who gave him reproductions of classical art. Dali claims in his autobiography, *The Secret Life of Salvador Dali* (1942), that from earliest childhood his behavior was marked by fits of violent hysteria.

Before he was ten, Salvador had completed two ambitious oil paintings, *Joseph Greeting his Brothers* and *Portrait of Helen of Troy*. After receiving his elementary education at the Colegio de los Hermanos de la Doctrina Cristiana, Figueras, he attended the Colegio de los Hermanos Maristas, and completed his six years of baccalaureate studies at the Instituto in Figueras.

In adolescence Dali received instruction from Juan Nuñez at the Figueras municipal school of drawing. He admired the 19th-century Spanish painters of genre scenes for their precise and detailed realism, and later was impressed by Ernest Meissonnier, the leading French practitioner of this type of painting. "Dali had the courage," Dali wrote, "to paint like Meissonnier in the midst of the 'modern' epoch and his success at painting like Dali has not suffered because of it."

The young Dali was also interested in the English Pre-Raphaelites, and he greatly admired Vermeer and Velázquez. About 1918 he experimented with impressionism and pointillism. Sev-

°dä´ lē, säl´´ vä thô

UPI/BETTMAN ARCHIVE

SALVADOR DALI

eral small, brightly colored pictures in this style were painted in the Spanish fishing village of Cadaqués. *A Self-Portrait of the Artist at his Easel, Cadaqués* (ca. 1918–19) is owned by A. Reynolds Morse, a Cleveland industrialist whose collection of Dali's work of all periods is extensive.

By 1920 Dali had been influenced by Italian futurism, and he painted for a time in that manner. Assured of his son's artistic promise, Dali's father finally agreed to his making a career of painting. In 1921 Dali entered the Escuela Nacional de Bellas Artes de San Fernando, Madrid, where he rapidly absorbed the academic instruction of his teacher, Moreno Carbonero, and won several prizes. Among his fellow students were Federico García Lorca and Luis Buñuel. At this time he abandoned bright colors and, influenced by the Cubist Juan Gris, began to paint in subdued tones. A more important influence, however, was that of the Italian metaphysical painters, Giorgio de Chirico and Carlo Carrà, whom he discovered in 1923, their work being well known in avant-garde circles in Spain.

The poetic and philosophical vision of de Chirico, combined with his reading of Freud, was crucial to Dali's development. These new inspirations led him far from the teachings of the academy and he began to paint mysterious still lifes after the manner of de Chirico and Carrà. His relations with school authorities grew increasingly stormy, and in 1924, charged with inciting the students to insurrection, he was suspended for a year. In May 1924 Dali was briefly imprisoned in Figueras and in the town of Gerona for alleged subversive political activi-

ties. He returned to the Madrid school in 1925 but was permanently expelled "for extravagant personal behavior" a year later. According to Dali, the expulsion stemmed from his refusal to submit to an art history examination administered by teachers he regarded as intellectual inferiors.

Meanwhile, Dali had taken part in group exhibitions in Madrid and Barcelona, and in November 1925 his first solo show was held at the Galeria Dalmau, Barcelona. His paintings of 1925–27 were in a variety of styles—meticulous realism, as in *Basket of Bread* (1926), Picassoesque cubism in several "Harlequin" pictures, and neoclassicism (*Venus and Cupid* and *Neo-Cubist Academy*). In 1926 he exhibited in a group show with the Sociedad de Artistas Ibéricos (Society of Iberian Artists) in Madrid. The same year, having seen reproductions of early works by Yves Tanguy in the magazine *Revolution Surréaliste,* he began to practice automatistic drawing methods and to build up his store of forms and images. One of his 1927 canvases, *Blood is Sweeter than Honey,* is considered a forerunner of his hallucinatory art of psychological obsessions.

In 1928, traveling by taxi, Dali visited Paris for the first time. His aim was to see Picasso, Versailles, and the Musée Grévin, Paris's famous wax museum. On this trip he met Picasso and on a second visit that year met Joan Miró, who introduced him to the Surrealists. (In his autobiography Dali said that, after meeting Breton, he began referring to him as "my new father, André Breton.") Returning to Barcelona, Dali published a manifesto, *Groc,* and invited the Surrealist group to Cadaqués, where he had been living since 1925. Back in Paris in 1929, he signed a contract for an exhibition at the Galerie Goemans and returned home to prepare for it.

For several months the influence of Miró prevailed, but by the summer of 1929 Dali had abandoned abstraction and was painting in his mature style. He set out to depict, in the meticulous technique of a miniaturist, exact, Meissonnier-like transcriptions of the images of his dreams and hallucinations; he later called this method, derived from the surrealist principle of automatism, "paranoiac-critical." Dali's "critical paranoia" was the process by which he claimed to loosen the moorings of rationality and unleash the visions of his subconscious—while remaining aware that reason had been deliberately suspended. In *The Shock of the New* Robert Hughes defined Dali's "paranoiac-critical" method as simply "looking at one thing and seeing another." The method's results can be seen in such Dali paintings of 1929 as *The Lugubrious*

Game, with his allusions to the "shame" of onanism; *Accommodations of Desire,* with its multiple lion heads in various stages of incompletion; *Profanation of Host;* and *Illumined Pleasures.*

Dali moved to Paris in the fall of 1929, and his paintings caused a sensation. "Dali had a brilliant sense of provocation," Hughes noted, "and if his images are to be rightly seen they must be set, in retrospect, into the context of a less sexually frank time. Today, the art world is less easily alarmed by images of sex, blood, excrement, and putrefaction, but fifty years ago it was still quite shockable. . . . " He was at once designated an official Surrealist by Breton, who wrote the catalog introduction to Dali's first Parisian solo show, which was held at the Galerie Goemans in November.

As James Thrall Soby pointed out in *Salvador Dali* (1946), the young Spaniard brought "a new objectivity" to surrealist painting by depicting "the unreal world with such extreme realism that its truth and validity could no longer be questioned." Dali called his technique the "handmade photography of concrete irrationality." In 1930 Dali, whose verbal gifts were to prove almost as useful in constructing the "Dali myth" as his striking visual imagery, expounded his ideas in the book *La Femme visible.* He wrote that his aim was "to systematize confusion and assist in discrediting completely the world of reality."

In 1928 Dali collaborated with the director Luis Buñuel on *Un Chien andalou* and in 1930 on *L'Age d'or;* both films have become classics of surrealist cinema. About 1930 Dali became involved with Gala (born Elena Diaranoff), the ex-wife of Surrealist poet Paul Eluard. They were married in 1942 in a civil ceremony in New York City. She modeled for many Dali paintings.

Dali applied his "paranoiac-critical" method in a group of paintings dealing with the legend of William Tell (1930–34), and in 1932–35 with the figures from the French painter Jean François Millet's *Angelus.* Dali's Freudian interpretation of these themes prompted critics to wonder if they were out of admiration or derision—or in a spirit of derision masking an underlying admiration. In his typically provocative manner of overstatement, Dali praised "the genius of François Millet [noted for his realistic depiction of 19th-century French peasantry] whose erotic cannibalism shows through the tragic myth of 'The Angelus.'"

In 1931 Dali painted *The Persistence of Memory* (Museum of Modern Art, New York City), which is thought to be his masterpiece and has been called "the most widely celebrated surrealist canvas ever painted." (The melting watches are Dali trademarks and Philippe Halsman, in his 1954 photograph of the painting, substituted Dali's face for the flaccid timepiece in the foreground.) In *Persistence of Memory,* time itself, here represented by the limp metal watches, seems to have passed away, as has the mustachioed biomorphic blob in the foreground. Only the landscape, based, as many of Dali's backgrounds are, on the rocky coast of his native Catalonia, is immune to the ravages of time; yet even the cliffs seem suspended in space, defying the laws of gravity and the solidity of matter.

In his paintings of the 1930s, Dali frequently made use of the disturbing double or multiple image, as in *The Invisible Man, Diurnal Fantasies,* and *Memory of the Child-Woman,* all of 1932, and *Apparition of Face and Fruit Dish on a Beach* (1938). The first New York City solo show of Dali's paintings was in November 1933 at the Julien Levy Gallery; a year later he traveled to America for the first time. A number of paintings of 1933–34 evince Dali's obsession with cephalic deformations, as in *Myself at the age of ten when I was the Grasshopper Child* (1933), and *Atmospheric Skull Sodomizing a Grand Piano* (1934). In 1933 Dali illustrated Lautréamont's *Les Chants de Maldoror,* the advanced 19th-century prose poem which influenced the Surrealists.

On vacation in Rosas on the Catalan coast in 1934–36, Dali painted a comparatively lyrical series of beach scenes and became interested in the paintings of Arnold Böcklin and the music of Wagner. From 1934 to '37 Dali helped to popularize surrealism in the United States. Dali's essay, "The Conquest of the Irrational," appeared in 1935 and from 1936 to '38 he participated in the major Surrealist group shows held in London, Paris, New York City, Mexico City, Tokyo, and other world capitals.

Dali's notoriety and growing commercial success earned Breton's stern disapproval. Breton felt that surrealism had liberated Dali from the extreme academic realism of Meissonier, and he deeply admired the artist's ability to reveal the nonrationality of objects and "to implement all the possibilities of the innately savage mind and eye," as Anna Balakian wrote in *André Breton (1971).* To Breton, however, exploitation of surrealism for personal gain was a cardinal sin, and in 1938 he concluded that Dali's art had become commercialized, that the flamboyant artist had "sold out." Expelling Dali from the Surrealist ranks, he branded him "Avida Dollars," an anagram of the artist's name. (The incident became a part of surrealist lore, and in later years Dali humorously embraced the derogatory appellation.)

When the Spanish Civil War broke out in 1936, Dali avoided taking a stand. Nevertheless, it became obvious over the years that his sympathies, quite unlike Picasso's, were unreservedly with the totalitarian Franco regime. Just six months before the Civil War commenced, Dali completed what was possibly his last truly powerful picture: *Soft Construction with Boiled Beans; Premonition of Civil War* (1936). Its imagery, recalling the nightmarish visions of Hieronymous Bosch, was intended to portray a people torn apart. Dali wrote, with characteristic bombast, "I showed a vast human body breaking out into monstrous excrescences of arms and legs tearing at one another in a delirium of auto-strangulation." He explained the boiled beans in the title by reference to his obsession with the imagery of edible objects, his need to introduce "some mealy and melancholy vegetable" into the painting.

From 1937 to '39 Dali traveled extensively in Europe. In London, in 1938, he visited Sigmund Freud, who remarked, "What interests me is not your unconscious but your conscious." In *The Unspeakable Confessions of Salvador Dali* (1981), the artist modestly described the encounter: "Two geniuses had met without making sparks. His ideas spoke for him. To me, they were useful crutches that reinforced my confidence in my genius and the authenticity of my freedom, and I had more to teach him than I could get from him." Several trips to Italy deepened Dali's appreciation of the Renaissance masters, especially the mannerist and baroque painters of the 16th and 17th centuries, whose influence is reflected in the attenuated figures and exaggerated perspective of such works as *Palladio's Corridor of Dramatic Surprises* (1938). The Surrealists, however, regarded Dali's apparent return to academism as a further "betrayal" of the movement. In 1939 he briefly visited New York City to execute *The Dream of Venus* for the World's Fair.

With the start of World War II in September 1939, Dali moved from Paris to the region of Bordeaux and Arcachon in southwest France, and when Germany invaded he fled via Spain and Portugal to the US, arriving in August 1940. He lived for a time at his friend Caresse Crosby's home in Virginia, where he wrote his autobiography, and later settled in Pebble Beach, California. The "Dali legend" had already been fostered by such exhibitionist antics as delivering a lecture in London in a deep-sea diving suit and by crashing through Bonwit Teller's Fifth Avenue window after one of his displays had been altered, and in the US Dali's outrageous self-promotion continued. His American success was confirmed by the retrospective MOMA gave

him in 1941; the show toured the US for two years. In 1942 *The Secret Life of Salvador Dali* was described by *New York Times* reviewers as "shocking, too intimate, sadistic," and "a wild jungle of fantasy." Dali also designed the sets and costumes and composed the libretti for the ballets *Bacchanale* (1939), *Labyrinth* (1941), and *Mad Tristan* (1944). His novel *Hidden Faces* (1944) was, according to Edmund Wilson, "a potpourri of the properties, the figures and the attitudes of the later and gamier phases of French romantic writing."

Dali's return to academism in 1937–39 led in the late 1940s to an interest in religious subject matter. About this time he introduced what he called his "atomic," or "nuclear mystic," technique, meaning the explosion of forms so as to dramatize their impact. In 1948, after the publication of his *Fifty Secrets of Magic Craftsmanship*, Dali returned to Spain, thus making no secret of his support of the dictator Francisco Franco. "Our invincible Caudillo Generalíssimo Francisco Franco," he said, as quoted in *The New York Times Magazine*, "is the genius of our people, without a doubt. *Bueno,* there are two: Velázquez and the Generalíssimo." He settled in Port Lligat, which was declared a national scenic preserve by the government, and with great fanfare proclaimed his allegiance to the Roman Catholic Church. Of Dali's large religious paintings Jacques Busse wrote in the *Dictionnaire de peintres, sculpteurs, et graveurs* (1976): "Their forced originality does not compensate for the stiffness of a technique which aims at being classical." These paintings include *The Madonna of Port Lligat* (1950), for which Gala modeled and which Dali gave to the Pope; *Christ of St. John of the Cross* (1951); and the large, ambitious *Sacrament of the Last Supper* (1955; National Gallery of Art, Washington, D.C.). In *A Concise History of Modern Painting* Herbert Read savaged this phase of Dali's career: "Salvador Dali's work has sunk lower still, cynically exploiting a sentimental and sensational religiosity. . . . The theatricality, which was always a characteristic of his behavior, is now at the service of those reactionary forces in Spain whose triumph has been the greatest affront to the humanism which, in spite of its extravagance, has been the consistent concern of the Surrealist movement."

In 1952 Dali completed a series of illustrations for Dante's *Divine Comedy*. Two years later he visited Pope John XXIII in Rome, and in 1961 he designed scenery and costumes for the *Ballet de Gala.* By this time Dali had had retrospectives in Tokyo (1964) and New York City (1966). In the 1960s and '70s he experimented with holography and introduced stereoscopic images into

his paintings. A Salvador Dali museum, the Teatro Museo Dali, was established in Figueras in 1970, and on March 7 1971 a Dali Museum in Cleveland was inaugurated, putting the A. Reynolds Morse Collection on permanent exhibition.

Reviewing a 1980 Dali retrospective at the Centre Georges Pompidou (Beaubourg), Paris, Hilton Kramer of *The New York Times* (January 20, 1980) commented on the artist's later work: "His loss of artistic power, the absence in his work of any real imagery, coincided with the intensified effort on Dali's part to make himself into a Dali creation. . . . [But] in his best paintings of the '30s Dali was a magician." The consensus among critics is that "almost all the works of art on which Dali's fame as a serious artist rest were painted before his thirty-fifth birthday, between 1929 and 1939," to quote Robert Hughes.

According to Peter Conrad of the *New Statesman* (June 25, 1976), "Dali's career has depended on his public flagrancy." Conrad added that Dali derived from the romantic dandyism of Baudelaire and Oscar Wilde "his horror of nature, and his desire to exterminate it by making himself over into art, armoring himself with affectation. . . . Dali's loathsome gastronomic tastes and the morphological comedy of his art both derive from this vengeful attitude to nature."

Dali continues to live in the mansion he built near Cadaqués, in Port Lligat. On his regular visits to New York City, Dali installs himself in the plush St. Regis Hotel. With his dark hair and the handlebar moustache waxed to rapier sharpness that has become his trademark, his flowing cape and silver-headed cane, Dali flamboyantly attends art and theater openings and other high-profile social events. In 1981 he was awarded Spain's highest decoration, the Gran Cruz de la Orden de Carlos III. Gala, Dali's Russian-born wife and muse, died in June 1982. The following year the Museum of Contemporary Art, Madrid, mounted a major Dali retrospective which featured many of the paintings he executed before embracing surrealism in 1929.

"The only difference between myself and a madman is that I am not mad," the witty Dali said in a much-quoted remark that could stand as a definition of his concept of "critical paranoia."

Dali's work is in museums throughout the world. A comprehensive guide to public collections of his work was published by the Cleveland Art Museum in 1974.

EXHIBITIONS INCLUDE: Gal. Dalmau, Barcelona, Spain 1922; Gal. Goemans, Paris 1929; Gal. Pierre Colle, Par-

is 1931, '33; Gal. d'Arte Catalonia, Barcelona, Spain 1933, '34; Julien Levy Gal., NYC 1933–41; Zwemmer Gal., London 1934; MOMA, NYC 1941–42; M. Knoedler and Co., NYC from 1943; Bignou Gal., NYC 1945, '47, '48; Carstairs Gal., NYC 1950–'60; Santa Barbara Mus. of Art, Calif. 1953; Philadelphia Mus. of Art 1955; Casino Communal, Knokke-le-Zoute, Belgium 1956; Prince Hotel Gal., Tokyo 1964; Gal. of Modern Art, NYC 1965–66; Boymans-Van Beuningen Mus., Rotterdam 1970–71; Mus. de l'Athénée, Geneva 1970; Whitechapel Art Gal., London 1971; Boymans-Van Beuningen Mus., Rotterdam 1972; Städtisches Gal., Frankfurt, W. Ger. 1974; Tate Gal., London 1980; Mus. of Contemporary Art, Madrid 1983. GROUP EXHIBITIONS INCLUDE: Dalmau Gal., Barcelona, Spain 1921, '22; Pittsburgh International, Carnegie Inst. 1928; "New Super-Realism," Wadsworth Atheneum, Hartford, Conn. 1931; "Exposition Surréaliste," Gal. Pierre Colle, Paris 1933; "International Exhibition of Cubism and Surrealism," Copenhagen 1935; "Fantastic Art, Dada and Surrealism," MOMA, NYC 1936; "Exposition Internationale du Surréalisme," Gal. des Beaux-Arts, Paris 1938; "Exposicion Internacional del Surrealismo," Gal. de Arte Mexicano, Mexico City 1940; "Four Spaniards," Modern Inst. of Art, Boston 1946; "Exposition Internationale du Surréalisme," Gal. Maeght, Paris 1947; "Surrealisme en Abstractie," Stedelijk Mus., Amsterdam 1951; "Exposition Internationale du Surrealisme," Mus. Nat. d'Art Moderne, Paris 1959; "Masters of Surrealism from Ernst to Matta," Obelisk Gal., London 1961; "Six peintres surrealistes," Gal. André François Petit, Paris 1963; São Paulo Bienal 1965; "Dada, Surrealism and Their Heritage," MOMA, NYC 1968; "Surrealism," Moderna Mus., Stockholm 1970.

COLLECTIONS INCLUDE: Salvador Dali Mus. Figueras, Spain; MOMA, and Guggenheim Mus., NYC; Nat. Gal. of Art, and Hirshhorn Mus. and Sculpture Garden, Washington, D.C.; Philadelphia Mus. Art: Cleveland Mus. of Art, and Dali Mus., Cleveland; Denver Art Museum; Santa Barbara Mus. of Art, Calif.; Tate Gal., London; Glasgow Art Gal., Scotland; Mus. Nat. d'Art Moderne, Paris; Stedelijk Mus., Amsterdam; Boymans-Van Beuningen Mus., Rotterdam; Kunsthaus, Zurich; Neue Natl. Gal., Berlin.

ABOUT: Current Biography, 1951; Dali, S. La Femme visible, 1930, L'Amour et la mémoire, 1931, The Conquest of the Irrational, 1935, Declaration of the Independence of the Imagination and Rights to His Own Madness, 1938, The Secret Life of Salvador Dali, 1942, Hidden Faces, 1944, Fifty Secrets of Magic Craftsmanship, 1948, Mystical Manifesto, 1951, The Cuckolds of Old Modern Art, 1956, The Tragic Myth of Millet's *Angelus,* 1963, Diary of a Genius, 1964, Dali by Dali, 1970; Gerard, M. Dali, 1968; Hughes, R. The Shock of the New, 1981; Lassaigne, J. La Peinture espagnola, 1952; Levy, J. Surrealism, 1936; Morse, A. R. A New Introduction to Salvador Dali, 1960; Nadeau, M. A History of Surrealism, 1973; Oriol, A. A. Mentira y Verdad de Salvador Dali, 1948; Orwell, G. Dickens, Dali and Others: Studies in Popular Culture, 1946; Parinaud, A. The Unspeakable Confessions of Salvador Dali, 1981; Raynal, M. (ed.) Histoire de la peinture

moderne: De Picasso au Surréalisme, 1958; Read, H.
A Concise History of Modern Painting, 1959; Soby, J.
T. Salvador Dali, 1946; Tapié, M. Dali, 1957; Walton,
P. Dali: Mirò, 1967. *Periodicals*—Life February 19,
1945, April 23, 1951; New Statesman June 25, 1976;
New York Times March 22, 1970, January 20, 1980,
April 19, 1983; New York Times Magazine November
22, 1981; Time February 26, 1940.

D'ARCANGELO, ALLAN (June 16,
1930–), American painter and printmaker,
has taken as his trademark the pop iconography
of the superhighway: its blacktop, signposts, me-
dian dividers, barriers, and broken white lines.
From this essentially banal material he has fash-
ioned "non-abstract abstractions,"as they are cal-
led by Gregory Battcock, that give the viewer a
chilling sense of the lifeless and illogical geome-
try imposed by man on the landscape.

A native of Buffalo, New York, D'Arcangelo
majored in history and government at the Uni-
versity of Buffalo, receiving a bachelor's degree
in 1953. In New York City he studied painting
at City College and at the New School for Social
Research, and then privately with Boris Lurie
from 1955 to 1956. For the next two years he
worked with John Golding and Fernando Belain
at Mexico City College. In the mid-1960s, he
taught painting at the School for Visual Arts,
New York City.

D'Arcangelo's first North American solo show,
at Long Island University in 1961, revealed his
interest in the pop aesthetic. A year later he did
a well-known portrait of Marilyn Monroe, in the
flat vocabulary of children's pop-up paper cut-
outs, that just predates Andy Warhol's *Marilyn*
silkscreen paintings. The viewer is invited to
"assemble" the star just as the real woman was
a product, and victim, of her own audience. In
the highway scenes of 1963 D'Arcangelo tapped
into a storehouse of material he would continue
to use to the present day. His preference for mass
symbols is tempered by an awareness of surreal-
ism; critics have pointed out his debt to René
Magritte and the dislocating perspective of Gior-
gio de Chirico. One can also find in this work a
rather bleak picture of our speed-obsessed soci-
ety. Such typical D'Arcangelo images as *Moon*
(1963), four views of a night highway, the road
stretching flatly to infinity (as it does in all his
works) with a red Gulf gas station globe floating
high in each frame like the rising moon, are
completely American in character. Most of these
paintings are composed solely of roads and signs,
cleanly and sharply painted; even when
D'Arcangelo introduces a figure, as in *Smoke
Dream #1*, in which the head of a woman fills
the usually empty sky over the inevitable high-

ALLAN D'ARCANGELO

way, it is clearly the sexual fantasy of a driver
with white-line fever.

Throughout the 1960s, D'Arcangelo worked
constant variations on this formula. He intro-
duced real objects into his paintings—the three
rear-view mirrors of *Place of the Assassination*
(1965), for example—used multiple images, or
expanded the works to incredible size, as in the
huge styrofoam painting he floated in Sag Har-
bor, Long Island (ca. 1965) or the 50-by-60-foot
mural of road barriers he painted on the side of
a building on Manhattan's Lower East Side
(1967). Striped road barriers have appeared reg-
ularly in his work since the later 1960s; they
function both as strong forms with endless possi-
bilities for manipulation, and, apparently, as
both a visual and psychological barrier to help
the artist overcome his obsession with the vanish-
ing point. Describing D'Arcangelo's series of
"Barriers," Nicholas Calas wrote that the artist
"weights his pictures with constructions, wheth-
er beams of bridges coated in primer orange or
warning signs striped white or black or white
and red, superimposing an irregular H on a ze-
braic net over the pictorial space. Cadmium or-
ange or stripes brightened with white lift the
monochrome sky out of the background." In
some ways more op than pop, the barriers are
used by D'Arcangelo to confound conventional
perspective; the artist plays with negative and
positive space, sometimes deliberately subvert-
ing the spatial strategies that have come to be ex-
pected from him. D'Arcangelo also executed a
few sculptures in this style (*Multiple Sculpture*,
1970).

D'Arcangelo's "Constellation" series (early

1970s) began as an amplification and variation of the "Barriers," with more complex orderings of stripes, but soon evolved into experiments with graphite and dry pigment affixed to canvas—quite a radical departure in technique for an artist known for his hard-edged work in acrylics. D'Arcangelo accelerated his move from hard precision even further by smudging his works, as in *Constellations 33, 86, 89*, and *90*. Occasionally he produced images of a rare complexity and evocativeness. Of a print in the Pace Gallery's "Bicentennial Print" show in 1976, Richard Lorber wrote in *Arts Magazine* (January 1976): "Allan D'Arcangelo subtly combines silkscreen, lithographic and embossing techniques in filmy metallic darkness to abstract a kind of industrial landscape seen through a fractured pyramid eye of the back of a dollar bill—the most haunting and impressive work of the group." In the late 1970s, for example in the silkscreen *Resonance* and *Mr. and Mrs. Moby Dick*, both of 1978, he returned to a hard-edged style with an increased, even dizzying mastery of ambiguous space.

The artist, who lives and works in New York City and Kenoza Lake, New York, rarely gives clear explanations of his work. "It has always been difficult for me to make statements about a particular work because so much seems to go unsaid or rest in the spaces between the words."

EXHIBITIONS INCLUDE: Gal. Genova, Mexico City 1958; Long Island Univ., N.Y. 1961; Thibaird Gal., NYC 1963; Fischbach Gal., NYC 1963, '64, '65, '67, '69; Gal. Ileana Sonnabend, Paris 1965; Gal. Neuendorf, Hamburg, W. Ger. 1965; Dwan Gal., Los Angeles 1966; Gal. Rolf Ricke, Kassel, W. Ger. 1967; Miami Gal., Tokyo 1967; Gal. Lambert, Paris 1968; Inst. of Contemporary Art, Philadelphia 1971; Albright-Knox Art Gal., Buffalo, N.Y. 1971; Marlborough Gal., NYC 1972, '75; Virginia Mus. of Fine Arts, Richmond 1979. GROUP EXHIBITIONS INCLUDE: Inst. of Contemporary Arts, London 1963; "Pop Art U.S.A.," Oakland Art Mus., Calif. 1963; Salon de Mai, Paris 1964; "The New American Realism," Worcester Art Mus., Mass. 1965; "Two Decades of American Painting," MOMA, NYC 1966; "American Painting Now," Inst. of Contemporary Art, Boston 1967; "Color: Image: Form," Art Inst., Detroit 1967; "The Highway," Inst. of Contemporary Art, Philadelphia 1970; "Amerikanische Graphik seit 1960," Bundner Kunsthaus, Chur, Switzerland 1972; "In Praise of Space: The Landscape in American Art," Corcoran Gal. of Art, Washington, D.C. 1976; "American Art Since 1945," MOMA, NYC 1976; Bicentennial Print Exhibition, Pace Gal., NYC 1976.

COLLECTIONS INCLUDE: MOMA, and Whitney Mus. of Am. Art, NYC; Brooklyn Mus., N.Y.; Albright-Knox Art Gal., Buffalo, N.Y.; Hirshhorn Mus. and Sculpture Garden, Washington, D.C.; Detroit Inst. of Arts; Gemeentenmus., The Hague; Städtische Kunstsammlung, Gelsenkirchen, W. Ger.

ABOUT: "The American Landscape: Paintings by Allan D'Arcangelo" (cat.), Burchfield Center, Buffalo, N.Y., 1979; Calas, N. Art in the Age of Risk, 1968, (and others) Icons and Images of the Sixties, 1971; Kultermann, U. The New Painting, 1969; Lippard, L. R. Pop Art, 1966; Pellegrini, A. New Tendencies in Art, 1966. *Periodicals*—Art and Artists January 1972; Art International January 1969; Art Now February 1969; Arts Magazine January 1976, June 1982; XXe siècle (Paris) December 1975.

DA SILVA, MARIA ELENA VIEIRA. *See* **VIEIRA DA SILVA, MARIA ELENA**

DAVIE, (JAMES) ALAN (September 28, 1920–), British painter, was one of the first artists in Great Britain to work in the style of expressive abstraction. In his forceful, richly colored paintings Davie used symbols suggestive of ritual and magic.

James Alan Davie was born in Grangemouth, Scotland. His father was a painter and etcher, and both parents were amateur musicians. He studied music at an early age and began to paint at 16. From 1937 to '40 he studied at the Edinburgh College of Art, of which he wrote: "They did their best to teach me that I couldn't paint and that painting was difficult. . . . There I learned to hate art." However, while attending the Edinburgh he became interested in primitive and exotic art and in jazz, learning to play the clarinet and saxophone.

While serving in the Royal Artillery during World War II, Davie began writing poetry. After his discharge in 1946 he worked as a professional jazz musician and also taught painting to children. He was struck by the power of the raw, spontaneous imagery generated by children, as he was by the improvisational element in jazz. Improvisation was to become his method of artistic composition.

In 1946, in Edinburgh, Davie had his first solo show, and the following year he married Janet Gaul, an artist and potter. As a result, he recalled, " . . . I really began to paint in the way I had learned to write and play jazz and in the way I had learned to make love . . . , and I discovered that I really am a child for evermore, and an animal still. . . . "

About 1947 Davie received a scholarship which enabled him to travel in France, Italy, Switzerland, Sicily, and Spain from 1948 to 1949. Peggy Guggenheim's Venice collection, in 1948, he saw the totemic, "predrip" paintings of Jackson Pollock. Along with the action paintings of Willem de Kooning, which he saw later, these

Jorge Lewinski

ALAN DAVIE

works influenced Davie's early canvases, in which an expressionistic brushstroke predominates. Moreover, action painting was adaptable to the improvisational style Davie was developing. From 1949 to 1953 he earned his living by making jewelry and teaching jewelry design at the Central School of Art, London.

Blue Triangle Enters (1953) is typical of Davie's work of the early 1950s, rich yet somber in color, and improvisationally executed with a vibrant, confident brushstroke. The paintings sometimes contained human forms, hints of perspective, and loosely painted geometric shapes, mostly squares, which compartmentalized the canvas. Numbers often appeared in the paintings, through they were to be replaced in later works by more cryptic symbols. Davie was influenced both by primitive art and Zen Buddhism, which he began to study in 1955. In some canvases animal, fish, bird, or reptile forms appear; an example is *Fish God Variation No. 2* (1953). *Painting in Yellow and Red* (1955) is suggestive of violent totemic imagery.

Davie visited New York City in 1956 for his first American show, which was held at the Catherine Viviano Gallery. Also in 1956 he was made a Gregory Fellow at the University of Leeds, a post he held for three years. In the late '50s he was developing a technique which has been called "unintentionalism," a style in which he attempted to avoid "the vanity and pretentiousness of conscious aspiration," to quote Davie. "The right art is purposeless, aimless," Davie explained. "The more obstinately one tries to learn how to paint for the sake of producing a work of art, the less one will succeed."

In the late '50s Davie invented new symbols, derived from the unconscious and from his interest in myth and magic, which he combined with ancient symbolism. His continuing emphasis on spontaneity and improvisation is evident in *Female, Male* (1955; Albright-Knox Art Gallery, Buffalo, New York). In that canvas, to quote John Russell's article in *Contemporary Art 1942–72*, "The frankly erotic imagery is depicted with an aggression that becomes part of the content." The influence of primitive art is visible in the sexual symbolism of the violently painted triptych *Marriage Feast* (1957). Sheldon Williams observed in *Contemporary Artists* (1977) that Davie's symbols contain "no hint of ancient Egypt or Mexico" but are closer to "the *vévers* of Haitian voodoo [and] the runic marks left by Celtic Britons." Another triptych of 1957 suggesting primitive religious rites and magic is *The Creation of Man,* with its frenzied brushwork. *Gateway to the Bird Heaven* (1959) shows greater control in the central color areas within the doorway, but the sides are dominated by scribbled circular motifs. Davie's work of the late '50s has affinities with that of the painters of the Cobra Group, particularly Karel Appel and Asger Jorn, whose style of expressive abstraction also incorporated signs, symbols, and myth. "Davie formed one of the few real bridges between English and Continental art [in the '50s]," Edward Lucie-Smith noted in *Late Modern,* "and was exhibited in European exhibitions where English painters were seldom seen."

The catalog to the "Magic and Strong Medicine" show at the Walker Art Gallery, Liverpool, in 1973, commented on the role of magic in Davie's art: "Many of his paintings end up with titles which suggest magic and it is not difficult to see that the signs and images of which they mainly consist belong to a mental world somewhere between dream and purposeful invention, a timeless and ancient world that responds with ambiguous emotions, fearful and joyful, to the experiences of life."

Davie received the Prix Guggenheim from the Musée d'Art Moderne, Paris, in 1956, and the Critic's Choice Award in London in 1956, '58, and '60. In 1959–60 he lectured in London, Oxford, Leeds, Liverpool, and Nottingham.

In the 1960s Davie's dark, somber colors gave way to a brightly colored palette. His "Red Temple" series of the early '60s depicts a holy place where all questions will be answered. In *Magic Mirror* (1962), with its clutter of signs, and, especially, in *Delicious Morsel for the Crocodile* (1963), real objects are simplified beyond recognition and boldly outlined in black. By this time, despite Davie's improvisational

method, the abstract-expressionist scribbling of the 1950s canvases had evolved into a more controlled doodling. His range of symbols included fish, flags, candy walking-sticks, ace-of-clubs-like crosses, snakes, masks, checkered squares, crescent moons, targets, African artifacts, and fertility symbols. This iconography was continued in the early 1970s in such works as *Bird's Idol No. 4* (1970) and *Witch Gong* (ca. 1973). In *New Tendencies in Art* Aldo Pellegrini described Davie's palette as "violent—reds, greens, explosive yellows—mixed at times with vaguely drawn lines of delicate violet color and white backgrounds of intensively expressive texture. The aggregate is baroque, but with a vitality seldom found in modern painting."

In the mid-'70s Davie began to work in a new medium, translating his watercolors and oils into wool tapestries, with the help of his daughter Jane and her husband. *Flag Walk no. 4* (1974) and *Prayer Mat* (1976) are examples. Davie traveled in the West Indies in 1976, and since then has spent much time in the Caribbean. It was there that Davie's style regained its earlier freedom, and his symbols became more calligraphic. The looser style appears in two series of works, both dating from about 1980, "Homage to the Earth's Spirit" and "Spirit Chaser." Many paintings were done in gouache and recall Joan Miró, although the symbolism is quite different.

Alan Davie owns two country houses, one a converted stone barn in Rush Green, Hartfordshire, the other in Buryan, Cornwall. His goal is, in his words, "to hoodwink consciousness so that our growing inner being can gain full force." He paints to find enlightenment and revelation, and his approach is essentially romantic. "His [Davie's] stance," Norbert Lynton said in *The Story of Modern Art,* "[is] that of the inspired soothsayer, but a physical being as well as a spiritual one, resisting the inroads of rational civilization. He wrote in 1958: 'When I am working, I am aware of a striving, a yearning, the making of many impossible attempts at a kind of transmutation—a searching for a formula for the magical conjuring of the unknowable. Many times the end seems just within reach, only to fly to pieces before me as I reach for it. In this respect I feel very close to the alchemists of old; and, like them, I have in the end reached some enlightenment in the realization that my work entails a kind of symbolic self-involvement in the very process of life itself.'"

EXHIBITIONS INCLUDE: Grant's Bookshop, Edinburgh 1946; Gal. Michelangelo, Florence 1948; Gal. Sandri, Venice 1948; Gimpel Fils, London from 1950; Catherine Viviano Gal., NYC 1956, '57; Wakefield City Art Gal., Yorkshire, England 1958; Carnegie Inst., Pitts-

burgh 1961, '62; Gal. Rive Droite, Paris 1961; Gal. del Naviglio, Milan 1961; Martha Jackson Gal., NYC 1961, '65; Stedelijk Mus., Amsterdam 1962; Gal. La Medusa, Rome 1963, '69; Gimpel-Hanover Gal., NYC 1964; Graves Art Gal., Sheffield, England 1965; Kunstkring, Rotterdam 1966, '67; Gimpel-Hanover Gal., Zürich 1967, '71, '74; Kunstverein, Düsseldorf 1968; Gimpel Fils, NYC 1969; Gal. Stangl, Munich 1970; Gimpel and Weitzenhoffer Gal., NYC 1972, '74, '84; Royal Scottish Academy, Edinburgh 1972. GROUP EXHIBITIONS INCLUDE: Gimpel Fils, London 1949, '50; "Space in Colour: 7 Works," Hanover Gal., London 1953; "50 Ans d'Art Moderne," Palais des Beaux-Arts, Brussels 1958; "British Painting 1720–1960," Pushkin Mus., Moscow 1960; "British Painting 1720–1960," Hermitage, Leningrad 1960; Carnegie Inst., Pittsburgh 1961, '74; Salon de Mai, Mus. Nat. d'Art Moderne, Paris 1964; Cracow, Poland 1966; Kunstmus., Basel 1969; "British Painting and Sculpture 1960–1970," Nat. Gal. of Art, Washington, D.C.; Triennale of India, Delhi 1971; Edinburgh Festival 1972; "Hommage à Picasso," Kestner Gesellschaft, Hannover 1972.

COLLECTIONS INCLUDE: Tate Gal., Victoria and Albert Mus., Arts Council, Peter Stuyvesant Foundation, London; Scottish Nat. Gal. of Modern Art, Edinburgh; Arts Council of Northern Ireland, Belfast; Stedelijk Mus., Amsterdam; Boymans-van Beuningen Mus., Rotterdam; Staatliche Kunsthalle, Baden-Baden; Mus. des XX Jahrhunderts, Vienna; Peggy Guggenheim Collection, Venice; MOMA, NYC; Albright-Knox Art Gal., Buffalo, N.Y.; Rhode Island School of Design, Providence; Carnegie Inst., Pittsburgh; Mus. of Art, San Francisco; Tel-Aviv Mus., Israel.

ABOUT: "Art and Inspiration" (cat.), Gal. Michelangelo, Florence, 1948; Bowness, A. Alan Davie, 1967; Heron, P. (ed.) "Space in Colour" (cat.), Hanover Gal., London, 1953; Horovitz, M. Alan Davie, 1963; Lucie-Smith, E. Late Modern, 1969; Lynton, N. The Story of Modern Art, 1980; "Magic and Strong Medicine" (cat.), Walker Art Gal., Liverpool, 1973; Measham, T. The Moderns 1945–1975, 1976; Pellegrini, A. New Tendencies in Art, 1966; Read, H. Contemporary British Art, 1951, A Concise History of Modern Painting, 1959; Moore, E. (ed.) Contemporary Art 1942–72: Collection of the Albright-Knox Art Gallery, 1973. *Periodicals*—Art International (Lugano) April 1972; Arts Review May 1971; Aujourd'hui (Paris) April 1960; Das Kunstwerk (Baden-Baden) October–November 1970; (London) Times Educational Supplement June 1960.

DAVIS, STUART (December 7, 1894–June 24, 1964), American painter, was among the first American artists to integrate the advances of early French modernism into a distinctively American art.

Born in Philadelphia, Davis grew up in an artistic environment; in a brief autobiography published in 1945 he said, in his typically brisk, humorous, no-nonsense fashion, "In writing au-

Minneapolis Tribune

STUART DAVIS

tobiographical sketches it is not unusual for artists to dwell on the obstacles they have had to overcome before gaining opportunity to study. But I am deprived of this satisfaction because I had none." His father, Edward Wyatt Davis, was art director of the *Philadelphia Press,* and his mother, Helen S. Davis, was a sculptor. Among the artists working as illustrators on the *Philadelphia Press* were John Sloan, Everett Shinn, George Luks, and William Glackens. These artists and the painter Robert Henri were Edward Davis's close friends and the nucleus of the group that was to become famous as The Eight.

When Edward Davis was appointed art editor of the *Newark Evening News* in 1901, the family moved to East Orange, New Jersey, where Stuart attended high school. Soon afterwards Sloan, Shinn, and other members of the Philadelphia group moved to New York City, where Henri opened his own art school in 1909.

The following year young Stuart Davis left high school to attend Henri's classes in New York. He found Henri's liberal, nonacademic teaching to be stimulating, and recalled that "enthusiasm for running around and drawing things in the raw ran high." Students were encouraged to make sketches in streets, restaurants, theaters, bars, and alleyways and to transform them into paintings in the studio. Davis and his friend Glenn Coleman were already jazz enthusiasts, and they regularly frequented Newark dives to listen to black piano players. This passion for jazz stayed with Davis all his life, and in many of his later pictures he created visual equivalents for its lively, syncopated rhythms.

In Davis's early watercolors of Negro dancehalls and bars there was a strong feeling for atmosphere and locale, but also a selectiveness and sense of design rarely found in the work of the Henri group, who were popularly known as the Ashcan School. Davis's 1912 watercolor of Romany Marie's restaurant in Greenwich Village, a favorite haunt of artists and writers, was a memento of a now-vanished New York bohemia. In 1913 Davis did cartoons and a cover for *The Masses,* the influential leftist magazine of which John Sloan was then editor. He also supplied cartoons for *Harper's Weekly.*

Although Davis admired Henri as a teacher, he had an uneasy feeling that "the whole Henri idea tended to give subject matter, as such, a more important place than it deserved in art." He also thought that in the work of Henri's colleagues and students "the borderline between descriptive and illustrative painting and art as an autonomous sensate object" was never clearly established. This belief was confirmed after the electrifying 1913 Armory Show in New York City, which Davis called "the greatest single influence I have experienced in my work." He added, "I resolved that I would quite definitely have to become a modern artist." He himself had five watercolors in the American section, making him, at 19, the youngest exhibitor.

Faced with the Armory Show's dazzling array of modern European art, ranging from impressionism to Kandinsky's color abstrations, Davis was particularly drawn to Gauguin, Van Gogh, and Matisse for their bold use of color and simplified forms. He sensed in them "an objective order that was lacking in my own work, and that was not related to any particular subject matter." He found in Matisse "the same kind of excitement I got from the numerical precision of the Negro piano players in the . . . saloons." His appreciation of Cézanne and the Cubists, the more intellectual phase of modernism, came later.

In 1915 Davis spent the first of many summers in Gloucester, Massachusetts. *Gloucester Terrace,* a landscape painted outdoors in the summer of 1916, had intense color and heavy impasto and was influenced by Van Gogh and the Fauves. His vision was still based on an expressionistic view of nature, although in one canvas painted in Gloucester in 1918, *Multiple Views,* he arbitrarily juxtaposed various elements in the landscape.

In 1917 Davis had his first solo show, at the Sheridan Square Gallery, New York City. The following year he served briefly as a map-maker in the Army Intelligence Department.

From 1919 to 1923, Davis divided his time be-

tween New York City and Gloucester; he spent the summer of 1923 in Santa Fe, New Mexico, where John and Dolly Sloan had bought a house. During this period his working methods changed. He later wrote, "I used to wander over the rocks [in Gloucester] with a sketching easel, large canvases, and a pack on my back looking for things to paint. . . . After a number of years the idea began to dawn on me that packing all that junk, in addition to toting it all over the cape, was irrelevent to my purpose. . . . Following this revelation my daily sorties were unencumbered except by a small sketchbook of the lightest design known and a specially constructed Duraluminum fountain pen." His painting became more conceptual as he began to bring "drawings of different places and different times into a single focus,"

Meanwhile certain aspects of European modernism had become more familiar in New York, at least in art circles, through exhibits and magazine reproductions. Davis particularly admired Léger's modified cubism, based on the geometric shapes of machinery, and his use of flat tones of pure color. Another liberating factor was the presence in New York of two Frenchmen, Francis Picabia and Marcel Duchamp, who had both exhibited in the Armory Show and were leaders of the "antiart" movement which preceded dada. The witty iconoclasm of Duchamp's readymades and the opportunity of seeing cubist papiers collés made it easier for Davis, in his words, "to sew buttons and glue excelsior on the canvas without feeling any sense of guilt."

In 1921 Davis became the first artist to use a single commercial object, a pack of cigarettes, as the entire subject of a picture when he painted *Lucky Strike*, now in the Museum of Modern Art, New York City. In technique, *Lucky Strike* was the simulation of a "collage" in paint and looked forward to the pop art of the 1960s. Davis was even more direct in *Odol* (1924); the unglamorous disinfectant bottle in the picture was clearly inscribed "It Purifies."

In 1925 Davis had a solo show at the Newark Museum, New Jersey. About this time he began to apply cubist methods to the shapes and rhythms of New York City. He loved the city, but unlike the Ashcan School or some of the American Scene painters of the '30s, his treatment was never illustrational. There was always a sense of locale, but his main concern was to analyze and rearrange the forms "in terms of angular variation from successive bases of directional relation," to quote the artist. Several sketches made in 1926 on the platform of the elevated railway demonstrate his approach; one sketch, for example, is inscribed "construction plan."

Edith Halpert became Davis's dealer in 1927, and that same year he moved further in the direction of postcubist space organization in *Percolator* (Metropolitan Museum of Art, New York City), using a simplified household object as a motif. He took a more drastic step in 1927–28 when, in Davis's words, "I nailed an electric fan, a rubber glove, and an egg beater to a table, and used them as my exclusive subject matter for a year." *Eggbeater No. 1* (Phillips Collection, Washington, D.C.) was his first truly abstract painting, with the subject serving merely as the point of departure. One of the several critics who paid attention to his new work wrote in 1928 that "Davis's paintings are all logical and as his logic has improved, his painting has progressed. His work is no more haphazard than a Bach fugue."

In 1928 Mrs. Juliana Force of the Whitney Studio Club, New York City, purchased two Davis paintings. In his autobiographical sketch he wrote, "Having heard it rumored at one time or another that Paris was a good place to be, I lost no time in taking the hint." He sailed for Paris, taking with him one suitcase and a packing-case containing two of the "Egg Beater" paintings. In Paris he rented a studio in the rue Vercingétorix and remained for nearly a year. "I liked Paris the minute I got there," he recalled. "Everything was human-sized." With his vision liberated by his "abstract kick," as he called it, he was able to introduce representational elements into his Paris paintings without sacrificing the formal integrity of the canvas. His Paris street scenes of 1928, including *Place Pasdeloup* (Whitney Museum of American Art, New York City), are among his most lyrical and personal statements. The buildings are flattened out and stylized into patterned shapes, but retain the particular charm of the Parisian scene. In retrospect these Paris cityscapes seem to some critics to express the essence of "An American in Paris" in the '20s no less than George Gershwin's popular musical composition. In Paris, in 1929, Stuart Davis married Bessie Chosak, a native of Brooklyn. She died in New York City in 1932.

Davis recalled that on his return to New York in August 1929 he "was appalled and depressed by its giantism," yet "as an American I had need for the impersonal dynamics of New York City." For a while his paintings juxtaposed Paris, New York, and Gloucester in a cubistic kaleidoscope of visual experiences.

As a result of the Wall Street crash of 1929 and the ensuing Great Depression, the whole problem of what constituted "American art" was being reconsidered. There was an upsurge of realistic painting of the "American scene," rang-

ing from the fluent, socially conscious urban reportage of Reginald Marsh to the deliberate "folksiness" of the Regionalists, and the critic Thomas Craven was virulently attacking "Frenchified" American painters. Although Davis was no ivory tower aesthete, he was utterly opposed to cultural isolationism and provincialism and, being highly articulate, capably defended his position.

In 1932 Davis painted a mural for the men's lounge in Radio City Music Hall. His bold assertive shapes and clear, sophisticated colors were admirably suited to mural painting, and very different in spirit from the Mexican muralists who were then greatly admired. This mural was recently acquired by MOMA. Davis painted three other major murals during the 1930s—*Swing Landscape* (1938; University of Indiana, Bloomington); an abstract mural for radio station WYNC based on musical and electronic symbols; and a huge *History of Communications* (later destroyed), for the New York World's Fair of 1939.

Davis was politically active in the 1930s. One of the first to enroll in 1933 in the New Deal-sponsored Federal Arts Project, he also participated from the beginning in the left-wing Artists' Union, later the Artists' Congress, of which he became secretary in 1936. In outspoken articles in the Union's publication, *Art Front,* he attacked the cultural chauvinism of the Regionalists and their supporters. But despite his liberal sympathies he was opposed to the use of art as a vehicle for propaganda, which led to disagreements with other Union members. He resigned from Artists' Congress in 1940 to devote more time to his painting.

In 1939 Stuart Davis married Roselle Springer. Their son Earl was born in 1952.

In Davis's paintings of the '30s, line had played an important role, especially in the compositions based on the Gloucester and New York waterfronts. Beginning in 1940 with *Report from Rockport* and *Hot Still-Scape for Six Colors,* color became increasingly active and vibrant; the lively, dancing shapes, like pieces of a jigsaw puzzle, at times recalled Miró, but the tightly organized neocubist structure differed essentially from Miró's floating, semisurrealist space. Davis compared *Hot Still-Scape* to the syncopated rhythms of a jazz composition, "where the tone-color variety results from the simultaneous juxtaposition of different groups[of instruments]."

Like Seurat, whom he admired—he kept a large reproduction of *Les Poseuses* in his New York studio—Davis planned his pictures carefully, making dozens of notes and written observa-

tions but avoiding a rigid preconceived idea. He composed his paintings first as drawings and gradually increased the visual impact through the use of what he called "stimulating color intervals." The results were never overly cerebral or deliberate, but full of the nervous energy and exhilarating tension that he felt in the American environment.

Davis was delighted when, at the 1943 opening of his solo show at the Downtown Gallery, New York City, some friends arranged for performances by a three-piece ensemble of talented black musicians and by the jazz singer Mildred Bailey. Piet Mondrian attended the opening and complimented Davis on his work.

In 1945 Davis had a retrospective at MOMA. His paintings of the late 1940s and '50s tended to drop references to external reality in favor of more schematic pictorial structures. Often they incorporated letters or words that reflected his love for jazz and the American vernacular. They often have amusing titles, as in *Owh! in San Pao* and *Something on the Eight Ball* (1953–54). When he died in New York City at the age of 70, he left unfinished on his easel a painting called *Switchsky's Syntax.*

There were many exhibitions and honors in Davis's last years and after his death. On December 2, 1964 the Fine Arts Commemorative postage stamp designed by Davis was issued by the US Post Office Department. A memorial exhibition organized in 1965 by the National Collection of Fine Arts opened at the Smithsonian Institution, Washington D.C., and went on tour.

Stuart Davis was short, stocky, and robust—forthright and friendly, but never ingratiating. He had a dry, deadpan, debunking humor and his manner of talking out of the side of his mouth called to mind W. C. Fields. Davis could be gruff and abrupt, but he was infinitely patient with anything he considered important.

One of the most articulate of artists, Davis had no use for the pretentious jargon all too frequent in pronouncements on art. His autobiographical sketch sums up his artistic aims: "Paris School, abstraction, escapism? Nope, just color-space compositions celebrating the resolution in art of stresses set up by some aspects of the American scene."

EXHIBITIONS INCLUDE: Sheridan Square Gal., NYC 1917; Whitney Studio Club, NYC 1920, '26, '29; Newark Mus., N.J. 1925; Downtown Gal., NYC from 1927; MOMA, NYC 1945; Walker Art Center, Minneapolis 1957; Nat. Collection of Fine Arts, Smithsonian Inst., Washington, D.C. 1965; "Stuart Davis: Art and Art Theory," Brooklyn Mus., N.Y. 1978; "Stuart Davis: Art and Art Theory," Fogg Art Mus., Cambridge, Mass. 1978. GROUP EXHIBITIONS INCLUDE: Armory Show, NYC

1913; "Painting and Sculpture by Living Americans," MOMA, NYC 1930–31; "American Painting and Sculpture," MOMA, NYC 1932–33; Annual, Whitney Mus. of Am. Art, NYC from 1934; "Abstract Painting in America," Whitney Mus. of Am. Art, NYC 1935; Cincinnati Modern Art Society 1941; "Portrait of America (Artists for Victory, Inc.)," NYC 1944–45; American Painting Exhibition,Tate Gal., London 1946; American National Exhibition, Moscow 1959; Downtown Gal., NYC 1963.

COLLECTIONS INCLUDE: Metropolitan Mus. of Art, MOMA, Whitney Mus. of Am. Art, and Solomon R. Guggenheim Mus., NYC; Williams-Proctor Inst., Utica, N.Y.; Phillips Collection, and Hirshhorn Mus. and Sculpture Garden, Washington, D.C.; Wadsworth Atheneum, Hartford, Conn.; Pennsylvania Academy of Fine Arts, Philadelphia; Cleveland Mus. of Art; Walker Art Center, Minneapolis; Amon Center Mus., Fort Worth, Tex.; Los Angeles County Mus. of Art.

ABOUT: Barr, A.H., Jr. "Masters of Modern Art" (cat.), MOMA, NYC, 1954; Davis, S. Stuart Davis, 1945 (Am. Artists Group, NYC, monograph no. 6); Guilbaut, S. How New York Stole the Idea of Modern Art, 1983; Janis, S. Abstract and Surrealistic Art in America, 1944; Kelder, D. (ed.) Stuart Davis, 1971; Lane, J. R. "Stuart Davis: Art and Art Theory" (cat.), Brooklyn Mus., N.Y., 1978; Marks, C. From the Sketchbooks of the Great Artists, 1972; Rose, B. American Art Since 1900, 2d ed. 1975; Sweeney, J. J. "Stuart Davis" (cat.), MOMA, NYC, 1945. *Periodicals*—Art Digest April 15, 1931, April 1, 1935, February 15, 1943; Art Front February 1935; Art News Summer 1953, April 1957, September 1962, September 1964; Arts Magazine Yearbook no. 4 1961; Creative Art September 1931; Harper's December 1943; New York Herald Tribune January 9, 1955; Museum of Modern Art Bulletin Spring 1951; New York Sun April 4, 1931; The New Yorker October 27, 1945; Transition no. 14 1928.

*DE CHIRICO, GIORGIO (July 10, 1888– November 21, 1978), Italian painter, was, if any one 20th-century artist can be so considered, the father of surrealism. His visionary canvases of 1910–14 fulfilled many of the declared aims of surrealism years before that term even existed, and achieved them without the Surrealists' literary and Freudian paraphernalia. De Chirico's *pittura metafisica* paintings of 1916–19 made him a progenitor of the Metaphysical School as well.

Giorgio de Chirico was born to Italian parents in the small harbor town of Volos, capital of Thessaly, the coastal province in eastern Greece. His father, Evariste de Chirico, a member of the Sicilian aristocracy of Palermo, had settled in Volos as a construction engineer for the Thessalonian railway lines; his mother was from Genoa. Giorgio was the second of three children. His sister died in childhood; his younger brother, An-

°də kē´ rē kō, jôr´jō

Courtesy of Robert Miller Gallery, New York; © Steven Soloman

GIORGIO DE CHIRICO

drea, became a composer, writer, and painter known professionally as Alberto Savinio. De Chirico described his father as one of those "19th century European engineers, bearded and powerful."

Always conscious of his Greco-Latin heritage, de Chirico at an early age came under the spell of the Greek myths. The ordered beauty of classical antiquity and the hard, clear Attic light became part of his vision. The classical component in his early paintings, and the presence in them of trains and geometric shapes, can be traced to his parentage and childhood.

In 1899 the family moved to Athens. About 1900, after receiving early instruction in drawing from his father, de Chirico was enrolled by his parents in the Polytechnic Institute, Athens, where he studied drawing and painting for four years. His first painting was a still life of lemons. In 1905 de Chirico went to Italy, and in the museums of Milan and Florence he made copies of Botticelli, Uccello, and other Quattrocento masters.

Following his father's death in 1906, the young artist moved to Munich with his mother and brother. Andrea studied music and Giorgio entered the Academy of Fine Arts, where he remained for two years. His teacher was Hackl, but the Academy bored de Chirico, who was equally unimpressed by the painting that had developed outside the school, including that of the Secessionists. However, he was influenced by the painter and illustrator Franz von Stück, a cofounder of the Munich Secession group, and by the strange, fantastic art of Max Klinger, especially Klinger's series of engravings, "Paraphrase

on the Discovery of a Glove." The strongest in-
fluence on de Chirico was that of the Swiss-
German painter Arnold Böcklin, whose fin-de-
siecle romanticism and melancholy atmosphe-
res were linked to the symbolist preoccupation
with death and the hearafter. These interests
were deepened by de Chirico's reading of Scho-
penhauer and Nietzsche, whose ideas profound-
ly affected his work. Hitherto de Chirico had
painted little else but landscapes and seascapes,
the originality of which was limited to their dra-
matic lighting. Nietzsche reawakened his inter-
est in early myths, especially those with a
divinatory and pre-Freudian content. He was
also stirred by the aesthetic theories of Nietz-
sche, who argued that the artist's task was to
"refute reality."

In 1909 de Chirico moved to Italy, going first
to Milan, then to Turin, where Nietzsche had
spent his last years of lucidity. Nietzsche had de-
scribed Turin's squares as "spectral," and de Chi-
rico was overwhelmed by the city's rectilinear
architecture and symmetrical arcades; but the
statues mounted on pedestals so low that the si-
lent figures seemed to join in with the crowds of
passers-by stunned the artist. The unusually long
shadows cast by the statues produced in him "an
emotional shock that was to trigger a prodigious
phase of creativity," Gérard Legrand wrote.
"The urban landscape shed its everyday charac-
teristics and became imbued with an unexpected
sense of melancholy, presentiment, and
fatality."

In 1910, while living in Florence, de Chirico
completed the first of his haunting, shadow-
ridden metaphysical paintings, *The Enigma of
an Autumn Afternoon* and *The Enigma of the
Oracle*. On July 14, 1911, de Chirico joined his
brother in Paris. Through a friend, he met the
painter Pierre Laprade, who arranged for the
two *Enigma* paintings to be shown at the Salon
d'Automne in 1912. A self-portrait painted in
1911 bore the characteristic title *What Shall I
Love Unless It Be the Enigma?*

His unique, compelling style matured in Par-
is. In such haunting paintings as *The Nostalgia
of the Infinite* (1913–14; Museum of Modern
Art, New York City), *Joys and Enigmas of a
Strange Hour*, and the dreamlike *Melancholy
and Mystery of a Street* (1914) the arcaded
squares of Italian cities are endowed with spec-
trality. In the last mentioned painting the silhou-
etted figure of the little girl running with her
hoop, the exaggerated perspectives of the ar-
cades, the ominously gaping wagon, the great
shadow of the unseen, arcade-hidden classical
statue, and the characteristic late afternoon light
are images whose power to disturb is unsur-
passed in modern painting.

De Chirico described his paintings of 1910–14
as depictions of a "convalescent world." The in-
spiration for these odd and melancholic scenes
had come to de Chirico in the Piazzo Santa Cro-
ce, Florence, in 1910. "I had just come out of a
long and painful intestinal illness," he recalled,
"and I was in a nearly morbid state of sensitivity.
The whole world, down to the marble of the
buildings and the fountains, seemed to me to be
convalescent. In the middle of the square rises
a statue of Dante draped in a long cloak. The au-
tumn sun, warm and unloving, lit the statue and
the church facade. Then I had the strange im-
pression that I was looking at these things for the
first time. . . . "

According to Robert Hughes, de Chirico's link
to art's tradition of the irrational comes in part
from his distortion of perspective. In a de Chiri-
co, Hughes explained, "Space rushes away from
one's eye, in long runs of arcades and theatrical
perspective; yet its elongation, which gives far
things an entranced remoteness and clarity, is
contradicted by a Cubist flattening and com-
pression. . . . When the picture plane is flat-
tened but the things on it are still wrenched out
of reach by de Chirico's primitive and inconsis-
tent one-point perspective, the eye is frustrated."

At the Salon des Indépendants, in 1913 and
'14, de Chirico exhibited the works he had paint-
ed in Paris. Many of them had in the beginning
been inspired by the Gare Montparnasse and a
recurrent symbol was a train in the distance—
the train that one always misses in dreams. These
paintings include *The Anxious Journey* (1913;
MOMA), with its Kafkaesque arcades leading
nowhere and its unattainable sky, *Infinite
Languor*, (1913), and *Soothsayer's Recompense*
(1913–14). In *Infinite Languor* and other works,
the classical statue of the sleeping Ariedre is
placed incongruously in a deserted square, while
a locomotive puffs away in the distance against
a greenish sky. "Sometimes the horizon is de-
fined by a wall behind which rises the noise of
a disappearing train," de Chirico said of the po-
etry of his landscapes. "The whole nostalgia of
the infinite is revealed to us behind the geomet-
rical precision of the square." The phrase
"nostalgia of the infinite" was to be adopted as
a credo by the Surrealists, who saw in de Chiri-
co's work "the very essence of disquieting
poetry" to quote Hughes. In the post–World
War I years de Chirico's paintings of 1910–14
were to be seen as prophetic visions of a civiliza-
tion about to collapse.

De Chirico's paintings in Paris's Salon des
Indépendants of 1913 were noticed by Picasso
and Guillaume Apollinaire, the poet and cham-
pion of avant-garde art. Apollinaire befriended
de Chirico, published two articles on him in his

magazine *Soirées de Paris*, and pronounced him "the most astonishing painter of the younger generation." Although he knew the poet well enough to paint his portrait, de Chirico was a solitary who formed few close friendships and became even more of a loner in later years in Italy. Nor did he embrace the cubism extolled by Apollinaire and his circle; he was far more impressed by the primitive vision of Henri Rousseau.

In 1914, with war imminent, the human figure reappeared in de Chirico's canvases, but in the form of robots or mannequins instead of live men and women. Represented as blind and deaf, these tailor's dummies, who dominate *The Philosopher and the Poet* and *The Disquieting Muses* (1916), "are metaphors of fragmented, modernist consciousness," according to Hughes. The disturbing *Portrait of Guillaume Apollinaire* (1914) shows a classical bust wearing dark glasses in the foreground; above, the silhouette of Apollinaire is set against a mournful green sky and a white circle resembling a bullet hole is drawn on the side of the forehead—grimly prophetic in view of the ultimately fatal head wound the poet sustained in World War I. No human figures, only geometric shapes, appear in *The Evil Genius of a King* (1914–15). Perspective, the symbol of reason and stability in the Renaissance, is here used to create a vertiginous irrationality and imbalance.

De Chirico returned to Italy from Paris in the summer of 1915 and was called up for military service. Posted to Ferrara, he suffered a nervous breakdown. In the military hospital he painted and chose the word "metaphysical" to describe his work. In 1916 he produced some of the most significant of his "mannequin" paintings, including *The Disquieting Muses*, several versions of *Hector and Andromache*, and *The Jewish Angel*. In 1917, while still hospitalized, he met Carlo Carrà, formerly a Futurist painter who now fell under de Chirico's influence. From their conversations, the *pittura metafisica* movement was founded. Soon de Chirico's brother, Alberto Savinio, and the painters Giorgio Morandi and Filippo de Pisis joined the group.

The aim of Scuola Metafisica was a new, visionary artistic reality which the painter would create in states of reverie. To achieve this dislocation of everyday reality, de Chirico introduced incongruously juxtaposed inanimate objects—cookies, children's toys, mechanical drawing instruments, armatures, maps, mannequins, and antique busts—painted with exquisite precision. *The Great Metaphysician* (1917), *The Landscape Painter* (1918), and *The Sacred Fish* (1919) are of this phase. De Chirico contin-

ued this series of "Metaphysical Interiors" through 1919. Although the technique and spatial organization were similar to his pre-1914 canvases, the imagery lacked the trancelike spontaneity of his early work.

Discharged from the army in 1918, de Chirico had a successful solo show the following year at the Casa d'Arte, Rome. Also in 1919, he settled in Rome and affiliated himself with *Valori Plastici*, an influential art journal which became the official organ of the Metaphysical School. About 1920, in an astonishing about-face, de Chirico published an article in that magazine attacking modernism and advocating a return to the Italian classical tradition. He denounced his earlier technique as "inadequate" and blamed his materials, declaring, "The chronic fatal disease affecting painting today is oil pigment." In his autobiography, *Memorie della mia vita* (1945; published in English translation as *The Memoirs of Giorgio de Chirico*, 1971), the artist traced his sharp break with modernism to the day he stood before a Titian and experienced a "revelation of what a great painting should be." For several years thereafter he abandoned oil paint and copied works by Italian old masters, including Michelangelo's *Holy Family*. In 1919 he painted a Raphaelesque work, *The Return of the Prodigal Son*, and a *Self-Portrait* with an effigy of his mother.

Despite this disavowal of modernism, from which critics date the steady decline of his creative powers, in 1920 de Chirico signed the manifesto of Italian dadaism, which appeared in *Bleu*, a review published in Mantua. From 1921 to '25 he made frequent trips to Paris and met with André Breton and the Surrealists, although he broke with them in 1926 and Breton denounced de Chirico's post-1917 work. In the mid-1920s, working primarily in tempera, de Chirico painted romantic subjects, including nudes, portraits, landscapes, and a group of legendary scenes such as *The Departure of the Knight Errant. The Disquieting Muses* of 1925 was one of his last important metaphysical works; thereafter, his great visionary period would be recalled only by the occasional introduction of mannequins in classical drapery, fragments of Greek columns, Roman soldiers, or prancing, long-maned white horses frolicking by the seashore. These motifs, in such paintings as *Mannequins on the Seashore* and *Horses on the Beach*, both of 1926, and *The Archaeologists* (1927), were little more than blandly decorative stage sets—far removed from the artist's earlier theater of silence.

In 1929 de Chirico designed the sets for the Monte Carlo production of Diaghilev's ballet *Le*

Bal. That year he also published *Hebdomeros*, a complex "dream-novel" which has been interpreted as a defense of his oneiric method of composition. "I paint what I see with my eyes closed," de Chirico had remarked when creating his pictures of 1910–14, and the protagonist of *Hebdomeros*, like the author, believed in premonitory dreams.

After 1930 de Chirico further estranged himself from his past, bitterly condemning his earlier works and renouncing his former friends. He returned to Italy in 1931 and married Isabella Far, a Russian-born writer on art. His painting more and more took on a quality of academic realism, which proved quite acceptable to the fascist regime of Benito Mussolini. In 1933 de Chirico painted frescoes for the Palazzo della Triennale, Milan. He executed a series of neosurrealist canvases entitled "Mysterious Bathers," but most of his pictures of the 1930s would "have been at home in the Salon of 1855," as John Canaday said. He frequently treated subjects from Greek mythology, including *The Dioscuri* (1935), in compositions also populated by figures in modern dress.

De Chirico came to the United States in the fall of 1936 and lived in New York City until early 1938. He took up residence in Paris but with the outbreak of war in September 1939 returned to Italy. He lived first in Milan and then in Florence, moving to Rome when the allies liberated the city in 1944.

In 1948 de Chirico won a suit against the organizers of the Venice Biennale for including, without his permission, a group of his early canvases in an exhibit of metaphysical paintings. Two years later he staged a "counter-Biennale" by showing his later pictures in Venice's Ca' Giustiniani.

In the 1950s and '60s de Chirico's work, not infrequently marked by a florid, romantic grandiloquence, became increasingly academic. He produced canvases in the manner of Géricault and Delacroix; nudes supposedly inspired by Rubens and Renoir; still lifes echoing Chardin and Courbet; and Barbizon-style landscapes. The only original works were a series of intriguing, if disconcerting, "Self-Portraits" displaying what the French critic Jacques Busse described as "megalomaniac self-satisfaction." Most distressing of all, though, were the re-makes he began in the mid-1950s of his themes of 1910–20. These contrived pastiches, which made the work of forgers easier, reproduced the external qualities of his inspired motifs but completely lacked the poetry and underlying fatalism of the paintings of his youth.

A de Chirico retrospective was mounted in Milan in 1970; two years later the artist returned to New York City, his first visit in over 30 years on the occasion of one of the largest retrospectives ever in Manhattan. Held at the New York Cultural Center, the show filled four exhibition floors with some 150 paintings, drawings, and sculptures, covering six decades of de Chirico's career. Among the neoclassical and neosurrealist works exhibited were *The Painter* (1968), *Hippolytus* (1969), and *The Disquieting Muses* (1970).

In 1975 de Chirico was given his first show in Paris since 1928; it was held at the Musée Marmottan in honor of his election to the Institut de France in 1974. This was one of the rare occasions that he showed his latter-day versions of the themes of his metaphysical period. De Chirico had admitted in 1955 that he now painted "so-called metaphysical works of Italian piazza pictures for anyone who wants to order and pay for them."

De Chirico died in his luxurious apartment near the Piazza di Spagna, Rome. He was a tall, imposing man with brown eyes and silvery hair combed over his forehead; his somber expression was accentuated by a sullen mouth. Having lived in Rome since 1944, he had an apartment filled with baroque frames, ancient tapestries, and silverware, and it was, according to Pierre Martory of *Paris-Match* (December 15, 1978), protected like a bank. He and his wife were surrounded by a retinue of servants. De Chirico hated to entertain visitors, but when they arrived he would, after long preliminaries, make a brief appearance in his dimly lit studio—"like a divinity descended from Olympus," as Martory put it—and would either say nothing or make a few dogmatic utterances in a muffled voice. One of his favorite expressions was "lasciate me tranquillo"—leave me in peace.

In his *Memoirs* de Chirico railed against the idea that spirituality, torment, and anxiety are the wellsprings of artistic creation. He declared that supposition to be merely "the trenches in which the modernists hide in order to conceal their ignorance and their impotence." "We are living in an age of plastic decadence," he said. Denying that he had ever been a Surrealist, de Chirico claimed that only in his neoclassic period had he begun to do the "good painting" which was steadily advancing "toward the heights of mastery that have been achieved by only a few major artists of the past." But in 1913, when he was producing the mysterious works which are among the most original and influential in 20th-century art, he had said, "To become truly immortal a work of art must escape all human limits: logic and common sense will only in-

terfere. But once these barriers are broken, it will enter the regions of childhood vision and dreams."

EXHIBITIONS INCLUDE: Casa d'Arte, Rome 1919; Gal. Arte, Milan 1921; Gal. de l'Effort Moderne, Paris 1925; Gal. Paul Guillaume, Paris 1926, '27; Gal. Surréaliste, Paris 1928; Arthur Tooth and Son, London 1928, '31; Gal. Flechtheim, Berlin 1930; Gal. di Palazzo Ferroni, Florence 1932; Gal. Milano, Milan 1932, '37; Kunsthaus, Zürich 1933; Pierre Matisse Gal., NYC 1935; Julian Levy Gal., NYC 1937; Gal. della Cometa, Rome 1937; Gal. Il Milione, Milan 1937–39; Lefevre Gal., London 1938; Art of This Century Gal., NYC 1943; Inst. of Modern Art, Boston 1944; Ca' Giustiniani, Venice 1950; MOMA, NYC 1955; Gal. La Barcaccia, Rome 1961; Gal. Gissi, Turin 1964; Gal. la Medusa, Rome 1966, '69; Gal. Jolas, Milan 1968; Palazzo Reale, Milan 1970; New York Cultural Center, NYC 1972; Art Gal. of Ontario, Toronto 1972; Mus. Marmottan, Paris 1975; Artcurial Gal., Paris 1978; MOMA, NYC 1982.
GROUP EXHIBITIONS INCLUDE: Salon d'Automne, Paris 1912–13; Salon des Indépendants, Paris 1913–14; "Esposizione," L'Epoca, Rome 1919; "Fiorentina Primaverile," Florence 1922; Biennale Romana 1923, '25; Venice Biennale 1924, '32, '48; La Peinture surréaliste, Gal. Pierre, Paris 1925; "Exposition surréaliste Au Sacre du Printemps, Paris 1928; "Surrealistische Malerei und Plastik," Kunsthaus, Zürich 1929; "Super-Realism," Wadsworth Atheneum, Hartford, Conn. 1931; International Surrealist Exhibition, Burlington House, London 1936; "The Sources of Modern Painting," Mus. of Fine Arts, Boston 1939; "Fantastic Art, Dada, Surrealism," MOMA, NYC 1947; "20th Century Italian Art," MOMA, NYC 1949; "Exposition d'Art Moderne Italien," Mus. Nat. d'Art Moderne, Paris 1949; "Futurismo e Pittura Metafisica," Kunsthaus, Zürich 1950; "Les Sources du XX siècle," Mus. Nat. d'Art Moderne, Paris 1960; "Italien 1905–1925," Kunstverein, Hamburg 1963; "Homage to Silence," Loeb Gal., NYC 1966; "Arte Moderna in Italia 1915–1935," Palazzo Strozzi, Florence 1967; "Dada, Surrealism and their Heritage," MOMA, NYC 1968.

COLLECTIONS INCLUDE: Gal. d'Arte Moderna, Rome; Civica Gal. d'Art Moderna, Turin, Italy; Peggy Guggenheim Collection, Venice; Tate Gal., London; Staatliches Mus., Berlin; Kunstmus., Winterthür, Switzerland; Neue Pinakotek, Munich; Kunsthaus, Zürich; Olympia Mus., Athens; Metropolitan Mus. of Art, and MOMA, NYC; Albright-Knox Art Gal., Buffalo, N.Y.; Munson-Williams-Proctor Inst., Utica, N.Y.; Wadsworth Atheneum, Hartford, Conn.; Philadelphia Mus. of Art; Art Inst., Chicago; City Art Mus., St. Louis, Mo.; Mus. of Art, San Francisco.

ABOUT: Brunio, C. (ed.) Catalogo Generale: Giorgio de Chirico, 1971; de Chirico G. Memorie della mia vita, 1954; Far, I. Giorgio de Chirico, 1968; Goldwater, R. and others (eds.) Artists on Art, 1945; Hughes, R. The Shock of the New, 1981; Legrand, G. Giorgio de Chirico, 1979; Raynal, M. (ed.) Histoire de la Peinture Moderne, 1950; Read, H. A Concise History of Modern Painting, 1959; Soby, J. T. The Early Chirico, 1941, Giorgio de Chirico, 1955; Venturi, L. (ed.) La Peinture Italienne, 1952; Vitrac, R. Giorgio de Chirico et son oeuvre, 1927. Periodicals—Art Front January 1936; Artforum September 1966; Candido (Milan) July 1958; London Bulletin October 1938; Minotaure (Paris) May 1934; New York Times November 21, 1978; Paris-Match December 15, 1978; XXe siècle (Paris) March 1938; Valori Plastici (Rome) April–May 1919, May–June 1929.

*DE CREEFT, JOSÉ (November 27, 1884–September 11, 1982), Spanish-American sculptor, was one of the foremost advocates of the direct carving revival of the 1910s, '20s, and '30s, an international movement that included, among others, Robert Laurent, William Zorach, Ossip Zadkine, Eric Gill, Henri Gaudier-Brzeska, Henry Moore, and Barbara Hepworth. Reacting to what was perceived as a serious depletion of sculptural vitality caused by the Victorian practice of sending the artist's original clay or wax model to be enlarged in stone by professional carvers, these sculptors sought a direct confrontation with their materials in the manner of the classical and Renaissance masters. De Creeft, widely known for his semiabstract portraits of women in stone, wood, and repoussé sheet metal, perfected his style and craft through eight decades of consistent development, with little regard to the numerous and transitory movements in sculpture since World War I.

De Creeft was born to an impoverished family of noble lineage in Guadalajara (Valley of Stone), a small town on the Hanares River in Spain. His father died when de Creeft was still a child, soon after the family had moved to Barcelona. At the age of 13, he was apprenticed to an "imagier" to learn the carving of saints, madonnas, and other religious figurines from wood. This early contact with, and reverence for, the raw materials of sculpture played an important role in his eventual rejection of academic methods.

He soon left the "imagier" for a more lucrative job at a Barcelona sculpture foundry. There he learned the techniques of bronze, brass, and lead casting and had his first exposure to the working methods of professional sculptors. By the age of 16, already determined to pursue a career in art and stifled by the limited possibilities in Barcelona, de Creeft set off for the capital, Madrid. His technical experience won him a prestigious apprenticeship with Augustín Querol, the official government sculptor. De Creeft was fascinated by Madrid—he often visited the Prado to sketch or simply to admire the

°də krĕft, hō sä´

Waintrob-Budd, NYC

JOSÉ DE CREEFT

works of art—but not so by his new job, which offered little opportunity for creativity or innovation. In a matter of months he left Querol's atelier to hone his skills as a draftsman for the Madrid Administration of Bridges and Roads.

These were hard years of work and study. De Creeft was forced to use his small rented room as a studio where, because of his extreme poverty and lack of reputation, he could attract only children as his models. In 1903 his portraits of children were included in an exhibition sponsored by El Círculo de Bellas Artes in Madrid and were well received by the public. Impatient to make a name for himself, in 1905 he left Madrid for Paris, where he met Rodin, who counseled him to seek further academic education. De Creeft therefore enrolled in the Académie Julien in 1906. The following year he won top prize in the Académie's student sculpture contest with *Torso* (1907), a life-sized terra cotta.

In Paris de Creeft began to struggle with the idea whose resolution would decide his identity as an artist: the conflict between the academic training that he craved and the urge to an individual expression, which he did not yet trust. Fascinated by the ideas of Picasso and the Cubists (Picasso and Juan Gris had studios in the Bateau-Lavoir, the same ramshackle building on the rue Ravignan as did de Creeft), he was nonetheless fearful of being drawn too closely into any other artist's circle. He was also wary of abstraction for its own sake and always equated "free form" sculpture with furniture; he preferred the expressiveness of the human form above any other kind. In his own work, already sensuous, fluid, and compact, he drew upon

Eastern art and philosophy, as well as the African and other tribal sculpture being mined by Picasso, to create images of archetypal women, timelessly seductive. ("When most people see something they like," he said over 70 years later, "they want to possess it. By painting or drawing what they like, artists can possess such things. That's why I make sculptures of women.") He spent hours at the Museé Guimet studying Cambodian sculpture and reading Hindu and Buddhist literature late into the night. Many of his later sculptures are of black or Asian women, including *Negra sum sed formosa* (1942, I Am Black but Comely), in black Belgian marble, and the larger *Maya* (1937), in black granite.

De Creeft's preference for small sculptures at this stage was probably due to his ever-present lack of funds; they were also easier to tranport in the event of a sudden eviction. Slowly, however, the weight of poverty was beginning to lift. In 1909 his work was shown at the Salon des Artistes Français, and the favorable reception he received landed him several commissions. Nonetheless, he could not eke out a living on commissions alone, and, having tired of the Académie, he went to work in 1911 for the Maison Gréber, a large Parisian company specializing in the reproduction and repair of statuary. The skills he acquired there in stone and wood carving dovetailed well with his own aesthetic goals. In accordance with the practice of the day, de Creeft did not work directly in stone, but made a clay model which was sent to a *metteur aux points* (setter of points, so-called after the pointer, a kind of three-dimensional pantograph used in the trade), who would recreate the model in stone to the desired size. De Creeft had begun to feel that this "translation" of the artist's work was artificial, and that some elements of design or imagination were bound to be lost in the process. The art academies did not teach direct carving, so his only recourse was to learn on the job at a stonecutter's shop.

During his three years at the Maison Gréber de Creeft enjoyed the luxury of constant contact with raw materials, and he developed the necessary "feel" for the sculptural potential hidden in the shape and texture, the grains and irregularities, of each piece with which he worked. However, because full-time employment hampered his artistic career, he was probably the only artisan happy to take his leave when World War I brought work at the shop to a halt. (He resumed his job there after the war, when there was a booming demand for headstones.) De Creeft began to work at his own sculpture harder than ever, still modeling his ideas in clay, but saving the cutter's fee by reproducing them in stone himself. He soon discovered, however, that his

translations were as unsatisfactory as anyone else's; he felt the "will" of the stone to select its own form. After abandoning the use of clay scale models, he experimented briefly with small, rough maquettes in wax or plaster, but even these lacked the requisite spontaneity. In 1915, in a fit of cathartic frustration, he smashed almost all of his molds and models—more than a hundred—thus liberating himself from what he called "their tyranny." The immediate result was work of a new urgency and freshness that no technician in stone could equal. Among his early carved pieces still extant are the 18-foot-tall *Poilu* (1920) and *Maternity* (1922), both in granite.

Between 1919 and 1928, de Creeft exhibited his work alongside that of Bourdelle, Lipschitz, and other prominent sculptors at the Salon d'Automne, the Salon des Tuileries, the Société Nationale des Beaux-Arts, and other galleries in Paris. The largest project that he undertook during these years was in Majorca (1926–28), where he created over two hundred pieces of sculpture, including architectural ornaments and fountains, for a fortress recently purchased by the painter Roberto Romonje. As a result of this intensive and prolonged work in stone, he contracted pneumosilicosis, a debilitating lung disease caused by the inhalation of silicon dust (from granite), which left him unable to carve for many months.

In 1928 de Creeft sailed to England (with some three tons of sculpture and unworked stone). There he married Alice Robertson Carr, a Seattle-born sculptress, who bore him two children. They were divorced in 1938; in 1944 de Creeft married the New York City sculptor Lorrie Goulet, with whom he had a daughter in 1948. In 1929 he emigrated to the United States, becoming a US citizen 11 years later. He held his first American solo show at the Seattle Art Museum only a few months after his arrival. It was quickly followed by others at the Ferargil Galleries, New York City, in 1929 and at the Arts Club of Chicago in 1930. In 1932 the New School for Social Research, New York City, held a larger, comprehensive exhibition of his recent work. De Creeft taught sculpture there from 1932 to 1948 and from 1957 to 1962 and also at the Art Students League from 1932 to 1962.

The 1930s, '40s, and '50s were his most creative and successful years; his reputation became well established as he refined, but rarely deviated from, the style that made him famous. Much of his best work—*Slave* (1936), *Maya, Astonishment* (1941), in green serpentine, a bust of Rachmaninoff (1945), for which he prepared by listening for hours to the composer's music,

the monumental *Poet* (1950) for Fairmont Park, Philadelphia—were done in this period. As Rodin (and Michelangelo before him) had done, de Creeft gave the essential elements of each work a high luster while leaving other areas rough with chisel or bushhammer marks or virtually untouched; this was to give the impression that the figure had emerged from the stone, rather than been imposed on it. He often scoured the stony farmlands of upstate New York and New England for granite fieldstones suitable for carving; they sat in his New York City studio for months while he slowly envisioned the appropriate image to suit each stone. De Creeft also did pieces in hammered ½-inch sheet lead, notably *Saturnia* (1938) and the beautifully wrought *Himalaya* (ca. 1938); his single best-known work, however, is probably the atypical bronze group *Alice in Wonderland* (1959–60) in New York City's Central Park. In 1961 he was awarded a Ford Foundation fellowship and the American Federation of Arts mounted a major retrospective of his work that traveled to 14 major US museums.

De Creeft continued work, albeit at a somewhat slower pace, until his death in Manhattan at the age of 97. "I work differently now," he said in 1980. "Many things are too heavy, but this is not really so bad. My work is more sloppy, but it has much more spirit." He had long outlived those contemporaries alongside whom he had fought to free carved sculpture from its academic restraints (all except Moore, who now does little direct work, and was, in any case, one of the youngest members of the group). His sculpture, little changed from the 1920s (as can be seen in such late pieces as *Summer,* 1977) survives, like the Coelacanth, as a kind of antediluvian reminder of past struggles.

EXHIBITIONS INCLUDE: Seattle Art Mus. 1929; Ferargil Gal., NYC 1929; Arts Club of Chicago 1930; New School for Social Research, NYC 1932; Philadelphia Art Alliance 1933; Georgette Passedoit Gal., NYC 1936–49; The Contemporaries, NYC 1956–66; Whitney Mus. of Am. Art, NYC 1960; Kennedy Gals., NYC 1970–79; La Caixa Gal., Madrid 1980. GROUP EXHIBITIONS INCLUDE: Salon des Artistes Français, Paris 1909; Salon de Paris 1909, 1910–12, '14; Salon de la Société Nat. des Beaux-Arts, Paris 1916, '18, '20, Salon d'Automne, Paris 1920–'27; Salon des Indépendants, Paris 1922–25, '28; Salon des Tuileries, Paris 1925–27; "Portrait of America (Artists for Victory, Inc)," Metropolitan Mus. of Art, NYC 1942; Annual, Pennsylvania Academy, Philadelphia 1945; "Sculpture in Our Time," Detroit Inst. of Arts 1959.

COLLECTIONS INCLUDE: Brooklyn Mus., N.Y.; Columbia Univ., Mus. of the City of New York, IBM Collection, MOMA, and Whitney Mus. of Am. Art, NYC; State

Univ. of New York, New Paltz; Hirshhorn Mus. and Sculpture Garden, Washington, D.C.; Univ. of Nebraska, Lincoln; Univ. of San Francisco Mus. of Art; Seattle Art Mus.; Wichita Art Mus., Kans.

ABOUT: Campos, J. José de Creeft, 1945; Chanin, A.L. and others, Modern Art, 1959; Puma, F. (ed.) 7 Arts, 1954; Ritchie, A.C. Sculpture of the Twentieth Century, 1952; Zorach, W. Painters and Sculptors of Modern America, 1942. *Periodicals*—American Artist March 1947; Art Digest December 1, 1944, January 15, 1954; Magazine of Art February 1944.

DE **KOONING, ELAINE** (March 12, 1920–), American painter, is best known for her portraits and scenes of bullfighting and ballplaying in a style uniting realism with the gestural techniques of abstract expressionism. Her career has involved constant experimentation with new ways of deriving emotion and insight from the elements of painting. "In a real sense," she told Eleanor Munro in an interview for *Originals: American Women Artists*, "it seems to me there's only one single idea running through one's life, even if we find an infinite number of ways of expressing it."

Born in New York City, she was christened Elaine Marie Catherine Fried, the daughter of Charles Frank Fried, an accountant, and Mary Ellen (O'Brien) Fried. She began drawing seriously at the age of five and dancing at the age of seven, encouraged by her mother, who took her on frequent trips to museums and the theater. After graduating from Erasmus Hall High School, Brooklyn, in 1936, she briefly attended Hunter College in Manhattan, then enrolled in the Leonardo da Vinci Art School (1937) and the American Artists School (1938), both in New York City. In 1938 she began studying with the Abstract Expressionist painter Willem de Kooning, whom she married in 1943.

At the beginning of her career, Elaine de Kooning's forte was draftsmanship. Although she was elated to discover, in 1937, the abstract movement in American art, her early paintings, done in the left-wing spirit then prevailing the art schools, were turgid examples of social realism, from which she was rescued by Willem de Kooning, who persuaded her to try still lifes. Under his tutelage, she learned to analyze spatial relationships among objects and to make each brushstroke an active part of the composition. She began painting portraits in the mid-1940s, and in 1950 she was chosen by Clement Greenberg and Meyer Schapiro to participate in the "New Talent" show at the Kootz Gallery in New York City.

By the middle of the next decade de Kooning

ELAINE DE KOONING

had developed her uniquely realistic abstract expressionist style. Realism and abstract expressionism, in her opinion, are not in opposition. "For the painters who lived with and learned from it, abstract expressionism has opened up new ways of meshing paint with the image, whether or not the image is representational," she told the *New York Post* (October 21, 1962). The artist-writer Fairfield Porter, who painted realistically but supported avant-gardism in his criticism, and who inspired de Kooning to begin painting portraits, called her style "analytic Cubism without the cubes" in *Art News* (April 1954). As her career progressed, she found ways of making the activity of the paint correspond in striking ways to the activity of the subject.

Many of de Kooning's portraits are life-sized, and most are of men—a reaction, in part, to the misogyny of the artist's mother, who preferred her sons to her daughters, and who thus invested maleness with the quality of a mysterious ideal. "I became fascinated by the way men's clothes divide them in half . . . ," de Kooning told Munro. "I was interested in the gesture of the body—the expression of character through the structure of the clothing. I centered the figures; I thought of them as spinning—'gyroscope men,' isolated in space." During the 1950s she began painting groups of athletes, especially baseball and basketball players, from photographs, and later traveled with the New York Yankees and Baltimore Orioles, developing her paintings from sketches made at the games.

In 1957, the year after she and Willem de Kooning separated, she went to teach for a year at the University of New Mexico, Albuquerque.

The landscape of the Southwest vitalized her sense of color. "For years I worked with dense colors that were linked in a close tonality," she explained to Lawrence Campbell of *Art News.* "I felt let out of prison when I began to see the 'separateness' of colors—even close colors, blue next to green, orange next to pink, ocher next to citron yellow.... You experience drawing in the mind—you are always outside of it—but color engulfs. You feel color with your muscles or your skin." This new interest in the physical effects of her paintings led her to increase their size up to 20 feet high and to reorient them horizontally.

Her years in New Mexico also gave her a new subject: bullfighting. Virtually every weekend she went across the border into Mexico to see the corrida. The pastel sketches she made in the arena were translated into mural-sized paintings whose brushwork conveyed the energy and emotion of the ritual combat. *Arena* (1959), one of the largest of the series, measures 10 feet by 20 feet and contains brushstrokes that are 11 feet long. Typically for de Kooning, these monumental works were balanced by smaller canvases (including *Redondo*, 18 inches high, and *Colorado*, seven inches high), black-and-white drawings, pastel sketches, and watercolors.

When de Kooning returned in 1959 to New York City, she worked for a time on her bullfighting series and then turned again to portraiture, painting mostly standing figures and returning to a vertical format. Among her subjects were the artist Fairfield Porter, the poets Frank O'Hara and Edwin Denby, and jazz pianist Thelonious Monk. She had a knack for capturing a personality in the pose alone, without resorting to detail. Frank O'Hara's portrait, for example, has no face. De Kooning explained in *Art in America* (January–February 1975), "First I painted the whole structure of the face; then I wiped out the face, and when the face was gone, it was more Frank than when the face was there." Lawrence Campbell, reviewing a show of de Kooning's portraits at the Graham Gallery, New York City, remarked of this portrait, "One spots the ear and the skull and these are so correct that they infer all the rest of the face."

The Graham Gallery show brought de Kooning a commission from the White House to paint President John F. Kennedy's portrait for the Truman Library in Independence, Missouri. After making sketches of Kennedy in December of 1962, de Kooning spent nearly a year struggling to achieve a portrait that combined spontaneity with likeness, producing a vast number of paintings and drawings in the process. Kennedy's assassination in November 1963 so traumatized her that she stopped painting and turned

to bronze sculpturing during a year of teaching at the University of California at Davis. She returned to portraiture in 1965. "For me, doing portraits is an addiction," she explained. "I don't choose to do portraits—I just do them." Among her models in the 1960s and 1970s were the writers Donald Barthelmé and John Ashbery and the painters Robert de Niro, Aristedemos Kaldis, and Alex Katz. In 1976 she began a series of paintings and lithographs of a statue of Bacchus that stands in the Luxembourg Gardens, Paris, "I like the way the gray light shimmers all over the form of the statue," de Kooning told Munro. "And I like the pose: from one angle you see a single female nymph supporting that enormous male figure." Her 1981 show at Spectrum Fine Arts, New York City, presented sports paintings done over the course of three decades, and in 1982 she showed at the Phoenix II, Washington, D.C., a set of watercolor landscapes entitled "Italian Summers: 1973–1981."

Elaine de Kooning was a staff critic for *Art News* in 1948–49 and has since been a contributing reviewer. Willem and Elaine de Kooning never obtained a divorce; they have remained friends and live near each other on Long Island, in the East Hamptons. Her teaching credits have included faculty appointments at Yale (1967), Pratt Institute (1968), Carnegie-Mellon University (1969–70), the University of Pennsylvania (1971–72), Parsons School of Design (1974–76), Brandeis University (1975), Rice University (1976), and the University of Georgia (1976–78). In 1982 she was named Avery Professor at Bard College.

EXHIBITIONS INCLUDE: Stable Gal., NYC 1954, '56; Tibor de Nagy Gal., NYC 1957; Univ. of New Mexico, Albuquerque 1958; Gump's Gal., N. Mex. 1959; Dord Fitz Gal., Amarillo, N. Mex. 1959; Lyman Allyn Mus., New London, Conn. 1959; Holland-Goldowsky Gal., Chicago 1960; Howard Wise Gal., Cleveland 1960; Ellison Gal., Fort Worth, Tex. 1960 Tanager Gal., NYC 1960; Graham Gal., NYC 1960 '61, '64, '76; De Aenille Gal., NYC 1961; Drew Univ., N.J. 1966; Montclair Art Mus., N.J. 1973; Illinois Wesleyan Univ., Bloomington 1975; St. Catherine's Col., St. Paul, Minn. 1975; Spectrum Fine Art Gal., NYC 1981; Phoenix II, Washington D.C. 1982. GROUP EXHIBITIONS INCLUDE: "New Talent," Kootz Gal., NYC 1950; International Biennial Exhibition of Painting, Tokyo 1954; "Expressionism 1900–1955," Walker Art Cntr., Minneapolis 1956; Pittsburgh International, Carnegie Inst. 1956, '64; "The New York School: The Second Generation," Jewish Mus., NYC 1957; "Younger American Painters," MOMA, NYC 1957–59; "Action Painting," Houston Mus. of Fine Arts 1958; Walker Art Cntr., Minneapolis 1960; Hallmark Art Award Exhibition, 1960; Annual, Whitney Mus. of Am. Art 1963, '74; "Focus," Philadelphia Mus. of Art/Mus. of the Philadelphia Civic Cen-

ter 1974; "American Self-Portraits 1670–1973," Nat. Portrait Gal., Washington, D.C. 1974.

COLLECTIONS INCLUDE: Univ. of Arkansas, State University; Ciba-Geigy Corp.; Elmira Col., N.Y.; Kennedy Library, Boston; MOMA, NYC; Montclair Art Mus., N. J.; State Univ. of New York at Purchase; Harry S Truman Library, Independence, Mo.

ABOUT: Current Biography, 1982; Munro, E. Originals: American Women Artists, 1979. *Periodicals*—Art in America January–February 1975, May–June 1976, October 1981; Art News April 1954, December 1960, April 1963; New York Post October 21, 1962.

DE **KOONING, WILLEM** (April 24, 1904–), American painter and sculptor, was a pioneer of abstract expressionism and has been a major force in American art since the late 1940s. He and Jackson Pollock were the leaders of the branch of abstract expressionism that emphasized gesture, or action, painting and the all-over approach to compositional organization. De Kooning's explosive brushstroke and physical, attack-the-canvas style were much imitated in the 1950s by second-generation Abstract Expressionists. He has become an American culture hero in his lifetime.

He was born in Rotterdam, the Netherlands, the son of Leendert and Cornelia (Nobel) de Kooning. Willem's parents were divorced when he was three and it was initially decided that he would stay with his father, but after an appeal to the court the mother obtained custody of her son. Both parents remarried and had other children. Leendert de Kooning, who became a fairly prosperous distributor of wines, beers, and soft drinks, had little time for his son, and the mother—a "formidable lady" in Elaine de Kooning's estimation—was a bartender in a café frequented by sailors.

Conflicting childhood emotions aggravated by these early experiences and love-hate feelings towards his mother have been seen as contributing to the savagery and obsessiveness of de Kooning's "Women" pictures of the early 1950s. "The turbulence," the artist's wife, Elaine, said, "came from his image of women, of his consciousness of their role—and it was not sweet." According to her, de Kooning's ambivalence, his sense of women as both loving redeemers and dominating predators, stemmed from childhood experiences with Cornelia, who "was no pink, nice lady. She could walk through a brick wall. . . . Bill says she was a hysteric. If he laughed at her, or she got angry, she would grab a knife and raise it as though she was going to kill herself, yelling, 'Cora cannot stand this a moment longer!'"

© Hans Namuth, 1984

WILLEM DE KOONING

At the age of 12 Willem had to work for a living. He left grammar school and was apprenticed to a commercial art and decorating firm run by Jan and Jaap Giddings. In 1916, recognizing de Kooning's ability, Jaap Giddings urged the boy to enroll in evening classes at the Rotterdam Academy of Fine Arts and Techniques, which was unique among European art schools in that it had retained the craft traditions of the old guilds. In addition to the conventional academic disciplines—perspective, proportion, anatomy, drawing from casts and from the live model—lettering and house-painting techniques such as wood graining and marbleizing were emphasized. De Kooning also attended lectures on art theory and history.

In 1920 he left the Giddings firm to work for Bernard Romein, the art director of a large department store, but de Kooning continued to attend night classes at the academy. "At that time we were influenced by the de Stijl group," he recalled. Besides Mondrian and constructivism, de Kooning was learning about modern art movements in Germany and Paris and about the architecture of Frank Lloyd Wright. At this time his ambition was simply to support himself as a commercial artist, and he entertained thoughts of immigrating to the United States, where, he said, "they were a lot better at commercial layout. Also, the girls looked fantastic. And those Western movies, and the jazz, and Louis Armstrong—I liked that a lot." In 1924 he traveled with friends to Belgium, testing the feeling of independence from Holland. Although de Kooning visited museums, it was not an art tour and he supported himself with odd jobs and sign

painting. According to Thomas B. Hess, the Belgian trip was "a dry run for his emigration."

De Kooning returned to Holland in 1925, completed his studies at the academy, and made luckless attempts to embark for America. In 1926, on his third try, he managed to stow away in the crew's quarters of the SS *Shelley,* which docked at Newport News, Virginia, on August 15. Lacking proper papers, he stole away from the ship and found work on a coaler sailing to Boston. On board he obtained documentation making him a legal alien. From Boston de Kooning went to New Jersey, where, with the help of a friend, Leo Cohan, he found lodging in a Hoboken boarding house.

De Kooning was penniless and the only English word he knew was "yes." However, within three days of settling in Hoboken he got a $9-a-day house-painting job, and in 1927 he moved to New York City, taking up residence in Greenwich Village. For the next eight years de Kooning earned his living from commercial art, sign painting, department store displays, lettering, carpentry, and nightclub murals.

Shortly after arriving in New York, de Kooning had met John Graham, the gifted, knowledgeable, and eccentric Russian émigré painter and collector. Graham had known Picasso in Paris, and he educated de Kooning and other young New York artists in the finer points of cubism. In the late 1920s de Kooning also met the painters Stuart Davis and Arshile Gorky. The Armenian-born Gorky, who was then painting his way through the history of modern art, became a close friend. Other confreres were the sculptor Ibram Lassaw and the poet and dance critic Edwin Denby, whom de Kooning met in 1934. In Holland, de Kooning had painted in a traditional, conservative manner, but, influenced by his American colleagues, he began to experiment in a variety of modern styles.

In 1935 de Kooning was persuaded by friends to join the Works Progress Administration's (WPA) art project. The perfectionist de Kooning at first balked at receiving payment from the Federal Arts Project—not because he feared his independence or integrity would be compromised, but because he didn't believe his canvases were worth money. Nevertheless, the project enabled de Kooning for the first time to devote his full energies to painting, though he had to resign after a year when it was discovered that he was an alien. Prompted by the WPA experience, de Kooning now decided to paint first and do odd jobs on the side.

In the late 1930s de Kooning and Gorky shared a studio. Their artistic tempers were matched, and there was intense interaction between the two for the next decade. American art in the Depression years was dominated by regionalism and social realism, but de Kooning and Gorky, both of whom revered the modernist Stuart Davis, were key figures in what amounted to an artistic underground. Despite widespread Depression-induced despair, there was ebullience and camaraderie in the artistic circles in which de Kooning moved. "I didn't have any money," he recalled, "but I was never poor"; and somehow he always managed to get the finest materials for his work.

With his blue denims, Dutch accent, commitment to European painting traditions, and uncompromising professionalism, de Kooning was a charismatic figure, and already a coterie of aspring painters were imitating his art. In *The New York School* Dore Ashton discussed de Kooning's "myth": "He had been considered . . . a 'painter's painter' since the thirties. He was . . . absolutely incorruptible, a man who lived a life of total honesty, and who chose the uncomfortable rather than conform to anyone else's idea of what a painter's life should be. . . . Throughout the forties, those who gravitated to New York . . . heard stories of de Kooning's courageous resistance of blandishments both from dealers and from occasional patrons. It was well known that he and Gorky chose poverty rather than to compromise in their work."

De Kooning destroyed most of his works of the late '20s and early '30s, and the mural projects to which he had been assigned by the WPA were never executed. By the mid-1930s, however, two themes, abstraction and figuration, were dominant in his art. There was a series of high-key color abstractions based largely on objects-in-interior motifs. His other abstractions, including *Pink Landscape* (ca. 1938) and *The Wave* (1940–41), suggested landscape. In these abstractions the organization of space and the imagery were close to Miró as well as Gorky, and the influence of the automatic drawing technique and the biomorphic shapes of surrealism was also felt, although de Kooning was to resort to automatist doodling much less than such Abstract Expressionists as Pollock, Kline, and Motherwell.

Other de Kooning paintings and drawings were of men standing or sitting in interiors which looked like a shallow stage. These figure studies were the artist's response to the Depression-era call for a proletarian art, but de Kooning transcended social-realist formulas. For example, the painting *Two Men Standing* (ca. 1938) recalls Gorky's *The Artist and His Mother* (1925–29; Whitney Museum of American Art, New York City). De Kooning also made pencil

sketches of standing and seated men in a studied classical mode that revealed his academic training. In one (*Seated Man,* ca. 1939) the artist himself, stripped to the waist, gazes passively into space, and another, a pencil drawing of about 1938, is entitled *Self-Portrait with Imaginary Brother.* "[De Kooning] rejected the Hooverville starvelings of the politically oriented artists as well as their poster-style drawing and color," Harold Rosenberg wrote. "So in the period of proletarian art de Kooning produced a series of paintings of brooding men that were near self-portraits executed as curious experiments with perspective."

In 1938 de Kooning met Elaine Fried, a young art student of whom he made a sensitive, Ingres-like pencil drawing in 1940 or '41. They were married in 1943, and Elaine de Kooning became a noted painter and art critic in her own right. After meeting Elaine, de Kooning turned his attention from the male to the female figure, an interest that evolved in the late '40s and early '50s into his famous "Women" series. Some earlier "Women" pictures, including *Queen of Hearts* (ca. 1943) and the more formalized *Pink Lady* (ca. 1944), were lyrical in comparison to the demonic goddesses he would later create.

By the mid-1940s de Kooning's aim was to reconstitute the human figure within an abstract framework that would retain vestiges of cubist structure. In some paintings the cubist organization of space was combined with biomorphic shapes, as in *Pink Angels* (ca. 1945), with its close-hued, pastellike, yet slightly acid, coloring. In *Pink Angels* one can see de Kooning gaining confidence in his use of gestural brushstrokes, as the angels are "dissolved in a swirl of disembodied limbs," to quote *Makers of Modern Culture.* According to Rosenberg, *Pink Angels* is also "scrawled with contours . . . that present another of de Kooning's inventions of those years . . . the floating shape flicked by his inspired drawing from studies of the human figure, city streets and interiors, impressions of Old Masters, the spontaneous movements of the hand."

In 1942 de Kooning had contributed to a group show curated by John Graham for McMillen Inc., a decorating firm whose exhibition included works by Jackson Pollock and Lee Krasner. Also, de Kooning's *Elegy* (1939) had been exhibited in a 1943 group show at the Bignou Gallery, New York City, and was purchased by Helena Rubinstein. Although his work was arousing interest, de Kooning dodged success as assiduously as other artists pursued it. His standards were so high, and his ambitions so great, that he regularly abandoned canvases that

disappointed him—and most did—after having struggled with them for months. "I'm not ready," he would say when fellow artists or dealers implored him to show, and it was whispered in art circles that de Kooning was a brilliant painter who might never produce a body of work.

In 1948, however, the Egan Gallery in Manhattan arranged a solo exhibition of de Kooning's recent paintings. The 44-year-old artist showed striking black and white abstractions—shiny black enamels and oil on paper—in which line was "allowed to function independently of form, its normal job of describing contour [having been] minimized in the interest of an all-over movement of swiftly excuted dramatic movement," as Barbara Rose explained. His largest black painting, *Painting* (1948), was acquired by the Museum of Modern Art, New York City, the first museum purchase of a de Kooning. These compositions were entirely abstract, but de Kooning gave them evocative and allusive titles such as *Light in August* (ca. 1947), a reference to the Faulkner novel, *Black Friday* (1948), and *Dark Pond* (1948).

Many art historians date the emergence of the postwar New York School from the time of de Kooning's Egan Gallery show. In 1949 de Kooning again made history when he, his friend Jack Tworkov, Franz Kline, and other first-generation Abstract Expressionists rented a meeting place at 39 East 8th Street. For the next ten years the twice-a-week meetings, panel discussions, and parties held at the Club (it was sometimes called the Eighth Street Club or the Painters' Club) were the focal point of New York School activities. According to William Barrett, " . . . The two stalwarts who were really the artistic and moral center of the Club were . . . de Kooning and . . . Kline. [They] were the champions who gave confidence to other members that their own gropings in art might also be significant."

In the years of abstract expressionism's international triumph, de Kooning and Pollock were consecrated by rival critics as avatars of the movement that had helped New York City replace Paris as the world capital of art. De Kooning's advocate and close friend was Harold Rosenberg of *The New Yorker,* and closely identified with Pollock was Clement Greenberg of *Partisan Review.* Indeed, as Pollock became a legend in the years after his untimely death, de Kooning was turned by critics into a mythic figure, the American Picasso who, as Robert Hughes wrote, "subsumes the history of art in his own person, becomes a touchstone of the culture, and so transcends all questions of 'originality.'"

For example, Rosenberg's existentialist interpretation of action painting—"At a certain moment," he wrote, "the canvas began to appear to one American painter after another as an arena in which to act"—was based on de Kooning's work.

De Kooning took two years (1950–52) to complete his *Woman I* (MOMA), the first painting in a new series of "Women" that changed the course of American art. Supporters of abstract expressionism who thought Pollock and de Kooning had made figuration obsolete were shocked by de Kooning's "Women." For example, Clement Greenberg, the "guru" of abstract expressionism, had solemnly declared, "It is impossible today to paint a face." With his love of paradox, de Kooning replied, "That's right, and it's impossible *not* to."

In his "Women" de Kooning achieved, to quote Diane Waldman, "a radical synthesis of figuration and abstraction." These canvases were in the all-over style—that is, there was no fixed center of interest—and he used the violent, slashing brushstrokes of action painting; yet, the fragmented, distorted, and "violated" woman images created a psychological tension and an explosive discharge of energies and aggressions that purely nonobjective art could never achieve.

De Kooning's vision of women has been described as "bringing together something of the *Venus of Willendorf*, of the big women in Rubens's paintings, and of the banality of American fashion and advertising images of the fifties." *Woman I* has been called "a witness of our time, a female Saturn who devours her children" (or, perhaps, is caught devouring the bones of her lover), but de Kooning insisted that he is not a misogynist. "She has nothing to do with women," he said. "I'm afraid of her myself." He felt that many critics failed to perceive the comic force, the "hilarity" of these paintings.

The "Women" paintings were as much "about" the interpretation of the figure and its ambiguous environment—or "no-environment," as de Kooning put it—as they were renderings of the primordial female image. Unable to sell the "Women," de Kooning's dealer, Sidney Janis, urged him to go back to abstractions, but the artist went on painting women as well as purely abstract canvases for five years.

About 1952 de Kooning began spending his summers in East Hampton, a then sparsely settled beach community on Long Island, and landscape motifs (or rather the exuberance aroused by the experience of landscape) thereafter permeated his abstractions. In 1955 he produced the first in a series of abstract cityscapes which includes *Gotham News* (1955–56; Albright-Knox Art Gallery, Buffalo, New York) and *Easter Monday* (1955–56; Metropolitan Museum of Art, New York City), two of his finest achievements. Though they are in no way descriptive, these canvases convey a definite sense of "place" and communicate what Harold Rosenberg called the "unfinished, hairy quality" of the New York scene. As de Kooning himself said, "Even abstract shapes must have a likeness." Another notable work in the series, his *Suburb in Havana* (1958), with its warm, sultry tones, was inspired by a visit to Cuba.

In 1961 de Kooning became a United States citizen. The following year he laid plans for the construction of a vast studio in the Springs, an area of East Hampton, and in 1963 abandoned his large Greenwich Village loft and took up permanent residence there. Among the last canvases he painted in New York City were two lyrical, soft-colored landscape abstractions, *Rosy-Fingered Dawn at Louse Park* (Stedelijk Museum, Amsterdam) and *Pastorale,* both of 1963.

The new series of "Women" he had begun in 1961 were not as savage as their predecessors. The two nudes in *Clam Diggers* (1964) were blond, Rubenesque Venuses, loosely and exuberantly painted. In *Woman, Sag Harbor* (1964; Hirshhorn Museum and Sculpture Garden, Washington, D.C.) and *Woman in the Water* (1967), the monstrously predatory figures were themselves "devoured" by the swirls and slashes of pigment that defined and enveloped them. As always, the "sweet" colors, especially the pinks and oranges, contrasted with the drastically distorted female apparition, thereby creating a disturbing tension.

Invited to hold a solo show at MOMA in 1958, de Kooning declined—probably the only artist ever to do so—saying, "I'm not ready. I'm still working out of doubt." A decade later, however, he agreed to a major retrospective and explained his past wariness: "Having a retrospective is being tied up like a sausage and stamped 'Finished.'" The show opened at the Stedelijk Museum, Amsterdam, traveled to the Tate Gallery, London, and on to MOMA. De Kooning returned to Holland for the opening, his first visit in 43 years, and his arrival in Amsterdam was a national event. He visited his 92-year-old mother (who died the following year) and his older sister. Altogether it was a happy experience, and a means, as Charlotte Willard noted, of "finally laying boyhood rages to rest."

In 1969 de Kooning began his "Montauk" series of landscape abstractions, in which, as Hilton Kramer wrote in *The New York Times*

(February 10, 1978), "the land, sea and sky disappear into the high-spirited, disorderly gyrations of paint. . . . " Kramer called the artist's East Hampton abstractions "the most orthodox examples of Abstract Expressionist painting that Mr. de Kooning has ever produced," but after de Kooning moved to the countryside, his colors had become softer, his work calmer, even jubilant. More important in his paintings of the '60s and '70s was the reconciliation of abstract and figurative motifs. According to one critic, "Figures shimmer and dissolve into landscape, and landscape merges into gestural rhythm, so that the figurative/abstract polarity has little meaning."

In 1969 de Kooning traveled to Japan and from there to Rome, where he executed his first sculptures, small figures freely modeled in clay and later cast in bronze, or, in a few cases, in bronzelike polyester resin. Visiting New York for an exhibition, an enthusiastic Henry Moore recommended that they be enlarged. Eighteen pieces, including two large works, *Clam Digger* and a headless *Seated Figure,* were exhibited at the Sidney Janis Gallery, New York City, in 1972. In *Art News* (November 1972) Peter Schjeldahl described the sculptures' "gouged and battered" surfaces and "twisted and yanked" limbs. Critics have agreed that de Kooning's aggressively shaped sculpture is closer to his paintings of the early '50s than to his comparatively pastoral East Hampton landscapes.

An exhibition titled "Willem de Kooning in East Hampton" opened at the Solomon R. Guggenheim Museum, New York City, in February 1978. Except for two canvases from 1962, the show's 84 paintings and drawings had been produced in the period following the artist's move to Long Island in 1963. While admiring de Kooning's "extraordinary energy and confidence," the singing color, the "fresh and succulent look" of the pigment, and the "appealing kinetic power" of the rhythms, Hilton Kramer admitted to finding much of the exhibition "dispiriting." He remarked that "those delectable painting surfaces which begin by seducing the eye" end "in a suffocating surfeit of sweetness and charm." The slack, loose structure, a result of the artist's rejection of the "Cubist imperative," seemed to Kramer "utterly feckless in the face of the painterly energy it is called upon to support." Whether through overindulgence in sheer painterliness, a failure of will, or "intellectual sloth," de Kooning, in Kramer's view, had not achieved the kind of transcendent "late style" in which the art of such modern masters as Cézanne and Matisse had culminated.

In the drawings, paintings, and sculpture by de Kooning that were exhibited in 1984 at the Whitney Museum, it was apparent that drawing has been central to his art in every phase of his long career, notwithstanding the wide variety of techniques he has used. (For example, in 1966, in an attempt at "self-renewal," he had executed a series of automatic drawings, made with eyes closed or while watching television, sometimes scribbling with the left hand or with both hands at once.) As Grace Glueck wrote in *The New York Times* (December 16, 1983), "A brilliant and remarkably inventive draftsmanship is the artist's greatest strength, and it's when draftsmanship provides the bones of his painting, as in the 1940's and early 50's, that the work is at its peak." In Glueck's view, the weakness of de Kooning's abstract landscapes is that in these "broadly brushed affairs . . . the taut, hard-won structure of his earlier work is banished by gesture and painterly 'accident'. . . . They have lost the dramatic structural tension the artist once maintained."

The untitled abstractions de Kooning began painting in the early 1980s differ markedly from his abstract landscapes. In these recent works the thick impasto of the 1970s gives way to a lighter, smoother, more delicate brushstroke, and the overall composition is tighter, more rigorously structured. The shapes recall de Kooning's abstractions of the late '40s, but they evoke serenity and contemplativeness rather than expressionistic angst. The most striking quality of these abstractions, though, is their luminosity. To quote Jörn Merkert, the new canvases are "shot through with flickering, almost transcendental light, . . . suffused with a blinding brilliance that transmutes color into apparitions."

In *Look* magazine Charlotte Willard described de Kooning's enormous Long Island studio as "probably the most expensive in the world." The artist's design took shape around the steel girders he saw advertised in a local paper at bargain prices. He has removed walls, hauled away windows, dismantled the fireplace time after time, and still he continues to make changes. In fact, Willard wrote, "He has treated the structure like a huge canvas, a jigsaw puzzle of his life. . . . "

When working at his easel, de Kooning covers the floor with trial sketches. The term action painting suggests absolute spontaneity, but little in de Kooning's work is unpremeditated. His aim has always been, as Clement Greenberg put it, "a synthesis of tradition and modernism," and he has scraped out much more than he ever painted. In his struggle for perfection de Kooning smashed, discarded, or gouged many canvases, including some that would probably have

been notable additions to his body of work. He has also paid a high price physically for his genius. In the late '50s he began to drink, hoping to palliate recurrent anxiety attacks. Instead he became a heavy drinker, though he swore off alcohol in 1978.

De Kooning sees very few people, and John Russell wrote in *The New York Times* (February 5, 1978) that it was no small achievement for a famous artist to live as a recluse in East Hampton, which is now a retreat for successful artists and for hordes of affluent Manhattanites. Contrary to what the size and vehemence of many of his canvases might lead one to expect, de Kooning in his 70s was "small and delicate, with an altar-boy's fringe of fair hair, an almost weightless walk and a quickness of response which most people lose in first youth." He speaks "in a light and rapid utterance that is full of unreconstructed Dutch vowel sounds," and likes to bicycle or walk by the ocean, collecting shells and other marine treasures on the beach. Russell noted that de Kooning uses, apart from knives and spatulas, everyday house-painters' brushes. Beneath every canvas-in-progress, sheets of newspaper are laid out to catch the paint that drips down or is wiped off as the paintings progress.

Willem and Elaine separated in 1955; never divorced, they have remained close. In 1956 de Kooning moved in with Joan Ward, his other, "unofficial" wife, who is the mother of his only child, Lisa, born in 1956. In 1977 de Kooning and Joan separated; she kept the modest house they had purchased in East Hampton in the early '60s, and he moved into his nearby studio. Next door to the studio is a frame house de Kooning built for Lisa in 1981.

De Kooning discusses his work and ideas in the same vivid, unconstrained, but at times ambiguous, manner in which he paints. In a 1965 interview with the British Broadcasting Corporation he remarked: "I get freer. I feel I am getting more to myself in the sense [that] I have all my forces. I hope so, anyhow. . . . I am more convinced about picking up the paint and the brush and drumming it out." On another occasion he said, "I'd like to get all the color in the world in one single painting."

EXHIBITIONS INCLUDE : Egan Gal., NYC 1948, '51; Sidney Janis Gal., NYC 1953, '56, '59, '72; Mus. of Fine Arts, Boston 1953; Venice Biennale 1954; Martha Jackson Gal., NYC 1955; Allan Stone Gal., NYC 1962, '64, '65, '66, '71; Smith Col. Mus. of Art, Northampton, Mass. 1965; Hayden Gal., Massachusetts Inst. of Technology, Cambridge 1965; M. Knoedler & Co., NYC 1967, '69; Stedelijk Mus., Amsterdam 1968–69, 76; Tate Gal., London; 1968–69; MOMA, NYC 1968–69; Baltimore Mus. of Art 1972; "Drawings/Sculptures,"

Walker Art Center, Minneapolis 1974; Seattle Art Mus., 1976; "Willem de Kooning in East Hampton," Solomon R. Guggenheim Mus., NYC 1978; "Willem de Kooning: Drawings, Paintings, Sculpture," Whitney Mus. of Am. Art, NYC 1983–84. GROUP EXHIBITIONS INCLUDE: "New Horizons in American Art," MOMA, NYC 1936; McMillen Inc., NYC 1942; Bignou Gal., NYC 1943; Whitney Mus. of Am. Art Annual, NYC from 1947; Venice Biennale 1950, '54, '56; "The New American Painting," MOMA, NYC 1958; "New Images of Man," MOMA, NYC 1959–60; "New Images of Man," Baltimore Mus. of Art 1960; "Painting and Sculpture of a Decade '54–64," Tate Gal., London 1964; "New York School: The First Generation, Paintings of the 1940's and 1950's," Los Angeles County Mus. of Art 1965; "New York Painting and Sculpture, 1940–1970," Metropolitan Mus. of Art, NYC ca. 1972; "The Golden Door: Artist-Immigrants of America, 1876–1976," Hirshhorn Mus. and Sculpture Garden, Washington, D.C. 1976; "Group Sculpture Show," Xavier Fourcade Inc., NYC 1981.

COLLECTIONS INCLUDE: Metropolitan Mus. of Art, MOMA, Whitney Mus. of Am. Art, and Solomon R. Guggenheim Mus., NYC; Albright-Knox Art Gal., Buffalo, N.Y.; Wadsworth Atheneum, Hartford, Conn.; Hirshhorn Mus. and Sculpture Garden, Washington, D.C.; Mus. of Art, Carnegie Inst., Pittsburgh; Baltimore Mus. of Art; Art Inst. of Chicago; Tate Gal., London; Mus. Nat. d'Art Moderne, Paris; Stedelijk Mus., Amsterdam; Israel Mus., Jerusalem; Australian Nat. Gal., Canberra.

ABOUT: Ashton, D. The Unknown Shore: A View of Contemporary Art, 1962, The New York School: A Cultural Reckoning, 1973, American Art Since 1945, 1982; Barrett, W. The Truants: Adventures Among the Intellectuals, 1982; Greenberg, C. Art and Culture, 1961; Hess, T. B. Willem de Kooning, 1959, (ed.) "Willem de Kooning" (cat.), MOMA, NYC, 1968; Hughes, R. The Shock of the New, 1981; Gaugh, H. F. Willem de Kooning, 1983; Janis, S. and others De Kooning, 1960; Larson, P. and others "De Kooning: Drawings/Sculptures" (cat.), Walker Art Center, Minneapolis, 1974; Lucie-Smith, E. Late Modern: The Visual Arts Since 1945, 1969; Merkert, J. and others Willem de Kooning: Drawings, Paintings, Sculpture, 1983; O'Doherty, B. American Masters: The Voice and the Myth In Modern Art, 1974; Ritchie, A. C. Abstract Painting and Sculpture in America, 1950; Rose, B. American Art Since 1900, 2d ed. 1975; Rosenberg, H. De Kooning, 1974, The Anxious Object, 1964; Sandler, I. The Triumph of American Painting, 1970, The New York School: The Painters and Sculptors of the Fifties, 1978, "Willem de Kooning in East Hampton" (cat.), Solomon R. Guggenheim Mus. NYC, 1978; Wintle, J. Makers of Modern Culture, 1981. *Periodicals*—Art d'aujourd 'hui (Paris) June 1951; Art News November 1955, September 1972, November 1972, February 1982; Chroniques de l'art vivant (Paris) June 1969; Location Spring 1963; Look May 27, 1969; Museum of Modern Art Bulletin Spring 1951; Newsweek January 2, 1984; New York February 20, 1978; New York Times February 5, 1978, February 10, 1978, May 11, 1983, December 16, 1983; New York Times Magazine

November 20, 1983; Times Literary Supplement February 17, 1984.

SONIA DELAUNAY

*DELAUNAY, SONIA (November 14, 1885–December 5, 1979), French-Russian painter, was a vital participant in the most creative years of the School of Paris. She collaborated closely with her husband Robert Delaunay in the creation of orphism, but her own contributions were long undervalued. It was only in her 80s and early 90s that she finally received due recognition as a superb colorist, a versatile painter and designer, and the grande dame of abstract art.

Sonia Delaunay was born to a Russian-Jewish family in the village of Gradizhsk in the Dnieper region of the Ukraine. She was the youngest of three children of Elie Stern, a manufacturer, and his wife, Anna Terk Stern. At the age of five she went to live in St. Petersburg with her maternal uncle, Henri Terk, a lawyer who later adopted her. Her intense and instinctive feeling for color is sometimes attributed to her background.

Sonia grew up in a world of cultural sophistication and money; she spent two or three months of every year in Finland and traveled with her foster parents to Switzerland and Italy, where the family visited museums. When she was visiting Berlin in 1897, the eminent artist Max Liebermann, a friend of her uncle, gave her her first box of paints.

In 1903 Sonia was sent by her foster parents to Germany, where she spent two winters studying painting and drawing in Karlsruhe. She resented the severe discipline imposed by her drawing teacher, Professor Schmidt-Reutte, but during these months in Karlsruhe she became acquainted with the newest trends in German painting. She also read Meier-Graefe's pioneering book on impressionism and discovered the work of Cézanne.

Sonia arrived in Paris in 1905, the year of the fauve exhibit at the Salon d'Automne. She enrolled at the Académie de la Palette, which she later described as a "horrible art school." Her fellow students included Ozenfant, Segonzac, and other young artists still influenced by the Post-Impressionists. It is indicative of Sonia's independence of spirit that she found Matisse, then the leader of the most advanced trends in French painting, "too timid, too bourgeois." She was thrilled, however, by the work of Gauguin and Van Gogh.

In 1906 Sonia was living in a pension on the Boulevard Montparnasse and had a studio in the rue Campagne-Première. The influence of Gauguin and Van Gogh was evident in the studies of peasant women she painted during a summer trip to Finland in 1907 and in two remarkable canvases executed in Paris in the same year—*Philomène,* a female portrait with some fauve elements, and the vibrant *Yellow Nude,* which is close to the work of the German Expressionists particularly Kirchner, without sacrificing her own warm palette.

Her family was eager for her to return to Russia and to the relative stability and security of bourgeois life, but Sonia had other ideas. Through a friend she met the noted German art collector and writer Wilhelm Uhde, who in 1901 gave Sonia her first solo exhibition (and her only major one-person show before 1953) in his gallery in the rue Notre-Dames des Champs. A sensitive and intelligent man of great integrity, Uhde accepted Sonia's suggestion of a "marriage of convenience" which would enable her to remain in Paris, and they were married in London early in 1909. Apart from the practical considerations, their relationship was based on warm friendship and a shared passion for art, but not on romantic attraction. Uhde introduced Sonia to Braque, Picasso, Derain, Pascin, and other luminaries of the Paris art world. She was particularly impressed with an articulate young painter with a pink face and clear eyes, Robert Delaunay. She first encountered him in 1907, when he was doing his military service. They met again the following year at one of Uhde's evenings. "I was carried away by the poet in him, the visionary, the fighter," she recalled. Delaunay was bursting with new ideas, especially about the color theories of the chemist Eugène Chevreul, and eager to expound them; he was about to begin his "Saint-Séverin" series and was

°də lā nā´

excited by his recent discovery of the paintings of the Douanier Rousseau.

There was an immediate rapport between the two young artists. Their friendship soon deepened into love and in 1910 Wilhelm Uhde gallantly agreed to a divorce. Sonia and Robert were married in November and moved to the rue des Grand-Augustins, where they kept their studio until 1935.

Different in temperament, Robert and Sonia were mutually supportive. Robert, with his round face and florid complexion, was loquacious and cheerfully argumentative; Sonia, a handsome, dark-haired young woman, was self-assured but less verbal than her husband. Robert described her as "Russian by birth but French by nature." She had a practical sense in day-to-day living which her husband lacked. Theirs was one of the happiest and most productive partnerships in the history of 20th-century art.

In 1909 Robert painted the first of his famous "Eiffel Tower" series. He was evolving the style that the poet Guillaume Apollinaire later named "orphism," an amalgam of fauve color, futurist dynamism, and analytical cubism which sought to emulate the rhythms but not the appearance of nature. His work and his ideas had a strong influence on Sonia, and about 1911 she abandoned her figurative, fauve-expressionist style for a more abstract idiom. Her painting in the years that followed had many similarities to Robert's and she was long considered to be in his shadow, but her feeling for color was more instinctive and emotional, her imagery in painting more restricted, and the basis of her art less intellectual.

In January 1911, their son Charles, a future jazz historian, was born. Sonia made him a patchwork blanket that is often called her first abstract work. Its design undoubtedly influenced the color-square paintings of Paul Klee. The blanket is now in the Musée d'Art Moderne de la Ville de Paris.

The Delaunays' home was a meeting place for some of the era's most gifted artists, writers, and musicians, among them the Douanier Rousseau (until his death in 1910), Fernand Léger, and the poets Guillaume Apollinaire and Blaise Cendrars, whom Sonia called "the truest and greatest poet of our time." Early in 1913, Sonia made a collage of cutout rectangles of paper for the binding of Cendrars's well-known poem Les Pâques a New York.

Robert Delaunay, in his "Eiffel Tower" and his "Windows" paintings, had developed the idea of "simultaneity," a kaleidoscopic combination of forms, rhythms, and colors to convey the multiple energies and sensations of modern life,

including the new vibrations generated by electrical power. Sonia applied these concepts in her own way in her collaboration with Cendrars on the first "simultaneous" book—the poet's La Prose du Transsibérien et de la Petite Jehanne de France. (It was estimated that her dynamic designs printed on folded sheets of paper would, unfolded and laid end to end, equal the height of the Eiffel Tower.)

A productive year for Sonia Delaunay was 1913. Gifted with a special flair for the decorative and applied arts, she designed the first "simultaneous dresses," disposing colors and shapes so as to mold and enhance the body's natural contours. She also made several studies for Bal Bullier (Musée d'Art Moderne, Paris), a futurist painting inspired by a popular dance-hall in Montparnasse. In the same year she sent 20 paintings and objects of her own design, including the Cendrars book-binding, to the Deutscher Herbstsalon in Berlin. Robert had painted Disques, his first purely nonobjective work, in 1912. The disc, with its references not only to the sun but also to electric light bulbs, became a favorite theme with both artists. One of Sonia's most vibrant color abstractions, Prismes electriques, inspired by the color and circular light effects of the electric street lamps on the Paris boulevards, was exhibited in the 1914 Salon des Indépendants along with Robert's monumental Hommage à Blériot, which was based on themes of aviation and the Eiffel Tower.

When war broke out in August 1914, the Delaunays were vacationing in Fuenterrabia, in the Basque region of northern Spain. Robert had been invalided out of military service in 1908 and the Delaunays decided to settle in Madrid. In 1915 they moved to the milder climate of Lisbon, where they remained until 1917 and were welcomed as celebrities by the painters of the Portuguese avant-garde. Their stay in Portugal was marred by one ridiculous episode: the French consul is said to have accused the Delaunays of using their "simultaneous discs" to signal German submarines in the Atlantic. Also, their correspondence in the prewar years with Franz Marc, August Macke, and other German artists of the Blaue Reiter group made the authorities suspicious.

Sonia noted that "the light of Portugal was not violent, but exalted every color," and thus the Portuguese experience heightened the Delaunays' sensitivity to the interplay of warm and cool colors. Sonia was also attracted by the costumes, artifacts, peasant crafts, and children's toys of Portugal; under the spell of this colorful environment she combined figurative and descriptive elements with her more abstract idiom.

Marché au Minho (1916), painted in encaustic on canvas, is a market scene, with long-horned cattle, an aqueduct, and peasant women with colored patches on their clothes. Her Portuguese still lifes contain some elements of fauvism and all her Portuguese paintings convey a feeling of joy and contentment.

In 1915 Sonia Delaunay's works were exhibited in the Nya Konstgallerien, Stockholm, and at Blomquists Kunsthandel, Oslo. Among the paintings shown were the highly schematized *Danseuse* and self-portrait. Heads and bodies were made up of half-circles comprising arc-bands of resonant color.

In 1917 the Delaunays settled in Vila do Conde, near Porto, and rented a villa which they named "Le Simultané." Later in the year they left Portugal for Spain. In Madrid they met Serge Diaghilev, who introduced them to the composers Manuel de Falla and Igor Stravinsky, and invited Robert to design sets and Sonia costumes for a London revival of Fokine's ballet *Cléopâtre.* The original 1909 production had been designed by Léon Bakst, but Sonia made no attempt to emulate in her costumes the lush exoticism of Bakst; apart from a certain frontality and Cleopatra's serpent headdress there were only hints of ancient Egypt. Instead Sonia gave free rein to her own concepts of color and form in such piquant details as the concentric circles of color and protuberant nipples of Cleopatra's breasts. Some critics felt that there was a conflict between the actual rhythms of the dance and Sonia's costumes, which even in repose suggested motion.

The Delaunays returned to Paris in 1920. Robert had been disinherited by his uncle, who disapproved of his career, and Sonia had lost the income she had received from rents paid on her apartments in St. Petersburg until the Russian Revolution of October 1917. "We were left penniless," Sonia recalled, "but we wept for joy." Sonia's strong practical sense corresponded with her desire to eliminate the distinction between "free" and applied art that had first appeared in the Renaissance. While Robert's geometry of color and shape was expressed chiefly in painting, Sonia, out of sheer necessity, succeeded in extending the same aesthetic into the decorative arts.

Sonia was not interested in fashion as such—she left innovations of shape to the couturiers—but she had strong feelings about fabrics and textiles as expressions of the modern sensibility. Her "simultaneous dresses" of 1913, with their severe geometric design and vivid color, had been amazingly prophetic of the postwar Art Deco style. In the 1920s she effected what amounted to a revolution in fashion, designing thousands of fabrics that were printed, mostly on silk, in Lyon. Many of her motifs were variations of themes from her paintings.

In collaboration with the French couturier Jacques Heim, Sonia opened her own Boutique Simultanée, which was represented in the Salon d'Automne of 1924 and at the 1925 Exposition des Arts Décoratifs that is now regarded as the climax of Art Deco. It was also in 1925 that she created for a journalist friend her first painted automobile, a perfect symbol of the Jazz Age. Sonia's boutique attracted attention throughout Europe—Gloria Swanson and Nancy Cunard were among her clients—until the economic collapse of the early 1930s brought an end to the enterprise.

Many critics have chided Sonia for devoting so much time and energy to such "lesser" genres as fashion design, furniture coverings, rugs, hangings, and book jackets, but for her it was important to apply the principles of abstract art to the redecoration of modern life. Her designs using stripes, zig-zags, diamond shapes, spirals, and colored circles find an echo in the work of such contemporary American artists as Kenneth Noland and Frank Stella, but without their paintings' cool, hard edge quality. Sonia, like her husband, always remained in the French painterly tradition.

Between the wars, the Delaunays lived in the Boulevard Malesherbes, where they entertained many of the Surrealist poets. In 1930–31 several of Sonia's works were included in an exhibition organized by the American Federation of Arts, "Decorative Metalwork and Cotton Textiles," which traveled to the Museum of Fine Arts, Boston, the Metropolitan Museum of Art, New York City, the Art Institute of Chicago, and the Cleveland Museum of Art.

By the mid-'30s Sonia had returned to painting. In 1936 the Delaunays were commissioned to paint enormous murals for the Paris International Exposition of 1937. Robert painted *Air, Iron and Water* and *Red Still Life* for the Palais de l'Air and Sonia completed three huge, spectacular murals for the Palais de l'Air and the Palais des Chemins de Fer: *Portugal, Les Voyages Lointains,* and *Moteur d'Avion.* She was awarded a gold medal.

After the German invasion of France in 1940, the Delaunays fled to the Midi. Robert, who had been gravely ill for some time, died in Montpellier on October 25, 1941. Sonia spent the remainder of the war years with her close friends Jean Arp and Sophie Taueber-Arp in Grasse, where she produced mostly small gouaches. Sophie's death in 1943 was another severe blow. In later

years Sonia suggested that her discovery of black as an expressive color in the postwar years was related to tragic events of the 1940s.

Back in Paris in 1945, Delaunay participated in all the groups that were seeking to reestablish abstract art. She exhibited with the group called Art Concret, helped to found the first Salon des Réalités Nouvelles, and in 1947 took part in the exhibit "Tendances de l'Art Abstrait" at the Galerie Denise René, Paris.

Apart from the addition of black to her palette, Sonia's paintings in oil and gouache from 1946 to her death in 1979 were logical extensions of her earlier work. They relate to one or another of her three main motifs, which she termed "endless rhythm," "rhythm-color," and "colored rhythm," with rhythm understood to be a combination of light and movement. In 1956 she took up lithography again, achieving the same intense, vibrant purity of color as in her paintings.

Delaunay devoted much time and effort to preserving her husband's work and perpetuating his memory, and although she continued to work and to exhibit, her own contribution was not widely recognized until 1967, when she was given an important retrospective exhibit at the Musée National d'Art Moderne, Paris. It seemed fitting that in 1970, at the age of 85, she was included in a group show in Lausanne called "Jeunesse et Présence," along with such lively veterans as Picasso, Miró, and Calder.

In 1972, Sonia Delaunay published new editions of her lithographs, painted a dozen large canvases and many smaller ones, began work on an edition of Rimbaud's *Illuminations,* and supervised the completion by Aubusson of a series of wall-hangings. In 1975 her works were shown in the Pavillon de Marsan in the Louvre. The following year, when she was 91, she oversaw the selection and installation of a large Robert Delaunay retrospective in the Orangerie des Tuileries. In the same year she was made a Chevalier de la Légion d'Honneur. In 1977 a private gallery in Paris organized limited editions of shawls, scarves, tablecloths, and plates that she had designed.

During her last years Sonia Delaunay lived in a small but comfortable two-story apartment in a quiet street off the Boulevard Saint-Germain. For the most part she worked on small oils and gouaches and made frequent entries in her journals. The rooms were enlivened with plants and flowers; on the walls were her own creations, paintings by her husband, and works by Jean Arp, Fernand Léger, and other friends and colleagues of the past. She was amiable and serene, but also had an imperious side that is reflected

in her nicknames, "the tsarina" and "Catherine the Great." She died in her Paris apartment in late 1979.

Although she was opposed to any kind of literary element in painting, Sonia Delaunay often found analogies between the work of poets and writers and her own approach to art. In a short essay written in 1958, she declared, "The theater of color must be composed like a verse of Mallarmé, like a page of Joyce." Elsewhere she said, "Just as in written poetry it is not the assembling of words that counts but the mystery of creation which either does or does not convey an emotion—so too with colors, it is the poetry, the mystery of an inner life which emerges, radiates, and communicates itself to the beholder."

EXHIBITIONS INCLUDE: Gal. Notre Dame des Champs, Paris 1907; Nya Konstgal., Stockholm 1915; Blomquists Kunsthandel, Oslo 1915; Gal. Fermé la Nuit, Paris 1929; Gal. Bing, Paris 1953; Rose Fried Gal., NYC 1955; Städtisches Kunsthaus, Bielefeld, W. Ger. 1958; Fetscherin Gal., Munich 1959; Nora Gal, Jerusalem 1960; Brook Street Gal., London 1961; Gal. Denise René, Paris 1962; Mus. d'Art Moderne, Paris 1967; Gal. del Naviglio, Milan 1969; Gimpel-Weitzenhoffer Gal., NYC 1970; Mus. of the Univ. of Texas, Austin 1970; Gimpel Gal., London 1971; Pavillon de Marsan, Mus. du Louvre, Paris 1975. GROUP EXHIBITIONS INCLUDE: Deutscher Herbstsalon, Berlin 1913; Salon des Indépendants, Paris 1914; Salon d'Automne, Paris 1924; Exposition des Arts Décoratifs, Paris 1925; "Trente ans d'art indépendant 1884–1914," Grand Palais, Paris 1926; "Trente ans d'art indépendant 1884–1914," Grosse Berliner Kunstausstellung, Berlin 1926; "Decorative Metalwork and Cotton Textiles," Mus. of Fine Arts, Boston 1930; "Decorative Metalwork and Cotton Textiles," Metropolitan Mus. of Art, NYC 1930–31; "Decorative Metalwork and Cotton Textiles," Art Inst. of Chicago 1930–31; "Decorative Metalwork and Cotton Textiles," Cleveland Mus. of Art 1930–31; "Tentoonstelling abstrakte Kunst," Stedelijk Mus., Amsterdam 1938–39; "Réalités Nouvelles," Gal. Charpentier, Paris 1939; "Art Concret," Gal. Drouin, Paris 1945; "Tendances de l'Art Abstrait," Gal. Denise René, Paris 1947; Bezalel Mus., Jerusalem 1952; "Great Women Artists," Delius Gal., NYC 1955; "Exposition d'Art Français," Tokyo 1961; Nat. Gal. of Canada, Ottawa 1965; "L'Avant-Garde de l'Europe de l'Est 1910–1930," Akademie der Künste, Berlin 1967; "Jeunesse et présence," Gal. Alice Pauli, Lausanne, Switzerland 1970; Pittsburgh International, Carnegie Inst. 1970.

COLLECTIONS INCLUDE: Mus. Nat. d'Art Moderne, Mus. de la Ville de Paris, and Mus. des Arts Décoratifs, Paris; Mus. des Beaux-Arts, Lille, France; Mus. des Beaux-Arts, and Mus. des Tissus, Lyons, France; Mus. des Beaux-Arts, Grenoble, France; Tate Gal., London; Städtisches Kunsthaus, and Deutsches Spielkarten Mus., Bielefeld, W. Ger.; Stedelijk Mus., Amsterdam; Nat. Gal. of Canada, Ottawa; MOMA, NYC; Joseph Hirshhorn Foundation, Washington, D.C.; Mus. of New Delhi, India; Nat. Bezalel Mus., Jerusalem.

ABOUT: Clay, J. The Golden Years of Visual Jazz: Sonia Delaunay's Life and Times, 1965; Cohen, A.A. Sonia Delaunay, 1975, (ed.) The New Art of Color: The Writings of Robert and Sonia Delaunay, 1977; Comfort, C. F. and others "Robert and Sonia Delaunay" (cat.), Nat. Gal. of Canada, Ottawa, 1965; Current Biography, 1977; Damase, J. "Sonia Delaunay" (cat.), Gal. de Verenne, Paris, 1971, Sonia Delaunay: Rhythms and Colors, 1972; Lhote, A. Sonia Delaunay, ses peintures, ses objets, ses tissus simultanés, ses modes, 1925. *Periodicals*—Art News March 1975, March 1980; Arts (Paris) February 26–November 3, 1964; New York Times December 6, 1979, February 17, 1980; New York Times Magazine July 16, 1978; XXe siècle (Paris) no. 7 1956, May 1963.

PAUL DELVAUX

***DELVAUX, PAUL** (September 23, 1897–), Belgian painter, writes: "All subjects can serve to express an atmosphere. Railway stations, skeletons, temples, the sea, lamps, all these elements, while being reproduced very faithfully, become strange and even disturbing if you place them in a special context which transforms their truth (or their reality) into a more essential truth and gives them a far more intense interest. This, I believe, sums up what I have tried to do in my pictures since 1936."

A leading Belgian Surrealist, Delvaux was born in Antheit, near Huy in the province of Liège, Belgium. His father, Jean Delvaux, was a lawyer at the Court of Appeals in Brussels. Paul attended primary school in the Saint-Gilles district of Brussels. Music lessons were given in the school's museum room, where stuffed animals were displayed in glass cases. Paul was fascinated by an écorché in papier-mâché, and by the skeletons of a man and a monkey.

The worlds of fantasy and mythical antiquity acted powerfully on Delvaux's imagination in his early years. At the age of ten, he read the edition of Jules Verne's *Voyage to the Center of the Earth* with vivid illustrations by Edouard Riou. From 1910 to '16 he studied Greek and Latin at the Athénée de Saint-Gilles, and was an avid reader of the *Odyssey*.

In 1916 Delvaux enrolled in the Académie des Beaux-Arts, Brussels, in the architecture class of Pierre-Joseph van Neck. A fellow student remembers that he drew, in charcoal on brown paper and touched up with gouache, a huge version of *The Capture of Alesia by the Romans*. In 1918–19 he studied decorative painting with the Symbolist artist Constant Montald. In the summer of 1919, which Delvaux and his family spent in Zeebrugge on the Belgian coast, the painter Frans Courtens, who admired the young

man's talent, helped to overcome his parents' opposition to his pursuing a career in art.

In 1920 Delvaux took evening classes at Brussels's Académie des Beaux-Arts and received a thoroughly classical training. His first works were in the style of postimpressionism, and in 1922 he painted his first railway stations, a subject to which he often returned after becoming a Surrealist. By 1924 Delvaux had a studio in his parents' house in Brussels, and the following year he exhibited at the Galerie Breckpot, Brussels, with his friend Robert Giron, later the director of the Palais des Beaux-Arts, Brussels. About 1925 he painted a large-scale family portrait titled *Femme au grand chapeau et autres personnages* (Woman with a Big Hat and Other People).

Delvaux's early work was influenced by the Belgian Expressionists Constant Permeke and Gustave de Smet, and his paintings of 1926–27 show the influence of James Ensor, a Belgian master of paintings of the fantastic and macabre. He also admired the classical draftsmanship of David and Ingres. In 1926 Delvaux visited Paris and was overwhelmed by an exhibition of Giorgio de Chirico's metaphysical paintings at Paul Guillaume's gallery. "I was haunted by his poetry of silence and obsession," Delvaux said. On his return to Brussels he saw surrealist work at the Galerie L'Epoque and met René Magritte, who, though a year younger than Delvaux, was already an established Surrealist painter. It was the influence of de Chirico and Magritte that guided Delvaux to surrealism, the style he adopted about 1936.

In the late '20s Delvaux was active in the artis-

*del võ´, põl

tic life of Brussels. His painting, *Le Couple* (1929; Musée Royaux des Beaux-Arts de Belgique, Brussels), with its muted coloring and the peasantlike heaviness of the two figures, shows that he was still influenced by Permeke and de Smet. But the painting also foreshadows the artist's later surrealistic studies of the female nude and of erotic themes. In *Le Lever* (1931–32) the female nude and the bedroom interior were depicted in expressionistic realism, but the view from the bedroom window showed classically proportioned buildings with no human beings, creating the strange, dreamlike atmosphere which would soon pervade all of his work.

Most of Delvaux's surrealist paintings depict nude or seminude women, and these studies of the female form were anticipated in his work of the late '20s and early '30s. *Une Grande maternité* (1931–32), which Delvaux later destroyed, could be given a Freudian interpretation to reveal a deep mother fixation. Commenting on the archetypal woman who frequently appears in Delvaux's mature work, the French critic Otto Hahn speculated that the artist had had "a childhood protected by the authority of an adored and respected mother. According to Hahn, Delvaux's discovery of surrealism coincided with the death of his mother, Laure, on the night of December 31, 1931.

It was in 1936 that Delvaux realized that de Chirico and Magritte "were the springboards that brought me into my own world." Delvaux's work is in the style of figurative surrealism. Like de Chirico, he uses deep perspective and, like Magritte, he depicts objects realistically. In *Femme au Miroir* (1936, Woman at the Mirror) the setting is a dreamlike grotto that opens onto a desert. The full-breasted nude woman with the wide-eyed, impassive expression, the delicate oval mirror, and the lace festoon is painted in a style reminiscent of the cool, erotic mannerism of the 16th-century School of Fontainebleau. This and other, similar paintings were exhibited in a 1936 showing of Delvaux and Magritte in the Palais des Beaux-Arts, Brussels. The exhibition, which had a succès de curiosité, demonstrated that Delvaux's surrealism was more ingratiating and less disquieting than Magritte's.

Another early surrealist work was *Femme à la rose* (Rose Woman) in which the rose grows from the floor of a long corridor which extends in perspective towards a distant blue sky, and two women, like sleepwalkers, pass without meeting. Somnambulistic men and women who pass but fail to see each other, fail to awaken from their solitude, is a recurring motif in Delvaux's post-1936 work.

In 1937 Delvaux and Magritte joined a newly formed avant-garde group in Brussels, Les Compagnons de l'Art (Companions of Art). The next year Delvaux participated in the International Surrealist Exhibition at the Galerie des Beaux-Arts, Paris, which was organized by André Breton and Paul Eluard. Although Delvaux never joined the circle of Surrealists around Breton, his contribution to surrealism was recognized by Breton and Eluard. Breton described Delvaux's work as "dream photography," and Eluard dedicated the poem *l'Exil* to him.

Delvaux's two trips to Italy, in 1938 and '39, further stimulated his fascination with classical settings. In 1939, in Brussels, he painted the first of several pictures thematically related to his painting *The Phases of the Moon* (1939; Museum of Modern Art, New York City). One recurring character in those works is Jules Verne's learned professor Otto Lidenbrock, who is so absorbed in scientific discussions that he is blind to the wonders of the world around him and to the nearby presence of the sensuous nude women. In *The Man in the Street* (1940) a man reading his newspaper, oblivious to three solemn nudes among the trees, wears the characteristic garb (dark suit and bowler hat) of many of Delvaux's and Magritte's male figures. One of Delvaux's important paintings, *Pygmalion* (ca. 1939), is a novel rendering of the Pygmalion myth, in which the artist himself, depicted in early youth, has become the statue and a flesh-and-blood Galatea embraces him and seeks to bring him to life. Commentators have interpreted Delvaux's strange juxtapositions as symbols of repression, voyeurism—in many paintings a well-dressed man peers at nude women, who ignore him—and the utter failure of the sexes to communicate with each other.

In May 1940 the German Army attacked and occupied Belgium, and the panic of the Belgian people inspired Delvaux's painting *La Ville inquiète* (1941, The Troubled City), which is far more crowded and animated than his usual compositions and recalls Poussin's *Rape of the Sabines*. The grimness of the war years may account for the emergence of the macabre in Delvaux's work.

Skeletons, based on the careful study of bones and skulls he had made two years earlier in the Museum of Natural History, Brussels, began to appear in Delvaux's compositions in 1943. This was in the tradition of James Ensor, but the voluptuous neoclassicism of Delvaux's work had not disappeared: about 1944 he painted several versions of *Sleeping Venus,* with echoes of Giorgione and Titian as well as Ingres's *Stratonice.* (One *Sleeping Venus* is in the Tate Gallery, London.) After the Liberation, in 1944–45, a Del-

vaux retrospective was held at the Palais des Beaux-Arts, Brussels, which included a film on his work with commentary by Paul Eluard and a monograph by René Gaffé, *Paul Delvaux ou les rêves éveillés* (1945, Paul Delvaux or the Awakened Dreams).

In the postwar period surrealism became fashionable in America and lost its shock value in Europe—a development viewed with horror by orthodox Surrealists like Breton. In 1945–46 Delvaux, Max Ernst, and Salvador Dali submitted sketches to the Hollywood producers Albert Lewin and David Loew on the theme of *The Temptation of St. Anthony* for the film *Bel Ami.* In 1947 Delvaux designed the sets for Jean Genet's ballet, *Adame miroir,* presented in 1948 at the Théâtre Marigny, Paris. There is a strong theatricality in Delvaux's painting *La Première rose* (1947, The First Rose), in which Greco-Roman and modern elements are combined, as in the juxtaposition of the dark-haired, fully dressed woman and the blond nude, each holding a small rose and casting a long shadow. In 1950 Delvaux was appointed professor of monumental painting at the School of Art and Architecture, Brussels; he taught there until 1962.

In the 1950s Delvaux painted several large murals, sometimes using trompe l'oeil techniques. One of the most important was completed in 1959 for the Palais des Congrès, Brussels, and another was installed in 1960 at the Institute of Zoology, Liege. Delvaux was represented at the Venice Biennale of 1956 in an exhibit at the Belgian pavilion titled "Le Fantastique dans l'art" (The Fantastic in Art).

Delvaux and his wife, the former Anne Marie de Maertelaere, whom he had married in 1949, settled in 1955 in Boitsforts, a suburb of Brussels. Many of Delvaux's paintings from this period are of the trains and railway stations of Brussels which had captured his imagination in his youth. One of the most haunting of these is *Tramway de notre enfance, Solitude* (1955, Tramway From Our Childhood, Solitude; Mons Museum, Belgium), in which a little girl, seen from the back, stands in a deserted street as the tram car approaches.

Delvaux's naturalistic surrealism gained influence outside of Belgium in the 1960s. The filmmaker Alain Resnais and the writer Alain Robbe-Grillet were directly inspired by the dreamlike vistas and enigmatic imagery of Delvaux's paintings in making their landmark experiment in cinematic surrealism, *Last Year at Marienbad (1961). In 1962 a large Delvaux retrospective was held in Ostend*, Belgium; many viewers were scandalized by *La Visite* (1939), in which a nude boy enters a room where a blond

nude sits cupping her ample breasts in her hands. The treatment is cool and detached, notwithstanding the painting's sensual and voyeuristic undercurrent. Stylistically, *La Visite* bears affinities with the work of Balthus. Delvaux was awarded Belgium's Quinquennial Prize in 1965.

In the United States Delvaux is less well known than in Europe, and his work has had a mixed reception. Reviewing his show at the Julian Levy Gallery, New York City, a New York *Herald Tribune* critic found the scenes unrelated to Greek and Roman ideas "more dream-like and romantic than his classical designs, which are interesting but depend too much on the use of stock formula." Henry McBride, writing in the New York *Sun*, felt that Delvaux too often repeated the same hallucinatory vision. In 1963, when Delvaux had a solo exhibition at the Staempfli Gallery, New York City, there was a revival of interest in surrealism and *Time* magazine (June 28, 1963) described Delvaux's paintings as "so full of chilling secrets that they rarely fail to haunt." But Hilton Kramer of *The New York Times* called Delvaux's paintings in the Staempfli Gallery "the most witless parody of academic painting in modern times," an example of surrealist art "degenerating into academic pastiche." However, a *Christian Science Monitor* critic praised Delvaux's "painted silences" and was especially intrigued by his railroad pictures. "Almost compulsively does he dwell upon slight and seemingly trifling elements, but they add up and make a "puzzling and often fascinating inventory of fantastic adventure."

Paul Delvaux still lives and works in a small house in Boitsforts, though he also maintains a residence in Brussels. He is a tall man who stoops slightly, and his aristocratic features are made even more distinguished by his mane of long white hair. A very private man, Delvaux is nonetheless unfailingly courteous and obliging. He paints in blue jeans and sandals in a studio against one wall of which is a row of skulls, with several sets of toy trains nearby. Delvaux dismisses Freudian explanations of trains as symbols of the male sex drive as he does the view that trains are a metaphor for death; he paints trains, he said, because they remind him of happy trips he took in his childhood. His sensual, somnambulistic nudes, described by Otto Hahn as "vacant-eyed Jocastas," are, Delvaux claims, merely "extras" in a "poetic composition." However, they convey a sense of malaise, and Delvaux admits that "eroticism has caused me no end of problems."

EXHIBITIONS INCLUDE: Palais des Beaux-Arts, Brussels 1944–45; Julian Levy Gal., NYC 1946, '49; Gal. Drouin, Paris 1948; Palais des Beaux-Arts, Charleroi,

Belgium 1957; Mus. des Beaux-Arts, Ostend, Belgium 1962; Staempfli Gal., NYC 1963, '69; Palais des Beaux-Arts, Lille, France 1966. GROUP EXHIBITIONS INCLUDE: "Le Sillon," Brussels 1924; Gal. Breckpot, Brussels 1925; Palais des Beaux-Arts, Brussels 1936; International Surrealist Exhibition, Gal. des Beaux-Arts, Paris 1938; "Le Fantastique dans l'art," Venice Biennale 1956; "Peintres et sculpteurs de la generation de 1900," Mus. Royal des Beaux-Arts, Antwerp 1966; "Fantastic Art," Chicago Mus. of Contemporary Art ca. 1968; "Painters of the Mind's Eye: Belgian Symbolists and Surrealists," New York Cultural Center 1974.

COLLECTIONS INCLUDE: Mus. Royaux des Beaux-Arts, Brussels; Mus. des Beaux-Arts, Ghent; Mus. des Beaux-Arts, and Mus. de l'Art Wallon, Liège, Belgium; Mus. des Beaux-Arts, Ostend, Belgium; Koninglijk Mus. von Schone Kunsten, Antwerp; Mus. Boymans-Van Beuningen, Rotterdam; Landsmus., Hanover, W. Ger.; Mus. des XX Jahrhunderts, Vienna; Peggy Guggenheim Collection, Venice; Tate Gal., London; MOMA, and Rockefeller Univ., NYC; Brooklyn Mus.; Art Inst. of Chicago.

ABOUT: Butor, M. and others Delvaux, 1975; de Bock, P.-A. Paul Delvaux, der Mensch, der Maler, 1965; "Paul Delvaux" (cat.), Gal. Drouin, Paris, 1948; "Paul Delvaux" (cat.), Palais des Beaux-Arts, Lille, France, 1966; Gaffé, R. Paul Delvaux ou les rêves éveillés, 1945; Spaak, C. Paul Delvaux, 1948. *Periodicals*—Cahiers d'art (Paris) 1946; Christian Science Monitor July 5, 1963; New York Herald Tribune December 15, 1946; New York Sun February 18, 1949; New York Times March 15, 1969; Nouvel observateur (Paris) June 3, 1969; Time June 28, 1963, March 4, 1974.

***DERAIN, ANDRÉ** (June 10, 1880–September 8 [or 10], 1954), French painter, best known for his early work in the fauve style. The son of a prosperous pastry cook who also acted as a municipal councilor, Derain was born in Chatou, a small town on the Seine west of Paris. While going to school he helped with the family business, working as a delivery boy. As a student at a lycée in Paris he won prizes in drawing and science, but his parents, ambitious for him to become an engineer, sent him in 1986 to the Ecole des Mines. While in Paris Derain took lessons in painting and eventually—between 1898 and '99—was enrolled in informal classes taught by Eugene Carrière. One of his fellow students was Henri Matisse, several years his senior. Far from being influenced by Matisse's protofauve style, Derain at this point was painting landscapes recalling Corot. One of his few dated canvases, *The Road to Carrières* (1899), bears, however, suggestions of Cézanne or Gauguin with its planes of flat color. Other influences now crowded in as Derain began a close study and copying

ANDRE DERAIN

of the old masters in the Louvre. (It is reported that he was once ejected from the museum because the gallery attendants objected to his interpretations of a painting by Ghirlandaio.) Thus early was established Derain's studious, art-historical approach and the eclecticism of style that characterized his oeuvre and that once prompted Picasso, himself no mean borrower, to remark cynically: "Derain, guide to the museums!" Further academic study came in 1904 when he enrolled at the Académie Julian, much to the dismay of his great friend, the avant-garde painter and writer Maurice Vlaminck.

In July 1900 Derain had begun the lifelong friendship with Vlaminck that was to prove vitally significant to their careers. Vlaminck was an anarchist and supporter of Dreyfus, and his bohemianism greatly shocked Derain's staid bourgeois family—the more so when, in the winter of 1900–01, the two friends created a studio in an abandoned restaurant on an island in the Seine at Chatou. There they painted and entertained their free-spirited Parisian colleagues. Encouraged by Vlaminck's example, Derain now began to paint landscapes with simplified forms, in bold, pure colors; in later days he recalled this Chatou period as one when they were "always drunk with colour . . . and with the sun which imparts life to colour." It was Derain who, at the great 1901 Van Gogh exhibition in Paris, introduced Vlaminck to Matisse.

During Derain's years of compulsory military service (1901–04), he managed to continue painting: *The Ball at Suresnes* (1903) is a powerful if somewhat clumsily constructed scene of

°də ran´, än drä´.

soldiers at a dance hall; Derain is the tall soldier in the background. He also produced several portraits and his first book illustrations—these latter for two of Vlaminck's novels, *D'un lit à l'autre* (1902, From Bed to Bed) and *Tout pour ça* (1903, All for That). Most important of all, this period marks the beginning of Derain's long years of correspondence with Vlaminck. These letters, a direct, spirited outpouring of Derain's reactions to art and life, reveal his development as an intellectual—he was reading Nietzsche, Zola, and Balzac—and his growing skepticism about the anarchist and socialist views of his friends. Self-doubt and the questioning of ideas and institutions became a lifelong characteristic; as he wrote in one of these letters, "Doubt is everywhere and lies in everything."

Never very vocal about his own paintings—for his language, he declared, was the paintings themselves—Derain used his letters as a means of formulating general artistic theories, strong opinions he was capable of also expressing verbally. His friend the critic Georges Hilaire has described the painter's sometimes disdainful, lofty air as he held forth with friends, and Fernande Olivier, Picasso's mistress, described the youthful Derain as: "Slim, elegant, with a lively colour and enamelled black hair. With an English chic, somewhat striking. Fancy waistcoats, ties in crude colours, red and green. Always a pipe in his mouth, phlegmatic, mocking, cold, an arguer." Despite his disputativeness—which, for example, did not endear him to Gertrude Stein—and contrary to his later reputation as being the hermit of Chambourcy, Derain had many friends. His circle included, besides Vlaminck and Matisse, other painters such as Braque, Modigliani, Balthus, and the American Leland Bell; the sculptor Alberto Giacometti; and the writers Guillaume Apollinaire and Max Jacob.

Fond of good food and convivial gatherings, Derain also had the capacity for an enormous amount of hard, concentrated work. Prodigiously strong and athletic, this tall, imposing man was said to resemble the bust of a Roman emperor, with his massive head and aquiline nose, burly chest, and huge hands. A 1912 *Self-Portrait* and the *Last Self-Portrait* of 1953 confirm the description. In October 1907 Derain married Alice Princet, former wife of an insurance actuary, and moved from Chatou to a Montmartre studio. In 1941 his only child, André, was born, the son of one of his models; the child was later formally adopted by Mme. Derain.

While the great still life painted in 1904—a study of plates, decanters, and a large swath of crumpled cloth, all casually arranged on a table top—shows the continued influence of Cézanne, another work of the same year, *Bridge at Le Pecq,* reveals in its neoimpressionist, divisionist manner the beginning of the impact of Matisse's style on Derain. Matisse's comradeship and encouragement now became strongly influential; it is said that Matisse's respectable appearance and reasonable manner persuaded Derain's bourgeois parents to allow their son to become a full-time painter after his army stint was completed. In any case, the two artists worked together and painted one another's portraits (both now in the Tate Gallery, London).

The year 1905 was an important one for Derain. He joined Matisse at Collioure on the Mediterranean coast of France, and later in the year the influential dealer Ambroise Vollard (to whom Matisse had introduced him) bought up all the pictures in Derain's studio. Upon Matisse's advice, Derain exhibited several landscapes in Paris at the 1905 Salon d'Automne—together with, among others, Matisse, Othon Friesz, Rouault, and Vlaminck, the group subsequently known as the Fauves. It was around 1905, also, that Derain had his first show at the Berthe Weill Gallery, Paris. Two visits to London at Vollard's instigation, one late in 1905, the other in the following year, produced a number of vibrant pictures of Thames-side scenes. Like *The Dancer* (ca. 1906), *Portrait of Vlaminck* (1905), and the later *Woman with Shawl* (1908; posed for by Mme. Matisse), the Thames pictures represent Derain in his fauvist style and are among the best known and most acclaimed of his works. Although the London canvases are difficult to date precisely—a recurrent problem in any consideration of Derain's paintings—differences in style are apparent. Two views of the Houses of Parliament are more akin to neoimpressionism, whereas *Blackfriars Bridge* is a pronouncedly fauve work, solidly composed and painted in intense contrasts of color.

Traveling next to L'Estaque, the Provençal town where Cézanne had worked out his pioneering analysis of form, Derain painted the local scene. In *Turning Road, L'Estaque* (ca. 1906) there can be detected the influence of Gauguin, whose Tahitian painting Derain had had the opportunity to see in a local private collection; unlike some of Derain's earlier fauvist works, the forms here are even more solidly conceived, more definitely outlined, and the composition as a whole is more deliberate. At this point, as Derain wrote to Vlaminck, he was seeking a resolution to his self-doubts, looking for a permanent artistic form, "something which . . . is fixed, eternal and complex." Years later, however, the ever ambivalent Derain was capable of reversing this with the observation that "Cézanne disturbs

me. His efforts to achieve perfection are incompatible with the liberty of human thought. He has been searching for the absolute which inhibits the natural flowering of life. Over-indulgence in reality spells death."

Experiments with other media followed. In 1906, again at Vollard's behest, Derain executed a series of over one hundred designs for ceramic ware: tea sets, plates, and vases. In 1907 he made his first experiments in graphic art, a series of wood engravings, and did two of his first sculptures, human figures, in stone. Also in 1907, Derain signed his first contract with Daniel-Henri Kahnweiler, thus joining those other shapers of 20th century art, especially Picasso and Braque, who had their earliest showings at Kahnweiler's Paris gallery.

About 1908 Derain, now a member of the Picasso–Braque circle, began to be attracted to cubism. In 1909 he painted with Braque at Carrières-Saint-Denis, and the following year painted with Picasso in Cadaqués, Spain. However, Derain was never directly allied with the movement; his interest was, rather, a manifestation of his devotion to Cézanne, from whose principles of formal organization cubism was largely derived. This reverence was, most likely, increased after Derain had viewed the famous 1907 Cézanne retrospective in Paris. Abandoning fauvism and its brilliant colors, Derain now began to paint austere, classically composed landscapes and still lifes using a darker palette and simpler color harmonies than theretofore. As he noted, "If you rely on the sheer force of the color as it leaves the tube, you won't get anywhere. That's a theory for a dyer." By 1910 his *The Old Bridge at Cagnes* revealed the growth of what was to be characteristic of Derain's style: a solidly architectonic underpinning. *Saturday* (1911–14), a domestic grouping, *The Two Sisters* (1914), and *The Last Supper* (1914) are notable examples of his work in the years just before World War I. Full of references to the art of earlier periods, they have a basic monumentality and a detached and gravely serious manner.

Because of this eclectic approach it is difficult to divide Derain's career into stylistic categories, and the problem is complicated by the absence of dating. Nevertheless, it is generally agreed that his most innovative work was done before World War I. From 1914 to '18 he served in the French army, during which time, in lieu of painting, he did pastels and drawings and made masks from copper artillery shell cases. After demobilization, rejecting both fauvism and cubism—which latter, as early as 1917, he had dismissed as "really very stupid"—he turned to older, more realistic and classic modes of paint-

ing. Even before this, of course, Derain's search for a permanent, fixed artistic form had been manifested in various enthusiasms for the art of other eras and cultures. Thus right before the war, in 1912 or '13, his discovery of the Italian Primitives gave a certain Gothic quality to such paintings as *The Two Sisters,* and in 1914 he became interested in Coptic mummy portraits.

In 1919 Derain—and Picasso and Matisse as well—turned to more naturalistically modeled portraits and figures of nudes or harlequins and to realistic landscapes. Subsequently, the influence of Italian 15th-century painting in general, and of Raphael in particular, as well as of Pompeian wall paintings can be detected—the latter in his *Portrait of an Englishwoman* (ca. 1920). From the 1920s on, Derain, aloof from contemporary art trends and from any alliance with abstractionism, continued to hold his own course, even refraining in later years from exhibiting. As his friend Alberto Giacometti remarked, "Everything that appeared true and valid for the majority of painters today meant nothing to Derain. Everything to him is a dark abyss in which you are bound to lose your way." It was not until after his death that the obscurity which veiled the last part of Derain's life was lifted; numerous retrospective exhibitions were mounted and scholarly reevaluation of his contribution undertaken.

Between 1920 and 1930, while maintaining a studio in Paris, the artist traveled extensively, to Rome in 1921 to look at the Raphaels, and throughout the south of France. In 1935 he separated himself further from the mainstream when he moved from Paris to live in seclusion in Chambourcy, a small village northwest of *la capitale.* From 1930 on, his paintings—landscapes, still lifes, and studies of nude models—became more and more conservative, with increasing references to art of the past, an amalgam of styles and forms which is difficult to categorize. Some critics have dismissed this later body of work, despite its evident technical quality, as uninspired and static, overly derivative and, in the case of the nudes especially, insipid. Such judgments have prompted, and continue to rouse, much debate, however.

A certain political notoriety has further clouded Derain's reputation. During the occupation of France he was reported to have been seen frequently in collaborationist circles; in 1940 he worked in Vichy, seat of the puppet French government, and in 1941 (together with Vlaminck, Friesz, Kees van Dongen, and André Dunoyer de Segonzac) he spent a week in Germany at the invitation of the Nazi government. A popular interpretation of this vacation in hell is that the

artists were naive and allowed themselves to be coerced into the trip on the promise that, in exchange, French artists who had been interned during the occupation would be freed. In any case, although Derain was allowed to live without harassment throughout the war, a painting of his, *The Return of Ulysses* (ca. 1931), which hung in the Chambourcy studio, was slashed by the Germans (it was restored in 1954). Despite the fact that Derain was shunned after the Liberation, in 1944, when he returned to Chambourcy, he was offered (reportedly) the directorship of the Ecole Nationale des Beaux-Arts, a post which he turned down.

Meantime, Derain continued to work successfully as an illustrator and in other media, showing a freedom and a lightheartedness that is absent from his paintings. The bronze sculptures he began to execute at the beginning of World War II show the influence of several forms—African, Romanesque, archaic—that variously attracted him. In 1919 he had done sets and costumes for the London production of Diaghilev's ballet *La Boutique Fantasque* (set to Respighi's adaptation of Rossini's music); Derain's gay designs won great acclaim, and from 1932 to '36 he worked on several other Ballets Russes productions. In 1945 he did stage sets in London once again, and at the very end of his life, in 1951 and '53, executed sets for *The Barber of Seville* and other operas presented at the Aix-en-Provence Festival.

In an extraordinary portrait painted in 1936 by a fellow artist, Balthus, and now in New York City's Museum of Modern Art, Derain stands, imposing and rather ominous, with his jowly face, cold eyes, and massive bathrobed body, while an adolescent female model, her clothing in disarray, sits slumped in the background.

Sinister Landscape (ca. 1952), with its dark, lowering clouds that threaten to submerge the fields, gives the key to the loneliness and suffering—perhaps actual melancholia—that marked Derain's last years. Nevertheless, he continued working. As he had noted of himself, "I concentrate too much and too effectively on my painting and am in too close a contact with it. I can visualize the shapes I want to portray and it is these shapes that are killing me." In 1953 Derain suffered a stroke that affected his eyesight, and one day in September of the following year he was struck down by a car while attempting to cross the road near his home. He died a day later, on September 8 (or September 10, according to some accounts), and was buried at Chambourcy in a tomb designed by an architect friend.

EXHIBITIONS INCLUDE: Gal. Paul Guillaume, Paris 1916; Gal. Alfred Flechtheim, Berlin 1922, '29; Brummer

Gal., NYC 1922, '36; Kunsthalle, Bern 1935; "Paintings from 1938 and After," Pierre Matisse Gal., NYC 1941; "Hommage à Derain," Gal. de Berri, Paris 1949; Mus. d'Art Moderne, Paris 1954; "Cinquante tableaux importants d'André Derain," Gal. Charpentier, Paris 1955; Wildenstein Gal., London 1957; Gal. D. Mouradian et Vallotton, Paris 1959; Hirschl & Adler Gal. Inc., NYC 1964; Gal. Knoedler, Paris 1971; Mus. Toulouse-Lautrec, Albi, France 1974; Theo Waddington and Co. Inc., NYC 1981; "André Derain in North American Collections," Norman McKenzie Art Gal., Univ. of Regina, Saskatchewan, Canada 1982; Univ. Art Mus., Univ. of California, Berkeley 1983. GROUP EXHIBITIONS INCLUDE: Salon des Indépendants, Paris 1905–10; Salon d'Automne, Paris 1905–08; Gal. Berthe Weill, Paris ca. 1906–08; Grafton Gals., London 1910; Armory Show, NYC 1913; Neue Gal., Berlin 1914; "Les Maîtres de l'art indépendant, 1895–1937," Mus. du Petit Palais, Paris 1937; Venice Biennale 1954; São Paulo Bienal 1955.

COLLECTIONS INCLUDE: Mus. Nat. d'Art Moderne, Paris; Tate Gal., London; Kunstmus., Basel; Hermitage, Leningrad; Royal Mus. of Fine Arts, Copenhagen; Glasgow Art Gal.; Mus. of Modern Art, NYC; Nat. Gal. of Art, and Hirshhorn Mus. and Sculpture Garden, Smithsonian Instn., Washington, D.C.; Art Inst. of Chicago; Carnegie Inst., Pittsburgh; City Art Mus., St. Louis, Mo.; Nat. Gal. of Canada, Ottawa; Mus. de l'Annonciade, Saint-Tropez, France.

ABOUT: Derain, A. Lettres à Vlaminck, 1955; Hilaire, G. Derain, 1959; Hunter, S. Modern French Painting, 1855–1956, 1956; Muller, J.-E. Fauvism, 1967; Olivier, F. Picasso and His Friends, 1965; Parke-Taylor, M. "André Derain in North American Collections" (cat.), Norman McKenzie Art Gal., Univ. of Regina, Saskatchewan, Canada, 1982; Raynal, M. and others. The History of Modern Painting: Fauvism-Expressionism, 1950; Sutton, D. André Derain, 1959.

***DE RIVERA, JOSÉ** (September 18, 1904–), American sculptor, is best known for sculpture composed of highly polished loops of metal, in which light and space are as important as the maternal. Since the mid-1950s these often rotating works have developed into a personal, elegant, sculptural calligraphy and resemble in some ways Picasso's spontaneous pen-light drawings in space, although they usually require two or three years of controlled manual labor to reach completion.

De Rivera was born José A. Ruiz in West Baton Rouge, Louisiana, to Joseph V. Ruiz, a sugar-mill engineer of Spanish origin, and Honorine Montomat Ruiz, a descendant of French settlers who had come to Louisiana in the late 18th century. José later took his maternal grandmother's name. He had an older brother, a younger sister, and two older stepbrothers, and he remembers his childhood as being a happy one.

°də rē vā´ rä, hō sā´

Courtesy Grace Borgenicht Gallery

JOSÉ DE RIVERA

When he was six years old, José's family moved to New Orleans, where he worked in the sugar mill where his father was engineer. It was there that José developed the manual dexterity that would later enable him to produce his sculptures. In 1924, two years after graduating from high school, he moved to Chicago, where he easily found jobs as a machinist, blacksmith, and tool and die maker. In 1926 he married Rose Coselli, from whom he was later divorced, and in 1929 their son Joseph was born.

In Chicago de Rivera visited the Art Institute and the Field Museum, and was especially inspired by the Egyptian sculpture he saw there. In 1928 he enrolled in evening classes at the Studio School of Art, Chicago, where he studied drawing under the muralist John W. Norton until about 1930. Norton pointed out the sculptural quality of de Rivera's "cubist drawings," and in 1930 de Rivera created his first sculpture, *Owl* a simplified, angular work influenced by Egyptian art and apparently made by cutting away at a metal cylinder. His *Bust* and *Form Synthesis in Monel Metal,* both of 1930, clearly show the influence of Brancusi. These highly polished works differ from de Rivera's later sculptures in the concentration of their mass. De Rivera has acknowledged that, in addition to Brancusi, he has been influenced by Mondrian and the Belgian sculptor and painter Georges Vantongerloo, who was associated for several years with the de Stijl movement in Holland. De Rivera's *Bust* was included in the Art Institute of Chicago's 35th American Painting and Sculpture Exhibition of 1930, and his work was also shown in the Institute's 36th exhibition of the following year.

During his travels in Spain, France, Italy, Greece, Egypt, and North Africa in 1932, de Rivera was again inspired by Egyptian as well as by archaic Greek sculpture. On his return to the United States, de Rivera resolved to devote himself full time to a career as a sculptor. From 1934 on, he exhibited regularly in the Whitney Museum of American Art Annual, New York City. He worked from 1937 to 1938 in the Sculpture Division of the Works Progress Administration's Federal Arts Project, executing a sculpture, *Flight,* which still survives, for Newark Airport, New Jersey. It is a birdlike work, midway between figuration and abstraction, and is denser and less curvilinear than his later sculptures. In 1938 he found a personal idiom with *Red and Black (Double Element),* a work made up of two metal sheets cut into curved shapes, hammered into concave forms, and then painted red on the inside and black on the outside. Moving away from the concept of sculpture as mass, this work foreshadows his postwar pieces, yet in 1938 de Rivera was making such dark, heavy, "embryonic" works in stone as *Life.* In 1938 de Rivera was represented in the Museum of Modern Art's "Twelve Americans" show, which opened in New York and then toured. The following year he made reliefs for the Soviet pavilion at the New York World's Fair; his medium there was stainless steel, which was to become his most widely used material. He move definitively toward abstraction after working on a commission for a cavalry monument in El Paso, Texas, from 1938 to 1940. He had found the commission too tiring and vowed to make only nonrealistic sculptures thereafter. "What I make represents nothing but itself," he said.

During World War II de Rivera served in 1942–43 in the US Army Air Corps in North Africa, and then, from 1943 to 1946, he designed and constructed three-dimensional training aids for the US Navy. His work was exhibited in 1945 at the Harvard University School of Design, Cambridge, Massachusetts, along with that of the abstract painter Burgoyne Diller. The following year de Rivera had his first solo show at the Mortimer Levitt Gallery, New York City.

After the war, in such works as *Yellow Black* (1946–47), in aluminum, and *Copper Construction* (1949), de Rivera continued to develop the style he had invented in 1938 with *Red and Black (Double Element).* In both of the later pieces, which show a strong constructivist geometric influence, he put holes in the curved metal sheets. With *Blue and Black* (1951) he began to cut the rounded shapes into points, a trend he was to continue in the 1950s.

De Rivera taught at Brooklyn College in 1953

and was a visiting teacher at Yale University for
the next three years. The Metropolitan Museum
of Art, New York City, bought one of his works
in 1955, the year of his second marriage, to Lita
Geronimo. From 1956 to 1957 de Rivera was vis-
iting critic and teacher at the North Carolina
School of Design, Raleigh.

In 1954 de Rivera began making the curved,
tubular works for which he has become famous,
and two years later he made a construction (for
the Statler Hilton Hotel in Dallas) that revolves
slowly on its base. These and similar works rep-
resent the culmination of his moving away from
a definition of sculpture as mass and of his stated
desire "to make a formal relationship between
the material, space and light, to arrive at an
equilibrium of the three elements." These works
are essentially linear designs in space that are
different from every angle. Those sculptures
that rotate create optical illusions in which the
perspective of the solid material in space is dis-
torted by reflections of light. As the sculptures
turn, the space within them opens and closes,
thus carrying further the tendency of the Rus-
sian Constructivists of the early 1920s to reject
mass and volume in favor of open form and
sheer dynamism. De Rivera terms these works
"Constructions," and one of the first of these so-
called curved-rod sculptures was *Construction
No. 27* (1956), with its elegant whiplash line and
movement. In spite of their extreme finish, these
sensuously lyric pieces are so animated by ease
and lightness that the great labor that went into
their making is difficult to perceive.

De Rivera begins with metal sheets—often
stainless steel, but sometimes bronze, aluminum,
or other metals—which he pounds into shape.
He makes two opposite halves, which he then
welds together into a tube, often supported by
steel triangles inside. The smaller constructions,
such as *Construction No. 29* of 1956, are made
up of non-hollow metal bars. The polishing of
the surface sometimes takes months.

Since 1954 de Rivera has made many of these
constructions, and to him the experience of cre-
ating is all-important. "I like to do it by hand,"
he said, "because I can follow the form as it de-
velops. You can see possible formal relationships
that you might not be aware of. It's not just the
accomplishment, it's the experience of doing it.
While I'm making a sculpture, I'm already
thinking of the next one." He is critical of those
artists who merely design their works and then
have them built industrially: "My notion is that
the primary function of an artist is the creation
and production of work."

One of de Rivera's most spectacular sculptures
has been the *Brussels Fair Construction* of 1958.

Although most of his works have a continuous
linear movement, there are some in which the
loop is "cut," as in *Construction No. 72* (1960)
and *Construction No. 88* (1965). In 1966–67 de
Rivera collaborated with Roy Gussow to create
Infinity, a stainless-steel work that at the time
was the largest abstract sculpture ever commis-
sioned by the federal government. Measuring 16
feet by 13 feet by 8 feet, it was placed on a high
granite trylon in front of the south entrance of
the Smithsonian Institution's National Museum
of History and Technology, Washington, D.C.
In the late '60s de Rivera began varying the
tube's thickness so that at times it became deli-
cately slender, as in *Construction No. 117* (1969).
Then he started to use tubes with rectangular,
and sometimes triangular, cross
sections—*Construction No. 127* (1970) is an ex-
ample—instead of round ones. His large-scale
work *Construction No. 158* (1974–75) took two
years to make. When it was exhibited at the
Grace Borgenicht Gallery, New York City, Hil-
ton Kramer of *The New York Times* (May 16,
1975) described it as "a seemingly simple con-
ception that acquires gentle elaborations and
complexities as it turns on its pedestal [and]
traces an unexpected lyrical course in the space
it occupies."

As Dore Ashton wrote in *Arts Magazine,* "De
Rivera was one of the first American sculptors
to utilize the gleaming metals favored by indus-
try in an esthetic way." Despite de Rivera's often
austere use of these materials, there is nothing
mechanistic about his constructions, whose slen-
der, seemingly effortless curves create, again
quoting Hilton Kramer, "graceful arabesques
that seem to dissolve into light and space before
our very eyes." Kramer further stated that over
the years de Rivera has upheld the constructivist
ideal "with a singular force and integrity."

In 1972 Grace Glueck described de Rivera
(who lives and works in New York) as "a large,
brawny man who for relaxation reels in quarter-
ton marlin on deep-sea fishing trips." Such terms
as constructivism and minimalism do not really
apply to his sculpture, for as de Rivera himself
said: "I don't belong to any particular period or
school—my job is to make work and then project
the experience." John Gordon has also quoted de
Rivera as saying: "Art for me is a creative process
of individual plastic production without imme-
diate goal or formality. The prime function is
the total experience of the production, the social
formation, the communication of that experi-
ence. In the attempt to find plastic harmony in
my work, I am conscious always of the necessity
for a prime, visual, plastic experience. The con-
tent, beauty and source of excitement is inherent
in the interdependence and relationships of the
space, material and light, and is the structure."

EXHIBITIONS INCLUDE: Mortimer Levitt Gal., NYC 1946; Grace Borgenicht Gal., NYC from 1952; Walker Art Center, Minneapolis 1957; Whitney Mus. of Am. Art, NYC 1961, '72; La Jolla Mus. of Contemporary Art, Calif. 1972. GROUP EXHIBITIONS INCLUDE: American Exhibition, Art Inst. of Chicago 1930, '31; Annual, Whitney Mus. of Am. Art, NYC from 1934; "Twelve Americans," MOMA, NYC 1938; New York World's Fair, NYC 1939; Harvard Univ. School of Design, Cambridge, Mass. 1945; Pittsburgh International, Carnegie Inst. 1958, '61; "Recent Sculpture U.S.A.," MOMA, NYC 1959; "Sculpture in the Open Air," Battersea Park, London 1963; New York World's Fair, Flushing Meadow 1964; Los Angeles County Mus. 1967; Philadelphia Mus. of Art 1967.

COLLECTIONS INCLUDE: Metropolitan Mus. of Art, MOMA, and Whitney Mus. of Am. Art, NYC; Munson-Williams-Proctor Inst., Utica, N.Y.; Newark Mus. Association, N.J.; Univ. of Pennsylvania, Philadelphia; Smithsonian Inst., Mus. of Science and Technology, and Hirshhorn Mus. and Sculpture Garden, Washington, D.C.; Virginia Mus. of Fine Arts, Richmond; Art Inst. of Chicago; City Art Mus. of St. Louis, Mo.; San Francisco Mus. of Art; Tate Gal., London.

ABOUT: Craven, W. Sculpture in America, 1969; Rickey, G. Constructivism: Origins and Evolution, 1967; Tibbs, T. S. (ed.) "Jose de Rivera, Retrospective Exhibition 1930–71" (cat.), La Jolla Mus. of Contemporary Art, Calif., 1972. Periodicals—Arts Magazine April 1956; New York Herald Tribune May 28, 1961; New York Times May 16, 1972, May 21, 1972, May 16, 1975, November 29, 1975; New Yorker June 3, 1961; Washington Post February 20, 1967.

Jorge Lewinski

NIKI DE SAINT-PHALLE

*DE SAINT-PHALLE, NIKI (October 29, 1930–) French sculptor, became prominent in the 1960s and is considered a postmodernist. In Art Moral, Art Sacré Pierre Restany situated her work "halfway between Robert Rauschenberg and Louis Nevelson."

De Saint-Phalle was born in Neuilly-sur-Seine, near Paris. She comes, she said, "from a respectable family" attached to institutionalized religious beliefs, but in her life and career she has broken drastically with her staid beginnings. When she was three, her family moved to New York City, where Niki was raised. In 1948 she married the writer Harry Matthews, by whom she had two children, Laure and Philippe; they were to separate in 1960.

De Saint-Phalle returned to Paris in 1951 and the following year began to paint. In 1956 she made her first object-reliefs and assemblages and held her first solo exhibition in St. Gallen, Switzerland. Using the collage technique, she incorporated diverse objects, some of them in plaster, and the resulting creations combined baroque extravagance with a wild, often disturb-

°da saN fäl

ing fantasy. In 1960 she met a kindred spirit, the Swiss sculptor Jean Tinguely, a leader of the Nouveaux Réalistes, whose work was in the vein of American pop art. They lived together in Paris, and their close association contributed to her artistic development and seems to have stimulated her considerable imaginative powers still further.

In 1960 de Saint-Phalle combined assemblage and dart throwing in her Death of St. Sebastian. Cork targets were introduced into her assemblage and darts were distributed among the spectators, inviting their participation. More macabre and shocking to the Parisian public was Autel-tir (1962), a mixed-media altarpiece assemblage containing aerosol paint cans which exploded when shot with a rifle—a neodadaist expression of the absurdity of the idea of permanence. In the early '60s de Saint-Phalle made frequent use of this "splatter" technique, in which small containers of paint were shot with a .22-calibre rifle, causing the paint to ooze onto an assemblage or sculpture.

Lucy Lippard described the de Saint-Phalle of the early '60s as a "compelling religious fetishist and mythologian," whose art's "sacrilegious" elements made her work the more provocative. One of her most nightmarish assemblages was Altar OAS (1962), a gilded wooden triptych on which the objects, also painted gold, are attached without plaster. Toy guns point at crucifixes; an enormous, ferocious-looking bat, wings outstretched, dominates the center panel; and parts of baby dolls fill up the rest of the space. In her triptych, Les Femmes (The Women), and her assemblage, Tête Blonde, both of 1964, the diversi-

ty of incongruous objects creates a sense of destruction and decay. In *Ghea* (1964), an assemblage mounted on wood, a bizarre earth mother is covered with carnival dolls, one of them issuing from her loins.

The earth mother motif culminated in *Hon* (1966, She), a huge reclining female figure de Saint-Phalle created in collaboration with Tinguely and the Swedish sculptor Per Olof Ultvedt. *Hon*, originally erected in Stockholm's Moderna Museet but since destroyed, was 82 feet long, 20 feet high, and 30 feet wide. It was conceived as a "walk-in" environment; observers entered a passageway between the colossal woman's legs to find themselves in a kind of funhouse which included a silk-lined "lovers' nest," a gallery of fake paintings, a cinema for Greta Garbo movies, an aquarium, a planetarium, and a milk bar inside one of the breasts. Another bar had a Coca Cola dispenser; a built-in microphone in the boudoir for lovers broadcast their pillow talk in the bar. There was a viewing platform in *Hon*'s head, and her heart and lungs would expand and contract to simulate breathing; the recumbent colossus was brightly colored.

This exuberantly outrageous work—free of the morbidity of the artist's assemblages—helped to make de Saint-Phalle a celebrity. By the mid-'60s she had had solo exhibitions in Paris, Stockholm, Copenhagen, Los Angeles, New York City, Brussels, and Geneva. Her reputation was due in part to the succès de scandale of her works, and she was never averse to publicity—but her talent and originality were undeniable.

Soon after *Hon*'s completion de Saint-Phalle abandoned "religious" triptychs and "splatter packets" for large-scale sculptures. In 1965 she began her series of "Nanas" (*nana* is French slang equivalent of "broad" or "dame"), gigantic female statues usually made of papier-mâché or plaster on chicken-wire frames (in recent years the frames have been polyester or fiberglass). De Saint-Phalle wanted to make her Nanas the mother goddesses of the modern era. A typical early Nana was *Elizabeth* (1956), an 8-foot-tall woman whose head was tiny compared to her comically corpulent body and elephantine legs. Other similar Nanas are *Miss Miami Beach, Eva, Charlotte* and *Clarice Again*. The goofy Nanas are generally painted in bright colors in fantastic, "free-form" patterns. Pierre Restany described them as evoking a "Dubuffet revised and corrected by [Karel] Appel."

In 1966 one of de Saint-Phalle's Nanas formed part of the décor for a Roland Petit ballet, and at the 1967 International Exhibition, Montreal, she staged, on the roof of the French pavilion, a warlike confrontation between her Nanas and Tinguely's so-called infernal machines. Some years later a group of her colossal, bulbous females were temporarily installed outdoors in New York City's Central Park, adding a delightful carnivalesque element to the urban scene.

De Saint-Phalle also made prints of the Nanas and other subjects. In the late '60s she executed a series called "Love," combining childlike scribbling with vibrant colors. About 1970 she made inflatable "Nanas" (silk-screens on plastic), showing them frolicking or running. Though not so immobile as earlier Nanas, they were no less abundantly endowed.

In the 1970s de Saint-Phalle continued to make satirical "Nana" sculptures, but other works of that period combined naiveté and the macabre. *Diana's Dream* (ca. 1970) blended the morbid imagery of her early reliefs with the style of the "Nanas." *Original Sin* (1970), featuring an enormous Eve and a colossal, ithyphallic Adam, is at once playful and disturbing. In 1972 de Saint-Phalle published an illustrated storybook, *The Devouring Mothers*, and also produced a series of polyester sculptures depicting the story's fantastic events. *Teatime* and *Funeral of Father*, both of 1972, were variations on the theme of the devouring mother.

Since 1961 de Saint-Phalle had participated, usually with Tinguely, in numerous happenings throughout Europe and in the United States. She contributed to a John Cage-like "concert" at the American Embassy, Paris, in 1961, organized by the vanguard American artists Robert Rauschenberg and Jasper Johns. With the dancer Merce Cunningham, Rauschenberg, and Tinguely, de Saint-Phalle staged a performance called *The Construction of Boston* at an off-Broadway theater in New York City the following year. The critically successful show was proof, de Saint-Phalle said, that "people are tired of the theater and movies. They want *real* entertainment."

An example of de Saint-Phalle's large-scale works of the 1970s is *Dragon*, a 40-meter playhouse which is installed in a private garden. However, she also worked on a small scale, making jewelry in gold and enamel in the form of Nanas and colorful animals. In the late '70s de Saint-Phalle made small-scale "Nanas," which nevertheless evoked the monumentality of her larger pieces, as in *The Elephant and Nana*. She began making full-size animal sculptures, such as *The Big Bird* with its outstretched wings, which were designed to be hung on walls. An admirer of the Art Nouveau architect Antoni Gaudí, she created models of amorphous buildings including *Summer Palace,* which is inhabited by fat people, and *Church of All Religions,* whose imagery is less disturbing than her early,

sacrilegious triptychs. In Paris, in 1973, she made experimental films.

Reviewing her 1978 exhibit at Gimpel and Weitzenhoffer, New York City, a critic wrote, "The artist is not as rambunctious as she was in the Pop days, but then, who is?" He mentioned the polyester figurines, and the prints, mostly silk-screened, containing "more of the artist's playful grotesqueries," and concluded, "Her bloated figures . . . with their menacing pinheads, make her seem a deadly serious Surrealist under all the whimsy, and not far from Dubuffet."

A strikingly beautiful woman, Niki de Saint-Phalle lives and works mostly at Soisy-Sur-Ecole, near Paris, but, a free spirit, she rarely stays very long in any one place. She continues to pursue the three-dimensional realization of her personal fantasies, never seeking to imbue her playful yet archetypal creations with existential metaphysics. "I do not have the notion of a work of art," she said; "I was never at the Ecole des Beaux-Arts. For me sculpture is not culture, but a way of living. My artistic education comes from the cathedrals, the postman Cheval, a naive artist [named], and the architect Gaudí." De Saint-Phalle is the author of *Please Give Me a Few Seconds of Your Eternity* (1970) and *Love* (1971).

EXHIBITIONS INCLUDE: St. Gallen, Switzerland 1956; "Firing Session," Moderna Mus., Stockholm 1961; Gal. J, Paris 1961; Gal. Koepke, Copenhagen 1961; Gal. Rive Droite, Paris 1962; Dwan Gal., Los Angeles 1962, '63; Alexandre Iolas Gal., NYC 1962, '65, '66; Hanover Gal., London 1964, '68; Palais des Beaux-Arts, Brussels 1964; Gal. Alexandre Iolas, Geneva 1964; Stedelijk Mus., Amsterdam 1967; Gimpel and Hanover Gal., Zürich 1968, '70; Kunstverein, Hanover, W. Ger. 1969; Gal. Alexandre Iolas, Paris from 1970; Gimpel and Weitzenhoffer, NYC from 1972. GROUP EXHIBITIONS INCLUDE: Salon Comparaisons, Paris 1961–63; "Les Nouveaux Réalistes," Gal. J, Paris 1961; "The Art of Assemblage," MOMA, NYC 1961; "Labyrinthe Dynamique," Stedelijk Mus., Amsterdam 1962; Biennal des jeunes, Paris 1963; Winterjest International Exhibition, Montreal 1967; "Dada, Surrealism and Their Heritage," MOMA, NYC 1968; "Pop Art, Nouveau Réalisme," Knokke-le-Zoute, Belgium 1970; "Douze ans d'art contemporain en France," Grand Palais, Paris 1972; "Hommage à Picasso," Kestner Gesellschaft, Hanover, W. Ger. 1973.

COLLECTIONS INCLUDE: Mus. 'Art Moderne, Paris; Stedelijk Mus., Amsterdam; Nellens Collection, Knokke-le-Zoute, Belgium; Moderna Mus., Stockholm; Rabinowitch Park, Jerusalem.

ABOUT: Cabanne, P. and others L'Avant-Garde au XXe siècle, 1969; de Saint-Phalle, N. Please Give Me a Few Seconds of Your Eternity, 1970, Love, 1971; Descar-

gues, P. (ed.) "Niki de Saint-Phalle" (cat.), Gal. Alexandre Iolas, Paris, 1965; Henri, A. Environments and Happenings, 1974; Lippard, L. R. Pop Art, 1966; Restany, P. (ed.) "Niki de Saint-Phalle" (cat.), Gal. Rive Droite, Paris, 1962. *Periodicals*—Art in America December 1979; Arts Review December 1972; L'Express (Paris) March 23, 1970; New York Times January 13, 1978; Quadrum 18 (Brussels) 1965.

***DE STAËL, NICOLAS** (January 5, 1914–March 16, 1955), Russian-French painter, exercised his lyrical gifts in a mode midway between figuration and abstraction. He was born in St. Petersburg, Russia. His father, Baron Vladmir Ivanovitch De Staël, came from a distinguished family of Baltic origin and with a long military tradition. At the time of Nicolas's birth, Baron De Staël was Deputy Governor of the Fortress of Peter and Paul. Among his ancestors was Baron Eric De Staël, whose wife, Germaine Necker, was the famous Madame de Staël, author of *Corinne*. Nicolas's mother, Liobov Berednikoff, came from a rich family, and was a lover of music and painting. As a very young child Nicolas was a page at the court of Czar Nicholas II.

In 1919, fleeing the Bolshevist revolution, the De Staël family immigrated to Ostrow, Poland, then to Berlin, and finally, in 1920, to Brussels. Nicolas's father died in September 1921; a year later his mother died after a long illness. Seven-year-old Nicolas and his two sisters, aged nine and five, were taken in by a family friend in Brussels. From 1922 to 1930 Nicolas studied at the Jesuit Collège de Saint-Michel, Brussels, then continued his studies in 1930–31 at the Collège Cardinal Mercier at Braine L'Allaud, Belgium. He received a classical education and became enamored of Greek tragedy, but he also distinguished himself as a sportsman, winning awards for fencing, tennis, and swimming.

In 1932 De Staël entered the Académie Royale des Beaux-Arts, Brussels. He traveled in 1933 with a friend to Holland, where he was deeply moved by the works of Rembrandt, Vermeer, Seghers, and Koninck. On his return to Brussels he received a commission to decorate an apartment for the royal children in the palace of Laeken. At the end of the year he left for Paris. There he was exposed for the first time to the modern movement, in the paintings of Cézanne, Matisse, Braque, and Soutine. Desperately poor, he took on odd jobs. Nevertheless, in 1934 De Staël traveled with his friend Emmanuel d'Hooghvorst to Spain. He returned to France and visited his sister Olga, who had become a nun, and then went on to Italy.

De Staël returned to Brussels in 1935, and worked on decorative projects for the Interna-

*də stäl, nē´´ kō lä´

tional Exhibition. Constantly on the move, he traveled with friends in the summer of 1936 to Morocco. Finding Morocco a painter's paradise, he visited Fez, Marrakesh, Rabat, and Kenitra. The following year he stopped briefly in Algeria before making a second tour of Italy.

In Morocco he had met a woman painter, Jeannine Guilloux, and her son, who later became the poet Antoine Tudal. De Staël immediately formed a liaison with Jeannine, and early in 1938 they established a home in Paris. Feeling the need of discipline and guidance, he worked with Fernand Léger at the Académie Libre for a short time. He also spent time at the Louvre copying Chardin. During a 1939 trip to Brittany with Jeannine, he met her cousin Jean Deyrolle; the three began to paint together. Very little is known about De Staël's life and work during this period. Slow to mature and a ruthless self-critic, he destroyed most of the evidence.

After the declaration of war in September 1939, De Staël abandoned painting. In 1940 he joined a cavalry unit of the Foreign Legion and served for a few months in Tunisia. When he was demobilized at the end of 1940, he settled in Nice with Jeannine and at once resumed painting. His work in 1941–42 was representational; he did several portraits of Jeannine, described by one critic as "tentative and rather mannered," and some Cézanne-esque still lifes. These are the earliest of his works to survive. In Nice he associated with Magnelli, Jean Klein, Le Corbusier, and Robert and Sonia Delaunay. The birth of a daughter, Anne, in 1942 added to the difficulties of the war years. Since neither he nor Jeannine could find a market in Nice for their paintings, they moved to Paris in September 1943.

In Paris, De Staël's work became nonfigurative. Again supporting himself on odd jobs, he made contact with other artists of the School of Paris, notably Pignon, Pierre Tal Coat, and Jean Bazaine. In April 1944 he was represented in a group exhibit of abstract paintings at the Galerie l'Esquisse that also included work by Kandinsky, Magnelli, and Domela. Another group show followed in February 1945 at the Galerie Jeanne Bucher.

In 1944 De Staël became friendly with Georges Braque and an older fellow-Russian named Lanskoy. Braque, who rarely associated with younger artists, took a great interest in De Staël's work. Although De Staël was not directly influenced by Braque and Lanskoy, he benefited by his contact with those older artists. By late 1945 the tentative, linear style of his first nonfigurative works had given way to a bolder, far more painterly approach.

In 1945 Jeanne Bucher held the first important solo exhibition of De Staël's works. Although some of his motifs may have originated in nature, his paintings of this period were primarily investigations of the abstract play of forces and lines. The colors were somber, predominantly ochers, terre-verte, and black. De Staël's technique was gestural. His style owed nothing to the geometric abstractions of the first generation of nonobjective painters in Paris; instead it anticipated what became known as lyric abstraction.

The artist later remarked on his transition from representation to abstraction: "When I was young I painted Jeannine's portrait. I painted two pictures like this and then I looked at them and wondered what it was. . . . Little by little I felt it was too limiting to paint objects naturalistically, because when I concentrated on any object, just a single object, I was overwhelmed by the number of co-existing objects. After that I tried to obtain freedom of expression."

He suffered a personal tragedy in February 1946, when Jeannine died "as a result of the complications of an operation for the removal of a child she had resigned herself not to keep," as he later explained. She had also been weakened by malnutrition and the hardships of the war years. In May 1946 De Staël married Françoise Chapoutan, with whom he had a daughter, Laurence, and two sons, Jérome and Gustave. His marriage to a Frenchwoman made it possible for him to acquire French nationality in 1948.

The nine years from 1946 until his death in March 1955 were De Staël's most creative. During the first postwar years his paintings were characterized by violent struggle, reflected in such titles as *The Hard Life* (1946), *Marathon* (1948), *Lightning* (1946), *Resentment* (1947), and *In the Cold* (1947). In 1949 his work changed direction, becoming tranquil and static. During this period, which lasted until 1952, one critic wrote: "The brush and more often the palette-knife organize the surface in large, clear-colored patches with rare nuances. . . . His palette includes brilliant reds, serene blues, golden ochres and amethyst violets. Staël creates light even out of black." Such paintings as *Roofs* and *Fallen Leaves* (both of 1951) and *The Park of Sceaux* (1952) contain no immediate references to ordinary reality, but they evoke images, often of landscape, in the mind of the viewer.

By 1949 De Staël was beginning to acquire an international reputation. His Paris dealers Louis Carré, René Drouin, and Jacques Dubourg bought his pictures, and he made friends with an American dealer, Theodore Schempp, who organized a solo show for him in New York City in 1950. De Staël traveled in the Netherlands and

Belgium in 1949, and his happy private life was reflected in his paintings. "I want to achieve a harmony," he wrote in 1951. "I use painting as my material. I mostly paint without a concept. I also start with a clearer image." The importance of gesture in De Staël's painting has led critics to compare his work to the so-called action painting of the New York School; at least one writer, however, has described De Staël's works as a last creative outburst of the impressionist vision rather than as the equivalent of American abstract expressionism.

In the summer of 1951 De Staël paid his first visit to London, where a solo exhibit of his work was held at the Matthieson Gallery. He was fascinated by the light and movement of the Park of London and was greatly intrigued by the paintings of Constable, Turner, and Whistler. London also reawakened his response to the range of grays. Back in Paris he studied Bonington and Corot and began a series called "The Roofs of Paris," using broad rectangular planes of an infinite variety of grays. He wrote in a letter at this time, "I think I shall be able to evolve, God knows how, towards more light in painting, but it puts me in a disagreeable state of permanent worry."

In his canvases of 1952 to 1955 he achieved a blend of abstraction and figuration. After attending a floodlit soccer match between French and Swedish teams at the Parc des Princes on the outskirts of Paris, the artist made a series of small preparatory canvases of soccer players that marked a transition back toward representation. The studies' broad patches of color and thickly painted shapes were a form of tachism. He began to work outdoors in Normandy and in the Seine Valley in 1952, only suggesting natural surroundings through light and shapes saturated with paint. That same year he worked on ballet projects with René Clair and Piette Lecuire. In 1953, he visited Florence, Ravenna, Venice, and Milan before leaving for New York to attend his second exhibition in the city, held this time at the Knoedler Gallery. In the summer of 1953 he traveled again through Italy, and on down to Sicily.

De Staël's friendship with the poet René Char and his desire for more light drew him to the south of France. In the fall of 1953 he bought a home at Ménerbes between Avignon and Apt; the following year he moved to Antibes. He remained in Provence until his death, except for brief trips to Paris and Gravelines in the summer of 1954 and to Spain in the autumn. Inspired by the brilliant light of the Midi, De Staël's paintings of 1953–54—among them *Martigues* and *Marseilles* (both of 1953–54) and *Agrigento*

(1954)—were characterized by intense color harmonies which one critic described as "exalted and often violent."

In the autumn of 1954 De Staël abandoned the spatula for the brush and began to work with thin washes. *Sunset* (1954), which recalls Turner, *The Gulls* and the large, unfinished *The Orchestra* exemplify his final style.

In 1955 everything in the artist's life and career seemed to be positive. He had a wife and four children, important dealers, and an international reputation. Then, on March 16, 1955, he committed suicide by jumping out of a window in Antibes. He had been depressed for some time. His controversial move from abstraction to a form of representation just as he was being recognized as a major artist seems to have created serious emotional problems for him. For some artists success can be as unnerving as failure. His experience of being orphaned and uprooted as a child and his years of struggle and dire poverty may have contributed to his underlying malaise.

Everything about the tall, large-limbed De Staël was big, including his sweeping gestures, his preference for enormous canvases, and his extravagant application of paint. His letters and notes reveal the complexity of his character and of his approach to painting. His stepson Antoine Tudal quotes the following observations from De Staël's working notes: "Rembrandt's Indian Turban is like a brioche, Delacroix sees it as a meringue, Corot as a dry biscuit, and it is neither a turban nor a brioche, nothing but an illusion of life as painting will always be." At the time of his suicide at the age of 41, De Staël, the painter of skies, seas, clouds, and musicians, felt that he no longer had the strength to carry on. His last, unfinished canvases were homages to music.

In 1954 De Staël had written to the dealer Paul Rosenberg: "I know what my painting is—underneath its appearance of violence and perpetual forces at play, it is something fragile, in the good, in the sublime sense. It is as fragile as love."

EXHIBITIONS INCLUDE: Gal. l'Esquisse, Paris 1944; Gal. Jeanne Bucher, Paris 1945, '58; Gal. Jacques Dubourg, Paris 1950, '51, '57, '58, '69; Theodore Schempp Gal., NYC 1950; Matthieson Gal., London 1952; Knoedler Gal., NYC 1953; Phillips Gal., Washington, D.C. 1953, '56; Paul Rosenberg Gal., NYC 1954, '55, '58, '63; Mus. Grimaldi, Antibes, France 1955; Mus. Nat. d'Art Moderne, Paris 1956; Whitechapel Art Gal., London 1956; Kunsthalle, Bern 1957; Gal. Kestner-Gesellschaft, Hanover, W. Ger. 1959; Kunstverein, Hamburg, W. Ger. 1960; Gal. Gimpel and Hanover, Zürich 1963; Gal. Louis Carré, Paris 1964; Kunsthaus, Zürich 1965; Art Inst. of Chicago 1965; Gal. Messine, Paris 1965, '69; Solomon R. Guggenheim Mus., NYC 1966; Foundation Maeght, Saint-Paul-de-Vence, France 1972.

GROUP EXHIBITIONS INCLUDE: Gal. l'Esquisse, Paris 1944; Gal. Jeanne Bucher, Paris 1945; "Contemporary Art: Great Britain, United States, France," Art Gal. of Toronto 1949; "Modern Paintings to Live With," Louis Carré Gal., NYC 1950; "Advancing French Art," Washington, D.C. 1951; "Peintres Actuels de Paris," Kunsthaus, Zürich 1952; "Europe: The New Generation," MOMA, NYC 1952; "The Classic Tradition in Contemporary Art," Walker Art Center, Minneapolis 1953; São Paulo Bienal 1953; Venice Biennale 1954.

COLLECTIONS INCLUDE: Mus. Nat. d'Art Moderne, Paris; Mus. des Beaux-Arts, Antibes, France; Tate Gal., London; Boymans-Van Beuningen Mus., Rotterdam; Kunsthaus, Zürich; MOMA, NYC; Albright-Knox Art Gal., Buffalo, N.Y.; Mus. of Fine Arts, Boston; Phillips Gal., Washington, D.C.; Cincinnati Mus. of Art; Art Inst. of Chicago; Melbourne Mus., Australia.

ABOUT: Bénézit, E. (ed.) Dictionnaire des peintres, sculpteurs et graveurs, 1976; Cooper, D. Nicolas De Staël, 1961; Courthion, P. Peintres d'Aujourd'hui, 1952; De Staël, N. Letters to Pierre Lecuire, 1966; Duthuit, G. Nicolas De Staël, 1950; Gindertael, R. van Nicolas De Staël, 1951; Kramer, H. The Age of the Avant-Garde, 1974; "Nicolas De Staël" (cat.), Mus. Nat. d'Art Moderne, Paris, 1956; Tudal, A. Nicolas De Staël, 1958. *Periodicals*—Arts (Paris) June/July 1957; Cimaise (Paris) June 1955; Jardin des arts (Paris) July 1972; L'Oeil (Paris) December 1955; Réalités (Paris) August 1969

JEAN DESWASNE

* DEWASNE, JEAN (May 21, 1921–), French painter, was a leader of the constructivist-derived abstraction that flourished in France after World War II. He was born in 1921 in Lille, where his father was an engineer. This manufacturing city in the industrial north of France is also a cultural center with a large university and has one of the most important art museums in Europe. As a boy, Dewasne was given intensive training in music and the classics. His feeling for organization and structure led him to enroll in the architecture section of the Ecole des Beaux-Arts, Paris, where he studied for two years. In 1941 he had his first exhibition, in German-occupied Paris. His early paintings were in a figurative, "postcubist" style, and showed a particular concern with the formal problems of chiaroscuro.

In 1943 Dewasne painted his first picture that verged on total abstraction, but the decisive breakthrough came in 1945. The years following the Liberation in France corresponded in Dewasne's thinking to a need for painting to liberate itself from all figurative subject matter. In his view a landscape, a nude, or a still life was a barrier between the artist and his plastic means, an unnecessary intrusion. He also felt that easel painting, with its refinements of line and color, served only to decorate the homes of the wealthy bourgeoisie, and bore no relation to the striving for democracy, science, and progress in the modern world. He declared that "It is not with two old ideas (representational art and easel painting) that one can create a new idea." Abstraction for Dewasne was synonymous with both liberation and true modernity. Like Léger, but using more abstract means, Dewasne was buoyed by an optimistic belief in the rationality of the world of industry and its relevance to the art of our time.

Dewasne's type of thinking can be traced back to the de Stijl group in Holland and the leaders of the Bauhaus in the 1920s, but such ideas were relatively new in Paris in the late '40s, especially after the stifling years of Nazi occupation, when France had been isolated from all progressive trends. Soon after the Liberation, Americans involved in the arts circulated copies of the "Guggenheim Museum Notebooks" in Paris, containing reproductions of the museum's vast collection of Kandinsky's abstract paintings. Dewasne was excited by this discovery, and also by courses he was attending at the Paris Conservatoire given by the French organist and composer Olivier Messiaen. As a result of his studies and his conversations at the Conservatoire with the modern composer Pierre Boulez, Dewasne became interested in the complex rhythms and rigorous disciplines of the new musical techniques, including the direct use of magnetic tapes, precursors of "concrete music."

Often, on Thursday evenings at Paris's Denise René Gallery, Dewasne would meet the experi-

mental painters (Hans Hartung, Gérard Schnei-
der, Serge Poliakoff, Nicolas de Staël, and Jean-
Jacques Deyrolle) who were then campaigning
for abstract art. In 1946 an annual salon called
"Réalités Nouvelles" was founded to promote
nonobjective art, and Dewasne was elected to
the committee, which included Jean Arp, An-
toine Pevsner, and Sonia Delaunay. At 25 he was
awarded the Kandinsky prize, and in 1948 he
painted his first mural, *La Joie de Vivre.*

In 1950 Dewasne founded "The Studio of Ab-
stract Art" at the Académie de la Grande
Chaumière in Montparnasse, where he taught a
course called the "Technology of Painting." This
involved the study of color chemistry, the theory
of vision, and the physiology of perception.
Meanwhile, to his own art, he applied a Carte-
sian logic, seeking a return to first principles,
and he undertook a study of the writings of Paul
Klee and the earliest abstractionists.

Between 1950 and 1953 Dewasne organized
a series of "Lectures on Abstract Art" in
Saint-Germain-des-Prés, Paris. Influenced at
this time by a book by Henri Lefèvre, *Logique
formelle et logique dialectique,* he hoped for a
synthesis between what he called the "structures
of visual language" and Hegelian-Marxist think-
ing.

Dewasne soon severed relations with the De-
nise René Gallery, where Op artist Victor Va-
sarely was the rising star, and also parted
company with Marxists who were promoting the
socialist realism of painter André Fougeron.
Meanwhile, his own art was evolving rapidly.

In 1951 Dewasne made a remarkable discov-
ery. On a nondescript piece of land at Sarcelles
near Pontoise he came upon an object that fasci-
nated him—the back of a racing automobile. It
was in hard metal and three-dimensional and
yet was in no way sculptural. On the contrary,
it was functional, rational, and "aerodynamic."
Dewasne bought it on the spot and painted it in
vivid varnished colors. He named it *Tomb of
Anton Webern* in homage to the great Austrian
composer of atonal music. This was the first of
Dewasne's "Antisculptures."

His painting style had changed considerably
since his postcubist days. He had developed a so-
called positive-negative idiom which abolished
any distinction between far and near, back-
ground and foreground. His shapes were precise
and his colors bold and clear, applied in flat ar-
eas with no nuances or half-tones. Dewasne used
industrial lacquer pigments to achieve the
smooth, hard, bright surface he desired.

In the 1950s and early '60s Dewasne traveled
throughout Europe and the United States, exhib-
iting his works and lecturing. His murals execut-
ed in silicone paint, as well as his constructions,
which were in a new territory between painting
and sculpture, became larger and more com-
plex. In 1967, after completing a 297-foot-long
mural for the Faculty of Medicine at the Univer-
sity of Lille, Dewasne painted a mural 10 feet
high and 198 feet long for the ice stadium in
Grenoble, as part of the decorations for the 1968
Olympic Games.In 1968 Jean Dewasne repre-
sented France in the Venice Biennale, and in
1969 an important show was devoted to him at
the Musée d'Art Moderne de la Ville de Paris.

A critic in *Le Nouvel observateur* described
Dewasne's large and ambitious murals in Lille
and Grenoble as "a modern and barbaric music
which is played not only in space but in time."
The writer remarked that they could not be tak-
en in at one glance and that each one was not so
much an image as a journey. In fact *The Long
March* was the title of a work completed by De-
wasne in 1968, a sequence of 28 movable lac-
quered plywood panels 5 feet tall and extending
for 298 feet around the walls of a large gallery.
The Long March was shown six years later at the
Museum of Art in the Carnegie Institute, Pitts-
burgh. Donald Miller, reviewing the Carnegie
show in *Art News,* wrote that "Dewasne's bril-
liant hard-edged forms combine in an optical
parade."

Grenoble '70, completed in 1970 and measur-
ing 13,200 square feet, was the biggest mural in
Europe. A new, "environmental" dimension to
Dewasne's work was added in 1972 with the
completion of *L'Habitacle rouge* (Red Dwell-
ing), a walk-in cabin, 33 feet long, 17 feet wide,
and 13 feet high. It was painted vermillion on
the outside and spray-painted in bright patterns
on the inside. It was illuminated by two banks
of light, and silvered ceiling reflected the bold
acrylic shapes on the walls.

From 1973, Dewasne was closely associated
with the Renault automobile works. In 1974 he
completed four murals for Renault's computer
building in Paris, and the backs of automobiles
that he uses for his "Antisculptures"are of Re-
nault manufacture. One of the most successful
of his recent large-scale commissions was a 735-
foot-long mural for the subway station in Hano-
ver, West Germany. Circular motifs suggesting
wheels are combined with rectangular shapes.
The bold color scheme is blue, red, black, and
white; the white, as in all of Dewasne's paintings,
large or small, is used for internal demarcations
and to intensify the visual force of the ensemble
through strong contrasts. Dewasne called this
mural "a great responsibility. Thousands of peo-
ple will live with it every day."

With his architectural background, Dewasne

is keenly aware of scale. Whether he is working on what he calls "maxi-paintings" on movable aluminum panels, medium-sized compositions, "mini-paintings," or graphics, the shapes are carefully related to the overall size of the composition. When his murals consist of a sequence of panels, some panels restate or reverse the motifs of others. *Art News* described his patterns in *L'Habitacle rouge* as "random, asymmetric, sometimes based on train wheels, railroad tracks and engines." There is a lucid, cerebral element in the formal language of Dewasne's vivid "oleo-glycerophthalic paintings," but there is also, to quote Alain Jouffroy, an expression of "the need for madness and merriment."

In a statement entitled "General Theory of Esthetic Creation," Dewasne wrote: "In the course of the formulation of the work, the author knowingly [runs] the maximum of dangers possible; many errors [are] voluntarily touched upon, many losses envisaged. In the choices constantly incited by the creation, the author [opts] for the risk. His strategy of decision always [leads] him towards the uncomfortable, the unknown. When the evolution of the happenings of the creation at its various levels [seems] too sober, he voluntarily[provokes] skidding. If the position shows itself to be unmaintainable the creator has some chance to advance towards some interesting result. The work of art does not have to search for a maximum probability. It would quickly become banal and boring. It must deliberately opt for the most unforeseen probability. When a fairly improbable plastic thought comes up with a new solution it immediately acquires the most powerful affective charge. Here, logic does not control creation, it is at its service: it does not close, it opens."

In his "Antisculptures," exhibited in the Musée d'Art Moderne, Paris, in July 1975, Dewasne took a series of identical backs of Renault automobile chassis and painted each one in a different way. He was treating these products of technology, "involuntary" sculptures created by engineers and mechanics, like paintings, but instead of working on flat surfaces he used the convex and concave formations to show the varied interactions of color and form. The *Nouvel observateur* critic praised the "verve and humor" of these "Antisculptures," and admitted that they challenged customary ideas of "an easel-painting hung on the living-room wall." At the same time he wondered whether the use of industrial technology to display the painter's "brio," and of multiplying these objects, did not in the long run reduce them to a decorative role, and make them just another product for the art market. However, another writer viewed Dewasne's experiments with color and form as the expression of a sensitivity that "extends Mondrian's philosophical vision" and "turns away from nostalgia to affirm a violent and systematic love of modern life."

Jean Dewasne, affable, round-faced, with heavy glasses and thinning black hair, has been described as looking "more like a math professor than a painter." His wife's given name is Mythia.

Dewasne's Paris studio, ideal for his purposes, is an enormous converted garage, a gift to the artist from the Renault company. By an interesting contrast, the entrance to the thoroughly modern world of Dewasne's studio is in a narrow street in the ancient and historic Marais district. It is a short walking distance from the new Pompidou Centre (Beaubourg) for the arts. The austerity of the studio's whitewashed walls is relieved by tropical plants and by the brilliant colors of the artist's paintings and three-dimensional works. Dewasne is businesslike, well-organized, and always lucid in the articulation of his aesthetic ideas. He explains that he is primarily interested in color, its massing and its rhythms: "I study what is between these masses, and also what is between the rhythms. . . . One uses new technology to create new ways of thinking. . . . That is what interests me as well."

EXHIBITIONS INCLUDE: Arne Bruun-Rasmussen Gal., Copenhagen 1949, '55; Palais des Beaux-Arts, Brussels 1955, '59, '69; Gal. Cordier, Paris 1956, '63; Gal. Lorenzelli, Milan 1961; Carrefair Gal., Brussels 1962; Gal. Hybler, Copenhagen 1963; Esbjerg Mus., Denmark 1963; Cordier-Ekstrom Gal., NYC 1965; Kunsthalle, Berne 1966; Mus. d'Art Moderne, Paris 1969, '75; Gal. Creuzevalt, Paris 1971; Lefebre Gal., NYC 1972; Gal. Artel, Geneva, Switzerland 1973; Louisiana Mus., Humlebaek, Denmark 1974; "The Long March," Mus. of Art, Carnegie Inst., Pittsburgh 1974; Gal. Mark, Zurich 1975; Mus. d'Art Moderne de la Ville de Paris 1975; Carnegie Inst., Pittsburgh 1975; Gal. Attali, Paris 1975; "Jean Dewasne, Muraliste, Kunstverein, Hanover, W. Ger. 1975; Gal. d'Arte Contacto, Caracas, Venezuela 1976; "Gouaches et dessins," Gal. Asbaek, Copenhagen 1977; Gal. Groninger, Groningen, Neth. 1977; "Conceptions," Inst. Français, Stockholm 1978; Mus. of Modern Art, Caracas, Venezuela 1979; Grand Palais, Paris 1980; "La Longue marche," Centre Georges Pompidou, Paris 1981. GROUP EXHIBITIONS INCLUDE: Salon des Réalités Nouvelles, Paris 1945; Venice Biennale 1968; "The Non-Objective World 1939–1955," Annely Juda Fine Art, London 1972; "Douze ans d'art contemporain en France," Grand Palais, Paris 1972; Art Fair, Cologne 1975; "Artists from France," Covent Garden, London 1976; "Paris—Paris 1937–1957," Centre Georges Pompidou (Beaubourg), Paris 1981.

COLLECTIONS INCLUDE: Mus. des Beaux-Arts, Brussels; Centre Georges Pompidou (Beaubourg), Paris; Mus. de Grenoble, France; Carnegie Inst., Pittsburgh; Solomon R. Guggenheim Mus., and MOMA, NYC.

ABOUT: Contemporary Artists, 2d ed. 1983; Descargues, P. Jean Dewasne, 1952; Dewasne, J. Traité d'une peinture plane, 1972; Jouffroy A. (ed.) The Paris International Avant-Garde, 1966. *Periodicals*—Art News September 1975; Cimaise (Paris) nos. 115–116 1974; Le Nouvel observateur (Paris) September 1968; Quadrum 7 (Brussels) 1959.

DIBBETS, JAN (May 9, 1941–), Dutch painter, has since 1967 extended the boundaries of traditional Dutch interior and landscape painting, with its concern for light, space, and above all orderliness, to the realm of conceptual art. The result has been work of an unusual freshness and simplicity that has, in some cases, much in common with abstract painting. Dibbets "works from scratch," wrote Thomas Hess in *New York* magazine. "He uses a camera and treats it with the innocence of an ancient Egyptian who has just invented the ruler." Another critic called him "Vermeer with a camera."

Dibbets was born Gerardus Johannes Maria Dibbets in Weert, a small town in rural southern Holland. From 1953 to 1959 he attended Weert's Bisschoppelijk College; then for two years (1961–63) studied painting at the Academie voor Beeldende en Bouwedde Kunsten in Tilburg and privately with Jan Gregoor. Dibbets's favorite artists are Pieter Saenradam, a premodern painter of church interiors whom he calls "the 17th-century equivalent of Mondrian," and Mondrian himself. (Rarely has a conceptualist placed himself so firmly in an art-historical tradition.) His paintings of the 1960s show the influence of Saenradam's careful perspective and Mondrian's simple, geometric schemas.

Dibbets, a drawing instructor from 1964 to 1967, held his first solo show at the Galerie 845, Amsterdam, in 1965. In 1967 he married Bianka Francisca de Poorter, a part-time model, with whom he had one child, Hiske Karool. Later that year Dibbets studied in London at the St. Martin's School of Art on a grant from the British Council. There he met the conceptualists Richard Long, Barry Flanagan, and Sol Le Witt, whose combined influence seems to have pushed him away from painting and toward newer techniques. Like Le Witt and others, Dibbets found it easy to start his break with tradition by relying on simple geometry and repetition. His last "painting," which was just stacks of canvases (1967), was followed immediately by squares of sod stacked in the same manner. Multiples, stacks, and arrays, although used in his subsequent work as organizing principles, quickly took second place to a subtler concern: probing the illusions of vision.

While working as an art instructor at Atelier

JAN DIBBETS

Waddington Galleries, Ltd., London

63 in Haarlem (1968–71), Dibbets produced his "Perspective Corrections": photographs of string laid out on the floor of his studio in simple geometrical shapes which appear, confusingly, to be on a vertical, not horizontal, plane. The aim here, as in much of his later work, was deliberate defiance of illusionistic perspective. *12-Hour Tide Object with Perspective* (1969) was plowed into the sand of a beach by a tractor. Viewed from above, the plowed pattern was a trapezoid, but in Dibbets's photo, taken at eye level, it appears to be a rectangle. An *Art In America* critic called these works "complex pseudo-documents of altered nature." Between 1969 and 1971 Dibbets executed several works which were self-reflexive to their sites. Two of these were shown at the Galerie Yvon Lambert, Paris, in 1970: *Numbers on Walls,* in which he photographed numbered sections of the gallery's walls from a fixed distance and then hung each photograph over its corresponding section, and *Shadow Piece,* in which he outlined with tape the shadows cast on the gallery walls on a sunny day so that visitors would be made aware, as the shadows moved, of the rotation of the earth. Dibbets extended his interest in shadows into photography with *Shadows of My Studio Photographed Every 10 Minutes* (1969) and *Shadows on the Floor of the Galleria Sperone* (1971). In an interview with Charlotte Townsend, of *Artscanada,* the artist explained: "I would like my work to have about it the quality of a clock that runs all the time. I would like to make it so simple that you hardly think about it any more, so that, translated from reality, the pieces would become another reality themselves. . . . Most of my

work deals with light, what light is, how you see, what is real, how things are. What interests me are the levels of reality. . . . what changes in your environment without you touching it, what goes on every day, like the sea."

Dibbets has regularly experimented with nonphotographic media, keeping the same simplicity of idea and execution. In 1968 he aired *T. V. as a Fireplace,* a film loop of a roaring fire, on Dutch television. This idea, which approaches a species of pop in its artful banality, seems to have paved the way for the "Yule Log" fireplace tape broadcast regionally in the US each Christmas. Using the world post as a medium to gauge international response to conceptual art (or perhaps simply the willingness of the citizens in various countries to obey or play along), Dibbets sent out worldwide bulletins which read "Send the right side of this bulletin (stamped) by return post. . . . Each returned bulletin will be marked on a world map by a straight line from your home to Amsterdam." The resulting maps were shown at Dibbets's gallery, Art and Project, in Amsterdam. The creation of film loops of raised and lowered window blinds or dizzyingly oscillating views of the ocean occupied him in 1971–72.

In his "Dutch Mountain" series (1971–72), probably his best-known works, Dibbets slyly constructed photographic "hills" of grass, beach, and ocean for his relentlessly flat country. He carefully controlled the rotation and tilt of his camera while shooting, then fitted together the images to create the humped outline of a mountain. According to John Russell (*The New York Times* October 9, 1974), the "Dutch Mountains" exemplify Dibbets's talent at conveying "the irony of the thing known very well and ever so delicately turned inside-out.Who before Mr. Dibbets thought that the sea could form as a mountain and stay there?" In a related series the artist photographed flat expanses of beach and fit them together to resemble the parabolic trajectory of a comet (the "Comet" series, 1973).

Ann-Sargent Wooster of *Artforum* (January 1976) has pointed out the affinities of Dibbets's "Structure Pieces" and "Structure Panoramas" (mid-to-late 1970s) with the late paintings of Monet and Jackson Pollock. Dibbets chose as his subjects in these works flowers, grass, shrubs, and fallen leaves, changing the angle, focus, lighting, or distance from shot to shot and then grouping the photographs together in vast compositions (some more than 10 feet high). One views these works in much the way one looks at color field paintings, with the extra twist that these are images of reality. "Both Monet and Dibbets," wrote Wooster, "are producing decorative works in which the emotional and visual content is lessened by the suppression of visual incident into a continuous frieze or field." At the same time, she continues, Dibbets uses texture and linear rhythms in a way similar to Pollock, but without Pollock's energizing "expansiveness." Another reviewer, taking the "Structure Pieces" at face value as photographic works, praised their "direct, intense apprehension of unreconstructed Nature . . . a kind of epiphany of the natural world, an experience that only total visual absorption in a limited and intensified area of engaged vision can create."

A homebody who spends much of his time with his close-knit family, Dibbets said: "Most of the things I do relate to my own experience in my own house; all the pieces I do in galleries have been done before. I think them out at home, in my own chair." One writer described his home as "a hotel for artists (mostly American) visiting Amsterdam over the last four years." Dibbets and his wife speak five languages and collect Art Deco furniture and objects.

The artist believes in a reductive simplicity. "I have never done anything to make something clear to someone else and so I can have no general ideas about what art should be. For myself, I know that art is a kind of elimination process. You don't come near the truth about life or anything else by making it more complicated." In this he is like Mondrian, who attempted to reduce nature to the vertical and the horizontal. But, Dibbets claims, "I tried to go in the opposite direction from Mondrian . . . to go from abstraction back to reality."

EXHIBITIONS INCLUDE: Gal. 845, Amsterdam 1965; Gal. Swart, Amsterdam 1965–67; Gal. Konrad Fischer, Düsseldorf 1968, '71, '73, '74; Seth Siegelaub Gal., NYC 1969; Videogal. Gerry Schum, Düsseldorf 1969, '70; Art and Project, Amsterdam 1969, '71, '73, '75; Mus. Haus Lange, Krefeld, W. Ger. 1969; Gibson Gal., NYC 1969; Gal. Yvon Lambert, Paris 1970, '72, '74; Gal. Françoise Lambert, Milan 1970; Gal. Sperone, Turin 1971, '73, '74; Bykert Gal., NYC 1971; Stedelijk van Abbemus., Eindhoven, Neth. 1971; Gal. MTL, Brussels 1972, '75; Jack Wendler Gal., London 1972–74; Gal. Toselli, Milan 1972; Israel Mus., Jerusalem 1972; Stedelijk Mus., Amsterdam 1972; Leo Castelli Gal., NYC 1973, '75, '78; Gal. Rolf Presig, Basel, 1974; Cusack Gal., Houston, 1975; Calire Copley Gal., Los Angeles 1975; Scottish Arts Council Gal., Edinburgh 1976; Arnolfini Gal., Bristol, England 1976; Unit Gal., Chapter Arts Centre, Cardiff, Wales 1976. GROUP EXHIBITIONS INCLUDE: "When Attitudes Become Form," Kunsthalle, Bern 1969; 10th Biennial of Tokyo, 1970; "International," Solomon R. Guggenheim Mus., NYC 1971; "Konzept-Kunst," Kunstmus., Basel, 1972; Documenta 5, Kassel, W. Ger. 1972; Venice Biennale 1972; "Contemporanea," Parcheggio di Villa Borghese, Rome 1974; "Projekt '74," Kunsthalle, Cologne 1974;

"Eight Contemporary Artists," MOMA, NYC 1974; Multiples Gal., NYC 1977.

COLLECTIONS INCLUDE: Stedelijk Mus., Amsterdam; Art and Project, Amsterdam; Gemeentemus., The Hague, Neth.; Von der Heyd Mus., Wuppertal, Neth.; Kaiser Wilhelm Mus., Krefeld, W. Ger.; Angelo Baldessarre Collection, Bari, Italy; Konrad Fischer Collection, Düsseldorf; Pier Luigi Pero Collection, Turin; Reinier Lucassen Collecion, Amsterdam; Jack Wendler Collection, London; Solomon R. Guggenheim Mus., NYC.

ABOUT: *Periodicals*—Artforum April 1973, December 1974, May 1980; Art in America January/February 1976; Art International Summer 1970; Art News Summer 1972; Artscanada August/September 1971; Arts Magazine April 1970; New York June 1974 Studio International June 1972, January 1973.

Photo by George Yater

EDWIN W. DICKINSON

DICKINSON, EDWIN W. (October 11, 1891–December 2, 1978), American painter and draftsman, is best known for his small, romantic landscapes in the 19th-century tradition, though his mysterious, multilayered imagery and technical range reveal influences as diverse as late Renaissance mannerism and surrealism.

Edwin Walter Dickinson was born in Seneca Falls, New York, a town in the region of the Finger Lakes. He was the son of a Presbyterian clergyman, Edwin H. Dickinson, and the former Emma Carter. He had two brothers and a sister.

When Edwin was about 12 his mother died, and the family moved to Buffalo, New York, where he attended public schools. The family spent their summers in Sheldrake, on Lake Cayuga, a place which is evoked in some of Dickinson's paintings. In addition to reading and walking, Edwin loved the sea, and his first ambition after leaving high school was to become a naval officer. He took the entrance examination for the United States Naval Academy at Annapolis, but failed in mathematics and was refused admission. Since boyhood he had enjoyed sketching, and he found himself irresistibly drawn to a career in art.

In 1910, at the age of 19, he went to New York and studied for a year at the Pratt Institute in Brooklyn. From 1911 to 1913 he was enrolled at the Art Students League in Manhattan, where his teachers were William Merritt Chase and Frank Vincent DuMond. During the summers of 1912–14 he studied under Charles W. Hawthorne, whom Dickinson has credited with being the most important influence on his career.

Dickinson settled in Provincetown, Massachusetts in 1913. His paintings of this period were often inspired by the surrounding landscape and seascape, but they also have elements anticipating his later imagery. In an early self-portrait of 1914, Dickinson, according to an interview in 1960, "breached the painter's rule of never painting against the light . . . the face is in shadow, but one eye does emerge." A critic viewing Dickinson's 1961 retrospective at the Graham Gallery, New York City, found expressionist undertones in the 1914 *Self-Portrait* and fauvist and abstract tendencies in certain canvases of 1915, but noted that Dickinson was generally unaffected by the techniques of modern art.

After a brief period of teaching in 1916 at the Buffalo Academy of Fine Arts, New York, Dickinson went to New York City in 1917 to work as a telegrapher for the US Army. Later that year he fulfilled his boyhood ambitions by serving as a radio operator in the US Navy during World War I.

After his discharge from the service in 1919, Dickinson enrolled at the Académie de la Grande Chaumière, Paris, and also worked on his own. *Antoinette* (1919; Hirshhorn Museum and Sculpture Garden, Washington, D.C.) combines fauvist rhythms with cool tonalities. Nudes painted from life at this time are portrayed from unusual angles which anticipate such pictures as *The Fossil Hunters*. In 1919 he was included in a group exhibition, "American Painters," at the Musée du Luxembourg, Paris. Dickinson also visited Spain, where he was deeply impressed by

El Greco, Velázquez, and Zurbaran. During 1920 he painted several watercolors, but soon realized that oil was his "natural medium."

On his return to the United States in 1920, Dickinson spent a year in upstate New York and in 1921 settled once again in Provincetown. Though he welcomed the influence of Cape Cod on his work, his living conditions in the 1920s were rigorous: "I painted, cooked, and slept in the studio for which I paid $50 a year. It was heated by a coal stove. The floor was made tight with inverted old canvases tacked down, the walls and ceilings being covered with building paper. I considered my circumstances far more luxurious than other people's." Outstanding works of this period are *The Cellist* (1924–26), with its rhythmic distribution of objects around the musician who is seen from above, and *The Fossil Hunters* (1926–28), in which, Barbara Rose observed, "bodies tumble down on one another, entwined in drapery, smoke and haze, evoking ghostly images, effecting mysterious transformations."

In 1927 Dickinson had his first solo exhibition at the Albright Art Gallery, Buffalo. The following year he married Frances Foley, also an artist; they had a daughter, Helen, and a son, Edwin.

During the 1920s and 1930s Dickinson painted many of his most important large works, described by one critic as "monochromatic spellbinders." Paintings such as *Woodland Scene* (1929–35), and the mysterious *Composition with Still Life* (1934–37; Museum of Modern Art, New York City) required meticulous labor. In a statement in *Art USA Now* Dickinson explained that the large figure compositions he had been painting since 1915 required one hundred to four hundred sittings each. "After working on a composition for two years or more," he wrote, "my own development during that period made keeping the painting up-to-date, as it were, impossible. After years of work on it, a painting could not be quite completely reorganized, nor thrown away, so I often felt forced to stop work on it and begin another."

For those with no taste for these ambitious and enigmatic works, Dickinson did completely different paintings which he called *"premier coup"* (first shot). These were small works painted outdoors, usually in a single sitting. Their muted, atmospheric quality led some critics to compare them to the late Turner. Dickinson first painted these *premier coup* pictures in Provincetown and did many more while living in France (Brittany, Provence, and Paris), in 1937 and 1938.

After returning to America in 1938, the Dickinsons moved from Provincetown to Wellfleet, Massachusetts, where they continued to spend summers after moving to Manhattan in 1944. In 1943 he began one of his most impressive paintings, *Ruin at Daphne,* on which he worked for nearly ten years, and which was later acquired by the Metropolitan Museum of Art, New York City. This architectural fantasy was originally inspired by his interest in the Roman arena and other ruins at Arles in Provence, which he had visited in the late 1930s. An intricate perspective scheme results from the juxtaposition of several viewpoints. The almost surreal interplay of columns, Piranesi-like spiral stairways, arches, and pediments in an ambiguous space can be interpreted as symbolizing inner confusion and uncertainty. But Dickinson, who named his pictures only after their completion, was always reluctant to discuss the symbolism of his paintings. In 1952 he stopped work on *Ruin at Daphne,* leaving the outer rim red whereas the central area is in grayish tones.

Dickinson taught in New York City at Cooper Union, from 1945 to 1949, and at the Art Students League from 1945 to 1960 and again from 1963 to 1966. He was a dedicated teacher, asserting he had always taught "for pleasure and secondly as a means of earning a living." He was always fond of travel and in the summers of 1959 and 1960 he visited Mediterranean ports as a passenger on freighters. His drawings made on these trips, combining precision with sensitive shading, display his skill as draftsman.

Many of Dickinson's landscapes and large canvases of the 1940s and '50s were painted on Cape Cod; they include *Wellfleet Harbor* (1946) and *A Cottage Window and Oar* (1955). Dore Ashton observed in *The New York Times* (August 30, 1959) that Dickinson's palette "is geared to the dimmed blues of the sea, the white-to-taupe tones of the sands, and the delicate greens of seaside vegetation."

In February 1961 some 150 of Dickinson's paintings and drawings were shown at the Graham Gallery in the artist's first retrospective. Also in 1961 he was elected to membership in the American Academy of Arts and Letters. He had other retrospectives at the Whitney Museum of American Art, New York City, in 1965, and at the Venice Biennale of 1968. His last important New York showing was held at the Graham Gallery in 1972. He died in 1978 on Cape Cod, aged 87.

Edwin Dickinson was a slight, distinguished-looking man, courteous in manner, and with a pleasant, resonant voice. His face was described in *Art USA Now* as being "as anachronistic as his art; one notices first the splendid gray moustache and beard, at once Edwardian and Renaissance, but it is his eyes that hold one; enigmatic, pene-

trating, both direct and evasive." In November 1964 Raphael Soyer made a sensitive study in oil of Edwin Dickinson, whom he included in his large painting *Homage to Thomas Eakins* (1966). In his book recording this and other studies for the group portrait of leading figurative artists, Soyer commented on Dickinson's "bare, neat and orderly" studio in Wellfleet, its whitewashed walls "decorated with pale maps of the Mediterranean and of the Greek Isles." Dickinson was preparing to deliver a lecture at a university on "Application of the Principles of the Housekeeping of the Palette," and Soyer commented that this reflected his meticulous attitude, as did the "arithmetical exactness" of his explanation of why it sometimes took him years to finish a painting: " . . . My paintings are never completed. My 'finished' paintings are only three-fifths finished."

EXHIBITIONS INCLUDE: Albright-Knox Art Gal., Buffalo, N.Y. 1927; Annual Nat. Academy of Design, NYC 1929, '49; Passedoit Gal., NYC 1936, 1938–42; Andrew Dickson White Mus. of Art, Cornell Univ., Ithaca, N.Y. 1957; Cushman Gal., Houston 1958; Art Gal., Boston Univ., School of Fine and Applied Arts 1958; Circulating Exhibition, MOMA, NYC 1961; James Graham and Sons, NYC from 1961; Syracuse Univ., N.Y. 1965; Whitney Mus. of Am. Art, NYC 1965; Hawthorne Memorial Gal., Provincetown, Mass. 1967; Venice Biennale 1968; Inst. of Contemporary Art, Boston 1970; Weedom Gal., Boston 1970; Wellfleet Art Gal., Cape Cod, Mass. 1972; Charles Burchfield Center, Buffalo, N.Y. 1977. GROUP EXHIBITIONS INCLUDE: "American Painters," Mus. du Luxembourg, Paris 1919; Pennsylvania Academy Annual 1922; Pittsburgh Annual, Carnegie Inst. 1926, '28; "Romantic Painting in America," MOMA, NYC 1943; "Fifteen Americans," MOMA, NYC 1952; Nat. Inst. of Arts and Letters, NYC 1954.

COLLECTIONS INCLUDE: Metropolitan Mus. of Art, MOMA, Whitney Mus. of Am. Art, Nat. Academy of Design, and Sara Roby Foundation, NYC; Albright-Knox Art Gal., Buffalo, N.Y.; Andrew Dickson White Mus. of Art, Cornell Univ., Ithaca, N.Y.; Mus. of Fine Arts, Springfield, Mass.; Bowdoin Col. Mus. of Fine Arts, Brunswick, Maine; Hirshhorn Mus. and Sculpture Garden, Washington, D.C.

ABOUT: Baur, J.I.H. (ed.) New Art in America, 1957; Current Biography, 1963; "Edwin Dickinson: Retrospective" (cat.), Graham Gal., NYC, 1961; "Fifteen Americans" (cat.), MOMA, NYC, 1952; Goodrich, L. The Drawings of Edwin Dickinson, 1963; Nordness, L. (ed.) Art USA Now, 1962; Protter, E. Painters on Painting, 1963; Rose, B. American Arts Since 1900, 2d ed. 1975; Soby, J.T. and others "Romantic Painting in America" (cat.), MOMA, NYC, 1943; Soyer, R. Homage to Thomas Eakins, Etc., 1966. *Periodicals*—Art Digest April 15, 1938, August 1, 1945; Art News November 1965, November 1977; Arts and Architecture April 1961; New York Times August 30, 1959, December 3, 1978; Studio October 1961.

*DIEBENKORN, RICHARD (CLIFFORD)

(April 22, 1922–), American painter, was a leader of the West Coast School of abstract expressionism. In the mid-1950s he abandoned nonobjective painting for a figurative style, but subsequently returned to an abstract mode, more firmly structured than his earlier work.

Richard Clifford Diebenkorn Jr. was born in Portland, Oregon, the son of R. C. and Dorothy (Stevens) Diebenkorn. In 1924 his father, a successful sales executive, moved the family to San Francisco. Richard, an only child, had a solitary disposition. The greatest influence in his boyhood was that of his grandmother, Florence Stevens, with whom he spent his summers and who knew absolutely which books at which time to give him—Arthurian legends one year, English history the next. He admired the illustrators Howard Pyle and N. C. Wyeth, especially the former, and early on knew he wanted to be an artist. But at Lowell High School, San Francisco, art—especially modern art—was considered an "effete activity." Consequently, "I drew at home, not at school. . . ." He was encouraged to draw by the family cook, who provided him with art supplies.

After completing high school, Diebenkorn persuaded his father to let him enroll at Stanford University, Palo Alto, California, in 1940. When America entered the war in December 1941, he knew he would soon be in the military. He was an art major, but in his first two years he eagerly studied other subjects and acquired lasting interests in music, history, and literature. He said, "It was mostly the world of writing that opened up—Faulkner, Hemingway, Sherwood Anderson."

In his third year at Stanford, Diebenkorn studied with Daniel Mendelowitz, who had been a pupil of the Ashcan School painter Reginald Marsh and admired the realists Charles Sheeler and Edmund Hopper and the early abstractionist Arthur Dove. He took his student to Sarah Stein's house in Palo Alto, where Diebenkorn first saw the work of Cézanne, Matisse, and Pi-

°dē´ bən kôn

casso. Cézanne "rapidly became ever more marvelous" for him, Diebenkorn said (he was to carry a book of Cézanne reproductions in his Marine seabag during the war).

Diebenkorn's 1943 painting *Palo Alto Circle* reflected his interest in Hopper, but already, as Maurice Tuchman noted in *Art Journal*, his work contained personal elements, notably the fusing of "spatially separated planes into one flat surface" and an "abiding passion for strong, clear sunlight."

In the summer of 1943, after he enlisted in the Marine Corps Officer Training Program, Diebenkorn transferred from Stanford to the University of California, Berkeley. A Marine superior told him to specialize in art, and he spent a semester studying with the painter, critic, and teacher Erle Loran, a disciple of Hans Hofmann and author of a book, *Cézanne's Composition*. Diebenkorn felt he was now acquiring a "real education, . . . and a good one." Assigned to a base in Quantico, Virginia, near Washington D.C., he made careful pencil drawings of fellow marines and frequently visited Washington's Phillips Collection, "as a kind of retreat from service," Diebenkorn said. "I looked at the paintings of Matisse, Picasso, Braque, Bonnard. . . . " The picture which he most admired was Matisse's *L'Atelier, Quai Saint-Michel*. This masterful painting of a studio interior with a reclining nude was instrumental, to quote Tuchman, in fostering the young artist's "potential ability to fully integrate line with shape, form with color, and keen observation with frankly abstract formal handling." In 1944–45, while studying the A. E. Gallatin Collection at the Philadelphia Museum of Art, he was impressed by Cézanne's *The Balcony*. "I like any Cézanne I've ever seen, Diebenkorn said, "because he had the spirit of modernism." About this time he happened upon *DYN* magazine and "saw pictures of paintings that were a new breed of cat to me altogether." These were by artists of the emerging New York School, and he especially enjoyed the "immediacy" of Robert Motherwell's *The Room*.

Diebenkorn was slated for combat in Japan when the atomic bombs were dropped. Discharged in 1945, he returned to California and painted *Untitled* (1945), one of his few surviving canvases from this period. In this early attempt at abstraction, which shows the influence of Motherwell, there was still the suggestion of a figure, a helmeted, warriorlike personage. The composition was marked by a boldly assertive compartmentalization of space.

In January 1946 Diebenkorn enrolled at the avant-garde California School of Fine Arts, San Francisco, and studied with the painter David Park, who became a close friend and mentor. Diebenkorn was regarded as, one of the teachers recalled, "a star among students," and he won the Albert Bender Grant-in-Aid, a fellowship enabling young California artists to be exposed to art in New York City. In the fall of 1946 Richard and Phyllis (Gilman) Diebenkorn (they had married in 1943) and their infant daughter Gretchen settled into a studio in Woodstock, New York. In New York City Diebenkorn, on the advice of Park, looked long and hard at Miró. He was particularly impressed by Miró's *Person Throwing a Stone at a Bird* and was affected by what he described as the "weight and opacity and somberness" of Miró's color.

In the spring of 1947 the Bender grant money ran out and the Diebenkorns returned home. There was now a second child, Christopher James, and the family struggled until September 1947, when Diebenkorn began teaching at the California School of Fine Arts. The school was at that time among the leading experimental art schools in the country; the Abstract Expressionist Clyfford Still was one of the senior faculty members and Mark Rothko taught summer sessions in 1948 and '49.

Stimulated by the work of Still and Rothko, Diebenkorn began painting in an abstract manner. In 1948 he was given a solo show at the California Palace of the Legion of Honor, San Francisco. The work he exhibited was rooted in cubism but contained biomorphic imagery, possibly derived from his study of Miró. In 1949 he obtained the BA degree from Stanford.

Intrigued by magazine photographs of the Southwest, Diebenkorn moved to Albuquerque, New Mexico, and in January 1950 enrolled in the state university. Away from his Abstract Expressionist colleagues in California, he began, according to *Life* magazine, "to create a less abstract art based on recollections of the California landscape he had left behind." But he was also moved by the sparse desert landscape of the Southwest, with its brilliant light and flat planes. The pink coloration typical of New Mexico is evident in *Albuquerque #4* (1951; St Louis Art Museum). Emblems, cryptic signs, and letters of the alphabet appeared in his work at this time, in a manner reminiscent of Adolph Gottlieb's "Pictographs." Moreover, Diebenkorn's abstract paintings of California and New Mexico landscapes were in the action, or gestural, style of Willem de Kooning.

Diebenkorn was awarded his MA degree by the University of New Mexico in 1952. In the fall of 1952, after spending the summer in California and seeing a Matisse exhibition in Los Angeles,

Diebenkorn took a teaching position at the University of Illinois, Urbana, where he remained one year. One of his most striking Illinois pictures, *Urbana No. 2* (later entitled *The Archer*), was inspired by an Altamira cave painting he had seen in a color reproduction. In 1953, after a brief stay in Manhattan, where he became friends with Franz Kline, he returned to California and settled in Berkeley. The following year Diebenkorn had a solo show at the San Francisco Museum of Art and was included in the "Younger American Painters" show at the Guggenheim Museum, New York City. His painting *Berkeley No. 8* (1954; North Carolina Museum of Art, Raleigh), though abstract, reflected his interest in Soutine's uprooted landscapes, with what the artist called "their almost totally broken surfaces."

In early 1955 Diebenkorn became assistant professor of drawing and painting at the College of Arts and Crafts, Oakland, California, a post he held about five years. In late 1955 he was represented in a group show at the Poindexter Gallery, New York City. He impressed a *New York Times* critic with his ability to suggest vast spaces even when working in a small format. He joined the Poindexter Gallery, which in March 1956 held the first of his periodic solo shows there. A *New York Times* reviewer called him a "rising star" of the abstract-expressionist movement, but one statement foreshadowed the change soon to occur in Diebenkorn's work: "They [the paintings] resemble aerial photographs of a big varied landscape with shore-line, mountains, cliffs and fields: the contours, perhaps, of California."

In 1955, months before his solo Poindexter show, Diebenkorn had decided to abandon abstract expressionism, even though nonrepresentation was dominant in American painting. He explained: "I was encumbered with style and too concerned with style. . . . My painting was too inbred. Representation was a challenge I hadn't faced."

Diebenkorn introduced figuration into his painting but did not entirely reject abstract-expressionist technique. He retained what he had learned from de Kooning—identified by Dore Ashton in *American Art Since 1945* as "the heavily impastoed stroking of sandy yellows, turbid greens, brilliant blues and reds"—in his figurative work. Also, Diebenkorn's human figures were, Ashton said, placed "in settings that were conceived with an intense awareness of their psychological effect." One or two figures became the focal point of his vertical-horizontal structures, as in *Girl on Terrace* (1956), *Man and Woman in a Large Room* (1957; Hirshhorn Museum and Sculpture Garden, Washington, D. C.), *Woman on Porch* (1958), and *Pouring Coffee* (1958). The figures, though not individualized, are living, tangible presences.

With two other West Coast artists, David Park and Elmer Bischoff, both of whom had taught at the California School of Fine Arts and had also broken away from abstractionism, Diebenkorn exhibited his new figurative paintings at the Oakland Museum of Art in 1957. That exhibition, and Diebenkorn's solo show at the Poindexter Gallery early in 1958, caused much excitement: his work was acclaimed as a bold departure that heralded the advent of a new realism in painting. *Time* (March 17, 1958) magazine mentioned Diebenkorn's early admiration for Edward Hopper, but Diebenkorn's figurative pictures had less affinity with American realism than with the French modernism of Manet, Matisse, Vuillard, and Bonnard.

The emergence in the early 1960s of pop art, with its cool objectivity, made Diebenkorn's lyrical, carefully worked oils seem overly "aesthetic." But Diebenkorn and his West Coast colleagues were uninterested in being fashionable or part of a popular movement; as John Canaday wrote in *The New York Times* (May 26, 1968), "They merely painted, and their survival outside the system of competitive exploitation remains one strong indication of their merits as artists."

Diebenkorn continued to work in Berkeley. In 1958 he was among the 17 American artists exhibited in the United States pavilion at the Brussels World's Fair. The show traveled to London, where Diebenkorn's work was enthusiastically received. He returned to London in 1964 for a solo show at the Waddington Galleries, and during that year he visited the Soviet Union under the auspices of a State Department cultural exchange program. He showed slides of about one hundred of his paintings to the Russians, who criticized the absence of social message in his work.

In 1966 Diebenkorn was named professor of art at the University of California, Los Angeles, and moved south, setting up his studio in Venice, California, near the old Ocean Park amusement pier. The following year, the figure disappeared from his canvases, but the abstract style to which he returned was moored, as always, to reality. As had been his custom, Diebenkorn named the pictures he began in 1967 after the locale where they were painted. The acclaimed "Ocean Park" series is, it appears, ongoing. The careful structuring of color he had admired in Matisse became more pronounced, and as Gordon J. Hazlitt wrote in *Art News*, "The 'Ocean Park'

abstractions are less floating and lyrical than his early work, more reserved in hue and much more geometric." "Diebenkorn's unerring choice of color," Ashton commented, "and his instinctive feeling for the embodiment of daylight as it graces various surfaces give his 'Ocean Park' series a quiet splendor few American painters have achieved."

Richard Diebenkorn is a tall, dark-haired, sturdily built man, with a shy but friendly manner. He dresses casually and works every afternoon, seven days a week, in the light, airy two-story building he designed and built in 1976 on a busy, commercial street in Venice, near Santa Monica. Unlike many contemporary artists, Diebenkorn is a throwback to the conception of the artist as "existential" loner that was popular in the '50s; he considers himself among the older cast of artists who "enjoy [their] solitude and enjoy the attempt to pull [their] thing together." Of his "Ocean Park" series, he said: "My painting is a problem-solving thing and I have only acknowledged this in the last 10 or 12 years. . . . I used to believe in inspiration and had ideas in the middle of the night and all that. But when I hurried to the studio to get them down I would be disappointed. . . . Such initial ideas simply don't have the visual complexity I want from myself now. That complexity comes from the process of elaborating the work itself, from actually doing it."

EXHIBITIONS INCLUDE: California Palace of the Legion of Honor, San Francisco 1948, '60; Paul Kantor Gal., Los Angeles 1952, '54; San Francisco Mus. of Art 1954, '72; Oakland Art Mus., Calif. 1956; Poindexter Gal., NYC 1956, '58, '63, '66, '68, '69, '71; Pasadena Art Mus., Calif. 1960; Phillips Collection, Washington, D.C. 1961; Martha Jackson Gal., NYC 1963; Waddington Gals., London 1964–65, '67; Washington [D.C.] Gal. of Modern Art, 1964–65; Stanford Univ. Art Gal., Calif. 1964, '67; Marlborough Gal., NYC 1971, '75; Albright-Knox Art Gal., Buffalo, N.Y. 1976–77. GROUP EXHIBITIONS INCLUDE: "Contemporary Painting in the U. S.," Los Angeles County Mus. of Art 1951; "Younger American Painters," Solomon R. Guggenheim Mus. NYC 1954; São Paulo Bienal 1955; Pittsburgh Intl. 1955–70; Poindexter Gal., NYC 1955; Whitney Annual, NYC from 1955; "Seventeen Contemporary American Artists," Brussels World's Fair 1958; "New Images of Man," MOMA, NYC 1959–60; "New Images of Man." Baltimore Mus. of Art, 1959–60; "Painting and Sculpture of a Decade," Tate Gal., London 1964; "The Figurative Tradition in Recent American Art," Venice Biennale 1968; "L'Art vivant aux Etats-Unis," Fondation Maeght, Saint-Paul-de-Vence, France 1970; "Fifteen Abstract Artists," Santa Barbara Mus., Calif. 1974; "California Landscape, a Metaview," Oakland Mus., Calif. 1975.

COLLECTIONS INCLUDE: Metropolitan Mus. of Art, MOMA, Whitney Mus. of Am. Art, and Solomon R. Guggenheim Mus., NYC; Brooklyn Mus., N.Y.: Albright-Knox Art Gal., Buffalo, N.Y.: Corcoran Gal. of Art, Phillips Collection, and Hirshhorn Mus. and Sculpture Garden, Washington, D.C.; Art Inst. of Chicago; Baltimore Mus. of Art; Chrysler Mus., Norfolk, Va.; Cleveland Mus. of Art; Cincinnati Art Mus.; Des Moines Art Center, Iowa; Phoenix Art Mus., Ariz; California Palace of the Legion of Honor, and San Francisco Mus. of Modern Art, San Francisco; Oakland Mus., Calif.; Stanford Univ. Mus. and Art Gal., Calif.; Los Angeles County Mus. of Art; Norton Simon Mus. of Art at Pasadena, Calif.; Royal Ontario Mus., and Art Gal. of Ontario, Toronto.

ABOUT: Ashton, D. American Art Since 1945, 1982; Buck, Robert T. (ed.) Richard Diebenkorn: Paintings and Drawings, 1943 to 1980; Current Biography, 1971; Geldzahler, H. New York Painting and Sculpture: 1940–1970, 1970; Nordness, L. (ed.) Art USA Now, 1962; Pellegrini, A. New Tendencies in Art, 1966; Rose, B. American Art Since 1900, 2d ed. 1975; Russell, J. "Richard Diebenkorn, The Ocean Park Series: Recent Work" (cat.), Marlborough Fine Art, Ltd., London, 1973; Selz, P. "New Images of Man" (cat.), MOMA, NYC, 1959; Smith, H. R. "Recent Paintings by Richard Diebenkorn" (cat.), California Palace of the Legion of Honor, San Francisco, 1960. *Periodicals*—Art Journal Spring 1977; Art News January 1977; Artforum March 1977; Life November 4, 1957; New York Times March 4, 1956, March 17, 1958, December 5, 1976; Newsweek November 30, 1964; Time March 17, 1958, June 27, 1977.

DILLER, BURGOYNE (ANDREW) (January 13, 1906–January 30, 1965), American painter, was one of the first purely abstract artists in the United States. "His work," Philip Larson said in the catalog to a Diller retrospective at the Walker Art Center, Minneapolis, "bridges the gap between geometric art of the first decade of this century and the minimalist attitudes of the early 1960s."

Diller was born and reared in Battle Creek, Michigan. He began to draw and paint in his early teens, and in 1926 and '27 he studied at Michigan State University, East Lansing, before moving to New York City in 1928. There he took classes at the Art Students League in 1928 and '29 with George B. Bridgman and Boardman Robinson; his teachers at the League in the summer of 1929 were William von Schlegel and Ki-

Photo by Rudolph Burckhardt

BURGOYNE DILLER

mon Nikolaides. Eager to learn differing approaches to art, Diller studied with Jan Matulka from 1929 to '31, and, briefly, with A. S. Baylinson and Charles Locke in 1931– 32. In the summer of 1932 he attended the German émigré artist George Grosz's classes, and he studied privately with Hans Hofmann in New York in 1932 and '33. Hofmann's theory of advancing and receding colors was greatly to influence his work.

In his early painting Diller was influenced both by Cézanne and cubism. In *Art News* (October 1968) Lawrence Campbell wrote, "Diller once said that he wished to penetrate the inner construction of perceived reality, and that this intention came about as the result of a sudden realization of the expression of a volume in a Cézanne still life he saw at the Chicago Art Institute when he was 18." Diller began by painting landscapes and city scenes in an expressionist style, but his work became increasingly abstract. In the early 1930s he produced his first geometric paintings, influenced first by the suprematism of Kasimir Malevich and El Lissitzky, then by the de Stijl artists Piet Mondrian and Theo van Doesburg. The aesthetics of the Bauhaus also contributed to his development. In 1932, at the Art Students League, he took part in the first group exhibition of abstract art in the United States.

In 1933 Diller had his first solo show, at the Contemporary Art Gallery, New York City. By 1934, when he had a second solo exhibition, at New York City's Theodore Akohn Gallery, it was clear that he was a convinced disciple of Mondrian's neoplasticism—and had become the first American artist to embrace the principles of

geometric abstraction. According to Lawrence Campbell, "Asked why he used only reds, blues and yellows, he [Diller] stated that he sought the expression of space volume resulting from a maximum recessive contrast, and that other colors were ambivalent and did not separate from each other completely."

About 1934 Diller made his first relief constructions, using painted dowels and strips of wood on masonite. One construction of 1934 is now in the collection of the Hirshhorn Museum and Sculpture Garden, Washington D.C., but at the time he had trouble selling his work and received almost no public recognition. In 1936 he joined the American Abstract Artists group, which by the late '30s included Josef Albers, Ilya Bolotowsky, Fritz Glarner, Lee Krasner, Willem de Kooning, Carl Holty, I. Rice Pereira, and Ad Reinhardt. American Abstract Artists sought to make New York City the world center for modern art and was "the focus for the energies of the emerging American avant-garde," according to Barbara Rose. The association held annual exhibitions in which Diller showed until 1939.

From 1935 to 1940 Diller was supervisor of the Mural Division of the Works Progress Administration's (WPA) Federal Arts Project in New York. In 1940 he became assistant technical director of the entire project and the following year was appointed director of the WPA's New York City War Service Art Section. Also in 1941 he was commissioned as a lieutenant in the Training AID Development Center of the US Navy. After the war Diller built a studio in Atlantic Highlands, New Jersey, and in 1945 he became an instructor of design at Brooklyn College, a post he held until 1964.

Diller divided his paintings into three groups or series. In those of the "First Theme" a few "free-form" or rectangular elements were placed on a monochromatic (white in the early works) background. One of Diller's techniques was to draw a grid on the canvas in charcoal and experiment with color by pinning rectangles of construction paper to the canvas, a method similar to procedures developed by Mondrian. In several "First Theme" paintings the rectangles are contiguous, with no indication of a grid; but in "Second Theme" works, begun about 1943, the grid was visible. In Diller's "Third Theme" paintings, which he began about 1945, a more complex grid was revealed, depicting "elements in activity." These works were influenced by Mondrian's "Boogie-Woogie" paintings of 1942–44. Diller and Fritz Glarner were the leading American exponents of neoplasticism, although each artist developed independently within the tradition of geometric abstraction.

In 1951 Diller was represented in the prestigious "Abstract Painting and Sculpture in America" exhibition at the Museum of Modern Art, New York City, and in 1945 he was visiting critic at the Yale University School of Art and Architecture, New Haven, Connecticut. However, his geometrically severe, angular work failed to gain a wide audience, though fellow artists recognized his importance. About 1958 he returned to his "First Theme" style, but instead of exclusively white backgrounds he experimented with gray and eventually settled on black. One painting from this series, completed in 1960, was acquired in 1968, three years after the artist's death, by Joseph H. Hirshhorn and is now in the Hirshhorn Museum and Sculpture Garden. Reminiscent of Barnett Newman's stripe paintings, it consists of a white vertical stripe, and white, yellow, red, and blue rectangles on a black background. Diller's way of isolating and "monumentalizing" simple elements in these "neo-First Theme" paintings was absorbed by the younger generation of Minimalist artists of the 1960s.

In 1961 Diller made his first relief construction, and about 1963 he began translating the two-dimensional rectilinearity of his paintings into sculptures made from blocks, which he called "Color Structures." Philip Larson explained that the artist "wanted an enduring material that would express eternity," and Diller chose black granite for his "Projects for Granite." (When granite proved too costly, he executed the series in formica-covered plywood.) Although Diller was a nonrepresentational artist, several of the sculptures suggest a sort of primitive figuration.

With the rise of hard-edge abstraction in the '60s, Neoplasticists who had belonged to American Abstract Artists—Diller, Bolotowsky, and Glarner—received greater public recognition. Diller was awarded a Purchase Prize by the Ford Foundation in 1963, but after years of relative neglect he was uncertain of his achievement. In his all-white studio in New Jersey he painted slowly, methodically, sometimes producing no more than one painting a month. He enjoyed conversation, but became increasingly reclusive during the last 20 years of his life. "Fearful of leaving his grand scheme unfinished," Philip Larson wrote, "he shunned the daylight, shut out visitors and retreated further into solitude." Uncertain that his work would be remembered, Diller was often deeply despondent for long periods and sank into alcoholism, which led to his death in New York City at the age of 59. At that time he was planning a memorial for Jews killed in World War II, based on one of his granite projects.

Diller was described as looking like "an older James Dean." He was averse to purely intellectual interpretations of his art. "After all," he declared, "you can't eliminate [the] feeling you have for the total thing . . . if you're thinking . . . of the intellectual resolving of a problem—after all, the visual thing is quite something else. It's certainly not an intellectual process. . . . There are certain kinds of relationships between your elements—line, plane and movement—but this doesn't make a painting."

EXHIBITIONS INCLUDE: Contemporary Arts, NYC 1933; Theodore Akohn Gal., NYC 1934; The Pinacotheka, NYC 1946, '49; Rose Fried Gal., NYC 1951; Gal. Chalette, NYC 1961, '62, '64; Retrospectives: New Jersey State Museum, Trenton 1966; Noah Goldowsky Gal., NYC 1968–70, '72; Walker Art Center, Minneapolis, 1971–72. GROUP EXHIBITIONS INCLUDE: "Abstract Art," Art Students League, NYC 1932; "American Abstract Artists," Whitney Mus. of Am. Art, NYC 1937–40; "Jose de Rivera; Burgoyne Diller," Harvard School of Design, Cambridge, Mass. 1945; "Abstract Painting and Sculpture in America," MOMA, NYC 1951; Whitney Annual, NYC 1952–54, 1964: "Konkrete Kunst," Helmhaus, Zurich 1960; "Geometric Abstraction in America," Whitney Mus. of Am. Art, NYC 1962; São Paulo Bienal, 1963; "The New Tradition: Modern Americans Before 1940," Corcoran Gal. of Art, Washington, D.C. 1963; "American Sculpture 1962–64," Whitney Mus. of Am. Art, NYC 1965; "The Non-Objective World 1924–1939," Gal. Jean Chauvelin, Paris, Annely Juda Fine Art, London, and Gal. Milano, Milan 1971; "Geometric Abstraction 1926–1942," Mus. of Fine Arts, Dallas 1972; "Post-Mondrian Abstraction in America," Mus. of Contemporary Art, Chicago, 1973.

COLLECTIONS INCLUDE: Metropolitan Mus. of Art, MOMA, Whitney Mus. of Am. Art, and New York University, NYC; Albright-Knox Art Gal., Buffalo, N.Y.; Mus. of Fine Art, Syracuse, N.Y.; Newark Mus., N.J.; Yale Univ., New Haven, Conn.; Corcoran Gal. of Art, Hirshhorn Mus. and Sculpture Garden, Smithsonian Inst., Washington, D.C.; Los Angeles County Mus., Calif.

ABOUT: Larson, P. Walker Art Gallery Catalog, Minneapolis, 1971; Pincus-Witten, R. "Post–Mondrian Abstraction in America" (cat.), Museum of Contemporary Art, Chicago 1973. Periodicals—Artforum February 1972; Art News January 1953, May 1961, October 1968; Arts May 1961; Leonardo (Oxford, U.K.) Winter 1972.

DINE, JIM (June 16, 1935–), American painter, emerged in the early 1960s as a leader of the neo-dada movement. James Dine was born in Cincinnati, Ohio, the son of Stanley and Eunice (Cohen) Dine. He has a younger brother. In an *Art News* (September 1977) interview with

Jorge Lewinski

JIM DINE

John Gruen he recalled: "My father was defi-
nitely not inclined toward the arts. My mother,
on the other hand, was artistic. She loved music."
Dine began drawing in his early teens, although
he "was encouraged by no one," as he told
Gruen. When he was 15 his mother died, his fa-
ther remarried, and Dine left home to live with
his grandparents. In his grandfather's hardware
and plumbing supply store he came into contact
with the objects that have fascinated him ever
since—hammers, saws, shovels, wrenches, sinks,
and other domestic tools and fixtures. Now on
his own and determined to be an artist, Dine
took classes three nights a week at the Cincinnati
Art Academy under Paul Chidlaw.

In 1952, upon graduating from high school,
Dine entered the University of Cincinnati, but
stayed there only a year. ("I couldn't take it. I
was at sea with my psyche.") He then tried the
School of the Museum of Fine Arts, Boston, but
was discouraged to find that "they wouldn't
leave [him], alone" and he left after six months.
He returned to Ohio and at 19 enrolled in the art
department of Ohio University, Athens. Al-
though he found the art department "hopeless,"
the faculty and administration did not interfere
with his instinctual approach to art and one
teacher, Dwight Mutchelor, helped him to ex-
plore the possibilities of drawing. He earned the
BFA from Ohio University in 1957, and stayed
on for another year doing postgraduate work,
"painting like crazy, drawing like crazy, and
making prints." He described his work of that
period as "figurative and expressionist."

At Ohio University, Dine met Nancy Minto,
a fellow art student whom he married in 1957.

After Dine had completed his postgraduate year,
in 1958, he and Nancy decided to try and make
it in New York City.

In 1958 the Dines settled on Long Island,
where Jim taught at Patchogue for a year. They
next moved to New York City, and he taught at
the Rhodes School, a private high school near the
Museum of Modern Art. In the two years he
taught there he took his students every day to
MOMA and the Whitney Museum of American
Art. In Ohio Dine had eagerly scanned issues of
Art News and thereby "schooled [himself] totally
in the New York School," learning about de Koo-
ning, Pollock, Franz Kline and other Abstract
Expressionists before he arrived in New York.
Now he met several of the younger New York
artists, including Claes Oldenburg, who later
took part in the first "happenings," or artists' the-
ater events, in Manhattan. "I also met Lester
Johnson and Red Grooms, and everybody was
incredibly productive and incredibly young,"
Dine recalled. He was also an early admirer of
the work of Jasper Johns and Robert Rauschen-
berg, which broke with abstract expressionism
and anticipated pop art.

Together, Dine and Oldenburg established
the Judson Gallery, in the Judson Street Church,
Greenwich Village, where Dine held his first
solo show in 1958. The following year Dine
showed with Oldenburg at the Judson Gallery
and participated in several group exhibitions
there before joining the Reuben Gallery, located
in downtown Manhattan.

Dine's first show at the Reuben Gallery, in
1960, consisted of works made up of found ob-
jects—discarded clothing and other refuse taken
mostly from trash cans around the city. Reas-
sembled in a new context to create works of art,
found objects are, according to Lucy R. Lippard,
"impermanent, perishable gutter art." The use
of found objects had been originated many years
before by Marcel Duchamp, and "rubbish
constructions" had been created in Germany by
Kurt Schwitters in the years following World
War I. In Dine's use of found objects he was re-
belling against both abstract expressionism and
traditional aestheticism, the attitude that certain
objects are suitable for art and others are not.
Dine's seemingly "antiart" approach, like that of
Rauschenberg, Johns, and Oldenburg, constitut-
ed a kind of neodadism which retained elements
of abstract expressionism.

Dine's involvement with happenings also be-
gan in 1960. He had met Allan Kaprow, an artist,
teacher, and progenitor of the happenings fad,
and with Kaprow, Oldenburg, and others Dine
helped create spontaneous, ostensibly bizarre
events intended to fill the void between the visu-

al and the performing arts. Dine's happenings were more structured than his colleagues'. In his *Car Crash,* held at the Judson Gallery in November 1960, a male and female car performed an amorous dance and eventually changed sexes. Meanwhile, on stage, Dine himself tried to "communicate" with the audience by drawing and trying to coax words out of a machine. He staged four happenings over a period of a year and a half, then stopped, feeling that they were becoming too "chic."

In 1962 Dine joined the Martha Jackson Gallery, New York City. His first show there, in 1962, features ties, hats, suspenders, and coats in works termed "object paintings" by critics. *The Coat* was realistically painted in a tweed pattern on the canvas but was fastened by real buttons. Gigantic striped ties were freely painted on huge canvases and labeled in stenciled letters. In these and other works, with their "giantism of popular imagery," to quote Lippard, Dine was still concerned with the materiality of the paint. His most "far out" work, to use the parlance of the time, was *Twelve Ties Hidden in a Landscape,* in which 12 actual ties hung in a row between two canvases.

Dine held only one show at Martha Jackson before joining the Sidney Janis Gallery, Manhattan, where in 1962 he exhibited in the important "New Realists" group show. At this time Dine was producing new canvases inspired by memories of his grandfather's hardware store that incorporated workman's tools. These works were given such literal titles as *Five Feet of Colorful Tools, Six Saws,* and *Crescent Wrench.* In some works, such as *Colorful Hammers,* the tools were painted; in others visual tension and a curious ambiguity were created by the interaction of unadulterated objects with a painted background. These tool paintings were first exhibited in Europe, at a solo exhibit at the Galleria Dell'Ariete, Milan, in 1962, and at Paris's Ileana Sonnabend Gallery and at the Palais des Beaux-Arts, Brussels, in 1963.

Dine had three shows at the Janis Gallery, in 1963, '64, '66. His 1963 exhibit featured what were called "room paintings," which used imagery from the home. Some of the "rooms," four of which were children's rooms, projected out into space. *Black Child's Room,* for instance, had a bureau, glued shut, 17-1/2 inches deep. Whether the canvas's three-dimensional object was a bureau, a sink, a washbasin, or a chair, the work functioned as a painting, not as a sculpture or an environment. These daring constructions caused Dine to be instantly dubbed a Pop artist, but he always resented the label. Edward Lucie-Smith noted that Dine was "essentially a combine or assemblage painter" and in this respect was far closer to Johns and Rauschenberg than to such Pop artists of the 1960s as Lichtenstein and Robert Indiana. As Dine explained, "Pop is concerned with exteriors. I'm concerned with *interiors.* When I use objects I see them as a vocabulary of feelings." He considers his work to be autobiographical.

This subjective approach was evident in his 1964 solo show at the Janis Gallery, which included images of himself as an unseen figure, the "invisible man," in a series of paintings of bathrobes shaped to his own rather thickset proportions. There remained references to abstract expressionism in the manner of paint application. Several paintings incorporated objects, but Dine's strength and skill as a draftsman were displayed in his drawings of everyday objects.

In his 1966 show at the Janis, Dine was still concerned with objects, but they had moved away from wall support to become virtual sculptures. He used such objects as hats, boots, and hands, which were executed in aluminum, the hardness of metal having replaced softer materials. He also employed such effects as exaggeration as a means of aesthetic transformation; for example, *The Long Boot,* an exemplary work of neodadaism, was nearly 10 feet long.

By 1966 Dine's reputation was well established. In that year he and his family spent two months in London, where he had been commissioned by the firm of Editions Electo to execute a series of prints. He had had a successful show of his paintings at London's Robert Fraser Gallery in 1965, and during his 1966 visit he showed a series of drawings and collages, some done in collaboration with the British artist Eduardo Paolozzi, at the Fraser. The drawings were of male and female sex organs—inspired by graffiti Dine had seen in London—but he did not consider them pornographic. "I see them [sex organs] as objects," he said. "They represent a very natural part of my style." But the London police disagreed and confiscated 21 of his works on grounds of obscenity. They also seized the remaining copies of the Fraser show catalog, in which the introduction, written by a Jesuit priest, Father Cyril Barrett, maintained that the drawings were "not in the least lascivious or erotic. He [Dine] has taken the scribblings of frustrated men or rebellious adolescents and redeemed them by endowing them with style and gentle humor."

Dine returned to New York in 1966 and taught at Cornell University, Ithaca, until 1967, when the Dines returned to London, where they lived for five years. One of his closest friends was the American painter R.B. Kitaj, who had been

living in London since 1953. The Dines resided in Battersea and later on Chester Square. Dine had stopped painting in 1966, but in '69, when he designed the sets and costumes for a play produced in London based on Oscar Wilde's *Dorian Gray*, he began to paint again. His resumption of artistic activity also seems to have been stimulated by his first visit to Paris, in 1968, and by the European experience in general, which, he said, "made me understand myself."

In 1970 Dine was given a retrospective exhibition at the Whitney Museum and had solo shows in Berlin, London, Munich, Turin, Brussels, New York City, and Toronto. With London as his home base, he commuted to various cities on the continent. "At one point," he recalled, "I went to Rome and got a job on a movie directed by Elio Petri. I did the paintings for the actor playing an artist in the film. I also began to do a lot of writing—prose and poetry. . . . "

In 1971 Dine returned home. "I felt I *had* to be back in Ameica," he explained. "I felt it was my landscape." The Dines bought an old farmhouse in Vermont, where they still live. During his years in London he had intensively studied printmaking and had collaborated with Lee Friedlander on an album of etchings and lithographs. After returning to the US, he produced "The 30 Bones of My Body," a series of monochrome drypoints of tools. Throughout most of his European stay he was without a New York gallery; in 1970 he began showing at the Sonnabend Gallery, which had opened a branch in lower Manhattan's SoHo section, but in 1975 he joined the Pace Gallery, New York City, which has remained his dealer. "I continued to work—drawing mainly," Dine said of that period (the early '70s). "The fact is, throughout the years, my work hasn't really changed dramatically. It's only strengthened."

Dine's January 1977 exhibition at the Pace Gallery was an unqualified critical success. His series of monumental bathrobes, an obsessive theme, was highly praised, as were his powerful drawings of nudes. The show included 11 monumental paintings of "invisible man" bathrobes, the treatment of which, according to Hilton Kramer of *The New York Times* (January 9, 1977), revealed Dine as "a more sober and a more somber artist" than he had been in the '60s. Dine admitted that "the robes have become much more mysterious than they used to be, and that's because I understand them more." However, he pointed out that "I don't have a bathrobe to paint from. What I use is what I've used from the very beginning—a newspaper ad which I clipped out of *The New York Times* back in 1963. The ad shows a robe with the man

airbrushed out of it. Well it somehow looked like me, and I thought I'd make that a symbol for me."

In his 1977 show at the Waddington and Tooth Galleries, London, entitled "New Works on Paper," Dine displayed traditional representational paintings. Dore Ashton said that, in the 1970s, "Dine restored the lyric element to his painting. . . .He painted a series of still-lifes that resurrected both the old-master display of painterly bravura and the new-master display of irony."

Jim Dine is short, stocky, bearded, and balding. He has described himself as looking "like a Tartar," and one writer called him "a reclusive, secret man" who "exudes both energy and a strong sense of diffidence." Proficient in many media, Dine has had a long-standing interest in pottery and makes ceramics in his Vermont studio. Dine and his wife have three sons, Jeremiah, Matthew, and Nicholas. Although the Dines spend most of the year at their Vermont farmhouse, where they lead what Dine calls a Tolstoyan existence close to nature; he travels to New York City each week to visit his analyst.

"What I try to do in my work," Dine said, "is explore myself in physical terms—to explain something in terms of my own sensibilities." Referring to the solitary and subjective nature of his work, he said, "The only dialogue I can have is in the mirror in the morning. The decisions I have to make about a painting have to be mine, that's all. If there is a moral issue it's between me and the mirror. It's not between anyone else."

EXHIBITIONS INCLUDE: Judson Gal., NYC 1958; Reuben Gal., NYC 1960; Martha Jackson Gal., NYC 1962; Gal. dell'Ariete, Milan 1962; Gal. Rudolf Zwemmer, Cologne, 1963; Palais des Beaux-Arts, Brussels 1963; Sidney Janis Gal., NYC 1963–64, '66; Gal. Ileana Sonnabend, Paris 1963, '69; Robert Fraser Gal., London 1965, '66; Andrew Dickson White Mus. of Art, Ithaca, N.Y. 1967; Whitney Mus. of Am. Art, NYC 1970; Ileanna Sonnabend Gal., NYC 1970–75; Mus. Boymans-Van Beuningen, Rotterdam 1971; Pace Gal., NYC 1977; Waddington and Tooth Gals., London 1977; MOMA, NYC 1978; Tacoma Art Mus., Wash. 1979; Gal. Claude Bernard, Paris 1979. GROUP EXHIBITIONS INCLUDE: Judson Gal., NYC 1959; participated in Happenings at Judson Gal., NYC 1960–61; "New Forms–New Media," Martha Jackson Gal., NYC 1960; "New Realists," Sidney Janis Gal., NYC 1962; "Black and White," Jewish Mus., NYC 1963; "Six Painters and the Object," Solomon R. Guggenheim Mus., NYC 1963; "American Drawings," Solomon R. Guggenheim Mus., NYC 1964; "American Pop Art," Stedelijk Mus., Amsterdam 1964; Venice Biennale 1964; American Exhibition, Art Inst. of Chicago 1964; Pittsburgh International 1964, '67, '74; ROSC, '67, Dublin 1967; Documenta 4, Kassel, W. Ger. 1968; Whitney Mus. of Am. Art Biennial, NYC 1973; "Dine: Kitaj," Cincinnati Mus. of Art 1973; Leo Castelli Gal., NYC 1983.

COLLECTIONS INCLUDE: MOMA, Whitney Mus. of Am. Art, Guggenheim Mus., Jewish Mus., and New York Univ., NYC; Albright-Knox Art Gal., Buffalo, N.Y.; Brandeis Univ., Waltham, Mass.; Gal. of Modern Art, and Hirshhorn Mus. and Sculpture Garden, Washington, D.C.; Oberlin Col., Ohio; Mus. of Fine Arts, Dallas, Tex.; Art Gal. of Ontario, Toronto; Tate Gal., London; Stedelijk Mus., Amsterdam; Stedelijk van Abbe Mus., Eindhoven, Neth.; Moderna Mus., Stockholm.

ABOUT: Amaya, M. Pop Art and After, 1966; Ashton, D. American Art Since 1945, 1982; Boyle, R. F. and others "Dine: Kitaj" (cat.), Cincinnati Mus. of Art, 1973; Dine, J. and others Work From the Same House, 1969, Welcome Home Lovebirds, 1969, Adventures of Mr. and Mrs. Jim and Ron, 1970, Letters to Nancy, 1970; Kozloff, M. Renderings, 1968; Lippard, L. R. Pop Art, 1966; Lucie-Smith, E. Late Modern: The Visual Arts Since 1945, 1969; Rose, B. American Art Since 1900, 2d ed. 1975; Russell, J. and others Jim Dine: Complete Graphics, 1970. *Periodicals*—Allen Memorial Art Museum Bulletin (Oberlin, Ohio) Fall 1965; Artforum September 1978, February 1982; Art International (Lugano) February 1971; Art Journal Spring 1980; Art News November 1964, March 1970, September 1977; March 1979; January 1980; March 1982; Arts Magazine January 1974; May 1980; Connaissance des arts (Paris) November 1979; 57th Street Review (New York) November 1966; Metro (New York) no. 7 1962; New York Times January 9, 1977, July 28, 1978; Studio International September 1966.

*DI SUVERO, MARK** (September 18, 1933–), American sculptor, who emerged in the early 1960s with the second generation of Abstract Expressionists, is best known for what has been described as "hulking open forms in rough-hewn planks, beams, and steel rods that balance precariously in asymmetric compositions." In his celebration of industrial images and materials and his concern with the urban environment, di Suvero has sought to bring sculpture out of the confines of studios, galleries, and museums and into the outdoors, with the aim of reaching a large public and heightening its awareness of form and space. Even the largest of his works possess a quirky humor, and even friendliness, that have made them remarkably acceptable to an audience usually hostile to prominent avant-garde sculpture.

Born in Shanghai of Italian parents, di Suvero was the third child of Vittorio di Suvero, a Venetian of Sephardic Jewish descent, and the former Matilde Millo, of French and north Italian stock. Vittorio, a former naval officer, had moved in 1930 to China, where he served as an agent of the Italian government in business dealings in Shanghai and T'ien-ching. After the outbreak of World War II, the family left China for the

Roberta Richards, ConStruct

MARK DI SUVERO

United States, settling in San Francisco in 1941. Vittorio, who had been trained in naval architecture, was employed in a shipyard, while his wife taught school in the city.

Mark had originally been christened "Marco Polo," but as this seemed unsuitable for a boy growing up in San Francisco, he called himself Mark Shawn. As a boy he was taught art, after school hours, by a Mrs. Lowell from Boston, who started him as a sculptor. In 1953 di Suvero entered San Francisco City College, then enrolled in the University of California at Santa Barbara. As he recalled in 1975, "I became depressed with the fact that [at Santa Barbara] I couldn't make an original contribution in my major, philosophy," (However, di Suvero's profound interest in philosophy persists, infusing his sculpture with a subtle, not easily defined spirituality.) He did find an outlet for his creativity in a sculpture course given by Robert Thomas. In 1955 he transferred to the Berkeley campus of the University of California, where he obtained his degree in philosophy in 1957. While at Berkeley he continued to work in sculpture, with Stephen Novak as his teacher.

Later in 1957 di Suvero and his friend, the sculptor Charles Ginnever (also to become well known for monumental works in steel), drove from California to New York City. In Manhattan both felt the strong impact of the New York School painters, especially Franz Kline and Willem de Kooning, with their bold and spontaneous thrusts of the paintbrush, while at the same time absorbing the industrial imagery of the city's bridges, docks, and skyscrapers. About 1958 di Suvero moved into an old grain ware-

°dē sōō vâ´rō

house on Front Street, near the South Street Seaport. He supported himself through a variety of jobs, including carpentry. He was delivering a load of lumber in March 1960 when his spine was crushed in an elevator accident. It was feared that he would never walk again, but within two years he was able to abandon his wheelchair. Permanent impairment of his legs and back has not prevented him from pursuing a type of sculpture involving strenuous physical effort and frequent risk.

Seven months after his accident, di Suvero had his first solo exhibition in New York City, at Richard Bellamy's Green Gallery. The sculptures consisted of found objects which evoked associations with their former functions. Into his sculptures di Suvero incorporated such "junk" materials as wood, rope, chains, bolts, and nails. Among the pieces were *Che Faró senza Eurydice* and *Barrel,* (both of 1959), and the well-known *Hankchampion* (1960), named after di Suvero's younger brother Hank, who helped to assemble its massive, weathered wooden beams. Di Suvero's penetration of space by weathered beams recalled the gestural thrusts of de Kooning and especially Kline. Critics recognized that di Suvero's work belonged in the cubist-constructivist tradition. Like the Constructivists of the early Russian revolutionary period and the German Bauhaus artists of the 1920s, di Suvero wanted to make art not only relevant to the workaday world, but a prime force in the creation of a just society. So striking was this new sculpture, both formally and in intention, that critic and art historian Sidney Geist claimed of the Green Gallery show that it was "one of those moments of which one can say that 'From now on nothing will be the same.'"

During the early months of his recuperation, di Suvero worked on small pieces, sitting in his wheelchair and welding his sculptures on his lap (he wore an asbestos apron) or on a low bench. In *Attic* (1961) he used steel in combination with wood for the first time. With its springy bounce, *Attic* was an early example of the motion that di Suvero liked to introduce into his sculptures, following the examples of Calder. Another di Suvero work of 1961 in steel and wood was *Eatherly's Lamp,* a reference to the American bombardier who dropped the atomic bomb on Hiroshima.

Together with sculptors Tom Doyle and Peter Forakis, di Suvero founded the Park Place Gallery in Manhattan in 1963. In 1966 he exhibited several new, large-scale works, including *The A Train* and *New York Dawn (For Lorca),* giant mobiles expressing the vitality of the urban environment, within what Edward Lucie-Smith has called a "junk ethos." Hilton Kramer wrote in *The New York Times* (January 30, 1966) that, like the English artist Anthony Caro, di Suvero had given sculpture "an almost architectural range." Kramer found "something Whitmanesque in the gesture and sweep of Mr. di Suvero's sculptural imagination," and admired his aim to make sculpture "a glorious public art . . . robust enough to stand its ground amid the tumult of modern life." Despite the urban character of di Suvero's forms and materials, some critics have surmised that his sense of monumental scale springs from the grandeur of the California landscape—San Francisco Bay, the Golden Gate Bridge—where he was raised.

In another important di Suvero mobile of the 1960s, *Pre-Columbian* (1965), the sculptor invited spectators to swing from an automobile tire suspended from the piece. There were similar invitations to playful viewer participation in *Love Makes the World Go 'Round* (1963), *Laurie's Love Seat* (1964), and *Nova Albion* (1964–65). As Jim Fuhr wrote in a di Suvero catalog in 1979, "The large outdoor pieces take you in as one of their working parts, either as a participant in their volumes of activated spaces, or as a passenger on the various seats, beds and platforms. . . . "

Because of di Suvero's vocal opposition to American escalation of the fighting in Vietnam, he was chosen in 1966 to design the 55-foot-high Peace Tower in Los Angeles, to which artists throughout the world were invited to contribute panels protesting the war. In addition to his massive outdoor pieces, di Suvero continued to produce modestly scaled sculptures. In a group show at the Noah Goldowsky Gallery, New York City, in 1968, he exhibited a group of tabletop works, including *Vietnam Piece.* In 1971 he reaffirmed his opposition to the war in his steel sculpture *Homage to the Viet Cong.*

Driven by his intense antiwar sentiment di Suvero left the United States in 1971 for Europe. He spent time in Venice, collaborating with engineers on a lock system designed to cope with that city's flooding problems. Wherever he went his sculpture reflected his affection for machine shops, garages, and other places where things of metal are made and repaired. In the Netherlands, where he had a 1972 solo exhibition in the Stedelijk van Abbemuseum, di Suvero worked and lived in a factory in Eindhoven. His most prestigious European show was that held in the Jardin des Tuileries, Paris, in 1975. This was an unprecedented honor, for no contemporary artist, and no American, had ever shown there before. Later that year the five large outdoor sculptures on display in the Tuileries were

shipped to New York City as part of a city-wide exhibition sponsored by New York and by several cultural organizations as an extension of a concurrent di Suvero retrospective at the Whitney Museum of American Art. This long-planned exhibition had been delayed, first because of the artist's reluctance to return to the United States during the Vietnam War, and then because of the Tuileries show. Fifty pieces under 14 feet high were on view at the Whitney, and a dozen or more enormous sculptures were set up at open-air sites in the five boroughs.

Hilton Kramer wrote in *The New York Times Magazine*, "Nothing like this one-man sculptural blitz has ever before occurred in New York." Crowds gathered at various sites throughout the city to watch di Suvero, clad in safety-orange coveralls, assemble his sculpture with huge cranes which, he has said, he uses the way an action painter uses his brushes. After the huge I-beams, cables, and plates were in place, the artist would clamber over the work, as much as five stories from the ground, tightening bolts, tensioning wires, and checking welds. Among the pieces included in the New York show were *For Lady Day* (1968–69), in black steel and named for the blues singer Billie Holiday, and set up in Manhattan's Battery Park; *Praise for Elohim Adonai* (1966), in wood and steel with a rotating top section, erected in the Seagram Building Plaza, Manhattan; and the bright red *Are Years What?* *(For Marianne Moore)*, dating from 1967, and installed in Prospect Park, Brooklyn. Another red sculpture, *Ave*, one of several pieces di Survero had made and installed in Chalon-sur-Saône, France, in 1973, was set up in Flushing Meadow Park for the exhibition.

Also included in the New York show was the bold, monumental *Ik Ook* (meaning "I too," in Dutch), which di Suvero had created in Eindhoven in 1971–72. This painted steel construction contained a dramatic kinetic element in the form of a horizontal swing, but, as Barbara Rose has pointed out, "Movement, per se . . . is not central to di Suvero's esthetic as it is to that of exclusively kinetic artists like Len Lye and George Rickey."

Most of di Suvero's large-scale pieces showed a development toward spareness. In contrast, his small mobiles, such as the "spinners," "tumble pieces," and "puzzles," exhibited at the Janie C. Lee Gallery, Houston, in early 1978, reflected his fascination with intricate engineering. One exception to di Suvero's tendency to decrease the number of parts in his large pieces is *Isis,* a 35-ton, 45-foot by 65-foot by 33-foot sculpture which has as its main element a section of a ship's bow. *Isis* was commissioned by the Insti-

tute of Scrap Iron and Steel, Inc., and donated in July 1978 to the Hirshhorn Museum and Sculpture Garden, Washington, D.C. The Hirshhorn Museum already owned di Suvero's *The A Train*. Abram Lerner, a director of the Hirshhorn, explained in *Art News* (July 1978) that di Survero was chosen by the Institute "because of his ability to transform this metal [scrap] into something exciting, ecstatic, adventurous, contemporary."

Isis was assembled in di Suvero's Petaluma, California studio, but in 1978 he moved back to New York City. Despite his popular success—as a creator of immense public sculpture he is only slightly less well known than Alexander Calder—his work has sometimes aroused controversy. In September 1976 his *X-Delta* (1970), composed of rusted I-beams, was installed on the campus of Dartmouth College, Hanover, New Hampshire. When *X-Delta* was erected, some students publicly protested against this "abomination, looking as though some truck had turned over and dumped the sculpture on the lawn." During the first big football weekend it was painted with graffiti. A further provocation was the sculpture's swinging mattress, which delighted children and the more adventurous students. Purists, however, claimed that the rugged geometry of the piece suffered from the frivolous addition of a bed. Martin Amis, in *The New Statesman* (February 6, 1976), also raised the objection, in another instance, that di Suvero's massive, supposedly playful constructions, many of which have beams or plates that swing when pushed, might be quite dangerous. To date, however, there have been no reports of serious injury resulting from a design or construction flaw in di Suvero's works.

Mark di Suvero is an impressive-looking man with gray eyes, long, flowing red hair, and a shaggy beard. He still uses as his main working area the Front Street building in lower Manhattan he moved into more than 20 years ago; he has reinforced the structure and put in a skylight. When installing a sculpture he works with speed and intensity, usually wearing work clothes, sneakers, a construction worker's red hard-hat, and sometimes a welder's mask. Hilton Kramer described him in 1976 as "a bearded patriarch with an ungainly walk and a generous, open smile, noisy and even rude to those he deemed the uptown enemies of art but gentle to his friends and associates." Jim Fuhr, commenting on di Suvero's 1979 show in Chicago, praised the "living energy" of his work, which "reduces the physical and psychological distance between the audience and the work of art, and so removes many obstacles to enjoyment, delight, and perception." *North Star: Mark di Suvero*, a film

produced by, among others, art historian Barbara Rose and directed by François de Ménil, was released in 1977.

EXHIBITIONS INCLUDE: Green Gal., NYC 1960; Park Place Gal., NYC 1964, '66, '67; Dwan Gal., Los Angeles 1965; Lo Giudice Gal., Chicago 1968; Stedelijk van Abbemus., Eindhoven, Neth. 1972; Wilhelm-Lehmbruck Mus. der Stadt Duisberg, W. Ger. 1972; Inst. of Contemporary Art, Univ. of Pennsylvania, Philadelphia 1974; Jardin des Tuileries, Paris 1975; Whitney Mus. of Am. Art, NYC 1975–76; Janie C. Lee Gal., Houston 1978; ConStruct, Chicago 1979. GROUP EXHIBITIONS INCLUDE: "Recent American Sculpture," Jewish Mus., NYC 1964; Annual, Whitney Mus. of Am. Art, NYC 1966, '68, '70; "American Sculpture of the Sixties," Los Angeles County Mus. of Art 1967; "American Sculpture of the Sixties," Philadelphia Mus. of Art 1967; International, Solomon R. Guggenheim Mus., NYC 1967–68; "Plus by Minus: Today's Half-Century," Albright-Knox Art Gal., Buffalo, N.Y. 1968; Documenta 4, Kassel, W. Ger. 1968; Noah Goldowsky Gal., NYC 1968; "New York Painting and Sculpture: 1940–1970," Metropolitan Mus. of Art, NYC 1969–1970; "Works for New Spaces," Walker Art Center, Minneapolis 1971; Middelheim Biennale, Antwerp, Belgium 1971; "Art in Space," Detroit Inst. of Arts 1973; "New York Collection for Stockholm," Moderna Mus., Stockholm 1973; Venice Biennale 1975; "Ideas in Sculpture," Renaissance Society, Univ. of Chicago 1977; ConStruct, Chicago 1978.

COLLECTIONS INCLUDE: Whitney Mus. of Am. Art, NYC; Storm King Art Center, Mountainville, N.Y.; Wadsworth Atheneum, Hartford, Conn.; Hirshhorn Mus. and Sculpture Garden, Washington, D.C.; Art Inst. of Chicago; Detroit Inst. of Arts; City Art Mus., St. Louis, Mo.; Bradley Sculpture Garden, Milwaukee; Dallas Mus. of Fine Arts; Los Angeles County Mus.; City of Chalon-sur-Saône, France; Rijksmus. Kröller-Müller, Otterlo, Neth.

ABOUT: Current Biography, 1979; Fuhr, J.- "Mark di Suvero" (cat.), ConStruct, Chicago, 1979; Lucie-Smith, E. Late Modern: The Visual Arts Since 1945, 1969; Rose, B. American Art Since 1900, 2d ed. 1975. *Periodicals*—Architectural Digest December 1983; Art in America May/June 1974; Art Journal Spring 1978; Art News March 1966, February 1967, July 1978; Art Press (Paris) December 1973–January 1974; Artforum Summer 1967, November 1972; Arts Magazine November/December 1960; New Statesman February 6, 1976; New York December 15, 1975; New York Times January 30, 1966, April 10, 1983; New York Times Magazine January 25, 1976; Studio International January 1964; Time August 1971, December 1, 1975.

DIX, OTTO (December 2, 1891–July 25, 1969), painter and graphic artist, was an important German Expressionist, though he was not as widely known outside Europe as some of the oth-

German Information Center, NYC

OTTO DIX

er members of that diverse group. From the beginning of his career until the late 1970s scarcely a year (except during World War II) has gone by without at least one exhibition of his work; not until 1978, however, was there an individual showing in the United States. Dix's career was long, enormously productive, and as varied in approach as the social currents to which his art was always a response.

He was born in Untermhausen, near Gera, in Thuringia, the son of a foundry worker. As a child Dix showed great talent in drawing and was given private lessons by his school art teacher. Posing, at the age of ten, for his older cousin Fritz Atmann, he was confirmed in the desire to be an artist too. Portraiture, in fact, was central to Dix's art, and he is now regarded as one of Germany's greatest portraitists. "Trust your eyes" was his motto in assessing a sitter's character. His own truth-seeking gaze is recorded in a lifelong series of self-portraits—in pen, pencil, prints, and oils—that reveal the artist's commanding, handsome features: his high forehead, aquiline nose, firm lips and determined jaw, his keen, narrowed eyes under heavy brows.

From 1905 to '09 Dix served as an apprentice to a decorative painter in Gera and then studied, until 1914, at the Dresden Kunstgewerbeschule. With the outbreak of World War I he enlisted in the German army and saw active service as a gunner and member of a shock-troop corps on the fronts in Flanders, France, and Russia. The experience had the most profound effect on his social outlook and his art.

Before the war the influence of impressionism (which can be detected in a series of small land-

scapes painted in the environs of Dresden about 1910) had begun to give way to other modes. Typical of his meticulously drawn portrait paintings of 1912–13 is his Dürer-esque *Self-Portrait with Carnation* (1912). The effect of the 1913 Dresden exhibition of the work of Van Gogh can readily be sensed in Dix's *Sun Setting over a Winter Landscape with Ravens* (1913). The emphatically rendered bright rays of the sun and the black forms of birds swooping low over the bare fields are unmistakable allusions. Successively, the influences of expressionism, cubism, and futurism reached Dix and can be traced in the many works—including hundreds of drawings and a number of gouaches—done during the war. *Self-Portrait as Mars* (1915), an oil on canvas in the cubist style, contrasts with *Self-Portrait as a Soldier* (1917), a straightforward drawing of a helmeted, guncarrying young man whose unflinching gaze takes in and will remember the brutalities he is party to. By war's end Dix was working in the dada style, an anarchistic reaction to the war and a disavowal of bourgeois social conventions.

At the end of the war Dix resumed his formal art training, first at Dresden where from 1919 to '22 he was enrolled at the art academy (at which the Expressionist painter Oskar Kokoschka had just started to teach). There Dix became a member of Gruppe 1919, an Expressionist group allied to the Brücke (Bridge) movement. The erotic *Moon Woman* (1919) dates from this period and impulse; a contemporary critic referring to it and to several of Dix's other paintings stated that "he swings the brush like an ox, and every blow is a scream of color."

In 1920 Dix's nihilist mode gave way to a less dynamic, less personal form of expressionism know as *Neue Sachlichkeit* (new objectivity)—or, more precisely in Dix's case, an aspect of *Neue Sachlichkeit* that is defined as verism. The Verist painters, Dix, George Grosz, and Max Beckmann, practiced a meticulous realism stylistically inspired by German painting of the 15th and 16th centuries—Dix acknowledged a debt to Cranach, Dürer, and Grünewald in particular—but directed toward a relentless exposure of the hypocrisies of contemporary German life. As Dix put it, "Where emotion and expression are left out, they cannot be replaced by form and color alone. My endeavor is to achieve a representation of our age, for I believe that a picture must before all express a content, a theme."

Dix's first works in the verist style include the well-known double portrait *The Parents of the Artist, I* (1921), with its bent, workworn figures; *The Worker,* also of 1921, with a discouraged middle-aged man posed against his factory building, his eyes as blankly staring as the empty windows behind him; and a series of paintings of war cripples, among them *The Match Seller, I* (1920). These paintings range from compassionate, if disillusioned, commentaries on the life of the postwar German proletariat to bitterly ironic depictions of the residual effects of that war on its veterans. After 1921 the mood became more bitter in its concern with physical and psychological manifestations of the economic and political chaos that wracked Germany.

As did most of the Expressionists, Dix made especially powerful statements in the various graphic media. His first (and almost his only) woodcuts are symbolic expressions executed in 1919–20 under the influence of Brücke. Always a superb draftsman, Dix was drawn naturally to the more linear techniques involved in engraving, lithography, and etching. His great masterpiece in this last medium is a series of 50 prints entitled "War" (1924), a clear, factual record of the World War I battlefields; One of the most powerful etchings was *Meeting a Madman at Night.* The "War" series was preceded by an oil painting, *The Trench* (completed in 1923; destroyed by the Nazis in World War II), detailing the particular horrors of trench warfare. Sometimes compared to Goya's *The Disasters of War,* Dix's etchings are, however, elaborately detailed and calligraphic in the northern, Gothic tradition, and far more objective, even impassive. Like *Beggar* (1920), an etching of a crippled veteran neglected by heedless passersby; *Prague Street in Dresden* (1921), an etched version of a collage painting; or *Two Sacrifices of Capitalism* (1923), a pen drawing of a grotesque whore and a mutilated veteran, they make their effect by their very literalness. As Dix explained many years later in a conversation with the critic Fritz Loffler, "It was my endeavor to present war objectively, without any desire to invoke pity. . . . I avoided depicting battles. . . . I depicted states of affairs produced by war, and the consequences of war, simply as states of affairs." At the same time, Dix could indulge in a somewhat heavy-handed humor, as in *Departure from Hamburg* (1921), a painting of a sailor surrounded by an almost surrealist assemblage of objects referring to his calling.

In 1922 Dix was invited to Düsseldorf by the influential art dealer Johanna Ey, and until 1925 he studied at the Düsseldorf Academy, where he became a member of Das junge Rheinland (Young Rhineland), another of the socially conscious avant-garde groups, facets of the expressionist movement, formed in several German cities in this era. A major watercolor period marks the Düsseldorf years—watercolors that could be produced easily and sold inexpensively

and thus ensure some income during the great German inflation. The largely figurative subjects are similar to those of his oils. It was in Düsseldorf, in 1923, that Dix married Martha Lindner; in 1924 their first child, Nelly, was born. Like his two other children, Ursus and Jan, she became the subject of many affectionate drawings and paintings.

Mordant, brutally frank paintings of prostitutes—*Pimp and Girls* (1922), *Salon* (1922), and *Girl at the Mirror* (1921)—form a related group of works that continued to probe postwar social degradation overlooked if not actually condoned by capitalist society. These paintings aroused such public outcry that Dix was brought up on charges of indecency. Acquitted and undeterred, he went on to do such works as the analogous color lithograph *The Procuress* (1923).

Dix's great series of verist portraits throughout the 1920s—perhaps his best-known works—continued the unsparing psychological revelations of this "half masochist, half moralist," as the critic Werner Haftmann dubbed him. In the *Portrait of the Attorney Dr. Fritz Glaser* (1921) or his *Self-Portrait with Model* (1923), which shocks with its contrast between the fully clothed, rigorously controlled artist and the lush female model, the clarity of the revelation is abetted by the painting technique. Dix had evolved, based upon late medieval methods, a way of achieving a three-dimensional quality and a glazed, enameled finish. Also, in 1925, on a visit to Italy, Dix discovered the works of the Mannerists, Bronzino and Pontormo, which confirmed his developing style of portraiture: a ruthless setting forth of the grotesque in an immaculate, detached, absolutely clear manner. Later portraits, like those of the laryngologist Dr. Meyer-Hermann (1926; Museum of Modern Art, New York City) or of the writer Sylvia von Harden (1926), are merciless records of unattractive features, verging on a form of caricature in their exaggeration. Largely uncommissioned, these portraits were also, in the main, uncontested by their subjects. In the case of the physician's picture, the instruments looming behind him add to the anxiety produced by his bland, disconcerting stare. The Harden picture is a send-up of the absurdities and pretensions of a whole bohemian subculture. Nevertheless, when it was acquired by the Musée National D'Art Moderne, Paris, Harden posed for photographers in front of it, dressed in the same costume she had worn for the portrait, and gave out postcards of the painting to her friends.

In 1925 Dix moved to Berlin and then in 1927 returned to teach in Dresden. In 1931 he was elected to membership in the prestigious Prussian Academy, an honor stripped from him by the Nazis in 1933. Because of his revolutionary antimilitaristic views, Dix was, from the start, persecuted by the new government. He was also dismissed from his post at Dresden, and left for Schloss Randegg, the home of his brother-in-law, near Singen, Germany. In 1934 he was banned from exhibiting, though a showing in Switzerland in 1938 kept his reputation alive. Meantime, about 260 of his works were confiscated and eventually either sold or destroyed.

Moving from Randegg in 1936 to the country house he had built at nearby Hemmenhofen, on Lake Constance, Dix established what was to be his studio-home for the rest of his life. It was at Randegg and Hemmenhofen, during what he termed his years of "inner emigration," that the artist rediscovered landscape. Temporarily it became a substitute for the city life and faces that were his characteristic themes. Human figures, in fact, are absent from the idyllic distant views in *Randegg under Snow with Ravens* (1935), *Lake Constance'* (1939), and *Oberrhein at Evening* (1940).

As part of the Nazis' official exhibition of Degenerate Art, Dix's earlier paintings toured Germany in 1937, and in '39 he was arrested and briefly held by the Gestapo on suspicion of being implicated in the Munich plot to assassinate Hitler. Finally, at the age of 53, Dix was drafted into the Volkssturm (Home Guard), and a month later was captured by the French, and interned at Colmar, France during 1945–46. *Self-Portrait as Prisoner of War* (1947) shows the worn and aging artist before a tangle of barbed wire; the all-seeing narrowed eyes look bleakly at the prospect before him, the gaze no longer as defiant as that of the young soldier in his World War I self-portrait drawing. After the war Dix taught briefly at the Art Academy in Dresden before moving back to his home in Hemmenhofen, West Germany.

From 1945 on, Dix's work began to show a return to an expressionist style, freer in color and brushwork. The glazing technique, employed since about 1923, gave way to use of impasto. Religious themes, which he had occasionally used before, in what has been called his "Christian mysticism" period, also began to be prominent. Heralded by a 1930s series of allegorical paintings of St. Anthony and St. Christopher, *Christ and Veronica* (1943; Collection of the Vatican, Rome), *Great Crucifixion* (1948), and *Ecce Homo, II* (1949) bear unmistakable references to contemporary life and his prison experience: the artist depicts a society that stands by, allowing suffering and sacrifice. A se-

ries of 37 lithographs (1959–60) was devoted to scenes of the life of Christ, and in the same years Dix was commissioned to execute three stained-glass windows on the life of St. Peter for a church at Kattenkorn. These, and a commission to do a mural, *War and Peace* (1960), for the townhall at Singen, were especially fitting for one whose work was always intended as communication, as social art.

With such paintings, and a large number of pastels and color lithographs, Dix was busy up to his very last years, save for an interval of relative inactivity following the death of his beloved daughter Nelly in 1955. After 1948 Dix, who had always remained faithful to the representation of the human form, despite new abstract trends in art, came into demand again as a portraitist. These later studies, unlike the portraits of the '20s, are softer, less analytic, more concerned with social status and occupation. Dix was made a member of the Academy of Arts in West Berlin in 1955 and was inducted into the German Academy of Arts in East Berlin in 1956.

Regular trips back to Dresden and journeys to the south of France and in 1962, to Rome, gave him added stimulation and new subjects. In 1967 a last trip to Greece resulted in a stroke; two years later Dix died at Singen and was buried near the grave of Nelly at Hemmenhofen.

When asked, in later years, to write his memoirs, Dix firmly declined, indicating that it was in his art—and especially in his self-portraits—that his life and its search for truth were revealed.

EXHIBITIONS INCLUDE: Gal. Arnold, Dresden, 1916; Nationalgal., Berlin 1925; Staatliche Gemäldesammlungen, Munich 1925; Gal. Wolfsberg, Zürich 1938; Gal. der Stadt, Stuttgart, W. Ger. 1971; Mus. d'Art Moderne de la Ville de Paris 1972; Serge Sabarsky Gal., NYC 1978. GROUP EXHIBITIONS INCLUDE: "Dresden Sezession Gruppe 1919," Gal. Emil Richter, Dresden 1919; "Neue Sachlichkeit," Mannheim 1925; Venice Biennale 1928; "International Exhibition of Modern Art," Brooklyn Mus., N.Y. 1928; "German Painting and Sculpture," MOMA, NYC 1931; "Modern Works of Art," MOMA, NYC 1935; "Exhibition of German Art," Dresden, W. Ger. 1946; Documenta 1, Kassel, W. Ger. 1955; "German Art of the 20th Century," MOMA, NYC 1957; "Twentieth-Century Master Drawings," Guggenheim Mus., NYC 1964; "German Realists 1919–1933," Piccadilly Gal., London 1977; "Documents from the Life and Work of Otto Dix," Germanische Nationalmus., Nuremberg, W. Ger. 1977; "The Vatican Collections—The Papacy and Art," Metropolitan Mus. of Art, NYC 1983.

COLLECTIONS INCLUDE: Germanische Nationalmus., Nuremberg, W. Ger.; Nationalgal., Berlin; Staatliche Kunstsammlungen, Dresden W. Ger.; Kunstmus.,

Düsseldorf; Wallraf-Richartz Mus., Cologne; Mus. Folkwang, Essen, W. Ger.; Gal. Nierendorf, Berlin; Gal. Dr. Klihm, Munich; Kunsthaus, Zurich; Mus. Nat. d'Art Moderne, Paris; MOMA, NYC; Detroit Inst. of Arts.

ABOUT: Dube, W.-D. The Expressionists, 1972; Haftmann, W. and others. German Art of the Twentieth Century, 1957; Hughes, R. Shock of the New, 1981; Löffler, F. Otto Dix, Life and Work, 1982; Lynton, N. The Story of Modern Art, 1981; Myers, B.S. The German Expressionists: A Generation in Revolt, 1957; Shikes, R. E. The Indignant Eye, 1969; Vott, P. Expressionism: German Painting 1905–1920, 1980; Willett, J. Expressionism, 1970, Art and Politics in the Wermar Period: The New Sobriety, 1917–1933, 1981. *Periodical*—Art in America September 1981.

*DUBUFFET, JEAN** (July 31, 1901–), French painter and sculptor, is one of the few artists of major international importance to have appeared in France since World War II. One of the first modern painters to eschew traditional art materials, he broke violently with the conventions of easel painting and became known in the late 1940s for the raw, primitive imagery he developed for the style called *art brut.*

Dubuffet was born in Le Havre, the son of a wine and liquor merchant. He recalled in a *New Yorker* interview of 1962: "My parents were bourgeois . . . they had a house and a chauffeur and other servants . . . I hated my *famille de commerçants* and their constant talk of money." He entered the Ecole des Beaux-Arts in Le Havre in 1916, but was bored with his native city and in 1918 went to Paris to live alone and paint. He had miserable lodgings in Montparnasse and studied briefly at the Académie Julian. The following year he met Suzanne Valadon, Raoul Dufy (also a native of Le Havre), Max Jacob, and Fernand Léger.

Dubuffet did his military service in 1922–23 as a meteorologist, stationed at the Eiffel Tower. After his discharge he briefly abandoned painting, feeling that his work was too imitative of his friends Valadon, Dufy, and Léger. He traveled to Italy in 1923 and to Switzerland and Brazil in 1924, returning to Le Havre in 1925 and entering his father's wine business. In 1927 he married Pauline Bret, who bore him a daughter.

In 1930 Dubuffet founded his own wholesale wine business in the Bercy section of Paris, but three years later he put an associate in charge of the business and resumed painting and a bohemian life. Now divorced from Pauline, and married to his second wife, Lili, he took cheap lodgings on the Left Bank and painted a few portraits, including one of Lili. He also modeled

°dü bü fä´, zhäN

JEAN DUBUFFET

theatrical masks and made marionettes for his own puppet show, using his friends as models. (Three of the masks, reminiscent of the work of Belgian Expressionist James Ensor, are now in the Hirshhorn Museum and Sculpture Garden, Washington, D. C.) In 1937 Dubuffet abandoned painting a second time and, in order to provide for his family, became absorbed once more in the wine business.

With the coming of war in 1939 the business closed down and Dubuffet was mobilized, but he was discharged in 1940 because of his inability to submit to military discipline. He started another wine business with a new associate, but in 1942 left the running of it to his partner and devoted himself wholeheartedly to painting. He was developing his own means of expression, using extraordinary mixtures of sand, ashes, and cinders, bound by a congealing thick crust. The clotted surface was then incised with line drawing, in a "primitivist" reductive style. Fortunately, in those grim years of German occupation he had discerning friends who were sympathetic to his work and eager to make it better known.

In the fall of 1944 Dubuffet's first solo exhibit was held at the Galerie René Drouin, Paris. He showed some works of 1942 which were relatively subdued, but he also exhibited more recent and far more controversial canvases. The pigment was thickly laid on in gaudy colors—"More fauve than the Fauves," he observed—and with an expressionistic intensity. Marionettelike figures, the Métro, Paris streets, the countryside, horses, cows, and graffiti-covered walls were favorite themes. Many viewers, as well as the more academic artists and critics, were infuriated by the savage scrawls and deliberately primitive, childlike handling, but others were intrigued and sensed the presence of a truly original and provocative artist, one who called his style *art brut*, or raw art.

Preferring amateur spontaneity to professional skill, Dubuffet wanted, as it were, to start from scratch, inspired by the untutored, uncensored vision in the drawings of children, naives, "savages," and psychotics—all of which he considered "art brut." There was also in Dubuffet's figurative compositions the direct influence of Paul Klee.

From October 1944 to March 1945 Dubuffet concentrated on lithographs. When he resumed painting he completed, within a few days, three mural-size canvases of jazz musicians, including *Jazz nouvelle Orléans*. Later in 1945 he made walls the subjects of several paintings, and the following year he published a collection of statements titled *Prospectus aux amateurs de tout genre*. In the late '40s he made three trips to North Africa, especially enjoying the Sahara, journeys which inspired his series of paintings of 1947–49, *Roses d'Allah, clowns du désert*.

Dubuffet's first American exhibition was held at the Pierre Matisse Gallery, New York City, early in 1947; it included the 1945–46 works along with paintings from earlier in the decade. Clement Greenberg, the first American critic to take serious notice of Dubuffet, found the earlier work "impoverished" but the 1945–46 canvases "on the whole . . . original and profound." Greenberg felt that *Vue de Paris* (1946) showed "how completely Dubuffet has assimilated all that the School of Paris has had to teach since 1908." He compared *Grand Paysage,* also 1946, with Klee-influenced works by American painters, and pointed out that whereas Americans saw Klee in terms of mysticism, "Dubuffet means matter." Greenberg recognized Dubuffet as a major painter, "even though his art still suffers under the limitation of being too essentially personal."

In Paris in the late '40s Dubuffet began to collect and exhibit works by children, criminals, psychotics, and other creators of *art brut*. He subsequently installed this collection in a Musée de l'Art Brut, a private foundation which is at present located at 137, rue de Sèvres, Paris.

Dubuffet spent a few months in New York City in the early '50s, living in Greenwich Village and working in a loft just off the Bowery. Thomas B. Hess, who visited the loft, described Dubuffet's working methods in an article in *Art News* (May 1952). Dubuffet covered a masonite panel with spot putty. He then drew on the drying putty with a corner of the putty-knife. Then

he beat and manipulated the surface until it looked, to quote Dubuffet, like "the hide of a hippopotamus." The wrinkled surface was left to dry overnight before the paint was applied. Depending on the effect desired by the artist, the paint could be splattered on the surface, dripped, or applied with a rag or a housepainter's brush. Dubuffet's relief paintings of the mid-1940s had been done in oil, but, impatient with the long-drying oil medium and eager for quick results, he was now experimenting with putties and other materials.

A Dubuffet retrospective was held in Paris in 1954 at the Cercle Volnay. Critics saw an affinity between Dubuffet and the avant-garde playwright Eugene Ionesco, both of whom were interested in the postwar, existentialist idea of the "absurd." Edward Lucie-Smith described Dubuffet's statements about his art as those of "a man of culture who is sophisticatedly obsessed with the anti-cultural." Referring to his "Corps de dame" series of 1950, which manipulated deliberately crude, aggressive images in the spirit of art brut, Dubuffet remarked, "It pleased me . . . to juxtapose brutally, in these feminine bodies, the extremely general and the extremely particular, the metaphysical and the grotesquely trivial. In my view, the one is considerably reinforced by the presence of the other." Animal forms, especially cows, received the same savagely humorous treatment, as in the densely pigmented Vache la belle allègre of 1954. Also in 1954, Dubuffet exhibited a series of about 40 small statues made from slag, coal residue, and other refuse. Michel Seuphor wrote: "These statuettes have a flavor of belated expressionism, as in fact does all Dubuffet's work."

In 1955 Dubuffet settled in Vence, in southern France. There were Dubuffet exhibitions in 1960 in Italy, the Netherlands, Germany, and the Musée des Arts Décoratifs in Paris. Some 200 of his works were shown in a retrospective at the Museum of Modern Art, New York City, in 1962. By that time most American critics agreed with Clement Greenberg, who had written in the mid-1940s that Dubuffet was "the most original painter to have come out of the School of Paris since Miró." A New York Times critic said, "The element that unites Dubuffet's disparate qualities [is] tremendous gusto for life." The MOMA retrospective subsequently traveled to Chicago and Los Angeles.

Dubuffet's prolific output has tended to fall into "cycles." In 1964 a catalog raisonné of his works was begun, initiated by the artist and published under the direction of Max Loreau, in which the successive cycles were enumerated and given bizarre but apt and literal titles by Dubuffet, for instance, "Monolithic Personages, Wagons, Gardens" to describe a series from the years 1954–56. This catalog provides a complete inventory of the artist's immense and various oeuvre.

Nineteen-sixty-six was an eventful year for Dubuffet. There were retrospectives at the Tate Gallery, London, the Stedelijk Museum, Amsterdam, and the Solomon, R. Guggenheim Museum, New York City. That same year Dubuffet began a series of architectural sculptures in polysterene painted in vinyl. These were translations into three dimensions of works that had occupied him between 1962 and 1966 ("the Twenty-Third Period of My Work") to which he gave the coined name "L'Hourloupe." They were drawings which he published as a small book with accompanying text; the drawings were in red and blue lines, and have been described as "free-form, abstract shapes, flowing and changing like amoebae, filled with suggestions of organisms, even at times of human figures." The original inspiration for the drawings had come in July 1962 while doodling with a red ballpoint pen while talking on the telephone. The coined French word hourloupe suggested to Dubuffet, as he later remarked, "something rumbling and threatening with tragic overtones."

Somewhat in the subversive spirit of dada, Dubuffet in 1968 published the pamphlet Asphyxiante culture. Two years later he exhibited the sculptured and painted walls of a Cabinet logologique and other architectural elements destined for a "Villa Falbala," conceived by Dubuffet as a "mental" space, a completely uninhabitable and nonfunctional dwelling, the epitome of the "absurd."

A mammoth retrospective at the Guggenheim Museum in May 1973 gave New Yorkers the opportunity to see the later phases of Dubuffet's work. There were over 300 paintings, sculptures, and drawings filling the entire museum. In the preface to the catalog, Dubuffet was quoted as saying that the form he adopted was "that of an uninterrupted and resolutely uniform meandering script." Critic Emily Genauer, who had enjoyed Dubuffet's earlier works, felt that the new show, the largest ever assembled at the Guggenheim, "will serve his reputation badly." She remarked that "Dubuffet's is an intensely paradoxical wit that must be taken in small doses," and noted that in his late paintings and sculptures the artist "uses non-stop writhing, sinuous black contours tightly containing areas of parallel lines in a fresh palette of red, white and blue." Some viewers were reminded of giant jigsaw puzzles or graffiti-scrawled subway cars,

and Genauer added that "the line that seems to ramble so capriciously always turns back on itself. The palette that seems so robust turns monotonous and palls. There is no variation in texture, accent or emphasis in these compositions. . . . "

A self-proclaimed enemy of laws, institutions, and a traditional vision of the world, Dubuffet in 1977, at the age of 75, became involved in a court battle with Renault, the giant, state-owned automobile industry. Four years earlier the president of Renault had commissioned works by Dubuffet, J. R. Soto, Victor Vasarely, and Jean Dewasne for dining rooms and entrance halls in the company's ultramodern aluminum and glass headquarters at Boulogne-Billancourt, on the outskirts of Paris. Dubuffet was also asked for a "monument" to adorn the building's huge courtyard, and in September 1974 Dubuffet presented a 20-by-18-foot model of his outdoor piece which was planned to cover 2000 square yards and to be a fiberglass and concrete structure. It was accepted and construction began. But in the middle of 1975 Renault's new president decided that "the automobile business had nothing to do with art" and construction was halted. The concrete, however, had already been poured.

The whole structure, comprising a big pool surrounded by a maze of alleyways and small towers and called *Salon l'Eté* by Dubuffet, was to have been painted white, blue, and black; the towers and the overhangs were meant to "evoke trees with their leaves, and clouds, a summer promenade." The artist, enraged by the company's decision to raze the unfinished structure, sued Renault and challenged their "right to destroy." The company argued that the model was the work of art, not the unpainted, unfinished concrete maze in the Renault courtyard, which was already beginning to deteriorate. The case dragged on for years. Dubuffet won, but the piece was eventually bought by Fiat.

Jean Dubuffet, a short, bald man with pale blue eyes, was described by Flora Lewis of *The New York Times* (May 6, 1977) as having "a shining, shaven pate, huge pointed ears, a large soft and mobile mouth and enormous hands that mold the air with monumental fingers." She added that he "looks decidedly elfin." Alexander Liberman, who photographed Dubuffet in 1952, wrote, "He looks like a being who could have lived untold years ago. . . . It is hard to penetrate Dubuffet's shell of self-protection from everyday life." He likes to wear blue jeans when working in his rue de Vaugirard studio, and has abandoned traditional tools and materials.

It is too early to assess Dubuffet's vast output, but it may be that his *art brut* creations of the

'40s and '50s in which, to quote Alexander Liberman, "he assaults the concept of beauty with the violence of the primitive," are his most original contributions to the art of our time. Dubuffet wrote in 1967: "It is always a matter of giving the person who is looking at the picture a startling impression that a weird logic has dictated the painting of it, a logic to which the delineation of every object is subjected, is even sacrificed, in such a peremptory way that, curiously enough, it forces the most unexpected solutions, and, in spite of the obstacles it creates, brings out the desired figuration."

EXHIBITIONS INCLUDE: Gal. René Drouin, Paris 1944, '46, '47; Gal. André, Paris 1945; Pierre Matisse Gal., NYC 1947–59; Kootz Gal., NYC 1948; Gal. Geert van Bruaene, Brussels 1949; Arts Club of Chicago 1949; Cercle Volnay, Paris 1954; Gal. Rive Gauche, Paris 1954; Inst. of Contemporary Arts, London 1955; Gal. Rive Droite, Paris 1957; Arthur Tooth & Sons, London 1958, '60; Gal. Daniel Cordier, Paris 1960; Mus. des Arts Décoratifs, Paris 1960; MOMA, NYC 1962, '72; Palazzo Grassi, Venice 1964; Philadelphia Mus. of Art 1964–65; Solomon R. Guggenheim Mus., NYC 1965, '73; Tate Gal., London 1966; Stedelijk Mus., Amsterdam 1966; Pace Gal., NYC from 1968; Montreal Mus. of Fine Arts 1969; Grand Palais, Paris 1973; "Jean Dubuffet: A Retrospective Glance at Eighty," Solomon R. Guggenheim Mus., NYC 1981.

COLLECTIONS INCLUDE: MOMA, and Solomon R. Guggenheim Mus., NYC; Hirshhorn Mus. and Sculpture Garden, Washington, D.C.; Art Inst. of Chicago; Mus. Nat. des Beaux-Arts, Brussels; Stedelijk Mus., Amsterdam; Mus. des Beaux-Arts, Lyons, France; Kunsthaus, Zürich; Fondat Moltzau, Oslo.

ABOUT: Bénézit, E. (ed.) Dictionnaire des peintres, sculpteurs et graveurs, 1976; Current Biography, 1962; Dubuffet, J. Prospectus aux amateurs de tait genre, 1946, Prospectus et tous écrits suivants, 1967, Asphyxiante culture, 1978; "Jean Dubuffet" (cat.), Solomon R. Guggenheim Mus., NYC, 1973; "Jean Dubuffet: A Retrospective Glance at Eighty" (cat.), Solomon R. Guggenheim Mus., NYC, 1981; Greenberg, C. Art and Culture, 1961; Liberman, A. The Artist in his Studio, 1960; Limbourg, G. L'art Brut de Jean Dubuffet, 1953; Loreau, M. Catalogue général des travaux de Jean Dubuffet, 1966; Lucie-Smith, E. Late Modern: The Visual Arts Since 1945, 1969; Parrot, L. Jean Dubuffet, 1944; Ragon, M. Dubuffet, 1959; Selz, P. "The Work of Jean Dubuffet" (cat.), MOMA, NYC, 1962. *Periodicals*—Art News May 1952; New York Post May 5, 1973; New York Times May 6, 1977; New Yorker March 17, 1962; Newsweek February 26, 1962; Pantheon (Munich) April, May, June 1976; Time November 7, 1960.

***DUCHAMP, MARCEL** (July 28, 1887–
October 2, 1968), French-American painter and
sculptor, has been recognized since the late
1950s as one of the century's most influential art-
ists. His immense reputation is due less to his ac-
tual output as a painter—until 1969 he was
thought to have abandoned painting almost half
a century before—than to his epigrammatic pro-
nouncements ("Beware wet paint." "I don't be-
lieve in art. I believe in artists.") and his
influence as iconoclast and provocateur. He was
a Dadaist years before dada was christened and
launched, and, paradoxically, his antiart ges-
tures inspired legions of artists, from the Dada-
ists and Surrealists of the '20s and '30s to the
young American painters of the period 1955–75
who reacted against abstract expressionism. Pop
art, happenings, op art, and conceptual art had
all been anticipated and then quickly discarded
by Duchamp in the years 1912–26.

He was born in Blainville, Normandy, on the
outskirts of Rouen. His father, Eugène Du-
champ, was a prosperous notary and a kindly,
tolerant man. His mother, though a talented mu-
sician, was rather dour. The third of six children,
Marcel grew up in a happy, affectionate, and
art-loving home. His maternal grandfather,
Emile-Frédéric Nicolle, was a skilled amateur
engraver and painter. Marcel's oldest brother,
Gaston, abandoned a career in law and took the
pseudonym Jacques Villon when he went to Par-
is in 1895 to become a painter. Another older
brother, Raymond, left medical studies for
sculpture and was to become famous under the
name Raymond Duchamp-Villon.

Like his older brothers, Marcel displayed a
precocious talent for drawing and sketching. In
1902 he painted his first oil, *Landscape at
Blainville,* in a freely brushed impressionist
style. By 1904, when he joined his brothers in
Paris and entered the Académie Julian, his por-
traits and landscapes showed the strong influ-
ence of Cézanne. The father, with typical
French practicality, provided each of his sons
with a modest allowance but carefully deducted
the sums from their future inheritance.

After spending the year of 1905 in military
service, Marcel was back in Paris drawing car-
toons for *Le Rire* and *Le Courrier Français* in
which his facility as a draftsman was obvious.
These were the early years of modern art's hero-
ic period: Matisse was experimenting with the
vivid colors of fauvism; Picasso's large canvas of
1907, *Les Demoiselles d'Avignon,* prepared the
way for the cubist revolution; and the strident
manifesto issued by the Italian Futurists in 1909
was yet another challenge to outworn traditions.
Catching up with these trends, Duchamp, him-
self a gifted colorist, had been drawn into the

MARCEL DUCHAMP

color-intoxicated fauve movement by 1908. In-
fluences of both Cézanne and Matisse are evi-
dent in his painting of 1910, *The Chess Players*
(Arensberg Collection, Philadelphia Museum of
Art), with its purples, greens, and muted golds.
Chess Players is also notable for its depiction of
members of the artist's family and for how it re-
veals Duchamp's fascination with chess. "There
is a great correlation between chess and art," Du-
champ said. "They say chess is a science, but it
is played man against man, and that is where art
comes in."

Within a year Duchamp had discovered in
cubism ways in which to represent the essence
of the game of chess. In *Portrait of Chess Players*
(1911; Philadelphia Museum of Art) he eliminat-
ed his brothers' wives, the grass, the shrubbery—
everything not directly related to chess—and
changed his palette to the muted tones and frag-
mented planes of analytical cubism. On week-
ends Duchamp joined his brothers and other
Cubists in the town of Puteaux, about five miles
from Paris. The so-called Puteaux Cubists, also
known as the Section d'Or (Golden Section) cir-
cle, reacting against the more intuitive approach
of Picasso and Braque, planned their paintings
with geometrical precision. They were im-
pressed by young Duchamp's work when it was
exhibited in 1912 at the Salon of the Golden Sec-
tion, Paris; but Marcel was bored by their eccle-
siastical debates on the formal dogmas of
cubism, of which he remarked, "A technique
can be learned, but you can't learn to have an
original imagination."

Duchamp's painting *Yvonne and Magdeleine
Torn in Tatters* (1911) showed that he was mov-

ing in a direction quite outside orthodox cubism, one that allowed him to adopt the cubist method of dissecting and fragmenting forms to depict motion in time. For instance, in *Yvonne and Magdeleine* the eerily distorted profiles of his two youngest sisters were shown in progression from youth to old age. The representation of motion was further developed in his *Sad Young Man in a Train* (1911), whose subject Duchamp explained was himself on a train trip home to Rouen. The figure is rendered in successive profiles which jolt across the canvas in interlocking planes, suggesting machinery in motion. This was Duchamp's first articulation of the strange mechanical imagery that was to become central to his art. Duchamp works of this period, like *Sad Young Man* and the even more revolutionary *Nude* Descending a Staircase of 1911, are widely thought to have been inspired by the Italian Futurists and their methods of representing motion. But the first major exhibition of futurist paintings did not open in Paris until February 1912, and Duchamp did not recall having read the Futurist manifestoes or having seen any futurist work until after the Nude was completed. His vibrating train passenger and peripatetic nude were inspired by the stop-action photography of Jules Etienne Marey, whose sequential depictions of body movement were then appearing in popular magazines.

The genesis of Duchamp's famous *Nude Descending a Staircase* was a series of overlapping sketches of a figure first ascending, then descending, a staircase. In the first version of the painting of the descending "nude," clearly inspired by Marey's chronophotographs, certain anatomical features were discernible whereas others were shown in cross-section. In *Nude Descending a Staircase No. 2*, completed in early 1912, the nude figure emerged as a quasi-mechanical abstraction, and the analysis of downward motion took shape in dozens of angular, overlapping planes, swirling lines, and staccato arcs of dots. The color was the near-monochrome of analytical cubism.

In March 1912 Duchamp sent the *Nude* to Paris's Salon des Indépendants, where the Puteaux Cubists were exhibiting. The picture, in the lower left corner of which Duchamp had painted the title, provoked the Puteaux group's angry consternation. Even his brothers urged him to withdraw the painting from the show or at least to eliminate or change the title. "I said nothing to my brothers," Duchamp recalled. "But I went immediately to the show and took my painting home in a taxi. It was really a turning point in my life. . . . I saw that I would not be very much interested in groups after that."

The furor of the Puteaux Cubists was as nothing compared to the shock and hostility the *Nude* provoked at the historic Armory Show in New York City in 1913, the first large-scale confrontation of the American public with European modernism. A Chicago newspaper critic advised viewers to eat three Welsh rarebits (to induce nightmares) and sniff cocaine if they wanted to understand the picture. Another critic likened it to "an explosion in a shingle factory," and a wittier commentator retitled it "Staircase Descending a Nude." There were many radical works in the Armory Show, but Duchamp's *Nude* was the succès de scandale. It has been suggested that in a country as mechanized as the United States, Duchamp's mechanization of the human figure may have had an unconscious appeal, even to those who were appalled or bewildered. In any event the picture, now one of modernism's canonical images, was bought for $324 by F.C. Torrey, a San Francisco dealer. Three other "shocking" Duchamp entries were sold, and the show altogether netted him $970.

In Paris in 1912, after withdrawing his *Nude* from the Salon des Indépendants, Duchamp set to work on another large painting in the same manner, *The King and Queen Surrounded by Swift Nudes,* the first of a series of erotically suggestive titles. In July 1912 he traveled alone to Munich, his first trip outside France, and stayed there for two months. Duchamp dismissed Munich as "just another art factory," but during his stay he completed two remarkable oils: *The Passage from the Virgin to the Bride* (Museum of Modern Art, New York City) and *Bride* (Philadelphia Museum of Art). He also made the first sketch for the extraordinary work that was to occupy him for the next ten years: *The Bride Stripped Bare by Her Bachelors, Even*, more popularly known as the *Large Glass* (1915–23). *Passage* and *Bride* marked the culmination and virtually the close of Duchamp's painting career. "From Munich on," he said, "I was finished with Cubism. The whole trend of painting was something I didn't care to continue. . . . After Munich I tried to look for another, personal way."

Back in Paris in September 1912, Duchamp was relatively aloof from the art world. To make a living he worked in 1913 as a library clerk in the Bibliothèque Saine-Geneviève. The job gave him time to work on *The Bride Stripped Bare*, and he preserved the notes and ideas he jotted down at idle moments in a green cardboard box. There he is also believed to have consulted monographs on Leonardo da Vinci and editions of Leonardo's manuscripts, especially the sections dealing with perspective.

In *Art in America* (January 1977) Theodore

Reff discussed the similarities between Leonardo and Duchamp, two enigmatic, elusive, and highly intellectual men whose interests ranged from art through mechanics, optics, mathematics, alchemy, and more. Refusing to be "just painters," both artists stressed the conceptual nature of art, were more interested in processes than final products, and left behind a plethora of detailed notes.

During this period Duchamp became friendly with the flamboyant writer Guillaume Apollinaire and the mercurial painter Francis Picabia. These blithe spirits kept open what Duchamp called a "corridor of humor" which cut through the dense thickets of pseudoscientific art theory. Duchamp, a master of irony who delighted in puns and playful alliterations, remarked that his attitude toward aesthetics, physics, and the machine age was tempered by "humor and laughter, . . . my pet weapons. This may come from my general philosophy of never taking the world too seriously for fear of dying of boredom." Reacting against the "retinal" art (that which emphasizes visual and emotional rather than intellectual qualities in painting) of the past as well as the public's worship of that art, Duchamp set out "to put painting once again at the service of the mind," as he said. To that end he used irony, shock tactics, and the instruments and mathematical methods of modern technology. For example, in his magnum opus, the *Large Glass,* he would substitute glass for canvas and mechanical tools for the brush. "I unlearned to draw," he said. "I had to forget with my mind."

As early as 1911 Duchamp had expressed his interest in the formal possibilities of moving mechanical parts in his *Coffee Mill,* a diagrammatic picture painted as a decoration for his brother Raymond's kitchen. Duchamp claimed that the basis of much of his later work was in *Coffee Mill.* His *Chocolate Grinder* (1913), a small painting on canvas, became, with its three interlocking revolving drums, the image of an erotic mechanism; the grinder was to be a central element of the *Large Glass*'s masturbatory Bachelor Machine.

"Every fifty years or so some new scientific law is discovered that cancels out some old law," Duchamp once said. "I have my doubts, that's all. The word 'law' is against my principles." His skepticism about science aroused his interest in chance, which in turn led to his development of the subversive concept of the readymade, or found, object. One of his earliest readymades, purchased in a Paris department store in 1914, was a galvanized iron rack for drying wine bottles. For Duchamp the *Bottle Rack* which he signed, answered the question "What is Art's relation to life?" and it "mocked seven centuries of high art," to quote Calvin Tomkins. Duchamp explained that he wanted to establish himself "as far as possible from 'pleasing' and 'attractive' physical paintings." By taking an object out of one context and placing it in another—where any man- or machine-made object became art simply by declaration of the artist—Duchamp hoped to create "a new thought for that object."

Duchamp's readymades, which at this time included the front wheel of a bicycle mounted upside down on a kitchen stool, so challenged centuries-old concepts of "good taste" that Duchamp was to be taken up as the patron saint of both dadaism and surrealism. In 1934 the Surrealist "pope," André Breton, defined readymades as "manufactured objects promoted to the dignity of objects of art through the choice of the artist."

When war broke out in 1914, Duchamp's mild heart condition kept him out of the army. Accepting an invitation from the art critic Walter Pach to come to America, he sailed in June on the liner *Rochambeau.* He was astonished on his arrival in New York City at being greeted by a crowd of reporters who were eager to interview the painter of the notorious *Nude Descending a Staircase No. 2.*

In New York Duchamp was at once received into the circle of the avant-garde photographer and art impresario Alfred Stieglitz. With his puckish charm, irreverent wit, gaiety, and handsome, chiseled features, Duchamp was much in demand socially and many women fell in love with him. He and Picabia, who joined his friend in New York in 1915, enjoyed the free and easy atmosphere of the city. Duchamp's close friends and patrons in Manhattan were the collectors Walter and Louise Arensberg, who made available to him, rent-free, a studio on West 67th Street, where Duchamp continued to work on his *Large Glass.*

Volumes have been written about *The Bride Stripped Bare by Her Bachelors, Even.* It was a transparent construction, two large sheets of glass between which the fantastic mechanisms he had previously sketched on the walls of his Paris studio were outlined in fine lead wire and painted foil. The *Glass* is, Robert Hughes wrote, "a machine: or rather, a project for an unfinished contraption that could never be built because its use was never fully clear, and because (in turn) it parodies the language and forms of science without the slightest regard for scientific probability, sequence, cause and effect."

Mocking the pseudoscientific claims of the Cubists, Duchamp declared that the "fourth dimension" was really the sexual act. But the act

of love in the *Glass* becomes a symbol of the frustration of sex in the modern, mechanized world. In the upper half of the *Glass,* the Bride perpetually disrobes while the puppetlike Bachelors below masturbate, making the chocolate grinder turn. Duchamp later published his notes on the project—describing, among other things, how the "Love Gasoline" activates the "desire motor"—under the title *Green Box.*

In New York City Duchamp renewed his attack on traditional art with more ready-mades. One was a store-bought snow shovel signed by the artist and called *In Advance of the Broken Arm.* Another thoroughly Dadaist act occurred in 1917 when he sent to an exhibition of New York City's Society of Independent Artists (which he had helped to found) a porcelain urinal. Purchased from a plumbing supply firm, it was christened *Fountain* and signed *"R. Mutt."* After the Society indignantly refused on moral grounds to exhibit it, Duchamp defended "Mr. Mutt," observing, "It is a fixture that you see every day in plumbers' show windows." Besides, he added, "The only works of art America has given [us] are her plumbing and her bridges." The Independent Artists remained intransigent, and Duchamp resigned from the Society.

These iconoclastic gestures made Duchamp a culture hero to the young artists who launched the dada movement in Zürich, Switzerland in 1916. These gifted rebels derided the war-torn world's pretensions to civilization with their outrageous "antiart" creations and activities. Duchamp applauded the cabaret the Dadaists staged, but he never formally joined this or any other group.

With Man Ray and Picabia, Duchamp frequently contributed to *291,* Alfred Stieglitz's art review, and in 1917 his journals, *The Blind Man* and *Rong-Wrong,* were published. Duchamp returned to Paris in 1919 and met the Dadaists. On his return to New York City, he began signing his readymades Rrose Sélavy—and even had himself photographed in the clothes of a woman of fashion by Man Ray. (Sélavy was a pun on c'est la vie and Rrose came from the verb *arroser:* "Arroser, c'est la vie"—"To water, that's life.")

In 1920 Duchamp and his friend and patron Katherine Dreier founded in New York City the Société Anonyme for the promotion of modern art. That year he also exhibited *L.H.O.O.Q.,* his notorious "assisted readymade" of 1919. This was a reproduction of Leonardo's *Mona Lisa* to which Duchamp added a moustache and goatee. Duchamp's mockery of the sacred in art extended to the punning title: pronounced in French, l-h-o-o-q is *Elle a chaud au cul,* meaning "She's got a hot ass."

True to his Dadaist resolve to "annihilate" painting, Duchamp ceased working on the *Large Glass* in 1923, leaving it in what he called a state of "definitive incompletion." From 1923 to '42, he lived more or less regularly in Paris and went "underground" as an artist. Except for occasional experiments in mechanics and optics, he devoted himself to chess and published a study of the game, *Jeu de la reine,* in 1926. Also that year, he and Man Ray collaborated on *Anemic Cinema,* a film which alternated shots of revolving spirals with titles composed of Duchamp's elaborate puns and anagrams.

In 1934 Duchamp published his explanatory notes for the *Large Glass* in a limited edition of 300 copies, with each set of "instructions," reproduced exactly as he had written them, placed with no regard for order in a green cardboard box. Surrealism was then at its height, and in a poetic essay entitled "Lighthouse of the Bride," published in the December 1934 issue of *Minotaure,* André Breton hailed the *Large Glass* as a magical lighthouse whose purpose was "to guide future ships on a civilization which is ending." Breton and Duchamp were lifelong friends—Duchamp was one of the few artists of Breton's acquaintance never to be denounced for compromising official surrealism's impossibly strict aesthetic standards—and Breton's was the first important monograph on Duchamp, now one of the modern era's most written-about figures.

During a visit to the US in 1936, Duchamp spent several months repairing, in the garage of Katherine Dreier's Connecticut home, *Large Glass,* which had splintered while being shipped by truck ten years before. Duchamp retained the weblike pattern of cracks in the pane so that the work could be considered completed "by chance." Eleven of his works were included in the influential "Fantastic Art, Dada, Surrealism" show of 1936 at MOMA. In 1938 Duchamp designed the International Surrealist Exhibition in Paris, transforming the central hall into a dark grotto carpeted with leaves and roofed with coal sacks. Gallery-goers had to grope their way with flashlights.

Duchamp spent the early years of World War II in Paris, methodically packing reduced reproductions of 68 of his works—paintings and readymades—in a specially designed leather-covered box which he called his *Boîte-en-Valise* (Box in a Suitcase). He had 20 copies of each item made up by commercial printers and hardware stores. In June 1942 he sailed from Lisbon to New York City, where other artist-refugees, including the leading Surrealists, had preceded him. Duchamp was the only one of the artists-in-exile who felt completely at home in New York,

and in 1955 he adopted US citizenship, feeling that there was greater artistic freedom in America than in Europe. "Since tradition is less venerated here it is a better terrain for new developments," Duchamp explained.

Duchamp lived in a Greenwich Village apartment and took a small studio over a store at 210 West 14th Street. In 1942, in Manhattan, he and Breton organized an International Surrealist Exhibition in which a maze of twine was woven around the paintings. From 1942 to '44, Duchamp, Breton, and Max Ernst edited *VVV*, the Surrealist's official magazine. An exhibition of the three Duchamp brothers' work at the Yale University Art Gallery in 1945 enhanced Marcel's American reputation. At the International Surrealist Exhibition held in Paris in 1947, two of the rooms, the Salle de Pluie and Le Dédale, were based on designs by Duchamp, who also created for the catalog cover a life-sized foam-rubber breast mounted on black velvet. By 1950 most of Duchamp's oeuvre was in American collections, notably those of Katherine Dreier and the Arensbergs. Most of his works now belong to the Philadelphia Museum of Art.

In the late '40s and early '50s, Americans of the New York School, led by Pollock and de Kooning, were forging action painting, a new style of expressionism. These artists, with their emotional and sensuously "retinal" approach, were not interested in Duchamp. Although his belief that "art is all a matter of personality" accorded with their radical subjectivism, the detached ironist Duchamp had long ago rejected art-as-self-expression so that the mind could take precedence over the soul in painting and sculpture.

In 1951 de Kooning had described Duchamp as a "one-man movement . . . a truly modern movement because it implies that each artist can do what he thinks he ought to." But it was the breakthrough of Robert Rauschenberg and Jasper Johns in the late '50s that led to the recognition that Duchamp was possibly the most influential artist of the third quarter of the 20th century. Rauschenberg's combines, his "anything goes" philosophy which freed him to make art from Coke bottles, automobile tires, and stuffed goats, and such Jasper Johns pieces as the bronze sculpture of beer cans erased the line between art and life that Duchamp's readymades had blurred. Johns's and Rauschenberg's work would have been truly scandalous were it not that the public was now less shockable than in 1915—a situation for which Duchamp more than any other single artist could claim credit. Moreover, the pop art of the 1960s, with its dead-pan commentary on mass-produced objects, derived its aesthetics from Duchamp's

questioning of the distinction between art and any other man-made device. Calvin Tomkins described Andy Warhol's Campbell's soup can as "perhaps the final apotheosis of the 'readymade.'" In the '60s Duchamp was also hailed as a prophet of op art because of the rotating optic machines he had devised in the 1920s. The ultra-avant-garde musician John Cage and the experimental dancer Merce Cunningham were influenced by Duchamp, as were the Conceptual artists of the 1970s, though few if any of them possessed Duchampian humor and irony.

Duchamp was amused and gratified at his sudden canonization as a hero of modern art, but the irony that his "antiart" readymades of the World War I period were now admired as art and preserved in museums did not elude him. According to Duchamp, the Neo-Dadaists had violated the spirit of dadaism in their retention of traditional "museum" concepts of formalistic harmony and beauty.

In 1927 Duchamp had married Lydia Sarrazin-Levassor, the daughter of a French automobile manufacturer, but they were divorced within four months. In 1932 he stuck up an intimate companionship with an attractive widow, Mary Reynolds, with whom he was happily involved until her death in 1950. In 1954 he married Alexina Sattler, a charming woman known in the art world as Teeny. Duchamp's last years were spent in comfort and happiness with his wife in their West 10th Street apartment; on visits to France they stayed in a small apartment in Neuilly which had been owned by Duchamp's sister, Suzanne. He liked to relax by playing chess, and one of his chessboards had pieces designed by Max Ernst.

In 1968, during his annual late summer trip to France and Spain, Marcel Duchamp died in Neuilly, near Paris, a few months after celebrating his eighty-first birthday. Since World War II Duchamp had encouraged the belief that he had "retired" from art, preferring to play chess and to cultivate the mystique of silence. In fact, he had been secretly working since 1946 on a composition which he did not complete until about 1966. Duchamp's last work was a room-sized environment entitled *Etant Donnés: 1) La Chute d'eau; 2) Le Gas d'éclairage* (Given: 1) The Waterfall; 2) The Illuminating Gas) and was exhibited for the first time in 1969 at the Philadelphia Museum. *Given* is housed in a room empty but for a wooden door in which peepholes have been drilled at eye level. Through the holes one sees a lifelike nude woman lying on her back; her explicitly reproduced genitalia face the viewer and in one hand she holds aloft a kerosene lantern. Behind her is a pastoral landscape,

painted in perspective, containing a mechanical waterfall, and bathed in brilliant summery light. Calvin Tomkins wrote that *Given* contradicts every assumption ever made about Duchamp's art and that the blond-haired woman in the piece is "splayed so indecorously that she achieved the almost-obsolete power to shock an unprepared viewer."

Duchamp was never as highly regarded in France as in the US. However, the controversial Centre Georges Pompidou at Beauborg, Paris, opened in 1977 with a Duchamp exhibition.

EXHIBITIONS INCLUDE: Pasadena Art Mus., Calif. 1963; "Marcel Duchamp: Ready-Mades, etc. (1913–1964)," Gal. Schwarz, Milan 1964; Arts Council of Great Britain, Tate Gal., London 1966; Philadelphia Mus. of Art 1969; Centre National d'Art et de Culture Georges Pompidou (Beaubourg), Paris 1977. GROUP EXHIBITIONS INCLUDE: Salon of the Golden Section, Paris 1912; Armory Show, NYC 1913; "Fantastic Art, Dada, Surrealism," MOMA, NYC 1936; International Surrealist Exhibition, Paris 1938 '47; International Surrealist Exhibition, NYC 1942; Yale Univ. Art Gal., New Haven, Conn. 1945; "20th Century Art from the Arensberg Collection," Art Inst. of Chicago 1949; "The Art of Assemblage," MOMA, NYC 1961.

COLLECTIONS INCLUDE: MOMA, NYC; Arensberg Collection, Philadelphia Mus. of Art; Yale Univ. Art Gal., New Haven, Conn. (Société Anonyme Collection); Mus. National d'Art Moderne, Paris.

ABOUT: Barr, A. H. "Fantastic Art, Dada, Surrealism" (cat.), MOMA, NYC, 1936; Brown, M. W. The Story of the Armory Show, 1963; Cheney, S. The Story of Modern Art, 1958; Hamilton, R. The Bride Stripped Bare . . . etc. (a typographic version of Marcel Duchamp's Green Box), 1960; Hughes, R. The Shock of the New, 1981; Janis, S. Abstract and Surrealist Art in America, 1944; Lebel, R. Marcel Duchamp, 1959; Lippard, L. R. Pop Art, 1966; Motherwell, R. (ed.) Dada Painters and Poets: An Anthology, 1951; Paz, O. Marcel Duchamp, 1968; Read, H. A Concise History of Modern Painting, 1959; Rose, B. American Art Since 1900, 2d ed. 1975; Schwarz, A. The Complete Works of Marcel Duchamp, 1969; Tomkins, C. The Bride and the Bachelors, 1965, The World of Marcel Duchamp, 1966, Off the Wall, 1980. *Periodicals*—Art in America January–February 1977; Art News April 1977; MD January 1970; Minotaure (Paris) December 1934; View no.1 1945.

***DUFY, RAOUL** (June 3, 1877–March 23, 1953), French painter, was, if not a great innovator, certainly one of the most perennially popular of modern artists—as attested to by the wide availability of inexpensive reproductions of his paintings and by the many attempts to imitate his essentially inimitable style. His charmingly

RAOUL DUFY

decorative pictures, with their lively, sunny scenes and gay colors, were not the effortless, naive renditions they may seem; they were, in fact, based on carefully worked out aesthetic principles, having to do with the expression of light and color. At the same time, however, Dufy explained that "I don't follow any system. All the laws you can lay down are only so many props to be cast aside when the hour of creation arrives." He was, indeed, a painter who believed that "eyes are made to obliterate everything that is ugly." He once compared himself to an earlier interpreter of the *douceur de vivre*, the 18th-century painter Fragonard.

One of nine children, Raoul Dufy was born in Le Havre and grew up in a music-loving household. His father, a none-too-prosperous businessman, was an amateur organist; one of Dufy's brothers became a professional organist and another was the editor of the Paris *Courrier Musical*. (This family background had a profound effect on Dufy's later choice of themes in his paintings.) Forced at the age of 14 to leave school and begin work, Dufy took a job as clerk in a coffee-importing firm. He began his artistic training in 1892 with evening classes at the Ecole Municipale des Beaux-Arts du Havre; among his fellow students were Georges Braque and Othon Friesz. The latter, with whom he set up a small studio, and with whom he later lived for a short time in Paris, became his close lifelong friend. Early influences on Dufy were the paintings of another native of Le Havre, the impressionist Eugène Boudin, and, above all, the work of Delacroix. After a year's compulsory military service (1898–99), Dufy went on to Paris where,

°dü fē,´ rä ōōl´

with a year's grant awarded by the Havre Municipality, he studied at the Ecole des Beaux-Arts. He was oppressed by the masterpieces in the Louvre, but he admired the impressionist paintings exhibited in Durand-Ruel's window and the Cézannes shown at Vollard's gallery.

Even in those impecunious student days Dufy was conspicuous among his fellow artists for his neat, nonbohemian dress, his careful putting aside of money in order to attend concerts. A short, stocky but debonair figure, invariably sporting a boutonniere, Dufy in later years was distinguished by the quiet elegance of his clothes. In old age, his curly white (once blond) hair, bright blue eyes, snub nose, small mouth, and his fresh, rosy complexion still gave him, as people said, the look of an English choirboy. Even when in great pain as a result of the rheumatoid arthritis he developed at about age 60, Dufy remained cheerful and uncomplaining; when physically unable to paint he occupied himself with planning out his next projects.

While Dufy's earliest paintings, such as an 1898 *Self-Portrait,* were academic, the Van Gogh exhibition at Bernheim's gallery in 1901 was an exciting experience for him, and his work soon thereafter showed the influence of impressionism and the first manifestation of what would later become characteristic themes and mood: outdoor scenes, dominated by high, bright skies and peopled with crowds of pleasure seekers—as in his *Beach at Sainte-Adresse* or *The Courtyard of the Louvre,* both painted in 1902. His long and successful career may be said to have begun in that year with the purchase of his pastels by the dealer Berthe Weill; his first individual show, of Havre landscapes, was held in her gallery four years later.

About 1904, with such a painting as *Yacht with Flags at Le Havre,* Dufy began to paint in a new manner, tending to fauvism. A decisive turning point in his career came in 1905 when he saw Matisse's great fauvist masterpiece *Luxe, calme et volupté.* Many years later Dufy recalled that "I understood the new *raison d'être* of painting and impressionist realism lost its charm for me as I beheld this miracle of the creative imagination at play, in color and drawing." In 1906, while on a painting trip to Normandy with Albert Marquet, another member of the Fauves group, Dufy did such canvases as *Old Houses on the Waterfront at Honfleur* and *The Sunshades.* With their summary treatment of forms and concentration instead on juxtaposition of planes of brilliant color, they are full-fledged examples of the new fauve style. But while the Fauve painters were concerned primarily with color, Dufy, a superb draftsman, rejected what

he felt was their use of color merely for color's sake; he always placed design considerations first.

Another stylistic transition came in 1907 while in Provence with Braque, both of them trying to relive Cézanne's aesthetic development in L'Estaque. There Dufy began painting in a more classical manner. As in *Green Trees at L'Estaque* (1908), brilliant colors gave way to a subdued palette and he became concerned with the rendition of volumes. As a result, his paintings declined in popularity and failed to sell. While the experiment led Braque to the development of cubism, Dufy went only so far, and was never formally aligned with this movement, although certain later paintings—*Neapolitan Fisherman* (1914) or *Homage to Mozart* (1915) —have an affinity with cubist developments.

No more an Expressionist than he was a Cubist, Dufy returned from a trip with his friend Friesz to Munich in 1910 relatively untouched by German expressionism. His somewhat stark *Munich Landscape* (1910) notwithstanding, Dufy was by temperament a painter of the south: open, sunny vistas along the French Riviera, in Sicily, or in Morocco. There is a world of difference psychologically as well as geographically, for example, between the detached, distant view from a hotel window of the more sinister quarters of a port city (as in *Port of Marseilles,* 1925) and the intense, claustrophobic quality of studies of decadent café life by some of the northern Expressionist painters.

In 1909, in order to make a living, Dufy turned from painting to woodcuts, a medium natural to his talents as a draftsman. Working in his Paris studio and at a commune for married artists at Orgeville, he completed in 1910 his illustrations for *Le Bestiaire* by the poet Guillaume Apollinaire. Dufy's sense of ornamental design is evident in the perfect symmetry of the overall composition and of line in these plates. At this juncture, too, came his opportunity to develop as he did into one of the most superb decorative artists of the 20th century. With the backing of the couturier Paul Poiret, Dufy set up a printing plant near his Montmartre studio and began to imprint dress fabrics with his woodblock designs. The new venture proved an immediate commercial success and eventually led to commissions for tapestry designs and to an appointment to the staff of the Bianchini-Férier silk firm at Lyons (1912–32). Through these varied activities and his later interest in ceramics, Dufy helped to break down the barrier between the fine and the applied arts.

Although he did not serve in World War I, Dufy was employed doing woodcuts on patriotic

themes for various publications; and from 1917 to 1918 he worked at the Musée de la Guerre, Paris, purchasing contemporary paintings for the collection. A year spent in Vence, on the Riviera, in 1920–21 proved to be the great watershed in Dufy's development. Thereafter, in loving contemplation of the scenes before him, he created a reality of his own, a highly personal mode of vision, the basis of what is now considered most characteristic of his style. " . . . We need something more than the satisfaction of vision alone, we need to create the world of things unseen," he proclaimed. After all, he once quipped, "Nature . . . is only a hypothesis."

It may be in relation to this intuition that, although crowds of people enliven most of his canvases, Dufy was almost wholly unconcerned with individualizing their figures. For the same reason, perhaps, Dufy's formal portraits are few in number and the several studies of female nudes posed decoratively in his studio lack truly sensual effect, as compared, for instance, to those of Matisse.

A trip to Italy in 1922 only confirmed his distrust of any lessons to be learned from the old masters and reaffirmed his independence of thinking—while it also established his delight in the landscape. Sicilian towns like Taormina became favorite subjects.

Now, inspired by the intense, unchanging Mediterranean light, he began to suffuse his canvases with the ambient tone considered appropriate to them (blue for seascapes, green for landscapes), and to work out his other theories of handling color. "Color without light is lifeless," he declared years later in a letter to the critic and painter André Lhote. "Without light forms fail to come to life, colors alone not being enough to make them stand out. We perceive light first of all, color afterwards." From 1936 on Dufy in fact mixed with his oil colors a substance developed by the chemist Jacques Maroger, which had the effect of ridding pigments of their opacity and allowing light to strike through them. Despite Dufy's success with this medium and his willingness to share it with others, no other artist ever adopted it. To illustrate his theory that color lingers after a shape or object has moved on, Dufy often allowed color to extend beyond contour lines, or divided objects into zones of different colors, as in *The Races* (1935) or *Race Horses* (undated watercolor).

Formal perspective gave way to an organization of elements according to a personal hierarchy of their importance; this accounts for the seeming childlike quality of some of his compositions. Because very often there is no central point or object around which these compositions

are grouped or on which sight lines converge, the viewer's eye is free to gaze at random, thus enhancing the sense of movement that is central to Dufy's art.

Unconcerned with volumes, Dufy employed quick, unconnected lines (often compared to hieroglyphs) to establish figures; because of the way color escapes these fleeting contours the effect of movement is even further increased. In *The Paddock at Deauville* (1930) the nervous lines that indicate the horses' bodies also allude to their perambulation of the bridle path, as the flickering suggestions of leaves allude to the movement of the air in the trees above. The cinematic unfolding of Dufy's scenes also stems from his manner of painting landscapes (and interiors too) as if the artist were hovering not far above them, perhaps in a balloon. Almost invariably, also, his canvases were organized with a high horizon line running pronouncedly along near the top. Thus a sense of great, retreating distance is achieved in *Cowes Regatta* and *Paris*, both of 1934, in farm scenes such as *The Harvest* (1930), or in *The Artist and His Model in the Studio at Le Havre* (1929).

Dufy's paintings and drawings in the 1920s and '30s are a happy, nostalgic record of a gilded age, along the beaches of the Riviera, at fashionable casinos and racetracks, or in other society settings. These splendid, celebratory works are not necessarily elitist, however, for their creator was concerned with rendering beauty "accessible to all, by putting order into things and thought." Never pompous, they are light of touch—as in *The Coronation of King George VI* (1937)—and often betray traces of witty, ironical comment, as in the family group *Riders in the Forest* (1931) or the drawing *Baccarat at Deauville* (1928). Touches of personal whimsy also enliven many of the paintings. Almost transparent butterflies, as large as some of the other figures, float casually over the near distance in *The Marne* (1935) or *The Bay of Sainte-Adresse* (1924). In *The Blue Train* (1935), with its child's toy cars puffing across the landscape, an artist's easel perches insouciantly in the foreground, its white canvas bare of any traces of paint.

Many viewers and critics have felt that had Dufy lived in another age he would have been a great painter of wall or ceiling decorations. Among his actual decorative projects was the vast *Celebration of Electricity*, painted for the 1937 Paris World's Fair. Composed on 250 separate wood panels, it was nearly 200 feet long and 32 inches high. The piece was literally the largest painting ever made, and although the composition was carefully thought out, it conveys a sense of joyous improvision. (The American art-

ist Robert Rauschenberg is at work on a composition that, when completed, will be the largest painting ever.)

Other commissions included the decoration of the dining room of his physician Paul Viard (1927–32), a wall painting of French explorers for the Monkey House at the Jardin des Plantes, Paris (1938), and an allegorical painting of the Seine (in collaboration with Othon Friesz) for the Theater of the Palais de Chaillot (also 1938). Besides these Dufy also executed sets and costumes for ballets and plays, and between 1923 and 1930 designed a number of ceramic vases and tiles for the Catalan potter Jose Llorens Artigas.

Typical of Dufy's interest in the practical, technical underpinnings of art was his approach to tapestry design. Between 1937 and 1949 he produced a series of cartoons for tapestries and founded an atelier dedicated to the revival of high-warp weaving, a process that would ensure the incorporation into the finished product of a feature peculiar to Dufy's mode of composition: the high backgrounds quite as full of visual interest as foreground scenes.

First stricken with severe arthritis in 1938, Dufy moved to the south of France for relief and spent the years of the German Occupation mainly in Nice and Perpignan, unharassed by the Nazis. Although basically apolitical, he did speak out against the collaborationist press; at the same time he was capable of defending his friends Friesz and André Derain (both of whom had gone to Germany during World War II on a goodwill trip) from charges of collaboration.

In the later years of Dufy's life, paintings having to do with music abounded. From his usual high vantage point the artist looks down on orchestras on the concert stage, focused on individual instrumentalists (*The Double-Bass Player,* 1946) or on a single instrument (*The Red Violin,* 1948). This last, like many of the compositions on the theme of music, was painted in what Dufy called "tonal color," harmonious variations of a single tone, set off by patches of white— quite different from his earlier diversity of palette. In a note on the reverse of one of his watercolors Dufy wrote: "Imitate the main theme and the timbre of the instrument playing it . . . by imparting a particular light effect to a group of instruments and giving it a pecular form and stamp that have nothing to do with the instrument or players, but which stand as an abstract sign interpreting the music at a given passage." There is basis, therefore, for what the renowned cellist Pablo Casals once said of Dufy: "I can't tell what piece your orchestra is playing, but I know what key it is written in!" Certainly,

Dufy's love of this other art is summed up in one of his very last canvases, *Homage to Bach* (1952). Here a violin is posed against a sign lettered with Bach's name, and surrounded by walls patterned with allusions to music: bell-like flower forms and arabesques of leaves.

After several years of rigorous attempts at a cure, in the south of France and in Spain, Dufy went to the United States in 1950, to be treated at the Jewish Memorial Hospital in Boston. From there he traveled with his American friends and patrons, Mr. and Mrs. Louis Bergman, to Arizona, seeking further relief in the dry climate. Several paintings and sketches, including a drawing of the Brooklyn Bridge and a watercolor of *Fishing Smacks in Boston Harbor,* record his impressions of his second trip to America (he had been there earlier, in 1937). Replying to criticism that these works were, after all, inappropriately French in spirit, Dufy's rejoinder was: "There are, of course, differences between the American and the French scene, but they are superficial. A painted landscape is not nature, anyway. Art is a creation."

After Dufy's return to France in 1951 he eventually settled in Forcalquier (near Avignon, and recommended for its dryness). There, two years later, he died suddenly of a heart attack. His last evening had been spent listening to a recording of Wagner. Raoul Dufy is buried in Nice in a cemetery overlooking his beloved Mediterranean. "If Fragonard could be so gay about the life of his times, why can't I be just as gay about mine?" the artist had once mused, and he expressed his regret that he could give his viewers only a fraction of the great joy he had experienced and tried to capture in his painting. Gertrude Stein summed up the essence of his art when she wrote, "Dufy is pleasure."

EXHIBITIONS INCLUDE: Gal. Berthe Weill, Paris 1906; Gal. Bernheim-Jeune, Paris 1921; Carstairs Gal., NYC 1936; Gal. Louis Carré, Paris 1941, '50; Palais des Beaux-Arts, Brussels 1943; Niveau Gal., NYC 1949; Mus. d'Art Moderne, Paris 1953; Tate Gal., London 1954; Mus. de Lyon, France 1959; Wildernstein's, London 1975; Mus. d'Art Moderne de la Ville de Paris 1976. GROUP EXHIBITIONS INCLUDE: Salon des Artistes Français, Paris 1901; Salon des Indépendants, Paris 1903–11, '13, '20, '23, '26, '34, '36; Salon d'Automne, Paris 1906–07, '10, '21, '22, '27, '43; Salon des Artistes Décoratifs, Paris 1921–23, '39, '47; Gal. Les Centaures, Brussels 1923; "Exposition de l'Ecole de Paris," Prague 1931; Palais des Beaux-Arts, Brussels 1934; "Exposition des maîtres de l'art indépendant," Petit Palais, Paris 1937; "Exposition des Fauves," Kunsthalle, Bern 1950; Venice Biennale 1950, '52; "Wild Beasts," MOMA, NYC 1976.

COLLECTIONS INCLUDE: Mus. d'Art Moderne, Mus. du

Petit Palais , and Gal. Louis Carré, Paris; Mus. des
Beaux-Arts, Nice, France; Mus. des Beaux-Arts, Brus-
sels; Stedelijk Mus., Amsterdam; Royal Mus. of Fine
Arts, Copenhagen; Kunstmus., and Gal. Beyeler, Basel;
Staatsgal., Stuttgart; Tate Gal., London; MOMA, NYC.

ABOUT: Cogniat, R. Raoul Dufy, 1962; Courthion, P.
Raoul Dufy, 1951; Lassaigne, J. Dufy, 1954; Marks, C.
From the Sketchbooks of the Great Artists, 1972;
Rădulescu, V. Raoul Dufy, 1973; Sussan, R.B. Raoul
Dufy, Paintings and Watercolours, 1958; Werner, A.
Raoul Dufy (1877–1953), 1953, Raoul Dufy, 1973.

EPSTEIN, SIR JACOB (November 10, 1880–
August 19, 1959), American-born British sculp-
tor, was a leader of the pre–World War I avant-
garde in Britain, where he helped to revive the
art of direct carving. He is best known for his
portraits in bronze and his monumental stone
carvings. For decades he was subjected to the
ridicule and vituperation of a conservative press
and a backward-looking art establishment.

Epstein was born in New York City, on Hester
Street, the Jewish quarter on the Lower East
Side. He was the third of eight children in a fam-
ily of Russo-Polish descent. A solitary child, he
spent much of his time reading and showed an
early interest in painting and drawing. Epstein
delighted in the life of his teeming immigrant
neighborhood, and when his parents moved to
a "better," uptown address, he stayed behind in
a rented room on Hester Street. From a window
in his room that overlooked the marketplace, he
studied the faces, gait, and gestures of the people
below and attempted to capture their character
in drawings and paintings.

In 1896 Epstein enrolled in New York City's
Art Students League, which he attended inter-
mittently until 1902. Dissatisfied with his work,
he decided that, to capture more fully the sub-
jects he was trying to paint, he needed to "see
things in the round," and thus resolved to be-
come a sculptor. To support himself and gain ex-
perience, Epstein worked in a bronze foundry,
while taking a night class in sculpture at the Art
Students League with George Gray Barnard.
Having begun making illustrations in 1900, Ep-
stein received his first commission the following
year, illustrating Hutchins Hapgood's book *The
Spirit of the Ghetto.* For this project he drew on
his sketches of Lower East Side street life. Ep-
stein used the proceeds from this group of draw-
ings to go to Europe, where he hoped to find
more encouragement and better training in
sculpture than had been available in the United
States.

Epstein arrived in Paris in 1902. Though he
could not speak French, he was admitted to the

SIR JACOB EPSTEIN

Ecole des Beaux-Arts. Because of his fellow stu-
dents' hostility to foreigners—which may have
been exacerbated by Epstein's personality,
which was not ingratiating—he did not get on
well at the Ecole. After finding two days' work
smashed to the ground by students who were
probably jealous of Epstein's superior talent, he
left the school for the Académie Julian, which
charged tuition. Epstein studied hard—again he
was unpopular with the other students—but the
reverence accorded the professsors, or "masters,"
on their cursory twice-weekly visits to the class-
rooms struck the independent Epstein as exces-
sive. As if in anticipation of his later battles with
critics, he would cover his work in progress with
a cloth when the master entered. This flaunting
of Académie decorum earned him the appella-
tion *"ce sauvage Américain."*

Epstein's early efforts in sculpture were ambi-
tious and caused him continual frustration; very
few of his works survive from this period. To re-
lax, he visited the Louvre and the Trocadéro,
where he studied ancient rather than contempo-
rary art, though he was to call Rodin "without
dispute the greatest master of modern times."
He was especially impressed by the sculpture of
pre-Classical cultures in Greece, Assyria, and
Egypt. In *English Art and Modernism
1900–1939* Charles Harrison noted that at the
time Epstein studied in Paris "the practice of
sculpture was still seen as essentially a matter of
mastery over modelling techniques. [Epstein's]
early practice of carving was encouraged by an
individual preference for the sculpture of early
cultures." He also began to study and collect Af-
rican tribal art, which greatly influenced his

work. In 1904 he visited Florence and London. Despite the attractions of Paris, Epstein was eager for new surroundings, and in 1905 he settled in London.

The art scene in Britain early in this century was rather provincial, especially in sculpture. Nevertheless, in London Epstein met the painters Augustus John and Ambrose McEvoy, the etcher and architectural draftsman Muirhead Bone, and other members of the New English Art Club. Stimulated by the new environment, he settled in Fulham, and in 1905, after a brief visit to New York, he married Margaret Dunlop, a native of Scotland.

After years of hard work, Epstein's career, with help from Muirhead Bone, was beginning to take off. In 1907, the year he became a British citizen, Epstein received his first major commission when the architect Charles Holden contracted him to carve 18 over-life-size figures for the British Medical Association's headquarters in the Strand. But the idea of executing a series of portraits of noted doctors and medical researchers was rejected by Epstein as dull and unimaginative, and he proposed instead to illustrate the evolution of human life in 18 stages, from birth to death. The plan was approved, but when Epstein's series of carved stone figures on the new Medical Association building was unveiled in 1908, there was a tremendous outcry in the British press. Public taste was scandalized by the nudity of the figures, one of which was a woman in an advanced stage of pregnancy, the distortion of the bodies, and the extreme naturalism of the faces. Epstein was castigated as tasteless, untalented, and immoral, but a defense was mounted and the sculptures saved. However, they were eventually torn down when the Rhodesian government purchased the building in the mid-1930s. The outraged Epstein called the destruction "the latest attempt to dictate London taste in sculpture. This time from Rhodesia. . .

The removal of the British Medical Association sculptures which 23 years ago won against the [indigenous] Philistines [represents the] victory of the Philistines from the outposts of Empire." The contretemps of 1908 embittered Epstein and left him permanently suspicious of art critics and journalists.

In 1908–10 Epstein studied portrait modeling, first using his wife as a subject, and later his daughter Peggy Jean. He received his first portrait commissions in this period, but for years the public saw him as an artist of the obscene and disgusting. He was rejected for membership in the Royal Society of British Sculptors and, until late in life, he received only three more large-scale commissions. Nevertheless, in 1910 he was commissioned by Robert Ross, Oscar Wilde's friend and literary executor, to carve a monument for Wilde's tomb in the Père Lachaise cemetery, Paris. While working in Paris for six months on the 20-ton monument, Epstein met Picasso, Modigliani, and Brancusi. Of the three, the charismatic Modigliani made the greatest impression on him.

When Epstein installed his *Tomb of Oscar Wilde* in 1912, his work again aroused violent protests. The central figure, carved in a formalized, somewhat Assyrian style, was naked, with genitals exposed. To quiet the public, a bronze fig leaf was placed over the genitals, but it was removed after the uproar had subsided. Not finding in Paris the right atmosphere for his work, Epstein departed for Pett Level on the Sussex coast, where he immediately began producing his most experimental sculptures.

Epstein was too much an individualist to attach himself to passing movements, but in London, in 1910–11, he had met the gifted young French sculptor Gaudier-Brzeska, the painter and writer Wyndham Lewis, the British philosopher T. E. Hulme, who had defended Epstein's work, and Ezra Pound. They were active in the vorticist movement, that peculiarly English variation of cubist futurism. Epstein was briefly involved with the Vorticists in 1913, the year he executed *The Rock Drill*. Modeled in plaster and later cast in bronze, *The Rock Drill* is a hybrid between a pneumatic drill and a visored robot. The Italian Futurists saw the machine age as the harbinger of mankind's glorious destiny, but Epstein's vision of the mechanistic culture was less sanguine. He described *The Rock Drill* as "the sinister armoured figure of today and tomorrow. Nothing human, only the terrible Frankenstein's monster into which we have transformed ourselves."

The Rock Drill was exhibited in 1913 under the auspices of the newly formed London Group, which reacted against the conservative British art establishment and included Epstein as a charter member. Also about 1913, he produced such semiabstract sculptures as *Cursed be the Day Wherein I was Born*, which shows the influence of African carving. Other works from this period are *Venus*, which addresses vorticist concerns, and the marble *Mother and Child*. Epstein would later return to these mythic themes.

World War I had little effect on Epstein's career, but he was saddened by the wartime deaths of the brilliant Henri Gaudier-Brzeska and T. E. Hulme. The latter had been the model for one of Epstein's finest portrait busts. The geometric simplifications of his stone carvings, considered

so revolutionary in their day, do not always carry conviction, but Epstein's portraits in bronze, influenced by Rodin but with a rugged texture and an uncanny ability to capture the sitter's inner life, are among his most admired works today.

In 1916 Epstein moved to Bloomsbury, and the following year, having been turned down for employment as a war artist, he was called up for service in the Artists Rifles. He served an uneventful term as a private until 1918, although in 1917 he had exhibited at the Leicester Galleries, London, along with other artists in the armed forces. The Leicester Galleries were to remain his dealers from then on.

Epstein thought of himself not as a revolutionary but as a sculptor in the great tradition, and he borrowed from primitive, classical, and contemporary art. In his first large sculpture in bronze, *The Risen Christ* (1917–20), he was inspired by pre-Renaissance religious art, in which Christ and the saints had not yet become standardized in appearance. The head was modeled after the composer Bernard Van Dieren, his friend, whose book *Jacob Epstein* was published in 1920. As usual, reviews of *The Risen Christ* were largely condemnatory and failed to understand that Epstein was attempting to reinvigorate religious art and bring it into the present by endowing his figures with an emotion more powerful than passive reverence. He defended *The Risen Christ* simply by calling attention to the banal, unimaginative quality of most contemporary religious sculpture.

In 1921 Epstein met Kathleen Garman, his eventual wife and the subject of many of his bronze portraits. The following year he took a cottage at Loughton, in Epping Forest. Despite uniformly unfavorable and often malicious reviews of his work in the popular press, Epstein scored major successes in the 1920s. In 1924 he embarked on two major projects, one, a portrait bust of Joseph Conrad, involving modeling, the other, a large memorial to the author W. H. Hudson in Hyde Park, a direct carving. Epstein worked enthusiastically on the bust of Conrad and completed it in 21 days. In his book *Sculpture* (1952), the British sculptor Arnold Auerbach wrote: "The bust of Joseph Conrad . . . is undercut with an intensity of darks which somehow conveys the aloof pessimism of the sitter . . . yet the forms which make up the head are built up piece by piece into a structural design." Old and ailing, Conrad died six months after the bust was finished.

Epstein's *Memorial to W.H. Hudson, Rima* was commissioned by the Royal Society for the Protection of Birds. The model had been approved in advance, but Prime Minister Stanley Baldwin and other onlookers were horrified when the carved stone relief was unveiled in 1923. The public and press were outraged, not only by the nudity of the female figure but by the expressive distortion of her shape, for Epstein, in keeping with the spirit of Hudson's famous book, *Green Mansions*, wanted to emphasize primitive strength rather than decorative charm. The artist intended the relief to be viewed as a self-contained entity, not as a "complement" to the beauty of the park.

Also in the mid-1920s Epstein met the Patels, two sisters from India who thereafter became his models. He worked primarily with Sunita Patel and her young son, both of whom he took to live in his house. In 1926 Sunita modeled for *Visitation* (cast in 1955), and in 1927 she and her son posed for *Madonna and Child,* one of the finest of Epstein's larger bronzes. In this work, to quote Arnold Auerbach, "There seems no hesitations, no lack of fusion between spiritual conception, general shape and interior modelling." As in *The Risen Christ,* the emphasis was on the face, hands, and feet instead of the body. When the art dealer Lord Duveen asked why the Madonna was not a beautiful woman, Epstein replied that to him the strong and sturdy Madonna *was* beautiful, the more so for not being an imitation of someone else's conception of beauty. Sunita was to Epstein a woman "of the eternal oriental type," and therefore presented a more honest image than the usual stereotyped depictions of an ethereal Madonna. A cast of the *Madonna and Child* is in the cloister of the Riverside Church, on New York City's Upper West Side.

In 1926 Epstein visited the US for the first time in almost 25 years to attend a large solo exhibition of his work at the Ferragil Galleries, New York City. Portraits commissioned during this visit included busts of Frans Boas, John Dewey, and Paul Robeson. In the Robeson bust he fully captured the great actor and singer's radiant dignity. In New York he helped to defend Brancusi's *Bird in Flight* in the famous court case resulting from the federal government's refusal to classify the sculpture as anything other than turned metal.

Epstein returned to England in 1927 and the following year received what was to be his last large commission for more than a decade. Asked by Charles Holder to carve two large sculptures for the Underground headquarters building at St. James' Park, Westminster, Epstein set to work on the over-life-size figures of *Night* and *Day.* Each sculpture, carved in the stolid Egyptian manner, has two figures, a man and a child. In *Day* the child is standing; in *Night* he is lying

across the lap of the brooding figure whose hand hovers over the child's face. Arnold Auerbach noted a discrepancy between the loosely modeled, almost baroque realism of the child's overhanging leg and foot in *Night* and the simplified flat planes which contribute to the work's stone monumentality. However, these London Underground carvings, which, of course, elicited the disapproval of the press, were a refreshing change from the blandness and conventionality of most public sculpture in Britain between the wars.

In the 1930s Epstein's only commissions were for his much sought-after bronze portraits, which paid for the larger projects he executed privately. Among the important portrait busts he produced in the '30s and '40s are those of Albert Einstein, Somerset Maugham, Sir Winston Churchill, Pandit Nehru, and the actress Joan Greenwood. In 1931, after three years of work, he completed *Genesis,* a marble carving depicting a pregnant woman with one hand folded across her swollen belly. The sculpture, a simplification of reality rather than an abstraction, was attacked in the press as obscene and "unfit to show" and one "critic" described the figure as a "Mongolian moron." About this time an amusing expression of British philistinism appeared in the magazine *Punch:*

> There's a wonderful trio called Stein,
> There's Gert and there's Ep and there's Ein,
> Gert's verses are bunk,
> Ep's statues are junk,
> And nobody understands Ein.

In contrast to the opprobrium heaped on his carvings, a group of vibrant landscape watercolors which Epstein had done in Epping Forest in 1933 sold rapidly. But *Ecce Homo* (1935), a controversial carving of Christ, was unfavorably received and remained unsold in the artist's studio for 25 years. The massive stone carving of *Adam,* also titled *Ecce Homo,* and reluctantly exhibited by the Leicester Galleries in 1938–39, was sold to a sideshow in Blackpool, though it was soon rescued by friends of the artist. Critics, even those sympathetic to Epstein, have complained of strained and self-conscious elements in the primitivism of *Adam* and some of his large stone carvings.

Epstein's standing with the British public improved in the 1940s. His autobiography *Let There Be Sculpture*, appeared in 1940. Though he received no commissions for large sculptures, Epstein executed several compositions on his own, including the 84-inch-high *Jacob and the Angel*, one of his most successful and expressive carvings. He also made sketches, maquettes, and sculptures of characters from Milton's *Paradise Lost*, including the bronze *Lucifer* of 1945. In 1949 Epstein, nearly 70 years old, received an important commission for the Festival of Britain from the Arts Council. Completed in 1951, *Youth Advancing*, was the first of several large commissions he was to receive in his last years. From 1949 to '59 Epstein completed ten large commissioned sculptures, an estimated 86 portrait busts, and innumerable drawings. His large-scale commissions included *Madonna and Child* (1952), which is widely thought to be his masterpiece and is installed at the Convent of the Holy Child Jesus in Cavendish Square, London; the ambitious *Social Consciousness*, which is in the Philadelphia Museum of Art; and *Christ in Majesty* and *TUC War Memorial*, both of 1957.

By the early '50s Henry Moore had changed the direction of British sculpture. An ironic consequence of England's late acceptance of modern sculpture was that Epstein's once scandalously radical work was now labeled conservative and traditional by the avant-garde. Also, Epstein, who believed the purpose of art was to serve humanity and communicate with an audience, condemned abstract sculpture as a chic, passing fad.

Epstein was awarded an Honorary Doctorate from Oxford University in 1953 and was knighted in 1954, receiving the Order of the British Empire. He became seriously ill in 1958 but continued to work until his death in London at the age of 78. Memorial retrospectives were held at the Leicester Galleries in 1960 and the Edinburgh Festival Society in '61.

Jacob Epstein and Kathleen Garman were married in 1951. He was a burly, heavy-set man. Extremely outspoken, he often seemed arrogant and overbearing. Though embittered by decades of hostile criticism, he was genial and relaxed in the company of friends. Whatever the ultimate assessment of his work, the emotional power and grasp of character in his portrait busts and figures in bronze is virtually unmatched in modern sculpture, and as Albert Elsen observed, it was Epstein more than any other artist who "helped to raise British sculpture out of mediocrity."

In *Let There Be Sculpture*, which was reissued in 1955 under the title *Epstein: An Autobiography,* he wrote: "My outstanding merit in my own eyes is that I believe myself to be a return in sculpture to the human outlook, without in any way sinking back into . . . flabby sentimentalizing or the merely decorative, that went before."

EXHIBITIONS INCLUDE: Hebrew Inst., NYC 1898;

Leicester Gals., London 1917–33, from 1938; Twenty One Gal., London 1921; Ferargil Gals., NYC 1927; Zwemmer Gal., London 1930; Knoedler Gal., London 1930; Redfern Gal., London 1932; Arthur Tooth and Sons, London 1933, '36, '38; Tate Gal., London 1952; Mus. and Art Gal., Nottingham, England 1959; County Cathedral, Warwickshire, England 1959; Tate Gal., London 1961; Edinburgh Festival Society 1961; Auckland City Art Gal., New Zealand 1961; Mercury Gal., London 1966; Anthony D'Offay Gal., London 1973. GROUP EXHIBITIONS INCLUDE: "Post-Impressionists and Futurists," Doré Gal., London 1913; "Twentieth Century Art," Whitechapel Art Gal., London 1914; "The London Group," Goupil Gal., London 1914, '15; "Festival of Britain, 1951," South Bank and Battersea Park, London 1951; Edinburgh Festival 1961; "Modern Sculpture from the Joseph H. Hirshhorn Collection," Solomon R. Guggenheim Mus., NYC 1962.

COLLECTIONS INCLUDE: Tate Gal., Imperial War Mus., Royal Inst. of British Architects, and Bowater House, London; Ashmoleen Mus., and New College, Oxford; Manchester City Art Gal., England; Coventry Cathedral, England; Leicester City Art Gal., England; Bristol Gal. of Art, England; Art Gal. and Mus., Glasgow; Aberdeen Art Gal., Scotland; Fairmount Park, Philadelphia; Hirshhorn Mus. and Sculpture Garden, Washington, D.C.

ABOUT: Arnason, H. H. "Sculpture from the Joseph H. Hirshhorn Collection" (cat.), Guggenheim Mus., NYC, 1962; Auerbach, A. Sculpture, 1952; Buckle, R. (ed.) "Epstein" (cat.), Edinburgh Festival, 1961, Jacob Epstein, 1963; van Dieren, B. Jacob Epstein, 1920; Epstein, J. The Sculptor Speaks, 1930, Let There Be Sculpture, 1940, Epstein: An Autobiography, 1955; Lady Epstein (ed.) Epstein: Drawings, 1962; Goldwater, R. and others (eds.) Artists on Art, 3d ed. 1958; Harrison, C. English Art and Modernism 1900–1939, 1981; Ireland, G. Epstein: A Camera Study of the Sculptor at Work, 1953; Powell, L. B. Jacob Epstein, 1932; Read, H. A Concise History of Modern Sculpture, 1964; "Rebel Angel: Sculpture and Watercolors by Sir Jacob Epstein 1880–1959" (cat.), Birmingham Mus. and Art Gal., England, 1980; Schinman, E. P. and others (eds.) Jacob Epstein: A Catalogue of the Collection of Edward P. Schinman, 1970; Wellington, H. Jacob Epstein, 1925.

ERNST, JIMMY (June 24, 1920–February 6, 1984), American painter, decided early in life not to become an artist, for fear of being occluded by the shadow of his father, the Surrealist Max Ernst. Suddenly, at the age of 20, he felt the urge to paint, but not in the style of the elder Ernst. Instead, quickly abandoning all schools and movements, he struck out in search of an individual style and produced some of the most subtly mysterious images of recent years.

Ernst was born in Bruel, near Cologne. His

JIMMY ERNST

mother, Louise Strauss Ernst, was divorced from his father in 1922; Jimmy remained with her in Cologne, while he attended public school and completed a three-year apprenticeship in printing and typography. In 1938 he came to the United States, sponsored by the anthropologists Franz Boas and Gladys Reichard. Reichard was doing field work in Colorado with the Navajos, and for three months, Ernst, acting as her assistant (although he knew little English), lived among these Indians. His name and connections helped him to land a job as an office boy at the Museum of Modern Art, New York City, and later work with advertising agencies and art galleries. He began painting in 1940 shortly after his father arrived from Europe, just before the war. In 1943 Ernst first exhibited his paintings, at the Norlyst Gallery in Manhattan.

Briefly in this early period Ernst experimented with automatism (the use of free visual association to produce bizarrely original images), a working method of surrealism that had also fascinated Max Ernst (although the elder Ernst's work drew more often on consciously summoned, ironic absurdities). As Robert Kinsman notes in *The Art of Jimmy Ernst*, Ernst's art-historical and aesthetic sensibility at this time outstripped his technical abilities, a view supported by the paintings themselves, which are ambitious but somewhat awkward and unsure. Through the late 1940s, in what has been called his "jazz" period, Ernst attempted to create a visual analogue to jazz music; as a result his improvisations gained shape and metaphoric weight. In some of these works the first stages of the artist's tendency to subdivide his canvases into autonomous areas can be seen.

Through the mid-1950s Ernst turned from the vibrant, variegated colors of the "Jazz" series to purifying whites and blacks. He sometimes fractioned the white canvases (through which gleamed traces of colored underpainting) with thin black lines. These enclosed areas may be meant to represent simultaneous incidents or points of view (although there is certainly nothing representational going on within them) or more simply the artist's method of activating and organizing his surfaces. In *Animal and Mineral* (1952), a work which reflects his continuing fascination with natural symbols and the forms of life, earth, and energy (even at his most abstract), a black field was painted first, then overlaid with the main fields of muted colors, leaving a sinuous black edge that looks improvised, but was, in fact, the product of considerable control. By this time Ernst had abandoned automatism as his powers of composition and paint-handling increased, reasserting control over his imagery. For the most part, his more colorful impulses were restricted to collages and gouaches—*Collage and Countercollage* (1952) and *Contemporary Icons* (1954), for example—until the late 1950s.

Several group exhibitions in 1954, including three at the Metropolitan Museum of Art, New York City, and a touring show sponsored by the American Embassy in France, brought him his first substantial public exposure. That year, he was awarded the Art Institute of Chicago's Norman Weit Harris Prize for painting. In 1959 he won a competition to create a mural on "The Riches of Nebraska" for the Continental Bank in Lincoln; this was one of the artist's few public commissions. For this large work he used more vibrant colors than before, and this led directly to an increase in color in his paintings. At the same time he developed his so-called stone wall style, fragmented compositions of stone-shaped areas knit by a web of lines. As in *Rim Rock* (1960), Ernst now dealt more effectively than before with tensions of surface and depth and between the part and the whole.

In 1961 Ernst traveled through Russia and Europe on grants from the Guggenheim Foundation and the State Department. Visiting the grave of the poet and novelist Boris Pasternak had a profound effect on him; he painted several works in honor of the Nobel Prize winning Russian, who died without honor in his own country. Like many artists before him, Ernst was inspired by the stained-glass masterpieces of Europe's Gothic cathedrals to use clear, glowing colors and heavy black outlines in his own work. This was less a departure for him than a variation of his own inclinations. *There Are No Silent Poets* (1963), one of the homages to Pasternak, reveals in its complex web of lines an evocation of gothic arches, rose windows, and groined vaults.

Ernst delved deeper into subtle variations of shade and texture in the mid-1960s, sometimes in black-on-black works, and also increased the complexity of his grids, using more diagonals than before. In a series of silkscreens of the early 1970s he used Navajo decorative motifs, perhaps recalling the months he spent on the Navajo reservation in 1938; these patterns appeared as well in his paintings, such as *Oraibi*. In 1976, at the Grace Borgenicht Gallery, New York City, he showed several striking paintings, in which overall patterns resembling densely interlinked palmyra fronds are veiled by gauzy clouds emanating from a central sphere. One critic called these recent paintings "finely layered images that often suggest cosmic landscapes. . . . These exotic and atmospheric works metaphorically explore the layered structure of natural phenomena and the multiple levels of human perception and experience."

Aged 63, Jimmy Ernst died at a Manhattan radio station just hours after having helped hang his solo show at the Armstrong Gallery, New York City. He was waiting to appear on a talk show to promote the exhibition and his recently published memoir, *A Not-So-Still Life*. The artist was survived by his wife, the former Dallas Bauman Brody; a daughter, Amy Louise, who works in the field of museum administration; and a son, Eric, who is a painter. The artist had been made a member of the American Academy of Arts and Letters in 1983.

Ernst lived in East Hampton, Long Island, and expressed a deep concern for the problems of the artist in a number of articles, including "A Letter to the Artists of the Soviet Union," (*The Art Journal*, Winter 1961–62) and "Freedom of Expression in the Arts II," (*Art Journal*, Fall 1965). A letter to *Art In America* (September/October 1966) described with pointed sarcasm the merchandizing of the American artist and his or her work, especially after death (or in the death-in-life, as he described it, of an academic tenureship). Ernst firmly believed that art is indispensable to culture, even though modernism has far outrun mass taste or comprehension. "Artists and poets are the raw nerve-ends of humanity; they are small in number and their contribution is not immediately decisive in everyday life. By themselves they may not be able to save the life on this planet, but without them there would be very little left worth saving."

EXHIBITIONS INCLUDE: Norlyst Gal., NYC 1943–46; Laurel Gal., NYC 1948–50; Grace Borgenicht Gal., NYC from 1951; Walker Art Cntr., Minneapolis 1954;

Kunstverein, Cologne 1963; Detroit Inst. of Arts 1963; Arts Club of Chicago 1968; Gal. Lucie Weill, Paris 1972; Armstrong Gal. NYC 1984. GROUP EXHIBITIONS INCLUDE: Annual, Whitney Mus. of Am. Art, NYC 1949–72; "Young American Painters," Solomon R. Guggenheim Guggenheim Mus., NYC 1954; "One Hundred Years of American Painting," Metropolitan Mus. of Art, NYC 1954; "Young American Painters," Whitney Mus. of Am. Art, NYC 1955; Venice Biennale 1956; "American Abstract Expressionists and Imagists," Solomon R. Mus., NYC 1961; Whitney Mus. of Am. Art Biennial, NYC 1973.

COLLECTIONS INCLUDE: Whitney Mus. of Am. Art, and Solomon R. Guggenheim Mus., NYC; Albright-Knox Art Gal., Buffalo, N.Y.; Hirshhorn Mus. and Sculpture Garden, Washington, D.C.; Continental Bank, Lincoln, Nebr.

ABOUT: Arnason, H. H. "American Abstract Expressionists and Imagists" (cat.), Solomon R. Guggenheim Mus., NYC, 1961; Ernst, J. A Not-So-Still Life, 1984; Kinsman, R. The Art of Jimmy Ernst, 1963; Sweeney, J. J. "Jimmy Ernst" (cat.), Kölnischer Kunstverein, Cologne, 1963. *Perodicals*—Art in America September/ October 1966; Art Journal Winter 1961–62, Fall 1965; Arts Magazine June 1976; Magazine of Art April 1950; The New Republic March 23, 1963; New York Times February 7, 1984; Time February 3, 1961.

German Information Center, NYC

MAX ERNST

ERNST, MAX (April 2,1891–April 1, 1976), German-French painter, was a leading Surrealist. Born in the small Rhineland town of Brühl, near Cologne, Germany, he was the son of Philipp Ernst, a schoolmaster who taught the deaf, and Louise (Kopp) Ernst. The father was a strict disciplinarian, a deeply religious man, and a rather pedestrian amateur painter. He was responsible for Max's strict Catholic upbringing, but the boy's inquiring, rebellious nature brought him into conflict with family, school, and church. According to Robert Hughes, the father was "a strong, dogmatic man, and Ernst's battle with him—which clearly went on, in the artist's memory, long after the old man's death—provided one of the obsessive themes of his art."

Ernst saw his father at work on a small watercolor in 1894, and two years later the five-year-old himself made a series of drawings. As a teenager the precocious Ernst read Nietzsche and Freud, studied abnormal psychology, and became fascinated by the art of psychotics and mental patients, then a new field of investigation in the clinic.

From the age of 15 Ernst traveled whenever possible, visiting museums and drawing and painting from nature. He felt an affinity with the early German painters, who were well represented in the museum in Cologne. By the time he had completed his studies at the gymnasium in Brühl, and entered the University of Bonn in the winter of 1908–09, Ernst had read most of the important works of modern literature and seen many of the advanced paintings of the early 20th century.

To please his father, Ernst studied philosophy and psychology at Bonn. However, he neglected his school work for painting, which he pursued on his own, never receiving formal training. In such early canvases as *Landscape with Sun* (ca. 1909), which are marked by strong color and vigorous brushwork, the influence of Van Gogh is apparent. In 1911 he met the Expressionist painter August Macke, who introduced him to members of der Blaue Reiter. After seeing the Sonderbund exhibition in Cologne in 1912, Ernst committed himself to a career as a painter, and in 1913 he participated in the First German Herbstsalon (Autumn Salon), which was held in Berlin's avant-garde Der Sturm gallery. His fellow exhibitors included Paul Klee, Marc Chagall, and several of the Italian Futurists. In 1912 Ernst had met the French painter Robert Delaunay and the poet Guillaume Apollinaire when they visited the Rhineland, and the young German artist made a brief trip to Paris the following year. At the 1914 Werkbund exhibition in Cologne, the last manifestation of German modernism before World War I, Ernst met Hans Arp, who became a close friend.

In the war Ernst served in France and in what is now Poland as an artillery engineer for the German army. Ernst was wounded twice, each time in the head, and his seeming invincibility

earned him the nickname "the man with the iron skull" from his fellow soldiers. However, August Macke and Franz Marc, the gifted young Expressionists who had influenced Ernst, were killed in action in France. Both Marc and Ernst had been impressed by Delaunay's orphism, an optical variant of cubism, and Ernst incorporated elements of Delaunay's color symbolism and of Marc's animism in his *Flowers and Fish*, painted in 1916, the year of Marc's death.

Invalided home from the army in 1917, Ernst exhibited with the Zürich Dadaists and, in 1918, traveled to Cologne, where he renewed contact with Arp. Finding that they shared in the disillusionment that had led to the creation of dadaism in Zürich in 1916, the two artists launched a dada movement in Cologne in 1919. "We young people came back from the war in a state of stupefaction at the absurdity, the total swinishness and imbecility of what had gone on for four years," Ernst said of the spirit behind dadaism. "We had to get back somehow at the 'civilization' which was responsible for the war."

Dadaism was a radical protest against conventional artistic and social values, and dada in Cologne, during its brief but turbulent existence, exasperated both the British army of occupation and the German police. The most outrageous event staged by Ernst, Arp, and Johannes Baargeld, their fellow Dadaist, was the Cologne exhibition of 1920. Entered through a public toilet, the show featured such "shocking" items as a statue of Field Marshal von Hindenburg smeared with red paint and studded with nails. Ernst was delighted when the police closed the exhibit and elated when, a few days later, they asked him to re-open the show, because having shut it down had given the police a bad name.

Ernst had been influenced by Picasso and the sculptor Alexander Archipenko, but about 1919 he saw de Chirico reproductions in the magazine *Valori Plastici*. In 1919, influenced by de Chirico's disconcerting imagery, Ernst invented his dada collages, which were to influence the Surrealists. Using clippings from newspapers, magazines, and illustrated catalogs and cut-up fragments of old engravings, wallpaper, textiles, and other materials, Ernst extended the principle of collage to include readymade images. These "visible poems," to borrow Herbert Read's term, differed from cubist collage in that they "aimed at a new kind of surprising and shocking anecdotal art," to quote Ernst. Influenced by dadaist shock tactics, and even more by the Freudian concept of the release of inhibitions, Ernst declared that the readymade images he used "transformed into revealing dreams my most secret desires."

Shortly after his return to Cologne in 1918, Ernst had married Louise Strauss, an art historian. Born in 1920, their son Jimmy became a noted American painter. In 1927, after divorcing his first wife, Ernst was to marry Marie-Berthe Aurenche.

In 1920 Ernst took part in the large Dada Fair held in Berlin, and with Arp he produced the series of collages called "Fatagaga" (*fabrication de tableaux garantis gazométriques*). Arp and Ernst introduced chance elements into the construction of these works, thus anticipating the surrealist technique of random creation. Ernst's collages attracted the attention of André Breton and Paul Eluard, who mounted an exhibition of the dada collages at the Galerie au Sans Pareil, Paris, in 1921 under the title "Beyond Painting." During the summer of 1921 Ernst's links to France were strengthened by his meeting with Eluard, whose volume of poetry *Répétitions* he illustrated with collages. At this time the Ernst paintings that were in the spirit of his collages included *The Hat Makes the Man* (1920; Museum of Modern Art, New York City) and *Hydrometric Demonstration* (1920).

In 1922 Ernst left Germany for good and entered France illegally, staying in Eaubonne with Eluard and his wife Gala (who later became Salvador Dali's wife, model, and muse). Ernst's monumental paintings of this period—*The Elephant Celebes* (1921; Tate Gallery, London), *Oedipus Rex* (1922), and *Ubu Imperator* (1924) —combined solid craftsmanship with aggressively powerful and disturbing imagery. Moving to Paris later in 1922, Ernst illustrated Eluard's *Les Malheurs des immortels* and experimented with automatic writing under the guidance of Breton, Eluard, Francis Picabia, and others. From 1922 to '24, Ernst earned a living working in a studio which manufactured souvenirs of Paris.

Pietà, or Revolution by Night (1923), marks the end of Ernst's Dadaist period and recalls the conflicts of his childhood. The bowler-hatted father figure, who holds on his lap the sparingly sketched son, was based on Ernst's father, who had painted religious pictures, in one of which the face of the infant Jesus was modeled after that of young Max Ernst. Childhood experiences inspired *Two Children are Menaced by a Nightingale* (1924; MOMA), in which a pastoral landscape is the setting for a scene of utter terror. In this strange work, painted images are combined with wooden constructions, including a hinged swinging gate and an alarm bell. Towards the latter a man carrying a small girl reaches as he runs or, perhaps, falls—the dreamlike ambiguity heightens the effect of psychic

dislocation—across the roof of a wooden house. Against a background in vertiginous perspective, a girl pursues, or perhaps flees from, a nightingale, whose song has felled her sister. Erotic and astrological symbols provide the imagery of the painting *Men Shall Know Nothing of This* (1923; Tate Gallery, London).

After the demise of the dada movement, in 1922, the circle of writers soon to be known as Surrealists gathered around André Breton in Paris. In 1922 Breton defined surrealism as "a certain psychic automatism that corresponds rather closely to the state of dreaming," and he elaborated these ideas in the "Surrealist Manifesto" of 1924. After a short trip to the Far East with the Eluards, Ernst joined the Surrealist group in 1924. Until the arrival of Ernst, the preoccupations of the Surrealists had been almost exclusively literary. But the German artist's collages of cutouts from magazines and catalogs "struck the Surrealist writers as Lautréamont applied to art: a view through the gap in bourgeois reality into a world rendered wholly permeable to the imagination, . . . " to quote Hughes.

In 1925 Ernst invented *frottage*, a technique similar to brass rubbing in which designs are made by placing paper on a rough or uneven surface and then rubbing the paper with charcoal, crayon, pencil, or paint. Because of the striking random patterns formed from this process, Breton hailed *frottage* as the plastic equivalent of automatic writing. In 1926 Ernst used this technique to make a series of 34 drawings, "Natural History," so entitled because the shapes resembled mysterious plants and animals.

After the discovery of *frottage*, Ernst, influenced by his fellow Surrealist Joan Miró, adapted the process to oil painting. Ernst's *Two Sisters* (1926) is an example of this method, which is known as *grattage*. In 1926, keeping to the spirit rather than the letter of surrealism, Ernst collaborated with Miró on the set design for Diaghilev's production of *Romeo and Juliet*. Breton accused Ernst of having betrayed surrealism through the commercialization of his art, and at the first Paris performance the Surrealists staged a hostile demonstration, showering the audience with leaflets and provoking such an uproar that the police had to be called in. The incident severely strained Ernst's and Breton's friendship.

In 1929 Ernst published his first collage-novel, *La Femme 100 têtes*, the title being a pun on the French words *cent* (a hundred) and *sans* (without). The captions accompanying each of the collages were full of surrealist black humor. A more dramatic book of collages was *Une Semaine de bonté* (1934). Ernst's collage-novels were composed of altered engravings, many of which were plates from 19th century novels, adventure magazines, or technical manuals. With their disquietingly incongruous imagery, the two collage-novels "form an encyclopedia of our century's anxieties," as John Russell wrote in *Max Ernst* (1967).

Ernst appeared in the role of a brigand in *L'Age d'or,* the surrealist film devised by Dali and Luis Buñuel. The Paris debut of the film at Studio 28, where there was also group exhibition with paintings by Ernst, provoked violent demonstrations by right wingers, and *L'Age d'or* was subsequently banned.

In 1933 Ernst was among the artists whose work was singled out by the Nazis as "degenerate," and in this decade his attitude towards surrealism changed. Observing the deteriorating political and economic situation in Europe, Ernst realized that surrealism's revolutionary program—which was based on the belief that a reconciliation of the rational and the intuitive could transform human consciousness itself—had failed. Significantly, he was the only Surrealist to refer directly in his work to the dark events of those years.

In 1933, the year the Nazis seized power, Ernst painted *The Petrified City*, in which an unidentified acropolis has been turned to stone in the aftermath of a cosmic catastrophe. This compelling work, a variation of his "Forest" pictures of the late '20s, now appears to have foretold the devastating consequences of nuclear warfare. Ernst introduced fantastic and sinister imagery in his "Garden Aeroplane Trap" series of 1935, in which poisonous plants, painted in cool colors and with dry precision, lurk inside walled areas, waiting to destroy passing planes. In his painting *Europe After the Rain 1* (1933), Ernst envisioned the Continent being overwhelmed by a monstrous flood tide. His canvases *The Barbarians March West* (1935) and *The Angel of Hearth and Home* (1937), in which the "angel" performs a frenetic war dance, are pessimistic evocations of the apocalyptic forces mankind seemed determined to set loose.

While spending the summer of 1934 in Switzerland with Alberto Giacometti, Ernst produced his first important sculptures (he had made cubist-influenced reliefs in the period 1916–19). Working in plaster, he produced *Oedipus* in 1934 and *Lunar Asparagus* in 1935. The following year 48 of his works in both media were included in the influential "Fantastic Art, Dada, Surrealism" show at New York City's Museum of Modern Art.

In 1938 Ernst broke with the Surrealists over Breton's call for the expulsion of Eluard. That same year, although he had little money, Ernst

moved with the painter Leonora Carrington into a house in Saint-Martin d'Ardèche, near Avignon in southern France. Disregarding the now dire European political situation, he restored and decorated his new home as if he would always be living there.

With the outbreak of world war in 1939, Ernst was interned by the French as an enemy alien. Always able, as John Russell pointed out, "to build an ark for himself," at least spiritually, Ernst used the time in detainment to work in the decalcomania technique with oil paint. But in 1940, when the German armies overran France, Ernst escaped. With the help of his son Jimmy, now a US citizen, the noted art collector Peggy Guggenheim, and other Americans, he made his way via Spain to New York City on July 14, 1941, white haired and looking older than his 50 years. Ernst separated from his second wife and married Guggenheim in December 1941.

In the fall of 1942 Peggy Guggenheim opened a gallery in Manhattan to house her vast collection of modern paintings, which included 14 of her husband's. Although not unknown, Ernst found making a living in the US difficult. His 1942 show at the Valentin Gallery, New York City, was enthusiastically received by young artists, but the press was hostile and the public did not buy his work. In 1943 Ernst painted the large *Vox Angelica*, which he described as an "autobiographical account, in episodes of dream and reality, of [my] peregrinations from one country to another." A very different, nightmarish quality pervades *The Eye of Silence*, also of 1943.

In 1944 Ernst produced his best-known and most successful sculpture, the bronze piece mischievously entitled *The King Playing with the Queen*. Herbert Read wrote that the spirit of Ernst's sculptures "is uncanny rather than in any sense spiritual." Read observed that whereas Ernst practiced sculpture only sporadically, he carried over into that medium "the wit and fantasy of his paintings."

Ernst liked America, its speech, landscape, and traditions, but he was stung by accusations of "moral turpitude" directed at him when he divorced Peggy Guggenheim in 1942 and took up with the young painter Dorothea Tanning. Criticism was silenced by his marriage to Tanning in 1946, but the charges never ceased to rankle him.

From 1942 to '52, and again in 1956–57, Ernst lived in Sedona, Arizona. The landscape and light of Arizona strongly affected his art of the '50s, '60s, and '70s. *Coloradeau of Medusa* (1953), inspired by the Colorado River, is a "mindscape" painted in interpenetrating layers

of color which give the appearance "of rock strata seen through a heat haze," to quote Ian Turpin. Ernst, however, saw himself as a European. In 1949–50 he returned to Paris for his first postwar visit and was reunited with Arp, Eluard, Tristan Tzara, Giacometti, and other old friends. Although in 1951 he was to be honored with a retrospective in his home town of Brühl, Ernst was little known in Europe.

In 1954, however, Ernst won the coveted international grand prize for painting at the Venice Biennale, and his reputation grew steadily over the next 20 years. He moved back to France in 1955, settling in Huismes, Touraine, in the Loire Valley. In 1958 he acquired French citizenship. *After Me, Sleep* (Beaubourg, Paris), one of his most poetic canvases, softer and gentler than his usual work, was painted in that year.

Color had always been secondary to Ernst's concern for content and evocative imagery, but *The Marriage of Heaven and Earth* (1962) expressed a new interest in color and light. Much of Ernst's painting of the 1970s was in the lighter, more lyrical manner of *Marriage of Heaven and Earth*, though he sometimes reverted halfplayfully to the styles and techniques of his dada and surrealist periods.

In 1964 Ernst moved to Seillans, France. Major Ernst retrospectives were mounted at MOMA in 1961 and at the Grand Palais, Paris, and the Guggenheim Museum, New York City, in 1975. Ernst worked as a designer for the film industry and the theater from 1966 to '68. In 1970 he traveled in Germany, where his work was being exhibited in Stuttgart, Düsseldorf, and Hamburg.

Max Ernst died in Paris just one day before his 85th birthday. He was a slender, good-looking man, slightly above average in height, with blue eyes and long silky white hair. Women found him attractive, and his relations with them were often turbulent. Alexander Liberman, who photographed Ernst in his Huismes studio in 1960, found the artist's agreeable manner to be "self-conscious and studied." Referring to himself in the third person, Ernst wrote, "It is difficult . . . to reconcile the gentleness and moderation of his expression with the calm violence which is the essence of his thought." "Painting is a landscape of the mind," said Ernst, whose avowed aim was "to bring into the light of day the results of voyages of discovery in the unconscious" and to record "what is seen on the frontier between the inner and the outer world."

EXHIBITIONS INCLUDE: Gerson Club, Rome 1913; Gal. Der Sturm, Berlin 1916; Gal. au Sans Pareil, Paris 1921; Gal. Centaure, Brussels, 1926, '27; Gal. Bernheim-Jeune, Paris 1928; Julien Levy Gal., NYC 1931–

32, '36, '43; Mayor Gal., London 1933, '37; Gal. Cahiers d'Art, Paris 1934; Valentin Gal., NYC 1942; Gal. Denise René, Paris 1946; Palace of the Archbishop of Cologne, Brühl 1951; Kunsthalle, Bern 1956; Mus. Nat. d'Art Moderne, Paris 1959; MOMA, NYC 1961; Gal. Le Point Cardinal, Paris 1961; Tate Gal., London 1962; Wallraf-Richartz Mus., Cologne 1962; Kunsthaus, Zürich 1963; Kunsthalle, Hamburg 1964; Moderna Mus., Stockholm 1969; Rice Univ., Houston 1970–73; Guggenheim Mus., NYC 1975; Grand Palais, Paris 1975. GROUP EXHIBITIONS INCLUDE: "Rheinische Expressionisten," Buchhandlung Cohen, Bonn 1910; "Rheinische Expressionisten," Gal. Feldman, Cologne 1912; "Erster Deutscher Herbstsalon," Gal. der Sturm, Berlin 1913; "Sturm-Ausstellung III," Gal. Dada, Zürich 1917; "Dada Ausstellung," Kölner Kunstverein, Cologne 1919; "Dada-Vorführung," Bauhaus Winter, Cologne 1920; "Erste Deutsche Dada-Messe," Kunsthandlung Otto Burchardt, Berlin 1920; Salon des Indépendants, Paris 1923; "Exposition: La Peinture surréaliste," Gal. Pierre, Paris 1925; Studio 28, Paris ca. 1930; "Newer Super-Realism," Wadsworth Atheneum, Hartford, Conn. 1931; "Fantastic Art, Dada, Surrealism," MOMA, NYC 1936; "Artists in Exile," Pierre Matisse Gal., NYC 1942; "Abstract and Surrealist Art in the United States," Mus. of Art, San Francisco 1944; "Exposition internationale du surréalisme," Gal. Maeght, Paris 1947; São Paulo Bienal 1951; Venice Biennale 1954; Documenta 1–3, Kassel, W. Ger. 1955, '59, '64; "The Art of Assemblage," MOMA, NYC 1961; "Dada, Surrealism and their Heritage," MOMA, NYC 1968; "Surrealismus 1922–1942," Haus der Kunst, Munich 1972; "Surrealismus 1922–1942," Mus. des Arts Décoratifs, Paris 1972.

COLLECTIONS INCLUDE: MOMA, and Guggenheim Mus., NYC; Wadsworth Atheneum, Hartford, Conn.; Yale Univ., New Haven, Conn.; Philadelphia Mus. of Art; Hirshhorn Mus. and Sculpture Garden, Washington, D.C.; Washington Univ., St. Louis, Mo.; Tate Gal., London; Manchester City Art Gal., England; Mus. Nat. d'Art Moderne, Paris; Gal. Civica d'Arte Moderna, Turin, Italy; Peggy Guggenheim Collection, Venice; Kunstmus., Bonn; Kunstmus., Dusseldorf; Kestner-Gesellschaft, Hanover, W. Ger.; Wallraf-Richartz Mus., Cologne; Stadtmus., Brühl, Cologne; Mus. Boymans-Van Beuningen, Rotterdam; Gemeentemus., The Hague; Kunsthaus, Zürich; Kunstmus., Basel; Mus. des XX Jahrhunderts, Vienna; Tel Aviv Mus., Israel.

ABOUT: Arp, H. and others Hommages à Max Ernst, 1960; Bousquet, J. Max Ernst, 1950, Max Ernst: oeuvre sculpté, 1961; Diehl, G. Max Ernst, 1973; Ernst, M. (and others) Misfortunes of the Immortals, 1948, La femme 100 têtes, 1929, Une Semaine de Bonté, 1934, A lintérieur de la vue; 8 poèmes visibles, 1948, Beyond Painting and Other Writings by the Artist and his Friends, 1948, (and others) At Eye Level: Poems and Comments: Paramyths: New Poems and Collages, 1949, Sept microbes vus à travers un tempérament, 1953, Histoire naturelle: dessins inédits, 1959, Journal d'un astronaute millénaire, 1969, Ecritures, 1970; "Fantastic Art, Dada, Surrealism" (cat.), MOMA, NYC, 1936; Hughes, R. Shock of the New, 1981; "Max

Ernst" (cat.), MOMA, NYC, 1961; "Max Ernst, a Retrospective" (cat.), Solomon R. Guggenheim Mus., NYC, 1975; Read, H. A Concise History of Modern Painting, 1959, A Concise History of Modern Sculpture, 1964; Russell, J. Max Ernst: Life and Work, 1967; Spies, W. Max Ernst: Frottages, 1969, Max Ernst: Loplop. The Artist in the Third Person, 1983; Turpin, I. Max Ernst, 1979, Waldberg; P. Max Ernst, 1958. *Periodicals*—Arts Magazine Summer 1971; L'Oeil (Paris) no. 16 1953; New York Times April 2, 1976, September 4, 1983.

ESCOBAR, MARISOL. *See* **MARISOL**

ESTES, RICHARD (1936–), American painter, is a leading Photo-Realist. Estes paints what he sees with the detailed precision of photography, but he is not a camera. In his choice of subject matter and his attention to minute details, there is considerable selectivity and control as well as personal vision. In no sense a slavish copying of reality, his work is more "painterly" than that of the other New Realists of the 1970s.

Estes was born in Evanston, Illinois, a prosperous lakefront community on the northern outskirts of Chicago. In 1952 he enrolled at the Art Institute of Chicago, and in the catalog to the traveling Estes retrospective of 1978, the artist mentioned the impact impressionist paintings had made on him while he was a student. "The big Seurat, 'La Grande Jatte,' was very impressive," he recalled. "I don't think what I liked as a student would still be my favorite paintings, though. I liked Renoir a lot then, but I don't like him that much now. Degas I always liked a lot." One of his drawing teachers, Isobel Mackinnon, had studied with the Abstract Expressionist Hans Hofmann, "so I had a lot of push-pull," Estes said, referring to Hofmann's method for teaching the organization of space in abstract compositions.

After graduating from the Art Institute in 1956, Estes went to New York City for six months and then moved back to Chicago. He returned to New York two or three years later to work for a magazine publisher, doing pasteups, color overlays, and other technical jobs. By 1965–66 he had saved enough money to take two years off and concentrate on painting. Young realists like Philip Pearlstein, Alex Katz, and Richard Diebenkorn (then in his representational phase) were showing at the galleries, and Estes recalled that he "sort of liked them, but . . . was really only interested in very old-fashioned, traditional painting."

Photo Courtesy Clare Stone Studio

RICHARD ESTES

From 1965 to '67 most of Estes's paintings were figurative, although the figure would subsequently be phased out. He had begun to work from photographs, using a polaroid camera, instead of following the traditional art-school method of sketches and preliminary drawings. His figures were engaged in typical urban activities—waiting for a bus, crossing the street, and so on. Estes was not, then or later, much interested in abstract expressionism or pop art: "Most of it seemed kind of silly," he said. His favorite artists were Vermeer, Degas, and the Americans Eakins and Hopper. Critics have noted an affinity between such works as Hopper's *Early Sunday Morning* (1930) and *Nighthawks* (1942) and Estes's virtually empty cityscapes of the 1970s. However, Hopper never introduced such meticulous detail into his urban scenes, and Estes, unlike Hopper and other earlier painters of the urban American landscape, did not focus on the isolation of the city dweller. His subject was the man-made environment of the city itself.

By the late 1960s Estes's individual technique had evolved. Smooth, precise brushwork was combined with what Harry F. Gaugh described in *Art in America* (November/December 1978) as "non-photographic structuring of composition through the selection and emphasis of detail." Photographs provided the point of departure, but beneath the complex surface were "strong geometric and abstract underpinnings."

A key painting for Estes's later development was *Automat* (1967). Four people seated at a table in a restaurant, an old-fashioned automated cafeteria, are depicted from a bird's eye viewpoint. The square table tilts against a rectangular floor pattern; because of the angle of vision, the faces are not visible. This striking work, as Gaugh pointed out, "brings to mind Busby Berkeley as much as Mondrian." In addition to the picture's cinematic quality, it anticipates Estes's later depopulated cityscapes.

In New York City Estes was fascinated by the complexity of the urban landscape. In *Grand Luncheonette* (1969) the real subject of the painting was the interplay of signs and buildings reflected on the windows and facades of other buildings. The illusion of deep space was created by the inclusion of mirror images of scenes that were outside the picture's actual vista or setting. By 1970 Estes, in his determination to avoid narrative, had eliminated most figures from his canvases. "When you add figures," he explained, "then people start relating to the figures and it's an emotional relationship. The painting becomes too literal, whereas without the figure it's more purely a visual experience." Buildings can be viewed in Estes's paintings as abstract pictorial elements, and, as Ralph Pomeroy noted in *Contemporary Artists* (1977), "Estes's interest in and use of buildings is akin to that of Sheeler and O'Keeffe in the '30s." The human element is conspicuous by its absence in such works as *Pix Theatre* (1968), which nevertheless can be seen as social comment. An empty car is parked outside a movie house with a marquee advertising *Topless Bikini* and *Erotica*, while one of the posters above the doorway announces the FIRST NEW YORK SHOWING of HOT GIRLS FOR MEN ONLY. The "cool" manner of statement and the lurid banality of the subject matter have affinities with pop art, but the painstaking, highly finished technique belongs to the so-called new realism which was popularized in the early '70s by Estes and other artists whose treatment of realistic subject matter was wholly modern.

Bus Window, on which Estes worked intermittently from 1968 to '73, also downplays the human presence. The potential close-up of the bus driver is obliterated by the reflection of a street sign. Multiple reflections became increasingly important in Estes's pictures; most important were reflections in store windows, especially those in which the window on the opposite side of the street was mirrored. This complex and intriguing interplay between reality and its image transcends slavish literalism.

With the British painter Malcolm Morley and other artists, Estes was represented in a 1969 group show at the Milwaukee Art Center entitled "Aspects of New Realism." He exhibited in the Whitney Annual in 1970 and '72 and took part in the "Neue Amerikanische Realisten" show in Hamburg and Bremen, West Germany.

In 1972 Estes's paintings, and hyper-realism generally, were much discussed at Documenta 5, Kassel, West Germany. Those Germans who remembered their own Neue Sachlichkeit (New Objectivity) movement of the Weimar years, with its stark, linear realism and mercilessly clear parodistic detail, were fascinated by the American new realism. Notable Estes works of the early '70s were the tightly structured *Diner* (1971), with its three metallic telephone booths in the left foreground, and *Helene's Florist*, also of 1971, organized along strongly horizontal lines. *Diner* was acquired in 1977 for the Hirshhorn Museum and Sculpture Garden, Washington, D.C. *Helene's Florist* is signed by the artist in a typically oblique fashion. His name—spelled "Richad"—comes last on a luncheonette menu which, posted in the window, also offers SHRIMP CREVOL and CHILLI E BEANS. In *Paris Street Scene* (1972) a license plate on one of the cars parked on a deserted street reads: 19 ESTES 72. Unlike the frontal composition of many Estes cityscapes, the Paris street is shown in deep perspective, with the houses on the left mesmerizingly reflected in the large plate-glass shop window on the right. The overall effect borders on the surreal.

The new realism of Estes and like-minded artists won further acclaim through group shows which toured Europe in 1974 and '75. These exhibitions included European as well as American Photo-Realists, but it was the Americans, particularly Estes, whose work aroused the greatest interest among Parisians.

Photo-realism was far removed from the traditions of the School of Paris and from American action painting of the 1950s. Moreover, it was a style critics could not easily classify, partly because the underlying sensibility was more elusive than the secular spiritualism of the Abstract Expressionists or the deadpan irony of the Pop artists. The work was flat (and thus modern) and rejected narrative even though it was realistic; but critics sympathetic to the avant-garde were troubled by photo-realism because it is a canon of modernism that the invention of photography had made realistic picture painting obsolete.

Many American critics and museum-goers found Estes's depopulated urban landscapes disturbing. A view of Times Square titled *Canadian Club* (1974) aroused in Gaugh disconcerting thoughts of the neutron bomb and a world drained of people, despite the picture's dazzling sun-drenched scene. Estes's "beautiful but airless" portrayal of Venice, *Murano Glass* (1976), reminded the critic of Canaletto's *vedute* of that insular city. Apropos of his New York views, Estes remarked, "Of course, Canaletto never had those plate glass windows to play with."

Estes's meticulous technique, as well as his freedom from the compulsion to depict absolute likenesses, were documented in photographs showing the progress of his *Downtown,* a large, complex painting begun in September 1977 and completed the following spring. Like his other city views, *Downtown* was based on Sunday photographs, there being, Estes explained, "too much traffic during the week." The artist begins by doing his own color printing, and then he blocks in large areas in outline with diluted acrylic on the sized canvas. Next come broadly painted highlights and shadows. Having taken the acrylic as far as he can, Estes then uses oil paint, working methodically from loosely brushed areas to fine details. Although the surface of Estes's pictures seems glisteningly smooth, "the pigment is applied with considerable painterly élan," as Pomeroy pointed out.

A traveling retrospective of 21 Estes paintings, covering a period of 13 years, was organized by the Boston Museum of Fine Arts in the winter of 1978. Entitled "Richard Estes: The Urban Landscape," the exhibit showed at the Hirshhorn Museum for four months in 1979. Nineteen of the pictures were of New York City locales, and in the catalog to his exhibition at the Hirshhorn, Estes wrote: " . . . For the past twenty years I've lived in a man-made environment and I've simply painted where I've been. If I had lived in Maine, I certainly would not have painted the same thing. I would be out there painting rocks and trees. You look around and paint what you see. That's what most painters have done."

Richard Estes is short and dark-haired, affable in manner but reclusive by nature. He divides his time between his Manhattan studio and his home on the northern coast of Maine, where he ignores the landscape and concentrates entirely on perfecting his paintings of city views. His immaculate Maine studio is huge, having served earlier in the century as a ballroom. Some viewers, though they admire Estes's technical virtuosity, find his kind of hyper-realism cold, dehumanized, and overly cerebral. "I think the popular concept of the artist is [of] a person who has this great passion and enthusiasm and super emotion," Estes commented. "He first throws himself into this great masterpiece and collapses with exhaustion when it's finished. It's really not that way at all. Usually it's a pretty calculated, sustained, and slow process by which you develop something. . . . I think the real test is to plan something and carry it out to the end . . . it's not done with the emotions; it's done with the head."

EXHIBITIONS INCLUDE: Allan Stone Gal., NYC from 1968; Hudson River Mus., NYC 1968; "Richard Estes: The Urban Landscape," Mus. of Fine Arts, Boston 1978, Hirshhorn Mus. and Sculpture Garden, Washington, D.C. 1979; John Berggreen Gallery, San Francisco 1979. GROUP EXHIBITIONS INCLUDE: "Survey of American Painting," Vassar Col., Poughkeepsie, N.Y. 1968; "Aspects of New Realism," Milwaukee Art Center, 1969; Whitney Annual, NYC 1970, '72; Biennial Exhibition, Corcoran Gal. of Art, Washington, D.C. 1971; "Neue Amerikanische Realisten," Gal. de Bremen, W. Ger. 1971; Documenta 5, Kassel, W. Ger. 1972; "American Art: Third Quarter Century," Seattle, Wash. 1973; "12 American Painters," Mus. of Fine Arts, Richmond, Va. 1974; "Contemporary Realist Painting," Mus. of Fine Arts, Boston 1975.

COLLECTIONS INCLUDE: Whitney Mus. of Am. Art, NYC; Hirshhorn Mus. and Sculpture Garden, Washington, D.C.; Toledo Mus. of Art, Ohio; Art Inst., Chicago; Rockhill Nelson Mus., Kansas City, Mo.; Des Moines Art Center, Iowa; Kaiser Wilhelm Mus., Krefeld, W. Ger.

ABOUT: Lucie-Smith, E. Super Realism, 1979; P-Orridge, G. (ed.) and others Contemporary Artists, 1977; "Richard Estes: The Urban Landscape" (cat.), Mus. of Fine Arts, Boston, 1978. *Periodicals*—Art and Artists February 1970, August 1974; Art in America November/December 1978; Art International (Lugano) no. 5 1971, March/April 1976; Art News, April, 1982. Arts March 1968; Studio International March 1972; XXe siècle (Paris) December 1976.

***ESTÈVE, MAURICE** (May 2, 1904–), French painter, writes: "Maurice Estève was born on May 2, 1904 in Culan, Cher [France]. He spent his childhood in Berry [Cher, central France].

"His visit to the Louvre in 1913 was a revelation to him; but he did not return permanently to Paris until 1924, after a year's stay in Barcelona, where he was head of a design studio in a textile manufactory. He became acquainted with Catalonian Romanesque art. In Paris he attended the free studio of the Colarossi Academy, but he was essentially self-taught, guided by paintings he admired in the Louvre or in exhibitions; he became involved with those he called primitives—Ucello, Fouquet (to whom he was to pay homage in a canvas of 1952), and he discovered Cézanne.

"From 1928 onward, he abandoned working from nature and entered upon 'plastic construction' from the standpoint of the ordered transposition of reality as perceived by the senses.

"His first one-man show in 1930 at the Galerie Yvangot in Paris brought his work to the attention of Maurice Raynal who wrote: 'This art is sympathetic because of its sincerity and its dis-

MAURICE ESTÈVE

dain for facile seductions that have an immediate attraction but do not stay with one for long. Talking with Estève, I found in him something of the character of the late lamented Juan Gris, and that is not the smallest praise I can give him.'

"From 1929 Estève took part in the Salon des Surindépendants, where he showed regularly until 1938.

"In 1937 he worked under the direction of Robert Delaunay on the great decorations for the Railway and Aviation pavilions at the Paris International Exhibition.

"He exhibited in Stockholm (Svensk-Franska Konstgalleriet) in 1937, and in Prague (SV Gallery) in 1938.

"Pierre Francastel wrote an important monograph on Estève in 1956 for the Editions Galnis, and in 1969 wrote a preface for the catalog to the artist's first exhibition of collages in Zürich, which revealed a new aspect of Estève's inventive talent combining imagination and technique, form and content."

———

Maurice Estève is a member of the School of Paris's middle generation, which gained prominence after World War II. Influenced by the postcubist style of Picasso and Braque, Estève painted figures, studio interiors, and still lifes in the 1930s. He continued to paint those subjects in the following decade, but incorporated semigeometrical shapes and his canvases became more colorful.

In 1941, with Jean Bazaine, Edouard Pignon, and other younger avant-garde French painters,

°es tev´, mô rēs´

he participated in the important "Jeunes Pein-
tres de la Tradition Française" (Young Painters
of the French Tradition) exhibition at the Salon
d'Automne, Paris, which helped to keep alive
the spirit of the School of Paris during the years
of German occupation. Estève thereafter
showed regularly at the Salon d'Automne.

In the 1950s Estève's work was associated with
the tachist branch of European expressive ab-
straction. The abstractions of Tachist painters
were primarily based on natural appearances.
By the mid-50s Estève was internationally re-
nowned, and in 1961 a retrospective of his work
was given at the Kunsthalle, Düsseldorf.

Maurice Estève is a quiet man who has never
sought publicity. He returns periodically to his
native Culan to "get back to the source," but he
does not paint there, only draws. He paints in his
small but light-filled studio in the rue Monsieur-
le-Prince, Paris. There, in keeping with his me-
thodical approach, everything is orderly—small
jars of color neatly lined up on the table, draw-
ings in portfolios, canvases stacked against the
wall according to size. In a *Le Monde* (April 26,
1972) interview, Estève remarked, "I don't know
if I'm painting landscapes, still lifes or figures. .
. . " The interviewer asked: "What are you
painting then?" "A canvas, a picture," the artist
replied. "I find painting exciting to the extent in
which it resembles neither music nor literature.
It's something else. The more it is specifically
what it is—a language of forms, colors and
light—the more it excites me and interests me."

EXHIBITIONS INCLUDE: Gal. Yvangot, Paris 1930;
Svensk-Franska Konstgal., Stockholm 1937; S.V. Gal.,
Prague 1938; Gal. Saint-Germain-des-Près, Paris 1942;
Gal. Friedland, Paris 1942; Gal. Louis Carré, Paris
1942–50, '65; Kunsthalle, Bern 1952; Statens Mus. for
Kunst, Copenhagen 1956; Gal. Villand-Galanis, Paris
1960; Kunsthalle, Düsseldorf 1961; Neue Gal., Zürich
1969, '73; Gal. Claude Bernard, Paris 1972–74. GROUP
EXHIBITIONS INCLUDE: Salon des Surindépendants, Paris
ca. 1931–39; "Jeunes peintres de la tradition
Francaise," Salon d'Automne, Paris 1941; Bazaine,
Estève, Lapicque," Stedelijk Mus., Amsterdam 1946.

COLLECTIONS INCLUDE: Mus. d'Art Moderne, Paris;
Tate Gal., London; Sonja Henie and Niels Onstad
Foundations, Oslo; Statens Mus. For Kunst, Copenha-
gen.

ABOUT: Dorival, B. Les Peintres du XXe siècle, 1957;
Elgar, F. Estève-Dessins, 1960; Francastel, P. Estève,
1956; Huyghe, R. Les Contemporains, 1949; Lescure,
J. "Bazaine, Estève, Lapicque" (cat.), Gal. Louis Carrè,
Paris, 1945; Lucie-Smith, E. Late Modern: The Visual
Arts Since 1945, 1969; Read, H. A Concise History of
Modern Painting, 1959. *Periodicals*—Arts (Paris) April
1963; L'Intransigeant (Paris) November 25, 1930; Le
Monde (Paris) May 28, 1965, April 26, 1972.

***ETIENNE-MARTIN** (February 4,
1913–), French sculptor, has taken the rela-
tionship of art and architecture to its ultimate
psychological extent. His subject is the intangi-
ble mystery of the "dwelling," and, most specifi-
cally for him, the obsessive quest to recapture
the comforting envelopment of his own child-
hood home—a kind of sentimental nostalgia
which is almost universal but is rarely seen in the
work of an important modernist. "The sculpture
of Etienne-Martin," wrote R.V. Gindertael in
Quandrum 19, "escapes the connections of mod-
ern art in order to find its initial reason for being
and the original sense of the plastic act: the pene-
tration of the secret of the universe," which, for
Etienne-Martin, is the secret of ultimate memo-
ry, of the womb.

He was born Martin Etienne in Loriol,
Drôme, where his father was a court clerk. His
earliest (and for his art, most productive) memo-
ries are of the family's large house. While his fa-
ther was fighting in the trenches during World
War I, he was attentively raised by his mother
and grandmother. "I was never a child like the
others," he wrote. "Out of my loneliness, I grad-
ually created a personal and peculiar myth," in
which he raised the house—maternal in its es-
sence—to the level of a magical dwelling of per-
fect happiness and enchanted mystery. Later in
life he was embittered and frustrated when the
death of his parents forced him to sell the house;
this frustration was to supply the energy for his
"Demeure" (Dwelling) series of the 1950s and
'60s.

Etienne-Martin began sculpturing in college
before entering the Ecole des Beaux-Arts, Lyons,
in 1929. In 1933 the école awarded him a schol-
arship to study in Paris; there he attended the
Ranson Académie, working under Aristide Mail-
lol and Charles Malfray, who first gave him a
sense of his own baroque temperament and
strengths as a sculptor. In 1935 he met Marcel
Duchamp, who encouraged in him a continuing
program of intellectual and plastic experimenta-
tion. With a number of friends he had made in
Lyons and Paris, including the sculptor François
Stahly (whose career parallels Martin's in many
ways), he joined the writer Marcel Michaux's
idealistic Groupe Temoignage. In one of the
group's publications, Martin, already seeking be-
yond the physicality of wood and plaster to an
intangible spiritual power, wrote: "The impact
of the thousand mysterious experiences of each
moment is so steeped in eternity that we invari-
ably see man face to face with the ultimate. That
seems to me absolutely fundamental. I try to ex-
press this in sculpture."

In his early work of the 1930s, however, Mar-
tin was still searching for the most effective style

°ā tyen mär taN

and subject to embody his mystical perceptions. As might be expected from his training with Maillol, the figure was his point of departure. *Le Sauterelle* (1933, *The Grasshopper*) has some of the squared, totemic quality of Egyptian or pre-Columbian sculpture (probably translated through the work of Henry Moore), while the blocky *Abécédaire No. 1* (1934, *Spelling Book No. 1*) shows a cubo-futurist influence. In 1935, inspired by "memories of extraordinary encounters," he began his first major series, the "Nuits" (Nights), all roughly modeled seated women, with two works in bronze and stone. Others in the series were carved in wood (a medium for which Martin showed particular sympathy and understanding) and wrapped or hung with string, a combination Henry Moore also used.

Shortly after his marriage to Ann Talboutier in 1938, Martin was drafted into the French Army to participate in the futile defense against the German invasion. Soon captured, he was put into forced labor on a farm, but was repatriated within a year and returned to Drôme with his family. He was briefly associated with the architect Bernard Zehrfuss's Oppède community, where he carved *Nuit Oppède* (1942). The series culminated with *Nuit ouvrante* (Opened Night), a bronze figure with hinged arms that open maternally.

From 1944 to 1947 Martin lived with the painter Alfred Manessier, whom he had met at the Académie Ranson, in Montagne au Perche. There, his material of choice became the gnarled trunks and roots of exotic hardwoods—plane tree, lime, acacia, almond, and tulip—which he twisted and carved into works "massive, enigmatic, and squat, surging, it seems, from the fount of the ages, from the heart of the Gallic forest," according to Pierre Brisset of *L'Oeil*. *Grand Dragon* (1946), a thrusting, convoluted lime root with secret, mysterious recesses, is the perfect example of this style. Parallel with the "Nuits" he began a series of "Couples" which extended through the mid-1950s; the first of these was *Grand couple* (1946) in alder wood. "In my sculpture inspired by the couple," wrote the artist, "I do not seek to express their conflict, but the rare moment when two beings are in harmony. . . ." Others in the series include a *Grand couple* (1948–49) in bronze and the asymmetrical, entwined *Couple rouge* (1956, Red Couple).

In 1946 Martin, still almost completely unknown in Paris art circles, met the influential Michel Tapiès, the first critic to champion his work. He returned to Paris in 1947, meeting, among others, Brancusi, Dubuffet, and the mystic Gurdjieff, whose books were then greatly in vogue and who made a strong impression on him. About this time the sculptor's reputation began to solidify: he won the prize given by the Salon de la Jeune Sculpture in 1949 and the next year was elected a member of the salon's committee; he also exhibited regularly in group shows at the Galerie Denise Breteau, Paris.

For the next five years, while supporting himself with a variety of other sculptural projects, Martin labored sporadically on *Hommage à Lovecraft* (1956, dedicated to the horror-fantasy pulp writer H. P. Lovecraft), a large, architectonic, plaster construction pierced by numerous small cells or grottoes (at the time he could not afford to cast such a large and complex work in bronze). "When I created *Hommage à Lovecraft*," he wrote, "I discovered that it was something more than a sculpture. An event which I had personally felt and lived was in each of its forms." *Hommage à Lovecraft* can be considered the first of the artist's "Demeures" (Dwellings)—discounting a series of tentlike cloth structures he made in the late '40s. *Demeure No. 1* (1956) is composed of four interlinked rectangular structures laced with windows and open rooms (each representing, he said, "the processes of my thoughts, of my life in its various phases"), enclosing a womblike interior space. By the time of *Demeure No. 3* (1960) there was enough room within the piece for someone to sit and meditate. Intended by the artist as a unification of art and architecture in the manner of ancient monuments such as the Egyptian Sphinx and Etruscan tomb sculpture, the "Demeure" series was also meant to awaken in the viewer the primeval longing for a safe and familiar home. In this he was evidently highly successful, for soon after his first solo show at Denise Breteau, in 1961, French critics were hailing him as one of the country's best sculptors. Retrospectives at the Kunsthalle, Bern (1962), the Stedelijk Museum, Amsterdam (1963), and the Palais des Beaux-Arts, Brussels, were held shortly thereafter. In 1963 he won the Brill Copley Foundation Prize and in 1966 the International Grand Prize for Sculpture at the Venice Biennale. In 1968 he was given a chair at the Ecole National Supérieure des Beaux-Arts, Paris; the following year he was unanimously awarded the International Grand Prize for the Arts, Paris. The "Demeure" series continued through the 1960s and included *Demeure No. 5 (Le Manteau)* (1962, The Cloak), an elaborate chasuble of cloth and rope evocative of ancient occult rituals; *Demeure No. 8 (Soleil)* (1963, Sun Dwelling), of tulipwood; and the huge *Demeure No. 10* (1965), a bronze large enough to hold five other sculptures and a number of spectators.

In a radical departure from his previous work,

Martin showed in 1968 and again in 1974 a game-book, *Abécédaire and Other Places* (published as a kind of catalog by Editions Claude Givaudan in 1967), which was concerned solely with his personal history and his development as an artist. After reconstructing a model of the lost home of his infancy, participants were invited to place representations of his sculptures in appropriate rooms. Lacking a thorough knowledge of the man and his work, most found *Abécédaire* self-indulgent and hermetic. "A work of this sort is hard to seize," an *Art News* reviewer wrote, ". . . the more so in that it has a little of that formidable *Lyonnais* spirit which is almost unparalleled in France: a mélange of esotericism, satanism, exorcism, black masses, and *angelisme* (which Larousse defines as a 'desire for extreme purity')." Martin returned to more conventional works in the late 1960s and '70s, notably with *Janus nuit* (1969).

Pierre Brisset described Etienne-Martin as sporting "a patriarchal beard" and having "a clear, malicious, lively eye and a powerful carriage." The artist, since 1958 a professor at the American School in Fountainbleau, was admitted to the Académie des Beaux-Arts in 1971.

EXHIBITIONS INCLUDE: Gal. Denise Breteau, Paris 1961, '62; Kunsthalle, Bern 1962; Stedelijk Mus., Amsterdam 1963–64; Palais des Beaux-Arts, Brussels 1965; Lefebre Gal., NYC 1965–66; Gal. Claude Givaudan, Paris 1968, '74; Centre Nat. d'Art Contemporain, Paris 1968; Mus. Rodin, Paris 1972; Art Curial, Paris 1982. GROUP EXHIBITIONS INCLUDE: Gal. Denise Breteau, Paris 1950s; Salon de Mai, Paris 1961, '63; Venice Biennale 1966.

COLLECTIONS INCLUDE: Palais des Beaux-Arts, Brussels; Michel Coutourier Collection, Mus. Rodin, and Centre Nat. d'Art Contemporain, Paris; Kunsthalle, Bern; Stedelijk Mus., Amsterdam.

ABOUT: Jouffroy, A. The Paris International Avant-Garde, 1966. *Periodicals*—Art News January 1968; Connaissance des arts (Paris) May 1977; L' Oeil (Paris) August 1982; Quadrum 19 (Brussels) 1965; XXe siècle (Paris) June 1977.

EVERGOOD, PHILIP (October 26, 1901– March 11, 1973), American painter, leading Realist of the 1930s. He was born in the art studio of his father, Meyer Evergood Blashki, in New York City. Meyer's middle name, Evergood, was a literal translation of Immergut, his mother's maiden name. Meyer, who had broken with orthodox Judaism to become an artist, painted in a lyrical impressionist style.

Philip Evergood's mother came from a

Pach Bros, NYC

PHILIP EVERGOOD

wealthy and cultivated English gentile family; she traveled widely, spoke several languages, and was interested in music. As a child Evergood showed great musical ability, and when he was eight his mother took him to England to be educated. He was miserable at the various boarding schools he attended, the last one being a preparatory school for the Royal Naval Training College, Osborne. He passed his written examinations for Osborne, but the Committee of Admirals, startled that someone named Blashki should wish to join the British Navy, held up his admission. Evergood's father wrote to Winston Churchill, then First Lord of the Admiralty, asking whether it was the name that caused the problem. Churchill replied frankly that, unfair though it might be, a name like Blashki "has an effect on us Anglo-Saxons." He added, "I would advise you as man to man to change your name legally to Evergood." Blashki complied.

Evergood's mother entered her son at Eton, where he spent the four years of World War I. His tutor at Eton encouraged Evergood to express himself in drawing. After graduating in 1919, Evergood accompanied a friend to Belgium for tutoring in French, Latin, and mathematics, but spent his spare time in museums studying the old masters. Admitted to Trinity Hall College, Cambridge, he returned to England, his career plans still uncertain.

Evergood's only rewarding experiences at Cambridge were frequent visits to the Fitzwilliam Museum. In 1921 he decided he wanted to be an artist and applied for admission to the Slade School, London. He took samples of his work, including a study of his own hands, a

drawing of his mother, and some Biblical sub-
jects, to the formidable Henry Tonks, head of
the Slade School, who looked at the drawings
and said: "My boy, you can't draw, but your
drawings did something to me which few do. . .
. They made me laugh. I will take you at the
Slade."

Evergood underwent two years of rigorous ac-
ademic training, with the emphasis on drawing.
He did no painting but studied sculpture.

On graduating from the Slade in 1923, Ever-
good suddenly felt that the US was his native
country, and obtained American citizenship. He
rejoined his family in New York City and stud-
ied for a year at the Art Students League, where
one of his teachers was George Luks, who had
been a prominent member of the Ashcan School.
Evergood still concentrated on drawing and
learned etching from friends who let him use
their press.

After terrible conflicts with his father, who
felt that his son was becoming a "waster and a
playboy," Evergood returned to Europe in 1924.
He studied briefly at the Académie Julian with
Jean-Paul Laurens and worked for a short time
with André Lhote, but he disliked Lhote's rigid
rules of composition. Evergood then began to
paint seriously on his own. In Paris he met Julia
Cross, a painting and ballet student, whom he
was to marry. At this time one of his still lifes was
accepted by the National Academy of Design,
New York City.

After a year in Paris, Evergood traveled in Ita-
ly and spent several months in Cagnes, in the
south of France. In 1926 he returned to America
to be near his ailing mother, who died the fol-
lowing year. In 1927 he joined a group of young
New York artists at the Dudensing Galleries,
which gave him his first solo show. The *New
Yorker* critic Murdoch Pemberton wrote: "He is
immensely facile; . . . he can paint like every
good painter you have come across. Eventually
he will be full of guts, and, we hope, of
Evergood." Other critics noted the strong influ-
ence of El Greco and Cézanne.

By 1929, when he painted *Solomon at the
Court of Sheba,* a more personal note was appar-
ent. The figures, all nude, have a whimsicality
recalling Cranach; there are hints of fantasy in
Evergood's subsequent work, which borders on
surrealism. In 1930, after a solo exhibit at the
Montross Gallery, New York City, Evergood re-
turned to Paris, where he briefly studied engrav-
ing with Stanley William Hayter at Atelier 17.
In 1931 he and Julia Cross spent six months in
Spain, where he was more impressed than ever
by El Greco. Back in Paris he decided not to be
an expatriate painter, and the couple returned
to New York City and married.

The Evergoods had returned at the height of
the Great Depression and were virtually penni-
less, but Julia's mother found them jobs at Ame-
lia White's Gallery of American Indian Art, on
Madison Avenue. After 1932, reacting to the De-
pression, Evergood abandoned the purely imagi-
native for a social realist style and for themes
taken from his own life and experiences. His so-
cial realism was, of course, narrative, but the pic-
tures were saved from the merely illustrational
by the artist's forthright, idiosyncratic style.
Dance Marathon (1934), for instance, captured
perfectly the tawdry glitter of its subject.

Evergood's growing concern for the human
drama was influenced by his friendship with
John Sloan, the pioneer of urban realism, but the
evolution of his style owed more to his study of
Grünewald, Bruegel, Bosch, and El Greco, and
the graphic work of Goya, Daumier, and Tou-
louse-Lautrec. In his use of color in paintings of
the mid-1930s he avoided conventional harmo-
nies; in *Nude by the El* (1934) he delighted in
the raucous disharmony of the strident red of the
velvet couch, the pinks on the wall, and the
crude green house paint of the elevated struc-
ture.

Evergood joined the New Deal's Public Works
of Art Project in 1934, working for it and its suc-
cessor, the Federal Art Project of the Works
Progress Administration, until about 1937. In
1935 he joined the Midtown Gallery, but two
years later moved to the A.C.A. Gallery, with
which he was to remain.

In the politically turbulent '30s Evergood be-
came deeply involved in liberal and radical
causes—Negro rights, the plight of coal miners,
the Spanish Loyalists, and, during World War II,
Russian war relief. He was also active in the left-
ist American Artists' Congress. Evergood was ar-
rested in Hoboken, New Jersey, for sketching the
slums and was beaten up by the police in 1936
while participating in the "219 Strike," orga-
nized by 219 artists to protest layoffs from the
Federal Art Project. He and his fellow strikers
spent the night in jail, and Evergood said that
only someone who had been through these expe-
riences could have painted *American Tragedy*
(1937). This canvas, based on a bloody confron-
tation between picketing strikers and police out-
side a steel mill in Gary, Indiana and painted in
part from newspaper photographs, was one of
Evergood's most militant, and propagandistic,
works. However, when he combined satire and
a touch of fantasy with his social comment, as in
My Forebears were Pioneers (1940; Whitney
Museum of American Art, New York City)
Evergood transcended social-realist propagan-
da. In that painting a dried-up, very smug old
lady sits in a rocking chair against a dilapidated

Gothic revival house amid a scene of utter devastation.

Evergood first achieved widespread recognition as a mural painter. In 1937 he completed a 27-foot-long mural, *The Story of Richmond Hill,* for the public library at Richmond Hill, Long Island, a Utopian community founded in 1870. Despite strong opposition by more conservative members of the community—the figures were thought to look like idealized Russian peasants—the mural was accepted. It is now considered the best of Evergood's mural projects of the '30s and early '40s.

By this time Evergood's easel paintings were reaching a wider public. Some of his canvases painted during and immediately after World War II were violently satirical, suggesting the influence of the German Expressionist Max Beckmann; but in other works of the '40s a tendency towards fantasy and allegory was noticeable, even in pictures with social messages, as in *Moon Maiden* (1944). An increasing sensuousness in his handling of the female nude, along with tongue-in-cheek humor, culminated in *The Jester* (1950), an allegory of the follies of the world. The tension in Evergood's work between the linear and the painterly was largely resolved in *Enigma of the Collective American Soul* (1959), which combines forceful drawing with a shimmering paint quality. Also the satire is less heavy-handed than in earlier works: a buxom beauty queen holds a huge trophy topped by a rocket, and in the background a baleful Winston Churchill and a smiling Dwight Eisenhower enact their ritualistic public gestures. However, Evergood's interest in social comment and satire waned as he grew older.

In 1943 Evergood, with ten other artists, was invited by the War Department to make a pictorial record of the war; but after giving up his teaching job he was rejected by the Army as artist-correspondent, with no reasons given. He took a job at the Midtown Frame Shop, in Manhattan, which he quit after Joseph H. Hirshhorn bought nine of his pictures. He was not yet financially independent, but his work was becoming better known. In 1946 he had an exhibition at the Tate Gallery, London; in 1950 and again in 1958 he was awarded a Gold Medal by the Pennsylvania Academy of the Fine Arts. A 1960 retrospective exhibition at the Whitney Museum of American Art traveled to Minneapolis, San Francisco, and other cities.

In 1952 Evergood and his wife moved to Southbury, Connecticut. He died in Bridgewater, Connecticut.

Philip Evergood was a flamboyant, colorful, and complex man. He had a booming voice and gentle manner and in middle age sported a small moustache. With his pudgy build, penetrating gaze, and sensuous mouth, vividly depicted in his *Self-Portrait with Divining Rod* (ca. 1954), he resembled the actor Charles Laughton.

In his best paintings Evergood combined a keen sense of drama with ironic humor, and thus gave his social criticism zest. As John I. H. Baur observed, "Despite the fact that he has painted many hasty and even some downright bad canvases, he has never painted a dull or a conventional one." In the New York *Herald Tribune* Emily Genauer wrote of his Whitney retrospective, "His pictures remain exuberant, astonishingly alive."

EXHIBITIONS INCLUDE: Dudensing Gals., NYC 1927; Montross Gal., NYC 1929, '33, '35; A.C.A. Gal., NYC 1942, '46, '48; Tate Gal., London 1946; Tweed Gal., Univ. of Minnesota, Duluth, 1955; The Am. Academy of Arts and Letters, NYC 1956; Whitney Mus. of Am. Art, NYC 1960; Gal. of Modern Art, NYC 1969; Kennedy Gals., NYC 1972. GROUP EXHIBITIONS INCLUDE: Nat. Academy of Design Annual, NYC 1924, '27; "Murals by American Painters and Photographers" and "New Horizons in American Art," MOMA, NYC 1932, '36; Whitney Annual 1934–65; 46th Am. Exhibition, Art Inst. of Chicago 1935; Am.-British Goodwill Exhibition 1944; "Ten Modern Masters of American Art," Am. Federation of Arts tour 1959–60.

COLLECTIONS INCLUDE: Metropolitan Mus. of Art, MOMA, and Whitney Mus. of Am. Art, NYC; Brooklyn Mus. of Art; Boston Mus. of Fine Art; Fogg Mus., Cambridge, Mass.; Baltimore Mus. of Art; Carnegie Inst., Pittsburgh; Chicago Inst. of Art, Ill.; Corcoran Gal. of Art, and Hirshhorn Mus. and Sculpture Garden, Washington, D.C.; Wadsworth Atheneum, Hartford, Conn.; Los Angeles County Mus. of Art; Mus. of New Mexico Art Gal., Santa Fe, N.M.; Nat. Mus. Melbourne, Australia.

ABOUT: Baur, J. I. H. New Art in America, 1957; "Philip Evergood" (cat.), Whitney Mus. of Am. Art, NYC, 1960; Lippard, L. R. The Graphic Work of Philip Evergood, 1982; Meyers, B. Encyclopedia of Painting, 1955; Rose, B. American Art Since 1900, 2d ed. 1975; "Twenty Years Evergood" (cat.), A.C.A. Gal., NYC, 1946. *Periodicals*—Art Digest March 1, 1938, June 1, 1938, November 1, 1942, April 15, 1946, January 1, 1950; Art News December 21, 1929, January 1952; Direction April 1938; New York Herald Tribune April 6, 1960; Magazine of Art November 1943; New Yorker April 16, 1960; Parnassus March 1939.

***FAHLSTRÖM, ÖYVIND** (1928–November 9, 1976), Swedish painter and Conceptualist, created what are among the most obsessively abstruse and visually difficult paintings in contemporary art. They are also, for the knowledgeable

°fäl´ strööm, oi´ vint

Courtesy Arnold Herstand and Co., NYC; Photo by Lars Wiklund, 1976

ÖYVIND FAHLSTRÖM

and sympathetic viewer able to relax logical understanding, among the most intellectually rewarding (in much the same way as is *Finnegan's Wake*), if only for the glimpse they give of "an eccentricity so extreme," according to Peter Schjeldahl of *The New York Times*, "yet so consistent, that it suggests the normal consciousness of another species." Fahlström's art did not spring, in the main, from the visual concerns of modernism (although it has obvious roots in dadaist collage and American pop and affinities with the symbol-laden paintings of Giuseppe Capogrossi and Ronald Kitaj) but developed rather, out of the artist's knowledge of ancient texts, structural linguistics, semiotics, game theory, music, literature, and pop and pulp mass culture. From this eclectic mixture he produced collage-like paintings that progressed from almost complete hermeticism early in his career, to partial accessibility through their Pop elements and gamelike structure in the mid-1960s, to the level of complicated polemics when a radical ideology had begun to supplant other influences in the 1970s.

Of Norwegian-Swedish parentage, Fahlström was born and spent his childhood in São Paulo, Brazil. In 1939 the family moved to Sweden; from 1949 to 1952 he studied art history and archaeology, notably the Aztec and Mayan hieroglyph systems from which he developed the "character-forms" and general compositional principles of his early paintings, at the University of Stockholm. For several years he supported himself as a journalist (publishing articles on the sociological significance of comic strips) and drama critic while writing poetry, experimental

plays, and philosophic manifestoes. He was self-trained in art, plunging directly into a refined, antiformalist abstraction. Kate Linker of *Artforum* described his first drawings, shown in 1952 at the Galleria Numero, Florence: "Scrambled organic forms—really graphemes—group and regroup, collide and explode. Space is in a constant alignment and dispersion. A shifting equilibrium among the swarming multiplicity of forms presents an image of simultaneity." Traits in these early works (*Opera*, 1952, for instance)—bizarre and abrupt transitions and juxtapositions, crowding of the picture plane with a myriad of small forms and fragments, and an attempt to convey both spatial and temporal change through some system of form arrangement—pervade his entire oeuvre.

In the 1950s Fahlström traveled extensively between Paris and Rome, meeting Matta and Giuseppe Capogrossi, among others. Capogrossi's endlessly varied use of a single dentate symbol probably encouraged Fahlström, about 1955, to develop his own system of "character-forms": essentially simple abstract glyphs of various classifications, recognizable as belonging to a particular category regardless of the artist's manipulations and distortions, and intended to supply a totally accessible, because unreferential, visual language. Actually, in such works as *Serial Painting* (1957), in which character-forms, stacked in hierarchies of cells, are being eaten (or maybe created and disgorged) by a creature or machine, the result was not accessibility but, for most viewers, total obfuscation. Because *Ade-Ledic-Nander II* (1955–57) has a readable, if unusual, ancillary text—a short story about three warring alien clans by the science fiction writer A. E. Van Vogt (probably the most metaphysically ambitious and sweepingly illogical of contemporary science-fiction authors)—the painting is at least partially decipherable, although Fahlström's exhaustive 50-page analysis is a prerequisite to full understanding.

Feast on Themes of Mad (1958) and the more ambitious *Dr. Livingstone, I Presume* (1960–61), hectic and scrambled collage-paintings composed of snippets from the popular humor magazine *Mad* and other periodicals, prefigure Fahlström's extensive use of the comic strips after his arrival in the United States on a scholarship in 1961. (According to Suzi Gablik, Fahlström married his second wife, artist Barbro Östlihn, in 1960 on the prerequisite that she take on the time-consuming task of copying the original collage of *Dr. Livingstone* into paint.) In New York City he met Robert Rauschenberg, Claes Oldenburg, and Roy Lichtenstein and became acquainted with the novels of William

Burroughs (especially *Naked Lunch* and *Nova Express*), a writer whose use of "cut-up" and "fold-in" random prose and fascination with science-fiction ideas, police action, and political repression finds parallel in Fahlström's work. Fahlström also associated with John Cage, the leading American exponent of avant-garde, randomized music. In Fahlström's first American work, *Sitting, Like Pat with a Bat on Her Hat* (1962, usually referred to as *Sitting . . .*), he used the aleatory techniques of Burroughs and Cage on character-forms, bits of *Batman* comics, and other material, enclosing the discordant result in comic-strip frames and creating the exact opposite, he claimed, of "a closed, boxlike and centered composition." Resembling an entire human memory—conscious as well as unconscious—ground up and deposited on canvas, *Sitting . . .* attempts to portray the discontinuity of time, objective reality, and human thought.

In 1962 Fahlström invented the "variable" painting. *Sitting, Six Months Later* (1962), the first of these, is composed of 21 movable magnetic shapes—cut out of sheet metal, coated with vinyl, and painted in comic-book style—of clouds, parts of bodies, a Bat-cape, and a miniature reproduction of *Sitting . . .*, among other things. The owner or viewer is free to continue the artistic process by rearranging the image. Although not for the most part true games, the variable paintings such as *Switchboard* (1963) and *The Planetarium* (1963–64) have a gamelike structure that, according to the artist, "does not involve either the one-sideness of realism, nor the formalism of abstract art, nor the symbolic relationships in surrealistic pictures, nor the balanced unrelationship in 'neodadaist' works. . . . The finished paintings are somewhere at the point of intersection between paintings, games (of the same type as Monopoly and war games), and puppet shows." Fahlström did not limit himself to easel-sized works. *Dr. Schweitzer's Last Mission* (1966–67) occupied a full room at the Sidney Janis Gallery, New York City. His most ambitious work was not a painting at all but a complex bit of technological theater, *Kisses Sweeter Than Wine*, for the 1966 "Theater and Engineering" show at the New York Armory. Devised with the help of engineers from Bell Laboratories, it included a silver, radio-controlled singing blimp, a flying frogman, a giant bust of President Lyndon Johnson, and shrouded protesters bearing placards of Mao Zedong and Bob Hope. Fahlström also directed a number of documentary and experimental films.

The Cold War (1964–65) was one of Fahlström's first comprehensible political sat-

ires. Overt references to East–West conflict are mixed with less obvious but more terrifying images—Clark Kent (in Fahlström's work Superman always stands for America) ripping open his shirt to reveal the eye of a hurricane (the result of a nuclear explosion?), or laboratory mice with real knife blades hidden in their backs. Fahlström both attacked and parodied the indiscriminate and biased presentation of news by mass media; like Hans Haacke, another artist whose work has journalistic aspects, he was news-obsessed. "I deplore my incapacity to find out what is going on, what life and the world are about, through the confusion of propaganda, communications, language, time. . . . " By the early 1970s his art had changed from one of abstruse symbolic manipulation with elements of political satire to one primarily concerned with transmitting masses of "unknown facts"—information and trends deemphasized or hidden by governments (usually the US, always the safest target for radical artists). In this he may have taken his cue from the plays of Bertolt Brecht, which were meant to rouse the viewer to political action, or equally from the scabrous underground "comix" of Robert Crumb, S. Clay Wilson, and "Spain." *World Trade Monopoly* (1970), *Pentagon Puzzle* (1970), and *CIA Monopoly* (1971) are satiric versions of Monopoly or other games played for real countries by the harsh rules of *realpolitik*. In *World Map* (1972 and later versions), Fahlström crammed hundreds of facts, figures, and quotes on the state of the world—which he considered to be fueled mainly by lust, greed, deceit, and repression—into a mythical global map peopled by cartoonish leaders, factotums, and brutal police. The "Chile" series and *Latin-American Puzzle*, his last works, condemned the continuing involvement of the US in that region's internal affairs, using not facts but quotes from the poetry of Sylvia Plath, Georg Trakl, and García Lorca. To accusations that he had given over to productions "dour and simplistic as any Weatherman communiqué," as Robert Hughes said in *Time* magazine, Fahlström replied: "Critics see my work largely in terms of its success or failure as propaganda art. Apparently it is difficult for them to accept that—even though my sympathies are clear—my work is about certain facts, events and ideas, rather than for or against them. . . . I see myself as a witness rather than as an educator." Fahlström, politically active in life as well as art, belonged to a number of organizations including the committee supporting the defendants in the Attica prison riot trial of the early 1970s.

Öyvind Fahlström contracted cancer and died in New York City in 1976 at the age of 48. His

impact on contemporary art has been peripheral at best. However, wrote Gablik in *Art in America* (March/April 1977), "Fahlström's uncompromising view of things, the legacy of his loose, teeming, chaotic, prickly images with their peculiar blend of science fiction and *Mad* comics, of lurid obsenities and blasphemous humor, all those gorillas, footballs, coffins, hermaphrodites, penises, rockets, esophaguses, zeros and unmade beds—will not subside easily into a convenient pigeonhole of art history."

EXHIBITIONS INCLUDE: Gal. Numero, Florence 1952; Gal Aesthetica, Stockholm 1955; Gal. Daniel Cordier, Paris 1958, '62; Gal. Blanche, Stockholm 1959; Cordier and Ekstrom Gal., NYC 1964; Sidney Janis Gal. NYC 1967, '71, '73, '76; Gal. Zwirner, Cologne 1969; Moore Col. of Art, Philadelphia 1973; Foster Gal., Eau Claire, Wis. 1973; Gal. Bucholz, Munich 1974; Gal. Multhipla, Milan 1974; Gal. A. Iolas, Paris 1975; Gal. Bandouin Lebrun, Paris 1977; Centre Georges Pompidou (Beaubourg), Paris 1980. GROUP EXHIBITIONS INCLUDE: São Paulo Bienal 1959; Pittsburgh International, Carnegie Inst. 1960; "New Realists," Sidney Janis Gal., NYC 1962; "Nine Evenings," Moderna Mus., Stockholm 1964; Venice Biennale 1964, '66; "Theater and Engineering," New York Armory, NYC 1966; "Towards a Cold Poetic Image," Gal. Scharz, Milan 1967; Documenta 4, Kassel, W. Ger. 1968; "Art and Technology," Country Mus., Los Angeles 1968; "Pop Art Redefined," Hayward Gal., London 1969; "Swedish Art: Contemporary Themes," Mus. of Modern Art, Tokyo 1972; "Swedish Art: Contemporary Themes" Mus. of Modern Art, Kyoto, Japan 1972; "New York Collection for Stockholm," Moderna Mus., Stockholm 1973; "Buruchello, Erro, Fahlström, Leibig," Kunstverein, Munich 1975; Solomon R. Guggenheim Mus., NYC 1983.

COLLECTIONS INCLUDE: Wallraf-Richartz Mus., Cologne; Stadtisches Mus., Stuttgart, W. Ger.; Daniel Cordier Collection, Paris; J. Delpedi Collection, Sevres, France; G. Cavellini Collection, Brescia, Italy; Harry Abrams Collection, and Solomon R. Guggenheim Mus., NYC.

ABOUT: Ekbom, T. and others Öyvind Fahlström, 1967; Jouffroy, A. Le Belcanto de Fahlström, 1975; Oliva, A. and others Öyvind Fahlström, 1975. *Periodicals*—Art in America March/April 1977; Art International April 1964, Summer 1966; Art News Summer 1966; Artforum October 1978; New York Times April 4, 1971, April 15, 1973; Quadrum 8 (Brussels) 1960; Time April 12, 1971.

***FAUTRIER, JEAN** (May 16, 1898–July 21, 1964), French painter, was, along with Jean Dubuffet, the founder of "matter informalism." That is, he based his painting not on preexisting regular forms, but on spontaneous expression determined by the painting material itself (in the

°fō´ tryā, zhäN

United States, the same impulse spawned abstract expressionism). All such artistic categories are to a greater or lesser extent imprecise, mere conveniences, and certainly the postwar *Art informel* movement in Europe, despite the claims of French critic Michel Tapié, did not spring forth uninfluenced by other styles or tendencies. Nonetheless, Fautrier's later work represented a real departure from what had gone before; the very animosity of the critics (with two notable exceptions) toward his paintings was the surest indication of this.

Fautrier was born in Paris just before the turn of the century. After his father's death when Jean was ten, his mother brought him to London, where, at the age of 13, he was admitted to the Royal Academy School. There he studied with Richard Sickert; later he attended the Slade School, London, and had his first exhibition and sale when he was 15. Fautrier was called up for service in the French Army in 1917. During the war he was wounded, then gassed.

After his recovery, he settled permanently in Paris, painting regularly and meeting the collectors Jeanne and Marcel Castel, who gave him his first Parisian exhibition in a small garage they had converted to a gallery. A 1925 exhibition was a greater success, but at about that time Fautrier, already painting still lifes and the figure in an expressionist style (*Black Nude,* 1926, *Pears,* 1927), abandoned what interest he had in bright colors and imagery, turning to a dull palette of grays, blacks, browns, and ochers. This, combined with his solitary nature—he had few friends among artists or critics—discouraged any active interest by collectors. In 1928 he met the writer André Malraux, who became his lifelong advocate, and who was, with Jean Paulhan, instrumental in reestablishing Fautrier's reputation after the war. Malraux encouraged him to do a series of lithographs illustrating Dante's *Inferno;* many of these are quite abstract, and anticipate his later work, as do Fautrier's pastels of the period, which are composed primarily of an amorphous cloud of color against a flat background. A few sculptural experiments, in cast bronze, show a progression from physical grace (*Nude with Raised Arms,* 1927) to distortion (*Woman Dressing Her Hair,* 1929). In the early '40s he was to do a series of bronze heads but sculpture never assumed for him the same importance as painting.

The 1930s were a difficult time for Fautrier. Unable to earn a living from art, in 1935 he moved to Tignes, Val-d'Isère, a popular resort area in northeastern France, where he worked as an innkeeper, ski instructor, and builder of ski facilities. He found time for painting only at

night. In 1936 he married Jeannine Aeply, his second wife; they had two daughters. About 1930 he had developed the painting technique he was to refine for the rest of his career: instead of painting directly on the canvas, he glued layers of paper to it, creating a thick, absorbent ground on which to apply an increasingly viscous impasto.

Fautrier believed that "painting is something that can only destroy itself, that must destroy itself in order to re-invent itself," and in 1942 his own work underwent a rupture with the past which led to a completely new style. That year marked the beginning of his "Hostage" series. Called by Malraux "hieroglyphs of suffering," and inspired by the mass deportations of the war, the "Hostages" were amoebic, nearly featureless heads, built from a thick, smooth impasto that has been compared to hardened lava. "The paintings put great stress upon the tactility of the painter's materials, the evocative quality of the surface itself," wrote Edward Lucie-Smith. "There is a narcissism in this which tells us something about the waning vitality of French painting, but it was also a genuine innovation." By now Fautrier had perfected his collage-painting technique: he first primed the paper ground with white paint, then painted the image in flesh-tones, covered it with more white, and so on in successive layers until the final coats, when he added pastel dust for color. On top of it all, he painted the most generalized features, using a transparent wash. The result, though the product of meticulous effort, appeared spontaneous and unplanned.

With the "Hostage" series, first shown in 1945 at the Galerie Drouin, Paris, to considerable critical confusion and distaste (despite the support of Malraux and Paulhan, these works at first appeared irredeemably odd), Fautrier proved himself part of the same nascent movement that spawned Dubuffet at virtually the same moment. Comparing the two artists, Aldo Pellegrini wrote in *New Tendencies in Art*: "In contrast to Dubuffet, Fautrier's work is neither aggressive nor polemical. On the contrary, a sort of calmness seems to flow from it. The surface of the impasto reveals very sober impressions of regular and ample spatula work. What is surprising is the contrast between the strong, almost aggressive quality of the relief of the impasto and the delicately tenuous traces of color with which [it] is covered. [These traces of color] are blue, ocher, and rose, very soft, almost transparent. But this apparent contrast helps Fautrier to give the medium a floating aspect of lightness, and more than anything it serves to create a sense of ambiguity in the work, something to which the artist was particularly given." Pellegrini goes on to claim the Fautrier "revolutionize[d] profoundly the ideas and concepts of what was then the vanguard" and that he led the way to the international informalist movement of the '50s. With Karel Appel, Willem de Kooning, Dubuffet, Wols, Mark Tobey, Georges Mathieu, and others, Fautrier participated in the first informalist exhibition, organized by Michel Tapié in 1951 at the Galerie Paul Facchetti, Paris.

Despite his seminal influence, Fautrier's paintings were never popular; from 1949 to 1953 he was forced to support himself making highly accurate copies of modern masterpieces by a method he himself devised. In the early 1950s Fautrier experimented with combining rectangular and irregular forms—for example, *Deep Water* (1950), *Little Yellow Geometry* (1957), and *Game of Lozenges* (1958), the last a rectangle divided into square cells and streaked with blue, pink, and yellow. A series called "Blotters" (early 1960s), paint thinly washed onto and absorbed into blotting paper, recalled the pastels of 1928.

In the early 1960s Fautrier finally achieved the international recognition he deserved, sharing the first prize with Hans Hartung at the Venice Biennale in 1960 and winning the Grand Pix in 1961 at the Tokyo Biennial. For many years a resident of a Paris suburb, Fautrier was also a world traveler, visiting the Netherlands, Italy, Belgium, the United States, Spain, the Canary Islands, and Morocco. Never a theorist, he justified his work purely in terms of his own desires. "I paint because I take pleasure in painting. Other people's painting is of no use to me. I intend painting to serve my own purposes."

EXHIBITIONS INCLUDE: Gal. Bernheim, Paris 1927; Gal. de la Nouvelle Renue Française, Paris 1933, '39, '53; Gal. Alfred Poyet, Paris 1942; Gal. René Drouin, Paris 1943, '45, '58; Gal. Billiet-Caputo, Paris 1950; Gal. Rive Droite, Paris 1955, '56, '57; Alexander Iolas Gal., NYC 1956; Sidney Janis Gal., NYC 1957; Gal. Apollinaire, Milan 1958, '62; Gal. 22, Düsseldorf 1958, '59; Gal. l'Attico, Rome 1958, '59, '63; Inst. of Contemporary Art, London 1958; Hanover Gal., London 1959; Minami Gal., Tokyo 1959; Gal. l'Immagine, Turin, Italy 1960; Kunstnernes Hus, Oslo 1963; Moderna Mus., Stochholm 1963; Mus. d'Art Moderne de la Ville de Paris 1964; Gal. Michel Couturier, Paris 1968; Staempli Gal., NYC 1970; Gal. Jean Castel, Paris 1979; Josef-Hanbrick-Kunsthalle, Cologne 1980. GROUP EXHIBITIONS INCLUDE: "Signifiants de l'informel," Gal. Paul Facchetti, Paris 1951; Venice Biennale 1960; Tokyo Biennial 1961.

COLLECTIONS INCLUDE: Mus. d'Art Moderne, Mus. d'Art Moderne de la Ville, and Gal. René Drouin, Paris; Gal. Apollinaire, Milan.

ABOUT: Bénézit, E. (ed.) Dictionnaire des peintres, sculptures, et graveurs, 1976; Lucie-Smith, E. Late Modern: The Visual Arts Since 1945, 1969; Meyers, B.S. and others Dictionary of 20th Century Art, 1974; Pellegrini, A. New Tendencies in Art, 1966; Verdet, A. Fautrier, 1950. *Periodicals*—Art International (Lugano) no. 3 1960; La Bieñnale di Venezia (Venice) January/March 1959; Variété (Paris) July/August 1945.

Edith Ferber

HERBERT FERBER

FERBER, HERBERT (April 30, 1906–), American sculptor and painter, writes: "I was born April 30, 1906, in New York City, of Jewish immigrant parents who came to the US in their infancy. We lived until my tenth year in a Jewish-Irish ghetto where I learned the meaning of difference, became a member of a street gang for defense and war, and at the same time went to public school in a starched white shirt as a prize student who was advanced quickly by appreciative teachers. Finances were slim; there were few books, certainly none on Art in our home, but there was ambition for the only son to have a profession.

"High school taught me how to construct a sentence and that English prose and poetry existed in a different and mysterious, less materialistic, world. Running head on, and suddenly, into John Milton and Shakespeare was a barely understood revelation. It also revealed that science, which later became important in my life, had its mysterious applications too.

"I enrolled in the College of the City of New York because it was close to home, free, and because two uncles had preceded me there. I was to attend for one year, for predental school requirements, but the taste of culture nurtured a reluctance to leave that world. An easing situation at home allowed me another year and then another and another.

"An introduction to old master painting and sculpture led to an intense interest in the history of art. With two friends, whose studies were in the humanities (I was a science major), I explored the city museums and books on art history. At the dental school of Columbia University I discovered a talent for drawing and carving because our curriculum included anatomical studies, and the drawings from nature by the Old Masters acquired new meaning for me. At the age of twenty-one I began to copy their drawings and to sketch from nature and from sculptures in the Metropolitan Museum of Art. This led me, in 1927, to enroll at the Beaux-Arts Institute of Design, a most conservative and academic, but tuition-free, night school for sculpture. Since there was no drawing or painting available there, I became a student in a life class in modeling. Thus began a divided life of dental practice, university teaching, and research on the one hand, and Art on the other. Dentistry supported Art and I was able to avoid financial dependence on others or on odd jobs which other artists faced.

"About 1927 I also began to make etchings, having learned the process from a book. These were good enough to be shown at the annual national shows and selling them turned me into a professional artist with the ever-elusive goal of being able to live by that means. I had been working in isolation, but on graduation from dental school in 1930 I was able to postpone a staff appointment long enough to enjoy a Tiffany Foundation Fellowship which brought me into contact with a group of young painters and with the then small world of New York Art galleries, the Museum of Modern Art, the old Whitney Museum, and working artists. A slowly developing awareness of modern Art produced in my own work a range from representation, social consciousness, expressionism and surrealism, to abstraction. I attended the lectures of Meyer Schapiro at the New School for Social Research; his brilliance and enthusiasm were an inspiration and confirmation for my continuing career as an artist.

"I had given up modeling in clay by 1931 and had begun to carve wood and stone. These were figurative and expressionist works influenced by Romanesque, Gothic, and pre-Columbian sculpture. They were shown in various New York galleries and at the same time introduced me to more artists, writers, and critics. New York in the late '30s and early '40s was an exciting cultural stew. Artists, writers, and other intellectual

refugees from totalitarian Europe leavened the ferment which stimulated the New York School. Orozco and Rivera worked in New York as did Léger, Duchamp, Hans Hofmann, Ernst, Dali, Kiesler, and many others.

"By 1945 I found the representational well drying up for me, and I began to try abstracting from nature and inventing forms by means of automatic drawing. The gallery I had been showing with was unsuitable for these new works and I joined the Betty Parsons Gallery. There I met congenial artists and became part of the nucleus which grew to be the New York School of Abstract Expressionism. This small group of friends and a few from other galleries provided mutual support in the face of general rejection; with their eager talk and theorizing they gave each other a sense of exhilarating adventure into new forms. There was an endless stream of conferences and discussions; the "Subjects of the Artist," an art school and weekly meeting place, provided a forum for native and European artists, psychoanalysts, critics, etc. The adventure produced, eventually through their work, an ineradicable stamp on the body of Art and on the immense literature which came to surround that work.

"Now all modes of Art have become acceptable to the public, including reproductions represented as Art. This encompassing but passionless embrace by these 'lovers' has slight commitment to searching for meaning and understanding. Art is a language for conveying profound humanistic discourse which may be lost in the deluge of production, reproduction, and consumption accepted as a delightful and superficial by-product of what our society considers its more serious efforts in technology and applied science.

"The dilemma poised for artists lies in this unquestioning acceptance. How to make art which communicates and at the same time challenges the powers of understanding? In my own work I have attempted to fuse an acknowledgement of the urban and industrial society around me with a lyrical and humanist ingredient to produce forms which challenge the eye and the mind and yet remain subtle and mysterious in their various levels of meaning."

The son of Louis and Hattie (Lebowitz) Silvers, Herbert Ferber is one of the most inventive of the openwork sculptors using soldered metal; he is also a distinguished painter. His first sculptures were large nudes, but after a trip to Germany, in the late '20s, he infused his work with the violent distortions of expressionism. In the mid-1940s he abandoned representation, and by 1950 was associated with such sculptors of the New York School as Theodore Roszak and Ibram Lassaw, whose style of openwork metal sculpture paralleled developments in abstract expressionist painting. Ferber often worked on a monumental scale, and in the '60s his forms became simpler, more streamlined. He has had retrospectives at the Whitney Museum of American Art, New York City, in 1962–63, and at the San Francisco Museum of Art in 1962.

Outstanding sculptures by Ferber include *The Flame* (1949), composed of lead and brass rods; *. . . And the Bush was not Consumed* (1951–52), a metal construction on the facade of the B'nai Israel Synagogue, Millburn, New Jersey; *Sun Wheel* (1956; Whitney Museum of American Art, New York City); *Spherical Sculpture* (1954–62), a bronze work measuring 36½ by 25 inches; *Sculpture to Create an Environment*, which was commissioned in 1961 by the Whitney Museum and is now at Rutgers University, New Brunswick, New Jersey; *Homage to Piranesi* (1962–63), a copper piece measuring 92 by 49 inches; and "Calligraphs," the monumentally scaled series he did in the 1960s.

Ferber's monumental *. . . And the Bush was not Consumed* was exhibited by the Museum of Modern Art, New York City, in its "Fifteen Americans" show of 1952. Reviewing a Ferber show at the André Emmerich Gallery, New York City, in 1977, Noel Frackman of *Arts Magazine* (May 1977) wrote: "As a sculptor Herbert Ferber has produced some of the strongest, most arresting, and most surprising monumental steel pieces around. As a painter, his recent canvases are soft-edged, gently geometrized decorative canvases chiefly concerned with color sensations."

Herbert Ferber's marriage to Sonia Stirt in 1932 ended in divorce 11 years later. His second wife was the art historian Ilse Falk, whom he married in 1944. His present wife, Edith (Popiel) Ferber is a photographer. They live in a building on Macdougal Street in Greenwich Village that has been completely remodeled; the garage and studio are on the ground floor, and the walls of the spacious living quarters above are hung with paintings by Robert Motherwell, Adolph Gottlieb, and other artists and by Ferber's own large canvases. For years Ferber had a farm in northern Vermont where he summered, but the Ferbers now have a country residence closer to Manhattan, near Great Barrington, Massachusetts. Herbert Ferber, gray haired and bespectacled, is friendly, soft-spoken, and articulate. He rightly claims to have been the first to use the term "environment" in relation to sculpture. Ac-

cording to *The Oxford Companion to Twenti-eth-Century Art* (1981), his *Interior,* executed for the Whitney Museum, exemplified "the idea of sculpture as environment: a construction into which the spectator could enter and move, participating in the space defined, not displaced, by the sculpture."

EXHIBITIONS INCLUDE: Midtown Gal., NYC 1937, '43; Betty Parsons Gal., NYC 1947, '50, '53; Samuel Kootz Gal., NYC 1955, '57; Bennington Col., Vt. 1958; André Emmerich Gal., NYC from 1960 to 1977; "Sculpture of Herbert Ferber," Walker Art Center, Minneapolis 1962–63; Des Moines Art Center, Iowa 1962–63; San Francisco Mus. of Art 1962–63; Dallas Mus. for Contemporary Arts 1962–63; Santa Barbara Mus. of Art, Calif. 1962–63; Whitney Mus. of Am. Art, NYC 1962–63; Univ. of Vermont, Burlington 1964; Dag Hammarskjöld Plaza Sculpture Garden, NYC 1972; M. Knoedler & Co., Inc., NYC from 1978; "Sculpture and Paintings by Herbert Ferber," Roy Boyd Gal., Chicago 1978. GROUP EXHIBITIONS INCLUDE: Nat. Academy of Design, NYC 1930; Corcoran Gal. of Art, Washington, D.C. 1933; Mus. du Jeu de Paume, Paris 1938; Golden Gate Intl. Exposition, San Francisco 1939; New York World's Fair, 1940; Whitney Annual, NYC from 1948; "Abstract Art in America," MOMA, NYC 1951; "Fifteen Americans," MOMA, NYC 1952; "New Decade Exhibition," Whitney Mus. of Am. Art, NYC 1955; Carnegie Intl., Pittsburgh 1958; Documenta 2, Kassel, W. Ger. 1959; State Department Exhibition, Moscow 1959; Battersea Park, London 1963; "American Sculpture," Mus. Rodin, Paris 1965; "Dada, Surrealism and their Heritage," MOMA, NYC 1968; "Dada, Surrealism and their Heritage," Los Angeles County Mus. of Art 1968; "Dada, Surrealism and their Heritage," Art Inst. of Chicago 1968; "American Painting and Sculpture—The First Decade," MOMA, NYC 1969; "Nelson Aldrich Rockefeller Collection of 20th Century Art," MOMA, NYC 1969; "Nelson Aldrich Rockefeller Collection of 20th Century Art," Antwerp Biennale 1971; "Sculpture 1945–75," Nat. Collection of Fine Arts, Smithsonian Inst., Washington, D.C. 1975; "Painting and Sculpture Today," Indianapolis Mus. of Art 1978.

COLLECTIONS INCLUDE: Metropolitan Mus. of Art, Whitney Mus. of Am. Art, MOMA, and Loeb Student Building, New York Univ. NYC; Albright-Knox Art Gal., Buffalo, N.Y.; New York State Building Complex, Albany, N.Y.; Storm King Mus., N.Y.; Newark Mus., N.J.; Rutgers Univ., New Brunswick, N.J.; Bennington Col. Mus., Vt.; Univ. of Vermont, Burlington; Yale Univ., New Haven, Conn.; Williams Col. Art Gal., Williamstown, Mass.; Nat. Gal. of Art, Washington, D.C.; Detroit Inst. of Arts; Walker Art Center, Minneapolis; Pasadena Mus. of Modern Art, Calif.

ABOUT: Anderson, W. V. "The Sculpture of Herbert Ferber" (cat.), Walker Art Center, Minneapolis, 1962; Baur, J.I.H. "Nature in Abstraction" (cat.), Whitney Mus. of Am. Art, NYC, 1958; Goldwater, R. What is Modern Sculpture?, 1972; Goossen, E. C. Three American Sculptors, 1959; Lucie-Smith, E. Late Modern:

The Visual Arts Since 1945, 1969; Miller, D. C. "15 Americans" (cat.), MOMA, NYC, 1952; Ritchie, A. C. Sculpture of the Twentieth Century, 1952; Rose, B. American Art Since 1900, 2d ed. 1975. *Periodicals*—Art in America December 1954, April 1961, November–December 1975; Art International May 1, 1960, February–March 1976; Art News November 1952; Artforum March 1971; Arts Magazine May 1963, May 1977; College Art Journal Summer 1958; Magazine of Art May 1947; New York Times October 20, 1940, March 12, 1950; Tiger's Eye December 1947, June 1948; Time December 13, 1937.

FLAVIN, DAN (April 1, 1933–), the best-known American light sculptor, was born in Jamaica, New York, the older of fraternal twins. His family was Roman Catholic, and Flavin has described his father, Dan Sr., as "an ascetic, remotely male, Irish Catholic truant officer." His mother was of German descent. As a young boy he began drawing by himself. From 1947 to 1952 he attended the Saints Joachim and Anne Parochial School; he was then sent by his father to the High School Department of Cathedral College of the Immaculate Conception Preparatory Seminary in Douglastown, New York. Flavin recalled: "I continued to draw, to doodle somewhat privately in class, in the margins of my textbooks." In 1951, at the age of 18, he "began to think about art—a Roman Catholic version of it of course." He was especially fond of the solemn, high funeral mass.

Flavin entered the US Air Force Meteorological Technicians Training School in 1953 and served as an air weather service observer in South Korea in 1954–55. After his discharge from the Air Force he returned to New York City. He enrolled in 1956 at the New School for Social Research, and from 1957 to 1959 he studied at Columbia University, taking survey courses in art history and participating in Ralph Mayer's Tools and Materials program. A self-taught artist, he was by 1957 producing small drawings, watercolors, and paintings, and in that year he showed his work at a group art exhibit by the Roslyn Air Force Station in Roslyn, New York.

In February 1959 Flavin left Columbia to devote himself full-time to art. Like other young New York artists of the late 1950s, he regarded the work of Jackson Pollock as the terminal point of Western painting, but he was soon to react against what Thomas B. Hess has called "the poetics of of Abstract Expressionism." By 1960 he had a studio, which he has described as "a small, sunny railroad flat on Washington Street . . . on Manhattan's West Side below Fourteenth Street and near the Hudson River waterfront."

© R. L. Schulman; Courtesy Leo Castelli Gallery, NYC

DAN FLAVIN

In 1961 Flavin married Sonia Severdija. In the same year he had his first solo show, at the experimental Judson Gallery in downtown Manhattan which consisted of watercolors and constructions.

About this time Flavin and his wife rented a large loft in the Williamsburg section of Brooklyn, and the artist soon began to use artificial illumination in works that he called "icons." Some of these icons were painted, boxlike constructions with electric lights attached; others were flat surfaces framed in electric bulbs.

In 1963 Flavin first became aware of the artistic possibilities of fluorescent light. It was, in his words, "a buoyant art and insistent gaseous image which, through brilliance, somewhat betrayed its physical presence into approximate invisibility." Flavin may have seen in the easy availability of fluorescent light an analogy to the philosophy of the medieval English scholar William of Ockham, who taught that universal concepts were natural signs based on the similarity in things that men discover by experience. Rejecting the doctrines of St. Thomas Aquinas, Ockham argued that "reality exists only in individual things and that universals are merely abstract signs."

The first of these fluorescent works, *The Diagonal of May 25, 1963,* was a standard, eight-footlong tube that projected white light, as well as its own shadow, into the surrounding space. Flavin dedicated this piece to Constantin Brancusi, whose *Endless Column* he greatly admired. *The Nominal Three* (also 1963) was dedicated to William of Ockham, and consisted of three fluorescent units: a single tube, a double tube, and three tubes joined together. Flavin also experimented with environmental and optical concepts by placing a red neon tube vertically in the corner of a room; he wrote, "I realized that the actual space of a room could be dissipated and played with by careful, thorough composition of the illuminating equipment." He was aiming at a kind of dematerialization of the art object, substituting instead the junction of fields of light and shadow. In the fluorescent pieces he was, as he noted in *Artforum* (December 1965), "planting illusions of real light at crucial junctures in the room's composition," creating a setting of which the tubes were the focus. These pieces marked the point, as Edward Lucie-Smith has observed, "at which minimal art meets kinetic art."

Marcel Duchamp was among those who recognized the originality of Flavin's work, and it was on Duchamp's recommendation that he won the 1964 William and Noma Copley Foundation award in Chicago. Flavin's exhibit that year at the Green Gallery, New York City, included his *Monument 7 for V. Tatlin,* commemorating the great Russian Constructivist who dreamed of art as a science. Tubes of cool white fluorescent light were combined so as to convey, in Flavin's words, "a vibrantly aspiring order, in lieu of his [Tatlin's] last glider, which never left the ground."

In 1966 Flavin's work was included in the seminal group exhibition "Primary Structures," held at the Jewish Museum, New York City, and he also participated in a group show in Eindhoven, the Netherlands, titled "Art Light Art." That same year he received an award from the National Foundation of Arts and Humanities. Always an able and articulate exponent of his ideas, Flavin taught for a semester in 1967 as guest lecturer on design on the graduate faculty of the University of North Carolina at Greensboro. An important 1967 show at the Museum of Contemporary Art in Chicago enhanced his already considerable reputation.

Flavin's earlier fluorescent works were minimal in form, but later he began to compose in colored light, arranging his light sources to achieve color mixtures, reflections, and areas of varying intensity. Within this activity he could cross-refer to painting, in his shadings of tones and hues, and sculpture, in the volumes created by light and shadow in the gallery space. In a construction shown at the Dwan Gallery, New York City, in 1968, he created an interplay of pink, gold, and daylight fluorescence.

A Flavin retrospective at the National Gallery of Canada, Ottawa, in 1969 was followed in 1970 by another retrospective at New York's

Jewish Museum; the artist was just 36. The New York show received a mixed response from critics. The conservative John Canaday, writing in *The New York Times* (January 24, 1970), considered the exhibit a typical example of "art salesmanship." He remarked that although he "spent a long time examining Mr. Flavin's tubes," they did not grow on him. Canaday concluded: "As boutique decoration, acceptable although obvious . . . as works of art to be taken seriously—no go." Emily Genauer in *Newsday* (January 31, 1970) doubted whether "commercially available light bulbs arranged like dominoes or matchsticks" should be considered works of art. She advised visitors to the exhibition not to look at the bulbs themselves, because "it is the shaped pools of light they shed that are arresting and even mysteriously pleasing." Genauer felt that Flavin's work was essentially stage design, but that Flavin's concepts were "still too elementary to be taken very seriously except by kids (and kid curators)."

Other critics, however, have taken a more positive view of Flavin's work, and see him as a pioneer who uses light as a medium in order to transcend it. John Russell, for example, admires the skill with which Flavin can "involve the spectator in ways which neither conventional painting nor conventional sculpture has at its disposal."

Unlike the stark, impersonal approach of his friend, the Minimalist sculptor Donald Judd, Flavin often gives his pieces titles referring either to individuals he admires or to contemporary events. His last *Monument 7 for V. Tatlin* dates from 1969, and in 1970 he titled a red, green, and yellow fluorescent construction *To the Young Women and Men Murdered at Kent State.* To the "Art for McGovern" demonstration held in Houston in 1972, Flavin contributed a poster with the words "I BELIEVE HIM" superimposed on a stirring photograph of the liberal candidate for the presidency.

Reviewing Flavin's two-part exhibition at the John Weber Gallery, New York City, in 1971, David L. Shirey of *The New York Times* (October 30, 1971) wrote that in Flavin's investigations of "real" light he did not seem to have made much progress since his first New York exhibition in 1961. But Shirey added that "repetition does not necessarily invalidate the experimental or esthetic value of his investigations of light." In the winter of 1971, Flavin had a new show at the Leo Castelli Gallery in SoHo. In the London *Guardian* (December 3, 1971) Richard Roud noted: "Instead of a glaring strip, we get a diffused glow proceeding from the reflected light of the tubes—each of which are of a different color." Roud felt that "his attempts to achieve a new richness and complexity have only served to point out a certain poverty of spirit." Roud concluded that Minimalists should "stay minimal."

In 1973 Flavin was guest professor at the University of Bridgeport in Connecticut. Also that year he was represented in a group show of "Young American Artists" in Oslo, and in 1974 his work was seen in "Illuminations and Reflections" at the Whitney Museum of American Art, New York City.

Two big pieces in Flavin's 1977 exhibition at the Heiner Friedrich Gallery, New York City, attracted particular attention. Thomas B. Hess of *New York* magazine (February 14, 1977) described them as "two square grids of tutti-frutti radiance" confronting one another "from corners along a northeast–southwest axis." While this exhibition was on, Flavin was "going public" by adding a group of fluorescent installations to three railroad tracks in Grand Central Terminal. (He chose Grand Central because it was "a place that could use some help.") John Russell reported in *The New York Times* (October 28, 1977) that "on the tracks where Mr. Flavin has gone to work, a central stream of 'daylight white' runs in troika style with a stream of pink light (to the left) and gold light (to the right)." Russell observed that "these two well-chosen colors have intimations of luxury and high spirits that are not exactly an everyday experience at Grand Central." Flavin said of the work: "It shouldn't weigh heavily on the mind. . . . It's not something to pause over."

In 1980 Flavin was the third internationally known Minimalist to be given an exhibit at the Laguna Gloria Art Museum in Austin, Texas, following Carl Andre and Christo. Susan Platt in her review in *Art Week* (January 19, 1980) was of the opinion that Flavin's show was the weakest of the three. Flavin used ultraviolet light to mask the gallery walls. Platt observed: "Taken at face value as four installations of fluorescent works, this exhibit is a piece of history rather than a current statement about either Flavin or art. . . . In talking to Flavin I had the uncomfortable feeling that he didn't believe in himself anymore. He seemed to be doing what comes along, rather than consistently working with a coherent theoretical substructure to his activities." Flavin's most recent exhibit of light sculpture was held in the spring of 1984 at Leo Castelli's spacious gallery on Greene Street in SoHo.

Dan Flavin lives and works in Garrison-on-Hudson, New York, and in Bridgehampton, Long Island. He is a tall, heavyset man with

plump, cheerful features. His wife Sonia takes an active part in the installation of his exhibits. Their son, Stephen Conor, was born in 1964.

In Flavin's writings he is extremely outspoken in responding to hostile criticism, and he has also written articles attacking the prevailing system of art education in America. He once described one of his own works—an eight-foot strip of fluorescent light placed diagonally on the wall—as his "diagonal of personal ecstasy." According to the St. Louis Museum curator, Emily S. Rauh, Flavin has likened his work to the bardic tradition, "the presentation of a song and then its disappearance along with the creator." In a journal entry in 1962 Flavin wrote: "I can take the ordinary lamp out of use and into a magic that touches ancient mysteries. And yet it is still a lamp that burns to death like any other of its kind. In time the whole electrical system will pass into inactive history. My lamps will no longer be operative; but it must be remembered that they once gave light."

EXHIBITIONS INCLUDE: Judson Gal., NYC 1961; Kaymar Gal., and Green Gal., NYC 1964; Ohio State Univ., Columbus 1965; Gal. Rudolf Zwirner, Cologne 1966; Nicholas Wilder Gal., Los Angeles 1966; Kornblee Gal., NYC 1967; Gal. Sperone, Turin 1967, '68; Mus. of Contemporary Art, Chicago 1967–68; Gal. Heiner Friedrich, Munich 1968, '70, '71; Dwan Gal., NYC 1968, '70, '71; Nat. Gal. of Canada, Ottawa 1969; Jewish Mus., NYC 1970; Leo Castelli Gal., NYC from 1970; Ace Gal., Vancouver 1972; City Art Mus., St. Louis 1973; Kunsthalle, Cologne 1973–74; Fort Worth Art Mus., Texas 1975, '76; Heiner Friedrich Gal., NYC 1977; Laguna Gloria Art Mus., Austin 1980; Castelli Greene Street Gal., NYC 1984. GROUP EXHIBITIONS INCLUDE: "Art Exhibit by Men of Roslyn Air Force Station," Roslyn, N.Y. 1957; "New Work," Green Gal., NYC 1963, '64; "Black, White and Gray," Wadsworth Atheneum, Hartford, Conn. 1964; "Flavin/Judd/Morris/Williams," Green Gal., NYC 1965; "Primary Structures," Jewish Mus., NYC 1966; "Dan Flavin/Larry Zox," Kornblee Gal., NYC 1966; "Kunst Licht Kinst," Stedelijk van Abbemus., Eindhoven, Neth. 1966; "American Sculpture of the Sixties," Los Angeles County Mus. 1967; "Plus by Minus: Today's Half Century," Albright-Knox Art Gal., Buffalo, N.Y. 1968; "Minimal Art," Gemeentemus., The Hague, Neth. 1968; "Andre/Flavin/Judd/LeWitt/Morris," Pennsylvania State Univ., Univ. Park 1969; "New York Painting and Sculpture, 1940–1970," Metropolitan Mus. of Art, NYC 1969; "Spaces," MOMA, NYC 1970; Sixth Guggenheim International, Solomon R. Guggenheim Mus. NYC 1971; "Art and Technology," Los Angeles County Mus. 1971; "Diagrams and Drawings," Rijksmus. Kröller-Müller, Otterlo, Neth. 1972; "Art in Space: Some Turning Points," Inst. of the Arts, Detroit, Mich. 1973; "Illuminations and Reflections," Whitney Mus. of Am. Art, NYC 1974; "Light/Sculpture," William Hayes Ackland Memorial Art Center, Chapel Hill, N.C. 1975; "Minimalism to Expressionism: Painting

and Sculpture Since 1965," Whitney Mus. of Am. Art, NYC 1983.

COLLECTIONS INCLUDE: Pasadena Art Mus., Calif.; Nat. Gal. of Canada, Ottawa; Stedelijk Mus., Amsterdam; Whitney Mus. of Am. Art, NYC; Philip Johnson Collection, New Canaan, Conn.; Dr. Peter Ludwig Collection, Aachen, W. Ger.; Count Giuseppe Panza Di Buomo Collection, Milan.

ABOUT: Arnason, H.H. History of Modern Art, 1968; "Art and Technology" (cat.), Los Angeles County Mus., 1971; Battcock, G. (ed.) Minimal Art: A Critical Anthology, 1968; Calas, N. and E. Icons and Images of the Sixties, 1971; Lucie-Smith, E. Late Modern: The Visual Arts Since 1945, 1969; Muller, G. The New Avant-Garde: Issues for the Art of the Seventies, 1972; Russell, J. The Meanings of Modern Art, 1981; Wasserman, B. Modern Painting: The Movements, The Artists, and Their Work, 1970. *Periodicals*—Art and Artists March 1970; Art News January 1970, October 1971; Art News Annual vol. 35 1969; Arts Magazine September 1978; Art Week January 19, 1980; Christian Science Monitor February 14, 1970; New York February 14, 1977; New York Times November 24, 1968, January 24, 1970, October 30, 1971; Studio International (London) no. 915 1971, no. 949 1972.

FRANCIS, SAM(UEL LEWIS) (June 25, 1923–), American painter, is a leading second-generation Abstract Expressionist. Living in France in the early 1950s, he was an influence on the European *art informel* (art without form) movement.

Francis was born in San Mateo, California. His father was a professor of mathematics, his mother an accomplished pianist. In adolescence he was interested in music and literature, having little concern for the visual arts. He feels his art has been influenced more by writers than by other artists; his favorite authors are Herman Melville, William Blake, and Freidrich Hölderlin, and he also likes American poetry, beginning with the imagism of William Carlos Williams. As Peter Selz wrote in *Art in America*, "All this appears to add up to a taste for monumentality, lyricism, and a romantic-subjective concept of the self."

Francis's early interests included botany and medicine, which, along with psychology, he studied at the University of California, Berkeley, from 1941 to '43. In 1943 he enlisted in the US Army Air Corps as a fighter pilot. "Perhaps it was my training in the Service that taught me that nature has form and structure, [that] it makes sense," Francis said. "It is a structure that only seems to be formless, but underneath it is based on facts that act in a certain way." As a result of an injury sustained in a plane crash in

André Emmerich Gallery, NYC

SAM FRANCIS

1944, he contracted spinal tuberculosis. During painful months of recuperation, first in a Denver hospital, then in San Francisco, he took up painting, having been given a box of watercolors to relieve the boredom. (Henri Matisse had also begun to paint while bedridden and recovering from an illness.) Painting, Francis said, became for him "a way back to life." As James Johnson Sweeney observed in the catalog to a 1967 Francis retrospective at the Houston Museum of Fine Arts, "The world he knew from the flat of his back on his hospital cot was the play of light on the ceiling, the dawn sky and sunset sky effects over the Pacific, when his cot was wheeled out on the hospital balcony." Francis remarked that what interested him was "not just the play of light, but the substance of which light is made."

While Francis was in a Veterans Administration hospital in San Francisco, he received instruction from the expressionistic figure painter David Park, who taught at the avant-garde California School of Fine Arts, where Francis later studied. In 1946 one of Francis's first watercolors, probably a landscape, was included in the 66th Annual Exhibition of the San Francisco Art Association. Released from the hospital in 1947, he convalesced at the artists' colony in Carmel, California. In his early watercolors his subject was not so much the sky as the endlessness beyond it, glimpsed through a break in the clouds. His paintings soon lost any trace of representation, and in Carmel in 1947 he painted his first abstract picture.

By 1948 his health was restored and Francis returned to Berkeley, where he majored in the fine arts, earning the BA degree in 1949 and the

MA in '50. His earliest abstract paintings, beginning with *Untitled* (1947), were ambitious, showing the influence of older artists such as the Abstract Expressionists Clyfford Still, who also taught at the California School of Fine Arts, Arshile Gorky, and Mark Rothko, both of whom had exhibited at the San Francisco Museum of Art. The influence of the "automatic gesture" of abstract surrealism was also apparent. *Untitled (Pale Green)* of 1948 could easily pass for an early Rothko, but Francis's painting was softer and even less concerned with underlying form. By the end of 1948, while Rothko was still layering his atmospheric rectangles, Francis "had already begun to explore the expressive quality of running and dripping paint, independent of shape," to quote R. T. Buck Jr.'s essay in the catalog to the 1972–73 Francis retrospective at the Albright-Knox Art Gallery, Buffalo, New York.

Finding his own idiom, Francis achieved a major breakthrough in *Opposites* (1950), one of his last Berkeley paintings. In this eight-by-six-foot canvas the sparkling white gesso ground is covered with patches and stains of red pigment, reminiscent of red blood corpuscles. The large picture gave the impression of a fragment of continuous space. *Opposites* rivaled Still and Rothko in size and only Pollock and Barnett Newman in New York City were working on a larger scale at that time. But the decisive influence at this stage of Francis's development was Pollock's "dripped" canvases. "Although most of the second generation has chosen de Kooning as a model," Barbara Rose wrote in *American Art Since 1900*, "a few, like Helen Frankenthaler, Sam Francis, and Friedel Dzubas, rejected de Kooning's ties to Cubist space and composition, and were drawn to Pollock's open, loose painting."

Opposites exemplified the values of the new American painting, and Francis helped to introduce these concepts into Europe after his arrival in Paris in the summer of 1950. For a short time he studied at the Académie Fernand Léger, and not surprisingly Léger disliked his work. As if to compensate for this lack of sympathy, Francis established close friendships with the Canadian painter Jean-Paul Riopelle, an Expressive Abstractionist, and with young American artists living in Paris, including Al Held, Norman Bluhm, and Joan Mitchell. He also met Alberto Giacometti and the critics Pierre Schneider and Georges Duthuit, Matisse's son-in-law. Francis and his friends held forth in a café in the rue du Dragon. According to Dore Ashton in *American Art Since 1945*, Francis "startled his French colleagues with his huge canvases, figured with rounded biomorphic shapes that seemed to flow downward in a kind of organic metaphor. Fran-

cis's predilection for huge surfaces and his later tendency to open out the center of his work with dazzling white areas made a strong impact."

Francis spent the summers of 1951 and '52 in southern France, near Aix-en-Provence. In Paris he had responded to the subtler, muted but luminous colors of the Ile de France, but his stays near Aix, Cézanne's native city, caused him to use brighter, yet delicately rendered colors. He was included in a group exhibition at the Galerie du Dragon, Paris, in 1951. Georges Duthuit called the art favored by Francis, Riopelle, and their friends *abstrait chaud* (hot abstraction), as opposed to *abstrait froid* (cold abstraction), the geometric art then in vogue. The Francis/Riopelle group had no interest in Pablo Picasso, but Monet and Matisse were important to them.

Priscilla Colt pointed out that, far more than in the work of native French Abstract Expressionists like Georges Mathieu and Pierre Soulages, "Sam Francis's art assimilates to itself peculiarly French characteristics [such as] a sensuous lyrical colorism which ties it closely to the Watteau-to-Matisse tradition of French hedonism." Perhaps for this reason, Francis was appreciated in France long before his work was acclaimed in the US. Also, he was absent from the New York art scene in the early '50s, the years of abstract expressionism's much publicized triumph.

In 1952 Francis has his first solo exhibition of monochrome oils, some measuring ten feet in length, at the Galerie du Dragon, and he was included in the "Signifiants de l'informel" (Significant Informalists) exhibition (Studio Paul Facchetti) organized by the critic Michel Tapié. One of Francis's 1952 oils, *Deep Blue*, over eight feet high and nearly six feet wide, was purchased by Georges Duthuit and his wife; Madame Henri Matisse also acquired an early Paris painting. Some of Francis's oil canvases have been described as resembling Cézanne and Monet landscapes cleared of objective natural forms and leaving only the dazzling colors. Francis himself has said, "I make the late Monet pure."

During a visit to the Venice Biennale of 1952, Francis discovered Byzantine art, whose successful handling of the essence of light and space he admired. In 1953, after three years of virtual monochrome, he returned to the use of brilliant color, as in *Big Red* (1953), a ten-by-six-foot canvas which was acquired in 1955 by the Museum of Modern Art, New York City, along with *Black in Red* (1953). These were the first Francis paintings to enter a public collection. In 1953 he was included in the "Un Art autre" exhibition at Paris's Studio Paul Facchetti. Michel Tapié, the show's organizer, identified the emergence of a new "informal" art which came to be called tachism, the European version of abstract expressionism.

In 1954 Francis traveled to California, returning to Paris via New York City. The following year he received his first museum exhibition when seven of his paintings were included in the "Tendances Actuelles" (Current Tendencies) show in the Kunsthalle, Bern. His 1955 solo exhibition at the Galerie Rive Droite, Paris, was described by Pierre Schneider in *Art News* (Summer 1955) as "probably the most stimulating show in Paris at present." His renown was certified by the previously mentioned MOMA purchases and by the acquisition in 1955 by the Guggenheim Museum, New York City, of *Red and Black* (1954), a canvas whose tufts of color had a mosaic effect inspired by his interest in Byzantine art.

After spending the summer of 1956 at Paradou in southern France, and, in his words, "resting in the light of the Midi," Francis began work on triptych mural panels for the Basel Kunsthalle. "[Painting the mural] is like filling great sails dipped in color," he commented. The three panels of this enormous project, completed in 1958, were separated in the 1960s. One was acquired by the Pasadena Museum, California, another was destroyed in shipment, and a third is in the Stedelijk Museum, Amsterdam. In these panels large areas of white ground were opened up, leaving the lower part of the composition free of color and comparatively weightless. Earlier in 1956, at the Martha Jackson Gallery, Francis had his first New York City exhibition. Parker Tyler, reviewing the show in *Art News* (February 1956), wrote that Francis's texture paintings, when "scaled up to mural dimensions," issued an aesthetic challenge comparable to "Rothko's stratified color panels." He described Francis's style as "a kind of gargantuan Pointillism." Twelve of Francis's oils were included in the group show "Twelve Americans," held in 1956 at MOMA.

From January to November 1957 Francis traveled around the world, with long stop-overs in New York City, Mexico, and Japan. In Japan he was commissioned to execute a mural for the Sogetsu School, Tokyo, run by the sculptor and flower arranger Sofu Teshigahara. As Sherman Lee wrote, "Sam Francis's works are much admired in Japan, and with good reason, for they had much in common with the 'flung ink' (*haboku*) landscapes of the revered 15th-century master Sesshu." Francis's feeling for the contemplative in Oriental art, as well as his gestural manner of paint application, made him increasingly receptive to Japanese calligraphic and dec-

orative traditions. After returning to Paris he began to paint under a pronounced influence from Oriental art, a trend culminating in *The Whiteness of the Whale* (1957; Albright-Knox Art Gallery). That painting was one of a group that alluded to Melville's *Moby Dick*. It presented, in the words of R. T. Buck Jr., "a unique archipelago of pigments in a white sea. . . . It is as if the artist were trying to release the painting into the air [and achieve an effect of] soaring in space." For Melville, white had represented "the heartless voids and immensities of the universe," as Buck pointed out.

In 1959, after recuperating in San Mateo from an operation, Francis spent six months in New York City working on a 34-foot-wide mural for a Park Avenue branch of the Chase Manhattan Bank. In Paris in 1960, fascinated with the color blue, he began his "Blue Balls" series, on which he worked for two years. In these paintings blue circles and ovoids float or swirl like balloons toward the edges of the canvas, leaving most of the center a clear white expanse. He described his method as a "controlled accident."

In 1961, while hospitalized in Bern for tuberculosis of the kidney, Francis worked extensively in watercolor. Late in the year he returned to the US to convalesce in Santa Barbara, California. In 1962 he settled in Santa Monica, where he later bought a house once owned by Charlie Chaplin. Meanwhile, from 1960 to '63, he worked at lithography and in 1962 won a prize at the International Biennial Exhibition of Prints, Tokyo. He made another group of lithographs in 1963 at the Tamarind Lithography Workshop in Los Angeles.

Returning to Japan in 1964, Francis made his first sculptures, four blue and white ceramic wall pieces. In 1965, also in Japan, he worked on a large standing ceramic sculpture. G. S. Whittet wrote in *Studio International* that although Francis had spent much time in Japan, "restlessness rather than the quiet contemplative spirit of the Orient is the keynote: he is in fact taking something to the East rather than away from it."

By the mid 1960s Francis's interest in the suggestion of a void on the canvas culminated in a series of large acrylic paintings, many of them untitled, in which narrow streams of color and the picture edges defined an immense white form. Francis called these canvases "sail paintings," remarking that he has always been interested in the suction effect of wind. These paintings, along with the color-field canvases of his contemporaries, are considered forerunners of minimal art.

A major retrospective of Francis's work was held at the Houston Museum of Fine Arts in 1967, and the following year there were important exhibitions in Tokyo, Basel, Amsterdam, and Paris. While in Tokyo in 1968 he published in a Japanese periodical an article on Bonnard which is considered a revealing commentary on his own painting.

Francis continued the counterplay of a vast white center and configurations of color at the edges in his mural commissioned in 1969 for the National Gallery of Art, Berlin, a building designed by Mies van der Rohe. The 26-by-40-foot painting was installed in the fall of 1971.

Reviewing a 1970 exhibition of five large Francis paintings at the Los Angeles County Museum of Art, Peter Plagens in *Artforum* (February 1970) propounded two possible judgments: "1) Francis is getting designy, product-oriented, and predictable within his own mannerism, or 2) Francis is making it tough again, reducing and reexamining his tools." Plagens opted for the second interpretation, but in *The Dictionary of Painters, Sculptors and Engravers* (1976) Jacques Busse noted that Francis's painting has been considered "a comfortable art, more concerned with gustatory pleasure (like *haute cuisine*) than spiritual risks." In *Late Modern* Edward Lucie-Smith argued that abstract expressionism had not traveled well outside of America. For example, Francis "as a Paris-domiciled American, introduces the European element of 'taste,' which immediately compromises the rigour of the style." Francis's work is greatly admired in Japan.

Sam Francis is married to the former Mako Idemitsu; they have a son, Osamu. The artist lives and works mainly in Santa Monica, while maintaining studios in Venice Beach, California, Paris, Bern, and Tokyo. His studios are usually huge warehouses and hangars, which he sometimes makes available to other artists. He is of medium height and rather plump; his once blondish hair is now white. His tubercular condition is cured, and in his 50s Francis continued to be energetic and productive. He summed up his approach to painting, declaring, "Everything that grows out of emotion is all right. . . . "

EXHIBITIONS INCLUDE: Gal. du Dragon, Paris 1952; Gal. Rive Droite, Paris 1955, '56; Martha Jackson Gal., NYC 1956–59; Klipstein and Kornfeld, Bern from 1957; Kunsthalle, Bern 1960; Moderna Mus., Stockholm 1960; Kestner-Gesellschaft, Hanover, W. Ger. 1963; Mus. of Fine Arts, Houston 1967; Univ. Art Mus., Berkeley, Calif. 1967; Centre National d'Art Contemporain, Paris 1968; Pierre Matisse Gal., NYC 1968; Stedelijk Mus., Amsterdam 1968; André Emmerich Gal., NYC 1969, '71, '83; Felix Landau Gal., Los Angeles 1969–70; Los Angeles County Mus. of Art 1970; "Paintings 1947–1972," Albright-Knox Art Gal., Buf-

falo, N.Y. 1972–73. GROUP EXHIBITIONS INCLUDE: Salon
de Mai, Paris 1950; Gal. du Dragon, Paris 1951;
"Signifiants de l'informel," Studio Paul Facchetti, Par-
is 1952; "Un Art autre," Studio Paul Facchetti, Paris
1953; Pittsburgh Intl. 1955; "Tendances actuelles,"
Kunsthalle, Bern 1955; "12 Americans," MOMA, NYC
1956; "New American Painting," Intl. Circulating Ex-
hibition, MOMA, NYC 1958–59; São Paulo Bienal
1959; Documenta 2 and 3, Kassel, W. Ger. 1959, '64;
"American Abstract Expressionists and Imagists," Solo-
mon R. Guggenheim Mus., NYC 1961; "Vanguard
American Painting," Intl. Biennial Exhibition of
Prints, Tokyo 1962; "Aspects of Postwar Painting in
America," Solomon R. Guggenheim Mus., NYC 1976.

COLLECTIONS INCLUDE: MOMA, and Solomon R. Gug-
genheim Mus., NYC; Albright-Knox Art Gal., Buffalo,
N.Y.; Nat. Gal. of Art, Phillips Collection, and Joseph
H. Hirshhorn Mus. and Sculpture Garden, Washing-
ton, D.C.; Yale Univ. Art Gal., New Haven, Conn.;
Mus. of Art, Carnegie Inst., Pittsburgh; Nelson Gal.,
and Atkins Mus., Kansas City, Mo.; Fort Worth Art
Center Mus., Tex.; Dallas Mus. of Fine Arts, Tex.; San
Francisco Mus. of Art; Santa Barbara Mus. of Art,
Calif.; Los Angeles County Mus. of Art; Seattle Mus.
of Art; Art Gal. of Ontario, Toronto; Montreal Mus. of
Fine Arts, Montreal; Tate Gal., London; Mus. d'Art
Moderne, Paris; Kestner-Gesellschaft, Hanover, W.
Ger.; Nationalgal., W. Berlin; Offentliche Kunstsam-
mlung, Basel; Stedelijk Mus., Amsterdam; Moderna
Mus., Stockholm; Nat. Mus. of Western Art, Tokyo;
Idemitsu Art Gal., Tokyo; Ohara Mus., Okayama, Ja-
pan.

ABOUT: Ashton, D. American Art Since 1945, 1982;
Buck, R. T., Jr. and others "Sam Francis: Paintings
1947–1972" (cat.), Albright-Knox Art Gal., Buffalo,
N.Y., 1972; Lucie-Smith, E. Late Modern: The Visual
Arts Since 1945, 1969; Lee Nordness (ed.) Art USA
Now, 1963; Rose, B. American Art Since 1900, 2d ed.
1975; Schneider, P. Louvre Dialogues, 1971.
Periodicals—Art in America March 1968; Art Journal
Fall 1962; Art News Summer 1955, February 1956,
April 1967, Summer 1971; Artforum February 1970;
Arts January 1959; Quadrum 10 (Brussels) 1961; Stu-
dio International August 1965; Time January 16, 1956,
November 13, 1972.

***FRANKENTHALER, HELEN** (December
12, 1928–), American painter, was a leading
Abstract Expressionist of the second generation.
The stained canvas method of painting she de-
veloped in 1952 looked forward to the color-
field painting of the 1960s.

She was born in New York City, the third and
youngest daughter of Alfred Frankenthaler, a
noted justice of the New York Supreme Court,
and the German-born Martha (Lowenstein)
Frankenthaler. She described herself as having
been "a willful child," but her father thought she
"was special." Reared in New York City, Helen

°fran´ kən thä la

The Reiter-Dulberg Labs, Inc., NYC

HELEN FRANKENTHALER

attended the exclusive Brearley School, Manhat-
tan, and "prepped" for college at the Dalton
School, also in Manhattan, from which she grad-
uated in 1945. While at Dalton she became fa-
miliar with the museums, art galleries, and
exhibitions of contemporary art in New York.

Frankenthaler's art teacher at Dalton was the
celebrated Mexican painter Rufino Tamayo,
who recommended that she study painting at
Bennington College, Vermont. There her in-
structor was Paul Feeley, an academic Cubist
(Frankenthaler described one of her early paint-
ings, Woman on a Horse, as being "out of a bad
period of Picasso"). At Bennington she also
showed literary talent, serving as editor of the
college newspaper before graduating in 1949.

Returning to New York City, Frankenthaler
found that there was "something explosive" go-
ing on in the art world. Arshile Gorky, who had
died in 1948, was much admired and Jackson
Pollock was becoming famous for his "dripped"
painting technique. Moreover, enthusiasm for
Mondrian, Miró, and Matisse now prevailed.

In her early days as a New York artist
Frankenthaler shared a Greenwich Village stu-
dio and its rent with Friedel Dzubas, whom she
had met at the home of the critic Clement Gr-
eenberg. Her circle of friends included the
young painters Robert Goodnough, Larry Riv-
ers, Grace Hartigan, and Joan Mitchell, all of
whom became leading second-generation Ab-
stract Expressionists. Exposed to the emerging
New York painting styles, Frankenthaler shed
the conventional cubism she had been schooled
in by Feeley. She briefly studied with the semi-
abstract painter Vaclav Vytlacil at New York

City's Art Students League and with Hans Hofmann at his School of Fine Art, Provincetown, Massachusetts, in the summer of 1950.

At the beginning of the decade Frankenthaler's work already showed the influence of the thin curvaceous lines and ambiguously biomorphic shapes of Gorky, but her colors were paler, dreamier, more delicate. Later she went directly to Gorky's own sources of influence, Kandinsky and Miró. From Kandinsky's earlier lyrical abstractions she learned that pictures could be "improvisations" rather than carefully planned constructions. Miró's witty and imaginative vision made her realize that a picture need not be "serious," and a Pollock exhibition at the Betty Parsons Gallery, New York City, in the fall of 1950 was a revelation to her. Pollock's vigorous technique, with complicated abstract linear rhythms "dripped" onto enormous canvases laid on the floor, represented a revolutionary break with the tradition of easel painting. She admired the way Pollock managed, in her words, to "learn it all, but throw it out," and to create "a limitless but still censorable 'sketch'" on a vast scale. In 1951 she was stunned by Pollock's black-and-white drawings and, later, visited his studio, where she was influenced by his method of dripping thinned oil paint.

Frankenthaler's paintings had first been exhibited in New York City in 1950, in a Bennington College show at the Seligman Gallery. In 1951 she was included by the artist Adolph Gottlieb in a "New Talent" show at the Kootz Gallery, New York City. Also that year, she took part in the annual Ninth Street Show, mounted in Greenwich Village by vanguard New York artists, and her first solo exhibition was held at the avant-garde Tibor de Nagy Gallery, New York City. Her exhibited paintings showed that her ties to cubist space had been loosened and that she was introducing biomorphic shapes in the manner of Miró and Gorky.

Frankenthaler had thus far painted on primed small-sized canvases, but about 1952, the year of her breakthrough, she adopted the idea of the large, "open" canvas. Influenced by Pollock's gestural painting and all-over use of color, she adapted his methods and materials in a manner which revealed her talent as a colorist. "Unlike Pollock," she said, "I didn't feel like using a stick, dripping enamel, but I liked his idea of rolling out unsized, unprimed cotton duck on the floor." Her experiments with oil paint thinned to a watery pigment and poured onto unprimed canvas led to an important new technique, the soak-stain, achieved by allowing the color to soak into the weave of the canvas. By this saturation method she eliminated brushwork and paint texture, and made a new kind of color painting possible. As Barbara Rose said in *American Art Since 1900,* " . . . Frankenthaler's gifts as an original colorist and her lyric sensibility equipped her to achieve a unique interpretation of Pollock's methods. With her, the conflict between painting and drawing that had plagued too many Abstract Expressionists did not exist because she chose to draw in paint." Frankenthaler was still an action painter, but her work was part of the trend toward lyrical abstraction. She stressed the expressive power of color, and her expansive, fieldlike canvases conveyed feelings of softness, openness, and luminosity.

After spending the summer of 1952 painting and sketching landscapes in Nova Scotia, Frankenthaler produced her masterpiece, *Mountains and Sea,* a large, lyrical abstraction stain-painted directly onto raw canvas. Its fragile blues and pinks and soft greens subtly suggested a landscape, but its seeming lack of structure and the thinness of the soaked paint made the work seem pallid, tenuous, and empty to many who first saw it. However, two little-known artists from Washington, D.C., Morris Louis and Kenneth Noland, visiting Frankenthaler's studio in 1953, were profoundly influenced by *Mountains and Sea.* They had found Pollock's vision too personal to guide them and his method impossible to advance, but, as Noland recalled, "Frankenthaler showed us a way to think about, and use, color." Louis felt that Frankenthaler, with her new articulation of color-space, "was a bridge between Pollock and what was possible." They returned to Washington and adopted the technique of staining paint onto the raw fabric of the canvas, attempting to achieve a pure fusion of form and manner and the maximum "opticality." This marked the beginning of the style Clement Greenberg called post-painterly abstraction. *Mountains and Sea* now hangs in the National Gallery of Art, Washington, D.C., on long-term loan from Frankenthaler.

Reviewing Frankenthaler's seven solo exhibits at the Tibor de Nagy Gallery between 1951 and '58, critics praised her willingness to treat each canvas as an entity in itself. She explored various possibilities in her painting, including the comparatively heavily impastoed textures of her canvases of 1954–55. These more pigmented works recalled the gestural brushwork of Willem de Kooning, even though they were stained canvases; indeed, not until a 1959 exhibition of Morris Louis paintings were flatter canvases than Frankenthaler's produced. Among the most acclaimed Frankenthaler paintings of this period are the dramatic *Trojan Gates* (1956; Museum of Modern Art, New York City) and *Blue Territory*

(Whitney Museum of American Art). In 1956 she designed two 13-foot tapestries for the Temple of Aaron, a synagogue in St. Paul, Minnesota.

Frankenthaler married the leading Abstract Expressionist painter Robert Motherwell in April 1958. Their honeymoon was spent traveling in France and Spain. On returning to their New York City brownstone on East 94th Street, the couple set about creating a "Madrid image," which resulted in chalk-white walls, Mediterranean-blue ceilings, tiled floors, and natural-wood doors.

In addition to participating in group shows Frankenthaler won a first prize in the 1959 Paris Biennale for her painting *Jacob's Ladder,* and a 1960 solo exhibition at the Jewish Museum, New York City, covered her work from the early '50s on. In the May 1960 issue of *Art News* James Schuyler praised Frankenthaler's "special courage . . . in going against the think-tough and paint-tough grain of New York School abstract painting. Often pale (not weak), soaked-in (only sometimes), quickly dwelt upon—she . . . chanced beauty in the simplest and most forthright way."

During the 1960s Frankenthaler's painting underwent radical changes. She simplified her abstract imagery and gave her work a more obviously formal structure. In 1963 she began to use acrylic paints, which resulted at first in a hardening of the edges of her forms and the disappearance of what has been called the "residual turpentine-halo" of her earlier work. The ambiguous space and fragile color of her canvases of the '50s evolved into more consciously designed shapes, frequently painted in opaque hues. *Small's Paradise* (1964; Smithsonian Institution, Washington, D.C.) was part of a series painted in the early '60s displaying her interest in symmetry and geometry within a square format.

In 1964 Frankenthaler took part in a Tate Gallery, London, show of American painters and sculptors, and she and Motherwell were among the four artists chosen to represent the United States at the Venice Biennale of 1966. Beginning with *Five Color Space* (1966), Frankenthaler explored pictorial tensions by pushing her shapes to the very edges of the canvas. Yet even in such abstract works as *Mauve District* (1966), *Indian Summer* (1967; Hirshhorn Museum and Sculpture Garden, Washington, D.C.), *Yellow Canon* (1968), and *Sky* (1970) landscapes continued to be her "essential catalysts of feeling," to quote Irving Sandler. A Frankenthaler retrospective was held at the Whitney Museum in 1969, followed by a European tour sponsored by the International Council of MOMA. Her paintings of the 1970s were complex, poetic, and radiant.

Frankenthaler often works with her canvas on the floor, à la Pollock, using housepainter's brushes, sponges, or "various things at the end of a pole," to quote her. She may later move a picture to the wall and change its position back and forth, watching it develop from different sides. In this respect she maintains the tradition of action painting. As Paul Richard wrote in *The Washington Post* at the time of her exhibition at the Corcoran Gallery of Art, Washington, D.C., "Because her method is intuitive, her pictures flirt with failure. . . . The blobs of color she presents are large enough to read as fields, but their surfaces aren't flat. The color seems to move, to billow. Her outlines grow from inside out."

Reviewing Frankenthaler's show at the André Emmerich Gallery, New York City, in December 1977, the *Newsweek* critic said: "Many of her pictures now seem too accommodating— they announce out loud their subtlety and lyricism. . . . Frankenthaler's lovely pictures may float a little too comfortably on the wall." In *The New York Times* (December 2, 1977) Hilton Kramer declared that Frankenthaler "had remained consistently the best" of the second-generation abstract New York School painters. He continued: "There may be times when one feels that she has not put enough into a particular picture, but even where visual incident is reduced to a minimum in her painting, there is a quality—a mode of lyricism and eloquence— that is very much her own." Kramer particularly admired "the pictures painted in somber earth colors," including *Selene,* with its "earthy densities of shadow occupying all but the border of light and the top of the picture." He also discerned in the abstract equivalents of sky and horizon "the essential 'landscape' that seems always to be at the heart of these paintings."

Helen Frankenthaler's marriage to Robert Motherwell ended in divorce in 1970. She lives in an apartment on Manhattan's Upper East Side. *Toward a New Climate,* a film about Frankenthaler, was produced in 1978. Paul Richard described her at 46 as "beautiful . . . and intimidating," with huge brown eyes, dark brown hair, and a regal posture. "Her movements, like her pictures, convey simultaneously a sense of fluid flow and extraordinary tension." Reserved, she is "almost impossible to interview." She dislikes what she calls "gossip about the personality of the artist," and Richard noted that when asked about her art, her answers, preceded by long pauses, seemed "intentionally bland." But in *Art News* (November 1977) Frankenthaler recalled her early admiration for Pollock and reaffirmed her commitment to "ambiguous space that's both

smack on the surface (the surface of a picture is, after all, flat!) and yet travels miles in space. . . . Color can be beautiful in terms of how it works in space; how it moves, yet remains in place. If color doesn't move in space (drawn in space), it is only decoration."

EXHIBITIONS INCLUDE: Tibor de Nagy Gal., NYC 1951–58; André Emmerich Gal., NYC from 1959; Jewish Mus., NYC 1960; Gal. Lawrence, Paris 1961, '63; Bennington Col., Vt. 1962; Kasmin Gal., London 1964; Whitney Mus. of Am. Art, NYC 1969; Waddington Gals. II, London 1973, '74; Metropolitan Mus. of Art, NYC 1973; "Helen Frankenthaler: Paintings 1969–1974," Corcoran Gal. of Art, Washington, D.C. 1975; GROUP EXHIBITIONS INCLUDE: "Bennington College Alumni Paintings," Jacques Seligmann and Co., NYC 1950; "Fifteen Unknowns," Kootz Gal., NYC 1950, "New Talent," '51; "U.S. Painting: Some Recent Directions," Stable Gal., NYC 1955; Pittsburgh International 1955–64; "Artists of the New York School: Second Generation," Jewish Mus., NYC 1957; "Young America 1957: 30 American Painters and Sculptors under 35," Whitney Mus. of Am. Art, NYC 1957; Documenta 2, Kassel, W. Ger. 1959; São Paulo Bienal 1959; Biennale de Paris, Mus. d'Art Moderne, Paris 1959; "Post-Painterly Abstraction," Los Angeles County Mus. of Art 1964; Tate Gal., London 1964; Venice Biennale, U.S. Pavilion 1966; Expo '67, Montreal 1969; Pennsylvania Academy Annual, Philadelphia 1968; "New York Painting and Sculpture: 1940–1970," Metropolitan Mus. of Art, NYC 1969–1970; "L'Art vivant aux Etats-Unis," Fondation Maeght, Paris 1970; "Abstract Painting in the 70's" Boston Mus. of Fine Arts 1972; "The Great Decade of American Abstraction: Modernist Art 1960–70," Mus. of Fine Arts, Houston 1974; "American Abstract Art Since 1945," Whitney Mus. of Am. Art, NYC 1975; "Color as Language," Intl. Circulating Exhibition, MOMA, NYC 1975; "Color as Language," Intl. Circulating Exhibition, Mus. de Bellas Artes, Caracas, Venezuela ca. 1975; "Aspects of Postwar Painting in America," Solomon R. Guggenheim Mus., NYC 1976.

COLLECTIONS INCLUDE: Metropolitan Mus. of Art, MOMA, and Whitney Mus. of Am. Art, NYC; Brooklyn Mus., N.Y.; Newark Mus., N.J.; Albright-Knox Art Gal., Buffalo, N.Y.; Chicago Art Inst.; Detroit Inst. of Arts; Wadsworth Atheneum, Hartford, Conn.; Yale Univ. Art Gal., New Haven, Conn.; Walker Art Center, Minneapolis, Minn.; City Art Mus., St. Louis, Mo.; Hirshhorn Mus. and Sculpture Garden, Washington, D.C.; Carnegie Inst., Pittsburgh; Cleveland Mus. of Art; Baltimore Mus. of Art; San Francisco Mus. of Art; Academy of Fine Arts, Honolulu; Victoria and Albert Mus., London; Wallraf-Richartz Mus., Cologne; Australian Nat. Gal., Canberra; Nat. Gal. of Victoria, Melbourne; City of Auckland Art Gal., New Zealand; Israel Mus., Jerusalem; Tokyo Mus.

ABOUT: Cheney, S. The Story of Modern Art, 1958; Goossen, E. C. "Helen Frankenthaler" (cat.), Whitney Mus. of Am. Art, NYC, 1969; Hunter, S. American Art of the 20th Century, 1972; Prown, J. D. and others

American Painting, 1969; Rose, B. American Art Since 1900, 2d ed. 1975; Sandler, I. The New York School, 1978; "Young America 1957: Thirty American Painters and Sculptors under Thirty-Five" (cat.), Whitney Mus. of Am. Art, NYC, 1957. *Periodicals*—Art International October 1961; Art News November 1955, May 1960, November 1971, November 1977; Artforum October 1965; Arts November 1971; Life May 13, 1957; Mademoiselle August 1969; New York February 17, 1969; New York Times December 2, 1977; Newsweek December 5, 1977; Studio International August 1965; Time May 2, 1960; Washington Post April 19, 1975.

***FREUD, LUCIAN** (December 8, 1922–), German-British painter, noted for his disturbing vision of humanity, is the grandson of Sigmund Freud. His father, Ernst, an architect, was Freud's younger son; his mother Lucie has been the subject of many of her son's paintings. There was an older brother, Stephen, and a younger brother, Clement, who became a noted British television personality. The family was well-to-do, and Lucian was born and grew up in Berlin, with summers spent in Potsdam. At school, as the Nazis gained influence after 1929, he was both fascinated and alarmed by the games of his schoolmates as they mimicked their elders and scribbled ominous symbols on walls. He also saw the taunting of Jews by street gangs, and this instilled in him permanent fears, hostilities, and obsessions.

In 1932, when he was nearly ten, his family moved to safety in England. Instead of adapting to his new surroundings, Lucian fiercely guarded his independence and resisted "normal" education. He was constantly in and out of schools, but showed an interest in drawing. He roamed the streets of London studying faces, the kind he would one day paint. At 17 his first drawing, a self-portrait, was published in *Horizon,* Cyril Connolly's literary magazine. In 1941, with Britain at war, he smuggled aboard a merchant ship. For five months he was on convoy duty and drew endlessly; on leaving the Merchant Navy he decided to work full-time as an artist.

In 1942 Freud studied briefly at the Central School of Arts and Crafts, London, and took classes in sculpture. He studied drawing part-time at Goldsmith's College, London, in 1942–43, and painting at the East Anglia School, but was basically self-taught. In his drawings of the early '40s there was a stylized distortion of the figure and at times a satiric edge reminiscent of Georg Grosz. He also tended to give a full frontal treatment to the face. Freud's focus thus far had been on graphics, but in 1945 he began to work seriously in oils. One of his first important paint-

°froid, lōō′ sē ən

Photo courtesy Anthony d'Offay Gallery, London; Photo by Rose Boyt

LUCIAN FREUD

ings was *Woman with a Daffodil* (1945), described by John Gruen in *Art News* as "a somber and arresting portrait, charged with the tension and psychological penetration that would find even fuller and more cohesive expression in the years to come."

Since 1945 Lucian Freud has been a close friend of Francis Bacon. Freud, an admitted "loner," said, "If I *have* a best friend it must be Francis. . . . He is very gregarious, and can do things I could never do. . . . He is a less private person." Among Freud's outstanding paintings is the small, compelling portrait of Bacon he painted on copper in 1952. Freud's work in the late '40s and early '50s, like that of Bacon, Sutherland and, to some degree, Henry Moore, reflected the tensions and anxieties of the immediate postwar period, but Freud never belonged to any movement. His closest affinities in those years were to the Neue Sachlichkeit artists of Berlin in the 1920s, Otto Dix and Georg Grosz. There was also something of the neurotic intensity of the Austrian Egon Schiele. Freud's style combined primitivism with the sharp focus and sense of psychological malaise of the Surrealists, but without their fantastic imagery. In *Father and Daughter,* an oil of 1949, the figures are frontally posed and have the fixed, anxious stare of so many of his subjects. A major canvas in this vein is *Interior in Paddington* (1951; Walker Art Gallery, Liverpool), exhibited in the Festival of Britain competition. A tense, bespectacled young man with tousled hair, tieless, in a crumpled overcoat, stands in a bleak, anonymous middle-class London room overlooking a quiet street. He holds a cigarette in his left hand, his

right hand is clenched, and his back is to the wall. His fixed stare is not aimed at the spectator, but is "directed by some inner anxiety," As Terry Measham wrote in *The Moderns 1950–1975* (1976). As in other works by Freud, plant forms are used as "emotional key-signatures," according to Measham. Here the tall, spiky, palmlike plant in a large pot in the right foreground has a predatory aspect. The entire picture conveys, under a banal surface, a feeling of latent disturbance, even menace, that is Pinteresque, though Freud's paintings preceded Harold Pinter's plays.

In the 1950s Freud made numerous trips to Paris and traveled in Greece. In his etching *Ill in Paris,* the prickly leaf of a rose extends threateningly over the head of a sick woman whose eyes are feverishly dilated. A similar theme is handled on a larger scale in his oil, *Hotel Room* (1953–54; Beaverbrook Art Gallery, New Brunswick, Canada). A somber young artist stands silhouetted against the window as a gaunt women lies in bed in the foreground. Here again the scene is depicted with meticulous but selective detail.

In his paintings of the 1960s and later, the brushwork, no longer concealed, served to model faces and bodies in a more sculptural manner. His admiration for Bacon's paintings was partly responsible for this change. Several portraits of naked girls painted in the '60s recalled Bacon, but without the stark Gothic terror. Yet, as John Gruen pointed out, "the poses and general ambiance have that fearful 'something' that gives Freud's oeuvre its intimation of emotional disarrangement and paralysis." This disquieting mood prevails even in his still lifes, which include *Buttercups* and *Interior with Plant,* both of 1968.

In 1974 Freud was given a retrospective exhibition at the Hayward Gallery, London. In April 1978 Freud, aged 55, had his first show in America, at the Davis and Long Gallery, New York City, but critical reception was mixed. Both Hilton Kramer in *The New York Times* and John Ashbery in *New York* magazine felt that Freud's painting did not travel well. Ashbery noted that, although his portraiture seemed to take a rather bleak view of humanity, his art was "both less disturbing and less glamorous than any association with the name Freud might conjure up." Whereas a picture of a naked youth on a couch holding a net uncomfortably close to his genitalia was vaguely disturbing, another painting, *The Big Man,* of a portly middle-aged executive in a three-piece suit sitting rigidly in a chair, was "almost a send-up of the corporate academic portrait," to quote Ashbery. The one landscape

in the show was *Adventure Playground,* a junk-filled backyard painted with careful, precise objectivity. "Seldom have so much sensitivity, tact and skill been used to such negative ends," Ashbery concluded.

Of the show's several portraits of the artist's aged mother reading or resting on a bed in an awkward position, Hilton Kramer remarked that what distinguished them was the way the clothes were painted. "When it comes to the painting of human flesh, Mr. Freud has a rather coarse, dry touch from which all the 'juice' of visual delicacy seems to have been drained." Kramer felt that Freud had discovered the pleasures of "painterly" painting too late—and it was true that some of the artist's early works—especially *Father and Daughter*—in the show, painted in the cool precisionist style of Otto Dix, had an intensity and hypnotic power lacking in more recent canvases. There were also remarkable drawings from the early '40s which Kramer thought were uncannily reminiscent of the work of David Hockney; other works from that period recalled the taut, nervous linearity of Egon Schiele. But Kramer considered Freud's work on the whole "a special taste."

Lucian Freud has been married twice: to Kathleen "Kitty" Garman, the daughter of the sculptor Sir Jacob Epstein, from 1948 to '52, and to Lady Caroline Maureen Blackwood, from 1953 to '57. When interviewed by John Gruen, Freud remarked that he had "several children strewn about" whom he visited from time to time. The artist lives and works in isolation, keeping contact with others at a minimum. "Usually, I pick up my mother and see her or paint her. In the afternoons I wander about. I like walking the streets. I call people from street phones. I see very few people actually." He maintains various London addresses, including a studio consisting of two small rooms in a remote section of the city. Freud told Gruen that one room served as his daytime studio and the other was used exclusively for nighttime painting. Freud needs very little sleep and often paints "long into the night." "The people who pose for me at night are encouraged to fall asleep, because I like painting the sleeping figure." Each room contains a small bed, an easel, a painting table, and a couple of chairs. Freud keeps his whereabouts a secret—he has no telephone and can be reached only by telegram, to which he will respond when it suits him.

Gruen described Freud as a "slim, rather unkempt figure [with] the crumpled look of someone who had gone without sleep for days." The extraordinary face is "a composite of the poetic features of Jean-Louis Barrault and Baudelaire,"

and the restless, intelligent eyes are "a watery blue green." Freud remembers his grandfather as "a gentle man, very good to us," but has read few of his forebear's works other than *Studies in Hysteria,* which he liked. "I've never been psychoanalyzed myself," Lucian said. "I'm very wary of it."

In a 1956 issue of *Encounter,* the British literary periodical, Freud wrote: "A painter's tastes must grow out of what so obsesses him in life that he never has to ask himself what it is suitable for him to do in art. . . . The painter's obsession with his subject is all that he needs to drive him to work. . . . My work is purely autobiographical. . . . I work from people that interest me and that I care about and think about, in rooms I live in and know."

EXHIBITIONS INCLUDE: Hanover Gal., London 1954; Marlborough Fine Art, Ltd., London 1958, '63, '68; Gray Art Gal., Hartlepool, Durham, England 1972; Anthony d'Offay Gal., London 1972, '78; Hayward Gal., London 1974; Bristol City Art Gal., England 1974; Birmingham City Mus. and Art Gal., England 1974; Leeds City Mus. and Art Gal., England 1974; Davis and Long, NYC 1978. GROUP EXHIBITIONS INCLUDE: Lefevre Gal., London 1944; "Recent Paintings," Lefevre Gal., London 1946; London Gal., 1947; "La Jeune peinture en Grande Bretagne," Gal. René Drouin, Paris 1948; Hanover Gal., London 1950, '52; "21 Modern British Painters," Vancouver Art Gal., Canada 1951; Venice Biennale, 1954.

COLLECTIONS INCLUDE: Tate Gal., Arts Council, British Council, and Royal Col. of Art, London; Gray Art Gal., Hartlepool, Durham, England; Univ. of Liverpool, and Walker Art Gal., Liverpool; Mus. and Art Gal., Walsall, England; MOMA, NYC; Beaverbrook Foundation, Fredericton, New Brunswick, Canada.

ABOUT: Measham, T. The Moderns 1950–1975, 1976; Russell, J. (ed.) "Lucian Freud" (cat.), Hayward Gal., London, 1974. *Periodicals*—Architectural Review December 1972; Art in America January/February 1971; Art News April 1977; Guardian February 19, 1974; New York April 24, 1978; New York Times April 7, 1978; (London) Times March 2, 1978.

FRINK, ELISABETH (November 14, 1930–), British sculptor, was born in Thurlow, Suffolk. She attended the Convent of the Holy Family in Exmouth, Devon. She began to consider a career in art at 16, when she read a book about Rodin. That same year (1946) she enrolled at the Guildford School of Art, Surrey, with the intention of becoming a painter, but when she left the art school three years later Frink had decided to be a sculptor.

She spent the next four years at the Chelsea

Jorge Lewinski

ELISABETH FRINK

School of Fine Arts, London, where she studied
with the sculptor Bernard Meadows and was
considered among the school's most gifted stu-
dents. Her earliest sculptures were in plaster; lat-
er she worked in cement and cast her pieces in
bronze. The first sculptures she did at the Chel-
sea School—roughly-textured warriors and
birds—were expressionistic and "slightly
violent," to quote her. "Aggression is perfectly
normal when you're young," Frink remarked in
an interview with Adele Freedman of the
Toronto Globe and Mail. "I was nine when the
war started. I was very, very aware of aggres-
sion. I was brought up in Suffolk where the air
force was stationed. A lot of bombers crashed
near us. By the time I was 15 I knew about Bel-
sen: it couldn't fail to make an impression. Art-
ists are recorders of the times."

In 1951, while still a student at Chelsea, Frink
had her first London exhibition, and within two
years, the prestigious Tate Gallery had bought
one of her pieces. In 1955, two years after leav-
ing the Chelsea School, she had an important
show at the St. George's Gallery, London. In
1956 she married Michael Jammet. Divorced in
1963, they had one child, Lin.

Sheldon Williams wrote in *Contemporary
Artists* that Frink's sculpture "started out by
swinging to and fro between the lepidoptera im-
agery of Germaine Richier and the sort of force-
ful presentation that was later to be associated
with Ipoustéguy." She soon found her own equa-
tion, however, in both her sculpture and her
graphic work. She is a lover of animals, but never
treats them in her work in an insipid fashion.
One favorite theme has been that of horse and

rider—"Man and horse are wonderful together,"
Frink said—but this motif is treated in a manner
quite unlike that of Marino Marini. Her sincere
feeling for nature and the animal world also in-
cludes a preoccupation with the male figure. She
commented to Adele Freedman: "I think men
are strong but incredibly vulnerable. That's the
wonderful thing about men."

There was a steady, logical progression in
Frink's treatment of the human figure. Her
roughly textured *Seated Man* (1954) betrays no
emotion. In her *Warrior* (1957) the battered,
war-weary head seems to have become one with
the helmet. Her bird sculptures, with their erod-
ed surfaces and spindly legs seem menacing.
(Her "Birdman" bronzes of the 1960s were cross-
es between man and bird.) In 1959 she had her
first New York City exhibition, at the Bertha
Schaefer Gallery. Reviewing her second 1961
showing at the gallery, Brian O'Doherty of *The
New York Times* (October 31, 1961) was greatly
impressed by the "power and . . . strangled
urgency" of her pieces. With their "caves of
shadow" and "acidic broken surfaces," they re-
minded O'Doherty of the "mummified bodies
uncovered at Pompeii." He noted that "the limbs
of her figures tend to be rudimentary and vesti-
gial, and both men and birds have clipped and
futile wings." O'Doherty described Frink's
Birdman—leaning into the wind, legs telescop-
ing into points, and testing rudimentary, ineffec-
tual wings—as "a moving allegory of modern
man." The New York *Herald Tribune* (Novem-
ber 12, 1961) called her human figures
"shrivelled ghosts in bronze."

By 1963 Frink already had sculptures in the
Tate Gallery, the National Gallery of Australia,
and the Walker Art Gallery, Liverpool. She had
also executed public commissions, including a
figure for the Manchester Airport. Eric Newton,
in his review of her third show at the Wadding-
ton Galleries, London, observed in *The
Guardian* (December 3, 1963) that, although in
her bronze sculptures Frink used many of the
fashionable sculptural mannerisms popularized
by Giacometti, "behind the mannerisms is a
ruthless, aggressive power that turns each one of
her sculptures into a dramatic statement." New-
ton was particularly struck by the slightly more
than life-sized *Judas Figure,* which he described
as "a Caliban-like creature with a muscular torso
and a gesture that suggests guilt defending itself
against virtuous indignation." Newton added,
"Each of her sculptures, single figures or groups,
is either attacking or resisting attack."

In the 1960s Frink taught for several years at
the Chelsea School of Art and was also an in-
structor in London at the St. Martin's School of

Art and the Royal College of Art. When she exhibited at the Waddington Galleries in 1965, Christopher Andreae wrote in the *Christian Science Monitor* (December 24, 1965) that her works "still reflect a mood now associated with the '50s, when British sculpture really made a name for itself." Frederick Laws noted in *The Guardian* (December 11, 1965) that Frink was "a sculptor of rare gift and seriousness," one who did not follow fashion. "The core of her work," he said, "is always figurative, indeed biological. . . . " Laws found a disturbing ambiguity in some of her hybrid creatures, especially *Homme Libellule* (Dragonfly Man), a piece which alludes to the myth of Icarus. Included in the Waddington exhibition was a new bird series, "Standards," in which, to quote Andreae, "the customary image of an eagle perching on a pedestal is taken firmly out of the realm of static heraldry."

Frink's exhibit at Waddington I, London, in 1969 was dominated by her adaptation of the classic horse and rider theme. However, Norbert Lynton observed in *The Guardian* (December 16, 1969) that unlike the "archaic Greek smiling horseman," the famous equestrian statue of Marcus Aurelius, and the condottieri by Donatello and Verrocchio, all commanding figures, Frink's rider was weak in arms and legs, and "sexless," whereas the straddling legs of the horse "suggest the possibility of speed" and in its "thrusting neck a sort of determination" can be seen. Lynton remarked that Frink's sculptures as well as her drawings "prophesy dementia," but he was not sure if that feeling had been intended by the artist. Lynton added that he felt a similar uncertainty "with almost all twentieth-century adaptations of classical themes, in any medium."

From 1969 to 1973 Frink lived and worked in Anduze, in the Gard region of France. At the time of the Algerian war she had made the 25-inch-high brass sculpture *Head with Goggles,* the first in a series that she completed in Anduze in 1969. She recalled later: "I was very conscious of the police in France; I was interested in the Ben Barka case." (Mehdi Ben Barka, a leader of the Moroccan independence movement, was kidnapped in 1965 and decapitated.)

Frink was made a Commander of the Order of the British Empire in 1969. In 1970 she married Edward Pool; they were divorced in 1972, the year she was made an Associate of the Royal Academy. Her third marriage, in 1974, was to Alexander Czaky.

A Frink retrospective was held in 1972 at the Waddington Galleries, showing approximately 60 sculptures of the previous 16 years. Writing in *The Guardian* (October 15, 1972) Hilary Spurling called attention to the "calmness and firmness" and "radiant composure" of Frink's tall standing figures, the seven-foot-high *Horse and Rider,* and the massive, imperturbable bronze heads. The comparative serenity of later works was very different from the tormented, often menacing animal and human forms of the '60s, such as *Assassins* (1963). Reviewing Frink's 1979 solo exhibition at the Terry Dintenfass Gallery, New York City (her first Manhattan showing since 1961), Hilton Kramer in *The New York Times* (February 2, 1979) admired the "terrific power and vitality" of her art. Kramer described the large, over-size "Tribute Heads" (1976) as "complex symbols, signifying struggle and exhaustion." The heads were heroic in scale, but antiheroic in spirit, unlike the nude male figures, notably the 76-inch-high *Running Man.* Kramer remarked: "Miss Frink lavishes on the male physique the kind of passionate observation that male sculptors traditionally devoted to the female nude. . . . Elisabeth Frink is the real thing—a sculptor of large powers essaying large themes."

For a number of years Elisabeth Frink has lived and worked in Dorsetshire, while maintaining an address in London. She is a handsome woman with strong, but not hard, features, passionate in her commitment to life and art, and with a warm, friendly manner. her Dorset home is a stable. As she cheerfully remarked to Adele Freedman, "I live where the horses live." She feels that in her latest sculpture she is working towards greater simplicity of form, "using anatomy to suit myself." She does not work from live models.

When asked by Freedman if figurative art was dead, she replied: "I haven't finished with heads. A person's whole life passes through his head. Certainly heads have so much to say." On another occasion she said: "There's very little you can do, I've discovered, to help people— short of living and working in a poor community. Perhaps through one's work, one can touch a few people. I am only suited to sculpting. I think I can say more through that to civilize people."

werp Biennale, Belgium 1959; Open-Air Exhibition, Battersea, London 1960; Waddington Fine Arts, Montreal 1970; Summer Exhibition, Royal Academy, London 1971, '72; Mixed Exhibition, Park Square Gal., Leeds, England 1971; Mixed Exhibition, Balcome Gals., Sussex, England 1971.

COLLECTIONS INCLUDE: Tate Gal., Arts Council of Great Britain, and Contemporary Art Society, London; Fitzwilliam Col., Cambridge, England; Walker Art Gal., and Conventry Cathedral, Liverpool; Manchester Airport, England; Cathedral, Harlow Town, England; MOMA, NYC; Kennedy Memorial, Dallas; Nat. Gal., Melbourne, Australia.

ABOUT: P-Orridge, G. and others (eds.) Contemporary Artists, 1977. *Periodicals*—Architectural Review December 1972; Art International (Lugano) February 1970; Christian Science Monitor December 24, 1965; Guardian December 3, 1963, December 11, 1965, December 16, 1969, October 15, 1972; New York Herald Tribune November 12, 1961; New York Times, October 31, 1961, February 2, 1979; New Yorker November 28, 1959; October 15, 1972; Toronto Globe and Mail September 8, 1979; Transatlantic Review Summer 1973.

FULLER, SUE (August 11, 1914–), American artist, writes: "I was born during the interval when Marcel Duchamp was involved in painting several versions of *Nude Descending a Staircase*. I like to think of it that way because the coming of age of modern art in America was my aesthetic life.

"As a child I frequently went to Carnegie Institute in Pittsburgh with my parents— especially to the International Exhibitions, selected and arranged by Homer St. Gaudens— where contemporary paintings and sculpture from all over the world were exhibited. Thus was I taught indirectly by the great contemporary artists of modern persuasion. In high school, the first books on modern art I encountered were at the studio of Ernest Thurn in Gloucester, Massachusetts, where I studied painting one summer.

"Now, looking back, it is hard to believe that modern art had few advocates or even friends in America, and bookstores in places like Pittsburgh carried no books on the subject.

"In the summer of 1934, after my sophomore year at Carnegie Institute of Technology, I returned to Thurn's School where Hans Hofmann was teaching as guest artist. This was my first direct contact with one of the giants of modern art and I was ready for it. Hofmann repeatedly chose my work as examples for the class.

"In 1937, in Munich, Germany, there was an exhibition of modern art, the direct antithesis of

Holly Bower

SUE FULLER

Carnegie Institute's International Exhibitions. Hitler-dominated Germany suppressed modern art and titled its exhibition there 'Degenerate Art.' Seeing this exhibition taught me what the constitution of the United States means by 'freedom of expression.'

"When I first came to New York City there was no Museum of Modern Art. Ten years later, it was my privilege to be a teacher of children's classes there, where I promptly introduced contemporary materials for the students to work with. An exhibition of my students' work entitled 'Mobile Design' was held at the Museum of Modern Art—a slide talk of which was circulated 1946–47.

"During World War II, New York was the refuge for European artists, one of whom, Stanley William Hayter, set up his print workshop Atelier 17 at the New School for Social Research. I enrolled in 1943, produced some experimental plates, became Hayter's assistant, researched and perfected methods, printed editions of plates made there by André Masson and Marc Chagall which were sold by dealer Curt Valentin. A great wealth of artists such as Calder, Miró, Matta, Lipchitz, and many others made prints at Atelier 17 at this time. I was being taught directly by modern artists.

"Aesthetically, the flood of European artists into America was catalytic. I attended an eight-session workshop held by Josef Albers at the Camera Club in New York, and learned of Bauhaus fundamentals. This experience was the keystone resolving the direction of my work. The exhibition of Gabo and Pevsner at the Museum of Modern Art inspired me, and I began

making what I called 'String Compositions.' Since I was making soft-ground etchings at Atelier 17, using textures, I reduced the texture to a single thread and proceeded from there. Searching for methods of producing color prints led me to Mary Cassatt, whom I discovered to be far more experimental in her printmaking than she had been considered to be. The *Magazine of Art* published an article I wrote on the subject in 1950.

"By the age of 33, I had both Tiffany and Guggenheim fellowships, and two years later, a grant from the National Institute of Arts and Letters. In 1950 my *String Composition No. 11* was exhibited in the Museum of Modern Art's 'Abstract Art in America.'

"About this time I also went to England to study glassmaking with glass-house apprentices, at the Stourbridge School of Art. Finding glass far removed from me as a possibility for making my 'String Compositions,' I returned to teach at the University of Georgia as guest artist, where I imbued the ceramics teacher with my zeal for glass. He later helped establish creative glass-making as part of the college curriculum in America.

"By 1950, Chickopee Mills and the plastics industry produced plastic monofilament which I started using in my string compositions. But like the transparent plastic produced by Union Carbide in 1934 which turned brown in 2 years, plastic monofilament was as yet an unstable material. The plastic industry was still in its infancy—so much so that my vision of transparent string compositions as floating sculpture had to wait another ten years for realization even on a modest scale.

"In 1955 both the Whitney Museum and the Metropolitan Museum bought one of my string compositions for their permanent collections. By this time the frames I designed were made in alumimum by the Matheson Tool Company.

"In the early '60s, a physicist, Dr. Robert Feller of Mellon Institute, Pittsburgh, tested the threads used in my string compositions, until I felt confident the palette of colors used was permanent. Roy Slipp of Clearfloat Inc., Attleboro, Massachusetts, embedded my first string compositions. As the capacity of the plant grew, so the size of work I sent them increased. In 1967 I was granted a patent on the process by the United States government.

"In the early '60s the first computer was being developed, but Gabo's linear geometric volumes were already in existence. Also in the early '60s computer graphics made possible by large digital computers with X-Y platters were a fact, but my string compositions spanned the 20 years between. In 1965 embedment in plastic made what appears to be a floating sculpture of linear geometric progressions a reality.

"Josef Albers attended my exhibition in 1969 and requested we trade works. I was indeed honored. In the beginning of the '70s larger string-composition embedments were produced in prism shapes I designed.

"My work was handled by Bertha Schaefer from 1949 until her death in 1971. Prior to this association my work was on consignment with various galleries including Lowengrund, Kleeman, Kraushaar, and Willard. Arthur and Madeleine Lejwa of Galerie Chalette became my dealers in the early '70s. The association continues as Chalette International."

The daughter of a construction engineer whose projects included the designing of bridges, Sue Fuller recalls that her earliest childhood memories of her Pittsburgh home were of glass and thread. "Our house had a sunporch with windows of beautiful prismatic leaded glass. Every day that area was iridescent." She also retains vivid impressions of her mother's knitting and crocheting; the designs and textures of her mother's hand-work expecially intrigued her.

Sue Fuller's "String Compositions" were the results of her printmaking experiments in the 1940s. In 1945 she found among her mother's belongings a partially worked collar of Arabian lace. She cut it into three pieces and used it as a collage on her soft-ground plate in the semiabstract etching, *The Hen*. This was featured not long afterwards in a show of printmakers at MOMA. As she continued in her search for new techniques of printmaking Fuller became dissatisfied with the "immobility" of manufactured materials—"so I pulled or stretched them: reassembled them: then finally reduced their entire structure down to one thread." She began making abstract drawings in thread which furnished the themes for two prints, *Lancelot and Guinevere* and *Concerto*.

Her studio was soon filled with string compositions for use in her etchings. Writing in *Art International,* Rosalind Browne described what followed: "At first she taped them to sheets of paper, then nailed them to frames for greater security and finally she used pegs and double frames to insure the stance of their counterpoint. While gazing at the play of sunlight on her wedded fibers, it seemd to her the structures had a compelling presence of their own." Fuller's visit shortly before to an exhibition of the Constructivists Naum Gabo and Antoine Pevsner at MOMA, and her admiration for their structures

in string and lucite, suggested to her new possibilities for her own work.

She abandoned printmaking in order to develop her original form of sculpture. In 1949 *Life* magazine reproduced one of her gigantic "Cat's Cradles" in color, and commented that "a New York artist named Sue Fuller . . . does something with string apparently no one else has thought of doing before." The photograph showed Fuller seated on the ground among the balls of twine, gazing at the play of light on the web of colored strings anchored to their large wooden frame.

Finding wood, thread, and dyes distressingly impermanent, Fuller, always a perfectionist, sought the aid of modern industry in providing more durable materials for her art. This was in keeping with the philosophy of the Bauhaus which had long influenced her thinking. Aided by the rapid developments in the field of plastics, in 1949 she had "stumbled upon her first piece of plastic thread." The following year she negotiated with the Pittsburgh Plate Glass Company to set one of her large constructions between two sheets of double-paned thermo glass. The problems involved took several years to solve.

By 1960 she was able to have even her smallest pieces embedded in plastics. Before long these "Plastic Embedments" were being made in the full round, which created changing tensions when the construction was viewed from different angles or under various kinds of light.

Despite her passion for technical precision, there is nothing mechanistic about Fuller's creations. What one might call the "poetic" or "musical" side of her vision was enhanced by a trip to Japan in 1954. There she revelled in the "glorious temple sculpture" and the beauty of a culture that cherished artists and teachers. She joined a calligraphy class in Japan and also produced some remarkable collages.

In 1965 a major exhibition of Fuller's work at the Bertha Schaefer Gallery, New York City, where she had been showing since 1949, won critical acclaim. A review in the New York *Herald Tribune* (May 29, 1965) praised the "great intricacy and beauty" of her string compositions, in which "a magic sense of depth is achieved as threads and strings spin elliptical configurations, which are then encased in transparent plastic." John Gruen, also writing in the *Herald Tribune* (June 6, 1 965), noted that Fuller had been "doing her thing" for a good 20 years, and described her compositions as "a kind of 21st century weaving." The works, for all their complexity, were "charged with taste and economy," and a *New York Times* critic saw in

the tensions created by these multicolored wire-and-string constructions a suggestion of "taut energy being held at the breaking point."

In the July/August 1965 issue of *Craft Horizons* magazine, Alice Adams observed that the earlier string compositions in the show consisted of an "elliptical meshing of threads wound diagonally from one peg to another of peg-lined heavy steel frames." The critic remarked that she had never felt that these frames, however beautiful in themselves, were the right solution as supports for Sue Fuller's "delicate constructions." She preferred the more recent work in the show in which the frame had been abandoned "in favor of a clear disk of Plexiglass, notched on the edges and around which fine Saran threads are wound to form complex, constellation-like compositions. The disk is then cast upright in a thick sheet of plastic or on an angle, as though floating in the center of a transparent cube." *Time* magazine also found the latest, plastic-embedded works the most intriguing.

Fuller's successful exhibit at Bertha Schaefer was followed in September 1965 by her first showing in Boston. Mrs. Eleanor Rigelhaupt, a well-known Boston collector and patron of the arts, curated the work of Fuller for the première of her new gallery at 125 Newbury Street. Some 20 of the string compositions were shown, along with earlier etchings and cloth collages. Edgar J. Driscoll, Jr., writing in the Boston *Sunday Globe* of September 19, 1965, admired the flawless composition and execution of these "cobwebs of three-dimensional abstract design," in which "colors are wonderfully soft, feminine and subtle," constantly changing before the eyes. Driscoll compared the effect of the most recent "threaded wonders" embedded in plexiglass to "capturing a snowflake and preserving it for all time."

In a statement made at the time of the Boston exhibit, Fuller said: "The path of a trajectory to the moon, or in orbit around Mars is a line drawing. Translucency, balance, and precision are the aesthetics associated with such graphics. My work in terms of linear geometric progression is visual poetry of infinity in the space age."

Robert Taylor, writing in the Boston *Globe*, saw a relationship between Sue Fuller's abstract linear rhythms and "the precisionist clarity of vision encountered in such artists as Mondrian or Albers." Taylor found the seven etchings in the show "decorative enough" but interesting chiefly as preludes to "her more striking mature statement in the geometries of space." Jane H. Kay of the *Christian Science Monitor* detected Japanese influences in the calligraphy of the early soft-ground etchings, such as *Cock* (1945), and

in the "delicate and fragile textures" and horizontal grouping of an early collage of cloths (*Misaki*).

By 1967 Fuller's "String Compositions" had been added to the collections of MOMA, the Whitney Museum of American Art, and the Metropolitan Museum of Art, all in New York City, the Wadsworth Atheneum in Hartford, Connecticut, and other American museums. She was also represented in London's Tate Gallery and the Honolulu Academy of Art. There was an enthusiastic response to her show at the McNay Institute in San Antonio, Texas, in January 1967. Glenn Tucker in the San Antonio *Light* called it "the most exciting and important art exhibition [in] years." He compared her delicate constructions with their "technical and poetic wizardry" to music—indeed, the very term "string compositions" suggested such an analogy, and he described them as being "as balanced as a baroque fugue and as complete as a Mozart symphony."

In a handsomely mounted exhibit at the Norfolk Museum, Virginia, in March 1967, the cubed "Plastic Embedments" were illuminated by diffused light from below. Cornelia Justice, in a review in the Norfolk *Ledger-Star,* called them "exciting inventions of multiplicity in disembodied space." Screens of heavy cord were fanned out into the gallery itself "to intrigue the viewer to wander into and among the maze of web-like constructions."

The "environmental" possibilities of Fuller's art were explored even further in the installation of her exhibit at the Bertha Schaefer Gallery in the fall of 1969. Reviewing the show in *Art News* (October 1969), Rosalind Browne wrote; "Four giant white nylon rope constructions formed an environment of ellipsoid convolutions that hugged the ceilings or stretched to the floor." Describing the "intricate gossamer complexes" of the embedments themselves, Browne added: "Breathtaking precision fans thousands of taut hairlines into interlacing curves. Yet no formula could capture the subtle thrusts of asymmetry that turns mathematical configurations into poetry."

In 1973 Fuller was awarded a Mark Rothko Foundation Fellowship, and the following year she received a Carnegie Mellon University Alumni Merit Award. In 1975 the Solomon R. Guggenheim Museum, New York City, acquired one of her string compositions. Fuller holds a patent for her process of embedment in plastic from the United States government. Fascinated by the possibilities of "computer art," Fuller takes the discoveries of modern science and technology in her stride as she sees no conflict between chemistry and poetry: both can be fused or transformed by what she refers to as the "alchemy of perception." Her embedded networks have no titles, only numbers, because "they aren't realistic images of anything."

Two films on Sue Fuller's work have been made by Maurice Amar: *Exhibit* (1969), under the sponsorship of the New York Arts Council, and *Work in Progress* (1974).

Sue Fuller is a short, stocky, cheerful woman, blue-eyed and fair-complexioned, who, to quote Patricia Boyd Wilson of the *Christian Science Monitor,* "speaks in a rich, low voice often interrupted by a deep chuckle or spontaneous laughter." Her enthusiasm, tenacity, and dedication in pursuing her unique vision do not prevent her from appreciating other types of art. She enjoys "the way painters like Pollock and de Kooning use paint," and says, "I'm a precise artist, but not everybody has to be precise. I have found that when there's a valid reason for a work of art, it comes through."

For many years Sue Fuller had a large studio-workshop in downtown Manhattan in a spacious 19th-century cast-iron office building. She has a residence on the Upper East Side, but since January 1975 has been living in Southampton, Long Island, where she continues to explore new ways of achieving her ideal of "Transparency, Light, and Balance."

EXHIBITIONS INCLUDE: Bertha Schaefer Gal., NYC 1949–69.

COLLECTIONS INCLUDE: Metropolitan Mus. of Art, Whitney Mus. of Am. Art, MOMA, and Solomon R. Guggenheim Mus., NYC; Chicago Art Inst.; St. Louis Art Mus.; Des Moines Art Center; Tate Gal., London; Corcoran Gal. of Art, Washington, D.C.; Chase Manhattan Bank, NYC.

ABOUT: *Periodicals*—Art International January 1972; Christian Science Monitor September 17, 1965; Craft Horizons April 1954, July/August 1965; New York Herald Tribune May 29, 1965, June 6, 1965; Norfolk Ledger-Star March 7, 1967; San Antonio Light January 8, 1967; Boston Sunday Herald September 19, 1965.

***GABO, NAUM** (August 5, 1890–August 23, 1977), Russian-American sculptor, was a leading practitioner and theoretician of constructivist art. He was born Naum Neemia Pevsner in Briansk, Russia, into a large, well-to-do family. His father, Boris Pevsner, was an industrialist involved in copper refining. Naum's older brother, Antoine Pevsner, was to win renown as a Constructivist painter and sculptor. In a memoir

°gä´ bō, noum

Jorge Lewinski

NAUM GABO

published in 1964, another brother, Alexei, recalled that Naum in childhood was considered a "mischievous daredevil."

On completing his high school education in Kursk, in 1910, Naum enrolled as a medical student at the University of Munich. The following year he studied natural sciences and in 1912 switched to engineering, subjects that were to influence his conception of art. In 1911–12 Naum attended lectures on art history by the celebrated art historian Heinrich Wölfflin, who stimulated his interest in the nature of creativity. He visited exhibitions of the avant-garde Blaue Reiter group, which had been founded in Munich in 1911 and whose membership included Wasily Kandinsky and Franz Marc. Naum's interest in modern art deepened in 1913–14, when he visited his brother, Antoine, in Paris. There he was exposed to cubism, including the work of the pioneering Russian-born Cubist sculptor Alexander Archipenko, and introduced to the writings of the Cubists Albert Gleizes and Jean Metzinger. Naum was now committed to a career in art rather than engineering.

After returning to Munich in 1914, Naum executed his first sculpture, *Negro Head*, a figurative work. When Germany declared war on August 1, 1914, Naum and his brother Alexei left the next day for Copenhagen to avoid being interned as enemy aliens. Their father had sworn that none of his boys should fight for the Czar, and Gabo and Alexei settled in Oslo, Norway for the duration of the war. In 1915, when they were joined by Antoine, Naum changed his surname to Gabo, to avoid being confused with Antoine.

During these years of relative solitude in Nor-

way, Pevsner and Gabo laid the basis for what was to become known as constructivism, although Pevsner's style developed much later than his brother's. In Oslo, in 1916, Gabo held his first exhibition.

Gabo's earliest works were figurative and markedly influenced by cubism. However, trained in engineering, he subsequently experimented with geometric principles of construction, producing abstract pieces that displayed mathematical precision *and* aesthetic sophistication. Years later he recalled, "In the epoch in which I was born and grew up, the basis of life was a new principle in everything—in mathematics, physics, chemistry and bio-physics." His background in science notwithstanding, Gabo was more concerned with aesthetics than mechanical usefulness. For instance, he was fascinated by the Norwegian landscape, with its contrasts of solid masses and vast emptiness, and by the seemingly endless depths of its fjords.

In his sculptures of 1916, including *Bust* and *Head of a Woman*, Gabo sought new ways to resolve the relation of space to sculptural mass. When, at the urging of Heinrich Wölfflin, he had gone on to Italy in 1913, he had been dismayed by Renaissance sculpture, with its emphasis on mass and its closed surfaces. Whereas earlier sculptors had thought of sculpture in terms of mass situated in space, Gabo conceived of space "as material by itself, a structural part of the object. . . . " He began to experiment with three-dimensional heads and figures made of intersecting planes of cardboard, wood, or metal. Superficially, they resembled cubist works, but they anticipated Gabo's later works in plastic by their concern with interior space and their transformation of the mass of the head into lines or edges forming a geometric void, as in *Constructed Head No. 2* (1916).

After the 1917 Revolution, it was hoped by artists like Gabo and Pevsner, who returned to Russia, that the Soviet government would be receptive to avant-garde art. In Moscow, Lunacharski was commissar of cultural affairs and modernists like Kandinsky, Kasimir Malevich, and Vladimir Tatlin (who is credited with coining the term constructivism) flourished. During this boldly experimental period several of Gabo's friends were appointed to professorships; although he refused a chair, he exerted influence at the state art school and was coeditor of *Izo,* the official art weekly. Gabo's few surviving works from this period were inspired by the postcubist style and show the influence of Archipenko. In addition to wood and metal he began to use celluloid and clear plastic in his structures, though he was hampered by the shortage of available

materials. About 1919 Gabo designed a project for a radio station at Serpuchov and produced his first motor-operated construction.

By 1920 the harmonious relationship between the avant-garde and the state was showing signs of strain. Unlike Tatlin and other Productionists who received official support, Gabo and Pevsner rejected utilitarian art and deplored the subordination of creativity to political ends. In 1920 the two brothers issued their groundbreaking *Realistic Manifesto*, which took issue with the Productionists and elaborated the central tenets of constructivism. "The most important idea in the manifesto," Gabo recalled, "was the assertion that art has its absolute, independent value and a function to perform, whether capitalistic, socialistic, or communistic. Art will always be alive as one of the indispensable expressions of human experience and as an important means of communication." Rejecting the aesthetic of art as imitation of nature, and accepting new scientific conceptions of the universe, Gabo called space and time "the only forms on which life is built" and on which art should be constructed. His concern with kinetic rhythm and time in visual art found expression in 1920 in a motorized steel sculpture, *Kinetic Composition,* which possibly was the first mobile.

However, opposition to abstract art in the Soviet Union was growing. "The government was only tolerating all of us," Gabo recalled, and in 1922 many studios, including those of Pevsner, Kandinsky, and Malevich, were closed without explanation. Disillusioned, Gabo went to Berlin in 1922 for the "First Russian Art Exhibition," which was organized by the Soviet government, and held at the Galerie van Diemen. He never returned to the USSR; Pevsner left Moscow in early 1923 and stayed with his brother in Berlin for nine months before moving to Paris. Gabo had been represented in the Berlin show by eight works, including the heads and torsos he had made in Norway and his new *Kinetic Construction-Standing Wave*, a revolutionary sculpture which opened the way to kinetic art. Although Gabo did not further develop kinetic sculpture, he prized *Kinetic Construction*, and in 1965, after his first major retrospective exhibition, which toured Europe and ended in London, he donated it to the Tate Gallery.

Gabo remained in Berlin for ten years and created architectural designs which reflected his ideas about the crucial function of space in the determination of form. In 1922 he made his remarkable model, *Project for a Monument for a Physics Observatory*, 14 inches high, in plastic, metal, and wood. For the first time, as Herbert Read noted, "new materials like glass and plastic were . . . used to express a new sense of space and dynamic rhythm, and also a sense of social relevance." His *Column* (1923; Guggenheim Museum, New York City), 41½ inches high, in plastic, metal, and wood, was one of several "Columns" and "Towers" he created at this time. Of one of these he wrote: "I consider this 'column' the culmination of that search . . . for an image which would fuse the sculptural element with the architectural element into one unit." He also designed a *Monument for an Airport* (1924–25).

During his years in Germany Gabo was in contact with Laszlo Moholy-Nagy, the influential Bauhaus architect whose constructivist designs and theories were influenced by Gabo. Gabo never joined the Bauhaus faculty, but he lectured there in 1928 and published an article in one of the school's collections of critical essays. As John Russell pointed out in *The New York Times* (August 24, 1977), Gabo not only contributed greatly to the cultural life of the Weimar Republic, but "carried the Constructivist esthetic into places where no one would have expected to find it." For instance, he and Pevsner were commissioned in 1926 by Serge Diaghilev to design sets and costumes for the ballet *La Chatte,* which was produced in Monte Carlo, Paris, London, and Berlin in 1927.

Gabo visited his brother in Paris several times in the 1920s. In 1932, after Nazi storm troopers raided his studio, Gabo left Berlin for Paris, where he lived for three years and experienced severe financial hardship. His work was devoutly admired by segments of the Paris avant-garde, but the larger public remained ignorant of his sculpture. From 1932 to '35 he belonged to the constructivist Abstraction-Création group, which had been formed in reaction to surrealism. Along with Kandinsky and Mondrian he wrote articles for the association's publication.

In 1935 Gabo moved to England, where he met the sculptor Henry Moore and the art critic Herbert Read, who became his close friend. In 1937 Gabo collaborated with the painter Ben Nicholson and the architect Leslie Martin in editing *Circle*, a constructivist manifesto which John Russell called "a classic of its time." In the works Gabo constructed in England curvilinear rhythms replaced the planes and angles of his earlier sculptures. *Spherical Theme* (1937), in opaque plastic, and *Construction in Space with Crystalline Center* (1938), in clear plastic, have wiry linear patterns which vary according to the spectator's angle of vision. Gabo exhibited at the Lefevre and other London galleries and was represented in the important Museum of Modern Art show, "Cubism and Abstract Art," in 1936 in

New York City. He also exhibited at the Chicago Arts Club in 1936, and two years later James Johnson Sweeney and Julian Levy mounted an exhibition of his work which traveled to Vassar College, Poughkeepsie, New York, and to the Wadsworth Atheneum, Hartford, Connecticut.

Throughout World War II Gabo lived mainly in Carbis Bay, Cornwall, and joined the Design Research Unit in 1944. In 1946 he moved to the United States, where he was already well known in art circles. He showed with Pevsner at MOMA in 1948 and with Josef Albers at the Chicago Arts Club in 1952. That year Gabo became a naturalized American citizen.

In the United States Gabo found it easy, even appropriate, to execute large-scale works. In 1950 the Baltimore Museum of Art, after mounting an exhibition of his sculptures, commissioned, for a stairwell, his *Construction Suspended in Space*, a rhythmic, open sculpture in aluminum, bronze, plastic steel, and gold wire. In 1953 the architect Walter Gropius, the former head of the Bauhaus, asked Gabo to join the Harvard University Graduate School of Architecture and Design faculty, where the sculptor taught from 1953 to '54. In 1954 Gabo was commissioned to design a huge sculpture to be erected in a plaza adjoining the Bijenkorf department store, Rotterdam, a building designed by the Bauhaus architect Marcel Breuer. The 80-foot vertical composition in metal and plastic, which Gabo considered his greatest work, was completed in 1957, after meeting with strong opposition from town planners and engineers. Gabo modeled the composition's double stem and branches after a tree, thus giving his geometric forms an organic quality.

Another architectural-sculptural commission was for a 1956 bas-relief, in plastic and wire, in the lobby of the United States Rubber Company building at Rockefeller Center, New York City. In *The Artist's Voice* (1962) Gabo explained that he used plastics for only one reason: "to accentuate the transparent character of space." "In Gabo's work," John Milner wrote in *Makers of Modern Culture*, "self-expression gave way to investigation of the nature of space and the manipulation of materials. Empty space is, in fact, the precise material of his constructions and his distribution of plastics, glass and metals a system of articulating and elucidating that space."

The decade of the 1950s was dominated by expressionist movements that contained nothing of constructivism's geometric austerity, but as George Rickey observed in *Artforum* (November 1977), "Constructive art continued vigorously but quietly, both in Europe and America." Gabo, although acknowledged as an artist of great importance, was still little known outside the art world. However, he reached a larger public with a major exhibition that toured the Continent and opened at the Tate Gallery in March 1966. Commenting on Gabo's work in *The New York Times* (March 27, 1966), Gene Baro praised "its range of sensibility, its technical method, its respect for materials and meticulous craftsmanship." When two years later the Albright-Knox Art Gallery, Buffalo, New York, exhibited over one hundred Gabo works, a *Newsday* (March 9, 1968) critic wrote that the sculptor's "open, abstract, transparent compositions, done over half a century ago, anticipated in many ways, especially in their relationship of solid forms to enclosed space, the continuing experiments of artists today," especially in "kinetic, minimal and optical art."

In England Gabo had met an American, Miriam Israels, whom he married on October 13, 1936. They had a daughter, Nina Serafina Gabo. Soon after arriving in America, Gabo and his family moved to Middlebury, Connecticut. He kept in close touch with his English friends, and in 1971 he received an honorary knighthood from Queen Elizabeth II. His last major sculpture, unveiled in October 1976, was a fountain for St. Thomas's Hospital, London, titled *Revolving Torsion.*

Naum Gabo died in Waterbury, Connecticut. Albert Elsen wrote in *Art News* (October 1977) that Gabo's death meant "the loss of a genuine hero of modern sculpture," who had "created a brilliant series of transparent constructions that gave tangible form to light, space and movement." In the 1940s, when Gabo's art was called "irrelevant" by politicized critics who felt his sculpture should "comment" on the struggle against fascism, Gabo wrote an eloquent letter to Herbert Read: "Must I, ought I, to keep and carry the horror through my art to the people? What can I tell them about pain and horror that they do not know? I am offering in my art what comfort I can to alleviate the pains and convulsions of our time. . . ."

EXHIBITIONS INCLUDE: Open-air exhibition, Tverskoi Boulevard, Moscow 1920; Kestner-Gesellschaft, Hanover, W. Ger. 1930; London Gal. 1938; Wadsworth Atheneum, Hartford, Conn. 1938; Julian Levy Gal., NYC 1938; Vassar Col., Poughkeepsie, N.Y. 1938; Baltimore Mus. of Art, Md. 1950; Massachusetts Inst. of Technology, Cambridge 1951; Pierre Matisse Gal., NYC 1953; Boymans-Van Beuningen Mus., Rotterdam 1958; Stedelijk Mus., Amsterdam 1958, 1965–66; Tate Gal., London 1966, '76; Albright-Knox Art Gal., Buffalo, N.Y. 1968; Mus. de Peinture et de Sculpture, Grenoble, France 1971; Los Angeles County Museum of Art 1979. GROUP EXHIBITIONS INCLUDE: "Erste Russische Kunstausstellung," Gal. van Diemen, Berlin 1922;

"Constructivistes Russes: Gabo et Pevsner," Gal. Percier, Paris 1924; "Van Doesburg: Pevsner: Gabo," Little Review Gal., London 1936; "Pevsner: Gabo," Arts Club, Chicago 1936; "Cubism and Abstract Art," MOMA, NYC 1936; "Constructivist Exhibition," Kunsthalle, Basel 1937; "New Movements in Art: Contemporary Work in England," London Mus. 1942; "Naum Gabo—Antoine Pevsner," MOMA, NYC 1948; "Albers: Gabo," Arts Club, Chicago 1952; "61st American Exhibition," Art Inst. of Chicago 1954; Documenta 1, Kassel, W. Ger. 1955; "50 ans d'art moderne," Exposition Universelle et Internationale de Bruxelles, Belgium 1958; Mus. Nat. d'Art Moderne, Paris 1971; "The Non-Objective World 1914–1955," Annely Jude Fine Art, London 1973; "The Non-Objective World 1914–1955," Univ. of Texas, Austin 1973.

COLLECTIONS INCLUDE: Tate Gal., and St. Thomas's Hospital, London; Mus. Nat. d'Art Moderne, Paris; Nationalgal., Berlin; Kunsthaus, Zürich; Bijenkorf Building, Rotterdam; MOMA, Solomon R. Guggenheim Mus., and Rockefeller Center, NYC; Albright-Knox Art Gal., Buffalo, N.Y.; Hirshhorn Mus. and Sculpture Garden, Washington, D.C.; Baltimore Mus. of Art.

ABOUT: Gabo, N. Realistic Manifesto, 1922, Three Lectures on Modern Art, 1949, Of Divers Arts, 1962; Kirk, K. The Artist's Voice, 1962; Pevsner, A. A Biographical Sketch of My Brothers Naum Gabo and Antoine Pevsner, 1964; Read, H. "Naum Gabo—Antoine Pevsner" (cat.), MOMA, NYC, 1948, Philosophy of Modern Art, 1952, (and others) Gabo: Constructions Sculpture Paintings Drawings Engravings, 1957, Read, H. A Concise History of Modern Sculpture, 1964; Rickey, G. Constructivism: Origins and Evolution, 1967; Wintle, J. (ed.) Makers of Modern Culture, 1981. Periodicals—Art and Artists June 1976. Art News January 1977; Artforum November 1977; New York Times March 27, 1966, August 24, 1977; Newsday March 9, 1968; Oeil (Paris), September 1979; Studio International April 1966, September 1969, November 1971; Time April 22, 1966.

GATCH, LEE (September 10, 1902–November 10, 1968), American painter, developed a "soft," semiabstract personal symbology based on natural forms and rural landscapes. The human form plays a central role in his work as well, often within a theatrical context. Gatch was a painstaking paint handler who had mastered every technique of composition; his imagery, however, is rooted in psychological ambiguity and a private mysticism, and runs the gamut from the precisely descriptive to the tantalizingly vague and suggestive.

Gatch, of Irish-American descent, was born in rural Maryland, near Baltimore. As a youth he was an avid hunter, fisherman, and hiker. He was first inspired to become an artist, he later claimed, when he discovered a simple sketch on

American Academy & Institute of Arts and Letters, NYC

LEE GATCH

the cracking plaster wall of an abandoned house he was exploring. Enrolling in the Maryland School of Fine Arts (1920–24), he studied with Leon Kroll and John Sloan, one of the Eight. In 1924 he made the pilgrimage to France to attend the American School in Fountainbleu on a scholarship. After traveling in France and Italy, he settled in Paris, where he roamed through the galleries and museums (he expecially admired the work of Derain, Vuillard, and Bonnard and absorbed much from these quintessentially French colorists) and took private lessons with the Cubist André Lhote at the Académie Moderne. The formal and compositional training he received from Lhote greatly affected his early work, as can be seen in a self-portrait of 1925 and *The Artist's Sister* of 1926.

In a June 1949 letter to his friend, the collector Duncan Phillips, founder of the Phillips Collection in Washington D.C., Gatch described in detail his artistic development. He wrote: "In 1925, back in the United States, several years of painting went by before I realized I was entirely too pre-occupied with technique. With this realization, the desire for color began. I began to design differently, more two-dimensionally." After his first solo show, in 1927 at J. B. Neumann's New Art Circle, New York City (where Gatch was then living), drama and movement, expressed in broader, more active drawing and color swatches, began to dominate formal precision. *Tornado* (1930) is a good example of this—even the choice of such a violent, elemental subject reveals his new direction.

At an exhibition of children's art at New York City's Cooper Union, Gatch saw an all-red pic-

ture that inspired him to do a number of monochromatic paintings, such as *Red Landscape* (1930) and *Pennsylvania Farm* (1936). (His own work, although achieved only after laborious adjustment and readjustment of form and color, often has a childish, artful simplicity, much like that of Paul Klee.) His horses and humans, flattened and infused with light, were still at this time essentially realistic, but an increasing interest in compositional experiments and surface effects gradually led him toward abstraction. "My canvases became larger and narrower," he wrote Phillips; "the design began to stretch itself, and to fill the elongated space was a problem—I had to invent, to pull at the forms, sometimes employing a sequence of planes in thick paint at various angles to one another. By 1935 the angularity of expression had softened through the insinuation of a fresh vision towards a sensuous arabesque in nature."

In 1935 Gatch married the Precisionist painter Elsie Briggs; soon after, they moved to an old stone house (which Gatch rebuilt) near Lambertville, New Jersey. Their daughter, Merryman, is now an actress. Through the 1940s, not unaware of abstract expressionism, but committed to some form of representation (if not realism), Gatch used landscape as a source for an abstract, personal symbolism. "By 1940," he wrote, "my way to abstraction was becoming clearer to me. As to color, I planned my canvases as a single unit of color: a unit of red, or green or blue, etc. I packed into them innumerable forms by making them vague, as if out of focus of just visible by a variation of tone. . . . I wished to make the color field scintillate, breathe with a sparkle like the unevenly dyed threads in a Navajo blanket." Real linear objects—drilling rigs (*Oil Wells,* 1944), power lines (*High Tension Tower,* 1945), or clotheslines (*Monday,* 1944)—function as abstract composional dividers. Occasionally, as with the multiple cross motif of *Easter Morning* (1943), his form language was more connotative and universal.

A natural mysticism, not unlike that of Morris Graves, pervades much of Gatch's work of the '50s, as does playfully theatrical multiple framing of figures. *The Flame* (1950) and *Night Gothic* (1957) aspire to spiritual mystery. "The lamp and the moon," he said, "are subjective and prophetic symbols of the flame of the spirit and its passage from fullness to waning, from life to death." At the same time, Gatch revealed a fascination with stage and carnival performers and did a number of works placing single figures within rectangular curtained areas. Around these pictures Gatch used broad picture frames covered with carefully patterned bits of colored tapes. The figures themselves are maximally distorted, more metaphors than unique individuals, as in *The Thespian Bow* (1957) and *The Fire Eater* (1958). A reviewer of his 1958 show at the World House Galleries said: "The art of Lee Gatch is essentially one of mutation, or a series of mutations arrested at different levels, from that which is directly perceived and experienced to its ultimate distillation on canvas. The kernel of the initial motivating impulse is retained, but it is filtered through a succession of transformative stages until the removal from the object is so great that the painting often appears to have been fabricated from wholly visionary materal."

In the 1950s Gatch also began making collages, staining pieces of canvas and assembling them on larger grounds in skewed rectangles. *Arch of Silence* (1959), *Tundra Tapestry* (1961), and *Hedgerow* (1961) exemplify this style, which led directly to the artist's compositions in flagstone. In his self-described search for "a finer mystical expression and a greater economy of means in reaching the essence of the idea," Gatch hit upon stone as the material of ultimate purity, perhaps because of its age, inert quality, and monumentality. Some of these relief-collages, notable *The Mistletoe Creed* (1962), have forms resembling the dolmens of Stonehenge. Others incorporate the prehistoric fossils often found in slate, (*Jurassic Frieze* and *Fossil Tablet,* both of 1962). *Pompeian Gesture* (1966) is based on the geometry of classical architecture.

Gatch was included in the Venice Biennale in 1950 and 1956; in 1957 he won the Art Institute of Chicago's Blair Prize and in 1959 the Temple Award of the 2nd Biennial of American Painting and Sculpture at the Detroit Institute of Arts. The Whitney Museum of American Art, New York City, organized a major retrospective of his work in 1960.

Lee Gatch died in his home in Lambertville in November 1968. The critic Perry Rathbone, who visited Gatch in his "tiny abode of weathered stone," compared the house, with its whitewashed studio, to "the retreat of a Taoist sage." Rathbone discussed the "spiritual and artistic hardship" of Gatch and Paul Klee, whose work Gatch had first seen at the Neumann Gallery in 1927. Like Klee, Gatch claimed "the deepest respect for the laws of organization," and his mysticism was rooted in logic and sensitivity to order. "To me," he said, "art is a science of experience; the flesh, the heart, or the dream."

A touring retrospective of the artist's paintings was organized by the National Collection of Fine Arts, Washington D.C., in 1971–72.

EXHIBITIONS INCLUDE: J. B. Neumann's New Art Circle,

NYC 1927, and New Art Circle Gal. 1932, '34, '37, '46, '49; Willard Gal., NYC 1943; Grace Borgenicht Gal., NYC 1954; Phillips Collection, Washington, D.C. 1954, '56; World House Gals., NYC 1958, '60; Whitney Mus. of Am. Art, NYC 1960–61; Staempfli Gal., NYC 1963, '65, '67, '72; Nat. Collection of Fine Arts, Smithsonian Instn., Washington, D.C. (and U.S. tour) 1971–72. GROUP EXHIBITIONS INCLUDE: "Young American Group," J. B. Neumann's New Art Circle, NYC 1928; Annual, Whitney Mus. of Am. Art, NYC 1937, '49–65; "The Ten: Whitney Dissenters," Mercury Gal., NYC 1938; Pennsylvania Academy Annual, Philadelphia 1939, '41, '44–46, '48; Golden Gate International Exposition, San Francisco 1939–40; "Advanced Trends in Contemporary American Art," Detroit Inst. of Arts 1944; Carnegie Inst. Annual, Pittsburgh 1945, '50; Venice Biennale 1950, '56; "Paintings by Lee Gatch, Karl Knaths, Ben Shahn," Santa Barbara Mus. of Art, Calif (and tour) 1952; "Painters of Expressionistic Abstractions," Phillips Collection, Washington, D.C. 1952; Art Inst. of Chicago 1954, '56–57; Carnegie Inst. International, Pittsburgh 1955–64.

COLLECTIONS INCLUDE: Whitney Mus. of Am. Art, NYC; Albright-Knox Art Gal., Buffalo, N.Y.; Hirshhorn Mus. and Sculpture Garden, Smithsonian Instn., and Phillips Collection, Washington, D.C.; City Art Mus., St. Louis, Mo.; Art Inst. of Chicago; Detroit Inst. of Arts.

ABOUT: Cheney, Seldon The Story of Modern Art, 1958; Rathbone, Perry T. Lee Gatch (monograph published by the Am. Federation of Arts) 1960; Rose, B. American Art Since 1900, 2d ed. 1975. *Periodicals:* Art in America Fall 1956; Art News December 1950, March 1960; Arts Magazine May 1958; Magazine of Art December 1949.

***GIACOMETTI, ALBERTO** (October 10, 1901–January 11, 1966), Swiss sculptor and painter, was one of the few major European sculptors of the post–World War II period. He was born in Borgonovo and reared in Stampa, a Swiss village near the Italian border. He came from a family of artists. His father, Giovanni Giacometti, was a minor landscape painter in the postimpressionist manner, and his godfather, Cuno Amiet, was a Fauvist. Alberto's brother Diego, born in 1902, became a sculptor; he later modeled extensively for Alberto and helped in the casting of his sculptures. Alberto was deeply attached to his mother, and after 1922, when he settled in Paris, he frequently visited her in Stampa.

Giacometti began to paint in 1913 and modeled his first bust the following year. By 1916 he had begun a series of busts of his brother. In 1919–20, in Geneva, he studied at the Ecole Beaux-Arts under the painter David Estoppey, and attended the Ecole des Arts Industriels,

© Michael Holtz, Paris

ALBERTO GIACOMETTI

studying painting and sculpture with Maurice Sarkissoff, a disciple of Alexander Archipenko. He traveled in Italy in 1920–21, visiting museums and closely scrutinizing the old masters, especially the paintings of Giotto and Tintoretto. It was then that Giacometti became fascinated by the immobility of archaic art.

In 1922 Giacometti arrived in Paris and enrolled at the Académie de la Grande Chaumière in the sculpture class of Antoine Bourdelle. He disliked Bourdelle but studied with him for three years before deciding that Bourdelle had nothing more to give him. Meanwhile Giacometti made drawings in the museums from Chaldean and Egyptian sculpture, and copied a Fayum portrait. It was at this time that Giacometti first sensed that the closer he came to capturing the density of reality, the more it eluded him.

In 1926, having left Bourdelle's class the year before, Giacometti abandoned the academic style of sculpture. From 1925 onwards he made flat figurative forms which show the influence of cubism and which, in their shapes, are reminiscent of primitive idollike statuary. In 1926 he began his "Woman-Spoon" series; The Couple also dates from that year.

In 1927 Giacometti moved into a studio in the rue Hippolyte-Maindron in Paris, where he was to live and work until his death. Diego's workshops were in the same building, across a narrow courtyard, and for years the two brothers worked together, designing chandeliers, lamps, and other furnishings for the interior decorator, Jean-Michel Franck. Alberto showed for the first time in 1927, at the Galerie Aktuaryus, Zürich, with his father.

*jä ko mät´ tē, äl ber´ tō

By the end of the decade Giacometti viewed the human figure not as a closed mass but as an open construction. In 1929 he joined the Surrealists and quickly became their leading sculptor. It is likely that surrealism appealed to Giacometti as a means of solving an artistic dilemma, though he was to prove too independent for orthodox Surrealists. He had attracted attention in avant-garde circles with his series of "Plaques" (1927–28), sculptures which alluded only slightly to the human figure. Uncertain of how reality ought to be perceived, Giacometti "expressed a doubt whether these plaque sculptures, which were modelled from memory, corresponded to a desire to make something he saw in things or to express the way he felt about them or [to] 'a certain feeling for form that is inside you and that you want to bring outside,'" to quote *The Oxford Companion to Twentieth-Century Art* (1981). With its strict insistence that creativity springs from the imagination and not from observation of the external world, surrealism would have been an antidote for the artist's confusion.

Giacometti's closest associates among the Surrealists were André Masson, the writer Michel Leiris, and Joan Miró. His first solo show in Paris was at the Galerie Pierre Colle in 1932, and he was included in the historic "Fantastic Art, Dada, Surrealism" show at MOMA in the winter of 1936–37. In his Surrealist period, which lasted until 1935, Giacometti produced such sculptures as *Reclining Woman* (1929), *Study for a Surrealist Cage* (1930), one of a series of so-called wire space cages which were virtually drawings in space, and especially *The Palace at 4* A.M. (1932–33; Museum of Modern Art, New York City), a construction in wood, glass, wire, and string. "I don't know why it's inhabited by a backbone in a cage," Giacometti said of *The Palace*, a fragile, enigmatic mansion with oddly juxtaposed elements. "On the other side is placed the statue of a woman, in which I discover my mother as she impressed my earliest memories. . . . I can say nothing of the object on a board which is red; I identify with it."

Giacometti's *Woman with Her Throat Cut* (1932), and *Suspended Ball* (1930–31) are possibly his best-known surrealist works. In the former, "the figure, sprawled on the floor with a knife-cut in its cervical column, is part scorpion and part sacrificial victim—spiky, bony, and malevolent," as Robert Hughes described it in *The Shock of the New*. "Georges Bataille's view that 'copulation is the parody of crime' was widely shared in the surrealist circle, and Giacometti's sculptures of the thirties seem to accept it as a text." *Suspended Ball*, for example, suggests the perpetual frustration of sexual desire.

Giacometti's last object-sculpture was *The Invisible Object* (1934), a figure of a woman clasping an unseen shape between her hands. In 1935 he broke with the Surrealists, feeling the need to work from the human model, the study of nature being proscribed by group doctrine. He also resented the hierarchical discipline of the surrealist movement. Giacometti renounced his surrealist work as "worthless, fit for the junk heap," and declared that his sole object was to "put into place" a human head. In 1935 he executed a cubist *Head* (later destroyed) and a series of portrait busts of his brother. From then on he pursued an anxiety-ridden interrogation of nature, destroying more work than he produced, and did not exhibit again until 1948.

In 1938, while recuperating from a broken foot in a Geneva hospital, Giacometti studied the movements of patients in wheelchairs, in plaster casts, and on crutches, observations which influenced his approach to figuration. On his return to Paris in 1939, he became friendly with Picasso, Sartre, and Simone de Beauvoir, and held forth with them at the Café Deaux Magots on the Left Bank. In his sculpture, Giacometti was experimenting, using various methods of distortion in an attempt to reconcile his perception of the model with his interior vision. Giacometti was attempting to develop a new phenomenology of perception, a way of reproducing objects as they actually appear, not as they were traditionally represented in art. As a result, he stopped working from the model and began executing heads and female figures from memory. "In 1940," he recalled, "to my great horror, my statues began to dwindle. I wanted to reproduce from memory a girlfriend whom I loved. . . . I wanted to make her 80 centimeters high. Well, it became so small that I could no longer manage to put in any detail. . . . All my statues, inexorably, ended up being one centimeter high. One push of the thumb, and presto! no statues!" In 1940, during the early days of World War II when he returned to Geneva, Giacometti is said to have carried the entire contents of his studio in a wooden matchbox.

Giacometti remained in Geneva until 1945, when he returned to Paris. Slowly and with great difficulty, Giacometti began to work in a larger style. "I had had enough," he explained. "I swore that I would no longer let my statues get even one inch smaller. So this is what happened: I kept the height, but it became thin, thin, immense and threadlike." Giacometti's etiolated matchsticklike figures, with their "gaunt frames, knobby ravaged skin, and wiry solitude," have been described by Hughes (among others) as "the visual metaphor of Existentialist Man." Sometimes, as in the unforgettable, 70-inch-high

Man Pointing (1947; Tate Gallery, London) or in *Man Crossing a Square* (1949), his figures are alone. Others are clustered in groups, as in *City Square* (1948–49) and *Three Men Walking* (1949). Herbert Read called attention to the disturbing quality of these individuals-within-groups, "each intent on his own purpose and direction but constituting, in the totality of their movements, a spatial texture." Giacometti labeled these groups "constructions," saying, "I have never regarded my figures as a compact mass, but as transparent constructions." Thus the persistent surreality of his work, even though he had abandoned the enigmatic content of his surrealist sculpture of the 1930s.

Critics are fond of discussing Giacometti's work in terms of how it symbolizes the crushing isolation of modern man, and what Read called the "mournful sense of inner emptiness" is clearly present in those sculptures whose figures stand on pedestals and inhabit skeletal frameworks. An example is the 69¾-inch-high *The Cage* (1950). One of Giacometti's most haunting creations is an 11¾-inch-high bronze, in which a figurine in a box, which is sandwiched between two other, houselike boxes, is walking from one to another.

In addition to his figures, Giacometti modeled innumerable portrait busts, which he never considered finished, of the two people closest to him—his Swiss wife Annette and his brother Diego. Annette, whom he met in 1949 and who always addressed him with the formal *vous,* and Diego appear in his paintings, most of which date from 1947. His figures, perilously attenuated like his sculptures, are represented in the large, barren, mysterious space of his studio. Linear suggestions of an inner framework or enclosure encourage the sense of isolation in such oils as *Diego* (1952) and *Annette Seated* and *Elongated Head of Diego,* both of 1954. Giacometti also painted several still lifes in a similar manner.

In the early 1950s Giacometti's work entered a third phase. The sculptor ceased to think of his figures as representational, seeing them instead as replications of essence, of the reality underlying appearances. For this reason Jean-Paul Sartre, the leading postwar exponent of existentialism, saw in his friend Giacometti's sculpture a visual metaphor of the phenomenology of being—a way of seeing man unsentimentally in his concrete situation; man laid bare, the social, spiritual, and metaphysical veils stripped away—he had been developing. In a remarkable *Art News* (September 1955) article entitled "Giacometti in Search of Space," Sartre showed a keen awareness of the formal qualities as well as the psychological implications of Giacometti's sculpture

and painting. Regarding Giacometti's "framing" of his figures, Sartre wrote, " . . . They keep an imaginary distance with respect to us, but they live in a closed space which imposes on them its own distances, in a prefabricated void which they do not succeed in filling and which they submit to rather than create." Plaster was Giacometti's favorite medium in sculpture, and as Sartre said in an article for *Derrière le miroir* (Paris; May 1954), "Kneading the plaster, out of fullness he creates emptiness."

Picasso, although entirely different from the Swiss artist in temperament and outlook, greatly admired Giacometti's work. According to Françoise Gilot, Picasso remarked, "Sculpture with Giacometti is the residual part, what remains when the mind has forgotten all the details. He's concerned with a certain illusion of space that is far from my own approach but it's something no one ever thought of before in just that way. It's really a new spirit in sculpture."

Giacometti's association with Samuel Beckett began in 1951, and he was the natural choice to design the set for the 1952 Paris production of *Waiting for Godot.* Also in 1951, Giacometti signed an exclusive contract with the prestigious Galerie Maeght, Paris.

Giacometti achieved international fame in the late '50s, but, devoted entirely to his work, his personal life was unchanged, even uneventful. In 1955 large Giacometti exhibitions were held concurrently at the Arts Council Gallery, London, and the Guggenheim Museum, New York City. He received the Guggenheim International Award in 1958, the Sculpture Prize at the Carnegie International, Pittsburgh, in 1961, the Grand Prize for Sculpture at the Venice Biennale of 1962, and the Grand Prize for Art of the City of Paris in 1965. Despite these successes, Giacometti was haunted by a sense of failure, feeling that his search for a figure that would express what he called the "totality of life" had been frustrated, in part by the evanescent nature of the world of actuality. "Art interests me very much," he said, "but truth interests me infinitely more." Examples of his later sculpture are *Bust of Diego on a Stele* (1958), and *Monumental Head* (1960), both in the Hirshhorn Museum and Sculpture Garden, Washington, D.C.

The Alberto Giacometti Foundation was established in Zürich in 1965. In early 1966 Giacometti traveled to Stampa to visit his mother. He died suddenly there on January 11. A large retrospective was held in 1969–70 at the Musée de l'Orangerie des Tuileries, Paris.

Alberto Giacometti had a wiry build and stood about five feet ten. His face, according to Alexander Liberman, who photographed him in his

Paris studio, was that of a *condottiere,* "thick, curly brown hair [encasing] his head like medieval headgear." Liberman was struck by "the long, straight, noble nose" and "the deep creases from cheek to thick-lipped mouth." For Françoise Gilot, Giacometti's "deeply furrowed face" had "the strength and nobility of the head of a lion." His small, crowded studio in the Alésia district gave, in Liberman's words, an "over-all impression of monochromatic grayness," entirely consonant with the tonalities of his painting. Hundreds of cigarette butts littered the floor. "In the darker corners of the room," Liberman wrote, "his long, narrow life-size figures of white plaster seem like apparitions from another planet."

Even when conversing with friends in his studio or meeting them in one of his favorite Montparnasse cafés, Giacometti was obsessed by his search for the unattainable. This led to self-deprecations which could become tiresome to the listener. But the self-belittling strain was in no way a strategy for suppressing or concealing an obstreperous ego; nor was it a device for eliciting the compassion of others, for Giacometti was a singularly honest and intelligent man. Like Cézanne, he was haunted by the difficulty, perhaps the impossibility, of realizing his sensations. "One does that which escapes one most," said the artist who smashed or discarded much of his work. "I have always failed . . . but I am sure no one can realize that for which he strives. . . . I make a head to understand how I see, not to make a work of art."

At the time of Giacometti's death, Hilton Kramer observed that Giacometti "in utterance and appearance seemed the very embodiment of the archetypal avant-garde figure," but he had very little influence on younger artists in Europe or America. In the catalogto an important Giacometti exhibition at the Sidney Janis Gallery, New York City, in 1976, James Lord wrote, "He foresaw with melancholy clairvoyance that he stood at the extreme end of a tradition."

EXHIBITIONS INCLUDE: Gal. Pierre Colle, Paris 1932; Julian Levy Gal., NYC 1934; Peggy Guggenheim's Art of this Century, NYC 1945; Pierre Matisse Gal., NYC from 1948; Venice Biennale 1950, '62; Gal. Maeght, Paris from 1951; Arts Council of Great Britain, London 1955; Solomon R. Guggenheim Mus., NYC 1955; Kunsthalle, Bern 1956; Kunstmus., Zurich 1962; Gal. Beyeler, Basel 1963; MOMA, NYC 1965; Louisiana Mus., Humblebaek, Denmark 1965; Tate Gal., London 1965; Mus. de l'Orangerie des Tuileries, Paris 1969–70; Solomon R. Guggenheim Mus., NYC 1974–75; Sidney Janis Gal., NYC 1976; Galerie Claude Bernard, Paris, 1976; Fondacion Jean March Madrid, 1976; Fondation Maeght, Saint-Paul-de-Vence, France 1978, 1979; Serpentine Gal., London, 1981. GROUP EXHIBITIONS IN-CLUDE: Salon des Tuileries, Paris 1925; Gal. Aktuaryus, Zurich 1927; "Exposition Surréaliste," Gal. Pierre Colle, Paris 1933; "International Surrealist Exhibition," New Burlington Gals., London 1936; "Fantastic Art, Dada, Surréalism," MOMA, NYC 1936–37; "Exposition internationale du surrealisme," Gal. des Beaux-Arts, Paris 1938; Art of this Century, NYC 1942; Venice Biennale 1948; "Sculpture de Rodin à nos jours," Maison de la pensée Française, Paris 1949; "L'Ecole de Paris 1900–1950," Royal Academy of Art, London 1951; Open Air Exhibition of Sculpture, Battersea Park, London 1951; "Recent Trends in Realistic Painting," Inst. of Contemporary Art, London 1952; "New Images of Man," MOMA, NYC 1959; Carnegie International, Pittsburgh 1961; Knoedler Gal., New York.

COLLECTIONS INCLUDE: Mus. Nat. d'Art Moderne, Paris; Kunsthaus, and Alberto Giacometti Foundation, Zurich; Tate Gal., London; MOMA, and Solomon R. Guggenheim Mus., NYC; Albright-Knox Art Gal., Buffalo, N.Y.; Hirshhorn Mus. and Sculpture Garden, Washington, D.C.

ABOUT: "Alberto Giacometti" (cat.), Orangerie des Tuileries, Paris, 1969; Dupin, J. Alberto Giacometti, 1969, Ford, J. A Giacometti Portrait, 1980; Genet, J. Giacometti, 1957; Hughes, R. The Shock of the New, 1981; Leiris, M. Giacometti, 1951; Liberman, A. The Artist in His Studio, 1960; Lucie-Smith, E. Late Modern: The Visual Arts Since 1945, 1969; Osborne, H. (ed.) Oxford Companion to Twentieth-Century Art, 1981; Read, H. A Concise History of Modern Sculpture, 1964; Sylvester, D. "Alberto Giacometti" (cat.), Tate Gal., London, 1965. *Periodicals*—Art News September 1955, March 1976, January 1980; Cahiers d'art (Paris) nos. 8–10 1932; Minotaure (Paris) December 1933; Oeil (Paris) November 1976, August 1978, December 1978; New York Times January 18, 1976; XXe siècle (Paris) January 1952, June 1957; June 1977.

GLARNER, FRITZ (July 20, 1899–September 18, 1972), Swiss-American painter, managed, within the narrow tenets of neo-plasticism adopted from his friend Piet Mondrian, to create in his geometric paintings a "dynamic equilibrium" by the relatively simple (though radical in context) use of tondo-shaped canvases and trapezoidal rather than rectilinear forms. Despite the strong influence of Mondrian, Glarner's undogmatic,intuitive approach to composition was in direct opposition to that of the Dutch master; whereas Mondrian had written "It is above all the composition which must suppress the individual," Glarner claimed, "A visual problem is never put a priori as a mathematical problem, but is born in the process of painting and evolves in a state of unawareness of the painter."

"We all saw it from Cubism," Georges Vantongerloo, the Constructivist sculptor and for-

mer member of de Stijl, once told Glarner, "but you came from a different place." Vantongerloo referred not only to Glarner's artistic development, but also to his personal history. Unlike the other developers of neoplasticism (all northerners), Glarner was, as he himself liked to point out, "a Mediterranean type." Of Swiss-Italian parentage, Fritz Glarner was born in Zurich and moved to Naples at the age of five. After spending two years in Paris and one in Chartres (1910–13), the family returned to Naples, where Glarner began art study at the Accademia di Belle Arti (until 1921). There he spent most of his time copying paintings and plaster casts of the Renaissance and Baroque masters and studying perspective and chiaroscuro—hardly the typical education for a major Abstractionist. Glarner, who supported himself painting portraits in the 19th century academic style, was totally ignorant of contemporary art when he came to Paris in 1923 to continue his studies at the Académie Colarossi (1924–26). "I had never seen a Cubist painting," he said. "In fact, I had never even seen Cézanne." Cézanne, and after him Seurat, had an immediate and important influence on him.

In Paris, Glarner frequented the Closerie des Lilas, Le Dôme, and other cafés, where he met Vantongerloo, Theo van Doesburg, Jean Hélion, Robert and Sonia Delaunay, and, in 1928, Mondrian. At first, none of them took him seriously as an Abstractionist, but the influence on him of these geometric painters was to be deep and long-lasting. Initially, however, he kept to a representational style of still-life painting, simplifying the forms to bring out their rectilinearity and using long diagonals to activate the composition (for example, in *L'Equerre*, 1928, Set Square). "Little by little, I was compelled to dematerialize the object," he said of this period, "eliminating everything that seemed to me to be superficial, reducing it to an appearance that was no longer specifically the appearance of a *form-symbol.* . . . To bring about a purer and closer relationship between form and space has been my problem since that time."

Glarner first exhibited in Paris at the Galerie d'Art Contemporain in 1926, and had a solo show at the Galerie Povlozky in 1928, the year he married an American, Louise Powell. By 1933, when he became a member of Vantongerloo's short-lived Abstraction-Création group, Glarner had abandoned naturalism for a kind of Constructivist–suprematist abstraction, but he was still using the still life as a basis for his compositions and was not to find his mature expression for another decade.

After spending a year in Zürich the Glarners settled in New York City in 1936. (Glarner became a US citizen in 1944.) In 1938 he joined the recently organized American Abstract Artists group (AAA), which was fervently promoting the utopian ideals of geometrical abstraction as against the social-realist and American-scene painting then filling the museums. The AAA included among its members Burgoyne Diller, Charmion von Wiegand, Harry Holtzman, Carl Holty, and such illustrious émigrés as Josef Albers, Laszlo Moholy-Nagy, and, shortly after he arrived in New York in 1940, Mondrian himself. Glarner and Mondrian quickly resumed their friendship and became quite close. Glarner accepted him as his master and adopted the two basic tenets of neoplasticism: that the intention of painting has to be purely two-dimensional, and that pictorial equilibrium is created through the dynamic of opposition.

One year after Mondrian's death in 1944, Glarner began a series of "relational paintings," so-called because the essence of their meaning is to be found in the relationship between color, line, and form. These were at first rather Mondrian-esque, but soon Glarner began introducing innovations that Mondrian would never have considered: the wedge or trapezoidal form, used to create the dynamic equilibrium that even Mondrian acknowledged his own pictures often lacked, and the tondo (as in *Relational Painting: Tondo 2 1944–45*, which not only is round but incorporates "stopped lines" that break into the white spaces). Glarner found a way of bringing the pictorial center of his tondos to the circumference by focusing the viewer's attention on the circumferential cardinal points. He thus eliminated, in his opinion, any naturalistic interpretation—"a sun, a moon, or any symbol"—of its circular shape. His palette, which had originally included soft pinks, blues, and browns, was stripped and refined as well; he now used exclusively the primaries, black, glistening white, and an infinite, almost sensuous range of pure grays.

After a short period of further development, (until about 1949), Glarner's style became stabilized. *Relational Painting 60* (1952) is representative. A maze of trapezoidal forms, slipping over and under one another in an indeterminate space and punctuated by thick black dashes, leads the eye in an oscillating pattern over the picture plane. The larger masses, vertical in emphasis as in most of Glarner's work, are clustered toward the top of the frame; there is a spot of great illusory depth at the lower left where smaller forms converge in a rectilinear spiral.

Although Glarner was usually considered one of the most talented of the heirs of Mondrian,

not all critics responded to his very active images, which still bore the marks of his struggle with the canvas. "At times," wrote David L. Shirey in *The New York Times* (February 19, 1971) of Glarner's only major retrospective in the US, "he overuses the wedge image and overpopulates the canvas with too many rectangles in a cloying profusion of color. Rather than produce a canvas full of life, he produces a hodgepodge with a surfeit of meaningless geometry." However, his best and largest works—the murals for the Time-Life Building (1957), the Dag Hammarskjøld Library at the United Nations (1961–62), and the Nelson Rockefeller apartment (1963–64), all in New York City—seem to activate the architectural space they occupy, making the rectilinearity of the rooms appear an outgrowth of the paintings themselves.

Glarner traveled to Ticino, Italy, several times between 1965 and 1966 to work on a suite of lithographs at the studio of the sculptor Renno Rossi. In 1966 he suffered a serious injury in a shipboard accident while returning from Europe and was unable to continue painting. After completing a final project, the mural for the Justice Building at the Empire State Mall in Albany, New York, he moved to Locarno, Switzerland, where he died in 1972. Major retrospectives of his work were mounted in 1970–71 at the Institute of Contemporary Art, Philadelphia, and in 1972 at the Kunsthalle, Bern.

EXHIBITIONS INCLUDE: Milan 1921; Gal. d'Art Contemporain, Paris 1926; Gal. Povlozky, Paris 1928; Civic Club, NYC 1931; Kootz Gal., NYC 1945; Fried Gal., NYC 1949, '51; Gal. Louis Carré, Paris 1952, '55, '66; Mus. of Art, San Franscisco 1970; Inst. of Contemporary Art, Philadelphia 1970–71; Gimpel Fils, London 1972; Gimpel and Hanover Gal., Zürich 1972; Kunsthalle, Bern 1972; Graham Gal., NYC 1980. GROUP EXHIBITIONS INCLUDE: Salon d'Art Français Contemporain, Paris 1929; Abstract-Création Exhibition, Paris 1931; Kunsthaus, Zürich 1936; "American Abstract Artists," Whitney Mus. of Am. Art, NYC 1938; "American Abstract and Surrealist Art," Art Inst., Chicago 1947; "Abstract Painting and Sculpture," MOMA, NYC 1951; São Paulo Bienal 1951; Pittsburgh, International, Carnegie Inst. 1952; Tokyo Biennale 1953; "Glarner: Vantongerloo," Rose Fried Gal., NYC 1954; "Younger American Painters," Portland Art Mus., Ore. 1955; Documenta #1, Kassel, W. Ger. 1955; "Twelve Americans," MOMA, NYC 1956; Biennial, Corcoran Gal., Washington, D.C. 1957; American Exhibition, Moscow 1959; "A Survey of Geometric Abstraction in America," Whitney Mus. of Am. Art, NYC 1962; "The Formalists," Gal. of Modern Art, Washington, D.C. 1963; "Mondrian, De Stijl, and Their Impact," Marlborough Gerson Gal., NYC 1964; Venice Biennale 1964; "Schweitzer Malerei 1945–65," Pforzheim, W. Ger. 1966; "The 1930's, Painting and Sculpture in America," Whitney Mus. of Am. Art, NYC 1968; "The Swiss Avant-Garde," Cultural Center, NYC 1971; "Die

Gruppe der Zürcher Konkreten," Bündner Kunstmus., Zürich 1979.

COLLECTIONS INCLUDE: Albright-Knox Art Gal., Buffalo, N.Y.; MOMA, and Whitney Mus. of Am. Art, NYC; Mus. of Art, Baltimore; Dartmouth Col., Hanover, N. H.; Nat. Gal., and Hirshhorn Mus. and Sculpture Garden, Washington, D.C.; Mus. of Art, Philadelphia; Yale Univ., New Haven, Conn.; Kunstmus., Bern; Kunstmus., Basel; Kunstmus., Winterthur, Switzerland; Kunsthaus, Zürich; Time-Life Corp.; Empire State Plaza, Albany, N.Y.; Nelson Rockefeller Collection; Dag Hammarskjøld Library, United Nations, NYC.

ABOUT: Baur, J.I.H. Revolution and Tradition in American Art, 1951, (ed.) New Art in America, 1957; Edgar, N. Fritz Glarner's Geometry: A Personal Language, 1970; McCabe, C.J. The Golden Door, 1976; Staber, M. Fritz Glarner, 1972. *Periodicals*—Art International January 1936, Summer 1968, November 1969; Arts Magazine June 1959, December 1980; Bulletin of Museum of Modern Art Spring 1951; New York Times February 19, 1971.

GOTTLIEB, ADOLPH (March 14, 1903– March 4, 1974), American painter, was a first-generation Abstract Expressionist and a leading member of the post–World War II New York School. He was born in New York City, the son of Emil and Elsie (Berger) Gottlieb. His father was in the wholesale stationery business. Thomas B. Hess, in *New York* magazine (February 7, 1977), suggested that memories of the family storeroom ("a vast dim space lined with shelving and compartments, all labelled—pencils above, pens below, erasers to the left, inks beyond") may have contributed to "images concerned with the storage and retrieval of archetypical themes and paternal rites" in Gottlieb's "compartmentalized" paintings of the 1940s.

Gottlieb left high school in 1920 to study painting with John Sloan and Robert Henri at the Art Students League, but, apart from two brief periods of study at the League and classes at the Parsons School of Design later on, he was self-taught. In 1921 he worked his passage to Europe and attended sketch classes without instruction at the Académie de la Grande Chaumière and other studio schools in Paris. He later visited Berlin and Munich.

Returning to New York City in 1923, Gottlieb finished high school and studied at the Parsons School of Design and again at the Art Students League. For the next five years he continued to paint while supporting himself by doing odd jobs, including sign painting and teaching at settlement houses and summer camps.

Gottlieb began as a representational painter,

© Marlborough-Gerson Gallery, NYC; Photo by F.K. Lloyd

ADOLPH GOTTLIEB

and first achieved recognition when he won second prize in a national competition sponsored by the Dudensing Galleries, New York City, in the summer of 1929. In May 1930 the gallery presented a joint exhibition of the work of Gottlieb and the first-prize winner, Konrad Cramer. The *Art News* critic wrote of Gottlieb's paintings: "At present there is a wide range of variety in his interests—figures, still lifes, landscapes and street scenes. In the majority of these, the artist's enthusiasm appears to have somewhat outdistanced his technical ability." In February 1934 Gottlieb's oils were exhibited at the Uptown Gallery, and his watercolors were shown in May at the offices of Theodore A. Kohn and Son.

On June 12, 1932 Gottlieb married Esther Dick. In the summer of 1935 he returned to Europe for two months. Later that year in New York he helped to found the Ten, an independent group of painters working in a more or less expressionist idiom and unsympathetic to the prevalent styles of social realism and regionalism. The group included artists who were later to become well-known—Mark Rothko, Ilya Bolotowsky, Ben-Zion, and Lee Gatch—and Gottlieb exhibited annually with the Ten until 1939. In 1936 he was employed as an easel painter on the Federal Arts Project (FAP); his paintings executed for the FAP included *Sun Deck* (1936; University of Maryland, College Park). In its muted palette and sensitive application of paint *Sun Deck* recalls the pictures painted in the 1930s by Milton Avery, an artist much admired in those years by younger painters like Gottlieb and Rothko. Gottlieb was also interested in the color of Matisse at a time when many ad-

vanced New York painters were studying Picasso or Miró.

In 1937 Gottlieb left the FAP and lived for a year in the desert near Tucson, Arizona, painting semiabstract still lifes and landscapes. His series of still lifes based on cactus forms have been regarded as a prelude to his pictographs of the 1940s. As a result of winning a nation-wide competition sponsored by the US Treasury, Gottlieb was commissioned in 1940 to execute a mural in the Yerrington, Nevada, post office, and in April of that year he had a solo show at the Artists Gallery, New York City. Reviewing the exhibition, Emily Genauer wrote that Gottlieb was "a romantic, working in deep and somber tones sometimes organized into quiet austere arrangements of still-life, and sometimes into landscapes that have an imaginative, unworldly air."

About 1941 Gottlieb began to evolve the series he called "Pictographs"—stylized symbolic motifs based on human and natural forms isolated in rectangular compartments, and painted mainly in earth, clay, and mineral hues. He had long been interested in primitive art, and his stay in Arizona had made him aware of the imagery and mythical lore of the American Indians. His interest in Greek mythology was evident in *The Eyes of Oedipus* of 1941. The painting's compartmentalization was not only a means of structuring the canvas, but allowed for the introduction of enigmatic, totemic symbols—circles, crosses, dots, arrows, human eyes and noses, serpents, suns, and moons. Among the best known of these paintings, in which mythic content was expressed in biomorphic forms, are *The Enchanted Ones* (1945), and *Voyager's Return* (1946; Museum of Modern Art, New York City). Gottlieb's style, a kind of abstract surrealism with symbolic overtones, was paralleled in the mid-1940s in the work of Rothko, Barnett Newman, and William Baziotes. At the same time, the orderly, rectangular configurations in Gottlieb's canvases owed something to the influence of Mondrian, whose presence in New York from 1939 until his death in 1944, was, as Thomas B. Hess has observed, "crucial to the opening phases of Abstract Expressionism."

Throughout the 1940s and into the early 1950s, Gottlieb was clearly identified with the pictograph style. Asked why he compartmentalized his pictures, he replied, in *Arts and Architecture,* "I am like a man with a large family and must have many rooms. The children of my imagination occupy the various compartments of my painting, each independent and occupying its own space. At the same time they have the proper atmosphere in which to function together, in harmony and as a unified group." In

1943 he and Rothko published a five-point aesthetic manifesto in *The New York Times* (June 7, 1943). They were responding to *Times* critic Edward Alden Jewell, who had, rather vulgarly, attacked Gottlieb's painting *Rape of Persephone* and Rothko's *Syrian Bull,* dismissing them as example of ersatz surrealism. Aided by Barnett Newman, Gottlieb and Rothko published a strident polemic which sought to justify use of primitive imagery, mythic themes, and surrealist ideas and to define the terms of the new, avant-garde American painting. In their now-famous letter they also declared that "the subject is crucial and only that subject-matter is valid which is tragic and timeless. That is why we profess spiritual kinship with primitive and archaic art."

One of the finest of Gottlieb's later pictographs is *Labyrinth No. 2* of 1950. Its subtle color and evocative symbolic imagery of arrows, pyramids, eyes, disks, and faces recall the work of Paul Klee, but structurally the painting owes something as well to the Uruguayan artist Torres-Garcia as well as to Mondrian—although, unlike Mondrian's rigid rectangles, Gottlieb's compartments are uneven and have a handmade look.

In 1944–45 Gottlieb was president of the Federation of Modern Painters and Sculptors. He was one of three avant-garde Abstractionists selected in 1951 by the architect Percival Goodman to provide decorations for Congregation B'nai Israel, a new synagogue, school, and center in Millburn, New Jersey. He designed the huge ark curtain—19 feet high and 8 feet wide—which incorporated stylized representations of traditional Jewish iconography. Two years later he was hired by Goodman to design the ark curtain for a new synagogue in Springfield, Massachusetts. This time his design was made into a wool tapestry. His most ambitious architectural commission, the 1300-square-foot facade of the Milton Steinberg Memorial Center in New York City (1952–54), was a kind of checkerboard pattern made up of 91 individual window panels covering four floors. One-third of the surface was devoted to abstract compositions derived from Jewish religious symbolism. After the work was completed, Gottlieb remarked, according to the New York *Herald Tribune:* "It's a satisfaction to reach a larger audience than normally sees modern paintings. Work of this kind has to be more intellectual, less subjective than easel painting. Its effect on my oils will probably be to lead me, in reaction, to more subjective abstraction than ever."

Meanwhile there had been a change of direction in Gottlieb's style. In the early 1950s he gradually broke through the rigid linear framework of his pictographs in search of a new freedom of spatial depth. He enlarged the scale of his work and enriched the range of his color. In some of his new canvases the single totemic image was lifted out of the pictograph context to become a picture in its own right. At the same time the symbols themselves became simpler and less specific, until in many instances they were reduced to two essential images: a peaceful disk for the sun or moon and an angry exploding ball for the earth—the basic composition and symbology of his best-known work. In 1951 he began a series of "Stratified Landscapes," in which the compartmentalized grid of the pictograph paintings was abandoned in favor of zoned compositions divided by a horizontal line. In one of the key paintings of this new phase, *The Frozen Sounds, No. 1* (1951; Whitney Museum of American Art, New York City), the celestial symbols—abstract black or red shapes—hang above the horizon against a richly textured white sky; the lower section symbolizes the earth seething in chaos. Gottlieb worked variations on this theme throughout the 1950s.

In November–December 1957 a retrospective of 31 of Gottlieb's paintings from 1941 to 1957 was held at the Jewish Museum, New York City. Carl Baldwin, reviewing the show for *Arts Magazine,* noted that in addition to works containing an overall calligraphy or pictography of signs and symbols, as in *Sounds and Night* (1948), there were canvases featuring "powerful, heavy lines which form entanglements or cages" (*Unstill-Life* of 1952). In a third category were Gottlieb's most characteristic works of the 1950s, "pictures which are divided strictly in two with a polemical opposition of the iconic upper part and the activated lower part." Typical of this phase were *Groundscape* (1954–56), *Burst* (1957), and *Counterpoise* (1959, 108 inches by 90 inches), in which the dark brown disk of the sun hangs peacefully above the boiling yellow mass of the earth. Much was made of the supposed analogy (never endorsed explicitly by the artist) between Gottlieb's bursting planets and the fireballs of atomic explosions.

According to Thomas B. Hess, Gottlieb "loathed all literary and storytelling painting." His interest in Freudian theory and in primitive and archaic mythology led him towards an art deliberately filled with cosmic symbolism. Edward Lucie-Smith called Gottlieb an artistic "rhetorician"—rhetoric meaning the use of "vague, expansive, generalized symbols." He noted that Miró in the late 1930s had also used cosmic symbols, but painted them "more lightly and crisply," without overstressing their deeper meanings. Gottlieb, however, Lucie-Smith add-

ed "makes me feel that I am being asked to take a weighty significance on trust"—a significance "not inherent in the color or the brushwork." Skillfully professional as Gottlieb's virtuoso handling of paint was, not all critics were convinced that the large scale and ambition of the artist's work was adequately supported by the repetition of such "cosmic" dualities, which after constant repetition skirted the cosmically banal. In some of his paintings of the 1960s, such as *Three Elements* (1964), Gottlieb developed an elaborate patina of paint, "layer caressed over burnished layer." Hess saw analogies to the glazed surfaces of the African sculpture and the Japanese masks that Gottlieb ardently collected.

Gottlieb was of medium height, with a ruddy complexion and a small moustache. He had a cocksure manner and was assertive, even dogmatic, in his opinions. Until the stroke that paralyzed him in his last years, he had a brisk walk, decisive gestures, and, according to Hess, an "Indian-straight posture." In November 1972 he had a solo show at the Marlborough Gallery, New York City. He had worked on the last picture in a wheelchair, his left arm in a sling, using assistants as his "hands." A mural-sized painting, *Flotsam,* was finished in 1973, a year before his death in New York City at the age of 71. In his last year he also made monotypes, 20 of which were exhibited with other late works at the André Emmerich Gallery, New York City, in February 1978.

Gottlieb did not make preliminary drawings for his pictures, but developed his visual ideas while working on the canvas. Some of his best works, like *From Midnight to Dawn* (1956), with its radiant blues and the sparkling blacks of its abstract calligraphy, were painted over old pictures which subtly influenced the new work. Gottlieb made an important contribution to abstract art in America, but given the multiple choices now possible, posterity has not endorsed his sweeping statement to interviewer Seldon Rodman: "We're going to have perhaps a thousand years of nonrepresentational painting now." In 1962 Gottlieb summed up his own exploration of the irrational and rational polarities of art and his concern with subjective content and ordered space when he declared that "the whole effort of my work is to make a synthesis of all these things. In other words, to get a totality of experience which is emotional, irrational, and also thoughtful."

EXHIBITIONS INCLUDE: Uptown Gal., NYC 1934; Theodore A. Kohn and Son, NYC 1934; Artists Gal., NYC 1940, 1942–43; Wakefield Gal., NYC 1944; Gal. 67, NYC 1945; Nierendorf Gal., NYC 1945; Kootz Gal., NYC 1947, 1950–54; Kootz Gal., Provincetown, Mass.

1954; Bennington Col., Vt. 1954; Martha Jackson Gal., NYC 1957; Jewish Mus. NYC 1957; André Emmerich Gal., NYC 1958, '59; Gal. Rive Droite, Paris 1959; Inst. of Contemporary Arts, London 1959; French and Company, NYC 1960; Sidney Janis Gal., NYC 1960, '62; Walker Art Center, Minneapolis 1963; São Paulo Bienal 1963; Marlborough-Gerson Gal., NYC 1964, '65; Whitney Mus. of Am. Art, NYC 1967; Solomon R. Guggenheim Mus., NYC 1967; Marlborough Gal. d'Arte, Rome 1970; Marlborough Fine Art Ltd., London 1971: "Paintings 1971–1972," Marlborough Gal., NYC 1972; Marlborough-Godard Gal., Toronto 1973; "Paintings 1945–1974," André Emmerich Gal., NYC 1977; "Pictographs," Edmonton Art Gal., Alberta, Canada Ca. 1977; "Late Works and Monotypes," André Emmerich Gal., NYC 1978. GROUP EXHIBITIONS INCLUDE: Dudensing Gals., NYC 1930; "The Ten: Whitney Dissenters," Mercury Gal., NYC 1938; Annual, Whitney Mus. of Am. Art, NYC from 1940; Pittsburgh International, Carnegie Inst. 1952–70; "The New American Painting," MOMA, NYC International Circulating Exhibition, 1958–59; Documenta 2, Kassel, W. Ger. 1959; "Past and Present," Corcoran Gal., Washington, D.C. 1966; "Dix ans d'art vivant," Maeght Fondation, Saint-Paul-de-Vence, France 1967; "American Artists of the 60's," Boston Univ. Art Gal. 1970; "New York Painting and Sculpture, 1940–70," Metropolitan Mus. of Art, NYC 1970; Abstract Painting in the 70s," Mus. of Fine Arts, Boston 1972; "Amerikanische Abstrakte Malerei," Marlborough Gal. AG, Zürich 1973; "Aspects of Postwar Painting in America," Solomon R. Guggenheim Mus., NYC 1976.

COLLECTIONS INCLUDE: Metropolitan Mus. of Art, MOMA, Solomon R. Guggenheim Mus., and Jewish Mus., NYC; Brooklyn Mus., N.Y.; Newark Mus., N.J.; Albright-Knox Art Gal., Buffalo, N.Y.; Munson-Williams-Proctor Inst., Utica, N.Y.; Addison Gal. of Am. Art, Andover, Mass.; Brandeis Univ., Waltham, Mass.; Art Inst. of Chicago; Carnegie Inst., Pittsburgh; Corcoran Gal. of Art, and Hirshhorn Mus. and Sculpture Garden, Washington, D.C.; Flint Inst. of Arts, Mich.; Des Moines Inst. of Arts, Iowa; Dallas Mus. of Fine Arts; Isaac Delgado Mus. of Art, New Orleans; Los Angeles County Mus.; Bezalel Mus., Jerusalem.

ABOUT: Ashton, D. The New York School: A Cultural Reckoning, 1973; Baur, J.I.H. Nature in Abstraction, 1958; Current Biography, 1959; Greenberg, C. Art and Culture, 1961; Guilbaut, S. How New York Stole the Idea of Modern Art: Abstract Expressionism, Freedom, and the Cold War, 1983; Hess, T.B. Abstract Painting, 1951; Lucie-Smith, E. Late Modern: The Visual Arts Since 1945, 1969; Rodman, S. Conversations with Artists, 1957; Rose, B. American Art Since 1900, 2d ed. 1975; Sandler, I. The Triumph of American Painting: A History of Abstract Expressionism, 1970, "Adolph Gottlieb: Paintings 1945–1974" (cat.), Marlborough-Gerson Gal., NYC, 1977; Seuphor, M. Dictionary of Abstract Painting, 1957. *Periodicals*—Art Digest April 1, 1945; Art International (Lugano) vol. 3 1959; Art News March 1955, April 1966, December 1973; Arts and Architecture September 1951; Arts Magazine February 1960, July 1977, April 1978; Liv-

ing Arts June 1963; New York December 4, 1972; February 7, 1977; New York Herald Tribune September 19, 1954; New York Times June 7, 1943, June 13, 1943, February 23, 1964, March 5, 1974, February 17, 1978; Studio April 1968.

GRANDMA MOSES. *See* **MOSES, GRANDMA**

GRANT, DUNCAN (JAMES CORROWR) (January 21, 1885–May 10, 1978), painter and designer, practiced over his long career a poetic decorative style that he exercised not only in paintings but also in the decorative arts. Grant was also a member of the influential Bloomsbury Group. He was born in Rothiemurchus in the Scottish county of Inverness, the only child of Major Bartle Grant and Ethel (McNeil) Grant. Both his grandmothers were English. Much of Grant's boyhood was spent in India, where his father's regiment was stationed, but there were journeys home on leave every two years. In 1894, he entered Hillboro Preparatory School in Rugby, England, where he remained for five years. Because his parents were still abroad, Duncan spent his holidays—and found an antidote to his misery at school—with his father's sister, Lady Jane Strachey, a remarkable, highly cultivated woman. His aunt had ten children, five boys and five girls, all distinguished by wit, taste, learning, and imagination. One of the brothers, Lytton Strachey, became a renowned critic and biographer and a leading member of the Bloomsbury Group. Grant's artistic interests were already awakened, and he is said to have "prayed that one day God would make him paint like Burne Jones."

In 1899 young Duncan Grant entered St. Paul's School, London, as a day student. Since it was assumed that he would follow an army career, he was placed in the "Army Class" and forced to concentrate on mathematics, of which he understood nothing. Lady Strachey, seeing his unhappiness, persuaded his parents to let him leave St. Paul's and go to the Westminster School of Art, London, in 1902. There he received encouragement and advice from the French artist Simon Bussy, a pupil of Gustave Moreau at the Ecole des Beaux-Arts, Paris, and a lifelong friend of Matisse. Bussy was also engaged to one of Grant's Strachey cousins. Nonetheless, Grant achieved no particular distinction at the Westminster School of Art and was refused admission to the Royal Academy School.

Far more important than classes to his early development was his journey to Italy in 1902–03.

Jorge Lewinski

DUNCAN GRANT

He copied the Masaccios in the Carmine in Florence and was deeply impressed by the paintings of Piero della Francesca in Arezzo. In 1906 he spent a year in Paris, where he studied with Jacques-Emile Blanche, an able painter, a talented writer, and a friend of Marcel Proust. On Blanche's advice Grant studied the Chardins in the Louvre, and while there, he was captivated by the French Impressionists. On his return to London he entered the Slade School of Art, but remained only half a term. He then took a studio in Fitzroy Square where he could work independently.

An enthusiastic traveler, Grant journeyed to Sicily, Tunisia, and Greece. His quietly lyrical *The Lemon Gatherers* (1911; Tate Gallery, London) was inspired by memories of Sicily and Piero della Francesca. Revisiting France in 1909, Grant called on Matisse at his home outside Paris. Back in London, he was introduced by Lytton Strachey to that brilliant circle of friends later known as the Bloomsbury group. The group revolved around the daughters of Sir Leslie Stephen, Vanessa and Virginia. Vanessa later married the critic Clive Bell and became a distinguished painter in her own right. Virginia, who as novelist and essayist became the most renowned member of the group, married Leonard Woolf in 1912. The oldest member was Roger Fry, already well known as a painter and an art authority, whose company Grant found stimulating. Others in the circle were John Maynard Keynes, E.M. Forster, and Desmond MacCarthy and his wife. A few years younger than the others, Grant was nevertheless at home with their cosmopolitan outlook, their pacifistic

socialism, their freedom from convention, and the devotion to art and ideas that underlay the irreverent wit of their conversation. Grant himself took little active part in these discussions, but he had great personal charm and under his somewhat diffident manner a distinct individuality could be discerned.

In 1910 Grant exhibited with the Friday Club in a show organized by Vanessa Bell at the Alpine Club Gallery, a Chelsea studio that was a melting place for the Bloomsbury Group. In the same year an event of major importance for the British art world occurred—the first Post-Impressionist Exhibition, organized by Roger Fry. Fry coined the term "Post-Impressionism" to cover artists as diverse as Van Gogh, Cézanne, Seurat, and Gauguin, all of whom emphasized design and composition, which had been generally neglected by the Impressionists. Fry also included in the show works by their successors, Matisse, Picasso, Derain, Vlaminck, and Othon Friesz. The British public, who considered even the French Impressionists daringly "advanced," were scandalized by the exhibition. Grant, however, was extremely receptive to the new movements. He had been studying the old masters for several years, and agreed with Fry that the Post-Impressionists had rediscovered some of the principles of the European painting tradition.

While Grant's own work was always strongly influenced by the French, he developed a lyrical, decorative, and particularly English form of post-impressionism. His canvases between 1910 and 1914 showed great variety. There were echoes of Cézanne in *Still Life* (ca. 1912, Courtauld Institute, London) and in *Tents* (1912). A sensitive portrait of James Strachey, Lytton's younger brother, painted in 1910, recalls Whistler in its composition and in the Japanese screen in the background, but was more vivid in color. The style of this portrait contrasted with the spirited, humorous arabesque of *Man with Greyhound* (1913). The distortion and patterned areas in *The Tub* (1913) owed something to Matisse, whose work, along with that of Picasso, Grant had first seen in the Stein Collection in Paris in 1908. Whatever the references to other artists, Grant's pictures all had a personal touch, and were, Raymond Mortimer said, "vernal, gay and lyrical with a charming air of spontaneity."

In 1911 Grant took rooms in London in a house where Adrian and Virginia Stephen and Maynard Keynes also lived. He collaborated that same year with Roger Fry, Albert Rutherston, and others in the decoration of a room, since destroyed, at the Borough Polytechnic. Also in 1911, Grant became a founder of the London Group, which represented the most advanced British art of the time.

When Fry organized the Omega Workshops for the production and sale of applied art in July 1913, Grant found an ideal outlet for his decorative talents. He designed book jackets, fabrics, carpets, and marquetry trays and painted screens, table-tops, and pottery. He was so highly regarded by the Parisian avant-garde that in 1914 he was invited to design a production of Shakespeare's *Twelfth Night* for Jacques Copeau's Théâtre du Vieux-Colombier in Paris. In that production, in which the young Louis Jouvet gave a memorable comic performance as Sir Andrew Aguecheek, Grant used Omega textiles, his own and Vanessa Bell's, for the costumes. In these years Grant enjoyed the hospitality and encouragement of the eccentric art-loving Lady Ottoline Morrell, described by Quentin Bell as "that fantastic, baroque flamingo." Bertrand Russell, D.H. Lawrence, Aldous Huxley and the painter Mark Gertlep were frequent guests at Lady Ottoline's home.

This exciting and productive period was suddenly interrupted by the outbreak of World War I in August 1914. A conscientious objector, Grant worked on farms in Suffold and Sussex, but did not neglect his painting. In 1915 he showed in the Vorticist exhibition at the Doré Gallery, London, and in 1915–16 he designed costumes for a New York City production of *Pelléas and Mélisande,* also directed by Copeau. In 1916 he began working on the land at Charleston, a house near Lewes, Sussex, where Clive and Vanessa Bell lived; Charleston was to be Grant's home for some 60 years.

In London, after the war, Grant took a studio in Hampstead, and then one in Fitzroy Street previously occupied by the painter Walter Sickert. During the next few years Grant saw much of Sickert, who gave him encouragement and advice but had little influence on his painting. In 1920 Grant had his first solo show, at the Carfax Gallery, London. From 1922 on, often in collaboration with Vanessa Bell, he designed decorations for many interiors, including Keynes's rooms at King's College, Cambridge.

Grant's decorative gifts were at their freshest and most delightful in such works as *Two Figures with Scroll* (1920) in oil on paper. Not wishing to become trapped by his natural facility, Grant set out to create realistic volumes in space in many of his oils of the 1920s, but several critics felt that in such instances he was working against his temperament. Roger Fry wrote in 1924, "The effort to create complete and solidly realized constructions in a logically coherent space has, I think, hampered rather than helped his expression. Duncan Grant co-ordinates more fully on the flat surface than in three dimensions."

Grant's imaginative textile designs, produced for the firm of Allan Walton & Co. between 1932 and 1939, were well received by the more discriminating sections of the public. Conservative English taste, however, still found Grant's work as a whole distressingly "advanced," although it was anything but startling by Parisian avant-garde standards. The conventionally minded were taken aback by what John Russell has described as Grant's "mingling of Post-Impressionist influence with subject matter that was suffused with an amiable paganism." Grant's three painted panels commissioned in 1935 by the Cunard-White Star Company to decorate a large room in the liner *Queen Mary* were rejected out of hand on the insistence of the company's chairman, Sir Percy Bates. For some time the panels were housed in the canteen of London's National Gallery.

Despite this setback, Grant's reputation had been steadily growing in the English art world, as was indicated by the title of a 1934 exhibition at Thomas Agnew and Sons, London: "From Gainsborough to Grant." In 1926 and again in 1932 he had represented England in the Venice Biennale. His works of the 1930s—especially *Long Decoration—Dancers* (1934), in a joyous mythological vein, and the richly painted *Figure in Glass Case* (1938)—are among his most personal. Until 1938 some of his most appealing landscapes were painted in Cassis, in southern France.

During World War II Grant lived quietly in Charleston. His painting underwent no marked change and he still practiced two distinct styles: the decorative, in which he was most himself, and the more solidly three-dimensional, as in *Haystack before Trees* and *The Gazebo at Charleston* (both ca. 1940).

One of his finest works was a full-length portrait of Vanessa Bell painted in 1942. The affinity between Grant's work and that of Vanessa Bell has often been noted, and there was undoubtedly a reciprocal influence, although, as Mortimer pointed out, Vanessa Bell was "altogether a graver, less exuberant artist."

In the 1950s and '60s, Grant and the type of art he represented were eclipsed by Henry Moore, Ben Nicholson, and Graham Sutherland and by younger men, notably Francis Bacon and Lucian Freud. Nevertheless, Grant's creative activity did not diminish over the years. In 1956 he designed a production of the 17th-century English composer John Blow's opera *Venus and Adonis* for the Aldeburgh Festival. His retrospective exhibition at the Tate Gallery in 1959 was the subject of Clive Bell's last newspaper article.

In his later years Grant, whose works were in many public and private collections in Britain, received several honorary degrees and many tokens of affection and esteem. In 1970 he was the subject of a film by Christopher Mason, *Duncan Grant at Charleston.* The film gave a vivid and intimate picture of Charleston, the house which had become a meeting place and summer residence of the Bloomsbury group between the wars, and in which every room had been painted and decorated by Grant and Vanessa Bell. Some viewers of the film were confused by the fact that the 85-year-old Grant, with his handsome, clean-shaven features and dark hair, looked much younger than his interviewer, Quentin Bell, the son of Clive and Vanessa.

Grant's 90th birthday in 1975 was marked by an exhibition at the Tate Gallery, a show at the Anthony D'Offay Gallery, London, and his first solo show in New York City, at Davis & Long Ltd. In his very last years—he died at the home of friends in Aldermaston at the age of 93—he grew a long beard which gave him a fantastic yet benign appearance, like an aged sprite in a fairy tale. In an obituary notice in *The New York Times,* John Russell observed that Grant "preserved into extreme old age the vivacity of interest and the immediacy of human contact that in earlier years had made him irresistible to men and women alike."

EXHIBITIONS INCLUDE: Carfax Gal., London 1920; Paul Guillaume and Brandon Davis, Ltd., London 1929; Thomas Agnew & Sons, London 1937; Leicester Gals., London 1945; Tate Gal., London 1959, '75; Arts Council Gal., Cambridge, England 1969; Anthony D'Offay Gal., London 1972, '75; Davis & Long, Ltd., NYC 1975. GROUP EXHIBITIONS INCLUDE: "Friday Club," Alpine Club Gal., London 1910; "Exposition de Quelques Indépéndants Anglais," Gal. Barbaqanges, Paris 1912; "20th Century Art Exhibition," Whitechapel Art Gal., London 1914; "Vorticist Exhibition," Doré Gal., London 1915; "The New Movement in Art," Mansard Gal., London 1917; Venice Biennale 1926, '32; "From Gainsborough to Grant," Thomas Agnew & Sons, London 1934; Exposition Internationale d'Art Moderne, Paris 1946; "Paintings by Duncan Grant and Vanessa Bell," Royal West of England Academy, Bristol 1966; "British Art 1890–1928," Columbus Gal. of Fine Art, Ohio 1971.

COLLECTIONS INCLUDE: Tate Gal., Courtauld Inst. Gals., and Arts Council, London; Mus. and Art Gal., Brighton, England; City Art Gal., Birmingham, England; City Art Gal., Manchester, England; Leiscestershire Mus. and Art Gal., Leiscester, England; Scottish Nat. Gal. of Modern Art, Edinburgh; Nat. Gal. of Victoria, Melbourne, Australia.

ABOUT: Bell, Q. Bloomsbury, 1968; Morphet, R. (ed.) "Duncan Grant: A Display to Celebrate His 90th

Birthday" (cat.), Tate Gal., London, 1975; Mortimer, R. Duncan Grant, 1944; Shone, R. Bloomsbury Portraits: Vanessa Bell, Duncan Grant, and Their Circle, 1976. *Periodicals*—Apollo (London) November 1967; Art and Artists April 1980; Burlington Magazine (London) May 1951; Connoisseur (London) May 1972; New York Times May 12, 1978.

GRAVES, MORRIS (COLE)

GRAVES, MORRIS (COLE) (August 28, 1910–), American painter, has an almost mystical sensitivity to and sympathy for birds, small animals, and unspoiled nature, as revealed in his delicate oils, gouaches, and drawings. According to his biographer, F.S. Wight, Graves is himself *"birdlike*: receding, private, mobile, and migratory"; in later life at least he has come to possess some of the elusiveness of an endangered species. Self-taught, he belongs to no school or movement. Beyond his association with the Federal Art Project, his admiration for Mark Tobey, and his lifelong fascination with the art and philosophy of the Far East, Graves is a thorough individualist who has paid little attention to the problems and struggles of modernism. Instead he has pursued a style farther and farther from that of his contemporaries even as he has personally retreated before what one writer called "the onrush and outrage of machine noise."

The son of backcountry Oregon homesteaders, Morris Cole Graves was a frail child. He dropped out after two years of high school in Seattle, where his family had moved when he was a boy, to enlist as a seaman with the American Mail Line. In three short trips to the Orient (1928–31), he saw Hawaii, the Philippines, Hong Kong, and, most important, Tokyo. "In Japan," he said, "I at once had the feeling that this was the right way to do everything. It was the acceptance of nature, not the resistance to it." From these excursions date his earliest drawings—sketches of local birds and animals—his love of Asian art, and his interest in Vedanta and Buddhist philosophy. Graves continued to draw after returning to the US in 1931. He spent a brief period studying animals in the Los Angeles Zoo, finished high school in Beaumont, Texas, while staying with relatives, and traveled as far as New Orleans before coming back to Seattle in late 1932.

These were the worst years of the Depression, and as an unknown artist Graves lived a Spartan existence, as did most of his friends. The lack of economic opportunity hardened his migratory restlessness. He took up oil painting at this time, producing dark, heavily impastoed studies of birds (he had already found his subject matter) on sacking, the only canvas he could afford. *Moor Swan* (1933), his first important oil, won

Xenia Cage, NYC

MORRIS GRAVES

a $100 acquisition prize from the Seattle Art Museum. (*Moor Swan* is the only painting to survive from this early period; the others were destroyed in a fire.) In 1935 Graves made a second trip to Los Angeles with the painter Guy Anderson, living and painting in a Model-T laundry truck. After working as a gardener's caretaker he again returned to Seattle when his father died in 1936. That year the Seattle Art Museum mounted his first, well-received solo show, which led to his being employed as an easel painter by the Federal Art Project of the Works Project Administration on and off from 1936 to 1939. In the late 1930s he painted two rather unusual series (in light of his later work): the "Nightfall Pieces" (1938), drawings of decayed European furniture thought by some critics to be intended as a protest against the Munich Pact, and the "Purification Series" (1938–39), semiabstract works called by Joseph Dreiss of *Arts Magazine* "gruesome and convulsive surfacings of the unconscious."

Graves had been gradually working toward a more ethereal style; in about 1937–38 he switched to tempera, ink, gouache, and wax on rice paper, materials "not as physically present as canvas and oil." *Bird in the Mist* (1937) already has the sensitive hand and hallucinatory quality of the later bird studies for which he is best known. Graves's interest in Zen Buddhism was deepened by his meeting in 1937 with the avant-garde composer John Cage, who considered himself a Buddhist and who in his music sought to achieve a Zen quality of random playfulness. Graves's work, however, was in no way random; instead, a powerful, almost religious

symbolism, drawn from Japanese and Chinese painting and philosophy and from his own deeply felt connection with nature, illuminated with intense feeling each painting, however successful or unsuccessful technically. "I paint to evolve a changing language of symbols," he wrote in 1942, "a language with which to remark upon the qualities of our mysterious capacities which direct us toward ultimate reality. I paint to rest from the phenomena of the external world—to pronounce it—and to make notations of its essences with which to verify the inner eye."

The influence of Mark Tobey, whom Graves met in 1939, and who shared his interest in Zen Buddhism, can be seen in *Bird Singing in the Moonlight* (1939), and the famous "Blind Bird Series" (1940). He adopted Tobey's "white writing," simply white calligraphic brushstrokes on a dark ground, to give his own painting the ghostliness of a nocturnal vision. (In fact, Graves in the 1940s led a nocturnal existence himself, often painting right through the night at his house, "The Rock," on an island in Puget Sound, in the state of Washington.) For Graves the very act of painting was fraught with danger, "complexly painful, full of desperate and anxious feelings . . . a mixture of anxiety and despair," to quote the artist. His insecurity can be seen in *Little Known Bird of the Inner Eye* (1941), which depicts a solitary, four-legged red bird trapped and fearful in a red dream or thought. Graves's art, suggested J.H. Baur, exists on "another spiritual level . . . so veiled, withdrawn, and intangible that it dissolves when one attempts to grasp it, yet continues to captivate the mind."

In 1942 Graves was given his first substantial national exposure when he placed 31 works in the "Americans 1942" exhibition at the Museum of Modern Art, New York City. He was drafted later that year but was discharged as a conscientious objector in 1943. During the war years he painted the "Joyous Young Pine Series," undeniably the happiest of his works, and a series of "wave" pictures, such as *Sea, Fish, and Constellation* (1944), which incorporated the curvilinear conventions of painting swirling water in Japanese and Chinese art. In 1946 he was awarded a Guggenheim traveling grant to paint and study in Japan. However, permission to enter the country was denied him by the American authorities (probably because of his military discharge), and he had to be content to study the collection of Asian art at the Honolulu Academy of Art. There he painted a series of Chinese bronzes, such as *Ceremonial Bronze Taking the Form of a Bird,* which were shown at the Willard Gallery, New York City, in 1948. Upon his return to the US he began construction of an elaborate new house in Edmonds, Oregon, with the Japanese painter Yone Arashiro. Between 1948 and 1956 he traveled extensively through Europe, Mexico, and Japan, but painted relatively little of note beyond *Flight of Plover,* which Wight called "the finest and purest Graves—a fluid pattern of living motion." The increasing urbanization of the Northwest made it harder and harder for him to work; the pressure of men and machines seemed to rob him of his inspiration. In about 1957 he abandoned the Edmonds house; in protest he painted the "Machine Age Noise" and "Spring and the Machine Age Noise" series. In these uncharacteristically bitter works, ravening masses of red and black—noise, soot, and exhaust—attack and destroy nature.

Graves continued his migratory life in the late 1950s, '60s, and '70s. He lived in County Cork, Ireland, traveled to India and Japan (1961–64), Asia (1971 and '73), and Africa and South America (1972). In the mid-1960s he painted small, concentrically shaped mandalas derived from the patterns of minnows swimming in circles. He then began a series of still lifes of glass bottles and flowers bathed in light against rich brown or green backgrounds (as in *Winter Bouquet,* 1976). In these late works, which exist "in an ambience of quietude and delicious resignation," according to Dreiss, Graves seems to have discovered the simple pleasure and peace of domesticity. "To the feelings of anxiety and despair," Graves wrote of the act of painting, "is always added a kind of awful delight, a kind of bliss, also a not-caring and a caring simultaneously in an obsessive way, also a sadness and a sense of futility—futility because the experience does not endure, is not final, but must always ebb and be re-experienced."

EXHIBITIONS INCLUDE: Seattle Art Mus. 1936, '56; Willard Gal., NYC 1942, '43, '44, '45, '48, '53, '54, '55, '59, '71, '73, '76, '78, '83; Univ. of Minnesota, Minneapolis 1943; Arts Club, Chicago 1943; Detroit Inst. of Arts 1943; Phillip Gal., Washington, D.C. 1943, '54; Philadelphia Art Alliance 1946; Santa Barbara Mus. of Art, Calif. 1948; California Palace of the Legion of Honor, San Francisco 1948; Art Inst., Chicago 1948; Los Angeles County Mus. of Art 1948; Margaret Brown Gal., Boston 1950; Beaumont Art Mus., Tex. 1952; Kunstforneing, Oslo 1955; Boston Mus. of Fine Arts 1956; Bridgestone Mus. of Art, Tokyo 1957; La Jolla Art Mus., Calif. 1957; Phoenix Art Mus., Ariz. 1960; Kalamazoo Inst. of Arts, Mich. 1961; Pavilion Gal., Balboa, Calif. 1963; Univ. of Oregon, Eugene 1966; Richard White Gal., Seattle 1969; Charles Campbell Gal., San Francisco 1979; Whitney Mus. of Am. Art, NYC 1983. GROUP EXHIBITIONS INCLUDE: "Americans 1942," MOMA, NYC 1942; "Romantic Painting in America," MOMA, NYC 1943; "Contemporary Painting and Sculpture," Univ. of Illinois, Urbana 1955; Mus. of

Fine Arts, Houston 1956; Inst. of Contemporary Arts, London 1957; Brussels World's Fair 1958; Seattle World's Fair 1962.

COLLECTIONS INCLUDE: Art Inst., Chicago; Baltimore Mus. of Art; Cleveland Mus. of Art; San Francisco Mus. of Art; Whitney Mus. of Am. Art, Metropolitan Mus. of Art, and MOMA, NYC; Phillips Gal., and Hirshhorn Mus. and Sculpture Garden, Washington, D.C.; Boston Mus. of Fine Arts; Detroit Inst. of Arts; Milwaukee Inst. of Art; Albright-Knox Art Gal., Buffalo, N.Y.; Wadsworth Atheneum, Hartford, Conn.; Harvard Univ., Cambridge, Mass; Pasadena Art Mus., Calif.; Univ. of Illinois, Urbana; Univ. of Nebraska, Lincoln; Santa Barbara Mus. of Art, Calif.; Seattle Art Mus.; Portland Art Mus., Oreg.; Art Gal. of Ontario, Toronto; Tate Gal., London; Worcester Art Mus., Mass.

ABOUT: Baur, J.I.H. (ed.) New Art in America, 1957; Cheney, S. The Story of ModernArt, 2d ed. 1958; Kuh, K. The Artist's Voice, 1960; Soby, J.T. and others-(eds.). "Romantic Painting in America" (cat.), MOMA, NYC, 1943; Wight, F. Morris Graves, 1956. *Periodicals*—Arts Magazine June 1976; Perspectives U.S.A. Winter 1955; Village Voice October 4, 1983.

EMILIO GRECO

***GRECO, EMILIO** (October 11, 1913–), Italian sculptor, has, like several other leading Italian sculptors of the postwar period, achieved his own personal synthesis of tradition and modernism.

When interviewed by Gian Maria Dossena for the magazine *Europeo* (May 12, 1978), Greco recalled his difficult early years: "I was born into a very poor family in Catania [Sicily]. There were eight of us: my father, my mother, an elderly sister of my father's, my sisters, my brother and myself, all living in a house below street level. My father was an upholsterer, and he sent me to school at great sacrifice to himself. When I was three, we moved into a house with real windows, and balconies overlooking the Via Cestai. I slept in the room where my father worked in the daytime, amid the strong smell of oakum and of servicetree fruits hanging from the ceiling to ripen. From the windows I could see the Teatro Machiavelli with its posters of gaudily colored puppets. Those were my first subjects. I drew them on the paving stones of the courtyard with scraps of old plaster. My father earned one lira a day, and my mother was always working away at her sewing machine. My aunt was constantly going around to borrow from the neighbors. When I began school, I would go on my free afternoons to the shop off a barber who tinted the photographs of people who had died. He had painted flowers and nude women on the walls of his shop, and he had put coats of oil paint on three rusty old bicycles that

he rented out to lads in the neighborhood. The oil colors didn't dry on the metal, and the boys would come back looking like an artist's palette. Those were my first colors.

"Among the barber's clients was a sculptor of funerary monuments, which he copied from a book of funerary monuments in a Milan cemetary. Nearby lived another stonecutter who carved the angels to place on the tombs. He gave me my first job, for when I was thirteen my father fell ill and I left school and had to look for work. I was thirteen, it was 1926. It was on funerary monuments that I learned how to give shape to marble. In the evening I modeled in clay, imitating classical works. I had great curiosity. I read Dostoyevsky, Tolstoy, Gorky, and then Plato, Petrarch, Proust. I got books from the public library or borrowed them from friends. I slept with Leopardi's *Canti* under my pillow. I restored myself by reading. During the day I toiled away at marble, and at night I read.

" . . . As a lad I also made renderings for architects, with chiaroscuro and all the tricks that go with that type of work. When I went for my military service in Palermo, I had already acquired so much skill that it was easy for me to be admitted to the academy as an outside student. And I began to take part in a few exhibitions. When I returned to Sicily after being sent to Albania, I began to sculpt again. To earn my living I taught drawing, as well as Gothic calligraphy. I was called up in 1943 and sent to Rome to make drawings of fuses for shells. Two of my terra-cottas were exhibited in the Rome Quadriennale, and the National Gallery of Modern Art had acquired one for five thousand lire. The

allies were landing at Gela. I just had time to send a little money to my family in Sicily. The military technical office to which I had been assigned was transferred to Florence, and I escaped to Rome. I hid in the garret of an itinerant vendor of knitted goods. I had corrected a ration card which enabled me to get one hectogram [just over 3½ ounces] of black bread a day, which I would dip in a cabbage soup in a trattoria on the Via Ripetta. I had such a famished look that a waiter would, on the sly, slip me something to eat into my raincoat pocket. His name was Alfredo. One day a customer in the trattoria, hearing that I was a sculptor, and after looking at my feet, ordered a portrait in plaster of his daughter in exchange for a pair of shoes. When the allies arrived I managed to set myself up in one of their camps selling portraits to the soldiers at five "*am-lire*" apiece. I did them in five minutes. Sometimes they paid me in cigarettes, but I couldn't take them out of the camp: so I modeled a statuette in clay of a seated woman, inspired by a fortune-teller who went around the camp reading palms. In the hollow part of the statuette I hid the cigarettes which I took outside and sold. Maybe that's one of the reasons I don't smoke. I keep the statuette as a talisman."

In 1945 Greco married Fernanda (Nanda) De Andreis, whom he made the subject of several sensitive portraits and figure studies. A daughter, Antonella, was born in October 1949.

Emilio Greco's first solo show was held in the Galleria Il Cortile, Rome, in 1946, and was an immediate success. In 1948 he won the San Vincente Prize for sculpture. Among his works of the late 1940s were *The Prize Fighter* and *Dying Horse*, both very different from his later themes. At the Rome Quadriennale of 1952 he was awarded the Parliament Prize. His distinctive style, marked by sophistication, elegance, and charm, was fully displayed in the seductive bronze *Seated Figure* (1951, 52½ inches high), now in the Tate Gallery, London. In this piece, there are echoes of later Etruscan sculpture and the 16th-century Italian Mannerists, and a stylized grace that recalls the sensuous nudes in the paintings of Modigliani. Greco has said: "Woman is my chief source of inspiration; the female nude, the Venus who embodies all Venuses. . . . The female body is the most harmonious of nature's creations. To reinvent it, to give it new form, is to make poetry."

In 1953 Greco was the prizewinner in the national competition for a monument to *Pinocchio* to be erected in Collodi, a picturesque outlying district of the Tuscan town of Pescia, and the birthplace of Carlo Lorenzini, the author of that famous children's story. Greco's *Pinocchio,*

erected on the grounds of Collodi's majestic 18th-century villa, was done, the artist said, as "a semi-abstract monument, because the theme was abstract, a puppet who becomes human, and a Good Fairy who represents the mother that never existed. And so I constructed a kind of ballet on the hollow trunk of the olive tree, while expressing the concept of liberation by a beating of wings [referring to the great bird hovering above]. The idea came to me between trains, at the Pisa railway station; I sketched the design on the back of a bust." Although controversial at the time it was erected (because it was not "naturalistic"), Greco's *Pinocchio* is among his most popular works.

Greco won the Grand Prize for Sculpture at the 1956 Venice Biennale. He recalled: "I didn't have a lira. I had spent everything on casting the bronzes. I was waiting for something to happen while drinking coffee at Florian's with Fausto Pirandello. I was dismayed at the thought that they had given me room number 17. Luciano Minguzzi arrived making excited gestures, and he told me that I had been awarded the prize. I forgot about number 17, and I borrowed the money to treat everyone to dinner."

Greco's next major commission was in 1959, for the bronze doors of one of the portals of Orvieto Cathedral. For the main entrance Greco created a 24-foot-high, two-ton bronze relief, completed in 1964, and depicting the seven corporal works of mercy as understood in Catholicism. One scene, which eventually turned out to be the most popular of the panels, showed Pope John XXIII on his visit to Rome's Regina Coeli prison in 1958. There were angry objections to installing modern doors on a Romanesque-Gothic structure. One critic complained that "it is like inserting a modern canto into *The Divine Comedy*." After that furious controversy had died down, Greco said, "I had the great satisfaction of receiving the commission for a monument to Pope John for St. Peter's. I saw Pope John for the first time at Castel Gandolfo on August 12, 1960: he was so jovial with the people he was visiting, with his fan-shaped ears. There was no controversy regarding this monument, except for a small incident with Cardinal Cicognani, because in the scene of the visit to the sick, next to the figure of a blind woman, I had modeled a dog, a really fine mongrel. Cicognani said that he didn't want dogs in church, and I said that the dog was meant to represent fidelity, and that I was very pleased with the composition and that dogs had been portrayed in churches in every period. Then Pope Paul VI saw a photo of the relief and gave his approval. Paul VI made me a present of a walking stick that had belonged to Pope John." The monument to John

XXIII was completed in 1966 and unveiled the following year.

In 1966 Greco, accompanied by his daughter Antonella, made a trip to Greece via Brindisi and Corfu, and visited Sicily to see the Greek monuments of the 6th century B.C. A journey to Iran followed in 1967; he was greatly impressed by Teheran and Isfahan. There was another trip to Sicily in 1968.

Greco remarried in 1969; his second wife, Anna Padovan, was a former student of languages at the University of Pisa. She had posed for Greco's commemorative medal for the Rome Olympics of 1960. A son, Alessandro, was born in May 1970.

By the late 1960s Greco had participated in many international exhibitions. He has been well-represented in Japan, and Greco explained how this came about: "I have been twice to Tokyo for my exhibitions. The first time was in 1971. A Japanese commission had come to Italy and had seen my exhibit at the Palazzo dei Diamanti in Ferrara. They asked me to transfer it *en masse* to Japan. At present there is no Japanese city that doesn't have something of mine. In Hakone they've created a Greco Garden." A *Grande Bagnante* (Great Bather) by Greco is in the center of the Ginza in Tokyo.

J.P. Hodin has described Emilio Greco as "modest in spite of all his successes, childlike, often gay, though suffering from asthma, hay fever, and arthritis." For reasons of health and absolute isolation, in 1967 Greco built a studio at the seaside (Lungomare Di Sabauda); he also maintained a studio in Rome. When Gian Maria Dossena visited Greco in his Rome studio in May 1978, the artist was preparing to send 40 sculptures and about 200 drawings and etchings to Moscow for an exhibition. (His pen drawings express form through crosshatching, with only an occasional fine contour.) The female figure was still the dominant theme.

Emilio Greco is a friendly, communicative man, balding, with dark, expressive eyes and a sensitive mouth. He described his way of life to Dossena: "I like to stay home on Sundays. Listening to records, reading books. On Sundays the deserted city is quieter. I listen to music. I draw. I work. I work with the humility of the artisan, believing truly that humility is at the root of all creation. Verrocchio was a goldsmith, Ghiberti was a goldsmith."

Greco has also written poetry, and a volume of his verse was published in Milan in 1952. One of his poems is titled *Dialogue with My Sculpture.* It has been pointed out that in spite of the elongations, simplifications, and even distortions in Greco's sculpture, he has remained in-

different to contemporary developments, and that, like his friend Giacomo Manzù, he is linked to the tradition of the 16th-century Mannerists. One critic wrote that it is hard to see in his figures anything other than "charming decorative objects," and Edward Lucie-Smith asserted that "Greco's female nudes are seductive images which seem, ultimately, to fail because of their superficiality."

On the other hand, Eric Newton of *The Guardian,* reviewing Greco's 1959 show of 20 bronzes at Roland, Browse and Delbanco's gallery in London, wrote that although Greco's "feminine suavity" could easily lead to "the temptation of excessive sensuousness," Greco resisted that temptation "by acutely realizing what his figures are doing" and by his fine "sense of the skeleton beneath the muscle." Referring to Greco's "slight distortions" and his feeling for "an inherent rhythm in the model," Newton observed that Greco's is "essentially the classic approach to art—that of Ingres, for example." The American curator-critic Bernard S. Myers has written: "His work manifests a lyrical classicism, verging at times on mannerism, but embodying a sense of fantasy and removal in the elongated movements of his figures."

Greco himself claims: "I believe that an artist always finds the means to express himself. In the figurative arts one certainly finds the manner of expressing oneself if one has something to say, something true, which does not depend on fashion or commercial considerations."

EXHIBITIONS INCLUDE: Gal. Il Cortile, Rome 1946; Gal. Il Secolo, Rome 1948; Gal. Bergamini, Milan 1950; Rome Quadriennale 1952; Roland, Browse and Delbanco, London 1952, '55, '59; Antwerp Biennale of Sculpture, Belgium 1953; Gal. L'Obelisco, Rome 1954, '57; Mus. of Art, Rhode Island School of Design, Providence 1954; São Paulo Bienal 1957; Ente Premi Roma, Palazzo Barberini, Rome 1958; Städtische Gal., Munich 1959; Künstleraus, Vienna 1960; Mus. Rodin, Paris 1961; Shirokiya Foundation, Tokyo 1961; The Contemporaries, NYC 1961; Gulbenkian Foundation, Lisbon, Portugal 1963; Albert Hall, Canberra, Australia 1966; Nat. Gal. of Victoria, Melbourne, Australia 1966; Gal. Civica d'Arte Moderna, Ferrara, Italy 1970. GROUP EXHIBITIONS INCLUDE: "Arte Italiana Contemporanea," Bienal Hispano-Americano de Arte, Madrid 1955; Venice Biennale 1956; "Artistas Italianos De Hoje," São Paulo Bienal 1957; "50 ans d'art moderne," Palais International des Beaux-Arts, Brussels 1958; "Sculpture Italienne Contemporaine d'Arturo Martini à Nos Jours," Mus. Rodin, Paris 1960; Biennale Nazionale d'Arte, Milan 1965; "Arte Italiano Contemporaneo des de 1900," Mus. de Arte Moderna, Mexico City 1966; "Mostra Internazionale d'Arte," Palazzo Strozzi, Florence 1967.

COLLECTIONS INCLUDE: Gal. Nazionale d'Arte Mod-

erna, and Pinacoteca Vaticana, Rome; Gal. d'Arte Moderna, and Gabinetto Stampe, Milan; Gal. Internazionale d'Arte Moderna, Venice; Gal. d'Arte Moderna, Florence; Mus. di Capodimonte, and Accademia di Belle Arti, Naples; Mus. Revoltella, Trieste, Italy; Mus. Nat. d'Art Moderne, Paris; Tate Gal., London; City Art Gal., Leeds, England; Mus. Royal des Beaux-Arts, Brussels; Mus. Municipal de Sculpture en Plein Air, Antwerp, Belgium; Rijksmus. Kröller-Müller, Otterlo, Neth.; Wallraf-Richartz Mus., Cologne; Kunsthalle, Mannheim, W. Ger.; Neue Pinakothek, Munich; Art Mus., Worcester, Mass.; City Art Mus., St. Louis, Mo.; County Mus. of Art, Los Angeles; Art Gal. of Toronto; Nat. Gal. of South Australia, Adelaide; Nat. Gal. of Victoria, Melbourne, Australia; Queensland Art Gal., Brisbane, Australia; Art Gal., Auckland, New Zealand; Shirokiya Foundation, Tokyo; Nat. Mus. of Modern Art, Kyoto, Japan.

ABOUT: Bellonzi, F. Emilio Greco, 1962; Bénézit, E. (ed.) Dictionnaire des peintres, sculpteurs et graveurs, 1976; Carandente, G. (ed.) Nouveau dictionnaire de la sculpture moderne, 1960; Degenart, B. "Emilio Greco" (cat.), Städtische Gal., Munich, 1959; Hodin, J. P. Emilio Greco: Sculpture and Drawings, 1971; Lucie-Smith, E. Late Modeon: The Visual Arts Since 1945, 1969; *Periodicals*—Art News and Review April 1954; Domus (Milan) January 1951; Europeo (Rome) May 12, 1978; Guardian September 22, 1959; New York Herald Tribune January 3, 1960; Life October 30, 1970; New York Times March 12, 1961, August 17, 1970; Studio International September 1965; Time December 21, 1953, May 12, 1958, August 31, 1970.

GROOMS, RED (CHARLES ROGERS)

(June 2, 1937–), American painter, filmmaker, and environmental artist, is the wittiest, and certainly the most inventive, of the artists to emerge from the Happenings scene of the late 1950s. Bursting with the wicked fun of parody, Grooms's elaborate tableaux anticipated the cool attitude of pop, with its reliance on the aesthetics of popular culture, but his approach has always been enlivened by a gusto all his own. Grooms admires the crowd-mocking bunkum of P.T. Barnum, and the elite absurdism of Marcel Duchamp, but his penchant for the grotesque and cartoonish equally links him with such sarcastic social observers as Ralph Steadman and Öyvind Fahlström. His art, with its mixture of knowing satire, art-historical allusions, funky inventiveness, and weirdly logical vacillations of scale, mood, and media, is, as has often been observed, "hard to pigeonhole."

Charles Rogers Grooms was born in Nashville, the son of a Tennessee Highway Department engineer. As a boy, Red, who early acquired the nickname for his carrot-colored hair and liking for red clothes, constructed elaborate toy circuses in his backyard in an attempt to emulate the

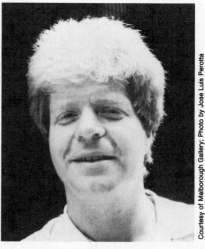

Courtesy of Malborough Gallery; Photo by Jose Luis Perotta

RED GROOMS

Ringling Brothers. During his senior year in a Nashville high school he decided to become a painter and enrolled in the Famous Artists Correspondence Course. For a short period in 1955 he attended the George Peabody School for Teachers, Nashville, and then went to Chicago to study at the Art Institute. Although he found the Institute "too academic," he was impressed by the city, which later became the subject of one of his major three-dimensional constructions, *City of Chicago* (1967).

In 1958 Grooms spent a brief period studying with Hans Hofmann in Provincetown, Massachusetts. From Hofmann he absorbed much of the vigor and painterliness of abstract expressionism, but his vision was essentially figurative and his temperament more breezily extroverted than that of the intense, tormented painters of the 50s. Later in 1958 Grooms moved to New York City, where he supported himself at odd jobs and began experimenting with action painting and junk sculpture. After exhibiting his works at the Delancey Street Museum, lower Manhattan, he became a member of the Reuben Gallery, along with Allan Kaprow, Jim Dine, Claes Oldenburg, and George Segal, all of whom were to play important roles in the happenings and performance movements of the 1960s.

Grooms, who wanted to transfer the visual energy of abstract expressionism from the studio to the city environment, was one of the first creators of happenings. The term "happening" had been coined by Kaprow (another former student of Hofmann's), who in 1958 created his first "total environment"—a combination of theater and art which provided the arena for a series of

actions to be carried out by participants according to a predetermined scenario. At the same time Kaplow allowed room for the improvised and the unexpected. Grooms, who participated in some of Kaprow's early works, at once saw the possibilities of this free-wheeling, open-ended approach.

In December 1959 Grooms staged his first happening at the Reuben Gallery, a converted boxing-gym loft in lower Manhattan. It was a widly comic dada melodrama, *The Burning Building*, written, directed, and performed by himself. The show opened on the first night with someone appearing from backstage to ask for a match, which a member of the audience obligingly provided. This was unplanned: no one backstage had a match, and the piece required a lit candle. This beginning worked so well that it was deliberately used in other performances. (Adrian Henri, in his book *Total Art: Environments, Happenings and Performance,* saw in this an analogy with collage, in which chance is used in the initial stages, but the resulting combinations are then fixed.) The performance of *Burning Building* lasted only ten minutes. Grooms played Pasty Man, a good-natured pyromaniac frantically pursued by a Keystone-Kop-like fireman. The climax came when Pasty Man Grooms somersaulted from the *Burning Building* set (which recalled the German expressionist decor for *The Cabinet of Dr. Caligari*) into the astonished audience. As Judd Tully recalls, "*Burning Building* spread the newly incubated Happening like brush fire through the funky lofts, storefronts and alleyways of Lower Manhattan."

While studying painting and sculpture at Oskar Kokoschka's school in Salzburg in 1960, Grooms met Mimi Gross, daughter of American sculptor Chaim Gross. They were married in 1964. Gross, herself a talented artist, soon became a brilliant and enthusiastic collaborator in Grooms's many projects. Together they traveled on the cheap all over Europe and the Near East. In the summer of 1961 they were staying outside Florence in a kind of "commune" with other young artists, poets, and musicians. Raphael Soyer, in *A Painter's Pilgrimage,* recalled his visit to this colony, and described Red as "a cross between Li'l Abner and Bergman's *Seventh Seal* knight—tall, hungry-looking, sharp-elbowed, red-haired." Grooms wore "a turtle-neck mustard-yellow sweater which, with his red hair, created a strange harmony, or rather combination of colors." Soyer remembers Gross as lively, chubby, and disheveled, "attired tightly in red and brown, her hair like Medusa's."

Later that summer they made what amounted to a honeymoon trip through northern Italy in a horse-drawn gypsy wagon which Gross had gaily and vividly decorated. (Her painting was at that time strongly influenced by German expressionism.) In the course of their circuitous journey, which took them to Verona and other historic cities, they staged clever puppet shows. Supposedly, Ruckus was the name of the horse that drew their wagon, hence the name Ruckus Manhattan which was given to Groom's spectacular environmental project of 1976.)

In 1962 Grooms, aged 25, collaborated with the photographer-filmmaker Rudolph Burkhardt on *Shoot the Moon,* a cinematic tribute to the turn-of-the-century French director Georges Méliès, called "the Jules Verne of the cinema." The production incorporated some of Méliès's revolutionary ideas, especially the notion that the director should combine dramatics, painting, sculpture, design, architecture, and mechanics to achieve a unique blend of poetry and magic. Other films by Grooms include *The Unwelcome Guests* (1961), *Hippodrome Hardware* (1972–73), *The Conquest of Libya by Italia* (1972–73), and *Ruckus Manhattan* (1975–76).

Grooms explored another aspect of mixed media in his three-dimensional tableau of 1963, *The Banquet of Douanier Rousseau,* which recalled the famous Paris gathering of 1908 that included Picasso, Guillaume Apollinaire, Marie Laurencin, and other artists and writers. This was among the first of Grooms's many affectionate and jokily irreverent allusions to art history and past cultures. In recent years he has painted portraits—some poignant, some corrosive—of such fellow artists as Franz Kline, Andy Warhol, Josef Beuys, and Alberto Giacometti (all 1983–84). His large canvas depicting a nocturnal meeting in Washington Square Park between Willem de Kooning and Mark Rothko was displayed in his 1984 show at New York City's Marlborough Gallery.

In 1963 Grooms began showing at the Tibor de Nagy Gallery, New York City, where he exhibited until 1970. He was also represented in several group exhibitions, including "The American Realism" at the Worcester Art Museum, Massachusetts, in 1965, and "Still Life" at the Museum of Modern Art, New York City, in 1966.

By the mid-1960s, happenings had moved to the West Coast to be succeeded on the New York scene by Be-Ins, Love-Ins, and finally by anti-Vietnam war rallies in Central Park and elsewhere. Amid all this turmoil Grooms's work maintained its fantasy, humor, and bite; his mixed-media tableaux were like comic strips in three dimensions. The film world of the 1930s

was affectionately satirized in *Hollywood (Jean Harlow)* (1965, painted wood), now in the Hirshhorn Museum and Sculpture Garden, Washington, D.C. This was followed in 1965–66 by the mixed-media *Loft on 26th Street,* also acquired by the Hirshhorn. Grooms said of his loft studio in Manhattan, on which the piece was based, "I had such a strong feeling about it—as if the place were really me." Because the building was scheduled for demolition, Grooms devoted seven months, working ten hours a day, to constructing this elaborate and amusing scale model, in which he introduced painted cardboard cutouts of his wife Mimi, his brother Spencer, his friends, and Grooms himself, preparing French fried potatoes. With their uproarious vitality, good humor, and bizarre extravagance, Grooms's tableaux are at the opposite pole from those of the California artist Edward Kienholz, who savagely dissects the ugly and sinister aspects of the American scene with an equally sharp satiric eye.

Grooms's film *Fat Feet,* made in Chicago in 1966, wittily combined caricatures of city architecture with animation and live dancing figures in masks. Two of the performers were Grooms's friends, the Chicago painters Roland and Ellen Ginzel. (Ten years later the Ginzels' son, Andrew, was part of the team that worked on *Ruckus Manhattan.*) Red and Mimi Grooms visited Chicago again in the fall of 1967 to create an environmental piece in the Allan Frumkin Gallery. In 1968 they completed *The City of Chicago,* a mixed-media environment 25 feet square, the first of a series of detailed and abundantly documented "sculpto-picto-ramas," to use Red Grooms's own terms. Dozens of sketches made on walking tours, from rooftops, and from the study of photographs and postcards were used in preparing the immensely detailed work. A wealth of historical and even art-historical allusions added to the undeniable, if parodic, authenticity of this giant mockery of the city.

After its successful installation, *Chicago* was dismantled and shipped to the Venice Biennale of 1968, where many critics considered it the best American work in the show. After its return it served as the set for a new Grooms movie, *Tappy Toes,* completed in 1970. Like *Fat Feet,* *Tappy Toes* combined sculptures, architecture, painting, music, and film, with added touches derived from Busby Berkeley spectaculars. Meanwhile *Chicago* toured various museums in the United States under the sponsorship of the Smithsonian Institution, and the impressive but relatively fragile piece is now in storage at the Art Institute of Chicago.

Discount Store, commissioned by the Walker Art Center of Minneapolis in 1970 was Grooms's next large construction. His brother Spencer joined the team of friends who helped to build this sprawling work, in which viewers could wander among three-dimensional cutout display counters and life-sized pasteboard shoppers and salespersons, to the accompaniment of canned music. *Discount Store* was described by critic Judd Tully as a "virtuoso pastiche of consumer cannibalism."

Leaving the Midwest, Grooms returned to the theme of the Big Apple in a series of lithographs loosely titled "No Gas." The Apollo 15 moonlanding of 1971 inspired *Scott and Irwin on the Moon,* exhibited in the "Ten Independents" show at the Solomon R. Guggenheim Museum, New York City, in the spring of 1972. The 14-foot-high astronauts were made with acrylic paint, gesso, thick canvas, and foam rubber over an armature of wood and styrofoam, and set before a cut-out of the lunar module in an eerie moonscape. Grooms remarked: "I wanted to do the sort of thing the people [at Cape Kennedy] were doing—building something incomprehensible, then try[ing] to get it off the ground."

In the fall of 1973 a Grooms retrospective was installed in the Rutgers University Art Gallery, New Brunswick, New Jersey: it included *Chicago, Discount Store,* and the *Astronauts* tableau. The exhibit then traveled to the New York Cultural Center and was seen in 1974 in the Museo de Arte Contemporaneo, Caracas.

The Groomses' new gallery in New York, the Marlborough, together with a nonprofit organization called Creative Time Inc., helped to sponsor their most ambitious environmental project, the phenomenally popular *Ruckus Manhattan: A Sculptural Novel about New York.* (The name "Ruckus" had by now become Grooms's trademark. He called his film company Ruckus, and the enthusiastic and youthful team that worked on the new venture called themselves the Ruckus Construction Company—even publishing one hilarious issue of a "journal" called *The Daily Ruckus.*) Part of this wonderfully elaborate and grotesque magnum opus, which caricatures buildings and objects as well as people, was opened to the public under the aegis of Creative Time on November 20, 1975 on the ground floor area of a high-rise at 88 Pine St., in the Wall Street district. In May 1976 the second phase of *Ruckus Manhattan,* with some notable additions, was staged at the Marlborough Gallery. Thomas B. Hess, writing in *New York* magazine, described *Ruckus Manhattan* as "a multidimensional, mixed-media, walk-through, polychrome sculpture" of notable (and not so notable) landmarks in lower Manhattan. Adults as well as children delighted in the inventiveness

of Grooms's vision of Manhattan, which, to quote *The New Yorker*, "combines the populism of a W.P.A. mural with the irreverence of subway graffiti." It was actually possible to climb a narrow stairway to the top of their 30-foot-high mock version of the World Trade Center. The crazily tilted Woolworth Building had a garish 5-and 10-cent store dragon, armored in nickels and dimes, wrapped around its middle, and visitors could enter a tiny model of the lobby; Mr. Woolworth himself could be seen peering out of the art deco skyscraper. The Statue of Liberty, largely the work of Mimi Gross Grooms, had the wide-brimmed hat and broad features of the colorful former New York Congresswoman Bella Abzug: she held aloft an electrically lighted cigar and her high platform shoes in bright scarlet were those of an Eighth Avenue streetwalker. The Marlborough Gallery *Ruckus* included a graffiti-covered New York subway car with a grotesque but disturbingly familiar array of passengers, and an adult bookstore, whose furtive, bilious customers pored over the assorted pornography on display. Grooms's teeming Manhattan, according to *The New Yorker*, "seems inspired by a Hieronymus Bosch with a sense of humor." *The New York Times* architect critic Ada Louise Hoxtable was so impressed with *Ruckus Manhattan's* mixture of inspired satire and loving observation that she wrote: "The entire project is carried out with an eye so skillful and sure that it grasps the most salient features of every structure and turns them into a succinct statement on the human and urban condition."

While Grooms was working on *Ruckus Manhattan*, the Paris dealer Roger d'Amécourt visited him in New York and invited him to Paris, with a view to treating the Parisian scene in a similar fashion. In the late fall of 1976 Grooms went to Paris, and a large store space near the Père Lachaise cemetery was made available to him. He worked for seven months of motifs inspired by Paris and French culture but because of the much smaller dimensions of the Galerie Roger d'Amécourt, the exhibit that opened in May 1977 consisted of individual pieces in various media and of different sizes. There were some amusing and cleverly observed relief sculptures in paper and gouache. A wizened old lady walked her dog in *Rue de la Roquette*, and some rather jaded passengers appeared in *Dans le Métro* (very different from the wacky vulgarity of *Ruckus Manhattan's* New York subway). One of the highlights of the show was *Claude Monet*, with the paunchy, white-bearded Grand Old Man of impressionism painting away in his garden in Giverny, as a buxom "muse" (in three dimensions) rises out of the famous water-lily pond. Grooms's versatility and witty perceptions

of the French tradition were shown in some relatively straightforward works on paper—a large gouache of a glowering Victor Hugo, the writer's features superimposed on handwriting and with Gothic towers and crenellations rising out of the lofty forehead, and a bespectacled Pierre Bonnard (the great colorist and devotee of "Japonisme") in colored inks on Japanese paper. The show, while highly entertaining, was definitely the work of "an American in Paris"—one felt that New York and Chicago were Grooms's true arenas.

Red and Mimi Grooms separated in 1977. (An Alice Neel portrait of the couple, executed before their separation, shows the strain of their deteriorating marriage.) Red Grooms now works mostly in New York. Tall and lanky, he still has the soft Tennessee drawl of his early years. His open, boyish face was described by *Newsweek* as "the map of America—floppy red hair, frank blue eyes, farina skin." He has more than once been compared to the cartoon character L'il Abner—in physical appearance, not mentality. Critic Barbara Rose was struck by his "good-natured grin that makes one think of a cheerful clown."

Critical response to Grooms's work has on the whole been very favorable. John Canaday called him the "Bernini of pop art," even though he "violates every principle of every esthetic code." Grooms's links on naive art and pop have been duly noted, but another writer observed that he is "more skilled and sophisticated than true primitives," and that his works, unlike those of many Pop artists, are "non-campy comments on life." Some critics have treated Grooms's works with condescension, especially the tableaux, and Thomas B. Hess found "too much floating hostility" in Grooms's cartoonish figures. But in an artistic scene marked all too often by portentous theorizing and art works carefully drained of any vitality, Grooms's comical exuberance, lively imagination, and essentially good-humored satire have made a refreshing and much-needed contribution. His is an essentially public art. Red Grooms has said, "I like to make sort of documentaries," but his art transcends pictorial journalism because for him it is, and has always been, a life-enhancing activity.

EXHIBITIONS INCLUDE: Sun Gal., Provincetown, Mass. 1958; City Gal., NYC 1958–59; Reuben Gal., NYC 1959–60; Nashville Artists' Guild, Tenn. 1962; Tibor de Nagy Gal., NYC 1963–70; Allan Frumkin Gal., Chicago 1967; Walker Art Center, Minneapolis 1971; 924 Madison Avenue, NYC 1971; John Bernard Myers Gal., NYC 1971–74; Rutgers Univ. Art Gal., New Brunswick, N.J. 1973; New York Cultural Center, NYC 1973–74; Mus. de Arte Contemporaneo, Caracas,

Venezuela 1974; "Ruckus Manhattan," 88 Pine Street, NYC 1975; "Ruckus Manhattan," Marlborough Gal., NYC 1976; Gal. Roger d'Amécourt, Paris 1977; Marlborough Gal., NYC 1981, '84. GROUP EXHIBITIONS INCLUDE: "New Media—New Forms I," Martha Jackson Gal., NYC 1960; American Exhibition, Art Inst. of Chicago 1964, '66; "The American Realism," Worcester Art Mus., Mass. 1965; "Still Life," MOMA, NYC 1966; Venice Biennale 1968; "Ten Independent Artists," Solomon R. Guggenheim Mus., NYC 1972; "Extraordinary Realities," Whitney Mus. of Am. Art, NYC 1973; "The Great American Rodeo," Fort Worth Art Mus., Tex. 1976–77.

COLLECTIONS INCLUDE: MOMA, and New School Art Center, NYC; Hirshhorn Mus. and Sculpture Garden, Washington, D.C.; Chrysler Art Mus., Provincetown, Mass.; Chicago Art Inst.; Milwaukee Fine Arts Gal., Univ. of Wisconsin; Fort Worth Art Mus., Tex.; Wilmington, Delaware Art Mus.; Cheekwood Mus., Nashville, Tenn.; Mus. de Arte Contemporaneo, Caracas, Venezuela; Moderna Mus., Stockholm.

ABOUT: Cate, P. D. "The Ruckus World of Red Grooms" (cat.), Rutgers Univ. Art Gal., New Brunswick, N.J., 1973; Current Biography, 1972; Henri, A. Total Art: Environments, Happenings and Performance, 1974; Kaprow, A. Assemblage, Environments and Happenings, 1966; Kirby, M. Happenings: An Illustrated Anthology, 1966; Lippard, L. Pop Art, 1966; Tully, J. Red Grooms and Ruckus Manhattan, 1977. *Periodicals*—Art News January 1973, April 1976; Encore September–October 1962; New York June 28, 1976; New York Times June 15, 1969, May 7, 1976, April 13, 1984; New Yorker May 31, 1976; Newsweek January 30, 1967; Print Magazine September–October 1970; Time April 9, 1965; Village Voice November 24, 1975; Washington Post April 4, 1971.

GROPPER, WILLIAM (December 3, 1897–January 6, 1977), American painter, injected into the mainstream of social realism a raw vitality, both graphic and emotional, that sprang from his years as a muckraking political cartoonist for the left-wing press. For most of his life a devout proletarian and communist sympathizer, Gropper did satiric battle with the gross injustices of capitalism (while disingenuously ignoring the egregious errors of labor and the horrors of Stalinism), but his work displays a basic humanism and passion for justice that tempers his straight-from-the-shoulder style. In pure graphic ability (if not in political effectiveness) he can be compared to George Cruikshank and Thomas Nast.

Gropper was born into a poor family of Jewish immigrants on Manhattan's Lower East Side. His mother, a sweatshop seamstress, supported the family, and as a child Gropper helped her by carrying bundles of work to and from the shop.

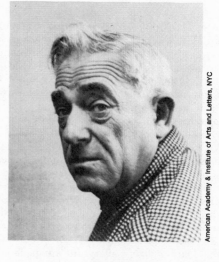

American Academy & Institute of Arts and Letters, NYC

WILLIAM GROPPER

No scholar, Gropper left high school in 1912, but he had already discovered a strong draftsman's gift and excelled in the life drawing classes he took from George Bellows, Robert Henri (both of the Eight), and Howard Giles at the Ferrer School (1912–15). He paid for the lessons with his meager wages as a bushel boy in a loft factory, later as a handyman and advertising artist.

At the Ferrer School the newest ideas of the Parisian avant-garde were heatedly discussed (Marcel Duchamp was often present). Of the 1913 Armory Show, Gropper wrote: "The effect of these strange pictures hit me . . . they crowded my brain in a kaleidoscope of nightmares, grotesqueries, and all manner of wild goings-on." Gropper absorbed the experiments of modernism and used them as an underlying framework in his paintings, which are nonetheless primarily in the service of a much older tradition, that of social satirists such as Honoré Daumier. Gropper also attended the hidebound National Academy of Design, where his rebellious temperament eventually got him expelled—he refused to spend the required sterile hours copying from plaster casts—and the New York School of Fine Arts. He won every drawing prize the School of Fine Arts had to offer.

In 1919 Gropper was hired as a cartoonist for the New York *Tribune*. While doing a story for the paper on the Industrial Workers of the World (the "Wobblies"), he became radicalized, and began donating illustrations to such leftist sheets as *Rebel Worker* and *Revolution*. This quickly led to his dismissal from the *Tribune*. In 1922 he went to Cuba with the journalist Robert Reis. Returning destitute to the US, Gropper

bummed across the country, working as a sign painter, and ended up back in New York City as a dishwasher on the Bowery.

Through a stroke of luck he began to sell drawings to *The Dial* in 1924, the year he married Sophie Frankel, and then to *Pearson's Magazine,* the New York *World,* and the Yiddish Communist daily *Morning Freiheit.* He joined the staffs of the two last-mentioned papers in 1925. At the same time he contributed frequently to the *New Masses,* the *Daily Worker,* and other leftist and labor magazines, usually for free. This did not keep him from working for the very organs of the "bourgeois establishment" that he mocked—*Vanity Fair, Esquire, Fortune,* and others. That money paid his rent and enabled him to devote most of his time to radical causes. Although he never joined the Communist (or any) party, Gropper was a founder of the John Reed Club and the leftist American Artists' Congress. In 1927 he traveled to the USSR with Scott Nearing, Theodore Dreiser, and Sinclair Lewis to attend the Soviet's tenth anniversary. Two years later he published *The Golden Land,* a book of the drawings he had made there. In 1930 he returned to Russia as a delegate to the Kharkov Conference of Writers and Artists.

Two cartoons of the mid-1930s are representative of Gropper's style and concerns. *Capitalist Cartoon Number 1* (1933, ink and chinese white) depicts an arachnoid robber baron, with the body of a bursting bag of gold, clutching factories, ships, trains, armaments, and Congress in eight greedy hands. Between his Pierpont Morganish jaws he grinds the bodies of farmers and workers. The whole, although hardly subtle in impact, is done with complete assurance of line and detail. A savagely funny drawing of Emperor Hirohito, then the very symbol of Japanese imperialism, improbably pulling a rickshaw loaded with the Nobel Peace Prize, created an international incident with the honor-conscious Japanese when it appeared in *Vanity Fair* in 1935. Gropper, unperturbed, directly counterattacked with a cartoon in the *New Masses* called *Behind the Japanese Screen,* a clever pastiche of Japanese drawing styles and Gropper's own blunt caricature.

Gropper had begun to paint sporadically as early as 1921, but did not have a solo show until 1936, at the A.C.A. Gallery, New York City. There he showed, among others, *The Peasants* (1927), an early example of his expressionist social realism and one of the first of many on the rural poor, and *The Senate* (1935), an indictment of laziness and complacency in government. He returned to that subject often, usually, he said,

"when a Senator makes a speech that makes me mad." His second show, at the same gallery, was a great success; New York City's Metropolitan Museum of Art bought two of his works. In the 1930s he also executed a number of murals, including *Wine Festival* (1934) for the Schenley Products Company and, for the Works Progress Administration, *Construction of a Dam* in the Interior Building in Washington, D.C. He completed a mural for the Northwest Postal Station in Detroit in 1939 which now hangs at Wayne State University.

Gropper's paintings have often been dismissed as mere cartoons translated into oil, most recently by Barbara Rose. But Lewis Mumford, reviewing Gropper's second show for *The New Yorker,* found much more in his canvases than the artist's obvious political viewpoint. "As a painter," Mumford said, "he is distinguished by a subtle palette and by his marvellous sense of movement and action. . . . In his power of condensation, Gropper has few rivals; he concentrates in the smallest possible compass, with admirable economy of line and mass, something that another painter might require a whole acre of canvas to express." To Gropper, regardless of the relative merits of his cartoons and paintings, formal concerns were always less important than message. "We painters of the People must not only tell them the truth in human justice and righteousness," he told fellow Social Realist Phillip Evergood, "but we must convince them. The awareness of this truth makes us more alive to the fact that we must say it better and with more conviction than anyone else in order to be accepted." Though he always saw himself as a painter of "the People," his drawing *Art Patrons* (late 1930s) shows the sort of high-toned crowd he began to see at his shows; he drew them with the same acidity to be found in similiar works by Daumier.

In the early 1940s Gropper turned from painting sympathetic portraits of laborers (*Old Woman Sewing,* late 1930s, *Cotton Pickers,* 1942) to full-time work in antifascist activities, which included organizing the "Meet the Axis" exhibition in 1941. In 1944 the Joint Anti-Fascist Refugee Committee honored him with a banquet on his 47th birthday. Perhaps as a relief from political cartooning, in the latter part of the decade he painted a series on legendary American figures—Rip van Winkle, Johnny Appleseed, and Paul Bunyon, among others. When he returned to the United States in 1950 after a two-year tour of eastern Europe, he also returned to familiar themes in such paintings as *Untouchables* (1950), another satiric attack on senatorial venality, and *Piece Work* (1950), showing a dismal sweatshop not unlike the one his mother had

toiled in a half-century before. Gropper was one of a number of artists harassed by the House Committee on Un-American Activities (HUAC) in the 1950s, and, as a result, his patronage among the rich and conservative declined. If anything, this was an encouragement to him.

Two grants—from the Ford Foundation and the American Federation of Art—kept him going through the mid-1960s; occasionally his work took on an unaccustomed optimism, notable in paintings such as *The Baker* and *The Wedding* (both of 1965). In 1967 he finished his last major public commission, the stained-glass windows for Temple Har Zion in River Forest, Illinois. The next year he was elected to the National Institute of Arts and Letters.

Gropper found time in the 1970s to attack police brutality and the corrupt regime of Chicago's Mayor Richard Daley, but a planned series of paintings and lithographs on the ballet was left unrealized. Gropper died of a heart ailment in 1977 at Manhasset, Long Island. In a revealing statement he said in 1968: "I lean toward those who are struggling for something better. I want to paint the truths that I feel, and, at times, I have been criticized for that. . . . I can't close my eyes and say it is the best of all possible worlds and let it go at that."

EXHIBITIONS INCLUDE: A.C.A. Gal., NYC from 1936; Associated Am. Artists Gals., NYC 1945, '51, '52, '65; Silvan Simone Gal., Los Angeles 1959, '60; Gal. de Tours, San Francisco 1962, '65; Lowe Art Mus., Univ. of Miami, Coral Gables, Fla. (and tour) 1968; A.C.A. Gal., NYC (and U.S. tour) 1971–72; Wortsman Rowe Gal., San Francisco 1975. GROUP EXHIBITIONS INCLUDE: "Murals by American Painters and Photographers," MOMA, NYC 1932; Whitney Mus. of Am. Art Annual, NYC 1933–55; "Three Centuries of U.S. Art," Mus. du Jeu de Paume, Paris 1938; Carnegie International, Pittsburgh 1938, '39; "Art in Our Time," MOMA, NYC 1939; New York World's Fair, Flushing Meadow 1939; Golden Gate International Exposition, San Francisco 1939–40; "Romantic Painting in America," MOMA, NYC 1943; Carnegie Inst. Annual, Pittsburgh 1943–50; "The Lower East Side: Portal to American Life (1870–1924)," Jewish Mus., NYC and Smithsonian Instn., Washington, D.C. 1966–68.

COLLECTIONS INCLUDE: Metropolitan Mus. of Art, MOMA, Whitney Mus. of Am. Art, Mus. of the City of New York, NYC; Brooklyn Mus. of Art, N.Y.; Syracuse Univ., N.Y.; Newark Mus., N.J.; Wadsworth Atheneum, Hartford, Conn.; Fogg Art Mus.; Cambridge, Mass.; Brandeis Univ., Waltham, Mass.; Philadelphia Mus. of Art; Phillipps Collection, Hirshhorn Mus. and Sculpture Garden, Smithsonian Instn., Library of Congress, Washington, D.C.; City Art Mus., St. Louis, Mo.; Walker Art Center, Minneapolis; Los Angeles County Mus. of Art; Nat. Gal. of Prague, Czechoslovakia; City Mus., Sofia, Bulgaria; Mus. of Western Art, Moscow; Mus. of Israel, Tel-Aviv.

ABOUT: Cheney, S. The Story of Modern Art, 1958; "Gropper" (cat.), A.C.A. Gal., NYC, 1956; Gropper, W. 56 Drawings, 1929, Collection of Drawings, 1930; "William Gropper: Fifty Years of Drawing 1921–71" (cat.), A.C.A. Gal., NYC, 1971; Rose, B. American Art Since 1900, 2d ed. 1975; Schapiro, D. (ed.) Social Realism: Art as a Weapon, 1975; Soyer, R. Diary of an Artist, 1977; Lozowick, L. William Gropper, 1981. Periodicals—Art and Artists October 1975, September 1977.

***GROSS, CHAIM** (March 17, 1904–), American sculptor, is best known for his lively, naturalistic figure compositions, carved in wood. He was born in Wolow, a small village in the densely wooded mountains of Galicia, then an Austrian crown-land, now part of Poland. He was the youngest of ten children of Moses Gross, a lumber merchant, and the former Lea Sperber. One of his brothers, Naftoli, became a well-known writer and poet in Yiddish. The family were Hasidic Jews whose approach to life was devout yet festive, with great respect for orthodox Jewish culture and for intellectual pursuits but also with a keen awareness of the beauty of their physical surroundings. Because of his father's trade, wood—central to Gross's work as a sculptor—was the focus of his childhood.

Despite all the misfortunes and often terrifying experiences of Chaim Gross's boyhood and adolescence, many of his earliest memories of Austria were happy ones which contributed to some of his most important expressions in art— for example memories of the forests around Wolow, his father's lumber mill, and the sight of peasants carving figures and toys from wood. As he wrote in his book *The Technique of Wood Carving*, "Summer days meant happy days in the surrounding forests or watching the magic circus that came to town once a year. The colorful circus decorations and performances of the acrobats made so deep an impression that it later greatly influenced my work."

When he was six his family moved to the village of Slobodka Lesnia, where they hired a young man to tutor Chaim and his brother Avrom-Leib in the Holy Scriptures. In 1912 the Gross family moved to the city of Kolomyja, in what is now the southwest Ukraine in the USSR. There, besides being enrolled in a government school, Chaim attended *cheder*, or Hebrew school; but he found it hard to adjust to the restrictions both of school and of city life, and preferred to stay at his Uncle Aaron's bucolic farm.

With the outbreak of World War I in 1914, Russian troops occupied Kolomyja, and the young boy witnessed a brutal attack on his parents by Cossacks. Galicia had become a shifting

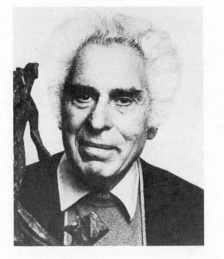

CHAIM GROSS

battleground for Austrian and Russian troops, and later Gross was pressed into service as a stretcher-bearer and grave-digger with the Austrian military. In 1916, after several frustrated attempts, he escaped, and the 12-year-old boy made his way to Stryj, through Silesia, and from Vienna to Budapest. There he supported himself for two years at a succession of menial jobs before apprenticing himself to a jeweler. During these years he developed the habit of sketching constantly in his spare time.

By the end of the war Chaim Gross was determined to be an artist. For six months between 1919 and 1920, after working during the day in the goldsmith's shop, he attended evening classes at a free art academy established in Budapest under the short-lived communist regime of Bela Kun. At the academy Gross drew from the model; his teacher, Bela Utz, a Postimpressionist painter who later escaped from Budapest and went to Russia, would also take his class to the Budapest Museum, where Gross remembers seeing paintings by Pieter Brueghel the Elder, El Greco, and Marc Chagall. He recalls that he was so absorbed by his artistic interests that he was only dimly aware of the political struggles of the time.

In 1920 Bela Kun's government was overthrown by the right, and Gross, as an alien, was held in a detention camp and then deported to his native Galicia. Shortly after his return to Kolomyja, conflict broke out again between Poland and Russia. Gross was imprisoned, but he escaped and fled to Vienna, planning to join Naftoli in New York, where his brother had been living since 1914. While in Vienna, waiting for his brother to send the necessary funds, Gross enrolled in the Kunstgewerbeschule (School of Arts and Crafts) and studied drawing for almost a year. Finally, having obtained their passports and passage money, Gross and his other brother, Avrom-Leib, sailed from Le Havre, arriving in New York City on April 14, 1921.

The early days in a new and strange environment were hard for Gross, who took a job delivering fruit and vegetables and enrolled in night classes at the Educational Alliance Art School on the Lower East Side. He was strongly influenced by the school's director, Abbo Ostrowsky, and in that first year met Isaac and Moses Soyer, as well as Philip Evergood, Peter Blume, Barnett Newman, Adolph Gottlieb, and Saul Baizerman. Gross also met Raphael Soyer, who was then studying at the National Academy of Design and who became his lifelong friend. The warm, cultivated milieu of the Soyer home provided a nurturing atmosphere that had been lacking in Gross's life since his own family had been dispersed in 1914.

For five years after his arrival in New York, Gross worked at his delivery job while attending art schools in the late afternoon and evening. In 1922 he enrolled at the Beaux-Arts Institute of Design and took courses there in sculpture and drawing until 1926. His most important mentor was Elie Nadelman, with whom he studied not carving but modeling in clay from a posed live model. He was greatly impressed by Nadelman's exhibition at the Knoedler Gallery, New York City, in 1927, but even before that he had learned from Nadelman, to quote Roberta K. Tarbell, "about abstraction of forms, the beauty of the simple, curved contour line, a love of folk art, and a belief in the human figure as the most important subject. . . ."

During this period Gross supported himself by doing various odd jobs, including posing as a model and working in a soup kitchen. He spent his summers with the Soyer brothers at the artists' colonies in Woodstock and Provincetown, where he executed a great number of spirited watercolors. After leaving the Beaux-Arts Institute he studied carving with Robert Laurent at the Art Students League, New York City, for a brief period in 1926–27. This was his last experience as a student, and from then on the technique of direct carving became his chosen métier. Gross's two earliest wood carvings, *Girl with Animals* and *Mother and Child,* were done in 1926 in Laurent's class. The forms of these rough-hewn, almost primitive works were solid and compact, unpierced by voids. They were carved in lignum vitae, a hard wood which Gross has described as "my first choice because its ex-

treme density gives me the greatest carving satisfaction I have ever experienced." It has long been among his favorite materials.

Gross's first exhibition was in a group show at the Independent Students Gallery, New York City, in 1926, and soon afterward he opened a small studio on East 14th Street. He taught wood carving two nights a week at the Educational Alliance and occasionally did odd jobs such as house painting and delivering newspapers, but most of his time was devoted to sculpture. This was a period of great privation, when he sometimes went for days without a proper meal. At one point he left the city for a brief stint of menial but steady employment, leaving behind a vague note on his studio door expressing weariness of life. His friends interpreted this message as a suicide note, and a wealthy and conscience-stricken collector, atoning for his neglect of Gross, paid $90 for one of his sculptures—the first purchase of one of the artist's works. Commenting later on his sudden "resurrection," Gross quipped: "The market value of my work took a sharp drop."

Despite Gross's association with the Lower East Side during the Depression years, there were no political or sociological overtones in his genre figures of the period. While his real subject throughout his career has been the human figure, between 1931 and 1933 he carved several abstract portraits in wood, his only nonobjective sculptures. One of these, exhibited in April 1931 at the Society of Independent Artists, New York City, was titled *Portrait of a Famous Man*, but was dubbed "Eddie Cantor" by the newspapers because of its bulbous eyes and generally recognizable features. Another abstract piece, also exhibited in 1931, was a two-part columnar sculpture titled *Lindbergh and Hauptmann Trial*, inspired by the famous kidnapping case. Gross has said that the segment of the Lindbergh half of the sculpture represents the pilot's famous plane, with Lindbergh, Mrs. Lindbergh, and their baby on top. In the Hauptmann portion there is a ladder, a head, the ransom money, the baby upside down, and the tears of the family on top.

A work far more typical of Gross's usual style is *Happy Mother* (1931), carved in Circassian walnut; the reclining figures of the mother and her baby appear to be floating in space. The same fascination with lilting movement and levitation has inspired Gross's many carvings of acrobats and dancers, which constitute about one-quarter of his oeuvre. (His first stone sculpture, carved as early as 1929, represented *Two Circus Girls*.) When asked by a friend during the 1930s why he did so many acrobats, he answered that the combination of two or more figures offered infinite possibilities for design. "If it is beautiful, why shouldn't I continue?"

Gross's first solo show was held in March 1932 at Gallery 144 in Greenwich Village. At the request of Renée Nechin, whom Gross married in December of that year, the sculptor William Zorach wrote the introduction to the exhibition catalog. Zorach there observed of Gross's work: "He has an inherent and natural feeling for carving directly in his material, which releases the possibilities of natural expression as no amount of modeling can."

From 1932 to 1952 Renée and Chaim Gross's home and studio was at 63 East 9th Street, and was a meeting place for many artists. Gross did not begin to support himself by his art alone until 1933 when he joined the New York Public Works of Art Project, born of the Depression. In 1934 he became an American citizen, and in 1935 he joined the New Deal's Federal Arts Project. During the same year he was awarded by the US Treasury Department a $3,000 commission to execute a sculpture, *Alaskan Snowshoe Mail Carrier*, for the Post Office Department building in Washington, D.C. Gross's second solo exhibition was held at the Boyer Gallery, Philadephia, in 1935, and his third was at the New York City gallery of the same name two years later. William Schack, reviewing the New York show in *Parnassus*, wrote that Gross's work was "saved from softness by the lusty forms and the nature of the wood he prefers." In 1937–38 Gross carved a 7-by-12-foot limestone relief, *Riveters* (also called *Steel Workers*), as an overdoor panel for the facade of the Federal Trade Commission building, Washington, D.C.

For the New York World's Fair of 1939–40, Gross was commissioned to execute the monumental four-figure plaster group *Harvest* in the courtyard of the France Overseas building, and *Line-man*, also in plaster, for the Finland building. In 1940, at the fair, he performed the virtuoso feat of carving the statue *Ballerina* out of a six-foot-long log of imbuya wood, working before audiences totaling more than 100,000 people, while explaining to the viewers what he was doing. After its completion, *Ballerina* was acquired by The Brooklyn Museum of Art.

In 1942, in the Metropolitan Museum of Art's important "Artists for Victory" exhibition, Gross won a $3,000 purchase prize for his 1938 statue in Macassar ebony of the circus performer Lillian Leitzell. In 1942 and 1947 there were showings at the Association of American Artists Gallery, New York City, of Gross's drawings and watercolors, but he did not have another major sculpture exhibition until 1947. Ever since the

1920s, when he had gone sketching with Raphael Soyer, Gross had produced deft and lively watercolors, some of which, according to Soyer, had "a semi-wild flavor," with an expressive distortion of natural elements. About 1943 another, very different vein appeared in his "fantasy drawings," depicting surrealistic images from his dreams and the subconscious; for which critics have furnished Freudian interpretations. These disturbing images were also an expression of his horror and bitterness at the slaughter of the Jews by Nazis.

In Gross's 1947 show of sculpture at the A.C.A. Gallery, New York City, there were the typical figures of buxom, full-hipped and narrow-waisted young women and their mothers, all with exuberantly curving contours. An exception, however, was the somber *My Sister Sarah: In Memoriam*, a massive sculpture in hard, dark cocobolo wood, in which mother and child are austerely pressed into an elongated, concave arc. (This piece is now in the Hirshhorn Museum and Sculpture Garden, Washington, D.C.) After that, Hebrew iconography began to appear in Gross's work, a renewed emotional involvement with Judaism, reinforced by the Holocaust and his own personal losses. He first visited Israel in 1949 and has been there many times since. From 1950 to 1957 he carved in wood seven variations on the theme *Lot's Wife*. *Naomi and Ruth* was carved in stone in 1956.

By the early 1950s Gross had arranged to have several bronzes cast from his wood carvings, and consequently these early bronze sculptures resemble carvings. In 1957 he began to create free conceptions in bronze, such as *Baby Balancing* (owned by the Des Moines Art Center, Iowa), and he was evidently making a rapid transition from carver to modeler. Although throughout the 1960s he continued to do carvings in wood and stone, he tended increasingly, from 1957 on, to model in plaster on armatures for casting in bronze—a difficult method owing to the quick drying of plaster. A film about the artist, *The Sculptor Speaks*, was produced by Lewis Jacobs in 1957. That same year Gross went to Rome and there worked on six sculptures in his new medium. The first pieces were included in a retrospective, "Four American Expressionists," held at the Whitney Museum of American Art, New York City, in 1959. In the catalog to the show Lloyd Goodrich discussed Gross's new bronzes: "They display the freer style of a modeler as compared with a carver [and] a more aerial kind of design. . . . These bronzes indicate a liberating and unfolding of Gross's concepts of form."

During the artist's stay in Europe in 1959, several months of which were spent in Rome, he visited Israel, Sicily, Amsterdam, Rotterdam, and Paris. Fired by his enthusiasm for the pioneering achievements of the School of Paris earlier in the century, he planned a series of sculptures in homage to Picasso, Braque, Renoir, Degas, and other heroes of modern art. He began with Chagall, whom he knew personally and with whom he had artistic and cultural affinities. Between 1961 and 1962 he modeled in plaster and had cast in bronze four versions of *Homage to Chagall*. He became indeed so absorbed in the Chagall theme that he never went on to make his contemplated sculptures of other artists of the Paris School. However, he did a lithograph in 1965, entitled *Homage to Jacques Lipchitz* (now in the collection of MOMA).

Gross continued in the 1960s to do figures of dancers and circus acrobats, and he often made use of the greater freedom allowed by plaster and bronze to create multifigured compositions, as in *Ballerinas* (1960), *Bareback Riders* (1961), and *The Hennefords Family Acrobats No. 1* (1964). At times he enclosed his animated figures in a circular form (*Happy Children No. 1*, 1968), but these circular or oval shapes often took on a symbolic meaning, as in *Seven Mystic Birds* (1961; Jewish Museum, New York City). Religious motifs also appear frequently in Gross's work of the '60s and '70s. During the 1960s he designed and cast monumental menorahs for several synagogues, and in 1970–71 he created six 9½-foot-high bronze relief panels devoted to the Ten Commandments for the International Synagogue at New York City's Kennedy Airport. *Mother Israel* (1966) combines dignity, playfulness, and warmth. During the 1970s his sculptures became increasingly abstract, while still retaining recognizable human figures; Old Testament and Judaic themes predominated, in such bronzes as *Jacob's Dream* (1976); *Abraham, Isaiah* and *In Memory of Six Million* (all of 1976–77); and *Jonah and the Whale* (1977). Gross does not, however, consider these works "Jewish art."

The Grosses have two children, Yehudi Zachary and Mimi, the latter a talented artist formerly married to the painter Red Grooms. Chaim Gross is a solidly built man with strong features, a florid complexion, dark eyes under heavy black eyebrows, and a high forehead framed by a halo of snow-white hair. His old friend Raphael Soyer described him as "a loyal man, a self-born type whose knowledge is instinctive, not deliberate." His manner, whether he is in a serious or a jovial mood, conveys geniality and a certain shrewdness. He has always been an avid collector; the walls of the Grosses' large living room in their present downtown Manhattan town house are hung with many

paintings and drawings by artist friends, and he has over the years assembled an impressive array of African wood carvings. The spacious basement studio is filled with Gross's own work representing every period of his career.

EXHIBITIONS INCLUDE: Gal. 144, NYC 1932; Boyer Gal., Philadelphia 1935; Boyer Gal., NYC 1937; Associated American Artists Gals., NYC 1942, '47, '69; Massillon Mus., Ohio 1946; Jewish Mus., NYC 1953, '77; Duveen-Graham Gal., NYC 1957; Forum Gal., NYC 1962, '74; "Sculpture and Drawings," Nat. Collection of Fine Arts, Smithsonian Inst., Washington, D.C. 1974. GROUP EXHIBITIONS INCLUDE: Independent Students Gal., NYC 1926; Society of Independent Artists, NYC 1931; Exposition Universelle, Paris 1937; "Trois siècles d'art aux Etats-Unis," Mus. du Jeu de Paume, Paris 1938; "Portrait of America (Artists for Victory Inc.)," Metropolitan Mus. of Art, NYC 1942; Boston Arts Festival 1954, '63; Am. Nat. Exhibition, Sokolniki Park, Moscow 1959; "Four American Expressionists: Doris Caesar, Chaim Gross, Karl Knaths, Abraham Rattner," Whitney Mus. of Am. Art, NYC 1959; "American Sculpture," Newark Mus., N.J. 1962; "Paintings and Sculpture from the Olga Hirshhorn Collection," Katonah Gal., N.Y. 1976; "The Golden Door: Artist Immigrants of America, 1876–1976," Hirshhorn Mus. and Sculpture Garden, Washington, D.C. 1976.

COLLECTIONS INCLUDE: Metropolitan Mus. of Art, MOMA, Whitney Mus. of Am. Art, and Jewish Mus., NYC; Brooklyn Mus. of Art, N.Y.; Syracuse Univ. Art Collection, N.Y.; Newark Mus.; Philadelphia Mus. of Art; Hirshhorn Mus. and Sculpture Garden, and Nat. Collection of Fine Arts, Smithsonian Inst., Washington, D.C.; Delaware Art Mus., Wilmington.

ABOUT: Current Biography, 1966; Getlern, F. Chaim Gross, 1974; Goodrich, L. and others "Four American Expressionists" (cat.), Whitney Mus., NYC 1959; Gross, C. A. Sculptor's Progress: An Autobiography, 1938, Fantasy Drawings, 1956, The Technique of Wood Carving, 1957, (and others) Sculpture in Progress, 1972; Lombardo, J. V. Chaim Gross, Sculptor, 1949; Tarbell, R. K. "Chaim Gross" (cat.), Jewish Mus., NYC 1977; Zorach, W. "Chaim Gross" (cat.), Gal. 144, NYC, 1932. Periodicals—American Magazine of Art January 1936; Art News February 1952, March 1969; Life January 1951; Magazine of Art December 1938; New York Times March 25, 1967, March 18, 1974; Parnassus February 1937; Time April 29, 1957; April 6, 1962.

*GROSZ, GEORGE (July 26, 1893–July 6, 1959), German-American painter renowned for his savage caricature drawings of life in Germany after World War I. Executed in a tense linear style, these satires were often touched up with watercolor to heighten the vicious thrust of line and theme.

He was born Georg Grosz, the son of north

GEORGE GROSZ

German peasant-craftsmen, in Berlin, but spent his early childhood in the small town of Stolp, Pomerania, where his father managed a Freemason's lodge. After the father's death the family moved back to Berlin and then once more returned to Pomerania. There Grosz's mother worked as the manager of an army officers' club. The stiff, monocled Hussars encountered in his youth were later to figure importantly in the artist's social commentaries. After being expelled from school at the age of 13 for striking one of his teachers, Grosz began studying drawing with a local decorator and then, from 1909 to 1911, was enrolled at the Dresden Academy. Japanese art, the satirical sketches of Daumier, Rowlandson, and Goya were among his earliest influences. Between 1912 and 1914, with the help of a scholarship, he studied at the Berlin Academy of Arts and Crafts. Only then did he begin to teach himself to paint in oils, a medium not included in the strict academic curriculum of either Berlin or Dresden. Sketches of Berlin cabaret life—humorous caricatures of the habitués drawn in his already characteristic dry, linear manner—which he successfully sold to magazines, earned Grosz enough money to take a short trip to Paris in 1913; the sojourn had little immediate effect upon his art. Only later did the influence of Robert Delaunay, Picasso, and the Italian Futurists become apparent. What did exert an important influence on his work at this point were the cartoons of Wilhelm Busch, creator of the famous Max und Moritz comic strip (ancestor of the American Katzenjammer Kids).

From 1914 to 1916, when he was invalided out, Grosz fought with the German infantry in

World War I. In 1917 he returned to service and then was sent to a military hospital with a nervous breakdown. His experiences on the front and in the hospital, and, in particular, the disillusion suffered on his return to dreary civilian life in Berlin, profoundly affected the themes and purposes of Grosz's art. Disgust with war profiteers who flourished while others were needlessly maimed, the cynicism of army doctors and nurses, the corruption of the officer class, the wanton mutilation of bodies and souls became his subjects in a series of vitriolic drawings published between 1916 and 1917 in portfolio form and in the journal *Die neue Jugend.* One of the most famous of these satires is the sketch of a doctor inspecting a skeleton and pronouncing it "*K V*" (*Kriegsverwendungsfähig*/fit for military service). With such works, and with an article he wrote for the pacifist journal *Die weissen Blätter,* Grosz's reputation became established.

Toward the end of the war the artist allied himself with the antiestablishment, antiaesthetic movement known as dada. Thus in 1919, when the Expressionist painter Oskar Kokoschka begged the political factions then bitterly struggling for power in Germany not to endanger culture, Grosz brusquely asserted that the entire art world, Kokoschka included, was not worth one worker fighting for his daily bread. In addition to dada, however, other elements began to shape and enrich Grosz's vision: cubism, the quasi-surrealist images of the Swiss painter Paul Klee, and the montage effects of early cinema. *Metropolis* (1917), a drawing of lecherous, clothed men and nude women parading down a disintegrating street, reflects dada style and owes something also to futurism. His most futurist work is *The Dedication to Oskar Panizza* (1917–18), showing a funeral that has turned into a riot. The sufferings of Germany's "winter of hunger" (1917–18) were tellingly revealed in the futurist-inspired *Germany, A Winter's Tale* (1918; the title was taken from Heinrich Heine's satirical poems of 1844). An oil painting with elements of collage, it is a kaleidoscopic arrangement of buildings and figures illustrating types which particularly earned Grosz's scorn, such as the Professor or the Junker.

It was in 1918 that Grosz joined the German Communist Party; in later years, disillusioned with communism, he broke with the party. More specific, less allegorical barbs were now aimed at social conditions by such caricatures in watercolor and collage as *Diamond Profiteers* (1920) or *Engineer Heartfield* (1920), a study in brutality; and the famous portfolios of drawings that pilloried the Weimar Republic, beginning with *Das Gesicht des herrschenden Klasse* (1979; The Face of the Ruling Class) and including *Ecce*

Homo (1922) and *Spiesserspiegel* (1924; Mirror of the Boobs). So incensed were the authorities at, for example, Grosz's caricature of Chancellor von Hindenburg, or his portrayal of a prostitute wearing a cross, or a representation of Christ in a gas mask (the last an illustration to Jaroslav Hašek's novel *The Good Soldier Schweik*) that they prosecuted him several times in the years 1922–29 for indecency, slander, and blasphemy. In 1923 *Ecce Homo* was confiscated and a number of plates destroyed. Despite, or perhaps because of, this notoriety, Grosz's work sold well, especially among those against whom his satire was most directly aimed.

Notwithstanding the clear objectivity of treatment, the artist's passionate sense of purpose is manifest, and unlike that other great social satirist, Daumier, he spared no one. He attacked middle-class family life, as in the well-known lithograph *Christmas Eve* (ca. 1922); his figures of prostitutes and crippled beggars inspire revulsion more than pity. "I made careful drawings but I had no love of the people. . . . I was arrogant enough to consider myself as a natural scientist, not as a painter or satirist," Grosz later confirmed; and again: "Among the masses I found scorn . . . fear . . . falsehood, betrayal, lies and filth. . . . I have never indulged in worshipping them. . . . "

In Grosz's desire to be objective, not to betray his emotional involvement, he was allied, at least marginally, with the *Neue Sachlichkeit* (New Objectivity) movement—or, more precisely, verism—launched by Otto Dix and Max Beckmann in about 1920. Like Dix, Grosz on occasion painted straightforward, sober, naturalistic portraits such as that of the poet Max Hermann-Neisse (1927). In general, a calmer, more detached tone became characteristic of his work toward the end of the 1920s. A drawing like *The Café* (1925) is less tense than similar scenes done in the previous decade—such as the 1919 pen drawing of a café with its crowd of bestial people; the 1928 watercolor *Two War Veterans,* although certainly satirical in intent, is relaxed and naturalistic in treatment. He never recaptured the savage, incisive power of his earlier work.

Invited to teach at the Art Students League, New York City, in 1932, Grosz accepted readily; he arrived in the US only a few days before Hitler came to legal power. In 1938 Grosz became a citizen. His experience was very different from that of other European artists-in-exile who later fled to America and stayed only temporarily. Unlike them, Grosz had since boyhood wanted to live in the United States. One of the first authors he read and admired was James Fenimore

Cooper, and in 1917, in the midst of the war, he had relieved his misery by painting *I Remember New York*, a watercolor of a then only imagined skyscraper city. And not only had Grosz very early changed the original spelling of his first name (Georg), but he always affected American clothes and a Yankee persona to match. He was of medium height, plumpish, dark-eyed, and had a keen expression and a quick, direct manner of speaking which often masked a deep inner tension.

Upon the arrival of his wife (the former Eva Louise Peter, whom he had married in 1920) and their two sons, the artist established a studio-home in Douglaston, Long Island. Viewing with dismay the rise of nazism in his homeland, Grosz now actively attacked the new regime in many drawings such as *After the Questioning* (1935), with its figures of Gestapo officers leaving a room after having ransacked it, and presumably carried off its occupant. Years before, he had begun to reveal the growth of anti-Semitism in Germany in prophetic drawings; in fact, the entire spirit of nazism is implicit in his earlier targets. In 1937 his work was rounded up and included in the infamous official exhibition, "Entartete Kunst" (Degenerate Art), which toured Germany. It has been suggested that the antifascist caricatures done in America lack the bite of Grosz's earlier, post–World War I satires. They are illustrations rather than visceral reactions to the surrounding evil, as in *Ecce Homo*. Perhaps more inspired by the working out of his own American dream, perhaps merely in an effort to make a living in a society where art directed to social problems was not wanted, Grosz now turned his back on actuality. Perhaps, too, he was weary of rage; as he himself noted, "In portraying and satirizing the events of the day . . . the artist is like a fiddler scraping on too small a violin. There is only a small place in great art for the quips and digs and innuendo of the satirist." For whatever reason, in his many sketches of New York life, especially of Central Park, he never dealt with the effects of the Great Depression as did other Social Realists such as Ben Shahn or Jack Levine. He was successful as a teacher; his League classes were popular, and from 1933 to '37 he ran a school of his own, the Sterne–Grosz School, New York City. His students remember hilarious mimicry of certain Prussian types. The recipient of many commissions for book and magazine illustrations, popular with dealers and collectors, Grosz fared very well. His ambition now, he said, was to become another Norman Rockwell, portraying life as it should be—an ironic quip, one of his characteristic attempts to pose as if caring for nothing. Another, more serious side to Grosz's first years in

the US is presented by his determined study of the history of art: he made frequent sketching trips to the museums, and from about 1936 began to work determinedly in oils, evolving his own new methods (which he documented on the backs of his canvases), even making his own brushes and grinding pigments—mixing them with sand, or wax, or even, on occasion, Coca-Cola. All of this, as he replied to critics who felt he had rejected his earlier purposes, was "not an escape, it was a new beginning." Others saw it as a new academism, a refuge from an increasingly disturbing reality.

From 1936 to about '46 the artist spent most of his summers on Cape Cod, there discovering the painting of landscapes and nudes. Greatly attached to these, for him, novel surroundings, he painted a series of lonely dune scenes, tinged with a certain brooding melancholy, among them *End of the World*: endless, barren dunes mirroring a livid sunset. The same sense of impending doom, a vision of a world bent on destruction, informs *Interregnum,* a series of drawings published in 1936. In the artist's own words: "Fantasy may be uninhibited fancy, which has no contact with the world of reality. But it may also lurk beneath a simple object in nature, like a tree or a rock or a sand dune. It is perfectly logical and natural . . . that to the line that we find in nature we should add other lines that are the product of our inner vision. Such drawing can present both the outer husk and the inner essence. It is infinitely superior to the . . . camera. You cannot take a camera with you into your dream world."

With the advent of World War II the melancholy vision became overt pessimism; paintings such as *The Survivor* (1944), or the nightmarish, almost surrealistic *The Pit* (1946), or *A Piece of My World I* and *II* (1946) express Grosz's hopelessness. In 1947–49 he did his famous "Stickmen" series, monochrome watercolors of eerie skeleton figures with spidery limbs, huge heads, and bulbous insect eyes—frenzied survivors in a ruined world. Over and over again in many of his later works he used the same image: holes turn up in banners waved aloft, holes appear in artist's canvases or in sheets of music. The allusion is certainly to the void; it may also, more hopefully, hint at the continuing search for beauty and truth even in the face of destruction.

After 1946 Grosz lived in Huntington, Long Island. Afflicted with alcoholism, he drank more and more heavily: "That's the only way I can endure life," he acknowledged. Separated from his wife and children and increasingly withdrawn from the contemporary, largely abstract expressionist, art scene, he nevertheless continued to

paint and draw (his works still sold well) and to teach at the League, at other art schools, and in his own home.

In March 1954, Grosz did illustrations for a feature story in *Life* magazine, a piece on a Polish UN delegate who had defected to the West. Thereafter, the artist produced almost no paintings or drawings except for a strange watercolor of a clown's face (1954), unrelated to anything else in his oeuvre and enigmatically entitled *Hommage à Gogol*—perhaps prophetically too, in light of Grosz's own end. Gogol, also a social satirist who had worked many years in exile, died only nine days after his return to Russia. In any event, what is probably Grosz's last work was a brilliantly colored watercolor, *Old Man Watering Flowers* (ca. 1954).

In 1950 Grosz had been invited by the Congress of Cultural Freedom to go to Germany as a delegate; after an agonized decision he reluctantly left New York. He made a second trip in 1956 and then three years later decided to resettle in Berlin. As he had admitted years before, in his autobiography, there were indeed limits to his Americanization: "Although I tried to imitate Walt Whitman . . . and even succeeded in gaining the reputation of being [an] optimist—there still remained in me something unchangeable, something I consider schizophrenic—a margin of inflexibility that was like a mighty immovable stone." Shortly before Grosz's repatriation he was awarded the gold medal of the American Academy of Arts and Letters. He arrived in Berlin on May 27, 1959; on July 6th, after an evening spent drinking with friends he was found dead, suffocated by his own vomit, in his apartment. As this artist—who always regretted that it had not been possible for him to be a painter of joyous, pretty things—had once commented, "Next to me there is always a hell."

EXHIBITIONS INCLUDE: Gal. Hans Goltz, Munich 1920; Gal. Flechtheim, Berlin 1923, '27; Kunsthaus, Zürich 1930; Weyhe Gal., NYC 1931; Art Inst. of Chicago 1936; MOMA, NYC 1941; Associated Am. Artists Gal., NYC 1943, '46, '48; Whitney Mus. of Am. Art, NYC 1954; Heckscher Mus., Huntington, N.Y. 1959; Albertina, Vienna 1965; Kupferstichkabinett, Dresden, E. Ger. 1966; Harvard Univ., Cambridge, Mass. 1973; Frankfurter Kunstverein 1976; Piccadilly Gal., London 1980. GROUP EXHIBITIONS INCLUDE: "Erste Internationale Dada-Messe," Kunsthandlung Dr. Otto Burchardt, Berlin 1920; "Neue Sachlichkeit," Städtische Kunsthalle, Mannheim, Ger. 1925; "Recent Paintings by English, French, and German Artists," Mayor Gal., London 1935; "Entartete Kunst," toured Germany 1937; MOMA, NYC 1940, '83; "L'Art en Europe autour de 1918," Ancienne Douane, Strasbourg, France 1968; "Gemälde, Bildwerke und Zeichnungen des XX Jahrhunderts," Nationalgal., Berlin 1969;

"Berlin in the Twenties," Annely Juda Gal., London 1978.

COLLECTIONS INCLUDE: Nationalgal., Berlin; Wallraf-Richartz Mus., Cologne; Staatsgal., Stuttgart; Kunsthalle, Hamburg, W. Ger.; Mus. d'Art Moderne, Paris; Tate Gal., London; MOMA, and Whitney Mus. of Am. Art, NYC; Art Inst. of Chicago; Nat. Gal. of Art, and Hirshhorn Mus. and Sculpture Garden, Washington, D.C.

ABOUT: Arnason, H.H. A History of Modern Art, 1968; Bauer, J.I. "George Grosz" (cat.), Whitney Mus. of Am. Art, NYC, 1954; Bittner, H. (ed.) George Grosz, 1960; Grosz, G. George Grosz: An Autobiography, 1983; Hofbauer, I. (ed.) George Grosz, 1948; Myers, B. S. The German Expressionists: A Generation in Revolt, 1963. *Periodicals*—New York December 12, 1983; New Yorker November 27, 1943, December 4, 1943, December 11, 1943; New York Review of Books March 1, 1984; Village Voice November 22, 1983.

GUSTON, PHILIP (June 27, 1913–June 7, 1980), American painter, was born in Montreal, Canada, to immigrant parents, and moved with his family to Los Angeles at the age of six. A precocious child, he began drawing seriously when he was 12, and on his 13th birthday his mother presented him with a one-year correspondence course from the Cleveland School of Cartooning. After the initial excitement, though, his interest in that branch of art ebbed, and by the time Guston entered Manual Arts High School, Los Angeles, in 1928, he already had higher ambitions.

Among Guston's fellow students at Manual Arts was Jackson Pollock, whose elder brother Charles was studying art in New York City. The school had a remarkable teacher, Frederick John de St. Vrain Schwankovsky, who exposed his pupils to *Creative Arts, The Arts,* and other art periodicals, and showed them slides of European paintings, especially cubist works. Guston and Pollock both wanted a creative arts project and resented the fact that much of the school's budget went to athletes. They produced a broadside with satirical drawings attacking the English department. A second pamphlet, illustrated with Guston's drawing of a tail-wagging dog titled "Shall the Tail Wag the Dog?" led to their prompt expulsion in 1929, just before the Wall Street Crash.

In 1930 Guston had the good fortune to win a year's scholarship to the Otis Art Institute in Los Angeles, but he soon discovered the school's limitations. "There I was, thinking about Michelangelo and Picasso and I had to study anatomy and build clay models of torsos." One day, in exasperation, Guston collected all the plaster casts he could find into an enormous pile and be-

Photo by Steven Sloman

PHILIP GUSTON

gan to draw them. His future wife, Musa Mc-Kim, happened to enter the studio at that moment and her report of Guston's heap of casts spread rapidly.

Bored by the institute's curriculum, Guston began striking out on his own, and soon made the acquaintance of writers and other ambitious artists. The tall, slender young man was remembered by a school-friend in later years as "a fashion plate and choosy about girls." (A striking photograph of him was taken in 1930 by Edward Weston.) To earn a living, Guston worked with a furrier whose inner office, fortunately for Guston, an avid reader, was lined with books, mostly on philosophy and theology; then in a large cleaning plant; and for a while he drove a delivery truck. However, at night and on weekends he continued to attend classes and study painting.

As the Depression deepened, Guston witnessed not only strikes and strike-breakers in Los Angeles, but also a reactionary art climate in which modernism was popularly regarded as something alien and effete that had been introduced by "decadent" Easterners. For about two years Guston occasionally worked as an extra in movies; he became fascinated by the make-believe world of movie lots. At this time he met the artist Fletcher Martin, who was also working in the film studios. Besides studying the theoretical and artistic side of filmmaking, Guston, long before the emergence of pop art, was interested in the comic strip and the animated cartoon as expressions of a vigorous and authentic popular American culture.

After leaving Otis, Guston, who was an essen-

tially self-taught artist, began to draw incessantly at home, and made copies from reproductions of Italian old masters in books borrowed from the Los Angeles Public Library. Through Loren Feitelson, who ran a life class, Guston was introduced in 1930 to the art-loving millionares Walter and Louise Arensberg, whose Hollywood house was decked with masterworks of the modern era. In the Arensbergs' living room the 17-year-old Guston saw Rousseau's *Merry Jesters,* Chagall's *Half Past Three* (also called *The Poet*), and several works by Giorgio de Chirico. Guston was impressed less by de Chirico's famous *Soothsayer's Recompense* of 1913 than by his later work, *The Poet and His Muse* (ca. 1925), with its two mannequin figures in the cramped space of a room interior. At this time Guston also admired the heavy-limbed Roman women of Picasso's neoclassic period. He always retained his admiration for both de Chirico and Piero della Francesca, saying that he loved them for their muteness. "They don't demand love. They stand and hold you off."

By 1932 many young painters in Los Angeles, including Guston, were drawn to Marxism, and they saw the social content of the Mexican muralists, especially Siqueiros and Orozco, as a way of combining militant politics and high artistic standards. The flamboyant radical David Alfaro Siqueiros came to Los Angeles in 1932 at the invitation of the Chouinard Institute, and later that year Guston and his friends responded to the John Reed Club's call to "abandon decisively the treacherous illusion that art can exist for art's sake," undertaking to paint "portable" murals on the theme of the American Negro. Guston's mural, based on newspaper accounts of the trial of the Scottsboro boys, showed Ku Klux Klanners whipping a rope-tied black man. One morning a band of raiders, thought to be led by the chief of the notorious "Red Squad," entered the John Reed Club with lead pipes and guns and destroyed several murals. According to Guston, they shot out the eyes and genitals of his own completed work, and when the artist sued, the hostile judge declared that the murals had been destroyed by the artists themselves to draw attention to their cause.

The spirit of the New Deal, however, was an antidote to these reactionary trends, and in 1934 California's first federally sponsored art program, the Civil Works Administration Arts Projects, was created. Guston joined the project and collaborated with his friends Reuben Kadish and Harold Lehman on a 525-foot mural at the Frank Wiggins Trade School depicting the history of crafts and trades from Egypt to modern times. However, a quarrel with the program's federal administrators led to the young artist's

dismissal from the job. Encouraged by Siqueiros, Guston, Kadish, and a poet friend, Jules Langsner, then traveled to Mexico.

In Mexico City, Guston disliked the work of Diego Rivera and had mixed feelings about José Orozco. Siqueiros made the greatest impact on him, but in general he was unsympathetic to the expressionism of the Mexican muralists; his greatest admiration was still reserved for the Italian Renaissance masters, especially Masaccio. Siqueiros and Rivera had persuaded the University of Mexico City to offer a huge wall in Emperor Maximilian's former palace in Morelia (now a museum) to Guston and Kadish for a fresco. They completed the project in less than four months and returned to California, but in the winter of 1935, on the urging of Jackson Pollock and his brother Sandy, Guston left for New York. He was not yet 23, but his professional experience, especially as a muralist, was considerable.

Guston at once got on the mural project sponsored by the Works Progress Administration (WPA). He found the cultural life of New York City in the late 1930s, including the activities of the Federal Theater, stimulating. He married Musa McKim in 1937, a time of ideological ferment and acute awareness of the growing menace of fascism. Guston and his wife attended rallies in support of Spain's beseiged Republican government, as well as other demonstrations, and his painting *Bombardment*, in tondo form, was exhibited in a show mounted by the League Against War and Fascism; the canvas was later included in the 1938 Whitney Museum Annual.

Guston's work in the pre-World War II years was still in the socially conscious, figurative style of mixed realism and surrealism which was then popular with the New York avant-garde. But by 1939, when he received his first important WPA commission, for that agency's building at the New York World's Fair, he had already moved away from the Renaissance aesthetic to which he had been attached. He said: "I became aware of the total picture space—the total picture plane, that is—as against just using volumes in an empty space." Guston had been impressed by Léger's great painting of 1919, *The City,* and he began to see cubism as a modern expression of the complex rhythms of Piero della Francesca and Uccello.

Guston's theme for his World's Fair fresco, painted on a concave wall, was "Maintaining America's Skills." After the completion in 1940 of his next major commission for the WPA, a mural for a Queensbridge housing project titled *Work and Play,* he resigned from the federal agency and withdrew with his wife ·to Wood-

stock, New York, where he began to concentrate on the specific problems of easel painting.

Guston considered *Martial Memory* (St. Louis Art Museum, Mo.), a semisymbolic scene of boys in combat painted in the winter of 1940–41, his first mature statement as an easel painter. Art historian H.W. Janson has remarked that in this picture "Guston has found the true image of this war-torn world." In these years, though, the artist found time to carry out two more mural projects. The first, executed in 1941, in collaboration with his wife, was for the U.S. Forestry Building in Laconia, New Hampshire. The second was for the Social Security Building in Washington, D.C.; completed in 1942, its theme was public communications.

In the fall of 1941 Guston accepted a teaching position in the art department of the State University of Iowa, Iowa City, where he remained until 1945. The art department had long been dominated by the Midwestern regionalism of Grant Wood (who died in 1942), but Guston, with his strong, outgoing personality, brought a new spirit into the department. He introduced his students to Picasso, Braque, Léger, Piero della Francesca, and, as one of his students recalled, to de Chirico "about whom he was mad." Guston himself was feeling his way towards a more subjective and imaginative, less socially conscious, vision, strongly influenced by his fascination with Dürer's famous engraving, *Melancolia.* In an essay in the March 1943 issue of *Art News* dealing with his Social Security Building murals, Guston is quoted as saying, "I would rather be a poet than a pamphleteer."

In his oil painting *Holiday* (1944), Guston took up once again the children's-game motif of *Martial Memory,* but the treatment was quieter, more lyrical. The crowning work of his Iowa period was *If This Be Not I,* completed in 1945, a complex allegorical tableau, "enacted," to quote Dore Ashton, "in a round of ambiguities." It was an expression of his "desire to stress poetic rather than topical values." The painting is now in the Washington University Art Collection, St. Louis, Missouri.

In the fall of 1945 Guston began teaching at Washington University, Şt. Louis, where his fluency and passion for the subject of art deeply impressed his students. Also in 1945, his first New York City solo exhibition was held at the Midtown Galleries and he was awarded first prize at the Carnegie Institute Annual, Pittsburgh. Thus, at 34 Guston's reputation was growing, and he was the subject of a feature story in *Life* magazine (May 27, 1946). The few paintings of Guston's St. Louis period that have survived, including *Performers* and the two versions of

Porch (all 1947), show the influence of Max Beckmann in the compressed, claustrophobic space and the use of masks and musical instruments, along with echoes of de Chirico's *pittura metafisica.*

Guston left Washington University in 1947 and withdrew to Woodstock, where he was visited by Pollock and de Kooning, through whom he became aware of the changing artistic climate in New York. There, painters, many of whom he had known on the WPA, were moving away from cubist principles toward what critic Clement Greenberg described as "symbolical or metaphysical content." Guston also sensed this new mood on his occasional visits to Peggy Guggenheim's Art of the Century Gallery in Manhattan. His own change to a more abstract idiom came in his canvas *Tormentors,* painted in Woodstock in the winter of 1947–48. Its nocturnal imagery, as is evident from the preliminary drawing, was derived from the motif of the masked and hooded figures associated with the Ku Klux Klan, and which he had depicted representationally in *The Conspirators* 16 years before. In the finished canvas the forms were flattened and the shapes abstracted. Only linear schematizations of the hoods and of the sole of a shoe studded with nails, indicate the evil human presences.

After receiving a Prix de Rome and a grant from the American Academy of Art and Letters, Guston left for Italy in October 1948. He recalled: "It was thrilling to go to Arezzo or Orvieto for the first time. I went to Arezzo many times, and to Florence. Seeing the frescoes, the Uffizi in Florence, and Siena excited and exhausted me." His travels in Europe took him to Spain, where he admired El Greco and Goya, to France, where he was moved by Manet and Cézanne, and to Venice, where he looked with fresh and inquiring eyes at the "painterly painters" Titian and Tintoretto. He painted only sporadically, and was still trying to determine how to reconcile pure form and pure expression in his own work.

In the fall of 1949 Guston returned to America and settled once again in Woodstock, but he succumbed to depression and his work did not go well. That winter he and his friend, the painter Bradley Walker Tomlin, took a loft together at University Place and 13th Street in Greenwich Village, and soon thereafter Guston moved to West 10th Street, where he maintained a studio for several years. Late in 1951, having finally recovered from his long depression, he and his wife moved to the city. He was carried away by the exciting atmosphere of those early years of the triumph of the New York School, the sense,

as he recalled, "of embarking on something in which you didn't know the outcome."

Guston's *Red Painting,* dating from 1950, was entirely abstract, but its deep red rectangular shapes and airless atmosphere were reminiscent of the *Porch* pictures. In *White Painting* (1951) the structural element had receded, and the forms created, in Ashton's words, "a network of interweaving spaces that were all light and flow." Conversations with Abstract Expressionist Robert Motherwell during the 1950s helped to crystallize Guston's ideas and his commitment to a personal form of action painting.

In January 1952 at the Peridot Gallery, New York City, Guston held his first Manhattan solo show since 1945, and his paintings were praised for their "calligraphic lightness." His next exhibition, held in 1953 at the Egan Gallery, New York City, led some critics to describe his work as "abstract impressionism." The painter Fairfield Porter, writing in *Art News* (February 1953) and with canvases such as *To B.M.T.* (1952, dedicated to Bradley Tomlin) in mind, wrote, "Where he weaves the paint again and again the color gets pinkish and translucent, like a bit of sky from Sisley or Pissarro." In Guston's canvases of the mid-'50s, including *Attar* (1953), *Zone* (1953–54), *Beggar's Joys* (1954–55), and the important picture *Voyage* (1956), Guston, to quote Aldo Pellegrini, "begins with a dense matter base, but his ample brushstrokes appear as if interrupted and are not directed toward the creation of a climate of violence in the picture: instead they become ordered and pacified to form a work of lyrical and contemplative quality. . . . " The British critic Edward Lucie-Smith took a negative view of Guston's work, which, he felt, "typifies the boneless aspect of abstract expressionism. Too often his pictures are no more than a riot of lush paint and sweet color."

In the fall of 1955 Guston, along with Kline, de Kooning, Rothko, and other leading New York painters, joined the prestigious Sidney Janis Gallery, where he was to show regularly until 1961. His paintings of the late 1950s, including *To Fellini* and the gouache *Actor* (both 1958), *Painter I* (1959), and *Painter II* (1959–60), show signs of anxiety, turbulence, and struggle, with more markedly expressionist rhythms than in the earlier, more lyrical abstractions. In all his work of the '50s Guston, unlike Pollock and de Kooning with their all-over treatment of the canvas, tended to retain a central focal point.

In the '60s Guston's palette became increasingly dark and dense, and towards the end of the decade he began to reintroduce figures, now broadly caricatured. There had been hints of figuration in *Alchemist* of 1960, described by Dore

Ashton as "a mass of tangled, darkened strokes engulfing densities struggling to be forms." By the time of his first major retrospective, at the Solomon R. Guggenheim Museum, New York City, in 1962, his palette had darkened still further, with rusty oranges, dark reds, and various shades of gray. When part of the Guggenheim exhibition was shown at the Whitechapel Gallery, London, early in 1963, British critic David Sylvester remarked that Guston's paintings were "intensely withdrawn and private, with the privacy of the dark, not the ivory tower." In the "black" canvases exhibited at the Jewish Museum, New York City, in 1966, there were, to quote one writer, "bobbing, headlike forms" and "teetering balances." In the words of Dore Ashton, "The comic, the grotesque, and the ironic were waiting in the wings of Guston's drama, just as they had done in previous periods of his life."

There had always been a caricatural tendency in Guston's drawing, but it was not until 1968 that the shift to the grotesque, to cartoonish figures that are either pathetic wretches or menacing bullies, entered his painting. That was a peak year of college campus demonstrations against the Vietnam War and of violent clashes between police and antiwar protesters at the Democratic Convention in Chicago. Outraged by these events, Guston developed a new kind of figurative imagery, with echoes of such expressions of 20th-century angst as de Chirico's impaled gloves and the Surrealists' use of dislocated human members. He was also influenced by the literature of Kafka and Isaac Babel. He withdrew to Woodstock in 1969 and became a close friend of Philip Roth, who had recently published the controversial novel *Portnoy's Complaint*.

Among the earliest of the "new" Gustons was *The Studio* of 1969, in which an Ubu-like figure, wearing a Ku Klux Klan hood and holding a cigarette in his outsized left hand, paints a "self-image" on a small canvas. Sinister cigar smoking Klansmen appear in *Riding Around* of 1969, and the blunt, simplified grotesquerie of the figures and the automobile recall the artist's early admiration for the Krazy Kat cartoons. Two Klansmen's hoods, a clock, a truncated cast of a foot, and other incongruous objects are included in *Wasteland* of 1970. Always mindful of the Italian Renaissance, Guston had in mind the disturbing imagery of Signorelli's apocalyptic frescoes in Orvieto.

In 1970 Guston and his wife left for Rome, where he had been offered a studio by the American Academy. He spent much of his time, as on a previous visit, exploring the hill towns as well as Orvieto, Florence, and Venice. On a trip to Sicily the Gustons enjoyed seeing a performance of the traditional Sicilian puppet plays, which appealed to the artist's sense of theater and contributed to the symbolism of some of his subsequent paintings.

The Gustons returned to Woodstock in the summer of 1971 and for several years he painted large compositions of objects in his studio, firmly delineated and solidly modeled (*Painter's Table* of 1973 is an example). His paintings from 1974 on became more metaphorical, as in *Desert* and *Cave* (both 1974) and *Source* (1976), the last mentioned a hybrid of Byzantine icon, the American cartoon, and late modern scale.

As Roberta Smith wrote in an article on "The New Gustons" in *Art in America* (January-February 1978), the artist's work since the late '60s, with its "cartoonish images of swollen, large-scale forms," was never as well received as his abstract expressionist canvases of the 1950s, or his youthful work as muralist and figurative painter, and was "ignored by the institutions which contributed to his earlier reputations." Roberta Smith also commented that although his recent paintings were "often indiscriminate and heavy handed," they made "the figurative work of his youth look old and academic." Although Guston's cartoonish grotesques were out of sync with the styles (minimalism and conceptual art) that dominated the art scene of the late '60s and early '70s, his late works looked forward to the neoexpressionist figuration of the 1980s. The raw imagery and crude draftsmanship (which is often deliberate) favored by Neoexpressionists seem to have captured the anxious spirit of their times in a manner recalling the ominousness and despair of Guston's caricatural works.

On June 7, 1980 Philip Guston suffered a heart attack and died the same evening in Woodstock, 20 days before what would have been his 67th birthday. Shortly before his death he had received a Creative Arts Award from Brandeis University, Waltham, Massachusetts, citing him for "notable achievement in the arts." He was survived by his wife Musa, a daughter, Musa Jane Mayer of Yellow Springs, Ohio, and two grandchildren. *Philip Guston,* a film directed by Michael Blackwood, had been released in 1972.

Guston and his wife had lived for several years in the Woodstock cottage which had a comfortable kitchen, small rooms lined with books and pictures, and a large, orderly whitewashed studio. From 1974 Guston exhibited with the David McKee Gallery, New York City, and came into town about once a month. Heavier than in his youth and gray haired, Philip Guston was a good-looking man, affable in manner, widely

read, and highly articulate. In relation to his art he had, in the words of his friend, the poet Frank O'Hara, "a kind of introspective aggressiveness," and a constant questioning about the nature of painting which Dore Ashton summed up by titling her 1976 book on Guston, *Yes, but.* . . .

However the drastic changes in his work may be evaluated in the future, Guston tried to avoid the impasse that has been the fate of so many former Abstract Expressionists and sought constant rejuvenation. On a wall in his Woodstock studio, near reproductions of his beloved Mantegna and Piero, Guston copied out on a large sheet a quotation from Charles Dickens that he obviously applied to himself. "I hold my inventive capacity in the stern condition that it must master my whole life, often have complete possession of me, make its own demands on me, and sometimes for months together put everything else away from me. . . . " About his own painting Guston remarked in a statement made in 1972: "It has always been difficult for me to explain my own work, feeling of course that the meaning is always in the painting itself." Replying in 1977 to an *Art News* questionnaire about early influences, he cited de Chirico and Picasso, and described the qualities that had most affected him in his work—" . . . a particular blend of the comic and self-irony (masked perhaps), going together with other ingredients mysterious to me, which causes that surprise I feel necessary for my spirits. . . . "

EXHIBITIONS INCLUDE: State Univ. of Iowa, Iowa City 1944; Midtown Gals., NYC 1945; School of the Mus. of Fine Arts, Boston 1947; Munson-Williams-Proctor Inst., Utica, N.Y. 1947; Univ. Gal., Univ. of Minnesota 1950; Peridot Gal., NYC 1952; Egan Gal., NYC 1953; Sidney Janis Gal., NYC 1956–61; São Paulo Bienal 1959; Venice Biennale 1960; Solomon R. Guggenheim Mus., NYC 1962; Whitechapel Gal., London 1963; Rose Art Mus., Brandeis Univ., Waltham, Mass. 1966; Jewish Mus., NYC 1966; Marlborough Gal., NYC 1970–72; Boston Univ. 1970; David McKee Gal., NYC from 1974. GROUP EXHIBITIONS INCLUDE: Annual, Whitney Mus. of Am. Art, NYC 1938–63; Carnegie Inst. Annual, Pittsburgh 1941–49; Pittsburgh International, Carnegie Inst. 1950, '55, '58, '64; "Twelve Americans," MOMA, NYC 1956; São Paulo Bienal 1957; Documenta 2, Kassel, W. Ger. 1959; "American Abstract Expressionists and Imagists," Solomon R. Guggenheim Mus., NYC 1961.

COLLECTIONS INCLUDE: Metropolitan Mus. of Art, MOMA, and Whitney Mus. of Am. Art, NYC; Albright-Knox Art Gal., Buffalo, N.Y.; Munson-Williams-Proctor Inst., Utica, N.Y.; Hirshhorn Mus. and Sculpture Garden, Washington, D.C.; High Mus. of Art, Atlanta; Detroit Inst. of Arts; Univ. of Texas, Austin; San Francisco Mus. of Art; Los Angeles County Mus.

ABOUT: Arnason, H. H. "Philip Guston" (cat.), Solomon R. Guggenheim Mus., NYC, 1962; Ashton, D. Yes, but . . . A Critical History of Philip Guston, 1976; "Philip Guston" (cat.), Stedelijk Mus., Amsterdam, 1962; Lucie-Smith, E. Late Modern: The Visual Arts Since 1945, 1969; "The New American Painting" (cat.), MOMA, NYC, 1958; Pellegrini, A. New Tendencies in Art, 1966; Rose, B. American Art Since 1900, 2d ed. 1975; "Twelve Americans" (cat.), MOMA, NYC, 1956. *Periodicals*—Art in America January–February 1978; Art News March 1943, February 1953, April 1958, December 1959, May 1962, May 1965, November 1977; Art News Annual October 1966; Arts June 1956; It Is Spring 1958; Life May 17, 1946; New York Times June 10, 1980; Observer January 20, 1963; L'Oeil (Paris) July–August 1960; Perspective Winter 1948; Studio International February 1965.

***GUTTUSO, RENATO** (January 2, 1912–), Italian painter and draftsman, is the leading Social Realist in Italy. Guttuso rejected abstraction in favor of what he calls "the figurative alternative" in modern art.

The son of a land surveyor, Guttuso was born in the Sicilian town of Bagheria, near Palermo. From early childhood he spent time with Emilio Murdoko, a cart painter whose shop was opposite the Guttuso home, and while attending the secondary school in Palermo, he frequented the studio of the Futurist painter Pippo Rizzo. Guttuso finished secondary school studies in 1928 and enrolled in the Faculty of Law, Palermo, two years later. He began to paint seriously in 1931 and subsequently left Sicily, going first to Naples and then to Rome. The following year he worked in Rome as a picture restorer, at the Galleria Perugia and the Galleria Borghese. His earliest paintings were in the romantic style of the Roman School. In 1933 he met the sculptors Giacomo Manzù and Pericle Fazzini. He fulfilled his military service as an officer in 1935 in Milan, where he met the painter Lucio Fontana, the critic Roberto Longhi, and the writer Alberto Moravia, whose portrait he painted in the early '80s. Guttuso had grown up under the rule of Mussolini, and between 1935 and 1937 he became progressively committed to antifascism. He abandoned the conventional nudes and landscapes of his early work for powerful depictions of the human drama.

After returning to Rome in 1937 Guttuso painted large compositions, including *The Execution in the Countryside* (1938), dedicated to Federico García Lorca, and *Homage to Lorca* (1939). At this time Guttuso was greatly influenced by Picasso: "For years I carried a picture postcard of *Guernica* in my pocket," he recalled. Picasso's influence is evident in Guttuso's con-

Photo by Oscar Savio

RENATO GUTTUSO

troversial *Crucifixion* (1940–41), which depicted a nude woman at the foot of the cross and a modern city in the background. Nevertheless, the painting won him the Bergamo Prize in 1942.

About 1938 Guttuso founded La Corrente, an antifascist artists' group which protested the provincialism of official cultural policy and defended modern art. Other members included Mirko, Afro, Renato Birolli, Ennio Morlotti, and Bruno Cassinari.

Guttuso was a Social Realist but not a Socialist Realist in the sense of subjagating art to propagandistic ends. He worked within a broader humanist tradition, whose antecedents included Giotto, Caravaggio (whose *Crucifixion of St. Peter* moved Guttuso to tears), Rembrandt, Goya, Géricault, Delacroix, Daumier, Courbet, and Van Gogh. The last-named's expressive, highly charged emotional style was an inspiration to Guttuso.

In 1942, with Italy at war and allied with Hitler, Guttuso joined the then clandestine Communist party. As a partisan resistance fighter in the Abruzzi region in 1943, he designed antifascist and anti-Nazi propaganda posters. His book of anti-Nazi watercolors and drawings, titled *Gott Mit Uns* (1945), won for him the 1945 World Peace Prize in Warsaw. In 1946, with Birolli, Morlotti, Fazzini, Alberto Viani, and others, Guttuso founded the Fronte Nuovo delle Arti. The group was antifascist, affirming the interdependence of art and the social revolution, and intent on preserving the figurative tradition, regarded by those artists as the embodiment of the humanism of art. They stressed the idea of the "committed" artist, a popular concept

among progressive artists and intellectuals in the postwar years.

Though he was a communist party member, his expressionist artistic temperament often clashed with the aesthetics of Soviet-sponsored socialist realism. However, Guttuso was strongly supported by the comparatively liberal Italian Communist party. Nevertheless, his paintings of the 1940s and early '50s expressed social truths and protested cruelty and injustice. Guttuso's *Assassination* denounced the Mafia, a subject he returned to in *The Mafia* (1948; Museum of Modern Art, New York City), which also shows his awareness of modern abstract design. Between 1947 and '52, when the influence of neo-realism in Italian films was at its peak, Guttuso painted a series of large-scale compositions dealing with contemporary social problems and recent historical events. Among them were *Peasants Occupying Uncultivated Lands in Sicily* (1947–50) and *Battle of the Ponte Ammiraglio* (1951–52). But he also painted landscapes, still lifes, and studio interiors which were influenced by cubism and rarely had political content. However, his still lifes of tools are representations of real objects *and* symbols of human labor.

After 1952 Guttuso abandoned epic subject matter for humbler, more intimate themes, which frequently explored the ordinary, "everyday" aspects of human activity and of the lives of workers. *Carrying the Harvest* (1953), representative of this phase, seems to have been influenced by Courbet. Of this stage in his career, Guttuso said, "From 1952 to 1954, after a period when I was closest to cubism, I was very naturalistic and pushed my investigations towards a realism that was too objective." He remarked in 1958, "I have painted very few political themes in my life, but they [the Americans] see propaganda even in my still lifes."

Though political overtones can be read into Guttuso's *Young Picasso at Barcelona* (1956)— he had met Picasso in Milan in 1953—his interest in and mastery of the human figure predominate in *Four Figures on the Beach* (1957) and in his many forceful drawings of bathers sunning themselves at the seaside. According to Edward Lucie-Smith, " . . . Guttuso . . . discovered a kind of neo-baroque idiom in which to describe the lives of 'ordinary people'—workers, people on the beach. Where Léger, in his late years, looked back towards the baroque of Poussin, in trying to create an 'art of the people,' Guttuso based himself on the more tactile art of the Carracci, and of Caravaggio." He also painted landscapes devoid of figures, as in *Orange Orchard* (1957). At the Venice Biennale of 1956 his large

painting, *La Spiaggia* (The Beach), came in second in balloting by the jury for the international prize.

Guttuso's first solo exhibit in the United States was held at the A.C.A. Gallery, New York City, in 1958. Guttuso illustrated an edition of Dante's *Divine Comedy* using bright colors and vigorously expressive—even brutal—draftsmanship. This crude, gestural style—subtlety has never been Guttuso's aim—is distantly related to the explosive brushstrokes of Pollock, whose ability Guttuso respected, though he did not much care for the American's work and certainly did not share his aesthetic of abstractionism. The subject matter and highly emotional content of the *Divine Comedy* illustrations allowed Guttuso to distort the human figure more than he had ever done before.

In 1960 Guttuso attended the World Freedom Conference in Wroclaw, Poland, and also that year won the Marzotto Painting Prize. He became professor of painting at the Accademia delle Arti, Rome, the following year. In 1967 Guttuso had a retrospective at the Musée d'Art Moderne, Paris, and in 1968 he served as guest professor at the Kunstschule, Hamburg. He was awarded an Honorary Degree in Letters at the University of Parma, Italy, in 1971. Two years later Guttuso was elected to the town council of Bagheria, Sicily, and in 1976 he became an Italian Senator.

Guttuso's canvases of the 1970s were less political and less violently expressionistic than his earlier work. He did a series of paintings bringing together artists such as Dürer, Van Gogh, Courbet, and Picasso, as if paying homage to the masters of a tradition of which he considers himself a part. Paintings in this series include *La Visite* (1970) and *Arles* (1978), one of his most striking pictures, subtitled *Van Gogh takes His Severed Ears to a Brothel*.

A handsome, intense, and thoughtful man, Renato Guttuso lives in Milan and has a summer home in Velate-Varese, a small town in the neighboring hills. The American painter Raphael Soyer and his wife Rebecca visited Guttuso in 1963 and were pleased by the "unaffected warmth" with which Guttuso and his wife received them. Impressed by the vigor of Guttuso's work, Soyer saw on this visit Guttuso's rather free variations of some of the Italian Realist's favorite pictures. *Death of Marat* by David; *Head of an Executed Man* by Géricault; a detail from Courbet's large *Studio*; and a self-portrait of Van Gogh.

On a visit to the Soviet Union Guttuso was well received by the authorities, but he perceived an antagonism toward his work on the part of academicians—according to Guttuso an antagonism that was shared (though for vastly different reasons) by young Russian rebels who wished to embrace abstraction. Guttuso has never absolutely decried official Soviet art, but he deplores the "old-fashioned" character of Soviet art criticism, with its strict emphasis on content at the expense of form and aesthetic considerations. He was saved from the banality of socialist realism by his commitment to the humanist tradition in art.

Resolutely opposed to the abstractionists, and to what he considers their esoteric aesthetic polemics, Guttuso declared, "One must have the courage and the honor to go against the current, to be unpopular, and to paint, if necessary, *even ugly* pictures." "I believe ever more firmly," he said, "in an art in which it might be possible to give an account of passions and sentiments just as they are in the human heart; in themselves, and in their own reality, they are infinitely mysterious and hard to investigate, just as the image of the world *as it is* is also difficult, profound, and obscure."

EXHIBITIONS INCLUDE: Gal. La Cometa, Rome 1938; Gal. Zodiaco, Rome 1943; Gal. Margherita, Rome 1946; Hanover Gal., London 1950; Leicester Gal., London 1955; ACA Gal., NYC 1958; Heller Gal., NYC 1958; Vetrina di Chiurazzi, Rome 1958, '61; Gal. del Milione, Milan 1959, '66, '68; Pushkin Mus., Moscow 1961; Hermitage Mus., Leningrad 1961; Stedelijk Mus., Amsterdam 1962; Palais des Beaux-Arts, Charleroi, Belgium 1963; Nat. Gal., Berlin 1967; Kunsthalle, Reckling Hausen, W. Ger. 1967; Mus. d'Art Moderne, Paris 1967; Palazzo dei Normanni, Palermo, Sicily 1967; Gal. la Medusa, Rome 1968, '72; Forum Gal., NYC 1969; Gal. Michael Hertz, Bremen, W. Ger. 1970, '73; Mus. d'Art Moderne, Paris 1971; Gal. Schwartz, Milan 1972; Gal. di Palazzo d'Accursio, Bologna, Italy 1974; Il Corllezionista d'Arte Contemporanea, Rome 1975; Kunstverein, Frankfurt 1975; Toninelli Arte Moderna, Rome 1977; Marlborough Fine Arts Gal., London 1979; Acquavella Gals., NYC 1983. GROUP EXHIBITIONS INCLUDE: Quadriennale di Roma, Rome 1931, '43; "Sicilian Artists," Gal. del Milione, Milan 1932; "Cinque Artisti Siciliani," Gal. Mediterranea, Palermo, Sicily 1937; "Renato Guttuso, Orfeo Tamburi," Gal. Barbaroux, Milan 1941; "Italian Painters," London 1946; Venice Biennale 1948, '50, '52, '56; "Italienische Meister des XX Jahrhunderts," Vienna 1962; Dunn International, Tate Gal., London 1963; International Exhibition, Carnegie Inst., Pittsburgh 1964; Salon de Mai, Paris 1966.

COLLECTIONS INCLUDE: Gal. d'Arte Moderna, Rome; Pinacoteca di Brera, Milan; Gal. d'Arte Moderna, La Spezia, Italy; Gal. d'Arte Moderna, Palermo, Sicily; Gabinetto delle Stampe, Uffizi Gals., Florence; Tate Gal., London; Kunstakademie, Berlin; Altes Mus., E. Berlin; Nat. Mus., Prague; Nat. Mus., Budapest; Nat. Mus., Warsaw; Hermitage Mus., Leningrad; Stalin

Mus., Moscow; MOMA, NYC; Mus. de Arte Moderna, São Paulo; Gal. of New South Wales, Sydney.

ABOUT: Berger, J. Renato Guttuso, 1957; Cooper, D. (ed.) "Renato Guttuso" (cat.), Hanover Gal., London, 1950; "Guttuso" (cat.), Heller Gal., NYC, 1958; Levi, C. "Renato Guttuso" (cat.), Nat. Gal., Berlin, 1967; Lucie-Smith, E. Late Modern, 1969; Marchiori, G. Renato Guttuso, 1956; Moravia, A. Peintres contemporains, 1964; Morosini, D. Disegni di Guttuso, 1942; Soyer, R. Diary of an Artist, 1977; Ungaretti, G. Renato Guttuso: Zeichuungen 1930–1970, 1970. *Periodicals*—Art International (Lugano), April 1979; New York Times April 22, 1983; Opus International (Paris) January 1973; Paragone (Florence) 1957; Prospective (Rome) 1942; XXe siècle (Paris) June 1978.

GWATHMEY, ROBERT (January 24, 1903–), American painter, writes: "I'm interested in the human figure as well as thehuman condition. One might harken back to one of the earliest secular paintings in Siena's City Hall. Here Lorenzetti (active 1323–1348) has a composite mural. The central figure is comparatively large and represents Peace. There are two divergent groups, one representing 'Good Government,' the other 'Bad Government.' Also depicted is the dividing of the land. Following sketchily in the tradition one finds in Bruegel, Goya, Daumier, etc., I choose to be out of that tradition.

"I am a humanist, a way of life which rejects belief in any form of the supernatural and sets up the happiness of all mankind as the guiding ethical aim, using reason and science as solutions for human advancement."

———

Gwathmey was inspired by life in America, especially in the rural South and at the time of the Great Depression. Though concerned with social justice in his art, he never sacrificed formal values of line, color, pattern, and pictorial structure to political content.

He was born in Richmond, Virginia, the son of Robert and Eva (Harrison) Gwathmey. His father, a locomotive engineer, was killed in a train accident shortly before Gwathmey's birth. Robert's social awareness developed in adolescence as a result of attending the socialist Norman Thomas's summer speaking engagements in Richmond. After graduating from John Marshall High School, Richmond, Gwathmey worked on a rigging gang for the Conowerigo Dam on the Susquehanna River in Maryland and, later, on a freighter bound for Europe. In 1924–25 he studied at North Carolina State College, Raleigh. He transferred in 1925 to the

Photo by Walter Rosenblum

ROBERT GWATHMEY

Maryland Institute of Art, Baltimore, and prepared for his entrance the following year to the Pennsylvania Academy of Fine Arts, Philadelphia, where he studied until 1930. His teacher at the academy was the distinguished painter Franklin Watkins, who rigorously trained him in color and line and who "offered him the painterly ideals with which to construct his Jeffersonian principles," to quote Jonathan Ingersoll. At the academy Gwathmey also studied with George Harding and Daniel Garber, and supported himself by working in a settlement house in Philadelphia's Halion section.

In 1929, and again in '30, Gwathmey won Cresson scholarships, which enabled him to travel and study art in Europe. He returned to the US in 1931 and taught art at Beaver College, Jenkintown, Pennsylvania, until 1937. Because he was required to teach only two days a week, Gwathmey had time to develop his painting and to travel to New York City, for, as he said years later, "That is where art was made; it was the center."

Gwathmey's concern for social justice was intensified by the Depression, the Works Progress Administration programs which hired over 3,700 artists, and by his experience as vice-president of the Artists' Union. Like Ben Shahn, Philip Evergood, William Gropper, and Jack Levine, in the '30s Gwathmey painted from social reality, though he emphasized color and flattened forms instead of three-dimensional realism, and focused on the rural South, especially black communities, rather than on urban scenes. His renderings of sharecroppers, both black and white, cotton fields and tobacco crops, shanties,

sheds, and wildflowers were strongly felt evocations of life on the wrong side of the tracks in the Deep South.

During his years as a social activist, Gwathmey continued to teach. He was an instructor at the Carnegie Institute, Pittsburgh, from 1938 to '42, the year he joined the faculty of Cooper Union, New York City, where he taught for 26 years. He especially enjoyed teaching the freshman drawing class, because he considers drawing the foundation of painting and he wanted to start students on the right track. "I compartmentalize areas with supportive line," Gwathmey said of his own work.

In 1938 Gwathmey destroyed his entire corpus of work, declaring, "It takes about ten years to wash yourself of academic doctrine." He scored his first real success in 1939, when he won a 48 States Mural Competition. (A few years later *The Countryside,* his prizewinning mural, was installed in a post office in Eutaw, Alabama.) In 1940 he won the Artist as Reporter Competition, sponsored by the liberal New York City newspaper *PM,* with *Undermined,* his painting of a girl being rescued from a falling house. Gwathmey was in this period fascinated by farmers, by their lean frames, their stiffness of movement, and the deliberateness of their actions. He saw the farmer as a kind of Christ figure, engaged in a constant struggle with the land and with unpredictable social and economic conditions. Ingersoll saw parallels between these concepts, and Gwathmey's style generally, and Byzantine icons and medieval sculpture.

During World War II Gwathmey won increasing recognition. In 1943 his silkscreen, *The Rural Home Front,* was awarded first prize in the National Graphic Arts Competition sponsored by Artists for Victory. Since the '20s, Gwathmey had been disturbed by the plight of blacks in the South. "If I had never gone home," he said of a visit to his native Virginia in 1926, "perhaps I would never have painted the Negro." After 1926 he went to the South nearly every summer. *Hoeing* (1943) is one of several canvases showing black sharecroppers working in the fields or at household chores. He was also inspired by the southern countryside, remarking, "I am always surprised that earth can be so red."

The year 1944 was eventful for Gwathmey. He won the National Watercolor Exhibition Award at the San Diego Fine Arts Gallery for his *Sharecroppers;* his painting *Out of the South* was included in a Founders' Day exhibition entitled "Directions in American Painting"; and his first solo show was held at the A.C.A. Gallery, New York City. Also in 1944 he won a Rosenwald Fellowship, which enabled him to live on a tobacco farm in the South and work in the fields with sharecroppers. His paintings of 1944 included *Family Portrait* (Virginia Museum of Fine Arts, Richmond), depicting a black family on their front porch, and *Singing and Mending* (Hirshhorn Museum and Sculpture Garden, Washington, D.C.), with its bold design, simplified forms, and expressive negative space. The quasi-religious spirit of much of Gwathmey's work is exemplified in *Lullaby* (1945), a frontal view of a black woman with her baby which suggests a Madonna and Child motif.

Some Gwathmey paintings of the 1940s were more scathingly political than others. *Unfinished Business* (1941) shows a Ku Klux Klan hood and barbed wire on a pole marked "posted." In *Masks* (1946) an affluent white man holds a white mask over the face of a bound black man who is trying to pull his head away. However, Gwathmey was not exclusively concerned with the social message. In 1946 he declared: "Modern painting must, first off, have a simplified two-dimensional base and, second, a three-dimensional spatiality. These should be considered in direct color relations, with elimination of atmospheric effects created by chiaroscuro and impressionistic fuzziness." Gwathmey has spoken of his admiration for Picasso and, commenting on his dislike of naturalism, he once explained that he was concerned with a "realism" that finds "the essence of the image."

In the 1950s, '60s, and '70s, Gwathmey's style, without undergoing radical changes, evolved, his use of pattern becoming flatter and more decorative, with large areas of color set off by bold lines. In such canvases as *Portrait of a Farmer's Wife* (1953; Hirshhorn Museum and Sculpture Garden), *Striped Table Cloth* (1967), and especially *Migrant* (1976) his work took on more and more the quality of stained glass. In the catalog to the 1976 Gwathmey retrospective at the Terry Dintenfass Gallery, New York City, Ingersoll discussed the influence of Byzantine icons, as transmitted by such Russian modernists as Kasimir Malevich and Wassily Kandinsky, on Gwathmey in his movement toward color as subject. "Robert Gwathmey," he said, "highlights these gemlike colors with strong, angular, geometric lines that separate the forms and break the figures into multicolored expressions that suggest degradation and poverty. . . ." His watercolors, especially *Carrying the Sack* (1960; Hirshhorn Museum and Sculpture Garden), are less stylized than his oils, and in his drawings, which are usually studies for paintings, his lines are more delicate than in the oils.

In 1971 Gwathmey became a member of the National Institute of Arts and Letters and he also won the Joseph S. Isidor Gold Medal. In 1976 he was inducted into the National Academy of Design. He had retrospectives at the Randolph-Macon Woman's College, Lynchburg, Virginia, in 1967, and at Boston University in 1969.

In 1935 Robert Gwathmey married Rosalie Dean Hook, who had studied art at the Pennsylvania Academy; their son Charles, now a noted architect, was born three years later. After living in New York City for more than a quarter of a century, Gwathmey and his wife moved in 1966 to Amagansett, New York, though they maintain a pied-à-terre in Manhattan. A warm, friendly man, and an artist of the utmost integrity, Gwathmey articulated his aesthetic beliefs in a 1946 interview: "I believe that in painting the use of limited imagery is the best method of presentation of your content. . . . I believe that if the symbols are strong enough, they can transcend the literary in painting."

"Art is the conceptual solution of complicated forms," Gwathmey wrote, "the perceptual fusion of personality, not humble ornamentation or surface pyrotechnics. Beauty never comes from decorative effects but from structural coherence. Art never grows out of polished eclecticism or the inviting momentum of the bandwagon. It is, in part, a desire to separate truth from the complex of lies and evasions in which one lives."

EXHIBITIONS INCLUDE: A.C.A. Gal., NYC 1944, '46, '49, '57; Terry Dintenfass Gal., NYC from 1962; Randolph-Macon Woman's Col., Lynchburg, Va. 1967; Boston Univ. 1968–69; St. Mary's Col. of Maryland 1976. GROUP EXHIBITIONS INCLUDE: "American Art Today," New York World's Fair, NYC 1939; Golden Gate International Exhibition, San Francisco 1940; "PM Competition: The Artist as Reporter," MOMA, NYC 1940; Whitney Annual, NYC 1940–67; Carnegie Annual, Pittsburgh 1941, '43, 1944–50; Pennsylvania Academy Annual 1942–45, '47, '50, '52, '53, '58, 1961–64, 1966–68; "Portrait of America (Artists for Victory Inc.)," Metropolitan Mus. of Art, NYC 1944; "Portrait of America (Artists for Victory Inc.)," Nat. Academy of Design, NYC 1946; "Advancing American Art," U.S. Department of State South American tour 1947; "Reality and Fantasy 1900–1954," Walker Art Center, Minneapolis 1954; Corcoran Biennial, Washington, D.C. 1957; "New Vistas in American Art," Howard Univ., Washington, D.C. 1961; "The Portrayal of the Negro in American Painting," Bowdoin Col. of Art, Brunswick, Me. 1964; "American Painting and Sculpture 1948–1969," Krannert Art Mus., Univ. of Illinois, Champagne 1971; "Drawing–America 1973," Albrecht Gal. Mus. of Art, St. Joseph, Mo. 1973; "Contemporary Drawings," Hathorn Gal., Skidmore Col., Saratoga Springs, N.Y. 1975.

COLLECTIONS INCLUDE: Whitney Mus. of Am. Art, NYC; Brooklyn Mus., N.Y.; Philadelphia Mus. of Art and Pennsylvania Academy of Fine Arts, Philadelphia; Carnegie Inst., Pittsburgh; Mus. of Fine Arts, Boston; Brandeis Univ., Waltham, Mass.; Springfield Mus., Mass.; Hirshhorn Mus. and Sculpture Garden, Washington, D.C.; Butler Art Inst., Ohio; Virginia Mus. of Fine Arts, Richmond; Birmingham Mus., Ala.; Albrecht Gal. Mus. of Art, St. Joseph, Mo.; California Palace of the Legion of Honor, San Francisco; San Diego Mus.; Los Angeles County Mus.; Mus. of Modern Art, São Paulo.

ABOUT: Ingersoll, J. "Robert Gwathmey" (cat.), Terry Dintenfass Gal., NYC, 1976. Periodicals—American Artist December 1945; Art Digest January 15, 1941, February 1, 1946, April 15, 1949; Art News January 15, 1946; Carnegie Magazine (Pittsburgh) January 1944; Magazine of Art April 1946.

*HAACKE, HANS (August 12, 1936–), German artist, has used his work to expose the political, social, and economic underpinnings of the art world. Beginning in the early 1960s as a creator of simple—and institutionally acceptable, if aesthetically controversial—natural systems, Haacke has since seen his work banned by major museums in the United States and West Germany as he became increasingly politicized and critical of the art establishment and its benefactors. Haacke, however, has always maintained an appearance of objectivity, even of anonymity, presenting his "political systems" in the form of surveys, polls, or neutral gatherings of data. In fact, his most controversial works resemble a kind of investigative journalism couched in art terms and transplanted to the galleries. "The energy of information interests me a lot," he said in an Arts Magazine (July 1971) interview. "Information presented at the right time and in the right place can be potentially very powerful. It can affect the general social fabric."

Hans Haacke was born in Cologne. He spent his childhood there and in Bonn, and studied at the Paedagogium Otto Kuhne (1948–52) and the Nicholas-Cusanus-Gymnasium (1952–56), both in Bonn-Bad Godesberg. In 1960 he received a Master of Fine Arts degree from the Staatlische Hochschule für Bildende Kunst, Kassel, then studied printmaking for a year at Stanley William Hayter's Atelier 17 in Paris during the period of student riots over the French military intervention in Algeria. On a Fulbright Fellowship, Haacke attended the Tyler School of Art outside Philadelphia (1961–62). Upon his return to Germany he began to exhibit kinetic sculptures with the Zero Group (Gruppe Zero) in Düsseldorf, then the center of the European avant-garde art world. Headed by Otto Piene,

°hä´ kə, häns

Heinz Mack, and Günther Uecker, the Zero Group was dedicated to the lyrical synthesis of simple technology and nature. In 1965 he returned to the US with his American wife, Linda Snyder.

Like the work of the other Zero artists, Haacke's sculpture did not fit easily into the usual subgenres of gallery art, not did he ally himself with any firm ideology or doctrine. "I don't consider myself a naturalist, nor for that matter a conceptualist, an earth artist, elementalist, minimalist, a marriage-broker for art and technology, or the proud carrier of any other button that has been offered over the years." His reflective pieces of 1961—blocks and cylinders covered with highly polished aluminum-foil laminate—were sometimes positioned to reflect infinite regressions of each other, creating a simple feedback loop. These sculptures, and several later pieces, such as a series of balloons buoyed over jets of hot air and various kinds of flowing-water structures, which owed much to the work of Klaus Rinke, presaged his awareness of and interest in systems theory. The technical concept of a system was introduced to him by the English artist and critic Jack Burnham in the years 1963–64, along with the allied areas of cybernetics and operations research. "The concepts used in these fields seemed to apply to what I was doing, and there was a useful terminology that seemed to describe it [my work] much more succinctly than the terminology that I and other people had been using until then, so I adopted it," he explained.

Haacke applied the idea of a system—"a grouping of elements subject to a common plan and purpose"—to his sculpture with the aim of making "something which experiences, reacts to its environment, changes, is nonstable . . . something which lives in time and makes the spectator experience time." At first he investigated relatively simple meteorological systems. For example, *Weather Cube* (1965), one of a series of sealed acrylic "water boxes," exploits the cycle of condensation and evaporation. Droplets condense on or evaporate from the inner surface of the heated cube as the external (gallery) temperature varies from cool to warm. Said Haacke, "I was very excited about the subtle communication with a seemingly sealed-off environment [the cube] and the complexity of interrelated conditions determining the meteorological process." *Ice Stick* (1966), which Haacke considers "the reverse of the condensation pieces," is an upright refrigeration coil that collects and freezes atmospheric water vapor. The layers of ice wax and wane with the humidity and temperature of the gallery environment and even with how many spectators breathe on it. By this time Haacke's work bore little resemblance to sculpture in any traditional sense.

In the late 1960s Haacke gradually transferred his interest from simple physical systems to biological—or, more precisely, biosocial and/or ecological—systems. Typical of these biological systems were *Live Airborne System* (1965–68), the documented feeding of breadcrumbs to gulls off Coney Island; *Grass Cube* (1969), in which grass sprouted and died atop an acrylic cube during the course of an "Earth Art" exhibition at Cornell University; and *Ten Turtles Set Free* (1970), which is self-descriptive. When questioned in *Art and Artists* (November 1972) as to whether such works were banal, pointless, or absurd, Haacke replied: "I don't try to prove anything . . . all these circumstances create a friction between something cultural and something natural. . . . Only due to a shift out of the normal can we perceive common things and in a way that they become transparent for meanings beyond themselves." Haacke likened these works to Marcel Duchamp's assisted readymades, the difference being that these were systems, not objects.

Gallery-Goers' Birthplace and Residence Profile Part I (1969), exhibited at the Howard Wise Gallery, New York City, marked the emergence of Haacke's fascination with what he called "real and verifiable" social and political systems, those that "take place exclusively in the minds of people." Gallery visitors were asked to indicate their birthplace and current residence on maps with colored pins. Photographs were taken of each Manhattan residence (about 739 people responded) and later displayed in a Cologne gallery. As might be expected, Haacke's profile revealed that the great majority of his respondents came from geographically well-defined, upper-class or "intellectual" neighborhoods. His visitors' poll at the Museum of Modern Art's "Information" show in 1970 asked, "Would the fact that [New York] Governor Rockefeller has not denounced President Nixon's Indochina policy be a reason for you not to vote for him in November?"—a question that may have proved embarrassing to the curators of the museum, which was founded by Rockefeller's mother and at that time directed by his brother. (The vote was overwhelmingly affirmative; however, Rockefeller was reelected, proving that museum-goers do not represent an accurate cross-section of the state's electorate.)

Forewarned, New York City's Guggenheim Museum did not hesitate to cancel Haacke's scheduled solo show there in 1971 when director Thomas Messer accused the artist of "libelous muckraking" in his proposed *Real-Time Social*

Systems—photographic and written exposés of the holdings of two of New York City's major real-estate barons. The controversy resulted in generally negative publicity for the Guggenheim—an *Arts Magazine* (July 1971) writer charged the museum with catering only "to the tastes of both a self-defining mandarin class and an affluent and complacent bourgeoisie"—and a lot of positive publicity for Haacke that he would never have received otherwise. The *Real-Time Social Systems* were later displayed at the "Making Megalopolis Matter" show at the New York Cultural Center, Manhattan. Haacke's 1974 piece *Solomon R. Guggenheim Museum Board of Trustees* (exhibited shortly after he was awarded a Guggenheim Foundation Fellowship) listed each trustee's political and corporate affiliations in a brass-framed panel.

Haacke excited further controversy with his study of the owners of Manet's *Bunch of Asparagus* (1880) for the Wallraf-Richartz Museum's "Projekt '74" exhibition in Cologne. Grouped around the original painting (owned by the museum) were to be ten panels detailing "the social and economic position of the persons who have owned the painting over the years and the prices that were paid for it." This work too was banned, ostensibly because Haacke included among his owner-profiles one of Herman J. Abs, financier and chairman of the Wallraf-Richartz Kuratorium, who had arranged for the sale of the painting to the museum but who never actually owned it himself. More likely, it was Haacke's careful description of Abs's successful career as a banker during the Nazi period that gave the museum pause. "A grateful museum," director Horst Keller told Haacke, "and a grateful city or one ready to be moved to gratefulness, must protect initiatives of such an extraordinary character [the donation of valuable artworks] from any other interpretation which might later throw even the slightest shadow on them. . . . This aspersion, by implication, could adversely affect the museum's ability to attract devoted supporters from the private sector." Carl Andre, Sol LeWitt, Robert Filliou, and several other artists withdrew from "Projekt '74" in protest; Haacke showed the work at the Paul Maenz Gallery across town. Abs, not consulted by the museum until after the incident, said that the work did not offend him.

During the 1970s Haacke's interest in creating art systems became less apparent as he pressed on with attempts to reveal the often covert control of art institutions by private business. "On Social Grease" (1975) is a series of commemorative plaques photo-engraved with the thoughts on art of such political and corporate figures as Richard Nixon, C. Douglas Dillon, Nelson Rockefeller, and Robert Kingsley; Kingsley calls art "a social lubricant." *The Good Will Umbrella* (1977) exposes the profit motives behind the cultural underwriting of Mobil Oil, Chase Manhattan, Allied Chemical, and other powerful multinational corporations. For Haacke, art and politics are part of the same system. "Of course, I don't believe that artists really wield significant power. At best, one can focus attention. But every little bit helps."

EXHIBITIONS INCLUDE: Gal. Schmela, Düsseldorf 1965; Howard Wise Gal., NYC 1966, '68, '69; Hayden Gal., Cambridge, Mass. 1967; Paul Maenz Gal., Cologne 1971, '73, '74; Gal. Lambert, Milan 1972; Mus. Haus Lange, Krefeld, W. Ger. 1972; Gal. X-One, Antwerp, Neth. 1972; John Weber Gal., NYC 1973, '74, '75, '76, '77, '81, '83; Lisson Gal., London 1976; Stedelijk Abbemus., Eindhoven, Neth. 1978–79. GROUP EXHIBITIONS INCLUDE: "Nul," Stedelijk Abbemus., Eindhoven, Neth. 1962, '65; "Zero," Inst. of Contemporary Art, Philadelphia 1964; "Zero," Gal. of Modern Art, Washington, D.C. 1964; "Pilot Show," Signals Gal., London 1964; "Licht und Bewegung," Kunsthalle, Berlin 1965; "Directions in Kinetic Sculpture," Univ. of California, Berkeley 1966; "Kinetic Environments 1 & 2," Central Park, NYC 1967; "Air Art," Philadelphia Mus. of Art 1968; "The Machine as Seen at the End of the Mechanical Age," MOMA, NYC 1968; "Earth Art," Dickson White Mus., Cornell Univ., Ithaca, N.Y. 1969; "New Alchemy: Elements, Systems, and Forces," Art Gal. of Ontario, Toronto 1969; "Prospekt 68," Kunsthalle, Düsseldorf 1969; "Plans and Projects as Art," Kunsthalle, Berlin 1969; "Information," MOMA, NYC 1970; "Software," Jewish Mus., NYC 1970; "Air," Nat. Gal. of Victoria, Melbourne, Australia 1970; "Earth, Air, Fire, Water: Elements of Art," Mus. of Fine Arts, Boston 1971; "Prospekt 71," Kunsthalle, Düsseldorf 1971; "Konzept," Kunsthalle, Basel 1972; Documenta 5, Kassel, W. Ger. 1972; "Kunst im Politschen Kampf," Kunstverein, Hanover, W. Ger. 1973; "Live!" Stefanotty Gal., NYC 1974; "A Response to the Environment," Rutgers Univ., New Brunswick, N.J. 1975.

COLLECTIONS INCLUDE: Centre Georges Pompidou (Beaubourg), Paris; MOMA, NYC; Neuberger Mus., Purchase, N.Y.; Mus. Haus Lange, Krefeld, W. Ger.; Univ. of California, Berkeley; Art Gal. of Ontario, Toronto; Moderna Mus., Stockholm.

ABOUT: Burnham, J. Beyond Modern Sculpture, 1968; Haacke, H. Framing and Being Framed, 1975; Henri, A. Total Art: Environments, Happenings, and Performance, 1974; Lucie-Smith, E. Art in the Seventies, 1980. *Periodicals*—Art and Artists February 1972, November 1972; Art in America November 1974; Art International February 1968; Artforum June 1973, Summer 1981, October 1983; Arts Magazine May 1971, July 1971, February 1975.

*HAGUE, RAOUL (March 28, 1905–), American sculptor, has been a leading first-generation artist of the New York School. He adapted the technique of direct carving, in stone and, later, in wood, to the creation of large-scale abstract sculpture which suggests the human figure. He was born Raoul Heukelekian in Constantinople, of Armenian parents. His father, Nazar Heukelekian, was an import-export broker. Raoul attended high school at Roberts College Preparatory School, Constantinople. He came to the United States in 1921, studying first at Iowa State College, Ames, then moving to Chicago, where from 1922 to '25 he attended classes at the Art Institute. Settling in New York City, he studied in 1926–27 at the Beaux-Arts Institute of Design, where he began to sculpt. About 1927 he met Arshile Gorky, who introduced him to Willem de Kooning. From 1927 to '28 he studied with William Zorach at the Art Students League.

In New York, Hague (he had simplified his Armenian surname) met the sculptor John Flannagan, with whom he worked informally and who inspired him to use the technique of direct carving in stone, an approach also favored by Zorach. Hague and Flannagan became friends and went on expeditions to Long Island in search of unusual stones. In 1932, through Zorach, Hague met Dorothy Miller and her husband Holger Cahill, who included two of Hague's stone sculptures of 1931, Girl with Fur and another figure, in the 1933 group exhibit "American Sources of Modern Art" at the Museum of Modern Art, New York City.

Hague became a US citizen in 1930, and from 1935 to '39 he worked in the sculpture division of the Works Progress Administration's Federal Arts Project in New York City. He was represented in the "American Art Today" exhibit at the 1939 New York World's Fair.

From 1941 to '43 Hague served in the US Army with a mule outfit in Camp Hale, Colorado. He had stored his sculptures in a rented house in Woodstock, New York, and after his discharge he returned to Woodstock to live. There Hague endured severe economic hardship, but in 1945 he was included in the "Recent American Art" group show at the Curt Valentin Gallery, New York City. Also that year he received the Audubon Award and New York City's Whitney Museum of American Art began to show his work regularly in its influential annual exhibitions of contemporary work.

About 1945 Hague abandoned carving in stone for wood. A comparison of two pieces, Belgian Marble (1940) and Stony Ridge Chestnut (1945), shows that at first the change

of medium had little affect on the form of the sculptures. Indeed, Hague's pre-1950 sculptures, whether wood- or stone-carved, suggested the figure, especially the human torso, without ceasing to be abstract. However, through the organic medium of wood, his sculptures became more sensuous and graceful, as in two torsos of 1946, Chestnut Torso and Claverack Walnut. In both of these early wood carvings the original tree trunk is palpable. Soon Hague felt the need to cut deeper into the wood—"I had to get inside, to feel around in it," he explained—and his sculpture entered a transitional phase between figuration and pure abstraction. Champville Limestone (1947–48) is an example. In forgoing representation he was able to give greater attention to the challenge of the material.

During this period in Woodstock, Hague was associated with the Abstract Expressionist painters Bradley Walker Tomlin, whom he greatly admired, Philip Guston, and the writer James Baldwin. In 1950 Hague traveled to London, where he attended art history lectures at the Courtauld Institute. After visiting Paris, Rome, Greece, and Egypt, he returned in 1951 to Woodstock. There he made sculptures from the huge stumps and tree trunks he hauled out of the woods. As Irving Sandler wrote in Art News (November 1962), "The finished sculptures are named for the sites and the original blocks which fathered the thoughts." Characteristic titles are African Mahogany (1952) and Mount Marion Walnut (1952–54; Albright-Knox Art Gallery, Buffalo, New York). Although walnut is a favored material, Hague also worked with butternut, poplar, sycamore, and locust. Often the monolithic tree trunks take on the appearance of human torsos; at other times, especially in his later works, the images are totally abstract.

In October 1953 Hague held a private showing of his sculpture in John Hovannes's studio in New York City. The response of critics and buyers was not overwhelming, but the exhibition resulted in an article by Thomas B. Hess, "Introducing the Sculpture of Raoul Hague," in Art News (January 1955). In 1956 ten Hague sculptures were included in the important MOMA exhibition entitled "Twelve Americans." His one statement in the catalog was: "In the last thirty years, of all the artists I have known, there have been only three whose eyes I could trust—Gorky, Tomlin and Guston—and I have used them in my own development."

The MOMA exhibition was a turning point in Hague's career. His works were snapped up by MOMA, the Whitney Museum, the Albright-Knox Art Gallery, and two private collections. In 1959 Hague received a Ford Foundation grant

°häg, rä ool´

of $10,000 for creative sculpture. In 1962, at the age of 57, he had his first solo show, at the Egan Gallery, New York City; the first major retrospective of his work was held in 1964 at the Washington Gallery of Modern Art, Washington, D.C. A *Washington Post* (September 27, 1964) reviewer wrote, "For all its monumental simplicity, Hague's sculpture is complex beyond all appearances." The critic noted that he alluded less and less to recognizable forms in his work, and added: "Primarily, his sculpture is 'about' the substance from which it is wrested. These days Hague works almost exclusively in walnut, sometimes starting with pieces of tree weighing nearly half a ton. [He] thinks big, sees whole, and creates incredibly slowly."

Reviewing Hague's second solo show at the Egan Gallery, Stuart Preston of *The New York Times* (February 11, 1965) called Hague "a Yankee Brancusi." But he noted that in his "monumental carved and polished wood nonobjective sculpture," Hague was "less sophisticated than Brancusi, straightforward rather than refined, unconcerned in his boulder-like work with the mathematical perfection of a piece of sculpture such as 'As Bird in Space.' Preston added that Hague's sculpture "relates to the world of nature rather than to the realm of essence and gives expression to a plastic vision of unusual distinction and integrity."

In 1976 Hague participated in the group exhibition entitled "The Golden Door—Artist Immigrants of America, 1876–1976," which was held at the New York City Coliseum.

Raoul Hague continues to live and work alone in his Woodstock studio, more concerned with the expression of his artistic vision than with publicity and recognition. As Gerald Nordland wrote in the catalog to Hague's 1964 exhibition at the Washington Gallery, "He is not a careerist. He has not engaged in reputation building or aggressively sought out collectors, dealers or museum personnel. He confines his actions to the arena of his studio. His works proclaim his identity." A sturdily built man, with strong, sensitive features, Hague has been described as reserved but warm and friendly. He is reluctant to discuss his work, preferring to let his sculptures speak for themselves.

In the "Twelve Americans" catalog T.B. Hess wrote that Hague's "forms are 'difficult' and refer to themselves, with their own logic, to their own order. . . . Hague's sculptures are of an age that cannot deal in certainties. They are individual personalities, their humanity is specific and becomes general by the very strength of its unique, human quality. The fact that they are beautiful is what makes this quality so moving."

EXHIBITIONS INCLUDE: Egan Gal., NYC 1962, '65; Washington Gal. of Modern Art, Washington, D.C. 1964; Xavier Fourcade Gal., NYC 1980. GROUP EXHIBITIONS INCLUDE: "American Sources of Modern Art," MOMA, NYC 1933; "American Art Today," New York World's Fair, Flushing Meadow 1939; "Recent American Art," Buchholz Gal. and Curt Valentin Gal., NYC 1945; Whitney Annual, NYC 1945–67; "Twelve Americans," MOMA, NYC 1956; Am. Exhibition, Art Inst. of Chicago 1963; "Etats-Unis: Sculptures du XXe siècle," Mus. Rodin, Paris 1965; White House Festival of the Arts, Washington, D.C. 1965; "The Golden Door—Artist Immigrants of America, 1876–1976," Coliseum, NYC 1976.

COLLECTIONS INCLUDE: MOMA, and Whitney Mus. of Am. Art, NYC; Albright-Knox Art Gal., Buffalo, N.Y.; Hirshhorn Mus. and Sculpture Garden, Washington, D.C.

ABOUT: Miller, D. C. (ed.) "Twelve Americans" (cat.), MOMA, NYC, 1956; Nordland, G. "Raoul Hague" (cat.), Washington Gal. of Modern Art, Washington, D.C., 1964. *Periodicals*—Art News January 1955, November 1962, March 1980; Arts Magazine July 1956, December 1962; New York Times February 11, 1965; Washington Post September 27, 1964.

***HAJDU, ETIENNE** (August 12, 1907–), French sculptor, writes: "I came into the world (August 12, 1907, Turda, Rumania) with a little suitcase containing my genetic heritage, gifts of my mother and father. I later put into the suitcase my cultural heritage, all that I have learned, seen, heard, or touched. There was at that time in the mountains of Transylvania a vital popular art and there were books of high quality in my father's library. Driven by an inner necessity I had a tactile comprehension of things which led me instinctively to sculpture. As a result I carved wood and modeled clay without knowing that the art of sculpture existed, still less that I could become an artist.

"As an adolescent I attended a technical school in Ujpest, Hungary, where I learned modeling and woodcarving. Through young poets, writers, and artists I finally became acquainted with the living art of the '20s. All these new ideas disturbed me, I understood nothing. In Vienna, and later in Paris (1927), where I chose French nationality, I wanted to see my way clearly. Exciting things were happening all around me, everything had to be viewed afresh. Futurism, cubism, dadaism, surrealism, abstraction, each had its own truth, but I was searching for mine.

"Difficult years followed, both morally and materially. The war, then, living in solitude in the Pyrenees during the occupation, I worked as a stonemason in a marbleworks, in direct contact with the material.

°hä´jōō, ä tyen

ETIENNE HAJDU

"After long periods of uncertainty, I became convinced that I had to begin again from zero, starting with simple elements, basic forms as in the beginning of life, an archetypal cell which, segment by segment, evolves into an organic unity rich enough to signify the multiplicity of the universe. In this way there slowly emerged a plastic language whereby through an inner logic I arrived at the bas-relief (*Combat of Birds, Homage to Bela Bartok, Unity of Tension,* etc.) On a large surface I develop, I orchestrate my elemental forms by varied rhythms, now slow, now rapid, which lead me to differentiate space. The form does not adhere to the surface like successive layers of drapery. By eliminating the contours through undulating movements of the background instead of creating sharp contrasts of shadow and light (cubism), I sought transitions, variation, grays. Sculpture is generally thought of in terms of light, but in reality it is the science of shadows.

"I have carved a number of female figures in marble: women, with the suppleness of their bodies, their clothing and their hair, have enabled me through invented forms to take all kinds of liberties, and to express tenderness in many ways, and serenity (*Luce, Chantal, Woman in Black,* etc.)

"I draw a great deal. Paper allows for every kind of freedom, unlike marble, but like metal. I have also made a series of high reliefs in polished aluminum where the reflection of the forms through interaction gives echoes of light in order to escape from the heaviness of a space. *Between Two Stars* exists in a cosmic eddy, an imaginary space beyond points of reference.

"Between times, from 1957 on, I made *estampilles* (Stampings), a kind of engraving, or rather a digging into the white paper, without any inking in terms of light and shadow. This technique gave me ideas for book illustration, pages that are sculpted and structured like a poem paralleled to the written poem (*Regnes* by Pierre Lecuire, *Héraclite* and *Le Coups clairvoyant* by Jacques Dupin, *Ode à la neige* by Henri Pinchette)."

Pierre Granville, curator of the modern art section of the Musée des Beaux-Arts, Dijon, wrote in the catalog to a Hajdu sculpture exhibition at the museum in 1978 that Hajdu's art, "although linked to the baroque by its movement and the light that embraces it while constantly modifying it, is at the same time classical by virtue of its refining, its sense of synthesis, its elimination of superfluous detail following the example of Cycladic and Mesopotamian art. [His is] an art which cannot be summed up because it is multiple, because it is in a state of 'becoming,' an art which always remains itself, far from all compromise." Herbert Read saw in such works as *Delphine* (1960), in marble, "the influence of early Greek art (particularly of the subtle relief of Greek *stele*)."

Hajdu's rich and complex ethnic and cultural heritage have contributed to the unique character of his work. In Paris he studied with Antoine Bourdelle at the Grande Chaumière in 1927, but it was a Fernand Léger exhibition in late 1929 that had the greatest impact on him, making him question his aesthetic values. Among the artist friends working in Paris who introduced him to contemporary art was the abstract painter Maria-Elena Vieira da Silva. Hajdu especially admired the sculpture of Constantin Brancusi.

In 1935 Hajdu made a bicycle trip through France, visiting Romanesque and Gothic churches. The tympana on Romanesque portals revealed to him how a world could be organized within a given space. On a trip to Greece in 1937 he was impressed by Cycladic idols. About this time he became passionately interested in biology and took a course on the subject in Paris. This feeling for the organic links him in some ways to Jean Arp, although Hajdu's forms are less volumetric and more elegant.

In 1946, having survived World War II, Hajdu began to work on relief sculptures. Several of these works reflected his love of contemporary classical music, including his *Homage to Bela Bartok* (1948), in hammered copper, and a large relief in hammered aluminum and lead, *For Edgar Varèse* (1958). He won the Nor-

drhein–Westfalen prize for sculpture in 1965 and in the same year began to work for the Sèvres manufactory, adapting his new *estampille* process to ceramics.

Hajdu received many important commissions in the late '60s and '70s, including a portrait of President Georges Pompidou for the French government's department of coins and medals. He also designed carpets and tapestries for the Mobilier National in Paris. In 1973 he completed a series of sculptures in polyester, "Seven Columns for Stéphane Mallarmé." In the same year there was a retrospective of his work at the Musée d'Art Moderne, Paris, and another important retrospective opened in 1978 at the Musée des Beaux-Arts, Dijon, which traveled to other French cities.

Etienne Hajdu lives with his wife, Luce, in Bagneux, near Paris. "The great problem," he said, "is to express what is human in a different manner than the artists of the Middle Ages and Renaissance. Through invented forms I should like to express the human reality, the presence of man. His antagonisms as well."

EXHIBITIONS INCLUDE: Gal. Jeanne Bucher, Paris 1946, '48, '52, '57; M. Knoedler and Co., NYC 1958, '62, '69; Kestner-Gesellschaft, Hanover, W. Ger. 1961; Contemporary Arts Center, Cincinnati 1962; Phillips Collection, Washington, D.C. 1964; Gal. Knoedler, Paris 1965, '68; Mus. d'Art Moderne, Paris 1973; Mus. des Beaux-Arts, Dijon, France 1978–79; Gal. des Beaux-Arts, Bordeaux, France 1978–79; Maison des Arts et Loisirs, Sochaux, France 1978–79. GROUP EXHIBITIONS INCLUDE: Gal. Jeaune Bucher, Paris 1939; Salon de Mai, Paris 1947, '50, 1953–62; Middelheim Biennale, Antwerp, Belgium 1950–57; "The New Decade," MOMA, NYC 1955; São Paulo Bienal 1955; Pittsburgh International 1964.

COLLECTIONS INCLUDE: Mus. d'Art Moderne, and Mus. d'Art Moderne de la Ville de Paris; Mus. des Beaux-Arts, Dijon, France; MOMA, NYC; Albright-Knox Art Gal., Buffalo, N.Y.; Hirshhorn Mus. and Sculpture Garden, Washington, D.C.

ABOUT: Chevalier, D. Nouveau dictionnaire de la sculpture moderne, 1970; "Etienne Hajdu" (cat.), Mus. d'Art Moderne, Paris, 1973; Ganzo, R. Hajdu, 1957; Granville, P. "Etienne Hajdu" (cat.), Mus. des Beaux-Arts, Dijon, France 1978; Jianou, I. Etienne Hajdu, 1972; Read, H. A Concise History of Modern Sculpture, 1964; Seuphor, M. Hajdu, 1953. *Periodicals*—Chronique des arts (Paris) June 1973; XXe siècle (Paris) June 1969, December 1974.

HAMILTON, RICHARD (February 24, 1922–) British painter, is a leading first-generation Pop artist. Hamilton was born in

Jorge Lewinski

RICHARD HAMILTON

London. At the age of 11 he enrolled in evening art classes, and in 1936–37 attended evening classes at the Westminster Technical College, London, studying with the painter Mark Gertler. He also studied in 1936 at the St. Martin's School of Art, London, with Bernard Meninsky. Hamilton left school later that year to work in the advertising department of a commercial studio. He attended the Royal Academy Schools in London from 1938 to 1940 and in 1941 studied engineering draftsmanship, following which he worked as a jig and tool designer while continuing to study art in the evenings. In 1945, the war over, he resumed courses at the Royal Academy Schools but was expelled in 1946 for "not profiting by instruction."

Hamilton did his military service as a sapper in the Royal Engineers at Aldershot in 1946–47. In 1948 Hamilton was admitted to the Slade School of Art, London, where he studied etching with John Buckland Wright. He remained at the Slade for three years and his etchings were exhibited at Gimpel Fils, London, in 1950.

After leaving the Slade, Hamilton earned a living by making models and designing exhibitions, including the "Growth and Form" exhibition at the Institute of Contemporary Arts, London, in 1951. Then he worked as a teacher and lecturer; he was design instructor at the Central School of Arts and Crafts, London, from 1952 to '53, after which he became lecturer in basic design at the University of Durham, Newcastle-on-Tyne, where he remained until 1966. It is significant that in Hamilton's extensive technical training and employment, he never worked professionally as a painter, despite his

artistic skill. The future Pop artist was primarily involved with mass media and the inventive use of contemporary mechanical and technical processes.

As John Russell observed in the catalog to the 1973 Hamilton retrospective at the Guggenheim Museum, New York City, Hamilton "grew up in the England of George Orwell," an England "characterized by stratified inequalities—of money, of opportunity, of social endowment—which would now be unthinkable." As a young Londoner in the 1930s Hamilton "became a critic of society, whether he knew it or not. . . . He took nothing for granted." Even at 15 and 16 he was "alive . . . to living art" and a mentor paid his way to see Pablo Picasso's *Guernica* when it was shown in London. Industrial draftsmanship trained him in a precision "vastly greater than anything that was taught in art school," and he became aware of an image's potential power in a "nonart" setting.

Another factor in Hamilton's development was his fascination with American popular culture and mass-production techniques—a fascination shared by an entire younger generation in the war-weary, still heavily rationed Britain of the early 1950s. Pop art, "in its narrowest definition," to quote Edward-Lucie Smith, grew out of a series of discussions at London's Institute of Contemporary Arts among a small coterie called the Independent Group. It included artists, critics, and architects, among them Eduardo Paolozzi, Richard Hamilton, Peter Reyner Banham, and Lawrence Alloway. The first meetings were held in the winter of 1951–53, and the theme of the discussions was techniques (one topic was helicopter design); the meetings convened in the winter of 1954–55 were on popular culture. In *Pop Art* Lucy R. Lippard described the group's avid interest in, and the consumer's love of, "mass-produced urban culture: movies, advertising, science fiction, Pop music." They wished to destroy the distinction between so-called highbrow and lowbrow taste. "Expendable art," in the form of the best products of Hollywood, Detroit, and Madison Avenue, was proposed as "no less serious than permanent art." Lucie-Smith suggested that, in addition to being a delayed effect of wartime austerity, when America "had seemed an Eldorado of all good things from nylons to motor-cars," the new movement was a reaction against "the solemn romanticism, the atmosphere of high endeavour which had prevailed in British art during the 1940s."

Lectures by members of the Independent Group in the 1954–55 season included a talk by Reyner Banham on car styling (Detroit and sex symbolism) and one by Hamilton on consumer goods. In this first phase of English pop art Hamilton, who had never been to the United States, spoke "for a generation of English voyeurs, for whom America was wonderland, to be known vicariously from movies and magazines," to quote John Russell. In 1955 Hamilton organized an exhibition at the Institute of Contemporary Arts titled "Man Machine and Motion," in which he explored the visual explosion of the 20th century in terms of the images generated by the contact of men and machines. Photography, whether commercial or artistic, was to Hamilton not merely a documentary record but, to quote Lippard, "fantasy rooted in human fact." On the cover of the show's catalog Hamilton used the negative of a photograph taken by Jacques Henri Lartigue in 1912 at the Grand Prix, the earliest photographic image of a speeding automobile.

In 1956 the Independent Group mounted the now-celebrated "This Is Tomorrow" exhibition at the Whitechapel Art Gallery, London. Designed as a series of environments, "This Is Tomorrow" featured a Hamilton collage picture entitled *Just What is it that Makes Today's Homes so Different, so Appealing?* The picture was an inventory of pop images: in a tacky, ultramodern living room was a muscle-man cutout from a beefcake magazine; a nude stripper with sequined breasts; a theater poster of Al Jolson pleading for "Mammy" in *The Jazz Singer* (signifying the coming of sound to movies); a *Young Romance* comic-book cover (the kind of teenage True Love bathos the American Pop artist Roy Lichtenstein was to portray in the 1960s) framed on the wall; magnetic tape in the foreground (another technical innovation); and a ceiling that looked like the surface of the moon. The muscleman holds a huge lollipop on which the word POP is prominently inscribed. This provocative collage contained the fundamental motifs of pop art, whether American or English.

Hamilton met his idol, Marcel Duchamp, in 1956. He wholeheartedly endorsed Duchamp's statement, "Anything is art if the artist wills it," and shared Duchamp's fascination with the experimental, the mechanical, and the banal. In 1954, two years before *Just What is it that Makes Today's Homes so Different, so Appealing?*, Hamilton had painted *re Nude*, a tribute to and refurbishing of Duchamp's *Nude Descending a Staircase* (1912). But, unlike Duchamp, Hamilton's art focused on the social environment, always seeking, "the unique attributes of our epoch," as the artist put it. Hamilton is irritated by comparisons of his work and Duchamp's, but, as Thomas M. Masser pointed out in the catalog to Hamilton's 1973 retrospective at the Guggenheim Museum, New York City, the artist's

"thoughts on art were much influenced by his friendship with Marcel Duchamp." Masser described Hamilton as a "primary link between Duchamp and much current art," and added that, like Duchamp, "Hamilton is idea rather than form oriented. He is confident that art, above all, is the process of solving visual problems and that it has little to do with the attainment of style."

In 1957 Hamilton declared, as quoted in Mario Amayo's *Pop as Art,* that the qualities he sought in art were "popularity, transience, expendability, wit, sexiness, gimmickry and glamour." At this time Hamilton's work was virtually unknown to the British public. Hamilton's first pop painting was *Hommage à Chrysler Corp* (1957). In *Architectural Design* Hamilton wrote of *Hommage,* "The main motif, the vehicle, breaks down into an anthology of presentation techniques. Pieces are taken from Chrysler's Plymouth and Imperial ads, there is some General Motors material and a bit of Pontiac." Those images were juxtaposed with women's underwear and lipstick ads to produce a combination of cars and sex, a motif that was reprised in Hamilton's second pop painting, *Hers is a Lush Situation* (1957). In *She* (1958-61; Tate Gallery, London), an oil, cellulose, and collage on wood painting, he again drew attention to the erotic use of the female figure in advertisements; but here domestic machines—a toaster, vacuum cleaner, and kitchen range—replaced the automobile. Despite commercial advertising's capacity for exploitation, Hamilton's intention was not satiric. "It looks as though the painting is a sardonic comment on our society," Hamilton said of *She.* "But I would like to think of my purpose as a search for what is epic in everyday objects and attitudes."

Hamilton was the only first-generation Pop painter to express a political message in art. His oil and photomontage on panel, entitled *Portrait of Hugh Gaitskell as a Famous Monster of Filmland* (1964), was occasioned by that well-known Laborite's support of Great Britain's nuclear-arms policy. A picture of Claude Rains as the phantom of the opera from the cover of *Famous Monsters of Filmland* magazine was merged with a newspaper photograph of Gaitskell. With the help of his wife, the former Terry O'Reilly, Hamilton had started work on the "portrait" in the early '60s. But her death in a car accident in 1962, followed by Gaitskell's death in 1963, complicated Hamilton's work. This disturbing painting is owned by the Arts Council of Great Britain.

In 1966 Hamilton helped to organize a large exhibition at the Tate Gallery of Marcel Du-

champ's major works. Hamilton wrote the catalog for "The Almost Complete Works of Marcel Duchamp" and exhibited his reconstruction, which took him over a year to complete, of Duchamp's *The Bride Stripped Bare by Her Bachelors, Even.* (The original *Large Glass,* as the piece is also known, is badly cracked and unavailable for loan.) For the exhibition Hamilton also published, at his own expense, a version of *The Green Box,* Duchamp's notes on the construction of *Large Glass.* After this elaborate homage Hamilton declared, "I have got Duchamp out of my system."

When Hamilton visited the United States in 1963, American pop art was in full swing. In his catalog introduction to Hamilton's Guggenheim exhibition, John Russell discussed the immense differences between American and British pop. "Americans like to take their ideas one by one and hammer them home," he wrote, whereas the "English way is by contrast aloof, distanced, oblique." Hamilton in particular was described by Russell as "a man of many masks." Unlike the "heraldic, frontal echoless manner" of an American Pop artist like Robert Indiana, Hamilton's "preferred methods are oblique, multifarious and slow to reveal themselves."

Hamilton's 1970 retrospective at the Tate Gallery included a series of six fiberglass reliefs inspired by the spiral form of the Guggenheim Museum. Another series was based on an ordinary commercial postcard, and Marjorie Bruce-Milne, reviewing the show in the *Christian Science Monitor,* praised Hamilton's "skill in turning everyday material into a work of art." Hamilton's Guggenheim retrospective opened in September 1973 and included approximately 160 works, spanning the years 1949-73. Reviews were mixed. For Peter Schjeldahl of *The New York Times* (September 30, 1973), Hamilton was among those "artists considered first-rate in England [who] seem not to travel very well." Schjeldahl especially disliked "the strenuously cosy character of the artist's allusions and witticisms," and found "a stilted, patronizing air" in his uses of the pop vernacular. In *The New York Times* (September 14, 1973) James R. Mellow called Hamilton's art "a restless, if not terribly pointed, visual commentary of many aspects of contemporary culture." But in *New York* magazine Barbara Rose found Hamilton's "most elegant and witty" exhibition as providing "a kind of minichronicle of the debacle of the London art scene. . . ." Rose praised Hamilton as a painter whose understanding of the historical situation of contemporary art was reflected in his work.

Hamilton's attitude toward the art of the past and toward his own work was displayed in an ex-

hibition he selected for London's National Gallery in 1978. This was the second in the gallery's annual "Artist's Eye" series, which had been initiated by the sculptor Anthony Caro. Among the National Gallery paintings chosen by Hamilton were such masterpieces as Pisanello's so-called *Vision of St. Eustace,* Bosch's *Crowning with Thorns,* Velázquez's *Kitchen Scene with Christ in the House of Martha and Mary,* the wonderful self-portrait of the aged Rembrandt, Turner's *Evening Star,* and a Courbet still life. Hamilton's own painting in the show, a multiple-image oil and collage on wood panel called *My Marilyn,* celebrated the use of mass-production techniques as a means of reintroducing representation into modern art. Hamilton modestly wrote in the show catalog, "My inadequacy can help to sharpen the understanding of real achievement. . . . 'My Marilyn' can be used with other props in my staging as a device to stimulate response to the main performers." The "other props" included a mirror hung on the wall between the Bosch and another painting; an ironing board; an assortment of chairs; a carpet; and a color television set. Hamilton hoped that "to encounter these classic works in a context that differs from the usual museum arrangement will reinforce our appreciation of them." Hamilton also designed the exhibition poster, a freely sketched-in Hamiltonian version of Jan Van Eyck's famous Arnolfini wedding picture, which was, as the National Gallery's director, Michael Levey, observed, "a witty comment on images and the creation of images" and an illustration of Hamilton's Duchampian belief that "it is the mind of the artificer, not the artifact, that we are moved by."

Richard Hamilton has two children, Dominy and Roderic, from his 1947 marriage to Terry O'Reilly. The artist lives in London and maintains a studio in Muswell Hill. He is tall, thin, and bearded. A reclusive artist, reserved and somewhat aloof in manner, but with a dry humor, Hamilton was described by John Russell as "a quintessential Londoner." He works slowly, with extreme precision, and may take a year or more on one project. His statements about art are oblique and ambiguous. When asked in *Contemporary Artists* (1977) about the significance of the human figure in his works, Hamilton replied, "It, another self, real or semblance, revealed or implied, will always be a major factor in my art."

EXHIBITIONS INCLUDE: Gimpel Fils, London 1950; Hanover Gal., London 1955, '64; Robert Fraser Gal., London 1966, '69; Gal. Ricke, Kassel, W. Ger. 1967; Alexandre Iolas Gal., NYC 1967; Studio Marconi, Milan 1968, '69, '71, '72; Gal. René Block, Berlin 1970, '71, '73; Tate Gal., London 1970; Stedelijk van Abbemus., Eindhoven, Neth. 1970; Kunsthalle, Bern 1970; Whitworth Art Gal., Manchester, Eng. 1972; Inst. of Contemporary Arts, London 1972; Solomon R. Guggenheim Mus., NYC 1973; Nationalgal., Berlin 1974; Serpentine Gal., London 1975. Waddington Gals. II, London 1977; Gal. Maeght, Paris 1981. GROUP EXHIBITIONS INCLUDE: "This is Tomorrow," Whitechapel Art Gal., London 1956; "An Exhibit," 1957, "An Exhibit 2," Hatton Gal., Newcastle-on-Tyne 1958; "Nieuve Realisten," Gemeentemus., the Hague, Neth. 1964; Carnegie International, Pittsburgh 1964; Documenta 4, Kassel, W. Ger. 1968; "Information," Kunsthalle, Basel 1969; "Contemporary British Art," Mus. of Modern Art, Tokyo 1970; "British Painting and Sculpture," Nat. Gal., Washington, D.C. 1970 "Métamorphose de l'object," Palais des Beaux-Arts, Brussels 1971; "Graphische Techniken," Neue Berliner Kunstverein, Berlin 1973; "The Artist's Eye," Nat. Gal., London 1978; "20th Century Portraits," Carlton House Terrace, Nat. Portrait Gal., London 1978.

COLLECTIONS INCLUDE: Tate Gal., London; Arts Council of Great Britain; Solomon R. Guggenheim Mus., NYC; Peter Ludwig Collection, Cologne.

ABOUT: Amaya, M. Pop As Art: A Survey of the New Super-Realism, 1965; Finch, C. Pop Art—Object and Image, 1968; Hamilton, R. "The Artist's Eye" (cat.), National Gal. London, 1978; Lippard, L. R. Pop Art, 1966; Lynton, N. The Story of Modern Art, 1981; "Richard Hamilton" (cat.), Tate Gal., London, 1970; "Richard Hamilton" (cat.), Guggenheim Mus. NYC, 1973; Russell, J. and Gablik, S. Pop Art Redefined, 1969; Wintle, J. (ed.) Makers of Modern Culture, 1981; *Periodicals*—Architectural Design (London) March 1958, November 1961; Art and Artists (London) July 1966, November 1966; Art in America March 1970; Art International (Lugano) February 1963, January 1964; Christian Science Monitor April 13, 1970; Design (London) February 1960; Guardian July 25, 1966; New York October 22, 1973; New York Times September 15, 1973, September 30, 1973; New York Times Magazine July 21, 1974; Observer March 15, 1970; Studio International (London) October 1964, January 1968, March 1969, July–August 1969.

HANSON, DUANE (January 17, 1925–), American sculptor, is one of the most successful and durable artists of the super-realist, or photo-realist, movement. He became famous for his meticulously detailed, life-sized figures, cast in polyester resin or polyvinyl acetate, of careworn blue-collar workers, downtrodden businessmen, and bored housewives and shoppers. Even in galleries and museums, his sculptures are often mistaken for real people. The easy accessibility and shock value of his work have made it immensely popular with museum-goers—his 1978 retrospective at the Whitney Museum of American Art, New York City, attracted record

crowds—but rather less so with most critics, especially those with a formalist bent. In *The New Yorker* (February 5, 1972), Harold Rosenberg called Hanson's *Businessman* (1971) "neither a sculpture [nor] a concept but [a] technical feat that seems a step in advance of the waxworks museum," while in *Newsweek* (February 20, 1978) Robert Hughes claimed that Hanson's works have "a quotidian sourness about them, and their smell of perplexed defeat is as alluring to the sentimentalist as the moist gaze of a Landseer dog."

Of Swedish descent, Hanson was born in Alexandria, Minnesota, the son of Dewey Hanson, a Midwestern dairy farmer. He attended Parkers High School, Parkers Prairie, Minnesota, and continued his studies at Luther College, Decorah, Iowa, before transferring to the University of Washington, Seattle. In 1945 he transferred again, to Macalester College in St. Paul, where he worked with sculptors Alonzo Hauser and John Rood, and in 1946 became the first art major to graduate from the college. He taught art at high schools in Idaho and Iowa in the late '40s, and in 1951 earned an MFA from the Cranbrook Academy in Michigan, studying under Bill McVey and Carl Milles. About this time he married Janice Roche, an opera singer. After a brief attempt to sell his work in New York City, he was an art teacher at the US Army High School in Bremerhaven, West Germany from 1957 to 1960. In Bremerhaven he met sculptor George Grygo, who was experimenting with polyester resin and fiberglass as sculptural materials. Hanson returned to the US in 1960, first settling in Atlanta and then moving to Miami.

It took Hanson several more years to find a personal style. "I did some formalistic pieces," he told Martin H. Bush, the author of a book-length study of his work, "making pretty statements in stone, wood, and clay . . . even some welded works and paintings, but I never stuck with anything or tried to develop my work. It always ended up as decoration, and I felt unhappy about it. I wanted something that could really communicate with people." Undoubtedly, the emergence of pop art in the 1960s helped Hanson make his own statement. George Segal's bleak plaster-of-paris figures, which were giving sculptural realism new legitimacy, also inspired him. In 1966, angered by reports of the brisk trade in illegal and dangerous abortions in Miami, he made his first realistic figure, *Abortion*, a plaster model of a dead pregnant woman covered by a shroud. The piece was hesitantly accepted by the annual Sculptors of Florida exhibition, but was blasted by the critics. A *Miami Herald* critic wrote: "This we do not consider a work of art, since we inevitably consider all such treatments as outside the categories of art."

Not at all deterred, in 1967 Hanson created a series of increasingly grisly works in polyester resin, culminating in *Accident*, a depiction of a bloody motorcycle crash that was banned from an exhibition at the Bicardi Museum in Florida; *War*, a tableau of dead and dying soldiers meant to protest the Vietnam War; and *Riot*. Local controversy over these works was picked up by the national press; the publicity helped Hanson to place three sculptures in the Whitney Museum of American Art's 1969 exhibition "Human Concern/Personal Torment: The Grotesque in American Art." His first solo show in New York City was held at the O.K. Harris Gallery the following year. His most powerful protest piece was *Race Riot* (1969–71), in which a state trooper mercilessly clubs a prostrate black civil rights demonstrator.

Hanson abandoned macabre effects in 1969 to search for a way of making a more penetrating criticism of American society. "You can't always scream and holler," he said. "You have to whisper once in a while, and sometimes a whisper is more powerful than all the screaming . . . you can do." He shifted his attention from violence and protest to social caricature. The early pieces in this vein were strident pop archetypes—notably, *Supermarket Shopper* (1970), a portrait of a chunky housewife in curlers pushing a shopping cart full of frozen dinners and junk food, and *Tourists* (1970), which depicts two gawking sightseers, a tiny old man in garish shirt and Bermuda shorts, with an oversized camera, and his wife, in red toreador pants, clutching a plastic tote bag full of tour guides. By the mid-1970s Hanson's blatant parodies of ugly Americans had become less sarcastic and more compassionate. He examined blue-collar anomie in a portrait of a weary waitress (*Rita*, 1975), the lonely and hopeless lives of the elderly (*Seated Old Woman Shopper*, 1974), and the aimless affluence of the middle class (*Reclining Man Drinking*, 1972). "People today are at the mercy of big government, big society," he said. "The little guy is caught in between—not really being represented."

As Hanson developed this theme, he often captured the pathos—but not the poetry—of Segal's work. He began to pursue in earnest the trompe-l'oeil possibilities of the medium, taking great care to put his models—family, friends, and people on the street—at ease and in natural poses before making plaster molds of their bodies, from which he would then pull polyvinyl casts. Hanson would then spend days patching, painting, and applying hairs to the figures and searching for the perfect clothes and props. "I discovered the work could have impact if the work was even more real," he wrote in *Art News*.

"I worked with it to discover that illusion was good and not distracting." According to one writer, the result was "so uncanny that it is easy to imagine his sculptures breathing."

Critics in Europe and America were quick to link Hanson with the Photo-Realists (also called the New Realists, Super-Realists, or Hyper-Realists). In a critical essay on Hanson and his fellow realist sculptor John de Andrea in *Art in America* (November/December 1972), Joseph Masheck attempted to explain the difficulty that critics have had with Hanson's work. "Hyper-realist sculptures couldn't care less whether we find them bad art or not even art at all. They are oblivious to us because any consideration we give them has to be critical, and any consideration sophisticated enough to amount to criticism must at least account for, if not proclaim, abstract values. This is why we can experience difficulty and even annoyance with such works, despite their easy descriptive literalism." However, as Adrian Henri pointed out, Hanson's meticulous ultrarealism can be compared "with the extreme works of the Catholic Counter-Reformation" in Spain and South America in which the Madonna weeps "real" tears and the martyrs shed "real" blood.

In 1974, less than a decade after Hanson's first experiments with realism, a major retrospective of his work was mounted in West Germany and Denmark. The show elicited more favorable reactions from European critics than Hanson usually received in the United States. "Duane Hanson is a wolf in sheep's clothing," wrote a German reviewer. "He mocks real people . . . and not without reason. He shows hopeless and tired people living on the edge of society—people like you and me—and leaves us to come to terms with our own reality." The immense popularity of his retrospective at the Whitney, which included none of the grisly early figures—several of which Hanson had destroyed, along with all of his previous abstract work—indicated, however, that it was his work's illusionism and not its social commentary that attracted most viewers. (One piece, *Museum Guard*, 1976, was especially notorious for fooling first-time visitors. A similar device had been used for many years, but with less artistry, at Madame Tussaud's waxwork museum in London.) Wrote Gerrit Henry in *Art News* (April 1978): "As Hanson has observed, he makes his art for 'every man' and it is Everyman who has been turning out in droves for this show. In the throng, it's hard to tell the sculptures without a checklist."

From his first marriage, which ended in divorce, Hanson has three children: Craig Curtis, Paul Duane, and Karen Liane. His second wife is the former Wesla Host; they have two children, Maja and Duane Elwood Jr. In 1973 Hanson left New York City and moved to Davie, Florida, near Fort Lauderdale.

Hanson's *Self-Portrait* of 1976 shows him, in blue denim work clothes and seated on a high wooden stool, with a reflective expression and a rugged outdoorsy quality—"a Lone Ranger over the American social landscape," to quote Donald B. Kuspit of *Art in America* (November/December 1976). In a statement for *Contemporary Artists* he declared: "I don't think much about aesthetics or art, but I am aware of them intuitively. I want my sculptures to convey a certain sense of stylelessness which will capture the contemporary feeling of reality." He has also written, "If art can't reflect life and tell us more about life, I don't think it's an art that will be very lasting. . . . "

EXHIBITIONS INCLUDE: Wilton Gal., Conn. 1952; Gal. Netzel, Worpswede, W. Ger. 1958; Univ. of South Florida, Tampa 1968; Norton Gal., West Palm Beach, Fla. 1968, '81; O. K. Harris Gal., NYC 1970, '72, '74, '76, '81; Onnasch Gal., Cologne 1972; Neue Gal., Aachen, W. Ger. 1974; Württembergischer Kunstverein, Stuttgart 1974; Gal. de Gestlo, Hamburg, W. Ger. 1974; Mus. of Contemporary Art, Chicago 1974; Louisiana Mus., Humlebaek, Denmark 1975; Akademie der Kunst, Berlin 1975; Univ. of Nebraska Art Gals., Lincoln 1976; Ulrich Mus. of Art, Wichita State Univ., Kans. 1976; Virginia Mus. of Fine Arts, Richmond 1977; Colorado Springs Fine Arts Center, Colo. 1977; Nelson Gal., Kansas City, Mo. 1977; Atkins Mus. of Fine Arts, Kansas City, Mo. 1977; Portland Art Mus., Oreg. 1977; Univ. Art Mus., Univ. of California at Berkeley 1977; Des Moines Art Center, Iowa 1977; Corcoran Gal., Washington, D.C. 1977–78; Whitney Mus. of Am. Art, NYC 1978; Jacksonville Art Mus., Fla. 1980; Loch Haven Art Mus., Orlando, Fla. 1981; Lowe Art Mus., Univ. of Miami 1981. GROUP EXHIBITIONS INCLUDE: Walker Art Center, Minneapolis 1946; Silver Mine Gal., Wilton, Conn. 1952; Hollywood Art Mus., Fla. 1967, '68; "Human Concern/Personal Torment: The Grotesque in American Art," Whitney Mus. of Am. Art, NYC 1969; Sculpture Annual, Whitney Mus. of Am. Art, NYC 1970, '78; "Figures/Environments," Walker Art Center, Minneapolis 1970; "Figures/Environments," Indianapolis Mus. of Art 1970; "Figures/Environments," Mus. of Fine Arts, Dallas 1970; "Figures/Environments," Cincinnati Art Mus. 1970; "Depth and Presence," Corcoran Gal., Washington, D.C. 1971; "Radical Realism," Mus. of Contemporary Art, Chicago 1971; "Hyperréalistes Américains," Gal. de 4 Mouvements, Paris 1972; "Sharp-Focus Realism," Sidney Janis Gal., NYC 1972; Documenta 5, Kassel, W. Ger. 1972; Gal. de Gestlo, Hamburg, W. Ger. 1972, '74; "Recent Figurative Sculpture," Fogg Art Mus., Boston 1972; Biennial, Whitney Mus. of Am. Art, NYC 1973; Groningen Mus., Netherlands 1973; "Amerikanske Realister," Randers Kunstmus. Sweden 1973; Edinburgh Festival

© Harvey Stein, 1982

DAVID HARE

1974; "American Exhibition," Art Inst. of Chicago 1974; "Hyperréalistes Américain—Réalistes Européens," Kunstverein, Hanover, W. Ger. 1974; "Sculpture: American Directions 1945–1975," Smithsonian Inst., Washington, D.C. 1975; "Sculpture: American Directions 1945—1975," Dallas Mus. of Fine Arts 1975; "The New Realism: Rip-Off or Reality," Ulrich Mus. of Art, Wichita State Univ., Kans. 1975; "Aspects of Realism," Vancouver Centennial Mus., British Columbia 1976; "8 Contemporary American Realists," Pennsylvania Academy of Fine Arts, Philadelphia 1977; "Aspekts der 60er Jahre," Nat. Mus., Berlin 1978.

COLLECTIONS INCLUDE: Art Gal. of South Australia, Adelaide; Milwaukee Art Center; Mus. Boymans-Van Beuningen, Rotterdam; Nat. Mus., Utrecht, Neth.; Neue Gal., Aachen, W. Ger.; William Rockhill Nelson Gal., and Atkins Mus. of Fine Arts, Kansas City, Mo.; Norton Gal. and School of Art, West Palm Beach, Fla.; Virginia Mus., Richmond; Wadsworth Atheneum, Hartford, Conn.; Wallraf-Richartz Mus., Cologne; Whitney Mus. of Am. Art, NYC; Wilhelm Lehmbruck Mus., Duisberg, W. Ger.

ABOUT: Battcock, G. (ed.) Super Realism, 1975; Bush, M. H. Duane Hanson, 1976; Current Biography, 1983; Henri, A. Total Art: Environments, Happenings, and Performance, 1974; P-Orridge, G. and others (eds.) Contemporary Artists, 1977; Shipley, J. R. and others Contemporary American Painting and Sculpture, 1974. *Periodicals*—American Artist September 1981; Art in America November/December 1972, November/December 1976; Art News April 1978; Miami Herald October 30, 1966; The New Republic March 1978; New York Times June 7, 1970, January 23, 1972, February 10, 1978, May 21, 1978; The New Yorker February 5, 1972; Newsweek February 20, 1978; Village Voice December 24, 1970, September 23, 1971, January 20, 1972, February 22, 1974; Washington Post January 15, 1977.

HARE, DAVID (March 10, 1917–), American sculptor, painter, and photographer, was one of the few Americans accepted into the Surrealist coterie in the 1940s and made a name for himself in the 1950s with sensitively drawn sculpture in steel. As sculptural figuration was replaced in the 1960s by the massive, unitary constructions of Don Judd, Tony Smith, and Robert Morris (a style to which Hare was much opposed), he turned to painting, expressing elements of a deep and often disturbing personal symbolism through a variety of violent, erotic, or whimsical archetypal images. An intellectual rather than emotional artist (although his subject is those deeply felt emotions that are only safe to express in the stylizations of myth), Hare has always put development of idea before perfection of method. He told Seldon Rodman (*Conversations with Artists,* 1961), "I shift back and forth so quickly that I can never do any one thing in the best possible manner." Although Hare's sculptures sometimes suffer from this want of "working through," in his later paintings he has turned haste into an awkward power.

A native New Yorker, Hare moved to California with his family as a child and graduated with a degree in chemistry (his field was experimental color photography) from the University of Colorado in 1936. He worked as a professional photographer from 1938 to 1943, documenting surgical operations. The first show of his own work was held at the Walker Gallery, New York City, in 1939. In 1940 he collaborated with Clark Whistler of the Museum of Natural History, New York City, on a portfolio of color photos of the Indians of Arizona and New Mexico. Still in his early 20s, Hare linked up with the Surrealists, most of whom had fled to the United States shortly before the fall of Paris to the Nazis, and exhibited several photographs at their only expatriate group show in New York City in 1942. From 1942 to 1944 he edited the Surrealist journal *VVV*; in 1946, through his Parisian connections, he met Jean-Paul Sartre, who wrote a catalog introduction in 1948 to one of Hare's shows and published several of Hare's essays in the existentialist magazine *Les Temps Moderns,* which Sartre edited. Thus Hare, more than most American artists of his generation, and just at the time when American art was cutting the last of its connections to the Continent, was immersed in the European humanist intellectual milieu, particularly the philosophical struggles between the waning School of Paris Surrealists and the French Existentialists. This may help to explain

his antipathy to the tendency of American art toward non-objectivity for its own sake, which he expressed in a number of clear-eyed but acerbic statements both on fellow artists and what he considered the new American "academy."

"Without knowing the first thing about it," as he said, in 1942 Hare began making semiabstract figurative sculpture somewhat in the manner of Ernst: conglomerative imagery with mechanistic/sexual overtones, arrived at by Breton's "psychic automatism," or free visual association. "Surrealism helped loosen up the mind," he later wrote. "It is the only movement involved with the sources of creativity"— by which he meant the power of the subconscious. Hare cited Pablo Picasso, Julio Gonzáles, and Alberto Giacometti as the important influences on his style. Works such as *The Magician's Game* (1945), *Young Man* (1945), and *Young Girl* (1946), in plaster or cast cement, take the human form to bizarre, even sarcastic (or, to some, humorous) extremes: the head of *Young Girl* is nothing more than a gaping triangle with nubs of teeth. "Art through its activeness has to frighten or upset you," he said. In 1946 Hare's position as an authentic American Surrealist was cemented with solo shows at the galleries of Julien Levy, Sam Kootz, and Peggy Guggenheim, all exhibitors and supporters of surrealism, and with his inclusion in Dorothy Miller's *14 Americans* exhibition at the Museum of Modern Art. For the catalog of the Miller show he wrote: "I believe that in order to avoid copying nature and at the same time keep the strongest connection with reality it is necessary to break up reality and recombine it, creating different relations which will take the place of relations destroyed. These should be relations of memory and association." A typical theme of Hare's work is the creation of new relations in sexual terms: body parts, particularly genitalia or symbols of them, metamorphose into or simply coexist in the same space as other limbs and organs; hermaphrodites, both metaphorical and plainly illustrated, animal and human, often appear in the later paintings. "If a work of art appears as an old friend," Hare said, "if we are too much at ease in its presence, it is a failure. Art, like life, is subversive."

Hare's adoption in the 1950s of brazed and welded steel as a sculptural medium, and his partial renunciation of surrealism as a movement (although not as a way of making useful visual associations), encouraged some critics to connect him with the Abstract Expressionist school of sculpture, which included Herbert Ferber, Seymour Lipton, Ibram Lassaw, and Theodore Roszak. Certainly his work became more gestural and linear—"Hare's line," wrote Wade Saunders (*Arts Magazine*, December

1979) "has a richness as suggestive as mass"—and this can be seen in *Figure and Window No. 1* (1950), *Juggler* (1950–51), and his "landscape" sculptures of the mid-1950s. *Sunrise* (1954–55), one of a series made while Hare was living in Cannes (he shuttled back and forth from the US to France throughout the 1950s), is a celestial drawing in bronze sheet, steel rod, and stone. "It's the effect upon man of wind, sun, and storm, and his relation to them, that I'm after."

In the early 1960s Hare began to investigate the subject of his subsequent paintings—sexual and morphological ambiguities based on mythological archetypes—while taking steps toward a truly planar representation in steel rod and plate. The drawing in *Leda and the Swan at Sea* (1962), one of a number of works on this theme, is as fluid and personal as lines from a brush. Girl and swan intermingle; either can be read as the other depending on angle of view and interpretation of negative shapes. "Sometimes [Hare's] sculptures movingly convey otherness," wrote Saunders. "Leda flashes into view splayed out open over the swan, but she disappears as we walk around [the work]. Though visible she isn't palpable; she can't be moved from negative to positive space, from there to here, by us or by her swan." Hare worked on a "Centaur" series as well.

Clearly Hare's progress was toward painting. He gave up sculpture in 1965, when in any case his style was no longer in tune with the dominant formalism he thought seriously misguided. (At the end of the 1950s he wrote: "Modern art has gone through revolution, invention, perfection, acceptance, repetition, stylization, and putrefaction with a rapidity only equalled by man's investigation of the atom.") Originally his intention was to fuse sculptural and pictorial elements—"like the torso of a man on that of a horse, a centaur"—but that ambition was not realized for a decade. Instead he became occupied with exclusively pictorial images, though in an "impure" way that reflected a consciously assumed belief that excessive refinement would interfere with the blunt force of his ideas. Hare's images are never cleanly modeled or clearly defined, but are blocky, indeterminate amalgams of bodied and symbols, crudely but powerfully drawn in a variety of browns, purples, and creams.

The entire oeuvre of Hare's painting and drawing between 1966 and the mid-1970s, was devoted to the Greek creation myth of the Titan Cronus, son of Earth and Heaven, who, after castrating his father at his mother's behest, attempted to prolong his own rule by devouring his children. His twelfth son, Zeus, escaped by sub-

terfuge and later dethroned him, thus instituting the rule of the Olympians. Aside from its obvious Oedipal elements, the myth of Cronus has another dimension—that of the birth of time. Cronus, Father Time as he is often depicted, represents the first principle. To Hare, Cronus was "part man, part earth, part time. I use him as a symbol of growth through time. Primordial mud growing into life, growing into man, but always remembering its beginnings." His treatments of the subject ranged from the crucially important canvases of *Cronus Descending* (1968), *Cronus Old II* (1968), *Cronus Hermaphrodite* (1970), and *Cronus Elephant* (1975) to peripheral themes in *Ice Dog* (1967) (Cronus the bestial devourer) and *View from the Cave* (1971) (Cronus as Platonic wonderer). In 1975 he attempted a fusion of painting and sculpture in *Cronus Mad*. The entire series was exhibited at the Guggenheim Museum, New York City, in 1977; Katherine Kuh, writing in *Saturday Review*, called the show "baffling, fantastic, and yet curiously thought-provoking."

With the "Cronus" series and his later, humorous paintings of strangely mutated dogs and elephants (animals with which Hare has been fascinated since childhood), Hare reestablished himself as an important presence in American art, especially in the context of the neoexpressionist resurgence of the late 1970s and early 1980s. He currently lives and works in Manhattan.

EXHIBITIONS INCLUDE: Walker Gal., NYC 1939; Julien Levy Gals., NYC 1946; Art of This Century Gal., NYC 1946, '47; Kootz Gal., NYC 1946–59; Saidenberg Gal., NYC 1960, '61, '62, '63; Staempfli Gal., NYC 1960, '69; Portland Mus. of Art, Me. 1969; Alessandra Gal., NYC 1976; Solomon R. Guggenheim Mus., NYC 1977; Hamilton Gal., NYC 1979, '80. GROUP EXHIBITIONS INCLUDE: "14 Americans," MOMA, NYC 1946; São Paulo Bienal 1951, '57; "The New Decade," Whitney Mus. of Am. Art, NYC 1954; "International Sculpture," Mus. Rodin, Paris 1956; "Expo 58," Pavilion, Brussels 1958; Bicentennial, Carnegie Inst., Pittsburgh, Pa. 1962; "Dada, Surrealism, and Their Heritage," MOMA, NYC 1968; "New American Painting and Sculpture," MOMA, NYC 1969.

COLLECTIONS INCLUDE: MOMA, Whitney Mus. of Am. Art, and Solomon R. Guggenheim Mus., NYC; Albright-Knox Gal., Buffalo, N.Y.; Yale Univ. Art Gal., New Haven, Conn.; Wadsworth Atheneum, Hartford, Conn.; Brandeis Univ., Waltham, Mass.; Carnegie Inst., Pittsburgh; Washington Univ., St. Louis, Mo.

ABOUT: Blesh, Rudy, Modern Art U.S.A., 1956; Geoge, Howard Bauer, Sartre and the Artist, 1969; Miller, D. C., ed., Fourteen Americans, 1946; Rodman, Seldon, Conversations with Artists, 1961. *Periodicals:*—Art in America Winter 1956–57; Arts Magazine May 1976, April 1979, December 1979; Saturday Review October 1, 1977.

HARTIGAN, GRACE (March 28, 1922–), American painter, writes: "I was born in Newark, New Jersey in 1922, the eldest of four children. My father was an Irish-American of working-class origins; his father was a blacksmith. My mother, Grace Davis, is a Daughter of the American Revolution. Her mother had pretensions to aristocracy, having descended from a French family and a wealthy English coal-mining family. The conflict between my mother's and my father's background and personal ties made an atmosphere of constant tension, and when we moved from Newark to suburban New Jersey I spent a childhood in a self-made world close to nature, watching gypsies camping in a nearby field and immersing myself in reading and home-invented theatrics.

"My family suffered financial distress during the Depression, and when I graduated from high school in 1940 and could not afford to go to college, I married an idealistic young New Jersey boy. We wanted to move to Alaska and live as pioneers. We got as far as California where I had my son Jeffrey and began painting with the encouragement of my husband who was soon drafted as an Army private in World War II. I returned East, began training as a mechanical draftsman and studied painting with Isaac Lane Muse.

"In 1948 I divorced Bob Jachens, gave my son to his father's parents, asked my boss to fire me so I could collect unemployment compensation, found a loft in New York's Lower East Side, and dedicated myself to being an artist. The avantgarde atmosphere in New York at that time was a close and exciting one and I soon met Jackson Pollock and Willem De Kooning, the other 'Abstract Expressionists,' architect-sculptor Tony Smith, composers John Cage and Morton Feldman, and the 'New York Poets'—Frank O'Hara, Kenneth Koch, James Schuyler, John Ashbery, and Barbara Guest.

"In 1950 Clement Greenberg and Meyer Schapiro included me in a 'New Talent' show at the Kootz Gallery and I exhibited in the Ninth Street Show. I then had the first painter's show at the Tibor de Nagy Gallery, and a few years later Alfred Barr and Dorothy Miller of the Museum of Modern Art became interested in my work and included me in "12 Americans" and "New American Painting," which traveled throughout Europe. Their encouragement generated interest on the part of other museums and private collectors, notably Nelson Rockefeller.

Photo by William L. Klender

GRACE HARTIGAN

"In 1960, when I married John Hopkins, the reaction against the Abstract Expressionists had begun. I can truthfully say that since I left New York I have led an isolated creative life. The struggle in the 60s to find my own voice with the consciousness of 'movements'—pop, op, minimal—was an extra burden for a solitary artist.

"In the late '60s I began to investigate the city life around me from my downtown waterfront Baltimore studio, much as I had in the early '50s on New York's Lower East Side. Store windows, shopping centers, children's toys, art of the past revealed in coloring books, became my subject material. Now as before it is the vulgar and the vital and the possibility of its transformation into the beautiful which continues to challenge and fascinate me. Or perhaps the subject of my art is like the definition of humor—emotional pain remembered in tranquillity."

Grace Hartigan was one of the most talented of the second generation of Abstract Expressionists. She followed the example of Willem de Kooning and applied action, or gestural, painting techniques to studies of the human form.

Hartigan moved to New York City in 1948, the year she saw Jackson Pollock's "drip" paintings. Hartigan was herself working in abstract modes and, according to Irving Sandler in *The New York School* (1978), Pollock's breakthrough "revealed to her a new conception of painting: an allover labyrinthine image with no beginning and no end. . . . But at the same time she sought to achieve this effect, she felt that she could not adopt the 'drip' technique without lapsing into imitation."

Through Pollock, Hartigan met de Kooning. Influenced by his energetic brushwork, she continued for a time to paint nonobjective forms but soon began to study such old masters as Goya, Tiepolo, and Rubens. "I began to get guilty," she recalled, as quoted by Sandler, "for walking in and freely taking [Pollock's and de Kooning's] form . . . [without] having gone through their struggle for content, or having any context except an understanding of formal qualities. . . . I decided I had no right to the form—I hadn't found it myself—and that I had to paint my way through art history. . . . I started to paint from the masters, from reproductions, in a very free way."

Hartigan's work became figurative—she used models (two of whom were the poets John Ashbery and Frank O'Hara) and in 1954 started painting urban scenes, as in *Grand Street Brides* (1957), a study of mannequins of brides in a store window—but her brush strokes were broad and loose in the manner of de Kooning's gestural style. According to Sandler, Hartigan viewed painting "as an existential action, shaped by a 'vision of self as inviolable, powerful, and nervy—self as the only real thing in an unreal environment.'"

An illustrated article in *Life* magazine (May 13, 1957), titled "Women Artists in Ascendance," praised the "brilliantly bold semi-abstract style" Hartigan had developed "to capture the garish jumble and excitement of the market district of New York's Lower East Side." Irving Sandler, writing on abstract expressionism in *Contemporary Art 1942–72: Collection of the Albright-Knox Art Gallery* (1972), observed that Hartigan, with her "gestural brush handling" has emphasized the actual "process of painting." When she moved to Long Island in late 1957, Hartigan's forms ceased to be recognizable; she painted large color areas set off by bold lines in the style of gestural abstraction. The artist, discussing *New England, October* (1957; Albright-Knox Art Gallery, Buffalo, N.Y.), which she painted in East Hampton, Long Island, after an autumn trip to Maine, said, "I was interested in how to present an inner emotional state, in abstraction but related to nature."

It is noted in *Contemporary Art 1942–72* that Hartigan's recent work "has continued to preserve a quasi-representational, freely brushed approach, but with a more limited palette and an increased emphasis on linearity. . . . " Reviewing Hartigan's 1977 exhibit at the Genesis Gallery, New York City, in *The New York Times* (April 15, 1977), Hilton Kramer com-

mented on "the introduction of something like caricature into the figures, and especially the faces, that crowd these canvases." Dubuffet, he observed, rather than Matisse, appeared to be a source for her recent figurative work. "The color," Kramer added, "is a little cruder—no doubt by design. . . . Miss Hartigan can still fill a canvas with exceptional power. . . ."

Grace Hartigan has been artist-in-residence at the Maryland Institute's Graduate School of Painting since 1965. She has been married three times: to Robert Jachens, from 1941 to 1948; to Robert Keene, from 1959 to 1960; and to Winston Price, a research scientist at Johns Hopkins University, Baltimore, from 1960 until his death in 1981. She has one son, Jeffrey, from her first marriage.

EXHIBITIONS INCLUDE: Tibor de Nagy Gal., NYC 1951–55, '57, '59; Vassar Col. Art Gal., Poughkeepsie, N.Y. 1955; Martha Jackson Gal., NYC 1962, '64, '67, '70; Maryland Institute Col. of Art, Baltimore 1967; Univ. of Chicago 1967; Gertrude Kasle Gal., Detroit 1969, '72, '74, '76; William Ziegler Gal., NYC 1975; Am. Univ., Washington, D.C. 1975; Genesis Gal., Ltd., NYC 1977, '78. GROUP EXHIBITIONS INCLUDE: Ninth Street Show, NYC 1951; "Talent 1950," Kootz Gal., NYC 1950; Annual, Whitney Mus. of Am. Art, NYC 1955–63; "Rising Talent," Univ. of Minn., Minneapolis-St. Paul 1955; Modern Art in the U.S.," MOMA, NYC 1956; "Twelve Americans," MOMA, NYC 1956; São Paulo Bienal 1957; "Artists of the New York School, Second Generation," Jewish Mus., NYC 1957; Documenta, Kassel, W. Ger. 1959; "Contemporary American Art,"World's Fair, Brussels 1959; "Abstract Expressionists and Imagists," Solomon R. Guggenheim Mus., NYC 1960; Carnegie International, Pittsburgh 1962; "Figuration and Defiguration," Mus. of Ghent, Belgium, 1964; "The Johnson Collection: Art U.S.A.," Whitney Mus. of Am. Art, NYC 1965;"Creative Art Festival," Kent State Univ., Kent, Ohio 1966; "Selections from Albright-Knox," National Gal., Washington, D.C. 1968; "Wall Works," Martha Jackson Gal., NYC 1969; "American Painting Since World War II," Delaware Art Mus., Wilmington 1971; "Frank O'Hara, Poet Among Painters," Whitney Mus. of Am. Art, NYC 1974; Biennial Exhibition, Corcoran Gal. of Art, Washington, D.C. 1975; "Poets and Painters," National Collection of Fine Arts, Washington, D.C. 1976; Art in Embassy Program, State Department, Washington, D.C. 1978.

COLLECTIONS INCLUDE: Albright-Knox Art Gal., Buffalo, N.Y.; Metropolitan Mus. of Art, MOMA and Whitney Mus. of Am. Art, NYC; Brooklyn Mus. of Art, N.Y.; Princeton Univ., N.J.; Providence Mus. of Art, R.I.; Wadsworth Atheneum, Hartford, Conn.; Rose Art Mus., Brandeis Univ., Waltham, Mass.; Philadelphia Mus. of Art; Carnegie Inst. Mus. of Art, Pittsburgh; National Collection of Fine Arts, Washington, D.C.; Baltimore Mus. of Art; Art Inst. of Chicago; William Rockhill Nelson Gal. of Art, Kansas City, Mo.; St. Louis Art Mus.; Walker Art Cntr., Minneapolis; Minneapolis Inst. of Art; Detroit Inst. of Arts; Flint Inst. of Arts, Flint, Mich.; San Antonio Mus., Texas; Israel Mus., Jerusalem.

ABOUT: Hunter, S. and others New Art Around the World, 1966; Miller, D.C. (ed.) "12 Americans" (cat.), MOMA, New York City, 1956; Moore, E. (ed.) Contemporary Art 1942–72: Collection of Albright-Knox Art Gallery, 1972; Pellegrini, A. New Tendencies in Art, 1966; Sandler, I. The New York School, 1978. *Periodicals*—Art in America July 1975; Art News November 1977; Life May 13, 1957; New York Times April 15, 1977.

***HARTUNG, HANS** (September 21, 1904–), German-French painter, writes: "I was born in Leipzig in 1904. My parents and my ancestors were nearly all doctors or jurists. My maternal grandfather was also a self-taught painter and musician. I spent my youth in an artistic environment. At 12 my father introduced me to photography, and since I had a passion for astronomy I made myself a telescope. Then I went through a religious period and wanted to become a missionary. Eventually my interest in astronomy prevailed. The religious and human side of Rembrandt's work appealed to me and brought me to painting. Inspired by the woodcuts of the German Expressionists and the painting of Emil Nolde, I arrived in 1922 at an entirely abstract and quasi-gestural style of drawing and made completely 'informal' watercolors. Although abstract art could then be seen in a few galleries, I was quite unaware of it. I passed my baccalaureate in 1924 and my father asked me, 'What do you want to do now?' I announced that I wanted to be a painter. He advised me to study art history and philosophy at the university and, if I insisted, to enroll at the school of fine arts. I agreed, above all because I was deeply conscious of a lack of knowledge that made my resolve to break completely with the figurative art that had dominated Western art for thousands of years seem too pretentious.

"I wanted to learn and reflect as much as possible, by studying, at the university and the school of fine arts, the works of the old masters and my contemporaries.

"Then, in 1925, I heard a lecture by Wassily Kandinsky at the University of Leipzig that was a great surprise for me and a confirmation of my ideas, but which also made me realize that the path taken by Kandinsky in abstract art was not mine. Second event: the International Exhibition of Art in Dresden in 1926, which introduced me to new worlds and especially to the body of contemporary art that had developed in France and

°här´ tung, häns

Photo by Francois Walch

HANS HARTUNG

was on such a high level that I decided to go immediately to Paris. Which I did, as well as making trips to Italy, Belgium, and Holland. Everywhere I would make a close study of the works that moved me the most in museums and art galleries. On the spot or from reproductions, I copied certain pictures and I painted canvases in the spirit of Van Gogh, Cézanne, and the Cubists.

"For I believe that one cannot enter into and have a deep understanding of those one admires except by working for a while in their spirit. My last preoccupation was the cubism that followed the analytic period. My experiments in this vein, and my interest in the Golden Section, brought me back to abstract art. An abstract art that was free but very ordered. One day, in 1933, I broke with all that discipline, which I found sterile, and returned to the spirit of my first efforts of 1922–24. What a liberation!

"Nineteen-thirty-three and thiry-four—two happy years which I spent with wife, Anna-Eva Bergman, in the Balearic Islands.

"Anna-Eva, having fallen seriously ill and seeing war coming, separated from me and returned to her native Norway.

"Then came hard times. Owing to my opposition to the Nazi regime, I had settled permanently in Paris where my painting was to develop informalism and tachism.

"In this period (July 1939) I married Roberta González, daughter of the sculptor Julio González, for whom I have the highest admiration, both for him and for his great work.

"After war was declared, I enlisted, first in

1939 and again in 1943, in the Foreign Legion as a volunteer for the duration of the war. In November 1944, on the Vosges front, I was seriously wounded and had to have a leg amputated. In 1946 I became a French citizen.

"In 1952 Anna-Eva rejoined me in Paris and we remarried.

"My postwar painting was very turbulent and rebellious. After a few years I managed to control myself and control my destiny, and my painting became more reflective, more stable in its expression, giving way in the years 1955–60 to large 'signs' on unified grounds. Then came a purely graphic period which strongly influenced my painting after 1960, when scratching into the fresh, dark paint became my chosen means of expression.

"Subsequently I moved to the opposite method: big canvases without any graphic signs, made up solely of large brown or black surfaces applied with a spray-gun in accordance with their inherent dynamism. This period was followed after 1971 by large canvases in violent color and with great dynamic movement.

"A parallel development was my work in engraving and lithography which sometimes, in spirit, anticipated my painting.

"For several years my wife and I have been living on the Côte d'Azur."

In the 1920s Hans Hartung was one of the first artists to reject representation and to paint in an entirely abstract style. He developed a gestural, or action, painting style that anticipated abstract expressionism in the US and *art informel* (art without form) in Europe, movements that arose after World War II.

In the mid-1920s Hartung studied philosophy and art history at Leipzig University and received instruction at the Fine Art Academies of Dresden and Leipzig. After he left Germany and settled in Paris in 1935, Hartung exhibited every year at the Salon des Indépendants. His wife, Anna-Eva, recalled: " . . . He didn't sell a thing. . . . All the geometric artists considered him a savage with his spots and his action painting, which was rather dramatic and virulent. . . . " In 1938 Hartung's work was shown in London at the Burlington Galleries' anti-Nazi exhibition, "Twentieth Century Art."

After the ordeal of World War II and the amputation of his leg, Hartung returned to Paris in 1945 and began to work and exhibit again. His painting attracted the attention of leading critics. In his canvases of 1946–47, as Sheldon Cheney has observed, "the note of depth and somberness was especially marked." It was after

1950 that Hartung first saw the work of the American Abstract Expressionists. "At first I especially liked [Franz] Kline and [Jackson] Pollock, and later, the marvelous work by [Mark] Rothko," he said. (Rothko became a friend.) Hartung's earliest major success dates from the mid-1950s, when his abstract imagery had been reduced to what Edward Lucie-Smith called a "bundled sheaf of lines," brushstrokes, usually black, on a ground unvarying in tone. The black sprays and splashes are analogous to Japanese calligraphy. These works are sometimes referred to as his paintings of "long grasses."

There has been a tendency, as Henry Geldzahler pointed out in the catalog to the Hartung exhibition at the Metropolitan Museum of Art in 1975-76, for some French critics to overpraise the artist's work. For instance, one admirer called his paintings "a blend of the exacting discipline that governs French art with what is best and most distinguished in German poetry." But Lucie-Smith took a different view. He wrote: "During the art boom of the mid-1950s, [Hartung] was to score a resounding success, thanks to a rather limited formula for picture-making which is . . . easy to recognize. . . . No picture of Hartung's is wholly without energy, but once one has seen a group of them, it is certainly possible to wonder why a given mark, a given brushstroke, appears in one canvas and not in another." Alain Jouffroy feels that Hartung "has become too exclusively attached to calligraphic vehemence," but in Geldzahler's opinion the artist's recent work is a successful fusion of "tragedy and exhilaration."

Describing his gestural painting style in terms similar to those used by the critic Harold Rosenberg to identify the "existentialism" of American action painting, Hartung said, "What I like is acting upon the canvas." For Hartung the physical act of painting generates its own discipline and dynamics in which reflection and spontaneity are combined. John Canaday, reviewing a 1971 Hartung exhibit at the Lefebre Gallery, New York City, noted that Hartung "has always been more esteemed in Europe than in this country." According to Canaday, Hartung's historic achievement is that he was among those Europeans who were "the first to participate in the development of abstract painting, and who became, in their lifetime, the great men of its triumph." Hartung had of course anticipated such developments as art informel and action painting by a purely instinctive process, long before World War II.

After being divorced from the former Anna-Eva Bergman in the mid-'30s, Hartung married Roberta González in 1939 in Paris. They were divorced and he remarried his first wife in the early '50s.

Hans Hartung and Anna-Eva, herself a painter, live near Antibes, France, in a house he designed himself. They also have a home in Paris. Hartung's vast Antibes studio, with its four easels, opens onto an olive garden. Heidi Bürklin, who interviewed him in Paris in 1974, described his conversational manner: "Hans Hartung speaks, in a charming mixture of German and French, in a very precise manner, in sentences which are linked and in rhythm. He laughs often, and he speaks much faster when he recalls the dark years."

Summarizing his beliefs, Hartung said: "The first and most important thing is to remain free, free in each line you undertake, in your ideas and in your political action, your moral conduct. The artist especially must be free from outer constraint. Everything we feel deeply must be expressed."

EXHIBITIONS INCLUDE: Gal. Heinrich Kühl, Dresden 1931; Bloqvist Kunsthandel, Oslo 1932; Gal. Lydia Conti, Paris 1947–48; Kunsthalle, Basel 1952; Lefebre Gal., London 1953; Palais des Beaux-Arts, Brussels 1954; Gal. Craven, Paris 1956; Gal. de France, Paris from 1956; Kestner-Gesellschaft, Hanover, W. Ger. 1957; Kleemann Gal., NYC 1957, '59; Lefebre Gal., NYC 1961, '71; Kunsthaus, Zürich 1963–64; Mus. Civico di Torino, Italy 1966; Mus. Nat. d'Art Moderne, Paris 1969; Gal. Maeght, Zürich 1973; Wallraf-Richartz Mus., Cologne 1974; "Paintings 1971–1975," Metropolitan Mus. of Art, NYC 1975–76. GROUP EXHIBITIONS INCLUDE: Salon des Indépendants, Paris 1935–38, '45; "Twentieth Century Art," Burlington Gals., London 1938; Salon des Réalités Nouvelles, Paris 1939, '46, '48; Guggenheim Intl., Paris 1956; Venice Biennale 1960 (Grand Prize for Painting); Expo '67, World's Fair Montreal 1967; ROSC '67, Dublin 1967; "Painting in France 1900–1967," Nat. Gal., Washington, D.C. 1968.

COLLECTIONS INCLUDE: Mus. d'Art Moderne de la Ville de Paris, and Mus. Nat. d'Art Moderne, Paris; Fondation Maeght, Saint-Paul-de-Vence, France; Tate Gal., London; Gal. Nazionale d'Arte Moderna, Rome; Kunstmus., Basel; Wallraf-Richartz Mus., Cologne; Kunstsammlung Nordheim-Westfalen, Düsseldorf; Foundation Domnick, Moderna Mus., Stockholm; Metropolitan Mus. of Art, MOMA, and Solomon R. Guggenheim Mus., NYC; Albright-Knox Art Gal., Buffalo, N.Y.; Philadelphia Mus. of Art; Hirshhorn Mus. and Sculpture Garden, Washington, D.C.; Mus. de Arte Moderna, Rio de Janeiro; Israel Mus., Jerusalem.

ABOUT: Apollonio, U. Hans Hartung, 1966; Geldzahler, H. "Hans Hartung: Paintings 1971–1975" (cat.), Metropolitan Mus. of Art, NYC, 1975; Gindertael, R. V. (ed.) Hans Hartung, 1961; Lucie-Smith, E. Late Modern: The Visual Arts Since 1945, 1969; Pellegrini, A. New Tendencies in Art, 1966; Rousseau, M. and others

Hans Hartung, 1949. *Periodicals*—Art d'aujourd'hui (Paris) March/April 1954; Cahiers d'art (Paris) no. 2 1949; Cimaise (Paris) September–December 1974; L'Oeil (Paris) September 1974; Réalités (Paris) May 1963; Studio July 1961, September 1964; Time April 1, 1957; XXe siècle (Paris) May/June 1959.

HAYTER, STANLEY WILLIAM (December 27, 1901–), English printmaker and painter whose Atelier 17 has been the most important influence on artistic printmaking in this century, was born in Hackney, London, in 1901. An ancestor, Charles Hayter, (1761–1828), was a distinguished miniature-painter and portrait draftsman who was appointed professor of perspective to Princess Charlotte; his work is well represented in the Victoria and Albert Museum. Two of his sons were well-known painters—the younger, John, was S.W. Hayter's great-great-grandfather.

Bill Hayter, as he is generally called, was educated at the Whitgift Middle School in Croydon, and in 1917 went on to study chemistry and geology at King's College, London. After graduating with honors, he joined the Anglo-Iranian Oil Company and worked with them as an oil chemist in Abadan, in the Persian Gulf, between 1922 and 1925.

By 1925, when he traveled in Iran, Iraq, Saudi Arabia, and Egypt, Hayter had begun to paint in his spare time and to experiment with etching. He recalls: "My father was a painter and a lot of people in my family before, so I was messing about with painting fairly seriously when I was a child. I was painting all the time when I was in the East." He had decided to become a professional artist at the termination of his Persian contract, but his scientific background has always been evident in his fascination with the technical problems of engraving, his analytical approach to color, form, and perspective, and his constant experimentation.

Hayter says that he "didn't do much with prints" until he went in April 1926 to Paris, where he met "all those characters"—Calder, Miró, Arp, Picasso, and the Surrealists Yves Tanguy, Max Ernst, and André Breton. At one time Hayter had a studio next door to "a terribly nice chap," Alberto Giacometti.

After working for six months at the Académie Julian, Hayter made his first drypoints, woodcuts, and aquatints. He was aware that the art of the engraver in the 1920s had in no way kept up with the new language of form that had been developed by progressive painters since the beginning of the century. The work of the best-known painter-etchers was technically competent but

Photo by Arno Mandello

STANLEY WILLIAM HAYTER

unadventurous and naturalistic. "Printmaking," says Hayter, "was a poor ralation in those days. I had the idea somebody ought to do something about it. I was a scientist. After dealing with physics and clinical problems, it was fairly simple. You get a lot of people together and experiment."

Among the very few artists concentrating on engraving at the time of Hayter's arrival in Paris were Jacques Villon and Joseph Hecht. Hayter was particularly impressed by Hecht's masterly use of the burin, the original tool of the engraver. The direct attack on the copper plate gave an immediacy of approach surpassing the more pictorial technique of the etching needle. In Hayter's words, "The burin is a kind of plough which goes ahead of the manipulator in an exploratory and inventive way, and not behind him." Hayter was also influenced by the Surrealists' emphasis on automatism and use of the resources of the subconscious. As he wrote in his seminal book *New Ways of Gravure* (1949), "The sensation of the printmaker is rather that of submitting to the evolution that the plate dictates to him."

In 1927 Hayter founded an atelier in Paris as a center for research into the techniques and methods of printmaking. That year he also held his first solo show in the Galerie Sacre du Printemps, Paris. Among those who worked in the atelier in its early years were Miró, Arp, and Tanguy. Picasso, Ernst, Chagall, Lipchitz, and Calder also came to the workshop to learn the graphic process. The studio did not take its now world-famous name Atelier 17 until 1933, when Hayter moved his establishment to number 17

rue Campagne-Première in Montparnasse. The workshop was never in a strict sense a place of formal instruction to students, but rather, to quote Graham Reynolds, "a meeting-ground for like-minded people" interested in "cooperative and progressive experimentation in techniques and media." Hayter likes to say that he has spent the last 50 years "un-teaching." At the same time he has pointed out that "of the people who've passed through the shop, there might be 50 teaching in university departments in America now."

Hayter exhibited with the Surrealists in Paris in 1933, and three years later took part in the international surrealist exhibition in London. The first group show of Atelier 17 artists was held in 1934 at the Galerie Pierre, Paris, and at the Leicester Galleries, London. Hayter's paintings of the 1930s were mostly large canvases with abstract or near-abstract motifs similar in theme and style to his prints. But while his engravings were predominantly black and white, his paintings contained areas of usually strident color to which forceful whirling black lines in the spirit of automatic writing provided a restless counterpoint. The space was always highly activated. Many of his prints were illustrations of poems by his friends, very freely interpreted. The Surrealist Paul Eluard was inspired by Hayter's work to write *Facile Proie* (Easy Prey), which was published together with eight engravings in 1939.

Hayter visited war-torn Spain in 1937 on the invitation of the liberal Ministry of Art of the Republican government. Progressive circles in Paris, including the Surrealists, were deeply concerned with the outcome of the Spanish Civil War and, in Spain, Hayter painted the six-foot *Maneating Landscape* to evoke the horrors of civil war. Back in Paris Hayter was commissioned by the great publisher and picture dealer Ambroise Vollard to make a series of plates as illustrations for Cervantes's tragedy *Numancia,* dealing with the heroic struggle of a city in Spain against the Romans in 133 B. C. The project was halted by the death of Vollard in 1939, but Hayter published some of the prints individually. The engraving *Douro* showed the torn flesh and outstretched limbs of the river-goddess Douro, a symbolic character in Cervantes's play. *Douro* and *Runner* were more explicit in the use of the human figure than Hayter's previous prints. They are examples of Hayter's uninhibited use of the burin, which was combined in *Douro* with an etched soft-ground texture.

In 1939 Hayter returned to London, and in 1940, only a few weeks before the Germans occupied Paris, he left for the United States. He taught at the California School of Fine Arts in San Francisco, and in the fall of 1940 reestablished Atelier 17 at the New School for Social Research, New York City. That year Hayter married the American sculptor Helen Elizabeth Philips. In his engravings from 1940 on, Hayter explored new concepts of space and movement as his use of textures became more complex. His themes, as in *Cruelty of Insects* (1942) were often akin to those of André Masson, but the print *Myth of Creation* recalled the loose organization and freedom of line of Arshile Gorky's paintings.

Tarantelle of 1943, with its swinging, dancing rhythm, is one of the best examples of Hayter's use of mixed intaglio techniques. Burin and soft-ground etching were used; two silks pressed into the soft-ground on the copper plate created an interesting moiré effect. According to Hayter, "Technique is a process which sets the imagination free and makes its action visible: it has no other function."

The influence of Atelier 17 under Hayter's inspired guidance was as great in America as it had been in Paris. In 1944 the work of the Atelier was shown at the Museum of Modern Art, New York City, and circulated in major US museums. A duplicate show toured South America under the auspices of the State Department. Although *New York Times* critic Howard Devree wrote, "My own interest in the work is largely mechanical rather than esthetic," the exhibit was on the whole warmly received and several critics commented on the modesty of Hayter, who was so dedicated to the idea of the workshop as a collective enterprise that he often neglected to sign his name to his own prints.

In 1945 Hayter moved Atelier 17, which had outgrown its quarters at the New School, to a loft building on East 8th Street. Reginald Marsh, Abraham Rattner, and Isabel Bishop were among the American artists who frequented the studio to share Hayter's researches into the graphic media and to improve their own techniques. In *New Ways of Gravure* Hayter discussed his theories and experiments in printmaking and the great contribution of two earlier masters of line-engraving, Mantegna and William Blake.

Cinq personnages of 1946 was an early example of Hayter's use of a plate printed with three colors and intaglio black in one operation. At that time the use of color in printmaking was largely confined to lithographic, woodblock, and silkscreen processes. Hayter's technique, called viscosity printing, allowed up to three inks of different colors and viscosities to be rolled onto different levels of the plate after the line intaglio had been rubbed in. Complex and demanding, viscosity printing is still not used widely by

printmakers; more influential was Hayter's simple determination to use a variety of colors in intaglio. Due to his pioneering efforts color intaglio is now as widespread and popular as black and white.

Hayter was appointed professor of art at Brooklyn College, but in 1950 he decided to return to Paris and revive Atelier 17 there. He left the New York studio under the direction of his pupils. (It was closed in 1955.) In 1951 Hayter was awarded the Legion of Honor by the French government and in 1958 he represented Great Britain at the Venice Biennale, along with the painter William Scott and the sculptor Kenneth Armitage.

Students came from as far away as Peru and Japan to study in the reestablished Atelier 17 in the rue Daguerre. Hayter enjoys the mixture of nationalities and finds that the work of his students stimulates his own creativity. He goes to the studio twice a week to see how they are getting on. "They don't need somebody to hold their hand," he says. "They're all perfectly competent printmakers."

In the last 25 years Hayter has continued to paint and experiment with printmaking with undiminished energy and enthusiasm. Having by the 1950s mastered the process of printing from three to six colors from a single plate in one operation (some applied in restricted areas by hand) he began in the 1960s to work more intensively in silkscreen.

His second book, *About Prints,* was published in 1962. Although, like his earlier book, it contains much discussion about theories of printmaking, Hayter now says he is doubtful about theories, which can so easily become doctrine—"and that's hell and desolation."

In his paintings of the 1960s and early '70s—*Silken Sea* (1965), *Nénuphars* (1969), and *Voyage* (1973) are examples—fluorescent waves, ripples, and winding stripes and ribbons of color evolve from spontaneous, free-form drawings. Since Hayter's basic expression is linear, the drawing is more evident in the prints, although he still uses vibrating color. Some of his silkscreen prints, including *Slip Stream* and *Cross Currents,* have shimmering, eye-dazzling surfaces akin to op art. The constant recurrence of themes relating to water recalls Hayter's admiration for Leonardo's studies of the movement of waves, in which art and science are combined. Hayter is also interested in optical illusions, as in his "vanishing column" motifs, explored both on canvas (acrylic is his favorite painting medium) and in his prints.

A retrospective show of Hayter's engravings at the Victoria and Albert Museum in 1967 was held simultaneously with "10 Years of Painting" at London's Grosvenor Gallery. In 1969 there were retrospective print exhibitions at the Musée des Arts Décoratifs, Paris, and the Smithsonian Institution, Washington, D.C. Hayter's paintings were shown at the Musée de la Ville de Paris in 1972, and there was a painting retrospective (1940–1975) at the Galerie de Seine, Paris, in 1976.

Critics of these shows were unanimous in acknowledging Hayter's pioneering efforts in "the evolvement of new methods, new materials and a radically new approach to printmaking." Atelier 17, with its diversity of talent and its "atmosphere of exploration and discovery," was described as "the most influential print workshop of the 20th century." Hayter's own prints were praised in the London *Observer* for their "combination of skill and imagination, of craftsmanship, sensitivity and instinct," and a *Christian Science Monitor* (June 8, 1973) writer declared that Hayter's recent paintings "joyously affirm the vitality of color." The most negative reaction came from a *Washington Post* critic who wrote that, although Hayter was the first to put many colors in his etchings, "his colors do not move me" and "his textures seem to [be] just textures." He added: "I admire Hayter's lines. They are long and free and elegantly curved, but they appear so often that eventually they assume the look of something done by rote." But *Christian Science Monitor* reviewer Marjorie Bruce-Milne found that "Hayter's works seem to have an inborn life. They suggest the passing of clouds over a sunny landscape, or the ever-varying movements of currents in deep water."

Nineteen-seventy-seven marked the 50th anniversary of Hayter's first solo show in Paris and his founding of Atelier 17, but the artist at 75 was anything but the "grand old man" resting on his past achievements. Extraordinarily active and vigorous, he plays tennis for recreation, and continues to produce paintings and prints, many of which are based, in his words, on "far-out bits of geometry with a few irrational elements creeping in." The Atelier, which remains as experimental as ever, is now housed in new quarters in the rue Didot.

Hayter is of medium build, his once light brown hair is now white and there are strong lines in his face and around his clear blue-gray eyes. He talks volubly and amusingly on a multitude of subjects, ranging from poetry, literature, history, and metaphysics to the latest developments in science and technology. Hayter's own studio is in his residence near the Observatoire in Montparnasse. In the lower room a ping-pong

table serves as a catch-all for a multitude of papers, correspondence, drawings, and cases of engravings and lithographs. The stacks are filled with canvases, and a large unfinished painting on the easel usually dominates the room. The books on the shelves reflect Hayter's intensely scientific concerns—Goethe's *Color Theory*, *The Psychology of Seeing* by R.L. Gregory, a treatise on *Wave Mechanics*, and works on optics and calculus. Hayter will explain, with an enthusiasm that makes the listener feel that he or she is participating in the discovery, that his latest print is a "game between continuity and discontinuity," or he may point out that "a bee's eye can see ultraviolet rays."

Two sons, William and Julian, were born of Hayter's marriage to Helen Phillips, from whom he is now separated. His present wife is the Irish poet Desirée Moorhead. He has had a long and fruitful association with writers and poets, particularly the Irish. He did three engravings for a deluxe edition of his neighbor Samuel Beckett's *Still*, published in 1974. When someone remarked that Hayter could write a fascinating book about all the major artists who have worked with him in Atelier 17, he insisted that he would never do it, adding jokingly, "To write it frankly I'd have to wait until they're all gone!"

Mauricio Lasansky and Gabor Peterdi are among the many printmakers active in America who found their own direction through Atelier 17. When reminded of the Atelier's 50th anniversary, Hayter remarked: "50 years, frightful! Age doesn't interest me. I'm busy getting on with my paintings and drawings and prints."

EXHIBITIONS INCLUDE: Gal. Sacre du Printemps, Paris 1927; Claridges Gal., London 1929; Gal. Vignon, Paris 1932; Mus. of Fine Arts, San Francisco 1940, '48; Art Inst., Chicago 1941; Marian Willard Gal., NYC 1941; Mortimer Brandt Gal., NYC 1945; Gal. Jeanne Bucher, Paris 1946; Durand-Ruel Gal., NYC 1947; Gumps Gal., San Francisco 1948; Iolas Gal., NYC 1949; Gal. Louis Carré, Paris 1951; Gal. Denise René, Paris 1955; California Palace of the Legion of Honor, San Franciso 1956; Whitechapel Gal., London 1957; Howard Wise Gal., NYC 1961; Seibu Gal., Tokyo 1962; Victoria and Albert Mus., London 1967; Grosvenor Gal., London 1967; Mus. des Arts Décoratifs, Paris 1969; Smithsonian Instn., Washington, D.C. 1969; Univ. Art Mus., Austin, Tex. 1970; Mus. de la Ville de Paris 1972; Neptune Gal., London 1975; Gal. de Seine, Paris 1976. GROUP EXHIBITIONS INCLUDE: Gal. Pierre, Paris 1934; Leicester Gals., London 1934; Surrealist Exhibition, London 1936; International Exhibition of Surrealism, Gal. des Beaux-Arts, Paris 1938; MOMA, NYC 1944; Palais des Beaux-Arts, Brussels 1948; Salon de Mai, Paris 1951–68; Kunsthalle, Bern 1954; Nasjonalgal., Oslo 1955; Venice Biennale 1958; Inst. of Contemporary Arts, London 1962; Mus. of Modern Art, Haifa, Israel 1969; Rio de Janeiro Biennale 1972; Newcastle Cultural Center, England 1973; Northern Illinois Univ., De Kalb 1975.

ABOUT: Current Biography, 1945; Hayter, S. W. New Ways of Gravure, 1949, About Prints, 1962; Reynolds, G. "The Engravings of S. W. Hayter" (cat.), Victoria and Albert Mus., London, 1967; *Periodicals*—Art News May 15–31, 1941; Christian Science Monitor March 1, 1967, June 8, 1973; International Herald Tribune June 11–12, 1977; Newsday April 29, 1970; Newsweek November 10, 1944; The Observer February 19, 1967; Washington Post May 24, 1973.

HELD, AL (October 12, 1928–), American painter, emerged in the early 1960s as a leader of the Post-Painterly Abstraction School.

Held was born in Brooklyn, New York, where he graduated from high school in 1944. He served in the US Navy from 1945 to '47. Having grown up during the Great Depression, Held was sympathetic to the left, and after his discharge from the Navy joined a politically active group of artists, writers, and musicians called Folksay. In 1948 he enrolled in the Art Students League, New York City, under the GI Bill, studying anatomy and drawing. Among his teachers was Harry Sternberg. At this time he was interested in the social realist style, but in 1949 his artistic views changed when he saw Jackson Pollock's "dripped" canvases.

In 1950 Held went to Paris and studied art at the Académie de la Grande Chaumière with Ossip Zadkine. He took a studio in the Montparnasse area and for six months painted huge figures on paper before turning to abstraction. He attempted to reconcile Pollock's subjective "drip" technique with the objectivity of Mondrian's geometric abstraction. The resulting canvases were exhibited in Held's first solo show, which was given at the Galerie Huit, Paris, in 1952.

Held returned in 1953 to New York City, where he was encouraged by the Abstract Expressionist Mark Rothko. Also in 1953 he married the sculptor Sylvia Stone. Later that year a fire in his East Broadway loft destroyed almost all his paintings.

From 1954 to '55 Held lived in San Francisco, working odd jobs, including carpentry, driving a truck, and road construction. He moved back to New York in 1955 and there operated a small business until 1960. The first group show in which he participated in Manhattan was at the Tanager Gallery in 1955, and his first New York City solo show came four years later at the Poindexter Gallery.

During the 1950s Held was influenced by abstract expressionism, and his works were thickly impasted with gestural brushstrokes. About

© Hans Namuth, 1984

AL HELD

1960, along with other Abstract Expressionists, Held changed direction. He abandoned oil painting and took up acrylics, and his style changed as well as his technique. He continued to build up the paint in heavy layers but began using bright colors to paint large, flat, geometrical works. He and other Post-Painterly Abstractionists, "purified" abstract expressionism by giving shapes stronger definition and clarity and by reducing the gestural element. His brushstrokes were still visible, but they seemed thinner and less anarchic. *House of Cards* (1960) is an example of this "loose" geometry; it consists of circles, squares, triangles, and jagged lines.

In the mid-1960s Held further simplified his canvases, using fewer but larger areas of color. His forms became increasingly bold and dramatic, and his paintings assumed the monumental dimensions of a mural, as in the 71-by-49-inch *Venus Arising* (1963) and the ll4-by-114-inch *Maltese Cross* (1964). These were followed in 1965 by *The Big N*, a painting which is monochromatic except for two small nicks at the top and bottom which turn a huge rectangle into the letter "N." *Greek Garden* (1966) occupies an entire wall and is the culmination of Held paintings that physically confront the viewer. Although his canvases of the '60s were in the style known as hard edge, his forms were less precise than those of Ellsworth Kelly, due to Held's grounding in abstract expressionism. In continuing to use a heavy impasto and an allover texture he had learned from action painting, Held differed from "pure" Hard Edge and Color Field painters like Morris Louis and Kelly. Also, Held's forms retained their asymmetry, a

characteristic of abstract expressionsim, though they were combined with geometric designs.

Held gained wide recognition in the 1960s. He became associate professor of art at Yale University in 1962; was awarded the Logan Medal by the Art Institute of Chicago in 1964; and won a Guggenheim Fellowship in 1966. Also in 1966, he won international renown with his first museum show, held at the Stedelijk Museum, Amsterdam. Dutch critics applauded Held's originality and were impressed by the enormous scale of his work.

Held's paintings after 1964 were as large as before, but they were intended to confront the viewer optically as well as physically. Color was abandoned and structural unity and spatial organization were more and more emphasized. He retained geometric designs but made them more complex, creating an elusive three-dimensionality with black lines on a white field and sometimes with white lines on a black ground. Cubes, cylinders, and other three-dimensional shapes were suggested by outlines which were not shaded; the result was a shifting perspective and a problematic organization of space. An example of Held's move from warm to cool art is *B/WX* (1968; Albright-Knox Art Gallery, Buffalo, New York), which Henry Geldzahler described in *Contemporary Art 1942–72* as "a thickly and strictly drawn black-and-white accumulation of primary architectonic forms" which represented a departure from the "enormous and heavily painted color abstractions with which [Held] was previously identified." These works, more cerebral than Held's earlier paintings, were called "the geometry of a dream world" by Hilton Kramer of *The New York Times* (February 23, 1979).

During the 1970s Held increased the perceptual complexity of his works by varying the thickness of the line and broadening his range of scale. Into a painting with minute shapes he would introduce superstructures so large they were cut off by the edges of the canvas. These structures not only overlap and intertwine but are contained one inside another, implying worlds within worlds. *Flemish 1* (1972) is an example of this form of abstract illusionism. As Marcia Tucker explained in the catalog to Held's 1974 retrospective at the Whitney Museum of American Art, New York City, the artist had moved from two-dimensional to three-dimensional geometry and was now moving beyond the Euclidean in search of an elusive fourth dimension. About 1978 Held added color to these complex works. Having concluded his formal search, he felt he could now leave behind the tracing of geometric shapes in black and

white and return to color without neglecting his concern with space and structure. The vibrancy of bright colors made his paintings more energetic and added solidity to the shapes, which without any loss of complexity seemed less elusive.

Describing Held's work of the late '70s in *American Art Since 1945,* Dore Ashton wrote: "The subtleties available in abstruse geometries, with all their ambiguous implications of space and time, were expressed with great delicacy in Held's huge canvases. . . . He had begun a series of 'Solar Wind' paintings in which minute circles and triangles floated among the familiar geometric figures, producing illusions of endless space and complete disorientation in relation to earthly affairs. The dream of Kandinsky was realized in other terms: Held's carefully sanded surfaces became disembodied, while the linear plays on perceptual complexities are complicated by random details."

Al Held and his wife Sylvia were among the first artists to move to the SoHo area of lower Manhattan, where they live and work in a spacious loft. They spend summers in the country. Mara, their daughter, was born in 1954.

EXHIBITIONS INCLUDE: Gal. Huit, Paris 1952; Poindexter Gal., NYC 1959, '60, '61; Gal. Renée Ziegler, Zürich 1964, '70, '77; Gal. Gunar, Düsseldorf 1964; André Emmerich Gal., NYC from 1965; Stedelijk Mus., Amsterdam 1966; Gal. Müller, Stuttgart, W. Ger. 1966; Mus. of Art, San Francisco 1968; Corcoran Gal. of Art, Washington, D.C. 1968; Donald Morris Gal., Detroit 1971, '74; André Emmerich Gal., Zürich 1974; Whitney Mus. of Am. Art, NYC 1974; Jared Sable Gal., Toronto 1975; Adler Castillo Gal., Caracas, Venezuela 1975; Gal. Marguerite Lamy, Paris 1977. GROUP EXHIBITIONS INCLUDE: Gal. Huit, Paris 1952; Tanager Gal., NYC 1955; "Neue Amerikanische Malerei," Kunstmus., St. Gallen, Switzerland 1959; "American Abstract Expressionists and Imagists," Inst. of Contemporary Art, Boston 1961; "Toward a New Abstraction," Jewish Mus., NYC 1963; "Post-Painterly Abstraction," County Mus. of Art, Los Angeles 1964; "Concrete Expressionism" New York Univ., NYC 1965; "Systemic Painting," Guggenheim Mus., NYC 1966; Documenta 4, Kassel, W. Ger. 1967; "Large Scale American Paintings," Jewish Mus. NYC ca. 1969.

COLLECTIONS INCLUDE: Metropolitan Mus. of Art, MOMA, and Whitney Mus. of Am. Art, NYC; Albright-Knox Art Gal., Buffalo, N.Y.; Everson Mus., Syracuse, N.Y.; Brandeis Univ., Waltham, Mass.; Dayton Art Inst., Ohio; Mus. of Art, San Francisco; Kunsthalle, Basel; Kunsthaus, Zürich.

ABOUT: Ashton, D. American Art Since 1945, 1982; Moore, E. (ed.) Contemporary Art 1942–72: Collection of the Albright-Knox Art Gallery, 1972; Rose, B. American Art Since 1900, 2d ed. 1975; Tucker, M. (ed.) "Al Held" (cat.), Whitney Mus. of Am. Art, NYC,

1974. *Periodicals*—Art in America January 1962; Art International (Lugano) May 1968, Summer 1974; Art News April 1965, April 1967, November 1976; Artforum Summer 1964, March 1968; Arts Magazine May 1971, April 1980; New York Times February 23, 1979; Perspecta: The Yale Architectural Journal (New Haven, Conn.) no. 11 1967; Studio International November 1964, January 1966.

***HÉLION, JEAN** (April 21, 1904–), French painter, is best known for his dramatic, and, at the time, shocking, reversal in mid-career from one of France's most prominent geometrical abstractionists to a painter of figures and scenes of Parisian street life. Chronological analysis of his work reveals, however, a strong internal consistency and a natural, if subtle, evolution toward figuration in his early paintings. Although Hélion's "abstract decade" has left a profound mark on his palette and sense of composition, today he paints in a full-blooded fashion, displaying a worldly interest, even affection, for his subjects.

Born in Couterne, Normandy, Hélion had two years of schooling at the Ecole Auguste Janvier (1912–14) before the war. He briefly studied chemistry at the Institut Industriel du Nord in Lille (1920), but left after a year for Paris, where he found work as an architect's draftsman— excellent training for a future disciple of neoplasticism—while taking classes in architecture at the Ecole des Arts Décoratifs. In the early 1920s he began painting city scenes, portraits, and still lifes in watercolor and oils, showing his work on the streets and squares with other young artists. In 1925 the dealer Georges Bines offered him a contract to paint full-time, and he abandoned his architectural apprenticeship.

Influenced in turn by the work of Cézanne, the Fauves, the Cubists, and the Constructivists, Hélion had by the late 1920s developed a disciplined abstract style, colorful and streamlined but still drawn from real life. After his meeting in late 1929 with Theo van Doesburg, the founder of neoplasticism, he became convinced of the necessity of an impersonal "machine art" of universal geometricity. Late that year Hélion, Van Doesburg, Otto Carlsrund, and Léon-Arthur Tutundjian formed the short-lived Art Concret group, describing themselves as "the painters who think and measure." With his shock of dark hair, intense, pale face, and horn-rimmed spectacles, Hélion, the very image of the '30s intellectual, spoke forcefully in the artists' cafés of the union of art, mathematics, and the aesthetic of the machine. His own work, such as *Orthogonal* (1929–30), was measured out with draftsman's tools: in accordance with the tenets

°ā´´ lē äN´, zhäN

JEAN HELION

of neoplasticism, the paintings were composed exclusively of right angles, flat planes, and lines, using only the primaries, black, gray, and white. *Orthogonal* appears, in the words of an *Art in America* writer, "a rigidly doctrinaire and somewhat ponderous work." In 1930 Art Concret was dissolved. The following year Hélion helped found the Abstraction-Création group (which later included Vantongerloo and Mondrian) out of the remnants of several similar groups and soon assumed control of the group's publications. Very quickly, however, he broke ranks with orthodox neoplasticism with *Circular Tensions* (1931–32), in which he used the "forbidden" curve. Clearly unable to submit himself for long to any dogmatic style, he began the search for a natural, rather than exclusively intellectual, source for his abstractions. In 1932 his first solo show was held at the Galerie Pierre, Paris.

Following a summer of drawing in the countryside around Couterne in 1932, Hélion began his "Equilibrium" series (1932–35), which shows the strong influence of Léger. Shaded, bulging planes—Léger's *dégradé*—and curved bars replaced the rectilinear severities of Mondrian and Van Doesburg. His palette loosened as well, increasing in saturation and including greens, violets, and mixed grays. "Indeed," wrote Sheldon Williams in *Contemporary Artists*, "the color areas in these new paintings were like great luminous lenses. They clubbed together on canvas to form compositions whose nearest visual complements were the bulky make-up of the fat upholstery of easy chairs and sofas." In 1936, two years after his departure from the dissolving Abstraction-Création association, Hélion rein-

troduced the figure, perceptibly if abstractly modeled against a planar background. *Brilliant Figure* (1936), openly constructed, and *Blue Figure* (1936), compact and rather sculptural, represent the two stylistic poles of these early figurative attempts. Inexorably pursuing a course away from the main branch of modernist evolution (as it was then perceived), in 1939 he finally committed himself fully to the figure, beginning with *The Cyclist* (1939), which had most of the earmarks of his work through the early 1960s: tightly organized composition, limited palette, and a restriction to three or fewer figures spaced evenly across the canvas. When asked later what had led to his rejection of abstraction, Hélion answered simply, "I was nostalgic for the things and people I had loved."

This nostalgia stemmed partly from the fact that he was no longer living in Paris, but, since 1936, in the United States (he married his first wife, the American Jean Blair, in 1932 and made several trips to New York City and Rockbridge Baths, Virginia through the 1930s). His studio in New York was a meeting place for several future members of the New York School, including de Kooning, Ad Reinhardt, and Arshile Gorky. After the German invasion of France in 1939, Hélion left his wife and newborn son to enlist in the French Army, but was quickly captured by the Germans and interned in a work camp in Pomerania. He later managed to escape from a POW camp in Stettin, Germany and made his way back to the US in 1942, where he published a best-selling book about his war experiences, *They Shall Not Have Me*, in 1943.

In 1946 Hélion returned to France, where he has since lived. He immediately resumed his exploration of the figure, peopling his canvases with anonymous smokers, dreamers, falling men, men in fedoras clutching newspapers, and nude young women, all set against carefully planned, architectural backgrounds. The bulging Légerian volumes of the 1930s work gave way to supple lines; the drawing of the bathing girl in *A Rebours* (1948, Backwards) almost Matissean in its economy, flexibility, and sensuality, shows how far from the comparative stolidity of the "Equilibrium" series Hélion had come. Those who esteemed him as a leading Abstractionist before the war, however, had considerable difficulty accepting the new work, which seemed to many a rejection of the moral precepts of modernism; for many years Hélion found himself isolated from the mainstream of French art. "I wonder if the gulf which separates my painting from what is generally considered contemporary won't soon appear to have been an illusion," he wrote in 1959. "And whether all the valid painting being done today doesn't bear

certain resemblances which escape us at the present time."

Hélion's realistic painting went through several well-defined stylistic periods, evolving from the linear, still semiabstract style of the late 1940s, to a more strictly realistic, painterly phase in the 1950s and '60s (*Portrait of Jean-Pierre Bugart,* 1959; *Red Butcher Shop,* 1963), to a deft linearism again in the mercantile panoramas of the 1970s and '80s (*Marketplace Triptych,* 1973–74; *Lobsters and Kippered Herrings,* 1975). Regardless of style, Hélion always binds his compositions with vibrant color: "It is the color of the painting that will guide the thought of the spectator," he said. There is no unnecessary effort in the late paintings; no line, no object is out of place, and none is extraneous. Hélion has managed to harness the urban complexities of his subjects, their fleeting entrances and exits, kisses and embraces, to a geometrical rigor that is unforced and natural.

Jean Hélion married his second wife, Jacqueline Ventadru, in 1965; they have five children. He has had more than 50 solo shows in the US and Europe. In 1964 he designed the sets and costumes for a production of *King Lear* on French television. Also in 1964 he expressed his concern with relating his personal ideograms to reality: "There is the tree, still vaster and deeper than the image I get from it.

"Each confrontation with nature is a rude humiliation for our concepts.

"Yes only the concept is transmittable."

EXHIBITIONS INCLUDE: Gal. Pierre, Paris 1932, '38; Gal. John Becker, NYC 1932, '33; Gal. Cahiers d'Art, Paris 1936, '56, '58, '61; Valentine Gal., NYC 1936, '37; Putzel Gal., Hollywood, 1936, '37; San Francisco Art Mus. 1937, '43; Art Club of Chicago 1938, '43; Grand Rapids Mus., Mich. 1938; Arts Club of Lynchburg, Va. 1939; Whyte Gal., Washington, D.C. 1939; Passedoit Gal., NYC 1940; Virginia Mus. of Fine Arts, Richmond 1942; Art of this Century, NYC 1943; Bennington Col., Vt. 1943; Stendahl Gal., Los Angeles 1943; Rosenberg Gal., NYC 1944, '45; Hollins Col., Va. 1944; Mus. of Fine Arts, Baltimore 1945; Crosby Gal., Washington, D.C. 1945; Gal. Renou et Colle, Paris 1947; Hanover Gal., London 1951; Sala degli Speechi, Venice 1951; Gal. del Milione, Milan 1951; Feigl Gal., NYC 1951; Gal. San Marco, Rome 1951; Chez Mayo, Paris 1953; Gal. Louis Carré, Paris 1963; Gal. of Modern Art, NYC 1964; Gal. Yves Lambert, Paris 1964; Leicester Gals., London 1965; Gal. du Dragon, Paris 1966, '67; Gal. Il Fanto di Spade, Rome 1968; Gal. Ennomia, Milan 1969; Gal. Palais, Paris 1970; Gal. Chauvelin, Paris 1974; Gal. St. Germain, Paris 1975; Gal. Flinker, Paris 1975, '78, '80; Los Angeles County Mus. of Art 1975; Spencer Samuels Gal., NYC 1976; Mus. d'Art Moderne de la Ville, Paris 1977; Gal. Rue de Tournon, Paris 1978; Mus. Ingres, Moutauban, France 1978; Gal. Poll, Berlin 1980. GROUP EXHIBITIONS INCLUDE: Foundation

Maeght, St.-Paul-de-Vence, France 1965, '67; Mercedes-Benz Gal., Paris 1971; "European Painting in the Seventies," Los Angeles County Mus. of Art 1975; "Peinture Aujourd'hui," Maison de la Culture, Fontenay-sous-Bois, France 1976; Venice Biennale 1976; Mus. Ingres, Mountauban, France 1980.

COLLECTIONS INCLUDE: Solomon R. Guggenheim Mus., and MOMA, NYC; Tate Gal., London; Mus. d'Art Moderne, Paris; Mus. of Fine Arts, and Albright-Knox Art Gal., Buffalo, N.Y.; Mus. of Fine Arts, Boston; Art Inst., Chicago; Mus. of Fine Arts, San Francisco; Rhode Island Sch. of Design Mus., Providence; Mus. of Fine Arts, Raleigh, N.C.; Mus. de Grenoble, France; Mus. of Fine Arts, Denver, Colo.; Mus. of Fine Arts, Seattle; Mus. of Fine Arts, San Diego, Calif.

ABOUT: Abadie, D. Hélion ou la force des choses, 1975; Bruguiere, P. and others Paintings by Jean Hélion 1928–1964, 1964; Current Biography, 1943; Hélion, J. They Shall Not Have Me, 1943, Kaleidoscope, 1973; Jakovski, A. Arp, Calder, Hélion, Miró, Seligmann, 1933; P-Orridge, G. and others (eds.) Contemporary Artists, 1977; Read, H. (ed.) A Coat of Many Colors, 1952. *Periodicals*—Art and Literature March 1964; Art in America September 1976; Art News March 15, 1944, February 1960, November 1964; Arts et lettres (Paris) May 25, 1958; Daedalus Winter 1960; Minnesota Review April 1961.

HEPWORTH, BARBARA (January 10, 1903–May 20, 1975), British sculptress, was an important figure in the establishment of abstraction as a dominant mode of 20th-century British sculpture. She was born in Wakefield, Yorkshire, the first of three daughters. Her father was an engineer, and the family was poor. In a pictorial autobiography published in 1970 she wrote of her childhood upbringing as "a strange mixture of frugality and strong discipline." But it was a loving environment and her mother encouraged her interest in music, dance, and literature.

Barbara Hepworth recalled that all her early memories were of forms and shapes and textures. As she rode with her father through the West Riding landscape, "The hills were sculptures: the roads defined the form." When she was seven, a slide lecture on Egyptian sculpture presented by her school's headmistress fired her imagination. By the time she was 15, Barbara was sure she wanted to be a sculptress. With the encouragement of the headmistress, she won a scholarship to the Leeds School of Art.

It was at Leeds in 1920 that she first met Henry Moore, his friend Raymond Coxon, and Edna Ginesi, who later married Coxon. In 1921 the four set out for the Royal College of Art, London. Barbara Hepworth was then a handsome young woman of 16; although she was first con-

Jorge Lewinski

BARBARA HEPWORTH

sidered too young to enter the school, she was given a test and allowed to stay.

The four friends received their diplomas from the Royal College in 1924 and were awarded traveling scholarships. Hepworth went to Italy, arriving in Florence at night with only £9 in her pocket. "The light at dawn was so wonderful in the eyes of a Yorkshirewoman who had spent three years in London smog," she recalled. She visited Florence, Siena, Lucca, and Arezzo and became especially interested in Romanesque and early Renaissance sculpture. She married the British sculptor John Skeaping in the Palazzo Vecchio, Florence; they then moved to the British School in Rome. "During this period," she wrote, "I really learned to carve marble [with Italian master carver Ardini], and have loved the quality ever since." She visited Carrara and studied the mechanics of moving weights. After two years in Italy, they returned to London in 1926.

They found a studio in St. John's Wood where they gave a private exhibition of their work in 1927. For 14 days no one came; then Richard Bedford of the Victoria and Albert Museum brought George Eumorphopoulos, who bought several works from each of them, including Hepworth's Seated Figure in marble. Eumorphopoulos helped the two artists to hold their first show at the Beaux-Arts Gallery in June 1928, and he remained a friend until his death during World War II.

Hepworth's hardwood and stone sculptures of the 1920s were naturalistic, but spare and simplified. A pair of doves in Parian marble, reproduced on the cover of the catalog to the 1928 Beaux-Arts Gallery show and now in the Man-

chester City Art Gallery, and a torso in the collection of the Earl of Sandwich are among the few surviving examples of her early style of carving.

A son, Paul, was born in 1929, and the following year Hepworth and Skeaping had a second joint exhibition at Tooths in New Bond Street. After the show "suddenly we were out of orbit," Hepworth remembered, and the marriage was amicably dissolved in 1933. She enjoyed family life, but was conscious that "the dictates of work are as compelling for a woman as for a man."

In 1930 Barbara Hepworth met the British painter Ben Nicholson; at once she recognized a consonance between his paintings and her sculpture. She became part of what her friend the critic Herbert Read described as "a gentle nest of artists"—Henry Moore and his wife Irina, the painter Ivon Hitchens, and her close friends Douglas and Mary Jenkins. In Pierced Form (1931), which was destroyed during World War II, she discovered the sculptural potential of the hole, which was to be so important in her later work and in her friend Moore's.

She and Ben Nicholson traveled to France together in 1932. They visited Constantin Brancusi's Paris studio and went to Meudon to see Jean Arp; he was not at home, but Sophie Taeuber-Arp showed them her husband's white plaster sculptures, and Hepworth admired "the way Arp had fused landscape with the human figure." The impact of Brancusi and Arp drew her closer to abstraction. In Paris she and Nicholson joined the Abstraction-Création group. On their way back from Avignon and Saint-Rémy, where they made drawings, they called on Picasso and Braque in their studios.

The results of this exposure to the European avant-garde were seen in a joint exhibition by Hepworth and Nicholson at the Tooth Galleries late in 1932. Herbert Read observed that Hepworth's sculptures combined "the organization of masses in expressive relation" with "the revelation of the potentialities of the sculptural material."

Hepworth and Nicholson were married in 1933. In October of 1934, in their Hampstead home, she gave birth to triplets—Simon, Rachel, and Sarah. When she began carving again in November 1934, her work became more formal, without a trace of naturalism. "I was absorbed" she said later "in the relationships in space, in size and texture and weight, as well as in the tensions between the forms."

In London in 1934–35 Barbara Hepworth joined Unit One, a group of architects, painters, sculptors, and decorators. The members of Unit One often met in the Nicholsons' studio and this

led to the formation of the Constructive group, which in 1935 published the first issue of the journal *Circle: An International Survey of Constructive Art.* Hepworth's own carving became increasingly rhythmical, and for the first time she produced pure geometric shapes such as *Sphere and Marble*, and *Forms and Hollows.* Tension replaced movement, as in *Discs in Echelon* (1936; Museum of Modern Art, New York City).

As the political situation on the Continent worsened, the Nicholsons found themselves at the center of an international movement in art and architecture. Among the new arrivals to England were Naum Gabo and his wife Miriam, Walter Gropius, Marcel Breuer, Laszlo Moholo-Nagy, Erich Mendelssohn, and, in 1939, Piet Mondrian. "The red-letter days," Hepworth recalled in her autobiography, "were when Gabo or Calder, and later Mondrian, came to share nursery tea. Three pairs of eyes would watch every movement, and three pairs of ears listen to every word."

The approach of war in the late 1930s made life very difficult for British artists. In August 1939, just before the outbreak of war, the Nicholsons settled in St. Ives, Cornwall, which eventually became an artists' colony. For the first three years of the war Hepworth could draw only at night and make a few plaster maquettes. During the day she ran a nursery school and a successful vegetable garden to aid the war effort. In 1945 the Nicholsons found a large house at Carbis Bay, which gave Nicholson an adequate studio and allowed Hepworth the chance to resume her sculpture. Despite the limited space, she produced some of her best work in Cornwall in the mid-1940s. She responded keenly to the landscape around St. Ives and, as one critic noted, "in many of the works enclosures of space and light in arcs reflect her identification with the distinctive environment."

This new atmospheric feeling was apparent in the planewood *Tides* (1946), with a colored, hollowed-out interior that contrasts with the polished grain of its sides. "Color and form," the artist wrote, "go hand in hand: brown fields and green hills cannot be separated from the earth's shape." About 1948, with the help of the Gabos, Adrian Stokes, the potter Bernard Leach, the painter Peter Lanyon, and other friends, she was cofounder of the Penwith Society of Arts, which received an annual endowment from the Arts Council of Great Britain.

After witnessing a hospital operation in 1947, Hepworth made a series of drawings in oil and pencil, notable especially for the sensitive treatment of the hands. These were exhibited at the Lefevre Gallery, London, in 1948 and at Durlacher's, New York City, in 1949. The realism of these works seemed to critics a new departure, but Hepworth explained that "working realistically replenishes one's love for life, humanity and the earth. Working abstractly seems to release one's personality and sharpen the perceptions. . . ."

In 1949 she moved into the Trewyn Studio in St. Ives, where for the first time she had a spacious studio, a yard, and a garden where she could work in the open air. Her sculptures, along with paintings by John Constable and Matthew Smith, represented Britain at the Venice Biennale of 1950. She visited Venice on this occasion and noted that "as soon as people, or groups of people, entered the Piazza they responded to the proportions of the architectural space." Her observations influenced *Contrapuntal Forms* (1950), a blue limestone piece commissioned by the Arts Council for the Festival of Britain, and *Group* (1951), consisting of 11 white marble figures. Both sculptures deal with the opposition of vertical forms to the horizontal plane.

Barbara Hepworth and Ben Nicholson were divorced in 1951. That same year the director Michel St. Denis asked her to design the setting and costumes for a production of *Electra* at the Old Vic, starring Peggy Ashcroft. Although she felt that the theatre and its audiences had not caught up with the other arts in the integration of space, time, movement, and light, she enjoyed the commission. In 1954, she designed sets and costumes for Michael Tippett's opera *The Midsummer Marriage*, produced at the Royal Opera House Covent Garden in 1955.

Meanwhile she had suffered a personal tragedy: her eldest son Paul was killed on active service with the R.A.F. over Thailand in February 1953. In his memory, Hepworth carved a tender *Madonna and Child* for St. Ives Parish Church in a figurative style made more expressive by her long experience with abstract forms.

Hepworth was awarded second prize in March 1953 in the controversial competition on the theme of "The Unknown Political Prisoner." (Reg Butler was the winner.) In 1954 the Whitechapel Art Gallery, London, mounted a retrospective of her work since 1927.

On returning to England in 1955 from a trip to Greece, she found that 17 tons of Nigerian wood were awaiting her at Tilbury Docks. With much difficulty she had the massive slabs transported to St. Ives; from them she carved pieces that she called *Corinthos, Delphi, Phira, Epidauros,* and *Delos. Curved Form (Delphi)* used string in the hollow of the wooden form, a device that served both to define the space and to evoke Apollo's lyre.

For most of her career, Hepworth, like Moore, advocated direct carving, but in 1956 she began to work in plaster and bronze. Modeling and casting enabled her to work on a larger scale and to express her lyric gifts more spontaneously. The bronze *Sea Form (Porthmeor),* of which there is a cast in Antwerp's Middelheim Park, was inspired, the artist said, "by the ebb and flow of the Atlantic." The decade of the 1950s ended triumphantly when she was awarded the Grand Prize at the São Paulo Bienal of 1959. In the same year she visited the United States for the first time.

Before his death in 1961, her friend Dag Hammarskjöld, Secretary General of the United Nations, had discussed with her the kind of form he had envisaged for the front of the Secretariat in New York City. On hearing of his death, she made a large version of *Single Form,* a motif on which she had been working for some time. U Thant, the new Secretary General, suggested that this form be enlarged in bronze, according to Hammarskjöld's original idea; the 21-foot-high piece was unveiled in New York on June 11, 1964. In her speech Hepworth recalled that Hammarskjöld had related *Single Form* to "compassion and to courage and to our creativity."

In the 1960s Hepworth continued to investigate the possibilities of piercing through forms, both in bronze and in marble. The bronze *Rock Form (Porthmeor)* of 1964 exemplifies the organic mode, whereas *Four Square (Walk Through)* of 1966 returns to a more austere style. But however abstract her forms, they were never coldly rational: they always related to the living environment and the human scale.

Many honors and awards came to Barbara Hepworth in the 1960s. She was made Dame Commander of the Order of the British Empire in 1965 and received honorary degrees from the universities of Exeter and Oxford. She was particularly pleased when, in a picturesque ceremony in 1968, she was made a Bard of Cornwall and a Freeman of the Borough of St. Ives, her spiritual as well as her physical home for 30 years. In April–May1968 she had a major retrospective at the Tate Gallery, London

On May 20, 1975 Hepworth was fatally burned when her cigarette accidentally set fire to the sheets of her bed. Her death brought forth many tributes to Hepworth's achievements as an artist, her warmth and intelligence as a human being, and her enormous influence on modern British sculpture. She herself best described her ideal in her autobiography as "a rhythm of forms which has its roots in the earth but reaches outwards towards the unknown experiences of the future."

EXHIBITIONS INCLUDE: Alex Reid and Lefevre Gal., London 1937; City Art Gal. and Mus., Wakefield, England 1944, '51; Lefevre Gal., London 1946, '50, '52; Durlacher Gal., NYC 1949; Whitechapel Art Gal., London 1954, '62; Martha Jackson Gal., NYC 1955; Gimpel Fils, London 1956, '58, '61, '64, '66; Gal. Chalette, NYC 1959; Moderna Mus., Stockholm 1964; Rijksmus. Kroller-Müller, Otterlo, Neth. 1965; Tate Gal., London 1968; Marlborough Fine Art, London 1970, '72. GROUP EXHIBITIONS INCLUDE: With John Skeaping and William E. C. Morgan, at a studio in St. John's Wood, London 1927; Beaux-Arts Gal., London 1928; Tooth Gals., London 1930, '32; "Abstraction-Création: Art non-figuratif," Paris, 1934; "Abstract and Concrete," 44 St. Giles St., Oxford, England 1936; "New Movements in Art," London Mus. 1942; Temple Newsam House, Leeds, England 1943; Lefevre Gal., London 1948; Venice Biennale 1950; Festival of Britain, London 1951; SãoPaulo Bienal 1959; "Sculpture of the 20th Century," Grosvenor Gal., London 1960; Tokyo Biennal 1963; "Art in Britain," Marlborough Fine Art, London 1963; "Selected European Masters of the 19th and 20th Centuries," Marlborough Fine Art, London 1973; Edinburgh Festival 1973.

COLLECTIONS INCLUDE: Barbara Hepworth Mus., St. Ives, Cornwall, England; City Art Gal., Birmingham, England; City Art Gal., Leeds, England; Manchester City Art Gal., and Whitworth Art Gal., Manchester, England.

ABOUT: Bowness, A. The Complete Sculpture of Barbara Hepworth, 1960–69, 1971; Current Biography, 1957; Gibson, W. Barbara Hepworth, Sculptress, 1946; Hammacher, A. M. Barbara Hepworth, 1958, Hepworth, B. Barbara Hepworth: a Pictorial Autobiography, 1970; Hodin, J. P. Barbara Hepworth: Life and Work, 1961; Lange, A. de Barbara Hepworth, 1958; Lucie-Smith, E. Late Modern: The Visual Arts Since 1945, 1969; Osborne, M. (ed.) The Oxford Companion to Twentieth-Century Art, 1981; Read, M. Barbara Hepworth: Carvings and Drawings, 1952. *Periodicals*— (London) Sunday Times January 23, 1955; L'Oeil (Paris) October 1976; Studio December 1932, October 1946.

HERON, PATRICK (January 30, 1920–), British painter, critic, and polemicist is a leading member of the so-called middle generation of 20th-century British artists. Born in Leeds, Yorkshire, he was raised in St. Ives, Cornwall, where he lived until 1930. From 1935 to 1939, Heron worked in London, as a textile designer for Cresta Silks Limited, his family's company, and he studied part-time at London's Slade School of Art between 1937 and 1939.

During World War II Heron was a conscientious objector. In 1944 he rejoined Cresta Silks and worked there until 1950. In 1945 he married Delia Reiss. They had two daughters, Katherine Bride and Suzanna.

Jorge Lewinski

PATRICK HERON

Between 1945 and 1947, Heron's first art criticism appeared in *New English Weekly* and he gave a series of highly articulate talks on the BBC Third Programme. From 1947 to 1950, he served as art critic to the prestigious liberal weekly *The New Statesman and Nation.*

Heron's first solo show was held at London's Redfern Gallery in 1947; he exhibited there again in 1948, '50, '51, and '54. The Georges Braque exhibit at the Tate Gallery in 1946 had made a strong impression on him, and Braque and Bonnard were the strongest influences on his early work. Braque's influence is present in Heron's neocubist decorative portrait of T. S. Eliot (1949; National Portrait Gallery, London). His *Harbour Window with Two Figures: St. Ives: July 1950,* painted in a semiabstract, semifigurative style, owes much to the flattened, irregular shapes and condensed pictorial space of Braque's later works, though the color and imagery are Heron's.

A number of the canvases in his Redfern Gallery exhibitions were inspired by the harbor and the general atmosphere of Heron's St. Ives, and though established in London, he maintained contact with Cornwall. In 1947 he showed at Downing's Bookshop in St. Ives.

Heron's early work was also influenced by the luminous, near-abstract compositions of Nicolas de Staël. There are echoes of de Staël in the broad areas of color and sensuous manipulation of paint seen in *Still Life with Black and White Check Tablecloth* (1953). *The Girl in Purple* (1954), one of Heron's finest canvases of the 1950s, pays homage to Matisse as well as Braque.

However, Heron's paintings of 1950–55 are distinctly individual. Mostly interiors with figurative elements, they contain, as Malcolm Quantrill wrote in *Studio International* (March 1979), "definite evidence of his later abstract imagery." When these early canvases were exhibited at the Waddington Galleries, London, in 1979, along with paintings from the years 1970–77, Quantrill described these interiors of the '50s as "a mixture of sedateness and jauntiness."

Heron's first retrospective was held in 1952 at the Wakefield City Gallery; it then toured Britain. In 1953 he was among the younger British painters shown at the São Paulo Bienal. From 1953 to 1956 he served as painting instructor at the Central School of Arts and Crafts, London.

As teacher, critic and, from 1956 on, visiting lecturer at British art schools and colleges, Heron championed New York School abstract expressionism at a time when American art was not yet taken seriously in Britain. He defended the bold new work of Pollock, de Kooning and, especially Rothko and Adolf Gottlieb against critics who, to quote *The Guardian* (June 21, 1972), "could see virtue only in the homely compositions of Andrew Wyeth."

In 1955 Heron became the London correspondent for *Arts Magazine* in New York, a position he held until 1958. Editor Hilton Kramer considered Heron "the best art critic to have emerged in London since Roger Fry." (In later years, however, when New York solidified its position as the world capital of art and spawned a host of influential avant-garde styles, Heron wrote blistering politics against what he called "the American juggernaut.")

In 1959 Heron was awarded the Grand Prize at the John Moores Exhibition at the Walker Gallery, Liverpool. In 1960, he held his first American solo at the Bertha Schaefer Gallery, New York City. At the time known to Americans mostly as a distinguished art critic, he was now described in the New York *Herald Tribune* as "a member of the new group of British artists painting at St. Ives, in Cornwall." (Heron had returned to Cornwall in 1956 and was living near St. Ives at Zennor.) His paintings had become far more abstract in the late 1950s, and the *Tribune* noted that Heron's "interest in painting is in poetic symbols of the environment he occupies." In these "dominantly deep and luxuriously colored canvases," the critic continued, including *Two Squares in Green* and *Violet and Dull Green,* "there is much to be sensed, though very little to be specifically identified with them." The writer admired the "challenging richness and variation" of the canvases and noted that Heron's paintings "never once referred to an experience with nature, however remote."

Heron's most important publication of the 1950s was his book *The Changing Forms of Art* (1955). *The Guardian* (July 4, 1967) wrote that Heron's painting after 1957 was "an often tense, but always exciting balancing act between colors and the shapes they assume." Heron himself declared in a statement of 1962 that "color is the only direction in which painting can travel"; he later modified this rather dogmatic postion. In 1965 he was awarded the Silver Medal at the São Paulo Bienal and gave lectures in São Paulo, Rio de Janeiro, and Brasilia.

During a visit to Australia in 1967 Heron lectured in Perth and Sydney. He opened the lectures he gave in Sydney by stating, "The fact that painting comes before criticism is a fact of which many are increasingly unaware." His remark was greeted by a round of applause from "frustrated painters"—or so Heron assumed. Years later he realized "that a lot of, not socialists, or social realist critics, but conceptualist critics were sitting in the front row." Heron himself was opposed to both the Marxist viewpoint, as represented by British critic John Berger and Italian painter Renato Guttuso, and the cerebral approach of the Conceptualists.

His article, "A Kind of Cultural Imperialism," published in *Studio International* in February 1968, caused a sensation in its vehement attack on what he viewed as the domination of the British art scene by American trends. Though everything that was innovative was ascribed to America, Heron pointed out, in 1972, that he had been working on striped paintings as early as 1957, *before* Morris Louis did so in the US. While decrying the influence and prestige of American art—he particularly attacked Frank Stella and Donald Judd—Heron began to assert the superiority of British painters of his own generation. "Mr. Heron has now become a vociferous patriot, in addition to being a painter and critic," wrote Hilton Kramer in *The New York Times* (July 11, 1972). Heron himself humorously remarked in 1978: "I seem to be a kind of Colonel Blimp forever waving a Union Jack in some people's minds."

In the same *New York Times* article of July 11, 1972, which was a reviewing of Heron's show at the Whitechapel Art Gallery, London, Kramer observed that "Mr. Heron's current pictorial interests, as distinguished from his political obsessions, are much closer to the American art he regularly denounces than he appears to be aware." Kramer considered Heron at his best in such works as *Scarlet in Red with Orange* (1969), where the forms were at their simplest and fewest and were "closed" rather than "open." Kramer praised Heron as "an extremely gifted colorist," but felt that "this gift for color is not often enough supported by an equally strong gift for pictorial invention." London's *Observer* (June 5, 1972) remarked on the size and radiant color of the artist's later paintings, of which *Complicated Green and Violet: March 1972* was "a particularly sumptuous example." In the exhibition catalog, Heron wrote that he did not practice the techniques of extreme severity preferred by a number of younger English painters.

On a return visit to Australia in 1973, Heron again delivered the Power Lecture on Contemporary Art, this time entitled "The Shape of Color." In 1977 he was created a Companion of the British Empire in the New Year's Honor List. He delivered a series of lectures on "The Color of Color" at the University of Texas, Austin, in the spring of 1978, and in November of that year he lectured and taught in New York City.

Heron's exhibition at the Waddington Galleries in February 1979 consisted of two distinct groups of paintings, one from the period from 1950 to 1955, and the other from the years of 1970–77. The earlier works "with their structural quality, and their Braque-like figurative elements have a strong flavor of the School of Paris," according to the review in the London publication *Art and Artists* (April 1979). At the same time, the catalog introduction pointed out, "Already in these pictures are the seminal images of his abstract style which matured from 1956." Typical of the later works were *Rumbold Vertical Three: Orange Disc in Scarlet with Green: July 1970*, and *Complex Greens, Reds and Orange: July 1976–January 1977*.

Patrick Heron is above medium height, with clear-cut features, and has a self-assured, animated manner. He lives in a hillside house called Eagle's Nest, three miles from St. Ives. "Nothing grows (on the hillside) except heather, a few wild rhododendron bushes, and, at the moment, bluebells," wrote *The Guardian* reporter (July 1, 1972). However, the previous owner of Eagle's Nest had planted "an extraordinary exotic garden on the rocky outcrop around the house." The writer noted that Heron grows uneasy if he feels that the configurations of the landscape have influenced the shapes in his paintings, or that "his visual experience of the Atlantic horizon was affecting his work."

Because Eagle's Nest is too small to accommodate Heron's largest canvases, which sometimes measure nearly 7 feet high by 15 feet wide, Heron works in a vast studio in St. Ives that once belonged to Ben Nicholson. He works rapidly, sketching with a felt pen on canvas the outlines of forms already drawn on old newspapers and discarded envelopes.

Heron has defined his aims as follows: "The secret of good painting—of whatever age or school, I am tempted to say—lies in its adjustment of an inescapable dualism: on the one hand there is the illusion, indeed the sensation of depth; and on the other there is the physical reality of the flat picture surface. Good painting creates an experience which contains both." He discussed his primary concerns in the lecture entitled "The Shape of Color" which he delivered in Australia in 1973: "Because painting is particularly concerned with the *seen,* as distinct from the *known,* pictorial space and pictorial color are virtually synonymous.And so, in manipulating color, painting is organizing the very stuff of which sight or vision consists."

EXHIBITIONS INCLUDE: Redfern Gal., London 1947, '48, '50, '51, '54, '56, '58; Downing's Bookshop, St. Ives, Cornwall, England, 1947; Wakefield City Art Gal., England 1952; Waddington Gals., London from 1959; Bertha Schaefer Gal., NYC 1960, '62, '65; Gal. Charles Lienhard, Zurich 1963; Dawson Gal., Dublin 1967; Richard Demarco Gal., Edinburgh 1967; Kunsternes Hus, Oslo 1967; Mus. of Modern Art, Oxford, England 1968; Waddington Fine Arts, Montreal 1970; Rudy Komm Gal., Sydney, Australia 1970; Harrogate Festival, England 1970; Whitechapel Art Gal., London 1972; Bonythorn Gal., Sydney, Australia 1973; Skinner Gal., Perth, W. Australia 1974; "Prints on Prince Street," NYC 1974; Rutland Gal., London 1975; Gal. Le Balcon des Arts, Paris 1977; Univ. of Texas at Austin Art Mus. 1978; "Patrick Heron: Paintings 1950–55 and 1970–77," Waddington Gals. II, London 1979. GROUP EXHIBITIONS INCLUDE: Salon de Mai, Paris 1949; "Aspects of British Art," Inst. of Contemporary Arts, London 1950; São Paulo Bienal 1953, '65; "British Art 1900–1950," Copenhagen 1954; John Moores Exhibition, Walker Gal., Liverpool 1959; "Eleven British Painters," Jefferson Place Gal., Washington, D.C. 1959; Pittsburgh International, Carnegie Inst. 1961; "British Art Today," Mus. of Art, San Francisco 1962; "Painting and Sculpture of a Decade: 1954–1964," Tate Gal., London 1964; "British Painting and Sculpture 1960–1970," Nat. Gal. of Art, Washington, D.C. 1970; Sydney Biennale, Sydney Opera House, Australia 1973; "Europalia '73, Great Britain; Henry Moore to Gilbert and George," Palais des Beaux-Arts, Brussels 1973; "British Painting '74," Hayward Gal., London 1974; "The British Are Coming," Cordova Mus., Lincoln, Mass. 1975.

COLLECTIONS INCLUDE: Tate Gal., Victoria and Albert Mus., British Mus., Nat. Portrait Gal., British Council, Arts Council of Great Britain, Peter Stuyvesant Foundation, Calouste Gulbenkian Foundation, and Contemporary Art Society, London; Fitzwilliam Mus., Cambridge, England; City Art Gal., Manchester, England; City Art Gal., Leeds, England; City Art Gal., Sheffield, England; City Art Gal., Bristol, England; Nat. Mus. of Wales, Cardiff; Art Gal., Aberdeen, Scotland; Boymans-Van Beuningen Mus., Rotterdam; Brooklyn Mus., N.Y.; Albright-Knox Art Gal., Buffalo, N.Y.; Smith Col. Mus. of Art, Northampton, Mass.; Univ. of Michigan Mus. of Art, Ann Arbor; Toledo Mus. of Art, Ohio; Mus. of Fine Art, and Mus. d'Art Contemporain, Montreal; Toronto Art Gal., London Art Gal., Ontario, Canada; Vancouver Art Gal., British Columbia; Nat. Gal. of Queensland, Brisbane, Australia; Art Gal. of South Australia, Adelaide; Nat. Gal. of Western Australia, Perth; Power Collection, Sydney, Australia.

ABOUT: Heron, P. The Changing Forms of Art, 1955, Ivon Hitchens, 1955, Braque, 1958, "Patrick Heron" (cat.), Whitechapel Art Gal., London, 1972. "Patrick Heron: Paintings 1950–55 and 1970–77" (cat.), Waddington Gals. II, London, 1979; P-Orridge, G. and others (eds.) Contemporary Artists, 1977; Smith, B. (ed.) Concerning Contemporary Art: The Power Lectures 1968–1973, 1975. *Periodicals*—Art and Artists April 1979; Art International (Lugano) February 1963, March 1979; Art News and Review May 1950; Arts March 1956, May 1958; Arts Review July 1972; Artscribe Spring 1976; Australian (Sydney), June 1973, Guardian July 4, 1967, August 8, 1970, October 12, 1971, June 21, 1972, July 1, 1972; New York Herald Tribune April 17, 1960; New Statesman March 1963; New York Post April 17, 1960; New York Times April 17, 1960, January 3, 1971, July 11, 1972; Observer May 14, 1967, June 25, 1972, May 19, 1974; Studio International December 1966, February 1968, December 1969, December 1970, February 1974, March 1979.

HIRSCHFELD, AL(BERT) (June 21, 1903–). Wit, inventiveness, an acute yet never malicious perception of character, and an unerring decorative sense, these are the qualities that have distinquished the caricatures of Al Hirschfeld for nearly six decades. Though he has traveled extensively, and recorded many aspects of the passing scene, his chosen arena is the world of theater and entertainment. The Hirschfeld caricatures of productions, performers, actors, and playwrights appearing weekly in the Sunday *New York Times* have become part of American theatrical history and capture the excitement of the Broadway stage and of theater generally, and the artist has been compared to Cruikshank, Daumier, and Toulouse-L'autrec.

As William Feaver wrote in his book *Masters of Caricature,* "Hirschfeld has done a great deal through his drawings to reinstate caricature as an art form, as opposed to an aspect of political cartoons and satire." Hirschfeld himself, in his autobiographical preface to *Hirschfeld's World,* remarked that he "would feel more comfortable being classified as a 'characterist', if there were such a word or school," than as a caricaturist. (Interestingly, William Hogarth, in his 1753 treatise on aesthetics, *The Analysis of Beauty,* also distinguished between "character" and "caricature," regarding the former as his province.)

© Margo Feiden Galleries, 1973

AL HIRSCHFELD

Albert Hirschfeld was born in St. Louis, Missouri, one of three sons of Isaac Hirschfeld, a salesman, and Rebecca (Rothberg) Hirschfeld, a Russian immigrant. As a boy in St. Louis, Al took art lessons, and showed such aptitude for drawing, painting, and sculpturing that his mother decided his talent could best be developed in New York City. In 1915 the family moved to uptown Manhattan, where Al attended public schools and took classes at the National Academy and the Art Students League. Economic pressures forced him, at 15, to take a job as an office boy in a New York motion-picture studio. This was his first contact with the entertainment world; hardly an auspicious beginning it nonetheless led, two years later, to his becoming art director for the movie producer David Selznick. Soon afterwards he was working in the art department of Warner Brothers.

Hirschfeld had saved enough money by 1924 to quit his job and go to Paris, intending to become a painter. He settled on the Left Bank and studied painting and sculpture at the Académie Julienne. He recalled: "In Paris, in those halcyon years, I grew a beard, wore wooden sabots, corduroy pants, lumberjack shirts, and seriously painted in oil on Belgian canvas." He has retained the beard (now a majestic white) over the years, but his work, from the mid-1920s, underwent drastic changes. He found that he was losing interest in painting and sculpture, and that "most of my paintings were really drawings in color, and my drawings were really sketches for paintings." After a brief "flirtation" with watercolor, he found that printmaking suited his talents, and as Lloyd Goodrich wrote in his

introduction to *Hirschfeld's World,* the artist's lithographs of those years "reveal a skillful draftsman fully aware of what was going on in the international art scene." But Hirschfeld came to realize that "my real satisfaction, was the image in pure line"; allowing for considerable changes in his draftsmanship, the black and white medium of line has remained his prime means of expression ever since.

Hirschfeld discovered what was to become his true Métier as a result of a sketch he made, on one of his occasional visits to New York City from Europe, of the French actor-playwright Sacha Guitry, then making his debut on the Broadway stage. The sketch, doodled on the back of the theater program, was admired by Hirschfeld's companion, press agent Dick Maney, who persuaded him to redo the drawing on a clean sheet of paper. Maney showed the finished drawing to a friend on the editorial staff of the New York *Herald Tribune,* and the following Sunday the sketch appeared on the cover of the *Tribune's* drama page. From then on Hirschfeld made a weekly contribution to the Sunday edition.

During his stay in Europe he extended his formal art training by studying at the County Council in London. He also made the first of several trips to the Soviet Union, and in 1927 was the *Tribune's* theater correspondent in Moscow. That was still a vital period in the Soviet theater. The era of Meyerhold and other innovative directors and designers. One of Hirschfeld's early lithographs, *Soviet Worker, Moscow,* dates from 1927; the style, like his other prints of the '20s and early '30s, is an emphatic, chiaroscuro manner recalling William Gropper, very different from his later style.

For a number of years Hirschfeld's identification with progressive politics was reflected in his art, and he contributed, without pay, drawings to the communist *New Masses* (he broke with that periodical in the 1930s). "I have . . . been closer to Groucho Marx than to Karl," Hirschfeld later said of his disenchantment with orthodox leftism.

Hirschfeld's comedic flair was evident in a caricature he made in the mid-20s of the Scottish comedian Sir Harry Lauder which appeared in *The New York Times,* the first of hundreds of such drawings executed for that newspaper over the next half century.

As late as 1931 Hirschfeld was still, in his words, "toying with the unrewarding chore of copying nature—in oil and watercolor." He had exhibited sculpture at the Newhouse Galleries, New York City, in 1925 and other shows in the late '20s held in Paris, New York, St. Louis, and

Chicago were favorably received, but the quintessential Hirschfeld began to emerge as a result of a visit to the island of Bali in 1931. His theater drawings of the 1920s had a stylized, geometric, somewhat Art Deco flavor, influenced by cubism, Aubrey Beardsley, John Held Jr., a chronicler of the flapper era, and the Mexican caricaturist Miguel Covarrubias, who drew for *Vanity Fair, Fortune,* and other American magazines. Typical of Hirschfeld's earlier style are his portraits of Florence Reed as Mother Goddam in *Shanghai Gesture* (1926) and Basil Rathbone in profile as the Homme Fatal in *The Command to Love* (1928). In Bali in the Dutch East Indies (now Indonesia), Hirschfeld's fascination with drawing "blossomed into an enduring love affair with line" and he observed that "the Balinese sun seemed to bleach out all color, leaving everything in pure line. The people became line drawings walking around."

Moreover, Hirschfeld admits to having been influenced far more by the drawings and prints of Harunobu, Utamaro, and Hokusai than by the painters of the West. He wrote in 1979: "Since the day I left Bali heading for Paris and eventually the USA, I have never had the slightest interest in watercolor or oil paint." He admired the life-sized Javanese shadow puppets, and the graceful, sinuous lines of his fully developed style often suggest the undulation of Balinese dancers. This Oriental feeling is particularly noticeable in his unique treatment of hands, which have a flowerlike suppleness and elasticity, whether the subject be George Gershwin at the piano, Gwen Verdon and the dancers in *Sweet Charity* (1966), or Hirschfeld's delightful self-caricature which has become his trademark.

The new linearity is evident in the theater caricatures of the 1930s, although there is a certain hardness in the drawing, compared to the subtlety and calligraphic fluency of his later style. Flat areas of black are combined with the graphic line—there are no half-tones or shading (which is advantageous for reproduction, especially when reduction is necessary). There was already a lively use of decorative textures, as in the fur cap and peasant blouse of Jimmy Durante as a mad Russian in the musical *Stars in Your Eyes* (1939). In his interpretation of William Saroyan's first play, *My Heart's in the Highlands* (1939). Hirschfeld displayed his ability to combine various characters and scenic elements of the production in a unified overall design which is full of movement and telling contrasts.

In 1927 Hirschfeld had married Florence Ruth Hobby; they were divorced in 1942. In the early 1940s, on an assignment at the Summer Theater at Eaglesmere, near Hershey, Pennsylvania, he met the guest star, the charming and gifted German-born actress Dolly Haas. He recalled in his book *The American Theatre as Seen by Hirschfeld,* "I thought she was the greatest actress I had ever seen: I married her." They were married on May 8, 1943, and in the fall of 1945 their daughter Nina was born. Hirschfeld celebrated the event by including her name in a drawing of the musical *Are You With It?,* and added to the circus background a poster of a newborn infant reading from a large book. Lettered on the poster were the words "Nina the Wonder Child." From then on the name Nina was ingeniously worked into each drawing for the Sunday *New York Times.* It might appear in the folds of a sleeve, a robe or skirt, in shoelaces, strands of hair, or somewhere in the background. When there was more than one Nina, a tiny numeral was inscribed next to the familiar Hirschfeld signature, for the benefit of the many thousands of *Times* readers for whom "finding the Ninas" had become an incurable addiction.

Hirschfeld's 1932 book of lithographs, *Manhattan Oases* had captured the atmosphere of the Prohibition-era speakeasies. His book *Harlem* (1941), for which William Saroyan wrote the text, was a vivid record of the black music and dance of the time. His next collaboration with an author began in the mid-1940s when he and the humorist S.J. Perelman, another theater aficionado, worked together in Philadelphia on the book for a "futuristic" musical comedy, *Sweet Bye and Bye.* They were later joined by the composer Vernon Duke and by Ogden Nash, who supplied lyrics. Despite this array of talents, the show opened and closed in one night in Philadelphia, never reaching Broadway. A much happier venture was the trip around the world Hirschfeld and Perelman took in 1947, which led to their best-selling book *Westward Ha!,* published the following year.

Among Hirschfeld's most memorable theatrical caricatures of the 1940s was his impression of the Broadway production of George Bernard Shaw's *Man and Superman* (1947), with G.B.S. as the smiling puppet-master working the strings of Maurice Evans as John Tanner, and the British actress Frances Rowe as Ann Whitfield (the Nina was in Shaw's beard). Another was of a resplendent Mae West in *Diamond Lil* (1949), reclining on chaise longue against a lush hearts-and-flowers background. In the 1950s the range of the drawings continued to embrace admirably orchestrated composite scenes, such as *West Side Story* (1957) and the off-Broadway dramatization of James Joyce's *Ulysses in Nighttown* with Zero Mostel (1958). Hirschfeld's striking images of individual performers included Ethel Waters (1953), who, the artist remarked, "makes

me cry when she says hello," and an irate, heavily bewhiskered Orson Welles in the title role of *King Lear* (1956), which, because of an accident, had to be performed from a wheelchair. In every instance there is a sense of movement and gesture, whether or not physical action is being portrayed. Caricature has been called "the gesture of a face," and in terms of recognition Hirschfeld's performers, far from being photographic likenesses are, to quote Lloyd Goodrich, "more like the person than the person himself."

With undiminished verve and ever-increasing variety of line and composition, the Hirschfeld theater chronicle has continued through the 1960s and '70s into the early '80s. The evolution of his style since the 1920s, along with the changing character of the American stage, can be studied in *The American Theatre as Seen by Hirschfeld,* a collection of his theatrical caricatures grouped according to decades and published in 1961. *Hirschfeld by Hirschfeld,* published in 1979 with an introduction by John Russell, featured more recent drawings, mostly from the 1970s, and portrayed stars of Hollywood, television, opera, and ballet as well as theater performers and personalities. Among the last-mentioned group, some of the gems include Jack Lemmon in *Tribute* (1979), Angela Lansbury as the rascally Mrs. Moffatt in the Harold Prince/Stephen Sondheim musical drama *Sweeney Todd* (1979), and the intense, embattled, pipe-smoking producer Joseph Papp. Hirschfeld is undoubtedly relieved not to be a drama critic, for in addition to the hit shows he has, in his many years of theatre-going, inevitably witnessed disastrous, or merely mediocre, productions and performances. Yet even from the least promising material he has been able to extract images which, in Goodrich's words, "speak to the eye in direct physical terms." Hirschfeld has a special feeling for details of costume which are rendered as expressively as the people and contribute to the total "persona."

Since 1969 Hirschfeld has been represented exclusively by the Margo Feiden Galleries, New York City.

In addition to his drawings in black and white, his color lithographs of Balinese dancers and Japanese Nô and Kabuki players have been exhibited there. His works in color, which are boldly decorative, display yet another facet of his talent, but black and white is still his most personal means of expression.

Al and Dolly Hirschfeld have an attractive apartment in a brownstone on the Upper East Side of Manhattan. Their daughter Nina, who also lives in New York city, is married and has a son, Matthew. The most unusual feature of

Hirschfeld's studio is a homely, well-worn barber chair in which he sits at his drawing table, transforming rough sketches and scribbles made in the darkness of the theater—he has even learned to draw in his pocket—into a "designed composition for a finished caricature." In *Hirschfeld's World* he writes, "Working on a 20-by-30-inch triple ply, cold pressed illustration board, I use the whole board for the drawing, regardless of the size it eventually winds up in reproduction."

The New York Times (November 24, 1981), reporting a party given for him at Broadway Joe's, a midtown Manhattan restaurant, described Al Hirschfeld as "a familiar, gracious figure, with an elegant ascot and the neat Vandyke beard that he first grew as an art student in Paris." Actually the beard is more Assyrian than Vandyckian, and, in its whiteness, contrasts dramatically with his brown eyes and bushy black eyebrows. He has a warm, sympathetic personality, and although he relishes the frequent absurdities and vagaries of the world he portrays, he also appreciates and conveys its magic. He is no corrosive satirist like George Grosz, and, as he has observed, "It is never my aim to destroy the play or the actor by ridicule . . . the aim is to recreate the performed character and not reinterpret the 'character' by ridicule or aggressive insult. "Nearly as deft with the written word as with pen and pencil, Hirschfeld wrote in 1979: "The problem of placing the right line in the right place has absorbed all of my interests across these many years. . . . I am still enchanted when an unaccountable line describes and communicates the inexplicable."

EXHIBITIONS INCLUDE: Newhouse Gals., NYC 1925, '28; Guy Mayer Gal., NYC 1942; Heller Gal., NYC 1960; Hammer Gal., NYC 1967; Mus. of Performing Arts, Lincoln Center, NYC 1969; Margo Feiden Gals., NYC from 1969; Gracie Mansion, NYC 1983; Harvard Theatre Collection, Fogg Mus., Cambridge, Mass. 1983.

COLLECTIONS INCLUDE: Metropolitan Mus. of Art, MOMA, Whitney Mus. of Am. Art, Mus. of the City of New York, New York Public Library, and Mus. and Library of Performing Arts, Lincoln Center, NYC; Fogg Mus., Cambridge, Mass.; Cleveland Mus. of Art; City Art Mus., St. Louis, Mo.

ABOUT: Current Biography, 1971; Feaver, W. Masters of Caricature, 1981; Hirschfeld, A. Manhattan Oases, 1932, (and others) Harlem, 1941, (and others) Westward Ha!, 1948, Show Business is No Business, 1951, The American Theatre as Seen by Hirschfeld, 1961, (and others) The Lively Years 1920–1973, 1973, Hirschfeld by Hirschfeld, 1979, Hirschfeld's World, 1981. *Periodicals*—Look November 8, 1960; New York Times June 21, 1978, November 24, 1981; Playbill September 1963, December 1973.

HITCHENS, (SIDNEY) IVON (March 3, 1893–), British painter, was a doyen of modern painting in Britain. Born in London, the son of painter Alfred Hitchens, Ivon at the age of five entered Bedales School, near Petersfield, Hampshire, one of the earliest coeducational schools in England, and remained there until 1909. The schools's encouragement of student creativity, combined with Hitchens's family environment, nurtured his artistic leanings. A trip in 1909–10 to New Zealand via Ceylon and Australia helped him to develop his already strong feeling for color.

After his return to London, Hitchens studied art at St. John's Wood Art School from 1911 to 1912. He continued his studies at London's Royal Academy School until 1914 chiefly under the tutelage of the well-known painter William Orpen. In 1918, after the end of World War I, Hitchens spent another year at the Royal Academy School.

As one British critic observed, Hitchens, like his contemporary Ben Nicholson, was "a slow starter." In 1922 he joined the Seven and Five Society in London (its other members were Ben Nicholson, Henry Moore, David Jones, John Piper, and Barbara Hepworth), and in 1923 he traveled in France. Hitchens met Ben and Wilfred Nicholson in 1924, and the following year he stayed with them in Brampton, Cumberland. By that time he had developed a strong feeling for landscape, as revealed by a group of early watercolor and pencil landscapes dating from 1922 that indicate some of his compositional preoccupations. Specifically, the forms of farm buildings and trees were treated in simplified planes and subordinated to an overall decorative rhythm. These were tentative beginnings, because, in the 1920s, the modern movement had not yet taken hold in official British art circles.

Hitchens had his first solo show in 1925, at the Mayor Gallery, London, and he was represented in a group show of "Flower Paintings" at Heal's Mansard Gallery in 1927. Hitchens's second solo show was held in 1928 at Arthur Tooth and Sons, London. The following year he became a member of the London Artists' Association, and in 1931 Hitchens was elected to the relatively progressive London Group.

Hitchens's *A Landscape at Selborne* (1929) depicts a view from a balcony window with a cat asleep in the foreground. It has a joyously rhythmic quality and a lyricism that he would subsequently carry much further.

In 1932 and 1933, when he was 40 years old, Hitchens's true individual development began. At that time, he was strongly influenced by Wassily Kandinsky's ideas about the primacy of color

Jorge Lewinski

IVON HITCHENS

and the "musical" character of painting. A growing freedom and "musicality" are evident in *Autumn Composition, Flowers on a Table* and *Still Life*, both painted in 1932 and both tending further toward abstraction than any of his previous work. In *Reclining Nude* (1933) the figure merges effortlessly with its surroundings in an expressive counterpoint of freely brushed areas of color and bold directional lines.

In 1935 Hitchens married Mary Cranford Coates. Mrs. Hitchens identifies so closely with her husband's work that she refers to canvases in progress as "our painting"; still, she does not hesitate to voice her honest critical opinion.

Control (1935), a watercolor, chalk, and India-ink painting, was one of a group of symbolic religious pictures painted in an abstract idiom. An oil called *Abstract Composition* (1935) has a calligraphic quality that reminded some critics of early Hans Hartung, the noted Tachist.

In 1937 Hitchens became a member of the Society of Mural Painters. His festive canvas *Coronation* (1937), painted in the year of the coronation of King George VI, was one of a number of abstract or near-abstract pictures which, though influenced by Kandinsky's idea of painting as "visual music," were distinctly personal in their decorative handling of form and color. However, *Winter Stage, Moatlands Park* (1936; Tate Gallery, London) provided a clearer indication of the future course of Hitchens's painting. It is one of his first ambitious landscape compositions, characterized by multiple centers of vision and by flat unmodeled planes of color.

Hitchens's tendency to paint landscape was

accentuated by World War II, which isolated British artists, particularly those above the age for active military service. Hitchens's London studio was bombed in 1940, and he and his wife moved to Petworth, Sussex, where they settled permanently. Petworth House, the home of Lord Egremont, had been one of Turner's favorite haunts, and Hitchens, despite his near-abstract idiom, temperamentally belongs to the romantic English landscape tradition of Constable and Turner, for whom nature as landscape was a primary source of inspiration. Hitchens's son John Patrick, who like his father and grandfather became a painter, was born in 1940.

The Sussex war years were a productive period. Hitchens's lyrical semiabstractions include *Green Plantation* (1943), painted near the artist's house, and *Interior, Boy in Bed* (1943), one of several canvases that included John Patrick in the motif. Landscapes were interspersed with flower paintings, including *Autumn Group* (1941) and *Balcony with Flowers* (1943). "I love flowers for painting," he said. "One can read into a good flower picture the same problems that one faces with a landscape, near and far, meanings and movements of shapes and brush strokes." His paintings, a critic noted, have tended to be cyclical in both color and composition, sometimes vernal, sometimes autumnal.

With the war over, in 1945 Hitchens shared a retrospective exhibition at Temple Newsam, Leeds, with Henry Moore. In 1946 he was represented in the "International Exhibition of Modern Painting" organized by UNESCO in Paris, and also in exhibitions of modern British painting held at the Tate Gallery and the Jeu de Paume, Paris. Some of Hitchens's finest canvases date from the immediate postwar years, among them *Winter Walk, No. 1* (1948), with its rich, mellow tones and its suggestion, through color, of space and depth; *Shrouded Water, No. 1* (1948), painted in the artist's woodland; and the fluid, evocative *Yellow Depths* (1950).

An exhibition in 1950 at London's Leicester Galleries consisting almost entirely of reclining nudes revealed a different aspect of Hitchens's work. The exhibition was an instant success. The *Sunday Times* of London critic wrote that Hitchens had "wrought a double change in his pictures, making them both richer in color and broader in construction." Hitchens lodged his models in a yellow trailer near his house. He painted them on couches—"because they chatter less in that position"—their faces left almost blank and their bodies, according to *Time* magazine, with "more paint than flesh about them." The review described them as "limp, heavy figures painted in broad strokes of summery colors."

In 1951 Hitchens was awarded a Purchase Prize in the Arts Council's Festival of Britain exhibition, "60 Paintings for 51." In 1954 he completed his first large-scale commission, a vast mural, 20 feet by 69 feet, in the hall of the English Folk Song and Dance Society's headquarters on Regent's Park Road, London. *Tree Landscape* (1955) was typical of his easel paintings of the mid–1950s. Boldly brushed, painterly areas of color provide the main architecture of the picture, which is randomly transversed by directional lines that Hitchens calls "formes," meaning "two-dimensional marks on the canvas not representing anything." Hitchens favors paintings much wider than they are high because a wide friezelike picture forces the eye to "read" across it.

Hitchens exhibited at the Venice Biennale of 1956, and his work subsequently toured Vienna, Munich, Paris, and Amsterdam under the auspices of the British Arts Council. In the following year he was created a Companion of the Order of the British Empire. His "Firewood Ride" paintings of 1957 are among his most satisfying creations, fulfilling his expressed desire that "vision, emotion and memory orchestrate one sound. . . . "

Reviewing a Hitchens retrospective at the Tate Gallery in 1963, *The Guardian*'s critic commented that Hitchens was a painter "who depends almost entirely on the quality of paint." He had evolved, the reviewer continued, a method consisting of "a series of simplifications in which the observant eye loses touch with the thing seen and becomes a product of the brush itself." As a result, "what began as a tree, a pond, or a patch of light and water becomes an area of paint enlivened by the sensitivity of the hand that held the brush." There had been a development in Hitchens's work from the early '30s to the early '60s "in the direction of even greater breadth, simplicity and succulence."

There were times, however, the critic added, as in the 1954 mural for the English Folk Dance Society, when Hitchens understood that "succulence is not enough," and that strong linear scaffolding was required. His ability to build a solid structure on a large scale was indicated by another mural, this one for the new University of Sussex in Brighton. The mural, measuring 12 feet by 24 feet and titled *Day's Rest, Day's Work,* was installed at the university in the autumn of 1963. This important work represented the culmination of the many figure studies Hitchens had done over the years. One opinion held that however "magnificently designed" this and Hitchens's 1954 mural were, an acute conflict existed "between the abstract-decorative and the faithful-to-nature elements," a conflict in which

"the decorative comes off second best in precisely the situation where one would expect it to dominate."

Hitchens's paintings were first shown in the United States in 1966, at the Poindexter Gallery, New York City. Hilton Kramer described the artist in *The New York Times* as "a painter of uncommon delicacy" who had "preserved the integrity of pure painting at a time when most English art was irredeemably in thrall to literary ideas." Kramer especially admired *Arched Dell* (1964), but felt that there was now something "a bit mannered in the way the artist places his wide swaths of color across the horizontal plane of the picture surface." In Kramer's opinion, "An imagery already fragile has been further refined without being strengthened or enlarged in the process." Kramer compared the imagery and painterly technique of Hitchens to the work of the American Arthur Dove and the Russian-born Parisian Nicolas de Staël, but added that unlike those artists Hitchens had never resolved the wavering "between a visual generalization and a report of concrete sensation." Despite these limitations, Hitchens remains "a pure and undefiled sensibility."

Ivon Hitchens was described in *Time* as "a mild, silver-haired sparrow of a man." He and his wife live in a crowded Sussex cottage, and Hitchens prefers to work outdoors. When he discusses his own work, it is nearly always in terms of music. He has said that his method is like "playing a tune—playing one color off against another. Sometimes it jars; sometimes there is no harmony and I have to start afresh. But when it fits it's wonderful!"

EXHIBITIONS INCLUDE: Mayor Gal., London, 1925; Arthur Tooth and Sons, Ltd., London 1928; Alex Reid and Lefevre Gal., London 1933, '35, '37; Leicester Gal., London 1940, '42, '44, '47, '49, '50, '52, '54, '57, '59; Graves Art Gal., Sheffield, England 1948; British Pavilion, Venice Biennale 1956; Gimpel Fils, London 1956; Waddington Gal., London from 1960; Tate Gal., London 1963; Southampton Art Gal., England 1964; Poindexter Gal., NYC 1966; Basil Jacobs Fine Art Ltd., London 1971; Rutland Gal., London 1972. GROUP EXHIBITIONS INCLUDE: "7 and 5 Exhibition," Waler's Gals., London 1922; "Flower Paintings," Heal's Mandard Gal., London 1927; "Objective Abstractions," Zwemmer Gal., London 1934; Venice Biennale 1936, Pittsburgh International, Carnegie Inst. 1937, '50; "Contemporary British Art," British Pavilion, New York World's Fair, NYC 1939; Temple Newsam, Leeds, England 1945; "Modern British Painting from the Tate Gallery," London 1946; "Modern British Painting from the Tate Gallery," Jeu de Paume, Paris 1946; "International Exhibition of Modern Painting," UNESCO, Paris 1946; "International Exhibition of Contemporary Art," Cairo, Egypt 1947; "Contemporary Art," Art Gal. of Toronto 1949; Sāno

Paulo Bienal 1951; "60 Paintings for 51," Arts Council, Festival of Britain 1951; "Hitchens, Sutherland, Moore," Crane Gal., Manchester, England 1953; "Masters of British Painting 1800–1950," MOMA, NYC 1956; "British Painting 1700–1960," Pushkin Mus., Moscow, 1960; "British Painting 1700–1960," Hermitage, Leningrad 1960; "British Art Today," San Francisco Mus. of Art, 1962; "British Art Today," Dallas Mus., of Art 1962; "British Art Today," Santa Barbara Mus., Calif., 1963; "British Painting in the Sixties," Contemporary Art Society, Tate Gal., London 1963; "Decade 40's: Painting, Sculpture and Drawing in Britain 1940–49," Whitechapel Art Gal., London 1972.

COLLECTIONS INCLUDE: Tate Gal., Victoria and Albert Mus., Arts Council of Great Britain, British Council, and Contemporary Art Society, London; Fitzwilliam Mus., Cambridge, England; Ashmolean Mus., Oxford, England; Leeds Art Gal., England; Nat. Mus. of Wales, Cardiff; Mus. Nat. d'Art Moderne, Paris; Natl. Gal., Oslo; Art Mus., Gothenburg, Sweden; Albright-Knox Art Gal., Buffalo, N.Y.; Toledo Mus. of Art, Ohio; Seattle Art Gal.; Mus. of Fine Arts, Montreal; Nat. Gal. of Canada, Ottawa; Art Gal. of Toronto; Nat. Gal. of South Australia, Adelaide; Nat.Gal. of Victo ria, Melbourne; Nat. Gal. of New South Wales, Sydney; Nat. Gal. of New Zealand, Wellington.

ABOUT: Heron, P. The Changing Forms of Art, 1955, Ivon Hitchens, 1955; "Ivon Hitchens" (cat.), Arts Council of Great Britain, London, 1963; "Objects Abstractions" (cat.), Zwemmer Gal., London, 1934; Read, H. Contemporary British Art, 1951; Rothenstein, J. British Art Since 1900, 1962. *Periodicals*—Apollo (London) November 1947; ARK 18 (London) November 1956; Arts Review June 1971; Country Life (London) March 1949; Guardian July 11, 1963; Listener (London) July 15, 1954; London Magazine February 1966; New York Times February 5, 1966; Quadrum 2 (Brussels) November 1956; Painter and the Sculptor (London) Autumn 1957; The Studio September 1950, December 1956; Time November 27, 1950, August 18, 1961.

HOCKNEY, DAVID (July 9, 1937–), British painter, graphic artist, photographer, and stage designer, was acclaimed in the early 1960s as the Wunderkind of British art. He is noted for his cool, witty, highly accomplished figurative style.

Hockney was born into a working-class Yorkshire family in the industrial city of Bradford in the north of England. He attended the local council school in Bradford (where his sister and two brothers also went) until 1948, when he won a scholarship to the Bradford Grammar School. Deciding that he wanted to be an artist, and bored by his schoolwork, he contributed drawings and cartoons to the school magazine and made posters for the debating society.

At 16 Hockney, with his parents' consent, en-

Jorge Lewinski

DAVID HOCKNEY

tered the Bradford School of Art, where he studied from 1953 to '57. The training was thoroughly academic, and in his last year he realized he knew nothing about modern art. Hockney's first contact with contemporary British painting came when he met the artist Joseph Kramer. In 1958 he saw the work of Alan Davie, whose painting formed one of the few real bridges between English and Continental art at that time. Davie's work made Hockney enthusiastic about expressive abstraction. As he wrote in his autobiography, *David Hockney by David Hockney,* "It [Davie's art] confused me at first, but I could cope with it—I wasn't thrown into complete disarray." One of Hockney's first works in oil was a portrait of his father, painted in 1955, which was sold for £10.

A conscientious objector, Hockney worked in a hospital, from 1957 to '59, as an alternative to military service. In 1959 he entered the Royal College of Art, London. The previous year there had been an important exhibition at the Tate Gallery, London, of American abstract expressionism, and the canvases Hockney painted in his first year at the Royal College were in that vein. Also in 1959, he joined a group of Royal College students who were experimenters; among them was the American R.B. Kitaj, who became friends with Hockney.

Kitaj's intense preoccupation with "the world outside the canvas," to quote Lucy Lippard, rather than in pure abstraction, and his interest in popular culture and urban life, made him a major influence on third-phase pop art in Britain. Even during his abstract-expressionist period, Hockney had drawn from the live model

and, owing in part to Kitaj's influence, he began to introduce figurative elements, sometimes inspired by graffiti, children's art, and primitive painting, into his compositions; unadulterated abstract expressionism had already become "too barren" for him.

After 1960, Hockney's work developed rapidly. His new pictures attracted attention at the 1961 Young Contemporaries show in London, where he exhibited with Allen Jones and other Royal College students. Among Hockney's pictures were *Jump* and *The First Tea Painting,* both of which had abstract-expressionist elements but also included writing, heart shapes, and graffitilike figuration. At this time Hockney was influenced by the American Larry Rivers, who had visited England and whose work was described by Hockney as "a kind of seminal pop art."

In 1961 Hockney began doing graphic work, which was based on ideas he gleaned from such poets as William Blake and Walt Whitman. His first etching was titled *Myself and My Heroes,* the heroes being Whitman and Mahatma Gandi, and included quotations from them that he reproduced in small lettering. In the summer of 1961 Hockney visited New York City. He found the city, including its gay bars, stimulating. William Lieberman bought some of his etchings for the Museum of Modern Art, and he met the avant-garde artist Claes Oldenburg. In New York Hockney dyed his hair platinum blond; the bleached hair and horn-rimmed glasses became part of his dandified "persona," which was to help make him a celebrity in the so-called swinging London of the 1960s.

In New York Hockney had been impressed by the enormous size of the abstract paintings he saw. In September 1961, after returning to London, he began to paint on a 7-by-11-foot canvas an amusing three-figure composition titled *Demonstration of Versatility—A Grand Procession of Dignitaries in the Semi-Egyptian Style.* The idea was loosely inspired by Constantine F. Cafavy's poem *Waiting for the Barbarians.* The three figures—a mitred ecclesiastic, a medaled warrior, and a top-hatted industrialist—were depicted in a faux-naif, semi-Egyptian manner. The procession advanced from right to left on a descending slope against a background of raw canvas; there were stylistic allusions to Kitaj, Francis Bacon, and abstract expressionism, and ironic quotations, some graffitilike, enlivened the composition. The painting, which was exhibited at the 1962 Young Contemporaries show, marked the emergence of a witty, irreverent, and altogether personal style. George Butcher wrote in *The Guardian* (June 21, 1962),

"Underlying this procession of personalities and history is a deliberate esthetic of contrast and contradiction." The painting typified what critics have termed the "cheekiness" of Hockney's early work.

Hockney graduated from the Royal College of Art in 1962 with a gold medal. He had gone to Italy for the first time the previous year, and in the summer of '62 he again visited Italy and also traveled to Berlin. In London he cut a spectacular figure with his dyed hair and gold lamé dinner jacket. The erotic, more specifically, the homoerotic motif appeared often in his work from this period onwards. The subject was handled in a cool, drily humorous, and ironically detached manner, as in *Picture Emphasizing Stillness* (1962), in which his treatment of the human figure, and his deliberately awkward drawing, were influenced by Jean Dubuffet.

Although Hockney's work was widely associated with British pop culture of the early '60s, his figuration was more whimsical, capricious, hard-edged, and less stereotyped than that of true pop art. In 1963 he completed a cycle of 16 Hogarth-inspired etchings, "A Rake's Progress," which he had begun in 1961. This narrative series chronicled his misadventures in New York City and registered his ambivalence to life in the 20th-century metropolis. Many of the sparse, wiry drawings are full of deadpan humor and express ironic enjoyment of the American city scene; at times, however, the tone is biting and indignant, as in *Bedlam*, in which five automatons are ruled by pocket transistor radios that have become part of their anatomy.

In September 1963 Hockney traveled to Egypt to make illustrations for the color magazine supplement of the London *Sunday Times*. On his return to London, Hockney painted the highly original *Great Pyramid at Giza with Broken Head from Thebes* and *Four Heads (Egyptian)* which featured one large sculpturesque head and, in the horizontal band above it, three smaller heads painted in the flat, stylized, semi-Egyptian style of paper cutouts.

In late 1963 Hockney had two exhibitions running concurrently in London: "A Rake's Progress" and his other etchings were shown at the Print Centre, while his first solo exhibit of paintings and drawings was held at the Kasmin Gallery. Reviewing both shows, a *Guardian* (December 11, 1963) critic admired "the texture and fluidity of paint" in such canvases as *Four Heads (Egyptian)* and described Hockney as "a rapidly developing painter with a style which is his and nobody else's." He added that Hockney had "left Pop art a long way behind."

The shows were a financial success, and as soon as they were over Hockney visited Los Angeles for the first time. Southern California was appealing to Hockney and he spent several months there. California helped to crystallize Hockney's mature style—a cool, streamlined neoclassicism, more mannered and less spontaneous than his early work, but often displaying a charming oddity and decorative inventiveness. His first painting in Los Angeles was *Plastic Tree Plus City Hall* (1964); also that year he painted *California Art Collector,* in which a lady in a dark green dress, rendered in the artist's typical "cutout" style, sits in a flowered armchair in a garden with two pieces of sculpture, one a William Turnbull. In the upper-left background is a swimming pool—the private pool is a favorite Hockney subject—painted not from nature but from an advertisement in the *Los Angeles Times*. Hockney insists the picture is "a complete invention."

In 1964 Hockney taught at the State University of Iowa, and the next year served on the faculty of the University of Colorado, Boulder. He continued to travel extensively in the United States before returning to London in late 1965 for a show at Kasmin's. In 1966 he visited Beirut to "get atmosphere" for a series of prints illustrating homoerotic poems by Cafavy. In London he worked on his first stage project, designing the sets and costumes for a production of Alfred Jarry's *Ubu Roi* at the Royal Court Theatre. The British art critic David Thomson found Hockney's subtle and elegant designs unsuited to the deliberate crudity and coarseness of Jarry's "schoolboy shocker."

Hockney eagerly returned to Southern California and joined the faculty of the University of California, teaching at the Los Angeles campus in 1966 and the Berkeley campus for 12 weeks in 1967. Hollywood inspired a number of paintings and drawings of landscapes and interiors, executed in a cool, spare, almost precisionist style. They show a fascination with the streamlined synthetic comforts of California suburban living, as in *Beverly Hills Housewife* (1966). He also turned to the problem of "fixing," or defining, the movement of water, either in the artificial setting of a swimming pool, as in *Two Boys in a Pool, Hollywood* (1965) and *A Bigger Splash* (1967), or in the stylized spray of water sprinklers (*A Neat Lawn,* 1967). Edward Lucie-Smith found the California paintings "disconcertingly dull when compared to his previous work." He felt that the artist's capacity for "stringent irony" had given way to complacency in Hockney's wholehearted acceptance of California affluence and that region's "laid back" style of living.

In the late '60s Hockney traveled in the US

and Europe, but still spent much of his time in Southern California. In 1968, in Santa Monica, he painted a large double portrait of his friends Don Bachardy and the author Christopher Isherwood. During a 1968 visit to New York City he made studies for the double portrait *Henry Geldzahler and Christopher Scott*, which he began in London and completed in 1969. The art critic and curator Geldzahler called Hockney a "sophisticated primitive," but there is a more naif quality in the preliminary pencil drawing than in the glassy smoothness of the finished Geldzahler painting.

In the late '60s Hockney drew many skillful portraits of his friends, but he undertook in March 1969 a series of etched illustrations for a selection of Grimm's fairy tales. Trips to the Rhineland helped Hockney create the appropriate "atmosphere" for these etchings, which were more complex technically than his previous prints. Unlike his etchings, Hockney's paintings have become less dependent on literary sources. Moreover, in the late '60s his work became more realistic, partly as the result of his interest in the paintings of Balthus, Giorgio Morandi, and Edward Hopper.

Hockney's well-known 1970 painting, *Le Parc des sources, Vichy,* is 10 feet across. The attractive formal garden was ideally suited to the artist's use of Renaissance perspective—"I get ideas from Piero della Francesca all the time," Hockney said—and there are surrealist overtones in the three chairs in the foreground, their backs to the viewer. Two of the chairs are occupied by friends but the third is empty, because "the artist has had to get up to do the painting," Hockney explained.

Hockney traveled in 1970 to Morocco and Spain, and to Japan, Indonesia, Burma, and Hawaii in 1971. He thought Japan ugly when he was there but beautiful in retrospect; the trip inspired *Mount Fuji and Flowers* (1972; Metropolitan Museum of Art, New York City).

In the spring of 1970 Hockney had a large retrospective at the Whitechapel Gallery, London. His paintings, drawings, and prints have been shown in solo and group exhibitions throughout Europe and the US. In June 1975 he designed sets and costumes for a production of Stravinsky's opera *The Rake's Progress* at the Glyndebourne, London. For New York City's Metropolitan Opera, he designed décor and costumes for *Parade*, in 1980, and a three-part performance of Stravinsky's *The Rite of Spring, Le Rossignol,* and *Oedipus Rex* in late 1981. The director Jack Hazan made a biographical film about Hockney, entitled *A Bigger Splash,* in 1974.

In 1977 Hockney's autobiography was published in a sumptuously illustrated edition and sold 18,000 copies in England in six months. This "instant journal" was described as "a candid, reflective and sometimes spicy book." In November 1977 Hockney's recent paintings and drawings and a series of etchings based on Wallace Stevens's poem *The Man with the Blue Guitar* were exhibited at the André Emmerich Gallery, New York City. Reviewing the show in *The New York Times* (November 4, 1977), Hilton Kramer was impressed by the "sheer technical virtuosity" of *Looking at Pictures on a Screen* (depicting Henry Geldzahler) and *Model with Unfinished Self-Portrait,* but found their style, with its "meticuously plotted allusiveness," to be "superficial, even reactionary." Concerning Hockney's work as a whole, Kramer wrote, "So long as he sticks to the comedy of manners, and the comedy of taste that is their corollary, he can be brilliant [but] there is a spiritual quest at the heart of modernism that is alien to the very nature of Mr. Hockney's art."

In *Newsweek* (November 14, 1977) Hockney's portrait *My Parents,* was called the most affecting picture in the Emmerich Gallery show, because in it the artist conveyed feeling with "rigorous spareness." The critic noted the "blend of naïveté and sophistication" in Hockney's treatment of subject matter and added that the artist's "interest in capturing the style of things has helped make him a master draftsman." The writer praised Hockney's "wit and high spirits" but asserted that at times "he's too clever for his own good."

David Hockney is still based mainly in Southern California, although in recent years he has also lived and worked in London and Paris. He is tall, flaxen-haired, and energetic; his round face is given a somewhat owlish look by horn-rimmed glasses. He has retained his Yorkshire accent. Hockney is less flamboyant than in the early '60s, when his notoriety in England was comparable to Andy Warhol's in America. He now dresses more casually but still has a dandyish liking for vivid colors and for patterns of polka-dots, stripes, and checks. According to the London *Observer* (April 5, 1970), "The popular image of the golden-haired playboy flitting between California and Europe is a mask to conceal a patient and dedicated craftsman."

The *Newsweek* critic remarked that Hockney, "together with R. B. Kitaj, Francis Bacon and a few other artists in Britain, . . . has served as a healthy foil to abstract art" and "has challenged the assumption that painting must surrender to photography the role of interpreting the manners of men." Hockney is reluctant to discuss his

work because; in his words, "my paintings seem to me to be self-explanatory. . . . Nevertheless, if a short statement is in order, then I can say that my primary interest is in pictures of all kinds— paintings, drawings, photographs, prints, etc.— but best of all I like handmade pictures; consequently, I paint them myself. They always have a subject and a little bit of form. . . . "

EXHIBITIONS INCLUDE: Kasmin Gal., London from 1963; Print Centre, London 1963; Alan Gal., NYC 1964; MOMA, NYC 1964, '68; Stedelijk Mus., Amsterdam 1966; Palais des Beaux-Arts, Brussels 1966; Landau-Alan Gal., NYC 1967; André Emmerich Gal., NYC 1969, '70, '72, '77, '83; Whitechapel Gal., London 1970; Mus. des Arts Décoratifs, Paris 1974; Gal. Claude-Bernard, Paris 1975; Nicholas Wilder Gal., Los Angeles 1976; Gal. des Ponchettes, Nice, France 1977; M.H. deYoung Memorial Exhibition, San Francisco 1979; Tate Gal., London 1980; Grey Art Gal., New York 1980. GROUP EXHIBITIONS INCLUDE: "London Group," R.B.A. Gals., London 1960; "Young Contemporaries," R.B.A. Gals., London 1960, '62; "The Graven Image," R.B.A. Gals., London 1961, '63; "Nieuwe Realisten," Germeente Mus., the Hague 1964; "The Harry N. Abrams Family Collection," Jewish Mus., NYC 1966; Pittsburgh International 1967; São Paulo Bienal 1967; Venice Biennale 1968; "British Painting and Sculpture, 1960–1970," Nat. Gal. of Art, Washington, D.C., 1971; "La Peinture Anglaise aujourd'hui," Mus. d'Art Moderne, Paris 1973; "European Painting in the '70s," Los Angeles County Mus. of Art 1975–76; "Pop Art in England," Kunstverein, Hamburg, W. Ger. 1976.

COLLECTIONS INCLUDE: Arts Council of Great Britain, Victoria and Albert Mus., Tate Gal., Contemporary Society, and British Council, London; City Art Gal., Bradford, England; Whitworth Art Gal., Manchester, England; Stedelijk Mus., Amsterdam; Mus. Boymans-Vans Beuningen, Rotterdam; Mus. des Beaux-Arts, Ghent; Städtische Kunstsammlungan, Darmstadt, W. Ger.; Metropolitan Mus. of Art, and MOMA, NYC; Hirshhorn Mus. and Sculpture Garden, Washington, D.C.; Philadelphia Mus. of Art; Art Inst. of Chicago; Detroit Inst. of Arts; Minneapolis Inst. of Arts; Baltimore Mus. of Art; Oregon State Univ., Corvallis; Olinda Mus., São Paulo; Nat. Gal. of New South Wales, Australia.

ABOUT:"David Hockney: Paintings, Prints and Drawings 1960–1970" (cat.), Whitechapel Gal., London 1970; Finch, C. David Hockney in Image as Language: Aspects of British Art 1950–1968, 1969; Hockney, D. David Hockney by David Hockney, 1977, China Diary, 1982; Lippard, L. R. Pop Art, 1966; Lucie-Smith, E. Late Modern: The Visual Arts Since 1945, 1969; Stangos, N. (ed.) Pictures by David Hockney, 1979. *Periodicals*—Appollo (London) January 1979; Ark (London) Summer 1962; Art and Artists May 1966; April 1970; September 1980; Artforum October 1983; Art International (Lugano) March 1964; September 1979; Art News September 1966, May 1969, April 1979, February 1980; Art Spectrum January 1975; Arts

Magazine May–June 1964, June 1980, June 1982; Guardian June 21, 1962, December 11, 1963; International Herald Tribune November 2, 1974; London Times September 25, 1968; Le Monde (Paris) October 31, 1974; New York Times October 11, 1964, November 4, 1977; The New Yorker July 30, 1979; Newsweek November 14, 1977; Observer April 5, 1970; Studio December 1963; Studio International December 1968; Time May 29, 1972.

HOFMANN, HANS (March 21, 1880– February 17, 1966), German-American painter, was immensely influential both as a teacher of the advanced European style of painting and as a modern artist. He has been called the "dean" of the New York School of abstract expressionist painting.

Hans Hofmann was of the pre–World War I generation of Picasso and Braque. He was born in the hamlet of Weissenburg, in the farming country of central Bavaria. In 1886 his father became a government official and the family moved to Munich. There Hans attended public schools and, later, the Gymnasium, where he excelled in science and mathematics. He also studied music, becoming proficient in violin, piano, and organ, and began to draw.

Hofmann was to say later that nature is the painter's true teacher, and his own love of nature seems to date from childhood visits to the grain farm of his maternal grandfather, Frederik Manger. He enjoyed the spectacle of the Altmuehthal barge canal that skirted the wide fields, and the sight of the fieldhands slowly making their way through rows of ripening hops to the farmhouse.

In 1896 Hofmann left home and, through the influence of his father, obtained a position as assistant to the Director of Public Works of the State of Bavaria. This enabled him to develop his technical knowledge of mathematics and mechanics, resulting in his invention of an electromagnetic comptometer, somewhat similar to the now-familiar calculating machine. (Hofmann later was to inform his students that, originally trained as a scientist, he was predisposed to an Aristotelian sense of order.) His father sent him money to encourage further scientific studies, but instead Hofmann used the disbursement to enroll in a Munich art school. He studied painting with teachers who, traditional in their outlook, taught him the basics. The life studies he made as a student show his early interest in the creative contrast of line against line and form against form and in the definition of volume through the abrupt opposition of dark and light planes.

About 1898 Hofmann studied with Willi Sch-

André Emmerich Gallery, NYC

HANS HOFMANN

wartz, who introduced him to impressionism. Hofmann was also influenced by the art of the Secessionist movement which prevailed in Munich at the turn of the century. In 1900 Hofmann met Maria ("Miz") Wolfegg, whom he was to marry, and painted her portrait the next year. That work and a self-portrait of 1902, both of which show the influence of impressionism and the divisionist style of neoimpressionism, are among the few works painted by Hofmann before his immigration to America in 1930 that were not destroyed in the two world wars.

In 1903, through Willi Schwartz, Hofmann met the nephew of Phillip Freudenberg, the wealthy Berlin department-store owner and art collector. The nephew introduced Hofmann to his uncle, who became the aspiring young artist's patron and who, in 1904, paid his way to Paris. Though he often summered in Germany, Hofmann, with Freudenberg's help, was to stay in Paris for the next decade.

In 1904 Hofmann attended evening classes at the Académie de la Grande Chaumière, in Montparnasse, and briefly worked in the same class as Henri Matisse at the Académie Colarossi. This introduced him to fauvism, and at the Café du Dôme, a gathering place for artists, Hofmann met modern painters, including Robert Delaunay, who became a close friend and helped Hofmann develop as a colorist. Hofmann also met Picasso, Braque, Juan Gris, and other protagonists of the emerging cubist movement. The still lifes, landscapes, and figures he painted in those years were in the cubist style. Moreover, of the three styles—fauvism, cubism, and German expressionism—from which Hofmann developed his concept of art, the principles of cubism were to be the foundation of his theories.

In 1909 Hofmann participated in the "Neue Sezession" exhibition in Berlin, and his first solo show was held in 1910 at Paul Cassirer's Berlin gallery. The outbreak of World War I in the summer of 1914, together with the illness of his sister, returned Hofmann to Munich. Assistance from his patron, Freudenberg, ended with the start of war, and Hofmann, to earn his living, decided to teach (a lung condition kept him out of the army). In the spring of 1915 he opened the Hans Hofmann School of Fine Arts in the Munich suburb of Schwabing. The school, devoted to spreading the ideas he had absorbed in Paris, was immediately successful. While in Munich, Hofmann was influenced by the lyrical abstraction of Paul Klee and Wassily Kandinsky, leaders of the Blaue Reiter School of German expressionism.

Among the Americans who studied with Hofmann was Worth Ryder, an art professor who, in 1930, invited Hofmann to teach at the summer session of the University of California, Berkeley. In August 1931 Hofmann, at the age of 51, had his first American exhibition, consisting of drawings, at the California Palace of the Legion of Honor, San Francisco. The vastness of California awed Hofmann and influenced his organization of space and form in drawings.

Because of the rapidly deteriorating political situation in Germany, Hofmann, on the advice of his wife, who had stayed in Munich, closed his school in 1932 and settled permanently in the United States. He spent the winter of 1932 teaching at the Art Students League, New York City. In the fall of 1933 he opened his own school on Madison Avenue, which was succeeded in October 1934 by the Hans Hofmann School of Fine Arts, at 137 East 57th Street. During the summers of 1933 and '34 he served as guest instructor at the Thurn School of Art, Gloucester, Massachusetts, and in 1935 he opened his noted summer school at Provincetown, Massachusetts. In 1936 the Hofmann School in New York City moved to 9th Street, in Greenwich Village, and remained there until 1938, when it moved to its permanent location at 52 West 8th Street. In August 1939 Hofmann's wife (after a long courtship they had married in 1923) came to the United States, and two years later Hofmann became an American citizen.

After a lengthy period of working only on drawings, Hofmann had begun to paint again in the summer of 1935. After 1936 he focused attention on the use of color, and in such works as *Still Life, Pink Table* (1936), *Little Blue Interior* (1937–38), and *Still Life Magic Mirror* (1939)

choice of color was determined by the sharp definition of relationships in space. His pre-1940 paintings were somewhat eclectic, usually representing a synthesis of the movements with which he had been associated in Europe. Only after 1940, when his work became progressively abstract, did he achieve a truly individual idiom.

Although virtually none of the first-generation Abstract Expressionists studied with Hofmann—by the time he was established in Greenwich Village they were in their late 20s or early 30s—his teaching of cubist composition and fauvist coloring profoundly influenced American abstract expressionism. "His school," Dore Ashton wrote, " . . . was . . . a magnet that drew visitors constantly." According to Calvin Tomkins, the younger, avant-garde New York painters "often dropped by his studio in the evening to hear his impromptu lectures, after which they usually went to a local cafeteria to continue the discussion." Over the years his pupils included Burgoyne Diller, Lee Krasner, Helen Frankenthaler, Red Grooms, Louise Nevelson, Larry Rivers, Richard Stankiewicz, and Clement Greenberg, the influential critic and early proponent of abstract expressionism, who learned the doctrines of modern painting from Hofmann.

Between 1940 and 1948 Hofmann painted canvases marked by a nervous, supple "handwriting" which derived from Kandinsky and Klee and anticipated the gestural abstraction of Jackson Pollock. Examples of this phase are *Spring* (1940), *Yellow Sun* (1943), *Fairy Tale* (1944), *The Circus* (1945), *Fantasia* (1945–46) and *Apparition* (1947). During this period there were numerous exhibitions of Hofmann's work. A large retrospective at the Addison Gallery of American Art, Andover, Massachusetts, early in 1948 coincided with the publication by the Addison Gallery of Hofmann's book, *Search for the Real and Other Essays*. In these essays Hofmann urged painters to respect the flatness of the canvas and stressed compositional "oppositions"—of differing colors, of movement and countermovement (stasis), of the contours of objects (positive planes, in Hofmann's terminology) and surrounding areas of open space (negative space). The crucial opposition, Hofmann believed, was tension between the two-dimensional (flat) surface plane and three-dimensional depth, the resolution of which he termed "push-pull." For him painting was "forming with color" and creative expression was "the spiritual translation of inner concepts into form." "In sum," Barbara Rose explained, "Hofmann stressed the active line, intense color, and assertive paint application."

In 1949 Hofmann traveled to Paris and visited the studios of Braque, Brancusi, and Picasso. A 1949 exhibit of his work in Paris, however, went practically unnoticed. His paintings of the years 1948–55 had a free, tachist quality; the richly textured surfaces were balanced by a few flat, almost geometric shapes, brightly colored but preserving unity in the treatment of light. *Composition No. III* (1953) and *Exuberance* (1955) are examples of this phase. In 1956 he designed a mosaic mural for the lobby of the William Kaufmann Building, 711 Third Avenue, New York City.

After 1955 rectilinear elements became more prominent in Hofmann's compositions. In *Flowering Swamp* (1957; Hirshhorn Museum, Washington, D.C.) a yellow-green rectangle in the lower left-hand corner and a vivid red square in the center, serve as counterpoints to the violently abstract-expressionist brushwork of the large areas. But Hofmann's approach varied from canvas to canvas—to the bafflement of critics. *Oceanic* (1958; Hirshhorn Museum) has swirling brushstrokes and a "floating" space reminiscent of Willem de Kooning, although the blue and yellow areas have a vibrancy that is unlike the frequent "chalkiness" of de Kooning's palette. *Cathedral* (1959) has a more disciplined, geometric organization.

In August 1958 Hofmann closed his New York school and gave up teaching to devote his full time to painting. He moved his studio to the school's quarters on West 8th Street. Also that year he executed a mosaic mural for the New York School of Printing, New York City.

In the Venice Biennale of 1960 Hofmann was one of the four artists—the others were Phillip Guston, Franz Kline, and Theodore Roszak—chosen to represent the United States. After attending the Biennale, Hofmann and his wife traveled in France and Germany. Maria Hofmann died in 1963, and the artist subsequently married Renate Schmidt, who inspired his "Renate" series.

For many years his importance as a teacher had overshadowed his work as a painter, and not until his participation in the 1960 Venice Biennale did his painting receive international recognition. The success of his pupils, however, eventually drew attention to his work. Hofmann's last works were serene, ethereal.

Although Hofmann was over 50 years old when he came to the United States, the stocky, robust, ruddy-complexioned artist exuded youthfulness throughout his life. He wrote: "The profound meaning of all art is to keep the human spirit in a state of eternal youth, in response to a world that is perpetually changing. The aim of art is to counterbalance the banal weight of ev-

eryday life; it must give us the constant esthetic joy that we need."

EXHIBITIONS INCLUDE: Gal. Paul Cassirer, Berlin 1910; California Palace of the Legion of Honor, San Francisco 1931; Isaac Delgado Mus. of Art, New Orleans 1941; Art of This Century, NYC 1944; Arts Club of Chicago 1944; Mortimer Brandt Gal., NYC 1946; Betty Parsons Gal., NYC 1947; Kootz Gal., NYC 1947–66; Addison Gal. of Am. Art, Andover, Mass. 1948; Baltimore Mus. of Art 1954; Bennington College, Vt. 1955; Philadelphia Art Alliance 1956; Rutgers Univ., New Brunswick, N.J. 1956; Whitney Mus. of Am. Art, NYC 1957–60; Fränkische Gal. aur Marientor, Nuremberg, W. Ger. 1962; MOMA, NYC 1963; Santa Barbara Mus. of Art, Calif. 1963; André Emmerich Gal., NYC from 1967. GROUP EXHIBITIONS INCLUDE: Neue Sezession, Gal. der Sturm, Berlin 1909; "Abstract and Surrealist Art in America," Mortimer Brandt Gal., NYC 1944; "Contemporary American Painting," Whitney Mus. of Am. Art, NYC 1945; "Abstract and Surrealist American Art," Art Inst. of Chicago 1950; "Abstract Painting and Sculpture in America," MOMA, NYC 1952; "Nine Americans," Sidney Janis Gal., NYC 1954; "International Exhibitions of Contemporary Painting and Sculpture," Carnegie Inst., Pittsburgh 1958; "Nature in Abstraction," Whitney Mus. of Am. Art, NYC 1958; Documenta 2, Kassel, W. Ger. 1959; Venice Biennale 1960; "American Abstract Expressionists and Imagists," Guggenheim Mus., NYC 1961; "Hans Hofmann and his Students," International House, Denver 1963; "Two Decades of American Painting," Nat. Mus. of Modern Art, Tokyo 1966; "American Art at Mid-Century," Nat. Gal., Washington, D.C. 1973; "The Great Decade of American Abstraction: Modernist Art 1960–70," Mus. of Fine Arts, Houston ca. 1974; "20th Century American Drawing, Three Avant-Garde Generations," Guggenheim Mus., NYC 1976.

COLLECTIONS INCLUDE: Metropolitan Mus. of Art, MOMA, Whitney Mus. of Am. Art, and Guggenheim Mus., NYC; Albright-Knox Art Gal., Buffalo, N.Y.; Newark Mus., N.J.; Philadelphia Mus. of Art; Hirshhorn Mus. and Sculpture Garden, Washington, D.C.; Baltimore Mus. of Art; Cleveland Mus. of Art; Walker Art Gal., Minneapolis; John Herron Art Inst., Indianapolis; Dallas Mus. of Fine Arts; Santa Barbara Mus. of Art, California; Hans and Maria Hofmann Gal., Univ. of Calif., Berkeley; Mus. of Fine Arts, Montreal; Art Gal. of Ontario, Toronto; Mus. des Beaux-Arts, Grenoble; Peggy Guggenheim Collection, Venice.

ABOUT: Ashton, D. The New York School: A Cultural Reckoning, 1973, American Art Since 1945, 1982; Greenberg, C. Art and Culture, 1961, Hans Hofmann, 1961; Hofmann, H. Search for the Real and Other Essays, 1948; Hunter, S. Hans Hofmann, 1963; Rose, B. American Art Since 1900, 2d ed. 1975; Tompkins, C. Off The Wall: Robert Rauschenberg and the Art World of Our Time, 1980. *Periodicals*—Artforum Summer 1969, January 1971; Art Journal Spring 1963; Art in America May/June 1973; Art News February 1950, January 1967; Arts February 1959, December 1970/January 1971; Arts and Architecture May 1946; Cimaise (Paris) January 1959; Derrière le miroir (Paris) January 1949; It Is (NYC) Winter/Spring 1959; Nation April 21, 1945.

HOPPER, EDWARD (July 22, 1882–May 15, 1967), American painter and etcher, was born in Nyack on the Hudson River. His father, Garrett Henry Hopper, of English and Dutch descent, ran a dry goods business; his mother, Elizabeth Griffiths Smith Hopper, was of mixed English and Welsh descent. There were two children, Edward and his sister, Marian. The boy went to a local private school and then to Nyack High School. He often spent Saturdays at the town's busy shipyards, acquiring a liking for boats that lasted all his life.

As a child, Hopper loved to draw, and after he left high school his parents did not oppose his desire to study art. But they felt that a painter's career was precarious, so in 1899, at their urging, he enrolled in a school for illustrators in New York City. The following year he transferred to the New York School of Art, also known as the Chase School. For a year he studied under Robert Henri, who had become the leading teacher at the school; his fellow students included George Bellows, Rockwell Kent, Guy Pène du Bois, Walter Pach, and Gifford Beal. Another of his instructors was Kenneth Hayes Miller, also an important Realist, but it was the stimulating teaching of Henri that made the greatest impression on Hopper. He exhorted his students to look at the life around them, and to paint directly and boldly with a broad brush. Henri's artistic viewpoint, though unorthodox by academic standards, was hardly radical, and was based on the tradition of such masters as Velázquez, Hals, Goya, and Daumier, and the preimpressionist work of Manet and Degas. Over 20 years later Hopper wrote of Henri: "No single figure in recent American art has been so instrumental in setting free the hidden forces that can make of the art of this country a living expression of its character and its people."

Even after Hopper left the New York School of Art in 1906, Henri's influence persisted. Through the years, though, Hopper came to realize the limitations of Henri's approach—the excessive concern with subject matter and illustrational values and the lack of attention to form and design.

In October 1906, at the age of 24, Hopper went to Paris. A well-built young man, over six-feet tall, with a high forehead, keen blue eyes, and a full-lipped, sensitive mouth, he was thoughtful, taciturn, and rather shy. Hopper stayed with a middle-class French family on the

Collection of Whitney Museum of American Art, New York; Geoffrey Clements photography

EDWARD HOPPER

rue de Lille on the Left Bank; he taught himself to read French, but never learned to speak it easily. Avoiding art schools as well as the bohemian life, he lived quietly, reading French literature and painting on his own.

In Paris he drew and painted city scenes on the spot. His painting style, very different from Henri's dark tonalities, was closer to impressionism in its emphasis on color and light. Like so many artists before and since, he found the light of Paris "different from anything I had ever known." Hopper always retained a strong interest in light, but unlike such American Impressionists as Childe Hassam, he also concentrated on architectural forms and large masses and volumes.

In addition to cityscapes in oil, Hopper made numerous drawings and watercolors of Parisian life. Some, including a charcoal or black crayon drawing of 1906–07 or 1909, *On the Quai,* were surprisingly reminiscent of Seurat's drawings, which Hopper had never seen. About the same time he did a series of illustrative, posterlike watercolors of the Paris Commune of 1870–71, titled *L'Année terrible* (The Terrible Year, the name given by Victor Hugo to his cycle of poems on the same theme). In later years Hopper never showed or mentioned these early works, which reveal a much greater feeling for French life than one would suspect in a painter so thoroughly identified with the American scene.

In the course of Hopper's European stay he visited England, Germany, Holland, and Belgium, but not Italy. His favorite painters were those Henri also admired—Goya, Manet, and Degas. These were years of great artistic ferment in Paris, but although Hopper visited the Indépendants and the Salon d'Automne, fauvism, cubism, and the other avant-garde movements made little or no impression on him. However, through another Henri student, Patrick Henry Bruce, he did become acquainted with Impressionist paintings. In some ways he felt more kinship to French art prior to the impressionists and Postimpressionists, and he later contrasted the weight and substance of Courbet with what he callled the "paper quality" of Cézanne. He also preferred the sober 19th-century American Realist Thomas Eakins to Manet. Yet he admired Manet and Degas, and as late as 1962 he could say, "I think I'm still an Impressionist."

Hopper returned to America in the summer of 1907, but went abroad again in 1909 for about six months, spent entirely in France, mostly in Paris. After a third trip in the summer of 1910 to France and Spain, he never visited Europe again.

From 1908 he lived in New York City, making his living by commercial art and illustration; he painted in his free time and during the summer. As early as 1908, at the age of 26, he had found the kind of subject matter that he was to treat later in a more developed way. *Tramp Steamer, Tugboat, The El Station,* and *Railroad Train,* all painted in 1908, still showed Henri's influence in their broad, simplified style. Henri's dark palette, though, had been discarded, and there was none of the concern of Henri and the Ashcan School with obvious human interest. Hopper was already trying to capture the color and light of outdoor America, so different from that of France. Meanwhile he supported himself, working three or four times a week in an advertising agency. He found the work uncongenial and liked illustrating even less. As he said later, "I was a rotten illustrator—or mediocre, anyway," but Lloyd Goodrich believes that some of the illustrations found among his drawings after his death were "honest, strong and often humorous." Hopper told Goodrich that he was not interested in drawing people "grimacing and posturing." He added, "Maybe I am not very human. What I wanted to do was to pa int sunlight on the side of a house."

Hopper spent several summers after 1910 working at Gloucester, Ogunquit, and Monhegan Island along the New England coast. *Italian Quarter, Gloucester* (1912) showed firm construction and an angularity which, he said, "was just natural to me: I liked those angles." *Corner Saloon* (1913; Museum of Modern Art, New York City) struck a more personal note, with a quiet melancholy which anticipated the mood

that would prevail in his most famous later works. He exhibited in a group show of Henri students in 1908 and in a show arranged by Sloan, Henri, and others in 1910, but his early paintings, unspectacular and lacking in technical brio, met with little success, and were considered "hard," even by his friends and former fellow students. One oil, *Sailing,* shown in the famous Armory Show of 1913, was priced at $300 and sold for $250; it was his first sale of a painting, and his last for ten years.

Lacking opportunities to exhibit, Hopper did little painting between 1915 and 1920. In 1915 he took up etching and in the next eight years produced about 50 plates. Shunning charm and technical subtleties, his etchings, to quote Goodrich, "presented everyday aspects of the contemporary world, mostly in the United States, with utter honesty, direct vision, and an undertone of strong emotion." Among his best etchings of this period were *American Landscape* (1920) and *Night Shadows* and *Evening Wind* (both 1921). *Evening Wind* and a few other prints portrayed nude women in city interiors, a motif often to recur in later works. His favorites among earlier printmakers were Rembrandt and Charles Meryon, with his brooding, obsessive views of 19th-century Paris. Hopper's prints were represented in several exhibitions from 1920 on, and won him two prizes in 1923.

In 1920 the recently organized Whitney Studio Club, a lively center for independent artists, gave Hopper his first solo exhibition, of his Paris oils, and in 1922 a show of his Paris watercolor caricatures. During the early and middle 1920s he drew regularly from the nude in the Club's evening sketch class. His studies in black conté crayon and red chalk of the nude show a feeling for the structure and movement of the female body rarely present in his paintings.

Encouraged by his success in prints, Hopper began about 1920 to paint again in oils. His paintings displayed a new assurance and boldness in the ability to use unhackneyed, unglamorous aspects of the urban scene as material for art. This phase culminated in *House by the Railroad* (1925), in which a mansard-roofed house, bathed in strong light and deep shadows, stands alone beyond railroad tracks that cut sharply across the foreground. There is no tree or bush in sight. This work, which is one of his best known and which can be considered the archetypal Hopper painting—stark, haunting, utterly American—-is now in the Museum of Modern Art.

In 1923 Hopper began to work again in watercolor. Many of his best-known watercolors were painted on the spot in Gloucester, Massachusetts,

a seaside town he liked for its light and the spare New England character of its architecture. His watercolors met with prompt critical approval. *The Mansard Roof* was exhibited at and purchased by the Brooklyn Museum of Art in 1923. It was Hopper's first sale of a painting since the Armory Show of 1913. Through the 1920s his reputation grew steadily. Several articles were written about him, and in December 1929 he was included in the new Museum of Modern Art's first show of contemporary American art, "Paintings by 19 Living Americans."

Meanwhile there had been changes in Hopper's personal life. On July 2, 1924, he married the painter Josephine Verstille Nivison, who had also been a Henri student. They were inseparable and shared identical beliefs, ideas, and tastes (including an admiration for Degas). Jo, as she was called, was the model for many of Hopper's female figures. The couple had no children, and led an austere life devoted entirely to painting. After their marriage they lived on the top floor of an old brick house at 3 Washington Square North, in Greenwich Village, where Hopper had been staying since 1913, and spent their summers mostly in New England. In 1930 they built a plain shingled house in South Truro, Cape Cod, which was their summer home from then on. Hopper painted many of his post-1930 landscapes there. As he once said, "There's a beautiful light there—very luminous—perhaps because it's so far out to sea; an island almost."

The real inspiration of Hopper's work, however, was always the contemporary American city. He did not portray its spectacular or dynamic aspects, or see it as a setting for human activity, as the Henri group had done, but sought to express its architecture and lighting, its intimate moments of solitude and stillness. Hopper's city, as Goodrich observed, was "monumental and immobile." His cityscapes contain few or no people, and convey, as no other American painter has done, the monotony and loneliness of urban life. However, the effect is far from depressing, for the intensity of his observation gives his works a haunting poetic quality, suggesting far more than they describe.

The particular Hopper mood, and his extreme selectivity, are seen at their very best in what is possibly his masterpiece, *Early Sunday Morning* (1930), in the Whitney Museum of American Art, New York City. The painting shows an empty street with a row of identical houses that obviously continue beyond the edges of the canvas on either side. The very clarity and precision of Hopper's vision makes this utterly mundane scene seem strange, even desolate. As in a number of his other works, Hopper conveyed spatial

continuity by strong horizontal lines. (In other instances, as in *Manhattan Bridge Loop* [1928], and *New York, New Haven and Hartford* [1931], a railroad track serves this compositional function.) In the severe simplicity of its design, its strict frontality and rectilinearity, *Early Sunday Morning* is as tightly composed as a Mondrian. When, years later, Goodrich told Hopper that in a lecture he he had shown a slide of Hopper's *High Noon* (1949) alongside a Mondrian, Hopper's only comment was "You kill me!"

An understated but inescapable sense of alienation emerges from many of Hopper's figures. *New York Movie* (1939), with its solitary usherette in a dim theater, is an example. *Nighthawks* (1942), another of his best-known works, makes effective use of the contrast between the harshly lit occupants of the lunch counter and the surrounding darkness of the empty street at midnight. Hopper often set out to depict the interior and exterior of a building simultaneously—"the connection," as he wrote to Charles Burchfield, "for which so few try." Often, his nude female figures exude a latent but powerful sexuality (as in *Night Warriors*, 1928); Hopper was often called a Puritan, but as Goodrich has pointed out: "Underlying Hopper's naturalism was that deep sensualism which is fundamental to all vital art."

Hopper's figures at their least successful are wooden and lifeless, retaining some of the conventions of commercial illustration. "It must be admitted," wrote Rob Silberman in *Art in America* (September 1981), "that when Hopper was not great, he was frequently not even good." Even at their best his figures have little individuality. Their anonymity is, however, expressive of the impersonality of Hopper's vision of the city. The "aloneness" in these works reflects a uniquely American experience, as do, in their very different way, the plays of Eugene O'Neill. But Hopper had none of the self-conscious chauvinism of the Midwestern Regionalist painters. "Racial character," he said, "takes care of itself if there is honesty behind it." Although his canvases may remind Americans of vividly familiar sensations and environments, he created images in his best work which were distillations of experience and have an impact that transcends their specifically American context. Hopper was one of four artists chosen by the American Federation of Arts to represent the United States in the Venice Biennale of 1952, the others being Alexander Calder, Stuart Davis, and Yasuo Kuniyoshi.

Hopper's lack of sensuous paint quality and of textural variety were most apparent in his country and coastal scenes, which are largely bereft of the penetrating eye of his urban works. His trees tend to be graceless, heavy clumps, and despite his love of boats he had little feeling for the look of water. The hills he painted during three trips to Mexico lack real interest. However, the masses of trees in the dark woods along the country road in *Gas* (1940) contrast effectively with the brightly illuminated red pumps of the filling station and evoke the loneliness of the traveler at night. In one of the best of Hopper's later works, the severely geometric *Rooms by the Sea* (1951; Yale University Art Gallery, New Haven, Connecticut), the empty room, with an open doorway looking out on blue water—here admirably felt—and strong sunlight creating a diagonal pattern on the walls and floor, is satisfyingly bare and pure. Hopper was 69 when he painted this picture. In 1955 he was elected to the American Academy of Arts and Letters and received the National Institute's Gold Medal for painting.

A vivid description of Hopper at 81 was given by the painter Raphael Soyer, who in 1963 included him in his large group portrait, *Homage to Thomas Eakins.* Soyer felt "a loneliness about him, an habitual moroseness, a sadness to the point of anger." He spoke little while posing for Soyer, but his remarks, made in a loud, sepulchral voice, were always trenchant. Well-read and completely familiar with the history of art, Hopper nonetheless expressed little interest in the contemporary art scene. In *Diary of an Artist,* Soyer, recalling their meetings of 1963, wrote of Hopper: "His work is like himself—frugal, lonely, weighty, truthful, unadorned, unsentimental." Yet Soyer detected touches of humor and warmth under the outwardly cold and aloof exterior.

Edward Hopper died in his Washington Square studio on May 15, 1967 in his 85th year. His wife followed him less than a year later. While suspicious, like many Realists, of all theories of art, Hopper could on occasion write with the precision and clarity of his best paintings. In the preface to his 1933 solo show at MOMA he wrote: "My aim in painting has always been the most exact transcription possible of my most intimate impression of nature. If this end is unattainable, so, it can be said, is perfection in any other ideal of painting or in any other of men's activities." A French critic was struck by the fact that Hopper, with his "schematic realism," used 19th-century pictorial means to describe typically American 20th-century urban landscapes, and called him a "figurative painter of an abstract reality." Commenting on the important Hopper retrospective at the Whitney Museum of American Art, New york City, in the fall of 1980, Mark Stevens wrote in *Time* (Sept. 29) that "it has never seemed quite right to call him a realist. . . .

His exacting sense of fact, combined with his otherworldly sense of light, link him to the nineteenth-century American luminists such as Fitz Hugh Lane and to the transcendentalists such as Emerson." Stevens concluded his review: "In Hopper's light there's a sad elation." John Russell of *The New York Times* (May 13, 1977) summed up Hopper's distinctive contribution: "Not merely is he fundamental to the history of American painting, but he is also fundamental to the history of American life, as it was lived during his long career."

EXHIBITIONS INCLUDE: Whitney Studio Club, NYC 1920, '22; Brooklyn Mus. of Art 1923; Rehn Gal., NYC 1924, '27, '29, '41, '43, '48; St. Botolph Club, Boston 1926; Morgan Memorial, Hartford, Conn. 1928; MOMA, NYC 1933; Arts Club of Chicago 1934; Carnegie Inst., Pittsburgh 1937; Whitney Mus. of Am. Art, NYC 1950, '64; Mus. of Fine Arts, Boston 1950; Detroit Inst. of Arts 1950; Rhode Island School of Design, Providence 1959; Wadsworth Atheneum, Hartford, Conn. 1960; Philadelphia Mus. of Art 1962; Munson-Williams-Proctor Inst., Utica, N.Y. 1964; Whitney Mus. of Am. Art, NYC 1980 (retrospective that toured Europe and United States, 1980–82). GROUP EXHIBITIONS INCLUDE: Harmonie Club, NYC 1908; Armory Show, NYC 1913; "Paintings by 19 Living Americans," MOMA, NYC 1929; Annual Exhibition, Art Inst. of Chicago 1943; Venice Biennale 1952; São Paulo Bienal 1967.

COLLECTIONS INCLUDE: Metropolitan Mus. of Art, MOMA, and Whitney Mus. of Am. Art, NYC; Brooklyn Mus., N.Y.; Munson-Williams-Proctor Inst., Utica, N.Y.; Wadsworth Atheneum, Hartford, Conn.; Yale Univ. Art Gal., New Haven, Conn.; Mus. of Fine Arts, Boston; Addison Gal. of Am. Art, Phillips Academy, Andover, Mass.; Fogg Art Mus., Cambridge, Mass.; Phillips Collection, and Hirshhorn Mus. and Sculpture Garden, Washington, D.C.; Pennsylvania Academy of Fine Arts, Philadelphia; Toledo Mus. of Art, Ohio; Cleveland Mus. of Art; Art Inst. of Chicago; Walker Art Cntr., Minneapolis; Indianapolis Mus. of Art; Dallas Mus. of Fine Arts.

ABOUT: American Artists Group. Edward Hopper, 1945; Cheney, S. The Story of Modern Art, 2d ed. 1958; Current Biography, 1950; Goodrich, L. "Edward Hopper" (cat.), Whitney Mus. of Am. Art, NYC, 1964, Edward Hopper, 1971; "Edward Hopper" (cat.), MOMA, NYC, 1933; Levin, G. Edward Hopper: The Complete Prints, 1979, Edward Hopper as Illustrator, 1979, Edward Hopper: The Art and the Artist, 1980; O'Doherty, B. American Masters: The Voice and the Myth, 1973; Rose, B. American Art Since 1900, 2d ed. 1975; Soyer, R. Homage to Thomas Eakins, Etc., 1966, Diary of an Artist, 1977. *Periodicals*—Art Digest January 15, 1941; Art in America September 1981; The Arts April 1927, June 1927; Arts January 1978; Magazine of Art (Washington, D.C.) May 1937, December 1948; New York Times May 17, 1967, May 13, 1977; New York Times Magazine September 5, 1971; New Yorker January 17, 1948; Reality Spring 1953.

*HUNDERTWASSER (December 15, 1928–), Austrian painter, combined the forms of expressive abstraction with the decorative patterns of Art Nouveau. He was born Friedrich Stowasser in Vienna. His mother was Jewish, his father, who died in 1929, Christian. As a child Friedrich collected pressed flowers and colored pebbles and liked exotic plants and fabrics. In 1936 he attended the experimental Montessori School in Vienna, where he displayed, to quote from his final report, an "extraordinary feeling for color and form."

The Hitler years, following the annexation of Austria in 1938, deeply affected young Stowasser, intensifying his restlessness and search for identity. (Sixty-nine of his Jewish relatives were deported to camps in eastern Europe and killed.) He began to draw seriously in 1943, first in pencil, then crayon, then watercolor; his subjects were the city's baroque palaces and picturesque views of the Vienna woods. During the fighting of 1944 and the brief period of Russian occupation, Friedrich lived with his mother in a cellar, with gunfire often raging nearby.

In 1948 he enrolled in the Akademie der Bildenden Künste, Vienna, but stayed only three months. He was deeply moved by art for the first time at an exhibit in the Albertina of the Expressionist painter Erich Kampmann, and was even more impressed by a 1948 exhibit at Vienna's Neue Galerie commemorating the gifted Expressionist Egon Schiele. This led Stowasser to study the work of other turn-of-the-century Viennese Secessionists, particularly Gustav Klimt, whose sumptuous color and richly decorative allover patterning influenced him. Though Hundertwasser—the name he adopted in 1949—was to revolt against the worldly, refined, sophisticated side of Viennese artistic tradition, his work was highly influenced by the ornamental style of the Vienna secession movement. Some critics have seen his attachment to this older mode of Viennese modernism as a limitation.

With René Brô, a French painter, Hundertwasser traveled in Tuscany, in 1949, and was moved by the Sienese medieval frescoes. His watercolors of this period show the influence of Paul Klee, as in *Many Transparent Heads* (1949–50), but his touch was much heavier and his imagery far more tangled and aggressive than Klee's. He first visited Paris in 1950 and entered the Ecole des Beaux-Arts, but left after one day. The subjects of his Paris watercolors were water and boats, as in *Path of a Steamer (1)* and *In Mezzo al Mare—Singing Steamer*, both done about 1950.

In 1951 Hundertwasser traveled to Morocco and Tunisia. For six months he lived in Marra-

°ho͞on´ dət väs´´ əh

Jorge Lewinski

HUNDERTWASSER

kesh among the native population and became an interested in Arab folk music. After returning to Vienna he joined the Art Club gallery, where his work was exhibited for the next two years. His personality as well as his art scandalized the public and the press, much as the Expressionist Oskar Kokoschka had shocked the Viennese bourgeoisie more than four decades earlier. Tall and thin, red-haired and bearded, wearing deliberately colorful, "folkloric" clothes, Hundertwasser championed an antirational, antimechanistic, "back-to-nature" philosophy which anticipated the hippies of the 1960s and the more radical wings of the ecology movement. Those disturbed by the fantastic, and somewhat schizophrenic, imagery of such works as *Devouring Fishes and Cyclists* (1951), a watercolor he had painted in Marrakesh, were further outraged by the artist's "open letters of counterattack," which he addressed to critics, galleries, and public officials. His 1952 exhibit at the Art Club included a lecture—"My Aspiration: To Free Myself from the Universal Bluff of Our Civilization."

In 1953, during Hundertwasser's second stay in Paris, he began to use the spiral, which became an obsessive motif in his work. To Hundertwasser the spiral was an emblem of "life's introversions," the spiral nebulae of the universe and the ancient myth of the labyrinth. According to *The Oxford Companion to Twentieth-Century Art,* the spiral symbolized "creation, life, the circulation of the blood, [and] the unending path which does not close upon itself." Aldo Pellegrini noted, "His [Hundertwasser's] pictures are fashioned by spiral bands with an al-

most organic character, which develop from a center, and enlarge irregularly as they go, strewn here and there with small colored forms that are almost geometric." This "labyrinthine structure" is combined with "vivid, saturated color."

Among the earliest of his spiral-motif paintings were *The Garden of the Happy Dead* (1953), with its lush green tonalities, in oil on hardboard, and *Arab Geographer with Satellite* (1953). Klimt had used the spiral in a purely ornamental manner, but Hundertwasser gave it depth and texture; he used the spiral to express his detestation of the straight line, which, Hundertwasser declared, "leads to the destruction of mankind."

From 1953 to '56 Hundertwasser was represented by the Galerie Paul Facchetti, Paris. In 1954 he contracted jaundice, and during his stay in the Santo Spirito Hospital, Rome, he painted watercolors, including *Head with White Windows.* While hospitalized he also developed the theory of "transautomatism," a somewhat obscure concept loosely derived from the surrealist principle of automatism. According to one critic, being "transautomatic" is to be "turned on visually," but transautomatism also seems to postulate instinctual, self-generated, antimechanistic methods of work for the artist and a creative act of entering into the "religious" aura of an artwork on the part of the observer. Also at this time, he began to number his works.

In the summer of 1956 Hundertwasser signed up as a crewman on a ship sailing the North Sea, an experience that may have inspired the watercolor *Singing Steamer (II).* Also in 1956 he published *La Visibilité de la création transautomatique.* Hundertwasser began to be recognized outside of Austria, where he was a *succès de scandale,* more notorious than honored, when he won the Prix du syndicat d'initiative at the Bordeaux Biennal of 1957. At this time Hundertwasser began to experiment more and more in mixed techniques, as in *Snail Sleep of an Austrian Landscape Night.*

Hundertwasser's romantic preference for the natural and irregular was expressed in his manifesto of July 1958, entitled "Verschimmelungsmanifest" (Mouldiness Manifesto Against Rationalism in Architecture), in which he repudiated the Bauhaus-Le Corbusier aesthetic and praised the decorative patterns of the Jugendstil and the extravagant curvilinear buildings of Antoní Gaudí in Barcelona which suggest natural forms (an admiration shared by Salvador Dali). He also praised rust, rot, and decay as mankind's truest friends. Hundertwasser read his much-publicized manifesto first at a

congress in the Seckau monastery in Austria, then in galleries in Munich and Wuppertal. He was awarded the Sambra Prize at the São Paulo Bienal of 1959 and caused a scandal that autumn when he became guest lecturer at the Kunst hochschule, Hamburg. He enlisted his pupils in a plan to paint, over a period of two days and nights, a continuous spiral that was to extend ten miles through the city. Consequently, he was asked to resign his lectureship.

Hundertwasser spent the year of 1961 in Japan and won the Mainichi Prize of the 1962 Tokyo International Art Exhibition. Returning to Venice in 1962, he married Yuuko Ikewada, whom he had met in Japan, and acquired a studio in a palazzo in the Giudecca, opposite San Marco. Hundertwasser was Austria's sole representative at the Venice Biennale of 1962; his work aroused great interest, and as his reputation grew so did his prices. Typical of his use of complex techniques was *Thousand Windows,* done in 1962 in Vienna and Venice, with a mixed medium of egg tempera, oil on wrapping paper over jute, and other ingredients.

A journey to Greece and the Greek islands in 1963, and a voyage from Rhodes to Venice in 1964, inspired two works in mixed techniques: *The End of Greece* (September 1963) and *The End of the Greeks—the Ostrogoths and the Visigoths* (1964).

In 1966 Hundertwasser and Ikewada were divorced. An unhappy love affair was indirectly reflected in two paintings of the late middle 1960s: *The Way to You* and *Yellow Houses*; in the latter a woman's face fills one of the windows. Masklike faces with staring slits for eyes are recurrent iconographical elements in his work.

Hundertwasser traveled in Uganda and the Sudan in 1967, and, characteristically, he lived among the common people. His Sudanese friend Sulaiman was the inspiration for one of his most attractive mixed-media works, *The Court of Sulaiman,* a lush and sinuous design with gold paint which evokes the Ottoman court of Suleiman the Magnificent. Nineteen sixty-seven was also the year of Hundertwasser's provocative "naked speech," which he delivered in the nude in Munich to protest rationalized architectural forms and mass society's production of an "antihuman" environment. He repeated the speech in Vienna in early 1968 and also wrote "open letters" to the press which aroused further controversy.

Hundertwasser briefly visited California in 1968 for his first major show in the United States, which was held at the University of California, Berkeley. From April to June of that year he sailed from Sicily to Venice and around the Aeolian islands in an old wooden 12-ton ship, the *San Giuseppe I.* He spent four years, 1968 to '72, converting the vessel for his own use and renamed it *Regentag* (Rainy Day). In the early '70s he collaborated with the director Peter Schamoni on a film, *Hundertwasser's Rainy Day* (1972), and also put together a portfolio of his graphic works entitled *Look at it on a Rainy Day.*

Continuing to protest against the standardization of culture and the dehumanization of modern society, Hundertwasser issued a manifesto in 1972 entitled "Your Right to Windows—Your Duty to the Trees." He declared that everyone should design their own house front, and that trees, if desired, should be allowed to grow indoors; he illustrated his thesis with architectural models.

For years Hundertwasser had collaborated with Japanese woodcutters; he was, in fact, the first European painter whose wood blocks were cut by Japanese masters. In 1973 his first woodcut portfolio, *Nana Hyaku Mizu,* was published. In October of that year he had his first exhibit at Auerbach Fine Art, New York City (the gallery's director, Joachim Jean Auerbach, is a collector of his work).

Since 1973 Hundertwasser has spent most of each year in New Zealand, though he still maintains La Picaudière (his apartment in Venice) and a country home his mother purchased that is the artist's pied-à-terre in southern Austria. In the mid-1970s he inaugurated Conservation Week in New Zealand to protest French atomic tests in the Pacific; in the early 1980s he participated in the campaign to end proliferation of nuclear weapons and to prevent nuclear war.

Better known in Europe and Japan than in the United States, Hundertwasser is a complex personality. His talent for attention-getting, as manifested in his extremes of dress—or undress—is in contrast to the quiet, solitary individual who has disappeared for months on end to live among the inhabitants of, for instance, an African village. In photographs, the tall, bearded artist often has a haunted look, yet Joachim Jean Auerbach has described him as having a childlike quality and sensibility. In New Zealand Hundertwasser's favorite pastimes are sailing the *Regentag* and flying kites.

Some critics see in his work—which combines primitivism and fantasy as well as baroque density and archaic, often rigid forms—a kinship with such diverse creations as Gaudí's architecture, Byzantine mosaics, the Jugendstil, Oriental color traditions, and Austrian peasant woodcarvings. In *Hundertwasser* (1976) Werner Hof-

mann compared the artist's paintings, with their expanding spirals, to Japanese paper flowers that open when thrown into water, and Hundertwasser himself described his pictures as "a slow explosion." "My revolution, like dripping water, is a quiet one," he said. Dissenting critics, however, have charged that he is overrated, that his greatest talent is for self-promotion and gnomic proclamations about his own artistic importance. But in the catalog to a Hundertwasser exhibition at the Tel Aviv Museum in 1976, Pierre Restany wrote: "Hundertwasser's obsession resembles no other. It is the obsession of an extreme talent, settled very early in the formal elements of a language that is decorative, expressionist, and at the same time autosymbolic."

EXHIBITIONS INCLUDE: Art Club, Vienna 1952, '53; Gal. Paul Facchetti, Paris 1954, '56; Gal. del Naviglio, Milan 1955; Gal. Kamer, Paris 1957, '58; Gal. Raymond Cordier and Co., Paris 1960; Tokyo Gal. 1961; Venice Biennale 1962; Gal. La Medusa, Rome 1962, '68; Kunsthalle, Berne 1964; Stedelijk Mus., Amsterdam 1964; Moderna Mus., Stockholm 1964–65; Mus. des XX Jahrhunderts, Vienna 1965; Hanover Gal., London 1967; Kunstverein, Berlin 1967; Univ. Art Mus., Univ. of Calif., Berkeley 1968–69; Auerbach Fine Art, NYC 1973; Auckland City Art Gal., New Zealand 1973; Tel Aviv Mus., Israel 1976. GROUP EXHIBITIONS INCLUDE: Exhibited regularly at Salon des Réalités Nouvelles and Salon de Mai, Paris; Bordeaux Biennal 1957; São Paulo Bienal 1959; International Art Exhibition, Toyko 1962.

COLLECTIONS INCLUDE: Solomon R. Guggenheim Mus., NYC; Ny Carlsbergfondets, Copenhagen; Oesterreichische Gal., Upper Belvedere, Vienna; Oesterreichische Bundeskunstförderung, Vienna; PrintRoom, Akademie der bildenden Künste, Vienna.

ABOUT: Auerbach, J. J. Hundertwasser, 1973; Chipp, H. B. and others Friedrich Hundertwasser, 1968; "Friedrich Hundertwasser" (cat.), Art Club, Vienna, 1953; Hofmann, W. Hundertwasser, 1976; Osborne, H. (ed.) Oxford Companion to Twentieth-Century Art, 1981; Pellegrini, A. New Tendencies in Art, 1966; Restany, P. "Hundertwasser" (cat.), Gal. Kramer, Paris, 1957; "35 Tage Schweden" (cat.), Moderna Mus.; Stockholm, 1964. *Periodicals*—Cimaise (Paris) May 1956; London Observer April 9, 1967; New York Times May 17, 1969; Nouvelle revue Française (Paris) 1954, 1960; L'Oeil Fall 1961; Quadrum (Brussels) no. 14 1963; San Francisco Sunday Examiner and Chronicle October 28, 1968; Stern (Hamburg) March 17, 1968; Studio International November 1964; Time March 5, 1965.

INDIANA, ROBERT (September 13, 1928–), American painter, writes: "I was born in New Castle, Indiana, in 1928, which at that time was very close to the population center of

Photo by Rummler

ROBERT INDIANA

the United States, directly beneath Muncie, which entered historico-sociological tracts as the 'typical' American town ['Middletown'] and was circumscribed by such picturesquely named hamlets as Spiceland, Maplevalley, Shirley, Cadiz, Honey Creek, Economy, and Dublin. The country seat of Henry County, New Castle has entered literary history as the Freehaven of *Raintree County* on the banks of the fictional Shawmucky River, instead of the real-life Big Blue, in the mind of author Ross Lockridge, Jr., with whom I share the same birthplace. And it is from the literary standpoint that I know that place best, having seen it only once 20 years later, for I was immediately whisked away from parents that I have never seen; I know only their names, which are words.

"Via Richmond, a Quaker town which is perilously close to Ohio, I came to grow up in or near Indianapolis (which is at the very center of the state that I was to choose for my final name), halfway to Terre Haute, dangerously close to Illinois, and the subject of my first word painting. Just like the holy English Motherland, Indiana then was great automobiles and good writers, not artists. Dusenberg and Tarkington were the names proudly vaunted, along with that of the Depression's most famous gangster, Dillinger, whose home town, Mooresville, was where I attended my first year of school and where, soon after his death, one of the most significant events of my life as a young artist took place. My very modest, quiet Hoosier schoolmarm decided that her pupil was destined for a conspicuous future and asked if she could keep two of my drawings so that she might treasure them for that realiza-

tion. Thirty-five years later I returned to Mooresville and tracked her down—which required some sleuthing because my teacher, Ruth Coffman, had become Mrs. Maurice Haase—and upon having coffee with her at her home she excused herself, went into her bedroom and brought forth from her hope chest those same two drawings.

"Given the barbaric state of elementary art education in Indiana at that time, I had practically no art training until I entered Arsenal Technical High School in Indianapolis, an extraordinary secondary institution more like a college, with a 75-acre campus next to the site of Booth Tarkington's *Magnificent Ambersons,* where I encountered another woman important in my life, again a teacher, but this time a noted watercolorist in her own right and a non-Hoosier from Philadelphia. Miss Sara Bard, very prim, proud, and dedicated, was my best art teacher and influenced my choice of art school. Though I won a scholastic scholarship to the local [Indianapolis] art school, John Herron, I gave it up for a five-year alternative via the GI Bill and three years of the Air Force, studying after discharge at the Art Institute of Chicago [1949–53] and the University of Edinburgh [1953–54] on a traveling fellowship from the Art Institute. Another strong teacher at Arsenal Tech, Miss Ella Sengenberger, of the journalism department where I worked on the school newspaper, had prepared me for my fate in the service, because in Anchorage, Alaska, I edited the *Sourdough Sentinel.* That until my mother became mortally ill and I had to return home on emergency furlough. As I entered the door of our home in Columbus, Indiana, she tried to say, 'Did you have something to eat?' and in five minutes after my arrival she was dead. Her last word accounts for some of my first word paintings, i.e., EAT/DIE. These I wove into the theme of my 'American Dream' paintings, the first of which was my first major painting sold in New York, incredibly enough, to the Museum of Modern Art, from an otherwise totally unsuccessful two-man exhibition. From my first one-man show at the old Stable Gallery in New York one third of the paintings exhibited went into major museum collections. With the surge and popularity of the so-called pop movement, I crested on a wave of unexpected acceptance, a phenomenon hitherto rare for American artists. [My word painting] LOVE was the apex which peaked with an edition of 330,000,000 United States postage stamps bearing that motif, spreading it probably to every country in the world, for it was the most popular commemorative stamp ever issued, save for Christmas specials, being unprecedentedly reissued twice. This along with the uncounted plagiarisms made LOVE the most widely seen image of any artist in the twentieth century."

————

Robert Indiana is best known for the verbal imagery he incorporates in his colorful pop paintings. His subject matter is the American Dream, which he represents in words, such as EAT, LOVE, DIE, TILT, and TAKE ALL, or sentences, such as JUST AS IN THE ANATOMY OF MAN, EVERY NATION MUST HAVE ITS HIND PART (from his painting *Selma, Alabama* [1965], a reference to the tragic bombing of black school children in the early days of the civil rights struggle). He paints, stencils, or sculpts words in the gaudy colors of signs and encloses the messages in geometric shapes.

He was born Robert Clark in New Castle, Indiana. His father, Earl Clark, deserted the family while Robert was still a child, and his mother, Carmen, was forced to earn a living from the 25-cent meals she cooked in cheap roadside coffee shops, the type evoked by his EAT paintings of the 1960s.

At the age of 12, Robert went to live with his remarried father in Indianapolis. There he attended Arsenal Technical High School and painted enough on weekends to give a local solo show of watercolors. His early paintings were influenced by the American Realists Edward Hopper and Reginald Marsh and by the Precisionists Charles Demuth and Charles Sheeler.

While still in high school, Indiana attended Saturday classes at the John Herron School of Art, Indianapolis. A National Scholastic Art Awards scholarship in 1946 enabled him to attend John Herron full-time, but he quit, as he put it, "to secure a larger scholarship via the Army Air Corps." While in the military he took evening classes at Syracuse University and the Munson-Williams-Proctor Institute, Utica, New York.

After his discharge in 1949, Robert Indiana enrolled at the Art Institute of Chicago, where he studied for four years and supported himself with odd jobs. He exhibited his work in a North Side Chicago bar with his schoolmate Claes Oldenburg, who was also to become an important Pop artist. Clark changed his name to Indiana in the 1950s.

In 1953 Indiana attended on scholarship summer classes at the Skowhegan School of Painting and Sculpture in Maine. He shared the school's Fresco Prize for a mural protesting the Korean War. Also in 1953, a George Brown Traveling Fellowship enabled him to study at the University of Edinburgh, Scotland, and thereby complete requirements for the BFA degree from the

Chicago Art Institute. He found Edinburgh and its university far from stimulating, but he belonged to the university's Poetry Society and printed his own verses on a hand press. He toured the Continent and attended a summer seminar in art history at the University of London.

In 1954, when Indiana ran out of funds, he borrowed his return fare from the American Embassy and settled in New York City. From 1954 to '56, he took odd jobs, experimented with kinetic light works, and spent much of his time writing. He had no use for the "painterly" brushwork of abstract expressionism. Influenced by Dubuffet, he sometimes used an impasto texture on his canvases, but later abandoned this approach in favor of flat, even surfaces.

Indiana moved in 1956 to a studio on Coenties Slip in lower Manhattan, near the harbor. His neighbors were the Hard-Edge abstractionists Ellsworth Kelly and Jack Youngerman; another painter he met there was James Rosenquist, who became a seminal Pop artist. The artists living at Coenties Slip kept their distance from the Abstract Expressionists, whose "headquarters" were Greenwich Village; according to Dore Ashton in *American Art Since 1945*, the Coenties Slip group engaged in "an informal but protracted conversation, seeking possibilities not only in the immediate past of the New York School but also in the entire spectrum of the modern tradition."

Indiana began a series of hard-edge paintings based on the fan-shaped leaves and symmetrical curves of the gingko plant, which grew along the Slip, and the avocado plants in his studio. In 1958 he was employed at the Cathedral of St. John the Divine, transcribing a book about the Cross. He became so absorbed by the project that he spent a year painting a large Crucifixion mural; the mural was drawn in black and composed of paper picked up from his studio floor. The bold, spiky forms were abstract but suggestive of the three crosses, with Christ flanked by the two thieves. The mural was included in a group exhibition of liturgical art that toured the United States in the fall of 1977.

In 1959, after painting a series of circles, Indiana's only purely abstract works, he began to develop imagery derived from the harbor surroundings of his studio. He collected found objects from the docks—rough beams and planks, rusted iron wheels, and wooden sockets—and combined them into intriguing constructions. These were enlivened with stenciled lettering, painted in the gaudy colors of signs—"more profuse than trees," he said—around his studio. Inscribed with such words as HOLE, SOUL, HUB, and PAIR, these highly

original constructions were exhibited at the Studio for Dance, New York City, in 1961. One of his stenciled works, *MOON*, was included in the 1961 "Art of Assemblage" exhibition at the Museum of Modern Art, New York City. Indiana's series of "LOVE" paintings were displayed at this first solo show, at the Stable Gallery, New York City, in 1962.

Like most pop art, Indiana's "American Dream" series, begun in 1961, alluded to banal objects, especially road signs, commercial slogans, juke boxes, and pinball machines. The first of these paintings, made up of four star-studded circles containing numbers and the words TILT, TAKE ALL, and THE AMERICAN DREAM, was purchased by MOMA. Later paintings in the series featured the single word EAT, which was balanced on other canvases with the word DIE. (According to one writer, the EAT/DIE equation stemmed from the fact that Indiana's father had dropped dead after eating breakfast.) Private and personal associations abound in Indiana's work, along with an often mocking commentary on the American Dream, a concept he finds "pretty hard to swallow."

Robert Indiana also made a large sculpture of Corten steel using a phonetic spelling of the Hebrew letters for love, "ahavah." After being displayed outside the Jewish Museum, New York City, it was sent to Israel and there set up near the pavilion designed by Frederick Kiesler to house the Dead Sea scrolls. Corten steel is an alloy with a copper content, which rusts only up to a certain point, giving it a rich, warm permanent patina.

The LOVE paintings and several "number" works were exhibited at a solo show at the Stable Gallery in 1966. In 1968 Indiana was given a major retrospective at the Institute of Contemporary Art, Philadelphia, that traveled to San Antonio and Indianapolis.

When, on September 17, 1970, Robert Indiana received a Doctor of Fine Arts Degree from Franklin and Marshall College, Lancaster, Pennsylvania, part of the citation read:

Paradoxically, Indiana's seemingly impersonal form gives even greater immediacy and power to statements of deep human concern. To a troubled world he presented YIELD BROTHER, in response to Bertrand Russell's plea for support for his peace program. To the secessionist states, whose citizens, in his own words, "were willing to die for the perpetuation of human slavery," Indiana offered a remarkable series, each painting beginning with the words, JUST AS IN THE ANATOMY OF MAN EVERY NATION MUST HAVE ITS HIND PART, and followed by ALABAMA, MISSISSIPPI,

LOUISIANA or one of the ten other states. In still other works, Indiana has entered into dialogue with Whitman, Melville and Longfellow, commemorated old New York, Marilyn Monroe, his mother and father, and the Brooklyn Bridge. With his now famous LOVE, this people's painter gave new form to an old word, providing the highway sign for an entire generation.

Now that the hectic '60s have become history, Indiana has painted several series of "Autoportraits," dated from 1960 through 1969. The basic form of each canvas is a five-pointed star set within a circle which is set within a square. Each star contains the letters IND, and each circle is inscribed with the date of the year and numbers, words or parts of words relating to Indiana's personal experiences of that year.

The quintessentially American Pop artist, Indiana contributed to the Bicentennial Year celebrations spectacular sets and costumes for a revival of the Virgil Thomson—Gertrude Stein opera, *The Mother of Us All,* which premiered at the Santa Fe Festival in August 1976. Indiana was allowed to choose the production's director and he selected the Englishman Peter Wood, whose Broadway staging of Tom Stoppard's *Travesties* he had admired. In 1964 he had collaborated with Andy Warhol on the film *Eat.*

In the catalog to Indiana's 1968 retrospective exhibition, John W. McCoubrey wrote: "His allusive paintings . . . stand for an exhaustive range of the culture with which he so deeply identifies. He is an American painter of signs. He is also a people's painter." "Robert Indiana . . . ," wrote Lucy R. Lippard in *Pop Art,* "has from the beginning straddled the gap between Pop iconography and abstraction. . . . His contribution has been the marriage of poetry and geometric clarity via the inclusion of American literature and history in a non-objective art."

Robert Indiana occupies an entire building in downtown Manhattan and has a house in Vinalhaven, Maine, where he spends the summer. His spacious quarters in New York City provide an effective setting for his paintings and sculptures, and a home for four companionable cats. *Robert Indiana,* a film shot in the artist's Manhattan studio, was made by John Huszar in 1972.

In contrast to the bold impact of his canvases, Indiana is quiet and reflective, but very articulate and gently humorous, with a clear idea of what he wants to achieve. He is of medium height, tending to plumpness and with graying curly hair. He is very well-organized, and in his paintings, with their wealth of allusions, precise, hard-edge technique, and utterly contemporary spirit, there is more than at first meets the eye. In the same room with one of his "Autoportrait"

series, several canvases refer to artists he has admired. A *Homage to Stuart Davis* uses a juxtaposition of yellow and blue, a favorite Davis colorscheme, and contains the word CHAMP, an allusion to *Champion,* one of Davis' later paintings. A *Homage to Picasso* includes the word "Ruiz," for Picasso, like Indiana, changed his name. Most significant of all is one of Indiana's versions of a 1928 painting by Charles Demuth which made a lasting impression on him: *I Saw the Figure Five in Gold.*

Regardless of changes in artistic fashion, Robert Indiana strives to remain what he has always felt himself to be, the American Painter of Signs, embracing both the positive and negative aspects of the American Dream.

EXHIBITIONS INCLUDE: Stable Gal., NYC 1962, '64, '66; Walker Art Center, Minneapolis 1963; Inst. of Contemporary Art, Boston 1963; Gal. Alfred Schmela, Düsseldorf 1966; Herron Mus. of Art, Indianapolis 1968; Toledo Mus. of Art, Ohio 1968; Denise René Gal., NYC 1972, '75, '76; New York Cultural Center, 1973; Univ. of Texas, Austin 1977. GROUP EXHIBITIONS INCLUDE: "The Art of Assemblage," MOMA, NYC 1961; "New Realists," Sidney Janis Gal., NYC 1962; "Americans, 1963," MOMA, NYC 1963; "Formalists," Washington Gal. of Modern Art, Washington, D.C. 1963; New York World's Fair, Flushing Meadow 1964–65; "White House Festival of the Arts," Washington, D.C. 1965; Whitney Mus. of Am. Art Annual, 1965–67; "Word and Image," Solomon R. Guggenheim Mus., NYC 1965; "New Forms—New Shapes," Stedelijk Mus., Amsterdam 1966; Carnegie International, Pittsburgh 1967; São Paulo Bienal 1967; Documenta 4, Kassel, W. Ger. 1968; "Pop Art Redefined," Arts Council of Great Britain, London 1969; "Monumental Sculptures," Inst. of Contemporary Art, Boston 1971.

COLLECTIONS INCLUDE: Albright-Knox Art Gal., Buffalo, N.Y.; Baltimore Mus. of Art; Carnegie Inst. of Arts, Pittsburgh; Detroit Inst. of Art, Detroit; Honolulu Academy of Arts, Honolulu; Inst. of Contemporary Art, Philadelphia; Los Angeles County Mus.; Metropolitan Mus. of Art, and Whiteny Mus. of Am. Art, NYC; Art Gal. of Ontario, Toronto; San Francisco Mus. of Art; Stedelijk Mus., Amsterdam; Univ. of Texas Art Mus., Austin; Walker Art Center, Minneapolis; Wallraf-Richartz Mus., Cologne; Hirshhorn Mus. and Sculpture Garden, Washington, D.C.

ABOUT: Abrams H. Varieties of Visual Experience, 1972; Amaya, M. Pop Art and After, 1966; Calas, N. and E. Icons and Images of the Sixties, 1971; Current Biography, 1973; Feldman, E. B. Art as Image and Idea, 1967; Lippard, L. R. Pop Art, 1966. *Periodicals*—Art News May 1961, September 1962, November 1963, May 1966; Denver Post August 9, 1976; New York Times July 18, 1976; Time June 21, 1963, August 23, 1976.

***IPOUSTÉGUY, JEAN (ROBERT)** (January 6, 1920–), French sculptor, developed his own brand of figurative surrealism, at once elegant and brutal. A self-described Freudian, Ipoustéguy invests his figures, finely crafted in a semirealistic style from cement, bronze, marble, or ceramic, with extreme mental and physical—especially erotic—anguish; their bodies, disjointed and distorted, plunged through walls or inextricably melded with another figure in an architectonic embrace, express the universal fears of self-alienation, dehumanization, and death. At the same time, he alludes to ancient and classical sources in subject matter and perfection of finish—and in his faith that the human form is still a fit subject for sculptural investigation. "I am the last of the sculptors you can understand," he told *Art International* (February 1970). "In my bronzes I (try) to show something inside the figures to excite the imagination of the viewer. . . . Inside is meant to be the mystery of life. I want the beholder to question what the mystery is."

Of Basque ancestry on his mother's side, Ipoustéguy was born in Dun-sur-Meuse, France. He had little formal schooling, but at the age of 18 studied painting at the artist Robert Lesbounit's atelier in Paris. Through the 1940s Ipoustéguy painted and designed tapestries and stained-glass windows; during World War II he worked as a laborer at a submarine base in Bordeaux, an experience later commemorated in the mysterious tableau *Discours sous Mistra* (1964–66, Discourse Under Mistra). In 1947 he was commissioned to do the frescoes for the Church of St. Jacques, Montrouge. Two years later he moved from Paris to Choisy-le-Roi and began to make sculpture, mostly bronze abstractions cast from plaster originals. Early influences included Brancusi, Henry Moore, and especially the sculptor-engraver Henri-Georges Adam, whom Ipoustéguy met in 1953. Ipoustéguy first exhibited his sculpture in 1956 at the Salon de Mai, Paris; his first solo show was held at the Galerie Claude Bernard, Paris, in 1962, and his first New York City show was at the Albert Loeb Gallery in 1964.

Several stylistic features that have persisted throughout Ipoustéguy's career were already evident in such early, essentially abstract works as *Cénotaph* (1957), *Casque fendu* (1958,Cloven Headpiece), and *Plage et falaise* (1960, Beach and Cliff): the use of separate forms joined roughly together; smoothly finished, bloated volumes articulated by cracks and fissures; and the juxtaposition of organic shapes with harsh geometrical or mechanical forms. "The primary formal nucleus," wrote an *Art International* (Summer 1964) critic of this early work, "is a fis-

Courtesy of the Galerie Claude Bernard, Paris

JEAN IPOUSTÉGUY

sured ovoid form which incarnates the minimal, specifically sculptural articulation, connotes the promise of birth, the suggestion of death-in-life, of destruction, extinction. . . . "

With Ipoustéguy's switch to figurative sculpture about 1959, his work took on the monumental frontality of Egyptian hieratic sculpture and the anatomical idealism and preoccupation with the male figure of classical Greek figuration. (Ipoustéguy also copied some of the accidental attributes of ancient and classical sculpture, as had Rodin and Moore before him; he lopped off arms and heads, prepared carefully "decayed" surfaces, and gave many of his bronzes an antique patina, first developed in the 19th century, to simulate the color of bronze long-buried in the ground.) His male figures, unlike those of antiquity, are not heroic or graceful. The David of *David and Goliath* (1959) is a faceless upper torso wearing armor (or skin) cracked as if under great pressure; Goliath is a defeated mass of abstract flesh. *Alexander at Ecbatana* (1965) portrays the conqueror as an unstoppable juggernaut with three arms and three profiles; before him lies the city to be crushed. "The Baroque mannerisms of these figures," wrote Charles Spencer in *Contemporary Artists,* "and their universal pretensions, as faceless giants either blind or shielded, [present] godlike creatures, not human beings. There is no denying the audacity of these conceptions, the impressive handling of form, the powerful intellectual and spiritual questioning they propose." The *Man Passing Through Door* (1966), who is literally walking *through* a louvered door, has a misshapen head and three hands, one of which holds a

small circular mirror; a dog's head is concealed behind the door. Small details like the mirror and the dog's head, and the found objects that occasionally appear in his bronzes (as in *Hair of the Wolf*, 1962) make a symbolic subtext that Ipoustéguy claims, as would any Surrealist, not to understand completely; these details represent eruptions from his subconscious, only partially controlled.

La Femme au bain (1966, Woman in the Bath) marked a turning point in Ipoustéguy's career; it was his first major female figure (and his finest) and his last major bronze for a decade; he gave it a reflecting golden surface, then unique in his oeuvre. Reclining naked in her tub, she pulls a blank mask off her face; underneath she is screaming in pain, fear, or ecstasy. A hinged plate, which may represent skin, armor, or the surface of the water, can be lifted off her body by the viewer. There are holes in the loosely jointed body where hidden objects can be felt. "The commingling of acute distress and sophisticated voluptuousness is particularly evocative of our age," wrote Donald Miller of *Woman*. "By any measure, *Woman in the Bath* is an extraordinary accomplishment. The sense of anguish is unforgettable."

Ipoustéguy spent a year in the quarries at Carrara (1967–68); thereafter he began to work in the more deliberate medium of marble, producing a large number of small studies and several major works. Although Michel Peppiatt of *Art International* (January 1969) felt that the new marbles lacked spontaneity and penetration and seemed "to extol a kind of anatomical lifelessness," at least one work, *La Mort du père*, (1967, The Death of the Father), is outstanding. Inspired by the deaths of Pope John XXIII and Ipoustéguy's own father in 1967, the 14-piece tableau portrays the father, accurately modeled in bronze, laid out in his coffin and wearing a bishop's mitre; over him crouches his misshapen son, the sculptor himself, ready to chip away at the father's head with carving tools. Arrayed alongside are marble heads in progressive stages of decay, also wearing mitres. Critics have seen in this work a commentary on the death of the Catholic Church, but it seems likely that the religious elements have a more arcane, Oedipal meaning. *The Agony of the Mother* (1970–71) and *The Death of the Brother* (1972), in bronze, are variations on the same theme.

In 1973–74 Ipoustéguy spent the year drawing in Berlin under the auspices of the German Academic Exchange Service. One hundred and thirty-three of these works, mostly full or partial nudes or abstract bits of anatomy rendered in charcoal, crayon, and wash, were shown at the Galerie Claude Bernard, Paris, in 1974. Ipoustéguy returned to bronze wholeheartedly at the end of the 1970s with *La Maison* (1976, The House), a massive cube formed by the intertwined limbs of two lovers, and *La Mort de L'Evêque Newmann* (1977, The Death of Bishop Newmann), in which the dark bronze bishop, lying dead on a snowy field of marble at the feet of indifferent passers-by, exhibits three faces: the decayed face of death, the mask of ecclesiastical authority, and the mask of religious ecstasy. Ipoustéguy's work continued to be shown periodically at the Galerie Claude Bernard, as well as in Germany, Italy, and elsewhere in Europe (where he is considered a major artist), but rarely in the United States. (In New York City, two minor sculptures and ten drawings were exhibited in a tiny Guggenheim Museum show in 1983).

Jean Ipoustéguy lives and works in Paris. Annette Michelson claimed him as the outstanding figure in contemporary French sculpture. "There is a sense, or several, in which [Ipoustéguy's] work is commemorative; it evokes memories of personal existence and extinction, celebrates history and myth, the evolution of sculpture and of styles, welding them through a positive and critical use which avoids the pitfalls of syncretism into a personal language. Its density, richness and explosive potential are unequalled by any French sculptor of his generation."

EXHIBITIONS INCLUDE: Gal. Claude Bernard, Paris 1962, '64, '66, '68, '69, '71, '72, '74, '75, '77, '79; Albert Loeb Gal., NYC 1964; Hanover Gal., London 1964; Leverkusen Mus., W. Ger. 1965; Gal. Thomas, Munich 1966; Gal. Birch, Copenhagen 1967; Gal. Galatea, Turin, Italy 1968; Gal. Odyssia, Rome 1968; Pierre Matisse Gal., NYC 1968; Gal. la Nuova Pesa, Rome 1968; Kunsthalle, Darmstadt, W. Ger. 1969; Badischer Kunstverein, Karlsruhe, W. Ger. 1970; Von der Heydt Mus., Wuppertal, W. Ger. 1970; Gal. Veranneman, Brussels 1970; Gal. Forma, Bologna, Italy 1971; Gal. Buchholz, Munich 1972; Gal. Gabbiano, Rome 1973; Tolarno Gals., Melbourne, Australia 1973; Nationalgal., Berlin 1974; Artel Gal., Geneva, Switzerland 1974; Kunsthalle, Berlin 1979; Mus. Ingres, Montauban, France 1979; Mus. d'Art Moderne de la Ville de Paris 1982; Solomon R. Guggenheim Mus., NYC 1983. GROUP EXHIBITIONS INCLUDE: Gal. Nationale des Beaux-Arts, Paris 1945; Gal. Claude Bernard, Paris 1956, '58; Salon de Mai, Paris 1956; Pittsburgh International, Carnegie Inst. 1961; "Three Sculptors: Berrocal, Ipoustéguy, Müller," Albert Loeb Gal., NYC 1962; Venice Biennale 1964; "Ten Years of Painting and Sculpture," Tate Gal., London 1964; Solomon R. Guggenheim Mus., NYC 1967; "The Obsessive Image," Inst. of Contemporary Arts, London 1968; Expo '70, Osaka, Japan 1970; "Zeitgenossen," Kunsthalle, Recklinghausen, W. Ger. 1970; International Exhibition of Modern Sculpture, Tokyo 1971; "Imagine per la Città," Genoa, Italy 1972; "30 Internationale Künstler," Bonn, W. Ger. 1974;

"Les Mains regardent," Centre Georges Pompidou (Beaubourg), Paris 1977; "La Furie controlée," Hôtel Salomon de Rothschild, Paris 1978; "Weltbewerb Internationales," Congress Centrum Berlin, Kunsthalle 1978.

COLLECTIONS INCLUDE: MOMA, and Solomon R. Guggenheim Mus., NYC; Carnegie Inst., Pittsburgh; Hirshhorn Mus. and Sculpture Garden, Washington, D.C.; Tate Gal., and Victoria and Albert Mus., London; Gal. Claude Bernard, Paris; Gal. Galatea, Turin, Italy; Peter Stuyvesant Foundation, Cape Town, S. Africa; Nationalgal., Berlin; Nat. Gal., Ottawa; Louisiana Mus., Humlebaek, Denmark; Mus. de Grenoble, France.

ABOUT: Arnason, H. H. History of Modern Art, 1968; Burnham, J. Beyond Modern Sculpture, 1968; P-Orridge, G. and others (eds.) Contemporary Artists, 1977; Read, H. A Concise History of Modern Sculpture, 1964; Schwartz, P. W. The Hand and Eye of the Sculptor, 1969. *Periodicals*—Art International Summer 1964, January 1969, February 1970; Arts Magazine December 1962.

Photo by Ira Friedlander

PAUL JENKINS

JENKINS, (WILLIAM) PAUL (July 12, 1923–), American painter, writes: "The sharing of my work with others has become a dominant motif. This does not mean talking about it—it means experiencing the fact. A painting becomes a fact that takes on its own life and ends up finding its own place in the world. An extraordinary thing is the element of surprise and persistent alarming impulse that the mind or the psyche will suggest. My Western mind was very fortunate because in the beginnings in Kansas City, Missouri, from the years 1923 until the outbreak of World War II in 1941, I was constantly exposed to the Eastern art at the William Rockhill Nelson Art Gallery. I was drawn to a carved wood sculpture of Kwan Yin, who, I was told, was the goddess of mercy. Her solemn dignity and utter grace somehow touched something in me. I was fortunate also to be brought up by an extraordinary liberal mind at that time, the Reverend Burris Jenkins, who showed courage and vision in asking Frank Lloyd Wright to build a new church when the old one on Lindwood Avenue burned down. And then there was the teacher, the first great teacher, Marjorie Patterson, who encouraged me to become totally expressive in writing and acting when I was at Westport High School. I wrote monologues which I gave on stage. I acted. I sculpted in a ceramic factory where I worked part-time. I painted at my home at 3729 Broadway. I was given one of the storage bins in the cellar and became used to working under the glaring eye of a naked light bulb. Marjorie Patterson had a keen and intense spiritual side to her nature. She was the first person to act

as a mystic guide when I experienced either psychic or spiritual manifestations. The Far East, my great-uncle Burris Jenkins, and my great teacher catapulted me into the labyrinth, the maze, of living and seeming to have no other choice than to paint.

"After the Art Students League years in New York City I went to Europe in the winter of 1953, first spending time in Sicily, at Mount Etna; then Spain, the Prado; then Paris and the dominant influences of the I Ching Book of Changes and of the Seine river. I must be near great water. I suppose, if there is credibility in it, that this has to do with a strong Cancerian nature in my chart. It is not that I believe occult things; it is that I am fascinated by them as some men are fascinated by Arabic or dialects of obscure tribes—they all are other languages that our civilization has left us. And it is how we interpret the language that makes it crass and dubious or mysterious and rewarding—the reward being to wonder.

"The dominant attitude of a man makes itself felt, no matter what style, what direction he finds himself eventually committed to. I want to be remembered for discovering the unknown, which seems very secret but is actually familiar—more like rediscovering a forgotten fact."

———

Paul Jenkins belongs to the second generation of Abstract Expressionists. Fascination with Eastern religions, an intensive study of the color theories of Newton and Goethe, and the artist's skill and originality in the handling of his medi-

um have made the visionary paintings of Paul Jenkins unique in contemporary nonobjective art.

Jenkins's early experiences in the theater, mentioned in his biographical statement, helped to foster his concept of painting as action and communication. He was born in Kansas City, Missouri, but graduate from Struthers High School, in Ohio, after which he acted professionally at the Cain Park Theater and was awarded a fellowship to the Cleveland Playhouse.

Jenkins served as a pharmacist's mate in the United States Naval Air Corps during World War II, and in 1944 he married Esther Ebonhoe, a scene and costume designer for the Pittsburgh Playhouse. After his discharge from the service in 1945 he attended a playwriting course at the Carnegie Institute of Technology, Pittsburgh, but continued to paint in oils, without any formal training.

Jenkins moved to New York City in 1948, and spent four years studying at the Art Students League. By far the most influential of his teachers was Yasuo Kuniyoshi, whose style blended an Oriental formalism with something of the direct simplicity of American primitives. During these years Jenkins was introduced to the mystical teachings of Gurdjieff, whose theories of "Objective Art" were included in P.D. Ouspensky's book, *In Search of the Miraculous.* Gurdjieff maintained that certain special persons can transcend their physical body and develop a second, "astral" identity. Gurdjieff's idea of an "astral presence" was to influence Jenkins's later paintings and his "mediumistic" view of himself as an artist.

In his graphite drawings of the 1940s (*Light Between,* 1943, and *Hat,* 1945), Jenkins worked in a detailed, decorative representational style. He was greatly impressed by a photograph of a veiled equestrian statue taken in New York City in 1951 by an unknown photographer, and this inspired a 1952 oil-painting, *Veiled Equestrian,* which, though still representational, stressed the mysterious, phantomlike nature of the subject. Other paintings from this early New York period, including *Sea Escape* (1951) in ink and watercolor, have a nocturnal romanticism reflecting Jenkins's admiration for the West Coast artist Morris Graves, but show distinct abstract tendencies.

In March 1953 Jenkins settled in Paris after traveling in Italy, Sicily, and Spain. In Paris he admired the small, almost abstract sketches of the Symbolist painter Gustave Moreau in the Moreau Museum, and was deeply moved by a large Redon exhibition then on view. Jenkins also met the influential critic Michel Tapié, who supported the Parisian painters working in a direction parallel to that of the Abstract Expressionists in New York. Among them was the short-lived German painter Wols, who had died in 1951 but whose free subjective improvisations of line and color helped to liberate Jenkins's vision and technique. Carl Jung's *Psychology and Alchemy* was another strong influence on Jenkins as was the Jungian concept of the "dark journey." His work became more fluid and more purely abstract, as in *Underpass* (1953), in gouache and ink and inspired by accounts of French explorers of underground caves, and *Hommage à Melville,* in tempera and also of 1953. The color, although luminous, was still muted: it did not yet have the iridescence of his later works.

In March 1954 Jenkins held his first solo show, at the Studio Paul Facchetti, Paris. It was well received by French and American critics in Paris and was followed in June by a solo show in Frankfurt, Germany. After his Paris exhibit, Jenkins thought of himself as a continuer of Odilon Redon and the art of "making the invisible visible," as the artist put it.

Later in 1954 Jenkins participated in his first group show, "Divergences" at the Galerie Arnaud, Paris. His oil, *The Astrologer,* was a typical work of this period—freely brushed, liquid skeins and stains of color evoking a journey into the unknown. His daughter, Hilarie Paula Jenkins, was born in Paris in July of that year.

About this time Jenkins, a tireless experimenter with paint, began to use Winsor and Newton powdered pigments and a viscous enamel paint called Chrysochrome, to achieve greater variety of texture. In 1955 Jenkins had his first American solo show at the Zoe Dusanne Gallery, Seattle (the Seattle Art Museum was to be the first museum to acquire a Jenkins painting). In New York City, Martha Jackson, whom he had met in Paris, invited him to become a member of her new gallery. She acquired his lustrous oil *The Alchemist* (1955), larger in scale than his previous works and revealing Jenkins as a "magician" of color, a term he himself had used about Redon.

Jenkins's first solo show in New York City was held in March 1956 at the Martha Jackson Gallery. His admiration for Hokusai's line and for the subtle tonalities of Far Eastern art were reflected in *Water Crane.* In this and in *Divining Rod,* purchased by John I.H. Baur for the Whitney Museum of American Art, New York City, Jenkins used the Chrysochrome enamel paint to trace very precise and "gestural" white lines over the thinly applied areas of color.

Esther and Paul Jenkins were divorced in

1957. Later that year Jenkins saw in New York City the huge abstract paintings of Morris Louis in which the canvas was stained with thinned pigments. Before 1956 Jenkins's paintings had been no larger than eight feet by five feet, and were usually smaller. Since his first stay in Paris in 1953 he had been using unstretched canvases, placed horizontally on the floor, and "pouring" the shapes into each other to get "defined veils." Although after 1960 he sometimes worked on stretched canvases, he found that when the work was over six feet by ten feet, the unstretched canvases obtained the best result. The breadth and sweep of his later large-scale paintings and their freedom of handling were greatly helped by the gift in 1958 of an Eskimo ivory knife from the painter (and Jenkins's future wife) Alice Baber. He did not know at the time that this was to become one of his most essential tools, but "it was [later] found to control and make precise designations and fusions at the same time."

Reviewing Jenkins's 1959 solo show at the Galerie Stadler, Paris, Clement Greenberg called him "one of the most individual painters of his time." From 1959 on, Jenkins titled his paintings "Phenomena," accompanied by an identifying word or phrase. *Phenomena Big Blue,* completed and shown in the winter of 1960–61 at Karl Flinker's gallery in Paris, was one of the first of his canvases to be painted entirely in acrylic. His search for density, substance, and luminosity in his "veils of color"led him in 1963 to use an acrylic liquitex matte varnish which enabled him, in his words, "to go to a very, very deep and rich cadmium red, flaming orange, intense violet, or translucent blue."

Throughout the 1960s, when pop art was in vogue, Jenkins continued to develop and expand his lyrical, essentially romantic form of abstract expressionism, with growing success and international acclaim. *Phenomena Astral Signal* of 1964 is a characteristic work in which, as usual, the loose unstretched canvas (nine feet eight inches by six feet eight inches) was stained by pigments suspended in a liquid medium which the artist "swooshed around." Sometimes, to quote a *Time* magazine article of 1968, he "kneads and hauls on the canvas as if it were sail." Jenkins almost never uses a brush, but the colors are never smeared, and "even when dry, his canvases manage to look fluid," to quote *Time*. The veils of color could be gossamer-thin or have the rich depth of stained glass. Some of Jenkins's abstractionist colleagues found the results a bit too slick, while acknowledging their fluid grace; but Jenkins's liquid abstractions have their own magic, creating vibrant and evocative images. (Jenkins's canvas-staining methods were appropriated for the popular film

An Unmarried Woman [ca. 1978], in which actor Alan Bates plays a charming, successful, middle-aged New York School painter.)

Jenkins's visit to Japan in 1964, the year of his marriage to Baber, intensified his interest in the art and culture of the Far East; he and Alice were invited to have a two-artist show in Osaka. That same year a film, *The Ivory Knife: Paul Jenkins at Work,* was produced by Martha Jackson. In 1968 it won the Golden Eagle Award at the Venice Film Festival. Amid his many travels and solo shows Paul Jenkins had not abandoned his interest in the theater. His full-length play, *Strike the Puma,* was produced off-Broadway in 1967.

Martha Jackson, who had shown Jenkins's work regularly for 14 years, died in 1969. Two years later Jenkins's first American retrospective was held at the Museum of Fine Arts, Houston.

For several years the more perceptive critics had realized that Jenkins's oils and watercolors, however abstract, were inspired by the natural world. In *Phenomena Himalayan* of 1971, for instance, the reference to landscape was obvious. The most spectacular canvas in Jenkins's show "Winds and Land Masks," at Gimpel and Weitzenhofer, New York City, in November–December 1976, was called *Phenomena Monongahela,* in which there is a dizzying and exhilarating sensation of windswept skies, breathtaking vistas of mountaintops, valleys, and winding rivers as if seen from outer space. Intermingling with the liquid zones are granulated veils of color compared by Gordon Brown in *Arts Magazine* to "colored sands carried by the winds," an effect achieved by mixing powdered glass with the pigment. Critic John Russell observed that "for some of us, Paul Jenkins has always been a closet landscape painter." Bruce Hooton in *Art World* quoted Hart Crane, "The River spreading flows and spends your dreams," and added, "I, for one, choose to join the artist in his dream. Thank God for phenomena and wonder." Each observer, wrote another critic, "will see these mindscapes differently."

The immense scale on which Paul Jenkins usually works has made it essential for him to have several large studios on Broadway, in downtown Manhattan. One studio is in the building across the street from his equally spacious studio-living quarters, previously occupied by Willem de Kooning. Jenkins, with his strong features, white hair and beard, and dramatically dark eyebrows, is among the most photogenic of artists. He is warm and friendly, and his personality combines a gentle spirituality with latent power and a hint of sensuality. There is something faunlike about him, reminiscent of ancient carvings of

Pan. In his unique art Jenkins has sought, in his words, "to achieve a kind of form in its own discovered space, a kind of light which reveals itself from within, while the reflected element affirms itself from without."

EXHIBITIONS INCLUDE: Studio Paul Facchetti, Paris 1954; Zimmergal. Franck, Frankfurt, W. Ger. 1954; Zoe Dusanne Gal., Seattle 1955; Martha Jackson Gal., NYC 1956, '58, '60, '61, '64, '66, '68, '69, '70, '71; Gal. Stadler, Paris 1959; Arthur Tooth and Sons, London 1958, '60, '63, '66; Gal. Karl Flinker, Paris 1961, '62, '63, '65; Tokyo Gal. 1964; Mus. of Fine Arts, Houston 1971; San Francisco Mus. of Art 1972; Gimpel Fils, London 1972; "Winds and Land Masks," Gimpel and Weitzenhofer, NYC 1976. GROUP EXHIBITIONS INCLUDE: "Divergences," Gal. Arnaud, Paris 1954; "Artistes Etrangers en France," Petit Palais, Paris 1955; "Recent Drawings U.S.A.," MOMA, NYC 1956; "New Trends in Paintings," Arts Council of Great Britain, London 1956; "Young America, 1957," Whitney Mus. of Am. Art, NYC 1957; Bicentennial, Carnegie Inst., Pittsburgh 1958; "Abstract Expressionists and Imagists," Solomon R. Guggenheim Mus., NYC 1961; "Réalités Nouvelles," Mus. d'Art Moderne, Paris 1963; Gutai Mus., Osaka, Japan 1964; "Painting without a Brush," Inst. of Contemporary Art, Boston 1965; Biennial, Corcoran Gal. of Art,Washington, D.C. 1966; "In Honor of Dr. Martin Luther King, Jr.," MOMA, NYC 1968; "Trends in Twentieth Century Art," Univ. of California at Santa Barbara 1970; Gal. d'Art Moderne, Basel 1970; "American Painting since World War II," Delaware Mus., Wilmington 1971.

COLLECTIONS INCLUDE: Albright-Knox Art Gal., Buffalo, N.Y.; Chrysler Mus., Norfolk, Va.; MOMA, Whitney Mus. of Am. Art, and Solomon R. Guggenheim Mus., NYC; Massachusetts Inst. of Technology, Cambridge; Stanford Univ. Mus., Palo Alto, Calif.; Walker Art Gal., Liverpool; Staqtsgal., Stuttgart, W. Ger.; Art Gal. of Ontario, Toronto; Univ. of California Art Mus., Berkeley; Bezalel Nat. Art Mus., Jerusalem; Stedelijk Mus., Amsterdam; Des Moines Art Center, Iowa; Dallas Mus. of Fine Arts; Tate Gal., London; Hirshhorn Mus. and Sculpture Garden, Corcoran Gal. of Art, and Smithsonian Inst., Washington, D.C.; Phoenix Art Mus., Ariz.; Univ. of Texas at Austin.

ABOUT: Cassou, J. "Jenkins" (cat.), Gal. Karl Flinker, Paris, 1963; Elsen, A. Paul Jenkins, 1972; Jenkins, P. with others (eds.) Observations of Michel Tapié, 1956. *Periodicals*—Art International (Lugano) March 1964; Art News December 1961, November 1966; Art World November 22, 1976; Arts Magazine December 1976; Christian Science Monitor January 17, 1972; France-Amérique (Paris) November 2, 1958; It Is Spring 1960; Metro June 1962; New York Post November 2, 1958; May 15, 1960; New York Times March 23, 1960; Studio March 1963; Time April 11, 1968.

JOHNS, JASPER (May 15, 1930–), American painter, is best known for the paintings of flags, targets, and Arabic numerals he did in the 1950s. With Robert Rauschenberg, Johns was the first major American artist to break with abstract expressionism.

He was born in Augusta, Georgia, the son of Jasper Johns, a farmer, and the former Jean Riley. His parents divorced soon after he was born and Johns was reared by grandparents and aunts and uncles in Allendale, South Carolina. Johns's family was poor, and he attended a one-room school where an aunt taught all the grades. He finished high school in Sumter, South Carolina, while living with his mother and stepfather. For a year and a half, in 1947–48, he attended the University of South Carolina, Columbia, before moving to New York City.

"I didn't know artists," Johns said, "but at an early age I realized that in order to be one I'd have to be somewhere else." To please his family he promised to attend a commercial art school in New York. According to his close friend, John Cage, "After applying for a scholarship he was called into an office and it was explained that he could have the scholarship but only due to his [financial] circumstances since his work didn't merit it. He replied that if his work didn't merit it he wouldn't accept it." Johns promptly quit the school, having studied there six months; the scholarship incident still galls him.

Johns worked as a messenger boy and then as a shipping clerk for six months before being drafted into the US Army. He served two years and returned to New York City in 1952. Feeling that he "really didn't know much," he enrolled at Hunter College on the GI Bill. He attended a lecture on *Beowulf,* a French class that was over his head, and an art class; then he dropped out. Alone, ill from hunger and boredom, and wanting to be an artist but knowing nothing about the New York art scene, he took a job in an uptown bookstore.

In his early New York days Johns visited museums and galleries, but he could not yet relate the modern art he saw to his own experience. "I remember seeing things like Pollock's painting on glass," he told Grace Glueck of *The New York Times* (October 16, 1977), "and an incredible Noguchi sculpture of balsa wood and string, but then it was hard to give what I saw a value."

While working at the bookstore, Johns met the artist Sari Dienes and the art historian Suzi Gablik. At soirées given by Dienes, Johns encountered people "who moved in a larger society," especially the avant-garde composer John Cage and the ultramodern dancer and choreographer Merce Cunningham, and through

Photo by Judy Tompkins, NYC

JASPER JOHNS

Gablik he met Robert Rauschenberg, a young artist and fellow Southerner.

"He [Rauschenberg] was kind of an 'enfant terrible' at the time," Johns said, "and I thought of him as an accomplished professional." Rauschenberg had had a few shows, had studied at Black Mountain College with Josef Albers, and was developing a radical art style that was to be labeled "post-abstract expressionist" and "postmodern." Rauschenberg persuaded Johns to quit his bookstore job, and they began to collaborate on free-lance window displays for Tiffany's and Bonwit Teller's to earn pocket money. Johns and Rauschenberg also moved into separate cold-water lofts in the same downtown Manhattan (Pearl Street) building, and for several years the two struggling young artists worked closely together. They were different in temperament: Rauschenberg was outgoing, voluble, and prone to explosive bursts of creativity, whereas Johns was reserved and withdrawn, and he worked with great deliberation. According to Michael Crichton, the author of *Jasper Johns* (1977), "Rauschenberg was exasperating and shocking where Johns never desired to shock." Johns and Rauschenberg saw one another's work daily, and, as Calvin Tomkins said in *Off the Wall* (1980), "The interchange on aesthetic terms was similar in intensity to what took place between Picasso and Braque from 1909 to 1914. . . ."

The mutual support was crucial because their art abruptly departed from the abstract-expressionist style which prevailed in New York City in the mid-1950s. Although they admired the Abstract Expressionists, many of whom en-

couraged them, and assimilated gestural brush-work into their styles, Johns and Rauschenberg believed art to be biographical but not necessarily "transcendental" or "self-expressive" in the manner of action painting. Influenced by the aesthetic theories of their friend John Cage and by Marcel Duchamp's readymades, they wanted to eradicate the boundaries separating art and life. They explored the ambiguous gap between representation and nonobjective art, and broke new ground by incorporating unusual as well as commonplace objects—stuffed animals, inner-tubes, old quilts, and brooms—into their paintings, combines, and assemblages. "The kind of exchange we had," Johns explained, "was stronger than talking. . . . It's nice to have verbal ideas about painting but better to express them through the medium itself."

One day in 1954 Johns destroyed all his work, because he wanted to be an original artist and his paintings, including abstract collages that he thought resembled those of Kurt Schwitters, were too obviously derivative. However, four pieces that were owned by friends survived. One is a small collage of 1954 titled *Construction with Toy Piano*, incorporating a toy piano with numbered keys that, when pressed, make sounds. "I was interested," Johns explained, "in the idea of a painting that did more than one thing, that had another aspect." Another construction, *Untitled* (ca. 1954), is a collage of printed matter in a box, with a cast of a woman's face at the bottom. The face is that of Rachel (Rosenthal) Moody, who lived in the same building as Johns. Max Kozloff, in his *Jasper Johns* (1969), saw "the artist to come" in these works, but felt they were "fragmented, rather precious objects" and compared them unfavorably to the work of Joseph Cornell.

In 1954 Johns had a dream in which he saw himself painting a large American flag and soon afterward he painted one, using encaustic, a neglected medium that he helped to revive. "Using the design of the American flag took care of a great deal for me," Johns said, "because I didn't have to design it. . . . So I went on to similar things like the targets, . . . things the mind already knows. That gave me room to work on other levels." By painting the flag—which in actuality is flat cloth—in encaustic, with its heavily encrusted surface, Johns succeeded in forcing viewers to see freshly a familiar image. Because the American flag is not "art" in the traditional sense, Johns's carefully wrought, and impersonally rendered, picture raised the questions "What *is* painting?" and "What is the difference between art and reality?"—the kind of teasing problems Johns's work deliberately poses.

Ideas suggested in his early series of "Flags" were explored further in the "Target" series. Unlike an American flag, a target can be many things, even though Johns's format was invariably that of concentric circles of color. In his first target painting, *Target with Plaster Casts* (1955), Johns combined an encaustic and collage target with plaster casts of parts of the body, painted in different colors and set in boxes behind hinged doors above the bull's eye.

An equally provocative work was *Target with Four Faces* (1955), in which cut-off plaster casts were placed in a row above the target surface. The red, blue, and yellow target was painted on newspapers pasted on canvas. The plaster faces, seen from the tip of the nose down and tinted orange, were all variations of the same woman. The impact of the overall image was disturbing: the eyeless faces above the target suggested, with chilling impersonality, a firing squad or a booth in a shooting gallery. But, like all of Johns's work, it could be interpreted on many levels, or seen simply as a physical object, "the same way you look at a radiator," the artist remarked. Johns's *Tango* (1955) painting incorporated a small music-box which, when wound, made "plinking" sounds. With both *Tango* and the targets, Johns said that he "wanted to suggest a physical relationship to the pictures that was active."

In 1955 Johns also painted his first numerals, a step towards abstraction in that numbers, unlike flags and targets, have no physical reality. Johns's numbers, in encaustic and collage on canvas, had the rich impasto and sensuous textures of abstract expressionist works, but the presence of familiar, "given" imagery produced a totally different, colder effect than a "hot" expressive painting by Jackson Pollock or Willem de Kooning. Moreover, at a time when flatness, the integrity of the picture plane, was an article of faith among painters and critics, Johns attached the two-knobbed front panel of a drawer to his all-gray canvas of 1957, *Drawer,* and superimposed one canvas on another in *Canvas* (1957).

When Johns's constructions and collages of 1955–58 were exhibited in his first solo show, at the Leo Castelli Gallery, New York City, in early 1958, they created a sensation. The exhibit was a sell-out and *Art News* put *Target with Faces* on the cover of its January 1958 issue. However, in some quarters Johns's banal, everyday images were considered a nihilistic put-on, and a few of the Abstract Expressionists sensed that their hard-won preeminence might be threatened. In *Other Criteria* (1972) Leo Steinberg quoted one action painter as saying, "If this is painting, I might as well give up." Steinberg was reminded of the consternation of the Fauves and other avant-garde Parisian artists when they saw Picasso's *Demoiselles d'Avignon* in 1907.

Controversy over Johns's work raged for years. *Time* magazine, enjoying the art-world contretemps, dubbed him "the brand-new darling of the art-world's bright, brittle avant-garde." In response, and as if to imply that his sudden fame was for the wrong reasons, Johns's *False Start* (1960) was painted in oils, not encaustic, and had riotous color laid on in large, explosive brushstrokes. But even in this more direct, "painterly" work, Johns asked questions. The word GRAY was stenciled on a patch of yellow, BLUE on orange, and so on. For Johns, these obviously mismatched labels signified that, formally, *False Start* was *about* color. Obeying his idiosyncratic sense of logic, he followed with *False Start*'s "twin," *Jubilee,* a "negative" version in somber black and white. Here the stenciled labels ORANGE, BLUE, RED, and so on are even more incongruous. Johns's use of witty pictorial irony to comment on his art-world acclaim can be seen in *The Critic Sees* (1961), a sculptmetal-on-plaster-with-glass depiction of a pair of glasses that frame lips and teeth instead of eyes.

In the late 1950s the art of Johns and Rauschenberg was termed "neodadaism." The designation accurately described Johns's first sculptures, which appeared in 1958 and played on the confusion between readymade and handmade objects. *Flashlight I* (1958) was sculptmetal over an actual flashlight. The similarly designed *Light Bulb I* (1958) achieved a strange, fossilized dignity, the more striking for so disposable an item. In 1959 Johns met Marcel Duchamp, the veteran, iconoclastic French artist who, with his provocative readymades of 1914, had anticipated the dada movement. The two men had much in common: both were intellectual artists—"There are no accidents in my work," Johns declared— and though both had keen senses of humor, they were private individuals who could seem cold and detached. There are similarities in their work, but Duchamp's objects are "antiart," intended to scandalize, and Johns's creations, however unorthodox, are, in spirit and technique, imbued with aestheticism.

In 1960 Johns heard that Willem de Kooning had remarked sarcastically of Johns's dealer, Leo Castelli, that an artist could give him two beer cans and he would sell them. "I thought," Johns said, "what a wonderful idea for a sculpture." He used two Ballantine Ale cans to produce *Painted Bronze (Beer Cans),* which appeared to be two ale cans on a base but was in fact a bronze sculpture with the Ballantine logo painted in carefully

simulated lettering. One of the "cans" is crumpled. Soon afterward, he did the sculpture *Painted Bronze*, an exact reproduction of a Savarin coffee can containing paintbrushes. Also in 1960, Johns began to work in a new medium, lithography, using that process for his series "Flag I, II, III." He also applied that method to his *Map* (1961), in which the outline of the United States is the framework for a play of colors painted in the broad, splashy brushstrokes and "drips" of action painting, though in a controlled, carefully thought-out manner.

Johns's use of common objects to explore the gap between art and life strongly influenced the pop art movement which emerged in the early '60s, but Johns himself cannot be considered a Pop artist. As Lucy Lippard pointed out, the "painterly surface" of Johns's objects "rids them of the newly minted mass-produced aura typical of Pop. . . . [But] once it was realized that the question 'Is it a flag or is it a painting?' had no answer—was not important—the way was wide open to Pop Art."

The close personal and professional relationship between Johns and Rauschenberg ended acrimoniously in the summer of 1962; there are images of loss and desolation in Johns canvases of the early '60s, but those themes are enigmatically stated. His *Diver* (1962) suggests, as John Russell observed in *The New York Times* (October 21, 1977), "that the diver in question is not so much cleaving the water for pleasure as throwing himself overboard, as Hart Crane threw himself overboard in April 1932." An oil of 1963 is entitled *Periscope (Hart Crane)*.

In the 1960s Johns also treated the traditional theme of the artist's studio. In his enormous *Untitled* (1964–65) three canvases are fitted together to form an ensemble, but the subject is less the studio than the elements of painting itself—color, line, canvas, paint. As in Rauschenberg's combines, actual objects are attached to the surface: a broom suspended from a nail on the far right may represent the artist's brush as well as "sweeping the studio"; a stretched canvas is hinged to the lower left corner; and an ordinary 12-inch ruler hangs from the top left panel. Over the broad flat areas of blue, red, and yellow of the painting's three segments are smears of rainbowlike color. At the bottom of the third segment are two impressions of the artist's own hand. *Studio 1964* also incorporates real objects, including a string of beer cans. The huge and complex *According to What* (1964), a centerpiece of Johns's 1977 retrospective at the Whitney Museum of American Art, New York City, is composed of vertical segments, and its title, stenciled on a canvas in the lower left corner,

seems to ask: "According to what rule shall I paint?" Johns pays homage to de Kooning in the slashing brushstrokes and to another pioneer of abstract expressionism, Hans Hofmann, in the hard-edged rectangles of pure color superimposed on the freely brushed areas. There are also allusions to Johns's earlier work: a coat hanger, bent and twisted, hangs from a nail; a vertical band of color circles framed in rectangles runs down the center; letters, set on their side and arranged vertically, are hinged so that they can be opened out at an angle to the picture surface; and there is a long silkscreened swath of newspaper. In *American Art Since 1900* Barbara Rose called *According to What* a catalog of "varieties of representation."

In the 1970s Johns added to his repertory of images, while retaining bits and pieces of earlier motifs. In 1967, while driving through Harlem, he momentarily glimpsed a store with a wall painted to simulate flagstones, and from 1972 on, the flagstone image was combined or juxtaposed with the crosshatching technique which has become Johns's principal visual motif.

Crosshatching, too, was derived from a fleeting visual experience. "I was riding in a car," Johns explained, "going out to the Hamptons for the weekend, when a car came in the opposite direction. It was covered with these marks, but I only saw it for a moment—then it was gone— just a brief glimpse." In *New York* magazine (February 27, 1984) Kay Larson described Johns's crosshatched paintings of the '70s as "crisscrossed strokes of color set off against other strokes like the zigzags in a herringbone tweed. These works were smart, even beautiful, but remote and unrevealing. . . . "

The immense four-panel *Untitled* (1972), in oil and encaustic on canvas with objects added to the fourth panel, combined several motifs: the left-hand panel had the colorful crosshatching, the two central panels had the flagstone motif, and wooden strips attached to the right-hand panel with wing nuts were numbered, as if for easy assembly and disassembly. Reinforcing the idea of dismemberment, casts of parts of the body were fixed to the strips. As Michael Crichton noted, there is a progression from the disconcertingly concrete reality of the casts on the right, through the textured representation of the flagstones, to the figurative abstraction of the crosshatching on the left. The movement, he said, is "from the specific to the unspecific, from three-dimensionality to flatness." Johns's paintings of 1973–76 were all variations on the crosshatching theme. The poster he designed for his 1977 retrospective at the Whitney Museum used crosshatching as a background for a lively painting of his famous Savarin coffee can.

Johns has commented that in his work of the 1970s he was in emotional and artistic hiding. But in the impressive canvases he exhibited at Leo Castelli's Greene Street Gallery, SoHo, in February 1984, Johns's first showing of new work in eight years, the artist "[stuck] his head above ground," to quote Larson. Several paintings were crosshatched, but others contained autobiographical references and provocative allusions to motifs Johns had developed years before. For example, *Perilous Night* contains, as Larson noted, "an encaustic painting of one of Johns's crosshatched prints, next to a John Cage score [also titled *Perilous Night*], and under a trio of dangling forearms." There was a silkscreened photograph of the young Leo Castelli on another canvas, and a Savarin coffee can painted on another.

Since 1963 Johns had been a director of the Foundation for Contemporary Performance Arts, Inc., and has served as artistic advisor to the Merce Cunningham Dance Company. In 1973 he was elected to membership in the National Institute of Arts and Letters.

Jasper Johns has largely abandoned New York City for the upstate village of Stony Point, where he resides. At 47 he was described by Grace Glueck as "a large man whose slightly scarred face, aquiline nose and stern mouth (that can break into an impish smile) give him the appearance of an Indian brave." Johns's is a guarded and reticent personality, but as John Cage said, "There are evidently more persons in him than one."

"The verbal and intellectual elements of Johns's enigmatic pictures [do] not relate to anything outside the paintings themselves," Calvin Tomkins wrote; "everything [refers] back to the hermetic world of the canvas and its own internal relationships." "I've attempted to develop my thinking in such a way that the work I've done is not me—not to confuse my feelings with what I've produced," Johns said. "I don't want my work to be an exposure of my feelings."

EXHIBITIONS INCLUDE: Leo Castelli Gall., NYC from 1958; Gal. Rive Droite, Paris 1959, '62; Gal. Ileana Sonnabend, Paris 1962; Jewish Mus. NYC 1964; Whitechapel Art Gal., London 1964; Ashmolean Mus. of Art and Archeology, Oxford, England 1965; Nat. Collection of Fine Arts, Smithsonian Instn. Washington, D.C. 1966; MOMA, NYC 1968, '71; Philadelphia Mus. of Art. 1970; Kunsthalle, Bern 1971: Stedelijk Museum, Amsterdam 1972; Whitney Mus. of Am. Art, NYC 1977-78. GROUP EXHIBITIONS INCLUDE: "Artists of the New York School: The Second Generation," Jewish Mus., NYC 1957; "Sixteen Americans," MOMA, NYC 1959; Carnegie International, Pittsburgh 1958, '61, '64, '67; Venice Biennale 1958, '64; Whitney Mus. of Am. Art, NYC 1960-72, Biennal 1973; "Painting and

Sculpture of a Decade 1954–64," Tate Gal., London 1964; Documenta 3 (1964), 4 (1968) Kassel, W. Ger.; São Paulo Bienal 1967; "New York Painting and Sculpture: 1940–70," Metropolitan Mus. of Art, NYC 1969–70; "Idea and Image in Recent Art," Art Inst. of Chicago 1974.

COLLECTIONS INCLUDE: MOMA, and Whitney Mus. of Am. Art, NYC; Hirshhorn Mus. and Sculpture Garden, and Smithsonian Instn, Washington, D.C.; Albright-Knox Art Gal., Buffalo, N.Y.; Brandeis Univ. Art Collection, Waltham, Mass.; Des Moines Art Center; Dallas Mus. of Fine Arts; San Francisco Mus. of Modern Art; Victoria and Albert Mus., London; Stedelijk Mus., Amsterdam; Moderna Mus., Stockholm; Mus. Ludwig, Cologne; Kunstmus., Basel; Kunsthaus, Zürich; Ohara Mus. of Art, Kurashiki, Japan; Seibu Mus. of Art, Tokyo.

ABOUT: Amayo, M. Pop Art and After, 1966; Calas, N. and Calas, E. Icons and Images of the Sixties, 1971; Crichton, M. Jasper Johns, 1977; Current Biography, 1967; Kozloff, M. Jasper Johns, 1969; Lippard, L. R. Pop Art, 1966; Lucie-Smith, E. Late Modern: The Visual Arts since 1945, 1969; Rose, B. American Art Since 1900, 2d ed. N.Y., 1975, (ed.) Readings in American Art Since 1900: A Documentary Survey, 1968; Steinberg, L. Other Criteria: Confrontations with Twentieth Century Art, 1972. *Periodicals*—Artforum March 1965; Art in America August 1964; July–August 1969; Art International September 1969; Art Journal Spring 1977; Newsweek February 24, 1964, October 21, 1977; New York November 7, 1977, February 27, 1984; New York Times October 16, 1977, October 21, 1977; Time May 4, 1959.

JONES, ALLEN (September 1, 1937–), British painter, lithographer, and sculptor, has been dubbed "Britain's foremost sex artist." His work has been the object of much publicity and controversy, largely for its curious blending of formalist concerns with outright, obsessive eroticism. Intelligent and technically adroit, Jones has recently shifted away from an over-obvious voyeurism toward a more subtle exploration of sexual theatricality.

Jones was born in Southampton, England. Educated in London, from 1955 to 1959 he attended the Hornsey School of Art, and from 1959 to 1960, the Royal College of Art, from which he was "ejected" after a year of study but where he met other young artists such as David Hockney, R. B. Kitaj, and Peter Phillips. This group of painters, most working in some erotic or erotimechanical area of pop, around 1960 became known as the "New Generation." Although Jones was (and often still is) classified as a Pop artist, he does not think of himself as such. In a 1965 *Studio International* interview he said: "I admit that I have a liking for things that are specifical-

Jorge Lewinski

ALLEN JONES

ly related to advertising and commercial reproduction processes, and they appear in my work. But I wouldn't say that they are special or that I am emphasizing them to make a particular point. It's not my intention to identify with mass-produced objects. I use them because I like them from a formal point of view." Overall, Jones claimed to be more concerned with understanding and exploiting various formal principles than with any satiric or other message conveyed through commercial or popular symbols. "The problem," he continued, "is to make the viewer aware that he is looking at a convention rather than at an actual figure, that the picture is about *how* we perceive rather than *what* we perceive, that there should be no confusion of Art with Life."

Jones first became known through two "Young Contemporaries" shows in London, in 1960 and 1961. Included were several self-portraits and a series of surreal paintings based on battlefield maps, complete with flags, fragments of figures, and notes on field maneuvers (notably *The Battle of Hastings*, 1961–62). Jones had remarked that these rather disjointed paintings are about deep space, the canvas functioning as a field to be activated; all of his subsequent work continues to deal with these most basic formal problems.

Cartography did not make Jones famous, however; buses did. In the early 1960s when, recently married to Janet Children, he was making his living as a lithography teacher at the Croydon School, the artist turned to the portrayal of size and speed in a series of paintings and lithographs of buses, planes, and parachutes. The best

known are the buses, cartoonish vehicles in extreme close-up, as in *3rd Big Red Bus* (1962) and the five-lithograph suite, *A Fleet of Buses* (1966). In most of these works the central object occupies the entire canvas, with sides or top lopped off. The paintings, rhomboidally shaped to give the maximum impression of speed, often have tires dangling on small, separate canvases tacked on below. Jones's planes use the same configuration, turned upside down to suggest an airplane's cockpit. His 1963 and 1964 exhibitions at Arthur Tooth and Sons, London, brought him particular acclaim.

In 1963 Jones began centering his work on the human figure, in gradually sexier settings. The early works of this type, such as *Bikini Baby* (1963) and a lithographic *Self-Portrait* (1963), which portrays the artist as a decrepit old man below an alluring pinup, are humorous and relatively harmless. Hermaphroditic figures, as in his plexiglass sculpture *Hermaphrodite* (1965) and the "Concerning Marriages" series, in which male and female parts and clothes are inextricably confused, also fascinated him. Even in this figurative work Jones plays to the bottom of the canvas, where he allows feet, shoes, and more anonymous objects to accumulate. There is, as well, already the erotic obsession with ties, thighs, cleavage, spike heels, and stockings that distinguishes his later work.

Exclusively female imagery predominates in his work between 1965 and the mid-1970s. As with other Pop artists, his themes and visual vocabulary are drawn from advertising, but, in Jones's case, his examples are the extreme graphics seen in Soho or Times Square. His women, now objectified and dehumanized, were reduced to those parts most appealing to the fetishist—skin-tight black stockings, impossibly spike-heeled shoes, breasts, dark-lipsticked lips. Gone also is the lighthearted quality of the earlier work, replaced by a polished, super-realist professionalism appropriate to the demanding eye of the voyeur. Some of this erotica is subtle, some blatant. *Sheer Magic* (1967) shows a woman's foot (in the inevitable high-heels) and calf which explodes at the knee into a colorful bull's-eye. Despite the swirling color, one's attention remains riveted to the leg. In *You Dare* (1967) a blue pair of legs with green shoes jumps in from the left onto a floor of red and yellow checkered tiles. These paintings are three-dimensional in that they are extended laterally towards the viewer at the bottom edge; the foot in *Sheer Magic* rests on an actual shelf which projects below it from the canvas, while a set of checkerboard steps draws the viewer into *You Dare* for a better look at the blue-stockinged legs.

Fully three-dimensional, and far less subtle, is Jones's *Green Table* (1972), a sculpture of a leather-clad dominatrix on all fours who supports a glass tabletop on her back, so that the sculpture as a whole forms an outré coffee table. The tabletop is also a palette, with rainbow splotches of color circling its surface. This piece in particular has been attacked by feminist and other critics as representative of Jones's insulting portrayal of women as no more than functional objects. All those legs, shoes, underclothes, etc., claim these critics, represent and exploit objectionable male fantasies, and cannot be divorced, as Jones might wish, from their reactionary symbolism. But whether Jones is making fun of how sex is viewed in our society or is simply inspired by it, he maintains that his chief concern is not the content of the canvas, but the form it takes and its effect on the viewer. "Eroticism transcends cerebral barriers," he says, "and demands a direct emotional response—confronted with an abstract statement people readily defer to an expert; but confronted with an erotic statement everyone is an expert. It seems to me a democratic idea that art should be accessible to everyone on some level, and eroticism is one such level." Nonetheless, all that separates this work from high-quality, rather mild pornography is Jones's formal brilliance: his clever manipulations of flatness and space, surface and edge, color and texture, and the cerebral perfection of the fetish image.

This style, pursued for over a decade without major innovations, ultimately proved a stumbling block to Jones's progress. It is true that the theme of voyeurism eventually led him to more penetrating investigations of social and sexual theater, allowing him to continue his experiments with visual and participatory art in a new vein, but the erotic value of the work was worn out with repetition, and critics began to wonder out loud just who the admirers of this "artistic pornography" were. In 1979, however, at his first retrospective (at the Serpentine Gallery, London), it was evident that in his most recent work he had returned to a freer, more imaginative and less polished style, which lacked the high gloss of advertising art and was instead reminiscent of his earliest work in its verve and bright, Matissean color. This change did not come without warning: paintings from almost a decade earlier, such as *Hot Wire* (1970) in which a women carefully tightropes over a snake waiting lazily on the ground, foreshadow the subtler, more humorous exhibitionism to come.

By 1980 Jones was completely committed to this theatrical expression of viewing. *Double Act* and *Counterpoint*, both of 1980, are examples. The first shows a circus act in which a woman,

seen only from the legs down, balances on a masked man's shoulders as if preparing to jump. The audience is represented by the knees and bosom of a woman in a balcony seat, sitting almost close enough to touch the performers. In *Counterpoint*, two pairs of legs, androgynous and disembodied, dance in a circle of stage footlights. Again there is a curtain, and again a balcony-seated spectator visible only by hand and foot—there are no faces anywhere. Though the figures are still truncated and depersonalized, the subject is now some quirky amalgam of sex and vaudeville; the paintings are in the service of a universal, not sex-specific, voyeurism.

Allen Jones, who had been a visiting professor at a number of colleges including the University of South Florida, Tampa, and the University of California at Irvine, was awarded the Prix des Jeunes Artists at the 1963 Paris Biennale and a Tamarind Lithographic Fellowship in 1966. An accomplished lithographer, he is considered one of the most important figures in the postwar print revival in the United Kingdom. *Sheer Magic*, a book of his essays and reproductions from his work, was published in 1982.

EXHIBITIONS INCLUDE: Arthur Tooth and Sons, London 1963; '64, '67, '70; Richard Feigen Gal., NYC 1964, '65, '70; Richard Feigen Gal., Chicago 1965; MOMA, NYC 1966; Gal. der Speigel, Cologne 1967, '71; Gal. Milano, Milan 1969, '72; Boymans-Van Beuningen Mus., Rotterdam 1969; Gal. Springer, Berlin 1970; Marlborough Graphics, London 1971; Studio d'Arte Condotti, Rome 1972; Marlborough Fine Art, London 1972; Tolarno Gals., Melbourne, Australia 1973; Hogarth Gals., Sydney, Australia 1973; Gal. von Leoper, Hamburg, W. Ger. 1973; Seibu Gal., Tokyo 1974; Meitetsu Gal., Nagoya, Japan 1974; Waddington Gals. II, London 1976, '77, '80; Inst. of Contemporary Arts, London 1978; Serpentine Gal., London 1979. GROUP EXHIBITIONS INCLUDE: "Young Contemporaries," London 1960, '61; Paris Biennale 1961, '63, '65, '71; "British Art Today," San Francisco Mus. of Art 1962; "Image in Progress," Grabousk Gal., London 1962; "The New Generation," Whitechapel Gal., London 1964; "Contemporary British Painting and Sculpture," Albright-Knox Art Gal., Buffalo, N.Y. 1964; Documenta 2, Kassel, W. Ger. 1964; "London: The New Scene," Walker Art Gal., Minneapolis 1965; "Op-Pop," Moderna Mus., Stockholm 1965; "Contemporary British Painting," Palais des Beaux-Arts, Brussels 1966; "Recent British Painting," Tate Gal., London 1967; "New Aspects of British Art," Australia and New Zealand tour 1967; "Obsessive Image," Inst. of Contemporary Arts, London 1968; "L'Art vivant 1965–68," Foundation Maeght, St.-Paul-de-Vence, France 1968; "Pop Art Redefined," Haywood Gal., London 1969; "British Painting and Sculpture 1960–70," Nat. Gal. of Art, Washington, D.C. 1970; "British Watercolors and Drawings," Matsuzakaya Department Store, Tokyo 1972; "Hyperréalistes Américains/Réalistes Européens," Centre Nat. d'Art Contemporain, Paris

1974; International Biennale of Figurative Painting, Tokyo 1974.

COLLECTIONS INCLUDE: Tate Gal., Victoria and Albert Mus., Arts Council of Great Britain, Contemporary Arts Society, and Stuyvesant Collection, London; City Art Gal., Birmingham, England; Walker Art Gal., Liverpool; Mus. des Beaux-Arts, Ghent, Belgium; Stedelijk Mus., Amsterdam; Boymans-Van Beuningen Mus., Rotterdam; Kunsthalle, Hamburg, W. Ger.; Wallraf-Richertz Mus., Cologne; Moderna Mus., Stockholm; Gulbenkian Foundation, Lisbon; MOMA, NYC; Eastman House, Rochester, N.Y.; Art Inst. of Chicago; Pasadena Art Mus., Calif.; Vancouver Art Gal., British Columbia; Nagaoka Mus., Japan; Univ. of Sydney, Australia; Nat. Gal. of West Australia, Perth.

ABOUT: "Image and Progress" (cat.), Grabousk Gal., London, 1962; Jones, A. and others Waitress, 1971, Allen Jones Projects, 1971, Sheer Magic, 1982; Lippard, L. R. Pop Art, 1966; Lucie-Smith, E. Late Modern: The Visual Arts Since 1945, 1969; "The New Generation" (cat.) Whitechapel Gal., London, 1964. *Periodicals*—Apollo December 1980; Art and Artists March 1979; Art International June 1967, March 1970, Summer 1976; Arts Review January 1964; Studio International November 1965, June 1968.

Photo by John Lefebre

ASGER JORN

***JORN, ASGER** (April 3, 1914–May 1, 1973), Danish painter, was a leader of Cobra, the art group that helped to establish abstract expressionism in Europe after World War II. He was born Asger Oluf Jörgensen in Vejrum, Denmark, in the western part of the Jutland peninsula. His parents were teachers. In 1929 the family moved to Silkeborg, a small town in central Jutland, which Jorn considered his home town.

In 1930 he studied painting privately with Martin Kaaland-Jörgensen and began to paint small landscapes and portraits. From 1930 to '35 he took a teacher training course in Silkeborg, where he taught for a short time. He went to Paris in 1936 hoping to study with Wassily Kandinsky, whose work he knew from reproductions in *Linien,* a Copenhagen magazine devoted to nonfigurative art. Although Kandinsky was living in Paris, he was completely unknown—at that time no major gallery would have shown his work—and took no pupils. Consequently, Jorn studied at the Académie Contemporaine with Fernand Léger. Léger's artistic viewpoint was markedly different from that of the young Dane, but Jorn respected his teacher and willingly submitted to the disciplines and rules laid down by Léger. He collaborated with Léger in large-scale decorations for the Palais des Temps Nouveaux at the Exposition Universelle (Paris Universal Exposition) of 1937. Léger introduced Jorn to the modern architect Le Corbusier, who

was in charge of the project. Jorn's interest in the problems of town planning date from this time. Nevertheless, he thoroughly disliked Le Corbusier's extremely functional architectural concepts, which Jorn denigrated as "functionalist-Calvinist architecture, that mother of all the arts who strangles her children." In the 1950s Jorn was to found the Movement for an Imaginist Bauhaus and the International Situationist Movement, art groups which were hostile to functionalism and neoplasticism.

In 1937 Jorn returned to Denmark and took part in the "Linien" group exhibition in Copenhagen, which that year included works by Kandinsky, Klee, Ernst, Arp, Tanguy, and Miró. He considered these artists his real teachers, representing a liberated creative spirit. From 1938 to '40 Jorn studied at the Art Academy, Copenhagen. He had his first solo exhibition in 1938, in Copenhagen.

Throughout the war years Jorn lived in Denmark, and he produced more than 70 paintings in 1940 alone. Their varied style shows that he was striving to rid himself of School of Paris influences, including Léger's formalism, and to acquire greater freedom and spontaneity. Jorn considered his *Blue Painting* of 1940 important in his development, because that work made him aware of the "automatism" inherent to the creative process. As he came to trust the unconscious more and more, his imagery became increasingly primitive, his style convulsive.

For about 18 months between 1942 and '45, during the German occupation, Jorn put out monthly issues of the banned periodical *Land og Folk* using a clandestine printing press. He was

°yôrn, as´ gǝ

a leader of the Danish Abstract Surrealist group of artists, and in 1944–45 he had two solo shows in small galleries. In 1945 he changed his name from Jörgensen to Jorn. His "Didaska" series of watercolors date from this period; many of them now belong to Copenhagen's Royal Museum. He also produced a set of 23 etchings, later published in Paris under the title *Occupations: 1939–1945*.

Jorn spent the summer of 1946 painting in Swedish Lapland and in 1947–48 he painted in Tunisia, inspired, it is thought, by the example of Paul Klee, who had visited Kairouan in 1914. Jorn's Tunisian paintings were shown at his first exhibition in Paris, which was held at the Galerie Breteau in 1948.

Jorn became a cofounder in 1948 of Cobra, the name being an acronym formed from the cities—Copenhagen, Brussels, and Amsterdam—from which the group's leaders hailed. Other prominent Cobra members were the Belgian poet Christian Dotremont, whom Jorn had met in 1947 at an international artists' conference in Brussels; the Dutch painters Karel Appel, Corneille, and Constant; and the young Belgian painter Pierre Alechinsky. Cobra rejected School of Paris formalism, academic cubism, and constructivism. The Cobra artists were forerunners of *art informel* (art without form), the European movement corresponding to American abstract expressionism, and "were interested in giving direct expression to subconscious fantasy, with no censorship from the intellect," to quote Edward Lucie-Smith. Their explosive brushwork was similar to American action painting, a style appropriate to their aim of fusing "the surrealist dream with concrete life [to create] a romantic realism," as a Cobra manifesto put it.

Jorn was totally involved with Cobra from 1948 to '51, the years comprising the movement's brief but dramatic life span. He took part in several group exhibitions, contributed to *Cobra*, the group's official magazine, and edited a series of monographs on his colleagues.

In 1950 Jorn entered a period of crisis in his personal life as well as in his art. He was living in extreme poverty, first in Islev, a municipality of Copenhagen, and then in Suresnes, on the outskirts of Paris, and his marriage to the former Kirsten Lyngborg, whom he had wed in 1939, had been dissolved. Also, he grew dissatisfied with the imagery he had developed during World War II—a bestiary of infernal animals which he believed to be derived from Scandinavian mythology—and tried in vain to "exorcize" this fantastic menagerie. Jorn's "Aganak" series of animal sketches date from this troubled period; his Aganak was a combination of scarab and crocodile.

Matters were further complicated in May 1951 when Jorn fell ill with tuberculosis and was hospitalized in Silkeborg for 17 months. With his life hanging in the balance, he began to reassess his position as an artist, and set down his reflections in his first major book, *Held og Hasard*. After his recovery in 1952, Jorn worked prodigiously at painting, engraving, and making ceramics. This ambitious period culminated in a series of paintings and related studies entitled "On the Silent Myth" and "The Season."

In late October 1953, Jorn left Denmark for the Continent, thus beginning his career as a European rather than a merely Danish artist. He spent the winter of 1953–54 in Switzerland and executed a series of etchings which were published in Munich in 1961 under the title *Schweizer Suite: 1953–4* (Swiss Suite: 1953–4). Jorn traveled to Italy for the first time in 1954. The spiritual renewal stimulated by that visit is evident in a series of ceramics he made in the Mazzotti factory of Albissola, Italy, in collaboration with Appel, Enrico Baj, Corneille, and other artists. Jorn taught himself to improvise directly from the ceramic material, and his feeling for color was enriched by the use of brilliant and luminous glazes. In 1955 Jorn settled in Paris, where he and Enrico Baj founded the Movement for an Imaginist Bauhaus. Jorn's International Situationist Movement began as a socio-political group which studied problems such as urban planning and the psycho-geography of cities; by the late '60s it had embraced anarcho-communism.

The years 1956–58 marked Jorn's breakthrough to artistic maturity and the growth of his international reputation. His paintings of this productive period include *To Guillaume Apollinaire, Letter to My Son* (1956–57), *The Defender* and *Stalingrad,* both of 1957, *Le Timide orgueilleux* (Timid Arrogance, 1957; Tate Gallery, London) and *The Stubborn Bird* (1957). In 1958 he was represented in the "50 ans d'art moderne" (50 Modern Artists) group show at the Brussels World's Fair and in the International Exhibition at the Carnegie Institute, Pittsburgh. Also in '58, his study of aesthetics, *Pour la forme: Ebauche d'une methodologie des arts,* was published.

Jorn's major achievement of 1959 was the completion in Albissola of *Aarhus,* a giant 10-by-88-foot ceramic mural commissioned by the Danish government for a new school in Aarhus, Denmark. The nine-ton mural, which was transported to Aarhus for reassembly and installation in the fall of 1959, is "probably the most remarkable as well as the biggest work ever made in the ceramic medium" in the opinion of Guy Atkins.

Unlike the work of his Cobra colleagues, in the 1960s Jorn's canvases continued to be abstract. *Untitled* (1961; Albright-Knox Art Gallery, Buffalo, New York) is "one of a large group of Jorn's works in which the movement of color, line, and areas of light dominates the artist's concern," according to *Contemporary Art 1942-72.* "Inspired by the images of Nordic myths and legends, magic, and strange cults, Jorn has attempted to portray his visionary world in a direct and expressive manner, using primary colors and spontaneous, uneven application of paint." "I believe," Jorn said of his approach to expressionism, "that color immediately and totally transmits the content of a painting."

Jorn had his first solo exhibition in the United States in 1962, at the Lefebre Gallery, New York City. That same year his largest—11 feet 6 inches by 17 feet 9 inches—and most emphatically stated painting, *Stalingrad: No Man's Land* or *The Mad Laughter of Courage,* was shown in "Art Since 1950" at the Seattle World's Fair. In 1963-64 Jorn produced a brilliant series of collages which were exhibited in Munich and Paris. The collages shown in Paris, at an exhibit entitled "Réforme de la publicité," were made up of posters torn from hoardings and reassembled. His first major international retrospective was mounted at the Kunsthalle, Basel, Switzerland, in 1964 and traveled to the Stedelijk Museum, Amsterdam, and the Louisiana Foundation in Denmark.

Jorn briefly visited Mexico and the US in 1965, and between 1965 and '71 he completed murals for a bank in Havana, Cuba. In the summer of 1966 he worked in London preparing for an exhibition at Arthur Tooth and Sons. Along with oil paintings, he produced a series of pictures in Rowney's acrylic paints on paper, which were exhibited at the Lefebre Gallery in 1967. In the show catalog Lawrence Alloway observed that through the 1960s Jorn's style had become "more raw and summary," and that he was "now of an age to take advantage of the accumulated history of his signs," an iconography of "heads and bodies, animals and hybrids, encounters, and crowds of cellular swarms." Three years later Jorn had an exhibition of oil, acrylics, and collages at the Lefebre.

Jorn's activity as a printmaker was second in importance only to his work as a painter. Since 1939 he had worked in various graphic media, but his first color etchings were produced in Munich in 1958. In 1971 he executed a series of prints, *Entrée de secours*, issued by Visat in Paris, with a preface by the Surrealist painter Matta. Some of these colored dry-point engravings were embellished by aquatint. A retrospective of Jorn's lithographs, etchings, and woodcuts was held at the Lefebre Gallery in 1976-77. The catalog quoted the German critic Wieland Schmied: "Jorn's engravings combine Ensor's bizarre fantasies with Munch's dreamy expressiveness." The retrospective bore out Werner Haftmann's observation in the preface to Jorn's *Swiss Suite* that the artist's graphic work was "solidly involved in a personal iconography that always sought expression in Jorn's oeuvre from the very outset."

Asger Jorn died in Silkeborg, Denmark. He was survived by his second wife, the former Matic van Domselacf, whom he had married in 1951. Jorn was never as well known in the US as in Europe, where "he came to be accepted as one of the fixtures of post-war art," to quote Hilton Kramer of *The New York Times* (November 11, 1977). Jorn was a robust, independent man, with a neat gray-white beard and an engaging smile. A free spirit, he never sought material success, believing in the primacy of the *act* of painting, which he feared the striving after of fame and success might corrupt. In a letter to John Lefebre, printed in the catalog to his 1970 show at the Lefebre Gallery, Jorn summed up his aesthetic: "I am mainly interested in the process of painting as a direct, non-literary and non-linguistic medium, for human and spiritual communication."

EXHIBITIONS INCLUDE: Pustervig Kunsthandel, Copenhagen 1942; Macholms Kunsthandel, Copenhagen 1945; Gal. Breteau, Paris, 1948, '51; Gal. Birch, Copenhagen 1948, '64; Kunstvoreningen, Copenhagen 1953; Gal. L'Asterisco, Rome 1954; Gal. del Naviglio, Milan 1955; Gal. Taptoe, Brussels 1956; Gal. Rive Gauche, Paris 1957-67; Inst. of Contemporary Arts, London 1957, '58; Gal. van de Loo, Munich 1958, '63, '66; Albissola Marina, Italy 1959; Arthur Tooth Gal., London 1961, '66; Lefebre Gal., NYC 1962, '67, '70, 1976-77, '83; Gal. del Cavallino, Venice 1962; Kunsthalle, Basel 1964; Stedelijk Mus., Amsterdam 1964, '76; Louisiana Foundation, Humlebaek, Denmark 1964; Kunstforening, Bergen, Norway 1965; Gal. Jeanne Bucher, Paris 1969; Kestner-Gesellschaft, Hanover, W. Ger. 1973. GROUP EXHIBITIONS INCLUDE: Salon des Indépendants, Paris 1937; "Linien," Den Frie, Copenhagen 1937; "Jorn/Wemaere," Dam & Fonss, Copenhagen 1938; "Dansk Kunst i dag," Statens Mus. for Kunst, Copenhagen 1941; "Christoffersen-Jorn-Nielsen," Maelholms Kunsthandel, Copenhagen 1945; "Abstrakt Kunst," Reykjavik, Iceland 1947; "La Fin et les Moyens," Brussels 1949; "Cobra," Stedelijk Mus., Amsterdam 1950; "Cobra Group," Palais des Beaux-Arts, Liège, Belgium 1951; "Peintures et gravures danoises," Mus. Gal., Paris 1953; "Contemporary Arts in Scandinavia," Brownstone Gal., NYC 1954; Carnegie Inst., Pittsburgh 1955; "Cobra Group," Gal. Taptre, Brussels 1956; "50 ans d'art moderne," World's Fair, Brussels 1958; Interntional Exhibition, Carnegie Inst., Pittsburgh 1958;

Documenta 2, Kassel, W. Ger. 1959; "Art Since 1950," World's Fair, Seattle 1962; "Cobra et Apres," Palais des Beaux-Arts, Brussels 1962; "Private Views," Tate Gal., London 1963; "Painting and Sculpture of a Decade 1954–1964," Tate Gal., London 1964; "Peggy Guggenheim Collection," Tate Gal., London 1965; "Cobra Group," Mus. Boymans-Van Beuningen, Rotterdam 1966; "ROSC 67: the Poetry of Vision," Royal Dublin Society, Dublin 1967; "Symfoni i seks satser," Gal. Birch, Copenhagen 1968.

COLLECTIONS INCLUDE: Statens Mus. for Kunst, Copenhagen; Louisiana Mus., Humlebaek, Denmark; Art Mus., Silkeborg, Denmark; Fijens Stiftmus., Odense, Denmark; Kunstpavillonen, Esbjerg, Denmark; Nordjyllands Mus., Aelborg, Denmark; Nationalmus., Stockholm; Konstmus., Goteborg, Sweden; Stedelijk Mus., Amsterdam; Gemeentemus., The Hague; Stedelijk van Abbemus., Eindhoven, Neth.; Mus. Royal des Beaux-Arts, Brussels; Moderna Gal., Ljubljana, Yugoslavia; MOMA, and Solomon R. Guggenheim Mus., NYC; Albright-Knox Art Gal., Buffalo, N.Y.; Carnegie Inst., Pittsburgh; Inst. of Contemporary Arts, Boston; Cincinnati Art Mus; Philadelphia Mus. of Art; Inst. of Contemporary Art, Berkeley, Calif.

ABOUT: Alloway, L. "Asger Jorn" (cat.), Lefebre Gal., NYC, 1967; Atkins, G. Asger Jorn, 1964, A Bibliography of Jorn's Writings to 1963, 1964, (ed.) Asger Jorn's Aarhus Mural, 1964, Asger Jorn, the Crucial Years: 1954–1964, 1977; Jorn, A. and (others) La Chevelure des choses 1948–53, 1961, Gedanken eines Künstlers, 1966; "Asger Jorn" (cat.), Lefebre Gal., NYC, 1970; Lucie-Smith, E. Late Modern: The Visual Arts Since 1945, 1969; Moore, E. (ed.) Contemporary Art 1942–1972: Collection of the Albright-Knox Art Gallery, 1972; Pellegrini, A. New Tendencies in Art, 1966; Ragon, M. Vingt-cinq ans d'art vivant, 1969; Schmied, W. and others "Asger Jorn" (cat.), Lefebre Gal., NYC, 1977. Periodicals—Art and Artists October 1966; Combat-Art (Paris) October 17, 1960; Living Arts March 1964; Quadrum (Brussels) no. 12 1962; London Times May 2, 1973; New York Times November 11, 1977; XXe siècle (Paris) June 1970.

JUDD, DONALD (June 3, 1928–), American sculptor of the Minimalist School, was born in his grandparents' house in Excelsior Springs, Missouri. His father's work for Western Union necessitated six transfers during Judd's boyhood and adolescence. The family moved first to Omaha, Nebraska, where Judd studied art privately, then successively to Kansas City, Missouri, Des Moines, Dallas, Philadelphia, and finally in 1943, to New Jersey. There, Judd graduated from Westwood High School in 1946. " . . . As we moved east the landscape became too organized and suburbia too continuous," (Judd told Cue magazine (April 10, 1976). And "too much moving," he said, left him with too few friends and increased his natural shyness.

Judd served with the US Army in Korea from 1946 to 1947, then came to New York City in 1948. He worked for a BS degree in philosophy at Columbia College (which he received in 1953), attended the College of William and Mary in Williamsburg, Virginia in 1948–49, and took art courses at the Art Students League in New York City. Eventually, in 1962, he earned an MA in art history at Columbia University.

During his first years in New York, Judd worked in a settlement house and lived in a cold-water flat on East 27th Street. Though the New York School was in its heyday, with Pollock, Kline, and de Kooning regularly gathering at the Cedar Tavern in Greenwich Village, Judd kept to himself. At the time, he was painting dark, flat abstractions. His paintings of the 1950s were influenced by Barnett Newman and Mark Rothko, among others.

By 1953 Judd was teaching art part-time at the Christadora Home and, later, at the Police Athletic League. That year he was included in a group exhibition at the City Center Art Gallery; in 1956 he held a two-person show with Nathan Raisen at the Panoras Gallery; and in 1957, also at Panoras, Judd mounted his first solo show.

Between 1959 and 1965 Judd wrote reviews and articles for major art periodicals, including Art News and Arts Magazine, that had considerable influence on trends in criticism and in avant-garde painting and sculpture. "His aesthetics were pointed (to borrow a trope from Paul Valéry) like a revolver at your head," Hess recalled in New York magazine (April 11, 1977).

Judd was inevitably led by his aesthetics—a desire to avoid even the slightest degree of three-dimensional illusionism—from painting to sculpture, a transition he made in 1961. His first sculptural reliefs were exhibited at the Green Gallery, New York City, in 1963, and his wooden piece, Untitled (1963), represented a radically new kind of abstraction in sculpture. It was based, as Robert Hughes wrote in Time magazine, on "the elimination of hierarchies," and it bore affinities with similar developments in the painting of the early 1960s. Like Frank Stella's striped abstractions and the symmetrical chevrons of Kenneth Noland, Judd aimed to achieve in sculpture what Hughes called the "flatly decorative, unmodified, take-it-or-leave-it quality" of the reductive painting mode.

From 1962 to 1964 Judd was an instructor at the Brooklyn Institute of Arts and Sciences. In 1964 he married Margaret Hughan (Julie) Finch, a dancer and choreographer, with whom he has two children, Flavin Starbuck (named after light sculptor Dan Flavin, whose work Judd admires) and Rainer Yingling.

Judd was awarded a travel grant from the Swedish Institute of Stockholm in 1966, and in the years between 1966 and 1968, he taught sculpture at Dartmouth College and Yale University. In 1968 he received a Guggenheim Fellowship, and in the same year, led the Emma Lake Artists' Workshop at Lac La Rouge, Saskatchewan, Canada.

By the late '60s Judd was regarded as *the* Minimalist sculptor par excellence. In his statements and in his work, it was clear that Judd rejected the additive and assembled approach that characterized much 20th-century sculpture, including the work of Picasso, Julio González, and David Smith. "I don't like sculpture with a handled look," he told the *National Observer* (February 20, 1967), "just as I don't like evidence of brushwork in printing. All that implies expressionism, implies that the artist is involved with the work as he goes along. I want the material to be material when you look at it."

Since 1964 Judd's pieces, including his freestanding boxes and objects, have been manufactured industrially according to his specifications, a method that gives his work its characteristic precision and anonymity.

The influential and prestigious Leo Castelli had become Judd's dealer in 1966, and two years later the artist was given an important retrospective at the Whitney Museum of American Art, New York City. The *Christian Science Monitor* reviewer found the exhibit to be "an astonishing experience." In "his rows of identical boxes and anonymous-looking forms," the critic wrote, Judd was concerned above all "with self-contained wholeness. . . . The parts are entirely subordinate to the whole." Aware that the work of Judd, like his contemporaries Robert Morris, Dan Flavin, and Sol LeWitt, had borne the label "boring," the *Monitor* writer said that he experienced "sheer delight" in Judd's "use of vivid metallic paints, colored plexiglass, painted galvanized iron, aluminum, brass and steel," and that he responded to "the vitality of new materials used in an unhistorical yet balanced way." On the other hand, the art critic for *Time* (March 22, 1968) did not discern variety or vitality in Judd's Whitney show. The works, he said "have all the cozy warmth and intimacy of an assembly line or a bank vault." In response to the "boredom" charge, Judd had once written, "I can't see how any good work can be boring or monotonous in the usual sense of the word." And on another occasion: "There is a lot more variety in my work than is casually apparent."

Untitled (1969; Albright-Knox Art Gallery, Buffalo, N.Y.) made of galvanized iron bands and translucent orange plexiglass is typical of Judd's approach. The work consists of ten identical boxes cantilevered from a wall at regular vertical intervals. Each unit is 27 inches wide and 24 inches deep. The intervals that separate the ten units are exactly equal to their height of six inches. *Untitled*'s use of translucent orange plexiglass within galvanized iron bands bears out Thomas B. Hess's observation at the time of Judd's Whitney retrospective: the artist, he said, "was a master of strange, delicate color harmonies as well as of blunt, love-me-or-love-me-not shapes."

In 1971, *Artforum* editor John Coplans organized a large exhibition of Judd's work at the Pasadena Art Museum. Not a retrospective like the Whitney Museum show of 1968, the show, wrote Hilton Kramer in *The New York Times* (May 14, 1971), was "most specifically conceived to define an [artistic] attitude" rather than "to recount the history of a career." Judd had dedicated the exhibition catalog to California Minimalist Larry Bell, and Kramer noted that whereas it had once been possible to see Judd's work in relation to his New York contemporaries, especially Robert Morris and Carl Andre, this show revealed a closer aesthetic affinity to Bell and other California Minimalists whose work was marked by a certain elegance. Judd's increasing use of colored plexiglass, polished aluminum, and polished brass "give to his sculpture an extremely opulent, even luxurious appearance. "Thus our most doctrinaire minimalist," Kramer concluded, "has revealed himself . . . to have been a closet hedonist all along."

Robert Hughes, reviewing the show in *Time*, found Judd's work "a good deal less cold and unenjoyable than its philosophy suggests," and described the artist's use of materials as "instinctively exquisite." Hughes observed that a piece like *Untitled, 1970* seemed bald at first, consisting of "a run of identical flat sheets of galvanized iron, each 5 feet by 4 feet, along the gallery wall"; but "the silvery flakes and washes caused by the galvanizing bath, rising through the darker metal and catching the light like mica [erase] that sense of program and frigidity. . . . " Judd at 42, as decreed Hughes, is "possibly the most influential sculptor of his generation."

In November 1968, the Judd family moved into a five-story cast-iron building on Spring Street in downtown Manhattan's SoHo, where they were among the earliest homeowners. By 1974 the neighborhood, to Judd's dismay, had become too chic. "This area was done for when they started calling it SoHo," Judd said. "It's a press agent's name. . . . " Later on, the Judds bought land in Texas. "I'm against an 'artists'

world," Judd said, and left his New York quarters for two vast airplane hangers in Texas.

Judd's 1977 exhibition at the Heiner Friedrich Gallery, in SoHo, consisted of a series of 15 box-like structures, each one measuring five feet square and three feet high, and elegantly made of the very best American Douglas-fir plywood. Thomas B. Hess of *New York* (April 11, 1977) found the show to be "unabashedly radiant. The whole gallery floats in an odor of forest and fresh sawdust." The pieces are "laid out like the ruins of an ancient city," the *New York Times* review (April 1, 1977) stated. "The wood itself has a warmth of color and a hypnotic moiré texture, both of which contribute to the final effect of as grand an ensemble as we shall see this season." The exhibit traveled to the Cincinnati Contemporary Art Center in June 1977, coinciding with the inauguration of the artist's 16-foot steel "dropped plane" on the campus of North Kentucky University.

Donald Judd was described in *Cue* magazine as "a tall, bearded man in his late 40s, and tending toward the chunky side." He wears his long hair "wrapped in a small bun at the nape of his neck, Navajo style." Hess has written that Judd is "a difficult, three-dimensional man," full of "odd perceptions and eccentricities." The same complexity could be found, the writer said, in the artist's work: "If his sculptures often look fanatical in their uncompromisingly explicit structures, all sorts of other things go on around them and within them. . . ."

Judd admires the work of Dan Flavin, Larry Bell, John Chamberlain, Claes Oldenburg, and Frank Stella, all of whom are his contemporaries. He owns an Oldenburg papier-mâché hot dog, and a huge wall-piece by his friend John Chamberlain. The bedroom is lighted by a room-length fluorescent sculpture by Flavin, and contains a gold and black table by Roy Lichtenstein.

According to Judd, a box is a box is a box, with no free associations permitted to detract from its concrete reality. His article "Specific Objects," published in the *Art Digest* (*Arts Yearbook 8*) in 1965, is unequivocal: "Three dimensions are real space. That gets rid of the problem of illusionism and of literal space, space in and around marks and colors—which is riddance of one of the most salient and most objectionable relics of European art. The . . . limits of painting are no longer present. A work can be as powerful as it is thought to be. Actual space is intrinsically more powerful and specific than paint on a flat surface."

EXHIBITIONS INCLUDE: Panoras Gal., NYC 1957; Greer Gal., NYC 1963–64; Leo Castelli Gal., NYC from 1966; Ferus Gal., Los Angeles 1967; Retrospective, Whitney Mus. of Am. Art, NYC 1968; Irving Blum Gal., Los Angeles 1968, '69; Stedelijk Van Abbemus., Eindhoven, Neth. 1970; Pasadena Art Mus., Calif. 1971; Gal. Daniel Templon, Paris 1972; Gal. Gian Enzo Sperone, Turin 1973; Lisson Gal., London 1974; Retrospective, Nat. Gal. of Canada, Ottawa 1975; Heiner Friedrich Gal., NYC 1977. GROUP EXHIBITIONS INCLUDE: City Center Art Gal., NYC 1954; "Donald Judd and Nathan Raisen," Panoras Gal., NYC 1956; Roko Gal., NYC 1962; "Shape and Structure: 1965," Tibor de Nagy Gal., NYC 1965; "Flavin, Judd, Morris," Green Gal., NYC 1965; São Paulo Bienal (and Smithsonian Inst., Washington, D.C.) 1965; "Primary Structures," Jewish Mus., NYC 1966; "American Sculpture of the Sixties," Los Angeles County Mus. of Art 1967; Guggenheim International Exhibition, NYC 1967–68, '71; "Plus by Minus; Today's Half-Century," Albright-Knox Art Gal., Buffalo, N.Y. 1968; Whitney Mus. of Am. Art Annual, NYC 1968, '70; "The Art of the Real: U.S.A. 1918–1948," MOMA, NYC 1968; "Sonsbeek 71," Sonsbeek Park, Arnhem, Neth. 1971; ROSC '71, Royal Dublin Society, Dublin 1971; Whitney Mus. of Am. Art Biennial, NYC 1973; "Some Recent American Art," Nat. Gal. of Australia, Melbourne (toured Australia and New Zealand) 1974; "Dan Flavin, Don Judd, Sol LeWitt," Gal. La Bertesca, Milan 1974; "Minimalism to Expressionism: Painting and Sculpture Since 1965," Whitney Mus. of Am. Art, NYC 1983.

COLLECTIONS INCLUDE: MOMA, Whitney Mus. of Am. Art, Solomon R. Guggenheim Mus., and Foundation for Contemporary Performance Arts, NYC; Albright-Knox Art Gal., Buffalo, N.Y.; Storm King Art Center, Mountainville, N.Y.; Southmall Project, Albany, N.Y.; Hirshhorn Mus. and Sculpture Garden, Washington, D.C.; Dayton Art Inst., Ohio; Akron Art Inst., Ohio; Art Inst., Chicago; Walker Art Center, Minneapolis; St. Louis Art Mus., Detroit Inst. of Arts, Michigan; Milwaukee Art Center; Fort Worth Art Mus; Art Mus. of South Texas, Corpus Christi; San Francisco Mus. of Art, Calif.; Pasadena Art Mus., Calif.; Nat. Gal. of Canada, Ottawa; Art Gal. of Ontario, Toronto; Tate Gal., and Victoria and Albert Mus., London; Centre Nat. d'Art Contemporain, Paris; Mus. d'Art et d'Industrie, Saint-Etienne, France; Stedelijk Van Abbemus., Eindhoven, Neth.; Rijksmus. Kröller-Müller, Otterlo, Neth.; Wallraf-Richartz Mus., Cologne; Moderna Mus., Stockholm; Kunsthaus, Zürich.

ABOUT: Battcock, G. (ed.) Minimal Art, 1968; Burnham, J. Beyond Modern Sculpture, 1968; Rose, B. American Art Since 1900, 2d ed. 1975; Smith B. Donald Judd: Catalogue Raisonné, 1975. *Periodicals*—Art and Artists February 1967; Artforum June 1965, May 1966; Art News September 1966; Arts Magazine February 1960, March 1960, April 1961, February 1963, March 1964, April 1967, February 1973; Christian Science Monitor March 27, 1968; Cue April 10, 1976; Museum Journal (Amsterdam) April 1969; National Observer February 20, 1967; New York April 11, 1977; New York Times May 14, 1971; Observer February 3, 1974; Time May 24, 1971.

KAPROW, ALLAN (August 23, 1927–), originated the "happenings" of the late 1950s and '60s. A happening, as he defined it, is "a convergence of events which are being performed in more than one unity of time and place," a loose description that well conveys the equally undefined nature of the happenings themselves. His work has had a definite, if difficult to assess, impact on the development of theater, dance, performance art, even film and video, but little effect on the thriving traditional visual arts of painting and sculpture, which he had declared moribund as late as the mid-1970s. The idea of the happenings may in the end prove more important to the evolving theories of modern art than any individual event (most of which were, by nature and intent, transient), especially in Kaprow's case. As a theoretician, he is articulate, illuminating, and insightful, but his happenings and performances (at least after their novelty had waned in the mid-1960s) possess an academic quality verging, according to some critics, on the dry and humorless.

Kaprow was born in Atlantic City, New Jersey, and spent his childhood in Tucson, Arizona, where he studied at the High School of Music and Art from 1943 to 1945. He majored in art and philosophy at New York University (1945–49), and enrolled in Hans Hofmann's painting school (1947–48). Through Hofmann he began to develop an expressive, high-spirited style of action painting, based on real landscapes and figures, which was to lead, by a number of well-defined and documented steps, to the happenings of a decade later. In 1950 Kaprow dropped his plans to finish a master's degree in philosophy at NYU and instead took Meyer Schapiro's courses in art history at Columbia University, where he earned an MA in 1952. Immediately he landed a job as an art history instructor at Rutgers University, New Brunswick, New Jersey (1952–61). With a number of Hofmann's students he cofounded the Hansa Gallery (named after their teacher), a cooperative artists' gallery on East 10th Street in Greenwich Village. In regular shows there from 1953, his paintings became increasingly wild, energetic, and three-dimensional. "I had begun to clarify, even then, what was a multi-leveled attitude toward painting," he wrote. In 1955 he married Vaughan Peters, with whom he had three children.

The two major influences that steered Kaprow to the first happenings were Jackson Pollock and the avant-garde composer John Cage. The work of Pollock, the apotheosis of an art of action, provided Kaprow with a rationale to progress beyond traditional painting. His canvases, wrote Kaprow in a 1958 *Art News* article, "The Legacy of Jackson Pollock," were so huge and all-embracing that "they ceased to become paintings and became environments"; they pointed the way to a new form of art in which "action" would predominate over "painting." "Objects of every sort are materials for the new art: paint, chairs, food, electric and neon lights, smoke, water, old socks, a dog, movies, and a thousand other things. . . ." In fact this was the way Kaprow's own art was developing: toward what he called "action-collages" (as in *Penny Arcade*, 1956, and *Wall*, 1957–59). The other major influence was that of Cage, whose theories Kaprow absorbed while taking his course in experimental music at the New School for Social Research (1956–58) in Manhattan. No kind of experimentation was anathema to Cage, the most radical and influential native modernist in American music; at the time, his direction was "towards theater"—where, he believed, could be the found most effective integration of art and "real" life—and all his students were thus propelled. Secondary influences—really, precedents—for Kaprow's happenings were the publicly staged absurdities of the post-World War I Dadaists, the theories of Antonin Artaud, and the escapades of Yves Klein, the French New Realist.

In 1965 Kaprow explained his evolution from collage to environments and happenings: "The action collages then became bigger, and I introduced flashing lights and thicker hunks of matter. These parts projected further and further from the wall into the room, and included more and more audible elements: sounds of ringing buzzers, bells, toys, etc., until I had accumulated nearly all the sensory elements I was to work with during the following years. . . . " His works expanded until they filled the gallery, creating an integrated environment for the spectator. "I immediately saw that every visitor to the environment was part of it. And so I gave him opportunities like moving something, turning switches on—just a few things. Increasingly, during 1957 and 1958, this suggested a more 'scored' responsibility for the visitor. I offered him more and more to do until there developed the Happening. . . . The integration of all elements—environment, constructed sections, time, space, and people—has been my main technical problem ever since." Kaprow's progress did not occur in a vacuum, as he readily acknowledges. Robert Rauschenburg, Claes Oldenburg, and Jim Dine, among others, were also working on theatrical pieces, although they soon returned to more traditional areas; in Europe, Wolf Vostell and the Fluxus Group, and in Japan, the Gutai Group, were all investigating similar directions.

In 1959 Kaprow staged his first major happening, *18 Happenings in 6 Parts*, at the Reuben Gallery, New York City, which he had divided into three rooms with clear plastic walls. The visitors, whose tickets directed them to specified seats in each room at particular times and with strictly choreographed movements, witnessed, among other events, a girl squeezing oranges, an artist lighting matches and painting, and an orchestra of toy instruments. Rauschenberg, Jasper Johns, Alfred Leslie, and Lester Johnson were among the performers. Although tightly scripted and planned, Kaprow's early happenings maintained an air of unstructured spontaneity; this was because they had none of the usual trappings of theatre—plot, dialogue, character, or professional performers—and no resemblance to the traditional visual arts. According to drama critic Richard Schechner of *The New York Times*, what Kaprow and others in the field were producing was "a new theater [that] combines associative variations on visual-aural themes, chance permutations, games and journeys."

Surprisingly, *18 Happenings in 6 Parts* was quite successful, and for a time happenings and performances by Kaprow and others were eagerly sought out (they were sometimes hard to find, being staged in lofts, empty lots, stores, classrooms, train stations, and other unconventional places) by the wealthy and fashionable looking for the latest trend. Undoubtedly, this period of trendiness helped inject the term "happening" into the idiosyncratic vocabulary of the 1960s. Encouraged, Kaprow regularly staged events in the New York City area through that decade, among them *Apple Shrine* (1960, at the Judson Gallery, Greenwich Village, which he directed), *A Service for the Dead* (1962), *Eat* (1964, at the Old Ebling Brewery in the Bronx), and many others. In *Coca Cola, Shirley Cannonball?* (1960), a huge boot (of cardboard) kicked an oblate ball around a school gymnasium to the beat of a fife and drum, while in *A Spring Happening* (1961) the audience was terrorized by a power mower and an electric fan "attacking" them in a dark tunnel. In *Words* (1962), spectators were invited to rearrange words painted on cardboard on the gallery walls. For the Museum of Modern Art's "Hans Hofmann and His Students" traveling show, Kaprow created *Push and Pull: A Furniture Comedy for Hans Hofmann*, which consisted of two furnished rooms that could be rearranged by visitors. (Some older women, Kaprow noted, were appalled and began to houseclean.)

As befitted a college professor (he taught at the State University of New York, Stonybrook, from 1961 to 1969, was an associate dean at the California Institute of the Arts from 1969 to 1973, and was made a professor at the University of California at San Diego, an important center for West Coast performance, in 1974), Kaprow increasingly staged his happenings on college campuses, where he could get university funding, large protected spaces, and a willing population of performers (his students). The more forward-looking of the museums, notably the Chicago Museum of Contemporary Art, also supported his work.

Kaprow's permanent move to California in 1969 (he had made a number of West Coast trips through the 1960s) marked a change in his work. *Fluids* (1967), at the Pasadena Art Museum, an unusually sculptural series of monoliths of ice and rock salt left to melt in the hot sun, is considered by Kaprow "pretty much the end of my spectaculars." By then he had completely eliminated the separate audience of the early works, leaving only participants (for example, the volunteers who stacked the ice blocks for *Fluids*). A further change in orientation occurred as Kaprow abandoned the term "happenings," which, he felt, had been commercialized and misused, about 1971 for the more neutral "activity." The activities were smaller in scale and emphasized sociological and psychological interactions over "spectacle." The result was pieces "revolving around routines of domesticity, private life and finally to sensitized, subjective, and psychological pieces dealing with individual psychic responses," he wrote. The new work is represented by *Routine* (1973), in which two back-to-back performers mime each other's facial expressions through mirrors; *Comfort Zones* (1975), in which the performers walk toward one another until their proximity becomes uncomfortable; and *Maneuvers* (1976), a complicated routine for seven couples passing and repassing through doorways. (These pieces also reveal Kaprow's interest in nonverbal, social feedback systems.) It is these later works, with their (possibly satirical) pretense to scientific or sociological methodology—he routinely describes his activities in the language of scientific experimentation—that have been unfavorably compared with the earlier, more bravura happenings. In response, Kaprow has claimed that many critics are applying inappropriate critical standards to events in which, for the most part, they have not participated.

A dark, compact man with intense features and a full, black beard, Kaprow now teaches in the Visual Art Department of the University of California at San Diego. He is the author of more than one hundred journal articles and a number of books, films, and videotapes about his happenings and performances. There is no doubt that his work helped spawn the flourishing per-

formance movement (especially on the West Coast and in Europe), but the categorization of all this work, Kaprow's included, remains problematical. Is it the "new art" of which Kaprow wrote in 1959, or simply hybridized subcategories of already established genres?

EXHIBITIONS INCLUDE: Hansa Gal., NYC 1953, '54, '57, '58; Urban Gal., NYC 1955; Sun Gal., Provincetown, Mass. 1957; "Intermission Piece," Reuben Gal., NYC 1959; "18 Happenings in 6 Parts," Reuben Gal., NYC 1959; "Apple Shrine," Judson Gal., NYC 1960; "A Service for the Dead," Maidman Playhouse, NYC 1962; "Bon Marche," Bon Marche Department Store, Paris 1963; "Birds," Univ. of Southern Illinois, Carbondale 1964; "Eat," Old Ebling Brewery, Bronx, N.Y. 1964; "Orange," Coral Gables, Fla. 1964; "Calling," NYC 1965; "Calling" North Brunswick, N.J. 1965; "Gas," East Hampton, N.Y. 1966; "A Three-Country Happening," Buenos Aires, Argentina 1966; "Moving," Inst. of Contemporary Arts, Chicago 1967; "Fluids," Pasadena Art Mus., Calif. 1967; "Runner," Washington Univ., St. Louis, Mo. 1968; "Transfer," Wesleyan Univ., Middletown, Conn. 1968; "6 Ordinary Happenings," Berkeley, Calif. 1969; "Publicity," Inst. of the Arts, Burbank, Calif. 1970; "Car Spaces," Inst. of the Arts, Burbank, Calif. 1970; "A Sweet Wall," Gal. René Bloch, Berlin 1970; "Print-Out," Cultural Affairs Commission, Milan 1971; "Mesage Units," California Inst. of the Arts, Valencia 1972; "Meters," California Inst. of the Arts, Valencia 1972; "Entr'acte," California Inst. of the Arts, Valencia 1972; "Basic Thermal Units," Volkwang Mus., Essen, W. Ger. 1973; "On Time," Gal. Gérald Piltzer, Paris 1974; "Warm-Ups," Center for Advanced Visual Studies, Massachusetts Inst. of Technology, Cambridge 1975. GROUP EXHIBITIONS INCLUDE: Woodstock Art Association, N.Y. 1947; Jabberwocky Gal., NYC 1952; "The New York School—Second Generation," Jewish Mus., NYC 1957; Pittsburgh International, Carnegie Inst. 1958; "Ray Gun Spex," Judson Memorial Church, NYC 1960; "Environments, Situations, Spaces," Jackson Gal., NYC 1961; "Eleven from the Reuben Gallery," Solomon R. Guggenheim Mus., NYC 1965; "Happening and Fluxus," Kölnicher Kunstverein, Cologne 1970; "Aktionen der Avant-garde," Neue Berliner Kunstverein, Berlin 1973; "Poets of the Cities, New York and San Francisco 1950–1965," Mus. of Fine Arts, Dallas 1974.

COLLECTIONS INCLUDE: MOMA, NYC; Chicago Mus. of Contemporary Art.

ABOUT: Henri, A. Environments and Happenings, 1974, Total Art, 1975; Kaprow, A. Assemblage, Environments, and Happenings, 1966, Untitled Essay and Other Works, 1967, Echo-logy, 1975; Kirby, M. Happenings, 1965; Tomkins, C. Off the Wall: Robert Rauschenburg and the Art World of Our Time, 1980. *Periodicals*—Art in America January/February 1967, January/February 1974; Art International January 25, 1963; Art News October 1958, May 1961, January 1963, April 1967, February 1971, May 1972; Art Voices Winter 1965; Artforum March 1966; Arts Magazine September 1976, January 1978; Domus (Milan) January 1977, April 1980; Drama Review Spring 1968; It Is Autumn 1959; New York Times June 12, 1966; Vanguard December 1977/January 1978; Village Voice October 7, 1959; Vogue April 1964.

KATZ, ALEX (July 24, 1927–), American painter, who worked representationally when abstract expressionism dominated American art, though he was influenced by action painting. He is best known for cool, outsized portraits of his New York City friends.

Katz was born in the Sheepshead Bay area of Brooklyn, New York. His father, the late Isaac Katz, had run the family tile factory in Russia before the 1917 Revolution; after a few years in Berlin he immigrated to the United States and became a coffee merchant. Alex's mother, the former Alla Marion, also came from Russia and had studied acting at the Stanislavsky school in Odessa. In New York City, during the early 1920s before her marriage, she had been an actress in the Yiddish theatre. Alex Katz has one brother, Bernard.

In 1929 the family moved to St. Albans, Queens, where Alex grew up. He told Jerry Tallmer in an interview in the *New York Post* (March 11, 1978), "We were in the country-club section, so to speak, up near the Naval Hospital. I hadn't been back in 30 years. Went back last spring." Smiling, he added "I think the neighborhood went up a little bit."

Although his family had wanted him to pursue a more conventional career, Katz attended a vocational high school in order to study art daily. In August 1945 he joined the US Navy, devoting his free time to drawing and painting watercolors. He was discharged in July 1946 with the rank of seaman first class and soon afterward enrolled at the Cooper Union School of Art, New York City, where he studied for three years. Among his teachers were Robert Gwathmey, Morris Kantor, Carol Harrison, and Peter Busa. According to Irving Sandler in *Alex Katz* (1979), "Conventional figurative styles struck [Katz] as provincial and spent," and at Cooper Union he learned a modernist approach to figurative painting. In 1949, the year of his graduation, he received a scholarship for summer study at the Skowhegan School of Painting and Sculpture, Skowhegan, Maine, where he worked under Henry Varnum Poor, who urged him to work out of doors, an approach that had been rejected at Cooper Union. "I really liked it, got a real kick out of painting outdoors," Katz recalled. In Skowhegan he became interested in Matisse and in some of the New York School art-

Photo by Ada Katz

ALEX KATZ

ists, especially Jackson Pollock. Although he never painted nonrepresentationally, his paintings from nature concentrated on mood rather than actual appearance.

During 1951 and 1952, having returned to New York City, Katz painted human figures, often from snapshots, using wood instead of canvas. He combined recognizable three-dimensional subject matter with a flat treatment. Like the Abstract Expressionists, though in a different, realistic idiom, he focused attention on the painting as an object in itself. Influenced by Pollock's gestural style, for a time he painted scenes of nature in the energy-packed all-over manner; the brushstrokes are highly visible in those pictures, in contrast to his later, smoother technique. During the early and mid-1950s Katz also painted Cézanne-like landscapes and sundrenched interiors. In those years he attended the Painters' Club, which had been founded by the seminal Abstract Expressionists, and became friends with many of the New York School painters and their poet-allies, including John Ashbery and Kenneth Koch, and made his living carving frames, painting houses, and assisting muralists. In 1953 he exhibited with Lois Dodd, a former fellow student at Cooper Union, at the Tanager Gallery, Manhattan, and the following year held his first solo exhibition, at the Roko Gallery, New York City.

About 1955 Katz began making small paper collages, depicting in a simplified style figures in interiors, landscapes, and seascapes. His small collages—anomalous at a time when abstract expressionism had popularized large-scale canvases—were composed of thin paper cutouts

painted with watercolor; moreover, he avoided the mixed textures and materials usually found in collage. In his paintings Katz made his brush-strokes less visible, thus enabling him to work with flat patches of color.

In 1957 Katz began to work primarily in portraiture. The following year he married Ada del Moro and produced a series of paintings of her. Although executed on a larger, sometimes life-size scale, they resembled in feeling the tiny figurative cutouts of his collages. As Thomas B. Hess wrote in *New York* magazine (October 3, 1977), "Katz has been concerned for over twenty years with ideas of intimate scale (very small or very large: you can envelop it or it can embrace you) and classic shape (simple outlines, flat planes, abrupt transitions)."

Katz developed a new technique in 1959, when, dissatisfied with a figure he was painting, he cut it from the canvas and pasted it to plywood. He cut around the contours of the figure and painted the figure directly onto the wood, which he then trimmed. Some of the cutouts, representing Ada, his son Vincent, and his friends, were painted on both sides and set up as free-standing figures; others were attached to walls. Katz used this method in *British Soldiers* (1961), life-size figures in painted wood made as stage props for an off-Broadway play by Kenneth Koch, *George Washington Crossing the Delaware*. Katz also contributed cutouts of Washington crossing the Delaware and of the proverbial cherry tree and hatchet. *Time* magazine described the sets, displayed in June 1962 at the Jackson Gallery, New York City, as "a kind of instant folk art." Reviewing a collection of Katz's cutout portraits in a solo show at the Tanager Gallery in 1962, Irving Sandler wrote in the *New York Post* that the lifelike cutouts were "humorous take-offs on the 'reality' of pictorial images, on New Realism, and on the present tendency of painting and sculpture to merge." This phase of Katz's work is often classified as pop art, but unlike Pop artists Katz used personal friends and art-world celebrities as subject matter rather than pop-culture icons.

In 1962 Katz enlarged his pictures, hardened his contours, and used brighter colors. He also switched from wood to canvas to accommodate the larger images of his portraits, although often the faces were cut off by the edge of the canvas, as in a cinematic close-up; an example is *Red Smile* (1963). "Movies and television are important to me," Katz explained. "I like the way television exploded the scale. The way it makes the 14-inch screen seem enormous. You want to run out of the room sometimes; they push it out so fast and so aggressive. That was a quality I ad-

mired in the paintings of [Franz] Kline and [Willem] de Kooning. I think it had a lot of influence on these paintings of mine."

Among the most striking examples of Katz's approach in the early and mid-1960s are *Painting of Elaine de Kooning* (1965), in which the picture is cropped at the lip line to focus on the tense, anxious eyes, and *Upside Down Ada* (1965), in which formal considerations are combined with a whimsical reminder of an actual human presence.

From 1961 to 1963 Katz taught at the Yale University School of Art, New Haven, Connecticut. In 1965 he began to make prints, the first of which were screenprints based on his 1956 collage and cutout compositions. Meanwhile Katz's work continued to be influenced by the theater and poetry. He designed sets and costumes for ballets premièred by the Paul Taylor Dance Company in 1960 and 1964. His paintings of the mid- and late 1960s included, besides single portraits, complex compositions of his friends and family in pairs and in large groups, as in *The Cocktail Party* and *The Lawn Party,* both of 1965. *The Lawn Party,* 9 by 12 feet, was painted outdoors at Katz's summer house in Maine. Thomas B. Hess noted that Katz treats subject matter taken from his everyday leisure life—parties, picnics, pets—"as if it were a bucolic Age of Gold where everybody is youthful and it's always time for tea." Although Katz captured the likenesses, characteristic poses, and gestures of his friends, there was no deep probing of their psyches.

Katz's figures, as David Antin observed in his *Alex Katz,* have a certain glamor because "they are generally from a particular part of the art and poetry world of New York City. . . . " In the late '60s Katz concentrated on cutout portraits of his New York friends, some of them well known art-world figures such as dance critic Edward Denby and photographer Rudy Burckhardt. They were shown either by themselves or in groups of two or more. The most ambitious of the cutout groups was *One Flight Up* (1969), consisting of 38 head-and-shoulder portraits, among them likenesses of curator Henry Geldzahler, painter Philip Pearlstein, critic Irving Sandler, and dancer Paul Taylor. The cutouts were set on a metal table and arranged in groups at various angles; the heads could be seen from back or front. The critic Scott Burton called the work "one of those absolutely uncategorizable triumphs of American eccentricity."

Katz began making large flower pictures in 1966, using a decorative stylization that some critics felt worked better than in his portraits. Katz became increasingly concerned with patterning and stylization, seemingly at the expense of characterization in such bland-faced portraits as *Ada with Superb Lily* (1968) and *Self-Portrait with Sunglasses* (1969), in his portraiture of the late '60s. Critics have described Katz's portraiture as impassive and aloof, and Hilton Kramer was troubled by an emotional emptiness in his work. However, Irving Sandler and David Antin both assert that Katz brilliantly portrayed the manners, attitudes, and styles—the urbanity, natural grace, and cool, easy assurance—of the Kennedy '60s. "The cool that Katz cultivates is conveyed not only by the smoothness of the painting," Sandler wrote, "but also by the flatness of his images and their huge size and internal scale, all of which distance the portrait from the audience."

In the late 1960s Katz continued his theater work, designing sets and costumes for a 1968 production of Ibsen's *Little Eyolf* in Southampton, New York, and for *Private Domain,* presented by the Paul Taylor Dance Company at the New York City Center in 1969. He also worked as a book illustrator from 1967 to 1970.

A retrospective exhibition of Katz's works opened at the Museum of Fine Arts at the University of Utah, Salt Lake City, in 1971 and toured the United States. In 1971–72 Katz taught at the University of Pennsylvania School of Art, Philadelphia, and was awarded a Guggenheim painting grant in 1972. An exhibition of his prints that opened at the Whitney Museum of American Art, New York City in 1974 toured the United States in 1975. Reviewing Katz's print exhibition, in *The New York Times* (September 22, 1974), James R. Mellow wrote "Behind the self-effacing first appearance of his paintings and prints, there is an artist who is as rigorously dedicated to formal considerations as Matisse."

The culmination of Katz's large scale portraiture was *Billboard*—23 enormous heads of young women painted in a style verging on that of comic-strip cartoons. Installed in 1977 at Seventh Avenue and 42d Street, Manhattan, the billboard stretched 240 feet and was raised on a central tower 57 feet high. It was executed from Katz's maquette by a professional sign painter, Jerry Johnson.

Alex Katz was described by Jerry Tallmer as "a boyish, long-jawed 50-year old who talks broad New Yorkese with a slight stammer." In *Newsweek* (December 13, 1963) Jack Kroll commented on the artist's "friendly scowling smile, his dark, high, domed forehead, black tango dancer's hair, and amiably Mephistophelean eyebrows." Katz and his wife, who is a biologist, have one son, Vincent. Katz divides his time between New York City and Maine.

Though his art may seem simple and his interpretation of the human face superficial, Katz is attempting to transcend realism and create a visual language in which "the image and symbol are one," to quote the artist. Katz wants his symbols to be "clear as well as multiple," but he insists that the clarity of his work should not be confused with simplicity. "Complicated works of art," said, "never line up with a simple explanation."

EXHIBITIONS INCLUDE: Roko Gal., NYC 1954, '57; Univ. Park, Pennsylvania State Univ. 1957; Sun Gal., Provincetown, Mass. 1958; Tanager Gal., NYC 1959, '62; Stable Gal., NYC 1960, '61; Thibaut Gal., NYC 1963; Fischbach Gal., NYC 1964, '65, '67, '68, '70, '71; David Stuart Gal., Los Angeles 1966; Bertha Eccles Art Cntr., Odgen, Utah 1968; "Alex Katz at Cheat Lake," Mont Chateau Lodge, Morgantown, W. Va. 1969; "Alex Katz," Mus. of Fine Arts, Univ. of Utah, Salt Lake City 1971; Gal. Dieter Brusberg, Hanover, W. Ger. 1971; Reed Col., Portland, Ore. 1972; Carlton Gal., New Rochelle, N.Y. 1973; Marlborough Gal., NYC from 1973; Assa Gal., Helsinki 1973; Marlborough Goddard Gal., Toronto and Montreal 1974; "Alex Katz Prints," Whitney Mus. of Am. Art, NYC 1974; Marlborough Fine Art Gal., London 1975; Gal. Marguerite Lamy, Paris 1975; Gal. Arnesen, Copenhagen, 1975; "Alex Katz: Some Recent Paintings," Fresno Art Cntr., California 1977–78; Marlborough Gal., Zürich, 1977; Rose Art Mus., Brandeis University, Waltham, Mass. 1978. GROUP EXHIBITIONS INCLUDE: Tanager Gal., NYC 1953, '57; Annual Exhibition, Stable Gal., NYC 1955, '56; "Metropolitan Younger Artists," New York Art Alliance, Tanager Gal., NYC 1959; "Young America 1960" Whitney Mus. of Am. Art, NYC 1960; "The Figure," Houston Mus. of Fine Arts, Texas 1961; "Shows of Last Year," Yale Univ. Art Gal., New Haven, Conn. 1962; "Maine and its Artists, 1910–1963" Colby Col., Waterville, Maine 1963; Annual Exhibition, Art Inst. of Chicago 1964; "American Collage," 1965, "Two Decades of American Painting," 1966, MOMA, NYC; "Large Scale American Paintings," Jewish Mus., NYC 1967; "Realism Now," Vassar Col. Art Gal., Poughkeepsie, N.Y. 1968; "Aspects of a New Realism," Milwaukee Art Cntr., Wis. 1969; 2d Coltejar Biennale of Art, Medellin, Colombia 1970; "Contemporary Realism," Pennsylvania Academy of the Fine Arts, Philadelphia 1971; "Colossal Scale," Sidney Janis Gal. NYC 1972; "American Drawings 1970–73," Whitney Mus. of Am. Art, NYC 1973; "Contemporary American Artists," Cleveland Mus. of Art, Ohio 1974; "Portrait Painting 1970–75," Allan Frumkin Gal., NYC 1975; "Recent Work: Ten Artists," Marlborough Gal. NYC 1976; "America, 1976," US Dept. of the Interior Bicentennial Show, Corcoran Art Gal., Washington, D.C. 1976–78; "Artists' Sets and Costumes," Philadelphia Col. of Art 1977–78.

COLLECTIONS INCLUDE: Metropolitan Mus. of Art, MOMA, Whitney Mus. of Am. Art, and New York Univ. Coll., NYC; Mus. of Art, Rhode Island School of Design, Providence; Wadsworth Atheneum, Hartford, Conn.; Mus. of Fine Arts, Boston, Mass.; Fogg Art Mus., Harvard Univ., Cambridge, Mass.; Rose Art Mus., Brandeis Univ., Waltham, Mass.; Dartmouth Col. Mus., Hanover, N.H.; Bowdoin Col. Art Mus., Brunswick, Maine; National Coll. of Fine Arts, Smithsonian Inst., Washington, D.C.; Hirshhorn Mus. and Sculpture Garden, Smithsonian Inst., Washington, D.C.; Cleveland Mus. of Art, Ohio; Allen Memorial Art Mus., Oberlin, Ohio; Mus. of Fine Arts, Cincinnati; Art Inst. of Chicago; Inst. of Arts, Detroit; Des Moines Art Cntr., Iowa; Milwaukee Art Cntr., Wis.; Univ. of Wis. Art Center, Madison; Tamayo Mus., Mexico City; Mus. of Contemporary Art, Utrecht, Neth.; Staatliche Mus., Berlin; Neue Gal, Aachen, W. Ger.; Atheneum, Helsinki; Tokyo Gal., Japan.

ABOUT: Battcock, G. Minimal Art: A Critical Anthology, 1968; Current Biography, 1975; "Alex Katz" (cat.), Marlborough Gal., NYC, 1973; "Alex Katz Prints" (cat.), Whitney Mus. of Am. Art, NYC, 1971; "Realism Now" (cat.) Vassar Col. Art Gal., Poughkeepsie, N.Y., 1968; Sandler, I. Alex Katz, 1979; Sandler, I. and Berkson, W. (eds.), Alex Katz 1971. Periodicals—Art in America, January–February 1967; January–February 1975, September–October 1977; Art International (Lugano) November 20, 1967; Art News January 1959, September 1959, February 1962, April 1971; Arts May 1967; New York October 3, 1977; New York Post March 11, 1978; Studio International (London) March–April 1975; Village Voice March 15, 1976.

KELLY, ELLSWORTH (May 31, 1923–), American painter and sculptor, emerged in the late 1950s as a leading Post-Painterly Abstractionist. His paintings of bold yet simple shapes containing large blocks of unmodulated color paved the way for minimal art.

He was born in the upstate New York town of Newburgh. The Kellys moved their brood of three boys to Pittsburgh and then, when Ellsworth was six, to Oradell, New Jersey, where the father, Allan Kelly, worked for an insurance company. Ellsworth became interested in art early on and, fascinated by birds and by color, spent his free time visiting the nearby Hackensack Wildlife Reservation.

Kelly attended Dwight Morrow High School, Englewood, New Jersey, where the future astronaut Walter M. Shirra Jr. was a classmate. After graduating from high school, Kelly studied in 1941–42 at the Pratt Institute, Brooklyn. Drafted into the United States Army Engineer Corps in 1943, he served in a camouflage unit and took part in the Normandy landings of June 6, 1944. Stationed in France through 1945, Kelly developed an interest in the stylized and geometric approach to forms in Romanesque churches and Byzantine mosaics.

On his return to the US, Kelly studied drawing and painting on the GI Bill at the School of the

Jack Mitchell, NYC

ELLSWORTH KELLY

Museum of Fine Arts, Boston, from 1946 to '48. There his teacher was Karl Zerbe, who introduced him to European expressionism. During these years Kelly lived and taught art at Norfolk House Center, Roxbury, Massachusetts. By 1948 he had decided that Boston was a "dead end" and that postwar American culture was stifling. Under the GI Bill, Kelly returned to Europe and enrolled at the Ecole des Beaux-Arts, Paris. Completing his studies at the Beaux-Arts in 1950, he remained in Paris four more years and taught at the American School there in 1950–51.

According to *The New York Times* (December 12, 1982), Kelly, "along with Sam Francis, Joan Mitchell and Jack Youngerman, . . . was part of the last generation of American artists who felt the need to live or expatriate themselves in France." In Paris, through his close friend Youngerman, Kelly met the archaeologist Henri Seyrig, who befriended him as did Alexander Calder, who encouraged Kelly and helped him financially.

Kelly's earliest paintings had been figurative, small, largely monochromatic, and influenced by the expressive figuration of Picasso and Klee. In 1948–49 he produced pictures that, although representational, ceased to be meticulously detailed. He painted heads, seemingly made of large smooth stones with rectangular noses. *Faces of Stone* (1949) consisted of five oval forms arranged to suggest physiognomical qualities. He worked from objects, both man-made and natural, but his interest in the purely visual and formal characteristics of his subject caused his forms to depart from nature. Kelly achieved a remarkable combination of literalness and abso-

lute abstraction in *Window* (1949; Musée d'Art Moderne, Paris), a wooden framework mounted on canvas which had been inspired by a window in the Musée d'Art Moderne.

Window was included in the 1968 exhibit at the Museum of Modern Art, New York City, titled "The Art of the Real: USA 1948–1968." In the catalog, *Window* was reproduced on the page opposite Georgia O'Keeffe's "prophetic" *Lake George Window,* painted 20 years earlier, in 1929. This juxtaposition, as E.G. Goossen observed in the catalog, "points up not only our sense of what is factually real in each, but also how the real can be achieved in either two or three dimensions." Both works were examples of what Goossen called "uncompromising objectivity." Kelly's *Window,* with its superimposition of a stark wooden framework on canvas, looked forward to his hard-edged paintings of the 1950s and '60s.

In Paris Kelly had found a city where "things began and were clarified" and where it was possible to "[find] your own way," as he told *Artnews* (March 1983). He visited the studios of Brancusi, Georges Vantongerloo, Francis Picabia, Alberto Magnelli, and Jean and Sophie Taueber-Arp, and was influenced by Magnelli's geometrical abstractions and by the biomorphic shapes favored by the Arps. Beginning in 1950, Kelly further developed the relief concept of *Window* in a series of low-relief wood constructions, some white on white, others with arrangements of colored geometrical forms. These works were influenced by constructivism and Mondrian. Kelly also experimented with low-relief constructions in which string or wire was sewn on canvas or laced on wood. These works were shown in a group exhibition at the Salon des Réalités Nouvelles, Paris, in 1950, and at Kelly's first solo show at the Galerie Arnaud, Paris, in 1951.

At this time Kelly produced what were probably the first shaped canvases, a practice that was to be popularized by Frank Stella in the early 1960s. For these unorthodox compositions Kelly used such motifs as the changing shadows on a staircase and an hourglass-shaped painted wooden panel based on the reflection of an arched bridge on water. In an interview with Henry Geldzahler in *Art International* (February 1964), Kelly explained that it is everyday objects—"a fragment of a piece of architecture, or someone's legs, or sometimes the space between things"—from which he derives new forms.

The first paintings that Kelly acknowledged to be abstract developed in 1950 from the operation of chance. As the Surrealist Arp had done

35 years before, Kelly dropped torn pieces of discarded drawings onto a canvas and then fixed them in place according to where they had fallen. This collage he also painted by chance, the choice of color being determined by slips of paper, on which the names of different colors were written, that he drew from a hat. This experiment convinced Kelly that forms and the interrelation of shapes independent of what he called the "rhetoric of color" were to be the focus of his concern in painting. Several of his chance compositions, such as *Brush Strokes Cut Into 49 Squares and Arranged by Chance* (1951) anticipated his sectioned panel paintings.

In the early '50s Kelly also investigated methods of serial construction in a series of Mondrian-like grid paintings, in which colors, and in some cases units of measurement, were positioned by chance. His collages had been relatively small, but now he began to work on large paintings consisting of carefully proportioned rectangles of pure color. *Colors for a Large Wall* (1951; MOMA) consisted of 64 panels, each painted in a single unmodulated color and all joined to form an eight-foot square. In 1952–53 he executed another seies of paintings in which each color appeared on a separate panel; the color panels, stretched side by side, were to be "read" as one painting. Kelly's intention was to turn color itself into subject matter—color freed from subservience to form and with each hue having its own "reality."

In 1954, when Kelly returned to the US, abstract expressionism dominated the New York art scene. He took a studio on Coenties Slip in lower Manhattan, where a community of young artists lived. Among them were, at one time or another, Youngerman, Robert Indiana, Agnes Martin, and James Rosenquist, all of whom were to react against action painting. There Kelly began producing his characteristic curvilinear compositions with large blocks of color whose edges traced the outline of biomorphic shapes. His paintings of 1954–55 were almost entirely black and white. When color was introduced, it was usually a single color against a neutral black or white ground. Although they did not appear to be figurative, all of Kelly's early paintings were abstractions of things he had seen. His paintings increased in size, and the black and white curved shapes, which were fragments of images cut off by the edge of the canvas, played on the rectangle itself.

In 1956 Kelly's first American solo show was held at the Betty Parsons Gallery, New York City. His sharp, precision-contoured forms containing one uniform color and set against a uniform background, also in one flat color, were in complete contrast to the emotionally charged painterliness of abstract expressionism. Critics felt that Kelly's work inaugurated a new trend, one that was later christened "post-painterly abstraction" when Clement Greenberg, one of modern art's preeminent theoreticians, turned his back on the gestural wing of abstract expressionism and embraced the new style. In 1959 the term hard-edge painting was coined by Lawrence Alloway to describe the "new abstraction," whose leading practitioners were Kelly, Stella, Morris Louis, and Kenneth Noland. Alloway defined hard edge as a term referring "to the new development that combined economy of form and neatness of surface with fullness of color, without continually raising memories of earlier geometric art. . . . What one sees is exactly what there is." Although Kelly has been called the father of hard-edge painting, he resists being circumscribed by that label. "I am not interested in outlines," he told Geldzahler, "but in the masses and the color: the outline serves me only to give quietness to the image."

Reviewing a 1959 Kelly exhibition at Betty Parsons, a critic wrote, "He makes everything look surperficially easy, but a second glance takes in subtleties of formal calculation that owe much of their striking appearance to surprise." In 1958, Kelly had a solo show at the Galerie Maeght, Paris, and was one of 17 artists whose work was exhibited in the American pavilion at the Brussels World's Fair. In 1959 his work was included in MOMA's prestigious "Sixteen Americans" show. In the exhibition catalog Goossen wrote, " . . . With Kelly the color lies on the surface (it is a kind of spaceless skin), and though it plays an important role in the sensuous result, the true burden of the sensuous excitement is carried by the contours."

During the early '60s Kelly simplified his shapes, the effect of which was to make them bolder. His colors became clearer, his contrasts stronger as he began using three colors per painting instead of two. Reviewing Kelly's 1961 show at Betty Parsons for *The New York Times* (October 21, 1961), Stuart Preston wrote that his shapes had grown "more flexible, twisting and bulging in places with a formal tension as if they were made of India Rubber."

In 1962 Kelly had his first solo show in England, at the Tooth Gallery, London. A *Guardian* (June 9, 1962) critic pointed out that one significant aspect of Kelly's art was the creation of a "parity of figure and field," which means that in Kelly's paintings foreground and background are ambiguous; negative and positive spaces are balanced and can be "read" interchangeably. For instance, Kelly never calls a

painting "Blue Form on Red Ground" or "Red Form on Blue Ground," but rather *Blue Red* or *Red Blue*.

Typical Kelly paintings of the early '60s are *Red White* (1961; Hirshhorn Museum and Sculpture Garden, Washington, D.C.) and *Blue White* (1962; Brandeis University, Waltham, Massachusetts). Sam Hunter described *Blue White* as "a feat of equilibrium of force met with counterforce, to the end of creating many levels of arrested action in movement." Hunter pointed out that in spite of the differences of Kelly's style from abstract expressionism, with its "essentially romantic quest for self-definition," a painting like Kelly's *Blue White* owes much to that movement, especially in the work's "interplay of legibility and confusion and in its imposing scale (108 by 103 inches). Another similarity between Kelly's use of color and strong line and abstract expressionism is all-over pictorial organization, that is, no canvas in either style has a fixed center of attention.

As early as 1958, when the all-over red-saturated *Broadway* (Tate Gallery, London) was painted (it is one of the most "color field" of Kelly's canvases), critics had noted the heraldic, bannerlike quality of the artist's work. In addition to the influence of Arp, such works as *Blue Red Green* (1962–63; Metropolitan Museum of Art, New York City) and *Blue Green Red 1* (1965; Stedelijk Museum, Amsterdam), with their bright clear color fields and taut boundaries, recalled the paper cutouts of Matisse. Late in 1963 Kelly had his first solo museum exhibition when 33 of his works were displayed at the Washington Gallery of Modern Art, Washington, D.C. By this time Kelly's work had become larger, although his paintings rarely exceeded the relatively human scale of ten feet. A *Washington Post* (December 14, 1963) critic found a roomful of Kelly's works to be "quiet yet lyrical." However, when the exhibit traveled to Boston, a reviewer described the ensemble as "a momentarily arresting experiment in optics, a game of visual gymnastics [in which there is] a certain coldness, a depersonalization in the approach. . . ."

In 1963, when the Metropolitan Museum purchased *Blue Red Green*, Kelly became one of the youngest artists to have a picture acquired for that prestigious institution's permanent collection. In 1964 he was awarded one of six first prizes at the Carnegie International, Pittsburgh, for his painting *Blue, Black and Red.* But not all critics were favorably disposed to Kelly's blocks of color and geometric or biomorphic shapes. Emily Genauer of the New York *Herald Tribune* (October 30, 1964) wrote that *Blue,*

Black and Red "has the impact of a billboard and about as much depth." Edward Lucie-Smith wrote that in many Kelly paintings "it seems as if the canvas, already very large, has not been big enough to accommodate the form, which is arbitrarily sliced by the edge, and continues itself in the mind's eye of the spectator. As a device to impart energy and interest to the painting, this is quite successful, but there is something rather gimmicky and tricky about it."

Kelly exhibited regularly at the Sidney Janis Gallery, New York City, from 1965 to the early '70s, when he moved to the Leo Castelli Gallery, SoHo. He was one of four painters chosen by Henry Geldzahler to represent the US at the Venice Biennale of 1966. Among the paintings he showed there was *Green Red Yellow Blue*, which consisted of four separate panels, each 76½ by 57½ inches and each spaced nine inches apart.

Kelly was massively represented at the Metropolitan Museum of Art's gigantic centennial show, "New York Painting and Sculpture: 1940–1970," as two of the exhibition's 40 galleries were devoted to him. Included was *Spectrum V*, a 1969 version of his 13-panel serial painting, measuring approximately 7 by 37 feet. Also included were 30 of Kelly's pen-and-ink drawings of flowers and foliage. Although ostensibly different from his bold, monumental paintings, these drawings had the voluptuousness of shape and economy of rendition of his work in other media.

In the 1970s Kelly continued to produce single-panel paintings as well as rows of single-colored painted panels. In his compositions with shapes he still favored the unbroken curved line. Kelly's early works were featured in his 1973 retrospective at MOMA, and his last pieces in the exhibit were his first steel sculptures, which date from the mid-50s.

Kelly feels that it was the unpainted steel pieces that stimulated him to use gray, which he calls "a denial of color," in his paintings. His 1977 exhibit at the Leo Castelli Gallery, New York City, included a four-canvas work which combined three tones of gray with white. Also shown were two-panel paintings in dead black and bone white; these juxtaposed shaped canvases were called "diagonal paintings" by Kelly. By eliminating color, he was free to concentrate on refining the single shape and to explore its ambiguous relationship to geometry. As Kelly said before the opening of his "Recent Paintings and Sculptures" show at the Metropolitan Museum in April 1979, "I felt that the interest of the forms would be diluted by strong color." Kelly explained that, with one exception, the works were wall pieces, whether painted on canvas or made

of flat sheets of steel. "They're about shape, really, and about your presence in the room with them." The austerity of the pieces struck some viewers as bleak and empty, but for Kelly the emphasis on shape rather than color was a logical progression, one which sprang naturally from his obsession with transmuting natural forms into nonfigurative shapes. In the winter of 1982–83 the first exhibition dedicated exclusively to Kelly's sculpture was held at the Whitney Museum of American Art, New York City.

Ellsworth Kelly lives in Chatham, New York. There he works in a large building which houses two small studios for sculpture and drawing and a vast space which is reserved for painting. His studio is crowded with the avocado and rubber plants which have provided motifs for many of his drawings. The sparseness and anonymity of his painting and sculpture is reflected in Kelly's personality. He is not a "scene-maker" in the New York art world, and at his rare public appearances he is quiet, courteous, and conservatively dressed.

Rejecting the "hard-edge" label—"I'm not interested in edges, I'm interested in mass and color"—Kelly believes that art has to do with play and discovery. With the deceptive simplicity that characterizes his work he declared, "The most pleasurable thing in the world, for me, is to *see something*, and then to translate how I see it."

EXHIBITIONS INCLUDE: Gal. Arnaud, Paris 1951; Betty Parsons Gal., NYC 1956–63; Gal. Maeght, Paris 1958, '64; Arthur Tooth & Sons, London 1962; Washington Gal. of Modern Art, Washington, D.C. 1963–64; Inst. of Contemporary Art, Boston 1963–64; Sidney Janis Gal., NYC from 1965; Irving Blum Gal., Los Angeles 1967, '68; Albright-Knox Art Gal., Buffalo, N.Y. 1968; MOMA, NYC 1973–74; Ace Venice, Venice, Calif. 1975; Janie C. Lee Gal., Houston, Tex. 1976; Leo Castelli Gal., NYC 1977, 1982–83; "Recent Paintings and Sculptures," Metropolitan Mus. of Art, NYC 1979; Blum Helman Gal., NYC 1982–83; Whitney Mus. of Am. Art, NYC 1982–83; St. Louis Art Mus. 1983. GROUP EXHIBITIONS INCLUDE: "Premier salon des jeunes peintres," Gal. Beaux-Arts, Paris 1949; "Réalités nouvelles cinquième salon," Palais des Beaux-Arts de la Ville de Paris 1950; "Réalités nouvelles 1950, numéro 5," Salon des Réalités Nouvelles, Paris 1950, '51; "Young America 1957," Whitney Mus. of Am. Art, NYC 1957; Carnegie International, Pittsburgh 1958, '61, '64, '67; Brussels World Fair 1958; "Sixteen Americans," MOMA, NYC 1959–60; Whitney Annual, NYC 1959–63, 1965–69; "American Abstract Expressionists and Imagists," Solomon R. Guggenheim Mus., NYC 1961; São Paulo Bienal 1961; "Geometric Abstraction in America," Whitney Mus. of Am. Art, NYC 1962; Venice Biennale 1966; Documenta 3 and 4, Kassel, W. Ger. 1964, '68; "Primary Structures: Younger American and British Sculptors," Jewish Mus., NYC

1966; "Serial Imagery," Pasadena Art Mus., Calif 1968; "Plus by Minus: Today's Half-Century," Albright-Knox Art Gal., Buffalo, N.Y. 1968; "The Art o the Real: U.S.A. 1948–1968," MOMA, NYC 1968 "New York Painting and Sculpture: 1940–1970," Metropolitan Mus. of Art, NYC 1970; Whitney Biennial NYC 1973; "Drawing Now," MOMA, NYC 1976; "20(Years of American Sculpture," Whitney Mus. of Am Art, NYC 1976; "Cronaca," Gal. Civica, Modena, Italy 1976.

COLLECTIONS INCLUDE: Metropolitan Mus. of Art MOMA, and Whitney Mus. of Am. Art, NYC; Albright-Knox Art Gal., Buffalo, N.Y.; Brandeis Univ. Waltham, Mass.; Worcester Mus., Mass.; Carnegie Inst. of Art, Pittsburgh; Washington Gal. of Modern Art, and Hirshhorn Mus. and Sculpture Garden Smithsonian Inst., Washington, D.C.; Chicago Art Inst.; Cleveland Mus.; Cincinnati Art Mus.; Walker Art Gal., Minneapolis; San Francisco Mus. of Art; Los Angeles County Mus.; Fort Worth Art Center Mus., Tex.: Art Gal. of Ontario, Toronto; Mus. d'Art Moderne, Paris; Fondation Maeght, Saint-Paul-de-Vence, France; Stedelijk Mus., Amsterdam; Rijksmus. Kröller-Müller, Otterlo, Neth., Wallraf-Richartz-Mus., Cologne; Tate Gal., London.

ABOUT: Baker, E. C. "Ellsworth Kelly: Recent Paintings and Sculptures" (cat.), Metropolitan Mus. of Art, NYC, 1979; Coplans, J. Ellsworth Kelly, 1973; Geldzahler, H. "New York Painting and Sculpture: 1940–1970" (cat.), Metropolitan Mus. of Art, NYC, 1969; Goossen, E. G. "The Art of the Real: U.S.A. 1948–1968" (cat.), MOMA, NYC, 1968; Lucie-Smith, E. Late Modern: The Visual Arts Since 1945, 1969; Miller, D. (ed.) "Sixteen Americans" (cat.), MOMA, NYC, 1959; Moore, E. (ed.) Contemporary Art 1942–72: Collection of the Albright-Knox Art Gallery, 1972; Nordness, L. (ed.) Art USA Now, 1962; "Painting, Sculpture and Drawings of Ellsworth Kelly" (cat.), Washington Gal. of Modern Art, Washington, D.C., 1963; Pellegrini, A. New Tendencies in Art, 1966; Rose, B. American Art Since 1900, 2d ed. 1975; Sandler, I. The New York School, 1978. *Periodicals*—Art International April 1962, February 1964; Art News April 1977, March 1983; Guardian June 9, 1962; New York Herald Tribune October 30, 1964; New York Times October 25, 1959, October 21, 1961, February 18, 1977, April 27, 1979, December 12, 1982, Washington Post December 14, 1963.

***KIENHOLZ, EDWARD** (1927–), American sculptor and painter known for his often horrorific environmental tableaux, was born in the small town of Fairfield, in rural Washington state. His family farmed, and although preoccupied with art since childhood, Kienholz had no formal art training. Instead, he led an erratic student career at Washington State College in Pullman and at the Eastern Washington College of Education in Cheney; by 1952 he had completed his student years at Whitworth College in Spokane.

°kēn´holz

Courtesy of Apollon Die Insel

EDWARD KIENHOLZ

Between 1950 and 1956, Kienholz held down a succession of odd jobs—hospital orderly, attendant in a mental institution, dance-band manager, car salesman, bootleg-club manager, window-display artist, vacuum-cleaner salesman—that brought him into contact with the less refined, sub-middle-class sides of modern American life. This vagrant working pattern would influence his later work, according to a British critic who wrote in *The Guardian* (May 27, 1971): "Memories of the shutting away from sight of madness, illness and sex, and of the desolation of public eating places were to recur later in the tableaux. . . ."

By 1953 Kienholz had moved to Los Angeles and been married and divorced. Initially a painter, he made his first reliefs in the early 1950s, during a stay in Las Vegas. They were constructed from wood pieces roughly nailed together and often painted with a broom. He continued to work in this vein after 1954, using a shack in Los Angeles as his studio. These so-called junk constructions are "the leftovers of human experience," Kienholz told the *National Observer* (January 23, 1967). "I worked mostly in wood reliefs until 1956, when the pieces started to become three-dimensional. There were a lot of reasons for this development, all of them personal. I come from a small town in the state of Washington for example, and grew up on a farm. Maybe paint and canvas just seems effete." Kienholz further said that he had not heard of Kurt Schwitters, the German Dadaist and collage and construction artist of the 1920s, until his own first New York show in 1963. Neither did he know at the time he began his constructions

that Jean Tinguely in Europe, Robert Rauschenberg in New York, Tom Westermann in Chicago, and Yves Klein in Paris were creating similar assemblages. "I think all this assemblage sprung up of its own accord . . . ," Kienholz remarked. "All independent. A three-dimensional thing was happening."

Kienholz tried in vain to interest Los Angeles dealers in his work. He finally opened his own gallery—the Now Gallery—in the rear of a movie theater, and in 1957, he joined Walter Hopps in directing the Ferus Gallery in Los Angeles, which they ran until 1963. (Hopps later became a museum director.)

Kienholz experimented from 1956 to 1958 in abstract expressionism, without producing a personal statement. The first developing of his own expression is seen in *The Little Eagle Rock Incident* (1958). It combines elements of abstract expressionist painting with sculpture and assemblage in a spirit of angry sociopolitical comment. The work anticipated Kienholz's first major environmental tableau, *Roxy's* (1961), named after a notorious wartime Las Vegas brothel which Kienholz "reproduced" as it had been in 1943. A large room contains a tableau of meticulous period detail—jukebox against the wall, cheap calendar, copies of *Life* magazine, a Bakelite radio set, and a large photograph of a saluting General MacArthur. The prostitutes are limp, decayed mannequins called "Cockeyed Jenny" and "Fifi, A Lost Angel." The madam has a warthog's skull as a head; "Five Dollar Billie," a ravaged mannequin with an innocent face, has dangling, shrivelled legs and lays on a sewing-machine table. *Time* magazine (April 8, 1966) described Billie as being "like a pathetic machine; she Yo-Yo's pelvically if a spectator peddles the foot treadle." The disturbing symbolical and allegorical elements combine in *Roxy's* oppressively hideous living room, to which Kienholz adds a sardonic detail: a sergeant's jacket bedecked with a good-conduct medal.

"I wanted to communicate the different worlds that exist in a whorehouse," Kienholz said of the piece, "the one that the patron lusts for, as well as the tormented inner world of its employees. And also the tension inside the invisible customer." The spectator becomes the voyeur, in effect the "invisible customer," in Kienholz's walk-through tableau, and some have been profoundly shocked by his imagery. One critic felt that Kienholz represented an aspect of "junk art," that is "the liking for the complex, the sick, the tatty, the bizarre, the shoddy, the viscious, the overtly or covertly sexual. . . ." Others see Kienholz's anger as directed against the corruption of society, indicting neither its victims nor

the individuals viewing its victims. As with other satirists, from Hogarth to Grosz, Kienholz's relationship to his subject matter was one of love-hate.

Kienholz's work has been described as neo-dadaist; his tableaux, composed as they are of junk, discarded furniture, paint and plaster, are carefully thought out, well executed, and of serious intent—the reverse of dadaism. In fact, one critic called them "predominantly and curiously anti-Dada." Others labeled them the ultimate in pop, though they lacked the cool deadpan detachment of pop art.

Kienholz's next completed piece, in 1961, was a small nativity scene described in *The Observer* (June 6, 1971) as "a way-out version of a Christmas crib done with total piety." In late August 1961, Kienholz began work on *The Beanery,* an elaborate and weirdly realistic life-sized reconstruction of a famous old Los Angeles bar called "Barney's Beanery." Kienholz had pondered this project since 1958, and took six months to plan and construct it.

"I sat down at Barney's Beanery for four years," he recalled, "looking around, asking myself how I'd duplicate that old bar in new materials." The kick rail came from the actual Beanery, and all other aspects of the bar—signs, soiled floors, scarred furnishings—he carefully reproduced. Completed, it is a multi-media walk-in environment, which includes recorded bar conversation, blaring jukebox music, plastic food and the aroma of kitchen and washrooms. The barroom itself is scaled down by one half, but the customers at the crowded bar are life-sized and clothed. Up to their shoulders, they are realistic, but their heads are clocks whose hands are stopped at ten past ten (this, according to Kienholz, marks eyebrows and symbolically conveys the regulars' habit of killing time). Barney, the proprietor, is the only figure with a "real" head on his shoulders.

In 1963 *The Beanery* was installed at the first exhibition of the Los Angeles branch of New York's Dwan Gallery. As visitors entered the double doors into the 22-foot-long and 6-foot-wide tableau, they passed a newspaper in a vending rack, its headline shrieking, "Children kill children in Vietnam." "That symbolized the world situation," Kienholz explained. "You escape from it into Barney's." *The Beanery* was acquired by the Stedelijk Museum, Amsterdam.

Kienholz's environmental tableaux, wrote the *Washington Post* (December 10, 1967) critic, deal with "familiar, every day horrors—senseless death, loveless sex, joyless birth." Kienholz's work in 1964 bore this out. In *The Birthday,* a young pregnant woman lies in agony on an ex-

amination table in a doctor's office. From her distended stomach seven huge curving lucite arrows, each illuminated from a hidden source, arise to convey her pain. Almost everything, including the woman's body and her few belongings, is coated with liquid fiberglass and painted gray. A greeting card which lies on the floor reads:

> Dear Jane,
> I couldn't come down now because Mary needs me here. Ma says she might make it later. Keep a stiff upper lip kid. (ha-ha) Dick

One is intended to "read" the entire tableau, because Kienholz is, in his way, as literary an artist as Hogarth.

State Hospital (1964) is viewed through the barred window of a door. In a big, gray, anonymous box, on two metal bunk beds, lay two identical and naked bony old men, their wrists chained to the bed. Their heads are illuminated goldfish bowls each with two swimming black fish that symbolize their aimless, endlessly revolving thoughts. There is a smell of Lysol in the air.

The tableau that created the greatest furor was *Back-Seat Dodge—'38* (1964). This brutal, explicit lovers' lane scene intends to evoke the 1940s, an era of swing bands, and sweater girls, and adolescent sexual encounters in the backseats of cars. A battered Dodge sedan is radically foreshortened, its front seat and much of its hood removed. While the car's radio blares the hit tunes of the period over and over again, a man and a girl make love—a partial plaster cast of a woman is fondled by a man made of chicken wire—on an actual back seat. Both bodies are joined to a single wire and plaster head. When the car door is opened the interior is flooded with light, and the startled viewer can see himself, as voyeur, reflected in the inside mirrors. Beer bottles are strewn on fake grass islands around the central motif. Kienholz told *The Guardian* (April 18, 1970) that *Back-Seat Dodge—'38* springs from "the experience of millions of American adolescents caught with maturing sexual appetites in a society which demanded virginity and Victorian marriage."

In one of his most compelling tableaux, *The Wait* (1964–65), the skeleton of an old lady is seated amid objects that evoke her past—the portrait of a young man dressed in the style of 1910 and photographs of young men and women in the uniforms of World War II; at her feet is an old sewing basket, and images commemorating incidents from her past are packed into fruit jars and strung like a necklace around her throat. Her head is the largest of the bottles, at the bot-

tom of which is the portrait of a young girl from the year 1910 that represents the figure's younger self. The searing theme of the tableau is, as one critic observed, an old woman "alone with her past and terrified of her future."

In March 1966 Kienholz's three-dimensional tableaux, soon-to-be exhibited at the Los Angeles County Museum, drew the ire of members of the Los Angeles County Board of Supervisors. Until opening night they threatened to bar the show and to cut off public support from the year-old museum unless "Five Dollar Billie" was removed from *Roxy's* and the door of *Back-Seat Dodge*—'38 kept closed. The board members considered both works to be pornographic and dangerous to the morals of the community. Museum officials, backed by testimonials from four prominent California art experts, refused to impose censorship; their only compromise was to label the exhibit "restricted to adults."

Another environmental work that aroused anger and controversy was Kienholz's *Portable War Memorial,* completed in 1969 during the Vietnam War. Faceless US Marines, arranged in a group based compositionally on the famous wartime photograph of soldiers raising the American flag on Iwo Jima, lunge forward to plant the flag, in the hole that would normally hold a large parasol, in the middle of a garden table. The gesture is meant to proclaim the glories of a Coca-Cola civilization. The tableau contains products of the American consumer society—a hot-dog-and-chili stand, a Coca-Cola machine with a rack full of empty bottles—and on the far left the truncated figure of a woman, with only her head and her lower legs visible, is encased in an upturned garbage can, its bottom removed. On the back wall, behind the woman and the marines, is an Uncle Sam recruiting poster from World War I. On a recording, Kate Smith sings "God Bless America." On a large panel dominated by an inverted white cross with the inscription "Portable War Memorial, Commemorating V [blank] Day 19 [blank]," are the chalked-in names of 475 countries that, like the thousands of men who lost their lives defending them, no longer exist.

Portable War Memorial was widely denounced as an insult to the United States, and even when it was exhibited in Europe some considered Kienholz an apostle of anti-Americanism. *Portable War Memorial* was shown in 1969 at the Hayward Gallery, London, and in 1971 was bought by Dr. Peter Ludwig of West Germany, the world's foremost collector of pop art.

By the late 1960s Kienholz had a considerable reputation on the West Coast, but his work had received little attention in New York and most of his critical acclaim had come from Europe. The success of a 1970 European traveling show of his work won him greater recognition in New York, though he was indifferent to his reception there. "New York has always been essentially hostile and to show there is more trouble to me than it's worth," he said. "I don't fit into that comfortable notch like the other artists. . . ."

Kienholz maintained a deep feeling for California and was included in the fall 1970 show devoted to West Coast art at London's Hayward Gallery. *Five Car Stud,* a life-size, walk-in assemblage exhibited there, depicts castration in three stages. First, a black man and a white woman sit in a parked car. Then, four cars pull up and surround them. Finally, a half-dozen white men brutally attack the lone black man. Kienholz's aggressive black humor was still present in a 1972 assemblage titled *Tadpole Piano with Woman Affixed Also.* In 1975 his work was again shown in Great Britain, at the Edinburgh Festival.

By the late 1970s his assemblages, though still polemical, became more abstract. His "Volksempfänger," or "People's Radio," series was shown in Berlin's Nationalgalerie in 1977. The radio has a dual meaning for Kienholz as a receiver of broadcast signals and as a cryptogram for the German male and washboards—cheap, mass-produced objects—were used as cryptograms for the German female. Oblique references to Nazi propaganda were underlined by broadcast tapes of Wagner's music.

Art Week noted the change. Reviewing an exhibit held in Seattle and titled "Edward Kienholz Sculpture: 1976–1979," an *Art Week* critic (December 1, 1979) detected in the new work "a latent formalist vocabulary" and "a pure, or nearly pure, esthetic purpose especially in the 'White Easel' series." This series was "more problematical than the other works, primarily for the lack of overt sociological clues." In each of these pieces Kienholz recreated a portion of his studio wall, with found objects placed against it "in anticipation of being assembled into a work of art," possibly, the critic suggested, a punning comment on his own methodology.

Edward Kienholz, a burly, thick-set, gregarious man with a short beard, lives with his wife Lynn and his two children, a boy and a girl, in a house high on the Hollywood Hills. On a visit in 1967, one critic described the artist's workroom, in which "hammers, power saws, [and] chisels lie on the floor in disarray." Successful on his own terms, Kienholz is bitterly hostile to what he considers the parasitic fringes of the art world—the speculating buyers, unscrupulous

dealers, most critics, publicists and commentators on art, and trendy gallery-goers, whom he'd satirized in his large installation *The Art Show*. He disdains the "pop" label, and he told a British critic in 1971: "I build things about thoughts and areas in which I'm confused." He has an intense love of America, but "I would," he says, "in my way, presume to change it."

The rise of assemblage and environmental art in the early 1960s "has to do with sensing and fearing rapid change," Kienholz commented. "No sooner do you make peace with society than it changes again. I think the artists are trying to hold onto things."

EXHIBITIONS INCLUDE: Café Gal., Los Angeles 1955; Coronet Louvre, Los Angeles 1955; Syndell Studios, Los Angeles 1956; Ferus Gal., Los Angeles 1959, '60, '63; Pasadena Art Mus., Calif. 1961; Iolas Gal., NYC 1963; Dwan Gal., Los Angeles 1963, '64; Dwan Gal., NYC 1965, '67; Inst. of Contemporary Art, Boston 1966; Univ. of Saskatchewan, Regina, Canada 1966; Gal. of Modern Art, Washington, D.C. 1967; Hayward Gal., London 1969; Art Mus. Ateneum, Helsinki 1969; Moderna Mus., Stockholm 1970; Städtisch Kunsthalle, Düsseldorf 1973; Gal. Bocchi, Milan 1974; Edinburgh Festival 1975; Nationalgal., Berlin 1977; "Edward Kienholz Sculpture: 1976–1979," Univ. of Idaho Art Gal., Moscow 1979; "Edward Kienholz Sculpture: 1976–1979," Univ. of Washington Henry Gal., Seattle, 1979. GROUP EXHIBITIONS INCLUDE: Vincent Price Collection, Pasadena Art Mus., Calif. 1958; "Art of Assemblage," MOMA, NYC 1961; "Fifty California Artists," Whitney Mus. of Am. Art, NYC 1962; "Box Show," Dwan Gal., Los Angeles 1964; "Sculpture of the Sixties," Los Angeles County Mus. 1967; "Dada, Surrealism and their Heritage," MOMA, NYC 1968; Documenta 4 and 5, Kassel, W. Ger. 1968, '72; "The Machine," MOMA, NYC 1968; "West Coast Art," Hayward Gal., London 1970.

COLLECTIONS INCLUDE: Whitney Mus. of Am. Art, NYC; Centre Nat. d'Art Contemporain, Paris; Stedelijk Mus., Amsterdam; Moderna Mus., Stockholm; Neue Gal., Aachen, W. Ger.; Mus. of Modern Art, Tokyo.

ABOUT: "The Art of Assemblage" (cat.), MOMA, NYC, 1961; Bénézit, E. (ed.) Dictionnaire des peintres, sculpteurs et graveurs, 1976; Henri, A. Environments and Happenings, 1974; Lippard, L. R. Pop Art, 1966; Russell, J. and others Pop Art Redefined, 1969. *Periodicals*—Art in America October–November 1965; Art Week (Los Angeles) December 1, 1979; Artforum April 1966; Guardian April 18, 1970, May 27, 1971; Life January 14, 1966; National Observer (Washington, D.C.) January 23, 1967; Newsweek December 20, 1965, August 9, 1971; Observer June 6, 1971; Studio International September 1965; Time April 8, 1966; Washington Post December 10, 1967.

KING, PHILLIP (May 1, 1934–), British sculptor, came to prominence in the 1960s as one of the abstractionists who, following Anthony Caro's lead, revolutionized British sculpture. He was born in Kheredine, Tunis, and at the age of 11 came with his family to England. He served in the Royal Signal Corps in 1952–54, and from 1954 to 1957 he read languages at Cambridge University but also began to show an interest in sculpture. While still a student he had an exhibition at the Heffers Gallery, Cambridge, which revealed him, according to Norbert Lynton, as "a Matisse-inspired modeller of figures." In 1957–58 he studied at the St. Martin's School of Art, London, under the sculptor Anthony Caro, whom he already knew and admired.

As Robert Melville pointed out in *The New York Times*, the year spent at St. Martin's under Caro "cured him of any desire to go in for expressive pinching and squeezing"; in other words, he lost all interest in modeling in clay. Caro was at this time experimenting, breaking with the figurative tradition; although still not certain of his direction, he was a stimulating teacher.

King married Lillian Odelle in 1957; they have a son, Anthony. In 1959, immediately after studying with Caro, King had the very different experience of working for Henry Moore. As his assistant for two years, King did rough chipping, fixed up armatures, and polished bronzes. He admired Moore as a personality, and, to quote Melville, "something rubbed off on him in Moore's studio," although the work he produced at that time was closer to Brancusi than to Moore. From 1959 on, King taught at the St. Martin's School, and in 1960 he was awarded the Boise Scholarship.

Pop art came to the fore in London in 1961–62 and King's sculpture of the early '60s, although abstract, contained pop elements. *Ripple* and *Rosebud* (both 1962) and *Tra-la-la* and *Circlerettee* of 1963 were in plastic, an often-used material in pop, and color played an important role. King's formal vocabulary was limited to a few primary forms, planes assembled in simple volumes, often cones, as in *Rosebud* and the base of *Tra-la-la*. Besides plastic, King has worked in fiberglass, aluminum, and sometimes welded steel.

King's first London exhibition, held in 1964 at the Rowan Gallery, included *Rosebud, Twilight* (1963), made of plastic, aluminum, and wood, and one of his best-known pieces, *Genghiz Khan* (1963; Stuyvesant Foundation Collection, London). *Genghiz Khan*, 7 feet by 12 feet by 9 feet, is a kind of cone in deep purple plastic surmounted by dramatic batlike wings. Norbert

Jorge Lewinski

PHILLIP KING

Lynton, in an important article on King in *Art International* (September 1977), called it "an enlarged, Baroque version of *Rosebud,* and added that "the floating shapes at the top echo ideas King had been playing with on paper in 1961."

Lynton described King's exhibit of 1964 as "lyrical in a light and impersonal way that was quite new and has remained unique. The forms hovered, flowed and swooped." The colors sometimes accentuated the forms, sometimes modulated them, and sometimes diminished or contradicted them through effects of contrast. Lynton saw in the show the first signs of "a new spirit in British art, optimistic, affirmative and generous."

King taught for one term at Bennington College, Vermont, in 1964, and the following year he was awarded a Peter Stuyvesant Foundation travel bursary. His work during 1964–65 has been termed "baroque," and in some of his pieces he continued to explore the possibilities of the cone. In the plastic 7½ feet by 11 feet by 9 feet *Through* (1965), the cone is sliced and eroded, "the product of a geological shift and external forces," to quote Lynton. Sketches for this piece show King to have been toying with the idea of rollers and waves for the piece's footing, but he gave the actual sculpture a stepped base in order to suggest more effectively "a shifting, syncopated relationship to the sliced cone."

King's interest in the suggestion of movement led him in 1966–67 to produce sculptures of a different sort. In *Slant* (1966), in arborite painted red, and *Nile* (1967), in arborite and plastic, King created what Lynton called "a series of angled planes charlestoning across the floor." *Nile*

has as its terminus a slanting plane which directs the eye of the viewer back to the other end. His sculptures were taking on the character of tableaux, or, in a sense, "environments" that could be walked around, and in this way they showed an awareness of American minimal art. This was an important step, for until Caro's breakthrough in the early '60s, British had yet to come to terms with the developments of American Abstract Expressionist sculptors like David Smith.

Span (1967) is made up of a double box, two leaning slabs, and two square columns, the bases of which are truncated pyramids. The elements are placed so that the spectator can move between them, walking *in* the sculpture, not just around it. Two other large pieces, *Call* and *Blue Blaze* (both 1967), were further variations on the theme of the tilting plane. Lynton has written that "the King that is revealed in these sculptures is the sculptor-dancer. . . . Colour and high gloss counteract mass: slants and slopes send the eye out beyond the silhouette: contrary elements act as spring-boards."

In 1967 King was made a trustee of the Tate Gallery, London, and in 1968 he and the Op painter Bridget Riley were selected to represent Great Britain at the Venice Biennale. In the catalog to the British pavilion exhibit at the Biennale, Alan Bowness wrote: "The enigmatic character of King's work springs from a built-in, subliminal effect of paradox. Each sculpture is so very much more remarkable than its bare, factual existence as a physical object in space."

King, extremely successful by his mid-30s, resigned from the Tate Gallery in 1969 and took a studio in the country while maintaining a home in suburban London. Robert Melville saw these moves as signs "that he has no intention of becoming England's pet sculptor," enjoying the kind of English success which, in the words of another critic, "is a form of quiet strangulation." However, Melville was disappointed in one of King's new works, *Dunstable Reel* of 1970, which was exhibited that year at the Rowan Gallery. "All the magic is in the title," Melville wrote. "We force ourselves to see these steel sheets as a ring of country dancers." The piece was painted scarlet and a resonant yellow, giving it a bright, summery quality; it has since been set up in a school in Leicestershire. Lynton described *Reel* (1968), *Dunstable Reel,* and *Quill* (1971) as "performances to be observed rather than spaces to be occupied." They were "physically light works without mass," and he saw in them "gaiety without silliness: a radical sort of sculpture that engages our senses irrepressibly."

These were also sculptures that could exist out

of doors, thus introducing the element of natural light. *Sky* (1969), for instance, was conceived for the open air, and is now in Osaka, Japan. *Ascona* (1972), originally silver and purple but now all silver, is an open-air piece that reflects constantly changing light and shadows, and has been described as "a contained dance." Many of King's sculptures are hollow, and he has said that "sculpture is about breathing in and breathing out." The urge to "build places" and create an environment was evident in a large piece called *Open Bound* (1973), in steel, aluminum, and wood, which dominated King's 1973 exhibit at the Rowan Gallery. He used elements made of steel mesh which held the wooden "core" of the sculpture a few inches off the ground. As Christopher Andreae noted in the *Christian Science Monitor,* "The transparency of the mesh provides an openness which is in contrast to the spaces it and the other 'walls' of the sculpture enclose." Steel mesh was also used in a larger piece, *Open (Red-Blue) Bound* of 1974–75, in which color, to quote Lynton, "adds to the excluding/enclosing ambiguity."

King's "aedicular" and environmental tendency was carried further in *Sure Place* (1976–77), a loosely assembled tent of slate and steel which combined many of King's divergent interests— an extended cone shape, forms leaning against each other, and the suggestion of a human presence. The rhythmic structuring of *Sure Place* was even more evident in *Open Place* (1977), also in steel and slate. King has always been unorthodox in his attitude towards materials, often juxtaposing opaque and transparent surfaces, and he uses whatever materials best express his idea. "I am not terribly interested in technology for its own sake," he has said. "For me a technique has to be very banal and ordinary so that you don't have to think about it."

The figurative impulse latent in several of King's works (including the *Genghiz Khan*) came to the surface in his *Rock Place* (1976–77), exhibited in 1977 at the Rowan Gallery. In this piece, a lump of slate set in asphalt in a steel dish and girdled with steel cable could be seen as a humorous allusion to Aphrodite rising from the sea.

Phillip King was made a Companion of the British Empire in 1975. He lives in a roomy 19th-century row house in suburban London. He and his wife Lillian have remodeled the rooms to create what Meryle Secrest of *The Washington Post* described as "individually sculptural spaces, each one focussed on a deep garden of spectacular beauty." From there King commutes to his studio in the country. He says that he "couldn't imagine living anywhere else than in suburban London because I like the idea of being on the edge of a big scene." *Open Led Blue Bound,* a film about the artist, was commissioned by the Arts Council in 1974.

Secrest described King as "tall, with an extremely intelligent and extremely vulnerable face." He is modest in manner with "an English way of dismissing his talent and ideas," but he has unequivocally expressed his aims as a sculptor: "I would like my work to be essentially something of *nature,* not evocation of nature but appearing as nature itself, by growing within its own laws, determined by our mutual reaction— for instance, our mutual near-ness or far-ness during the working process; my physical make-up equals its physical make-up. Not a metaphor for something else but an identity being revealed."

EXHIBITIONS INCLUDE: Heffers Gal., Cambridge, England 1957; Rowan Gal., London 1964, '70, '72, '73, '75, '77, '79; Richardd Feigen Gal., NYC and Chicago 1966; Isaac Delgado Mus. of Art, New Orleans 1966; Gal. Yvon Lambert, Paris 1968; Whitechapel Art Gal., London 1968; Venice Biennale (with Bridget Riley) 1968; Museum Boymans-Van Beuningen, Rotterdam 1968; European Museum Tour (Otterlo, Düsseldorf, Bern [Kunsthalle], Paris [Mus. Galliéna], Belfast [Ulster Museum] 1974–75; Arts Council Touring Exhibition (Great Britain) 1975–76; Oriel Gal., Welsh Arts Council, Cardiff 1976; Hayward Gal., London 1981. GROUP EXHIBITIONS INCLUDE: "British Sculpture," Jewish Mus., NYC 1961; "British Sculpture," Madrid and Bilbao 1961; Third International Biennale des Jeunes Artistes, Paris 1963; "Nieuwe Realisten," Gemeente Mus., The Hague 1964; Documenta 3, Kassel, W. Ger. 1964; "The English Eye," Marlborough-Gerson Inc., NYC 1965; "The New Generation," Whitechapel Art Gal., London 1965; "London: The New Scene," Walker Art Center, Minneapolis (US tour) 1965–66; Gal. dell'Ariete (with Wiliam Tucker), Milan, Turin, and Munich, 1966; "Chromatic Sculpture," Arts Council touring exhibition (Great Britain) 1966; International Sculpture Exhibition, Soonsbeek, Arnheim, Holland 1966; "Primary Structures," Jewish Mus., NYC 1966; "New Shapes of Color," Stedelijk Mus., Amsterdam (traveled to Stuttgart and Bern) 1966–67; "Young British Sculptors," Kunsthalle, Bern (traveled to Amsterdam and Düsseldorf) 1966–67; Carnegie Institute, Pittsburgh 1967; Fifth Guggenheim International Exhibition, Solomon R. Guggenheim Mus., NYC 1967; "Art for the City," Inst. of Contemporary Art, Philadelphia 1967; Documenta 4, Kassel, W. Ger. 1968; "International Sculptors Symposium for Expo '70," Osaka, Japan 1969; "Contemporary British Art," Nat. Mus. of Modern Art, Tokyo 1970; "British Sculpture Out of the Sixties," Inst. of Contemporary Arts, London 1970; "British Sculpture '72," Royal Academy, London 1972; "Henry Moore to Gilbert and George," Palais des Beaux-Arts, Brussels 1973; "The Condition of Sculpture," Hayward Gal., London 1974; "Silver Jubilee Exhibition of Contemporary British Sculpture," Battersea Park, London 1977; "British Artists of the

'60's," Tate Gal., London 1977; "British Art 1940–80," Hayward Gal., London 1980; "British Sculpture in the 20th Century," Whitechapel Art Gal., London 1982.

COLLECTIONS INCLUDE: Arts Council of Great Britain, British Council, Contemporary Art Society, Calouste Gulbenkian Foundation, Peter Stuyvesant Foundation, and Tate Gal., London; Scottish Nat. Gal. of Modern Art, Edinburgh; Leicestershire Education Authority, Leicester; Ulster Mus., and Art Gal., Belfast; Centre Nat. d'Art Contemporain, Paris; Mus. Royaux des Beaux-Arts de Belgique, Brussels; City of Rotterdam Kröller-Müller Nat. Mus., Otterlo, Neth.; Gal. d'Arte Moderna, Turin; MOMA, NYC; Felton Bequest, Melbourne; Nat. Gal. of Australia, Canberra.

ABOUT: Lucie-Smith, E. Late Modern: The Visual Arts Since 1945, 1969. Thompson, D. "Phillip King" (cat.), Rijksmus. Kröller-Müller, Otherlo, Neth., 1974. *Periodicals*—Art and Artists February 1974; Artforum May 1965, December 1968; Art in America May 1967; Art International September 1977; Arts Review February 8, 1964, July 15, 1972; Christian Science Monitor December 7, 1973; Le Monde May 18, 1975; New York Times August 16, 1970; Spectator August 22, 1970; Studio International (London) October 1966, January 1968; Washington Post November 8, 1970.

KING, WILLIAM (DICKEY) (February 25, 1925–), American sculptor, writes: "Am thirty years now in this trade. Attitude seems function of time. Gratitude predominates: if it weren't for sculpture I'd have to go to work. And of course fear: will I have to get a job some day? Then rage: who do they think they are!

"Without an audience I'd feel no gratitude, only rage and fear. I know a lot of artists who feel only that, all the time. Something's wrong, don't you know."

The art of sculpture is rarely associated with the comic spirit, but the work of William King combines humorous, even mocking comments on the human spectacle with formal inventiveness and keen observation, most notably in the elongated figures for which he is best known.

William Dickey King was born in Jacksonville, Florida. His father was a civil engineer, his mother a schoolteacher. He grew up in Florida "during the land boom" and originally planned to be an engineer like his father and older brother. As for art, King recalled, "I didn't know there was any such thing." He remembers, however, playing in the soft, sandy, golden-white coral formations around Miami: "I used to sit in my backyard when I was a kid and with a screwdriv-

WILLIAM KING

er and hammer I would carve this stuff [coral] into cities, roads and tunnels."

In 1942 King enrolled in the University of Florida, Gainesville, as an engineering student, but he later switched to architecture. "I hated the school," he recalled and his only pleasurable outlet there was playing clarinet or saxophone in various Glenn Miller-type dance bands. But this was not enough for King, who decided to leave school one day in 1944 when, either in calculus or chemistry class, it hit me—there's got to be another way."

Fascinated since childhood by airplanes, he took flying lessons and found work in a Miami metal shop, patching seaplanes for Pan American Airways. King planned to go to U.C.L.A. to study architecture further, but a young woman at Pan Am had so raved about New York that he decided to visit the city en route to Los Angeles.

Once in New York, King had no wish to leave, and in 1945 he enrolled in Cooper Union, still intent on becoming an architect. "The first day of school there was a drawing class, and we'd sit in a room and draw. I thought, this is school, exclamation point, question mark. This is delicious."

Soon thereafter, he accompanied an art class to a David Smith exhibit in Greenwich Village. A classmate touched one of the metal sculptures, and when reproached by the gallery personnel she burst into tears. King told her, "Don't cry, I'll make you another." "I had no welding equipment," he recalled, "so I put together a piece with bolts." That was King's first sculpture.

King was set on his course as a sculptor by a visit in 1948, when he was 23, to an Elie Nadel-

man show at the Museum of Modern Art. He enjoyed the wit and originality of Nadelman's sculptures, and thought, "I bet I could do that." He was further encouraged by winning the Cooper Union sculpture prize that same year.

After graduating from Cooper Union in 1948, King attended the Skowhegan School of Painting and Sculpture in Maine, and in 1949 entered the Brooklyn Museum Art School, where he studied with Milton Hebald. He was already exhibiting, and a Fulbright Grant in 1949 enabled him to spend a year at the Accademia di Belle Arti, Rome. He found the sculptural activity in Rome at that time, especially on the via Margutta where Ercole Fazzini and other sculptors had their studios, stimulating and rewarding.

King returned to Europe in 1952 to enroll at the Central School of Arts and Crafts, London. He also took this opportunity to travel in Italy and Greece.

In 1948 King had married Lois Dodd. Their son, Eli, was born in 1953. The marriage was dissolved that same year. Two years later, King wed Shirley Bowman.

From 1953 to 1960 King was sculptor-instructor at the Brooklyn Museum School of Art and was exhibiting regularly in the Whitney Museum Annual. Active in the burgeoning Greenwich Village art scene, in 1952 he helped to found the Tanager Gallery, an artist-run cooperative that showed young, second-generation members of the New York School. In the spring of 1954 King had a solo show at the Alan Gallery, New York City, and the exhibition catalog related King's work to "the funerary figures and animals of the Wei dynasty, the painted sculpture of archaic Greece, [and] Romanesque and Gothic polychromed wood carvings." The writer added, "King is perhaps the only twentieth century artist whose work stems directly from early New England ship's carvers and vane-makers. . . . " A comical note was sounded in many of the pieces, including *Summertime,* in terra cotta, and *Daphne and Charlie,* in pinewood. As noted in the catalog, "King's shrewd, sometimes bitter, often humorous, though never malicious, observation of his fellow man seems a peculiarly American characteristic."

In 1956 King, using his wife Shirley as the model, executed the bronze, *Venus* (Hirshhorn Museum and Sculpture Garden, Washington, D.C.). Unlike King's later sculptures, this piece has a three-dimensional, volumetric quality, reminiscent of Marino Marini. According to King, "It was modelled in clay (not plasticine), and cast in the usual way. It was really about the first time I'd tried this method—all the others (about thirty-five pieces) I'd made directly in

wax. There must be literally hundreds of Venuses in this more or less traditional pose. . . . Anyway, it was the one in the Uffizi [the Medici Venus] as far as the pose is concerned that set me on to the idea. . . . As you may gather, I was really quite taken with Greek and even Roman sculpture. . . . " King's second visit to Rome, in 1955–56, had heightened his feeling for the expressive possibilities of the human figure, although he never became a traditionalist, or "neo-classical," sculptor.

By 1961, when King exhibited his bronze sculpture, *Swinging,* at the Alan Gallery, he had evolved the witty, elongated figurative style in which he has, with many variations, continued to work. Moreover, he has worked in practically every medium, from wood and bronze to vinyl. As one critic noted, "The stilt-legged intellectuals he has been making for about 20 years . . . are essentially portraits of the artist as actor." In addition to works that seemed to caricature various social types, there were a few rather anguished figures which some critics, to King's annoyance, compared to Giacometti. King was moved to declare that he "couldn't stand Giacometti," but he has since modified this view.

In 1965 King's marriage to Shirley Bowman ended in divorce and he married Ann Kobin, from whom he was divorced ten years later.

While maintaining a residence in New York City, King also had a studio in a barn on the Dominy farm in East Hampton, Long Island. He was a lecturer in sculpture at the University of California, Berkeley, in 1965–66. In the '60s and '70s he received several important public commissions, including a mural for the Banker's Trust, New York City.

In 1971 five giant aluminum figures in King's characteristically whimsical style were placed with some of his other pieces in the Hammarskjöld Plaza Sculpture Garden at the corner of Second Avenue and 47th Street in Manhattan. The five figures, which were moved the following year to Brooklyn's Cadman Plaza, included a 12-foot man smoking—"me yakking away," King explained—and an 11-foot woman gardening, modeled after his wife Ann, who, he said, "has a way with plants." King enjoyed listening to the direct, untutored reactions of passersby, who were uninfluenced by art critics. "I only make things that people can respond to without intermediaries," King said.

King had two shows at the Terry Dintenfass Gallery, New York City, in 1973. The first, in January, included two enormous assemblages of slotted aluminum plates, *Magic* and *Surprise,* along with maquettes and drawings relating to these images. In *Magic,* which is 18 feet long,

each of the two figures stands on one leg, their bodies stretching horizontally as they reach to join hands. In *Surprise,* the two seated figures face each other, their arms raised high, suggesting amazement. Peter Schjeldahl of *The New York Times* (January 7, 1973) noted the "open, environmental effect" of these pieces, and their "naive energy." "King here is a humorist in the tradition of Chaplin," he commented.

The second show at Dintenfass, in December 1973, consisted, Hilton Kramer said in *The New York Times,* of "a multitude of miniature grotesques." There were 14 bronzes and 34 ceramics, all derived from the observation of living models. Some, including a bronze called *Self,* were said to be portraits. Kramer observed that King's gifts as a master of comic gesture were as much in evidence as ever, but that, additionally, there was an "appetite for the grotesque" that sometimes surfaced. When this occurred, the sculptor's customary elegance and "choreographic lightness" gave way to "something akin to ferocity."

A new series of comic figures appeared in King's show at the Dintenfass Gallery in 1976. The figures were carved from wood and could be fitted together and taken apart "like good-natured Tinker Toys," to quote a *Newsday* (April 25, 1976) critic. The most remarkable sculptures in the show were the tennis players, including a skillfully carved and joined figure of a woman tennis player, enigmatically entitled *Ad Hear.* Standing on tiptoe she reaches high with her racket, stretched to the peak of her form, with a "bland, smug expression" on her face, totally confident of her power to win.

Daumier and Noël Coward were alluded to by Vivien Raynor in her *New York Times* review of King's exhibit of ceramic figures at the Zabriskie Gallery, New York City, in November 1977. The exhibit included three large metal compositions, each nine feet tall—*Hurry, Maybe,* and *Victory*—with each group comprising two figures in motion. In *Victory* a standing figure holds up the arm of its squatting partner. Raynor admired the ingenuity with which the legs were foreshortened, and described *Victory* as a powerful work with a suggestion of mockery. King himself called these large sculptures "a bit unsettling."

In 1977 William King moved into a studio he had built by himself in Springs, Long Island. He still has a large loft space in downtown Manhattan, with a studio nearby. The loft apartment, though spacious and orderly in contrast to his studio, has an array of his sculptures of different periods and sizes. One of the most striking is an elongated top-hatted *Uncle Sam* covered in black suède; many of King's smaller pieces are made of vinyl. In one corner is a harpsichord; for a time his son Eli made harpsichords to order, as King proudly points out.

An influential teacher, Kings has served as mentor for such notable sculptors as Marisol and George Segal. The strong element of satire in their work reflects King's influence.

William King, tall, lanky, and with gray hair and moustache, has been described as being "like some whimsical, long-legged Monsieur Hulot," and resembling "one of his own jaunty, angular figures." He has an easy-going manner, and his ironic way of speaking is accentuated by a gently self-deprecating sense of humor. Despite his seemingly lighthearted approach to art, he takes politics seriously and often donates his time to fighting the good fight for worthy causes. "It's exciting," he said of politics; "I think it's an art form."

EXHIBITIONS INCLUDE: Alan Gal., NYC 1954–61; Terry Dintenfass Gal., NYC 1962–77; San Francisco Mus. of Art 1970; Dag Hammarskjöld Plaza, NYC 1971; Wadsworth Atheneum, Hartford, Conn. 1972; Zabriskie Gal., NYC 1977. GROUP EXHIBITIONS INCLUDE: International Sculpture Exhibition, Philadelphia Mus. of Art 1948; "New Talent," MOMA, NYC 1950; Whitney Annual, NYC 1950–68; Contemporary American Exhibition, Univ. of Illinois, Urbana 1953–57, 1963–65; Pittsburgh International, Carnegie Inst. 1958; "Art in Embassies," Nat. Collection of Fine Arts, Washington, D.C. 1967–68; Grand Rapids Art Mus., Mich. 1973; Inst. of Contemporary Art, Boston 1976; "Super Sculpture," Arts Council of Greater New Orleans 1976; Grand Palais, Paris 1976.

COLLECTIONS INCLUDE: Addison Gal. of Am. Art, Andover, Mass.; Brandeis Univ.; Waltham, Mass.; Hirshhorn Mus. and Sculpture Garden, Washington, D.C.; Allentown Art Mus., Pa.; New York Univ., NYC; Cornell Univ., Ithaca, N.Y.; Syracuse Univ. N.Y.; Univ. of California at Berkeley; Miami-Dade Jr. Col., Fla.

ABOUT: "William King" (cat.), Alan Gal., NYC, 1954; Kramer, H. The Age of the Avant-Garde, 1974; Lippard, L.R. Pop Art, 1966; Pierson, W. and others, Art of the United States: A Pictorial Survey, 1960; Seuphor, M. Dictionary of Modern Sculpture, 1959. *Periodicals*—Art in America November 1969; Art International (Lugano) November 1972; Art News May 1981; Artforum May 1970; Arts November 1977; Artweek January 13, 1979, April 18, 1981; New York Post March 21, 1972; New York Times January 7, 1973, December 1, 1973, November 25, 1977; Newsday April 25, 1976, August 1, 1976.

***KITAJ, R(ONALD) B(ROOKS)** (October 29, 1932–), American-British painter, was acclaimed as a major English Pop artist in the early 1960s. However, Kitaj rejected that label, and his figurative art is now noted for its literary and narrative content.

Of Hungarian ancestry, Ronald Brooks was born in Cleveland, Ohio, to Jeanne Brooks, a schoolteacher. She married her second husband, Dr. Walter Kitaj, a research chemist and Viennese refugee, in 1941. In boyhood Ronald took drawing classes at the Cleveland Museum of Art. His family moved to Troy, New York, in 1943, and he continued to draw at Troy High School, which he attended from 1946 to 1950.

In 1950 Kitaj, aged 17, signed aboard a Norwegian ship bound for Havana and Mexico. Working as a merchant seaman in the early 1950s, he found time to read voraciously. "Kafka and Joycean exile meant more to me then than the gorgeous Brueghels and Velázquezes in the great Hapsburg collection," Kitaj said. His art, with its literary content, reflects his random, eclectic approach to reading.

Kitaj is a basically self-taught artist, although there were brief periods of study at art schools. In 1950–51 he attended New York City's Cooper Union, and in 1951–52 took a course at the Academy of Fine Arts, Vienna. In 1953 he joined the National Maritime Union and traveled on American ships to Europe, North Africa, and South America. In 1955 he was drafted into the US Army, which posted him to France and Germany as an illustrator for the Armed Forces Central Europe. Kitaj's tour of duty ended in 1957, and he settled in London the following year.

On the GI Bill, Kitaj attended the Ruskin School of Art, Oxford University, in 1958–59. Wanting to become a "scholar-painter," Kitaj was drawn to Oxford in part because of the American expatriates—Henry James, T.S. Eliot, and Ezra Pound—who had studied there. From 1959 to '61 he took classes at the Royal College of Art, London, where his fellow students included Peter Phillips, Derek Boshier, Allen Jones, and David Hockney. Under the sway of American abstract expressionism they were rejecting the solemn romanticism of British art of the 1940s. "I learned more, I think, about an attitude to painting merely from watching him," Allen Jones said of Kitaj's presence at the Royal College. "The influence wasn't one of imagery but of a dedicated professionalism and real toughness about painting." But through his paintings, which from 1957 on explored problems of representation, Kitaj influenced his slightly younger British colleagues in the direction of a new figurative style. In *Pop Art* Law-

R. B. KITAJ

rence Alloway wrote: "Kitaj's preference as a painter is for an art that is not bound completely to the marks on the canvas. The world outside the canvas, and the routes and chances of connectivity with the painting, is his preoccupation."

Kitaj's work is full of allusions, often obscure, to earlier art, to history, mythology, modern literature, and topical events. These motifs are the vessels of Kitaj's determination to "re-endow painting with its ancient, premodern capacity to communicate life experience—to make it readable," as Franz Schulze said in *Art News* (January 1982). Early examples of his "literary" approach are a 1958 life drawing, *Already, in the Third Decade of the 19th Century,* and *The Murder of Rosa Luxemburg,* an oil on canvas with collage of 1960. The latter illustrated what Alloway called Kitaj's use of "visual jumps in presentation techniques"; the artist was probably moved to paint the slain Marxist leader by the "compassionate idealistic socialism" to which Kitaj says he has been attached since youth. Included in *The Murder*'s fragmented imagery is a smeared head, a symbol of sudden violence that was to recur in such later works as *An Urban Old Man* (1964).

The first phase of British pop art dates from the appearance in 1956 of Richard Hamilton's *Just What is it that Makes Today's Homes so Different, so Appealing?* collage, the second from the more abstract pop paintings of the late '50s, and the third from the public debut of Kitaj and his Royal College peers in the 1961 Young Contemporaries exhibition in London. These painters linked their art to the city environment,

°ki tī´

deriving their imagery from the usual sources in popular culture, such as mass media, but also from distinctly urban phenomena, such as graffiti.

Although Kitaj was identified as the leader of the London pop movement, his paintings, so complex and hermetic that they have been compared to the *Cantos* of Ezra Pound, defied easy classification. Kitaj's work was colorful, figurative, and devoid of perspective in the manner of pop art, but his images were inspired by Eliot, James Joyce, and Walter Benjamin, not by soup cans or romance and war comics. As Alloway observed, "Pop elements in [Kitaj's] art, when they occur, are simply a bit of the treasury of forms and communication available to human beings. . . . " "The term 'pop' has to be stretched rather far to cover his work," Edward Lucie-Smith remarked in *Late Modern*.

In 1963 Kitaj's first solo show was held at the Marlborough New London Gallery. The London *Times* declared that the exhibit had put "the whole new wave of figurative painting in this country in perspective" and described Kitaj's art as "a sort of collage of ideas." A characteristic work of 1963 was *Untitled (The Times Literary Supplement Cover)*, a pencil and collage which was entitled *An Urban Old Man* in 1964. It contains sociological comment and hints obliquely at violence. In the early '60s Kitaj also influenced young painters as a teacher. He was a drawing instructor at the Ealing Technical College and Camberwell School of Art and Crafts, London, from 1961 to '63, and taught part-time at London's Slade School of Fine Art from 1963 to '67.

In February 1965 Kitaj returned to the US for the first time in nine years for the opening of his first New York City show, at the Marlborough-Gerson Gallery. Americans found his "collages of madcap memorabilia, portraiture, and complex puns" to be startlingly different from the brash soup-can and cartoon imagery of American pop. In the *New York Post* (February 7, 1965) Charlotte Willard noted that Kitaj's surreal and literary titles were "the launching pads for wild painting-collages." For example, *The Baby Tramp*, a collage-painting whose various elements are open to different readings, referred to the Depression-stricken 1930s, when whole families were dispossessed and forced to take to the road. Kitaj gave the title *The Production of Waste*, an economist's catch phrase, to a 1963 oil showing, in montagelike news photo form, a trio of allegorical figures, poverty, stupidity, and avarice. "I wanted [*The Production of Waste*] to smell of those imperfections in the world which professional economics is often moved to treat," Kitaj explained.

The Kitaj show was praised by most New York reviewers, but in the New York *Herald Tribune* (February 14, 1965) John Gruen described it as "a potpourri of literary and visual allusions. . . . What it all amounts to is a dazzling emptiness. In effect Kitaj is an overly mannered painter and self-conscious painter, a merely adequate draftsman, a totally undisciplined collagist with bravura enough to make it all seem *outré*, or charged with a significance that it seldom possesses."

In 1967 Kitaj returned to America as visiting professor of art at the University of California, Berkeley. Also in California, in 1969, he worked at the vast Lockheed plant in Burbank with mechanics on fiberglass sculpture depicting early industrial imagery. He remarked: "I would have committed a lot of these ideas to painting if it hadn't been for the invitation to come here. So this experience hasn't really inspired another sequence. But I believe in Ezra Pound's dictum 'make it new,' and it's given me a chance to work in a new dimension." (However, he had collaborated with the British sculptor Eduardo Paolozzi on two compositions in 1960–62.)

In 1970, Kitaj had a show at Marlborough's New London Gallery. *The Observer* (April 26, 1970) critic wrote that Kitaj "moves in the Gothic world of the grotesque, the learned, the sensitive, the obsessive" but added that Kitaj's work "is easy on one plane, puzzling on another." In *The Guardian* (May 8, 1970) Michael McNay commented, "The surfaces are dry and meager, the colours about as anonymous as anti-rust paint, the separate incidents in any one picture inscrutable." McNay cited as an example *Walter Lippmann* (1966), which showed "a yellow-haired Nordic woman climbing a ladder in the foreground, a man behind her in a great-coat drinking wine, and at the top of a short flight of stairs in the background, there is a slightly sinister, slightly challenging meeting between a man and a woman. At the bottom right there is a portrait of Walter Lipmann." Also vexed by the indecipherability of Kitaj's paintings, Franz Schulze complained that the iconography of *Walter Lippmann* "is so private that . . . we are obliged to regard the work chiefly as a vessel of form rather than of narrative. But that . . . is precisely what Kitaj doesn't want us to do. He prefers to engage us in ideas, to tell us stories, to teach us. . . . "

Kitaj rejects the formalist idea that painting is self-referential, that it is simply an abstract arrangement of colors, lines, and planes whose form *is* its content. Thus he invests his painting with narrative, or literary, significance in an attempt to create an art for "the people," an art

that communicates modern experience to a large public. However, the paradox of Kitaj's art is that his paintings are formally arresting but their meanings are obscure.

A characteristic "problem-picture," or history-painting, is *The Autumn of Central Paris (After Walter Benjamin)* (1972–74). As usual, Kitaj combines old-style "good drawing" with contemporary pictorial devices, and the painting is imbued with a sense of doom. The subject is a Parisian café attended by a small coterie including Walter Benjamin, a German Jew and leftist-modernist critic who is a tragic hero to the contemporary literati. Benjamin had fled to France to avoid Nazi persecution, but when the German army entered Paris in 1940 he attempted to escape to safety in Spain. Near the border he saw a patrol of guards he took to be Nazis; thinking himself doomed, he committed suicide. The "Nazis" turned out to be Spanish soldiers who would have allowed safe passage over the border. In the painting, contrasting with the nonchalance of the party at the table, is a man with a pick, silhouetted in red in the foreground, who is taking apart not only the sidewalk on which they are sitting but, symbolically, the society so eloquently evoked by Benjamin in his unfinished study of Paris.

In 1970–71 Kitaj was visiting professor at the University of California, Los Angeles, and two years later he was given a two-man show at the Cincinnati Museum of Art with his friend Jim Dine. Kitaj was asked by the Arts Council of Great Britain in 1975 to act as one of the buyers of work by British artists (the Arts Council annually allots money for this purpose). Kitaj said that he would only purchase pictures that represented people, inasmuch as abstract art had been quite sufficiently championed by previous buyers. He entitled a 1976 exhibition of paintings and drawings he had chosen "The Human Clay"; the show was held at London's Hayward Gallery. In addition to such obviously representational works as William Coldstream's *Westminster* were figurative pieces by artists usually considered abstractionists or near-abstractionists, including Anthony Caro, Eduardo Paolozzi, and William Turnbull. John Russell, reviewing the show for *The New York Times* (September 5, 1976), found Kitaj's work, including *To Live in Peace (The Singers)* (1973–77), by far the most exciting, and called him "the most inventive living representational painter."

Kitaj's immense success in England has not been duplicated in the United States, perhaps because his work had much closer affinities with the younger, 1960s generation of British painters than with his American counterparts. Also, he

has made no secret of his aversion to the "established" art of New York City, from the various phases of post-painterly abstraction to the "new" realism. "One gets the impression," Schulze wrote, "that Europe adores [Kitaj] because Europeans tend more than Americans to want ideology to marry art, while Americans are more ambivalent about him because of an almost opposite inclination—fostered by almost four decades of New York formalist esthetics—to value the artwork if it is self-referential and to suspect it if it is not." However, the American poet-critic John Ashbery has long championed Kitaj's work, and in a *New York* magazine review of a Kitaj show at the Marlborough Gallery, New York City, he commented: "Kitaj's works teem with references to films, poetry, novels, photography, but make their effect with purely plastic means. . . . " Ashbery noted that the artist's work of the late '70s "focused on isolated moments in the lives of the strange individuals who comprise humanity." Kitaj's reputation in the US was enhanced by the retrospective that opened at the Hirshhorn Museum and Sculpture Garden, Washington, D.C., in the fall of 1981.

R. B. Kitaj married Elsi Roessler, an Ohioan he met in Vienna, in 1953. Their son, Lemuel, was born in 1957 and their daughter, Dominic Lee, was adopted in 1964. His wife's death in 1969 was disruptive of his work for several years. Kitaj lives in what he calls "our melancholic old London," but keeps a large house in a side street of Sant Felu, a town on the Mediterranean coast of Spain. The bearded artist was described by Michael McNay as "a private man, deep-chested and leonine, courteous but reserved, and slightly old-fashioned in speech."

In the catalog to the "Human Clay" exhibition Kitaj wrote: "Don't listen to the fools who say . . . that pictures of people can be of no consequence . . . there is much to be done. . . . If some of us wish to practice art for art's sake alone, so be it [and] good pictures, great pictures, will be made to which many modest lives can respond. When I'm told that good art has never been like that, I doubt it, and in any case, it seems to me at least as advanced or radical to attempt a more social art as not to. . . . No one can promise that a love of mankind will promote a great art but the need feels saintly and new and . . . poetic to me. . . . "

EXHIBITIONS INCLUDE: Marlborough New London Gal., London 1963, '70; Marlborough-Gerson Gal., NYC 1965; County Mus. of Art, Los Angeles 1965; Stedelijk Mus., Amsterdam 1967; Mus. of Art, Cleveland 1967; Univ. of California, Berkeley 1967; Gal. Mikro, Berlin 1969; Kestner Gesellschaft, Hanover, W. Ger. 1970; Boyman-van Beuningen Mus., Rotterdam 1970; Marl-

borough Gal., NYC from 1974; Marlborough Fine Art, London 1980; "R. B. Kitaj," Hirshhorn Mus. and Sculpture Garden, Washington, D.C. 1981; "R. B. Kitaj," Cleveland Mus. of Art 1982; "R. B. Kitaj," Städtische Kunsthalle, Düsseldorf 1982. GROUP EXHIBITIONS IN-CLUDE:"Young Contemporaries," London 1961; "Amerikanische Graphik seit 1960," Kunsthaus, Chur, Switzerland 1972; "Jim Dine/Kitaj," Cincinnati Mus. of Art 1973; "Arte Inglese Oggi 1960–76," Palazzo Reale, Milan, Italy 1976; "The Human Clay," Hayward Gal., London 1976.

COLLECTIONS INCLUDE: Tate Gal., Victoria and Albert Mus., Arts Council of Great Britain, and Stuyvesant Foundation, London; Mus. of Art, Oxford, England; Walker Art Gal., Liverpool; City Art Gal., Birmingham, England; City Art Gal. Sheffield, England; Stedelijk Mus., Amsterdam; Boymans-Van Beuningen Mus., Rotterdam; Gemeentemus., the Hague; Nat. Gal., Berlin; Kunsthalle, Hamburg; Wallraf-Richartz Mus., Cologne; Kunstmus., Gotenburg, Sweden; Kunsthalle, Basel; MOMA, NYC; Albright-Knox Art Gal., Buffalo, N.Y.; Cincinnati Mus. of Art; Chicago Art Inst.; Baltimore Mus. of Art; Mus. de Arte Moderna, São Paulo; Art Gal. of South Australia, Adelaide.

ABOUT: Current Biography, 1982; Haftmann, W. "R. B. Kitaj: Complete Graphics 1963–1969" (cat.), Gal. Mikro, Berlin, 1969; Hyman, T."R. B. Kitaj: Decadence and Renewal" (cat.), Marlborough Gal., NYC, 1979, "R. B. Kitaj" (cat.), Hirshhorn Mus., Washington, D.C., 1981; Kitaj, R. B. "The Human Clay" (cat.), Hayward Gal., London, 1976, Kitaj: Paintings, Drawings, Pastels, 1983; Lippard, L. R. Pop Art, 1966; Lucie-Smith, E. Late Modern: The Visual Arts Since 1945, 1969; Schmied, W. "R. B. Kitaj" (cat.), Boymans-Van Beuningen Mus., Rotterdam, 1970. Periodicals—Architectural Design June 1970; Art International (Lugano) Summer 1970, April 1974; Art News January 1982; Artscribe no. 5 1977; Guardian May 8, 1970; New York April 16, 1979; New York Herald Tribune February 14, 1965; New York Post February 7, 1965; New York Times February 14, 1965, April 17, 1968; September 5, 1976, March 30, 1979; Observer April 26, 1970; Time February 19, 1965; April 23, 1979.

*KLEIN, YVES (April 28, 1928–June 6, 1962), French painter and conceptualist, was a seminal figure in the development of nontraditional art genres—kinetic sculpture, performance art, conceptualism, minimalism, even "mail art." Despite his relatively short career (he died at the age of 34), he exerted an immense, if somewhat tangential, influence on contemporary movements in the United States, Japan, and Europe, especially Germany and Italy. He was the leading member, with Jean Tinguely, Niki de St. Phalle, Cesár Baldaccini, Daniel Spoerri, and others, of the Nouveaux Réalistes, a group founded in 1960 and dedicated, according to

critic Pierre Restany, to registering the social reality in its raw state, ready-made, without symbolistic intervention. As much a visionary and metaphysician (and a quintessentially French one) as an artist or performer, Klein sought the essense of reality not in any objective image, but in the spiritual (l'immatériel) and the fearful calm of the void (le vide)—Sartre's l'être et le néant (being and nothingness). He dreamed of creating "through silence, but eternally, an immense painting lacking any sense of dimension."

What separated Klein from other philosophically oriented artists were his thoroughgoing eclecticism—he borrowed from such disparate sources as dada, judo, Rosicrucianism, and science fiction—and his unflagging flamboyance. Such exploits as exhibiting a bare white gallery, in Le Vide (The Empty), and having nude young women smear themselves with paint and roll on canvas in public (the Anthropométries) excited public fascination, outrage, and even ridicule, but never indifference. (Klein relished his notoriety and, like any popular performer, had to top his last act with the next. Although some of his work and many of his pronouncements had more than a taint of the frivolous, Klein was at bottom intensely serious: "I want to play with human sentimentality, with its 'morbidity,' in a manner that is cold and ferocious."

Klein was born and raised in Nice. His father, Fritz Klein, was Dutch Malaysian, and his mother, Marie (Raymond) Klein, was French. Both parents were painters, but Ives was self-taught—his brand of art certainly was not, and could not be, taught in any academy. He studied for two years (1944–46) in Nice at the Ecole Nationale de la Marine Marchande and the Ecole Nationale des Langues Orientales. For a time he played jazz piano for a local Paris band, but in about 1946 he met the poet Claude Pascal and the artist Arman (Augustin Fernández), who shared many of Klein's ideas and aspirations and began painting. He also discovered the esoteric texts of the Rosicrucians, an occult Christian sect, and took up the study of judo, at which he excelled, earning a fourth-degree black belt from the Kōdōkan Academy in Tokyo and writing a standard French text on the subject. It has been surmised that the study of judo accounts for the ceremonial character of his work (like all Japanese martial arts, the sport is highly ritualized); certainly his skill enabled him to survive such performances as Leap into the Void (1962), in which he swan-dived off the roof of a building. Klein himself claimed that judo taught him "that pictorial space is above all the product of spiritual exercises," and that judo itself is "the discovery by the human body of a spiritual space," a definition that applies just as well to his Anthropométries.

°klīn, ēv

Returning to France in 1955 from a world tour that included Italy, Germany, Ireland, Japan, and Spain (where he had his first European exhibition), Klein immediately took his place at the head of the Parisian avant-garde. From about 1950 he had been painting large monochromatic canvases in a variety of colors—green, yellow, sulphurous orange, and ultramarine. Unlike Kasimir Malevich's white-on-white paintings or Ad Reinhardt's all-over black ones, Klein's "monochrome propositions" had no underlying structure, no detail although some had a surface texture. "I espoused the cause of pure color," he said, "which had been invaded by guile, occupied and oppressed in cowardly fashion by line and its manifestation: drawing in Art." His works were meant to convey pure space, pure void, and an ecstatic loneliness. Klein showed the monochromes in 1955 at the Club des Solitaires, Paris, and in early 1956 at the Galerie Colette Allendy, Paris. By late 1956, to avoid, as he said, the various colors "making a composition on the wall," he settled on one particular shade of simmering blue, which he dubbed "International Klein Blue" (IKB), as the only appropriate color—the absolute blue of the sky or the sea—for *le vide*. His first all-blue show, "L'Epoque Bleue," was held in Milan in 1957.

Over the next two years Klein was to step permanently outside the accepted boundaries of art (the monochromes, with their numerous artistic precursors, raised no great controversy). In 1957 he staged the first of his antiart "events" in a double show at the Galerie Iris Clert, Paris, and the Galerie Colette Allendy: the release of 1,001 blue balloons, which he called an "aerostatic sculpture" (and which the founders of the German Gruppe Zero repeated with white balloons in the early 1960s); the exhibition of his first sponge sculptures (natural sponges soaked in resin and covered in IKB; they had a definite smell when the humidity was high); and his first, rather tentative, fire paintings. In 1958 he achieved real notoriety with the famous *Le Vide* exhibition at Iris Clert. Klein throughly cleaned the gallery for two days, painted it stark white, and sat waiting in the perfectly empty space, watched over by a Garde Republicáin, for his visitors. In the blank gallery he offered the consummate expression of void. "Klein represented the artist returned to innocence," wrote Jack Burnham. "What effulgences he gave off were due to earlier works in the minds of his admirers." His admirers were relatively few (but included Albert Camus, who wrote "with the void, full powers" in the gallery book), and when word of his "performance" spread, thousands of the incredulous flocked to the show, causing a near riot, and the press ruthlessly tore him apart. Klein was unperturbed, in fact considered it his "greatest success yet." During the show he sold "zones of immaterial pictorial sensibility"; they were purchased with gold leaf, which Klein then tossed into the Seine while the buyer burned his receipt.

Klein's ideas became ever more grandiose (and less capable of complete realization). Immediately following *Le Vide* he embarked on his "Blue Revolution," aiming to use "the entire surface of France" for his next painting. He produced scores of blue sponge sculptures and reliefs between 1958 and 1960. He exhibited together with the sculptor Jean Tinguely at Iris Clert in late 1958; Tinguely's haphazard machines whirled two monochromes about in crazy arcs. Amazingly, Klein won the chance to decorate the new opera house at Gelsenkirchen in the Ruhr (his only public commission) with two huge IKB monochromes and two sponge reliefs (1957–59). Also in 1958, he first conceived, with the architect Werner Ruhnau, of an "architecture of the air": great floating cities walled by jets of air or flame. "Klein's supreme ambition," wrote Restany, his longtime friend and admirer, "the final goal of his method, was to sensitize the whole planet, to return by the architecture of air to the state of nature in a technical Eden."

The first public performance of Klein's *Anthropométries* (1960) at the Galerie Internationale d'Art Contemporain, Paris, was his greatest succès de scandale. To the strains of his *Symphonie monotone* (composed 1947), a sequence of ten-minute tones punctuated by ten-minute silences, Klein in full evening dress directed two nude models, "human brushes" as he called them, to coat themselves with IKB and lie, jump, and roll on canvases spread on the floor. The occasion was filmed for the grotesque but perversely popular *Mondo Cane* (1961, directed by Gualtierro Jacopetti), a cinematic work that brought him international recognition but did little to enhance his credibility as a serious artist. The *Anthropométries* themselves are surprisingly delicate and erotic. J.A. Thwaites of *Art and Artists* (July 1974) called them "the only creative figure painting since the war. . . . What nudes they are—the most human and the most painterly since Corinth and the early Kokoschka. And all done on the principle of 'Look! no hand!'" From this period also date his *Monogold frémissants,* monochromes of trembling gold leaf, and his red "fire" monochromes. Blue, red, and gold were for him symbolic of the elements: air/water, fire, and earth.

The *Cosmogénies* (1960–61, Cosmogonies)

followed. In a further attempt to express, even to make use of, the immaterial, Klein sprinkled powdered pigment on canvases and left them out in the rain, set them amidst waving reeds, or strapped them to the roof of his car before a long drive in a blinding storm. The action of wind and water "sensitized" the canvas and created the work of art without the egotistic involvement of the artist, who need not be anywhere about. The resultant images are at once fundamentally familiar and completely inhuman. Also in 1961, Klein perfected his *Fire Paintings* (1961–62), blue, red, and coppery pigments flashed and melted on smoky asbestos sheets by Klein wielding a blow torch. The act of painting these was itself a spectacular event; the paintings are strikingly beautiful, but eerily full of the fear of death—they are like visions of hell.

A major Klein retrospective was held in 1961 at the Museum Haus Lange, Krefeld, West Germany. For this show he created *Fire Fountain* (1961), a hissing, steaming confluence of jets of fire and water, and *Fire Wall* (1961), in the museum's garden. The fire pieces were studies for the "architecture of the air," as were his blue *Planetary Reliefs* (1961), speculative maps of the planets and the earth as seen from space. He made his only trip to the United States in April 1961, showing at the Leo Castelli Gallery, New York City, and the Dwan Gallery, Los Angeles.

Klein's death of a heart attack came five months after his marriage to Rotraut Uecker and shortly after he attended a screening of *Mondo Cane* at Cannes. (Some sources imply, rather improbably, that the heart attack was caused by his realization that the film was not solely about him.) His influence has been enduring; besides his own nurturing of the New Realist group, which included many of the best postwar French artists, his work was the immediate inspiration for the Nul group in the Netherlands and the Gruppe Zero in Germany, and an encouragement to the "happenings" artists in the US. Klein was one of the first (and arguably the most effective) of the color-field painters, and his concern with the immaterial, the spiritual, and natural processes is echoed in much current performance and narrative art. His audacious and meteoric career, which oscillated between utopian aspirations and inspired tricksterism, has served as a kind of paradigm for the radical avant-garde artist. Restany sees his influence as yet more profound: "In him the need was expressed to give his creation the fundamental norms of a cosmogenesis. Not content to foresee the future ethereal world, he wanted to establish its image for us through a method of perceiving cosmic energies. And it is thereby that he exercises in us, laggards in a world of mutation and

obliged to create entirely by ourselves a new understanding and a new psychology, a powerful attraction, an undeniable fascination."

EXHIBITIONS INCLUDE: Tokyo 1953; Madrid 1954; Club des Solitaires, Paris 1955; Gal. Colette Allendy, Paris 1956, '57, '58, Gal. Apollinaire, Milan 1957, '61; Gal. Iris Clert, Paris 1957, '58 '59; Gal. Schmela, Düsseldorf 1957; Gal. One, London 1957; Gal. Internationale d'Art Contemporain, Paris 1960; Gal. Rive Droite, Paris 1960; Mus. Haus Lange, Krefeld, W. Ger. 1961; Leo Castelli Gal., NYC 1961; Dwan Gal., Los Angeles 1961; Gal. La Salita, Rome 1961; Tokyo Gal. 1962; Alexander Iolas Gal., NYC 1962; Gal. Tania, Paris 1963; Kaiser Wilhelm Mus., Krefeld, W. Ger. 1963; Gal. Bonnier, Lausanne, Switzerland 1964; Gal. Alexandre Iolas, Paris 1965; Stedelijk Mus., Amsterdam 1965; Palais des Beaux-Arts, Brussels 1966; Jewish Mus., NYC 1967; Louisiana Mus., Humlebaek, Denmark 1968; Inst. für Moderne Kunst, Nuremberg, W. Ger. 1968; Nat. Gal., Prague 1968; Gal. Couturier, Paris 1968; Mus des Arts Décoratifs, Paris 1969; Mus. d'Art Moderne, Grenoble, Switzerland 1969; Gal. Martano, Turin 1969; Gal. Blu, Milan 1969; Gal. dell'Obelisco, Rome 1969; Gal. Civica d'Arte Moderna, Turin 1970; Modern Art Mus., Belgrade 1971; Kunstverein, Hanover, W. Ger. 1971; Kunsthalle, Bern 1971; Gimpel Fils, London 1973; Tate Gal., London 1974. GROUP EXHIBITIONS INCLUDE: Gal. Iris Clert, Paris 1958; Solomon R. Guggenheim Mus., NYC 1983.

COLLECTIONS INCLUDE: MOMA, and Solomon R. Guggenheim Mus., NYC; Mus. Nat. d'Art Moderne, Paris; Stedelijk Mus., Amsterdam; Kunstmus., Düsseldorf; Kaiser Wilhelm Mus., Krefeld, W. Gar.; Gal. d'Arte Moderna, Turin; Kunsthaus, Zürich; Gelsenkirchen Opera House, W. Ger.; Louisiana Mus., Humlebaek, Denmark; Gal. Nazionale d'Arte Moderna, Rome.

ABOUT: Blesh, R. and others Collage: Personalities: Concepts: Techniques, 1962; Burnham, J. Beyond Modern Sculpture, 1968; Henri, A. Total Art: Environments, Happenings, and Performance, 1974; Klein, Yves Klein (Madrid) 1954; Passoni, A. Yves Klein, 1970; Pellegrini, A. New Tendencies in Art, 1966; Restany, P. Yves Klein, 1982. *Periodicals*—Art and Artists July 1974; Art et création (Paris) January/February 1968; XXe siècle (Paris) no. 21 1963.

KLINE, FRANZ (JOSEPH) (May 23, 1910– May 13, 1962), one of the most original and dynamic exponents of first-generation abstract expressionism, was born in Wilkes-Barre, Pennsylvania, in the industrial heart of anthracite coal country. His parents were Anthony Kline (born in Hamburg, Germany) and Anna Rowe (born in Cornwall, England). They had four children, Frederick, Franz Joseph, Louise, and Jacques. When Franz was seven his father died; three years later his mother married Ambrose Snyder, who was in charge of a roundhouse, where locomotives were serviced.

Photo by Elisabeth Zogbaum

FRANZ KLINE

Kline was fascinated by the railroad that cut through the beautiful landscape around Wilkes-Barre. Even after he had become a sophisticated New Yorker, he always felt nostalgia for his early surroundings, as was evident from the titles of some of his later works—*Lehigh, Pa., Mahoning,* and *Delaware Gap* (1958). *Chief* (1950) and *Cardinal* were named after two famous trains that had fired his imagination as a boy, and one of his last pictures, painted in 1961, was called *Caboose.*

In 1919 Kline enrolled in Girard College, Philadelphia, but six years later his mother withdrew him, and he began attending Lehighton High School. In 1929 the burly, tough-looking Kline was captain of the varsity football team. Determined to be an artist, Kline studied painting in the art department of Boston University from 1931 to 1935. His teachers were Frank Durkee, John Grosman, and Henry Hensche. In 1937 he set out for Paris, but ended up in London, where he studied at Heatherly's School with Bernard Adams, Steven Spurrier, and Frederick Whiting. In London he met and married Elizabeth Vincent Parsons, a dancer with the Sadlers Wells Ballet.

Having acquired a solid academic background in art, Kline returned to the United States in 1938. After a brief period as a designer for a Buffalo department store, he settled permanently in New York City. Kline was keenly interested in the city environment, his woodcut, *MacDougal Street, Greenwich Village* (ca. 1938) and 1939 watercolor *Fulton Fish Market,* both shown in the annual Washington Square outdoor show of 1939, and an oil, *Sheridan Square,*

Evening (1940), were in the spirit of the Ashcan School artists John Sloan and William Glackens, but they also reflected Kline's admiration for the 19th-century romantic painters Ralph Albert Blakelock and Charles Ryder.

As a result of the Washington Square show, Kline was hired in 1940 as an assistant to the well-known stage designer Cleon Throckmorton, who had created the original sets for *The Emperor Jones, Alien Corn,* and *Porgy and Bess.* Throckmorton had his workshop in a huge studio on West 3d Street, which was visited by many of the famous writers and artists of the day. Among them was Reginald Marsh, although Kline did not meet him. He did not enjoy Marsh's graphic descriptions of the New York scene, feeling that they lacked emotional depth. It was the emotional impact that he admired in the works of Honoré Daumier and Ryder, as well as their painterly qualities. Years later, in a 1957 interview with Selden Rodman, Kline said, "The final test of a painting, theirs, mine, any other, is: does the painter's emotion come across?" He had great respect for the art of the past, and it is significant that his favorites among the old masters were Goya, Rembrandt, and Velázquez.

Kline's precarious early years in New York—he had only a few friends—were a period of study and experimentation. In 1943, in the 117th annual exhibition of the National Academy of Design, New York City, his 1941 oil, *Palmetron, Pa.,* a vigorous scene of the railroad country of Pennsylvania, was awarded the S.J. Wallace Truman prize for a landscape by an artist under 35 years of age. The following year *Lehigh River* (1944) won a similar award. The climax of Kline's early style was reached in *Chinatown* of 1948, a semirepresentational oil strongly influenced by impressionism and cubism. Already in *Studio Interior* (1946), Kline's emphasis was less on the subject and more on the handling of paint and space. *The Dancer* (also 1946, oil on composition-board) was much closer to abstraction, and marked a turning point in his progress. This trend was carried still further in *Rice Paper Abstract* of 1949, a small drawing in which the point of departure was a favorite rocking chair that had already appeared in *Studio Interior.* The chair-form was more apparent in *Rocker* (1951, oil on rice paper), the painting, with its expressive economy of line, indicated Kline's growing concern with linear structure. At the same time he was becoming more and more interested in the work of such diverse American modernists as Milton Avery, Willem de Kooning, Marsden Hartley, Robert Motherwell, and Bradley Walker Tomlin.

When in 1949 Kline projected one of his small rocking-chair drawings onto a wall with a Bell-opticon machine, he discovered the expressive power, quite independent of the image represented, of his graphic style in large scale: the work was reduced to the tension between dark strokes and the white ground. A similar transformation occurred when a drawing made in 1948 after a photograph of the dancer Vaslav Nijinsky as Petroushka was expanded into the 1950 abstraction *Nijinsky*. After some experimentation, Kline arrived by 1950 at a direct, abstract, and gestural style, restricting his palette to black and white and working on a very large scale. In an interview some years later, Kline discussed this development: "It wasn't a question of deciding to do a black and white painting. I think there was a time when the original forms that finally came out in black and white were in color, say, and then as time went on I painted them out and made them black and white. And then, when they got that way, I just liked them, you know."

In 1950 Kline submitted *Painting* to a viewing at the Whitney Museum of American Art, New York City, where it was favorably received. That same year he had his first solo show, at the avant-garde Egan Gallery, New York City, and the exhibit had an extraordinary impact. Among the paintings on view were *Chief* and *Cardinal,* large black-and-white canvases, which were, to quote John Gordon, "as bold and powerful as the great trains after which they were named." Kline's paintings of 1950, and of the decade that followed, were fully realized conceptions; while showing a knowledge of the work of Pollock, de Kooning, and other important painters of the post-World War II New York scene, they were truly original works which helped to establish the international reputation of the New York School.

Kline's canvases, which appeared so effortlessly composed and executed, were often the result of great struggle. As he remarked to Sylvester: "Some of the pictures I work on a long time and they look as if I'd knocked them out." Kline would make sketch after sketch in oil on telephone-book pages, whose print pattern prevented any illusion of perspective recession. (These sketches, such as *Untitled* of 1950, are now prized by collectors.) Kline retained this closed, nonillusionistic picture plane when scaling up to his large canvases, but he also wished to suggest space and light; in his best work he succeeded in having it both ways. Because he liked a hard surface, he preferred to paint on canvas tacked to the wall rather than stretched; he could then bear down hard with his wide house-painting brushes.

Recognition came very quickly to Kline. He was discussed in Thomas B. Hess's book *Abstract Painting* in 1951, and in 1952 *Chief* was acquired by MOMA. Kline was invited to teach at Black Mountain College in North Carolina, where the cream of the avant-garde taught summer classes. In 1953 he accepted a position at Pratt Institute, Brooklyn, and the following year he was an instructor at the Philadelphia Museum School of Art.

Kline's work was included in the exhibit "American Artists Paint the City," selected by Katherine Kuh for the U.S. section of the 1956 Venice Biennale. Although his canvases of the 1950s were never representational, their vehement black strokes communicated the thrust and dynamism of New York City. The fact that they bore such titles as *New York* (1954), *Third Avenue,* or *Wanamaker Black* (1955) was less important than the visions they conveyed—the span of a suspension bridge, the grid of a building under construction, or the overhead tracks of the old El. There is no doubt that Kline identified with the raw vigor and restlessness of New York. He once said of a downtown loft-building bearing a 100-foot neon sign advertising The American Doll Co., "It's so beautiful it breaks your heart."

In 1955 Kline was included in the influential MOMA exhibit, "Twelve American Painters and Sculptors." Two years later the Whitney purchased *Mahoning* (1956), and in 1958–59 Kline was represented in the important "The New American Painting" exhibit, which caused a stir in Paris, London, Berlin, and five other European cities before its final stop at MOMA.

This triumphant tour marked the widespread acceptance of abstract expressionism, although it still aroused (and arouses) fierce controversy outside the urban centers. The term "action painting," coined by critic Harold Rosenberg, was particularly appropriate to Kline's large, bold, slashing canvases, powerful in appearance and packed with energy. Some of his strongest black-and-white paintings date from the late 1950s and include *Requiem* and *Siegfried,* both of 1958.

The "written" aspect of Kline's style appealed to the Japanese, who have bought much of his work. Among his contemporaries, Mark Tobey, Pollock, and de Kooning had all in different ways been influenced by the graphic brushwork of the Far East, but Kline was wary of admitting to Oriental influence in his painting, explaining, "People sometimes think I take a white canvas and paint a black sign on it. But this is not true. I paint the white as well as the black, and the white is just as important." On another occasion

he said, "It's not symbolism any more than it's calligraphy."

In 1960 Kline won a prize at the Venice Biennale. The artist was not overwhelmed by his growing success, nor was he inclined, like Barnett Newman, to make portentous statements about his aims. Working away quietly in his studio on West 14th Street, he continued to search for the most direct means of expression. His four-panel, 10-by-13-foot painting of 1960, *New Year Wall: Night,* owned by Mr. and Mrs. Thomas B. Hess, is widely regarded as the culmination of his black and white period. In Kline's paintings of the 1950s, half-suppressed areas of color had sometimes appeared alongside the black forms, and in 1959 he began to incorporate color into his compositions—not the pastel colors which in de Kooning's work contrasted so provocatively with his emphatic lines and vehement brushwork, but deep vibrant colors, dark greens, blues, purples, and reds. *Orange and Black Wall* and *Provincetown II* (both 1959) and *Reds over Black* (1961) are examples of this later phase.

Possibly aware of the danger of an impasse in continuing the reductive black and white approach, Kline was seeking greater richness and complexity. The results are impressive, but often lack the powerful, concentrated impact of the black and white paintings. In the opinion of Edward Lucie-Smith, "We are never made to feel that the colour is essential to the statement already being made by the design. Its purposes are purely cosmetic." He still produced some black-and-white paintings after 1960, including *Palladio* (1961; Hirshhorn Museum and Sculpture Garden, Washington, D.C.) and *Caboose* (also 1961), which shows a growing concern with mass.

In 1961, at the height of his career, Kline entered the hospital for tests which revealed the deterioration of an old rheumatic heart problem. He was put on a strict diet, but he died in New York Hospital on May 13, 1962, shortly before his 53d birthday. *Franz Kline Remembered,* a film directed by Carl Colby and produced by Courtney Sale Ross, was aired on the Public Broadcasting System in 1984.

Kline's painting has often been compared to that of the Parisian, Pierre Soulages. In addition to the fact that Soulages never went through a realistic period, there are important differences. As Herbert Read observed, "Both use strong, vital linear forms. In the case of Soulages they are more orderly, organized in a classical sense . . . whereas Kline is open, moving out towards the edges of the canvas with a bursting energy." In other words, Soulages retains some of the controlled elegance of the School of Paris, but Kline expressed in his own way the raw power of New York.

Franz Kline also stood apart from his egotistic colleagues in the New York School. At the Cedar Bar on University Place in Greenwich Village, that favorite rendezvous of the avant-garde in the 1950s, his gently ironic manner contrasted markedly with the robust extroversion of de Kooning and the moody truculence of Pollock. Frank O'Hara recalls that "alone he was serious, attentive, philosophical" whereas "in public he was gregarious, a marvellous raconteur, and a tremendous fan of Mae West and W.C. Fields." Kline was noted for his open and generous dealings with other artists; moreover, he and de Kooning were the animating spirits behind the Painters' Club in the late '40s and early '50s.

Kline was short and stocky, dark-haired, with a long face and rather melancholy features which, along with his small moustache, gave him a resemblance to the actor Ronald Colman. "Kline was not a verbal or glib character," wrote William Barnett in *The Truants.* "His talk was usually the smallest of small talk; so that when the occasional bursts of generalization came, they could carry a kind of simple and earthy eloquence. He was also a very physical man, . . . and powerful; . . . and his stubby fingers, when they sketched an occasional gesture in conversation, seemed to be testing the sensuous feel of what he was saying. He couldn't escape being a painter even when he talked."

Universally acknowledged as a master of the gestural aspect of abstract expressionism, Kline avoided making extensive statements about his work. He declared in a 1958 interview with Frank O'Hara, published in the *Evergreen Review*: "You paint the way you have in order to give, that's life itself, and someone will look and say it is the product of knowing, but it has nothing to do with knowing, it has to do with giving." Referring to the vibrant and essentially urban energy of his painting, he said: "Hell, half the world wants to be like Thoreau at Walden, worrying about the noise of traffic on the way to Boston; the other half use up their lives being part of that noise. I like the second half."

EXHIBITIONS INCLUDE: Egan Gal., NYC 1950, '51, '54; Margaret Brown Gal., Boston 1952; Inst. of Design, Chicago 1954; Allen Frumkin Gal., Chicago 1954; Sidney Janis Gal., NYC 1956, '58, '60, '61, '63; Gal. La Tartarugo, Rome 1958, '63; Arts Club of Chicago 1961; Gal. of Modern Art, Washington, D.C. 1962; Stedelijk Mus., Amsterdam 1963; Whitechapel Art Gal., London 1964; Marlborough-Gerson Gal., NYC 1967; Whitney Mus. of Am. Art, NYC 1968. GROUP EXHIBITIONS INCLUDE: Outdoor Exhibition, Washington Square, NYC 1939; Annual Exhibition, Nat. Academy of Design, NYC 1942–45; Annual, Whitney Mus. of

Am. Art, NYC from 1952; "Younger American Painters," Solomon R. Guggenheim Mus., NYC 1954; "Twelve American Painters and Sculptors," MOMA, NYC 1955; Venice Biennale 1956, '60; São Paulo Bienal 1957; "Nature in Abstraction," Whitney Mus. of Am. Art, NYC 1958; "The New American Painting," MOMA, NYC 1959; Documenta 2, Kassel, W. Ger. 1959; "American Abstract Expressionists and Imagists," Solomon R. Guggenheim Mus., NYC 1961; "Painting and Sculpture of a Decade, 1954–64," Tate Gal., London 1964; "Six American Painters," Gal. Knoedler, Paris 1967; "Contemporary Art: Dialogue Between East and West," Nat. Mus. of Modern Art, Tokyo; "American Art at Mid-Century," Nat. Gal., Washington, D.C.

COLLECTIONS INCLUDE: Metropolitan Mus. of Art, MOMA, Whitney Mus. of Am. Art, and Solomon R. Guggenheim Mus., NYC; Albright-Knox Art Gal., Buffalo, N.Y.; Munson-Williams-Proctor Inst., Utica, N.Y.; Hirshhorn Mus. and Sculpture Garden, Washington, D.C.; Walter P. Chrysler Mus. of Art, Provincetown, Mass.; Carnegie Inst., Pittsburgh; Mus. of Art, Baltimore; Art Mus., Cleveland; William Rockhill Nelson Gal. of Art, Kansas City, Mo.; North Carolina Mus. of Art, Raleïgh; Mus. of Fine Arts, Houston; Art Gal. of Ontario, Toronto; Tate Gal., London; Kunsthalle, Basel.

ABOUT: Ashton, D. The New York School: A Cultural Reckoning, 1973, American Art Since 1945, 1982; Barrett, W. The Truants: Adventures Among the Intellectuals, 1982; Bénézit, E. (ed.) Dictionnaire des peintres, sculpteurs et graveurs, 1976; Dawson, F. An Emotional Memoir of Franz Kline, 1967; Gaugh, H.F. Franz Kline: The Color Abstractions, 1979; Goodrich, L. and others American Art of our Century, 1961; Gordon, J. "Franz Kline: 1910–62" (cat.), Whitney Mus. of Am. Art, NYC, 1968; Greenberg, C. Art and Culture, 1961; Hess, T.B. Abstract Painting, 1951; Kuh, K. The Artist's Voice, 1962; Lucie-Smith, E. Late Modern: The Visual Arts Since 1945, 1969; Mitchell, F. The Early Works as Signals, 1977; O'Hara, F. "Franz Kline" (cat.), Whitechapel Gal., London, 1964, Art Chronicles, 1975; Read, H. A Concise History of Modern Painting, 1959; Rodman, S. Conversations with Artists, 1957; Rose, B. American Art Since 1900, 2d ed. 1975; Sandler, I. The Triumph of American Painting: A History of Abstract Expressionism, 1970, The New York School: The Painters and Sculptors of the Fifties, 1978. Periodicals—Art News December 1952, November 1962, March 1967; Art News Annual 1958; Evergreen Review Autumn 1958; The Studio March 1964; XXe siècle (Paris) Christmas supplement 1958.

*KNATHS, KARL (October 21, 1891–March 9, 1971), American painter, was one of the few US-born artists to find a personal expression in cubism. The bulk of his work—almost entirely landscapes and still lifes—stands midway between representation and abstraction, but his overriding concern with compositional structure

°k'näths, kärl

Photo by George Yater

KARL KNATHS

frequently brought him close to complete abstraction.

Knaths, of German-Austrian parentage (his father was a baker), was born in the industrial town of Eau Claire, Wisconsin and spent his childhood in Milwaukee. "As a child," Knaths wrote, "nature was my great passion"; the forms of hunting equipment, handtools, and country furnishings often appear in his later still lifes. When his father died in 1904 Knaths went to Portage, Wisconsin to live with his uncle, also a baker. Although he drew constantly from an early age, he did not see an original painting until he enrolled in 1911 at the Chicago Art Institute. With the outbreak of World War I, he left school to work as a railroad-car painter, then came to New York City briefly before settling in Provincetown, Cape Cod, where he was to live the rest of his life. In 1922 he married the pianist Helen Weinrich.

Knaths's education at the Chicago Art Institute had been conservative, but on the Cape he met artists familiar with the latest experiments of the Parisian avant-garde. His own style progressed rapidly through impressionism to a softened synthetic cubism, as in Geraniums in Night Window (1922). The flaming rooster of Cock in Glove (1928), staring at a greenish-yellow glove, is an incongruous subject for cubism, but is typical of Knaths's thoroughly American sensibility. Common, workaday objects—a glove, a hacksaw, a duck decoy—give an almost regional or genre flavor to much of his work.

In 1930 Knaths had his first solo show, at the Charles Daniel Gallery, New York City. During the 1930s, he showed with the American Ab-

stract Artists and worked as a muralist for the Federal Arts Project. Duncan Phillips, the founder of the Phillips Collection in Washington, D.C., was the first critic and collector to take a serious interest in Knaths; Phillips amassed one of the largest collections of his work and championed him in a number of critical articles as a true synthesist of European and American styles.

Despite the strong influence on him of the School of Paris, Knaths never left the United States. As he explained: "Paris was for me like a distant dream. I was very shy and could certainly not have had the courage to approach men like Picasso, Matisse, or Braque. I had first to study, to understand. And later, when I had gotten out of their work what I needed, when I had found my way, why should I have gone over then?" As well as having a good domestic source of ideas in the work of Carl Holty, John Ferren, the Russian-born John Graham, and others of the American Abstract Artists, Knaths began to read theoretical articles by Gino Severini, Piet Mondrian, Paul Klee, and Wassily Kandinsky, and to plan his compositions around rules that he had formulated from their ideas. Believing that color and spatial harmonies are as mathematically measurable as are musical harmonies, he derived his color schemes before putting brush to canvas from musical and color charts hung on the walls of his studio. But all was not rigidly preplanned, according to Lloyd Goodrich: "Once the directional lines and general forms are drawn on the canvas, he does not stick too closely to them. They are a sort of scaffolding, to be discarded as the structure takes shape." Nor did Knaths take his forms directly from nature. "The approach," he said, "is from the canvas to nature, and not from nature to the canvas."

Heavy black or white outlines and simplified forms marked Knaths's canvases of the 1930s and '40s, as, for example, in *Maritime* (1931) and *Duck Decoy* (1931). His *Moby Dick* (1935) is crammed with telling textural and regional detail: the trellis pattern on the wall and the swirling wood grain of the floor contrast with the simplified bust, book, and wooden ship model. Hard on the heels of this rather descriptive work came Knaths's most abstract period, in which he seemed to move backward to a more analytic version of cubism. In *Turkey in the Straw* (1941) one can barely discern the outlines of the fiddler, the turkey, and the moon in the complex grid which the artist somewhat awkwardly laid over the scene. *Doomsday* (1941), *Gear* (1945), and *Mexican Platter* (1946) are similarly abstract. More successful, and more suited to his real nature and abilities, were his paintings of the 1950s and '60s, in which, said one critic, "pictorial structure did not constrain but enhanced his nat-

ural predilection for color." The tranquil landscapes and still lifes of *Pine Timber* (1952) and yet another *Duck Decoy* (1954) are loosely cubist but retain many realistic details. *Clock and Crock* and *Swamp*, both of 1966, exemplify the increased clarity and delicacy of his 1960s work, which is freely painted with a freshness that recalls Raoul Dufy and the later Matisse. "The essence of this work," wrote John Ashbery in *Art News* (November 1967), "is orphid sweetness distilled for the eye, but in such a way as to keep the other senses alert and expectant."

Knaths, a strongly built man with a broad, open face who often sported a beret, died in Hyannis, on the Cape. The following year a retrospective of his work was mounted by the Rosenberg Galley, New York City (an earlier retrospective had been held there in 1963). Knaths once explained his aesthetic approach as follows: "If I have been concerned with the purely plastic problems of painting, it has been because I hoped that through a better understanding of pictorial composition I could bring out what I felt in living. . . . The difficulty for me in the plastic approach is to bring the composition back to what is real in the feeling of my own environment. While I want the dominant emphasis to be on the plastic element rather than on the natural aspect, still I do not want the result to contradict the object, to intercept my personal visual experience."

EXHIBITIONS INCLUDE: Charles Daniel Gal., NYC 1930; Phillips Memorial Gal., Washington, D.C. 1930, '57; Paul Rosenberg and Co., NYC from 1945; Wisconsin State Univ., Eau Claire 1966; Phillips Collection, Washington, D.C. 1971; International Exhibition Foundation, Washington, D.C. 1973–74. GROUP EXHIBITIONS INCLUDE: "American Exhibition," Art Inst. of Chicago 1928; "Tercentenary Exhibition," Boston 1932; Pittsburgh Annual, Carnegie Inst., 1946; "American Painting Today," Metropolitan Mus. of Art, NYC 1950; "Four American Expressionists," Whitney Mus. of Am. Art, NYC 1959; Nat. Acad. of Design Annual, NYC 1962, '63, '65.

COLLECTIONS INCLUDE: Whitney Mus. of Am. Art, NYC; Albright-Knox Art Gal., Buffalo, N.Y.; Phillips Collection, and Hirshhorn Mus. and Sculpture Garden, Washington, D.C.; Univ. of Wisconsin, Eau Claire.

ABOUT: Goodrich, L. Four American Expressionists, 1959; "Karl Knaths" (cat.), Phillips Memorial Gal., Washington, D.C., 1957; "Karl Knaths" (cat.), Paul Rosenberg and Co., NYC, 1972; O'Connor, F. V. (ed.) Art for the Millions, 1973; "Recent Paintings by Karl Knaths" (cat.), Paul Rosenberg and Co., NYC, 1951; Ritchie, A. C. Abstract Painting and Sculpture in America, 1951; Rose, B. American Art Since 1900, 2d ed. 1975. *Periodicals*—Art International April 1979; Art News November 1967.

***KOKOSCHKA, OSKAR** (March 1, 1886–February 22, 1980), Austrian painter and graphic artist, poet and playwright, was one of the major Expressionists of our time. His robust, colorful personality, which helped him surmount many crises and vicissitudes in his long career, was also displayed in his numerous writings, from the controversial plays and poems of his rebellious youth in pre–World War I Vienna, to his lively, free-wheeling autobiography *My Life*, written in 1971.

Kokoschka was born in Pöchlarn, Austria—a town on the River Danube—to parents in modest circumstances. His father, born in Prague of a patrician family, was a skilled goldsmith; his mother was the daughter of a forester, from the mountains of Styria. From his mother, Oskar inherited his deep love of nature. He had a younger sister and brother; an older brother died in early childhood.

In 1889 the family moved to an apartment house on the outskirts of Vienna, where Kokoschka was to spend his boyhood. His father began giving him books, among them an edition of the *Orbis Pictus* (Visible World in Pictures) by the 17th-century Moravian humanist John Amos Comenius. This work, Kokoschka declared in his autobiography, influenced his entire life. His father also gave him an illustrated edition of the Greek myths. The boy found the pictures more impressive than the text, which took too long to read. One Christmas he received a paint-box, and thereafter, when he finished his school homework, he passed the time by painting.

After elementary school, Kokoschka attended the Realschule, the "modern" high school, in Währing, a district of Vienna. Here he studied for seven years. The curriculum concentrated on physics, chemistry, and mathematics, for which he had no aptitude. Only foreign languages came easily to him, largely because of Dr. Leon Kellner, an inspiring teacher who was president of the Austrian Shakespeare Society. According to Kokoschka, his love of England was instilled by Dr. Kellner. Years later Kokoschka looked back on the school as a microcosm of the old Austrian Empire, for among the students were boys from the Alpine countries as well as Hungarians, Slavs, Jews, Triestines, and Sudeten Germans.

In 1904, through the offices of a sympathetic drawing master at the Realschule, Kokoschka obtained a scholarship to the Kunstgewerbeschule (School of Arts and Crafts). It was assumed that he would become a teacher; Kokoschka never dreamed of going to the Akademie, where they trained "artists." In the early years of the 20th century the Vienna School of Arts and Crafts was among the most

OSKAR KOKOSCHKA

progressive educational institutions in Europe, its curriculum strongly influenced by the then prevalent Jugendstil, the German version of art nouveau. Among Kokoschka's fellow students at the school was Egon Schiele, who became a close friend and whose early death in the influenza epidemic of 1918 was to deprive the world of a gifted Expressionist painter. Most of the professors at the school were also members of the Wiener Werkstätte, a workshop cooperative founded by artists of the Vienna Secession, an art nouveau group that in 1897 had withdrawn from the official Viennese art association and whose first president was the eminent painter Gustav Klimt. The Wiener Werkstätte, with its motto "To the age its art, to art its freedom," set out to revive craftsmanship in all branches of the so-called applied arts.

Kokoschka took all the craft subjects taught at the school, as well as a special life-class and lessons in anatomy offered for prospective teachers. However, his unacademic approach to drawing the model startled and intrigued his teachers. As a student he hardly ever went to see Vienna's remarkable collection of old masters at the Art History Museum, feeling more at ease in the neighboring Museum of Natural History, and was particularly impressed by the masks, implements, weapons, and textiles in the museum's ethnographic department. Despite his sympathy with Oceanic, African, and pre-Columbian art, he had no desire to imitate them. As he said years later, "I am not a savage. I am not a primitive man," although he acknowledged that "I felt we had a common language."

In 1907, while still a student at the School of

°kō′ kosh kä

Arts and Crafts, Kokoschka produced his first oil paintings, *The Trance Player* and *Portrait of Frau Hirsch*. Already his own imaginative form of expressionism was emerging. In the same year—he was only 21—he wrote the plays *Sphinx and Straw Man*, and *Murderer, Hope of Women*. These works, displaying what one writer called "a precocious competence," rank high as expressionist drama and they also contain elements of symbolism. Kokoschka's varied activities reflected the contemporary cultural ferment in Vienna, where Freud had brought out his *Interpretation of Dreams* in 1900, Hugo von Hoffmansthal was writing his poems and playlets, and Gustav Mahler composed *Kindertotenlieder* (Songs on the Deaths of Children) between 1901 and 1904 and *Das Lied von der Erde* (Song of the Earth) between 1907 and 1910.

In Kokoschka's last year at the art school, in 1908, he was brought by Professor Carl Otto Czescka into close contact with the Wiener Werkstätte, receiving minor commissions from them and painting a number of postcards that were printed as chromo-lithographs. One of these postcards, published in 1908, portrays Kokoschka himself as a rider. The flat design and the children's-picture-book quality of the imagery were very much in the decorative spirit of the Werkstätte. In 1908 the Werkstätte also published Kokoschka's *Dreaming Boys*, his book of poems and colored lithograph illustrations, which has been called "a delightful autumn fruit of Jugendstil and Symbolism." The work was dedicated to Klimt, whose strong influence appears in the illustrations. This was Kokoschka's first self-contained series of graphic works.

Also in 1908, the artist was invited to participate in the first Kunstschau, an international art exhibition organized by Klimt and other ex-Secessionists whose artistic aims had changed since 1897. The Secessionists had begun in opposition to academicism and eclecticism in late 19th-century art, and the discovery of psychological truth had been their guiding aesthetic principle. By 1908, however, even the fine art produced by Klimt and his followers had been reduced to a decorative function, having little in common with the raw, aggressive expressionism of which Kokoschka was to be a progenitor. To the "Kunstschau 1908" Kokoschka contributed a tapestry cartoon painted in tempera on four large canvases, which he called *Bearers of Dreams*; he also exhibited a painted clay bust on a pedestal, a self-portrait with open mouth, which he titled *The Warrior*. These works were exhibited in a separate room in the Kunstschau, and they offended the art-deco-primed sensibilities of official critics and the staid Viennese public.

The performance of Kokoschka's *Murderer, Hope of Women* in the Kunstschau's open-air garden theater in 1909 scandalized Vienna's cultivated middle class. Even the once-radical Secessionists—now concerned with the "modest and profitable task of beautifying daily life and the domestic environment of the élite," to quote Carl E. Schorske—were unprepared for the violent love-hate passions of young Kokoschka's play. In his autobiography, Kokoschka wrote that a storm of protest and indignation broke over him on opening night, though historians such as Schorske and Peter Vergo consider the artist's claims somewhat exaggerated. Nevertheless, acting on the recommendation of the Ministry of Culture and Instruction, the director of the Arts and Crafts School withdrew Kokoschka's stipend, forcing the artist to leave school.

Rapidly becoming the enfant terrible of the Vienna art world, Kokoschka was defended by the modern architect Adolf Loos and the writer Karl Kraus, a biting critic of Viennese society and of the current art deco trend. Loos, a radical innovator, had declared war not only on the pseudo-Renaissance architecture of the later 19th century, but on the decorative emphasis of Jugendstil. (In his Steiner House, built in Vienna in 1910, for example, Loos abolished every suggestion of ornament.) He received no public commissions, his ideas being thought too austere.

Kokoschka painted Loos's portrait in 1909, one of an extraordinary series of portraits painted in the years 1908–14. Stylistically, they represent the triumph of the artist's personal form of expressionism over the art-nouveau influences of the preceding years. As Schorske said, Kokoschka and Loos "assaulted the Kunstschau's aesthetic synthesis of painting and architecture on both flanks," with Kokoschka proceeding from "the abstract explorations of the erotic life of his Kunstschau works to . . . a new kind of psychological portraiture." The portraits also included studies of such personalities as Kraus, the poet Richard Dehmel, the composer Anton von Webern, and the actress Tilla Durrieux. One of the most striking portraits in the series is that of Herwarth Walden, whom Kokoschka met in 1910 in Berlin. In that year the influential Walden began editing *Der Sturm*, a weekly magazine that discussed contemporary avant-garde trends and reproduced many of Kokoschka's drawings.

Considerable though Kokoschka's later achievement was, he never surpassed the compelling power of these portraits. They show an extraordinary psychological understanding of the subjects, an awareness of their innermost life. The hands are as expressive as the faces, whose subtlest idiosyncrasies are observed. Kokoschka deliberately sacrificed color and form in order

to focus on the human quality of his sitters. His strategy for coaxing inner truth from his subjects was "to keep them moving and talking, to summon up their vitality, so that their faces would become luminous as consciousness, as spirit," wrote Schorske. Color is little more than a ground tone, as practically everything is achieved by the tense, searching, restless energy of the calligraphic line. The double portrait of Dr. Hans Tietze and his wife Erica Tietze-Conrat (1909; Museum of Modern Art, New York City) is another outstanding example.

After his expulsion from school, Kokoschka left Vienna for a short stay in Switzerland, where he painted several portraits and a *Winter Landscape*. Going on to Berlin in 1910, in addition to meeting Walden and becoming one of *Der Sturm*'s chief contributors, he held his first solo exhibition at the Paul Cassirer Galerie.

Between 1910 and '14 Kokoschka traveled frequently from Vienna to Berlin. In 1911, when 25 of his pictures and several drawings were shown at the Hagenbund exhibition in Vienna, his work was again denigrated by defenders of premodern taste. Archduke Francis Ferdinand, heir to the Austrian throne, expressed disgust, saying, "The fellow deserves to have every bone in his body broken."

In 1912, in Berlin, Walden organized a second exhibition of Kokoschka's work, at the Sturm gallery. It was at this time, in Vienna, that Kokoschka became friendly with the talented and beautiful Alma Mahler, widow of the famous composer Gustav Mahler and doyenne of Vienna's fashionable society. Kokoschka described their liaison as "an exceedingly passionate relationship, which lasted three years," the "most unquiet" time of his life. His best-known painting is the one commemorating this love affair, *The Tempest*, also called *The Wind's Bride* (1914; Kunstmuseum, Basel). His brushwork had now become more lush and dynamic; the color, no longer separated from the line, was broadly applied with a thick brush or palette knife. By this time, too, Kokoschka had moved from the purely psychological to a broader, more objective or, as it were, a more cosmic outlook. This new phase could therefore be described as "expressionist baroque."

At the outbreak of World War I in 1914, Kokoschka joined a cavalry regiment of the Austrian Army, serving on the Eastern Front. In 1915, severely wounded in the lungs and head, he was sent to a hospital in Vienna. He was returned to the front, but continued lung trouble and mental unbalance due to the head wound sent him back to the hospital in 1916. His painting *Knight Errant*, summing up this war experience, was inspired by the seemingly endless journey by hospital train from Russia back to Vienna.

Discharged from the army in 1917, Kokoschka went to Sweden to consult a neurologist, and there painted *Stockholm Harbor*. In the same year his play *Sphinx and Straw Man* was given its premiere at the Dada Gallery in Zürich. Later in 1917 he settled in Dresden, where he moved chiefly in a circle of young poets and actors. Between 1917 and 1918 he painted the ambitious portrait compositions *Exiles* and *Friends*, which show a profound change from such works as *The Tempest* and *Knight Errant*. Autobiographical emphasis was now succeeded by mystical, humanitarian concerns, a response to the crass absurdity of the war.

In 1918 Kokoschka wrote the play *Orpheus and Eurydice* which, he claimed, grew out of the repeated hallucinations he had experienced in the hospital camp on the Eastern Front. Others of Kokoschka's plays, *Hiob* and *The Burning Bush*, were produced by Max Reinhardt in 1919 at the Kammerspiele, Berlin, with scenery designed by the artist. It was at this time, in a gesture truly allied to the contemporary dada movement, with its deliberate, outrageous flouting of conventions, that Kokoschka had made for himself a life-size female doll, in the company of which he was often seen at the theater in Dresden. He called it the Silent Woman; it was his way of exorcising the memory of Alma Mahler.

In 1921 Kokoschka was appointed professor at the Bruhlshen Terrace Academy, Dresden, a post he held until 1924, when he resigned in protest over the dismissal of Jewish artists. Throughout the 1920s, with the grim memories of war receding, Kokoschka traveled a great deal, mostly in southern countries. Immediately after giving up teaching he stayed briefly at Blonay, near Vevey, Switzerland, where he painted a number of landscapes. His father's death brought him back to Vienna, where he painted a portrait of the composer Arnold Schoenberg. Then his travels began—reflected in more landscapes and city views. He visited Bordeaux, Biarritz, Avignon, Aigues-Mortes, and Marseilles; Toledo, Madrid, and Lisbon; and, in the north, Amsterdam. The vast, almost topographical cityscapes he painted were brighter and more strongly colored than his previous works, one of the most vivid and dynamic of them being *Marseilles Harbor* (1925; St. Louis City Art Museum). These works are really "portraits of cities," although, as Sheldon Cheney observed: "Seldom has nature been treated so cavalierly." Even if these panoramic paintings do not have the concentrated power of Kokoschka's psychological

portraits of the pre–1914 years, they are outstanding landscapes in a century in which that genre has not been especially favored.

Kokoschka first visited London in 1926. His views of the Thames include the vibrant and colorful *Waterloo Bridge*. Always interested in nature, he visited the London Zoo where he painted *The Mandrill* and *The Tiglon*, (a cross between a lion and a tiger). From 1928 to '30 there were further travels—to Tunisia, Istanbul, Jerusalem, Ireland, Egypt, Algeria, and Italy, during which he painted constantly. In 1930, when Paul Cassirer's heirs presented a large exhibition in their Berlin gallery of Kokoschka's North African and Turkish pictures, some German critics, believing Paris to be the only center of progressive art, derisively labeled Kokoschka a *Mitropamaler*, a Cook's Tour painter. It is true, as they implied, that Kokoschka had been untouched by cubism and related School of Paris movements, and his loosely organized canvases did not even fit in with the accepted Central European mode of expressionism. He was, and remained, a stubborn individualist.

Canceling his contract with Cassirer, Kokoschka returned to Vienna in 1931. That year he had an important exhibition at Georges Petit's Paris gallery; on the whole, however, his works have never been widely acclaimed in France. (The first solo exhibition of his painting to be held in France was at the Galerie des Beaux-Arts in Bordeaux in 1983, three years after his death.)

With the rise of fascism the political climate in Europe was growing more tense. After the assassination of Chancellor Dollfuss by Austrian Nazis in 1934, Kokoschka fled Vienna and took refuge in Prague. He loved that cosmopolitan city, and between 1934 and the autumn of 1938 painted 16 studies of the Czech capital, more than he had done of any other city. He was as fascinated by the river Moldau as he had been by the Thames, and wrote in his autobiography: "I enjoyed painting the city, not to represent its topography, not to capture momentary sensations in the Impressionist manner, but because cities today are built upon sand, and their inhabitants neither preserve the past nor count on the future, which they tend on the contrary to fear." In Prague he painted Tomas Masaryk, the aging socialist president of the Czechoslovakian republic, so soon to fall to the Nazis. (Like the artist, Masaryk was an admirer of Comenius, whom Kokoschka painted in the background of the portrait.)

In 1937, in Vienna, Kokoschka had his first retrospective show, but in Hitler's Germany, that same year, 417 of his works were confiscated as "degenerate" and 16 of them were shown in the notorious Entartete Kunst (Degenerate Art) exhibition in Munich. Germany's annexation of Austria and the tragic collapse of the Spanish Republic deeply affected Kokoschka. In 1938, following Hitler's invasion of Czechoslovakia, he and his friend and future wife Olda Palkovska left Prague and went to London. After a stay in Polperro, Cornwall, Kokoschka returned to London in 1940, during the darkest days of the Battle of Britain. In 1941 he and Olda were married at a registry office in an air-raid shelter. In articles and a number of allegorical pictures Kokoschka expressed his horror at the destruction and human degradation caused by the war. These large allegorical paintings, including *Alice in Wonderland* (1942) and *What We Are Fighting For* (1943), have not been universally admired. Some critics have found the composition disorganized, the colors murky, and the overall expression turgid—and these works do raise the question, "Is allegory feasible in modern painting?" Still, Kokoschka's sentiments were admirable, and he used the money earned by these paintings to help war victims. During his first months in London he had painted the portrait of the Soviet ambassador, Ivan Maisky. He donated the fee (£1,000) for the picture to the Stalingrad Hospital Fund, with the stipulation, as he recalled in *My Life*, "that [the money] be used to help the German as well as the Russian wounded, but I don't know whether my wish was carried out."

After the war Kokoschka traveled to Prague on his Czech passport, now once again valid, to see his sister. Returning to London, he applied for a British passport and then went to Vienna to find his brother, who had been in hiding but had survived. The artist was made an honorary citizen of Vienna in 1946, and the following year he became a British subject. In 1947 he traveled to Switzerland for a major retrospective at the Basel Kunsthalle. In the Valais, in southern Switzerland, he painted a series of boldly conceived landscapes; stylistically they are his own synthesis of impressionism and expressionism. Later, in 1949, Kokoschka visited the United States for the first time and served as an instructor of painting at the Boston Museum of Fine Arts.

In 1953 Kokoschka and his wife settled permanently in the southern Swiss village of Villeneuve, on Lake Geneva. He spent nearly every summer of the years 1954–62 teaching in Salzburg at an International Summer Academy, which he called his "School of Seeing." So many students came, from all over the world, that he had to hire teaching assistants. In 1955 he was invited by the conductor Wilhelm Fürtwangler to design a production of *The Magic Flute* for that year's Salzburg Festival.

Still an indefatigable traveler, Kokoschka between 1956 and '62 made trips to Greece, England, Italy, the US (1957), Germany, Genoa, Sicily, and Rome. In 1962, no longer able to bear the strain of his rigorous approach to teaching, he left his "School of seeing." It was thereupon transformed into a state-run academy, where, to Kokoschka's dismay, instruction began to be given in what he called "the execution of so-called non-objective art"—a far cry from his own exuberant, baroque-expressionist style.

In the 1950s and '60s Kokoschka received many honors: the Order of Merit from the West German Federal Republic in 1956, Commander of the Order of the British Empire in 1959, and, in 1960, the prestigious Erasmus Prize, awarded by the Netherlands.

In London in 1967 there was a retrospective at the British Museum of his considerable body of graphic work. Titled "Kokoschka: Word and Vision 1906–66," it included his illustrations of his own literary works, those of his contemporaries, and the classics. In the graphic media Kokoschka preferred the lithograph in black and white to any other technique, though he produced many colored lithos. He rarely did engraving, and the woodcut was too slow a technique for his impulsive nature. In 1976, in tribute to his 90th birthday, exhibitions were held in Bregenz, Austria, and at the Marlborough Gallery, London. Four years later Kokoschka died in a hospital in Montreux, Switzerland. The 93-year-old artist had been one of the very few survivors of the pioneering years of the modern movement early in the 20th century.

Tall and angular, with gray hair combed down over his forehead, rugged features, and a determined chin, Kokoschka, even in his 90s, gave an impression of peasant sturdiness and independence. An inveterate nonconformist, his very signature, "OK," might be considered a symbol of his resilience. His capacity, as he put it, to "enjoy life like a lemon, to the last drop," was combined with a pessimistic view of the human condition, especially in its political manifestations.

Contemporary critics have praised Kokoschka for his poetic insight, his compulsive animation of paint, and his lifelong quest for the reality beneath the surface, through portraits, landscapes, and allegorical compositions—although to some viewers his extraordinary portraits of the years 1908–14 were his supreme achievements. G.S. Whittet wrote that Kokoschka "was probably the last painter of modern times capable of carrying into paint the externalized figuration of internal anguish and frustration." Kokoschka's strong influence can be seen in the work of Neoexpressionist painters of the 1980s like Julian Schnabel.

In an eloquent passage in *My Life* Kokoschka wrote: "In a face I look for the flash of the eye, the tiny shift of expression which betrays an inner movement. In a landscape I seek for the trickle of water that suddenly breaks the silence, or a grazing animal that makes me conscious of the distance or height of a range of mountains." A quotation from the catalogue of the 1967 British Museum exhibition sums up the artist's approach: "Art without vision is hostile to life, and hostile to the world."

EXHIBITIONS INCLUDE: Paul Cassirer Gal., Berlin 1910, '18, '23, '25, '27, '30; Gal. der Sturm, Berlin 1912, '16; Gal. Lang, Darmstadt, Ger. 1920; Gal. Caspari, Munich 1921, '26; Richter, Dresden, Ger. 1921; Neue Gal., Vienna 1924, Kestner-Gesellschaft, Hanover, Ger. 1925; Gemeente Mus., Amsterdam 1927; Kunsthaus, Zürich 1927, '47; Leicester Gals; London 1928; Kunsthalle, Mannheim, Ger. 1931; Gal. Georges Petit, Paris 1931; Gal. Feigl, Prague 1933; Austrian Museum for Art and Industry, Vienna 1937; Buchholz Gal., NYC 1938, '41; Gal. St. Etienne, NYC 1940, '43, '49, '54; Arts Club of Chicago 1941; City Art Mus., St. Louis, Mo. 1942; Kunsthalle, Basel 1947; Stedelijk Mus., Amsterdam 1947; Inst. of Contemporary Art, Boston 1948; Feigl Gal., NYC 1949; Phillips Gal., Washington, D.C. 1949; Haus der Kunst, Munich 1950, '76; Wallraf-Richartz Mus., Cologne 1951; Inst. of Contemporary Arts, London 1952; São Paulo Bienal 1953; Mus. of Art, Santa Barbara, Calif. 1954; California Palace, San Francisco 1954; Gal. Welz, Salzburg, Austria 1954; Nat. Gal., Prague 1956; Kunsthalle, Bremen, W. Ger. 1956; Marlborough Fine Art, London 1960, '67, '76; Tate Gal., London 1962, '69, '74, '76; Marlborough-Gerson Gal., NYC 1966; "Kokoschka: Word and Vision 1906–66," British Mus., London 1967; Oesterreichische Gal., Vienna 1971; Nationalgal., Prague 1971; Serge Sabarsky Gal., NYC 1971; Marlborough Gal., London 1976; Victoria and Albert Mus., London 1976; Bregenz, Austria 1976; Gal. des Beaux-Arts, Bordeaux 1983. GROUP EXHIBITIONS INCLUDE: "Kunstschau 1908," Vienna 1908; "Kunstschau 1909," Vienna 1909; Hagenbund, Vienna 1911; Neue Sezession, Munich 1914; "Marc, Campendonk, Kokoschka," Gal. Der Sturm, Berlin 1915; Gal. Dada, Zürich 1917; Venice Biennale 1922, '32, '48, '52; Internationale Kunstaustellung, Dresden, Ger. 1926; Pittsburgh International, Carnegie Inst. 1933; "Entartete Kunst," Munich 1937; "Der Sturm," Kunstmus., Bern 1944; "Klimt, Schiele, Kokoschka," Neue Gal., Vienna 1945; Documenta 1, Kassel, W. Ger. 1955; "Art in Revolt: Germany 1905–1925," Marlborough Fine Art, London 1959; "European Art: 1912," Wallraf-Richartz Mus., Cologne 1962; "L'Art en Europe autour de 1918," Ancienne Douane, Strasbourg, France 1968; "Gemälde, Bildwerke und Zeichnungen des XX Jahrhunderts," Nationalgal., Berlin 1969.

COLLECTIONS INCLUDE: Kunsthistorisches Mus., and Albertina, Vienna; Nationalgal., and Staatliche Mus.,

Berlin; Kunsthalle, Hamburg; Kunsthalle, Bremen, W.
Ger.; Kunsthalle, Mannheim, W. Ger.; Wallraf-
Richartz Mus., Cologne; Folkwang Mus., Essen, W.
Ger.; Narodni Gal., Prague; Stedelijk Mus., Amster-
dam; Stedelijk van Abbemus., Eindhoven, Neth.; Mus.
Boymans-Van Beuningen, Rotterdam; Mus. Royaux
des Beaux-Arts, Brussels; Mus. des Beaux Arts, Liège,
Belgium; Tate Gal., London; Scottish Gal. of Modern
Art, Edinburgh; Kunstmus., Basel; Kuns-
thaus, Zürich; Moderna Mus., Stockholm; MOMA,
NYC; Providence Mus., R.I.; Fogg Art Mus., Harvard
Univ., Cambridge, Mass.; Phillips Gal., and Hirshhorn
Mus. and Sculpture Garden, Washington, D.C.; Inst.
of Arts, Detroit; City Art Mus., St. Louis, Mo.; Art Inst.,
Minneapolis; Speed Art Mus., Louisville, Ky.

ABOUT: Bultmann, B. Oskar Kokoschka, 1961; Cheney,
S. The Story of Modern Art, 2d ed. 1958; Goldscheider,
L. Kokoschka, 1967; Heilmaier, H. Oskar Kokoschka,
1929; Hodin, J.P. Kokoschka: The Artist and His Time,
1966; Hoffmann, E. Oskar Kokoschka: Life and Work,
1947; Kokoschka, O. Mörder Hoffnung der Frauen,
1907, Sphinx und Stroh-
mann, 1908, Die träumenden Knaben, 1908, Der bren-
nende Dornbusch, 1911, Hiob, 1911, Dramen und
Bilder, 1913, Orpheus und Eurydike, 1916, Vier Dra-
men, 1919, Thermopylae: Ein Triptychon, 1955, Spur
in Treibsand, 1956, Mein Leben, 1971; "Kokoschka"
(cat.), Tate Gal., London, 1962; "Kokoschka: Word
and Vision 1906–1966" (cat.), British Mus., London,
1967; Plaut, J.S. Oskar Kokoschka, 1945; Read, H. A
Concise History of Modern Painting, 1959; Reynal, M.
and others, History of Modern Painting: Fauv-
ism, 1950; Russell, J. Oskar Kokoschka: Watercolours,
Drawings, Writings, 1958; Schorske, C. Fin-de-Siècle
Vienna, 1980; Westheim, P. Oskar Kokoschka, 1918;
Willett, J. Espressionism, 1970; Wingler, H. M. (ed.)
Schriften 1907–1955, 1956. Periodicals—American
Artist April 1, 1976; Apropos (London) March 1945;
Burlington Magazine (London) November 1942;
Frankfurter Zeitung (Frankfurt) December 1931; Fr-
eie Deutsche Kultur (London) May–June 1944; New
York Post March 1, 1976; New York Times February
23, 1980.

*KOMAR, VITALY (1943–) and
MELAMID, ALEKSANDR (1945–), Soviet
painters and Conceptualists, are with sly and de-
adpan humor savaging the archetypal excesses
of capitalism—"an overproduction of things, of
consumer goods," says Komar—and
communism—"an overproduction of ideology."
Few Westerners unfamiliar with the arcana and
iconology of socialist realism as practiced in the
USSR can fully appreciate, beyond the level of
easy amusement, their truly subversive parodies
of Soviet art, for which they were forced to leave
the country in 1977. Perhaps perversely, their
quick acceptance in the US may prove more
frustrating than did Soviet censorship. Working
together to avoid "personal expression" in what

° vē´´ tä´ lē; mel ä mēd´

Peggy Jarrell Kaplan

VITALY KOMAR

is surely a unique partnership in the ego-ridden
world of art, they do not practice any one style
or profess any point of view, but rather draw on
all materials, all styles, and all periods of art to
produce their cautionary ironies aimed at those
prone to accept the prevailing dogmas. "There
is an ancient tradition of deception called art,"
they say, "and because a viewer may believe in
art, he never sees the world as it is. Only the le-
vels of deceit change from style to style."

Komar and Melamid, both Jews, were born in
Moscow and graduated from traditional Moscow
art academies. They both joined the youth sec-
tion of the Artists' Union, the necessary step for
any artist attempting to make a living from art,
and thus, at least publicly, committed them-
selves to the state style. However, they claim,
"from the beginning, our work was a lie." Find-
ing in each other a secret subversive, they began
working together around 1965, eventually join-
ing the tenuous network of dissident artists who
exhibit their unapproved works privately or
smuggle them into the West.

The two artists had created their own counter-
part to American pop art which they called
"sots" art, from sotsiality, or socialist. "The gen-
eral idea of your Pop art and our Sots art is to
provide understanding of modern life and of the
products of mass civilization," said Melamid.
Whereas pop art glorifies to the point of absurdi-
ty the ubiquity of unnecessary objects in Ameri-
can society, sots art ridicules by magnification
the banal invasion of socialist realism into every
area of Soviet life and art. For example, the two
painted in perfect Soviet poster style a portrait
of Melamid's father wearing the heroically fore-

sightful expression usually reserved for Lenin. *Don't Babble* (1973) depicts a worker holding a finger to his lips; *Laika Cigarette Box* (ca. 1973) uses the Sputnik dog (much exploited as a national mascot in its day) as both propaganda and American-style advertising symbol. Other works less subtly questioned the Soviet insistence on artistic realism. Finding a painting in the garbage signed by one N. Buchumov, about whom they could discover nothing, in 1973 Komar and Melamid concocted a "biography" of the artist and completed Buchumov's oeuvre, painting 59 small landscapes on cardboard. Buchumov, they claimed, was a dedicated Realist who had lost an eye in a brawl with a Moscow modernist in the 1920s; true to his creed, he painted the side of his nose into every work. In another series, Komar and Melamid decided to give pop art a "history" by aging paintings by Andy Warhol, Roy Lichtenstein, and Robert Indiana with a blowtorch, just as party historians fabricate historical documents "proving" that one or another leader was an important associate of Lenin or helped lead the defense of Stalingrad.

In 1972 Komar and Melamid showed some of their tamer works to the Artists' Union and were immediately expelled for "distortion of Soviet reality and nonconformity with the principle of Soviet realism." They then joined the Union of Graphic Artists, but were again expelled when they first applied for exit visas in the mid-1970s. As known dissidents it was difficult for them to make a living; they were denied the standard artists' wage and could find little other work. On the other hand publicity in the West, beginning in 1974 with articles by Hendrik Smith in *The New York Times* and Herbert Gold in the *Los Angeles Times,* afforded them a measure of protection from further persecution. Their privately shown environmental work, *Paradise* (1973), with its bizarre images in Stalin dripping blood and a lice-covered Buddha, attracted considerable attention outside the Soviet Union, as did their participation in the notorious 1974 outdoor show of contemporary Soviet avant-garde art which was brutally suppressed by the KGB. Their first US show, organized by the mathematician Melvyn Nathanson and Melamid's cousin, Aleksandr Goldfarb, at the Ronald Feldman Fine Arts Gallery, New York City, in 1976 led to their dismissal from jobs they had found as book designers and night-school teachers. The increasing difficulty of smuggling out paintings forced them to work in a smaller format and to develop conceptual pieces that could be transmitted on paper. Words began to play a large role in their work, directly and indirectly. In *Color Writing: Ideological Abstraction #1* (1974) they assigned a color to each letter of the

ALEKSANDR MELAMID

Cyrillic alphabet, then encoded a "secret" article in the Soviet constitution that guarantees freedom of speech, assembly, and religion. Quite deliberately, the artists made it impossible to crack the code. A similar work, *Music Writing: Passport,* was performed in 20 cities worldwide on February 7, 1976. Notes were assigned to each Cyrillic character, and then articles printed on the Soviet passport were played as a musical composition.

Nor did the artists restrain themselves from parodying the foibles of the West. "Ours is the art of incongruity," says Komar, "for we are the middlemen of East and West. Unlike many Russian artists, we believe there is a world culture." *A Catalogue of Super Objects—Supercomforts for Superpeople* (1976, color photos and text) offers, among other things, self-listening and self-smelling devices, a cage for the face which guarantees purity of thought, and a tongue ring that runs words into pearls—all objects, noted an *Artforum* (January 1978) critic, that would fit unobtrusively in the pages of *The New Yorker.* Their series "Scenes from the Future" (1974) depicts such capitalist monuments as the Solomon R. Guggenheim Museum and the Kennedy Airport in ruins. Komar and Melamid believe that "all existing states are very similar to each other, independent of whether they acknowledge equality or inequality between people, whether they embody a policy of the majority or the minority." Thus their piece *Trans-State,* an alternative fictional federation of "state-individuals" or "I-states" of which the

founding father was Louis XIV, who said "L'état, c'est moi."

Komar was finally allowed to emigrate to Israel in 1977, and Melamid followed him soon after. There, they stages a happening near Jerusalem in the Valley of Hinnom, which in its Greek form is Gehenna, the New Testament word for Hell. The artists built a temple of aluminum topped by a red star, then burned it, Komar's Russian suitcase, and other objects from their past in an evident purification rite. They used these "holy relics" again in the installation *The Testament of the Priest and the Teacher: A Complete Religious System with Text, Icon, and Relics* (1978) at the Feldman Gallery. Komar in Hebrew means "priest" (in Russian it means "gadfly") and Melamid means "teacher"; in this piece they farcically equated their exit from the USSR with the ancient exodus of the Jews.

Since then the artists have moved to New York City, where they have recently started a business—"Komar and Melamid, Inc., We Buy and Sell Souls"— and embarked on a series of subtle pastiches of Soviet realism in the style of Caravaggio and other old masters. Although they are safe from political persecution, their work still has the ability to outrage. Their life-size *Portrait of Adolf Hitler* (1980–81), which apes the recent rebirth of admiration for the Führer, was slashed by a spectator reportedly "tired of irony." James Gambrell wrote in *Artforum* (April 1982): "This Hitler is a work of aggressive political Pop, whose transgression makes portraits of Marilyn Monroe or even Mao Zedong seem insipid by comparison."

According to *Newsweek*, Vitaly Komar is "tall and goateed" with "some of the ponderous presence of a Dutch burgher sitting for Frans Hals." Aleksandr Melamid is "spindly and curly-haired," looking "like a reject from the Marx Brothers." At the time of their first New York City show, Komar said: "The West still accepts the idea of the artist as an individual. We work together as a unit and express no personal cause of our own, but a social tendency. Whatever changes in the world balance affects us. As the earth turns, we turn with it."

EXHIBITIONS INCLUDE: "Retrospectives," Blue Bird Cafe, Moscow 1967; Gal. of the Faculty Club, Academgorosk, Pushino, USSR; outdoor exhibition, Belijaevo and Igmailovskii Park, Moscow 1972; Ronald Feldman Fine Arts Gal., NYC 1976, '77, '78, '80, '84; "Music Writing: Passport," simultaneous performance, Europe, U.S.S.R., U.S., Israel, Canada, Australia 1976; White Gal., Tel Aviv 1978; Israel Mus., Jerusalem 1978; Wadsworth Atheneum, Hartford, Conn. 1978; Gowanus Memorial Artyard, Brooklyn, N.Y. 1982. GROUP EXHIBITIONS INCLUDE: Outdoor exhibition, Mos-

cow 1974; "The Museum of Drawers," Israel Mus., Jerusalem 1977; "New Art from the Soviet Union," Arts Club, Washington, D.C. 1977; "New Art from the Soviet Union," Johnson Mus. of Art, Cornell Univ., Ithaca, N.Y. 1977; "New Art from the Soviet Union," Pratt Manhattan Center Art Gal., NYC 1978; "Dissident Art," Bellinzona, Switzerland 1978; "Dissident Art," Gazzetta del Popolo, Turin, Italy 1978; "Artist and Society 1948–1978," Tel Aviv Mus. 1978; "International Survey of Contemporary Painting and Sculpture," MOMA, NYC 1984.

ABOUT: Nathanson, M. Komar/Melamid, Two Soviet Dissident Artists, 1979. *Periodicals*—Art in America January/February 1979; Art News January 1978, December 1980; Artforum January 1978, April 1982; The Guardian February 7, 1976; Los Angeles Times September 22, 1974; New York Times March 19, 1974, September 29, 1974; February 7, 1976, January 29, 1984; Newsweek February 10, 1976; Village Voice February 7, 1984.

KOONING, ELAINE DE. *See* DE KOONING, ELAINE

KOONING, WILLEM DE. *See* DE KOONING, WILLEM

KRASNER, LEE (LENORE) (October 27, 1908–June 19, 1984), American painter, was a first-generation Abstract Expressionist. Until the 1970s, her importance was played down or ignored; she was victimized by sexist biases in the art world and underrated because she was popularly known as the wife of Jackson Pollock, to whom Krasner was married for 11 years.

She was born Lenore Krassner in Brooklyn, New York. Her parents, Joseph and Anna (Weiss) Krassner, were Jewish immigrants from a forest village near Odessa, Russia, where they had worked for a rabbi. Lenore, the next to last of six children (five girls and one boy), was the first to be born in the US. The family made a living by operating a small food market in Brooklyn, but life was hard. "Everyone had to work," Krasner told Eleanor Munro, author of *Originals: American Women Artists.* "Every penny had to be dealt with." As a child she enjoyed her father's renditions of Russian folktales, her brother's Enrico Caruso records, her own reading of Russian fairy tales and the great Russian authors, and the orthodox services in the local synagogue.

In 1922 Lee decided to become an artist, and transferred from Brooklyn's Girls High School, where she had flunked most of her courses in the

© Harvey Stein, 1982

LEE KRASNER

prelaw curriculum, to Washington Irving High School, Manhattan, where women could major in art. From 1926 to '29 she studied drawing at the Women's Art School, Cooper Union, New York City, and in 1928 took George Bridgman's life drawing class at the Art Students League. She left Cooper Union for the conservative National Academy of Design and studied there until 1932. Her instructors were startled and irritated by her unconventional self-portrait of 1930, which showed her, Munro said, as "a stalwart, muscular young woman in overalls, painting outdoors in a grove of trees."

In 1929 New York City's Museum of Modern Art opened and Krasner saw her first live Picassos, Matisses, and other modern School of Paris works. Krasner described her visits to MOMA as "an upheaval . . . , something like reading Nietzsche and Schopenhauer. A freeing . . . an opening of a door." Inspired by Picasso and Matisse, she turned out at the stodgy academy a picture in light, vivid colors, which prompted her teacher, Leon Kroll, to tell her to go home and "take a mental bath." She also became aware at the academy of the secondary role assigned to women who aspire to be artists. Krasner was to discover that art-world sexism was not confined to teachers with heads buried in 19th-century sand. Hans Hofmann, the quintessential European avant-gardist, showered double-edged praise on an early Krasner painting, saying, "This is so good you would not know it was done by a woman."

In 1932, a peak Depression year, Krasner left school and took a waitressing job at Sam Johnson's, a Greenwich Village nightclub/restaurant.

Among the artists and intellectuals who assembled there were Harold Rosenberg, later a prominent art critic who championed abstract expressionism and befriended Krasner, and the critic Lionel Abel. In 1933, considering a career as an art teacher, Krasner took courses at the City College of New York and at Greenwich House. When the New Deal's Public Works of Art project got underway the following year, Krasner was able to transfer her ambition from teaching art to painting. From 1935 to '43 she worked off and on for the Works Progress Administration's Federal Art Project, executing murals left unfinished by artists who had left the project. "That whole experience," Krasner told Munro, "introduced me to scale. . . . "

In the 1930s the prevailing styles, on the project and in American art generally, were social realism and regionalism, but Krasner was already a modernist. Her preference for European modernism was reinforced by studying from 1937 to '40 with Hans Hofmann, who stressed cubist design and the exuberant colors of the Fauves. She was also influenced by the ideas of the Russian-American Surrealist painter and mystic John Graham, who, in his book *System and Dialectics in Art* (1937), dismissed the intellect as a "useless tool" and declared," . . . The things we know impede us from seeing things we do not know." Her friends at this time were the vanguard New York painters: Graham, David Smith, Arshile Gorky, and Willem de Kooning. Her own works, abstractions from nature uniting form and line in a manner that made the paintings look completely nonobjective, had Picassoesque elements but anticipated the explosive brushwork of gestural, or action, painting.

In the late '30s Krasner joined American Abstract Artists (AAA), an exhibiting association of advanced painters, and in June 1940 showed her canvases for the first time, at the fourth annual AAA group exhibit at the American Fine Arts Galleries, New York City. John Graham invited her to take part in an exhibit of American and French painters at New York City's McMillan Gallery (1942). Among the Americans were Stuart Davis, Walt Kuhn, de Kooning, and Jackson Pollock. Krasner had met Pollock in 1936 at an Artists Union party, but he had made little impression on her and she knew nothing of his work until visiting his studio just before the Graham exhibition. "I was totally bowled over by what I saw," Krasner said. She told Cindy Nemser, author of *Art Talk,* that Pollock's work was "a force, a living force, the same sort of thing I responded to in Matisse, in Picasso, in Mondrian." She was, in her words, "hit so hard" that she was impelled to abandon Hofmann's practice of painting abstractions from nature, reject all out-

side references, and attempt to treat the canvas as a "thing in itself." But it was not easy to absorb what Pollock was doing, and for years Krasner was blocked, producing nothing on her canvases but gray slabs out of which no image would emerge.

Krasner and Pollock lived together in Greenwich Village, and on October 25, 1945, shortly after her father passed away, they were married in the Marble Collegiate Reformed Church—thus making her break with the world of the synagogue final. In November the couple moved into an old farmhouse in The Springs, a community near East Hampton, Long Island. The marriage was difficult, aggravated by Pollock's heavy drinking, volatile moods, and infidelity; but they respected and encouraged each other's work and shared "experience on the same level," as Krasner put it. They visited each other's studios—his was in the barn, hers in an upstairs bedroom—only by invitation.

Krasner's artistic "black-out period" was one in which "the canvases would simply build up until they'd get like stone and it was always just a gray mess," she told Nemser. "The image wouldn't emerge. . . . " But she kept struggling and in 1946 the motif she called the "Little Image" broke through the "gray matter." She produced a series of small canvases—most of them about 20 by 30 inches—composed of an all-over network of coiled lines and varied textures applied in thick viscous paint. Among the "Little Image" paintings to which Krasner gave titles are *Noon* and *Shell Flower,* both of 1947, *White Squares* (1948), and *Continuum* and *Night Light* (both of 1949). This period of her work ended with what she called her "hieroglyphs," whose manner of execution involved a process with similarities to automatic writing. Nemser described Krasner's works of 1946–49 as "a calligraphy of the soul." The Abstract Expressionist Bradley Walker Tomlin saw her "Little Image" works in 1949 and, apparently influenced by Krasner, that year began his paintings that incorporated pictographic imagery.

In 1950 Krasner began to paint more thinly on larger canvases, often using two colors, red and green being her favorites. She had her first solo exhibition in 1951, at the Betty Parsons Gallery, New York City. Two years later she tore and cut pieces from the exhibited oil paintings and from black and white drawings hanging in the studio; she glued these fragments of canvas and paper onto raw canvases, thereby producing her first collage-painting. Characteristic works in this series are *Black and White* (1953), *Forest No. 1* (1954), and *Bald Eagle* and *Porcelain,* both of 1955.

In August 1956, while Krasner was traveling in France, Pollock was killed in a car crash. For some time her career was interrupted by the responsibilities devolving from her position as executrix of her late husband's estate and, in a sense, as caretaker of the "Pollock legend." But when she went back to work, Krasner became more daring, using larger images and freer, more aggressive brushwork. In *Earth Greens* and *The Seasons,* both of 1957, images suggestive of nature emerged unintended from her language of abstraction—the reverse of her handling of nature in the abstractions of the mid-'30s.

Seventeen of the canvases she had painted since Pollock's death were shown in 1958 at Krasner's solo exhibition at the Martha Jackson Gallery, New York City. In the New York *Herald Tribune* (March 2, 1958) Emily Genauer described the mood of the series as one of "evolution . . . of masses burgeoning with growth, within the canvas." But the *Time* (March 17, 1958) critic commented on the somber tonalities and felt that the abstract designs "mostly seem to express death-haunted themes."

In 1959 Krasner, in collaboration with another artist, completed a mosaic for the Uris Building, New York City, on which she strove "to bring the mosaic technique into today—to break through the rigidity." Also that year, her art changed, due in part to her insomnia and habit of working long into the night. She began painting in umbers and off-whites, a phase that continued into the early 1960s. Works in this series were exhibited in 1960 and '62 at the Howard Wise Gallery, New York City, and included *Charred Landscape, Fecundity, Uncaged, White Rage,* and *Assault on the Solar Plexus.* The last named was "an embarrassingly realistic title," Krasner admitted to Nemser. "I experienced it. I had had [a] blow-up with [Clement] Greenberg [the influential critic and early supporter of Pollock], my mother died shortly before, the Pollock estate was pulled out of the Sidney Janis Gallery and frozen. I didn't know how to deal with Pollock. It was a rough life. I think my painting is so autobiographical if anyone can take the trouble."

Krasner's canvases of 1959–62 were large and near-violent in a way that, inevitably, recalled Pollock. But, as Krasner pointed out, even if she had never met Pollock she could not have avoided his influence, because "he changed the whole art world." In the early '60s Krasner imposed more order on the turbulence, and her canvases became more colorful. In 1964 the forms again became large, and more of the canvas was left blank, creating white shapes within colored ones, as in *Combat* (1965). Other works of the mid-'60s, notably *Kufic* (1965), were compara-

tively lyrical and had a delicate, Klee-like linearity. In the late '60s the edges of the forms became more defined, recalling her early affinity with Matisse. Paintings in this vein include *Pollination* (1968), *Mysteries* (1972), and *Peacock* (1973).

A major Krasner retrospective was mounted at the Whitechapel Art Gallery, London, in 1965. The well-received exhibit toured England under the auspices of the Arts Council of Great Britain. That show and the retrospective she was given at the Whitney Museum of American Art, New York City, in 1973–74 focused attention on her important contribution to abstract expressionism.

In the 1970s, Krasner used larger, simpler, and severer forms in works that resembled collages and contained flat patches of vibrant color. About 1975 she began a series of collages incorporating pieces of drawings, apparently from a female model, she had done while working with Hofmann in the late '30s. Reviewing a 1977 exhibition of these collages at the Pace Gallery, New York City, Donald B. Kusbit wrote in *Art in America* (November/December 1977), "In Krasner's collages the figure drawings become gestures and the material for a new process."

Lee Krasner owned a home in East Hampton, a Victorian clapboard house in a small field, and a large East Side Manhattan apartment decorated with Victorian furniture. Both homes contain studios. She was of medium height and was described by Vivien Raynor in *The New York Times Magazine* (April 2, 1967) as having "a long nose and a very full, wide mouth; her eyes—seen when she briefly removes her dark glasses—are pale blue-gray." With her often abrasive manner—probably the result of years of struggle to assert her identity as an artist—she was not an "easy" person. She found relaxation in gardening, tending house plants, cooking, and entertaining friends. A feminist, she joined the picket line at MOMA, in 1972, to protest the museum's relatively few exhibitions of women artists.

"One could go on forever as to whether the paint should be thick or thin, whether to paint the woman or the square, hard edge or soft, but often such questions become a bore" Krasner said. "They are merely problems in esthetics, having to do with the outer man. But the painting I have in mind, painting in which inner and outer are inescapable, transcends technique, transcends subject and moves into the realm of the inevitable"

EXHIBITIONS INCLUDE: Betty Parsons Gal., NYC 1951; The House of Books and Music, E. Hampton, N.Y. 1954; Stable Gal., NYC 1955; Martha Jackson Gal.,

NYC 1958; Howard Wise Gal., NYC 1960, '62; Sigma Gal., E. Hampton, N.Y. 1961; Whitechapel Art Gal., London 1965; Marlborough-Gerson Gal., NYC 1968, '69; Marlborough Gal., NYC 1973, '75; "Lee Krasner; Large Paintings," Whitney Mus. of Am. Art, NYC 1973–74; Corcoran Mus. of Art, Washington, D.C. 1975; Pace Gal., NYC 1977 '79; Janie C. Lee Gal., Houston 1978. GROUP EXHIBITIONS INCLUDE: "Pink Slips Over Culture," A.C.A. Gal., NYC 1937; 4th Annual Exhibition of the American Abstract Artists, Am. Fine Arts Gal., NYC 1940; 5th Annual Exhibition of the American Abstract Artists, Riverside Mus., NYC 1941; McMillan Gal., NYC 1942; "Challenge to the Critic," Gal. 67, NYC 1945; Whitney Annual, NYC 1956, '57; "Arte Nuova," Palazzo Graneri, Turin, Italy 1959; "Panorama," Gal. Beyeler, Basel 1961; "Nine Artists through Six Decades," Howard Wise Gal., NYC 1963; "Large American Paintings," Jewish Mus., NYC 1967; "The New American Painting and Sculpture: The First Generation," MOMA, NYC 1969; "Amerikanische Abstrakte Malerei," Marlborough Gal., Zürich 1973; Whitney Biennial, NYC 1973; "American Self-Portraits 1670–1973," Nat. Portrait Gal., Washington, D.C. 1974; "American Self-Portraits 1670–1973," Indianapolis Mus. of Art 1974; "Surrealität-Bildrealität 1924–1974," Staatliche Kunsthalle, Baden-Baden, W. Ger. 1975.

COLLECTIONS INCLUDE: Metropolitan Mus. of Art, MOMA, and Whitney Mus. of Am. Art, NYC; Brooklyn Mus., N.Y.; Newberger Mus., State Univ. of New York, Purchase, N.Y.; Philadelphia Mus. of Art.

ABOUT: Ashton, D. The New York School, 1973; Friedman, B. M. "Lee Krasner: Paintings, Drawings and Collages" (cat.), Whitechapel Art Gal., London, 1965; Munro, E. Originals: American Women Artists, 1979; Nemser, C. Art Talk 1975; Tucker, M. "Lee Krasner: Large Paintings" (cat.), Whitney Mus., NYC, 1973. *Periodicals*—Art in America November/December 1977, March/April 1966; Art News November 1955; Artforum March 1968, December 1973; Arts Magazine February 1977, April 1973; Guardian September 27, 1965; New York Herald Tribune March 2, 1958; New York Times July 16, 1950, June 21, 1984; New York Times Magazine April 2, 1967; Time March 17, 1958; Vogue June 1972.

KRUSHENICK, NICHOLAS (May 31, 1929–), American painter, has been called the only truly abstract Pop painter. The impact of his work of the mid-1960s, for which he is best known, is belligerently visual and visceral. The bright, flat colors heavily outlined in black, brash juxtapositions of active organic shapes with bold stripes and grids, ambiguous pictorial movement and depth, and flippant titles speak directly to the viewer's sense of pleasure and fun without, in most cases, evoking a strong intellectual or critical response. "The element that I look for is a power feeling," he told *Art in America*.

Dale Schwallenberg

NICHOLAS KRUSHENICK

"If the painting also offers a wild kind of color power, I'm for it. The forms are just a way of getting to the feeling." Krushenick's work resembles nothing so much as abstract cartoons, superficially similar to some of Roy Lichtenstein's less representational paintings without that Pop artist's underlying parodic intent.

Born into a poor East Bronx family, Nicholas Krushenick started painting in 1947 while in the army and attended the Art Students League, New York City, from 1948 to 1950, where he developed what he described as a "Picasso-like" figurative style. From 1950 to 1951, he studied with Hans Hofmann, who steered him toward abstraction. "He was my idea of what an artist is—a dirty old man painting away at eighty years old."

In 1951 Krushenick married Julie Greenfield; they have a son, Shawn. Through the 1950s Krushenick supported himself and his family by designing window displays for New York City department stores and working for the Whitney and Metropolitan museums and the Museum of Modern Art. His own work was representational, painted in one or another abstract expressionist idiom. In 1953–54 he made his first totally abstract paintings and collages (the latter simply pieces of ripped paper prominently stapled to backing boards). His first solo show was held in 1957 at the Camino Gallery, a small cooperative on New York City's East 10th Street. That same year, Krushenick, his brother John (also a painter), and Sam Goodman founded the cooperative Brata Gallery, also on East 10th, where they shared space with Ronald Bladen, Al Held, George Sugarman, Ed Clark, and Sal Romano.

Discussing the small 10th Street galleries which flourished in Greenwich Village in the years of abstract expressionism's international triumph, Irving Sandler reported that, "apart from the Tanager Gallery, the most important . . . were the Brata and the Reuben. The leading Brata artists were painters Held, . . . Bladen, and . . . Krushenick, and sculptor . . . Sugarman. They worked in a gestural manner during the fifties but by the end of the decade, they had begun to react against the spatial ambiguity of gestural art and instead, to clarify their forms and colors."

In 1960 Krushenick showed paintings and huge stapled collages—some, like *The Steel Ball Will Get Us All* (1960), painted over with frenzied brushstrokes—in black, white, orange, and blue. These bore some resemblance to the late *découpages* of Matisse, whose work Krushenick admits to be the major influence on his art. The last series of paintings he completed before turning to a hard-edged style were triptychs dominated by bold black "x"s dripped and splattered with paint (for example, *X Marks the Spot,* 1960).

By 1962 Krushenick had developed his familiar repertoire of forms: clouds, loops, "x"s, pinwheels, and other vaguely organic shapes overlapping a background field of latticework, stripes, or irregularly cropped, receding angular planes. He had abandoned oils in favor of the new acrylic paints, which gave him "the kind of hard, clear colors I wanted": usually deep blue, yellow, and scarlet, but also magenta, green, orange, and, in the later 1960s, white and silver. Every color was surrounded by a thick black outline like those in circus posters. "The moment you divide two colors with a black line, the colors become more vibrant to each other—the mixing quality that usually occurs is made to disappear—they stay *pure* red and *pure* yellow," the artist explained in *Art International* (April 1968). Despite his flat shapes, heavy, even brushstrokes, and broad outlines, Krushenick was able to create surprisingly deep, confusingly ambiguous pictorial spaces. In *Gypsy Joint* (1962), a fat loop, anchored to the bottom of the picture, sits forward of an irregular lattice that seems to float somewhere in the middle distance. In *The Nurburg Ring* (1964), a shrinking spiral of overlapping forms resembling the iris of a camera lens recedes into the picture plane, but similarly shaped forms at the top of the picture have the shallow flatness of a theater curtain. In *Goldfinger* and *James Bond Series #2,* both of 1965, pinwheel forms appear to roll back into soft billowing stripes. Writing in *Art International* (September 1965) Lucy R. Lippard was intrigued by Krushenick's "hilarious

Bondian vulgarity." "They [his paintings] tread just that narrow margin between drama and nonsense . . . and there is a sort of comic-book oriental or dimestore art nouveau flavor about them as well." However, she balked at the "unpleasant airlessness in most of these works. . . . The bands and loops and scales have gotten fatter, and incoherent in a stentorian way." Krushenick's shows at the Graham, Fischbach, and Pace galleries in New York City and at galleries in Stuttgart, Paris, and Zürich were nonetheless very popular, and few other critics wrote disapprovingly. "The energy, the slightly outrageous energy, subverted formal analysis," wrote Corinne Robins in *Arts* (December 1975). "The stripes waved, the clouds sailed past your vision, and the words dried up."

Carrying over formal techniques developed in his collages, Krushenick experimented in the later '60s with shaped canvases. A cloud descends like the smoke trail of a crashing plane from the top of the symmetrical composition through a sky of red and green stripes in *The Red Baron* (1967), while in *Polar White* (1967), the left edge of the wooden panel is determined by the shape of a white featherlike form. The 1970s saw further changes in his style; besides a general refinement of technique, he abandoned organic forms for lightning bolts and jagged comic-book explosions, as in *Electric Soup* (1969) and *Winter Tinger* (1971). By 1972, he had also replaced his fields of stripes with small-squared grids; in *Big Frog Mountain* (1972) a bar just on the surface cuts the work diagonally in two, while at a greater depth a black-and-white grid encroaches on, or is being engulfed by, a monochromatic field. Krushenick's manic energy is subdued, but the effect is more spatially and emotionally disturbing. The small black-and-white squares or, later, diamonds (as in *Tailgate*, a silkscreen of 1978) march through all his work of the '70s, erupting through and devouring fields of orange, purple, yellow, or blue, and attacking broad diagonal bands and corner strips.

Krushenick, his wife, and their son moved to California from Ridgefield, Connecticut, in the mid-1970s. The artist won a Tamarind Lithography Award in 1965 and a Guggenheim Fellowship in 1967; he has been a visiting artist or critic at nearly a dozen US colleges and universities. A tall, affable man, he said in an *Art in America* interview that he has a vocabulary of forms and shapes that he is in love with and that he feels must be dynamic and not literal. "They have to have a certain kind of mystery, so you can't identify them, but they suggest many forms."

EXHIBITIONS INCLUDE: Camino Gal., NYC 1957; Brata Gal., NYC 1958, '60; Graham Gal., NYC 1962, '64; Fischbach Gal., NYC 1965; Gal. Muller, Stuttgart 1966, '67; Gal. Sonnabend, Paris 1967; Pace Gal., NYC from 1967; Siden Gal., Detroit 1967; Gal. Nächst St. Stefann, Vienna 1967; Walker Art Center, Minneapolis 1968; Gal. Der Spiegel, Cologne 1968; Dartmouth Col., Hanover, N.H. 1969; Marcus-Krakow Gal., Boston 1969; Gal. René Ziegler, Zürich 1969, '70; Univ. of South Florida, Tampa 1970; Gal. Beyeler, Basel 1971; Lehman Col., NYC 1972; Gal. Kestner-Geschellschaft, Hanover, W. Ger. 1972; Gal. René-Mayer, Düsseldorf 1973; Univ. of Alabama, Birmingham 1973; Glenn Gal., Corona del Mar, Calif. 1973; California State Univ., Long Beach 1973; ADI Gal., San Francisco 1974; Portland Center for the Visual Arts, Oreg. 1974; Henry Gal., Univ. of Washington, Seattle 1974; Reed Col., Portland, Oreg. 1974; Foster-White Gal., Seattle 1975; California State Univ., San Bernardino 1975; Alfred Univ., N.Y. 1976; Univ. of Kentucky, Lexington 1976. GROUP EXHIBITIONS INCLUDE: Camino Gal., NYC 1957; Raymond Creuze Gal., Paris 1958; Pollack Gal., Toronto 1960; MOMA, NYC 1963; "Post-Painterly Abstraction," Los Angeles County Mus. of Art 1964; "Systemic Painting," Solomon R. Guggenheim Mus., NYC 1966; Documenta 5, Kassel, W. Ger. 1968; Art Mus. Ateneum, Helsinki 1969; "Moon and Space," Gal. Bayeler, Basel 1970; "American Art Since 1960," Art Mus., Princeton, N.J. 1970; Larry Aldrich Mus., Ridgefield, Conn. 1971, '75; Whitney Mus. of Am. Art Biennial, NYC 1973; Segunda Beinal Americana de Artes Gráficas, Cali, Colombia 1973; Leavin Gal., Los Angeles 1974.

COLLECTIONS INCLUDE: Albright-Knox Art Gal., Buffalo, N.Y.; Chrysler Art Mus., Provincetown, Mass.; Mus. of Fine Arts, Dallas; Coca-Cola Corporaton; Los Angeles County Mus. of Art; Metropolitan Mus. of Art, MOMA, and Whitney Mus. of Am. Art, NYC; Owens-Corning Corporation, N.Y.; Walker Art Center, Minneapolis; Aldrich Mus. of Contemporary Art, Ridgefield, Conn.; Washington Gal. of Modern Art, and Hirshhorn Mus. and Sculpture Garden, Washington, D.C.; Stedelijk Mus., Amsterdam; Folkwang Mus., Essen, W. Ger.; Finch Col. Mus., N.Y.; White Mus., Cornell Univ., Ithaca, N.Y.; Elvehjem Art Center, Univ. of Wisconsin, Madison; Power Gal., Univ. of Sydney, Australia.

ABOUT: Lippard, L.R. Pop Art, 1966; Moore, E. (ed.) Contemporary Art 1942–72: Collection of the Albright-Knox Art Gallery, 1972; Sandler, I. The New York School: The Painters and Sculptors of the Fifties, 1978; Schmied, W. Nicholas Krushenick, 1972; Swanson, D. Krushenick, 1968. *Periodicals*—Art in America May 1969; Art International September 1965, April 1968; Art News March 1967; Arts December 1975.

***LAM (Y CASTILLA), WIFREDO (OSCAR DE LA CONCEPCIÓN)** (December 8, 1902–September 11, 1982), Cuban painter, was at one time ranked with Ernst, Tanguy, and Dali as an eminent Surrealist. Although today he is rather less esteemed, largely due to the overpow-

°wē frä´ dō

Christophe Laurentin

WIFREDO LAM

ering (and freely acknowledged) influence on him of Picasso, his mentor, the artist is, if not highly original, nonetheless important as the only non-European contributor to surrealism. Lam's imagery, drawn from the vegetal and animal forms of his native Caribbean and the animistic symbology of voodoo, has an undeniable power of its own.

Wifredo (or Wilfredo) Lam was born in the sugar-farming town of Sagua la Grande, Cuba, the son of an 84-year-old Chinese trader and scribe (who lived to the age of 108) and an African-Indian-Latin mother. The family, living in the Castilian quarter and near the black quarter, was exposed to the uneasy, sometimes violent coexistence of Latin Catholicism and displaced African religions; Lam drew on this tension in his later work. He began drawing as a child—"I realized at the earliest age that I could be nothing but a creator, a painter or a poet," he said—and quickly developed a skillful, economical hand. When he moved with part of the family to Havana in 1916 he spent much of his time painting in the Botanical Gardens. From 1918 to 1923 he studied at the Academia San Alejandro, first exhibiting his work at the Havana Painters' and Sculptors' Association. Late in 1923 he went to Spain, where he was to live until the advent of Franco in 1937, to study with the renowned academician Fernández Alvarez de Sotomayor. His first solo exhibition in Madrid was held in 1928. In 1929 he married his first wife, Eva Piriz; she and his first son, born in 1930, died of tuberculosis in 1931.

Lam encountered the works of Picasso in 1936, on the eve of the Spanish Civil War. Picas-

so's use of African tribal forms was a revelation to Lam; he immediately abandoned academic realism for a Picassian cubo-surrealism with heavy emphasis on primitive iconography. *Guernica* (1937), in particular, made such a powerful impression on Lam that quotes from that work thereafter cropped up regularly in his paintings. In early 1937 he took part in the defense of Madrid against the Nationalists before succumbing, not to a war wound, but to food poisoning. While hospitalized he met the sculptor Manolo Hugué, who wrote him a letter of introduction to Picasso. Lam went to Paris, where Picasso, always warm to the flattery of sincere imitation, introduced him to the leading lights of the School of Paris, then composed mostly of Surrealists, and touted him as a major new talent. He was quickly accepted, exhibiting in Pierre Loeb's gallery in 1938 and showing jointly with Picasso at the Perls Galleries, New York City, in 1939. The flat, neoprimitive style of Picasso was not the only influence on Lam—he absorbed ideas from Ernst, Tanguy, Arshile Gorky, and Henri Rousseau as well—but it was by far the most important one.

When the Germans took northern France in 1940 Lam fled to Marseilles, where he took ship for Martinique with 300 other French intellectuals, André Breton, the painter André Masson, and Claude Levi-Strauss among them. After a brief internment in a Martinique concentration camp, Lam made his way to Cuba. There, out of the shadow of Picasso, he began to develop his own idiom, a compendium of bizarre, spiky distortions of animals and plants, the forms of tribal art and weapons, and a system of personal symbols in part based on voodoo. (There is some question as to whether Lam was an adherent or student of voodoo, a mere spectator of occasional rituals, or simply aware of it as one potent force in his Afro-Cuban heritage. He did attend voodoo ceremonies in Haiti in 1946.) *The Jungle* (1942–43), probably Lam's best-known work, exhibits all the characteristics of his mature style: thoroughly savage, skeletal figures merging with dense foliage, flatly painted in thinned-out olives and browns. Lam said the painting "Was engendered by a return to the primordial sources of tropical nature; it is the fruit of an intellectual intuition . . . it is but a moment of my existence." Breton, who wrote a book on Lam, said of him: "Although a master of technique and quickly aroused by the social issues of the time, Lam was intensely drawn to the treasury of primitive vision." *The Jungle*, which now seems rather tame but which at the time was thought dangerously violent and erotic, caused an uproar when it was displayed at the Pierre Matisse Gallery, New York City, in 1943. In 1944 he married his

second wife, Elena Holzer, a chemist and cancer researcher.

By the late 1940s Lam had virtually halted his stylistic development (a typical example of the period is *Murmur of the Earth*, 1950). He divagated from it thereafter only to assimilate other primitive sources—horned New Guinea masks, for example—that fitted in with his preexisting morphology of menacing pale figures outlined in black on dark backgrounds. Between 1947 and 1952 he traveled to Cuba, Italy, Britain, and New York City before settling again in Paris. He divorced his wife in 1950. After further travel to Sweden and the Mato Grosso, Brazil (where he posed among outlaws as a gem prospector), he set up a studio in Abisola, near Genoa, a popular summer watering place for artists. There in 1960 he married his third wife, Lou Laurin, who bore him three sons. Lam maintained good relations with the Castro regime, visiting the new Cuba in 1963 and returning in 1966 to paint the mural *The Third World* in the presidential palace. Financially successful, he exhibited regularly throughout Europe, the US, and Latin America, and maintained homes in Sweden, Italy, and France.

In the 1970s Lam's work became somewhat more abstract, as in *A la Fin de la nuit* (1970, *At the End of the Night*). This was not a matter of any new dedication to abstraction, but simply a refinement of his technique and a greater use of geometric forms. He also experimented with bronze sculpture, much in the manner of Ernst and Miró, and the fashioning of ceramic talismans of birds, fish, and snails. In 1980, at Castro's invitation, he made one of his last public appearances at the May Day ceremonies in Havana. He died at his home in Paris after a long illness.

EXHIBITIONS INCLUDE: Sagua la Grande, Cuba 1923; Leon, Spain 1932; Gal. Pierre Loeb, Paris 1938, '39, '45; Pierre Matisse Gal., NYC 1941, 1942–45, '46, 1957–60, '82; Centre d'Art, Port-au-Prince, Haiti 1946; Ministry of Education, Havana 1951; Inst. of Contemporary Arts, London 1952; Gal. Maeght, Paris 1953; Gal. Colibri, Malmö, Sweden 1955; Mus. de Bellas Artes, Caracas, Venezuela 1955; Palacio de Bellas Artes, Maracaibo, Venezuela 1957; Gal. Cahiers d'Art, Paris 1957; Univ. of Notre Dame, Ind. 1959; Gal. La Cour d'Ingres, Paris 1961; Gal. del Obelisco, Rome 1961; Albert Loeb Gal., NYC 1961; Gal. Krugier, Geneva 1963, '70; Biblioteca Nacionál, Havana 1963; Mus. de Arte Moderna, Havana 1965; Gal. Anderson, Malmö, Sweden 1965; Kunsthalle, Basel 1965; Kestner Gesellschaft, Hanover, W. Ger. 1965; Stedelijk Mus., Amsterdam 1967; Moderna Mus., Stockholm 1967; Palais de Beaux-Arts, Brussels 1967; Mus. d'Art Moderne, Paris 1968; Kunstkabinett, Frankfurt, W. Ger. 1969; Gimpel Fils Gal., London 1970; Gal. Gimpel and Hanover, Zürich 1971; Ordrupgaardsamlingen, Co-

penhagen 1978; Artcurial, Paris 1979. GROUP EXHIBITIONS INCLUDE: "Lam, Picasso," Perls Gal., NYC 1939; "First Papers of Surrealism," NYC 1942; "Cuban Painters," Mexico City 1946; "International Exhibition of Surrealism," Gal. Maeght, Paris 1947; "International Exhibition of Surrealism," Prague 1948; "Cuban Painting," Women's Club, Havana 1949; "50 Years of Modern Art," Brussels 1958; Pittsburgh International, Carnegie Inst. 1959; Documenta 2, Kassel, W. Ger. 1959; "Zeugnisse der Angst in der Modernen Kunst" (Testimonies of Angst in Modern Art), Darmstadt, W. Ger. 1963; "Exposition Surréaliste," Gal. Charpentier, Paris 1964; "Greats and Newcomers of Today," Mus. d'Art Moderne de la Ville, Paris 1966; "ROSC," Dublin 1967.

COLLECTIONS INCLUDE: Mus. Nat. d'Art Moderne, and Mus. d'Art Moderne de la Ville, Paris; Mus., Moderna Mus., Stockholm; Tate Gal., London; Art Inst., Chicago; Rhode Island School of Design, Providence; Hirshhorn Mus. and Sculpture Garden, Washington, D.C.; Stedelijk Mus., Amsterdam; Univ. of Caracas, Venezuela; Centro Médico, and Presidential Palace, Havana; MOMA, and Solomon R. Guggenheim Mus., NYC.

ABOUT: Breton, A. Lam, 1946; Charpier, J. Lam 1960; Grall, A. (ed) Wifredo Lam, 1970; Jouffroy, A. Lam, 1972; Juin, H. Lam, 1964; Leiris, M. Wilfredo Lam, 1970; Ortiz, F. Wifredo Lam y su Obra Vista a través de Significados Críticos, 1950; P-Orridge, G. and others (eds.) Contemporary Artists, 1977. *Periodicals*—Art International no. 9 1965; Art News September 1950; Cahiers d'art (Paris) December 1945/January 1946; L'Oeil (Paris) November 1979; XXe siècle (Paris) May 1963.

***LANDUYT, OCTAVE** (1922–), Belgian painter, ceramist, sculptor, and jewelry designer, carries on the Flemish tradition, stretching from Pieter Breughel the Elder to James Ensor, of creating fearful and fantastic figures stamped with the mark of decay and death. Landuyt's refined handling of paint and clay and his glowing impasto colors ameliorate, to some extent, the queasy impact of his images, but his sensibility is inescapably macabre. "Landuyt's work is not for those who look for laughter or a lightening of the spirit," wrote Rona Dobson of *Art News* (April 1982). "Rather it is a compellingly insistent bad-dream melodrama."

Octave (or Octaaf) Landuyt was born in the medieval town of Ghent, in Flanders, to a working-class family that lived over a slaughterhouse. He studied crafts and industrial design at the academy in Courtrai, where he was later to head the Industrial Bureau for Design. A rebellious youth, he left his family for Brussels as an adolescent. His early painting style, a kind of "magic realism" with affinities to the work of the Americans Edward Hopper and Charles Sheeler, de-

°län´ doit, ok täv´

OCTAVE LANDUYT

scribed, in the words of one writer, "Kafka-esque somnambulists" with "big heads, pinched lips, and faraway eyes" roaming a "desolate urban decor." Already there was a harsh, if somewhat shallow, moralism inherent in his work, a Calvinistic warning about the unavoidable perils of soullessness in the modern city.

In his 30s Landuyt switched to a more emotive and melodramatic style, painting anonymous, spiritless, and panicked beings, with thick encrustations of golds, blues, and fiery reds, against engulfing black backgrounds. *Purification by Fire* (1957), for example, depicts the charred, moon-faced head of a man, pockmarked with jewels of paint; the figures in *Formes couchées* (1958, Reclining Forms), who float unanchored in a deep red field, are cut off disturbingly by the edge of the canvas. *Formes couchées* won Landuyt an International Guggenheim Award in 1958; the following year some of his more sensational works were exhibited in a solo show at the Landry Gallery, New York City, his first US exposure. His reputation in Belgium increased immensely thereafter; according to Dobson, his work was so quintessentially Flemish that it had to be seen out of context to be appreciated by the Belgians themselves.

Landuyt spent several years working in a biology laboratory, and made use of this experience in his next series, the "Surfaces essentielles" (early 1960s). Emile Langui wrote in *Quadrum 12*: "By studying the strict sciences and by patiently manipulating the microscope, he has discovered, beyond matter-of-fact biology, through intuition as much as observation, certain unsuspected se-

crets of Life, a few obscure laws of creation and of the structure of Creation." It is obvious from Landuyt's work that these "obscure laws" have largely to do with the morbid romance of decay. He developed a new semiabstract style based on the dissolving structures of biological organisms, glamorized by his brilliant colors and virtuoso handling of impasto—"creepy-crawly surfaces" as one critic called them. "What is striking," wrote Sidney Tillim in *Arts Magazine*, "is the thematic consistency of his world view, his dialectic which subsumes the higher and lower life forms under a cosmology driven by anxiety; by an existential vision of an *élan vital* [in his work] the flesh of a woman and the bark of a tree have the same interior life." Such paintings as *Surface essentielle oeil* (1960) and *Essence végétal* (1961) suggest that Landuyt is a "vitalist"—an artist who attempts to portray or capture the lifeforce directly in his work—in the same way that the term applies to certain sculptors, notably Theodore Roszak, whose late welded work has definite stylistic and thematic similarities with Landuyt's "Surfaces essentielles". Very occasionally in Landuyt's paintings, life outweighs death. *Soleil végétal* (1961) portrays a glowing, yellow-orange ball of flowers and leaves, a kind of solar dandelion.

Landuyt has since made regular forays back to figurative representation of beings in the throes of inner anguish. *L'Assassin au clair de lune* (1964, Assassin by Moonlight), a monumental head with cavernous features peering from behind bars; *Le Chevalier à la rose* (1968, Knight of the Rose), in which the tiny, flayed cavalier is rendered even more insignificant by his huge, distorted horse; *Jamais la peur ne finira* (1973, Fear Will Never Stop), a portrait of a terrified monkey; and the recent *The Blindfold, Introspective* (1980)—all typify Landuyt's tortured realism. His ceramic sculptures and even his jewelry partake of the same obsessions: the sculptures, if anything, are even more graphic in their lovingly detailed decomposition, as in the grotesque *Tête florale* (1961, Floral Head).

Considered one of the best painting teachers in Belgium, Landuyt is currently a professor of plastic arts at the Ecole Normale in Ghent. An insomniac who bears a passing resemblance of a balding, moustacheless Edgar Allan Poe, he spends much of his time in his fortresslike home in the marshlands of Heusden. He has filled this labyrinthine dwelling with skeletons and Egyptian mummies adorned with jewelry of his own design, fetish figures from a variety of tribal cultures, and his own bizarre creations. In addition to the Guggenheim prize, he has won the Lugano International Exposition Prize (1956), the Prix Monique de Groot (1958), and the Prix Europe (1958).

EXHIBITIONS INCLUDE: Landry Gal., NYC 1959, '60; Arts of Belgium, NYC 1960; Abbaye de St. Pierre, Ghent, Belgium 1961; Cultural Center, Venlo, Neth. 1974. GROUP EXHIBITIONS INCLUDE: Palais des Beaux-Arts, Brussels 1954, '58; International Exposition, Lugano, Switzerland 1956; São Paulo Bienal 1957; Carnegie International, Pittsburgh 1958; Documenta 2, Kassel, W. Ger. 1959; Venice Biennale 1960; "Ghent: A Thousand Years of Art and Culture," Mus. des Beaux-Arts, Ghent, Belgium 1975; "The Flemish Identity in Modern Painting," Tampa Mus., Fla. 1980.

COLLECTIONS INCLUDE: MOMA, NYC; Mus. of Modern Art, São Paulo; Wadsworth Atheneum, Hartford, Conn.; Mus. des Beaux-Arts, Ghent, Belgium; Palais des Beaux-Arts, Brussels; Carnegie International Collection, Pittsburgh.

ABOUT: "The Flemish Identity in Modern Painting" (cat.), Tampa Mus., Fla., 1980; Pellegrini, A. New Art Around the World, 1966. Periodicals—Art International (Lugano) September/October 1976; Art News April 1982; Arts Magazine June 1959; Connaissance des arts (Paris) August 1977; Quadrum 12 (Brussels) 1962.

PETER LANYON

LANYON, PETER (February 8, 1918–August 31, 1964), British painter, was credited with reconciling the tradition of English landscape painting with an abstract idiom. He was born of Cornish parents in the old fishing town of St. Ives. His father, W.H. Lanyon, was an amateur photographer and musician. Lanyon was proud of his ancient Cornish heritage, and the wild, remote and mysterious landscape off west Cornwall never lost its hold on him. "I live in a country which has been changed by men over many centuries of civilization," he once remarked. "It's impossible for me to make a painting which has no reference to the very powerful environment in which I live." In addition, southwest Cornwall, and St. Ives in particular, was the scene of much artistic activity in Lanyon's early years.

Lanyon was educated at St. Erbyn's School in Penzance and at Clifton College. In 1936 he studied art privately in St. Ives with Borlase Smart, and in 1937 continued his studies at the Penzance School of Art.

In the same year, Lanyon met Adrian Stokes, the distinguished writer on art, who "discovered" the young artist painting a landscape by the side of a road. Stokes's book *Colour and Form* (1937) was to have a marked influence on Lanyon's work. Also in 1937, Lanyon traveled to Johannesburg and Holland, and on Stokes's advice, he moved for four months to London to study at the Euston Road School the following year. In the summer of 1938, he visited the Cézanne country in Aix-en-Provence.

It was on Adrian Stokes's advice that Ben Nicholson, his wife Barbara Hepworth, and Naum Gabo moved to St. Ives when war broke out in September 1939. Those artists had a profound influence on Lanyon's work, and left a lasting impression on him. As long after as 1971, Gabo recalled his first meeting with Lanyon: "I remember him arriving at my studio with a portfolio in response to my invitations after I met him with friends in Carbis Bay," he wrote in the catalog introduction to a Lanyon exhibition at Basil Jacobs Fine Art Ltd., London. "Looking through his sketches and paintings, the very first few attracted my attention so strongly that I did not really need, later, to look at the rest so attentively. . . . The way the volumes, the surfaces and the lines, the inside world of the objects, were treated in the sketches told me that before me was a young but already accomplished artist. Already in these sketches his vision was manifestly abstract in its approach to the world, though naturalistically rendered." For six months during 1939 Lanyon took private art lessons from Ben Nicholson, and, to quote Gabo, "he very soon found himself entirely at home in the abstract world, which he used in his painting only as a means to convey his vision of the naturalistic world." By late 1939 Lanyon had stopped painting landscape studies and begun instead to make relief constructions in wood, cardboard, string, and other materials.

From 1940 to 1945 Lanyon served in the Royal Air Force, rising to the rank of corporal, as an aero-engine fitter and engine equipment specialist in the Middle East, Palestine, and Italy. While in Italy he painted *Black Form,* executed

in a wax medium on wood. "He stayed away long enough to mature both in life and in art," Gabo observed, "but he did not lose his artistic energy and the clarity of his vision."

Lanyon threw himself into his work upon his return to Cornwall in December 1945. He rejected pure abstraction, and his characteristic pictures of 1946–47 were concerned with birth and regeneration. *The Yellow Runner* (1946) was, he said, "a painting of fertility. The seed is where the yellow runner finds the flower, or the seed finds the womb in the centre section."

Lanyon married Sheila St. John Browne in 1947, and six children were born to them between then and 1954. Lanyon's painting *Prelude* (1947) combined ideas of underground mining and women giving birth. *Generation* (1947) in oil on plywood, was the culmination of the 1946–47 phase of his work. Like *The Yellow Runner* and *Prelude* it had a personal relevance and, at the same time, strongly reflected the influence of Gabo.

Lanyon's personal style first emerged in 1949. He had traveled in Italy in 1948, and he began once again to associate paintings with particular places, as in *Portreath* (1949), one of the first pictures in which he successfully worked out his new "constructive" conception of landscape. It harkened back to his *Box Construction* of 1939. Significantly, Lanyon continued throughout his career to make constructions as preparation for paintings. The first version of *Portreath* shows that he still used Ben Nicholson's painstaking method of scraping paint off of a board with a razor-blade. The Arts Council of Great Britain would not tolerate the constant scratching out and repainting of the canvas it had provided, and Lanyon rapidly painted a second verison.

Lanyon had been an active member of the Crypt Group of artists in St. Ives in 1946–47, and in 1949 he became a founding member of the Penwyth Society of Art in St. Ives, though he resigned after one year. He was represented in 1947 and again in 1949 in group exhibitions of abstract art at the Salon des Réalités Nouvelles, Paris, and in October 1949 he had his first solo exhibition, at the Lefevre Gallery, London. The following year, he began teaching at the Bath Academy of Art at Corsham Court, a post he held until 1957.

Saint Just (1951), now owned by the Bristol City Art Gallery, England, is widely thought to be Lanyon's finest painting. Saint Just is the last town in England before Land's End. It is "an old mining town, with disused mine shafts all round it," according to Lanyon. His abstract, postcubist picture portrays "the place complete, with all its associations," through the masterful use of a limited range of local colors—damp dark greens, pale cerulean blues, and rich blacks and grays; the central black section in the vertical canvas represents the mineshaft. The work was conceived as the central part of an ambitious polyptych, a form inspired by Lanyon's admiration for early Italian religious painting.

On an Italian Government scholarship, Lanyon spent the early part of 1953 in Rome. Upon his return, he painted *Europa* (1954), one of several pictures with a reference to the figure directly involved with the landscape. "In the painting the scene is set in the landscape, and the figures could be rocky boulders," he remarked in a recorded talk. Granite boulders and the dry stone walls on the Land's End Road had played a prominent part in his Cornish paintings of the early 1950s.

Lanyon went to New York City in January 1959 for his first American exhibition, held at the Catherine Viviano Gallery. He enjoyed far more success in the United States than he had had in England, and during his stay in New York, he met Franz Kline, Robert Motherwell, and Adolph Gottlieb. Lanyon's greatest admiration and affection were reserved for Mark Rothko. He had little contact with de Kooning, to whose painting technique his own work bore superficial resemblance. Later in 1957, Lanyon again visited Italy, and made a return visit to New York in 1959.

Between 1957 and 1960, Lanyon ran an art school at St. Peter's Loft, St. Ives, with Terry Frost and William Redgrave. In 1959 he took up gliding as a hobby. "The purpose of gliding [is] to get a more complete knowledge of the landscape," he said. "The pictures now combine the elements of land, sea and sky—earth, air and water. I had always watched birds in flight exploring the landscape, moving more freely than man can, but in a glider I [am] similarly placed." For some time he had been interested in the idea of weather paintings. An awareness of changing weather had first been introduced into English landscape by Constable. For Lanyon the idea of weather was associated with the sensation of vertigo.

The gliding pictures include *Solo Flight* and *Soaring Flight* both of 1960, and *Drift* (1961). Lanyon began to introduce more and more color, although he had been more of a tonal painter than a colorist. In 1960 he worked on a stained-glass construction commissioned by the Arts Council, and in May of the same year he completed a ceramic mural for the University of Liverpool Civil Engineering Building. (Maxwell Fry was the architect.) From 1960 to 1964, Lanyon was visiting lecturer at the West of En-

gland College of Art, Bristol, and in 1961 he was elected Bard of the Cornish "Gorsedd," for his services to Cornish art.

He made two brief visits to New York in 1962, and served as visiting painter at the San Antonio Art Institute in Texas in 1963. Lanyon traveled to Mexico in March 1963. He was always stimulated by unfamiliar landscapes, but feeling happiest when painting in Cornwall and neighboring counties in southwest England, he did not paint and only photographed Mexico. *Mexico* (1963) was based on one of his photographs of a brightly colored slide in a children's playground. *Eagle Pass* (1963) and *Saltillo* (1963) were also inspired by the Mexico trip.

In February 1964, Lanyon lectured for the British Council in Prague and Bratislava, Czechoslovakia. He began in 1964 to lay on colors in flat planes, as in *Clevedon Bandstand* (1964). Clevedon is a holiday resort on the Bristol Channel to which Lanyon took his students to discuss landscape painting. In his last gliding pictures of 1964, including *Fistral* (Fistral Bay is near the Cornish coastal resort of Newquay) and *Glide Path*, Lanyon attached objects and alien materials to the canvas in an attempt to break down the distinction between painting and construction, late developments representing no fundamental change in his work.

Lanyon's career came to an early end as a result of injuries received in a gliding accident in Somerset on August 27, 1964. He died four days later, aged 46. His last completed canvas was *Autumn*.

Peter Lanyon was remembered by his family and his many friends as a warm, vital, and sensitive man, with an attractive "open-air" appearance. For all his close association with the Cornish coast and countryside, there was nothing parochial in his approach to art. It is as a landscape painter that he probably will be remembered, and Lanyon himself called his pictures "images of [my] environment. My concern is not to produce pure shape or color on a surface, but to inform and fill up every mark I make with information which comes directly from the world in which I live."

In a letter written in March 1952, Lanyon affirmed both his link to English landscape tradition of the past and his own original contribution: "Paint represents experience and makes it *actual*. My source is sensuous . . . plastic form is arrived at not by modelling with chiaroscuro and fixed perspective but by sensory paint manipulation. . . . My art follows Constable—it is to be found in the hedgerows. . . ."

EXHIBITIONS INCLUDE: Lefevre Gal., London 1949; Downing's Bookshop, St. Ives, Cornwall, England 1951; Gimpel Fils, London 1952, '54, '60, '62; City Art Gal., Plymouth, England 1955; Catherine Viviano Gal., NYC 1959, '62, '63, '64; São Paulo Bienal 1961; Sail Loft Gal., St. Ives, Cornwall, England 1962; Marion Koogler McNay Art Inst., San Antonio, Tex. 1963; Gimpel and Hanover Gal., Zurich 1964; Arts Council Exhibition, Tate Gal., London 1968; Basil Jacobs Fine Art Ltd., London 1971. GROUP EXHIBITIONS INCLUDE: Salon des Réalités Nouvelles, Paris 1947, '49; "21 Modern British Painters," British Council exhibition touring United States and Canada 1950–51; "Sixty Paintings for 51," Arts Council Exhibition, Festival of Britain, London 1951; "Tendances de la peinture et de la sculpture britannique contemporaine," Gal. de France, Paris 1952; "International Watercolor Exhibition," Brooklyn Mus., N.Y. 1953; "Figures in their Setting," Contemporary Art Society exhibition, Tate Gal., London 1953; Pittsburgh International, Carnegie Inst. 1955, '58, '61, '64; "Contemporary British Art," British Council exhibition touring Denmark and Norway 1956; "New Trends in British Art," Rome-New York Art Foundation, Rome 1957; "Young British Painters," Arts Club of Chicago 1957; "Young British Painters," Albright-Knox Art Gal., Buffalo, N.Y. 1957; "Young British Painters," Nat. Gal. of Canada, Ottawa 1958; Whitechapel Art Gal., London 1958; "Six British Painters," Kunstkring, Rotterdam 1958; "Six British Painters," Kunstverein, Düsseldorf 1958; "Six British Painters," Kunstgilde, Zurich 1958; Documenta 2, Kassel, W. Ger. 1959; International Art Exhibition, Tokyo 1959; "European Painting and Sculpture Today," Minneapolis Inst. of Arts 1959; "British Painting 1720–1960," British Council exhibition, Pushkin Mus., Moscow 1960; "British Painting 1720–1960," British Council exhibition, Hermitage, Leningrad 1960; "British Art Today," San Francisco Mus. of Art 1962; "Three Contemporary Painters," Arts Council Gal., Cambridge, England 1963; "Englische Malerei der Gegenwart," Kunstverein, Dusseldorf 1964; "British Painting and Sculpture 1960–1970," Nat. Gal. of Art, Washington, D.C. 1970.

COLLECTIONS INCLUDE: Tate Gal., Victoria and Albert Mus., Arts Council of Great Britain, British Council, Contemporary Art Society, and Peter Stuyvesant Foundation, London; City Mus. and Art Gal., Birmingham, England; City Mus. and Art Gal., Plymouth, England; Whitworth Art Gal., Univ. of Manchester, England; Calouste Gulbenkian Foundation, Lisbon, Portugal; Nat. Gal., Prague; Albright-Knox Art Gal., Buffalo, N.Y.; Art Mus., Princeton Univ., N.J.; Yale Univ. Art Gal., New Haven, Conn.; Smith Col. Mus. of Art, Northampton, Mass.; Carnegie Inst., Pittsburgh; Cleveland Mus. of Art; Nat. Gal. of Canada, Ottawa; Art Gal. of Ontario, Toronto; Art Gal. of Victoria, Melbourne, Australia; Art Gal. of South Australia, Adelaide.

ABOUT: Bowness, A. "Peter Lanyon" (cat.), Tate Gal., London, 1968; Cheney, S. The Story of Modern Art, 2d ed. 1958; Gabo, N. Peter Lanyon, 1971, "Peter Lanyon" (cat.), Basil Jacobs Fine Art Ltd., London, 1971; Heron, P. The Changing Forms of Art, 1955; Read, H. Contemporary British Art, 2d ed. 1964; Ro-

thenstein, J. British Art Since 1900, 1962. *Periodicals*—Art News and Review March 1954; Arts February 1956; Cimaise (Paris) April–June 1960; Guardian May 17, 1962; London Magazine July1961; London Times September 2, 1964; Painter and Sculptor Autumn 1962; Studio November 1962; Studio International August 1965; XXe siècle (Paris) December 1963.

***LASANSKY, MAURICIO** (October 12, 1914–), American printmaker, has been equally influential as an artist and teacher. "The copper plate," Lasansky declared in 1949, "is not a passive medium for reproduction purposes, but rather is an active participant in determining the ultimate form of the work of art."

Soon after the invention of printing in the West in the mid-15th century, the graphic arts became an important means of expression, especially in the hands of such master engravers as Martin Schongauer and Albrecht Dürer in Germany and Andrea Mantegna in Italy. In the 17th century, the art of etching, as developed by Jacques Callot, reached great heights with Rembrandt, and in the early 19th century the aged Goya, already a master of etching and aquatint, was among the first to adopt the newly invented medium of lithography. But in the course of the 19th century the graphic arts became, all too often, "a passive medium" for the reproduction of painting and drawing or for literary illustration rather than an independent art form. Even in an artist of the stature of Whistler, etching was an accompaniment to his painting, achieving sensitive, but essentially pictorial, effects.

This line of development continued with some exceptions into the early 20th century. The pioneer of an entirely new direction in printmaking was the Englishman Stanley William Hayter, who felt that the full possibilities of the intaglio techniques of etching and engraving had been ignored or overlooked for many decades. Hayter's Atelier 17, founded in 1933 in Paris at 17 rue Campagne-Première in Montparnasse (hence its name) became the most influential print workshop of the century. After Hayter moved to the United States in 1940 and set up an Atelier 17 in New York City, one of the most gifted artists to work with him was the young Mauricio Lasansky, who already had a considerable reputation in his native Argentina, but whose style was strongly affected by Hayter's experimental approach. Lasansky rapidly developed his own imagery, which was less cerebral and more colorful and emotional than that of Hayter, and infused with a very Spanish feeling for dramatic symbolism. The expressive power of Lasansky's prints, his complex yet bold and

MAURICIO LASANSKY

direct use of the intaglio medium, and his genius as a teacher have contributed to the widespread acceptance of printmaking as a major art form.

Lasansky was born in Buenos Aires, Argentina, of eastern European parentage. His father, whose country of origin has been variously given as Russia, Poland, and Lithuania, was an immigrant printer of banknote engravings who had practiced his craft in Philadelphia before settling in Argentina. His son's first interest was music. In 1927, at the age of 13, Mauricio was taking music lessons and already drawing and trying his hand at etching and engraving. A slight, but fortunately temporary, hearing impediment caused him to discontinue his music and turn to the study of sculpture.

Buenos Aires during Mauricio's early years was a fairly lively and cosmopolitan cultural center. However, as Alan Fern notes in the foreword to *Lasansky: Printmaker* (1975), the city was "oriented to Europe, but generally conservative in taste." In 1930 Lasansky received a first mention for sculpture at the Mutualidad Fine Arts Exhibit in Buenos Aires and a third prize the following year. In 1933 he entered the Superior School of Fine Arts, Buenos Aires, where he took courses in sculpture, painting, and engraving.

His earliest prints, executed in a relief etching technique on zinc plates, already showed great assurance. The themes are generally tragic and the treatment expressionistic, somewhat in the Latin-Mexican manner, as in *Velorio* (Vigil) and *Maternidad,* both of 1933. The plates were printed with black ink on newsprint, and the type created a texture while also making a gray,

°läz än´ skē, mô rē´ tsyō

thus mitigating the starkness of the black and white. There is angry social protest in the relief etching on zinc, *Prisioneros* (Prisoners) of 1934, and a note of pathos in *Huerfanos* (Orphans), possibly executed in the same year. *Suicidas,* a deep bite etching, and the linoleum cut *Cena* (Supper), both of 1935, have a semiprimitive bluntness akin to German expressionism.

Lasansky received a Purchase Award at the Provincial Salon in La Plata, near Buenos Aires, in 1934, and an award for the best engraving at the Mutualidad Fine Arts Exhibit in Buenos Aires the following year. Also in 1935, he had his first solo show, at Fort General Roca, Rio Negro, Argentina. There was still a strong literary and poetic element in his work; he numbered many poets and writers among his friends, but there were very few art exhibitions from abroad, and Lasansky was aware of the comparative isolation of Buenos Aires in the visual arts.

The sense of isolation was even more marked in Córdoba, Argentina, where Lasansky moved in 1936 to direct a government art school, the Free Fine Arts School, in the Villa María. On December 16, 1937 he married Emilia Barragan, of whom he has made several striking portraits, mostly in profile, over the years.

Solo shows in Córdoba, Buenos Aires, and other cities and a series of awards brought Lasansky national recognition. His prints of this period have a romantic, at times even sentimental, character. One of the simplest and most appealing is *Changos* (Peasant Children) of 1936, an etching on zinc. In the more elaborate and descriptive *Changos y Burritos* (Children and Little Donkeys) there may be touches of drypoint, a method he had used in some of his earlier prints in order to enrich the tones. In *Maternidad,* a drypoint of 1937, and the etching *Figura* (1938) there are surrealist elements, including abrupt contrasts of scale and incongruous imagery, but compared to Lasansky's mature work there is nothing in these prints that could be considered in any way avant-garde.

In 1939 Lasansky was appointed director of Taller Manualidades, in Córdoba. A series of delicate, lyrical, somewhat manneristic drypoints of women, several inspired by his wife, appeared in 1940–41; possibly the most successful was *La Rosa y el Espejo* (The Rose and the Mirror) of 1941. Bizarre fantasy marked his drypoint, Themes from Heine's *Cancionero* (Book of Songs) of 1942. Although he had achieved a measure of success, Lasansky felt the need for artistic growth and for contact with the more daring, experimental forms of contemporary art, known to him only through reproductions in the few advanced art publications from abroad that were available in Agentina.

In 1940 Francis Henry Taylor, director of the Metropolitan Museum of Art, New York City, while on a South American trip, saw Lasansky's work and met the artist. Taylor recommended him for a Guggenheim Fellowship that would enable him to study printmaking. The grant was made, and in 1943 Lasansky arrived in New York, where he eagerly studied the Metropolitan Museum's extensive print collection and explored new techniques of gravure in S. W. Hayter's Atelier 17.

Miró, Chagall, and other leading artists who had engraved and printed with Hayter in Paris had moved to New York City in the late 1930s. Inevitably, these new international contacts and Hayter's experimental methods brought about a profound change in Lasansky's approach to printmaking. This is evident in the strong, abstract linear rhythms of *La Mariposa* (The Butterfly) of 1944, in which engraving with the burin, a method Lasansky considers more direct and challenging than etching with a needle, is combined with aquatint and soft ground. In the lithograph *El Cid* (1944) and the engravings *La Lágrima* (The Tear) and *Apocalyptic Space,* both of 1945, some of the images recall the agonized horse in Picasso's *Guernica.* The scraping and burnishing of certain areas became an integral part of the printmaking process.

Lasansky had his first American solo exhibit at the Whyte Galleries, Washington, D.C., in 1944. About that time he obtained a renewal of his Guggenheim Fellowship and, determined not to return to the provincial atmosphere of Córdoba, he sent for his wife and children. Printmaking offered no guaranteee of a successful career in New York in 1945, and Lasansky saw more opportunity in a smaller, less competitive atmosphere. Henry Allen Moe, an influential member of the Guggenheim Foundation, persuaded Virgil M. Hancher, president of the State University of Iowa, Iowa City, to recommend Lasansky to Lester D. Longman, the progressive head of the art department. Longman's policies represented a complete breakaway from the regionalism of Grant Wood which had dominated the Iowa art scene in the 1930s. In 1945, after meeting Lasansky at a Whitney Museum opening, Longman invited him to the University of Iowa as a visiting lecturer and asked him to create a department of graphic arts. Lasansky went to Iowa "for one year," but was such an immediate success as a teacher and organizer that he stayed permanently. His self-portrait, an engraving of 1945 in which the long, bearded face gazes intently at the viewer from behind heavy dark-rimmed spectacles, recalls El Greco's awesome Grand Inquisitor, Don Fernando Niño de Guevara, in the Metropolitan Museum, and is

one of his most powerful prints—a strong, authoritative image.

In about 1947 Lasansky was promoted from assistant professor to full professor of art. This was a particularly dynamic period for the Iowa art department. Many students were World War II veterans availing themselves of the GI Bill, and a number of them were married. All were seriously motivated in their art studies, and some were extremely talented. Even those who did not intend to specialize in the graphic media were inspired and immensely stimulated by Lasansky's teaching. He said: "If I teach anything at all, it is the sense of responsibility one must have as an artist. . . . When they ask me how I teach, I can only say that there is no formula. I look upon each student as an artist. I assume that he is sensitive." Lasansky believes in "freedom backed by self-discipline," and that the artist should draw inspiration from tradition, from the sum of human endeavors, past and present. He has always insisted on respect for the materials, the copper plate, the tools, the various stages of printing and mounting. He once said, "In this class we never discuss technique—only concepts." This was a slight exaggeration, but in fact he regarded technique only as a means to an end. Whereas the activating of the surface and the handling of space, both in Lasansky's own prints and in the aesthetic of the Iowa print workshop, owed much to the Cubist-Expressionist Picasso of the late 1930s and something to the imaginative "free form" of Miró and Chagall, there was no danger of eclecticism, nor was any formula imposed on the students. Lasansky did not want to produce "little Lasanskys," and would say, "Don't try to be academic, don't try to be modern—learn to find *yourself* in your work, and to capitalize even on your mistakes."

Without being a purist, Lasansky especially favored the intaglio method of engraving, the direct use of the burin on the metal plate, "because with it one cannot achieve speedy results." He did not encourage the lithographic medium which, he felt, was "essentially a technique for transcribing a drawing." Stimulated and emboldened by Lasansky's teaching, even the less gifted students often produced work of which they would not have thought themselves capable, but only the strongest were able to sustain the momentum after leaving the university. Some went on to head print departments in other centers, so that Lasansky, in the words of Alan Fern, "has been instrumental in establishing the print in America as a viable, independent art form."

Although Lasansky spent untold hours with his students, his own studio was generally closed to them, thus enabling him to pursue his own work undisturbed. His prints became larger, more dramatic in theme and more complex in technique. One major cycle (1946–48) was the four etched and aquatinted prints on copper titled "For an Eye an Eye," symbolic visions of violent confrontation. More subjective and personalized are the strong and sensitive portraits of himself and his family in which, through the use of several plates, subtle luminous color provides a rich counterpoint to the blacks and grays. Among these prints are *My Boy* (1947), a portrait of his eldest son; *My Wife* (1947); a frontal *Self-Portrait* (1948), more detached and quizzical than the engraving of 1945; and the narrow, vertical portrait of his daughter Aitana (1948). The portraits of his family are tender without sentimentality and have a sophistication which reminded one critic of Velázquez's portrayal of members of the Spanish royal family. At the same time their structure and linearity recall Modigliani's portraits; the tensions within the drawing enhance the power of the image.

Lasansky's humanism, and something of the free-wheeling fantasy of Chagall, though in a more somber vein, can be seen in *Bodas de Sangre* (Blood Wedding) of 1951, inspired by the play of Federico García Lorca, and in *Firebird* (1952–53), an evocative blend of figurative and abstract images.

In 1952 Lasansky became an American citizen. A Guggenheim Fellowship in 1953 enabled him to spend one year in Spain and France. Given his temperament, the elegant, hedonistic side of the French tradition had little appeal for him; his strongest affinities have always been with the Spanish heritage—El Greco, Velázquez, Goya, Picasso, Miró.

The experience of visiting Franco-ruled Spain in the aftermath of the Civil War was combined with Lasansky's renewed study of Goya's prints to form the basis of the enigmatic imagery of *España* (1956), done two years after his return to Iowa. In that piece the horse and rider motif of *El Cid* (1944) has been transformed into the baleful vision of the looming outsized figure of a white-robed monk who bestrides a small patient horse as a grieving woman mourns her dead infant lying on the ground. *Nacimiento en Cardiel* (Birth in Cardiel) of 1958, in tones of yellow, ochre, and black, is also Spanish in theme and spirit, evoking both the hard life of the peasantry and the closeness of family ties. In 1959 Lasansky returned to the portrayal of his own family in almost life-sized individual standing figures of himself, his daughter Maria Jimena, his wife, and Luis (his youngest child). To

achieve this monumental scale, unprecedented in printmaking, he joined several master plates together.

Their main residence was in Iowa City, but the Lasanskys also owned a house and land on the island of Vinalhaven, off the coast of Maine where they spent the summer months. They did very little "socializing"—the emphasis was on work and family activities.

Lasansky has been the recipient of innumerable awards and purchase prizes, and, in addition to his many solo shows, joint exhibitions of the artist and his students were widely acclaimed. Among the most memorable were "A New Direction in Intaglio" at the Walker Art Center, Minneapolis, in 1949, and "Intaglio," a Latin-American Traveling Show of 1959, which toured for a three-year period under the auspices of the United States Information Agency.

Lasansky's commitment to human values found expression in a series of drawings completed in the summer of 1966 and titled "The Nazi Drawings." Kneeland McNulty, curator of prints and drawings at the Philadelphia Museum of Art, wrote of this fierce indictment of the Nazi era: "The degradation of all mankind by its own brutality and avarice, unmercifully exposed in life-sized figures, has here been translated into a dance of death culminating in man's self-destruction." Skull-helmeted Nazis—murderers and torturers—a moon-faced prostitute, mutilated victims, agonized infants, mitred clerics witnessing the atrocities in craven helplessness or bland complacency—these are among the dramatis personae of these drawings in which echoes of Goya's Disasters of War, Grünewald, George Grosz, and Otto Dix are given a new and terrifying immediacy. In Lasansky's words: "No matter how technologically advanced or sophisticated, when a man negates this divine right [to live in dignity] he not only becomes self-destructive, but castrates his history and poisons our future. That is what the 'Nazi Drawings' are about."

In protest against political repression in Argentina, Lasansky in 1966 declined an invitation to exhibit in the Rooms of Honor at the Third Biennial of Fine Arts, Córdoba. The latent anticlericalism in much Latin culture is reflected in such prints as the life-sized Pope and Cardinal (1966) and Pope and Crying Boy (1967), the latter composed of nine assembled plates. The prelates are seen as ominous, predatory yet haunted and guilt-ridden figures. A more optimistic and festive note appears in works of the late '60s and '70s dealing with Mexican themes. (Though still based in Iowa City, the artist and his family have acquired another residence, in Mexico.) In Oriental Image (1969), the "Bleeding Heart" prints of 1970, and especially Quetzalcoatl (1972), the blacks and browns have given way to primary colors, and fragmented images have been created by the fragmentation of the actual copper plates Quetzalcoatl is made up of 54 separate plates, many cut into irregular shapes. Young Nahua Dancer, begun in 1961 but not completed until 1973, has brilliant colors and is an outstanding example of Lasansky's extraordinary technical resourcefulness, his constantly renewed exploration of space and scale, and his determination to find the most expressive image possible. "In a sense," Alan Fern wrote, "Lasansky's whole life has been a search for freedom."

A proud and devoted family man, Mauricio Lasansky is the father of three boys and two girls. His eldest son, Guillermo Abraham, now an artist, was born in 1938; his other sons, Leonardo and Luis Phillip, were born in 1946 and 1954, respectively. His elder daughter, Rocio Aitana, was born in 1942, and Maria Jimena was born in 1947.

Lasansky is below medium height; a powerful and engaging personality belies a soft-spoken manner, and he is very much "his own man." His intensity is leavened by a sense of humor that is not without its ironic side. His shrewd insight into character and his ability to penetrate to the core of an artistic problem have contributed to his great success as a teacher—which matches his achievements as an artist. Even in the heyday of abstract expressionism he never abandoned his concern with the human figure. Lasansky's credo as artist and teacher is summed up in his statement of 1949: "The artist must be an inventor as well as a craftsman. He will combine the experience in printmaking techniques of the last four hundred years in one print—if it is necessary or desirable."

EXHIBITIONS INCLUDE: Fort General Roca, Rio Negro, Argentina 1935; Mueller Gal., Buenos Aires 1943; Whyte Gal., Washington, D.C. 1944; San Francisco Mus. of Art 1945; Chicago Art Inst. 1947; Des Moines Art Center, Iowa 1949; Walker Art Cntr., Minneapolis 1949; Honolulu Academy of Arts 1950; Mus. de Arte Contemporaneo, Madrid 1954; Mus. de Arte Moderno, Barcelona, Spain 1954; Univ. of Iowa Mus. of Art, Iowa City 1957; Traveling retrospective sponsored by Am. Federation of Arts, 1960–62; Brooklyn Mus., N.Y. 1961; Annual Exhibition, Pennsylvania Academy of Fine Art, Philadelphia ca. 1966; "The Nazi Drawings," Des Moines Art Center, Iowa 1966–67; "The Nazi Drawings," Philadelphia Mus. of Art 1966–67; "The Nazi Drawings," Univ. of Iowa Mus. of Art, Iowa City 1966–67; "The Nazi Drawings," Whitney Mus. of Am. Art, NYC 1966–67; "The Nazi Drawings," Palace of Fine Arts, Mexico City 1969; "The Nazi Drawings,"

Dickinson Col., Carlisle, Pa. 1974. GROUP EXHIBITIONS
INCLUDE: "A New Direction in Intaglio," Walker Art
Cntr., Minneapolis 1949; "Contemporary Art in the
U.S.," Worcester Art Mus., Mass. 1951; "75 Living
American Printmakers," Fairfield, Conn. 1953; Inter-
national Exhibition of Contemporary Gravure, Lju-
bljana, Yugoslavia 1955, '57, '63, '64, '67; Smithsonian
Instn. Traveling Show, Washington, D.C. 1956; Expo-
sition Bienal Interamericana de Pintura y Grabado en
México, Mexico City 1958; "Intaglios," Latin-
American Traveling Show 1959; "Contemporary
American Prints," Brooklyn Mus., N.Y. 1959–60;
"American Prints: 1950–60," Yale Univ. Art Gal., New
Haven, Conn. 1960; "Lasansky and His Students,"
sponsored by U.S. Information Agency and the Pali-
sades Foundation, toured Germany, Austria, and Italy
1963; New York World's Fair, Flushing Meadows
1964–65; "The Artist as His Subject," MOMA, NYC
1967; British International Print Show, Bradford, En-
gland 1969; Venice Biennale 1970; "Graphik der
Welt," Albertina, Vienna 1971; "Oversize Prints,"
Whitney Mus. of Am. Art, NYC 1971; "American
Prints: '72," Iowa State Univ., Ames 1972; Internation-
al Biennial Exhibition, San Juan, Puerto Rico 1974.

COLLECTIONS INCLUDE: MOMA, Whitney Mus. of Am.
Art, and New York Public Library, NYC; Syracuse
Univ., N.Y.; Yale Univ., New Haven, Conn.; Philadel-
phia Mus. of Art, and Pennsylvania Academy of Fine
Arts, Philadelphia; Nat. Gal. of Art, and Library of
Congress, Washington, D.C.; Cleveland Mus., Cincin-
nati Art Mus., Art Inst. of Chicago; William Rockhill
Nelson Gal., of Art, Kansas City, Mo.; City Art Mus.,
St. Louis, Mo.; Walker Art Cntr., Minneapolis; Univ.
of Iowa Mus. of Art, Iowa City; Des Moines Art Cntr.,
Iowa; Indiana Univ., Bloomington; Louisiana State
Univ., Baton Rouge; Pasadena Art Mus., Calif.; San
Francisco Art Association; Art Inst. of Los Angeles; Se-
attle Mus., Wash.; Mus. Nacional de Bellas Artes, and
Mus. Municipal, Buenos Aires; Mus. Municipal and
Mus. Provincial de Córdoba, Argentina; Uffizi Gal.,
Florence; Victoria Mus., Melbourne, Australia.

ABOUT: Arnold, P. The Influence of Lasansky on Print-
making in the U.S., 1955 (MFA thesis, Univ. of Minne-
sota, Minneapolis-St. Paul); Fern, A. and others,
Lasansky: Printmaker, 1975; Friedman, W.M. and
others "A New Direction in Intaglio" (cat.), Walker Art
Center, Minneapolis, 1949; Hayter, S.W. New Ways of
Gravure, 1949, About Prints, 1962; Lieberman, W.
Masters of Modern Art, 1954; Lindemann, G. Prints
and Drawings: A Pictorial History, 1970; McNulty, K.
and others, The Nazi Drawings, 1966; Zigrosser, C.
Prints and Their Creators—A World History, 1974.
Periodicals—Art Digest November 1951; Look Febru-
ary 21, 1967; Revista (Barcelona) April 1954; Time De-
cember 1, 1961.

*LASSAW, IBRAM (May 4, 1913–), Ameri-
can sculptor, writes: "In 1905, during a period of
Czarist oppression and pogroms, my father fled
to the United States and worked in Texas and

Photo by Arnold Newman

IBRAM LASSAW

New York. After a few years he returned to
Odessa, Russia, and married his childhood
sweetheart. They immigrated to Alexandria,
Egypt, where my father worked as an accoun-
tant for an English firm. It was in Alexandria
that I was born and attended my first school, a
French Lycée where I remember singing, 'Nous
sommes des petits soldats de France' in class. In
1921, when I was eight years old, my parents,
my younger sister, and I moved to the United
States.

"From my earliest memories I was always
modeling in clay. One day in 1926, I was visiting
the Brooklyn Children's Museum and noticed
they were offering a sculpture class for children
on Saturday mornings. I joined immediately.
The teacher was Dorothea Denslow, a young
sculptor who had studied with Leo Lentelli and
at the Art Students League. From that time on
I knew I would be a sculptor.

"During high school and college (College of
the City of New York) I attended classes at the
Beaux-Arts Institute of Design in New York. By
1933 I had left college and set myself up in a
Greenwich Village cold-water flat-loft. That
same year my work became exclusively abstract
open-space sculpture. Since 14 I had read all the
books on the history of art and soon became in-
terested in current directions. I haunted the mu-
seums and galleries, and read the new issues of
Cahiers d'art and Les Formes at the art reading
room of the New York Public Library. I was in-
fluenced by the works of many modern artists,
including Brancusi, González, Lipchitz, the Rus-
sian Constructivists, and others.

"To me the frontier of sculpture was in the di-

°las´ sô, ib răm´

rection of 'open-space,' opening up and entering completely into the solid monolithic mass. My contribution to sculpture is concerned exclusively with the penetration of space, or 'deep space.' From my earliest years I have had a great interest in science—the structure of things, the atom, cosmology, etc. In art school one studied nature, e.g., the human body; but I am inspired by the structure of all nature—stars, galaxies, subatomic particles, as well as our intimate physical world. I have pondered the seemingly subtle interrelationships of all parts of the universe, which led me to an appreciation of the philosophies and religions projected by mankind.

"During the thirties I was employed by the WPA arts projects in New York. Amazingly, I was free to experiment in the abstract direction, and produced many sculptures that art critics and the public of that time considered 'crazy' or incomprehensible. I am eternally grateful for that freedom. The sculptures were assigned to public buildings but I have never learned what became of them. In April 1942 I was drafted into the armed forces of the United States and had to resign from the arts project.

"After leaving the army, I again took a studio in Greenwich Village. In 1944 I was married to Ernestine Blumberg; we had a daughter, Denise. We lived in a large, bare industrial loft which we converted into bedroom, kitchen, living room, and studio, having no closed walls but open shelf divisions much in the style of present lofts which artists convert. I worked in my studio, welding sculptures to the sounds of music from my large record collection, Bach, Vivaldi, etc. It was the open space of contrapuntal sound interrelationships that inspired me.

"Although I exhibited in group exhibitions from the 1930s and was included in Whitney Museum exhibitions, no one bought my work before 1950. I was a founding member of the American Abstract Artists. Our friends were painters, sculptors, musicians, and writers such as William de Kooning, David Smith, John Cage, David Hare, and Harold Rosenberg. In 1949 a group of artists founded what was always known only as The Club. The sculptor Philip Paviar ented a loft for our first meeting place. It was there that the phrase 'Abstract Expressionism' was first used.

"In 1951, I had my first one-man show at the Kootz Gallery and after that my work began to sell more or less regularly. By 1954, we bought some land in East Hampton, New York, where we built a house and studio and where we still live. Many artists such as Balcomb Greene, James Brooks, Jackson Pollock, Marca-Relli, and numerous others had begun to move to this area,

making it for the second time in its history beloved of artists."

————

In the early 1930s, supported by the Works Progress Administration's Federal Arts Project, Lassaw became one of the first Americans to construct abstract sculpture. In 1936 he was a founder of American Abstract Artists (AAA), an association of younger New York painters and sculptors who fought for local recognition of avant-garde art styles. Lassaw served as president of AAA from 1946 to '49.

In the early 1950s Lassaw's open forms became more and more expressive, and, along with Theodore Roszak and Herbert Ferber, he was recognized as a leading New York School sculptor whose work paralleled developments in abstract expressionist painting. Later he was influenced by the teachings of Eastern mysticism, and his sculpture reflected the serenity valued in that philosophy.

In the catalog to the "12 Americans" exhibition at the Museum of Modern Art, New York City, in 1956, Dorothy C. Miller drew attention to Lassaw's Mediterranean heritage and to the influence of Near Eastern sources; she noted that he had "developed, very early, a purely abstract 'space' sculpture in plastics, wood, and metal, later in welded metals." In *Late Modern* Edward Lucie-Smith compared Lassaw's "open, rather calligraphic work" to "the strokes of abstract expressionist brushwork, transferred to a different medium."

Lassaw's major works include *Pillar of Fire,* an architectural commission for the Beth El Temple, Providence, Rhode Island; *Monoceros* (1952; MOMA); and *Theme and Variations* (1957; Albright-Knox Art Gallery, Buffalo, New York). In the *Dictionary of Twentieth Century Art* (1974) Bernard S. Myers wrote that Lassaw is important for "his urban-inspired space cages of soldered metal and for his metaphorical imagery." In *American Art of the Twentieth Century* (1973) Sam Hunter said that the intellectual currents contributing to the theoretical basis of Lassaw's art include "Taoist and Zen teachings, the psychology of Jung, and other non-rational sources. . . . Few artist have made more personal and poetic statements in sculpture out of the collective impulse of abstract expressionism than Ibram Lassaw." Hunter was impressed by "the ideal calm which Lassaw's personal presence radiates."

EXHIBITIONS INCLUDE: Kootz Gal., NYC 1951–64; Massachusetts Inst. of Technology 1957; Gal. Claude Bernard, Paris 1960; Duke Univ., Durham, N.C. 1963;

Albright-Knox Art Gal., Buffalo, N.Y. 1964; Benson Gal., E. Hampton, N.Y. 1966; Sachs Gal., NYC 1967; Gertrude Kasle Gal., Detroit 1968; Carnegie Mellon Univ., Pittsburgh 1969; Parish Art Mus., Southampton, N.Y. 1970; Heckscher Mus., Huntington, N.Y. 1973; Zabriskie Gal., NYC 1977. GROUP EXHIBITIONS INCLUDE: Salon des Réalités Nouvelles, Paris 1950; "Abstract Painting and Sculpture in America," MOMA, NYC 1951; "Sculpture of the Twentieth Century," MOMA, NYC 1952; Venice Biennale 1954; "The New Decade," Whitney Mus. of Am. Art, NYC 1955; "Modern Art in the United States," Tate Gal., London 1956; "Twelve Americans," MOMA, NYC 1956; São Paulo Bienal 1957;Am. Pavilion, Brussels World's Fair 1958; Pittsburg International 1958 (and most subsequent annuals); Documenta 2, Kassel, W. Ger., 1959; "Paths of Abstract Art," Cleveland Mus. of Art 1960; "Art Since 1950," Seattle World's Fair 1962; "Sculpture of our Time," Washington Gal. of Modern Art, Washington, D.C. 1963; "United States Sculpture of the Twentieth Century," Mus. Rodin, Paris 1965; "International Exhibition of Art," Israel Mus., Jerusalem 1965; "Art of the United States 1670–1966," Whitney Mus. of Am. Art, NYC 1966; "The American Painting and Sculpture—First Generation," MOMA, NYC 1969; "Drawing in Space: 19 American Sculptures," Katonah Gal., Katonah, N.Y. 1972; "Sculpture—American Directions 1945–75," Nat. Collection of the Fine Arts, Smithsonian Inst., Washington, D.C. 1975; "The Golden Door: Artist-Immigrants 1876–1976," Hirshhorn Mus. and Sculpture Garden, Washington, D.C. 1976; "Twentieth Century American Drawings," Whitney Mus. of Am. Art, NYC 1978.

COLLECTIONS INCLUDE: MOMA and Whitney Mus. of Am. Art, NYC; Brooklyn Mus. of Art, N.Y.; Albright-Knox Art Gal., Buffalo, N.Y.; Newark Mus., N.J.; Wadsworth Atheneum, Hartford, Conn.; Fogg Mus., Harvard Univ., Cambridge, Mass.; Mus. of Fine Arts, Springfield, Mass.; Worcester Art Mus., Mass.; Williams Col., Williamstown, Mass.; Nat. Collection of Fine Arts, Smithsonian Inst., Washington, D.C.; Baltimore Mus. of Art; Carnegie Mellon Univ., Pittsburgh; Wichita Art Mus., Kans.; Univ. of North Carolina, Greensboro; Univ. of Berkeley Mus., Calif.; Mus. of Modern Art, Rio de Janeiro; Peggy Guggenheim Collection, Venice; Israel Mus., Jerusalem; Birla Mus., Calcutta, India.

ABOUT: Ashton, D. The New York School, 1971; Baur, J.I. (ed.) "Nature in Abstraction" (cat.), Whitney Mus. of Am. Art, NYC, 1958; Hunter, S. American Art of the Twentieth Century, 1973; Lucie-Smith, E. Late Modern: The Visual Arts Since 1945, 1969; Miller, D.C. (ed.) "Twelve Americans" (cat.) MOMA, NYC, 1956; Motherwell, R. and others Modern Artists in America, 1951; Myers, Bernard S. and others, Dictionary of Twentieth Century Art, 1974 ; Ritchie, A.C. "Abstract Painting and Sculpture in America (cat.), MOMA, NYC, 1951, "Sculpture of the Twentieth Century" (cat.), MOMA, NYC, 1952; Rose, B. American Art Since 1900, 2d ed. 1975; Rosenberg, H. The Anxious Object, 1964; Selz, J. Modern Sculpture, 1963.

LAURENS, HENRI (February 18, 1885–May 5, 1954), French sculptor, painter, and illustrator, was best known for his sculpture in the cubist style. He was born into a working-class family in Paris. After attending Bernard de Palissy's school of decorative arts, he served as an apprentice in a decorator's workshop, making realistic terra-cotta figurines. From 1988 to 1906 he took drawing classes in the evenings with the academic sculptor Jacques Perrin. His next employment was as an ornamental stonecutter. Laurens's first independent work was done under the influence of the master, Auguste Rodin. In 1911 he met the painter Georges Braque (they remained close friends for life), who introduced him to cubism, it is reported, by making drawings in the new style on the walls of Laurens's studio. With Jacques Lipchitz, Laurens is acknowledged as one of the pioneers in adapting cubism to sculpture, working at first with papiers collés (pasted papers) and constructions analogous to the ones being created by Braque and Picasso. He was included in the Salon des Indépendants, Paris, in 1913 and '14. He has his first solo show in 1916, and in 1921 Daniel-Henri Kahnweiler became his dealer. Admired by members of the postcubist Purist movement for the crystalline perfection of his style, Laurens was chosen by them in 1925 to exhibit his work in the Pavillon de l'esprit nouveau designed by the architect Le Corbusier for the Paris Exhibition of Decorative Arts. After 1925, however, in an effort to attain greater freedom of form, Laurens abandoned cubism and proceeded to create more naturalistic organic shapes.

Between 1902 and 1905 Laurens established himself in a Montmartre studio with his wife, Marthe Duverger. From this early period there exist a charcoal drawn *Self-Portrait* (1905) and a sculpture of his wife that indicates Rodin's influence. Thereafter he worked to liberate himself from the academic style. How far he had succeeded by 1912 may be surmised from a photograph of a now lost tombstone figure created for his mother's grave. The draped female torso, while it appears to lack traditional subtleties of modeling, retains traditional proportions and mass.

Because of a bone malady, one of Laurens's legs had to be amputated in 1914 and he was exempted from service in World War I; for the rest of his life he was frequently in severe pain. His first works in the cubist style, small painted figures in wood and plaster, date from about 1915, several years after his initial meeting with Braque. Taking both medium and subject matter—largely still-life arrangements—from cubist painting, the sculptor produced papiers collés such as *Dish with Grapes* and painted wood con-

structions such as that of a wine bottle (1916). Between 1916 and '18 he produced a number of corner-shaped reliefs constructed in wood and cardboard; the back planes meet at an angle and thus keep the constructions upright and self-supporting. Among these are *Woman with a Mantilla* (1918); like the earlier free-standing *Clown* (ca. 1914) it is a wittily bizarre allusion to visage and figure by means of an assemblage of intersecting geometrical forms: triangles, cones, cylinders, and circles. A construction in sheet iron painted red and black (1914) is one of his earliest works in metal and his first purely abstract sculpture.

The use of color, in fact, was particularly significant in Laurens's oeuvre up to about 1928. Different colors, without naturalistic reference, were applied to each plane in order to emphasize and distinguish them, as in the painted wood *Head* (1915–18). As he stated: "I wanted to do away with variations of light and, by means of color, to fix once and for all the relationship of the components, so that a red volume remains red regardless of the light. For me, polychrome is the interior light of the sculpture."

Between 1919 and '24 Laurens worked on relief sculptures in terra cotta, wood, and stone, and also did some spare, linear, cubist-inspired ink drawings. Toward 1921, however, a tendency to curved forms, as opposed to the hard, angular planes of cubism, began to manifest itself and by 1925 he had definitely evolved a new style and subject matter. Figures of women, emphasizing volumes and the sensuous, undulating contours of their bodies, thereafter dominated his work. He also worked in the more conventional materials of stone and bronze, which gave his pieces a traditional sculptural solidity and monumentality. A last cubist construction, however, dates from about a decade after this. In 1936–37 he devised a hanging construction of wood, cardboard, and metal (now lost) for a pavilion built by Le Corbusier for the Paris World's Fair.

Examples of Laurens's postcubist style range from *Crouching Woman* (1931), a blocky abstract in wood, to *The Earth* and *The Water* (1937), large terra-cotta reliefs for the Paris World's Fair, to *Siren* (1941), a bronze figure, and to *Luna* (1948), a kneeling form, her hand raised above her head, executed in marble. *Reclining Woman with Raised Arms*, a bronze of 1949, has affinities with Matisse's sculpture and painting.

Throughout most of his life Laurens was hard pressed financially and frequently was obliged to make small terra-cotta pieces—instead of bronzes—for quick sale by his agent. In 1927,

however, he was able to move to a little cottage, the Villa Brune, near the Porte de Chatillon. Here, a larger studio and a garden gave him room to work in stone and bronze (when he could, he used the latter material more and more frequently). Between 1932 and '33 the sculptor and his wife spent half the year at Etang-la-ville, not far from Paris, and near the studio of the sculptor Aristide Maillol. It was here that Laurens began work on his first truly monumental pieces, the *Oceanid* and the *Undine;* both exist in smaller versions as well. A first trip to the seaside, in 1937, confirmed his interest in marine-inspired forms, and he began his series of figures of "Sirens" (1937–38).

Besides his work as a sculptor, Laurens designed the set for *Le Train bleu* for Sergei Daighilev's Ballets-Russes in 1925; executed, between 1926 and '31, various decorative commissions; and did numerous drawings and graphics for books, beginning in 1917 with illustrations for *Poèmes en prose* (Prose poems) by his friend Pierre Reverdy. Rarely among Laurens's work in any medium is there an expression of disturbing, negative emotions. Terror and violence are, however, evoked in "Les Fusillés" (1939–44, The Executed), a series of dry-point etchings, one of which he used as an illustration for Paul Eluard's poem *La Dernière nuit* (1942, The Last Night). Increasingly, the trajic events of the Second World War had a profound effect on Laurens's work. He remained in Paris throughout the German occupation, and like Picasso was under constant surveillance by the Gestapo and forbidden to exhibit. More than ever he was pressed to make ends meet. While *The Flag* (1939), a seated figure, is considered to express hope for a French victory, *The Farewell* (bronze version, 1941)—a huddled female shape, folded in on herself—alludes to the fall of France; in 1955 this moving, despairing figure was placed on the artist's grave in the cemetery at Montparnasse. *Woman Flower* (1942), whose spiky, extended fingers protect her face, probably also refers to the horrors of the war years, while *Dawn* (1944) expresses the joy of the Liberation, in celebration of which Laurens and Picasso were both invited to exhibit at the Salon d'Automne of that year. The tormented reclining *Archangel* of 1946 was conceived as a memorial (not completed) to his friend, the writer Max Jacob, who had perished in a concentration camp. One of Laurens's last commissions was for a tabernacle and alter for the church of the Dominicans of Saulchoir (1950).

Henri Laurens has been lovingly eulogized by his friend, the art dealer Daniel-Henri Kahnweiler, in an essay included in Werner Hofmann's 1970 monograph on the sculptor. As

described by Kahnweiler, Laurens was a sweet and gentle person who lived always simply and modestly, working on despite poverty, physical pain, and the dangers of wartime Paris. Throughout his life he derived special pleasure from music, and enjoyed the friendship of a wide circle of artists, musicians, and writers. One of Kahnweiler's moving anecdotes relates how, when Laurens failed to receive the sculpture prize at the 1950 Venice Biennale, Henri Matisse shared his painting prize with him, and then Laurens was feted at a great dinner organized by his artist friends. The joyous innocence of most of his work bespeaks the serene nature of its creator and is carried through into the creations of his last years: *The Female Centaur* (1953) and *The Little Spaniard* (1954), both sprightly bronze figures. On May 8, 1954, while taking a walk to relax from his work, Laurens died suddenly. As his wife has recorded, "He . . . died amongst the people in the street, whom he had loved so much."

EXHIBITIONS INCLUDE: Gal. de l'Effort Moderne, Paris 1916; Brummer Gal. NYC 1938; Arts Club of Chicago 1941; Buchholz Gal., NYC 1947; Palais des Beaux-Arts, Brussels 1949; Mus. Nat. d'Art Moderne, Paris 1950; Curt Valentin Gal., NYC 1952; Traveling exhibition, Krefeld, W. Ger., Hamburg, Berlin, and Basel 1955–56; Grand Palais, Paris 1967. GROUP EXHIBITIONS INCLUDE: Salon des Indépendants, Paris 1913, '14; Pavillon de l'espirit nouveau, Paris Exhibition of Decorative Arts, 1925; Petit Palais, Paris 1937; Salon d'Automne, Paris 1944; Venice Biennale 1948, '50; São Paulo Bienal 1953; "Pioneers of Modern Sculpture," Haywood Gal., London 1973; "Modern European Sculpture 1918–1945," Albright-Knox Art Gal., Buffalo, N.Y. 1979.

COLLECTIONS INCLUDE: Mus. Nat. d'Art Moderne, and Grand Palais, Paris; MOMA, NYC; Albright-Knox Art Gal., Buffalo, N.Y; Hirshhorn Mus. and Sculpture Garden, Washington, D.C.; Stedelijk Mus., Amsterdam; Hanover Gal., London.

ABOUT: Cassou, J. "Henri Laurens" (cat.), Mus. Nat. d'Art Moderne, Paris, 1951; Elsen, A. Origins of Modern Sculpture: Pioneers and Premises, 1974, Modern European Sculpture 1918–1945: Unknown Beings and Other Realities, 1979; Giedion-Welcker, C. Contemporary Sculpture: An Evolution in Volume and Space, 2d ed. 1961; Goldscheider, C. Laurens, 1959; Hofmann, W. Henri, Laurens: Sculptor, 1970; Read, H. A Concise History of Modern Sculpture, 1964; Ritchie, A.C. Sculpture of the Twentieth Century, 1953; Rosenblum, R. Cubism and Twentieth-Century Art, 1976.

LAWRENCE, JACOB (September 7, 1917–), American painter, was the first black artist to be part of the modern movement in American painting. His inspiration has been drawn entirely from the black experience.

Born in Atlantic City, New Jersey, he was the eldest child of a broken family, and for years was shunted back and forth between his mother and his foster parents. In 1930 Jacob moved with his mother to New York City, where he was educated, though he quit high school after two years. His artistic education began at the Utopia Children's Home, a Harlem after-school center, where he was encouraged by a leading black artist and teacher, Charles Alston.

Through Alston, Lawrence began in 1930 to study at the Harlem Art Workshop, which was housed in the 135th Street Public Library. In the mid-1930s he attended classes taught by members of the Works Progress Administration's Federal Arts Project at a studio on 141st Street.

In 1936–37 Lawrence, unable to find other employment, worked for the New Deal-sponsored Civilian Conservation Corps. In 1937 he received a full-time scholarship to the American Artists School, where he studied for two years under Anton Refregier, Sol Wilson, and Eugene Moreley. In the mornings he worked at the school, but spent his afternoons in the 135th Street Library, which housed the famous Schomberg collection of books by and about blacks, reading voraciously about blacks who had made their mark in history. After a year he completed a narrative series of 20 gouaches on the life of Toussaint L'Ouverture, the liberator of Haiti. "I couldn't get it all in one picture," he later explained, "so I made it into a series." The Harmon Foundation purchased the entire set.

In 1938 Lawrence had his first solo show, at the Harlem YMCA, and later that year he was accepted into the Federal Arts Project. For 18 months he worked in the project's easel division, but the oils and gouaches he produced at that time have been lost. Lawrence's experience with the Arts Project was of critical importance. "It was my education," he said. "I met people like Saroyan, just on the edge of fame. They all used to talk about what was going on in the world. Not only about art, but everything."

The intense social consciousness of the WPA milieu further stimulated Lawrence's interest in the history of blacks in America. During and immediately after his months with the WPA he completed three series of paintings, pictorial biographies of Frederick Douglass (1939), the great abolitionist and orator; Harriet Tubman (1940), the black Civil War heroine active in the Underground Railroad; and the white abolitionist John Brown (1941).

Photo courtesy of Terry Dintenfass Gallery, NYC

JACOB LAWRENCE

In 1940 Lawrence, whose reputation was enhanced by two solo exhibitions, at the Baltimore Museum of Art in 1939 and at Columbia University New York City, in 1940, was awarded a Rosenwald Foundation fellowship which allowed him to travel and paint. About this time he became ambitious beyond the anecdotal and the biographical, and began to portray the plight of the blacks as a group. In 1940 and 1941 he worked on one of his best-known series. " . . . And the Migrants Kept Coming," 60 gouaches (gouache was a favorite medium) dealing with the experiences of black migrants who left the rural South during and after World War I to look for jobs in the industrial North. The series showed the suffering and disillusion of these immigrants in their struggle for survival. The figures were reduced to flat patterns in a manner recalling Ben Shahn, but without that realist's sophistication. "He combines bright, often raw color with neutrals and sharp browns and blacks," one critic wrote of Lawrence's style and approach, "giving his social themes a symbolic sense and relieving them of the taint of sentimentality."

In late 1941 Lawrence was in New Orleans, doing research and celebrating his recent marriage to the West Indian painter Gwendolyn Knight, when word came to him of the success of his first major solo exhibition at Edith Halpert's Downtown Gallery, New York City. Halpert, one of the leading art dealers in the US, showed all 60 "Migration of the Negro" paintings, and Lawrence was catapulted to art-world fame. *Fortune* magazine published a portfolio of color reproductions of 26 of the paintings, and

critical response to the show was overwhelmingly enthusiastic. Two museums—the Museum of Modern Art, New York City, and the Phillips Memorial Gallery (now the Phillips Collection), Washington D.C.—each purchased half of the 60 paintings, taking the even- and odd-numbered pictures respectively. In the fall of 1943 the entire series was exhibited at MOMA.

Acutely aware of the plight of impoverished blacks in an urban environment, Lawrence executed a series of 30 gouaches depicting life in Harlem. But when the series was exhibited at the Downtown Gallery in May 1943, the reviewer for *Art Digest* called Lawrence a "natural designer" and commented on the "cut-out kindergarten gaiety" of these works. Several pictures from the Harlem series were reproduced in *Vogue.*

In 1942 Lawrence participated in the Artists for Victory exhibition at the Metropolitan Museum of Art, New York City, and was awarded the watercolor prize. In November 1943 he enlisted in the Coast Guard as a steward's mate and was assigned to the Coast Guard station in St. Augustine, Florida. Shocked at the humiliating discrimination he and his wife experienced, he vented his bitterness in angry drawings very different from his usual compassionate approach. His next assignment, as a member of the Coast Guard's first racially integrated crew, on the weather-patrol ship *Sea Cloud* was more fortunate, and he has referred to that wartime experience as "the best democracy I've ever known." Encouraged by the captain of the *Sea Cloud,* who helped him obtain the rank of petty officer, third class, Lawrence was given enough free time to produce a documentary series of eight paintings on life in the Coast Guard. His theme was the unity of blacks and whites in the face of war. The Coast Guard pictures were shown at MOMA and were later exhibited throughout the US.

In December 1945, shortly after his discharge from the Coast Guard, Lawrence showed his "John Brown" series at the Downtown Gallery. After being circulated nationally by the American Federation of Arts, the entire series was purchased by Milton Lowenthal, a discriminating collector of modern American painting, and is now in the Detroit Institute of Arts.

In 1946 Lawrence was awarded a Guggenheim Foundation fellowship and began work on a series of 14 paintings in tempera on the theme of war. When they were exhibited in the Downtown Gallery in December 1947, a *New York Times* critic called them "a unique individual reaction to the world crisis." The series is now in the Whitney Museum of American Art, New

York City. *Fortune* magazine commissioned Lawrence in 1947 to travel through the South to record the effects of industrialization on the black population. The resultant ten pictures were reproduced in *Fortune* in August 1948. About that time Lawrence illustrated *One Way Ticket* (1949), a book by the black poet Langston Hughes.

In October 1949 Lawrence, suffering from nervous depression, voluntarily entered a mental hospital in New York City to undergo therapy. After being discharged in July 1950, he worked on a series of paintings depicting hospital life. Despite the somber subject matter, these paintings, executed in casein, were lighter in tone than his earlier work and less jagged and busy in pattern. When they were exhibited at the Downtown Gallery, one reviewer wrote that the paintings "bring into vivid focus the dark underside of man's emotional life as it is revealed under clinical conditions."

In a more lighthearted vein, Lawrence painted *Vaudeville*, based on youthful memories of the legendary Apollo Theatre in Harlem. A Chapelbrook Foundation fellowship awarded in 1955 enabled him to embark on an enormous 60-panel series, "Struggle: From the History of the American People." The paintings were executed in egg-tempera, which Lawrence has described as "a brush medium that cannot be manipulated like oil. You have to get it all right down; you cannot linger over it." Like much of his work, the "Struggle" series was an intensely personal history, often accompanied by lengthy written texts. Thirty of the paintings, covering incidents from the Revolutionary War onwards, were exhibited in January 1957 at the Alan Gallery, New York City.

Much of Lawrence's work in the late 1950s and early '60s dealt with the ordeal of desegregation in the South. "Ordeal of Alice," among the works exhibited at the Terry Dintenfass Gallery, New York City, in the spring of 1963, was a dreamlike study of a young black schoolgirl surrounded by nightmarish figures representing her antiintegrationist tormentors. Lawrence commented: "You and I may be frustrated. But maybe we have the insight to work it out. These people have no insight. It's said that they're that way. They're worse off than the girl."

In 1964 Lawrence traveled to Nigeria and returned with a group of paintings inspired by that visit. When they were shown at the Dintenfass Gallery in January 1965, a New York *Herald Tribune* critic called the works "freer in form and mood than in the past. . . . His composition is much airier, relaxed [and] reveals a new note of fantasy." Jacob Lawrence in 1970 was pres-

ented by the National Association for the Advancement of Colored People with its highest award, the Spingarn Medal, for "his eminence among American painters" and for "the compelling power of his work, which has opened to the world . . . a window on the Negro condition in the United States."

Throughout his career Lawrence had been a teacher, at the experimental Black Mountain College in North Carolina in 1946; at Brandeis University, Waltham, Massachusetts, as an artist-in-residence in 1965; and at the Pratt Institute, Brooklyn, in 1970–71, where he was coordinator of the arts and assistant to the Dean of the Art School. Since 1972 he has been teaching at the University of Washington, Seattle, where he and his wife reside.

Jacob Lawrence is a quiet, thoughtful man, with brown eyes and black close-cropped hair, now graying. His favorite recreations are playing chess and listening to music. "The human subject," he once said, "is the most important thing," and he summed up his artistic beliefs in these words: "To perfect my craft, I study and experiment. . . . I try to observe to my fullest capacity the life and people around me. . . . " Although resisting labels, he has said, "In form and content I am considered an Expressionist and/or Social Realist," and he affirms that "the content of my work is mainly of the Black experience."

EXHIBITIONS INCLUDE: Harlem YMCA, NYC 1938; Baltimore Mus. of Art 1939; Columbia Univ., NYC 1940; Downtown Gal., NYC 1940–53; Portland Mus. of Art, Oreg. 1943; "Migration of the Negro" series, MOMA, NYC 1943, '71; "John Brown" series, American Federation of Art Traveling show 1947; Alan Gal., NYC 1957; Traveling exhibition to Nigeria, organized by Am. Society of African Culture 1962; Terry Dintenfass Gal., NYC 1963, '65, '68, '73; Harlem Studio Mus., NYC 1969; Whitney Mus. of Am. Art, NYC 1974. GROUP EXHIBITIONS INCLUDE: "Artists for Victory," Metropolitan Mus. of Art, NYC 1942; Afro-Am. Art Pavilion, World's Fair, Spokane, Wash. 1974; "Fragments of American Life," Art Mus., Princeton Univ., N.J. 1976; San Jose Mus. of Art, Calif. 1976.

COLLECTIONS INCLUDE: Metropolitan Mus. of Art, MOMA, and Whitney Mus. of Am. Art, NYC; Brooklyn Mus., N.Y.; Phillips Collection, Smithsonian Inst., Hirshhorn Mus. and Sculpture Garden, and Howard Univ., Washington, D.C.; Albright-Knox Gal., Buffalo, N.Y.; Philadelphia Mus. of Art; Mus. of Fine Arts, Boston; Brandeis Univ., Waltham, Mass.; Worcester Art Mus., Mass.; Detroit Inst. of Arts; Walker Art Center, Minneapolis; St. Louis Art Mus., Mo.; William Rockhill Nelson Gal., Kansas City, Mo.; Portland Art Mus., Oreg.; Univ. of Georgia, Athens; Arkansas Art Center, Little Rock; New Orleans Mus. of Art; Mus. of Fine Art, São Paulo; Vatican, Rome.

ABOUT: Baur, J.I.H. (ed.) New Art in America, 1957; Bearden, R. and others Six Black Masters of American Art, 1972; Brown, M. W. (ed.) "Jacob Lawrence" (cat.), Whitney Mus., NYC, 1974; Current Biography, 1965; Eliot, A. 300 Years of American Paintings, 1957; Fine, E. H. The Afro-American Artists: A Search for Identity, 1973; Gruskin, A. D. Painting in the U.S.A., 1946; Larkin, O.W. Art and Life in America, 2d ed. 1960; Lewis, S. and others (eds.) Black Artists on Art, 1971; Nordness, L. (ed.) Art: USA Now, 1962; Rodman, S. Conversations with Artists, 1957. *Periodicals*—Studio January 1961; Time February 24, 1961.

Photo by Anne Madden

LOUIS LE BROCQUY

***LE BROCQUY, LOUIS** (November 10, 1916–), Irish painter, writes: "In Ireland my name suggests Huguenot origin. In fact, my great-grandfather, Ange van den Eynde, came to this country as an officer in the Belgian Remonte in search of horses. He married a Kilkenny woman and my Walloon grandfather, Louis Le Brocquy, came later to marry their daughter. My mother's people were from Limerick and Galway; Norman stock, Cromwellian settlers— the Tribes of Galway. As Elizabeth Bowen perceived, Ireland makes Irish.

"I was born and lived in Dublin, but my childhood memories are of the magic wonder of the County Roscommon (a comparatively dull county) where my maternal grandfather lived. I was first stimulated, later unhappy, and finally bored, at a private, Catholic boarding school in County Wicklow. Meanwhile, I sometimes painted pictures without much enthusiasm.

"At 17 I vaguely considered studying architecture, but accepted a course of chemistry at Dublin University, simultaneously entering the Greenmount Oil Refinery, founded in Dublin by my paternal grandfather. After some three years there, I was quite unexpectedly impressed by the ancient European art of painting, largely from reproductions. In particular, Vermeer, Rembrandt, Velázquez, and Manet overwhelmed me. In 1938, I left Dublin suddenly to study on my own, and, with my father's best help, visited the London National Gallery, the Louvre, Venice, and the Prado Collection (then at Geneva). I got back to Ireland in 1940, where I made a precarious living, eventually painting the nation's apotheosis, the Irish Tinkers or *Travelling People*. Seven years later, these paintings had some success in London and I followed them, joining the new Gimpel Gallery and taking an active part in the London of the '50s, dominated by the art of Moore and Sutherland and including Lanyon, William Scott, Pasmore, Lucian Freud, and Bacon.

"Nineteen-fifty-eight found me in Carras, a remote village in the French Alpes-Maritimes (next to the even remoter village of Le Broc) and married to the young painter Anne Madden. There I have since worked quietly and ever more inwardly."

———

There are two main periods in the work of Louis Le Brocquy (his family name rhymes with "rocky"). Before 1955 his painting was influenced both in form and spirit by Picasso's synthetic cubism, but there was already a sense of human solitude, a theme that dominates his later work. His post-1955 painting showed at first an affinity with the *art informel* (art without form) of Jean Fautrier, but that manner of expressive abstraction soon gave way to the influence of Francis Bacon, an acquaintance of Le Brocquy. However, Le Brocquy's imagery expresses in a very personal way his concept of man as a solitary being. In *Male Presence* (1956) and *Willendorf Venus* (1964; Hirshhorn Museum and Sculpture Garden, Washington, D.C.) the rough, thickly textured human image is set in an ambiguous ground rendered in areas of smoother pigment, creating an effect not only of isolation but of what one critic called "presence-absence."

Le Brocquy is also a noted designer of textiles and tapestry. In 1940 he designed sets and costumes for the Gate Theatre and the Olympia Theatre, Dublin. In 1953 he executed mosaic commissions for the College of Further Education, Merthyr Tydfil, Wales, and for St. Ignatius Church, Galway, Ireland in 1957. He taught at the textile school of the Royal College of Art,

London, from 1954 to '57 and was elected a Fellow of the Society of Industrial Arts, Dublin, in 1960. Three years later he became a member of the Irish Council of Design.

Le Brocquy has exhibited at such prestigious institutions as the Tate Gallery, London, and the Salon de Mai, Paris, and he was represented in the Venice Biennale of 1956. In 1958 he was awarded a Guggenheim International Fellowship. He received an honorary doctor of literature degree from Dublin University in 1962 and in 1975 the French government made him a Chevalier de la légion d'honneur.

In recent years Le Brocquy has been producing serial portraits of William Butler Yeats, James Joyce, and Samuel Beckett. In the fall of 1983, Le Brocquy showed his recent series of portraits of Shakespeare (or, more precisely, of the traditional Shakespeare image, inasmuch as it is not known what Shakespeare really looked like) at the Gimpel & Weitzenhoffer Gallery, New York City.

French Embassy Press & Information Division, NYC

FERNAND LÉGER

EXHIBITIONS INCLUDE: Gimpel Fils, London from 1947; Leicester Gals., London 1948; Dawson Gal., Dublin 1962, '66, '69, '71; Municipal Gal. of Modern Art, Dublin 1966; Ulster Mus., Belfast 1967; Fondation Maeght, Saint-Paul-de-Vence, France 1973; Gal. Bossola, Turin 1974; Arts Council, Belfast 1976; Mus. d'Art Moderne de la Ville de Paris 1976. GROUP EXHIBITIONS INCLUDE: "40 Years of Modern Art." Inst. of Contemporary Arts, London 1948; Salon de Mai, Paris 1949; "Irish Painting," Inst. of Contemporary Art, Boston 1950; Venice Biennale 1956; "50 ans d'art moderne," Exposition Universelle et Internationale de Bruxelles, Belgium 1958; Carnegie International, Pittsburgh 1961, '64; "British Painting in the Sixties," Contemporary Art Society, Tate Gal., London 1963; "The Irish Imagination 1959–1971," Municipal Gal. of Modern Art, Dublin 1971–72.

COLLECTIONS INCLUDE: Nat. Gal., and Municipal Gal. of Modern Art, Dublin; Ulster Mus., Belfast; Tate Gal., and Victoria and Albert Mus., London; City Art Gal., Leeds, England; Mus. de Nantes, France; Fondation Maeght, Saint-Paul-de-Vence, France; Albright-Knox Art Gal. Buffalo, N.Y.; Hirshhorn Mus. and Sculpture Garden, Washington, D.C.; Detroit Inst. of Arts; Carnegie Inst., Pittsburgh; Univ. of Chicago Mus., and Chicago Arts Club; Mus. de Arte Moderna, São Paulo.

ABOUT: Gaunt, W. A Concise History of English Painting, 1964; Read, H. A Concise History of Modern Painting, 1959. *Periodical*—New York Times October 14, 1983.

LÉGER, FERNAND (February 4, 1881–August 17, 1955), French painter, was one of the major artists of the twentieth century. In addition to painting, Léger devised sets and costumes for ballets and operas, made movies, illustrated books, was a muralist, mosaicist, and ceramist, and a designer of stained glass and tapestries.

In its course, Léger's oeuvre embraced, and quickly discarded, impressionism, Cézanne's principles of the geometric basis of art, cubism, and purism. But his style was always his own, and favorite motifs were carried over from stage to stage. Characteristically, too, Léger worked in series; numerous related drawings, watercolors, gouaches, and oil studies (sometimes difficult to date in precise sequence) generally culminated in a large, more or less definitive statement of the theme in hand.

Fernand Léger was born on a farm in Argentan, Normandy, the son and grandson of peasants engaged in the raising of livestock. At the age of 16 Léger was apprenticed for two years to an architect in Caen, France, then in 1900 he worked in Paris as an architectural draftsman. In 1902 he served in a French army engineers unit; he returned to Paris in 1903, resumed work in an architect's office, and took a job as a photo retoucher. The practical mechanical knowledge acquired in these years was as important to the formation of Léger's style as were his art studies, which began in Paris, in 1903, at the Ecole des Arts Décoratifs, the Académie Julian, and (informally, since he did not pass the entrance examination) with Jean-Léon Gerôme and other teachers from the Ecole des Beaux-Arts.

Léger's development up to 1909 can only be surmised—he deliberately destroyed almost all his canvases from before that date in his desire to repudiate impressionism. Of this earliest period only a few paintings, such as *My Mother's*

°lä zhä´, fĕr´ nän

Garden (1905), survive. Another 1905 canvas, the geometrically articulated *Corsican Village at Sunset*—painted on a trip to that island to recuperate from illness—points to a new source of inspiration, the work of Cézanne. Léger undoubtedly saw the 1904 Paris Salon d'Automne Cézanne exhibition, and its impact would have been reinforced by the great 1907 Cézanne retrospective which had such crucial effect on so many young artists, notably Pablo Picasso and Georges Braque.

While these two painters, in 1907–08, were formulating cubism in their Montmartre studios, Léger was at work in his studio in La Ruche (the Beehive), across the Seine on Montparnasse. Here, in 1909, he painted *Woman Sewing*. His concern with rendering volumes composed of rigid planes (evidence of Cézanne's geometry), metallic in articulation and color, resulted in the creation of a robotlike figure, devoid of movement; only the pose suggests that the painting might have been inspired by a frequently observed attitude of the artist's mother. *Nudes in the Forest* (1910–11) certainly relies on Cézanne's spheres, cones, and cylinders. The woodsmen hewing trees and the felled trunks are reduced to machinelike shapes painted in somber machine tones of gray and green. The new interest here, however, is in movement; Léger himself called the painting "a battle of volumes," and in fact there are affinities with Uccello's *Battle of San Rommano.*

In 1910, with his friend the painter Robert Delaunay, Léger viewed the first cubist paintings of Braque and Picasso—what he termed "spider webs"—at Daniel-Henri Kahnweiler's gallery. This was also the time of the Paris publication of the Futurist manifestoes. Undoubtedly the Futurists' celebration of dynamism and modern technology reinforced Léger's own enthusiasms; but his interest was then and always in representing movement and machinery for themselves, whereas the Futurists went on to inject programmatic meaning into their work. As for cubism, Léger and his Montparnasse colleagues—among them Delaunay, Jacques Villon, Albert Gleizes, Jean Metzinger, Francis Picabia, Marie Laurencin, Henri Le Fauconnier, and Alexander Archipenko—developed their own less purely conceptual strain. Gathering at Villon's studio, they formed the Section d'Or (Golden Section) group, represented in the important Cubist exhibitions at the Salon des Indépendants, Paris, and the Salon d'Automne, Paris, in 1911 and 1912.

Among Léger's cubist-variant works were *Three Figures* (1910–11), *The Wedding* (1911), and *Nude Model in the Studio* (1912). In opposition to the disintegration of static forms that absorbed Picasso and Braque, he insisted on color and movement and the rendition of volumes in machine-turned cylindrical shapes. (In 1911 the critic Louis Vauxcelles waggishly pronounced his work not cubism but *tubism*.) Machinelike as the figures appeared, they were realized as objects, not as intellectualized concepts of figures.

With *Woman in Blue* (1912), which has been called one of Léger's closest approaches to cubist painting, pure color begins to be introduced into his palette, to create form and give movement. Perhaps this was a resurfacing of previously rejected fauvist influence. Geometric areas of pure blue and red, enclosed within tightly drawn lines, are superimposed over the seated figure. For the first time, as Léger put it, he tried "to liberate pure color in space." The effort continued over the years, beginning in 1913 and 1914 with a series of paintings conceived as purely visual experiences and generally grouped under the series title "Contrast of Forms." The works so entitled, both dated 1913, are almost abstract assemblages of cylindrical and conical volumes in brightly highlighted primary colors, cascading down the picture plane. The series also includes works in which form is more recognizable: *The Staircase* (1913), *Woman in Red and Green* (1915), and *Village in the Forest* (1914).

Public recognition came to Léger in 1913. He signed his first contract with the dealer Kahnweiler; gave his first lecture, at the Académie Wassilieff where he discussed the origins of contemporary painting; and was praised for his "agreeable and happy simplicity" in Guillaume Apollinaire's book, *The Cubist Painters.* In this year also *Three Figures* was shown at the famous Armory Show in New York City.

The outbreak of World War I put an abrupt end to all this. From 1914 to 1917 Léger served in the French army as a sapper and an ambulance bearer, with no opportunity for more than quick pencil sketches of the *poilus* for whom he developed an abiding sympathy. Some of these informal drawings of soldiers in action have survived. Gassed at Verdun, Léger was discharged, and with this entered a new phase, his mechanical period. During the war, as he recalled, he had been "dazzled by a breech of a 75 [artillery weapon] in full sunlight, [by the] magic of light on the bare metal." The visual experience, he felt, did more for his stylistic development than all the museums in the world. This turning point in his career is summed up in *The Card Players* (1917), in which the figures of *poilus* and officers, intently playing a card game, are transmuted into metallic objects of war: guns, cartridge

clips, tanks. Léger's response to the war had nothing in common with the Italian Futurists' protofascist glorification of militarism and violence. Léger was always a man of the left and a man of peace.

The beauty of machines seduced him, but Léger insisted that, instead of merely copying them, he "invented images of machines, for there was never any question in plastic art, in poetry, in music, of representing anything." Paintings done after his return to Paris in 1918 such as *The Propellers* (1918) and *The Typographer* (1919) are composed of allusions to machine parts modeled in color, arrayed against suggestions of mechanical or architectural supports. Léger completed his great masterpiece, *The City*, in 1919. A montage of literal renditions of parts of industrial structures, signs, and robot figures, in brilliant colors used to suggest depth, it was painted with what Robert Rosenblum in *Cubism and Twentieth-Century Art* termed an "impersonal perfection" suited to its theme. Although Léger had not yet visited the United States, *The City* suggests an American rather than a European urban environment. Some years later the American artist Stuart Davis called Léger "the most American painter painting today."

The Mechanic (1920) reintroduces the human figure, the creator of these machines, into Léger's work. The composition can be regarded in several ways. Most immediately, perhaps, it recalls the bold naiveté of the paintings of Henri Rousseau, whose truly original, primitive style had much fascination for Léger. Again, the composition, a rounded human form superimposed upon a matrix of flat color planes, can be regarded as another of Léger's studies in contrasts. A third element is at work here as well, for the mechanic, sharply profiled, is projected from and dominates his background, as in a movie closeup shot. The device, a way of giving an object "a personality it never had before, . . . new lyric and plastic power," became a favorite of the artist's; it was exploited to the full in such a work as *Nude on a Red Background* (1927). In 1916 Apollinaire had taken Léger to see his first Charlie Chaplin film; from then on movie making was a vital part of his life.

"For me," Léger declared, "the human figure . . . has no more importance than keys or bicycles." The paintings that followed *The Mechanic*—such as *Three Women* (1921), *Woman and Child* (1922), and *The Readers* (1924)—bear out Léger's admission. The great bodies, as expressionless and interchangeable as machines, with hair resembling lengths of sheet metal, are superimposed on geometrically or-dered backgrounds and surrounded by machine-made objects no less inert than they are. For all the modernness and abstraction of these works, they have their origin in French classical painting, the work of Poussin, David, or Ingres, or, even further back, in the blocky frontality and impassivity of ancient sculpture. Many of Léger's contemporaries, certainly Picasso, were similarly attempting to emulate the calm and balance of classical composition.

At the same time Léger was also reflecting in his work the somewhat analogous aesthetic principles of purism, as formulated by the painter Amédée Ozenfant and the painter-architect Le Corbusier. They called for an art suited to the new machine age, ordered compositions of functional objects, painted in low-key colors. Although Léger later discounted the influence of this movement, saying that purism was "a closed world," and "too meager" for him, it was with Ozenfant (and Marie Laurencin) that, in 1924, he opened the first of his ateliers; and one of his still lifes, *The Baluster* (1925), was hung in a demonstration house built by Le Corbusier for the International Exhibition of Decorative Arts held in Paris in 1926.

Léger's modifications of purism resulted in the elegant, if austere, geometric precision of *The Great Tug* (1923)—the boat shown poised against Seine river factories—and still lifes such as *The Siphon* (1924), in which a disembodied hand (again the movie closeup shot) working the lever becomes part of the soda-bottle mechanism. In 1924 Léger also made *Le Ballet mécanique,* a 15-minute film sequence, without scenario, simply of objects or parts of objects like machine parts in motion.

A series of "Mural Compositions" (1924–25) were designed to harmonize with purist-inspired architecture, evoking calm and balance with flat planes in muted colors, for "pure color," Léger now argued, "is capable of destroying a wall." These paintings represent his closest approach to the kind of abstraction characteristic of Piet Mondrian. They are also distinguished by their use of a compositional device akin to the cinematic quick cut. The design is divided, the forms dislocated and repeated, so that there is a sensation of flickering movement back and forth into space. This Léger termed "the new realism," the result of the speed of modern life which allows the eye only enough time to take in fragments of an image.

By the end of the 1920s Léger was, as he put it, trying to free objects in space. His brief, quasi-surrealist period in the early 1930s is related to this aim rather than to any attempt to produce a hallucinatory effect. Thus, in his *Mona Lisa*

with Keys (1930), a great key ring, a can of sardines, and a replica of Leonardo's famous portrait hang suspended in pictorial space, isolated from one another, their odd assemblage simply reinforcing their own individual realities. By the 1930s objects of the nonmechanized world, the enduring features of the countryside such as cows, trees and roots, earth and hills, became important in his pictorial repertoire. In *Woman Bathing* (1931) and *The Forest* (1936), natural forms, precisely arranged, are clearly represented.

Despite Léger's extensive travel for lectures and exhibitions throughout Europe, and in 1931, 1935, and 1938–39 to the United States, his work, so the artist contended, "continues and develops absolutely independently of my geographic location." This disclaimer notwithstanding, the war years (1940–45) spent in exile in America did change his painting. Certainly, he admitted, "I painted in American better than I have ever painted before"; over 120 large canvases, with many preparatory drawings and studies attest to the stimulating effect of his new surroundings. Most important, he developed a new way of freeing color in space; the concept henceforth affected both his easel paintings and his murals. In Marseilles, just before he left France, the artist had seen a group of dockworkers swimming in the harbor. "Struck by the intensity of the contrasts of movement," he recalled, he began the "Divers" series, largely completed in America. Canvases such as *The Polychrome Divers* (1942–46) explore the movements of figures seen from all angles as they leap into the water, limbs and bodies revolving in a complex geometric pattern. The way bands of primary colors play over the figures was based upon an observation made in New York City, where he had been "struck by the neon advertisements flashing all over Broadway. You are there, you talk to someone, and all of a sudden he turns blue. Then the color fades—another one comes and turns him red or yellow. The color . . . is free: it exists in space. I wanted to do the same in my canvases. . . . I could never have invented it. I am not capable of such fantasies."

Léger was an inspiration to American artists. In 1940 he lectured at Yale University, and in the summer of 1941 he taught at Mills College, Oakland, California. The influence of his doctrine of new realism (first propounded in a lecture given at the Museum of Modern Art, New York City, in 1935) influenced such avant-garde artists as Stuart Davis and Arshile Gorky, who responded to his belief in the significance of forms derived from modern technology. Ultimately, too, Léger's work was a forerunner of the pop art of the early 1960s with its literal images of mass-produced objects, devoid of narrative context. Roy Lichtenstein is especially indebted to Léger.

Back in France, at the end of World War II, Léger began to create with the same optimistic exuberance that had marked his return to Paris after the first war. In 1949 he established a studio at Biot, near Cannes, where with his former pupil Roland Brice he turned to ceramic sculpture. The large polychrome *Walking Flower* (1950) is a joyful expression of creative renewal.

Paintings of workers busy on their construction jobs, or robustly enjoying their time off, celebrate this postwar period of recovery. In *Builders* (1950), with its strident contrasts between human figures, cloud shapes, and a gridwork of mechanical structures, the workers move through and animate the scaffolding they have erected—unlike the 1920s mechanic dominating his construction, or the reclining "machine goddesses" dominated by their surroundings. And whereas Léger's post–World War I *poilus* were robotic objects, these new French construction workers have become subjects, more individualized than any figures in his previous paintings. (A biographical footnote to this is that Léger had now formalized his bond with "the people" by joining the Communist Party.)

One of his "Leisure" series, a canvas begun in the United States in 1944 and finished about three years after his return home, incorporates gay images of bicycles, flowers, birds, and figures of men and women in holiday attire. A reference to the peacetime activities of the modern bourgeoisie, it also pays witty tribute to established French tradition. A figure in the foreground, reclining à la Mme. Récamier, holds a piece of paper inscribed "Homage à Louis David," one of Léger's favorite classical painters.

Popular recreations and amusements were always a favorite theme of Léger's. Throughout his life he did series of paintings of acrobats, dancers, and cyclists. His *Three Musicians* (1944), based on a 1925 drawing and recalling Rousseau, reflects his love of the dance hall; his *Big Julie* (1945) is a monumental closeup of a superbly aloof performer shown with her bicycle and juggler's hoops, figure and objects conspicuously contrasted. But it was the circus, which he termed "the land of the active circle," that especially attracted him. *The Great Parade* (1954) explodes with the color and movement of the circus parade and its promise of fun and thrills available to everyone. Léger's work was distinguished by boldness and strength rather than subtlety. In *Life with Picasso* (1964) Françoise Gilot quotes Picasso: "[Léger's art is] open and fresh, but it doesn't go beyond what it shows you at first glance."

In 1919 Léger had married Jeanne Lohy, who died in 1952. Two years later he wed Nadine Khodessevitch.

Still actively at work on sculpture, paintings, ceramics, and mosaics, Léger died at his home in Gif-sur-Yvette, at the age of 74. At Biot, the Musée National Fernand Léger was built by his widow and friends between 1957 and 1960 and now houses the largest collection of his works. Fittingly, for a man who had little respect for formal museums, its facade is enlivened by one of his own mosaics, a vast expanse of figures representing soccer players and cyclists, in bold Mediterranean colors. Nearby, some of his large brightly colored ceramic sculptures form a playground for children. As Léger once remarked, a work of art "does not want to prove anything; its appeals to the sensibility, not to the intellect. Above all, it is a matter of enjoying art, not of understanding it."

EXHIBITIONS INCLUDE: Gal. Kahnweiler, Paris 1912; Gal. de l'Effort Moderne, Paris 1919; Anderson Gal., NYC 1925; Gal. Alfred Flechtheim, Berlin 1928; Leicester Gal., London 1928; Kunsthaus, Zürich 1933; Art Inst. of Chicago 1935, '53; MOMA, NYC 1935, '55, '60; Pierre Matisse Gal., NYC 1938; Palais des Beaux-Arts, Brussels 1938; Dominion Gal., Montreal 1943; Retrospective, Mus. National d'Art Moderne, Paris 1949; Tate Gal., London 1950; Sidney Janis Gal., NYC 1951–52; Venice Biennale 1952; Mus. des Arts Décoratifs, Paris 1956; Solomon R. Guggenheim Mus., NYC 1962; Moderna Mus., Stockholm 1964; Mus. des XX Jahrhunderts, Vienna 1968; Mus. d'Art Contemporain, Montreal 1970; Albright-Knox Art Gal., Buffalo, N.Y. 1982. GROUP EXHIBITIONS INCLUDE: Salon d'Automne, Paris 1908–11; Salon des Indépendants, Paris 1911, '20, '21; Exhibition of Modern Art (Armory Show), NYC 1913; "Braque, Léger, Picasso," Mus. d'Art Français, Paris 1931; "Le Cubisme 1911–18," Gal. de France, Paris 1945; "The Artist in the Machine Age," Gal. Louis Carré, Paris 1950; "Un Siècle d'art Français," Petit Palais, Paris 1953; Documenta 1, Kassel, W. Ger. 1955; "Léger and and Purist Paris," Tate Gal. London 1970.

COLLECTIONS INCLUDE: Mus. National Fernand Léger, Biot, France; Kunstmus., Basel; Mus. National d'Art Moderne, Paris; Gal. Louis Carré, Paris; Rijksmus. Kröller-Müller, Otterlo, Neth.; MOMA, NYC; Solomon R. Guggenheim Mus., NYC; Albright-Knox Art Gal., Buffalo, N.Y.; Philadelphia Mus. of Art; Nat. Gal. of Canada, Ottawa.

ABOUT: Buck, R. T., Fry, E. F., and Kotik, C. Fernand Léger, 1982; Cassou, J. and Leymarie, J. Léger, dessins et gouaches, 1972.; Cooper, D. Fernand Léger et le nouvel espace, 1949; Delevoy, R. L. Léger: Biographical and Critical Study, 1962; Golding, J. Cubism: A History and an Analysis, 1907–1914, 1959; Green, C. Léger and the Avant-garde, 1976; Kuh, K. Léger, 1953; "Léger and Purist Paris" (cat.), Tate Gal., Lon-don, 1970; Léger, F. Functions of Painting, 1973; Rosenblum, R. Cubism and Twentieth-Century Art, 1960; San Lazzaro, G. di (ed.) Homage to Fernand Léger, 1971; Schmalenbach, W. Léger, 1976.

***LEONCILLO (LEONCILLO LEONARDI)** (1915–September 1968), Italian sculptor, was one of the few modern sculptors to work mainly in ceramics (the American Peter Voulkos, whose work shares some expressive and coloristic affinities with that of Leoncillo, is another).

Born in Spoleto, Leoncillo attended the Perosa Argentina Institute in Perugia, then ran a pottery workshop in Umbertide, Umbria, still an active center of cottage-industry ceramic manufacturing. Like virtually all Italian sculptors, he began by modeling the figure after the Classical and Renaissance masters. Instead of the traditional marble or bronze, he worked in terracotta (harking back to a much older tradition), quickly mastering the immense technical difficulties of the medium for large work and developing a vigorous, expressionistic style. "In his youthful works," wrote Roberto Salvini, "from 1935 on, he renders the whirling and dramatic expression of Scipione with a simplifying, almost rococo lightness of touch, and in deformed figures of ancient mythology (Harpies, Sirens, Hermaphrodites) he gives expression to his feeling for a bizarre (and somewhat sinister) mystery of life." Borrowing from the techniques and tradition of brightly glazed practical ware and the polychromed cubist constructions of Picasso, Leoncillo gradually perfected a repertoire of vivid low-temperature glazes, enamels, and slips which he used not to decorate but to define and energize his forms.

In 1942 Leoncillo moved to Rome, where he was one of the founders of the Nuova Secessione Artística (later the Fronte Nuovo delle Arti), a group of young artists, including Giulio Turcato, Antonio Corpora, and Pericle Fazzini, who were rebelling against the bloated neo-Roman style fostered by Mussolini. During the 1940s, Leoncillo moved from an expressive, naturalistic figuration to a more analytical concern with formal rhythms of volumes and planes; his work was still powerfully, almost violently, emotional. "The romantic and dramatic spirit of his vision," wrote Salvini, "is more evident in the works which in 1943 and 1944 were inspired by the Resistance, and reaches its culmination in the *Monument to the Women Partisans of the Veneto* (1955–56) in a language that has been enriched by his knowledge of Picassian neo-Cubism."

°lā ŏn chē´ lō, lā´´ ō när´ dē

Leoncillo abandoned the figure in the late 1950s for purely formal, or in Michel Tapié's term, which Leoncillo used, "informal" experiments. This is a risky step for any ceramist sculptor to take. Although clay has infinite plastic and expressive abilities, it is physically weak (severely limiting size and form) and its very plasticity provides no material structure upon which the formalist can base his concept. Leoncillo solved these problems by concentrating on the most basic contrasts of form—deep cuts in rough, concave or convex curves, with raw colors defining and amplifying the slashed and bruised surfaces. Such works as *White Cut* (1959), *Black Cut* (1959), *Taglio Grande* (1960, Great Cut), and *Mutilazione* (1963, Mutilation) have the imposing presence of ancient and scarred sacrificial stones. Of these violent concretions, Umbro Apollonio wrote in *Quadrum* that they seemed to be made of "a flesh scarcely calmed from its spasms, and the lacerations, the caresses, the confusion mingle in a complete and full human experience. . . . Thus Leoncillo may claim to have attained an emotive power in binding the rages and torments into the transcendent solidity of a structure which, in its surprises and inactivity of matter, brings the most suitable affirmation." Leoncillo also used a slab-built architectural motif, as in *Sentimento de Tempo* (1961, Sentiment of Time) and *Amanti Antichi* (ca. 1962, Ancient Lovers). With the later 1960s he returned to the figure, albeit in a very free way, in *Pietà* (1964) and the pink and white *Classical Lovers* (1965).

During the 1950s and '60s Leoncillo taught ceramic sculpture at the Academy of Fine Arts, Rome. He participated in many major exhibitions in Italy and elsewhere, including the 1955 Quadriennale of Rome, the Venice, São Paulo, and Antwerp biennials, and Expo '67 in Montreal. His work is virtually unknown in the United States, despite the strong resurgence of interest in ceramic and polychrome sculpture, especially on the West Coast.

Leoncillo died in Rome. Considered in Europe one of the greatest ceramists of his time, he once said that his "feeling for nature" made him search for a "nature parallel" to, not an imitation of, nature itself.

EXHIBITIONS INCLUDE: Gal. La Tartaruga, Rome 1957. GROUP EXHIBITIONS INCLUDE: Venice Biennale 1950, '54, '60, '68; Rome Quadriennale 1955; Expo '67, Montreal; Spoleto Festival, Italy; São Paulo Bienal; Antwerp Biennial, Belgium.

ABOUT: Abrams, H. New Art Around the World, 1966; Read, H. A Concise History of Modern Sculpture, 1964; Salvini, R. Modern Italian Sculpture, 1959; Seu-

phor, M. The Sculpture of this Century, 1960. *Periodicals*—Domus (Milan) April 1962; L'Oeil (Paris) January 1960; Quadrum 15 (Brussels) 1963.

LEVINE, DAVID (December 20, 1926–), American painter and caricaturist, whose work is divided into two distinct categories with little in common except their figurative basis—deft, sensitive, and thoroughly traditional watercolors and oils, and brilliant, incisive caricatures which have won him an international reputation and given rise to a host of imitators.

David Levine was born in Brooklyn, New York, the only child of Harry Levine a pattern-maker in the garment business, and the former Lena Isaacman, a trained nurse. "I have never left Brooklyn," Levine told Jerry Tallmer in a *New York Post* interview (April 8, 1978); "I'm a Brooklyn nationalist." He began to draw at the age of six, and his social conscience was aroused early in life by visiting the garment district sweatshops where his father worked, until the breaking of the pattern-makers' strike caused the elder Levine to lose his job and go into business for himself. During 1936–38 David, while still in elementary school, attended classes at Pratt Institute and the Brooklyn Museum Art School. At home he was not allowed to read the Sunday comics in what were considered "fascist newspapers," but at a neighbor's apartment he devoured the adventures of Buck Rogers, Flash Gordon, and other comic book heroes, and from 1940 to 1943, as a student at Erasmus Hall High School, he drew the comic strip for the school paper.

After graduating from high school, in 1944 he enrolled in the Stella Elkins Tyler School of Fine Art of Temple University, Philadelphia, with the intention of obtaining a teaching certificate. In his early teens he had enjoyed visiting the Brooklyn Museum, but at Tyler his artistic horizons were widened by his introduction to the theories of Dr. Albert C. Barnes, his discovery of the Philadelphia Museum's splendid art collection, and his meeting the art dealer Roy Davis and the artist Aaron Shikler, both of whom became lifelong friends. His favorite painters in the Philadelphia Museum were Vuillard, Corot, and Thomas Eakins, all of whom were to influence his handling of paint and his feeling for atmosphere and light. He also felt a kinship with the warmly humanistic realism of the Eight, especially George Luks, William Glackens, and John Sloan.

Levine's studies were interrupted during 1945–46 by service in the Army. He was first sent to Egypt, "to guard eight warehouses of sporting goods and cameras which playboys

from Europe came in to buy on Saturdays," as he told Tallmer. He was subsequently posted to Belgium and Germany, and worked for a while on the GI newspaper *Stars and Stripes*."By then," he recalled, "I was a cartoonist."

Following his discharge, he availed himself of the GI Bill and returned in 1946 to the Tyler School of Art, receiving his Bachelor of Science and Bachelor of Fine Arts degrees three years later. Returning to New York City, he studied for a year with Hans Hofmann, although it is impossible to discern in Levine's work the slightest influence of that doyen of the Abstract Expressionist School. As Thomas S. Buechner observed in his introduction to *The Arts of David Levine,* the period of study with Hofmann "provided a close-up look at the directions modern art was taking, and an opportunity to reject them— which he did."

Levine's first solo exhibition of paintings was held at the Davis Gallery, New York City, in 1953; he continued to exhibit at the same gallery until 1963. His subjects were garment-workers in two different aspects of their lives: in the workshop and relaxing at the beach in Coney Island." His favorite painting medium has always been watercolor, and even his oils, with the paint thinly applied, suggest a watercolor treatment. The atmospheric quality of his interiors and beach scenes evokes Whistler, and their technique has something of the fluidity of the watercolors of Homer and Sargent. In a statement of 1972 Levine wrote of his watercolor *Coney Island Bathing* (1965; Hirshhorn Museum and Sculpture Garden, Washington, D.C.): "The exotic tangle of color, ethnic variety, eternals of human relationships, drama and comedy, all of this, served up with traditional and contemporary awareness, is the subject of my *Coney Island.*" A reviewer for the New York *Herald Tribune* wrote, "It is remarkable the way Levine . . . is able to work in the idiom of the 19th century masters and still keep his pictures intense, direct and personal." On the other hand, Brian O'Doherty of *The New York Times* (November 16, 1963) took a negative view of Levine's rejection of abstractionism and other contemporary trends, describing his work as being "totally unconnected to present-day problems and life, a fatal evasion."

Although Levine in the 1950s was concentrating on serious painting, he continued satirical drawing as a hobby. In the late '50s a new acquaintance, Shelly Fink, suggested that he design Christmas cards "with a real ring of the Dickensian period." This venture, which lasted three years, was hardly a success, but in seeking to give his designs the 19th-century "look," Le-

vine steeped himself in the English cartoonists and illustrators of that period, notably George Cruikshank, Dicky Doyle, who did the *Punch* covers, and Sir John Tenniel, who illustrated *Alice in Wonderland* and *Alice Through the Looking Glass.* He also studied the lithographs of Daumier and Gavarni and the imaginative and dramatic engravings of Gustave Doré. Levine thus acquired a remarkably rich and varied repertoire of cross-hatching which, combined with his skillful draftsmanship, gives his pen-and-ink technique its unique quality.

His first caricatures appeared in *Esquire* in 1958; the magazine's editor, Clay Falker, commissioned Levine to do small spot drawings to accompany *Esquire's* regular features, including film and book reviews. Levine explained later: "Whenever I couldn't think of what to draw I would do a caricature of someone prominent in that field." Commissions for other publications followed, but it was with the founding of *The New York Review of Books* in 1963 that Levine reached a wider audience and came into his own as a caricaturist. Every month since then, from 10 to 12 Levine drawings have appeared in the magazine, and Levine estimates that over the years he has done between 1,500 and 1,700 caricatures. Also in 1963 he began to exhibit at New York City's Forum Gallery, which has represented him ever since. In 1966 the gallery presented his first show of original drawings for his caricatures. Hilton Kramer commented in *The New York Times* (December 17, 1966): "Levine has more or less singlehandedly revived the art of literary and political caricature from the doldrums in which it had long lain."

Some Levine caricatures are of famous figures of the past, others are of contemporaries, but the latter are drawn only from photographs, never from life. He also relies heavily on old prints and drawings; although his cross-hatch technique and certain conventions—the large heads, the exaggeration of the nose and ears—hark back to 19th-century models, the finished caricature is altogether personal, not only a likeness but a witty and perceptive comment on the subject, whether a literary, artistic, or political figure.

Outstanding drawings of the 1960s include, among the writers, Edith Sitwell (1965), like an eccentric Edward Lear character, using her curving pointed nose as a pen; a baleful André Malraux (1965), as one of the gargoyles of Notre Dame; and Colette (1966), as a fastidious cat. Among the artists, Francis Bacon (1966) paints his screaming pope who is plugged into an electric chair. Henry Moore (1966) crouches in a fetal position in the hole of one of his sculptures. While Levine's political sympathies are with the

social democratic left, he has little sympathy or respect for establishment politicians of any ideological stripe. One of his political cartoons of 1966—President Lyndon Johnson displaying a scar shaped like the map of Vietnam running down his belly—has become a classic. A career high point was reached in 1968 when both *Time* and *Newsweek* featured cover drawings by Levine on the first week of January. On the *Time* cover, Johnson was a tormented, bealeagured King Lear; on the *Newsweek* cover, five Republican presidential candidates rode the GOP elephant's trunk. The Vietnam and Watergate political crises produced devastating Levine cartoons, in many of which a subtle emphasis on pointed, fanglike teeth in a mirthless smile conveys Levine's feelings about such national leaders as Nixon and Kissinger. The artist insists, however, that he has only "one basic point of view—power is to be absolutely mistrusted. There are no good guys." In an inspired parody of Bruegel's *The Blind Leading the Blind,* Levine showed four successive presidents, two from each party, clinging to each other as they stumble into the proverbial "quagmire" of Vietnam.

Exhibits of Levine's work were held in the California Palace of the Legion of Honor, San Francisco, in 1968–69 and again in 1971–72; in the Graphic Arts Division of Princeton University Library, New Jersey in 1969; and in the Brooklyn Museum in 1971, when he participated in a major two-man show with Aaron Shikler. Levine's first Paris exhibition was held at the Galerie Yvon Lambert in 1972. His work is much admired in France, where a strong tradition of pictorial satire has existed from the time of Daumier to the present, but despite the renown and effectiveness of Thomas Nast in the days of Boss Tweed, political caricature with real satirical bite has never truly flourished in the US, where there exists a tendency to regard the lampooning of any political figure as "disrespectful."

Levine's caricatures were first published in book form in 1966 under the title *The Man from M.A.L.I.C.E.* A second collection, *Pins and Needles,* selected by John Updike, was brought out in 1969 and consisted mainly of literary and cultural celebrities of the past and present; many of the drawings had first appeared in *The New York Review of Books.* This was followed in 1970 by *No Known Survivors,* selected by John Kenneth Galbraith. In 1971 Levine, already the recipient of several awards, was elected to the National Academy of Design. His drawings covering a period of 15 years were exhibited at the Forum Gallery in 1976 and were published in a handsome catalog titled *Artists, Authors and*

Others, with an introduction by US Senator Daniel P. Moynihan, a personal friend of the artist and one of the subjects on display. Among the highlights of the exhibition were a willowy, fin-de-siècle Aubrey Beardsley (1967) using his long tapering fingers as additional supports; a wistful, nude Raphael Soyer (1975) in the exact shrinking pose of Edward Munch's angst-ridden adolescent girl in the painting *Puberty* (Soyer has the drawing on his studio wall); Walt Disney (1974), a major boyhood influene on Levine) looking, to quote Moynihan, "a little like a mouse studying to be a rat"; a priapic Picasso (1973), with a bull's horns and ears, in pursuit of a cow; a languid liquid-eyed Marcel Proust (1974), with the steam from his teacup rising in delicate art nouveau arabesques, and a formidable, bespectacled Henrik Ibsen (1971), his severe, judgmental features framed by his mane of white hair and prodigious whiskers. Samuel Beckett (1971) becomes a gaunt, scruffy, elongated, rather terrifying nocturnal apparition, and in 1968 a self-caricature of Levine himself, in profile and with the usual outsize head, busily sketches. Moynihan wrote in his introduction " . . . We are fortunate to have in David Levine a public figure who is first of all an artist but also an artist with politics, a man who accepts both, and knows that both matter, and knows which matters most."

The two branches of Levine's art, caricatures and watercolors, were exhibited at the Forum Gallery in April 1978. Vivian Raynor of *The New York Times* (April 14, 1978), noted that whereas the popularity of Levine's "carefully hatched" caricature portraits was due in part to their antiestablishment flavor, which made them "emblematic of the period," his straight watercolors would seem to make the artist "something of an establishment figure" himself. The watercolors, skillfully executed with loose washes and puddles of color over a neutral-tinted ground, included Coney Island beach scenes; male nudes; a portrait of the artist's square-headed father (1977); and sensitive studies of young women, of which Raynor's favorite was a near-profile head entitled *Bone Tight* (1977). However, the critic discerned "Victorian fustiness" in both the watercolors and the caricatures, and noted the artist's prediclection in both fields for exaggerated noses.

A comprehensive selection of Levine's work was published in 1978 under the title *The Arts of David Levine,* with a foreword by Thomas S. Buechner, former director of the Brooklyn Museum. The watercolors included *Coney Island Patchwork* (1977), *Gaunt,* a standing, long-necked female figure (1976), and *Portrait of Cecily* (1977) from the private collection of Jo-

seph H. Hirshhorn. An oil on board, *Presser* (1968), recalled Levine's early memories of the garment district. The many superb caricatures included a potato-faced but sympathetically depicted Rembrandt (1970), selecting a plumed hat for a sitter from his collection of fancy and exotic headgear (artists are usually viewed by Levine in a kindlier light than personalities in other fields); a maniacally staring Richard Wagner (1972), holding a cluster of thunderbolts and out-sized music notes; Marilyn Monroe (1973), seen unexpectedly but tellingly as a far-from-fragile *monstresaeré* with a baseball bat slung over her shoulder; C.P. Snow (1972) as Humpty-Dumpty perched on a computer; a primly smirking T.S. Eliot (1974); and a pugnacious Norman Mailer (1973), wearing boxing gloves and emerging from a book. As usual the sharpest darts were aimed at political figures: Nixon as the Godfather (1972) and Little Bo-Peep (1973); the late J. Edgar Hoover (1972) as a kind of squashed apple against a spider's web dotted with captured flies; Leonid Brezhnev (1977) with his mask of inscrutability; and Jimmy Carter (1978) up to his chest in water, a bewildered grin on his face, and four rings circling his head and one around his neck like lopsided halos or hoops tossed at a fairground sideshow.

Levine has been accused of relying on formula, but there is great variety in his use of cross-hatching and shading to create form and structure. One of the most striking images is that of Mao Tse-Tung in profile, as stylized as a Japanese print. In his foreword, Thomas S. Buechner said of Levine's caricatures, "Their bite is reinforced by the hilarity of his vision—Nixon *is* funny as the Godfather—and made truly wonderful in that great Daumier sense by some of the most glorious draftsmanship of our time."

David Levine has been described by Malcolm Muggeridge as "a solidly built man with . . . a faraway look in his eyes. Posture and style suggest an equable, wry, kindly disposition." Amiable, unassuming, and given to simple attire, he has been described as "looking like an accountant." He lives with his wife, the former Mildred Eisenberg, in a brownstone house in the Park Slope section of Brooklyn. They have two children, Matthew and Eve. Buechner has pointed out that Levine "is also very funny," and that he "reacts to tragedy with unintentional smiles and covers shyness with quipping bravado."

Although Thomas Nast's cartoons in the 1870s helped bring about the downfall of the corrupt Tammany boss William Marcy Tweed, Levine is under no illusion that he could topple governments by the power of his pen. Nevertheless, he realizes the importance of humor and satire as weapons in a free society, and his spirit of independence is crucial to his whole being as man and artist. He is quoted by Buechner as saying, "To the degree that there is anti-Semitism in the world, I acknowledge being Jewish; in the same sense, when cartooning is ridiculed, I confess to being a cartoonist."

EXHIBITIONS INCLUDE: David Gal., NYC 1953–57, 1959, 1961–63; California Palace of the Legion of Honor, San Francisco 1959–60,1968–69, 1971–72; Forum Gal., NYC from 1963; Graphic Arts Division, Princeton Univ. Library, N.J. 1969; Lunn Gal., Washington, D.C. 1971; Gal. Yvon Lambert, Paris 1972; Pierson Col., Yale Univ., New Haven, Conn. 1973; Hirshhorn Mus. and Sculpture Garden, Washington, D.C. 1976; Am. Cultural Center, Paris 1979; Gal. Claude Bernard, Paris 1979, '83; Phillips Gal., Washington, D.C. 1980; Gal. Bartsh and Chariau, Munich 1983. GROUP EXHIBITIONS INCLUDE: Whitney Mus. of Am. Art Annual, NYC 1960, '62; Nat. Academy Annual, NYC 1962; Pennsylvania Academy Annual, Philadelphia 1966, '69; Brooklyn Mus., N.Y. 1971.

COLLECTIONS INCLUDE: Forum Gal., NYC; Brooklyn Mus., N.Y.; Mus. of Art, Pennsylvania State Univ., University Park; Hirshhorn Mus. and Sculpture Garden, Washington, D.C., Cleveland Mus. of Art; Gal. Claude Bernard, Paris.

ABOUT: Buechner, T.S. "David Levine and Aaron Shiklev" (cat.), Brooklyn Mus., N.Y., 1971; Currrent Biography, 1973; Feaver, W. Masters of Caricature: From Hogarth and Gillray to Scarfe and Levine, 1981; Levine, D. The Man from M.A.L.I.C.E., 1966, Pins and Needles, 1969, No Known Survivors, 1970, "Artists, Authors and Others: Drawings by David Levine" (cat.), Forum Gal., NYC, 1976, The Arts of David Levine, 1978. *Periodicals*—American Artist November 1971; Connaissance des arts (Paris) April 1979; New York Herald Tribune November 16, 1957; National Observer October 1966; New York Post April 8, 1978; New York Times November 16, 1963, December 17, 1966, April 14, 1978; Newsweek May 3, 1971.

LEVINE, JACK (January 3, 1915–), American painter, was a leading exponent in the 1930s and '40s of an expressionistic, satirically sharp-edged art of social consciousness. He was born in the South End slums of Boston, the youngest of the eight children of Samuel Levine, a shoemaker, and a Jewish immigrant from Lithuania. When he was eight his family moved to the suburb of Roxbury where he took his first lessons in art at the Jewish Welfare Center and later studied at the Boston Museum School. His skillful drawings in the manner of Leonardo da Vinci, Mantegna, and other Renaissance masters attracted the attention of Denman Ross, who lectured on the theory of design at Harvard

JACK LEVINE

University. Levine became Ross's pupil and protégé, and between 1929 and 1931 underwent Ross's highly methodical teaching. In additon to emphasizing mathematical theories of composition and a scientifically planned palette, Ross introduced his pupil to the great European tradition of the past, especially three masters Levine has continued to admire, Degas, Rembrandt, and Daumier.

After what he described as "a very conservative adolescence," Levine joined the WPA Federal Arts Project in the fall of 1935. He took a studio in the Boston slums and felt, as he said, "a strong motivation toward social art." He portrayed the life of the poor in the city streets and satirized the corruption and hypocrisy of civic authorities and other "pillars of society." At this time he was discovering the impassioned painting of three leading European Expressionists— Rouault, Soutine, and Kokoschka. Levine's technique, with its tense, emotionally charged brushstrokes, rich, glowing colors, and emphatic distortions, was strongly influenced by those artists, although his work placed a more obvious emphasis on social content. The biting satire of the early George Grosz was another important influence.

Levine's canvas *Brain Trust* was included in the "New Horizons" exhibit of WPA work at the Museum of Modern Art, New York City, in 1936, but the painting that established his reputation was *The Feast of Pure Reason* (1937). This ironically titled picture, now in MOMA's permanent collection, presented an unholy triumvirate—a policeman, a capitalist, and a gangster-politician. Beneath the surface carelessness of

Levine's expressionistic brushwork and his bold deformations of natural appearances was a sound foundation of drawing and a command of the painting medium remarkable in a 22-year-old. This painting, with its angry, accusing satire, made a strong impact, and Levine was praised by some critics as a prominent new American artist. But its enlarged heads and brash distortions infuriated others, who thought of social realism either in terms of the "folksy" genre painting of Benton and Curry, the reportorial approach of Reginald Marsh, or the strident militancy of the Mexican muralists.

Levine's first solo show, held in January 1939 at New York City's Downtown Gallery, was criticized by Edwin Alden Jewell of *The New York Times* for relying too heavily on caricature, but Martha Davidson of *Art News* regarded the exhibit's largest canvas, *The Street* (1938), as one destined to become "a landmark in American painting." Early in 1942, Levine was selected by MOMA as one of 18 artists to be featured in its "Americans, 1942" exhibition. Raphael Soyer remembers the Jack Levine of the early 1940s as "quiet, pale, with thick heavily-rimmed glasses."

In 1942, Levine entered the US Army. While stationed at Fort Oglethorpe as a private in the Medical Corps, he learned that *String Quartet*, one of his strongest canvases, had been awarded a $3,000 second prize in the "Artists for Victory" show at the Metropolitan Museum of Art, New York City. Levine was later transferred to the Corps of Engineers, and rose to the rank of sergeant. He was placed on detached duty as a soldier-artist.

After his military discharge in 1945, Levine came to New York City and received a Guggenheim Fellowship. His first important postwar picture, *Welcome Home* (1946), was a bitterly satiric study of a solemn and stuffy ceremonial dinner for a pompous, bemedalled but obviously noncombatant general "back from the wars." Later this painting was to draw the ire of the House Committee on Un-American Activities (HUAC).

Levine was, in his own words, "turned off by abstract expressionism," which by 1950 had become the dominant avant-garde form in American painting, and he continued in the early '50s as a painter of protest and social comment. His most powerful statement in this vein was his large canvas *Gangster's Funeral* (1952–53; Whitney Museum of American Art, New York City), a savage indictment of human corruption as personified by gangster-tycoons. James Thrall Soby writing in *Saturday Review,* called *Gangster's Funeral* Levine's finest picture, and "one of the most remarkable images achieved by a 20th century American artist."

Levine's interest in old-master techniques had been enhanced by an 11-month stay in Rome during 1950–51 on a Fulbright Fellowship. Throughout the 1950s, his work increasingly showed the influence of Rubens, along with echoes of Italian mannerist and baroque painting and of El Greco. Other favorites were Titian, Tintoretto, and Rembrandt. Although there were still pungent statements and thrusts at authority (*The Trial,* 1953–54), many critics as well as the artist's friends, detected a "mellowing" in Levine's vision, possibly due, some felt, to his greatly improved circumstances. The targets of his satire seemed less clearly defined and more diffuse than in the "socially conscious" years of the '30s and '40s. The times had changed, and though Levine still thought of himself as a satirist, there was not the same angry urgency.

Levine's growing technical facility and fluency were manifested in compositions with opulently fleshed Rubenesque nudes and blowsy showgirls in burlesque semiattire, and the social criticism was still oblique. Levine painted a series of parodies on the classic themes of "The Judgment of Paris" and "The Three Graces." Other canvases, including straightforward portraits and paintings on Old Testament themes, had no perceptible satiric content. Levine does not deny that there have been changes in his approach; with middle age, he said, "I'm more interested in wisdom and control. Maybe life is more complex than I thought."

Levine's early work still had the power to arouse controversy. In 1959 his painting *Welcome Home* (1946), which had been included in a State Department show in Moscow, was attacked by President Eisenhower, who found it more like a "lampoon" than art. Levine was also under fire from HUAC as a "subversive" artist, but Eisenhower backed down and the State Department show was not censored.

Jack Levine's allegiance to the realist and humanist trend in art was symbolized by his inclusion in Raphael Soyer's large group portrait, *Homage to Thomas Eakins* (1964), along with Edward Hopper, Reginald Marsh, Edwin Dickinson, and other American figurative artists admired by Soyer. In the Eakins painting Soyer feels that he caught Levine's "tenseness, the intellectual brooding in his blue eyes under the thick lenses, the mobility of his features."

Much of Levine's satire in the late '60s was directed at the art establishment and its hangers-on. *For the Sake of Art—Avant-Garde* (1969–71) depicts a pretentious couple at a cultural function. His pictures with political allusions had a complexity lacking in the more trenchant earlier statements; among these later paintings were *Our Presence in the Far East* (1972), on the theme of Vietnam, and *The Patriarch of Moscow on a Visit to Jerusalem* (1975). The latter picture, based on a scene that Levine had actually witnessed, shows the Patriarch Pimen clad in white, wearing motorcycle goggles, and looking like "an enigmatic Byzantine Hell's Angel," to quote the artist.

Recognition Levine could never have anticipated 40 years earlier came in 1973 when his *Cain and Abel* canvas was purchased for the Vatican's gallery of contemporary religious art. On the whole, however, Levine's later canvases have not found favor with critics sympathetic to avant-garde American art. Barbara Rose has described his work as "little more than illustrational reformulations of academic painting."

Jack Levine is married to the painter Ruth Gikow. Their daughter, Susanna, is also an artist. The Levines live in an attractive old (1846) Greenwich Village house. His walk-up studio is just around the corner; it is an untidy attic room with wooden rafters and a skylight. Since 1976 he has been working on several large paintings freely based on *Volpone* by Ben Jonson, whom Levine considers "the Brecht of his day." He has not used a model for ten years, and his knowledge of the musculature of the human back, as displayed in his unfinished canvas *David and Goliath,* is rarely encountered in artists of today. He is even more deeply involved in studying the under-painting and meticulous glazing techniques of the old masters, and has little concern with objections that these traditional methods have little relevance to the modern vision. Although Levine is a shy person who does not consider himself "a man of words," he is articulate and can be quite scathing about the post-World War II art scene. He considers abstract expressionism to be the creation of critics and compares it to "induced labor."

Gray-haired, slightly stooping, and heavily bespectacled with furrowed features, Levine, to quote Amei Wallach of *Newsday,* "nurses his grudges lovingly, gloating over them like a humorous Scrooge." Although his greatest impact was made in the '30s and '40s, Levine has a solidly established reputation, and quite enjoys being, in his words, "on the shelf." "I'm rather a timid family man who doesn't drink and has just given up smoking," he once wryly commented. "I intend to stay well like Titian. When I die, they won't make *The Levine Story* with Charlton Heston."

EXHIBITIONS INCLUDE: Downtown Gal., NYC 1939, '48, '52; Boris Mirski Art Gal., Boston 1950; Inst. of Contemporary Art, Boston 1952; Alan Gal., NYC 1953, '57, 1959–60, '63, '64, '66; Whitney Mus. of Am. Art, NYC

1955; Berkshire Mus. Pittsfield, Mass. 1963; Kennedy Gal., NYC 1972, '73, '75; Jewish Mus., NYC 1978. GROUP EXHIBITIONS INCLUDE: "New Horizons," MOMA, NYC 1936; Annual, Whitney Mus. of Am. Art, NYC 1938–67; "Americans, 1942," MOMA, NYC 1942; "Artists for Victory," Metropolitan Mus. of Art, NYC 1942; São Paulo Bienal 1951; Venice Biennale 1956; State Department, Moscow 1959.

COLLECTIONS INCLUDE: Metropolitan Mus. of Art, MOMA, and Whitney Mus. of Am. Art, NYC; Brooklyn Mus., N.Y.; Boston Mus. of Fine Arts; Fogg Art Mus., Cambridge, Mass.; Addison Gal. of Am. Art, Andover, Mass.; Phillips Gal., and Hirshhorn Mus. and Sculpture Garden, Washington, D.C.; Walker Art Center, Minneapolis.

ABOUT: Cheney, S. The Story of Modern Art, 1958; Current Biography, 1956; Getlein, F. Jack Levine, 1966; Rose, B. American Art Since 1900, 2d ed. 1975. *Periodicals*—Art Digest September 15, 1952, March 15, 1955; Art News May 1948; New Republic October 6, 1958; New York Times September 21, 1952, November 11, 1975, November 11, 1978; Newsday April 25, 1972.

LeWITT, SOL (1928–), American sculptor and graphic artist, has been called "the high priest of Conceptual art." As if elaborating on this characterization, another critic has written: "Although it sounds like a contradiction, LeWitt is an artist who is not interested primarily in the visual form of his art. He thinks of art as idea: a philosopher of the discipline, he is searching for the irreducible minimum of his work, the indivisible core."

Born in Hartford, Connecticut, to a middle-class family of Russian-Jewish descent, LeWitt has said that his first impulse to be an artist was a rejection of his family's and society's bourgeois values and an expression of his need to establish himself as an individual.

Upon receiving his bachelor of fine arts degree from Syracuse University, New York in 1949, LeWitt moved to New York City, where he found work as a graphics designer. He became fascinated by typography, and traces back to those early days his interest in producing what he calls his "bookworks." So far he has completed more than 30 of these inexpensive editions, which he hopes "communicate" his works and ideas to an audience not confined to the art world.

At one time, in order to survive, LeWitt took a job as a night receptionist at the Museum of Modern Art, New York City, at $40 a week—something he remembered with amusement years later, in 1978, when he had his retrospective at the same museum—and from 1960 to 1965 he worked at the museum's Information and Sales Desk. Starting in the mid-1960s, LeWitt was also active as a teacher in New York: he taught at MOMA's art school from 1964 to '67, at Cooper Union in 1967–68, at the School of Visual Arts in 1969–70, and in New York University's art department in 1970.

At another time in the '60s, LeWitt was employed in the graphics division of the architectural firm headed by I. M. Pei, an experience that stimulated LeWitt's interest in architecture and introduced new ideas into his work. Meanwhile he was painting in a fairly conventional manner, and discussing politics and art with his friends, who then included the art critics Lucy R. Lippard and Michael Kirby, the painter Robert Ryman, and the sculptors Dan Flavin, Tom Doyle, and Eva Hesse. LeWitt and his friends felt that by the late '50s art, "in the last mushy stages of abstract expressionism . . . needed a more rigorous approach" in order to become more scientific and more rational.

LeWitt then came upon the work of the English photographer Eadweard Muybridge (1830–1904), whose recording, with a score of cameras, of the sequential movements of horses and human figures had led to the development of the motion picture. LeWitt credits Muybridge's use of a serial system, relying on signs for its language, syntax, and narrative, as an important source for his own concern with finite systems, beginning in the late 1960s. LeWitt believes that his use of a system has provided his work with objectivity and has rescued it from the baneful dependence on taste.

Acknowledging that he also had seen "hints of system" in the sculpture of Donald Judd, Dan Flavin, and Robert Morris, LeWitt has stated, however, that it was Jasper Johns's "use of alphabets and numbers as systems" that he found truly liberating. Moreover, it was Johns's recognition "that flat was flat and things 3-D were 3-D" that enabled LeWitt to draw "directly on the wall."

LeWitt's "Wall Drawings"—Grace Glueck has called them "gossamer pencillings"—have covered entire walls and have borne such literal titles as *Ten Thousand Lines, Ten Inches Long*. Frequently they have been executed by one or several assistants, in accordance with LeWitt's belief that "the idea becomes a machine that makes the art." A wall drawing in LeWitt's 1971 exhibition at the Protetch-Rivkin Gallery, Washington, D.C., was drawn by a Corcoran School student with galvanized nails that left a fine black line on the gallery's white plaster wall.

In 1960 LeWitt moved into a "seedy but cozy loft on Hester Street," on Manhattan's Lower East Side, where he has lived and worked ever

since. Between 1962 and 1964 he produced wooden structures that were among the first in the idiom later known as minimal. Inspired by such forerunners as Ad Reinhardt, Jasper Johns, and the Constructivists, LeWitt was paring his art down to simple geometric forms and progressions by the middle 1960s. In his cube structures, notably SERIAL PROJECT 1 (ABCD) (1966), he arranged open and closed modular units on a four-part grid in every possible variation. While he invited the viewer's active participation in the work through hidden but suggested elements, LeWitt wrote in *Artforum* (Summer 1976) that "Conceptual art is made to engage the mind of the viewer rather than his eye or emotions."

In 1966 LeWitt had his first exhibition at the Dwan Gallery, New York City. Two years later his show at that gallery had as its main feature an arrangement, in rows, of "chesthigh, white-painted metal columns, each incorporating three cubes" that came in three variations. A series of working sketches, computation sheets, and diagrams (including one titled *21 Variations in Which Cube No. 3 Is Predominant*) were also displayed. Discussing the exhibition, Peter Schjeldahl pointed out the LeWitt was offering "a sort of specimen of the creative process," rather than visual effect and "environment."

In January 1972 LeWitt's color etchings were shown at MOMA. That April, when they were exhibited again, with a group of drawings, at the Lunn Gallery, Washington, D.C., Paul Richard noted that although these works were "almost mechanically produced," their original concepts arose spontaneously and intuitively, as if to embody LeWitt's view that "irrational thoughts should be followed absolutely and logically."

By 1974 LeWitt had become concerned that his geometric works in color were "too pretty," and in April 1974 he displayed, on the large white walls of the Max Protetch Gallery, Washington, D.C., a set of small dark notations in black graphite consisting of detailed instructions for the location of eight key points. Although one critic wrote that this work was "refined almost to the point of non-existence," LeWitt rejects the term "minimalist" to describe his approach. He adheres firmly to the conceptualist rationale, always maintaining, however, that "Conceptual art is only good when the ideas are good."

At LeWitt's January 1975 show at the Protetch Gallery, the idea of the cube provided the basis for the 122 pieces of sculpture exhibited. These white-tinted metal objects were all "permutations" of the edges of what he called an "incomplete open cube," and although no two pieces were alike, in each one of the cube's presence was "never seen" but "always sensed."

Autobiography 1979 is one of LeWitt's later works. Included in his exhibition at the John Weber Gallery, New York City, in January 1980, this thoroughly conceptualist work was described by Grace Glueck "as a mammoth wall grid of tiny square photographs in black and white detailing every object and situation in" LeWitt's studio.

In 1978 LeWitt became the first Minimalist and Conceptualist artist to be given a full-scale retrospective at MOMA. One reviewer at the show observed: "The point of LeWitt's work is that the line is the genesis of all form," and in a work such as his walldrawing *10,000 Lines, 10 Inches Long,* LeWitt dramatized all of line's functions. This exhibition, like other LeWitt shows, contained "dizzying clusters of cubes," including *Variations of Incomplete Open Cubes,* in which the same shape appeared as a drawing, a photograph, and a sculpture, and *Modular Cube/Base* (1968), executed in steel.

When this same retrospective was shown in the fall of 1979 at the Museum of Contemporary Art, La Jolla, California, one critic discerned, from his photographs and his praise of "the ziggurat forms in New York architecture," that LeWitt had been strongly influenced by contemporary architecture. This influence did not surprise the writer because LeWitt lived in Manhattan, "a predominantly architectural environment." However, LeWitt has insisted that his art is not the same as architecture: "Architecture and three-dimensional art are of completely opposite natures. The former is concerned with making an area with a specific function. Art is not utilitarian."

LeWitt is "a low key, unassuming man," according to Grace Glueck of *The New York Times* (January 29, 1978). Nevertheless, he has had a great influence on other Conceptual and post–Conceptual artists and is known for his generous support, financial and nonfinancial, of young artists and their work. In fact, by 1977 he had bought some 800 items of current art, which he donated that year to the Wadsworth Atheneum in his native Hartford.

Despite LeWitt's success he has continued to lead a somewhat Spartan existence in his Hester Street studio, sometimes rising at 5 A.M. to do his work, which includes subtle constructions that Grace Glueck has called a "jungle gym for the mind." Seeing each of his works as "an exercise in the creation of a system," LeWitt has offered this guide to his artistic ambitions: "A lot of the things I do are trying to make order out of chaos. But my ideas are not about anything but themselves. I'm not attempting a world view. I start with an idea and work it out. The viewer starts

from the outside and works it in. I like reading detective stories—they're all about getting to the crux of things, starting from the outside and getting to the inside. I give the viewer all the clues and he arrives at the idea."

EXHIBITIONS INCLUDE: Daniel Gal., NYC 1965; Dwan Gal., NYC 1966, '68, '70, '71; Dwan Gal., Los Angeles 1967; Konrad Fischer Gal., Düsseldorf 1968, '69, '71; Gal. l'Attico, Rome 1969; Gemeentemus., The Hague 1970; Protetch-Rivkin Gal., Washington, D.C. 1971; Solomon R. Guggenheim Mus., NYC 1971; MOMA, NYC, 1971–72, '78; Lunn Gal., Washington, D.C. 1972; Kunsthalle, Bern 1972; Walker Art Center, Minneapolis 1972; Gal. Yvon Lambert, Paris 1973, '74; John Weber Gal., NYC from 1973; Stedelijk Mus., Amsterdam 1974; Max Protetch Gal., Washington, D.C. 1974; Hammarskjøold Plaza Sculpture Garden, NYC 1976; Mus. of Contemporary Art, La Jolla, Calif. 1979; "Wall Drawings 1968–81," Wadsworth Atheneum, Hartford, Conn. 1981. GROUP EXHIBITIONS INCLUDE: "Box Show," Byron Gal., NYC 1965; "New Dimensions," Sachs Gal., NYC 1966; Sculpture Annual, Whitney Mus. of Am. Art, NYC 1967; Documenta 4 and 5, Kassel, W. Ger. 1968, '72; "Young American Artists," Wide White Space Gal., Antwerp, Belgium; Tokyo Biennale 1970; "Anti-Materialism," Mus. of Art, La Jolla, Calif. 1970; Guggenheim International Exhibition, NYC 1971; "Small Series," Paula Cooper Gal., NYC 1973; "Kunst-über Kunst," Kunstverein, Cologne 1974; Venice Biennale 1980.

COLLECTIONS INCLUDE: Los Angeles County Mus. of Art; Art Gal. of Ontario, Toronto; Scottish Nat. Gal. of Modern Art, Edinburgh; Louisiana Mus., Humlebaek, Denmark; Kaiser Wilhelm Mus., Krefeld, W. Ger.

ABOUT: Battcock, G. Minimal Art: A Critical Anthology, 1968; "Sol LeWitt" (cat.), Stedelijk Mus., Amsterdam, 1974; "Sol LeWitt" (cat.) MOMA, NYC, 1978; Meyer, U. Conceptual Art, 1972; Pincus-Witten, R. Postminimalism, 1977. Periodicals—Art International (Lugano) April 1971; Art News April 1978; Art Week October 6, 1979; Artforum April 1967, Summer 1967; Arts Magazine November 1966, February 1968, February 1972; Christian Science Monitor March 3, 1978, August 2, 1978; Museum-Journal (Amsterdam) June 1970; New York Times January 29, 1978, February 3, 1978; Newsweek February 13, 1978; Studio International December 1969, April 1969; Washington Post April 19, 1972, April 25, 1974, January 23, 1975.

*LICHTENSTEIN, ROY (October 27, 1923–), American painter, is one of the pioneers of the pop art movement of the 1960s. He was born on New York City's Upper West Side, to Milton and Beatrice (Werner) Lichtenstein. His father was a prosperous realtor, and he has a sister, Renée. From 1939 to '40 he studied with the American Scene painter Reginald Marsh at New York City's Art Students League. After

Malcolm Lubliner Photography, Los Angeles

ROY LICHTENSTEIN

graduating from Benjamin Franklin High School in 1940, Lichtenstein enrolled in the fine arts department at Ohio State University, Columbus, where Marsh had begun teaching. In February 1943 Lichtenstein entered the United States Army; after serving as a cartographic draftsman in Europe he was discharged in January 1946 with the rank of private first class. He returned to Ohio State obtaining his BFA degree in 1946 and an MFA in '49.

On June 12, 1949, Lichtenstein married Isabel Wilson. With a family to support, he taught at Ohio State as an assistant professor from 1949 to'51 and worked as a commercial artist and free-lance sheet-metal and window designer in Cleveland from 1951 to '57. During his years in Cleveland, Lichtenstein became engrossed in American folklore. Especially interested in themes relating to the Wild West, he painted a series of cowboys and Indians in which cubism was combined with the traditional styles of such Western painters as Frederic Remington.

In 1957 Lichtenstein accepted a position at the State College of New York, Oswego, where he taught for three years. There he began to work in the gestural manner of abstract expressionism after Willem de Kooning. In 1960 he tried, and failed, to interest Leo Castelli, the influential art dealer, in his paintings. "Nobody thought much of [Lichtenstein's] abstract work . . . " Calvin Tomkins noted in Off the Wall.

Lichtenstein joined the faculty of Douglass College, New Brunswick, New Jersey, in 1960. Through his colleague, Allan Kaprow, an avant-garde artist and sponsor of "happenings" in New York City, he met Robert Rauschenberg, Jasper

Johns, and Claes Oldenburg, young artists who had absorbed abstract expressionism and were developing new, even more radical styles.

At Oswego, Lichtenstein had executed abstract-expressionist paintings incorporating imagery from comic strips. In late 1960, to quote Tomkins, Lichtenstein's "own moment of truth arrived when one of his young sons pointed to a Mickey Mouse comic book, and said . . . , 'I bet you can't paint as good as that.'" Lichtenstein produced an outsized picture of Donald Duck tugging a fishing pole whose hook is caught in his own pants' seat, and called it, "Look, Mickey, I've hooked a Big One!" " . . . There was something about its 'dumb,' banal look that fascinated the artist," Tomkins reported. "From that moment, Lichtenstein abandoned de Kooning and began making pictures based on comics and commercial ads, painting them in the flat, mechanical style of commercial art, in simple colors, with Ben Day dot backgrounds."

Lichtenstein's use of "banal" subject matter, kitschy icons of low-brow culture, was the result of his search for permanent aesthetic values amid the constantly shifting patterns of American mass culture. Comics fascinated him because they represented an industrial exigency—the need for a rapid and cheap method of printing color—applied to an artistic medium. He felt that out of the images—Mickey Mouse, Donald Duck, Steve Canyon, Wonder Woman—popularized by generations of comics illustrators, familiar symbols had emerged that he hoped to "bend toward a new classicism," to quote the artist.

In 1961 Kaprow persuaded Lichtenstein to take his pictures to Ivan Karp of New York City's Leo Castelli Gallery. "They were strange, unreasonable, outrageous," Karp recalled. "I got chills from those pictures." He showed the paintings to Castelli the same day and Castelli, after some hesitation, responded enthusiastically to Lichtenstein's revolutionary cartoon style. In 1962 the Castelli Gallery mounted a solo exhibition of his comic-strip paintings—a show which was a sensation in the New York art world. That same year Lichtenstein took part in an important group show at the Sidney Janis Gallery, New York City, titled "The New Realism." A typical 1962 canvas was the 68-by-80-inch *Blam,* inspired by a Milt Caniff comic-strip image of a Communist-piloted fighter of the Korean War going up in flames; Lichtenstein's version, however, was stylistically closer to Léger's bold, mechanical cubism.

The "New Realism" show marked the rapid triumph of pop art, and Lichtenstein gained overnight fame as a leader of the New Realists,

as Pop artists were sometimes called. Lichtenstein's droll humor and irony were widely appreciated, but his style was mistakenly thought to have been achieved by meticulously reproducing comic-strip panels. On closer inspection, however, it was clear that certain details were accentuated and others eliminated. "I think," Lichtenstein explained in *Art News* (November 1963), "my work is different from comic strips—but I wouldn't call it transformation. . . . What I do is form, whereas the comic strip is not formed in the sense I'm using the word; the comics have shapes, but there has been no effort to make them intensely unified. The purpose is different, one intends to depict and I intend to unify. And my work is actually different from comic strips in that every mark is really in a different place, however slight the difference seems to some."

In an article on Lichtenstein and other Pop artists in the *New York Post* (December 2, 1962), Irving Sandler cautioned against assuming that the new school represented a move away from abstraction and a return to figuration. He felt that the New Realists had found a clever solution to the problem of depicting three-dimensional figures while retaining, indeed stressing, the two-dimensional picture surface. Commercial art is by its nature flat and nonillusionistic, and the "serious" artist's picture is also flat, like the billboard or the cartoon frame. Moreover, Matisse and Léger, by their simplification of pictorial means, had cleared the way for the New Realists, and Sandler attributed the new pop medium's success to the "cock-eyed confrontation of Henri Matisse and Milt Caniff."

Sandler claimed that pop art foreshadowed the rapprochement of the avant-garde artist and American society, the wedding of high and low culture. The earlier generation of Abstract Expressionists had sought to transcend their "alienation" from philistine America by painting radiantly spiritual works, but Pop artists took with alacrity crass, mass-produced artifacts as their subject matter and then commented ironically on them. Lichtenstein, for instance, once declared that he saw no difference between painting a Coca-Cola bottle and painting a wine bottle, as Picasso and his contemporaries had done.

Lichtenstein's pop style was not universally acclaimed. Reviewing Lichtenstein's Castelli Gallery exhibition in *The New York Times* (October 27, 1963), Brian O'Doherty labeled him "one of the worst artists in America." Struck by the deliberate banality of Lichtenstein's subject matter, he remarked that the artist "briskly went about making a sow's ear out of a sow's ear." To

the charge of impersonalism raised by pop art's detractors, Lichtenstein replied, "I want my work to look programmed and impersonal, but I don't believe I'm being impersonal while I do it."

In addition to gleaning ideas from comic books such as *Armed Forces at War* and *Teen Romance*, Lichtenstein caused a stir with his impassive versions of modern masterpieces. In 1963 he translated Picasso's violently distorted *Woman with Flowered Hat* into his own cool cartoon-style idiom, Ben Day dots and all, while preserving the original design. In a typical pop gesture, Lichtenstein made a painting of a diagram of a Cézanne portrait of Mme. Cézanne that had been published in a much respected book by Erle Loran. Lichtenstein entitled his version *Portrait of Mrs. Cézanne,* and this provoked Loran's fury.

The deadpan humor of Lichtenstein's work can be seen in a comic-book inspired canvas of the early '60s, in which a vapid blonde gushes to her artist boy friend: "Why Brad, darling, this painting is a masterpiece! My, you'll soon have all of New York clamoring for your work!" In 1963 Lichtenstein was one of ten young painters and sculptors commissioned by Philip Johnson, architect of the New York state pavilion at the 1964 World's Fair, to paint works measuring 20 square feet on the outside wall of the pavilion's circular theater. By late 1964, Lichtenstein had passed from such renderings of love and war comics as *Hopeless* (1963), *Good Morning, Darling . . .* and *As I Opened Fire . . . ,* both 1964, to landscapes and sunsets done in a highly personal pop impressionistic vein. In mid-decade Lichtenstein's work became increasingly abstract as the images moved closer and closer to the spectator, though his new subject matter was, like the comic strips, at an ironic distance from reality. His new work referred to, rather than reproduced, such subjects as travel posters advertising Greek monuments, as in *Temple of Apollo* (1964), or dime-store art. "'Reference,'" Lichtenstein said, "is a much better word for what I do than 'parody' or 'homage.'"

Some of Lichtenstein's works, particularly those depicting explosions, in his 1964 exhibit at the Castelli Gallery were executed in what was for him a new medium, enamel on steel. The outcome of this experiment was his "sculpture," a medium in which he began working in 1965. *Ceramic Sculpture 12,* in glazed ceramic and nine inches high, was composed of precariously stacked cups and saucers, made with the assistance of a professional ceramist. Similar pieces were in the form of pitchers or heads of comic-strip characters. Lucy R. Lippard observed that

these witty creations were "the first sculptures about painting," for each object was treated with the flattening, two-dimensional devices of Lichtenstein's painting—half-tone screening with Ben Day dots, heavy outlines, solid shadows in color, and metallic highlights.

Lichtenstein's series of "Brushstroke" paintings (1965–66) were his rendition of an expressionistic or action-painting brushstroke. He precisely suggested the heavy impasto and explosive energy of, say, a de Kooning sweep of the brush, but in a manner that was pure Lichtenstein pop—cool, flat, sleekly smooth, and against a background of Ben Day dots. *Big Painting #6* was shown at the National Gallery of Art, Washington, D.C. in an exhibit of contemporary American art from the 1966 Venice Biennale. *Yellow and Red Brushstrokes* (1966) is another noted painting in the series.

The move toward abstraction in the "Brushstroke" pictures was continued in Lichtenstein's "Modern Paintings" series (1966–67). Those works were based less on the paintings themselves than on color plates of masterpieces in books and magazines. Art Deco elements figured prominently in his *Modern Painting with Clef* (1967; Hirshhorn Museum and Sculpture Garden, Washington, D.C.). *Modern Sculpture with Black Shaft* (1967; Hirshhorn Museum), in aluminum and glass, recalls Mondrian and de Stijl.

Lichtenstein's experiments in flat commercial styles culminated in his pop billboard on the outskirts of Beverly Hills which advertised his 1967 solo show at the Pasadena Art Museum. He executed another billboard for Expo '67, the World's Fair, Montreal.

Lichtenstein's 1968 solo show of 80 works at London's Tate Gallery, the first exhibition of pop art ever held there, impressed British critics. Norbert Lynton of *The Guardian* called Lichtenstein the "pop painter par excellence," and in the London *Observer* (January 7, 1968) Nigel Gosling predicted that the artist might prove to be "the calmest crystallizer of our generation, a kind of Ingres from Manhattan."

Lichtenstein's paintings of the 1970s were executed in his pop art style, but compositional allusions to Cézanne, Matisse, Léger, and Mondrian were combined with contemporary motifs. In the 1970s and early '80s he painted these series: "Mirrors" (1970–72), in which Ben Day dots are sometimes used in an impressionistic manner; "Entablatures" (1971–76); "Still Lifes" (1972–75); "Triptychs (Going Abstract)" (1972–74), which allude to Mondrian and de Stijl; "Artist's Studio" (1973–74), which was inspired by Matisse; "Trompe l'Oeil" (1973);

"Cubism" (1973–75); "Futurism" (1974–76); "Purism" (1975–76); "Office Still Lifes" (1976); "Surrealism" (1977–79); "Amerind/Surreal" (1978–79); "Expressionism" (1979–80); and "Brushstrokes" (1980–81). The exhibition "Roy Lichtenstein 1970–1980" opened at the Saint Louis Art Museum in 1981 and traveled to cities in the US, Europe, and Japan.

Acknowledging his debt to Léger, Lichtenstein included a Léger reproduction in his *Studio Wall with Sketch of Head* (1973). *Artist Studio—the Dance* (1974) was a typically "cool" homage to Matisse. Over 60 years earlier Matisse had included elements of his famous painting *The Dance* in another composition, a studio interior. Lichtenstein drained *The Dance* of its spectacular color, reconciled the image with other Matissean elements, and combined it, as John Russell noted, with "memories of his own earlier preoccupations."

The ambiguity of Lichtenstein's work, its impersonality accentuated by his use of pastiche, is evident in his recent series of bronze "Sculptures" (1977–80). They were inspired, the artist said, by the outward appearance, not the Freudian content, of surrealism. In an interview with Philip Smith in *Arts* (November 1977), he stated that his recent sculptures were "about transparent things like glasses or lamps or mirrors, things that you can somehow see through, or which reflect." The work, according to Lichtenstein, was "very two-dimensional but it depicts something three-dimensional." *Cup and Saucer I* (1977), for example, includes the cup as well as coils of steam arising from the "coffee."

Roy Lichtenstein's marriage to Isabel Wilson ended in the late '60s in divorce; she received custody of their two sons, David and Mitchell. Lichtenstein maintains two homes, one in Southampton, Long Island, the other a nine-room floor-through apartment in a converted warehouse in lower Manhattan.

Lichtenstein has been described as "a quiet, slim man . . . with a faintly aristocratic face, pale girlish eyes and graying hair." In the *Arts* interview Lichtenstein said of his work: "I get interested in different things but I think I approach them from the same viewpoint. . . . When I was doing the comic-strips I was doing the same thing as I'm doing now, but it means something entirely different. Even if my approach is the same, I express a different feeling in my comic-strips, Picassos or brushstrokes. . . . In much of my work I want it to look as though the subject were described to me by someone and I hadn't actually seen the source. . . . You can understand a work as it is and it really doesn't matter exactly what the artist had

in mind. It's still a painting that looks beautiful or doesn't."

EXHIBITIONS INCLUDE: Carlebach Gal., NYC 1951; John Heller Gal., NYC 1952, '53, '54, '57; Leo Castelli Gal., NYC from 1962; Gal. Ileana Sonnabend, Paris 1965; Cleveland Mus. of Art 1966; Contemporary Arts Center, Cincinnati 1967; Pasadena Art Mus., Calif. 1967; Walker Art Center, Minneapolis, Minn. 1967; Stedelijk Mus., Amsterdam 1968; Tate Gal., London 1968; Solomon R. Guggenheim Mus., NYC 1969; Univ. of California, Irvine 1970; Gemini G.E.L., Los Angeles 1970; Irving Blum Gal., Los Angeles 1971; Contemporary Art Mus., Houston 1972; Gal. Beyeler, Basel 1973; Mayor Gal., London 1974; Centre Nat. d'Art Contemporain, Paris 1975; Blum Helman Gal., London 1978; Mayor Gal., London 1978; Fort Worth Art Mus., Tex. 1981–82; Saint Louis Art Mus., 1981; Whitney Mus. of Am. Art, NYC 1981; Mus. des Arts Décoratifs, Paris 1982; Mus. Ludwig, Cologne 1982; Orsanmichele, Florence 1982; Fundación Juan March, Madrid, Spain 1983; Seibu Mus., Tokyo 1983. GROUP EXHIBITIONS INCLUDE: "New Paintings of Common Objects," Pasadena Art Mus., Calif. 1962; "The New Realism," Sidney Janis Gal., NYC 1962; "Pop Goes the Easel," Contemporary Art Mus., Houston 1963; "Word and Image," Solomon R. Guggenheim Mus., NYC 1965; Whitney Annual, NYC 1965–72; Venice Biennale 1966, '70; Carnegie Intl., Pittsburgh 1967; ROSC '67, Dublin 1967; Documenta 4, Kasssel, W. Ger. 1968; "New York Painting and Sculpture: 1940–70," Metropolitan Mus. of Art, NYC 1969; Whitney Biennial, NYC 1973; "Idea and Image in Recent Art," Art Inst., Chicago 1974; "American Pop Art," Whitney Mus. of Am. Art, NYC 1974.

COLLECTIONS INCLUDE: MOMA, Whitney Mus. of Am. Art, and Solomon R. Guggenheim Mus., NYC; Albright-Knox Art Gal., Buffalo, N.Y.; Hirshhorn Mus. and Sculpture Garden, Washington, D.C.; Art Inst., Chicago; Detroit Inst. of Arts, Mich.; Pasadena Art Mus., Calif.; Tate Gal., London; Stedelijk Mus., Amsterdam; Wallraf-Richartz Mus., Cologne.

ABOUT: Amaya, M. Pop Art . . . and After, 1965; Compton, M. Pop Art, 1970; Hughes, R. The Shock of the New, 1981; Lippard, L. R. Pop Art, 1966; Lucie-Smith, E. Late Modern: The Visual Arts Since 1945, 1969; Rose, B. American Art Since 1900, 2d ed. 1975; Tomkins, C. Off the Wall, 1980; Waldman, D. Roy Lichtenstein, 1971. *Periodicals*—Art in America January–February 1967; Art International January 1978; Art News January 1952, March 1954, February 1957, November 1963, March 1976, November 1981; Artforum September 1963, October 1963, February 1966, May 1967; Arts Magazine April 1962, November 1977; Guardian January 5, 1968; Life January 31, 1964; New York Post December 2, 1962; New York Times October 27, 1963; Observer December 31, 1967, January 7, 1968; La Quinzaine littéraire (Paris) January 1968; Time June 23, 1967.

LINDNER, RICHARD (November 11, 1901–April 16, 1978), German-American painter, was an original figurative painter in an era dominated by abstraction. He was born in Hamburg, to a German father and an American mother. When he was still a boy his parents moved to Nuremberg, but he was to have no nostalgic feelings about that ancient city. Years later he recalled, "I did drop in on *The Mastersingers of Nurenberg* once, but I couldn't sit it out." On the other hand, the hectic, dislocated, and "liberated" Germany of the Weimar Republic years influenced the content and character of his work throughout his life.

Lindner started out as a concert pianist, but in 1922 he gained admission to the Kunstgewerbeschule in Nuremberg by submitting a friend's drawings. After two years he moved to Munich, where he remained from 1924 to 1927, studying first at the Kunstgewerbeschule, then at the Academy of Fine Arts. In 1927–28 he lived in Berlin, where he took courses at the Fine Arts Academy. The 1920s, years of financial chaos and growing political tension in Germany, gave rise to the savage expressionism of Georg Grosz, Otto Dix, and Max Beckmann, and dada and cubism lingered in the air. The great German movies, from *The Cabinet of Dr. Caligari* (1919) to *The Blue Angel* (1930), contributed to the undertones of repressed violence and perverse eroticism in Lindner's vision.

In 1929 Lindner returned to Munich, where he became art director of the well-known publishing house of Knorr and Hirth. Munich was the cradle of the growing Nazi movement, and Lindner was well aware that as a Jew and a social democrat he had every reason to fear a fascist take-over. On the day after Hitler seized power in 1933, he left Germany for Paris.

Like many other refugees, he lived from hand to mouth in Paris, earning a precarious living as a graphic artist and painting seriously on his own account. At the outbreak of World War II in 1939, he was interned as an alien by the French government, but was released five months later. He tried, unsuccessfully, to join both the British and French armies. Arrested by order of the Gestapo, he managed to escape from a second-floor window while handcuffed to a chair. He never forgot the sang-froid with which customers in a nearby café welcomed him and released him from his handcuffs.

After making his way to the south of France, he immigrated to the United States in 1941 and settled in New York City. There he had no success as a painter and earned his living as a magazine illustrator for *Vogue, Fortune,* and *Harper's Bazaar.* He met several American artists, and

Evelyn Hofer, NYC

RICHARD LINDNER

Saul Steinberg, an emigré like himself, became a lifelong friend. Lindner became an American citizen in 1948.

Although a highly competent graphic designer and illustrator, Lindner was stimulated by New York City's urban tension, which helped him at long last to find (in 1950 when he returned to painting) a satisfying means of expression. Then he was able to combine memories of Berlin between the wars with more recent impressions of the glare and bustle of New York street life in startling images transformed by his own bizarre and highly charged fantasy.

Between 1952 and 1965 Lindner taught at the Pratt Institute, Brooklyn, where he originated a course called "Creative Expression." More important, teaching enabled him to give up illustration forever. *The Meeting* (1953; Museum of Modern Art, New York City) is the most autobiographical of all his paintings and may well be, to quote Hilton Kramer, "the key to his oeuvre as a whole." Eight human figures and an enormous cat are compressed into a claustrophobic, purely schematic interior space. The cast of characters, painted with a smooth, clean-cut, streamlined precision akin to the cubism of Léger, includes the artist as a child in a sailor suit and also consists of portraits of some of his artist friends and fellow emigrés: Saul Steinberg in profile seated on the far right, Hedda Sterne on the upper right, and Evelyn Hofer in frontal view on the lower left. Mad King Louis II of Bavaria, in his robes of state, symbolizes a decadent, resplendent, and extravagantly over-ripe European culture. The central figure, seen from the back, is one of Lindner's archetypes—the

stout, corseted, black-stockinged, domineering whore, the urban "femme fatale," the symbol, in Kramer's words, of "that nexus of power, appetite and money that haunts his work to the end." The huge, hypnotically staring cat adds to the sense of eerie menace.

Lindner was 53 when he had his first solo show at the avant-garde Betty Parsons Gallery, New York City, in 1954. His work bore so little relationship to the abstract expressionism then dominating the art world that it seemed archaic and was given small welcome. "One critic wrote that I ought to consult an analyst," Lindner later recalled. Two important paintings of 1955, *Girl* and *Boy with Machine,* continued Lindner's childhood-memory motif. Commenting on these pictures over 20 years later, Hilton Kramer described them in *The New York Times* (March 4, 1977) as "cool and detached in method yet powerful in the emotion they express." Kramer wrote that Lindner, far from being a realist, was "a fantasist," and added, "His figures with their swollen bodies . . . are figments of a dream."

Lindner exhibited again at the Betty Parsons Gallery in 1956 and '59. In 1957 he received the William and Norma Copley Foundation Award and lectured at the Yale University School of Art and Architecture, New Haven, Connecticut.

Despite his growing recognition, it was not until the advent of pop art in the early 1960s that Lindner's work was widely praised. Even then, acclaim was based on a misunderstanding, for many assumed that his painting was derived from the pop art movement. Actually, although Lindner admired pop art, his aims as a painter were very different. The "essential scenario" of his art, to quote Kramer, "was derived from something personal and European, something closer to early Brecht and *The Blue Angel* than to anything discovered in New York."

Although Lindner's sensibility remained European, his vision also embraced what one critic called "the apocalyptic honky-tonk that has taken over the New York streets." There were no genre elements and very few definitions of locale. Whether the subject was *Coney Island* (1961) or *42nd Street* (ca. 1965), his imagery was both timeless and obsessive, tapping the viewer's fears and fantasies. "His men and women," wrote John Canaday in *The New York Times* (April 27, 1968), "seem to be mutually predatory sexual brigands." Yet they are "remarkably devoid of allure, even while aggressively endowed with every physical attribute of voracious sexuality. . . ."

The most penetrating analysis of Lindner's world was made by critic Sidney Tillim in his catalog preface to the artist's first London exhibition, held at the Robert Fraser Gallery. He wrote that Lindner's paintings, in their combination of "infantilism and perversity and their sophisticated 'biological' primitivism . . . show the congenital infections of a social order in which violence and eroticism are the recurrent compensation for conformity." These elements, according to Tillim, provided the link between the Germany of the 1920s and the America of the 1950s and '60s.

Lindner found much stimulation in the hectic New York scene and the more garish manifestations of popular culture. "You see women in the streets all wrapped up like candy packages," he said, and he called Macy's "the greatest museum in the world. . . . Even the chandelier department is a sort of phony Versailles." *Rock Rock* (1967)with an electric guitar superimposed on a flashily-dressed figure, was Lindner's comment on the sexually ambiguous folk-rock balladeer of the 1960s.

Regarding what have been called his "nightmare women," Lindner said, "I was talking about this to Bill de Kooning. Bill and I are always accused of being woman-haters. The fact is we love women." But, he said later, "I am not in the least attracted to the kind of woman I paint. However I think one must deal with one's complexes." One British critic in *The Guardian* saw in Lindner's "escape into violence and perverse eroticism" one consequence of a reaction against the pressures of conformity, whether of the authoritarian German variety or of American mass culture.

According to John Russell of *The New York Times* (April 18, 1978), Lindner was "loved by many beautiful women." His first wife had been a fellow art student in Germany. After some years she fell in love with a writer, a close friend of Lindner's, and when he fell ill and died she committed suicide. In 1968 he married Denise Kopelman, a Frenchwoman many years his junior. From then on he divided his time between New York City and the Place de Furstemberg in Paris, where Delacroix had once had his studio.

The fetishism of clothes continued to fascinate Lindner in the late 1960s and the 1970s. *No* (1967) presented a bold girl in a yellow miniskirt, blue blouse, and red hair, staring brazenly at her audience; she was, one critic observed, "a female deity who invites seduction as she rejects it." Other Lindner figures sported teenagers' gang jackets and bat-winged sunglasses. For Lindner it was not a matter of art becoming more realistic, but of American life becoming more fantastic, corresponding more and more to his own vision of decadence. Yet, as many critics have observed, his intense and subjective vision

was always served by a very disciplined, "objective" technique.

Although Lindner had a retrospective show at the Musée National d'Art Moderne, Paris in the early '70s, he never had one in the US. However, the exhibition of two 1955 paintings, (*Girl* and *Boy with Machine*), in his March 1977 exhibit at the Cordier and Ekstrom Gallery, New York City, demonstrated the evolution of his style from the Léger/Beckmann volumes of his early period to the flatter, more evocative treatment of figures and space in his more recent canvases, notably *Encounter* (1976). *Encounter* pictures a couple dancing in what is unmistakably the light of New York City.

Richard Lindner died suddenly in Manhattan at the age of 76, while his later paintings were in view at the Sidney Janis Gallery, New York City. In a commemorative article in *The New York Times*, Hilton Kramer described the small, wiry man with the bright blue eyes as "gentle, affable, amusing and wonderfully intelligent, with the kind of easy and interesting talk, always delivered in a distinctive stage whisper, that Americans recognized as having been nurtured on the European café life of another era." John Russell called him "one of the foremost figure painters of the second half of this century and the creator of a private mythology as compelling as any in modern art."

For Lindner all art was to some extent erotic. "The artist's prime motivation is instinctual and sensual," he insisted. "Most adults don't have time for erotic fantasies—they're too busy. But artists, like children or primitive people, haven't much to do but dream."

EXHIBITIONS INCLUDE: Betty Parsons Gal., NYC 1954, '56, '59; David Cordier and Michael Warren, NYC 1961; Robert Fraser Gal., London 1963; Cordier and Ekstrom Gal., NYC 1963–69, 1977; Gal. Claude Bernard, Paris 1965; Gan. Galatea, Turin, Italy 1965; Kestner-Gesellschaft, Hanover, W. Ger. 1968; Gal. Boisserée, Cologne 1971; Spencer Samuels Gal., NYC 1971; Mus. Nat. d'Art Moderne, Paris 1972, '74; Mus. Boymans-Van Beuningen, Rotterdam 1974; Kunsthaus, Zürich 1974, '75; Gal. Multiples, Paris 1975; Harold Reed Gal., NYC 1977; Sidney Janis Gal., NYC 1978. GROUP EXHIBITIONS INCLUDE: Walker Art Center, Minneapolis 1954; Art Inst., Chicago 1955, '57; Whitney Mus. of Am. Art, NYC 1959; Annual, Whitney Mus. of Am. Art, NYC 1962, '65, '67; Documenta 3 and 4, Kassel, W. Ger. 1963, '68; "Painting and Sculpture of a Decade 54–64," Tate Gal., London 1964; Tokyo International 1965; São Paulo Bienal 1967; "The Obsessive Image," Inst. of Contemporary Arts, London 1968; "The Poetry of Vision," Royal Dublin Society, Dublin 1971; "Twenty-Five Years of American Painting 1948–1973," Des Moines Art Center, Iowa 1973.

COLLECTIONS INCLUDE: MOMA, and Whitney Mus. of Am. Art, NYC; Hirshhorn Mus. and Sculpture Garden, Washington, D.C.; Art Inst., Chicago; Mus. of Art, Cleveland; Rhode Island School of Design, Providence; Tate Gal., London; Mus. Nat. d'Art Moderne, Paris; Kunsthalle, Hamburg, W. Ger.; Wallraf-Richartz Mus., Cologne; Mus. Boymans-Van Beuningen, Rotterdam.

ABOUT: Ashton, D. Richard Lindner, 1970; Lippard, L. R. Pop Art, 1966; Tillim, S. "Richard Lindner" (cat.), Robert Fraser Gal., London, 1963. *Periodicals*—Art International (Lugano) April 1974; Graphics (Zürich) vol. 5, no. 24 1949; Guardian July 11, 1962;New York Post January 14, 1967; New York Times March 8, 1964, April 27, 1968, April 29, 1969, March 4, 1977, April 18, 1978, April 30, 1978; Time March 20, 1964; World Journal Tribune January 15, 1967.

LIPCHITZ, JACQUES (August 22, 1891– May 26, 1973), Lithuanian-American sculptor, was one of the century's major artists, whose transparent sculptures and elaborate bronzes displayed the wide range of influences comprising his distinctive personal style.

He was born Chaim Jacob Lipchitz in the village of Druskieniki, Lithuania (then part of Czarist Russia) to Abraham Lipchitz, a successful building contractor, and Rachel Leah (Krimsky) Lipchitz. There were five younger children in the family. Lipchitz has recalled that he had a lifelong interest in sculpture, though during his childhood he "had no idea what sculpture was." Yet, he modeled continually in clay, and was fascinated by the shape and texture of the stones he habitually stuffed into his pockets. In 1902 he was sent to school in the nearby town of Bialystok, where for the first time he saw plaster molds that were white—"so I painted my clay sketches white and felt that I had become a sculptor." His father had little enthusiasm for his efforts and wanted him to become an architect or a mechanical engineer, but his mother was more sympathetic.

From 1906 to 1909 Lipchitz attended high school in Vilna, the capital of Lithuania. He was determined to become a sculptor, but study in St. Petersburg and Moscow was forbidden to Jews. During his years at Vilna he had learned about Paris as an art center and, encouraged by Ilya Yakovlevich Günzberg, protégé of a well-known Russian sculptor, Mark Antokolski, he decided to go there. His mother gave him the money for the journey without his father's knowledge and arranged for him to be smuggled across the border. In October 1909, at the age of 18, he arrived in Paris. His father eventually forgave his departure, and contributed to his support as long as he was able to.

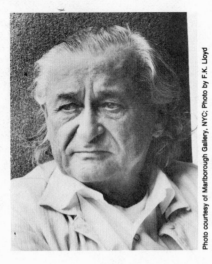

Photo courtesy of Marlborough Gallery, NYC; Photo by F.K. Lloyd

JACQUES LIPCHITZ

In Paris Lipchitz took a small suite of rooms at a hotel on the Boulevard Saint-Michel, and enrolled as an *élève libre* (free pupil) of Jean-Antoine Ingalbert at the Ecole des Beaux-Arts. He then transferred to the smaller and more personal sculpture classes of Raoul Verlet at the Académie Julien, and in the evenings attended drawing classes at the Académie Colarossi. In the academy he learned the traditional process of beginning with a clay sketch, a method he continued to use because it enabled him to fix an idea immediately and to change it rapidly. He also learned to carve directly in stone.

About 1911, the year Lipchitz set up his own studio in Montparnasse, he began to make some small bronze heads, including *Head of Mlle. S.* and *Little Italian* (1911) and an admirably simplified *Head of a Woman* (1912). He visited galleries and museums, especially admiring the Louvre's Egyptian and Archaic Greek sculpture. In 1913, through the Mexican painter Diego Rivera, Lipchitz met Picasso and other Cubists. That same year the poet Max Jacob introduced him to Modigliani, whom Lipchitz remembered many years later in a vivid and touching memoir. Soutin, Chagall, and the sculptors Brancusi, Zadkine, and Archipenko were also active in Paris at that time.

In 1911 Lipchitz learned that his father had suffered financial ruin. He moved to cheaper lodgings, and for a while supported himself by pushing carts at night and hoisting sacks of vegetables at railroad stations. He contracted tuberculosis and went to Belgium to convalesce, but did not completely recover. When he returned to Russia in 1912 for military service he was rejected for reasons of health.

He went back to Paris in 1912—"with a proper passport" but without much money—and took a studio in the rue de Montparnasse. The first major example of his traditional and pre-cubist phase was *Woman with Gazelles,* exhibited in a group show in Paris in 1912. Though it received critical acclaim, Lipchitz was becoming dissatisfied with an imitative and naturalistic approach. After visiting Picasso's studio in 1913 he entered what he called his "proto-cubist" phase: "I experimented both with an angular geometry, as in *The Encounter* (1913), and a more curvilinear, even baroque manner as in the *Woman with Serpent.* African wood-carvings, then beginning their great vogue in the Parisian avant-garde, had a tremendous appeal for him and he began a fine collection of them, although he later denied that his work was influenced by African primitive art.

Lipchitz was moving ever closer to cubist circles. In 1914 he visited Spain and Majorca with Diego Rivera (at that time a Cubist) and other friends. In the Prado in Madrid he discovered El Greco, Tintoretto, and Goya, instantly relating El Greco's expressive, angular paintings to cubism. In the countryside in the north of Majorca, Lipchitz began three important pieces which showed that he had taken the final step towards cubism. These were the bronzes *Sailor with Guitar,* the more decorative *Toreador,* and the cubistically fragmented *Girl with Braid.* He returned to Paris with these new works still unfinished at the end of 1914.

As a Russian national Lipchitz was not conscripted, and was free to explore the possibilities of cubism in sculpture. His bronze *Head* of 1915 was his most nonrealistic work up to that time, yet it still retained "the sense of *organic* life" that he advocated in place of a completely nonobjective approach.

In 1916 Lipchitz met Juan Gris, who became a close friend, and about this time was also introduced to Gertrude Stein. (In 1920 he did her portrait in the hope she would buy it, but she never did.) Also in 1916, Modigliani painted his remarkable double portrait of Lipchitz and his wife Berthe (Kitrosser), whom the sculptor had married the previous year. In 1915 and 1916 Lipchitz produced several of his major stone sculptures, including *Figure, Standing Figure,* and *Man with a Guitar* (the last-mentioned is now in the Museum of Modern Art, New York City.) During this period, to quote Michel Seuphor, Lipchitz "built his figures out of purely plastic elements that subsequently and somehow tied up with the human motif."

The influence of Juan Gris can be felt in several stone reliefs, some of them painted, which

Lipchitz carved in 1918, using still-life objects or musical instruments, that were part of his basic vocabulary. After the war his reputation grew and in 1920 his dealer, Léonce Rosenberg, gave him his first solo exhibition. In 1922 Dr. Albert C. Barnes began to buy his works, commissioning five bas-reliefs for the Barnes Foundation in Merion, Pennsylvania. "From this point forward," the artist recalled, "everything was much easier."

Between 1919, when he made the bronze *Harlequin with Accordion,* and 1925, when he completed the bronze *Bather,* Lipchitz's work went through a transitional cubist period. He also did several realistic portraits, including busts of Jean Cocteau, Raymond Radiguet, Gertrude Stein, in 1920, Coco Chanel, in 1921, and his wife Berthe in 1922. In 1924 he became a French citizen.

Although cubism had been a liberating force for Lipchitz, he was now searching for new inspiration. In 1925 he moved from the relatively austere discipline of cubism to a series of "transparents," using the *cire-perdue,* or "lost-wax," technique. There were still cubist elements in his new sculptures, but by piercing the solid form with grids and ribbons of metal, Lipchitz has said that he found himself playing with space, with a kind of lyrical, open construction that was a revelation to me." Typical of this open-spaced, predominantly curvilinear approach were *Pierrot Escapes* (1926) and one of his major commissions, the *Joy of Life,* over seven feet high, completed in 1927 for the Vicomte Charles de Noailles's estate in Hyères, in the south of France. It is an abstracted design of dancing figures expressed by intertwining sections of square-edged bronze. Because of its garden location, Lipchitz suggested installing a machine so that the sculpture could rotate, thus anticipating the mobile. A smaller but significant piece was *Reclining Nude with Guitar* (1928), of which the first version, now in MOMA, was made out of black basalt. Conceived in curvilinear volumes, the sculpture was, in Lipchitz's words, "a total assimilation of the figure to the guitar-object." His monumental bronze *Figure,* more than seven feet high, on which he worked from 1926 to 1930 and which is now in MOMA's garden, is an awesome, totemlike sculpture whose upper part suggests a head with staring eyes. Although Lipchitz acknowledged the resemblance of *Figure* to African sculpture, he saw it as the logical outcome of the findings of his cubist and postcubist years.

In 1930 Lipchitz had his first large retrospective exhibition of one hundred sculptures at Jeanne Bucher's Galerie de la Renaissance, Paris.

In the 1930s his work took on an increasingly emotional, baroque, and symbolic quality; his frequent use of Biblical and mythological themes was due in no small part to his anxiety over political events in Europe. One of his first Biblical themes was the *Return of the Prodigal Son,* completed in 1930; it represented for him "the idea of the son who is returning home, the artist who is returning to nature. *Song of the Vowels* (1932), commissioned for a garden in the south of France (one cast is now in Otterlo, another in Zurich, another in the Billy Rose Sculpture Garden of the Israel Museum, Jerusalem), was not, as many have thought, inspired by Rimbaud's poem *Le Chant des voyelles.* Lipchitz had read about a papyrus discovered in Egypt concerning a prayer called "The Song of the Vowels," composed entirely of vowels and designed to subdue the forces of nature. Lipchitz incorporated the motif of two women harpists in the overall form of this monumental sculpture.

In 1931, disturbed by the rise of fascism in Germany, Lipchitz made his first study for *Prometheus,* a reclining figure with arched back and scream-distorted mouth. He returned again and again in the 1930s to the theme of struggle, with *Jacob and the Angel* (1932), *David and Goliath* (1933), and other studies of Prometheus. By now he had adopted a much more plastic, modeled manner than in his cubist work of the 1920s, but he still preserved strong rhythms conveyed by repetitions and variations of the lump and the bulge that gave a heavily baroque emphasis to his forms. During 1932 and 1933 he returned to portraiture, and modeled a vigorous head of the Romantic painter Géricault, whom he greatly admired.

In 1935 Lipchitz had his first large exhibition in the United States, at Joseph Brummer's New York City gallery, but he did not at that time visit America. In 1936 he was commissioned by the French government to design one of the gates of the Scientific Pavilion of the 1936–37 World's Fair in Paris. His 30-foot sculpture, of Prometheus strangling the vulture, symbolized both the struggle of science against darkness and ignorance, and the hope for democracy in the world. The sculpture, exhibited at the Grand Palais during the Paris World's Fair, was violently attacked by reactionary journals. An entire room was devoted to Lipchitz's sculpture at the exhibition "Les Maîtres d'aujourd'hui," held at the Petit Palais during the fair.

Lipchitz's response to the tragedy of the Spanish Civil War and mounting world tension was reflected in the turgid, bulbous volumes and agitated rhythms of *Europa and the Bull* (1938). After Germany's invasion of Poland in 1939,

Lipchitz found it impossible to work. He and his wife Berthe fled Paris in May 1940, when France was invaded by the Germans. Helped by friends, they reached the free zone of France and settled in Toulouse. Lipchitz made one "very free and baroque" bronze sketch called *Flight* (1940) and a companion piece, *Arrival,* after reaching New York City on a Portuguese ship in June 1941. He had no money, and knew not a word of English. "It was like starting my life all over again," he recalled.

To earn his living Lipchitz accepted commissions for portraits. One of the best known, that of the painter Marsden Hartley (1942), required 27 sittings. But he refused an offer of a teaching position; as he explained many years later, "Teaching is death." A number of solo shows at Curt Valentin's Buchholz Gallery, New York City, beginning in 1942, helped Lipchitz establish himself in the United States.

The Pilgrim (1942) was the first of a series of strange, expressionistic bronzes with fantastic surrealistic and symbolic overtones, a trend carried even further in the tangled, visceral forms of *The Prayer* (1943). These ragged, "vegetable" creations have not been universally admired. Of this series Arnold Auerbach noted: "Their life is natural and not sculptural in character," suggesting that Lipchitz, having ceased to believe in an intelligible world, had become "an illustrative commentator on his times."

Lipchitz returned to more monumental and architectural concepts in 1943–44, when he worked on a new version of *Prometheus Strangling the Vulture,* commissioned for the Ministry of Health and Education in Rio de Janeiro. In 1946 he visited Paris for the first time since the war; he exhibited at the Galerie Maeght and was made a Chevalier de la Légion d'Honneur. He wrote in his autobiography: "When I returned to the United States my first wife did not want to come back with me. She did not like America; so I went back alone. . . ." They were divorced in 1947, and Lipchitz later married Yulla Halberstadt, a Berlin refugee from Nazism whom he had met in New York. Their daughter Lolya Rachael was born in October 1948.

By 1948 Lipchitz had settled in Hastings-on-Hudson, New York, but still kept his studio in Manhattan. He began a series of studies for a *Notre Dame de Liesse* (Our Lady of Joy), commissioned by Father Couturier for the Church of Notre-Dame-de-Toute-Grâce at Assy. Lipchitz agreed to accept the commission provided that his sculpture carry the inscription: "Jacob Lipchitz, Jew, faithful to the religion of his ancestors, had made this Virgin to foster understanding between men on earth, that the life of the spirit may prevail."

The bronze models for *Our Lady of Joy,* along with many of his works, were lost in a fire that destroyed his Manhattan studio in January 1952. However, he soon resumed work on the Madonna and on another project, *The Spirit of Enterprise,* for Fairmount Park, Philadelphia, completed in 1958 and installed in October 1960.

Lipchitz had a retrospective in 1954 at MOMA, as well as in Minneapolis and Cleveland. In 1955 he created his first "semiautomatics," developed from plunging a handful of clay, plasticene, or hot waxy material into a basin of cold water and, using only his sense of touch, manipulating the form according to his state of mind. At first the procedure was purely automatic, later, after taking out the form, he would consciously develop whatever image it suggested to him. One of these semiautomatics of 1955–56 was called *Only Inspiration,* another *Remembrance of Löie Fuller.* About 1956 he had the idea of taking real objects—flowers, leaves, string, sticks, or pieces of clothing, and incorporating them into wax models for bronze sculpture, using the difficult *cire perdue* process. These curious little sculptural montages, or assemblages cast in bronze, were shown in an exhibition called "A La Limite du possible" at Fine Arts Associates, New York City. They included *The Artichokes* (1958) and *The Bone* (1959).

In 1958 Lipchitz became an American citizen. To celebrate his 70th birthday, he announced in 1961 his gift of 300 original plaster models of his sculpture to the American-Israel Cultural Foundation for the Jerusalem Museum of Art. A full-scale retrospective, "Fifty Years of Lipchitz Sculpture," was held at the Otto Gerson Gallery, New York City.

In the autumn of 1962 Lipchitz visited Israel, and in 1963 began spending his summers in Pietrasanta, Italy. During the summer of 1964 in Italy he worked on sketches for the monumental sculpture *Peace on Earth* for the Los Angeles County Music Center, dedicated in 1969, and also for the *Bellerophon Taming Pegasus,* a large commission (completed in 1966) from Columbia University Law School. In these and other late sculptures, the heavily rhetorical baroque forms and emphatic symbolism were as pronounced as ever.

Lipchitz had retrospectives in 1970–1972 at the Tel Aviv Museum and the Nationalgalerie, Berlin. He was then working on monumental sculptures, notably *Government of the People* for the Municipal Plaza, Philadelphia, and *Our Tree of Life* for Mount Scopus in Israel, installed there in 1978. A major Lipchitz retrospective

was held at the Metropolitan Museum of Art, New York City, in 1972.

Jacques Lipchitz died in Capri, Italy at the age of 81. A few months before his death an hour-long film, made in Pietrasanta and produced and directed by Bruce R. Basssett, was shown on American television. The *New York Times* television critic wrote that the renowned sculptor at the age of 80 was "a gregarious bear of a man," seen actively working with two young assistants on his massive *Government of the People* project. Lipchitz was a sturdily-built man, six feet tall, with blue eyes and gray hair that had once been light brown. In his younger days he had somewhat Napoleonic features, and, in the opinion of one writer, "a physiognomy . . . of great spiritual fineness." Raphael Soyer, who visited him in Pietrasanta in August 1966, was charmed by his speech, a mixture of French, English, Russian, and Yiddish, and by his "fusion of sophistication and folksy intelligence." Lipchitz's lifelong hobby had been collecting primitive art of all kinds, especially sculpture, from many parts of the world. Lipchitz himself, according to one writer, "has every right to be included along those who have been called 'the primitives' of the new tradition in sculpture." For Jacques Lipchitz the practice of his art had great social and symbolic significance as a manifestation of the free democratic spirit. He once described himself as "a violent partisan of personality and creative expression." He wrote: "The work of art should go from the unconscious to the conscious and then finally to the unconscious again. This is an idea I am still to work out and, who knows, perhaps some day I will succeed."

EXHIBITIONS INCLUDE: Gal. Léonce Rosenberg, Paris 1920; Gal. de la Renaissance, Paris 1930; Joseph Brummer Gal., NYC 1935; Buchholz Gal., NYC 1942, '43, '46, '48, '51; Gal. Maeght, Paris 1946; Portland Art Mus., Oreg. 1950; MOMA, NYC 1954; Walker Art Center, Minneapolis 1954; Cleveland Mus. of Art 1954; Fine Arts Associates, NYC 1957–63; Stedelijk Mus., Amsterdam 1958; "Fifty Years of Lipchitz' Sculpture," Otto Gerson Gal., NYC 1961; "Fifty Years of Lipchitz' Sculpture," Cornell Univ., Ithaca, N.Y. 1962; Marlborough-Gerson Gal., NYC 1963, '66, '68; Art Gal., Univ. of California at Los Angeles 1963; Tel Aviv Mus. 1970–71; Nationalgal., Berlin 1971–72; Metropolitan Mus. of Art, NYC 1972. GROUP EXHIBITIONS INCLUDE: Salon d'Automne, Paris 1913; "Les Maîtres d'aujourd'hui," Petit Palais, Paris 1937; Venice Biennale 1952; "A la limite du possible," Fine Arts Associates, NYC 1963; "Scultura Internazionale," Marlborough Gal. d'Arte, Rome 1968; "The Cubist Epoch," Los Angeles County Mus. of Art 1970; "Pioneers of Modern Sculpture," Hayward Gal., London 1973.

COLLECTIONS INCLUDE: Metropolitan Mus. of Art, MOMA, Whitney Mus. of Am. Art, Solomon R. Guggenheim Mus., and Jewish Mus., NYC; Hirshhorn Mus. and Sculpture Garden, and Phillips Collection, Washington, D.C.; Albright-Knox Art Gal., Buffalo, N.Y.; Harvard Univ., Cambridge, Mass.; Art Inst., Chicago; Mus. of Art, Cleveland; City Art Mus., St. Louis, Mo.; San Francisco Mus. of Art; Tate Gal., London; Mus. Nat. d'Art Moderne, Paris; Stedelijk Mus., Amsterdam; Gemeente Mus., the Hague; Kunsthaus, Zürich; Gal. Nazionale d'Arte Moderna, Rome; Bezalel Nat. Art Mus., Jerusalem.

ABOUT: Arnason, H. H. History of Modern Art, 1968; Jacques Lipchitz: Sketches in Bronze, 1969; Auerback, A. Sculpture, 1952; Bénézit, E. (ed.) Dictionnaire des peintres, sculpteurs et graveurs, 1976; Current Biography, 1962; Hammacher, A. M. Jacques Lipchitz: His Sculpture, 1961; Hope, H. R. The Sculpture of Jacques Lipchitz, 1954; Lipchitz, J. The Lipchitz Collection, New York, Museum of Primitive Art, 1960, My Life in Sculpture, 1972; P-Orridge, G. and others Contemporary Artists, 1977; Patai, I. Encounter: The Life of Jacques Lipchitz, 1964; Raynal, M. Lipchitz, 1947; Seuphor, M. The Sculpture of this Century, 1959; Wight, F. S. "Jacques Lipchitz" (cat.), Univ. of California Art Gals., Los Angeles, 1963. *Periodicals*—Art News April 1950, November 1961, March 1978; Arts de France (Paris) no. 6 1946; New York Times May 28, 1973; Partisan Review Winter 1945.

LIPPOLD, RICHARD (May 3, 1915–), American sculptor, achieved international prominence with his gossamer constructions in wire, among the most original and appealing works in contemporary American abstract sculpture. He was born in Milwaukee, Wisconsin, the son of Adolph Lippold, a mechanical engineer, and the former Elsa Schmidt, both of German extraction. He has one sister, Jane.

Lippold attended public schools in Milwaukee until he was 18. From 1933 to 1937 he studied at the Art Institute of Chicago, majoring in industrial design. He spent several summer vacations painting in Mexico and also visited the southwest.

After graduating in 1937 with a BFA degree from the Art Institute, where he had also studied piano and dance, Lippold worked as a professional designer for Chicago corporations. He traveled frequently during this period (1937–40), maintaining his own studio in Milwaukee and doing freelance work. In 1940 Lippold married the dancer Louise Greuel. They have two daughters, Lisa, born in 1943, and Tiana, born in 1947. Their son Ero was born in 1959.

From 1940 to 1941 Lippold taught at the Layton School of Art, Milwaukee. After spending the summer of 1941 in Mexico, he gave up his career as an industrial designer in order to teach

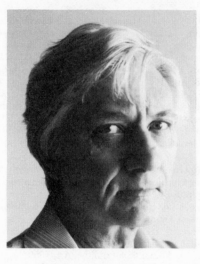

RICHARD LIPPOLD

art at the University of Michigan, Ann Arbor, for the next three years.

Lippold first turned to sculpture in 1942. Self-taught, although strongly influenced by the constructivist works of Antoine Pevsner and Naum Gabo, he began to produce small constructions made of iron, brass, and copper wire. Most of his earliest pieces were carefully balanced, delicate objects, composed of linear elements in wire, sometimes with metal shapes set in between them. At this time he was also composing music.

In 1944 Lippold resigned from the University of Michigan and moved to New York City. For a year he and his wife and child lived on the proceeds from the sale of a Hammond organ which had been given them by Lippold's father as a wedding present. He was still undecided about whether to pursue music or sculpture; meanwhile, his wife continued to study modern dance with Martha Graham and Merce Cunningham.

From 1945 to 1947 Lippold taught at Goddard College, Vermont, and acquired property for a summer home in the White Mountains. His works were first seen in public in 1945, when two of his pieces were included in William Valentiner's "Origins of Modern Sculpture" show at the City Art Museum, St. Louis, Missouri, and the Detroit Institute of Arts. His first solo show was held at the Willard Gallery, New York City, in 1947; by then his sculpture had grown larger and more elegant, and he was beginning to concentrate on the space delineated by his wire forms. He remarked that he used "hair-thin wire" in order to "induce the viewer to look into the space," adding that "the material for me becomes minimal and the space becomes

maximal." In the same year, 1947, he headed the art department at Trenton Junior College, New Jersey, and taught part-time at Queens College, New York.

In the summer of 1948 Lippold was artist-in-residence at the experimental Black Mountain College in North Carolina. His works from that summer were shown in his second solo exhibit at the Willard Gallery in 1948. He was now beginning to employ simple geometric forms to give overall structure to his work.

Lippold's third solo show at the Willard Gallery, held in 1950, contained only one immense sculptural construction, *Variation Within a Sphere No. 7: Full Moon.* It consisted of a series of open-work squares set within each other, with wires radiating out to both floor and ceiling like shafts of light. While the construction suggested the radiation of moonlight, and Lippold claimed to have derived this and similar works from the effects of moonlight filtering through mist, *Full Moon* fell entirely within the constructivist tradition. At the same time, as was pointed out in *Life* magazine, "Lippold also interprets it as a symbol of the tenseness of the world today. If one of the taut key-wires were to snap, the whole structure would collapse." *Full Moon* was purchased by the Museum of Modern Art, New York City, and in 1955 was exhibited in Paris in the "Salute to France" show.

Also in 1950 Lippold was commissioned by the former Bauhaus architect Walter Gropius to make an outdoor construction in stainless steel. Entitled *World Tree,* the piece was placed outside the Graduate Law School Center at Harvard University.

In 1952 Lippold began his teaching at Hunter College, New York City, held his fourth solo show at the Willard Gallery, and was represented in the important "15 Americans" show at MOMA. That same year he completed his sculpture for the International Sculpture Competition, sponsored by the Institute of Contemporary Arts, London. Lippold's cagelike wire construction won third prize (the first-prize winner was Reg Butler). Lippold's piece was exhibited at London's Tate Gallery in 1953 and was reproduced in *Art News* in February of that year.

Several of Lippold's constructions of the late 1940s and early '50s had had the stars as a theme. In 1953 a giant sun—its full title was *Variation Within a Sphere, Number 10: The Sun*—was commissioned by the Metropolitan Museum of Art, New York City. This was the first time the museum's trustees had actually commissioned a piece of modern sculpture. According to *Newsweek,* Lippold "set out on the three-year-long task . . . with the dedication and self-

effacement of an anonymous Oriental craftsman." About 14,000 welding joins were needed to create the network of fine gold wire. Completed in 1956, it is 222 feet long and 11 feet high; its installation in the museum took two weeks. The "sun" was exhibited in semidarkness against a black backdrop, producing a glittering effect as light flooded the construction. Lippold has said that he wanted his work to appear to exist in limitless, "outer" space. His meticulous construction was recorded on film, and is now one of the most admired pieces in the Metropolitan Museum's American wing.

At the invitation of the German government, Lippold traveled to Germany in 1954, and also visited Austria and Paris. He returned to Paris in 1955 for the installation of *Full Moon* at the Musée d'Art Moderne, and traveled in France and England. In subsequent years he visited Spain, Italy, Switzerland, Germany, Denmark, Turkey, Greece, Madeira, and the British Isles. In 1955 Lippold moved with his family to Lattingtown, Locust Valley, Long Island, where he found a studio large enough to suit his needs.

Lippold's work, with its imaginative use of materials and handling of space, lends itself admirably to interior settings. Among his many commissions in the late '50s were gigantic wire constructions for the lobby of the Inland Steel Building in Chicago (1957) and the Four Seasons Restaurant in the Seagram Building, New York City (1959). In 1959 he designed the stage setting for *The Sybil,* a ballet choreographed by John Butler and performed at the Festival of Two Worlds, Spoleto, Italy. One of his most evocative creations was *Flight,* his radiant wire construction commissioned in 1961 and installed in 1963 in the lobby of the Pan-Am building at 45th Street and Vanderbilt Avenue, Manhattan. The entire interior space of the lobby is brought into play, with the strands of wire converging from surrounding walls and changing daylight pouring from the windows. The project was conceived in collaboration with the architects of the building, Emery Roth and Sons.

Another work commissioned in 1961 was *Orpheus and Apollo,* installed the following year in the lobby of Philharmonic Hall in Lincoln Center, New York City. This five-ton, dangling construction of shining metal slats, suspended from the ceiling and spanning 190 feet, has inspired mixed reactions. Some compared it to a multiple Sword of Damocles hanging overhead. (At one time it was declared a hazard by the Buildings Department.) Hilton Kramer in *The New York Times* (January 14, 1968), discussing *Orpheus and Apollo* and *Gemini II* (1965–66, for the Jesse H. Jones Hall of the Performing Arts in

Houston), among other works, wrote: " . . . What we see in his *oeuvre* is the subversion of the Constructivist esthetic for decorative ends." To critics in the 1950s who referred to his constructions' skillful lighting effects as "jewelry" or who complained that his finished work looked more like aerial rigging than sculpture, he replied: "Our faith is in space, energy and communications, not in pyramids and cathedrals."

Lippold has always sought to "marry his art to the building it inhabits." One of the most architectural of his constructions was his *Baldacchino* (1967), a canopy over the altar of the Cathedral of St. Mary the Virgin, San Francisco. The architects with whom he collaborated on this project were Pietro Belluschi, Luigi Nervi, and the firm of McSweeney, Ryan and Lee.

In 1969 Lippold traveled to Morocco. His major commission in that year was for the lobby of the North Carolina National Bank, Charlotte.

In 1973 Lippold's *Sun,* which had been stashed away for years in the Metropolitan Museum's storage rooms, was brought out for inclusion in the museum's spectacular exhibition, "Gold." Also in 1973 he had his first show in several years at the Willard Gallery, where his smaller works disppointed one critic who found a "disconcerting, compressed busyness" had replaced the artist's original harmony of line, volume, and material. In 1976 Lippold finished work on a 115-foot construction in front of the Air and Space Museum on the Mall in Washington, D.C.

Richard Lippold is a slim man, five feet eleven inches tall, with gray eyes and graying, light brown hair. He has a clipped, rapid fire manner of expression. At one end of his spacious, white-walled stable-turned-studio in Locust Valley is a modern-looking organ made to his specifications. The concerts he occasionally gives in his studio are evidence of the continued importance to him of music. He has remarked jestingly that some people consider the handsome pipe organ in his studio to be one of his best works. His finest constructions, according to one critic, "have a baroque symmetry as logical as a Bach cantata."

A statement written by Lippold in 1977 for *Contemporary Artists* contains these observations: "We of this moment have learned to hurl ourselves through space, time and energy with speeds and sensations beyond the dreams of our forefathers."

EXHIBITIONS INCLUDE: Willard Gal., NYC 1947, '48, '50, '52, '62, '68, '73; Arts Club of Chicago, 1953; Layton Art Gal., Milwaukee 1953; Brandeis Univ., Waltham, Mass. 1958. GROUP EXHIBITIONS INCLUDE: "Origins of Modern Sculpture," City Art Mus., St. Louis, Mo. 1945; "Origins of Modern Sculpture," Detroit

Inst. of Arts 1946; Annual, Whitney Mus. of Am. Art,
NYC 1947, '48; São Paulo Bienal 1948; "Fifteen
Americans," MOMA, NYC 1952; "The Unknown Po-
litical Prisoner," Tate Gal., London 1953; "Salute to
France," Mus. d'Art Moderne, Paris 1954; "New
Members," Nat. Inst. of Arts and Letters, NYC 1964;
"Gold," Metropolitan Mus. of Art, NYC, 1973.

COLLECTIONS INCLUDE: Metropolitan Mus. of Art,
MOMA, and Whitney Mus. of Am. Art, NYC; Mun-
son-Williams-Proctor Inst., Utica, N.Y.; Newark Mus.,
N.J.; Wadsworth Atheneum, Hartford, Conn.; Yale
Univ. Art Gal., New Haven, Conn.; Addison Gal. of
Am. Art, Andover, Mass.; Fogg Art Gal., Cambridge,
Mass.; Hirshhorn Mus. and Sculpture Garden, Wash-
ington, D.C.; Des Moines Art Center, Iowa; Detroit
Inst. of Arts; Virginia Mus. of Fine Art, Richmond.

ARCHITECTURAL COMMISSIONS INCLUDE: Four Seasons
Restaurant, Seagram Building, Pan-Am Building,
Philharmonic Hall, Lincoln Center, NYC; National
Air and Space Museum, Washington, D.C.; Inland
Steel Building, Chicago; North Carolina Nat. Bank,
Charlotte; Jesse H. Jones Hall of the Performing Arts,
Houston; St. Mary's Cathedral, San Francisco; Mus. de
Vin, Pauillac, Gironde, France.

ABOUT: Baur, J.I.H. The New Decade, 1955; Brummer,
C. L. Contemporary American Sculpture, 1948; Cur-
rent Biography, 1956; Miller, O. C. (ed.) "15
Americans" (cat.), MOMA, NYC, 1952; Moilach, D. Z.
Direct Metal Sculpture, 1966; P-Orridge, G. and others
(eds.) Contemporary Artists, 1977; Read, H. A Concise
History of Modern Sculpture, 1964; Rickey, G. Con-
structivism: Origins and Evolution, 1967; Ritchie,
A. C. Sculpture of the Twentieth Century, 1952; Seu-
phor, M. The Sculpture of this Century, 1960; Trier,
E. Form and Space Sculpture in the 20th Century,
1968. *Periodicals*—Life June 12, 1950; New York
Times January 14, 1968; Newsday May 25, 1973, Au-
gust 19, 1973; Newsweek July 30, 1956; Time August
15, 1955.

LIPTON, SEYMOUR (November 6, 1903–),
American sculptor, was a pioneer of direct-metal
sculpture in the United States. Born in New York
City to Simon Lipton, a candy-store owner, and
the former Gussie Cohen, he had two brothers,
Martin and Leon, and a sister, Martha. From
childhood on Seymour Lipton was interested in
art, and at the age of 12, he began making pencil
drawings and painting. He attended Morris
High School in the Bronx, where he belonged to
the art and poster clubs. His favorite sport was,
and remained, tennis. After graduating from
high school in 1921, he studied for a year at the
College of the City of New York and from 1923
to 1927 at Columbia University, from which he
obtained his degree, in dentistry.

During his last three years at Columbia Lip-
ton wrote poetry, read widely in aesthetics and

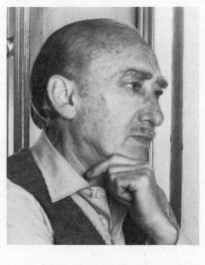

SEYMOUR LIPTON

philosophy, and attended art shows, becoming
interested in modern art after seeing the work of
Matisse and the Cubists. Although he was preoc-
cupied with the question of beauty, he was en-
tirely self-taught as a sculptor, and this lack of
formal training in the opinion of many critics,
accounted for his work's freshness and innova-
tive character. His lack of training in drawing,
too, affected his sculptural ideas, for, as he ex-
plained years later, "My drawing has a certain
kind of schematism which lends itself to an econ-
omy and simplification of forms in silhouette."

In about 1928 Lipton made small carvings in
ivory and gold, mostly for jewelry, and before
1930 he made a two-foot-high clay statue,
Leonardo da Vinci Holding a Bird. But it was in
1932 that Lipton devoted himself seriously to
sculpture. The works he produced during the
next few years were, in his words, "mostly wood-
carvings, representational in form and social in
substance." He first exhibited at a New York
City chapter of the John Reed Club, in 1933–34,
and showed there again in 1935. His sculptures
of the 1930s suggest the influence of Barlach and
primitive carvings, and their titles—for instance,
Lynching (1935) and *The Dispossessed* (1937)—
reveal their socially conscious themes.

Lipton's first solo show was held at the A.C.A.
Gallery, New York City, in 1938. In the years
1939–41 he opened up his forms and began to
seek a means of interpreting man's inner life and
the dark forces that lie beneath the surface of na-
ture. His next solo exhibition took place in 1943
at the Galerie St. Etienne, New York City. The
late '30s and the '40s were arduous years, and to
support his family Lipton taught sculpture: at

the New School for Social Research, New York City, from 1940 to 1948; at the Cooper Union Art School, New York City, in 1943–44; and at the New Jersey State Teachers College, Newark, in 1944–45.

In the 1930s, when he had been guided by social realist themes, Lipton's chief formal concern was the depiction of the human figure. In the early '40s, however, he was influenced by surrealism, and themes of social protest gave way to more complex subject matter as, during World War II, he was at pains to express man's experience of tragedy. As a result, Lipton evolved a personal metaphorical style with what Albert E. Elsen has described as "some of modern sculpture's most ferocious imagery." (At this time the artist also turned from the use of wood and stone to lead and bronze.) The titles of his early postwar pieces refer to the sense of horror and spiritual conflict that he sought to convey: *Dissonance* (lead, 1946); *Famine* (lead, 1946); *Moloch* (bronze, 1946); and *The Mortal Cage* (bronze, 1947). A "Moloch" series in lead followed in 1948. Albert E. Elsen has written of Lipton's sculptures of the mid- and late 1940s: "These are brutal images, often of fantastic mythological hybrids or mutants from biology, endowed with hook or horn. . . ." Lipton described the "harsh tensions" of man and the struggle to achieve balance as "the realism that I'm trying to get at in sculptural language." In those days Lipton still worked in a tiny studio, which, in 1964, the critic Katherine Kuh remembered having visited nearly 20 years earlier. "Even in those excessively cramped quarters he was producing experimental sculpture that already bristled with his personal stamp," she wrote in the *Saturday Review.*

Lipton's first solo show at the Betty Parsons Gallery, held in 1948, brought him recognition as a leading American sculptor.

In the 1950s Lipton developed his characteristic style in bronze and nickel silver on sheet steel and Monel metal. Becoming increasingly aware of the polarities in human existence, he began to see tension and struggle as part of growth and of the regenerative powers of nature. According to Barbara Rose, Lipton "outlined the 'main genesis of artistic substance' as 'the bud, the core, the spring, the darkness of earth, the deep animal fountainhead of man's forces.'" Thus in the early 1950s Lipton temporarily abandoned the human figure, which had been less important in his work since the early '40s, and drew upon biological imagery—including plant forms, as in *Sanctuary* (1953), in nickel silver over steel—in order to express the processes of metamorphosis and regeneration. Typical works of this period,

in which symbols drawn from nature were often juxtaposed to mechanical imagery, are *Jungle Bloom* (bronze over steel, 1953), *Sea King* (1956), *Desert Briar* (1955), and *Earth Forge II* (1955; MOMA).

From the 1950s on, Lipton has followed a consistent technical procedure in sculpture. He begins with a spontaneous drawing in black crayon, from which he constructs a small maquette in Monel metal. The full-scale sculpture, like the model, is made of thin, malleable sheet metal, brazed edge to edge after Lipton has cut out his shapes with metal shears. The shapes can later be joined, when desired, by welding. He varies the surfaces by the application of melted nickel silver and bronze, which gives a glowing, somewhat impressionist texture and an antimechanical character to the finished piece.

Lipton was represented in the "12 Americans" show at the Museum of Modern Art, New York City, in 1956. Lipton's self-described "concern with internal-external anatomy" and with the tension between inside and outside were evident in the heavy convoluted leaf forms of such pieces appearing in the show as *Sanctuary* (1953), which MOMA had purchased two years before the exhibition, and the aggressively poised *Storm-Bird* (1953; Collection of Nelson A. Rockefeller).

In his monumental *Prophet* (1956), Lipton returned to motifs involving the human figure. Human imagery was also evoked in *Ancestor* (1958) and *Sentinel* (1959). Humanistic elements were also present in the curving zoomorphic shapes of *Manuscript* and *Scroll,* both of 1960, which expressed the artist's view of the unfolding process of being in the cosmos and in human history. Of his *Mandrake* (1958; Hirshhorn Museum and Sculpture Garden, Washington, D.C.) Lipton wrote, in 1972, that this work "deals with forms and imagery [illuminating] the ogres of man's inner and outer existence," and that its title "resulted from the suggestion of a plant-woman-birth straining presence."

Lipton was awarded the acquisition prize at the São Paulo Bienal of 1957; in 1958 a room was devoted to his work at the Venice Biennale and he was represented at the Brussels World's Fair. Two of his most important commissions in the 1950s were for Temple Israel in Tulsa, Oklahoma (1954), and Temple Beth-El in Gary, Indiana (1955).

In *Contemporary Artists,* G.S. Whittet asserted that Lipton's works of the 1960s "took on more ambitious schemes in what has been described as 'ideographic idioms.'" One of these works, *The Ring* (1963), featured two shieldlike discs in bronze-coated metal, expressing the life

force evident in nature. Another important sculpture of the period, *Archangel,* was commissioned for Philharmonic Hall at Lincoln Center, New York City, and after five months' intensive work, was unveiled in February 1964. Although one critic complained that *Archangel* (eight feet ten inches high) "sits in an area whose ceiling is much too low for its bulk," Lipton explained that he wanted to give the work a feeling of pressure in order to heighten its impression of bursting energy and release. "I thought the spot needed something voluptuous, baroque," he said, adding that he also wanted to make it an affirmation of life and that he had "never enjoyed any work so much in my life."

A Lipton retrospective was held in 1964 at the Phillips Collection, Washington, D.C., and in March 1965 an important solo exhibition of his work opened at the Marlborough-Gerson Gallery, New York City. In the latter show's catalog, Sam Hunter observed that Lipton's inventive capacity and rich existential meanings "had been obscured for a time by the . . . advances of abstract expressionist paintings," and he compared Lipton's "combined mechanical, botanical and sexual metaphors" to Dylan Thomas's surrealistic imagery. Albert Elsen also stressed analogies between Dylan Thomas's poetry and such Lipton works as *Séance* (1961), *The Ring* (1963), *Gateway* (1964), and, in its urgent, thrusting movement, *Portrait of a Poet* (1962). Seeing *The Empty Room* (1964) as an example of how "old forms continue to beget new ones" in Lipton's work, Elsen pointed out that, though the "room" was empty of man's physical life, the upright form, partially enclosed by the "wall" and rising above it, stood "positive and totem-like," symbolizing man's spiritual struggle and the triumph of life over death.

Elsen also praised Lipton for remaining unaffected by changes in artistic fashions: "For Lipton to polish steel into semaphores, hang straight golden rods from ceilings, sew burlap on wire frames or cast someone in plaster would be an artistic and personal lie."

On November 16, 1930, Lipton married Lillian Franzblau. They have two sons, Michael and Alan, and now live in Lattingtown, Locust Valley, Long Island. For many years Lipton has also had his studio and part-time residence in a brownstone on Manhattan's Upper West Side. Five foot nine, with brown eyes, gray hair, and a small moustache. Lipton is cordial in manner and highly articulate. Jewish by birth, he belongs to no religious organization, although he says that he is basically a religious man: "Maybe I'm too fanatically a zealot about creative work. I have almost a religious involvement about it. Art has a kind of sacred significance to me."

In a passage in his notebook, quoted in the catalog to his 1965 solo show at the Marlborough-Gerson Gallery, Lipton expressed his artistic credo: "The high road, if there is one for sculpture, is along the historic path of the meaning of man's life. The big symbolism is of the soul of man today, as it has always been. To be achieved, this must be rendered in the plastic language of today. . . . The Greek tragic playwrights, Shakespeare, Dylan Thomas, Bach, funerary bronzes of ancient China, Oceanic sculpture, Franz Kline, the metaphysical reality of Klee, H. Bosch, the wild ocean beach, gnarled roots, spring in the woods are some of the things I've felt strongly about."

EXHIBITIONS INCLUDE: A.C.A. Gal., NYC 1938; Gal. St. Etienne, NYC 1943; Betty Parsons Gal., NYC 1948, '50, '52, '54, '58, '61; American Univ., Washington, D.C. 1951; Munson-Williams-Proctor Inst., Utica, N.Y. 1956; Venice Biennale 1958; Phillips Collection, Washington, D.C. 1964; Marlborough-Gerson Gal., NYC 1965; Milwaukee Mus. of Fine Arts 1968; Marlborough Gal., NYC 1971, '76; Massachusetts Inst. of Technology, Cambridge 1971; Nat. Collection of Fine Arts, Washington, D.C. 1979. GROUP EXHIBITIONS INCLUDE: John Reed Club, NYC 1933–34, '35; New York World's Fair, Flushing Meadow 1940; Sculptors' Guild Annual, NYC 1941–44; American Painting and Sculpture Annual, Art Inst. of Chicago 1947, '57; "Abstract Painting and Sculpture in America," MOMA, NYC 1951; "The New Decade," Whitney Mus. of Am. Art, NYC 1955; "12 Americans," MOMA, NYC 1956; São Paulo Bienal 1957; Brussels World's Fair 1958; Documenta 2, Kassel, W. Ger. 1960; Spoleto Festival, Italy 1962; "New American Painting and Sculpture," MOMA, NYC 1969.

COLLECTIONS INCLUDE: Metropolitan Mus. of Art, MOMA, Whitney Mus. of Am. Art, and New School for Social Research, NYC; Brooklyn Mus. of Art, N.Y; Munson-Williams-Proctor Inst., Ithaca, N.Y.; Albright-Knox Art Gal., Buffalo, N.Y.; Wadsworth Atheneum, Hartford, Conn.; Franklin Inst., Philadelphia; Phillips Collection, Washington Gal. of Modern Art, and Hirshhorn Mus. and Sculpture Garden, Washington, D.C.; Baltimore Mus. of Art; Des Moines Art Center, Iowa; Detroit Inst. of Art; Univ. of Michigan Mus., Ann Arbor; Santa Barbara Mus., Calif.; Art Gal. of Ontario, Toronto; Didrichsen Foundation, Helsinki; Tel-Aviv Mus., Israel.

ABOUT: Brumme, C.L. Contemporary American Sculpture, 1948; Current Biography, 1964; Elsen, A.E. Seymour Lipton, 1970; Giedion-Welcker, C. Contemporary Sculpture: An Evolution in Volume and Space, 1960; Hunter, S. American Art of the Twentieth Century, 1973; Miller, D.C. (ed.) "12 Americans" (cat.) MOMA, NYC, 1956; P-Orridge, G. and others (eds.) Contemporary Artists, 1977; Read, H. A Concise History of Modern Sculpture, 1964; Rose, B. American Art Since 1900, 2d ed. 1975; Seuphor, M.

The Sculpture of This Century, 1960; "Seymour Lipton" (cat.), Marlborough-Gerson Gal., NYC, 1965; Strachan, W.J. Towards Sculpture: Drawings and Maquettes from Rodin to Oldenburg, 1976. *Periodicals*—Art in America Winter 1956–57; Art International no. 1 1965; New York Herald Tribune February 22, 1964; Magazine of Art November 1947; New York Times February 19, 1964; New York Times Magazine September 30, 1962; Register of the Museum of Art (Lawrence, Kansas) April 1962; Saturday Review February 29, 1964.

***LORJOU, BERNARD** (September 9, 1908–), French painter, has been placed in the tradition of Van Gogh, the Fauves, and Soutine for his bright palette and vigorous brushwork. With a subversive sense of humor, Lorjou rebelled against what he has termed the "fanaticism" of nonobjective abstraction and the tired remnants of French academicism in the search for a fresh realism that would integrate art and contemporary life.

Bernard Lorjou was born in the village of Blois, in France's Loire Valley. His parents were poor, and his childhood difficult. At the age of 13, he went to work in Paris in the silk trade; within two years he began to study painting and drawing at the evening school of the City of Paris (nonetheless, he considers himself essentially a self-taught painter). For many years he earned his living as a silk designer in the studio of Francis Ducharne. In 1931 he was greatly impressed by the works of El Greco, Goya, and Velázquez which he saw during a trip to Spain. On his return, he set up his own design shop, intending to sell to American textile manufacturers, but because of the war he was never able fully to develop the business.

As a painter, Lorjou labored in obscurity for two decades before receiving any substantial recognition. About 1950, he said, "It has taken me twenty years to reach my present stage of success, twenty years of toil and frustration. That is something the younger generation of artists has to realize. It takes that much time before you start to earn any recognition at all." (This was before the current era of instant reputations predicted by Warhol.) His first real success came in 1947, when he showed his painting *Miracle of Lourdes* (1947), a crowded, vertical canvas at once allegorical and realistic, at the Salon d'Automne. The next year Lorjou and Bernard Buffet, with whose work his has much in common, shared the prestigious Prix de la Critique. The American collector Domenica Walter discovered Lorjou at about this time and introduced him to fellow buyers.

In 1948 Lorjou and nine other artists, including Buffet and André Minaux, formed the so-called Man as Witness group (L'Homme Temoin), dedicated to the rejection of nonfigurative abstraction and Picassan surrealism, then powerfully influential, and the erection in their place of a new edifice of realism based on an expressionistic interpretation of the figure. "The danger," Lorjou noted, "is to revert to a banal realism in painting. That would get us nowhere and only give a smug satisfaction to the tiresome academicians at the Ecole des Beaux-Arts." A number of the Man as Witness artists, such as Buffet, did not manage to avoid that banality. Lorjou, at least at this stage and in his major works, found a vigorous figuration that stemmed equally from medieval allegory painting and the Spanish and German Expressionists. His *The Atomic Age* (1951, approximately 21 by 12 feet), possibly his finest work and witty rebuttal to Picasso's *Guernica*, created a sensation when it was first shown at the Salon des Tuileries, Paris. While using several of the same elements as *Guernica*—a screaming horse and a bull's head, for instance—Lorjou rejected Picasso's synthesizing flatness in favor of realistic, if fantastic, imagery. *The Atomic Age*, like *Miracle of Lourdes*, is crowded with figures, animals, and details of all kinds; it obliquely condemns war and the possibility of man-made apocalypse.

In 1952 Lorjou showed at the Venice Biennale, and the next year had his first solo show at the Wildenstein Gallery, New York City. By then he had turned for the most part to less controversial subjects in a series of lesser works—still lifes, interiors, landscapes, flowers, clowns. Some of these paintings retain the power, on a smaller scale, of the earlier canvases—for example, *Piece of Meat* (1953) and portraits of a chicken hanging by its neck and the decapitated head of an ox, all rendered in appropriately violent brush and knife work. Like his friend Buffet, Lorjou made continual, not entirely successful attempts to achieve a new expressive figuration; he painted furniture and figures with the same robust hand, which many critics found invigorating. However, he was hampered by a dependence on the stock figures of French comedy—Harlequin, Pierrot, Colombine—a vein already exhausted, for many, by Picasso, and even further debilitated by Buffet. Lorjou's flower paintings of the period are much like Van Gogh's (*Yellow Flowers in a Jug*, ca. 1958), although he claimed a dislike for the Dutch painter. Several works show the influence of Gauguin, such as *Homage to Gauguin* and *The Child and Sorcery* (both mid-1950s).

Lorjou has always been something of a prankster, so much so that occasionally his jokes have

lôr zhōō, bĕr när´

been accused of upstaging his work. At the Brussels International Exhibition of 1950 he created a stir by showing his work in a separate little shack he constructed—at the same time a pretense of populist modesty and a rejection of the abstract art all around. In 1957 he pulled off another publicity coup by boycotting the galleries entirely and exhibiting in a boatlike booth at the yearly fair on the Esplanade des Invalides. His 1958 defamation suit against Bernard Dorival, the assistant curator of the Musée d'Art Moderne, Paris, who had spoken against Lorjou and his work, was legally unsuccessful but was nonetheless good press. In a further poke at the Parisian art world he scheduled a major exhibition titled "Le Bal des fols" (The Fool's Ball) to coincide with the 1960 Paris Biennale.

Of Lorjou's many scenes of Chartres Cathedral in the mid-1960s, René Huyghe wrote, in the catalog to the artist's show at the Galerie André Urban, Paris, "If Lorjou does violence to the cathedral, it is in order to give it the character of an apparition, rising up in revolt against the traditional limitations of the national temperament and aspiring towards lyricism." André Urban points out in the same catalog that Lorjou's views of Paris do not resemble postcards even though they portray famous sites such as the Sacre-Coeur, the Eiffel Tower, and the Arc de Triomphe. "His vision," wrote Urban, "in its originality transposes everything in the interest of the picture; [his] pure blazing colors [convey] the angry intensity of his expression."

Despite his early disapproval of distortion and abstraction, Lorjou's figures of the 1970s grew increasingly distorted and abstract. The object in *Man's Head and Object* (ca. 1973) is a curious blend of cubistic, surreal, and purely abstract elements, as are the figures themselves in *Conversation* and *Hippie on the Banks of the Seine* (both of 1973). With the later '70s came an entirely new method of working, the mythologizing of contemporary events—the "School of the Event," as he called it—which included a series on the kidnapping of J. Paul Getty III. In a 1974 statement, Lorjou described these works as being similar in intention to the Bayeux tapestries; magical in that they tell stories that have happened elsewhere or in another world, but which are inspired by the truth of our world. Concerned with the indiscriminate visual bombardment of the public by television and film, and the subsequent falling off, in his view, of understanding and appreciation for painting, Lorjou asserted that, to survive, art must escape both from the dusty world of the studio and from the falsity of technology while preserving its essential poetic vision and its vital connection with the events of the present.

EXHIBITIONS INCLUDE: Wildenstein Gal., NYC 1953; Gal. Charpentier, Paris 1954; Gal. André Urban, Paris 1957, '66; Wally Findlay Gals., NYC 1973; Gal. des Theatre, Paris 1978; Gal. St. Martin, Paris 1978. GROUP EXHIBITIONS INCLUDE: "L'Homme Temoin," Paris 1948; Brussels International Exhibition 1950; Salon des Tuileries, Paris from 1951; Venice Biennale 1952; Esplanade des Invalides, Paris 1960.

ABOUT: Bénézit, E. (ed.) Dictionnaire des peintures, sculpteurs et graveurs, 1976; Dorival, B. Les Peintres du XXe siècle, 1957; Huyghe, R. Les Contemporains, 1949. *Periodicals*—Jardin des arts (Paris) March 1974; L'Oeil (Paris) June 10, 1978.

LOUIS, MORRIS (November 28, 1912– September 7, 1962), American painter, was a key figure in the second wave of abstract expressionism and a pioneer in the development of color-field painting.

He was born Morris Louis Bernstein in Baltimore, Maryland, where his Russian-born, father, Louis Bernstein, owned a small grocery store. Morris attended Baltimore public schools and Baltimore City College. In 1929, shortly before graduation, he left college to take advantage of a scholarship to the Maryland Institute of Fine and Applied Arts. He left the Institute in 1933, without completing the course, and supported himself for three years by doing various odd jobs while continuing to paint in a Baltimore studio.

In 1936 Louis moved to the Chelsea district in New York City, where he met Jack Tworkov Arshile Gorky, and the Mexican muralist David Siqueiros. Like many of his contemporaries, Louis worked in the easel-paintng division of the Federal Arts Project. With Jackson Pollock, who was only ten months his elder, he explored automatic painting procedures and the techniques of using Duco enamel pigment in a workshop run by Siqueiros. It was at this time that he began to use the name Louis for professional purposes. One of his paintings, *Broken Bridge*, was exhibited in 1939 at the New York World's Fair in Flushing Meadow.

In 1940 Louis returned to Baltimore, where he painted and taught privately. Had Louis not left New York in 1940, one critic observed, he might well have become "one more of the celebrated artists of the forties who revolutionized American painting." As it was, Louis, withdrawn by nature, isolated himself in Baltimore, away from the New York art world, and concentrated on his own personal experiments. In 1947 he married Marcella Siegel, a writer and editor for the United States Public Health Service, and moved to her apartment in Silver Spring, Maryland. He remained in the Washington, D.C. area for the rest of his life.

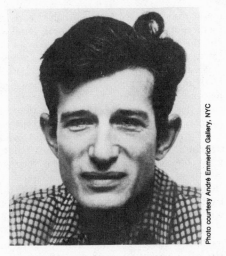

Photo courtesy André Emmerich Gallery, NYC

MORRIS LOUIS

In 1948 Louis began to use Magna colors, an oil-compatible acrylic paint manufactured by his friend Louis Bocour. For the next four years he exhibited annually with the Maryland Artists group at the Baltimore Museum of Art. When the Louises moved in 1952 to a house in Washington, D.C., Louis became an instructor at the Washington Workshop Center, a gathering place for supporters of avant-grade art. By all accounts, Louis was an excellent teacher. It was at the Center that he met Kenneth Noland; the two soon became friends. Twelve years younger than Louis, Noland, as gregarious as Louis was retiring, kept in contact with what was happening in New York. He had met Pollock, David Smith, and the critic Clement Greenberg and was able to inject new ideas into the somewhat provincial artistic circles of Washington.

Louis was experimenting in the early 1950s with spatial problems rooted in cubism, seeking a transition between Pollock's linear web paintings of the late 1940s and his own feeling for color-space. In April 1953, he showed 16 paintings, including the "Charred Journal, Firewritten" series and several collages, in his first solo exhibition, at the Washington Workshop Center Art Gallery. During the same month Louis and Noland went to New York. They visited Clement Greenberg and saw recent paintings by Franz Kline and Jackson Pollock, but the crucial experience for Louis was a visit to Helen Frankenthaler's Manhattan studio. He was fascinated by her lyrical *Mountain and Sea* (1952) and her original staining technique, in which she poured thinned paints on unsized cotton duck. All sense of foreground and background was eliminated

and a new kind of color-space emerged, purely abstract but evocative of landscape and wide expanses. Both Louis and Noland had found Pollock "too personal" to serve as a guide, but, in Noland's words, "Frankenthaler showed us a way to think about, and use, color." Louis later characterized Frankenthaler as "a bridge between Pollock and what was possible."

This New York visit was the catalyst for the emergence of what is often called the Washington Color School. On their return to Washington, Louis and Noland worked closely together on the new concepts. Early in 1954, the two showed some of their new paintings at the Kootz Gallery, New York City, in an exhibition selected by Clement Greenberg and called "Emerging Talent."

Louis's real breakthrough was revealed some months later when, at Greenberg's suggestion, he sent nine large canvases entitled "Veils" to the New York dealer Pierre Matisse. To make these paintings, Louis had loosely stapled partially sized canvas to a vertical scaffolding, then poured thin, quick-drying acrylic paint down over the surface in billowing curves. The paint was guided by folds in the canvas and, perhaps, by a stick wound with cloth. Brush-drawing, linear contours, and gestural evidence of the artist's hand were eliminated. The muted transparent color became, as Greenberg said of Frankenthaler's stains, "one with the fabric," achieving complete integration of the paint and the canvas.

Always self-critical, Louis later destroyed all the work done in 1955, stained paintings without the veil motif. In the canvases of 1956 and '57 that he exhibited at his solo show at the Martha Jackson Gallery in New York City in 1957, Louis abandoned staining almost entirely, striving for greater intensity and saturation of color. He looked to Matisse, not so much for color as for touch, design, and what he called the French master's "thin, breathing surfaces." The exhibition was not a success and Louis destroyed most of the unsold pictures. He returned to painting "Veils," aiming at greater openness and expansiveness.

Twenty-three of the new "Veils" were shown at French and Co., New York City, in 1959. The color was applied either in overlapping, flamelike configurations flowing up or down the raw canvas or in diaphanous, superimposed parallel or slightly tapering bands. The very large *Saraband* was the most admired of these pictures which, to quote Barbara Rose, "appear to materialize like natural phenomena emerging from a mist." Another critic has written that "abstract painting came into its maturity, its full autonomy," with Louis's "Veils."

Louis continually advised his students: "Don't find a formula and follow it. Risk everything." From 1954 to '57 he himself had experimented with a series of "Florals" with vaguely flower-shaped forms radiating in thin washes from a dense center. In the spring of 1960, he began another series of "Florals" to which he gave the generic name "Aleph," the first letter of the Hebrew alphabet and for Louis the symbol of a fresh beginning. Waves of newly prominent color flowed from the central core; broad areas of canvas around the periphery were bare.

The "Aleph" series was followed in the summer of 1960 by the first of the so-called "Unfurleds," huge paintings in which irregular rivulets of color stream diagonally across the corners of the canvas, leaving the center blank. The artist did not allow the colors to interpenetrate or overlap, so that they would be presented in their purity. "The banked rivulets," one critic wrote, "open up the picture plane more radically than ever, as though seeing the first marking we are for the first time shown the void [represented by] "the dazzling blankness of the untouched canvas."

Louis gave these paintings, which he considered his most ambitious works, names from the Greek alphabet, from *Alpha* (again the pristine beginning) all the way to *Alpha-Omega*. *Alpha-Pi* was acquired in 1967, five years after Louis's early death, by the Metropolitan Museum of Art, New York City; *Delta-Gamma* (1960) is now in the Museum of Fine Arts, Boston. If these enormous canvases could be seen in sequence, side by side—which would require an immense space—one might have the sensation of fluttering, multicolored wings or banners, exactly the effect suggested by the title of the series, "Unfurled." For Louis the "Unfurleds" were a supreme effort to liberate color, a process begun by Matisse in his paintings before 1914.

In 1960, Louis showed five canvases at the Institute of Contemporary Art, London. He also signed a contract with the New York dealer Lawrence Rubin, who arranged for several exhibitions of the artist's work in Paris in 1961 and '64. In 1961, Louis moved to the André Emmerich Gallery, New York City, and had his first solo show at that prestigious art house.

Early in that year, Louis stopped painting "Unfurleds" and began a series of stripe paintings, in which bands of saturated color of varying widths were placed side by side near the edges of the canvas. Some of the paintings, such as *No. 19* (1962), have very narrow vertical shapes that emphasize the sharp juxtapositions of pure color, in others of a horizontal format the stripes seem to float in mid-air. Without the im-

agistic associations of Frankenthaler's early stain pictures or of his own earlier "Florals," and without the epic scale of the "Unfurleds," Louis's "Stripes" were, in Robert Hughes's words, "sealed against everything but color." Both Noland and Louis held that in the new "color painting" color should be "self-declaring," free from the cubist legacy of structure; the simple formats of Louis's stripes and Noland's concentric rings demonstrate this "self-canceling structure." Louis brought to his last paintings what one critic termed "a new feeling of exactness," but he never adopted the "hard-edge" approach favored by his friend Noland and others of the post-painterly abstraction school later in the 1960s.

Louis's health was failing and in July 1962 a medical diagnosis revealed cancer of the lung. His left lung was removed. During the summer of 1962 he corresponded with André Emmerich about his forthcoming New York exhibition and ordered new paints from Bocour, but he never recovered enough to resume painting. He died in Washington, D.C. in his 50th year.

A posthumous exhibition of Louis's work opened at the Emmerich Gallery in October 1962. There was a memorial show of 17 paintings from the years 1954–60 at the Solomon R. Guggenheim Museum, New York City, in 1963, and several retrospectives in Europe and the US between 1963 and '67. In May 1968 two paintings by Louis, two by Noland, and a large metal construction by the British sculptor Anthony Caro were installed in a temporary exhibition at the Metropolitan Museum. Reviewing the exhibition, Hilton Kramer called the two painters "gifted decorators who supply the spectator's eye with a delicious field of purely visual sensation." He noted the "quick, watercolorlike lyric thrust" of Louis's work, and remarked that Louis and Noland had "led the movement toward pure color abstraction that currently enjoys a large influence and a prosperous market."

Assessing Louis's contributions nearly 20 years after his death, when color-field painting was no longer seen as a radical force in contemporary American art, Robert Hughes summed up Louis's work as "wholly decorative, in the Matissean sense of that word: that is to say, august and 'life-enhancing,' but offering no commentary on the contingencies of life. . . . The paintings Frankenthaler, Noland, Louis, and Jules Olitski did in the 1960s," he continued, "were, as a whole, the most openly decorative, anxiety-free, socially indifferent canvases in the history of American art."

EXHIBITIONS INCLUDE: Washington (D.C.) Workshop Center 1953, '55; Martha Jackson Gal., NYC 1957;

French and Co., NYC 1959, '60; Inst. of Contemporary Art, London 1960; Gal. Neufoille Paris 1961; Gal. Lawrence, Paris 1961; André Emmerich Gal., NYC from 1961; Solomon R. Guggenheim Mus., NYC 1963; Venice Biennale 1964; Stedelijk Mus., Amsterdam 1965; Whitechapel Art Gal., London 1965; Los Angeles County Mus. 1967; Washington (D.C.) Gal. of Modern Art 1967; Mus. of Fine Arts, Boston 1973. GROUP EXHIBITIONS INCLUDE: "American Art Today," New York World's Fair, Flushing Meadow 1939; Maryland Artists Annual, Baltimore Mus. of Art 1948–52; "Emerging Talent," Kootz Gal., NYC 1954; "American Abstract Expressionists and Imagists," Solomon R. Guggenheim Mus., NYC 1961–62; Metropolitan Mus. of Art, NYC 1958; "Art Since 1950," Seattle World's Fair, Wash. 1962; "Three New American Painters: Louis, Noland, Olitski," Norman Mackenzie Art Gal., Regina, Canada 1963.

COLLECTIONS INCLUDE: Metropolitan Mus. of Art, MOMA, and Solomon R. Guggenheim Mus., NYC; Everson Mus. of Art, Syracuse, N.Y.: Nat. Collection of Fine Arts, Smithsonian Instn., and Hirshhorn Mus. and Sculpture Garden, Washington, D.C.; Mus. of Fine Arts, Boston; Ulster Mus., Belfast.

ABOUT: Fried, M. Morris Louis, 1970; "Morris Louis" (cat.), Hayward Gal., London, 1974; Rose, B. American Art Since 1900, 2d ed. 1975. *Periodicals*—Art International (Zürich) no. 6 1957, no. 5 1960, no. 8 1962; Art News October 1962, October 1963, April 1, 1970; Artforum October 1971; Arts November 1963; Baltimore Sun November 10, 1957; New Statesman May 28, 1960.

***LOWRY, L(AURENCE S(TEPHEN)** (November 1, 1887–February 23, 1976), British painter, was known for his hauntingly realistic depictions of the life and scenery of England's industrial Midlands.

L. S. Lowry was born in Rusholme, a suburb of Manchester, where his father was an estate agent. His mother came from an old Lancashire family of hatters, and Laurence Stephen, an only child, was reared in a quiet, staid middle-class home. From 1894 to 1904 he attended, without distinction, Victoria Park School, Manchester. He recalled: "My father never thought I would amount to anything. I was no good at school at all, just lazy. Time went on and on, until an aunt of mine remembered that I'd drawn little boats when I was eight years of age. So that was that. It was any port in a storm." He took private painting classes, but did not yet plan to become a professional artist.

In 1909 the Lowry family moved from Manchester to the industrial suburb of Pendlebury, a part of Salford. Until 1915 Lowry attended the Manchester Municipal Art College, and afterwards he took occasional classes at the Salford

Jorge Lewinski

L. S. LOWRY

School of Art. Lowry is usually thought of as a "primitive" artist, but he had a sound academic training, though eventually he found the drawing of life studies and the copying of ancient statues stultifying. About 1915, when he was in his late 20s, he discovered his métier. "One day," Lowry said, "I missed a bus and took a good look around. I'd never seen a cotton mill before and I became obsessed by the scene [of industrial life that] everybody thought . . . was ugly and horrible. Nobody else was painting life seriously, I thought. So I decided to. I'm fascinated by the odd and the sad."

Between 1915 and 1920, as he became increasingly interested in the Salford industrial scene, Lowry developed his unique idiom. For the next 20 years he produced seemingly childish industrial "townscapes," which were dominated by factory chimneys and populated by cursory, doll-like figures, described in *Time* (January 2, 1967), as "match-stick manikins that move like bumpkin puppets in their ragamuffin clothes and clodhopper boots." The overall effect of his palette was black and white, although other colors were also used. During this period Lowry exhibited in Manchester and at the Paris Salon d'Automne, and his painting, *An Accident* (1926), was purchased by the City Art Gallery, Manchester.

Lowry became a member of the Royal Society of British Artists in 1934. Thereafter he exhibited regularly in group showings in London, but received little public recognition until his first solo show, at the Lefevre Gallery, London, in 1939. At that exhibition a painting was bought for the Tate Gallery, and from then on his fame and popularity steadily grew.

Lowry's scenes of Salford, Swinton, and Manchester, paintings that date from the late 1920s through the '30s, are his most popular works. In *The Guardian* (September 23, 1966) Harold Riley described the pictures of those years, Lowry's so-called middle period, as "revealing a stunning technique of marvellous paint textures, glazing over dried white paint, and a novel way of engraving the paint surface to break dark tones dramatically from black to white." Riley praised Lowry's compositions as basic, tight, and precise. *A Street Scene, St. Simon's Church* (1928), with its crisp drawing and sharp silhouettes, exemplifies his work of this period. However, the Lancaster milieu is transformed by the artist's close observation of detail and his imaginative reflection on the total scene rather than simply reproduced, or "mirrored."

Despite his growing celebrity, Lowry, a solitary man, preferred, as one critic wrote, "to stand aside and watch." From 1943 on, he had exhibitions at the Lefevre Gallery, but continued to live in the Salford area until 1948, when he moved to a small, dilapidated house in Mottram-on-Longdendale, Cheshire. (He had been living with his parents in Pendlebury.)

In 1948 Lowry became a member of the London Group, an exhibiting Association of British artists representing diverse styles and trends but united in their aloofness from the academies. In Lowry canvases of the late 1940s, including *Cripples* (1949), critics discerned the influence of Brueghel. Like Brueghel, Lowry was attracted to the grotesque and his work contained elements of satire. Again like Brueghel, he often tilted the ground in his teeming street scenes to make the silhouettes of his figures more visible. The people in his crowds are clearly defined, and he suggested distance and perspective by diminishing the size of the figures until they faded away as dots or small brushstrokes. "All those people in my pictures," Lowry told *Newsweek,* "they are all alone. . . . They can't contact one another. We are all of us alone. Crowds are the most lonely thing of all."

Publications of color lithographs of Lowry pictures enhanced the artist's popularity in Britain in the late '40s. Lowry considered *Punch and Judy,* drawn on stone and published in 1947, the best print of his work. *Punch and Judy* sympathetically portrays children who must find amusement in the cramped playground of an industrial city. In *Mill Scene,* another print from an oil painting, Lowry captured what the London *Observer* described as "the gritty cheerfulness of a fast-vanishing North."

Occasionally, Lowry painted London scenes, some of them inspired by the destructiveness of wartime bombing, which deeply saddened him. His most popular London picture, *Piccadilly Circus,* was in a happier vein; it contains one of Lowry's rare depictions of automotive traffic, although it is possible that the red buses are included only for their striking color. Asked how he, a provincial unaccustomed to urban rigors, managed to stay long enough in London to paint Piccadilly, Lowry replied: "I never stayed overnight. . . . I always took the six o'clock train home to Manchester."

Lowry received two honorary degrees from Manchester University and was elected an associate of the Royal Academy in 1955 and a Royal Academician in 1962. He was given a special concert on his 65th birthday by the Halle Orchestra in Manchester, and in July 1967 a stamp of a Lowry painting was issued by the General Post Office, an indication of the popularity of the man acclaimed in *The Guardian* as "the greatest English provincial artist."

An Arts Council exhibition of Lowry's work opened at London's Tate Gallery in November 1966 and subsequently toured England. Marjorie Bruce-Milne, reviewing the show for the *Christian Science Monitor,* praised his "masterful treatment of crowds" and his "astringent sense of humor." A dissenting opinion, however, was voiced by Robert Hughes, who, in an *Observer* (May 21, 1967) article titled "What's Wrong with Lowry?", attributed Lowry's immense popularity to the English "fondness for provincial eccentrics." Hughes declared that, as a social realist, Lowry was not realistic enough, not a close observer. Hughes accused Lowry of "slack, wilful drawing" and of a reliance on "easy stereotypes which have no impulse as form." Responding to this attack, in *The Guardian* (August 31, 1968) Michael McNay observed that "Lowry does not mean to be a realist, and is much less so than, say, Monet." He argued that Monet intended paintings such as *Gare Saint-Lazare* as faithful optical records, but "when Lowry paints Pendlebury he intends a metamorphosis."

Lowry's quiet, well-ordered life was unaffected by his celebrity or by the high prices his work fetched. A reclusive bachelor, he continued to live alone in his tiny house in Mottram, three miles from Glossop, Cheshire. The house was filled, according to *Newsweek,* with "a jumble of Victorian armchairs, ceramic cats, a studio, a bed, and fourteen prized clocks." The clocks, Lowry said, were "wonderful companions . . . , real friends." He loved Pre-Raphaelite painting, especially the works of Ford Madox Brown and Dante Gabriel Rossetti, and acquired paintings and drawings by them. However, after his death

several of those works were discovered to be forgeries.

Lowry's success was a source of both joy and sadness. "All my happiness and unhappiness were that my view was like nobody else's," he said. "Had it been like theirs, I should not have been lonely; but had I not been lonely, I should not have seen what I did. Perhaps I should have got out of it all before." Lowry thought of his populous urban scenes as episodes in what he called "the battle of life. . . . To say the truth, I do not care for people the way a reformer does. But they are part of a private beauty that has haunted me most of my life."

EXHIBITIONS INCLUDE: Lefevre Gal., London from 1939; City Mus. and Art Gal., Salford, England 1941; Mid-Day Studios, Manchester 1948; Retrospective, City Art Gal., Salford 1951; Crane Gal., Manchester 1952, '55, '58; Retrospective, City Art Gal., Manchester 1959; Robert Osborne Gal., NYC 1959; Altrincham Art Gal., Lancashire, England 1960; Retrospective, Graves Art Gal., Sheffield 1962; Stone Gal., Newcastle-upon-Tyne 1964; Retrospective organized by Arts Council, Sunderland Art Gal. 1966, Tate Gal. 1966–67; Northern Ireland Arts Council, Belfast 1971. GROUP EXHIBITIONS INCLUDE: Academy of Fine Arts, Manchester, England 1932–76; Arlington Gal., London 1936; "Manchester Group," Mid-Day Studios, Manchester, England 1946–51; Royal Academy, London, 1956–74; "Exhibition to Honour L. S. Lowry," Monks Hall Mus., Eccles, England 1964.

COLLECTIONS INCLUDE: Tate Gal., Arts Council of Great Britain, Imperial War Mus., Royal Academy, and Collection of H.M. the Queen, London; City Art Gal., and Central Library, Manchester, England; City Mus. and Art Gal., Salford, England; City Art Gal., Sheffield; Walker Art Gal., Liverpool; Nottingham Castle and Art Gal.; Royal Scottish Academy, Edinburgh; Art Gal. and Mus., Glasgow; Art Gal. and Mus., Aberdeen; Mus. and Art Gal., Newport, Wales; MOMA, NYC.

ABOUT: Clark, K. C. A Tribute to L. S. Lowry 1964; Collis, M. The Discovery of L. S. Lowry, 1951, L. S. Lowry, 1972; Levy, M. The Drawings of L. S. Lowry, 1963, L. S. Lowry: Painters of Today, 1961, The Paintings of L. S. Lowry, 1975; Mullins, E. L. S. Lowry Tate Gallery, London, 1966. Periodicals—Christian Science Monitor December 14, 1967; Guardian October 31, 1964, September 23, 1966, November 26, 1966, August 30, 1968, November 9, 1974; New Statesman (London) February 1976; Newsweek January 2, 1967; Observer May 21, 1967; Time January 2, 1967.

MacIVER, LOREN (February 9, 1909–), American painter, gained prominence in the 1940s for her evocative paintings of everyday images, displayed in abstract, subtly colored patterns. She was born in New York City, the

Pierre Matisse Gallery, NYC

LOREN MacIVER

daughter of Charles Augustus Paul Newman and Julia MacIver. Her mother, of Scottish-Irish descent, chose to keep her maiden name, and Loren also decided to use the name MacIver. She began to paint as a child, and at the age of ten enrolled for one year in the Art Students League, New York City, her only formal training as an artist. She continued to paint throughout public school and high school, but without any great ambition. "I never thought of painting as a career," she said of those early years. "I cannot tell you how casual it was. I never intended to be a painter. I just liked to paint."

In 1929, at the age of 20, Loren MacIver married the poet Lloyd Frankenberg. They lived in Greenwich Village, and from 1931 to 1940 spent their summers (as well as one difficult winter in 1932), at North Truro on Cape Cod, Massachusetts, in a shack they built out of driftwood. MacIver's first museum purchase was, in fact, a painting titled The Shack, acquired by the Museum of Modern Art, New York City in 1935. Her earliest paintings had been in a naive style, but about this time she began to create flat, vaguely geometrical compositions by using areas of color that blended together. Objects were reduced to simple forms which became, in a sense, symbols of those objects. Although the symbols appeared at first to be purely abstract forms, they eventually revealed themselves to the careful observer. MacIver has retained this approach to her work, wanting the viewer first to appreciate the painting formally, as if it were an abstract work, then gradually to absorb the blend of reality and fantasy.

From 1936 to 1939 MacIver was one of the

many artists who worked with the New York Federal Arts Project, in the easel painting division. During this time she began to gain recognition. Her firt solo exhibition was held in 1938 at Marian Willard's East River Gallery, New York City. She and her husband spent the winter of 1939 and part of the following year at Key West, Florida. Their Florida home inspired such works as *Moonlight,* a poetic transmutation of reality in which the bed was distorted and the floral pattern, liberated from the quilt, seemed to extend beyond it. In 1940 she showed for the first time at the Pierre Matisse Gallery, New York City, the beginning of a long and rewarding affiliation.

About 1940, MacIver took they city as her theme, though only a few of her works contained figures. She generally concentrated on the hidden beauty of inanimate objects, ranging from the realistic *Window Shade* (1948) to the near-abstract *Ash Can.* In *Ash Can,* that far-from-romantic object was rendered in terms of translucent, jewellike color within a spare linear framework. She emphasized, in one critic's words, "the poetic content of a prosaic group of details, such as children's chalk marks for hopscotch or a streaming window, wet with rain."

MacIver's nonurban subjects include *Tree* and *Puddle,* both of 1945. She also painted some portraits of clowns, notably *Jimmy Savo* (1944) and *Emmett Kelly* (1947). In 1946 she was included in MOMA's "Fourteen Americans" exhibition.

In 1940 MacIver was commissioned to design the lighting and décor for four MOMA "coffee concerts." She also began doing illustrations for books and magazines. In 1947 she painted a mural for the S.S. *Argentina,* and the following year she executed murals for four ships of the American Export Lines, the *Excalibur, Exeter, Exochorda,* and *Excambion.*

In July 1948 MacIver traveled to Europe with her husband, her first trip abroad. They visited France, Italy, England, Ireland, and Scotland. After returning to New York in October, she painted many works inspired by her trip. These canvases were generally larger and more vivid in color than her previous paintings. *Venice* (1949; Whitney Museum of American Art, New York City), is one of her most beautiful works. Her evocations of places visited in Europe were more realistic than her earlier paintings, although the abstract tendency predominated in a few of these canvases.

In the early 1950s MacIver returned to city themes, while retaining the brighter palette of her Europe-inspired works. She now chose more colorful subject matter, such as iridescent oil slicks and fire-escapes covered with sparkling raindrops. Typical of this phase was *Taxi* (1952), which demonstrated her formal interest in the atmospheric effects of light and rain. *Oil Splatters and Leaves* (1950), in which she began with two-dimensional subject matter, was more abstract in treatment.

In 1953 she and Irene Rice Pereira, with whom she had shown at the Santa Barbara Museum of Art, California, in 1950, were given a joint exhibition at the Whitney. I. Rice Pereira's geometric abstraction hung in sharp constrast to MacIver's fluid, lyrical, and gently symbolic work. Characteristic MacIver paintings of the late 1950s were *Snowscape* (1957), inspired by snow on a studio skylight, and *Skylight Moon* (1958; Hirshhorn and Sculpture Garden, Washington, D.C.). MacIver was awarded the Corcoran Gold Medal and First Clark Prize at the 1957 Corcoran Biennial, which was held in Washington, D.C. She was made a member of the National Institute of Arts and Sciences in 1959.

About 1960, MacIver began to experiment with cloth, newspaper collages, and pastels. In painting she continued to develop her subtle, introspective style, as in *Night Shadows* (1961; Albright-Knox Art Gallery, Buffalo, New York). She and her husband returned to Europe several times in the 1960s. (A delightful photograph taken in 1963 shows her and Lloyd Frankenberg seated outside the aptly named Sympathic-Bar in Paris with the genial owner and his wife. In the photograph MacIver has sensitive, finely drawn features and wears her hair in a bob with bangs, evoking the Greenwich Village of an earlier day.

MacIver had an important solo exhibition at the Phillips Collection, Washington, D.C., which opened in 1965 and then went on tour. Her 1966 exhibit at the Pierre Matisse Gallery, titled "Paintings 1963–1966," contained two of her most haunting canvases, inspired by a visit to Istanbul. One was titled *Byzantium,* 31 inches by 100 inches, an unusually large (for her) horizontal painting in which the skyline of Istanbul with its mosques and minarets was the shadowy background to a dazzling pattern of lights. The other canvas, smaller and vertical in composition, was *Blue Mosque.* Both paintings were dated 1965. In 1966 MacIver, who always felt at home in France, moved to Paris, where she lived and worked until 1970, painting from time to time in Provence. She was given a retrospective, which then went on tour, at the Musée d'Art Moderne de la Ville de Paris in 1968. Her canvases painted in the Midi include a series inspired by the mistral (1968), and *Le Marché à Toulon* and *Patisserie,* both of 1970. *First Snow* (also 1970) was an evocation of winter in Paris.

She wrote, in connection with this and related paintings, a statement published in *Art Now: New York 1971–72:* "Snow in Paris sifts into the corner of the cobblestones leaving black wet centers. Many plants and trees still green, the ivy heavily backed with it, the street lamps a dazzle, you can touch the SILENT whiteness."

From 1970 to the present, Loren MacIver has lived and worked in New York, surmounting health problems to go on creating what *Time* magazine has called "a world of intimate, poetic response. Two recent examples are *Green Votive Lights* and *Subway Lights,* both 1980. She has continued to exhibit at the Pierre Matisse Gallery. *Loren MacIver,* a film by Maryette Charlton, was released in the late 1960s.

Interviewers have found MacIver friendly and sympathetic, but she prefers to let her work speak for itself. In the catalog to MOMA's 1946 show, "Fourteen Americans," she contributed these thoughts: "Quite simple things can lead to discovery. This is what I would like to do with painting. Starting with simple things, to lead the eye by various manipulations of colors, objects and tensions toward a transformation and a reward. . . .

"My wish is to make something permanent out of the transitory, by means at once dramatic and colloquial. Certain moments have the gift of revealing the past and foretelling the future. It is these moments that I hope to catch."

EXHIBITIONS INCLUDE: East River Gal., NYC 1938; Pierre Matisse Gal., NYC from 1940; Circulating Exhibition, MOMA, NYC 1941–42; Vassar Col. Art Gal., Poughkeepsie, N.Y. 1950; Phillips Collection, Washington, D.C. 1951, 1965; Mus. d'Art Moderne de la Ville de Paris 1968. GROUP EXHIBITIONS INCLUDE: Whitney Mus. of Am. Art Annual, NYC, 1944–69; "Fourteen Americans," MOMA, NYC; Santa Barbara Mus. of Art, Calif. 1950; São Paulo Bienal 1951; Whitney Mus. of Am. Art, NYC 1953; "50 Modern American Artists," Mus. Nat d'Art Moderne, Paris 1955; Pittsburgh International, Carnegie Inst. 1955, 58; Corcoran Biennial, Washington, D.C. 1957; Venice Biennale 1962 "U.S.A. Art Vivant," Mus. des Augustrins de Toulouse, France 1966.

COLLECTIONS INCLUDE: Metropolitan Mus. of Art, MOMA, and Whitney Mus. of Am. Art, NYC; Brooklyn Mus., N.Y.; Albright-Knox Art Gal., Buffalo, N.Y.; Vassar Col. Art Gal., Poughkeepsie, N.Y.; Munson-Williams-Proctor Inst., Utica, N.Y.; Newark Mus., N.J.; Wadsorth Atheneum, Hartford, Conn; Yale Art Gal., New Haven, Conn.; Philadelphia Mus. of Art; Nat. Gal. of Art, Corcoran Gal., Phillips Collection, and Hirshhorn Mus. and Sculpture Garden, Washington, D.C.; Walter Art Center, and Baltimore Mus. of Art; Art Inst. of Chicago; Detroit Art Inst.; Los Angeles County Mus.; Bibliotheque Nat., Paris.

ABOUT:Baur, J.I.H. "MacIver and Pereira" (cat.), Whitney Mus., NYC, 1953; Cheney, S. The Story of Modern Art, 2d ed. 1958; Current Biography, 1953; Genauer, E. Best of Art, 1948; "Loren MacIver" (cat), Phillips Collection, Washington, D.C., 1965; "Loren MacIver: Recent Paintings" (cat), Pierre Matisse Gal., NYC, 1981; "MacIver: Paintings 1963–66" (cat), Pierre Matisse Gal., NYC, 1966; Miller, D.C. (ed.) "Fourteen Americans" (cat.) MOMA, NYC, 1946. *Periodicals*—Art News October 1946, September 1947; Saturday Review February 7, 1953; Time January 26, 1953.

***MAGRITTE, RENÉ (FRANÇOIS GHISLAIN)** (November 21, 1898–August 15, 1967), the leading representative of Belgian surrealism, was born at Lessines, a small town in the province of Hainaut, halfway between Charleroi and the North Sea. Lessines is in the Walloon region of Belgium, which may explain why Magritte was more receptive to French influence than his Flemish colleagues. In 1899, a year after he was born, his family moved to nearby Gilly, and 11 years later the Magrittes went to live in Châtelet, where Magritte and other local children studied sketching. During summer vacations spent with relatives at Soignes, Magritte would often visit the old cemetery. The granite monuments in the cemetery and the wooden caskets in its crypt were to play an important role in his iconography. "When I was a child," he recalled, "at night I would have suddenly a feeling of anxiety. Now I know it signifies a sense of mystery, of the unknown."

When Magritte was 14 his mother drowned herself in the Sambre river. The devastating effect on him of this tragedy is rarely reflected in his pictures, which though disquieting, are marked by an oblique and ironic wit. In 1913 Magritte moved with his father and two brothers to Charleroi, where he met his future wife, Georgette Berger.

After receiving a classical education in Charleroi, Magritte, who had become interested in painting, studied intermittently between 1916 and 1918 at the Royal Academy of Fine Arts, Brussels. His family settled in Brussels permanently in 1918. The following year Magritte began to associate with the city's young painters, poets, and musicians, and in 1920 he became friendly with E.L.T. Mesens, who has written extensively on Magritte's work.

In 1922 Magritte married Georgette Berger. To earn a living he worked as a designer in a wallpaper factory, but devoted his lesiure time to painting. While at the Brussels Academy he had received an illustrated catalog of futurist pictures through which, as he later recalled half-

°mä grēt´, rə nā´.

RENÉ MAGRITTE

seriously, he "came to know of a new way of painting." Not long afterwards he became aware of cubism, but Magritte already knew that he would follow a different path. In a letter written over 40 years later he observed: "I cannot doubt that a pure and powerful sentiment, namely eroticism, saved me from slipping into the traditional chase after formal perfection. My interest lay in provoking an emotional shock."

The catalyst that led to Magritte's mature style was a reproduction his lifelong friend Marcel Lecomte showed him in 1922 of Giorgio de Chirico's 1914 painting, *The Song of Love,* with its strange and haunting juxtaposition of a classical bust, a rubber glove, and a sphere in an architectural dream setting rendered in exaggerated perspective. Adding to the sense of dislocated reality, the upper section of a locomotive appears above a brick wall in the background, with a large puff of smoke billowing from its stack. Magritte, in an autobiographical sketch dating from 1962, wrote that he had been "moved to tears" by this painting. Elsewhere he praised de Chirico as "the greatest painter of our time," in that his work dealt "with poetry's ascendancy over painting and the various manners of painting." He added that de Chirico "was the first to dream of *what must be painted* and not *how to paint.*" This literary approach was to be typical of orthodox surrealism. André Breton, the founder of the movement, and Yves Tanguy, one of its leading painters, both received a strong impact from de Chirico's work about this time, as did Magritte's Belgian contemporary Paul Delvaux, another noted Surrealist. Magritte's painting of 1922, *Young Girl,* still owed much to the cubo-futurist

tradition, although there were elements suggestive of the skewed geometry of de Chirico's *pittura metafisica.*

For the next few years Magritte's painting was strongly influenced by de Chirico's metaphysical interiors. Together with E.L.T. Mesens and others, he took part in activities that paralleled those of the Parisian Surrealists. In 1924 Magritte contributed a statement to the final number of the dada review *391.* The following year, encouraged by a contract he signed with the new Galerie Le Centaure, Brussels, he devoted his whole time to painting and produced as many as 60 pictures.

By 1926, when Magritte painted his first truly personal picture, the large *Menaced Assassin,* he had gradually freed himself from de Chirico's influence, although there are still echoes of that painter's manipulation of space. A nude woman lies on a sofa in the background, bleeding from the mouth. Her assassin, in a dark and "correct" business suit, listens to a phonograph, unaware that his exit is barred by three men peering over a grilled window to the rear of the room. Meanwhile his two captors, identical in facial type, and wearing the dark clothes and bowler hats often seen on male figures in surrealist painting—there are many similar figures in Delvaux's pictures—await him to the left and right of the foreground, carrying, respectively, a bludgeon and a net. Magritte used a smooth and meticulously realistic technique to create a mood of "somnambulant irrationality," to quote James Thrall Soby. This painting is in some ways prophetic of the work of Balthus, whom Magritte greatly admired.

Magritte's first solo show, held in 1927 at the Galerie Le Centaure, was unfavorably received by the critics. In August he and his wife moved to Perreux-sur-Marne, a suburb of Paris. At this time Magritte was closely associated with the Parisian Surrealists, especially Breton and Paul Eluard. He was greatly impressed by Max Ernst's illustrations for two books of poems by Eluard, *Répétitions* and *Malheurs des immortels.* He found in Ernst's collages, assembled from old magazine illustrations, close parallels to the imaginative climate of his own art.

Some of Magritte's most startling imagery dates from his years in Paris. *Man with Newspaper* (1927–28; Tate Gallery, London) was one of the earliest of his compartmentalized scenes; here the four room interiors are identical except for the disappearance in three of them of a seated man reading a newspaper. *The False Mirror* (1928; Museum of Modern Art, New York City) is perhaps Magritte's best-known painting. (In modified form this eye image

strongly resembles the corporate logo of CBS Television.) The enormously magnified eye, filling the entire canvas, reflects a cloud-filled sky; the black pupil, in a kind of visual pun, might suggest a solar eclipse. Although the initial shock may soon wear off, the image is an effective visual metaphor for the illusory nature of appearances. *Threatening Weather* (1928; Collection of Roland Penrose, London) is another characteristic work. Three incongruously juxtaposed objects, a headless and armless female torso, a tuba, and a wicker chair, all white, are suspended in a misty blue sky over a tranquil sea and a barren, lonely coastline. *The Empty Mask,* also of 1928, features an irregular screenlike shape placed in an arbitrary shallow stage, and divided into six compartments, as if to suggest the workings of the unconscious within a framework symbolizing the human head. The imagery within each compartment recurs in other Magritte paintings and includes a serene sky with horizontal clouds, flaming coals, sleigh bells, windows on an anonymous Brussels facade, and a petrified forest. The huge metal bells of *Flowers of the Abyss, I* (1928), "sprout," in his words, "like dangerous plants from the edge of a chasm." The surrealist belief in the liberation of the spirit through the "mythical and marvellous" and the subversion of "normality" is illustrated in his well-known *On the Threshhold of Liberty* (1929), in which an antiquated cannon is placed in an ambiguous setting rendered in perspective. The walls of this space are divided into segments, one of which, in the upper-left-hand corner, contains part of a female torso; other divisions contain typical elements in Magritte's repertoire: the cloud-filled sky, bells, a forest, wood-graining, and staid rows of windows.

In 1930, tiring of the polemics of Parisian artists, Magritte returned to Brussels. He renewed his old contacts with artists and writers of the Belgian Surrealist group. Among his new associates were Paul Colinet and Marcel Marieu. Except for occasional visits to France, Holland, and England, Magritte spent the rest of his life in Belgium.

The dadaist cult of the absurd found expression in his *The Key of Dreams* (1930), in which objects are compartmented and inscribed with utterly inappropriate names—a woman's high-heeled shoe is labeled "the moon," a bowler "the snow," and so on. This deliberate defiance of logic in the service of a deeper meaning was carried to its extreme in a realistic picture of a pipe, inscribed "This Is Not a Pipe." (*This Is Not a Pipe* was to be the title of French thinker Michel Foucault's important study of Magritte.)

The tuba and the chair Magritte had shown hovering in the sky in *Threatening Weather* reappeared on the floor of a room in *The Ladder of Fire, I* (1933). They are being consumed by a fire kindled by a flaming bundle of paper. Fire was one of Magritte's obsessions. (Dali found it a potent symbol as well); he was also fascinated by windows and the idea of transparency. In *The Human Condition I* (1934), one of his best-known and most copied works (contemporary illustrators have found him the most assimilable of Surrealists), the subject is ostensibly a painting in front of a window, but, as Magritte pointed out, "I placed a picture that represented precisely the portion of landscape blotted out by the picture. . . . For the spectator it was simultaneously inside the room, in the picture, and outside, in the real landscape, in thought. Which is how we see the world, namely, outside of us, having only one representation of it within us." *The Red Model* (1935) contains one of Magritte's more disquieting images: workmen's boots on the ground in front of a planked wall turn into human feet—recalling the garments of freshly flayed human skin worn by the Aztecs. Magritte returned so often to this and earlier motifs that it is hard to establish his stylistic evolution in strictly chronological terms. Human feet sprout from ladies' high-heeled pumps in *Philosophy in the Boudoir* (1947), a title taken from a famous work by the Marquis de Sade. A combination of anger and eroticism is conveyed by women's breasts staring out of a translucent silk peignoir. The shoes, it has been said, "shout a cry of alarm."

Magritte's first solo exhibit in America was held at the Julien Levy Gallery, New York City, in 1936—Levy was a great supporter of surrealism—and between 1930 and 1940 he was represented in all major international exhibitions of surrealist art. He also wrote numerous articles and short statements for surrealist publications. His design for the cover of number 10 of the review *Minotaure* in 1937 showed a bull's skeleton, draped in black and placed on a ruined rampart, with Paris in the background—taken by some as a premonition of the disaster that was soon to befall France.

Another element in Magritte's symbology was the dismembered female torso, indicative of the strain of misogyny that underlies his and many Surrealists' work. In *The Eternal Evidence* (1930) a woman's figure was actually split up into five separate panels, to be displayed one above the other. In the more pictorial canvas of 1935, *The Ides of Summer,* a headless and armless marble torso on a stone balustrade is itself fractured horizontally with one part fitting inside the other. But not only female figures went through strange transformations. In the enig-

matic 1937 canvas *The Therapeutic II,* a man, his hat stuck on a nonexistent head, sits on a sandy beach; he is draped in a heavy cloak, his left hand holds a traveling bag and his right hand rests on a cane. The cane casts the ominous shadow dear to the Surrealists. His torso is a birdcage with two white doves. Dislocation of scale contributes to the surprise element of *Time Transfixed* (1939), in which a steaming locomotive plunges out of a fireplace into a staid bourgeois room as if emerging from a tunnel.

During the war years Magritte tried to apply a Renoir-like impressionist technique to his customary themes. These experiments were so badly received by friends and critics alike that he finally abandoned them, and they are rarely shown. For several months in 1948, while preparing an exhibition for the Galerie du Faubourg, Paris, Magritte even tried reviving the technique of the early 20th-century Fauves, but he soon reverted to his more familiar manner, using the meticulous, painstaking technique that was his heritage from the early Flemish masters. He took part in important exhibits in Paris and New York and showed regularly in the Salon de Mai, Paris.

The artist's postwar period, in some ways less inventive than his earlier phases, included bizarre interpretations of such well-known works as Manet's *The Balcony* (1868) and David's *Madame Récamier* (1800). In his transposition of the Manet (1949) and of the famous David portrait (1951) the human figures were replaced by coffins. His most original and haunting picture of the postwar years was *Empire of Light II* (1950; MOMA); it shows a tree-lined street at night, with a street light glimmering through the darkness, although there is broad daylight above the rooftops. A street scene of 1953, *Golconda,* depicts a downpour of bowler-hatted businessmen descending from the sky.

From 1951 to 1953 Magritte worked on a commission from the Casino, at Knokke-le-Zoute on the North Sea, to design eight themes for murals in the grand salon. The actual murals, bearing the overall title of *The Enchanted Realm,* were executed by Raymond Art and his assistants after oil studies by Magritte.

Throughout the 1950s Magritte was fascinated by "calcified" subjects; the best known are *The Invisible World* (1953–54), in which a massive boulder waits on a balcony overlooking the sea, and *The Castle of the Pyrenees* (1959). Here a medieval castle is perched on a similar boulder, which, defying gravity and logic, floats above the sea in a blue, cloud-filled sky. As James Thrall Soby has observed, Magritte "uses space to heighten his art's ambiguity."

Magritte's first retrospective exhibition in the United States was held in 1960 at the Museum for Contemporary Arts, Dallas. By the 1960s surrealism had long been superseded as an international movement, but Magritte remained faithful to its principles to the very end. In 1965, two years before his death, he painted a picture which summed up his deliberately enigmatic vision, *Exhibition of Painting.* In the foreground of an empty landscape, a bowler hat on a stand shaped like a large chess-man (similar chesslike objects had been used in his earlier works) is balanced by a solemn penguin. In the cloudy sky, a tall dark form—an opening in the heavens or a colossal funereal slab—looms inexplicably.

In the last year of his life—he died in the Brussels suburb of Schaerbeek at the age of almost 70—Magritte supervised the construction of eight bronze sculptures based on images from his paintings. *Delusions of Grandeur,* derived from a canvas of 1948 in which cross-sections of a female torso of diminishing size are inserted one inside the other, was the first to be cast. *The Therapeutist* was based closely on the painting of 1937. The lower half of the sculpture was cast from a man's legs and feet, and the torso from a specially constructed birdcage. Both works are now in the Hirshhorn Museum and Sculpture Garden, Washington, D.C. Films about the artist include *Gustave de Smet, René Magritte, Edgard Tytgat,* produced and directed by R. Cocriamont in 1946, and *La Leçon des Choses, ou Magritte,* produced and directed in 1960 by Luc de Hersch, with commentary by Magritte.

René Magritte was a quiet, heavy-set man, as stolid-looking as the stone chair depicted in one of his canvases. He was sometimes photographed wearing the dark clothes and bowler hat of his archetypal "little man." His home, presided over by his wife, was scrupulously tidy. In his script for *René Magritte: Middle Class Magician,* a film aired on the BBC in 1965, George Melly, referring to Magritte's preference for bourgeois surroundings and an utterly conventional way of life, observed: "He is a secret agent, his object is to bring into disrepute the whole apparatus of bourgeois reality. Like all saboteurs, he avoids detection by dressing and behaving like everybody else." The order and routine of his life provided a secure springboard for his "trips into surreality."

Magritte's best work, while rarely as shocking as that of some other Surrealist artists, such as Dali, has its own disturbing kind of magic. His philosophical outlook, questioning the truth of outward appearances, was expressed in his statement: "Resemblance—which can be made visible through painting—only encompasses figures

as they appear in the world: people, curtains, weapons, stars, solids, inscriptions, etc." Magritte wanted to see these phenomena "spontaneously brought together in an order in which the familiar and the strange are restored to mystery." Elsewhere he observed, "Sometimes when I look at my painting I think I am in the heart of mystery, and there is nothing in the world which can explain it."

EXHIBITIONS INCLUDE: Gal. Le Centaure, Brussels 1927; Palais des Beaux-Arts, Brussels 1933, '39, '54; Julien Levy Gal., NYC 1936–38; Gal. Dietrich, Brussels 1941, '44, '46, '48, '51; Gal. du Faubourg, Paris 1948; Alexandre Iolas Gal., NYC 1953, 1957–59, '62, '65; Venice Biennale 1954; Dallas Mus. for Contemporary Arts 1960; Mus. of Fine Arts, Houston 1960–61; Walker Art Center, Minneapolis 1962; MOMA, NYC 1965; Tate Gal., London 1969. GROUP EXHIBITIONS INCLUDE: "L'Art Vivant en Europe," Palais des Beaux-Arts, Brussels 1931; "Fantastic Art, Dada, Surrealism," MOMA, NYC 1936–37; "Trois Peintres Surréalistes," Palais des Beaux-Arts, Brussels 1937; "Exposition Internationale du Surréalisme," Gal. des Beaux-Arts, Paris 1938; Pittsburgh International, Carnegie Inst. 1938, '50, '58, '64, '67; "Art in Our Time," MOMA, NYC 1939; "First Papers of Surrealism," 451 Madison Avenue, NYC 1942; Documenta 2, Kassel, W. Ger. 1959.

COLLECTIONS INCLUDE: MOMA, NYC; Yale Univ. Art Gal., New Haven, Conn.; Hirshhorn Mus. and Sculpture Garden, Washington, D.C.; Univ. of St. Thomas, Houston; Los Angeles County Mus. of Art; Tate Gal., London; Mus. des Beaux-Arts, Ghent, Belgium; Mus. des Beaux-Arts, Liège, Belgium; Casino, Knokke-le-Zoute, Belgium; Moderna Mus., Stockholm.

ABOUT: Bénézit, E. (ed.) Dictionnaire des peintres, sulpteurs et graveurs, 1976; Breton, A. Le Surréalisme et la peinture, 1945; Calvocaressi, R. Magritte, 1979; Cheney, S. The Story of Modern Art, 2d ed. 1958; Foucault, M. This Is Not a Pipe, 1983; Geblik, S. "The Vision of René Magritte" (cat.), Walker Art Center, Minneapolis, 1962; Larkin, D. Magritte, 1975; Lucie-Smith, E. Late Modern: The Visual Arts Since 1945, 1969; Nougé, P. René Magritte ou Les Images défendues, 1943; "René Magritte" (cat.), Obelisk Gal., London, 1961; "René Magritte" (cat.), Hirshhorn Mus. and Sculpture Garden, Washington, D.C. 1974; "Magritte: Word vs. Image" (cat.), Sidney Janis Gal., NYC, 1954; Raynal, M. Modern Painting, 1953; Rubin, W.S. Dada and Surrealist Art, 1968; Schneede, U. Rene Magritte: Life and Work, 1983; Scutenaire, L. René Magritte, 1947; Soby, J.T. "René Magritte" (cat.), MOMA, NYC, 1965. Periodicals—Art News and Review November 14, 1953; Arts (Paris) July 11–17, 1962; London Bulletin April 1938; New York Times Magazine May 22, 1966; XXe siècle (Paris) December 1963.

*MANESSIER, ALFRED (December 5, 1911–), French painter whose religious beliefs were reflected in his canvases, stained-glass windows, and tapestries. He was born in Saint-Ouen, Somme department, just north of Paris, the only son of Nestor and Blanche (Tellier) Manessier. His father was a wholesale wine merchant, and his paternal grandfather a designer and cutter of oranamental building stone. He grew up in Abbeville and Amiens and at the fishing port of Le Crotoy, where he visited his maternal grandmother, a ropemaker. There he painted pictures of fishing boats and the bay of the river Somme. He responded to the play of light over the river.

Alfred attended the Lycée and the Ecole des Beaux-Arts, in Amiens, where he studied architecture. In 1929 he enrolled as an architectural student at the Ecole des Beaux-Arts, Paris, but hated the atmosphere of the school and spent most of his time in the Louvre, copying paintings by Tintoretto and Rembrandt. At the art academies of Montparnasse he found greater freedom of expression, and at the Académie Ranson met the young painters Le Moal and Bertholle and the sculptor Etienne-Martin. They came under the influence of the painter Roger Bissière, who encouraged his pupils to study Braque and Picasso. Manessier, working with Bissière, turned from realistic landscapes to paintings in the cubist tradition. He exhibited his canvases for the first time at the Salon des Indépendants in 1933, and showed at that Paris gallery again in 1934 and '35.

Manessier left Paris after his father died in 1936, but in 1937 he was asked by the architect Aubley to assist in the decoration of the Pavillon de l'Air et des Chemins de Fer for the Paris World's Fair. He was now turning toward surrealism, for as one critic wrote, "Its tormented and fantastic forms satisfied his need for violence." In 1937, with his friends Le Moal, Bertholle, Etienne-Martin, and others, he took part in the exhibition "Témoignages" (Testimonies) at the Galerie Bretau, Paris. In the following year his work appeared in a group exhibition "Matières et Formes" in the same gallery, and in 1939 he was represented in the second Salon des Jeunes Artistes, Paris.

In October 1938 Manessier married Thérèse Simonet. They had two children, Jean-Baptiste, who was born in 1940, and Christine, born in 1947.

Manessier served in the French Army in 1939 and 1940. Recalling the stifling artistic climate during the Nazi occupation of France, Manessier said: "For me, war liquidated surrealism. . . . And nothing seemed more important to me than to get out of the nightmare, regain contact with

°mă nā´ syä, al fred´

Jorge Lewinski

ALFRED MANESSIER

nature, find life again and affirm its laws." In 1941 he was included in an exhibition at the Galerie Braun called "Vingt Peintres de Tradition Française." These young artists proclaimed their allegiance to styles of painting branded by the Nazis as "degenerate," yet reaffirmed a peculiarly French type of cubism or semiabstraction that maintained its link with reality and sought to express light through the use of color. The same group showed in 1942 in the "Sous le Signe de l'Esprit" exhibit at the Galerie Berri-Raspail. It is believed that these shows were sanctioned by the Nazis in order to demonstrate the "decadence" of modern French painting.

During a brief visit to the Somme in 1943, while staying in the Grand Trappist Monastery of Soligny-la-Trappe, Manessier underwent a reconversion to Roman Catholicism. "His aspirations toward light," one critic wrote, "were elevated to the spiritual plane. . . ." He settled for a while in Bignon, Normandy, where, in accordance with the growing "inwardness" of his vision, he painted compositions with figures heightened by a dramatic lighting recalling Georges de la Tour. *The Pilgrims of Emmäus,* in this vein, was shown in the Salon de la Libération in Paris in 1944.

His subsequent paintings, according to one critic, showed "a kind of vaulted Gothic mysticism," and were predominantly nonfigurative, though he was never to be a total abstractionist. His work reached a wider public in 1946, as the result of a group exhibition (with Le Moal and Singier) at the Galerie René Drouin, Paris. One critic wrote of his new paintings: "On a solid base of pure color, Manessier builds a painting

which lifts itself into the sky with the liberty and transparent color of the stained glass windows of cathedrals."

This was a prophetic statement, for in 1948 Manessier had the opportunity to capture the expressive radiance and strength of colored light when he was commissioned to design stained-glass windows for the church of Bréseaux, in the department of Doubs, a project he completed in 1950. Other commissions followed, for churches at Assy, Basel, and Arles. Several critics have felt that Manessier's art, with its spiritual involvement, its rich coloring, and its highly schematized signs and symbols, has found its most perfect expression in stained-glass windows.

Manessier has also designed tapestries. The earliest of these, *Le Christ à la Colonne,* in collaboration with the sculptor Henri Laurens, was executed in 1949 for the Oratory of the Dominicans of Saulchoir, in the Seine-et-Oise department, near Paris. That same year he designed three tapestries for the National Ministry of Education. He also made a series of lithographs with Easter themes.

In 1950 Manessier's work was shown in Toronto and Dublin, and the following year he was included in group exhibitions of French painting in Stockholm and Göteborg, Sweden. In his five-foot wide painting *Crown of Thorns* (1951), the religious connotation was expressed in a symbolism that the British critic G. S. Whittet compared to the use of emblems by Paul Klee. Linear structure was combined with high-keyed color and a two-dimensional but animated treatment of the picture plane. The Carnegie Institute, Pittsburgh, first showed his work in 1951, when he also had exhibitions in London, Basel, Brussels, and Turin. A characteristic work of 1951 is *Variations of Games in the Snow,* now in the Solomon R. Guggenheim Museum, New York City.

From 1953 on, Manessier received several major awards, including first prize in painting at the São Paulo Bienal of 1953 and a prize at the 1955 exhibition of sacred art in Vienna. He had solo shows in Belgium and Holland in 1955, and in that year contributed paintings to the "New Decade" exhibition at the Museum of Modern Art, New York City. In 1955 he was awarded the $2,000 grand international prize of the Carnegie Institute for his *Crown of Thorns,* the first nonfigurative painting to win the Carnegie award. This work was described by one critic as "a radiant liturgical painting," but another observed: "While the artist's reverence is not to be doubted, this sketchily suggested and somewhat distorted head with spiky accompaniment probably will prove a shock to the orthodox."

However, still another critic, commenting on *Crown of Thorns*, wrote that Manessier, in his nonfigurative approach to a religious subject, had no intention of "aggressiveness or scandal." On the contrary, "he wants to transmit through his paintings his emotion and his mystic faith in life."

In the mid-1950s, Manessier often stayed at Le Crotoy, Somme, which he had known since boyhood. Many pictures he painted there were inspired by the hard light of the northern skies on stretches of water and sand. But *Night* (1956) has a soft and mysterious resonance, intensified by the velvety black of the abstract but evocative "signs." Again one is reminded of stained glass. In 1958–59 Manessier designed stained-glass panels and woven decorations for the chapel of Hem, built by the Swiss architect Bauer.

At this time he began his long and frequent visits to Moissac in Haute-Provence, famous for its Romanesque church and cloister. His keen response to the light of the region and to the geological formations of the surrounding hills was expressed in the canvases shown in his exhibit at the Galerie de France, Paris in 1959. A painting of 1961–62 was titled *Offering to the Earth*.

Unlike their American abstractionist contemporaries, Manessier and other French nonfigurative painters of his generation had a pronounced decorative tendency. In 1960 Manessier designed sets and 330 costumes for the Massine ballet *The Human Comedy*, inspired by Boccaccio's *Decameron* and performed at the Ballet Festival at Nervi, near Genoa. In 1963 he designed the costumes for Brecht's *Galileo* for the Théâtre National Populaire, Paris (his son, Jean-Baptiste, designed the settings). It was in 1962 that Manessier received the two most prestigious awards of the Venice Biennale, the International Grand Prize for Painting and First Prize of the International Institute of Liturgical Art.

Between 1959 and 1965 there were numerous commissions for stained glass and tapestries. Among his tapestry designs were *Gregorian Chant* for the Foyer de la Musique in the Radio-Télévision Française building, and *Espace Sousmarin* (Undersea World) for the assembly room of the Port Authority of Le Havre.

In each period, along with major religious themes, Manessier painted more intimate works, often stimulated by his immediate surroundings and his travels, which included a trip to Spain in 1966. A group of his paintings shown at the Galerie de France in 1970 was inspired by the forests and lakes of Canada. He portrayed the Great North as though seen from an airplane. He said: "To see a landscape from an airplane is a fascinating experience for me. The great rhythms of

nature are things that transform not only oneself but one's painting." *Manessier*, a film by Yvan Butler, was released in 1971.

One critic, writing in 1966, asserted that Manessier, Estève, Poliakoff, and other post–World War II French abstract painters were "minor masters" who had done little to renew the language of painting. However his contribution may ultimately be regarded, Manessier has created a personal style, a sensitive and expressive blend of abstract form and spiritual content. A critic writing in 1953 admired the artist's "finely balanced compositions and their exciting, harmonious color orchestrations," qualities which his painting has retained over the years.

Alfred Manessier is a tall, thin, friendly man who gives an impression of inner vitality and warmth. He has a Paris studio, and until his children were grown he spent each summer with his family by the seashore. With his religious beliefs, Manessier regarded his art as a reaction against the materialism of the age. He said: "I paint in response to my desire for harmony and unity, as a renewal of self, as a renewal of this world lost from grace." He described his aesthetic aims as follows: "The object is to put the spiritual equivalences of the exterior and the interior world into the open by authentically plastic means, and to make these equivalences intelligible by transposition and transmutation."

EXHIBITIONS INCLUDE: Gal. Billiet Caputo, Paris 1949; Gal. Jeanne Bucher, Paris 1949; Gal. Apollo, Brussels 1951; Gal. de France, Paris 1952, '56, '58, '59, '66, '70; Gal. Pierre Matisse, NYC 1953; Palais des Beaux-Arts, Brussels 1955; Kestner-Gesellschaft, Hanover, W. Ger. 1958; Kunsthaus, Zürich 1959; Mus., Amiens, France 1961; Phillips Collection, Washington, D.C. 1964; Kunsternes Hus, Oslo 1965; Mus. Fabre, Montpellier, France 1968, '74; Kunsthalle, Bremen, W. Ger. 1970; Univ. of Notre Dame, South Bend, Ind. 1972; Mus. d'Art Moderne de la Ville de Paris 1972; Caloute Gulbenkian Foundation, Lisbon, Portugal 1973; Mus. des XX Jahrhunderts, Vienna 1974; Gal. Editalia, Rome 1975. GROUP EXHIBITIONS INCLUDE: Salon des Indépendants, Paris 1933, '34, '35; "Témoignages," Gal. Bretau, Paris 1937; "Montières et formes, Gal. Bretau, Paris 1938; Salon des Jeunes Artistes, Paris 1939; "Vingt peintres de tradition Française," Gal. Braun, Paris 1941; "Sous le signe de l'esprit," Gal. Berri-Raspail, Paris 1942; Salon de la Libération, Paris 1944; Gal. René Drouin, Paris 1946; Moderna Mus. Stockholm 1951; São Paulo Bienal 1953; Exhibition of Sacred Art, Vienna 1955; "New Decade," MOMA, NYC 1955; International Exhibition of Contemporary Art, Carnegie Inst., Pittsburgh 1955; Venice Biennale 1958, '62; International Exhibition of Painting, Tokyo 1963, '65; Expo '67, Montreal, 1967; "French Painting Since 1900," Royal Academy, London 1969; "Paris et la peinture contemporaine depuis un demi-siècle," Montevideo, Uruguay 1972; "La Peinture en France de 1900 à 1960," Belgrade, Yugoslavia; "Biennale Européenne de la gravure," Mulhouse, France 1974.

COLLECTIONS INCLUDE: MOMA, and Solomon R. Guggenheim Mus., NYC; Phillips Collection, Washington, D.C.; Carnegie Inst., Pittsburgh; Mus. Nat. d'Art Moderne, Paris; Neue Nationalgal., Berlin; Folkwang Mus., Essen, W. Ger.; Boymans-Van Beuningen Mus., Rotterdam; Stedelijk van Abbemus., Eindhoven, Neth.; Moderna Mus., Stockholm; Sonia Henie-Niels Onstads Foundation, Oslo; Kunsthaus, Zürich; Mus. of Contemporary Art, Skopje, Yugoslavia; Mus. de Arte Moderna, São Paulo.

ABOUT: Cayrol, J. "Manessier" (cat.), Mus. de Poche, Paris, 1966; Cheney, S. The Story of Modern Art, 1958; Current Biography, 1957; Hodin, J. P. Manessier, 1972; Huyghe, R. Les Contemporains, 1949; Pellegrini, A. New Tendencies in Art, 1966; P-Orridge, G. and others (eds.) Contemporary Artists, 1977; Ritchie, A. C. (ed.) "The New Decade" (cat.), MOMA, NYC, 1955. *Periodicals*—Connaissance des arts (Paris) no. 50 1956; Le Monde (Paris) March 18, 1970; New York Times October 14, 1955; L'Oeil (Paris) no. 16 1956; Time October 24, 1955; XXe siècle (Paris) no. 20 1962.

GIACOMO MANZÙ

*MANZÙ, GIACOMO** (December 22, 1908–), Italian sculptor, was born in Bergamo, the next-to-youngest of the eight children of Angelo and Marie (Pesenti) Manzoni. (He later adopted the Bergamask dialect form of his name, Manzù.) His father was a shoemaker and also served as sacristan at a church in Bergamo. As a boy Giacomo was, according to *Time* magazine (August 11, 1958), "fascinated by the flow of robes and the carefully poised stance of the church dignitaries." He knew, even at that early age, that he wanted to be a sculptor. "At seven," *Time* noted, "he tried to translate his impressions into clay figures."

The house Manzù grew up in was next to a convent, and he made drawings on the courtyard walls while listening to the nuns singing. An amateur artist saw these drawings and encouraged him. At 11 Manzù learned how to use the chisel as an apprentice to a craftsman who carved wooden angels and other church decorations. In 1921 he worked in a gilder's shop making stucco friezes and ceiling ornamentation. In the evenings he studied intermittently with A. Fantoni, but was mainly self-taught.

By the time he was 16, Manzù was spending his spare time making clay models of a goat. Sometimes his brothers and sisters posed for him. A brief period of study at the Accademie Cigognini, Verona, in 1927 was interrupted by military service, which began in April of the following year. While he was stationed in Verona he studied in his free time at the Academy of Fine Arts. He made sketches of his fellow soldiers and did a self portrait. He also made some documentary films with a used camera.

After a visit to Paris, making his first contact with impressionism, Manzù moved in 1929 to Milan, where he lived and worked in a cellar and later in a garage. His sculptures first attracted attention in group exhibitions in Milan in 1930 and 1932. He was associated during those years with the artists Sassu, Birolli, and Grosso, and the architects Persico and Muzio. In 1930 Muzio gave him his first commission, the decoration of the chapel of the Università Cattólica del Sacro Cuore, Milan, with saints and other figures in cement, stucco, metal, and granite. Manzù's usual subjects at this time were tender, romantic figures of women and adolescents. As Mario Miniaci wrote in the catalog to Manzù's show at the World House Gallery, New York City, in April 1960, the artist's "cultural development was that of a self-educated man, reflecting personal taste rather than academic training." Manzù was deeply impressed by Etruscan sculpture and 13th-century stone statuary.

Manzù's marble statue, *The Sulamite Woman,* exhibited in a group show at the Galleria del Milione, Milan, in 1932, has been described as possessing "a mystical languor" inspired by his reading of the Bible. In 1933 he made a life-sized copper figure, *Young Girl on a Chair* (now in Rome's Galleria Nazionale d'Arte Moderna), incorporating a real kitchen chair. He returned to this theme in his work of the 1950s.

In 1933 Manzù returned to Bergamo, and on January 13, 1934 he married Antonia Oreni. They had three children: Carla and Mileta, both of whom died in 1937, and a son, Pio. (The Manzùs were separated in 1952.) In the first head he modeled of his wife, Manzù used diaphanous wax, and later bronze.

°măn zōō´, jä´kō mō

Manzù visited Rome in 1934 and made a second trip to Paris in 1936. He was included in the Venice Biennale of 1936 and 1938. His *Young David* of 1938 brought particularly favorable comment. The first of his long series of bronze sculptures of cardinals, which appear to be "sunk into hieratic anonymity within the robes of their calling," to quote *The Spectator,* was exhibited in Milan in 1938 and attracted much attention. Manzù maintained that the cardinal figures interested him "not because of their religious content, but because of their form and line. In a way they are my abstractions." Among the cardinals only the eight-foot bronze of Cardinal Giacomo Lercaro in the Cathedral of San Petronio, Bologna, is an individual portrait.

In 1939, just before the outbreak of World War II, Manzù carved a bas-relief showing a weeping family and a German soldier with a swastika standing before Christ on the cross. This piece, and a series of other "Crucifixions," reflected Manzù's concern with social problems, and at that time of ascendant fascism were considered highly controversial.

From 1940 to 1942 Manzù taught at the Albertina Academy of Fine Arts, Turin. He settled in Clusone, in northern Bergamo, in 1942, and it was there, while on vacation, that he created one of his most personal sculptures, a bronze high relief titled *Self-Portrait with Model at Bergamo* (1942; Hirshhorn Museum and Sculpture Garden, Washington, D.C.). In 1972 Manzù described this work as "a unique piece," meaning that there was only one cast, "made with the fervor that always accompanies my work." He recalled, "This bronze first took shape in my thoughts towards 1939 . . . and was executed without models, which is true of almost all my work." While living in Clusone during the war years he produced a large number of sketches of cardinals, artists, and models, many of which survive, but there is no trace of a suite of 45 drawings in which Manzù satirized the Axis and depicted Nazi atrocities.

Manzù spent much of 1944 as a partisan, hiding from the Germans. After the war he successfully resumed his career. In 1947 he was given a show at the Palazzo Reale, Milan, which included 50 bronzes and one hundred drawings, and for which the noted Italian art critic Lionello Venturi wrote the catalog introduction. Manzù gained worldwide recognition in 1948, when he was awarded the Grand Prize for Italian Sculpture at the Venice Biennale. Also in 1948, his work was included in the exhibition of 20th-century Italian art at the Museum of Modern Art, New York City. Discussing his art in the show's catalog, James Thrall Soby and Alfred H. Barr referred to Manzù as one of the three "Ms" of modern Italian sculpture, the other two being Marino Marini and Arturo Martini. Soby and Barr described Manzù's work as "warm, tender, romantic, belonging essentially to older sculptural tradition."

In 1952 Manzù offered the Brera Academy in Milan, where he had been a professor of sculpture for some years, a plan for a complete revision of the school's teaching methods. When this was not accepted, he resigned, later claiming that "you can't teach art, only techniques." In 1954 he moved from Clusone to Milan, and from 1954 to 1958 was an instructor, along with Oskar Kokoschka, at the International Summer School in Salzburg. While teaching at Salzburg, Manzù executed a figure, *Caravaggio*, for which the young American artist Red Grooms, then a student at the summer school, posed.

Manzù completed the cardinal series in 1958. By then, he explained, they had lost meaning for him, having become "too empty, too easy"; indeed, the sculptures themselves had become more than a little formulaic.

In 1950 Manzù won an international competition organized by the Vatican to design reliefs for the fifth bronze door of St. Peter's Basilica, and in 1956 he received a commission to do the central portal of Salzburg Cathedral. The 6,600-pound bronze doors for Salzburg's baroque cathedral are regarded as among Manzù's greatest achievements. Dedicated in August 1958, after three years of intense work, they were conceived in the tradition of classical Greece and the Italian Renaissance. The four bas-reliefs on the doors depict four saints of charity—St. Martin, St. Severinus, St. Engelbert Kolland, and St. Francis. In 1958, the year Manzù moved from Milan to Rome, the definitive model for the 25-foot-high bronze door at St. Peter's was cast by the foundry. Manzù had designed six models before arriving at his final design. The door, installed in 1964, is known as the "Door of Death" and is opened only during funerals; Manzù's bas-reliefs show the deaths of heroes of the Old and New Testaments. However, Manzù chose in the lower-right-hand panel to depict the praying figure of Pope John XXIII, who had died in 1963 and whose portrait bust he had executed in 1960–62.

Discussing the bronze panels for St. Peter's, Edward Lucie-Smith felt that although Manzù had been genuinely moved by the themes, especially the recent death of Pope John, the reliefs, for all their virtuoso craftsmanship, were "an anthology of other men's ideas," notably Donatello, Bernini, and Medardo Rosso. "The great ghosts of Italian art haunt Manzù's work and will not be exorcized." Other critics have praised the

"beauty and warmth" of the panels, and of Manzù's work in general. Among other religious commissions were the bronze doors for the Church of St. Laurence, Rotterdam, completed in 1968.

In contrast to the spirituality of the cardinals and the various bronze doors, Manzù's female figures, often of adolescent girls, have an ingenuous and tenderly sensuous quality. *Young Girl on a Chair*, a bronze of 1955, is now in the Hirshhorn Museum and Sculpture Garden, Washington, D.C., which owns 12 sculptures by Manzù. The collector Joseph H. Hirshhorn was a long-time admirer of the artist's work. The sculpture, with its bronze figure, which, like the copper version of 1933, sits on an actual wooden kitchen chair, anticipates some of the methods of pop sculpture, although the spirit is completely different. Manzù has said: "I am convinced that the chair motif, along with the portrait of Inge and the Cardinals, are among the better things I have done." Critics have also praised his "miraculously poised" young dancers. The bronze *Dancer with Skirt* (1956; Hirshhorn Museum) is an outstanding example, combining a long-legged adolescent awkwardness with an inner poise and serenity.

In 1964 Manzù moved to Campo del Fico in Ardea on the outskirts of Rome, where he still lives and works. In 1969 he had an important solo exhibition at MOMA, and also that year a museum was established in Ardea to house a collection of his works. In the summer of 1977 a major Manzù retrospective was held in the artist's native Bergamo, and a more modest, but still impressive, showing of his drawings and sculptures took place in 1978 at the Phoenix Art Museum in Arizona. The latest piece in the show, cast in 1978, represented, to quote *Art News* (October 1978), "a pair of unabashedly amorous lovers." Their eroticism was in startling contrast to the religious themes of some of Manzù's other works.

In spite of his commissions for the Vatican, Manzù has never been a strictly orthodox Catholic, but is a humanist in the widest sense. He sent red roses for the funeral of Palmiro Togliatti, who had headed the Italian Communist Party, but has described his political affiliation as with "poetry and poverty." In 1966 he was awarded the Lenin Peace Prize.

Giacomo Manzù works in a huge, uncluttered studio in Ardea. The painter Raphael Soyer, who visited him in September 1964, described him as "stocky, heavy-nosed, with a small mouth, warm alert eyes. He wore a small black-and-white checked cloth hat, deliberately, it seemed to me, askew on his head, and a black smock—

altogether a droll, sympathetic figure, a combination of laborer and comic actor." Soyer admired the "compactness and self-containment" of Manzù's figures. Since neither artist spoke the other's language, they communicated through an interpreter. Soyer noticed some canvases stacked against the wall, and Manzù admitted that the he always painted, but he evidently "didn't think enough of them to show them."

Manzù has always found it difficult to speak about his work—as the interpreter remarked to Soyer, "Manzù doesn't talk. He just answers questions"—but in 1972 the artist declared: "What is most important is the drive to create, which at times also gives us the hope of preserving the infinite. This is always the thought that accompanies our work, but it is a rare thing when the form preserves it." On another occasion he observed: "Each man has his way of expressing the poetry within him. Some sculptors try the abstract way. My way is the figurative way."

EXHIBITIONS INCLUDE: Gal. del Milione, Milan 1933; Gal. della Cometa, Rome 1937; Gal. Barbaroux, Milan 1941; Gal. Galatea, Turin, Italy 1944, '45; Palazzo Reale, Milan 1947; Inst. de Arte Moderno, Buenos Aires 1949; Hanover Gal., London 1953,'56, '65, '69; Gal. Welz, Salzburg, Austria 1954, '55, '74; Haus der Kunst, Munich 1959; World House Gals., NYC 1960; Tate Gal., London 1960; Mus. Boymans-Van Beuningen, Rotterdam 1968; MOMA, NYC 1969; Mus. of Modern Art, Tokyo 1974; Bergamo, Italy 1977; Phoenix Art Mus., Ariz. 1978. GROUP EXHIBITIONS INCLUDE: Gal. del Milione, Milan 1932; "Mostra Sindicale," Milan 1934; Venice Biennale 1936, '38, '48, '56; "Contemporary Italian Art," Kunsthalle, Bern 1938; Quadriennale, Rome 1942; "Twentieth-Century Italian Art," MOMA, NYC 1948; Hanover Gal., London 1952, '53; "Morandi and Manzù," Kunstverein Mus., Winterthür, Switzerland 1956; Pittsburgh International, Carnegie Inst. 1958–70; "20 Italian Sculptors," Tate Gal., London 1966; Expo '67, Montreal 1967; International, Solomon R. Guggenheim Mus., NYC 1967–68; "Masters of Modern Italian Art," Mus. of Modern Art, Kyoto, Japan 1972; "Hommage à Picasso," Kestner-Gesellschaft, Hanover, W. Ger. 1973.

COLLECTIONS INCLUDE: Gal. Nazionale d'Arte Moderna, Rome; Manzù Mus., Ardea (near Rome); Gal. d'Art Moderna, Venice; Turin Mus., Italy; Tate Gal., London; Middelheim Park, Antwerp, Belgium; Kunsthalle, Mannheim, W. Ger.; Wallraf-Richartz Mus., Cologne; Nat. Mus., Oslo; MOMA, and Rockefeller Center, NYC; Albright-Knox Art Gal., Buffalo, N.Y.; Hirshhorn Mus. and Sculpture Garden, Washington, D.C.; Cleveland Mus. of Art; Nat. Gal. of Ontario, Toronto.

ABOUT: Current Biography, 1961; Micheli, M. de Giacomo Manzù, 1971; Miniaci, M. "Giacomo Manzù" (cat.), World House Gals. NYC, 1960; Pacchioni, A.

Giacomo Manzù, 1948; Pepper, C. B. An Artist and the Pope, 1968; Ragghianti, C. L. Giacomo Manzù—Sculptor, 1957; Read, H. A Concise History of Modern Sculpture, 1964; Rewald, J. Giacomo Manzù, 1966; Ritchie, A. C. Sculpture of the Twentieth Century, 1952; Seuphor, M. The Sculpture of this Century, 1960; Soby, J. T. and others "Twentieth-Century Italian Art" (cat.), MOMA, NYC, 1949; Soyer, R. Diary of an Artist, 1977; Venturi, L. "Giacomo Manzù" (cat.), Palazzo Reale, Milan, 1947. *Periodicals*—Art News December 1956, May 1960, October 1978; Connaissance des Arts May 1979; Domus (Milan) February 1937; Pinifarina (Turin) no. 5 1964; Spectator May 15, 1953; Time April 8, 1957, August 11, 1958.

CONRAD MARCA-RELLI

MARCA-RELLI, CONRAD (June 5, 1913–), American painter who began as an Abstract Expressionist, revolutionized collage painting in the 1950s. His technique of using cut-out shapes of painted canvas arranged on the canvas ground helped raise collage, in one critic's estimation, "to a scale and complexity equal to that of monumental painting."

Conrad, or Corrado, Marca-Relli was born in Boston, Massachusetts, the son of a journalist and news commentator. His early childhood was spent in Europe and Boston. He began to draw when he was in Italy with his father, and has always retained a strong feeling for the Italian cultural heritage. In 1926, when he was 13, his family moved permanently to New York City. He decided to devote himself to painting in 1930, and though he studied in various small art classes and at Cooper Union for one year, he was largely self-taught as an artist. He set up his own studio in New York in 1931, and for the next three years supported himself with occasional illustrations and covers for newspapers and magazines, as well as by teaching. From 1935 to 1938 he taught in the mural and easel painting divisions of the Works Progress Administration's (WPA) Federal Arts Project. While on the WPA project he met artists who were to influence his development, including Franz Kline, Willem de Kooning, and John Graham. Through them he was introduced to European modernism, particularly the work of Picasso, Matisse, and Miró. In the late 1930s he was briefly influenced by the Mexican muralist, Orozco. In 1940 he traveled to Mexico, and from 1941 to 1945 served in the US Army, holding the rank of private first class. He first showed his work, a painting titled *Reveille*, in a "Soldier-Artists" group exhibition held at the Contemporary Arts Gallery, New York City.

After his discharge from the military, Marca-Relli spent a year in Woodstock, New York, where he resumed painting. His appreciation for "the pace and texture of European life," as one critic put it, led him to spend the next three years in Rome and Paris, where his earliest important paintings were executed. They were shown at his first solo show, held at the Niveau Gallery, New York City, in 1947, and contained motifs from circus life and Italian architecture. The surrealist manner in which these subjects were organized, with flat, cut-out shapes set in expansive dream spaces with distant perspectives, reflected such influences as the *pittura metafisica* of Giorgio de Chirico and the naïve paintings of Henri Rousseau. Marca-Relli wrote in the show's catalog that "the lonely street of our childhood, the whistle of the train in the still night, an old circus poster—these are my seeds." He continued in this surrealist vein through most of 1949, the year of his second solo show at the Niveau Gallery.

In 1949–50, Marca-Relli helped to organize the Painters' Club, an association of artists and intellectuals who played important roles in the development of the New York School. His large, semiabstract works shown at the New Gallery, New York City, in 1951 reflected the influence of Miró and Gorky. Brilliant in color, their fluid line and organic, biomorphic forms derived from surrealist notions of automatic writing. Although these paintings were well received, Marca-Relli felt that he had not yet found his true idiom. In 1951 he returned to Rome in order to rethink the premises of his art. That same year he married Anita Gibson.

In Rome, where he remained until early 1952, Marca-Relli was attracted by the formal order of

ancient and Renaissance buildings, as well as by their texture and solidity. The paintings he exhibited at the Stable Gallery in 1953, the year after his return to Manhattan, depicted city squares, with harbors and buildings used as the basis for formalizations of horizontal and vertical elements as in *Cityscape* (1952). There were still traces of surrealist nostalgia in the empty spaces and eerie light. Marca-Relli's low-keyed palette was made up of mat blacks, whites, grays, umbers, and ochres. The spare elegance of his paintings reflected a European taste, and was in marked contrast to the rough, seemingly unfinished treatment found in his Abstract Expressionist contemporaries of the New York School.

As he tightened his pictorial structure, Marca-Relli felt a growing kinship with the modern Italian painter Giorgio Morandi, who, in his simple but classically perfect still-life forms, had achieved a vision of harmony and order. Morandi's influence can be seen in *Still Life* (1952–53), which was virtually complete when Marca-Relli visited Mexico in the summer of 1953. There he was impressed by the tactile qualities of the adobe buildings, their surfaces brilliant in the hard light. When he ran out of paint that summer, he began to experiment with collage, finding that this provided a plastic equivalent for the textures and volumes of architecture. After his return from Mexico in the fall of 1953, he reworked *Still Life*, adding strips of raw canvas directly to the table and to the oblong form resting on it. He also reworked *Seated Figure, Outdoors*, partially completed before his trip to Mexico, by substituting a few areas of raw canvas for the heavily built-up paint surfaces that he felt had obscured the composition's structural clarity and solidity. It was one of a group of figurative works, some of which he had already exhibited at the Stable Gallery early in 1953.

From late 1952 through 1955, Marca-Relli was almost exclusively concerned with the single human figure, beginning with *Sleeping Figure* (1953–54; Museum of Modern Art, New York City). In this series, for which he never used a model, he sought what he called the "architecture of the human figure." He had moved in 1953 to East Hampton, Long Island, where he came into closer contact with de Kooning and Pollock, whose work inspired him to balance his desire for classical harmony with the spontaneity and freedom of abstract expressionism. Beginning with a rough sketch on the bare canvas, he cut out segments of unpainted canvas, either raw or primed, with a razor blade. After pinning them to the supporting canvas, he often rearranged them as the addition of other segments altered the relationships. By 1955 Marca-

Relli had begun to add paint to some of the canvas strips, still using a subdued cubist palette of ochres, grays, and off-whites. By this means collage became, as one critic observed, "a painting with oil and canvas."

In 1954–55, and again in 1959–60, Marca-Relli was a visiting teacher at Yale University. By 1956 his mastery of collage enabled him to undertake such ambitious mural-sized figure compositions as *Trial* (1956; Minneapolis Institute of Arts) and *The Battle* (1956; Metropolitan Museum of Art, New York City). In these works, which Marca-Relli described as "the architecture of an event," he introduced a multitude of figures in action. The compositions included tightly compressed canvas swatches in biomorphic shapes vigorously brushed with black or colored areas of paint. In his oil and canvas collage, *The Dweller* (1957), he returned to a single human figure, although the human image was fragmented and almost submerged behind the veil of shredded canvas strips. *Odalisque* (1957; Albright-Knox Art Gallery, Buffalo, New York) explicitly refers to the pictorial tradition of the reclining nude, with the canvas's flatness emphasized by the collage fragments. In his collages of 1958, which include *The Surge*, he abandoned his former subdued palette for brilliant reds, blues, and yellows, often painted directly onto the canvas.

The few months spent in the south of France in the summer of 1958 inspired Marca-Relli to use the sharp contrasts and greater translucency of Mediterranean light in his work. In 1961, finding canvas too pliable, he sought materials of greater resiliency. He tried using thin sheets of metal, as in the small collage *Untitled* (1961), but found metal too rigid and awkward. In 1962 he found a solution in sheets of vinyl plastic which combined resistance and flexibility. In his painted vinyl collage *Plan B* (1962; Museum of Fine Arts, Houston), vinyl sheets were nailed directly to a wooden support. From 1960 to 1967 Marca-Relli made annual trips to Europe. In 1963 he began to create aluminum collages and shallow aluminum reliefs, relying on a few basic forms cut with clean, precise edges. Among these new pieces were *Runway No. 3* (1963) and *Lockheed 200* (1964), both containing references to sections of airplanes. In 1965 the painter told an interviewer: "In painting . . . I feel that when I bring it down to very simple shapes . . . the ambiguous is created."

In 1964 Marca-Relli extended his collages into three-dimensional space by means of shallow aluminum reliefs, as in *Untitled* in the Whitney Museum of American Art, New York City. This led inevitably to the free-standing aluminum

sculptures of 1966, which transformed collage into tangible, physical objects. In both the reliefs and the sculptures, the sections were shaped by hand, giving the artist's personal touch to the products of the machine.

In 1966 Marca-Relli returned to paint and canvas, producing compositions in which isolated painted shapes filled a bare field. His "Untitled" pieces of 1967 have been compared to Japanese-style ideograms.

From 1965 to 1967 Marca-Relli was artist-in-residence at the New College, Sarasota, Florida. In 1966 he joined the Marlborough-Gerson Gallery, New York City, and in the fall of 1967 he was given a major retrospective at the Whitney Museum which traveled to the Rose Art Museum of Brandeis University.

In 1973 Marca-Relli's love of the Mediterranean and of European life led him to settle in Ibiza, Spain. He is less known in Europe than in the US, where he is considered a leading representative of the second wave of Abstract Expressionists, and is noted for being the only one of those artists to have specialized in collage. In an interview with Gladys S. Kashdin, recorded in her unpublished doctoral dissertation at Florida State University, Marca-Relli discussed his love of travel and of Europe at a time when American art was aggressively asserting its independence from the Continent:" . . . I live to visit places that affect me. . . . I've been told that it was wrong. . . . It's as if you have to do it just here and [must] shut your eyes to other things. I don't believe in shutting my eyes to anything. . . . Art is art everywhere."

EXHIBITIONS INCLUDE: Niveau Gal., NYC 1947, '49; Gal. Il Cortile, Rome 1949; New Gal., NYC 1951; Stable Gal., NYC 1953, '55, '56, '58; Frank Perls Gal., Hollywood, Calif. 1956; Gal. del Naviglio, Milan 1957; Gal. La Tartaruga, Rome 1957; Kootz Gal., NYC 1959, '60, '61, '62, '63, '64; Playhouse Gal., Sharon, Conn. 1960; Bolles Gal., San Francisco 1961; Gal. Schmela, Dusseldorf 1961, '71; Gal. de France, Paris 1962; Tokyo Gal. 1963; Gal. Bonino, Buenos Aires 1965; Makler Gal., Philadelphia 1967, '75; Whitney Mus. of Am. Art, NYC 1967; Rose Art Mus., Brandeis Univ., Waltham, Mass. 1967–68; Seattle Art Mus. 1969; Marlborough Gal., NYC from 1970; Mus. of Fine Arts, Fort Lauderdale, Fl. 1971; Gal. Carl Van der Voort, Ibiza, Spain 1972; Gal. Inguanzo, Madrid 1972, '73; Marlborough Gal., Zürich 1974; Marlborough Goddard Gal., Toronto 1975; "Homage to La Belle Epoque," Alex Rosenberg Gal., NYC 1983–84. GROUP EXHIBITIONS INCLUDE: "Soldier-Artists," Contemporary Arts Gal., NYC 1941; "Abstraction Today," New Gal., NYC 1950; Annual, Whitney Mus. of Am. Art, NYC 1953–1969; Venice Biennale 1955; São Paulo Bienal 1959; Documenta 2, Kassel, W. Ger. 1959; Segunda Bienal Internacional de Mexico, Mexico City 1960; "The Art of Assemblage," MOMA, NYC 1961; "Art Since 1950,"

World's Fair, Seattle 1962; "Art of the United States," Whitney Mus. of Am. Art, NYC 1966; "Dorazio, Marca-Relli, Pasmore," Arts and Crafts Center, Pittsburgh 1968; "American Painting: The 1950's," Am. Federation of Artists Gal., NYC 1968; "American Drawing of the Sixties," New School Art Center, NYC 1969; "American Painting 1970," Virginia Mus., Richmond 1970.

COLLECTIONS INCLUDE: MOMA, Whitney Mus. of Am. Art, and Solomon R. Guggenheim Mus., NYC; Albright-Knox Art Gal., Buffalo, N.Y.; Wadsworth Atheneum, Hartford, Conn.; Mus. of Art, Carnegie Inst., Pittsburgh; Cleveland Mus. of Art; Art Inst., Chicago; Detroit Inst. of Arts; Minneapolis Inst. of Arts, and Walker Art Center, Minneapolis; Mus. of Fine Arts, Houston.

ABOUT: Agee, W. C. "Marca-Relli" (cat.), Whitney Mus., NYC, 1967; Arnason, H. H. Marca-Relli, 1963; "Conrad Marca-Relli" (cat.), Niveau Gal., NYC 1947; "Marca-Relli" (cat.), Kootz Gal., NYC 1959; Miracle, G. and others Marca-Relli, 1975; Moore, E. (ed.) Contemporary Art 1942–72: Collection of the Albright-Knox Art Gallery, 1972; Seitz, W. "The Art of Assemblage" (cat.), MOMA, NYC 1961; Tyler, P. Marca-Relli, 1960. *Periodicals*—Art Digest March 1953, March 15, 1955; Art International (Lugano) December 5, 1963; Art News November 1955; Arts Magazine June 1959, May 1960, February 1979.

***MARINI, MARINO** (February 27, 1901–August 6, 1980), Italian sculptor, graphic artist, and painter, is best known for his sculptural variations on the horse-and-rider theme. He was born in Pistoia, in a house on the Piazza San Pietro, and studied painting and sculpture at the Academy of Art in Florence under the naturalistic artist Domenico Trentacoste. In this period Marini concentrated on painting and drawing, but he also modeled a few heads and was interested in the impressionist sculpture of Medaro Rosso.

A visit to Paris in 1919, when he was 18, introduced him to the new tendencies in modern art. In his own career he attempted a synthesis between modernism and antique sculpture, especially that of the archaic Etruscans and Romans. As he acknowledged, "My first love was the Etruscan civilization, upon which, so to speak, I was born."

Marini's early nudes and portraits were painted in a solid, ponderous style with something of the archaism of the Italian painter Massimo Campigli. As a young man he was also deeply impressed by the sculpture of Rodin and Wilhelm Lehmbruck. After graduating from the Florence Academy in 1926, he returned to Paris in 1928 and stayed a year. There he met a bril-

°mä´´ rē´ nē, mä´´rē´ nō

MARINO MARINI

liant group of Italian artists then living in the French capital, among them de Chirico, de Pisis, Campigli, and Magnelli. He also met Picasso, Braque, Tanguy, and the sculptors Henri Laurens and Julio González. The medieval sculpture he saw in his travels in France, Germany, Holland, and England was to affect his style in later years.

Marini's early figure studies in terra-cotta recalled Campigli's neoclassical young women with their hour-glass waists and decorative clothing. These were followed by works of a more rugged realism in the Roman manner, including torsos of boxers and fairground athletes. Marini's true career as a sculptor can be said to have begun with *Il Cieco* (1928, *The Blind Man*). *Il Popolo* (1929, *The People*) was the first work in which his individual style was clearly revealed. Both these sculptures had a static quality, but expressed deep human feeling.

In 1929 Marini succeeded Arturo Martini as professor of sculpture at the School of Art at the Villa Reale in Monza, a post he held until 1940. He won a Grand Prix for sculpture at the Rome Quadrenniale of 1935, and in 1937 was awarded a prize for his works shown at the Paris Exposition.

On December 12, 1938 Marini married Mercedes Pedrazzini, whom he and their friends nicknamed Marina, as if to stress the mutual sympathy that was to be sustained throughout the sculptor's life. Marini resigned from his teaching position at Monza in 1940, when he was made professor of sculpture at the Brera Academy, Milan. His figure of *Poma*, modeled in 1941, has been described by one critic as "a delightful

synthesis of the ancient and the modern, of the sensuously domestic and the monumental."

From 1942 until the end of World War II, Marini lived in Ticino, Switzerland, where he met Giacometti, Fritz Wotruba, and Germaine Richier. The death and destruction of the war years intensified his feeling for suffering humanity, and this was reflected in his work.

In 1946 Marini returned to Italy and settled in Milan in a house in the Piazza Mirabello. He spent his summers in Germinaia al Forte dei Marmi, and returned from time to time to a house he owned near Locarno.

As early as 1935 Marini had discovered the age-old theme of the horse and rider which he was to make his own. He was partly inspired by the Han dynasty tomb horse. In his first works on this motif, such as *Cavalier* (1936), the horse and rider were represented as distinct beings, each existing independently of the other. When he returned to the theme in the postwar years, as in his masterful *Horse and Rider* (1949–50; Krayenbuhl Collection, Zurich) in polychrome wood and standing 71 inches high, horse and rider were completely fused. The rider, his arms outthrust on either side, seemed like a rigid column set astride the tense elongated body of the horse. In *Falling Horse and Rider* (1953) elements of time, space, and movement were successfully integrated. Marini also produced studies of horses alone.

In addition to their classical formality, all these works, whether of horses and riders or horses alone, such as *Great Horse* (1951), owe something to Marini's interest in medieval sculpture. They are, as one critic pointed out, "suggestive of deeper emotion and anxiety, symbols, often, of tragic apprehension about mankind." One of Marini's most expressive pieces, a bronze *Piccolo miracolo* (1955), echoes Picasso's *Guernica* in the horse's agonized gesture.

In 1950 Marini's first exhibition in the United States was held at the Buchholz Gallery, New York City. On this occasion he met Jean Arp, Alexander Calder, Jacques Lipchitz, Max Beckmann, and Lyonel Feininger. On his return journey he stopped in England, where Curt Valentin introduced him to Henry Moore. Marini later met Moore in Forte dei Marmi, where the British sculptor also spent his summers; they were friends for many years. In 1952 Marini received the international grand prize for sculpture at the Venice Biennale.

In the late 1950s, concurrently with his horse and rider series, Marini produced the "Jugglers" and "Dancers" series. The "Dancers," including the bronze *Dancer* (1954; Hirshhorn Museum

and Sculpture Garden, Washington, D.C.), were reinterpretations of a favorite sculptural motif of Degas.

Although less well known than his full-figure pieces, Marini's portraits are among the most impressive in modern art, and were a logical outgrowth of his humanism. His inspiration sprang in part from Etruscan and Roman portrait busts, with their brusque realism and economy of form; there was perhaps some Egyptian influence as well, especially in his beautiful terracotta heads. One of Marini's earliest sculptured portraits was that of the painter Campigli, executed in 1940. His postwar portraits include heads of Carlo Carrà (1946), Igor Stravinsky (1951), Henry Miller (1961), and Arp, Chagall, and Henry Moore (1962). Despite Moore's objection to prolonged sittings, he agreed to pose briefly for Marini, who modeled the British artist's head in clay, with only three sittings of an hour or two. Later the head was cast in bronze in an edition of six. Like Marini's other portraits, the head of Moore combines deep psychological realism with the artist's genius for modeling and surface texture. One cast of the Moore portrait was presented to London's National Portrait Gallery by artist and sitter in 1969.

In 1962–63 Marini's work was included in an impressive exhibition organized by the German city of Darmstadt and entitled "Zeugnisse der Angst in der modernen Kunst" (Evidences of Anxiety in Modern Art). Such an exhibition could only have occurred in postwar Europe, with its burden of guilt and fear carried over from the years of Nazism, war, and mass murder. Marini's work, while classically restrained in comparison to that of other, more obviously expressionistic artists such as Max Ernst, Beckmann, Richier, and Giacometti, was nevertheless deeply humanistic. For instance, there was great dramatic intensity, and even a kind of desperation, in his enigmatic *Horses and Riders.* Critics noted the "inexorable tension" and the disturbing imbalance of his *Falling Horse and Rider* of 1953.

Important Marini retrospectives were held in the Kunsthaus, Zürich, in 1962, and in the Palazzo Venezia, Rome, in 1966.

Marini had begun his career as a painter of nudes and portraits and after his middle period, in which he concentrated on sculpture, he began to paint again in 1948–49. Some of his paintings were nearly abstract, others contained metaphorical figures, but the stress was always on the play of color and the modulation of the picture surfaces to express spatial movement. One critic argued that the decorative style of his paintings "is notably at variance with the grandeur and seriousness of the sculpture." Other critics have found his graphic work more impressive than his painting.

A Marino Marini Museum was inaugurated in 1973 in Milan; it contains some of his most important works in sculpture, painting, and graphic art. In 1976 the Haus der Kunst in Munich organized an exhibit of Marini's entire graphic work, lithographs and etchings.

Marini attached great importance to a clear architectural structure, but he was essentially a modeler. He sometimes carved in wood, but rarely used stone. At pain to obtain a perfect finish, he worked with a chisel on his bronze casts, and opened up the surface to produce the desired texture. He often exploited the blemishes or joints produced by the process of casting. In the course of the sculpturing or modeling process, Marini added coloring, which consequently formed an integral part of the finished work.

In his last years Marino Marini lived and worked mostly in Milan, but he also owned a home in Viareggio. He was a pleasant, thoughtful man, completely dedicated to his work, and his life was enriched by his long, happy marriage to Marina.

In an interview published in *The New York Times* (February 19, 1950), Marini said that he thought of his work as the "new renascence of sculpture in Italy, the new humanism, the new reality." But the epic, optimistic humanism of the Renaissance was no longer possible. As Marini declared in a 1968 interview: "My statues of riders express the anguish provoked by the events of my age. . . . For the last fourteen years my works have been intended to be tragic rather than heroic."

Although Marino Marini's work does not belong to the more radical movements in contemporary art, it testifies to the vigor of the figural tradition in modern sculpture. It is a synthesis of his own lyrical, human sensibility and his cultural heritage.

EXHIBITIONS INCLUDE: Gal. Milano, Milan 1932; Gal. Sabatéllo, Rome 1933; Buchholz Gal., NYC 1950; Watkins Gal., Washington, D.C. 1950; Hanover Gal., London 1951, '56; Kestner-Gesellschaft, Hanover, W. Ger. 1951; Curt Valentin Gal., NYC 1953; Boymans-Van Beuningen Mus., Rotterdam 1955; Pierre Matisse Gal., NYC from 1955; Kunsthaus, Zürich 1962; Mus. di Palazzo Venezia, Rome 1966; Gal. Tonnelli Arte Moderna, Rome 1970; Salotto Piero della Francesca, Milan 1972; Gal. d'Arte Moderna, Milan 1974; Haus der Kunst, Munich 1976; Castello Sforzesco, Milan 1976. GROUP EXHIBITIONS INCLUDE: Venice Biennale 1930, '32, '34, '48, '52, '62, '64; Rome Quadrenniale 1935; Paris Exposition 1937; "Marini, Moore, Wotruba," Gal. Wolz, Salzburg, Austria 1952; Documenta 1, 2, and 3, Kassel, W. Ger. 1955, '59, '64; Pittsburgh Internation-

al, Carnegie Inst. 1955–67; "Sculpture of the 20th Century," Grosvenor Gal., London 1960; "Evidences of Anxiety in Modern Art," Darmstadt, W. Ger. 1962–63; "Scultori Italiani Contemporanei," Palazzo Reale, Milan 1971; "Masters of Modern Italian Art," Nat. Mus. of Modern Art, Kyoto, Japan 1971; Masters of Modern Italian Art," Mus. of Modern Art, Tokyo 1971; "19 Sculptors of the '40s," Univ. of California, Santa Barbara 1973; "Twelve Views of Mankind," MacRobert Centre Art Gal., Univ. of Stirling, Scotland 1974.

COLLECTIONS INCLUDE: Marino Marini Mus., and Gal. Civica d'Arte Moderna, Milan; Gal. d'Art Moderna, Florence; Peggy Guggenheim Collection, Venice; Gal. d'Arte Moderna, Trieste, Italy; Tate Gal., and Nat. Portrait Gal., London; Mus. Royal des Beaux-Arts, Brussels; Rijksmus. Kröller-Müller, Otterlo, Netherlands; Boymans-Van Beuningen Mus., Rotterdam; Nationalmus., Gothenburg, Sweden; Neue Nationalgal., Berlin; Kunstmus., Hamburg, W. Ger.; Kunstmus., Düsseldorf; Albertina Academy, Vienna; MOMA, NYC; Albright-Knox Art Gal., Buffalo, N.Y.; Wadsworth Atheneum, Hartford, Conn.; Hirshhorn Mus. and Sculpture Garden, Washington, D.C.; Inst. of Fine Arts, Detroit; Mus. of Fine Arts, San Francisco; Portland Mus. of Art, Oreg.; Art Gal. of Ontario, Toronto.

ABOUT: Apollonio, U. Marino Marini, Sculptor, 1958; Arnason, H.H. History of Modern Art, 1968; Bardi, P.-M. Marino Marini: Graphic Work and Paintings, 1960; Bénézit, E. (ed.) Dictionnaire des peintres, sculpteurs et graveurs, 1976; Caballo, E. Marino Marini: Diario fotográfico raccontato da Marina, 1976; Carrieri, R. Marino Marini, 1948; Cooper, D. Marino Marini, 1959; Current Biography, 1954; Fierens, P. Marino Marini, 1936; Hammacher, A.M. Marino Marini: Sculpture: Painting: Drawing, 1971; Myers, B. S. and others (eds.) Dictionary of Modern Art, 1974; Read, H. A Concise History of Modern Sculpture, 1964; Trier, E. The Sculpture of Marino Marini, 1961; Waldburg, P. and others Complete Works of Marino Marini, 1971. Periodicals—New York Times February 19, 1950, November 1, 1983, August 7, 1980; Newsweek February 27, 1950; XXe siècle (Paris) December 1975.

MARISOL (May 22, 1930–), Venezuelan-American sculptor, was born Marisol Escobar in Paris to well-to-do Venezuelans, Gustavo Escobar, who worked in real estate, and the former Josefina Hernandez. In Spanish, Marisol means "sea and sun." She spent much of her childhood in Paris, but her world-traveling family, which included her brother Gustavo Escobar, now an economist, moved frequently, enjoying a comfortable, nomadic life in Europe, Venezuela, and the United States. Her mother died during the early years of World War II, when Marisol was about 11. The loss of her mother was cushioned by the nurturance of her father. The Escobars moved in the company of sophisticated intellectuals, and later, when Marisol became an artist,

© 1979 Helaine Messer

MARISOL

her father encouraged her and provided her an income.

The Escobars lived in Caracas, Venezuela during most of the war and subsequently moved to Los Angeles, where Marisol attended the Westlake School for Girls. She looks upon herself today as American rather than French or Venezuelan, but has said that living in different cultures as a child was more important to her artistic development than her later attendance at art schools.

At the age of 16, Marisol decided to be a painter, and studied with Howard Warshaw at the Jepson School, Los Angeles; she was already adept at representational drawing. She returned to Paris in 1949 to study at the Ecole des Beaux-Arts, where she was instructed to paint in the style of Bonnard. In 1950, at the Art Students League, New York City, she was influenced by Yasuo Kuniyoshi, who worked in a highly decorative naive manner. In the years 1951–54 she took courses at New York City's New School for Social Research but also studied with the so-called dean of abstract expressionism, Hans Hofmann, at his schools in Greenwich Village and Provincetown, Massachusetts. Marisol considers that period of study with Hans Hofmann a crucial part of her art education, and acknowledges that she learned more from him than from any of her other teachers. "I would go into class and I was very intimidated," she recalled. "I think I was one of the youngest people in the class. [Hofmann] was very enthusiastic about his school and the students. The atmosphere was very encouraging."

Meanwhile, Marisol had become part of the

beat generation that flourished in Greenwich Village. "In the fifties when I came to this country," she said, "the students were really unaware. I didn't want to go to college because it was do dead there. Only a few people were protesting. They were the beatniks. I used to hang around with them in the Village, and everyone thought they were a bunch of kooks." Unlike many artists of her generation, Marisol did not become a de Kooning-like action painter. Instead, she began informally to learn the techniques of sculpture, especially the skills of molding, carving, and carpentry. Indeed, Marisol is an entirely self-taught carpenter who hasn't "read even a single book on the subject." In reacting against the New York School—a rebellion that could not have been easily done at that time, especially for a young woman—she was influenced by three notably non-European sources: the representations of people and animals in an exhibition of pre-Columbian Mochica pottery jars in a Manhattan gallery; the small Mexican boxes with hand-carved painted figurines inside, which she saw in a display of South American folk art at a friend's house; and the early North American folk art to which she was introduced by her friend and mentor William King, who in the '50s was instructor of sculpture at the Brooklyn Museum Art School.

Inspired, Marisol began making small figures in clay and wood. In an interview with *The New York Times Magazine* (March 7, 1965) she recalled: "It started as a rebellion. Everything was so serious. . . . I started doing something funny so that I would be happier—and it worked."

Marisol first exhibited her sculpture at the co-operative East 10th Street galleries like the Tanager, which were showing avant-garde works by younger New York School artists. Also in the late '50s she dropped the surname Escobar, feeling that the single name Marisol had more distinction. The playful sculptures she made from 1953 on included roughly carved wooden figures of people and animals and small, often erotic terracotta figures, which she sometimes placed behind glass in boxes. *Figures in Type Drawer* (1954), in clay and wood, was a characteristic early work. In 1957, when her carved wood animals and totemic figures were exhibited at the Leo Castelli Gallery, a *New York Times* critic wrote that if they had been discovered by archaeologists in a South American jungle they would have elicited no surprise.

Important developments in her work had occurred by 1958, when her exhibition at the Castelli Gallery was discussed in *Life* magazine. This was a new Marisol, who, always responsive to diverse aesthetic influences, had discovered the possibilities of mixed media. She has been enchanted by an early American coffee grinder in the shape of a man, a wooden figure with wheels, and by old hat forms which resembled large heads. Marisol also began to work on a larger scale, carving portraits of families out of mahogany, although later she preferred pine. The combines of Robert Rauschenberg and Picasso's playfully unorthodox use of materials in his sculptures were additional sources of inspiration. Marisol's interest in mixed media led her to brighten up her groups with color, which she still used sparingly at this stage.

Marisol's individual style and method were already apparent in one of her earliest life-size groups with a topical motif, the 66-inch-high *The Kennedy Family* (1962), in wood and other materials. The bodies were composed of simple wooden boxlike volumes, with spheres, rather like hat-blocks, forming the basis of the heads. The wittily rendered and clearly identifiable features, hair, parts of clothing, and other accessories were drawn or painted on in a summary, almost childlike manner. Jack and Jackie and Caroline and John-John were represented in strict frontality, set on a low pedestal. John-John, then an infant, was depicted on a horizontal rectangular wooden shape "held" by his mother. The group, like most of Marisol's sculptures, was virtually an assemblage, inasmuch as such accessories as flower pots, mirrors, and television sets were used in the composition.

The Bathers, a construction of painted wood, plaster, and other materials, was also completed in 1962. Marisol's penchant for daringly erotic imagery found expression in a small combine, six inches high, called *Love* (1962). It consisted of the upturned plaster mask of a face—Marisol's own features—with the neck of an actual coca-cola bottle stuck in the mouth. This made *Love* the Marisol work with the closest affinity to mainstream pop imagery, though she rarely used commercial products in her constructions.

The piece in Marisol's 1962 Stable Gallery exhibit that most contributed to her fame was *The Family* (1962; Museum of Modern Art, New York City), an 83-inch-tall group in painted wood and mixed media representing a farm family from the dust bowl. Another piece from the show, *The Generals* (1961–62; Albright-Knox Art Gallery, Buffalo, New York), consists of nearly life-size caricatures of George Washington and Simón Bolívar seated on a large toy horse. The hands of both generals are plaster casts of the artist's own hands, and both real and gold teeth are set in the horse's mouth. The barrel forming the body of the horse contains a tape recording of a march by David Amram, special-

ly composed for the sculpture. *The Generals* gently satirized military pomposity.

The success of the Marisol exhibition at Manhattan's Stable Gallery earned the artist a place in the MOMA group show entitled "Americans, 1963"; of the 15 artists represented, her works proved the most popular with the public. Commenting on the exhibit, which took place at the time of pop art's ascendancy, Irving Sandler observed that Marisol "is related to the pop artists in that she parodies them."

Marisol's relation to pop art is problematical. According to Lucy Lippard, "Hers is a sophisticated and theatrical folk art [that] has little to do with Pop Art. . . . " In the '60s she presented such pop subjects as John Wayne and President Kennedy but disclaimed any intention of a political statement, insisting that her considerations were purely aesthetic. However, in a 1975 interview with Cindy Nemser, Marisol maintained that her work was "social criticism," and thus fundamentally different from the advertising images of Roy Lichtenstein and James Rosenquist. "My work had a lot of content," she remarked. "My idea was to work for everybody, because I saw that art had become such a high-brow thing—just for a few people. It's just that I think people see it, so why should I explain every detail? I remember when I did a group of politicians, a man came up and he said, 'Well, is this political art?' And I said, 'No, it has nothing to do with it.' I'm surprised that, up to this day, some people never understood what I was saying. . . . I always thought everybody knew it."

Marisol had close links with the world of pop. She was taken up by the media as a symbol of '60s glamour, and her frequent escort at parties was Andy Warhol, of whom she made an ingenious many-sided portrait drawn on sculptured wood in 1963. Warhol enhanced her celebrity in avant-garde circles by starring her in his underground movie *The Kiss* and included her, along with Baby Jane Holzer and other "superstars," in his *13 Most Beautiful Girls*.

Self-portraiture, virtually absent in Marisol's 1962 exhibit, dominated her show at the Stable Gallery in 1964 and has been central to her work ever since. Again and again she has half-mockingly introduced her own image—painted, photographed, wood-carved, and molded out of plaster—into her sculpture. Face masks, noses, hands, and other anatomical parts with herself as a model are simply stuck on the flat, chunky blocks, alternating with illusionistic drawings and other devices. In her Douanier Rousseau-like group, *The Wedding* (1962–63), figures of Marisol serve as both the bride and the groom,

and the groom's top hat is festooned with a photograph of the artist. Another construction, *Tête-à-Tête*, shows three images of Marisol seated at a table.

This preoccupation with self-image has provoked charges of narcissism. But Marisol dismisses Freudian interpretations of herself or her work. "Of course every artist puts himself into his work," she told *The New York Times Magazine*. "But the truth is, I use my own face because it's easier. When I want to make a face or hands for one of my figures, I'm usually the only person around to use as a model."

From 1966 on Marisol showed her work at the prestigious Sidney Janis Gallery, New York City. Her first exhibit there drew the biggest crowds in the gallery's history. It was her most "environmental" show, the main attraction a group of life-size figures called *The Party,* in which she gave her exotic, masklike face over a dozen different representations. Carved wood was still her basic medium, but she was beginning more and more to use plastic, terra cotta, paper, plexiglass, and other materials. These works also contained elements of assemblage, as some of her "guests" wore elegant evening clothes or scraps from Marisol's own wardrobe. The fantastic coiffures of the women were carved in wood; the top of one society lady's head contained a TV set; and a butler and a maid carried trays of glasses. The public admired Marisol's technical bravura, and the artist, whose Garbo-like air of mystery had been much touted in the glamour magazines, was photographed seated in profile and dressed in black among the standing figures; her expression was characteristically enigmatic. The *New York Times* critic John Canaday wrote: "Marisol's talent is that she always seems about to teeter off the edge into mere trickiness, but somehow remains surefooted in one eccentric indulgence after another."

Marisol's portraits, whether of celebrities or of less trendy folk, are done from photographs, as she considers enforced sittings "a form of torture." In 1967 she completed a commission from the London *Daily Telegraph* for a group portrait in sculpture and drawing called *The Royal Family*. It was exhibited in the Hanover Gallery, London, that same year. Later in '67 the group was presented, along with other life-size figures, in a delightful show called "Heads of state," at the Sidney Janis Gallery.

Marisol avoided overt political commentary, but the hollow, cadaverous image of the aging Spanish dictator Generalissimo Francisco Franco raised unpleasant associations. Paper was employed for Franco's head, hat, hands, white

gloves, insignia, and epaulettes, and the body was of wood. Moreover, there was exaggeration and a touch of the absurd in all the "Heads of State" sculptures. The figure of Prime Minister Harold Wilson, whom the artist considered "a very likable man," was given a massive, rounded head of laminated wood. The *Daily Telegraph* likened the overall shape of the six-foot-two-inch-high statue to that of "an unusually healthy pouter pigeon—or an Egyptian mummy." President Lyndon B. Johnson, in a sculpture not destined for the White House, was shown as a lowering, rumpled, domineering figure, pushing relentlessly forward and holding in the palm of his left hand three wooden "birds" with human heads—his wife Lady Bird and his daughters Linda Bird and Lucy Bird. The piece is viewed by feminists as a satire of male domination.

The largest and most impressive sculpture in the collection was the massive, nine-foot-high figure of President Charles de Gaulle, raised on a wheeled black-and-gold state carriage. A typically odd touch was the small hand by his head, cast from Marisol's own left hand and complete with her signet ring. The general's body was like an immense coffin-shaped box, and his jowls, carved from wood, rolled imposingly down from his chin. Particularly pleased with this work, Marisol noted that "it isn't really a caricature at all, is it? I found myself putting together a fairly straightforward likeness of de Gaulle." In preparing these figures she consulted dozens of color and black-and-white photographs of her subjects and sketched profiles of each piece on her whitewashed studio walls while waiting for the wood to be delivered.

The Marisol sculpture that aroused controversy was the seven-foot-high figure of Father Joseph Damien, the Belgian leper missionary in Hawaii. Intended for the Capitol's Statuary Hall in Washington, D.C., her model was rejected by the Hawaiian House of Representatives in March 1967, because she had shown in Father Damien's features traces of the leprosy that eventually killed him. The rejection provoked a heated debate, following which the Hawaiian Senate endorsed Marisol's model and the House of Representatives reversed its earlier decision.

According to Marisol, the years 1964–67 were exciting, but the popular image of her as a Manhattan party girl was, she believes, vastly exaggerated. She went to parties—one or two every couple of months—to relax, because "it's very depressing to be so profound all day." In 1968, when the mood of the country became ugly, Marisol "started getting very depressed." She traveled to the Far East and discovered that Western culture was not "the only thing that existed"; but, upon returning to the US a year later, her anxiety deepened. Unable to work, she spent a year in South America and Central America.

Marisol returned to the more subdued, inner-directed America of the '70s and, accordingly, her work changed. The "quest for self"—a persistent theme that was often a search for self-definition as a woman—was not jettisoned, but she withdrew from the social world into identification with the mythic underworld of the sea. She began producing sculptures of fish; many of them are sharklike predators, but joined to their bodies is Marisol's angst-ridden face. "When I came back [from the Far East] I felt like doing something very pure, . . . " she told Nemser. "In some cases I worked on one piece for six months. I wanted to do something very beautiful. Most of the fish are evil fish. . . . I haven't analyzed what I am doing this time. . . . I think it is unconscious. The shark and the barracuda are the most beautiful. They scare you, and so they must have impressed me."

In her 1973 show at the Janis Gallery, Marisol exhibited exquisite carved fish figures, most of them in mahogany to which as many as 30 coats of stain had been applied. The pieces included *Zebra* (1971), *Needlefish I,* and *Barracuda.* The pencil and crayon drawings in her 1975 exhibit were marked by strange, surreal, often highly erotic imagery. Among them were *Double Flower* (1973), *The King of Hearts* (1974), and drawings with such bizarre titles as *Lick the Tire of My Bicycle,* and *Platinum Spread Lips with a Mouth Full of Gold.* A sculpture of 1974, *Face and Breasts,* was in plaster and rope. Marisol's solo show at the Sidney Janis Gallery, New York City, in the spring of 1984 included a striking recreation in three dimensions of Leonardo's *Last Supper,* and a polychromed *Annah,* based on Gauguin's painting of a Japanese woman. The *New York Times* critic considered the *Annah* piece "the strongest and most beautiful in the show."

Marisol has been a naturalized American since 1963. The strikingly beautiful artist has been described as a "Latin Garbo," and one writer described her "extraordinary . . . face, with arched nostrils, slim Spanish nose, high cheekbones, all emerging from a streamlined, inky wave of hair. . . . " According to Nemser, "Marisol speaks in soft, girlish tones; her conversation is ingenuous, her smile infectious. Yet one never quite knows who the real Marisol is and what she really thinks. Perhaps that is her message: We must go on playing various roles until we can play no more."

Whatever the ultimate assessment of Marisol's

work may be, her highly original sculpture of the 1960s had a galvanizing effect on other artists as well as on the gallery-going public. Although their spirit is ironic and detached, those assemblages are not without a certain wry affection, especially in the representations of children. Beneath the satiric comedy of her groups, such as *Double Date* (1962–63), critics have sensed the melancholy of individuals isolated from each other in modern society, an alienation emphasized by Marisol's recurrent self-portraiture. She told *Art News:* "It isn't like the Renaissance anymore, when artists glorified man. People are different now. People must think of themselves because they are so lonely and isolated. Especially in a big city. You become your own best friend."

EXHIBITIONS INCLUDE: Leo Castelli Gal., NYC 1957, '58; Stable Gal., NYC 1962, '64; Arts Club, Chicago 1965; Sidney Janis Gal., NYC 1966, '67, '73, '75; Hanover Gal., London 1967; Boymans-Van Beuningen Mus., Rotterdam 1968; Venice Biennale 1968; Moore Col. of Art, Philadelphia 1970; Art Mus., Worcester, Mass. 1971; New York Cultural Center 1973; Ohio Univ., Athens 1974; Estudio Actual, Caracas, Venezuela 1974. GROUP EXHIBITIONS INCLUDE: Festival of Two Worlds, Spoleto, Italy 1958; "Humor in Art," Mus. of Fine Arts, Dallas 1958; "Pan-American Art," Art Inst. of Chicago 1959; Carnegie International, Pittsburgh 1959, '64, '67; "The Art of Assemblage," MOMA, NYC 1961; "Wit and Whimsey in Twentieth Century Art," Am. Federation of Arts, NYC 1962–63; Annual, Whitney Mus. of Am. Art, NYC 1962, '64, '66; "Americans, 1963," MOMA, NYC 1963; "Americans, 1963," Art Inst. of Chicago 1963; "Painting and Sculpture of a Decade: 1954 to 1964," Tate Gal., London 1964; "New Realism," Hague, Neth. 1964; "Art of the U.S.A. 1670–1966," The Whitney Mus. of Am. Art, NYC 1966; "II Internationale der Zeichnung," Darmstadt, W. Ger. 1967; "American Sculpture of the Sixties," Los Angeles County Mus. 1967; "The New American Painting and Sculpture," MOMA, NYC 1969.

COLLECTIONS INCLUDE: MOMA, and Whitney Mus. of Am. Art, NYC; Albright-Knox Art Gal., Buffalo, N.Y.; Yale Univ. Art Gal., New Haven, Conn.; Nat. Portrait Gal., Washington, D.C.; Baltimore Mus. of Art, Md.; Art Inst. of Chicago; Mus. of Fine Arts, Dallas; Mus. de Bellas Artes, Caracas, Venezuela.

ABOUT: Bernstein, R. and others (eds.) "Marisol" (cat.), Moore Col. of Art, Philadelphia, 1970; Lippard, L.R. Pop Art, 1966; Miller, D.C. (ed.), "Americans, 1963" (cat.), MOMA, NYC, 1963; Nemser, C. Art Talk, 1975. *Periodicals*—Art in America October 1981; Art International (Lugano) October 1973; Art News March 1964; Daily Telegraph Magazine September 15, 1967; Horizon March 1963; Life July 14, 1958; Look November 14, 1967; New York Post May 20, 1962, June 9, 1963; New York Times November 23, 1957, April 16, 1966, July 24, 1983; New York Times Magazine March 7, 1965; Quadrum 16 (Brussels) 1964; Time June 7, 1963, May 12, 1967.

MARSH, REGINALD (March 14, 1898–July 3, 1954), American painter and graphic artist, captured with unmatched vigor the teeming life of New York City. His canvases are packed with the swirling human energy—the crowds of hawkers, shopgirls, bums, railway men, burlesque queens, and businessmen—he found on Fourteenth Street, the Bowery, Coney Island, the Battery, and Fifth Avenue. Seen in its entirety, his very large oeuvre paints an incredibly detailed portrait of three decades of city life, from the 1920s to the 1950s—all the changes in fashion, architecture, even the favored proportions of the female figure, are to be found in his work. Originally a caricaturist and illustrator for newspapers and magazines, Marsh was a natural draftsman who could capture a pose and expression instantly. His freshest work was in brush and ink, watercolor, and egg tempera; the weight and solidity of oil was beyond him, though he sought incessantly for the lost painting secrets of the Renaissance and Baroque masters, which he believed would enable him to maintain his lightness of touch in the heavier medium.

Born in the Montparnasse district of Paris, Marsh was the second son of Fred Dana Marsh, a well-to-do painter, muralist, and inventor, and Alice Randall Marsh, a miniaturist. In 1900, when Reginald was two years old, the family moved to Nutley, New Jersey. Marsh always loved drawing, but received little encouragement at home, for his parents knew how difficult it was for an artist to earn a living. In 1916 he enrolled at Yale University, attending the highly academic Art School in his senior year. "I was taught drawing from the antique," he wrote, "and painting from still life by the pedants of the school, in a way that would make their 'old master' heroes turn in their graves." Though he rebelled against this instruction, already preferring to draw directly from life, he learned a respect for the methods of the "old masters" that only grew with time.

Between his junior and senior years, Marsh took courses at the Art Students League. In his last year at Yale he worked as an illustrator for the *Yale Record,* eventually becoming the paper's art editor. At the same time, he acquired a taste for fine living that never left him. "From college days," wrote his friend Lloyd Goodrich in his book-length study of the artist, "he was a member, if a somewhat misfit one, of the upper classes. His attitude toward them was ambivalent; they both attracted and repelled him, but they furnished material for one side of his art."

In 1920 Marsh went to New York City and began peddling illustrations to the *Evening Post,* the *Herald,* the old *Vanity Fair,* and *Harper's Bazaar.* Between 1922 and 1925 he drew the

Pach Bros., NYC

REGINALD MARSH

vaudeville circuit—his "Cartoonicle Chronicles" humorously summed up each act's artistic merit, or lack of it—and criminal court for the *Daily News.* "I must have covered and drawn at least 4,000 vaudeville acts," he recalled. "It took the place of an art school, and was very good training because you had to get the people in action, and sketch them quickly."

Marsh did not begin painting and drawing seriously on his own until 1923, the year of his marriage to the sculptress Betty Burroughs, the daughter of Bryson Burroughs, then the curator of paintings at the Metropolitan Museum of Art. Continuing his work as an illustrator, now for *The New Yorker* (from 1925), and also as a set designer for John Murray Anderson's Greenwich Village Follies, Marsh took up his studies again at the Art Students League. Although he worked under such notables as John Sloan, George Luks, and Boardman Robinson, the greatest influence on him was that of Kenneth Hays Miller. "Miller combined an interest like Marsh's in contemporary city matter with deeply pondered insight into basic principles of form and design," wrote Goodrich. "He interested the younger man to become more aware of plastic principles as embodied in the art of the past, and to apply these principles to the raw material of the present." Marsh already had the dream, engendered during a trip to Paris in 1926, to paint his surroundings with the mastery of figure, color, and composition of a Michelangelo, a Raphael, or a Rubens. To that end he spent hours copying the masters and studying anatomy.

As his paintings, lithographs, and watercolors of the late 1920s and early '30s reveal, Marsh ob-

served the urban scene with a sharp, often satirical eye, not unlike Duamier's, and did not shrink from portraying New York in all its fecund variety. Two favorite subjects were bums (*The Bowery,* 1930, and similar works throughout his career), whom Marsh captured in all their seediness but refrained from satirizing in order to capture their sympathetic humanity; and striding, radiant young women (*The Battery,* 1928, *High Yaller,* 1934, among many others), always voluptuous, sexy, and often a little vacuous. Marsh also had an eye for architectural details; in such works as *Chatham's Square* (1931), *Tattoo and Haircut* (1932), and *Smoke Hounds* (1934), the brownstone facades, cast-iron pillars, and hand-painted signs over brightly lit windows create a palpable and vivid environment for his derelicts and passersby. Marsh would return time and again to paint favored spots like Coney Island, where, he wrote in awe, "a million near naked bodies could be seen at once, a phenomenon unparalleled in history. . . . Crowds of people in all directions, in all positions, without clothing, moving—like the great compositions of Michelangelo and Rubens. I failed to find anything like it in Europe." Marsh loved to compress the orgiastic confusion of crowds on the beach into impossibly dense groupings of bodies, or mix fun-seekers with circus oddities at the amusement park. Burlesque halls, with their leering males and full-bodied strippers, were another favorite theme. The rich, when he deigned to paint them at the opera or theater, were always shown as pale, effete, and snobbish, the women thin and lackluster.

Marsh had his greatest success with those painting media that allowed the maximum freedom to his brush—chinese ink, watercolor, fresco, secco, and especially egg tempera, which he liked for its immediacy, clarity, and transparence. He struggled for years to develop an oil painting technique like that of his idol, Rubens, but almost always at the expense of his natural vitality and fluidity of expression. His experiments with the Maroger medium, a pasty oil formula developed by his teacher Jacques Maroger, were disasters, both garish and muddy at the same time—witness *Pink Elephant* (1943) or *Hudson Burlesk, Union City, New Jersey* (1945). Marsh's was essentially a linear and gestural talent that only bogged down in thick color or impasto.

In 1934, Marsh, having divorced his first wife, married the painter Felicia Meyer. The next year he began teaching at the Art Students League, where his warmth, enthusiasm, and absorbing interest in art made him one of the most sought-after instructors. Also in 1935 the Treasury Department Art Program (TRAP) commis-

sioned him to paint two frescoes for the Post Office Building in Washington, D.C., *Transfer of Mail from Liner to Tugboat* and *Sorting Mail.* Two years later he was hired to do the frescoes for the rotunda of the old Customs House in lower Manhattan, again on a nautical theme. Marsh and his wife moved in 1937 to One Union Square, where their neighbors included the artists Raphael Soyer and Isabel Bishop, who became his close friends.

Through the late 1940s and early '50s Marsh's scenes grew more mannered and slightly fantastic, less firmly rooted in the real. Typical was the series called "Eyes Tested" or "Eyes Examined," in Chinese ink, tempera, or watercolor from about 1944. These depict a group of lounging bums and a lone girl (a favorite Marsh "situation") under the surreal stares of a row of optometrists' signs, which stand for the voyeurism of both artist and viewer. The influence of Renaissance figurative conventions cropped up increasingly in the later paintings as well. *Swinging Chairs* (1951), more a sketch in oil than a fully realized painting, owes less to observation of Coney Island thrill-seekers than to the angels of Michelangelo. Figures, particularly the bums, became inordinately tall and thin (*The Bowery–Adam Hats*, 1952), looking not unlike the totemic lamp posts that regularly and symbolically appeared with them. Toward the end of his life Marsh professed a profound nostalgia for the New York of his youth, also in a sense meaning the art world of his youth, in which naturalism had still dominated. "All the things of the old days were so much better to draw," he said in 1954, referring to the vanished El, the old painted signs, even the ornate cast-iron lamp posts, now replaced by functional steel or aluminum; all these "are out of date today. Nobody wants them."

On July 3, 1954, the artist died of a heart attack in Dorset, Vermont, at the age of 56. Often described as a likable man, he had a round, cherubic face and short red hair. In his autobiography, Raphael Soyer wrote, at the time of Marsh's death, "One constant memory of him is that of a man always drawing, painting, experimenting with color, but above all drawing, drawing, drawing." Soyer noted a certain childlike quality in Marsh, an "unabashed delight in little things." Several major retrospectives of his work have been held since his death, including two at the Whitney Museum of American Art, New York City.

EXHIBITIONS INCLUDE: Whitney Studio Club, NYC 1924, '28; F. Valentiner Dudensing, NYC 1927; Weyle Gal., NYC 1928; Marie Stevens Gal., NYC 1929; Frank Rehn Gal., NYC 1930–53; Berkshire Mus., Pittsfield, Mass. 1944, '53; Whitney Mus. of Am. Art, NYC 1955, '83; Univ. of Arizona Art Gal., Tucson 1969; Associated Am. Artists Gal., NYC 1976. GROUP EXHIBITIONS INCLUDE: "American Exhibitions," Art Inst. of Chicago 1931, '32, '35, '37, '38, '40; "American Painting and Sculpture," MOMA, NYC 1932–33; Annual, Whitney Mus. of Am. Art, NYC 1932–54; Pittsburgh International, Carnegie Inst. 1933, '35, '37; "A Century of Progress," Art Inst. of Chicago 1933; "American Art Today," N.Y. World's Fair, Flushing Meadow 1939; "Art in Our Time," MOMA, NYC 1939; Watercolor Annual, Pennsylvania Academy 1941; Biennial, Corcoran Gal., Washington, D.C. 1945.

COLLECTIONS INCLUDE: Metropolitan Mus. of Art, and Whitney Mus. of Am. Art, NYC; Hirshhorn Mus. and Sculpture Garden, Washington, D.C.; Yale Univ. Art Gal., New Haven, Conn.; Art Inst. of Chicago; Detroit Inst. of Art.

ABOUT: Goodrich, L. "Reginald Marsh" (cat.), Whitney Mus. of Am. Art, NYC, 1955, Reginald Marsh, 1977; Marsh, R. Anatomy for Artists, 1945; Soyer, R. Diary of an Artist, 1977. *Periodicals*—Apollo March 1981; Art News November 7, 1936.

MARTIN, AGNES (March 22, 1912–), Canadian-American painter, won recognition in the late 1950s as a leading artist of the second generation of the New York School. Her use of monochromatic colors on a rectangular grid is regarded as a forerunner of minimalism.

Agnes Martin was born in Maklin, Saskatchewan, Canada, and brought up in Vancouver. She came to the United States in 1932, studied fine arts at various universities, and became an American citizen in 1940. Two years later, when Martin received her Master of Fine Arts degree from Columbia University, she headed for New Mexico, where she taught painting at the University of New Mexico, Albuquerque, and studied American Indian culture.

New Mexico for her was frontier country, reminiscent of her childhood in the vast expanses of western Canada. "The land is effective there," she said of the New Mexico landscape. "Isn't there something ecological about painting?" She began to paint the mountaintops that loom over Taos, but in her effort to express their overwhelming power she discovered the need for symbolic, or abstract, pictorial means.

During the 1940s and 1950s Martin also taught at East Oregon College, La Grande, and between 1941 and 1957 she lived at various times in New York City, New Mexico, and Portland, Oregon. She joined the Ruins Gallery group, in Manhattan, in 1956, whose members included Louis Reiback, Bea Mandelbaum, and Clay Spohn.

Courtesy of the Pace Gallery, NYC

AGNES MARTIN

In 1957 Martin returned to New York, where she was to spend the next ten years. She settled on Coenties Slip, on the southern tip of Manhattan, and held her first solo exhibition in 1958, at the Betty Parsons Gallery. Two of her paintings of this period, *The Spring* (1957) and *White Study* (1958), were later described by Hilton Kramer of *The New York Times* (March 18, 1973) as "pure distillations of Rothko, but Rothko drained of all sensuous color and reduced to an almost mystical white light." Dore Ashton recalled that first exhibition as being "filled with the palest of canvases—the sands of the desert seemed to have impregnated her imagination."

Reviewing Martin's second exhibit at Betty Parsons, held in 1959, Dore Ashton observed in *The New York Times* (December 29, 1959) that "Miss Martin has gone to deeper earth colors, loam browns, deep siennas, clay yellows and brown-blacks. All of her paintings are symbolic of specific experiences and bear titles such as 'Wheat,' 'Tideline,' 'Earth' and 'Birds'." Ashton concluded: " . . . Miss Martin is able to make abstractions with the simplest of means that yet suggest the profound experiences from which they come."

In New York Martin associated with Ellsworth Kelly, Jack Youngerman, Robert Indiana, and James Rosenquist, all of whom lived on Coenties Slip and reacted against abstract expressionism; but her own work followed a completely individual course. In her third show at Betty Parsons, held in 1961, and in subsequent exhibitions, she was at pains to retain in her art the "mystical light" of which Kramer wrote, but, as he pointed out, "in forms that would remove it from the ar-

bitrary inventions of romantic painting." A New York *Herald Tribune* critic, reviewing her 1961 show at the Parsons-affiliated Gallery II, wrote that Martin exhibited "a fresh serenity and maturity." He added: "Large and intensely reserved, her canvases, of uniform design and pattern, suggest cuneiform texts or textile weaving." The color consisted largely of monochrome grays and browns, and the critic concluded that although it was indeed "creative art," it was "almost totally wanting in life or vitality."

By 1961 Martin had found the form she was seeking in rectangular grid designs which have remained the basic constituents of her pictorial vocabulary. Her work reflected a geometric purism that anticipated both minimalism and certain aspects of op art. A series of small drawings in black and colored inks dating from 1959 to the mid-1960s, but not exhibited until 1978, illustrated the artist's development before her larger grid paintings became widely known.

Agnes Martin exhibited frequently at the Robert Elkon Gallery, New York City. Her paintings of the 60s were like large drawings. *Untitled* (1963) is, in fact, a square ink drawing measuring 8 by 8 inches. In her paintings and drawings, "fine lines," to quote Barbara Rose's article in *Art International* (January 1964), "revealing tiny irregularities of pressure, are orderd into parallel bands or regular grids that have a strangely restful quality." About 1963 her painting became more delicate and less austere. Her paintings and drawings, while preserving the same structure as before, were concerned with a subtle exploration of tones of gray.

Martin was represented in several important group shows in the '60s, including "Black, White, Gray" at the Wadsworth Atheneum, Hartford, Connecticut, in 1963, "The Responsive Eye" at the Museum of Modern Art, New York City, in 1965, and "Systemic Painting" at the Solomon R. Guggenheim Museum, New York City, in 1966. She left New York in 1967, just as her spare and precise abstract canvases were beginning to influence other artists. She moved to Cuba, a small town in northern New Mexico, and for several years gave up painting almost entirely. "I left New York in 1967," Martin explained, "because every day I suddenly felt I wanted to die and it was connected with painting. It took me several years to find out that the cause was an overdeveloped sense of responsibility."

This "quiet heroine," as *Newsweek* called Martin some years later, used her self-imposed exile to build a house in the desert, meditate, write, and make occasional prints. Meanwhile her work was being seen and discussed in New

York. In 1969 she and the Minimalist sculptor John McCracken were exhibited together at the Elkon Gallery. The usually conservative *New York Times* critic John Canaday, in his May 10, 1969 review of the show, found nothing to praise in the work of McCracken, whom he called "an absurd non-artist," but found Martin's paintings "delightful." He described them as "6 feet square and covered to within a half-inch or so of their edges with a geometrical mesh of horizontal and vertical lines, frequently . . . spaced and about the distance of the lines on an ordinary sheet of graph paper. The background color . . . is delicately flecked or mottled here and there. . . . One feels a poetic sensibility at work here—reserved, perhaps even a little removed, but warm." Hilton Kramer has observed that two distinct traditions converge in her work— pictorial constructivism and romantic abstraction. In this "hidden" romantic or lyrical element her work "differs from the bulk of Minimal art."

Paradoxically, it was during her non-productive period that Martin, who had been regarded in some quarters as a gifted minor artist, came to be considered an exemplar of the new "cool painting," and was well on her way to becoming, according to *Newsweek*, "a modern myth." Her canvases were painted in thin layers of acrylic, allowing the texture of the canvas to show through. Parallel lines were penciled on these large surfaces, sometimes both horizontally and vertically. The grids varied in composition from painting to painting.

In 1971 Martin published "On a Clear Day," a suite of prints which were exhibited in 1973 at MOMA. In 1974 she began to paint again and in the following year her new works were shown at the Pace Gallery, New York City. Ten of her canvases of 1975 were exhibited at Pace in May 1976, concurrently with eight of her earlier, 1961–67, pictures at the Elkon Gallery. Thomas B. Hess, reviewing the Pace show in *New York* magazine (May 31, 1976), noted that the new paintings by Martin were not coordinates of the grid that had dominated most of her earlier work. They consisted of "dark pink and light pink and gray (that reads blue) vertical bands (or stripes) from about two to eight inches wide." The stripes were deployed with enough trembling variations to suggest, as Laurence Alloway wrote, "a veil, a shadow, a bloom."

In 1978 Martin exhibited a group of small watercolors at the Pace Gallery to wide critical acclaim. One reviewer commented that "with each successive exhibition, the abstinent linear style has yielded to an indulgent painterliness which allows a greater formal breadth." John Ashbery of *New York* magazine (April 17, 1978), wrote that her new watercolors, "however evanescent . . . they appear," were visual counterparts of "the whispered sequences of Webern's music, where one can hear and distinguish seemingly for the first time a B-flat from an A-sharp. . . . " Ashbery paid tribute to the artist's "long, solitary, but finally exemplary journey. . . . "

Agnes Martin continues to live and work in her house in Cuba, New Mexico. She is a quiet, essentially private person who enjoys solitude and has a cheerful disregard for externals.

Agnes Martin has written of her work: "I paint out of joy of experience. I paint without representational object. I paint beauty without idealism, the new real beauty that needs very much to be defined by modern philosophers

"My paintings have neither objects, nor space, nor time, nor anything—no forms. They are light, lightless, about merging, about formlessness breaking down form. . . . You wouldn't think of form by the ocean.

"These paintings are about freedom from the cares of this world—from worldliness."

EXHIBITIONS INCLUDE: Betty Parsons Gal., NYC 1958, '59, '61; Robert Elkon Gal., NYC 1961, '63, '64, '65, '66, '70, '72, '76; Gal. II, NYC 1961; Nicholas Wilder Gal., Los Angeles 1966, '67, '70; School for Visual Arts, NYC 1971; Inst. of Contemporary Art, Univ. of Pennsylvania, Philadelphia, 1973; MOMA, NYC 1973; Kunstraum, Munich 1973; Kunsthalle, Tübingen, W. Ger. 1974; Kaiser Wilhelm Mus., Krefeld, W. Ger. 1974; Scottish Nat. Gal. of Modern Art, Edinburgh, 1974; Pace Gal., NYC from 1975. GROUP EXHIBITIONS INCLUDE: Pittsburgh International, Carnegie Inst. 1961; "Geometric Abstraction in America," Whitney Mus. of Am. Art, NYC 1962; "Six American Abstract Painters," Tooth Gal., London 1962; "Formalists," Gal. of Modern Art, Washington, D.C. 1963; "Black, White, Gray," Wadsworth Atheneum, Hartford, Conn. 1963; "American Drawings," Solomon R. Guggenheim Mus., NYC 1965; "Art Across America," (traveling show) Mead Corporation, 1965; "The Responsive Eye," MOMA, NYC 1965; "Systemic Painting," Solomon R. Guggenheim Mus, NYC 1966; "A Romantic Minimalist," Inst. of Contemporary Art, Univ. of Pennsylvania, Philadelphia 1967; Biennial, Corcoran Gal. of Art, Washington, D.C. 1967; "Form, Color, Image," Detroit Inst. of Arts 1967; "The Art of the Real," MOMA, NYC 1968; "The Pure and Clear, " Philadelphia Mus. 1968; Robert Elkon Gal., NYC 1969; "White on White," Mus. of Contemporary Art, Univ. of Pennsylvania, Philadelphia 1972; Documenta 5, Kassel, W. Ger. 1972; "Nine Artists/Coenties Slip," Downtown Whitney Mus., NYC 1974; "Critical Perspectives in American Art," Univ. of Massachusetts, Amherst 1976; "Drawing Now," Kunsthaus, Zürich 1976; Biennial, Whitney Mus. of Am. Art, NYC 1977.

COLLECTIONS INCLUDE: MOMA, Whitney Mus. of Am. Art, and Solomon R. Guggenheim Mus., NYC; Wads-

worth Atheneum, Hartford, Conn.; Larry Aldrich Mus., Ridgefield, Conn.; Woodward Foundation, Washington, D.C.; Los Angeles County Mus. of Art; Art Mus., Pasadena, Calif.; Stedelijk Mus., Amsterdam; Israel Mus., Jerusalem.

ABOUT: Alloway, L. and others "Agnes Martin" (cat.), Inst. of Contemporary Art, Univ. of Pennsylvania, Philadelphia, 1973; Rose, B. American Art Since 1900, 2d ed. 1975. *Periodicals*—Art and Artists October 1966; Art in America September/October 1978, October 1983; Art International (Lugano) January 1964; Artforum November 1966, June 1971; New York May 31, 1976, April 17, 1978; New York Times December 29, 1959, May 10, 1969, March 18, 1973; Newsweek December 24, 1973; Quadrum 20 (Brussels) 1966; Studio International February 1974; Time June 1, 1970; Vogue June 1973.

Courtesy of the Consulate General of Belgium

FRANS MASEREEL

***MASEREEL, FRANS (LAURENT WIL-HELMINA ADOLF)** (July 30, 1889–January 3, 1972), Belgian painter, draftsman, and wood engraver, was born in Blankenberge, Belgium, where his well-to-do Flemish parents owned a villa. Masereel's father died before Frans was five and, some years later, his mother married a Dr. Lava, a liberal-minded man who helped to modify the strict Catholic outlook of the Masereels.

The family, who all came from Ghent, spent the summer months at their seaside house in Blankenberge. These yearly visits to the sea, where Masereel learned about boats and fishermen, made a lasting impression on him.

Music also had an important place in Masereel's childhood. His mother sang and played the piano, and Frans played the cello in the family quartet. Later, as a pupil at the Ghent Conservatory of Music, he won a first prize for singing. He had a fine basso and a deep, melodious speaking voice. Throughout his life he enjoyed playing the accordion.

In a 1965 statement, Masereel recalled, "Very early, as soon as I could hold a pencil, I began to draw." After secondary school he entered the Academy of Fine Arts in Ghent, where he first came into contact with the poor, for many of the students came from indigent backgrounds; the bourgeoisie had little use or respect for artists. At this time Masereel met a man 20 years his senior, Jules de Bruycker, a talented artist who had experienced years of poverty before his powerfully satirical work was recognized. Masereel later declared that de Bruycker had taught him to see and to draw.

Leaving the Academy after only a year and a half to travel abroad, Masereel first went to England to learn the language, then visited Ger-

many, the Netherlands, and Paris. In 1911 Masereel and his new wife, Pauline Imhoff, left for Tunisia, where they lived for two years. Hitherto Masereel had concentrated on drawing, but in Tunisia, dazzled by the brilliant light, he devoted himself almost exclusively to painting. On his return from Africa he decided to settle in Paris, finding the artistic climate of Belgium too limited. In Paris Masereel drew everywhere, entirely for his own pleasure, without showing his drawings to anyone. His keen social awareness was evident in a watercolor, probably dating from 1912, that he exhibited in the Salon des Indépendants: the subject was the eviction of tenants unable to pay their rent.

Masereel began to submit drawings to the satirical weekly *L'Assiette au Beurre*. He had long had a fondness for medieval woodcuts, Bible illustrations, and playing cards. Without any previous experience in the technique of wood engraving, Masereel tried his hand at the craft unaided; despite his lack of technical training, he may be best remembered for his outstanding work as a graphic artist.

When war broke out in August 1914, Masereel was in Brittany. Anxious about his family, he left for Ghent but was advised to make his escape, as the Germans were approaching the city. He went back to Paris via Dunkirk, traveling mostly on foot, passing wounded soldiers, demolished houses, and streams of refugees, evidence of war's devastation and misery that he was never to forget, and which he was to make a major theme in his work.

On the advice of Henri Guilbeaux, formerly editor of *L'Assiette au Beurre,* Masereel moved

°mäz´ rēl, fräns

to Geneva, which at that time was a meeting place for pacifists, conscientious objectors, revolutionaries, and other opponents of the war, led by the writer Romain Rolland. Guilbeaux and Rolland were then working for the International Red Cross, and Masereel joined them as a translator of letters, mostly from Flemish into French. Rolland and Masereel became better acquainted at Villeneuve, where Masereel visited him in October 1917. Rolland, then aged 50, described the 28-year-old Masereel as "an athletic fellow, with a black beard and glasses; he is reserved, like a Spaniard, and one could take him for one." He added: "He is very likeable, and certainly very kind, incapable of the slightest pettiness. The present spectacle is incomprehensible to him, and fills him with horror."

By late 1916, with Claude Le Maguet, Masereel had founded the review *Les Tablettes,* which continued to appear until early 1919, and in which he published 48 woodcuts. He also contributed regularly to the journal *La Feuille.* For this work, with its constant deadlines and necessity for bold graphic impression, he used brush and India ink to create strong contrasts in black and white, impossible in charcoal or pen and ink. This technique was to have a lasting influence on his style in all media. His first brush drawings dealt with the fate of the soldiers sacrificed, but his work soon became a passionate indictment of those who built their fortunes on suffering—politicians, magnates, arms manufacturers, and the like. Despite their often bitter humor the drawings were not caricatures. In the preface to a 1920 selection of these drawings, a critic wrote: "Each drawing an order, each curve a warning." But, he added, "Each drawing has a heart."

Masereel's first woodcuts, published in *Les Tablettes* in 1916, were slight but already had his individual stamp. The artist was completely unaware of the revival of woodcut in Germany in the pre-World War I years, under the influence of Edvard Munch, and in France, where several artists, including Félix Vallotton and Raoul Dufy, were working with simplified forms. Masereel depended instead on inspiration from older periods: the era of woodcut Bible illustration; the work of Albrecht Dürer; possibly Japanese ukioy-e seen in Paris. His first important illustrative works were his 57 woodcuts for *Quinze poèmes* by the Belgian poet Emile Verhaeren, published in 1917. In these he still used crosshatching, but in two other albums that appeared in 1917, *Debout les morts* (Arise Ye Dead) and *Les Morts parlent* (The Dead Speak), he used solid areas of black and white. In the interplay of light and dark, and in the new emphasis given to the figures, Masereel achieved what amounted to a Flemish style of wood engraving,

direct and clear, and, to quote Roger Avermaete, "as far removed from the elegance of the French as from the savage vigor of the Germans."

During his stay in Geneva, from 1916 to 1922, Masereel met, in addition to Romain Rolland, Stefan Zweig, who wrote the first monograph on Masereel, published in Berlin in 1923. Through Zweig, Masereel made the acquaintance of several eminent German writers, including Rainer Maria Rilke, Hermann Hesse, Theodor Däubler, and Carl Sternheim.

In 1918 Masereel's first "story without words," an illustrated book without text, titled *25 Images of the Passion of a Man,* was published in Geneva. Then followed *My Book of Hours* (1919), the best-known and one of the finest of his "stories without words"; there were editions in several countries, including the United States and China. Also in 1919 he did woodcut illustrations for works by Rolland, Georges Duhamel, Walt Whitman, and other authors. In 1920 he made his first large woodcut to be published as an original print, *Smoke,* in which women's and men's bodies emerge like smoke from factory chimneys. *Souvenirs of My Land* of 1922 contains 16 woodcuts filled with haunting visions, some harsh and bitter, some sad, some lyrical, some festive and some erotic, all relating to the artist's native Flanders.

In 1922 Masereel returned to Paris and lived in Montmartre; though in 1923 he traveled in Germany and central Europe, he was barred from Belgium because of his antiwar activities in Geneva. About this time he met the artist Georg Grosz, whom he described as "the only artist with whom I have found much in common so far." Grosz believed, like Masereel, "that art must as far as possible be action, and that the artist must not be indifferent to social questions."

Masereel's album of woodcuts, *La Ville,* was published in both Paris and Munich in 1925. In a series of one hundred wood engravings Masereel showed how man's individuality is liquidated in the hurly-burly of the modern city. That same year Masereel, while keeping his Paris residence, bought a fisherman's house at Equihen in the Pas-de-Calais on the English Channel, a house already converted to a studio by its previous occupants. He worked there regularly until 1939.

Between 1925 and 1927 Masereel created his most comprehensive cycle of illustrations: 666 woodcuts for Rolland's novel *Jean-Christophe,* and 167 woodcuts for the Belgian writer Charles de Coster's comedic epic from the Flemish past, *The Glorious Adventure of Tyl Ulenspiegl.* Masereel rightly considered the illustrations for the Ulenspiegl series to be among his finest works. Sixteenth-century Flanders, with its tor-

tures and burnings at the stake, its crowded streets and taverns, its cruelties and its tenderness, all dominated by the invincible spirit of the trickster Tyl, provided an ideal subject for Masereel. With solid areas of black and white, the artist conveyed not only distance but, when needed, dazzling light. Despite Masereel's strong influence on several Flemish wood engravers, 11 years elapsed before the Ulenspiegl illustrations were published in Belgium, and only towards the end of his life did he gain recognition in his own country. A fine edition of *Tyl Ulenspiegl* with Masereel's illustrations, was published in New York City in 1943. The parallel was inescapable between Spanish oppression in 16th-century Flanders and the horrors of the Nazi occupation of Belgium.

As a result of his regular visits to a seaside cottage in Equihen in the Pas-de-Calais, Masereel's painting, neglected since 1920, took on a new importance. Some of his paintings of the later 1920s dealt, like his woodcuts, with city life, but less polemically and with greater monumentality (for example, *Paris Landscape, Montmartre,* 1927). There were also harbor scenes, in which palette was somber and earthy, reminiscent of such Flemish expressionists as Permeke. Although immersed in the life of his time, Masereel, at least in his painting, was impervious to the influence of the School of Paris. His sympathies were much more with the German Expressionists, like Grosz, and he also felt an affinity with the work of Otto Dix and Max Beckman. For Masereel painting was, as he wrote to Rolland, "a new profession to be mastered," and an opportunity to pursue a more peaceable vision than that of the teeming, agitated world of his wood engravings.

Between 1929 and 1931 Masereel, now gaining a reputation in Europe, designed cartoons for 13 mosaics for a solarium owned by the collector Georg Reinhardt. In the years 1928–32 he was represented in over 30 solo exhibitions in France, Belgium, Holland, Germany, and Switzerland. His work was also popular in the Soviet Union. A comprehensive exhibition held in Moscow in 1930 and 1931 in the Museum of Modern Western Art (the Pushkin Museum from 1948) later traveled to Karkhov, Kiev, and Odessa. In 1935 and 1936 Masereel and his wife spent several months in the USSR; the artist made an india-ink sketch of Maxim Gorki on his deathbed. The Masereels traveled about Russia—the Volga, the Caucasus, the Black Sea, the Caspian Sea, with Moscow as their main base, and his impressions of the Soviet Union influenced a series of woodcuts, *From Black to White,* made in 1939. Although never a Communist Party member, Masereel had been deeply committed to socialist ideals since his youth.

In the meantime civil war had broken out in Spain. Masereel was invited by the Union of Painters, Designers, and Sculptors to form a delegation to go to Spain and choose art to be shown in France in support of the Republican cause. Masereel went to Spain full of hope, but returned deeply discouraged at the probable outcome of the conflict. He was in sympathy with Léon Blum's Popular Front government in France, and contributed regularly to a weekly called *Vendredi.* He also organized a course of drawing and painting for workers' groups.

At the outbreak of World War II, Masereel realized that his abhorrence of Nazism was even greater than his pacifism, and he joined the French propaganda services, drawing pamphlets which were dropped behind the German lines. A few days before the occupation of Paris in 1940 he fled the city, eventually settling in Avignon, where he met his future second wife, Laure Malclès. He painted a little and did a good deal of drawing (*Danse macabre,* 1941) and illustration.

By late 1943 Avignon had become unsafe, and Masereel moved to Laussou in the Pyrenees. After the Liberation Masereel stayed for four years in Laussou, having nowhere else to go. He returned to painting and wood engraving, and in 1946 taught a course at the Arts Centre in Saarbrücken where Laure Malclès was also teaching. He had many exhibitions, and in 1948 visited Belgium for the first time since the war. He found it "a country morally Americanized. There's no room for anything but 'gangsterism' and 'pin-up girls.'"

In 1949 Masereel settled in Nice, overlooking the docks. Nice was to be his home for the rest of his life, and it provided him with two of his favorite subjects, vivid sunlight and a harbor. Although he enjoyed painting, wood engraving was always the craft dearer to his heart. Large and small albums of his woodcuts appeared regularly in the late 1940s and early '50s, beginning with the optimistic *Jeunesse* (1948), with a preface by Thomas Mann, and ending with *Les Mains* (1951, The Hands). Numerous large woodcuts made from 1947 to the end of his life dealt with women. In his earlier woodcuts eroticism had usually had painful consequences, but now the motif was treated joyously, with Malclès as a constant inspiration. She was a great comfort during the artist's two eye operations in 1950. Fortunately his sight returned and he could resume work; he was awarded the Grand Prize for engraving at that year's Venice Biennale.

Despite his personal fulfillment and growing international recognition, Masereel remained keenly aware of the human tragedy. His grim-

mest and most hallucinatory series of drawings were the 26 reproduced in *The Apocalypse of Our Time* (1954), in which the individual is annihilated in a chaos of guns, panicked mobs, and crumbling buildings. Two world wars had left their mark on Masereel; as he said, "This suffering has probably sharpened my fighting instinct."

He revisited Russia in 1956 and two years later traveled to China, where he was disappointed by the fact that Chinese artists were still chained to a naturalism inherited from Russian socialist realism. He brought back many sketches and watercolors from this visit, and in 1959 produced a large woodcut, *Souvenir de Chine*.

Masereel's wife Pauline had been an invalid for many years, confined to her room in Nice. She died on September 10, 1968, aged 90. Four months later Masereel married Laure Maclès. In the last 20 years of his life Masereel received many honors. His first official recognition by a Belgian institution came in 1951 when he was elected Associate Member of the Acádemie Royale des Sciences, des Lettres, et des Beaux-Arts of Belgium. He was awarded several prizes and honorary degrees in Germany, and, for his 80th birthday, the municipality of Blankenberge organized a large exhibition of his work. He was particularly pleased with an exhibit held that year in the Salle des Fêtes, Antwerp.

His last visit to Belgium was in 1971, to receive the newly created Achille van Acker prize, awarded to socially concerned artists. In June 1971, after his return to Nice, he fell seriously ill with pneumonia; he died in Avignon at the age of 82. His last woodcut, dating from 1971, was called *Un Original*, and shows a man dancing in the street, oblivious of the indignant stares of "respectable" passersby.

Frans Masereel was tall and well-built, with a long, grave face. Reserved in manner, he had an underlying warmth. He never wavered in his hatred of injustice. The powerful social criticism of his woodcuts, always tempered with compassion, influenced graphic art in many countries, and he is regarded by some as the most important wood engraver of the first half of the 20th-century.

On receiving the Joost van den Vondel prize in Nünster, West Germany in 1962, Masereel declared: "For me, art is in the first place human communication addressed to all men, of which the form and the content, as well as the understanding and the heart, must be at the highest possible level. If these postulates are not respected, there can be no great art."

EXHIBITIONS INCLUDE: Graphisches Inst., Winterthur, Switzerland 1921; Gal. Alfred Flechtheim, Berlin 1922; Gal. Billiet, Paris 1922–26; Mus. of Modern Western Art, Moscow 1926, '30, '35; Gal. Le Centaure, Brussels 1926; Gal. Billiet-Pierre Vorms, Paris 1928, '31, '33; Kunstverein, Kassel, W. Ger. 1929; Stedelijk Mus., Amsterdam 1930; Kestner Gesellschaft, Hanover, W. Ger. 1931; Leicester Gal., London 1935; Perls Gal., NYC 1939; Biblioteca Nacional, Bogota, Colombia 1941; St. Etienne Gal., NYC 1946, '49; Kunsthalle, Hamburg, W. Ger. 1950; Palais des Beaux-Arts, Brussels 1951; Boymans-Van Beuningen Mus., Rotterdam 1951; Gal. Kléber, Paris 1953; Deutsche Akademie der Künste, Berlin 1957; Traveling exhibitions in China (Peking, Shanghai, Wuhan), 1958; Gal. La Poupe, Brussels 1960; Obécni Dum Prague 1963; Gal. Vyncke van Eyck, Ghent, Belgium 1963, 1967–68; Gottlieb Library, Brandeis Univ., Waltham, Mass. 1964; Gal. Municipale des Ponchettes, Nice, France 1965; Mus. des Beaux-Arts, Paris 1966; Kunsthalle, Weimar, E. Ger. 1969; Salle des Fêtes, Antwerp, Belgium 1969; Maison des Jeunes et de la Culture, Chinon, 1971; "Frans Masereel—Human Expressions," Walter Engels Gal., Toronto 1972; "In Memoriam Frans Masereel," Gal. Vyncke van Eyck, Ghent, Belgium 1973. GROUP EXHIBITIONS INCLUDE: "Dix graveurs sur bois du nouvel essor," Paris 1923; "Groupe des Treize et des Indépendants d'Avignon," Avignon, France 1941; Venice Biennale 1950; "L'Art Belge de 1910 à 1950," Kunsthalle, Basel 1952; "Six artistes Belges," Petit Palais, Paris 1952; "L'Art Belge contemporain," Moderna Gal., Ljubljana, Yugoslavia 1953; "Belgian art of the late 19th and 20th centuries," Pushkin Mus., Moscow 1956; "Les Peintres et graveurs Belges contemporains," Mus. de peinture, Bordeaux, France 1957; "Artists Against Atomic War," Munich 1958; "Les Revenants 1948–1961," Mus. d'Antibes, Château Grimaldi, France 1961; "L'Expressionisme flamand en art graphique'," Librairie La Proue, Brussels 1962; "Belgische graveurs, Hulde ans Frans Masereel," Kunstcentrum Nautilus, Antwerp, Belgium 1965; "Intergrafik 67," Altesmus., Berlin 1967; "Les Cinq," Staatliche Mus., Berlin 1968–69; "Xylon V," Mus. d'Art et d'Histoire, Geneva, Switzerland 1969; "Gravure 70," Carpentras, Vaison-la-Romaine Festival, 1970; "La Figure humaine dans l'art, 1910–1960," Malines, Belgium 1971; St. Etienne Gal., NYC 1975, '79.

COLLECTIONS INCLUDE: Cabinet des Estampes, Bibliothèque Royale, Brussels; Mus. des Beaux-Arts, Liège, Belgium; Frans Hals Mus., Haarlem, Netherlands; Gemeentemus., the Hague; Boymans-Van Beuningen Mus., Rotterdam; Mus. Nat. d'Art Moderne, and Petit Palais, Paris; Mus. de Périgord, Périgueux, France; Mus. Grimaldi, Antibes, France; Deutsche Akademie der Künste, and Graphisches Kabinett der Staatlichen Mus., Berlin; Wallraf-Richartz Mus., Cologne; Kupferstich-Kabinett, Dresden, E. Ger.; Kunstmus., Winterthur, Switzerland; Staatliche Kunstsammlung, Munich; Mus. of Fine Arts, Riga, U.S.S.R. Nat. Mus., Warsaw; Yugoslav Academy of Art, Zagreb; Hermitage Mus., Leningrad; Pushkin Mus., Moscow; MOMA, NYC; Brooklyn Mus., N.Y.; Mus. of Art, Philadelphia; Vasco da Gama Inst., Goa, India.

ABOUT: Avermaete, R. Frans Masereel, 1977; Billiet, J. Frans Masereel, l'homme et l'oeuvre, 1925; Durtain, L. Frans Masereel, 1931; Egbert, D. D. Social Radicalism and the Arts, Western Europe, 1970; Furst, H. The Modern Woodcut, 1924; Masereel, F. 25 Images of the Passion of a Man, 1918, My Book of Hours, 1919, Souvenirs of My Land, 1922, La Ville, 1925, Jeunesse, 1948, Les Mains, 1951; Mesnil, J. Frans Masereel, 1934; Ziller, G. Frans Masereel, 1949; Zweig, S. and others Frans Masereel, 1923. *Periodicals*—L'Art Libre (Brussels) October 15, 1919; Arts et métiers graphiques (Paris) May 15, 1930; Journal de Genève (Geneva) December 5–6, 1964; Les Lettres Françaises (Paris) May 15, 1953; Le Monde (Paris) January 5, 1972; Studio July 1928; Times Literary Supplement July 29, 1960.

GEORGES MATHIEU

*MATHIEU, GEORGES (January 27, 1921–), French painter and pioneer of lyrical abstraction, was one of the most provocative figures in the post–World War II Paris art scene.

He was born into a family of bankers at Boulogne-sur-Mer. Mathieu traces his ancestry on his mother's side back to the 11th-century crusader Godfrey of Bouillon, and the feudal traditions of medieval France have long fascinated him. Mathieu's varied and thorough education included the study of languages, mathematics, philosophy, and literature at a succession of schools in Boulogne, Versailles, Rouen, and Douai; In 1940 he returned to Douai in northern France, from Paris, and two years later painted his first pictures in oil. They were representational works, based on a visit to London shortly before the war, and included *Oxford Street by Night, The Thames at Chelsea,* and a portrait of the noted British actress Margaretta Scott.

After the liberation of France from the Nazis in 1944 Mathieu served as interpreter for the United States Army at Cambrai. A book on the novelist Joseph Conrad whose portrayal of loneliness and "the void" resonated with his own life of comparative isolation in the north of France, convinced Mathieu that his own paintings did not have to represent forms in nature. Although at that time he knew very little of contemporary painting—there had been no contact with the outside world under the Occupation—his canvases were from then on entirely abstract. One of his earliest paintings of 1944 was called, significantly, *Inception.* It was "gestural" and freeform, an impulsive calligraphy in somber tones. The rejection of all reference to nature was a radical departure from the formal geometry in the Mondrian tradition, as practiced by Auguste Herbin, or from the ordered structure of Jean Bazaine, Mathieu's contemporary. Mathieu's link with the past may have been Leonardo da Vinci, who discovered landscapes in the stains, crevices, and irregularities of an old wall. As one critic noted, *Inception* reflects "a climate of dereliction and distress" rather than "the sheer joy of painting."

Mathieu continued to paint throughout 1945 and '46, first in Arles, Provence, then at the home of a friend in Istres, northwest of Marseilles. The spontaneous whiplash calligraphy of *Evanescence* (1945) anticipated to a surprising degree the interlacing forms that Jackson Pollock was to develop independently in New York City in about 1947. In 1946 Mathieu exhibited at a salon devoted to painters under 30.

In 1947 Mathieu returned to Paris as public relations manager of an American company, United States Lines. He exhibited three canvases, *Survival, Disruption* (both 1946), and *Conception,* for the first time in the Salon des Réalités Nouvelles, Paris. Although Sartre's existentialism had habituated Paris intellectuals to the idea of the individual's total freedom within a metaphysical void, Mathieu's radical manner bewildered critics and the public at a time when geometrical abstraction was the favored "advanced" style. He was classified as a "musicalist," but from 1947 on Mathieu referred to his own work as lyrical abstraction.

At about this time, Mathieu was discovered by the critic Jean-José Marchand, who wrote the preface for the catalog to an exhibit called "L'Imaginaire," organized by Mathieu in 1947 at the Galerie du Luxembourg, Paris. Mathieu was the leader of a group of painters in revolt against neoplasticism and other branches of geometric abstraction; this diverse group practiced

in different ways what Mathieu was to promote as lyrical abstraction. In Paris he had discovered the work of Hans Hartung, whose painting in black sprays and splashes recalled Japanese calligraphy, and the free improvisations (*art informel*) of another German-born painter, Wols. Both of these artists were included in the "L'Imaginaire" exhibit.

In 1948 Mathieu, always an energetic promoter of his ideas, organized the exhibitions "H. W. P. S. M. T. B." (initials which stood for, among others, Hartung, Wols, and Mathieu) and "White and Black." Mathieu was also responsible for the first confrontation of American and French avant-garde painting, at the Galerie Montparnasse, Paris, in 1948. It then became clear that there were definite correspondences between the work of Mathieu and Pollock. In the late 1940s both artists were painting on canvases placed flat on the ground, flowing or dripping the liquid color onto the surface in sweeping gestures. Instead of straight lines and angles there was a predominance of curves, with the superimposed linear traceries creating an equivalent of space and depth. But there were important differences that became increasingly obvious as the 1940s drew to a close. Mathieu's calligraphic "signs" detached themselves from the monochrome background, whereas in Pollock's far more complex and turbulent canvases image and ground merged in such a way as to generate a seething field of energy. Despite Mathieu's aggressive approach there was in his work, especially from 1950 on, a certain elegance and panache, very different from the visceral and thoroughly American impulsiveness of Pollock, a reaction against the School of Paris notions of form.

André Malraux, taking note of Mathieu's work in 1949, exclaimed: "At last an Occidental calligraphist!" In the same year Mathieu sold his first canvas to the Italian art collector Carlo Frua de Angeli. In May 1950, when he had his first solo show at the Drouin Gallery, Place Vendôme, Paris, the full-fledged Mathieu style emerged, especially in such works as *Red Flamence*, a large, 97-by-78-inch painting. Savage black gashes exploded on a solid scarlet ground, and on top of the broad black strokes and patches, linear traceries in blue, red, and, especially, white were "written" at high speed, with the paint often squeezed directly out of the tube. This exhibition had the effect of a bombshell.

On the night of his mother's death in 1950, Mathieu painted two large canvases, *Homage to Death* and *Homage to Louis XI*, one of his first references to the medieval period.

In Positano, Italy, in 1951, Mathieu studied Gestalt theories of psychology, which he drew upon to develop further his conception of lyrical abstraction, postulating that the "sign" precedes the meaning and that the whole is more than the sum of its parts. Appropriating the terminology used by the Gestalt School to describe the whole, or integrated, personality, Mathieu maintained that each painting should be autonomous and self-fulfilling. He expounded these and other ideas in his article "Sketch of an Embryology of Signs."

Mathieu was an ardent monarchist, and his revolutionary painting technique coexisted with a thoroughly reactionary personal ideology—a combination of the progressive and the retrograde comparable to that of Salvador Dali. Mathieu later explained this seeming contradiction by quoting T. S. Eliot: "Nothing that is not fundamentally traditional can be really new."

In 1952 he painted two large-scale canvases with sonorous titles inspired by French history and the idea of *la gloire*—*Homage to Philip III the Bold* and *Homage to Marshal Turenne* (Louis XIV's greatest general). These paintings, both suggesting heraldic devices on banners, were exhibited at the Studio Facchetti, Paris, in 1952. That same year Mathieu had his first solo show in New York City, at the Stable Gallery. Mathieu paintings were acquired in 1953 by the Museum of Modern Art, Rio de Janeiro, the Art Institute of Chicago, and the Solomon R. Guggenheim Foundation of New York. From 1953 to '63 Mathieu directed *The United States Lines' Paris Review*, a prestigious bilingual magazine.

In 1954 Mathieu exhibited an explosive canvas in the Salon de Mai; over 18 feet wide and more than 8 feet high, it was called *The Battle of Bouvines*, a reference to the decisive victory of Philip Augustus in 1214 over the joint forces of the King of England, the Count of Flanders, and the Holy Roman Emperor—the battle that established the superiority of the Capetian dynasty in France and in which, according to Mathieu, his forebears figured prominently. This canvas has a light brownish-orange background, contrasting with the dramatic dark ground of *Les Capétiens partout* (1954, The Capetians Everywhere). The title may have been a belated answer to the popular-front slogan of the 1930s: "Les Soviets partout!"

A film produced by Mathieu in collaboration with Robert Descharnes was shown at the time of the *Battle of Bouvines* exhibition in the Salon de Mai. In this film Mathieu, always the showman and performer, donned a white helmet, black silk pants, and jacket, and, greaves attached to his shins with white cross-straps,

lunged at the hugh canvas with his long brushes like a medieval knight on his charger.

By the mid-1950s Mathieu was an international celebrity. His adroit showmanship and gift for self-promotion (again recalling Dali), reached a wilder public in May 1956 when he painted his largest canvas (12 by 4 yards), *Homage to Louis XIV*, on the stage of the Théâtre Sarah-Bernhardt, Paris, as part of the International Festival of Dramatic Art. Not only was this performance reminiscent of dada and surrealist antics of the 1920s, but it also anticipated American "happenings" of the late '50s and early '60s. For Mathieu the experience, over and above its publicity value, was an expression of the *élan vital* and a demonstration of his credo: "Speed, intuition, excitement: that is my method of creation."

In 1957 Mathieu began his worldwide travels. After arriving in Tokyo for his solo show, he proceeded to paint the entire exhibition on the spot, 21 canvases in three days. The pièce de résistance was the 25-foot-long *The Battle of Hakata* (A.D. 1281, when the Japanese defeated Genghiz Khan). For this pyrotechnic display, executed before spectators in the basement of a Tokyo department store, Mathieu stripped, put on a flowing blue-and-white kimono and a black waist sash, and wound a red *hachimaki* round his head. His all-out attack on the hugh canvas suggested the ferocity of samurai swordsmanship; the Japanese onlookers, usually reserved in the presence of foreigners, cheered and applauded after each brushstroke. Even before the show opened, *The Battle of Hakata* was purchased for three million yen (about $8,333) by a Japanese collector, who commented, "In many respects [Mathieu's] work resembles that of old Japanese art, where emphasis was placed on spirit rather than detail."

Further travels took Mathieu to Stockholm in 1958 (where he produced 26 canvases, including *Battle of Brunkeberg),* England, Spain, Italy, Switzerland, Germany, Austria, Brazil, and Argentina (where he painted *Homage to General San Martín*) in 1959, and Byblos, Lebanon in 1961 (*St. George Vanquishing the Dragon*). His titles had become increasingly grandiose, especially those referring to medieval French history, as in *Hugh Capet Writing to Constantine X* (1954) or *Duke Philip the Good Appeased by his Son* (1958). The Museum of Modern Art, New York City, owns the 1954 canvas *Montjoie Saint Denis* (The Battle Cry of Joan of Arc), wherein Mathieu once again achieved his favorite heraldic, bannerlike effect.

In an article of 1961, "For a Disalienation of Art," Mathieu discussed the relationship of the artist to the postwar world, reevaluating the then popular idea of the artist as one who is necessarily estranged from the dominant culture of his or her society. In 1962, when he produced his first sculptures, Mathieu amplified his conception of the *artiste engagé,* calling for the integration of the artistic sensibility with architecture, interior design, typography—indeed, with all aspects of everyday life.

In March 1962 he visited Jerusalem, where he exhibited at the Bezalel Museum and wrote an eloquent "Homage to Israel." In 1963 he painted, in just a few hours, an immense, intricate canvas, *The Victory of Denain* (a French victory of 1712 in the War of Spanish Succession), on the eve of a major retrospective at the Museum of Modern Art of the City of Paris. This show, and the publication of his book *Beyond Tachisme,* marked a climax in Mathieu's career.

Mathieu's work has been more admired in France than in the United States, and numerous French critics have called him "the most lucid painter of his generation." He also has his admirers in the Far East, and one Japanese professor went so far as to acclaim him "the greatest French painter after Picasso." However, the French critic Alain Jouffroy believes that, like certain other French abstract painters, Mathieu has not really renewed himself since 1956, however much he may have speeded up his pace. American critics, which intrigued at first by his "Paganini antics," have tended to see him primarily as a gifted, but hardly profound virtuoso. In 1960 a New York critic described Mathieu as "elegant, stylish, and fashionable," but doubted that he had "anything genuinely real or important to say." A *New York Times* writer commented that, though there might not be much weight to Mathieu's pictures, "he is a consummate master of the gesture, throwing off jets and spurts of paint as elegantly as the fountains of Versailles."

Meanwhile, the artist was inundated by commissions of all kinds. In 1966 the industrialist Guy Biraud engaged Mathieu to design a factory and its gardens at Fontanay-le-Comte (an area of 16,000 square meters). A metal sculpture in the artist's unmistakable calligraphic idiom rose from the roof of the main building. In the same year the versatile Mathieu designed 17 posters for Air France, and in 1969 he supplied cartoons for tapestries, in ten parts, on the theme of the planets for Gobelins manufactory. In 1970, after his one hundredth solo show, held at the Museum of Rennes, France, Mathieu invented a new technique of metal engraving which involved the direct use of acids on monetary coins. Since then he has designed for the Paris Mint a num-

ber of "Medallions in Honor of the Eighteen Moments of Western Consciousness." His design for the French ten-franc piece was chosen from among 342 others submitted. His ten-franc pieces were issued by the million in 1975 and '76; Mathieu was the third painter-sculptor since the Renaissance—after Leonardo da Vinci and Benvenuto Cellini—to have designed coins. He has also designed stamps for the Indian and French post offices, and in April 1973 he created eight sets of luminous projections for Bartók's opera *Bluebeard* at the Deutsche Oper, Berlin.

In addition to retrospectives and participation in group shows in many countries, Mathieu has been active as a writer and speaker. Despite his rightist ideology and worship of tradition, he is, as one critic has observed, "impassioned by the culture of his time." In articles and speeches he has called for a "New Renaissance," a trans-European cultural policy, and continued to denounce the indifference of politicans to "things spiritual" and to warn against the "threat" to individualism in a collectivist age.

Georges Mathieu is unmarried and lives in a stately villa on the edge of Paris. For years he drove a yellow Rolls Royce, and was nicknamed "The Duke of Brabant." Still slim and dapper, he cultivates the haughty, arrogant persona of an aristocrat, and, as one writer remarked, he "sports a moustache which turns down at the ends much as Salvador Dali's turns up." Over 20 years ago he told a reviewer that inasmuch as his huge pictures took no more than a couple of hours to paint, he had time for the music, philosophy, mathematics, poetry, and literature that comprise his other interests.

Mathieu's grand themes, flamboyant style, and provocative attacks on adversaries conceal the artist's "profound emotivity," in one critic's words. Though he asserted in 1957 that "in each new work I am actively destroying all I have done before," many critics doubt that his bravura method has enabled him to blaze new trails in the last two decades, and cite the dangers inherent in repetitiousness and a formulaic style. Undoubtedly Mathieu's recent ventures into new fields, from architecture to the designing of a ceremonial sword for a French academician, have enlivened and enriched the art world. However great his opposition to modern egalitarianism, there is much to applaud in his expressed wish for "not only creation shared by all, but creation made by all. The artist must not be a particular sort of man, but each man must become a particular sort of artist."

EXHIBITIONS INCLUDE: Gal. Drouin, Paris 1950; Stable Gal. NYC 1952; Studio Facchetti, Paris 1952; Salon de Mai, Paris 1954; Kootz Gal., NYC 1956, '60; Gal. Rive Droite, Paris 1956, '69; Inst. of Contemporary Arts, London 1956; Gal. Naviglio, Milan 1957; Mus. des Beaux-Arts, Liège, Belgium 1959; Kunstverein, Cologne 1959, '67; Kunsthalle, Basel 1959; Mus. of Modern Art, São Paulo 1960; New London Gal., London 1960; Marlborough Fine Art, London 1960; Bezalel Mus., Jerusalem 1962; Mus. d'Art Moderne, Paris 1963; Palais des Beaux-Arts, Brussels 1963; Gimpel Fils, London 1964, '72; Gal. Charpentier, Paris 1965; Manufacture Nat. des Gobelins, Paris 1969; Mus. of Rennes, France 1970; Mus. Monétaire de Paris 1971; Gal. Beaubourg, Paris 1974; Kunsthalle, Düsseldorf 1975; Retrospective (1944–1976), Antibes, France 1976; Retrospective of "Battles," Casino in Ostend, Belgium 1977. GROUP EXHIBITIONS INCLUDE: "Salon des moins de trente ans," Paris 1946; "L'Imaginaire," Gal. du Luxembourg, Paris 1947; "H.W.P.S.M.T.B.," Paris 1948; "White and Black," Paris 1948; Gal. Montparnasse, Paris 1948; "Nobility of the Everyday Object," Paris 1958; "Nobility of the Everyday Object," NYC 1958; "Drawings, Watercolors, Collages by Twentieth Century Masters," NYC 1960; "Le Dessin Français du XVII au XX siècle," Warsaw 1962; International Fair of Modern Art, Grand Palais, Paris 1976.

COLLECTIONS INCLUDE: MOMA, and Solomon R. Guggenheim Mus., NYC; Art Inst. of Chicago; Tate Gal., London; Mus. Nat. d'Art Moderne, Paris; Wallraf-Richartz Mus., Cologne; Staatsgal., Stuttgart; Mus. des 20 Jahrhunderts, Vienna; Mus. of Mosaics, Ravenna, Italy; Ohara Mus. of Art, Kurashiki, Japan.

ABOUT: Fitzsimmons, J. "Georges Mathieu" (cat.), Kootz Gal., NYC, 1956; Guitte, R. and others De l'Abstrait au possible, 1959; Haftmann, W. "Georges Mathieu" (cat.), Kunstverein, Cologne, 1967; Henri, A. Environments and Happenings, 1974; Lucie-Smith, E. Late Modern: The Visual Arts Since 1945, 1969; Marchand, J.-J. "L'Imaginaire" (cat.), Gal. du Luxembourg, Belgium, 1947; Mathieu, G. Beyond Tachisme, 1963; The Privilege of Being, 1967, From Revolt to Renaissance, 1973; Pellegrini, A. New Tendencies in Art, 1966; Quignon-Fleuret, D. Mathieu, 1977; Tapié, M. "Georges Mathieu" (cat.), Gal. Facchetti, Paris, 1952. *Periodicals*—New York Post April 24, 1960; New York Times December 11, 1960; Time April 5, 1954, March 7, 1955, September 15, 1957; Washington Post and Times Herald June 2, 1963.

***MATISSE, HENRI (EMILE BENOÎT)** (December 11, 1869–November 3, 1954), French painter, sculptor, and lithographer. Picasso once said of Matisse, "He is the North Pole, I am the South Pole." Seen in the overall perspective of modern art, the two great artists, so far apart temperamentally, seem to complement each other, yet the work of Matisse has a completeness of its own. Bursting upon the Parisian art scene in 1905 as leader of the Fauves, he renewed the entire course of painting. At the very end of his life, his unparalleled mastery of line,

°mă tēs´, äN rē´

French Cultural Service, NYC

HENRI MATISSE

color, and design, transcending the decorative, found novel expression in his deceptively simple paper cutouts, which like all his work had widespread influence.

Henri Emile Benoît Matisse spent his boyhood in the small town of Bohain-en-Vermandois, near Le Câteau-Cambrésis in France's gray industrial north, where he had been born. He was the son of Emile Matisse, a druggist and grain merchant, and Anna (Gérard) Matisse. Nothing in Matisse's background destined him for an artistic career. Until he was ten he attended the local school in Bohain. He went to Paris in 1887 to study law, passed his examinations with good grades, and in 1889 went back north to take a clerical job in a lawyer's office. There is no evidence that while in Paris he had visited any of the museums, even the Louvre.

Then, in 1890, back in his parents' home, came the event that changed his life. He was 20 and slowly recovering from an attack of appendicitis. In his own words, during "a fairly long convalescence, on the advice of a neighbor . . . I copied colored reproductions [with] a box of paints my mother had bought me." He also read a simple "how to paint" book by Frédéric Goupil—a chance experience he later spoke of almost in terms of a religious conversion. For the first time he felt "free, quiet and alone," and soon he realized he was "carried along . . . by a power alien to my life as a normal man."

Continuing to work in the lawyer's office, Matisse enrolled, without telling anyone, in a local drawing class, where he would work every morning for an hour before going to his job. Finding this double life intolerable, he an-nounced to his father that he was going to devote himself entirely to painting. His father said, "You'll die of hunger," but finally gave his consent, providing Henri with a small allowance.

In October 1891 Matisse returned to Paris and entered the class of the fashionable academic painter Adolphe William Bouguereau, at the Académie Julian. Taking an immediate dislike to that artist's much-acclaimed compositions of glossy and lascivious pseudoclassical nudes, painted in a slick, standardized technique, Matisse left the Académie Julian after only a few months. In 1892 he enrolled at the Ecole des Beaux-Arts, where, fortunately for Matisse, Gustave Moreau had earlier that year begun to teach. Moreau's own paintings were elaborate Biblical and mythological fantasies in a symbolist vein, executed in an extravagantly detailed technique. But he was a perceptive teacher who never imposed his style on others, and always encouraged his students to develop their own vision. Among Matisse's fellow students were Georges Rouault and Albert Marquet; the latter was to become a lifelong friend.

Moreau sensed Matisse's pictorial instinct and keen artistic intelligence, and said to him, "You were born to simplify painting," but there was nothing adventurous, much less radical in Matisse's work at the time. Advancing cautiously, making sure he understood each step, he spent countless hours in the Louvre making faithful copies of the old masters. In 1893 he produced a remarkable copy of a Dutch still life by de Heem. (Matisse later spoke of "the scale of silver and grays, so dear to the Dutch masters, from which I learned to make light sing out in subdued harmony and to get my values precisely in tune.") The Louvre occasionally purchased the best of these student copies, and over 20 years later Matisse bought back his de Heem imitation from the Louvre, using it as the basis for a large, brilliant, and very free interpretation.

In the summer of 1895 Matisse went to Pont-Aven, the village in Brittany where Gauguin had worked. His low-keyed paintings, however, showed no trace of Gauguin's influence, but reflected his admiration for Vermeer, Chardin, and Corot. Returning to Brittany in the summer of 1896, Matisse met an Australian Impressionist, John P. Russell, who had worked with Monet and who gave Matisse two drawings by Van Gogh, whom he had also known. The impact of impressionism, and Matisse's gradual liberation from the dark tonalities of "museum art," were evident in *La Desserte* (Dinner Table), painted in Paris in 1897. This large canvas was painted at the urging of Gustave Moreau, who was anxious that his pupil should paint a "masterpiece"

in the traditional sense—that is, a major effort to mark his graduation from apprenticeship to mastership. In *La Desserte* Matisse returned to a theme he had already treated in *Breton Serving Girl* (1896), but the new painting had far greater awareness of color, evoking the shimmering palette of impressionism. Exhibited in the relatively liberal Salon de la Société National in 1897, it aroused strong opposition, but Moreau defended it with alacrity, saying that the carafes were painted with such conviction that "you can hang your hat on their glass stoppers." The space in *La Desserte* was still the semirealistic, atmospheric space of the Impressionists, but the work (for many years in the collection of the actor Edward G. Robinson in Beverly Hills) marked a considerable advance.

In 1898, on the advice of the venerable and kindly Impressionist master Camille Pissarro, Matisse visited London to look at Turner. But this was also a wedding trip, for in January of that year he had married Amélie-Noélie-Alexandrine Parayre, from the Toulouse region. Matisse described her as "a person of great kindness, strength and gentleness" and she also had a strong practical streak, qualities that were to be a balm in the difficult years ahead. Three children were born of this marriage, Marguerite, Jean, and Pierre.

In the spring of 1898 Matisse and his bride extended their trip to include Corsica. On their return to Paris, in 1899, Matisse learned that his beloved teacher Moreau had died. His successor at the Beaux-Arts, Fernand Cormon, was appalled by Matisse's work in the classroom, and, on learning that he was nearly 30 years old, insisted that he make way for a younger student. Matisse wanted to continue his studies, and his next teacher was Eugène Carrière, a rather sentimental painter of mothers and children who worked in gray, murky, vaporous tones and was scandalized by Matisse's growing tendency to use bright colors. *Still Life Against the Light* of 1899, with its high-keyed palette, shows Matisse's newly found freedom and luminosity.

Also in 1899, Matisse scraped up the money to buy Cézanne's *Three Bathers* at Ambroise Vollard's gallery. He said later that this painting, which he kept until 1936 (when he donated it to the Musée d'Art Moderne de la Ville de Paris), "has sustained me spiritually in the critical moments of my career as an artist." Feeling himself lacking in the qualities of weight and volume that he admired in Cézanne's figures, Matisse enrolled in a sculpture class at the Ecole de la Ville de Paris. His eagerness to learn did nothing to alleviate his family's financial straits. Madame Matisse ran a dress shop to help make ends meet,

and for several months in 1900 Matisse and his friend Marquet were gilding cornices and doing other hackwork for the decoration of the Grand Palais, which had been built for the Paris Exposition. Meanwhile Matisse began working in clay in his studio on the Quai St. Michel on a piece called *The Slave,* a standing male nude inspired by Rodin's *Man Walking* and completed in 1903. In subsequent years he sometimes turned to sculpture as an adjunct to his painting. The sculptural sense was not, as it was with Picasso, an integral part of his vision, but it enriched his understanding of the human form. In contrast to his painting Matisse's sculpture often stressed massive volumes.

In March 1901, at a Van Gogh retrospective at the Galerie Bernheim-Jeune, Matisse, then 31, met two younger painters who were close friends, the 21-year-old André Derain and the tough, energetic Maurice Vlaminck, then 25. Physically both men were giants and living a bohemian hand-to-mouth existence in Chatou, near Paris; they were very different in appearance and personality from the serious, bearded, bespectacled Matisse, who even in his younger days looked more like a middle-aged doctor or professor than an avant-garde painter in early 20th-century Paris. But he was delighted to find that his new friends had, quite independently, arrived at an approach to color akin to his own. Derain was the more reflective and well read of the two, Vlaminck the more given to instinct. With Matisse they were to launch, in 1905, the movement called fauvism.

Matisse's solidly constructed nude study *Carmelina,* of 1903, shows that he was moving toward a personal style. He experimented with pointillism during and immediately after the summer of 1904, which he spent at Saint-Tropez in the south of France with Paul Signac, Seurat's only important follower. In the autumn of 1904 he painted a vibrant "divisionist" canvas with the Baudelairean title *Luxe, calme et volupté*; although working in dots of color helped to free him from tradition, he soon found the technique too inhibiting. The real liberation came in the summer of 1905, which Matisse and Derain spent at Collioure, a fishing village on the Mediterranean coast near the Spanish border. For the first time, Matisse ignored the hues of nature and the laws of perspective, and produced pictures, including *The Open Window* and *Interior at Collioure,* that are a riot of blazing color. Derain, too, was working in this vein, stressing color for color's sake.

The public was first confronted with these new trends in the Salon d'Automne of 1905 (the Salon d'Automne had been founded two years

before to sponsor the more advanced artists). Works by Matisse, Derain, Vlaminck, and other independents, including Marquet and Rouault, caused violent reactions among the visitors. One critic spoke of a "formless confusion of colors, blue, red, yellow, green, some blotches of color crudely juxtaposed; the barbaric and naive sport of a child who plays with a box of colors he just got as a Christmas present." The critic Louis Vauxcelles nicknamed the painters "Fauves," or wild beasts, and the term caught on.

It was ironic that their leader was the sober Matisse, but no work aroused greater fury than his *Woman with the Hat,* actually a portrait of Mme. Matisse. Shaken by the vehement reactions to the exhibit, the artist did not return after his first visit. To his amazement *Woman with the Hat* was sold, to two "eccentric" American expatriates, Leo Stein and his sister Gertrude. Leo described the painting as "a thing brilliant and powerful, but the nastiest smear of paint I had ever seen." Soon, other Matisse paintings were also hanging in the Steins' apartment at 27, rue de Fleurus. Upon meeting the artist, Leo found him "really intelligent . . . ,witty, and capable of saying exactly what he meant about art."

Matisse became friendly wih the Stein family, but after a while he felt much more at home with the retiring Michael Stein and his wife Sarah than with the high-strung Leo and the self-dramatizing Gertrude, who, he realized, was more interested in personalities than in painting and was soon to switch her allegiance to Picasso.

No sooner had the Salon d'Automne of 1905 closed than Matisse began work on a very large canvas, *Bonheur de vivre,* the only painting he sent to the Salon des Indépendants of 1906, where it was bought by Leo Stein. (It was later acquired by the idiosyncratic American collector Dr. Albert C. Barnes.) Taking as his point of departure one of his Collioure landscapes, Matisse revealed for the first time his feeling for sumptuous arabesque.

Luxe, calme et volupté and *Bonheur de vivre* marked the culmination of Matisse's experiments with his own version of expressionism and with the Synthetists' use of broad, flat areas of color. These paintings, milestones in the development of modern art, put Matisse at the vanguard of painting—a preeminence that would have been his alone for decades to come had it not been for the presence in Paris of Picasso.

Matisse and Picasso met at the Steins' in the fall of 1906, and it has been suggested that the impact of *Bonheur de vivre* may have prompted Picasso to paint the large, but radically different *Demoiselles d'Avignon* the following year.

There was a marked contrast between the calm, reserved 37-year-old Matisse, now the father of three children, and the mercurial Picasso, who was 12 years younger and had only recently passed from his Blue and Rose Periods. It was not until their later years, after World World II, that the tense, wary regard between them gave way to a warm mutual understanding and admiration.

In 1906 Matisse bought an African mask and became one of the first artists to take an interest in African art. In January of that year he met, through Sarah Stein, two more American collectors, the sisters Dr. Claribel and Miss Etta Cone, from Baltimore. Unlike Leo and Gertrude Stein, they remained loyal and enthusiastic patrons over the years, building up a major Matisse collection, even after his prices rose.

In the winter of 1905–06 Matisse had traveled to Algeria. Impressed by the intense light and color there, he painted, at Collioure that winter, the daring *Blue Nude,* which created a furor when exhibited at the Salon des Indépendants in 1907. Its dynamism was partly due to the tension between Matisse's emphasis on the three dimensionality of the figure (he used this same pose in several of his sculptures) and his desire to flatten form through color and design. In the summer of 1907 he and his wife visited Italy, where he far preferred the earlier Italian painters, especially Giotto, Duccio, and Piero della Francesca, to the masters of the High Renaissance.

In 1908 Sarah Stein persuaded Matisse to open a painting school, which he conducted about three years. Among the students were the young American Max Weber and the Englishman Matthew Smith. Students came from many countries, but those hoping impatiently to produce avant-garde masterpieces overnight were dismayed by Matisse's stern insistence on the most rigorous discipline in the study of the model. Sarah Stein kept invaluable notes on his teaching methods.

Matisse's growing success relieved his family of fear of poverty, but this did not mean that he had won critical acceptance in France. As late as 1910 one French critic wrote complacently, "We are happy to note that his disciples and active admirers include no one but Russians, Poles and Americans." Matisse's most ardent Russian collector was the wealthy textile importer from Moscow, Sergei Shchukin, who in 1909 commissioned for his Moscow mansion two huge canvases, *Music* and *La Danse,* both now in the Hermitage, Moscow. In *La Danse* Matisse carried even further the exuberant spirit of *Bonheur de vivre.* The ring of dancers in the earlier painting provided the theme—a joyous ex-

pression of the life-force through dynamic rhythms and saturated color. Matisse said later that he had aimed at "the bluest of blues for the sky, the greenest of greens for the earth, and a vibrant vermilion for the bodies."

Shchukin acquired 37 Matisses in all, many of which he hung in the same room as his impressive collection of Gauguins. Another Matisse masterpiece bought by Shchukin was *Harmony in Red* (1908–09), similar in its domestic theme to *La Desserte* but utterly different in its use of flat areas of color and lavish arabesque. In 1910 Matisse and Marquet went to Munich to see a large exhibit of Islamic art. Matisse was influenced by two-dimensional design, the sensuous, nonrealistic color, and the dense patterning of Persian and Indian miniatures in his canvas *The Painter's Family* of 1911, also acquired by Shchukin. Later in 1911 Matisse visited Shchukin in Moscow, where he was greatly impressed by the expressive line and pure, resonant color of Russian icons. After the 1917 Revolution all of Shchukin's paintings were confiscated by the Soviet government; many are now in the Hermitage.

Since 1909 Matisse and his family had been living in a villa at Issy-les-Moulineaux, near Paris, and by 1910 fauvism as a movement had disappeared. Although Matisse was as daringly experimental as ever, the analytical cubism of Picasso and Braque was now the most revolutionary trend in art. It has been said that Matisse looked at cubism "out of the corner of his eye." In his *Goldfish and Sculpture* (Museum of Modern Art, New York City), the sharp diagonal in the background and the sparseness of the composition owe something to cubism, but the color is pure Matisse, and the contorted figure is based on the pose of his own sculpture of 1907, *Reclining Figure*. In the winter of 1911–12 Matisse made two trips to Morocco and Tangiers. He loved North Africa, and in 1916 he summarized his sensations in *Moroccans at Prayer,* his most abstract painting yet. "It is the beginning of my expression with color," Matisse said, "with blacks and their contrasts."

As early in 1908 Matisse had had a small show at Alfred Stieglitz's gallery "291," New York City, and 13 of his paintings were included in the epoch-making Armory Show, in New York City, in 1913. Honorifically, his work aroused vitriolic reactions in the lay press, and when the show reached Chicago, Matisse was burned in effigy by university students there. When a reporter from *The New York Times* visited Matisse at Issy-les-Moulineaux, she was surprised to find "not a long-haired, slovenly dressed, eccentric man . . . but a fresh, healthy, robust blond

gentleman . . . whose simple and unaffected cordiality put me directly at my ease. . . . " Matisse urged her to "tell the American people that I am a normal man; that I am a devoted husband and father . . . that I go to the theater, ride horseback, have a comfortable home, a fine garden . . . just like any man." Later in 1913 Matisse acquired two important American patrons, John Quinn and Dr. A. C. Barnes, a millionaire from Philadelphia. When World War I broke out, in 1914 Matisse tried unsuccessfully to enlist. In 1915–16 he painted several of his best works, including *Studio, Quai Saint-Michel,* and *The Music Lesson.* Their spareness of construction and their geometric vision may have been in part a reaction to the anxiety of the war years, but were also due to Matisse's interest in recent developments in cubism. In 1916 he spent his first winter in Nice, and moved there with his family in 1917. The following year he visited the aged and ailing Renoir in nearby Cagnes. Between 1917 and 1918, from his room at the Hotel Beau Rivage overlooking the Promenade des Anglais in Nice, he painted his superb *Interior with a Violin,* which he rightly called "one of my most beautiful pictures." He was fascinated by the bright Mediterranean light and its sharp contrasts, and it was in Nice that he discovered what was to be one of his key motifs: the open window overlooking the sea and sky and linking the interior to the exterior.

In 1918 Matisse began his series of "Odalisques," which proved to be his most sumptuous and popular works, harking back to the Orientalism of Delacroix and moving away from both fauvist and cubist methods. *The White Plumes* (1919; Minneapolis Institute of Art), one of several studies of a young girl in a plumed hat, has the characteristic Matissean rhythm. His work of the 1920s reflects the mood of postwar relaxation shared even by the Cubists. Constantly reexamining the problem of placing the figure in its environment, Matisse sometimes opted for a flat, largely two-dimensional approach, as in the Odalisque painting of 1923, *The Hindu Pose.* At other times, as in *Decorative Figure on an Ornamental Background* of 1927, he treated the female nude with near-sculptural solidity, while relating it successfully with the lavish arabesques on the walls and rug.

Matisse's growing fame and prosperity enabled him to spend half the year in Nice and half in Paris. In 1920 he was commissioned by Diaghilev to do sets for the Stravinsky-Diaghilev ballet *Le Chant du Rossignol.* He was awarded First Prize in 1927 at the Carnegie International, Pittsburgh, for his painting *Le Compotier.*

In 1930, seeking an escape from his rigid pro-

gram of work, Matisse set out for Tahiti, stopping briefly in New York, where he admired the "majestic grandeur" of the city. In the three months he stayed in Tahiti he stored up impressions of light and color he was to draw upon years later, in the 1950s, but produced, with the exception of a pen-drawing of a Victorian rocking chair, only rough sketches for his notebook. Being, as John Russell has written, "a natural worrier who thrived on constructive anxiety," Matisse was temperamentally quite unsuited to the *dolce far niente* of the South Seas, and was unable to work there. "I am no Gauguin," he later remarked.

In October 1930 Matisse returned to the US to serve as juryman for the Carnegie International, afterwards returning to New York, where, when asked which American artist he would most like to meet, he promptly replied, "James Thurber!" From New York he traveled to Baltimore, to see the Matisses in the Cone Collection, and from there went to Merion, Pennsylvania, calling on Dr. Albert C. Barnes. The equable Matisse managed to get on with the difficult and often boorish Barnes, who commissioned him to decorate the entrance hall in his museum, the Barnes Foundation. Challenged by the idea of working on a large scale, Matisse set to work on the mural in Nice, in 1931, hiring the use of a film studio. He chose the theme of the Dance which he had used 22 years before for Sergei Shchukin's home, and after more than a year's work sent the completed painting to Barnes, only to discover that through an error in measurement the mural was too short by five feet to fit the hall's three arches. Matisse began again, and after 6 months the second version, even more stylized than the first, was completed and installed. The first version was purchased in 1937 by the Musée d'Art Moderne de la Ville de Paris.

Nowhere is Matisse's subtle simplicity more evident than in his line drawings, lithographs, and etchings. In 1932 he executed a series of etchings for an edition of Mallarmé's poetry—two of the finest are *Brise marine* and *Figure glorieuse*, the latter illustrating *The Afternoon of a Faun*. Whether working with pencil, pen or charcoal on paper, or with an etching needle on a copper plate, Matisse would repeatedly "draw" in the air before touching the surface. As he said: "Once my line, inspired by a bloom of its own, has shaped the light of the empty paper without spoiling *its* bloom of white, I stop."

In 1936 Matisse retrospectives were held in Paris, New York City, and Stockholm. In the late 1930s his style recalled the fauvism of his earlier years, but in a serene, graceful, and decorative manner. In *Girl on Red Background* (1936), the color serves mainly as an accompaniment to the calligraphic rhythm of the drawing, but is still pure and resonant. In 1938 Matisse was able to buy up several floors of the turn-of-the-century Hotel Régina in Cimiez, a suburb of Nice, for himself and his family. There he maintained a huge aviary, enjoying the brilliant plumage of the birds. His art collection included paintings by Courbet, Cézanne, and Picasso, and an ancient Greek statue of Apollo from Delphi.

Also in 1938 Matisse returned to theatrical design, producing sets and costumes for Léonide Massine's ballet *Rouge et noir*. He began to experiment with art paper as an alternative to oil painting, and used scissors alone in *The Dancer*, a little picture he gave to Massine in May 1938. Further explorations along those lines were interrupted in 1939 by World War II. That fateful year was also shadowed by his ill health and his grief over his separation from Madame Matisse, which had become final. He was in Paris when the German armies entered the city in 1940. Deeply distressed by the invasion, he returned to Nice, but felt too weak to go on painting. He fell seriously ill in July 1941, and was taken to a clinic in Lyons where the 71-year-old artist survived two serious operations. (The Dominican nuns who nursed Matisse spoke of him as "the man who came back from the dead.") Back in Cimiez, he was soon working as hard as ever, despite being unable to stand upright for more than a few minutes at a time.

The Nazis considered Matisse the "dean of degenerate art," but he was never personally molested during the period of German occupation. Yet he was not spared his share of anguish. His ex-wife and his daughter Marguerite (Madame Duthuit) were both members of the underground French resistance movement. In 1944 Marguerite was captured by the Nazis, tortured, and sent to Germany in a prison-train bound for Ravensbrück. An allied air raid stopped the train and enabled her to escape. Madame Matisse was imprisoned for six months at Troyes and then released.

None of the grimness of the wartime years was reflected in Matisse's paintings of 1941–45, for he felt that his vocation was to express joy. *Red Still Life with Magnolia* of 1941 has been compared in its disciplined composition to the Romanesque altarpieces of southwestern France, and its singing color has been described as "a clarion call amid the darkness." In *Tabac Royal* of 1942–43, Matisse's favorite theme, the young woman seated in an interior, is interwoven with familiar objects in his daily life—a lute, flowers in a vase, and the crockery jar labeled "Tabac Royal" which he also introduced in other paintings.

In 1943 Matisse moved to the hill town of Vence, and was soon branching out in new directions. He made preliminary studies for his enchanting lithographs illustrating the 16th-century French poet Ronsard's *Florilège des Amours.* The book was not published until 1948, as the German occupation of France had separated Matisse from his Swiss publisher. Also in 1943, he began to assemble compositions consisting of pieces of colored paper cut out with scissors.

In 1944, soon after the Liberation, a large-scale Matisse exhibition was held in Paris at the Salon d'Automne. In the late 1940s, although ailing and often bedridden, he enjoyed what appeared to be a new fauvism, a second youthful flowering. His splendidly decorative *Interior with Egyptian Curtain* was painted in 1948 at the age of 79. At Vence in 1949, out of gratitude to the Dominican nuns who had cared for him in his illness, he undertook the decoration of a Dominican chapel, of which he designed the layout and every detail of the furnishings, including the slender bronze crucifix, the six tall candlesticks on the altar, and the priests' brilliantly colored chasubles. Although he himself was an agnostic, Matisse wanted the chapel decoration to be a résumé and a resolution of the artistic problems that had always engrossed him. The mural motifs, including a large figure of St. Dominic and the 14 Stations of the Cross, were drawn in black on white ceramic tiles. Color was provided by the light pouring through the blue, green, and gold stained-glass windows whose semiabstract design, like that of the priests' vestments, was worked out with cut paper.

In the early 1950s Matisse, although confined to his bed and wheelchair, continued to develop his *gouaches découpées,* assembling mural-sized compositions out of pieces of commercial colored paper on which clear flat colors had already been painted by the artist for greater vividness. The paper was then cut out with long-bladed scissors, and the shapes placed, under his direction, by Lydia Delektorskaya (his secretary, companion, and model) on white or multicolored backgrounds. He said: "Cutting out in color reminds me of the direct carving of sculptors." His large-scale compositions, always inspired by the forms of nature, include *Blue Nudes; The Parakeet and the Siren* (1952); designs for tapestries; *Ivy in Flower* (1953), a model for a stained-glass window commissioned by Mr. and Mrs. Albert D. Lasker; and *L'Escargot* (1953). Matisse's illustrated book which he titled *Jazz,* with a text written by the artist and first published in 1947, was reissued in 1983. The imagery of the brilliantly colored cutouts—so vivid in hue that his doctor recommended that he wear dark glasses—was derived, according to Matisse, from his "memories of the circus, memories of folk-tales, memories of travel." He chose the title *Jazz* because of the pictures' discordant rhythms and their spontaneity. Matisse remained active until the end, and shortly before his death in 1954 at the age of 85 he could say with equanimity, "I have packed my bags, I am ready to go."

The photographer Alexander Liberman, who, visiting Matisse in Paris after World War II, was struck by the "extraordinary grandeur in his bearing," and remarked that of the many painters he had seen Matisse was the most awesome. Liberman noted the bald head, the small but penetrating, magnetic eyes behind the rims of his glasses, the quizzical smile, and the white, neatly clipped beard, "trimmed and shaped with a profound knowledge of form." His reserve seemed to Liberman "a self-imposed discipline on a tender, emotional nature." Françoise Gilot, when she and Picasso visited Matisse in Vence as he was recovering from his operation, found him in bed looking "very benevolent, almost like a Buddha." He was a witty conversationalist, and in Liberman's words, "In him intelligence, culture and wisdom blended with caustic French irony and doubt." Matisse described himself as "one who always remains an attentive spectator of life and of himself."

Matisse was exceptionally lucid when speaking or writing of his art. One of his most-quoted remarks dates from 1908: "What I dream of is an art of balance, of purity and serenity devoid of depressing or troubling subject matter, an art which might be for every mental worker, be he businessman or writer, like an appeasing influence, like a mental soother, something like a good armchair in which to rest from physical fatigue." Another of his sayings was "Exactitude is not truth." There was great creative tension beneath the sensuousness and simplicity of his art. He was concerned that his apparent facility not mislead younger painters. As he wrote to Henry Clifford, curator of painting at the Philadelphia Museum of Art, on the occasion of his 1948 retrospective: "I have always tried to hide my own efforts and wished my works to have the lightness and joyousness of a springtime which never lets anyone suspect the labors it has cost." Concerning his subject matter, he remained true to his statement of 1908: "What interests me most is neither still life nor landscape but the human figure. It is through it that I best succeed in expressing the nearly religious feeling that I have towards life."

EXHIBITIONS INCLUDE: Gal. Ambroise Vollard, Paris 1904; Gal. Druet, Paris 1906; Alfred Stieglitz's Photo-Secession Gal., "291," NYC 1908, '12; Gal. Bernheim-

Jeune, Paris 1910, '13, '19, '20, 1922–24, '27, '29; Leicester Gal., London 1919, '28, '36; Ny Carlsberg Glyptotek, Copenhagen 1924, '53; Brummer Gal., NYC 1924, '31; Venice Biennale 1928; Gal. Thannhauser, Berlin 1930; MOMA, NYC 1931, '51, '79; Gal. Georges Petit, Paris 1931; Marie Harriman Gal., NYC 1932; Pierre Matisse Gal., NYC 1934, '36, '38, '43, '49; Gal. Paul Rosenberg, Paris 1936, '37, '38; Salon d'Automne, Paris 1944; Philadelphia Mus. of Art 1948; Mus. Nat. d'Art Moderne, Paris 1949; Kunsthaus, Zürich 1959; Art Gal., Univ. of California, Los Angeles 1966; Grand Palais, Paris 1970; Mus. of Art, Baltimore 1971; Acquavella Gal., NYC 1973; Solomon R.Guggenheim Mus., NYC 1979. GROUP EXHIBITIONS INCLUDE: Salon de la Société Nat. des Beaux-Arts, Paris 1896; Salon des Indépendants, Paris 1901, '05, '06, '07; Salon d'Automne, Paris 1903, '05, '07, '10; Post-Impressionist Exhibition, Grafton Gals., London 1912; Armory Show, NYC 1913; "Matisse, Picasso," Gal. Paul Guillaume, Paris 1918; Pittsburgh International, Carnegie Inst. 1927; "Maîtres de l'art indépendant," Petit Palais, Paris 1937; "Les Fauves," Marie Harriman Gal., NYC 1941; "Matisse: Picasso," Victoria and Albert Mus., London 1945; "Matisse: Picasso," Palais des Beaux-Arts, Brussels 1945; Venice Biennale 1950, '54; "Le Fauvisme," Mus. Nat. d'Art Moderne, Paris 1951; "Les Fauves," Gal. Charpentier, Paris 1962; "Futurism: A Modern Focus," Solomon R. Guggenheim Mus., NYC 1973; MOMA, NYC 1983.

COLLECTIONS INCLUDE: Mus. Nat. d'Art Moderne, Mus. du Petit Palais, Mus. d'Art Moderne de la Ville de Paris, and Centre Georges Pompidou (Beaubourg), Paris; Mus. Henri Matisse, Mus. Henri Matisse, Cimiez, Nice, France; Tate Gal., London; Fitzwilliam Mus., Cambridge, England; Kunstmus., Basel; Bayerische Staatsgemäldesammlung, Munich; Nat. Gal., Oslo; Moderna Mus., Stockholm; Statens Mus. für Kunst, and Royal Fine Arts Mus., Copenhagen; Narodni Mus., Prague; Nat. Mus., Bucharest, Rumania; Hermitage Mus., Leningrad; Pushkin Mus., Moscow; MOMA, NYC; Brooklyn Mus. of Art, N.Y.; Albright-Knox Art Gal., Buffalo, N.Y.; Mus. of Fine Arts, Boston; Philadelphia Mus. of Art; Phillips Collection, Hirshhorn Mus. and Sculpture Garden, and Smithsonian Inst., Washington, D.C.; Mus. of Art, Baltimore; Art Inst., Detroit; Art Inst., Chicago; Mus. of Art, San Francisco; Honolulu Academy of Arts.

ABOUT: Aragon, L. Henri Matisse: A Novel, 1972; Arnason, H. H. History of Modern Art, 1968; Barr, A. M. "Matisse: His Art and His Public" (cat.), MOMA, NYC, 1951; Barnes, A. C. and others The Art of Henri Matisse, 1933; Bertram, A. Henri Matisse, 1930; Cassou, J. Matisse, 1939; Diehl, G. Henri Matisse, 1958; Elsen, A. E. The Sculpture of Henri Matisse, 1972; Flan, J. D. (ed.) Matisse on Art, 1973; Fry, R. Henri Matisse, 1930; Gilot, F. Life with Picasso, 1964; Goldwater, R. and others Artists on Art, 1972; Greenberg, C. Matisse, 1955; Hunter, S. Henri Matisse, 1956; Lassaigne, J. Matisse, 1959; Liberman, A. The Artist in His Studio, 1960; Liberman, W. S. Matisse: 50 Years of His Graphic Art, 1956; Matisse, H. Jazz, 1983; Muller, J.-E. Fauvism, 1967; Read, H. A Concise History of Modern Painting, 1959; Russell, J. The World of Matisse, 1969;

Wheeler, M. "The Last Works of Henri Matisse—Large Cut Gouaches" (cat.), MOMA, NYC, 1961. *Periodicals*—Art News October 1983; Art News and Review February 1956; Horizon March 1946; Le Point (Paris) July 1939; Studio May 1935; Verve (Paris) December 1937.

MATTA (ROBERTO ANTONIO SEBASTIÁN MATTA ECHAURREN)

(1911–) Chilean painter, has been acclaimed as one of the most prominent Latin-American painters of the generation following the Mexican muralists of the 1930s. A truly international figure, Matta has lived in Mexico, Italy, England, Spain, France, and the United States. In the 1940s his highly original form of surrealist abstraction had a decisive influence on the emerging New York School.

Matta was born in Santiago, Chile, of Spanish and Franco-Basque parents. At the age of nine he attended secondary school at the College of the Sacred Heart, Santiago. He had shown artistic leanings from earliest childhood, but at his parents' insistence enrolled in the School of Architecture at the National University of Chile, from which he graduated in 1931. In 1933 he decided to pursue his architectural studies in Europe, moved to Paris, and from 1934 to 1935 worked as an assistant to architect Le Corbusier, collaborating with him on the plans for the "Cité Radieuse." Matta's architectural training gave him an ability to manipulate forms in space that he was to make good use of in his art. "Painting," according to Matta, "always has one foot in architecture, one foot in the dream."

In 1935 Matta decided to devote himself to art. While traveling in Spain he met the Spanish poet Federico García Lorca, who gave him a letter of introduction to Salvador Dali in Paris. Through Dali the young Chilean met the founder, theorist, and "high priest" of the surrealist movement, André Breton. At that time Breton ran the Gradiva Gallery in the rue de Seine. Breton bought two of Matta's daringly imaginative drawings, encouraged him, and introduced him to the Surrealist group.

Matta was completely won over by surrealism, with its stress on the unconscious, "psychic automatism," and the role of chance in artistic creation. In 1938, at Trévignon near Concarneau in Brittany, he painted his first pictures, which he called "psychological morphologies." One of them was titled, in typically surrealist fashion, *The Morphology of Desire.* These early canvases were described 17 years later by Emily Genauer, writing in the New York *Herald Tribune Book Review,* as being covered with

Jorge Lewinski

MATTA

"strange, unidentifiable, jewel-like shapes exploding into whirling transparent vapors of rich color." Organic substances seemed to be dissolving and seething in a floating, indeterminate space. There were elements of what Breton called "absolute automatism" along with echoes of Miró's biomorphic near-abstractions. Matta's canvases won immediate acclaim, and Breton declared, "It is probably Matta who is on the surest path to the attainment of the supreme secret: fire's dominion."

That same year, 1938, Matta published "Mathématique sensible—architecture du temps" in the surrealist magazine *Minotaure*. Like other Surrealists he wished to create a new visual language of form and structure to express man's "contingent" situation in a perilous, ever-changing world, but he brought to his work a native vigor deriving from the intensity of his Latin American background.

In 1939, with the outbreak of war in Europe, Matta moved to New York City, the first Surrealist painter to arrive. Yves Tanguy came later that year; Max Ernst and André Masson followed in 1942. Breton and Marcel Duchamp were also in New York during the war years. Matta's first solo show in New York City was held at the Julien Levy Gallery in 1940. A *New York Times* critic called him "a brilliant, precocious acolyte of the surrealist movement during the 1930s," and museums and private collectors began to purchase his work.

Matta was now working on a larger scale, and his imagination was further stimulated by a trip to Mexico in 1941 with the American painter Robert Motherwell. This experience inspired

Listen to Living (1941; Museum of Modern Art, New York City), a canvas that suggests a volcanic eruption. The organic forces in nature were further evoked in *The Earth is a Man*. Following the Mexican journey, Matta introduced lurid bursts of yellow and orange and strident greens into his canvases.

Matta was represented in the group exhibition "Artists in Exile" held at the Pierre Matisse Gallery, New York City, in 1942. His work was praised by critics who felt he approached Miró in originality and brilliance, and his technical wizardry was much admired. He had a strong influence on Arshile Gorky, who became a close friend, and on other American abstract artists. Indeed, it was Matta who introduced Jackson Pollock to the avant-garde Art of this Century Gallery, which had been founded in Manhattan in 1941 by Peggy Guggenheim, who was to become Pollock's first important patron.

During 1943–44 Matta was one of the editors of the surrealist journal *VVV*, founded by Duchamp, Ernst, and Breton. The evolution of Matta's style in the direction of a richer use of the oil medium and deeper content was evident in one of his most important canvases, *The Vertigo of Eros* (1944, MOMA). Eros for Matta was the life-force, and this work in retrospect can be seen as one of the first "atomic age" or "space age" paintings. There is a sense of the weightlessness of matter in a state of constant flux amid limitless intra-atomic spaces. According to Matta, his aim was the "suggestive representation of the four-dimensional Universe."

After 1944 there was a change in Matta's work. Emily Genauer writes that he turned from "flowing, incandescent, jewel-box colors and shapes to paint agonized, brutal, insect-like figures, all claws, talons, and knotted nerves. Around them, threatening shapes hurtle through space." Some saw in this change the influence of the Duchamp of *Nude Descending a Staircase*, but these bizarre, mechanistic "humanoids," belonging more to the world of cybernetics than to the animal kingdom, were far more disturbing. The atomic bombs dropped on Japan in 1945 seemed to confirm this apocalyptic vision of human destructiveness compounded by fantastic scientific and technological inventions capable of upsetting the entire cosmos. A show titled "Parables," held in 1947 at the Manhattan gallery of Pierre Matisse (who became Matta's agent in 1945), contained paintings with such provocative titles as *Jittering the Feelings* and *Splitting of the Ergo*.

In 1947 Matta was represented in the International Surrealist Exhibition held at the Galerie Maeght, Paris. Soon afterwards, however, for

reasons never made clear, he was excommunicated from the Surrealist group by its pope, Breton. In 1948 Matta left New York and returned to Europe after a visit to his native Chile. He spent a year in Paris, exhibiting his paintings in 1949 at the Galerie Drouin. From 1950 to 1953 he lived in Rome. Shaken by the information that reached the world after the war concerning the horrors of the Nazi concentration camps, and appalled by the poverty he had seen during a visit to Sicily, Matta felt the need for a stronger human commitment in his work. In 1951 he showed two groups of paintings at the Sidney Janis Gallery, New York City, titled *France 1950* and *Italy 1950*. The gaunt, semihuman figures of his World War II period were reduced to sketchy abstractions moving in fathomless space. They suggested victimized creatures in a cruel and irrational universe. Howard Devree, writing in *The New York Times* (April 22, 1951), described the exhibit as "savagely introspective about the condition of man in a terrified world." There were hints of a more hopeful, life-affirming attitude in Matta's *To Cover the Earth with a New Dew* (1953; St. Louis Art Museum, Missouri), but a more ominous note was struck in another painting of the early 1950s, *Do Not Think of Fleeing,* described by one critic as resembling "a trial scene taking place in the middle of the aurora borealis."

In 1954 Matta moved back to Paris, although in the following years he made frequent trips to Bologna. He recieved an important mural commission for the UNESCO building in Paris in 1956. His paintings were now fetching very high prices, and in September 1957 a Matta retrospective opened at MOMA.

In the late 1950s Matta made his first sculptures, totemic figures like *The Clan* (1948; Hirshhorn Museum and Sculpture Garden, Washington, D.C.). In 1959, to his delight, he was readmitted to the Surrealist group. He still maintained that surrealism meant "being aware of all kinds of objects, to achieve the social and economic emancipation of the world, as well as of the mind."

The element of violence, always present or latent in Matta's work, reasserted itself in *The Basis of Things* (1964). The danger of the illustrational, stemming from Matta's surrealist aesthetic, particularly in its science-fiction phase, was noted by Hilton Kramer in his *New York Times* review (May 15, 1966) of Matta's six mural-sized canvases exhibited at the Alexander Iolas Gallery, New York City, in May 1966. Kramer commented on the explicitness of the "guns, helmets, and eviscerated bodies" dominating three "political" canvases, *Vietnam, Santo*

Domingo, and *Alabama* (all 1965), and admitted that "the violence usually prophesied in his pictures has here come to pass." Kramer, however, felt that the pictorial design of the paintings in no way compensated for their illustrational emphasis. He concluded: "Matta's paintings are often oversized illustrations rather than genuine pictorial realizations." Kramer saw a basic conflict between Matta's style and his ideology, adding that the polemical content of the pictures was "all but lost in their stylistic expertise."

Matta, as prolific as ever, is now a citizen of France and lives mainly in Paris and Rome. He is an intense, energetic man about five-feet-eight-inches tall, with brown eyes, red-brown hair, and a forceful presence. He is the father of twin sons by his first wife, Ann, who later married Marcel Duchamp. He second wife, Patricia, was divorced from him in 1949 and married Pierre Matisse. His third wife, the Italian actress Angiola Feranda, bore him a son, Iago. After their divorce he was married in 1954 to Malitte Pope. They have a daughter, Federica.

According to the British critic John Spurling, Matta's speech is marked by "punning ebullience," and he is given to such gnomic sayings as "Shake the eye before use and shake yourself with the shocked eye." Spurling in a *New Statesman* review of a Matta exhibition at London's Hayward Gallery in 1977, found the artist's recent huge and enveloping paintings disappointing "for all their size and rhetoric." He commented: "The promised voyage into the inner and outer space of a brave new world takes one hardly further than into the banal cul-de-sac of a comic strip." In contrast to the portentousness of this "apocalyptic science-fiction," Spurling appreciated the more modest scale of a selection of etchings at the Hayward Gallery and a series of ten prints at the Redfern Gallery, in which "Matta emerges as a quiet, sensitive colorist, master of water rather than fire."

Critical estimation of Matta's work has fluctuated over the years. Some young avant-garde American painters in the late 1940s proclaimed him the virtual heir to Picasso as an interpreter of the modern world. On the other hand, Hilton Kramer, writing in 1966, denied that he was "a major painter," while admitting that he had created "a distinct pictorial manner that already had its place in history." French critic Jacques Busse in the mid-1970s saw a basic conflict between Matta's allegiance to the "liberating, revolutionary" principles of surrealism and his often frightening visions of the future of scientific technology, given the irrationality of mankind and the unpredictability of the cosmos. Matta summed up his own view as follows: "If we fail

others, we fail our life. And it is in this sense that there will be a revolutionary erotic, that is to say that one will experience Eros (Life), the links between all beings, in a plan which should be realized, since it concerns us all. But one does not see it for the moment, just as one did not see that the earth was round and that it revolved." Matta's art, for all its unevenness, has been a serious attempt to express the challenge and uncertainties of a world in which "everything is . . . changing in front of your eyes." Matta shares the surrealist view of a universe in which chance and accident are seen as "a first principle of creation." Modern life, according to Matta, is above all a "voyage of being."

EXHIBITIONS INCLUDE: Julien Levy Gal., NYC 1940, '43; Pierre Matisse Gal., NYC 1942–47; Sidney Janis Gal., NYC 1949, '51, '55; Gal. Drouin, Paris 1949; Inst. of Contemporary Arts, London 1951; Allan Frumkin Gal., Chicago 1952–63; Alexander Iolas Gal., NYC from 1953; Pan American Union, Washington, D.C. 1955; MOMA, NYC 1957; Moderna Mus., Stockholm 1959; Allan Frumkin Gal., NYC 1960–65; Mus. Civico, Bologna, Italy 1963; Gimpel and Hanover Gal., Zurich 1964; Gal. Alexandre Iolas, Paris from 1966; Akademie der Künste, Berlin 1970; Andrew Crispo Gal., NYC 1975; Hayward Gal., London 1977. GROUP EXHIBITIONS INCLUDE: "Artists in Exile," Pierre Matisse Gal., NYC 1942; "Exposition internationale du surréalisme," Gal. Maeght, Paris 1947; "Parables," Pierre Matisse Gal., NYC 1947; Pittsburgh International, Carnegie Inst. 1955, '58, '67, '70; Documenta 2 and 3, Kassel, W. Ger. 1959, '64; "Dada, Surrealism and Their Heritage," MOMA, NYC 1968.

COLLECTIONS INCLUDE: MOMA, NYC; Hirshhorn Mus. and Sculpture Garden, Washington, D.C.; City Art Mus., St. Louis, Mo.

ABOUT: Bénézit. E. (ed.) Dictionnaire des peintres, sculpteurs et graveurs, 1976; Current Biography, 1957; Frumkin, A. Matta Drawings, 1975; Lucie-Smith, E. Late Modern: The Visual Arts Since 1945, 1969; Pellegrini, A. New Tendencies in Art, 1966; Read, H. A Concise History of Modern Painting, 1959; Waldberg, P. Surrealism, 1966. *Periodicals*—Art News March 1975; Cahiers d'art (Paris) no. 1 1953; Lettres Françaises (Paris) June 16, 1966; Magazine of Art March 1947; New Statesman October 28, 1977; New York Herald Tribune Book Review January 9, 1955; New York Times April 22, 1951, May 15, 1966; Quadrum 5 (Brussels) 1958; Time May 4, 1953.

MEADOWS, BERNARD (February 19, 1915–), British sculptor. Working almost exclusively in bronze, Meadows, like his contemporaries Reg Butler, Kenneth Armitage, and Lynn Chadwick, dispensed with the heroically monumental style of the previous generation of British sculptors, represented by Henry Moore and Barbara Hepworth, to investigate harsher aspects of form.

Meadows was born in Norwich, England, during the First World War. His artistic training began at the Norwich School of Art (1934–36); he then enrolled in London's Chelsea School of Art (1936–37), where he painted and studied sculpture with Henry Moore. Until 1940, he served as Moore's studio assistant, and the influence of the older sculptor on Meadows was decisive, both technically and, to a lesser extent, stylistically. From Moore, Meadows acquired a working method—extensive planning and sketching on paper, construction of a maquette, then expansion to full scale—and learned a respect for pre-Classical and Classical sculpture, while at the same time absorbing the sculptural innovations of Picasso and Arp.

The war interrupted his studies with Moore and his attendance at the Royal Academy of Art, which he began in 1938. Meadows served with the Royal Air Force from 1939, and from 1944 to 1945 spent time in India. After the war, he continued at the Royal Academy until 1947 (he now heads the sculpture department there), and also taught at the Chelsea School from the late 1940s to 1960. In 1952 (and again in 1964) he participated in the Venice Biennale; his first solo show was held in 1957 at Gimpel Fils, London.

Meadows gradually worked his way from two dimensions to three between the late 1940s and the early 1950s, first concentrating on painting, then casting bronze reliefs, and finally modeling in the round. In this early phase he abstracted from animals, but not the massive titanotheres on which Moore's pieces seem modeled; Meadows preferred spiky, open, and lightweight beings with a hint of menace or pathos, as in *Crab* (1952) or *Frightened Bird* (1955). For Moore's smoothness, Meadows substituted a rough, discordant surface that brings to mind the work of Chadwick or Germaine Richier, or the encrustations of Theodore Roszak at his least baroque. Where Moore's works are often dreamlike, Meadows's are nightmarish, with a touch of low wit. His *Fallen Bird* of 1962, with its crooked neck, splayed wings, and legs akimbo, is the visual equivalent of a frightened squawk. Reviewing Meadows's first New York City exhibition, at the Paul Rosenberg Galleries in 1957, a New York *Herald Tribune* critic wrote: "Not elegant in any way, this work is harsh, violent, sturdy,

and aloof, with power enough to make it poetic and interesting."

Now firmly recognized as one of Britain's most important new sculptors, Meadows spent the summer of 1960 in Florence. It was in all likelihood the Renaissance and Classical works he saw there that inspired him to turn to the figure. There was little of nobility or classical proportion in Meadows's "Armed Figures" of the early 1960s, however. Spindle-legged and square-bodied, clad in spiked plate, these figures are both belligerent and, because of the obvious weakness of the bodies beneath the armor, curiously vulnerable. Meadows made an accompanying series of "Armed Busts" in which he experimented extensively with contrasts of highly polished and rough-hewn areas. The head was often a separate cast, buffed and fitted into a socket on the armored shoulders.

The artist's series of "Pointing Figures" was begun during the mid-1960s. The inspiration for these works was said by Meadows to be a photograph of the film director Luchino Visconti peremptorily ordering his actors about. In some of the "Pointing figures" the gesture is protective, notably in *Pointing Figure with Child,* in which the artist contrasts the innocence of the "baby," larval and highly polished, with the hardened "parent," matte-surfaced and spiked. In others, the pointing motion is commanding, aggressive, and accusatory.

Continuing with the theme of threat and protection, Meadows created in the later 1960s the squat, pronged "Threatened People" series. *Help* (1966), an abstract work in which a polished spheroid with navel is squeezed between a cube and a pestlelike form, is really a de-anthropomorphizing of the palpable tension of the "pointing" and "frightened" figures. W.J. Strachan in *Connoisseur* claimed that Meadows's work as a whole has progressed from figurative schemata to metaphor or analogy. An important culmination of the artist's characteristic motifs of compression and rigidity, texture and gloss, vulnerability and coercion, organic resilience and surrender, is his large piece for the Eastern Counties Newspaper Building in Norwich, England. In this work, huge rough slabs of concrete sandwich apparently malleable, polished bronze forms.

In contrast to the truculence of some of his sculptures, and what one critic has called his "obsession with maleficent powers," Bernard Meadows has a cheerful, down-to-earth personality, and, according to John Russell, writing in *Contemporary Art 1942–72,* "a streak of raunchy humor." Russell sees Meadows as a leading

member of the talented "middle generation" of British sculptors—Armitage, Chadwick, and Butler among them—who led "an inner life that was both rich and wry, even if they disguised it beneath the sculptor's traditional bluffness and extroverted camaraderie."

EXHIBITIONS INCLUDE: Gimpel Fils, London 1957, '59, '63, '65, '67; Paul Rosenberg and Co., NYC 1957, '59, '62, '66, '67; Stedelijk Mus., Amsterdam 1965; Mus. der Stadt, Recklinghausen, W. Ger. 1965; Taranman Ga., London 1975, '78; Gal. Villand-Galanis, Paris 1977. Gal. de l'Ecole des Beaux-Arts, Rouen, France 1978; Fuji Television Gal., Tokyo 1979. GROUP EXHIBITIONS INCLUDE: Venice Biennale 1952, '64; "Sculpture in the Open Air," Battersea Park, London 1952, '58; Antwerp-Middelheim Biennale, Belgium 1953, '59; "Ten Young British Sculptors," British Council, London 1955, '57; São Paulo Bienal 1957; Expo '58 Brussels 1958; Documenta 2 Kassel, W. Ger. 1959; Pittsburgh International, Carnegie Inst. 1959, '62, '64; "Recent British Sculpture," Canada, Australia, Japan tour 1961; "Painting and Sculpture of a Decade, 1954–64," Tate Gal., London 1964; "International Contemporary Sculpture Exhibition," Mus. Rodin, Paris 1966; "British Sculptors '72," Royal Academy of Art, London 1972.

COLLECTIONS INCLUDE: Albright-Knox Art Gal., Buffalo, N.Y.; Joseph P. Hirshhorn Collection, Greenwich, Conn.; Tate Gal., London.

ABOUT: Hammacher, A.M. Modern English Sculpture, 1967; Lucie-Smith, E. Late Modern: The Visual Arts Since 1945, 1969; Moore, E. (ed.) Contemporary Art 1942–72: Collection of the Albright-Knox Art Gallery, 1972; Read, H. "Ten Young British Sculptors" (cat.), British Council, London, 1957, A Concise History of Modern Sculpture, 1964. *Periodicals*—Art in America Spring 1959; Christian Science Monitor November 29, 1967; Connoisseur April 1974; New York Herald Tribune January 17, 1959, October 14, 1967; Quadrum 6 (Brussels) 1959; Time March 12, 1965.

MELAMID, ALEKSANDR. *See* KOMAR, VITALY

*MICHAUX, HENRI (May 24, 1899–),
French painter, draftsman, and writer, developed a highly personal visual language of signs and ideograms to render what one critic called his "representations of an objectless world."

Michaux was born in Namur, Belgium, and spent his early years in Brussels. He had a soli-

°mē shō´, äN rē´

tary and difficult childhood, marked from infancy by "refusal symptoms," including, at times, the refusal of food. Four years at a boarding school in northern Belgium intensified his feelings of hostility and alienation. He received further schooling in Brussels during the German occupation of World War I, and immersed himself in the works of Tolstoy, Dostoyevsky, and the lives of the saints and mystics.

After graduation, Michaux studied medicine briefly and considered joining a monastery before signing up as a sailor in 1920. Leaving Rotterdam, he crossed the Atlantic for a voyage of several months, with ports of call at Savannah, Norfolk, Newport News, Rio de Janeiro, and Buenos Aires. Upon his return he felt more disoriented than ever. In 1922 he returned to Brussels, where he was deeply influenced by Lautréamont's *Chants de Maldoror* (a seminal work for André Breton and the Surrealists) and began writing. His first literary efforts were published in the Brussels review *Le Disque vert* whose director, Franz Hellens, encouraged him.

By 1924 Michaux had left Belgium for good and settled in Paris, where he has lived ever since. There he met Jean Paulhan of the *Nouvelle Revue Française,* who was responsible in 1927 for the publication of Michaux's first important literary work *Qui je fus.* Michaux also received support from the poet Jules Supervielle, who became a lifelong friend. Hitherto, Michaux had scorned painting as a representational art mirroring a reality he had always rejected, but in 1925 he discovered the works of Klee, Ernest, and de Chirico. Later, he recalled his "profound surprise" at being confronted with paintings which did not merely repeat reality, but translated and transformed it.

During 1925–1927 Michaux executed his first oil paintings and drawings, even then employing "*taches*" (patches, spottings) and indeterminate hieroglyphics. After a trip to the Amazon in 1927, Michaux returned to Paris early in 1929, but the death of his father and mother within ten days of each other prompted a new series of compulsive departures. During the next eight years he traveled extensively in Turkey, Italy, North Africa, South America, India, and China. He wrote and published several travel books, including *Ecuador* (1929), *Un Certain plume* (1930), *Un Barbare en Asie* (1933), and *La Nuit Remue* (1936). He drew very little, although his book *Entre centre et absence* (1936) was illustrated with Michaux drawings in which the influence of Oriental calligraphy was discernible.

In 1937 Michaux began to paint and draw regularly and had his first exhibition at the Librairie-Galerie de la Pléiade, Paris. In an exhibit at the Galerie Pierre, Paris, in 1938 he showed

HENRI MICHAUX

mainly gouaches with blue or black backgrounds, from which figures, heads, and landscapes emerged like eerie apparitions (*Le Prince de la nuit, Le Clown*). The works of the painter and the writer were now developing side by side. In his book *Peintures: sept poèmes et seize illustrations* (1939), poems and paintings faced each other, but the paintings were never "illustrations" of the poems: as the artist observed later, "The gouaches gave birth to the poems."

Michaux returned from a visit to Brazil in 1940 to a France occupied by the Nazis. He and his future wife fled to the south of France, where he continued to write, paint, and draw during the war years. In 1941 André Gide published a booklet entitled *Discovering Henri Michaux.* It was the text of an address Gide planned to deliver in Nice, but the Vichy government banned the event. Michaux's book *Arbres des Tropiques,* in which poems accompanied drawings executed in Brazil, was published in 1942. Michaux and his wife returned to Paris in 1943, where a year later he published *Exorcismes,* whose text and illustrations have been described as Michaux's "own private Resistance movement" by one critic.

In 1946 two works by Michaux were published. *Apparitions,* with drawings and rubbings, and *Peintures et dessins,* a portfolio of reproductions, some in color, some in black and white. The motto of Michaux's introduction to this second work was "Purpose—the death of art," a statement related to the surrealist belief in the subconscious rather than the rational intellect, as the source of new, powerful imagery. Michaux,

however, was hostile to all systems and literary theories, and found the Surrealists' methods monotonous and predictable.

By 1947 Michaux's wife had almost recovered from the tuberculosis she had contracted during the war, and the two made a trip to Egypt, but a year later she died of severe burns in an accident. Michaux's despair found expression in his lyrical poem *Nous deux encore* (We Two Again), and in a series of several hundred aquarelled pen-and-ink drawings, exhibited the same year at the Galerie René Drouin, Paris.

In 1950 Michaux resumed his search for the "sign" and published the portfolio *Mouvements,* a selection of drawings consisting of spottings of India ink banded together in rhythmic movement. The text, inspired by the drawings, was published alongside, but in the early 1950s Michaux "wrote less and less and painted more and more." In 1954 he exhibited his first large ink paintings at the Galerie Drouin, in which he pursued even further the translation of movement into graphic signs. His text on Paul Klee, *Aventures de lignes* (1954), contained observations equally applicable to his own work: "A line dreams. How rarely has anyone ever made a line dream. . . ."

In 1955 Michaux became a French citizen. Between 1956 and 1960 his sensibility, as expressed in drawings and paintings, was transformed by his experiments with hallucinogenic drugs, particularly mescaline. His drawing and painting technique changed to what Aldo Pellegrini termed a "rhythmic calligraphy of undulant ideograms" covering the entire pictorial surface. Michaux's new "all-over" style was reminiscent of Jackson Pollock, although on a much smaller scale. In fact the graphic signs, under the influence of mescaline, often became almost microscopic, requiring intense concentration and adjustment of vision on the part of the viewer. When asked why he, a distinguished poet, now painted so assiduously, Michaux replied: "Do you not see that my painting replaces words? Gestures, mimicry, sounds, lines, and colors: these are the primitive, pure, and direct means of expression."

In 1957 Michaux had exhibitions in Rome, London, and the United States. His first important retrospective was held in 1959 at the Galerie Daniel Cordier, Frankfurt. Michaux received the Einaudi Prize at the Venice Biennale of 1960. In 1963 he wrote a film scenerio, "Images du Monde visionnaire," directed by Eric Duvivier. A retrospective of more than 250 drawings and paintings at the Musée d'Art Moderne, Paris, in 1965 included large india ink paintings that contained more figurative allusions than in his earlier work.

From 1967 on, Michaux experimented with the acrylic medium. It is thought that some of the post-1968 acrylic paintings, called "Arrachements" (Tearings), may have been inspired by the turbulent "street action" and student strikes in Paris in May 1968. On viewing Michaux's exhibit at the Galerie Le Point Cardinal, Paris, one critic noted that crowds constitute the major theme of his paintings; the space is represented as "an area of exploded particles beyond identification and rushing hither and thither in tremendous uncertainty . . . like the crowd milling around a city like Calcutta."

Though Michaux no longer takes mescaline, his vision is still influenced by it. A conservatively dressed, clean-shaven Parisian resident, Michaux appears unremarkable. "But when he begins to talk," wrote one interviewer, "the look in his eyes becomes so intense, one would think he had stepped out of a drawing by another self-enclosed poet, Antonin Artaud." *Michaux ou l'espace du dedans* (Henri Michaux or The Inner Space), a film by Geneviève Bonnefoi and Jacques Veinat, was produced in 1965. Two years earlier, Michaux himself had collaborated with Eric Duvivier on a film entitled *Images du monde visionnaire.*

Michaux's so-called Orientalism has been compared to that of the American Mark Tobey, another artist strongly influenced by travels in the Far East, but Michaux's use of calligraphic imagery antedates by many years the abstract symbolism of Tobey and the action painting of Pollock and Georges Mathieu. However, the highly subjective and esoteric nature of Michaux's art may well limit its impact as well as its appeal. Though he has claimed his ambition is "to draw the consciousness of existence as well as the passage of time," he has also admitted a more personal one: "My art is a form of therapy, for overcoming phenomena. It liberates me and gives me pleasure. After all, in art one seeks pleasure more than in literature."

EXHIBITIONS INCLUDE: Librairie-Gal. de la Pléiade, Paris 1937; Gal. Pierre, Paris 1938; Gal. de l'Abbaye, Paris 1942; Gal. Rive Gauche, Paris 1944, '46, '51; Gal. René Drouin, Paris 1948, '49, '54, '56; Dussanne Gal., Seattle 1954; Ruth Moskin Gal., NYC 1956; Palais des Beaux-Arts, Brussels 1957, '61, '72; Gal. "One," London 1957; Gal. Daniel Cordier, Frankfurt, W. Ger. 1959; Venice Biennale 1960; Cordier-Warren Gal., NYC 1961; Robert Fraser Gal., London 1963; Cordier and Ekstrom Gal., NYC 1963, '65; Stedelijk Mus., Amsterdam 1964; Mus. d'Art Moderne, Paris 1965; Gal. Le Point Cardinal, Paris 1967, '71, '72; Gal. del Naviglio, Milan 1967; Gal. d'Art Moderne, Basel 1968; Palais des Beaux-Arts, Charleroi, Belgium 1971; Mus. des Beaux-Arts, Ghent,

Belgium 1971; Kestner-Gesellschaft, Hanover, W. Ger. 1972; Lefebre Gal., NYC 1975; Fondation Maeght, Saint-Paul-de-Vence, France 1976; Mus. des 20. Jahrhunderts, Vienna 1976–77.

ABOUT: Bénézit, E. (ed.) Dictionnaire des peintres, sculpteurs et graveurs, 1976; Bowie, M. Henri Michaux: A Study of His Literary Work, 1973; Broome, P. Henri Michaux, 1977; Gide, A. Découvrons Henri Michaux, 1941; "Henri Michaux" (cat.), Lefebre Gal., NYC 1975; Jouffroy, A. and others "Henri Michaux" (cat.), Mus. de Poche, Paris, 1961; Lucie-Smith, E. Late Modern: The Visual Arts Since 1945, 1969; Michaux, H. Ecuador, 1929, Un Certain plume, 1930, Un Barbare en Asie, 1933, La Nuit Remue, 1936, Entre centre et absence, 1936, Peintures: sept poèmes et seize illustrations, 1939, Arbres des Tropiques, 1942, Exorcismes, 1944, Apparitions, 1946, Peintures et dessins, 1946, Mouvements, 1950; Pellegrini, A. New Tendencies in Art, 1966. *Periodicals*—Das Kunstwerk (Baden-Baden) February 1977; Le Monde Weekly (Paris) April 22–28, 1971; L'Oeil (Paris) April 1976; Time December 7, 1959.

MANOLO MILLARES

***MILLARES, MANOLO** (February 17, 1926–August 14, 1972), Spanish painter, was a leading member of the Spanish avant-garde. Having begun as a Surrealist, he abandoned representation and evolved a highly personal means of expression in mixed media, working most notably with rough textiles.

Millares was born in the Las Palmas province of the Grand Canary Island of Tenerife. His father, Juan Millares Carló, was a university professor who was deprived of his chair when Franco came to power. Millares's uncle, Agustín Millares Carló, was a noted paleographer and historian, and the artist's brothers, Agustín and José Maria, became poets.

Because there were no specialized art schools on the Canary Islands, Millares was self-taught. He began drawing landscapes and portraits in the early 1940s and then progressed to watercolors, which he exhibited in his first solo show, held in Las Palmas in 1945. With their exhibition and visit of 1935, André Breton and the Surrealists had influenced the intellectuals of the Canary Islands. Millares read Breton's surrealist manifestoes, and his early work was influenced by both surrealism and Van Gogh. Millares's watercolors of the late '40s are Dali-esque and there are echoes of Miró in the series "Pictografías Canarias" (Canary Island Pictographs), which

he began in 1949. Some of his landscapes and portraits recall Van Gogh in their color and brushstroke, especially a self-portrait of 1950 in which the word "mad" and its French equivalent, "*fou*," appear in the upper left corner.

From 1949 to '51 Millares and his brothers published *Planas de Poesia*, a journal of literary criticism. One issue featured poems by Federico García Lorca, a martyr to the cause of Spanish democracy, with illustrations by Manolo. In 1951 the three brothers started *Los Arqueros*, an art review.

Miró's influence continued into the early '50s, when Millares's work became increasingly abstract. Like Miró he made abundant use of pictographic signs and symbols, although Millares's imagery differed from the older artist's. Many of the signs in "Pictografías Canarias" and other works of these years were derived from the ceramics and engraved stones of the Guanches, a tribe of farmers and shepherds who inhabited the Canaries until the arrival of the Portuguese and Castilians in the 15th century. Also, Millares's backgrounds were more solid and less ethereal than those of Miró.

In 1951, the year in which Millares embraced abstraction, he participated in the First Hispano-American Biennial with a nonfigurative canvas, *Aborigen*. That year he also had solo exhibitions in Madrid and Barcelona. In 1953 he produced the first of his "Walls," mixed-media works most of which were composed of sackcloth, paint, wood, and pieces of ceramic and were divided into rectangular areas. The use of symbols was

°mē lyä´rəs, mä nō´ lō

limited to a recurrent "Y" motif, just as symbols had appeared less often in the "Pictographs" after Millares's turn to abstraction.

Millares's move from the Canary Islands to Madrid in 1955 marked a turning point in his career. Aged 29 and already in command of his artistic vocabulary, in the next few years he was to develop new forms of painting which helped to keep modernism alive in Spain. He injected an element of disorder into his works, often by tearing holes in the burlap, as in *Perforated Wall* (1955), or by applying the paint very loosely. In 1956 he executed "Composition with Harmonious Textures," a series in which different kinds of burlap were applied to each other in the form of patches, with little paint added. At this time he met other young Spaniards who were rebelling against the aesthetic doctrines promulgated by Spain's reactionary government. In 1957, along with such artists and writers as Antonio Saura, Luis Feitó, Rafael Canoger, and Martín Chirino, he founded the El Paso group, which breathed life into the seemingly moribund Spanish art scene. An exhibiting association through 1960, El Paso made informalism, or expressive abstraction, an influential style of art in Spain. In opposition to the stultifying culture produced by decades of dictatorial rule, the group's manifesto called for "a new state of mind," "a new reality," and "the salvation of the individual."

In 1957–58 Millares broke free of two-dimensionality by forming clumps or knots in the cloth. He also introduced larger holes—gashes, really—and stitching into his works and began to apply paint, usually black, white, and red, in a fiercely emphatic manner. Inasmuch as black, red, and white are the traditional colors of anarchism, these works, simply called "Pictures," can be seen as a protest against totalitarianism in Spain. He continued work on this series through the early '60s.

Critics have seen in Millares's clumps of cloth a reference to the human figure. The Guanches had mummified their dead in stitched-together skins and cloth, and inasmuch as Millares had studied these ancient mummies in the Canarian Museum, Las Palmas, death and decay are considered major themes in his work. Black and white, the dominant colors in Millares's compositions, have been interpreted as representing the dialectic of life and death. Critics who view his work as a protest against oppression and injustice consider the violent splatters of paint and the use of rope to bind the clumps of cloth to be ominous symbols of fascism.

In his 1970 study of Millares, José María Morena Galván described his subject as "a painter whose work consists in transforming word com-mands into formal commands, and the reverse." This interpretation of Millares's work is lent credence by the anthropomorphic titles of various of his series, including the "Homunculus," begun in 1958, and the "Antropofauna," begun in 1969. For the latter series he used "red painted rags and rough textiles with drawn threads, dramatic smudges of paint and loosely organized scribbled forms," according to *The Oxford Companion to Twentieth-Century Art*. The scribbled forms are thought to have been inspired by Millares's interest in paleontology and archaeology.

Having participated in the São Paulo Bienals of 1954 and '57, Millares was represented in the Venice Biennale of 1958.

A powerful example of Millares's hand-made textures and black-and-white contrasts is *No. 165* (1961), which is in plastic paint on sackcloth, as is *Homunculus* (1964; collection of Mr. and Mrs. Pierre Matisse, New York City). The latter painting has a typically Spanish palette—rich brown, black, and white, enlivened by splotches and graffitilike marks in vivid red. Millares's work has affinities with *arte povera* (poor art). For example, in the "Homunculus" series, on which Millares continued to work, violence is expressed by splattered paint on ripped, twisted, and stretched material. In the earliest *Homunculi* the "figure" —the clumps of cloth were usually vertical, with two spindly "legs" projecting downward—was white against a black background, but in the early '60s the black began to envelop the white. However, in "Characters," a series dating from the mid-1960s, the paintings were almost completely white.

In the "Antropofauna" and "Fallen Characters" series of the late '60s and early '70s, white continued to predominate, but Millares began to use horizontal clumps, perhaps to signify death. The motif of mummified man that underlies all of Millares's work was prominent in his "Neanderthalia" series from the same years; but here the flesh and bones have been stripped away, leaving only the insides. On the gutted canvas two "noncolors," painted in a violently gestural manner, confront each other.

Millares also made three-dimensional objects, many of which were entitled *Artifacts for Peace*, and he produced a "Paint on Paper" series in the mid-'60s. The latter series was freely painted, with black, white, and various shades of red the dominant colors. The paintings *Adam* and *Eve*, both of 1966, show pink abstract forms surrounded by violent strokes of black.

Manolo Millares's died in Madrid at the age of only 46. The bearded artist, with his high forehead and pensive expression, was a sensitive

man, committed to bringing modern art to Spain through his highly individual, often disturbing vision. Critics have seen in the gradual lightening of his palette in the 1960s a sudden burst of hope, but there remained an underlying anguish. Millares himself said, "According to the most insistent examples of modern art, man breaks up and disintegrates in an uncontained spatial dimension. Thus we tacitly acknowledge the impossibility of the human being as an unimpaired physical phenomenon."

EXHIBITIONS INCLUDE: El Mus. Canario, Las Palmas, Tenerife 1945, '47, '48; Gal. el Jardín, Barcelona 1951; Sala Clan, Madrid 1951, '55; Gal. Buchholz, Madrid 1954; Pierre Matisse Gal., NYC 1960, '65, '71, '74; Mus. de Arte Moderno, Buenos Aires 1964; Mus. de Arte Modern, Rio de Janeiro 1965; Gal. Divulgacao, Lisbon 1965; Gal. Buchholz, Munich 1966, '68; Mus. d'Art Moderne de la Ville de Paris 1971; Gal. Rene Matras, Barcelona 1973; Albright-Knox Art Gal., Buffalo, N.Y. 1975; "Homage to Millares," Gal. Trece, Barcelona 1976. GROUP EXHIBITIONS INCLUDE: "Semana Internacional," Santander, Spain 1953; São Paulo Bienal 1954, '57; Venice Biennale 1956, '58, '68; Buchholz Gal., NYC 1957; "New Spanish Painting and Sculpture," MOMA, NYC 1960; Carnegie International, Pittsburgh 1961, '64, '67; "Contemporary Spanish Artists," Contemporary Art Mus., Houston 1966; International Festival of Painting, Cagnes-sur-Mer, France 1971.

COLLECTIONS INCLUDE: Mus. de Arte Moderno, Madrid; Mus. de Arte Moderno, Barcelona; Mus. Case de Colon, Las Palmas, Tenerife; Tate Gal., London; Centre Nat. d'Art Contemporain, Paris; Gemeentemus., The Hague; Mus. Boymans-Van Beuningen, Rotterdam; Städtisches Mus., Leverkusen, W. Ger.; Gal. Nazionale de Arte Moderna, Rome; Moderna Mus., Stockholm; MOMA, NYC; Fogg Mus., Harvard Univ., Cambridge, Mass.; Hirshhorn Mus. and Sculpture Garden, Washington, D.C.; Minneapolis Inst. of Art; Mus. of Fine Arts, Houston ; Mus. de Arte Moderna, Buenos Aires; Mus. de Arte Moderna, Rio de Janeiro; Mus., Jerusalem.

ABOUT: Ayllon, J. El Paso, 1962; Cerni, V.A. Coleccíon El Paso, 1957; França, J.A. "Homage to Millares" (cat.), Pierre Matisse Gal., NYC, 1974; Lucie-Smith, E. Late Modern: The Visual Arts Since 1945, 1969;

"Manolo Millares" (cat.), Pierre Matisse Gal., NYC, 1964; Osborne, H. (ed.), Oxford Companion to Twentieth Century Art, 1981; Pellegrini, A. New Tendencies in Art, 1966. *Periodicals*—Art in America September 1968; Art International Summer 1971; Art News May 1960, September 1960; Arts Magazine June 1960, April 1971, September 1974.

*MIRKO (BASALDELLA)** (September 28, 1910–1969), Italian sculptor and painter, was one of the most important sculptors to emerge in his native country in the 1950s. His work, usually of bronze, was invariably figurative and often on a heroic scale. Like many other Vitalist sculptors of his generation—including Henry Moore, whose upright *Motives* Mirko's *Motivos, Steles,* and *Idolos* of the 1950s superficially resemble— he aggressively opened up, cut away, distorted, and decorated the figure. Mirko belonged among those artists who, in Herbert Read's words, were trying to create "an icon, a plastic symbol of the artist's inner sense of numinosity or mystery." In the search for universal sculptural forms, he often drew upon primitive and mythological sources, always with an eye to the Italian, especially Italian Gothic, sculptural tradition, but he never carried his work to the point of pure abstraction. "Not only the claims of the past but a certain anxiety and rebelliousness about these claims enters into the conception of Mirko's art," wrote Hilton Kramer in *Arts,* "which is based nonetheless on the consummate felicities of sculptural craft which the tradition safeguards for the individual talent. The results are works of great beauty and power which are—over and above their immediate expressive meaning—symbols of this subtle dialectical involvement."

The son of a house painter, Mirko was born in Udine, near Venice. He studied in Venice, Florence, and Monza before coming under the influence of the figurative sculptor Arturo Martini, in Milan, from 1932 to 1934. Martini also shaped the career of Mirko's best-known contemporary, Giacomo Manzù. Mirko settled in Rome in the mid-1930s, first exhibiting his sculpture there in 1935, in Turin in 1936, and at the Galleria Nazionale d'Arte Moderna, Rome, in 1940. In 1947, a decade after he was first exposed to the French avant-garde during a trip to Paris with his brother, the noted painter Afro, Mirko embarked on a series of abstract paintings and figures. In 1950 he had his first major US show at the Catherine Viviano Gallery, New York City. Between 1949 and 1951 he completed a major commission, the

bronze gates and balustrades of the Ardeatine Caves memorial outside Rome, which commemorates the reprisal executions of 320 Italian civilians by the Germans in 1944. This led to other public commissions, including the murals and mosaics for the Food and Agriculture Organization building in Rome (1951) and the monument to World War II Italian dead in Mauthausen, Austria, in which he tackled the problem of the integration of architecture and sculpture. He was awarded second prize in the competition for the *Monument for the Unknown Political Prisoner* in 1953, and in 1955 won the grand prize for sculpture at the São Paulo Bienal.

Mirko treated his bisymmetrical, totemic figures and fierce, stylized animals of the late 1940s and 1950s—as in *Bull* (1948), *Hector* (1949), *Composition with Chimera* (1949), the "Chimaera" bronzes of the 1950s, and the columnar *Personaggio stele* (1957, *Stele Figure*)—both as fully rounded sculptural forms and as reliefs to be embellished with a rich variety of incisions, striations, gouges, and other scarifications intended, according to Hilton Kramer, to "give the work a continuous skin of sculptural nuances which are almost inexhaustible." In 1957 Mirko came to the United States, where he taught design at the Carpenter Center for Visual Arts at Harvard University; he became its director in the mid-1960s. In this period he began to deemphasize surface manipulation in favor of an increasing complexity of abstract, but still figurative, form, as in *Initiation* (1962, Krannert Art Museum of the University of Illinois, Urbana). Still working mainly in bronze, he also used brass and copper plate, marble, concrete, and exotic woods, and applied scraps of plywood and plastic, egg crates, and even bits of discarded student projects onto his wax originals before casting. Jane H. Kay commented in *Art News*: "Despite the contrived or haphazard nature of these origins, Mirko is bold and original."

Mirko believed that plastic form springs from "deep and remote motivations, in fact on primordial and subconscious impulses," that can reveal "the life of things and men" by "lines and surfaces, by contrasts of forms, by precipitations and reconciliations," to quote the artist. Though generally praised by American critics, Mirko's work, rooted as it was in the figure and in traditional craft, had little effect on American sculpture, which, led by the Formalists such as David Smith, the early Minimalists, the Conceptualists, and other eclectic groups, was in the 1960s heading in an entirely different direction. "The present temper of our own culture," wrote Kramer, "is either to deny the sovereignty of the past and go it alone or else to submit helplessly to its superficial attractions and hope the critics will mistake surrender for a new avant-garde. In neither case will Mirko serve as a suitable guide."

EXHIBITIONS INCLUDE: Gal. Obelisco, Rome 1947; Gal. Cairola, Genoa, Italy 1949–50; Catherine Viviano Gal., NYC 1950, '57; Inst. of Contemporary Arts, Boston 1965. GROUP EXHIBITIONS INCLUDE: Gal. Nazionale d'Arte Moderna, Rome 1940; Gal. Roma, Rome 1940; Knoedler Gal., NYC 1947, '48; Venice Biennale 1952, '54, '60; São Paulo Bienal 1955; "The New Decade," MOMA, NYC 1955.

COLLECTIONS INCLUDE: Krannert Art Mus., Univ. of Illinois, Urbana; Albright-Knox Art Gal., Buffalo, N.Y.; Food and Agriculture Organization, Rome; S. Seegar, Dallas; Harvard Univ., Cambridge, Mass.

ABOUT: "Mirko: Exhibition of Recent Bronze Sculptures" (cat.), Catherine Viviano Gal., NYC, 1957; Read, H. A Concise History of Modern Sculpture, 1964; Ritchie, A. C. The New Decade, 1955. *Periodicals*—Art in America Fall 1962; Art News February 1965; Arts June 1957.

*MIRÓ, JOAN (April 20, 1893–December 25, 1983), Spanish painter, sculptor, and ceramist, was celebrated for his highly individual style, abstract as well as figurative, characterized by its exuberant fantasy. Many critics regard him as the greatest artist of the surrealist movement.

Miró was born in Barcelona, the first son of Michel Miró Adziras and Dolores Ferra. Miró was always proud of his Catalan heritage, and there was a strong tradition of craftsmanship in his hardworking family. His father was a goldsmith and watchmaker, his paternal grandfather a blacksmith, and his maternal grandfather a cabinet-maker. Miró, although a poor student at school, had begun to draw at the age of eight, and in 1907 he entered La Lonja, an academy of fine arts in Barcelona. His family, feeling that an artist's life was too precarious, wanted him to take a job in an office, and he obediently took a job as a store clerk in 1910. Bored, depressed, and demoralized by the long hours and lack of vacations, he suffered a nervous breakdown, and convalesced in his parents' farmhouse in Mon-

°mir ō´, jō än´

Photo by Claude Gaspari; © Galerie Maeght, Paris

JOAN MIRÓ

troig, where he was often to stay in later years. Subsequently his parents realized that they had no choice but to let him pursue an artistic career, and in 1912 he enrolled in a Barcelona art school run by the architect Francesc Galí.

In an interview with Michael Gibson in *Art News* (January 1980), Miró recalled: " . . . Galí was very important to me because we did not restrict ourselves to painting. For instance, on Saturdays we would go for walks through the country, not at all to draw landscapes—no, but to walk through the countryside. 'Wear a crown of eyes around your head,' Galí would tell us. And when we got back to the academy one played the piano and read poetry. That brought me a great deal, as did the man's humanity. . . . " Galí instilled a sense of form in his pupils by having them draw objects they knew only by touch, and he required that modeling be done in clay. Another early formative influence was provided by the collections in the Museum of Romanesque Art, Barcelona—which Miró had visited since the age of ten.

During his years at Galí's academy, where he painted his first canvases, Miró also discovered the work of Monet, Van Gogh, Gauguin, Cézanne, and the Fauves and Cubists. In 1915, however, he decided that traditional art instruction was not giving him what he wanted, and he set himself up in a studio that he shared with his friend, a man named Ricart. His paintings at this time, influenced by Van Gogh and the Fauves, and later by the Expressionists, were already marked by a touch of his own buoyant humor. Among these early canvases were his first *Self-Portrait*, *Portrait of Ricart*, and *The*

Chauffeur, all dating from 1917, some expressionist nudes, and *Landscape with a Donkey*. The dealer José Dalmau took an interest in his work, and in 1918 gave him his first showing, at the Galeria Dalmau, Barcelona.

After this successful exhibition there was a marked change in Miró's work. He began a series of paintings that combined minutely realistic detail with light, delicate color. The earliest of these, *Montroig Landscape* (1919), has reminded contemporary critics of the delightful depictions of towns in the works of the Italian primitives, as well as of certain modern "naive" painters, such as the Douanier Rousseau. Among Miró's neoprimitive yet sophisticated and sunlit Catalan landscapes is *The Olive Grove*, also of 1919.

In 1919, Miró briefly went to Paris, which he was to revisit every year from then on. He was welcomed by Picasso, 12 years his senior, whom he had seen previously in Barcelona, but whom he had not dared approach. Picasso, who in 1921 purchased Miró's second *Self-Portrait*, painted in 1919, introduced him to the avant-garde poets Pierre Reverdy, Max Jacob, and the Dadaist Tristan Tzara. It was during this Paris visit that Miró became acquainted with the work of Rousseau. After his return to the Barcelona region later in 1919, his works, though still faithful to reality, began to show cubist influences, especially in his basic drawing style, which became more angular and formalized, with greater emphasis on planes. A series of still lifes, among them *Still Life with Toy Horse* and *Table with Rabbit*, both of 1920, combine cubist influences with colorful imagery inspired in part by Catalan folk art and the Catalan environment, the whole imbued with the artist's natural exuberance. These still lifes were shown in Miró's first Paris exhibition, held in 1921 at the Galerie La Licorne.

The outstanding work of Miró's early career was probably *The Farm*, completed in 1922, and on which he had worked for nine months. (It was later acquired by Ernest Hemingway.) It has Miró's typical freshness of approach, and whereas it reflects his admiration for Henri Rousseau it reveals an intricate calculation of compositional effect and marks the end of Miró's "poetic realist" period.

Several months of doubt and self-searching followed, from which he emerged after meeting in Paris with the painter André Masson, and the writers Jacques Prévert, Henry Miller, and other "free spirits." In *The Farmer's Wife* and *The Carbide Lamp*, both of 1922–23 (the latter in New York City's Museum of Modern Art), realism was combined with a strong element of fan-

tasy and greater intensity of mood. In *The Farmer's Wife*, the woman's enormous feet and the staring cat reveal the artist's growing imaginative freedom and mischievous humor.

By the early 1920s Miró was friendly with the Dadaist poets. During this period he also met the painter Max Ernst and the poet André Breton, and through them was introduced to surrealism. As early as the summer of 1923, during a stay in Montroig, Miró worked on two canvases (completed in 1924) that determined the future course of his art: *The Tilled Field* and *Catalan Landscape* (*The Hunter*). In the former there is still Miró's favorite sunshine-yellow tonality, but there is also a wild, almost Bosch-like transposition of images, as in the tree with its eye and ear, and animistic shapes derived from nature but totally nonrealistic. In the latter canvas (now in MOMA) Miró moved closer to a kind of surrealist abstraction; the imagery has become more teasing, sometimes suggesting organic forms seen through a microscope, but evoking through symbolic shapes the hunter, his dog, his gun, and other objects.

Miró, one of the signers of Breton's Surrealist Manifesto of 1924, was hailed by him as "the most 'surrealist' of us all." The painter was, for example, fascinated by the Surrealists' interest in automatic writing and the play of free invention. In Paris he took part, with the artists Yves Tanguy, Max Morise, and Man Ray, in the surrealist game called "The Exquisite Corpse." Tanguy would begin a sketch of a figure at the top of a piece of paper, then fold it over so that Miró could see only the lines where Tanguy had ended. Miró would draw more of the figure, then hide his creation by folding the paper over. Max Morise and Man Ray would in their turns complete the drawing—a strange hybrid. Picasso later recalled how, at the height of the surrealist movement, everyone was expected to do something outrageous in public—shock the bourgeoisie. One member of the group is reported to have said, "Bonjour Madame!" loudly to a priest in the Métro. The poet Eluard shouted: "Down with the Army; down with France" (and was roughed up and put in jail). But Miró, as Picasso observed, was the most cautious of men who would politely declaim: "Down with the Mediterranean!" When the group complained, "That doesn't mean anything," he replied: "Oh yes, it does. The Mediterranean was the cradle of our whole Greco-Roman culture. When I shouted 'Down with the Mediterranean,' I was saying 'Down with everything we are today!'"

One of Miró's most engaging paintings of 1924–25 (and one of the major works in his oeuvre) was *The Harlequin's Carnival*, with its tiny allusive figures, which are more "signs" than forms, its playfully poetic fantasy and festive color.

In 1925 Miró took part in the first Surrealist group exhibition, held at the Galerie Pierre, Paris, at which he was impressed by the work of Paul Klee. The following year Miró, in collaboration with Max Ernst, worked on costumes and settings for Serge Diaghilev's Ballets-Russes production of *Romeo and Juliet*. This concession to fashionable, "bourgeois" modernism infuriated Breton and the orthodox Surrealists, who now condemned him for lack of seriousness. Miró's essentially intuitive approach was indeed far removed from the more rigid, intellectual attitude of Breton, although the two remained on friendly terms.

It was in 1926 that Miró painted one of his most celebrated and haunting pictures, *Dog Barking at the Moon*, now in the Philadelphia Museum of Art. Sometimes interpreted as symbolizing the link between the physical world and the world of the intellect, the painting has also been regarded as an almost absurdist statement about the human condition.

Miró was married to Pilar Jonosca in 1928, the year of his trip to Holland. His admiration for Vermeer and the intimate realism of the Dutch genre painters led to a series of extremely free paraphrases titled "Dutch Interiors." Then, as if reacting against his own facility, Miró deliberately sacrificed elegance of line and gaiety of color in such subsequent works as *Spanish Dancer* (1928) and his series of dream-vision "Imaginary Portraits." His inventiveness was irrepressible, however, and in the early 1930s he began to experiment with collages and papiers collés, lithography and etching. In years to come he illustrated many books with color lithographs. In 1931 he exhibited his first surrealist "Sculpture-objects" at the Galerie Pierre. They were characterized, like his paintings, by great freedom of form and burlesque fantasy. The best known of these sculptures of the 1930s is *Objet Poétique* (1936), a construction of found objects which includes a bowler hat, a toy fish, a doll's leg, and a map, and is topped by a stuffed parrot.

Miró exhibited with the Surrealist painters in the Paris Salon des Indépendants in 1932, and in 1933 produced some of his most masterful paintings, including *Composition* (MOMA), a large, elegant canvas in which silhouetted free forms, analogous to some of Jean Arp's reliefs of the same period, dominate in their rich black against the subtle, resonant tonalities of the background. Like others of Miró's best paintings of the early '30s, it has an atavistic intensity and primitivism

which links it to the prehistoric cave-paintings of northern Spain, some of the silhouetted black shapes he employed are, in fact, reminiscent of bulls' horns.

From about 1934 a brutal eroticism accompanied by monstrous forms invaded Miró's work, and a note of feverish anxiety—reflecting his awareness of the imminence of civil war in Spain—appeared in his paintings of 1935–36. Although rarely overtly political, Miró, like Picasso and unlike Salvador Dali, supported the Spanish Republic in its stand against fascism. In 1937, the year of Picasso's *Guernica,* Miró worked for five months on *Still Life with an Old Shoe,* expressing his anguished feeling for his country and the poverty of the Spanish people. His large mural, *The Reaper,* painted for the Pavilion of the Spanish Republic at the Paris Exposition of 1937 (where *Guernica* was also shown) was a tortured and savage protest, as was his anti-Franco poster of that year, *Aidez l'Espagne.* In *Nocturne* (1938), Miró's favorite golden yellow of the sunlit earth is overwhelmed by the stark, black sky, relieved only by some ambiguous stellar shapes.

Between 1936 and 1940 Miró, living in France, did not return to Spain. In 1939, when residing in the village of Varengeville, Normandy, he suddenly turned his back on his so-called wild paintings and the horrors they evoked, and began a series of small lyrical paintings on burlap, followed by a group of 23 gouaches titled "Constellations." Still working on these as the Nazis were approaching Paris in 1940, he was able to get himself, his wife, and their one child, Dolores, on the last train leaving for the Spanish border. They went first to Montroig, then settled in Palma de Mallorca, with Miró's wife's family.

Many of the individual paintings in the "Constellations" series, were given elaborate fantasy titles, such as the one in MOMA, called *The Beautiful Bird Revealing the Unknown to a Pair of Lovers.* Speaking of the serene atmosphere and absence of violence in these gouaches, Miró recalled: "I felt a deep desire to escape. I closed myself within myself purposely. The night, music, and the stars began to play a major role in suggesting my paintings. Music had always appealed to me, and now music in this period began to take the role poetry had played in the early twenties, especially Bach and Mozart."

From 1942 to 1944 Miró, having returned to Barcelona, painted almost entirely on paper. In 1944 he began to work in ceramics, in collaboration with the Catalan ceramist Joseph Lloréns Artigas. From 1944 on he divided his time between Barcelona and Paris. His painted compo-

sitions became more elaborate, with the imagery sometimes tending to become repetitious and self-perpetuating. Such paintings as *Woman and Little Girl in Front of the Sun* (1946), however, have much of his former energy and exuberance. Françoise Gilot, in her book *Life with Picasso* (1964), records a conversation with him about Miró: "I told him that up to a certain point I admired Miró's work, especially what he had done between 1932 and 1940, but after that his inspiration had seemed to me to run out. I said that even if one liked Miró, one couldn't pretend that his was the painting of a seer, like Klee's for example. Pablo laughed. 'Miró's been running after a hoop, dressed up like a little boy, for too long now.'"

In 1947 Miró, by now world famous, went to the United States for the first time, and was struck by America's vitality and power. He received commissions for two large murals, one of which, a huge 9-by-32-foot canvas, was ostensibly for the restaurant of the Terrace Plaza Hotel in Cincinnati, a circular room with three windows. He painted it without assistance in New York City in eight months; the mural, in red, yellow, green, and black on a soft blue ground was subsequently moved to the Cincinnati Art Museum. Years later, in the course of the 1980 *Art News* interview, he remarked: " . . . We all knew it would wind up in the Cincinnati Museum; otherwise I would not have done it." The other mural commission, executed in 1950, was for the Graduate Center at Harvard University, Cambridge, Massachusetts. In 1956 Miró settled once again in Palma, where he lived and worked until his death. In 1957–58 he designed two walls (*The Wall of the Sun* and *The Wall of the Moon*) for the garden of the UNESCO headquarters in Paris. A series of large painted mural compositions followed in 1961–62; the unifying motif was the development of a single line on a monochrome ground.

Following his ceramic sculpture of the 1950s, some of which had a primitive totemic quality, sculpture in bronze played an important role in Miró's work in the 1960s and 1970s. Among the sculptures included in the large Miró show at the Galerie Pierre Matisse, Paris, in the spring of 1973, the critic Michael Peppiatt, writing in *Art International* (October 1973), was especially struck by *Woman* (1969), and *Personnage* (1970). *Woman,* $41\frac{1}{2}$ inches high, was described by Peppiatt as "a bronze stick-figure with a rich green 'patina' comprised of a concave casting of what looks like a crustaceous backbone and ribs serving as a body, a human left foot in the place of its right foot, and a large left hand making an Indian mudralike gesture." For the critic, this was a typical example of "the cosmic incongru-

ity of Miró's humor." Other works in the show, including *Monument* of 1971, were described as having "a [Henry] Moore-like appearance of worn stone."

In the garden of the Maeght Foundation in Saint-Paul-de-Vence, France, are a number of bulbous, aggressive-seeming sculptured and semiarchitectural forms by Miró, including an arch and a weather vane. In their way, these works express an anarchic primitivism which is a recurring element in the Spanish artistic tradition; only Miró, however, could have created these particular shapes.

In his catalog raisonné of Miró's work, Jacques Dupin wrote: "To the biographer's dismay Joan Miró seems to have taken every precaution to live a life preserved from the anecdotal and picturesque. . . . His personality is strong, rich and singular, and yet it defies any attempt at definition. . . . He admits to an immoderate love of solitude, and his silences are legend." Alexander Liberman, who photographed Miró in Paris in 1953, described him as follows: "Rotund, short, he easily breaks into a kind, witty innocent smile, but his gestures are formal and stylized. . . . His smile, as suddenly as it comes, disappears. . . . His face and body take on the forbidding stiffness and severity that only the Spanish can achieve. . . . Miró's humor, like a ray from the sun, fights off the ever-encroaching darkness and sadness in his Spanish temperament."

Miró was described by James M. Markham in a *New York Times* article (April 15, 1978), as "a diminutive giant" who at age 85 spent every day in his "white, shiplike studio . . . on the crest of a hill overlooking the Mediterranean." The still-prolific artist was producing "paintings, tapestries, stained-glass windows, ceramics, huge murals, sculptures, engravings and even costumes for an obscure Catalan troupe." Some of the paintings were "easily twice his diminutive stature." Many of his works now hang in the Foundation Joan Miró, founded in his honor and designed by the Catalan architect José Luis Sert. Opened in 1975, it is located in Montjuich, overlooking Miró's native Barcelona.

Markham went on to note that Miró's tender solicitude for his wife and daughter and his four grandchildren is in contrast with his often menacing representations of the female figure. Miró explained: "The woman is a symbol of procreation. On the one hand, it can create monsters and on the other can be very worthy and human."

Miró, however, rejected any categorizing, especially the suggestion that his art is abstract. "For me," he proclaimed, "a form is never something abstract: it is always a sign of something. It is always a man, a bird, or something else. It is never form for form's sake." Whatever his debt may be to surrealism, he declares: "I feel completely free, without any label." When asked by Markham whether his art was playful and funny or ominous and dark, the usually reticent Miró remarked: "I think there is a part that is very tragic, and there is the opposite part that is hope—above all in the things I have done recently. There is an element of tragedy, comedy and humor. It is the tragedy that leads to the optimism."

Although it is widely agreed that Miró's greatest paintings date from the mid-1920s to the early '40s, one critic, Gibson, observed that "the Miró of today still resembles the Miró of those Surrealist years." Miró agreed: "Yes. And more and more so. In the sense that as I go on I go further and further back toward my wellsprings." Those wellsprings, the artist explained, are that which is "pure and poetic. And sincere. And free."

EXHIBITIONS INCLUDE: Gal. Dalmau, Barcelona, Spain 1918; Gal. La Licorne, Paris 1921; Gal. Pierre, Paris 1925, '30, '31; Gal. Bernheim-Jeune, Paris 1928, '33; Valentin Gal., NYC 1930; Pierre Matisse Gal., NYC from 1932; Mayor Gal., London 1938, '75; MOMA, NYC 1940, '59; Gal. Maeght, Paris from 1948; Kunsthalle, Bern 1949; Palais des Beaux-Arts, Brussels 1956; Los Angeles County Mus. of Art 1959; Mus. Nat. d'Art Moderne, Paris 1962; Tate Gal., London 1964; Nat. Mus. of Modern Western Art, Tokyo 1966; Nat. Mus. of Modern Art, Kyoto, Japan 1966; Fondation Maeght, Saint-Paul-de-Vence, France 1968; Solomon R. Guggenheim Mus., NYC 1972–73, '83; Gal. Pierre Matisse, Paris 1973; Grand Palais, Paris 1974; Knoedler Gal., NYC 1975; Mus. Nat. d'Art Moderne, Centre Georges Pompidou (Beaubourg), Paris 1978; Mus. de Arte Contemporanco, Madrid 1978; "Selected Paintings," Hirshhorn Mus. and Sculpture Garden, Washington, D.C. 1980; "Joan Miró: the Development of a Sign Language," Washington Univ. Gal. of Art, St. Louis, Mo. 1980. GROUP EXHIBITIONS INCLUDE: Salon d'Automne, Paris 1923; "Exposition, la peinture surréaliste," Gal. Pierre, Paris 1925; "Newer Super-Realism," Wadsworth Atheneum, Hartford, Conn. 1931; "Newer Super-Realism," Julien Levy Gal., NYC 1931–32; Salon des Indépendants, Paris 1932; Salon des Surindépendants, Paris 1933; "Fantastic Art, Dada, Surrealism," MOMA, NYC 1936; Paris Exposition 1937; Pittsburgh International, Carnegie Inst. 1938, '39; "Spanish Masters of 20th Century Painting: Picasso, Gris, Miró," Mus. of Art, San Francisco 1948; "Spanish Masters of 20th Century Painting: Picasso, Gris, Miró," Portland [Oregon] Art Mus. 1948; Pittsburgh International, Carnegie Inst. 1950, '52, '55, '67, '70; Venice Biennale 1954; "Six Surrealist Painters," Palais des Beaux-Arts, Brussels 1967; "Dada, Surrealism and their Heritage," MOMA, NYC 1968; "Der Surrealismus 1922–1942," Haus der Kunst, Munich

1972; "Der Surrealismus 1922–1942," Mus. des Arts Décoratifs, Paris 1972; "Masters of Graphic Art: Goya to Henry Moore," Fischer Fine Art, London 1974.

COLLECTIONS INCLUDE: Foundation Joan Miró, Montjuich, Spain; MOMA, and Solomon R. Guggenheim Mus., NYC; Albright-Knox Art Gal., Buffalo, N.Y.; Wadsworth Atheneum, Hartford, Conn.; Mus. of Art, Philadelphia; Hirshhorn Mus. and Sculpture Garden, Washington, D.C.; Art Inst., Chicago; Baltimore Mus. of Art; County Mus. of Art, Los Angeles; Tate Gal., London; Mus. Nat. d'Art Moderne, Paris; Fondation Maeght, Saint-Paul-de-Vence, France; Stedelijk van Abbemus., Eindhoven, Neth.; Neue Nationalgal., Berlin; Kaiser Wilhelm Mus., Krefeld, W. Ger.; Kunsthaus, Zürich.

ABOUT: Barr, A.H. "Fantastic Art, Dada, Surrealism" (cat.), MOMA, NYC, 1936; Breton, A. Le Surréalisme et la peinture, 1928; Chilo, M. Miró, 1972; Current Biography, 1940; Dupin, J. Joan Miró: Life and Work, 1962; Gilot, F. Life with Picasso, 1964; Gomis, J. and others The Miró Atmosphere, 1959; Greenberg, C. Joan Miró, 1948; Liberman, A. The Artist in his Studio, 1960; Penrose, R. Miró, 1969; Reynal, M. (ed.) Peinture De Picasso au surréalisme, 1953; Soby, J.T. Joan Miró, 1959; Sweeney, J.J. "Joan Miró" (cat.), MOMA, NYC, 1943. *Periodicals*—Art International (Lugano) May 1972, Summer 1973, October 1973; Art News May 1970, January 1980; Art Press (Paris) June/August 1974; New York Times April 15, 1978, March 30, 1980, June 2, 1980, December 26, 1983.

MITCHELL, JOAN (February 1, 1926–), American painter, is one of the leading second-generation Abstract Expressionists. Born in Chicago, Mitchell is the daughter of a doctor; her mother was a poet, and both parents were interested in the fine arts. Her childhood years, when she lived in an apartment overlooking Lake Michigan, made a strong impression that would later surface in her work. In a conversation with Eleanor Munro, she described the lake: "[It] looked vast. No, infinite. Bleak. In winter it was icy, broken ice. Sometimes it's very blue." The "silence of cold," in Mitchell's words, influenced her vision as a painter: lake storms to her symbolize devastation, and yet she finds in them, despite her fear, a compelling, even attractive, quality; her work often conveys the sense of tempestuous waters

Mitchell was educated at the progressive Francis Parker School in Chicago, where her talent was discovered and encouraged by her art teacher. At the age of ten she had a show of watercolors. Joan also loved skating, and became a figure-skating champion in her school days. A friend who knew her then recalled that she was "always competitive; she had to be the first at everything."

Jorge Lewinski

JOAN MITCHELL

After studying for two years at Smith College, Northampton, Massachusetts, Mitchell attended the Art Institute of Chicago from 1944 to 1947. Her first paintings were figurative, and she spent much time at the Art Institute working from the model and "getting a straight academic training." During those years, she also studied intensively the works of Cézanne, Van Gogh, Kandinsky, and Matisse in the school's collection.

On a fellowship from the Art Institute, Mitchell went to Europe, where she lived and worked, mostly in Paris, from 1948 to 1949. In 1950 she received her MFA degree from the Art Institute. That same year she returned to New York City, which she had visited for the first time in 1947. Mitchell attended Columbia University, living and painting in a small studio on St. Mark's Place, in the East Village. She was married briefly to Barney Rossett, founder of Grove Press and a childhood friend from Chicago.

While in Paris she had painted in a semi-abstract style, but she now began to concentrate on landscape, with a growing freedom in her handling of paint. After Mitchell's move to New York, she had been strongly influenced by the work of Arshile Gorky and Willem de Kooning, whose paintings she saw at the Whitney Museum of American Art. Abstract expressionism was then at its height, and she watched other leading exponents of this style at work. Mitchell visited the studio of Franz Kline in 1950, and years later she told Marcia Tucker, "I saw those black and white paintings on a brick wall, and it blew my mind." She also watched de Kooning paint in his 4th Street studio in Greenwich Village, and ad-

mired his vibrant palette and powerful gestures. Another early influence was the muralist Orozco, whom Mitchell had met in Mexico when she lived there for two summers in her student days.

Once she had settled in the Village, Mitchell became affiliated with the younger painters, poets, and musicians of the New York School. Along with de Kooning, Klein, Philip Guston, and other artists, she frequented the Cedar Tavern and attended meetings and lectures at The Club, then the center of activities for the Manhattan avant-garde. Mitchell's first solo exhibition was in St. Paul, Minnesota, in 1950, but it was her inclusion in the 1951 "Ninth Street Show," in Greenwich Village and organized by The Club, that established her reputation as one of the more important younger abstract artists.

Mitchell's work has always had a landscape feeling, though there are no recognizable images. Prior to 1955 her paintings in New York contained suggestions of urban spaces, but, as Marcia Tucker observed, they "dealt with the imagery of the city more by virtue of their suggestive energy than by mimesis." Some of Mitchell's canvases were inspired by landscapes remembered from travels in Mexico, Europe, and the Midwest. These paintings, to Tucker, "had large, open, airy fields of white, against which terse, sketchy, horizontal skeins of paint were deployed. . . . " Many years later Mitchell recalled: "I was mad at a reviewer who reviewed my first show back in '51 and said it was like figures on ice. I thought skating had nothing to do with painting, and I didn't want anybody to know about the painting–skating thing. Well, I've come around now."

From 1953 to the early '60s she exhibited regularly at the Stable Gallery, New York City. In 1955 Mitchell traveled to Paris, where she met Kimber Smith, Shirley Jaffe, and Jean-Paul Riopelle, who became a close friend. In 1957 she was featured in a *Life* magazine article titled "Women Artists in Ascendance," which also mentioned Helen Frankenthaler and Grace Hartigan. As Barbara Rose pointed out 20 years later in *New York* magazine (April 8, 1974), the *Life* profile was, for its time, "revolutionary in its theme that women could be good abstract painters, competing with men on an equal footing." Mitchell recalled in 1974 that, although it was very difficult to be a woman painter in the early '50s in New York, especially when it came to finding a gallery, she had it easier "because I never even thought that I could be in the major competition, being female."

Whereas the first generation of Abstract Expressionists had made a point of avoiding Europe, several of the so-called second generation deserted New York for Paris, but Mitchell was the only one to remain in France. Feeling that New York had become too "big, successful and public," she settled in Paris in 1958, and the following year she took a studio in the rue Frémicourt. Though her aesthetic was close to that of the gestural Abstract Expressionists, especially de Kooning, and she remained on friendly terms with artists of the New York School, Mitchell always considered herself to be somewhat outside the "mainstream." Living in France gave her a greater sense of independence and enabled her to "keep her distance."

In her work of the late 1950s and early '60s the flavor and color of a remembered landscape was often the point of departure. But she waged a constant battle against the obtrusive image. In *Time* magazine she was quoted as saying: "I don't want to see anything on the canvas. For that, I could just as well look out of the window." She felt that a painting should not be describable in any terms *but* painting. "It has to mean something. But I don't know what that means."

The 1960s, when pop art dominated the New York scene, were difficult years for Abstract Expressionists; the cool, hard-edged precisionism and the deliberately antiaesthetic subject matter of the Pop artists were far removed from the urgency and emotionalism of action painting. But Mitchell refused to follow the newest trends; as she remarked to Eleanor Munro, "I knew then that I would do my own thing no matter what came."

In 1964 Mitchell moved into a house and studio in the country at Vétheuil, about an hour from Paris. The building was connected to the house in which Monet had lived and painted. Her style in the mid-1960s became denser and more painterly, with less white around the edges of the picture. In her canvases of the early '50s the bridge had been a favorite image. By the early 1960s, what has been described as a "cat's cradle form" frequently appeared. In about 1966, with the "La Seine" group of paintings, a circular form began to emerge. In 1967 the circular forms became more solid, detaching themselves from the thin, elusive webs and skeins of pigment in the background. Mitchell's preoccupation with figure-ground relationships, as distinct from "composition," was evident in her *Sans Neige II* (1969) and in the dense, clustering formations of *Blueberry* (1969–70).

Mitchell's group of paintings of 1970–71, including *Salut Sally, White Territory,* and *La Ligne de la Rupture*, is considered one of her finest series. These paintings, to quote Tucker, "juxtapose a sumptuous surface with a compositional awkwardness that makes them seem al-

most humanly vulnerable." Three important triptychs from 1971–72—*Bonjour Julie, Plowed Field,* and *Wet Orange*—were described by Tucker as "densely packed and intensely chromatic." *Les Bluets,* a triptych of 1973, was also included in her 1974 exhibit of large paintings at the Whitney Museum.

One of Mitchell's abstract landscapes of 1971, *Mooring,* included in her solo exhibition of 1972 at the Martha Jackson Gallery, New York City, was cited by Peter Schjeldahl in *The New York Times* as an example of Mitchell's discipline of sensibility, nerve and sheer skill." Two years later, Barbara Rose described the 48-year-old artist as "a brilliant painter of pastoral, light-filled canvases radiant with a love of nature." Concluding her review of this "really beautiful show" at the Whitney, Rose added, " . . . If one cannot help thinking that Monet's ghost still haunts Mitchell's garden, well, there are worse spirits to have around the house."

After comparative neglect in the 1960s, the decade of op and pop, Mitchell won recognition in the 1970s. She was awarded an honorary doctorate in 1971 by Ohio Wesleyan College, Delaware, Ohio and won a Brandeis Creative Arts Award Medal in 1973. Her 1974 Whitney exhibition confirmed, as Harold Rosenberg asserted in *The New Yorker* (April 29, 1974), "her presence as a leading 'second generation' Action painter." Rosenberg viewed her as "a kind of companion figure to de Kooning in the diptych of younger and older continuators of this mode."

Mitchell's 1976 exhibit at the Xavier Fourcade Gallery, New York City, included *Straw,* a painting over nine feet tall. Thomas B. Hess, reviewing the show in *New York* magazine (October 20, 1976), remarked on *Straw*'s "surface tension," generated by "long vertical strokes of yellow ocher at the bottom and of thalogreen and ultramarine at the top." "There's a madness in Mitchell's method," Hess observed. "She brings off a picture only after showing you all its possibilities for failure." Her exhibition at Fourcade in 1978 showed the tenacity with which she had held on to what Mitchell calls her "inscape." "I carry my landscapes around with me," she explained. Her steadfastness, as Ralph Pomeroy noted in *Contemporary Artists,* "is not merely a form of stubbornness . . . rather it is expressive of the nature of her talent and indicative of the quality of her art—which . . . is mined from a deep and inexhaustible vein."

Joan Mitchell, who lives and works in her whitewashed stone house on a hillside in Vétheuil, near Giverny, is a lean, angular woman, wiry, intense, and restless. Eleanor Munro sees her as "a Lautrec figure," her face "closed off by brown bangs that meet the top edge of her Chinesey-horizontal dark glasses." She leads a quiet life, seeing mostly the French and American painters and poets who come to visit her. She is possessed, wrote Monro, "of vast curiosity and blunt, disconcerting honesty." While painting, she listens to music of all kinds. Her deep feeling for nature, always her essential subject, and its impact on her vision as a painter are evident from these thoughts, quoted by Munro in *Originals: American Women Artists*: "I think of white as silent. Absolutely. Snow. Space. Cold. I think of the Midwest snow . . . icy blue shadows.

"I remember the yellow cornfields . . . Saugatuck in summer . . . oaks . . . dark birches . . . wild pines . . . those things cohere."

EXHIBITIONS INCLUDE: St. Paul, Minn. 1950; New Gal., NYC 1951; Stable Gal., NYC 1953, '54, '55, '57, '58, '61; Gal. Neufville, Paris 1960; Gal. del Ariete, Milan 1960; Dwan Gal., Los Angeles 1961; "Joan Mitchell Paintings 1951–1961," Southern Illinois Univ., Carbondale 1961; "Paintings by Joan Mitchell," New Gal., Hayden Library, Massachusetts Inst. of Technology, Cambridge 1962; Gal. Jacques Dubourg, Paris 1962; Gal. Lawrence, Paris 1962; Klipstein and Kornfeld, Bern 1962; Gal. Jean Fournier & Cie., Paris 1967, '69, '71, '76, '78, '80; Martha Jackson Gal., NYC 1968, '71, '72; "Joan Mitchell, 'My Five Years in the Country,'" Emerson Mus. of Art, Syracuse, N.Y. 1972; Ruth Schaffner Gal., Santa Barbara, Calif. 1974, '78; "Joan Mitchell," Whitney Mus. of Am. Art, NYC 1974; Xavier Fourcade Inc., NYC 1976, '77, '80, '81; "Joan Mitchell: Major Paintings," Richard Hines Gal., Seattle 1980. GROUP EXHIBITIONS INCLUDE: Ninth Street Show, NYC 1951; Annual, Whitney Mus. of Am. Art, NYC 1951, 1955–67; "U.S. Painting: Some Recent Directions," Walker Art Center, Minneapolis 1955; Pittsburgh International, Carnegie Inst. 1955, '58, '61, '70; Venice Biennale 1958; Documenta 2, Kassel, W. Ger. 1959; São Paulo Bienal 1959; "American Abstract Expressionists and Imagists," Solomon R. Guggenheim Mus., NYC 1961; "Forty Artists Under Forty," Whitney Mus. of Am. Art, NYC 1962; "Younger Abstract Expressionists of the Fifties," MOMA, NYC 1971; Biennial, Whitney Mus. of Am. Art, NYC 1973; "Women Choose Women," New York Cultural Center, NYC 1973; Biennial, Corcoran Gal. of Art, Washington, D.C. 1975, '81; "American Painting of the 1970's," Albright-Knox Art Gal., Buffalo, N.Y. 1978–79; "The Originals: Women in Art," Graham Gal., NYC 1980; "The Fifties: Painting in New York 1950–1960," Hirshhorn Mus. and Sculpture Garden, Washington, D.C. 1980.

COLLECTIONS INCLUDE: MOMA, and Rockefeller Inst. NYC; Albright-Knox Art Gal., Buffalo, N.Y.; Worcester Art Mus., Mass.; Carnegie Inst., Pittsburgh; Phillips Collection, and Hirshhorn Mus. and Sculpture Garden, Washington, D.C.; Art Inst., Chicago; Walker Art Center, Minneapolis; Mus. d'Art Moderne, Paris; Fondation Maight, Saint-Paul-de-Vence, France.

ABOUT: Friedman, B. H. (ed.) School of New York: Some Younger Artists, 1959; Munro, E. Originals: American Women Artists, 1979; "Nature in Abstraction" (cat.), Whitney Mus., NYC 1958; P-Orridge, G. and others (eds.) Contemporary Artists, 1977; Tucker, M. "Joan Mitchell" (cat.), Whitney Mus., NYC, 1974. *Periodicals*—Art in America July/ August 1974, March/April 1978; Art News October 1957, September 1958, April 1965, May 1967, April 1968, May 1972; Arts Magazine June 1980; Life May 13, 1957; New York April 8, 1974, October 20, 1976; New York Times April 30, 1972; New Yorker April 29, 1974; Time May 2, 1960.

MOORE, HENRY (SPENCER) (July 30, 1898–), British sculptor. If one test of a major artist is the power to transform the vision of an era, Moore ranks among the greatest creators in this century. Today he is the most famous living sculptor, and the fact that many younger artists rebelled against his influence is in itself a tribute to the worldwide impact of his work.

Henry Spencer Moore was born in Castleford, Yorkshire, the seventh of eight children. His father, Raymond Spencer Moore, was a self-educated coal miner. His mother, Mary, was a woman of exceptional character and great physical stamina which Henry inherited. Moore said later, "To be a sculptor, you have to have that sort of energy and that sort of stamina." His heritage from his father's side was, according to his friend, biographer, and fellow-Yorkshireman Sir Herbert Read, that of the typical North-country radical.

Castleford, with its dingy red-brick working-class houses and looming pit heaps, was a typical product of the Industrial Revolution, but Henry enjoyed the warm communal life of the streets and has declared he would not change his childhood for any other he can imagine. As a boy he liked the "feel" of different materials, whether he was whittling wood with his pocket knife or modeling in clay obtained from the local pits. He also recalls seeing the 11th-century carvings in Methley Church (about two miles from Castleford), "the first real sculptures that I remember."

At 12 Henry won a scholarship to the Castleford Grammar School. One day in Sunday school he heard the superintendent tell a story about the young Michelangelo, "the greatest sculptor in the world," and from that time if anyone asked him what he wanted to be in life, Henry would say "a sculptor." The art teacher at the Castleford Grammar School, Alice Gostick, recognized Henry's unusual aptitude for design. She organized pottery classes and introduced the pupils to the magazine *The Studio* at a time when art nouveau was at its height.

Photo by Amy Binder

HENRY MOORE

Moore decided at this time to become a professional artist. His parents did not discourage him, but his father was determined that his son should first, as he said, "get . . . qualified to earn a living." Accordingly, in 1914, the year war broke out, Henry, now 16, entered a teachers' training college in Leeds. In 1915 he became a student-teacher, and the following year he returned to the Castleford Grammar School as a full-time teacher.

Moore was called up in 1917 and was the youngest member of the Civil Service Rifles regiment. His inner equilibrium enabled him to withstand the terrible ordeal of the Western Front, but he was gassed at Cambrai and hospitalized for three months; the gas still affects his voice. He convalesced in England and returned to France in 1918, just as the Armistice was being signed.

Demobilized in 1919, Moore immediately applied for an ex-serviceman's grant to study at the Leeds School of Art. At that time art instruction in provincial schools was rigid and uninspired. Moore was 21, and, as he said later, "I was very lucky not to have gone to art school until I knew better than to believe what the teachers said." The vice-chancellor of Leeds University, Sir Michael Sadler, had a remarkable collection of modern European art, to which Moore had access. He also came across Clive Bell's writings on art and Roger Fry's book of essays, *Vision and Design,* in the Leeds Public Library. (Fry was the first English critic to write perceptively about African and Aztec sculpture.) Among Moore's contemporaries at Leeds was the sculptor Barbara Hepworth. In 1921 they both won

scholarships to the Royal College of Art in London.

Moore remembers that in his first months in London he "was in a dream of excitement." At the Royal College he had good teachers in the traditional manner and the opportunity to draw and model from life, but he gained far more from his twice-weekly visits to the British Museum. Inspired by the writings of Fry, he looked attentively at Egyptian and archaic Greek sculpture, which he preferred to Classical, and was impressed by the vigorous formalizations and inner vitality of African wood carving. Soon he found that "Mexican sculpture had more excitement for me than Negro sculpture." He saw a photograph of a reclining stone figure of Chac Mool, the Mayan-Toltec rain god from Chichén-Itzá, which stimulated his feeling for monumental forms and the relation of masses. The Chac Mool statue was to be the source of many of Moore's reclining figures.

Moore was already aware of Constantin Brancusi, Henri Gaudier-Brzeska, Amedeo Modigliani, and the early work of Jacob Epstein, but a visit to Paris in the summer of 1922 was of crucial importance to him, for there he saw in the Pellerin Collection Cézanne's enormous *Grandes baigneuses* (Large Bathers, now in the Philadelphia Museum of Art). Seeing that picture, in which the nudes "look as if they were cut out of mountain rock," had a tremendous impact, "like seeing Chartres Cathedral." As Moore found his way, he realized that his aim was vitality and expressive power, never "beauty" in the Greek or Renaissance sense.

Moore's earliest surviving independent carving, *Mother and Child* in Portland stone and dating from the summer of 1922, showed the influence of pre-Columbian sculpture, and a blockishness which stressed truth to the material. Moore was in those days a firm believer in the virtues of direct carving, whereas sculpture as taught in the schools still consisted almost entirely of modeling. Even Rodin had rarely held a chisel in his hand.

In 1925 Moore won a traveling scholarship which took him to France and Italy. In Florence he went every morning for a month to the Brancacci Chapel to look at Masaccio's majestic frescoes. He was critical of Donatello's "modeling" approach, but responded to the powerful overall rhythms of Michelangelo's figures in the Medici tombs. After seeing the great Italian art centers he began in his own mind to tackle the problem of how to get the two major sculptural achievements, European and non-European, to coexist.

After his return to London in 1926, Moore taught for two days a week at the Royal College as sculpture instructor, a post he held until 1932. *Head and Shoulders* (1927–28), carved in *verde di prato* and showing the combined influences of cubism and primitive sculpture, is considered by John Russell to be "the first outright masterpiece of his career," an expressive handling of "fully three-dimensional forms."

In 1929 Moore married Irina Radetzky, a student of painting at the Royal College. She was the daughter of an Austrian father killed in World War I and a Russian mother and trained as a ballerina. They moved into a large studio in Hampstead.

Although Moore's sculptures are never obviously autobiographical in content, they often present analogies with his personal life. For example, in the 12 months following his marriage he carved no less than five reclining female figures. This theme, by his own admission, had been an "obsession" with him for some time, but the new figures in these years of experiment and exploration showed a growing power, expressiveness, and originality. *Reclining Woman* (1930), carved in green Hornton stone, has a masklike face which recalls the Chac Mool, but, apart from the change of sex, the rigidity of the Mexican statue has been replaced by more sensuous and earthy qualities. Whether carving in stone or wood, Moore was always concerned with bringing out the particular character of the material.

Moore's first solo show at the Leicester Galleries, London, in 1931—Epstein wrote the catalog—was violently attacked in the London press as "immoral" and even "bolshevik." The *Morning Post* wrote, "The cult of ugliness triumphs at the hands of Mr. Moore." The public was baffled, among other things, by Moore's deliberate deemphasizing of the head, which sometimes had no features—later it was often split—so as not to detract from the overall structure.

In his mid-30s, Moore had clear views about modern sculpture in relation to the past. "Since the Gothic," he wrote in 1937, "European sculpture had been overgrown with moss, weeds—all sorts of surface excrescences which completely concealed shape. It had been Brancusi's special mission to get rid of this undergrowth, and to make us once again more shape-conscious." He felt that now there was no need to restrict sculpture as Brancusi had done "to the single (static) form unit. We can now begin to open out. . . . "

One factor in this "opening-out" was the influence of surrealism. The biomorphic forms of Arp—for whom Moore did not have unqualified admiration—and Picasso's so-called Bone Peri-

od, with its aggressive distortions and enclosed hollow spaces (as in the painting *Seated Bather* of 1930), had an impact on Moore's work, as did the Surrealists' love of found objects. Moore was never a wholehearted Surrealist, but over the years he built up an extraordinary collection of unusually shaped bones, rocks, and pebbles in his studio. He would be the last to deny the role of the unconscious in his work, but he said in reference to an excellent analysis by Erich Neumann, a disciple of Jung, called *The Archetypal World of Henry Moore*, "I began reading it, but gave up half way through the first chapter, as I did not want to be psycho-analyzed, nor understand what makes me tick. . . ."

In 1932 Moore took a part-time teaching position at the Chelsea School of Art. He continued to carve reclining figures but he also made a number of pieces that were purely abstract, though always suggesting organic life, and which appealed directly to the tactile sense. However, for many people Moore's majestic and mysterious reclining female figures of the middle and late 1930s are among his supreme achievements. The monumental *Recumbent Figure* of 1938 carved in Green Hornton stone and now in the Tate Gallery, has a massive serenity and strength and a flowing continuity of rhythms that almost turn the figure into a landscape of mountains, caverns, and valleys. Moore's larger pieces are seen at their best outdoors. As John Russell observed apropos of the large Moore retrospective in Paris in 1977, what makes Moore "a great *English* sculptor" is his interest in "the fusion of man and nature."

One of the more controversial features of Moore's sculpture in the 1930s was his use of the hole. In Paris Alexander Archipenko had been the first to pierce the figure with a hole as a link between inner and outer space, but Moore gave this innovation a much deeper significance. He stated in 1937: "The hole can itself have as much shape and meaning as a solid mass," and he wrote of "the mystery of the hole—the mysterious fascination of caves in hillsides and cliffs."

From 1933, Moore was a member of Unit One, a progressive artists' group to which his friends Barbara Hepworth and her husband, the abstract painter Ben Nicholson, belonged. In 1936 he participated in the International Surrealist Exhibition in London, and there were surrealist elements in his "stringed figures" of the late '30s, which were mostly interpretations of the human body with string drawn taut between the various components. This was a means of defining the space within the sculpture, and creating an opened-out instead of a closed figure. Some of these string-pieces were cast in lead.

This rather cerebral phase of Moore's sculpture was abruptly halted after the outbreak of World War II. He gave up his teaching post at the Chelsea School, and after his London studio was bombed in the blitz of 1940, he and Irina moved to a small farmhouse, Hoglands, at Perry Green near Much Hadham, Hertfordshire, where they have lived ever since. But Moore was often in London during the war years. In 1940 he was commissioned by the War Arts Committee to make drawings of Londoners confined by nightly air raids to deep shelters in the Underground. His *Shelter Sketchbooks* of 1941, of which the pages have been separated and are in various museums and private collections, are the best known of all his drawings. The groups of chalky, undifferential figures sprawled in uneasy slumber on bunks or in seemingly endless tunnels have an eerie, nightmarish quality. The "Shelter" drawings were followed in 1942 by drawings of miners at the coal-face; the technique recalled that of Moore's favorite draftsman of the last one hundred years, Seurat.

The tenderness and stoic endurance of mothers nursing or holding their children that Moore had observed in the shelters became the theme of another of his wartime commissions, the stone carving of the *Madonna and Child* for St. Matthew's Church in Northampton. In view of the modern decline of religious art, he was at first reluctant to tackle this theme, but because of his long experience of treating form for its own sake, he was able to give the *Northampton Madonna*, completed in 1944, the qualities he aimed at: "an austerity and a nobility," as well as "a quiet dignity and gentleness."

By the late 1930s Moore had become well known in art circles in England and abroad, but only after 1945, with the end of the war in Europe, did he become an international figure. As early as 1944 he had been making sketch-models of family groups in terra-cotta; buoyed by the feeling of optimism and human solidarity that came with the end of the war, he produced a splendid series of "Family Groups" in bronze. He was now sure enough of his concepts not to depend exclusively on direct carving in stone or wood, and to tackle what he called "the bronze thing." One of these large groups is in the garden of the Museum of Modern Art, New York City. Even his small-scale pieces on this theme have true monumentality.

Nineteen-forty-six was a particularly happy year for Moore. He visited New York on the occasion of his first retrospective exhibition, held at the Museum of Modern Art. In the same year his daughter Mary was born, and his treatment of the family motif took on a new gentleness and

intimacy. Between 1948 and 1950 Moore created a delightful series of small, bronze, ladder-back rocking chairs in which his wife sits holding his small daughter (the chairs actually rock). In a sketchbook of 1953–56 there are drawings of Mary doing her homework at her desk, with notes about a possible sculptural treatment. Between Mary (now married and a professional illustrator) and her parents there has always been a warm relationship. Moore said of her some years ago, "She doesn't let me put on false dignities, and I am glad."

Despite the many honors, awards, and major exhibitions of his work in the 1950s, and increasing demands on his time, Moore gave the appearance of retaining his basically simple mode of living, though he did become adept at keeping his work before the public and managing an expanding shop at Hoglands. In some of his sculptures bold, experimental ideas were adjusted to more traditional concepts (*King and Queen* and *Warrior with Shield,* both 1952–53). In a more abstract vein there was a series of "Upright Forms," still based essentially on the female body and culminating in the 132-inch-high *Glenkiln Cross* (1955–56), so called from the estate in Scotland on which it stands. In his brick wall relief for the Time-Life Building in London (1952–53), Moore used an abstract idiom to conform to the geometrical facade of the building, but in Herbert Read's opinion, the result is unsatisfactory because "it is impossible to assimilate the essentially free art of sculpture to the strictly functional needs of modern architecture." Moore never wanted to work directly for architecture, but he was glad to provide sculpture for a site where a work of art could function coherently. One of his greatest achievements was the *Reclining Figure* commissioned in 1956 for the UNESCO headquarters in Paris. That he was working on behalf of an international institution devoted to the dissemination of culture and understanding between peoples had great meaning for Moore. The massive female figure, carved in Roman travertine marble, gives, according to Read, "a tremendous impression of power held in reserve." This was the public art of Moore at its finest, the Moore who, wrote John Russell, "more than once became the keeper of Everyman's conscience."

In 1959 Moore developed the idea of a series of gigantic "Reclining Figures" designed in two or three pieces. In several versions of the *Two Piece Reclining Figure* of 1960, the lower limbs bent at the knee formed a clifflike extension pierced by an arch, a shape suggested, according to Moore, by one of Monet's paintings of the cliffs at Etretat. This association with water led to the idea of the 15-foot-high, two-piece *Reclining Figure* in bronze for the plaza of Lincoln Center, New York City. The powerful, ruggedly textured sculpture, designed to rise out of a pool of water, was unveiled in 1965, but it had been installed before the pool was properly waterproofed. Moore had also been told that the pool would be 14 inches deep and in making the sculpture he had allowed for its base to be submerged to that depth; the architect, however, designed the pool to be six inches deep, so the sculpture has never been seen in the way Moore intended it. Despite this disappointment, of the kind that often attends large-scale commissions, the Lincoln Center *Reclining Figure* is among Moore's most forceful and haunting images.

Meanwhile a younger generation of British sculptors, some of whom, like Anthony Caro, had been Moore's assistants or students, were working in a very different vein, with wrought iron or plastics as their chosen materials. Some young artists considered Moore's work rhetorical and mannered and his humanism irrelevant, but such swings of opinion are inevitable in the evaluation of any major figure in art or literature. Moore's link with the great tradition of sculpture was confirmed in 1972 when he was invited by the city of Florence to exhibit in the garden of the Belvedere fortress, overlooking the birthplace of the Renaissance. Moore wrote to the Mayor of Florence: " . . . I know that showing my work here would be a formidable challenge, but one I should accept." The exhibition was a triumph, and it was decided that Moore's *Warrior with Shield* would eventually be set up in the Piazza della Signoria.

In 1974 Moore donated a large number of his plaster sculptures and maquettes to the Gallery of Ontario, Toronto, and a Henry Moore Sculpture Center was opened. In May 1977 an admirably installed Moore retrospective—drawings and graphic work as well as sculpture—opened in the Musée de l'Orangerie des Tuileries, Paris, a fitting tribute to "un grand sculpteur anglais."Just before Moore left for Paris for the opening, he learned of the birth of a grandson.

Over the years Henry Moore has steadfastly resisted the temptation of becoming what Yeats called "the sixty-year-old smiling public man." He is cordial, direct, and unassuming—the local people of Much Hadham, whatever their opinion of his work, often refer to him affectionately as "Henry." He is below medium height, with gray-white hair, strong but kindly features, and questioning blue eyes. He has often been photographed, but photographs rarely capture his alert, responsive quality—and photographs never seem to do justice to the exquisite features and slender build of his wife Irina. their house in

Much Hadham is not large, but the grounds are now immense, and Moore has at least five studios. There is a maquette studio for small models in clay and plaster, also containing a rhinoceros skull and unusual stones and pieces of driftwood. He has a small studio for his graphic work where he recently produced, helped by two young assistants, a series of lithographs on the theme of Stonehenge. Moore had an open-air studio of plastic built for the Lincoln Center sculpture, and he finds it most useful. "It means that I can make large sculptures in natural light and can see them from all around at all times." In recent years Moore has done little direct carving. His models are enlarged in the spacious workshop by an assistant working in polystyrene and polyester. Then the piece, if it is to be in bronze, is flown to Berlin for casting; if in marble it is roughed out in Italy. But the finishing is always done by Moore himself, and he has often gone in winter to the mountains of Querceta, near Forte di Marmi, Italy, to explore the quarries for fresh marble, as Michelangelo did in Carrara over four centuries ago.

Moore recently completed a special arch construction for sheep to wander through in the large meadow behind his maquette studio. He still prefers to live and work in the country, because of "space, light, and distance."

Now that he is a great public figure, there are often groups of people, from Germany, Japan, or the United States, being given the "grand tour" of the grounds by assistants, with only a glimpse of Moore himself. But to those fortunate enough to spend time with him, he may show his small but choice art collection, which includes a large Degas drawing, a Vuillard painting, a small Mondrian, a bronze study by Rodin, several medieval pieces, and one work that gives him special pleasure—a Cézanne drawing after Rubens, a gift from friends on the sculptor's 70th birthday.

Herbert Read has written that Henry Moore's sculpture with its organic vitality has "forged a link in the chain of being." In addition to Moore's relationship to the great sculptural tradition, there has been a remarkable consistency of purpose in his life and work, despite much experimentation and stylistic variety. His aims have best been expressed by Moore himself, who has written eloquently about his art: "The whole of my development as a sculptor is an attempt to understand and realize more completely what form and shape are about, and to react to form in life, in the human figure, and in past sculpture. This is something that can't be learnt in a day, for sculpture is a never-ending discovery."

EXHIBITIONS INCLUDE: Warren Gal., London 1928; Leicester Gals., London 1931–60; Buchholz Gal., NYC 1943, '51; MOMA, NYC 1946–47; Venice Biennale 1948; Mus. Nat. d'Art Moderne, Paris 1949; Tate Gal., London 1951, '68; Kunsthalle, Basel 1955; Whitechapel Art Gal., London 1960; Marlborough Fine Art, London 1960–67; Kunstverein, Hamburg, W. Ger. 1960; Mus. Rodin, Paris 1961; Forte di Belvedere, Florence 1972; Mus. de l'Orangerie des Tuileries, Paris 1977. GROUP EXHIBITIONS INCLUDE: St. George's Gal., London 1926; International Surrealist Exhibition, London 1936; São Paulo Bienal 1953; Tokyo Biennale 1959.

COLLECTIONS INCLUDE: Tate Gal., Victoria and Albert Mus., Arts Council of Great Britian, and British Council, London; City Art Gal. and Mus., Leeds, England; City Art Gal., Manchester, England; Walker Art Gal., Liverpool; MOMA, and Solomon R. Guggenheim Mus., NYC; Mus. of Fine Arts, Boston; Fogg Mus., Cambridge, Mass.; Yale Univ. Art Gal., New Haven, Conn.; Albright-Knox Art Gal., Buffalo, N.Y.; Walker Art Center, Minneapolis; Mus. of Fine Arts, Santa Barbara, Calif.; Hirshhorn Mus. and Sculpture Garden, Washington, D.C.; Nat. Gal. of Canada, Ottawa; Gal. of Ontario, Toronto; Nat. Gal. of Victoria, Melbourne, Australia; Gal. des XX Jahrhunderts, Berlin; Pinakothek, Munich; Kunsthalle, Hamburg, W. Ger.; Kröller-Müller Mus., Otterlo, Neth.; Gemeente Mus., the Hague; Kunsthaus, Zürich; Tel Aviv Mus.; Billy Rose Sculpture Garden, Israel Mus., Jerusalem.

ABOUT: Cramer, G. Henry Moore, Catalogue of Graphic Work 1931–1972, 1973; Epstein, J. "Henry Moore" (cat.), Leicester Gals., London, 1931; Finn, D. Henry Moore: Sculpture and Environment, 1977; Grigson, G. Henry Moore, 1943; Grohmann, W. The Art of Henry Moore, 1960; Hedgecoe, J. and others Henry Moore, 1968; James, P. (ed.) Henry Moore on Sculpture, 2d ed. 1971; Marks, C. From the Sketchbooks of the Great Artists, 1972; Moore, H. Heads, Figures and Ideas, 1958; Neumann, E. The Archetypal World of Henry Moore, 1959; Read, H. Henry Moore, Sculptor, 1934, A Concise History of Modern Sculpture, 1964, Henry Moore, a Study of his Life and Work, 1965; Russell, J. Henry Moore, 2d ed. 1973; Sweeney, J. J. "Henry Moore" (cat.), MOMA, NYC, 1946; Sylvester, D. (ed.) Henry Moore, Sculpture and Drawings, vol. 1, 4th ed. 1957, vol. 2, 2d ed. 1965, vol. 3 1965. Periodicals—Apollo December 1930; Burlington Magazine (London) July 1948; Magazine of Art May 1951; L'Oeil (Paris) March 15, 1955; Partisan Review March–April 1947.

***MORANDI, GIORGIO** (July 20, 1890–June 18, 1964), Italian painter and etcher, who, despite his extremely limited subject matter—mostly variations on one theme, a single group of bottles and canisters on a table top—is accorded an important place in 20th-century Italian painting. The strange, reclusive Morandi spent almost his entire life in his native Bologna, constantly refining his methods and infusing his

°môr än´ dē, jôr´ jō

Courtesy of the Italian Cultural Institute of New York

GIORGIO MORANDI

humble still lifes with a metaphysical harmony and tranquility.

He was born in Bologna, the eldest of the eight children of Andrea and Maria (Maccaferri) Morandi. At the age of 16 he worked as a clerk in the exporting firm which employed his father, but in 1907 he enrolled at the Academy of Fine Arts, Bologna, where he studied for six years. However, his real art education came from the works he saw in museums and galleries. In 1909 he was deeply impressed by some reproductions of Cézanne paintings. Visiting the Venice Biennale in 1910, he saw 37 works by Renoir. He then went to Florence, where his greatest inspiration came from the paintings of Giotto, Masaccio, and Paolo Uccello. On a visit to Rome in 1911 he was particularly inspired by an exhibition of Claude Monet.

Morandi made his first engraving in 1912. A landscape painted in 1913, the year he completed his studies at the Bologna Academy, clearly shows the influence of Cézanne in its patchy, diagonal brushstrokes; its use of a curved road as an element in the composition recalls Cézanne's *Bend in the Road* painting of 1879–82. About this time Morandi saw works by Braque and Picasso, who, having taken Cézanne as their point of departure, were creating the cubist idiom. As Carter Ratcliff observed in *Saturday Review,* "Morandi flirted with Cubist devices, then quietly dropped them." In Florence, in 1914, he first saw paintings by the Futurists, the Italian answer to Braque and Picasso. Soon afterwards he met two of the leading Futurists, Umberto Boccioni and Carlo Carrà, at a Futurist soirée in Bologna. Also in 1914, Morandi painted several

still lifes in a cubo-futurist vein, and exhibited them at the Galleria Sprovieri, Rome. Later that year Morandi went to Assisi and Padua to study the frescoes of Giotto.

When Italy entered World War I in 1915, Morandi joined the Army, but fell ill and was discharged after six months. He convalesced in 1916 at Tole di Vergato, near Bologna, and resumed his painting. These works, hard-edge still lifes with very little modeling, show that he was moving towards greater clarity. He fell ill again in the winter of 1916, and after his recovery painted several still lifes of flowers in which the vase is placed centrally on a two-color background—a compositional formula to which he was to return sporadically throughout his career.

By 1918 Morandi had become marginally associated with the Scuola Metafisica of Giorgio de Chirico (whom he met in 1919) and Carrà. Their aim was, in de Chirico's words, "to see the enigma of things generally considered insignificant." Morandi was briefly influenced by their *pittura metafísica* while avoiding its more rhetorical aspects. De Chirico's influence is evident in *Still Life with Dummy* (1918), *Metaphysical Still Life* (1919), and other severe, hard-edged works using wooden mannequins and objects suspended in mid-air in a manner that anticipates the surreal imagery of Magritte. But after only two years Morandi discarded this artifice, adopting a more direct, meditative approach which was possibly influenced by the 28 Cézanne works he saw in the Venice Biennale of 1920. Morandi never felt the need to belong to a group; along with Cézanne and Chardin, the artist most akin to his withdrawn and contemplative spirit was the 15th-century Italian master Piero della Francesca.

By 1920 Morandi was working in solitude in a small studio in Bologna. In *Still Life in Black* (1920) he began to find his personal means of expression. The subject matter consists of a cluster of boxes, bottles, and pitchers, but the brushstroke has become more painterly. In the 1920s, in addition to still lifes, Morandi did a number of landscapes influenced by Cézanne, not in their brushwork, but in their fusion of architecture with landscape. Meanwhile he had become a master of the graphic medium, as displayed in his etchings of landscapes and still life. His first etchings, from 1912 to 1915, were in zinc, but from 1921 until 1933 he used both zinc and copper.

In 1914 Morandi had accepted a position teaching drawing and print making in the Bologna public schools. This activity was interrupted by the war years, but in 1920 he returned to teaching, which he continued to do until 1930.

His first works to be shown outside Italy were included in a group exhibition, "Das Junge Italien," held in Berlin and Hanover in 1921. The following year Morandi was briefly associated with the classically oriented "Gruppo Valori Plastici" who exhibited at the Florentine Primaverile, or Spring Exhibition. He was introduced in the catalog by de Chirico, who by then had become a completely classicizing painter. De Chirico asserted that Morandi "shared in that great lyricism, the metaphysics of the most ordinary objects." De Chirico continued: "In his old city of Bologna, Giorgio Morandi sings thus, in the Italian way, the song of the good artisans of Europe. He is poor, for the generosity of art lovers up to now has forgotten him."

Nevertheless, Morandi's work was receiving some recognition, and in 1926 he was invited by the critic Sarfatti to exhibit in the First Novecento Exhibition in Milan. He refused, though, to alter his painting to conform to the stilted, pseudoheroic neoclassicism advocated by Mussolini and fascist officialdom. Although he was no rebel, he remained very much his own man; even if his works exhibited in Milan did not bear the approved neoclassical stamp, his craftsmanship and his integrity could not be ignored. He was named Director of Primnary Schools for four small districts in the Reggio-Emilia and Moderna provinces for the 1926–27 school year, experiencing once again what de Chirico had described as "the dreary classrooms of a government school."

From 1927 to 1932 he spent his summers in Grizzana. He was giving great attention at this time to graphics, and in 1930 he was appointed professor of intaglio at the Academy of Fine Arts in Bologna, a post he held until 1958. Whereas his earlier still-life etchings had been, like his paintings, in the Chardin-Cézanne tradition (that is, arrangements of solid forms in space seen by a viewer), his still-life etchings and paintings from 1930 on have been described as "antiarrangements" in which, to quote one writer, "objects are lined up unceremoniously like so many shoes."

Morandi's etchings had won critical acclaim as early as 1918, and in the 1930s his fame as a printmaker was becoming international. But his paintings of the '30s remained largely unrecognized. As Morandi later wrote: "In the eyes of the Grand Inquisitors of Italian art, I remained but a provincial professor of etching at the Fine Arts Academy of Bologna."

From 1933 through 1938 Morandi spent his summers in Roffeno. His landscapes have the same spare forms and muted colors as his still lifes, but to some viewers they have much less individuality. But when not in Roffeno, he continued in the solitude of his Bologna studio to concentrate on refining his chosen motif of ceramic, china, and glass vessels, mostly bottles, assembled in the center of a table against a plain, neutral background. In his palette he favored clay whites and brownish tans, sometimes enlivened with touches of olive green, terra-cotta, or a grayish blue. The seeming repetitiousness of his use of bottles and jugs enabled him to emphasize shape and pattern, almost in the manner of an abstract artist, and to create subtle variations in color, form, and composition.

In 1935 critic Roberto Longhi, whose discussions of Caravaggio and other Renaissance artists had inspired Morandi in 1916, gave a lecture on Bolognese painting in which he surprised his audience by, at the very end, calling Morandi "one of the best living Italian painters." Here, for the first time in his career, Morandi was recognized as a modern artist, rather than as an anachronistic follower of 17th-century painting.In 1939 a small book on Morandi was written by Arnaldo Beccaría, who stressed the timeless, poetic qualities of Morandi's art and defined his objects as "personal alphabet" rather than as portraits of familiar household goods. Morandi was given his own room for an impressive retrospective of his work in 1939 at the Third Rome Quadriennale. The exhibition consisted of 53 paintings, watercolors, prints, and drawings. Some of the paintings were near-abstractions, and Giuseppe Marchiori, reviewing the exhibition in *Domus*, declared that Morandi's painting was "not an evocation of a dusty and forgotten domestic world," but the "plastic discovery of the object"; he went on to praise the paintings' "rigorous architectural and spatial unity." Later in 1939 Morandi went to the Valetta delle Lame in Grizzana, where he began spending long periods, including several winters, through 1944.

Although never politically active, Morandi had chafed under fascist aesthetics and the conservative, ultranationalistic mentality that had dominated Italian culture under Mussolini. However, as one writer has pointed out, such events of the late 1930s as "the Ethiopian war, the Rome-Berlin axis, and the shameful racial laws imposed in 1938 had made it possible for anti-Fascist opposition to express itself more openly." Morandi did respond in his art to the new optimism that was in the air, heightened during the war years by the defeat of the Fascists. Morandi's paintings from 1940–43 have greater freedom and assurance than his previous work, and some of his finest still lifes date from 1941. Although the basic elements are almost identical—three wine bottles, a small round dish, and a flowered vase—Morandi achieved

some remarkably subtle variations. A 1942 book on Morandi by Cesare Brandi noted the tendency towards abstract synthesis and compared his work to Cézanne and even to the abstractions of Kandinsky. These and other favorable judgments reflected the "cultural thaw" that was taking place in Italy in that critical period.

Although Morandi had participated in many group shows and had been given his own room at the Rome Quadriennale, he did not have a true solo exhibition until 1945, when his work was shown at the Galleria del Fiore, Florence. Three years later he was selected for membership in the Accademia di San Luca, Rome, and exhibited with Carrá and de Chirico at the Venice Biennale, where he was awarded the prize for an Italian painter by an international jury. Critics in America had been baffled when the relatively unknown Morandi was referred to by some Italian writers as their country's best painter, but his work's significance became clearer in 1949, when he was included in the "Twentieth Century Italian Art" exhibit at the Museum of Modern Art, New York City. In 1953 his prints were awarded the grand prize at the São Paulo Bienal, and in the last decade of his life he achieved the recognition that he felt to be his due, but which, with his solitary nature, he had never sought. He had his first New York City solo exhibition in 1955, at the Delius Gallery. The following year he retired from teaching and made his only trip outside Italy, visiting Winterthür, Switzerland, on the occasion of his exhibition at the Kunstmuseum. He also saw an exhibition of his beloved Cézanne at the Kunsthaus in Zürich.

Honors came to Morandi in his last years. In 1957 he received the grand prize for painting at the São Paulo Bienal, and he had his second and third New York City solo exhibitions in 1957 and 1960 at the World House Galleries. On the occasion of his 1962 solo show at Siegen, Westphalia, West Germany, he was awarded the Rubens prize (Siegen was Rubens's birthplace, but an artist more different from Rubens than Morandi is hard to imagine). Finally in 1963, his native city of Bologna conferred on him an ancient honor of its university, the Archiginnasio d'Oro.

Morandi's pictures of the late 1950s and '60s, especially his watercolors, reminded one French critic of the subtle, meditative paintings of the 13th-century Chinese artist of the Sung Dynasty, Mu Ch'i. In February 1964 Morandi painted his last picture, a study of flowers. After a serious illness he died in his home in the Via Fondazza, Bologna, at the age of almost 74.

Giorgio Morandi lived a celibate life in a house which he shared with his two unmarried sisters. The tall, lean artist was described by the critic Luigi Magnani: " . . . His face lean, skeptical, stern, but with a tuft of gray hair on his forehead which softened the ascetic expression on his face, [gives] him an appearance of gentleness and monklike innocence." Magnani noted, in the center of Morandi's studio (which also served as his bedroom) the easel "elevated like a small altar." On a table beside it was a "jumble of the most diverse objects" which the visitor recognized as "the *dramatis personae*, the humble players waiting to enter the scenes of his pictorial dramas."

A large-scale retrospective of Morandi's work was held at the Solomon R. Guggenheim Museum, New York City, in the winter of 1981–82; it had previously been shown at the San Francisco Museum of Modern Art, and later moved to the Des Moines Art Center, Iowa, which had organized the exhibition. It is doubtful whether the work of an artist such as Morandi is seen to best advantage "en masse." In the opinion of some visitors, a much smaller, carefully selected exhibition of those subtle and lyrical still lifes, which combined the artist's characteristic austerity with a sensuous feeling for paint, would have been preferable, avoiding an overall impression of monotony and of a frequent meagerness in the paint quality. However, in an article in *The New York Times* (November 15, 1981), a fellow painter, the West Coast artist Wayne Thiebaud, praised Morandi's work for its "rich array of evocative powers through such seemingly simple means," and commented on the artist's gnosticism, the religious movement "which searched for the substantial meaning in the world through inference." Carter Ratcliff was impressed by the "air of calm, relentless devotion" in the art of Morandi, whom he called "a painter of inanimate souls." Reproduced in the *Saturday Review* article was one of the artist's finest still lifes of 1943, with an alignment of objects treated in geometric, almost cubic forms, and painted in a somber but rich palette.

Morandi himself, with his natural reserve, was reluctant to talk abou this own painting. He once remarked, "My journey has been a slow one," and he lamented that "the young no longer know how to see." Magnani quoted him as saying, "You know, what is important and worthwhile in painting is the individual way of seeing things. Nothing else matters."

EXHIBITIONS INCLUDE: Rome Quadriennale 1939, '65; Gal. del Fiore, Florence 1945; Calcografia Nazionale, Rome 1948; Palais des Beaux-Arts, Brussels 1949; Gemeentemus., The Hague 1954; New Burlington Gal., London 1954; Delius Gal. NYC 1955; Kunstmus., Winterthür, Switzerland 1956; World House Gals.,

NYC 1957, '60; Haus Seel am Markt, Siegen, W. Ger. 1962; Kestner-Gesellschaft, Hanover, W. Ger. 1964; Scottish Gal. of Modern Art, Edinburgh 1965; Kunsthalle, Bern 1965; Venice Biennale 1966; Nazionale d'Arte Moderna, Rome 1966, '73; Nat. Gal., Copenhagen 1968; Nasjonalgal., Oslo 1968; Royal Academy of Arts, London 1970; Stedelijk Mus., Amsterdam 1972; Gal. d'Art Moderna, Bologna, Italy 1975; San Francisco Mus. of Modern Art 1981; Solomon R. Guggenheim Mus., NYC 1981–82; Des Moines Art Center, Iowa 1982. GROUP EXHIBITIONS INCLUDE: "Prima Espiosizione Libera Futurista," Gal. Sprovieri, Rome 1914; "Das Junge Italien," Nat. Gal. of Art, Berlin 1921; "Gruppo Valori Plastici," Primaverile Fiorentina, Florence 1922; "Prima Mostra Novecento," Milan 1926; Venice Biennale 1928, '48; Rome Quadriennale 1931; "Ancient and Modern Italian Art," Jeu de Paume, Paris 1935; "Modern Italian Art," Kunsthalle, Bern 1938; "Exhibition of Italian Art," Kunsthaus, Zürich 1940; "Twentieth Century Italian Art," MOMA, NYC 1949; "Twentieth Century Italian Art," Mus. Nat. d'Art Moderne, Paris 1950; "Modern Italian Art," Tate Gal., London 1950; São Paulo Bienal 1953, '57; "Manzù, Morandi," Kunstverein, Winterthür, Switzerland 1956; "Twentieth Century Italian Art from American Collections," Palazzo Reale, Milan 1960; "Grand Prize-Winners from the Biennale 1948–1960," Ca' Pesaro, Venice ca. 1961.

COLLECTIONS INCLUDE: Gal. d'Arte Moderna, and Mus. Civico, Turin, Italy; Mus. Nat. d'Art Moderne, Paris; Birmingham City Art Gal., England; Scottish Gal. of Modern Art, Edinburgh; Stedelijk Mus., Amsterdam; Gemeentemus., The Hague; Kunstmus., Winterthür, Switzerland; Nationalgal., Berlin; Kunsammlung, Düsseldorf; Hermitage, Leningrad; MOMA, NYC.

ABOUT: Cheney, S. The Story of Modern Art, 2d ed. 1958; Forge, A. (ed.) "Giorgio Morandi" (cat.), Royal Academy of Arts, London, 1970; Gnudi, C. Giorgio Morandi, 1946; "Gruppo Valori Plastici" (cat.), Primaverile Fiorentina, Florence, 1922; Magnani, L. and others "Giorgio Morandi" (cat.), Des Moines Art Center, Iowa, 1981; "Giorgio Morandi (1890–1964)" (cat.), Gal. Nazionale d'Arte Moderna, Rome, 1973; Vitale, L. Giorgio Morandi Pittore, 3d ed. 1970. Periodicals—L'Ambrosiana (Milan) February 1935; Art News February 1955; Arts Magazine December 1960; Il Bargello (Florence) March 1939 Domus (Milan) February 1939; Horizon July 1949; New York Times November 15, 1981; Réalités (Paris) September 1971; Saturday Review November 1981.

MORLEY, MALCOLM (1931–), British painter, is one of the most interesting artists of his generation. In the early 1980s Morley was recognized as a pioneer who had done photorealist painting well before that style became popular, and then moved on to more convulsive work which anticipated neoexpressionism.

Morley was born in London and studied art there at the Camberwell School of Arts and

MALCOLM MORLEY

Crafts (1952–53) and at the Royal College of Art (1954–57). (Before enrolling at Camberwell, Morley had been something of a juvenile delinquent and, as a teenager, had done time in a London jail; it was there that he began to think about a career in art.) At the age of 27 he moved to New York City, which he has described as "a psychic battleground . . . a place where you can work your head out [sic]." He was married briefly to an American—whom he had met on a bus—and lived first in Brooklyn, supporting himself by clerking in a bookstore and working as a waiter. It was while working one evening in a restaurant that he introduced himself to a diner who turned out to be Barnett Newman, a leader of the New York School and a painter Morley came to regard as his real teacher.

Morley himself has been active as a teacher in the United States—at Ohio State University (1965–66), the School of Visual Arts, New York City (1967–69), and the State University of New York at Stony Brook, Long Island. Still resident in New York, he lives by himself in SoHo, somewhat apart now from the more purely social aspects of the city art world. Indeed, Morley is critical of the current New York art scene. "I'd rather be the child of something," he said in 1984. "I'd rather be the child of Cézanne. The New York art world is betraying Cézanne. Cézanne, Manet, Velázquez—I think about them all the time in my studio, but I could never talk about it in a SoHo bar. There is an extraordinary ignorance about art among artists, much more than when I first came here." Morley also maintains a studio on Long Island, in the Hamptons, and of late has been traveling widely.

Morley, extremely articulate about his methods and intentions, works with great ease and much energy. "Painting, having the real power of the brush in your hand, is a strong physical process. The painting is a body of myself," he declared. Intensely alive to the physical and intellectual world about him, Morley directs upon this world a forthright, blue-eyed gaze under a high, domed forehead framed by tufts of white hair and beard.

Morley's earliest work was abstract, but in the mid-1960s he began to work out the first of his idiosyncratic styles, his own variant of super realism, or photo-realism. The paintings of this decade, hand-painted enlargements of photographs or other types of color reproductions, are not representations of an actual reality, however; they are facsimiles of reality, statements about the art of painting itself, and perhaps an ironic commentary on modern banal commercial images. His procedure involved subdividing the surface of his canvas into penciled squares and drawing a grid similarly over the chosen original. This grid was then cut up, and square by square—with the use of a magnifying glass to enlarge the small segments—copied onto his canvas, which was sometimes inverted, sometimes turned sideways as he worked. Paradoxically, an intensely "realistic" painting was thus achieved in an abstract, arbitrary manner. The juxtapositions of brilliant colors, thickly applied in high-gloss Liquetex acrylic paint, were supposed to be fused by the viewer's eye, just as the four-color printing process produced the tones of the original reproduction. In Morley's large-scale paintings, the image is framed within an expanse of unpainted or flatly colored canvas, to heighten the effect of the illusion of reality.

By means of this process Morley produced reworkings of ads, travel brochures, photographs, and posters—notably posters of ocean liners. *United States with New York Skyline* (1965) and *SS Amsterdam in Front of Rotterdam* (1966) are among the paintings for which he became known. According to William Zimmer of *The New York Times* (February 12, 1984), ships are for Morley "a metaphor, a potent one on the order of Citizen Kane's sled. During a World War II bombing raid on London, Morley and his parents had to flee their home, leaving behind a model ship Malcolm had just built and intended to paint the next day. "Maybe if I had gotten to paint that ship I would have been satisfied and [never] have become an artist," Morley muses, adding, "I am fond of saying this to German collectors." *Vermeer's Portrait of the Artist in His Studio* (1968) is another photo-realist work based on a color reproduction of this famous

masterpiece, while *Beach Scene,* also of 1968, reproduces a slick color snapshot of a "typical" American family on a Florida beach, with all their holiday-making paraphernalia. The satiric effect is undoubtedly intended.

In the 1970s, however, Morley began to modify and then abandon this style, which he himself labeled a "Dada gesture . . . not literal in the American sense of literalism." He now adopted a personal imagery mainly having to do with disaster and technological destruction. *Age of Catastrophe* (1976) and *The Ultimate Anxiety* (1978) are complex interweavings of images of crashing, colliding trains and planes; and in the latter work a modern train smashes down into an 18th-century Venetian scene—Morley's photo-realist reworking of a painting by Francesco Guardi. Morley's paintings of these years, with their narrative content, portentous imagery, and strong physicality looked forward to neoexpressionism. Morley's influence was acknowledged in 1982, when he was included in the influential "Zeitgeist" show, an international art exhibition held in 1982 in West Berlin near the wall dividing East and West. "Zeitgeist" documented a change in artistic taste (an angst-ridden embrace of the mystical, the poetic, and the erotic) and a return to expressionistic figuration which broke radically with the dominant styles of the 1960s and '70s, rejecting the "coolness" of pop and the stately formalism of minimalism and color-field painting.

Recent trips to England, Germany, and throughout the United States have enriched the content of Morley's works. *Landscape with Bullocks* (1981), one of a series of lyric landscapes figured with animals, recalls the English countryside; another series, of beach scenes, done at the same time, enlivens the usual banal repertoire of bathers-umbrellas-sailboats with unexpected bizarre touches. These works were done not in acrylics but in oils, with paint dripped onto the canvas or laid on in heavy impasto, resulting in exuberantly tactile surfaces. In contrast, a beach scene of the following year, *The Cradle of Civilization with American Woman,* makes shattering allusions to the imminent destruction of humanity. (This, in fact, seems to be the overwhelming concern of Morley's current works, as rich in composition as they are complex in imagery and associations.) Here, a nude woman, features obliterated, lies on a Mediterranean beach, seeking annihilation in sensuous union with the sun; vague figures of other bathers fill out the scene. References to classical sculpture include a veiled priapic figurine, symbol of blind desire; a horse and a helmet allude to the Trojan Horse, an age-old image of destruction. Another 1982 painting with drama

supplied by the very density of its imagery is *Alexander Greeting A.B. Seaman Ulysses M.A. Evans, Jr., at the Foot of the Collossus of Peanigh.* Both works were inspired by Morley's trip to Greece in the summer of that year. Both are the visionary paintings he believes to be the outcome of a lengthy course of psychoanalysis. He describes them as "psychodrama in painting form," and has said, "I'm after making pictures that contain a combination of images that have the power to brand, in the way that a branding iron sears."

These paintings of the '80s are based on watercolor studies, but Morley also does independent watercolor paintings which may or may not be developed into oils in the future. Among the latter is *Macaws, Bengals, with Mullet,* striking in its three-tiered composition: parrots in a jungle, tigers against a plain background, fish, below, in the sea, and vividly harmonious in its tones of blue, green, and yellow capped by the intense red of the macaw at the top. Morley's prints and drawings also reveal, in their strong calligraphic style, the artist's all-round technical proficiency.

In an article in *Art News* (March 1983), Michael R. Klein discussed Morley's attempts to "revise and revivify" the high tradition of Western painting. Klein writes: "Much like the composer Arnold Schoenberg—his 12-tone scale was a revolution for modern music, albeit a revolution built on the foundations of tradition— Morley's compilations of imagery are seeking to change our modes of visual expression."

As to what lies ahead for him, perhaps his own comment on his most recent work is indicative. "Each of the paintings is a revelation because I don't know until I begin what it implies. I get more of an implication as I go along. . . . I don't paint from faith or belief, only evidence."

EXHIBITIONS INCLUDE: Kornblee Gal., NYC 1957, '64, '67, '69; Xavier Fourcade Inc., NYC 1981, '82; "Malcolm Morley: Paintings 1965–82," Whitechapel Art Gal., London 1983 (retrospective exhibition, toured Europe and the United States [Brooklyn Mus. of Art] in 1983–84); "Malcolm Morley: New Paintings and Watercolors," Xavier Fourcade Inc., NYC 1984. GROUP EXHIBITIONS INCLUDE: "London Group," London 1955; "The Photographic Image," Solomon R. Guggenheim Mus., NYC 1967; "Aspects of a New Realism," Milwaukee Art Center 1969; "22 Realists," Whitney Mus. of Am. Art, NYC 1970; "Radical Realism," Mus. of Contemporary Art, Chicago 1971; "Sharp-Focus Realism," Sidney Janis Gal., NYC 1972; Documenta 5, Kassel, W. Ger. 1973; "One Major Work Each," Xavier Fourcade Inc., NYC 1980; "A New Spirit in Painting," Royal Academy of Arts, London 1981; "Zeitgeist," Martin-Gropius-Bau, Berlin 1982.

COLLECTIONS INCLUDE: Neue Gal., Aachen, W. Ger.; Wallraf-Richartz Mus., Cologne; Kornblee Gal., and Xavier Fourcade Inc., NYC.

ABOUT: Battcock, G. (ed.), Super Realism: A Critical Anthology, 1975; Compton, M. "Malcolm Morley: Paintings 1965–82" (cat.), Whitechapel Art Gal., London, 1983; Current Biography, 1984; Meisel, L.K. Photorealism, 1980. *Periodicals*—Art in America November 1972, December 1982; Art News March 1983; Arts Magazine May 1983; New York Times February 12, 1984, April 13, 1984.

MORRIS, GEORGE L(OVETT) K(INGSLAND) (1905–1975), American painter, sculptor, and critic, was one of the founders of the American Abstract Artists (AAA), the foremost pre–World War II American group promoting postcubist geometrical abstraction. He was an articulate spokesman for abstraction when the majority of American artists practiced either social realism or regional scene painting.

Morris was born in New York City. A graduate of the Groton Academy and the Yale School of Art (1928), he received his most important early training from John Sloan and Kenneth Hays Miller at the Art Students League. Morris was greatly influenced by his meeting with the collector A. E. Gallatin, who had acquired works by Paul Cézanne, Pablo Picasso, Juan Grís, Fernand Léger, and other School of Paris moderns. Gallatin had installed his collection in a large hall at New York University, calling this display "The Museum of Living Art." While Morris was in Paris (about 1930) studying at the Académie Moderne with Léger and Amédée Ozenfant, Gallatin took him to the studios of Picasso, Jean Arp, Piet Mondrian, Sonia and Robert Delaunay, and others.

By 1935 Morris had developed his own cubist idiom, as can be seen in *Stockbridge Church* (1935). Some artists have compared Morris's early works to those of Grís, but Morris's have a distinctly American flavor. The wallpaper collaged into *Apparition* (1936), for example, is of an entirely American pattern that no European artist would have used; similarly, in his *Indian Compositions* (1939), Morris used real birch bark.

The artist's first solo show was held in 1933, shortly after his return to the US at the Curt Valentin Gallery, New York City. Three years later, he helped found the American Abstract Artists, which, taking its cue from the writings of Mondrian, espoused geometrical abstraction as one way to achieve a purified aesthetic and ethical environment. Among its members were Burgoyne Diller, Ilya Bolotowsky, Harry Holtzman, Josef Albers, and, eventually, Mondrian

G.L.K. MORRIS

himself. Morris, who had been an early and frequent contributor to the fledgling *Partisan Review*, was made chairman of the AAA's publication committee, and edited several books on American abstraction, including *American Abstract Artists* (1946) and *The World of Abstract Art* (1957). His own writing style was notable for its clarity and concision.

Unlike Fritz Glarner, Bolotowsky, and other AAA members committed to neoplasticism, Morris would oscillate in his painting from complete nonrepresentation to the use of figurative elements within an abstract setting—closer to a cubist approach. "I disagree with my confrères who regard my return to naturalism as an apostasy," he wrote; "no artist can do more than to follow his personal instinct. I myself occasionally make use of representational symbols—and for no better reason than that I enjoy doing so." In *R.S.V.P.* (1946), for example, a floating string of pearls suddenly shows the geometric background to be a woman's figure; *Arizona Altar* (1949) contains all the expected symbols—cross, candles, curtains—seen from a variety of views. But these were only occasional deviations from what was, at bottom, Morris's firm commitment to geometrical abstraction—the kind of art he most often championed in his writing. Morris simply could not adhere to the kind of dogmatism Mondrian's search for formal purity inspired in his more slavish followers.

Pictorial space became Morris's overriding concern after 1950. He had previously limited himself, like many geometrical abstractionists, to a flat space consonant with the canvas surface. In *Unequal Forces* (1948) he took his first steps

away from this approach. In this painting, irregular, flattened polygons cast shadows on a flat plane behind them like geometrical clouds over a landscape. Morris then realized, as he recounted in the catalog to his 1971 retrospective at New York City's Hirschl and Adler Galleries, that "every spot can appear as though sustained in two places at once. There is its position on the picture surface, and at the same time its role in the perspective scheme. Inevitably such a dual placement arouses a pulsation; here new possibilities are offered, and these in turn require subjection."

Often Morris used a multicolored checkerboard pattern to create complex and ambiguous spatial movements, as in *Recessional* (1950), which has almost an op art feeling in its vertiginous oscillations. As in his earlier work, the artist sometimes used recognizable forms. Architectural and interior furnishings lent themselves particularly well to this treatment. In *Santo Spirito #3* (1961–65), Morris incorporated within a geometrical framework the arcades, pillars, doorways, statuary, and tiling of a Florentine church. Similar elements rotate in a funicular swirl in *Elegy on the Pennsylvania Station* (ca. 1964). In other paintings Morris was simply inspired by New York's energy, color, and movement, with no representational aim (*Times Square, P.M.*, 1970–71).

Throughout his career Morris turned to sculpture as a relief from purely pictorial problems, relishing "the slower tempo of its execution and diminished concern with accidentals." His sculpture, in bronze or marble, owes something to the compositional vigor of the Futurists and Cubists (*Configuration*, 1936), and the sensuous polish of Jean Arp (*Marble Concretion*, 1942). *Encircled Space* (1949–50), in beautifully finished bronze, demonstrates that Morris had the talent, if not the interest, to become a potent force in American sculpture.

George L.K. Morris was married to Estelle Frelinghuysen and lived mostly in New York City. He had no single approach to art and enjoyed experimentation. On the other hand he paid little attention to current trends, and for this reason, his later work is relatively little known. As Donelson Hoopes wrote in the catalog to the 1965 Morris exhibition at the Corcoran Gallery, Washington, D.C.: "While Cubism undoubtedly provided him with a definite grammar, the vocabulary and style have been distinctly Morris," and his themes "hauntingly, romantically American in flavor." Morris himself wrote in 1970: "I've never been one to pursue a single formal goal throughout the years. For me there is emotional release to be derived

from a tactical reversal." Dore Ashton described Morris as "one of those aristocratic American rebels who enjoys making the good fight." In 1983 William Phillips, editor of *Partisan Review*, remembered Morris as "a very decent and charming man [who] wrote with great insight and understanding about modern art. . . . I think he has to be ranked as one of the interesting and consequential figures in the development of American abstract art."

In his written critism and public debates Morris could display a "cheerful asperity" in attacking provincialism on the one hand and an overly doctrinaire modernism on the other. Ashton pointed out that Morris "always saw conflict as endemic to life." "Whenever a shape or line is entered on a picture surface," Morris said, "a conflict is instigated, and it is the artist's method of pacification which impels expression."

EXHIBITIONS INCLUDE: Valentin Gal., NYC 1933; Berkshire Mus., Pittsfield, Mass. 1933, '66; Mus. of Living Art, NYC 1935; Passedoit Gal., NYC 1937; Downtown Gal., NYC 1944, '45, '48, '51, '64, '66; Alan Gal., NYC 1955, '58, '61; Inst. of Contemporary Art, Washington, D.C. 1958; Corcoran Gal., Washington, D.C. 1965; Montclair Art Mus., N.J. 1971; Hirschl and Adler Gals., NYC 1971, '74. GROUP EXHIBITIONS INCLUDE: American Abstract Artists exhibitions from 1936; "Abstract Painting and Sculpture in America," MOMA, NYC 1951.

COLLECTIONS INCLUDE: Metropolitan Mus. of Art, and Whitney Mus. of Am. Art, NYC; Munson-Williams-Proctor Inst., Utica, N.Y.; Yale Univ. Art Gal., New Haven, Conn.; Berkshire Mus., Pittsfield, Mass.; Philadelphia Mus. of Art; Pennsylvania Academy, Philadelphia; Corcoran Gal., Phillips Collection, and Nat. Collection of Fine Arts, Washington, D.C.; North Carolina Mus. of Art, Raleigh; Dallas Mus. of Fine Art; Portland Mus., Oreg.; Honolulu Academy of Fine Arts; Hessisches Landesmus., Darmstadt, W. Ger.; Mus. of Tel Aviv.

ABOUT: Ashton, D. The New York School: A Cultural Reckoning, 1973; Cheney, S. The Story of Modern Art, 1958; Hoopes, D. "George K.L. Morris" (cat.), Corcoran Gal., Washington D.C., 1965; "George L.K. Morris: A Retrospective Exhibition" (cat.), Hirschl and Adler Gal., NYC, 1971; "George L.K. Morris: Abstract Art of the 1930s" (cat.), Hirschl and Adler Gals., NYC, 1974; Ritchie, A. C. Abstract Painting and Sculpture in America, 1951; Rose, B. American Art Since 1900, 2d ed. 1975. *Periodicals*—Art in America January 1976.

MORRIS, ROBERT (February 9, 1931–), American sculptor, is a Minimalist and, more recently, creator of earthworks who in his best-known works attempts to make three-

ROBERT MORRIS

dimensional forms free of every attribute and association save the basic physical necessities of shape, weight, mass, and space. A versatile, mercurial artist with a background in improvisational theater, Morris regards the objects he creates as part of a "situation," which, by definition, includes the beholder. One always feels prodded, sometimes kidded, by his work, which, buttressed by the artist's own important critical articles and statements, was particularly influential through the 1960s and early 1970s.

Robert Morris was born in Kansas City, Missouri. Between 1948 and 1950 he studied engineering at the University of Kansas City, and art at the Kansas City Art Institute. In 1951 he was a student at the California School of Fine Arts. He interrupted his studies in 1951–52 to serve with the US Army Engineers in Arizona and Korea. After his discharge, in 1953 he enrolled at Reed College, Oregon, remaining until 1955. That year he moved to San Francisco, where he painted and explored film and improvisatory theater. His first solo show of paintings, in an abstract-expressionist idiom, was held at the Dilexi Gallery, San Francisco, in 1957; he had a second exhibit at that gallery the following year.

It was only after moving to New York City in 1961 that Morris turned to sculpture. He abandoned painting because of the discrepancy he felt between the creative process and the final product, the latter never quite fulfilling the impulsiveness and promise of the former. His earliest sculpture, *Passageway* (1961), was an "environment," a tapering tunnel of gray plywood that viewers entered through the door of the artist's studio. This was followed by *Box with*

the Sound of Its Own Making, a nine-inch walnut cube containing a three-hour tape recording of the artist sawing and polishing the components of the box. For Morris the cube shape was a perfect example of closed, complete, and timeless form, yet the tape implied that the process of its making was continuous. *Column* (1961), in painted plywood, with its deadpan, anonymous surface, contained essential elements of the minimalist aesthetic. He employed mixed media in a neodada vein in *Plus and Minus Box* of 1961, later acquired by the well-known collectors Mr. and Mrs. Robert C. Scull.

In 1962–63 Morris took courses in art history at Hunter College in New York City for a master's degree; his dissertation was on Brancusi. He held his first New York City solo show in October 1963 at Richard Bellamy's Green Gallery. The exhibit included *Wheels,* in wood and metal, one of several pieces derived from the ideas of Marcel Duchamp and Jasper Johns, but which, to quote David Sylvester, "are less enigmatic and more abundant" than the work of those artists. Morris has always been interested in creating works that engaged the mind more than the body, and that employed a variety of media to pose problems rather than to present answers. He explored the relationship between the artist's ego and his work, and between the voyeuristic public and the artist, in *I-Box,* a mixed media work of 1962; its door, in the shape of a capital "I," opens to reveal a full-length nude photograph of Morris. In 1964, he showed two pieces made of lead at the Galerie Schmela, Düsseldorf, performed in an evening of speech and dance at the Kunstakademie with Yvonne Rainer, and signed a "statement of artistic withdrawal," in an attempt to cleanse his art of preconceived aesthetic ideas. He claimed that one way of demystifying art was to incorporate real objects—light bulbs, electrical parts, springs and so forth—into his work, as in *Metered Bulb* (1963), a self-described mixed-media work intended as a visual metaphor for the measurement of time and energy. Even more ambiguous was *Swift Night Ruler* (1963), an H.C. Westermannlike box on which a 12-inch ruler and the title appear.

Several of Morris's sculptures were shown in January 1963 at the Wadsworth Atheneum, Hartford, Connecticut, in a group exhibit titled "Black, White, and Gray." The Morris works on view were *Column* (1961), *Untitled* (1962) in plywood painted gray, and *Slab* (1962), also in plywood. (A later version of *Slab,* in aluminum, was constructed in 1968.) In December 1964 Morris showed seven large plywood pieces at the Green Gallery—one of them, the triangular *Corner Piece* in the now-customary gray ply-

wood, measured 78 inches by 108 inches. In January and February 1965 he put on the second part of his Green Gallery show, consisting mostly of lead reliefs—a medium he abandoned soon afterwards.

Between 1963 and 1965 Morris composed five dance pieces, including *2´3˝,* a miming of taped excerpts from Erwin Panofsky's *Studies in Iconology,* and *Site,* in which he wore a rubber mask of his own face made by Jasper Johns and moved various materials to reveal the performance artist Carolee Schneeman, in the pose of Manet's *Olympia,* reclining against a white board. In *Waterman Switch* Morris and Yvonne Rainer, nude and pressed together face to face, moved back and forth along wooden tracks. Dance works by Morris were also performed in New York City, Ann Arbor, Michigan, and Stockholm. At this time Morris, who hitherto had been classified by critics as a Pop and mixed-media artist, began to be grouped with other Minimalist sculptors such as Don Judd, Carl Andre, and Tony Smith.

In February 1966 Morris published the first of a series of articles on sculpture in *Artforum* magazine. These remain the most important sources on his ideas. In the first article Morris advocated "the simpler forms which create strong gestalt sensations," adding "in terms of solids, or forms applicable to sculpture, these gestalts are the simpler polyhedrons." In April 1966 he presented the second large showing of his gray polyhedrons at the Dwan Gallery, Los Angeles. These pieces were in fiberglass, and two of them incorporated fluorescent light. Also in 1966 Morris devised his first earth and soil project, another illustration of his concern with an art of process.

Morris showed in March 1967 what he called "permutation pieces," art to be rearranged every few days, at the Leo Castelli Gallery, New York City. He was one of the first American artists to be influenced by the work of the German Joseph Beuys, whose use of fat, rope, and other nonaesthetic materials is related both to what the French call *"art pauvre,"* and to the concept of "antiform." In the summer of 1967, in Aspen, Colorado, Morris began to make sculptures in cut felt. These, the first of his "soft" sculptures since his rope pieces of the early '60s, involved, to quote his article in *Artforum* (April 1968), "random piling, loose stacking, hanging, giving passing form to the material." Morris also continued to experiment with film and other media. He had his first solo museum show in Eindhoven, Holland in 1968. Morris's earthworks of 1968, related in some respects to his "antiform" felt sculptures, were random conglomerations of earth, felt, metal, grease, and other materials. As

Morris put it, they were "clearly marked off from the rest of the environment and there [was] not any confusion about where the work stops. In this sense [the work] is discrete, but not object-like." Again stressing process over static form, Morris devised works that changed or destroyed themselves. In 1968 and 1969 he created an outdoor project in which steam, escaping from valves in the ground, condensed and evaporated at rates varying with the external temperature, humidity, wind velocity, and other factors.

Early in 1969 Morris concentrated on other such process pieces. His "Anti-form" show at the Leo Castelli Gallery was similar to a project photographed in the Castelli warehouse titled *Continuous Project Altered Daily*. In one of his outdoor works, *Pace and Progress*, carried out in September 1969 in Edmonton, Canada, Morris rode a series of ponies back and forth between two points in a field, wearing down the grass in the area traversed and replacing each pony as it tired. A photographic record was produced by nine cameras placed at intervals along the path. The piece was eventually terminated by the stable owner, who stopped the operation when he noticed the adverse effect on his horses.

Morris in 1969 became the co-chairman of the New York-based Art Strike Committee and helped to organize the Peripatetic Artists Guild, described by Adrian Henri as "a means of bypassing the gallery situation by hiring the artist out at an hourly rate, like a workman." In 1969–70 Morris had a series of solo shows, at the Corcoran Gallery of Art in Washington, D.C., the Institute of Arts, Detroit, and the Whitney Museum of American Art, New York City. The Whitney show was closed at the artist's insistence in protest against the American invasion of Cambodia in the spring of 1970.

For his exhibition at the Tate Gallery, London, in 1971, Morris created an environment in which ramps, giant cylinders, and climbing frames provided, in Adrian Henri's words, "a kinetic playground for the participants." In the 1970s Morris turned increasingly to monumental sculpture. *Labyrinth* (1974), a plywood and masonite maze, was intended as a fusion of mental and physical involvement. *Observatory*, a huge outdoor project begun in 1971 and completed in 1977 in the Netherlands, alludes to the giant Neolithic henges in its deliberate orientation to the solstices and equinoxes. It has been pointed out that Morris's only historical references are to the anonymous past. A complex of boulders exhibited at Documenta 6, Kassel, West Germany, in 1977 recalls the menhirs of Avebury and Carnac. One of Morris's projects was included in 1979 in a group of land reclamation proposals, in which works by Robert Smithson, Beverly Pepper, and others were also shown.

Robert Morris, who lives and works in Manhattan, is a slender, intense man, bearded at the time of his Tate Gallery exhibit in 1971, but now clean-shaven. He is articulate, both orally and in his writing, which tends to be highly theoretical. The size, starkness, and opacity of his minimalist sculptures are intended to remind viewers that they are encountering real objects in an unadulterated present tense. Morris has said: "Simplicity of shape does not necessarily equate with simplicity of experience." The artist feels that his works in all media should not be analyzed (although he himself has provided their most adroit analyses), but experienced. In his words, "The particular concrete situation in a given time. That's where the fascination is."

EXHIBITIONS INCLUDE: Dilexi Gal., San Francisco 1957, '58; Green Gal., NYC 1963, '64, '65; Gal. Schmela, Düsseldorf 1964; Dwan Gal., Los Angeles 1966; Leo Castelli Gal., NYC from 1967; Gal. Ileana Sonnabend, Paris 1968; Stedelijk van Abbemus., Eindhoven, Neth. 1968; Gal. Enzo Sperone, Turin, Italy 1969; Irving Blum Gal., Los Angeles 1969; "Robert Morris," Corcoran Gal. of Art, Washington, D.C. 1969–70; "Robert Morris," Inst. of Arts, Detroit 1969–70; Whitney Mus. of Am. Art, NYC 1970; "Robert Morris," Tate Gal., London 1971; Inst. of Contemporary Art, Philadelphia 1974; GROUP EXHIBITIONS INCLUDE: "The Hard Center," Thibaud Gal., NYC 1963; "For Eyes and Ears," Cordier and Ekstrom, Inc., NYC 1963; "Black, White, and Gray," Wadsworth Atheneum, Hartford, Conn. 1963; "Mixed Media and Pop Art," Albright-Knox Art Gal., Buffalo, N.Y. 1963; "Flavin, Judd, Morris, Williams," Green Gal., NYC 1965; American Exhibition, Whitney Mus. of Am. Art, NYC 1966; "Primary Structures," Jewish Mus., NYC 1966; Intl. Inst. Torcuato de Tella, Beunos Aires 1967; Fifth Guggenheim International Exhibition, Solomon R. Guggenheim Mus., NYC 1967; "Kompas III," Stedelijk van Abbemus., Eindhoven, Neth. 1967; "Minimal Art," Gemeente Mus., Den Haag, Neth. 1968; "Plus by Minus: Today's Half-Century," Albright-Knox Art Gal., Buffalo, N.Y. 1968; "Art of the Real: USA 1948–1968," MOMA, NYC 1968; "Five Sculptors; Andre, Flavin, Judd, Morris, Serra," Univ. of California at Irvine 1969–70; "New York Painting and Sculpture: 1940–1970," Metropolitan Mus. of Art, NYC 1969–70; "Art in Process IV," Finch Col. Mus. of Art, N.Y. 1969–70; Annual, Whitney Mus. of Am. Art, NYC 1970; Documenta 6, Kassel, W. Ger. 1977; Venice Biennale 1980.

COLLECTIONS INCLUDE: MOMA, NYC; County Mus. of Art, Los Angeles; Tate Gal., London; Stedelijk van Abbemus., Eindhoven, Neth.; Kaiser Wilhelm Mus., Krefeld, W. Ger.; Nat. Gal. of Victoria, Melbourne, Australia.

ABOUT: Bénézit, E. (ed.) Dictionnaire des peintres,

sculpteurs et graveurs, 1976; Delahanty, S. and others "Robert Morris: Projects" (cat.), Inst. of Contemporary Art, Philadelphia, 1974; Goosen, E.C. "Art of the Real: USA 1948–1968" (cat.), MOMA, NYC, 1968; Henri, A. Environments and Happenings, 1974; Restany, P. L'Avant-garde au XXe siècle, 1966; Rose, B. American Art Since 1900, 2d ed. 1975; Sylvester, D. and others "Robert Morris" (cat.), Tate Gal., London, 1971; Tucker, M. Robert Morris, 1970. *Periodicals*—Art in America October 1979; Art News April 1965, December 1983; Artforum February 1966, October 1966, June 1967, April 1968, April 1969, April 1970, February 1973, October 1979; Arts Magazine March 1964, May 1968, November 1968.

GRANDMA MOSES

MOSES, GRANDMA (September 7, 1860–December 13, 1961), American painter, is the most widely known of American primitives in both the United States and Europe. To devotees of Americana and those who find the more complex and challenging forms of art in this century unsettling, the naive, decorative paintings of Grandma Moses and her phenomenal success have been reassuring.

Born and raised in the Washington County town of Greenwich, New York, Anna Mary Robertson stopped attending the rural one-room schoolhouse at the age of 12, when she started to work on neighboring farms. In 1887, she married Thomas Salmon Moses, a fellow farm worker, and moved with him to Virginia, where they farmed until 1905, when they purchased a dairy farm in Eagle Bridge, New York. During the years in Virginia, ten children were born to Anna Mary and Thomas Moses, but five of them died in infancy. Four years after she returned to New York State, Anna Mary's mother and father died.

Grandma Moses painted her first large picture in 1918 on the fireboard in her parlor; this work was followed about two years later by painted landscapes on the panels of her "tip-up" table, which eventually became her easel. In the next few years she also painted occasional pictures for relatives and friends.

After her husband died in 1927, Grandma Moses lived with her daughter in Bennington, Vermont, where she started making embroidered pictures from worsted yarn. When her daughter Anna died in 1932, Grandma Moses cared for the two motherless children until she returned to her own home in Eagle Bridge in 1935.

In her 70s Moses substituted painting for embroidery, finding painting to be "easier than embroidery" after she developed arthritis and neuritis. She knew practically nothing about art, least of all modern art, and her first paintings were copies of Currier and Ives prints and of postcards, which generally lack the vitality of her work after 1938. It was then that she began to compose original works, based on her early memories of life on the farm. She exhibited her pictures, along with her preserves, at county fairs.

In 1938 a group of her paintings, displayed in the window of Thomas's Drugstore in Hoosick Falls, New York, were noticed by the New York art collector Louis J. Caldor. After many efforts to get her work exhibited, Caldor succeeded in having three Grandma Moses paintings included in a show called "Contemporary Unknown American Painters" at the Museum of Modern Art, New York City, in the fall of 1939. Caldor also sent her art materials and equipment of better quality, which helped her to achieve a mastery of detail. In her essay "How I Paint," Moses commented, "I think I am doing better work than at first, but it is owing to better brushes and paint."

Caldor brought Moses's works to the attention of Otto Kallir at the Galerie St. Etienne, New York City, where she had her first solo exhibition in October 1940, titled "What a Farm Wife Painted." In November, she visited New York City to attend a showing of her work at the Gimbels Thanksgiving Festival. The following year she was awarded the New York State Prize at the Syracuse Museum of Fine Arts (later the Everson Museum of Art) for her painting *The Old Oaken Bucket.*

In the 1940s, Moses became more daring and began painting larger works with more extensive vistas. Instead of treating the landscape merely

as the surrounding scenery for a specific subject, such as a bridge or an automobile, she created a complete interrelationship of all the elements, in which nothing was favored or subordinated. Persuaded to increase the size of her works still further, she began to work on large canvases, having theretofore painted mostly on masonite board.

By the mid-1940s Grandma Moses was well known throughout the US and was receiving a great deal of "fan mail." Among her most popular works were *Catching the Thanksgiving Turkey* (Metropolitan Museum of Art, New York City), *Sugaring-Off*, and *Out for the Christmas Tree*. In her innocence, Moses could never comprehend the royalties that came to her for reproductions of her work.

Otto Kallir's book, *Grandma Moses: American Primitive*, was published in 1946; greeting cards with reproductions of her paintings began to appear; and in 1947 Moses received the award of Distinctive Merit from the Art Directors Club of New York.

In February 1949, Moses's youngest son, Hugh, died. Three months later President Harry Truman presented the Women's National Press Club Award for outstanding accomplishment in art to Grandma Moses in Washington, D.C. Further recognition came the following month, when she received an honorary doctorate from Russell Sage College, Troy, New York. Two years later Grandma Moses received another honorary doctorate, from Moore Institute of Art, Philadelphia.

A documentary color film on Moses by Erica Anderson, with narration by Archibald MacLeish, was released in 1950. That same year, when she celebrated her 90th birthday, a show of her work toured Europe, establishing her reputation outside the US.

At the age of 91, Grandma Moses ventured into a new medium—painting on ceramic tiles—under the supervision of Helen C. Beers. She completed about 85 of those during the 1950s. Her autobiography, *My Life's History*, was published in 1952, and the following year she was guest speaker at the New York *Herald Tribune* Forum in Manhattan. In 1955 Edward R. Murrow interviewed Grandma Moses for his *See It Now* television series, and filmed the evolution of one of her paintings from start to finish for this telecast. As part of a comprehensive touring exhibition of American primitive art in Europe in the mid-1950s, her work became more widely known on the Continent.

Despite her attention to detail, Moses was hardly a Realist as that term is generally understood. However, like a very different artist, Gustave Courbet, who refused to paint an angel because he had never seen one, she would never paint biblical scenes. She said: "I'll not paint something that we know nothing about; might as well paint something that will happen two thousand years hence." (All quotes by Grandma Moses from Otto Kallir, *Grandma Moses*, copyright © 1973, Grandma Moses Properties Co., New York.) She departed somewhat from this strictly practical outlook in the mid-1950s when she took up historical themes. During this period, she also painted President Eisenhower's farm.

The artist's one hundredth birthday, on September 7, 1960, was proclaimed "Grandma Moses Day" in New York by Governor Nelson A. Rockefeller. Astonishingly, the year 1960 marked a new step in her artistic development, when she illustrated Clement Moore's famous poem, *The Night Before Christmas*. She had never done book illustrations before, and her figures of Santa Claus and his reindeer made for the first appearance of fantasy in her work.

The Grandma Moses Story Book was published in 1961, the year she painted what are considered two of her finest works: *White Birches* and *Rainbow*, her last painting. Grandma Moses died in Hoosick Falls. She had kept on working almost to the very end, maintaining a hopeful, positive outlook.

From 1960 to 1964 an exhibit entitled "My Life's History" toured the US and Europe, and in 1968 the Grandma Moses Gallery was opened at the Bennington Museum, Vermont.

The French critic Jean Cassou remarked on the occasion of her hundredth birthday: "She would have us know that there is still a bit of paradise left on this earth." She herself, in one of her essays, equated work with happiness. Grandma Moses lacked the hallucinatory power of the greatest of all naive painters, Henri Rousseau, but her work is an authentic expression of a certain strain in the American rural tradition, as seen by a candid, uncomplicated soul. Though she did not paint directly from nature, her pictures were nearly always based on personal experience. Her own comments about her subject matter were characteristically homespun and straightforward:

"A landscape picture, an Old Bridge, a Dream, or a summer or winter scene,

"Childhoods memory, what everone fancys,

"But always something pleasing and cheerful and I like bright colors and activity. . . . "

EXHIBITIONS INCLUDE: Gal. St. Etienne, NYC 1940, '44, '47, '51, '53, '57, '61, '82; Gimbel's, NYC 1940; American-British Art Center, NYC 1942, '43, '48, '50, '52;

James Vigeveno Art Gals., Los Angeles 1944, '45, '46, '48, '49, '54; Syracuse Mus. of Fine Arts, N.Y. 1944, '52; Amherst Col., Mass. 1944; Norfolk Mus. of Arts and Sciences, Va. 1945; traveling exhibits in U.S. 1946–48, 1954–56; California Palace of the Legion of Honor, San Francisco 1948; Robert C. Vose Gal., Boston 1949, '51; traveling exhibit sponsored by U.S. Information Service (Vienna, Munich, Salzburg, Bern, Amsterdam, and Paris) 1950; Brooks Memorial Art Gal., Memphis 1951; Art Gal. of Toronto 1952; Santa Barbara Mus. of Art, Calif. 1953; Buffalo Historical Society, N.Y. 1954; "A Tribute to Grandma Moses," IBM Gal. of Arts and Sciences, NYC 1955; traveling exhibit in Europe (Bremen, Cologne, Hamburg, London, Oslo, Aberdeen, Edinbugh, and Glasgow) 1955–57; "My Life's History," IBM Gal. of Arts and Sciences, NYC 1960; "A Life's History in Paintings," traveling exhibit (toured 17 European cities) 1962–64; Hammer Gals., NYC 1964–65, '66, '67, '69, '71; Bennington Mus., Vt. 1965, '67, 1968–72; Maxwell Gals., San Francisco 1968; Gal. of Modern Art, NYC 1969; Old Capitol Mus., Jackson, Miss. 1972; Nat. Gal. of Art, Washington, D.C. 1979; Danforth Mus., Framingham, Ma. 1983; New York State Mus., Albany 1983; Mus. of Am. Folk Art, NYC 1984; Baltimore Mus. of Art 1984. GROUP EXHIBITIONS INCLUDE: "Contemporary Unknown American Painters," Members' Room, MOMA, NYC 1939; New York State Exhibition, Syracuse Mus. 1941; Everhart Mus., Scranton, Pa. 1943; "Portrait of America," Metropolitan Mus. of Art, NYC 1945–46; "Painting in the United States, 1945" (also 1946, '48, and '49), Carnegie Inst., Pittsburgh; Mus. of Fine Arts, Houston 1949; Pittsburgh International, Carnegie Inst. 1950; "American Primitive Painters from the 17th Century to the Present," circulated in Europe by Smithsonian Instn. for U.S. Information Agency, 1954–55; "American National Painters," circulated in U.S. by Smithsonian Inst. 1954–55; "American Primitive Paintings," circulated in U.S. by Smithsonian Inst. 1958–59; "American Traditionalists of the 20th Century," Columbus Mus. of Arts and Crafts, Ga. 1963; "Die Welt der Naiven Malerei," Salzburger Residenzgal., Salzburg, Austria 1964; "Le Monde des Naifs," Mus. Boymans-Van Beuningen, Rotterdam 1964; Mus. Nat. d'Art Moderne, Paris 1964; "Women Artists of America," Newark Mus., N.J. 1965; "Die Kunst der Naiven," Haus der Kunst, Munich, Kunsthaus, Zürich 1974–75.

COLLECTIONS INCLUDE: Metropolitan Mus. of Art, and Mus. of Am. Folk Art, NYC; Everson Mus. of Art, Syracuse, N.Y.; New York State Historical Assn., Cooperstown; Memorial Art Gal., Univ. of Rochester, N.Y; Mus. of Art, Rhode Island School of Design, Providence; Bennington Mus., and Shelburne Mus., Vt.; White House, and Phillips Collection, Washington, D.C: Abby Aldrich Rockefeller Folk Art Collection, Williamsburg, Va.; Atlanta Art Assn.; Birmingham Mus. of Art, Ala.; Art Inst., Zanesville, Ohio; Minneapolis Inst. of Art; Phoenix Art Mus., Ariz.; Centre Georges Pompidou (Beaubourg), Paris; Kunsthistorisches Mus., Vienna; Pushkin Mus., Moscow; Queensland Nat. Gal., Brisbane, Australia.

ABOUT: Cheney, S. The Story of Modern Art, 2d ed.

1958; Janis, S. They Taught Themselves: American Primitive Painters of the 20th Century, 1942; Kallir, J. Grandma Moses: The Artist Behind the Myth, 1982; Kallir, O. Grandma Moses, 1973, Grandma Moses: American Primitive, 2d ed. 1947, My Life's History, 1952; Kramer, N. (ed.)The Grandma Moses Storybook, 1961; "My Life's History: Paintings by Grandma Moses" (cat.), Hammer Gals., NYC, 1964. *Periodicals*—Art in America October 1955; Art News May 1951; Christian Science Monitor Magazine January 5, 1946; Die Welt (Hamburg) December 20, 1975; New York Times Magazine October 9, 1949; Paris-Match December 10, 1960; Southwest Art September 1980; Time April 2, 1979.

MOTHERWELL, ROBERT (January 24, 1915–), American painter, helped to transmit the values of European avant-garde painting to the American Abstract Expressionists of his generation. As an artist, writer, and spokesman for abstract expressionism, Motherwell strove to link American abstraction to European traditions in a manner that would permit a unique American modernism to flourish.

He was born in Aberdeen, Washington. His father, Robert Burns Motherwell, was of Scottish descent, and his mother, the former Martha Hogan, was of Irish origins. From 1918 to 1937 he lived mostly in San Francisco, where his father was president of the Wells Fargo bank. Basically self-taught, Motherwell cannot remember a time when he did not draw or paint. In 1926, at the age of 11, he won a fellowship to the Otis Art Institute, Los Angeles. "But I never was interested in the conventional route, art school, drawing from life, etc.," he recalled. "No one was teaching anything about modern art, and I didn't know how to get to what I wanted to do."

Although reared in California, Motherwell spent most of his summers at the seashore near Aberdeen, on the Pacific Coast, where his preference for living and working by the seaside was acquired. In a 1979 *Partisan Review* interview Motherwell remarked that the provenance of his basic colors—black, white, and ocher—was his California upbringing. "I grew up in a landscape not at all dissimilar from Provence, or from the central plateau of Spain, or from parts of Italy and the Mediterranean basin. In such landscapes, the colors are local, intense and clear, edges are sharp, shadows are black. . . . The hills of California are ocher half the year."

In 1932, after studying painting briefly at the California School of Fine Arts, San Francisco, Motherwell entered Stanford University, Palo Alto, California. He knew nothing about modern art until a friend took him to the home of Michael Stein, Gertrude's brother and a discerning

© Renate Ponsold

ROBERT MOTHERWELL

collector of modern French art. "When I saw those Matisses," Motherwell said, "it's as if an arrow shot through me—a shock of recognition. . . . This is what I really care about, I thought." He told *Partisan Review*: "Cézanne and Matisse were my first two loves in modernism, not only because of their color and light, but also because . . . their youths in nineteenth-century France were not dissimilar from mine in pre–World War II California: sunlit landscape, bourgeois placid life, inner torment, anxiety and artistic alienation. Painting was not only something to love. Its radiance was *everything*."

Finding the Stanford art department uninteresting, Motherwell majored in philosophy. At school he became interested in music, especially Bach, Haydn, and Mozart, heard Igor Stravinsky play and Gertrude Stein lecture, and wrote his undergraduate thesis on Eugene O'Neill's relation to psychoanalytic theory. Following his first visit to Europe, in 1935, Motherwell, a self-described "Francophile," steeped himself in modern French literature, giving special attention to the Symbolists Baudelaire, Mallarmé, and Valéry.

When Motherwell graduated from Stanford in 1937, his well-to-do father asked his only son what was it to be—a career in law or business? Wanting to paint, Motherwell temporized, enrolling in the graduate school of philosophy at Harvard University. The standoff with his father was resolved when he accepted a $50-a-week allowance, on the condition that he get a Ph.D., "to have a teaching position to fall back on if I didn't make it as a painter," Motherwell told *Art News* (March 1982). At Harvard Motherwell

concentrated on aesthetics, and wrote his Master's thesis on Delacroix before leaving in the summer of 1938 for the University of Grenoble, France.

Having acquired an intellectual training rare among painters, Motherwell was appointed assistant art instructor at the University of Oregon, Eugene, in 1939. But in September 1940 he left the Pacific Coast for New York City, where he was to live until 1973. Intending to obtain a Ph. D., he enrolled in the department of art history and archeology of Columbia University and studied with the influential art historian and proponent of modernism, Meyer Schapiro. Through Schapiro, Motherwell met the European Surrealists who had fled to New York—Matta, Marcel Duchamp, Max Ernst, André Masson, Ives Tanguy, Kurt Seligmann, and André Breton. Stimulated by these artists and by Schapiro's encouragement, in 1941 Motherwell devoted himself wholeheartedly to his painting, which, from the very beginning, was abstract.

He set up his studio in Greenwich Village, helped by the weekly subsidy from his father. (Motherwell's moneyed background set him apart from the penury of other first-generation Abstract Expressionists, as did his erudition.) In 1941 he studied engraving with Seligmann, and for four years maintained close association with the Surrealist artists-in-exile. "I didn't like the Surrealists' painting," he recalled, "but they were interested in ideas about art and they saw that I was." His own painting, however, was considered too "abstract" by the Surrealists.

Nevertheless, Motherwell was influenced by surrealist theories, particularly the principle of automatism, which corresponded to his interest in Freudian psychoanalysis and French Symbolist poetics. "I had had a firm intuition as a stranger that the New York painting scene was filled with technical talent, but lacked an original creative principle, so that its work appeared one step removed in origin," Motherwell commented, as quoted by Barbaralee Diamonstein. "I found that principle . . . in the Surrealists' own self-definition, 'psychic automatism,' by which they meant, in psychoanalytic jargon, free-association. In the case of painting, psychic automatism usually begins as 'doodling,' or scribbling. . . . " Motherwell's artful scribblings in the manner of Jean Arp and Joan Miró helped him to discover his individual style.

In the summer of 1941 Motherwell visited Mexico with the painter Matta, who had directed his initial automatistic exercises. About 1942 Motherwell's friend and fellow New York artist, William Baziotes, introduced him to Jackson Pollock, through whom he met Willem de Koo-

ning and the veteran abstractionist Hans Hofmann. Pollock was also interested in Freudian theory and he and Motherwell began to experiment in tapping the creative unconscious by means of the doodling process. Also at this time, with André Breton, William Carlos Williams, Ernst, and Matta as advisers, Motherwell became coeditor of the surrealist-oriented magazine *VVV*. (An asthma sufferer, Motherwell had been exempted from military service.)

In 1943 Motherwell, Pollock, and Baziotes were invited by Peggy Guggenheim to show their first collages at her Art of This Century Gallery, New York City. Collage was a new medium for those artists, and Motherwell and Pollock worked together in the latter's studio for mutual support and encouragement. Motherwell came to believe that "collages are a modern substitute for still life. . . . I do feel more joyful with collage, less austere [than in my painting]. [It is] a form of play."

Since hearing André Malraux speak on the Spanish Civil War at a 1937 rally in San Francisco, Motherwell had been deeply distressed by the Fascists' overthrow of the Spanish Republic. "[Spain] was the beginning of my political consciousness," he told *Art News,* "of the realization that the world could, after all, regress." His oil of 1941–44, *The Little Spanish Prison,* incorporated the yellow and red of the Spanish flag and irregular pale gray vertical bands suggestive of a prison's iron bars. As in all of Motherwell's work, the idiom was abstract but with thematic content—he has repeatedly stressed that his is an art of subjects. His painting and collage of 1943, *Pancho Villa Dead and Alive,* combining drip techniques with a logical, coherent structure, was purchased by the Museum of Modern Art, New York City, in 1944, the year of his first solo exhibition, at Peggy Guggenheim's avant-garde gallery. From 1944 onwards, Motherwell frequently contributed articles to *DYN* and *Partisan Review,* among other journals, and edited a series of important publications called *The Documents of Modern Art* (1944–52). About 1947 Motherwell and the critic Harold Rosenberg launched *Possibilities,* an art magazine which lasted one issue.

For about a month in 1945 Motherwell studied engraving at Stanley William Hayter's Atelier 17, New York City. He became friendly with Adolph Gottlieb and the following year met other emerging New York artists: Barnett Newman, Mark Rothko, Clyfford Still, and the sculptor Herbert Ferber. In his many articles as well as in his own work, Motherwell championed the cause of American abstract art at a time when regionalism and social realism were still popular,

if not dominant. It was also a period in which American institutions assumed indigenous abstract art to be a priori inferior to European modernism, a notion Motherwell sought to refute. In 1951 he was to join the "Irascibles," a group of 18 Abstract Expressionists who demanded recognition from New York City's Metropolitan Museum of Art. The abstract imagery of New York painters expressed, he said, "the desire for direct, intense living and immediate experience," and in a 1951 he described the abstract art of the New York School as "an effort to close the void that modern men feel."

Motherwell's inclusion in the 1946 "Fourteen Americans" exhibition at MOMA confirmed his eminence in the new generation of American artists. Though drawn to the sensuous "painterliness" of the School of Paris, Motherwell was conscious of his Puritan heritage, and this tension inspired an early abstract "self-portrait," *Homely Protestant* (1947–48), the title being a phrase taken from James Joyce.

In late 1948 and early '49 Motherwell painted *Granada,* the first in an ongoing series entitled "Elegy to the Spanish Republic." *Granada* originated the motif for which Motherwell is famous—Rohrshach-like black shapes on a much lighter ground. " . . . I felt that I had found an archetypal image," he recalled, "something that people who didn't know the title or even like abstract painting were affected by." He chose the series title because "the image made it my first public painting, and I wanted something that would connect with a larger public theme." But as Robert Hughes pointed out in *Time* (July 18, 1977), this was a nostalgic approach to the Civil War, seen from afar, retrospectively, by a noncombatant who spoke little Spanish and had no firsthand knowledge of Spain. There was none of the rage and immediacy of Picasso's *Guernica;* the "Elegy" paintings, black, tragic, Stonehenge-like shapes with freely brushed edges on a white ground, were far more oblique as statements, yet in their own way very expressive. The title of one work, *At Five in the Afternoon* (1949), was inspired by a famous Garcia Lorca poem. Motherwell called the "Elegy" series "a funeral song for something one cared about."

Motherwell was one of the guiding spirits of an association called the Painters' Club, which was founded in Greenwich Village in the fall of 1949 and became the center of New York's avant-garde. Public lectures and discussions were held weekly under the auspices of leading art-world figures, and during the '50s the Club became a gathering place for writers, musicians, scientists, critics, museum officials, art dealers,

and collectors. "We [the Abstract Expressionists] were trying to get at the truth," Motherwell said of the movement's "heroic" phase. "Also, nobody cared what we did. We were able to be very pure because nobody wanted to seduce us. . . . Maybe my generation was the last generation innocent enough to be romantic." One of Motherwell's most lyrical abstractions is *The Voyage* (1949), a progression across the canvas of simple but sophisticated shapes in a rather Spanish palette of brown, tan, black, and white.

Until 1950 there was a tension in Motherwell's work between automatism and the more coherent structure of the School of Paris, the contradictory pull between feeling and intellect, consciousness and unconsciousness that was reflected in *Pancho Villa Dead and Alive*. But in the early '50s he was influenced by Matisse, especially that master's lavishly colored paper cutouts, and Motherwell's *La Danse* (1952), a trio of elegant free-form black shapes progressing in a stately arabesque from right to left on a scarlet ground, can be seen as his homage to Matisse's late works.

In 1951 Motherwell painted a mural for the synagogue of Congregation B'nai Israel, Milburn, New Jersey; that same year he became associate professor at Hunter College of the City University of New York, where he was on the faculty for four years. He taught during the summer at the experimental Black Mountain College, in North Carolina, where he had given a course in 1945.

In the early '50s abstract expressionism divided into two styles: action, or gestural, painting and chromatic abstraction, which consisted of large color fields. According to Barbara Rose, Motherwell's work stood between the two. The almost totemic black silhouettes on a white ground of *Granada* had strongly influenced Franz Kline, although Motherwell was never as gestural a painter as he. Discussing his own use of color, Motherwell said: "Generally I use few colors: yellow ochre, vermilion, orange, cadmium green, ultramarine blue. Mainly, I use each color as simply symbolic: ochre for the earth, green for the grass, blue for the sky and sea. I guess that black and white, which I use most often, tend to be the protagonists."

By 1957 Motherwell's work had been exhibited in the United States, Europe, and Japan. His improved circumstances enabled him to purchase an 18th-century house in Provincetown, Massachusetts, and in 1958 he married the painter Helen Frankenthaler. The following year his first retrospective was held at Bennington College, Vermont.

After 1960 Motherwell carried economy of means, forms, and color even further than he had in the '50s. Examples of this new direction are *Voyage, Ten Years After* (1961) and *In Black and Pink with Number Four* (1968), in which a monumental graphic sign defines the space. In these and other canvases of the decade, accidents of the brush are retained. In 1967 he painted *Open No. 1,* the first of his "Open" series. Landscape was a frequent motif in the late '60s and early '70s, with the brilliant blues and greens of the Mediterranean often replacing the harsh monochrome of the Spanish countryside, as in *Summer Open, with Mediterranean Blue* and *Blueness of Blue,* both of 1974. Robert Hughes noted that "Motherwell blue" is "as promptly identifiable as Braque brown or Matisse pink." "If there is a blue that I might call mine, it is simply a blue that feels warm," Motherwell remarked, "that cannot be accounted for chemically or technically, but only as a state of mind." Motherwell was also inspired by Baudelaire's vision of the blue sea as escape and by Mallarmé's exaltation of *l'azur*. However, in *Arts Review* Kevin Power found the "Open" series unconvincing and lacking in inwardness, adding that in his view the "Opens" "flounder in an ambition that they cannot contain."

Motherwell's stance as a politically aware artist was maintained in the 1960s. In 1961 he signed the petition supporting French intellectuals who were being hounded by the government for their opposition to the Algerian War. In 1965 he publicly joined other American artists and intellectuals in protesting the war in Vietnam. "Without ethical consciousness," Motherwell declared, "a painter is only a decorator."

In 1971 Motherwell decided to live year round in a restored carriage-house in Greenwich, Connecticut. He continued to work in diverse pictorial modes, all of them abstract, and executed numerous etchings and lithographs in the '70s, but, to quote John Russell of *The New York Times,* "it is in the collage medium that Mr. Motherwell has always been most elegant." *NRF Collage No. 4* (1973), with its torn and pasted cutout of stiff paper on a resonant yellow ground, is an outstanding example.

In June 1977 a mammoth retrospective of some 150 Motherwell paintings and collages opened at the Musée d'Art Moderne, Paris, possibly the largest solo show ever given a living American artist by a French museum. This was appropriate because, as Hilton Kramer observed, "of the American painters of his generation . . . Motherwell has been one of the closest in spirit and in personal culture to the ideals of the School of Paris."

Although gratified by his success, Motherwell

•

admits to feeling an occasional bitterness and "a certain loneliness" at being one of the last survivors from what has been called the "heroic" era of abstract expressionism. But he enjoys his present life, divided between his country home in Greenwich and the Provincetown house where he spends his summers. He is proud of his two grown daughters and takes pleasure in "a marvelous home life I've never had before." The Greenwich house has a vast working area of seven studios, including a SoHo-sized loft. Each year he adds two or three canvases to his "Elegy" series.

Robert Motherwell has been married four times: to Maria Emilia Ferreira y Moyers, a Mexican actress, from 1941 until the late '40s; to Betty Little, the mother of his two daughters, Jeanie and Lise, from 1950 to about 1957; to the painter Helen Frankenthaler, from 1958 to 1970; and to Renate Ponsold, a German-born photographer, since 1972.

In his mid-60s, Motherwell is a pleasant, friendly, open, and remarkably articulate man with blondish hair and what Grace Glueck described as a "comfortably rumpled" appearance. In a *New York Times* (February 3, 1976) interview with Glueck he said, "If I'm really proud of anything, it's that my pictures are as fresh at 61 as they were at 30." Noting that today's art world wanted only "the latest thing," he hoped his new paintings for an important exhibit at the Knoedler Gallery, New York City, in 1976 would show the "eternal" quality of his work, not just the production for one year.

"All my life," Robert Motherwell said in the late 1970s, "I've been working on the work—every canvas a sentence or paragraph of it. Each picture is only an approximation of what you want. That's the beauty of being an artist—you can never make the absolute statement, but the desire to do so as an approximation keeps you going."

EXHIBITIONS INCLUDE: Art of This Century Gal., NYC 1944; Art Club of Chicago 1946; Kootz Gal., NYC 1946–50, '52–53; San Francisco Mus. of Art 1946; Sidney Janis Gal., NYC 1957, '59, '61, '62; Bennington Col., Vt. 1959; São Paulo Bienal 1961; MOMA, NYC 1965–66; Phillips Collection, Washington, D.C. 1965; Whitney Mus. of Am. Art, NYC 1968; Marlborough Gal., NYC 1969; David Mirvish Gal., Toronto 1970; "The Genesis of a Book," Metropolitan Mus. of Art, NYC 1972; Lawrence Rubin Gal., NYC 1972; Mus. of Fine Arts, Houston, 1972–73; Walker Art Center, Minneapolis, Minn. 1972; Mus. de Arte Moderna, Mexico City 1975; Knoedler Gal. NYC 1976, '78; Mus. d' Art Moderne, Paris 1977; Albright-Knox Art Gal., Buffalo, N.Y. 1983; "Robert Motherwell," Solomon R. Guggenheim Mus., NYC 1984–85. GROUP EXHIBITIONS INCLUDE: "First Papers of Surrealism," 451 Madison Avenue, NYC 1942; Art of This Century Gal., NYC 1943; "Fourteen Americans," MOMA, NYC 1946; "Introduction à la peinture américaine," Gal. Maeght, Paris 1947; "The Intrasubjectives," Samuel Kootz Gal., NYC 1949; "Younger American Painters, a Selection," Solomon R. Guggenheim Mus., NYC 1951; "Third International Art Exhibition," Japan 1955; "The New American Paintings," MOMA, NYC 1958; "American Abstract Expressionists and Insights," Solomon R. Guggenheim Mus., NYC 1961; "Paintings and Sculpture of a Decade," Tate Gal., London 1964; "The New American Painting and Sculpture, the First Generation," MOMA, NYC 1969; "New York Paintings and Sculptures, 1940–1970," Metropolitan Mus. of Art, NYC 1970; "American Art at Mid-Century," Nat. Gal. of Art, Washington, D.C. 1973; "Aspects of Postwar Painting in America," Solomon R. Guggenheim Mus. NYC 1976.

COLLECTIONS INCLUDE: Metropolitan Mus. of Art, MOMA, and Whitney Mus. of Am. Art, NYC; Albright-Knox Art Gal., Buffalo, N.Y.; Yale Univ. Art Gal., New Haven, Conn.; Fogg Art Mus., Harvard Univ., Cambridge, Mass.; Phillips Collection, and Hirshhorn Mus. and Sculpture Garden, Washington, D.C.; Cleveland Mus. of Art; Menil Foundation Collection, Houston, Tex.

ABOUT: Arneson, H. H. Robert Motherwell, 1977; Ashton, D. The New York School: A Cultural Reckoning, 1973, American Art Since 1945, 1982; Diamonstein, B. Inside New York's Art World, 1979; "Fourteen Americans" (cat.), MOMA, NYC, 1946; Guilbaut, S. How New York Stole the Idea of Modern Art: Abstract Expressionism, Freedom and the Cold War, 1983; Lucie-Smith, E. Late Modern: The Visual Arts Since 1945, 1969; Motherwell, R. and others (eds.) Modern Artists in America, 1951, The Dada Painters and Poets, 1951; O'Hara, F. "Robert Motherwell" (cat.), MOMA, NYC, 1965; Ritchie, A. (ed.) Abstract Painting and Sculpture in America, 1951; "Robert Motherwell—Collages 1943–1949" (cat.), Kootz Gal., NYC, 1949; Rose, B. American Art Since 1900, 2d ed. 1975; Sandler, I. The New York School: The Painters and Sculptors of the Fifties, 1978. *Periodicals*—Art and Architecture September 1951; Art International nos. 1–2 1959, April 20, 1966, October/November 1976; Art News May 1959, March 1982; Arts Magazine March 1975; Arts Review October 14, 1977; Nation November 11, 1944; New York Times April 13, 1974, January 17, 1976, February 3, 1976, October 30, 1983; Partisan Review Winter 1944, no. 3 1979; Studio March 1963; Time July 18, 1977; Vogue February 1965.

NAKIAN, REUBEN (August 10, 1897–), American sculptor, produced simple small forms in his early career but then moved to monumental and amorphous creations inspired by mythology. He was born in College Point, Long Island, New York, the youngest of five children of George and Mary (Malakian) Nakian, Armenians who had emigrated from Turkey to the

Photo by Lois Dreyer

REUBEN NAKIAN

United States in about 1880. In 1906 the family moved from College Point to 116th Street and Lenox Avenue, in New York City, and from there to various New Jersey suburbs— Rutherford (1908), Union City (1910), and Weehawken and Weehawken Heights (1911). Nakian's parents encouraged his artistic interests, and at the age of ten he was studying drawing, in which he soon developed remarkable skill. At 13 he took weekly drawing lessons with a German teacher at an academy in Jersey City. In addition to copying 18th- and 19th-century German engravings he studied the plaster casts of sculpture displayed in the basement of the Metropolitan Museum of Art, New York City.

After graduating from grammar school in Jersey City, in 1912, Nakian briefly attended the Art Students League, New York City. His family was still living in New Jersey, but Nakian was increasingly drawn to Manhattan. In 1913 he took a job in the office of the advertising agency for Philip Morris. He designed lettering for catalogs and made line drawings for cigarette ads. Over the next two years, he was also to work for *Century* magazine, running errands for its editor, the art nouveau poster artist and graphic designer, Will Bradley. Nakian also did lettering for the magazine's covers. He was impressed by reproductions of avant-garde art in the German periodicals *Jugend* and *Simplicissimus* that he saw in the office, and Bradley introduced him to the popular illustrator James Montgomery Flagg and to such eminent exponents of Ashcan School realism as John Sloan, Everett Shinn, and George Bellows.

Nakian found more to interest him in the eve-

ning classes that he attended in 1915 at the Independent Art School, which he described as "the only studio in New York that permitted modern training." His teachers there were Homer Boss and A. S. Baylinson. Influenced by Rubens and by Greek sculpture, he drew monumental nudes in red chalk, and studied clay modeling for a few months at the Beaux-Arts Academy, New York City.

In 1916 Nakian visited the studios of a number of artists, hoping to find a job as an apprentice. He showed his drawings to the sculptor Paul Manship, who accepted him as a studio apprentice. He was trained by Manship, who worked in classical styles, and also learned from Manship's chief assistant, the French-born Gaston Lachaise, the techniques of patination, cutting, and casting. He began to draw and sculpture animals and was influenced at this time by Cézanne and the near-abstract shapes of Brancusi. Nakian's first sculpture, a plastic statue-bank of a cow for a "Free Milk for France" campaign in 1917, was widely reproduced in replica.

When Manship went to Europe in 1920, Nakian moved into a new studio with Lachaise on Sixth Avenue between 10th and 11th streets. Nakian's works of the early 1920s, especially the terra-cotta and stone animal studies, were simple and compact. They included *Pouter Pigeon* and the wittily formal *Jack Rabbit*, the latter in limestone, carved in 1921, and 36 inches long. *Jack Rabbit* was reproduced in *The Dial* in May 1922.

In 1922 Juliana Force, who with Gertrude Vanderbilt Whitney had organized the Whitney Studio Club, visited the Lachaise-Nakian studio with the critic Forbes Watson. On Mrs. Force's advice, Nakian was given a monthly stipend of $250 in addition to the cost of his studio rental. He took a studio in Weehawken Heights, New Jersey, and in the following year six of his sculptures were shown at the Whitney Studio Club, from which the Whitney Museum of American Art evolved. Also in 1923, he met the sculptor William Zorach, who became a close friend.

Nakian moved in 1925 to a studio on the corner of Christopher and Gay Streets in New York City, and in the following year his *Pouter Pigeon* of 1921 was included in the "Exhibition of Tri-National Art" at the Wildenstein gallery, New York City, a show organized by the influential critic Roger Fry, who before World War I had exhibited French postimpressionist art in Great Britain. In November 1926 Nakian had his first solo show, at the Whitney Studio Club; he also met Brancusi and helped install the great sculptor's first US solo exhibition, a retrospective held at the Brummer Gallery, New York City, that same month.

A sculpture by Nakian in pink marble, *Young Calf*, carved in 1929, is now owned by the Museum of Modern Art, New York City. His work was becoming sufficiently well known to be included in the 1930 exhibition "46 Painters and Sculptors Under 35 Years of Age," at the recently opened MOMA. He sculptured at this time a series of "Seals," influenced by Brancusi but less abstract and more playful in spirit. One of these, in bronze, and balancing a ball on its nose, was purchased in 1931 by the Whitney Museum. Nakian received a Guggenheim Fellowship in 1930 and spent eight months traveling in France and Italy.

After moving in 1932 to a studio at 42 Washington Square South, in Greenwich Village, Nakian began a series of portraits of artists, including one of "Pop" Hart (George Overbury Hart), which were exhibited in a group show at the Downtown Gallery. In the same year he met Rose St. John, whom he married in 1934, in Greenwich VIllage. They had two sons, Paul, born in 1937, and George, born in 1940.

The success of Nakian's exhibition of portraits of artists at the Downtown Gallery in the late winter of 1933 led to an introduction, through Edith Halpert, director of the gallery, to Robert Straus, then an official of the National Recovery Administration. Straus commissioned Nakian to do portraits of Harold Ickes, Cordell Hull, Henry A. Wallace, Harry L. Hopkins, and other members of the Roosevelt administration. He worked on these busts in a studio in the Department of Commerce Building in Washington D.C. Reviewing a Nakian retrospective at Stamford, Connecticut, in *The New York Times* (September 2, 1977), Hilton Kramer described the head of Harry Hopkins as "a very strong work, at once cool, elegant, and full of character." Nakian made a portrait head of President Franklin Roosevelt from photographs, but the work that brought him his first real fame was *Babe Ruth*, an eight-foot sculpture completed in 1934.

Had he continued in this traditional realistic vein, Nakian might soon have become, in Kramer's words, "something of an institution," but in about 1935 he drastically revised his artistic concepts. This was brought about in part by his friendship with Arshile Gorky, whom he had met in 1933, the year he also met the seminal American modernist Stuart Davis. Conversations with Gorky introduced him to new ideas, such as those embodied by surrealism, and to avant-garde theories about the work of Cézanne, Picasso, and Ingres. Throughout the 1930s and most of the 1940s Nakian produced little sculpture but drew constantly. He moved in 1936 to Staten Island and, except for group shows, ceased to exhibit until 1949.

By the late 1930s Nakian had rejected the then dominant School of Paris aesthetics and turned for inspiration to earlier European art history, from the Tanagra figurines to Watteau, and from Greek vase painting to Rodin and Medardo Rosso. In his ink-and-wash drawings he treated Greek and Roman mythological themes with fantasy and sensual gusto, in a style that paralleled the new expressionistic and iconographic freedom that was beginning to make itself felt in American painting, notably in the work of de Kooning. Nakian infused his early terra-cottas including *Europa and the Bull*, which he began in 1938, completed in 1942, and later destroyed, with the same exuberant spirit. (He had met de Kooning in 1937, through Gorky.) From 1936 to 1939 Nakian worked in the sculpture division of the Federal Arts Project of the Works Progress Administration.

When Nakian turned again to portraiture in the early 1940s, the smooth surfaces and classical structure of the New Deal heads had been superseded by a far more personal, emotional, and expressionistic style, with rougher textures, a most unclassical informalism, and a seeming amorphousness. Many critics consider his bust of Marcel Duchamp, modeled in plaster in 1943 and later cast in bronze, to be his masterpiece in this vein. Kramer noted that this work, "so highly charged with energy and feeling," provided an ironic contrast to its subject, "a mandarin of the kind of detachment this portrait so drastically denies him." Today one of the cast bronze Duchamp heads is in the Hirshhorn Museum and Sculpture Garden, Washington D.C. Another portrait of 1943 in a similar style was the plaster head of Nakian's friend, the antique dealer Dikran Kelekian.

From 1946 to 1951 Nakian taught at the Newark School of Fine and Industrial Arts, New Jersey. Using a kiln at the school, he began a series of terra cottas and drawings based on ancient mythology. In 1948 he began his "Europa" terra cottas, a series he continued into the mid-1960s. Larry McCabe, one of the students who helped him fire the terra cottas, later became his permanent assistant.

Charles Egan, who had opened the Egan Gallery in New York City in 1945 and became Nakian's dealer, exhibited in 1949 the sculptor's terra-cotta drawings. These were called "stone drawings" because of the hardness of the material caused by the firing process. This was Nakian's first solo show since 1935, and it was followed by another solo exhibit at the Egan Gallery in 1950. His themes were now entirely hero-

ic, mythological, and erotic, and his style in the sculptures as in the drawings, was, to quote Hilton Kramer, "painterly and passionate." There are several versions of *Europa and the Bull*; one of them, dating from 1949–50 and modeled in terra cotta with a vehement sensuality that recalls de Kooning's "Woman" paintings of the 1950s, is in the Hirshhorn Museum. Nakian treated the same theme in plaster and bronze reliefs and in numerous pen and ink drawings. Leda and the swan is another Greek myth of passion and metamorphosis that fired his imagination. "Why wouldn't a sculptor be excited over the Greeks?" Nakian remarked. "Mythology offers everything imaginable to the artist—the figure, animals, lots of little people like cupids, action, and movement."

Nakian had left his New York studio in 1948 and set up a kiln near his house in Stamford, Connecticut. In 1952 he produced a large terra cotta, *Voyage to Crete*, yet another variation on the Europa theme. The major work in his solo show of sculpture and drawings at the Egan Gallery in 1954 was a large piece titled *La Chambre à Coucher de l'Empereur*, modeled in white plaster in 1954 and cast in 1958. Frank O'Hara, assistant curator of the MOMA, praised its "baroque lavishness of form and texture."

Nakian applied his vigorous abstract-expressionist approach to tragic as well as joyous mythological themes. He used a variety of media and gave a new importance to the armature in a large (11 feet high) sculpture of 1954, *Hecuba on the Burning Walls of Troy*. It was constructed in steel, plaster, glue, and wire mesh, but Nakian, "an exacting critic of his own work, though a generous one of others," to quote O'Hara, destroyed it. However, its spirit, and the technical innovations it contained, survived in the single-figure, seven-foot-high bronze *Hecuba* (1960–62), to which Nakian had originally planned to give the title *Hiroshima*.

The liberation of armature and its new expressive role were displayed in two large painted steel sculptures: *The Duchess of Alba* (in welded steel, ten feet long, begun in 1959, and now in the Los Angeles County Museum), which suggests in abstract form the duchess's chaise longue as well as her reclining figure, and *Mars and Venus* (1959–60), in which the black metal rods can be seen as the fateful couch and in which the interaction of the hovering black "leaves" in welded steel creates an equivalent of the embracing deities. Frank O'Hara described these works as "an original amalgamation of baroque indulgence with constructivist severity." These and other steel-plate constructions, made when Nakian was in his early 60s, earned the artist his first lavish critical acclaim.

In 1960 Nakian won a New York University competition among five invited American sculptors for the architectural decoration of the façade of the Loeb Student Center, which occupies the site of one of his former New York studios. The monumental group of shaped steel and aluminum forms (28 by 45 feet) were installed on the façade in the spring of 1961 and dedicated in July. From September to December 1961 a large solo show of his work, organized by MOMA, was mounted at the São Paulo Bienal. Nakian traveled to São Paolo with McCabe and Egan to help with the installation. The show included the *Head of Marcel Duchamp* and the large *Rape of Lucrece* (1958), in steel plate.

The late Frank O'Hara organized a large Nakian retrospective at MOMA in 1966, and the artist was represented at the Venice Biennale of 1968. In that year his large welded steel construction of 1959–60, *Mars and Venus*, was acquired by the Albright-Knox Art Gallery, Buffalo, New York. In a letter to the gallery in which he discussed this work Nakian declared that "the medium one uses should dictate its style." He added, "My large bronze abstractions are modeled in plaster: I think my steel pieces and my modeled ones related to each other. I usually begin my work from naturalistic drawings, and then work them up to abstractions."

Nakian received an Award of Merit for Sculpture from the American Academy of Arts and Letters and the National Institute of Arts and Letters in 1973. On November 5, 1976, the city of Stamford, Connecticut, paid official homage to its "favorite son," who was then in his 80th year, and in September 1977 a small, well-chosen exhibit of his work was mounted by Robert P. Metzger at the Stamford Museum and Nature Center. Meanwhile, as vigorous as ever, Nakian was working on several more versions of "Leda," one of which was 13 feet long, and he also carved a *Descent from the Cross* which was dedicated in an Armenian church in New York City in November 1977. This powerful work, a new departure for Nakian, is a ten-foot square carving in plaster, which, in the words of Hilton Kramer, "conveys its tragic emotion with a very affecting restraint."

Reuben Nakian in his 80s is a stocky, robust, outspoken man with a mane of white hair, strong features, and a genial smile. "The secret of being a great artist," he observed, "is not to drop dead too soon." He belongs to no school or movement and has always been his own man, with a certain nostalgia for the sculpture of the past. He disdains the work of many of his contemporaries, and has no use for cold, impersonal abstractions, minimalism, or fashionable pop "jokiness." In an interview in *The New York Times* (October 23,

1977), he remarked: "Most artists today don't have taste. They're all Bauhaus people. They don't know what real art is. They are Mickey Mouse entertainers instead of artists. They think a dot and a line and a helluva lot of messing around makes art. It doesn't. Painting is dead. Everything has been done. Sculpture is where it's at."

EXHIBITIONS INCLUDE: Whitney Studio Club, NYC 1926; Downtown Gal., NYC 1930–35; Corcoran Gal., of Art, Washington, D.C. 1935; Egan Gal., NYC 1949–55, 1959–70; Stewart-Marean Gal., NYC 1958; São Paulo Bienal 1961; Los Angeles County Mus. of Art 1962; Washington (D.C.) Gal. of Modern Art 1963; MOMA, NYC 1966; Venice Biennale 1968; Univ. of Bridgeport, Conn. 1972; Stamford Mus. and Nature Center, Conn. 1977. GROUP EXHIBITIONS INCLUDE: Whitney Studio Club, NYC 1923; Exhibition of Tri-National Art, Wildenstein Gal., NYC 1926; "46 Painters and Sculptors Under 35 Years of Age," MOMA, NYC 1930; Downtown Gal., NYC 1932; "Trois siècles d'art aux Etats-Unis," Mus. du Jeu de Paume, Paris 1938; "Modern American and European Sculpture," Mus. of Modern Art Gal., Washington D.C. 1938–39; Annual, Whitney Mus. of Am. Art, NYC 1949; "Modern Sculpture from the Joseph H. Hirshhorn Collection," Solomon R. Guggenheim Mus., NYC 1962; "Sculpture Open-Air Exhibition of Contemporary British and American Works," Battersea Park, London 1963; "Etats-Unis: Sculptures du XXe siècle," Mus. Rodin, Paris 1965; "Roots of Abstract Art in America 1910–30," Nat. Collection of Fine Arts, Smithsonian Inst., Washington, D.C. 1965–66; "American Sculpture of the Sixties," Los Angeles County Mus. 1967.

COLLECTIONS INCLUDE: MOMA, Whitney Mus. of Am. Art and New York State Theatre, Lincoln Center, NYC; Stamford Mus. and Nature Center, Conn.; Hirshhorn Mus. and Sculpture Garden, Washington, D.C.; Detroit Inst. of Arts; Los Angeles County Mus. of Art.

ABOUT: Lucie-Smith, E. Late Modern: The Visual Arts Since 1945, 1969; O'Hara, F. "Nakian" (cat.), MOMA, NYC, 1966. *Periodicals*—Art International May 1962, April 25, 1963; Art New York November 4, 1964; Art News May 1952, June 1958, November 1958, November 1964; Arts December 1926, November 1930; Design Quarterly no. 30 1954; New York Times May 8, 1949, June 14, 1970, November 5, 1976, September 2, 1977, October 23, 1977; New Yorker May 18, 1935; Portfolio and Art News Annual no. 4 1961; Quadrum 11 (Brussels) 1961; Studio News February 1934; Time June 30, 1967; Villager July 20, 1961.

***NAY, ERNST WILHELM** (June 11, 1902–April 8, 1968), German painter, survived years of persecution by the Nazis before and during World War II to emerge as one of Germany's strongest and most articulate abstractionists. Es-

ERNST WILHELM NAY

sentially a colorist whose chromatic sensibility derived from fauvism on the one hand and Die Brücke on the other, Nay evolved a succession of styles which encompassed expressive figuration, soft geometrical abstraction, abstract expressionism, and color-field painting. Tying together these developments was the artist's absolute determination to achieve "a language that no longer refers to anything beyond the canvas itself."

Born in Berlin, Nay studied from 1925 to 1928 with Karl Hofer, an Expressionist with French leanings, at Berlin's United States School for Fine and Applied Arts. Following Hofer, Nay's own early work exhibited the violent emotion of Germans such as Emil Nolde and Ernst Ludwig Kirchner, whereas in his use of color Nay was clearly the disciple of Henri Matisse and the Fauves. Between 1928 and 1930 Nay lived in Paris, where he first saw the work of Picasso, and where he flirted briefly with surrealism. After winning the Prix de Rome in 1930, he spent a year in Rome before returning to Germany to begin painting full time.

Nay's trouble with the Third Reich began about 1935. His figurative paintings, in a postexpressionist idiom, were unacceptable to Nazi ideologues. He was taken off the list of approved artists, barred from purchasing rationed artist's supplies, and forced to live on unemployment benefits of 40 marks a month; his work was even included in the notorious "Entartete Kunst" (Degenerate Art) exhibition in Munich in 1937. Learning of Nay's difficulties, the painter Edvard Munch invited him to Norway as his guest. Nay found the elder artist so diffident and reclu-

°nā, ernst vil´helm

sive that he soon moved to the countryside, eventually taking up residence on the remote fishing islands of Lofoten, in the Norwegian Sea.

"Somehow I drifted to those distant islands," Nay told Edouard Roditi in an *Arts Magazine* interview, "where I spent the best part of two years. I felt that I was a real man there, accepted by the local fishermen as an artist, a man with a skill and a profession, however strange and incomprehensible to them, and not looked upon, as in Oslo, as an exile who deserved sympathy and pity. I might of course have tried my luck elsewhere, but I somehow shrank from becoming a refugee, like so many German artists in those years." In Nay's Lofoten paintings there was a marked increase in sophistication of color. Figure and landscape blend together in torn blocks of glowing hues, rough and jagged shapes "out of which," Nay said, "dramatic gestures can develop."

With his return to Germany in 1939, he was quickly drafted into the army as a cartographer. Between 1942 and 1944 he was stationed in Le Mans, in northern France, where he found time to paint a few watercolor landscapes, increasingly abstract, in the muddy black-market pigments that were the only art supplies available. After the war, Nay began patching up the remnants of his artistic career, a difficult task as most of his work had been confiscated and destroyed by wartime censors. As Roditi noted, "Such a long interregnum of waste years makes it difficult for critics or historians to illustrate or explain an artist's evolution very clearly." By whatever route, in the early 1950s Nay had expunged from his paintings all reference to the figure, in favor of pure chromaticism. "Color," he said, "offers me the absolutely unequalled possibility of direct transference of the energies that are available to me." Usually his paintings were structured around soft geometrical elements—triangles and ovals. A typical example is *Ovestone* (1955), an oil in which black, white, ocher, and blue discs sail rhythmically to the lower right of the canvas over blurred swaths of color. There is no thoughtless spontaneity in these works; Nay was a conscientious craftsman with an almost musical sense of rhythm, and placed each color element just where it belonged. The result is unforced and harmonious.

After Nay moved to Cologne in 1951, he joined a Zen Buddhist group. It has been speculated that through color the artist was attempting to induce a direct spiritual enlightenment in the viewer. However, the artist himself warned against any simplistic analyses of his work. "I tend to proclaim the reality of each work of art as a thing in itself that neither designates another realm of reality nor gives an illusion of belonging to any such realm. . . . Most artists don't really know what they are doing and will gladly accept any interpretation of their work that flatters their ambition to appear profound. But Herr Nay [as he referred to himself] always knows what he is up to and is never prepared to accept any fanciful interpretations of his work."

In 1960 Nay painted a mural for the Chemical Institute of the University of Freiburg, Brisgau; also that year he won a Guggenheim Prize. In paintings such as *The Firmament* and *White Source* (1963), which were still gorgeously colored, a gestural brushstroke reappeared (possibly Nay had been influenced by the American Abstract Expressionists). *The Firmament*, for example, is populated with stars that are also eyes, although Nay probably would have denied any such symbolism, just as he always denied that his flowerlike watercolors of the 1950s were in fact based on flowers or anything beyond his own interior sense of color rhythms. Then, shortly before his death, there was yet another change in style. The circles and brushstrokes vanished, replaced by irregular, sharp-edged fields of color; the effect, as in *Ultramarine* (1967), was reminiscent both of Matisse's late cutouts and Jack Youngerman's color-field work.

Nay lived in Cologne with his young wife, who was also German, until his death at the age of 65. Roditi described him as typically Nordic in appearance, conveying "an impression of vigor, health, energy, and gusto," although Nay suffered from severe allergies. Hans Konrad Roethel explained Nay's several stylistic changes as stemming from his uncompromising attitude toward his work. "He fought his way with fiery perseverance, with embittered rigorousness. Like a berserker, he always turned his back on each goal immediately after it had been reached, continually summoning up new energy in order to wrench something never yet seen into the light." Nay himself said: "A work of art is a solution of problems of transmutation and requires no education, no intelligence, only a kind of will power, of emotional stress, of awareness of one's own means and ends too. In my case the product of all this is a picture that must be accepted independently and directly."

EXHIBITIONS INCLUDE: Gal. Nierendorf, Berlin 1925–28; Gal. Alfred Flechtheim, Berlin 1932; Gal. Günther Franke, Munich 1946–67; Kestner-Gesellschaft, Hanover, W. Ger. 1950; Kunstverein, Frankfurt, W. Ger. 1952; Kunstverein, Düsseldorf 1953, '59; Kleeman Gals., NYC 1955, '58, '59; Gal. der Speigel, Cologne 1957–67; M. Knoedler and Co., NYC 1961–68; Akademie der Künste, Berlin 1967; Mus. der XX Jahrhunderts, Vienna 1967; Nationalgal., Berlin 1969;

Kunsthalle, Bremen, W. Ger. 1973; Germanisches Nationalmus., Nuremberg, W. Ger. 1980. GROUP EXHIBITIONS INCLUDE: "Entartete Kunst," Munich (and tour) 1937; Documenta 1 and 2, Kassel, W. Ger. 1955, '59; "100 Years of German Painting," Tate Gal., London 1956; "German Art of the Twentieth Century," MOMA, NYC 1957; "German Art of the Twentieth Century," City Art Mus., St. Louis, Mo. 1957; "Kunst in Deutschland 1898–1973," Kunsthalle, Hamburg, W. Ger. 1974.

COLLECTIONS INCLUDE: Kunsthalle, Bremen, W. Ger.; Germanisches Nationalmus., Nuremberg, W. Ger.; Albright-Knox Art Gal., Buffalo, N.Y.; Hirshhorn Mus. and Sculpture Garden, Washington, D.C.

ABOUT: Abrams, H. New Art Around the World, 1966; Haftmann, W. Ernst Wilhelm Nay, 1960; Moore, E. (ed.) Contemporary Art 1942–72: Collection of the Albright-Knox Art Gallery, 1972; Roethel, H. K. Modern German Painting, 1954. *Periodicals*—Arts Magazine February 1964.

Photo by Robert Miller Gallery, NYC

ALICE NEEL

NEEL, ALICE (January 28, 1900–), American painter noted for her portraits and figurative work, was born in Merion Square, Pennsylvania. Her father, George Washington Neel, of Irish descent, was a clerk for the Pennsylvania Railroad and the son of a Civil War veteran. Her mother, the former Alice Concross Hartley, was descended from a signer of the Declaration of Independence and was a strong, intelligent, and somewhat willful woman. Alice was the third of their four children, two girls and two boys.

When Alice was three months old, the family moved to the small town of Colwyn, Pennsylvania, where she was raised. In a 1975 interview with Cindy Nimser she recalled: "It was a benighted little town; all the events for art were there, but there was no art." Alice was a pretty, blonde child with eyes that have been variously described as green and blue. From the beginning, she sensed that she was set apart from other people, though her mother's lament—"I don't know what you expect to do in the world; you're only a girl"—did not help Alice in her lifelong struggle against the passivity expected of women of her generation. When in 1971 Neel received an honorary doctorate of Fine Arts from Moore College of Art (formerly the Philadelphia School of Design for Women), she spoke of those early years: "I looked around and the world and its people terrified and fascinated me. I was attracted by the morbid and excessive, and everything connected with death had a dark power over me."

As early as high school, Neel saw art as her path to freedom, and in 1921 she enrolled in the Philadelphia School of Design for Women, where she drew from plaster casts and studied painting. But, restless and eager for experience, she felt confined by the school's cloistered atmosphere, and in 1924 she attended the Chester Springs Summer School of the Pennsylvania Academy of Fine Arts. There she met Carlos Enriquez, a fellow student and the son of a Cuban aristocrat.

Neel graduated from the Philadelphia School of Design in May 1925 and married Enriquez on June 1. In 1926 she and her husband traveled to Havana, where, that fall, she had her first solo exhibition. She showed about 12 paintings, including a portrait of the distinguished-looking Carlos, several moving studies of Havana beggars on a bench, and a picture of a native mother with her new baby. The canvases were in a loosely brushed expressionistic impasto which did not yet bear her distinctive imprint but did reveal her keen response to the life around her.

In December 1926, in Havana, she gave birth to her first child, a daughter named Santillana Enriquez. The next fall Neel moved with her husband to New York City, where in December 1927 her daugher died from diphtheria. Her *The Futility of Effort* (1930), painted with a strange, spare, deliberately childlike primitivism, was based in part on this tragic event and in part on a newspaper article describing the accidental death of an infant whose head was caught between the slats of its crib.

In 1928, to assuage her grief, Neel had another daughter, Isabella Lillian Enriquez, affectionately called Isabetta. She commemorated this event with her painting *Well Baby Clinic* (1928). Contrary to what the title suggests, the painting

presents a savage and terrifying image of motherhood and child-rearing among the city's poor. The women have bared breasts and bared teeth, and the babies, in the artist's words, look like "bits of raw hamburger." This and other early canvases, with their shrill tonalities and distorted drawing, bore affinities to the angst of Ensor, Munch, and the German Expressionists, although at this time Neel knew nothing of their work.

A distressing period followed the birth of Alice's second child. The marriage was in trouble, and when the stock market crashed in 1929, causing the collapse of sugar prices in Cuba, Carlos's parents stopped sending the allowance on which Alice and her husband had been living. In May 1930 Carlos took Isabetta to his parents in Havana and he went off to Paris alone, leaving Alice in New York City.

Although confused at first, she continued to paint, with financial help from her parents. In the summer of 1930 she worked in the Manhattan studio of Ethel Ashton and painted a number of nude and near-nude studies of her friends (*Ethel Ashton* and *Rhoda Myers with Blue Hat*). Her style had become stronger, simpler, and bolder, without the dark, heavy impasto of her earlier works. Speaking of these stark, compelling nudes she later recalled, "One of these I couldn't even get photographed. Exposed pubic areas were taboo."

In August 1930 the strain of her husband's desertion precipitated a nervous breakdown, followed by treatment in a Philadelphia hospital. Carlos returned to the United States and visited Alice at her parents' home where she was recuperating. But she attempted suicide, was hospitalized in Washington, D.C., and was later transferred to the Philadelphia General Hospital Suicide Ward, where drawing was encouraged as a form of therapy. Carlos left again for Europe, and in 1931 Alice entered a sanitarium in Gladwyn, Pennsylvania. One of her most moving and painful drawings of 1931 was *Suicide Ward, Philadelphia General Hospital,* in which the disturbed patients and the hospital staff were depicted in a terse, semiprimitive linear style.

Continuing to draw and paint, the strong-willed Alice Neel regained her health, and in the fall of 1931 she met Kenneth Doolittle, a guitar-playing, opium-smoking former sailor. The following year Neel moved to New York and lived with him on Cornelia Street in Greenwich Village, where her studio became a mecca for writers and artists, many of whom she painted, some naked, some clothed. She was fascinated then, as she has been ever since, by the "perverted" as well as by the so-called normal, and her subjects were radicals and bohemians, the 1930s forerunners of the beat generation. One painting, *Degenerate Woman* (1932), was removed from the street exhibition in Washington Square at the insistence of Catholic churches in the Village. Her 1933 nude portrait of the eccentric writer Joe Gould as a crazed satyr endowed with three sets of genitalia and her 1935 portrait of the poet Kenneth Fearing were, according to one critic, overly "encumbered by associational symbols." *Joe Gould* was so shocking that it was not exhibited until decades later. Her paintings of the early '30s also included a wonderful *Cat* (1932), several cityscapes—among them *Snow on Cornelia Street*—and still lifes in which "placement" was critically important.

In 1933 Alice Neel participated in the Public Works of Art Project, the precursor of the WPA, for which she was paid $30 a week, later increased to $35. In December of that year she broke with Doolittle—"A real male chauvinist," she told Nemser; "he thought he owned me"—after he, furiously jealous over the attentions paid her by another man, slashed her canvases and her clothes. The "other man" was John Rothchild, a well-to-do Harvard graduate who remained a lifelong friend and provided help when she needed it. Rothchild, who died in 1975, was the subject of a curious profile portrait painted by Neel from memory in 1935.

In the fall of 1935 Neel moved to an apartment near the waterfront and participated in longshoremen's rallies. She joined the WPA easel project, for which she was required to turn in one painting every six weeks, receiving a weekly stipend of about $27. She remained in the Project for the next seven years, but avoided the allegorical social themes so common to New Deal murals. However, her concern for people, especially the poor and suffering, found expression in her paintings of the El, the tenements and their inhabitants, and the street life around her. Indeed, though her political sympathies were with the left, she steered clear of social realism altogether.

In 1935 Neel met the Puerto Rican singer and guitar player Jose Santiago, who became the subject of the 1935 portrait *Jose.* Three years later he and Alice moved to Spanish Harlem, where in 1939 her first son, Richard Neel, was born. Jose left the same year, and Alice met Sam, a photographer and filmmaker described by Nemser as a "'mad' Russian intellectual." With Sam, whom Neel painted in 1940, she had a second son, Hartley Stockton Neel, born in 1941. Continuing to live in Harlem, Neel depicted what she has called "the face of Puerto Rico" in such portraits as that of the man in *TB, Harlem*

(1940)—compassionate but unsparing and unsentimental.

In 1944 Neel had a solo exhibition at the Pinacotheca Gallery, Rose Fried's first gallery, on West 58th Street. When, beginning in 1945, Rose Fried supported the new abstract expressionist painting, Neel left the gallery. Unlike such artists as Pollock and de Kooning, in the 1940s Neel painted still lifes, landscapes, seascapes, cityscapes, and portraits. From 1951 on she exhibited periodically at the A.C.A. Gallery, New York City.

Neel's portraits of the 1950s, including *John Rothchild* (1958) and *The Baron's Aunt* (1959), had the tense poses and vivid facial expressions that anticipated her later work, but the tonalities were darker and the brushwork more expressionistic. She received notices in the art press, but little recognition during the years of abstract expressionism's international triumph, when Neel's realistic style little appealed to critics. "I had no talent for the business of art," Neel said. "I never knew how to push myself, and still don't know how."

In the early 1960s, however, Alice Neel gained recognition as an artist. A group show of double portraits at the A.C.A. Gallery in the fall of 1960 was reviewed in the December issue of *Art News* and her work was illustrated for the first time in that magazine. Her arresting portrait, painted in late 1959, of the poet Frank O'Hara attracted much attention in the 1962 "Figures" exhibition at the Kornblee Gallery, New York City, and that same year her work was included in a group show organized by the Museum of Modern Art called "Recent Painting, USA: the Figure." The New York art scene was now becoming pluralistic—a development that coincided with what Alice Neel called "the abstract expressionist debacle"—and realism in various forms was being shown once again.

In 1962 Neel was awarded the Longview Foundation Prize by Dillard University, New Orleans—a black college—and Thomas B. Hess, who had been an early and influential supporter of abstract expressionism, selected her *Portrait of Stewart Mott* (1961) to present to Dillard. Neel showed the philanthropist and liberal political activist Mott with a beard and wearing a kilt. In December 1962 an illustrated article, "Introducing the Portraits of Alice Neel," appeared in *Art News,* and after 1963 she exhibited regularly at the Graham Gallery, New York City. In her doctoral address at Moore College of Art, Alice Neel credited "the women's lib movement" with "giving the woman the right to practice openly what I had to do in an underground way. . . . I have only become known in the sixties because before I could not defend myself."

In 1962 Alice Neel moved from Spanish Harlem to an apartment on 107th Street west of Broadway, where she has continued to live and work. She no longer paints the Harlem poor but her sympathies are unchanged: she is still worried by "the wretched faces in the subway, sad and full of troubles."

Neel's paintings of the '60s and '70s were brighter in color than her earlier works; her line had greater boldness and freedom, and her paint was less thickly applied. She has executed few commissioned portraits, as she prefers to choose her own subjects, many of whom are denizens of the art world. "I never wanted to work for hire," she explained, "because I don't want to do what will please a subject. The persons themselves dictate to a certain extent the way they are done. . . ." Indeed, her portraiture is never ingratiating, and the realistic painter Raphael Soyer, whose double portrait of 1973 with his twin brother Moses is one of Neel's most memorable works, described her figures as "a veritable inferno of humans [who] are almost convulsively alive—their hands, mouths, eyes grimace and contort." Soyer considers her the only true Expressionist now working in the US, although Neel herself is reluctant to accept that categorization. In the catalog to a 1975 Neel retrospective at the Georgia Museum of Art, Athens, Soyer discussed her approach to her sitters: "She seems to relish showing their physical inadequacies, exposing their nakedness, vulnerability, mortality, [qualities] sensed poignantly in her paintings of young people and children." Alluding to Gogol, Neel once described herself as "a collector of souls." As with Goya, her feelings toward her subject, whether sympathetic, hostile, ambivalent, or, in the case of children, tender without being sentimental, are always manifest. Again like Goya, this is not deliberate, but arises from the deepest empathy and from her awareness of the pressures of life, "as shown in the psychology of the people I painted." Among the most striking portraits in her 1975 retrospective were those of the then beardless Henry Geldzahler (1967), looking both imperious and apprehensive; Andy Warhol (1970), eyes closed and zombielike, his bare torso covered with a patchwork of scars, reminders of the shooting that nearly killed him; a proud and petulant Virgil Thomson (1971); two tense and revealing portraits of artist-couples who later separated, *Red Grooms and Mimi Gross* (1967) and *Benny and Mary Ellen Andrews* (1972); and the exceptional *The Soyer Brothers* (1973). In the nude portrait of *Village Voice* art critic John Perreault (1972) and the double portrait in the nude of Cindy and

Chuck Nemser (1975), her subjects' sex is fully displayed. One of her most unsettling pictures is of the transvestites Jackie Curtis and Rita Red (1970), members of Andy Warhol's entourage. On the other hand, there is great warmth in the family portraits, especially in *Mother and Child* (1967) of her daughter-in-law Nancy (Richard's wife) with Nancy's daughter Olivia. In her 1974 picture of Isabel Bishop the patrician features and quizzical expression of that painter were sympathetically captured. The backgrounds of many of these portraits were left partially unfinished or treated in planes of neutral color, so that the viewer's eye was led directly to the subject.

In her late 70s Alice Neel was still a free spirit, as alert as ever and as deeply involved in painting, in people, and in the world around her. Her plump, grandmotherly appearance and sometimes naive manner can be deceptive: she is warm, sociable, and outgoing, but as the critic John Russell said of heroic women like Neel and Louise Nevelson who "made it" in the male-dominated art world, "They are not people to tangle with. . . . The man has yet to be born who could sass some of those great seniors and get away with it." Neel especially is a tough survivor, and little escapes her scrutiny. One of her subjects—or "victims" as she sometimes calls them—Jack Baur, former director of the Whitney Museum of American Art, sent her a poem: "Ah! What innocent blue eyes/Soft as violets, sharp as knives,/ Dissecting all our private lives. . . ."

Neel has a disarming way of verbalizing the mental image of someone just met. "You're a Bohemian," she will exclaim, or: "You're a typical European"; "You look like a sailor"; "You're an Eastern princess"; "You belong in a medieval tapestry." Her pleasantly old-fashioned apartment on 107th Street is cluttered with canvases (her sitters do not invariably buy their uncommissioned portraits), and the room in which she does most of her painting is small but well-lit, has a high ceiling, and commands a fine view of the street. Neel does very few preliminary drawings before beginning a portrait—"I've been painting so long," she said, "I feel I'm a pro." Instead of posing her models she engages them in amiable conversation, and finds that eventually they take their own natural—and therefore most revealing—pose. She works rapidly, often making pungent comments as she paints. Her daughter-in-law Nancy, the subject of her most expressive paintings, acts as her assistant. Her son Richard became a lawyer, his brother Hartley a doctor.

In 1974, on the occasion of her large retrospective at the Whitney Museum, New York City, Alice Neel wrote: "I have always considered the human being the first premise—I feel his condition is a barometer of his era." Attacking "the dehumanization of today," she observed, "Hans Christian Andersen made Christmas trees, bottle necks and tin soldiers think and feel, but today it is fashionable to be 'cool' and to make depersonalized images. We must trot back to human size and human feelings."

EXHIBITIONS INCLUDE: Contemporary Arts Gal., NYC 1938; Pinacotheca Gal., NYC 1944; A.C.A. Gal., NYC 1951, '54; Graham Gal., NYC 1963, '66, '68, '70, '74, '76; Fordham Univ., Bronx, N.Y. 1965; Moore Col., Philadelphia 1971; Bowling Green Univ., Ohio 1972; Whitney Mus. of Am. Art, NYC 1974; Georgia Mus. of Art, Univ. of Georgia, Athens 1975; Fort Lauderdale Mus. of Art, Fla. 1978; Miller Gal., NYC 1982, '84. GROUP EXHIBITIONS INCLUDE: International Exhibition, Boyer Gal., Philadelphia 1933; A.C.A. Gal., NYC 1960; "Figures," Kornblee Gal., NYC 1962; "Recent Painting, USA: The Figure," MOMA, NYC 1962; "Contemporary American Figure Painting Group Show," Wadsworth Atheneum, Hartford, Conn. 1964; "The Emotional Temperatures of Art," traveling exhibition, Am. Federation of the Arts 1964–65; "Social Comment in America," MOMA, NYC 1967; "Contemporary Portraits," Circulating Exhibition, MOMA, NYC 1968–70; "Mom, Apple Pie and the American Flag," Graham Gal., NYC 1969; Whitney Mus. Painting Annual, NYC 1972; "Women Chose Women," and "Three Centuries of the American Nude," New York Cultural Center 1975.

ABOUT: Hills, P. Alice Neel, 1983; "Alice Neel" (cat.), Georgia Mus. of Art, Univ. of Georgia, Athens 1975; "Alice Neel" (cat.), Whitney Mus. of Am. Art, NYC 1974; Hope, H.R. "Alice Neel" (cat.), Fort Lauderdale Mus. of Art, Fla. 1978; Nemser, C. Art Talk, 1975. *Periodicals*—Artforum October 1983; Art in America January–February 1975; Art International December 1970; Art News January 1951, October 1954, December 1960, October 1962, January 1966, April 1976, January 1982; Arts Magazine October 1963, May 1978; Connoisseur (Des Moines, Iowa) September 1981; Ms October 1973; Nation February 15, 1971; New York March 4, 1974; New York Post July 5, 1975; New York Times January 20, 1968, February 9, 1974, July 24, 1983; Newsweek January 31, 1966; Village Voice February 21, 1974.

***NEIZVESTNY, ERNST** (April 9, 1926–), Russian sculptor and graphic artist, achieved immediate international celebrity in the early 1960s as the most prominent of the dissident artists in the Soviet Union. He was born Sverdlovsk, a town in the eastern foothills of the central Urals, where his parents still live. His father is a surgeon, specializing in children's ailments; his mother, who is Jewish, is a biochemist and also a poet and writer of children's books.

°nĕz vest´nē, ernst

Photo © Tapio Airaksinen

ERNST NEIZVESTNY

The Urals, where Neizvestny grew up, was a retreat for disaffected intellectuals, both communist and anticommunist. The atmosphere of tension made a lasting impression on the boy, who later recalled: "My war began in early childhood and it hasn't stopped. I have always had the feeling of being in the front line. Now I've reached the point where I only feel really well when I'm under stress."

Neizvestny's earliest artistic training was at a school for gifted children in Leningrad. In 1942, the year after the German invasion of Russia, Neizvestny, aged 16, volunteered for military service. Possessed of great physical strength and courage, he became in 1943 a lieutenant in charge of a platoon of commandos who were dropped behind German lines. He was severely wounded by a bullet which entered his chest and exploded in his back. Left for dead, he lay for hours on the battlefield, but miraculously survived and made his way back to the Russian lines. Many years later, in 1964, he was awarded the Red Star for Wartime Gallantry.

After his discharge from the army he studied art for five months in Samarkand and spent 1946 at an academy in Riga, Latvia. In 1947 he went to Moscow, where he took a complete course at the Surikov Institute, Moscow's leading art school. He also studied philosophy at Moscow University.

Neizvestny was ardently patriotic, and his early sculptures were in the official socialist realist style, with heroic, muscular workers as subject matter. But even in these convention-bound works there were signs of a vigorous individualism struggling to break through. He set out to re-

form official aesthetic taste from within, and joined the Union of Artists, which was slightly more liberal than the Academy of Fine Arts. It is true that both of these official organizations control all sanctioned visual art in the Soviet Union, but after the death of Stalin in 1953 there was, for a time, less insistence on monolithic orthodoxy. Neizvestny had no intention of opposing "private art" to "public art"; on the contrary, he firmly believed that sculpture should be an art for the masses, and he took advantage of this somewhat more relaxed atmosphere to challenge official taste.

But it was precisely the public aspect of his ambitious sculptural projects—and the fact that he won over a number of architects to his ideas (he attacked the "wedding-cake" style of Stalinist buildings)—that made him a threat to the authorities. Convinced that "art must reach a mass public" and that "the purpose of art is to reveal the human significance of *becoming*," he maintained that "the richest art, however ambitious, has been, and will be, created collectively," and insisted that "what is considered to be art and aims at harmony, is despicable." In these statements, with their stress on achievement and liberation, there were echoes of the poet Vladimir Mayakovsky's rebellion in the years immediately following the Revolution. Neizvestny, having grown up under the Soviet system, was not a rebel and iconoclast like Mayakovsky, but he was nevertheless engaged in a dialectic between his personal progressive, individualistic tendencies and the demands of the state, the only important sponsor of the arts.

By 1956, Neizvestny, aged 30, was already a mature personality. He had finished his studies at the Moscow Academy in 1954 and had begun to work by himself. In 1955 he made one of his first independent sculptures, *Soldier Being Bayoneted*, in bronze. During the war Neizvestny had come close to dying, but this did not lead to an obsession with death. While not minimizing its tragedy, he saw it as the counterpart of the energy of life, and his main emphasis was on human adaptability and strength of will. Thus, a number of his sculptures in the next few years were of war survivors, including the wounded and maimed. These works were figurative, with symbolic and expressionistic elements, but were aesthetically not altogether successful. An example is *Man with Artificial Limb* of 1957, which suggests that its soldier subject has lost his limb but not yet his life. In *All Clear*, a bronze of the same year, a soldier pulls off his gas mask to reveal a single, wary, searching eye. Despite the vigor of the forms, an unwelcome literary element often intruded, a recurring feature of much Russian art of both the pre- and

postrevolutionary eras. At the same time the stark, turbulent spirit of these works was hardly in keeping with "heroic" socialist optimism, and *The Suicide* was barely acceptable to the authorities.

It is not surprising that between 1958 and 1968 Neizvestny received only one official commission—a large sculptural ensemble for the Artek Pioneers' camp in the Crimea. It was not approved until 1967, and the ensemble bears marks of struggle and compromise. Since studios were reserved for "official" artists, Neizvestny worked in an unused shop in a back street near the center of Moscow. The workshop was small and badly lit; a small ladderlike staircase at the back led to a tiny upper room, filled with portfolios and drawings. There he stored numerous maquettes for unrealized public monuments.

In the years 1958–68 Neizvestny earned a precarious living selling small sculptures and drawings to private individuals, mostly scientists and others of the intelligentsia. All applications from abroad to buy his work were officially denied by the state Salon for the Sale of Art Objects. He could only obtain wood, stone, and other materials "privately," that is, on the black market. Casting in metal was a major problem, inasmuch as state foundries only accepted works for casting via state organizations. Neizvestny installed a small furnace in the back of his workshop and could only make very small casts. This meant that he had to cast large figures in many pieces, and this composite method was to influence his later monumental concepts.

The art of the postrevolutionary avant-garde in the Soviet Union, represented in the 1920s by such artists as Vladimir Tatlin and El Lissitzky, had long been suppressed. With the imposition of Stalinist socialist realism, it was difficult enough for artists of Neizvestny's generation even to see reproductions of modernist works in art magazines from abroad, let alone any originals. Neizvestny did succeed in seeing photographs of the sculptures of Henry Moore and Jacques Lipchitz, and he was deeply impressed by a photograph of Ossip Zadkine's monument *The Destroyed City*, erected in Rotterdam in 1953, and symbolizing in its tortured, twisted forms the grief of mankind stricken by the tragedy of war. Neizvestny's vision has always been anthropocentric, with the human figure as the field for all possible metaphors. Among earlier sculptors, Rodin and Emile-Antoine Bourdelle can be cited as influences, but whereas Rodin used the outward manifestations of the body to express emotion, Neizvestny was interested in its interior configurations. He has said: "I can work from inside the body instead of from the outside,

and what will be the exterior surface of the bronze feels no farther from the center of me than my own skin." He admires Moore and has been influenced by him, but that influence was limited by their utterly dissimilar temperaments.

Neizvestny's own work is closer in spirit to what at first sight may seem "old-fashioned modern," the semiexpressionist, postcubist style of sculpture produced after World War I by Lipchitz, Zadkine (both of Russian-Jewish origin), and the Spaniard Pablo Gargallo, who introduced Picasso to metal sculpture. Where Neizvestny himself has found the greatest freedom and fantasy of expression is in metal sculpture; he is least successful, according to the English Marxist John Berger, when the forms of the sculpture fail to do justice to his intentions. His work then becomes overly rhetorical and melodramatic. However, in such pieces as *The Stride* (1960), combining human and biological elements, and *Adam* (1962–63), in which sex is seen as a primal expression of energy, there is complete unity of form and content.

In 1961 Neizvestny held a solo show at the Friendship Club in Moscow, and the following year had his famous confrontation with Nikita Khrushchev. The Moscow Union of Artists decided to hold a group exhibit of work from the past 50 years at the People's Creation House. In keeping with the Union's "liberal" emphasis, Neizvestny was included. The artist Bilyutin, then running a teaching studio, managed to have the exhibit placed under the auspices of the Moscow City Council. The exhibition was then transferred to the Manège, a building near the Kremlin, but the show was considered so controversial that the public was excluded. It was the first official show of young, living Moscow artists since the 1920s, and the last. Khrushchev, then at the height of his power, coarsely denounced the more modernist art on exhibit and asked who was responsible for the show. Neizvestny stepped forward as the spokesman for the artists. Khrushchev began to shout at him, but Neizvestny shouted back: "You may be Premier and Chairman but not here in front of my works. Here I am Premier and we shall discuss as equals." A heated argument ensued which lasted for about an hour. Neizvestny declared that the art produced under Stalin was "rotten," and added, "The same kind of artists are still deceiving you." When Neizvestny referred to the work of his artist friends, he was accused of being a homosexual. Neizvestny replied: "In such matters, Nikita Sergeyevich, it is awkward to bear testimony on one's own behalf. But if you could find a girl here and now—I think I should be able to show you." This rough humor appealed to Khru-

shchev, who laughed heartily and was obviously impressed by the way the artist stood up to him. On his way out with his entourage, Khrushchev turned and said to Neizvestny: "You are the kind of man I like. But there's an angel and a devil in you. If the angel wins we can get along together. If it's the devil who wins we shall destroy you."

Neizvestny was not arrested by the Security Police on leaving the building, as he had feared. After this confrontation he and Khrushchev became friends, although the Soviet premier could never like or understand his work. After his fall from favor in 1964, Khrushchev said, "If I met him now, I would apologize." When Khrushchev died in 1971, his widow asked Neizvestny to carve the stone for his tomb in the Novodevichy cemetery on the outskirts of Moscow. The 15-ton tombstone combines an over-life-sized bust of Khrushchev, an excellent likeness, with interlocking black and white abstract stone shapes.

In the mid- and late-1960s Neizvestny's work was shown in several important exhibits outside of Russia. He participated in the "Sculptors' Drawings" exhibition held in 1965 at the Grosvenor Gallery, London. His vigorous drawings were exhibited at the Lambert Gallery, Paris, in 1966, and in 1970 he was represented in the "New Directions in Moscow" exhibit held at the Fine Arts Museum, Lugano, Switzerland. Although his work still did not meet with official approval, the Soviet authorities, because of his international reputation, permitted him unusual creative latitude. In 1971 he won the first prize in an international competition for the world's largest modern monument, a 265-foot-tall sculpture for the gigantic Aswan Dam in Egypt. This is one of Neizvestny's most successful creations; a crown of five tall concrete blades suggesting lotus petals is decorated on the interior of each blade with a formalized drawing in heavy black outlines of a worker. But the abstract rhythms of the monument predominate and make an impressive landmark. He calls the Aswan monument "my flower."

Among Neizvestny's more important commissions in the Soviet Union in the 1970s was a cement relief for the facade of the headquarters of the Central Committee of the Communist Party of Turkmenistan, in the city of Ashkhabad, completed in 1975. The flattened, blocked-in figures superimposed on a stone screen with an openwork design hardly conform to the official image of "Soviet man." When asked some years later in New York City how he was able to get it accepted, he laughingly replied, "I am diplomat." In fact, he had shown each individual part, in progress or completed, to the authorities, who found it acceptable because they could not foresee how the facade would look when finally assembled.

Neizvestny was also able to execute a large relief sculpture for the Moscow Crematorium, as well as a project for a *Monument to the Cosmonauts.* However, he was finding it increasingly difficult to exhibit his work publicly, and although not subject to as much official pressure as lesser-known artists, he finally decided that he had had enough. After numerous requests for permission to travel abroad, according to his account, Neizvestny "provoked" the Soviet authorities into expelling him in 1976. Because his mother was Jewish, he was given permission to emigrate to Israel. Khrushchev's family kept at its country estate all the works that the artist could not afford to take with him.

In Austria, Israeli officials told Neizvestny that he would have difficulty traveling on an Israeli passport and might not be able to accomplish the work he had in mind. They advised him to apply for a Swiss passport. He obtained one and settled in Zürich, but spent time traveling in Europe, collecting his sketches, pictures, and other objects that had been sent out of the Soviet Union. In the fall of 1976 he visited the United States, looking for a backer for a mammoth project he had been planning for 20 years—a colossal monument called *The Heart of Mankind,* or *The Tree of Man,* for which Soviet authorities had refused to provide space. The great heart-shaped structure was envisaged as consisting of seven strips of reinforced concrete forming a base for 800 small sculptures and reliefs in bronze, steel, aluminum, glass, enamel, and plastic. A central elevator shaft was to link the strips, and enable the viewer to see the monument from the inside. In September 1976 Neizvestny attended the unveiling of his bust of the composer Dmitri Shostakovich, whose 70th birthday was being celebrated at Kennedy Center in Washington, D.C.. A critic writing in the *Washington Post* called it "a bust which projects a sensation of great strength. . . . It is a powerful image."

A number of individual pieces conceived as part of a monumental *Tree of Life* were exhibited at the Städtische Museum in Schloss Morsbroich, Leverkusen, West Germany in October 1977, along with many of the sculptor's drawings. The recurring motif of the cross, obviously unacceptable to the Soviet authorities, was used as a symbol of human suffering. In the words of a writer for *Die Welt,* "It is a depiction of the human body winding compulsively, like the instrument of spiritual experiences." The critic referred to Neizvestny's works as "pieces of one

enormous confession." An *Art News* (February 1978) reviewer of the same show remarked, "The trouble is that sculptural form and explicit emotion are not easily reconciled."

On Neizvestny's second visit to the US he rented a big duplex studio in downtown Manhattan just south of Canal Street. He loves New York and intends to settle and work here, and wind up his affairs in Zurich. Switzerland provided a haven at the time of his leaving the Soviet Union, but he finds the Swiss environment confining and, as he says, "good for sleeping." If he can secure the necessary backing, America has the means, he feels, to sponsor his ambitious projects. His large studio is filled with his sculptures, which, to quote Anthony Astrachan of *The New York Times* (April 11, 1976), are "usually human figures with both mechanical and organic features, many of them gigantesque and caught in moments of tension that seem to express profound pain." Large-scale drawings in a similar vein are on the walls, and a series of powerful etchings for Dante's *Divine Comedy* are also on view. One series of 200 etchings is entitled *Man's Fate*. His etchings were shown at the New York Cultural Center in 1975, and Hilton Kramer wrote in his review that Neizvestny was "enormously impressive" as a graphic technician.

Ernst Neizvestny has a sculptor's build, and was described in *The New York Times* (September 26, 1976) as having "a chest like a barrel and arms like a stevedore." A French critic in *Dossier, magazine littéraire* (June 1977) wrote of him as "husky, round, and muscular, with a flashing smile, eyes bordered with mischief, colossal vigor, stubborn resolve, but also an intelligence always on the alert. . . . Neizvestny overwhelms you like a maelstrom." Although certain critics, especially in America, consider some of his works excessively rhetorical, none deny his tremendous energy, power, and ambition, and his courage in withstanding the creative isolation and constraint under which he labored for so long is widely praised. Neizvestny sums up his stubbornly independent attitude to life with a favorite Russian saying: "A man should stand on his own two feet, even if he has only one leg."

EXHIBITIONS INCLUDE: Druzhba (Friendship) Club, Moscow 1961; Grosvenor Gal., London 1964, '65; Mus., Belgrade, Yugoslavia 1965; Gal. Lambert, Paris 1966; Gal. La Barcaccia, Montecatini, Italy 1969; Gal. Il Gabbiano, Rome 1971; Tel Aviv Mus. 1972; New York Cultural Center, NYC 1975; Stedelijk Mus., Amsterdam 1976; Schloss Morsbroich, Leverkusen, W. Ger. 1977. GROUP EXHIBITIONS INCLUDE: "Young Moscow Artists," Moscow 1954; "The Nine," Moscow 1961; "Exhibition of the Belyutin Studio Group," the Manège, Moscow 1962; "Aspects of Contemporary Soviet Art," Grosvenor Gal., London 1964; "Sculptors' Drawings," Grosvenor Gal., London 1965; "New Moscow School," Pannati Gal., Florence 1969; "New Directions in Moscow," Fine Arts Mus., Lugano, Switzerland 1970; "Neizvestny and Other Soviet Artists," Gal. Anthea, Rome 1972; "Progressive Currents in Moscow 1957–70," Mus., Bochum, W. Ger. 1974; "Non-Conformist Russian Painters," Art League, Freiburg, W. Ger.; "Non-Conformist Russian Painters," Art Board, Charlottenburg, W. Ger.; "Unofficial Art from the Soviet Union," Inst. of Contemporary Arts, London 1977.

COLLECTIONS INCLUDE: Russian Art Mus., Leningrad; Fine Arts Mus., Lugano, Switzerland; Mus. d'Art Moderne de la Ville de Paris; Stedelijk Mus., Amsterdam; Mus. of Modern Art, Stockholm; Vatican Collection, Rome; Kennedy Center for the Arts, Washington, D.C.; Tel Aviv Mus.

ABOUT: Andreyev-Carlisle, O. Des Voix dans la neige, 1964; Bénézit, E. (ed.) Dictionnaire des peintres, sculpteurs et graveurs, 1976; Berger, J. Art and Revolution: Ernst Neizvestny and the Role of the Artist in the U.S.S.R., 1969; "Ernst Neizvestny" (cat.), Gal. Lambert, Paris, 1966; Golomshtok, I. and others "Unofficial Art from the Soviet Union" (cat.), London, 1977; Micheli, M. de Ernst Neizvestny, 1978; "Neizvestny: Drawings for Sculpture" (cat.), Grosvenor Gal., London 1965; Selvaggi, G. "Neizvestny and Other Soviet Artists" (cat.), Gal. Anthea, Rome, 1972. *Periodicals*—Art News December 1976, May 1977; Dossier, magazine littéraire June 1977; New York Times April 11, 1976, September 26, 1976, December 1, 1978; Opus International (Paris) December 1967; Studio International July 1969; Die Welt (Hamburg) October 29, 1977.

NEVELSON, LOUISE (September 23, 1899–), American sculptor, is generally regarded as the originator of environmental sculpture in America, as well as one of the most forceful, original, and colorful figures in contemporary art. In her 80s she continues to produce major work with undiminished vigor.

She was born Louise Berliawsky, in Kiev, Russia, into a Jewish family. In 1905 her parents Isaac and Minna Berliawsky immigrated with their four children to the United States. The family settled in Rockland, Maine, where the father ran a lumberyard. The rocky Maine landscape, with its rugged coastline and lofty pine trees, was the milieu of her childhood. Intimacy with wood—the living trees and the lumberyard's hewn planks—was another part of her heritage. In her speech she still retains traces of a New England accent.

Louise attended the Rockland public schools.

LOUISE NEVELSON

Though an average student in most subjects, she excelled in art and was encouraged by her teachers. "From earliest, earliest childhood," she recalled, "I knew I was going to be an artist. I felt like an artist."

In 1918 she graduated from Rockland High School and that same year met Charles Nevelson, whom she married two years later. Nevelson and his brothers were in the shipping business in New York. At the very outset of the marriage it was understood that in New York City, where they had moved, Louise would study art.

She took courses in painting and drawing with Theresa Bernstein and William Meyrowitz, and studied voice with Metropolitan Opera coach Estelle Liebling. She also attended courses in dramatics. In 1922 her son Myron (Mike) was born, but her marriage to Nevelson soon ended. There was little the two had in common, and Nevelson remarked years later that "the greater restriction of a family situation strangled me."

In 1929 she began to study art more seriously, taking courses at the Art Students League, New York City, with Kenneth Hayes Miller and Kimon Nikolaides. In 1931 Nevelson went to Munich and studied briefly with Hans Hofmann, who would later decisively influence the development of abstract art in the US. Through Hofmann she became familiar with the work and ideas of Picasso, Braque, Léger, and other pioneers of modernism in France. Her strikingly photogenic features also enabled her to work as a film extra in Berlin and Vienna.

In 1932, after her return to New York, she met Diego Rivera, whom she assisted on his mural for the New Workers' School on 14th Street. (Ben Shahn was also an assistant on this project.) She studied modern dance with Ellen Kearns and others, and in 1937 taught an art class at the Education Alliance School sponsored by the Works Progress Administration. Her studies in voice, dancing, and dramatics gave her, she said, "a rounded point of view."

The turning point in her life occurred when she began to make sculpture. As early as 1933 she had modeled a figure in plaster, *Earth Woman II*, though it was still closely related to her painting. She held her first solo exhibition at the Nierendorf Gallery, New York City, in 1941, and it was in the 1940s that she began to find her own way as an artist, producing a great many works in various media, stone, bronze, terra cotta, and wood. From the first there was an interesting duality between the real or fantastic world and her strongly geometric, almost classically cubist approach. Nevelson once said, "For me, Cubism and Expressionism are the two great movements." Hilton Kramer asserted that Nevelson's achievement was "to release a sculptural energy which is audacious and spendthrift in its overall force, but very exactly stated in its details." There are also elements of dada and surrealism, as other critics have observed. Examples of her work in the 1940s were the semicubist bronzes *Self-Portrait* (1942) and *Dancer* (1945).

In 1948 Nevelson traveled in England, France, and Italy, but two trips she made in 1949–50 to Mexico, where she was much moved by Mexican art and archaeology, had even greater impact. In those same years she worked at the Sculpture Center, New York City, in terra cotta, aluminum, and bronze, although she also produced the near-abstract *Cat* and *Abstract Bird Form* in marble. One of her most personal sculptures was *Archaic Figure with a Star on a Head* (1949–50), in plaster painted black. Although this was a period of feverish creativity for her, she had as yet won little recognition and faced difficult economic circumstances.

Nevelson was stimulated by a period of study in Stanley William Hayter's print workshop Atelier 17, in New York City in 1953–55. Hayter himself had returned to Paris in 1950, but Nevelson studied with his pupils Peter Grippi and Leo Katz. Her sculpture took a new direction with *Black Majesty* (1955, in wood painted black), an abstract but emotionally compelling work in which the assembled shapes evoke the image of the African continent. It became part of a strange and haunting environment, *The Royal Voyage*, exhibited in 1956 at the Grand Central Moderns Gallery, New York City. The theme of the show was the voyage of the Bride of the Black Moon, derived from an African legend.

The exhibition aroused considerable interest, and *Black Majesty* was acquired by the Whitney Museum of American Art, New York City. Nevelson wrote to the Whitney about this sculpture: "In all my work is the Image and the Symbol. I compose my work pretty much as a poet does, only instead of the word I use the plastic form for my images."

Although Nevelson had been working in wood since the early '50s, 1955 was the year when her assemblage style took shape. She began to compose her sculptures with wooden objects culled from ruined tenements, painted a uniform color and manipulated in various combinations. Beginning with *The Royal Voyage* (1956), her exhibits were in effect environments with a theme, although each piece could be enjoyed individually. The gallery allowed her to move the sculptures around during the installation, to achieve the maximum dramatic effect. Two remarkable exhibitions, "The Forest" and "Moon Garden + One" (the "one" was the viewer), were held at Grand Central Moderns in 1957 and 1958 respectively. For *The Forest* the gallery was bathed in an eerie lighting, wherein the piece *First Personage* (Brooklyn Museum, New York) stood, to quote one critic, "like a large and even threatening presence, a great beast of the forest." Shadow has always been part of Nevelson's vision: "I really deal with shadow and space. . . . I identify with the shadow."

In 1958 Nevelson moved to a studio in Manhattan's Little Italy. That same year the Museum of Modern Art, New York City, acquired one of her finest pieces, *Sky Cathedral*, in wood painted black. To unify the conception Nevelson painted many of her works black, a color symbolic of shadow and mystery as well as being, in her words, "the most aristocratic color."

Nevelson's use of boxes in the late 1950s (mostly milk cases and lettuce crates), as in *Moon Garden Reflections* (ca 1957), heightened the sense of secrecy and mystery. Until 1960 she made virtually all her own works, but in that year she began to have boxes specially constructed by a carpenter. Unlike the earlier "found" boxes, these were sleek and perfect, giving a more "hard-edge" quality to her sculptural compositions. *America-Dawn*, in wood painted white, and *Dawn*, painted black (both of 1962), are examples of this development. Sometimes Nevelson assembled numbers of boxes, each containing an assortment of shapes, to form an entire wall, as in *Totality Dark* (1962). That same year the Whitney Museum purchased another wall, *Young Shadows*, painted black and completed in 1960.

Nevelson's national and international reputation had been steadily growing. In 1960 she was included in MOMA's important "Sixteen Americans" exhibition, and she was represented in the United States pavilion at the Venice Biennale of 1962. In the 1960s her walls grew more ambitious in scale, achieving a serene and majestic presence. Nevelson's ability to interpret contemporary experience in a nonfigurative but humanly significant idiom was revealed in her nine foot high, black-painted curved wall, *Homage to the Six Million*. This commemoration of the Jews murdered by the Nazis in the holocaust was purchased in 1965 by the Israel Museum, Jerusalem.

In contrast, a festive, triumphant wall painted in gold, *An American Tribute to the British People*, which has the solemn resonance of organ music, was presented by the artist in 1965 to the Tate Gallery, London. It was lent by the Tate to the impressive Nevelson retrospective of 1966 at the Whitney Museum.

Nevelson's studio in the early 1960s, consisting of five stories and living space, was packed full with works completed and in progress. On a shelf in her living room was her collection of African masks and figures, American Indian pottery, pre-Columbian sculptures, and Puerto Rican santos, all crammed closely together. In 1967, at the age of 67, she made a drastic decision to divest herself of almost all her material possessions. She had already sold her Eilshemius paintings, and now she proceeded to sell her primitive sculpture and pottery. All of her furniture was either sold or put out on the street. She replaced her discarded belongings with practical steel filing cabinets, and the minimal furniture reflected her feeling that comfortable chairs produce boring, "soft" conversation. There was to be no distraction from her all-consuming purpose—work. One visitor remarked that Nevelson's house after 1967 resembled a monastery more than a garden by moonlight.

In some of her large sculptures of the 1970s Nevelson moved away from the box aggregations toward a more open form. *Bicentennial Dawn* (1975) evokes by analogy the varied highrise buildings in Manhattan. As she observed in a conversation with Diana MacKown, recorded in the book *Dawns and Dusks* (1976): "When I look at the city from my point of view, I see New York City as a *great big sculpture.*" She particularly admires the "two giant cubes" of the World Trade Center. Whether her pieces are set up temporarily in Central Park or permanently on Park Avenue, they look thoroughly at home in the urban environment. Nevelson remarked of a visit to Georgia O'Keeffe in New Mexico: " . . . The mountains are her landscape. Well, New York City is mine."

One of Nevelson's most interesting commissions in 1976 was the designing of a chapel for St. Peter's Lutheran Church, known in New York City as the "jazz church"; it was noted for its cultural activities, particularly in music and the performing arts. The chapel's pastor described it as "a white environment which has focus on the Good Shepherd." The sculpture was designed as a composition of white-painted wood forms on white walls, with a cross of gold leaf and white wood providing a focal point. Like Matisse in the Vence chapel, Nevelson designed the altar and the priests' vestments as well as the setting.

In April 1976 Nevelson held an "upstairs-downstairs" show at the Pace Gallery, New York City. On the ground level was *Moongarden Two,* with her familiar walls. The shallow boxes and crates making up the sculptural walls were packed with newel posts, moldings, balustrade sections, chair slats, and other fragments, painted entirely in black, as were the gallery walls. Downstairs, below ground level, was another grouping, *Dawn's Presence-Two,* painted a bright white, like the galleries themselves. The *Art News* critic noted that "Nevelson has not altered her assemblage style significantly since the 1950's" but added that "her works are always fresh in their power and visual poetry." *Moongarden Two* was praised by the writer for "creating a haunted and reflective, yet architecturally powerful environment." However, the reviewer found the presentation of the night-day contrast overly theatrical, and observed that "her 'walls' are not so cryptic as to demand such stagey over-explanation of their poetic content."

Louise Nevelson in her early 80s is a handsome woman, five-feet-seven-and-one-half inches tall, with a commanding and dramatic presence. Highly articulate and positive, and never shy of the limelight, she has been described by Hilton Kramer as "a prodigious personality—at once voluble, glamorous and utterly serious." She has a spectacular flair for dress, jewelry, and make-up, "but I don't like looking conventional or sweet." Though Nevelson is greatly admired by feminists, she insists that "the creative concept has no sex or is perhaps feminine in nature." She feels that her works are "definitely feminine . . . My work is delicate: it may look strong, but it is delicate. True strength is delicate. My whole life is in it, and my whole life is feminine. . . . "

Nevelson is a compulsive worker, rising at about five in the morning (hence the title of her book, *Dawn to Dusk*). In recent years she has made sculptures in Cor-ten steel as well as wood. "I work in a foundry in North Haven. I never sketch. I just say 'Cut me a two by four or a semicircle.'" Her four-story house in SoHo is attached to a five-story house and a garage which serves both as workroom and storage place. She calls her living room "the forest." Its trees are posts, with no two alike. Her work fills even the stairwell landings of her "Little Italy palazzo," as it has been called, but the living quarters are nearly empty of art.

Utterly independent, outspoken, and self-assured, Louise Nevelson once summed up the purpose behind her work in this way: "My total conscious search in life has been for a new seeing, a new image, a new insight. This search not only includes the object, but the in-between place. The dawns and the dusks. The objective world, the heavenly spheres, the places between the land and the sea. . . . "

EXHIBITIONS INCLUDE: Nierendorf Gal., NYC 1941–46; Lotte Jacobi Gal., NYC 1950, '54; Grand Central Moderns Gal., NYC 1955–58; Martha Jackson Gal., NYC 1959–69; Gal. Daniel Cordier, Paris 1960, '61; Staatliche Kunsthalle, Baden-Baden, W. Ger. 1961; Sidney Janis Gal., NYC 1963; Hanover Gal., London 1963; Gimpel and Hanover Gal., Zürich 1964; Pace Gal., NYC from 1964; Pace Gal., Boston from 1964; Whitney Mus. of Am. Art, NYC 1966, 1970–71; Rose Art Mus., Brandeis Univ., Waltham, Mass. 1967; Arts Club of Chicago 1968; Rijksmus. Kröller-Müller, Otterlo, Neth. 1969; Mus. Civico di Torino, Italy 1969; Mus. of Fine Arts, Houston 1969; Univ. of Texas at Austin 1970. GROUP EXHIBITIONS INCLUDE: "Young Sculptors," Brooklyn Mus. of Art 1935; Pennsylvania Academy Annual, Philadelphia 1944; Whitney Mus. of Am. Art Annual, NYC from 1946; "Sixteen Americans," MOMA, NYC 1960; Venice Biennale 1962; Documenta 3 and 4, Kassel, W. Ger. 1964.

COLLECTIONS INCLUDE: MOMA, Whitney Mus. of Am. Art, Jewish Mus., and New York Univ., NYC; Brooklyn Mus., N.Y.; Newark Mus., N.J.; Albright-Knox Art Gal., Buffalo, N.Y.; Hirshhorn Mus. and Sculpture Garden, Washington, D.C.; Brandeis Univ., Waltham, Mass.; Carnegie Inst., Pittsburgh; Detroit Inst. of Arts; Farnsworth Mus. of Art, Rockland, Maine; Univ. of Nebraska, Lincoln; Birmingham Mus. of Art, Ala.; Tate Gal., London; Israel Mus., Jerusalem.

ABOUT: Current Biography, 1967; Gordon, J. "Louise Nevelson" (cat.), Whitney Mus., NYC, 1967; Miller, D.C. (ed.) "Sixteen Americans" (cat.), MOMA, NYC, 1959; Nevelson, L. and others Dawns and Dusks, 1976; Read, H. A Concise History of Modern Sculpture, 1964; Rose, B. American Art Since 1900, 2d ed. 1975; Seitz, W. (ed.) "The Art of Assemblage" (cat.), MOMA, NYC, 1961. *Periodicals*—Art Digest October 15, 1942, April 15, 1943, June 1958; Art News May 1954, September 1961, November 1972, April 1976; Arts Magazine July 1977; Interior January 1977; Life March 24, 1958; New York Post December 28, 1976; Time February 3, 1958.

NEWMAN, BARNETT (January 29, 1905–
July 3, 1970), American painter, was a pioneer
of color-field painting and one of the most influ-
ential artists of the New York School. He was
born in Manhattan, the eldest son of Abraham
and Anna (Steinberg) Newman, Russian-Polish
Jewish emigrés who had come to the United
States in 1900. Barnett had a younger brother,
George, and two youngest sisters, Gertrude and
Sarah. Abraham Newman worked for years as
an agent for Singer sewing machines, but even-
tually earned enough money to set up his own
men's clothing manufacturing firm.

In 1911, when Barnett was six years old, the
family moved from the Lower East Side of Man-
hattan to the rural Tremont section of the Bronx.
There he attended elementary schools and later
studied at the community's National Hebrew
School, of which his father was a founder and
trustee. Newman also took piano lessons, and as
Thomas B. Hess wrote in his biography of Bar-
nett Newman, "Education and culture were giv-
en to the Newman children in generous doses
outside of regular class hours." European intel-
lectuals were welcomed as tutors into the New-
man household.

When he was ready for secondary school,
Newman insisted on being educated in Manhat-
tan, and enrolled at De Witt Clinton High
School. Having already discovered the Metro-
politan Museum of Art, he would often cut class-
es to study the museum's paintings and
sculptures.

In 1922 Barnett Benedict Newman, as he then
preferred to be called, obtained his mother's per-
mission to attend the Art Students League, a
year before his high school graduation. He en-
rolled in Duncan Smith's beginning class in an-
tique drawing, which he found both a struggle
and a challenge. His other teachers at the
League were John Sloan and William von Schle-
gel. The selection of his drawings of the Belve-
dere torso for the League's annual Concours
confirmed Newman in his resolve to be an art-
ist—to him the "highest role a man could
achieve."

Newman entered the College of the City of
New York in 1923, but continued to study at the
League about another year. At City College he
majored in philosophy, and his conception of art
was shaped by a philosophy course taught by
Scott Buchanan. The class studied texts from
Bertrand Russell back to Vico, but it was Spinoza
whose impact on Newman was greatest, espe-
cially the 17th-century thinker's principle of in-
tuition as a rational form of knowledge. This
idea was for Newman a "moment of self-
discovery—of what painting is—that it's some-
thing more than an object."

BARNETT NEWMAN

At C.C.N.Y. Newman wrote art and music re-
views for the college newspaper and was a mem-
ber of Colonia, the student literary society.
When he took his BA degree in 1927, he had de-
cided to become a painter at all costs. But New-
man's father, concerned about his son's ability to
support himself as an artist, offered him a tem-
porary partnership in the now thriving family
business. To finance his artistic career Newman
agreed to join the firm for two years, but the
stockmarket crash of October 1929 crippled his
father's business and set back Barnett's plans for
the future. He returned to the Art Students
League to work with Henry Wicky and John
Sloan, but felt that the time spent in the clothing
business had not been entirely wasted. For in-
stance, in the cutting room he had learned "the
difference between a form and a shape."

In order to support himself in the Depression
years, Newman decided to take the qualifying
exam for art teachers in New York City public
schools. He failed, but during the 1930s man-
aged to find occasional work as a substitute
teacher. In the early '30s he met Milton Avery
and Mark Rothko and became friendly with Ad-
olph Gottlieb. In 1933 Newman and his friend
Alex Borodulin, both aged 27, decided that art-
ists and intellectuals should become more active
in city politics. Newman offered his name for
candidacy as mayor, with Borodulin running for
city comptroller, on the Writers–Artists ticket.
He wrote a manifesto, *On the Need for Political
Action by Men of Culture*, which included a
"Program for the Arts," a "Program for Cultural
Life," a call for a Clean Air Department to com-
bat pollution, and the demand that playgrounds

for adults be built citywide. As he told A.J. Liebling of the New York *World Telegram* (November 4, 1933), "I don't particularly expect to be elected. We offer our names merely as focal points for a demonstration of the strength of the intellectuals in New York."

Most radical New York intellectuals of the '30s were attracted by Marxism, but Newman was an anarchist who rejected programmatic doctrines in art as well as politics. "In the twenties and thirties," he wrote in his foreword to the 1968 edition of Piotr Kropotkin's *Memoirs of a Revolutionist*, "the din against libertarian ideas that came from shouting dogmatists, Marxist, Leninist, Stalinist, and Trotskyite alike, was so shrill it built an intellectual prison that locked one in tight. The only free voice one heard was one's own." In *The New York School* Dore Ashton reported that "It was this obsessive need to have done with all rules and institutions that was to make [Newman] a valuable resource for his fellow artists."

Despite the hardships of the Depression, Newman, determined to be free and independent, refused to be subsidized by the Works Project Administration. On June 30, 1936, he married Annalee Greenhouse. They spent their honeymoon in Concord, Massachusetts, where Newman was able to research extensively the life of his hero, Thoreau.

To protest the stringent and stodgy academic standards of the New York City Board of Education, Newman in 1938 organized a group of substitute teachers who had failed the drawing part of the board examination. They showed their work at the A.C.A. Gallery, New York City, in an exhibit entitled "Can We Draw?" Max Weber, who had also failed the examination in his youth, joined the exhibition, for which Newman wrote the foreword to the catalog. Surprised by the publicity generated by the protest, the board agreed for the first time in its history to give the examination over again, but the results were the same. Newman failed.

In 1939 Newman, while continuing to teach, began to spend time at the Brooklyn Botanic Garden, studying botany. The following year he gave up full-time teaching and conducted an evening class at the Washington Irving Adult Center. His continued studies at the Brooklyn Botanic Garden led him to enroll in 1941 in the summer session at Cornell University, Ithaca, New York, where he studied botany and ornithology in order to learn more formally about the science of nature.

Newman did not serve in the military during World War II, having declared himself a conscientious objector in 1942. While spending August of 1943 at the Reed Studios in East Gloucester, Massachusetts, he met Betty Parsons, who was then operating a small art gallery in a bookshop called the Wakefield Gallery. In May 1944 Newman organized an exhibition of pre-Columbian stone sculpture at the Wakefield Gallery, and wrote the catalog foreword. He contributed an article on pre-Columbian stone sculpture to the magazine *La Revista Belga* and, also in '44, wrote the catalog introduction to Adolph Gottlieb's show at the Wakefield Gallery.

In the early 1940s Newman began to free himself from the conventions of the previous decade by executing a series of surrealist drawings using "automatic" procedures for unconscious imagery. (He subsequently destroyed his realistic paintings of the '30s, disparaging them as "student work.") At first his calligraphic pictures were in black and white, but he gradually introduced color. Examples of his mixed-media works on paper are *The Blessing* and *The Slaying of Osiris*, both of 1944, and *The Song of Orpheus* (1944–45).

In 1946 Newman moved to a studio on West 4th Street in Greenwich Village. Also that year, when Betty Parsons opened her gallery (then one of the few in New York City to show avantgarde art), Newman organized the opening exhibition, "Northwest Coast Indian Painting," and again he provided the catalog foreword. According to Ashton, the show "was designed to bring out the ritualistic aspects of primitive painting and . . . its tendency to abstraction." At this time Newman began exhibiting his own work in group shows at the Parsons Gallery. He felt that modern American painting was in a state of paralysis and that New York artists of the post–World War II years needed to break with the European past to make a new beginning. His idea of "creation out of nothing" was already taking shape in such works of the mid-1940s as his mixed media *Gea*, his oil *Genesis—The Break* (1946), and especially his oil *Genetic Moment* (1947). His imagery was dominated by vertical (male) and circular (female) forms, but as Hess pointed out the sexual forms soon became transformed "from symbols of other things into symbols about painting." The vertical and horizontal stripes became "subject matter" rather than "object matter" and "no longer [acted] as a shape but as a division."

Newman met Clyfford Still in New York City in 1946, and it was probably Still who interested him in the late paintings of Monet, in which color itself created the ambience, independently, it seemed to Newman, of the object represented. (It is significant that Monet's late paintings are now appreciated because they are thought by

some to look forward to abstract expressionism, although they can also be considered as the culmination of Monet's intensive study of nature.) In 1947 Newman organized an exhibition titled "The Ideographic Picture" at the Betty Parsons Gallery, which consisted of the work of such gallery artists as Hans Hofmann, Rothko, and Newman himself. Lucid and articulate as ever, Newman wrote the catalog foreword explaining the subject matter and objectives of the new abstract painting. Referring to the ritualistic art of the Kwakiutl Indians, Newman identified abstraction with "ignorance," or innocence, rather than with rational or empirical methods for knowing truth. This was the idea underlying his oil of 1947, *Death of Euclid.* In this painting, as in the slightly earlier oil *The Euclidean Abyss* of 1946–47, Newman sought to structure his composition, as Barbara Rose noted, "without recourse to the internal relationships of forms or the dry precision of geometric painting." The irregular, pulsating vertical band or bands used to divide the colored field in these works hinted at the aesthetic solutions he would hit upon later.

In September 1948 Newman, William Baziotes, David Hare, Robert Motherwell, and Rothko founded an informal discussion group, the Subjects of the Artist school. The aim of these abstractionists was a non-representational art which would nevertheless deal with the individual's deepest experiences in a tumultuous, crisis-ridden world. For Newman in particular this implied an ethical and philosophical, even metaphysical, approach. Distinguishing between modern European and contemporary American art, he asserted that Europeans like Miró, Kandinsky, and Mondrian had, even in their most abstract mode, based their images on objective natural forms, whereas the new American painters were creating a "truly abstract world" and were "at home in the world of pure idea."

A proselytizer for the new abstraction, Newman in his writings adopted a hortatory, moralistic tone. For example in "The Sublime Is Now," his important article in the December 1948 issue *The Tiger's Eye,* he announced: "We are reasserting man's natural desire for the exalted, for a concern with our relationship to the absolute emotions. . . . We are creating images whose reality is self-evident. . . . We are freeing ourselves of the impediments of memory, association, nostalgia, legend, myth . . . that have been the devices of Western European painting. Instead of making *cathedrals* out of Christ, man, or 'life,' we are making it out of ourselves. . . . "

Newman's breakthrough came in 1948 when he placed a vertical strip of masking tape down the center of a small, 27-by-16-inch canvas which had been painted solidly in Indian red. He painted the tape orange, thereby canceling the background for, to quote Hess, the orange itself "was neither a shape nor a division, but a two-edged drawing that held the red-brown together and pushed them apart. Thus did Newman discover his characteristic emblem of the stripe, or zip, as he called it. He gave this seminal canvas the elusive title *Onement I,* and it became the first of several *Onement* paintings.

In 1948 Newman was an associate editor of *The Tiger's Eye,* which was the organ of the Subjects of the Artist school.

Newman held his first solo show at the Betty Parsons Gallery in January 1950. Aline Saarinen, startled by Newman's use of color, gave him a favorable review in *The New York Times,* but most critics were hostile. Pollock and de Kooning were already finding a market for their pictures, but Newman's works were not in the style of action painting, to which gallery-goers and mainstream critics were becoming accustomed, and his ambition at least matched that of Pollock in that he wanted to articulate the surface of the painting as a "field" rather than as a composition. In 1967 Nicolas Calas, recalling Newman's 1950 solo show, wrote: "At last an artist had come forth to state in an abstract style that the Being is 'all in the now.'"

Newman's first stripe paintings were on small canvases, but he soon began to work on a large scale. His second solo show, held at the Parsons Gallery in April 1951, included the 18-foot-wide *Vir Heroicus Sublimis* (Museum of Modern Art, New York City). The exhibition was panned by some of Newman's artist friends as well as by the press. An exception was Tony Smith, at that time an architect but later a renowned Minimalist sculptor, who acquired many Newman canvases years before the artist was taken seriously by the critics and general public. Stung by the show's hostile reception, Newman removed his works from the gallery. Newman's painting—in which a band, or bands, of one color ran vertically or horizontally across a canvas painted another, intense color—bewildered those who identified abstract expressionism with the gestural brushstroke. In the early '50s a joke in art circles about the nongestural Abstract Expressionists was that Mark Rothko had drawn the shades on modern painting, Barnett Newman had shut the door, and Ad Reinhardt had switched off the lights.

In the '40s he had been an influential critic, writer, and theoretician, but in a panel discussion on "Aesthetics and the Artist" held at Woodstock, New York in August 1952, Newman, a

witty polemicist, stated the much-quoted aphorism, "Aesthetics is for the artist as ornithology is for the birds."

In the mid-1950s Newman went through a dismal period of artistic stagnation, and in November 1957, after a visit to Montreal, he suffered a heart attack. By the spring of 1958 he had recuperated, and in May held his first retrospective exhibition at Bennington College, Vermont. As the decade drew to a close his work was seen in several important group shows, including "The 1958 Pittsburgh Bicentennial International of Contemporary Painting and Sculpture" and "The New American Painting" exhibition which opened at MOMA in 1958 and toured Switzerland, Italy, Spain, Germany, Holland, Belgium, France, and England. The February issue of *Pageant* magazine published "Ten Americans to Watch in 1959." The sculptor David Smith, who had been *Pageant's* artist of the year of 1958, when asked by the magazine for his choice, replied, "I nominate Barney Newman, a painter whom few except artists know and who in my mind has broken a barrier in visual realization."

Newman's isolation ended in the 1960s when he rather than Pollock or the action painters was taken up by the Color-Field painters and the Minimalists. Nevertheless, Newman's work bore affinities with action painting: the paint was directly applied and Newman usually worked on a very large scale. Even those who were baffled by such paintings as the immense companion pictures of 1951–52 titled, respectively, *Adam* (Tate Gallery, London) and *Eve* were aware of the artist's "painterly" treatment of the surface.

In 1960 Newman conceived the idea of creating a cycle of 14 large paintings all of the same size and with vertical modulating "zips." These variations on a theme begun in 1958 were completed in 1966. He titled the series "The Stations of the Cross," with the Hebrew subtitle "Lema Sabachtani" (Why hast thou forsaken me?). Newman did not intend the series to be a representation of Christ's ascent to Calvary, but a symbolic reply to "the unanswered question of human suffering," as he put it. When the "Stations of the Cross" series was exhibited at the Guggenheim Museum, New York City, in 1966, it aroused intense controversy. Although the series was praised by a few critics, John Canaday of *The New York Times* bitterly attacked the museum and the show's curator, Lawrence Alloway, for mounting an "exhibition of such pretentious yardage." Emily Genauer of the New York *Herald Tribune* described the exhibition as "an adventure in emptiness" and, referring to the rather esoteric critical tracts on Newman's paintings and the artist's own occasionally elu-

sive polemics, remarked, "The more minimal the art, the more maximal the explanation." Even Harold Rosenberg, an ardent Newman partisan, considered the title "The Stations of the Cross" a mistake. In his 1978 book on Newman, Rosenberg said that he warned the artist against it on the grounds that "an event held sacred by a cult . . . ought not to be appropriated by outsiders and given changed meanings." But Newman, he reported, was confident of the "limitless applicability of his abstract idiom."

As a result of the storm that broke over "The Stations of the Cross," Newman for the first time became known outside the art world. Contributing to Newman's renown were the younger artists who praised his work: Frank Stella, Larry Poons, Robert Irwin, and Donald Judd (in *Studio International* [February 1970] the last named called Newman "the best painter in this country" and discussed his influence on minimalism). Among Newman's most popular late works were his exuberant *Who's Afraid of Red, Yellow and Blue?* (1966–67), *Chartres* and *Jericho,* both of 1969. In these two last mentioned works the "zip" split triangular canvases and the medium used was acrylic.

The concepts of "one-ness" and of abstract shapes as "living things" held for Newman religious connotations not unrelated to the Jewish mystical tradition. He conceived the idea of Place as a metaphysical alternative to the term "space," which is constantly used in the jargon of art criticism. The idea of "making a Place" motivated Newman's 1963 design for a synagogue which was never carried out except in the form of a model.

Newman's sculptures, although few in number compared to his paintings, have had a decided impact. *Here I,* included in his 1951 solo show, was intended, with its two vertical members, to underline the actuality of his bands and rectangles. *Here II* of 1965, one of his works at the São Paulo Bienal, had three vertical members which also corresponded to the vertical stripes in his paintings. Characteristically playing a paradoxical "number game," Newman gave *Here III* (1966) only one vertical. By far the most expressive of his sculptures was *Broken Obelisk* (1967), a 26-foot steel structure consisting of a pyramid topped by an inverted obelisk. It was on loan to the Corcoran Gallery, Washington, D.C., until July 1969 and was subsequently installed on the plaza of the Seagram Building in midtown Manhattan. One critic saw in *Broken Obelisk* allusions to the Six Day War of 1967 and another perceived references to the assassination of Martin Luther King Jr. Newman himself said that "it is concerned with life and

I hope I have transformed its tragic content into a glimpse of the sublime." Newman's reaction to topical events was more directly expressed in his *Lace Curtain for Mayor Daley,* composed of 96 barbed wire squares splattered with red paint and set in a rectangular frame. It was included in a group exhibit protesting the violent tactics used by the Chicago mayor's police force against demonstrators at the 1968 Democratic National Convention. According to Harold Rosenberg, "Newman's was the only work completely adapted to the subject of the show without departing from the artist's customary style."

In 1968 Newman participated in the International Seminar in Commemoration of Baudelaire, giving a lecture entitled "For Impassioned Criticism." He later traveled to Basel, Barcelona, and Madrid, where he looked at the Velázquez paintings in the Prado. On May 17, 1970, he was awarded the Brandeis University Creative Arts Medal in Painting for 1968–70. He died in New York on July 4, 1970 following a heart attack.

Barnett Newman was described in *Current Biography, 1969* as "a stocky man of striking appearance," with "a luxuriant white walrus mustache." He was clever, articulate, loved verbal puns, had courtly manners, and wore a gold-rimmed monocle on a black ribbon. The English painter Patrick Heron, who met Newman in New York in 1960, noted in *Studio International* (September 1970) the contrast between Newman's personal warmth and garrulity and the austerity of his work. Heron recalled "those terrific bursts of laughter . . . that erupted all the time one was with him." Although Newman's aesthetic premises can be challenged, his dedicated quest for the absolute made him, as Rosenberg said, "the outstanding metaphysical painter of the postwar era."

EXHIBITIONS INCLUDE: Betty Parsons Gal., NYC 1950, '51; Bennington Col., Vt. 1958; French & Company, NYC 1959; Nicholas Wilder Gal., Los Angeles 1965; Solomon R. Guggenheim Mus., NYC 1966; M. Knoedler & Co., NYC 1969; Pasadena Art Mus., Calif. 1970; Kammerkunsthalle, Bern 1970; MOMA, NYC 1971–72. GROUP EXHIBITIONS INCLUDE: "Can We Draw?" A.C.A. Gal., NYC 1938; Betty Parsons Gal., NYC 1946–49; "Abstract Surrealism," Chicago Art Inst. 1947; "American Painting," Walker Art Center, Minneapolis 1950; "The New American Painting," MOMA, NYC 1958–59; The Pittsburgh Bicentennial International of Contemporary Painting and Sculpture, 1958; Allan Stone Gal., NYC 1962; São Paulo Bienal 1965; "American Painting Now," U.S. Pavilion, Expo '67, Montreal 1967–68; "The Art of the Real: USA 1948–1968," MOMA, NYC 1968–69; "Richard J. Daley," Richard Feifer Gal., Chicago 1969; "New York Painting and Sculpture 1940–1970," Metropolitan Mus. of Art, NYC 1969–70; American Art of Mid-Century," Nat. Gal. of Art, Washington, D.C. 1973–74.

COLLECTIONS INCLUDE: Metropolitan Mus. of Art, and MOMA, NYC; Wadsworth Atheneum, Hartford, Conn.; Hirshhorn Mus. and Sculpture Garden, Washington, D.C.; Allen Memorial Art Mus., Oberlin Col., Ohio; Walker Art Center, Minneapolis; Detroit Inst. of Fine Arts; Univ. of Nebraska-Lincoln Art Gals.; Nat. Gal. of Canada, Ottawa; Tate Gal., London; Stedelijk Mus., Amsterdam; Moderna Mus., Stockholm; Kunstmus., Basel.

ABOUT: Ashton, D. The New York School: A Cultural Reckoning, 1973, American Art Since 1945, 1982; "Can We Draw?" (cat.), A.C.A. Gal., NYC, 1938; Current Biography, 1969; Hess, T.B. Barnett Newman, 1969; Hughes, R. The Shock of the New, 1981; Lucie-Smith, E. Late Modern: The Visual Arts Since 1945, 1969; Newman, B. "The Stations of the Cross" (cat.), Solomon R. Guggenheim Mus., NYC, 1966; Read, H.A. Concise History of Modern Painting, 3d ed. 1974; Rose, B. American Art Since 1900, 2d ed. 1975; Rosenberg, H. The Anxious Object, 1964, Barnett Newman, 1978; Sandler, I. The Triumph of American Painting: A History of Abstract Expressionism, 1970. *Periodicals*—Art in America Summer 1962; Art News Summer 1951, Summer 1958, Summer 1968; Art Press (Paris) December 1972; Artforum June 1966; Arts Magazine November 1967; New York Herald Tribune April 20, 1966; New York Times April 23, 1966, July 5, 1970; New York World Telegram November 4, 1933; Studio International February 1970, September 1970; Tiger's Eye December 15, 1948.

NICHOLSON, BEN (April 10, 1894– February 6, 1982), British painter and doyen of abstract painting in Britain, was born in Denham, Buckinghamshire, on the outskirts of London. The eldest child of the painter Sir William Nicholson and his first wife Mabel Pryde, herself a painter and the sister of the artist James Pryde, he was reared in the home of distinguished artists. William Nicholson, in collaboration with his brother-in-law James Pryde—the two were known as the Beggarstaff Brothers—helped to elevate the craft of poster-making to near artistic status.

From 1897 to 1903 the family lived at Chaucer's House, Woodstock, but in the next few years the Nicholsons moved frequently, living first in Hampstead, then in Bloomsbury, and afterward in Chelsea. From 1909 they maintained a country house at Rottingdean.

Young Ben Nicholson was educated at Heddon Court, Hampstead, and attended Gresham's School, Holt, for one term. Interested in painting and drawing, in 1910 he entered the Slade School of Fine Art, London, for formal instruction. However, the Slade's conventional and rigid curriculum, under the direction of Henry Tonks, bored Nicholson, whose pleasantest memories were of lunch-time discussions with

Photo by André Emmerich

BEN NICHOLSON

fellow student Paul Nash, who was to become a
renowned modernist painter and wood engrav-
er. Nicholson's earliest painting of note from this
period was *Striped Jug* of 1911, a school compe-
tition piece which shows the influence of his fa-
ther and the paintings of Vermeer.

In 1911, after three-and-one-half terms, Nich-
olson left the Slade and spent much of the next
seven years traveling abroad, partly for reasons
of health. He lived for four months in the house-
hold of a professor in Tours to study French;
studied Italian in Milan in 1912–13; and stayed
in Madeira in 1913–14. When World War I
broke out in 1914 he returned to England, but
poor health exempted him from military service.
During the war he lived in London and North
Wales and spent a brief period in Pasadena, Ca-
lifornia in 1917–18.

In 1910–11, when Nicholson was at the Slade,
Roger Fry had introduced England to Cézanne
and postimpressionism; but Nicholson, unlike
the most advanced of his fellow students, did not
much concern himself with the debate over
modernism then raging in London art circles.
He was influenced more by what he called the
"poetic idea" of his father's 19th-century-style
still lifes and landscapes than he was by Matisse.
Moreover, in the crucial years 1912–14, a period
of consolidation and gain for the English avant-
garde, Nicholson had been out of the country.
His work in those years consisted mainly of on-
the-spot studies of landscapes and buildings, the
few canvases he produced being done in what he
described as a "Vermeerish" manner. "I was in
the painting world and trying to get out," Nich-
olson recalled, and it was not until 1918, the year

his mother died, that he seriously applied him-
self to painting.

According to Frances Spalding of the *Times
Literary Supplement,* such Nicholson works of
the period 1918–20 as *The Lustre Vase, Blue
Bowl in Shadow,* and *The Red Necklace* "could
be mistaken for the elder Nicholson's works.
. . . The even lighting and low tones create an
Old Master style untouched by Post-
Impressionism. Mostly, however, they lack Sir
William's fluent touch and exhibit that suffocat-
ing illusionism from which Ben Nicholson after-
wards sought escape."

In 1920 Nicholson married the accomplished
painter Winifred Dacre Roberts. They main-
tained residences in Bankshead, Brampton, near
Cumberland, and in London, and wintered
1920–24 in Castagnola, Switzerland, near Luga-
no. Their marriage produced a daughter and
two sons. The Nicholsons were to obtain a di-
vorce, but in the '20s Winifred influenced her
husband. "She . . . provided the antidote to Sir
William's nonchalant art and out-of-date
dandyism," wrote Spalding. "Her unaffected di-
rectness and musical use of color encouraged her
husband's search for pictorial immediacy . . .
at a time when he was unable to see any way for-
ward. . . . "

Nicholson first felt the powerful impact of
cubism on a visit to Paris in early 1921. He
wrote: "I remember suddenly coming on a cubist
Picasso at the end of a small upstairs room at
Paul Rosenberg's Gallery. It must have been a
1915 painting—it was what seemed to me then,
completely abstract. And in the centre there was
an absolutely miraculous green—very deep,
very potent and absolutely real. In fact none of
the actual events in [my] life have been more
real than that, and it still remains a standard by
which I judge any reality in my own work.
. . . " Nicholson was also excited by other
School of Paris paintings, especially those by Pi-
casso, Braque, Derain, and Matisse, that he saw
in the years 1921–23, though his embrace of
cubism was at first tentative and the cubist influ-
ence was not fully absorbed into his work until
1924.

Nicholson's cubist approach was modified by
a soft, painterly tendency, an impressionist com-
ponent in his style which persisted through the
'20s. This lyrical impressionistic manner was evi-
dent in such landscapes as *Outskirts* (1923),
which shows a clear debt of Cézanne,
Dymchurch (1923), and *Landscape from Banks-
head Studio* (ca. 1925), with its loose brushwork
and airy colors. Similar qualities can be found in
Nicholson's still lifes—in which the influence of
Winifred's delicate, high-keyed flower paintings

has been detected—especially *Still Life—Bankshead* (1925). *Apples* (1927) is among the most Cézanne-esque of his early still lifes; here space and form merge through open contours, and volume is indicated with sensitive patches of green and yellow. The coloration of other still lifes and landscapes from the '20s are, in contrast, rather somber and earthy.

Nicholson held his first solo show in 1922, at the Adelphi Gallery, London, and the following year he and his wife exhibited together at Paterson's Gallery, London. In 1924 Nicholson was proposed by Ivon Hitchens for membership in the Seven and Five Society, an exhibiting association of British artists who called for a less subdued style of painting than that favored by Roger Fry and the Bloomsbury group. Influenced by Nicholson, Henry Moore, and Barbara Hepworth, among others, the Society turned increasingly toward pure abstraction. In 1935, the year before the Society was dissolved, the name was changed to the Seven and Five Abstract Group.

In the years that he painted his representational landscapes and still lifes Nicholson was also experimenting with abstraction and semiabstraction. In his completely abstract *Painting—Trout* of 1924 he adopted the broad, rectangular planes of synthetic cubism, but instead of the bold tones and rigorous structure of European cubism, Nicholson created a soft atmospheric effect through his characteristic use of pastel hues. Nicholson achieved greater individuality in his semiabstract *Flowers* (1927), one of his few flower paintings; a more forward looking work was his *Still Life—Jug and Playing-Cards* of 1929. The circle of the plate and the rectangles of the playing-cards and mugs were stressed as geometric forms in their own right and were placed against the rectangular table top in a way that anticipated the shallow space and geometric idiom of the later reliefs. Even here, however, there is a suggestion of deep landscapes space and an attempt—one that was to recur in the '40s and '50s—to synthesize the shallow, ambiguous space with the still-life motif. The palette is in a delicate scale of browns and tans.

During the 1920s and afterward, Nicholson drew *devant le motif;* he regarded drawing not as a preparatory study for painting but as an autonomous act, a way of keeping in touch with his sources of inspiration. "However 'nonfigurative' a painting may appear to be," he observed, "it has its source in nature." His lean drawing style has been linked by Stephen A. Nash to "the strong English tradition of linear abstraction going back to John Flaxman and William Blake."

In 1928 a naive approach to landscape painting had emerged in Nicholson's style. That approach was encouraged when, in August of that year, he and his artist friend Christopher Wood "discovered" the Cornish primitive painter Alfred Wallis in St. Ives, Cornwall. Influenced to a degree by Henri Rousseau, Nicholson's work in the simplified, "naive" mode is best illustrated by his *Pill Creek—Cornwall* of 1929. Impressed by Wallis's primitivism, Nicholson was even more struck by his sense of the "painting as object." Nicholson has described how Wallis would "cut out the top and bottom of an old cardboard box, and sometimes the four sides, into irregular shapes, using each shape as the key to the movement in a painting." Whether painting on cardboard or on any wooden support that was handy, Wallis would exploit the grain, texture, color, or edges of the support in that design. Nicholson, too, began to prepare textured grounds and to scrape the painting surface in order to stress the "materiality" of his paintings. This physical and nonillusionistic approach eventually led to his carved and painted abstract reliefs, with their self-contained and tactile character.

By the end of the '20s Nicholson had exhibited in many solo and group exhibitions in London, but it was only after 1930 that he arrived at the totally abstract style that revolutionized English painting. Several biographical factors played a role in his artistic development. After his first marriage was dissolved, he struck up a close friendship with the young sculptor Barbara Hepworth which led to marriage in 1933. Other than Nicholson, in the early 1930s Hepworth and Henry Moore–who joined the Seven and Five Society in 1931 and 1930 respectively— were the only important representatives of modernism in Great Britain.

Nicholson, usually in the company of Barbara Hepworth, visited Paris often in the years 1930–34. There he met Braque and Picasso, visited Brancusi and Jean Arp in their studios, and also made the acquaintance of Miró, Calder, Giacometti, and Mondrian. Though Nicholson's artistic affinities were closest to the lyrical synthetic cubism of Braque, in 1933 he and Hepworth were invited by Auguste Herbin and Jean Hélion to join the Abstraction-Création group in Paris, an association which since 1931 had encouraged various types of nonfigurative art but especially geometric abstraction.

In the early '30s cubism was still a vital force in French painting, and Nicholson was determined to come to grips with the style before attempting to progress beyond it. That is, he was not yet ready to abandon nature as the starting-point of his art. A key painting in Nicholson's de-

velopment was his well-known *Au Chat Botté* (1932; City of Manchester Art Galleries, England). He later discussed that painting: "About space construction: I can explain one aspect of this by an early painting I made of a shop window in Dieppe. . . . the name of the shop was 'Au Chat Botté' (Puss in Boots). . . . The words themselves had an abstract quality—but what was important was that this name was printed in very lovely red lettering on the glass window: *giving one plane*—and in this window were reflections of what was behind me as I looked in—*giving a second plane*—while through the window objects on a table were performing a kind of ballet and forming the 'eye' or life-point of the painting—*giving a third plane.*"

Nicholson was impressed by the structural rigor of Mondrian-style constructivism and he also admired the free forms of Arp, Calder, and Miró. By 1933, the year he executed *Painting,* a canvas mounted on board, Nicholson had developed a new vocabulary consisting of grids and circles. Instead of starting from reference points in nature, he began in purely abstract terms about formal relationships. But Nicholson's forms were less rigid than Mondrian's—his circles were irregular, his lines not perfectly straight, and the handling of the paint gave the surface a sense of animation.

Nicholson's breakthrough into the third dimension occurred in December 1933, when he completed his first relief. In that piece the linearity and irregular circles recalled his Miró-inspired canvases of previous months; the circles were excavated to various depths on the board and delicately scratched lines defined the intersection of actual planes in space; the palette was subdued and rather lyrical. By March 1934 Nicholson had begun to paint the reliefs all-white, an important step in the stage-by-stage purification and simplification to which his work was subjected in those years. When exhibited at the Leicester Galleries, London, in March 1934, these all-white carved and painted structures were misunderstood by reviewers in the popular press. However, more perceptive viewers, those familiar with modern art, realized that Nicholson's white reliefs, which were the culmination of his years of experimentation, were an important contribution to the modernist vocabulary. In retrospect they can be seen as anticipating the "less is more" approach adopted by Minimalist artists in the 1960s.

Despite the rigorous structure of Nicholson's nonobjective reliefs and paintings of the mid-'30s, he did not altogether abandon realistic subject matter. He found it possible to move back and forth between pure abstraction and repre-

sentationalism, and *Still Life* on which he worked intermittently from 1929 to '35 is one of his finest paintings. It has, to quote Stephen Nash, "the same esthetics of finely honed, chaste harmonies found in his non-objective work." In *Still Life–Greek Landscape,* from the period 1931–36, he reworked favorite themes in the light of his new stylistic approach. His many drawings from the '30s also provide evidence of his continued interest in representation.

In 1935 Nicholson became a co-editor—with Naum Gabo and the architect J.L. Martin—of *Circle,* a 300-page constructivist manifesto. It was largely through Nicholson's influence and the receptivity to modernism that he had helped to foster in England that Gabo, and Mondrian and, later, Walter Gropius and Marcel Breuer settled in London in the late '30s, having fled Nazi-controlled Germany. Gabo and Mondrian were Nicholson's neighbors in Hampstead. Though he did not fully subscribe to the Utopian ideology of Gabo, who saw constructivism as a new universal language, Nicholson nevertheless believed in the instrumental value of abstract art, its applicability to the affairs of everyday life in modern society. He wrote in 1941: "I think . . . that so far from 'abstract' art being the withdrawal of the artist from reality (into an 'ivory tower'), it has brought art once again into common everyday life."

In the late '30s Nicholson, seeking greater stylistic complexity, added color to some of his abstract reliefs, as in the horizontal *Painted Relief* of 1939. In that year, with Europe on the brink of war, Nicholson and Hepworth were invited by Adrian Stokes to move to Cornwall. Settling at Carbis Bay with their three children (triplets had been born to them in 1934), they later moved to St. Ives, at that time still a remote fishing village and artists' colony. Nicholson was to remain there until 1958.

Moved by the rugged beauty of the Cornish landscape, the seaside light, and the picturesque charm of the villages, Nicholson began to paint landscapes for the first time since leaving Cumberland in the 1920s. This "return to nature" harks back in some ways to his earlier primitivist style, but there was a tighter formal organization and his palette had brightened. The cool, silvery blues, so evocative of the rich coastal light that can be seen in Nicholson's later abstract and semirepresentational paintings, date from this period. In *Abstract Painting* (December 1942– April 1944) there is a balance between his love of sensuous color and rhythmical movement and his sense of classical order and restraint. As one critic pointed out, after Nicholson's move to St. Ives he "introduced elements derived from na-

ture even into his apparently non-figurative works"—thus their "silvery tonality" inspired by "the purity and whiteness of the light and blueness of the sea and sky. . . . " In *Abstract Painting* Nicholson's characteristic silvery blue was offset by the grays and yellow-green, a pattern of color suggestive of nature. In this respect Nicholson radically departed from the austere neoplasticism of Mondrian.

In 1944 a Nicholson retrospective was held at Temple Newsam House, Leeds. In late 1945 or early '46 he concluded his series of colored reliefs and began to concentrate on abstract linear paintings and abstracted still lifes. In certain works, notably *Towednack* (1946) and *Mousehole* (1947), Nicholson set himself the problem of juxtaposing an interior still life with a distant view through a window, creating a strong spatial pull between near and far. This type of motif was derived from such cubist works as Juan Gris's *Still Life Before an Open Window: Place Ravignan* of 1915, but Nicholson's evocation of the Cornish scene was entirely personal, and linked him to the great English landscape tradition of the 19th century.

The scale of Nicholson's work increased considerably in 1949, partly because he moved into a larger studio in St. Ives. His broader, more abstract conception of form is evident in *Still Life—Pierre Roche* (1949), one of several canvases that introduced Nicholson's mature still-life style of the '50s. Also in 1949, his first New York City solo show was held at the Durlacher Gallery. Nicholson was accorded international acclaim in succeeding years, receiving first prize for painting at the 1952 Carnegie International, Pittsburgh, and winning the Ulissi Prize with a retrospective exhibition at the Venice Biennale of 1954.

In 1950 Nicholson began to travel regularly to Italy and other Mediterranean countries, making drawings at such favorite locations as Pisa, Siena, Patmos, and Mycenae. His marriage to Hepworth was dissolved in 1951. That was the year of the Festival of Britain, and Nicholson, whose increasingly architectonic style lent itself to mural decoration, was commissioned to execute a mural for the Festival's Regatta restaurant on the south bank of the Thames. (Two years earlier he had designed two concave panels for the steamship *Rangitania* of the New Zealand Shipping Co.)

Nicholson's still lifes of the early '50s, with their finely balanced architectural and musical relationships, remain his best-known works on the Continent and in the United States. The exemplary *Tableform* (1952; Albright-Knox Art Gallery, Buffalo, New York) is essentially a cubist composition of flat overlapping planes. Despite its abstraction, the sky-blue pigment along the top of the painting suggests landscape. The palette of soft blues and browns is restrained and delicate, punctuated in the upper left by a bright spot of red.

In the mid-'50s Nicholson produced several painted geometric reliefs, including *Cantabria* of 1955. *Crete* (1956) is one of his largest and most monumental canvases; Nicholson had visited Crete on several occasions, and the somber blacks and rich reddish browns in the painting convey a sense of antiquity. There were Nicholson retrospectives in 1955 at the Tate Gallery, London, which owns some 63 of the artist's paintings, and the Stedelijk Museum, Amsterdam.

In 1957 Nicholson married Felicitas Vogler, a professional photographer. The following year he and his wife moved to Ticino, Switzerland, where they remained until 1972. They took a house in a spectacular setting high above Lago Maggiore overlooking the lake and the surrounding Alpine landscape. Nicholson found the landscape "entirely magical, and with the kind of visual poetry which I would like to find in my paintings." Almost immediately his work expanded in scale and became bolder in the handling of shape and color. His carved relief *Lindos* (July 1959) and the well-known *Ice—Off-Blue* (February 1969) in the Tate are examples. In these and related works Nicholson introduced textural variations by rubbing, scraping, and even scribbling the color.

Throughout the '60s and into the next decade Nicholson produced small relief projects, conceived as models for large, outdoor, free-standing walls which would effect a "dialogue" with their natural surroundings. This ambition, however, was realized only once, when a stone-gray concrete relief was constructed as a wall at Documenta 3, Kassel, West Germany in 1964; it was subsequently dismantled.

Concurrently with his work on reliefs, Nicholson produced many drawings, both on pure white ground and on paper tinted with light oil washes, as in *Sequence of Goblets* (1960) and *Brissago* (1968). Starting in 1966 he introduced into his reliefs the curves that had until then appeared only in his drawings and paintings; this gave a new element of resilience and movement to the reliefs. In his reliefs of the '70s, including *Carnac with Green* and *Obidos Portugal I*, both of 1971, the curving movement of the edges and the animated brushing of the surfaces enabled Nicholson to break away completely from the stasis of his earlier reliefs. He also used silvery mists of color in what was probably an attempt to open up the forms to light and distance.

In 1968 Nicholson was awarded the Order of Merit by Queen Elizabeth II. Three years later he moved from Ticino to Cambridge and a few years later took up residence in Hampstead, where he lived until his death in London at the age of 87. In his mid-80s he had continued to draw every day and work on new painted reliefs. Steven A. Nash wrote: "An esthetic of clarity and sensitivity reign[ed] as much in the management of his daily environment as in his work, from the furnishing of his studio to the way a handwritten note is 'drawn.'"

It is commonly assumed by art historians that for decades Nicholson was "the most convinced and consistent exponent of abstract art in England," to quote Sir John Rothenstein, curator of the Tate Gallery at the time of Nicholson's 1955 retrospective, but there is less agreement about his significance on the international art scene. Admittedly, one does not find in his work, with its serene pictorial harmonies, the sense of deep involvement with the ever-changing face of the modern world that is evident in Picasso and even in Mondrian. Nicholson's modernism seems at one remove from its European prototypes: it remains very English both in its cool understatement and its gently lyrical response to nature. Indeed, the carefully developed beauty of Nicholson's best work is, perhaps, both a strength and a limitation. As Nash pointed out, Nicholson's art "rarely admits strong emotion, and does not generally tend toward the monumental. Nicholson's visual poetry is intimate and lyrical—he is content to leave the epic mode to others."

Despite his standing as a leading abstractionist, Nicholson always sought to related his art to everyday life. "After all," he wrote, "every movement of human life is affected by form and color, everything we see, touch, think and feel is linked up with it, so that when an artist can use these elements freely and creatively it can be a tremendously potent influence on our lives."

EXHIBITIONS INCLUDE: Adelphi Gal., London 1922; Lefevre Gal., London 1930–54; Leicester Gals., London 1934; Temple Newsam House, Leeds, England 1944; Durlacher Brothers, NYC 1949, '51, '52; Phillips Memorial Gal., Washington, D.C. 1951; Venice Biennale 1954; Tate Gal., London 1955, '69; Stedelijk Mus., Amsterdam 1955; Laing Art Gal. and Mus., Newcastle-on-Tyne, England 1959; Marlborough Fine Art, London 1963, '67, '70, '71; Dallas Mus. of Fine Arts 1964; André Emmerich Gal., NYC 1965, "Works on Paper," 1974, '75; Marlborough-Gerson Gal., NYC 1965; Gimpel and Hanover Gal., Zürich 1966; Gal. Beyeler, Basel 1968; Arts Club of Chicago 1976; "Ben Nicholson, Fifty Years of His Art," Albright-Knox Art Gal., Buffalo, N.Y. 1978; Hirshhorn Mus. and Sculpture Garden, Washington, D.C. 1978–79; Brooklyn Mus., N.Y. 1979; "Ben Nicholson: The Years of Experiment 1919–1939," Kettle's Yard, Cambridge, England 1983. GROUP EXHIBITIONS INCLUDE: Paterson's Gal., London 1923; "Hepworth and Nicholson," Arthur Tooth and Sons, London 1932; "Abstraction, Création, Art Non-Figuratif," Gal. Abstraction-Création, Paris 1934; "Cubism and Abstract Art," MOMA, NYC 1936; "Contemporary British Art," organized by the British Council, London ca. 1937; British Pavilion, New York World's Fair, Flushing Meadow 1939; UNESCO Exhibition, Mus. Nat. d'Art Moderne, Paris 1946; "British Art: The Last 50 Years, 1900–1950," Knoedler Gal., NYC 1950; Carnegie International, Pittsburgh 1952; "Works by Nicholson, Bacon, Freud," British Pavilion, Venice Biennale 1954; "British Art Today," San Francisco Mus. of Art 1962; Documenta 3, Kassel, W. Ger. 1964; "The English Eye," Marlborough-Gerson Gal., NYC 1965; "British Painting and Sculpture, 1960–1970," Nat. Gal. of Art, Washington, D.C. 1970–71; "Geometric Abstraction 1926–1942," Dallas Mus. of Fine Arts 1972. "William and Ben Nicholson," Browse and Darby, London 1983; "The Nicholsons," Crane Kalman Gal., London 1983.

COLLECTIONS INCLUDE: Tate Gal., Victoria and Albert Mus., Arts Council of Great Britain, and British Council, London; Nat. Mus. of Wales, Cardiff; MOMA, and Solomon R. Guggenheim Mus., NYC; Albright-Knox Art Gal., Buffalo, N.Y.; Phillips Collection, and Hirshhorn Mus. and Sculpture Garden, Washington, D.C.; Mus. of Fine Arts, Boston: Cleveland Mus. of Art; St. Louis Art Mus., Mo.; Milwaukee Art Center; Nat. Gal. of Canada, Ottawa; Western Australian Art Gal., Perth.

ABOUT: Barr, A.H. Cubism and Abstract Art, 1936; "Ben Nicholson: A Retrospective Exhibition" (cat.), Tate Gal., London, 1955; Harrison, C. English Art and Modernism 1900–1939, 1981; Hodin, J.P. Ben Nicholson—The Meaning of His Art, 1957; Nash, S.A. "Ben Nicholson: Fifty Years of His Art" (cat.), Albright-Knox Art Gal., Buffalo, N.Y., 1978; Nicholson, B. and others, Circle: International Survey of Constructive Art, 1937; Read, H. Ben Nicholson, 1956, A Concise History of Modern Painting, 1959; Reid, N. Ben Nicholson, 1969; Russell, J. Ben Nicholson, 1969; Summerson, J. Ben Nicholson, 1948. Periodicals—Architectural Review May 1949; Art and Artists June 1976; Art d'aujourd'hui (Paris) March 1953; Art Digest April 1955; Art International (Lugano) Summer 1967; Cahiers d'art (Paris) nos. 1–2 1938; Country Life (London) July 17, 1975; Du (Zürich) August 1963; Horizon October 1941; (London) Sunday Times April 23, 1963; (London) Times November 12, 1959; New York Times July 6, 1969, February 10, 1982; Spectator October 27, 1933; Studio December 1932; Studio International December 1966, special edition 1969; Times Literary Supplement July 22, 1983.

*NOGUCHI, ISAMU (November 17, 1904–)
American sculptor, is a leading modernist whose
work fuses influences of both Eastern and West-
ern cultures. He was born in Los Angeles, the son
of a Japanese father, Yone Noguchi, a poet and
authority on Japanese art. His mother, Leonie
Gilmore, was a Brooklyn-born writer of Scottish,
Irish, and American Indian descent. At the age
of two Isamu went with his family to Tokyo,
where his father became a professor of English
at Keio-Gijuku University. From 1912 to 1917
he attended St. Joseph's College, the French Je-
suit elementary school in Yokohama. In 1918 his
mother, feeling that he needed a Western educa-
tion, arranged for the 13-year-old boy to return
to the United States. He was to study at the Inter-
laken School in Indiana, but it was used as a
training camp in World War I, and Noguchi
went instead to Rolling Prairie High School in
Indiana.

Noguchi remained in high school from 1918
to '22, uncertain whether to choose art or medi-
cine as his career. In 1922, in Stamford, Con-
necticut, he became an apprentice to Gutzon
Borglum, the sculptor who supervised carving of
the four colossal heads of American presidents
on Mount Rushmore. "All Borglum would let me
do," Noguchi recalled, "was pose on a horse as
General Sherman and work on heads of
Lincoln." After several months Borglum told
him he was not cut out to be an artist, and later
in 1922 Noguchi entered Columbia University,
New York City, as a pre-medical student.

Two years later Noguchi's interest in art re-
vived, encouraged by his mother, who had re-
turned to the United States, and by Onorio
Ruotolo, director of an East Side settlement
house, the Leonardo da Vinci Art School. Nogu-
chi had a solo show there in 1924, and made such
rapid progress that in 1927 he received a Gug-
genheim Fellowship to study in Paris. After at-
tending the Académie Colarossi and the
Académie de la Grande Chaumière, he worked
in the atelier of the great abstract sculptor
Brancusi. "I was transfixed by his vision," Nogu-
chi said. " . . . Brancusi showed me the truth of
materials and taught me never to decorate or
paste unnatural materials onto my sculptures, to
keep them undecorated like the Japanese
house." While in Paris, Noguchi also met Calder
and Giacometti, who was then in his surrealist
period.

Returning to New York in 1928, Noguchi
made a living by executing portrait sculptures.
His sitters included the composer George Gersh-
win, the architect Buckminster Fuller, and the
dancer-choreographer Martha Graham, for
whom he was later to design more than 20 sets.
He also made a number of abstract pieces in

ISAMU NOGUCHI

metal. In 1929 he exhibited a collection of 15
heads in bronze at the Eugene Schoen Gallery,
New York City. The show was so successful that,
with the money earned from sale of his works
and with a renewed Guggenheim Fellowship, he
was able to travel around the world in 1930–31.
He visited Berlin and Moscow, and took the
Trans-Siberian Railroad to Manchuria. He pro-
ceeded to Peking, where he studied Chinese cal-
ligraphy and brush drawing, and went on to
Japan, where he saw his father. He visited Tokyo
and worked with a Japanese potter in Kyoto.
These seven months in Japan renewed Noguchi's
feeling for his Japanese heritage and confirmed
his aesthetic beliefs. "My Japanese background,"
he explained, "gave me a sensibility for the sim-
ple. It taught me how to do more with less and
how to become aware of nature in all its details."

Noguchi returned to New York in 1932. He
was becoming increasingly successful and exhib-
iting widely. In 1935 he did his first set design,
for Frontier, a dance by Martha Graham, lead-
ing to numerous collaborations. "His sets are al-
ways dynamic, never a backdrop," Graham said.
"His sets become partners of the dancers and
they develop a formal relationship to each
other."

In 1935–36 Noguchi lived and worked in
Mexico, and executed a relief sculpture for the
Rodriguez market in Mexico City. His sculpture
already belonged to major collections and muse-
ums when, in 1938, he was awarded first prize
in a national competition to design a façade re-
lief for the Associated Press Building in Rocke-
feller Center, New York City. The sponsors of
the contest had envisaged a bronze plaque, but

°nō goo chē, ē zä´ moo

Noguchi persuaded them to have the plaque cast in stainless steel, a medium he had often used. Although more expensive, stainless steel, as Noguchi has pointed out, requires no special care, for it "retains its pristine surface and color until doomsday." Unveiled in 1940, the plaque was described in *Art News* as "a smooth-surfaced group, sweeping in rhythm, and an irregular diamond in outline."

After completing this sculpture in 1939, Noguchi left for a three months' vacation in Hawaii, where he had received an N.W. Ayer commission from the Dole Pineapple Company. That same year he received a commission for a fountain at the New York World's Fair. It was installed in the Ford Exposition Building and was acclaimed as "a strikingly modern abstraction depicting the feeling of power in an automobile." Noguchi has always been interested in industrial design, and in 1940 he designed playground equipment for *Architectural Forum's* design decade issue.

When in 1942 the US, at war with Japan, interned all Japanese and Japanese-Americans in the country, Noguchi went voluntarily to a relocation center at Poston, Arizona. When evacuees were allowed to leave the camps Noguchi returned to New York City. In a *New Republic* article, "Trouble among Japanese-Americans," he urged that the evacuees be returned "to their normal civilian status" and that the centers themselves be made "as much like other places in America as possible."

Noguchi successfully fused the aesthetic and the utilitarian in 1944 when he designed a coffee table for the Herman Miller furniture company and a table lamp for the Kroll Company. As early as 1942 Noguchi had made sculptures that were lamp-lit from the inside, and two years later he composed a lamp for his sister that was, in effect, a cylinder of aluminum on three legs. Since 1950 he has designed more than 100 lamps; he prefers to use paper made in Japan from the inner bark of the mulberry tree, for it hides the electric bulb and diffuses the light. The lamps have been sold inexpensively, but for Noguchi industrial design has "never been a business," but a labor of love. "I'm a sculptor and am really not interested in decoration." he said, "but I like to be able to approach people directly. That is why I have occasionally done public works, such as fountains."

In the late 1940s, as modernism gained the upper hand in American art, Noguchi took "new liberties in the postwar climate of adventure," to quote Dore Ashton. Although he worked primarily in wood in the '40s and '50s, and experimented with metals in the '60s and '70s,

Noguchi "never relinquished a tie to natural forms," as Barbara Rose wrote. "Like Calder, Noguchi has his roots deep within the French tradition. As Brancusi's assistant, he learned to love the purity of simple, closed forms and polished surfaces; his respect for materials may have come partly from his Japanese heritage. Adapting his forms from the organic shapes of the Surrealists, Noguchi purged them of much of their mythic content, using them instead as a point of departure for highly sophisticated and refined works, such as *Kouros* (1944–45)."

In 1949–50 Noguchi traveled to England, France, Italy, Spain, Greece, Egypt, India, Bali, and Japan. The visit to Japan made the deepest impression. He was inspired by primitive Japanese *haniwa* sculpture to create ceramic sculptures in clay, simplified forms based on the human figure. Noguchi also studied the ritualistic art of Japanese landscape gardening, and has himself created memorable architectural sculpture for gardens. In 1951–52 he designed the gardens for Keio-Gijuku University. Other important Noguchi works in this domain were the gardens for the *Reader's Digest* offices in Tokyo (1951), the "Park of Peace" in Hiroshima (1952), and the garden designed for the UNESCO building in Paris (1956–58). In the UNESCO project the sculptural shapes blend admirably with the natural environment, and there is an effective contrast between the roughly hewn stone and the smoothness of the enclosing glass façade.

In 1953, Noguchi married the Japanese actress Shirley Yamaguchi. They were divorced in 1955.

In London, in 1955, Noguchi designed highly original sets and costumes for a production of *King Lear,* with Sir John Gielgud in the title role. Noguchi's semiabstract and strongly formalized designs, and the performers' makeup which recalled the masks of No drama, were at variance with the casts' traditional Shakespearean style of acting, but the shapes and colors were beautiful and it was an altogether interesting venture.

The 1960s were a productive decade for Noguchi. In 1961 he established himself in an old factory building in Long Island City, Queens, which he divided into a studio and living quarters. He has maintained this studio as well as a residence in Manhattan. In the years 1960–64 he designed the garden for the Beinecke Rare Book and Manuscript Library at Yale University. This was followed in 1965 by a garden for Chase Manhattan Plaza, New York City, and by one of his major achievements, also completed in 1965, the Billy Rose Sculpture Garden of the Israel Museum, Jerusalem. The five areas of the garden are laid out on the slope of Neveh Shannan,

and the culmination of the gardens is the stone Fountain Hill. The fountain itself, designed by Noguchi, is made of red rock cut in the Negev desert. The garden provides a spectacular setting for large-scale works by outstanding modern sculptors.

Despite his many major commissions and his success with critics, museums, and collectors, Noguchi has had setbacks. He was deeply disappointed when his design for President Kennedy's tomb was rejected, as were some of his imaginative playground projects. Although, Martha Graham noted, "he broods about such things," his natural enthusiasm soon returns and he finds new outlets for his creative energy. His friend the late R. Buckminster Fuller has called him "one of the rare, intuitive question-askers and responders."

A retrospective of Noguchi's sculpture was held at the Whitney Museum of American Art, New York City, in the spring of 1968. One critic noted the variety of materials in which the sculptor has worked but felt that "it is his sculptures in granite and marble which both dominate this exhibition and seem to express the artist's closeness to the structures and contours of the earth." He added that "some of his sculptures can be seen as having sexual overtones." Another critic who wrote of the retrospective saw in *Woman with Child* (1959) "part-erotic, part-tender symbols of union." Noguchi insists that "a purely cold abstraction" does not interest him. "Art" he explained, "must have some kind of humanly touching and memorable quality." Even as abstract a piece as *Red Cube* (1968; on the plaza of the Marine Midland Building in Manhattan's financial district) a form as structural as the gleaming tower behind it, serves to animate and "humanize" the impersonal urban setting.

In 1968, Noguchi published his autobiography, *Isamu Noguchi: A Sculptor's World.* A critic praised its "cool restraint" and "limpid rhythms," while noting that "on every page an almost unbearable loneliness traces the artist's troubled search for his roots. . . . One feels that only through his work does he fully make contact with reality."

In the 1970s this ageless man continued his various activities with undiminished energy. In 1975 he exhibited his first collection of stainless steel sculptures at the Pace Gallery, New York City. Besides working in his converted warehouse in Long Island City, and going every summer to Lucca, Italy, he spends part of each year in Japan. In 1971 he dismantled a wood-trimmed 18th-century samurai's house and warehouse in Marugame, a city on the island of Shikoku, about one hundred miles from Osaka,

and had it moved and reconstructed to serve as his house and studio. In a small room on the main floor Noguchi holds the traditional tea ceremony and exhibits his sculpture. Rising at 7:30 A.M., he works outdoors in the yard by the warehouse like a master stonecutter of old. His Long Island living quarters are furnished with austere Japanese simplicity—shoji screens, akari lamps, and a legless bed.

Isamu Noguchi, still lean and muscular, has been described as having "the face of a doll and the compact body of a Japanese samurai swordsman." He tends to be quiet in company, but when talking about his work displays "the enthusiasm, fire and gestures of a much younger man." According to Robert Hughes, Noguchi is "the finest lyric poet of stone and its qualities in late twentieth-century sculpture, perfecting a combination between the Japanese ideal of *wabi*—'ultimate naturalness,' the right juncture of things-in-the-world—and the specific enterprises of modernism."

Poised between past and present, his Japanese heritage and his American experience, Noguchi defined himself as "the fusion of two worlds, the East and the West, and yet I hope I reflect more than both." He has also said, "The essence of sculpture is for me perception of space, the continuum of existence."

EXHIBITIONS INCLUDE: Leonardo da Vinci Art School, NYC 1924; Eugene Schoen Gal., NYC 1929; Marie Sterner Gal., NYC 1930; Albright-Knox Art Gal., Buffalo, N.Y. 1931; Mellon Gal., Philadelphia 1933; Honolulu Academy of Arts 1934, '39; Marie Harriman Gal., NYC 1935; Charles Egan Gal., NYC 1948; Mus. of Modern Art, Kamakura, Japan 1952; Stable Gal., NYC 1954, '59; Fort Worth Art Center Mus., Tex. 1961; Cordier and Ekstrom, NYC from 1968; Whitney Mus. of Am. Art, NYC 1968, '80; Gimpel Fils, London 1972; Gal. Gimpel, Zürich 1972; Pace Gal., NYC 1975, '80, '83. GROUP EXHIBITIONS INCLUDE: New York World's Fair, Flushing Meadow 1939; "Fourteen Americans," MOMA, NYC 1946; Expo '70, Osaka, Japan 1970; "Selections from the Guggenheim Mus. Collection 1900–1970," Solomon R. Guggenheim Mus., NYC 1970; "Noguchi, Rickey, Smith," Indiana Univ., Bloomington 1970.

COLLECTIONS INCLUDE: Metropolitan Mus. of Art, MOMA, Whitney Mus. of Am. Art, and Solomon R. Guggenheim Mus., NYC; Albright-Knox Art Gal., Buffalo, N.Y.; Hirshhorn Mus. and Sculpture Garden, Washington, D.C.; Beinecke Rare Book and Manuscript Library, Yale Univ., New Haven, Conn.; Honolulu Academy of Arts; Art Gal. of Toronto, Ontario; Keio Univ., Japan; Reader's Digest, Tokyo; UNESCO Building, Paris; Israel Mus., Jerusalem.

ABOUT: Ashton, D. American Art Since 1945, 1982, "Noguchi: New Sculpture" (cat.), Pace Gal., NYC,

1983; Baur, J.I.H. Nature in Abstraction, 1958; Blesh, R. Modern Art, U.S.A.: Men, Rebellion, Conquest: 1900–1956, 1956; Cahill, H. and others, Art in America: A Complete Survey, 1935; Cheney, M.C. Modern Art in America, 1939; Current Biography, 1943; Gordon, J. Isamu Noguchi, 1968; Kuh, K. The Artist's Voice: Talks with Seventeen Artists, 1962; Noguchi, I. A Sculptor's World, 1968; Ritchie, A.C. Abstract Painting and Sculpture in America, 1952; Rose, B. American Art Since 1900: A Critical History, 2d ed. 1975; Seymour, C. Tradition and Experiment in Modern Sculpture, 1949; Takiguchi, S. Noguchi, 1953. *Periodicals*—Christian Science Monitor August 23, 1973, August 24, 1973; New York Times April 6, 1970, July 13, 1971, May 17, 1975, November 10, 1977; Newsweek April 29, 1968; Saturday Review June 1, 1968; Smithsonian April 1978; Time May 6, 1940.

SIDNEY ROBERT NOLAN

NOLAN, SIDNEY ROBERT (April 22, 1917–), Australian painter, is considered the leader of the modern Australian school. A native of Melbourne, Nolan as a boy thrilled to tales of the legendary Australian outlaw Ned Kelly told him by his grandfather, a policeman. From 1934 to 1936 Nolan studied at the National Gallery School in Victoria, but he was largely a self-taught artist. In the years of Nolan's adolescence and early manhood the art scene in Australia was narrow and parochial. Most Australian artists still painted in the borrowed style of the 19th-century academic art, while treating such familiar subject matter as the aborigines, the bush, the wallabies, and the koalas. As one painter remarked, "You either have gum trees on each side with sheep in the middle, or sheep on the outside and gums in the middle." At a 1937 exhibition of modern European painting the director of Melbourne's National Gallery declared that, as long as he was in charge, no such "rubbish" would ever enter the museum's permanent collection. However, in those years a few Australian painters, including Russell Drysdale and William Dobell, were rebelling against this self-conscious provincialism and expressing a bolder, more honest vision, Dobell with his expressionistic portraits and Drysdale with his stark depictions of the harsh, lonely, silent world of the outback.

Given this background, it is all the more remarkable that as early as 1937 Nolan, then aged 20, was working in a postcubist vein, doing free, loose, nonfigurative drawings and abstract, Klee-like compositions in oil, some on paper, some on canvas. These very early works, which were to be unknown to the general public for more than two decades, revealed a far more complex artistic personality than the popular image of Nolan as a socially integrated painter of Australian mythology had previously suggested.

In 1938 Nolan became a foundation member of the Contemporary Art Society of Melbourne, and two years later he held his first solo exhibition, a showing of abstract works in his Melbourne studio. During World War II, from 1941 to 1945, he served in the Australian army, and was stationed in Wimmera, an isolated sector in the interior of the continent.

After his discharge, Nolan worked for two years as illustrator for Reed and Harris Publications in Melbourne. At that time most up-and-coming Australian artists were poor, and Albert Tucker, another Melbourne painter, desperately in need of money, sold Nolan a copy of the court proceedings against Ned Kelly for one shilling. This transcript rekindled his boyhood fascination with that colorful bandit and inspired one of Nolan's most celebrated motifs.

From 1945 on, while still working as an illustrator for Reed and Harris, Nolan produced pictures placing him unmistakably in the still-suspect modernist camp. By this time Russell Drysdale was generally accepted, but Nolan's paintings seemed to viewers with conservative tastes willfully eccentric and bizarre. These works were "regionalist," but only in the narrow sense that their settings were Australian; the treatment was postimpressionistic, with strong surrealist overtones, especially when the subjects related to disaster, death, and fate.

In 1945 Nolan painted *Ned Kelly and Horse*, one of the first works in an immense series dedicated to the so-called Kelly myth. The legendary Kelly, a descendant of Irish convicts, was a folk hero, an Australian Robin Hood of the late 19th century with great appeal to those who were

anti-authoritarian and pro-underdog, much as
Billy the Kid and Jesse James have appealed to
the American imagination. Kelly wore home-
made armor, including a metal-box helmet with
an eye-slit, and in Nolan's paintings he became
a surrealistic, almost demonic figure with a rec-
tangular body, a square black head, and fiery
red eyes. For Nolan, Kelly, the bushranger who
defied a whole continent, symbolized the erup-
tion of force and energy against repression. No-
lan was the first Australian artist to derive
mythological symbols from his country's com-
paratively recent past, a period corresponding to
the American Wild West, and his paintings ini-
tially shocked the public.

Nevertheless, the Kelly paintings gave Nolan
his first taste of popularity, his work having
heretofore been considered exhibitionistic and
strange. This greater acceptance led however, to
an over-simplified view of the artist as a kind of
sophisticated *faux-naïf*. Only after a retrospec-
tive held many years later, in 1961, in Newcas-
tle-upon-Tyne, England, was it realized than
Nolan, in his early explorations of 20th-century
painting, had moved rapidly from abstraction
through Picasso's surrealist images of the 1930s
and early Léger to primitive painting as exem-
plified by Henri Rousseau, though Nolan's work
lacked Rousseau's ingenuous charm. As R. A.
Davey wrote in *The Guardian* (March 18, 1961),
"It seems than Nolan, suspicious of the notion of
painting as a feast for the eye, sought deliberate-
ly to overcome his native sensibility, and at-
tempted to find images that were compelling in
spite of, or perhaps by virtue of, their unattrac-
tiveness in terms of color, shape, and
paint-handling." This uningratiating, deliber-
ately clumsy treatment was certainly appropri-
ate for such themes as Nolan's *Tarred and
Feathered* of 1946.

Another painting related to the Kelly story
was *Policeman in Wombat Hole* (1946), execut-
ed, as were several of his pictures of this period,
in Ripolin paints. The treatment is decorative,
fantastic, and grotesquely humorous; the police-
man, his head and shoulders buried in the or-
ange-colored earth and his arms and legs thrust
rigidly and diagonally upward, holds a piece of
paper bearing a message which begins: "Ned
Kelly and others stuck us up today, when we
were discovered. . . . " There were other
themes based on Australian folklore, including
pictures inspired by a fictitious lady named Mrs.
Fraser, called "the eccentric dryad of the
outback" by Nigel Gosling. A series of carcasses
of sheep in the outback gave the scene an almost
surrealist quality.

Beginning in 1948 Nolan painted a group of
townscapes set in the arid Australian plains.
Royal Hotel (1948), with its predominantly
burnt orange and pale blue color scheme, its sim-
plified composition and its solitary male figure,
is an outstanding example. The hallucinatory
brown-and-mauve landscape was an important
element in *The Death of Captain Fraser*, also of
1948. That same year Nolan married Cynthia
Hansen (she died in 1976).

In 1951 Nolan and his wife visited Europe,
and soon afterward took up residence in Cam-
bridge, England. In the mid-1950s Nolan
moved, permanently it has turned out, to Lon-
don. Since then the artist has traveled all over the
world but only occasionally revisited Australia,
even though he continued to be haunted, even
obsessed, by Australian themes. In that respect
Nolan is like the expatriate Irish writers who
have always carried Ireland with them. As *Time*
magazine (April 26, 1963) observed, Nolan
"remains as Australian as the emu or the
lyrebird." He has said that for him Australia
"contains all the sources of one's energy."

Nolan traveled in Greece in 1956, and became
absorbed in classical mythology while living on
the Greek island of Hydra. Four years later he
remarked: "I wanted to see if in painting non-
Australian myths I could achieve the same rela-
tionship between landscape and figures." How-
ever, as *Time*'s critic noted when commenting
on Nolan's 1959 show at the Matthiesen Gallery,
London, even his dreamlike *Greek Harbor* re-
vealed the artist's obsession with the surrealistic
qualities of the Australian outback. An ambitious
series of 75 paintings on the theme of "Leda and
the Swan" set the ancient legend against a land-
scape similar to that of the outback.

Nolan's first one-man exhibitions in England
had been held at London's Redfern Gallery in
1951 and 1952. He was awarded a painting prize
at the Venice Biennale of 1954, and two years
later he made his American debut at the Durl-
acher Gallery, New York City.

From 1957 to 1959 Nolan studied, as many
other contemporary artists have done, at S. W.
Hayter's famed print workshop in Paris, Atelier
17. In 1961 a Nolan retrospective was held in the
Hatton Gallery of King's College, University of
Newcastle-upon-Tyne, featuring pictures paint-
ed in the decade 1947–57 but including more re-
cent works. R. A. Davey discussed the change in
concept and technique since the already famil-
iar Ned Kelly paintings. Whereas in those earlier
works "the image itself [dominated] the painting
as a whole," in the more recent pictures "the im-
age [emerged] from, [was] utterly dependent
upon, the act of painting." This new develop-
ment could be seen in *In the Cave* (1957), in

which the main image suggested an aboriginal cave drawing of a human figure.

Also in 1961, Nolan exhibited at the American Embassy in Grosvenor Square, London, a set of sketches done in the course of a 50,000 mile journey across the North American continent. His record was not one of skyscrapers and neon signs, but of "places where civilization had failed to scratch the great, wild surface of America," as one critic observed.

In Nolan's 1962 show at the Durlacher Gallery there were fewer pictures of Ned Kelly, and the best of those showed the outlaw at the moment of his capture at Glenrowan. More important, in contrast to earlier versions of the subject, the emphasis was on decorative rather than on mythological values. Soon after that exhibit, Nolan went to Africa, but pointed out that "in painting Africa I am certainly not ditching Australia. There are the same unfolding perspectives, vista upon vista." In some of the African paintings he exhibited at London's Marlborough Gallery in 1963, he put an animal instead of a human figure in the landscape, as in *Young Monkey*. The ruggedness of his subject matter in such works as *Explorer, Rocky Landscape* was combined with a delicate technique, the result, Nolan explained, "of putting on layers of color, and then burnishing them off with [his wife's discarded nylon stockings] until I get the translucent quality I want."

In his 1968 show at the New London Gallery, it was apparent that Nolan had returned to the Ned Kelly theme, which was treated in two enormous panoramas, each consisting of nine large panels. One of them, *Riverbend*, was a blow-up of a mysterious outback scene, while the other, *Glenrowan*, seemed to be "the final apotheosis of the 'noble bandit,'" in a picture "handled with a fierce, almost wild energy," to quote Nigel Gosling. Another set of panels was based on Dante's *Inferno*, which Nolan had read in Robert Lowell's translation. In 1970 when the *Inferno* panels were shown in an Accrington gallery in the remote Yorkshire moors near Haworth in the Brontë country, a *Guardian* (June 5, 1970) critic wrote that along with "the ruptured grief-struck faces" were "gleams of unearthly beauty" that echoed Goya. "It is important to take Sidney Nolan straight, absolutely for what he is and says. . . . It is at once paint and nature and man: fused, penetrating and compelling."

In Nolan's 1972 show at the Marlborough Gallery new departures were evident, including a large mural which had been painted six years earlier, depicting the dragging of Hector before the walls of Troy. In contrast to this work, relatively traditional by Nolan's standards, was

Snake, a mural composed of over two hundred small variations of a single motif, a ritual snake's head. Struck by the cellular treatment of the image, Gosling wrote that the wall on which the snake segments hung "seems to vibrate like the inside of a beehive packed with larvae."

By 1973 Nolan was living in Putney (a residential district in London) with his wife and spending three months of each year in Australia. Following a visit in 1972 to a huge iron mine deep in the outback, he produced paintings of miners. He was moved by their sense of community and their courage; in fact, with their long gold hair and brown limbs, they looked to Nolan like apostles. "Their life is terribly hard," he remarked. "It is a sacrifice. And they know it. . . . Their life is violent, but they have no choice." He planned to paint a Last Supper with the miners as participants and his paintings of 1972–73 were individual studies for this project. Screenprints of some of the "Miner" paintings were included in Nolan's 1973 retrospective in Dublin; in one print the head of a miner wearing a yellow helmet was superimposed on a photograph of an explosion. In contrast to what one critic described as the "crude, ugly, violent" expression of the "Miner" series was the lyricism of the multipaneled allegorical mural, *Paradise Garden*.

Nolan's interest in allegory, which also found expression in his *Oedipus* and *Sphynx* pictures of 1975, is related to his love of poetry. He has illustrated poems by Robert Lowell and written poetry himself. Like much of his painting, Nolan's poetry reflects the harsh, often brutal, yet at times strangely beautiful reality of his native land and its people, as in these lines:

> They break each other on the floor
> and in a heavenly
> transcendental light
> they clean the dogs
> and do the flowers
> and eat each other
> cooked and raw.

Sidney Nolan has a long, handsome face of a type not uncommon in Australia. His work conveys a rugged power, but he himself was described by Merete Bates in *The Guardian* (June 20, 1973) as a "fragile, modest, shy, proud, and incredibly stubborn man. . . . " He is pleased that Australia is beginning to recognize its own artists, but feels that London is a city he "needs." "It's not that Australia isn't independent," he explained. "It's self-supporting, a continent. But I need London. The next generation—they probably won't." In *Time* (April 26, 1976) he described the framework of his art as "deep space," or "man in an extreme environment. . . . I sometimes feel closer to Herman Melville than

to anyone else. As in *Moby Dick*, he and I are juggling the same ingredients; the simple protagonist, the mysterious adversary, the all-powerful elements."

EXHIBITIONS INCLUDE: At his studio in Melbourne, Australia 1940; Contemporary Art Society, Melbourne, Australia 1943; Univ. of Melbourne, Australia 1946; Moreton Gals., Brisbane, Australia 1948; Maison de l'Unesco, Paris 1949; Macquarie Gals., Sydney, Australia 1949, '50, '51; David Jones Art Gal., Sydney, Australia 1949, '50, '65; Libreria di Quattro Venti, Rome 1950; Redfern Gal., London 1951, '52, '55; Durlacher Gal., NYC 1956, '58, '62; Gal. of Contemporary Art, Melbourne, Australia 1956; Whitechapel Art Gal., London 1957; Matthiesen Gal., London 1959; Phoenix Art Mus., Ariz. 1960; Hatton Gal., Univ. of Newcastle-upon-Tyne, England 1961; American Embassy, Grosvenor Square, London 1961; Inst. of Contemporary Arts, London 1962; Marlborough Gal. London 1963, '72; Marlborough Fine Art, Ltd., London from 1963; Qantas Gal., Edinburgh 1964; Qantas Gal., Paris 1964; Qantas Gal., London 1964; Qantas Gal., Sydney, Australia 1964, Marlborough-Gerson Gal., NYC 1965; Art Gal. of New South Wales, Sydney Australia 1967; New London Gal., London 1968; Aldeburgh Festival, Suffolk, England 1968; Nat. Gal., Melbourne, Australia 1970; Kunsthalle, Darmstadt, W. Ger. 1971; Ashmolean Mus., Oxford, England 1971; Tate Gal., London 1972; Ilkley Literature Festival, Yorkshire, England 1973; Marlborough Gal., Zürich 1973; Exhibition Halls, Royal Dublin Society, Dublin 1973. GROUP EXHIBITIONS INCLUDE: Pittsburgh International, Carnegie Inst. 1952, '64, '70, '71; Venice Biennale 1954; Documenta 2, Kassel, W. Ger. 1959; "Recent Australian Painting," Whitechapel Art Gal., London 1961; "Rebels and Precursors: Aspects of Painting in Melbourne 1937–1947," Nat. Gal. of Victoria, Melbourne, Australia 1962; "Rebels and Precursors: Aspects of Painting in Melbourne 1937–1947," Art Gal. of New South Wales, Sydney, Australia 1962; "British Painting in the Sixties," Tate Gal., London 1963; "Australian Painting Today," toured Australia and Europe, 1963; "The English Eye," Marlborough-Gerson Gal., NYC 1965; "Nolan, Piper, Richards," Marlborough New London Gal., London 1966; "Animal Painting: Van Dyck to Nolan," Queen's Gal., Buckingham Palace, London 1966.

COLLECTIONS INCLUDE: Tate Gal., Contemporary Art Society, Arts Council of Great Britain, and Gulbenkian Foundation, London; Nat. Gal., Melbourne, Australia; Western Australian Art Gal., Perth; MOMA, NYC.

ABOUT: Bonython, K. (ed.) Modern Australian Painting and Sculpture 1950 to 1960, 1960; Lucie-Smith, E. Late Modern: The Visual Arts Since 1945, 1969; Measham, T. (ed.) The Moderns 1945–1975, 1976; Neville, R. Paintings by Sidney Nolan, 1964; Nolan, S. Paradise Garden, 1971; Smith, B. Place, Task and Tradition: A Study of Australian Art Since 1788, 1945. *Periodicals*—Art International October 1973; Guardian March 28, 1961, June 5, 1970, April 25, 1973, May 4, 1973, June 20, 1973; New York Times March 1, 1962; Observer May 26, 1968, December 3, 1972; Studio no. 145 1953, no. 150 1955, no. 168 1964; Time October 10, 1960, April 26, 1963, April 26, 1976.

NOLAND, KENNETH (CLIFTON) (April 10, 1924–), American painter, has been a pioneer of hard-edge and color-field painting. He was born in Asheville, North Carolina, the third of four sons of Harry C. Noland, a pathologist. Asheville, the home town of novelist Thomas Wolfe, was both a rural town in the Appalachian Mountains and a fashionable resort and spa, and Noland considers himself fortunate to have grown up in a southern locale that was at once primitive and sophisticated.

Noland's mother was an amateur musician who played the piano, and his father was a Sunday painter. When Noland was about 14 years of age his father took him to the National Gallery in Washington, D.C., where the boy was particularly impressed by Monet. His father allowed him to use his artist's materials, and when Kenneth was a teenager his brother Harry, four years his senior, introduced him to jazz and literature. The youngest brother, Neil, became a sculptor, and he has assisted Kenneth with many facets of his work.

Drafted into the U.S. Army in 1942, when he was 18, Noland served in the Air Corps as a glider pilot and cryptographer. His father had been an "early bird," one of the first one hundred or so Americans to learn to fly, and as children Kenneth and his brothers had ridden in planes. This, along with his youthful ideas about the romance of flying, prompted Noland's choice of service in the Air Force. Most of Noland's tour of duty was spent in flyers' pools at stateside air bases, but in late 1944 he was stationed in Egypt and Turkey.

After the war Noland returned to Asheville, and in 1946 he and his brothers Harry and Neil enrolled in Black Mountain College, only 20 miles from their home town. Noland studied at Black Mountain from 1946 to 1948, and again during the summers of 1950 and 1951.

The guiding spirit of the Black Mountain College art department was the Bauhaus-trained Joseph Albers, who was primarily concerned with color relationships within a rigid geometric framework. Albers was on sabbatical when Noland arrived and was absent for most of his stay at Black Mountain, but Albers's influence on the curriculum was strong and Noland did study with him for one semester, in 1947, and familiarized himself with his instructor's color theories. However, during his two years at Black Mountain Noland's principal teacher was the veteran

Jorge Lewinski

KENNETH NOLAND

geometric abstrationist Ilya Bolotowsky. Noland found Bolotowsky, one of the charter members of the American Abstract Artists group of the mid-1930s, more open and more of a humanist than Albers, whose concepts Noland ultimately rejected as too rigid and "scientific." But the Bauhaus–Mondrian orientation of Black Mountain, as transmitted by both Albers and Bolotowsky, strongly influenced Noland, and its effect is apparent in his *Untitled* painting of 1947. Surrealism had little impact on Black Mountain, and Noland was still unaware of the breakthrough by the Abstract Expressionists in New York City. Instead he became interested in Paul Klee, who had combined cubist and abstract methods with fantasy and a magical sense of color.

In the fall of 1948 Noland went to Paris on the GI Bill, "to find out more about art." He studied with the sculptor Ossip Zadkine, who had taught at Black Mountain in 1945, the year before Noland had enrolled. Noland found Zadkine, like Bolotowsky, "very committed to art and very idealistic about teaching and a very, very generous, sympathetic man." But Zadkine's cubist orientation conflicted with the formal geometric abstraction Noland had absorbed at Black Mountain and which suited his own sensibility.

In 1949 Noland had his first solo exhibition, at the Galerie Raymond Creuze, Paris. The paintings showed an influence of the later works of Klee that was to last for several years. The exhibit aroused little public attention, but an *International Herald Tribune* critic noted the artist's gifts as a colorist, and observed that his "almost barbaric color arrangements" were

"combined with 'graffiti' suggesting animals, huts and cathedrals."

In Paris, Noland saw works by Matisse, Miró, and Picasso, but it was Matisse who had the greatest impact and made Noland realize "that I was going to have to revise my thinking about how to go about making pictures." He found it necessary to reject cubist structure—which he had learned from Mondrian as well as from Zadkine and Picasso— in order to develop what he called a true "color structure," with Matisse and Klee as guides.

Noland returned to the US in the summer of 1949, after spending less than a year in Paris, and settled in Washington, D.C., where he taught until 1951 at the Institute of Contemporary Arts, first as student-teacher under the GI Bill and subsequently as a full-time instructor. Robin Bond, an Englishman with whom he studied at I.C.A., reinforced his interest in Klee, which was reflected in his paintings *Untitled* (1951–52) and *In the Garden* (ca. 1952). Noland also taught at Catholic University, Washington, D.C., from 1951 to 1960.

During his summer at Black Mountain in 1950, Noland became friendly with Clement Greenberg, the influential critic and supporter of abstract expressionism, and met Helen Frankenthaler, who was to carry forward techniques developed by Jackson Pollock. Also in 1950, he married Cornelia Langer. She had been a student of the Abstract Expressionist sculptor David Smith at Sarah Lawrence, and introduced Noland to Smith at this time.

In 1952 Noland became close friends with Morris Louis, when both were teaching at the Washington Workshop, an evening school for the arts. Their close association was to last until Louis's death in 1962. They were different in temperment—Noland being outgoing and gregarious, Louis quiet and withdrawn—but each sought a new direction from abstract expressionism, which at that time was on the wane, as most second-generation New York School artists were content to imitate the action-painting style of Willem de Kooning. Noland provided the link with New York City, which he and Louis visited together in 1953. They saw canvases by Pollock and Franz Kline, but the decisive event was their visit to Helen Frankenthaler's studio, where they admired her poured stain-painting of 1952, *Mountains and Sea*. Noland later recalled: "We were interested in Pollock, but could gain no lead to him. He was too personal. But Frankenthaler showed us a way—a way to think about, and use, color."

Back in Washington, Noland and Louis experimented together with the stain technique, ap-

plying highly liquefied paint to raw, unprimed canvas. This method revealed the texture of the canvas and created a flat flowing, translucent effect. In 1953 Noland began to use Magna, a paint compatible with oil but which has acrylic-resin as a binding agent (Louis had begun using Magna earlier). Noland was to use that paint until 1962, when he changed to Aqua-Tec, a mixture of dry pigments with water-based plastic media. He was introduced to Aqua-Tec by David Smith.

In these early years of experimentation, Noland had not yet achieved a personal idiom, as Louis had in the series of "Veils" that he began in 1954. Noland's all-over abstractions showed influences ranging from Pollock and Frankenthaler to de Kooning and Clyfford Still; some canvases were thickly painted, others were stained in thin washes. Nevertheless, his work was now included in group shows, notably the "Emerging Talent" exhibit organized by Clement Greenberg at the Kootz Gallery, New York City, in January 1954. The most fluid and evocative of Noland's early canvases, In a Mist (1955), was included in "Young American Painters," a traveling exhibition organized in 1956 by Dorothy Miller for the Museum of Modern Art, New York City. Among other participants were Richard Diebenkorn, Sam Francis, and Ellsworth Kelly.

By 1956 Noland's circle paintings had emerged. Concerned as he was with "pure painting," he wanted to eliminate the gestural brushstroke characteristic of first-generation Abstract Expressionists and to expand his color effects. He became intensely involved with circular motifs within a square format. Commenting on Noland's use of these forms, one critic observed that "the circle is related to the cosmos, while the square is most closely associated with man and man-made forms like architecture." In Noland's Globe (1956), the square support contained a centered circle with a dark jagged contour that did not quite join, apparently floating over opalescent washes of color and surrounded by a large amount of raw canvas. This canvas was exhibited in Noland's first solo exhibition in New York City, at the Tibor de Nagy Gallery in 1957, when he was 33.

By late 1957 Noland's painting had become more geometric and hard-edged, and in 1958 he began painting concentric circle canvases. The concentric bands of color, varying in width, appeared to move outward from the center of the canvas to the edges. Until 1961 Noland often retained an uneven painterly edge at the outermost band, a last vestige of abstract expressionism, as in That (1958–59) and Mesh

(1959). The canvases were usually six-foot square, and, like Pollock, Noland frequently worked on the floor. The center ring was always painted first. Unlike Jasper Johns's Target with Four Faces (1958), which was partly built out from the surface of the painting and invited different "readings" or interpretations, Noland's images remained flat and non-symbolic, yet the entire surface of the canvas was animated by the highly charged color contrasts, whose luminous intensity owed something to Matisse.

The first showing of Noland's concentric circle canvases was at the French Company Gallery, New York City, in October 1959. The exhibit was organized by Clement Greenberg, who, in his article "Louis and Noland" in Art International (no. 5, 1960), declared that the two artists were "serious candidates for major status" among the younger Americans. The term "color painting" appeared in this article for the first time. The Washington Post review of the exhibit quoted a viewer as saying of Noland's technique: "It draws you into the center like a target and then throws you out to the edge like a pinwheel."

In 1962 Noland began a series of "cat's eye" paintings in which he used ovoid or ellipsoid shapes, as in New Problem (1962). In the spring he moved from Washington to the famous Chelsea Hotel on Manhattan's west side, and that September Morris Louis died in Washington. In 1963, while staying at the Chelsea, Noland developed his chevrons, in which the V-shaped motif, consisting of parallel stripes of different color, was centered and "suspended" from the top edge of the canvas, pointing to the center of the lower edge. Trans Flex (1963) and Magenta Haze (1964) are examples. Sometimes the V was placed off center, as in Bend Sinister (1964; Hirshhorn Museum and Sculpture Garden, Washington, D.C.) and Sarah's Reach, also of 1964. The shapes of the chevrons were intended primarily as vehicles for the colors, which were usually given maximum intensity. Turnsole, a circular motif of 1961, and several of the chevron paintings of 1963–64 were among the 13 pictures by Noland exhibited at the Venice Biennale of 1964.

Although hard-edged, Noland's structure owed much more to the chromatic abstraction of Mark Rothko and Barnett Newman than to earlier geometric art. Noland was always concerned with the relationship of the image to the edge of the canvas and with creating a purely "optical" space. By 1964 he had begun to alter the balance of his color, the proportions of the bands, and the shape of the support. Following the example of Mondrian and Bolotowsky, he set the square on end, as in Absorbing Radiance (1964) and

Saturday Night (1965). In 1966–67 he produced what he termed "attenuated needle diamonds" in an exaggeratedly narrow format, though he soon came to regard the diamond as too assertive and restrictive an exterior shape. In his search for a more neutral shape which would give him greater freedom in his use of color, he embarked in 1967 on his horizontal stripe series, and his working methods changed as well. He began to use tape to obtain a straight edge, a practice he has continued, and whereas previously he had painted freehand or with rollers, he now applied the paint in various ways—with rollers, a brush, a sponge, or a squeegee. Some of these horizontal stripe paintings were exceptionally long, notably *Via Blues* of 1967, which measures 90 1/8 inches by 264 inches. Like Noland's earlier "targets," this new phase was the subject of heated controversy in the art world. The artist was viewed, alternately, as "a messiah of modernism," to quote *Time* magazine, and as a mere decorator, "a good designer of sheets."

Via Blues and Noland's *Coarse Shadows* (1966) were exhibiting in the spring of 1968 at the Metropolitan Museum of Art, New York City, in a show that included two paintings by Morris Louis and a metal construction by another close friend of Noland's, the British abstract sculptor Anthony Caro. Hilton Kramer of *The New York Times* (March 4, 1973) wrote: "Whereas Mr. Louis' work boasts a kind of quick, water-colorlike lyric thrust, Mr. Noland's is cold, conceptual and aloof." But according to the critic Sam Hunter, Noland's painting dealt with "lyrical sensations," but always "in the context of a stressed formality."

A new phase began in 1971 with Noland's vertical plaid pictures, smaller than his horizontal stripe canvases and with the paint more loosely applied, as in *Abeyance* and *Gray Pioneer.* Noland's friendship with Caro had stimulated his interest in metal sculpture, and in 1971 he began work on two sculptures, *Vermont,* completed in 1973, and *Loom,* completed in 1974. He presented *Vermont* to the city of Tel Aviv, Israel, which he had visited in 1971 as a guest of the Tel Aviv Foundation of Literature and Art.

Noland's experience in sculptures prompted him in 1975 to move away from the rectangular format in his painting and to experiment with irregularly shaped canvases and with new and subtle color combinations (*Burnt Beige,* 1975, and *Lapse,* 1976). In the fall of 1975 Noland visited Australia and New Zealand and traveled in the Far East. The following year he was elected to the American Academy and Institute of Arts and Letters.

Public recognition of Noland's work peaked in 1977 when he was given a major retrospective at the Guggenheim Museum, New York City. Organized by Diane Waldman, the show traveled in September 1977 to the Hirshhorn and Corcoran museums in Washington, D.C. It included one large sculpture, *Ridge* (1975), in Corten steel, a popular metal among contemporary sculptors because it rusts uniformly.

Predictably, critical response to the Noland retrospective was divided. John Russell praised Noland's "angelic and wholly personal color sense" and called the exhibit "a show to lighten your step and bring smiles." Hilton Kramer was less enthusiastic, saying, "Despite the heat in all this color, the art itself is cold." Harold Rosenberg of *The New Yorker* (June 20, 1977) acknowledged that Noland had been "one of the spearheads of American formalist painting" in the latter half of the '60s, but questioned the importance of the artist's contribution to the abstract tradition. He contrasted Noland's work with the equally abstract, but very different, paintings of Barnett Newman; for Rosenberg, Newman's reductive method was based on "the profoundest feeling of the individual artist," whereas Noland's was a "collective" art, committed to "objectivity" and "bound by rules and principles rather than by an effort toward the realization of individuality." A *Village Voice* writer found the concentric circle paintings of the late '50s and early '60s "radiant, gorgeous, exhilarating," but considered much of the more recent work "disturbingly thin and bland." Mark Stevens of *Newsweek* (May 16, 1977) declared that Noland, in the plaid paintings and shaped canvases, "flirted with esthetic dandyism," creating effects that "border on the confectionery." However, he felt that Noland's combination of "cool calculation and lush color" gave his work "a graceful intelligence."

Noland and the former Cornelia Langer had three children—Lyndon, Bill, and Cody—but their marriage ended in divorce in 1957. In April 1967 he married Stephanie Gordon; they were divorced two years later.

Kenneth Noland is a slim, blue-eyed man with graying hair and a poised and pleasant manner. He lives and works at his farmhouse, called "The Gallery," in South Shaftsbury, Vermont. The farm, which once belonged to Robert Frost and was purchased by Noland in 1963, is near Bennington College, where the artist has taught from time to time. The house itself is small, but the adjacent barn, which Noland converted into a studio, is large. He said of Vermont: "[There is] a good light up there. A blue light." Noland also maintains a second home, which he described as "a renovated former flophouse," on the Bowery in lower Manhattan.

EXHIBITIONS INCLUDE: Gal. Raymond Creuze, Paris 1949; Tibor de Nagy Gal., NYC 1957–58; Jefferson Place Gal., Washington, D.C. 1958, '60; French and Company, NYC 1959; André Emmerich Gal., NYC from 1960; New Gal., Bennington Col., Vt. 1961; Gal. Lawrence, Paris 1961, '63; Jewish Mus., NYC 1965; Kasmin Gal., London 1965, '68, '70; Lawrence Rubin Gal., NYC 1969; Waddington Gal. II, London 1974; Solomon R. Guggenheim Mus., NYC 1977; Hirshhorn Mus. and Sculpture Garden, Washington, D.C. 1977; Corcoran Mus., Washington, D.C. 1977. GROUP EXHIBITIONS INCLUDE: "Emerging Talent," Kootz Gal., NYC 1954; "Young American Painters," MOMA, NYC 1956; "American Abstract Expressionists and Imagists," Solomon R. Guggenheim Mus., NYC 1961; Geometric Abstraction in America," Whitney Mus. of Am. Art, NYC 1962; "Art since 1950," Seattle World's Fair, Wash. 1962; "Toward a New Abstraction," Jewish Mus., NYC 1963; Venice Biennale 1964; Documenta 4, Kassel, W. Ger. 1968; "The Art of the Real," MOMA, NYC 1968–69; "New York Painting and Sculpture, 1940–1970," Metropolitan Mus. of Art, NYC 1968, 1969–70.

ABOUT: Ashton, D. American Art Since 1945, 1982; Current Biography, 1972; Hughes, R. The Shock of the New, 1981; Lucie-Smith, E. Late Modern: The Visual Arts Since 1945, 1969; Moffett, K. Kenneth Noland, 1977; Rose, B. American Art Since 1900: A Critical History, 2d ed. 1975; Sandler, I. The New York School: The Painters and Sculptors of the Fifties, 1978; Waldman, D. "Kenneth Noland: A Retrospective" (cat.), Solomon R. Guggenheim Mus., NYC, 1977. *Periodicals*—Art in America May/June 1977, Summer 1983; Art International (Lugano) no. 5 1960, February 1965; Art News November 1962; Arts Magazine December 1967–January 1968; International Herald Tribune April 29, 1949; New York Herald Tribune March 19, 1961; New York Times January 4, 1957, March 4, 1973, November 22, 1975; New Yorker June 20, 1977; Newsweek May 16, 1977; Observer April 4, 1965; Time April 18, 1969; Village Voice November 30, 1967, May 2, 1977.

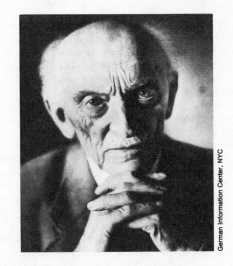

German Information Center, NYC

EMILE NOLDE

NOLDE, EMILE (August 7, 1867–April 13, 1956), German painter, was one of the founders of North European expressionism. He was born Emil Hansen, of a peasant family on a farm near Nolde, a small town in North Schleswig. "Intellectuals and literati call me an expressionist. I do not like this narrow classification. A German artist, that I am," the painter proclaimed. His art was indeed largely shaped by the scenery and "soul" of northern Germany—especially by that lonely, flat marshland country along the North Sea where most of his life was lived. Although Nolde was primarily a painter, many critics esteem his watercolors and prints far more than his strident, rough-mannered oils.

Despite the fact that he professed an antiintellectual attitude, Nolde wrote fairly voluminous-

ly. His autobiography and his extensive published correspondence with his Swiss friend Hans Fehr reveal a passionate devotion to art, give details of his development as an artist, and also record his religious feeling and deplorably naive political and nationalistic sentiments.

Nolde's artistic inclinations were manifested in early childhood; often neglecting his farm chores, he modeled clay figures, drew, and painted, using elderberry and beet juice for his colors. At 17 he started on his series of solitary travels from place to place in quest of training, determined to become an artist. Going first to the nearby city of Flensburg in Schleswig-Holstein, he became an apprentice wood-carver in a furniture factory and spent what little spare time he had studying with a professional painter and sketching landscapes and portraits. After four years Nolde left for Munich, then went to Karlsruhe where he attended formal art classes, and in 1889 arrived in Berlin. Here he eventually found employment in a large furniture works. Two years later he was accepted as a drawing teacher at the Kunstgewerbemuseum (Arts and Crafts Museum) in St. Gallen, Switzerland, and remained there until 1898. After his previous years of poverty, Nolde was, for a change, secure, and found friends who introduced him to a larger world—to contemporary thought and culture. Making one of his first trips outside of Germany, Nolde in Milan saw Leonardo's *Last Supper*; the great fresco profoundly inspired his later religious art. Meantime, in 1897, he produced his first major canvas, *The Mountain Giants*, and was busily painting (or, more accurately, caricaturing) the Swiss peasant types. His

taste for a certain kind of Germanic grotesque fantasy also resulted in a series of paintings of the Swiss mountains personified with troll-like features—as, for example, in *The Matterhorn Smiles* (1894). These grotesqueries, reproduced in the magazine *Jugend,* became extremely popular and an edition of 100,000 postcards was printed, earning Nolde enough money to give up his teaching post and go back to Munich. There he intended to study at the academy but, being rejected, studied instead privately with Friedrich Fehr and, in Dachau, with Adolf Hölzel. The influence of Hölzel, a nature painter in the lyrical, Romantic tradition, and of the allegorical nature paintings of Arnold Böcklin were critical to Nolde's development at this stage.

A trip to Paris in 1899, where he was enrolled briefly in the Académie Julian, gave him, as he later put it, "very little, and I had expected so much." But the work of Titian, Goya, Daumier, and Rembrandt did arouse his enthusiasm; above all, the impressionist paintings of Manet introduced him to the free use of color. He declared, however, "The sweetness of Renoir, Monet and Pissarro cannot touch my tougher Nordic senses." Two years later, Nolde moved on once again, this time to Copenhagen. In 1902 he married Ada Vilstrup, a Danish actress and entertainer. His solitary life had finally ended, but the restless peregrinations continued, this time between the island of Alsen, where he lived in a fisherman's shack, and Berlin, where until 1940 he spent his winters.

It was after his marriage that he changed his name to Nolde—perhaps in this way marking his transition from student to full-fledged artist—and began to concentrate on paintings of the northland scene. One of the first works, *Moonlit Night* (1905), evokes the lonesome moors, somewhat in the style of his teacher Hölzel. In contrast, *Spring Indoors* (1904) is a warm, impressionistic portrait of his wife, seated at a table reading. (It has been remarked that, although the two painters did not know one another's work, the canvas is reminiscent of the intimate interiors of the French Impressionist Pierre Bonnard, Nolde's exact contemporary.) In another 1904 painting, *Harvest Day,* Nolde's feeling for brilliant color was first truly manifested; he described himself "as if intoxicated when I painted this picture." Going beyond impressionism, he used thick brushstrokes (or in other paintings even applied the pigments directly with his fingers) to create a sense of rapid, joyous movement. The new manner shows the influence of the Postimpressionists Van Gogh and Gauguin, and of Edvard Munch, who was then still working in Germany and whom he later met, in 1906. The first of Nolde's paintings to

be publicly shown, *Harvest Day* was accepted for the 1905 exhibition of the Berlin Secession.

Formal alliance with his peers came in 1906 when Nolde was invited by Karl Schmidt-Rottluff to join and exhibit with Die Brücke (The Bridge). This group of avant-garde artists had seen Nolde's first individual exhibition at the Galerie Ernst Arnold, Dresden, and had been inspired by what they termed his "tempests of color." Nolde was the oldest member of the group. Stimulated by the sharing of aims and enthusiasms—for the work of Van Gogh and Munch and for African art—he produced a considerable body of paintings, notably of flowers and gardens. Within a year and a half, however, he became disenchanted and broke with Die Brücke. From that time on Nolde worked independent of any group, almost reclusively. Ultimately, indeed, although he was widely admired, he left no school of his own.

As might be expected from his training as a wood carver, Nolde had a special affinity for the graphic arts. Until, at the age of 60, bad eyesight forced him to give up printmaking, he produced a total of some 500 etchings, lithographs, and woodcuts, definitively cataloged by his friend, the connoisseur Gustav Schiefler, beginning in 1911. In general, the prints exist in their own right, rarely based on previous paintings. They constitute a body of work which defines Nolde as one of the greatest graphic artists of the 20th century.

His first etchings date from 1898; his final series of work in this medium dates from 1918–22. By the time he joined Die Brücke, he had developed his own technique, producing an aquatint effect and stressing tonal values rather than line. This technique he imparted to the Brücke artists, who in turn were responsible for introducing Nolde to woodcut and lithography. Nolde's first series of 30 woodcuts was completed in 1906. Again, tone was the important factor; stark black and white contrasts characterize works from the monumental face of the *Prophet* (1912) to the somewhat grotesque grouping of three figures called *The Family* (1917).

In the summer of 1910 Nolde was in Hamburg where, despite his frequently expressed aversion to modern technology, he succumbed to the pictorial interest of the harbor scene. By day sketching on a small boat, at night etching his plates, Nolde produced a large body of etchings, woodcuts, and brush drawings which convey the dynamic rhythms of the busy port.

Nolde first attempted lithography in Munich in 1907: a series of 31 prints of music-hall dancers. Not until 1913, back in his northern studio, did he really start to work intensively in this me-

dium, pulling prints over and over again to get variations in the coloring. "As a unit, Nolde's thirteen color lithographs of 1913 constitute the climax of German expressionist graphic art," according to the scholar Peter Selz. One of the most beautiful of the series is *Dancer,* a work which also reflects his great interest in "primitive" culture and in dance. Religious themes and various kinds of human encounters are also treated in this group. In 1926 Nolde produced another—and last—series of color lithographs.

The years 1909–12 were devoted to a substantial number of religious paintings which Nolde felt spiritually compelled to execute after a bout of severe illness. With Rouault and Chagall, Nolde is considered by Selz to have painted "the most significant twentieth-century pictures of explicitly religious subjects." These intensely personal renditions of Old Testament stories and scenes from the life of Christ are characterized by their dissonant colors, primitive mysticism, and the use of demonic or masklike faces—as in *The Last Supper* (1909). Its composition, a circle of masked faces pressed menacingly around Christ, points unmistakably to the influence of the Belgian painter James Ensor, whom Nolde eventually met in 1911, visiting him in his home in Ostend. Nolde, however, did not employ masks with Ensor's satiric intent. In any case, this painting, with *Pentecost* (also of 1909), may be said to be Nolde's first truly expressionist work. With the nine-part *Life of Christ* (1911–12) and the *Maria Aegyptiaca,* or *Life of St. Mary of Egypt* triptych (1912), Nolde began to simplify forms and to paint, not in the impressionist style, with broken brushstrokes, but in large areas of color. There was popular outrage at the violent, demonic spirit of these paintings, so different from the anemic and sentimental religious art that had been produced in the West since the early 19th century. The later *Entombment* (1915), a monumentally moving evocation of suffering and death, completes this religious series.

A group of etchings of religious subjects, printed in 1911, complements the fantasy and mystical fervor of the paintings. Of such a work as *Scribes,* Nolde's remark made some years earlier is appropriate: "My etchings . . . demand that the viewer leap drunkenly with them."

Upon the rejection of his *Pentecost* by the Berlin Secession in 1910, Nolde quarreled with this group, the most powerful of all German artists' associations. Joined by Max Pechstein, he founded the New Secession group. Roman Catholic church opposition to showing his *Life of Christ* cycle at the Brussels International Exhibi-

tion in 1912 led to Nolde's retreat from participation in the contemporary art world. Indeed, one of his lifelong regrets was that none of his religious art found a place in a church. There was no understanding among the clergy of his determination to recreate the spirit of Christianity as an appropriately primitive idiom. Despite these rejections he did periodically return, in later years, to religious art in various media. And he was eventually vindicated. In the years after the Second World War some of the religious paintings of this intensely German artist found ecumenical homes far afield: in the Dominican church at Assy, France; in the Church of St. Matthew in Northampton, England; and in the synagogue of the Hebrew University Medical Center in Jerusalem.

The strident colors of the *Dance Around the Golden Calf* (1910),with its nude women dancing in frenzied abandonment, are repeated in the yellows, reds, and purples of *Christ Among the Children* (1910); in the latter, these colors convey a pure, compassionate love. A particularly sensitive regard for children was in fact manifested in many paintings and watercolors throughout Nolde's life. A whole series of pictures contemporaneous with the religious paintings deals with children at play; in canvases such as *Wildly Dancing Children* (1909) the rapid strokes of vivid color leap over the surface, creating not only the figures of the dancers but their dance.

In conjunction with his attraction to the ritual use of dance and masks, Nolde had developed an interest in ethnographic art which, far ahead of his time, he declared should be exhibited as art in art museums. Because of this interest he was picked to serve as official artist on a small expedition (two physicians and a nurse) sent by the German government to investigate health conditions in the German South Seas colonies. Accompanied by his wife Ada, Nolde traveled across Europe and Asia to Melanesia. Between 1913 and 1914 his many drawing and watercolors of the natives (later reworked into woodcuts), and a few paintings, captured the sense of cultures and ways of life doomed forever by colonial exploitation.

Back in Germany, after the outbreak of World War I, Nolde turned to paintings of his northern homeland, ever fascinated by its brooding spaces, its vast, turbulent skies, the sunset light that transforms the color of the land. In 1916 he moved his summer home from Alsen to Utenwarf, on the mainland. When, after the war, the area was ceded to Denmark, he became and remained for the rest of his life a Danish citizen. In 1926 he moved back over the German border

to nearby Seebüll (not far from Nolde) and there designed for himself a villa, visible for miles across the marches, yet providing needed solitude and nearness to the land he loved and—eventually—a refuge from political persecution. In this region, as in the South Seas, Nolde found the union of self and nature that was central to his thought and art, and produced some of the most powerful of 20th-century landscapes. And always there were paintings of flowers. Whether in oil, like *Ripe Sunflowers* (1932), or in watercolor, like the late undated *Red Poppies,* these indeed bear out his passionate declaration about flowers, that he felt as if they loved his hands.

The sea, too, continued to fascinate him; often his canvases with the composition limited to depictions of sky and water express the feeling of being engulfed in surging waves, as in *The Sea III* (1913). Toward the end of his long life, gentler tones and mood characterized his seascapes (*Luminous Sea,* 1948). A similar softening of the often crude vitality of his oil paintings marks the last *Self-Portrait* (1947).

During the 1920 and '30s Nolde worked at refining his innovations rather than forging new styles. His work was widely exhibited and acquired by museums; in 1927, on the occasion of his 60th birthday, a major retrospective of his work opened in Dresden and toured throughout Germany. A Festschrift published for the occasion contained tributes by Paul Klee and other admiring artists. In 1931 he was named a member of the Berlin Academy. While his major work was done in the summers at Seebüll, his winters were still habitually spent in Berlin, a city which repelled him morally but attracted him pictorially (as had Hamburg) with its night life, music halls, and cafés where men and women confronted one another over their wineglasses. *A Glass of Wine* (1911), with its gaunt sophisticates, or *Slovenes* (1911), a study of a grimly depraved couple, are notable early examples of the Berlin scenes. Many years later, during World War II, these profoundly equivocal confrontations were recalled and became the subject of a number of watercolors.

Politically naive and proud of his Nordic peasant origins, Nolde was an early and ardent supporter of the Nazis with their ultra-nationalistic "blood and soil" ideology. In 1933 he became a member of the Nazi party. Despite his political affiliation and his nationalistic fervor the Nazis, who in art favored either a frigid, academic "100 percent Aryan" neoclassicism or a tired literalism, loathed Nolde's work for its distorted forms, its provocative subject matter, and the artist's obvious fascination with Slavic, Semitic, African, and other non-Nordic types. Nolde was de-

nounced by the authorities as a degenerate artist and subsequently forbidden to paint or purchase art materials. He never seemed to have understood the reasons for their condemnation. *Great Poppies—Red, Red, Red* (1942) is one of the very few paintings (all of flowers) which he succeeded in doing in those years. Twenty-seven of his paintings were included in the infamous exhibition labeled "Entartete Kunst" (Degenerate Art) assembled by the government in Munich in 1937. *The Mulatto* (1915) was singled out as an example of "decadence." All of Nolde's 1,052 works in German museums were confiscated, sold abroad, or burned. Despite his Danish citizenship he remained at Seebüll (his year-round home from 1941 on), and it was there that he painted, between 1938 and 1945, the remarkable series of about 1,300 small (generally five inches by ten inches) watercolors which he called his "ungemalte Bilder" (Unpainted Pictures). The term refers to the fact that Nolde intended them as substitutes for the proscribed oils; after the war, in a burst of creative activity, he painstakingly transcribed 105 of them onto canvas, preserving the same proportions and colors. Representative of these last great oils is, for example, *Girls from Far Away* (1947). One of his other plans for the series was to publish a selection of the sketches with appropriate written statements, culled from the notes which recorded his thoughts and feelings as he worked on the watercolors. Unlike the sketches, these notes are dated (1940 to 1944); one of them poignantly sums up the entire experience:

> Once I used to paint out of the fullness of a fierce, happy necessity. Nowadays driven by the urge to occupy myself. Yet I still hold my head high and only to you my little pictures, do I sometimes confide my grief, my torment, my contempt.

The "Unpainted Pictures" confirm Nolde's reputation as the greatest watercolorist among the Expressionists and one of the greatest artists of all time in this medium. Small enough so that they could be hidden easily and would not betray him by the smell of oil paint, these watercolors are not recordings of actual visual experience but evocations, by means of resonant color, of inner visions: memories of forms and figures seen years before, or pure inventions. Nolde had always found that watercolor enabled him to express "concepts that come wholly from within." The "Unpainted Pictures" are, in sum, a sort of painter's stream of consciousness, complemented by the written observations that accompanied their creation.

Most of the series is devoted to human relationships, confrontations of men and women (re-

calling the Berlin café vignettes) tinged with nostalgia and melancholy; many of the studies are of flowers, or of children. A few are landscapes or fantasy pictures—such as *Night Sparks,* a group of hobgoblins with wild hair and glowing eyes. Two of the "Unpainted Pictures," on exhibition at the 1980 Guggenheim Museum, New York City, showing of German expressionism, provide a key to Nolde's sense of the kinship of all nature. Despite their different subjects, *Sea with Mauve Clouds* and *Dahlias* are astonishingly similar constructs of billowing color shapes, verging on the abstract, in similar tones of mauve, blues, and yellow-orange.

Nolde's development as a watercolorist forms one of the most important chapters in his artistic career. He had begun working in the medium while he was at St. Gallen. *Before Sunrise* (1894), one of the sketches from this period, he himself considered a departure from the style of the others and a forerunner of his later, spontaneous style. In 1910–11, in Berlin, he first used absorbent Japanese paper and developed a way of moistening the paper and painting immediately on it, controlling the flow of color with a swab of cotton. No white areas are left. Most of Nolde's watercolors use this wet on wet technique. In contrast, a series of watercolor landscapes done at Utenwarf in 1918–19 was painted on nonabsorbent paper, with the white of the paper showing through and strong black outlines added to define the forms. After 1926 most of his watercolors lacked these pronounced contours. The "Unpainted Pictures," however—conceived in lieu of oils—were more deliberately painted, often in several layers of opaque colors, frequently altered, and employing contour lines.

"When the pure sensual force of seeing weakens, rational coldness can take over, leading to a slackening, and even destruction" and "the quicker a painting is done, the better it is": Such statements as these explain Nolde's virtuosity in a medium where change or repainting is difficult, where immediacy is the chief concern. In one of his earliest works, *Sunset,* done outdoors in the winter of 1908, there are traces of ice crystals; as the artist acknowledged, "I loved this collaboration with nature, yes, the whole natural alliance of painter, reality and picture."

Two years after Ada Nolde's death in 1946, the painter married Jolanthe Erdmann, the 26-year-old daughter of a friend. His last oils date from his 85th year, and he continued working in watercolors almost to the day of his death. Emil Nolde was buried with his first wife in a tomb in their beloved garden at Seebüll, West Germany. He was solitary by nature, with the stereotypical peasant's stubborness and taciturnity.

Always reluctant to part with his paintings and prints, Nolde left his large collection at Seebüll to be administered by the Stiftung Seebüll Ada und Emil Nolde (the Ada and Emil Nolde Foundation at Seebüll). In 1957 the studio-home was opened as the Nolde Museum, housing the works which bear out their creator's own definition of great art: the combination of "ability, fantasy and poetic power."

EXHIBITIONS INCLUDE: Gal. Ernst Arnold, Dresden 1905; Gal. Commeter, Hamburg, 1911; Neue Kunst Fides, Dresden, 1927; Kunsthalle, Basel 1928; Buchholz Gal., NYC 1939; Kunstsäle Bock, Hamburg, W. Ger. 1946; Kestner-Gesellschaft, Hanover, W. Ger. 1948; Kunstverein, Hamburg, W. Ger. 1957; Palaise des Beaux-Arts, Brussels 1961; Kunstverein, Hanover, W. Ger. 1961; Haus der Kunst, Munich 1962; MOMA, NYC 1963; Marlborough Fine Arts, London 1964, '67, '70; Kunsthalle, Cologne 1973. GROUP EXHIBITIONS INCLUDE: Secession, Berlin 1905; Die Brücke, Dresden, Flensburg, Magdeburg 1907; Neue Secession, Berlin 1910; Blaue Reiter, Gal. Hans Goltz, Munich 1912; Sonderbund Ausstellung, Cologne 1912; "German Painting and Sculpture," MOMA, NYC 1931; "Entartete Kunst," Haus der Kunst, Munich 1937; Die Brücke, Kunsthalle, Bern 1938; Venice Biennale 1952; "German Art of the Twentieth Century," MOMA, NYC 1957; "Art in Revolt: Germany 1905–1925," Marlborough Fine Arts, London 1959; "Nolde and Munch," Marlborough Fine Arts, London 1968; "Expressionism, a German Intuition 1905–1920," Solomon R. Guggenheim Mus., NYC 1980; "Expressionism—A German Intuition, 1905–1920," San Francisco Mus. of Modern Art 1981.

COLLECTIONS INCLUDE: Nolde Mus., Seebüll, W. Ger.; Kunsthalle, Hamburg, W. Ger.; Städtische Gal. im Landesmus., Hanover, W. Ger.; Wallraf-Richartz Mus., Cologne; Folkwang-Mus., Essen, W. Ger.; Kunsthaus, Zürich; MOMA, NYC; Busch-Reisinger Mus., Cambridge, Mass.

ABOUT: Fehr, H. Emil Nolde; ein Buch der Freundschaft, 1957; Gosebruch, M. Nolde: Watercolors and Drawings, 1973; Haftmann, W. and others, German Art of the Twentieth Century, 1957, Emil Nolde, 1959, Emil Nolde: The Unpainted Pictures, 1965; Hirschfeld, S.B. Expressionism: A German Intuition, 1905–1920, 1981; Sauerlandt, M. Emil Nolde, 1921, (ed.) Briefe aus den Jahren 1894–1926, 2d ed. 1967; Schiefler, G. (ed.), Emil Nolde—Das graphische Werk, vol. 1: Die Radierungen, 2d ed. 1966, vol. 2: Holzschnitte und Lithographien, 2d ed. 1967; Selz, P. Emil Nolde, 1963; Urban, M. Emile Nolde: Flowers and Animals; Watercolors and Drawings, 1966, Emile Nolde: Landscapes; Watercolors and Drawings, 1970.

***OKADA, KENZO** (September 28, 1902–July 25, 1982), Japanese-American painter, writes: "I was born in Yokohama, Japan, in 1902. My fa-

°ō kä dä, ken zō

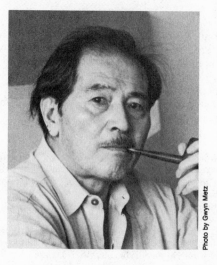

Photo by Gwyn Metz

KENZO OKADA

ther was a successful industrialist and I was brought up in the midst of the traditional culture of Japan. At the age of 12 I entered the Mejii Gakuin Middle School in Tokyo and two years after graduation enrolled at the Tokyo Fine Arts University, where I studied for a year and a half.

"In 1924, at the age of 22, I went to Paris to further my knowledge of European art and remained there for three years. During this period I studied for a while with Tsuguji Fujita, exhibited at the Salon d'Automne and was much influenced by the French Impressionists. It was a time of hardship, experiencing the poverty of a struggling young artist, and yet invaluable in the sense that the 'cornerstone' of my life as an artist took form.

"Two years after my return to Japan I had my first solo show in Tokyo. In 1936 I was awarded the important prize given by the Nikakai Group, the largest association of contemporary Japanese artists, and thereafter until 1950 exhibited annually with that group. Nineteen-thirty-six was also the year I first met Kimi, my wife, and we were married three years later. From 1940 to 1950 I taught at art institutes.

"In spite of the fact that my work had gained nationwide recognition, I became more and more dissatisfied with the limited aspects of the Japanese art circles and wanted to break away from not only these ties, but also from those of the rigid forms of tradition. This resulted in my determination to go abroad, but not to Paris, since France too was deeply rooted in tradition and would not be able to give me the freedom I was in search of—a freedom in which I could freely express myself. The only place that such

a liberty could be found, I felt, would be in the United States, a country that was still very young, and in 1950 my wife and I came to settle in New York City.

"In an environment where the customs and mode of living were so different from what I was accustomed to, it seemed at first impossible to paint. Despite the endless effort, no satisfaction could be derived from the results. It took some time to overcome this difficulty, but gradually and in a natural way I found myself creating what my innermost self was attempting to express. The creative evolution that had taken place within me opened the way to express my inborn cultural heritage through non-objective means, and this I believe was possible only in America where one encounters the freedom that constantly seems to expand.

"My first solo show in this country was in New York City at the Betty Parsons Gallery in 1953, and ever since that time my shows have been held there regularly. In 1960 I became a citizen of the United States.

"In recent years I have been spending one half of each year in New York and the other half in Tokyo. But wherever I am, the important thing for me is to be receptive to what nature has to offer, to see things as naturally as possible and to find the splendor of beauty in the simplest of forms. For nature with her unending evolution is always fresh, pure, and unpretentious and has been my greatest source of inspiration."

Reviewing an exhibition of Okada paintings at the Betty Parsons Gallery, Charlotte Willard wrote in the New York Post, that Okada "is the 'new' man of the 20th century—an artist who in his person and talents unites Eastern and Western cultures."

Only two years after his arrival in New York City from Japan in 1950, Okada became an abstract painter, and in 1953 his American work was shown at Betty Parsons, his first solo exhibition in the United States. A New York Times critic observed, "Nothing is patently connected with natural forms, and yet, with their feeling for light and luxuriant color, these insinuating canvases might be the abstracts of an orthodox Impressionist." Okada's second show at Betty Parsons, in 1955, was equally well received. The Herald Tribune (March 20, 1955) critic wrote, "The color of romantics such as Odilon Redon and Oriental mood give his work feeling. . . . " Okada represented the United States at the São Paulo Bienal of 1955, and two years later the artist declared that his painting style had been liberated in the US.

Leslie Judd Ahlander, reviewing an exhibition of new Okada paintings at the Gres Gallery, Washington, D.C., in the *Washington Post and Times Herald* wrote, "While keeping the same gentle, lyrical colors, he has strengthened his shapes, using squares and angles where formerly amorphous shapes prevailed." By 1964 his canvases, shown that year at Betty Parsons, had, according to the *Herald Tribune* "become more rigid, more resolute, somewhat less instinctive." But the critic added that Okada "had not lost his touch," and "continues to work the sort of magic that transforms a series of related abstract shapes into shimmering Oriental landscapes. . . . "

John Canaday pointed out in *The New York Times* (March 15, 1969) that, although Okada in the 1950s had been "one of the most sought after painters of the New York School," he "was never more than a fringe member," and had been "at once more subtle and more various than other abstract painters . . . who established a limited formula and stuck to it." Canaday called Okada's new works, shown in 1969 at Betty Parsons, "semi-abstract." His abstractions were "now combined with such familiar motifs as plum branches, moons, islands and clouds, and even the full standing figure of a Noh player." Reviewing a 1973 Okada exhibition at the Parsons Gallery Canaday noted that in the previous three or four years Okada had been "feeling his way out of abstraction." The Japanese sources of the figurative components—rocks, plants, flowers, waves, bamboo—were "easily identifiable." But Canaday pointed out that their "Japaneseness" lay "in an acutely refined estheticism rather than in these surface clues."

In addition to their Greenwich Village apartment, Kenzo Okada and his wife Kimiko, a dress designer, acquired in the 1960s a house in rural Rensselaerville, about 25 miles from Albany, New York. In Okada's words, "It is just like Japan—the moors, the quiet, unhurried countryside. . . . " He divided his time between New York and Tokyo, and, to quote Canaday, "harmonizes the spirit of his painting in the same way." Okada said that, whether he was in America or Japan, "I find myself in nature and nature in myself."

Kenzo Okada died in Tokyo, shortly after his retrospective exhibition there at the Seibu Museum of Art.

EXHIBITIONS INCLUDE: Hokuso Gal., Tokyo 1948, '50; Betty Parsons Gal., NYC from 1953; Corcoran Gal., Washington, D.C. 1955; São Paulo Bienal, 1955; Venice Biennale 1958; Ferus Gal., Los Angeles 1959; Massachusetts Inst. of Technology 1963; Albright-Knox Art Gal., Buffalo, N.Y. 1965; Retrospective traveling exhibition 1966–67: Asaki-Shimban Press Tokyo, Nat. Mus. of Modern Art, Kyoto, Japan, Honolulu Academy of Arts, M.H.Y. de Young Memorial Mus., San Francisco, Univ. Art Mus., Univ. of Texas, Austin; Seibu Mus. of Art, Tokyo 1982. GROUP EXHIBITIONS INCLUDE: Carnegie International, Pittsburgh 1955, '58; Columbia, (S.C.) Biennial 1957; "Japanese Reflections," Graham Gal., NYC 1958; Group show of Japanese painters, Gres Gal., Washington, D.C. 1960; Whitney Mus. of Am. Art, NYC 1965.

COLLECTIONS INCLUDE: Metropolitan Mus. of Art, MOMA, Whitney Mus. of Am. Art, Solomon R. Guggenheim Mus., and N.Y. Univ., NYC; Albright-Knox Art Gal., Buffalo, N.Y.; Brooklyn Mus. of Art, N.Y.; Wadsworth Atheneum, Hartford, Conn.; Yale Art Gal., New Haven, Conn.; Phillips Collection, Washington, D.C.; Boston Mus. of Fine Arts; Carnegie Inst., Pittsburgh; Baltimore Mus.; Art Inst. of Chicago; St. Louis City Art Mus.; San Francisco Mus.; Santa Barbara Mus.; Portland Art Mus.

ABOUT: *Periodicals*—Art News March 1955; Arts Magazine November 1959; New York Herald Tribune March 20, 1955, January 19, 1964; New York Post March 18, 1967; New York Times October 11, 1953, November 15, 1959, December 8, 1965, March 15, 1969, March 24, 1973, July 28, 1982; Time November 25, 1957; Washington Post and Times Herald November 27, 1960.

O'KEEFFE, GEORGIA (November 15, 1887–) American painter, though little known in Europe, enjoys great prestige in the United States, where her paintings of magnified flowers and monumental forms established her as one of the pioneers of American modernism. She was born near Sun Prairie, a small farming community in Wisconsin, the second of seven children. Her father was of Irish descent, her mother of Dutch and Hungarian origin. When she was about 15 the family moved to Williamsburg, Virginia, where they lived in an old-fashioned house surrounded by horses and trees. Early in her life, wrote Joan Didion in *The White Album*, "O'Keeffe seems to have been equipped with an immutable sense of who she was and a fairly clear understanding that she would be required to prove it."

She showed an early talent for drawing, and at ten had already resolved to be an artist. In 1905 she entered the Art Institute of Chicago, where her chief teacher was the draftsman and anatomist John Vanderpoel. She returned home the following year, but in the fall of 1907, shortly before her 20th birthday, she enrolled in the Art Students League, New York City.

At the League she studied with William Merritt Chase, whose bravura painting technique has been described as "Americanized Frans

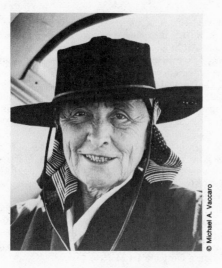

© Michael A. Vaccaro

GEORGIA O'KEEFFE

Hals." O'Keeffe, an able pupil, won a prize for a still life of a rabbit with a copper pot. But as she told Katherine Kuh, "I began to realize that a lot of people had done this same kind of thing before I came along. . . . I didn't think I could do it any better . . . so I stopped painting for quite a while." In 1908 she returned to Virginia and destroyed her student work. The thoroughly conservative American art world in the early years of this century seemed to offer her no alternative to a slick academicism.

From 1908 to 1912 she supported herself as a freelance commercial artist in Chicago, turning out detailed illustrations of lace and embroidery for an industrial company. Measles and resulting eye trouble made this intricate work impossible, and she returned once more to Virginia and her family.

O'Keeffe's interest in painting was revived by her visit in the summer of 1912 to an art class at the University of Virginia, Charlottesville, taught by a young instructor, Alon Bement. She decided to become a teacher. From 1912 to '16 she was supervisor of art in the public schools in Amarillo, Texas, and taught in summer school at the University of Virginia. Through Bement she was introduced to the ideas of Arthur Wesley Dow, who had studied with Gauguin and who rejected realism in favor of the simplified forms, flat patterning, and subtle color harmonies of Oriental art. Dow, an influential art educator, headed the department of fine arts at Columbia University, New York City, where O'Keeffe studied with him in the academic year of 1914–15. "It was Arthur Dow," she remarked later, "who affected my start, who helped me to find

something of my own." Dow stressed the importance of design, and of filling space "in a beautiful way."

She returned to Texas in the fall of 1915 to head the art department of West Texas State Normal College, Canyon. She began to draw and paint again, this time in a highly personal way. She found that she could "say things that I couldn't say in any other way—things I had no words for." She mailed a roll of her large charcoal drawings to a friend and former roommate in New York, Anita Pollitzer, to take the place of a letter, but warned her not to show them to anyone. Almost all of the drawings were abstract, suggesting the forms of nature but without specific imagery. Disregarding her friend's admonition, Miss Pollitzer took the drawings to show the pioneer artist-photographer and collector Alfred Stieglitz, who exclaimed with delight: "Finally, a woman on paper!" Stieglitz decided to exhibit the drawings in May 1916 at his famous avant-garde gallery "291," so named for its location at 291 Fifth Avenue.

She had returned meanwhile to Columbia to study with Dow. On hearing that her works were being exhibited without her authorization, the usually reticent O'Keeffe descended on "291" and demanded that they be withdrawn. Stieglitz, a persuasive talker, succeeded in pacifying her, and thus began an association that was to last the rest of Stieglitz's life. He encouraged the 29-year-old O'Keeffe to go on painting exactly as she pleased.

Having gone back to Texas she concentrated for a while on watercolors, and these, along with some drawings, were shown by Stieglitz at O'Keeffe's first solo exhibition in April 1917. This was the last show held at "291," for the building was about to be torn down. This time O'Keeffe came East to see the show and it was then that Stieglitz took the first of his many photographs of her.

One of O'Keeffe's watercolors, *Blue Lines Number 10* (1916), of the utmost simplicity and elegance, preceded Malevich's *White on White* (ca. 1918), an early abstract work, and is regarded as prophetic of the minimal art of the 1960s. In her autobiography O'Keeffe wrote: "*Blue Lines* was first done with charcoal. Then there were probably five or six paintings of it with black watercolor before I got to this painting with blue watercolor that seemed right."

In 1918 O'Keeffe quit her teaching job in Texas and moved to New York City with the intention of painting full-time. She became part of the Stieglitz circle, and although some critics saw in her work the influence of Stieglitz's photography, her style of abstraction was very much her

own. She sometimes used a grayed palette with dark greens and muted violets, as in the watercolor *Portrait W, No. II* (1917), in which the simplified image, removed from any recognizable context, creates a dreamlike effect. She had also been working for some years in oils. Her "Black Spot" series of 1919 in oil, more hard-edge in treatment, evoked landscapes without seeming to refer to one—an attempt to find in nature a corresponding image for inner emotional states. These and her other abstractions were close to the methods of the Symbolists, especially their attempts to reproduce musical or rhythmic movement in language. Indeed, several of her titles refer to music, including her "Music—Pink and Blue" series in 1919. She was intrigued by "the idea that music could be translated into something for the eye," a concept that Kandinsky had explored in Europe.

On January 29, 1923 the first major exhibition of O'Keeffe's work opened at the Anderson Galleries, New York City. The show was called "One Hundred Pictures"; there was no catalog and the paintings were unsigned and without titles. She believed that any personal quality in a picture should be signature enough. There was certainly no mistaking the austere but poetic style of her paintings, forthright like herself, yet described by the painter Marsden Hartley as full of "utterly embedded femininity." Stieglitz, whom she married in December 1924, showed her work in solo exhibitions annually until 1946. After attending a group show in 1925, Edmund Wilson wrote, "Georgia O'Keeffe outblazes the other painters in the exhibition: Marin, Hartley, Dove, and Demuth."

Representational forms, although highly stylized, appeared increasingly in O'Keeffe's work after her marriage, when she and Stieglitz moved into an apartment high up in Manhattan's Shelton Hotel. Her first painting inspired by the city was her oil *New York with Moon* (1925), and in 1926 she painted *The Shelton with Sunspots*. At their summer home in Lake George, in the foothills of the Adirondacks, O'Keeffe painted *Lake George Window* (1929; Museum of Modern Art, New York City). It was included in MOMA's exhibition of 1968, "The Art of the Real," as a distant forerunner of minimalism, and was reproduced in the catalog opposite Ellsworth Kelly's severely abstracted *Window* (1949). One critic wrote in the catalog that "in its uncompromising objectivity, O'Keeffe's vision seems more coordinate with the art of the last decade than with that of her own generation."

O'Keeffe has always painted works in series. Her first paintings of single flowers, magnified

tremendously and presented frontally, date from 1924. Although not universally admired, they are among her most popular works. There is a strange combination of smooth, nonexpressive brushwork with voluptuous organic formations, and it is not surprising that sexual symbolism has been read into such paintings as *Black Iris* (1926), *Two Calla Lilies on Pink* (1928), and the "Jack-in-the-Pulpit" series of 1930. O'Keeffe vigorously rejects all Freudian sexual interpretations of her flower-paintings. As she wrote in 1939, addressing her critics in general, " . . . You hung all your own associations with flowers on my flower and you write about my flower as if I think and see what you think and see of the flower—and I don't."

From 1929 on, O'Keeffe spent much of her life in New Mexico, although she did not settle there permanently until 1949, four years after Stieglitz's death. Her first summer in New Mexico, in 1929, was spent in Taos at the house of Mabel Dodge Luhan, where D. H. Lawrence had stayed before he went to Italy. O'Keeffe was thrilled by the hard blue sky and the bare ocher-colored landscape around Taos. *Black Cross, New Mexico* (1929) was one of several paintings inspired by traditional symbols of the Mexican-American population. Returning to Taos in the summer of 1930, she painted one of her finest canvases, *Ranchos Church,* now owned by the Metropolitan Museum of Art, New York City. The region's scarcity of flowers led her to discover new subject matter: "There was no rain, so the flowers didn't come. Bones were easy to find, so I began collecting bones." One of the bleached bones she brought back to New York was the subject of her well-known painting *Cow's Skull—Red, White, and Blue* (1931). She also painted the skulls of horses and rams, sometimes decked with a single, bright-colored flower. Her treatment of these motifs, which for her had infinite meanings, gave the New Mexico bone pictures a surrealistic quality, more instinctive than deliberate.

At times O'Keeffe's style had affinities with the precisionism of Demuth and Sheeler. This was evident in a series of Canadian barns, among them *Stables,* that she painted in 1932 on a visit to the Gaspé, where she was moved by the simple, low barns painted white with dark red or tar-paper roofs "that reflected the blue of the sky." Two years later she painted *Barn with Snow* at her Lake George farmhouse. Unlike Demuth and Sheeler, O'Keeffe had no interest in the machine and its products. Apart from a few city scenes, urban and industrial America is absent from her work. She has resisted all attempts to link her with a particular school. "I was in the Surrealist show when I'd never heard of Surreal-

ism. I'm not a joiner, and I'm not a precisionist or anything else."

In 1934 a young man who was teaching O'Keeffe to drive took her to the Ghost Ranch area near Abiquiu, New Mexico, "I knew the minute I got up here that this is where I would live," she said later. Stieglitz loved Lake George and New York City, but hated Taos, which he sometimes referred to as "chaos." While he was alive O'Keeffe most often spent her summers in New Mexico and her winters in New York. In 1940 she bought the small, remote Ghost Ranch home which she still owns. Stieglitz died in 1946, the year of O'Keeffe's retrospective at MOMA. After his death she move to a more amply appointed house in Abiquiu, which she still maintains. However, she prefers the solitude and simplicity of her small ranch house amid the "living deadness" of the desert, where she lives and works most of the year.

In 1953, when she was in her middle 60s, O'Keeffe traveled to France, Germany, and Spain. Five years later she took a three-and-a-half-month trip around the world by air, with stopovers that included seven weeks in India. Preferring the Orient to Europe, in 1960 she visited the Far East again. The experience of air travel opened up an entirely new field of subject matter. From the air she "noticed a surprising number of deserts and wonderful rivers. . . . You see such marvelous things, such incredible colors." A series of paintings of 1958–60 were inspired by the twisting, ribbonlike lines of rivers and recalled her early abstractions, but she claimed that "there's nothing abstract about these pictures; they are what I saw—and very realistic to me. I must say I changed the color to suit myself. . . . " O'Keeffe gave these pictures such titles as *It Was Yellow and Pink*.

A later group of paintings was based on the theme of sky and clouds as seen from the air. Three pictures from the "Sky above Clouds" series were painted in 1963. The fourth, *Sky above Clouds, IV*, by far her largest canvas—24 feet wide—was done in 1965. She relates that "when the show arrived at the Whitney [for her 1970 retrospective] we couldn't get the *Clouds* upstairs. It had to be on the ground floor and the rest of the show was on the floor above."

Beginning in 1970, O'Keeffe painted a series using as a motif a black rock in her collection. *Black Rock with Blue, III* (1970), a simplified dark form resting on a white surface and silhouetted against her favorite hard blue sky, was described by one critic as being "as absolutely of the earth as the cloud pictures are of the sky." She developed this theme in *Black Rock with Blue Sky and White Clouds* (1972).

Although O'Keeffe has always preferred visual imagery to the spoken or written word, she published a lavishly illustrated autobiography, *Georgia O'Keeffe*, in 1976. She did the writing herself, citing her weariness "of all the sexy things they were writing about my paintings. I complained about those Freudian interpretations of my flowers." Small and slender, but possessed of immense willpower, O'Keeffe in her 97th year still has the high cheekbones, luminous green eyes, and firm "pioneer woman" facial structure that had so fascinated Stieglitz. Her white hair is drawn back severely in the way she has worn it for nearly half a century. Recently she has taken up pottery, saying, "I must learn to make the clay speak." Douglas Davis, visiting the artist in her New Mexico home in 1976, wrote in *Newsweek* that she looks and lives "the life of a serene mistress of the desert." He remarked that "coming upon Georgia O'Keeffe sitting in the desert in front of her low adobe house is like coming upon an image in one of her paintings. . . . Against the blue sky and the flat horizon, she forms a precise outline. There is no mistaking who this is. . . . "

Georgia O'Keeffe was present at a celebration give in her honor on her 90th birthday at the National Gallery, Washington, D.C., on November 15, 1977. A film on her work was shown, sponsored by the National Foundation for the Arts and the Xerox Corporation.

In social issues as in artistic movements Georgia O'Keeffe, who dislikes crowds of any sort, is definitely "not a joiner." Despite her early struggles in a male-dominated art world, she has resisted all efforts to enlist her in the feminist movement, nor will she participate in exhibitions featuring only women artists.

In her personality and in her art she has been remarkably consistent over the years. Underlying the relentlessly sharp, smooth handling and the abstract tendencies of her work is a kind of nature-romanticism that is peculiarly American in its sense of unbounded space. Amid the wide vistas, stark earth colors, bleached bones, and vast sky of the Southwest, she has staked out her territory: "I have used these things to say what is to me the wideness and wonder of the world as I live in it."

EXHIBITIONS INCLUDE: Alfred Stieglitz's Photo-Secession Gal. "291," NYC 1917; Anderson Gal., NYC 1923–24; Stieglitz's Intimate Gal., NYC 1926–29; Brooklyn Mus., 1927; An American Place, NYC 1930–46; Art Inst. of Chicago 1943; MOMA, NYC 1946; Downtown Gal., NYC 1952–61; Worcester Art Mus., Mass. 1960; Amon Carter Mus. of Western Art, Fort Worth, Tex. 1966; Whitney Mus. of Am. Art, NYC 1970. GROUP EXHIBITIONS INCLUDE: Photo-Secession

Gal. "291," NYC 1916; Society of Independent Artists Annual, NYC 1917; "Seven Americans," Anderson Gal., NYC 1925; "Abstract Painting and Sculpture in America," MOMA, NYC 1951; "The Art of the Real," MOMA, NYC 1968.

COLLECTIONS INCLUDE: Metropolitan Mus. of Art, Whitney Mus. of Am. Art, and MOMA, NYC; Brooklyn Mus., N.Y.; Albright-Knox Art Gal., Buffalo, N.Y.; Phillips Memorial Gal., and Hirshhorn Mus. of Sculpture Garden, Washington, D.C.; Cleveland Mus.: Art Inst. of Chicago; St. Louis Art Mus., Mo.; Indianapolis Mus. of Art; Walker Art Center, Minneapolis; Amon Carter Mus., Fort Worth, Tex.; Philadelphia Mus. of Art; Detroit Inst. of Arts; Phillips Academy, Andover, Mass.; Tate Gal., London; H.H. Thyssen-Bornemisza Collection, Lugano.

ABOUT: Current Biography, 1941; Didion, J. The White Album, 1979; Goodrich, L. and others Georgia O'Keeffe, 1970; Goossen, E. C. "The Art of the Real" (cat.), MOMA, NYC, 1968; Kootz, S. M. Modern American Painters, 1930; Kuh, K. The Artist's Voice, 1962; Nordness, L. (ed.) Art USA Now, 1963; O'Keeffe, G. Georgia O'Keeffe, 1976; Ritchie, A.C. "Abstract Painting and Sculpture in America" (cat.), MOMA, NYC, 1951; Rose, B. Readings in American Art Since 1900, 1968, American Art Since 1900, 2d ed. 1975. Periodicals—American Artist January 1976; Art Digest May 1, 1938; Art in America October 1963; Artforum May 1966; New York Times Book Review December 12, 1976; Newsweek November 22, 1976; Time October 24, 1960.

Photo by Hannah Wilke

CLAES OLDENBURG

***OLDENBURG, CLAES (THURE)** (January 28, 1929–), American sculptor and painter, has been called the "pope" of pop art. He is known for his outsized soft sculptures which parody consumer goods and for his "happenings" and environments.

He was born in Stockholm, Sweden, the son of Gösta and Sigrid Elisabeth (Lindforss) Oldenburg. His father was a Swedish consular official and his mother had been a concert singer. The Oldenburgs lived in Oslo, Norway, from 1933 to 1937, when they moved to Chicago, where the father was Swedish consul-general. Knowing no English Claes coped with being an outsider in the strange new environment by creating Neubern, an imaginary island society in the South Atlantic. His imagination was further stimulated by an aunt in Sweden who compiled scrapbooks for him filled with collages of advertisements and other pictures she had clipped from magazines. "Everything I do is completely original—I made it up when I was a little kid," Oldenburg claimed, as quoted in Makers of Modern Culture.

At the Latin School, a private institution in Chicago, Claes played football, took part in plays, and edited school publications. Writing was his main interest when he entered Yale University in 1946. He obtained the BA degree in 1950, having attended art classes only in his final year.

Returning to Chicago, Oldenburg worked at a variety of odd jobs, including that of apprentice newspaper reporter for City News Bureau. He was detailed to the police beat, and he later told Grace Glueck of The New York Times Magazine "I got a lot of my Happening ideas from this beat." Within two years, however, journalism had palled, and from 1952 to 1954 he took night classes at the Chicago Art Institute under Paul Weighardt. Oldenburg became a naturalized American in 1953.

After leaving the Institute and spending about six months in California, Oldenburg returned to Chicago, and in 1955–56 worked as an art editor and illustrator for Chicago magazine. (He is possibly the only Pop artist to have actually drawn comic strips professionally before assimilating that idiom to an artistic style.) By 1956 he felt it was time to move on to a new city, and he moved to New York, which seemed to him less "rigid and conservative" than Chicago.

Oldenburg rented an apartment on Manhattan's Lower East Side and earned a meager living by part-time work, shelving books in the library of Cooper Union. Walking to work he became fascinated by the New York City street scene—store window displays, "bag" ladies and Bowery derelicts, and the piles of garbage and bundled debris which he considered a kind of sculpture. Even street refuse, Oldenburg told Glueck, assured "accidental esthetic values."

°kläs

Oldenburg had intended to become a traditional figurative painter, but, as John Rublowsky observed in *Pop Art*, "his concern gradually shifted from composition and paint to volume and form, from the purely visual to the tactile, from painting to sculpture." From the late 1950s, Oldenburg was associated with a group of New York City artists which included Allan Kaprow, an American inventor and theorist of "happenings," Jim Dine, Red Grooms, Lucas Samaras, the sculptor George Segal, Robert Whitman, and George Brecht. Attempting to generate something new in art beyond abstract expressionism, these artists were experimenting with avant-garde, nonlinear theater performances, or happenings, and environmental art works. Oldenburg was also influenced by the Céline novel *Death on the Installment Plan*, with its grim depiction of city life, Dubuffet's *l'art brut*, Duchamp's readymades, the impulsive randomness in abstract-expressionist painting, and Jim Dine's unorthodox use of materials.

In 1958–59 Oldenburg produced a number of "drawing-objects" by using the technique of assemblage in a manner recalling the Dadaist Kurt Schwitters. His first solo show, held at the Judson Gallery in Greenwich Village, in May 1959, consisted largely of abstract sculptures made of paper, wood, string, and bundles. Also displayed in the show were Oldenburg poems in large type, which had been inspired by his ramblings through the city streets.

Early in 1960 Oldenburg joined Jim Dine in a Judson Gallery show that explored street themes through a series of environments. One of Oldenburg and Dine's environments, entitled *The Street,* was primarily made of paint, cardboard, burlap, and street detritus. After 1960, Oldenburg's materials changed from cardboard to muslin or burlap dipped in plaster, stretched on chicken-wire or screen, and covered with bright paint straight from the can.

In December 1961, Oldenburg opened *The Store*. This popular environment evolved from a 1960–61 series of watercolors into three-dimensional replicas of pastries, vegetables, meats, clothing, and other goods. These items were displayed on the counters and shelves of the "store" he had rented on lower Manhatten's East 2nd Street. *The Store,* Calvin Tomkins reported, was "stocked with . . . replicas of . . . the sort of cheap household goods available in cut-rate shops on Fourteenth Street," and "neighborhood kids wandered in and out on opening day pocketing items that the uptown culturati were purchasing for fifty dollars and up. . . . " Oldenburg served as proprietor and kept *The Store* open for two months.

Oldenburg had been toying for some time with his so-called ray gun concept, which he adapted from comic-strip science fiction, and called his store the Ray Gun Manufacturing Company. After the *Store* exhibition closed, the "store" was converted into Oldenburg's new studio. There he sponsored a series of ten happenings, and in February 1962 its name was changed to the Ray Gun Theater. Oldenburg's happenings were visual compositions of sound, music, and "actors" that incorporated the unrehearsed behavior of the audience into performances. These happenings, the first of which was called *Store Days I,* were, to quote Adrian Henri's *Total Art*, "personal, physical, concerned with objects and basic human and domestic predicaments"—and they were sometimes quite comical. Oldenburg's other happening's include *Injun* (1962), performed for the Dallas Museum of Art, *Washes* (1965), which took place in a New York swimming pool, and *Autobody* (1963), which "happened" in a Los Angeles car lot. That phase of Oldenburg's career is recorded in three books: *Store Days: Documents from the Store* (1967), *Injun and Other Histories* (1966), and *Ray Gun Theater* (1967).

In 1962 Oldenburg created his first soft sculpture. He used cloth, plastic, foam rubber, and, later, vinyl or canvas stuffed with kapok to make giant models of hamburgers, a slice of chocolate layer cake, an ice-cream cone, a wash basin, an egg beater, and shoestring potatoes spilling out of an overturned bag. These objects were taken directly from everyday reality and given an element of parody by their colossal dimensions; the distortion of scale recalled the surrealistic effect of René Magritte paintings in which an apple or rose ominously fills an entire room. The soft sculptures were exhibited, along with samples from *The Store*, at a sell-out show at Manhattan's Green Gallery in September 1962.

After the Green Gallery show closed, Oldenburg lived for a time in California, seeking an environment congenial to the development of his new thematic environment, "The Home." An early product of this series was *Bedroom Ensemble* (1963), whose exaggerated modern décor was inspired by a Malibu motel with rooms decorated in the skins of tigers and leopards. Oldenburg wanted "The Home" to be a metaphor for volume, and in *Bedroom Ensemble* the bed, table, and other furnishings, all rhomboidal, were treated as abstractions, notwithstanding their recognizability. The fake zebra coach had an imitation leopard-skin coat draped over it. The sheets were made of shiny white vinyl and the bedspread was quilted black plastic; the bureau had a huge metal "mirror," and the "paintings" on the walls were ordinary

textiles—but with a black pattern that suggested an imitation Jackson Pollock. The dimensions of this nightmarish environment were based on a room at the Sidney Janis Gallery, New York City, where it was exhibited in a group show, "Four Environments by New Realists," in the winter of 1963–64. With his *Bedroom Ensemble* and his *Ping-Pong Table* (1964), the latter in plywood, plaster, and metal, rhomboidal in shape and suggesting motion, Oldenburg extended the range of "cool" pop imagery. Like his soft objects, these creations were conceived as "new ways of pushing space around," to quote Oldenburg.

For his 1966 show at the Janis Gallery, Oldenburg created a soft bathroom with fixtures as limp as a Dali watch. In 1964 he had contrasted "soft" and "hard" versions of an everyday object by juxtaposing *Switches Sketch* in vinyl, cloth, and kapok and measuring 42 by 42 inches, and the 48-by-48-inch *Switches,* two electric switches magnified and precisely rendered in wood.

The 1966 Janis Gallery show also included "movement drawings," in crayon and watercolors, sketching Oldenburg's ideas for a series of "Colossal Monuments." Few of these fantastic projects have been executed, but his plans for monumental landscape objects have included a vacuum cleaner for New York City's Battery Park; an ironing-board above Manhattan to serve as weather dome and airport; a giant banana for Times Square; a ski jump for Oslo, Norway which he called *Frozen Ejaculation; Thames Ball,* two enormous lavatory balls that were to float in the Thames near Westminster; a lipstick tube that was to replace the Fountain of Eros in London's Piccadilly Circus; a *Teddy Bear,* for New York City's Central Park, whose scale was to match the high rises bordering the park; a pair of miniskirt-high knees for London's Chelsea Embankment; and a giant windshield wiper for a Chicago park that was to dip into Lake Michigan. Oldenburg's drawings of his monumental proposals displayed, Adrian Henri said, "a graphic style that can range from a Watteau-like delicacy to the toughness and accuracy of a blueprint." These drawings were shown at the Museum of Contemporary Art, Chicago, in 1967.

The first Oldenburg monument to be realized was his movable *Lipstick (Ascending) on Caterpillar Track.* The gigantic piece was erected in May 1969 on Yale University's Beinecke Plaza and was donated by the artist to his alma mater in the name of his newly formed Colossal Keepsake Company. Although Yale students appreciated it as a "statement" affirming love and protesting war, or as a symbol of the coeduca-tional environment then being planned for the school, *Lipstick* met considerable opposition from faculty and staff. The university administration, while declaring itself "grateful for the thought," did not commit itself to keeping *Lipstick* as a permanent campus monument. Since its installation, the lipstick tube has spent much time on loan to other universities.

In 1969 the Museum of Modern Art, New York City, held a major Oldenburg retrospective which included more than 100 works in three dimensions and approximately 300 drawings. The exhibit toured Europe and was shown at the Tate Gallery, London, in 1970.

Oldenburg does not want his giant-scale objects to be collected; in a collection, he believes, a work is drained of its vitality and loses touch with the surrounding environment from which its visual power derives. Nevertheless, his objects have been purchased by art collectors and shown to effect in galleries.

Not surprisingly, so provocative an artist has aroused mixed critical reaction. In her catalog introduction to the 1969 Oldenburg retrospective at the Museum of Modern Art, Barbara Rose maintained that "an un-derstanding of Oldenburg's art . . . is absolutely essential for an understanding of what is at stake in the art of the sixties." However, other critics have regarded the artist's neodadaist creations as glorified trivia, expensive jokes whose humor quickly wears thin. The English critic G. S. Whittet acknowledged Oldenburg's debt to Marcel Duchamp and observed, "He [Oldenburg] engages outrage to outwit the apathetic."

Reviewing Oldenburg's show at the Leo Castelli Gallery, New York City, in *The New York Times* (November 12, 1976), Hilton Kramer remarked that such objects as the 8-foot typewriter eraser (in both "hard" and "soft" versions), the cigarette butts and giant ashtray, all of which had once been the occasion for "shock and dismay," now looked gentler and more graceful. "Has he softened his jokes," Kramer asked, "or have we just gotten used to them?" The critic suggested that Oldenburg's fame and prosperity had enabled him to use expensive technology in the realization of his projects and this had resulted in "an expensive, glossy, even glamorous look," reminiscent, Kramer thought, of "the elegant perfection of [Jean] Arp's later works."

Since 1976 Oldenburg has realized a few of his monumental projects with the help of Lippincott, Inc., a sculpture factory in Connecticut run by Don Lippincott and Roxanne Everett. Oldenburg's *Inverted Q* has been executed by Lippincott, and a drawing of a proposed colossal monument adorns the company's factory wall.

On April 13, 1960, Oldenburg married Patricia Joan Muschinski, who assists in the execution of his large-scale projects and sews his soft sculptures. In 1969 he moved to New Haven, Connecticut, where he converted a former garment factory into a studio. However, he also maintains a studio in Manhattan.

Although Oldenburg does not mind when his objects elicit laughter from viewers, he insists that his work is not intended to be humorous and is not meant to be "art" but that it *is* intended to be important. Oldenburg declared: "I'm not terribly interested in whether a thing is an ice-cream cone or a pie. . . . The fact that I wanted to see something flying in the wind made me make a piece of cloth, the fact that I wanted to see something flow made me make an ice-cream cone. [I made these things in order to] give a concrete statement to my fantasy, instead of painting it, to make it touchable. . . . If I didn't think what I was doing had something to do with enlarging the boundaries of art, I wouldn't go on doing it."

EXHIBITIONS INCLUDE: Judson Gal., NYC 1959; Reuben Gal., NYC 1960; Green Gal., NYC 1962; Dwan Gal., Los Angeles, 1963; Sidney Janis Gal., NYC 1964–67, '69, '70; Gal. Ileana Sonnabend, Paris, 1964; Moderna Mus., Stockholm, 1966; Irving Blum Gal., Los Angeles, 1968; Richard Feigen Gal., Chicago, 1969; Retrospective, MOMA, NYC 1969; Retrospective, Tate Gallery, London, 1970; Pasadena Art Mus., California 1971; Leo Castelli Gal., NYC 1974, '76; Kunstmus., Basel 1975; Mayor Gal., London, 1975; Mus. des XX Jahrhunderts, Vienna, 1976. GROUP EXHIBITIONS INCLUDE: Judson Gal., NYC 1959–60; "New Forms—New Media," 1960; "Environments, Situations, Spaces," 1961, Martha Jackson Gal., NYC; "Sixteen Americans," MOMA, NYC 1963; "Four Environments by New Realists," Sidney Janis Gal., NYC 1963–64; "Painting and Sculpture of a Decade 1954–64," Tate Gal., London 1964; "Six from the East," Mus. of Art, San Francisco 1966; "Dine, Oldenburg, Segal," Art Gal. of Ontario, Toronto 1967; Mus. of Contemporary Art, Chicago 1967; "The Obsessive Image, 1960–1968," Inst. of Contemporary Arts, London 1968; "Pop Art," Hayward Gal., London 1969; "Expo '70," Osaka, Japan 1970; Documenta 5, Kassel, W. Ger. 1972; "American Pop Art," Whitney Mus. of Am. Art, NYC 1974.

COLLECTIONS INCLUDE: MOMA, NYC; Albright-Knox Art Gal., Buffalo, N.Y.; Brandeis Univ. Waltham, Mass.; Allen Art Mus., Oberlin Col., Ohio; Art Inst. of Chicago; City Art Mus., St. Louis, Mo.; Mus. of Fine Arts, Houston, Texas; County Mus. of Art, Los Angeles; Pasadena Art Mus., California; Art Gal. of Ontario, Toronto; Vancouver Art Gal., British Columbia; Tate Gal., London; Mus. des Beaux-Arts, Brussels; Stedelijk Mus., Amsterdam; Rijksmus. Kröller-Müller, Otterlo, Neth. Kaiser Wilhelm Mus., Krefeld, W. Ger.; National Mus., Stockholm; Kunstmus., Basel.

ABOUT: Amaya, M. Pop Art and After, 1966; Current Biography, 1970; Henri, A. Environments and Happenings, 1974; Kramer, H. The Age of the Avant-Garde, 1974; Lippard, L. R. Pop Art, 1966; Rose, B. American Art Since 1900, 2d ed. 1975; Rose, B. Claes Oldenburg, 1970; Rublowsky, J. Pop Art, 1966; Russell, J. and Gablik, S. Pop Art Redefined, 1969; Tomkins, C. Off the Wall 1980. *Periodicals*—Artforum January 1966, May 1966, November 1969; Art in America September 1974; Art News May 1967; Art Now: New York October 1969; Art Voices Summer 1965; Connoisseur October 1973; Newsweek March 21, 1966; New York Times November 2, 1976, November 24, 1976; New York Times Magazine September 21, 1969; Time October 10, 1969.

OLITSKI, JULES (March 27, 1922–), American painter and sculptor, won international renown in the 1960s with his vast, misty color-field canvases and was a leading exponent of what the influential critic Clement Greenberg called "post-painterly abstraction." He was born in Snovsk, in the Soviet Union, the only child of Jevel and Anna (Zarnitsky) Demikovski; he later adopted the name Olitski from his half-sister, Roslyn (Olitski) Palatsky. The family moved to Gomel, Russia, in 1923 and, when Jules was less than two years old, to the United States. Olitski grew up in Brooklyn.

Visiting the New York World's Fair of 1939, he was impressed by the exhibition of old masters, especially the Rembrandt portraits. When he graduated from Tilden High School in 1940, he won a scholarship to Pratt Institute, Brooklyn, to study drawing. In 1940 he studied with the Impressionist painter Samuel Rothbort and painted landscapes outdoors, around Sheepshead Bay. He studied drawing and portrait painting at the National Academy of Design, New York City, and took evening classes in figurative clay sculpture at the Beaux-Arts Institute. Olitski has continued to draw from life throughout his career; a group of those drawings were exhibited at the Corcoran Gallery of Art in Washington, D.C. in 1974.

In 1942 Olitski met the painter Victor Thall, under whose influence he began to paint in a manner strongly reminiscent of fauvism. He married Gladys Katz in the same year. (They had a daughter, Eve, before being divorced in

Photo courtesy of Knoedler Gallery, NYC

JULES OLITSKI

1950.) After his army service from 1942 to 1945, he studied at New York University and the National Academy of Design, still concentrating on conventional portrait painting.

Aided by the GI bill, Olitski went (in 1948) to Paris, where he enrolled at the Académie de la Grande Chaumière and studied sculpture with Ossip Zadkine. For about six months he worked on what he called "blindfold paintings," hoping to break away from the academic style. He began to produce heavily impastoed, abstract pictures reminiscent of French painter Jean Fautrier. His first solo show took place at the Galerie Huit, Paris, in 1950.

He left Paris in 1951 and returned to New York, earning a BS degree in art education at New York University in 1952 and an MA degree in 1955. While working for his MA he taught art history part-time at NYU and in 1955–56 served as curator of the university's art gallery. In 1956, he married Andrea Hill Pearce, who later bore him a daughter, Lauren. During the academic year of 1956–57 he was assistant professor of art at the State University of New York at New Paltz, and in 1957 became associate professor and chairman of the department of fine arts at C. W. Post College on Long Island; he remained at C. W. Post until 1963, when he joined the faculty at Bennington College, Vermont.

Throughout the 1950s Olitski painted in the impasto style he had adopted in Paris. The canvases he exhibited at his first solo show in the United States, held at the Zodiac Gallery (part of the Iolas Gallery), New York City in 1958, were subtle and somber in color and so heavily built up with molded and kneaded plaster that a reviewer described them in the *New York Times* (May 24, 1959) as "non-objective bas-reliefs" occupying a territory between painting and sculpture. Although essentially abstract, they contained allusions to landscape. Clement Greenberg found Olitski's paintings interesting and the two men became friends.

The paintings shown at French & Company, New York City, in 1959 were still heavily textured, their surfaces enriched with spackle, paint, colored pigments, and acrylic resins. Then, in 1960, Olitski radically altered his style. Working on much larger canvases, he banished all tactility and spatial illusions from his pictures. In a complete break with his previous impasto, he began to use broad, flat areas of color and to pour pigment onto the canvas or stain the surface with dyes. In both the works he exhibited at French & Company in 1960 and those he showed at the Poindexter Gallery, New York City, in October 1961, sharp-edged pools of opulent primary colors floated against dark backgrounds. One of the earliest of these pictures, *Osculum Silence,* so-named because it reminded the artist of "the intense silence of a kiss," won second prize for painting in the 1961 International Exhibition of Contemporary Painting and Sculpture at the Carnegie Institute, Pittsburgh. This award to the relatively unknown Olitski was all the more remarkable because the other two prizes in painting went to Mark Tobey and Adolph Gottlieb, both established artists.

Olitski continued to experiment in the early 1960s. In the 1961 canvases that he called "Italian paintings" because they were exhibited in Florence, Olitski used homemade paints similar to Liquitex. In 1962 he adopted from Kenneth Noland and Morris Louis, two other prominet prominent post-Pollock abstractionists, the staining technique they, in turn, had adopted from Helen Frankenthaler. Applying thinned Magna acrylic directly onto unprimed canvas with brushes, sponges, and, occasionally, rollers, Olitski stressed the two-dimensional nature of the canvas. He exhibited stained works in this vein in his annual shows at the Poindexter Gallery from 1962 through 1965. One painting in the 1963 show, *Born in Snovsk* (Art Institute of Chicago), reminded one critic of "magnified cross-sections of cells."

By late 1963 Olitski was wondering whether, in the words of one critic, it was possible "to paint an abstract picture where the separate stained areas were not of a single uniform color, and yet maintain a basic 'flatness.'" He started to apply paint to narrow, vertical canvases with a roller, rolling one color into another to produce a range of color variations. In his 1964 paintings,

sometimes called the "Curtain Pictures," the only distinct color areas were small round or rectangular shapes near the edges of the canvas. Four major 1964 works in the "curtain" style,—*Deep Drag, Flaming On, Hot Ticket,* and *Tin Lizzie Green,*—were included in the 1965 exhibition "Three American Painters" at the Fogg Art Museum of Harvard University, which traveled to the Pasadena Art Museum, California. In the catalog to this exhibition of work by Olitski, Noland, and Frank Stella, the show's curator, Michael Fried, had called Olitski "one of the finest and most resourceful colorists of the century."

In the mid-1960s the artist said, "I would like to make paintings by spraying colors into the air and having them remain there." By late 1965 he was giving serious consideration to the technique of spray painting. He experimented with electric-powered spray guns, sometimes manipulating as many as three at a time and using as many as ten on a single canvas. The innumerable flecks of color, varying in size from tiny dots to larger beads and splashes, created an all-over effect of great richness. Comparing the blended colors of Olitski's early spray paintings to the "atmospheric effects" of sunlight, sky, and clouds, Barbara Rose called them "the first fully abstract version of Impressionism."

In 1966 Olitski was one of four painters (the others were Helen Frankenthaler, Roy Lichtenstein, and Ellsworth Kelly) chosen by Henry Geldzahler to represent the United States at the Venice Biennale of 1966. The following year he was awarded first prize at the Biennial of the Corcoran Gallery for a peach, green, mauve, and pink spray painting entitled *Pink Alert.* Later in 1967 Olitski had a retrospective of 42 paintings from the years 1963–67, at the Corcoran Gallery, the Pasadena Art Museum, and the San Francisco Museum of Art.

In 1966 Olitski had thickened his pigment by adding pure ammonia. He further altered his spray technique in 1968, when he added aquatec gel to the pigment to give it a greater viscosity and to impart a tougher surface to the canvas. He began to define the edges of his pictures with brushstrokes or bands of sprayed color. By now he had discarded the narrow vertical format of his first spray paintings and moved on to squares or extreme horizontals: *Yellow Empress Pose* (1968), for example, is over 20 feet wide but only 18 inches high. This elongated format heightened the tension between the sprayed color-field and the brushed-in edges of the canvas.

Olitski spent seven weeks in England in 1968. As a result of a conversation with the British abstract sculptor Anthony Caro during that visit,

he decided to extend his spray technique to three dimensions. Working in St. Neots, near Cambridge, England, he completed a series of 20 sculptures. Five pieces from the series were exhibited in 1969 at the New York City's Metropolitan Museum of Art in the first solo show the museum ever devoted to a living American artist. These massive, low-lying sculptures, elliptical and circular shapes that measured up to 28 feet long and 12 feet wide, were executed in aluminum that had been completely covered with sprayed acrylic lacquer. In a statement in the Metropolitan Museum's *Bulletin,* the artist wrote, "Sculpture is surface. . . . Surface is inevitably color—if only the color of untreated surface. . . . The excitement and problem in a sculpture lies in the multiple points of view that can be seen only one at a time . . . with sculpture the cumulative experience consists in looking by going *around* and *around* colored surface, while in painting it lies in looking *across* and *across* colored surface." Like Caro, Olitski prefers an indoor setting for his sculptures. As he explained in a 1975 interview, "In an enclosed space art has a greater possibility of being itself than when it is seen in relation to nature."

In the early 1970s the surfaces of Olitski's canvases became rougher. He used rollers and squeegees to scrape the surface, and muted his colors. He continued making sculpture. A series of painted steel "Ring Pieces" composed of concentric circles—among them the 1972 pieces *Honey, Bewray,* and *Sortilege*—were followed in 1974 by the "Greenberg Variations," an allusion both to Bach's *Goldberg Variations* and to his friend Clement Greenberg. In the largest and most complex of the "Greenberg" series, the curvilinear bands of metal characteristic of the earlier pieces were cut into segments and stacked vertically. One critic has found the "openness, layering and complexity" of Olitski's later sculptures in his mature paintings as well; the artist himself sees his painting and sculpture as closely related in all their successive phases.

In 1973, the Whitney Museum of American Art, New York City, mounted a major Olitski retrospective. Kenworth Moffett, the show's curator and a champion of formalist criticism, wrote in the catalog of Olitski's "decisive" importance for younger painters. Harold Rosenberg, on the other hand, found most of the paintings "essentially inert, with surfaces disagreeably insensitive," and less successful than Mark Rothko's paintings in achieving suspended color masses.

Since 1975 Jules Olitski has divided his time between his Manhattan studio and his country residence in Meredith, New Hampshire; he also

has a home in Florida.

EXHIBITIONS INCLUDE: Gal. Huit, Paris 1950; Alexander Iolas Gal. NYC 1958; French & Co., NYC 1959, '60; Poindexter Gal., NYC 1961–65; Gal. Lawrence, Paris 1964; Kasmin Ltd., London 1964–66; David Morvish Gal., Toronto from 1964; André Emmerich Gal., NYC 1966–68, 1978; "Olitski: Paintings 1963–67," Corcoran Gal. of Art, Washington, D.C. 1967; "Olitski: Paintings 1963–67," Pasadena Art Mus., Calif. 1967; "Olitski: Paintings 1963–67," San Francisco Gal. of Art 1967; "The Sculpture of Jules Olitski," Metropolitan Mus. of Art, NYC 1969; Lawrence Rubin Gal., NYC 1972; "Jules Olitski Retrospective," Whitney Mus. of Am. Art, NYC 1973; "Jules Olitski Retrospective," Mus. of Fine Arts, Boston 1973; "Jules Olitski Retrospective," Albright-Knox Art Gal., Buffalo, N.Y. 1973; Knoedler Contemporary Art, NYC 1973, '74, '75, '76, '77; "Jules Olitski Life Drawings" (circulating show), Corcoran Gal. of Art, Washington, D.C. circulating 1974–76; Olitski, New Sculpture," Mus. of Fine Arts, Boston 1977; "Olitski, New Sculpture," Hirshhorn Mus. and Sculpture Garden, Washington, D.C. 1977. GROUP EX-HIBITIONS INCLUDE: Pittsburgh International, Carnegie Inst. 1961; Annual, Whitney Mus. of Am. Art, NYC 1964, '67, '68, '72; "Three American Painters," Fogg Art Mus., Cambridge, Mass. 1965; "Three American Painters," Pasadena Art Mus., Calif. 1965; Venice Biennale 1966; Biennial, Corcoran Gal. of Art, Washington, D.C. 1967, '75; Documenta 4, Kassel, W. Ger. 1968; "New York Painting and Sculpture: 1940–1970," Metropolitan Mus. of Art, NYC 1969; "Color and Field: 1890–1970," Albright-Knox Art Gal., Buffalo, N.Y. 1970; "Color Field Paintings to Post Color Field Abstraction—Art for the 70's," Nelson Gal., Atkins Mus., Kansas City, Mo. ca. 1971; "The Great Decade of American Abstraction—Modernist Art 1960–1970," Mus. of Fine Arts, Houston 1974; "America VIII: Post-war Modernism," San Jose Mus. of Art, Calif. 1977.

COLLECTIONS INCLUDE: MOMA, and Whitney Mus. of Am. Art, NYC; Princeton Univ., N.J.; Hirshhorn Mus. and Sculpture Garden, Washington, D.C.; Boston Mus. of Fine Arts; Massachusetts Inst. of Technology, Cambridge; Detroit Inst. of Arts; Dallas Mus. of Fine Art; Krannert Art Mus., Ill.; Seattle First Nat. Bank; Israel Mus., Jerusalem; Newsweek, Japan.

ABOUT: Cabanne, P. and others L'Avant-Garde au XXe siècle, 1969; Current Biography, 1969; Moffett, K. "Jules Olitski" (cat.), Boston Mus. of Fine Arts, 1973; Rose, B. American Art Since 1900, 2d ed. 1975; Rosenberg, H. Art on the Edge, 1975. Periodicals—Art International (Lugano) April 1963, January 1968, December 1972, April 1973, May 19, 1975; Artforum November 1965, January 1967, April 1969; Arts Magazine November 1975, May 1976; Das Kunstwerk (Stuttgart) May 1975; New York May 28, 1973; New York Times May 24, 1959; Studio International October 1970; Time June 14, 1968, July 16, 1973.

***OZENFANT, AMÉDÉE** (April 15, 1886–May 4, 1966), French painter and cofounder of the purist movement, was born in Saint-Quentin, an industrial town in northern France. His family were prosperous bourgeois. Ozenfant's first training was at the local art school, the Ecole Municipale de Dessin Quentin-Latour (where Henri Matisse also studied). According to his *Mémoires,* when very young he "found charm in drawings that represented nothing." About 1905 Ozenfant came to Paris and studied architecture and painting at the Académie La Palette. Still under the influence of impressionism, as were so many of his contemporaries, he gradually developed a less spontaneous manner, inspired by the example of one of his fellow students, André Dunoyer de Segonzac. From this Ozenfant turned to pointillism, attracted by its spontaneous approach to painting. This penchant for system and order became the basis of his aesthetic credo.

In 1908 the first showing of Ozenfant's work was held at the Société Nationale des Beaux-Arts, Paris. In the years 1909–13 he traveled extensively, going to Italy, Belgium, and Holland, and three times to Russia. On his first visit there, in 1912, in St. Petersburg, he married Zina Klingberg; they were divorced six years later. About this time Ozenfant had discovered and come to admire the work of the Spanish Cubist Juan Gris, and began painting in the cubist style himself.

Ozenfant's contributions to art theory are, however, considered more significant than his actual paintings. Indeed, he is ranked as one of the most erudite of the Paris avant-garde of the time; he attended Henri Bergson's classes in philosophy at the Collége de France and also studied mathematics and logic there with Henri Poincaré and music history with Romain Rolland. From childhood on Ozenfant had been in delicate health and thus was exempted from service in World War I. In 1915 he founded at his own expense a cubist-oriented art review, *L'Elan;* among its contributors were Dunoyer de Segonzac, Picasso, the poet Guillaume Apollinaire, the writer Max Jacob, and the painters Matisse and André Derain. The lively journal managed to keep an exchange of cultural ideas current during the war. Serving as its editor until 1917, Ozenfant began to formulate his criticism of recent trends in cubist painting, especially the decorative tendencies which he felt were weakening the original crystalline purity of the style.

Such criticism evolved into an aesthetic manifesto, formulated by Ozenfant and the painter-architect Charles-Edouard Jeanneret (later known as Le Corbusier)—whom he met in

°ô´ zäN fäN, ä mā dā´

1918—and launched by them in their book *Après le cubisme* (After Cubism). Issued in Paris in 1918, it became the first statement of the principles of the art movement known as purism; coincident with its publication the two artists held their first joint exhibition of purist paintings and drawings at the Galerie Thomas, Paris. Included in the show was Ozenfant's *Bouteille, pipe et lettres* (1918; Bottle, Pipe and Letters). An exemplar of the new style, it is a composition in which each form is recognizably depicted. The object is absolute, shown in its entirety, not fragmented (as in a cubist disintegration of form), and in its most characteristic aspect; while static and restrained, the painting as a whole has a geometric, architectural harmony. There is no subjective content; the assemblage exists on its own without literary or personal allusions.

Purist theory was further developed in issues of the journal *L'Esprit nouveau* (The New Spirit), published by Ozenfant and Jeanneret in Paris between 1920 and '25. Considered one of the most fascinating of all modern art periodicals, it went far beyond the immediate concerns of the postwar artists who formed the School of Paris, including articles on philosophy and psychology, politics and economics, music and literature. Between 1923 and '25, as the contents of the magazine reveal, purism had become part of an international aesthetic, merging French ideas with German Bauhaus theories of design. Ultimately, in fact, purism had more influence on architecture and design than on painting. The final, definitive statement of purism principles was given in the book *La Peinture moderne* (Modern Painting), Ozenfant's and Jeanneret's last joint venture, published in 1925.

In essence, purism was a neoclassical movement, calling for a return to the analytical objectivity of the first cubist paintings produced in what Ozenfant and Jeanneret termed cubism's "heroic" period. In particular, they championed the style of Gris—his detached, geometrical forms and precisely interlocked planes. They were also closely associated, between 1919 and 1924, with Fernand Léger, who shared their belief in the primacy of the object, their interest in massive forms, and their need to clarify volume and color. However, Léger was only peripherally a member of the purist movement. Ozenfant and Jeanneret deplored the whimsy, the personal allusions, the use of rich color they detected increasingly in the work of Picasso and Braque. The integrity of the object was being destroyed, and cubism was becoming more and more abstract, an art for the artist's sake rather than an attempt to communicate with the spectator. The Purists sought an art in harmony with modern

technological civilization, the standardized products of which fascinated them. As Ozenfant commented, "Art is the demonstration that the ordinary is extraordinary," and he himself, in 1910, inspired by the beauty of the automobile engine, had designed the body work for his own car, called the Hispano-Ozenfant. The purist goal was an ordered, objective approach to the painting of inanimate objects, for human beings are "geometric animal[s], animated by a geometric spirit." As set forth in *After Cubism*, the artist is a mechanism that reacts with great precision to sense stimuli. If artists are machines, so are their paintings in their capability of producing certain effects on spectators. But for all their intellectuality, their lack of extra-pictorial contexts, the works of Ozenfant and Jeanneret were never pure abstractions. Nonrepresentational art they rejected as being too close to the merely decorative. It is one of the ironies of art history that purism eventually developed into a completely abstract style.

Ozenfant's purist painting, worked in flat areas of generally pastel colors, consist mainly of simple, machine-made objects: wine bottles, glasses, and pitchers. Representative of the elegant simplicity of these still lifes is *Nacres No. 2* (1922; Mother-of-Pearl). Painted in delicate pearly tints, with silhouettes of the assemblage of bottles and glasses overlapping one another, the forms nevertheless merge distinctly. In the same way, *Grande composition puriste* (1926) is a carefully planned grouping of objects—a kind of artist's modern mass production. Preliminary drawings for the work are as precisely finished as the final painted statement.

The collaboration of Ozenfant and Jeanneret ceased after 1925, the year in which they worked on the Pavillon de l'Esprit Nouveau designed by Le Corbusier for the International Exhibition of Decorative Arts in Paris. It displayed the architect's paintings as well as those by Ozenfant and Léger. Thereafter, Ozenfant was increasingly active as a teacher. And while he continued for a few years to paint purist still lifes, in 1926—the year he was remarried, to Marthe-Thérèse Marteau—the human figure began to reappear on his canvases after about a decade's absence. While purism was indeed primarily concerned with developing an art for the new technological age, Ozenfant and Jeanneret had placed the human figure, as the most perfect of all machines, first in their hierarchy of acceptable art objects. Thus, between 1925 and '28, Ozenfant worked on a large figurative mural, *Les Quatres races* (The Four Races), now in the Musée Nationale d'Art Moderne, Paris. From 1931 to '38 he was employed on an even more vast painting, *La Vie* (Life), composed of

over one hundred figures. In the 1920s, also, Ozenfant had worked out a new technique, painting in small strokes with a soft brush, heavily loaded with pigment, and thus achieving a painted-relief effect. *La belle vie* (1929), a painting of divers in different poses (which caused a great stir when exhibited in 1930); *Figures by a Lake* (1931); *Love, I* (1930), and *Sleep* (1931), paintings of lovers embracing, are examples of the new manner and subject matter.

In 1928 Ozenfant, writing independently, published *L'Art*; it was first translated into English in 1931 as *The Foundations of Modern Art* and is regarded as a classic statement of art theory, still widely read. In this work purist ideas on art were enlarged and applied to life as a whole; as Ozenfant declared in the prefatory pages: "I consider 'Art' as a preface. All our acts are the preface of what we shall never realize: our Ideal." Written in Ozenfant's characteristically aphoristic style, it shows his interest in a wide range of matters. Beginning with a description of his first sight of Paleolithic cave paintings, which inspired feelings of the essential nobility of the human spirit, Ozenfant goes on to propound theories of what forms please and why, and to a consideration of the eternal values in art. The book is dedicated to those "whose desire is worthily to create but who are troubled by the meaningless imbecilities offered as the very last word in civilization. Now homage to our ancestors; and faith in the rising young!"

In his later years, rejecting both abstract art and surrealism, Ozenfant turned to somewhat enigmatic, mystical paintings, difficult to classify stylistically. He returned to landscapes (which he had done in precubist days), now characterized by featureless, distant views across to ranges of hills (*Blue Mountains in Provence,* 1961), or out over fields to a dominant architectural structure, such as the spans of a Roman aqueduct (*Beziana II,* ca. 1959). An almost abstract motif recurs in several other late paintings: a view from windows in a bare corner of a room toward the sky (*Window and Sky,* ca. 1966). In other works geometrical arrangements of white sails against a uniformly blue background (*Lake with Sails*) or the stripped masts and hulls of yachts at anchor recall the purist geometric orientation of earlier years, but are painted in a much weightier, more intense manner.

In 1924 Ozenfant had opened an atelier in Paris with Léger. Its interior, designed by Jeanneret and himself, was an outstanding example of the purist aesthetic. In 1930 he established his own Académie Ozenfant, moving it to London in 1935 and in 1938 to New York City. There he lived until 1955, "very happy with my urban New York life where the pace is exactly geared to the needs of my work." The Ozenfant School of Fine Arts, at 208 East 20th Street, became famous as a center of avant-garde painting, but despite its reputation it has little influence on the development of the emerging American art of the time. In these years Ozenfant also lectured throughout the world, including Greece and the Middle East, and in various parts of the US. He taught at the New School for Social Research from 1939 to '43, lectured also at Yale, Harvard, and Cooper Union, and, having become an American citizen, served as a commentator on art for Voice of America broadcasts between 1949 and '52. He was dismissed from this assignment, however, because his liberal sentiments brought him under suspicion from witch hunters working for Senator Joseph McCarthy.

In 1955 Ozenfant closed his school and returned to Paris, eventually settling in Cannes where he opened a studio for foreign students. He died there shortly after his 80th birthday.

Amédée Ozenfant was a highly articulate, intellectually stimulating man, with aquiline features and a somewhat severe expression. Official recognition of his distinguished career came during his lifetime when he was made a Chevalier of the Legion of Honor in 1949 and an officer of the Order of Arts and Letters in 1962. Despite these honors, his painting was largely forgotten. Not until some years after his death was there a major retrospective of his work. In 1973, in an effort to revive his reputation, 74 of his paintings and drawings were shown at the Knoedler Gallery, New York City. This bringing together of works from his purist period to his last years illustrated his own verbal summation of his career: "I have often been criticized for my two apparently irreconcilable drives: the obsession with permanence and my all-absorbing interest in the present. Can't people realize that the present is our own moment of eternity?"

EXHIBITIONS INCLUDE: Société Nat. des Beaux-Arts, Paris 1908; Gal. Hodebert, Paris 1928; Arts Club of Chicago 1940; Gal. Katia Granoff, Paris 1962, '63; M. Knoedler and Co., NYC 1973. GROUP EXHIBITIONS INCLUDE: Purist Exhibition, Gal. Thomas, Paris 1918; Purist Exhibition, Gal. Druet, Paris 1921; "Cercle et carré," Gal. 23, Paris 1930; "Europeans in America," MOMA, NYC 1946; São Paulo Bienal 1955; "Art en Europe autour de 1918," Ancienne Douane, Strasbourg, France, ca. 1960.

COLLECTIONS INCLUDE: Gal. Katia Granoff, and Mus. Nat. d'Art Moderne, Paris; Tate Gal., London; Mod-

erna Mus., Stockholm; Kunstmus., Basel; Tretyakov
Gal., Moscow; Phillips Collection, Washington, D.C.

ABOUT: Cogniat, R. Ozenfant, 1963; Golding, J. and
others, "Léger and Purist Paris" (cat.), Tate Gal., London, 1970, "Ozenfant" (cat.), M. Knoedler and Co.,
NYC, 1973; Nierendorf, K. Amédée Ozenfant, 1931;
Ozenfant, A. with others, Après le cubisme, 1918;
(with others) La Peinture moderne, 1925, L'Art: Bilan
des arts modernes et structure d'un nouvel esprit, 1928,
Mémoires 1886–1962, 1968. *Periodicals*—Art News
April 1973.

Jorge Lewinski

EDUARDO PAOLOZZI

***PAOLOZZI, EDUARDO** (March 7, 1924–),
one of Britain's most original and important
sculptors and graphic artists, was born in Edinburgh, of immigrant Italian parents. He grew up
in the tough, working-class dockland area of
Leith, Scotland. The family business was making
ice cream, without benefit of mechanical refrigeration or advanced machinery, and Eduardo
helped day and night in the shop. He acquired
a taste for pulp novelettes and science-fiction
stories and for American films which came to
the Leith movie house. In retrospect he regards
these early experiences of the world of synthetic
fantasy as his introduction to surrealism.

Paolozzi collected cigarette-cards and comic
books given him by customers. He was so delighted with these pictures, produced by cheap
screenprinting and photolithographic processes,
that by the age of 16 he had decided to become
a commercial artist and produce these exciting
images himself. By then Britain was at war, and
in 1943 Paolozzi was attending classes at the Edinburgh College of Art while awaiting his call-up papers. After his demobilization in 1944 he
was accepted at the Slade School of Fine Arts,
which had at that time been evacuated to Ruskin
College, Oxford. Although fascinated by the ethnographical collections in the Pitt Rivers Museum at Oxford, he felt stifled by the academicism
of the Slade, and continued to pursue his own
unorthodox interests. He would cut out details or
whole pages from comics and glossy magazines
and paste them into scrapbooks, juxtaposed with
images of classical painting and sculpture. Because quality paper was in those days almost impossible to obtain, Paolozzi would paste these
scraps into the pages of second-hand books—
science manuals, novels, or volumes of poetry.

When the Slade returned to London in 1946,
Paolozzi found the atmosphere less claustrophobic. Some new students were war veterans, more
mature and skeptical than the typical "Slade
product." Paolozzi became a close friend of William Turnbull, also a native of Scotland. Turnbull, who had flown a bomber during the war,
was to become an eminent sculptor. In 1947
Paolozzi's first solo show of drawings and montages was held at the Mayor Gallery, London,
and it brought him just enough money to travel
to Paris with Turnbull.

In Paris they admired the fine collection of
primitive art in the Musée de l'Homme, and met
several of the leading Dada and Surrealist artists
and poets. In the stimulating atmosphere of the
immediate postwar years, Miró, Giacometti,
Ernst and Arp were eager to share their ideas
and discuss their work. Paolozzi was particularly
interested in the paintings of Jean Dubuffet,
who found inspiration in crude graffiti and had
a large collection of what he called *art brut* (raw
art), some of it produced by psychotics. Paolozzi
was also influenced by his contacts with Giacometti and the Dadaist poet Tristan Tzara, who
had an unusual collection of European and African art.

Paolozzi was encouraged by the fact that collage, which he had been practicing for years in
his scrapbooks, was in Paris considered a serious
activity. He gleaned further material from the
American magazines and comic books sent regularly to the GIs stationed in Paris after the war.
Thus, what later would be known as American
pop culture was an essential ingredient in
Paolozzi's kaleidoscopic view of the postwar

°pou lô′tsē, ā dwär′ dō

world. Collage became, as Rosemary Miles has pointed out, "the foundation-stone of his creativity," both in his graphic work and in his sculpture. In Paolozzi's words, "All human experience is a collage."

In 1949 Paolozzi returned to London, and found a teaching post in the textiles department of the Central School of Arts and Crafts, where he taught until 1955. Nigel Henderson, a former fellow student at the Slade, and his wife offered Paolozzi the use of a cottage in Essex where he began to experiment with printmaking and to absorb what he had discovered in Paris.

He developed an original method of silkscreening in which he succeeded in combining the transfer of the drawn image with a special photographic developing process. His print *London Zoo Aquarium* (1951) was an example of this technique. A number of Paolozzi's early works were inspired by underwater life, as in *Aquarium,* which also shows the influence of Paul Klee. Primary sources of inspiration for him were mechanical forms, on which Paolozzi imposed, as had the Dadaists, more irrational aspects.

Much of Paolozzi's graphic work of the early 1950s was commercial design for textiles and wallpapers, but he also used montage to create head and figure studies. His view of the increasing mechanization of life was expressed in the 1954 print, *Automobile Head,* in which all the elements of the montage were wheels, gears, and other mechanical parts within a contour suggestive of a human head and shoulders in profile—the crankshaft became the spinal column. This imagery, influenced by Dubuffet's *Art brut,* recalls Paul Valéry's statement: "Man is only man on the surface. Remove his skin and immediately you come to machinery."

Paolozzi was a member of the Institute of Contemporary Art, London, an independent group of young artists, architects, and writers who were interested in the heterogeneous materials of contemporary life, including drawings and diagrams in engineering and scientific manuals, the covers of cheap magazines, American advertising, the packaging of consumer goods—all those elements which had never been considered art, but which were to become the essential sources for pop, of which Paolozzi was an important forerunner. At one of the I.C.A.'s meetings in 1952 Paolozzi bombarded the audience with slides of what he called "Bunk" material, an assortment of popular imagery that he had collected in Paris and London.

From 1955 to 1958 Paolozzi taught sculpture at the St. Martin's School of Art, London. As in his graphic work, Paolozzi in his sculpture estab-

lished a rugged human image closely linked to technology, an expression of his belief in the meshing of art and life. His first sculptures in the early 1950s had been mainly in cement, each piece an accumulation of signs suggesting the world of insects and marine creatures, the matrix of creation from which life painfully emerged. In 1953 he was commissioned by the Municipal Council of Hamburg, West Germany to design a fountain for a public garden. In the same year he received the British Critics' Prize.

In 1956 Paolozzi took part in the important "This is Tomorrow" exhibition at the Whitechapel Gallery, London; the show was designed as an environment and included Richard Hamilton's famous collage picture, *Just What Is It that Makes Today's Homes so Different, so Appealing?,* containing many of the future conventions of pop art. But Paolozzi's work at this time had none of pop's tongue-in-cheek optimism. In his disturbing *Head* of 1957 and the menacing *Japanese War God* of 1958, both in bronze, the inner structure was composed of bits of machinery and other chaotic debris of industrialism. The overall images were ravaged, corroded, lopsided, barely human, looking, wrote Michael Middleton, like "refugees from some atomic holocaust."

Paolozzi received a Norma and William Copley Foundation award in 1956, and the Davis E. Bright Foundation award in 1960 for the best sculptor under 45. In 1960 he accepted a visiting professorship at the Hochschule für Bildende Künste in Hamburg, where he remained for two years. The new environment gave him material for his next major graphic work, an animated film titled *History of Nothing.* The stills were made from book illustrations of German interior decoration, machinery, and landscapes. The effects were wildly surrealistic. In one sequence an enormous butterfly with a mechanistic body appeared to be trapped in an eerily empty apartment. In another, a nightmarish machine was perched on top of a Versailles-like building on an old postcard. As they flashed on the screen the images were accompanied by exotic, primitive music, intended to create, in Diane Kirkpatrick's words, "a peculiar reality in the viewer's mind."

However, Paolozzi preferred to transpose the kinetic atmosphere of film into the static medium of prints. After his return to London in 1962, he began to collaborate with Chris Prater, formerly a commercial printer, in an attempt to expand the potential of serigraphy. Soon they were using as many as 16 colors on one print and skillfully incorporating photographic processes. The print *Four Images from Film* (1962) was derived from *History of Nothing* and used a vigorous dy-

namic and diagonal linear pattern combined with the simultaneous presentation of independent images. *Metalization of a Dream* (1962–63) was the first print in which the collage was made specifically for silkscreening. Here a single mechanistic image, reproduced by photolithography from a collage made in Germany, created its own bizarre presence in the static atmosphere of a cell-like room.

Paolozzi's far more complex print of 1964, *Conjectures to Identity* with its incongruous juxtaposition of images (all originating in collage), laid the basis for his major achievement in the medium, a series of 12 screenprints produced in 1964–65 and entitled "As Is When." Inspired by the life and thought of 20th-century Austrian philosopher Ludwig Wittgenstein, the series was described by *Time* magazine as consisting of "complicated geometric patterns [which] lock and jostle as if deployed by the mathematical brain of a computer." One print suggested a mechanized transposition of the *Laocoon*—whose wrestling forms Paolozzi admired—and effectively conveyed the inward struggle and tortured life of the influential philosopher. Since one of the few ways Wittgenstein could relax was watching American films, Paolozzi entitled one of the prints *Wittgenstein at the Cinema Admires Betty Grable.* The most dynamic and vividly colored print was *Wittgenstein in New York* (1965), in which mass technical culture is summarized by the juxtaposition of machines, an airplane, skyscrapers, an American flag, and automatized men. "Wittgenstein was a spark for me," Paolozzi said, "and from that spark I made a graphic monument."

Paolozzi's stay in Germany gave him a new approach to machinery and inspired his cleancut, hard-edged sculpture of the 1960s. Unlike his previous constructions, which seemed to have been assembled, to quote *The New York Times,* "from the odds and ends of a ruined wasteland," the new works, in brightly painted aluminum, suggested nonfunctioning machines or sterile computers. Despite their dadaist absurdity, their buoyant logical architectural structure was derived from the rational order of technology. Paolozzi called some of these robotic constructions "idols"—the six-foot-high *Hermaphroditic Idol, No. 1* (1962) is an outstanding example—and maintained that such images represented the "rational order in the technological world [and] can be as fascinating as the fetishes of a Congo witch-doctor." Some of his glossy aluminum constructions suggest a fantastic but oddly coherent architecture. *The City of the Circle and the Square* (1963) now in the Tate Gallery, London, is over 7 feet high, but, despite its size,

the wheel and assorted geometric and boxlike structures are reminiscent of the delicate, small-scale language of an artist Paolozzi had always admired—Paul Klee.

In 1962 Paolozzi was represented in the exhibit "British Art Today," which toured the United States. In 1967 he was awarded first prize in sculpture at the Carnegie International Exhibition in Pittsburgh. The University of California at Berkeley invited him in 1968 to be a guest professor. In California he passed up the West Coast art scene in favor of trips to Disneyland, movie studios, computer centers, wax museums, and lingerie showrooms. He considered Los Angeles "the culmination of techno-kitsch." He explained: "The man who works in the highly scientific and sophisticated radar room in the control tower of the Los Angeles airport goes to lunch. What does he do? He climbs into his Buick to be served by topless waitresses."

On his return to London later in 1968, Paolozzi began to teach ceramics at the Royal College of Art, a post he still holds. In 1970 he visited Japan, where he acquired a large number of brilliantly colored model robots in tin and plastic to add to his vast collection of toys and other miscellaneous objects. In the early 1970s Paolozzi further experimented with photo-etching, and in 1973 began using images based on sonic rather than visual experiences. His silkscreen *Leonardo* (1974), was derived from an anonymous abstract painting of the 1920s which was supposedly an interpretation of organ music. In Paolozzi's print series of 1974–76, musical construction acted as a scaffold for the total design.

Paolozzi's concern with the relationship between music and the visual arts was intensified during his stay in Berlin in 1974–75 as the guest of the German Academic Exchange service. Earlier in the century, Paolozzi knew, Klee and Kandinsky had thought along similar lines, and the 12-tone row composer Arnold Schoenberg had also been a painter. In his new series of prints Paolozzi used abstract, predominantly linear rhythms as metaphors for soundwaves and variations in tone and pitch. His *Ravel Suite* (1974), with its delicate greenish grays—evocative of the subtle nuances of Ravel's works for violin or piano—is very different from the series of nine prints entitled "Calcium Light Night" (1974–76), with their large, dynamic clashing diagonals and orchestration of pastel colors. This series was dedicated to the eclectic American composer Charles Ives; the series title was taken from Ives's song about torchlight parades of students in Central Park. Yet another print was inspired by Turkish music.

In a more recent development, Paolozzi has

moved away from the highly sophisticated, cerebral, semimechanical techniques of his silkscreens, photo-etchings, and relief sculptures to the earliest of all printing techniques, the woodcut. In 1976 he dedicated a suite of six woodcuts to the memory of Charles Rennie Mackintosh, the great turn-of-the-century Scottish architect, artist, and furniture designer, a leading representative of art nouveau and a pioneer of the modern movement. Summing up the latest directions in Paolozzi's work, Rosemary Miles wrote that during the 1970s the artist withdrew "from the iconography of the 'consumer society' . . . into a more ascetic form of expression, dependent on the intangible (mathematics and music) for its existence."

Paolozzi spent a brief period in Germany in 1976 as visiting professor of ceramics at Cologne University. In 1977 a retrospective of his graphic work was held at the Victoria and Albert Museum, London. He is a short, stocky man with dark curly hair. He has homes in London and in Thorpe-le-Soken, Essex, but is so frequently on the move that he is often hard to locate. Possessed of an analytical, many-faceted mind and great physical energy, he is sometimes accessible and articulate, sometimes gruff and uncommunicative.

Paolozzi has made an important contribution to sculpture and the graphic arts. As a sculptor he represents a reaction against the monumental Neocubist humanism of Henry Moore, and he has followed a path very different from the minimalism of his friend William Turnbull. Commenting on his obsession with detail, he has said: "I always prefer a busy or crowded sculpture, whether tiny Byzantine or Gothic ivory relief or the huge *Porte d'Enfer* of Rodin." *The New York Times* described Paolozzi as "a brilliantly compulsive maker of images, whose machine-age totems are sustained by unflagging invention."

EXHIBITIONS INCLUDE: Mayor Gal., London 1947–49; Hanover Gal., London 1958; Betty Parsons Gal., NYC 1960, '62; Waddington Gals., London 1963; MOMA, NYC 1964; Robert Fraser Gal., London 1964, '66; Pace Gal., NYC 1965–67; Rijksmus. Kröller-Müller, Otterlo, Neth. 1967; Tate Gal., London 1971; Marlborough Fine Arts, Ltd., London 1976; Victoria and Albert Mus., London 1977; Kunstverein, Kassel, W. Ger. 1980; Kunstverein, Münster, W. Ger. GROUP EXHIBITIONS INCLUDE: Venice Biennale 1952, '60; "This is Tomorrow," Whitechapel Art Gal., London 1956; São Paulo Bienal 1957, '63; "New Images of Man," MOMA, NYC 1959; Documenta 2, 3, and 4, Kassel, W. Ger. 1959, '64, '68; "British Art Today," 1962; Solomon R. Guggenheim Mus. International, NYC 1967; Carnegie International, Pittsburgh 1967; "Pop Art Redefined," Hayward Gal., London 1969; Expo '70,

Osaka, Japan 1970; "British Sculpture in the 20th Century," Whitechapel Art Gal., London.

COLLECTIONS INCLUDE: Albright-Knox Art Gal., Buffalo, N.Y.; Solomon R. Guggenheim Mus., NYC; Tate Gal., London; Hirshhorn Mus. and Sculpture Garden, Washington, D.C.

ABOUT: Amaya, M. Pop Art and After, 1965; Bénézit, E. (ed.) Dictionnaire des peintres, sculpteurs et graveurs, 1976; Lippard, L. R. Pop Art, 1966; Lucie-Smith, E. Late Modern: The Visual Arts Since 1945, 1969; Miles, R. The Complete Prints of Eduardo Paolozzi: Prints, Drawings, Collages, 1944–77, 1977; "New Images of Man" (cat.), MOMA, NYC, 1959; Paolozzi, E. The Metalization of a Dream, 1963; Read, H. A Concise History of Modern Sculpture, 1964. *Periodicals*—Architectural Design April 1958; Art d'aujourd 'hui (Paris) March 1953; Christian Science Monitor November 29, 1967; Guardian May 13, 1965, April 15, 1966; Horizon September 1947; (London) Times May 2, 1958; New York Post March 16, 1958; New York Times March 15, 1960; Newsweek March 3, 1969; Observer June 18, 1967; Time December 14, 1959; Times Literary Supplement December 8, 1972.

PASMORE, (EDWIN JOHN) VICTOR

(December 3, 1908–), British painter and sculptor, was suddenly "converted" in the late 1940s from a sensitive figural style to the uncompromisingly abstract idiom for which he is best known.

Edwin John Victor Pasmore was born at Chelsham, Surrey, the son of cultivated parents. His father, E.S. Pasmore, was a physician, and his mother was a Sunday painter. His childhood was spent in the country. Fascinated at an early age by the visual quality of forms, he depicted with painstaking care every element in a given scene or landscape in his childhood sketches. He was given encouragement both at his preparatory school and at Harrow, where he learned to understand and appreciate the Impressionists. The landscapes he painted during his school days already had the light, atmospheric quality that was to characterize his work of the early 1940s.

After finishing at Harrow School, Pasmore was compelled by the death of his father to find immediate employment. He joined the local government service, and from 1917 to 1937 worked as a clerk for the London County Council, at the County Hall. During those years he painted on Sundays, making paintings from sketches in a room he had rented off Theobalds Road in the Holborn district. He also attended evening classes at the nearby Central School of Arts and Crafts, where his teacher was A.S. Hartrick, a man well acquainted with the impressionist and postimpressionist movements in France.

Jorge Lewinski

VICTOR PASMORE

"One's development is the ultimate result of one's background and the influences one undergoes," Pasmore later reflected. And in his case he was most influenced by the Impressionists, by Cézanne and Gauguin, by Whistler, Charles Conder, and Japanese prints, and even by Chardin in certain still lifes he painted at that time.

Pasmore first exhibited his work in a group show held in 1929–30 at the Zwemmer Gallery, London. In 1932, he was invited to join the London Artists' Association and held his first solo exhibition, at the Cooling Galleries, London. His contact with the London Artists' Association, later known as the London Group, was a turning point in his career. The work of its members ranged from fauvism to cubism, and for the first time Pasmore began to think of art in terms of the modern movements. It was at this time that his friendships with the painters William Coldstream, Claude Rogers, and Graham Bell began; all three artists were to figure prominently in Pasmore's career in the years ahead.

Pasmore's painting in the years 1930–36 reflected fauvist, cubist, and even abstract influences; in the winter of 1933–34 he contributed some near-abstract works to an exhibition of "objective abstractionists" at the Zwemmer Gallery. He experimented with several styles in the early and mid-'30s, but in 1936 he returned to impressionism, finding it more suited to his temperament than the exuberance of fauvism or the violence of expressionism. As for cubism and abstraction, he later realized that his understanding of those movements in the 1930s was relatively superficial, and that his ventures into abstraction did not fully "engage the mind."

In 1937, Pasmore, along with Rogers, Bell, and Coldstream, was a founding member of the Euston Road School. This group sought to return to a more realistic style of painting, neither abstract nor surrealist; as a result, staunch avant-gardists dubbed their program "reactionary" and "violently retrograde." In fact, however, the Euston Road School's program called for the teaching of painting in a step-by-step, nearly scientific manner, and this "objective" approach had an effect on Pasmore's subsequent work.

In 1938, through the help of Sir Kenneth Clark, the 30-year-old Pasmore was at last able to leave the London County Council and became a full-time painter. His work during the period of the Euston Road School's existence (1937 to '40) included portraits that showed the influence of Degas, and still lifes and interiors which, in their diffusion of color and painterly qualities, were closer to Sickert and Bonnard.

The outbreak of war in 1939 was the beginning of another difficult period for Pasmore, heralding gradual changes in his work. His personal circumstances changed as well, for in 1940 he married Wendy Blood, also a painter. (They have two children, John and Mary.) Between 1939 and '43 he painted a series of landscapes, interiors, and figure subjects which have been widely admired and which showed a return to the influence of Whistler. Reviewing a 1965 Pasmore retrospective at the Tate Gallery, Norbert Lynton of *The Guardian* (May 15, 1965) called these pictures, especially the series devoted to the Thames valley, "the finest tonal paintings since Whistler's, but demonstrating a more rigorous sense of form than his." Outstanding works of this period were *The Flower Barrow* (1938–42; National Gallery of South Australia, Adelaide), *View on the Medway* (1940–43), and the subtle and sensitive *Girl with a Curtain* (1943; National Museum of Wales, Cardiff).

In 1943–44 he continued to paint scenes of the Thames valley, but in a more intellectualized vein, with an increased concern for spatial relationships. Typical of this phase were *Chiswick Reach* (1943) and *The Quiet River* (1943–44), as well as other river scenes at Chiswick and Hammersmith, and landscapes painted at Cambridge and Blackheath. Between 1943 and '47 Pasmore was engaged "in retracing the development of French painting from Cézanne to Seurat through a conscious process of historical study," to quote Jasia Reichardt. The impact of Seurat was apparent in the more rigorous composition, the stress on structural elements, and the semi-pointillist technique of *The Thames at Chiswick, No. 3* (1946–47) and *Garden in Spring* (1945–47). The culmination of this phase was *The Park* (1947).

By the end of 1947 Pasmore's work had become more abstract. In *The Gardens of Hammersmith* (1947; National Gallery of Canada, Ottawa) the landscape was reduced to a protoabstract play of dots and lines, and Pasmore was convinced that his path lay in the direction of complete abstraction. So absolute was his rejection of early influences that he would later refer—most unjustly in the view of those who had admired the sensitivity of his figurative work—to "the time when I used to paint photographically."

Taking his point of departure from trees (as Mondrian had), the spiral motion of waves, and the rectilinear forms of city buildings, Pasmore worked his way, between 1948 and '52, to total abstraction. Collage was one means of freeing himself from dependence on sensation, as in *Abstract in White, Brown, Grey and Ochre* (1949), a collage on canvas now in London's Tate Gallery. The technique was that used by Picasso and Braque in 1912–13, combined with compositional elements reminiscent of his countryman Ben Nicholson. Pasmore was convinced, as he pointed out in the catalog to his 1949 exhibition at the Redfern Gallery, London, that abstract painting "associates itself more directly with music and architecture than with poetry and drama." There was still some reference to nature in *The Snowstorm (Spiral Motif in Black and White)*, an abstract oil of 1950–51 based on interlocked spirals recalling Celtic ornament, and Pasmore used similar motifs in a mural executed for the 1951 Festival of Britain on the south bank of the Thames. This was the second time he had worked within an architectural scheme, the first being a mural, which developed into a relief, for the Kingston bus garage canteen. Pasmore claimed that the bus drivers and other workers using the canteen, after their initial bafflement, had come to accept, even like, this nonfigurative work.

In 1952–53 Pasmore entered what has been called his "classic and rational" period, strongly influenced by the writings of Charles Biederman, which he had studied. Finding the two-dimensional rectangle of the canvas limiting, he had produced some oval paintings (inscribing the oval within the rectangle), in which the spiral theme was combined with stuck-on pieces of newspaper. The spiral motifs were gradually replaced by more formal elements, and he also introduced the third dimension in a series of relief constructions. One of the earliest was *Relief Construction in White, Black and Indian Red* (1951), in painted wood. Always preoccupied with light, Pasmore began to introduce into his three-dimensional constructions materials through which light could penetrate and thus become part of the structure. Among the most elegant of these works was *Transparent Relief Construction in Black, White and Ochre* (1954), in painted wood on perspex. Even in these abstract creations—which were revolutionary in the context of postwar British art of the 1950s—some critics saw an atmospheric Whistlerian delicacy.

In the meantime Pasmore had joined the Penwith Society in St. Ives, Cornwall, the home of Ben Nicholson and Barbara Hepworth (with whom he exhibited in 1950). In 1951–52 he organized the first exhibitions in Britain devoted solely to abstract art, held at London's A.I.A. Gallery. He also became influential as a teacher and art theorist, propounding ideas closely related to Bauhaus doctrine as well as to his own personal form of neoplasticism. One of his teaching posts was at London's Central School of Arts and Crafts, from 1949 to '53. He tended to be arbitrary and dogmatic in his views, uttering such sweeping statements as "Picasso is a nineteenth century artist; Mondrian is more evolved," and, more surprisingly, "The important thing in Rembrandt is the silhouette." He regarded figuration of any kind as utterly obsolete. Even Paul Klee he found too "literary."

Between 1954 and '61 Pasmore was master of painting in the fine art department at Durham University. His assistant was Richard Hamilton, the Pop artist who succeeded him in the post. Pasmore established a basic course founded on scientific principles of analytical research. As a pedagogue, he wanted to influence the practical application of design to industry, architecture, and other functional aspects of life—again in the spirit of the Bauhaus in Weimar Germany. From 1955 on he was consulting architectural designer for the planning of the South–West Housing Area of Peterlee New Town, collaborating with architects and thus putting his conception of art at the service of the community. In 1955–57 Pasmore organized summer schools at Scarborough for the study and development of new methods of art teaching. An exhibit entitled "The Developing Process," held at the I.C.A., London, in 1959, illustrated the development of Pasmore's students following his basic course. In the exhibition's catalog, Pasmore described his course as being founded "not on a static imitating system, but on a dynamic voyage of discovery. . . ."

In the summer of 1956 Pasmore completed what was probably the first permanent constructivist sculpture in a public building in Britain—two almost identical reliefs with clusters of vertical planes, installed in the entrance hall of the Stephenson Engineering Building, Durham Uni-

versity. In addition to his constructivist work he continued in the late 1950s and early 1960s to paint on a two-dimensional surface. He used colors sparingly in those years (only one or two colors in addition to black and white), but an exception was the series of paintings executed in 1958 consisting of streaks, lines, and simple curves in the colors of the spectrum.

Pasmore was made Companion of the British Empire in 1959, and was subsequently selected as one of the British representatives at the Venice Biennale of 1960. In his constructions of the 1960s he continued to make novel use of materials like plastic, formica, and cellulose. He liked to combine logic with the unexpected. In such works as *Golden Brown I* (1962) and *Black Abstraction* (1963), purely geometric elements were juxtaposed with irregular colored surfaces, which were sometimes painted in a pointillist technique.

Reviewing the 1965 Pasmore retrospective at the Tate Gallery, Norbert Lynton commented that "whereas Pasmore's voice has remained radical, his productions have fused revolution with traditional virtues of British art. . . . For all the bareness of his means, the abstract works tend towards atmospheric effects of an entirely landscape kind." The critic Charles Spencer has remarked on Pasmore's abiding admiration for Constable and Turner. An interesting American reaction to Pasmore's Tate retrospective was expressed by Christopher Andreae of the *Christian Science Monitor* (June 4, 1965). Andreae pointed out that although Pasmore had worked independently of Nicholson and Hepworth, he was very much of the same school. "He represents the movement in England which has made of 'abstraction' a pleasant, palatable, discreet art, an art of calm shapes and peaceful colors. . . . "

Lynton sensed a persistent duality in a show of Pasmore's works held at the Marlborough New London Gallery in 1969. In his *Guardian* review (March 22, 1969) Lynton described this duality as "a vocabulary of hard against soft, defining against diffusing."

Pasmore's work of the 1970s had titles like *Linear Symphony, Black Symphony,* and *Black Development in Two Movements,* an indication, according to John Spurling of the *New Statesman,* that Pasmore was "still pursuing Whistler's repeated analogies with music." Spurling noted that "Framing is as important to Pasmore as it was to Whistler: the board paintings are set in the middle of shallow white boxes, while the thin canvases are stuck onto panels of brown, grained wood, sometimes heavily varnished." Spurling found some of the paintings dry, "and the cause," he wrote, "is perhaps

to be found in Pasmore's curiously old-fashioned insistence on the importance of abstraction. Having made the traumatic break with Whistler's Nature, he is unable to forget that he was a bondman. He's proud of his freedom, still talking about it, but he doesn't entirely enjoy it."

Victor Pasmore was described in the *Christian Science Monitor* as "tall, with a massive head, a grizzled beard and formidable eyebrows shadowing deep-set eyes." The writer saw him as "an impressive figure, but not an intimidating one. . . . The eyes are kind." His personal geniality is in contrast to his brusque, offhand manner in voicing his ideas about art. He live with his wife Wendy in a beautiful Regency house facing Blackheath in southeastern London, but has also spent much time in recent years on the island of Malta. His son John is a professional photographer and sculptor.

"Abstract art," Pasmore declared in 1962, "is, in itself, not a philosophy, but merely a new tool for human expression and human development which has emerged at a time when traditional techniques were proving inadequate. . . . Like the discoveries of modern science, this tool is neutral; produced in freedom it is also free, waiting only to sense the master who is able to take it up. Like all great styles, the content and meaning of modern abstract art are what the artist and society put into it."

EXHIBITIONS INCLUDE: London Artists' Association, Cooling Gals., London 1932; Wildenstein Gal., London 1940; Redfern Gal., London 1947, '49, 1950–51, '52, '55; I.C.A., London 1954; Arts Council Gal., Cambridge, England 1955; O'Hara Gal., London 1958; British Pavilion, Venice Biennale 1960; Mus. des Arts Décoratifs, Paris 1961; Stedelijk Mus., Amsterdam 1961; Palais des Beaux-Arts, Brussels 1961; Louisiana Mus., Copenhagen 1961; Kestner-Gessellschaft, Hanover, W. Ger. 1962; Kunsthalle, Bern 1963; Tate Gal., London 1965; Mus. of Modern Art, São Paulo 1965; Marlborough New London Gal., London 1966, '69, '72; Gal. Lorenzelli, Bergamo, Italy 1970; Arts Club of Chicago 1971; Marlborough Fine Art, London 1972, '77, '80; Marlborough Gal. A.G., Zürich 1973; Marlborough Gal., NYC 1983. GROUP EXHIBITIONS INCLUDE: "17 Artists," Zwemmer Gal., London 1929–30; "Objective Abstractions," Zwemmer Gal., London 1934; "Contemporary British Art," British Pavilion, New York World's Fair, Flushing Meadow 1939; "British Art Since Whistler," Nat. Gal., London 1940; "The Euston Road Group," Ashmolean Mus., Oxford 1941; "Modern British Paintings from the Tate Gallery," Brussels 1946; "Modern British Paintings from the Tate Gallery," Amsterdam 1946; London Group, 1947; "Contemporary British Art," New Burlington Gals., London 1949; "Barbara Hepworth, Ben Nicholson, Victor Pasmore," Penwith Society, St. Ives, Cornwall, England 1950; Carnegie International, Pittsburgh 1950, '61, '64, '67; "Abstract Art," A.I.A. Gal., London 1951; "Space and Colour," Hanover Gal., London

1952; "Nine Abstract Artists," Redfern Gal., London 1955; "Masters of British Painting," MOMA, NYC 1956; "This Is Tomorrow," Whitechapel Art Gal., London 1956; "Three Masters of Modern British Painting," Arts Council, London 1958; International Art Exhibition, Tokyo 1959; Exhibit II (with Richard Hamilton), Hatton Gal., Newcastle-upon-Tyne, England 1959; Documenta 2 and 3, Kassel, W. Ger. 1959, '64; Guggenheim Award Exhibition, Solomon R. Guggenheim Mus., NYC 1960; San Marino Biennale, Italy 1963; "Painting and Sculpture of a Decade, 1954–1964", Tate Gal., London 1964; "Marlborough Graphics," Marlborough New London Gal., London 1965, '66, '67; Expo '70, Osaka, Japan 1970; Venice Biennale 1971, "20 Century Drawings and Watercolors," Marlborough Fine Art, London 1974.

COLLECTIONS INCLUDE: Tate Gal., Victoria and Albert Mus., Arts Council of Great Britain, and British Council, London; Walker Art Gal., Liverpool; City Art Gal., Manchester; City Art Gal., Leeds, England; City Art Gal., Bristol, England; Nat. Mus. of Wales, Cardiff; Scottish Nat. Gal. of Modern Art, Edinburgh; Boymans-Van Beuningen Mus., Rotterdam; Rijksmus. Kröller-Müller, Otterlo, Neth.; Gal. Nazionale d'Arte Moderno, Rome; Mus. des XX Jahrhunderts, Vienna; MOMA, NYC; Albright-Knox Art Gal., Buffalo, N.Y.; Art Inst. of Chicago; Nat. Gal. of Canada, Ottawa; Nat. Gal. of Victoria, Melbourne; Nat. Gal. of South Australia, Adelaide; Nat. Gal. of New South Wales, Sydney.

ABOUT: Bell, C. Victor Pasmore, 1944; Pasmore, V. "Victor Pasmore" (cat.), Redfern Gal., London, 1949; P-Orridge, G. and others (eds.) Contemporary Artists, 1977; Read, H. A Concise History of Modern Art, 1959; Reichardt, J. Victor Pasmore, 1962; Ritchie, A. C. "Masters of British Painting, 1800–1950" (cat.), MOMA, NYC, 1956; Seuphor, M. Dictionary of Abstract Painting, 1957. *Periodicals*—Art and Artists March 1969; Art in America no. 4 1960; Art International (Lugano) March 1972; Art News Summer 1956, May 1981; Art News November 12, 1949, April 27, 1959; Aujourd'hui (Paris) no. 4 1955; Burlington Magazine (London) May 1960; Christian Science Monitor February 10, 1951, December 11, 1965; Guardian May 15, 1965, May 23, 1968, March 22, 1969; Horizon March 1945; London Sunday Times February 5, 1961; New Statesman and Nation June 4, 1965, September 23, 1977; New York Times October 14, 1983; (London) Times March 8, 1961; Zodiac (Brussels) no. 1 1957.

PEARLSTEIN, PHILIP (May 24, 1924–), American painter, is one of the leading proponents of a return to realism in painting and is best known for his boldly rendered nudes.

He was the only child of David Pearlstein and the former Libby Kalser. His father sold chickens and eggs to support the family through difficult Depression years in his native Pittsburgh. In high school, the 17-year-old Pearlstein won a *Scholastic Magazine* art contest. Reginald Marsh chose two of his paintings, *Merry-Go-Round* and

PHILIP PEARLSTEIN

Wylie Avenue Barber Shop, the latter located in the black section of Pittsburgh, to appear as full-color reproductions in *Life* magazine.

After high school, Pearlstein studied at the Carnegie Institute of Technology, Pittsburgh, until he was drafted into the US Army. His wartime service included painting signs for an infantry unit. At the end of World War II, in 1946, he returned to Carnegie.

Pearlstein earned his BFA degree in 1949, and then moved to New York City, to attend New York University's Institute of Fine Arts. For several months he shared a room with a former Carnegie classmate, Andy Warhol, with whom he would be compared years later. Pearlstein supported himself by drafting industrial trade catalogs with graphics designer Ladislav Sutner. For eight years he drew Sutner's precise Bauhaus images, and at night he painted. At times, his style was still expressionistic.

In 1950 Pearlstein married the painter Dorothy Cantor. Then, and in the years following, he painted with the turbulent brushstrokes of abstract expressionism, but his subject matter— landscapes, figures, even objects found in plumbing catalogs—was realistic. He briefly anticipated Warhol's pop paintings with *Superman, The American Eagle, Statue of Liberty,* and *Dick Tracy,* some of which were seen in group shows in New York City at the Creative Gallery, in 1952, and at the Tanager Gallery, in 1952 and '53.

Two of his expressionistic figurative works were selected by Clement Greenberg, the champion of abstract expressionism, to be included in the "Emerging Talent" show at the Kootz Gal-

lery, New York City, in 1954. He attracted attention but not praise. One reviewer dismissed his canvases as "analogous to Soutine."

During the summer of 1954 in Maine, Pearlstein found the subject that would sustain his full interest and inspire all of his paintings of the next few years: the rocky landscape. The earliest canvases, which had been based on landscape drawings, were seen at Pearlstein's first solo show at the Tanager Gallery in 1955. Uprooted trees and splintered rocks characterized scenes of violent upheaval. The *New York Times* review (February 5, 1955) described them as "less statements of fact than they are statements of brusque expressive brushwork, from which the image emerges after a tussle."

Other paintings based on the Maine drawings were shown at the Peridot Gallery, New York City, in 1956, 1957, and 1959. Pearlstein's style remained the same, but he brightened his somber palette with touches of orange, carmine, and pale green. Dore Ashton called Pearlstein "an authentic heir to the expressionist–naturalist tradition" (*New York Times*, February 21, 1956). A year later she noted in the *Times* that, unlike the work of other expressionists, each of Pearlstein's paintings was "a document of exhaustive study."

Pearlstein won a Fulbright Fellowship and spent the year 1958–59 in Italy. He made detailed drawings of Roman ruins, which reminded him of Maine rocks on a larger scale, and executed studies of the cliffs at Positano. These drawings served as the basis for a series of massive canvases—eight feet across—which he painted after his return to the US. They were exhibited at the Allan Frumkin Gallery, New York City, in 1962. One critic pointed to the conflict between Pearlstein's closely observed realism and his abstract, garish color and expressionistic brushwork. Pearlstein himself realized that his style was, as he put it, "schizoid." "I began my studies of the Roman ruins initially as compositional schemes," he said in an *Art in America* interview in September 1981. "I was aware of all the metaphorical implications. You can't help it; a world has died and you are seeing the remains with all their emotional overtones. That's what I was not interested in, and tried to eliminate from the drawings. But when I made paintings from those drawing, I was trying to express something emotional in a more general way— and of course those works relate to Abstract Expressionism."

His large Italian landscapes became increasingly realistic and precise, but the decisive change in Pearlstein's approach was still to come. Since 1959 he had been meeting once a week with a group of artists in the studio of Mercedes Matter. They drew models from life. The manner in which Matter posed the models caused Pearlstein to look at them as impassively as he did the rocks in Maine and the ruins in Rome. Also in 1959, he began teaching at Pratt Institute, Brooklyn, a post that he held until 1963. Teaching forced him to talk about his work, to formulate coherent ideas about realism.

In the summer of 1962, Pearlstein published "Figure Paintings Today Are Not Made in Heaven" (*Art News*.) "The naked human figure," he proclaimed, is "conceived as a self-contained entity possessed of its own dignity, existing in an inhabitable space, viewed from a single vantage point." His stated artistic aims and his new choice of subject matter ran counter to the prevailing aesthetic that was based on the flatness of the picture plane and held realism in contempt.

His realism was first seen in an exhibition of male and female figure drawings at the Allan Frumkin Gallery in 1962. The couples were viewed in close-up, and the treatment was cool, unsentimental, depersonalized, clinically explicit yet sexless. Irving Sandler's review in *Art News*, which appeared in the same issue as Pearlstein's article, noted that the figures had "the matter-of-fact quality of the mountains and the rocks in the earlier pictures. . . . "

In order to rid himself of the rhetoric of abstract expressionism, Pearlstein took the crucial and final step of painting the nude model directly from life. What emerged has been described as "the proto-typical Pearlstein picture"—one or two nude figures, seen in close-up, at odd angles, totally unidealized, drastically foreshortened, and often with hands, feet, or even heads cropped out of the picture. "Without the head, you're not so directly concerned with the personality of the model," he said.

Pearlstein does not structure his work strictly in relation to the edge of the canvas. Often he has a general idea of the overall image and begins by painting a foot or some other part of the body; then he works his way deliberately across the canvas, and the cropping occurs when he reaches the edge. "I remember giving problems at Pratt where I had students deliberately set up a situation using simple geometric forms to make the picture-plane fight for its life," he said "You do that by pushing things to the extreme edge."

The first Pearlstein nudes painted directly from life were exhibited at the Frumkin Gallery in 1963. Pearlstein "has not only regained the figure for painting," commented *Arts Magazine*, "he has put it *behind* the plane and in deep

space. He paints the nude not as a symbol of beauty and pure form but as a human *fact*—implicitly imperfect." Physical imperfections were accentuated by the harsh, artificial light and cold shadows in which Pearlstein bathed his figures. Primarily a draftsman, he painted in a near-monochrome, with touches of color reserved mostly for the accessories—chairs, drapes, rugs—which added to the arid, unsensual quality of his images. "My paintings were not small and they were not sentimentalized," Pearlstein explained. "My reputation had more to do with painting ugly figures than with realism." He denies psychological overtones or relationships, as well as the metaphysical despair that has been read into his paintings. His titles are as factual and literal as the canvases—*Male and Female Models Sitting on Floor, Two Models with Blue Drape,* and *Female Model on Ladder.*

In the 1960s this emotional neutrality was in keeping with the emphasis on "cool" which was manifested in Andy Warhol's repetitive images and in minimal art. The advent of photo-realism in the 1970s led to a renewed interest in Pearlstein's work, and he has been regarded as a forerunner of that movement, though his intention—technical command—is different.

In 1965 Pearlstein began painting portraits, with the same relentless matter-of-factness that characterized his nudes. His sitters have included his dealer Allan Frumkin (1965), Leonard Bocour (1966), the painter Raphael Soyer, the artist's two daughters, Julia and Ellen, in a double portrait of 1967, and his son William. Also in the mid–1960s, he began making lithographs.

In 1970–71 a major Pearlstein retrospective toured the Georgia Museum of Art, Athens, the Wichita Art Museum, and the Vassar College Art Gallery. The "international abstractionist barrier" had been broken, it was said after his solo shows in Germany, Sweden, and Switzerland. John Perreault of the *Village Voice* (April 13, 1972) called the artist's paintings "tough and uncompromising." Pearlstein's "stark style, his persistence, his single-mindedness [make] a unique statement and a unique criticism of modernism."

In 1974 Pearlstein was awarded the Painting Prize in the First International Biennial of Figurative Painting, Tokyo. A major Pearlstein retrospective was mounted by the Brooklyn Museum of Art in the summer of 1983.

The large paintings in Pearlstein's show at the Frumkin Gallery in 1976 represent a new departure. The spirit of the nudes was as austere and impersonal as ever, but they appeared as single, greater-than-life-size figures done with a meticulously rendered "prop"—an oak stool, a plat-

form rocker, or a ladder. *Female Model on Lozenge-Patterned Drape* introduced a range of colors not seen before in Pearlstein's work. Likewise, *Two Female Models on Eames Chair and Stool,* compositionally close to his earlier works, was remarkable for the artist's attentiveness to a floral rug. The large format gave Pearlstein's figures a certain monumentality, and in the catalog another new feature, "the incredible rendering of complex shadow patterns," was discussed.

Philip Pearlstein lives with his family in a four-story brownstone on New York City's Upper West Side. He has a collection of pre-Columbian sculpture, Japanese block prints, classical artifacts, an assortment of rocks and fossils, and Oriental rugs which often appear in his paintings.

His work, he says, "has to do with taking realism as an art idea and using it for its own sake, rather than as a vehicle for social comment or any other literary kind of statement."

EXHIBITIONS INCLUDE: Tanager Gal., NYC 1955, '59; Peridot Gal., NYC 1956, '57, '59; Allan Frumkin Gal., Chicago 1960, '65, '69, '73, '75; Allan Frumkin Gal., NYC from 1962; Georgia Mus. of Art, Athens 1970–71; Wichita Art Mus., Kans. 1971; Vassar Col. Art Gal., Poughkeepsie, N.Y. 1971; Hansen-Fuller Gal., San Francisco 1972; Gal. M.E. Thulen, Cologne 1972; Gal. Ostergren, Malmö, Sweden 1972; Gal. Kornfeld, Zürich 1972; Finch Col., NYC 1974; Miami Art Center 1975; Gimpel Fils, London 1975; Marianne Friedland Gal., Toronto 1975; Donald Morris Gal., Detroit 1976; Brooklyn Mus. of Art, N.Y. 1983. GROUP EXHIBITIONS INCLUDE: Creative Gal., NYC 1952; Tanager Gal., NYC 1952, '53; "Emerging Talent," Kootz Gal., NYC 1954; Pittsburgh International, Carnegie Inst. 1955, '67; Whitney Annual, NYC 1955–72; "Ten American Artists," Palazzo Venezia, Rome 1959; Biennial Exhibition, Corcoran Gal., of Art, Washington, D.C. 1967, '71; Holland Festival, Hague 1968; "Return to the Figure," Pennsylvania Academy of Fine Arts, Philadelphia 1971–72; Nat. Academy of Arts and Letters, NYC 1973; "American Drawing 1970–1973," Yale Univ., New Haven, Conn. 1973; First International Biennial Exhibition of Figurative Painting, Tokyo 1974; "Portrait Painting 1975," Allan Frumkin Gal., NYC 1975; "Nothing but Nudes," Downtown Whitney Mus. of Am. Art, NYC 1977; "The Figure Thirteen Ways," Landmark Gal., NYC 1978.

COLLECTIONS INCLUDE: MOMA and Whitney Mus. of Am. Art, NYC; Hirshhorn Mus. and Sculpture Garden, and Corcoran Gal., Washington, D.C.; Art Inst. of Chicago; Philadelphia Mus. of Art; Allentown Art Mus., Pa.; San Antonio Mus. Association, Tex.; Vassar Col. Collection, Poughkeepsie, N.Y.; Williams Col. Mus. of Art, Williamstown, Mass.; Peter Ludwig Collection, Aachen, W. Ger.

ABOUT: Current Biography, 1973; Kramer, H. The Age

of the Avant-Garde, 1973; "Pearlstein" (cat.), Georgia Mus. of Art, Athens 1970. *Periodicals*—American Artist Magazine February 1973; Art and Artists September 1973; Art in America September–October 1971, September 1981; Art News September 1961, Summer 1962; Arts Magazine April 1963; New York Times February 5, 1955, February 21, 1956; March 12, 1957, February 17, 1974, February 15, 1976, August 1, 1983; Newsweek December 24, 1973; Paris Review Spring 1975; Village Voice April 13, 1972, February 14, 1974.

***PEREIRA, I(RENE) RICE** (August 5, 1907– January 11, 1971), American painter, was best known for her spatial paintings on glass. Highly individualistic, these paintings were not readily defined by contemporary art movements of their time, and Pereira, who from the exhibition of her first abstract works in 1937 until her death in 1971 was widely recognized, has suffered neglect.

She was born Irene Rice near Boston in Chelsea, Massachusetts, to Emanuel Rice, a Polish Immigrant, and Hilda Vanderbilt, of American and German descent. The family moved to the Berkshires area, then to Boston, and finally to Brooklyn, where Irene attended high school. She was a lonely child whose greatest pleasure was reading, and in her teens she aspired to be a poet. Her father's death in 1922 forced her to assume financial responsibilities for her family—which included a younger sister—and she took a job as a stenographer. In the evenings she took a class in fashion design at the Traphagen School at Washington Irving High School, and she studied literature at New York University. Her introductory art classes were taken at Washington Irving High School, and in 1927 she enrolled in evening classes at the Art Students League. She studied there for three years under Richard Lahey and Jan Matulka. In general, she worked from a model, but also experimented with cubist abstraction. David Smith, Lucille Corcos, and Burgoyne Diller were her fellow students.

In 1929, she married Humberto Pereira, a commercial artist and painter, and became professionally I. Rice Pereira. The Pereiras lived in New York, and Irene Pereira continued to work as a secretary. It was at this time that her interest in philosophy began to develop.

In the summer of 1931 Pereira sailed to Europe. Enroute, she made sketches of the ship's machinery that would influence later paintings. She traveled to Paris and studied at the Académie Moderne with Amédée Ozenfant, whose theories of "unadorned functionalism" she adopted. She also traveled in Switzerland and Italy, and then went to North Africa. There, she saw the immense Sahara desert. Her first

sight of it, she later said, was the greatest experience of my life." Her earliest direct encounter with vast space and light, it would have a great influence on her aesthetic outlook and, eventually, on her paintings.

Pereira returned to the United States in 1932, and spent the summer of that year on Cape Cod. From 1933 to 1937, she painted boats and related motifs—anchors, wharves, rigging, machinery—with bold, strong brushstrokes in a basically realistic style, though she was beginning to experiment with geometric abstraction and to incorporate her knowledge of machinery.

Pereira had three solo shows at the A.C.A. Gallery, New York City, in 1933, '34, and '35 when she exhibited her first purely abstract works in a group show held in the East River Gallery, New York City in 1937. In relation to her work as a whole, these canvases are transitional. They are geometric and in a foreshadowing of her first paintings on glass, they show a growing concern with light as a phenomenon independent of representation. However, they are more heavily painted than her later work. She grounded works such as *The Diagonal* (1938) in Mondrian's neoplasticism and Russian constructivism but departed from both forms by emphasizing textual variation and surface toning.

Her marriage to Humberto Pereira ended in divorce in 1938. In the years 1935 to 1939, Pereira was associated with the Works Progress Administration's Federal Arts Project. She planned courses in industrial design and worked as an instructor of design, painting, and composition in the Design Laboratory and, later, in the Easel Division. During this period she was part of the group known as the American Abstract Artists, which included Josef Albers, Ilya Bolotowsky, Fritz Glarner, and Burgoyne Diller.

Pereira was searching, she said, for the "plastic equivalent for the revolutionary discoveries in mathematics, physics, biochemistry and radioactivity." At that time (about 1940) she was painting rectilinear grids and mazes, and her abstractions painted between 1940 and 1942 were simple and two-dimensional. In 1941 she began to work on translucent parchment, and some of these paintings, including *White Lines* (1942; Museum of Modern Art, New York City) were marked by a strict linearity.

After 1942 Pereira's compositions became more complex, and she achieved the illusion of planes receding into space. She had first painted on glass in 1939, and now used glass to further increase this ambiguous sense of depth: by setting up two or three parallel planes she incorporated light and added to the complexity of perception, since now the planes shifted as the

viewer moved. In some ways, Pereira anticipated op art. Her work on parchment and, later, with gold and silver leaf, on marble dust, mica, and transparent lacquers anticipated abstract expressionsim. Though she would abandon painting on glass, Pereira considered the glass and parchment pieces that incorporated natural light to be mediators between the mind and divinity. "Light exists in the depths of man's psyche," she said.

In 1946, she was included in the prestigious "Fourteen Americans" show organized by Dorothy C. Miller at the Museum of Modern Art. In her works done on canvas and parchment between 1948 and 1950, Pereira first painted the backgrounds and then the rectangles, which seemed to rest on planes closer to the viewer. With this method, she achieved even greater depth illusion by causing a multi-planar sensation on a single plane.

Pereira had married George Wellington Brown in 1942, and they were divorced in 1950. She spent that summer in England, where she met the poet George Reavey, who was teaching at the University of Manchester. They were married on September 9, and lived nine months in Salford, a suburb of Manchester. Deprived of light, as she was in the bleak, industrial region, Pereira realized the importance of light in her work. The violent, highly emotional drawings she produced—which were "automatic" works in the surrealist sense of the word—are the antithesis of her firmly structured geometric compositions. These drawings reveal a very different side of her nature (even though her ordered works were *not* plotted in advance, and contained an element of intuition). Her mystic sense of depth symbolized for Pereira life and infinity, and she believed that geometric forms are symbolic reflections of the structure of the universe.

In May 1951 Pereira returned to the United States. During the summer she taught art classes at Ball State Teachers College, Muncie, Indiana, and in the fall she and Reavey settled in New York City. Throughout the 1950s she tempered the strict geometry of her compositions with greater freedom in the surfaces and backgrounds, as in *Toward the Absolute* (1955) and *Landscape of the Absolute* (1955; Whitney Museum of American Art, New York City). She reduced the complexity of her works in the 1960's. The backgrounds now are sometimes divided into horizontal zones that give the illusion of landscape. *Light Sphering Itself* (1964), with its suggestion of beach, ocean and sky, is an example.

A major exhibit of Pereira's works, shown with the works of Loren MacIver at the Whitney Museum in 1953, confirmed her stature as an innovator. She was included in "Nature in Abstraction," the Whitney's group show of 1958 which toured the United States.

In her later years, Pereira increasingly characterized her art in intricate metaphysical essays, while the paintings themselves became clearer. Some of her last paintings, such as *The Intimate Power* (1968), are devoid of natural allusions and the compositions are simplified. A religious attitude is present in some of her writings—five books and an extensive output of poems and essays—which include *Light and the New Reality* (1951), *The Nature of Space* (1956), *The Lapis* (1957), and *The Crystal of the Rose* (1959). While strengthened belief may have led her to convert to Catholicism in 1963, it did little to explain her more complex works. In fact, Pereira's writings often made their interpretation more difficult.

Irene Rice Pereira died at age 64, on a visit to Marbella, a resort west of Málaga on Spain's Costa del Sol. Her friend Therese Schwartz, in an article titled "Demystifying Pereira" in *Art in America* (October 1979), described her as she was in 1951: "small, dark and shapely," with a dynamic manner and a beautiful speaking voice. Her studio, on West 15th Street near Greenwich Village was "orderly and designed for work."

As an artist, she dedicated most of her life to a search for light. "It is only an incident that light defines objects," she said, "but the flow of light from out of the depth of the painting, that is the thing that makes a synthesis between inner and outer reality."

EXHIBITIONS INCLUDE: A.C.A. Gal., NYC 1933, '34, '35, '46, '49; Howard Univ., Washington, D.C. 1938; Julian Levy Gal., NYC 1939; Art of this Century, NYC 1944; Arts Club, Chicago 1945; Mus. of Art, San Franciso 1947, '53; Barnett Aden Gal., Washington, D.C. 1948; Phillips Academy, Addison Gal. of Am. Art, Andover, Mass. 1949; Mus. of Art, Santa Barbara, Calif. 1950; M.H. deYoung Memorial Mus., San Francisco 1950; Mus. of Art, Baltimore 1951; Ball State Teachers Col., Muncie, Ind. 1951; Phillips Gal., Washington, D.C. 1952; Vassar Col., Poughkeepsie, N.Y. 1953; Univ. of Michigan, Ann Arbor 1954; Corcoran Gal., Washington, D.C. 1956; Lee Nordness Gal., NYC 1958, '59, '61; Rome-New York Foundation, Rome 1960; A.A.A. Gal., Washington, D.C. 1961; Gal. Internationale, NYC 1964; Univ. of North Carolina, Chapel Hill 1968. GROUP EXHIBITIONS INCLUDE: East River Gal., NYC 1937, '39; "Fourteen Americans," MOMA, NYC 1946; São Paulo Bienal 1951; "Loren MacIver and I. Rice Pereira," Whitney Mus. of Am. Art, NYC 1953; Whitney Mus. of Am. Art, NYC 1955, '56; "20th Century Highlights," United States Information Agency, Washington, D.C. 1957; "Nature in Abstraction," Whitney Mus. of Am. Art, NYC 1958; Corcoran Gal., Washington, D.C. 1970.

COLLECTIONS INCLUDE: Metropolitan Mus. of Art, MOMA, Whitney Mus. of Am. Art, and Solomon R. Guggenheim Mus., NYC; Finch Col., N.Y.; Vassar Col., Poughkeepsie, N.Y.; State Univ. of New York, New Paltz; Newark Mus., N.J. Wadsworth Atheneum, Hartford, Conn.; Mus. of Fine Arts, Boston; Phillips Academy, Andover, Mass.; Brandeis Univ., Waltham, Mass.; Smith Col., Northampton, Mass.; Howard Univ., Washington, D.C.; Mus. of Art, Baltimore; William Rockhill Nelson Gal. of Art, Kansas City, Mo.; Art Inst., Chicago; Art Inst., Detroit; State Univ. of Iowa, Iowa City; Walker Art Center, Minneapolis; Ball State Teachers Col., Muncie, Ind.; Isaac Delgado Mus. of Art, New Orleans; Art Mus., Phoenix, Ariz.; Mus. of Fine Arts, Dallas; Mus. of Art, San Francisco.

ABOUT: Baur, J.I.H. "Loren MacIver, I. Rice Pereira" (cat.), Whitney Mus. of Am. Art, NYC, 1953; Hitchcock, H.-R. Painting Toward Architecture, 1948; Janis, S. Abstract and Surrealist Art in America 1944; Kootz, S.M. New Features in American Painting, 1943; Miller, D.C. (ed.) "Fourteen Americans" (cat.), MOMA, NYC, 1946; Pellegrini, A. New Tendencies in Art, 1966; Pereira, I. R. The Transformation of "Nothing" and the Paradox of Space, 1955, The Nature of Space, 1956, The Lapis, 1957, The Crystal of the Rose, 1959; Ritchie, A.C. Abstract Painting and Sculpture in America, 1951. Periodicals—American Contemporary Art October 1944; Art in America July 1947, October 1979; Art News September 1952; Palette Spring 1952; Vogue June 1970.

Grace Borgenicht Gallery, NYC

GABOR PETERDI

PETERDI, GABOR (September 17,1915–), Hungarian-American printmaker and painter, carries on the tradition of technical innovation in printmaking begun in Stanley William Hayter's Atelier 17, where he studied for several years. His prints, dark, brooding scenes of violence during the war years, became by the 1960s luminous and colorful landscapes; his paintings followed this trend, capturing in a maze of alphabetic brushstrokes the depths of tropical or arctic vistas.

A Hungarian by birth, Peterdi grew up near Budapest. He was an artistic prodigy, entering the Hungarian Academy of Fine Arts in 1929, at the age of 14, and the following year winning the Prix de Rome. After brief study in Rome, he went to Paris, where he attended the Académie Julien, the Académie Scandinave, and, most importantly, Hayter's Atelier 17, the last from 1933 to 1939 and again in 1947 when the workshop was moved to New York City. Peterdi was one of a number of artists, among them Karl Schrag and Mauricio Lasansky, strongly influenced by Hayter's artistic and pedagogical style. Hayter's own intaglio work was aggressively linear, and he started all his students with the burin, which Peterdi quickly mastered. Peterdi went on to explore such exotic techniques as viscosity printing

(the printing of three colors at one time by rolling nonmixing inks on different levels bitten into the plate), first developed at Atelier 17, and the use of power tools to cut, gouge, and engrave the plate.

Peterdi spent some time in Germany in the 1930s and his work of the period shows the influence of German expressionism and surrealism. His etching/engravings Despair I (1938), the "Black Bull" series (published by Jeanne Bucher in 1939), and The Great Battle (1939), are masterly, chaotic imbroglios of men and beasts, full of violent forebodings. The artist immigrated to the US in mid-1939, when it was obvious that Europe was to be engulfed in war, and joined the US Army. Later he captured the horror of war in such prints as Still Life in Germany (1946), The Death of Dawn (1947), Sign of the Lobster (1947, his first color print), and the tumultuous Apocalypse (1952). Uniting these works are their overall dark cast, savagely gouged white areas, active, sometimes frantic line-work, and complex, surreal imagery.

In 1948 Peterdi organized a print workshop in the basement of the Brooklyn Museum. A number of artists, Peterdi included, ran individual studios under the aegis of the museum, teaching every printing method and style in an atmosphere of productive chaos rather different from the strict regime under Hayter at Atelier 17. This workshop was one of the most important seedbeds for the postwar renaissance in American printmaking. Peterdi stayed until 1953, when he became a visiting professor at Yale University and Hunter College in Manhattan. Stylistically and technically, this was a period of

consolidation and growth. He began combining multiple printing techniques in one work: for example, *Miracle of the Forest* (1949), a linoleum cut, of two figures in a glade, is overprinted with a second plate etched, engraved, and aquatinted. Abstract themes of war and primordial strife persisted in his work, as in *The Massacre of the Innocents* and *The Black Horn,* both of 1952, and *The Vision of Fear* (1953). He wrote: "All miracles of nature and behind it all the lingering terror of the atomic age—I want to paint all this and say, 'A man was here.'"

Increasingly in the 1950s Peterdi turned to natural forms—plants, bones, boulders—as sources for abstraction. At the same time the complex vigor of life, and not the imminence of destruction, became his inspiration. This can be seen in the "Germination" series he began in 1952, the "Swamp" series (1954), and the "Rock" series (1955). Peterdi described his *Burning Rocks* (1955) as "a volcanic eruption symbolizing the cataclysmic power of nature." Depictions of the earth in upheaval gave way, in the late '50s and early '60s, to gentler representations of waving vegetation, especially in his paintings. There could not be a greater contrast between the print *Apocalypse* (1955) and the painting *The Gentle Greens of Spring* (1957), which won the prize at the Eighth Annual New England Exhibition of Painting and Sculpture. Executed in a fine, nervous calligraphy resembling that of Mark Tobey, Peterdi's paintings are active conglomerations of colored brushstrokes which, when seen from a distance, resolve into universalized landscapes in aerial or closeup view. In both prints and paintings he is expert at capturing the mood of a scene, whether the frigid beauty in *Arctic Night IV* (1964; he toured Alaska in the early '60s), dense undergrowth (*Cathedral,* 1958), or tropical seascapes (*Sea and Land and Moon,* 1967, based on a trip to Hawaii). Wrote Judith Tannebaum of his paintings in *Arts Magazine* (December 1974): "All-over patterns of zig-zag strokes superimposed on pastel-like variegated fields of color suggest, define, and transform landscape and seascape elements. Peterdi's vibrant tones both veil and reveal the forms of rolling hills, reefs, and waves, and evoke palpable atmospheric states." Late representative works such as *Gold Meadow* (1976), *Boiling Sea* (1978), and *Wetland Rust* (1979) hover on the verge of realistic representation, but still require an act of imagination by the viewer to yield a specificity of place. His recent prints, some as large as the paintings and utilizing every kind of technique, have developed along the same lines.

Peterdi's *Printmaking, Methods Old and New,* now a standard text on the subject, was published in 1959 and has since gone through several editions, the last in 1980. In 1969 the artist published a second book, *Great Prints of the World.*

Peterdi now lives in Rowayton, Connecticut. Despite his long career as a teacher, he believes that "the artist's only responsibility is to create memorable images."

EXHIBITIONS INCLUDE: Ernst Mus., Budapest 1930, '34; Nat. Gal., Prague 1930; Gal. Nazionale, Rome 1930; Gal. Jeanne Bucher, Paris 1936; Julien Levy Gal., NYC 1939; Norlyst Gal., NYC 1943, '44; Laurel Gal., NYC 1948, '49; Philadelphia Art Alliance 1950, '55; Smithsonian Instn., Washington, D.C. 1951; Grace Borgenicht Gal., NYC from 1952; St. George's Gal., London 1958; Mus. of Fine Arts, Boston 1959; Brooklyn Mus. 1959; Corcoran Gal., Washington, D.C. 1964; Far Gal., NYC 1970; Nielsen Gal., Boston 1975. GROUP EXHIBITIONS INCLUDE: Salon des Indépendants, Paris 1936, '38; Library of Congress, Washington, D.C. 1943, '47; Print Club, Philadelphia 1948; Brooklyn Mus. 1948, '49, '64; MOMA, NYC 1949; Pennsylvania, Academy of Fine Arts, Philadelphia 1949, '61.

COLLECTIONS INCLUDE:Metropolitan Mus. of Art, and MOMA, NYC; Brooklyn Mus., N.Y.; Albright-Knox Gal., Buffalo, N.Y.; Princeton Univ., N.J.; Wadsworth Atheneum, Hartford, Conn.; Mus. of Fine Arts, Boston; Phillips Academy, Andover, Mass.; Brandeis Univ., Waltham, Mass.; Corcoran Gal., and Smithsonian Instn., Washington, D.C.; Mus. of Art, Baltimore; Cleveland Mus. of Art; Chicago Art Inst.; Honolulu Academy; Mus. Nazionale, Rome; Nat. Gal., Prague; Nat. Gal., Budapest.

ABOUT: Hayter, S.W. New Ways of Gravure, 1949; About Prints, 1962; Johnson, U. American Prints and Printmakers, 1980; Peterdi, G. Printmaking, Methods Old and New, 1959; Great Prints of the World, 1969. *Periodicals*—Art News May 1977; Arts Magazine December 1974; New York Times November 1, 1959, October 30, 1962; Washington Post February 23, 1964.

***PEVSNER, ANTOINE** (January 18, 1886– April 12, 1962), Russian sculptor and painter, was a leading Constructivist. He was born into a large, well-to-do family in the Russian City of Orel. There is some dispute over the year of Pevsner's birth, which is often given as 1886, but Jacques Busse, author of an article on Pevsner in the *Dictionnaire des peintres, sculpteurs et graveurs,* records 1884 as the correct date. His father, Boris Pevsner, was an industrialist involved in cooper refining, and his two elder brothers were engineers. One of them, Alexei, published a biographical sketch in 1964 of Antoine and Naum, a younger brother with whom Pevsner wrote the "Constructivist Manifesto." Pevsner's family encouraged him to study art, and in 1902 he entered the School of Fine Arts

°äN twän´

ANTOINE PEVSNER

in Kiev. He studied there until 1909, although the instruction he received interested him less than the Pechersky Monastery and Kiev's medieval art. The Russian medieval icons conveyed mobility in the arrangement of planes rather than the placing of figures in action; this created an inverted perspective that intrigued Pevsner. In 1910, he continued his studies at the Academy of Fine Arts in St. Petersburg. Again, he was disappointed in the instruction, and more than ever impressed by Russian and also Byzantine icons.

In St. Petersburg he was introduced to impressionism, cubism and fauvism, and decided to leave for Paris where he arrived in time for the 1911 cubist exhibition at the Salon des Indépendants. It is said that in Paris he preferred the metal architecture of the Eiffel Tower to cubist paintings, which he found disappointing. He returned to Russia for a year before settling in Paris in 1913. He met Alexander Archipenko and Amadeo Modigliani, and it has been claimed that their friendship inspired him to paint his first abstract canvas, *Study of a Head.*

When Germany declared war on August 1, 1914, Pevsner's brothers Naum and Alexei were in Munich. (Naum had not yet changed his surname to Gabo and was at that time trained in medicine and engineering.) To avoid internment as enemy aliens in Germany and the draft in Russia, Naum and Alexei left Munich the next day for Scandinavia and settled in Oslo for much of the war's duration. By that time, Naum had taken up figurative sculpture and had changed his surname to Gabo, to avoid being confused with his brother Antoine. During this period in Norway, from 1915 to 1917, Pevsner and Gabo laid the basis for what was to become constructivism.

Among Gabo's most significant works in those years is *Constructed Head; No. 2* (1916), a semi-abstract metal sculpture based on the disposition and interlocking of precisely defined planes and on the rhythmic organization of space. Pevsner would develop his own individual style much later than his brother. At this time he was still a painter, and his canvases, including *Carnival* and *The Absinthe* (both later acquired by the Moscow State Museum of Modern Western Art), were expressionistic, with elements of fantasy. He was increasingly drawn to sculpture, and with Gabo he experimented in a new art, which, they explained, would be "capable of utilizing emptiness and liberating us from the compact mass."

After the outbreak of the Russian Revolution in 1917, Pevsner and Gabo returned home, eager to bring their already formed concepts for a future art into the fervent atmosphere of experimentation and innovation in art and social structure that marked the first phase of the revolutionary era. Immediately Pevsner was appointed a professor at the State School of Fine Arts, Moscow; his teaching colleagues were Kandinsky, Malevich, and Tatlin.

In 1919 Pevsner and Gabo formulated their "Constructivist Manifesto," also called the "Realist Manifesto," which they posted on the walls of Moscow in August 1920.

The Manifesto declared for thought over feeling, reality over allegory and abstraction. Works of art must be "constructed," in the strictest sense of the word (the term "constructivism," was coined by Vladimir Tatlin): all the arts—painting, sculpture, architecture—must be synthesized and collectively subordinated to an overall construction, the "backbone" of which is time and space. Above all, "Art will always be alive as one of the indispensable expressions of human experience. . . . " Very few of Pevsner's works survived this Moscow period; however, it seems that he was at this time more concerned with the development of ideas than the realization of art.

In 1920, Pevsner married Virginia de Voinoff-Chilingarian, a singer. That year, government authorities demanded an art of revolutionary propaganda that was accessible to all. Kamenev (Trotsky's brother-in-law and one of Lenin's successors) had already denounced certain avant-garde artists in the Soviet of April 1919, and opposition to abstract and experimental art spread. Before long, constructivism was superseded by socialist realism, the "official" art of the state.

Between 1920 and 1922 Gabo produced his

first abstract constructions in wood, metal, and plastic materials; in 1920, he created a motorized steel sculpture, *Kinetic Composition,* possibly the first mobile. In 1922, he left Russia for Berlin, ostensibly to participate in the First Russian Art Exhibition, organized by Soviet artists in Berlin. Still a painter, Pevsner had moved from the figurative style of his pre-1917 canvas *The Absinthe* to the near-abstraction of *Woman's Head,* in which the head was reduced to a circle within a triangle, and then to the total abstraction of *Abstract Forms,* a painting in encaustic. In the fall of 1923, he joined his brother in Berlin.

In Berlin, Pevsner met Marcel Duchamp and Katherine Dreier, and it is believed that under Duchamp's influence Pevsner abandoned painting for sculpture. He settled in Paris in the winter of 1923. (He became a French citizen in 1930.) He established himself as a major Constructivist sculptor with works such as *Projection into Space* (1924; Baltimore Museum of Art), in oxidized iron and which corresponded aesthetically to the aims of the Futurist sculptors; *Torso* 1924–26) a copper and plastic construction now owned by the Museum of Modern Art, New York City; and *Portrait of Marcel Duchamp* (1926), in celluloid and zinc and now in the collection of the Yale University Art Gallery, New Haven, Connecticut. In 1926, the lyrical constructivism developed by Pevsner and Gabo reached a larger audience when the two brothers were commissioned by Serge Diaghilev to create sets and costumes for the ballet *La Chatte* which was successfully produced in Monte Carlo, Paris, London, and Berlin in 1927.

Throughout the 1920s, Gabo had visited his brother in Paris, and finally, in 1932, Gabo left Nazi-threatened Berlin "for political reasons," and joined Pevsner in Paris. He became a member of the Abstraction-Création group in Paris, whose members included Auguste Herbin, François Kupka, Mondrian and Pevsner, who had joined in 1931.

Pevsner was now finding his own idiom as a sculptor. In 1932 he published his manifesto, "Nonfigurative Art," in *Abstraction-Création,* the group's magazine. The first phase of his sculpture reached its peak in *Construction for an Airport* (1935) in which the theme—dynamic surfaces evolved from linear elements—was expressed with great force and individuality. He carried this theme further in *Developable Surface* (1936), an outstanding work that came to represent the *leitmotiv* of his career.

In *Contemporary Artists* Konstantin Bazarov described Pevsner's method in creating his series of "Developable Surfaces": "Using bronze wires welded together to give an effect of uncompromising severity and bareness, he constructs parabolas, spirals and other curved surfaces, each of which seems to extend indefinitely into the surrounding space, so that in place of defined volumes there are dynamic curves exploding outward in all directions." From then on Pevsner's work was based on the principle of "implied movement."

During World II Pevsner lived and worked in seclusion in Paris. (His brother passed the war in England and later moved to the US, where he became a naturalized citizen.) *The Black Lily (Spiral Construction* (1943; Hirshhorn Museum and Sculpture Garden, Washington, D.C.), in bronze, dates from this period. After the war, in 1946, Pevsner cofounded, with Auguste Herbin, Albert Gleizes, and others, a new art association called Réalités Nouvelles. He participated in their group exhibitions, from 1947 until his death. In addition, a major showing of his work was held in 1947 at the Galerie René Drouin, Paris.

Although Pevsner contributed to various international exhibitions in Europe and the United States in the 1930s, it was only after World War II that he was recognized and honored as one of the pioneers of constructivist sculpture. In 1953, he took Second Prize in the much-debated international competition for design and construction of a monument to the Unknown Political Prisoner, organized by the Institute of Contemporary Arts in London. (The Englishman Reg Butler won First Prize.) In 1956 an important Pevsner retrospective was held at the Museé National d'Art Moderne, Paris, and in 1958 an entire room at the Venice Biennale was devoted to his work.

Pevsner's commissions from abroad include two large architectural sculptures, one executed in 1950 for the Cité Universitaire, Caracas, Venezuela, another completed in 1955 and erected in front of the Technical Center of General Motors, Detroit. Pevsner gave the Detroit piece the metaphorical title *Bird Ascending.*

In 1961, Pevsner was named as a Chevalier de la Légion d'Honneur by the French government. He died in Paris in the spring of 1962.

Antoine Pevsner was described by a writer who visited him in his studio on the outskirts of Paris early in 1957 as "a small slight man with the high forehead and the pallor of an indoor intellectual—receding grey hair, the ghost of a white mustache hardly visible." When Alexander Liberman photographed Pevsner in 1953, he found the studio "filled with carefully displayed sculptures, each one breaking up space in a willfully preconceived manner."

Pevsner used the precision instruments of an engineer as artistic tools and was one of the first to use a blowtorch in sculpture. He wanted his works to be regarded not only as sculptural parallels to certain technological processes but as poetic creations in their own right. As he told Liberman, "Art must be inspiration controlled by mathematics. I have a need for peace, symphony, orchestration."

EXHIBITIONS INCLUDE: Gal. René Drouin, Paris 1947; Mus. Nat. d'Art Moderne, Paris 1956–57. GROUP EXHIBITIONS INCLUDE: Tverskoi Boulevard Open-Air Exhibition, Moscow 1920; "Erste Russische Kunstausstellung," Gal. van Dieman, Berlin 1922; "Constructivistes Russes: Gabo et Pevsner," Gal. Percier, Paris 1924; "Van Doesburg: Pevsner: Gabo," Little Review Gal., NYC 1926; "Cercle et Carré," Gal. 23, Paris 1930; "Pevsner: Gabo," Arts Club, Chicago 1936; "Cubism and Abstract Art," MOMA, NYC 1936; "Art of Our Time," MOMA, NYC 1939; "Réalités Nouvelles," Gal. Charpentier, Paris 1939; "Art concret," Gal. René Drouin, Paris 1946–47; "Pevsner: Gabo," MOMA, NYC 1948; "Antoine Pevsner: Max Bill: Georges Vantongerloo," Kunsthaus, Zürich 1949; "Festival of Britain 1951," Battersea Park, London 1951; "Chefs d'oeuvres de XXe siècle," Mus. Nat. d'Art Moderne, Paris 1952; "Chefs d'oeuvres du XXe siècle," Tate Gal., London 1952; "Seven Pioneers of Modern Sculpture," City Hall, Yverdon, Switzerland 1954; "The Sources of Contemporary Art," Stedelijk Mus., Amsterdam 1956; Venice Biennale 1958.

COLLECTIONS INCLUDE: Nat. d'Art Moderne, Paris; Tate Gal., London; Stedelijk Mus., Amsterdam; Kunstmus., Basel; Peggy Guggenheim Foundation, Venice; Mus. of Modern Art, Vienna; Tretyakov Mus., Moscow; MOMA, and Solomon R. Guggenheim Mus., NYC; Albright-Knox Art Gal., Buffalo, N.Y.; Yale Univ. Art Gal., New Haven, Conn.; Phillips Collection, and Hirshhorn Mus. and Sculpture Garden, Washington, D.C.; Mus. of Art, Baltimore; Art Inst., Chicago; General Motors, Detroit; City Univ., Caracas, Venezuela.

ABOUT: Bénézit, E. (ed.) Dictionnaire des peintres, sculpteurs et graveurs, 1976; Bill, M. Das Werk, 1938; Current Biography, 1959; Drouin, R. (ed.) "Antoine Pevsner" (cat.), Gal. René Drouin, Paris, 1947; Liberman, A. The Artist in This Studio, 1960; Massat, R. Antoine Pevsner et le constructivisme, 1956; Moore, E. (ed.) Contemporary Art 1942–1972: Collection of the Albright-Knox Art Gallery, 1972; "Naum Gabo and Antoine Pevsner" (cat.), MOMA, NYC, 1948; Peissi, P. and others Antoine Pevsner, 1961; Pevsner, A. A Biographical Sketch of my Brothers Naum Gabo and Antoine Pevsner, 1964; Pevsner, A. and others Realist Manifesto, 1920, New Concepts in Collecting Modern Art, 1957; P-Orridge, G. and others (eds.) Contemporary Artists, 1977; Read, H. A Concise History of Modern Sculpture, 1964; Seuphor, M. Le Style et le cri, 1965. Periodicals—Abstraction-Création (Paris) 1933; Art News March 1958; New York Times May 28, 1962; Réalités nouvelles (Paris) no. 4 1950; XXe siècle (Paris) no. 1 1951, no. 12 1959.

*PICASSO, PABLO (RUIZ) (October 25, 1881–April 8, 1973), Spanish painter, sculptor, graphic artist, and ceramist, is probably the most written about artist in history, with Leonardo da Vinci a close runner-up. Like Michelangelo in the 16th century, Picasso, through his boundless energy and productivity and the range and power of his vision and personality, left an indelible stamp on the art of his time. It is impossible to imagine the modern world without Picasso, for more than any other artist he has shaped our awareness of what it feels like to live in this turbulent century. Though his work has been neatly divided by art historians into "periods," the giant Picasso retrospective of 1980 at the Museum of Modern Art, New York City, showed the recurrence of certain basic motifs amid the dazzling succession, and sometimes coexistence, of styles. Picasso stated in 1923: "I do not believe that I have used radically different elements in the different manners I have used in painting. . . . Whenever I have had something to say, I have said it in the manner in which I felt it ought to be said." His lifelong friend, the art dealer Daniel-Henri Kahnweiler, once commented, "I know of no art that is autobiographical to such a degree," and called him "a man of the immediate moment."

The diversity of Picasso's genius, the complexity of his character, and his paradoxical, often contradictory, statements on art prompted the writer Georges Ribémont Dessaignes to remark, "Nothing that anyone can say about Picasso is correct." And there is considerable critical disagreement in the assessment of his work after World War II. With New York replacing Paris as the art center of the world, Picasso has had less direct influence on artists who reached maturity after 1950 than Kandinsky, Mondrian, Miró, and Duchamp. Even Matisse, especially with his late paper cutouts, had greater impact on such styles as color-field painting. One body of opinion insists that in his later years Picasso lost touch with the contemporary world and was using his inexhaustible inventiveness to plunge, in the words of Konstantin Bazarov, "into a kind of retrospective working of his former innovations." The English Marxist critic John Berger accused the artist of retreating "into an idealized and sentimentalized pantheism" instead of traveling outside Europe and becoming "the artist of the emerging world." Berger also remarked on the absence in Picasso of a culminating "late style" comparable to that of Titian, Goya, Monet, or Cézanne.

Even if Picasso's work after 1945 was less innovative than his creations of the pre–World War I period, these indictments fail to do justice to the positive achievements of his later years, es-

°pē kä´ sō, pä´ blō

Photo by Douglas Duncan

PABLO PICASSO

pecially his ceramics and some of his most brilliantly personal sculptures. Above all, there was the youthful vigor and enthusiasm with which he pursued his art until the very end. If he often gave the impression in the 1950s and '60s of "a giant at play," he was still a giant.

Finally, his late phase cannot be isolated from the totality of his work, and many artists have built whole careers on one brief phase of the Picasso oeuvre. Even after the cubist movement had long passed its peak, the demonic energy and passion of *Guernica* (1937) was a major influence on Jackson Pollock and other Americans. The impact of Picasso's few "junk reliefs" of 1913–14 was felt not only in Russian constructivism and certain aspects of dada, but in the assemblages of the late 1950s and '60s in the United States, most notably in the revolutionary combine-paintings of Robert Rauschenberg. Also, magazine reproductions of the open-work metal sculptures of Picasso and Julio González from the early 1930s were a point of departure for David Smith, who did for sculpture in the postwar years what Pollock and de Kooning did for painting.

If in terms of sheer painting Matisse and Braque are supreme in this century—Picasso was never primarily a colorist—the uniqueness of Picasso's genius lies partly in the fact that he seems to have relived the entire history of art from prehistoric cave paintings to American comic strips. He was convinced that, in his words, "the whole world is open before us, everything waiting to be done, not just redone."

He was born in Málaga, Andalusia, the eldest child of Don José Ruiz Blasco, a painter and teacher at the San Telmo School of Arts and Trades, and Doña Maria Picasso Lopez. Pablo's sisters, Lola and Concepción (Conchita), were born in 1884 and 1887 respectively. Pablo could draw, it is said, before he could speak, and he began to paint at the age of seven. He attended bullfights with his father, and his earliest picture was a bullfight painting, *Picador* (1889–90). In 1891 Don José accepted a position as art teacher at the Instituto da Guarda, a secondary school in Coruña, on the Atlantic coast of Spain, where Pablo moved with his family. The following year he studied drawing and painting at the school under the instruction of his father, who allowed him to finish details of his own paintings, some of which were of doves (later a frequent Picasso motif). In 1894 Don José, discouraged, is said to have handed his precocious son his palette, brushes, and paints, declaring that he would never paint again. In *Success and Failure of Picasso* John Berger writes that if this actually happened "it is likely to have been a deeply formative experience for the young Picasso. . . . Is it likely that a boy will ever believe in progress step by step when at the age of puberty he is suddenly told by his father that he deserves to take his father's place and that his father is going to step down?" According to Berger, the guilt Picasso may have felt could have been relieved by the belief that "the only thing which can count is the mysterious power he feels within himself."

In 1895 Don José was offered a post as professor at the La Llonja School of Fine Arts in Barcelona. On the way the family stopped off in Madrid, where Pablo visited the Prado for the first time. He applied for entrance to the La Llonja School and, through his father's influence, was allowed to take the entrance examination for the advanced class in drawing, which he passed brilliantly, completing the examination in one day. Later that year Don José found Pablo his own studio in the calle de la Plata, near their home in the calle de la Merced. In the winter of 1895–96 Pablo painted a large "academic" subject-picture, *First Communion,* for which his father was the model for the male figure. The painting was shown in the Municipal Exhibition of 1896, along with works by Isidro Nonell and other Catalan artists. Pablo's second large subject-picture, *Science and Charity,* in which his father posed for the doctor by the bedside of a sick child, was completed early in 1897, and received an honorable mention in the National Exhibition of Fine Arts in Madrid.

In September 1897 Pablo left for Madrid, and repeated his Barcelona feat by completing in one day the drawing examination for admission to advanced classes at the Royal Academy of San Fernando where he stayed only a few months,

which led to a falling out with his father. He returned to Barcelona in 1898 to recover from an attack of scarlet fever, and joined a group of bohemian artists and poets at the Café Els Quatre Gats (The Four Cats), among whom were the painter Isidro Nonell, the poet Jaime Sabartès, who years later in Paris became Picasso's secretary, and the art historian Miguel Utrillo. This circle of Catalan intellectuals aroused his interest in Toulouse-Lautrec and other fin-de-siècle artists of France and northern Europe, and he also gained an appreciation of El Greco, Velázquez, Zurbarán, and medieval Catalan art, especially the Romanesque frescoes.

The year 1900 saw the first publication of his drawings in the magazines *Joventut* (Youth) and *Pel et Ploma* (Brush and Pen). With his friend Carlos Casagemas, Picasso made his first visit to Paris, where the dealer Berthe Weill bought three pastels of bullfights. Picasso's first Paris picture, *Moulin de la Galette* (1900), shows the influence of Toulouse-Lautrec and has a sultry nocturnal atmosphere, very different from Renoir's joyous rendering of the same locale 23 years earlier. During a brief stay in Madrid in 1901, he was cofounder, with the young Catalan writer Francisco de Asis Soler, of the review *Arte Joven* (Young Art), serving as art editor and illustrator of the four issues that were published before the journal folded. He returned to Paris in the spring of 1901 and had his first exhibition, at the gallery of Ambroise Vollard, showing mostly cabaret and race-course scenes painted in an energetic, impressionistic, but not yet completely personal style.

Picasso's so-called Blue Period, with its melancholy waifs and derelicts painted in cool, predominantly blue tonalities, dates from late 1901. At this time, to quote Sabartès, "he believes Art to be the Child of Sadness and Pain," and the pictures reflect his sense of isolation, his lack of funds, and the poverty and dejection he saw in the streets and cafés of Paris and Barcelona. Some of these canvases border on sentimentality, but others, including his compelling *Self-Portrait* (Paris, winter of 1901) and *Two Women at a Bar* (Barcelona, 1902) are strong personal statements, revealing Picasso's powerful, expressive draftsmanship. Previously he had signed his works Pablo Ruiz, or P. Ruiz Picasso, but from now on he signed himself with his mother's family name.

About 1902, the eccentric poet-critic Max Jacob, who had attended Picasso's opening at Vollard's gallery in 1901, became the young artist's close friend, and that fall Picasso moved into Jacob's small, fifth-floor room on the Boulevard Voltaire. They shared their poverty, and in later,

prosperous years Picasso would remember those days with nostalgia. Early in 1903 Picasso left once again for Barcelona, where he remained a whole year and where, in the spring, he painted the large allegorical canvas later called *La Vie*. The most ambitious work of his Blue Period, it had echoes of Purvis de Chavannes and Gauguin, and the standing male figure, which began as a self-portrait, was given the features of his friend Casagemas, whose suicide in February 1901 over an unhappy love affair had greatly distressed Picasso. The style of this moody, enigmatic work, if carried further, could easily have led to a near-academic symbolism, but Picasso's Spanish expressionism rescued him. In *The Old Guitarist* (Barcelona, autumn of 1903), distortions inspired by El Greco and the 16th-century Spanish Mannerists create a drastic compression of the forms within the rectangle of the canvas which anticipates cubism and avoids the bathos inherent in the theme, especially as the guitarist is blind. But blindness in the figures of Picasso's Blue Period—*The Blindman's Meal* is another example—carries implications of an inner vision and the compensation of spiritual depth, of a heightened sensitivity to feeling and touching. There was also the Spanish concern with physical disability, found in Velázquez and Goya, and present in two small Picasso sculptures, *Mask of a Blind Singer* and *Mask of a Picador with Broken Nose,* both of 1903, which show dramatic insight into character.

Picasso left Barcelona for Paris in the spring of 1904, never to return to Catalonia except for brief visits. Settling for good in Paris, he moved into the dilapidated wooden building at 13 rue Ravignan in Montmartre, whimsically named the "Bateau-Lavoir" by Max Jacob, after the barges on the Seine where working women did their washing. The painter Kees van Dongen and the poet André Salmon were already living there; Max Jacob brought the writer Maurice Raynal (who became Picasso's lifelong friend) and the poet Guillaume Apollinaire, and the Bateau-Lavoir became known as the *rendezvous des poètes*.

About this time Picasso met the Spanish sculptors Pablo Gargallo and Julio González, and soon afterwards the French painters André Derain, Fernand Léger, Henri Rousseau, and Maurice Vlaminck. In 1904, while working on his poignant and masterful etching, *The Frugal Repast* (again a blind man, here caressing a beloved companion), Picasso met the beautiful Fernande Olivier. A fellow-tenant in the building, where Picasso was to live until 1909, Olivier became his mistress and frequent model. In her book *Picasso and his Friends* she described the artist at the time of their first meeting as "small, black, thick-

set, restless, disquieting, with eyes dark, profound, piercing, strange, almost staring. [There was] a thick lock of hair, black and shiny, slashed across his intelligent and obstinate forehead. [He was] half bohemian, half workman in his dress."

The year 1905 saw an improvement in Picasso's circumstances. His happiness with Fernande and recognition by a small but growing circle of friends were reflected in his first Rose Period paintings—tenderly lyrical circus scenes of youthful mountebanks and harlequins with their families and pets. *Young Acrobat on a Ball,* in the Hermitage, Leningrad, and *The Family of Saltimbanques,* in Washington, D.C.'s National Gallery, are outstanding works of this period, which also included exquisite dry points and etchings of similar subjects. In the summer of 1905 he visited Holland, which he did not care for but where, during his month-long stay, he painted the robust nude study *Dutch Girl.* There was a more detached mood in the paintings he did in Paris in the fall of 1905, when *Woman with a Fan* and *Young Girl with a Bushel of Flowers* were bought by the American expatriates Gertrude and Leo Stein (the latter had previously purchased the gouache *The Acrobat's Family with a Monkey*).

Picasso soon became a frequent visitor at the Stein's salon in the rue de Fleurus, where he was to meet Matisse in 1906. (At this time Picasso's work was far less radical than that of Matisse and the Fauves, who scandalized viewers at the opening of the Salon d'Automne in October 1905.) That winter he began his famous portrait of Gertrude Stein; the anecdote about how, after some 80 or 90 sittings, he painted out the head and remarked irritably, "I no longer see you when I look at you," is now legendary.

In May 1906, eager to renew contact with his roots and stimulated by pre-Roman Iberian sculpture he had seen at the Louvre, Picasso left with Fernande for Spain. One of his first canvases to reflect the archaic quality of Iberian sculpture was *Women with Loaves,* begun in Gosol in the Pyrenees and completed after his return to Paris. There he resumed his portrait of Gertrude Stein without the model, repainting the head from memory and giving it the masklike severity and flat, simple planes of Iberian sculpture while preserving, even emphasizing, the character of the subject. Although the style of the head differs from that of the rest of the figure, the painting works, conveying Gertrude's massive, dominant presence and keen intelligence. When her friends protested that she did not resemble her portrait (now in the Metropolitan Museum of Art, New York City) Picasso replied, "Never mind—in time she will look just like it." Ger-

trude herself declared years later in her idiosyncratic style, "It is the only portrait of me which is really I for me."

Picasso's assimilation of the Iberian style was advanced in the *Self-Portrait* of 1906 and was carried even further in the squat heavy proportions of *Two Nudes,* which was painted later that year and represented a complete break with the graceful lyricism of the Rose Period. But none of Picasso's colleagues and admirers were prepared for the visual assault and battery of the very large canvas he completed in July 1907, *Les Demoiselles d'Avignon* (MOMA). Early gouache studies for the painting show that the original theme was to be two men, a sailor and a medical student, visiting a brothel, and the title alluded to a street in the red-light district of Barcelona. As the idea developed, all anecdote was eliminated and only the five female nudes remained. Their stark primitivism went far beyond the formalizations of Iberian sculpture, and was a frontal attack on virtually the entire tradition of Western painting. Even more shocking was the irruption of the two right-hand nudes, completed after the rest of the composition.

In May or June of 1907, while still working on the painting, Picasso had discovered African sculpture in the Musée de l'Homme, the ethnographic museum in the Trocadéro. African woodcarvings had already been collected by Vlaminck, Derain, and Matisse, but Picasso responded more viscerally than any of his colleagues to the hypnotic intensity and nonrealistic geometrization of these ancestral images. They also provided a release for his restless search for more vital means of expression. Once again the confrontation of styles in the painting heightened its dramatic tension. Matisse's large *Bonheur de vivre* (1905, Joy of Living) had been a challenge, but Picasso's more immediate influences were the electric palette and violent compressions and distortions of the late paintings of El Greco, and the impersonality and shifting rhythms of Cézanne's *Bathers.* (Years later, when Picasso was asked whether El Greco and Cézanne had been his major influences, he replied, "Everyone has to have a father and mother.")

Even Picasso's more advanced fellow artists and supporters were dismayed upon first viewing *Les Demoiselles* in the Bateau-Lavoir. Matisse thought it was a hoax that would discredit modern art, and Georges Braque, in a much-quoted remark, said that Picasso was trying to "force us to eat rope and drink paraffin instead of our accustomed food." The Russian collector Sergei Shchukin, a Picasso supporter since 1905, exclaimed, with tears in his eyes, "What a loss for

French art!" But eventually all of them were affected by this revolutionary canvas, a major step in the evolution of cubism and a painting that, after more than 75 years, has not lost its impact. Among the very few who admired it from the beginning was the German-born Kahnweiler, who became Picasso's main dealer and a close personal friend.

Now there was no going back. The momentum generated by *Les Demoiselles* was carried further in the so-called African or protocubist paintings of the winter of 1908–09. In the fall of 1908 Braque showed at Kahnweiler's gallery the highly abstracted L'Estaque landscapes he had painted in the summer. The critic Louis Vauxcelles, who had coined the term "fauve," reviewed the show in *Gil Blas* (November 4, 1908), writing that everything was reduced "to geometric schemes, to cubes," and by late 1910 the term cubism was common among avant-garde painters and critics.

Meanwhile Picasso had become fascinated by the naive paintings of Henri Rousseau, the Douanier, and in 1908 bought his *Portrait of a Woman* from a bric-a-brac merchant. In November he and Fernande gave the famous banquet for Rousseau which was attended by Apollinaire, the painter Marie Laurencin, Brague, and Gertrude Stein, among others. Picasso was touched and amused when the old artist said to him: "You and I are the greatest painters of our time. You in the Egyptian, I in the modern style."

Braque and Picasso, so different in appearance and personality—the one short, impulsive, and mercurial; the other tall, slow-moving, and reticent—became close friends in the winter of 1908–09. This was the beginning of an extraordinary collaboration in which, "roped together like mountaineers," in Braque's felicitous phrase, they were to create the style known as analytical cubism. It was a radically new resolution of the age-old problem of interpreting the three-dimensional world in terms of the two-dimensional picture surface. In analytical cubism, multiple views of any given object were juxtaposed or superimposed in order to express the idea of its structure and position in space. This was the ultimate rejection of Renaissance perspective and illusionism. But as Picasso insisted, "When we invented cubism we had no intention whatever of inventing cubism. We wanted simply to express what was in us."

Analogies have been made between cubism and Einstein's relativity theories and the mathematician Herman Minkowski's concepts of time-space, but whatever validity these comparisons may have, no such theoretical program was drawn up by the artists themselves. Cubism was a reshaping of the visible world in terms of form and color, keeping, in Picasso's words, "within the limits and limitations of painting."

A key work in the development of Picasso's analytical cubist style was *Fernande,* painted in Horta de Ebro, Spain, in the summer of 1909, a year he always regarded as one of his happiest. The head is broken into sharply defined light and dark planes, and color, as in all cubist paintings, is completely subordinated to formal structure and tends to the monochromatic. Picasso sometimes crystalized his discoveries by working them out in three dimensions, and in Paris in the fall of 1909 he modeled *Head of a Woman (Fernande)* in the studio of his friend Julio González. By destroying the continuity of the surface, and reducing the outward form to sharp-edged geometric planes, Picasso brought out the internal focus of the head in this, one of the earliest pieces of cubist sculpture. Both the painting and the bronze sculpture are in MOMA. The few landscapes painted by Picasso in Horta, while still owing much to Cézanne, show how readily the spare, blocklike forms of the Spanish buildings and the dried-out monochromatic tonalities of the landscape lent themselves to the geometric cubist treatment.

In 1909 Picasso moved to a larger Paris studio at 11, Boulevard de Clichy, near Place Pigalle. Early in 1910 he ceased work on *Girl with Mandolin* (the "girl" was Fanny Tellier), in which sculptured roundness was giving way to a flattening of the forms, producing the effect of a fragmented low relief. There was increasing subdivision of the forms into shaded, faceted, overlapping planes in two remarkable portraits painted in 1910. One was of the German artist-critic and collector Wilhelm Uhde, who, like Kahnweiler, had admired the *Demoiselles d'Avignon* from the outset; the other was of the art dealer Ambroise Vollard. Despite the utterly nonrealistic technique, Picasso captured the personalities of his sitters so successfully that a four-year-old girl immediately identified the bearded, snub-nosed Vollard, with his bulldog features. Over 24 years later the painter (and Picasso biographer) Roland Penrose, who had never met Uhde, recognized him in a crowded café. The portrait of Kahnweiler, also completed in 1910, was less individualized. But however intricate and "hermetic" the pictorial scaffolding in their figures and still lifes, Picasso and Braque never embraced complete abstraction, always leaving some clue for the viewer, some link, however tenuous, with reality. Their works of this period resemble each other so closely that it is often very hard to tell them apart.

The title of one of the culminating works of Picasso's analytical cubism, *Ma Jolie (Woman with a Guitar)* of 1911–12, was the name of a popular song, and was a reference to his new mistress, Eva (Marcelle Humbert), whom he met at the Steins' in the fall of 1911 when his relationship with Fernande was deteriorating. Lettering, an element first introduced by Braque in his canvas *The Portuguese* (1911), appeared in *Ma Jolie* and other works of 1911–12, combining what was literally real with the artist's personal interpretation of reality. In the spring of 1912 Braque, in a reminder of his early apprenticeship as painter-decorator, began to introduce areas of paint that simulated wood paneling, and later, marble surfaces. In a playfully inventive spirit, Picasso, in May 1912, pasted to the middle of an oval picture, *Still Life in a Chair*, a piece of actual oilcloth printed to look like the canework seat of a chair. The oval form of the canvas is framed in rope, and the oilcloth is itself partly painted over, creating a sophisticated interplay between different levels of reality. The *Still Life with Chair Caning*, as it is now called, was Picasso's first collage. During the summer of 1912, which Braque and Picasso spent together at Sorgues, near Avignon, the two painters experimented with flatter color areas and cutout paper, a development that was to lead to synthetic cubism.

Beginning in 1912, Picasso applied the principles of collage cubism to three-dimensional constructions in colored papers (*Guitar,* 1912), sheet metal and wire (another *Guitar* of 1912), cardboard and string (*Violin,* 1913–14), and painted and natural wood (*Mandolin*). The earliest of these constructions, which would now be called assemblages, were seen by Vladimir Tatlin and other Russians when they visited Paris in 1912, and this led to the movement in Russia called constructivism, which later spread to other countries. With a few works done almost as a sideline, Picasso affected the whole course of modern sculpture.

Picasso's happiness with Eva and his growing financial success were reflected in the lyricism and vivid color, enlivened by pointillist stippling, of his still lifes of 1914, notably *Green Still Life* (MOMA), painted that summer in Avignon. It is an example of what has been called "rococo" cubism. Stippling was also used in his playfully inventive polychrome sculpture of 1914, the *Glass of Absinthe,* in which the glass is dissected and recomposed to indicate its roundness, transparency, and hollowness, and the surface of the liquid within. A real absinthe spoon holding a replica of a lump of sugar is placed on top of the glass—the ensemble is yet another interplay of varying degrees of reality.

When war was declared on August 2, 1914, Braque and Derain were mobilized and Picasso saw them off at the station in Avignon. He later said, "I never saw them again." Like so many Picasso remarks, this was not meant to be taken literally, but after the war he and Braque were to follow very different paths, and there was no longer among Paris-domiciled artists the cohesiveness of the heroic years of cubism. As Spaniards, Picasso and Juan Gris, another pioneer of cubism, were neutrals and they remained in Paris. Picasso, somewhat isolated and little affected by the war, continued to paint in a colorful, decorative synthetic, cubist idiom. In 1915 he shocked his admirers and followers by making pencil drawings of Max Jacob and Ambroise Vollard in a meticulous style and technique harking back to the neoclassicism of Ingres, but he did not abandon cubism. Also in 1915 he painted his large (nearly six-feet-high) *Harlequin,* which was simpler and bolder in treatment than his rococo cubist works and initiated the "classic" period of synthetic cubism.

Both the neoclassic and decorative tendencies in Picasso's works were furthered by his association with Serge Diaghilev's Ballets Russe's. In May 1916 the avant-garde writer and poet Jean Cocteau brought the great impresario Diaghilev to Picasso's studio on rue Schoelcher in Montparnasse, and in August Picasso agreed to design the curtain and costumes for a ballet, *Parade,* in which the fairground action was devised by Cocteau and the music composed by Erik Satie. In January 1917 Picasso visited his family in Barcelona, and in February he and Cocteau left for Rome to join Diaghilev and the Ballets Russe's. In Rome Picasso enjoyed the company of the dancer Léonide Messine, the composer Igor Stravinsky, and the great Russian designer Léon Bakst. Visiting Naples and Pompeii, he was stimulated by the Pompeian frescoes and late antique sculpture, which contributed to his so-called classic period of the early 1920s. While attending rehearsals and performances of the troupe, he met the classically beautiful ballerina Olga Koklova, whom he was to marry in 1918. (Eva had died in December 1914 in Paris.)

The opening performance of *Parade,* at the Théâtre du Châtelet in wartime Paris (May 18, 1917), caused a near riot, as the audience was outraged by the "cacophonous" music of Satie and by Picasso's ten-foot-high cubist costumes, which towered up like a skyscraper and were outfitted with cowboy boots. Only the appearance onstage of Guillaume Apollinaire in uniform, his head bandaged from a severe war wound, managed to pacify the angry theatergoers, who suspected a sinister German plot. (Apollinaire, one of cubism's champions, died in the

influenza epidemic of 1918.) Picasso designed sets and costumes for other Diaghilev ballets in the postwar years, but none had the impact of *Parade*; in the '20s, the public became more accepting of experiment and novelty. Although there was not a single public show of Picasso's works between 1909 and 1919, Diaghilev introduced him to the middle class and thus secured his renown, which was to increase steadily from then on.

Picasso and Olga Koklova were married on July 12, 1918 in Paris. Their move to an elegant apartment at 23, rue La Boëtie marked the beginning of an affluent and fashionable phase of Picasso's career, strongly affected by Olga's conventional tastes and social pretensions. Picasso, at first fascinated by this glittering world, so different from his early surroundings, would eventually react violently against this whole way of life.

Meanwhile, happy in his marriage and his growing celebrity, he was working simultaneously, and with equal mastery, in two styles. The culminating works of his synthetic cubist period are the two versions of the *Three Musicians,* painted in Fontainebleau in the summer of 1921. The more concentrated of the two is in MOMA; the other, more complex work is in the Philadelphia Museum of Art. The commedia del l'arte theme of masked performers is combined with a Spanish sense of mystery and drama. The brilliantly decorative MOMA version has been reproduced on the sleeves of record albums, and its syncopated rhythms evoke the Jazz Age at its height. Some regard these paintings, and the sumptuous still lifes of 1919–24 which Picasso painted in Paris and in Juan-les-Pins on the Riviera, as "adulterations" of cubism. By this time cubism was indeed far less radical than it had been in its analytical phases and it was entering the public domain, at least in sophisticated circles; but at their best these works, with their daring transposition of reality, far transcend the superficially decorative and reflect the general relaxation of tensions in the postwar period.

Simultaneously with the synthetic cubist works, Picasso made striking pencil portraits of Satie and Stravinsky (both in 1920) and painted such monumentally neoclassic compositions as *Two Seated Women* (1920) and *Three Women at the Spring* (1921; MOMA), ponderous, sculpturally modeled figures painted in terra-cotta tonalities recalling Pompeii. Their impassivity and the objectivity of the style are very different from the lyrical classicism of the Rose Period; even in his figurative works of the early 1920s the impact of cubism was felt.

It is a tribute to Picasso's mastery that he was able to breathe life into the classical tradition, and it is significant that Stravinsky, with whom Picasso has often been compared, adopted a neoclassic style in music after 1918, reflecting a need for order in fragmented societies recovering from the shock of world war. For Picasso the style also provided a degree of relaxation from the more exacting explorations of cubism.

By late 1924 Picasso's mood was changing. There was growing tension in his marriage with Olga—despite the birth of their son Paulo in 1920, their differences in temperament and taste made crisis inevitable—and his frequenting of fashionable society, which had always involved a high degree of role playing, had lost its appeal. As Roland Penrose wrote, "In the world of his thought he was still isolated and lonely." Picasso's restlessness, and the influence of Surrealism—André Breton's "First Surrealist Manifesto" had been published in October 1924—were reflected in the new and disquieting note sounded in his works of 1925. The frenzied expressionism of *The Dance* (Tate Gallery, London), completed in Monte Carlo in June, was in complete contrast to the classical drawings of dance which he continued to produce. It was typical of Picasso that there should be contrasts within one picture. In *The Dance* the black silhouetted profile behind the violently distorted dancer on the right was a memento of the death of his old friend Ramón Pichot, and there was sadistic fury in the angry distortions of *The Embrace* (1925), also painted when his marriage was in turmoil.

Among Picasso's close friends were the Surrealist poets and writers Louis Aragon, Breton, and Paul Eluard. They and their followers applauded the demonic intensity of this new phase of Picasso's work, which seemed to have its sources in the unconscious, but Picasso could never accept the literary and often photographic approach of surrealist painting. For him even the most highly charged ideas and feelings needed to be expressed in powerful, self-contained *visual* imagery.

Picasso found some relief from his bitter mood when, in January 1927, he met the 17-year-old Marie-Thérèse Walter, who became his mistress six months later. Picasso, still officially married to Olga, kept the liaison secret for years, and his first paintings of Marie-Thérèse date from 1932; her blond, sensuous beauty was to be a major inspiration for his vibrant, colorful, curvilinear baroque-expressionist works of the early 1930s. Meanwhile the late 1920s saw some of Picasso's most obsessively surrealist imagery, especially in the paintings and drawings of bathers in his so-

called Bone Period, or metamorphic phase. They are like savage parodies of his serene neo-classic giantesses by the sea; their strongly mod-eled forms suggest sculpture. In fact, Picasso, in March 1928, had renewed his acquaintance with his old friend, the sculptor and master blacksmith from Barcelona, Julio González, who taught him the welding technique. Contrasting with the biomorphic forms of the Bone Period drawings and paintings of ball-playing bathers (possibly influenced by his younger friend Joan Miró) were his drawings for iron-wire constructions, linear scaffoldings that are virtually drawings in space and related, however distantly, to the human figure. This space-geometric approach was used in Picasso's large painting of 1927–28, *The Studio* (MOMA). Major metal sculptures resulting from the collaboration with González were the large, fantastic, semiabstract *Women in the Garden* (1929–30), in wrought iron and incorporating naturalistic philodendron leaves, and *Head of a Woman* (1930–31), containing painted iron, sheet metal, springs, and such found objects as colanders—an anticipation of American "junk sculpture" of the late 1950s.

Although he retained his Paris apartment, Picasso in 1932 bought a small 18th-century chateau in the village of Boisgeloup, near Gisors, northwest of Paris. He transformed the stables into various kinds of studios, with the coach house serving as a sculpture studio. From January to March of that year he painted a series of brilliantly colored portraits, nudes, and scenes of sleeping women, inspired by his involvement with Marie-Thérèse. These erotically charged canvases, combining extravagantly exaggerated forms (recalling Fuseli and Ingres) with vivid color, sensuously serpentine contours, and heavy black tracery, included *The Dream, The Mirror,* and *Nude on a Black Couch*. They culminated in one of Picasso's masterworks, *Girl Before a Mirror* (1932; MOMA). This complex, richly patterned painting suggests not only self-contemplation but inner tension, growth, and awareness of changing physical, mental, and emotional states. To quote Alfred H. Barr, the young woman's figure is "simultaneously clothed, nude and x-rayed." These paintings were paralleled by a series of over-life-size heads of Marie-Thérèse modeled in clay and wet plaster; some are classically restrained, others have forcefully exaggerated features. Another by-product of the liaison with Marie-Thérèse was a series of over 40 etchings, executed in 1932–34, on the theme "The Sculptor's Studio."

After years of estrangement, Picasso separated from Olga in 1935, the year Marie-Thérèse gave birth to his daughter, Maia. Also that year, which he later described as "the worst time in my life," he ceased working at Boisgeloup. To restore order and a semblance of continuity in his life, Picasso invited his old friend from the early Barcelona days, Jaime Sabartès, to move in with him in Paris and handle his business affairs. Sabartès moved to Paris with his wife and served for years as the artist's faithful secretary, watchdog, and general factotum. But Picasso's inner turmoil caused him temporarily to stop painting. Instead, influenced by the Surrealists, he experimented with stream of consciousness writing, composing "automatic" poems whose imagery was very different from the controlled energy of even his most violently expressionistic paintings.

Picasso's somber mood coincided with the darkening atmosphere of the 1930s, as the shadow of fascism spread across Europe and war seemed imminent. The element of the savage and monstrous crept into his art. The bull became a frequent motif, appearing in a series of agonized bullfighting subjects, and the Minotaur, the fabulous monster with the body of a man and the head of a bull, is the dominant figure in Picasso's most ambitious etching, the *Minotauromachia* of 1935, executed the year before the outbreak of the Spanish Civil War. In this powerful and enigmatic print, the bullfight theme is represented by the sadomasochistic image of a female matador, her breasts bared, stretched over a disemboweled horse. As the hairy Minotaur, who has risen from the sea, advances menacingly, he is confronted by the calm innocence of a little girl, with flowers in one hand and holding a candle aloft in the other. While a frightened bearded man scurries up a ladder, Spanish-looking women with a dovecote watch the scene below from their balcony. Picasso would never explain the dreamlike imagery which must have held private meanings for him, but which also seems strangely prophetic of the nightmare that would soon engulf the world. The *Minotauromachia* anticipates some of the themes of *Guernica*.

In 1936 Paul Eluard introduced Picasso to the vivacious, dark-haired Dora Maar, who later became his mistress and the subject of many paintings and drawings in the late '30s and early '40s. Although his personal life improved, Picasso was deeply affected by the outbreak in July 1936 of civil war in Spain. The beleaguered Republican government, acknowledging Picasso's wholehearted opposition to the Falange and General Franco, named him director of the Prado, although he did not go to Spain. In January 1937 he etched the savagely satirical *Dream and Lie of Franco*, with an accompanying poem, using the format of an American comic strip.

With Dora Maar's help Picasso found a new

studio at 7, rue des Grands-Augustins, and soon afterward, the Spanish Republican government invited him to paint a mural for the Spanish pavilion at the Paris World's Fair. Upon learning of the bombing, on April 26, 1937, of the defenseless Basque town of Guernica by German planes flying for Franco, Picasso knew that he had found his theme for the mural. He immediately began work in his new studio on sketches, done at white heat but always firmly controlled, for the huge canvas (nearly 12 feet high and 26 feet wide) which has become famous as *Guernica*. In keeping with the tragic theme, and mindful of Goya's "Disasters of War" etchings, Picasso used only black, white, and gray. He incorporated earlier motifs, but gave them epic significance. Moreover, he drew on his personal symbolism to express horror at the impersonal, mechanized barbarity of modern warfare in which, unlike the firing squad in Goya's *Third of May* painting in the Prado, the attackers do not see their victims. The stark light of an electric bulb forming the apex of the composition recalls the Eye of God in medieval Spanish frescoes of the Apocalypse, as the sudden explosion destroys human beings, animals, buildings, and the humble objects of everyday use. But the horse, the bull, and other images in the *Guernica* can, as always in Picasso, be interpreted on various levels, without diminishing the overall vision of a world shattered and fragmented by war. The mural, completed in less than a month, was installed in mid-June of 1937 in the Spanish pavilion of the Paris International Exhibition, along with a Mercury Fountain by Alexander Calder.

For many years *Guernica* was on loan to the Museum of Modern Art in New York City, where it influenced the younger American painters of the 1940s. Picasso refused to allow the work to go to Spain as long as the Franco dictatorship held power, but in 1980, seven years after the artist's death, and with democracy restored to his native land, it was sent to Madrid and installed in a specially designed annex to the Prado.

Picasso once said, "The painter makes paintings in the urgent need to discharge his own emotions and visions," and the urgency of *Guernica* was carried over into a series of agonized "postscripts," one of the most powerful of which was the small but concentrated *Weeping Woman* of October 1937 (Collection of Roland Penrose, London). Here Picasso used strident green, yellow, and red to express what Van Gogh called "those terrible things, the human passions." The subject was Dora Maar, but the splintered image, in its anguished intensity, is like a modern reinterpretation of the tragic mask of antiquity.

Picasso was in Antibes when war was declared in September 1939. He spent part of 1940 in Royan, near Bordeaux, returning frequently to Paris. In 1939–1940 a major retrospective, "Picasso: Forty Years of His Art," was held at MOMA. During the grim years of war and German occupation Picasso remained in Paris, working unceasingly in his studio and even, in 1941, writing a surrealist farce, *Le Désir attrapé par la queue* (Desire Caught by the Tail), in which the theme of hunger was treated with grotesque humor. It was given a reading in the artist's studio in March 1944 by a group of his friends, including Dora Maar, Jean-Paul Sartre, Simone de Beauvoir, and Albert Camus. Braque and his wife were in the audience. Picasso, forbidden to exhibit by the Nazi authorities, but not personally molested, became a living symbol of the creative spirit in a darkened world. His wartime canvases, including *Still Life with Steer's Skull* (1942), painted in a severely limited palette, in a modified cubist-expressionist manner and thoroughly Spanish in mood, reflect in their claustrophobic compression the tenseness and bleak austerity of the time. Materials for sculpture were hard to obtain, but Picasso's resourcefulness and humor came to the rescue in his *Bull's Head* of 1943, assembled from the handlebars and saddle of a derelict bicycle, a completely convincing "metamorphosis." In May 1943 he met Françoise Gilot, a young art student only a third his age. Intelligent and independent, she was a promising painter, and would soon replace the high-strung Dora Maar in his affections.

Also in 1943 Picasso made numerous drawings for a large sculpture, *Man with Sheep,* which he modeled in wet plaster and completed in one or two days sometime during 1944. The life-size statue, unlike anything Picasso had done before, and recreating in modern terms an archetypal theme, was later cast in bronze and was set up in 1953 in the little square of Vallauris, in the south of France near Antibes.

Following the liberation of Paris in August 1944, Picasso, after years of isolation from the outside world, was happy to open his studio to hosts of visitors, including GIs and admirers from the United States and Britain. He was reunited with Eluard, Aragon, and other friends from the Resistance, and on October 5 it was announced that he had joined the French Communist Party. He felt that it was the communists who had offered the most courageous and consistent opposition to the Nazi occupiers, and he declared, "I have always been in exile, now I no longer am." On October 6 there were violent demonstrations against Picasso at the reopening of the Salon d'Automne (dubbed, on this occasion, the "Salon de la Libération"), which

showed 74 of his paintings and five sculptures. The more radical forms of modernism had been banned by the Germans and their Vichy collaborators, and the demonstrators were mostly conservative Beaux-Arts students who attacked both Picasso's art and his political stance.

In April 1945 Françoise Gilot moved in with Picasso, the beginning of an association of more than 11 years. Picasso seemed to invent a new style for each of the women in his life, and in the Paris print workshop of Fernand Mourlot he made a series of lithographs of Françoise. At first he portrayed her realistically, as he had with Olga and Dora Maar, but in May 1946, after telling her, "You're like a growing plant," he painted her as a *Woman-Flower* with a stemlike body and with her cool, candid face surrounded by petals.

In July he and Françoise moved to Antibes, where Romuald Dor de la Souchère, curator of the Antibes Museum in the Palais Grimaldi, offered Picasso an entire floor of the museum as a painting studio. In return Picasso presented him with about 30 paintings produced that summer, including the Arcadian *Joie de vivre*. These charming, lighthearted paintings, thoroughly Mediterranean in spirit and full of dancing nymphs, flute-playing fauns and frolicking centaurs and goats, are less "important" than his wartime works, but they reflect the holiday mood of the immediate postwar years as well as his happiness and "second youth" with Françoise. Their first child, Claude, was born in 1947, and their daughter, Paloma, in April 1949.

In June 1947 Picasso and Françoise moved to Golfe-Juan, and in August he began making ceramics at nearby Vallauris, revitalizing the local pottery industry which had been in decline since World War I. Ceramics, as Roland Penrose pointed out, gave Picasso "a wide field for experiment in which the element of chance, so frequently his ally, plays an important part. [Ceramics had] the attraction for Picasso of combining painting and sculpture with utilitarian function." With boundless inventiveness, variety, and humor he produced an enormous quantity of ceramics, including plates, pitchers, decorative bowls, female statuettes, and animal and bird figures. The full-breasted female forms sometimes have a Minoan look, and their faces often have Françoise's features.

Amid all his artistic activities, Picasso did not neglect politics. In August, accompanied by Paul Eluard, he attended the Congress of Intellectuals for Peace in Wrocław, Poland, where a Russian delegate echoed the hostile views of a Moscow magazine that had condemned Picasso's works as "a sickly apology for capitalist aesthetics." The French Communist Party intellectuals were far more sophisticated than their Russian and East European counterparts, and in February 1949 Louis Aragon chose a Picasso lithograph of a pigeon or dove for a poster announcing the second Peace Congress, which was to open in Paris in April. Picasso's daughter, born that month, was named Paloma, the Spanish word for dove, after the artist's *Dove of Peace*, which was then being seen on posters throughout Paris and has become known worldwide as a symbol of the peace movement.

In January 1951, deeply disturbed by American intervention in the Korean War, Picasso painted *Massacre in Korea*, his most politically pointed picture, but also widely considered his least successful as a work of art. It is a programmatic rather than a felt statement. Picasso was more himself in the two large panels he executed for a deconsecrated 14th-century chapel in Vallauris which had been revived as a "temple of peace." The archaic, allegorical imagery in the *War* and *Peace* murals (installed in 1954) was far removed from socialist realism, but was the more effective in its message in that it expressed contrasting sides of Picasso's own nature. As Paul Eluard wrote, "He wants to defeat all tenderness with violence and all violence with tenderness."

Whatever his political sympathies, which caused a temporary drop in his sales in the United States, Picasso could never conform to the aesthetics of orthodox communism, and a line-drawing of Stalin, done at Aragon's request after the Soviet leader's death in 1953 and published in *Les Lettres Françaises*, drew the ire of the party faithful. Indeed, as Norman Mailer observed, Picasso was one of communism's "heretical geniuses."

Some of Picasso's most brilliantly inventive sculpture dates from 1950, notably the pregnant *She-Goat, Woman with Baby Carriage,* and *Little Girl Skipping Rope,* in which the limp rope itself is the child's support. In 1951, the year Picasso was made an honorary citizen of Vallauris, he created such memorable visual puns as *Baboon and Young,* in which the utterly convincing head is composed of two of his son Claude's toy automobiles, and the composite, painted sculpture *Goat Skull and Bottle* (completed in 1952). When, some years later, he was given a barbecue grill by American friends, with instructions for fitting the parts together, he said, "If it can't be assembled, I'll make a Venus out of it." Paradoxically, his sculpture reveals more of his private, improvisatory, "sketching" spirit than his work in any other medium.

By 1953 the relationship with Françoise had become strained. In her revealing book *Life with*

Picasso she described her discomfort at the presence in the same town of Picasso's estranged wife Olga (who died in 1955) and complained of what she called the artist's "Bluebeard complex" in his relationships with women. His need to dominate a worshipful entourage was creating a kind of Byzantine court atmosphere around him which she found oppressive. Françoise left Picasso in the late summer of 1953 and took the children with her to Paris. Her book is a candid, perceptive, and often humorous account of her years with Picasso. Though she never conceals his human flaws, her conversations with him about painting provide fascinating insights into his creative genius. Publication of Gilot's *Life with Picasso* in 1964 infuriated the artist and, sadly, led to a permanent rift between him and their children.

Picasso's despondency at Françoise's departure from Vallauris led to a remarkable series of drawings, published under the title "Picasso and the Human Comedy," in which with bitter irony he dwelled on the cruel contrast between an aged, frustrated artist and a female model who is eternally young and beautiful. He also poked wicked fun at the art world and its hangers-on. He soon found a devoted companion in the dark-haired Jacqueline Roque, whose profile reminded him of one of the women in Delacroix's *Women of Algiers.*

Picasso was deeply moved by the death, on November 3, 1954, of Henri Matisse; their old rivalry was in the distant past and they had become friends. Partly as a tribute to Matisse's odalisque paintings, Picasso began a series of dazzling variations on Delacroix's *Women of Algiers.* These were followed by 44 free versions, completed in 1957, of Velázquez's masterpiece, *The Meninas* (Maids of Honor) in the Prado. His third series in this vein was his 27 variations (1960–61) on Manet's *Déjeuner sur l'herbe* (Luncheon on the Grass). As Vicky Goldberg wrote in the *Saturday Review,* "The ransacking of art history he undertook in the Fifties and Sixties . . . was not so much a poverty of themes as an effort to nail down his place in the historic pantheon."

On March 2, 1961 the 80-year-old Picasso married Jacqueline Roque in Vallauris. In June they moved into a large villa called Mas Notre-Dame-De-Vie, near the village of Mougins in the hills above Cannes. It was here that Picasso lived for the rest of his life. In spite of the greater privacy afforded by his new home and by Jacqueline's solicitude, he continued to be a public figure. The gregarious, "performing" side of Picasso—the obverse of his dark, ruthlessly egomaniacal side—was expressed in his clowning for photographers. But none could disturb his solitude when he worked.

In 1963 a Picasso museum opened in Barcelona, and in the fall of 1966 Picasso's 85th birthday was celebrated by a giant Paris retrospective which filled the Grand Palais (paintings), the Petit Palais (drawings, sculpture, and ceramics), and the Bibliothèque Nationale (prints). It was at that time the largest assemblage ever seen of the works of a single artist.

In August 1967 a 50-foot-high steel sculpture, based on a 42-inch-high model by Picasso, was constructed by the American Bridge Company and erected at the new Civic Center in Chicago. Its semiabstract forms, which seem to combine the features of a woman with the head of a dog, received both critical praise and derision. *Portrait of Sylvette,* installed in 1968 on the urban, building-cluttered campus of New York University, was an enlargement of a metal cutout based on a portrait of the 20-year-old ponytailed Sylvette David which had been painted in 1954. No Picasso work is without interest, but these sculptures give the impression of small-scale pieces blown up rather than truly monumental works, although Picasso had long been fascinated by the idea of sculpture conceived as architecture.

Picasso continued to the very end to explore the world around him in his own distinctive language. After the death in February 1968 of Sabartès, he donated the "Meninas" series to the Picasso Museum in the memory of his old friend. In *Seated Man Wearing a Hat,* painted in Mougins in November 1971, one month after his 90th birthday, there appears for the first time a sense of exhaustion and bewilderment, not in the very free handling, but in the content of what is almost certainly intended as a self-portrait. The eyes, always so important in Picasso, express anguish and alarm in *Couple with Bouquet,* in spite of the bright, festive colors, and there is a note of desperation in *The Kiss* (October 1969), in which an aged bearded man seems to contemplate, not his loving but helpless companion, but the approach of death, a subject Picasso could never bear to discuss. In those last few years memories of Spain came crowding in, as in *The Matador* (October 1970), and a series of 17th-century cavaliers and musketeers, painted with a kind of furious hilarity. Eroticism flares up in some wildly distorted nudes. In this impulsive medley of neocubist and expressionist images, compositional rigor has given way to an almost slapdash bravado, a headlong defiance of fate, recalling Dylan Thomas's "Do not go gentle into that good night, . . . Rage, rage against the dying of the light." Though the paintings are un-

even, Picasso's last etchings and aquatints show no diminution of his wit, his imagination, his technical mastery, or his vision of the world as a stage with himself as the leading player.

Pablo Picasso died in his sleep at Mougins at the age of 93. By his bedside was a bundle of colored crayons tied with a rubber band, in case he should have an inspiration during the night. He was buried in the grounds of the 17th-century chateau of Vauvenargues, which he had acquired in 1958. Later in 1973 a mammoth show of his paintings done since 1969 was held in the Palace of the Popes in Avignon, turning the bare Gothic walls into a blaze of strident color. Not all the works were masterpieces, but the ensemble was a final tribute to Picasso's phenomenal creative energy, which, over a period of 70 years, had given, to quote from *Hamlet,* "the very age and body of the time his form and presence."

With his short, powerful build and piercing, magnetic eyes, Picasso, dark-haired in his youth and bald in his old age, was always a charismatic figure, a myth in his own lifetime. The dramatic, often disturbing contrasts in the complex personality of the man behind the myth have been copiously documented. Picasso was certainly the supreme artistic force of this century, though his influence, especially in the US, has been less in the decades after World War II than that of such aritists as Joan Miró and Marcel Duchamp. It is too early to have a definitive perspective on his life and work, but, then, finality was never his aim, and his whole career was "work in progress." As he once said, " . . . The painter never finishes . . . you can never write 'The End.'" Regarding his own work, he said in 1960, "If all the ways I have been along were marked on a map and joined with a line, it might represent a Minotaur."

EXHIBITIONS INCLUDE: Els Quatre Gats, Barcelona 1900; Ambroise Vollard, Paris 1901, '09; Gal. Berthe Weill, Paris 1902; Gal. Thannhäuser, Munich 1909, '22; Photo Secession Gal., NYC 1911; Stafford Gal., London 1912; Gal. Rosenberg, Paris 1919, '24, '36, '39; Gal. Georges Petit, Paris 1932; Wadsworth Atheneum, Hartford, Conn. 1934; New Burlington Gals., London, 1938; "Picasso: Forty Years of His Art," MOMA, NYC 1939–40; Gal. Louise Leiris, Paris 1948, '57, '59; Arts Council Gal., London 1948, '56; Gal. Nazionale d'Arte Moderna, Rome 1953; Mus. de Arte Moderna, São Paulo 1953; Mus. des Art Décoratifs, Paris 1955; Bibliothéque Nationale, Paris 1955; Haus der Kunst, Zürich 1955; Mus. of Art, Philadelphia 1958; Tate Gal., London 1960; "Hommage à Picasso," Grand Palais, Petit Palais, and Bibliothéque Nat. Paris 1966; Mus. Nat. d'Art Moderne, Paris 1971; Palace of the Popes, Avignon 1973; "Pablo Picasso: A Retrospective," MOMA, NYC 1980; "Picasso: The Last Years,

1963–1973," Solomon R. Guggenheim Mus., NYC 1984. GROUP EXHIBITIONS INCLUDE: Armory Show, NYC 1913; "Picasso and Matisse," Leicester Gals., London 1919; "Exposition, la peinture surréalists," Gal. Pierre, Paris 1925; International Exhibition, Petit Palais, Paris 1937; Salon d'Automne (Salon de la Libération), Paris 1944; "Picasso and Matisse," Victoria and Albert Mus., London 1945; "The Cubist Spirit and Its Time," Tate Gal., London 1947; Venice Biennale 1950; Salon de Mai, Paris 1952; "The Art of Assemblage," MOMA, NYC 1961; "The Essential Cubism: Braque, Picasso and Their Friends, 1907–20," Tate Gal., London 1983.

COLLECTIONS INCLUDE: Metropolitan Mus. of Art, MOMA, and Solomon R. Guggenheim Mus., NYC; Albright-Knox Art Gal., Buffalo, N.Y.; Yale Univ. Art Gal., New Haven, Conn.; Mus. of Fine Arts, Boston; Fogg Art Mus., Harvard Univ., Cambridge, Mass.; Smith Col. Mus. of Art, Northampton, Mass.; Philadelphia Mus.; Philadelphia Mus. of Art; National Gal. of Art, Phillips Collection, Hirshhorn Museum and Sculpture Garden, and Smithsonian Inst., Washington, D.C.; Cone Collection, Baltimore Mus. of Art; Cleveland Mus. of Art; Columbus Mus. of Art, Ohio; Toledo Mus. of Art, Ohio; Art Inst. of Chicago; Detroit Inst. of Arts; Santa Barbara Mus. of Art Calif.; Tate Gal., London; Ashmolean Mus., Oxford; Mus. Nat. d'Art Moderne, Centre Georges Pompidou (Beaubourg), Mus. d'Art Moderne de la Ville de Paris, and Mus. Picasso, Paris; Mus. des Beaux-Arts, Liege, Belgium; Stedelijk Mus., Amsterdam; Municipal Mus., The Hague; Rijksmus. Kröller-Müller, Otterlo, Neth.; Nasjonalgal. Oslo; Göteborg Konstmus. Göteborg, Sweden; Kunsthalle, Hamburg; Kunstmus. Hanover; Kunstsammlung Nordrhein-Wertfalen, Düsseldorf; Kunstmus., Basel; Thyssen-Bornemisza Collection, Lugano, Switzerland; National Gal., Prague; Hermitage Mus. Leningrad; Pushkin State Mus. of Fine Arts, Moscow; Israel Mus., Jerusalem; Hiroshima Mus. of Art, Japan; Queensland Art Gal., Brisbane, Australia.

ABOUT: Arnheim, R. Genesis of a Painting: Picasso's *Guernica,* 1962; Ashton, D. (ed.) Picasso on Art: A Selection of Views, 1972; Barr, A. H. Picasso: Fifty Years of His Art, 1980; Berger, J. Success and Failure of Picasso, 1965; Blunt, A. and Pool, P. Picasso: The Formative Years, 1962; Cooper, D. The Cubist Epoch, 1970; Elgar, F. Picasso, 1955; Geiser, P. (ed.) Picasso: 55 Years of His Graphic Work, 1962; Gilot, F. and Lake, C. Life with Picasso, 1964; Hughes, R. The Shock of the New, 1981; Olivier, F. Picasso and His Friends, 1965; Penrose, R. Picasso: His Life and Work, 3d ed. 1981, The Sculpture of Picasso, 1968; Ramié, G. Picasso: Pottery, 1962; Rubin, W. (ed.) "Pablo Picasso: A Retrospective" (cat,), MOMA, NYC, 1980; Stein, G. Picasso, 1939; Uhde, W. Picasso and the French Tradition, 1929.

***PIGNON, EDOUARD** (February 12, 1905–) French painter, lithographer, ceramist, stage designer, and a leading exponent of social realism, was born in Bully, in the Pas-de-

°pē nyäN, ā dwär´

EDOUARD PIGNON

Calais in northern France, the son of a miner. His father's family had been miners for three hundred years at Marles-les-Mines. Pignon attended the communal school in Bully, and in 1920, at the age of 15, followed his father down into the mines. Soon he found life as a pit-boy unendurable and became a cement-maker. Always an avid reader, in 1923 he began to draw, mostly portraits and landscapes. After serving for two years (1925–27) in Syria with the French Air Force, he returned to Bully, determined to become a painter, and then left for Paris. Between 1927 and 1932 he worked at the Citroën, Renault, and other factories in the Paris area, but was laid off with each new wave of unemployment and antiunion sentiment. Meanwhile, he took evening classes at the Ecole Montparnasse, mainly under the painter Auclair. He also studied philosophy and political economy at the Workers' University, and sculpture at the School of Applied Arts.

Pignon first exhibited at the Salon des Indépendants, Paris, in 1932, receiving early encouragement from the critic Georges Besson. In 1933 he left the auto factories for various jobs, including that of photograph retoucher. Also in 1933, he exhibited with, among others, Frans Masereel, an artist who shared his social concerns, at the Salon des Artistes du Travail, Paris. The next year he participated in the "Exhibition of Revolutionary Writers and Artists," along with Fernand Léger, André Lhote, Maria Vieira da Silva, and others. He also took small roles in various theater companies, appearing in *Les Races* by Bruckner with the Raymond Rouleau company in Salacrou's *Les Frénétiques,* staged

by Charles Dullin at the Théâtre de l'Atelier. He also acted in Shelley's *The Cenci* with Antonin Artaud at the Comédie Wagram.

By 1935 Pignon's financial situation was critical. He took a job as a manual laborer in a factory, but his health so deteriorated that he could no longer draw or paint. Fortunately, Georges Dayez, whom he had first met at the School of Applied Arts, offered him employment in his father's lithography workshop, which was less physically demanding and gave him far more time for art. He began to take part in group exhibitions, such as the 1937 Durand-Ruel group show "50 Contemporary Painters," which included Jacques Villon, Lhote, Yves Tanguy, and François Gruber, and the exhibit organized for the opening of Romain Rolland's *14 Juillet* in the foyer of the Alhambra Theatre. Among those participating were Braque, Matisse, Picasso, Léger, Henri Laurens, Jacques Lipschitz, Gruber, and Jean Marchand. This was at the height of the Front Populaire, under the government of Léon Blum. It was in the course of this exhibition that Pignon first met Picasso, who encouraged him.

In 1938 Pignon was working as a typesetter for the weekly newspaper *Regards.* That year he sent three pictures to the Salon des Surindépendants, including one of his first major paintings, *The Billiard Table.* Its semifigural, semicubist idiom combined the influences of Braque and Villon. Another of the three paintings, *Maternity*, was acquired by the painter and critic Lhote, who wrote an article praising Pignon.

In 1939 Pignon held his first solo exhibition, at the Galerie d'Anjou, Paris. At the beginning of World War II he was briefly mobilized into the French Air Force, but returned to Paris within a year to join the resistance movement. He took part in an important "manifesto exhibition" held in the Galerie Braun, Paris, in 1941 titled "Jeunes peintres de tradition Française." This show was a deliberate—and somewhat risky—assertion of French identity in the face of the German occupation, and an affirmation of modernism that opposed the Nazi attack on "degenerate art." Pignon was represented in another important exhibition in 1943, "Douze peintres d'aujourd'hui." In the Salon d'Automne of 1943 he showed a large mural executed for the Professional School for Girls at Creil.

After the Liberation the same group of painters—Pignon, Lhote, Alfred Manessier, George Bazaine, and others—continued to exhibit together. When their work was shown at the 1944 Salon d'Automne de la Libération, Paris their

painting seemed timid when compared to the abstract movement represented by Klee, Kandinsky, Mondrian, and Malevich, from which they had been completely cut off in the war years. In 1945 Pignon was one of the founders of the Salon de Mai in Paris, and he also took part in a 1945 group exhibition at the Palais des Beaux-Arts, Brussels, that represented what might be termed the "official" French avant-garde art of the immediate postwar years, an amalgam, according to Edward Lucie-Smith, of fauvism, cubism, and expressionism.

In the summer of 1945, which he spent at Collioure, Pignon painted the series "Catalanes" and "Netmenders." He was influenced both by Matisse's bold use of color and the cubist organization of space. He had his first postwar solo show in Paris at the Galerie de France in 1946. In a statement made in 1947 he expressed his opposition both to nonobjective art and to the socialist realism advocated by orthodox French Stalinists and at the same time affirmed his attachment to "reality." He declared, "Abstraction is simply a negation of life, and also a laziness of the spirit."

After visiting Marles-les-Mines in 1947, Pignon did several paintings of miners. He was represented in the French pavilion at the Venice Biennale of 1948, and designed sets and costumes for Supervielle's *Shéhérézade,* produced by Jean Vilar at the Avignon Festival. When Pignon's *Sails of Ostend* and *Miners of Marles-les-Mines* were exhibited at the Galerie de France in 1949, a conflict was discernible between his nonrealistic formal aesthetic and his emotional commitment to the proletariat. Impressed by Picasso's *Guernica* Pignon followed the Spaniard in refusing to make artistic compromises for the sake of immediate popular appeal. On the contrary, he considered his approach truly revolutionary, in that he sought to raise and develop the intellectual/political consciousness of the common people.

In 1949 Pignon visited Italy for the first time and made hundreds of drawings after Giotto, Piero della Francesca, and Signorelli. Nineteenfifty was the year of his first visit to London, on the occasion of his exhibit at the Leicester Gallery. Also in 1950 he settled in Sanary (Var) in Provence, where he began a series of works on the themes of grape gathering and olive trees. By this time his style was fully formed; he had shed the influences of the academic cubists Lhote and Villon, and was closer in spirit to Picasso's expressionism.

Pignon shared the Museum Prize at the São Paulo Bienal of 1951 with the sculptor Germaine Richier. Picasso invited Pignon to work with him in his studio at Vallauris, where Pignon began his activity as a ceramicist. Pignon was accompanied by his wife Hélène Parmelin, who shared his political views. Also in 1951 he designed sets and costumes for Jean Vilar's Théâtre National Populaire production of Bertolt Brecht's *Mother Courage* at Surennes. In Pignon's 1952 solo exhibition at the Galerie de France, Paris, the artist showed paintings and drawings on the theme of the "Dead Worker," a subject he had first treated in a canvas of 1936. These new works were, according to Pignon, "a reply to what the so-called socialist realist painters were doing at the time . . . that thin broth they wanted to impose on the people in the people's name by flattering its worst tastes and instincts." In his most important canvas of the "Dead Worker" series, Pignon employed a method of outlining that both links and separates the forms, using the human figure to express powerful and elementary emotions.

Pignon returned for several months in 1953 to Vallauris, where, encouraged by Picasso, he produced more ceramics. Meanwhile, "remarkably uninfluenced by his formidable colleague" (to quote Patrick O'Brian), he painted several "Nudes with Olive Trees," a continuation of the "Grape-Pickers" series. At his 1954 solo show at the Maison de la Pensée Française, Paris, he exhibited his Vallauris ceramics as well as watercolors which were also shown at the University of Louisville, Kentucky in the United States.

The term "baroque" has been applied to Pignon's 1955 paintings on themes of "Grafting Jasmine," "Grape Gathering," and "Electricians at Work," which were marked by a looser, more expressive style and inflated forms. Pignon was active as a stage designer in 1956, in addition to exhibiting his landscapes at the Perls Gallery, New York City.

In 1958 Pignon designed a large ceramic decoration for the Paris pavilion at the Brussels International Exposition, and an entire room was devoted to his work at the Venice Biennale. A return trip to Marles-les-Mines in 1960 inspired a series of "Cockfights," marked by sharp lines and aggressive color. Several summers spent in Italy between 1958 and 1962 resulted in the "Threshing" series and the turbulent "Corn Gatherers." In 1960 he did his first paintings of "Divers." Then came the menacing "Battles" series (1963–65). Pignon has stated that for him the "Battle" pictures were "war itself." He added: "I condemned nothing. I took no position. I did not commit myself. I merely wanted an expression of violence." In 1966 he had a major retrospective at the Musée National d'Art Moderne, Paris. Other retrospectives followed in 1969, and in 1970 he completed an impressive ceramic sculpture for the Centre d'Activités

Culturelles, Argenteuil, France; it was made up of nearly five thousand elements, and its total weight was almost one hundred tons.

Edouard Pignon, a stolid, good-natured, handsome man with a miner's tough physique, has been described by Bernard Dorival as "that giant with powerful hands." He lives in Paris with his wife, Hélène, who has written her own vivid and affectionate reminiscences of Picasso. Pignon was much stimulated by his long and close friendship with Picasso, while preserving his individuality. Françoise Gilot, in her book *Life with Picasso*, remembered Pignon as "a good talker," with a wide knowledge of the arts and strong opinions. In the foreword to *Edouard Pignon*, a book published in 1965, Robert Rousseau saw an affinity between Pignon's scenes of combat and Jackson Pollock's style of action painting, though Pignon might not appreciate the comparison. Although both artists "plunge" themselves into their work, for Pollock the physical act of painting was its own justification, but for Pignon the significance of the theme is of prime importance, however impassioned the means of expression. In his forceful, if uneven, work, Pignon has staked out an independent position in the contemporary art scene, rejecting both abstraction and the literalness of neorealism. In his view "the abstractionists have, if I may say so, interiorized painting. It needs once again to consult the world." Although firmly committed, as always, to the political left, he has taken issue with programmatic socialist realism. He declared in 1970: "I am convinced that one insults what is termed the people by setting out to create a type of painting made to its measure. The artist works primarily for himself and his own needs. If the drama of his period concerns him, that drama will pass into his work. Painting for the people does not exist; there is painting pure and simple, and one day the people will recognize itself in it, just as it now turns to certain writers of the past."

EXHIBITIONS INCLUDE: Maison de la Culture, Paris 1939; Gal. d'Anjou, Paris 1939; Gal. de France, Paris from 1946; Gal. Apollo, Brussels 1948; Leicester Gal., London 1951; Maison de La Pensée Française, Paris 1954; Allen R. Hite Art Inst., Univ. of Louisville, Ky. 1954; Perls Gal., NYC 1956, '58; Mus. de Metz, France 1960; Mus. des Beaux-Arts, Nantes, France 1961; Maison de la Culture, Le Havre, France 1963; Mus. d'Art et d' Histoire, Geneva, Switzerland 1964; Mus. Nat. d'Art Moderne, Paris 1966; Galleria Nuova Pesa, Rome 1969; Mus. Galliéra, Paris 1970; Mus. Ingres, Montauban, France 1970; "Oeuvres de 1936 à 1973," Dalles Rooms, Bucharest, Rumania 1973; Gal. Verrocchio, Pescara, Italy 1974; Gal. d'Arte Moderna, Bologna, Italy 1975; Mus. d'Art Moderne de la Ville de Paris 1976; Mus. Gal. de La Seita, Paris 1981. GROUP EXHIBITIONS

INCLUDE: Salon des Indépendants, Paris from 1932; Salon des Artistes du Travail, Paris, 1933; Gal. Billiet, Paris 1933; "L'Association des ecrivains et artistes révolutionnaires," Porte de Versailles, Paris 1934; "50 Contemporary Painters," Durand-Ruel, Paris, 1937; Alhambra Theater, Paris 1937; Salon des Surindépendants, Paris 1938; "Jeunes peintres de tradition Française," Gal. Braun, Paris 1941; "Douze peintres d'aujourd'hui," Gal. de France, Paris 1943; Salon d'Automne, Paris 1943; Salon d'Autome de la Libération, Paris 1944; Salon de Mai, Paris from 1944; Palais des Beaux-Arts, Brussels 1945; Venice Biennale 1948; São Paulo Bienal 1951; "New Decade," MOMA, NYC 1955; "De l'Impressionisme à nos jours," Mus. d'Art Moderne, Paris 1958: "European Art after the War," Stedelijk van Abbemus., Eindhoven, Netherlands 1961; Documenta 3, Kassel, W. Ger. 1964; "20 French Painters," Palais des Beaux-Arts, Brussels 1966; "10 Ans d'Art Vivant 1955–1965," Fondation Maeght, St.-Paul-de-Vence, France 1967; "Painters of Paris since 1950," Gulbenkian Foundation, Lisbon, Portugal 1971; "Tapisseries modernes de l'Atelier Plasse le Caisne," Mus. d'Histoire d'Art, Luxembourg 1973; "Hommage à Pablo Neruda," Mus. Céret, France 1974; "Peintres du Nord," Crédit du Nord et Union Parisienne, Lille, France 1975.

COLLECTIONS INCLUDE: Mus. Nat. d'Art Moderne, and Centre Nat. d'Art Contemporain, Paris; Mus. de Metz, France; Mus. de Peinture et de Sculpture, Grenoble, France; Tate Gal., London; Mus. Royal, Brussels; Stedelijk Mus., Amsterdam; Mus. d'Histoire et de l'Art, Luxembourg, Belgium; Mus., Goteborg, Sweden; Mus. des Beaux-Arts, La Chaux de Fonds, Switzerland; MOMA, NYC; Mus. de Arte Moderna, São Paulo; Johannesburg Mus., S. Africa; Mus. of Modern Art, Tokyo; Wellington Mus., N. Z.

ABOUT: Bénézit, E. (ed.) Dictionnaire des peintres, sculpteurs et graveurs, 1976; Calles, A. and others Pignon, 1970; Courthion, P. Peintres d'aujourd'hui, 1952; Dorival, B. (ed.) "Edouard Pignon" (cat.), Mus. Nat. d'Art Moderne, Paris, 1966; "Edouard Pignon: 50 peintures de 1936 à 1972" (cat.), Gal. de France, Paris 1962; "Edouard Pignon, Retrospective 1938–1970" (cat.), Mus. Ingres, Montauban, France, 1970; Elgar, F. Cinq peintres d'aujourd'hui, 1943; Gilot, F. Life with Picasso, 1964; Lefebvre, H. Pignon, 1956; Lucie-Smith, E. Late Modern: The Visual Arts Since 1945, 1969; O'Brian, P. Picasso: A Biography, 1976; Parmelin, H. Cinq peintres et le théâtre, 1957.

PIPER, JOHN (EGERTON CHRISTMAS)

(December 13, 1903–), was a leading British representational painter, primarily of landscapes and old buildings in rural settings. One of England's most versatile artists, he has worked in theatrical design, book illustration, stained glass windows, and written art criticism.

Piper was born in Epsom, Surrey. Although near London, the area was at that time rural. He was the youngest of three sons of Charles A. Pip-

Jorge Lewinski

JOHN PIPER

er and Mary Ellen (Matthews) Piper. A founder of the successful law firm of Piper, Smith, and Piper, Charles Piper was an art lover whose views had been shaped by the writings of John Ruskin. He welcomed his youngest son's artistic talent and encouraged him, taking John to London's Tate Gallery and once traveling to Paris to visit the Louvre. By the age of 12 Piper was fascinated by church architecture, and began making tracings of stained glass and rubbings from monumental brasses.

Piper's interest in Gothic architecture grew during his years at Epsom College, and as a teenager he became local secretary of the Surrey Archaeological Society. He was by then drawing and painting regularly, mostly choosing architectural subjects in England and in Italy, where he holidayed with his family. In 1921 he left school, joined his father's law office as an articled clerk, and for the next five years was a Sunday painter. Meanwhile his artistic interests widened. He listened to Mozart and Beethoven, attended Diaghilev ballets, and played the piano in an amateur dance band. He also read D.H. Lawrence and James Joyce and wrote verse, publishing in 1921 a collection of poems, *The Wind in the Trees*, with his own illustrations.

Through his father's friends in the arts, Piper was introduced to contemporary French painting, and by the time Charles Piper died, in 1926, he had decided to abandon law and become a painter. He enrolled in the Richmond School of Art, studying with T.M. Smith and Raymond Cox, and then attended the Royal College of Art, London, where he studied from 1926 to '28 with Sir William Rothenstein. Piper's early work was,

however, considered unpromising by his teachers.

Despite his discouraging experiences at art schools, Piper worked morning and night at his painting—and lived on a pittance. For several years he depended on a small allowance from his mother and earnings from reviews of art, architecture, music, and the theater which, from 1928 to '38, he published in journals and magazines. This was a seminal moment in 20th-century British art: the impact of cubism and abstract painting was felt for the first time and Diaghilev had introduced modernism to ballet and the theater, developments Piper chronicled regularly in *The Listener* and the *Nation and Atheneum*, among other publications.

During these years Piper contributed woodcuts to magazines, and in 1927 and '31 his paintings were exhibited with those of other young artists at the Arlington and Mansard Galleries in London. Piper's early pictures were straightforward realistic views of the landscape of England's south coast. However, S. John Woods wrote that Piper in his mid–20s displayed a characteristic "frontality of approach and a play of vertical against horizontal, . . . with forms and lines penetrating in a way that clearly owes much to his love for stained glass."

Piper soon became a member of the 7 and 5 Society, which included Frances Hodgkins, the artist from New Zealand, and the British painters Christopher Wood and Ben Nicholson. The influence of Nicholson was particularly strong and this, together with his visit to Paris in 1933, brought about a change in Piper's artistic style. In Paris he had met Braque, Léger, Brancusi, and Jean Hélion, and under their influence he abandoned representation in 1934. For a year he experimented with three-dimensional constructions, often using sea motifs, and in 1935 he returned to painting, producing a series of abstract compositions in which the relationships of recurrent forms are changed in successive pictures. Piper's use of color and texture also developed considerably during this period.

Piper's links with the avant-garde movement were strengthened by his marriage in 1935 to Mary Myfanwy Evans, a writer and university lecturer in English. They founded *Axis*, a quarterly review of contemporary abstract painting and sculpture, whose layout and production was handled by Piper. But there was a poetic and romantic strain in Piper's nature that could not long be satisfied by nonobjective painting, and Myfanwy Piper's compilation of essays, *The Painter's Object* (1937), contained an article by him prophesying the end of his abstract phase. He wrote: " . . . The tree standing in the field

has practically no meaning at the moment for the painter. . . . But the object must grow again: must reappear as the 'country' that inspires painting."

By the late 1930s Piper was moving decisively from abstraction to romanticized depictions of landscape and topography, and there was a resurgence of his earlier interest in architecture. *Axis* ceased publication in 1937, and Piper's exhibition of collages at the London Gallery in 1938 was seen as marking his break with abstractionism. However, his oil paintings of this period, though they contain abstract elements, evoke the English landscape, and his style remained expressionist in his use of color and attentiveness to contrasting textures. When applied to his renderings of buildings, this textural richness gave many of his pictures a dramatic quality.

In the period immediately before World War II, Piper undertook several new endeavors. In 1937 he did his first theater work, designing sets and costumes for a production of Stephen Spender's *Trial of a Judge* at the Unity Theatre, London. The next year he published the first of a series of articles for the *Architectural Review,* celebrating in words and illustrations the architecture and arts and crafts of England. His use of collage in the letterpress illustrations of these articles has been widely imitated. Several of the articles, together with pieces written for other magazines, were collected in his book *Buildings and Prospects* (1945).

With the outbreak of World War II, in 1939, Piper was appointed an official war artist. Attached first to the Ministry of Information and later to the Ministry of Transport, with the assignment of illustrating the effect of the conflict on the home front, he recorded the damage inflicted by aerial bombardment and fire on historic buildings such as Coventry Cathedral and the House of Commons. In 1941 Piper was commissioned by the Queen to make two series of watercolors of Windsor Castle. These were later exhibited at London's National Gallery and won him, for the first time, a wide audience.

Piper's work of this period, independent as well as commissioned paintings, was decidedly romantic—the artist's antidote to the ugliness of war. This neoromanticism was also, Piper maintained, the result of his having seen the truth of Ruskin's dictum, "You will never love art well 'till you love what she mirrors better."

During the war Piper produced memorable work for the London theater: a front-of-stage cloth for the 1942 production of *Facade,* by Edith Sitwell and William Walton; sets and costumes for Walton's and Frederick Ashton's ballet, *The Quest,* produced at Sadler's Wells in 1943; and in 1945, just after the war, the striking sets for the Old Vic's *Oedipus Rex,* starring Laurence Olivier and Sybil Thorndike. Piper also designed the sets and costumes for the 1946 Glyndebourne production of Benjamin Britten's opera *The Rape of Lucretia.*

In the postwar years, Piper's dark palette of the 1939–45 period gave way to warmer hues, and his approach to landscape increasingly emphasized topographical structure. Reviewing a 1948 Piper exhibition at the Buchholz Gallery, New York City, a critic noted that his experiments with abstract art had given a new freedom to his handling of "openly avowed subject matter." Piper continued to design sets and costumes for the theater in the '40s and '50s, and with Benjamin Britten and Eric Crozier he formed the English Opera Group, which was dedicated to presenting British operas, in 1947.

By 1950 Piper's reputation was established, and he received many commissions, including the design of the main vista of the Festival Gardens for the 1951 Festival of Britain. He also wrote several books, most of them in collaboration with John Betjeman, including *Murray's Berkshire Architectural Guide* (1949) and the *Shell Guide to Shropshire* (1951). All were illustrated with photographs taken by Piper and only one did not feature his drawings. He also illustrated volumes of poetry by Betjeman, C. Day Lewis, and other writers, and designed book jackets. Piper's lithographic work in Fernand Mourlot's Paris print workshop in 1953 increased his expertise in graphic media.

Since childhood Piper had studied stained-glass design, and in the mid-1950s he began to work in that medium. He was commissioned to plan the three east windows of Oundle School Chapel. The windows, installed in 1956, showed nine figures of Christ and combined abstract design with deep religious feeling. (In 1939, shortly after the war began, Piper had been received into the Church of England.) He designed windows for Eton College Chapel in 1958; for Nuffield College Chapel, Oxford University, in 1961; and for the rebuilt Coventry Cathedral in 1962. Piper's incandescent 6,000-square-foot baptistery window at Coventry, his best-known stained glass design, has been called "the one sure blaze of individual genius in the Cathedral." Piper has also designed mosaics for the British Broadcasting Company's television center, the headquarters of the North Thames Gas Board, and the British Embassy in Rio de Janeiro.

In the late '50s some English critics dismissed Piper as "a poetic painter of the Anglo-Saxon twilight," considering him limited and unadven-

turous, but in *The Story of Modern Art* (1958) the American art historian Sheldon Cheney asserted that Piper's work deserved to be taken seriously as modern art. Cheney acknowledged that Piper's direction "was toward neoromanticism, with a good deal of harking back to a nostalgic Gothicism," and that his paintings since 1935 "were distinctly 'views,' often dramatic, sometimes theatrical"; yet, Cheney pointed out, Piper's *Portland* (1954), a painting of the famous Portland stone, "indicates an instinctive feeling for abstract values, call them formal or plastic."

Piper's work in stained glass inspired him to paint nontopographical subjects. One critic, describing his 1960 show at the Durlacher Brothers Gallery, New York City, wrote that, instead of "darkly romantic, misty landscapes," Piper was now painting "the glowing furnaces of England's industrial cities" in pictures "full of fire and light."

Since he reverted to representation, Piper's style has undergone little change. Although the cities of Rome and Venice have inspired such works as his watercolor *St. Agnese and the Bernini Fountain of the Four Rivers* (1962), Piper's work has remained firmly within the English romantic tradition. The absence of human figures in Piper's vast oeuvre has been noted by critics, including Myfanwy Piper who, in the catalog to his first 1963 exhibition at the Marlborough Fine Art Gallery, referred to his "empty stage." Robert Melville wrote in the catalog to the 1964 Piper retrospective at the Marlborough that the artist was a humanist, for whom man, though undepicted, "remains in his work the measure of all things."

Some critics, though they consider Piper to be "a great master of effects," have felt him to be the victim of his own versatility. Reviewing Piper's paintings and drawings exhibited at Marlborough Fine Art, London, in 1977, Malcolm Quantrill wrote in *Art International* (December 1977) that "Piper as an artist sees landscape and its architectural trappings as one continuous stage set. He is essentially a journeyman painter and consequently he always needs a specific job to do. . . ." In postwar Britain Piper has been dethroned to some extent by such artists as Graham Sutherland, Ben Nicholson, S. W. Hayter, Francis Bacon, and the Pop painters of the 1960s. In *Modern English Painters* John Rothenstein assessed Piper's contribution, observing that whereas no one—least of all Piper himself—would claim that all his works are of equal value, the best "represent an exhilarating combination of the romantic and the particular searchingly understood."

Piper and his second wife, Myfanwy, live at Fawley, near Henley-on-Thames, Oxfordshire, in an old farmhouse which in 1962 lacked electric light but has since been modernized. He is the father of two sons and two daughters. From 1928 until being divorced in 1933, Piper was married to Eileen Holding, who had been a fellow student at the Richmond School of Art. In November 1983 the Tate Gallery, London, mounted the largest exhibition yet held of Piper's work.

Piper's attitude toward the arts was expressed in his book *British Romantic Artists* (1942): "Romantic art deals with the particular. [It] is the result of a vision that can see in things something significant beyond ordinary significance: something that for a moment seems to contain the whole world."

EXHIBITIONS INCLUDE: London Gal. 1938; Leicester Gals., London 1940, '45, '46, '51, '57, '59; Curt Valentin (Buchholz) Gal., NYC 1948, '50, '55; Durlacher Brothers Gal., NYC 1957, '60; Arthur Jeffress Gal., London 1960, '62; Marlborough Fine Art, London 1963, '64, '67, '72, '77; Marlborough New London Gal., London 1969; Hammer Gal., London 1970; Lincoln Cathedral Centenary Festival, Lincoln, England 1973; Univ. of York, England 1975. Tate Gal., London 1983–84. GROUP EXHIBITIONS INCLUDE: Arlington Gals., London 1927; Mansard Gal., London 1931; "New English Art Society, Seven and Five," Zwemmer Gal., London 1932; "Abstract-Concrete," Zwemmer Gal., London 1935; Lefevre Gal., London 1938; Temple Newsam, Leeds, England 1941; Temple Newsam, London 1941; "Festival of Britain," Main Vista, Festival Gardens, Battersea, London 1951; Aldeburgh Festival, England 1955; Gloucester Art Gal., London 1960; Marlborough Gal., London 1966; "British Graphics," Kunsthalle, Hamburg, W. Ger. 1966; International Art Fair, Kunsthalle, Basel 1970; "Contemporary British Painters and Sculptors," Marlborough-Godard Gal., Toronto 1973; "20th Century Drawings and Watercolors," Marlborough Fine Art, London 1974.

COLLECTIONS INCLUDE: Tate Gal., Victoria and Albert Mus., British Council, Contemporary Art Society, and Guildhall Art Gal., London; City Art Gal., Birmingham, England; City Art Gal., Coventry, England; Art Gal. and Mus., Glasgow; Art Gal. and Industrial Mus., Aberdeen, Scotland; MOMA, NYC; Phillips Collection, Washington, D.C.; Inst. of Arts, Detroit; Nat. Gal. of Canada, Ottawa; São Paulo Mus.; British Embassy Mus., Rio de Janeiro.

ABOUT: Betjeman, J. John Piper, 1944; Cheney, S. The Story of Modern Art, 1958; Melville, R. "John Piper" (cat.), Marlborough Fine Art, London, 1964; Osborne, H. (ed.) The Oxford Companion to Art, 1970; Piper, J. The Wind in the Trees, 1921, Poetry Collection, 1924, Shell Guide to Oxfordshire, 1938, British Romantic Artists, 1942, Buildings and Prospects, 1945, (and others) Murray's Architectural Guide to Buckinghamshire, 1948, Romney Marsh, 1950, (and others) Murray's Berkshire Architectural Guide, 1949, (and

others) Shell Guide to Shropshire, 1951; Piper, M.
"John Piper" (cat.), Marlborough Fine Art, London,
1963; Rothenstein, J. Modern English Painters: Wood
to Hockney, 1974; Woods, S. J. John Piper: Paintings,
Drawings and Theatre Designs, 1932–54, 1955.
Periodicals—Art International (Lugano) December
1977; Arts Review February 1973; Burlington Maga-
zine (London) December 1977; (London) Sunday
Times May 20, 1962.

MICHELANGELO PISTOLETTO

***PISTOLETTO, MICHELANGELO** (1933–),
Italian painter, was strongly influenced by pop
art, and became known in the 1960s for his pho-
tographic figures applied collage-fashion to
highly polished mirror backgrounds in which
spectators could see themselves reflected. Since
these works were predominantly figurative, Pis-
toletto was regarded by many critics as part of
the so-called "new realism," a movement
founded in 1960 by French critic Pierre Restany
and his associates. But since the 1960s Pistoletto
has found other uses for mirrors, and has ex-
plored completely different forms of art, often
involving audience participation.

Pistoletto was born in Biella, Piedmont. The
following year the family moved to Turin,
where the artist still lives. Until 1957 Pistoletto
assisted his father as a restorer of paintings. He
did not begin painting until 1956, but held his
first solo exhibition only four years later at the
Galleria Galatea, Turin. From the very begin-
ning, while still using the conventional medium
of paint on canvas, Pistoletto stressed the alien-
ation and anonymity of his life-sized figures. His
early series of paintings with gold, silver, and
bronze backgrounds stimulated an interest in the
use of reflection as an integral part of the work,
and led to his first tableaux (1961–62) backed by
stainless steel mirrors. In these works life-sized
figures based on photographs were drawn and
painted, usually in shades of gray on tissue pa-
per, both before and after their application to
the steel sheets. The backgrounds were left emp-
ty, to be filled by the reflections of the real
world, slightly distorted by bends in the mirror.
In *Seated Figure* (1962), a collage on polished
steel now in the Kaiser-Wilhelm Museum in
Krefeld, West Germany, the seated male figure
is presented in profile facing the viewer's right;
the spectator, reflected in the mirror back-
ground, completes the composition.

In his first mirror tableaux Pistoletto usually
represented single figures, facing the spectator
or in profile, but he soon found that the sense of
participation was even greater when the view-
er's reflection appeared among groups of collage
figures, which often had their backs turned to
the spectator. However, in *Sacra Conversazione*
(1963), four standing figures are bunched closely
together leaving very little room for the reflec-
tion. Pistoletto insisted that figures and reflec-
tion be viewed simultaneously for the work to be
fully grasped. "The right kind of spectator," he
said, "is the one who complies with the condi-
tions imposed by reality, and, consequently, es-
tablishes contact with himself, with the painted
figures, and hence with me—all in a simple act
of availability."

Life and art do not always blend impercepti-
bly; there can be incongruity. The reflected im-
age of a priest may appear next to the collage
figure of *Nude Woman Telephoning* (1965). But
Pistoletto feels that such startling juxtapositions
are equally successful as a fusion of art and reali-
ty. Another ingenious example of Pistoletto's
concern with capturing life itself is *Balcony with
Three Men* (1964).

In his earlier tableaux Pistoletto had sup-
pressed color and detail, but he gradually began
to add those elements to his works. About 1965
he began dealing in a detached manner with so-
cial themes, believing that "he who makes a pro-
test painting arrests his vision at the fact that he
portrays." In his tableaux *No, All' Aumento Del
Tram* (a protest against the increase in street-car
fares), *Rally I,* and *Vietnam,* people march in
demonstrations, although none of them express
passionate protest—the statement remains
"cool."

In the late 1960s Pistoletto turned to more
"everyday" figures and added brighter colors.
The title of his tableau of 1968, *Annunciation,*
suggests a 20th-century remake of religious an-

nunciation scenes, but in this piece hope is not gained but lost. While a man behind a counter, his face turned away from the viewer, speaks on the telephone, a woman in a raincoat with a forlorn, or at least vacant, expression on her face, is apparently awaiting bad news. Both figures are situated on the left side of the mirror. Robert Murdock, in the catalog to Pistoletto's 1967 exhibition at the Albright-Knox Art Gallery, Buffalo, New York, wrote that "the general mood of his tableaux and the grouping of figures in them seem more related to the work of certain Italian Renaissance painters, such as Andrea Mantegna and Piero della Francesca, than to modern Italians."

Although the human figure is of great importance to Pistoletto—his *Self-Portrait with Soutzka* (1967), two embracing figures in transparent painted paper on polished steel, is one of his most personal works—he has also made still-life tableaux such as *Philodendron* (1965) and *Glasses and Ruler on Cube* (1968) in which the only figures were the reflected viewers. After he had achieved recognition in the early 1960s, Pistoletto, eager to avoid repeating himself, began to explore other uses of the mirror. In 1964 he tried painting some of his figures on plexiglass instead of steel. In 1966 he created *Cubic Meter of Infinity*, a cube of mirrors facing inward, and thus eternally reflecting nothing but themselves—a more conceptual work than the tableaux. Pistoletto also made a series of so-called "Minus Objects," including a paper rose with a metal stem, a cardboard maze, and a fiberglass well lined with stainless steel. In 1966, instead of mounting a conventional exhibition, he opened his studio to the public; as he later explained, "Given that I had already 'opened' the pictures to the presence and participation of others, why not 'open' a physical space too?"

In 1968 Pistoletto made *Venus of the Rags*, a mountain of rags and old clothing in which a reproduction of an antique statue of Venus stands with her back to the audience. When this tableau was installed in 1980 at the University Art Museum, Berkeley, California, one woman, as Pistoletto observed, "took off her own coat—it was a red coat—and put it on the rags. I think that was a good answer." It was certainly compatible with the artist's idea of audience participation.

From 1968 to 1970 Pistoletto performed street theater with a group of artists called ZOO. Working in mixed media, and influenced to some extent by Grotowski's concept of "poor theater," the group staged performances in Atlanta, California, and elsewhere in the US.

Pistoletto returned to the mirror as medium in the 1970s but with a different emphasis. He began making sharply focused photo-silkscreens of figures on polish stainless steel. *Grimace* and *Marcel Duchamp Sitting on Brancusi*, both of 1974, have the slight "funhouse" warp of the earlier tableaux. In 1975 Pistoletto used mirrors to create a tunnel effect in *Father, Son and Creativity*. *Cage Environment*, also of 1975, is a serial work in which the reflected image of the viewer appears behind bars.

In 1979 Pistoletto began making "arrows," a new motif in his art. His first was a large concrete arrow resting on the floor and pointing toward a mirror on the wall, its reflection pointing back. It was acquired by the Los Angeles Institute of Contemporary Art. *One Arrow* (1980) was similarly arranged, but the arrow was a cage filled with rags, bones, and earth. Measuring 8 feet by 6 feet, by 12 feet, it was exhibited at the Clocktower in New York City.

In the spring of 1980 a Pistoletto retrospective toured the United States, visiting seven cities in four states (Texas, Georgia, California, and New York). This was by no means a conventional retrospective; the exhibition was different at every location, and required the collaboration of other artists and the audience in the creation of sculptures, theater pieces, and music, as well as showings of Pistoletto's permanent works. This series of shows was the culmination of Pistoletto's concern with audience participation. As Marjorie Welish wrote in *Art in America*, "By transfering his open-studio experience to the open road, he exposed himself and his art to external circumstances. . . . It is to Pistoletto's credit that he converted what might have been only a windfall of personal publicity into an occasion for shared exposure, generosity and warmth."

Micheangelo Pistoletto is dark-haired, with Italian good looks, and enjoys his contact with a wide public, though he is by nature detached rather than gregarious. Marjorie Welish has remarked on his "fundamental humanism." Thomas B. Hess, reviewing a Pistoletto show at the Sidney Janis Gallery, New York City, in *New York* magazine, observed: "When Pistoletto attempts social comment, as in some cages that say 'see, all humanity is in a cage; you too,' the results are banal. His humor is better." Hess added, "Pistoletto's real talent is for optics," and he observed that the artist provides "extraordinary illusions and optical experiences that would have enchanted Hoogstraten—and maybe Vermeer." Some critics have compared Pistoletto's "cool" work and his anonymous alienated figures with that of recent Italian filmmakers such as Michelangelo Antonioni, but Pistoletto himself says: "I think I've been more influenced by the vision of

science—the perception of the relativity of time. Nothing is fixed any more. The rapport, or contrast, between the immobility of the pasted figures on the mirrors and the movement of what's actually reflected in them is for me what makes the picture."

EXHIBITIONS INCLUDE: Gal Galatea, Turin, Italy 1960, '63; Gal. Ileana Sonnabend, Paris 1964, '67; Gal. Sperone, Turin, Italy from 1964; Gal. del Leone, Venice 1964, '66; Walker Art Center, Minneapolis 1966; Studio Pistoletto, Turin, Italy 1966; Mus. Boymans-Van Beuningen, Rotterdam 1967; Albright-Knox Art Gal., Buffalo, N.Y. 1967; Gal. dell'Ariete, Milan 1970, '72; Gal. Kestner-Gesellschaft, Hanover, W. Ger. 1973, '74; Sidney Janis Gal., NYC 1974; Gal. Sperone, Rome 1975; Palazzo Grassi, Venice 1976; "Le stanz," Gal. Christian Stele, Turin, Italy 1976; Neue Nationalgal., Berlin 1978; Clocktower, NYC 1979; Centre Georges Pompidou (Beauborg), Paris 1981. GROUP EXHIBITIONS INCLUDE: Premio San Fedele, Milan 1958; San Marino Biennale, Italy 1959, '61; "Nieuwe Realisten," Gemeente Mus., the Hague 1964; "The Object Transformed," MOMA, NYC 1966; Documenta 4, Kassel, W. Ger. 1968; Warhol-Pistoletto," The New Gal., Cleveland 1969; "Land Art-Arte Povera-Conceptual Art," Mus. di Torino, Turin, Italy 1970; "Contemporanea," Villa Borghese, Rome 1974; "Realismus and Realität," Kunsthalle, Darmstadt, W. Ger. 1975.

COLLECTIONS INCLUDE: Albright-Knox Art Gal., Buffalo, N.Y.; Los Angeles Inst. of Contemporary Art; Kaiser-Wilhelm Mus., Krefeld, W. Ger.; Kunstmus., Düsseldorf; Gal. Sperone, Turin, Italy.

ABOUT: Boatto, A. Pistoletto dentro fuori lo specchio, 1969; Friedman, M. "Michelangelo Pistoletto, a reflected world" (cat.), Walker Art Center, Minneapolis, 1966; Krimmel, B. "Michelangelo Pistoletto, 1974; Lippard, L.R. Pop Art, 1966; Lucie-Smith, E. Late Modern: The Visual Arts Since 1945, 1969; Measham, T. (ed.) The Moderns 1945-1975, 1976; Pistoletto, M. Le Ultime Parole Famose, 1967, L'Uomo Nero, il Lato Insopportabile, 1970; "Michelangelo Pistoletto" (cat.), Albright-Knox Art Gal., Buffalo, N.Y., 1967; P-Orridge, G. and others (ed.) Contemporary Artists, 1977; Schmied, W. "Michelangelo Pistoletto" (cat.), Gal. Kestner-Gesellschaft, Hanover, W. Ger., 1973. *Periodicals*—Art in America February 1981; Art International (Lugano) no. 8 1964, no. 10 1966; New York December 2, 1974; New York Times April 30, 1967, February 2, 1969.

***POLIAKOFF, SERGE** (January 8, 1900 or 1906–October 12, 1969), Russian-French painter and engraver, held an important place in the post–World War II Paris School of expressive abstraction.

Poliakoff was born (the year is in dispute) into a rich and prominent family of landowners, resi-

Jorge Lewinski

SERGE POLIAKOFF

dent in Moscow. Much of his childhood was spent in the home of his father, a well-known breeder of race horses, who passed on to his son a love of horses and racing. The young Poliakoff also stayed with his sisters, one of whom was married to the Moscow Prefect of Police, the other to Prince Galitzin. Growing up in this wealthy and cultivated milieu, he displayed musical talent at an early age. After the outbreak of the Revolution, he fled Russia in 1918 with his aunt, Nastasia Poliakoff, a celebrated singer whose performances he accompanied on guitar during their wanderings in Turkey, Bulgaria, Yugoslavia, Germany, and Austria. They finally reached Paris, where Poliakoff settled in 1923.

For the next 20 years or so, Poliakoff earned his living as a guitarist, performing in the evenings with balalaïka orchestras in Russian cabarets in Paris. In 1929 he began to paint, and also that year, supported financially by his guitar playing, he attended classes at the Académie Frochot, the Académie Billule, and the Grande Chaumière in Montparnasse, where his teachers were Othon Friesz and Ivan Cerf. He had already begun to exhibit his work (nudes and portraits), all later destroyed.

The years of 1935 to 1937 were spent in London, where Poliakoff studied first at the Chelsea School of Art, then at the Slade School. He explored the museums assiduously, and was greatly impressed by the Italian primitives in London's National Gallery. He claimed that his study of Egyptian sculpture in the British Museum influenced the formal, hieratic style of his mature compositions. In London, in 1936, Poliakoff married Marcelle Perreur-Lloyd, and their son Alexis was born six years later.

°pō lĭ´ ä kôf, serzh

In 1937 Poliakoff returned to Paris. Until this time his painting had been figurative—his nudes are said to have had a touch of Velázquez—but after meeting and being encouraged by Kandinsky in 1937, and becoming a close friend of Sonia and Robert Delaunay in 1938, he began to work in an abstract style. He exhibited his first abstract painting in a group show at the Galerie le Niveau, Paris, in 1938, and for the next seven years he showed regularly at the Salon des Indépendants.

Poliakoff's first solo show of abstract work was in 1945 in Paris, at Maurice Pannier's Gallerie l'Esquisse, one of the very few galleries that had exhibited abstract painting in the last years of the German occupation. Also in postwar Paris, Poliakoff was represented in the earliest (1945) exhibition of the Salon des Réalités Nouvelles, and in 1946 he participated in group shows at the Galerie Denise René and the Salon des Surindépendants. In a review of the Surindépendants exhibit, one critic noted that Poliakoff's canvases were "as agreeably variegated as a Bokhara or Samarkand carpet," but Poliakoff was disturbed by this well-intended compliment. Fearing that his paintings might lapse into the decorative, he subdued his palette. The decorative urge, though, was still present, for in 1946 he made cartoons for the furnishing fabrics company Bauret-Varin (Jean Bauret was at that time a great admirer of abstract painting). In 1947 Poliakoff was awarded the Kandinsky Prize, established by the painter's widow, and from then on he progressed steadily toward his leadership position among the abstract painters of the postwar School of Paris.

It had been Kandinsky who turned Poliakoff toward abstraction, and in 1952 the work of another great Russian modernist, the late Kasimir Malevich, began to influence his painting and to help him develop the style that characterized his best-known canvases. Poliakoff's mature style, as exemplified by *Composition abstraite* (later acquired by the Galerie Springer, Berlin), could be described as neocubist. The surface was freely organized in a continuum of precise planes and sharp, rectilinear contours, but without falling into rigorous geometricality or into what became known later as "hard-edge" painting. The large, simple angular shapes interlocked contingently to form a single layer of paint applied with a palette knife so as to reveal the underpainting and emphasize the substance of the pigment. His colors were sober, severe, and low-keyed, the surfaces toned "to achieve an intense vibration of the planes," as Aldo Pellegrini observed. Another critic, commenting on the hard-to-define "Russian-ness" in Poliakoff's work, traced certain elements in his canvases—the interlocking geometric planes, the mystical vibrancy of the color (despite its low key), and the hieratic stylization—back to Russian icon painting and Orthodox church art. Though similar influences could be found in another eminent Russian-born painter then working in Paris, Poliakoff's friend Nicolas De Staël, Poliakoff seems to have had no predilection for the representational elements that concerned De Staël. Poliakoff's titles, for instance, were never more specific about "content" than *Abstraction, Composition in Red and Yellow,* or *Composition in Green and Yellow.*

Poliakoff had discontinued his professional guitar playing in 1952, after signing an agreement with the Galerie Bing, Paris, which enabled him thereafter to live on the sale of his pictures. His interest in the theater led him in 1957 to design the setting for the ballet *Contre-point,* with music by Marius Constant and choreography by Roland Petit. His work in other media includes eight etchings in 1961 for an edition of Plato's *Parmenides.* In his colored lithographs, as in his paintings, the flattened planes were clearly demarcated, but the forms tended to be even more angular, and the colors more intense.

In 1960 Poliakoff was given a retrospective exhibition in Bern, the first of several in various European countries. He became a French citizen in 1962 and acquired a small property in the Alpes-Maritimes, while still maintaining a residence in Paris. He was made Commandeur des Arts et des Lettres in Paris in 1962, and three years later was awarded the International Prize at the Tokyo Biennale. He visited Venice in September 1969, on the occasion of his solo show at the Galleria del Naviglio. The chromatic range of Giotto's frescoes in the Scrovegni Chapel in Padua influenced his very last works. Poliakoff died in Paris in the fall of 1969. Several retrospectives were held after his death, including one at the Musée National d'Art Moderne, Paris, in 1970.

Serge Poliakoff, according to John Russell, author of the introduction to the catalog of a retrospective held at London's Whitechapel Art Gallery in 1963, had "the countryfied English clothes, the horseman's walk," and the "air of being at ease with all the world" which suggested a great landowner. He added that Poliakoff as a youth had arrived penniless in Constantinople with his aunt, and that his "landowning" consisted of a tiny patch in the Alpes-Maritimes.

The growing controversy surrounding the question of the validity of paintings as art objects apparently had little effect on Serge Poliakoff. Like other abstract painters of the School of Par-

is who came into prominence immediately after 1945, he was eclipsed in the '50s by the rapid rise and international acceptance of the vigorous New York School. One French critic called Poliakoff and his French contemporaries *minor* masters, notwithstanding their gifts as colorists, their technical skills, their sense of composition, and the refinement of their culture. Without going that far, other critics have considered that Poliakoff elaborated upon, rather than originated, ideas in 20th-century abstract painting. Poliakoff summed up his own views in a group of *pensées* that included the following statements: "Many people say that in abstract painting there is nothing. As for me, I know that were my life three times as long it would not suffice to say all that I see." His feeling for musical values was reflected in his observations that "one must listen to a form when one has seen it." "When a picture is silent," he declared, "that means that it is successful."

EXHIBITIONS INCLUDE: Gal. Zack, Paris 1937; Gal. l'Esquisse, Paris 1945; Tokanten Gal., Copenhagen 1948, '49; Gal. Denise René, Paris 1950; Gal. de Beaune, Paris 1950; Gal. Dina Vierny, Paris 1951, '65; Gal. Ex-Libris, Brussels 1952; Palais des Beaux-Arts, Brussels 1953; Gal. Bing, Paris 1954, '56; Gal. der Spiegel, Cologne 1954, '64; Knoedler Gals., NYC 1955; Gal. del Naviglio, Milan 1957, '66, '67; Gal. Berggruen, Paris 1957, '59; Kunsthalle, Hamburg, W. Ger. 1958; Kunsthalle, Basel 1958; Hanover Gal., London 1958, '60, 1961; Gal. Knoedler, Paris 1959; Kunsthalle, Bern 1960; Gal. Bonner, Lausanne, Switzerland 1962; Gal. Artek, Helsinki 1963; Whitechapel Art Gal., London 1963; Kunstmus., St. Gall, Switzerland 1966; Maison de la Culture, Caen, France 1968; Lefebre Gal., NYC 1968; Gal. del Naviglio, Venice 1969; Mus. Nat. d'Art Moderne, Paris 1970. GROUP EXHIBITIONS INCLUDE: Salon des Artistes Français, Paris 1932; Gal. le Niveau, Paris 1938; Salon des Indépendants, Paris 1938, '39, '45; Salon des Réalités Nouvelles, Paris 1945; Salon des Surindépendants, Paris 1946; Gal. Denise René, Paris 1946; Salon de Mai, Paris 1946, '62; "Arte d'Oggi," Palazzo Strozzi, Florence 1949; "L'Ecole de Paris," Royal Academy, London 1951; "L'Art du XXe siècle," Mus. Nat. d'Art Moderne, Paris 1952; "Témoignages pour l'art abstrait," Séminaire des Arts, Brussels 1952; "Arte Astratta Italiana e Francese," Gal. Nazinale d'Arte Moderna, Rome 1953; "Tendances actuelles de l'école de Paris," Kunsthalle, Berne 1954; Pittsburgh International, Carnegie Inst. 1958; Documenta 2, Kassel, W. Ger. 1959; "Peintres Français d'aujourd'hui," Art Mus., Tel Aviv 1960; Venice Biennale 1962; Tokyo Biennial 1965; Menton Biennale, France 1966.

COLLECTIONS INCLUDE: Centre Nat. d'Art Contemporain, Manufacture Nat. de Sèvres, and Manufacture Nat. des Gobelins, Paris; Mus. des Beaux-Arts, Lille, France; Mus. de Peintures et de Sculptures, Grenoble, France; Tate Gal., London; Mus. Royal des Beaux-Arts, Brussels; Mus. des Beaux-Arts, Liège, Belgium; Stedelijk Mus., Amsterdam; Boymans-Van Beuningen Mus., Rotterdam; Oeffentliche Kunstsammlung, Basel; Kunstmus., Berne; Nationalgal., Berlin; Kunsthalle, Hamburg, W. Ger.; Wallraf-Richartz Mus., Cologne; Folkwang Mus., Essen, W. Ger.; Nat. Gal., Oslo; Moderna Mus., Stockholm; Statens Mus. for Kunst, Copenhagen; MOMA, and Solomon R. Guggenheim Mus., NYC; Phillips Collection, Washington, D.C.; Art Inst. of Chicago; Mus. of Modern Art, Sâo Paulo; Mus. of Modern Art, Rio de Janeiro; Mus. of Modern Art, Buenos Aires.

ABOUT: Bénézit, E. (ed.) Dictionnaire des peintres, sculpteurs et graveurs, 1976; Cassou, J. Serge Poliakoff, 1963; Pellegrini, A. New Tendencies in Art, 1966; "Serge Poliakoff" (cat.), Mus. Nat. d'Art Moderne, Paris, 1977; Ragon, M. L'Aventure de l'art abstrait, 1956, "Poliakoff" (cat.), Mus. de Poche, Paris, 1956; Russell, J. "Serge Poliakoff" (cat.), Whitechapel Art Gal., London, 1963. *Periodicals*—Actualité artistique internationale (Paris) October 16, 1952; Art News and Review May 24, 1958; Le Figaro (Paris) November 19, 1964; Le Monde (Paris) January 2, 1969; San Diego Union September 27, 1964; XXe siècle (Paris) May–June 1959.

POLLOCK, (PAUL) JACKSON (January 28, 1912–August 11, 1956), American painter, was the most influential artist of his generation, a leading innovator in modern painting, and a myth in his own lifetime. With his New York School colleague Willem de Kooning, he was a pioneer of the action, or gesture, brushstroke, the truly expressionistic feature of American abstract expressionism. In his so-called dripped canvases, Pollock developed the technique of all-over composition, a major contribution to the evolution of pictorial space, in which the painting has no fixed center of interest. More than any other first-generation Abstract Expressionist, Pollock was responsible for New York City's succeeding Paris as the world capital of modern art.

Paul Jackson Pollock was born on a sheep ranch in Cody, Wyoming. His father, LeRoy Pollock, of Scotch-Irish background, was a farmer who later worked as a surveyor. His mother, the former Stella May McClure, was of Irish descent. Jackson was the youngest of five brothers, the eldest of whom, Charles, was the first to become a painter. Two other brothers also became painters, and the other became a writer.

Jackson's family was constantly on the move, and by the age of ten he had lived in six states. In 1923 LeRoy Pollock settled for a time on a truck and dairy farm in Phoenix, Arizona, and as a boy Jackson worked as a farmhand, milking cows, plowing, and cutting alfalfa. He explored the rivers, hills, and Indian ruins of the region, and visited Indian reservations where ceremonial dances and sand paintings were tourist attrac-

JACKSON POLLOCK

tions. His sophisticated aesthetic appreciation of pre-Columbian and American Indian art came later, but was reinforced by these boyhood memories.

After a brief stay in Arizona the family moved to California, and in 1926 was living in Riverside, near Los Angeles. By the following summer Jackson, though not yet 16, was nearly six feet tall, with a powerful athletic build, light brown hair, and deep-set, intense hazel eyes. As B. H. Friedman wrote, " . . . He would have been cast as a cowboy, even including that suggestion of vulnerability and shyness in his eyes." (By this time Pollock had begun to use his middle name, preferring to be called "Jack" instead of "Paul.")

In the summer of 1927 Jackson and a younger brother, Sandy, worked at surveying. Pollock was already developing a taste for alcohol, but found that he could resolve—or "act out," as he put it—his tensions and anxieties through drawing. After the family moved to Los Angeles he enrolled at the Los Angeles Manual Arts High School, where he met Philip Guston and Manuel Tolegian, two artists with whom he was to have frequent contact for the rest of his life. He was expelled from Manual Arts during the 1928–29 academic year for being a "troublemaker." Among other things, he, Guston, and Tolegian had prepared and distributed the *Journal of Liberty*, two mimeographed sheets attacking the high-school faculty for its over-emphasis on athletics. Pollock also angered school authorities when he gave money to two girls so they could run away from home. He was readmitted on partial probation but left without graduating in 1930. Though still confused and groping, he

knew only that he wanted to be, in his words, "an Artist of some kind."

His brother Charles had been enrolled in the Arts Students League, New York City, since 1926, and in 1930 Jackson joined him there. At the League, Pollock studied with the noted Regionalist painter Thomas Hart Benton. After briefly being influenced by synchronism and cubism in Paris, Benton, about 1920, vehemently rejected European modernism and began concentrating exclusively on American subjects, realistically handled. He cultivated a tough, hairy-chested, "all-American" posture, heaping scorn on cosmopolites, intellectuals, foreigners, socialists, and other "degenerates," including the progressive American artists of the Stieglitz group. Benton's exaggeratedly masculine stance may have appealed to the Pollock brothers, despite the crudities and limitations of his thinking, because there was a rhythmic energy in Benton's increasingly stylized compositions. Although he eventually rebelled against his teacher's story-telling realism—"He drove his kind of realism at me so hard I bounced right into nonobjective painting," Pollock recalled—he was influenced by Benton and was to stay on friendly terms with him after their student-teacher relationship ended in 1931. "It was better to have worked with him than with a less resistant personality," Pollock said, "[though] the only American painter who interests me is [Charles] Ryder. . . . "

During his years at the League, Pollock made several cross-country trips to visit his family in California. Excited by the adventure of being "on the road," he loved moving fast through the countryside in a car, truck, or freight train, and made sketches along the way. The feeling for vast space in his mature work can be traced in part to the exhilaration he had felt as a teenager in working with a surveying crew out West, and in studying the sweep of the landscape from the top of a freight car.

Pollock was introduced to Renaissance art by Benton, and his sketchbooks of the years 1931–34 contain drawings after Michelangelo, Tintoretto, and El Greco. With the exception of de Kooning, Pollock was more influenced by the old masters than were his peers among the New York School, whose attention was riveted on the postcubist developments of European modernism. Indeed, save for Picasso, the great early 20th-century modernists—Mondrian, Kandinsky, Braque, Matisse—held comparatively little interest for Pollock.

Pollock now turned to the Mexican muralists, José Orozco, Diego Rivera, and D. A. Siqueiros, not for their realism or their political subject matter, but for their violent distortion of forms

and their hard-hitting expressiveness. A painting in oil done by Pollock about 1933 echoes the agonized faces and writhing contours of Orozco, but Pollock's shapes were engulfed by a mysterious tidal wave which accentuated the effect of chaos and upheaval.

In the Depression years of the 1930s Pollock survived by doing odd jobs, including ten-dollar-a-week work as a school janitor, and was helped by being able to live with his brother Charles in Grenwich Village. In the summer of 1935 he joined the easel-painting division of the New Deal-sponsored Federal Arts Project (FAP). He painted two murals for Greenwich House, and worked on the FAP intermittently until early 1943, when it was discontinued.

In 1936 Pollock participated in the experimental workshop run by Siqueiros at Union Square in lower Manhattan. Siqueiros's use of duco and other enamels and his experiments with what he called "controlled accidents" seem to have influenced Pollock, although he did not use techniques of this kind until some ten years later. Among Pollock's few surviving paintings from these years, *Night Pasture*, done before 1937, is quite Bentonesque, and *Landscape with Rider* (1937) shows Ryder's influence. But these and his convulsive, turbulent seascapes of the 1930s have expressionistic contours, vehement brushwork, and rather muddy color, and show that the artist was moving toward abstraction.

In the late 1930s, along with Orozco's influence, the impact of Picasso made itself felt in Pollock's work, the powerful, passionate Picasso of *Minotauromachia* and *Guernica* who had absorbed some of surrealism's concern with the unconscious and the dream-state. Pollock's painting *Masked Image* of 1938 contains patterns recalling Picasso's masterful *Girl Before a Mirror* (1932), but instead of Picasso's sharply outlined shapes and firm structure, Pollock created writhing, pulsating, and somewhat blurred images suggesting the primitive masks and totems he admired in the Indian art of the Northwest.

In 1937 Pollock, who had been drinking heavily, began psychiatric treatment for alcoholism; two years later he was taken on as a patient by Dr. Joseph L. Henderson, a Jungian he saw on a weekly basis. Henderson's analyses of Pollock's drawings—drawings not specifically done for Henderson—were published in a 1970 monograph titled *Jackson Pollock: Psychoanalytic Drawings.* Henderson commented: "His own highly developed function of intuition needed no help from anyone, but did need to be rescued from a crucifying sense of isolation."

While Pollock was on the FAP he met the Russian-born avant-garde painter John Graham, who was also a dealer and who gave the artist his first public exposure. In November 1941 Graham began arranging an exhibit for McMillen Inc., a Manhattan interior decorating firm that showed art. The show was called "American and French Paintings," and the exhibitors, in addition to Graham, included Stuart Davis, Walt Kuhn, Arshile Gorky, the then unknown Willem de Kooning, Pollock, and the Brooklyn-born Lee Krasner. At the McMillen show, which was mounted in 1942, Pollock hung his painting, *Birth,* which, though still indebted to Picasso and surrealism, had whirling rhythms that were very much Pollock's own.

It was at this time that Pollock and Krasner fell in love. As Clement Greenberg wrote years later: " . . . Even before their marriage [in 1945] her eye and judgment had become important in his art, and continued to remain so." Krasner's support of her husband was to be total, as, it seems, was his encouragement of her. It was, however, only after Pollock's death that her own talent as a painter was recognized. Because she was a woman, few of the New York School painters took her work seriously (Bradley Walker Tomlin and Pollock, though he was hardly free of "macho" attitudes, were notably less chauvinistic than their peers). Krasner once said, "I would give anything to have someone giving me what I was able to give Pollock."

During the winter of 1941–42 Pollock had been introduced to the surrealist technique of "automatic" creation, a method for deriving fresh abstract imagery from the unconscious, by his friend Robert Motherwell. In 1942–43 he had a curatorial job at the Museum of Non-Objective Painting, the forerunner of the Solomon R. Guggenheim Museum, and it was at this time that he met Peggy Guggenheim. She invited William Baziotes, Motherwell, and Pollock to make collages for her surrealist-oriented Art of this Century Gallery, which opened in New York City in October 1942. Pollock's collages have apparently been lost, but for Guggenheim's next show, "Spring Salon for Young Artists," held in 1943, the 31-year-old Pollock contributed a large (40 inches by 55¾ inches) oil, *Stenographic Figure,* which, according to Jean Connolly of *The Nation,* "made the jury starry-eyed." Pollock was subsequently proclaimed by Robert Coates in *The New Yorker* "a real discovery."

In 1943 Pollock quit his museum job after receiving a commission to paint a huge mural for the entrance hall of Peggy Guggenheim's Upper East Side home. As Barbara Rose observed, "This was the first mural-size painting by an artist of Pollock's generation." In this canvas, Picasso's in-

fluence was no longer visible; although there were still figurative elements, these "figures" were rhythmically intertwined in a bold and very personal calligraphy.

Although *Mural* was painted on a vertical surface with conventional paint, Pollock was discovering the scale and technique that suited him. Totemic and animalistic images, ritual themes, and ideographic signs were present in other friezelike canvases of 1943, including *Guardians of the Secret, The She-Wolf,* and *Pasiphaë.* This blend of the abstract and the symbolic characterized the works exhibited in Pollock's first solo show, held at Guggenheim's Art of this Century gallery in the winter of 1943. In his catalog introduction to the exhibit, James Johnson Sweeney stated that "Pollock needs self-discipline" but also declared that the young painter offered "unusual promise in his exuberance, independence, and native sensibility." For *The New York Times* critic, Pollock's abstractions were "not without precipitate violence" and were "extravagantly, not to say savagely, romantic." Although Clement Greenberg was rather ambivalent in his review of the show for *The Nation,* he would become Pollock's most influential champion.

Pollock was by now the "star" of Peggy Guggenheim's gallery. In *Gothic* (1944) he eliminated all traces of figuration in favor of an overall effect of movement which was heightened by the increasingly gestural style of his painting. He studied printmaking at Stanley William Hayter's Atelier 17 in New York City during 1944–1945; though sympathetic to Hayter's concept of "line as a self-expressive force," he did not take to the refractory (for Pollock at any rate) medium of engraving.

In October 1945 Pollock and Lee Krasner were married. They had been living together in Pollock's studio on University Place in Greenwich Village, and when they decided to marry Krasner expected only an informal civil ceremony, but Pollock insisted on a "real" marriage with a "real" minister. With Peggy Guggenheim's help, they bought a large 19th-century farmhouse in the Springs, Long Island. Their property in the Hamptons included a barn which became Pollock's studio.

In 1947 Pollock's slim monthly stipend—which had at first been one hundred dollars but had risen to three hundred—was cut off when Guggenheim closed her gallery and moved to Italy. For the next few years Lee and Jackson survived on the sale of a handful of paintings. They did without hot running water in their house (until MOMA purchased a Pollock), and, unable to afford a car, they rode bicycles everywhere.

It was while leading this relatively quiet life in the country that Pollock entered his most creative period (his alcoholism was cyclical, and in 1948–50 he didn't drink). The dense, thickly impastoed works of 1946, including the famous *Eyes in the Heat,* were followed in 1947 by Pollock's breakthrough, his first drip paintings—one of the most radical developments in art since cubism's heroic period. Rejecting the entire tradition of easel painting, and abandoning the slow method of painting with a brush, he laid his huge, unprimed canvases on the floor and dripped, dribbled, or spattered the paint, usually from a stick or slat. He sometimes used aluminum paint and enamel pigment, alone or mixed with oil. He became obsessed with the sheer expressiveness of superimposed skeins or whorls of paint as a means of attaining a more expansive pictorial space and a more direct emotional and physical release.

Pollock had admired the sand paintings of the Indians of the American southwest, and his method of working, attacking the canvas from all sides, was itself a kind of war dance. "On the floor I am more at ease," he said. "I . . . can . . . literally be *in* the painting. This is akin to the method of the Indian sand painters. . . . " The emphasis was on spontaneity, but Pollock declared (with some exaggeration), "I can control the flow of paint. There is no accident." He was more explicit in a much-quoted statement which appeared in *Possibilities 1,* a review edited by Robert Motherwell and published just once, in the winter of 1947–48: "When I am *in* my painting, I am not aware of what I am doing. . . . I have no fears about making changes, destroying the image, etc., because the painting has a life of its own. I try to let it come through. It is only when I lose contact with the painting that the result is a mess. . . . "

Barbara Rose has called the drip paintings, with their all-over pictorial organization, "the first significant change in pictorial space since Cubism." Philosopher William Barrett has observed that the "impulse in Pollock's painting" did not come from "the Cubist idiom. . . . It did not operate within the convention of strict and controlled form; if anything, it was disruptive of form. Pollock is very much in the American grain, like the writers Walt Whitman or William Faulkner, who throw themselves on the vitality of their inspiration, trusting that its sheer vital flow will be sufficient to generate enough form to sustain the work."

Between 1947 and 1950 Pollock produced his most important group of large-scale drip paintings, including *Cathedral* (1947); *Number 1; White Cockatoo* (1948); *Lavender Mist;* and

Autumn Rhythm (1950), which was the culmination of this phase and was acquired by the Metropolitan Museum of Art, New York City, in 1957. "It was a great drama," Hans Namuth said of Pollock at work on such masterpieces; "the flame of explosion when the paint hit the canvas; the dancelike movement; the eyes tormented before knowing where to strike next; the tension; then the explosion again. . . . "

By 1950 Pollock was the most discussed and controversial American painter of his day. A film, *Jackson Pollock*, with narration by the artist, was produced by Hans Namuth and Paul Falkenberg in 1951. The term "action painting," stressing explosive, gestural brushstrokes, was coined at this time by the critic Harold Rosenberg; although this was eventually misapplied to New York School abstract expressionism in general, it was a particularly apt description of Pollock's method. Motherwell's psychological interpretation is of interest: "He [Pollock] was, perhaps, a passive man: his struggle was to become active: it is therefore ironical that he became the image of the Action Painter."

Most lay critics, including the writer who called Pollock "Jack the Dripper," stressed what seemed to be the frenzied violence of his work. This emphasis, in turn, promoted the myth of the rough, tough, all-American Frontiersman or Cowboy. Nor did Pollock discourage this image: he wore cowboy boots, blue jeans, and a neckerchief; was known to threaten, when drunk, to "bust up" a bar; and drank to excess at a time when the mystique of alcohol for those who had grown up in the 1920s and '30s was comparable to that of hallucinogenic drugs for the generation of the 1960s. Pollock's own statements also contributed to his legend. For example, he once remarked to de Kooning, who was the more "intellectual" of the two artists, "You know more, but I feel more"; and when Hans Hofmann, the European-born-and-educated "dean" of abstract expressionism, expressed fear that nature had ceased to be important in the artist's dripped paintings, Pollock replied, "I am nature."

This "Noble Savage" myth had a particular appeal for the French post–World War II avant-garde, for whom Pollock represented the "real America." Actually, as William Rubin of *The New York Times Magazine* pointed out, there was more angst and violence in Pollock's pre-drip paintings of 1940–46. In the "poured" paintings of 1947–1950, there is often, to quote Rubin, "an almost rococo delicacy," and whatever violence they contain is countered by "exuberance . . . grace, fragility and even charm." For Rubin, Pollock's painting of these

years is a "lyrical art, choreographically supple and rhythmic." The line of development implicit in Pollock's drip paintings was to be carried forward in the 1950s and '60s by such color-field painters as Helen Frankenthaler and Jules Olitski.

Between 1950 and 1952 Pollock reintroduced figurative elements into some of his canvases, including *Number 29*, executed mainly in black Duco enamel on raw canvas. (He had begun numbering his works because numbers "make people look at a picture for what it is—pure painting.") Color and vastness of scale returned in *Blue Poles* (1952), in which some critics saw analogies to the immensity of the American landscape, as in the plains of Arizona or the Grand Canyon. His output lessened in the years immediately before his death, and although still doing drip paintings, he began to explore other means of expression. He was using brushes again, and richer textures. In his works of 1952–54 he often recapitulated earlier themes, recalling the turbulent seascapes and totemic imagery of the '30s and early '40s, as in *Ocean Grayness* (1953) and *White Light* (1954). *Search* (1955), for example, used a thick, heavy impasto. But these late works reveal doubts, conflicts, and hesitations, as if Pollock feared that he had reached an impasse.

Although Pollock was selling paintings to museums and collectors across the country and was becoming famous in Europe, his acclaim and modestly growing income only aggravated his depression and unease. "I feel like a clam without a shell," Pollock said of his celebrity. "Pollock wanted to become a celebrity, and he did," painter Ad Reinhardt trenchantly observed. "He got kicked out of the '21' Club many times." Frank O'Hara described him as "tortured with self-doubt and tormented by anxiety." A coterie of worshipful admirers sprang up around him (though his legion of followers was never as large as de Kooning's), especially at the Cedar Bar in Greenwich Village, the meeting place of New York School painters and their devotees from the mid-1940s to about 1960. Quiet, shy and a "good listener" when sober, Pollock could become bellicose or hesitate between morose taciturnity and affectionate bonhomie in his increasingly frequent and prolonged bouts of drunkenness. Motherwell remembers him as "a deeply depressed man . . . and like most depressed men rather reticent. . . . Beneath his depression you could always sense his potential rage."

In an effort to curb his alcoholism Pollock sought the advice of a health faddist who put him on a diet of raw vegetables and a peculiar

protein emulsion which he often took with him to bars. In 1955 he reentered analysis, but his anguished mood persisted. By 1955–56 he was producing very few paintings.

The "Pollock myth" was compounded by the manner of the artist's death. On August 12, 1956 he was driving to a concert near his Long Island home in a green 1950 Oldsmobile convertible (which he had acquired in a trade for two paintings). With him were two friends, a young woman named Edith Metzer and Ruth Klugman, a painter. Feeling weak and overcome by fatigue, he decided to return home. Speeding along the dark road, he hit a hump and the car overturned; he and Metzer were killed, Klugman was seriously injured. It was technically an accidental death, but to many it seemed the inevitable outcome of Pollock's self-destructiveness, a bent shared in varying degrees by other American artists of his generation. A friend is quoted as saying of Pollock, "He was born with too big an engine inside him. He had to paint to survive. And he had stopped painting."

Although the impact of Jackson Pollock's work in America and subsequently in Europe was enormous, the ground had been prepared in the United States by the teaching of the veteran Cubo-Abstractionist Hans Hofmann, and by the presence in New York during the war years of the French Surrealists. But Pollock's contribution was radical in the complete change he brought about in the treatment of pictorial space, and in the all-consuming energy of his commitment. Like every daring innovation, his art aroused controversy. The eminent British critic, Sir Herbert Read, at first characterized Pollock's work as "vacuous nihilism," but later acknowledged his pioneering importance. Whether his intensely subjective art was seen as a gesture of alienation or one of liberation, it struck a chord in an anxiety-ridden post–Hiroshima world, for his work was bound up with the exploration of outer space and man's inner being.

Despite the impossible expectations thrust upon Pollock as an American culture hero, his aspirations as a painter were international, and he considered the idea of "an isolated American painting" as absurd as "the idea of creating a purely American mathematics or physics." The "all-or-nothing" character of his art and his self-destructive impulses precluded the possibility of an "old-age" style as achieved by Matisse and Picasso—a phenomenon rare in American art and literature—but his revolutionary contribution to painting was summed up by de Kooning, who said, "Jackson broke the ice."

EXHIBITIONS INCLUDE: Peggy Guggenheim's Art of this Century, NYC 1943–47; San Francisco Mus. of Art 1945; Arts Club of Chicago 1945; Betty Parsons Gal. NYC 1948–51; Gal. del Naviglio, Milan 1950; Bennington Col., Vt. 1952; Sidney Janis Gal., NYC 1952, '53, '55; Kunsthaus, Zürich 1953, '61; MOMA, NYC 1956–57, '67; São Paulo Bienal 1957; Marlborough-Gerson Gal., NYC 1964, '69; Yale Univ. Art Gal., New Haven, Conn. 1978; Mus. d'Art Moderne de la Ville, Paris 1979; Centre Georges Pompidou (Beaubourg), Paris 1982. GROUP EXHIBITIONS INCLUDE: "American and French Paintings," McMillen Gal., NYC 1942; "Spring Salon for Young Artists," Peggy Guggenheim's Art of this Century, NYC 1943; Annual, Whitney Mus. of Am. Art, NYC 1946–54; "Large-Scale Paintings," MOMA, NYC 1947; Venice Biennale 1950; São Paulo Bienal 1951; Pittsburgh International, Carnegie Inst. 1951, '52; "Fifteen Americans," MOMA, NYC 1952; "Younger American Painters," Solomon R. Guggenheim Mus., NYC 1954; "The New American Painting," MOMA, NYC 1958; "20th Century American Drawing: Three Avant-Garde Generations," Solomon R. Guggenheim Mus., NYC 1976; MOMA, NYC 1983.

COLLECTIONS INCLUDE: Metropolitan Mus. of Art, MOMA, Whitney Mus. of Am. Art, and Solomon R. Guggenheim Mus., NYC; Albright-Knox Art Gal., Buffalo, N.Y.; Munson-Williams-Proctor Inst., Utica, N.Y.; Hirshhorn Mus. and Sculpture Garden, Washington, D.C.; Mus. of Fine Arts, Dallas; San Francisco Mus. of Art; Peggy Guggenheim Collection, Venice; Kunstsammlung Nordsheim-Westfalen, Düsseldorf.

ABOUT: Ashton, D. The New York School: A Cultural Reckoning, 1973; Barrett, W. The Truants, 1982; Bénézit, E. (ed.) Dictionnaire des peintres, sculpteurs et graveurs, 1976; Busignani, A. Pollock, 1971; Current Biography, 1956; Friedman, B. H. Jackson Pollock: Energy Made Visible, 1972; Greenberg, C. Art and Culture, 1961; Janis, S. Abstract and Surrealist Art in America, 1944; O'Connor, F. V. Jackson Pollock, 1967; O'Hara, F. Jackson Pollock, 1959; Ritchie, A. C. Abstract Painting and Sculpture in America, 1951; Robertson, B. Jackson Pollock, 1960; Rodman, S. (ed.) Conversations with Artists, 1957; Rose, B. American Art Since 1900, 2d ed. 1975; Sandler, I. The Triumph of American Painting: A History of Abstract Expressionism, 1970, The New York School: The Painters and Sculptors of the Fifties, 1978; Sweeney, J. J. "Jackson Pollock" (cat.), Art of this Century, NYC, 1943; Wysuph, C. L. (ed.) Jackson Pollock: Psychoanalytic Drawings, 1970. Periodicals—Art News May 1951, December 1981; Artforum September 1965, February 1967, May 1967; Arts and Architecture February 1944; Esquire December 1983; Harper's Bazaar February 1952; Life August 8, 1949, November 9, 1959; New York Times December 2, 1982; New York Times Magazine January 27, 1974; New Yorker August 5, 1950; Possibilities 1 Winter 1947–48.

*POMODORO, ARNALDO (June 23, 1926–), Italian sculptor, writes: "When I started working with art, I knew very little about it, because I was living in the small provincial town of Pesaro. Everyone there felt very tied to classical art, to the Renaissance, to the world of Urbino and Piero della Francesca. I knew almost nothing at that time of what was going on, because after the war there were scarcely any books to read, and our heritage from fascism was a kind of stifling, autocratic culture. So I chose to go to a totally different school, a technical school. I actually studied engineering and architecture because my family resisted the idea of my becoming an artist. But I used to go to the library in Pesaro and look at everything. There I found a small book on Paul Klee; I didn't know anything about Paul Klee, he came as a complete surprise to me. Incidentally, it was in this way that I discovered the technique of the negative forms which I later used in my castings of small plaques.

"In 1953 I traveled to Milan where there was a big show of Picasso which was very exciting for me. It was an influential show and so was a Mondrian exhibition that I also saw there. Altogether, it was a fantastic time in Milan. From then on, I went there regularly to see shows and buy art books until I realized that I really had to move and leave the countryside. In 1956 I was invited to enter the Venice Biennale where I saw for the first time a large painting by Jackson Pollock. Then I asked myself at a certain point, what can one do after Brancusi or after Arp? I realized that their perfection of the form in our time was inappropriate and it had to be destroyed. The action in my sculpture, the destruction, was a very important moment. First, I thought to explore the solid geometric shapes, cones, spheres (cubes); I thought I could investigate the column and try to get beneath its skin, and I wanted to find what is inside a form which seems so perfect and absolute, superficially. The erosion and flaws of my first columns were human proposals. They were there because I essentially wanted to investigate the energy inside of a form. I never clean the insides of my sculptures, the corroded parts. I retain the rough-cast erosion effect. But the forms are very ambiguous.

"In Chicago when I saw my large disc installed in front of a university building, it was just beautiful, because the sun passed across it. I confess that I rather hate to see my work in museums, in galleries. If I examine my own work it is only to see if it is technically ok, and that's all. Anyway, there are moments when some of my sculptures, exhibited in a particular place, seem to change, and I'm able to look at them as for the first time, freshly. I can enjoy my sculp-

ARNALDO POMODORA

tures in a park, in an ancient public square, like Pesaro, or on a great university campus, as they were at Berkeley. I like to see people lean their bicycles on the sculptures, and birds come to rest, to see them humanized. I feel popular, plebeian, at one with the world. But, then, when I travel out into our suburbs and slums, where our society has its ghettos and its factory-prisons, I feel not only despondent but in contradiction with myself, with my own art. I am wounded by this reality, and I have to reorder all my priorities. Then, monumentality and sculptural beauty seem unrelated to life or to reality. For my work, then, I hope to strike a balance between an absolute artistic quality, as in a museum experience, and the sense of being in the midst of life, a part of its movement and its hope for change."

Arnaldo Pomodoro was born at Morciano, in the north-central Italian region of Romagna. When he was a small child, his family move to the village of Orciano, near Pesaro in the Marche region.

During the artistically sterile war years in Italy, young Pomodoro, in his visits to the library at Pesaro, not only discovered the small book on Klee mentioned in his autobiographical sketch but read widely in modern Italian literature. While attending lectures at the Art Institute of Pesaro, from 1949 to 1950, he read classical and modern theater works; his favorite dramatists were Aeschylus, Brecht, and Sartre. Pomodoro's main interest in those years was designing sets for the stage, and he won a prize in a set-

designing contest in 1953. The following year he won another prize for his sets for a production of Brecht's *St. Joan of the Stockyards.*

In the early '50s Pomodoro served an apprenticeship as a goldsmith and began designing jewelry in gold, in association with his younger brother, Giò, who was also to become a leading Italian sculptor. Arnaldo's background in architecture, engineering, stage design, and jewelry making was to contribute to the structural and textural qualities of his sculpture. Other early influences were the important Picasso exhibition in Milan in 1953 and the pictographic imagery of Paul Klee.

In 1954 Pomodoro moved to Milan. His first exhibition, of jewelry he had made with his brother, was held that same year at Florence's Galleria Numero and then traveled to Milan's Galleria Montenapoleone. When shown in Rome the following year, his jewelry attracted the attention of critics. Referring to their calligraphic designs, L. Cinisgalli described Pomodoro's pieces as "a bewildering piece of writing".

Pomodoro's first sculptures were exhibited in 1955 at the Galleria del Naviglio, Milan. He was invited to show in the Triennale Exhibition in Milan. Gatto, the gallery director who presented Pomodoro's works at the Galleria del Cavallino, Venice, in 1955 and 1956, wrote of the artist's "rugged intellectualism" and his expression of "destructive forces" in his areas of reliefs on flat surfaces. He exhibited in New York City and Buenos Aires in 1957.

In 1958 and 1959 Pomodoro traveled in Europe, studying in museums in Paris, Brussels, Frankfurt, Cologne, and Zürich. He met Alberto Giacometti and the painter Georges Mathieu in Paris, in 1959, and that same year made his first visit to the United States, where he organized an exhibition of Italian artists at the Bolles Gallery in San Franciso and New York City. In 1960 he met David Smith and Louise Nevelson in New York. Nevelson became a close friend; although Nevelson's works are mainly in wood and Pomodoro's in bronze or steel, there are affinities, especially in the environmental aspect of their sculpture.

Arnaldo and Giò Pomodoro were, in the '50s and '60s, collaborating in the search for a new visual language. In 1960 and '61, the Pomodoro brothers became active members of an artists' group called Continuità (Continuity). The group's theorist, Giulio Carlo Argan, explained that "continuity" implied "absence or interdermination of limits". The group was a reaction against the more fragmentary approach of the so-called Informalists, the European Expressive Abstractionists.

The years 1961 and 1962 were crucial in the evolution of Pomodoro's sculpture. In the 1962 sculpture exhibition in Spoleto, Italy, he displayed his first work in steel, a large, 5.6-meter cylinder; he created a number of metal columns, blocks of bronze, wheels, cubes, and compact spheres in the following years. The smooth, polished shapes of these monumental forms were broken or torn away in places to reveal the complex reticulations of the internal structure. The effect was both impressive and disturbing. The Italian critics Nello Ponente and Maurizio Fagiolo observed of these sculptures: "They certainly have reference to our daily lives, to the idols of our society, to technological imperatives, but they are not imitative or conceptual: they are critical. . . . The irrational is converted into an organic structure."

Pomodoro traveled to Brazil for the 1963 São Paulo Bienal, where he won the International Prize for sculpture. This was followed in 1964 by the National Prize for Italian sculpture at the Venice Biennale. Among his bronze pieces shown in Venice, *Homage to a Cosmonaut* and *The Traveler's Column,* both of 1962, are now in the Hirshhorn Museum and Sculpture Garden, Washington, D.C., and *Sphere No. 1* (1963) is in the Museum of Modern Art, New York City.

Although Pomodoro's early sculptures were in the style of expressive abstraction, in the early '60s he began to work in the branch of concrete art that emphasizes machinery. Typical of his metal sculpture is *Grande Omaggio alla Civiltà Tecnologica* (Grand Homage to Technological Culture), a large (78 feet by 27 feet) relief in bronze and cement he executed for the College of Further Education, Cologne.

From 1965, Pomodoro exhibited regularly at the Marlborough Galleries in Rome and New York City. Frank O'Hara dedicated a poem to Pomodoro for his New York City exhibition of 1965, and a *Time* magazine (December 3, 1965) article, entitled "Dissatisfied Aristotle," which discussed Pomodoro's search for the true nature of form within matter, further established the artist's reputation in America. "For me the sphere is a perfect, almost magical form," Pomodoro said in *Time.* "Then you try to break the surface, go inside and give life to the form." Commenting on what *Time* called his "eroded geometrics," Pomodoro observed, "The contrast between the polished and torn surfaces is precisely the difficulty of the indivdaul to adapt to a new world."

While teaching at Stanford University, Palo Alto, California, in 1966, Pomodoro met Allen Ginsberg, Gregory Corso, and other poets and artists of the beat movement. He responded

sympathetically to their experience of, and literary meditation on, alienation, the "fractured structure" of life. The sketch books Pomodoro brought to Italy from the United States were filled with carefully worked out drawings that were to provide the basis for his later, large-scale sculpture. His monumental *Sfera Grande* (Big Sphere) was shown on the roof of the Italian pavilion of Expo '67, Montreal. Also in 1967, Pomodoro was one of six recipients—the others were Josef Albers, Francis Bacon, Eduardo Paolozzi, Joan Miró, and Victor Vasarely—of prizes given by the Carnegie Institute, Pittsburgh.

From 1968 to 1972 Pomodoro spent long periods in his country studio, often working with new materials. One of his first major exhibitions in Italy, "Sculpture in the City," was held in Pesaro during the summer of 1971. Several of his sculptures were purchased by the city of Bologna to be erected permanently in a historic city square. He was commissioned by the city of Modena to create a work in memory of the Italian resistance partisans of the Second World War.

The city of Milan staged a major retrospective of Pomodoro's works in 1975 at the Rotonda della Besana. His most ambitious environmental sculpture, *Pietrarubbia's Work,* was shown in an unfinished state at the Milan retrospective; the completed work was the focal point of Pomodoro's impressive exhibition at the Marlborough Gallery, New York City, in the fall of 1976.

The main features of *Pietrarubbia's Work* are monumental bronze doors. The title, Pomodoro explained, "refers to the ruin of a medieval castle surrounded by a hamlet or a group of houses actually to be found near Pesaro in central Italy." Photographs of the now desolate village were included in the show. The "sculpture-village," as Pomodoro likes to call the piece, has five parts: the "Foundation" is an earth floor set in a bronze frame; the "Use," in bronze and iron, comprises a cube, a triangle (a lever), and the elevated wall; the "Relationship," involves the massive and movable bronze doors, which Bruce Hooton in *Art World* (November 26, 1976) compared to "huge vertical trays of gold type"; the "Quotidian" consists of two elements, what the artist called "the wall of personal experience" and the meeting hall, which house a small throne; finally there are the "Absolutes," the blade of pain, and hope, with a nucleus, rings, and a fringe that Pomodoro had not yet completed. The symbolism seems to suggest that, although the past is petrified and the present is ambiguous, the present can never fully obliterate the buried memories of the past. On one of the walls is a line from the Italian poet Eugenio

Montale, *"Lo sai: debbo riperderli e non posso"* (You know it: I must lose you again and I cannot). "The village is alive if for no other reason than the writing on its walls (verses), but even so it's a place that can be thought of as uninhabitable," Pomodoro commented.

Pietrarubbia's Work was enhanced by elements characteristic of Pomodoro's sculptural style: the dense abstract calligraphy the artist consistently uses in his complex pieces, and tactile aggregations, which, when applied to bronze walls or slabs, were compared in the *Time* article to "the innards of computers." The Marlborough Gallery exhibition also showed smaller, but highly original, examples of Pomodoro's curious abstract calligraphy in "Fogli di Cionaca" (Chronicles), a series of bronze tablets, measuring approximately 39 inches by 27 inches. Although they are in low relief, their organization in parallel horizontal bands and the linearity of their "signs" recall Pomodoro's early admiration for Paul Klee. All of Pomodoro's works, large or small, are amazing feats of casting.

Arnaldo Pomodoro lives and works in Milan. A quiet, thoughtful man, his expression is usually serious, but he has a warm, engaging smile. A lover of modern literature, poetry, and the theater, in conversation he expresses his ideas clearly and persuasively. He has found analogies between the modernist mindset, as reflected in the work of T.S. Eliot, Soren Kierkegaard, and Franz Kafka, and his resolution of questions of form and content in sculpture. In his ongoing exploration of the relationship between technological society and man, Pomodoro has striven for a sculptural form that satisfies the emotions as well as the intellect. His sculpture has suggested to some observers the chasm that still exits "between machine-age perfection and man's inner doubts."

EXHIBITIONS INCLUDE: Gal. Numero, Florence 1954; Gal. Montenapoleone, Milan 1954; Gal. del Cavallino, Venice 1955, '56; Gal. del Naviglio, Milan 1955, '58; Gal. Bonino, Buenos Aires 1957; Kölnischer Kunstverein, Cologne 1958, '65, '69; Gal. Int. d'Art Contemporain, Paris 1959, '62; Marlborough Gal. d'Arte, Rome 1965, '74; Marlborough Gal., NYC 1965–76; Wadsworth Atheneum, Hartford, Conn. 1971; "Sculture nella città," Pesaro, Italy 1971; Rotonda della Besana, Milan 1975; Mus. d'Art Moderne de la Ville de Paris 1976. GROUP EXHIBITIONS INCLUDE: Venice Biennale 1956, '64, '72; "Italy: New Vision," World House Gal., NYC 1957; Pittsburgh International, Carnegie Inst. 1958, '61, '64, '67; Documenta 3, Kassel, W. Ger. 1959; "Italian Sculptors of Today," Dallas Mus. for Contemporary Art 1960; "New Works from Italy," Bollas Gal., San Francisco 1961; Sculpture Exhibition Spoleto, Italy 1962; "Continuità," Gal. Levi, Milan 1962; São Paulo Bienal 1963; Peggy Guggenheim Col-

lection, Tate Gal., London 1964; Mus. of Modern Art, Tokyo 1967; Italian pavilion, Expo '67, Montreal 1967; "New Italian Art 1953–71." Walker Gal., Liverpool 1971; Finch Col. Mus. of Art, N.Y. 1974; Twentieth-Century Monumental Sculpture Exhibition, Marlborough Gal., NYC 1974.

COLLECTIONS INCLUDE: Albright-Knox Art Gal., Buffalo, N.Y.; Art Inst. of Chicago; MOMA, NYC; Art Mus., Princeton Univ., N.J.; St. Louis City Art Mus., Mo.; Mus. de Bellas Artes, Buenos Aires; Nat. Gal. of Victoria, Melbourne, Australia; Mus. Royal des Beaux-Arts, Antwerp, Belgium; Mus. de Arte Moderna, Rio de Janeiro; Wallraf-Richartz Mus., Cologne; Tate Gal., London; Gal. Nazionale d'Arte Moderna, Rome; Peggy Guggenheim Collection, Venice; Boymans-Van Beuningen Mus., Rotterdam; Hirshhorn Mus. and Sculpture Garden, Washington, D.C.

ABOUT: Fagiolo, M. and Ponente, N. New Art Around the World, 1966; "Arnaldo Pomodoro" (cat.), Marlborough Gal., NYC, 1976; "Arnaldo Pomodoro: An Overall View of his Work, 1959–1969" (cat.), Mus. Boymans-Van Beuningen, Rotterdam, 1969. *Periodicals*—Art World November 26, 1976; New York Times October 24, 1965; Studio International April 1964; Time December 3, 1965.

***POMODORO, GIÒ** (November 17, 1930–), Italian sculptor, was born in Orciano de Pesaro, a country town in the Marches. His older brother, Arnaldo, was also to become a noted modern sculptor. In 1945 the family moved to Pesaro, where Giò attended the Technical Institute. At 20, influenced by reproductions of the Surrealists, he began to make small silver reliefs and jewelry. During his military service in Florence in 1952–53 he visited the Numero Gallery, where he saw reproductions of the action paintings of Jackson Pollock and Franz Kline and of David Smith's sculpture *Agricola.* Influenced by abstract expressionism, Giò began to make automatic drawings and signs, as well as assemblages of iron and stone, which were later shown at the Numero Gallery.

In 1954 Giò Pomodoro moved to Milan. There he collaborated with his brother in designing and executing jewelry in gold and silver which was exhibited in the Montenapoleone Gallery. In Milan he associated with a group of Italian painters linked to tachisme, the French equivalent of American action-painting, and made his first sculptures in welded iron. In 1955 he exhibited at the Obelisco in Rome, the Cavallino Gallery, Venice, and the Naviglio in Milan.

Giò showed a series of silver reliefs worked in negative on cuttle-bone in the Medals section of the Venice Biennale of 1956. He was strongly influenced by Pollock's "Convergences" series and the paintings of Kline in the US pavilion, and has often spoken of Pollock, Kline, and Smith as the "founding fathers" of the post–World War II avant-garde. From an earlier generation, Paul Klee was a major influence on his aesthetic approach.

In 1957 Pomodoro was an active contributor to the Milan review *Il Gesto.* He took part in an exhibit called "Nuclear Art," and with his brother joined the Continuità (Continuity) group, which sought to combine modernism with traditional elements of "great" Italian art from premodern eras. He soon broke away from the "Il Gesto" group to pursue the concept of "informalism," based on the automatic sign and the expressive possibilities of the medium. Pomodoro made negative images in clay which, with assemblages of wood and wax, were afterwards cast in metal. Two series in this vein were "Vegetable Situations" and "Growths."

Pomodoro married Gigliola Gagnoni in 1958. That same year he held a solo show at the Helios Gallery, Brussels, and was invited to exhibit at the Carnegie Institute, Pittsburgh and the World House Gallery, New York City.

Pomodore's search for what he termed a "spatial continuum" led to sculptures created by an original method. Over a basic wooden structure, he stretched fabric, sometimes inserting other forms. Wires were attached to the fabric to pull it in other directions. After a negative of the sculpture had been achieved in the fabric, it was covered with plaster and the wires were cut away. A wooden framework was attached to carry the weight and protect the fragile plaster. Raised to a vertical position, the fabric was stripped away to reveal the original plaster version upon which the sculptor might still work. Among sculptures created by this method, practiced by Pomodoro for several years, were *Co-existence* and *Fluidity,* shown in the Galerie Internationale, Paris, early in 1959.

Giò Pomodoro's political sympathies are unequivocally with the left, but his work is at the farthest remove from socialist realism. Nevertheless, his thinking has been influenced by Marx's Hegelian-derived notion of the master-slave dialectic. *Opposing Fluidities,* exhibited at Documenta 2 in Kassel, West Germany in 1959, was the result of his need to react against the fragmentary methods of informalism, which is a variant of expressive abstraction, and to submit his "surfaces with signs" to a more controlled structuring.

Between 1960 and 1963 Pomodoro explored the more formal possibilities of his new technique. Characteristic works were his large bronzes of 1962, *Matrix,* 62¼ inches high, now

°pō´´mō dôr´ō, jē´ō

owned by the Hirshhorn Museum and Sculpture Garden, Wshington D. C., and *Grandi Contatti* (Large Contacts), over 7½ feet high. Giò's work was very different from that of Arnaldo. Both had begun by collaborating in jewelry design, but Arnaldo's sculpture of the '60s and later, although on a very large scale, retained a jeweller's precision and finish. Giò's work could be considered a fluid modern Baroque. The Italian critics Nello Ponente and Maurizio Fagiolo noted in *New Art Around the World* that "Giò Pomodoro establishes a relationship between surface and space" in which "the three-dimensional element is not blocked, not forced into geometric forms, but is open to other possible movements and non-Euclidian spatial definitions."

In 1961, the year his son Bruno was born, Giò Pomodoro was again invited to show the Carnegie Institute. In the following year his room at the Venice Biennale won him the Bright Prize for sculpture. He joined the prestigious Marlborough Gallery, Rome, and remained with it until 1967.

Pomodoro's interest in continuous surfaces took a new form when, in 1963, he began his series of "Folle" (Crowds). He had a solo exhibit at the Palais des Beaux-Arts, Brussels, and his large sculpture, *One,* was acquired by the Tate Gallery, London. One of his large "Crowd" sculptures of 1964 entered the collection of the Rome Gallery of Modern Art.

On Pomodoro's first trip to the United States in 1965 he met Barnett Newman and Mark Rothko in New York City, and this experience confirmed his interest in giving works of art a human scale. After his return from America he began a series of "Squares," dedicated to the 17th-century Baroque architect Borromini, whose dynamic structures and undulating rhythms he greatly admired. These researches led to the series of "Radicals" in which Pomodoro explored the idea of the spiral as the matrix of "action in tension."

In 1966–67 Pomodoro visited New York a second time and began to work in marble. One of these pieces, *Black Liberator,* was dedicated to American blacks. Another large sculpture, *Great Ghibelline,* was acquird by Nelson Rockefeller.

Pomodoro's major works of the 1970s were in stone, using marble from Belgium, Portugal, Egypt, and other countries. Despite the change in medium and a more geometric and monumental emphasis, the theme of tension within the double or single images was still present. One piece was entitled *Vertical-Horizontal.* Another sculpture, *T-Vertical-Horizontal,* in three sections and executed in 1973–74 in black serpentine stone, was dedicated to the socialist Allende

government of Popular Unity in Chile. It was influenced by the Russian suprematism of the early revolutionary period. A series of "Arches" in black marble was followed in 1975 by the powerful "Suns." These massive pieces, recalling on a much larger scale the Futurist Boccioni's sculptural experiments of 1912–13, have a symbolic, even cosmic meaning, as suggested by titles like *Sun the Producer—Communal Harvest; Sun and Girder; The Gate and the Sun; Displaced Sun.* The "sun" concept embraces the life-giving forces in nature as well as the mechanized energies released by modern industry and harnessed to the needs of humanity. Pomodoro has pointed out that "natural sunshine, producing color and light" is different from "industrial sunshine," but both are part of today's world.

Giò Pomodoro's studio is in Milan, but he spends time each year in the quarries of Querceto among the stonecutters. He is a warm, friendly, and approachable man, always willing to discuss his work and his ideas. Marcello Venturoli, describing a conversation with Pomodoro in Milan, in an article in *Il Giornale,* noted that the artist's face from the front has a soft, almost feminine quality, but the features in profile are sharp and pointed. Venturoli felt that gentleness and toughness are combined in Pomodoro's nature. Although his works may be in the nonfigurative, constructivist tradition, Pomodoro has never wanted to produce an "élitist" art. "It is not true," he said, "that art is apart from life. Think how much natural sculpture there is in the planet. The real is today. . . . We have won an inheritance of awareness (thanks to the founding fathers of the avant-garde): a unity in suffering, a consciousness of the toil of man, of the necessity for choice and struggle."

EXHIBITIONS INCLUDE: Gal. Numero, Florence 1954; Gal. dell'Obelisco, Rome 1955; Gal. del Cavallino, Venice 1955, '56; Gal. del Naviglio, Milan 1955, '56; Gal. Helios Art, Brussels 1958; Gal. 22, Düsseldorf; Kunstverein, Cologne 1958; Gal. Internationale d'Art Contemporain, Paris and Brussels 1959, Paris 1961; Marlborough-Gerson Gal., NYC 1964; Marlborough Gal. d'Arte, Rome 1964, '67; Gal. de France, Paris 1968; Gal. Pierre, Stockholm 1969; Felix Landau Gal., Los Angeles 1969; Martha Jackson Gal., NYC from 1970; Gal. Françoise Mayer, Brussels 1971; Gal. del Naviglio, Milan 1974. GROUP EXHIBITIONS INCLUDE: Gal. Numero, Florence 1953; Venice Biennale 1956; "Arte Nucleare," Gal. S. Fedale, Milan 1957; "New Decade," Minneapolis 1958; Documenta 2 and 3, Kassel, W. Ger. 1959, '64; Tate Gal., London 1964; Pittsburgh International, Museum of Art, Carnegie Inst. 1964; Scottish Nat. Gal. of Modern Arts, Edinburgh 1966; Expo '67, Montreal 1967; Jewish Mus., NYC 1968; L'Art vivant," Fondation Maeght, Saint-Paul-de-Vence, France 1968; "Scultori Italiani Contemporanei," Royal Palace, Milan 1971.

COLLECTIONS INCLUDE: Gal. of Modern Art, Rome; Tate Gal., London; Hirshhorn Mus. and Sculpture Garden, Washington, D.C.; Phoenix Mus., Arizona; Société des Beaux-Arts, Brussels; Wilhelm Lehmbruck Mus., Duisburg; Kunst und Museumverein, Wuppertal.

ABOUT: Abrams, H. New Art Around the World, 1966, Selected Paintings and Sculptures from the Hirshhorn Museum and Sculpture Garden, 1974; "Giò Pomodoro: Sculpture 1972–74" (cat.), Galleria del Naviglio, Milan, 1974. *Periodicals*—Bolaffiarte March/April 1976; Corriere della Sera May 19, 1974; Il Giornale June 13, 1975.

POONS, LARRY (October 1, 1937–), American painter, became famous in the mid-1960s for his optically active and tightly organized paintings of dots and lozenges on contrasting fields of pure color. Only in his late 20s at the time of his rise to prominence, he was heralded by critics as the youngest and possibly the most promising of the "color-field" or "post-painterly abstractionist" group which included Kenneth Noland, Jules Olitski, and Frank Stella. By the 1970s, however, Poons had abandoned his engaging early style for highly textured "drip" paintings which seemed to be inspired equally by the work of Olitski and Jackson Pollock and by false-color satellite images of the earth.

Born in Tokyo and raised in the United States, Poons first planned to be a composer and spent two years at the New England Conservatory of Music, Boston (1955–57). He studied aleatory composition at the New School for Social Research, New York City, with John Cage, whose theories were an important influence on Poons's later, more randomly composed work. In 1958 Poons left the conservatory to take up painting at the Museum of Fine Arts School, Boston. "I decided I just didn't have it as a composer," he explained in a 1970 *Artforum* interview. "I never felt quite at home with really composing serious music and that always kept me nervous. When I got down to painting, I knew where I was, knew what I was doing." His early paintings—such as the "Art of the Fugue" series (1958–59), in which squares and rectangles laid out on a diagonal grid are meant to suggest, through rhythms of color, shape, and depth, analogous musical rhythms—owe an obvious debt to the work of Mondrian (especially the "Boggie-Woggie" series) and Theo van Doesburg. Sidney Tillim of *Arts Magazine* (February 1965) praised these early works, calling them "remarkable for their immediate and qualitative grasp of abstractionist shape and structure, and their gradual but unerring formulation of a new

mode of drawing in space, which is at once schematic yet vibrant, determined yet open."

In the early 1960s Poons began to paint colored dots, and later elliptoids, that appear to be floating on vibrant fields of pure color, often of complementary hue (for example, sky blue, deep green, and lavender ovals on a red ground in *East India Jack*, 1964). Painstakingly worked out beforehand on graph paper, these paintings possess at once an aggressive flatness and an astonishing inner space; the dots or ovals drift deep within a limitless space while being achored to the surface by faint traces of the penciled-in grid on which they were laid out. Although quite large (often 6 feet by 12 feet or larger), the pictures give the impression of being fragments of yet larger patterns. "The edges define but don't confine the painting," Poons told Lucy Lippard of *Art International.* "I'm trying to open up the space of the canvas and make a painting that explodes instead of going into the painting." According to one critic, Poons's "uncanny scaling and sensitivity to colors and values" enables him to "change the spatial and chromatic 'timbre' of individual zones at will." Poons's occasional intuitive deviations from his preplanned patterns give the paintings an agreeable sense of visual tension, as do their huge dimensions, which engulf the viewer in a sea of color, and the flashing retinal afterimages caused by his frequent use of adjacent complementaries. (According to Lippard, Poons never noticed the afterimages until they were pointed out to him by a friend; he then whimsically proceeded, notably in *Nixes' Mate* (1964), to paint "false" afterimages approximately where the "real" afterimages appear.)

From the time of his first solo show, at the Green Gallery, New York City, in 1963, Poons was hailed by critics as continuing the tradition of all-over painting begun by Pollock, expanding the color-field terrain staked out by Olitski, Barnett Newman, and Mark Rothko, and spearheading the op art movement that was then filling the galleries. (He was included in the Museum of Modern Art's influential "Responsive Eye" exhibition in 1965.) However, Poons always disavowed any connection with a well-defined program or ideology, claiming, "What is important about painting is the contradictions of choices, decisions, believing in choice and allowing yourself to make choices." Disagreement over his exact postion in current art trends did not prevent his solo shows from being hugely successful; the paintings, of which he could produce only a handful each year, were usually sold before the exhibitions opened.

By 1966 Poons had entered a transitional peri-

od. He began to dispense with the underlying grids and vibrating color combinations; he made freer use of closely valued colors and let slight imperfections remain on the canvas. The result was work that seemed less intellectual and more sensual. As he continued to experiment, the lozenges expanded, losing their precise outlines, and began to group together like clusters of protozoa seen through a slightly out-of-focus microscope. Increasingly, Poons allowed the canvas to become thick and blistered with paint (for example, in *Night Journey*, 1968); eventually he dispensed altogether with the lozenges, the underlying grid, and the effort to expand the pictorial space beyond the painting's edge in order to explore the interaction of color and surface texture. Laying his canvases on the floor, or, later, hanging them on the wall, Poons poured, dripped, and splattered layer upon layer of acrylic pigment, letting the character and viscosity of the paint create a surface with almost geologic relief. As he gained skill in this technique, his colors, at first gray and muddy, regained much of their former purity and vividness. The influence of Olitski, whose work had already taken this turn, could be strongly seen in such paintings as *Railroad Horse* (1971) and *Firstwild* (1972); color wars for dominance with tactility, while composition is decidedly secondary, being in most cases variations of vertical or diagonal striations.

This thoroughgoing change of style, which Poons continued to refine through the 1970s, alienated many of his former supporters, most of whom in any case were turning to minimalism and away from painterly painting. Nor did advocates of abstract expressionism, which Poons's work superficially resembled, necessarily respond to his new tactility and freedom. As late as December 1979, Barbara Cavaliere wrote in *Arts Magazine*: "Poons equals Pollock's or Still's process minus their commitment to a metaphysical, ethically responsible content." But James Monte, writing in the same issue, claimed that with his 1979 solo show at the André Emmerich Gallery, New York City, Poons "more than fulfilled his early promise," adding, "The problems the art world had had with Larry Poons' paintings [have] to do as much with the intellectual, social, and political loyalties within the world as [they do] with the quality of his pictures."

Poons, who was artist in residence at the Institute of Humanistic Studies in Aspen, Colorado from 1966 to 1967, is the author of *The Structure of Color*.

EXHIBITIONS INCLUDE: Green Gal., NYC 1963, '64, '65; Leo Castelli Gal., NYC 1967, '68; Kasmin Gal., London 1968, '71; Lawrence Rubin Gal., NYC 1969, '70, '71, '72; David Mirvish Gal., Toronto 1972, '73; Knoedler Contemporary Art Gal., NYC 1973, '74, '75, '76, '77, '78, '79; Antwerp Gal., Anvers, Neth. 1977; Wuppertal Mus., W. Ger. 1978; André Emmerich Gal., NYC 1979, '80. GROUP EXHIBITIONS INCLUDE: "Formalists," Gal. of Modern Art, Washington, D.C. 1963; Carnegie Inst., Pittsburgh 1964, '67; Allen Art Mus., Oberlin Col., Ohio 1965, '76; "The Responsive Eye," MOMA, NYC 1965; "Systemic Painting," Solomon R. Guggenheim Mus., NYC 1966; Biennial, Corcoran Gal., Washington, D.C. 1967, '69; Annual, Whitney Mus. of Am. Art, NYC 1968, '72; Albright-Knox Art Gal., Buffalo, N.Y. 1968; Documenta 4, Kassel, W. Ger. 1968; "The Art of the Real 1948–68," NYC 1968; "Painting in New York 1944–69," Pasadena Art Mus., Calif. 1969; "Color and Field 1890–1970," Albright-Knox Art Gal., Buffalo, N.Y. 1970; Biennial, Whitney Mus. of Am. Art, NYC 1973; "The Great Decade of American Abstraction: Modernist Art 1960–1970," Mus. of Fine Arts, Houston 1974; "Surface, Edge and Color," Whitney Mus. of Am. Art, NYC 1977.

COLLECTIONS INCLUDE: Albright-Knox Art Gal., Buffalo, N.Y.; MOMA, and André Emmerich Gal., NYC; Nat. Gal. of Victoria, Melbourne, Australia; Stedelijk van Abbemus., Eindhoven, Neth.; Milwaukee Art Center; Graham Gurd Col., Boston.

ABOUT: Poons, L. The Structure of Color, 1971. *Periodicals*—Art International April 1967; Artforum April 1965, December 1970, March 1972; Arts Magazine February 1965, December 1979.

*PORTINARI, CÁNDIDO (TORQUATO)

(December 29, 1908–February 6, 1962), Brazilian painter, was born in the small town of Brodowski (also spelled Brodosque) in the state of São Paulo, the second of 12 children of coffeepickers who had emigrated there from Italy. He began to paint at the age of eight, but his schooling was irregular, as he had to help in the fields. In one of his brief periods at school he broke his leg playing soccer, which left him with a permanent limp. The artist said that the accident was fortuitous because it left him with more time for painting and none for soccer.

At school and at work young Portinari scribbled drawings on paper, fences, and walls. When he was nine years old, some itinerant painters came to Brodowski to decorate the local church, and Cándido was allowed to watch. Soon he was given permission to mix the paint, and finally he was allowed to paint stars on the ceiling. It was then that he decided to become an artist.

In 1918, when he was about 15, his family had saved enough money to send him to Rio de Janeiro. There Portinari found lodgings in the bathroom of a boarding house; he had to be out by five in the morning when the boarders would

°pôr tē nä´ rē, căn´ dē dō

Photo by Manchete Pictorial Parade

CÁNDIDO PORTINARI

want to bathe. He enrolled at the National School of Fine Arts and got a job with a photographer drawing enlargements of photographs. For several years he continued to study, living meagerly on whatever he could earn from occasional portraits.

In his early 20s Portinari won a few prizes and obtained more portrait commissions. Finally, in 1928, he won the Prix de Voyage, a traveling scholarship which enabled him to go to Europe, where he lived from 1928 to 1930, spending most of this time in Paris but also visiting museums and galleries in the French provinces, Spain, Italy, and England. Portinari·read widely, but did almost no painting at this time. He was not influenced to any great extent by the modern trends he encountered in Europe, and the artistic and social life of Paris bore no relation to his own concerns. However, the works of Pascin influenced his drawing, and he maintained later that in Paris, "I really commenced to see my native village. I found that I can paint nothing at first sight. I must wait and let imagination work." While in Paris he met and married a young Uruguayan, María, and returned with her to Rio in 1930.

Portinari was broke, and the Rio art world was scandalized that the winner of a Prix de Voyage should have returned only with one small canvas. Looking for work, the artist convinced a graduating class of 40 architects that he could do their portraits more cheaply than a photographer; this was his first job. In 1932 his circumstances began to improve. The painter Léonard Foujita visited Rio and became interested in Portinari's work. Through Foujita, Portinari met

people in the diplomatic and foreign colony who asked him to paint their portraits. But the contact with Foujita also encouraged him to try more modern forms of expression. The first picture he painted in his new style (which he later referred to as his "brown style") was *Coffee,* which in 1935 won a second honorable mention in the Carnegie International Exposition, Pittsburgh, and brought Portinari to the attention of North Americans.

In 1936 Portinari obtained his first adequately paid position, on the faculty of the University of the Federal District, Rio de Janeiro. He stayed there until the spring of 1939, when the university closed. From the mid-1930s on, no doubt influenced by the new school of Mexican muralpainting, Portinari began to execute pictures portraying the life of poor Brazilian peasants, cowherds, and coffee-bean pickers. In 1936 he received his first fresco commission for the Ministry of Education, for whom, between 1936 and 1945, he completed three frescoes: *The Labor of the Brazilian Land, Children's Games,* and *The Four Elements.*

The Museum of Modern Art, New York City, bought one of his paintings, *Morro,* in 1939. *Morro* depicts life in a poor black quarter with sympathy and dignity—and without social propaganda. Also in 1939, the first comprehensive exhibition of his works was held in Rio. In 1940 his growing international reputation was confirmed when MOMA gave him a solo exhibition. This was the occasion of Portinari's first visit to the United States, accompanied by his wife and their one-and-a-half year old son, Joao Cándido. After many years of going to American movies, Portinari found Manhattan disappointingly unexciting, but he was impressed by the cafeterias and by "the fruit of the United States, so polished and well kept, just as though it had been waxed." Portinari's work was also shown in 1940 at the Detroit Institute of Arts, and in a LatinAmerican Exhibition at the Riverside Museum in the Bronx.

As a result of these exhibitions Portinari's painting was praised as being "remarkably varied in technique, in style, and in theme." His art ranged from portraits with "a Renaissance straightforwardness," through monumental female groups such as *Women Planting* and the looser technique of his genre subjects, to fantastic and eerie designs like *Carcass, Burial,* and *Scarecrow.* He portrayed the native workers of Brazil without romanticism or exoticism, as real people who work, play, love, marry, and die. *Burial in the Hills* was described as "a quiet story about life and death—as natural as the hills and the horizon." Portinari did many paintings of

blacks, who make up 30 percent of Brazil's population, and he also painted Indians. Some American critics were disturbed by his tendency towards exaggeration and distortion for dramatic effect, but there was general appreciation of the freshness of Portinari's color, whatever the style or subject. He liked "violent yellows, rich red-browns, green blacks, and electric blues," particularly blues. He himself said, "People are all colors in Brazil, especially blue." Even at their most fantastic, his pictures were distinguished by strong and effective draftsmanship.

In 1941–42 Portinari painted murals for the Hispanic section of the Library of Congress in Washington, D.C. In these works he adopted a completely new style which showed the influence of Picasso and the Expressionists, and was to dominate his final period. In 1944 he executed a decorative series, for a building in the city of São Paulo, which is often called his "Biblical Cycle" and in which he achieved a high degree of emotional expressiveness. From this time on, he adopted an aesthetic similar to that of the Mexican painter Rufino Tamayo, in opposition to that of David Siqueiros, José Orozco, and Diego Rivera. Like Tamayo, he felt that the art of Latin America was sufficiently developed to aim at a program more universal than the illustration of a social program or of folkloric themes. Yet Portinari, who has been called "the Puvis de Chevannes of the coffee-pickers," did not abandon subjects relating to his native land, continuing the sympathetic portrayal of the humble inhabitants of the city outskirts and the countryside whom he knew so well. It was above all in his easel paintings and brush drawings, as distinct from his murals, that he depicted the misery of the native populations.

In 1944 Portinari designed compositions on ceramic tiles on the life of St. Francis of Assisi for the facade of the church of Pampulha, and the following year he completed *Stations of the Cross* for the cathedral of Belo Horizonte. He returned to Europe in 1946 and had a successful exhibition at the Galerie Charpentier, Paris. On that occasion his canvas *Composition 1945* was acquired by the French government, and Portinari was awarded the Legion of Honor. In 1947 he held exhibits in Buenos Aires, Montevideo, and Punta del Este.

Of his late murals the most important were the monumental compositions *War* and *Peace* (both 1953–56) for the South Lobby on the ground floor of the General Assembly building of the United Nations in New York City. The two 36-by-46-foot murals were executed in oil on cedar plywood. In *War* Portinari avoided any realistic reference to present-day conflicts and

the paraphernalia of war. As he explained: "War today is no longer a battlefield: it is human suffering, torn fields, ruined cities, women and children sacrificed, the world shaken by cataclysm." In *Peace* Portinari said that he was inspired by the serenity and peacefulness of the spirits described in *The Eumenides* by Aeschylus. He sought, in his words, "to make use of simple and pure forms, bathed in a light capable of suggesting an atmosphere of brotherhood and understanding among men."

The Wild Beasts, a study in oil for *War,* was among the works shown in Portinari's exhibition at Wildenstein, New York City, in the spring of 1959. Other paintings included *Preparation for a Hammock Burial, The Outlaw, The Washerwomen, The Scarecrow,* and *Boy with a Slingshot.* In the foreword to the catalog, Brazilian ambassador Jayme de Barros wrote that Portinari was "not only the greatest modern painter of Brazil" but was also "the first Brazilian painter who was projected upon the international scene." The ambassador praised "the strong expressiveness of his art, the high resonance of his colors, the oppressiveness of the light, the melancholy composition of the backgrounds." However, the French critic Jacques Busse, reviewing Portinari's work as a whole, preferred the "grandiose naïveté," freshness, and sincerity of the early period, with its blacks "as hieratic as figures of Antiquity," to the more sophisticated later works with their echoes of Tamayo, expressionism, and Picasso.

Cándido Portinari died in Rio de Janiero at the age of 53. Short and slightly plump, with sandy hair turning gray, Portinari had a pleasant manner and a lively, often satirical sense of humor. Throughout his life he worked conscientiously and wholeheartedly at his painting, in which the French critic Jean Cassou found the same "savage rhythms we hear in the music of Villà-Lobos." Another French critic, Germain Bazin, wrote: "In [the artist's] unbridled projection of expression, we feel a force which strives to be free, a rigorous and healthy sap which is that of the great Brazilian land."

EXHIBITIONS INCLUDE: MOMA, NYC 1940; Detroit Inst. of Arts 1940; Gal. Charpentier, Paris 1946; Mus. of Modern Art, Rio de Janiero 1953; São Paulo Bienal 1955; Wildenstein, NYC 1959; "Cem Obras Primas de Portinari," Mus. de Arte de São Paulo Assis Chateaubriand 1970. GROUP EXHIBITIONS INCLUDE: International Exposition, Carnegie Inst. Pittsburgh 1935; Latin-American Exhibition, Riverside Mus. Bronx, N.Y. 1940.

COLLECTIONS INCLUDE: MOMA, NYC; Archives of the Library of Congress, and Hispanic Foundation, Library of Congress, Washington, D.C.; Mus. d'Art Moderne, Paris.

ABOUT: Bénézit, E. (ed.) Dictionnaire des peintres, sculpteurs et graveurs, 1976; Current Biography, 1940; de Andrade, M. Portinari, 1939; de Aquino, F. Cándido Portinari, 1966; de Barros, J. "Cándido Portinari," (cat.), Phaidon Dictionary of 20th-Century Art, 1978; Wildenstein, NYC, 1959, Dorn, G. M. Cándido Portinari: A Bibliography, 1974; Leão, J. Portinari: His Life and His Art, 1940; "Portinari of Brazil" (cat.), MOMA, NYC, 1940. *Periodicals*—Newsweek October 21, 1940; Time August 12, 1940.

RICHARD POUSSETTE-DART

POUSSETTE-DART, RICHARD (June 8, 1916–), American painter, began his career as an Abstract Expressionist of the first generation. He was born in St. Paul, Minnesota, the second of three children. His father, Nathaniel Poussette, was a painter, writer, and lecturer on art; his mother, Flora Louise Dart, was a poet. When they married, they hyphenated their names as a sign of mutual affection and respect.

When Richard was two years old the family moved to Valhalla, New York, where the children grew up in a happy, intellectually and artistically stimulating atmosphere. Richard at first attended public schools, but his secondary education was completed, in 1935, at the Scarborough School, Scarborough-on-Hudson, New York. He enrolled in Bard College, Annandale-on-Hudson, but dropped out before the end of the school year, finding that the stultifying curriculum interfered with his determination to think for himself. He moved to New York City, where from 1936 to '40, he worked as an office clerk and bookkeeper. He devoted much time at night to drawing and painting. A typical canvas of this period was a 1939 portrait of the young artist Lydia Modi, strong in design and characterization and somewhat Picasso-esque in its drawing. In 1940 he quit working at menial jobs and began painting fulltime. He had no formal art training and was completely self-taught .

Poussette-Dart described the years that followed as "a period of desperation," of struggle for survival, despite help from his family and friends. Two early marriages, one to Lydia Modi, ended in divorce, but he was determined to go on painting and in 1941 had his first solo show, at the Artists' Gallery, New York City. He was then working in a semiabstract style containing elements of late cubism and surrealism. *East River* (1939) and *Fugue* (1940), with its assertive calligraphy, and *City* (1940) were characteristic works. In a 1974 monograph on the artist, J.K. Monte wrote: "A thick ornamental line encloses intelligently considered organic shapes in these pictures."

Poussette-Dart had three shows at the Marian Willard Gallery, New York City, in 1943, '45 and '46, and in '44 he was included in the "Abstract Painting and Sculpture in America" exhibition at the Museum of Modern Art, New York City. One of his boldest works from the early '40s was *Symphony Number 1, The Transcendental* (1942). Its heavy impasto and mysterious biomorphic shapes concealed a firm vertical and horizontal structure. It conveyed a sense of deeply felt emotion and, like other works of those years, it was an exploration of "the inward nature of man and the world." *Palimpsest* (1944), also painted in a thick impasto, combined forceful calligraphy with a carefully controlled latticelike structure.

At the time of his second, 1945 show at the Willard Gallery, Poussette-Dart met Evelyn Gracey, a poet and schoolteacher whom he married in 1946. They had two children, Joanna, born in 1947, and Jonathan, born in 1952. A painter, Joanna Poussette-Dart is considered a leading Neo-Abstract Expressionist.

In 1947 Peggy Guggenheim gave Poussette-Dart a solo exhibition at her Art of This Century Gallery, New York City. "I strive to express the spiritual nature of the Universe," the artist wrote in the show's catalog. "Painting is for me a dynamic balance and wholeness of life; it is mysterious and transcending yet solid and real." An *Art Digest* critic, though finding his canvases "large, even monumental in size and symphonic in concept," was baffled by them but added, "There is still the possibility that we don't have the perception to see what the painter is getting at."

In 1948 Poussette-Dart affiliated himself with the Betty Parsons Gallery, which was then one

of New York's preeminent showcases of avant-garde art. His work during the '40s had in many ways paralleled the stage of surreal biomorphism through which such first-generation Abstract Expressionists as Pollock, Rothko, Newman, and Gottlieb passed on their way to developing individual styles. But although Poussette-Dart shared the Abstract Expressionists' tragic view of life and their spiritual attitude towards painting, some of his canvases, including *Figure* and *Forestness*, both of 1946, bore affinities with Jean Dubuffet's *art brut*. After 1950, when Pollock, Rothko, and Newman abandoned surrealistic abstraction for a more purely painterly and nonobjective approach, Poussette-Dart retained biomorphic forms and symbols, though he tended increasingly to dissolve them in color and light over the surface of the canvas.

A change of surroundings was partly accountable for these developments in his work. In the first years of their marriage, the Poussette-Darts had lived in a large cold-water flat on East 56th Street near the East River. In 1950 they moved to the rural Eagle Valley, New York, where Richard used a barn for his studio. Though becoming better known, he still faced financial hardships and expressing his complex, almost mystical vision on canvas was a constant struggle. In 1954 the Poussette-Darts moved to nearby Monsey, New York, but in '58 they converted to their needs a large fieldstone carriage-house in a wooded and comparatively isolated section of Suffern, New York, where they still live and work.

A Solomon R. Guggenheim Fellowship in 1951 enabled Poussette-Dart to paint for a year free of money worries. His canvases of the early '50s, including *The Magnificent* (1950–51; Whitney Museum of American Art, New York City) and *Golden Dawn* (1952), had rich, heavily encrusted textures and were infused with the artist's personal lyricism. Reviewing Poussette-Dart's "Predominantly White" exhibition at the Betty Parsons Gallery in November 1955, an *Art News* critic called him "one of the most original and solitary artists we have around." His work of the late '50s showed even greater assurance, culminating in *White Gothic Number 3* (1957), with its undulating vertical rhythms, *Spanish Presence* (1957), and especially *Blood Wedding* (1958). In that glowing canvas, the "rich tapestry-like surface is rent by a vertical band of violent red just to the left of center," to quote John Gordon. J.K. Monte observed that repeated overpainting in *Blood Wedding* resolved the tension between painterliness and linear calligraphy without losing "color luminosity or surface coherence."

Poussette-Dart's work entered a new phase in the '60s with his series of "Presence" paintings. The more traditional expressionism of the earlier works was succeeded by an all-over pictorial configuration. The small points of pigment recalled the pointillist technique of Seurat and his colleagues, except that Poussette-Dart did not use the dots of color to form distinct shapes. The value changes were so slight that at least half of the new paintings, beginning with *Red Presence* and *Golden Presence,* both completed in 1961, were impossible to photograph in black and white. Others, in which there was a central shape, usually a variation on the circle motif, were more easily "read" in black and white, but only in color could their muted radiance and vibrant surfaces be appreciated.

There has always been a strongly poetic, spiritual, and mystical quality in Poussette-Dart's vision. The artists he admires most are El Greco, Rembrandt, Van Gogh, and Ryder. "I am concerned with what burns its way through to its own reality," he said. "It is the quality of penetration and intensity which is religious in an art sense and which is art in a religious sense."

His paintings of the '60 and '70s have been of two general types. The "Hieroglyph" series, including *Hieroglyph of Light* (1966–67) and the nocturnal *Hieroglyph Number 2, Black* (1973–74), consist of small shapes within an unfocused, all-over patterning which causes the eye to wander over the entire surface. In the second type the eye immediately focuses on a centralized shape, usually circular or elliptic. This series includes *I, of the Circle* (1965–67) and *Presence, Red* (1968–69). The artist's work often suggests constellations, as in *Star Space* (1962), which combines all-over calligraphy and textures with a circular shape, just off center, that unifies the work and intensifies its impact.

Two major retrospective exhibitions at the Whitney Museum, in 1963 and '74, paid tribute to Poussette-Dart's importance in American painting of the post–World War II era. In 1967 he received a National Endowment for the Arts award for individual artists. Two major works of the 1970s summed up his recent pictorial achievements—a triptych with circular forms entitled *Presence* (1973–74; North Central Bronx Hospital) and a three-panel mural from the "Hieroglyph" series, an iridescent work appropriately titled *Radiance* (1973–74).

Richard Poussette-Dart is a gentle, thoughtful man, introspective but friendly and courteous. He is a pacifist and a vegetarian. From 1971 to '73 he taught at Sarah Lawrence College, Bronxville, New York. The artist's present serenity is far removed from the turbulence of his early

years. He is interested in world cultures and comparative religions, from which he appropriates ideas, symbols, and forms for his art. Both he and his wife write poetry, and in one of his notebooks Poussette-Dart composed a verse that corresponds to the cosmic and "magical" spirit he seeks to express in his paintings:

Art is never finished
It remains open at both ends.
It has no ends It remains
revealing itself. Not
to be known Always known
Yet always unknown.

EXHIBITIONS INCLUDE: Artists' Gal., NYC 1941; Willard Gal., NYC 1943, '45, '46; Peggy Guggenheim's Art of This Century Gal., NYC 1947; Betty Parsons Gal., NYC 1948–61, '64, '67; Whitney Mus. of Am. Art, NYC 1963, '74; Washington Univ., St. Louis, Mo. 1969; "Richard Poussette-Dart: Presences," MOMA, NYC 1969; Obelisk Gal., Boston 1970; Andrew Crispo Gal., NYC 1974, '76; Marisa del Re Gal., NYC 1981, '83. GROUP EXHIBITIONS INCLUDE: "Abstract Painting and Sculpture in America," MOMA, NYC 1944; Whitney Annual, NYC 1949–72; "Abstract Painting and Sculpture in America," MOMA, NYC 1951; "The New Decade," Whitney Mus. of Am. Art, NYC 1955; "American Abstract Expressionists and Imagists," Solomon R. Guggenheim Mus., NYC 1961; "New York School: The First Generation: Paintings of the 1940s and 1950s," Los Angeles County Mus. of Art 1965; "The New American Painting and Sculpture: The First Generation," MOMA, NYC 1969; "American Art at Mid-Century I," Nat. Gal. of Art, Washington, D.C. 1973; "American Art Since 1945," Worcester Art Mus., Mass. 1975; "Abstract Expressionism: The Formative Years," Cornell Univ., Ithaca, N.Y. 1978.

COLLECTIONS INCLUDE: MOMA, and Whitney Mus. of Am. Art, NYC; North Central Bronx Hospital, N.Y.; Albright-Knox Art Gal., Buffalo, N.Y.; Addison Gal. of Am. Art, Andover, Mass.; Corcoran Gal. of Art, and Hirshhorn Mus. and Sculpture Garden, Washington, D.C.; Univ. of Nebraska, Lincoln; Pasadena Mus. of Art, Calif.; Joseph Pulitzer Collection; H.H. Thyssen-Bornemisza Collection, Lugano.

ABOUT: Baur, J.I.H. The New Decade, 1955; Current Biography, 1976; Gordon, J. "Richard Poussette-Dart" (cat.), Whitney Mus. of Am. Art, NYC, 1963; Hobbs, R. C. and Levin, G. Abstract Expressionism: The Formative Years, 1981; Monte, J.K. "Richard Poussette-Dart" (cat.), Whitney Mus., NYC, 1974; "Richard Poussette-Dart" (cat.), Andrew Crispo Gal., NYC, 1976; Rose, B. American Art Since 1900, 2d ed. 1975; Sandler, I. The Triumph of American Painting, 1970. *Periodicals*—Art Digest January 15, 1945, March 15, 1947; Art News April 1961, May 1963; Arts Magazine January 1965; Nation October 13, 1951.

RATTNER, ABRAHAM (July 8, 1895– February 14, 1978), American painter, was a versatile artist noted for his religious paintings and his work in color lithography and stained glass. An Expressionist by temperament, he is considered one of the foremost colorists of 20th-century American art. The turbulently emotional yet disciplined style of his later work is reminiscent of abstract expressionism, but he never abandoned figuration.

Rattner was born in Poughkeepsie, New York, the son of a rabbinical student, who had emigrated from Russia, and a Rumanian mother. The family was poor and Abraham attended the local high school. In 1914, he entered George Washington University, Washington, D.C., to study architecture, the influence of which can be seen in the monumental quality of his compositions. From 1915 to '17 he took night courses at Washington, D.C.'s Corcoran School of Art and an anatomy course at a medical school. In 1917 he enrolled at the Pennsylvania Academy of Fine Arts, Philadelphia, but after the US entered World War I he joined the Army and was sent to France. Serving in the Camouflage Section of the Fortieth Engineers, he saw action in 1917–18 at the second battle of the Marne and at Château-Thierry.

In 1919 he returned to the Pennsylvania Academy and, after winning the Cresson Traveling Fellowship in 1920, moved to Paris. Rattner studied at the Ecole des Beaux-Arts with Fernand Cormon in 1921, at the Académie de la Grande Chaumière with the sculptor Bourdelle in 1922, and at the Académie Ranson with Paul Sérusier and Jules Maurice in 1923–24. Rattner lived in relative poverty, taking jobs as a porter, agricultural laborer, and worker in a print factory. In 1922 he lived for a time in Giverny, where he claimed to have spied from the bushes as Monet painted his waterlilies. In 1923, when he set up a studio in Montmartre, he was influenced by the cubism of Picasso and Braque, by futurism, and by Georges Rouault, to whom his work has been compared in its emotional intensity.

In Paris in 1924 Rattner married Bettina Bedwell, a fashion correspondent for the New York *News* and the Chicago *Tribune*. Also in 1924 he was included in two group exhibitions in Paris, at the Salon d'Automne and the Salon des Indépendants. The following year he showed at Paris's Salon des Printemps, and in 1927 he joined the Minotaure group in Paris, whose members recognized his brilliance as a draftsman through his work on their publications.

Recalling his formative years in Paris, Rattner said: "When I came to Paris to paint, Cubism

Courtesy of Kennedy Galleries, Inc., NYC: Photo by Malcolm Varon

ABRAHAM RATTNER

and Futurism to me were only visual devices for breaking up an object or producing lines of movement on a canvas. . . . Coming from America, my understanding was superficial. I quickly found that the new art was an effort to understand nature, a really new perception, a bridge between subjective and objective realities." In his early works, and through the 1930s and '40s, Rattner united cubism with expressionism, developing his own flow of forms, distortions of the figure, glowing color, and dramatic contrasts between light and dark.

Rattner's first solo show was at the Galerie Jacques Bonjean, Paris, in 1935, and his *Card Party* painting was purchased by the French Government for the Musée du Jeu de Paume. In 1936, while still living in Paris, he had three solo exhibitions in the US, at the Julian Levy Gallery, New York City, the Arts Club, Chicago, and the Courvoisier Gallery, San Francisco. His painting *Springtime Showers* (1939) was described by Bernard S. Myers as displaying "a unique handling of color chords and variations, together with the fascinating rhythm of repeated heads and umbrella handles."

When the Nazis rolled into Paris in 1940, Rattner returned to the US. His automobile trip with Henry Miller through the East, the Midwest, and the South resulted in Miller's indictment of the American consumer society, *The Air-Conditioned Nightmare,* and in over 500 drawings and watercolors by Rattner. Two of the most striking watercolors, both of 1940, are *Pittsburgh with Henry Miller* and *Express Highway in Four Sketches.* About this time he executed small paintings of air raids, bombed

cathedrals, and other scenes of war's devastation. His outrage at the inhumanity of man to man in the war years was expressed in such works as *Survivors* (1942) and the ironically titled *City Still Life* (Walker Art Gallery, Minneapolis), which portray the desolation of a bombed-out town. By contrast, works inspired by his travels in the US were peaceful, revealing another side of his temperament. Rattner once said, "All our lives we are torn between the oppression of reality and utopia."

From the 1940s on, Rattner's vigorous expressionist tendencies became even more emphatic. *The Emperor* (1944; Whitney Museum of American Art, New York City) is characterized by jewellike colors and intricate patterns. That painting, as well as *Song of Liberation* (1945), reflect Rattner's admiration for Romanesque art, Byzantine mosaics, Greek Orthodox icons, and show that he was still influenced by Picasso. But his approach had become less deliberate and more spontaneous. "I am breaking away as far as possible from the deliberate, the intellectual, the pure," he declared. "I seek the impure to express emotion, the feeling, the thing."

In the late '40s and early '50s Rattner supported himself by teaching. He was an instructor at the New School for Social Research, New York City, in 1948; visiting artist at Yale University and a teacher at the Brooklyn Museum School in 1949; and artist-in-residence at the American Academy, Rome, in 1951.

The tragedy of the Nazi's near extermination of European Jewry and the dropping of the atomic bomb on Hiroshima and Nagasaki deeply affected Rattner. He became more aware of his Jewish heritage and began painting Biblical subjects. A major work of the mid-'50s was his large-scale *Last Judgment Triptych,* of which he said, "The painting became the interpretation of the final reality of the atom. The form and the color become the apocalyptic metaphors." But eschatology was not Rattner's only religious theme. He painted Old Testament events—a recurrent theme was Moses and the burning bush—and created his own "icons."

In the mid-'50s Rattner moved towards a more abstract type of expressionism, as in *Prairie* (1955) and *Gargoyles* (1959), and his surface textures and color became more sensuous. He designed tapestries and mosaic columns for the Fairmount Temple Anche Chesed, Cleveland, Ohio, in 1957; the following year he designed a mosaic wall for St. Leonard's Friary and College, Centerville, Ohio, and stained-glass windows for the Flint Institute of Arts, Michigan, and for the Loop Synagogue, Chicago. He was given a retrospective exhibition in 1959 by the American Federation of Arts in New York City.

In the 1960s Rattner painted a series of works based on the Book of Ezekiel, in which the tension between figuration and the richly textured surface was pronounced. He was among the American artists whose work was shown in the Soviet Union in 1962. His *Last Judgment Triptych* was exhibited at the New York World's Fair, 1964; also that year he painted a crucifixion entitled *Deux Personnages*.

About 1972 Rattner excuted a series of stained-glass works titled "The Divine Image," which depicted the burning bush and the flames of hell. In a nonreligious vein he painted a series of "Prizefighter" pictures marked by violent, agitated brushwork. In 1977 Rattner was awarded an Honorary Degree for Humanity by Michigan State University, Lansing.

Abraham Rattner died in New York City. He had lived for years on Greenwich Street in downtown Manhattan and frequently visited Paris. He was an intense man with strong, sensitive features and curly, unruly gray hair. In his later years Rattner grew a beard, which, with his bushy eyebrows, made him look rugged and patriarchal. In the catalog to the 1981 Rattner show at the Kennedy Galleries, New York City, Martha Fleischman described him as "a deeply spiritual man, moved by feelings of compassion and outraged by injustice and war. Never a believer in 'art for art's sake,' Rattner once said: 'Use any and all ideas; create a symphony of emotion, explore all instruments of expression; the important idea is that the painter's nature be given the widest latitude for its own expressive realization.'"

Rattner's mystical conception of art as a personal spiritual search was expressed in his statement, "Oh to arrive at that degree of interpretation of my own relationships with the things, objects, ideas, thoughts, which strike me; to become the color-form of all experience, of those deep moments of despair or those very rare ones of utter delightfulness in a color so subtle as to be on some faraway heavenly reality."

EXHIBITIONS INCLUDE: Gal. Jacques Bonjean, Paris 1935; Arts Club, Chicago 1936; Courvoisier Gal., San Francisco 1936; Julian Levy Gal., NYC 1936, '39, '41; Stendhal Gal., Los Angeles 1941; Paul Rosenberg & Co., NYC 1941–56; Philadelphia Art Alliance 1945; Baltimore Mus. of Art, Md. 1946; Santa Barbara Mus. of Art, Calif. 1947; Vassar Col., Poughkeepsie, N.Y. 1948, '52; Univ. of Illinois, Urbana 1952, '55; Downtown Gal., NYC 1957–66; Corcoran Gal. of Art, Washington, D.C. 1958; Whitney Mus. of Am. Art, NYC 1959; Am. Federation of Arts, Traveling Exhibition 1959–60; Peale House of Pennsylvania Academy of Fine Arts, Philadelphia 1966; Kennedy Gals., NYC 1969, '70, '72; Nat. Collection, Washington, D.C. 1976; "Four Decades of Abraham Rattner," Kennedy Gals.,

NYC 1978; "Abraham Rattner, Watercolors," Kennedy Gals., NYC 1981. GROUP EXHIBITIONS INCLUDE: Salon d'Automne, Paris 1924; Salon des Indépendants, Paris 1924; Salon des Printemps, Paris 1925; Annual Exhibition, Pennsylvania Academy of Fine Arts, Philadelphia 1945; Carnegie International, Pittsburgh 1949; Biennial Exhibition, Corcoran Gal., Washington, D.C. 1953; Edinburgh Festival, Scotland 1964; "International Expressionism Exhibition," Guild Hall, E. Hampton, N.Y. 1968; World's Fair, Osaka, Japan 1970; Univ. of Illinois, Urbana 1973; "Jewish Experience," Jewish Mus., NYC 1975.

COLLECTIONS INCLUDE: Metropolitan Mus. of Art, Whitney Mus. of Am. Art, Jewish Mus., and New School for Social Research, NYC; Albright-Knox Art Gal., Buffalo, N.Y.; Vassar Col., Poughkeepsie, N.Y.; Cornell Univ., Ithaca, N.Y.; Newark Mus., N.J.; Yale Univ., New Haven, Conn.; Dartmouth Col., Hanover, N.H.; Brandeis Univ., Waltham, Mass.; Williams Col., Williamstown, Mass.; Pennsylvania Academy of Fine Arts, Philadelphia; Phillips Gal., and Hirshhorn Mus. and Sculpture Garden, Washington, D.C.; Mus. of Art, Baltimore; St. Louis Art Mus., Mo.; Chicago Art Inst.; Des Moines Art Center, Iowa; Walker Art Center, Minneapolis; Fort Worth Art Center, Tex.; Santa Barbara Mus. of Art, Calif.; Mus. du Jeu de Paume, Paris; Vatican Mus. of Contemporary Art, Rome; Bazalel Mus., Israel.

ABOUT: Fleischman, M. "Abraham Rattner, Watercolors" (cat.), Kennedy Gals., NYC, 1981; Getlein, F. Abraham Rattner, 1960; Leepa, A. Abraham Rattner, 1974; Nordness, L. Art USA Now, 1963. *Periodicals*—Art Digest October 1, 1944, February 1946, December 1952; Art in America December 1982; Arts and Architecture January 1957; College Art Journal Autumn 1949, Spring 1957; Esquire June 1939; Magazine of Art December 1945; Verve January–March 1939.

***RAUSCHENBERG, ROBERT** (October 22, 1925–), American painter, possibly the most important and influential American painter of his generation, was born in Port Arthur, Texas, an oil refining town on the Gulf of Mexico. He was named Milton but changed his name to Robert as a young man. His father, Ernest Rauschenberg, an employee of the local light and power company, was the son of an immigrant doctor from Berlin who had married a full-blooded Cherokee Indian. Robert grew up in a comfortable home, but Port Arthur was no cultural center. Robert Hughes wrote in *Time* magazine that Port Arthur's "symphony orchestra was the jukebox, the comics its museum." The Rauschenberg family were active in the local Church of Christ, a fundamentalist sect, and the nearest things to art in the home were the gaudy chromo-litho holy cards pinned up in the living room. Years later Rauschenberg introduced nostalgic allu-

°rou´ shən bûrg

Photo by Cameraphoto, Venezia

ROBERT RAUSCHENBERG

sions to these cheap icons into such early combines as *Collection* (1953–54) and *Charlene* (1954). The "unaesthetic" surroundings of his boyhood contributed to his later incorporation of the most ordinary objects of daily life into his ingeniously outrageous creations.

Recalling his spotty education in the Port Arthur public schools, Rauschenberg said, "I excelled in poor grades." He enjoyed drawing but, to please his parents, after his graduation from Thomas Jefferson High School in 1942 he enrolled in a pharmacy course at the University of Texas, Austin. However, Rauschenberg said, "I was expelled within six months for refusing to dissect a live frog in anatomy class."

About 1943, Rauschenberg was drafted into the US Navy, assigned to the hospital corps, and sent to San Diego Naval Hospital for training. He spent the rest of the war working as a neuropsychiatric technician in various Navy hospitals in California. "This is where I learned how little difference there is between sanity and madness," said Rauschenberg, who is convinced that "a combination of both is what everyone needs."

While stationed in California, Rauschenberg visited the Huntington Art Gallery in San Marino and for the first time saw "real" paintings— Sir Joshua Reynolds's *Portrait of Mrs. Siddons as the Tragic Muse*, Gainsborough's *Blue Boy*, and Thomas Lawrence's *Pinkie*. He was struck by the idea that "someone had thought these things out and made them" and, having been encouraged by fellow recruits whose portraits he had sketched in pencil, it occurred to him that he, too, could become a painter.

After his discharge from the Navy in 1945, Rauschenberg spent time in Louisiana and California and then enrolled in the Kansas City Art Institute. The GI Bill took care of tuition and provided living expenses, and he earned extra money working on window displays for local merchants. Rauschenberg saved his money for a trip to Europe, and sailed for France in the fall of 1947. His brief period of study at the Académie Julian, in Paris, was unrewarding, inasmuch as Rauschenberg spoke no French and lacked the technical background to profit from formal instruction. But at the school he met Susan Weil, an American student with whom he returned to the United States in 1948 and whom he married two years later.

Earlier in '48 Rauschenberg had read an article in *Time* about the pioneer geometric abstractionist Josef Albers, who was then teaching at Black Mountain College in North Carolina. A veteran of the Bauhaus in Germany, Albers was described as the most stringent disciplinarian in art in the US. Aware of his need for a nose-to-the-grindstone education, Rauschenberg enrolled in Black Mountain. Albers hated and denounced Rauschenberg's work, having no sympathy for the young artist's unsystematic, freewheeling approach, and yet Rauschenberg considered Albers "the most important teacher I've ever had." Rauschenberg's art bears no obvious affinities with geometric abstraction, but Albers's austere color exercises and his concern with the effect of juxtaposed colors influenced Rauschenberg's all-white and all-black paintings of 1951–53. Even more important was Albers's practice of having his students bring into class "interesting" discarded objects—bicycle wheels, old tin cans, stones—in order to study their "accidental" aesthetic qualities. Rauschenberg later praised Albers for having given him "a sense of discipline that I couldn't have worked without."

Among the experimental artists at Black Mountain was the avant-garde composer John Cage, the Marcel Duchamp of music with whom Rauschenberg was to become friends in 1951, and the dancer Merce Cunningham, with whom Rauschenberg was later to collaborate in New York City. Cage was one of the pioneers of "happenings" as well as of environmental and conceptual art, and it was his example, his uncompromising pursuit of the new and radical in art, that inspired Rauschenberg's much-quoted statement: "Painting relates to both art and life. . . . I try to act in the gap between the two."

In the fall of 1949 Rauschenberg returned to New York City and studied at the Art Students League. At the Cedar Tavern, in Greenwich Vil-

lage, he met some of the leading Abstract Expressionists, including Motherwell, Tworkov, and Kline. Art materials were beyond his means, but blueprint paper in wide sheets cost only $1.75 a roll, and between 1949 and '51 Rauschenberg and his wife experimented with the photographic blueprint process. One of them would lie naked on a large sheet of blueprint paper while the other went over the paper with a portable sun lamp. When the paper was developed, the exposed areas turned blue, leaving a ghostly monotype impression of the nude model. Only one of these blueprints survives, *Female Figure* (ca. 1949).

In these blueprint experiments, two aspects of Rauschenberg's later, advanced work were present—collaboration with another artist and the idea that any kind of object could be used in a work of art. Anything, from fishnets to doilies, could be dropped on the blueprints and leave its mark. When used to decorate Bonwit Teller's windows on Fifth Avenue, these experimental works attracted the attention of *Life* magazine, which devoted a "Speaking of Pictures" article to the Rauschenbergs in April 1951.

In May 1951 Betty Parsons, owner of the most advanced American gallery, gave Rauschenberg his first New York City solo show. The exhibit consisted mainly of white paintings in oil, of which the best-known surviving example is *22 The Lily White*. Lines containing a variety of numbers are incised into the painted surface to activate the picture plane. The title was taken from a popular song and, because galleries mark purchased works with red stars, Rauschenberg playfully included a red star in the lower right. However, none of the 17 paintings he showed were sold. Reviews of the first Rauschenberg exhibition ranged from the merely tolerant to the mildly dismissive, and one perceptive critic noted that "his pictures seem to be spawning grounds for ideas rather that finished conceptions. . . . "

Later in 1951 Rauschenberg, now strongly influenced by the ideas of John Cage, painted a series of all-white paintings whose only "image" was the play of light on the canvas or the shadow cast by the viewer. These were followed by a series of all-black paintings, dense and tarry, in which torn and crushed newspapers were pasted down and coated with enamel, creating a rumpled surface, "as irregular," Barbara Rose said, "as the crumbling façades of New York's decaying downtown neighborhoods."

In the fall of 1951 Susan Rauschenberg filed for divorce. According to Calvin Tomkins, Robert Rauschenberg's bisexuality "was apparent to everyone concerned by now (Rauschenberg included), but he and Susan were still in love. . . . " The break with Susan and Christopher, his new-born son, was emotionally wrenching, and during 1951–52 Rauschenberg removed himself from New York, traveling in Italy, France, Spain, and North Africa with Cy Twombly, a young artist he had met at Black Mountain. In Morocco Rauschenberg made collages and fetishlike constructions out of odds and ends—including sticks, bones, hair, rocks, and feathers—and made wooden boxes with small objects in them. These latter recalled the boxes of Joseph Cornell, though Rauschenberg was unfamiliar with his work, and were executed in the spirit of Marcel Duchamp's dadaist readymades. In 1953 these constructions were shown in two similar exhibitions, one in Rome, the other in Florence, under the title "Contemplative Boxes and Personal Fetishes."

In Florence, Rauschenberg was deeply impressed by Leonardo da Vinci's unfinished *Adoration of the Magi* in the Uffizi. The internal complexity of this canvas, in which, as Rauschenberg said, "the tree, the rock, the Virgin are all of equal importance," is analogous to the intricacy of Rauschenberg's combine-paintings of 1955 and later. He has claimed that this painting by Leonardo "provided the shock which made me paint as I do now." Among the modern influences on Rauschenberg were the collages of the German Dadaist Kurt Schwitters and the "antiart" works of Marcel Duchamp, the veteran iconoclast who later became his friend.

When Rauschenberg returned from Europe, he took a $10-a-month cold-water loft on lower Manhattan, near the harbor, where he lived in virtual isolation and on a food budget of 15 cents a day. But, taking advantage of his poverty, he spent his days scouring the city for refuse and worked long into the quiet nights of an area hectic from nine to five but deserted in the evenings and on weekends.

Unable to afford the ten-cent subway fare to Greenwich Village, now the art world's avant-garde center, Rauschenberg developed his own idiom—unlike most of the painters of his generation, imitators of either Willem de Kooning or Jackson Pollock. In the Fulton Street loft he tested new ideas and, making use of the odd, castoff items he found on the street or on the beach at Staten Island, he began more and more to include collage elements in his paintings. One of the works exhibited in his third solo show, at New York City's Stable Gallery in late 1953, was a "grass painting," small boxes of soil, plant matter, and birdseed which the artist "watered into growth." Rauschenberg's all-black paintings had offended the more somber and "spiritual" of the

first-generation Abstract Expressionists, and the curator of the Stable show had at first refused to exhibit his grass painting. Rauschenberg may have enjoyed the stir aroused by his more outré works, but his motivation was not the dadaist desire to shock but the urge to expand the frontiers of art.

"A painting is not art simply because it is made of oil and paint or because it is on canvas," Rauschenberg has said, and in 1955 he coined the term "combine-painting" to describe a new format. Incorporating actual objects far more directly than in traditional collage, Rauschenberg assimilated unexpected and often incongruous elements from real life into startling overall configurations, while allowing each object to retain its identity. For example, one day in 1955 he found himself short of canvas and stretched his patchwork bed-quilt over a frame. "It looked strange without a pillow," he said, so he added one and dribbled paint over it, naming the resulting creation *Bed* (Collection of Leo Castelli, New York City). When hung on a wall it became a colorful and, strangely enough, well-organized painting with its own coherence and energy. Its initial appearance at Rauschenberg's March 1958 solo show at the Leo Castelli Gallery, New York City, aroused heated controversy, because it looked as though a murder or rape had taken place in the paint-splashed piece, and in the same year *Bed* had the distinction of being barred from the Festival of Two Worlds in Spoleto, Italy.

Rauschenberg's reputation as the avant-garde's new enfant terrible was strengthened by his best-known combine, *Monogram*, which he began in 1955 and worked on intermittently for the next three years. It is a stuffed Angora goat with an old rubber tire around its belly and its muzzle thickly made up with paint; the platform on which the goat stands is painted in a bravura manner derived from abstract expressionism. The title *Monogram* is appropriate because this is Rauschenberg's best-known image, his "signature." There is autobiography is *Monogram* (in Port Arthur, Rauschenberg had a pet goat that was put to death by his father), but according to Robert Hughes the goat is "a mute emissary from Eden—a survivor of Nature in a flood of Culture, an innocent witness to events before the Fall." Decades later, *Monogram* retains its power because, as Hughes said, "goats are the oldest metaphors of priapic energy. This one . . . is one of the few great icons of male homosexual love in modern culture: the Satyr in the Sphincter, the counterpart to Meret Oppenheim's fur cup and spoon."

Since about 1952 Rauschenberg had been influenced by the aesthetic theories of his close friend John Cage and had been working with Merce Cunningham's ultramodern dance troupe. In the winter of 1954 he met Jasper Johns, another aspiring young artist from the South, and the following year Rauschenberg moved into a loft in the Greenwich Village building where Johns had his studio. The two painters supported themselves by doing stunningly realistic window displays for Tiffany's and Bonwit Teller's, collaborating under the fictitious name "Matson Jones." They were well paid for their displays but accepted only enough free-lance work to cover basic living expenses, reserving most of their free time for developing their art.

As the two young men's personalities differed—Rauschenberg was brash and outgoing and seemed to know everyone in the New York art scene; Johns was quiet, almost taciturn—so, too, did their art. The cool, reflective work of Johns was colder and more hermetic than Rauschenberg's, but both men admired the Duchampian attitude and were advanced experimenters, constantly questioning the nature of reality and art. Their use of such urban debris as wire coat-hangers, Coco-Cola bottles, and commercial products made them forerunners of pop art, although they were so original that they cannot be said to belong to any specific movement.

Rauschenberg and Johns lived together in Manhattan until 1962, when they parted ways. "The break," Calvin Tomkins said, "was bitter and excruciatingly painful. . . . " In the late '70s Tomkins reported that "The breach between [the two artists] had never really healed. . . . The contrast between these two artists whose work still means so much to one another . . . has never ceased to fascinate the art world: Johns moving always deeper into himself, into paradox and enigma, Rauschenberg turning outward to the world at large, trying to annex as much of it as possible into his work."

In 1959, a year after he and Johns had established themselves as rising stars of the Leo Castelli Gallery, Rauschenberg introduced sound into his art by wiring to a picture called *Broadcast* three radios tuned to different stations. *Canyon* (1959) features, among other elements, a large stuffed eagle in simulated flight, a fragment of mirror reflecting the outside world, and a dangling pillow suspended below the canvas from a tipped-up stick, thus calling attention to the space beyond the picture. Without any obvious message, this combine was a celebration of a natural environment that is increasingly threatened by the intrusions of culture. *Trophy II* (1960–61), a three-panel work

dedicated to Marcel Duchamp and his wife Tini, included a hand-painted necktie and a water-filled glass with a chained spoon in it. The enormous *Barge,* painted in 1962, has been described as "a kind of reverie in which the spectators are invited to join." All Rauschenberg's combines, whatever their degree of complexity, have a basically rectangular structure—they are never amorphous.

In 1959–60 Rauschenberg made a series of multiple-image illustrations for Dante's *Inferno,* transferring pictures from newspapers and magazines by means of frottage. In the 1960s he increasingly used silkscreen transfers of photographs in juxtaposition with images and designs produced by other means to create striking kaleidoscopic effects, similar to those he had formerly obtained by incorporating actual objects.

The silkscreen paintings *Axle* and *Retroactive,* both dating from 1964, used the multiple image of John Kennedy as a popular emblem of change in American society, embedding it in general topical material. In 1965 *Axle* was awarded the gold medal at the Corcoran Gallery's biennial competition of contemporary American painting. In June 1964 Rauschenberg became the first American artist to win the coveted international grand prize in painting at the Venice Bienniale. This and other European exhibitions that his dealer, Leo Castelli, arranged for Rauschenberg established him as *the* leading international avant-garde painter, one who had, in reacting against abstract expressionism, vastly expanded the range of possibilities for painting in contemporary art.

As if to counteract his sudden emergence as culture hero, Rauschenberg entered once again into collaboration with the Merce Cunningham Dance Company and with other experimental dance groups. In 1964 he traveled with John Cage and the Merce Cunningham Company to Europe and the Far East as set and costume designer, lighting expert, and stage manager. Through the rest of the '60s he took part in multimedia events and "happenings" and, on occasion, he even danced with various companies. In a dance that he himself choreographed, *Pelican,* he performed on roller skates, wearing a stylized landing gear, or helmet. The dance was accompanied by a tape recording, consisting of a collage of sounds from radio, movie, and television sources, made by Rauschenberg.

Another collaboration was with Billy Klüver, a scientist from Bell Laboratories. In 1966 he and Rauschenberg set up a nonprofit foundation named Experiments in Art and Technology (EAT). Its stated aim was "to catalyze the inevitable involvement of industry, technology and the arts," to bring together artists and scientists so that American technology might be "humanized." "To a significant minority of American artists in the sixties, the making of individual paintings or sculptures was no longer enough," wrote Rauschenberg's biographer Calvin Tomkins. "The exemplary figure for these artists was Rauschenberg, who had made his art out of the real world and then had left it to move into dance, theater, and advanced technology." Financial support for EAT on the part of large corporations began to dry up in about 1970, the year Rauschenberg came to regard the foundation as a drain on his time.

In the 1970s Rauschenberg concentrated on printmaking, combining photo-images and hand-drawing. In his search for new materials Rauschenberg, accompanied by printers, assistants, and friends, went in 1975 to India and worked at Gandhi Ashram on constructions and multiples of molded paper, bamboo, printed sari-cloths, and mud. One group of works related to these ventures was the "Hoarfrost" series (1974–75), which, the artist explained, were "done in silk, cotton or cheesecloth, presenting the imagery in the ambiguity of freezing into focus or melting into view."

Rauschenberg's large 1977 retrospective at the Museum of Modern Art, New York City, was a triumph: his works seen as a whole, despite the multiplicity and complexity of the often disparate elements, displayed a unity, coherence, and harmony that were "classical" in the truest sense, and showed an admirable feeling for color and design. The large scale of the combines was seen as an intrinsic part of their authority. A *Village Voice* critic wrote that "the exhibition is jammed with enough major works to flesh out a dozen careers," and added, "Rauschenberg is to mid-century America what Picasso was to Paris in the early years of this century."

Since 1980, Rauschenberg has wanted, as he put it, "to get involved in places which haven't had contemporary American art to look at, countries such as China, Russia, Sri Lanka, Egypt. Not only to show work there but to *make* work in their setting. . . . " In the summer of '82 Rauschenberg worked in the People's Republic of China with artisans at the world's oldest paper mill, in Jing Xian, Anhui Province. There he made a series of 70 sets of paperworks entitled "Seven Characters," each consisting of a montage of images taken from Chinese posters.

Robert Rauschenberg's New York base is a rambling 19th-century five-story building in downtown Manhattan, but he spends most of his time in a wooden frame house on the island of

Captiva, in the Gulf waters south of Tampa, Florida.

Since the first color silkscreen paintings of the early '60s, Rauschenberg's work has been concerned with world events, perhaps because the artist is, in his words, "one of the painters . . . who think that painting is communication." Rauschenberg is a liberal social activist who has worked for CHANGE, Inc., a fund for needy artists; lobbied for legislation that would guarantee an artist's royalty on resales of work; raised $400,000 through sales of his paintings for Senator Edward M. Kennedy's 1980 bid for the Democratic presidential nomination; and donated prints to raise money for the reelection campaign of the progressive Ohio Senator Howard Metzenbaum.

A prolific artist, Rauschenberg has been at work since about 1981 on his *Quarter Mile Piece*, a mélange of images and sounds reflecting the chaos and the beauty of the modern world. Scheduled to be finished in 1984, *Quarter Mile Piece* will be the world's largest painting, measuring approximately 1,320 feet in length. In the studio Rauschenberg often listens to music while he works. He especially likes Talking Heads, a New Wave art-rock band, and designed the special limited edition cover of their hit album, *Speaking In Tongues* (1983).

"My reputation," Rauschenberg told *Art News* (February 1983), "has been as the latest 'avant-garde' or 'enfant terrible,' things like that. But those remarks only relate back, retrospectively, into the art world. I have a sense that the art world is almost bored with the fact that you care about politics, as opposed to 'how cool can you get in the gallery'. . . . I don't think I've ever been abstract. I think that my work is a conversation that goes on with people that I don't have the opportunity to meet."

EXHIBITIONS INCLUDE: Betty Parsons Gal., NYC 1951; Stable Gal., NYC 1953; Gal. d'Arte Contemporanea, Florence 1953; Gal. dell' Obelisco, Rome 1953; Egan Gal., NYC 1955; Leo Castelli Gal., NYC from 1958; Gal. Ileana Sonnabend, Paris from 1963; Jewish Mus., NYC 1963; Whitechapel Art Gal., London 1964; Stedelijk Mus., Amsterdam 1968; Kölnischer Kunstverein, Cologne 1968; Mus. d'Art Moderne de la Ville de Paris 1968; Inst. of Contemporary Art, Univ. of Pennsylvania 1970; Mus. d'Arte Moderna, ca' Pesaro, Venice 1975; MOMA, NYC 1977, 1982–83; Sonnabend Gal., NYC 1977, '83; "Quarter Mile Piece," Edison Community Col., Fort Myers, Fla. 1982. GROUP EXHIBITIONS INCLUDE: "Ninth Street show," NYC 1951; "Artists of the New York School: Second Generation," Jewish Mus., NYC 1957; "Art of Assemblage," MOMA, NYC 1961; "Art Since 1950, American and International," Seattle World's Fair 1962; "Six Painters and the Object," Solomon R. Guggenheim Mus., NYC 1963; "Four Germi-

nal Painters, United States of America," Venice Biennale 1964; "Two Decades of American Painting," Nat. Mus. of Modern Art, Tokyo 1966; "American Painting Now," U.S. Pavilion, Expo '67, Montreal 1967–68; "Dada, Surrealism, and Their Heritage," MOMA, NYC 1968; "New York Painting and Sculpture: 1940–1970," Metropolitan Mus. of Art, NYC 1969–70; "Duchamp, Johns, Rauschenberg, Cage," Contemporary Arts Center, Cincinnati 1971; "Idea and Image in Recent Art," Art Inst. of Chicago 1974; "The Great American Rodeo," Fort Worth Art Mus., Tex. 1976; Leo Castelli Gal., NYC 1983; "Art and Dance," Neuberger Mus., Purchase, N.Y. 1983.

COLLECTIONS INCLUDE: MOMA, and Whitney Mus. of Am. Art, NYC; Yale Univ. Art Gal., New Haven, Conn.; Wadsworth Atheneum, Hartford, Conn.; Corcoran Gal. of Art, and Hirshhorn Mus. and Sculpture Garden, Washington, D.C.; Philadelphia Mus. of Art; Art Inst. of Chicago; Des Moines Art Center, Iowa; San Francisco Mus. of Modern Art; Walker Art Center, Minneapolis, Minn.; Kunsthaus, Zürich; Mus. Ludwig, Cologne; Kunstsammlung Nordchein-Westfalen, Düsseldorf; Moderna Mus., Stockholm.

ABOUT: Current Biography, 1965; "Robert Rauschenberg" (cat.), Nat. Collection of Fine Arts, Smithsonian Instn., Washington, D.C., 1976; Rose, B. American Art Since 1900, 2d ed. 1975; Tomkins, C. Off the Wall: Robert Rauschenberg and the Art World of Our Time, 1980. *Periodicals*—Art Digest September 1953; Art in America May–June 1966, September–October 1973; Art News January 1955, April 1960, April 1963, February 1983; L'Express (Paris) October 20, 1968; Life April 9, 1951; National Observer October 10, 1966, New York Times May 30, 1951, April 28, 1963, December 14, 1974; Observer February 9, 1964; Time November 29, 1976; Village Voice March 16, 1967, April 14, 1977 Vogue October 15, 1965.

RAY, MAN (August 27, 1890–November 19, 1976), American painter and photographer, integrated photography and avant-garde painting. More European than American in outlook, he was a progenitor of dadaism and played an important role in French surrealism. True to the spirit of the movements he helped to develop, he was an impish, irreverent iconoclast with a keen sense of mockery. As Alden Whitman wrote in Man Ray's *New York Times* obituary, he "used the materials of art to poke fun at its serious ideas."

Man Ray was born Emmanuel Radenski in Philadelphia, the son of Russian-Jewish immigrants who moved to Brooklyn in 1897. (Little is known of his childhood and other sources give his family name as Rudnitzky.) Emmanuel had begun to paint at age five, but his parents disapproved, hoping he would become an engineer or architect. In his autobiography, *Self-Portrait*

Jorge Lewinski

MAN RAY

(1963), he tells of stealing tubes of oil and painting in secret. In high school he neglected the classroom in order to paint or draw, and his excellence in both mechanical and free-hand drawing won him a college scholarship in architecture. However, he spurned college to look for a job in New York City. After a brief stint as apprentice to an engraver, he worked in an advertising office while taking night courses at the National Academy of Design. Dissatisfied with being allowed only to draw from plaster casts, he did not remain long at the Academy. He was next hired to do layouts for a publicity firm, and when it went out of business he worked as mapmaker for a map and atlas publisher. From 1911 to 1913 to took life classes at night at Ferrer Center. During his lunch hour he visited galleries, including the avant-garde of "291" of Alfred Stieglitz, who introduced him to photography and to the artwork of such European moderns as Cézanne, Picasso, and Brancusi. He was also stimulated by the Ash Can School painters Robert Henri and George Bellows.

For a short time Emmanuel lived in the studio of the sculptor Loupov, whose former wife, Adon (Donna) Lacroix, a Frenchwoman and teacher, he married in 1914. She translated for him the poems of Rimbaud and Lautréamont, whose writings encouraged him in the spirit of revolt.

Man Ray was influenced by the 1913 Armory Show, New York City, which introduced him to cubism, but his landscapes, including *The Village* and *The Hill* (1913), were still romantic in treatment of subject. In 1915 he had his first solo show of paintings, at Manhattan's Daniel

Gallery. The 12 works he exhibited showed traces of fauvist influence, but the human figures were reduced to flat, disarticulated forms. Some compositions resembled the cutouts of tailors' patterns. The show was not well received by critics, but Jerome Eddy, a Chicago collector, purchased six paintings for $2,000, a sum that enabled Man Ray to open a Manhattan studio. (He and his wife had been living in Ridgefield, New Jersey, since about 1914.)

In 1915 Man Ray met Marcel Duchamp, whose *Nude Descending a Staircase* had been the succès de scandale of the Armory Show. This began a lifelong friendship. Man Ray shared Duchamp's passion for chess, and Duchamp encouraged Man Ray in his iconoclastic view on art. "I was a Dadaist from 1915 on," Man Ray recalled, "before I even knew of the existence of Dada. I've always done things one wasn't supposed to do." Anticipated by Duchamp, the dada movement was founded in Zurich in 1916 by artists and writers appalled by World War I and contemptuous of the values that had caused mass destruction. The Dadaists wanted to overthrow all artistic schools, whether traditional or modern. With Duchamp and Francis Picabia, Man Ray founded the New York branch of dadaism, and in his exhibitions of 1915–19 he sought to provoke public participation in the dadaist experience. For instance, he hung one of his canvases by its corner, so that viewers had to straighten it to see it. Duchamp, Man Ray, Picabia, and Walter Arensberg also founded the Society of Independent Artists in 1915, renting a Grand Central showroom in which artists could exhibit anything they wished for a fee of two dollars. (When his urinal, entitled *Fountain,* was disqualified, Duchamp resigned from the society.) In 1916 Man Ray mounted his series of collages, called "Revolving Doors," on a turnstile, so they could be seen in succession "ad infinitum." By this time he had moved back to New York City, where he was working for an advertising agency and beginning to experiment in figurative abstraction.

In 1918 Man Ray made his first "aerographs," photographic works on which he painted with an airbrush. He and his wife were divorced that same year. In 1920 he helped to found, with Katherine Dreier, Marcel Duchamp, Henry Hudson, and Andrew McClaren, the Société Anonyme, which campaigned for the exhibition and collection of modern art in the US.

In 1921 Man Ray joined Duchamp in Paris. Avoiding the American expatriates—"I felt ill at ease among Americans," he explained—he was welcomed by the Parisian Dadaists and held an exhibition at Paris's Librairie 6. Invitations to the

opening were yellow paper triangles stating that the exhibiting painter was a former coal merchant who was now president of the Chewing Gum Trust. The catalog notes were written by Louis Aragon, Paul Eluard, Max Ernst, and Tristan Tzara, among others. Also in 1921 Man Ray developed the "Rayograph," a technique of placing objects on light-sensitive photographic paper, thereby producing a ghostly surrealistic imprint and making the camera unnecessary. In 1922 he published a series of Rayographs in an album titled *Les Champs delicieux* (Delightful Fields), with an introduction by Tristan Tzara.

In the early '20s Man Ray was also creating dadaist objects. His first two, a glass cylinder full of metal ball-bearings and a sewing machine wrapped in a blanket (entitled *The Enigma of Isidore Ducasse*) had been made in New York City in 1920; *Le Cadeau,* his first Paris object, was an old flatiron, rendered useless by the row of tacks glued to its underside. One of his best-known dadaist creations was *Object to be Destroyed* (1923), a metronome with a photograph of an eye paper-clipped to the arm. According to Man Ray, his dadaist objects were "the result of looking at something which in itself has no quality or charm. I pick something which in itself has no meaning at all. I disregard completely the aesthetic quality of the object; I am against craftsmanship. I say the world's full of wonderful craftsmen, but there are very few practical dreamers."

When surrealism evolved from dadaism in 1924, Man Ray was embraced by the writers and intellectuals who had given birth to the new movement. Also in 1924, he produced his most famous photograph, *Violon d'Ingres,* in which the musical instrument's sound-holes were painted on the back of Kiki, a well-known Montparnasse model with whom he had a tempestuous affair. The title is a verbal as well as visual pun; *Violon d'Ingres* means "avocation" as distinct from vocation, and it was said that the painter Ingres was at least as proud of his violin playing as of his art.

In Paris, Man Ray aroused much interest and curiosity, but his art did not sell. To earn a living he decided to emphasize photography, although his first love was painting. He photographed Jean Cocteau, who dubbed Man Ray "the poet of the darkroom," and recommended him to his famous friends. "One after another," Man Ray wrote in *Self-Portrait,* "the painters arrived in Paris to join the Surrealist group and were consecrated by my portraits." However, the struggling artist-photographer received no fees from the painters. Fortunately, the great couturier Paul Poiret engaged him as a fashion

photographer—"A solution for a frustrated painter who couldn't sell his stuff," according to Man Ray—and he was soon moving in the circles of the Parisian *beau monde.* Man Ray's photographic portraits of such notables as Breton, Eluard, Tzara, Salvador Dalí, Le Corbusier, Picasso, Georges Braque, André Derain, and others constitute an important artistic chronicle of the '20s and '30s.

Man Ray was represented in the first surrealist exhibition, held in Paris in 1925, and throughout the '20s his work was reproduced in the magazine *La Révolution Surréaliste.* In 1923 he had made his first film, *Return to Reason,* and in 1924 had shot *Anémic cinéma* using motifs he and Duchamp had developed four years earlier. In 1927 he made another avant-garde film, *L'Etoile de mer* (Star of the Sea), which was followed in 1929 by *Le Mystère du château de soie* (The Mystery of the Chateau of Dice). The latter was filmed at the home of the Comte and Comtesse de Noailles, whose houseguests provided the cast.

In the early 1930s Man Ray experimented with "solarization," wherein he exposed a photographic negative to light, bleaching the background and surrounding the objects with a dark, fuzzy edge that often made the pictures resemble paintings. Many of the photographs Man Ray published in the book *The Age of Light* (1934) were solarizations. In 1935 he illustrated a Paul Eluard volume of poems with solarized nudes.

Man Ray realized that success as a photographer was detrimental to his career as a painter. He regarded painting as an "activity that expresses my private life" and kept a huge canvas on the wall over his bed; every morning before going to his studio he would add a few brushstrokes. *The Lovers, or Observatory Time,* a large, serene landscape with huge red lips floating in the sky, was painted in this manner in 1932–34. In 1938 he executed the *Imaginary Portrait of D.A.F. de Sade,* in which the subject was painted in the image of stones of the Bastille. Other surrealistic paintings include the dream-inspired *Fair Weather* and *Return to Reason,* both of 1939. "I have no school," Man Ray remarked; "I am only my fantasy."

Man Ray left Paris for Lisbon in 1940, just before the Nazi occupation. He then moved to New York City and in 1942 settled in Hollywood, where he lived until 1950. He was offered jobs as instructor at an art school, cameraman, and creator of special effects in movies, but turned them down because he wanted to paint without distraction. He succeeded and found time to work in Hollywood as a photographer as well. One canvas, *Soleil de nuit* (1943, Night

Sunshine), shows the influence of Max Ernst and Giorgio de Chirico. He also created dadaist objects "out of materials picked up by chance"; he called them "objects of my affection, made to amuse, bewilder, or inspire reflection." These were exhibited in New York City in 1945, a year after his large retrospective at the Pasadena Art Institute, California. In 1946, in a double ceremony, he married Juliet Browner and his friend Max Ernst wed Dorothea Tanning.

After returning to France with his wife in 1951, Man Ray, less active as a photographer, resumed his search for new artistic techniques. He continued to manufacture "absurd" objects, one of which, *Pain peint* (1960), was a French bread painted blue. He maintained a Paris studio in the rue Férou and from 1953 to 1968 spent his summers in Cadaqués, Spain. Man Ray was awarded the Gold Medal for photography at the Venice Biennale of 1961, and in 1966 he had a retrospective at the Los Angeles County Museum of Art.

Throughout the '60s and into the '70s Man Ray painted oils and watercolors wrote, and took photographs. Many of his photographs were shown, along with other Man Ray works, in a major retrospective at the New York Cultural Center in 1974–75. In the spring of 1975 an exhibition of his photographs toured the United States.

Man Ray died in his sleep in his Paris studio. He was a small, intense man with dark eyes and a high forehead. In *Paris-Match* (1976) the journalist Alexandrian speculated that beneath the mocking wit and humor of "the last of the red hot Dadas," there was a secret fear that if he were too greatly admired as a photographer his painting would be overlooked. "If I contradict myself," Man Ray said of his artistic diversity, "if I move from style to style, so does nature. I first painted a landscape in 1913. The landscape made me cry. I regretted that I could not carry my emotion over into the painting. I would see a gnarled tree, an old barn, and [want] to transfer my emotion to the canvas, but I couldn't. Then I found I could if I did something incomprehensible, mysterious, ignoring all my logical training."

EXHIBITIONS INCLUDE: Daniel Gal., NYC 1915, '16, '19, '27; Librairie 6, Paris 1921; Gal. Surréaliste, Paris 1926, '28; Julien Levy Gal., NYC 1932, '45; Curt Valentin Gal., NYC 1936; M.H. de Young Memorial Mus., San Francisco 1941; Pasadena Art Inst., Calif. 1944; Los Angeles County Mus. of Art 1945; Gal. Furstenberg, Paris 1954; Inst. of Contemporary Arts, London 1959, '75; Bibliothèque Nationale, Paris 1962; Art Mus., Princeton, N.J. 1963; Los Angeles County Mus. of Art 1966; Mus. Boymans-Van Beuningen, Rotter-

dam 1971–72; New York Cultural Cntr. 1974. GROUP EXHIBITIONS INCLUDE: "Forum Exhibition of Modern American Painters," Anderson Gals., NYC 1916; Society of Independent Artists Annual, 1917; "Salon Dada," Gal. Montaigne, Paris 1922: "Exposition Surréaliste," Gal. Pierre, Paris 1925; "Surrealist Exhibition," Julien Levy Gal., NYC 1932; "Fantastic Art, Dada and Surrealism," MOMA, NYC 1936–37; "Exposition Internationale Surréaliste," Gal. des Beaux-arts, Paris, 1938; "The Art of Assemblage," MOMA, NYC 1961–62; "Dada, Surrealism and their Heritage," MOMA, NYC 1968.

COLLECTIONS INCLUDE: MOMA, NYC; Albright-Knox Art Gal., Buffalo, N.Y.; Yale Univ. Art Gal., New Haven, Conn.; Philadelphia Mus. of Art; Hirshhorn Mus. and Sculpture Garden, Washington, D.C.; Columbus Gal. of Art, Ohio; Tate Gal., London; Mus. d'Art Moderne, Paris; Mus. Boymans-Van Beuningen, Rotterdam; Staatsgal., Stuttgart, W. Ger.; Petit Palais, Geneva; Moderna Mus., Stockholm.

ABOUT: Aragon, L. and others Man Ray: Sixty Years of Liberties, 1971; Jean, M. The History of Surrealist Painting, 1960; Langsner, J. (ed.) "Man Ray" (cat.), Los Angeles County Mus. of Art, 1966; Penrose, R. Man Ray, 1975; Ray, M. The Age of Light: Photographs 1920–34, 1934, Alphabet for Adults, 1948, Electricité: 10 Rayographes, 1931, Les Mains libres, 1937, L'Oeuvre photographique, 1962, La Photographie n'est pas l'art, 1937, Revolving Doors, 1972, Self-Portrait, 1963, Les Voies lactées, 1972; Ribemont-Dessaignes, G. Man Ray, 1924; Waldberg, P. Surrealism, 1965; Walsh, G. (ed.) Contemporary Photographers, 1982; Wintle, J. (ed.) Makers of Modern Culture, 1981. *Periodicals*—New York Times November 19, 1976.

***RAYSSE, MARTIAL** (February 12, 1936–), French painter, assemblagist, and filmmaker, has nimbly eluded convenient categorization. An original member of the New Realists group, he is widely credited with founding French pop art about 1960; in the late 1960s he turned to filmmaking, producing dislocated works with a mildly radical flavor, then switched again in the late 1970s to more traditional pastels and paintings of exotic private visions. Uniting these disparate styles and subjects is the artist's acute sense of the ridiculous, and his active determination to subvert our comfortable relations with "high" art.

Born in Golfe-Juan, near Nice, Raysse was the son of a potter and first worked in the basement of his parents' house as a studio assistant. At an early age he met Henri Matisse, whose cutouts inspired him to try his hand at collage. After a stint in the French Army, for which he was totally unsuited, Raysse was discharged for "mental instability" and he returned to Nice to devote

°rās, mä´ shəl

© Patrice Moreau, Paris

MARTIAL RAYSSE

himself to art. There, he had his first solo show
in 1957, at the Galerie Longchamp. With Yves
Klein and the painter and assemblagist Arman
(Augustin Fernández), both friends from Nice,
he formed the so-called "Nice" group, which lat-
er became the nucleus of the New Realists.
Raysse took part in the first new realism group
show at the Festival d'Art d'Avant-Garde in Par-
is in 1960.

The new realism, wrote Pierre Restany, the
influential critic and the group's mentor, at-
tempted to register "the sociological reality
without any controversial intention . . . the
complete possession of social reality without any
transformation," and Raysse's first assemblages
certainly embody this aim. About 1959 he seized
on the supermarket as the source and nexus of
modern consumer culture. He created immense
concatenations of detergents, beauty aids, kitch-
en utensils, toys, and plastic products of all kinds.
Colonne folle (1959, Crazy Column), for exam-
ple, is a tower of gumball machines, toys, and
plastic flowers, while *Hygiene de la vision:
étalage de Prisunic* (1960, Hygiene of Vision:
Display of Prisunic) is nothing more than shelves
full of common household items. One critic cal-
led these works "totems of today." Alluring
women, painted, photographed, or ripped di-
rectly from poster or magazine advertisements,
usually appear in these assemblages to "sell" the
products; later the women, now luridly colored
bathing beauties from the Côte d'Azur or per-
fect urban clotheshorses, became icons them-
selves. "I wanted my works to possess the same
self-evidence as mass-produced refrigerators,"
Raysse said. This interest in sterile but fascinat-

ing commercialism culminated in the environ-
ment *Raysse Beach* (1962) at the Stedelijk
Museum, Amsterdam, and the Alexandre Iolas
Gallery, New York City. An entire room full of
products and pseudo-products was crowned
with a neon sign flashing "Raysse Beach" over an
inflatable swimming pool. "He is a creator of the
artificialdom of contemporary times," wrote
Sheldon Williams in *Contemporary Artists*, "and
he gives to a manmade fabricated existence ab-
solute veracity. Neon is true and so are aniline
dyes. The best buys from the supermarket look
well on the right girl."

These assemblages have obvious affinities
with those of the other New Realists, particularly
the petrified feasts of Daniel Spoerri and the
"accumulations" of Arman, but it is American
pop, from Kienholz's tableaux to Warhol's Brillo
boxes to Mel Ramos's *Velveeta Girl*, that has the
closest relation to Raysse's work. Sheldon Wil-
liams has pointed out the correspondence be-
tween Raysse's women and the Great American
Nudes of Tom Wesselmann. Raysse's interest in
American culture (or rather, Gallic stereotypes
of the jazzy US) is made explicit in two all-neon
works of the mid-1960s, *America, America*
(1964), in which the sound of a hand snapping
its fingers is visualized by a cascade of red neon
stars, and *Hello, Hello* (1964), a telephone blink-
ing on and off to the rhythm of its ring. Raysse
made numerous trips to New York and Los An-
geles in the '60s, no doubt to immerse himself in
the greatest consumer culture of all.

In his quest for an artificial beauty Raysse
paused in his glorifications of modern gaucherie
to begin a series of "modernizations" of past mas-
terpieces, using images photographically repro-
duced on the canvas. In his version of Pierre-
Paul Poudhon's neo-classic *Cupid and Psyche*,
titled *Tableau simple et doux* (1965, Simple,
Gentle Scene), Psyche is lemon yellow and Cu-
pid, who holds a neon heart in his hand, is hot
pink. *Made in Japan* (1964), also the generic title
for this series, is a makeover of Ingres's
Odalisque in bile green, while another work by
Ingres (admittedly an easy target), *The Turkish
Bath* (in Raysse's version called *Tableau Turc et
invraisemblable* [1965, Improbable Turkish Pic-
ture], is composed of multiple levels of textures,
16 in all—velvet, paint, paper, and neon among
them. Of his general method in these collages,
he wrote: "A photograph is trompe-l'oeil, a fic-
tional space. So I try to substitute a space that's
a reality. In what I do, the photograph never
turns into different planes, never indicates any
perspective. The planes are a structuring of the
picture itself, conceived in its totality." Not so
much a direct assault on high art, these paintings
spoof our diminished perceptions of the masters.

Nor has Raysse spared more recent art: one of his "Tableaux de mauvais goût" (Pictures in Bad Taste) is a mountain painted in abstract-expressionist style and entitled *An Anguished Struggle in the Frozen Solitude* (1964). Cubism, or maybe the work of Mondrian, is the target in his *Tableaux of géométric variables,* women's faces broken up into rectangles and absurdly rearranged (an eye next to a mouth, for instance).

Theater and film opened new areas of investigation for Raysse in 1966. That year he designed the sets and costumes for Roland Petit's ballet *Elage de la folie* (In Praise of Folly) and made two short films, *Jesus Cola* and *Homero Presto.* He worked with Petit again on *Paradise Lost* (1967), designing a flashing neon serpent that upstaged Adam and Eve (Rudolf Nureyev and Margot Fonteyn). But after 1968, wrote Restany in *Domus* (February 1973), "the Matisse of neon and fluorescent paint, the illusionist of happiness, the decorator of the joy of capitalist living," as he called the artist, became "the producer of engagé films," à la Godard. However, the video *Portrait electro-machin-chose* (1968, Electro-Thingummy Portrait), the short *Camembert Martial extra-doux* (1970, Camembert Martial Extra Mild), and his first feature-length film *Grand départ* (1971, The Big Break) have less to do with Marxist–Leninist political commitment, as Restany claims, than with a surreal structuralism. *Grand départ* starts conventionally, but as soon as the young protagonist leaves home on his bicycle, he acquires a split personality, a bizarre language, and the head of a cat. Dreamlike scenes, with colors garish as those in his paintings, were achieved by leaving parts of the film in color negative.

After 1969, Raysse showed less frequently. This was partly due to the demands of filmmaking, but he was also undergoing a period of creative pupation. He experimented with silkscreen (*Six images calmes,* 1972, Six Calm Images), paper sculpture, drawing, and painting. "Loco Bello," a 1976 series of paintings of masses of vegetables, magicians, kings, and odd beings were surprising for their traditional technique, the last thing anyone expected from Raysse. In 1978 he did a series of temperas, "Spelunca," inspired by his emergence from a cave during a trip to Italy. This small event came to symbolize for him his rebirth as an artist. At once pastoral, lyrical, and faintly farcical, the "Spelunca" portray other-worldly islands or grottoes floating in the middle of the canvas. In one, the giant goddess of destiny stands on a beach, holding up the earth like a beachball; in another, a hermaphrodite reclines, also on a beach, with balancing scales perched on his/her head. A third depicts an enigmatic mass religous ceremony. Raysse's latest works (1979–81) are portraits of women, slightly coarsened to resemble gauche peasants. Why the artist has turned to more traditional forms is not easy to explain; in his personal vision he may have foreseen the general retreat from and reassessment of modernism.

Martial Raysse, who won the David Bright Award at the Venice Biennale of 1969 and now lives and works in Paris, summed up his credo of a new realism in *Le Monde* (November 16, 1972): "I have always believed that the aim of art is to change life. But it seems to me that the important thing today is to change what surrounds you at every level of human relationships. Some imagine that life imitates itself. Others know that life invents itself. One does not quote Rimbaud. One lives it."

EXHIBITIONS INCLUDE: Gal. Longchamp, Nice, France 1957; Gal. d'Egmont, Brussels 1959; Gal. Schwarz, Milan 1961; Gal. Schmela, Düsseldorf 1962; Alexandre Iolas Gal., NYC 1962, '66; Dwan Gal., Los Angeles 1963, '64, '67; De Young Mus., San Francisco 1963; Gal. Alexandre Iolas, Paris 1964, '65, '67, '69; Stedelijk Mus., Amsterdam 1964; Palais des Beaux-Arts, Brussels 1967; Gal. des Speigel, Cologne 1967, '69; Mus. of Contemporary Art, Chicago 1968; Gal. Alexandre Iolas, Geneva, Switzerland 1969; Gal. Flinker, Paris 1978; Centre Georges Pompidou (Beaubourg), Paris 1981; Sidney Janis Gal., NYC 1982. GROUP EXHIBITIONS INCLUDE: "Groupe de nouveaux réalistes," Festival d'art d'avant-garde, Paris 1960; Biennale des Jeunes Artistes, Paris 1961; "The Art of Assemblage," MOMA, NYC 1961; San Marino Biennale, Italy 1963; "Cinquante ans de collage," Mus. d'Art Moderne, Paris 1964; "Cinquante ans de collage," Mus. d'Art et d'Histoire, St. Etienne, France 1964; "Arena of Love," Los Angeles 1965; "L'Ecole de Nice," Nice, France 1966; Venice Biennale 1969.

COLLECTIONS INCLUDE: Stedelijk Mus., Amsterdam; Stedelijk van Abbemus., Eindhoven, Neth.; Louisiana Mus., Humlebaek, Denmark; Kaiser Wilhelm Mus., Krefeld, W. Ger.; Gal. Alexandre Iolas, Paris; Mus. Cantini, Marseilles.

ABOUT: Hahn, O. Martial Raysse ou l'obsession solaire, 1965; Lippard, L. Pop Art, 1966; "Martial Raysse" (cat.), Stedelijk Mus., Amsterdam, 1965; "Martial Raysse" (cat.), Alexandre Iolas Gal., NYC, 1966; "Martial Raysse" (cat.), Dwan Gal., Los Angeles, 1967; Pellegrini, A. New Tendencies in Art, 1966; Popper, F. L'Art cinetique, 1970; P-Orridge, G. and others, (eds.) Contemporary Artists, 1977. *Periodicals*—Domus (Milan) February 1973; Le Monde (Paris) April 28, 1967, November 16, 1972; Quadrum 17 (Brussels) 1964; Paris Review February 1967.

***REDER, BERNARD** (June 29, 1897–
September 7, 1963), European-American sculp-
tor and designer, expressed his belief in the su-
preme importance of "volumetricity" in
sculpture in a 1967 interview with his friend
John Rewald: "A piece of sculpture is a volume
which must have the same aspect from whatever
point it is viewed, not only when seen along a
horizontal or frontal line, but also from all per-
spectives. All aspects of a sculptural volume have
the same significance." With this as a guiding
principle, Reder, a prolific carver and modeler,
produced scores of figures, and designed cities,
giant ships, museums, and theaters. At his 1961
retrospective at the Whitney Museum of Ameri-
can Art, New York City, he supervised the con-
struction of special ramps which enabled the
public to view his work from above and below
as well as from the front and sides. Though lack-
ing in subtlety of expression, the artist's work is
supremely sensitive to mass, weight, volume,
and three-dimensional compositional tensions.

Reder was born in Czernowitz in the Ukraine
(then part of the Austro-Hungarian Empire,
now in the USSR) to Jakob and Hinde Gingold
Reder. The family, Chassidic Jews, ran an inn.
As a youth Reder spoke Yiddish at home; he at-
tended four years of *yeshiva*, and then, unusual
for a Chasid, a German-speaking public school.
He loved literature above all other studies, and
eventually mastered six languages.

In 1914 Reder was drafted into the Austrian
Army and served through World War I; he had
to walk most of the way home from Serbia at the
war's end. Shortly after his return he decided to
become a painter, but, unable to get into the Vi-
enna or Paris academies because of his lack of
training, enrolled in the Academy of Fine Arts
in Prague, studying graphic art and, in 1920,
sculpture under Jan Stursa. Reder so excelled at
anatomical drawing that he soon could draw or
sculpt the figure without a model.

Dissatisfied with clay and plaster as sculptural
media, Reder yearned to try direct stone carv-
ing. In 1922 he returned to Czernowitz, where
he worked for the next seven years as a stonema-
son and headstone carver. He was able to find
spare time to carve small sculptures for himself,
and also to draw, paint, and make woodcuts.
Within two years he had earned enough from his
masonry work to marry Gusti Korn, his home-
town sweetheart.

Reder shared his first studio with a neighbor-
ing farmer's cows and pigs. With little support
from the townspeople, and likely none at all
from the Chasids, who would have frowned on
his interest in the female nude, Reder sold none
of his early work; he gave it away or lost it in

American Academy & Institute of Arts and Letters, NYC

BERNARD REDER

moving. Czernowitz had no indigenous artistic
community, and Reder looked to Prague for the
advancement of his career. After winning an ar-
chitectural competition to design a monument to
Christopher Columbus in Santo Domingo, His-
paniola (now the Dominican Republic) in 1927,
he went to Prague for three months, looking for
publicity. His first solo show, of watercolors, was
held at the Rudolphinum there the next year. In
1930 the family moved to Prague, where Reder
was able to make a modest living from his work,
and where they felt safer from the anti-Semitic
attacks that occurred with increasing frequency
in the countryside around Czernowitz, which
was now held by Rumania.

Now the artist worked almost exclusively in
stone. His favorite subject remained the female
. nude, with an emphasis on rounded volumes, not
delicacy or facial expression. *Bather* and *Two
Bathers* (both of 1934) are characteristic of the
work of this period. Although small, they seem
heavy, with an air of immobility; at the same
time they convey a feeling of great size. Reder
never had trouble translating his sculpture from
maquette to full-scale piece: all the broadness of
a monument was already inherent in each work.
Reder's drawings and watercolors had some of
the rounded simplicity and love of feminine
curves seen in sketches by Renoir.

Reder first showed his sculpture in 1935 at the
Manés Gallery, Prague. Thirty-eight pieces were
exhibited, most in stone, but several in bronze or
wood. Encouraged by the positive reception giv-
en the Manés show, the artist went to Paris in
1937, renting a small villa near that of Aristide
Maillol, whom he had met on a brief trip to

°ber när´

France in 1934, and whose sculpture he greatly admired. Reder worked hard and mixed little with other artists; however, the general influence of Paris seems to have loosened up his eastern European stolidity, and, at least in his paintings, he began to move away from heavy, immobile figures. His sculptured nudes were still large, thick-limbed, and amply curved, but with more grace.

Just as he was beginning to receive real acclaim, Reder was forced to abandon his work as the Germans headed for Paris in 1939. After the initial panic, Reder, who had been staying with friends in Le Puy, returned to Paris, and unsuccessfully tried to get a US visa. He moved some of his work to a warehouse, where it survived the war; the rest was destroyed. While Maillol continued the effort to secure American visas for them, Reder and his wife fled France on a refugee train, the artist sketching on napkins and scraps of paper all the while. Finally they obtained a Cuban visa, and narrowly managed to board a boat from Lisbon to Havana.

In Havana Reder set up housekeeping in a friend's converted garage, where he also had his studio. In the crowded space he drew, painted, and sculpted, limiting the size of his works as much as possible. Still anxious to move to the US, the Reders obtained visas in 1943 and soon arrived in New York City by way of Miami, without friends, money, or much knowledge of English. Reder was lucky enough to land a fellowship soon after their arrival; with the money he bought a small house on Long Island and a huge piece of stone, from which he carved one of his best works, *Wounded Women*, over the next two-and-a-half years.

Wounded Women depicts a recumbent nude surrounded by five other women. The sculpture has a dynamism and at the same time a delicacy lacking in his previous works. There is much skillful undercutting and piercing of the mass, which required all his technical ability. While *Wounded Women* was being completed Reder supported the family by selling smaller pieces (with some difficulty, as he had no dealer and was a virtual unknown). He also suffered a temporary, partial paralysis of his arms during this period.

In 1945 the Whitney exhibited six of his sculptures. Three years later, Reder received US citizenship. Sturgis Ingersoll, an American collector, arranged to bring the artist's surviving works back from Europe, which meant a crowded home for Reder but good local publicity. In 1951 the Grace Borgenicht Gallery, New York City, became his dealer. Through the late 1940s and early 50s, the artist concentrated on woodcuts

and graphic work; his inspirations were traditional: the Bible, Chasidic folktales, the stories of Rabelais, the Apocalypse. Symbolic and allegorical, his work was freighted with association, yet fresh, not overbearing. He preferred to work with heavily grained wood in his woodcuts, and also experimented with color monotypes on glass.

In the early 1950s Reder began to transfer the increasing freedom and imaginativeness of his woodcuts into his sculpture. Two pieces, both in limestone, that mark this transition are *Bust of Centaur* and *Fantastic Bird*, both of 1950. They depict abstract but recognizable figures, which, in their stylization, indicate a distinct rethinking of his earlier direction. His interest in the fantastical increased during the years he spent in Rome and Florence (1954–58). Half-human, half-animal figures, many in bronze, now superseded the full-bodied women; working directly in plaster over an armature, Reder was able to explore more complex, interwoven forms that had an air of the baroque. (He would constantly reexamine and rework old themes—sculptures such as *Lady with House of Cards, Woman with Bird,* and *Noah's Wife Carrying Two Owls* were completed during this period, then refined and redone later in the US.) Reder's imagination dwelt upon birds, cats, horses, goats, cows, and figures from Jewish folklore in intricate styles of clothing and headdress, but he was also finally satisfied that he had fully realized his formal goal of complete "volumetricity," that is, of presenting characters and objects as complicated entities when viewed from every angle.

Reder often expressed his dislike of abstract art. Of his own *Woman with Sphere and Pyramid* (1959), which contains geometric shapes that serve no purpose but to demonstrate that abstract details can add up to a recognizable, nonabstract whole, he wrote, "I could not resist to give by this theme my reaction against abstraction—to say it is not necessary to break things."

On Reder's return to the US in 1958, World House Galleries, New York City, became his dealer. The Whitney Museum and the Museum of Modern Art both purchased important pieces from his January 1959 World House show. From about 1960 the artist began to produce a large number of sketches and studies for architectural and other projects. He firmly believed that many of society's ills were caused by crowding and poor distribution of space, and his plans for housing, theaters, and monuments addressed this problem. No structure of his design was taller than it was wide, one of the prime tenets of his "volumetric" theories. Reder's theater-in-the-

round, for example, was in the shape of a dimpled sphere; seats lined the walls, all equidistant from the stage. None of these innovative projects was ever built.

The last four years of Reder's life were extremely productive. He finished over three dozen bronzes, many worked directly in wax, a technique he had learned in a Verona foundry while in Italy on a Ford Foundation grant, as well as countless woodcuts, architectural plans, and drawings.

EXHIBITIONS INCLUDE: Rudolphinum, Prague 1928; Manés Gal., Prague 1935; Gal. de Berri, Paris 1940; Univ. of Havana 1942; Lyceum Gal., Havana 1942; Weyke Gal., NYC 1943; Philadelphia Art Alliance 1950; Philadelphia Print Club 1950; Jewish Nat. Mus., Jerusalem 1950; Tel-Aviv Mus., Israel 1950; Grace Borgenicht Gal., NYC 1951–58; Art Inst. of Chicago 1953; Gal. d'Arte Moderna L'Indiano, Florence 1956, '57; Palazzo Torrigiani, Florence 1957; World House Gals., NYC from 1959; Whitney Mus. of Am. Art, NYC 1961. GROUP EXHIBITIONS INCLUDE: "Czechoslovakian Art," Wildenstein Gals., Paris 1940; Whitney Mus. of Am. Art, NYC 1945; "Modern Sculpture from the Joseph P. Hirshhorn Collection," Solomon R. Guggenheim Mus., NYC 1962.

COLLECTIONS INCLUDE: MOMA, and Whitney Mus. of Am. Art, NYC; Hirshhorn Mus. and Sculpture Garden, Washington, D.C.

ABOUT: Arnason, H. H. "Modern Sculpture from the Joseph P. Hirshhorn Collection" (cat.), Solomon R. Guggenheim Mus., NYC, 1962; "Bernard Reder" (cat.), Whitney Mus. of Am. Art, NYC, 1961; Rewald, J. Sculpture and Woodcuts of Reder, 1957.

***REFREGIER, ANTON** (May 20, 1905–October 10, 1979), American painter and muralist, was a prominent Social Realist and also the artist most severely harassed by right-wing groups during the McCarthy era. Refregier's greatest work, his immense multipanel mural for the Rincon Post Office Annex in San Francisco, was repeatedly censored, altered, and threatened with removal for its alleged "Red" content and unflattering portrayal of aspects of California history. The artist himself was repeatedly accused of associating with communists and communist groups. The creation of major works of public art has always invited controversy, but rarely, if ever, in a democracy has there been an attempt to legislate the destruction of such a work on purely ideological grounds, as there was in this case. The flap over the Rincon mural virtually guaranteed that he would be given no other government commissions of similar scope and importance.

°rə frā´ gyā, än tōn´

The son of Russian industrialist Anton Refregier and his French wife, the former Valentin Beserkirchy, Refregier was born in Moscow. At the age of 15, he apprenticed himself to the sculptor Danila Vassilief in Paris, an experience which, he later wrote, "more than anything else influenced my future professional life." He emigrated to the US in 1921, enrolling at the Rhode Island School of Design on a scholarship. At that time northern Rhode Island was still an important textile manufacturing center, and Refregier supported himself during the summers working in the local mills. There he observed first-hand the execrable working conditions in American factories. After his graduation he worked as a painter for architects and interior designers, during Prohibition even decorating speakeasies on commission. "When the occasion called for flippancy," wrote Oliver Larkin of Refregier's mural for the Café Society Uptown, New York City (ca. 1935), "he could set weird flying figures and crazy balloons among high clean arches like a Miró of the nightclubs." But Refregier also began illustrating trade union publications. After studying with Hans Hofmann in Munich (1928), and working as a set designer with Norman Bel-Geddes, in 1936 he helped found an art school in Lake George, New York. In that year he also married Lila Kelly, an art student.

As he became increasingly interested in public art, Refregier's paintings of the 1930s acquired some of the political frankness and broad simplicity of form seen in the work of the Mexican muralists, such as David Siqueiros. Believing that "the artist can play a role leading anywhere that the people meet, if he believes in those people," Refregier began painting murals for the Works Progress Administration, notably his large panel on prisoner rehabilitation for Riker's Island, New York City. "Working in architecture," he wrote, "the artist will have to recognize the problems inherent in monumental art. He will have to accept discipline, which does not exist in the creative process of making an intimate statement in his studio. Art in architecture is a social art." Refregier also understood that the largest projects were going to those artists who best gauged official sentiment, that is, the limit to which artistic and political honesty could be pushed in a public work. His murals were, for the most part, not nearly as controversial as those being done at the same time by Diego Rivera and Ben Shahn. In 1935, for example, Refregier did two murals in New York City: one on circus life for the children's ward of Greenpoint Hospital, the other a panel on the Boston Tea Party for the Hotel Lexington's Revere Room which included a round-faced Fiorello La Guardia as one of the plotters. By the late 1930s

Refregier had built a reputation as one of the country's foremost muralists.

His easel paintings of the period were more likely to reflect his compassion for suffering and despair. "His bold emaciations and the harsh geometry of his light and shade," wrote Larkin, "spoke his pity for suffering and his reverence for the courage of pioneers." Often his pictures of the mid-1940s blend hope and foreboding, as in *Heir to the Future* (ca. 1945), but are just as often deeply pessimistic (*Broken Life*, 1946). In 1949 Refregier's book, *Natural Figure Drawing*, was published. Reviewing Refregier's solo exhibition that year at the A.C.A. Gallery, New York City, Stuart Preston of *The New York Times* (October 23, 1949) wrote that the artist was "like Ben Shahn in technique, and shares with him the same degree of didactic fervor." Preston praised Refregier's "technical sensibility" and added that while "hammering his points bluntly" the artist was able to "invest these scenes with remoter associations of wonder and terror."

By far the artist's best-known work is the Rincon mural, which he began in late 1941. Commissioned to paint a work on the history of California that would "relate to the people in *contemporary* idiom the history of their own experience, not as pageant, but as the growth of the city, a struggle of man against nature, and later on, the development of various inner tensions," Refregier designed a 240-foot, 27-panel overview of the state from Indian days, through the Spanish settlements, the Gold Rush and statehood, to modern industrial development, labor struggles, the building of the Golden Gate Bridge, World War II, and the signing of the United Nations Charter in San Francisco. Various interruptions, most importantly the war, delayed completion of the mural until 1949. To ensure historical and visual accuracy, Refregier read extensively in California history and, particularly in the sections covering more recent events, drew upon period paintings, engravings, and newspaper photographs.

Nonetheless, various groups, such as the Veterans of Foreign Wars, the Hearst Newspaper Syndicate, the Sailor's Union, and the American Legion, objected to certain details in the episodes depicting labor reform (although Refregier's depictions were fully substantiated in period sources). The artist was forced to change the wording on protest signs, obliterate insignia on clothing or entire figures, and in one case remove a portrait of the ailing, post-Yalta Franklin Roosevelt which government authorities thought unflattering. Through the early 1950s, as anticommunist hysteria increased, criticism of the work mounted. The mural was described by a California Congressman, Representative Hubert Scudder, as "artistically offensive and historically inaccurate," casting "a derogatory and improper reflection on the character of the pioneers and history of the great state of California" (several early panels contained scenes of violent struggle between pioneers and Indians), while the Russian-born Refregier was himself accused of associating with communists and spreading "communist propaganda." In 1953 a bill was introduced into Congress by the ultraconservative Scudder to remove the mural completely, which would have meant its destruction. Leading artists and museums rose to Refregier's defense, and the bill was ultimately shelved for want of conclusive evidence of the mural's subversive nature. "The saving of Refregier's mural," wrote William Hauptmann in his study of the incident for *Artforum* (October 1973), "represented the most important defeat of the attempt by certain government individuals to control public artistic endeavors."

The artist's optimistic side reasserted itself in the 1950s. In 1952 he won the Hallmark Art Award Competition, sponsored by the greeting card company, for *The Christmas Tree*, in which appeared such symbols as doves and lambs. About the same time he completed a mural for the Hillcrest Jewish Center on Long Island. "Organized religion is based on the same premises as the artist's," he wrote, "whose main concern is humanity. These premises are brotherhood of man, peace, and an ethical way of life." But, in the period of abstract expressionism's triumph, he added, "Today the main currents of art are away from human values." The universal themes of motherhood, familial love, the suffering of the poor and old, and the ageless rhythms of life close to the earth recur again and again in his work.

A trip to Mexico in the mid-1950s inspired Refregier to take up tapestry design; he executed commissions for the Sheraton Cleveland Hotel, the Roton Manufacturing Company in Woodstock, New York, and the Bowery Savings Bank in Manhattan. Like many of the surviving Social Realists, Refregier was encouraged by the social unrest of the 1960s toward sharp social comment—notably in *Church-Burners, Segregationists, Napalm, Vietnam* (all 1965–70)—but the artist turned again to idealized scenes of harmony and peace in the 1970s. At the time of his death in the fall of 1979, Refregier was in Moscow as the guest of the Artist's Union, preparing to paint a mural for a clinic. He was buried in the artist's cemetery near his home in Woodstock.

In a lecture delivered in 1957 on "Arts and

Architecture," Refregier, always conscious of the artist's social responsibility, declared, "I think non-objective art can play a role in the decoration of our architecture, but we will be poor in spirit if there is not, also, room for powerful thematic statements of deep concern to man."

EXHIBITIONS INCLUDE: La Salle Gal., NYC 1936; A.C.A. Gal., NYC 1942–73. GROUP EXHIBITIONS INCLUDE: Pittsburgh International, Carnegie Inst.; Whitney Mus. of Am. Art, and Metropolitan Mus. of Art, NYC; Palace of Legion of Honor, San Francisco.

COLLECTIONS INCLUDE: Metropolitan Mus. of Art, and MOMA, NYC; Corcoran Gal., Washington, D.C.; Walker Art Center, Minneapolis; Univ. of Arizona, Tempe; Univ. of Nebraska, Lincoln; San Francisco Mus. of Art; Oakland Mus., Calif.

ABOUT: Larkin, O. W. Art and Life in America, 1949; Refregier, A. Natural Figure Drawing, 1949. *Periodicals*—American Artist October 1966; Art Digest April 15, 1953; Art News April 1942, October 1949; Artforum October 1973; New York Times October 23, 1949, May 10, 1953, October 13, 1979; PM November 14, 1947.

***REINHARDT, AD(OLPH F.)** (December 24, 1913–August 30, 1967), American painter, was a leading first-generation artist of the New York School. He was born in Buffalo, New York, and in 1915 moved with his family to New York City, where he studied art history at Columbia College under Meyer Schapiro from 1931 to '35, the year of his graduation. In 1936–37 he took further courses at Columbia and also studied at the National Academy of Design with Carl Holty and Francis Criss.

Holty's influence on Reinhardt was considerable. In 1937 Reinhardt joined Holty in American Abstract Artists (AAA), becoming one of the association's youngest members and one of the first Americans to paint in a purely abstract style. He participated in AAA exhibitions for the next nine years. Reinhardt's early works reflected the kinds of abstraction then developing in New York City, showing such diverse influences as Piet Mondrian, Joan Miró, Jean Hélion, Stuart Davis, and Holty. However, Reinhardt's style in the 1930s was particularly endebted to cubism and to Mondrian's neoplasticism; his theories of art were influenced by Neo-Platonism.

Reinhardt, like many American artists, was sustained during the Depression by the easel painting division of the Works Progress Administration's (WPA) Federal Art Project, a New Deal agency which employed him from 1936 to '39. He designed décor for the New York

© Hans Namuth, 1984

AD REINHARDT

World's Fair of 1939. In the catalog to the 1980 Reinhardt retrospective at the Guggenheim Museum, New York City, Margit Rowell discussed the similarities between Reinhardt's development from 1938 to 1966 and Mondrian's evolution. Reinhardt's paintings of 1938–40 consist of closed, flattened shapes—either organic or geometric—set against a clearly defined ground. This geometric phase is evident in *No. 30, 1938* (Whitney Museum of American Art, New York City).

In New York City intellectual circles of the 1930s, the Marxist decade of East Coast writers and artists, art and politics were closely linked and social realism was highly regarded. But in an article written for the left-wing journal, *The New Masses*, in 1942 or '43, Reinhardt, discussing Mondrian, questioned the popular assumptions about the social value of art. He asserted that Mondrian's nonrepresentational art provided the exemplary solution to problems of content and, praising Mondrian's rigorous formalism, he asked of those who believed only realism to be socially and politically relevant: "What greater challenge today (in subjective and two dimensions) to disorder and insensitivity; what greater propaganda for integration, than this emotionally intense, dramatic division of space?"

By 1943 Reinhardt's forms had become, to quote Rowell, "loosened and fragmented into a gestural calligraphy combined with spots of darkened color that integrate figure and ground." His all-over calligraphic paintings were reminiscent of Mark Tobey's. Reinhardt had his first solo exhibition, in 1943 at Columbia University.

°rĭn´ härt

In 1944 and '46, before and after serving as a US Navy photographer in 1944–45, Reinhardt was a part-time staff artist and art critic for the New York City newspaper *PM.* He was noted for his caustic articles and for his scathing and remarkably ingenious cartoons satirizing the situation of contemporary art in American society. From 1946 to '50 Reinhardt took courses in art history at the New York University (NYU) Institute of Fine Arts, studying with Alfred Salmony and Guido Schoenberger. In 1947 he became assistant professor of art at Brooklyn College, a post he held until 1967.

Reinhardt had specialized in Oriental studies at NYU, and his paintings of 1947–49 are known as the "Persian Rug" series. He was inspired by Oriental, Indian, and Arabic decorative art, and these painting are characterized by patterns of relatively small, lightly gestural strokes on muted, nearly monochrome but luminous grounds. He used a narrow, vertical format in the "Persian Rug" series. Reinhardt's later rejection of action painting notwithstanding, his work of the late '40s was affected by abstract expressionism. His canvases of this period have been likened to those of Franz Kline and Robert Motherwell, and his later, near-monochromatic work is related to Barnett Newman's and Mark Rothko's. But the graphic, even calligraphic, character of his painting also had affinities with the type of lyrical abstraction that emerged in Paris in 1950 at the Salon des Réalités Nouvelles.

In 1950 Reinhardt and Robert Motherwell edited *Modern Artists in America,* which consisted primarily of conversations with contemporary artists (the journal lasted only one issue). Also in 1950, Reinhardt taught at the modernist California School of Fine Arts, San Francisco. Later teaching positions included the University of Wyoming (1951), Yale University (1952–53), Syracuse University (1957), and Hunter College of the City University of New York (1959–67).

In 1950 Reinhardt executed a series of "Dark Paintings," using black in a low-pitched chromatic scale. The move towards "noncolor" paralleled in some respects the development of Mondrian; but whereas Mondrian combined the primary colors within one composition, Reinhardt limited himself in each painting to chromatic variations of a single hue. He executed a large red painting, *No. 114* (1950; Philadelphia Museum of Art), which at first glance was one uniform field of color, but which on closer viewing disclosed subtle differences of value.

These near-monochromatic paintings were the culminaiton of what Stevens described in *Newsweek* (January 28, 1980) as "a long process of emptying out elements from his art." In the late '40s Reinhardt's geometric forms had "shattered into calligraphic strokes," to quote Barbara Rose. Thus, the mature, "purified" phase of his painting dates from the early '50s, when the written marks were reshaped into vertical and horizontal brushstrokes which ultimately became interlocking rectangles, as in *Red Abstract* (1952; Yale University Art Gallery, New Haven, Connecticut).

After 1953 Reinhardt confined himself to painting only black canvases. Barbara Rose explained: "In his search for an absolute, Reinhardt wished to arrive at an indivisible image and a single color; he sought a scheme that was, like the Buddha image in Eastern art, breathless, timeless, styleless, lifeless, deathless, endless." Reinhardt did not share Rothko and Newman's aspiration towards the "sublime," but he was profoundly interested in Asian art. Although he did not borrow from it, he praised Chinese art in *Art News* (December 1954) as being "'of the mind,' pure, free, true." He was moved by Chinese paintings that had what he termed a "'weightless nothingness,' with no explanations, no meanings, nothing to point out or pin down, nothing to know or feel." He could well have been describing his own black paintings, which, in their simplicity and meditative spirit, have been seen by critics as embodying the tranquillity spoken of in Zen Buddhism.

Reinhardt's all-black paintings were first shown at the Betty Parsons Gallery, New York City, in 1953. With the paintings' close, virtually indistinct tonal variations, their underlying rectilinear divisions were barely visible. This severely reductive style strengthened Reinhardt's position in the New York School as a spokesman for modernism and as a "self-appointed scourge," to borrow critic Dore Ashton's phrase. Reinhardt's somewhat mystical aesthetic position was that of a purist, an art-for-art's-sake extremist. "He contended," Irving Sandler wrote, "that the true goal of contemporary art was to distill the artness of art and that painting was diminished if impure elements such as representational imagery and illusionistic space were permitted." His tireless polemicizing for these views earned him the title "black monk of American art" from his peers, who nonetheless deeply admired his work. Moreover, his reductive art, which avoided the "storm and stress" quality of action painting, was to influence the Minimal painters and sculptors of the 1960s much more so than did the work of any other artist of Reinhardt's generation. However, the "spiritual" aspects of his work were hardly in accord with the Minimalists' insistence on a stubbornly literal conception of the "real," their "what you see is . . . what you see" aesthetic.

In 1958 Reinhardt described his "pure-painting idea" as having found its primary sources in impressionism, cubism, and post-plus-and-minus-Mondrianism." He felt that he was going "beyond Mondrian" by pushing form to the absolute limits of perception. Believing that form and content were one, he aspired to rid painting of all "nonart" content, and in unpublished notes he declared that only the irreducible experience of art as its own subject matter should remain. As Gertrude Stein had written "a rose is a rose is a rose," Reinhardt stated that "a nearly black square is a nearly black square is a nearly black square."

Abstract Painting (1960–62; Museum of Modern Art, New York City) was Reinhardt's "ultimate" black painting, a five-foot square symmetrically trisected and evenly painted canvas. The Minimalists were to admire *Abstract Painting* for its radical purity and impersonality. From 1960 on, he repeated this motif in paintings composed of large interlocking rectangles of black; slight variations of deep violet and olive were occasionally used.

Reinhardt held his first solo show in Paris at the Galerie Iris Clert in 1960; he had a second exhibit there three years later. Reinhardt had visited Japan, India, Iran, and Egypt in 1958 and three years later he traveled in Turkey, Syria, and Jordan. Also in 1961, he was represented in the important "Abstract Expressionists and Imagists" exhibition at the Guggenheim Museum. His national and international reputation had been growing slowly, and in 1964 his work was included in the "Painting and Sculpture of a Decade" show at London's Tate Gallery. In the spring of 1965 Reinhardt had concurrent solo shows at three New York City galleries, including the Graham Gallery on Madison Avenue. The Jewish Museum, New York City, held a large Reinhardt retrospective in 1966–67, the show that, as his friend Nancy Flagg said in *Art International* (February 1978), pushed him "over into the edge of shameless fame." In the late summer of 1967, Reinhardt died in New York City.

In *Contemporary Artists* Ralph Pomeroy said that Reinhardt's last paintings "represent one of the extremes of modernist purism," and Mark Stevens called Reinhardt "a radical Puritan" and compared him with Mondrian. Stevens felt that in banishing color, asymmetry, and touch, elements retained by Mondrian, Reinhardt had achieved "a smaller victory" than had the Dutch abstractionist. But in *Art in America* (March 1980) Paul Brach claimed that Reinhardt's paintings "are not a demonstration of Puritan rejection. They are, rather, the expression of emptiness in a spiritual space."

Ad Reinhardt's marriage ended in divorce in 1949; he had a stepdaughter, Anna. He was a quiet man of medium height with a thoughtful expression, an ironic smile, but a generally undistinguished appearance—not someone who stood out in a crowd. Reinhardt's art criticism could be scathing, with denunciations of the art world as corrupt and declarations that "art's reward is its own virtue." But Mark Stevens questioned the value of his writings, observing that, although some remarks may have been "tongue in cheek," his manner "was often that of a shrill moralist."

In his "Autocritique," published in a newsletter on the occasion of his 1963 MOMA exhibition, Reinhardt described his ascetic artistic ideal as "a pure, abstract, non-objective, timeless, spaceless, changeless, relationless, disinterested painting—an object that is self-conscious (no unconsciousness), ideal, transcendent, aware of nothing but Art (absolutely no anti-art)."

EXHIBITIONS INCLUDE: Columbia Univ., NYC 1943; Artists' Gal., NYC 1944; Betty Parsons Gal., NYC 1946–65; Gal. Iris Clert, Paris, 1960, '63; Städtisches Mus., Leverkusen, W. Ger. 1961; Inst. of Contemporary Arts, London 1964; Graham Gal., NYC 1965; Stable Gal., NYC 1965; Jewish Mus., NYC 1966–67; Städtische Kunsthalle, Düsseldorf 1972; Solomon R. Guggenheim Mus., NYC 1980. GROUP EXHIBITIONS INCLUDE: World's Fair, NYC 1939; Whitney Mus. of Am. Art, NYC from 1947; "Abstract Painting and Sculpture in America," MOMA, NYC 1951; "The New Decade," Whitney Mus. of Am. Art, NYC 1955; Pittsburgh International, 1955; "Abstract Expressionists and Imagists," Solomon R. Guggenheim Mus., NYC 1961; "Americans 1963," MOMA, NYC 1963; "Painting and Sculpture of a Decade, 1954–64," Tate Gal., London 1964; "New York School: The First Generation, Paintings of the 1940s and 1950s," Los Angeles County Mus. of Art 1965; Documenta 4, Kassel, 1968; "Plus by Minus: Today's Half-Century," Albright-Knox Art Gal., Buffalo, N.Y. 1968; "American Art in Mid-Century," Nat. Gal., Washington, D.C. 1973.

COLLECTIONS INCLUDE: Metropolitan Mus. of Art, MOMA and Whitney Mus. of Am. Art, NYC; Albright-Knox Art Gal., Buffalo, N.Y.; Yale Univ. Art Gal., New Haven, Conn., Philadelphia Mus. of Art; Mus. of Art, Carnegie Inst., Pittsburgh; Hirshhorn Mus. and Sculpture Garden, Washington, D.C.; Toledo Mus. of Art, Ohio; Art Inst., Dayton, Ohio; Univ. of Nebraska, Omaha, Nebr.; Mus. of Art, Baltimore; San Francisco Mus. of Art; Los Angeles County Mus. of Art; Tate Gal., London; Städtisches Mus., Leverkusen, W. Ger.; Nasjonal Gal., Oslo.

ABOUT: Ashton, D. The New York School: A Cultural Reckoning, 1973; Goossen, E. C. "The Art of the Real, USA 1948–1968" (cat.), MOMA, NYC, 1968; Hunter, S. and others "Ad Reinhardt" (cat.), Jewish Mus., NYC, 1966; Lucie-Smith, E. Late Modern: The Visual Arts

Since 1945, 1969; P-Orridge, G. Contemporary Artists, 1977; Reinhardt, A. and others (eds.) Modern Artists in America, 1952; "Ad Reinhardt: 25 Years of Abstract Painting" (cat.), Betty Parsons Gal., NYC, 1960; Ritchie, A. C. "Abstract Painting and Sculpture in America" (cat.), MOMA, NYC, 1951; Rose, B. American Art Since 1900, 2d ed. 1975; Rowell, M. "Ad Reinhardt and Color" (cat.),Solomon R. Guggenheim Mus., NYC 1980; Sandler, I. The New York School: The Painters and Sculptors of the Fifties, 1978; Tuchman, M. New York School: The First Generation, 1971; Wintle, J. (ed.) Makers of Modern Culture, 1981. *Periodicals*—Art in America September/October 1974, March 1980; Art News December 1953, December 1954, November 1956, May 1957, Summer 1957, June 1959, January 1960, March 1965, January 1966; Art International (Zürich) December 1962, October 1964, December 1966, February 1978; Artforum March 1966; Chroniques de l'art livant (Paris) June/July 1972; New York Post August 1962; Newsweek January 28, 1980; Studio December 1967.

Jorge Lewinski

CERI RICHARDS

***RICHARDS, CERI (GIRALDUS)** (June 6, 1903–November 9, 1971), painter and printmaker, was perhaps the only important Welsh modernist. He brought the emotional vibrancy so evident in his country's poetry and song to a body of work which C. G. Jung called "the most frank and revealing confessions of the age." Unconfined by, and unclassifiable within, any dogma or style, Richards made use of every resource of figurative abstraction and every sort of inspiration from the other arts, especially music, to create a rich and varied visual language in a great diversity of styles.

Ceri Giraldus Richards was born in the small mining village of Dunvant (or Dyfrant), near Swansea in south Wales. His father, Thomas, a tinplate roller in a local factory, and his mother, Sarah, both transmitted a deep love of poetry and music to their son, but bequeathed him no knowledge of the visual arts. Richards displayed an early facility at drawing (Henry Moore later called him the strongest draftsman of his generation), and studied technical drawing while working at an electrical engineering firm. When the firm closed in 1920, he first entertained the idea that his talents might lay in art, and enrolled in the Swansea School of Art (where, unfortunately, the program was, at best, meager). Early inspiration came from the collection of Daumiers and late Monets of the Davis sisters at Gregynog, which he claimed were the first important works of art he had ever seen. In 1924 he went to London on a scholarship to study at the Royal College of Art, where his painting teacher, Randolph Schwase, introduced him to the post-Impressionists and Picassian cubism. Although Richards later said that he was "trapped by Picasso," his early work betrays the strong influence of Matisse as well.

In 1929 Richards married Frances Clayton, a fellow student at the Royal Academy, and about two years later had his first solo show, in Swansea. He became friendly with the Welsh poet and artist David Jones, and with the poet John Tessimond, who introduced him to the music of Claude Debussy, Maurice Ravel, and other modern French composers. Musical themes and images were to become very important in his painting. *Reclining Nude* (1932), an expressionist figure of black-outlined forms, typifies his approach in this period. In 1933 he became interested in relief construction and collage and during the remainder of the decade made a great many cubist and dada-flavored reliefs. The first of these, made of metal, he destroyed, but subsequent efforts, on a wood substrate with painted paper, wood, and metal elements, were shown at the 1934 "Objective Abstractionists" exhibition at the Zwemmer Gallery, London, alongside the work of Victor Pasmore, Ivor Hitchens, and Rodrigo Moynihan. To some critics, the work of the Objective Expressionists, with whom Richards was briefly associated, presaged that of the American Abstract Expressionists; and indeed Richards's complete pictorial freedom, though in the service of representation, does have affinities with the approaches favored by the later artists. The paintings of Max Ernst, which Richards saw at the London Surrealist Exhibition of 1936, led him deeper into surrealism; *Variable Costerwoman* (1938), the finest and most original of his reliefs, owes a clear debt to Ernst, as does his abstractly erotic painting, *Les*

Femme possède toutes les qualités (1937, Woman Possesses All the Qualities). (The costers, London's curiously dressed street mongers, inspired Richards to do a number of other paintings—*Costerwoman*, 1939, for example—and linoleum cuts.) In 1937 Richards was visited in his studio by the sculptor Jean Arp, who greatly admired the reliefs. About this time Richards gave up commercial work and took up full-time teaching at the Chelsea School of Art, where his colleagues included Henry Moore and Graham Sutherland. His association with the school lasted many years.

With the outbreak of World War II in September 1939 all of London's art schools were closed, and Richards and his family—he now had a daughter, Rachel—left the city and moved briefly to Suffolk. Between 1940 and 1944 they lived in Cardiff, Richards serving as a firewatcher with the Airraid Protection Service during the Blitz. This experience inspired *Blossoms* (1940), flowerlike blooms of falling flame, and *Falling Forms* (1944). In 1942 Richards mounted his first solo show in London at the Léger Gallery; the following year he began a series of "paraphrases" of Eugene Delacroix's *Lion Hunt*, fascinated by its complexity and pictorial energy. The Royal Norwegian government-in-exile commissioned him in 1944 to paint a series of murals in the Norwegian Room of the Cardiff headquarters of the British Council in Wales.

At the war's end Richards returned to London with his family and new daughter, Rhiannon, and resumed his position at the Chelsea School. Always interested in poetry, he did a series of lithographs illustrating the poems of his good friend Dylan Thomas, notably for "The Force that Through the Green Fuse Drives the Flower" and "The Force that Drives the Water Through the Rocks Drives my Red Blood." Ready to adapt whatever material suited his temperament, Richards in the late 1940s turned to the baroque theme of The Rape of the Sabines (Rubens, an artist with whom Richards must have felt considerable sympathy, had done a version); his drawings, paintings, and lithographs on this subject are full of muscularity and sexual energy. Richards's love of music inspired such paintings as *Interior with Music by Albeniz* (1949), *Sunlight in a Room* (1950), and *Red and Green Interior* (1951–53), all of which revolve around a pianist and/or his instrument. (Richards was himself a skilled player.) These paintings are vibrant in color and rhythmically fragmented in a way that suggests the discordance of modern music; at the same time they are purposely reminiscent of the ordered interiors of Vermeer. This vigor and complexity also characterize his "Trafalgar Square" series (1951), done for the Festival of Britain.

Richards first became involved in theater design when he did the décor for the Globe Theatre's *Homage to Dylan Thomas*, mounted shortly after the poet's death in 1953. Deeply affected, Richards painted his own *Homage* in 1955, basing it on the "Author's Prologue" in Thomas's *Collected Poems*. In 1954 he designed the costumes and drop curtain for Lennox Berkly's *Ruth,* and in 1958 he did the costumes for Benjamin Britten's *Noyes Fludde* at the Aldeburgh Festival.

From 1958 to 1965, years in which Richards's reputation was at its highest—he served on the administrative board of London's Tate Gallery, was made CBE in 1960, saw a major retrospective of his work mounted at the Whitechapel Art Gallery, London, and won the Einaudi Prize at the Venice Biennale—he worked on what is probably his best-known series, "La Cathédral engloutie" (The Sunken Cathedral), inspired by the Debussy piano prelude. "Debussy is a visual composer," he said; "his sounds and structures are derived from a visual sensibility. He gives me a feeling of the sounds of nature, as Monet does." In the theme of the drowned cathedral, originally derived from the Breton legend of Ys, Richards found an endless source of visual material. "As I walk . . . images are created and destroyed, until what I am arriving at comes about . . . the very speed of composition gives rise to a flood of unexpected images, which adapts the passage of time to an infinite mutation." In works like *La Cathédral engloutie—flottant et sourd* (1962–65, The Sunken Cathedral—Floating and Hollow), he found a new freshness drawn directly from nature. "Subject is a necessity," he said. "Working through direct from visual facts to a more sensory counterpart of the reality of my subject, I hope that as I work I can create later on an intense metaphorical image for my subject." This freshness he continued to exploit in the "Cycle of Nature" series and in such individual paintings as *The Season* (1964), *The Crooked Rose* (1965) and *Root and Flower* (1965). With the directness and simplicity of expression sometimes achieved by artists in their last years he turned once more to the poetry of Dylan Thomas; his illustration for "Do Not Go Gentle into that Good Night," in which an owl carries away in his beak a shroud out of which a man falls helplessly into the void, is truly dark and disturbing. In the last two years of his life, after completing several major commissions including the windows and other décor for the Chapel of the Blessed Sacrament in the Liverpool Metropolitan Cathedral of Christ the King, Richards executed a number of illustrations for an edition of Thomas's play, *Under Milk Wood,* and painted works on Prometheus and Beethoven.

Ceri Richards died in London at the age of 68. He was survived by his wife, a talented artist who carried out his designs in fabrics, and their two daughters. In the catalog to the 1981 Richards retrospective at the Tate Gallery, Alan Bowness described the artist as he looked in the early 1950s: "a man of medium height, thick set but not flabby, rather powerfully built and with a strong, oddly restrained but alert and listening presence. . . . " Richards reminded Bowness of "a more conventionally good-looking Picasso," but his features suggested to others a mellower, more congenial Giorgio de Chirico. As a teacher he stressed the importance of draftsmanship, and, like Matisse in his short-lived art class early in this century, he bore down on any student who attempted to "go modern" without having mastered the essentials of form and structure. He was a rather shy man, with an amiable manner; he could, however, react sharply, with a hint of Welsh temper, to a remark or attitude he found annoying, but the irritation would soon pass.

Ceri Richards expressed his view of the link between painting, music, and poetry in this characteristic statement: "One can generally say that all artists—poets, musicians, painters, are creating in their own idioms metaphors for the nature of existence, for the secrets of our time. We are all moved by the beauty and revelation in their utterances—we notice the direction and beauty of the paths they indicate for us, and move towards them."

EXHIBITIONS INCLUDE: Glynn Vivian Art Gal., Swansea, Wales 1931, '32, '54, '64; Leger Gal., London 1942; Redfern Gal., London 1944–57; Bear Lane Gal., Oxford, England 1959; Whitechapel Art Gal., London 1960; Marlborough New London Gal., London 1963, '65; Kunstnernes Hus, Oslo 1967; Gal. d'Arte, Milan 1969; Castle Mus., Norwich, England 1969; Gal. Wolfensberger, Zürich 1970; Marlborough Fine Art, London 1970; Fischer Fine Art, London 1972, '74; Nat. Mus. of Wales, Cardiff 1973; Gal. Cavour, Milan 1974; Tate Gal., London 1981. GROUP EXHIBITIONS INCLUDE: "Objective Abstractionists," Zwemmer Gal., London 1936; "Surrealist Objects and Poems," London Gal. 1937; "New Movements in Contemporary Art," London Mus. 1942; "Six Contemporary British Artists," Buchholz Gal., NYC 1945; "Sixty Paintings for '51," Festival of Britain Exhibition 1951; Pittsburgh International, Carnegie Inst. 1953, '55, 1961–62; "Contemporary British Art," Kunstnernes Hus, Oslo 1955; "Contemporary British Art," Kunstforeningen, Copenhagen 1955; International Exhibition of Prints, Moderna Gal., Ljubljana, Yugoslavia 1959, '61; "British Painting 1920–1960," Pushkin Art Mus., Moscow 1960; "British Painting 1920–1960," Hermitage, Leningrad 1960; "The Art of Assemblage," MOMA, NYC 1961; Venice Biennale 1962; "British Art Today," San Francisco Mus. of Art 1962; "Trois Artistes Britan-

nique: Robert Adams, Herbert Dalwood, Ceri Richards," Mus. d'Art Moderne, Paris 1963; "54–64: Painting and Sculpture of a Decade," Tate Gal., London 1964; "Sidney Noland, John Piper, Ceri Richards," Marlborough New London Gal., London 1966; Aldeburgh Festival, England 1967, '72; "Britische Kunst Heute," Kunsthalle, Hamburg, W. Ger. 1968; International Print Biennale, Bradford, England 1972; "Dada and Surrealism Reviewed," Haywood Gal., London 1978; "Thirties," Haywood Gal., London 1979.

COLLECTIONS INCLUDE: Tate Gal., Arts Council of Great Britain, and British Council, London; Walker Art Gal., Liverpool; Whitworth Art Gal., Manchester, England; City Art Gal., Leeds, England; City Art Gal., Portsmouth, England; City Mus. and Art Gal., Southampton, England; Nat. Mus. of Wales, and Contemporary Art Society for Wales, Cardiff; Glynn Vivian Art Gal., and Mus., Swansea, Wales; Ulster Mus., Belfast; Gal. Civica, Turin, Italy; Villa Ciani, Lugano, Switzerland; Metropolitan Mus. of Art, NYC; Toledo Mus. of Art, Ohio; Nat. Gal. of Canada, Ottawa; Art Gal., Toronto; Nat. Gal. of Victoria, Melbourne, Australia; Nat. Gal. of South Australia, Adelaide.

ABOUT: Read, H. Art Since 1945, 1959; "Ceri Richards" (cat.), Tate Gal., London, 1981; Rothenstein, J. British Art Since 1900, 1962, Modern English Painters, 1974; Saniesi, R. The Graphic Works of Ceri Richards, 1973; Thompson, D. Ceri Richards, 1963. Periodicals—Art News and Review July 29, 1950; Manchester Guardian June 1960; New Statesman and Nation May 14, 1953, April 14, 1956; Observer July 3, 1960; Studio July 1963; Studio International July/August 1967.

*RICHIER, GERMAINE (September 16, 1904–July 31, 1959), French sculptor, developed a powerful style, rooted in traditional sculptural technique, that gave form to universal human anxieties. Her quasi-allegorical figures, compounded of human, animal, insect, and vegetable forms, are, at their best, chilling in their application of classical forms and conventions to deep-rooted images of fear, decay, and death.

Richier spent her childhood near Arles, in the south of France. From 1922 to 1925 she studied at the Ecole Regionale des Beaux-Arts in Montpelier under the sculptor Guignes, who was once Rodin's assistant. She continued her training in classical and expressive figuration in the Paris studio of Emile-Antoine Bourdelle, who had also worked with Rodin. For five years (1929–34) she worked alone in her studio; her first solo show, of torsos, figures, and portrait busts, was held at the Galerie Max Kagonovitch, Paris, and testified to her mastery of conventional techniques and a heavily Rodin-influenced style. During the war years she lived in Switzerland and the south of France, then returned to Paris to teach sculpture at the Anglo-French Art Center. In

°rē shyā, zhĕr mân

Photo Brassai Collection, F. Gulter, Paris

GERMAINE RICHIER

1955 she married the French poet Réne de Soleil.

Richier's style did not change until after World War II. As with many other European artists, the stupendous brutality of the conflict forced her to examine her own deepest fears. "What she wanted to evoke," wrote A.M. Hammacher, "was the hallucinatory images of the threat of death that becomes an inescapable reality, affecting man physically and mentally, to the very depths of his soul." Now her figures, in their increasingly exaggerated expressiveness, became mangled, lacerated, partially stripped of flesh to reveal the bone beneath. With *La Vierge folle* (1945, The Foolish Virgin) began the effacement of particularizing facial features that characterized all her later figures. Bats (*L'Homme chaune-souris*, 1946, The Bat-Man), spiders (*Petit araignée*, 1946, The Little Spider), hydras, devils, and other night creatures are melded with human forms in many of these works, which tap directly into the common fear of the loss of physical and psychological integrity.

She had not completely abandoned more conventional figuration; perhaps as a respite from her more disquieting fantasies she occasionally returned to a more peaceful style, as in *La Feuille* (1948, The Leaf) and, as late as 1954, *La Jeune fille a l'oiseau* (Young Girl with a Bird), in which the female figure is kept relatively intact and unwounded. *Storm* (1947–48) and *Hurricane* (1948–49) are figures halfway between her two extremes. Rough-surfaced and with a faint air of self-revulsion, they are nonetheless solid and full-bodied. But her controver-

sial crucifix for a church in Assy (1950), her series of attenuated and Giacometti-like Don Quixotes (1950–54), and the horrific *Le Berger de landes* (1957, Shepherd of the Moor) indicate that her overpowering fascination was with what one critic called "the subconscious memory of the spawning bestiary of the myth-laden Mediterranean littoral." *Shepherd of the Moor*, with its death's-head, eviscerated thorax, and fleshless supporting tripod, has affinities also to the grinning skeletons of Bosch. "There is a deep significance," wrote Hammacher, "in the fact that, fascinated by the structure of the sculptural figure, she made it subserve the feeling of decomposition. As a result, these figures enter our mind all the more forcibly. Under the spell of form, they desperately make themselves known as inimical to form."

Apart from formal creativity, Richier investigated a number of other sculptural media. She cast works herself in lead, sometimes inlaid with colored glass (*Per Somoza*, 1952) and decorated with brightly colored paint (*Le Couple*, 1959). She also experimented with placing sculpture in front of slate, gilded bronze, or painted backgrounds by her friends Maria-Elena Vieira da Silva, Hans Hartung, and Zao-wou-ki (a technique tried a few years earlier by Fernand Léger and the American sculptor Mary Callery). She tried her hand at ceramic tile decoration, oil painting, and engraving, illustrating several of her husband's books. As with many sculptors working primarily in cast bronze, much of her production was small in size and often more abstract than the major figurative works; for example, her small, plantlike pieces of the mid-1950s led directly to *La Grande spiral* (1959), one of her last and most abstract bronzes, which resembles a huge, helical plant.

In 1958, Richier won the grand prize at the Brussels International Exhibition. Shortly before her death in 1959, Alexander Lieberman visited her Montpelier studio. He wrote: "A woman of the south, she spoke French with the ripe accent of the Midi. She punctuated her meaning with the exuberant mimicry and generosity of gesture true to the Méridional. Her studio was clean and luminous, her tools neatly and precisely arranged." In contrast to the devastated aura surrounding much of her work, "kindness radiated around her. . . . In her presence one believed in the superior power of love."

EXHIBITIONS INCLUDE: Gal. Max Kaganovitch, Paris 1934; Petit Palais, Paris 1936; Anglo-French Art Center, London 1947; Gal. Maeght, Paris 1948; Allan Frumkin Gal., Chicago 1954; Hanover Gal., London 1955; Mus. Nat. d'Art Moderne, Paris 1956; Martha Jackson Gal., NYC 1957, '58; Walker Art Center, Min-

neapolis 1958; School of Fine and Applied Arts, Boston Univ. 1959; Stedelijk Mus., Amsterdam 1959; Mus. des Arts Décoratifs, Paris 1964; Gal. Creuzwault, Paris 1966. GROUP EXHIBITIONS INCLUDE: International Exhibition, Paris 1937; International Exhibition, NYC 1939; Kunsthalle, Basel 1944–45; Venice Biennale 1948, '52, '54, '58, '60, '64; São Paulo Bienal 1951, '53; Middelheim Biennale, Antwerp, Neth. 1953, '55; Pittsburgh International, Carnegie Inst. 1958; "New Images of Man," MOMA, NYC 1959; "New Images of Man," Baltimore Mus. of Art 1960; "Richier, César, Louis Lutz," Gal. Gimpel und Hanover, Zürich 1970.

COLLECTIONS INCLUDE: Mus. Nat. d'Art Moderne, Paris; Stedelijk Mus., Amsterdam; Moderna Mus., Stockholm; Louisiana Mus., Humlebaek, Denmark; Kunsthalle, Basel; Kunsthaus, Zürich; Kaiser Wilhelm Mus., Krefeld, W. Ger.; Hirshhorn Mus. and Sculpure Garden, Washington, D.C.

ABOUT: Cassou, J. Germaine Richier, ca. 1961; Crispolti, E. Germaine Richier, 1958; Hammacher, A.M. The Evolution of Modern Sculpture, 1969; Lieberman, A. The Artist in His Studio, 1962; Selz, P. New Images of Man, 1959; Solier, R. de, Germaine Richier, 1950. *Periodicals*—Arts de France (Paris) nos. 17–18 1947; L'Oeil (Paris) September 1955; XXe siècle (Paris) January 1957; Werk (Munich) March 1946.

RICKEY, GEORGE WARREN (June 6, 1907–), American sculptor, is known for his wind-powered kinetic works. He was born in South Bend, Indiana, the third of six children of Walter J. and Grace (Landon) Rickey, whose forebears were from New England. His father was an engineer for the Singer Sewing Machine Company; one grandfather was a judge, the other a clockmaker who, according to Rickey, was the only one who could make the town clock of Athel, Massachusetts run. One grandmother had taught drawing, and Rickey, his five sisters, and two cousins all had an aptitude for art.

At the age of five Rickey was taken to Scotland, where he received a British public school education at Trinity College, Glenalmond. In 1929 he was awarded a BA degree in European history from Balliol College, Oxford, and an MA Honors degree in 1941. There were also eight years of Latin in his background, and while at Oxford he also attended classes at the Ruskin School of Drawing and Fine Art. In 1929–30 he studied in Paris at the Académie André Lhote and the Académie Moderne, directed by Amedée Ozenfant; at that time his main interest was painting. One critic has suggested that Rickey's European and British education helped foster "his highly articulate speech and writing."

Returning to the United States, Rickey taught history at the Groton School, Massachusetts,

GEORGE WARREN RICKEY

Photo by Benigna Chilla

from 1930 to 1933. He resided in Paris in 1933–34, and traveled extensively in Europe. He had a studio in New York City from 1934 to 1942, when he was drafted by the US Army. While in New York he had had several mural commissions, and the technical training he received in the Army Air Corps convinced him that he had mechanical as well as artistic ability. After his discharge in 1945, he attended the Institute of Fine Arts of New York University until 1946, when he enrolled in the art department of the State University of Iowa. There, in 1947, he studied with the outstanding printmaker and teacher Mauricio Lasansky. Rickey continued his training at the Institute of Design, Chicago, a Bauhaus offshoot, in 1948–49.

In 1947 Rickey married Edith Leighton. They had two sons, Stuart Ross and Philip.

For almost a decade Rickey had known the work of Alexander Calder, especially the mobiles. He constructed his first mobile in 1945, but it was not until 1949, when his mechanical and manual talent surfaced, that he turned from painting to constructed works. His first kinetic sculptures were made from window glass, and in 1950 he turned to stainless steel, which from then on was his preferred medium. Rickey's early kinetic constructions were complicated, depending strongly on natural imagery, as indicated by such titles as *Silverplume II* (1951). His attempts at building large pieces made him resolve to learn welding, which the sculptor David Smith taught him in 1954.

From 1949 to 1955 Rickey taught at Indiana University, Bloomington. In 1955 the first New York City showing of his sculpture, held at the

Kraushaar Galleries, received an encouraging response from critics and collectors. In the same year he became head of the Art Department of Newcomb College, Tulane University, New Orleans. He began showing his sculptures in Europe in 1957, with an exhibit at the Amerika Haus, Hamburg. In 1959 he had his second New York show at the Kraushaar Galleries, exhibiting what he now called "kinetic sculptures" and what the New York *Herald Tribune* (January 11, 1959) called "both wonderful and dizzying." The "tilt, swing, balance, and sway" of Rickey's metal designs, enlivened by color, moved one critic to note that, while some of the pieces had affinities with Calder's mobiles, Rickey's interests were "as much related to the spirit of modern missiles as to anything earthbound." Among the titles were *Harlequin*, *The Bridge*, and *Portrait of a Lady*, but the subjects were essentially paraphrases, catching the spirit of the theme.

The award of a Guggenheim Fellowship in 1960 (renewed the following year) encouraged Rickey's commitment to movement as an aesthetic concern. After Rickey's 1961 show at the Kraushaar Galleries a *New Yorker* critic found Rickey to be as classic in his approach as Calder was romantic, and particularly admired "the thistle-like *Long Stem*, the lazily moving *Summer*, and the truly ecstatic *Nuages*.

Rickey's sculpture was included in several major international shows in the 1960s, among them "Bewogen-Beweging" at the Stedelijk Museum, Amsterdam, in 1961, and, three years later, Documenta 3, Kassel, West Germany. His 36-foot-tall mobile in stainless steel, *Two Lines— Temporal I*, was acquired in 1965 by the Museum of Modern Art, New York City, and set up in the museum's sculpture garden. Its two tapering metal blades do not touch, and are held together only by a narrow spar at their base. They stand as the wind moves them, either motionless or intersecting, to describe a great "x" in the air. Rickey's sculptures are usually intended for the outdoors, and the slow, solemn movement of their parts creates an effect of subtlety and calmness, very different from the playfulness of Calder.

In 1966 Rickey gave up teaching, and the following year published his book, *Constructivism: Origins and Evolution*, which he wrote out of a belief that constructivism was the most unexamined and undervalued of modern movements. It is widely regarded as the only authoritative general history of the subject. James R. Mellow of *The New York Times* (September 27, 1970) characterized Rickey's view of constructivist work as "conceptually structured and *built* rath-

er than [a style] issuing from an artist's expressive tendencies."

Rickey received numerous commissions in the late 1960s and throughout the 1970s. Among the most notable were *Two Rectangles, Vertical Gyrators*, executed in 1969 for a shopping center in Rotterdam, and a 60-foot-tall wind-motivated sculpture commissioned for the Albany Mall. In 1970 he organized a traveling exhibition titled "Constructivist Tendencies," to illustrate his personal view of that movement. The two-year tour began at the State University Art Gallery in Albany, New York and included the University of New Mexico, Albuquerque, and the University of California at Santa Barbara. The exhibition consisted of 84 paintings, sculptures, prints, and mixed-media objects, all drawn from the collection of constructivist works that Rickey and his wife had been assembling over the previous 20 years.

The first major viewing in New York City of Rickey's outdoor works took place in April 1975, when 22 of his pieces were displayed on the Robert Moses Plaza of Fordham University's Lincoln Center campus, one floor above street level. Grace Glueck of *The New York Times* (April 28, 1975) was impressed by the "elegant, kinetic structures whose thin steel blades and burnished paddles are moved by the wind in choreographic patterns." Gazing at *Space Churn with Octagon*, a 19-foot-high work of concentric finned rings churning the air in a rotary path when stirred by the wind, Rickey remarked to Glueck: "My concern is the movement, not the form. Or rather, I should say that movement *is* the form." He described *Two Red Lines*, a 36-foot-high structure consisting of two balanced red blades that moved together in a scissorslike action, as a "drawing in space." Asked why he powered the works by air currents rather than by machinery, he replied that he found more pleasure in natural movement. He also declared that motor-driven mechanical devices were limited and repetitious, adding, "I'm not trying to interpret or to demonstrate nature, but to make a happy alliance with it."

In 1979 Rickey received a Brandeis University Creative Arts Award for his contribution to American sculpture. In April–June 1979 he had an important show at Amerika Haus, Berlin, and in September–October of the same year a retrospective of his work was held at the Solomon R. Guggenheim Museum, New York City. The exhibition consisted of some 90 pieces, ranging from small kinetic jewelry to large hanging mobiles. John Russell wrote in *The New York Times* (September 7, 1979), "Each piece is continually on the move in a surreptitious, but purposeful

way. . . . ". Russell thought that the weaker pieces in the show—because more illustrative—were those resembling small household plants or climbing vines. On the other hand, the simplest and most impersonal forms, such as *One Plane Horizontal* (1969) and *Six Triangles Hexagon V* (1969), were, in Russell's opinion, completely successful. A *Village Voice* critic wrote in 1979 that "if Calder was a poet . . . then Rickey is the scientist" whose works rely on a "'50s technology that looks good even in the high-tech, post–meltdown '70s."

George Rickey lives with his family on the 30-acre tract in East Chatham, New York, they moved to in the early 1960s; he also owns a residence in West Berlin. Some of his tall pieces stand in the meadow next to his home in upstate New York, swaying gently in the wind and flashing in the sunlight. James R. Mellow described the artist in 1970 as "hale and hearty, beaming, bespectacled," and another writer said that, with his powerful frame and rugged vitality, and his shock of grizzled hair falling over clear blue eyes, he resembled "an athlete, a football player."

George Rickey, for whom the literary expression of artistic ideas comes easily, wrote in the catalog to his 1979 Guggenheim Museum retrospective: "I had to wonder whether Calder had said it all; when I found that he had not, I had to choose among the many doors I then found open.

" . . . I wanted the whole range of movements themselves at my disposal, not to describe what I observed in the world around me, but to be themselves, performing in a world of their own.

"I wanted movement which would declare itself quietly, slowly, deliberately. . . . I rejected jerks, bumps, bounces, vibrations and, for the most part, all sound. I also gave up, except for a very few lapses, color, optical effects, spots, stripes. . . . "

"Nature is rarely still . . . ," Rickey noted in *Art Journal.* "The artist finds waiting for him, as subject, not the trees, not the flowers, not the landscape, but the *waving* of branches, and the *trembling* of stems, the piling up and scudding of clouds."

EXHIBITIONS INCLUDE: Caz-Delbo Gal., NYC 1933; John Herron Art Inst., Indianapolis 1953; Kraushaar Gal., NYC 1955, '59, '61; Amerika Haus, Hamburg, W. Ger. 1957; Mus. of Art, Santa Barbara, Calif., 1960; Kunstverein, Düsseldorf 1962; Inst. of Contemporary Art, Boston 1964; Staempfli Gal., NYC from 1964; Corcoran Gal. of Art, Washington, D.C. 1966; Mus. Boymans-Van Beuningen, Rotterdam 1969; Univ. of California, Los Angeles 1971; Kestner-Gesellschaft,

Hanover, W. Ger. 1973; Nationalgal., Berlin 1973; Kunsthalle, Bielefeld, W. Ger. 1976; "George Rickey, Skulpturen, Material, Technik," Amerika Haus, Berlin 1979; Solomon R. Guggenheim Museum, NYC 1979. GROUP EXHIBITIONS INCLUDE: "American Sculpture," Metropolitan Mus. of Art, NYC 1951; Whitney Annual, NYC 1952, '53, '66, '70; "Recent Sculpture U.S.A.," MOMA, NYC 1959; "Bewogen-Beweging," Stedelijk Mus., Amsterdam 1961; Documenta 3, Kassel, W. Ger. 1964; "Art Today: Kinetic and Optic," Albright-Knox Art Gal., Buffalo, N.Y. 1965, '68; "New Directions in Kinetic Art," Univ. Art Mus., Univ. of California, Berkeley 1966; "Plus by Minus: Today's Half-Century," Albright-Knox Art Gal., Buffalo, N.Y. 1968; "Kinetic Art," Hayward Gal., London 1970; "Sculpture and Sculptors," Annely Juda Fine Art, London 1972; "The Non-Objective World," Annely Juda Fine Art, London 1974; "Sculpture '76," Greenwich Arts Council, Conn. 1976.

COLLECTIONS INCLUDE: MOMA, and Whitney Mus. of Am. Art, NYC; Albright-Knox Art Gal., Buffalo, N.Y.; New York State Capitol, South Mall, Albany; Montclair Art Mus., N.J.; Princeton Univ., N.J.; Yale Univ. Art Gal., New Haven, Conn.; De Cordova Mus., Lincoln, Mass.; Boston Mus. of Fine Arts; Corcoran Gal. of Art, Nat. Collection of Fine Arts, and Hirshhorn Mus. and Sculpture Garden, Washington, D.C.; Baltimore Mus. of Art; Brooks Memorial Art Gal., Memphis, Tenn.; Indiana Univ. Art Mus., Bloomington; Fort Worth City Hall, Tex.; Mus. of Fine Arts, Dallas; Oakland Mus. of Art, Calif.; York Univ., Toronto; Tate Gal., London; City of Rotterdam; Rijksmus. Kröller-Müller, Otterlo, Neth.; Nationalgal., Berlin; Kunsthalle, Hamburg, W. Ger.; City of Hanover, W. Ger.; City of Jerusalem, Israel; Modern Art Mus., Senri Hills, Osaka, Japan.

ABOUT: Current Biography, 1980; Lucie-Smith, E. Late Modern: The Visual Arts Since 1945, 1969; Moore, E. (ed.) Contemporary Art 1942–72: Collection of the Albright-Knox Art Gallery, 1972; Rickey, G. Constructivism: Origins and Evolution, 1967, "Letters from 31 Artists" (cat.), Albright-Knox Art Gal., Buffalo, N.Y., 1970; "George Rickey" (cat.), Solomon R. Guggenheim Mus., NYC, 1979; Rosenthal, N. George Rickey, 1977; Selz, P. (ed.) "George Rickey: Sixteen Years of Kinetic Sculpture" (cat.), Corcoran Gal. of Art, Washington, D.C., 1966. *Periodicals*—Artforum June 1962, May 1978; Art in America December 1965; Art International (Lugano) May 1965; Art Journal Summer 1963; Art News November 1961; Christian Science Monitor January 17, 1959, March 23, 1966; New Yorker October 21, 1961; New York Herald Tribune January 11, 1959, August 29, 1965; New York Times September 27, 1970, April 28, 1975, September 7, 1979; Studio International February 1967; Village Voice September 24, 1979.

RILEY, BRIDGET (April 24, 1931–), British painter, is a leader of the op art movement which flourished in the 1960s. Born in south

Jorge Lewinski

BRIDGET RILEY

London, she is the daughter of John Riley, a commercial printer, and Bessie Louise Riley. Her maternal grandfather, James Gladstone, helped Edison develop the electric light bulb.

Much of her childhood was spent in Cornwall, where her Aunt Bertha encouraged her to paint. After three years at Cheltenham Ladies College in Gloucestershire, from 1946 through 1948, here she studied drawing and classical painting under Colin Hayes, she went in 1949 to Goldsmith's College of Art, London, where she studied until 1952, mainly with Sam Rabin, concentrating on her drawing skills. At the age of 21, she transferred to the Royal College of Art to learn more about painting from such teachers as Frank Auerbach, Peter Blake, and Richard Smith.

In 1955 Riley left the Royal College before completing the four-year course of study to look after her father, who was recovering from a car accident. This was a period of intense personal crisis for her, marked by artistic doubts, misgivings, and lack of direction which led to a mental and physical breakdown during that year, when she was 24 years old. For a while, she returned to Cornwall to rest. The following year, from 1956 to 1957, while still under treatment at the Middlesex Hospital, she worked in a London store, selling glass.

In 1957, when she began teaching art to young children at the Convent of the Sacred Heart School in north London, she started on the long road to recovery and self-revelation.

Riley's practice of repeating simple art principles to her pupils stimulated new ideas in her. "I used to tell the kids to take three colors and eight spots and make a picture," she recalled, "and they'd come up with hundreds of combinations." Her "mesmerically repetitive designs," to quote the London *Observer* (August 1, 1971), can be traced back to those teaching days. From 1958 to '64, Riley supported herself by working periodically at the J. Walter Thompson advertising agency.

Her "therapy" was concluded successfully when, at the age of 27, she met Maurice de Sausmarez, a painter and teacher, at Thubron's Summer School, Norfolk. Sausmarez helped to dispel doubts about her artistic direction, and encouraged her to read and travel. She visited Spain, Portugal, and France in 1959, and the following year traveled to Italy, where she was impressed by the work of the Italian Futurists. Riley and Sausmarez were close, almost inseparable companions until his death in 1970.

In the 1950s Bridget Riley was a figurative and landscape painter who since 1958 had used pointillist techniques. Her self-discovery dates from 1959, when she made a copy of Seurat's *Le Pont de Courbevoie*. Her analysis of the Pointillists' use of color influenced her positive arrangement of stripes and dots on the canvas. *Pink Landscapes* of 1959–60 shows how closely she modeled the gradation of her brushstrokes on Seurat.

Though Seurat was her point of departure, she realized in about 1960 that figuration in its traditional modes, with romantic or symbolic overtones, would no longer play any part in her aesthetic. "For me nature is not landscape," she explained, "but the dynamism of visual forces—an event rather than an appearance." Painting provided for her "an arena in which to tap these visual energies. . . ." While teaching part-time at the Hornsey College of Art, London, in 1960, she began to experiment with field-painting, and subsequently developed her characteristic style, working primarily in black and white. Her kinetic approach to art was evident in her early nonfigurative paintings, in which "discs and square checkers became recessed by violent bending of the perspective, so that the flat canvas seemed to buckle and rear before one's eyes," to quote *Contemporary Artists*.

Riley's fascination with patterns based on repeating units, which had attracted her in her student days to the dots in Seurat's paintings, was intensified one day in Venice in 1960 when a violent rain squall swept across the pavement of a piazza. She noted how the drops and splashes of water broke up the stone pattern, creating a sense of chaos and instability. She also observed how the complicated inlays and bands of black-and-white marble tended to "disrupt" the over-

all shape of Pisan–Romanesque architecture, and wondered whether the equivalent of this "break-up" could not be found in painting. As Robert Hughes wrote in *Time* magazine (May 12, 1975), "That sense of disturbed equilibrium within what looks like a rigid serial structure was to be the essential 'subject' of Riley's work from then on."

Among the first paintings in Riley's new-found style were *The Kiss, Movement in Squares,* and *Zig-Zag,* all of 1961 and in tempera on board, and *Black to White Disks* (1961–62), in emulsion on canvas. *The Kiss* has been described as "a massive exercise in the movement of mass activated by the diminishing area of space that separates a straight and a curving boundary." Her first exhibition was held in 1962 at Gallery One, London. The impact on British critics was that of visual assault, and the "aggressive" aspect was stressed by *The Guardian*'s critic (October 31, 1963) in his review of another Riley show at Gallery One. Guy Brett wrote that her paintings "seem to have given up the struggle to probe deep into the spirit of man and have been content to bounce mercilessly upon his optic nerve."

Among the paintings in Riley's 1963 solo show at Nottingham University was *Fall*, in emulsion on hardboard. Here, a wavy line was repeated 240 times, forcing the spectator's eye to scan the picture restlessly, seeking in vain for a resting place. This painting, which now hangs in the Tate Gallery, London, prompted one critic to say that "the constant movement of the eye and the ever-present flicker of after-images lend the work a brittle energy and account for its electric charge."

Bridget Riley scored her first major success with her 1965 solo exhibition at the Richard Feigen Gallery, New York City. Robert Hughes described the nature of her paintings' visual assault on New York audiences: "Black elliptical dots on a white ground, arranged in a grid but turning fractionally to set up an irritating instability of focus: parallel stripes whose wavy motion produced something akin to seasickness." Also in 1965 she was included in a influential group exhibit, "The Responsive Eye," which opened at the Museum of Modern Art, New York City, and then toured the United States.

Riley's work became synonymous with the label "op." The nonobjective movement that came to be called op art played on the susceptibility of the human visual apparatus to striking optical illusions, to perceptual ambiguities, and Riley was influenced by the retinal and kinetic approach of the Hungarian-born painter Victor de Vasarely, who was also represented in the "Responsive Eye" show.

Though pleased by her international success, Riley was annoyed when the techniques of op art were appropriated by "a horde of fabric designers and window dressers," to quote *Time* (November 16, 1970). In their hands, op art became "a chic gimmick that could market anything from underwear to wallpaper." Riley later brought successful legal action against a New York businessman who bought one of her paintings and transferred the design to a fashion textile.

In 1968 Riley and the sculptor Phillip King represented Great Britain in the Venice Biennale, where Riley was awarded the International Prize for Painting. The only other contemporary British artist to win comparable international acclaim was Henry Moore, who had won the Biennale prize for sculpture in 1948. Commenting on the Biennale, a *New York Times* critic wrote that "Riley's years of self-preparation have given her art a quite exceptional internal logic. . . . Riley is talking about the business of seeing, the actual physical sensation of it, and how it is tied up with 'feeling' in other senses (visual dizziness relating to physical insecurity, relating to mental anxiety, for example)."

Riley's stripe paintings, beginning with *Apprehend* (1970), were less aggressive than her early black-and-white images, but still presented "tense, active situations." She denies, however, that she intends to hurt the eyes, declaring that she aims only for "a stimulating, an active, a vibrating pleasure." Her 1971 retrospective at the Hayward Gallery, London, enhanced Riley's already considerable reputation. David L. Shirey of *The New York Times* (August 25, 1971) wrote: "Within the last few years Miss Riley has introduced more colors into her painting and employed the stripe more frequently." He called Riley "the op artist of the greatest accomplishment." Her only coeval among Op artists was Vasarely, but Shirey felt that "Miss Riley's creation . . . benefits from her greater imaginative faculties."

In several of her large canvases of the 1970s—some up to eight feet wide—Riley achieve subtle yet striking effects through the juxtaposition of complementaries. Reviewing her 1975 show at the Sidney Janis Gallery, New York City, Robert Hughes was impressed by "the sharp, exhilarating flicker and reversal of green against red against blue" in *Paean* (1973). Hughes noted that a painting like *Shik-Li* (1975), with its "finely tuned ribbons of color," would not allow the eye to rest for long on any one point, because such a work "sets up an undulation of space that one feels as a physical pressure." He asserted, moreover, that her work, far from being merely an "optical gymnasium," had a "lyrical side" as well.

When Riley exhibited three years later at the Janis Gallery, John Russell of *The New York Times* (May 12, 1978) noted that black and white had been long discarded and, though the basic form was still wavy, "pale blue, pink and pale yellow make up the kind of gamut that once was called 'feminine.'" Reviewing the same exhibit, another *Times* critic felt that op art, which had caused such a sensation in 1965, had by now "withered on the vine," and wrote of Riley's later, quieter work: "Beautifully and flawlessly executed as these canvases are, they can't by definition aspire to be more than repetitious decoration."

Bridget Riley is English, not Irish, despite her name. "I am English and no Catholic," she explained. "My mother called me Bridget only because she had always wanted a daughter of that name." Riley lives alone, dividing her time between a Victorian house with four studios, one on each floor, in London's Holland Park, a studio in Cornwall, and another studio in the Vaucluse district of southern France. She has been described as "a woman of high wit, intelligence, . . . sensitivity," and great inner strength, though John Gruen detected "something tremulous and vulnerable" beneath the surface. She is known to be cool to strangers, but Gruen noted that "she quickly calms down and shows the amiability her friends are aware of." Considerate to her studio assistants, Riley works alongside rather than over them. Her designs are worked out meticulously on paper with explicit instructions and measurements; as one writer observed, "The program seems mechanical, [but] Riley is a romantic within the range of her methods."

In *Art News* (October 1965) Riley wrote: "the basis of my painting is this: that in each of them a particular situation is stated. Certain elements within that situation remain constant. Others precipitate the destruction of themselves. Recurrently, as a result of the cyclic movement of repose, disturbance and repose, the original situation is restated. . . . I want the disturbance of 'event' to arise naturally, in visual terms, out of the inherent energies and characteristics of the elements that I use."

EXHIBITIONS INCLUDE: Gal. One, London 1962; Gal. One, Nottingham Univ., England 1963; Richard Feigen Gal., NYC 1965, '66, '67, '68; MOMA, NYC 1967; Rowan Gal., London 1969, '71, '76; Kunstverein, Hanover, W. Ger. 1970; Kunsthalle, Bern 1971; Hayward Gal., London 1971; Kunstverein, Göttingen, W. Ger. 1972; Whitworth Art Gal., Manchester, England 1973; Gal. Beyeler, Basel 1974; Sidney Janis Gal., NYC 1975, '78; Coventry Gal., Sydney, Australia 1976; Albright-Knox Art Gal., Buffalo, N.Y. 1978; GROUP EXHIBITIONS INCLUDE: "Young Contemporaries," London 1955; "Towards Art," Arts Council of Great Britain, London

1962; "The New Generation," Whitechapel Art Gal., London 1964; "The Responsive Eye," MOMA, NYC 1965; "Jeunes Peintres Anglaise," Mus. des Arts Décoratifs, Paris 1967; Venice Biennale 1968; "British Artists: 6 Painters, 6 Sculptors," MOMA, NYC 1968; "Contemporary British Art," Nat. Mus. of Modern Art, Tokyo 1970; International Biennale of Prints, Tokyo 1972; "La Peinture Anglaise d'aujourd'hui," Mus. d'Art Moderne, Paris 1973; "British Painting '74," Hayward Gal., London 1974; "Art as Thought Process," Serpentine Gal., London 1975; "Contemporary British Art," Cleveland Inst. of Art 1976; "British Painting 1952–1977," Royal Academy of Arts, London 1977.

COLLECTIONS INCLUDE: Tate Gal., Victoria and Albert Mus., Arts Council of Great Britain, British Council, Gulbenkian Foundation, and Peter Stuyvesant Foundation, London; Fitzwilliam Mus., Cambridge, England; Walker Art Gal., Liverpool; Whitworth Art Gal., Manchester, England; Scottish Nat. Gal. of Modern Art, Edinburgh, Scotland; Ulster Mus., Belfast; Stedelijk Mus., Amsterdam; Mus. Boymans-Van Beuningen, Rotterdam; Kunstmus., Bern; Mus. des XX, Jahrhunderts, Vienna; MOMA, NYC; Albright-Knox Art Gal., Buffalo, N.Y.; Chicago Art Inst.; Walker Art Cntr., Minneapolis; Baltimore Mus. of Art; Pasadena Mus. of Art, Calif.; Nat. Gal. of Australia, Canberra; Art Gal. of South Australia, Adelaide; Art Gal. of Victoria, Melbourne; Power Inst. of Contemporary Art, Sydney, Australia; Auckland City Art Gal., New Zealand.

ABOUT: Current Biography, 1981; Lucie-Smith, E. Late Modern: The Visual Arts Since 1945, 1969; P-Orridge, G. and others (eds.) Contemporary Artists, 1977; "Bridget Riley: Paintings and Drawings 1961–1973" (cat.), Arts Council of Great Britain, 1973. *Periodicals*—Architectural Design August 1963; Art in America April 1975; Art International (Lugano) September 1962, March 1971; Art News November 1963, October 1965, September 1978; Arts Review May 1962; Guardian October 31, 1963; London Sunday Times July 4, 1976; New York Times February 28, 1965, December 29, 1968, August 25, 1971, May 12, 1978, May 26, 1978; Observer August 1, 1971; Observer Magazine September 1973; Studio International June 1968; Time November 16, 1970, May 12, 1975.

***RIOPELLE, JEAN-PAUL** (October 7, 1923–), French-Canadian painter, sculptor, and printmaker, has won international acclaim as the leading Canadian Abstract Expressionist. He was born in Montreal, the only son of an architect. His family, probably of Spanish origin, had settled in Canada in the 19th century. Riopelle began painting at the age of eight, receiving special attention in art class at school. Later, he studied engineering at Montreal Polytechnique. "It was while studying engineering that a very curious thing happened to me," he re-

°ryō pĕl´, zhän pōl

Jorge Lewinski

JEAN-PAUL RIOPELLE

called. "I used to go into the country on holidays
to do landscapes, which I like very much because
they are so free. Then I started to do seascapes
of the sea as seen from above, and I painted
three or four canvases of drifting shells. Quite
unintentionally, they turned out to be purely
abstract." He soon took up painting seriously,
and in 1943–44 studied at Montreal's Académie
des Beaux-Arts.

After serving as a fighter pilot near the end of
World War II, Riopelle began to paint again,
working with a group of young Montreal artists,
headed by Paul-Emile Borduas, who called
themselves the Automatistes. Their idea, derived
from surrealism, was to paint "automatically,"
letting the hand place the paint without any con-
scious direction from the brain. (This movement
paralleled in some ways the contemporary work
of Jackson Pollock in New York.) Riopelle exhib-
ited in Canada with the Automatiste group, none
of whom are painting in this manner today.

In 1945 Riopelle began to evolve his own style.
His aim was to discover and observe nature with-
out preconceived ideas. His first abstract paint-
ings, violent runs of color squeezed directly from
the tube, already revealed a powerful tempera-
ment. These canvases were little understood in
Canada, and Riopelle decided to go to Paris for
a year, earning his passage on a freighter "by
playing nursemaid to a shipment of horses." He
briefly returned home to marry Françoise
l'Espérance, a native of Montreal with whom he
had two daughters.

In 1946 Riopelle settled in Paris permanently.
Penniless and virtually unknown, he was none
the less cordially received by André Breton and

the Surrealists. In 1947 he took part in the great
International Exhibition of Surrealism held at
the Galerie Maeght, Paris. More significantly, at
the end of 1947, he was represented in "The
Imaginary," an exhibition devoted to what be-
came known as lyrical abstraction, organized by
Georges Mathieu at the Galerie du Luxembourg.
Also in 1947, Riopelle had exhibited with his Ca-
nadian group in a show called "Automatism."

Returning for a brief visit to Canada in 1948,
Riopelle, along with Borduas and his group,
signed the "Refus Global" manifesto. A general
protest against the restrictive conservative cul-
tural climate of French Canada, this was partly
inspired by surrealist ideas, but was above all an
expression of "multiple rejections." Back in Par-
is, Riopelle held his first solo show at the Galerie
Nina Dausset in 1949. In a preface to the catalog
André Breton wrote: "All the rose-windows of
the cathedrals fly joyously into splinters. The air
is about to flower. . . . For me it is the art of a
superior trapper. Traps laid bare both for earth-
ly creatures and those of the clouds." But Riopel-
le, whose art had less to do with surrealism than
with lyrical abstraction, never felt comfortable
within the rigid bureaucratic discipline imposed
by Breton, and in 1950 he left the Surrealist
group.

Not one picture had been sold in the 1949 ex-
hibition, and the next few years were difficult
for Riopelle and his family. He remembers that
after one of his return visits to Canada it took
him ten months to get the fare back to France.

In the early 1950s, Riopelle broke through to
the personal style that has become his signature.
From 1950 on he gradually abandoned the use
of brushes in favor of tubes of paint emptied di-
rectly onto the canvas; after 1952 he used palette
knives and spatulas to lay on and knead the col-
ors. He was influenced by the improvisatorial
methods of the American Abstract Expression-
ists, but his paintings, to quote *Newsweek*, "did
not have what one critic called the 'hairy' look
of American action painting." Riopelle com-
bined "the kinetic drive of Jackson Pollock" with
"the elegance and *cordon-bleu* quality of the
School of Paris." There was none of the aggres-
sion or anxiety found in Pollock, Kline, and de
Kooning in *Painting* (1951) and similar works
shown in a group exhibition called "Véhémences
confrontées," organized in 1951 by the influen-
tial critic, Michel Tapié at the Galerie Nina
Dausset, Paris.

Riopelle's pictures in the early 1950s were, in
the words of Aldo Pellegrini, "constructed with
small outlines in juxtaposed color of changing
orientation according to the all-over principle,
sometimes shot through by fine linear traces of

color in a manner that gives the surface a sense of mobility heightened by the succulent quality of the material." Between 1950 and 1954 Riopelle painted several large compositions, including *Homage to the Waterlilies of Monet.* He considered the late (1920s) work of Monet an important source of "informalism," Tapié's term for the European variety of lyrical abstraction. At this time Riopelle was friendly with the young American Expressive Abstractionist Sam Francis, who was also part of the informalist trend.

After exhibiting in several solo and group shows, Riopelle, from 1954 on, began to win international recognition. That year he was one of three artists chosen to represent Canada at the Venice Biennale. In 1954, and again in 1955, he had solo exhibits in New York City at the Pierre Matisse Gallery. Reviewing the second of these shows, the *Herald Tribune* art critic wrote of the artist's new abstractions, "They look rather like mosaics made of striated bits of marble organized into an incredibly intricate network." The critic considered that "the last two or three canvases" were "by far the best." In these, "the patterns congeal into mysterious suggestions of figures in landscape."

Towards 1956 Riopelle's outlines became larger and more simplified. There was still a mosaic quality in *Encounter* (1956; Wallraf-Richartz Museum, Cologne), but the slabs of color were broader; large, richly textured areas of red in the upper section of the canvas and green in the lower were traversed by lively configurations of white and black. The overall effect was analogous to a landscape with buildings seen from the air.

Riopelle insists that his paintings are not symbolic impressions of landscape. However, one time when his dealer Jacques Dubourg was showing some of his canvases to an American client, she said: "It's funny, but I seem to feel horses and rolling plains and huge skies in this one." Riopelle had, in fact, painted it just after returning from a visit to the Camargue—the "cowboy country" of southern France. Other large paintings evoked for some viewers the trees and forests of Canada.

By 1957 Riopelle's canvases, some of them huge, were selling for considerable sums; few buyers knew he was Canadian and not French. Although every year he and his wife and two children returned to Canada to visit family in Montreal, he otherwise rarely left Paris.

For some years Riopelle had been making sculptures. His vigorously informalist sculpture *Don Quixote* (1961), modeled in wax and cast in bronze, is now in the collection of the Hirshhorn Museum and Sculpture Garden, Washington,

D.C. In addition to his Paris apartment, Riopelle has a studio at Vanves, a suburb of Paris, and uses a foundry in a neighboring suburb.

In 1962, at the age of 39, Riopelle was awarded the UNESCO prize at the Venice Biennale. Michel Seuphor described Riopelle's canvases of this period as "large monochrome or polychrome symphonies . . . a kind of aerial impressionism . . . measuring its vehemence according to the capacity of the arm that executes the work and imposes its sovereign rhythm." Recognition in Canada came at last when, in January 1963, 82 paintings and sculptures were displayed at the National Gallery of Canada, Ottawa. At 40, Riopelle was the youngest Canadian artist ever to be so honored. The show moved to Montreal and then to Toronto, and in May an abbreviated retrospective of 31 paintings was held at the Phillips Collection, Washington, D.C. Also in May 1963, there was an exhibition of Riopelle's new paintings at the Pierre Matisse Gallery, along with some of his sculptures, none of which had been shown before in the United States. Irving Sandler in *The New York Times*, (May 12, 1963) described the bronzes, particularly one called *Gaulois,* as "bold, assured, ornamental, and suggestive of flowering life." Sandler felt that experience with sculpture had affected Riopelle's painting. Not only did the pigmentation in the canvases suggest relief sculpture, but "instead of dense panoramas extending, effectively, beyond the limits of the canvas, the new paintings, lighter in both spirit and color, are often units recognizing the boundaries of a frame." *The Tree* was an example of this new development. Sandler observed that pictures referring to the human figure were less successful than the lyrical landscapes. Leslie Judd Ahlander, in her review in *The Washington Post* of the artist's concurrent retrospective at the Phillips Gallery, Washington, D.C., wrote: "Interesting as Riopelle's technique is, it is his lyrical interpretation of nature that is most fascinating in his work."

Riopelle was always aware that the abstract expressionist method carries with it the dangers of repetitiousness and stylistic exhaustion, and he constantly sought to renew his style. Edward Lucie-Smith considered that Riopelle, in his work of the 1950s, had "an effective but limited formula." There was greater freedom and exuberance in his paintings of the 1960s, beside which, according to Robin Green of the *Toronto Globe and Mail,* his earlier works looked "oddly constricted." Green noted that in all this exuberance there was "a hint of realism creeping through the abstraction." In Riopelle's large paintings of the 1970s, such as the triptych *Vert-de-Gris* and *Lake of the Northeast* (both of

1975), there was a concern with figure-ground relationships. Riopelle strove to maintain the sparkling, kinetic surface of his earlier canvases, while introducing a subtle figuration. When these new works were exhibited at the Pierre Matisse Gallery in the spring of 1977, the critic of *Arts Magazine* saw in *Vert-de-Gris* a possible suggestion of a medieval altarpiece and thought "perhaps the images are totemic, sacred figures." Although it was "not possible to accurately formulate the iconography of a Riopelle painting," in the way one might analyze medieval art, it was evident that the artist had progressed "from pure sensations of color movement toward the symbolic."

Jean-Paul Riopelle is a robust, dark-haired man who gives an overwhelming impression of physical vitality and relaxed energy. Catherine Jones, interviewing him for the Canadian magazine *Maclean's,* wrote that he "looks like Chico Marx: he acts rather like him too," and another writer described him as "instinctive, spontaneous, and quick-witted," a man who "loves telling jokes" and who "drinks regularly and copiously, not to key himself up, but to reduce tension." Even though "he paints in a frenzy" when the spirit moves him, there is order and cleanliness in his light, airy studio.

His two passions besides painting were the circus and automobiles. At one time he owned five cars, his favorite being a 1931 Bugatti, which, according to Jones, he drove around Paris "with the same force, exuberance and freshness of spirit that characterize his paintings." He once built his own racing car, and when he was persuaded to give up racing because it was too dangerous, he acquired a 45-foot sailboat which he kept on the French Riviera. He does not object to being described as a Canadian painter, but says he is less at ease with Canadians than with other nationalities, because he feels "that both English and French-speaking Canadians have chips on their shoulders." Although Paris has been his base since 1946, he denies that it is his permanent home. "I never settle anywhere. I am a free bird."

Riopelle has no critical theory about his development as an artist, and has little interest in what is written about him. He dismisses the arbitrary division of his paintings into so-called phases ("tachiste," "controlled drip," etc.), and argues that "the imposed division between abstract and figurative art now is the problem of dealers and critics." He insists that he is not an abstract painter. "I still regard my work as figurative," he said, even though few viewers can pick out actual objects in his paintings. But, refusing as always to be pinned down, Riopelle declared in 1963:

"There is no figuration, there is only expression—and expression is just someone in front of things."

EXHIBITIONS INCLUDE: Gal. Nina Dausset, Paris 1949; Gal. Raymond Creuse, Paris 1950; Gal. Paul Facchetti, Paris 1952; Gal. Pierre, Paris 1952, '53; Pierre Matisse Gal., NYC from 1954; Gal. Rive Droite, Paris 1954; Gimpel Fils, London 1956; Gal. Jacques Dubourg, Paris 1956, '60; Kestner Gessellschaft, Hanover, W. Ger. 1958; Kunsthalle, Basel 1959; Arthur Tooth and Sons Gal., London 1959, '63; Nat. Gal. of Canada, Ottawa 1963; Phillips Collection, Washington, D.C. 1963; Mus. de la Province, Quebec 1967; Gal. Maeght, Paris 1970; Palais des Beaux-Arts, Charleroi, Belgium 1971; Gal. Maeght, Zürich 1972. GROUP EXHIBITIONS D INCLUDE: International Exhibition of Surrealism, Gal. Maeght, Paris 1947; "The Imaginary," Gal. du Luxembourg, Paris 1947; São Paulo Bienal 1951, '55, '61; "Véhémences confrontées," Gal. Nina Dausset, Paris 1951; Venice Biennale 1954, '62; "Younger European Painters," Solomon R. Guggenheim Mus. NYC 1954; International, Solomon R. Guggenheim Mus., NYC 1958, '60, '64; Pittsburgh International, Carnegie Inst. from 1958; "School of Paris 1959: The Internationalists," Walker Art Center, Minneapolis 1959; Salon de Mai, Paris 1960; "Eight Artists from Canada," Mus. Haaretz, Tel Aviv 1970.

COLLECTIONS INCLUDE: Nat. Gal. of Canada, Ottawa; Art Gal. of Ontario, Toronto; Solomon R. Guggenheim Mus., NYC; Hirshhorn Mus. and Sculpture Garden, Washington, D.C.; Los Angeles County Mus. of Art; Scottish Nat. Gal. of Modern Art, Edinburgh; Neue Nationalgal., Berlin; Kunsthaus, Zürich; Nat. Gal. of Victoria, Melbourne.

ABOUT: Bénézit, E. (ed.) Dictionnaire des peintres, sculpteurs et graveurs, 1976; Briton, A. "Jean-Paul Riopelle" (cat.), Gal. Nina Dausset, Paris, 1949; Lucie-Smith, E. Late Modern: The Visual Arts Since 1945, 1969; Pellegrini, A. New Tendencies in Art, 1966; "Riopelle" (cat.), Gal. Rive Droite, Paris, 1954. *Periodicals*—Art International (Lugano) March 1973; Arts Magazine June 1977; Canadian Art (Ottawa) October 1959; Chroniques de l'art vivant (Paris) May 1970; Derrière le miroir (Paris) April 1970; Guardian September 25, 1963; New York Herald Tribune April 20, 1955; Maclean's August 3, 1957; New York Times May 12, 1963, October 12, 1974; Newsweek May 27, 1963; Observer June 1959; Quadrum 11 1964, June 20, 1964; Washington Post May 19, 1963.

***RIVERA, DIEGO** (December 8, 1886– November 24, 1957), Mexican painter, whose murals depicting the actual and mythic history of Mexico inspired a renaissance of this form of art. Rivera, one of twin sons (his brother died soon after birth), was born in Guanajuato, a former silver mining town in central Mexico. His father was a schoolteacher who also served as ed-

°rē vâ rǝ, dyä´ gō

THE BETTMAN ARCHIVE, INC.

DIEGO RIVERA

itor of a local liberal newspaper and as a health inspector. "One of my earliest memories . . . is that I was always drawing," Rivera recalled, and he is said to have begun drawing at the age of three. In 1892 the family moved to Mexico City, and in 1897 Rivera started his formal study of art at the San Carlos Academy of Fine Arts.

Under such teachers as Santiago Rebull, a former student of Ingres, he received solid academic training in draftsmanship; one of his drawings, a head of a woman, done when he was only 12, shows amazing proficiency. (To the end of his life the artist held that his drawing was better than his painting.) Above all, however, Rivera's art and philosophy were shaped by the work of the printmaker José Posada, the Daumier of Mexico, whose mordant woodcuts embodying folk-art motifs satirized the regime of the dictator Porfirio Diaz. These enormously popular prints played an active role in rallying support for the 1910 Mexican Revolution. As Rivera noted, "Posada taught me the connection between art and life—that you cannot paint what you do not feel."

Expelled from the academy in 1902 because he had led a students' strike protesting the re-election of Diaz, the 16-year-old Rivera set up as an independent artist, traveling and painting throughout the countryside. In canvases such as *The Threshing Floor* (1904) there is a storytelling realism and a technique involving use of thin paint applied in small, smooth brushstrokes which were soon thereafter banished from his work, and only resurfaced after 1921. The influence of impressionism, which was beginning to find its way into Mexico, can also be detected in such paintings as his *Self-Portrait* of 1906.

In 1907 Rivera left for Spain to study under a three-year grant by the governor of the state of Veracruz, who had become interested in the young artist's work. *Head of a Breton Woman* (ca. 1908) was painted in the prevailing Spanish academic style: realistic, limited in palette, intense in its use of chiaroscuro. Dissatisfied with the restrictions of this mode, however, Rivera left for France, and from 1909 to '20 worked in Paris—aside from brief trips to Belgium, Holland, and England; annual journeys back to Spain; and a return trip to Mexico at the expiration of his grant (and the outbreak of the Revolution) in 1910. In Ambroise Vollard's famous Paris gallery he was introduced to the works of Matisse, Van Gogh, Renoir, and, above all, Cézanne; one of Rivera's favorite anecdotes was of his standing outside the gallery window all day in the rain, watching Vollard display Cézanne's canvases, one after another. The composition and coloring of *Landscape with Farmhouse* (1912) indicates the particularly strong impact of Cézanne's style. "This was the Paris I had come to find; this was where I would remain; and these were the artists and works I wanted and needed to know," Rivera said. With the renewal of his grant in 1911 he was free to continue to absorb these and many other contemporary cultural influences.

Among the other expatriate members of the School of Paris was a young Russian painter, Angeline Beloff, who in 1911 became Rivera's common-law wife, and by whom he had a son who died in infancy. With Beloff, Rivera now discovered cubism. Picasso subsequently became his close friend; the paintings of Gris and Braque were also influential as were the works of Modigliani, who painted his portrait. Rivera's *Young Man in Gray Sweater/Portrait of Jacques Lipchitz* (1914) is done in the earlier analytic cubist style, characterized by simultaneity of planes. *Marine Fusilier/Sailor at Lunch* (1914) illustrated the later synthetic phase, with its more decorative concerns: bolder colors, emphasis on surface textures. It was now that Rivera adopted the use of impasto and introduced specific Mexican motifs, as in *The Awakener/The Clock* (1914)—which juxtaposes a serape with a Russian balalaika and a sign printed in Cyrillic characters (allusions to his liaison with Beloff)— and *Zapata Landscape/The Guerrilla Fighter* (1915), with its strong colors, compositional allusion to the mountains of Mexico, and trompe l'oeil treatment of the wooden rifle and the woolen serape. Of the latter painting, Rivera himself commented that it was "probably the most faithful expression of the Mexican mood that I have ever achieved."

In 1917 Rivera, as he explained many years

later, stopped painting in the cubist manner be-
cause of the First World War, the Revolution in
Russia, and "my belief in the need for a popular
and socialized art. It had to be a functional art,
related to the world and to the times, and had
to serve to help the masses to a better social
organization." Readily apprehended content
now became important to him, and a return to
academic principles is seen, notably in a series
of portrait studies (paintings and drawings) exe-
cuted between 1917 and '20. Experiments in the
fauve style (a 1919 *Landscape*) or in the style of
Renoir—a number of female nudes—followed.
In sum, Rivera's Paris years are a reflection of
the major art movements of the late 19th and
early 20th centuries, absorbed and interpreted
by a highly gifted eye and hand.

In 1919 another young Mexican artist, David
Alfaro Siqueiros, arrived in Paris; his meeting
with Rivera proved enormously significant for
Mexican art and politics, as between them they
worked out a plan for the participation of artists
in the new revolutionary government. The con-
tribution was to consist of murals, with overt po-
litical and social content, in fresco—an art form
rooted in Mayan and Aztec tradition and well es-
tablished in post-Hispanic popular traditions of
wall decoration. According to Rivera's defini-
tion, the function of mural painting was not
merely to decorate but to extend the dimensions
of architecture. Now, in preparation, Rivera
spent his final year in Europe (1920–21) in Italy.
Many drawings attest to his intensive study not
only of fresco painting but of Etruscan and clas-
sical sculpture and of Pompeian and Byzantine
mosaics. He also perfected his revival of the age-
old encaustic technique of wall painting, which
involves fusing dry pigments with wax by the
application of heat. Thus equipped, Rivera re-
turned home in July 1921, to forge, together
with Siqueiros and José Clemente Orozco, an art
new in form and purpose for their country. The
Mexican art renaissance thus engendered had an
effect also upon the art of the United States,
where Orozco and Rivera visited and worked,
and where the decoration of public buildings
with frescoes of social significance was spon-
sored throughout the country by the WPA in the
1930s.

From the time of his return to the time of his
death Rivera had a stormy career, one that was
a "challenge to himself and to his audience," as
Florence Arquin has summed it up. In 1921 he
joined the Mexican Communist Party and began
writing for its official newspaper *El Machete*. In
1927 he was invited to the USSR, but two years
later was ousted from the party for intransi-
gence; although he continued to consider him-
self a communist he was not reinstated as a

member until the end of his life. Bitter political
or religious controversies resulted in destruction
or mutilation of some of his work; on occasion,
even, his life was threatened by would-be politi-
cal assassins. As his biographer Bertram Wolfe
noted, Diego Rivera's life was in every sense of
the word "fabulous." He was a born myth-
maker, larger than life not only in sheer physical
size—over six feet tall and weighing at various
times some 300 pounds—but in the tales he spun
about himself and in his recreation of Mexico's
history. His autobiography, *My Art, My Life,*
must be approached with some caution, there-
fore. A *Self-Portrait* drawing of 1918 provides a
truthful visual record in its uncompromisingly
realistic depiction of his own heavy features: the
high forehead, large, protuberant eyes, thick
nose, and full lips. Despite his huge bulk, his
shoulders were narrow and rounded, his sensi-
tive hands surprisingly small. Far from hand-
some, habitually sloppy of person and dress, he
was nevertheless enormously attractive to and
attracted by women. His energies, both for plea-
sure and for work, were prodigious; as Frida
Kahlo, one of his four wives, put it, "His capacity
for energy breaks clocks and calendars." And
one statistically minded scholar has computed
that by 1949 Rivera had covered a total wall sur-
face of two-and-one-half miles, one yard deep,
with his paintings.

Back in Mexico, "struck by the inexpressible
beauty of that rich and severe, wretched and ex-
uberant land," as he later exulted, Rivera's first
mural commission was for the amphitheater of
the National Preparatory School in Mexico City;
the allegorical theme was the Creation. Com-
pleted in 1922, it was hailed by his fellow artists,
reviled by the press. In 1923 he embarked on the
124 fresco panels for the great courtyard of the
Ministry of Education—the theme this time a
panorama of Mexican social history: its agricul-
ture and industry, its art, festivals, national aspi-
rations, and the land itself. The vast project,
which took four years of intense (if intermittent)
labor to complete, made the Mexican renais-
sance and Rivera internationally famous. Con-
currently he worked on the 30 frescoes for the
walls and ceilings of the assembly hall of the Ag-
ricultural School at Chapingo, near Mexico City.
These paintings, dealing with the Mexican earth
and its agricultural and mineral products, in-
clude several nude figures illustrating the theme;
most of these, and notably the great figure
Fecund Earth, were posed for by Guadalupe
Marín. Having left Angeline Beloff in Paris, Ri-
vera had married Marín; in 1921; they had two
daughters. The Chapingo frescoes are widely
considered to be the artist's masterpieces. Fin-
ished, with the National Preparatory School

paintings, in 1927, both cycles are the products of Rivera's own hand; his assistants were employed only on the preliminary work of mixing pigments and plastering.

Two years later the indefatigable Rivera began his work for the National Palace, Mexico City, and almost simultaneously for the Palace of Cortés, Cuernavaca. The latter project was commissioned by Dwight W. Morrow, then US Ambassador to Mexico, as a goodwill gesture. Among the highlights of the Cuernavaca murals, which deal with the conquest of Mexico, is the panel portraying the Indian revolutionary leader Emiliano Zapata, clad in white and leading a white horse. A replica of the panel hangs in the Museum of Modern Art, New York City.

On three walls facing and flanking the monumental stairway of the National Palace, Rivera started to paint an epic history of Mexico, from pre-Columbian civilization to the present and including a forecast of the future promised by the social revolution. In 1945 Rivera returned to paint other walls in the palace corridors, and it is here that he executed his famous lyric, non-propagandistic, panoramic vision of Tenochtitlán, the Aztec capital of Mexico. The whole vast assemblage, which has rightly been called "a world on a wall," was only completed two years before the artist's death; it involved about 26 years of often interrupted labor. "My National Palace mural is the only plastic poem I know which embodies the whole history of a people," its creator boasted.

From 1930 to '34 Rivera worked in the US, accompanied by his third wife, the gifted Mexican painter Frida Kahlo, whom he had married in 1930. Invited first to San Francisco, he did a fresco for the San Francisco School of Fine Arts. It incorporated a rather witty device, his self-portrait sitting on a scaffold working on the painting, his back to the viewer, ample buttocks hanging over his perch. Some tastes were offended. Later, in the 1940s, the work was deemed too conservative, too realistic in style, and it was covered over, not to be reinstated until after Rivera's death.

Rivera's second project in the US was for the garden walls of the Detroit Institute of Arts. Here, his 27-panel "Detroit Industry" painting (1932–33) aroused the ire both of those who wished for a more "aesthetic" subject and those conservatives—including the controversial right winger Father Coughlin—who objected particularly to his representation of *Vaccination*, feeling it was a blasphemous parody of a nativity scene. The furor eventually died down and critical opinion now holds this to be Rivera's finest work in the United States.

From Detroit he went to New York City, where he received a commission from Nelson A. Rockfeller to decorate the lobby of the RCA building in the new Rockefeller Center ensemble. From the start the commission was a cause célèbre; initially it had been proposed to offer the work either to Matisse, Piccasso, or Rivera on the basis of submitted examples. Upon the voluntary withdrawal of the first two, the field was left to Rivera, his illustrative program to be: Man at the Crossroads, Looking with Hope and High Vision to the Coming of a New and Better Future. The fresco, begun in March 1933, was completed in May with the help of several assistants, including Lucienne Bloch and Ben Shahn. A crisis developed when it was discovered that Rivera has painted in the face of Lenin. When he refused to paint it out, the fresco was ordered covered over, despite public demonstrations and protests from many American artists. Providentially, Bloch had managed to smuggle in a camera and had photographed the work; thus, after the authorities, despite their assurances to the contrary, had smashed it to bits in February 1934, Rivera was later able to reconstruct the mural in the Palace of Fine Arts, Mexico City. One of the ironies of the whole affair is that the Communist Party of the United States had protested Rivera's being chosen as muralist in the first place, claiming him to be a painter of palaces—a reference to his work at Cuernavaca—while reactionary opinion objected to Rivera's socialist leanings.

Back in Mexico, Rivera spent the next several years mainly doing easel paintings: portraits, including a 1938 picture of his friend the movie actress Dolores del Rio, and landscapes. In 1936, the year the Riveras entertained the exiled Leon Trotsky and his wife in Frida Kahlo's beautiful studio-home at Coyoacán, the painter essayed another mural. For the newly built Hotel Reforma he was to do movable panels illustrating the Carnival of Mexican Life. Fearful of the reaction to the caricatures of well-known political figures embodied in the mural, the hotel management secretly managed to have some of the figures changed; Rivera thereupon successfully sued and was allowed to make restorations and to be compensated for the work entailed. Later, the panels were removed from the hotel and installed in a travel agency.

In 1940 Rivera was called north once again, now to work on murals at the San Francisco World's Fair on Treasure Island. Celebrating the union of the cultures of North and South America, the work incorporates portrait studies, used allegorically, of Frida Kahlo (divorced since 1938, they were remarried in San Francisco in 1940), the industrialist Henry Ford, and the

movie stars Paulette Goddard and Charlie Chaplin. The movable frescoes, intended to be installed in the library of the State College of San Francisco, were instead stored in vaults; they were not removed until 1961, when they were hung in the lobby of a new arts building on the college campus.

In 1947 the artist designed one of his most lighthearted, personal murals, a loving evocation of his own life and that of his country. (Its spirit is only equalled by the insouciance of a much earlier project, the scenes and costumes he designed in 1928 for the ballet *HP/Horsepower,* composed by Carlos Chavez and first performed in 1932 at the Philadelphia Academy of Music.) Nevertheless, the installation of *Dream of a Sunday Afternoon in the Central Alameda Park* in the dining room of the new Del Prado Hotel in Mexico City touched off a violent demonstration. The long panel, showing a throng of merrymakers in the park, includes historical and contemporary figures: the artist's self-portrait as a fat, goggle-eyed little boy, holding hands with a festively dressed female skeleton, who in turn links arms with the printmaker Posada, and standing behind them, Frida Kahlo. Over the head of the great national hero Benito Juárez, Rivera chose to inscribe the legend *Diós no existe* (God does not exist). As a result, the archbishop refused to dedicate the new hotel and when a band of Catholic students broke in and defaced the mural the hotel management decided to screen it from public view. A footnote to this episode is that in 1956 Rivera, announcing that he was indeed a Catholic—despite having been rehabilitated by the Communist Party in 1954—repaired the damaged surface without painting in the legend again. The Del Prado mural now hangs, to even better effect, in the hotel lobby.

Scandal once again broke out over the mural Rivera worked on in 1952, to be shown in an exhibition of Mexican art in Paris. *The Nightmare of War and the Dream of Peace* included caricature figures of Uncle Sam, John Bull, and Marianne (France), facing portraits of Stalin and Mao Tse-tung. Fear of political embarrassment caused the Mexican government to confiscate Rivera's contribution; replicas of it were, however, sold at the entrance to the Paris exhibition, and the work was finally acquired by the Chinese government.

In 1954 Frida Kahlo died, ending a relationship central to Rivera's life, often shaken but never completely broken by his frequent infidelities. One year later he married Emma Hurtado, a long-time friend many years his junior. Then, stricken with cancer, Rivera journeyed to Moscow in 1956 for cobalt treatments, to which he responded favorably.

The American critic Sheldon Cheney, in *The Story of Modern Art,* criticized some of Rivera's early frescoes as being "too easy, to shallow" in their rhythms and composition, and the late political murals as "complex, somewhat overloaded." In between, Cheney wrote, "lie Rivera's masterpieces, richly decorative, vigorous, and animated, yet poised and serene," their colors "full, in an earthy way, solid and satisfying."

Active until shortly before his last illness, Rivera died of a heart condition in his suburban studio-home at San Angel. A state funeral was accorded him, and the eulogy was read by his friend the poet Carlos Pellicer. From 1943 on Rivera (since childhood interested in engineering and architecture) had been constructing a pyramidal building, based on Aztec and Mayan architecture and decorated with his own stone mosaics; in this he proposed to house the great collection of Mexican archeology he had built up over the years. Rivera intended the structure also as his tomb, but his ashes were instead interred in the Rotunda de los Hombres Ilustres in the capital. The collection was left as a legacy to the people of the country he so loved. His murals attest to that devotion and to the truth of his statement, "The most joyous moments of my life were those I had spent painting."

EXHIBITIONS INCLUDE: Mexico City 1910; Gal. Berthe Weill, Paris 1914; California Palace of the Legion of Honor, San Francisco 1930; MOMA, NYC 1931; Pennsylvania Mus. of Art, Philadelphia 1932; Pan-American Union, Washington, D.C. 1947; Mus. Nacional de Artes Plásticas, Mexico City 1949; "Diego Rivera: The Cubist Years," Phoenix Art Mus. 1984 (traveled to San Francisco Mus. of Modern Art [1984] and Mus. de Arte Moderno de Mexico, Mexico City [1984–85] GROUP EXHIBITIONS INCLUDE: Salon des Indépendants, Paris 1910; Salon d'Automne, Paris 1911, '13; Golden Gate Intl. Exposition, San Francisco 1946.

COLLECTIONS INCLUDE: Nat. Mus. of Modern Art, Nat. Inst. of Fine Arts, Gal. of Mexican Art, and San Carlos Academy of Fine Arts, Mexico City; Frida Kahlo Memorial Mus., Coyoacán, Mexico; Mus. of Art, Guadalajara, Mexico; MOMA, NYC; Art Inst. of Chicago.

ABOUT: Arquin, F. Diego Rivera: The Shaping of an Artist 1889–1921, 1971; Cheney, S. The Story of Modern Art, 2d ed. 1958; "Diego Rivera 50 años de su labor artistica. Exposición de homenaje nacional" (cat.), Mus. Nacional de Artes Plásticas, Mexico City, 1951; Rivera, D. My Art, My Life: An Autobiography, 1960; Wolfe, B. The Fabulous Life of Diego Rivera, 1963. *Periodical*—Artscanada (Toronto) December 1979–January 1980.

RIVERA, JOSÉ DE. *See* DE **RIVERA, JOSÉ**

RIVERS, LARRY (August 17, 1923–), American painter, sculptor, and graphic artist, was a leading second-generation Abstract Expressionist. He was born Yitzroch Loiza Grossberg in the Bronx, New York City, the only son of a Russian-Polish immigrant couple, Samuel and Sonya Grossberg. He has two sisters. Samuel Grossberg was a plumber who later owned a small trucking company.

When he was seven Rivers began studying the piano so that he could accompany his father, an amateur violonist. At 11, he switched to the saxophone. "In the early days," he told Frank O'Hara, "I really wanted to be a great jazz musician and my heroes then were Charlie Parker and Lester Young." At 17 he began his professional career with jazz bands, performing mostly at summer resorts, playing the Borscht Belt where his name was changed by a nightclub comedian with show-biz savvy who introduced his combo as "Larry Rivers and his Mudcats."

In 1942 Rivers enlisted in the United States Army Air Corps, but received a medical discharge the following year because of a physical disability. He supported himself by playing the saxophone with various bands in and around New York City. For the year 1944 he studied composition at the Juilliard School of Music, Manhattan. Seemingly destined for a musical career, he came into contact with the New York art world when, during a period of severe poverty, he took a job as a delivery boy for an art-supply house. "[I] felt here that I had discoverd the delights of art," Rivers recalled. "My heroes were Picasso and Gonzalez." At about this time he became friends with Jack Freilicher, the pianist with Johnny Morris's band. Morris's wife Jane was a painter interested in avant-garde art. With her encouragement Rivers began to paint in the summer of 1945, at Orchard Beach, Maine, where the Morris band was playing. In a *New York Times* interview (February 13, 1966) Rivers said that Jane Freilicher "was in touch with something that began to seem marvelous. She made the first inroad in stripping the jazz life of its glamour for me."

Later in 1945 Rivers married Augusta Berger, who had a young son from a previous marriage. Her marriage to Rivers lasted only a few months, though a son, Steven, resulted from it. After parting with his wife, Rivers moved to an apartment near the abstractionist painter Nell Blaine and became her "sort of unofficial student."

On her recommendation, Rivers enrolled in January 1947 under the GI Bill at the school of

LARRY RIVERS

Hans Hofmann, the influential German-born painter and so-called dean of abstract expressionism, who had helped to introduce European modernism into American art circles. He studied continuously with Hofmann in Greenwich Village and Provincetown, Massachusetts until May 1948, supporting himself with his music. In Provincetown, in 1947, he "spent the days in Hofmann's school . . . and played sax at the Sea Dragon every night of the summer. In the winter I went to Hofmann's school in New York and played almost every night." In addition to absorbing Hofmann's disciplined approach to abstract painting, Rivers was inspired by Hofmann's belief that contemporary painters faced basic problems of technique with which masters like Michelangelo, Rubens, Courbet, and Matisse had struggled as well. In 1948 Rivers studied concurrently with another Abstract Expressionist, William Baziotes, at New York University. Rivers planned to support himself by teaching but, though he received a degree in art education from NYU in 1951, his artistic success made a teaching career unnecessary.

By mid-1948 Rivers was searching for a way of applying Hofmann's ideas to a new representational art, one that would be freer than 19th-century realism. According to Irving Sandler, Rivers "wanted both to render his subjects literally and to reveal the act of painting. . . . But before facing these challenges, [he] felt compelled to convince himself (and the art world) of his 'genius,' to prove that he could draw and paint in a virtuoso fashion." Impressed by the Museum of Modern Art's great Bonnard show of 1948, he began to paint in the manner of that

master Impressionist. He was so successful that, in reviewing Rivers's first solo show, held in 1949 at the Jane Street Gallery in Greenwich Village, Clement Greenberg described Rivers as an "amazing beginner," and the following year Greenberg and the art historian Meyer Schapiro included him in the Kootz Gallery's "New Talent" show.

In 1950 Rivers took his first trip abroad, visiting France and Italy and spending eight months in Paris where he began to write poetry. On his return to New York he set up what Frank O'Hara described as "a Bohemian household . . . of staggering complexity." He brought to live with him his former mother-in-law, Bertha "Berdie" Berger, his son Steven, and Joseph, his ex-wife's son by an earlier marriage. He vowed to devote himself full time to painting "even if the boys starve," but from time to time took odd jobs to help make ends meets.

During this period Rivers met such first- and second-generation leaders of the New York School as the painters Franz Kline, Jackson Pollock, and Willem de Kooning and the poets John Ashbery, Kenneth Koch, and Frank O'Hara. In painting, Rivers's admiration shifted from Bonnard to Soutine, and his work began to show the influence of abstract expressionism, especially the gesture painting of de Kooning, who once said that Rivers's work "was like pressing your face in wet grass." In December 1951 Rivers was given a solo show at the prestigious and avantgarde Tibor de Nagy Gallery, where he was to hold solo exhibitions every year, except for 1955, through 1962.

In 1951, increasingly dissatisfied with what he called "the racing-elbow stroke and the big arc motion of the hand" of action painting, Rivers began work on his first major canvas, *The Burial* (Fort Wayne Museum of Art, Indiana). Based on Courbet's *Burial at Ornans* and completed in 1952, *The Burial* combined Rivers's interest in the old masters with the spatial expansiveness of abstract expressionism (the painting is five by eight feet). The artist also drew upon memories of his own grandmother's funeral, and in the future Rivers "would often paint subjects chosen from the history of art and from his autobiography," to quote Sandler.

Rivers moved to Southampton, Long Island in 1953, the year he decided to create a large picture based on the 19th-century German academician Emanual Leutze's banal and overfamiliar *Washington Crossing the Delaware* in the Metropolitan Museum of Art. Because his *Washington Crossing the Delaware* (1953) was "dedicated to a national cliché" but painted in the gestural manner of de Kooning, Rivers intended to shock New York's abstractionist establishment. Rivers explained: "I was energetic and ego-maniacal and, what is even more important, cocky and angry enough at the time to want to do something no one in the New York art world doubted was disgusting, dead and absurd, rearrange the elements, and throw it at them with great confusion. Nothing could be dopier than [such] a painting. . . . In relation to the immediate situation in New York . . . [it] was another toilet seat—not for the general public as it was in the Dada show, but for the painters."

Rivers's version showed skillful draftsmanship and a deft, fluid handling of paint, applied in thin washes. It was attacked as a pastiche of historical styles—Elaine de Kooning dubbed it "Pascin-Crossing-the-Delaware"—and critics felt that Rivers's considerable talent had been misused. However, the painting was acquired by the Museum of Modern Art, New York City. When the original was partly destroyed in a fire at the museum in 1958, Rivers was commissioned by MOMA to execute a new version two years later.

Rivers's deliberate use of a cliché-ridden popular image as subject matter can be seen in retrospect as an anticipation of pop art. As Sandler pointed out, "Rivers, like his mentors de Kooning and Hofmann, seemed ambitious for a masterly synthesis of tradition and modernism but, unlike them, he ended up by poking fun at that ambition." Thus Rivers also anticipated the ironic stance that would be taken up by such progenitors of the "cool" art of the '60s as Robert Rauschenberg, Jasper Johns, and Andy Warhol.

During the 1950s Rivers also painted the nude figure as well as portraits and landscapes. From 1951 until her death in '57, his mother-in-law Berdie posed for numerous Rivers pictures. The best known—and the most startling—was *Double Portrait of Berdie* (1955; Whitney Museum of American Art, New York City), in which the same figure was shown in the nude in two different poses, one fully frontal. In this personalized study of flabby, aging flesh there was a deliberate ambiguity in the contrast between representation and the abstraction of the loosely brushed areas of paint which left some of the canvas bare, as if to emphasize the process of painting itself. Rivers' concern with surface realism and the play of light was considered reactionary in orthodox avant-garde quarters, despite certain devices inherited from abstract expressionism. Moreover, his unflattering portrait of an older porcine woman was offensive to some viewers; even Rauschenberg, whose work of the early '50s was itself considered an effrontery to good taste, found Rivers's treatment of

subject to be extremely negative and harshly satiric.

Through the late 1950s and early '60s Rivers continued to derive his material from the old masters, from the world around him, and from photographs. For example, his 1964 version of David's full-length portrait of Napoleon, now in the Hirshhorn Museum and Sculpture Garden, Washington, D.C., was facetiously and perversely titled *The Greatest Homosexual,* and his *The Last Civil War Veteran* (1959) and *Dying and Dead Veteran* were based on *Life* magazine photos.

In 1961 Rivers began to insert images from the popular culture and from commercial advertisements into his painting. He noted that Rembrandt's famous *Syndics of the Cloth Drapers' Guild* was used as the trademark of Dutch Masters cigars, and in 1963 painted one of his best-known works, *Dutch Masters and Cigars,* a tongue-in-cheeck version of the cigar box label. In the previous year he had painted *Camels,* a large canvas which combined the graphic art of Camel cigarette packs with freely rendered studies of actual camels. Called "near-Pop," Rivers's works in this vein were certainly a source for pop art. But, while the Pop artists offered a deadpan satiric vision of commercialism and mass production, Rivers maintained a more "painterly" attitude. The *Manchester Guardian* critic, discussing Rivers's *Camels,* wrote that he "paints portraits of cigarette packages with the serious grace of Tiepolo."

In the early 1960s Rivers began to use stencils and other lettering devices in his paintings. In *Parts of the Face* (1961; Tate Gallery, London) and in some of his female nudes, parts of the anatomy were labeled, but in French, not English, producing a Brechtian distancing effect. Also in the '60s he introduced assemblage, kinetic techniques, and the materials of modern technology into his works. These developments culminated in his most ambitious project of that decade, a 33-foot, 76-panel work titled *The History of the Russian Revolution: From Marx to Mayakowski.* Inspired by Isaac Deutscher's biography of Trotsky, this mammoth creation, which took almost six months to produce, contained, in addition to 30 individual paintings on canvas, an assemblage of boxes, silhouettes, a long poem, an honor roll of martyrs, lead pipes, wooden rifles, and a real machine-gun. With typical flippancy, Rivers called it "the greatest painting-sculpture-mixed media of the twentieth century, or the stupidest."

Later acquired by Joseph H. Hirshhorn, probably Rivers's most enthusiastic patron, *Russian Revolution* was installed, along with more than 150 other works, at the Jewish Museum, New York City, which mounted a major Rivers retrospective in 1965. Reviewing the show, John Canaday called Rivers a brilliant painter "who can do anything he wants with a brush" and "the cleverest, even the foxiest, painter at work in the country today."

The retrospective also included some of Rivers's sculptures—he had had a solo show of sculpture at the Stable Gallery in 1954 and at the Martha Jackson Gallery in 1960—as well as a selection of his graphics, many of which were done in collaboration with his poet friends. In 1959 he and Frank O'Hara produced "Stones," a series of 12 lithographs created by a poet and artist working together in close, spontaneous interaction, rather than by the usual process of an artist illustrating previously written poems. In 1961 Rivers collaborated with Kenneth Koch on several painting-poems, including *New York, 1950–1960* and *Post Cards.*

In 1963, having retained his musician's union card, Rivers was a founder of the Upper Bohemian Six, a jazz group that performed on Monday nights at the Five Spot Café in Manhattan. That same year he produced one of his most successful works combining public and personal imagery, *Billboard for the First New York Film Festival* (Hirshhorn Museum). With his love of materials, Rivers used for that piece "large brushes, spray paint, charcoal, tape, lots of photo books on Hollywood, and my stepson."

In the 1950s and '60s Rivers performed on the stage, in Kenneth Koch's *The Tinguely Machine,* and in such experimental films as Jack Kerouac's *Pull My Daisy.* In 1964 he designed sets for two off-Broadway plays by Le Roi Jones and also held the post of artist-in-residence at the Slade School of Fine Arts, London.

Rivers ventured into yet another field when, in conjunction with the filmmaker Pierre-Dominique Gaisseau, he made a television travelogue about Africa, the result of four trips to Africa in six months. During the making of the film Rivers and Gaisseau were arrested in Lagos, Nigeria as enemy white mercenaries and narrowly escaped execution. The film, "Africa and I," was broadcast in April 1968 on the National Broadcasting Company's "Experiments in Television." A critic described the travelogue as "something like a Rivers canvas: Complex, brilliantly colorful, and maybe too tongue-in-cheek for serious consideration."

A retrospective of Rivers's drawings, entitled "Works on Paper: Then and Now," was held at the Marlborough Gallery, New York City, in January 1977. John Russell observed in *The New York Times* (January 7, 1977) that the earlier

drawings "wear very well" and had the tone of "intimate conversation." The later, more experimental ones gave the show "a jumpy, cheeky and relentlessly exploratory quality," and he added, "Some of the explorations come off better than others." Russell felt, for instance, that in Rivers's huge 85-by-100-inch drawings of the painter Barnett Newman "neither the weight nor the depth of Newman's humanity quite come across."

Rivers's skillful draftsmanship, technical virtuosity, irrepressible exhibitionism, and propensity for "in-jokes" were to be seen in his November 1977 solo show at the Robert Miller Gallery, New York City. Hilton Kramer, while praising the drawings in his *New York Times* review (November 6, 1977), found in the show "that mixture of earnestness, ambition, parody and outright vulgarity on which so much of [Rivers's] art has foundered in the past." Kramer felt that "the pressure to be 'original' at all costs has been especially damaging, and first of all because it so obviously runs against the grain of Mr. Rivers's gifts, which are fundamentally conservative in spirit." Thus the "willingness to be vulgar, silly, gaudy, campy and otherwise 'outrageous.'"

The garrulous Rivers is a popular lecturer in the United States and abroad, especially on college campuses. In 1976, accompanied by his son Steven, he visited the Soviet Union, under the joint sponsorship of the US State Department and the Soviet Artists' Union, as an emissary of American art. "We met both respectable artists and underground ones," he commented. "Much more goes on in Russia than we think."

Rivers's 1961 marriage to Clarice Price, a Welsh-born teacher of music and art, ended in amicable separation. They had two daughters, Gwynne and Emma. Larry Rivers divides his time between his remodeled Victorian home in Southampton, Long Island and his block-long loft in New York City. However, his world travels, his strong personality, and his star quality have caused some in the insular New York art world to grumble that he is an "art gadabout." Rivers is lithe and agile, with hawklike features and graying hair worn rather long. A voluble talker, he moves rapidly from one topic to another with the same "glancing obliqueness" that Edward Lucie-Smith has observed in Rivers's paintings of the early 1960s.

In the late 1950s Rivers discussed with Frank O'Hara the problems facing the figurative artist in an era when abstractionism was in vogue. "Certain painters will not allow a recognizable image in their work (or anyone else's) just as the nineteenth century scorned a painter who didn't make the image recognizable. Today the figure is the hardest thing in the world to do. If it doesn't turn into some sort of cornball realism, it becomes anecdotal, it seems. Today, knowing the odds against you, the figure seems a *stupid* choice. But if the problem is one of choosing between being bored and being challenged, having to do the difficult, I'll take the latter."

EXHIBITIONS INCLUDE: Jane Street Gal., NYC 1949; Tibor de Nagy Gal., NYC 1951–54, 1954–62; Stable Gal., NYC 1954; Martha Jackson Gal., NYC 1960; Dwan Gal., Los Angeles 1961, '63; Gal. Rive Droite, Paris 1962; Gimpel Fils, London 1962, '64; Jewish Mus., NYC 1965; Rose Art Mus., Brandeis Univ., Waltham, Mass. 1965–66; Art Inst. of Chicago 1970; Marlborough Gal., NYC 1970–71, '73; "Works on Paper: Then and Now," Marlborough Gal., NYC 1977; Robert Miller Gal., NYC 1977; "Larry Rivers: Performing for the Family," Guild Hall Mus., E. Hampton, L.I., N.Y. 1983; "Larry Rivers: Performing for the Family," Lowes Art Mus., Univ. of Miami, Coral Gables, Fla. 1983. GROUP EXHIBITIONS INCLUDE: "New Talent," Kootz Gal., NYC 1950; "Twelve Americans," MOMA, NYC 1955; Pittsburgh International 1955–67; São Paulo Bienal 1957; "Painting and Sculpture of a Decade 54–64," Tate Gal., London 1964; Documenta 3 and 4, Kassel, W. Ger. 1964, '68; "Modern Portraits: The Self and Others," Wildenstein, NYC 1976.

COLLECTIONS INCLUDE: Metropolitan Mus. of Art, MOMA, and Whitney Mus. of Am. Art, NYC; Brooklyn Mus., N.Y.; Hirshhorn Mus. and Sculpture Garden, and Corcoran Gal. of Art, Washington, D.C.; Art Inst. of Chicago.

ABOUT: Current Biography, 1969; Hunter, S. Larry Rivers, 1975; Lippard, L.R. Pop Art, 1966; Lucie-Smith, E. Late Modern: The Visual Arts Since 1945, 1969; Miller, D.C. (ed.), "12 Americans" (cat.), MOMA, NYC, 1956; "Modern Portraits: The Self and Others" (cat.), Wildenstein, NYC, 1976; O'Hara, F. Art Chronicles 1954–1966, 1975; Sandler, I. The New York School: The Painters and Sculptors of the Fifties, 1978; Selle, C. "Larry Rivers: Drawings 1949–1969" (cat.), Art Inst. of Chicago, 1970. *Periodicals*—Art in America December 1983 Horizon II September 1959; Manchester Guardian June 21, 1962; New York November 14, 1977; New York Times August 26, 1963, February 13, 1966, January 7, 1977, November 6, 1977, August 5, 1983; Quadrum 18 (Brussels) 1965.

ROBUS, HUGO (May 10, 1885–January 14, 1964), American sculptor, found his métier in figurative sculpture after a thorough and wide-ranging investigation of modernist trends in painting. His stylized small figures, well-crafted, graceful, and mysterious, are always emotionally and aesthetically satisfying.

The son of an iron moulder, Robus was born in Cleveland and studied at the Cleveland

American Academy & Institute of Arts and Letters, NYC

HUGO ROBUS

School of Art from 1904 to 1907. In the school's jewelry and design workshops, run by Horace E. Potter, he acquired the craft skills and respect for solid workmanship that were to support him and his family for most of his career. In 1907 he went to New York City to study drawing and painting at the National Academy of Art and Design. From 1909 to 1911 Robus honed his skills as a jewelry designer in Potter's own studio back in Cleveland, then, deciding to dedicate himself to art, traveled to Paris in 1912 to take classes at the Académie de la Grande Chaumière.

In France, and after his return to the US in 1914, Robus was committed to painting and did not seriously think of becoming a sculptor until 1920 (although he did study modeling briefly with Antoine Bourdelle). Instead, he worked earnestly through a succession of modernist styles, from a vividly colored impressionism (*Normandy, Vernon*, 1912), a Cezanne-like fauvism (*Village in France*, 1913), synchromism and futurism (*Backyards*, 1916, *Train in Motion*, 1917), and cubism (*The Horn Shop* and *Central Park*, both 1919–20). Robus may have been influenced in his direction by the American Synchromist Stanton Macdonald-Wright, with whom he lived in France. Eventually, this restless experimentation led him to reject painting. "Not only did form become tighter," Robus wrote of his late paintings such as *Steam Shovel* (1920), "but much pigment was used up in building accentuations well above the canvas surface. It seemed about time to experiment with a more proper medium for modeling." He started modeling in clay, and immediately

found sculpture more satisfying than the half-measure of a thick impasto, which only muddied the surface of his canvases. He never went back to painting.

After a long, epistolary courtship, Robus married a fellow art student at the Cleveland School of Art, Irene Bogart Chubb, in 1915. They settled in a spartan loft on 14th Street in New York City. There, while earning a rather meager living as an art teacher, jewelry maker, and batik fabric designer (his wife sewed the cloth into dresses), the artist made his first sculptures. *Modeling Hands* and *The General*, both of 1922, were influenced by the futurism of Umberto Boccioni but were less planar and more fluidly bulbous. Robus soon turned to simpler, less abstract means of expression, based invariably on the figure. "Abstractions have much interest for me," he wrote. "But because I never had quite the desired fullness of flavor from complete abstractions, I have preferred to base my efforts on recognizable forms."

Walking Figure (1923), sleekly rounded and life-sized (most of his sculpture is much smaller than life-size) was the first work that satisfied him. Already evident is the rhythmic pinching of some body areas and the swelling of others—tempered by an acute sense of the particular and realistic—which characterizes his mature style. A gentle humor sometimes appears in his work as well. Of *The Spirit of Youth* (1928), Sidney Tillim wrote in *Arts Magazine* (February 1963): "There's something of [George] Luk's cartoon character, the Yellow Kid, in the fabulously mischievous figures of the pragmatic Puck who is *The Spirit of Youth*. Perhaps the innocent side of the Roaring Twenties was never better expressed than by this ingratiating pagan." Describing *Dawn* (1933), a charming and sharply observed study of a pubescent girl, Tillim continued: "The body cascades in sinuous waterfall from between raised arms, flows into suavely flaring hips, then plummets to her knees, where a sharp break at the joints introduces astutely yet abruptly tubular members that express the vestigial awkwardness of the child-woman. . . . Her yawn is perfect, both in gesture and style."

In 1933 Robus was included in the annual sculpture exhibition at the Whitney Museum of American Art, New York City; he showed in nearly every subsequent annual until his death. Despite good notices and occasional important sales (his *Song* [1934] was purchased by New York City's Metropolitan Museum of Art), Robus was unable to make a living from his art until the mid-'50s. It is true that Robus's work was ill-suited to public monuments, an important avenue toward financial security for many sculp-

tors, and that he was not as careful to keep himself in the public eye as some of his contemporaries, such as Paul Manship. In the late 1930s he worked for the Federal Arts Project, and during the war years and intermittently thereafter taught sculpture at Columbia University. He did not have his first solo show until 1946, at the Grand Central Art Galleries on 57th Street.

By then, anxious to avoid the appearance of an over-easy facility, Robus abandoned his former lyrical smoothness for roughly modeled chunky figures, as in *Reunion* (1945) and the more elegantly proportioned *Girl On a Swing* (1946) and *Compassion* (1949). After 1950 Robus returned to his polished style of the 1930s, mixed with echoes of the even earlier futurism of *The General.* One critic felt that in this new work "his proportions go slack as the sense of the particular, both in detail and personality, is sacrificed to type," but the emotional warmth consistent throughout his work remained. *First Born* (1950) may be a work of "lesser vitality" but it is nonetheless affecting. Other calm and contemplative pieces of the 1950s are *Mother Cradling Child* (1957), *Meditating Girl* (1958), and *Yearning* (1958). *Three Caryatids without a Portico* (1954), abstract female figures cut off at neck and thigh, is one of his wittiest pieces.

Robus was a sculpture instructor at Hunter College, Manhattan, from 1950 to 1958, the year his wife died. In 1960 the Whitney Museum mounted the first retrospective of his sculpture. A second retrospective was held three years later at the Forum Gallery, New York City. He died in 1964.

Despite the proliferation of 20th-century sculpture into other media and other forms, Robus always worked with the traditional modeled clay cast into bronze. He explained: "The characteristics of the materials can occasionally enhance the appearance of works of art, but if the work is creative art, prominent markings in the stone are more apt to hurt the composition as a medium of expression conveying an idea. They distort or destroy pure form optically much more frequently than they enhance it . . . in creative art the material used should be quite secondary to aesthetic content and best serves its function when it in no way complicates expressive form to the eye."

EXHIBITIONS INCLUDE: Grand Central Art Gals., NYC 1946, '49; Munson-Williams-Proctor Inst., Utica, N.Y. 1948; Corcoran Gal., Washington, D.C. 1958; Whitney Mus. of Am. Art, NYC 1960; Forum Gal., NYC 1963, '66, '68; Nat. Collection of Fine Arts, Washington, D.C. 1979–80. GROUP EXHIBITIONS INCLUDE: Sculpture Annual, Whitney Mus. of Am. Art, NYC from 1935; "New Horizons in American Art," MOMA, NYC 1936;

"American Art Today," New York World's Fair, Flushing Meadow 1939; "Art in Progress," MOMA, NYC 1944; "Modern Sculpture from the Joseph H. Hirshhorn Collection," Solomon R. Guggenheim Mus., NYC 1962.

COLLECTIONS INCLUDE: MOMA, and Whitney Mus. of Am. Art, NYC; Hirshhorn Mus. and Sculpture Garden, Washington, D.C.

ABOUT: Rothschild, L. Hugo Robus, 1960. *Periodicals*—Arts Magazine June 1960, February 1963, March 1980.

***RODCHENKO, ALEKSANDR (MIKHAILOVITCH)** (November 23, 1891– December 3, 1956), Russian painter, sculptor, graphic artist, designer, and photographer, was one of the most dynamic figures in the short-lived Russian avant-garde and a fervent supporter of the Revolution. He was born in St. Petersburg, but was reared and educated in Kazan, a provincial university town on the Volga. His father, of peasant origin, was a stage-property maker at the local theater, and his mother, the subject of some powerful photographs taken by her son in the 1920s, was a washerwoman.

Since the late 19th century there had been several notable progressive art movements in Russia. The group Mir Iskousstva (World of Art), which included the future designers for Serge Diaghilev's Ballets-Russes, had rebelled against academism. From 1909 on, cubism and futurism had influenced such artists as Mikhail Larionov and Natalia Gontcharova, who created their own movement, rayonnism, which espoused a kind of futurist abstraction. However, the provincial milieu of Kazan was almost completely unaffected by these and other radical developments, and Rodchenko's works during those early years were strongly influenced by the Russian symbolist painter Mikhail Vrubel, who died in 1911. While at the Kazan School of Art (1910–14), Rodchenko studied art history extensively, and began to experiment with many kinds of media and subject matter under Nikolai Feshin and Georgii Medtvedev. Eager to join in the various futurist activities in Moscow, he moved there in 1914, and continued his art studies at the Stroganov Institute of Applied Art.

Rodchenko was soon caught up in the ferment of artistic discussion, innovation, and discovery which paralleled the heated debates of the political activists and intellectuals. There were passionate arguments between the partisans of Kasimir Malevich's suprematism, an extreme form of geometric abstractionism with metaphysical overtones, and the followers of Vladi-

°rôt´ chin kô, ä lek sän´ də

Corvina Press, Budapest, Hungary

ALEKSANDR RODCHENKO

mir Tatlin, who placed special emphasis on industrial and technological methods and materials—the movement later known as constructivism. Rodchenko met both Malevitch and Tatlin in 1916. While temperamentally inclined to favor Tatlin's approach, he pursued an independent course, absorbing what he needed from cubism and futurism. Among his earlier abstractions were his compass-and-ruler drawings, first exhibited in 1916, at *The Store*, a show organized in Moscow by Tatlin. Rodchenko was the first Russian artist to employ scientific instruments like the ruler and compass to create works of art.

Rodchenko's first three-dimensional constructions date from 1917. In that year, in collaboration with Tatlin and Georgii Yakulov, he completed the decoration of the interior of the Café Pittoresque in Moscow, which consisted of reliefs in wood, metal, and papier-mâché. Among his most original sculptures, executed between 1917 and 1920, were suspended abstract metal constructions with mobile elements; these creations, together with works conceived in a similar spirit by Tatlin, Antoine Pevsner and Naum Gabo, can be regarded as forerunners of kinetic sculpture."

The Russian Revolution, far from stemming this intense creative activity, gave added stimulus to the experimental fervor of this group of artists. They claimed to have anticipated the Revolution, and to have provided the basis for a truly revolutionary art. Rodchenko in particular believed, as David Elliott pointed out, that "it was the role of the artist to act as a catalyst for social change." He fully accepted the machine

age, and proclaimed the ideal of the artist-engineer and technician. Indeed, the new political order at first supported the turbulent artistic avant-garde.

Rodchenko rejected not only classical and traditional art but the ideas of such advanced artists as Wassily Kandinsky and Kasimir Malevich, whose abstractions were imbued with metaphysical and mystical content. Their work seemed to Rodchenko to be an escape into the past, a way of avoiding reality (although he had derived from Malevich's nonobjective suprematism the use of geometrical forms). In 1919 Rodchenko painted *Black on Black*, a reply to Malevich's *White on White*, and exhibited it at the important "Nonobjective Creation and Suprematism" show held in Moscow that year. At this time he delcared: "As a basis for my works I put nothing." By this he meant that he wished in his paintings and constructions to express, through forms that had no reference beyond themselves, the specific properties of color, line, and space. Some of his three-dimensional constructions between 1917 and 1920 were crudely assembled from industrial materials, without the refinement that was to characterize the later works of Gabo and Pevsner; but in their very ruggedness they were meant to be positive, energetic statements in keeping with the dynamic spirit of the Revolution.

In 1917 Rodchenko joined IZO NKP, an acronym for the visual arts division of the People's Commissariat of Enlightenment. In 1918 he was one of a group of artists who organized an industrial arts department for IZO NKP, and the following year he was appointed head of the purchasing committee for the Museum of Painterly Culture. In 1920 the old Moscow Institute of Painting, Sculpture and Architecture and the Stroganov Art School were renamed VKhUTE-MAS (Higher State Art-Technical Studios), and Rodchenko was among the new progressive artists taken in as teachers. In a system paralleling that of the Weimar Bauhaus founded a year earlier, there were eight studios or "disciplines" in the foundation course, each under a different teacher. Rodchenko was in charge of construction, the aim of which was the clear definition of form, placed with great precision on a plane or in space.

One of Rodchenko's former students, Galina D. Chichagova, recalled her first impressions of the new teacher. He looked, she said, "like a combination of pilot and motorist. He was wearing a beige jacket of military cut. . . . On his head was a black cap with a huge, shiny, leather peak. His face was very pale and had regular features, his lips stood out by their brightness

from the pallor of his face. The shining eyes were dark, outlined with thick eyelashes. . . . His way of talking and his behavior towards us was not that of a professor."

In 1920 Rodchenko married his colleague, the artist, graphic designer, and illustrator Varvara Fyodorovna Stepanova, whom he had known since 1915. Together they published the "Productivist Program," a manifesto which set forth the three basic elements of constructivism—"facture" (industrial materials), "tectonics," (the exploration of the character of these materials), and "construction." The ideas expressed in this program were also those of Tatlin.

An important exhibition, "5 x 5 = 25," was presented in 1920 by Rodchenko and his wife, along with A. Exter, L. Popova, and A. Vesnin. Rodchenko contributed five new paintings: *Line, Check,* and three monochrome canvases, *Red, Yellow,* and *Blue.* Later that year Rodchenko, to quote Gail Harrison Roman, "ended one career in art and began another." He declared that "the downfall of all the 'isms' of painting marked the beginning of my ascent." In the period 1915–21, having concentrated on experiments in form and the use of materials, the group of avant garde artists that included Rodchenko, Stepanova, and Tatlin, now decided to apply constructivist principles to utilitarian ends. Rodchenko abandoned sculpture and easel painting and turned his talents to applied design, typography, and photography. His revolutionary fervor was as intense as ever; in fact he felt he could best pursue the ideals of the revolution by putting his art at the service of the people, in order to enhance their daily lives and help to create what today would be called their "environment." Rodchenko agreed with his friend, the poet Mayakovsky, who had written in the early days of the revolution:

> Wipe the old from your hearts!
> The streets are our brushes!
> The Squares—our palettes!

But by 1923 it was clear that Soviet officialdom had become increasingly suspicious of cubism, futurism, and nonobjective art, and was advocating a literal, easily understood "socialist realism." Several leading avant-garde Russian artists who had held government teaching posts left the country. However, Rodchenko and Tatlin, whose works were devoted to practical ends, suffered relatively little interference during the 1920s. In 1923 Mayakovsky was still able to found his periodical *LEF* (Left Front of the Arts), and from 1923 to 1925 Rodchenko worked as its chief designer, as he did for its successor,

Novyi LEF (The New LEF), from 1927 to 1928. He designed covers, title pages, layouts, and illustrations, employing a wide range of constructivist devices. His striking and unconventional typographical layouts and brilliantly inventive use of photography and photomontage always favored the pictorial image over the printed word.

He had begun to experiment with photography during the early *LEF* years, and photomontages predominated on the covers of *Novyi LEF*. Rodchenko hailed photography as an antidote to fine art, and as an ideal medium for creative propaganda. In his photomontages he combined technological and industrial imagery with portraits, everyday objects, and bold precise lettering, creating an unusual spatial dynamism. His former colleague and cofounder of VKhUTEMAS, the Jewish painter and graphic designer El Lissitzky, who had left the country and formed contacts with the Bauhaus and de Stijl, was very influential in spreading the new ideas to other countries.

Rodchenko also designed illustrations and covers for other journals and books, and produced striking posters. In 1925 he photographed the side of Moscow's seven-story Mossel'prom department store on which were boldly lettered advertisements designed by himself.

At the World Exposition of Decorative and Industrial Arts, held in Paris in 1925, the Soviet Union, making its first appearance on the international art scene, used Rodchenko's cover design for its catalog. The Soviet pavilion included a "Reading Room for a Workers' Club" designed by Rodchenko in red, white, and black, and embodying constructivist principles in its simple geometric shapes and mass-producible furniture. Rodchenko visited Paris in March 1925 to supervise the installation of the "Workers' Club" in the Grand Palais, and while in Paris he was introduced by Mayakovsky to the poet Elsa Triolet-Aragon and the painter Fernand Léger. In the same year the Rodchenkos' daughter, Varvara, was born. She was to become a designer for books and an accomplished photographer.

By 1925 even productivism, with its utilitarian ideals, was considered suspect by reactionary soviet officials, but the anti-avant-garde tendencies of the government did not really take effect until after 1930, when Stalin had completely consolidated his power. In Moscow, in 1926, Rodchenko embarked on his first film project in collaboration with Lev Kuleshov. Rodchenko's photography of the late 1920s—in particular, his dynamic close-ups and unusual, oblique viewpoints—came in for much official criticism as "parodies" of the Soviet reality. In 1930 he be-

came a member of the October Artists' Union, but was expelled the following year for "propagating tastes alien to the proletariat." In 1930 he was excluded from a photographic exhibition and dismissed from his teaching post at VKhUTEIN (Higher State Art-Technical Institute), the successor to VKhUTEMAS. Dismayed by the simplistic rhetoric of socialist realism, which was made official in a series of decrees issued in 1932–34, Rodchenko was forced into an adversary position. Although, paradoxically, his sports photographs remained in favor and were regarded by the authorities as useful propaganda, his photography in general was attacked for its "formalism."

After 1936 Rodchenko found fewer outlets for his work, although his graphics, layouts, and photographs were sometimes used in official publications. Thrown increasingly on his own resources, he continued to photograph subjects that appealed to him and he also resumed easel painting, but his new canvases did not feature the geometric, "scientific" elements of his earlier paintings. They have been described by Gail Harrison Roman in *Art in America* as "personal, derivative-looking expressions using bold lines and colors"; some contained "hints of Surrealism."

There were difficult years for Rodchenko. His recollections of Mayakovsky, written in 1940, were not published in Moscow until 1973. By 1941, when he wrote his memoirs of his friend and mentor Vladimir Tatlin, the groups of artists with whom he had worked so closely in the past had become fragmented—some had died, some had left Russia, others were working in isolation. A gouache by Rodchenko dating from 1943–44 and titled *Expressive Rhythm* is extraordinarily prophetic of the abstract expressionism of Jackson Pollock and would certainly not have met with official approval. However, he still enjoyed a sufficient reputation to be appointed chief artistic consultant to the "Dom Tekhnika" exhibition, held in Moscow in 1944–45.

Although continually stifled by official policies, Rodchenko managed to survive and to continue working until his death in Moscow in 1956. Less than a year after his death, a solo exhibition of his work was held at the House of Journalists, Moscow. His wife and close artistic associate Varvara Stepanova died the following year.

A photograph of Aleksandr Rodchenko taken in 1947 shows him worn but cheerful and self-assured, wearing a cloth cap and with a camera slung around his neck. Despite his resilient nature, he could not help being deeply disappointed by the failure of Soviet officialdom to allow the creation of a new Soviet art, especially after the febrile excitement and promise of the early revolutionary years. His own ideal, as expressed in a slogan on one of his posters of 1923, had been "Everything for Everyone!" His belief in a true "people's art," as opposed to the triteness of the officially sanctioned socialist realism, was best expressed in his statement at the 1920 State Exhibition in Moscow: "Non-objective painting has left the museums; non-objective painting is the street itself, the squares, the towns, and the whole world. The art of the future will not be the cozy decoration of family homes. It will be just as indispensable as 48-story skyscrapers, mighty bridges, wireless, aeronautics, and submarines which will be transformed into art."

EXHIBITIONS INCLUDE: "Workers' Club," Grand Palais, Paris 1925; House of Journalists, Moscow 1957; MOMA, NYC 1971. GROUP EXHIBITIONS INCLUDE: "The Store," Moscow 1916; "Nonobjective Creation and Suprematism," Moscow 1919; State Exhibition, Moscow 1920; "5 x 5 = 25," Moscow 1920; "Erste Russische Kunstausstellung," van Diemen Gal., Berlin 1921; "Theatrical Decorative Art of Moscow 1918–23," Moscow 1923; "Exposition internationale des arts décoratifs et industriels," Paris 1925; Exhibition of Film Posters, Moscow, 1926; "Cubism and Abstract Art," MOMA, NYC 1936; "Art in Revolution," British Council, London 1971.

COLLECTIONS INCLUDE: MOMA, NYC; British Library, London; Mus. of Modern Art, Oxford, England; Rodchenko Archive, and George Costakis Collection, Moscow.

ABOUT: "Art in Revolution" (cat.), British Council, London, 1971; Barr, A. H. (ed.) "Cubism and Abstract Art" (cat.), MOMA, NYC, 1936; Bénézit, E. (ed.) Dictionnaire des peintres, sculpteurs et graveurs, 1976; Elliott, D. Rodchenko and the Arts of Revolutionary Russia, 1979; Lodder, C. Russian Constructivism, 1983; Read, H. A Concise History of Modern Sculpture, 1964; Seuphor, M. L'Art abstrait, ses origines, ses premiers maîtres, 1949. *Periodicals*—Art in America Summer 1980; Art News April 1971; Art Press (Paris) November/December 1973; Arts Magazine April 1973; Creative Camera May 1973; Iskusstvo (Moscow) no. 7 1972; New York Times September 23, 1979; Opus International (Paris) no. 4 1967, April 1969.

ROSENQUIST, JAMES (ALBERT) (November 29, 1933–), American painter and major Pop artist, is noted for ironic, large-scale works that "celebrate" Madison Avenue visions of American life.

Photo by Edith Dugmore

JAMES ROSENQUIST

He was born in Grand Forks, North Dakota, the only son of Louis Andrew and Ruth Clara (Hendrickson) Rosenquist. Both parents were employed in the aviation industry. Rosenquist has attributed his feeling for vastness to his early years on the plains of the Midwest, and once observed, "I'm a prairie-thinking man."

During the Depression years the family moved so much that by the time he entered fourth grade Rosenquist had attended eight grammar schools. His aptitude for drawing won him a School Scholastics Scholarship in 1948 to study for four Saturdays at the Minneapolis School of Art. In 1952 he graduated from Roosevelt High School in Minneapolis, and that summer took a job as an outdoor sign painter for W.G. Fischer, an industrial contractor specializing in painting huge gasoline tanks.

Rosenquist's interest in art became more clearly defined after he enrolled in 1953 in the University of Minnesota, where he studied drawing and painting for about three years and was encouraged by his teacher, Cameron Booth. On one of the several occasions when Rosenquist hitchhiked across the country, he stopped in Chicago, where he saw paintings by Cézanne and Matisse at the Art Institute. In adolescence Rosenquist also admired the Mexican muralists Orozco and Rivera.

For several months during 1954 he was employed at the Outdoor Advertising Company in Minneapolis. "I walked in their factory," Rosenquist recalled, "and saw sixty-foot-long paintings of beer glasses and macaroni salads sixty feet wide. I thought that this must be the misplaced tradition of Mexican mural painting and decid-

ed I wanted to work there." He painted, among other advertisements, seven identical ten-foot-tall signs of a little boy playing a tuba, eight coonskin "Davey Crockett" hats nine feet wide, and enormous pictures of airplanes, parrots, and whiskey bottles. The impersonal techniques of billboard painting and the huge scale of these assignments—in which, as one critic observed, the artist became accustomed to "moving like a fly over vast surfaces of milky skin or scarlet lipstick"—were to distinguish his mature work.

After obtaining the diploma of associate in arts from the University of Minnesota in 1954, Rosenquist, at the urging of Cameron Booth, applied for a scholarship to the Art Students League, New York City. He was awarded a one-year out-of-town scholarship and began classes at the League in the fall of 1955. Living and studying in Manhattan on his scanty savings alone was impossible, and in 1956 Rosenquist found work as a butler and chauffeur for Roland Stearns in Irvington, New York. On the top floor of the Stearns house was an octagon-shaped studio which was made available to him for painting. At that time the young artist also experimented with expressionist ink drawings.

In 1957 Rosenquist moved back to New York City, where he affiliated himself with the Amalgamated Sign and Pictorial Painters Union of America, local 230. During 1957 he was briefly employed painting large salami signs and political banners in Coney Island. He then worked for General Outdoor Advertising, a Brooklyn firm, painting whiskey bottles and bank signs. Discouraged by his inability to find steady employment or a loft that he could afford as a studio, he return for brief periods to North Dakota and Minnesota. It was in his between-jobs wanderings along the waterfronts of Manhattan searching for loft space that Rosenquist met Robert Rauschenberg, Jasper Johns, Robert Indiana, and other pioneers of pop art. He also knew Ellsworth Kelly and Jack Youngerman, young abstractionists who were living in an artists' colony on the lower tip of Manhattan, at Coenties Slip. However, according to John Rublowsky, "As an artist, Rosenquist was something of a loner. He never was a part of any particular circle. . . . He preferred to rely on himself, to develop a style that was independent of the things being done around him."

Finding a job with Artkraft Strauss Sign Corporation, which painted some of the world's largest billboards, Rosenquist left Minnesota for New York in 1958. Over the next two years he worked as a sign painter on huge displays, including the enormous billboards in the Times Square area. Occasionally he worked on a scaf-

fold as high up as 20 stories. He explained to a reporter for United Press International in the spring of 1960 that, although his own ambitions extended beyond commercial art, billboard painting enabled him to watch the unfolding of huge compositions and to see what happened to surface paint textures on a large area.

Meanwhile, Rosenquist had become interested in the large canvases of Jackson Pollock and Sam Francis, and his own paintings at that time were in a somber abstract expressionist manner. One of his pictures, *War Chant,* an abstract treatment of Indian signs and symbols which he had seen in Minnesota, was exhibited about 1960 at the Workshop Gallery, New York City.

By the summer of 1960 Rosenquist had earned enough money as a billboard artist to quit working a routine, nine-to-five job and to rent a loft at 5 Coenties Slip. He would spend hours at the window of his new quarters simply watching the ebb and flow of passers-by on the street. Rosenquist recalled that "suddenly, it seemed as though ideas came floating in to me through the window. All I had to do was to snatch them out of the air and begin painting."

His idiom developed from his painting of huge signs, and involved extreme close-ups of gigantic details of the human face and figure and of industrial objects. The almost academic, although usually fragmented, representation of commercial images, rendered in the garish or saccharine colors of advertising, were the basis for Rosenquist's unique variant of what was to be labeled pop art. His imagery included such products of American popular culture as glamour-girls, automobiles, jet planes, light bulbs, and Grand Rapids furniture. He has, however, repeatedly insisted that his subject matter is not popular images, and that it is the formal relationships of the subjects that at least partly determine his paintings' content. Many of Rosenquist's "anonymous images" and "no-images," as he has termed them, were taken from the commercial art of the late 1940s and early '50s—a period sufficiently remote that, in the early '60s, it could be viewed dispassionately, and yet recent enough to preclude nostalgia.

Among Rosenquist's favorite images was spaghetti, and in an early painting, *I Love You with My Ford* (1961), a field of immensely magnified spaghetti occupied almost the entire lower half of the eight-by-seven-foot canvas. In the picture's upper section was an outsized image of the front of a 1950 Ford sedan, and in the space between the Ford and the spaghetti were two fragmented faces, the depiction of a woman whispering into a man's ear. Many Rosenquist paintings make explicit the erotic "sub-texts" of modern advertising.

I Love You with My Ford and another large, arresting canvas of 1961, *The Light That Won't Fail* (Hirshhorn Museum and Sculpture Garden, Washington, D.C.), were among the works exhibited in Rosenquist's first solo show, at the Green Gallery, New York City, in February 1962. His work sold well from the beginning; more important, his paintings were included in the two New York City group shows that established the pop art movement's importance: the "New Realists" exhibition of 1962 at the Sidney Janis Gallery and the "Americans 1963" show at the Museum of Modern Art. Rosenquist was one of the original members of what Lucy R. Lippard called "the New York five" of hard-core Pop artists, the other four being Andy Warhol, Roy Lichtenstein, Tom Wesselmann, and Claes Oldenburg.

An ordinary black comb, of a type sold in every drugstore, figured prominently in *The Light That Won't Fail* and in one of Rosenquist's best-known canvases of 1963, *Early in the Morning.* Part of a comb, tremendously magnified, bisects the canvas horizontally, and other fragments represent a section of an orange, the legs of a striding male figure in floppy pajamas, and, in the two upper areas, clouds rendered in a smooth, almost airbrushed technique. The division of the canvas, here as in other Rosenquist paintings, owes something to cubism, but the fragmented images are combined "in a dream-like billboard Surrealism which marries Magritte's technique to collage space and composition," to quote Barbara Rose. Unlike the Surrealists, Rosenquist was not concerned with symbolism of any kind; he was interested in the work's direct visual impact on the spectator. He had also observed while painting billboards that the gigantic images, when seen close up, lost all meaning or recognizability.

However much Rosenquist might stress the abstract character of his imagery, its sociological implications were undeniable. His concern with political and social issues was especially evident in the largest and most controversial of his paintings, *F-111* (1965; Collection of Mr. and Mrs. Robert C. Scull). This mammoth work, made up of 51 interlocking canvas panels that altogether measured 10 by 86 feet, was first shown in Rosenquist's solo exhibition of 1965 at the Leo Castelli Gallery, New York City, where it filled four entire walls. *F-111* was originally inspired by a monstrous new fighter-bomber. (Ironically, the plane, at the experimental stage when Rosenquist's work was unveiled, was scrapped by military planners.) The painting was, among other things, an ironic comment on the American military-industrial complex and the threat

of total annihilation by thermonuclear war. The fragmented images superimposed on a multicolored picture of the bomber included such everyday features of American life as electric lightbulbs, glazed spaghetti, angel-food cake, a giant automobile tire, a radiantly happy towheaded child under an electric hair-dryer (which also suggested the nose of a rocket), and an umbrella opened over an atomic explosion—all artifacts of a culture both imperiled and (according to nuclear-arms deterrence theory) protected by glittering "high-tech" weaponry like the F-111. In addition to his antagonism to the American arms build-up, Rosenquist was expressing his outrage at the assassination of President John F. Kennedy, which he regarded as "the supreme example of 'horrible extravagance' in American society."

After being shown on a European tour and at the São Paulo Bienal of 1967, *F-111* was exhibited in early 1968 at the Metropolitan Museum of Art, New York City, in an exhibition called "History Painting—Various Aspects," which included Poussin's *Rape of the Sabines,* David's *Death of Socrates,* and Leutze's *Washington Crossing the Delaware.* In an accompanying statement Thomas M. Folds, Dean of Education at the museum, pointed out that, unlike the earlier examples of history-painting in the exhibit, Rosenquist's chief element was "not a great statesman, nor a philosopher or military hero, nor in fact a human being at all, but rather a great war-machine produced by an affluent economy to destroy its enemies." However, John Canaday of *The New York Times* (February 25, 1968) described it as "an outsize picture, aspiring to eloquence but ending in fustian. . . . " Responding to these comments Rosenquist declared that the painting did not aspire to eloquence, but was "meant to be a parallel to an inflated, warring society" as well as "an experiment with color and scale."

From the mid-1960s Rosenquist's international reputation grew and he made many trips abroad. In 1966 he attended the opening of "Two Decades of American Painting" in Tokyo, and in 1967 he went to Venice to suspend a painting on Mylar at the Palazzo Grassi. That same year he moved with his family to East Hampton, Long Island. (On June 5, Rosenquist had married Mary Lou Adams, a textile designer. They have a son, John Adams Rosenquist.)

In the late '60s Rosenquist experimented with different images and media, partly as a result of his interest in the problem of organizing a work as a total room environment. One of the most impressive of his environmental paintings was *Horizon Home Sweet Home* (1970), which experimented with color combinations by means

of a series of varicolored panels juxtaposed with a floor of dry ice. This work, shown at the Castelli Gallery in the spring of 1970, filled an entire room and included an actual fog created by the dry-ice machine.

In the 1970s pop art was already a noteworthy historical phenomenon, and the political and social climate in which the movement had flourished had changed. In *F-111,* Rosenquist had "tried to paint the portrait of a complete society," as John Russell observed in *The New York Times* (October 7, 1977). He had not subsequently found "a social theme as urgent as the theme of 'F-111.'" Reviewing a showing of Rosenquist's latest works at the Castelli Gallery, Russell commented that this "interesting and problematical artist," who had been in creative limbo for several years and whose way of painting was regarded in some quarters as "at once bland and overblown," had been thrown back on himself and had been facing the question, "What is there that is still worthwhile to paint?"

Rosenquist's answer, according to Russell, was "language," in the sense of "the enforced emigration of universally accepted signs from one context into another." An example was *Terrarium* (1977), in which the artist "gives an everyday mattress the look of a predator." Russell found the show "curious and provocative," and concluded that, though Rosenquist was identified with pop art, he was now presenting something quite different—"surrealism without literature."

In the late 1970s Rosenquist, working with several assistants, produced a number of large scale prints using color lithography, die cuts, and collage. The vastness of Leo Castelli's gallery on Green Street in SoHo was used to striking effect in the fall of 1983 when Rosenquist's huge new work, *Four New Clear Women,* was shown. Covering one entire wall and parts of two others, the four-canvas painting had late 20th-century America and space travel as its themes. The imagery consisted of fragments of the faces of wholesomely pretty young women against a background of a starry heaven and interlocking gear wheels which symbolize the "celestial mechanics" of time and space.

In addition to maintaining a large studio workshop in the Bowery, lower Manhattan, Rosenquist lives with his family in East Hampton, where he spends most of his time and enjoys sailing and fishing. He is committed to liberal causes, opposed the war in Vietnam, and was a supporter of New York's progressive mayor John V. Lindsay. He is a friendly man, standing 5 feet 11 inches tall, with blue eyes, thinning blond hair, and pleasantly youthful features.

In the *Buffalo Evening News,* James Rosenquist commented on what he called his "expendable" imagery and its sources: "Current methods in advertising, sublimation and the hard sell invade our privacy. It's like getting hit with a hammer: you become numb. But the effect can be to move you into another reality. These techniques are annoying in the form in which they exist, but when they're used as tools by the painter, they can be more fantastic." Referring to his painting *Nomad* (1963; Albright-Knox Art Gallery, Buffalo, New York), a work that has the effect of a composite billboard, Rosenquist said: " . . . I'm concerned with the scale and speed of recognition of ordinary things. It has to do with what I have to bring with me into the future. Generally I'm trying to prove to myself what I remember."

EXHIBITIONS INCLUDE: Green Gal., NYC 1962, '63, '64; Gal., Speroni, Turin, Italy 1964; Gal. Ileana Sonnabend, Paris 1964, '68; Dwan Gal., Los Angeles 1964; Leo Castelli Gal., NYC from 1965; Stedelijk Mus., Amsterdam 1966; Nat. Gal. of Canada, Ottawa 1968; Wallraf-Richartz Mus., Cologne 1972; Whitney Mus. of Am. Art, NYC 1972; Jared Sable Gal., Toronto 1975–76; "Paintings from the 60's," Mayor Gal., London 1982 Castelli Greene Street Gal., NYC 1983. GROUP EXHIBITIONS INCLUDE: "New Realists," Sidney Janis Gal., NYC 1962; "Pop Art USA," Oakland Mus., Calif. 1963; "Six Painters and the Object," Solomon R. Guggenheim Mus., NYC 1963; "Americans 1963," MOMA, NYC 1963–64; São Paulo Bienal 1967; "History Painting—Various Aspects," Metropolitan Mus. of Art, NYC 1968; Documenta 4, Kassel, W. Ger. 1968; "Pop Art," Hayward Gal., London 1969; "New York Painting and Sculpture; 1940–1970," Metropolitan Mus. of Art, NYC 1969–70; "American Pop Art," Whitney Mus. of Am. Art, NYC 1974; "American Painting of the 1970's," Albright-Knox Art Gal., Buffalo, N.Y. 1978.

COLLECTIONS INCLUDE: MOMA, and Whitney Mus. of Am. Art, NYC; Albright-Knox Art Gal., Buffalo, N.Y.; Hirshhorn Mus. and Sculpture Garden, Washington, D.C.

ABOUT: Amaya, M. Pop Art and After, 1966; Current Biography, 1970; Lippard, L.R. Pop Art, 1966; Pierre, J. "James Rosenquist" (cat.), Ileana Sonnabend Gal., Paris, 1965; Restany, P. Les Nouveaux réalistes, 1968; Rose, B. American Art Since 1900, 2d ed. 1975; Rublowsky, J. and others Pop Art, 1965; Russell, J. and others, Pop Art Redefined, 1969. *Periodicals*—Art International September 1963; Art News March 1978; Buffalo Evening News November 19, 1963; New York October 31, 1983; New York Times February 25, 1968, October 7, 1977, October 14, 1983; St. Louis Post Dispatch December 31, 1961; Time January 26, 1968; XXe siècle (Paris) June 1975.

***ROSZAK, THEODORE** (May 1, 1907–September 1, 1981), American sculptor, painter, and lithographer, created highly idiosyncratic sculpture notable for its complex form, marvelously textured surfaces, and unsettling air of biotic menace. Although this work is his best and most original, Roszak had already fully developed two very different styles of painting and sculpture before World War II, based respectively on the surrealism of Giorgio de Chirico and the slickly elegant constructivism of Laszlo Moholy-Nagy. The brutality of the war itself seemed to be the pivot of Roszak's conversion from Bauhaus optimism to an angst-ridden pessimism materialized in tortured hybrids of insect, plant, and animal forms.

Roszak was born in Poznań, Poland. His father, Kasper, was a baker and foundry worker; his mother, Praxeda, was a dress designer. The family emigrated to the United States in 1909 and settled in Chicago. At the age of 13 Roszak won a student art contest held by the Chicago *Herald-Examiner.* While still in high school he studied evenings at the Art Institute of Chicago with Charles Schroeder and Wellington Reynolds; after his high-school graduation in 1925 he became a full-time student there. He moved to New York City the following year to study drawing, painting, and lithography at the National Academy of Design and privately with George Luks, one of the Eight; he also took philosophy courses at Columbia University. In 1927 he returned to the Art Institute of Chicago and in 1928 had his first exhibition of lithographs at the Allerton Galleries, Chicago.

A facile draftsman, Roszak began as a traditional realist, as can be seen in *Peasant Woman* (1928). He probably would have developed along the lines of Luks, Leon Kroll, and George Bellows had he not encountered the modernist movements in Europe between 1929 and 1930 on an Anna Louise Raymond Fellowship for European Study. In Paris he looked at the Cubists and the Scuola Metafisica; in Prague and Brno he was deeply impressed by the Bauhaus-influenced Czech Industrial Artists Exhibition. An idealist and romantic by temperament, Roszak felt an instant sympathy with the Constructivists, who foresaw an imminent utopian harmony between art and the machine. Upon his return to the US in 1931, Roszak, newly married to Florence Sapir, a teacher, moved to the

°rō´zak

THEODORE ROSZAK

Tiffany Foundation's Staten Island artists' colony, where he trained in industrial design, toolmaking, and plastic and metal fabrication in preparation for his first series of sculptures. *Air-port Structure* (1932), his earliest work in metal (machined copper, aluminum, steel, and brass), comes directly out of the constructivist aesthetic by way of Art Deco and Flash Gordon; it resembles an upended airplane fuselage topped by a static discharger. While honing his fabrication skills as a marine engineer and draftsman at the Stevens Institute of Technology, Hoboken, New Jersey (1932–45)—moving from "muse to production manager" as he put it—Roszak developed a painting style composed of equal parts of de Chirico, Juan Grís, and the streamlined, "heroic" figuration made popular by Rockwell Kent and William Zorach. *Fisherman's Bride* (1934) and *42nd Street* (1935) are typical examples. Through the mid-1930s he produced wood and metal reliefs influenced by purism (*Form Within an Oval*, 1937) as well as three-dimensional sculptures based on the forms of machine tools (*Crescent-Throat Construction*, 1936).

By 1938, the year he joined Moholy-Nagy's Design Laboratory in New York City as an instructor, he had turned his attention mainly to sculpture. Of his elegant *Chrysalis* (1937) and the "Bi-polar" series, with its double-cone motif, an *Art News* (February 1979) reviewer wrote: "They do not so much occupy measurable space as defy gravity by seeming to float somewhere in front of the spectator. Solid, highly colored forms are counterposed against gleaming rings,

balls, and wires and levers which provide filigree detail. In many cases, the overall configuration suggests the human figure, though a clean, technological image continues to predominate." Although the "Bi-polars" have been overshadowed by the work that came after (the artist himself ignored them in the heat of his later production, leaving them untouched in a corner of his studio for more than 20 years until their resurrection in a 1979 retrospective at the Zabriskie Gallery, New York City), these works of the 1930s and early '40s rank among the most important expressions of the constructivist aesthetic in American sculpture. They have the freshness of small-scale precision and careful fabrication that was completely lost in the trends toward bloated vitalism in the 1950s and gigantism in the 1960s and '70s.

During World War II Roszak worked as an aircraft mechanic for the Brewster Aircraft Company, Newark, New Jersey (1940–45). Strangely, he did not emerge from that experience confirmed in his love for tightly crafted constructions, but rather may have been sickened by them (although he never lost his interest in aerodynamic forms). Instead, he wrote in his memoir, *In Pursuit of an Image*, that he underwent "almost a complete reversal of ideas and feelings." The unprecedented horror of the war, and his role in it as a maker of deadly aircraft, shook his faith in "machine art" and pure form. Seeking a more personal expression, he adopted both a new medium and new forms. Welding and brazing were just then beginning to be used by sculptors seeking an alternative to traditional techniques; preceded by David Smith and Julio González, who had both been welding since the 1930s, Roszak became one of the first to explore the new technology. Constructing an iron or steel armature from fairly detailed plans, he then coated the entire piece with low-temperature nickel-silver or steel braze; the result was a uniquely complex, rococo surface of rough and runny textures which perfectly complemented the convoluted, organic surrealism of his new forms. A miscegenation of extinct predators (the pteradactyl of *Spectre of Kitty Hawk*, 1946), winged insectoid shapes (*The Great Moth*, 1960), spiky plant forms (*Thorn Blossom*, 1947), and horrific skeletons and skulls (*Iron Gullet*, 1959) populates his sculptural production through the 1960s. "The idea of brutal ever-changing aspects of nature," wrote Jack Burnham, "nature as a series of conquering systems, predatory and threatening, became the center of Roszak's vision." Even his one piece on a literary theme, the *Whaler of Nantucket* (1952–53) (after Melville's *Moby Dick*), is shown pursuing what is surely the ultimate fictional crystalliza-

tion of natural menace, the white whale. Roszak himself has written revealingly of his motivation: "The forms I find it necessary to assert are meant to be blunt reminders of primordial strife and struggle, reminiscent of those brute forces that not only produced life, but in turn threaten to destroy it. I feel that, if necessary, one must be ready to summon one's total being with an all-consuming rage against those forces that are blind to the primacy of life-giving values. Perhaps by this sheer dedication, one may yet merge form and grace."

Critics have pointed out the stylistic analogues between the vitalist and expressionist movement in American sculpture of the 1950s (which included, besides Roszak, Seymour Lipton, Ibram Lassaw, David Hare, and Herbert Ferber) to the rise of abstract expressionism in painting, but Roszak, at least, pursued his bizarre vision without reference to the work of others. He aroused controversy in 1960 with the 37-foot aluminum eagle he created for the exterior of the US Embassy in Grosvenor Square, London, a building designed by Eero Saarinen, with whom Roszak had already collaborated on the Massachusetts Institute of Technology chapel in 1953. The work was attacked by members of Parliament and the British press for its anomalous, overscale gaudiness; American diplomats were discomfited by the fact that the eagle's head, which looks to the left in the Great Seal of the United States, looks to the right in Roszak's sculpture. Despite heated protest, the work was never removed. Another, less controversial public commission was the 25-foot-high *Sentinel* (late 1960s) on 27th Street and First Avenue in Manhattan

In the 1970s Roszak returned to drawing and lithography, treating themes of political and personal corruption, notably in *Flood Tide at Watergate* and *Rendezvous at Chappaquiddick*. The sculptor died in New York City in 1981. In a letter to *The New York Times* written after the artist's death, W. McNeil Lowry, a Ford Foundation vice-president, noted that it was fitting that the US Embassy eagle should be the Roszak work best known to the public, for "he looked like an eagle: he acted like one."

EXHIBITIONS INCLUDE: Allerton Gals., Chicago 1928; Roerich Mus. of Art, NYC 1935; Albany Inst. of History and Art, N.Y. 1936; Julien Levy Gals., NYC 1940; Artists' Gal., NYC 1940; Pierre Matisse Gal., NYC from 1951; Walker Art Cntr., Minneapolis 1956–57; Whitney Mus. of Am. Art, NYC 1956; Riverside Mus., Bronx, N.Y. 1968; Century Association, NYC 1971; Arts Club, Chicago 1976; Zabriskie Gal., NYC 1979. GROUP EXHIBITIONS INCLUDE: Annual, Whitney Mus. of Am. Art. NYC from 1932; "A Century of Progress," Art Inst. of Chicago 1933; "American Abstract Art," Whitney Mus. of Am. Art NYC 1935; "14 Americans," MOMA, NYC 1946; São Paulo Bienal 1951; International Exhibition, Tate Gal., London 1953; International Exhibition, Brussels 1958; Venice Biennale 1960; "Court of New Horizons," New York World's Fair, Flushing Meadow 1964–65.

COLLECTIONS INCLUDE: MOMA, Whitney Mus. of Am. Art, and Solomon R. Guggenheim Mus., NYC; Yale Univ. Art Gal., New Haven, Conn.; Pennsylvania Academy of Art, Philadelphia; Hirshhhorn Mus. and Sculpture Garden, Washington D.C.; Baltimore Mus. of Art, Cleveland Art Mus.; Art Institute of Chicago; Walker Art Center, Minneapolis; Phoenix Art Mus., Ariz.; Mus. de Arte Moderno, São Paulo; Tate Gal., London.

ABOUT: Andersen, W. American Sculpture in Process: 1930/1970, 1975; Arnason, H. H. "Theodore Roszak" (cat.), Whitney Mus. of Am. Art, NYC, 1956; Barr, A. H. Masters of Modern Art, 1954, Burnham, J. Beyond Modern Sculpture, 1968; Lucie-Smith, E. Late Modern: The Visual Arts Since 1945, 1969; Miller D. C. (ed.) "14 Americans" (cat.), MOMA, NYC 1946; Ritchie, A. C. Sculpture of the Twentieth Century, 1953; Roszak, T. In Pursuit of an Image, 1955. *Periodicals*—Art Digest October 15, 1952; Art in America Winter 1956; Art News February 1979; Arts Magazine December 1979; Magazine of Art February 1949.

***ROTELLA, MIMMO** (October 17, 1918–), Italian painter, was a pioneer of Italian new realism, a movement paralleling British and American pop art. He is best known for his collages made of mutilated posters torn from urban walls.

He was born Domenico Rotella in Catanzaro, in the southern Italian region of Calabria. In the ravaged towns of postwar Italy he was struck by the look of tattered wall posters, seeing in these "processed images both a symbol of contemporary conditions and the means of expressing them," to quote Charles Spencer's article in *Contemporary Artists* (1977).

Rotella did not discover his distinctive artistic idiom until he was past 30. The first of these works were in the style of postcubist abstraction, and in 1949 he participated in a group exhibition at the Salon des Réalités Nouvelles, Paris, which included both abstract and realistic painters. His first solo show was at the Galleria Chiurazzi, Rome, in 1951.

°rō tel´ lō, mē´ mō

A Fulbright scholarship enabled Rotella to study in the United States in 1951–52. In America he experimented, in a neodadaist spirit, with phonetic poems which were recorded for the Library of Congress, Washington, D.C. While an artist-in-residence at the University of Missouri, Kansas City, he painted an enormous mural and in 1952 exhibited at the Rockhill Nelson Gallery, Kansas City, Missouri.

Back in Rome, where he lived and worked in comparative solitude, Rotella began to make collages from posters confiscated from walls; he thought of these works as a species of abstract painting. He used the color and texture of the torn papers to create images that, in their sensitive, carefully balanced composition, were "not unlike the work of [Kurt] Schwitters," according to Spencer. Although their work was unknown to Rotella, the French artists Raymond Hains, Jacques de la Villeglé, and François Dufrêne had in the late '40s begun making collages by transferring fragments of ripped-down posters onto the canvas. Their work was known in France as the art of *affichisme*, or décollage. However, as Lucy Lippard pointed out in *Pop Art*, Rotella was the first to use *décollage* "in a Pop manner—concentrating on a single advertisement torn from a city wall, rather than the fragmented abstractions that they [the Affichistes as well as Rotella] had all made before." But inasmuch as artists were working independently in different countries in the same medium, as Alain Jouffroy observed, "it is not too much to speak of a European [décollage] movement." According to Jouffroy, the movement struck a balance "between nonformal art and automatic and gestural painting," expressing the "poetry of the street, archeology of the collective unconscious, the arcana of chance."

Rotella first exhibited his torn posters, which he termed *manifesti lacerati* (lacerated posters), in Rome in 1954. Rotella defended his lacerated posters against the adverse criticism they aroused: "Tearing the posters down from the walls is the only recourse, the only protest against a society that has lost its taste for change and shocking transformations. . . . The search which I am conducting is not concerned with aesthetics but with an unforeseen element and even with the moods of the material itself."

Rotella's work of the mid-1950s was colorful and dramatic, alternating busy areas with broad planes of hot color. By 1960 the mood had become less agitated. He combined broad areas of color with large shapes and began to incorporate photographic images, thus giving his work a narrative dimension which often took the form of moral pronouncements. He used photos of mov-

ie stars in a manner reminiscent of Andy Warhol, though "Rotella always remained more complex and painterly than the American artist," to quote Spencer.

In 1961 Rotella was invited by the critic Pierre Restany to join the Nouveaux Réalistes group which had been founded in Paris the previous year by Jean Tinguely and Yves Klein, among others. These New Realists were not traditional realists but used real objects in their wildly imaginative compositions. Through the group, Rotella met Hains, Villeglé and Dufrêne, and exhibited with them at Restany's Galerie J show titled "A 40° au dessus de dada" (40 Degrees Over Dada) in 1961. Restany wrote in the show catalog: "When he tears a poster, Mimmo Rotella is penetrated with the awareness of the grandeur of his gesture. For him it is the only conceivable means of appropriating an aspect of the real in its objective and sociological totality."

A characteristic Rotella work of the early '60s is *Metro-Goldwyn-Mayer* (1963). Rotella's use of a photograph of the MGM motto, Ars Gratia Artis (art for art's sake), surrounding the lion is significant in view of his desire to link artistic statement to the images and mass-production methods of contemporary society. In his "Cinecittà" series of 1962, Rotella used movie posters in a medley of images organized around a coherent historico-sociological theme. His interest in mass culture and mechanical means of reproduction led in 1963 to experiments with photo-reportage; works produced in this medium were termed mec (for mechanical) art by the Nouveaux Realistes. His use of newspaper photographs to record, for instance, the death of a soldier in Vietnam or of a Pope, as in *Vatican IV* (1963), and his incorporation of magazine covers or advertisements of still lifes, as in *Flask of Wine* (1963), anticipated what is now called photo-realist painting. In his humorous *Southern Spectacles,* a mec-art work of 1966, Rotella used elements of chance in the design. A large pair of spectacles, behind which two black dots form an almost Groucho-Mark-like leer, is juxtaposed with unidentifiable objects and words; these elements are covered with a design repeated desultorily, or an "accidental number of times." Rotella coined the term "artypo painting" for this combination of the mechanical and the fortuitous.

Mimmo Rotella lives and works in Paris, but Rome has always been "his city" and, he has said, his home is the city street. A 1961 photograph of the artist shows a wiry, intense, clean-shaven man dressed in workman's clothes and sitting atop a fireman's ladder. The ladder leans against a huge wall covered with a torn posters pasted

vertically, horizontally, and diagonally to form an immense and dynamic collage.

In the late 15th century Domenico Ghirlandaio wished to cover the entire circuit of the city walls of Florence with frescoes. Mimmo Rotella in 1961 declared, "If I had the strength of Samson, I would paste the Piazza di Spagna, with its tender, soft autumnal tints, over the red piazzas of the Janiculum, with its sunset glow."

EXHIBITIONS INCLUDE: Gal. Chiurazzi, Rome 1951; Rockhill Nelson Gal., Kansas City, Mo. 1952; Gal. del Naviglio, Milan 1955, '57, '58, '66; Gal. Selecta, Rome 1957; Inst. of Contemporary Arts, London 1957; Wittenberg Gal., NYC 1958; Gal. la Salita, Rome 1959, '61; Gal. J, Paris 1962, '65; Seven Arts Gal., London 1962; Gal. Apollinaire, Milan 1963; Gal. la Tartaruga, Rome 1965, '66; Gal. 20, Amsterdam 1967; Gal. Fitzroy, Brussels 1969; Gal. Mathias Fels, Paris from 1971; Gal. Marquet, Paris 1973. GROUP EXHIBITIONS INCLUDE: Salon des Réalités Nouvelles, Paris 1949; Intl. Print Biennale, Ljubljana, Yugoslavia 1959; "A 40° Au Dessus de Dada," Gal. J, Paris 1961; "The Art of Assemblage," Carnegie Inst., Pittsburgh 1961; "The Art of Assemblage," MOMA, NYC 1961; "Nouveaux réalistes," Neue Gal. im Künstlerhaus, Munich 1963; São Paulo Bienal 1963; "50 ans de collage," Mus. des Arts Décoratifs, Paris 1964; "50 ans de collage," Mus. d'Art et d'Histoire, Saint-Etienne, France 1964; "Pop Art, Nouveau Réalisme, etc.," Palais des Beaux-Arts, Brussels 1964, "Mec-Art," Gal. Blú, Milan 1966; "Italian Contemporary Painting," Jewish Mus., NYC 1968; "Décollages," Staatsgal., Stuttgart, W. Ger. 1971; "45 Ans d'architecture, dessin et art: Exposition Domus," Mus. des Arts Décoratifs, Paris 1973.

COLLECTIONS INCLUDE: Mus. d'Art Moderne, and Georges Pompidou estate, Paris; Gal. Nazionale d'Arte Moderna, Rome; Prearo Collection, Milan; Stedelijk Mus., Amsterdam; Univ. of Missouri, Kansas City; Mus. de Arte Moderna, São Paulo.

ABOUT: Gardner, P. "Rotella" (cat.), Rockhill Nelson Gal., Kansas City, Mo., 1952; Hahn, O. (ed.) "Rotella 1954–1968" (cat.), Gal. Fitzroy, Brussels, 1969; Lippard, L. R. Pop Art, 1966; Pellegrini, A. New Tendencies in Art, 1966; Ponente, N. (ed.) "Rotella" (cat.), Gal. del Naviglio, Milan, 1958; "Rotella" (cat.), Gal. Selecta, Rome, 1957; Villa, E. (ed.) "Rotella" (cat.), Gal. la Salita, Rome, 1959. *Periodicals*—Architecture d'aujourd hui (Paris) 1957; Les Lettres Françaises (Paris) March 1962; Marcatre (Rome) 1965; Metro (Milan) no.6 1962; Opus International (Paris) June/July 1974; XXe siècle (Paris) December 1975.

ROTHKO, MARK (September 25, 1903– February 25, 1970), American painter and pioneer Abstract Expressionist, was born Marcus Rothkovich in Dvinsk, Latvia, the son of Jacob and Kate (Goldin) Rothkovich. His father was a Russian-Jewish pharmacist, who, to save his boys from being drafted into the army, took his family to the United States in 1913. They settled in Portland, Oregon, where Mark attended public elementary and secondary schools. He had no thought at that time of becoming a painter, but was already concerned with social and cultural values. He later recalled that his one ambition was to become a labor leader.

Rothko entered Yale University in 1921 and studied in the liberal arts curriculum. Having no interest in formal learning, he left Yale in 1923 to "wander around" and "starve a bit." He was still unsure of his direction, but by 1925 he had settled in New York City, where he attended Max Weber's classes at the Art Students League. This brief period of study with Weber was the full extent of his formal artistic training, and Rothko always considered himself a self-taught painter. He exhibited paintings in 1929 at the Opportunity Gallery, New York City, and in the early 1930s he participated in group shows at the Secession Gallery. His early work consisted mainly of Oregon landscapes, cityscapes, portraits, and nudes.

Rothko's first solo exhibitions were held in 1933, at the Contemporary Arts Gallery, New York City, and at the Portland (Oregon) Art Museum. In 1935 he was cofounder, with his friend Adolph Gottlieb and other New York artists, of a group called The Ten, who were interested in abstraction, worked in a more or less expressionistic manner, and held annual shows until about 1940. Like many other American artists in the Depression years, Rothko worked, in 1936–37, on the Federal Arts Project of the Works Progress Administration in New York City. Social realism was then in vogue, but Rothko's cityscapes, though essentially realistic, had a subtlety of color which was altogether personal.

Rothko and Gottlieb admired the decorative color of Matisse and the sensitive tonalities and simplified design of Milton Avery, but Rothko was gradually coming under the influence of surrealism. He was impressed by the work of Dali, de Chirico, Miró, and Ernst, and had the opportunity of meeting the Surrealists who came to America from Europe during World War II. In the late 1930s and early '40s, Rothko also became interested in Greek mythology, philosophy, Jungian psychology, and primitive art and religion. He and Gottlieb set out their ideas in a letter to the editor of *The New York Times* published on June 13, 1943. The letter included the

Photo by Robet E. Mates; Courtesy of the Marborough-Gerson Gallery, NYC

MARK ROTHKO

statement, "We are for the large shape because it has the impact of the unequivocal. We wish to reassert the picture plane. We are for flat forms because they destroy illusion and reveal truth."

Rothko's obsession with mythology and the increasingly surrealistic direction of his painting were apparent in his first important solo show, held in 1945 at Peggy Guggenheim's Art of This Century Gallery. His surrealist phase was influenced by Max Ernst, Matta, and, especially, André Masson and Arshile Gorky. Vague totemic forms and strange, eerie biomorphic apparitions emerged out of shadowy, almost monochromatic tonalities. His pictures in the mid-1940s bore such enigmatic and ritualistic titles as *Baptismal Scene, Ancestral Imprint*, and *Vessel of Magic*. Aldo Pellegrini described these works as constituting "a complex of extraordinary imagination and high poetic content."

In March 1945, Rothko, who had been married once before, in the 1930s, wed Mary Alice ("Mell") Beistle; they had two children, Kate, born in 1951, and Christopher, born in 1963. A commercial artist, Mell did freelance work to support the family and to enable her husband to be a full-time artist in the years before Rothko's canvases began to sell.

Rothko's paintings of 1946, including *Entombment I* (Whitney Museum of American Art, New York City) and the watercolor *Prehistoric Memories*, still contained biomorphic shapes and could be regarded as abstract surrealism, but the ground of these pictures, a fluid dimensionless space, was already divided into the horizontal zones of color that anticipated the

cloudlike shapes and soft but intense color for which he was to become famous. After 1947 Rothko began to eliminate the biomorphic imagery and by 1950 his style had become entirely abstract. Abandoning all references to surrealism, he sought the poetry of pure forms, and restricted his imagery to diffuse and floating rectangles of color. He declared that he wanted no starting point in "memory, history, or geometry, which are swamps of generalization. . . . " His aim was direct communication of his emotion, in terms of paint and canvas. But however simplified his painting became, his reductive approach was very different from the formal purity and cerebration of geometric abstractionism.

The years 1947–48 were crucial for American painting, for it was then that Pollock, de Kooning, Kline, and Rothko, for all their differences, succeeded in giving what was now becoming known as the New York School a character distinct from that of modern European art. Rothko's canvases had none of the turbulence of those of his fellow Abstract Expressionists who were action painters; instead, his works invited contemplation and resonated, Rothko believed, with religious and tragic meaning.

From 1947 to 1951 Rothko showed regularly at the Betty Parsons Gallery, New York City. By now his paintings had nondescriptive titles and were very large. *Number 10, 1950* (Museum of Modern Art, New York City) is 90⅜ by 57¼ inches. It consists of monumental rectangles of varying size and glowing but subtle color (including dark blue, violet, golden yellow, and pale blue), blurred at the edges and appearing to float in space. In the 1940s Rothko had been hardpressed financially and had met with little understanding and recognition, except among his colleagues. In a letter to *The New York Times* in 1947, he wrote: "It is difficult for the artist to accept the hostile incomprehension of the public. Nevertheless, this hostility can be the instrument of his liberation. Divorced from any false illusion of security and solidarity he can equally well abandon the mixture of plastic conventions: the world of transcendental experience is then open to him."

After 1950, in the years of abstract expressionism's international triumph, critics were by no means hostile; most were respectful if a trifle bewildered. Reviewing the paintings in Rothko's last show at the Parsons Gallery, a *New York Times* (April 8, 1951) critic wrote: "They are given no titles, and in the accepted sense of the word, they represent nothing. They are expressions of pure and elementary color-form relationships. For line plays no part here, nor do images sully their serene expanses. One would

have to be blind indeed to deny that Rothko is a subtle and sensitive colorist."

In 1948 Rothko founded, with Motherwell, Newman, and Baziotes, the informal Subjects of the Artist School, which later became Studio 35. The name was chosen to emphasize that abstract art has a subject. In the summers of 1947 and 1949 Rothko taught at the California School of Fine Arts, San Francisco, and his presence there, together with his participation in museum exhibitions in San Francisco and Santa Barbara in 1946, introduced Rothko to younger painters who were to form the nucleus of the so-called Pacific, or West Coast, School.

Rothko was represented in the important "Abstract Painting and Sculpture in America" exhibition, held in 1951 at MOMA, and his work was seen there in other group shows in subsequent years. Apart from variations in color, there was little change in his style after the early 1950s. A typical arrangement of abstract rectangles was *Black, Pink and Yellow Over Orange* (1951–52; Hirshhorn Museum and Sculpture Garden, Washington, D.C.). The centralized image, as Barbara Rose has observed, was still, in a sense, a symbol, but of "oneness or wholeness or transcendent unity"—far more abstract and conceptual than the myth-laden symbolic works of his surrealist phase. The mood of silent contemplation emanating from Rothko's paintings has been likened to the transcendental spirit of Zen Buddhism, but Rothko himself was irritated by the comparison to Eastern religion. However, Werner Haftmann, writing in the catalog to the posthumous Rothko exhibition of 1972 at the Musée National d'Art Moderne, Paris, related the artist's work to his "Judaic feeling and Jewish religious sense, always present behind his irony and cynicism." This might have pleased Rothko more, for, as his friend the poet Stanley Kunitz reported, "I once told him that he was the last Rabbi in Western art, and he enjoyed that. . . . "

In 1954 Rothko began to show regularly at the Sidney Janis Gallery, New York City, one of the first important American galleries to support indigenous avant-garde art. He was also represented in major group exhibitions in Europe, including "Fifty Years of Art in the United States," held in 1956 at the Musée National d'Art Moderne, Paris, and the Venice Biennale of 1958.

Typical works of the middle and late 1950s and early 1960s were *Earth Red and Green* (1955), *Tan and Black on Red* (1957), and *Orange Red and Yellow* (1961). They were all variations on the now familiar Rothko theme, employing severely economical units of form and color. Despite wide acclaim, some critics found his canvases alarmingly empty. A New York *Herald Tribune* reviewer (April 27, 1955) wrote that "Rothko's pictures get bigger and bigger and say less and less." On the other hand, a *New Yorker* writer (April 23, 1955) declared that "largely through the size and the compactness of their arrangement the canvases . . . take on a brooding glow and a towering, almost totemic import that is quite impressive." More important, Clement Greenberg recognized the originality of Rothko's color, which he said "manifests itself first of all in a persistent bias toward warmth." He also praised the artist for "his willingness to accept something from French art *after* Impressionism; his way of insinuating certain contrasts of warm and cool [betrays] a lesson he learned from Matisse. [But] the simple and firm sensuousness, and the splendor, of Rothko's pictures belong entirely to himself."

In 1958–59 Rothko planned a series of eight large paintings, some of them 15 feet wide, as a mural for a room in the Seagram Building, the Manhattan skyscraper designed by the Bauhaus architect Mies van der Rohe. But when Rothko learned that they were to be hung in the building's opulent Four Seasons restaurant, he decided to keep the pictures, considering them too somber and serious to serve as a mere decorative backdrop for diners and amiable after-dinner chatter. Intended, like all of Rothko's work, as objects of contemplation, several of the paintings were later presented by the artist to London's Tate Gallery, where a Rothko room was installed in 1970.

In the 1960s, Rothko's work became larger and darker. *Blue, Orange and Red* (1961; Hirshhorn Museum, Washington, D.C.) still has the luminous glow of his paintings of the '50s, but the large central areas of nocturnal blue add a somber note. The muffled hues and murky, ominous browns, violets, and blacks of his later canvases, which replaced the sumptuous oranges, reds, and yellows, are now seen as reflecting a growing despondency which overtook the artist in the years when national and international acclaim of his work spread. As early as the 1950s the Marxist artist-critic John Berger had discussed the large abstractions of the New York School in terms which seem prophetic of Rothko: "These works in their creations and appeal are a full expression of the suicidal despair of those who are completely trapped within their own dead subjectivity." Rothko's sense of color and feeling for ambiguous space were by no means "dead," but it is clear that agonizing doubts and unbearable tensions were welling up beneath what Kunitz described as his friend's "paternal, avuncular manner."

It is dangerous to speculate on the state of mind that led to Rothko's suicide at a time when the 66-year-old artist was at the peak of his fame and of his artistic powers as well; but John L. Hess of *Art News* (November 1972) discussed with great perception the circumstances attending the artist's death. He mentioned Rothko's "resentment over his long, hard struggle in obscurity" and pointed out, ironically, that the artist's last few years of prosperity and art-world "stardom," when his paintings were selling for as much as $130,000, were even harder for him to accept. His marriage broke up. His health deteriorated. He drank heavily, and sank increasingly into depression and paranoia. Events in the art world—whose commercial aspects, the transformation of an art work into a commodity, Rothko detested—only added to his feelings of anxiety and guilt. He hated the new pop art and related developments, which he considered a betrayal of the spiritual values he and the other first-generation Abstract Expressionists had embraced. Another writer suggested that a cause of the suicide was "the justified anger of a man who felt destined to paint temples, only to find his canvases treated as trade goods." But here, too, were deep contradictions. As Hilton Kramer observed in *The New York Times Book Review* (March 26, 1978), Rothko liked to think of himself as a religious artist who professed to despise dealers, collectors, and men of money, yet he himself was equally "susceptible to the lure of Swiss bank accounts and other worldly temptations." Added to these guilt complexes were endless broodings about the fate of his own work, and whether it was "really understood."

Rothko's last major commission was destined for a religious shrine. In the 1960s, John and Dominique de Menil, wealthy French-born Americans who had settled in Houston, visited Rothko's New York studio and commissioned paintings for a chapel that eventually became part of the Institute of Human Development, on Houston's South Side. The 14 large abstract works, in somber, blood-dark hues, were first seen by the public when the Rothko Chapel, empty except for the paintings, wooden benches, and standing candelabra, was formally opened in February 1971, a year after Rothko took his life. To some the chapel itself was suicidally doleful, but others found it conducive to meditation. According to *Art News* (December 1976), it has since "become a magnet to people of all ages and nationalities and the setting for everything from a Buddhist wedding to international colloquia on world peace and religion." Stylistically, the panels could be considered color-field paintings, and they have affinities with minimal art.

Almost two years before Rothko committed suicide by slashing his wrists, he had signed a will leaving the bulk of his estate to a fund for elderly struggling artists. The will named his old friend and accountant Bernard J. Reis, the artist Theodoros Stamos, and Morton Levine, an anthropologist, as executors of the estate and trustees of the Mark Rothko Foundation. In 1969, Rothko's most prosperous year, he sold to the Marlborough Gallery, New York City, 87 paintings for over one million dollars, with an agreement not to sell to anyone else for eight years. In return, he could sell from pictures of his own choice to Marlborough each year at 90 percent of the going market value. In this way he hoped to pull out of the commercial racket by selling only a few paintings each year. "No more dealers, no more shows" were his words. After his death there was prolonged litigation involving the gallery, the Art Dealers Association, and lawyers and guardians for Kate and Christopher Rothko, who were still minors (his estranged wife, Mell, had died shortly after her husband). " . . . In the main," John Bernard Myers wrote in his article, "The Rothko Case," in *The New Criterion*, "the suit contended that the executors had conspired to defraud the Rothko estate and the Foundation by making deals with the Marlborough Gallery which greatly undervalued Rothko works sold outright to the gallery, thereby benefiting the gallery at the expense of the estate." The complicated and controversial disputes were eventually settled, when the presiding judge ruled in favor of the petitioners, removing the three executors from the Rothko estate and levying fines of more than $9 million against the executors and the gallery.

In 1961 Rothko had had a major show at MOMA which toured until 1963 as an International Circulating Exhibition. Significantly, an exhibition of Turner, the 19th-century romantic painter who became the earliest artist ever to be shown at MOMA, was mounted in 1966. Included in the show were some of Turner's tiny sketchbooks, in which luminous washes of color were laid in with three blurry-edged horizontal bands, denoting foreground, distance, and sky; one was called *Color Beginnings: The Pink Sky*. To many viewers, conditioned by abstract expressionism, they seemed like premonitions in miniature of Rothko's huge canvases. For Turner these color studies *were* just beginnings, with infinite possibilities, but for Rothko the reductive idiom was an end in itself, one single aspect of vision magnified to express totality. Whether this was a liberation or a severe limitation is the focus of critical discussion of the artist. For Edward Lucie-Smith, Rothko was "an artist of real brilliance imprisoned in a straitjacket." Lucie-

Smith observed that whereas the strength of Rothko's work was in its subtlety of color, its weakness lay "in the rigidity and monotony of the compositional formula." For others, his canvases express a deeply felt poetic, even tragic, vision.

Mark Rothko himself justified the size of his pictures and their psychological and environmental impact in a statement made in 1951: "I paint very large pictures. I realize that historically the function of painting large pictures is painting something very grandiose and pompous. The reason I paint them, however, . . . is precisely because I want to be very intimate and human. To paint a small picture is to place yourself outside your experience, to look upon an experience as a stereopticon view or with a reducing glass. However you paint the larger picture, you are in it. It isn't something you command." His expressed interest throughout his work was "towards clarity," and he set out to achieve, as he had stated, as early as 1943, "the simple expression of the complex thought."

EXHIBITIONS INCLUDE: Contemporary Arts Gal., NYC 1933; Portland Art Mus., Oreg. 1933; J.B. Neumann's New Art Circle, NYC 1940; Peggy Guggenheim's Art of This Century Gal., NYC 1945; San Francisco Mus. of Art, 1946; Santa Barbara Mus. of Art, Calif. 1946; Betty Parsons Gal., NYC 1947–51; Sidney Janis Gal., NYC 1955, '58; Venice Biennale 1958; Phillips Collection, Washington, D.C. 1960; MOMA, NYC International Circulating Exhibition, 1961–63; Marlborough Fine Art, London 1964; Memorial Exhibition, Gal. Internazionale d'Art Moderna, Ca' Pesaro, Venice, 1970; Marlborough Gal., NYC 1970; Kunsthaus, Zürich 1971–72; "Rothko, 1903–1970: A Retrospective," Solomon R. Guggenheim Mus., NYC 1978; "Rothko, 1903–1970: A Retrospective," Los Angeles Country Mus. of Art 1979. GROUP EXHIBITIONS INCLUDE: Opportunity Gal., NYC 1929; Secession Gal., NYC 1930; "The Ten: Whitney Dissenters," Mercury Gal., NYC 1938; Whitney Annual, NYC 1947–50; "Abstract Painting and Sculpture in America," MOMA, NYC 1951; "15 Americans," MOMA, NYC 1952; "Fifty Years of Art in the United States," Mus. Nat. d'Art Moderne, Paris 1956; Pittsburgh International, Carnegie Inst. 1958, '61; Venice Biennale 1958; Documenta 2, Kassel, W. Ger. 1959; "American Abstract Expressionists and Imagists," Solomon R. Guggenheim Mus., NYC 1961; "The New York School," Los Angeles County Mus. of Art 1965; "Two Decades of American Painting," MOMA, NYC 1966; "New York Painting and Sculpture 1940–1970," Metropolitan Mus. of Art, NYC 1969; "Malerei des zwanzigsten Jahrhunderts," Kunsthaus, Zürich 1970.

COLLECTIONS INCLUDE: MOMA, and Whitney Mus. of Am. Art, NYC; Brooklyn Mus., N.Y.; Albright-Knox Art Gal., Buffalo, N.Y.; Munson-Williams-Proctor Inst., Utica, N.Y.; Vassar Col., Poughkeepsie, N.Y.; Phillips Collection, and Hirshhorn Mus. and Sculpture Garden, Washington, D.C.; Art Inst., Chicago; Toledo Mus. of Art, Ohio; St. Louis City Art Mus., Mo.; San Francisco Mus. of Art; Contemporary Arts Mus., and Inst. for Religion and Human Development, Houston; Mus. de Arte Moderna, Rio de Janeiro; Tate Gal., London; Mus. d'Art Moderne, Paris; Boymans-Van Beuningen Mus., Rotterdam; Nationalgal., Berlin; Offentliche Kunstsammlung, Basel; Kunsthaus, Zürich; Peggy Guggenheim Collection, Venice.

ABOUT: Ashton, D. The New York School: A Cultural Reckoning, 1973, About Rothko, 1983; Cheney, S. The Story of Modern Art, 2d ed. 1958; Collier, O. Mark Rothko, 1947; Current Biography, 1961; Greenberg, C. Art and Culture, 1961; Haftmann, W. "Mark Rothko" (cat.), Mus. Nat. d'Art Moderne, Paris, 1972; Hobbs, R. C. and others, Abstract Expressionism: The Formative Years, 1981; Hughes, R. The Shock of the New, 1981; Janis, S. Abstract and Surrealist Art in America,1944; Lucie-Smith, E. Late Modern: The Visual Arts Since 1945, 1969; Pellegrini, A. New Tendencies in Art, 1966; Ritchie, A.C. "Abstract Painting and Sculpture in America" (cat.), MOMA, NYC, 1951; Rose, B. American Art Since 1900, 2d ed. 1975; Sandler, I. The Triumph of American Painting: A History of Abstract Expressionism, 1970, The New York School: The Painters and Sculptors of the Fifties, 1978; Seldes, L. The Legacy of Mark Rothko, 1978; Selz, P. "Mark Rothko" (cat.), MOMA, NYC, 1961. *Periodicals*—American Artist April 1978; Architectural Review October 1957; Art in America March 1976; Art News January 1961, November 1972; December 1976, October 1977; Artforum September 1965, November 1973; Arts Magazine April 1977; New York Herald Tribune April 17, 1955; New Criterion February 1983; New York Times June 13, 1943, April 8, 1951; New York Times Book Review March 26, 1978; New Yorker April 23, 1955; Partisan Review no. 2 1984.

***ROUAULT, GEORGES** (May 27, 1871– February 13, 1958), French painter and printmaker, was born in Belleville (now a suburb of Paris), the son of a Breton cabinetmaker. Rouault was preeminently an artist devoted to religious themes but not a "religious artist" in the conventional sense; he was only a few times ever commissioned to do work for an ecclesiastical institution. His entire oeuvre, however, was imbued with spiritual ardor and a compassionate love of humanity. It is generally considered that his early training in stained-glass studios was formative of his distinctive mature painting style, with its emphatic black contours and juxtaposed planes of radiant colors.

Passionate devotion to his art, his religion, and his family characterized this shy, independent man who forged his own artistic path and belonged to none of the 20th-century movements. Although his work is expressionistic and Rouault at one point reflected that "it is sometimes good

°roo ō´, zhôrzh

THE BETTMAN ARCHIVE, INC.

GEORGES ROUAULT

even for a painter to close his eyes for an instant," he was also capable of dismissing subjective artists as being "one-eyed" (while "objective artists are blind").

It is recorded that as a young man Rouault was pale and thin, with blond hair. Of average height, with small, sensitive hands, his own pensive features are often fused with the profoundly sad, suffering faces of his favorite subjects, pierrots and circus clowns: high, prominent forehead; wide, mobile mouth; short but slightly hooked nose; strong chin. Despite a reputation for outbursts of temper and a pugnacious tenacity—witness his long court battles with the heirs of his dealer Ambroise Vollard—photographs of Rouault reveal something in his eyes and mouth indicating an underlying mischievous humor. He found it difficult to talk about his art, but his letters, poetry, memoirs, and conversations with friends are eloquently expressive. A man of the people, his writing style was idiomatic, direct, and clear. Widely exhibited and highly respected before his death, Rouault, for all his diffidence, enjoyed the friendship of such fellow artists as Henri Matisse, Odilon Redon, André Lhote, and Maurice Denis, and of such critics and writers as Lionello Venturi, Léon Bloy, Jacques Maritain, and André Suarès.

Rouault's arrival in the world was dramatic. He was born in a cellar shelter during the artillery shelling of Paris in the course of the Commune revolt of 1871. A delicate child, he led a protected life in his parents' home and in the household of his maternal grandfather and aunts. One of his favorite childhood recreations was drawing on the tiles of his aunts' kitchen floor. Artistic influences surrounded him from the start, for the aunts were painters of fans and chinaware, and his grandfather amused him by showing him reproductions of the work of Courbet, Manet, and Rembrandt, and the Daumier lithographs he collected. "I went first to the school of Daumier" Rouault recalled.

His formal schooling was of short duration and at a Protestant school where his father, in reaction to certain official Roman Catholic dictates, enrolled him; after an episode in which Rouault had been, as his father deemed, unjustly punished by one of the teachers, he was withdrawn from the institution. At the age of 14 he was apprenticed to a stained-glass maker and then to Georges Hirsch, a restorer of stained glass. It is recounted that when the young apprentice had a lengthy errand to run, in another part of Paris, he would use his bus fare to buy paints and then, in order not to waste his employers' time or money, run all the way alongside the bus. Thus early was manifested his lifelong devotion to art, which he proclaimed would be to him the Promised Land "till I die." Meanwhile he attended evening classes at the Ecole des Arts Décoratifs, and in 1890 entered the Ecole des Beaux-Arts. There, along with Matisse, Albert Marquet, and others who later formed the Fauves group, he became a pupil of the Symbolist painter Gustave Moreau. With the encouragement of Moreau, who took a special interest in his development, Rouault competed for the Prix de Rome in 1893, with his *Ordeal of Samson,* but was unsuccessful; the following year he won the Prix Chenavard with his canvas *The Child Jesus Among the Doctors.* After another unsuccessful try for the Prix de Rome in 1895 he left the Ecole. Upon Moreau's death in 1898 the Gustave Moreau Museum was founded in Paris to house his paintings, and a few years later Rouault was appointed curator. Passages in his *Souvenirs intimes* eulogize Moreau; despite the differences in their approaches, Rouault all his life revered his master and gratefully acknowledged his influence. Rouault also maintained a life-long friendship with Matisse, the only one of his contemporaries he ever mentioned, although they rarely saw each other.

With the death of Moreau and a temporary separation from his family (who had gone to Algiers), Rouault experienced a period of depression and began to seek for direction in his art. The inspiration of Rembrandt as well as Moreau had been evident in many of the works he painted toward the turn of the century: landscapes such as the gouache and pastel *Night Landscape* (1897; variously known also as *The Workyard* or *The Quarry*), dark and often overworked treatments of Biblical subjects, and self-portraits such

as the dandified 1896 study, with his figure looming out of the Rembrandt-esque sfumato. Now a significant influence on his thematic orientation was provided by a visit in 1901 to the Benedictine Abbey of Ligugé, near Poitiers. It was there that he met the novelist and Catholic convert J.-K. Huysmans, who had established an artists' community at the Abbey and tried to persuade Rouault to join it. Even more significant to Rouault's career was his attachment to the Catholic intellectual Léon Bloy, dating from about 1903. The artist, whose Catholicism had become increasingly profound, found inspiration in Bloy's tragic novels Le Désespéré (The Desperate One, 1886) and La Femme pauvre (The Poor Woman, 1897), the latter with its dictum "If art does not go on its knees . . . it must necessarily go on its back or its belly." Despite the novelist's later rejection of Rouault's painting as "atrocities and vengeful caricatures," the two men's friendship lasted until Bloy's death in 1917. What he had failed to understand was that as Rouault's subjects became, from 1903 on, apparently more secular, and certainly less coventionally "pretty," they became more truly spiritual and concerned with the human condition, infused with a sort of divine rage.

Reflecting Bloy's own concern with sin and redemption—as focused on the characters of prostitutes—Rouault's oils and watercolors in 1903 and 1904 were largely studies of courtesans. With the stylistic influence of Van Gogh, Gauguin, and Cézanne, he had, from about 1898 on, developed a richer palette. These figures are modeled only summarily, however, the emphasis being on their suffering rather than on sensuous form. As Rouault summed it up, from this point on he had begun to paint "with an outrageous lyricism which disconcerted everybody . . . inspired [by] an inner necessity, and the perhaps unconscious desire not to fall full-length into conventional religious subject matter."

In 1903 Rouault participated with Matisse and others in the founding of the Salon d'Automne; although not a member of the Fauves group, he exhibited with them again in 1904 and 1905. Representations of prostitutes as well as clowns and other circus figures were prominent among his entries. The public, disturbed by their dark tonality, the heavy black outlines, and the sadness and anger in these paintings, rejected them. Undeterred, Rouault went on to paint a series of so-called grotesques, rendered with even more ferocity of intent and a frequent vein of caricature. About 1907 or '08 a more sensuous handling of pigment began to appear, and another subject entered his canon—satirical studies of judges that recall Daumier's prints, although more pointed in their indictment of bourgeois

corruption, smug indifference, and greed. The savage thrust of such a painting as Judges (1908) is related to later paintings such as The Three Judges (1913; Museum of Modern Art, New York City) or the canvas enigmatically entitled Mr. X (1911). When asked if this last was an actual portrait, Rouault replied that the subject had "existed eternally" and from the year 1897 on had "kept haunting my brain although I had not yet created him pictorially." Rouault specifically stated that he never wanted "to stir up malice or to incite class against class." His spirit was more that of the medieval moralist lamenting human frailty and corruption.

In 1908 Rouault married Marthe Le Sidaner; four children were born to them, one of whom, Isabelle, became her father's devoted helper in later years, taking upon herself arrangements with gallery directors and curators, and other tasks that might have kept the artist from his painting. For many years his wife helped to support the family by giving piano lessons. In 1910 the painter had his first solo show, at the Galerie Druet, Paris, and the critics' interest was now aroused. A year later he and his family moved to Versailles where he began his long friendship with Jacques and Raïssa Maritain. During the course of World War I, however, the Rouaults moved back to Paris.

The dealer and publisher Ambroise Vollard first met Rouault in 1907, attracted by the painted ceramics the artist had produced in 1906–07. By 1913 Vollard had become interested in Rouault's painting, and in 1917 they signed a contract under the terms of which Vollard bought up all of the hundreds of unfinished works in Rouault's studio and provided him with another studio, in Vollard's own home, in which to complete and sign them in due course. Thus began a long, often stormy, but magnificently fruitful collaboration. In 1914 Rouault began to make drawings for a project commissioned by Vollard, conceived of as a series of one hundred engravings to be published in two volumes, one to be titled Miserere, the other Guerre. The drawings, transformed first into oils or gouaches, were photoengraved on the largest copper plates the press could accommodate, measuring on an average 21 by 18 inches; they were then given to the artist for further work. "They gave me back the copper," he recounted, "and I just dug into it." The reworking and perfecting went on from 1922 to '27 and involved a combination of techniques: aquatint and drypoint, and the use of the roulette and direct application of acid with a brush. Many of the subjects were done over and over again in as many as 15 successive states. In 1927 58 plates were completed; after many vicissitudes (changes of plan, discussions and dis-

agreements between the collaborators, legal difficulties after Vollard's death in 1939, and the intervention of World War II) they were finally published, in one volume entitled *Miserere,* in 1948. Originally, the plan had been to issue the plates with a devotional text by Suarès; instead, the accompanying text consists of Rouault's preface, dedicating the work to Moreau and to his mother, and his captions inscribed in his own script. These embody scriptural passages, proverbs, and Rouault's gnomic utterances. Iconographically, the plates are for the most part concerned with New Testament themes though some are overtly secular and a few others deal with Greek mythological subjects. The whole is an expression of compassion for human suffering from "the insolences and abuses which seem to prevail in these days," and is considered by many critics to be one of the greatest achievements of modern sacred art.

Among the paintings Rouault executed during the war years were ones of clowns—*The Old Clown* and *Three Clowns,* both of 1917, for example—*The Lovely Madam X* (1915), a somewhat temperate satire on bourgeois indifference to the war, and various religious subjects, such as *Crucifixion* (1918). Grave, monumental, yet moving, this last is an almost abstract composition of planes of colors divided by black lines acting not to bind the surface, as do the lead strips in a stained-glass panel, but to set off the colors. The 1917 portrait of the ailing poet Henri Lebasque, however, omits the customary heavy outlining; the figure, painted with a realism unusual for Rouault, is modeled entirely by color.

In 1916 the artist was presented with another graphic commission, an opportunity to illustrate Vollard's own sequel to Alfred Jarry's play *Ubu Roi. Les Réincarnations du Père Ubu,* published in 1928 with 22 etchings and 104 wood engravings by Rouault, continues the fantasy and farce of Jarry's original satire on middle-class values and pedantry. Gouache studies for the prints exist—for example, two versions (dated to 1916) of *The Palace of Ubu Roi,* exotic landscapes dominated by a domed, Byzantine-inspired palace; its shape, which may be read as phallic, obsessively reappeared in many of Rouault's later landscapes.

It has been intimated by some critics that the reason Rouault, from about 1917 to '37, almost ceased to exhibit and apparently painted so little, was that he was kept isolated by Vollard's possessive protection. Certainly, he was kept fully occupied by the dealer's projects. He did not travel, and only in 1948 made his first trip to Italy. In these years Rouault did publish a good deal of his writings: critical articles, the *Souvenirs intimes* (with its lithograph portraits of Bloy, Moreau, Baudelaire, Verlaine, and others), and poetry. Many years later, in 1944, an important collection of his verse was issued under the title *Soliloques.* It consists of the verse Rouault composed in periods when, during the first war and World War II, he was unable to paint.

About 1928 Rouault had, however, begun to paint again, now superimposing colors applied with more and more impasto in broad, sweeping strokes, not only to get a richer tonality but to achieve what he felt was exactly the right tone. *The Workman's Apprentice,* a self-portrait painted as early as 1925, heralds the new style with its jewellike, incandescent colors. *Nude* (after 1930), the greatly beloved masterpiece *Christ Mocked by Soldiers* (1932), or *Head of Christ* (1937–38) represent a stylistic culmination, in that the color has become the form. To the decade of the '30s belongs a series of landscapes, possibly allusions to the Holy Land, with roads leading to a centrally placed domed structure similar to Ubu's palace. Characteristic of these compositions, with their sacral quality and glowing vitality of tone, is *Sunset* (1937–38).

In what became a procedure habitual to the painter, he also now reworked and slowly tried to bring to completion many older paintings, started years before. A famous example is *The Old King.* One of his greatest and most popular works, it was begun in 1916 and only finished in 1936; it shows, however, no break in style. This determined, painstaking approach, essentially reflecting Rouault's training as a craftsman, makes difficult any attempt to give an exact chronological outline of his stylistic development. Legal difficulties were also attendant on this practice. After Vollard's death, Rouault engaged in years of lawsuits with the dealer's heirs, trying to recover his some eight hundred still unfinished and unsigned paintings. Only in 1947 was the case settled, and the artist recovered the majority of his canvases; about 119, already sold, were not returned. In 1948, before public witnesses, Rouault burned 315 of those reclaimed works that he felt he would never be able, or did not want, to finish. In 1963 the remaining pictures that had not been finished and lacked his signature were given by his family to be housed in an as-yet-uncompleted national museum built in his honor. He was always bitter about what he felt was his "exploitation" by Vollard, and by the fact that success had come to him so late in life.

In 1929 Rouault turned in a new direction, to the creation of overtly decorative work, beginning with the execution of sets and costumes for Diaghilev's ballet *The Prodigal Son* (always a favorite theme of Rouault's), with music by Pro-

kofiev. The next year the artist began work on colored etchings to illustrate his own text, *Le Cirque de l'étoile filante* (The Circus of the Shooting Star), and in 1933 did two paintings—*Wounded Clown* and *Little Family*—that were subsequently replicated in tapestries. Other decorative projects occupied him toward the end of his life. Thus in 1945 the artist was given one of his rare ecclesiastical commissions, the designing of five stained-glass windows for the church at Assy on which Pierre Bonnard, Matisse, Jean Lurçat, Fernand Léger, and others also worked. In 1949 he designed enamels to be executed in the monastery workshops at Ligugé, and a year before his death a tapestry hanging based on his painting *The Countenance of Christ* (ca. 1946) was installed over the altar of the chapel at Hem, in the north of France.

A lessening of the artist's divine rage can be traced in his later years. Decorative borders appeared around a type of composition new to him, still-life flower pieces, such as *Bouquet* (ca. 1938) and *Decorative Flowers* (1948–52), painted for his wife as an anniversary present. Even during the years of World War II and the Occupation, which Rouault spent in the south of France, at Golfe-Juan, working on some of his unfinished canvases, a spirit of resignation is apparent. His somewhat muted concern for his country and for humanity informs *Head of a Clown* (1940–44), with lines of sorrow deeply emphasized on the gaunt cheeks, and *The Wise Pierrot* (1940–44), with its cool tones and the withdrawn serenity of what are probably Rouault's own features. The painting *Man Is Wolf of Man* (1940–48) repeats the subject and title of a plate in *Miserere;* but its figure of a hanged man seen against a background of burning buildings seems, again, a more detached commentary on war than the earlier print with its skulls and a skeleton clothed in a soldier's cap. In his last works Rouault turned to New Testament subjects; the radiant colors of *Ecce Homo* (1952) echo its creator's statement—made at war's end—that "I spent my life painting twilights. I ought to have the right now to paint the dawn."

The photographer Alexander Libeiman, who visited Rouault several times in the 1950s in his Paris living room with its dark gothic furniture, described him in *The Artist in his Studio* (1960) as "the short, stocky great man with the clown's face and the gestures of a prophet." His working costume was a white surgeon's coat tied with a simple belt, and he wore a white surgeon's cap on his head. He had a gift for mimicry, as Liberman noted: "An understanding of the theatrical gesture in a hey to Rouault's art as well as to his conversation."

Among the many honors that came to Rouault in these last years were the enormous 80th birthday celebration at the Palais de Chaillot, Paris, organized by the Centre Catholique des Intellectuels Français and, also in 1951, the designation of Commander of the Legion of Honor. (He had been named a member in 1924.) In 1953 Pius XII appointed him a papal knight. Actively painting right up to his death, at the age of 86, Rouault was given a state funeral, the first ever accorded an artist by the French government, in the Church of St. Germain-des-Prés.

EXHIBITIONS INCLUDE: Gal. Druet, Paris 1910, '11, '24; Gal. de la Licorne, Paris 1921; St. George's Gal., London 1930; Brummer Gal., NYC 1930; MOMA, NYC 1938, '45; Mus. of Fine Arts, Boston 1940; Kunsthaus, Zürich 1948; Palais de Chaillot, Paris 1951; Mus. Nat. d'Art Moderne, Paris 1952, '71; Gal d'Arte Moderna, Milan 1954; Mus. Toulouse-Lautrec, Albi, France 1956; Albertina, Vienna 1960; Mus. du Louvre, Paris 1963; Tate Gal., London 1966. GROUP EXHIBITIONS INCLUDE: Salon des Artistes Français, Paris 1895, '96; Salon des Indépendants, Paris 1902–12; Salon d'Automne, Paris 1903–08; "Les Maîtres de l'art indépendant," Petit Palais, Paris 1937; "Rouault: Braque," Tate Gal., London 1946; Venice Biennale 1948; "The Vatican Collections: The Papacy and Art," Metropolitan Mus. of Art, NYC 1983.

COLLECTIONS INCLUDE: Mus. Nat. d'Art Moderne, and Petit Palais, Paris; Stedelijk Mus., Amsterdam; Mus. of Fine Arts, Boston; Art Inst. of Chicago; Phillips Gal., Washington, D.C.; Albright-Knox Art Gal., Buffalo, N.Y.; MOMA, and Metropolitan Mus. of Art, NYC; Tate Gal., and Victoria and Albert Mus., London; Kunstmus., Basel; Kunsthaus, Zurich; Vatican Mus., Rome.

ABOUT: Courthion, P. Georges Rouault, 1962, Georges Rouault, 1977; Johnson, U. Ambroise Vollard Editeur, 1944; Liberman, A. The Artist in His Studio, 1960; Maritain, J. Georges Rouault, 1952; "Rouault: An Exhibition of Paintings, Drawings, and Documents" (cat.), Arts Council of Great Britain, Tate Gal., London, 1966; "Georges Rouault: Exposition du centenaire" (cat.), Mus. Nat. d'Art Moderne, Paris, 1971; Rouault, G. Souvenirs in times, 1926, Paysages legendaires, 1929, Le Cirque de l'étoile filante, 1938, Soliloques, 1944, Miserere, 1952, Correspondance, 1960, Sur l'Art et sur la vie, 1971; Soby, J.T. Georges Rouault: Paintings and Prints, 1947; Venturi, L. Rouault, 2d ed. 1948, Rouault, 1959; Vollard, A. Recollections of a Picture Dealer, 1936.

SAINT-PHALLE, NIKI DE. *See* DE SAINT-PHALLE, NIKI

***SANTOMASO, GUISEPPE** (September 26, 1907–), Italian painter, muralist, ceramist, and lithographer, has been called by Aldo Pellegrini an "informal abstractionist." Though clearly abstract in form, Santomaso's work is inspired by nature, and strikes a balance between emotion and intellect, poetry and exposition, and liberty and control. "His paintings," wrote Pellegrini, "are outstanding for their refined impasto, their color adjustment which is always well-tempered and their luminous characteristics." His artistic development has closely paralleled the general evolution of one branch of modernism from expressive realism to "international abstraction" to a species of color-field painting.

Santomaso was born in Venice and studied at the city's Academy of Fine Arts, where he later taught for many years. He first showed his work, which was more or less conventionally realistic, in 1928. While setting up solo shows in Amsterdam in 1937 and Paris in 1939, he discovered the work of Vincent Van Gogh and the cubism of Georges Braque. From Van Gogh he absorbed a passion for color, from Braque, the value of a well-ordered composition. The two impulses or styles coexist in and give tension to his work up to the present day. Other important influences were that of the painter and tapestry designer Jean Lurçat, the landscape painter Giorgio Morandi, and the sculptor Medardo Rosso.

In the early 1940s Santomaso exhibited in Genoa, Florence, Milan, and Rome. His painting at this time could be loosely described as post-impressionist, with some of the flavor of cubist subject matter, as in *Store and Guitar* (1940–44) and innumerable still lifes of pitchers, bottles, irons, and other household objects. In *Window* (1943), the artist used a rectangular pattern of mullions to make a first assay into semiabstraction.

Santomaso was associated in the mid-1940s with the artists Renato Birolli, Renato Guttuso, Ennio Marbotti, Guiseppi Pizzinato, and Emilio Vedova. This group later formed the so-called New Italian Artists' Secession, which became known as the Fronte Nuovo delle Arti (New Front of the Arts). This, the first postwar Italian movement oriented toward abstraction, firmly pushed Santomaso to the freedoms of his later style. In 1945 he edited and illustrated a collection of poems by Paul Eluard, *Grande air*. He was also interested in Byzantine art and spent long hours studying the mosaics in Venice's Basilica of San Marco. This may in part explain the rich encrustations of pigment that began to appear in his painting. *Nude* (ca. 1945), for example, is worked in a heavy impasto with occasional thick black outlines. *The Beggar* (ca.

© Graziano Arici Photos, Venice

GUISEPPE SANTOMASO

1947) and *The Fisherman* (ca. 1948), also thickly painted, are broken up into roughly geometrical shapes, but not so much so that the expression of pathos or stoicism on the subjects' faces is lost.

In 1952, along with Afro Basaldella, Mattia Moreni, Emilio Vedova, and others, Santomaso formed the Otto Pittori Italiani (the Italian Eight), which, according to Lionello Venturi, advocated an "abstract-concrete" style. Breaking through to what appeared to be complete abstraction in his own work, Santomaso began to develop a personal repertoire of signs, notably a swirled or knotted line, which he applied repetitively over heavily saturated colors. *The Sunken Boat* (1952), two works entitled *Dawn Over the Scythes* (both of 1953), and *Loose Tufts of Grass* (1954) demonstrate the various ways he used these linear motifs. There is something of Kandinsky in these works, not so much in style, but in their apparent spontaneity tempered by an invisible control. In 1954 this group of paintings won him the first prize at the Venice Biennale.

In the years that followed his interest in the black signs gradually gave way to a concern with the blending of irregular colored shapes, as in *From the Meridional Side* (1956). Santomaso arrived finally at an abstract expressionist or *tachist* style in the late 1950s. In *Fire of Santa Maria de Mar* (1959), a representative example, pigment is thickly and expressively applied with brush, palette knife, and spatter-stroke. Underneath the gestural surface, which is punctuated by active black forms reminiscent of the signs of a few years before, is a loose geometrical structure. Despite the thoroughly abstract nature of

°sän tō mä´sō, jōō zep´pä

the work, the artist still claimed to be working, however inscrutably, from nature. Evidence for this can be inferred from the changes in his palette and imagery stemming from his trips to Poland and Spain in 1958–60. As Umbro Apollonio wrote, "His painting presupposes a dialectical relationship between real and imaginary elements."

The 1960s brought a softening of Santomaso's tachist technique, then its eventual elimination by 1970. In this he followed the general movement of European and American Abstractionists away from an energetic emotionalism and toward a cooler, more color-based art. In Santomaso's work, this trend began in the later "Suite Friulana" series (*Number 12*, 1964, for example). A random but uniform distribution of spattered stars and a white horizon line are all that activate the deep blue field of *Blue Space No. 2* (1967). By the time of *Interrupted Azure* (1972) or *Gray-Blue* (1972) there is no gesturalism to be seen, only a confident manipulation of hues and values. It is difficult to see anything of nature in the irregular forms of, say, *Red With Angles* (1970), *Disquieting Space* (1972), or *Black and Yellow Tension* (1972), but despite this lack of "naturalism," their inspiration was presumably nature. Santomaso himself said: "One is within things and with things; there are no images without nature." In a more transcendental vein, Guiseppe Marchiore wrote in the catalog to the artist's 1960 solo shows in Brussels and Amsterdam: " . . . He reaches unknown depths of the soul."

EXHIBITIONS INCLUDE: Venice 1928; Gal. Charpentier, Paris 1940; Genoa 1940; Florence 1940; Milan 1942; Rome 1943; Hanover Gal., London 1953; Munich 1955; Grace Borgenicht Gal., NYC 1957, '59, '61, '62, '65, '68; Rome 1959; Palais des Beaux-Arts, Brussels 1960; Stedelijk Mus., Amsterdam 1960; Zürich 1966; Staatsgal. Moderner Kunst, Munich 1980. GROUP EXHIBITIONS INCLUDE: Exposizione al Ponte, Florence 1943; São Paulo Bienal 1953, 1961–62; Venice Biennale 1954, '62; International Exhibition of Engraving, Ljubljana, Yugoslavia 1957.

COLLECTIONS INCLUDE: Brooklyn Mus. of Art, N.Y.; Albright-Knox Art Gal., Buffalo, N.Y.; Mus. of Fine Arts, Boston; City Art Mus., St. Louis, Mo.; Gal. Nazionale d'Arte Moderno, Rome; Mus. of Modern Art, São Paulo; Mus. of Modern Art, Rio de Janeiro; Tel Aviv Mus.

ABOUT: Apollonio, U. Santomaso, 1959; Faziolo, M. and others New Art Around the World, 1966; "La Peinture de Santomaso de 1958 à 1960" (cat.), Palais des Beaux-Arts, Brussels 1960; Pellegrini, A. New Tendencies in Art, 1966; Venturi, L. Otto Pittori Italiani, 1952. *Periodicals*—Cahiers d'art (Paris) no. 2 1964.

SCOTT, WILLIAM (February 15, 1913–), British painter, has returned again and again from various forays into abstract styles to the traditional subjects of the tabletop still life, the landscape, and the female nude. Like the Italian painter Giorgio Morandi (who has also been neglected in the United States), Scott has found in the simple shapes of domestic scenes and objects an unlimited arena in which to test and refine the permutations of austere patterns and tonal relationships on flat planes of brilliant color.

William Scott, of Irish-Scottish parentage, was born in Greenock, Scotland, on the Clyde River. In 1924 his family moved to Ireland and Scott studied at the Belfast College of Art from 1928 to 1931. He spent three years at the Royal Academy Sculpture School (1931–34) before transferring to the Painting School, where he worked with the Bloomsbury writers Clive Bell and Roger Fry. Like virtually all British—and especially Scottish—painters of the period, he looked to Paris as the exemplar of modernism; the sensuous color of Derain and Bonnard and the flat tonalities of Cézanne, Manet, and Whistler had a great influence on him. As a student he spent much time copying the early Renaissance masters Fra Angelico and Piero della Francesca; their disciplined geometry appealed to him, as did the dry, matter-of-fact tonalities of the social-realist Euston Road School.

Scott lived in Cornwall with his friend Dylan Thomas in 1936, then spent the years 1937–39 traveling and teaching in France and Italy. In 1937 he married Mary Lucas. Two children, Robert and James, were born of this marriage.

Scott's paintings of the late 1930s, such as *Girl and Blue Table* (1938), *Breton Landscape* (1939), and *Seated Nude* (1939), were in a Gauguin-esque, unadventurous style. (Scott had, in fact, cofounded a summer school at Pont-Aven, Brittany, a favorite spot of Gauguin's.) "For my generation," he said, "neither surrealism nor abstract art had made an appeal, and yet there was little else to put in [their] place. . . . My painting is built on the painting that went before me." He loved French painting and French life, but, as John Russell pointed out, "He never went in for the richly cooked and oversauced way of painting that characterized the School of Paris in its decline. He stood for a barer, more summary way of dealing with the world."

In 1942, the year of his first solo show, at the Leger Gallery, London, Scott volunteered for the Royal Engineers; he found little time to paint seriously until the end of the war when, after a brief return to Brittany, he began teaching at the Bath Academy of Art, Corsham (1946–56).

Jorge Lewinski

WILLIAM SCOTT

There he took up the still life in earnest, turning away from an updated postimpressionism to a more austere and refined style, not unlike that of Ben Nicholson in his still lifes and Aegean landscapes of the 1950s. "Where Scott is exceptional," wrote Charles Spencer in *Contemporary Artists*, "is that, unlike his contemporaries, he progressed to the possibilities of post-Cubism, so that whilst retaining the native love for rich colour and the Scottish instinct for controlled design, he was able to develop a neocubistic formula for the heightened, dramatic presentation of everyday objects." Frying pans (as in *The Frying Pan*, 1946, and *Still Life with Frying Pan*, 1947), bottles, cups, and other kitchen utensils furnished much of his shape vocabulary. His color was restrained—"I've never been able to put on a canvas a red, a green, and a yellow"—but pure and vivid. Typically, he would set two fields of color against each other, heightened by white, black, or neutral-colored shapes; in *Colander, Beans and Eggs* (1948) the white colander, green beans, and brownish eggs sit on a blue table against a deep green wall. By no means as inspired a colorist as Bonnard or even Cézanne, both of whom had explored much of this territory before, Scott put increasing emphasis on the balance of shapes and the negative spaces created by their edges. "The subject of my painting," he told Tony Rothon in a *Studio International* interview, "would appear to be the kitchen still-life, but in point of fact . . . my subject is the division on canvas of spaces and relating one space or one shape to another . . . what I'm concerned about is the exact relationship between each of those forms,

and that fundamentally they should be irregular." By 1950 a definite undercurrent of sexual sybolism (of which Scott was fully aware) became apparent; for example, a bottle and two eggs make an obvious phallic symbol in *Frying Pan, Bottle, and Sardines* (1950). During the next two years his work became increasingly abstract and rectilinear.

In 1953 Scott visited New York, where he met Pollock, de Kooning, Rothko, and Franz Kline, among others. The brash confidence and overwhelming size of abstract expressionist painting both fascinated and repelled him. ("So much American painting is contrived," he said. "Those drips, they are absolute masters at knowing exactly where the drip is going to stop.") Largely in reaction to the American work he returned to England and lived in rural seclusion, determined to pursue a kind of "symbolic realism," antithetical, in his opinion, to abstraction. One positive influence of abstract expressionism was that he began working on a much larger scale. He was greatly influenced by a visit to the Lascaux caves in 1954. In 1958 the British Council organized a retrospective of his work at the Venice Biennale and in 1961 he won the Sanbra Prize at the São Paulo Bienal.

Scott's painting oscillated again toward abstraction in the late 50s. *Blue Painting* (1960), with its rounded rectilinear outlines (obvious reductions of the pans, bottles, and bowls) laid out on horizontal and vertical axes upon a predominantly blue field varied by scrapes, scratches, and blots of pigment right from the tube, illustrates the work of this period. Toward the end of the 1960s, just before his final return to a kind of rarefied representationalism, Scott painted a series of hard-edged, rather decorative public murals, incorporating flat bow-tie, triangular, or curved forms, often blue on a white field.

Pans, cups, and bottles, now only outlines or completely flat shapes without any pretense of illusionism, reappeared in his work about 1968. He also added related shapes taken, he said, from Egyptian hieroglyphs and arranged in hierarchical rows (as in "Egyptian Series 3," 1973). "Pavement graffiti by children and hieroglyphs incised on stone by the ancients are constantly on my mind. The relationship of children to early man and their significance to myself is important." In these later, highly purified works, Scott seems to have perfected the Platonic, and rather sparse, vocabulary of universal shapes he had been seeking, and at the same time achieved a relaxed visual harmony. "I feel that if the spectator looked at one of my paintings and felt like moving one of the forms even a quarter of an inch from its neighbouring form, the balance of

the painting would be thrown out. I'm what the Americans call a compositional painter. I paint compositions in the old-fashioned sense."

EXHIBITIONS INCLUDE: Leger Gal., London 1942, '44, '45; Leicester Gals., London 1948, '51; Whitechapel Art Gal., London 1950; Hanover Gal., London 1953, '54, '56, '61, '62, '63, '65, '67, '68, '69, '71; Martha Jackson Gal., NYC 1956 , '59, '62, '74, 1979–80; Mus. d'Art Moderne, Paris 1958; Venice Biennale 1958; Wallraf-Richartz Mus., Cologne 1959; Kunsthaus, Zürich 1959; Mus. Boymans-Van Beuningen, Rotterdam 1959; Gal. Galeatea, Turin, Italy 1959; Gal. Blu, Milan 1959; Gal. Charles Lienhard, Zürich 1959; Kestner Gesellschaft, Hanover, W. Ger. 1960; Kunstverein, Freiburg, W. Ger. 1960; Mus. om Ostwall, Dortmund, W. Ger. 1960; Städtische Gal., Munich 1960; Robles Gal., Los Angeles 1961; Mus. de Arte Moderna, Rio de Janeiro 1962; Mus. Nacional de Bellas Artes, Buenos Aires 1962; Ulster Mus., Belfast 1963; Gal. Anderson-Mayer, Paris 1963; Gal. Gimpel and Hanover, Zürich 1966; Dawson Gal., Dublin 1969; Bear Lane Gal., Oxford, England 1967; Demarco Gal., Edinburgh 1969; Scottish Gal. of Modern Art, Edinburgh 1971; Tate Gal., London 1972; Gimpel Fils Gal, London 1974, '76, '78; Gal. Moos, Toronto 1979; Imperial War Mus., London 1981. GROUP EXHIBITIONS INCLUDE: "Four Young British Painters," U.K. tour 1946; "Painter's Progress," Whitechapel Art Gal., London 1950; São Paulo Bienal 1953, '61; International Art Exhibition, Tokyo 1955; Pittsburgh International, Carnegie Inst. 1955; Venice Biennale 1958; "Some Aspects of Contemporary British Painting," Toronto Art Gal. 1963; Documenta 3, Kassel, W. Ger. 1964.

COLLECTIONS INCLUDE: Scottish Nat. Gal. of Modern Art, Edinburgh; Nat. Gal. of Victoria, Melbourne, Australia; Art Gal. of Toronto; Walker Art Gal., Liverpool; Solomon R. Guggenheim Mus., NYC; Albright-Knox Art Gal., Buffalo, N.Y.; Brooklyn Mus., N.Y.; Nat. Gal. of Western Australia, Perth; Mus. de Arte Moderna, São Paulo; Victoria and Albert Mus., and Tate Gal., London; Mus. Nat. d'Art Moderne, Paris; Kunsthalle, Hamburg W. Ger.; Gal. Nazionale d'Arte Moderna, Rome; Neue Nationalgal., Berlin.

ABOUT: Alley, R. William Scott, 1963; Bowness, A. (ed.) William Scott: Paintings, 1964; Klepac, L. William Scott: Drawings, 1975; Measham, T. (ed.) The Moderns 1945–1975, 1976; Moore, E. (ed.) Contemporary Art 1942–72: Collection of the Albright-Knox Art Gallery, 1972; P-Orridge, G. and others (eds.) Contemporary Artists, 1977; Read, H. A. Concise History of Modern Painting, 1959. *Periodicals*— Studio August 1962; Studio International December 1974.

SEGAL, GEORGE (November 26, 1924–), American artist, was the most important sculptor of the New Realists of the 1960s. He was born in New York City and grew up in the Bronx, where his father, the late Jacob Segal, ran a small kosher butcher shop—the inspiration for Segal's

© Helaine Messer

GEORGE SEGAL

famous *Butcher Shop,* an 8-by 4-foot tableau of 1965. George's mother, the former Sophie Gerstenfeld, was the model for the composition's knife-wielding figure. As Martin Friedman pointed out, "Segal's proletarian origins are manifest in the way he lives, thinks and works."

The family moved in 1940 to South Brunswick, New Jersey, where the father ran a chicken farm. Raising poultry was a risky venture for transplanted urbanites like the Segals, but the wartime demand for food for America's troops and her allies created a booming market. After years of poverty, the Segal family enjoyed a brief period of prosperity.

After finishing high school in 1941, Segal studied art for a year at Cooper Union, New York City. There, in addition to taking classes in drawing and painting, he carved his first plaster head. When his older brother was drafted into the army in 1942, Segal left school to help work his parents' chicken farm and found that poultry raising was an arduous full-time occupation. Despite the demanding work, he was able to register for part-time painting classes at Rutgers University, New Jersey, where he studied until 1946. On April 7, 1946, he married Helen Steinberg. Two children, Jeffrey and Rena, were born of this marriage.

A year of study at the Pratt Institute, Brooklyn, in 1947 was followed by another year at New York University, from which he graduated in 1950 with the BS degree in art education. Rather than teach, Segal bought his own chicken farm, hoping to secure financial independence. For the better part of the next decade he operated this farm across the road from his parents' home in South Brunswick.

While studying at NYU, Segal had been excited by the transformation of the New York art scene as abstract expressionism came to the fore. After collecting his degree he briefly pursued private study in painting with Hans Hofmann, the so-called dean of action painting. Although Segal respected what he called the "spiritualism" of abstract expressionism, he found it personally uncongenial. As he later explained, "I couldn't divorce myself from the sensual things of life-—things I could touch." In particular, he felt a need for the human figure as a means of objectifying inner experience.

The conflict between the abstract expressionist vogue and his own striving for representational figures was reflected in Segal's earliest drawings, pastels, and paintings, which he first exhibited in 1956 at the Hansa Gallery, an artists' cooperative in New York City's East Village. His paintings, somewhat influenced by de Kooning, received critical attention but did not sell. He had come to detest poultry farming, and he resigned himself to supporting his family indefinitely by teaching art and English classes in local high schools and community centers. He was, however, to gain financial independence and give up teaching six years later.

Through the Hansa Gallery, Segal met other young artists, including his eventual close friends Jan Muller and Allan Kaprow, who were reacting in different ways against abstract expressionism. Acknowledged as the originator of the "happening," an avant-garde synthesis of theater and the visual arts, Kaprow is reported to have staged his first such multimedia event on Segal's farm in 1958—the year Segal divested himself of the chicken business, and began sculpting. (The Segals kept the farm, got rid of the chickens.) Undoubtedly, Kaprow's total-environment experiments had influenced Segal inasmuch as his sculpture places figures in "real" environments.

In the catalog to his 1963 exhibition at the Galerie Ileana Sonnabend, Paris, Segal discussed his earliest ventures in sculpture: "I was preoccupied with the need to achieve my own grasp of pictorial space. I was not satisfied with any existing academic formulas. What would happen if I ventured into real space? I decided to do it. I created a space, or something occupying space by volume, and people call what I created sculpture." But Segal considered his work to be simply a concern for "the presence of man in his daily life." Despite the influence of the total-environment concept, there was a marked difference, as Elena Calas observed, between "the space-time focus of the Happenings" and the gesture frozen in time, the "weighty repose" that was to characterize Segal's figures. Segal partici-

pated in many happenings which took place on his farm, but he chose not to help Kaprow pioneer performance art, regarding himself as "less Wagnerian or grandly ambitious." He wanted to develop an art form based on what he described as "proletarian simplicity, the roughness of old surfaces—this being truthful to my ideas of form."

Segal's sculptures of 1958–60, the "primitive" phase of his development, were rough, crudely defined figures constructed of gobs of wet plaster shaped on armatures of wood, chicken-wire, and burlap. One of his first female figures was *Woman in a Red Jacket* (1958). In his 1959 exhibition of paintings at the Hansa Gallery, Segal showed three hulking nude male figure sculptures (he called them "self-portraits"), formed on wood and wire armatures, standing, sitting, or reclining in front of a trio of roughly brushed figure paintings based on the Biblical tale of Lot, his wife and daughters. The sculptures, in their whiteness, were themselves variations on the "pillar of salt" theme. Through these juxtapositions Segal expressed his desire to extend his painting ideas from the flat canvas into "real space." A few years later, he would completely abandon the canvas for the plaster image.

In 1960 one of Segal's students brought him a large supply of medical scrim, used by physicians in making plaster casts, with the suggestion that it might have an artistic use. Dissatisfied with his plaster-covered armatures, Segal was looking for a new way of creating figures. He had his wife Helen wrap his nude form in cloth strips, water soaked to activate the plaster. This was the genesis of *Man Sitting at a Table* (1960–61). The execution of this stiffly posed self-portrait was difficult and harrowing. When the plaster began to heat up, harden, and contract, the Segals panicked. Helen frantically helped to extricate her husband from the shrinking shell which, when finally pried off, took much of Segal's body hair with it. Segal subsequently refined the plaster-impregnated bandage technique, learning how to cast the figure in sections and convincing his wife and others to pose for him. As he told *Newsweek* (October 25, 1964), "Immediately I knew what I wanted to do . . . I had found my medium."

In the early 1960s Segal made castings of friends and relatives for such tableaux as *Woman Painting Her Fingernails* (1961) and *Women in a Restaurant Booth* (1961–62). He never imagined that his life-size tableaux would sell any better than his giant figurative canvases, but he was determined to go on making them, bearing in mind Brancusi's desire to fill the space he lived in with sculptures. He cleared out

his 300-foot-long chicken-house and filled it with such compositions as *Man on a Bicycle* (1961), *Bus Driver* (1962), *Lovers on a Bench* (1962), and *Dinner Table* (1962). The combination of white plaster figures and actual objects produced an oddly disturbing effect. Seeing the plaster cast sculptures in the important "New Realists" show at the Sidney Janis Gallery, New York City, a *New York Times* (October 31, 1962) reviewer declared them to be "the find of the exhibition . . . as memorable and upsetting as stumbling into a ghost town dusted with fallout."

Color was used in a few of Segal's works of 1963, not in the figures but in their setting. The bathroom tiles in *Woman Shaving Her Leg* were yellow, and brilliant red fluorescent lighting was used in *Cinema,* one of Segal's most celebrated pieces. The tableau was inspired by a scene briefly witnessed by Segal as he was driving home from New York at two o'clock in the morning—"a fellow reaching up to pluck off the last letter from an illuminated sign" on a theater marquee. In actuality the light was outside the theater, shining up from its low position on a wall; but as Segal reconstructed the scene in his mind the light emanated from behind the plexiglass wall, and that is how he built it. After constructing the sign, Segal posed a man in the manner of the theater attendant. "There was something about the formality, the proportions, and the qualities of emanating light that attracted me," the artist explained. "I was composing with bits of objects from the real world. . . . " The use of objects that were, in Segal's words, "considered low-class, anti-art, un-art, kitsch, disreputable" linked his sculpture to the pop movement of the early '60s.

A further development of Segal's casting process was seen in the heavy-limbed nude of 1964, *Woman Brushing Her Hair.* This over-life-size female figure, made from thick layers of bandage coated with handfuls of wet plaster, was seated on a battered wooden kitchen chair and leaned forward with clumsy grace. From the beginning, Segal looked for models who looked like what he called "real people" and whose appearance was deeply etched by life. "I didn't violate their habitual ways of sitting or standing—what they've been doing for years," he said. But Segal's figures are never photographic renderings. As Martin Friedman observed, " . . . Each completed figure, through his alchemy, is more a representation of the sculptor's feelings than a portrait of the person who is posing for him. Through his casting process they become anonymous beings in somber vignettes."

By the mid-1960s Segal, increasingly interested in the spatial relationships between the figures and their surroundings, began to create compositions containing two or more people in minimally defined settings. *Gas Station* (1964) took up an entire side of New York City's Green Gallery, where Segal had a solo show in March 1964. This elongated construction contained two figures carefully placed in relation to other components of the shallow space—a pyramid of oil cans, a stack of crates, tires, and a Coca-Cola machine. This schematic gas station was one of Segal's most "complete" environments.

In *The Diner* (1964–66), the mood was created not so much by the Formica counter, the coffee urn, and the other props, but, as a *Newsweek* (October 25, 1965) critic pointed out, by the way the heads of the waitress and the solitary male customer are cocked. "The two are alone, yet they draw in the viewer as if he too is in the diner, feeling the empty communion of today's Diner U.S.A. culture." One is reminded of Edward Hopper's 1942 painting *Nighthawks,* showing two customers sitting at a counter in a lonely coffee shop at the dead of night, and in fact Mark Rothko once told Segal that his sculptures were "walk-in Hoppers." In spite of similarities in mood and subject matter, Segal was not directly influenced by Hopper. He feels that his sculptures are the result of his need to combine his vision of the world of actuality with the visual impact of a painting by de Kooning or Rothko.

The Butcher Shop (1965) was a memorial to Segal's father, who had died around 1959. As Segal pointed out, "The figure is solidly three-dimensional but the chromium poles and spears become lines—they became immaterial and weightless." The chickens were plaster castings, but the sharp steel hooks, the knife, and the wooden butcher's block were real. The Hebrew letters on the shop window add to the classical severity of the composition.

The female nude is a recurrent motif in Segal's work because, he said, of his "unabashed heterosexual instincts." Typical of his ample, wide-hipped, stately nudes of the '60s is *Woman Buckling Her Bra* (1963); the standing female figure, lost in her thoughts while performing a casual everyday gesture, was reflected in a mirror, which added another dimension to the sculpture.

Segal's white plaster figures have changed very little over the years, but in 1965 he began painting some of his figures in vivid posteresque hues. An extreme example of his color experimentation is *The Costume Party* (ca. 1965). Inspired by a Halloween party he had attended, Segal wanted to introduce an element of fantasy that would contrast with what he called his

"relentlessly banal" subject matter. Segal's traveling retrospective of 1978–79 included several pieces whose figures were painted in vibrating primary colors—as in *Blue Girl on Black Bed* (1976)—but to some viewers the added color vitiated the mystery, inwardness, and strange poetry of Segal's characteristic works. Reviewing a Segal show at the Janis Gallery, a *New York Times* (January 28, 1977) critic wrote, " . . . The color seems gratuitous, even jarring to the emotional presence of the plaster figures. It looks rather gimmicky, and adds little." Segal was capable of a much more expressive use of color, as was evident from the large group of pastel figure drawings from the late '50s and early '60s which were included in his retrospective of 1978–79. John Russell wrote in *The New York Times* (June 1, 1979) that the pastel drawings "reveal a vivacity of pose and a resourcefulness of color that necessarily come out only rarely in the sculptures."

Far more satisfying than his color experiments are Segal's works that contain or suggest movement. One of his most "kinetic" compositions is the 1965–67 portrait of his friend John Chamberlain, the sculptor, who is shown welding a great twisted metal form. In *Man Leaving a Bus* (1967), a white plaster man is about to descend from the rear of an actual bus, a truncated section in yellow-painted metal, complete with glass and chrome fittings. In *The Subway* (1968) a plaster woman is seated in a subway car (a discard Segal bought from the New York Transit Authority) and flashing electric signs suggest movement between stations.

Segal has not hesitated to use technology in his compositions, particularly in his urban tableaux. In *Times Square at Night* (1970) the environment consists entirely of lighted signs behind the two figures. The signs were small scale, contributing to the effect of distance and perspective. In *The Bar* (1971) a man seated near a lighted Budweiser beer sign watches a working television set. These are among Segal's compositions that convey the anomie and loneliness of urban life.

In 1970 Segal received an honorary degree from Rutgers University, and the following year his work was exhibited in Holland, Germany, France, and Belgium. In 1973 he was invited to Israel under the auspices of the Tel Aviv Foundation for Art and Literature to create a work in honor of the new nation. Segal chose the theme of Abraham and Isaac, but there was apprehension about his so-called "desanctifying" style. Segal's heavy, brooding figure of Abraham contemplating his bound child was not impious, but Friedman voiced the critical consensus when

he remarked that "the realism of the encounter dissipates its spiritual effect."

In 1971 Segal changed his technique by shifting from "outside" to "inside" casting. The new process enabled him to make accurate impressions of models' hair, skin, and clothing. In 1974 he executed six small frontal torso sculptures, the "Girl in Robe" series. The shell-like casts were fastened to rectangular surfaces, and rough plaster backgrounds were build up around them. These headless "battered Aphrodite images," as they have been called, have a Greek character and provide an interesting counterpoint to the full-length tableau.

Among Segal's many variations on the theme of the nude is *Lovers on a Bed II,* an impromptu work of 1970. This sculpture of an embracing couple portrays two of the artist's friends, who quite unselfconsciously volunteered to pose while at a party on the Segal farm. The figures are more sad than erotic, for they recall those victims whose bodies have been preserved at Pompeii. On the other hand, his *Girl on a Red Wicker Couch* (1973), a lithe figure sprawled in a provocative Balthus-like pose, is distinctly erotic. One of the most striking of Segal's later tableaux is *Walk—Don't Walk* of 1976. Having noticed that "people moving around seem to be in some kind of hypnotic dream state," he wondered: "How would it be to see a group of people waiting on a street corner for a light to change?" Following what he called his "usual voyeuristic impulse," he placed two men and a woman on a chunk of sidewalk, cast in plaster and painted, next to a Walk—Don't Walk sign, one of those tapering aluminum columns which Segal finds "quite massive and impressive from a three-dimensional point of view." The three pedestrians are oblivious to one another as they wait for the light to change.

A major retrospective which opened at the Walker Art Center, Minneapolis, in late 1978, moved to San Francisco, and was shown at the Whitney Museum of American Art, New York City, from May to July 1979, brilliantly surveyed Segal's achievement. John Russell noted that earlier Segal pieces like *The Butcher Shop,* which had been so shocking when first exhibited, were now classics of the late modern era. The color pieces, which Segal had unveiled in 1976, were accorded a mixed reception, although *The Corridor* (1976), a blue figure of a young woman standing between a yellow door and a red chair with a black wall in the background, was impressive. According to Segal, the composition had been partly inspired by a never-exhibited Barnett Newman painting in black with a vertical yellow stripe in the left-hand corner.

George Segal, stocky, muscular, and bespectacled, still lives and works on his farm in South Brunswick, New Jersey, although he and his wife frequently visit in New York City. His attitude toward himself and his work is utterly unpretentious.

It is ironic that when Rodin first exhibited his *Age of Bronze* in the Paris Salon in 1877, critics, startled by its naturalism, accused the sculptor of having cast his figure from a live model, and all his life Rodin resented the unfounded accusation. With Segal on the other hand, the casting in plaster constitutes the very basis of his search for artistic truth, although for him "the hunt is not for verisimilitude, not for naturalistic reproduction—it's a hunt for the spirit." In these frozen moments from real life, Segal often seems, as Friedman observed, to be reflecting on mortality. Although his white figures strike viewers as sad, Segal asserts, "For me, these people have something like a structural dignity, an iron against the world."

Though it bears affinities with pop art, Segal's work is outside easily identifiable trends. "The history of American art has been an incredible succession of intellectual fashions for the last 15 years," Segal said, "and I think if there is any movement on the part of . . . artists, it's about synthesis. . . . I love to deal with abstraction. I love to probe and examine, but I feel it has to be rooted in reality."

EXHIBITIONS INCLUDE: Hansa Gal., NYC 1956–59; Rutgers Univ., New Brunswick, N.J. 1958; Green Gal., NYC 1960, '62, '64; Gal. Ileana Sonnabend, Paris 1963; Sidney Janis Gal., NYC from 1965; Gal. of Contemporary Art, Chicago 1968; Gal. der Spiegel, Cologne 1970; Gal. Onnasch, Cologne 1971; Univ. of Wisconsin, Milwaukee 1973; André Emmerich Gal., Zürich 1975; "George Segal: Environments," Inst. of Contemporary Art, Univ. of Pennsylvania, Philadelphia 1976; "George Segal: Sculptures," Walker Art Center, Minneapolis 1978–79; "George Segal: Sculptures," San Francisco Mus. of Modern Art1979; "George Segal: Sculptures," Whitney Mus. of Am. Art, NYC 1979. GROUP EXHIBITIONS INCLUDE: Boston Arts Festival 1956; "The New York School, Second Generation," Jewish Mus., NYC 1957; Whitney Annual, NYC 1960, '64, '68; "The New Realists," Sidney Janis Gal., NYC 1962; São Paulo Bienal 1963, '67; "American Pop Art," Nat. Mus., Stockholm 1964; Palais des Beaux-Arts, Brussels 1965; "American Sculpture of the Sixties," Los Angeles County Mus. of Art 1967; "Protest and Hope," New School Art Center, NYC 1967; "The 1960's," MOMA, NYC 1967; Art Gal. of Ontario, Toronto 1968; Documenta 4, Kassel, W. Ger. 1968; "The Obsessive Image," I.C.A., London 1968; "American Artists of the Nineteen Sixties," Boston Univ. 1970; Expo '70, Osaka, Japan 1970; "Figures/Environments," Walker Art Center, Minneapolis, Minn. 1970–71.

COLLECTIONS INCLUDE: MOMA, Whitney Mus. of Am. Art, and Solomon R. Guggenheim Mus., NYC; Albright-Knox Art Gal., Buffalo, N.Y.; Newark Mus., N.J.; Wadsworth Atheneum, Hartford, Conn.; Philadelphia Mus. of Art; Nat. Collection of Fine Arts, Smithsonian Instn., Washington, D.C.; Cleveland Mus. of Art; Art Inst. of Chicago, and Mus. of Contemporary Art, Chicago; Des Moines Art Center, Iowa; Walker Art Center, Minneapolis; Detroit Inst. of Arts; City Art Mus., St. Louis, Mo.; Joslyn Art Mus., Omaha, Neb.; Nat. Gal. of Canada, Ottawa; Art Gal. of Ontario, Toronto; Vancouver Art Gal., British Columbia; Kaiser Wilhelm Mus., Krefeld W. Ger.; Stedelijk Mus., Amsterdam; Nat. Mus., Stockholm.

ABOUT: Calas, N. and others Icons and Images of the Sixties, 1971; Current Biography, 1972; Friedman, M. and others "George Segal: Sculptures" (cat.), Walker Art Center, Minneapolis, Minn., 1978; Henri, A. Environments and Happenings, 1974; Lippard, L.R. Pop Art, 1966; van der Marck, J. "Eight Sculptors: the Ambiguous Image" (cat.), Walker Art Center Minneapolis, 1966. *Periodicals*—Art in America Summer 1983; Art International March 20, 1964; Art News February 1964, February 1977, January 1979, Summer 1981; New York Times October 31, 1962, January 28, 1977, June 1, 1979, April 27, 1984; New York Times Magazine May 20, 1979; Newsweek October 25, 1965; Playboy December 1971; Studio International January 1965.

***SHAHN, BEN(JAMIN HIRSCH)** (September 12, 1898–March 14, 1969), American painter, printmaker, illustrator, and photographer, was the most important artist in the social realist movement of the 1930s, which included Philip Evergood, William Gropper, and Jack Levine. Shahn applied his considerable talent as a draftsman, colorist, and typographer to satiric, sometimes bitter but more often compassionate commentary on American social injustice, working in a distinctive and lucid style that, despite its aesthetic sophistication, was far more influential on illustrators than on contemporary painters. As Shahn's art became widely popular in the 1950s and '60s, it lost much of the fresh indignation that had energized it; instead Shahn drew on allegory and myth to express the general texture of human suffering.

Shahn was born in the Lithuanian city of Kovno (now Kaunas) to a family of Jewish radical socialists. His father, Hessel, a carpenter and woodcarver, was exiled to Siberia a few years after Ben was born for harboring a fugitive. He escaped to America and in 1906 brought the family over to live in the crowded tenements of Brooklyn. Shahn was eight years old. "The immigration worked a cataclysmic change," he wrote in *Love and Joy About Letters*. "All the secure and settled things were not settled at all. I

° shän

American Academy & Institute of Arts and Letters, NYC

BEN SHAHN

learned that. . . . there was an American history and a world history that were remote and unreal and concerned people that were strange to me and had nothing to do with my family or with Abraham, Isaac, and Joseph."

At the age of 13, Shahn, who had begun drawing very early, was taken out of school and apprenticed to a commercial lithographer in Manhattan. There he laboriously mastered the complicated lithographic process while learning the rudiments of typography and logo design. At night he studied art at the Educational Alliance, the school for Jewish immigrants and workers on the East Side, getting his first taste of the great works of Western art, virtually unknown in the insular world of eastern European Jewry. Lithography was, at that time, an extremely lucrative profession for an immigrant; in 1921, now a journeyman, he was able to pay for classes at New York University. He spent his summers studying marine biology at the Woods Hole laboratories in Massachusetts. Later he transferred to City College and the Art Students League in New York. In 1922 he married Mathilda Goldstein, traveling with her to Europe in 1924–25 and again in 1927–29. Shahn took classes at the Sorbonne and the Grande Chaumière, carefully studying Dufy, Rouault, Modigliani, and Cézanne, and working through the style of each in turn. He returned in 1929 to New York City, where he shared a studio with Walker Evans, who taught him the basics of photography.

For all his newly acquired technical proficiency and experience of the world, Shahn still lacked a personal subject and style. "I had seen all the right pictures," he said, "and read all the right books. . . . But it still didn't add up to anything. . . . The French school [was] not for me." Shahn's family heritage of political protest pointed the way out of his dilemma. After completing the border illustrations and hand-lettered Hebrew text for a Haggadah (the prayerbook for the Passover ritual), he painted, in 1930, 13 satirical gouaches of the principal characters in the celebrated Dreyfus case (in which Alfred Dreyfus, a Jewish officer in the French Army, was twice convicted of treason on false evidence). The Dreyfus paintings were based in part on Shahn's sharp observations of period (late 19th century) photographs, a methodology he continued in the series of 23 gouaches called "The Passion of Sacco and Vanzetti" (1931–32). This, his first mature (and, to some, still his best) work of social criticism, was shown at the Downtown Gallery, New York City, in 1932.

While in Paris, Shahn had participated in mass protests against the trial and execution of Nicola Sacco and Bartolomeo Vanzetti, immigrant Italian anarchists, for the murders of a paymaster and a guard during the robbery of a Massachusetts shoe factory. "Ever since I could remember," wrote Shahn, "I'd wished that I'd been lucky enough to be alive at a great time—when something big was going on, like the Crucifixion. And suddenly I realized I was. Here I was, living through another crucifixion. Here was something to paint!" Shahn made palpable the social and political prejudice of judge and jury toward the defendants, in a terse unsentimental and newly expressive style, conveying the tragedy in the details of hands, faces, and postures. "The Passion of Sacco and Vanzetti," which became part of the continuing debate over the merits of the case itself, drew wide publicity and heated comment and thrust Shahn to the forefront of American Social Realists. In 1933 he painted 15 works on the conviction and imprisonment of the labor leader Tom Mooney.

Diego Rivera, the Mexican muralist, had seen Shahn's work and in 1933 invited him to work as his assistant on the RCA Building fresco at Rockefeller Center, New York City. Although the mural was never completed (because Rivera incorporated into it a likeness of Lenin), Shahn learned the techniques of large-scale work and in addition acquired something of Rivera's boldness of color and imagery. Possibly because of his connection with the mural, Shahn's satirical studies on Prohibition for the Central Park Casino mural (1934) and his panels on prison abuse and reform for Riker's Island Penitentiary (1934–35) were both rejected by New York City's conservative Municipal Art Commission as "unsuitable," a bitter disappointment to him.

He did complete public commissions for the Roosevelt Federal Housing Project in New Jersey (1937–38), where he lived for many years, for the Bronx Central Annex Post Office (1938, a collaboration with his second wife, the painter Bernarda Bryson), and for the Farm Security Building, Washington, D.C. (1940). The early murals, particularly the fresco at the Roosevelt Project, are crowded with didactic scenes of social injustice being overcome by enlightened education, housing, and labor reform; the Bronx Annex panels, in contrast, are calmer, more monumental treatments of individual laborers.

In 1935 Shahn took up photography for Roy Stryker's Farm Security Administration photography unit, along with Walker Evans, Dorothea Lange, Arthur Rothstein, Margaret Bourke-White, and others. By 1938 he had taken some 6,000 photos of the unemployed, homeless, and destitute of the South and Midwest, all "pictures that cried out to be taken," he said. These photographs had a profound effect on his painting, as can be seen not only in his murals but also in such easel paintings as *Years of Dust* (1936), *Man Eating Sandwich* (1938), *Vacant Lot* (1939), *Handball* (1939), *W.P.A. Sunday* (1939), and *Photographer's Window* (1940). "The use of documentary photos," wrote Daniela Palazzoli in *Contemporary Photographers* (1982), "enabled Shahn to avoid sentimentalism and idealization and to give his records a sense of objectivity by the care he took with realistic details." There was a philosophic dimension to Shahn's naturalism. He once said, in the 1930s, "There's a difference in the way a twelve-dollar coat wrinkles from the way a seventy-five dollar coat wrinkles, and that has to be right. It's just as important esthetically as the difference in the light of the Ile de France and the Brittany Coast. Maybe it's more important."

Shahn spent the late 1930s and early '40s distilling what were, for him, the important elements of the human image: broad, wary faces, more drawn than modeled, and strong, clenched hands dominating a stocky, shortened body. His figures appeared most often against architectural backgrounds; the impersonal geometry of empty brick walls, rows of tenement windows, tumbles of ruined masonry, or the blank shingles of boarding houses. Curiously, he did not treat the theme of war directly, but instead portrayed its effect on children. In *Reconstruction* (1945), for instance, Italian children, to quote James Thrall Soby, "pose and teeter upon the shattered blocks of ancient civilization." Nor did Shahn ever do a work on the Holocaust, although he did return to Old Testament themes later in life.

After World War II Shahn, now internationally known and respected, was besieged by requests for magazine and advertising illustrations. Perhaps in reaction to the commercialization (and widespread imitation) of his work, he initiated major changes in his style. His painting became much more simplified, more linear, and more intentionally crude; possibly under the influence of abstract expressionism, he replaced the somber blacks, browns, and maroons of his Depression-era work with exaggerated reds, pinks, blues, and greens. This style was well suited to reproduction in art lithographs and silkscreens, which Shahn produced in large numbers from the early 1950s.

With *Allegory* (1948) and *Epoch* (1950), his work took a turn toward symbolic abstraction. Through the 1950s and '60s images of mythological beasts (*Harpy*, 1951; *The City of Dreadful Night*, 1951; *Incubus*, 1954) and metaphors of collective anxiety (*Labyrinth*, 1952; *Age of Anxiety*, 1953; *Everyman*, 1954) vie with more decorative studies of musicians and instruments (*Composition for Clarinets and Tin Horn*, 1951; *Lute I*, 1957). Science—both its romance and its life-threatening power—fascinated him as well, as in *Blind Botanist* (first version 1954), *Helix and Crystal* (1957), and *The Physicist* (1961). Nor did he completely abandon more explicit political images. *The Defaced Portrait* (1955), a savagely painted-over portrait of a fat, beribboned general, and *Goyescas* (1956), in which a Franco-like figure in Bonaparte hat holds up a cat's cradle over a heap of the dead and dying, are his most effective indictments of militarism and tyranny, but they lacked the sharp specificity and impact of his photographically based works. The one major exception to this trend was the series "Kuboyama and the Saga of the Lucky Dragon" (1960–63; published in book form in 1965), concerning the disastrous fate of the crew of a Japanese fishing trawler that sailed too close to the H-bomb test on Bikini Atoll in 1954 and was covered with radioactive ash. The testimony of Aikichi Kuboyama, the crewman who died of radiation sickness, is expertly incorporated into the paintings (a technique Shahn used often), making real the incomprehensible threat of nuclear annihilation. In between these major works, Shahn made hundreds of drawings, prints, and portraits; designed theatre backdrops, posters, mosaic murals, and stained glass windows; wrote several books and illustrated many others; and lectured at a number of universities.

In his last years, despite his international reputation—his prestige may well be greater in Europe than in the US—and numerous honors, Shahn was no longer much discussed in the art world, which seemed to have passed him by.

(However, current Neoexpressionist painters owe him a large and unacknowledged debt.) On his part, he resented the dominance of action painting during the 1950s and early 1960s, although he was friendly with de Kooning and Pollock. "How many possible gestures of the arm are left?" he asked. "How many more accidents can the materials provide?" He liked pop, partly for its photographic inspiration, and above all he consistently championed the human form as the most expressive and powerful of images. "I believe that there is at this point in history," Shahn wrote in 1949, "a desperate need for the resurgence of humanism, a reawakening of values. I believe that art—art of any kind—can play a significant part in the reaffirming of man."

Less than a year after the death of his daughter Susanna, Ben Shahn died in New York City of cancer at the age of 70. His surviving daughter, Judith, is a talented artist. Retrospectives were held at the New Jersey State Museum, Trenton, in 1969, and a retrospective exhibition toured Japan, where Shahn's work had long been admired, in 1970.

EXHIBITIONS INCLUDE: Downtown Gal., NYC 1930, '32, '33, '44, '49, '51, '55, '59, '61; Harvard Society of Contemporary Art, Cambridge, Mass. 1932; Julien Levy Gal., NYC 1940; Art Inst. of Chicago 1945, '54; MOMA, NYC 1947, '69; Albright-Knox Art Gal., Buffalo, N.Y. 1950; Phillips Memorial Gal., Washington D.C. 1950; Arts Club, Chicago 1951; Mirsky Gal., Boston 1951; Santa Barbara Mus. of Art, Calif. 1952; Minneapolis Inst. of Arts 1953; U.S. Pavilion, Venice Biennale 1954; Detroit Inst. of Arts 1954; Gal. La Tartaruga, Rome 1955; Fogg Art Mus., Cambridge, Mass. 1957, '69; Am. Inst. of Graphic Arts, NYC 1957; Katonah Gal., N.Y. 1959; Gal. dell'Obelisco, Rome 1959, '60; Leicester Gals., London 1959, '64; Univ. of Louisville, Ky. 1960; Univ of Utah, Salt Lake City 1960; Stedelijk Mus., Amsterdam 1961; Staatliche Kunsthalle, Baden-Baden, W. Ger. 1962; Dartmouth Col., Hanover, N.H. 1963; Gal. Ciranna, Milan 1966; Philadelphia Mus. of Art 1967; Orland Gal., Encino, Calif. 1968; Kennedy Gals., NYC 1968, '69, '70, '71, '72; Mus. of African Art, Washington, D.C. 1968; New Jersey State Mus., Trenton 1969; Ankrum Gal., Los Angeles 1969; Nat. Mus. of Modern Art, Tokyo 1970; Gal. Ann, Houston 1972; Joseph Devernay-Berhen and Co., NYC 1972; Joseph Devernay-Esther Begell, Washington D.C. 1973, '76; Joseph Devernay Schloss Remseck, Basel 1974; Allentown Art Mus., Pa. 1975; Jewish Mus., NYC 1976; Lowe Art Mus., Syracuse, N.Y. 1977; Univ. of Georgia, Athens 1977; Maurice Spertus Mus. of Judaica, Chicago 1977; Univ. of Texas at Austin 1977; Cincinnati Art Mus. 1977; Amon Carter Mus., Fort Worth, Tex. 1977; Centre Culturel Américain, Paris 1978; Nandin Gals. NYC 1979. GROUP EXHIBITIONS INCLUDE: "33 Moderns," Downtown Gal., NYC 1930; "Murals by American Painters and Photographers," MOMA, NYC 1932; "Modern Works of Art: 5th Anniversary Exhibition," MOMA, NYC 1934;

"Photographs," W.P.A. Federal Art Project Gal., NYC 1936; "20th Century Artists," Whitney Mus. of Am. Art, NYC 1939; "American Realists and Magic Realists," MOMA, NYC 1943; "Survey of American Painting," Tate Gal., London 1946; "100 American Paintings of the 20th Century," Metropolitan Mus. of Art, NYC 1950; "De Kooning, Pollock, Shahn," Arts Club, Chicago 1951; "Roy and Marie Neuberger Collection," Whitney Mus. of Am. Art, NYC 1955; "50 Modern Artists," Brussels Exposition 1958; "18 Living Americans," Whitney Mus. of Am. Art, NYC 1959; "Oposizione al Nazismo," Gal. dell'Obelisco, Rome 1961; "The Painter and the Photograph," Univ. of New Mexico, Albuquerque 1964; "A Vision Shared: FSA Photographs," Witkin Gal., NYC 1976; Documenta 6, Kassel, W. Ger. 1977; "Les Années de l'Amérique en crise," Gal. Municipale du Château d'Eau, Toulouse, France 1980.

COLLECTIONS INCLUDE: Fogg Art Mus., Cambridge, Mass.; MOMA, Jewish Mus., Metropolitan Mus. of Art, and Whitney Mus. of Am. Art, NYC; Brooklyn Mus., N.Y.; Albright-Knox Art Gal., Buffalo, N.Y.; Baltimore Mus. of Art; Univ. of Arizona, Tucson; Art Inst., Chicago; Wadsworth Atheneum, Hartford, Conn.; Univ. of Illinois, Urbana; Newark Mus., N.J.; Phillips Collection, Washington, D.C.; Walker Art Center, Minneapolis; Santa Barbara Mus. of Art, Calif.; Wichita Art Mus., Kans.; Butler Inst. of Am. Art, Youngstown, Ohio.

ABOUT: Bush, M. Ben Shahn: The Passion of Sacco and Vanzetti, 1968; Pratt, D. The Photographic Eye of Ben Shahn, 1975; Prescott, K. W. Ben Shahn, 1976; Rodman, S. Portrait of the Artist as an American: Ben Shahn, 1951, Conversations with Artists, 1961; Shahn, B. Symposium: The Relation of Painting and Sculpture to Architecture, 1951, Paragraphs on Art, 1952, Love and Joy About Letters, 1954, The Biography of a Painting, 1956, The Shape of Content, 1957; Shahn, B. Ben Shahn, 1975; Soby, J. T. Ben Shahn, Penguin Modern Painters, 1947, Ben Shahn: This Graphic Art, 1957, Ben Shahn: Paintings, 1963; Weiss, M. Ben Shahn, Photographer, 1976.

*SIQUEIROS, DAVID ALFARO (December 29, 1896–January 6, 1974), Mexican painter, was, with Diego Rivera and José Clemente Orozco, a founder of modern mural painting in Mexico. A controversial leftist, Siqueiros declared that "modern Mexican painting is the expression of the Mexican revolution" and advocated a democratic, monumental public art.

He was born in Chihuahua, Mexico, into a cultivated family. His father was a lawyer, his mother the daughter of the poet and politician Felipe Siqueiros. From 1907 to 1910 he attended the National Preparatory School of Mexico City and in 1911 enrolled in the Academia de Arte de San Carlos, Mexico City. As a teenager he was interested in Mexican archeology and folk art

°sē kâ´ er ōs

DAVID ALFARO SIQUEIROS

and was an ardent supporter of Mexican rebels who opposed the draconian rule of President Porfirio Diaz. These interests were encouraged by his teacher at the academy, Dr. Atl. In 1912 Siqueiros attended the open-air academy in Santa Anita and studied at the Mexican Academy, Mexico City, with Orozco in 1913–14. However, his courses with Orozco were interrupted by the uprising against President Diaz, and in 1913 Siqueiros joined the revolutionary faction of General Venustiano Carranza, who two years before had sided with the rebel leader Francisco Madero. From 1914 to 1922 Siqueiros served on the general staff of the Mexican Army, rising to the rank of captain. During this period Siqueiros began to view painting in relation to the social changes for which he was fighting.

In 1919 Carranza, now president of Mexico, sent Siqueiros to Europe on a combined diplomatic and artistic mission. Posted to the Mexican Embassy in Madrid, he visited Paris in 1920, where he later met Diego Rivera and came into contact with cubism, futurism, dadaism, and other modern movements. In Barcelona, in 1921, he founded a review, *Vida Americana*, in which he published his "Manifesto to the Artists of America." In that first of three appeals to American artists he urged them to renounce their subservience to European aesthetics and called for the creation of a heroic, monumental art for the masses, and not for the exclusive enjoyment of the elite or a few privileged collectors. Siqueiros envisioned a humanistic art based on pre-Columbian traditions and the rich heritage of contemporary Mexican folk art.

After his return to Mexico in 1922 Siqueiros

was commissioned, along with Orozco, Rivera, and others, to paint murals in the National Preparatory School of Mexico City, a project completed in 1924. His contribution was *The Elements*, his first mural. The social content in this and other early murals by Siqueiros is marked by a quasi-religious symbolism. However, in *The Elements* Siqueiros failed to realize completely the aesthetic and social aims he had set forth in his first manifesto. In 1924 he and Orozco founded the Syndicate of Technical Workers, Painters, and Sculptors. Also that year he published a second manifesto, in which he wrote: "Our fundamental esthetic goal is to socialize artistic expression. . . . We hail monumental expression because such art is public property." In 1924–25 Siqueiros served as coeditor of the Syndicate's fiery magazine, *El Machete*.

About 1925 Siqueiros abandoned painting for five years to help organize labor unions in Guadalajara. (He did, however, paint one small picture, *The Proletarian Mother*, in 1929.) His militant communist politics tied the fortunes of Siqueiro's career to the changing political character of Mexican governments. In 1930 a conservative regime sent him to prison in Mexico City, where he resumed painting. Later that year he fled, first to Argentina, then to the United States, and in 1932 was officially banished by the Mexican government. Some of his paintings were subsequently destroyed, but, nevertheless, a solo exhibition of his work was held in the Casino Español, Mexico City, in 1932.

In the early '30s, while in exile, Siqueiros toured the US and South America; also, he further developed his concepts of a people's art by organizing teams of muralists, assistants he called mural block painters, who sprayed pigment on outdoor concrete facades. These collective works included a fresco of 1932 in the Plaza Art Center, Los Angeles. Also that year Siqueiros taught mural painting at the Chouinard School of Art, Los Angeles; one of his students was Philip Guston.

During this period Siqueiros was a productive easel painter. In 1931 he painted *Zapata*, a powerful head-and-shoulders image of the Mexican revolutionist and folk hero. (The over-life-size portrait [53¼ by 41½ inches] was owned by Charles Laughton, then by Tyrone Power, and is now in the Hirshhorn Museum and Sculpture Garden, Washington, D.C.). Zapata had also appeared in murals by Rivera and Orosco, but Siqueiros's monumental treatment, with its limited palette, is less decorative and colorful than Rivera's renderings and less expressionistic than Orozco's. Also in the early '30s, Siqueiros met the Russian

filmmaker Sergei Eisenstein, who influenced him in the use of photomontage, a technique Siqueiros used in such murals as *Portrait of the Bourgeosie* (1939) to dramatize his revolutionary message.

In 1933, during a stay in Buenos Aires, Siqueiros began to use synthetic resins to give a relief texture to the surfaces of his paintings and also began to experiment with weather-resistant plastics such as duco and ethyl silicate for his exterior murals. In 1936–37 he founded the Experimental Workshop in New York City, where he "demonstrated the use of new synthetic and industrial materials, photomontage, and drip techniques," according to *The Oxford Companion to Twentieth-Century Art.* Jackson Pollock studied briefly with Siqueiros at the workshop. In late 1937 Siqueiros went to Spain to serve in the Republican army; he was made a division commander and held the rank of colonel. The Spanish Civil War inspired one of his best-known and most powerful paintings, *Echo of a Scream* (1937; Museum of Modern Art, New York City), in duco on wood.

After returning to Mexico in 1939 Siqueiros founded the antifascist newspaper *Documental.* He was accused of complicity in the Stalin-inspired attempt in 1939 to assassinate Leon Trotsky, who was staying in Diego Rivera's home. Siqueiros was arrested and imprisoned, and after his release went into exile again. He traveled to Chile, where he initiated huge mural projects, including *Death to the Invader* (1942; Escuela Mexico, Chillan), which many consider his finest work, and then to Cuba, where he painted *Allegory of Racial Equality* (1943). He also spent time in Peru, Ecuador, Colombia, and Panama before returning to Mexico in 1944.

In addition to painting small-scale easel pictures and executing large murals for public buildings, in the late '40s Sequeiros continued to experiment with new materials and techniques. Among his Mexico City murals of this period were *New Democracy* (1945; Palace of Fine Arts, Mexico City) and *Patricians and Patricides* (1945). He also founded the Center for Realist Art, published articles on art, and in 1948 taught at the School of Fine Arts, San Miguel de Allende. Siqueiros gained international recognition when he was awarded the international second prize at the Venice Biennale of 1950 (first prize went to Henri Matisse).

In the early '50s Siqueiros began to explore the possibilities of what he termed "sculpto-painting" in an attempt to merge the relief qualities of sculpture with the painted surface. His chief mural commissions in that decade were *Ascent of Culture* (1952–56; University of

Mexico, Mexico City) and *Future Victory of Medical Science Against Cancer* (1958; Medical Center, Mexico City). He also painted easel pictures, including many portraits, made prints, and founded the review *Arte Publico.* In the mid-1950s he traveled to France, Poland, the Soviet Union, Egypt, and India. Siqueiros became executive secretary of the Mexican communist party in 1959 and, that same year, gave lectures in Venezuela and Cuba.

In 1960 Siqueiros started work on two important murals in Mexico City: *The Mexican Revolution,* a fresco commissioned by the National Museum of Anthropology and History, and *The Theater of Social Life,* commissioned by the Theater of the National Association of Actors. Both projects were interrupted in late 1960 when he was charged by the Mexican government with "social dissolution" and imprisoned. He was arrested because of his radical beliefs, not as the consequence of any overt political activities. Released in 1964, he completed the frescoes the next year and subsequently executed a government commission for a mural at Chapultepec Castle.

Siqueiros's next major work, executed with a team of assistants, was a gigantic mural decoration, *The March of Humanity in Latin America.* Painted on the interior and exterior of what was planned to be the Congress Hall of Mexico City, this ambitious project covered an area of 49,000 square feet and was completed in 1969, after nearly four years of work. This was the first time a building had been erected for the specific purpose of housing a mural. Siqueiros incorporated metal sculpture, painted and unpainted, into the ensemble, which culminated his determination to unite architecture, sculpture, and painting. Blending modernism and traditional elements, *The March of Humanity* has been described as "a baroque and futuristic extrapolation of realism." Many of the figures are painted with sweeping, flamelike strokes.

In 1968 Siqueiros was made president of the Academy of Arts, Mexico City. He received a retrospective at the Center for Inter-American Relations, New York City, in 1971, and also that year a three-dimensional mural was permanently installed in the Siqueiros Center, Mexico City.

Siqueiros died in Cuernavaca, Mexico, at the age of 77. A powerfully built man with strong features, he was committed to art as an expression of his political convictions, despite the constant threat of official reprisals. As Joseph Herman pointed out in an article on Siqueiros in *Art and Artists* (August 1969), "For the Mexican artist to paint political themes was as natural as for the medieval artist to paint religious ones."

Notwithstanding the didacticism of his work, Siqueiros fused his people's folklore with the pre-Hispanic Mexican tradition to create his own pictorial language. Despite Siqueiros's communism, he never subordinated his art to the dictates of socialist realism. Instead he advocated "a realism which continues to be more integral, more complete, more truthful, and which identifies the artists of every important period in art."

EXHIBITIONS INCLUDE: Casino Español, Mexico City 1932; Delphic Studios, NYC 1934; Pierre Matisse Gal., NYC 1940; Palacio de Bellas Artes, Mexico City 1947; ACA Gal., 1962; Gal. Misrachi, Mexico City 1964, '68; Marion Koogler McNay Art Inst., San Antonio, Tex. 1968; Center for Inter-American Relations, NYC 1971. GROUP EXHIBITIONS INCLUDE: "20 Centuries of Mexican Art," MOMA, NYC 1940; Venice Biennale 1950; "Masterpieces of Mexican Art from the pre-Columbian Epoch until Today," exhibit assembled by Fernando Gamboa (World Tour) 1952; Brussels International Exposition 1958; New York World's Fair, Flushing Meadow, Queens 1964–65.

COLLECTIONS INCLUDE: MOMA, NYC; Philadelphia Mus. of Art; Hirshhorn Mus. and Sculpture Garden, Washington, D.C.; Mus. de Arte Moderno, Mexico City; Mus. de Arte Moderno, São Paulo; Mus. de Arte Moderno, Rio de Janeiro; Tel Aviv Mus.; Mus., New Delhi.

ABOUT: De Micheli, M. Siqueiros, 1970; Myers, B. S. Mexican Painting in Our Time, 1956; Osborne, H. (ed.) Oxford Companion to Twentieth-Century Art, 1981; Read, A. M. The Mexican Muralists, 1960; Rodriguez, A. A History of Mexican Mural Painting, 1969; Tibol, R. Siqueiros, 1961. *Periodicals*—Art and Artists August 1969; Art Digest August 1, 1932; Artforum February 1977; Arte Publico (Mexico City) December 1952; Arts-Canada December 1979; Hoy (Mexico City) July 8, 1944; Les Lettres Françaises (Paris) November 1951; (London) Times January 7, 1974; Magazine of Art January 1944; Mexico en la Cultura (Mexico City) May 29, 1966, June 5, 1966; Romance (Mexico City) March 15, 1940; Studio International February 1974.

SMITH, DAVID (ROWLAND) (March 9, 1906–May 23, 1965), American sculptor and painter, was a contemporary of the first-generation Abstract Expressionist painters and was the earliest American sculptor to experiment with welded metal. His forceful and imaginative work profoundly influenced the development of modern sculpture in the United States and Great Britain. He is widely considered the finest sculptor North America has produced.

Smith's development as an artist was aided by his tough, even truculent, personality. He was restless, stubborn, ambitious on a grand scale,

Courtesy of the Marborough-Gerson Gallery, NYC

DAVID SMITH

and passionate, but was too disciplined an artist to be a bohemian. He struggled to attain both freedom and solitude, no matter the cost to himself or his friends, and in the years after his death he became an American artist-hero, his legend surpassed only by Jackson Pollock's and Willem de Kooning's.

David Rowland Smith was the descendant of a pioneer blacksmith who had settled in Decatur, a small town in eastern Indiana where Smith was born. His father was a telephone company engineer and unsuccessful part-time inventor; his mother was a teacher and staunch Methodist. The strenuous work habits Smith maintained throughout his life have been credited to the Midwestern virtues and Protestant work ethic implanted by his family.

By his mid-teens Smith knew he wanted to be an artist, and in 1923 he took a correspondence course offered by the Cleveland School of Art. In 1924 he enrolled in Ohio University, Athens, but stayed only one year, possibly because the study of art was costly and involved a long period of specialized training. Faced with the need to earn a living, in the summer of 1925 Smith worked in the steel frame assembly department of a Studebaker plant in South Bend, Indiana. There he learned to use a lathe, a soldering jig, and a spot welder, but never dreamed that these industrial techniques could be applied to art. Factory work was simply a means of earning money—more money than he would ever again earn, at least until the late 1950s when he was an internationally renowned artist.

In 1926 Smith moved to Washington, D.C., where he attended evening courses in art and

poetry at George Washington University. In the fall of 1926 Smith went to New York City and took evening classes at the Art Students League with Richard Lahey. The following year he studied painting full time at the League; his teachers John Sloan and, especially, the Czech Cubist Jan Matulka, who introduced him to constructivism and cubism, helped Smith find his artistic direction. Also in 1927, he married Dorothy Dehner, herself a painter. At this time—and, indeed, throughout his life—Smith was vexed by money problems, and whenever necessary he would find work aboard seagoing ships, drive a taxi, design window displays, or work as an art editor for *Tennis Magazine*. Nonetheless, in 1929 he bought a property for summer use in Bolton Landing, in the mountains above Lake George in upstate New York. (In those days even an artist of limited means could afford to purchase land.)

Smith continued to study painting at the League until 1930, when he met the modern painters Stuart Davis and Jean Xceron. Through them and John Graham, a White Russian emigré and an expert on avant-garde European trends, Smith was introduced to the small circle of New York modernists. He became friends with Arshile Gorky and Willem de Kooning, and they further exposed him to advanced art.

In the period 1930–33 Smith's emphasis changed from painting to sculpture, though he did not altogether abandon painting and drawing. In *Arts Magazine* (February 1960) he explained the transition: "My student period was involved with painting. The painting developed into raised levels from the canvas. Gradually the canvas was the base and the painting was a sculpture. . . . " These early works were, in effect, collages, midway between painting and sculpture.

Smith began to make polychromed wood sculptures in 1931, and the following year made his first sculptures in welded steel. In 1933 he painted the welded steel, making him probably the first to do so in the US. Smith's decision to work in metal was inspired by the reproductions he had seen in the magazine *Cahiers d'art* of the welded sculptures made by Picasso and the Spanish sculptors Julio González and Pablo Gargallo. For Smith, this approach was a means of drawing in space, the only major difference from painting being that of dimension. "I do not recognize the limits where painting ends and sculpture begins," he said. Previous sculpture had been an art of volume and mass, but Smith's knowledge of American industrial techniques provided him with the means to develop a personal and more linear visual language, one that made use of surrealist and expressionist imagery. "While my technical liberation came from Picasso's friend and countryman González," he explained, "my esthetics were more influenced by Kandinsky, Mondrian and Cubism."

In 1934 Smith rented working space and the use of a forge in the Terminal Iron Works on the Brooklyn waterfront, a workshop he kept until 1940. He and his wife traveled in Europe in 1935–36, visiting London, Greece, Crete, the Soviet Union, and, of course, Paris, where he studied etching with S.W. Hayter at Atelier 17.

In the 1930s Smith was already making original sculptures from steel and ready-made, or "found," scraps of metal and machine parts. He joined the Federal Arts Project of the Works Progress Administration in 1937, the year he began his "Medals for Dishonor," a series of 15 bronze plaques which he completed in 1940. Smith was keenly aware of the rise of fascism and the threat of global war, and these expressionist and semisurrealist images were "a searing moral indictment of the hypocrisies and injustices of contemporary society," to quote Barbara Rose. However, political tendentiousness would never again be as explicit in Smith's work.

Smith's first solo exhibition was held at Marian Willard's East River Gallery, New York City, in 1938. The following year his "Medals for Dishonor" were shown at the Riverside Museum, New York City, in the annual exhibition of the American Abstract Artists group.

In 1940 Smith moved permanently to Bolton Landing, where he could live in isolation and produce sculptures. However, during the war his output was curtailed because he was needed as a welder at the American Locomotive Company, Schenectady, New York, where he assembled railroad cars and tanks. In 1944 he was able to return to sculpture full time, and in January 1946 a large-scale retrospective of his work was mounted at the Buchholz Gallery, New York City. From 1948 to '50, the years of his emergence as a major American artist, Smith taught at Sarah Lawrence College, Bronxville, New York. His sculptures at this time were linear, resembling aerial drawings in metal, but had great vigor and tension. He called some of them "interiors," recalling Giacometti's surrealist construction of 1932–33, *The Palace at 4* A.M. One of Smith's most powerful open welded metal sculptures is *Blackburn—Song of an Irish Blacksmith* (1950), a tribute to a fellow metalworker in steel and bronze. Called a "rhapsody on male values and routines" by one critic, it is a complex interplay of quasi-geometric planes and fantastic plantlike and rodlike forms. In the early '50s Smith's sculptures became even more

linear and calligraphic, a rhythmic drawing-in-space akin to the surrealist device of psychic automatism and parallel, despite the difference in medium, to the spontaneity of American action painting. One of his best-known "open" pieces in steel is *Hudson River Landscape* (1951; Whitney Museum of American Art, New York City). Its configurations, inspired by train rides along the Hudson, suggested clouds, steps leading down a bank to the water, and the river's winding course. There were also intimations of landscape in another important work of 1951, *Australia*, in painted steel, whose silhouette has more than a hint of a kangaroo.

In 1950 Smith received a John Simon Guggenheim Foundation fellowship which was renewed the following year. In 1953 he began a series of "Tank Totems," foreboding images in polychromed steel, but other works of the '50s are notable for their wit and fantasy. An example is *Portrait of a Lady Painter* (1957), an over-6-foot-high bronze with a green patina. The "lady," complete with palette, merges with her rickety easel to form a bizarre and humorous image. The work is one of many Smith sculptures housed in the Storm King Art Center, Mountainville, New York.

Smith and his wife Dorothy were divorced in 1952, and the following year he married Jean Freas of Washington, D.C. They had two daughters: Rebecca, born in 1954, and Candida, born in 1955. Smith's second marriage ended in divorce in 1961.

In 1959 Smith returned to painting and to painting his sculptures. The sculpture itself changed in the late '50s, becoming larger in scale and more rigorously geometric, with fewer figurative elements and a less fanciful style. In 1958 he began using stainless steel in the creation of monumental outdoor sculptures. "Toward the end of the fifties," Rose wrote, "Smith's forms became more straight-edged, upright, and geometric, and less organic. . . . In the years before his death, his work came to fullest flowering in three major series, 'Voltri-Bolton,' 'Zig,' and 'Cubi.'" The series of "Zigs," which he began in 1960, posed the problem of integrating color and form, and the "Voltri-Bolton" series was to be the last in which Smith's forms were derived from the human figure. (According to Barbara Rose, much of Smith's work had until now been "based on relationships of the human figure," and throughout his career Smith made figure drawings.)

Smith took pride in his prodigious output of over 600 works, and in 1962, when Spoleto Festival officials invited him to spend a month in Italy, he worked fervidly in an old factory near Genoa to turn out 26 sculptures in 30 days. Many of these pieces were gigantic, including *Voltri VII*, a 200-foot-wide steel composition. The entire series, large assemblages of industrial scrap, was exhibited at the Spoleto Summer Festival.

Smith began work on his "Cubi" series of monumental stainless steel sculptures in 1963. Still convinced that metal was the quintessential 20th-century material, he retained in the "Cubi" pieces the unstable, dynamic quality of his earlier work, but moved closer to the geometric abstractions of such color-field painters as Kenneth Noland and Ellsworth Kelly. The metallic cubes and prisms with six faces (each face being a parallelogram) of the "Cubi" sculptures are surprisingly light in weight, a lightness seemingly at variance with their size and ostensible massiveness. Smith, who loved the countryside and preferred his work to be seen outdoors, polished the surfaces of his cubes so that they would reflect sunlight with dazzling metallic brilliance. The ideal outdoor setting for Smith's oeuvre was his home at Bolton Landing, which over the years became a one-man museum.

Despite their large scale, works like *Voltri-Bolton IV*, a stainless steel construction of 1962, are not monumental in the traditional sense. According to Edward Lucie-Smith, "There often seems to be a deliberate avoidance of the massive; there is a lack of sculptural density which can seem disconcerting. No image which Smith produced remains in the mind in the way that Moore's or Brancusi's images do. . . . One sculpture, seen in isolation, is usually much less effective than several from the same series, viewed together or in sequence."

Critics recognize the importance of Smith's use of welded steel and open forms in extending the boundaries of contemporary sculpture. Though his semisurrealist works of the early '50s are thought to be more expressive and moving than his later, more geometrically abstract style, his last sculptures with their superimposed cubic shapes "signalling like semaphores," as one critic put it, are regarded as forerunners of the "primary structures" of minimal art.

In 1964 Smith received a Brandeis University medal for lifetime achievements in the creative arts, and the following year he was appointed by the Johnson administration to the National Council on the Arts. In his last years Smith worked energetically in various media, and in 1964 alone he completed about 140 paintings of nude models. Several of his evocative abstract sculptures from this period were entitled "Becca," in dedication to his daughter Rebecca.

David Smith was killed in the spring of 1965 when his truck swerved off the highway near

Bennington, Vermont—a death eerily reminiscent of the car crash that had taken Jackson Pollock's life nine years earlier. Like Pollock, David Smith "had in his nature a destructive element which was the obverse of the trait he had in abundance: drive," as John Russell wrote in *Smithsonian* magazine (March 1977). In the early '50s Smith wrote, "The warpage is in me; I convey it to the person I live with," and his first wife has described him as living alone for long periods in Bolton Landing in a state of "the most awful inner turmoil and conflict." Smith resolved much of the violence and frustration arising from what he called the "battle of being" through his art. Russell noted that although Smith was "a mass of contradictions," his "blunt exterior" concealed an "inner delicacy, . . . a loving, tender, steadfast, marvelling disposition." The artist's contradictions surface in his creative endeavors. In his voluminous writings Smith emphasized the need for roughness, coarseness, and "unculture" in art, yet his own work contains much that is refined and lyrical while often conveying a brutal power.

Hilton Kramer described Smith's major achievement as having been the way he submitted "the rhetoric of the School of Paris to the vernacular of the American machine shop." A year before his death David Smith said: "I have no allegiance, but I stand, and I know I stand and I know what the challenge is, and I challenge everything and everybody. And I think that is what every artist has to do. . . . We (Americans) don't have the introduction that European artists have. We're challenging the world. . . . I'm going to work to the best of my ability to the day I die, challenging what's given to me."

EXHIBITIONS INCLUDE: Marian Willard's East River Gal., NYC 1938; Willard Gal., NYC 1940–56; St. Paul Gal. and School of Art, Minn. 1940–41; Buchholz Gal., NYC 1946; Kleemann Gals., NYC 1952; Walker Art Center, Minneapolis 1952; Cincinnati Art Mus. 1954; MOMA, NYC 1957; New Gal., Bennington Col., Vt. 1959; French and Company, NYC 1959, '60; Carnegie Inst., Pittsburgh 1961; Otto Gerson Gal., NYC 1961; Inst. of Contemporary Art, Univ. of Pennsylvania, Philadelphia 1964; Marlborough-Gerson Gal., NYC from 1964; Memorial exhibition, Los Angeles County Mus. of Art 1965; Fogg Art Mus., Cambridge, Mass. 1966; International Circulating Exhibition, MOMA, NYC 1966–67; Solomon R. Guggenheim Mus., NYC 1969; "David Smith: Painter, Sculptor, Draftsman," Hirshhorn Mus. and Sculpture Garden, Washington, D.C. 1982–83; "David Smith," Nat. Gal. of Art, Washington, D.C. 1982–83. GROUP EXHIBITIONS INCLUDE: Second Annual Membership Exhibition, American Artists' Congress, NYC 1938; "American Art Today," New York World's Fair, Flushing Meadow 1939; American Abstract Artists Exhibition, Riverside Mus., NYC 1939; Whitney Annual, NYC from 1941; "Fifteen American Sculptors," MOMA, NYC 1941–43; Venice Biennale 1954, '58; São Paulo Bienal 1959; Documenta 2 and 3, Kassel, W. Ger. 1959, '64; Pittsburgh International 1961; "Scultura nella città," Festival dei Due Mondi, Spoleto, Italy 1962.

COLLECTIONS INCLUDE: MOMA, and Whitney Mus. of Am. Art, NYC; Storm King Art Center Collection, Mountainville, N.Y.; Hirshhorn Mus. and Sculpture Garden, Washington, D.C.; Art Inst. of Chicago; Detroit Inst. of Arts; Albright-Knox Art Gal., Buffalo, N.Y.; Munson-Williams-Proctor Inst., Utica, N.Y.; Walker Art Center, Minneapolis; Nat. Gal. of Canada, Ottawa; Tate Gal., London; Wilhelm Lehmbruck Mus., Duisberg, W. Ger.

ABOUT: Ashton, D. The New York School: A Cultural Reckoning, 1973; Cone, J. H. and others "David Smith 1906–1965: A Retrospective Exhibition" (cat.), Fogg Art Mus., Cambridge, Mass. 1966; "David Smith" (cat.), Marlborough-Gerson Gal., NYC, 1967; Fry, E. F. "David Smith" (cat.), Solomon R. Guggenheim Mus., NYC, 1969; Gray, C. (ed.) David Smith by David Smith, 1968; Greenberg, C. Art and Culture, 1961; Hunter, S. American Art of the 20th Century, 1972; Johnson, U. E. "David Smith Sculptures" (cat.), Storm King Art Center, Mountainville, N.Y., 1971; Kramer, H. "David Smith" (cat.), Los Angeles County Mus. of Art, 1966; Krauss, R. Terminal Iron Works: The Sculpture of David Smith, 1971; Lucie-Smith, E. Late Modern: The Visual Arts Since 1945, 1969; McCoy, G. (ed.) David Smith, 1973; Rose, B. American Art Since 1900, 2d ed. 1975; Wintle, J. (ed.) Makers of Modern Culture, 1981. *Periodicals*—Art in America January–February 1966; Art News January 29, 1938, March 1960, February 1983; L'Art vivant (Paris) June 1969; Arts Magazine March 1956, February 1960; New York Times December 2, 1977, November 28, 1982; Smithsonian March 1977; Time November 18, 1940.

SMITH, TONY (1912–December 26, 1980), American sculptor, was widely regarded as the most important sculptor to emerge from the minimalist movement of the 1960s. An architect and teacher for most of his life, Smith turned to sculpture when he was almost 50 years old and quickly won international acclaim.

Anthony Peter Smith was born in South Orange, New Jersey, the oldest son of Peter A. Smith, a manufacturer of waterworks supplies. Bedridden in childhood with tuberculosis, he was isolated for several years from his five brothers and one sister. Because of the illness he was confined to a small building adjacent to the family home, and there he constructed "pueblo villages" from small medicine boxes. He was educated by private tutors and Jesuits, an experience which was, later, to help make him a sympathetic and avid reader of James Joyce. He decided quite early on a career in architecture

© Pach Bros., NYC

TONY SMITH

but his interest in sculpture was manifested in childhood as well.

After putting in two years at Georgetown University, the Jesuit-run institution in Washington, D.C., Smith attended night classes at the Art Students League, New York City, from 1933 to '36, studying under George Grosz and George Bridgman, among others. During this period he maintained himself by working as a toolmaker and draftsman. In 1937–38 he studied architecture at the New Bauhaus, Chicago, where he learned the constructivist aesthetic but felt that he received little benefit from the school. From 1938 to late '39 he worked as an assistant to Frank Lloyd Wright, who was developing "Usonian" houses, Wright's term for low-cost, US government-sponsored housing. Their angled outer walls resting directly on the ground have been seen as key elements in the later development of Smith's sculpture.

For the next 20 years (1940–60) Smith had his own architectural practice in New York City. Among his commissions were private houses on Long Island for the avant-garde art dealer Betty Parsons and the Abstract Expressionist painter Theodore Stamos. He married Jane Lanier Brotherton, a singer whose professional name was Jane Lawrence, and they had three daughters, Chiara, Anne, and Beatrice. The Smiths lived in South Orange, and from 1946 onward he taught architecture and design at New York University (1946–50), New York City's Cooper Union (1950–53), Pratt Institute, Brooklyn (1957–58), Bennington College, Vermont (1958–61), and Hunter College, New York City, from 1962.

Smith was a modern architect, but few of his

bolder, more radically experimental and monumental projects were realized. According to Edward Lucie-Smith, "He gave up architecture because he felt that buildings were too impermanent, and too vulnerable to alterations which would wreck the creator's intention." He tried unsuccessfully to forge a career in painting, and in the late '50s, taking visual cues from "sources as diverse as the serpentine Indian mounds of the Southwest, the half-finished airport at Newark, New Jersey, and the tetrahedral kites, towers, and gliders designed at [the turn of the century] by Alexander Graham Bell," he conceived of immense, Christo-like earthworks.

In the late '40s and early '50s, Smith was a friend of the New York Abstract Expressionists, especially Barnett Newman, Mark Rothko, Ad Reinhardt, and Jackson Pollock, and he purchased their work before they become famous. In 1960, while teaching full-time, he seriously took up sculpture, making cardboard and wooden sculptural maquettes.

Having not yet achieved his goal of creating "a reality which has not yet had any previous expression in art," In 1962 Smith saw a sign in Newark, New Jersey, advertising the Industrial Welding Company; it read: "You specify it: we fabricate it." Obsessed with the shape of an index card file he had seen on a friend's desk, Smith telephoned Industrial Welding and instructed them to build . . . a six-foot cube of quarter-inch hot-rolled steel with diagonal internal cross-bracing." When the box was delivered, Smith neither polished nor painted it. He placed it in the backyard of his South Orange home and left it to rust slowly among the trees. Entitled *The Black Box* (1962), this was Smith's first steel sculpture.

Over the next few years, Industrial Welding produced a dozen pieces for Smith, following either his blue-prints and models or instructions he gave over the phone. A *Washington Post* critic described these objects, which had accumulated in Smith's yard, as "strangely primitive, strangely heavy forms that seem as if they had always been there." "I don't think of them as sculptures," Smith said, "but as presences. . . . " His more conservative neighbors in South Orange also considered them "presences"—odd, unlikely, and, perhaps, even unwanted additions to their pleasant suburban neighborhood.

Smith gave these highly simplified pieces ambiguous names: one steel cube, "as tall as a man, as deep as a grave," according to the *Post,* is called *Die*. Smith explained that the size of *Die* was determined by the well-known Leonardo drawing of a man whose outstretched hands and feet

describe the corners of a square. Smith pointed out that a 10-foot cube was a small house, a 3-foot cube was a piece of furniture, and *Die* was a monument, his architectural training having forged a highly developed sense of scale.

Also in 1962, Smith completed the 46-inch plywood model for a massive 16-foot, 6-ton steel sculpture entitled *The Snake Is Out.* In a *Time* magazine (September 14, 1970) interview, he recalled that as soon as he had finished the maquette, he "realized the piece had a sense of movement, like a little dragon or a snake." He also remembered reading in a John McNulty short story that bartenders know a man has drunk too much when a vein protrudes from his forehead. The bartenders say, "The snake is out." (The element of humor often tempers the starkness of Smith's so-called primary structures.) The model remained on Smith's back porch until 1969, when he fabricated the piece in steel at the request of New York State for installation at the new Capitol Mall in Albany.

Another wood mockup dating from 1962 was *Playground.* Designed as a steel composition, it consisted of rectangular boxes fitted together. "I like shapes of this kind," Smith said of *Playground.* "They remind me of the plans of ancient buildings made of mudbrick walls." As early as 1961 Smith had produced the maquette for *Gracehoper,* later executed in sheet steel, a structure intended to be realized on a scale large enough to be as imposing as architecture. Using a triangular module, Smith created in this and other, later pieces, volumetric constructions that twist and turn in what Barbara Rose described as "an abstract version of contrapposto."

The French critic Jacques Busse, discussing the gigantism of Tony Smith's pieces, relates them to the large-scale canvases of Pollock, Clyfford Still, Rothko, Ad Reinhardt, and other Abstract Expressionists. According to Busse, these works of art are in accord with the vast sweep of the American continent and manifest their creators' awareness that through sheer size the attention of the spectator can be captured and his involvement assured. But the size of Smith's pieces was never arbitrary; scale was carefully considered and weighed against the piece's shape, function, and "feel."

In the spring of 1965, when he was already a white-bearded 53 years of age, Smith won sudden recognition with his huge work, *Free Ride,* at the "Primary Structures" exhibition in the Jewish Museum, New York City. He had had no solo gallery shows, having preferred to display his pieces on the grounds of his South Orange home.

In 1966 two of Smith's works were shown currently at two museums—the Wadsworth Atheneum in Hartford, Connecticut and Philadelphia's Institute of Contemporary Art—and he became more prominent in art circles. *Generation,* the larger composition, was displayed outside the Atheneum on an insurance company plaza and was described in *The New York Times* (November 27, 1966) as "a lantern-like form of . . . tetrahedral truss construction, no less than 30 feet high." Although Smith's massive abstract works have been classified as minimal art, they do not have the cool neutrality of the primary structures of such artists as Donald Judd or Robert Morris. "I've never called them sculpture," Smith explained, "that was other people. I'm interested in structures in which all materials are in tension. But I think the forms I'm involved with are rather more Stone Age than 'primary structure.'"

Also in 1966, Smith received the Longview Art Award and the National Council for the Arts Award. On October 13, 1967 Smith and his new mammoth piece, *Smoke,* made the cover of *Time* magazine. In the article he was described as "the most dynamic, versatile and talented new sculptor in the U.S. art world. [He is] the primary personification of a growing race of creators who have discarded modelling clay in favor of the blueprints, the chisel in favor of the welding torch, and Vulcan's forge for a sheet-metal fabrication shop." That same autumn the classical sky-lighted South Atrium of the Corcoran Gallery of Art, Washington, D.C. had housed—barely—his *Smoke,* an enormous open-form structure of black-painted plywood which stood 22 feet high and reached almost 50 feet in length. Hilton Kramer of *The New York Times* (October 7, 1967) called it "Mr. Smith's most interesting as well as his largest work to date." Kramer felt that the piece could open the door to new developments in the style known variously as the "primary structure" or "minimal sculpture." In *Smoke* Kramer felt, Smith "abandoned the massive monolithic profile that has characterized all his previous work, and has employed a series of triangular plywood piers to inflect and orchestrate the sculpture's interior space. In fact, if not in theory, 'Smoke' is closer in visual feeling to the fantasy architecture of expressionism than the conventions of geometric sculpture out of which it comes."

By 1968 Smith was frequently participating in national and international group exhibitions, and he had solo shows in Zürich, Paris, Detroit, and New York City. Also in 1968, he received a Guggenheim Award. It was evident, as a *New York Times* (December 5, 1971) critic observed, that Smith's talent was "for a sculpture that was monumental in scale and environmental in its

ambitions." Smith felt that indoor sculptures the size of *Smoke* were only a beginning, and he remarked, "I'm interested in fresh air." His massive pieces of 1967, *Night,* erected outdoors in Philadelphia, and *Cigarette,* installed on a street in Minneapolis, were described as behemoths to match the skyscrapers the way obelisks matched the pyramids." However, in 1971 Smith designed a large-scale indoor sculpture especially for the window-lined ground-floor gallery of the Museum of Modern Art, New York City. Titled *81 More,* it consisted of "a low triangular-shaped pedestal whose measurements are governed by a basic triangular module . . . its surface scored and subdivided into the 81 triangles from which the sculpture derives its name." These elements were topped by "15 tetrahedral forms, again based on the same module, [and] positioned in a rigorously prescribed order." The sculpture was painted an earthy red, unlike Smith's customary black pieces. After *81 More* was completed, Smith envisioned a never-realized version five times as large to serve as an environmental sculpture for an airport.

In recognition of the influence of architecture on Smith's work, he was awarded the Fine Arts Medal of the American Institute of Architects in 1971.

In 1972 one of Smith's earlier pieces, *Gracehoper,* was installed on the lawn in front of the new wing of the Detroit Institute of Arts. It was 46 feet long and 22 feet high, had been fabricated from steel sections from the model, was painted black, and looked like a giant insect.

Reviewing the Smith sculptures on view at the Fourcade/Droll gallery, New York City, in 1976, John Russell of *The New York Times* (March 28, 1976) praised the "sense of making and the sense of play" in *Spitball* and *Hubris.* Russell felt that *Spitball* had a "mysterious finality," and he discerned in it "overtones of a woman lying down with one knee in the air." The show included the model for *Hubris,* a work the artist hoped would be constructed on a monumental scale for a university campus.

Smith suffered a decline in health in the mid-1970s, but a *Village Voice* (May 28, 1979) reviewer was relieved to find in an exhibition of the artist's work at the Pace Gallery, New York City, "the brusque audacity we'd associate with a young upstart." The show was a successful "quasi-retrospective" and included, along with earlier works, two huge new pieces: *10 Elements,* composed of nonregular geometrical solids, and *Throwback* (1976–79), described in the *Voice* as a "marvelously quirky and compelling construction of fused regular geometrical solids." The critic noted that *Throwback,* in its

"twisting back around on itself," recalled earlier unitary pieces like *Willy, Cigarette,* and *The Snake Is Out.* In an *Arts Magazine* review of the Pace Gallery show, a critic observed that *Throwback* bore some resemblance to the human form and noted that Smith himself had proclaimed his deep regard for the Cubist sculptor Jacques Lipchitz. But the writer concluded that *Throwback,* like Smith's other pieces, resonated with a "multivalent symbolism" which brought Smith closer to the first generation of Abstract Expressionists, with whom he had "come of age" in the 1940s, than to the Minimalists.

Tony Smith died of heart failure in New York Hospital. At the time of his death he was professor emeritus of art at Hunter College, New York City, and was represented in museums, collections, and public places throughout the world.

When *Smoke* was installed at the Corcoran Gallery in 1967, Tony Smith was described in *Time* as "a blue-eyed, bearded man, beaming from behind horn-rimmed glasses." Modest and good humored, Smith was not given to solem proclamations about the importance of his work. "I think of my things as being stable, down-to-earth, ordinary in a sense," he said. "I don't want them to be 'An Experience.'" John Russell discussed the dualism in Tony Smith's work in his *New York Times* (May 4, 1979) review: "His sculptures come across on one level as pure geometry, pure engineering and pure design. But on another level they are full of sly humor, covert references to other art, and . . . allusions to cultures remote from his own." It is an oversimplification to describe Tony Smith's sculpture as minimal art or as an example of what one critic called the "single-unit Gestalt." "I really don't think about the current scene at all," Smith declared in 1966. "I did these [forms] because I was tired of having the houses I'd built as an architect changed—everything was impermanent, reduced. I wanted to make something with a kind of stability."

EXHIBITIONS INCLUDE: Wadsworth Atheneum, Hartford, Conn. 1966; Corcoran Gal. of Art, Washington, D.C. 1967; Inst. of Contemporary Art, Philadelphia 1966; Walker Art Center, Minneapolis 1967; Gal. Mueller, Stuttgart, W. Ger. 1967; Bryant Park, NYC 1967; Gal. René Ziegler, Zürich 1968; Gal. Yvon Lambert, Paris 1968; Donald Morris Gal., Detroit 1968; Fischbach Gal. NYC 1968; Univ. of Hawaii, Honolulu 1969; Newark Mus., N.J. 1970; Art Mus., Princeton Univ., N.J. 1970; New Jersey State Mus., Trenton 1971; Knoedler & Co., NYC 1971; MOMA, NYC 1972; Tawes Fine Art Center, Univ. of Maryland, College Park 1974; Fourcade/Droll, NYC 1976; Suzanne Hilberry Gal., Birmingham, Mich. 1977; "Tony Smith: Models and Drawings," Montclair State Col., Upper Montclair, N.J. 1978; Pace Gal., NYC 1979. GROUP EX-

HIBITIONS INCLUDE: "Black White and Gray," Wadsworth Atheneum, Hartford, Conn. 1964; "Primary Structures," Jewish Mus., NYC 1966; "American Sculpture of the Sixties," Los Angeles County Mus. of Art 1967; International Exhibition, Carnegie Inst., Pittsburgh 1967; Guggenheim International Exhibition, Guggenheim Mus., NYC 1967; Documenta 4, Kassel, W. Ger. 1968; Venice Biennale 1968; "Plus by Minus: Today's Half Century," Albright-Knox Art Gal., Buffalo, N.Y. 1968; International Exhibition of Modern Sculpture, Hakone Mus., Japan 1969; "New York Painting and Sculpture 1940–1970," Metropolitan Mus. of Art, NYC 1969; "Expo '70," Osaka, Japan 1970; "L'Art vivant Américain," Fondation Maeght, Saint-Paul-de-Vence, France 1971; International Biennial of Outdoor Sculpture, Antwerp, Belgium 1971; "National Welfare Rights Benefit Show," Washington, D.C. 1971; "Art and Technology," Los Angeles County Mus. of Art 1971; "Minimal Sculpture: The Classic Moment," San Francisco Mus. of Art 1971; "Annual Exhibition," Whitney Mus. of Am. Art NYC 1972, '73; "Contemporary American Artists," Cleveland Mus. of Art 1972; "200 Years of American Sculpture," Whitney Mus. of Am. Art, NYC 1976; "Project New Urban Monuments," Akron Art Inst., Ohio 1977; "Exhibition of Work by Newly Elected Members and Recipients of Honors and Awards," Am. Academy and Inst. of Arts and Letters, NYC 1978.

COLLECTIONS INCLUDE: Albright-Knox Gal., Buffalo, N.Y.; Memorial Art Gal., Univ. of Rochester, N.Y.; Princeton Univ., N.J.; Wadsworth Atheneum, Hartford, Conn.; Corcoran Gal. of Art, Washington, D.C.; Walker Art Center, Minneapolis Inst. for the Arts, Rice Univ., Houston; City of San Antonio, Tex.; Nat. Gal. of Canada, Ottawa; Banque Lambert, Brussels.

ABOUT: Lippard, L.R. Tony Smith, 1972; Lucie-Smith, E. Late Modern: The Visual Arts Since 1945, 1969; Rose, B. American Art Since 1900, 2d ed. 1975; Sabatello, R. (ed.), "Tony Smith" (cat.), Fischbach Gal., NYC, 1968; Wagstaff, S., Jr. "Tony Smith" (cat.), Wadsworth Atheneum, Hartford, Conn., 1966. Periodicals—Art May 1979; Art in America July 1967, June 1971; Art News December 1966, April 1971; Art Now: New York November 1969; Artforum December 1966, April 1974; Design Quarterly (Minneapolis) no. 78/79 1970; New York Times November 27, 1966, October 7, 1967, December 5, 1971, March 28, 1976, May 4, 1979, December 27, 1980; Time February 10, 1967, October 13, 1967, September 14, 1970; Village Voice May 28, 1979; Washington Post August 13, 1967.

SMITHSON, ROBERT (January 2, 1938– July 20, 1973), American artist, was a pioneer of earth art. He was born in Passaic, New Jersey, the only son of Irving and Susan (Duke) Smithson. His father worked for Auto-Lite, a firm dealing in car parts, but later went into real estate and then into banking. His mother was the daughter of an Austrian wheelwright. The family moved to Rutherford, New Jersey, not long af-

Photo by Nancy Holt

ROBERT SMITHSON

ter Robert's birth. There he was cared for by his hometown pediatrician, William Carlos Williams, whose writings were to influence him.

Smithson's interest in art and drawing was manifested in early childhood. When he was seven his father took him to the Natural History Museum in New York City, a museum which then and later he far preferred to the Metropolitan Museum of Art. Fascinated by dinosaurs and prehistory, at the age of seven he drew a mural-sized dinosaur for the hallway of his primary school. He also made a large paper construction of a dinosaur.

Although Irving Smithson was not artistic, he had, his son recalled, "a feeling for scenic beauty" and loved to travel. When Robert was eight, the year after World War II ended, his parents took him on a cross-country tour of the United States. His parents later encouraged him to plan family vacation trips to the sites of natural scenic wonders such as Yellowstone Park, the Grand Canyon, the California Redwoods, and the Mojave Desert. In 1948 the family moved to Clifton, New Jersey, where Smithson said his father built "a kind of suburban basement museum for me to display all my fossils and shells. . . . " (Smithson was also an avid collector of insects.) In 1950 Smithson made the first of several visits to Ross Allen's reptile farm in Florida, and as he approached teenaged adolescence Smithson seemed headed for a career as a naturalist.

Smithson was unhappy at Clifton High School, whose art curriculum he considered woefully inadequate and in 1953 he won a scholarship to the Art Students League, New York

City. The principal of Clifton High permitted him to attend high school in the morning and commute to the Art Students League in the afternoon. At the League he studied with the illustrator John Groth, whom Smithson later described as "a worthwhile teacher" with "a good sense of composition." In Manhattan Smithson made friends with students at the High School of Music and Art and frequented the Cedar Bar, then the unofficial Greenwich Village headquarters of the New York School, where he met Franz Kline and artists affiliated with Black Mountain, the avant-garde college in North Carolina. On scholarship he attended the Brooklyn Museum School, but only briefly—it was too far from New Jersey and Smithson preferred to attend life classes in the Urban Realist Isaac Soyer's studio near Central Park. Smithson's own works, mostly painted at home, were in casein.

In 1956–57 Smithson served in the Special Services division of the US Army. He was stationed at Fort Knox, "as a sort of artist-in-residence," doing "water-colors of local Army installations for the mess hall." Stationed at Fort Knox with Smithson was John Cassavetes, the actor and, later, experimental filmmaker.

After his discharge from the Army in 1957, the 19-year-old Smithson moved to New York City and then "hitchhiked all around the country." Out West he visited the Hopi Indian Reservation, where he was "privileged to see a rain-dance," and hitchhiked to Mexico City—trips to Mexico were virtual pilgrimages for "hip" New Yorkers in the '50s—to see the pyramids.

When Smithson returned to New York, the young bohemians of his generation had become known as "beats." Jack Kerouac's *On the Road* was the novel/manifesto-of-nonconformism, and Smithson met Kerouac, Allen Ginsberg, and the writer Hubert Selby. In 1958 he worked at Eli Willenz's 8th Street Bookshop, a gathering place for Village "beats" and intellectuals, and the following year he met the sculptor Nancy Holt, whom he was to marry in 1963 during a period of artistic crisis.

Smithson had his first solo exhibition in 1959, at the Artists Gallery, New York City, a nonprofit gallery run by Hugh Stix and his wife. The youngest artist ever to show there, Smithson exhibited abstractions with stripes, work which, he acknowledged, had grown "out of Barnett Newman." He soon introduced pieces of paper over the stripes, and then the stripes . . . got into a kind of archetypal imagistic period utilizing images similar . . . to Pollock's *She-Wolf* period and Dubuffet and certain mythological religious archetypes."

Quicksand, an abstraction in gouache from this period, attracted the attention of Charles Alan, who included it in a show at his Manhattan gallery. Smithson described the piece as "fundamentally abstract, [with] olives and yellows and pieces of paper stapled onto it; it had a kind of incoherent landscape look to it." *Quicksand* was also noticed by George B. Lester, who ran a gallery in Rome and gave Smithson a solo show there in 1961. This enabled the young artist to visit Europe. Lester remembers Smithson as shy and introverted, but possessed of strong feelings about art. He stayed in Rome less than three weeks, visited Siena, and developed a love of Byzantine culture. In fact, he deplored the Renaissance and regretted that art had moved beyond the Byzantine. At the same time he was fascinated by the baroque churches of Rome, which represented "the facade of Catholicism." "I was actually interested in religion . . . and archetypal things, . . . " Smithson said. "I wanted to understand the roots of . . . Western civilization [and see] how religion had influenced art." At this time he was also reading Jung and Freud. The desire to reach back to primal sources and to ancient mythology stayed with Smithson throughout his career.

Back in New York, Smithson had a solo exhibition of assemblages at the Richard Castellane Gallery in 1962. Smithson described this as "a very confused period," and the Castellane show—"a curious mélange of things"—included a stuffed pigeon taken apart and pasted on a board, among other neodada oddities. There were also paintings of scientific diagrams and rows of pickle jars filled with specimens the artist himself had dreamed up and given strange scientific-sounding names. After this exhibit he withdrew from the art world to reassess his ideas. Over the next year Smithson virtually stopped painting; he began to write but his jottings were mostly in the form of notes rather than fully developed articles or essays.

In 1963–64 Smithson worked on what he called "crystalline paintings," and in 1965 he reappeared on the art scene with a show of plastic sculptures at the John Daniels Gallery, New York City. Through the Daniels Gallery, he met some of the leading avant-garde American sculptors of the '60s, including Robert Morris, Donald Judd, Dan Flavin, and Sol LeWitt. Also that year he met Ad Reinhardt—the voluble first-generation New York School painter who had anticipated minimal art—and spoke at Yale with the critics Brian O'Doherty, John Hightower, and Paul Weiss on the topic "Art in the City." At this time he published his first articles on art.

An architect who had heard him at Yale invited Smithson to participate in the building of the Dallas–Fort Worth Airport. Asked, as the artist put it, to try "to figure out what an airport is," Smithson worked in Texas from 1965 through '66 as a consultant to the firm of Tibbetts, Abbott, McCarthy and Stratton, closely collaborating with the company's architects and engineers. "My first proposal was something called 'aerial art,'" he recalled, "which would be earthworks on the fringes of the airfield that you would see from the air." After making models of possible airports, Smithson became "less and less interested in the actual structure of the building and more interested in the *processes* of the building," including such preliminary aspects as "the boring of holes to take earth samples." In June 1967 he wrote an article called "Toward the Development of an Air Terminal Site." The firm eventually lost the Dallas–Fort Worth contract and Smithson's ideas were never realized.

In the mid-'60s Ad Reinhardt asked Smithson and Robert Morris to help organize an exhibition at the Dwan Gallery, New York City, called the "10 Show." Smithson contributed *Alogon,* a sculpture he described as being "like seven inverted staircases." The title *Alogon* came from the Greek word referring to the unnameable, the irrational number. Another composition executed at this time—*E Chambers,* one of his first experiments with reflection and the mirror image—so impressed Virginia Dwan that in 1966 she invited Smithson to join her gallery, where he was to have four solo exhibitions between 1966 and '70. In 1966 he was represented in the influential "Primary Structures" show at the Jewish Museum, New York City, with a piece called *Cryosphere,* which he described as "six hexagonal units that were linked up somehow in my mind with a notion of ice crystals."

Meanwhile, in 1966–69, Smithson traveled, sometimes alone but often with Virginia Dwan, Carl Andre, and Robert Morris, to decaying urban areas, industrial wastelands, and abandoned quarries in New Jersey. One such excursion, in 1967, was to Jersey's Pine Barrens to find a site for an outdoor show. But his experience of that postindustrial terrain led to the concept of "Non-Sites," a series of works which Smithson thought would create "a wholly new premise for contemporary sculpture." A *Non-Site* was a randomly arranged pile of natural waste collected from a despoiled area.

In 1966 Smithson drew up plans for his first earthwork, a *Tar Pool and Gravel Pit* for Philadelphia. His aim, as elaborated in an *Artforum* (September 1968) article titled "A Sedimentation of the Mind: Earth Projects," was to make the viewer "conscious of the primal ooze." In the summer of 1968, seeking locations for large-scale land-art projects, Smithson traveled to the deserts of California, Nevada, and Utah, and the following year he negotiated unsuccessfully with the government of British Columbia for a lease on an island near Vancouver, the proposed site of a large earthwork.

The originality of Smithson's ideas was first appreciated in Europe, and in 1969 he built *Asphalt Rundown* in a quarry near Rome. He was intrigued that in Rome "ruins melt and merge into new structures, and you get this marvelous and energetic juxtaposition occurring—with accident a large part of the process." He added that Rome "is like a big scrapheap of antiquities" and observed, "America doesn't have that kind of historical background of debris." In his *Partially Buried Woodshed* of 1970, executed in Kent, Ohio, Smithson dumped 20 cartloads of earth on a woodshed, forcing the structure's central beam to crack. Smithson found this "temporary kind of buried architecture" exciting, but a local newspaper derided the project in an article titled "It's a Mud, Mud, Mud World."

In 1968–69 Smithson began using mirrors in his landscape pieces, notably in a series of "Mirror Displacements" in Mexico. Of the fifth *Mirror Displacement,* which was installed in the lush jungle of Palenque in the Yucatan, Smithson wrote in *Artforum* (September 1968), "The double allure of the ground and the mirrors brought forth apparitions. Out of green reflections came the networks of Coatlicue, known to the Mayans as the Serpent Lady: Mother Earth. Twistings and windings were frozen in the mirrors."

Smithson's earth art culminated in 1970 with the completion of *Spiral Jetty.* Smithson's huge environmental sculpture, over 1500 feet long and 160 feet in diameter, projected into Utah's Great Salt Lake in the form of an archer's spiral. The entire work—which is no longer visible because the lake rose and claimed it—was covered with salt crystals.

The spiral form of Smithson's most famous work was "full of archaic implications," to quote Robert Hughes, "being a meander-maze, a distant but clear echo of the ancient symbol of the labyrinth as a rite-of-passage—a transformation of consciousness itself. The art historian Rosalind Krauss points out that the 'mythological setting' of *Spiral Jetty,* which fascinated Smithson, was the early Mormon settlers' belief that the Salt Lake was . . . bottomless, connected to the Pacific Ocean by a vast hidden canal whose suction of currents caused mighty whirlpools to form on the surface. 'In using the form of the spiral to im-

itate the settlers' mythic whirlpool,' Krauss argues, 'Smithson incorporates the existence of the myth into the space of the work.'"

In the early '70s Smithson continued to scour the US looking for land-art sites, but most of his proposals were vetoed by local authorities. Smithson felt that earth art could serve utilitarian social ends, and he recommended that land defaced by strip mining could be reclaimed through earthworks. Smithson tried unsuccessfully to interest companies engaged in strip mining in his visionary proposals, but in 1971 his desire to reclaim a mine-devastated site was realized when he built *Broken Circle—Spiral Hill* in a sand quarry near Emmen, Holland. Local residents had been granted jurisdiction over the abandoned quarry, and Smithson was gratified when they voted to maintain his earthwork after its completion.

In the early summer of 1973 Smithson traveled to Amarillo, Texas to inspect a desert lake, one he decided would be perfect for *Amarillo Ramp,* a work commissioned by the owner of the property. Smithson's last project, *Amarillo Ramp,* was one of those works in which, as one critic said, Smithson "reinvented the earth. Its look, its scale, its poetic function."

In a special issue of *Arts Magazine* (May 1978) devoted to Smithson, Will Insley described *Amarillo Ramp* as "a human-made structure in human-made Pecovas Lake." The *Ramp* is an earthwork which, when the lake is full, "curls out from the shore into several feet of muddy yellow water." As one walks up the incline, "the view constantly shifts." When one has climbed the ramp, which is only 12 feet high at its peak, views of the surrounding landscape appear which were not visible from the hill or shore from which one approached the structure, or from the beginning of the actual climb. The lake level is regulated by a dam, and when the lake bed is dry one may enter the crescent-shaped area contained by the wall of the ramp.

After staking out *Amarillo Ramp* in its final form, Smithson and a photographer set out on July 20, 1973 to photograph the work from the air. The plane crashed on a rocky hillside only a few hundred feet from the earthwork site. The pilot, the photographer, and the 35-year-old Smithson were killed. He left behind a large body of writing and ambitious plans—in the form of both drawings and lengthy prose descriptions—for projects which were not in sight of realization. However, in the era when the avant-garde virtually ceased to exist—it had been institutionalized by the schools and museums where its monuments were now enshrined like the Ark of the Covenant; by the foundations and corporations which cheerfully bankrolled the endeavors of vanguard artists; and by a growing audience of appreciators who clamored for ever newer and more radical assaults on artistic orthodoxy—Smithson succeeded in taking art out of the museum. His richly imaginative works accomplished what Hughes termed "a literal retreat to the desert away from those who would smother the artwork with love, a wish to breathe the air of a physical isolation that replaced the social and cultural isolation of the original *avant-garde.*"

In later years Smithson had changed from the shy, introspective young man George Lester had met in 1961. Photographs show the strong face of a man accustomed to deep thought and intense conviction. His essays were published with illustrations in *The Writings of Robert Smithson,* edited by his widow Nancy Holt. An exhibition entitled "Robert Smithson: Sculpture" was held in 1980 at the Herbert F. Johnson Museum of Art on the campus of Cornell University, Ithaca, New York. Comprising over 60 works of art, the show provided a comprehensive view of Smithson's development, from his early pieces which bore affinities with minimal art to his earthworks. Reviewing the show in *The New York Times* (November 30, 1980), John Russell wrote, "How should we regard him, if not as a lost leader and a source of energy too suddenly cut off?"

Smithson's artistic perceptions were, he said, not "predicated on any kind of scientific need." For him "the entire history of the West was swallowed up in a preoccupation with notions of prehistory and the great pre-historic epics starting with the age of rocks. . . . " In his *Artforum* (September 1968) article "Incidents of Mirror-Travel in the Yucatan," Smithson imagined the Mayan deity Tezcatlipoca, demiurge of the "Smoking-mirror," saying to him as he drove through the tropical landscape: "All those guidebooks are of no use. You must travel at random, like the first Mayans, you risk getting lost in the thickets, but that is the only way to make art."

EXHIBITIONS INCLUDE: Artists Gal., NYC 1959; Gal. George Lester, Rome 1961; Richard Castellane Gal., NYC 1962; John Daniels Gal., NYC 1965; Dwan Gal., NYC 1966, 1968–70; Gal. Konrad Fischer, Düsseldorf 1968; Gal. L'Attico, Rome 1969; Ace Gal., Los Angeles 1970; Ace Gal., Vancouver, British Columbia 1970; New York Cultural Center, NYC 1974; John Weber Gal., NYC 1976; "Robert Smithson: Sculpture," Herbert F. Johnson Mus. of Art, Cornell Univ., Ithaca, N.Y. 1980. GROUP EXHIBITIONS INCLUDE: "Current Art," Inst. of Contemporary Art, Philadelphia 1965; "Primary Structures," Jewish Mus., NYC 1966; "Color, Image and Form," Detroit Inst. of Arts 1967: "American Sculpture of the 60s," County Mus. of Art, Los Angeles 1967: "The Art of the Real: USA

1948–1968," MOMA, NYC 1968; "Minimal Art," Gemeentemus., The Hague 1968; "Prospect 68," Kunsthalle, Düsseldorf 1968, '69; "When Attitudes Become Form," Kunsthalle, Berne 1969; "Information," MOMA, NYC 1970; "Elements of Art," Mus. of Fine Arts, Boston 1971; Documenta 5, Kassel, W. Ger. 1972; "Contemporary Drawing," Whitney Mus. of Am. Art, NYC 1973.

COLLECTIONS INCLUDE: MOMA, and Whitney Mus. of Am. Art, NYC; Milwaukee Art Center; Neue Gal., Aachen, W. Ger.; Spiral Hill, Emmen, Neth.

ABOUT: Goossen, E. C. (ed.) "The Art of the Real? 1948–1968" (cat.), MOMA, NYC 1968; Holt, N. (ed.) The Writings of Robert Smithson: Essays with Illustrations, 1979; Hughes, R. The Shock of the New, 1981; Muller, G. The New Avant-Garde, 1972. *Periodicals*—Art in America November/December 1973; Art News February 1969; Artforum September 1968, January 1971, April 1974; Arts Magazine September/October 1973; Domus (Milan) December 1969, February 1974; New York Times November 30, 1980; Opus International (Paris) March 1971.

SNELSON, KENNETH (June 27, 1927–), American sculptor, photographer, and designer, delineates spatial forces through the discontinuous tension-compression structural system of his invention. His highly technical, even mathematical, work, which is at once elegantly simple and mysteriously insular, initially earned Snelson more of a reputation among engineers than artists. Some of his achievements border on the scientific—his novel atomic model, for instance—but his later sculptures, airy, complex, and playful, demonstrate that his outlook is primarily aesthetic.

Born in the small city of Pendleton, Oregon, where his father ran a photography shop, Snelson as a child was a dedicated builder of balsa-wood model airplanes. He served with the US Navy in 1945–46 and was stationed in Washington, D.C., where he took night courses at the Corcoran Art School. From 1945 to 1948 he studied at the University of Oregon, Eugene, on the GI Bill. By gradual steps he was drawn from business and accounting studies, which his parents urged on him, to architectural design and then to painting. "It had never occurred to me that someone from Pendleton, Oregon could be a painter. I always thought you hdd to be touched by God or something." Snelson became interested in the Bauhaus, logically enough for a student hesitating between design and painting, and in 1948 applied to Black Mountain College, in North Carolina, where Josef Albers was teaching during the summer session. John Cage, Richard Lippold, and Willem de Kooning also taught there that summer. However, it was the visionary architect and designer R. Buckminster Fuller who was the decisive influence on him. Fuller, already tinkering with designs for his geodesic dome, was proposing the combination of tension and compression as a basic structural principle which he called "energetic geometry." Sitting in on Fuller's classes, Snelson was enthralled. He independently applied this principle to sculpture, first devising "something like a swinging pendulum" of wire, thread, and clay ballast that moved "like a spinal column." Next he turned to rigid forms: in *Wooden Floating Compression Column* (1948) the two X-shaped compression members, one floating over the other, were entirely independent of each other, connected only by string under tension. This was the prototype for the "X-modular form," the most basic and versatile of tension-compression structures and the one most easily adapted to practical construction. "Suddenly I had made a closed system of solid objects which supported one another only through tension lines; a new kind of tension structure, in the same class as the kite, the balloon, and the wire-spoke bicycle. For me, that small amount of discovery was especially pure and beautiful." And on it he based his subsequent sculptural career.

In the spring of 1949 Snelson took one semester of engineering at Oregon State University, Corvallis. He returned to Black Mountain College that summer to show his work to Fuller. In turn Fuller helped Snelson publish his developments in *Architectural Forum* magazine and incorporated a tetrahedronally modified X-module into his spherical geodesic-dome design. (In 1955 Fuller was to coin the word "tensegrity" to describe the tension-compression structural principle.) Though mutually influential in a positive sense, their approach to design was entirely divergent. Fuller was a fervent proselyter for rational, anticipatory design as the key to the world's survival, whereas Snelson, an empiricist, has no predetermined world view and is willing to admit the "capricious" into his search for interesting forms. In his later writings Fuller was somewhat casual about fully attributing the original discovery of tensegrity to Snelson; this led to some bitterness on the part of the artist.

After a semester with Laszlo Moholy-Nagy at the Chicago Institute of Design, Snelson traveled to Paris in 1951. There he briefly flirted again with painting, studying under Léger at the Académie Montmarte, and made his first photographic panoramas (he had learned photography from his father)—360° views of the Bois de Boulogne and other spots taken with a special camera and lens, vintage 1912. "The panoramas," he said, "come out of a voyeuristic

impulse to see in all directions at once." Return-
ing to New York City in 1952, he supported him-
self as a television cameraman for news
programs while steadily refining his tension-
compression structures. These were first shown
publicly at the "Twentieth-Century
Engineering" exhibition at the Museum of Mod-
ern Art, New York City, alongside Fuller's own
adaptation of the tensegrity principle, in 1959;
his first solo show was at Pratt Institute, Brook-
lyn, in 1962.

The sculptures of this period, such as *Spring
Street* (1964), constructed of stainless steel or alu-
minum stock (the compression elements) and
high-tensile-strength wire (for tension) were
usually vertical and symmetrical along more
than one axis, which gave them the look of engi-
neering models. Snelson even patented his
"floating compression mast," a helical tower, in
1965. As the 1960s wore on, however, Snelson
grew more experienced and sophisticated, less a
slave to the difficulty of his designs, and his
sculptures became more horizontal and irregu-
lar. *Audrey I* (1965) is an early example.

Snelson's interest in physics led him, in the
mid-'60s, to attempt to create a new model of
the atom: to unravel, in his words, "a kind of
sculptural riddle . . . not yet solved convincing-
ly by science." The old planetary model of atom-
ic structure, with electrons orbiting around a
solar nucleus, had been rendered completely in-
adequate by quantum theory, and no easily en-
visioned representation had arisen to take its
place. Snelson realized that the tension-
compression forces binding his sculptures could
be applied metaphorically to describe the sub-
atomic forces binding the atom. After informal
study of basic atomic physics at Columbia and
New York universities, he devised a model
which used magnets to hold together the nucleus
and electron shells. In *Tellurium Atom* (1964)
the electron shells are concentric stainless-steel
polyhedral spheres composed of tangential cir-
cles; the circles represent the range of uncertain-
ty of each electron location. "I think I have a
fairly consistent picture of an atom," he has said,
"although it cannot at this point do what the sci-
entists require of a model—that is give them
more satisfactory statistical data than they have
now." In 1963 an early model was described in
Industrial Design magazine, and in 1966 and
again in 1978 Snelson had it patented. Nonethe-
less scientists are still undecided as to the
"objectivity" of Snelson's atom, and it has not yet
become a standard classroom aid.

Snelson's real breakthrough into recognition
as a serious artist came in 1966 with the first of
his solo shows at the Dwan Gallery, New York

City. He showed larger pieces including *Needle
Tower*, *Avenue K*, and *Four Module Piece* (all
of 1967–68), in an outdoor show in Bryant Park,
behind the New York Public Library, in 1968.
His work, clean-limbed, gravity-defying, the
epitome of a "scientific" art, was soon in demand
by major institutions such as the Rijksmuseum
Kröller-Müller, Otterlo, the Netherlands
(*Tapered Tower*, 1968), the Hirshhorn Museum
and Sculpture Garden, Washington, D.C.
(*Needle Tower*), and MOMA and the Whitney
Museum of American Art, New York City. By
the mid-1970s the sculptures were sprawling
and asymmetrical, looking less like television an-
tenna towers or regular crystals than like dia-
grams of the interatomic stresses in a protein
molecule. *Easy K* (1970), cantilevered over one
hundred feet of water at the Arnhem Museum
in the Netherlands, *Easy Landing* (1975–77, 17
by 63 by 45 feet), at the Nationalgalerie, Berlin,
and the whimsical *Forest Devil* (1977, 17 by 35
by 25 feet) are outstanding examples. "All of the
forces that are locked up in a piece like [*Forest
Devil*] are visible," Snelson said in 1981 " . . .
It should be thought of as a force diagram in
space. It is a formal statement, finally, since that
is what a sculpture does. It is the means by which
the sculpture is integrated that is the statement."

The artist married Katherine Kaufmann, a
psychotherapist, in 1972; they have two daugh-
ters, Andrea and Nicole. His orderly studio in
lower Manhattan is equipped like a commercial
metal-shop, with the addition of machines of his
own design for measuring and cutting cables. To
create his sculptures, Snelson first constructs a
maquette, using a minimum of mathematics,
then cuts and lays out a webbing of cables. The
notched and drilled metal tubes are then labori-
ously fitted into their proper places (a process
that can take a week or more with large pieces),
and the whole system is tightened with turn-
buckles to maximum rigidity. What results,
wrote Martica Sawin in *Arts Magazine* (Septem-
ber 1981), are sculptures that "delight the vision
with their gleaming tubular surfaces held aloft
by locked-in energy, in arrested-motion
acrobatics."

EXHIBITIONS INCLUDE: Pratt Inst., Brooklyn, 1962;
Dwan Gal., NYC 1966, '67, '68; Bryant Park, NYC
1968; Fort Worth Mus. of Art, Tex. 1969; Rijksmus.
Kröller-Müller, Otterlo, Neth. 1969; Kunsthalle,
Düsseldorf 1970; Kunstverein, Hanover, W. Ger. 1971;
John Weber Gal., NYC 1972; Gal. van der Voort, Ibiza,
Spain 1972; Waterside Plaza, NYC 1974; Gal. Buch-
holz, Munich 1975; Sonnabend Gal., NYC 1979; Za-
briskie Gal., NYC 1980, '82. GROUP EXHIBITIONS
INCLUDE: "Twentieth-Century Engineering," MOMA,
NYC 1959, '62; Annual Whitney Mus. of Am. Art,
NYC 1966–70; "Sculpture: A Generation of

Innovation," Chicago Art Inst. 1967; "Plus by Minus: Today's Half-Century," Albright-Knox Art Gal., Buffalo, N.Y. 1968; Expo '70, Osaka, Japan 1970; "L'Art vivant americain," Foundation Maeght, Saint-Paul-de-Vence, France 1970; "The Non-Objective World 1939–1955," Annely Juda Gal., London 1972; Biennial, Whitney Mus. of Am. Art, NYC 1973; "Art in Space: Some Turning Points," Detroit Inst. of Arts 1974; "Four Arts Society, Palm Beach," N.Y. Cultural Center, NYC 1975.

COLLECTIONS INCLUDE: MOMA, and Whitney Mus. of Am. Art, NYC; Hirshhorn Mus. and Sculpture Garden, Washington D.C.; Chicago Art Inst.; Milwaukee Art Inst.; Hunter Mus. of Art, Chattanooga, Tenn.; Stedelijk Mus., Amsterdam; Rijksmus. Kröller-Müller, Otterlo, Neth.; City of Hamburg, W. Ger.; City of Hanover, W. Ger.

ABOUT: Burnham, J. Beyond Modern Sculpture, 1968; "Kenneth Snelson" (cat.), Kunstverein, Hanover, W. Ger., 1971. *Periodicals*—Art News October 1968, February 1981; Art Voices Summer 1966; Artforum March 1967; Arts Magazine February 1968, September 1981; Industrial Design February 1963; Progressive Architecture June 1964.

***SOULAGES, PIERRE** (December 24, 1919–), French painter, is one of the Continent's leading abstractionists. He was born in Rodez, in southern France, the son of an artisan. The historic city of Rodez, with its fine fortress-like Gothic cathedral, was the capital of the mountainous Rouergue region until the 16th century, and even before the Roman occupation it had been an important Gaulish center. As a boy Soulages was fascinated by the prehistoric Gaulish or Celtic stone slabs incised with mysterious inscriptions in the Musée Fenaille in Rodez, and these rough "menhirs" with their strong, tense, engraved lines may have influenced the graphism of his paintings. The Rouergue region was also rich in Romanesque art, and when Soulages was about 13 he was deeply impressed by a visit with his school class to the magnificent pilgrimage church of Sainte-Foy in Conques, very near Rodez. In the dim, solemn and majestic nave he admired not only the primitive directness and sincerity of the stone carvings but the light filtering through the tall narrow windows and relieving the "live blackness" of the interior as well. He was shocked at hearing the teacher talk of the "clumsiness and barbarousness" of Romanesque architecture and sculpture. Many years later, when visiting Sainte-Foy with the writer and curator James Johnson Sweeney, Soulages recalled, "You know, it was here, at this very spot, that I decided to be a painter—not an architect, a painter."

PIERRE SOULAGES

While still a pupil at the Rodez Lycée, Soulages had begun to paint. "I would paint trees in winter," he said. "I never painted trees with foliage or things like that—black trees." He would use light-colored or sometimes brown grounds, and was drawn to this limited palette not for reasons of economy but because, as he later said, "The more limited the means, the stronger the expression." The negative spaces between the dark branches interested him as much as the tree forms themselves. Although he obviously did not yet think in those terms, he experienced the tracery of the branches as "a kind of abstract sculpture," creating an expressive movement in space. Commenting on the fact that "black has always remained the basis of my palette," Soulages has emphasized that this choice was not made for sentimental reasons: "In China black is not the color of mourning. It's just that I see black."

In 1938, when he was 18, he saw in the magazine *Radio Scolaire* two reproductions of old master drawings which made a lasting impression on him. One was a wash drawing of the Tiber near Rome by Claude Lorrain, executed with great breadth and freedom. The other was Rembrandt's moving brush drawing in the British Museum of a girl sleeping, probably Hendrikje Stoeffels. Soulages described it as a "series of very strong, very beautiful brushstrokes," but noted that "if you covered the woman's head the drawing began to live like an abstract painting, that is to say with only the visual quality of the forms, the space they create and their rhythms." He found that he preferred the drawing without the head.

*sōō lazh´, pyâr

Also in 1938, having persuaded his family to allow him to pursue an artistic career ("They assumed I wanted to be a drawing teacher") young Soulages moved to Paris. He entered the studio of René Jaudon, who, on the basis of Soulages's sketches, suggested that he prepare for the Prix de Rome. He was admitted to the Ecole des Beaux-Arts but was disappointed by the academic nature of the teaching. On the other hand, exhibitions of Cézanne and Picasso in Paris came as a revelation to him, for he had had no knowledge of modern developments in painting. His visits to the Louvre had already made him aware that the work of the old masters bore no relation to the dry teachings of the Beaux-Arts.

Still uncertain of his future course, Soulages returned to Rodez, and in September 1939 war broke out. Soulages, then 20 years old, was mobilized, but was discharged after the fall of France in 1940. In 1941 he was in Montpellier, which was in the as yet unoccupied zone of southern France. There he attended the Ecole des Beaux-Arts and enjoyed visiting the excellent Musée Fabre. In October 1942 he married the charming, petite Colette Llaurens.

When the Germans occupied the Midi in 1943, Soulages went into hiding. He worked in a vineyard (he has always been physically robust and good with his hands) and did no painting until the end of the war. His neighbor, however, was the novelist Joseph Delteil, who introduced him to, as Soulages called her, the "great lady of abstract art," Sonia Delaunay. From her he heard about abstract painting for the first time.

During the war years Soulages read French poetry from Villon to Baudelaire. As a man of the Midi he has always had a great feeling for the Provençal troubadours, especially the first troubadour Guilhem VII, Count of Poitou, and in recent years he made a prose translation of Guilhem's enigmatic and surprisingly "modern" poem about *Nothing*. For Soulages the metaphor, the condensed image, has always been more meaningful than descriptive anecdote, whether in poetry or painting.

In 1946, one year after the war's end, Pierre and Colette Soulages settled in Courbevoie, a suburb of Paris. He devoted his whole time to painting. With "no money, no canvas," he "set about painting on old sheets, or working in charcoal on paper."

Soulages's early paintings were completely abstract and nonfigurative, in black or brown on a white ground. They had a calligraphic quality which was later to disappear from his work, but even the line produced a sensation of color. The novelty of these paintings in a Paris emerging from the isolated and stifling years of Nazi occupation caused their rejection by several salons.

In his paintings of 1947, Soulages abandoned the semiexpressionistic calligraphy of his first abstractions, and began to cluster the forms into a more centralized image. Using very wide brushes, he created what amounted to big black "signs" on a light ground. It was important to him that the image, set down in a direct, abrupt manner, be absorbed by the viewer all at once. He wanted the immediacy of its impact to be like the resonance of a chord struck on a vast keyboard. Soulages exhibited several of his new canvases in the Salon des Indépendants, Paris. M. Gauthier, writing in *Opéra,* praised the "impressive symphony of dark colors."

In 1948 Soulages and his wife moved to Paris and took an apartment in the rue Schoelcher, overlooking the Montparnasse cemetery. By this time Soulages had met many painters and had become friends with Francis Picabia, who admired his work. He was invited to exhibit in the third Salon des Réalités Nouvelles, Paris, which had been founded shortly after the war to encourage abstract art. Soulages's work was noticed by the German O. Domnich who had come to Paris to select paintings for the first exhibit of abstract art to be held in Germany since the war. During the long period of Nazism all such work had been proscribed, and Mondrian and Kandinsky along with other modernists had been branded as "degenerate artists." Soulages showed six pictures in this "Grosse Ausstellung Französischer Abstrakter Malerei" (Great Exhibition of French Abstract Art) which toured in Stuttgart, Munich, Düsseldorf, and other German cities. Also included among the ten painters exhibited were Auguste Herbin, Hans Hartung, Gérard Schneider, François Kupka, and César Domela. The poster advertising the exhibition reproduced a black and white painting by Soulages, a canvas one German critic compared to a Bach largo.

Back in Paris, Soulages was visited by James Johnson Sweeney, the first American to take an interest in his work, and later the author of an authoritative book on the artist. In 1949 Soulages had his first solo show, at the Galerie Lydia Conti, Paris.

By the mid 1950s "signs" had become less important in Soulages's paintings. The brushstrokes were closer together and more numerous, and their repetition created a rhythm of space relationships which the artist described as the "beat of forms in space." His canvases have no titles except the date of their completion, *Peinture, 21 juin 1953* or *Peinture, 8 octobre 1954,* for example. Occasionally other colors, a pale blue or a rich tan emerged behind or in between the heavy black strokes, but color is used by Soulages to intensify the poetry and mystery of the image rather than for its sensuous appeal.

Soulages's style and approach were eminently suited to graphic art, and from 1957 on he made lithographs, etchings, and engravings. One of his innovations was the abolition of the rectangularity of the copper plate by cutting out the copper with acid and creating a jagged irregular shape. He was also interested in theater and ballet design. A theater project he worked on in Toulouse shortly after the war, in association with Fernand Léger, attracted the attention of the great actor-director Louis Jouvet, who engaged Soulages to design the sets for a dramatization of Graham Greene's *The Power and the Glory*. Plans for a Jouvet productin of Molière's *L'Avare*, in which Soulages agreed to introduce *some* suggestion of 17th-century France, were cut short in 1951 by the untimely death of Jouvet.

In 1957 Soulages spent several weeks in the United States. In New York he met Baziotes, Guston, de Kooning, Motherwell, Rothko, and other avant-garde painters, as well as the sculptors Herbert Ferber and Ibram Lassaw. Soulages's work has sometimes been compared to that of Franz Kline, but while there are superficial similarities, Soulages must have resented such remarks as those made by the art historian Edward Lucie-Smith, who called him "a sweeter and less committed version of Franz Kline." Soulages has pointed out that he had evolved his abstract idiom at a time when Kline was still working realistically. Moreover, Kline's painting is gestural, thrusting out towards the edges of the canvas and even (in the mind's eye of the viewer) beyond, and his vehement strokes, predominantly black on white, have the new dynamic energy of New York City. Soulages, however, has the French feeling for sensuous paint quality, and he maintains that his own painting is not gestural but is "an image which is in the process of taking shape." He also wants to create a sense of time suspended. Speaking of Cimabue's *Madonna with Angels* in the Louvre, Soulages said, "What I admire in the Cimabue is the remains of Byzantine hieraticism, and at the same time something new arising which one can only anticipate."

In 1957 Soulages moved his studio to the neighborhood of Saint-Julien-le-Pauvre, and was also awarded the Grand Prize at the Tokyo Biennial. On his trip to Japan in 1958 Soulages was warmly received by Japanese masters of callligraphy who felt an affinity to his visual "sign language." He went on to Cambodia, Thailand, and India, the first of several visits to the Far East. One of the most widely traveled of contemporary artists, Soulages visited Mexico in 1961 and was impressed by the massive forms of the Mayan temples in Yucatan.

Soulages's international reputation was growing steadily. Soulages's first solo show in New York City was held at the Kootz Gallery in 1959, and a large Soulages retrospective took place in Hanover, West Germany the following year. His varied commissions included two cartoons for Aubusson tapestries, one of which is in the Maison de la Radio, Paris, the other in the High School of St. Gall in Switzerland. His career reached a high point when he was awarded the Carnegie Prize in 1964.

In his canvases of the late '60s, there were still clusters of very wide brushstrokes, but they appeared to float in space, unlike his earlier "signs" which had been more or less parallel to the picture plane. Soulages says that he has no fixed idea in his mind when he begins a picture: "I work guided by an inner impulse, a desire for certain forms, colors, and textures." He achieves luminosity as well as drama and mystery in his blacks, and his canvases often convey a sense of illumination from hidden sources. He has defined oil painting as "a game of opaqueness and transparencies," and he adds: "Painting in the degree that it is a poetic experience, transforms the universe."

Since 1970 Soulages has produced a number of large, long, horizontal compositions, combining clarity of form with what James Johnson Sweeney has described as the "penetrating atmosphere of the mysterious luminosity of daylight." Soulages's interest in large-scale works may be traced back to such projects as the ceramic wall he designed in 1968 for One Oliver Plaza in Pittsburgh.

Pierre Soulages, a tall, strikingly handsome man with the warmth, charm, and exuberance of the Midi itself, lives with his wife Colette in a house they have acquired in a narrow street in the colorful, bustling fifth arrondissement on the Left Bank. The house has been completely remodeled in a spare and elegant style, with, not unexpectedly, black, brown, and white predominating. Soulages's studio, a short walk from the house, consists of large work spaces and an office. He paints his bigger canvases on the floor, applying the pigment with scoops of his own design, black rectangles of material at the end of long poles. He uses brushes as well, to vary the textural effects. Soulages seems a happy man, secure within himself, totally committed to his work, and unspoiled by his considerable success. He sees his art as a continuum, and what counts for him is not formal analysis but the emotion aroused in the viewer. "Each picture is at once a finished picture and, what is more important to me, a stage, a moment of something vaster, which is the succession of my canvases that I cannot foresee."

EXHIBITIONS INCLUDE: Gal. Lydia Conti, Paris 1949; Kootz Gal., NYC 1959; Landsmus., Hanover, W. Ger. 1960; Mus. d'Art Moderne, Paris 1967; Art Gal., Univ. of Maryland, College Park 1972. GROUP EXHIBITIONS INCLUDE: "Grosse Ausstellung Französischer Abstrakter Malerei," toured Stuttgart and other West German cities in 1948; Betty Parsons Gal., NYC 1949; "France-Amérique," Sidney Janis Gal., NYC 1950; "Advancing French Art," organized by Phillips Gal., Washington, D.C., shown in several Am. museums, 1950–51.

COLLECTIONS INCLUDE: Mus. d'Art Moderne, Paris; Kunsthaus, Zürich; MOMA, Brooklyn Mus., and Solomon R. Guggenheim Mus., NYC; Philipps Gal., Washington, D.C.; Mus. of Fine Arts, Boston; Art Inst. of Chicago; Fogg Mus., Cambridge, Mass.; Detroit Inst. of Art; Albright-Knox Art Gal., Buffalo, N.Y.; Nat. Gal., Ottawa; Mus. of Fine Arts, Montreal; Nat. Mus., Melbourne; Tate Gal., London; Neue Pinakotek, Munich; Wallraf-Richardz Museum, Cologne; Mus. de Arte Moderna, Rio de Janeiro.

ABOUT: Current Biography, 1959; Duby, G. Soulages: Catalogue Raisonné, 1974; Sweeney, J.J. Soulages, 1972. *Periodicals*—Christian Science Monitor April 14, 1967; L'Express (Paris) March 28, 1963; Figaro (Paris) March 28, 1963; Le Monde (Paris) June 26, 1972; Montreal Star August 3, 1968; New Yorker April 15, 1967; New York Herald Tribune May 15, 1955; New York Times April 27, 1954, November 15, 1957; Washington Post February 12, 1972.

***SOYER, ISAAC** (April 20, 1907–July 8, 1981), American painter and lithographer, the youngest of the three artist brothers, was born in the town of Borisoglebsk in the southern, Tambov region of Czarist Russia. He was born eight years after the twins, Raphael and Moses; he had two sisters and another brother, Israel, who became a writer. Their father, Abraham Schoar, who came from a small Lithuanian village, made a modest living teaching Hebrew and writing for newspapers. He also wrote Hebrew fairy tales for children. Despite frequent persecution of Jews in Czarist Russia, the Schoar home was a happy one, and the father, a sensitive, understanding, and cultivated man, encouraged Raphael, Moses, and Isaac to paint. Moses, writing a year before Abraham's death in 1940, described his father at 70 as "presenting the appearance of a Rembrandtesque scholar."

From early childhood the three elder Soyer brothers looked to America as a land of promise, a view shared by their parents. In 1912, when the Governor of the Tambov province refused to renew their residency permit, the Soyer family packed hurriedly and sailed for America. They settled in a poor neighborhood in the East Bronx, New York City, and changed the family name to Soyer.

© The Margo Feiden Galleries, NYC 1972

ISAAC SOYER

Life was not easy in the New World. Besides poverty was the problem of coping with an unfamiliar language, but the modest East Bronx apartment provided a haven from the pressures and uncertainties of the outside world. Despite living in cramped quarters, the three brothers continued to paint. "My brothers and I shared the same bedroom," Isaac recalled; "we would sketch each other, in the nude and with clothes on."

To help support the family, Raphael and Moses quit high school after only a year, and all three brothers worked long hours at very low wages, crowding in their education and artistic endeavors when they could. Hoarding nickels and dimes, Raphael and Moses scraped together enough tuition money to attend evening classes in drawing at Manhattan's Cooper Union, and in 1920 Isaac enrolled there. About 1918 the twins had begun to study at New York City's National Academy of Design, while also taking sketching classes at the Beaux-Arts Institute. In 1924 Isaac, too, went to the National Academy and the Beaux-Arts, and in 1925 he enrolled at the Educational Alliance, New York City.

Although the brothers tried to keep their artistic personalities distinct, and even took different studios, a so-called family style, despite individual differences, evolved. (Isaac cites the three Le Nain brothers of 17th-century France as a comparable phenomenon.) Aspects of the family style can be traced to the day when Moses brought home a copy of *The Liberator*, a magazine carrying reproductions of Daumier and of members of the Ashcan School, including John Sloan, Robert Henri, and George Luks. The

°soi´ er

brothers admired the warm humanism, social concern, and "relevance" of the artists represented. Moses had come into contact with Robert Henri, the guiding spirit of Ashcan School realism in the century's early years, at a Sunday art class Henri occasionally instructed. The Soyers were also influenced at this time by Degas and Rembrandt, and Isaac in particular was drawn to Vermeer. However, Rembrandt was "the biggest spiritual force in the development of my painting," Isaac said.

From 1924 to '26 Moses taught a life class at the Educational Alliance, but art was still a part-time activity for all three brothers, who continued to work at various jobs to support themselves (Isaac occasionally tutored youngsters in Hebrew). In 1926, when Moses left for Europe on a two-year traveling scholarship, Isaac took over his class at the Alliance. In 1928 Isaac married the exotic-looking Sofia Borkson, a painter he had met in his Alliance student days, and took her to Paris. There, in 1929, Isaac painted *Girl Embroidering,* a study of his wife, which, when purchased two years later by Mrs. Juliana Force, became the first of his paintings to be acquired by the newly founded Whitney Museum of American Art, New York City. From Paris the Soyers went to Madrid, where Isaac was impressed by the paintings of Velázquez and Goya. The influence of those masters can be seen in Isaac's early works, which date from his return to the United States in 1929.

In New York City during the Great Depression, Isaac, like his brothers, painted working-class genre subjects, a "non-Park Avenue" portrayal of derelicts on park benches, dreary rooms in employment agencies, relief stations, and breadlines. However, again like his brothers, he expressed concern and compassion without being propagandistic or didactic. But Isaac belonged to a generation younger than that of Raphael and Moses, and his approach was more directly shaped by the Depression and the worldwide social and political turmoil of the 1930s. His painting *Where Next?,* inspired by the tragedy of the Spanish Civil War, indicated to critics that his art had an international bearing beyond the New York scene. However, his best-known painting of the '30s was probably the expressive and skillfully composed *Employment Agency* (1937; Whitney Museum).

In the late '30s Isaac exhibited regularly at the Midtown Galleries, New York City. His palette was like Raphael's, but with less strongly accented grays and browns and with a more ambitious compositional approach, which can be seen in his large, richly colored allegorical pictures from the late '30s. The critic Henry McBride found in

Isaac's work "a classical feeling for balance and harmony," and *School Girls,* now hanging in the Art Students League, New York City, exemplifies Soyer's sensitive, muted tonalities and spiral design. Later his palette brightened, as in his paintings of Degas-like dancers, semiclad or nude, usually in repose, and often with the wistful, sad-eyed "Soyer look."

During World War II Isaac worked in a war plant in Buffalo, New York. Realizing that if he were put on an assembly line he would probably daydream about pictures, the plant managers gave him the job of "trouble-shooter," inspecting and stamping machine parts.

In the summer of 1943 Isaac taught at the Buffalo University State Teachers College, and he headed his own art school in Buffalo from 1945 to '46, when he returned to New York City. A snow scene he painted in Buffalo was acquired by the Albright-Knox Art Gallery.

From 1958 onward, Isaac taught at the Brooklyn Museum Art School, becoming one of the school's most popular teachers. He had long been associated with the New School for Social Research, New York City, which gave him a retrospective in 1976, and with the Art Students League, where he taught classes in life-drawing, painting, and composition. He said, "I try not to force my personality, my style or my point of view on a student."

Soyer's palette grew consistently lighter over the years. One of the most appealing of his later canvases, *Untitled Painting* (ca. 1974), is a very personal response to the problems of the so-called generation gap. In the foreground is the Soyers' son, Avron, bearded, with a wild Afro hairstyle and a distraught expression. In the middle ground sits his mother Sofia, regarding her son with concern and some bewilderment. The painting avoids becoming journalistic and sentimental by its understatement and subtle psychological insight. All three brothers appear in the background of Raphael's large canvas *Portraits at a Party,* which was painted in 1974, the year of Moses's death. The brothers had remained close throughout their careers.

Isaac Soyer in his 70s was a quiet, gray-haired man of great refinement and sensitivity; small of build, although slightly taller than his brothers, he had more angular features. He also had a warm, gentle manner and was much loved and respected as a teacher. He and his wife lived in a small but comfortable apartment on a tree-lined street in Manhattan's East Sixties; the main room was lined with books and paintings. Their son, Avron, trained as a sociologist. Until early 1977 Isaac maintained a studio in a different section of the Upper East Side.

Soyer died at Lenox Hill Hospital, New York City. He took a philosophical view of the fluctuations of the art scene, which had changed radically since the 1930s, when social realism was popular. He continued to paint in his idiom with unaffected simplicity, firmly believing that the humanistic representational tradition would outlast contemporary abstract trends. "The artist discovers significance and meaning in whatever environment he is cast by chance," Soyer said. "Wherever he is born and grows up, his life work is set for him, to paint with understanding and depth the people and the physical appearance of everything around him. . . . According to his talent, his command over his medium and technique, he will express upon canvas, in vibrant colors and exciting forms, his reactions to our tempestuously changing world."

EXHIBITIONS INCLUDE: Midtown Gals., NYC 1936, '38; Art Inst., Buffalo, N.Y. 1944; Margo Feiden Gals., NYC; Nelson Rockhill Memorial Art Gal., Kansas City, Mo.; Albright-Knox Art Gal., Buffalo, N.Y.; Art Alliance, Philadelphia; New School for Social Research, NYC 1976. GROUP EXHIBITIONS INCLUDE: Paris Exposition 1937; Golden Gate International Exposition, San Francisco 1939–40, New York World's Fair, Flushing Meadow 1939–40; Metropolitan Mus. of Art, NYC; Mus. of Modern Art, NYC; Whitney Mus. of Am. Art, NYC; Brooklyn Mus.; Chicago Art Inst.; Corcoran Gal., Washington, D.C.; Pennsylvania Academy of the Fine Arts; Syracuse Mus., N.Y.; Milwaukee Art Inst., Wis.; Rhode Island School of Design; "W. P. A. Art, Then and Now," Parsons School of Design, NYC 1977; "American Painting 1920–1945," Whitney Mus. of Am. Art, 1977–78.

COLLECTIONS INCLUDE: Whitney Mus. of Am. Art, NYC; Brooklyn Mus.; Albright-Knox Art Gal., Buffalo, N.Y.; Dallas Mus. of Fine Arts, Tex.; Brooks Memorial Gal., Memphis, Tenn.; Paris Mus., Southampton, L.I.; Ain Charod Mus., Jerusalem.

ABOUT: Myers, B. S. and others Dictionary of Twentieth Century Art, 1974; Rose, B. American Art Since 1900, 2d ed. 1975. Periodicals—Brooklyn Museum Art School Bulletin Winter–Spring 1961; New York Times July 16, 1981.

***SOYER, MOSES** (December 25, 1899–September 3, 1974), American painter, was a leading Urban Realist. The twin brother of Raphael Soyer and the older brother of Isaac Soyer, he was born in the town of Borisoglebsk in the Tambov region of southern Russia. Moses and Raphael were the oldest of six children of Abraham and Rebecca Schoar. Their father, a teacher of Hebrew literature and history and a writer of fairy tales, taught the twins and Isaac to draw and encouraged their artistic activity.

Courtesy of the Margo Feiden Galleries, NYC

MOSES SOYER

Because of the severe restrictions on Jews in Czarist Russia—in the fall of 1912 the government of Tambov refused to renew Abraham Schoar's residence permit—the family left Russia for the United States. The Schoars settled in a poor neighborhood in the East Bronx, New York City, and changed the family name to Soyer. Admitted to public school, the twins found it difficult to adjust to their new environment, even after they had learned English. Moses recalled: "We were happy only in the badly lighted and ill-ventilated back room in our apartment which our mother had allocated to us. Here we (including Isaac) did our lessons, posed for one another, and painted and drew."

Although the resemblance between Moses and Raphael was strong, they were not identical twins. Both were small and had dark brown eyes, but Moses's vigorous, stocky build and chubby features contrasted with Raphael's frail physique and thin, sensitive face. Moses was also more extroverted than the shy Raphael.

At 15, the twins entered high school but had to quit after a year to take low-paying part-time jobs to help support the family. However, they attended free evening drawing classes at Manhattan's Cooper Union, and in the fall of 1918 Moses and Raphael entered the National Academy of Design, New York City. While at the Academy Moses also attended a Sunday sketch class in Spanish Harlem, where the Ashcan School artists Robert Henri and George Bellows would criticize the drawings. Moses recalled the gaunt, sad-eyed and Lincolnesque Henri as "a warm, generous, magnetic personality," and he never forgot the night Henri showed him a re-

production in *The Liberator* magazine of a Daumier drawing of hungry men and women and their forlorn, undernourished children. "Ignorant as I was," said Moses, "I could not help but be struck . . . by the noble, unadorned simplicity of the drawing."

Moses took a copy of *The Liberator* home to show his brothers the Daumier drawing and the reproductions of works by John Sloan, Henri, George Luks, and other members of the Ashcan School. These discoveries, along with the influence of Degas which began about this time, laid the basis for what has been called the "family style" of the three Soyer brothers. However, Moses and Raphael, aware of the problem of being twins, decided on Moses's initiative to take separate studios and study in different schools. Raphael continued at the National Academy while Moses attended the Educational Alliance Art School on the Lower East Side.

Moses's earliest paintings included *Old Man with Cane* (1922) and *Old Man in Skull-Cap*, sympathetic studies reflecting his admiration for Rembrandt, who remained for Moses the greatest painter of all time.

From 1924 to '26 Moses taught a life-class at the Educational Alliance and painted *East Side Roofs* (1925) and other cityscapes. Among his students was Ida Chassner, who had studied dancing at the Neighborhood Playhouse. In 1926, when Moses was awarded a scholarship enabling him to travel for two years in Europe, he asked her to marry him. Tall and angular with wide-set blue eyes, Ida was the prototype for many of the young women he was to paint for the rest of his life.

The young couple left for Europe full of enthusiasm, but in retrospect Moses felt that he had been too young to absorb all that he saw. It is noteworthy that his 1926 painting of a street in Paris looked like downtown New York. Moses and Ida returned to the US in 1928, on the eve of the Great Depression, with a baby, their son David.

In 1928 the dealer J.B. Neumann, who had included Moses's paintings in group exhibitions and had introduced him to the work of the German Expressionists, gave him his first solo show in New York City. When the Works Progress administration (WPA) was created in 1935 by the Roosevelt Administration, Moses was one of the first artists to join. Assigned to the mural painting project, Moses painted ten murals on the theme of American children at work and play. In 1939 he collaborated with his brother Raphael on two murals for the post office in Kinsessing, Pennsylvania, although Moses eventually decided that such painting was not suited to his talents and left the mural project.

During the Depression, Moses's work, like Raphael's, depicted the hard times and careworn faces of those years. Without being propagandistic, there is implied social protest in *Hooverville* (1934), in oil on cardboard, as there is in *Men on the Waterfront* (1938), with its defeated and dejected dockworkers. Other works from this period are *Employment Agency* (1935) and *Out of Work* (1937). Moses painted with a heavy outline, using a palette knife more often than Raphael, and his compositions were more dispersed. The colors tended to be subdued.

From the 1940s, Moses painted some of his most personal and appealing works. These include portraits of artist friends, such as, in 1944, Abraham Walkowitz and Joseph Stella; studio interiors; pensive girls, as in *Girl in Orange Sweater* (1953; Whitney Museum of American Art, New York City); serious, angular, long-legged female dancers practicing, rehearsing, and in repose; tired seamstresses making costumes; and sympathetic studies of young lovers. In his nude or seminude figures of young women and his studies of dancers (*Three Dancers* [1954], *Seated Dancer* [ca 1957]), Moses's knowledge of anatomy enabled him to express "the give and take of muscular tension, the apparently careless but really practical control of posture," as Margaret Bruening noted. Charlotte Willard, in her introduction to *Moses Soyer* (1972), wrote, "His skinny American girl, driven by her dreams, Gothic in her sparseness, vulnerable but strong, is the Venus of our time."

Of his father's close relationship with his models, David Soyer stated that they "lived Moses's life with him, sharing his career [and] absorbing his humanistic point of view that the most important subject of art is man." Ida and Moses "adopted" each model, and the Soyer studio became the meeting place for the modern dancer Tamiris and many of the "barefoot girls" who became prominent in the avant-garde dance movement.

Moses Soyer was fortunate in his New York dealers. He had begun with J. B. Neumann, whom he described as "a genuine lover of art with a very cultivated background." In the early '40s Moses exhibited in the galleries of George Macbeth, who had helped to advance American painting with his 1908 showing of the then controversial Ashcan School. From 1944 onward, Moses was with the A.C.A. Gallery, whose director, Herman Baron, was a "true idealist with a strong point of view—that art should be brought to the broad masses of the people," to quote Moses.

Reviewing Moses's exhibit at the A.C.A. Gallery, a *Time* magazine (December 7, 1962) critic

wrote, "In such a painting as 'Young Girl,' subtlety of pose, the position of only a hand, can express as much emotion as the expression on the face." However, Hilton Kramer of *The New York Times* wrote unfavorably of the Soyer exhibition mounted by the American Academy of Arts and Letters, to which Moses had been elected: "Mr. Soyer is a sentimental realist whose artistic credo has led him to believe (so it seems) that any emotion worth expressing must be sweetened beyond recognition." Soyer's 1972 exhibition of drawings at the Huntington Gallery, New York City, was praised by Malcolm Preston of *Newsday* (December 14, 1972). Acknowledging that the artist was "indebted to the Realist tradition of the late 19th century," Preston noted that "there is in these drawings of Soyer a gentleness, a calmness and serenity that I know to be the essential character of Soyer himself."

Moses Soyer, aged 62, was described by Charlotte Willard as "a short erect man with graying hair, a fine head and large sad eyes." But when he smiled it seemed as if "behind a serious, almost tragic countenance, a gay imp [were] hiding." One's first impression of Soyer was that he was taciturn, but he spoke freely once he was certain of his listener's interest. His studio was on the top floor of a small building in Greenwich Village. He worked with his left hand, but, he said, "When I feel it becoming slick, I work with my right hand, and the work comes out better."

Soyer's favorite American artist was Thomas Eakins, and of the Old Masters, in addition to Rembrandt, he preferred the "quiet painters," Vermeer, Corot, Degas, and Cézanne. "I like the personal and the intimate," Soyer explained. "I like an artist who talks in a low voice."

EXHIBITIONS INCLUDE: Neumann Gal., NYC 1928; Little Gal., Washington, D.C. 1941; A.C.A. Gal., NYC from 1944; Saint-Lawrence Univ., Canton, N.Y. ca. 1969; Huntington Gal., N.Y. 1972.

COLLECTIONS INCLUDE: Metropolitan Mus. of Art, and Whitney Mus. of Am. Art, NYC; Brooklyn Mus., N.Y.; Detroit Inst. of Arts; Philadelphia Mus. of Art; Phillips Collection, Washington, D.C.; Worcester Art Mus., England; Toledo Mus. of Art, Ohio; Univ. of Kansas, Lawrence.

ABOUT: Brown, M. W. American Painting from the Armory Show to the Depression, 1955; Willard, C. and others Moses Soyer, 1972. *Periodicals*—Apollo (London) March, 1981; Newsday December 14, 1972; Time December 7, 1962.

***SOYER, RAPHAEL** (December 25, 1899–), American painter, writes: "I was born in December 1899, in Russia, one of six children. Art and literature were the daily possessions of our home. Our father was a writer and teacher and the other members of the family were always occupied with some form of creative work—writing, painting, embroidering.

"In 1912 my family came to America. Shortly after our arrival in this country my two brothers, Moses and Isaac, and I decided to give up any thought of going to college for the sake of studying in art school. In 1919 I entered the National Academy of Design where I studied for two or three years. A few months at the Art Students League followed. After leaving the League, I worked for a living in various factories and painted only in my spare time. This lasted for about five years.

"It is interesting to me now as I look back at all those years to realize that, as soon as I left the National Academy, I made a conscious effort to forget everything I had learned there. While some of my schoolmates, in their rebellion against the teachings of the academy, fell under the influence of Cézanne, Van Gogh, et cetera, and painted like them, I really started from the beginning again and painted, in a frank and almost naive manner, subjects of ordinary interest that were part of my immediate life (such as the *Dancing Lesson*, various portraits of my mother and father and other member of my family). The altogether simple way in which these were painted gave them a humorous aspect which was not intended. At that time I remember there was a flurry of discussion among art critics as to whether or not this humor was conscious on my part. That was also the time, in the middle and late '20s, when Rousseau-esque primitivism in art began to flourish here. Encouraged by a number of friends I could have naturally embraced this naive style as my own and remained a "primitive." But my eagerness to learn my craft and to widen the content of my paintings prevented me from acquiring the confining mannerisms of primitive art. Apropos of the subject of naiveté, Henry McBride, writing about my painting *Under the Bridge*, said, 'Alas, the artist who painted the *Bend of the Bridge* so well will never be naive anymore.' At that time too, I became fascinated by the art of Degas—wordly, analytical, refined—the antithesis of anything naive.

"Now I find myself looking back with longing on that period of my youth and struggle, though it may seem trite to say so. I shared my first studios with other young artists away from home and school. We roamed the streets of New York together, sketching the piers, the bridges and the

Photo by Budd

RAPHAEL SOYER

'El' structures. We painted our first hired models and tried to give those pictures a slightly Pascinish character, which at that time was considered the height of sophistication. We were young, industrious, and full of hope.

"In 1929, the year of the crash and the beginning of the Great Depression, my first solo exhibition was held at the Daniel Gallery. It was composed of a few street scenes, a portrait of my mother, the family group, *Dancing Lesson*, a still life or two, and several studies of Suzie, a Lautrecian model. On the whole, the show was favorably accepted by critics and artists. Mrs. Force of the Whitney Museum bought *New York Street Scene* and one painting was sold to the Howald Collection of the Columbus Museum, Ohio.

"A first solo exhibition is a big event in an artist's life and I still have a mental picture of the Daniel Gallery with my shyly intimate paintings on its walls.

As I look back and examine my work as objectively as I can, I find that I have followed a definite pattern. It is a picture of the life I have known. I find that I have never been swayed by fleeting 'innovations,' cubist or abstract, or by any aesthetic speculations for that matter. Rather, the emphasis in my work has been on content and mood. I think I have consistently retained in my work an enduring quality of frankness of outlook and technique."

Although critics have written of a "family style" in connection with the three Soyer broth-

ers—Raphael, Moses, and Isaac—and there are undoubted similarities of mood and subject matter, each has followed his own individual path. After the twins Raphael and Moses entered the free school of the National Academy of Design, New York City, in the fall of 1918, they became increasingly aware, in Raphael's words, "of our special problem of being twins, of having the same interests and attitudes, which tended to make our work look alike." They decided to study at different art schools, Raphael remaining at the National Academy. Only five foot two, and slight in build, the student Raphael was described by Lloyd Goodrich as "introspective, intensely shy, inarticulate, with a low, scarcely audible voice." His introversion was, however, balanced by "his quiet, almost desperate determination." Among his fellow students were Ben Shahn, Paul Cadmus, Sol Wilson, and the future art historian Meyer Schapiro, but Raphael's shyness kept him from knowing them.

Although the unaffectedly naive style of Raphael Soyer's earliest paintings (*The Bridge*, 1927, *Dancing Class*, 1929–30) was succeeded by a more sophisticated and craftsmanlike approach under the influence of Degas and, later, Pascin, his work has always retained a refreshing sincerity and candor. The Great Depression had a strong impact on his themes and treatment of subject matter, deepening his already pronounced humanism. *Office Girls* and *Shop Girls*, both of 1936, portray with great sympathy careworn urban workers in everyday street scenes. The faces have the wistfulness which, even when painting in happier times, Soyer imparted to his people; a similar melancholy marks his many self-portraits. The ruinous cost of the Depression in human terms was reflected in *In the City Park* (1934) and *Transients* (1936). However, unlike many of his painter friends who practiced an art of social protest, Raphael's pictures contained no overt propaganda. Like his brothers, he was an Urban Realist, not a Socialist Realist.

Women workers fascinated Soyer, and in the '30s and '40s he painted dressmakers, seamstresses, and many scenes of dancing classes. Modern dance was then in its heyday and Raphael knew many of the dancers personally. Significantly, he nearly always drew and painted them at rest or dressing, very seldom in action. His feeling for people was also expressed in his portraits, including those of his fellow artists and their wives. Among his favorite models in the early 1940s were Joseph Stella and David and Marussia Burliuk. Soyer's 1943 painting of the Burliuks is in the Joseph H. Hirshhorn Collection. Soyer's portraits, like his street scenes and interiors, had the quality of quiet intimacy.

From 1933 on, Raphael practiced lithography, a medium well suited to his firm yet sensitive drawing and his feeling for atmosphere and light. In paintings his color was relatively subdued; it has brightened in recent years but is always closely integrated with form.

On February 8, 1931, Raphael had married Rebecca Lutz, a warm, sympathetic women with a gentle, winsome quality that has reminded some people of Rembrandt's Saskia. They have a daughter, Mary.

In the 1930s Raphael showed regularly in the large annual exhibitions mounted by the Whitney Museum of American Art, New York City, as well as in other major American museums. He worked in the graphics division of the Works Progress Administration's Federal Arts Project, and in 1939 collaborated with his brother Moses on two murals for the post office in Kinsessing, Pennsylvania.

With the rise of abstract expressionism, and nonfigurative styles generally, in the late 1940s and early '50s, Raphael Soyer reaffirmed his belief in representational art as a means of expression and communication with others. He declared, "I choose to be a realist and humanist in art." In 1950 he and other figurative artists, including Henry Varnum Poor, banded together to protest the almost exclusive concern with nonobjective art shown by the "official" art world—museums, critics, and dealers. Raphael and his friends decided to express their views in a small annual publication called *Reality*, the first issue of which appeared in 1953. It lasted only a few years but made lively reading, and its identification of realism with the humanist tradition in art aroused heated controversy.

In the '50s Soyer's reputation suffered an eclipse and his work rarely appeared in the large national exhibitions, but he continued to have solo shows which were favorably received even by critics who were supporters of the new abstraction. Although he was regarded as a traditionalist, his integrity and perseverance in his own vision were respected, and there was even an increase in his sales. In 1949 Soyer became an associate of the National Academy of Design and in 1951 was elected to the honorific post of an Academician. In 1958 he was elected to membership in the American Academy of Arts and Letters.

Some of his colleagues joined the avant-garde, but Raphael continued to expand and develop his art on his own terms, working on a larger scale and tackling more complex themes. In his interiors as in his street scenes there was a stronger sense of depth and a greater freedom in color and brushwork. In *Pedestrians* (ca. 1959) he introduced five figures, based as always on friends and acquaintances, caught in the shifting movement of the street. His most impressive work in this vein was the large and nostalgic *Farewell to Lincoln Square* of 1959. The old Lincoln Arcade building, in which he and other artists had had their studios, was about to be demolished to make way for Lincoln Center. As the group of fellow tenants, looking anxious and rather sad, leave the square, Raphael in the background waves goodbye and Rebecca is seen in profile beside him. The group seems to fan out from a central core as the tenants disperse, and there is a touch of wry humor, not unusual in Raphael's work, as, in front of the bronze status of Dante in the top right-hand corner, a street sign points "One Way." Unusually vivid color contrasts can be seen in the clothes of two of the women.

Raphael Soyer's most ambitious undertaking in the '60s was *Homage to Thomas Eakins*, his largest painting. Inspired by the great Eakins exhibition of 1961–62, this important canvas completed in 1965 and acquired by the Joseph H. Hirshhorn Foundation was in the tradition of such works as Fantin-Latour's *Homage to Delacroix*. Grouped in front of the famous *Gross Clinic* and two other Eakins canvases are fellow painters whom Soyer considered to be in the tradition of the Philadelphia master—Leonard Baskin, Edward Hopper, Reginald Marsh, Jack Levine, John Koch, Edwin Dickinson, Henry Varnum Poor, John Dobbs, and Moses Soyer. Lloyd Goodrich, the former director of the Whitney Museum who has written extensively on Raphael Soyer's work, is included, and Goodrich persuaded the modest artist to be faithful to the tradition of "homage" paintings and introduce his (Raphael's) own likeness. Raphael appears inconspicuously in the left background, wearing horn-rimmed glasses. Behind him is his daughter, Mary, bringing in drinks. The many individual studies for the portraits, which are admirable likenesses, were exhibited, along with the large picture, at the Forum Gallery, New York City, in 1965.

In 1965–66, when the "hippie" counterculture and the anti–Vietnam War protests were gaining momentum, Soyer expressed his sympathies for those movements in *Village East Street Scene*, another of his outdoor group pictures. The bearded and bespectacled poet-guru Allen Ginsberg is depicted, as are the militant black playwright Le Roi Jones and the poet Gregory Corso. One of the main figures is a young blonde woman with gaunt features, Diane de Prima, who had often posed for Raphael, and the artist appears in the background. Soyer, who had lived and worked for seven years on lower Second Avenue, felt that the avant-garde poets of the East

Village were making "more sense" than the painters in their determination "to mirror our confused, unhappy time."

One of the most appealing of this group of paintings was *A Watteau* (1967), inspired by a "be-in" in Central Park and based on Watteau's *Gilles* in the Louvre. The central figure is a typical "flower-child" of the '60s, "a rapt-expressioned girl," one writer said, "holding a daffodil in one hand, the other raised open-palmed" in a ritualistic gesture of salutation. In the background are young people playing music or clapping out rhythms.

A Watteau was among the paintings exhibited at a large Raphael Soyer retrospective at the Whitney Museum in October 1967. The *New York Times* critic John Canaday called this "dean of American realists" less adventurous than either of his avowed masters (Eakins and Degas) and felt that his attempts in his latest works at "broken coloration" were based on a misunderstanding of Cézanne. Canaday considered Soyer "at his very appealing best in his most realistic, most personal observations" and added that "at 67 he is both the most modest and the best loved painter in the New York studios." Far from being an "embittered atavist," as he might well have become, Soyer had shown that "an artist's adherence to traditional technique need not deaden his brush or his sensitivity to the modern world as he knows it," to quote Canaday.

Recent exhibits of Raphael Soyer's drawings have included many of his warm, intimate, and sensuous studies of the female nude. Some of the most memorable drawings have been of pregnant women. His drawings, whose effect is often heightened with watercolor, constitute an independent branch of his work, not necessarily related to his paintings.

Beginning in 1959, the Soyers spent long vacations in Europe. They visited museums in more than a dozen countries and called on many artists. Raphael's very personal book, *A Painter's Pilgrimage* (1962), is illustrated with his drawings of details from Old Master paintings and sympathetic pencil sketches of European artists in their homes or studios. A large Soyer retrospective was held at the Hirshhorn Museum and Sculpture Garden, Washington, D.C., in 1982.

The Soyers live in a spacious apartment on Manhattan's Central Park West. Raphael's studio is nearby on the West Side. Though his humanistic realism is still considered old-fashioned, he has enjoyed considerable success but remains quiet, modest, and unassuming. A *Washington Post* interviewer in November 1968 described Raphael as a frail, pallid, gray-suited figure, with thick horn-rimmed glasses and "thinning hair rising two inches off his forehead as if to compensate for his stature, barely 5 feet." Speaking in "his Russian-accented voice, barely audible," Soyer was not optimistic about the future of painting, and with a faint smile called himself "the Last Mohican." He predicted that artists of the future would use the advanced technological media of photography, television, and film rather than paint in oil on canvas. Nevertheless, Soyer has always shown an interest in younger artists working in figurative styles different from his own, provided he is convinced that they are sincere, not jumping on the latest bandwagon.

He still loves New York—"a difficult, monstrous city that is my world"—and maintains firmly that "if the art of painting is to survive it must describe and express people, their lives and times. It must communicate. . . ."

EXHIBITIONS INCLUDE: Daniel Gal. 1929; Valentine Gal. 1933, '35, '38; Macbeth Gal. 1935; Associated Artists Gal. 1941, '48, '53; A.C.A. Gal. 1960; Forum Gal. 1965, '72; Whitney Mus. of Am. Art 1967; Margo Feiden Gal. 1972; "Street Scenes and Portraits," Forum Gal. 1977; Hirshhorn Mus. and Sculpture Garden, Washington, D.C. 1982.

COLLECTIONS INCLUDE:Metropolitan Mus, of Art, MOMA, and Whitney Mus. of Am. Art, NYC; Corcoran Gal. of Art, and Phillips Memorial Gal. of Art, Washington, D.C.; Detroit Inst. of Arts; Fogg Art Mus., Harvard Univ., Cambridge, Mass.; Mus. of Art, Carnegie Inst., Pittsburgh.

ABOUT: Goodrich, L. "Raphael Soyer" (cat.), Whitney Mus. of Am. Art, NYC, 1967; Soyer, R. A. Painter's Pilgrimage, 1962, Self-Revealment, 1969, Diary of an Artist, 1977; Soyer, R. (ed.) Homage to Thomas Eakins, 1966. *Periodicals*—American Artist June 1948; American Magazine of Art April 1939; Art Digest April 15, 1951; Art News December 1960, May 1966; Esquire March 1968; New York Post October 25, 1967; New York Times October 25, 1972; New Yorker March 19, 1948; Newsweek November 13, 1967; Time December 12, 1960.

SPENCER, SIR STANLEY (June 30, 1891–December 14, 1959), British painter, was born in the small Berkshire village of Cookham-on-Thames, the seventh son of William Spencer, a music teacher and organist. The strong sense of place in Spencer's painting grew very much out of the ambiance of Cookham, which became for Spencer a vessel containing memories of sacred places, especially the churchyard, the "holy suburb of heaven," where his grandparents were buried. Another early influence was his father's love of the Old Testament, from which, every

SIR STANLEY SPENCER

evening, he would read to the family. To young Spencer these Bible stories were real, and pertinent to life in his English village. From the Old Testament he acquired a sense of time as a continuum, a merging of past, present, and future.

Music was also pivotal in his development. His three older brothers were musicians and, with Spencer père, they formed a quartet. At night in bed, he would hear the muted strains of music lilting through his room. Particularly enamored of Bach's fugues, he later commented that their emphasis on rhythm and structure influenced his painting.

Spencer studied at the Maidenhead Technical Institute, Berkshire, in 1907–08. From 1908 to '12 he attended the Slade School of Art, London, where his principal teacher was Henry Tonks. During those years, Spencer became aware of cubism and saw the paintings of certain Italian primitives. He returned often to Cookham—this attachment to his "celestial city" earned him the nickname "Cookham" at the Slade—and once took a reproduction of Masaccio's *Tribute Money* to his brother Gilbert, a painter.

Spencer's early work at the Slade demonstrated skillful draftsmanship and a penchant for symbolic storytelling, often in the form of a realistically depicted Biblical scene. His paintings of that period include *Two Girls and a Beehive* (1910) and *John Donne Arriving in Heaven* (1911). The period between his leaving the Slade (1912) and his 1915 enlistment in the Royal Army Medical Corps was the most creative in his life. He had just turned 21 when he worked on such paintings as *Apple Gatherers* and *Zacharias and Elizabeth and the Centurion's Servant*. The

latter painting, and other religious pictures of the years 1912–13, had as their setting the streets of Cookham. Spencer was influenced by Italian Renaissance painters, but, as G.S. Whittet has observed, there were also hints of Pieter Brueghel the Elder "in the limited depths of the perspective and the grouping of the figures with their preoccupation in action recurring in the subsequent Resurrection paintings."

Perhaps more important, Spencer had attended the Slade in the critical years 1911–12, when Roger Fry introduced postimpressionism to the English art world. Fry mounted exhibitions of such painters as Gauguin, Van Gogh, Cézanne, and Matisse and argued that formal relations and the patterned, fauvist use of color were the most important aspects of contemporary painting. Among the Slade students influenced by Fry's ideas were a group of so-called Neo-Primitives which included Spencer, Mark Gertler, and Edward Wadsworth. Spencer had won the Slade's summer painting competition, and when Fry held his "Second Post-Impressionist Exhibition" later in 1912, three of Spencer's works were chosen for the show's English section by the influential Bloomsbury writer Clive Bell.

In 1916 Spencer was posted by the Royal Army to Greece, where he served two years with the Royal Berkshire infantry and was deeply moved by the hills and mountains of Greek Macedonia. The war affected him profoundly, and he kept a notebook of drawings done from imagination. Spencer also began reading the Confessions of St. Augustine, whose belief that the divine can be found in the immediate and the everyday was to be the inspiration for Spencer's mural in the Sandham Memorial Chapel at Burghclere, Hampshire.

The other source for the Burghclere memorial was the artist's memories of army life in Macedonia. Charles Harrison discussed the war's effect on Spencer: " . . . Spencer . . . , one of the pre-war Slade generation whose early work had been heavily dependent on late Pre-Raphaelite sources and mannerisms, found himself projected into a world more compelling to the extension of understanding than that upon which his cloistered imagination had been inclined to feed."

On his return to England in 1918, Spencer served as an official war artist in London. In 1919, after demobilization, he joined the New English Art Club, which had formed in opposition to the Royal Academy and to encourage modern painting, and maintained membership until 1927. He became friends with the painter Henry Lamb in 1920 and with the etcher Muirhead Bone in 1921. The following year Spencer

traveled with his sister and Richard and Hilda Carline to Yugoslavia, and he enrolled for one more term at the Slade School in 1923, the year he began the drawings on which his Burghclere mural was based.

Spencer wed Hilda Carline in 1925. They had two daughters, Shirin and Unity, but their marriage was stormy, filled with ambivalence and complex sexual passion. "After I married Hilda," Spencer later said, "my work began to include so much besides the divine vision. I have been incapable of painting a religious picture in the sense of *Zacharias* and some of my early pictures. I no longer have a clear vision of God, I'm somehow involved in the created. Sometimes I feel we are showing his creations to God. Take an Edwardian Old Lady—five feet high, bloated purple dress, ridiculous little feet pinched in ridiculous shoes. I am lifting her up to God. Look, isn't she bloody wonderful?"

After the war Spencer took up residence in Cookham, where he resumed work on *Swan Upping at Cookham,* a unique painting combining elements of cubism with a naive symbolism. From 1927 to '32 he worked on the Burghclere mural, which was commissioned by Mrs. Behrend, who had purchased *Swan Upping* and wanted to commemorate her brother, a World War I casualty. Spencer's mural of the Resurrection was given the setting of the Macedonian Valley, but almost all of his life's work was put into the 19 canvases it comprises. The end wall, with the *Resurrection of Soldiers,* completed in 1929, is particularly impressive. Charles Harrison commented on the mural: "Although the reiterated items of an individualistic, homespun Christian symbolism here as elsewhere tend to expose the lack of a sophistication which limits all Spencer's work, his scenes of army life in Macedonia evidently serve a highly idiosyncratic observation and a vivid recollection of events, and they thus catch a quality which we miss in the works of many more intelligent artists [who painted World War One scenes]."

Spencer and Hilda were divorced in 1935. Two years later he married an artist friend, Patricia Preece, but maintained a friendly relationship with his first wife. His second marriage was not a happy union. Spencer was capable of deep affection, but his quirky, compulsive temperament seems to have made him hard to live with.

In the 1930s, while still interested in symbolic narrative and religious allegory, Spencer became concerned with landscape, still life, genre subjects, and portraiture. He regarded his obsessive realism as part of a larger scheme of the fusion of the spiritual and the worldly.

A series of paintings on the theme of "Christ in the Wilderness" was among the works that absorbed Spencer in the late '30s, until the outbreak of World War II. In 1940 Spencer was sent as an official war artist to Port Glasgow, Scotland to do paintings of the shipyards, a project commissioned by the War Advisory Committee. The port itself and the shipyard workers were to become the models for another Resurrection series, larger in scale than his previous pictures on that theme but, in the opinion of critics, of less compelling spiritual content. The Burghclere mural is still considered his finest work.

In 1950 Spencer was made a Companion of the British Empire, and in 1958 he was knighted and awarded an honorary doctorate of Literature by the University of Southampton. He died in Cliveden, Buckinghamshire, aged 68. A few months before his death he told his elder daughter Shirin of his wish to continue his autobiography, begun about 1936, continued intermittently in the '40s, and addressed in the form of letters to his ex-wife Hilda.

Stanley Spencer was a small man of slight build, clean shaven, with clear-cut features and, in his later years, a fringe of gray hair over his forehead. His idiosyncratic personality seems to have stemmed from his solitariness and the frustrations of his personal life. As the years passed he had a growing need for self-revelation, and was a compulsive talker. According to his brother-in-law Richard Carline: "In his writing, as in conversation, Stanley was always confident of being understood," even when discussing abstruse ideas. Despite his later realism, Spencer's vision was essentially religious, seeing nature as revealed truth. He worked above all to give the Gospel narratives a contemporary interpretation. G.S. Whittet called him "a traditional primitivist whose iconography was based on naturalistic conventions . . . ," but Whittet added that Spencer's work was "less vital" than that of the inspired primitive Henri Rousseau, because of the former's tendency to overdescribe and his "somewhat pedestrian expression of atmosphere." Spencer's style, fluctuating between schematization in the direction of the Italian primitives and Brueghel and an obsessive fascination with detail, made him something of an anachronism in 20th century art.

Like William Blake, Spencer had a sense of the universe as a marriage of good and evil, the sacred and the profane. In a statement quoted in *The Guardian,* Spencer revealed the Blakean side of his nature: "The first place an artist should find himself is in prison, he is an artist and the moment he is an artist he starts to free himself."

EXHIBITIONS INCLUDE: Goupil Gal., London 1927; Arthur Tooth and Sons, London 1932, '33, '36, '50; J. Leger and Son, London 1939; Leicester Gal., London 1942; Temple Newsam House, Leeds, England 1947; Arts Council Gal., London 1954; Tate Gal., London 1955; Cookham Gal, Berkshire, England 1958; Worthing Art Gal., Sunex, England 1961; Kings Hall, Cookham, England 1962; City Mus. and Art Gal., Plymouth, England 1963; Llandaff Cathedral, Cardiff, Wales 1965; Nat. Gal. of South Australia, Adelaide 1966; Third Eye Centre, Glasgow 1975; Brighton Art Gal., England 1976. GROUP EXHIBITIONS INCLUDE: "Second Post-Impressionist Exhibition of English, French and Russian Artists," Grafton Gal., London 1912; 71st Retrospective Exhibition, New English Art Club, London 1925; "Meisterwerke Englischer Malerei aus Drei Jahrhunderten," Secession Gals., Vienna 1927; Venice Biennale 1932; Carnegie International, Pittsburgh 1933; Summer Exhibition, Royal Academy, London 1934; "Twee Euewen Engelse Kunst," Stedelijk Mus., Amsterdam 1936; "Contemporary British Art," World's Fair, Flushing Meadow, N.Y. 1939; "British Painting Since Whistler," Nat. Gal., London 1940; "War Artists," City Art Gal., Glasgow 1945; "Exposition Internationale d'Art Moderne," Mus. d'Art Moderne, Paris 1946.

COLLECTIONS INCLUDE: Stanley Spencer Gal., Cookham-on-Thames, England; Tate Gal., Imperial War Mus., and Royal Academy of Art, London; Fitzwilliam Mus., Cambridge; Ashmolean Mus., and St. John's Col., Oxford; Southampton Art Gal., England; Birmingham City Art Gal., England; City of Manchester Art Gal., England; Leeds City Art Gal., England; Aberdeen Art Gal., Scotland; Glynn Vivian Art Gal., Swansea, Wales; Belfast City Art Gal.; Stedelijk Mus., Amsterdam; MOMA, NYC.

ABOUT: Bratby, J. Stanley Spencer's Early Self-Portrait, 1969; Carline, R. Stanley Spencer and War, 1978; Collis, L. A Private View of Stanley Spencer, 1972; Collis, M. Stanley Spencer, 1962; Newton, E. Stanley Spencer, 1947; Rothenstein, E. Stanley Spencer, 1945; Spencer, G. Stanley Spencer, 1961; Spencer, S. and others, Sermons by Artists, 1934, Stanley Spencer—Resurrection Pictures, 1951; Wilenski, R.H. Stanley Spencer, 1924. *Periodicals*—Carnegie Magazine (Pittsburgh) November 1933; Guardian July 28, 1976.

SPOERRI, DANIEL (March 27, 1930–), a New Realist with a pronounced, almost extravagant sense of playful absurdity, is best known as the maker of *tableaux pièges* ("snare" or "trap" paintings), a form of assemblage in which randomly acquired objects—the remains of a dinner party, for example, complete with soiled dishes, ashtrays, and scraps of food—are fixed to the tabletop or other surface with nails or glue and mounted on a wall. His aim is to "trap" reality just as it is. Obsessed with the artistic properties of food preparation and ingestion, he

DANIEL SPOERRI

founded combination gallery-restaurants in Düsseldorf and wrote a number of dadaesque books about gastronomy. Suzanne Frank, reviewing his *The Mythological Travels* in *Arts Magazine* (Summer 1970), noted that Spoerri "adds two ingredients to Conceptual Art that are too often missing: one indispensable—poetry; the other desirable—humor; and the result is much more palatable, and even profound, and certainly varied, than some other current attempts to turn reality into art."

Born of Swiss parentage in Galati, Rumania, Spoerri emigrated to Switzerland as a child and was trained as a ballet dancer in Zürich and Paris. In Paris in 1954 he wrote concrete poetry. By 1955 he was a principal dancer with the State Opera Company of Bern and also one of the publishers of *Matérial*, a magazine of concrete and ideogrammatic poetry. After his move to Paris in 1959, he became the publisher of Editions MAT (Multiplication d'Art Transformable), and began his experiments with *tableaux-pièges*. In May 1961 he joined Jean Tinguely, Yves Klein, Martial Raysse, and other notable avant-gardists in "40° au-dessus de Dada" (Forty Degrees Above Dada), the first Paris exhibition, organized by the critic Pierre Restany, of the Nouveaux Réalistes, who specialized in the collection and rearrangement of found objects and other artifacts of industrial and post-industrial civilization. Spoerri's snare paintings such as *Catalogue Tabu* (1961), were immediately appreciated as deft examples of what Lucy R. Lippard called the New Realists' ability to detect "the hitherto unrecognized strangeness latent in every common object, old

or new." In 1962, he, Robert Rauschenberg, Tinguely, and others collaborated in the construction of a synaesthetic "Dynamic Labyrinth" at the Stedelijk Museum, Amsterdam, and the same year he contributed to the "Festival of Misfits" at London's Gallery One. For a time he was associated with the German-American group of environmental artists known as Fluxus.

Food as the stuff of art has always fascinated Spoerri. The processes undergone by edible objects—cutting, cooking, mastication, digestion, decay—are used by him as opportunities for demonstrating the kind of random change in which, he says, art exists. "There is a given order in the beginning when you start a meal," he explained, "then you end up with a mess." One of his first food "events" was the 1961 *Grocery Shop* in the Galerie Köpke, Copenhagen, in which perishable items were formally declared to be works of art. "To buy a tomato while realizing that it's a work of art that one is buying is participating in a great spectacle," Spoerri wrote in a text that accompanied the show. "In a spectacle what is false becomes true, provided one enters the game." Other events included baking loaves of bread inside shoes and displaying remnants of food that had been chewed by rats.

In 1970, Spoerri, then living in Düsseldorf, opened *Restaurant Spoerri*, where food was cooked and sold amid displays of his art and correspondence, and the Eat Art Gallery, where edible works by such artists as Joseph Beuys and Richard Lindner were commissioned and exhibited. Many of the banquets he cooked at both locations ended as *tableaux pièges*. For an art installation at the Sydney Biennale of 1979 he placed the corpse of a cow that had died of starvation on a floral carpet in front of a television set. Another restaurant idea—for an establishment where the chefs "would prepare for each customer whatever dish his face would inspire us to make"—has yet to be realized.

Daniel Spoerri, who is divorced and has two sons, lives in Paris. He has published books and articles in German, French, and English. In *The Mythological Travels* (1969), which was translated by the avant-garde poet Emmett Williams, he recounted the details of a visit to the Greek island of Symi, where he created 25 "archaeological objects" out of animal bones, old bottles, and similar debris, and explored, intellectually and gastronomically, the *keftedes*, or meatball, in all its infinite and sometimes horrific variations. An abridged version was published in 1982 as *Mythology and Meatballs.*

Spoerri shares the New Realists' desire to dissolve the boundaries between art and everyday life. Like Robert Rauschenberg's *Bed*, his works are an extension of the idea of the readymade, or found, object that originated with Marcel Duchamp. Spoerri acknowledged this fact when, in an exhibition of his objects displayed in a room in New York City's Chelsea Hotel, he put up a sign that said "I accuse Marcel Duchamp."

EXHIBITIONS INCLUDE: Gal. Schwarz, Milan, Italy 1961, '63, '65; Gal. Köpke, Copenhagen 1961; Gal. Lawrence, Paris 1962; Gal. Lauhaus, Cologne 1962; Studio F, Ulm, W. Ger. 1962; Gal. J, Paris 1963, '64; Gerstner and Kutter, Basel 1963; Gal. Zwirner, Cologne 1963, '64; Allan Stone Gal., NYC 1964, '65; Haus am Lutzowplatz, Berlin 1964; Green Gal., NYC 1965; Gal. Ad Libitum, Antwerp, Belgium 1965; City-Gal., Zürich 1966; Gal. Gunar, Düsseldorf 1968; Gegenverkehr, Aachen, W. Ger. 1969; Gal. Handschin, Basel 1969; Gal. al Vecchio Pastificio, Cavigliano, Italy 1970; Eat Art Gal., Düsseldorf 1970, '71; Gal. Denise René-Hans Mayer, Düsseldorf 1971; Stedelijk Mus., Amsterdam 1971; Gal. Seriaal, Amsterdam 1971; Gal. Bischofberger, Zürich 1971; Centre Nat. d'Art Contemporain, Paris 1972; Elaine Ganz Gal., San Francisco 1975. GROUP EXHIBITIONS INCLUDE: "The Movement Exhibition," Hessenhuis, Antwerp, Belgium 1958; "Festival of the Avant-Garde," Mus. d'Art Moderne, Paris 1960; "The Art of Assemblage," MOMA, NYC 1961; "40° au-dessus de Dada," Gal. J, Paris 1961; "Bewogen Beweging," Stedelijk Mus., Amsterdam 1961; "Dylaby," Stedelijk Mus., Amsterdam 1962; "The New Realists," NYC 1962; "Festival of Misfits," Gal. One, London 1962; "Happenings," NYC 1965; "Happening und Fluxus," Kunstverein, Cologne 1970; "Strategy: Get Arts," Düsseldorf 1970; Kunsthalle, Hamburg, W. Ger. 1971; Kunsthalle, Düsseldorf 1972; "Fluxshoe," Falmouth School of Art, Cornwall, England 1972; Sydney Biennale, Australia 1979.

COLLECTIONS INCLUDE: Stedelijk Mus., Amsterdam; Kunsthaus, Zürich; Kaiser Wilhelm Mus., Krefeld, W. Ger.; Mus. Nat. d'Art Moderne, Paris; Kunstmus., Düsseldorf.

ABOUT: Arnaud, N. Encyclopedie des farces attrapes, et mystifications, 1964; Henri A. Total Art, 1974; Higgins, D. and others. Architektur, Concept Art, 1969; Lippard, L. R. Pop Art, 1966; Pellegrini, A. New Tendencies in Art, 1966; "I Quadri a Trappola di Daniel Spoerri" (cat.), Gal. Schwarz, Milan, Italy, 1961; Restany, P. Un Manifeste de la Nouvelle Peinture, 1968; "Daniel Spoerri" (cat.), Centre Nat. d'Art Contemporain, Paris, 1972; "Daniel Spoerri" (cat.), Gal. Schwarz, Milan, Italy, 1963. *Periodicals*—Art and Artists July 1972; Art News January 1976; Arts Magazine Summer 1970; Newsweek January 31, 1983.

STAËL, NICOLAS DE. *See* **DE STAËL, NICOLAS**

***STAMOS, THEODOROS** (December 31, 1922–), painter, the youngest member of the first generation of Abstract Expressionists, was born in New York City. He was one of the six children of Theodoros and Stamatina (Apostolakos) Stamatelos, Greek emigrants from Sparta, where his father had been a fisherman. As one writer noted, "Stamos came from the poorest of the poor. His parents were . . . of working-class origin [and] had literally fought for their own survival and that of their children."

Theodoros received his education at Stuyvesant High School in New York. At the age of 14 he took some drawings, including one made from a newspaper photograph of a sculpture by Sir Joseph Epstein, to the American Artists School, and received a scholarship which enabled him to attend night classes in sculpture. (The American Artists School was communist-sponsored for the Lower East Side poor.) Because the students worked directly in clay from the model, Stamos never had any formal instruction in drawing. *Young Torso* of 1938 was one of his earliest sculptures.

About 1937 Stamos began to paint at home, and was encouraged by Joseph Solman, one of his teachers. He left Stuyvesant High School in 1939, three months before graduating, and in the same year, according to Thomas B. Hess *Art News* (February 1947), he was expelled from art school for radical "political activities". To support himself he worked at a variety of jobs—as a florist (1939), a teletype operator, a book salesman, a hat blocker, a tourist guide, and from 1941 to '48 he ran a frame shop on East 18th Street. A spleen operation disqualified Stamos from US Army service during World War II, and in these years he met Arshile Gorky, Fernand Léger, and Adolph Denn.

Stamos's early paintings had been in a semi-primitive style, with imaginary Greek scenes or landscapes along the New Jersey Palisades his subjects. Then, to quote Hess, "the large, simple, thickly painted shapes gave way to thinly painted, patterned works, which were strongly influenced by Milton Avery." Typical of this phase was the *Portrait of Dikran Kelekian* (1942).

In November 1943 Stamos held his first New York City solo show, at the Wakefield Gallery run by Betty Parsons, one of the first Manhattan dealers to support new avant-garde painting. It consisted of naive and decorative oils, and boldly simplified pastels (executed in the summer of 1943 at Rockport, Massachusetts) which approached the abstract. The *New York Times* reviewer praised his work for its "strength and originality."

About this time Stamos met Adolph Gottlieb

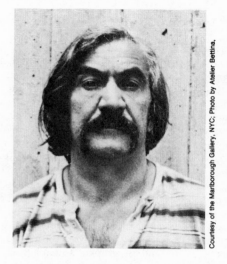

THEODOROS STAMOS

and Barnett Newman, and began to evolve the personal style that established his reputation as one of the most promising of the younger artists of the emerging New York School. He retained the large patterned forms, and started to paint the miscellaneous flotsam and jetsam cast up on beaches—shells, stones, driftwood, coils of rope, and marine creatures. These pictures were at first entirely realistic, but he gradually began to distort the forms and transpose them into abstract and symbolic patterns. His new work was exhibited at the Mortimer Brandt Gallery, New York City, in 1945, and critics saw a resemblance between certain of his canvases, notably *Dying Bird on a White Beach,* and *Little Bird on Rock,* with the nature paintings of Morris Graves. (Critics also believed at this time—mistakenly, as it turned out—that Stamos's biomorphic imagery had been primarily derived from Miró, rather than from the forms the artist had seen at the oceanside.) In 1945 Stamos also exhibited in the Whitney Annual; his painting was bought by collector Edward Root, who became a close friend and enthusiastic supporter. In April 1946 Stamos showed at the Brandt Gallery; the *Art News* critic (April 1946) wrote that Stamos's "quiet poetic quality" was enhanced by his "restrained colors and knowing textural contrasts."

In 1947 Stamos met Mark Rothko, as well as Kurt Seligman and other Surrealists, and the young artist traveled to New Mexico, California, and the Pacific Northwest. His pictures shown at the Betty Parsons Gallery, New York City, in Febraury 1947 were described as "ideographs." They were abstract interpretations of natural ob-

°stä´mos thä ô´ *thô* rôs

Courtesy of the Marlborough Gallery, NYC; Photo by Atelier Bettina.

jects, distinguished, according to the *Art Digest* reviewer, by "their paint quality and haunting color." Also in 1947, Stamos completed a mural commission for the SS *Argentina,* and became friendly with John Graham, the Russian émigré artist, collector, and curator who, in the 1930s, had kept painters like Willem de Kooning and Gorky abreast of developments among the older generation of European modernists.

Accompanied by the poet Robert Price, Stamos in 1948–49 traveled to France, Italy, Greece, and the Red Sea. In Paris he met Brancusi, Giacometti, Laurens, and Picasso. As copublisher of *The Tiger's Eye,* a quarterly review which became the "voice" of the Abstract Expressionists, Price was influential in avant-garde New York circles. For many years he and Stamos shared an apartment on West 83d Street, and their friendship, as John Bernard Meyers wrote in *The New Criterion,* was "a turning point for Stamos—both his painting and his personality. Price was as gentle, courteous, and reticent as Stamos was extroverted, rough-and-ready, and often rude." Moreover, Price introduced Stamos to Oriental culture, which was to strongly influence his work, and "pointed the way to a use of color that [released]the lyricism which was the essential quality of Stamos's vision and—contrary to his personality—his innermost need."

Stamos's new pictures, larger than his previous canvases, were shown at the Betty Parsons Gallery in 1949. Elaine de Kooning, in her *Art News* review (May 1949), wrote of Stamos's "precise and witty imagery," in which "moon-like, floral or altar forms rise quietly before backgrounds that become earth and sky in poetic borderless landscapes." It was at this time that the friendship between Stamos and Mark Rothko began to deepen. "By 1948," wrote Meyers, "the two of them were exchanging ideas and know-how daily. . . . Stamos was moving away from his biomorphic imagery, Rothko was abandoning the 'mythic' image and tending towards fields of color."

In 1950 Stamos had a solo exhibition at the Phillips Gallery, Washington, D.C. He also taught at the experimental Black Mountain College in North Carolina, where Kenneth Noland was one of his students. The following year he was awarded a Tiffany Fellowship, and built a house on Long Island designed by Tony Smith, who was then an architect and supporter of abstract expressionism but later became famous for his monumental abstract sculptures. Also in 1951 Stamos illustrated *The Snows of Cold Stone,* by the poet John Malcolm Brinnin.

Stamos's paintings exhibited in February 1952 at the Betty Parsons Gallery were considered by an *Art Digest* critic (March 1, 1952) to have "a new vigor and austerity, a sense of structure, a substantiality [achieved by means of] a few sweeping strokes of black cutting across areas of smoky color." In 1952 Stamos began painting his "Tea House" series, with a play of white on white enlivened by black calligraphic effects. Two years later he began a series of "Fields," derived from his Long Island environment of potato fields, trees, and the sea. This group, and a series based on terraces overlooking the Red Sea, were exhibited at the Parsons Gallery in January 1956. Stamos has continued to work frequently in series.

In 1955 Stamos began teaching at the Art Students League, New York City, and the following year he received the National Institute of Arts and Letters Award. In 1957, when he began his "Channel" series, Stamos's work took a new direction, with brighter colors and richer textures, though his sources of inspiration were still the Orient and nature. The titles of two of the paintings exhibited at the André Emmerich Gallery, New York City, in April 1958 were *Sun Forest* and *Solstice.* The *New York Times* reviewer (April 6, 1958) observed that these works with their "floating color" seemed to be "reaching forward for something new, something of more cosmic inspiration." Of his large (69 inches by 68 inches) painting *Byzantium II* (1958; Hirshhorn Museum and Sculpture Garden, Washington, D. C.) Stamos remarked in 1972: "*Byzantium II.* . . . was painted ten years after a visit to the many Byzantine churches scattered throughout Greece, and in Torcello, Italy, followed by much reading on the Empire. A series of paintings started to emerge from all this. They are not, in any sense, influenced by the architecture, mosaics, etc., but rather, I believe, by a reaction to what Byzantium was, is, and means today to our own culture and life-style in a more intriguing society than the Empire ever dreamed of."

A 12-year retrospective of Stamos's work was held at the Corcoran Gallery of Art, Washington, D.C., in 1958. The following year he received the Brandeis Creative Arts Award, and he won the Mainichi Newspaper Prize in the Tokyo International of 1961. At this time he moved to "The Barracks," his new home in East Marion, Long Island, and bought a house on West 83d Street in Manhattan.

In 1962 Stamos began a series of "Sun Boxes," in which two rectangles, suspended like reflections of one another, were balanced in fields of luminous color. In this same period he also produced a group of wall hangings based on cartoons fashioned from cut-out torn paper.

Always articulate, Stamos became guest lecturer at Columbia University in 1966, and two years later he was given a full professorship at Brandeis University, Waltham, Massachusetts. In 1969 he completed his first large-scale tapestry commission, *Blue Sun-Box,* for the lobby of an office building at 150 East 58th Street, Manhattan.

In 1970 Stamos began his "Infinity Series," in which he endeavored to push the forms nearer and nearer to the periphery of the actual canvas, leading to ever emptier expanses of radiant color. After a trip to Greece that year, he moved away from so-called sun-box format in favor of larger, more open rectangles, with wavelike washes of paint sweeping into various parts of the canvas.

After Rothko's suicide in 1970, Stamos supervised the installation of the Rothko Ecumenical Chapel in Houston, Texas. Over the years, a deep emotional bond had developed between the two artists, and Rothko's will named Stamos as one of the three executors of the late painter's estate. However, Rothko's daughter brought suit against the executors for negligence and, in a controversial decision, the court ruled in her favor. According to Meyers, "Stamos was so distraught by the Rothko trial that he suffered a few severe emotional breakdowns. The market for his paintings was put in lasting jeopardy. Stamos's only real possession was his house, which he lost as part of the judgment. Stamos thus lived in a state of constant worry and concern over his impending eviction. He began living for six months of the year on a remote Greek island [Stamos had built a studio on the Isle of Lefkas in 1972] when not teaching at the Art Students League. . . ."

The paintings Stamos exhibited in 1972 at the prestigious Marlborough Gallery, New York City, which he had joined the previous year, all bore the same title: "Infinity Field, Lefkada Series." His paintings from 1973 to 1977, in partial reaction to his previous emphasis on empty areas of color, were filled with small, highly active forms, intricately composed. These new pictures, exhibited in the spring of 1978 at the Meisel Gallery, New York City, were also titled "Infinity Field, Lefkada Series," and their average format was a near-square, approximately six feet by five feet. To the *Art in America* (March-April 1978) reviewer, "These forms seem a kind of fragmented grid, scattered yet not defused, hanging in the air, stirred by gentle winds."

Theodoros Stamos is considered, along with Adolph Gottlieb and William Baziotes, both of whom used biomorphic imagery, to represent the poetic-symbolic side of abstract expressionism. His latest work, though, reminds some viewers of the shapes found in one of the earliest American abstractionists, Arthur Dove, whose personal, almost mystical art Stamos has always admired. Stamos's *Homage to Milton Avery* (1968) was a tribute to another older American modernist.

Theodoros Stamos is married and has three sons, Jason, Damon, and Socrates. He was described by Dore Ashton, in a *New York Times* interview (January 20, 1956), as giving an impression of "grave fierceness," although "he often laughs, a high full laugh." Ashton observed: "He speaks haltingly, with a frown, his arched brows raised over black eyes that fix the listener intently, and with his mouth hidden beneath a dense shelf of moustache." Ralph Pomeroy commented in 1971 that Stamos "looks intensely Greek," and added that with his emphatic eyebrows and beaklike nose "he can . . . at times look like an angry eagle."

Stamos enjoys walking, fishing, and gardening. His hobby is collecting Tiffany glass, bentwood chairs, and other Art Nouveau objects and furniture.

He once said of his predilection for painting in series, "I am concerned with the idea of a thing—like a screen door or a tea ceremony—until I have exhausted it." The reference to the tea ceremony, and Stamos's fondness for subtle arrangements of color, texture and light, all point to the Oriental influences which, as one writer pointed out, "have always touched Stamos's thinking." Stamos himself has commented, "I'm interested in Oriental philosophy, but only for myself, not to talk about."

EXHIBITIONS INCLUDE: Wakefield Gal., NYC 1943; Mortimer Brandt Gal., NYC 1945, '46; Betty Parsons Gal., NYC 1947–53, '56; Phillips Collection, Washington, D.C. 1950, '54; Restrospective, Corcoran Gal. of Art, Washington, D.C. 1958–59; André Emmerich Gal., NYC 1958–63, '66, '68, '70; Gimpel Fils, London 1960; Retrospective, Spingold Theater Arts Center Gal., Brandeis Univ., Waltham, Mass. 1967; Waddington Fine Arts, Montreal 1968; Marlborough Gal., NYC 1972; Joslyn Art Mus., Omaha 1973; Athens Gal., Athens, Greece 1974; Meisel Gal., NYC 1977–78. GROUP EXHIBITIONS INCLUDE: "50 ans d'art aux Etats-Unis," Mus. d'Art Moderne, Paris 1955; "Nature in Abstraction," Whitney Mus. of Am. Art, NYC 1958; "The New American Painting," MOMA, NYC 1958–59; "American Abstract Expressionists and Imagists," Solomon R. Guggenheim Mus., NYC 1961; "Dada, Surrealism and Their Heritage," MOMA, NYC (and tour) 1968; "Trends in 20th Century Art," Santa Barbara Museum, Cal. 1970.

COLLECTIONS INCLUDE: Metropolitan Mus. of Art, MOMA, and Whitney Mus. of Am. Art, NYC; Albright-Knox Art Gal., Buffalo, N.Y.; Vassar Col. Art

Gal., Poughkeepsie, N.Y.; Munson-Williams-Proctor Inst., Utica, N.Y.; Rutgers Univ. Art Gal., New Brunswick, N.J.; Wadsworth Atheneum, Hartford, Conn.; Yale Univ. Art Gal., New Haven, Conn.; Rose Art Mus., Brandeis Univ., Waltham, Mass.; Phillips Collection, Corcoran Gal. of Art, and Hirshhorn Mus. and Sculpture Garden, Washington, D.C.; Baltimore Mus. of Art; Art Inst. of Chicago; Des Moines Art Center; Detroit Inst. of Art; Walker Art Center, Minneapolis; Calif. Palace of the Legion of Honor, and San Francisco Mus. of Art, San Francisco; Art Gal. of Ontario, Toronto; Mus. d'Arte Moderno, Rio de Janeiro; Tel Aviv Mus.

ABOUT: Ashton, D. The New York School: A Cultural Reckoning, 1973; Baur, J. I. H. "Nature in Abstraction" (cat.), Whitney Mus. of Am. Art, NYC 1958; Bénézit, E. (ed.) Dictionnaire des peintres, sculpteurs, et graveurs, 1976; Current Biography, 1959; Pomeroy, R. Stamos, 1971; Sawyer, K. B. Stamos, 1960. *Periodicals*—Art Digest March 1, 1952; Art in America March-April 1978; Art News February 1947, May 1949, March 1968; Arts and Architecture July 1947; New Criterion February 1983; New York Times January 20, 1956, December 23, 1977.

*STANKIEWICZ, RICHARD (October 18, 1922–March 27, 1983), American sculpture, wrote: "My birth was in Philadelphia on 18 October, 1922. There were the parents, two older brothers and a sister, the senior. Later there were to be a younger half-brother and half-sister. I am told the family was fairly comfortable at the time. However, my father died while I was young enough not to remember him, and the family fortunes declined. My mother remarried to a man who was rather unsatisfactory and that, with the coming of the Great Depression, made things hard; the family moved to Detroit where there were friends and relatives from the old country—Poland. I went to public schools for five years and then to a Catholic parochial school for three, where I had the advantage of an excellent teaching discipline but the depressing experience of a thick religious atmosphere that was sometimes awesome but also enigmatic, guilt-producing, and intimidating. Questioning soon led me to reject the Church. Returning to public schools I finished out in a good technical high school. It had been my hope for many years to become an artist but this was suppressed by the family as being impractical and it was intended that I should become an engineer. After being graduated I worked for a time in the Civilian Conservation Corps (CCC) and then in the drafting room of a Detroit tool and die shop. The prospect of life and a future working in Detroit industry looked so dismal that I left, joining the navy. World War II came on that same year and

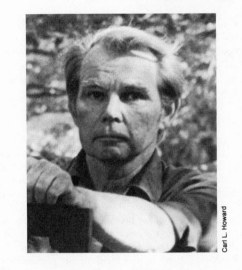

Carl L. Howard

RICHARD STANKIEWICZ

I was to see service on the West Coast, in Alaska and in Hawaii for six years, during which I took advantage of every library and museum I could and taught myself something about painting and sculpture. After the service and a bit of a respite I headed for New York City, having got the impression from [critic Clement] Greenberg in *Commentary* that Hans Hofmann was the man to supply what I was aiming for in painting. He was, but in the two years I attended his school I gradually tended away from painting and toward sculpture. From there I went to Paris, briefly to [Fernand] Léger and then for the rest of a year to Ossip Zadkine who was every enlightening and encouraging. Back in New York City I set up a studio and began to produce a body of work. My livelihood came from a variety of small jobs and part-time occupations and then from draftsmanship, a skill learned in high school and which finally gave my life a little economic stability. This was important for the production of art. Later I was to join the group forming the cooperative Hansa Gallery which, after the Tanager Gallery, was to precede the Tenth Street phenomemon. After five years I resigned from the Hansa and went over to the Stable Gallery. After three or four more years I married, adopted a son, Anthony, and had one born, Peter. Shortly after the marriage we moved to the town of Worthington, Massachusetts, where I still reside. For a period after leaving New York City I had a steady decline in sales at the Stable Gallery and soon dissociated myself from it. Soon after, I accepted a position at the State University of New York at Albany and became a professor of art, which position I still

hold. In recent years I have been represented by the Zabriskie Gallery, which is a happy association. At the moment I am engaged in divorcing my wife, who will have custody of the boys and so my life feels like a taking of a sharp new turn if not a new beginning."

Richard Stankiewicz made his artistic debut in the 1950s as a virtuoso of what came to be known as "junk" art. Shortly after returning from Paris, Stankiewicz, while digging a garden, stumbled onto the material—"rusty, iron things," in Stankiewicz's words—that he would henceforth adopt for his compositions. He began to create ingenious assemblages of molded metals and rusting machine and boiler parts. Early Stankiewicz sculptures contained representational elements, which he often gave a witty or parodic twist, as in *The Bride*, whose veil is composed of bedsprings. However, influenced by abstract expressionism, his work evolved into purely abstract constructions. In 1958, Stankiewicz said, as quoted in *The New York Times* (March 29, 1983), "I take the material that is already degenerating, flaking, and rusting, and then try to make something beautiful of it. It should hit people over the head and make them ask, 'What is beauty?'"

"In the background of Stankiewicz's art," Sam Hunter said in *New Art Around the World* (1966), "is a parenthood that includes the metal sculpture of Picasso, Julio Gonzáles, David Smith, and the machine fantasies of Picabia. [For Stankiewicz] the machine is simply an object with a history of use and deterioration and neither a symbol of hope for human betterment nor an impertinent reminder of the destruction of human values."

One of Stankiewicz's best-known and most appealing pieces is the 84-inch-high *Kabuki Dancer* (1956). G. S. Whittet described the work: "Around the central armature of a vertical pipe surmounted by a flanged drum, bent tubes, and grids adorned by two cusp-shaped appendages takes the instant pose of a female terpsichorean artiste about to break into rhythmic, musically inspired steps." In *Flower Sculpture* (1956), Stankiewicz used automobile cogs and fans to suggest organic forms. *Our Lady of All Protections* (1958; Albright-Knox Art Gallery, Buffalo, New York), one of his best naturalistic compositions, is constructed of scrap metal parts which, while preserving their original rough texture, subtly allude to animal or human forms. Although he has acknowledged a connection between this sculpture and religious imagery, Stankiewicz maintained that *Our Lady of All*

Protections is a whimsical piece and should not be read too closely or seriously. According to Sam Hunter there is a similarity between Stankiewicz's "technical innovations and caricatural energies" and the French sculptor Jean Tinguely's kinetic animations and "deflations of the machine." Hilton Kramer, reviewing the artist's 1980 retrospective at the Sterling and Francine Clark Art Institute, Williamstown, Massachusetts, in *The New York Times* (July 15, 1980), described Stankiewicz's work of the 1950s as "Constructivism with a sense of humor."

In the early 1960s, when Stankiewicz eliminated metaphorical references from his work, he made his sculpture more lyrical by simplifying his shapes. In the 1970s he further purged the "junk look" as well as the figurative allusions from his constructions. Hilton Kramer observed that although this shift "entailed a loss of the sculptor's characteristic humor," it made him "an even better sculptor . . . than he was in the 1950s." Reviewing Stankiewicz's 1977 exhibition at the Zabriskie Gallery, New York City, Kramer wrote in *The New York Times* (April 8, 1977): "Everything in the artist's new work is leaner, less elaborate, more concise and more sharply stated."

Richard Stankiewicz died in Worthington, Massachusetts, of cancer. From his marriage to Patricia M. Doyle, which ended in divorce, there were two children, Peter Alex and Anthony Leslie.

EXHIBITIONS INCLUDE: Hansa Gal., NYC 1953, '54, '55, '56, '57, '58; Stable Gal., NYC 1959, '60, '61, '64, '65; Gal. Neufville, Paris 1960; Tampa Art Inst., Fla. 1965; Nat. Gal. of Victoria, Australia 1969; Walters Gal., Sidney, Australia 1969; Zabriskie Gal., NYC 1972, '73, '75, '77; Oliver Wolcott Library, Litchfield, Conn., 1973; Dag Hammarskjöld Plaza, NYC 1975; Sterling and Francine Clark Art Inst., Williamstown, Mass. 1980; Herbert Johnson Mus., Cornell Univ., Ithaca, N.Y. 1980. GROUP EXHIBITIONS INCLUDE: "New Talent USA," Martha Jackson Gal. NYC 1956; Whitney Annual Mus. of Am. Art, NYC 1956, '60; Venice Biennale 1958; "Recent Sculpture USA," and "Sixteen Americans," MOMA, NYC 1959; "The Art of Assemblage," MOMA, NYC 1961; "Four Americans" Moderna Mus., Stockholm 1962; "Four Americans," Stedelijk Mus., Amsterdam 1961; "Sculpture in the Open Air," Battersea Park, London 1963; "Recent American Sculpture," Jewish Mus., NYC 1964; "The Machine as Seen at the End of the Machine Age," MOMA, NYC 1968–69; Berkshire Festival, Lenox, Mass. 1974; "Poets of the Cities," NYC 1974–75; "Poets of the Cities," San Francisco 1974–75; "Poets of the Cities," Texas 1974–75; "Poets of the Cities," Connecticut 1974–75; "Poets of the Cities," California 1974–75.

COLLECTIONS INCLUDE: MOMA, Whitney Mus. of Am. Art, and Solomon R. Guggenheim Mus., NYC; Al-

bright-Knox Art Gal., Buffalo, N.Y.; Storm King Art Center, N.Y.; Newark Mus., N.J.; Mus. of Fine Art, Springfield, Mass.; Smith Col. Mus. of Art, Northampton, Mass.; Philadelphia Mus. of Art; Joseph H. Hirshhorn Mus. and Sculpture Garden, Washington, D.C.; Art Inst., Akron, Ohio; Dayton Art Inst., Ohio; Art Inst. of Chicago; Walker Art Cntr., Minneapolis; Mus. Nat. d'Art Moderne, Centre Georges Pompidou, (Beaubourg), Paris; Moderna Mus., Stockholm; Tel Aviv Mus., Israel.

ABOUT: Callas, N. and others (eds.) Icons and Images of the Sixties, 1971; Goodrich, L. and others American Art of Our Century, 1961; Hunter, S. American Art of the 20th Century, 1972; Miller, D. (ed.) "Sixteen Americans" (cat.), MOMA, NYC, 1959; Porter, F. Art in its Own Terms: Selected Criticisms 1935–1975, 1979; "Richard Stankiewicz; Robert Indiana," (cat.), Walker Art Center, Minneapolis, 1936; Sandler, I. The New York School: The Painters and Sculptors of the Fifties, 1978. *Periodicals*—Art Digest December 1, 1953; Art International (Lugano) November 1969; Art News September 1955; Art Now no.4 1972; New York Times February 25, 1973, March 22, 1975, April 8, 1977, July 15, 1980, March 29, 1983.

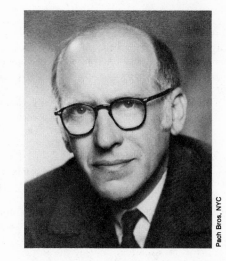

SAUL STEINBERG

STEINBERG, SAUL (June 15, 1914–), American painter and graphic artist, is considered the finest satirical artist produced by the United States. Born in Râmnicul-Sarat, a small town in southeast Rumania, he was the son of Moritz Steinberg, a printer and bookbinder, and Rosa Jacobson Steinberg. He grew up in Bucharest, the national capital, and has described the Rumania of the World War I years as "a corridor, a marginal place" on which neighboring powers Russia, Hungary, and Turkey had left their imprint. As a child he spoke three languages, Rumanian, French, and "the secret language of my parents," Yiddish. His sister, Lica, to whom he was always deeply attached, was born during the First World War.

In his father's workshop—Moritz was a manufacturer of cardboard boxes as well as a printer and bookbinder—Saul was fascinated by embossed paper, rubber stamps, colored cardboard, and type blocks, including the large wooden type used for posters. This kind of imagery recurs in innumerable variations in his graphic work up to the present day.

Saul attended high school in Bucharest, but, as he recalled, "My education, my reassurance, my comportment came out of reading literature. I found my real world, my real friends, in books." Jules Verne was among his favorite authors and, a precocious child, he read Maxim Gorky at the "much too early" age of ten and *Crime and Punishment* at 12. Like many gifted adolescents Steinberg was something of a misfit, and according to Robert Hughes he has remained "a loner, a cosmopolitan Jewish exile, a refugee, a man of masks, languages and doctored indentities."

Steinberg graduated from high school in 1932 and subsequently enrolled as a philosophy student at the University of Bucharest. The following year, however, he moved to Milan, where he lived for several years and studied architecture at the Reggio Politecnico. He received a Dottore Architettura degree in 1940 but realized he could never become an architect "because of the horror of dealing with people." Yet the training in precision rendering and the keen sense of architectural convention he acquired at the school contributed to the "reasoned lines" and subtle parodies of style in his later drawings. The Milan Polytechnic faculty was heavily influenced by late cubism, via the Bauhaus. "Our clouds came straight out of Arp, complete with a hole in the middle," Steinberg recalled; "even our trees were influenced by the mania for the kidney shape."

In 1934, when he began to draw from life, Steinberg discovered his gifts as a cartoonist. Given the "predictable" and "boring" nature of the controlled press in fascist Italy, humor magazines provided one of the few means of exploring "other aspects of life." One of his first drawings made in 1936 for *Bertoldo*, a satirical biweekly, showed a man looking into a mirror and exclaiming, "Dammit, this isn't me! I got lost in the crowd"—an early examination of the "identity" problem of "mass man." The treatment of line shows comic dexterity, but it is the view of a dome and a house through the background window that already has the true Stein-

bergian touch, while also recalling the drawings of Paul Klee. Before long he was able to make a living from his cartoons and enjoy a little of that *boulevardier* existence he had read about through Anatole France, whose writings he admired.

As a foreign Jew living in fascist Italy, Steinberg was acutely aware that the regime, under pressure from Nazi Germany, was becoming more anti-Semitic week by week. When in 1940 he received his Ph.D. in architecture, his diploma, awarded in the name of Victor Emmanuel III, King of Italy, carried the words: "Steinberg Saul . . . di razze Ebraica" (of the Jewish race), meaning that although he was a qualified architect he could be boycotted from professional practice. However, he did work for several months as an architect, and at the same time some of his drawings began to appear in the United States, in *Life* and *Harper's Bazaar* magazines.

In 1941 Steinberg decided to leave Italy. Memories of the Mussolini era, at once sinister and absurd, along with allusions to his Bauhaus-oriented architectural training in Milan, would appear many years later in such drawings as *Villa Maria No. I* (1969) and *Asmara* (1972), the latter a caustic reminder of the invasion of Abyssinia.

Steinberg's New York friend and agent, Cesar Civita, made it possible for him to escape from Europe. He left Italy for neutral Portugal, and sailed for America with a "slightly fake" passport, doctored with his own rubber stamp. On arriving in New York City he was detained on Ellis Island and deported on a cargo boat to Santo Domingo. After a year his visa came through, the editor of *The New Yorker* having agreed to sponsor him. In July 1942 he landed in Miami as an immigrant, and caught a bus to New York. Since then he has made many bus trips around the United States, preferring the bus to the automobile because "one has a much better and nobler view, as from horseback."

He now had a steady outlet for his drawings in *The New Yorker* and the liberal afternoon newspaper *PM*. He set out by train for Chicago and Los Angeles, and after seeing the West Coast returned via Arizona and Texas. The drawings inspired by this cross-country trip reflected the strangeness of America as viewed, or rather interpreted, by a young European who as yet spoke no English.

In 1934 Steinberg enlisted in the Navy, became a United States citizen, and had his first American solo show at the Wakefield Gallery, New York City. He was commissioned as an ensign and sent overseas to Colombo, in Ceylon, to Calcutta, and to Kunming in China, where he was attached to the 14th Air Force and given the task of teachng Chinese guerrilla fighters to blow up bridges. Since he spoke little English and even less Chinese, he drew pictures for them. He was then transferred to the European theater, via Cairo and Algiers, to Italy for the Office of Strategic Services, the forerunner of the CIA.

In October 1943 Steinberg returned to the United States and married the painter Hedda Sterne. (They were amicably separated, but not divorced, in 1960.) In 1945 while stationed in Washington, D.C., *All in Line*, a book of his wartime drawings of China, India, North Africa, and Italy, was published to wide acclaim. His captionless drawings spoke a universal language combining irony, witty and sometimes cruel observation, and a gift for bizarre, fantastic, and completely personal visual metaphors. One of his key images—repeated in many variations later on—was that of the "self-made artist," a little man grasping the pen that draws him, and thus fusing artist and motif. With ink, pen, and paper Steinberg, in 1945, created the supreme paradox—the artist drawing the artist drawing the artist. Although a virtuoso of style, Steinberg had declared, "Performance bores me. What interests me is the invention."

Steinberg was released from the Navy in 1946. As war correspondent for *The New Yorker* he covered the Nuremberg trials.

The first major recognition of Steinberg as an artist came in September 1946 when he was included in the important "Fourteen Americans" show at the Museum of Modern Art, New York City. A *New York Times* critic remarked that Steinberg's work in this exhibit made for "the most refreshing and humanly therapeutic show of the season."

Steinberg and his wife have been described as "epicures of travel." There was a trip to Mexico in 1947, and much traveling in the late '40s and '50s, before travel in the era of postwar affluence had become "homogenized by mass tourism." He did not work "en route" but from memory, which is why, as Robert Hughes pointed out in *Time* (April 17, 1978), his drawings of places, whether of Paris, Los Angeles, Istanbul, Tashkent, Palermo, or Samarkand, "all look equally exotic." A second Steinberg album, *The Art of Living,* appeared in 1949, and in 1950 he was hired in Hollywood as a "ghost painter," dubbing in drawings and paintings for the artist's hand of Gene Kelly in *An American in Paris.* Hollywood was not to Steinberg's taste, but he was amazed by Los Angeles, which he described as "the avant-garde city of parody in architec-

ture and even in nature (canyons and palm trees)." But Steinberg sees nature everywhere as a human fabrication, and once remarked, "When I admire a scene in the country, I look for a signature in the lower right-hand corner."

Another book of drawings, *The Passport,* was published in 1954, and the main theme was still travel. For several years Steinberg had been making drawings of ornate European railway stations and bridges and the *gallerie,* or arcades, in Milan and Naples, but since arriving in America his architectureal repertoire had been enriched by the more "old-fashioned," period-style skyscrapers and the outlandish "junk architecture" of Florida and Hollywood. There was also his horrified fascination with official documents, the whole bureaucratic paraphernalia of rubber stamps, illegible signatures, and passport photographs (in which Steinberg often substituted a fingerprint for the head)—documents, authentic or fake, which are supposed to "prove" one's existence in a bureaucratic, regimented mass society. These common elements verge on being clichés, but for their arrangement in aesthetically interesting compositions. Steinberg has also created a number of stylistic games with sheets of graph paper. For example, in *Graph Paper Cats* (1951) 16 solemn-faced bewhiskered cats—favorite Steinbergian animals with the artist's own expression—cling to the "screen" created by the grid of the paper. In *Birds on Graph Paper,* also 1951, some of the horizontal lines serve as perches. Surrealistic montages occur in the series of "Passports," along with such varied motifs as sphinxes, cowboys, locomotives and dog-walkers.

In 1952 there were four separate shows of Steinberg's work, in New York City, San Francisco, London, and São Paulo. His reputation was steadily growing, but many critics found him hard to classify: was he a cartoonist and social critic or a "serious" painter? For Milton Glaser, design director of *Esquire* magazine, Steinberg is the only artist "who had been able to achieve both at once."

Steinberg was photographed by Inge Morath in 1958 wearing a mask which was actually a drawing of his own face on a paper bag. Other paper masks, with slight variations, but unmistakably likenesses of Steinberg, moustached and with owlish spectacles, hang on the wall. The elusive artist felt intimidated when photographers pointed cameras at him, "so I made paper-bag masks of my face. I was able to relax inside the mask and show a constant public image of myself to the camera." This comment illustrates a major difference between Steinberg and Paul Klee, with whom the former's art has been compared. As Charles Spencer pointed out in *Contemporary Artists,* Klee's subject was "personal, not public, . . . not the passing parade. Steinberg tells you nothing about himself, he is a very private person, a private eye in fact."

In the late 1950s there were more travels—in Russia (he stole a telephone directory in Samarkand which is among his most prized possessions), in Spain, and in the Appalachian Mountain region of the southern United States. A tireless worker, he designed the decor for the Rossini opera *Count Ory,* performed at the Juilliard School of Music, New York City, in 1958, and also executed a mural for the US pavilion at the 1958 Brussels World's Fair. In 1959 he bought a house in Springs, East Hampton, Long Island. In his 1960 book of drawings, *The Labyrinth,* he explored optical illusions, patterns, and ideas created by letters, words, and geometrical shapes; these visual puns and metaphors all followed the artist's own logic of the absurd. Indeed, he has called drawing "a way of reasoning on paper," and he is as much "a writing hand" as a "seeing eye." However, the florid handwriting on his "Diplomas," mock passports, and in his comic-strip "ballons" is deliberately and tantalizingly illegible.

Steinberg's book *The New World* (1965) concerns itself with, among other things, numbers, concentric circles, questions marks, and "parodies of parodies." In 1964 he had traveled in Africa, Israel, India, and Japan. In Egypt he sailed with novelist Saul Bellow "in a small boat on the Nile, surrounded by hundreds of crocodiles." In Steinberg's personal menagerie crocodiles are his favorite monsters, whether serving as the dragon to be slain by the hero on horseback, himself pursued down a slope by a mammoth boulder (as in *Dragon, Hero and Ball* of 1968), or incongruously walking city streets, as in several drawings in his 1973 book, *The Inspector.*

Steinberg often uses color as a counterpoint to his uniquely expressive line. One of the most famous of his cartoons is *View of the World from 9th Avenue* (1975), in which New York City is separated by the Hudson River from a crazily telescoped America. This somewhat specialized view of the United States—as seen in the cartoon from the standpoint of a chauvinistic Manhattanite—is certainly not that of Steinberg himself, who has been to every state in the union and has created his own wide-ranging fantasy of America.

The vast Steinberg retrospective at the Whitney Museum of American Art, New York City, which opened in April 1978 displayed an astonishing variety of techniques. Among the clever-

est inventions was the arrangement of "pictures" in steep perspective on the large white panel that faced the viewer on entering the gallery. The "canvases" were actually cut out of wood, painted, and stuck on the surface; one was a Mondrian, the rest were typical Steinbergs. There were many mixed-media assemblages on the "work-table" theme, witty commentaries, as it were, on the very process of art. Several drawings from the 1960s included in the exhibit showed visitors in galleries looking at pictures—the "people" being much more outlandish than the works of art they were viewing. A series of landscape paintings from the 1970s, in oil on paper with low horizons and vast skies, showed yet another facet of Steinberg's talent; yet here, too, there is a strong element of parody. John Russell in his *New York Times* review (April 14, 1978) observed that "Where his close friend and colleague Richard Lindner [a fellow émigré] can set up a slow heavy vibration of complicated feeling, Mr. Steinberg . . . keeps the beat fast and light. . . . Where he does linger . . . repetition creeps in." Russell added that the exhibition "might have been cut by a quarter to its advantage." The elaborate catalog to the exhibition had a preface by the influential critic Harold Rosenberg. Steinberg, though gratified by the success of the show, remarked in typically oblique fashion, "I would like to retrospect the retrospective."

Saul Steinberg in his 64th year was described by Robert Hughes in *Time* magazine as "a solid, wiry man, rabbinically delicate in gesture and as immobile in repose as a large tabby cat." More than twenty years earlier Russell Lynes in *Harper's* magazine had seen Steinberg as "sharp-featured, moustached, bespectacled and blonde, . . . a wily, amused man with a strong sense of justice." Steinberg, when not traveling, divides his time between his book-lined duplex on Manhattan's Upper East Side and his modest Long Island studio. Always averse to discussing his art too solemnly, Steinberg has said: "I think of myself as being a professional. My strength comes out of doing work which is liked for itself, and is successful by itself, even though it is not always perfectly understood. I have never depended on art historians or the benedictions of museums and critics. That came later." He sees himself as "a writer who draws," and a clue to his widespread popularity can be found in his remark: "I appeal to the complicity of my reader."

EXHIBITIONS INCLUDE: Wakefield Gal., NYC 1943, '45; Mus. de Arte Moderna de São Paulo 1952; Frank Perls Gal., Beverly Hills, Calif. 1952; Inst. of Contemporary Arts, London 1952, '57; Betty Parsons Gal., NYC 1952, '66, '69, '73, '76; Sidney Janis Gal., NYC 1952, '66, '69,

'73, '76; Gal. Maeght, Paris 1953, '66, '77; Am. Federation of Arts, Circulating Exhibition, 1953–55; Kunsthalle, Hamburg, W. Ger. 1968; Nat. Collection of Fine Arts, Smithsonian Inst., Washington, D.C. 1973–74; Kunstverein, Cologne 1974; Gal. Maeght, Zürich 1977; Whitney Mus. of Am. Art, NYC 1978; Pace Gal., NYC 1982. GROUP EXHIBITIONS INCLUDE: "Fourteen Americans," MOMA, NYC 1946; "An Exhibition for Modern Living," Detroit Inst. of Arts 1949; "Contemporary Drawings from 12 Countries: 1945–1952," Art Inst. of Chicago 1952; "The Comic Spirit," Brandeis Univ., Waltham, Mass. 1953; "Golden Years of American Drawings: 1905–1956," Brooklyn Mus. ca. 1957; "A Decade of American Drawings: 1955–1965," Whitney Mus. of Am. Art, NYC ca. 1966; Salon de Mai, Mus. d'Art Moderne, Paris 1966; "American Drawings of the Sixties: A Selection," New School Art Center, NYC 1969, '70; "Le Dessin d'humour," Bibliothèque Nat., Paris 1971; "American Drawing 1970–1973," Yale Univ. Art Gal., New Haven, Conn. 1973; "The Object as Poet," Renwick Gal., Smithsonian Inst., Washington, D.C. 1977.

COLLECTIONS INCLUDE: Metropolitan Mus. of Art, MOMA, and Whitney Mus. of Am. Art, NYC; Albright-Knox Art Gal., Buffalo, N.Y.; Munson-Williams-Proctor Inst., Utica, N.Y.; Hirshhorn Mus. and Sculpture Garden, and Nat. Collection of Fine Arts, Smithsonian Inst., Washington, D.C.; Montclair Art Mus., N.J.; Fogg Mus., Harvard Univ., Cambridge, Mass.; Indiana Univ. Art Mus., Bloomington; North Carolina Mus. of Art, Raleigh; Art Inst., Detroit; Baltimore Mus. of Art; Victoria and Albert Mus., London; Mus. Boymans-Van Beuningen, Rotterdam; Fondation Maeght, Saint-Paul-de-Vence, France; Israel Mus., Jerusalem.

ABOUT: Current Biography, 1957; Hayes, B. H., Jr. American Drawings: Drawings of the Masters, 1965; The New Yorker Album of Drawings 1925–1975, 1975; P-Orridge, G. and others (eds.) Contemporary Artists, 1977; Rosenberg, H. Saul Steinberg, 1978; Sachs, P. J. Modern Prints and Drawings, 1954; Steinberg, S. All in Line, 1945, The Art of Living, 1949, The Passport, 1954, Dessins, 1956, The Labyrinth, 1960, The New World, 1965, The Inspector, 1973, *Periodicals*—Art in America November–December 1970; Art News November 1969; Chroniques de l'art vivant (Paris) October 1973; Creative Camera February 1969; Harper's August 1954; Life August 13, 1945, August 27, 1951; Manchester Guardian (England) May 2, 1952; New Statesman and Nation June 22, 1973; New York Herald Tribune Weekly Book Review June 17, 1945; New York Times April 14, 1978; New York Times Book Review January 15, 1961; Newsweek June 6, 1955; Saturday Review December 10, 1949; Time April 17, 1978.

STELLA, FRANK (PHILIP) (May 12, 1936–), American painter, reacted against action painting with his somber, self-referential nonfigurative compositions. In the early '60s he

Courtesy of Leo Castelli Gallery, NYC; Photo by Hollis Frampton

FRANK STELLA

helped establish minimal art as a dominant style of the New York School.

He was born in Malden, Massachusetts, a suburb of Boston, to Dr. Frank Stella, a gynecologist, and Constance Aïda (Santonelli) Stella. He attended art classes at his grammar school in Malden, and in junior high school became interested in pastels. From the beginning he had an adversion to conventional realistic drawing. "I wasn't very good at making things come out representationally," he explained, "and I didn't want to put the kind of effort that it seemed to take into it."

In 1950 Stella entered Phillips Academy, Andover, Massachusetts, where he studied painting with the abstractionist Patrick Morgan. Not surprisingly, Stella was soon drawn to the severe geometric abstraction of Mondrian. "I got the point of Mondrian right away," he said. "I liked it, and I liked organizing things in blocks, abstractly. . . . " Most of the works he painted at Andover were small geometrical compositions with shapes that were usually rectangular.

After graduating from Andover in 1954, Stella entered Princeton University. His major was history, but he continued to study painting, first with William Seitz and later with Stephen Green. Both men were involved in the avantgarde and they interested Stella in the galleries and museums of nearby New York City. He was drawn to abstract expressionism because of "the size of the pictures and the wholeness of the composition" and because he was an avid reader of periodicals like Art News, in which the new abstraction and the "idea of the artist as a terrifically sensitive ever-changing, ever-ambitious

person" was being romanticized. Also, because he had always enjoyed house painting, he liked the fact that the Abstract Expressionists used large brushes, and most of the paintings he produced at Princeton were abstract expressionist, including his covers for Nassau Lit, the college literary magazine. For his research project in his junior year he wrote an essay comparing Hiberno-Saxon manuscript illuminations to the paintings of Jackson Pollock.

In his final year at Princeton, Stella reacted against the extreme subjectivism of abstract expressionism. He started to search for a simpler, more direct style, and in January 1958 he saw the first New York exhibition of Jasper Johns's flag and target paintings. Impressed by Johns's choice of simple, even banal motifs and his use of rhythm and repetition, Stella began to paint in a "transitional" style, producing works with single or multiple box forms placed in various arrangements of bands or stripes. These compositions were shown at a group exhibit held in the spring of 1959 at the Allen Memorial Art Museum, Oberlin College, Ohio.

After obtaining a BA degree from Princeton in June 1958, Stella moved to New York City and took a cheap storefront studio near the Lower East Side, supporting himself by working as a housepainter a few days each week. Most painters of his age were imitating the "hot," explosive brushwork of de Kooning, but Stella continued to paint in an austere, semigeometric style, using unfashionable commercial colors that he purchased at a dollar a gallon. In late 1958 he began work on his innovative series of black stripe paintings, which, to quote Irving Sandler, "seemed to willfully challenge, indeed invert, every pictorial conception and romanticist justification of gesture painting 'with a cold, smartaleck, humorless methodicalness that showed up in the paintings . . . like a slap in the face.'"

In his black paintings Stella eliminated the box forms of his transitional style. The paintings consisted of stark, unmodulated stripe patterns—rectangular, notched, or diamondshaped. The patterns were arranged symmetrically in an all-over manner; that is, with equal emphasis over the whole canvas. The stripes, two and one-half inches wide, were freely applied with a housepainter's brush and the spaces between them were left as unprimed canvas.

Stella was determined to eliminate the three-dimensional image and, instead, to emphasize the flatness of the painted surface. Thus he achieved pure two-dimensionality by extending his stripes from the flat picture surface to the edge of the canvas. Reacting against the ambigu-

ity of negative space and shaded areas in abstract expressionist painting, Stella asserted that his work was "based on the fact that only what can be seen *is* there. . . . Any painting is an object and anyone who gets involved enough in this finally has to face up to the objectness of whatever it is that he is doing." Consistent with his Gestalt concept of the work as an object-in-itself, he used thick stretchers so that his paintings would protrude from the wall. Despite stylistic innovations, Stella has retained this device.

The black paintings brought Stella instant recognition in the New York art world. His *Club Onyx* was included in a group show at the Tibor de Nagy Gallery in April 1959, and *Clinton Plaza* was shown in October at the Leo Castelli Gallery. Four of his black paintings, including *The Marriage of Reason and Squalor,* were selected by Dorothy Miller for the "Sixteen Americans" show at the Museum of Modern Art, New York City, in 1959–60. At 23, Stella was the youngest artist represented in that influential exhibition which recognized the antigestural styles and the work of so-called Neo-Dadaists like Johns and Rauschenberg, who had also reacted against abstract expressionism and, like Stella, had recently been discovered by the influential dealer Leo Castelli.

In the exhibition catalog the Minimalist sculptor Carl André wrote: "Art excludes the unnecessary. Frank Stella has found it necessary to paint stripes. [He] is not interested in expression or sensitivity. He is interested in the necessities of painting. . . . His stripes are the paths of brush on canvas. These paths lead only into painting." Alfred H. Barr Jr., then director of MOMA's collections, admitted that he was "baffled" by Stella's paintings but "deeply impressed by their conviction."

At the beginning of the 1960s, however, Stella paid a steep price for having successfully challenged gesture painting's dominance in New York School aesthetic theories. First- and second-generation Abstract Expressionists perceived the cold, impersonal style of newcomers like Stella as a threat to their careers, and, to quote Sandler, "More than any other artist of his generation, Stella was the butt of ridicule, treated by his elders as the juvenile delinquent of contemporary art." Ironically, Stella's work was in some respects a continuation of abstract expressionist motifs: he worked on a grand scale, furthered the color-field tendency, and assimilated Pollock's all-over compositional method to his own style.

By mid-decade, the tide of battle had turned in favor of younger, Minimalist artists like Stella as Clement Greenberg's formalist doctrine of post-painterly abstraction came to dominate aesthetic discourse. The dean of American art criticism, Greenberg argued that abstract expressionism, like cubism in its heyday, had been *the* historically inevitable style of its time. After action painting, Greenberg went on, art must evolve in the direction of increased self-referentiality and formal purity—representation and illusion should be completely eliminated and flatness should become painting's fundamental aesthetic value. Stella's work was viewed as the logical extension of Greenberg's doctrine, though Greenberg himself was unsympathetic to Stella's pictures. Indeed, as Lucy R. Lippard wrote in the *Hudson Review,* Stella "did not write, but his ideas spread through conversations and through criticism."

After finishing the black paintings, the artistically restless Stella began a series executed in metallic aluminum paint. To Stella, black suggested chiaroscuro—and therefore the deep recession and illusionistic space that he rejected—so he chose the aluminum surface because it repelled the eye, was difficult to penetrate visually. The "Aluminum" paintings, like the "Black" series, consisted of simple stripe patterns, often beginning with a square or a cross. Stella, however, was distressed to find that some of the patterns were articulated in a manner that did not conform to the literal shape of the canvas. His solution to the problem of gratuitous space between the bands, or "stripes," was to cut the space away. Thus Stella became, along with Ilya Bolotowsky, the first contemporary artist to use shaped canvases. The "Aluminum" paintings were exhibited at Stella's first solo show, which was held at the Castelli Gallery, New York City, in the fall of 1960.

The aluminum paintings were followed by a "Copper" series, in which the shape of the framing edge departed even more radically from the canvas's basic rectangle. The canvases were L- or U-shaped or cut in whatever shape fitted the surface patterns.

In his "Benjamin Moore" series, named after a brand of alkyd paint which he used straight from the can, Stella returned to the dour simplicity of his black paintings. According to *Current Biography, 1971,* "The series consists of six square monochromatic stripe paintings, one each in red, orange, yellow, blue, green, and purple." The "Benjamin Moore" paintings were shown at Stella's first solo show in Europe, held at the Galerie Lawrence, Paris, in November 1961.

Stella returned to the investigation of shape in his "Purple" series (1963). These purple paintings, which he called "portraits" and named af-

ter such friends as Leo Castelli and Ileana Sonnabend, were polygons. In these works Stella shaped the outside edge of the canvas in various ways—making one work a trapezoid, another a pentagon, yet another a triangle, and so forth—and cut a parallel shape out of the inside, thus making the painting itself a framing edge for the internal space.

While spending the summer of 1963 as artist-in-residence at Dartmouth College, Hanover, New Hampshire, Stella experimented with joining wedge-shaped or chevron-shaped areas of stripes to create complex starlike forms. He also began using more than one metallic color in a single painting and adopted the practice of cutting notches in his canvases. Thus, in such compositions as his "Notched V" series (1964–65), Stella created what came to be known as nonrelational paintings. In these works the picture "image" was identical to the shape of the format, and internal relations among the parts were banished.

In 1964–65 Stella used fluorescent Day Glo paints in primary colors on square formats for his "Moroccan" series. (Day Glo fluorescent paints had been used earlier in the '60s by James Rosenquist and other Pop artists.) The "Moroccan" paintings included *Fez, Marrakech,* and *Sidi Ifni,* the final work of the series, in which he used ten different Day Glo colors.

Stella's work has been grouped with that of Morris Louis and Kenneth Noland, but he is more of a structuralist than a Post-Painterly Abstractionist. This was evident in the series of "irregular polygon" paintings he began in 1965. In these paintings, contrasting geometrical shapes were interlocked but unbroken by stripes. For this breakthrough series Stella used 11 different shapes and built four stretchers for each form, which permitted four possibilities of exploring color combinations for each image. This liberation from the austerity of minimalism gave him a new freedom and flexibility, though several critics complained that some of the irregular polygons were unnecessarily complex, too labyrinthine. Selections from this series were included in Stella's first solo museum exhibition, which was mounted at the Pasadena Art Museum in California in October 1966.

In the fall of 1967 Stella started work on his daring "Protractor" series, in which he used curved and concentric forms for the first time. The circular or semicircular edges of the canvas formats were executed through the use of protractors. The vivid fluorescent acrylic colors that he preferred had a decorative quality reminiscent of Matisse, although Stella's work was far more cerebral. Typical paintings in the

"Protractor" series were *Darabjerd III* (1967; Hirshhorn Museum and Sculpture Garden, Washington, D.C.) and *Ctesiphon III* (1968), a 10- by 20-foot shaped canvas acquired by the Wallraf-Richartz Museum, Cologne. The ancient city of Ctesiphon is a ruin near Baghad, and it has been suggested that Stella, while shunning the slightest hint of representation, may have had chariot wheels in mind when using these circular shapes. About three-quarters of Stella's "Protractor" series had been realized at the time of his retrospective exhibition at MOMA in the spring of 1970. At 33, he was the youngest artist ever to be so honored

From 1970 on, Stella introduced new materials into his work and gradually departed from the flat surface. This phase began with the "Polish Village" series, 40 drawings made during the spring, summer, and fall of 1970. By 1974 paintings based on each of these drawings had been completed, including *Lipsko I* and *Lipsko II,* both of 1972, constructions of paint, paper, felt, and canvas mounted on heavy cardboard bases. The titles of the "Polish Village" paintings were taken from the names of 18th-century wooden synagogues destroyed in Russia and Poland during the Second World War. In late 1974 Stella prepared 25 drawings for a series of pictures in honeycombed aluminum and named after neighborhoods in Rio de Janeiro. These "Brazilian" pictures, including *Joatinga I* (1975), were executed in bright-hued lacquers, had shiny metal surfaces, and were vigorously three-dimensional. In 1975 Stella prepared 28 drawings for the more complex "Exotic Bird" series. Each configuration, strikingly baroque compared to Stella's earlier works, was repeated in three different sizes. A typical work was *Puerto Rican Blue Pigeon,* all three versions of which were in lacquer, oil, and ground glass on etched honeycomb aluminum.

Stella's work took a dramatic and unexpected turn in the late 1970s, when he adopted a wild baroque expressionist style and applied it to three-dimensional relief constructions which hover between painting and sculpture. He continued to work with aluminum surfaces, but they were "painted in high colours, scribbled upon, incised, and generally filled with chaotic activity that seemed very remote from his austere stripes of the late '50s," to quote Dore Ashton.

Stella had always stayed at least one jump ahead of the avant-garde critics who saw his work as embodying their aesthetic axioms, and his three-dimensional compositions anticipated the neoexpressionist trend which emerged in the early '80s. However, unlike the creations of such Neoexpressionists as Julian Schnabel and

Francesco Clemente, Stella's paintings were nonfigurative, and he favored a more geometric line than those artists.

In the spring of 1983, Harvard University asked Stella to give the six celebrated Charles Eliot Norton lectures for the fall 1983 semester. By early summer Stella had prepared discussions on three artists: Caravaggio, Picasso, and Kandinsky.

In 1961 Stella married the noted critic and art historian Barbara Rose. They had two children, Rachel and Michael, but the marriage ended in divorce. Stella has since married a second time.

"My painting," Stella said in the early '60s, "is based on the fact [that] what you see is what you see." In 1983 he remarked: "I've always had the means to say what I want to say. Unlike Picasso, I'm not committed to a sense of reality. Painting to me is a brush in a bucket and you put it on a surface. There is no other reality for me than that."

EXHIBITIONS INCLUDE: Leo Castelli Gal., NYC from 1960; Gal. Lawrence, Paris 1961, '64; Kasmin Ltd., London 1964, '66, '68, '71; Pasadena Art Mus., Calif. 1966; Seattle Art Mus., Wash. 1966–67; Washington, D.C. Gal. of Modern Art 1968; Rose Art Mus., Brandeis Univ., Waltham, Mass. 1969; Irving Blum Gal., Los Angeles 1969, '71, '73; MOMA, NYC 1970; Lawrence Rubin Gal., NYC 1970, '71; Stedelijk Mus., Amsterdam 1971; Phillips Collection, Washington, D.C. 1973; M. Knoedler and Co., NYC 1973, '76; Kunsthalle, Basel 1976; Baltimore Mus. of Art, 1977; "Frank Stella Work 1953–76," Kunsthalle, Bielefeld, W. Ger.; "Aluminum Reliefs 1976–77," Mus. of Modern Art, Oxford; "Stella Since 1970," Fort Worth Art Mus., Tex. 1978–79. GROUP EXHIBITIONS INCLUDE: "Selections," Tibor de Nagy Gal., NYC 1959; "Three Young Painters," Allen Memorial Art Mus., Oberlin Col., Ohio 1959; "Sixteen Americans," MOMA, NYC 1959–60; "Abstract Expressionists and Imagists," Solomon R. Guggenheim Mus., NYC 1960–61; Whitney Mus. of Am. Art Annual, NYC 1963–72; Venice Biennale 1964; "Three American Painters," Fogg Art Mus., Harvard Univ., Cambridge, Mass. 1965; "Three American Painters," Pasadena Art Mus., Calif. 1965; São Paulo Bienal 1965; International Exhibition, Tokyo 1967; Documenta 4, Kassel, W. Ger. 1968; "The Art of the Real: USA 1948–1968," MOMA, NYC 1968; "New York Painting and Sculpture 1940–1970," Metropolitan Mus. of Art, NYC 1969–70; ROSC '71, Royal Dublin Society 1971; Whitney Biennial, NYC 1973; "A View of a Decade," Mus. of Contemporary Art, Chicago 1977; "Minimalism to Expressionism," Whitney Mus. of Am. Art, NYC 1983.

COLLECTIONS INCLUDE: MOMA and Whitney Mus. of Am. Art, NYC; Brooklyn Mus., N.Y.; Nat. Collection of Fine Arts, Smithsonian Instn. and Hirshhorn Mus. and Sculpture Garden, Washington, D.C.; Philadelphia Mus. of Art; Baltimore Mus.; Art Inst. of Chicago; Detroit Inst. of Arts; Des Moines Art Center, Iowa;

Walker Art Center, Minneapolis; Fort Worth Art Center, Tex.; San Francisco Mus.; Los Angeles County Art Mus.; Stedelijk Mus., Amsterdam; Kunstmus., Basel; Collection of Dr. Peter Ludwig, Wallraf-Richartz Mus., Cologne; Seibu Art Mus., Tokyo; Nagaoka Mus. of Modern Art, Japan.

ABOUT: André, C. "Sixteen Americans" (cat.), MOMA, NYC, 1959–60; Ashton, D. American Art Since 1945, 1973; Current Biography, 1971; Goossens, E.C. "The Art of the Real; USA 1948–1968" (cat.), MOMA, NYC, 1968; Kramer, H. The Art of the Avant-Garde, 1973; Lucie-Smith, E. Late Modern: The Visual Arts Since 1945, 1969; Richardson, B. Frank Stella: The Black Paintings, 1976; Rose, B. American Art Since 1900, 2d ed. 1975; Rubin W.S. "Frank Stella" (cat.), MOMA, NYC, 1970; Sandler, I. The New York School: The Painters and Sculptors of the Fifties, 1978; Wintle, J. (ed.), Makers of Modern Culture, 1981. *Periodicals*—Art in America March–April 1978; Art International January 1960; Art News September 1966, September 1982; Artforum March 1965, November 1966; Artscribe (London) July 1977; Hudson Review Spring 1968; Kunstwerk (Stuttgart, W. Ger.) April 1965; Life January 19, 1968; New York Times April 5, 1970, June 28, 1983, March 18, 1984; New Yorker May 9, 1970; Portfolio April–May 1974; Time April 3, 1978.

STILL, CLYFFORD (November 30, 1904–June 23, 1980), American painter, was one of the major figures of abstract expressionism. The vast, harsh spaces of his canvases, torn by thrusts of dry or blazing color, corresponded not only to the landscape of the Pacific Northwest where he was raised, but also to the romantic grandeur of his resistance to what he saw as an uncompromisingly decadent world. Like a stern prophet of art, he launched jeremiads against every modern tendency, while offering his own severe and difficult work as a vision of purity purged of any previous idiom.

Clyfford Still was born in the farm country of Grandin, North Dakota. His childhood years were divided between his father's homestead in Bow Island, Southern Alberta, Canada, and the family home in Spokane, Washington, where his father worked as an accountant. As a boy Still would steal time between farm chores to paint at every opportunity. To save his family embarrassment—they considered all artists "sissies"—he signed his paintings "Clyfford," a practice he continued throughout his life.

In the fall of 1925 Still visited New York City to see its art museums and galleries. He was disappointed by his visit to the Metropolitan Museum of Art, finding its masterpieces alien to him. After enrolling in the Art Students League he left in disgust after 45 minutes. At that time, he

Photo by Sandra Still

CLYFFORD STILL

later explained with characteristic vehemence, art schools were "putrefying with Bauhaus teaching."

Still obtained his BA degree in 1933 from the University of Washington, Spokane, where he had been awarded a scholarship in art. That same year he became a teaching fellow at Washington State University, Pullman, receiving an MA degree in 1935. Many artists during the Depression years worked for the Works Projects Administration, but Still refused, declaring he would never consider his art a "social utility." Instead he spent the summers of 1934 and '35 as a fellow at the Trask Foundation (now called Yaddo), in Saratoga Springs, New York. From 1935 to 1940 he was instructor at Washington State University, and from 1940 to 1941 was assistant professor there. During this period he painted realistic landscapes of the American West, and a series of distorted figure studies of bony, angular men and bloated, pregnant women. Twenty-two paintings in this violently expressionist style were exhibited in his first solo show, held at the San Francisco Museum of Art in 1943.

After America entered World War II, Still worked in the aircraft and shipbuilding industries of Oakland and San Francisco, drawing blueprints. He was able to return to painting in the fall of 1943, when he accepted a position as professor at the Richmond Professional Institute, a division of the College of William and Mary in Richmond, Virginia. His painting was becoming increasingly nonfigurative. Still was strongly influenced by the ideas of the abstractionist Hans Hofmann, who had been teaching in New

York since 1934, although he never actually met Hofmann or studied with him. He also admired the vast water-lily canvases of Monet's final period, works which were not generally appreciated until the 1950s. In Still's paintings before 1946 there were occasional references to the figure, but his canvases were essentially abstract, consisting of areas with an upward thrust and rough, jagged contours, painted in somber browns and blacks. The pigment, applied in heavy slabs, was almost as thick as a bas-relief.

Fourteen of these paintings were exhibited at Still's first solo show in New York City at Peggy Guggenheim's Art of This Century Gallery in February–March 1946. They seemed to many viewers to be related to the biomorphic surrealist abstraction, with its mythic and symbolic overtones, that at this time characterized Adolph Gottlieb's series of "Pictographs" and the "dream landscapes" of Mark Rothko. In fact, Rothko, in an introduction to the catalog, claimed that Still had created a new "generic myth," and Still himself said that these paintings were "of the Earth, the Damned, and the Recreated." They wereeven given mythic titles such as *Nemesis of Esther III, Buried Sun,* and *Jamais* (1944), but Still later repudiated these titles along with any mythical or surrealistic associations in the paintings themselves. *Jamais,* with its flamelike shapes, is now in Peggy Guggenheim's collection in Venice.

In 1946 Still returned to the west coast, to take a teaching position at the California School of Fine Arts, San Francisco. He remained there until 1950, except for a brief interval in 1947–48, when he returned to New York. With Rothko, William Baziotes, and Robert Motherwell, he helped to organize a group of painters that became known as "Subjects of the Artist." The sculptor David Have joined the group later. In 1948 he initiated and directed an advanced painting class at the California School of Fine Arts; his teaching had an immense influence extending far beyond the west coast. Along with Rothko, who taught at the California School in the summers of 1947 and '49, he stimulated the so-called San Francisco Renaissance. Still had many pupils, and became the leader of a new type of abstract expressionism, somewhere between the aggressive, visceral energy of de Kooning and the ethereal, contemplative art of Rothko. In his painting and in his teaching Still utterly rejected everything that cubism implied. Cubism's small scale, carefully structured relationships within the picture frame, its suggestions of horizon and recession, and above all its "well-madeness" and "prettiness," seemed to him to epitomize European "decadence."

In contrast to the balanced, harmonious works of the School of Paris, Still's paintings of the late 1940s, often mural-sized, were deliberately harsh and uningratiating. As Irving Sandler described them in *The Triumph of American Painting*: "They are generally composed of vertical, paint-encrusted areas of flat color whose contours are jagged. . . . The accent is on openness. No horizontals knit the verticals that might break the continuous plane." Sandler also noted that Still's colors "are dry and repeated in unrefreshing sequences, and the surfaces, consisting of paint troweled on with palette knives, are scabrous. In sum, these canvases, while elating, are nevertheless rude and dour." Even after Still had eliminated all surrealist metaphors, his paintings, as Barbara Rose pointed out, carried suggestions of "ravines, gorges, crevices and other natural formations." One striking canvas of the late '40s (when Still abandoned evocative titles) is *1948-D* (1948, 92 inches by 80 inches). Its vast blazing field of yellows and reds in a flamelike upward movement is dramatically contrasted with smaller, vertical, shredded shapes in black and white in the lower left. Still is considered one of the pioneers of the wall-size painting— neither mural nor easel-painting—favored by the first Abstract Expressionist generation, including Pollock, Rothko, and Newman.

In the late 1940s and early '50s Still exhibited more frequently, both in San Francisco and New York, than at any thereafter. In 1950 he moved to New York City, where he continued to live until 1961, with occasional trips to San Francisco. Although generally hostile to group exhibitions, Still in 1952 allowed seven of his paintings, dating from 1947 to 1952, to be shown in the Museum of Modern Art's important "Fifteen Americans" exhibition.

Throughout the 1950s Still's paintings became even larger than before, as well as more open as he simplified his forms. His canvases overwhelmed the spectator by their sheer size and their flat, weighty surfaces. The artist continued to show a preference for, in his words, "the vertical rather than the horizontal; the single projection instead of polarities; the thrust of the flame instead of the oscillation of the wave." The large, high-keyed *Untitled Painting* (1953; Hirshhorn Museum and Sculpture Garden, Washington, D.C.) was typical of his work of the period. Still described it as "an implosion of infinities in all categories and dimensions. . . . Not illustration, but a state of being."

Still, who often expressed scorn for galleries, collectors, and most museums, refused to exhibit in New York from 1952 to 1967; he considered the city too corrupt for his art. He did agree to show his work in 1959, when the Albright Gallery in Buffalo, New York offered him a major retrospective, on condition that he be permitted to select, hang, and catalog his work himself, while all other modern canvases were banished from sight. The 72 works covered 23 years of his career. An *Art News* critic (December 1959) found an "imposing grandeur" in Still's paintings, but Dore Ashton (*New York Times*, November 15, 1959), while acknowledging Still's "singular imagery" and recognizing the significance of his deliberately "anti-elegant" attitude, concluded that his paintings were "products of an excessive sentimentalism of awesome proportions." In 1964, out of gratitude to the Albright Gallery (now the Albright-Knox Art Gallery), Still generously donated 31 of his paintings, on condition that all the works be kept together. Until 1975 this was the only place where Still's work could be seen in depth.

In July 1961, Still, again proclaiming his disgust for the Manhattan art scene, left New York for a 22-acre farm in Westminster, Maryland. In that setting his paintings became brighter, more open, and less starkly dramatic. Their impact was as weighty as ever, but it is probably his works of the late '40s and early '50s which have had the greatest impact on contemporary artists. Such canvases as *Painting* (1951; MOMA), with its vast fissured shapes, massive central area of black, and jagged edges, influenced the ascetic abstractions of Barnett Newman, despite great differences in technique, and caused Still to be regarded as a forerunner of minimalism.

Still's next retrospective was in 1963, when 32 of his oils were presented in the inaugural show of the University of Pennsylvania's Institute of Contemporary Art, Philadelphia. The show was organized by the Art Institute's then acting-director Ti-Grace Sharpless (since famous as the radical feminist Ti-Grace Atkinson). A reviewer in *Time* (November 29, 1963) noted the activity that occurs in Still's paintings near the edges of the canvas, "where colorful jigsaw puzzles are chopped off as if they had turned the corner into a new dimension."

This "prairie Coriolanus," as *Times*'s Robert Hughes called Still (February 9, 1976), had permanently settled in a Victorian farm house and studio in New Windsor, Maryland, which he had bought in 1966. However, he consented to show his work once again in the city he once described as the "Sodom" of the art world, when in 1969 six of his major paintings were included in MOMA's "Abstract Expressionism" exhibition. In addition, five of his canvases were exhibited in the Metropolitan Museum of Art's centennial show, "New York Painting and Sculpture:

1940–1970." Also in 1969, Still's new dealer, Marlborough-Gerson, mounted a major retrospective of 45 oils and gouaches dating from 1943–46. Reviewers commented on the brighter color and more lyrical, atmospheric feeling of the works of the 1960s; some critics compared them to Monet's late water-lily paintings. David Shirey wrote in *Newsweek* about the show as a whole: "The powerful, mostly large-scale paintings . . . transcend the label of Abstract Expressionism and become epochal, timeless statements of man in raw, basic confrontation with himself."

In 1975 Still presented 28 paintings to the San Francisco Museum of Modern Art, again on the condition that they be permanently displayed as a group. They were shown by the museum the following year.

In 1978 Still was elected a member of the American Academy of Arts and Letters. From November 17, 1979 to February 2, 1980 he was the subject of the largest solo exhibition ever devoted to a living painter by the Metropolitan Museum of Art. It consisted of 78 paintings, many of which measured well over one hundred square feet. In the catalog Still called upon his notorious powers of invective to scorn the art-world establishment.

Clyfford Still died of cancer in Sinai Hospital, Baltimore, at the age of 75. In his last, increasingly reclusive years, he divided his time between his New Windsor studio and the 22-acre farm in Westminster. His wife Patricia, a skilled photographer, and his daughter Sandra have devoted themselves to photographing and cataloging his paintings.

Still was six feet tall, gaunt and erect, with silver hair, a close-cropped white beard, and piercing black eyes. He had a forbidding presence and such adjectives as "cantankerous," "willful," "intransigent," and "atrabilious" have been justly applied to him; no artist was ever more determined to control the fate of his work. However, the organizers of the 1966 exhibit at the Albright-Knox Art Gallery, where he was given a completely free hand, found him cordial and helpful. Ti-Grace Sharpless, who interviewed him in 1963, was intimidated at first, but wrote that after the initial guardedness he became "easy and relaxed." Regarding his painting Still said, "I speak of my work indirectly, and only to clear a way to it." In *Time* Robert Hughes observed that Still's "vast Wagnerian canvases," while never directly representational, are "a splendid addition to the romantic tradition of landscape as practiced in Europe from Turner to Van Gogh and in 19th-century America by the Hudson River School." Still, for his part, regarded himself as a loner and a visionary like Albert Ryder or William Blake. In a letter written in 1965 he summed up his philosophy: "I wanted a life I could respect. As a man it became necessary for me to repudiate the degenerate luxury of conformism and accept the responsibilities of clarifying and extending the living forces inherent in the disciplines of freedom." In his remarks to Sharpless he described the emergence of the abstract vision to which he remained constant for nearly four decades: "By 1941, space and the figure in my canvas had been resolved into a total psychic entity, freeing me from the limitations of each, yet fusing into an instrument bounded only by the limits of my intuition. My feeling of freedom was now absolute and infinitely exhilarating."

EXHIBITIONS: San Francisco Mus. of Art 1943; Peggy Guggenheim's Art of This Century Gal., NYC 1946; California Palace of the Legion of Honor, San Francisco 1947; Betty Parsons Gal., NYC 1947, '50, '51; Metart Gal., San Francisco 1950; Albright-Knox Art Gal., Buffalo, N.Y. 1959, '66, '72; Inst. of Contemporary Art, Univ. of Pennsylvania, Philadelphia 1963; Marlborough-Gerson Gal., NYC 1969, '70; San Francisco Mus. of Modern Art 1976; Metropolitan Mus. of Art, NYC 1979. GROUP EXHIBITIONS INCLUDE: "Fifteen Americans," MOMA, NYC 1952; Documenta 2, Kassel, W. Ger. 1959; "American Abstract Expressionists and Imagists," Solomon R. Guggenheim Mus., NYC 1961; "The New American Painting and Sculpture," MOMA, NYC 1969.

COLLECTIONS INCLUDE: MOMA, and Whitney Mus. of Am. Art, NYC; Albright-Knox Art Gal., Buffalo, N.Y.; Inst. of Contemporary Art, Univ. of Pennsylvania, Philadelphia; Hirshhorn Mus. and Sculpture Garden, and Phillips Collection, Washington, D.C.; San Francisco Mus. of Modern Art; Kunsthalle, Basel; Peggy Guggenheim Collection, Venice; Tate Gal., London.

ABOUT: Bénézit, E. (ed.) Dictionnaire des peintres, sculpteurs et graveurs, 1976; Current Biography, 1971; Miller, D.C. (ed.) "Fifteen Americans" (cat.), MOMA, NYC, 1952; O'Neill, J. P. "Clyfford Still" (cat.), Metropolitan Mus. of Art, NYC, 1979; Rose, B. American Art Since 1900, 2d ed. 1975; Rothko, M. "Clyfford Still" (cat.), Art of this Century Gal., NYC, 1946; Sandler, I. The Triumph of American Painting, 1970; Sharpless, T.-G. "Clyfford Still" (cat.), Inst. of Contemporary Art, Univ. of Pennsylvania, Philadelphia, 1963; "Clyfford Still" (cat.), Albright-Knox Art Gal., Buffalo, N.Y., 1966. *Periodicals*—Albright-Knox Art Gallery News (Buffalo, N.Y.) Summer 1960; Art Digest May 1950; Art International (Lugano) January 1960; Art News December 1959, December 1969; Artforum December 1963, February 1964, May 1977; Nation May 27, 1978; New York Times November 15, 1959, June 25, 1980, July 6, 1980; Newsweek July 7, 1980; Portfolio and Art News Annual no. 2 1960; Time November 29, 1963, February 9, 1976; Vogue February 1970.

SUTHERLAND, GRAHAM (VIVIAN)

(August 24, 1903–February 17, 1980), British painter, designer, and graphic artist, was the first British painter since Constable to enjoy an international reputation during his lifetime. Influenced by surrealism and British neoromanticism, he was best known as a portraitist and landscape painter.

Graham Vivian Sutherland was born in London, the son of G.H.V. Sutherland, a civil servant and lawyer, and of his wife Elsie. Raised in comfortable middle-class surroundings, he lived until he was nine either at Merton Park, Surrey, or at Rustington, Sussex. When he was 12 he entered boarding school at Sutton, passing his vacations at Swanage, Dorset, from which time, as his close friend Edward Sackville-West wrote, Sutherland "dates that mysterious intimacy with nature which has since developed into the basis of his art."

At school Sutherland showed an aptitude for Greek and Latin. He enrolled in Epson College when he was 11 and majored in the classics but the curriculum at Epson emphasized science, a field of study in which Sutherland was inept. To relieve his unhappiness he began to draw, and by the time he was 17 he had exhibited several landscapes at the Royal Academy, London. Having left Epson College in 1918, Sutherland was apprenticed the following year to the engineering branch of the Midland Railway Works, Derby. However, after a year of mechanical drafting, he decided to become an artist and in 1921 enrolled in Goldsmiths' College of Art, a branch of the University of London.

At Goldsmiths', where he studied for five years, Sutherland took courses in drawing and etching. Sales of his etchings date from 1925, when his first solo show of drawings and engravings was held at the XXI Gallery, London. He established himself as an independent artist and teacher in London, and in 1926 he was elected an associate member of the Royal Society of Painter-Etchers and Engravers. The following year he converted to Roman Catholicism, and on December 29, 1927 he married Kathleen Frances Barry, whom he had met when they were both students at Goldsmiths'.

Sutherland had a second solo exhibition of drawings and engravings at the XXI Gallery in 1928. That year he also joined the staff of the Chelsea School of Art and taught there until the beginning of World War II. (He taught engraving until 1932, then composition and, later, book illustration.) His etchings were still in an academic style; among those which he exhibited between 1930 and '34 with the London Group and at the Paris Salon d'Automne, Edward Sackville-

GRAHAM SUTHERLAND

West singled out *Pastoral* as displaying "some elements of his mature vision and method."

In the Depression year of 1931, the bottom having dropped out of the market for etchings and engravings, Sutherland turned to painting. In 1934 he made his first visit to Pembrokeshire in south Wales, which he revisited every summer until the war. There he discovered the mineral and vegetable forms that were decisively to influence his vision, especially its surrealist dimension.

In 1935, when he began to teach book illustration at the Chelsea School, Sutherland branched out into commercial art. He designed posters— for such companies as Shell-Mex, the Orient Line, and the London Transport Company—as well as ceramics, china, wallpaper, fabrics, and rugs for other businesses. His first solo show of paintings was held in 1938 at the Rosenberg and Helft Galleries, London.

From the very beginning of Sutherland's career as a painter, the essence of his study of landscape was the exact description of isolated forms in nature. Sometimes these forms appear strange or menacing, and it is significant that Sutherland participated in the International Surrealist Exhibition, held in London in 1936. Among the canvases he painted in 1936–40 were *Red Monolith* (1938), *Rocky Landscape with Cairn, Green Tree Form* (1940), *Black Landscape,* and *Gorse on the Seawall,* the last named painted at Trottiscliffe, near Maidstone, Kent, where the Sutherlands had moved in 1937.

Sackville-West discovered in Sutherland's paintings of those years the influence of William Blake and "a quality unique in modern land-

scape painting—an expression of doom and foreboding." From his storehouse of sketches of hollow tree trunks, branches and roots, gorse, plants, rocks, and other configurations suggesting the mystery of organic growth, Sutherland developed metamorphoses of natural forms which became convoluted and evocative in his paintings. The relationship between shapes inspired by inanimate nature and human and animal forms was often close. In his *Thorn Tree* paintings of the postwar years, for example, shapes reminiscent of anthropomorphic presences can be found in the landscape. For Sutherland, landscape painting involved capturing the essence of organic forms—a tree, a flower, even a face—what he called the "bringing out" of their "anonymous personality." He was also concerned that natural forms "bear the mold of their ancestry," and in a landscape he invariably saw the impress of the divine creation, of which, almost in the spirit of a medieval artist, he sought to catch a reflection.

"It was in this country [Pembrokeshire] that I began to learn painting," Sutherland recalled. "It seemed impossible here for me to sit down and make finished paintings 'from Nature.' Indeed, there were no ready-made subjects to paint. The spaces and concentrations of this clearly constructed land were stuff for storing in the mind. Their essence was intellectual and emotional. . . . I found that I could express what I felt only by paraphrasing what I saw. . . . I did not feel that my imagination was in conflict with the real, but that reality was a dispersed and disintegrated form of imagination."

When war broke out in 1939, Sutherland resigned from his post at the Chelsea School of Art. His second solo exhibition of paintings was held at the Leicester Galleries, London, in 1940, and in 1941 he became a salaried artist with the War Artists Advisory Committee, serving as official war artist until 1945. In that capacity he executed dramatic paintings of the bomb-scarred Wales countryside, destroyed buildings, and devastated city streets in which "the human element was either absent or unobtrusive," as one critic noted. In 1942 he visited Cornwall to make drawings of tin miners, and the following year his work was exhibited with Henry Moore's and John Piper's in a three-person show at the Leicester Galleries.

Sutherland first visited Paris in 1944. In the following year he bought the White House in Trottiscliffe, Kent, where he spent part of each summer for the rest of his life. His first postwar shows were held in London galleries, and in March 1946 his first solo exhibition in the United States was mounted at the Buchholz Gallery,

New York City. Reviews were mixed. Sutherland was praised as a colorist by the New York *Herald Tribune,* but the most favorable review came from Henry McBride of the New York *Sun,* who found that Sutherland "built his eye-music as steadily as Bach might have done." McBride also praised Sutherland's second show at the Buchholz Gallery, held in November 1948. However, Sam Hunter of *The New York Times* was disturbed by what he called "a gratuitous morbidity" in the artist's work and an *Art News* critic felt that Sutherland had "lost his bearings in a clash between emotion and intellect."

Meanwhile Sutherland had completed one of his most ambitious works, the *Crucifixion,* commissioned for St. Matthew's Church in Northampton, England, and unveiled on November 16, 1946. This painting was more expressionistically rendered than his previous works, and the imagery of the head of Christ crowned with thorns, a symbol, perhaps, of the agony of the war years, was to be developed in his many "Thorn Tree" paintings in the postwar period. "My mind was entirely preoccupied with the idea of thorns and wounds made by thorns," Sutherland said. In the countryside I began to observe thorn bushes and the structure of thorns, piercing the air in all directions. . . ." He went on to describe the transmutation that so often occurred in his work: "I made a few drawings, and as I was doing them a curious change took place. While preserving their own life in the space created by their spikes, the thorns rearranged themselves and became something else—a sort of paraphrase of the Crucifixion—the essence of cruelty." (Sutherland repeatedly uses the word "paraphrase" in describing his art. His conception of paraphrase has been defined as "the dislocation and reconstitution of particular forms through the artist's perception.")

In 1947 Sutherland made his first visit to the south of France; thereafter, he was to work in Villefranche, near Nice, for several months each year. Now that he could afford to travel freely, he met Picasso and Matisse and was able to have better exposure to the work of his contemporaries. He found new themes and images in olive-tree roots and vine stems ossified by the fierce sunshine of Provence and in the fossilized starfish and twisted flotsam and jetsam washed ashore by the Mediterranean.

Sutherland was now showing regularly in Europe and North America, and in 1948 his new works were exhibited in London and he was included in a group exhibition at the Galerie René Drouin, Paris, "La Jeune peinture en Grande-Bretagne," which traveled to the Musée d'Art Moderne, Brussels. With other British

painters, he exhibited in 1950 at the Stedelijk
Museum, Amsterdam, where he had a retrospec-
tive three years later. Two Sutherland retrospec-
tives were mounted in London in 1950–51, at
the Institute of Contemporary Arts and the Han-
over Gallery, and two years later he was given
a retrospective at the Venice Biennale, where an
international jury awarded him the acquisition
prize contributed by the Museum of Modern
Art, São Paulo.

In the early 1950s Sutherland received such
important commissions as the design of tapes-
tries for the Edinburgh Tapestry Company and
of a huge tapestry, *Christ in Glory in the
Tetramorph,* for the Coventry Cathedral, which
had been reconstructed after its demolition by
bombs during the war. He began work on this
project in 1952 and the 72-by-40-foot tapestry
was hung in the cathedral ten years later. *The
Origins of the Land,* a large mural, commis-
sioned for the Festival of Britain in 1951 was lat-
er acquired by the Tate Gallery.

In the late '40s Sutherland had become ac-
quainted with Somerset Maugham and re-
marked to a mutual friend that, had he been a
portraitist, Maugham's remarkable head and
personality would have been precisely the kind
to have inspired him. Soon afterwards Maugham
challenged Sutherland to paint his portrait. The
finished work, arguably Sutherland's best por-
trait, caused a sensation when it was unveiled in
1949. It is painted on an unusually narrow can-
vas and the model is seated on a bamboo stool,
his arms folded, legs crossed, the upper part of
the body erect, the jaw firmly set. The plain
background, ranging from apricot to yellow-
green and broken only by a few palm fronds at
the top, contributes to the monolithic quality
Sutherland was seeking. Maugham, the inscruta-
ble, sardonic observer of human behavior, is
made to look "like some hieratic, sophisticated
dinosaur," to quote one critic. The folds, pouch-
es, and wrinkles of Maugham's face constituted
"the same sort of expression of the process of
growth and struggle as he [Sutherland] found in
the rugged surfaces and irregular contours of a
boulder or a range of hills," wrote Douglas Coo-
per. Maugham himself called the portrait
"magnificent."

Sutherland's acclaimed rendering of
Maugham prompted the press magnate and pol-
itician Lord Beaverbrook to commission his own
portrait in 1950. Sutherland completed the Bea-
verbrook portrait at Cap d'Ail, a resort on the
French Riviera, in 1951. Again he described in
strong lines the folds and furrows of Beaver-
brook's face; he portrayed his sitter grinning
impishly, but the finished work seemed rather

dry and external in its approach, lacking the em-
pathy that made the Maugham portrait so com-
pelling.

In 1953 retrospective exhibitions of Suther-
land's work were mounted in Amsterdam and
Zürich, and 49 of his paintings were shown at the
Curt Valentin Gallery, New York City; the same
group of paintings was shown that year in a Tate
Gallery retrospective sponsored by the Arts
Council of Great Britain.

In 1954 a Parliamentary committee commis-
sioned Sutherland to paint a presentation por-
trait of Sir Winston Churchill in honor of the
Prime Minister's 80th birthday. With some re-
luctance, Sutherland consented and the first of
eight sittings took place in August 1954. Some of
the preliminary sketches are remarkable, includ-
ing a head study in black chalk that he did as
Churchill slept, still wearing his spectacles. Suth-
erland also made a brilliant oil study from life,
showing Churchill's abstract, brooding expres-
sion. Churchill would have preferred to have
been painted in his robes as Knight of the Gar-
ter—Sutherland's fine full-length study of him
in Garter robes is owned by the Beaverbrook
Foundation, New Brunswick, Canada—but
Sutherland depicted Churchill seated on a dais
in his customary House of Commons garb. Chur-
chill's expression was characteristically pugna-
cious, and he was positioned in his chair as if he
were about to rise to his feet at any moment. The
feet themselves were omitted, which some found
distracting, and the placement of the bulky fig-
ure in an ambiguous space faintly echoed the
horrific canvases of Francis Bacon. Sutherland
had set out to express Churchill's bulldog tenaci-
ty, but the angle of vision gave the head a grim
and rather saurian character. The picture also
captured unflatteringly the stiffness of old age,
and Sir Winston, at the unveiling of the portrait,
pronounced it "a remarkable example of mod-
ern art." But Churchill's "praise" was ironic; he
hated the picture and later said, "It makes me
look half-witted, which I ain't." After Lady
Churchill's death in late 1977 it was revealed
that, in compliance with her husband's wishes,
she had burned the painting before Sir Winston
had passed away. Sutherland remarked that the
destruction was "without question an act of
vandalism."

In 1954 Sutherland bought a home, La Villa
Blanche, in Menton on the French Riviera,
where he thereafter spent the winter months.
His life was outwardly uneventful, but he
worked constantly and received many honors:
the Order of Merit in 1960, an honorary degree
of Doctor of Literature from Oxford University
in 1962, and election as an Honorary Fellow of

the American Academy of Arts and Letters in 1972. Popular in France, he was appointed Commandeur des Arts et des Lettres in 1973 and was made an honorary citizen of Menton. In 1974 he became the first artist to receive the Shakespeare Prize of Hamburg, West Germany. Beginning in 1973 he was engaged in organizing the Graham Sutherland Gallery, Picton Castle, Pembrokeshire, which opened in 1976. The gallery is now known as the Graham and Kathleen Sutherland Foundation.

From June to October 1977 an exhibition of 24 portraits of Sutherland's sitters, including Konrad Adenauer, Beaverbrook, Somerset Maugham, Edward Sackville-West, Elie de Rothschild, and Helena Rubenstein, was held at the branch of the National Portrait Gallery at 15 Carlton Terrace, London. Of particular interest were the preliminary drawings and figure studies, which, as an *International Herald Tribune* critic pointed out, "illustrate Sutherland's method of 'stalking' his sitter to discover his or her essence."

At the Marlborough Gallery, London, a different facet of Sutherland's talent was displayed—original works in mixed media for a series of 14 aquatints entitled "Bees," on the theme of the life cycle of the honeybee. The *Herald Tribune* writer praised these works as "poetical and romantic to the last degree." John Spurling of the *New Statesman* (April 20, 1979) wrote that, though Sutherland was "bad at birds," he responded marvelously to insects, probably because he found them "complicated machine-like organisms, which are at once beautiful and sinister." Spurling commented that Sutherland's depictions of certain organic forms—twisted trees, thorns, roots, and insects—expressed in 20th-century terms the Gothic view "that man has been expelled from Eden, that he is heir to the bramble-thicket." Spurling felt that Sutherland's large oil paintings of the 1970s, even those depicting the intricacies of roots and rocks, had been "overwhelmed by [a] striving towards significance."

Graham Sutherland died in London at the age of 76. In his last years he divided his time, to quote *Time* magazine, "between the sun-swept luxury of the Riviera and the box-hedged comfort of his home in Kent." It has been said that Sutherland was "endowed from birth with the eye of a coastguard and the heart of a Franciscan." He was lean, elegant, and distinguished looking. Though a private person, he was warm and friendly and his sunny disposition had been enhanced by a happy marriage and a rewarding way of life. Yet there was an inner intensity beneath the surface, and he was never unaware of the world's torment and tragedy. "The closeness of opposites in life has always fascinated me," Sutherland said. "That is to say the tension between opposites. The precarious balanced movement—the hair's breadth between—beauty and ugliness—happiness and unhappiness—light and shadow. When the sky seems most superbly blue, it could at any moment be black."

EXHIBITIONS INCLUDE: XXI Gal., London 1925, '28; Rosenberg and Helft Gals., London 1938; Leicester Gals., London 1940; Buchholz Gal., NYC 1946, '48; Inst. of Contemporary Arts, London 1951; Stedelijk Mus., Amsterdam 1953; Kunsthaus, Zürich 1953; Tate Gal., London 1953; Curt Valentin Gal., NYC 1953; Paul Rosenberg & Co., NYC 1959, '64; Marlborough Fine Art, London from 1964; Gal. Civica d'Arte Moderna, Turin, Italy 1965; Kunsthalle, Basel 1966; Marlborough Gal., Zürich 1972; "Portraits by Graham Sutherland," Nat. Portrait Gal., London 1977. GROUP EXHIBITIONS INCLUDE: International Surrealist Exhibition, New Burlington Gals., London 1936; Leicester Gals., London 1943; "La Jeune peinture en Grande-Bretagne," Gal. Rene Drouin, Paris 1948; "La Jeune peinture en Grande-Bretagne," Mus. d'Art Moderne, Brussels 1948; Stedelijk Mus., Amsterdam 1950; Venice Biennale 1952, '54; "Masters of British Painting," MOMA, NYC 1956; "British Painting 1700–1960," Pushkin Mus., Moscow 1960; "British Painting 1700–1960," Hermitage Mus., Leningrad 1960; "British Art Today," Mus. of Art, San Francisco 1962; "Moore/Picasso/Sutherland," Marlborough Fine Art, London 1970; IXe Biennale Internationale d'Art, Menton, France 1972; Contemporary British Painters and Sculptors," Marlborough Fine Art, London 1974.

COLLECTIONS INCLUDE: Tate Gal., British Mus., Victoria and Albert Mus., Arts Council of Great Britain, British Council, Imperial War Mus., and Contemporary Art Society, London; Ashmolean Mus., Oxford; Fitzwilliam Mus., Cambridge; City Art Gal., Birmingham, England; City Art Gal., Leeds, England; Nat. Mus. of Wales, Cardiff; Mus. of Modern Art, Edinburgh; Glasgow Art Gal., Scotland; Mus. Nat. d'Art Moderne, Paris; Kunsthalle, Hamburg; Gal. des XX Jahrhunderts, Berlin; Albertina, Vienna; Kunstmus., Basel; Gothenburg Art Gal., Sweden; MOMA, NYC; Albright-Knox Art Gal., Buffalo, N.Y.; Phillips Collection, and Hirshhorn Mus. and Sculpture Garden, Washington, D.C.; Toledo Mus., Ohio; Chicago Art Inst.; Univ. of Nebraska, Lincoln; Mus. of Art, San Francisco; Santa Barbara Mus. of Art, Calif.; Mus. of Fine Art, Montreal; Nat. Gal., Ottawa; Toronto Art Gal.; São Paulo Mus.; Nat. Gal. of Australia, Melbourne.

ABOUT: Arcanyeli, F. Graham Sutherland, 1973; Barber, N. Conversations with Painters, 1964; Cooper, D. The Work of Graham Sutherland, 1961; Hayes, J. (ed.) "Portraits by Graham Sutherland" (cat.), Nat. Portrait Gal., London, 1977; Man, F. H. Graham Sutherland: das graphische Werk 1922–1970, 1970; Melville, R. The Imagery of Graham Sutherland, 1950; Sackville-

West, E. Graham Sutherland, 1943; Thuillier, R. Graham Sutherland: Inspirations, 1982. *Periodicals*—Art News March 1953; Artist March 1944; Arts Review April 1970; Horizon April 1942; International Herald Tribune July 12, 1977; Listener September 6, 1951; (London) Times February 18, 1980; New Statesman April 20, 1979; Signature July 1936; Time August 3, 1953, March 3, 1980.

SUVERO, MARK DI. *See* DI SUVERO, MARK

TAKIS (PANYIOTIS VASSILAKIS) (October 29, 1925–), Greek sculptor, writes: "I was born in Athens in 1925. My father came from the Greek peninsula of Peloponnesus, more precisely from the southern part of Agiditos; my mother is Athenian.

"My father's uncle left a big property on the outskirts of Athens to him and his brothers. They rented a large area near their property from the government and cultivated olive trees and vineyards. But after the catastrophe in Smyrna things changed for my family: the refugees from Smyrna were given my father's land on which to settle. The plantations were destroyed and my father was gradually ruined. I was eight years old when I saw the last olive tree being cut down and used as firewood in our house.

"That was the beginning of the destruction of the Attica landscape. Today it has completely disappeared. Two rivers, famous from antiquity, the Ilissos and the Kifissos, have been covered over by two ugly highways. Although the area of my father's property had been destroyed by the settling of the refugees, the destruction was hardly visible compared to what is left there today.

"I spent all my youth in this area on the outskirts of Athens, which at that time had the ambience of Attica, described in so many ancient writings. I still remember those rivers with their beautifully clean water where we children used to swim. The memory of those rivers is very important to me, because it was there that I realized and felt the meaning of volume, how a material can be transformed by water.

"I did not study in any art school, and left Greece for Europe in 1954. Being impressed by the technological landscape in Europe, I made my first works in metal and called them 'Signals.' In 1959 I made my first magnetic sculpture, which was as simple as a magnet holding a nail in the air.

"In Paris I met the poets of the Beat generation—Allen Ginsberg, Gregory Corso, and Wil-

Jorge Lewinski

TAKIS

liam Burroughs—and we became friends. I think my spirit was in very much the same direction as theirs, which made the contact very strong.

"About 1960 I had my first exhibition in New York, at the Iolas Gallery, and worked in the Hell's Kitchen area. I spent most of my evenings in Times Square, seeing two or three films one after the other until early morning. After the powerful reality of making iron sculptures and magnetic sculptures, I needed to escape into a dream world. I still love movies today.

"I lived in London, traveled a great deal through Europe, and often returned to the United States.

"I kept a diary which was published by Juilliard in 1961. I also wrote a few essays on art and ideas and held dialogues with friends and poets.

"In 1967 I received a letter from Professor Gyorgy Kepes, then Director of the MIT Center for Advanced Visual Studies in Cambridge, Massachusetts, inviting me to be guest fellow at the Center. I worked there with fantastic results in collaboration with the scientist Ain Sonin, and invented an oscillating machine for the purpose of producing electricity from the oscillation of the sea. A US patent was obtained for the machine. Also in 1967, I had a big exhibition at the MIT Gallery, and another in the same year at the Howard Wise Gallery in New York City.

"I met my wife Dorothea (DsDo) in 1967 in Venice, and I'm working and collaborating with her now.

"Since 1969 I have been living and working mostly in Europe, but plan to return to the States this year [1979].

"My work has developed and consists now of volume and sound."

———

Takis was born Panyiotis Vassilakis Takis. In 1954–58, while living in London, he built a series of abstract kinetic sculptures entitled "Signals." Constructed from steel wire, these were empowered by means of springs or by being weighted at the top. In the 1960s he was a pioneer of electro-magnetic sculpture, objects which moved in controlled magnetic fields. " . . . In his *Magnetic Ballets* and other such works," it is explained in *The Oxford Companion to Twentieth-Century Art,* "he created objects . . . which existed less for the sake of their intrinsic form than to reveal the operation of a natural force."

In a speech given at an international exhibition of kinetic sculpture at the University of California, Berkeley, in 1966, Takis explained that his use of electro-magnetism in sculpture was a search for "simple perfection, beauty and balance." He was specifically referring to a work of his in which darts played harplike notes on a magnetized wire.

Wall pieces that also functioned as musical instruments were included in Takis's solo exhibition at the Howard Wise Gallery, New York City, in April 1967. In the *New York Post* (April 15, 1967), Charlotte Willard commented that Takis had "taken up the ancient role of Daedalus." He had committed himself "to defying gravity not by machines, not by balloons, but by electro-magnetism. . . . This force, which can be made invisibly, silently and secretly to attract and hold objects suspended in space, Takis uses with grace, variety, originality."

Reviewing an exhibition at the Massachusetts Institute of Technology's Hayden Gallery for *The New York Times* (December 3, 1968), a critic described Takis's "magnetic sculpture" as "representative of a fast-moving new trend to merge the seemingly distant purposes of art and science." Reinhold added that the phenomenon of magnetic sculpture was an attempt "to embody and interpret natural and technological phenomena in art." Among the exhibits was a working model of a floating sculpture titled *The Perceptual Moving Bicycle Wheel of Marcel Duchamp* in homage to the French artist. Other works were based on traffic-light signals, airplane landing dials, and other technological indicators that control human lives. Takis observed: "They have a tragical aspect—if something goes wrong, we go down. At the same time you can see poetry in their movement."

A group of Takis's "Signals" was exhibited at the Hayden Gallery in 1969. Christopher An-dreae of the *Christian Science Monitor* (February 2, 1969) pointed out that, although the "Signals" were various "differently colored and shaped flashing lights perched on top of tall thin antennae" and made to twitch and revolve by the use of dials, they were not meant to be understood or obeyed like ordinary road signals or mechanical indicators. "The viewer must look for a message far more obscure and abstract than that of the dial indicating speed or the flashlight meaning danger." Wayne Anderson, director of exhibitions at MIT described Takis's signals and dials as "metaphorical objects, reminding us not only of the presence of unseen forces but also that ultimately their existence is something we cannot completely control and comprehend." Despite Takis's admiration for Duchamp, and the fact that his works are often entertaining, his aim has never been to create parodies of technological instruments in an ironic dadaist spirit. The fascination of his kinetic sculptures is that they are "highly poetic creations which bring us into direct contact with the fundamental and still mysterious forces which power nature and life," to quote *Contemporary Artists.*

Takis has been the subject of numerous films, including Colette Robert's *Meet the Artist* (1967); Mahmoud Khosrowshaki's *Takis Unlimited* (1967); Richard Edelman's *Takis, Chant of the Magnetic Minstrel* (1968); and Isaac Kleineman's *21st Century* (1969).

EXHIBITIONS INCLUDE: Hanover Gal., London 1955, '58, '66; Gal. Furstenberg, Paris 1958; Gal. Iris Clert, Paris 1959, '60, '71; Alexandre Iolas Gal., NYC 1959, '61, '63; Gal. Schwarz, Milan 1962, '68; Gal. Alexandre Iolas, Paris 1964, '66; Gal. Alexandre Iolas, Geneva 1965; Howard Wise Gal., NYC 1967, '69, '70; Hayden Gal., Massachusetts Inst. of Technology, Cambridge 1968–69; Gal. Iolas, Milan 1972; Centre Nat. d'Art Contemporain, Paris 1972; Zoumboulakis Gal., Athens 1974; Kunstverein, Hanover, W. Ger. 1974; Fred Lanzenberg Gal., Brussels 1975. GROUP EXHIBITIONS INCLUDE: Hanover Gal., London 1954; "Figures," Inst. of Contemporary Art, London 1955; "1st Exposition Internationale d'Art Plastique," Mus. d'Art Moderne, Paris 1956; "Sculpture d'aujourd'hui," Gal. Claude Bernard, Paris 1958; "Fourteen European Sculptors," Staempfli Gal., NYC 1959; "Konkrete Kunst," Helmhaus, Zürich 1960; "Art in Motion, Bewogen, Beweging," Stedelijk Mus., Amsterdam 1961; "For the Eye and for the Ear," Gal. Cordier-Ekstrom, NYC 1963; "Lumière et Mouvement Optique," Palais des Beaux-Arts, Brussels 1965; "Directions in Kinetic Sculpture," Univ. of California, Berkeley 1966; Carnegie International, Pittsburgh 1967; "The Machine as Seen at the End of the Mechanical Age," MOMA, NYC 1967; "Science-Fiction," Städtische Kunsthalle, Düsseldorf 1968; "New Alchemy, Elements, Systems, Forces," Art Gal. of Ontario, Toronto 1969; "Kinetic Exhibition," Hayward Gal., London 1970; "Douze ans d'art contemporain en France," Grand Palais, Paris 1972; Documenta 6, Kassel, W. Ger. 1977.

COLLECTIONS INCLUDE: Mus. d'Art Moderne, and Cntr. Nat. d'Art Contemporain, Paris; Fondation Maeght, Saint-Paul-de-Vence, France; Mus. de Grenoble, France; Tate Gal., and Arts Council of Great Britain, London; Mus. Schloss Morsbroich, Leverkusen, W. Ger.; MOMA, and Solomon R. Guggenheim Mus., NYC; Art Inst. of Chicago; Mus. of Fine Arts, Houston, Tex.; Art Gal. of Ontario, Toronto; Mus. of Tel Aviv, Israel.

ABOUT: Calas, N. and others Ikons and Images of the Sixties, 1971; Clay, J. "Takis" (cat.), Gal. Iolas, Paris, 1966; "Directions in Kinetic Sculpture" (cat.), Univ. of California, Berkeley, 1966; Osborne, H. The Oxford Companion to Twentieth-Century Art, 1981, Popper, F. L'Art cinétique, 1970; P-Orridge, G. Contemporary Artists, 1977; Takis, P. Poems 1942–46, 1972, Musique Magnètique, 1975. *Periodicals*—Art in America December 1965; Art News June 1964; Arts October 1964, June 1966; Burlington Magazine (London) December 1962; Christian Science Monitor February 2, 1969; Chroniques de l'art vivant (Paris) May 1971; New York Post April 15, 1967; New York Times December 3, 1968; L'Oeil (Paris) November 1964; Studio International (London) February 1967.

PIERRE TAL-COAT

TAL-COAT, PIERRE (PIERRE LOUIS CORENTIN JACOB), (December 12, 1905–), French painter, has been intent on capturing nature's most serene and ephemeral effects, moods, and placid states of energy. His later work might be considered a form of impressionism taken to its ultimate extreme, in which it is the lyrical modulation of light itself, and not what the light reveals, that is important. In the 1960s, the critic Henri Moldiney, describing one of Tal-Coat's Paris exhibitions, wrote that "the space of Tal-Coat has the structure of time itself."

He was born Pierre Louis Corentin Jacob in Clohars-Carnoët, Finistère, Brittany. The son of a fisherman, he was orphaned by the First World War and became a ward of the state. Clohars-Carnoët was then a summering place for a number of professional artists, and Pierre, who liked to draw, learned from them. In 1918 he began an apprenticeship with a blacksmith, and in his spare time made small sculptures from wood and clay. Later, after studying on a scholarship at the Ecole Supérieure in Quimperlé and working as a lawyer's clerk (1923), he was employed as a painter-ceramist and molder at a faience factory. During a brief stay in Paris in 1929, he attended the Académie de La Grande Chaumière, then toured Alsace and Basel and served in the French Army (1925–26). Moving to Brittany in late 1926, he took the name Tal-Coat (Face or Head of Wood) to avoid confusion with the well-known poet and painter Max Ja-

cob, who lived nearby. He married Bronislawa Lewandowska in 1927.

In the late 1920s and early '30s he divided his time between Brittany and Paris, becoming friendly with the American expatriates Ernest Hemingway and Gertrude Stein, and also with such Parisian avant-gardists as Francis Gruber, Francis Picabia, Albert Giacometti, and later, Blaise Cendrars and Tristan Tzara. Despite rubbing shoulders with these Dadaists and early Surrealists, Tal-Coat practiced a disciplined, robust realism. To promote his ideas he founded the Forces Nouvelles with a number of other young artists. His best-known work of this period, the monumental *Portrait of Gertrude Stein* (1936), for which he won the Prix Paul Guillaume, is as psychologically penetrating as the more famous Picasso portrait; Stein's physical solidity, her obdurate will and intelligence, and her devious wit come through clearly. Inspired by the brutalities of the Spanish Civil War, Tal-Coat painted a series of "Massacres." In these works, wrote E. Benézit, "[Tal-Coat's] graphism became more acute, more tragic, often more poignant; his palette was affirmed, producing violent harmonies." His portraits too became bolder, with heavy black outlines and vigorous brushstrokes.

With the outbreak of war in 1939 Tal-Coat again served in the military (1939–40). The rest of the war years, which he spent in Aix-en-Provence, were a time of contemplation for him. He did many still lifes, whose transparent colors and shapes outlined fluidly in black recall Dufy. Mirrors often appeared in these compositions, which were increasingly meant to solve general

pictorial problems posed by the emanation, transmission, and reflection of light. A series he called "Movements," originated in studies of fish at the aquarium at Trocadero. The "Movements," predominately in sea-green, aimed to capture the play of light on water or submerged rocks.

The Surrealist André Masson, whom Tal-Coat had met in 1947, stayed in Aix-en-Provence with him for three years. Masson's influence probably helped Tal-Coat in his transition from explicit to suggestive imagery, and the Surrealist also introduced him to Chinese landscape painting. Now, instead of working directly from nature, Tal-Coat seemed to be working out of his imagination toward nature. His own landscapes in Chinese ink—in which, wrote Bénézit, "the only trait was light"—were free and lyrical, composed of atmospheric washes, soft lines, and transparent colors unfettered by a too-close adherence to place or appearance. *Plateau Cevenol* (1954), a broadly X-shaped composition of fluttering brushmarks evocative of water, greenery, and hills, is typical. As with Zen painters, each mark has a transcendental significance; the scene is portrayed not rigidly, but complete with all its vague possibilities for change. G.S. Whittet wrote in *Contemporary Artists*, "It is this lack of precision in identification of the objects suggested in his landscapes that gives Tal-Coat's work its edge of interest, for though the associations are less than exact their massing and placing on the canvas have a direct and powerful dynamic." Tal-Coat painted figures as well, also in dispersing motion, as in *Femme qui passe*, (1956, *Woman Passing By*) or *The Journey III* (1959).

In 1961 Tal-Coat moved to Pierre de Bailleul, near Vernon. Having passed through a phase in the 1960s influenced by tachism (the "Tropeau" series, for example), in which his style became more linear and studiedly abstract, in the early 1970s Tal-Coat became increasingly interested in subtleties of texture and contrast. In works like *Traces dans le jaune* (1972, *Traces in the Yellow*) or *Dépôt* (1974), peaceful areas are interrupted by volcanic impasto splotches—an often violent geology built by the painter with a palette knife or roughened as the paint dried.

After the death of his wife in 1970, Tal-Coat traveled in Switzerland and Japan. In 1976 more than 200 of his works were shown in a retrospective at the Grand Palais, Paris. The intensity of his spiritual approach to art is reflected in his writing, which is oblique and lyrical. Of drawing, he writes: "Drawing is a journey! One's gaze leads to the apparition of light, accompanied by shadow, but not by contour, ideality, enclosure

and complacency. Drawing is from within, always changing in the appearing and disappearing, leading one's eye in that wandering encounter in movingness [*mouvance*].

"There is no line whatsoever in which the image could be enclosed. It is everywhere, the journeying of the eye, it is not line alone; in this line, however steady it may be, is space in all its parts, submitting to, becoming, light, shadow, light, space, journeying."

EXHIBITIONS INCLUDE: Gal. Fabre, Paris 1927, '30; Gal. Billiet Pierre Vorms, Paris 1933; Gal. Renour et Colle, Paris 1936; Julien Levy Gal., NYC 1936; Gal. de France, Paris 1943–50; Gal. Maeght, Paris 1954, '56; Kunsthalle, Bern 1957; Gal. Benno d'Incelli, Paris 1965, '68; Gal. Henri Bénézit, Paris 1968; Gal. Benadoz, Geneva, Switzerland 1970, '72, '75; Gal. Maeght, Zürich 1974; Ueno Royal Mus., Tokyo 1975; Open-Air Mus., Hakone, Japan 1975; Grand Palais, Paris 1976. GROUP EXHIBITIONS INCLUDE: "Forces nouvelles," Gal. Billiet Pierre Vorms, Paris 1935; "Nouvelle generation," Gal. Charpentier, Paris 1936; "Despierre: Gruber: Lasne: Marchand: Pignon: Tailleux: Tal-Coat," Gal. Jean Dufresne, Paris 1939; Salon de Mai, Paris 1945; "Young French Painters," Leicester Gals., London 1949; "New Painters," Modern Art Society, Cincinnati 1952; "Gruber, Marchand, Tal-Coat," L'Etoile Scellée, Paris 1953; "Moderne Französische Graphik," Maison de France, Berlin 1955; Documenta 1 and 2, Kassel, W. Ger. 1955, '59; Venice Biennale 1956; "15 Painters from Paris," Corcoran Gal., Washington, D.C. 1959; Menton Biennial, France 1963; "Painting in France 1900–1967," Nat. Gal., Washington, D.C. 1968; Baukunst, Cologne 1970; "Collections Genevoises—art du XXe siècle," Mus. Rath, Geneva, Switzerland 1973; "André de Bouchet, Pierre Tal-Coat," Chateau de Ratilly, Trevigny, France 1979.

COLLECTIONS INCLUDE: Mus. Nat. d'Art Moderne, Paris; Fondation Maeght, Saint-Paul-de-Vence, France; MOMA, NYC.

ABOUT: Bénézit, E. (ed.) Dictionnaire des peintres, sculpteurs, et graveurs, 1976; George, W. Oeuvres de Tal-Coat, 1929; Huyghe, R. Les Contemporaines, 1949; "Pierre Tal-Coat" (cat.), Gal. Maeght, Zürich, 1974; P-Orridge, G. and others (eds.) Contemporary Artists, 1977. *Periodicals*—Apollo June 1959; Art News December 1953; Derrière le miroir (Paris) May 1963; October 1972; L'Ephémère (Paris) no. 5 1968, no. 16 1970; Les Lettres Françaises (Paris) October 1972; La Revue des belles-lettres (Geneva) no. 3/4 1971; Transition (Paris) no. 5 1949.

***TAMAYO, RUFINO** (August 26, 1899–), Mexican painter, was born in Oaxaca, Mexico, to parents of pure Zapotec Indian stock. When he was 11 the Mexican Revolution broke out. Orphaned in 1911, he moved to Mexico City to live with his aunt. There Tamayo attended school

°tä mä´ ō, rōō fē´nō

Courtesy of the Rufino Tamayo Museum, Mexico City

RUFINO TAMAYO

and helped his aunt with her fruit market. The market was to be a recurrent theme in his work, and he is noted for the glowing colors he uses in depicting fruit.

About 1915 Tamayo's aunt sent him to commercial school, but he secretly studied drawing at night and abandoned the study of business management altogether in 1916. The following year he enrolled in a drawing class at the Academia de Arte de San Carlos, Mexico City. "At the academy the lessons were highly academic," Tamayo recalled, "which was not to my taste. We were made to copy plaster casts as precisely as possible, and I soon realized that this was not good for me." His impatience with the school's conservativism was exacerbated by visits to the academy's museum. "I saw old masters— European masters, and they all had a very strong personality," he told *Art News* (February 1979). "Well, I began to realize that to develop an individual personality was a very important thing." Tamayo stayed at the academy but attended classes less and less frequently and increasingly painted on his own.

In 1921, when the Mexican Revolution ended, Tamayo left the San Carlos Academy. He met José Vasconcelos, Minister of Education in the new government, who was also a native of Oaxaca. Vasconcelos took a liking to the young artist and appointed him head of the department of ethnographic drawing in the National Museum of Anthropology, Mexico City. Government policy in those years called for greater emphasis on the national heritage of earlier Mexican cultures, and Tamayo's job was, he said, "the real beginning for me, because it exposed me to pre-

Columbian art—to the popular art of my country, and immediately I noticed that *that* would be my source. From that moment on, it became the basis of my art." He made drawings of artifacts from the pre-Columbian period, and Aztec, Maya, and Toltec sculpture was to influence his work.

During the early 1920s Tamayo participated in a Vasconcelos-initiated open-air art program by teaching periodically in rural primary schools. This further exposed him to the Mexican Indians' folk art traditions, which he eagerly absorbed.

Tamayo left the Museum of Anthropology in 1923. He was out of sympathy with the social realist and historical narrative murals that the Big Three of Mexican painting—Diego Rivera, Orozco, and D.A. Siqueiros—were undertaking. Tamayo and such like-minded "antimuralists" as Carlos Orozco Romero and Carlos Mérida advocated an easel painting approach which stressed abstract and decorative qualities and stylization of form.

Because there were no art galleries in Mexico City in 1926, Tamayo arranged for his first solo show to be held in a small empty shop. His lyrical works were in marked contrast to the didactic, propagandistic painting of the muralists who then dominated Mexican art.

In September 1926 Tamayo and his friend the composer Carlos Chavez traveled to New York City. Tamayo met Miguel Covarrubias, a compatriot who introduced him into New York art circles, and both he and Chavez decided to stay. He held his first exhibition in the United States at the Weyhe Gallery, New York City, in October 1926; he sold several pictures, but the show was not a financial success. In Mexico he had felt that the anti-muralists produced "bad imitations of French art," and after arriving in New York he found that American painting, too, "was mostly an imitation of the Europeans." But in New York, at least, he was able to see "*real* French painting and German painting and early American painting. . . . It was the genuine article and it gave me an even bigger overall vision of what I wanted to do."

Influenced first by Matisse and later by Braque and Picasso, Tamayo developed a strongly individual style which adhered to international modernism and was, in part, a revolt against Mexican muralism. At the same time, his earthy yet vivid colors and many of his themes have been inspired by his native land, its life and legends.

In June 1928, Tamayo was obliged by ill health to return to Mexico City, where he obtained a teaching position at the National School

of Fine Arts. In Mexico City he exhibited at the Galeria de Arte Moderno and the following year taught at the Academy of Fine Arts, which was directed by Diego Rivera. He resigned from his teaching posts in 1930 and returned to New York City for a brief stay. In 1931, now established as a prominent young artist, he represented painters on a four-man Artists' Congress held at the Mexican Ministry of Education in Mexico City. For the next five years he was to divide his time between Mexico City and New York City, where in April 1931 he had a solo show at the Julien Levy Gallery. Typical Tamayo works of the '30s were *Nude, The Blue Chair, Still Life,* and *Homage to Juarez* (1932). In these canvases "a cubistically astringent view of subject matter" combined "emblematic forcefulness and poetic color," to quote *Art News.* In Tamayo's painting the Mexican sensibility became "a matter of *accent* rather than pure nationality" inasmuch as he integrated "Mexicanness" with an international style.

In 1932 Tamayo was appointed head of the department of plastic arts in the Mexican Ministry of Education and received an important commission for a mural at the Conservatory of Music, Mexico City, which he completed in 1933. The following year Tamayo married Olga Flores Rivas, a native of Oaxaca, a student at the conservatory, and a talented pianist. Tamayo and his wife often returned to Mexico but after 1936 their home base was New York City. There Tamayo had had a following for almost half a decade and was considered a major artist.

After 1935 Tamayo participated regularly in the Carnegie International, Pittsburgh. In February 1936 he attended the Artists' Congress in New York City, serving with Siqueiros and Orozco as a delegate of the Mexican League of Revolutionary Painters and Artists. Though Tamayo shunned propaganda in his work, he shared Siqueiros's and Orozco's identification with Mexican traditions and with the Mexican ambiance, which Tamayo defined as "tragic and full of sorrow."

Tamayo joined the Federal Art Project (FAP) of the Works Progress Administration (WPA) in March 1936. His designs for a mural for Kings County Hospital, Brooklyn, were rejected, and he went to work in the FAP's easel painting division until, a few months later, Congress barred foreign artists from the WPA and Tamayo was discharged.

From 1938 Tamayo spent winters in New York and summers in Mexico City, thus enabling him to keep in touch with both the mainstream New York art world and his Mexican roots. In September 1938 he began a nine-year teaching

stint at the Dalton School, New York City. Also that year, he executed a fresco for the National Museum of Anthropology, Mexican City.

The installation of Picasso's *Guernica* in New York City's Museum of Modern Art in September 1939 made a powerful impression on Tamayo, as in all probability did the main exhibition held that year at MOMA, "Picasso: Fifty Years of His Art." He had already been influenced by both the cubist and expressionist aspects of Picasso's work, absorbing these styles into his own idiom. In 1940 he participated in a MOMA exhibition of Mexican art. At this time Tamayo was coming to be regarded as one of the outstanding colorists of his generation.

Tamayo returned to mural painting in 1943 when he executed *Nature and the Artist,* a two-panel fresco, and *The Work of Art and the Observer* for the Hillyer Art Library, Smith College, Northampton, Massachusetts. His easel paintings during the World War II years depicted the horrors of armed conflict and contained a "ferocious lyricism . . . that seemed to dispel violence even as it portrayed it." In the fall of 1946 he began teaching drawing at the Brooklyn Museum Art School, a position he held for two years. His striking good looks and highly individual manner of instruction won him the devotion of his students.

In 1948 the Palacio de Bella Artes, Mexico City, gave Tamayo his first large retrospective— and the first real tribute from his own country. In 1949 he and his wife made their first trip to Europe, visiting France, Spain, Holland, Belgium, England, Italy, and remaining for some time in Paris, where they met Picasso. Tamayo admired Picasso as "the genius of the century," although he preferred Braque as a painter and had serious reservations about Picasso's moral character.

In 1950 Tamayo returned to Mexico City. Carlo Chavez, who had been appointed director of the National Institute of Fine Arts, invited him to execute a pair of murals for the Palacio de Bella Artes. That same year he revisited Europe and had a solo exhibition at the Venice Biennale. In subsequent years Tamayo completed such important murals as *Man* (1953), a fresco for the Dallas Museum of Fine Arts; *America* (1955), for the Bank of the Southwest, Houston; and *Prometheus* (1957), for the library of the University of Puerto Rico, San Juan. In his easel paintings of the '50s the element of fantasy predominated. *The Astronomer* (1954), with its swirling shapes, lyrical color, and elegiac mood, can be seen as a prophetic vision of the space age.

In 1957, after a third trip to Europe, Tamayo

and his wife settled in Paris, where they remained until 1964. "I went to Paris as a painter, not as a student," Tamayo explained, and there he exhibited at the Galerie de France and, in 1958, completed the fresco *Prometheus Bringing Fire to Man* for the Conference Hall in the UNESCO headquarters. In 1959 he was elected a member of the Academy of Arts of Buenos Aires, and two years later he was made an Honorary Member of the American Academy of Arts and Letters, a distinction reserved for artists, writers, and composers who are not US citizens.

In 1963 Tamayo painted two murals, *Israel Yesterday* and *Israel Today,* for the Israeli ocean liner *Shalom*. The following year he received the National Award for artistic merit from the President of Mexico. However, there was resentment in Mexico of Tamayo because he had become rich and famous in the US and Europe and had refused to use his "Europeanized" art as an instrument of propaganda. Nonetheless, he is represented by several major murals in Mexico City—including *Duality* (1964) for the National Museum of Anthropology and *San Cristobal* for the offices of Roberto García Mora—and was shown in the Mexican pavilion at the 1968 Hemisfair, San Antonio, Texas. Indeed, that same year he was honored for his 50 years as a painter by a retrospective at the Palacio de Bella Artes. Still, his greatest recognition has come from the US, Europe, and South America.

Tamayo's easel paintings of the 1960s, such as *Man in the Red Hat* (1963) and *Black Venus* (1965), contain Picasso-esque figurative elements but their mystery, lyricism, and glowing color are the artist's own. The feeling of mystery evoked by his paintings is due in no small part to the enigmatic and primitive character of his symbols—his response to pre-Columbian art—and the sensuousness of his palette. Tamayo's shapes are suffused by a variety of reds as well as nocturnal blues, pale mauves, purples, orange, salmon pink, and pistachio green.

In 1969 Tamayo was made an Officer of the Legion of Honor by the French government and was promoted to Commander six years later. A street has been named after him in Oaxaca, and in 1972 work began in Oaxaca on a museum to house his superb collection of over one thousand works of pre-Columbian Mexican art. His wife told *The New York Times* (January 6, 1978) the reason for this gesture: "We have no children. He has done well with his work and wants to give everything he has made to the country he loves."

Tamayo also proposed to the Mexican government that it build a museum in Mexico City to house the private collection of more than one hundred contemporary European and American paintings he had acquired during his travels abroad. To his dismay, the proposal initially met strong resistance, which Tamayo attributed to opposition from "so-called leftists," politicians who considered modern art as being "only for the élite and not for the people." Construction of the new institution, to be called the Museum of International Modern Art, got underway in February 1978, financed by private Mexican donors. The chosen site was Mexico City's Chapultepec Park, directly across from the National Archeological Museum.

In "Rufino Tamayo: Myth and Magic," the major retrospective which opened at the Phillips Collection, Washington, D.C., in late 1978 and traveled to the Guggenheim Museum, New York City, in the spring of 1979, examples of the native Mexican art that had influenced Tamayo were interspersed with the artist's paintings. Thus the show combined the naive vision and freshness of pre-Columbian works and Mexican folk art with Tamayo's highly sophisticated canvases, with their formalized treatment of the human figure and recherché use of color.

Tamayo and Olga—a handsome, strong-minded, and outspoken woman—live in enviable circumstances. They have a beautiful house in Mexico City and one in Cuernavaca. They are attended by six servants and have two chauffeur-driven cars. In the studio in his Mexico City house, the artist paints eight hours a day, but at night the Tamayos lead an active social life. "Most of our friends," he commented, "are writers and musicians—very few painters or sculptors." Tamayo is an excellent guitarist and likes to sing songs of his native Mexico.

In 1967 Tamayo declared, "Painting is a matter of the senses more than of the intellect. Classic art is very intellectual; baroque art is not. I prefer the latter. I have always considered feeling to be the most important element in an artist." In his latest works, Tamayo said, "I am limiting my palette as much as possible, and simplifying and restricting shapes. . . . With two or three colors at the most you can express more than plenty." According to the artist, his subject has always been man, "man who is the creator of all scientific and technological wonders." "As for myself," Tamayo remarked, "I look to the earth and also to outer space. I look and I paint and I feel a great love surging up in me. And always there is Mexico . . . there are spirits in my country . . . I strain to listen to their voices."

EXHIBITIONS INCLUDE: Mexico City 1926; Weyhe Gal., NYC 1926; Gal. de Arte Moderno, Mexico City 1928; Julien Levy Gal., NYC 1931, '37; Nat. Inst. of Fine Arts, Mexico City 1948; Palacio de Bella Artes, Mexico

City 1948, '68; Venice Biennale 1950; M. Knoedler &
Co., NYC 1950–62; Inst. of Modern Art, Buenos Aires
1951; San Francisco Mus. of Art 1954; Gal. Misrachi,
Mexico City 1962; Retrospective organized by
Mainichi newspapers, Tokyo 1963; Mus. of Modern
Art, Bosque de Chapultepec, Mexico 1964; Mexican
Pavilion, Hemisfair, San Antonio, Tex. 1968; Phoenix
Art Mus., Ariz. 1968; Palazzo Strozzi, Florence 1975;
Mus. d'Art Moderne de la Ville de Paris 1975; Mus. of
Fine Arts, Caracas, Venezuela 1975; Nat. Mus. of Mod-
ern Art, Tokyo 1976; São Paulo Bienal 1977; Phillips
Collection, Washington, D.C. 1978; Marion Koogler
McNey Art Inst. San Antonio, Tex. 1979; Solomon R.
Guggenheim Mus., NYC 1979. GROUP EXHIBITIONS IN-
CLUDE: Carnegie International, Pittsburgh 1935, '52,
'55, '59' 61, '64; Valentine Gal., NYC 1938; MOMA,
NYC 1940; Philadelphia Mus. of Art 1943; São Paulo
Bienal 1953; Documenta 2, Kassel, W. Ger. 1959; Nat.
Mus. of Modern Art, Mexico City 1961; Nat. Inst. of
Fine Arts, Mexico City 1961.

COLLECTIONS INCLUDE: MOMA, and Solomon R. Gug-
genheim Mus., NYC; Albright-Knox Art Gal., Buffalo,
N.Y.; Fogg Art Mus., Harvard Univ., Cambridge,
Mass.; Mus. of Fine Arts, Boston; Yale Univ. Art Gal.,
New Haven, Conn.; Philadelphia Mus. of Art; Phillips
Collection, Washington, D.C.; Art Inst. of Chicago;
Cleveland Mus. of Art; City Art Mus., St. Louis, Mo.;
Milwaukee Art Center; Minneapolis Inst. of Arts, and
Walker Art Center Minneapolis; Baltimore Mus. of
Art; Dallas Mus. of Fine Arts; Mus. of Modern Art,
Houston; Fort Worth Art Association, Tex.; San Fran-
cisco Mus. of Art; Los Angeles County Mus. of Art;
Mus. of Modern Art, Mexico City; Mus. of Modern Art,
Caracas, Venezuela; Mus. of Modern Art, Rio de Janei-
ro; Mus. Nat. d'Art Moderne, Paris; Mus. Royal, Brus-
sels; Kunsternes Hus, Oslo; Nat. Gal. of Modern Art,
Rome; Israel Mus., Jerusalem.

ABOUT: Cassou, J. Peintres contemporains, 1964;
Cheney, S. The Story of Modern Art, 2d ed. 1958;
Cogniat, R. Rufino Tamayo, 1951; Goldwater, R. Ru-
fino Tamayo, 1947; Gual, E.F. Drawings by Tamayo,
1959; Meyers, B.S. and others, Dictionary of 20th Cen-
tury Art, 1974; Raynal, M. Peinture moderne, 1953;
"Tamayo" (cat.), Phoenix Art Mus., Ariz., 1968; West-
heim, P. Tamayo, 1957. Periodicals—Art News Febru-
ary 1979; Arts Summer 1969; Christian Science Moni-
tor January 5, 1972; New York Times February 10,
1074, January 6, 1978.

***TANGUY, (RAYMOND-GEORGES)
YVES** (January 5, 1900–January 15, 1955),
French-American painter, was a leading Surre-
alist. Completely self-taught, Tanguy influenced
both the School of Paris and the New York
School.

Raymond-Georges-Yves Tanguy was born on
the fifth day of this century at the Ministère de
la Marine in the Place de La Concorde, Paris,
where his father, a retired naval captain, worked
as an administrator. Though born in Paris in a

Photo by Man Ray

YVES TANGUY

bed which had belonged to the great Realist
Gustave Courbet, Tanguy was the son of Breton
parents.

Tanguy's father, a stern and pious man, died
in 1907, and the seven-year-old Tanguy went to
live with relatives in the Finistère province of
Brittany. Thereafter, he spent his summer vaca-
tions in the family home at Locronan, near the
Atlantic coast. The harsh Breton landscape, with
its weathered, prehistoric menhirs and dolmens,
made a profound impression on the dreamy, in-
trospective boy. Although Tanguy insisted that
the landscapes of his maturity came solely from
within, critics regard those summers in northern
France as the inspiration for the desolate, myste-
riously dreamlike paintings of his later years. His
childhood was also marked by a deepseated at-
tachment to his mother.

After returning to Paris, Tanguy attended the
Lycée Montaigne and, later, the Lycée St. Louis
from 1909 to '17. One of his classmates at the
Lycée Montaigne was Pierre Matisse, the son of
the painter. Tanguy neglected his studies, and
had his disposition not been so solitary he could
have effortlessly played the part of classroom
rebel; instead, he drank heavily and further in-
toxicated himself by sniffing ether. Thus the
precocious interest in *le déreglement total des
sens* and the Rimbaud-like "aura" around his ad-
olescence. Tanguy showed little interest in art,
though as a youth he was impressed by the grand
indifference of the artist Toché, who took his ea-
sel and brushes into the Paris streets and painted,
oblivious to the stares and derogations of passers-
by.

In 1918 Tanguy joined the merchant marine

°täN ge´, ēv

as an apprentice officer, and in the next year and a half he traveled on French cargo ships to South America, Africa, Portugal, and England. Drafted into the French Army in 1920, he was posted to the provincial barracks in Lunéville, Lorraine. Tanguy's extreme boredom and depression were relieved only by his friendship with the young poet Jacques Prévert, a fellow conscript who shared his taste for mockery of all forms of authority and for rebellion against military discipline in particular. "During his military service Yves at once distinguished himself among his comrades by his eccentric habits," Roland Penrose wrote in the catalog to the 1983 Tanguy retrospective at the Solomon R. Guggenheim Museum, New York City. "He astonished them at table by devouring his own socks or with even more relish spiders spread on a slice of bread, a habit he continued to enjoy throughout life even when no longer pursued by hunger. . . . But another notable and alarming eccentricity happened when Tanguy occasionally found it necessary, usually after heavy drinking, to prove to himself the superiority of his own Breton skull by charging full tilt at a wall or bashing his cranium against the head of a friend."

Demobilized in 1922, Tanguy returned to Paris where he met his future wife Jeannette Ducrocq and was reunited with Prévert. The two friends shared their poverty and a passion for literature, especially Lautréamont's *Les Chants de Maldoror*, a canonical text for the Surrealists. They frequented bars and cafés and Tanguy, having no professional training, worked at an assortment of odd jobs—newspaper vendor, tramway conductor, and unloader of vegetables at the Halles market, among others.

Tanguy had begun to sketch casually, often on napkins in cafés, and he was encouraged by the painter Maurice Vlaminck. But the decisive moment came in 1923. While riding a bus, Tanguy saw a painting in the window of the Galerie Paul Guillaume and impulsively leaped off the moving vehicle to study the work more closely. It was *The Child's Brain,* an early painting by Giorgio de Chirico which had been loaned to the dealer by the then unknown André Breton. It was then that Tanguy decided to make painting his life's career.

In 1924 Tanguy met Marcel Duhamel, a friend of Prévert. A member of the Grosvenor Hotel's board of directors, Duhamel was a man of means who kept Tanguy supplied with art materials. Duhamel rented an old deserted house in Montparnasse at 54 rue du Château, and the three friends and their companions moved in together. Duhamel, Prévert, and Tanguy were incandescent spirits—humorous,

irreverent, and fun to be with. Moreover, they were Bohemian aficionados of the music hall and were addicted to popular serialized novels, especially crime fiction, and, above all, to episodic American films like *The Vampires* and *The Mysteries of New York.* Soon 54 rue du Château became a notorious hothouse of revolutionary ideas, a meeting place for the Surrealists, and a " menace to the neighborhood," to quote Penrose. At this time Tanguy began making drawings and watercolors; his progress as an artist was slow, as he insisted on learning on his own, without formal instruction. His early efforts had a naïve and rudimentary expressionistic quality.

Having already been influenced by André Breton's magazine *La Révolution Surréaliste,* Tanguy met the "pope" of surrealism in December 1925 and the two men became close friends. Tanguy immediately affiliated himself with the Surrealists, meeting the painter André Masson and the writer Louis Aragon. After contributing drawings to the June 15, 1926 issue of *La Révolution Surréaliste,* he was fully accepted into the group. When Tanguy joined them in the mid-'20s, the Surrealists were devising new ways of evoking what they called "the marvelous." With fellow painters Joan Miró and Man Ray, Tanguy took part in "The Exquisite Corpse," a collective game aimed at creating art by means of chance operations, and he experimented with psychic automatism, a procedure for tapping unconscious imagery.

Tanguy destroyed most of his pre-1926 paintings. Among his surviving canvases is *Rue de la Santé* (1925), a deliberately primitivist work with distorted perspective which had been inspired by the sight of a disturbingly empty crossroads. *The Bridge* (1925) is another seminaive primitivist painting. Although these pictures are heavily impasted with expressionistic brushstrokes, the influence of the hallucinatory realism and melancholy of de Chirico's Italian piazzas is pronounced.

The primitivist vein in Tanguy's work continued in 1926 with a series of collage paintings, including *At the Fair,* which depicts a circus levitation scene, and *The Lighthouse.* These were executed in a dadaist spirit, with Tanguy introducing for the first time such raw materials as matches, paper, and cotton. But later in 1926, probably as the result of experiments with psychic automatism, he painted his first truly surrealist pictures, two of the most notable being *Genesis* and *Dreamer.* In these hazy, mysterious paintings the relationship between object and space is radically altered. Geometry plays a negligible role and the oneiric element predominates.

In 1927 Tanguy married Ducrocq and his first solo exhibition was held at the Galerie Surréaliste in the rue Jacques-Callot, Paris. The foreword to the show's catalog was written by André Breton. By this time Tanguy had developed the style he was to adhere to all his life, and he began the practice of giving his paintings the cryptic and sometimes disquieting titles that form, as Penrose said, "A poetic hiatus between picture and title." For example, his best known picture of 1927 is entitled *Mama, Papa Is Wounded!* a phrase Tanguy and Breton discovered in a book of psychiatric case histories. The painting itself has Tanguy's characteristic imagery—ambiguous, semiorganic forms set in a bleak, dreamlike landscape. In this work, as in *Extinction of Useless Lights* and *A Large Picture Which Is a Landscape,* both of 1927, the blending of horizon and sky creates a sense of limitless space and the landscape is little more than a stage or platform on which his amoeboids perform mysterious games and rituals.

Tanguy, Prévert, and Duhamel parted company in 1928, leaving the rue du Château, and a period of serious financial distress began for Tanguy and his wife. Tanguy was less prolific, but his work made great progress and he took part in the "Exposition surréaliste" at the Sacre du Printemps Gallery, Paris, with Jean Arp, de Chirico, Max Ernst, Masson, Miró, Picabia, and others. A typical work of 1928 was *The Mood Is Now,* a somber, almost lunar landscape populated by strange biomorphic shapes. With his smooth naturalistic technique, Tanguy belonged, with Dali and Magritte, to the verist branch of surrealism rather than to the movement's abstract and more technically experimental wing, which was led by Ernst, Miró, and Masson. By 1929, when he exhibited with Dali, Magritte, and Arp at the Galerie Goemans, Paris, his contributions to *La Révolution Surréaliste* as well as his pictures were being discussed in Paris art circles.

In 1930 Tanguy visited North Africa, where he was moved less by the local culture than by the African sunlight and the desert landscape of cliffs and plateaux, with their rocky, stratified geological formations. The trip inspired a series of six or seven paintings in 1930–31 which were more varied and complex than his previous works. An outstanding example of his so-called post-African period is *L'Armoire de Proteus* (1931, The Closet of Proteus) in which Tanguy abandoned floating, vaporous backgrounds for tubular, petrified shapes with sinuous, fluid contours set on a flat yet broken clifftop or mesa. This painting and *Palace-Promontory* look forward to the crystalline compositions of Tanguy's later years.

After a brief period of relative stability, Tanguy was again plunged into poverty in 1932. In that year, while he and Jeannette were living next door to Alberto Giacometti on the Left Bank, Tanguy produced his first graphic work. He studied printmaking with Stanley William Hayter, who ran the celebrated graphic workshop Atelier 17 in Paris and who admired Tanguy's skill and ability to learn quickly. The Surrealist's graphic works are similar to his paintings but carry no titles.

The rise of fascism in Europe forced Tanguy in 1934 to consider fleeing to the United States but, unable to obtain the necessary papers, he remained in Paris. However, his first solo show in the US was mounted in 1935 at the Stanley Rose Gallery, Hollywood, and was followed by an exhibition at the Julien Levy Gallery, New York City, in 1936. These shows aroused interest in his work in American art circles, and in 1937 Tanguy was represented in the major "Fantastic Art, Dada, Surrealism" exhibition that Alfred Barr organized at New York City's Museum of Modern Art; moreover, MOMA acquired two of his paintings. At this time the "biomorphs" in Tanguy's pictures were becoming larger and less shapeless; often they resembled cartilage or bone and were set, as in *Jour de Lenteur* (1937), against an infinite earth/sky background devoid of clouds or sun.

In 1938 Tanguy visited London to attend an important exhibit of his work mounted by Peggy Guggenheim. He spent the summer of 1939 with Breton and the Surrealist painters Matta and Esteban Frances. Also that year he met the American Surrealist painter Kay Sage in Paris. When the French Army was mobilized, Tanguy was exempted from service because of disabilities incurred in his previous term of enlistment. After war was declared in 1939, he joined Kay Sage in New York City, where he was also reunited with Pierre Matisse, in whose Manhattan gallery he thenceforth exhibited.

In 1940 Tanguy and Sage toured the American Southwest; he was moved by the desert landscape and the quality of the light. In 1941 he obtained a divorce from his wife and married Sage, with whom he settled in Woodbury, Connecticut on a property called Town Farm the following year. Tanguy enjoyed the peaceful country life, and the recognition he received in the US brought an end to his financial troubles.

In America, where Tanguy was influenced by the brilliant light of the Atlantic coast, his work changed. According to John Russell of *The New York Times* (January 21, 1983), " . . . His American paintings are remarkable, above all, for the population explosion that caused him to

multiply the number of individual forms in his painting and bring them closer and closer to the viewer." Penrose wrote that "After his arrival in America, his palette evolved; earth colors gave way to more vivid reds and blues and the oceanic mists were dissolved in the intense light of New England." Penrose saw in the 1944 picture *Ma Vie, blanche et noire* (My Life, White and Black), with its ominous forms which looked manmade rather than organic, an expression of "the nightmare of efficiency peculiar to the 20th century." Reviewing a 1945 Tanguy exhibition at the Pierre Matisse Gallery, one critic wrote that "the shadow of the war extends over the entire exhibit." During those years Tanguy listed as his favorite artists de Chirico (in his metaphysical period), Hieronymus Bosch, and Paolo Uccello.

In the decade 1945–55, Tanguy worked in the studio he had built in the barn on his Woodbury property. The barn, which also housed Kay's studio, became a retreat for other artists in the area, including Naum Gabo, Alexander Calder, and Hans Richter. In 1948 he became an American citizen, and thererafter Tanguy exhibited frequently and to laudatory reviews. He traveled throughout the US and Canada and in 1952 visited Max Ernst in Sedona, Arizona. In the early '50s Tanguy suffered from poor health; he made a number of mostly untitled drawings, some in pen-and-ink and some in pencil, but he lacked the energy for large compositions. In 1953 the Tanguys went to Europe, where both had exhibitions. During his brief stay in France Tanguy revisited Locronan.

Tanguy returned to Woodbury in 1954 eager to resume work. In *8 x 8*, a film directed by his friend Hans Richter, he played the part of a chess bishop, a role to which, Richter said, the sly and complex Tanguy was eminently suited. Also in 1954 Tanguy worked fervidly for weeks on *Multiplication of the Arcs*, his last major painting. *Multiplication*, later acquired by MOMA, is predominantly gray, with some blue and slight touches of pink and yellow. The sky is desolate, and crowded into the foreground is a swarm of forms—rocks, bones, and biomorphic shapes. Resembling a city or planet or even "a gigantic boneyard set down in the sunlight of a Connecticut winter," to quote Russell, this mélange was the ultimate evolution of Tanguy's landscape of the subconscious. In an *Art Digest* (January 15, 1954) interview he remarked that his commitment to the surrealist principle of automatism remained total.

Tanguy's health rapidly deteriorated and in early 1955 he died suddenly at his Town Farm home. According to Kay Sage, his final wish was

that his ashes be scattered in the bay of Douarnenez, in Brittany, by Pierre Matisse. A retrospective was held posthumously in 1955 at MOMA, and an important exhibition which included some of his little-known early paintings was mounted at the Beaubourg, Paris, in 1982.

Yves Tanguy was described by Hans Richter as a "gentle man with a passion for order" who kept his house, and especially his studio, "immaculate." The studio was bare except for the painting he was working on, and his brushes were always carefully arranged. None of his paintings hung anywhere in the house; he was neither vain nor solicitous of the blandishments of others.

"I believe that there is little to be gained by exchanging opinions with other artists concerning either the ideology of art or technical methods," Tanguy said. "Very much alone in my work, I am, in fact, almost jealous of it. Geography has no bearing on it, nor have the interests of the community in which I paint." A slow, meticulous painter who worked only when inspired, Tanguy observed, "I work very irregularly and by crises—sometimes for weeks at a stretch, but never more than on one painting at a time, nor in more than one medium. Regular hours for work would be abhorrent, as anything resembling a duty is to me the negation of all fantasy in creative work."

EXHIBITIONS INCLUDE: Gal. Surréaliste, Paris 1927; Gal. des Cahiers d'Art, Paris 1935,'47; Stanley Rose Gal., Hollywood, Calif.1935; Julien Levy Gal., NYC 1936; Gal. Bucher-Myrbor, Paris 1938; Guggenheim-Jeune, London 1938; Pierre Matisse Gal., NYC 1939, '42, '43, '45, '46, '50, '63; Arts Club, Chicago 1940; Copley Gals., Beverly Hills, Calif. 1948; London Gal. 1950; Inst. of Contemporary Arts, Washington, D.C., 1952; Gal. dell' Obelisco, Rome 1953; Gal. del Naviglio, Milan 1953; MOMA, NYC 1955; Gal. Galatea, Turin, Italy 1971; Acquavella Gals., NYC 1974; "Yves Tanguy 1925–1955," Beaubourg, Paris 1982; Solomon R. Guggenheim Mus., NYC 1983. GROUP EXHIBITIONS INCLUDE: "Exposition surréaliste," Le Sacre du Printemps Gal., Paris 1928; "Arp, Magritte, Dali, Tanguy," Gal. Goemans, Paris 1929; "International Surrealist Exhibition," Burlington Gals., London 1936; "Magritte, Man Ray, Tanguy," Palais des Beaux-Arts, Brussels 1937; "Fantastic Art, Dada, Surrealism," MOMA, NYC 1936–37; "Art in Progress," MOMA, NYC 1944; "Phantastische Kunst des XX Jahrhunderts," Kunsthalle, Basel 1953; "Kay Sage, Yves Tanguy," Wadsworth Atheneum, Hartford, Conn. 1954; "Max Ernst, Yves Tanguy," Bodley Gal., NYC 1960; "Max Ernst, Yves Tanguy," Gal. A.E. Petit, Paris 1961; "Magritte, Tanguy," Mus. des Beaux-Arts, Montreal 1962; "Dada, Surrealism and Their Heritage," MOMA, NYC 1968; "Le Surréalisme 1922–1942," Haus der Kunst, Munich 1972; "Le Surréalisme 1922–42," Mus. des Art Décoratifs, Paris 1972.

COLLECTIONS INCLUDE: Metropolitan Mus. of Art, MOMA, and Whitney Mus. of Am. Art, NYC; Albright-Knox Art Gal., Buffalo, N.Y.; Wadsworth Atheneum, Hartford, Conn.; Yale Univ. Art Gal., New Haven, Conn.; Philadelphia Mus. of Art; Art Inst. of Chicago; Univ. of Illinois, Urbana; Washington Univ., St. Louis, Mo.; San Francisco Mus. of Art; Mus. d'Art Moderne de la Ville de Paris; Offentliche Kunstsammlung, Basel; Kunstsammlung Nordhein, Düsseldorf.

ABOUT: Barr, A. (ed.). "Fantastic Art, Dada and Surrealism" (cat.), MOMA, NYC, 1936; Breton, A. Le Surréalisme et la peinture, 2d ed. 1945, Yves Tanguy, 1946; Marchessau, D. Yves Tanguy, 1973; Matisse, P. (ed.), Yves Tanguy: A Summary of His Works, 1963; Maurel, J. and others, "Yves Tanguy: Retrospective 1925–1955" (cat.), Centre Georges Pompidou (Beaubourg), Paris, 1982; Penrose, R. "Yves Tanguy: A Retrospective" (cat.), Solomon R. Guggenheim Mus., NYC, 1983; Soby, J.T. "Yves Tanguy" (cat.), MOMA, NYC, 1955; Waldberg, P. Yves Tanguy, 1977. *Periodicals*—Art Digest January 15, 1954; Art in America November/December 1974; Art News May 1954; Horizon November 1946; Magazine of Art January 1947; Mizue (Tokyo) no. 12 1970; Museum of Modern Art Bulletin no. 4–5 1946; New York Times January 21, 1983; La Révolution Surréaliste (Paris) March 1928; Le Surréalisme au Service de la Révolution (Paris) December 1931; View Magazine (NYC) May 1942.

***TÀPIES, ANTONI** (December 13, 1923–), Spanish painter, is a leader of the post–World War II revolution in Spanish art. Starting out as a Surrealist in 1946, Tàpies moved on to what has been called "matter painting" or "matter informalism," a fusion of the abstract and the concrete in mixed-media tableaux, and helped establish the new abstraction as a dominant trend in west European art.

He was born into a middle-class family in Barcelona. His father, José Tàpies, was a lawyer, and his mother, the former Maria Puig, came from a family of booksellers. He had two sisters. Literature contributed significantly to the artist's development, from Tàpies's early discovery of his father's extensive library to his collaboration with the poet Joan Brossa and other writers. He was educated in a succession of Catholic schools in Barcelona, attending the College of the Sisters of Loreto from 1926 to 1929; the German School of Barcelona from 1928 to 1931; the Balmes College of the Order of Christian Schools in 1931; and the Liceo Pratico from 1934 to 1936.

A self-taught artist, Tàpies showed an interest in painting and drawing at an early age. He was 13 when the Spanish Civil War broke out, and he continued to paint and live in Barcelona during the three years of that tragic conflict. In 1969

ANTONI TAPIES

Tàpies recalled how the war had helped to shape his artistic vision: "The dramatic sufferings of adults and all the cruel fantasies of those of my own age, who seemed abandoned to their own impulses in the midst of so many catastrophes, appeared to inscribe themselves on the walls around me. . . . My first works of 1945 already had something of the graffiti of the streets and a whole world of protest—repressed, clandestine, but full of life—a life which was also found on the walls of my country." Another, more personal trauma followed in 1940, when he nearly died from a heart attack brought on by tuberculosis: Tàpies spent two years convalescing in the mountains where, despite his weakened physical condition, he pursued his art, began to read Nietzsche, Dostoyevsky, Ibsen, and Schopenhauer, and became interested in Eastern philosophy. After his recovery he developed his talent by making copies from reproductions of paintings by Van Gogh and Picasso.

In 1943, at his father's urging, Tàpies enrolled in the University of Barcelona, where he studied law for three years. The diversion from painting was, however, only temporary. He continued working on his art and even managed to attend the Nolsac Valls Academy of Drawing, Barcelona, for two months in 1944. At this time he used a heavy impasto in his painting and, more important for his later work, he experimented with collage, using materials such as earth, string, and paper.

In Barcelona, in 1946, Tàpies became friends with the poet and playwright Joan Brossa. The following year Tàpies concentrated on collages and entered a phase in which the influence of

°tä´ pē yes˝

surrealism was dominant. In 1948, reacting against the academicism and backwardness of Catalan art, he and Brossa helped to found *Dau al Set*, a magazine devoted to literature and art. Chiefly inspired by Brossa and by the existentialist writings of the young critic and philosopher Arnaldo Puig, the Barcelona-based Dau al Set (The Seventh Side of the Die) group hoped to revitalize the progressive spirit in Spanish art whose 20th-century progenitors had been Joan Miró and the architect Antonio Gaudí

Also in 1948, Tàpies exhibited in Barcelona's first Salon de Octubre, where he met Miró. Two years later his first solo show was held at the Galerias Layetanas, Barcelona, and he was awarded a French government scholarship which enabled him to study in Paris for the year 1950–51. There he met Picasso, who received him cordially and spoke with him in Catalan. After completing his studies, he visited Belgium and Holland.

Tàpies's works of the late '40s and early '50s show the influence of late surrealism, particularly the advanced surrealism of Miró, Klee, and Chagall. His canvases of this period are populated with the floating images and symbols associated with those artists, but Tàpies's surrealism is darker, both chromatically and psychologically, a quality which may derive from the indirect influence of Goya. Two works of 1949, both given the simple title *Pintura,* are characteristic of this early phase. However, his use of symbols became more personal in such works as *La Sonda del Brancatge* and *Bodega de Sirefala,* both of 1950, but works painted as late as 1953 still show the influence of Chagall and Miró. There are echoes of Chagall in *Pintura de la Carreta de Bous* (1952, Painting of the Oxcart), in which two embracing lovers are surrounded by floating images—a rowboat, an oxcart, a crescent moon, and a tree. *Dos Figures,* also of 1952, recalls Miró's surrealistic self-portrait.

In what was probably an attempt to break away from these influences Tàpies briefly experimented with geometric color studies, but then returned to a style of thickly applied paint, emphasizing the materiality of his medium by the use of rough textures and collage. Soon afterward, he began using oil paint mixed with earth and sand. In 1953 he had two solo exhibitions in the United States, one at the Martha Jackson Gallery, New York City, the other at the Marshall Field Art Gallery, Chicago. From then on Tàpies showed regularly in America.

Tàpies's mature painting style dates from 1955, a year after he married Teresa Barba. (Their three children are Antoni, Clara, and Miguel.) Within the next half-decade he was to re-

ceive international recognition and his work influence young Spanish painters, many of whom belonged to the Association des Artistes Actuels in Barcelona. Many of Tàpies's works of the '50s, such *Painting Red X* (1957) and *Large Painting* (1958), resembled time-worn, weather-beaten walls whose damaged surfaces were often graffiti-scrawled. *Calligraphic,* also of 1958, was the artist's version of an ancient stone tablet incised with indecipherable pictographs. By the end of the decade he had begun using such materials as string, cloth, cardboard, paper, and rags in collages whose rejection of the painted surface was reminiscent of Italian *arte povera* (poor art). During the same period Tàpies made lithographs, some of which were printed on newspaper. In these collages, too, he emphasized texture and worked in the style of *art informel* (art without form), the European version of American abstract expressionism.

In 1957 Tàpies was a founding member of El Paso, an exhibiting association of artists which established expressive abstraction as a major trend in Spanish art. The following year he was awarded a David Bright Foundation prize at the Venice Biennale.

Some of Tàpies's works of the 1960s resembled doors. *All Red* (1961) is divided into two rectangles with a surface texture that suggests old paint on a door or windowsill. A few years later he began using a cementlike material made from a mixture of glue, plaster of Paris, and sand. He would smooth the mixture into an immaculate, textured surface and then draw in the soft cement with his finger or a tool. In these works "there is always an extraordinary richness of texture, even though the first impression is one of ascetic sobriety," according to Aldo Pellegrini. Examples of these paintings, which are both minimal and dramatic, are *Petit blanc avec impression vertical,* which has only a single vertical mark on its surface, *Black with Two Lozenges,* and *Black with Red Stripe,* all of 1963. *Parenthéses posées sur gris* (1965) has only two curved marks, one on each side of the canvas. In *Sis unglades* (1966, Six Scratchings) the cement is dark gray and the texture is more irregular, but the only incisions are six emphatic dashes across the top of the surface. Other works in this medium are less minimal; an example is *Tête pyramide,* which resembles a child's spontaneous drawing and may have been inspired by Dubuffet, whose work Tàpies had seen in 1950.

Many of Tàpies's paintings of the late 1960s were, in effect, painted reliefs, with actual objects such as casts of feet, ears, and coffee cups embossed on the often monochromatic surface. Examples are *Cross, Cups and Ear* (1966) and

Four Cups (1967). Conversely, *Main-Loup* (1966, Wolf's Paw) has the imprint of a hand.

Tàpies continued to produce mixed-media works constructed from commonplace and discarded items in the late '60s and early '70s. In *Knot and Cord* (1969) a white rag is tied to a cord which crosses the canvas at an angle. In *Pressed Straw*, also of 1969, straw is the principal material. In contrast to his early surrealist canvases, Tàpies's "matter paintings" are abstract and yet in their use of ordinary materials are so concrete and literal that they border on sculpture. In some works, notably *Matter in the Shape of an Armpit* (1968), which Miró chose for his personal collection, there is a dramatic, typically Spanish realism, conveying the agony of a crucifixion. "[Tàpies] always attached great significance to the most minute or most painful accidents of human existence, with the result that he created a tragic artistic vision," to quote the *Praeger Encyclopedia of Art*.

Tàpies's work in other media includes the stage sets he designed in 1962 for a production of Joan Brossa's *Or: Sal*, and the mural he painted in the Handels-Hochschule, St. Gallen, Switzerland. He also executed a mural in 1971 for a theater in the same city. He has illustrated books by Brossa and other writers with lithographs and used the carborundum technique (an abrasive of silicon carbide) to obtain diverse textural results in his etchings. Tàpies has also designed tapestries and constructed assemblages which incorporate furniture.

In 1960 Tàpies acquired an ancient farmhouse at Campins, outside Barcelona near the forests of Montseny. Its peasantlike simplicity and sparse furnishings are in contrast to the ultramodern town house he built in 1963 in Barcolona with the help of the architect Josep-Antoni Coderch. It contains a spacious studio separated from the rest of the house by a patio with a jungle of plants. A library on the top floor houses a remarkable collection of poetry and Eastern and Western philosophy. Tàpies also owns some of the earliest printed books in Catalan. His father had been a Catalan nationalist and Tàpies takes pride in the originality and fierce spirit of independence of Catalan tradition. Suggestions of violence in his work— graffitilike scrawls, torn fabric, scraps of newspaper—can be interpreted as signs of the injustice and oppression imposed for so many years on his native Catalonia. "Tàpies brings the spectator face to face with one of the paradoxes of the radical art of the post-war epoch," Edward Lucie-Smith said. "He is in politics a liberal, and it is not without significance that he come from Barcelona, traditionally the center of left-wing sentiment in Spain. Yet his work is by its nature and concepts too ambiguous to give much uneasiness to the government."

Antoni Tàpies, six feet tall with brown eyes, dark brown hair, and an imposing presence, has been described as a "fiery Catalonian" with "the proud bearing of a bullfighter." Tàpies's aim is to confront the viewer with the real. He said, "To remind man of what he really is, to give him a theme of think about, to set up a shock in him which will rouse him from his artificial world— that is what I am trying to do in my work."

EXHIBITIONS INCLUDE: Gal. Layetanas, Barcelona 1950, '52, '54; Marshall Field Art Gal., Chicago 1953; Martha Jackson Gal., NYC from 1953; Gal. Sur, Santander, Spain 1955; Gal. Stadler, Paris 1956, '57, '64, '66, '69; Gal. Moos, Toronto 1964, '69; Sala Gaspar, Barcelona 1964, '65,'69, '70; Contemporary Arts, London 1965; Gal. Maeght, Paris 1967, '68, '79; Mus. des XX Jahrhunderts, Vienna 1968; Gal. Maeght, Zürich 1970, '75; Mus. d'Art Moderne de la Ville de Paris 1973; Hayward Gal., London 1974; Nationalgal., Berlin 1974; Gal. Juan Martin, Mexico City 1974; Fondation Maeght, Saint-Paul-de-Vence, France 1976; Albright-Knox Art Gal., Buffalo, N.Y. 1977; Mus. of Contemporary Art, Chicago 1977; Gal. Isernhagen, Hanover, W. Ger. 1979; "Bilder und Objekte 1948–1978," Badischer Kunstverein, Karlsruhe, W. Ger. 1980. GROUP EXHIBITIONS INCLUDE: Salon de Octubre, Barcelona 1948, '49; Carnegie International, Pittsburgh 1950, '52, '55, '67, '70; Bienal Hispano-Americana de Arte, Madrid 1951, '53, '55; Venice Biennale 1952, '54, '56, '58, '68, '72, '76; São Paulo Bienal 1953, '57; "Antonio Saura, Antoni Tàpies," Gal. van de Loo, Munich 1959; "Before Picasso—After Miró," Solomon R. Guggenheim Mus., NYC 1960; "Jean Dubuffet, Antoni Tàpies," Gal. dell' Ariete, Milan 1960; "Sam Francis, Antoni Tàpies," Gal. Otto Stangl, Munich 1961; Dunn International, Beaverbrook Art Gal., Fredericton, New Brunswick, Canada 1963; Tate Gal., London 1963; Documenta 3, Kassel, W. Ger. 1964; Biennale de Menton, France 1966; Biennale Internationale d'Arts Graphiques, Ljubljana, Yugoslavia 1967, '69; "Europa-America," Basel 1971; "Homage à Picasso," Nationalgal., Berlin 1973.

COLLECTIONS INCLUDE: Mus. of Modern Art, Barcelona; Mus. de Arte Contemporaneo, Madrid; Tate Gal., London; Nat. Gal. of Modern Art, Edinburgh; Mus. Nat. d'Art Moderne, Paris; Fondation Maeght, Saint-Paul-de-Vence, France; Stedelijk Mus., Amsterdam; Mus. Boymans-Van Beuningen, Rotterdam; Stedelijk Van Abbe Mus., Eindhoven, Neth.; Neue Nationalgal., Berlin; Kunsthalle, Hamburg; Kaiser Wilhelm Mus., Krefeld, W. Ger.; Mus. des XX Jahrhunderts, Vienna; Moderna Mus., Stockholm; Louisiana Mus., Copenhagen; Kunstmus., Basel; Kunsthaus, Zürich; Gal. Nazionale d'Arte Moderna, Rome; MOMA, and Solomon R. Guggenheim Mus., NYC; Albright-Knox Art Gal., Buffalo, N.Y.; Carnegie Inst., Pittsburgh; Mus. of Art, Baltimore; Mus. of Art, San Francisco; Mus. of Fine Arts, Houston; Mus. of Contemporary Art, Montreal;

Mus. de Arte Moderno, São Paulo; Nat. Gal. of Victoria, Melbourne.

ABOUT: Alloway, L. "Antoni Tàpies" (cat.), Solomon R. Guggenheim Mus., NYC, 1962; "Antoni Tàpies" (cat.), Hayward Gal., London, 1974; "Antoni Tàpies: Works 1969–1972" (cat.), Martha Jackson Gal., NYC, 1974; Cirici, A. Tàpies: Witness of Silence, 1972; Cirlot, J.E. Tàpies, 1960; Current Biography, 1966; Gimferrer, P. Tàpies and the Catalan Spirit, 1975; Ljinhartova, V. Antoni Tàpies, 1972; Lucie-Smith, E. Late Modern: The Visual Arts Since 1945, 1969; Pellegrini, A. New Tendencies in Art, 1966; Penrose, R. Tàpies, 1978; Praeger Encyclopedia of Art, 1971; Tapié, M. Antoni Tàpies, 1969. *Periodicals*—Ariel (Barcelona) November 1950; Chroniques de l'art vivant (Paris) March 1974; Cimaise (Paris) no. 6 1957; Derrière le miroir (Paris) December 1969; Le Monde (Paris) October 30, 1969; Studio International March 1970; Time August 28, 1964; La Vanguardia (Barcelona) December 1958.

WAYNE THIEBAUD

***THIEBAUD, WAYNE (MORTON)** (November 15, 1920–) American painter, was a progenitor of West Coast pop art, though he rejects the pop label, feeling that painting is inherently "anti-categorical." He is best known for his "pop" still lifes of bakeshop goodies.

Thiebaud was born in Mesa, Arizona. When he was one year old, his father, a Mormon bishop, moved the family to Long Beach, California, where Wayne attended public schools. During the 1930s he painted sets and directed lighting for high school plays. As a teenager he was an active Sea Scout, a good athlete, an amateur musician, a classroom (and street) debater, and he painted sets and directed lighting for school plays. Thiebaud also took an interest in the Museum of Science and Industry, Los Angeles, with its harshly illuminated dioramas of natural history and its displays of Hollywood movie posters and animated films.

After graduating from high school in 1938, Thiebaud took classes in commercial art, lettering, and cartooning at a Los Angeles trade school and worked briefly as an usher in a Long Beach movie house, for which he dressed in a Philip Morris page-boy uniform. A natural draftsman with a flair for caricature, he made movie posters which were displayed in the lobby.

Shortly after the bombing of Pearl Harbor, Thiebaud joined the US Army Air Corps, and from 1942 to '45 was stationed at Mather Field, near Sacramento. There he painted murals for the Army and contributed cartoons to the service magazines *Wingtips* and *Yank*.

After his discharge, Thiebaud spent several months in New York City, Sacramento, and Los Angeles doing layout work and commercial illustration. As one critic pointed out, "Thiebaud belongs in the category of artist more common in America than in Europe who came into the profession through commercial activities . . . before concentrating on easel painting." He spent three years in the Los Angeles office of Rexall Drugs, drawing what he called "the most banal illustrations—lipstick, hot water bottles, brassieres"—and cartooning for the company magazine. However, this work brought him into contact with a fellow designer, the sculptor Robert Mallary, who introduced him to the ideas of Sartre, Marx, Shakespeare, and the art historian Erwin Panofsky, and thereby helped to strengthen Thiebaud's resolve to become an artist.

In 1949, when he was almost 30, Thiebaud entered San Jose State College as an art major, studying art history for the first time. In 1950 he transferred to Sacramento State College and also became design and art consultant for the California State Fair and Exposition, a post he held until 1957. He began teaching art at Sacramento City College in 1951 while still working for his MA degree, which he received from Sacramento State in 1952. Also that year, his first solo show was mounted at the Crocker Art Gallery, Sacramento.

Thiebaud became chairman of the art department at Sacramento City College in 1954, a position he held for three years. In the eight years he taught at Sacramento City, Thiebaud strove to build up the art department, instituting courses in filmmaking, television production, and commercial art. He produced his own animated shorts to accompany art history classes and, in the mid-50s, worked locally as a free-

lance designer. From 1954 to '57 he also produced 11 educational films for Bailey Films, Hollywood.

During a leave of absence in 1956–57, Thiebaud worked as a commercial artist for an advertising firm in New York City. There he met Franz Kline, Willem de Kooning, whom he had long admired, Adolph Gottlieb, and Barnett Newman—the Abstract Expressionists who influenced Thiebaud in the '50s. "I was affected by people like Jackson Pollock and the whole Abstract Expressionist heroic group," Thiebaud recalled. "I was trying any desperate way to make my paintings look like art . . . and that's always a mistake."

Already, however, beneath the flurry of brushstrokes and spatterings, certain subjects were beginning to emerge—slot machines, cigar boxes, and dime-store windows. In the mid-50s, while painting a slot machine, Thiebaud "got so carried away with trying to make [an] artful Jackson Pollock surface that I lost my way." He subsequently reevaluated his assumptions about contemporary painting and realized that he wanted "to move closer to objects and try and deal more directly with them. I took certain old paintings and isolated the subjects, masked out the backgrounds as I felt they were too busy. I got to these very simple shapes: triangles, circles, squares, crescents. . . . " At this time his major influences were Van Gogh, Mondrian, especially his "little gouache flower paintings," Chardin, Hopper, and Eakins, as well as Morandi, Balthus, and the Bay Area artist Richard Diebenkorn. Thiebaud also admired Fatorri and other 19th-century Italian artists of the Macchiaioli School. In the decade of the '50s Thiebaud traveled in Mexico and visited Europe, where he studied the old masters. He appreciates Vermeer and Hopper for their painterliness and feeling for light as well as their treatment of themes from everyday life.

In 1960 Thiebaud was appointed associate professor of art at the University of California at Davis, where he still teaches. That same year he broke through to his characteristic style—bright, clean colors, firm, sharp drawing, and centered compositions. He applied this style to the subject matter he had been developing since the mid-'50s—such banal, everyday motifs as cigar-counters, pies, cosmetics, and children's toys.

In *Pop Art*, Nancy Marmer noted that "pre-Pop West Coast art [had been] either provincially retrogressive or imitatively Eastern," but in the work of such artists as Thiebaud, Ed Ruscha, and Mel Ramos pop art took root "easily, early, and . . . flourished smartly . . . in a milieu in which it could well have been invented." The features of California culture that gave rise to West Coast pop were identified by Marmer as "the backdrop influence of Hollywood and the hypertrophied 'neon-fruit supermarket' . . . , the Los Angeles hot-rod world, with its teenage rites, baroque car designs, kandy-colors, [the] notion of a high-polish craftsmanship, and, perhaps most influential, [the] established conventions of decorative paint techniques, [which have] flourished in the southern part of the state since the 1940's."

Pop art made its public debut on the West Coast in 1962, the year Thiebaud's work was included in a group show at the Pasadena Art Museum titled "New Painting of Common Objects." New York Pop artists, including Warhol and Lichtenstein, were represented along side Thiebaud, Ruscha, and other California painters. Thiebaud also had a solo show at the M.H. de Young Museum, San Francisco, in 1962. When his first New York City show was held at the Allan Stone Gallery in the same year, he was included in the pantheon of Pop artists. One critic, impressed by Thiebaud's luscious impasto, called him a "Pop Manet." A *The New York Times* (April 29, 1962) reviewer called him "a sort of Edward Hopper of the dinette tabletop." The Allan Stone Gallery has continued to be Thiebaud's dealer.

A typical painting of 1962–63 was *Yo-Yos* (Albright-Knox Art Gallery, Buffalo, New York). The forms, painted in a thickly brushed impasto, were repeated without reference to scale, and with a minimum of modeling. Thiebaud's use of repetition and his systematic variations of similar images, grouped or arranged in rows, was different from the mechanical repetitiveness of Warhol's silk-screened images. West Coast pop reflects California brightness and brashness, and thereby differs in manner from the cool style of New York pop.

In *Window Cakes* and *French Pastries* (Hirshhorn Museum and Sculpture Garden, Washington, D.C.), both of 1963, Thiebaud isolated the subjects, placing them, as usual, in rows in a vacant setting and making them solidly three-dimensional, an effect heightened by his depiction of the shadows cast by the pastries. Though derived from the conventions of commercial illustration, the drawing technique was combined with a brilliantly hued, luscious and oleaginous paint quality, thus producing what Marmercalled "an accessible, bright, and synaesthetic style." "Moral comment is implicit," Marmer declared. "If Thiebaud liked his subjects better, these paintings would be straight illustration." "In my opinion," Thiebaud wrote, "the painting of 'French Pastries' is actually the

American notion of French pastries. Almost all of my paintings from that period were done from memory. I try to make a summation of a number of variable visual experiences to try to make them seem like a singular event."

In the catalog to "The New Realists" exhibition held at the Sidney Janis Gallery, New York City, in late 1972, Thiebaud wrote that he was interested in "what happens when the relationship between paint and subject-matter comes as close as I can get it—white, gooey, shiny, sticky oil paint [spread] out on top of a painted cake to 'become' frosting. It is playing with reality—making an illusion which grows out of an exploration of the properties of materials."

About 1963 Thiebaud produced large figure paintings which surprised those who had tagged his bakeshop still lifes with the pop label. His female figures, presented in strict frontality, retained the anonymity of his still-life objects, but the treatment was more sympathetic. In the striking *Booth Girl* (1964), the bright blue booth of a movie theater and its occupant, an impassive young woman, are isolated in a uniform, blank, light-colored space with no indication of ground. Having none of Hopper's latent romanticism, the picture is coldly objective, almost unbearably realistic; yet its starkness implies vague social and moral comment. But Grace Glueck of *The New York Times* (July 22, 1977) contends that "his work has no message and reflects no anxiety." In *Oil* (1964) a dark-haired, well-built young woman in a bathing suit stolidly sits, presumably on a beach (the setting is blank apart from cast shadows), holding a cone of ice cream. Again the image is frontal, with the foreshortened legs thrust directly towards the viewer; the soles of the feet are as conspicuous as in a Caravaggio. In *Kneeling Women*, also of 1964, both women are dark-haired and wear bathing suits. Thiebaud's wife Betty Jean has been the model for many of her husband's iconic figures.

Thiebaud spent the summer of 1967 as visiting art critic at Cornell University, Ithaca, New York. About this time he began to produce landscape paintings. In *California Hillside* (1969) he painted trees isolated against the sun on the 45-degree slope of a hillside. The foliage is in brilliant blue and yellow and the trunks cast pale shadows on the ground.

In the 1970s cityscapes dominated Thiebaud's painting, especially the steep slopes of San Francisco's Potrero Hill district. The city scenes were described in *Art News* (February 1978) as "steep hillsides in careening, worm's eye perspectives, with streets that sometimes seem to shoot bolt upright"—an exact characterization of *Toward*

Twin Peaks (1975–76). Thiebaud continued to do figure paintings in the '70s, including *Betty Jean and Book*, and still lifes of food, such as *Boston Cremes* (1970) and *Banana Hands* (1975–76).

Thiebaud described how he became interested in cityscapes: "Going to San Francisco, I was first fascinated by those plunging streets, where you get down to an intersection and all four streets take off in different directions and positions. There was a sense of displacement, or indeterminate fixed positional stability. That led me to this sense of verticality that you get in San Francisco. You look at a hill, and visually it doesn't look as if the cars would be able to stay on it and grip. It's a very precarious state of tension, like a tightrope walk."

Thiebaud makes no generic distinctions between his object paintings, figure paintings, and landscapes, but considers his work a continuum of "scrambling around" among basically traditionalist concerns. According to *Contemporary Artists,* his work involves "at all times the resolution of problems worked out in the head before being committed to paper and canvas."

Thiebaud and the former Betty Jean Carr were married on December 11, 1959. They live in Sacramento and have three children: Twinka, Mallary Ann, and Paul LeBaron. The artist was described in *Art News* as "tall, rawboned, athletic, with craggy but finely chiselled features, deep-set brown eyes and a tousle of dark hair." He is a thorough going Westerner in appearance and manner, and a friend of his remarked, "It's like meeting Gary Cooper." Thiebaud is a perfectionist who works long hours each day and produces as many as 30 paintings a year. A traditionalist, he discusses his work mainly in terms of form and technique, avoiding grandiose statements. Although critics consider him a precursor of the Photo-Realists, he maintains: "My work is closer to caricature than to photo realism. . . . There's very little information there—mostly silhouettes, very simple shapes, very, very reduced sets of conclusions."

Thiebaud feels that immediacy and spontaneity are essential to good painting: "I see painters who have crystallized into a kind of convention and it's somehow become a grammar rather than a language. They've found a way to get the sentence structure right, and as a result of that they haven't been interrupted by the intimacy of whatever experience or emotion there is. One of the dreadful fears of painters I know who are very good is the fear of loss of inspiration. It's hard to keep on being a painter. You paint and paint and paint, and no one really cares an awful lot. How can they? Unless they're a painter, or

really love painting, it's almost too much to expect."

EXHIBITIONS INCLUDE: Crocker Art Gal., Sacramento, Calif. 1952; Artists' Cooperative Gal., Sacramento, Calif. 1954, '57, '58; M.H. de Young Mus., San Francisco 1962; Allan Stone Gal., NYC from 1962; Gal. Schwarz, Milan 1963; Stanford Univ. Mus., Calif. 1965; Nelson-Atkinson Mus., Kansas City, Mo. 1966; Pasadena Art Mus., Calif. 1968; Phoenix Art Mus., Ariz. 1976; Neuberger Mus., State Univ. of New York, Purchase 1977; San Francisco Mus. of Modern Art, 1978; Walker Art Center, Minneapolis, 1981. GROUP EXHIBITIONS INCLUDE: "New Painting of Common Objects," Pasadena Art Mus., Calif. 1962; "Pop Art, U.S.A.," Oakland Mus., Calif. 1963; "Nieuve Realisten," Gemeentemus., The Hague, 1964; Whitney Mus. of Am. Art Annual, NYC 1965, '67, '69; São Paulo Bienal 1967; ROSC '71, Dublin 1971; Documenta 5, Kassel, W. Ger. 1972; "The New Realists," Sidney Janis Gal., NYC 1972; "Twenty-five Years of American Painting 1948–73," Art Center, Des Moines, Iowa, 1973; "Separate Realities," Municipal Mus., Los Angeles 1973.

COLLECTIONS INCLUDE: Metropolitan Mus. of Art, MOMA, and Whitney Mus. of Am. Art, NYC; Albright-Knox Art Gal., Buffalo, N.Y.; Newark Mus., N.J.; Rhode Island School of Design, Providence; Wadsworth Atheneum, Hartford, Conn.; Rose Art Mus., Brandeis Univ., Waltham, Mass.; Fogg Art Mus., Harvard Univ., Cambridge, Mass.; Philadelphia Mus. of Art; Library of Congress, Washington Mus. of Modern Art, and Hirshhorn Mus. and Sculpture Garden, Washington D.C.; Chicago Art Inst.; Nelson-Atkins Mus., Kansas City, Mo.; San Francisco Mus. of Art; Oakland Mus., Calif.; Univ. Art Mus., Stanford, Calif.; Municipal Utility District Building, Sacramento, Calif.

ABOUT: Coplans, J. Wayne Thiebaud, 1967; Lippard, L. R. Pop Art, 1966; "The New Realists" (cat.), Sidney Janis Gal., NYC, 1962; Thiebaud, W. America Rediscovered, 1963. Periodicals—American Artist September, 1980; Art News May 1962, March 1966, February 1978; Christian Science Monitor January 4, 1972; Life June 15, 1962; Nation May 5, 1962; New York August 8, 1977; New York Times April 29, 1962, July 22, 1977, July 29, 1977; Time May 11, 1962, April 19, 1964.

THOMPSON, BOB (ROBERT LOUIS)
(June 26, 1937–May 30, 1966), American painter, was consumed by a love of jazz and the old masters. His emulation of the fast life of jazz musicians ultimately led to his death of complications from heroin addiction at the age of 28. His work, in which he adapted the compositions and colors of older painters into the rhythms of his own vibrantly expressive primitivism, has en-

Courtesy of the Vanderwoude Tananbaum Gallery, NYC

BOB THOMPSON

joyed a rebirth of popularity in the 1980s as figuration has emerged into the forefront of American painting.

Born Robert Louis Thompson in Louisville, Kentucky, he was the descendant of black slaves and farmers. His father, a club owner, was killed in a car accident when Bob was 13; his mother, a school teacher, then tried to steer him toward a career in medicine. "I painted a lot from the age of eight until twelve, but then my mother wanted me to be a doctor," he recalled. "But before that I had a brother-in-law [Robert Holmes] who was in my life very early, and he was a painter. So I was very attached to him, like a brother, and I started drawing with his instructions." To his mother's dismay, he once stole all the windowshades in the house, on which he copied the reproductions in art books.

After a semester at the Boston Museum School (1955), Thompson attended the museum school at the University of Louisville; the tall and effervescent youth was also a star basketball player. In the summer of 1958 he joined the migration of artists to Provincetown, Cape Cod, where he took classes with Seong May and where he met and was befriended by Jack Tworkov (whose roof he repaired), Mark Rothko (who hired him as a carpenter), Red Grooms, and Jay Milder, among others. That summer, noted the painter Emilio Cruz, Thompson was painting in an abstract expressionist manner, but his style veered abruptly when he encountered the figurative expressionism of the German-born artist Jan Müller. This work, as well as that of Lester Johnson, freed his own predilection for the figure (which, he said, "almost encompasses every form there is"), revealed in his intense interest in Piero della Francesca, who, along with Masaccio, he was copying at the time. To keep the formal and

coloristic energy of abstract expressionism, Thompson continued to work on a large scale and began to draw upon black American folk art, with its freely drawn, simplified figures, and brightly colored, active backgrounds. At the same time he borrowed compositional elements from sources as diverse as the early Renaissance painters, Hieronymus Bosch, Francisco Goya, and Paul Gauguin. Of his early subject matter, Paul Mocsangi wrote, in the catalog to Thompson's 1969 retrospective at the New School for Social Research, New York City, "One of the favorite motifs of his early works is the silhouette of a black man peeking out from behind a wall. Later, during the period influenced by Müller, we see strange, cryptic scenes performed by whites and watched by blacks." Such interracial psychodramas constitute a revealing subtext throughout his oeuvre. A hatted and cloaked figure, usually a concealed observer, who begins to appear in his paintings at about this time, is assumed by many critics to be the artist himself.

In early 1959 Jay Milder convinced Thompson to leave the university, two months before graduation, and take a studio with him in Manhattan, which they later shared with Grooms and Christopher Lane. Thompson became a dedicated jazz fan, associating with Jackie McLean, Sonny Rollins, Thelonious Monk, and the poet LeRoi Jones (Amiri Baraku). He hung out at the Cedar Bar, the off-hours "residence" of the Abstract Expressionists, and at jazz clubs, often staying up all night to sketch his idols. *Garden of Music* (ca.1960) contains portraits of Ornette Coleman on alto sax, Don Cherry on trumpet, Charlie Hayden on bass, and a number of other jazz greats, playing in an idyllic landscape. Drugs, then as now, were part of the musician's life, and soon after his arrival in New York Thompson began taking heroin. By 1961 he was an addict. In 1960, the year of his first New York City show, at the Delancey Street Museum, he married Carol Plenda.

Thompson nourished his passions for great art and great jazz for the rest of his career. According to one critic, "Thompson identified with the narratives and the structural sensibility of the Italian Renaissance masters. Their themes of harmony and discord, their extremes of joyous sensuality and fierce anxiety, their licentiousness and rigid moral codes, were all part of the music he heard and the life he experienced." His immersion in the work of artists he admired was so thorough that inevitably his enthusiasms spilled over into his paintings—a painting of 1960, *The Frog and the Princess*, owes an obvious debt to Cézanne's "Bathers," whereas his diptych *Expulsion and Nativity* is taken from Masaccio's *Adam and Eve Cast Out of Paradise* and Piero

della Francesca's *Nativity*—without lessening the freshness of his vision.

Regardless of his source, Thompson rarely attempted any kind of realistic modeling. Instead, he flattened and obscured his figures, generalizing their facial features and painting them as colorful silhouettes floating in an illusionistic space of shifting planes. Birds, symbolizing freedom, lurk in the background or are held captive by the figures (as in *Nudes with Birds*, 1964), while huge wing-shaped shadows threaten to engulf some paintings altogether (*The Family Portrait*, 1963). Narrative as well as realistic details are omitted, leaving the viewer to puzzle out his figures' often erotic/macabre actions, not to mention the autobiographical and art-historical sources upon which the artist drew. "My whole problem is trying to convey without detail," he said. Amazingly prolific, he turned out dozens of major paintings and hundreds of drawings a year. A side effect of this energy was that, by dint of his dissipated life, he was limiting his own future. Friends claim that he believed he would die young, like his father.

In 1961 Thompson won a Walter Gutman Foundation grant, which he and his wife used to go to Paris. A John Hay Whitney Fellowship the next year allowed him to stay in Europe. Thompson spent much of his time ecstatically hopping from museum to museum. He spent a brief but productive period in Ibiza, Spain, during which he took no heroin, having undergone a drug treatment program in London. In Spain he came further under the influence of Goya. The general tonality of his paintings darkened, in keeping with the atmosphere of anxiety and dread that underlies these works; a mélange of winged phantoms, harpies, and other night creatures, many derived from Goya's monsters of the "Los proverbios" or "Los disparates" etchings, nearly overpowers the figures (as in *A Caprice*, 1962).

Returning to New York City in 1963, Thompson joined the Martha Jackson Gallery and had a number of solo shows at other galleries in New York, Chicago, Detroit, and Provincetown. The years 1963 to 1965 were his most successful, professionally. He was one of the best-known black artists in the country, with a powerful patron in the eminent art historian Meyer Schapiro (who had discovered his work as early as 1959), and selling regularly to well-known collectors including Joseph Hirshhorn. But he had taken up heroin again; his work dropped off and his health began to fail. *Ascension to the Heavens* (ca. 1963), in which the hatted figure is seen twice, on the earth in the company of a white bird and carrying to the heavens a white woman with the

help of phantoms and ghosts, seems a clear premonition of his own death. In 1966, anxious to leave New York, he moved to Rome, studying in the churches and museums but doing little painting. A few months later he underwent an appendectomy and surgery on his gall bladder. On May 30, less than a month before his 29th birthday, he died of acute pulmonary edema.

What stands out now in Thompson's paintings is not his technical virtuosity, although that was formidable for such a young artist, but the painful honesty and emotional integrity of his vision. "I paint many paintings," he said, "that tell me slowly that I have something inside of me that is just bursting, twisting, sticking, spilling over to get out."

EXHIBITIONS INCLUDE: "Arts in Louisville," Ky. 1958; Delancey Street Mus., NYC 1960; Superior Street Gal., Chicago 1961; Martha Jackson Gal., NYC 1963, '65, '68, '76; Richard Gray Gal., Chicago 1964, '65; New School for Social Research, NYC 1969; Studio Mus. in Harlem, NYC 1978–79; Vanderwoude-Tananbaum Gal., NYC 1983. GROUP EXHIBITIONS INCLUDE: Provincetown Art Festival, Mass. 1958; Zabriskie Gal., NYC 1960; "Portraits from the American Art World," New School for Social Research, NYC 1965; "A Survey of Contemporary Art," J. B. Speed Mus., Louisville, Ky. 1965; Memorial Exhibit, Gal. 12 St. Marks, NYC 1967; "Afro-American Artists Since 1950," Brooklyn Col., N.Y. 1969; "Concept and Content—Cage, Thompson, and Tàpies," Martha Jackson Gal., NYC 1972; Albright-Knox Art Gal., Buffalo, N.Y. 1974; "Perceptions of the Spirit," Indianapolis Mus. of Art 1977; "Perceptions of the Spirit," Graduate Theological Seminary of Berkeley, Calif. 1977.

COLLECTIONS INCLUDE: Albright-Knox Art Gal., Buffalo, N.Y.; Hirshhorn Mus. and Sculpture Garden, Washington, D.C.; Chrysler Mus., Provincetown, Mass.; Martha Jackson Gal., NYC; Harry N. Abrams Collection; Mr. and Mrs. Ted Wardell Collection, Tokyo.

ABOUT: "Portraits from the American Art World" (cat.), New School for Social Research, NYC, 1965. "Bob Thompson (1937–1966)" (cat.), New School for Social Research, NYC, 1969; "Bob Thompson: Work in New York Collections" (cat.), Martha Jackson Gal., NYC, 1968; Periodicals—Art in America May 1983; Arts Magazine April 1983.

TILSON, JOE (August 24, 1928–), British painter and sculptor, writes: "I was born in South London on August 24, 1928. My mother was one of the many children of a policeman, my father the son of a blacksmith at Dulwich. He worked at the Cable and Wireless Company near the Strand. I started work at 14 as a joiner at a barfitting firm near the Elephant & Castle and later worked as a carpenter and then as a bricklayer's

JOE TILSON

labourer. After military service in the RAF in 1946, I went to St. Martin's School of Art in Soho in 1949 where I was a student with Frank Auerbach and Leon Kossoff; and then went to the Royal College of Art where I studied with Peter Blake and Richard Smith. On leaving the Royal College I went to Italy for two years and there met Joslyn Morton, daughter of Alastair Morton, the painter and weaver whose father, Sir James Morton, was a follower of William Morris and a friend of C.F.A. Voysey. She was studying sculpture at the Brera in Milan. We were married in Venice in 1956. We lived in Sicily and Rome and then for a few months we rented a very small house by the sea in Catalonia, Spain, where we were joined by Peter Blake. When we returned to London we lived in a shop near Portobello Road, and later I got a job teaching at St. Martin's School of Art. We also met R. B. Kitaj, David Hockney, Allen Jones, and, later, Patrick Caulfield, who were at the Royal College of Art. And we met older artists: William Turnbull, Richard Hamilton, and Eduardo Paolozzi. This was a time of radical change in British Art— there was no interest in Paris—everybody was interested in what was happening in New York and in London.

"I had decided at the age of eight that I was going to be a painter, so I painted and drew all the time from that age on; after the period of intensive study for six years in art colleges I went to Italy, where in 1955 I made my first wood relief. I continued making wood reliefs and large collaged paintings on my return to London. These were shown at the Biennale des Jeunes, Paris, in 1961, and then at the Marlborough Gal-

lery, London, in 1962. This show included the painted wood reliefs I had made in 1961 which began the series of works that included words and images from urban life. These were shown at the Marlborough in 1964 and at the Venice Biennale of the same year. My work developed in a more formal way for some time and then I made a series of works called 'Pages'—works containing large collage screen-printed texts— shown in Berlin and London. In 1970 I started work on *Alchera*, a project which has occupied me for the last six years. This project is concerned with Air, Fire, Earth, and Water as they relate to the cardinal points, the Lunar and Solar cycles, the Zodiac, Alchemy, etc. It is a synthesis of many ideas resulting in a series of works that have been exhibited at the Boymans-Van Beuningen Museum, Rotterdam; the University of Parma; and in Milan, Rome, and London. I live in the country in Wiltshire with my wife and three children, Jake, Anna, and Sophy."

Joe Tilson, who began making important wood-relief constructions in 1955, is considered a progenitor of pop art in Great Britain. His work of the 1960s has affinities with that movement, but he considers himself simply an "object maker." Among the modernist achievements he most admires are the Eiffel Tower, Antoni Gaudí's architecture, and Vladimir Tatlin's monument to the Third International. In Tilson's view these "objects" were made by artists who wanted to come to terms with society "by making things and getting away from the French history of art which is pictures on the wall." For this reason futurism, suprematism, dadaism, and surrealism have meant far more to him than the School of Paris.

Tilson was impressed by the important exhibition of new American art held in London in 1959—"It made me want to make bigger and simpler and grander things," he said—but he has little interest in total abstraction. "Most nonrepresentational paintings," Tilson said, "are so often either boring, meaningless, or merely decorative. I'm excited by very little of it— Barnett Newman, perhaps, and early Rothko."

Tilson's ideal is "an art that works on several levels at once, not quickly understood, but at the same time not easily exhausted." His frontally visual constructions in wood, painted in oil or acrylic and sometimes using the screen process, are, as Aldo Pellegrini said in *New Tendencies in Art*, "executed with the perfection of a cabinet maker"—the result of Tilson's early experiences as a joiner and carpenter. His imagery often incorporates lettering or typographical de-

signs, and Tilson also creates compartmentalized structures in which everyday objects such as locks and keys are isolated and enlarged, upsetting one's sense of normal scale (a device that stems from surrealism). He enjoys the "telescoping" of ideas, as in *Painted Vox-Box* (1963), a painted wooden relief of an open mouth with five wooden exclamation points inside. Tilson also exploits the dry, deadpan visual and verbal humor of pop art. For example, in one of his works the close-up of an eye on a television screen is labeled "LOOK."

Concerned with "communication," Tilson denies that his art is "literary" and stresses its purely pictorial nature: "What I want is to let my images impinge on the mind of the spectator." For several years he was obsessed with the image of the ziggurat, and *Zikkurat 7* (1967) is one of his most colorful and original pieces.

In 1963 Tilson completed *A-Z, A Contributive Picture*, a construction of the alphabet to which several artist friends contributed individual letters. *A-Z* is considered a pioneer work of English pop and was included in the large pop art exhibition at the Hayward Gallery, London, in 1969. Also that year he took up the "A-Z" theme again in a series of 26 separate screen prints, each 73½ by 49½ inches, in which he explored the expressive potential of collage. In the series, screened news photographs are juxtaposed with Tilson's original iconography, and there are oblique references to contemporary issues and events, but the ultimate meaning is ambiguous. The letter B, for example, is represented by "Snow White and the Black Dwarf." For the letter K, Tilson created a striking composite image alluding to the assassination of Martin Luther King, but instead of the anger of Goya's *Disasters of War* or Picasso's *Guernica* Tilson's statement was unemotional, detached, allowing the viewer to draw his or her own conclusions. Tilson's art is "cool" rather than "hot," and in a series devoted to Che Guevara, Tilson neither glamorized nor vilified the revolutionary leader. This series and other, similar prints, evince his preoccupation with the photographic image and his interest in the popular iconography of such notables as Che and Ho Chi Minh.

In his understanding of how human beings communicate, Tilson has been influenced by the French anthropologist Claude Lévi-Strauss and by semiology and French structuralism. Tilson pointed out that structuralism "teaches you that everything is a form of communication—even the way you dress is a form of language."

Although he has always found the city "visually exciting," Joe Tilson lives with his family in the country. "I make," Tilson said of his re-

cent work, "things that are big and hard and monumental out of ephemeral news photos. . . . By celebrating the ephemeral you can change people's attitudes toward it, make them more aware of nonpermanence, of the inevitability of change. That is why art is important. It can change your matrix of viewing, shift the framework through which you see the world."

EXHIBITIONS INCLUDE: Biennale des Jeunes, Paris 1961; Marlborough New London Gal., London 1962, '64, '66, '70; Walker Art Gal., Liverpool 1963; British Pavilion, Venice Biennale 1964; Stadtmus., Recklinghausen, W. Ger. 1965; Stedelijk Mus., Amsterdam 1965; Marlborough Graphics, NYC 1966; Gal. del Naviglio, Milan 1967; Gal. Ferrari, Verona, Italy 1968; Gal. Brusberg, Hanover, W. Ger. 1968; Waddington Gal., London 1971; Mus. Boymans-Van Beuningen, Rotterdam 1973–74; Marlborough, Rome 1975; Gal. Espace, Amsterdam 1976. GROUP EXHIBITIONS INCLUDE: "New Painting 1958–61," Arts Council traveling exhibition 1961; Biennale de Paris, Mus. d'Art Moderne 1961; Pittsburgh Intl. Exhibition, Carnegie Inst. 1961–62, '67; "British Art Today," San Francisco Mus. of Art 1962–63; "British Art Today," Dallas Mus. of Contemporary Arts 1962–63; "British Art Today," Santa Barbara Mus. of Art 1962–63; "New Painting 1961–64," Arts Council traveling exhibition 1964; "Op and Pop," Moderna Mus., Stockholm 1965; "Aspects of New British Art," New Zealand 1966; "Reliefs–Sculpture," Marlborough New London Gal., London 1966; "Jeunes Peintres Anglais," Palais des Beaux-Arts, Brussels 1967; "Hamilton, Kitaj, Paolozzi, Tilson: Graphics," Walker Art Cntr. Minneapolis, 1968; "Pop Art," Hayward Gal., London 1969; "Information," Kunsthalle, Basel, 1969; "Information," Badischer Kunstverein, Karlsruhe, W. Ger. 1969; "Contemporary British Art," Nat. Mus. of Modern Art, Tokyo 1970; "The Artist as Adversary," MOMA, NYC 1971; "Pop Art in England," Kunstverein, Hamburg 1976; "Pop Art in England," Stadtgal., Munich 1976; "Pop Art in England," York City Art Gal., England 1976.

COLLECTIONS INCLUDE: Tate Gal., and Victoria and Albert Mus., London; Arts Council of Great Britain; Walker Art Gal., Liverpool; Ferens Art Gal., Hull, England; Ulster Mus., Belfast; Boymans-Van Beuningen Mus., Rotterdam; Kunsthalle, Basel; Mus. of Modern Art, Rome; Mus. of Modern Art, Turin, Italy; MOMA, NYC; Mus. of Art, Carnegie Inst., Pittsburgh; Walker Art Cntr. Minneapolis; Mus. de Arte, Salvador, Bahia, Brazil; Nat. Art Gal., Melbourne, Australia; Dunedin Art Gal., New Zealand.

ABOUT: Amaya, M. Pop as Art, 1965; Bowness, A. "Joe Tilson" (cat.), Venice Biennale, 1964; Finch, C. Pop Art, Object and Image, 1968; Lippard, L. R. Pop Art, 1966; Pellegrini, A. New Tendencies in Art, 1966; Russell, J. and others Pop Art Redefined, 1969; Tilson, J. and others Notes for Alchera, 1974. *Periodicals*—Ark no. 11 1954; Art and Artists October 1966, June 1969, March 1970; Art International March 1961; Arts Review February 19, 1966; Collage (London) December 1968; Control (London) 1967; Quadrum (Brussels) no. 12 1962, no. 17 1965; Studio January 1964; Studio International October 1967.

***TINGUELY, JEAN** (May 22, 1925–), Swiss-French sculptor, is best known for his complicated "metamatics," or kinetic sculptures, which poke fun at modern technology. In the 1960s he was a member of the French Nouveaux Réalistes, whose work paralleled the pop art of Great Britain and the United States.

Tinguely was born in Fribourg, Switzerland, and reared in Basel, where his family moved in 1927. His father was a worker in a chocolate factory. Commentators on Tinguely's work have pointed to the significance of his Swiss background inasmuch as Switzerland is renowned for the precision of its industrial products.

An unruly and independent child who attended school irregularly, Jean had a reputation for being a practical joker. At the age of 14 he built a series of about 30 small watermills, each designed to make a different sound. The waterwheels were attached to hammers which tapped various tone-producing jam jars. This mechanized "orchestra" was the first of his moving constructions, and it, like most of Tinguely's later work, explored the relationship between sound and movement.

Despite his dislike of school, Tinguely was fond of reading, especially biographies of such heroes as Alexander the Great, Napoleon, and Lord Byron. At 15 he tried to join the Albanian garrison resisting the invading Italian forces of Benito Mussolini, but after being caught at the Italian border he was jailed for three days and sent home to Basel.

After taking a job in a Basel department store, Tinguely showed such promise in drawing that he was encouraged to enroll at the Basel Kunstgewerbeschule. He attended the arts and crafts school, sporadically, from 1941 to '45. In courses with Julia Ris he learned to make collages from ordinary scraps of cloth, wood, and metal, and became acquainted with the methods used by the Italian Futurists, among others, to represent motion in art. At this time Tinguely grew dissatisfied with his efforts at abstract painting. Interested in results less static than images on canvas, he suspended objects, including the doors of his apartment, from the ceiling and used a motor to rotate them at speeds great enough to cause "dematerialization." Tinguely defined dematerialization as the erasure of a concrete image by means of rapid motion; a swiftly revolving propeller could be said to be "dematerialized."

In 1945 Tinguely made his first compositions

°taN´ glē, zhäN

Jorge Lewinski

JEAN TINGUELY

in wire, wood, and paper, and even constructed "edible" grass sculptures. In 1949 he married Eva Aeppli, an artist, and two years later Tinguely and his wife left Basel for Paris. The Swiss, he later complained, as quoted in *Time,* were "suffocating in security and drowning in comfort." In Paris the couple lived in a shabby lean-to in the Impasse Ronsin, an artist colony founded by the sculptor Constantin Brancusi. A daughter, Maria, was born to the Tinguelys in 1952.

Tinguely's first solo show, entitled "Reliefs Meta-méchaniques" (Metamechanical Reliefs), was held at the Galerie Arnaud on the Left Bank in May 1954. The exhibit consisted of wire sculptures and a series of abstract shapes in sheet metal which rotated at varying speeds against a plywood background. Tinguely coined the term "metamechanics," or "metamatics" (beyond the machine), to describe his boisterously humorous pseudomachines, which he believed to transcend pure mechanics as metaphysics transcends physics. The reliefs in the 1954 exhibition were probably the first important constructions with built-in mechanical motion; they were also the first major works in which he used chance as part of the object's overall function.

Tinguely showed in April 1955 at the avant-garde Galerie Denise René, Paris, in a group show titled "Le Mouvement." The exhibition included works by Alexander Calder, Marcel Duchamp, and other artists interested in the aesthetics of motion. Tinguely exhibited a motorized wire sculpture and a hilarious sound-making painting machine—a metamatic robot, or "metarobot," whose "talents" included draw-

ing abstract pictures with a felt pen on a paper pad. Twenty of his new machines were shown later that year at the Galerie Samlaren, Stockholm, and one of the motorized painter-robots was sold.

During 1956–57 Tinguely's works became internationally known through group exhibitions in Switzerland, Italy, Belgium, the US, Japan, and other countries. In 1958 he showed at the Galerie Iris Clert, Paris, in collaboration with Yves Klein, the painter of all-blue canvases. Tinguely dematerialized Klein's paintings, and the exhibit was titled "Vitesse Pure et Stabilité Monochrome" (Pure Speed and Monochrome Stability).

A 1959 exhibition of 17 of Tinguely's metamatics at the Galerie Schmela, Düsseldorf, received international publicity. Prior to the show's opening, Tinguely flew over Düsseldorf in a small airplane and dropped thousand of handbills on which his manifesto, *Für Statik* (For Statics), was printed. The manifesto declared: "Everyting moves continuously. Immobility does not exist. . . . Accept instability. Live in Time. Be static with movements. . . . " At the Paris Biennale of 1959, Tinguely erected his sensational eight-foot *Metamatic No. 17* at the entrance of the Musée d'Art Moderne. This construction made some 40,000 different multicolored abstract paintings and drawings for museum visitors who invested a coin. Like other Tinguely metamatics, it emitted noxious fumes and made frenetic motions and clattering sounds.

K. G. Hultén credited Tinguely with "two of the most fascinating ideas of modern art: the 'Meta-matic' drawing machine and self-destructive sculpture." Both these art forms comment satirically on modern civilization's reliance on ever more sophisticated technologies. "Tinguely's machines work, but only just," Edward Lucie-Smith wrote in *Late Modern.* "They groan and judder, and one suspects that they often develop both functions and malfunctions which were not anticipated by their author. . . . In fact, they have been labelled 'pseudomachines' because they move without function." His functionless mechanisms are, perhaps, ironic deprecations of the "practicality" of machines.

The first major demonstration of Tinguely's self-destroying sculpture was at the Museum of Modern Art, New York City, when his masterpiece, a "happening-machine" titled *Hommage à New York,* made its debut in 1960. Tinguely persuaded hesitant museum officials that his multi-sound-producing machine, 23 feet long and 27 feet high, could be suitably displayed only in the sculpture garden. The huge kinetic

"junk" sculpture was composed of 15 motors, 80 different kinds of wheels, a piano, a bathtub, a meteorological trial balloon, two metamatics, bottles of foul-smelling chemicals, and assorted odds and ends from secondhand Manhattan machine and junk shops; uncharacteristically, Tinguely's contraption was painted white. On the evening of March 17, 1960, before some 250 invited spectators, including Governor Nelson Rockefeller, and the television cameras of the National Broadcasting Company (NBC), the sculpture was scheduled "to destroy itself in one glorious act of mechanical suicide," as Calvin Tomkins put it in *Off the Wall*. The machine failed to operate as expected and needed to be prodded by its creator. But it shook and rattled as smoke belched from its interior, and when the built-in fire extinguisher proved inadequate, a fireman and two museum guards smashed it with axes. After the machine's "death," Tinguely sat happily amid the rubble autographing fragments. Some reviewers in the popular press considered the show a failed joke, but John Canaday of *The New York Times* (March 18, 1960), though calling the event a "fiasco," defended *Hommage à New York* as "a legitimate work of art as social expression. . . . Tinguely makes fools of machines, while the rest of mankind supinely permits machines to make fools of them." The large self-destroying machine had the blessing of Marcel Duchamp, who praised it as a gallant gesture and a last-ditch attempt to destroy art "before it's too late"—that is, before such vital expressions of the "antiart" spirit as Tinguely's are tamed and made respectable by wide public approval.

In 1961 Tinguely was divorced and he married the avant-garde artist Niki de Saint-Phalle. She appeared with him in happenings and assisted in the presentation of his gigantic metamatic *Study No. 1 for an End of the World*. Encouraged by the success of *Hommage à New York*, Tinguely built this even more ambitious machine to portray "a lunatic end to everything monstrous in the world." *Study No. 1* was first displayed in September 1961 in the courtyard of the Louisiana Museum, Copenhagen, where 35 pounds of explosives were needed for its destruction. Because museum quarters were too confining for such demonstrations, Tinguely's second version, *Study No. 2 for an End of the World*, was set up, with the assistance of de Saint-Phalle, in the Nevada desert near Las Vegas. The exhibition was filmed in color by NBC.

In 1964 Tinguely created a monumental sculpture called *Eureka*, which he exhibited at the Swiss Provincial Exhibition, Lausanne. Two years later, in collaboration with de Saint-Phalle and Per-Olof Ultvedt, he built a gigantic sculpture called *Hon* (She), in the Moderna Museet, Stockholm. This reclining woman was so large that viewers were able to walk inside her. In 1967, again in collaboration with de Saint-Phalle, Tinguely created *The Earthly Paradise*, which was exhibited on the roof of the French pavilion at Expo '67, the World's Fair, Montreal. Later displayed in New York City's Central Park, *Paradise* was conceived as a combat between Tinguely's crazy machines and de Saint-Phalle's comical, garishly colored and grotesquely inflated "Nana" figures.

In contrast to the haphazard exuberance and spontaneity of the self-destroying machines, Tinguely's works since his series of "Copulations" (1965–66) have featured a unified overall concept and precisely calculated kinetic mechanisms. Pierre Restany, the leading theoretician of the Nouveaux Réalistes, termed this development "classicism," but Tinguely's work has shown no loss of inventiveness or witty irreverence. In May 1977 his *Krokrodrome*, an immense kinetic sculpture in welded iron, was installed on the ground floor of the Beaubourg, Paris. *Krokrodrome* resembles a mechanized dragon on which children can take rides; its tangled forms and rusted textures give it a bizarre, fantastic, even nightmarish appearance. The dragon is so large that exhibitions can be held in its interior. As in all of Tinguely's work, viewer participation is essential to the realization of his concept.

Since 1951 Jean Tinguely has spent most of his time in Paris, with frequent trips abroad. He has a studio at Soisy-sur-Ecole, Essones, France. He was described by Calvin Tomkins in *The Bride and the Batchelors* (1965) as "a short, dark-haired, unkempt young man with an unbridled imagination."

Tinguely told the *Saturday Evening Post* (April 21, 1962), "I'm trying to meet the scientist a little beyond the frontier of the possible, even to get there a little ahead of him." Whether Tinguely's work is a joyous celebration of the machine age or a dadaist attack on an era in which machinery, often useless and destructive, invades every aspect of life has been vigorously debated. "For me," Tinguely said, "the machine is above all an instrument which permits me to be poetic. If you respect the machine, if you enter into a game with the machine, then perhaps you can make a truly joyous machine—by joyous I mean free."

EXHIBITIONS INCLUDE: Gal. Arnaud, Paris 1954; Gal. Samlaren, Stockholm 1955; Gal. Denise René, Paris 1956, '57; Gal. Iris Clert, Paris 1958, '59; Gal. Schmela, Düsseldorf 1959; Staempfli Gal., NYC 1960, '61; Moderna Mus., Stockholm 1961, '66; Gal. Rive Droite, Paris

1961; Alexander Iolas Gal., NYC 1962, '65; Minami Gal., Tokyo 1963; Dwan Gal., Los Angeles 1963; Gal. Alexandre Iolas, Paris 1964; Gal. Gimpel and Hanover, Zurich 1966, '69; Rijksmus. Kröller-Müller, Otterlo, Neth. 1967; Hanover Gal., London 1968; Stedelijk Mus., Amsterdam 1968, '73; Gal. Alexandre Iolas, Milan, Italy 1970; Centre Nat. d'Art Contemporain, Paris 1971; Kunsthalle, Basel 1972; Tate Gal., London 1982. GROUP EXHIBITIONS INCLUDE: "Le Mouvement," Gal. Denise René, Paris 1955; "Vitesse pure et stabilité monochrome," Gal. Iris Clert, Paris 1958; Biennale de Paris 1959; "Hommage à New York," MOMA, NYC 1960; "Le Mouvement dans l'Art," Stedelijk Mus., Amsterdam 1961; "Le Mouvement dans l'Art," Moderna Mus., Stockholm 1961; "Le Mouvement dans l'Art," Louisiana Mus., Humleback, Denmark 1961; Salon de Mai, Paris 1963; Venice Biennale 1964; Swiss Provincial Exhibition, Lausanne, Switzerland 1964; "Kinetic and Optic Art Today," Albright-Knox Art Gal., Buffalo, N.Y. 1965; "Two Kinetic Sculptors," Jewish Mus., NYC 1966; Expo '67, World's Fair, Montreal 1967; Documenta 4, Kassel, W. Ger., 1968; "The 1960s," MOMA, NYC ca. 1969; "Eisen-und-Stahlplastik 1930–1970," Württembergischer Kunstverein, Stuttgart, W. Ger. 1970.

COLLECTIONS INCLUDE: MOMA, NYC; Mus. Nat. d'Art Moderne, and Centre Georges Pompidou (Beaubourg), Paris; Stedelijk Mus., Amsterdam; Stedelijk van Abbemus., Eindhoven, Neth.; Kunsthaus, Zürich; Kaiser Wilhelm Mus., Krefeld, W. Ger.; Kunstmus., Düsseldorf.

ABOUT: Henri, A. Total Art: Environment, Happenings, and Performance, 1974; Lippard, L. R. Pop Art, 1966; Lucie-Smith, E. Late Modern, 1969; Tomkins, C. The Bride and the Bachelors: Five Masters of the Avant-Garde, 1965, Off the Wall, 1980; Schwartz, R. W. The Hand and the Eye of the Sculptor, 1969. *Periodicals*—Art News May 1961; Art News and Reviews October 1959; Cimaise (Paris) March/April 1956, July/August 1962; Domus (Milan) June 1964; Jardin des Arts (Paris) May 1971; New York Times March 18, 1960; Saturday Evening Post April 21, 1962; Studio International February 1965; Time March 30, 1959.

TOBEY, MARK (December 11, 1890–April 24, 1976), American painter, developed an original, calligraphic style which he called "white writing." Reacting against three-dimensional illusionism, Tobey wanted to "smash form, to melt it in a more moving and dynamic way," and so he originated an all-over style of compositional organization which preceded that of Jackson Pollock.

Mark Tobey was born in Centerville, Wisconsin. His father was a carpenter, and when Mark, who was one of four children, turned 16 the family moved to Hammond, Indiana. At school his favorite subjects were the natural sciences,

MARK TOBEY

especially biology and zoology, but his aptitude for drawing and copying magazine covers was encouraged by one of his teachers.

In 1908 his father became ill and Mark had to leave school and find work. He got a job in Chicago sketching fashion figures for a mail-order catalog of women's wear. He admired the work of the famous American illustrator Charles Dana Gibson, who popularized the elegant "Gibson Girls." Hitherto self-taught, Tobey took classes at the Art Institute of Chicago, and became interested in painting in oils. He sought to emulate the flashing brushstrokes and crisp highlights of John Singer Sargent.

In 1911 he moved to New York City. Having a drawing technique acceptable to editors, he supported himself by doing fashion illustrations. He lived in Greenwich Village, read Russian literature, and took private art lessons with Kenneth Hayes Miller. Tobey, with his gift for catching a likeness, his skill in handling sanguine, charcoal, and pencil, and his engaging personality, received many portrait commissions. His first solo show, at M. Knoedler and Company, New York City, in 1917 was of portrait drawings, and included such distinguished personalities as Mary Garden, Muriel Draper, and the great French theatrical producer Jacques Copeau.

For several years Tobey worked in a meticulous classical style and had a lucrative career painting fashionable portraits, but he soon found that this form of art involved "too many dinner parties." Finding the social demands of his life in Manhattan too burdensome—there had also been a brief and unhappy marriage—Tobey

went in 1922 to Seattle, Washington, where for two years he taught art at the Cornish School. At this time he was described as "a handsome, restless stranger of thirty-two with blazing copper hair, a temperament to match, and no money."

During these early years in the Northwest Tobey began to study Chinese calligraphy with T'eng Kuei, a student at the University of Washington. The Pacific Coast, with its Chinese and Japanese population and its geographic position, was more open to the Far Eastern cultures by which Tobey was influenced.

About this time Tobey became aware of what he termed "multiple space," which he later called his "personal discovery of cubism," a discovery quite independent of advanced movements in Paris. He learned, as he said, that "depth is something felt rather than seen," and that space was "anywhere and everywhere." This concept, related in many ways to mystical Eastern thinking, would eventually find expression in the all-over calligraphy of Tobey's mature work.

In 1925 Tobey left for a two-year trip to Europe and the Near East. He became interested in the design of Arabic and Persian script. He had already shown a preference for rapid notations in his drawing, and his sketches, while still realistic, were marked by strong overall rhythms. When Tobey returned to Seattle in 1927, he and Mrs. Edgar Ames (whose portrait he painted) founded the Free and Creative Art School, which still exists. He continued to teach, but he divided his time between Seattle, Chicago, and New York City.

In 1928 Tobey had solo shows at the Arts Club, Chicago, and Romany Marie's Café Gallery in Greenwich Village. He used the browns and greens found in several prominent American artists at that time and his forms were realistic, but the compositions were firmly organized. A slight cubist influence was discernible. Although a talented painter, Tobey had not yet found his own visual language, and one reviewer called him "a stylistic wanderer." His strongest canvas of these years, *The Middle West* (1929), had a tension, a selectivity, and a dynamic handling of space far beyond the scope of the Regionalists of the 1930s.

From 1931 to 1938 Tobey was artist-in-residence at Dartington Hall, Devonshire, England, the famous progressive school and farm founded and directed by Leonard and Dorothy Elmhurst. His teaching was interrupted by trips to Mexico in 1931 and to the Far East in 1934. In Shanghai he resumed the study of Chinese calligraphy with T'eng Kuei, and this was followed by instruction in brushwork and meditation in a Zen monastery in Japan. These experiences marked the turning point in Tobey's artistic development and intensified the mystico-philosophical strain in his character. For some years Tobey had belonged to the Baha'i World Faith, which he continued to follow for the rest of his life. This universalist doctrine accepts the prophets of all the great religions and proclaims the equality of all mankind and the unity of all creation.

From Tobey's calligraphic studies in the Far East he also learned the "difference between volume and the living line." Thus, Tobey set out to fuse the expressive calligraphy of the East with Western forms and content.

He returned to San Francisco in 1935, and began to develop the calligraphic style, the "white writing," that was to release his true creativity. But to the bafflement of critics, Tobey did not immediately abandon his earlier figurative manner. In his tempera study for a 1935 mural, *Rising Orb*, inspired by the Baha'i religion, the style is a strongly formalized realism with a metaphysical content. Tobey explained that the man and woman on the left represent local time, and the orb with broken moorings represent solar time.

Another work painted in 1935 was the first true example of Tobey's mature style, a small tempera titled *Broadway Norm*. He used a continuous white calligraphic line on a muted background to express "figures caught in light." This was followed in 1936 by the larger *Broadway*, in which the entire painting was "written." These white-line paintings, which were to have such a great impact in New York, London, and Paris, were produced when the artist was over 45.

In 1938 Tobey left Dartington Hall and sailed to New York on the *Queen Mary*. The following year he returned to Seattle, and continued to experiment with white writing. In 1942 his *Broadway* was awarded one of the $500 purchase prizes at the "Artists for Victory" exhibition at the Metropolitan Museum of Art, New York City. But it was not until his 1944 solo exhibition at the Willard Gallery, New York City, that Tobey's reputation was firmly established. The show consisted of 19 gouaches from the years 1935–44, with predominantly gray and white tonalities. Some, including the crowded *E Pluribus Unum* of 1942, combined formalized representational elements with semi-abstract symbols. *Threading Light*, painted the same year, was entirely abstract. *The New York Times* called the exhibit "one of the most individual shows of the season," and Clement Greenberg, writing in the *Nation,* praised Tobey's white writing as being "one of the few original contributions to American painting."

Tobey was one of the "Fourteen Americans" selected for the Museum of Modern Art's influential exhibition of 1946. Reviewing his third show at the Willard Gallery, in November 1947, Margaret Bruening of *Art Digest* noted that in his new work the artist was "both enriching his rather austere palette, and subordinating his calligraphic patterns to breadth the design."

The first major retrospective of Tobey's work was held in San Francisco in the spring of 1951. After being shown in Santa Barbara and Seattle, the exhibit, covering the years 1917 to 1950, opened in October 1951 at the Whitney Museum of American Art, New York City. A smaller and more intimate show of his paintings opened that same month at the Willard Gallery. Impressed by the diversity of style and content over the years, Howard Devree wrote in *The New York Times* that Tobey's progress was not in "a steady straight line but rather [in] zigzags, with throwbacks to previous work and with premonitions of work to follow." Devree concluded that Tobey "remains one of the most challenging of contemporary painters . . . despite self-imposed limitations and the frequently rarefied, somewhat astringent character of his work."

Some critics felt that Tobey, in his all-over compositions (that is, painting with no fixed center of interest), had anticipated the action painting of Jackson Pollock which commanded the art scene in the early '50s. However, Tobey's inward, contemplative art bore no relation to the gestural violence of Pollock, nor, except for a few commissions, did Tobey ever work on the monumental scale of the Abstract Expressionists. He preferred a modest format and the more intimate technique of watercolor, tempera, and wash drawing. His closest affinity was to Paul Klee, especially in the use of line as an independent and autonomous pictorial element, and in the poetic, metaphysical, and philosophical reverberations of his work.

Like Klee, Mark Tobey loved music. In Seattle he played the piano and enjoyed composing; his flute solo was performed at the University of Washington, and a suite for children was among his compositions. He also wrote poetry. In 1956 he was elected a member of the National Academy of Arts and Letters in New York City.

After 1958, when he won first prize for painting at the Venice Biennale, Tobey was an internationally acclaimed figure whose paintings were sought after by museums and private collectors in many countries. Senior French critics declared him to be the most important American painter since Whistler, while at the same time calling him "one of the least American painters of the period." It is true that in the '50s he received more recognition in Europe than in America, where his work seemed almost diffident beside the more spectacular abstract expressionist canvases. But as Betty Bowen pointed out in the catalog to a 1970 retrospective held in Seattle to celebrate the artist's 80th birthday, Tobey remained very American in "his humanism, based on his grass-roots American love of liberty and individuality."

More of Tobey's finest works are owned by the Seattle Art Museum and by galleries and private owners in that city. These paintings include the enchanting gouache *June Night* of 1957 and the tempera *Written Over the Plains, No. 2* of 1959, with its mysterious white calligraphy and fluid pictorial depth which allows the picture, in Tobey's phrase, to "breathe."

In 1960 Tobey moved to a historic 15th-century house with a quiet garden in Basel, Switzerland. He remained there for the rest of his life, with occasional visits to Seattle. In 1961 he was given a large retrospective at the Musée des Arts Décoratifs in the Louvre, Paris, an honor never before accorded to an American painter. Tobey enjoyed the tranquillity of Basel, but missed the spontaneity and vivacity of American ways. In his 80s he suffered from chronic bronchitis and other ailments, but continued to paint, even undertaking large paintings with "a sustained energy that astonished his admirers," to quote John Russell. His last years were greatly eased by the presence of his devoted secretary and companion, Mark Gordon Ritter. Mark Tobey died in Basel at the age of 85. He was described in his *New York Times* obituary by John Russell as "one of the last of the great 19th-century Americans," who would be remembered "not only as a very fine painter but also as an authentic American original."

Mark Tobey was an impressive-looking man, gentle in speech and manner, with a benign presence and great personal charm. He stood six feet tall, with light blue eyes, gray-white hair (which turned white in his last years), and a neatly trimmed beard. Although his spiritual and mystical orientation was reflected in his personality, there was also something elusive, and stubbornly independent, in his make-up. As Russell pointed out. "He retained to the last a salty, uncompromising outlook on life."

In describing his own white-writing painting of 1945, *Agate World,* Tobey eloquently expressed what he was attempting in his art: "The moving white lines symbolize the light, the unifying thought which flows across the compartments of life, and these give strength to the spirit and are constantly renewing their energies so that there can be a greater understanding of life."

EXHIBITIONS INCLUDE: M. Knoedler & Co., NYC 1917; Arts Club, Chicago 1928; Willard Gallery, NYC 1944–54; Retrospective, Whitney Mus. of Am. Art, NYC 1951; Gal. Jeanne Bucher, Paris 1955; Retrospective, Seattle Art Mus. 1959; Mus. des Arts Décoratifs, Palais du Louvre, Paris 1961; "Tobey's 80: A Retrospective," Seattle Art Mus. 1970; Knoedler, NYC 1976. GROUP EXHIBITIONS INCLUDE: "Artists for Victory," Metropolitan Mus. of Art, NYC 1942; "Fourteen Americans," MOMA, NYC 1946; "Tendances Actuelles," Kunsthalle, Bern 1955; "Salute to France," Mus. d'Art Moderne, Paris 1955; Venice Biennale 1958.

COLLECTIONS INCLUDE: Baltimore Mus. of Art; Boston Mus. of Fine Arts, Albright-Knox Art Gal., Buffalo, N.Y.; Chicago Art Inst.; Cleveland Mus.; Wadsworth Atheneum, Hartford, Conn.; Metropolitan Mus. of Art, MOMA, and Whitney Mus. of Am. Art, NYC; Brooklyn Mus., N.Y.; Seattle Art Mus.; Santa Barbara Mus.; Toledo Museum, Ohio; Phillips Memorial Gal., Washington, D.C.; Nat. Mus. of Fine Arts, Belgrade; Mus. Civico, Turin; Gal. Nazionale d'Arte Moderna, Rome.

ABOUT: Bernier, G. The Selective Eye, 1955; Current Biography, 1957; Janis, S. Abstract and Surrealist Art in America, 1944; MacAgy, J. (ed.) "Tobey" (cat.), Whitney Mus. of Ame. Art, NYC, 1951; Miller, D. "Fourteen Americans" (cat.), MOMA, NYC, 1946; Rose, B. American Art Since 1900, 2d ed. 1975; Schmied, W. Tobey, 1967. *Periodicals*—Art News May 1951; Arts Magazine June 1975; New York Times April 25, 1976.

TOMLIN, BRADLEY WALKER (August 19, 1899–May 11, 1953), American painter, was a prominent member of the New York School. His work occupies a middle ground between the action painting style of Jackson Pollock and the chromatic abstractions of Mark Rothko and Adolph Gottlieb. Tomlin's painting contributed significantly to widespread acceptance of the abstract expressionist style.

Tomlin was born in Syracuse, New York, the youngest of five children of Charles H. and Matilda (Hollier) Tomlin. He was a delicate child whose health was poor. In 1913 Tomlin entered Central High School, Syracuse, where he studied with Cornelia Moses, a former pupil of the progressive teacher Arthur Wesley Dow. At 14 Tomlin was awarded a scholarship to study modeling in the studio of Hugo Carl Wagner. After graduating from high school, in 1917 he entered the John Crouse College of Fine Arts at Syracuse University and majored in painting; his teachers included Jeannette Scott and Carl T. Hawley.

At college Tomlin won the freshman prize for academic achievement. He was an excellent student but never robust—when required to pass a physical education exam, he had a friend take his place in the exercises. Although he took courses in military science, he was not called up when the US entered World War I. During his years at Syracuse University, where he remained until 1921, Tomlin received several commissions. In 1919 he won Second Prize in a contest held by the Onondaga County Tuberculosis Association for his Red Cross poster design. The following year he illustrated a children's book, A. Bennett-Edwards's *The Story of the Stork*, and in 1921, with the collaboration of Julian Mansfield, a fellow student, executed Mother Goose mural panels for the children's ward of the Crouse-Irving Memorial Hospital in Syracuse. Tomlin's drawings and posters of this period were bold and animated in design, simple in line but highly detailed, somewhat in the manner of Howard Pyle. Their popularity led Tomlin to a career in commercial art.

Tomlin received his Bachelor of Painting degree from Syracuse in 1921. He also won the university's Hiram Gee Fellowship of $500, which offered him the opportunity to study abroad. However, he delayed this trip to move to New York City. Before leaving, Tomlin received his first important commission, from Jerome D. Barnum Sr., editor of the Syracuse *Post-Standard,* who wanted a portrait of his son. The portrait, which won him a two-month scholarship to the Louis Comfort Tiffany Foundation, was later destroyed by Tomlin, who habitually discarded canvases that he disliked.

After settling in New York City, in 1922, he had considerable initial success, doing commercial art and painting watercolors and portraits. He soon designed his first magazine cover for Condè Nast, owner of *House and Garden* and *Vogue,* for whom he did free-lance work until 1929. Also in 1922, Tomlin held his first solo exhibition, a showing of watercolors at Skaneateles and and Cazenovia in upstate New York. Most of Tomlin's watercolors have been lost or destroyed, but they were described in reviews as precise, poetic, sensitive, lyrical, and softly realistic. His posters and magazine covers of this period were also gently realistic, but his treatment of subject matter was vividly animated.

In 1923 Tomlin availed himself of the Hiram Gee Fellowship money and went to Paris. He was lonely there, living in a cold, run-down apartment in the Place du Panthéon. In letters home he complained that he was "getting fed up with artists, poets and strange-looking people. They certainly seem to flock here from all parts of the earth." He studied at the Académie Colarossi and the Grande Chaumière and visited the museums, where he came to admire the work of Cézanne, Gauguin, and Van Gogh. (Tomlin made no mention in his letters of Picas-

so or other avant-garde artists.) He exhibited a still life, *Pitcher and Fruit,* at the Paris Salon, and in 1924 he copied Manet's *Balcony* at the Luxembourg Palace to fulfill the Fellowship's requirements. At this time he met Georges Braque and Gertrude Stein, to whom he later dedicated the painting *Number 9: In Praise of Gertrude Stein* (1950; Museum of Modern Art, New York City).

During his stay in Europe, Tomlin not only saw France and Italy but also went to England and visited Deeping St. James, where his English forebears had lived. When he returned to New York City in 1924, Tomlin became more active in artistic circles than he had been in 1922. He joined the Whitney Studio Club, where he was eventually to exhibit regularly, and spent the first of many summers in Woodstock, New York, as a member of the Woodstock Art Association.

About 1925 Tomlin rented a studio on the top floor of a home on East Fifty-first Street, where the painter Frank London and his family lived. For the next 20 years Tomlin and London were close friends: they painted together, traveled together, and criticized each other's work. Their paintings became so similar that a friend remarked that she was unable to tell their work apart. Not until the 1930s did their work begin to diverge.

Tomlin had begun to paint oils, rather than watercolors after his return from Europe. His painting at this time consisted mostly of still lifes, and some, especially his brightly colored depictions of tulips and sunflowers, are in the style of Vincent Van Gogh. Tomlin's first solo exhibition at the Montross Gallery, New York City, in 1926, was well received by critics, who praised his gift for color and design. Some reviews, however, claimed that his work was derivative and eclectic, a charge that was leveled at Tomlin throughout his career and greatly distressed him.

Later in 1926 Tomlin joined Frank London in Paris, where they shared Rodin's former studio at 54 Avenue du Maine. On this visit Tomlin enjoyed Paris. The Latin Quarter studio was comfortable, unlike his previous lodgings, and he and London frequented antique shops and flea markets.

In 1927 Tomlin returned to New York for his second solo exhibition at the Montross Gallery. Once more, despite the generally laudatory notices, there were complaints of lack of originality. *The New York Times* critic wrote: "Now we see Mr. Tomlin under the yoke of modernism, . . . adopting certain conventions which have been used by a number of contemporary painters." Tomlin's poor health—he had recurrent migraine headaches—had begun to plague him when he first moved in with London, and it did not improve after returning in 1928 from his third trip to Europe. However, he received several commissions for portraits and still lifes and decided to give up commercial art. His last commercial assignment was an ad design for a dinnerware sale at Macy's. His growing success led to his being taken on by the Frank K.M. Rehn Gallery, New York City, and thereafter Tomlin's work was included in exhibitions at most major American museums. The Whitney Museum of American Art, New York City, owns a lyrical, romanticized, self-portrait of 1932, but other paintings of this period show the influence of El Greco.

With the advent of the Depression, Tomlin received fewer commissions and found it increasingly difficult to sell his paintings, even at modest prices. To earn money Tomlin took up teaching in 1932. He taught for one year at the Buckley School, New York City, and was an instructor at Sarah Lawrence College, Bronxville, New York, until 1941; he held a third post, at the Dalton School, Manhattan, from 1933 to 1934. Finding the disciplinary responsibility and other tasks assigned to him irksome, Tomlin soon tired of teaching. Moreover, until the mid-1930s he was frustrated and upset, unsure of himself and the direction his work had been taking.

In 1937 Tomlin saw the major exhibition "Fantastic Art, Dada and Surrealism," at MOMA; although initially repelled by the paintings, he went back again and again. Fascinated by these advanced styles, he told a friend that other art styles looked dull in comparison. Two years later in 1939 he entered his cubist period, a drastic change from his figurative work of the past. For guidance and inspiration he turned, not to American artists, but to European Surrealists and other innovators, which again led to charges of being "derivative." But Tomlin's interpretation of cubism was original. His early cubist paintings such as *Outward Preoccupation* (1939) and *To The Sea* (1942) show that his interest was not merely in form, structure, and spatial relations, but in elements of symbolism and mysterious, dreamlike imagery.

Although he received his military draft notice in 1942, Tomlin was found unfit for service because of his delicate health. During the early '40s he exhibited new work at major museums; the reviews were not always favorable, but he was becoming well known to critics and collectors. He soon gained important sponsors such as Edward Wales Root, and Mrs. George Church, a loyal supporter, gave him a sizable bequest in 1942, which enabled him to indulge his expen-

sive tastes and buy a rambling Victorian house in Woodstock. Unable to maintain so large a dwelling, he sold it only two years later but kept its massive front doors as a memento and installed them in his small apartment in Frank London's house.

Although usually uninterested in art-world politics, and inclined to conservativism despite the "progressive" tendencies of his art, in 1941 Tomlin joined the American Federation of modern Painters and Sculptors. The Federation had seceded in 1940 from the American Artists' Congress, which had attempted to combine modernist aesthetics with the leftist politics of the Popular Front. Like the Artists' Congress, the Federation was internationalist, embracing the world tradition of art, and hostile to the chauvinism of American scene painting; but the Federation believed that the development of art was linked to the evolution of consciousness, not to revolutionary politics. With Mark Rothko, Adolph Gottlieb, Milton Avery, and other younger New York School painters, Tomlin participated in annual Federation showings and in "alternative" exhibitions that protested the policies of New York City museums, which at that time ignored modern American artists.

In 1944 Tomlin held his second and last exhibition at the Rehn Gallery, there were many sales and the judgment of critics was favorable. However, in 1945, distressed by the death of Frank London and feeling depressed, bored, unsure of his work, yet eager to explore new paths, he contacted Adolph Gottlieb, to whom he had written in 1941 expressing admiration for his work. Gottlieb's abstract series of "Pictographs" (1941–51) helped Tomlin move beyond his cubist still-life phase and, even more important for Tomlin's artistic development, Gottlieb introduced him to the Abstract Expressionists Robert Motherwell, Jackson Pollock, and Philip Guston.

Tomlin's *Arrangement* (ca. 1945), a loosely constructed still life in tones of aqua, rust, brown, red-orange, black, and white, is a transitional work, linking his cubism of the early '40s and his abstract works of the second half of the decade. In 1946 he completed his first abstract pictures, including *The Armor Must Change*, which received First Honorable Mention at the Carnegie Institute, Pittsburgh. Tomlin's use of automatic methods of composition had been prefigured in the loose forms of such paintings as *The Arrangement* and *The Armor Must Change*, and in 1948 he experimented often with automation. Its effects can be seen in the bold calligraphic style of *Tension by Moonlight* (1948). In other paintings of 1948—*Death Cry, No. 3*, and *Maneuver for Position*—Tomlin was

attempting to forge his own brand of expressionism. In 1949 *Arrangement* received the Purchase Prize at the University of Illinois. *Autocrat* (1949), seemingly an abstract portrayal of human society, the influence of Gottlieb's "Pictograph," with their mythological and Freudian symbols, is evident.

By 1948 Tomlin was a full-fledged member of the New York School: he shared a studio with Philip Guston in Woodstock during the summers; spent time with the Pollocks at their Long Island home; and occasionally worked in Motherwell's studio at Astor Place, Manhattan. He attended the Friday evening meetings of Studio 35 on East Eighth Street, where pioneers of abstract expressionism gathered to discuss new ideas and approaches to art. Following other members of the group, he began to number his works, rather than giving them titles like *No. 11* (1952–53) and *No. 13* (1952–53). He also began signing his canvases in lower case letters. About 1949 he left the Rehn Gallery, which he now considered too conservative, and was taken on by the soon-to-be-prominent Betty Parsons Gallery, where the leading avant-garde artists showed in New York.

After this postwar period of experimentation Tomlin still needed to achieve his own style. He accomplished this after 1949, only a few years before his death. He gave up the drab palette he had been using since his cubist period and began to experiment with color, using tertiary hues such as olive, mustard, pale blue, violet, ochre, and tan. In such paintings as *Number 20* (1949; MOMA, New York City) Tomlin's loose brushstrokes, as Barbara Rose observed in *American Art Since 1900,* were "hardened into simple curves, channeled into place by an underlying grid framework," which "allowed a greater freedom of movement than orthodox Cubist structure."

In a speech delivered in 1949 to the American Federation of Modern Painters and Sculptors, entitled "The Schism Between Art and the Public," Tomlin declared that abstract art would never be for the "common man" and that the artist must rely for support and patronage on perceptive collectors, galleries, and wealthy intellectuals. In 1950, the year of his first solo show at the Betty Parsons Gallery, John D. Rockefeller III purchased *Number 9: In Praise of Gertrude Stein* and became another of his patrons. In the fall of 1951 Tomlin suffered a heart attack and was hospitalized for months. He was released in 1952, and although the effort exhausted him, painted furiously to produce new works for his last, solo show at Betty Parsons, in 1953. The show was well received by critics, but Tomlin, nervous and exhausted, did not visit the exhibition until closing day.

In 1953 Tomlin purchased a house at The Springs, Long Island, near Jackson Pollock and his wife, the artist Lee Krasner. While dining with the Pollocks, he suffered another heart attack, was rushed to St. Vincent's Hospital in Manhattan, and died the next day. A memorial exhibition of his work was held in 1955 at the Phillips Gallery, Washington D.C.

Bradley Tomlin never married. He was elegant, handsome, modest, sensitive, quiet, socially at ease, and had a touch of the dilettante about him. "One would have thought [Tomlin] was the son of an Anglican bishop," his friend Robert Motherwell remarked. Though filled with self-doubt throughout most of his career, in the last five years of his life, when he emerged as a major and original painter, Tomlin found relative satisfaction and gained confidence in his work. In *A History of American Art* (1971) George M. Cohen described Tomlin's style as "rigid and clear," although many critics believe that, had Tomlin lived, "his mode would have approached the more fluid and complicated style of Pollock," to quote Cohen.

Tomlin was the author of two catalogs for solo exhibitions in Woodstock, New York, *Frank London* (1948) and Judson Smith (1952). His article, "Letter to Henry McBride," appeared in *Art News* (May 1953).

EXHIBITIONS INCLUDE: Skaneateles and Cazenovia, N.Y. 1922; Anderson Gal., NYC 1923; Montross Gal., NYC 1926, '27; Frank K.M. Rehn Gal., NYC 1931, '44; Betty Parsons Gal., NYC 1949, '50, '53; Phillips Collection, Washington, D.C. 1955; Art Gals., Univ. of California at Los Angeles, ca. 1957–58; Whitney Mus. of Am. Art, NYC ca. 1957–58; Albright-Knox Art Gallery, Buffalo, N.Y. 1975. GROUP EXHIBITIONS INCLUDE: International Exhibition, Carnegie Inst. Pittsburgh 1927, 1931; Biennial Exhibition, Corcoran Gal., Washington, D.C. 1943; "Abstract Painting and Sculpture in America," MOMA, NYC 1951; "15 Americans," MOMA, NYC 1952; "50 ans d'art aux Etats-Unis," Mus. d'Art Moderne, Paris 1955; "Am. Abstract Expressionists and Imagists," Solomon R. Guggenheim Mus., New York, 1961; "Two Decades of Am. Painting," National Mus. of Modern Art, Tokyo 1966; "The New Am. Painting and Sculpture," MOMA, NYC 1969; "Am. Art at Mid-Century," National Gal. of Art, Washington, D.C. 1973.

COLLECTIONS INCLUDE: Metropolitan Mus. of Art, MOMA, and Whitney Mus. of Am. Art, NYC; Albright-Knox Art Gal., Buffalo, NYC; Munson-Williams-Proctor Inst., Utica, N.Y.; Hirshhorn Mus. and Sculpture Garden, and Smithsonian Inst., Washington, D.C.; Univ. of Illinois, Urbana, Ill.; Cranbrook Academy of Art, Bloomfield Hills, Mich.

ABOUT: Ashton, D. American Art Since 1945, 1982, The New York School: A Cultural Reckoning, 1973; Rose,

B. American Art Since 1900, 2d ed. 1975. *Periodicals*—American Artist April 1945; Art Digest June 1950, June 1953; Art in America September 1975; Art News March 1923, November 1931, May 1950, June 1953; Arts April 1975; Magazine of Art May 1949; The Arts February 1926; Quadrum 8 (Brussels) 1960.

TOOKER, GEORGE (CLAIR, JR.) (August 5, 1920–), American painter, is often grouped with Peter Blume, Honoré Sherrer, and his teacher Paul Cadmus within American magic realism, a style defined by Barbara Rose as "a highly cultivated combination of precise technique and slick, polished surfaces with a perverse version of the everyday." Tooker's work, meticulously painted in tempera, embodies visually the convoluted and paranoid worlds of Franz Kafka, updated and applied to modern urban life.

Born in Brooklyn, George Clair Tooker, Jr. graduated from the exclusive Phillips Academy in Andover, Massachusetts, and then received a bachelor's degree from Harvard in 1942. After serving briefly with the US Marines, he gravitated to New York City, where he studied with Reginald Marsh, Kenneth Hays Miller, and Harry Sternberg at the Art Students League (1943–45). Marsh's urban scenes in tempera were an important influence on him, but the far more detailed and realistic tempera technique of Paul Cadmus, with whom Tooker studied privately in 1946, and Cadmus's surrealist-tinged subjects, had the greatest impact on Tooker's development.

A round self-portrait dating from 1947 shows Tooker holding before him a nautilus shell, a cryptic symbol of the inner complications of the subject that no portraitist can quite capture. In an interview with Selden Rodman, Tooker said: "Symbolism can be limiting and dangerous. But I don't care for art without it. The kind that appeals to me the most is a symbolism like a heraldic emblem, but never just that alone: the kind practiced by Paolo Uccello and Piero della Francesca." As did many of the Magic Realists, Tooker claimed as his antecedents and inspiration the painters of the Italian and Northern Renaissances. Tooker also used for his own ironic ends Christian religious iconography. The hieratic gesture of the main figure in *Bird Watchers* (mid-1950s) led Barbara Zacker of *Art News* (March 1975) to refer to him as "Jesus in a top coat."

At the same time, as Ralph Pomeroy notes in *Contemporary Artists*, Tooker is a completely modern artist whose allegorical vision springs from psychological models of Freud, the bu-

reaucratic nightmares of Kafka, and the theatrical dead-ends of Samuel Beckett. Without the direct finger-pointing of the Social Realists, he is unsettlingly specific about the shortcomings of our reified society. His surfaces, even the flesh of his subtly generalized figures, are portrayed as being hard and cold as marble; his scenes, almost all interiors, are illuminated by the chilly light of institutional fluorescents.

The Subway (1950; Whitney Museum of American Art, New York City) is one of Tooker's best-known paintings, and is representative of his mature work. Typically, he shows the achetypal New York City subway station as a sterile, forbidding place, receding angularly from a central figure, a woman whose face and gesture convey dread and loneliness. In complex repetitive alcoves lurk identical male figures, of which only a staring eye or overcoated back may be visible. The impossibility of communication, let alone compassion, between these people is assured by the mazelike and confusing architecture of the station—which is only a slight exaggeration of the real thing. (Despite this dismal atmosphere, Tooker maintains that he did not intend to denigrate the city.) Referring to Tooker's figures, Suzi Gablik of *Art News* (May 1964) noted that their "frozen, waxlike inwardness and blunted gestures are a contemporary throwback to Georges de la Tour." An apt student of art history, Tooker is well aware of de la Tour and modernized one of that artist's favorite effects, the play of candlelight on the female figure, in *Juke Box* (mid-1950s), showing the colored glare thrown onto the faces of two girls listening to a juke box.

Tooker's well-known *Government Bureau* (1956; Metropolitan Museum of Art, New York City) was inspired by the experience of the artist and his friend Bill Christopher when they laboriously attempted to have their rooming house reclassified as a two-family dwelling by the New York City Housing Authority. In the painting, anonymous civil servants, safe behind frosted glass cubicles impossibly small for them, wait with adding machines at the ready, their lips to small speaking holes. Hapless citizens, equally clonelike, queue up wearily in the labyrinthine corridors. Other important paintings of the 1950s and '60s include *The Red Carpet* (mid-1950s), in which three seated figures stare fixedly at symbols worked into an elaborate carpet; *Lovers I* (1959), one of his few sensual works; *Supper* (1963), in which another Christlike figure blesses a loaf of bread; and *Teller* (1968), a variation on *Government Bureau* in a fiduciary setting.

In the late 1970s Tooker was occupied with several series of lithographs—"Voice I" and "Voice II," for example—that exhibit the same careful draftsmanship, and much the same message, as his paintings. With the general rise in interest in all types of realism since the mid-1970s, Tooker's following, never large at best (he has only had a handful of solo shows), has slowly increased. In 1975 he was honored with a retrospective at the Whitney Museum, his only museum show.

Many critics have referred to Tooker as an American Surrealist, but in his interview with Rodman he denied the connection. "It is the novelty and shock value of the surrealists that disturbs me. I am after reality—painting impressed on the mind so hard that it recurs as a dream, but I am not after painting dreams as such, or fantasy." He continued, "I've been influenced by Magritte, I guess, but I don't really like his painting. His ideas seem bright and intellectual, rather than compulsive. . . . Painting, to be really convincing, has to come from a strong emotion, as it seems to in the work of Hopper, whom I admire greatly." Notwithstanding the bizarreness of their imagery, Tooker's paintings are only a step from the realism of Hopper, making plain the social and psychological fears and conundrums that Hopper implies. Realism, not surrealism, is the source of Tooker's art. "Nature," he said, "is so much richer than anything you can imagine."

EXHIBITIONS INCLUDE: Edwin Hewitt Gal., NYC 1951, '55; Robert Isaacson Gal., NYC 1960, '62; Durlacher Brothers, NYC 1964, '67; Jaffe-Friede Gal., Dartmouth Col., Hanover, N.H. 1967; Calif. Palace of the Legion of Honor, San Francisco 1974; Whitney Mus. of Am. Art, NYC 1975. GROUP EXHIBITIONS INCLUDE: Annual Exhibition, Brooklyn Society of Artists, Brooklyn Mus., N.Y. 1944; "15 Americans," MOMA, NYC 1946; Annual, Whitney Mus. of Am. Art, NYC 1947, '48, '49; "Symbolic Realism in American Painting 1940–50," Inst. of Contemporary Arts, London 1950; "19 Young Americans," Metropolitan Mus. of Art, NYC 1950; Biennial, Corcoran Gal., Washington, D.C. 1951; "The New Decade: 35 American Painters and Sculptors," Whitney Mus. of Am. Art, NYC 1955; Venice Biennale 1956; Festival of Two Worlds, Spoleto, Italy 1958; "Sixty Years of American Art," Whitney Mus. of Am. Art NYC 1960; Flint International, Flint Inst. of Arts, Mich. 1966; "Human Concern, Personal Torment: The Grotesque in American Art," Whitney Mus. of Am. Art, NYC 1969; "Human Concern, Personal Torment: The Grotesque in American Art," Univ. Art Mus., Berkeley, Calif. 1969.

COLLECTIONS INCLUDE: Metropolitan Mus. of Art, Whitney Mus. of Am. Art, MOMA, and Nat. Academy of Design, NYC; Phillips Academy, Andover, Mass.; Dartmouth Col., Hanover, N.H.; Nat. Collection of Fine Arts, and Archives of Am. Art, Washington, D.C.

ABOUT: "15 Americans" (cat.), MOMA, NYC, 1946; P-Orridge, G. and others (eds.) Contemporary Artists, 1977; Rodman, S. Conversations with Artists, 1961; Rosen, B. American Art Since 1900, 2d ed. 1975. *Periodicals*—Art and Artists April 1967; Art News May 1964, March 1975, November 1978.

FELIKS TOPOLSKI

*TOPOLSKI, FELIKS (August 14, 1907–), British draftsman, painter, and illustrator, is an institution in England, his adopted country. His role as an artist who vividly documents the passing scene is comparable to that of Constantin Guys in 19th-century Paris, and in England he has been hailed as a worthy successor to Hogarth, Gillray, Rowlandson, and Cruikshank.

He was born in Poland, the son of Edward Topolski, an actor, and the former Stanislawa Drutowska. When Feliks was a child, his mother divorced his father—who, "being an actor, tended to wander," Topolski said—and married an army officer. As a result, Feliks attended military schools as well as the Warsaw Academy of Art and briefly served as a reserve officer in the horse artillery. This was followed by what he describes as a period of "self-tutoring" in Italy and France.

To Topolski, England was exotic. Enchanted by London and its environs, he settled in England in 1935, becoming a British subject 12 years later. "The social style," he rhapsodized, "the grace—how shall I say it?—the old values that are now fading away; all these appealed to me."

Topolski expressed his affection for England and its people with fluid, animated, wryly humorous drawings. George Bernard Shaw praised Topolski as "an astonishing draughtsman; perhaps the greatest of all the impressionists in black and white." Topolski noted that although "G.B.S. never liked my interpretations of him . . . , all his friends did." Topolski illustrated editions of three Shaw plays: *Geneva, In Good King Charles' Golden Days*, both in 1939, and *Pygmalion*, in 1941.

From 1940 to '45 Topolski was an official British war artist. In this capacity, and as a Polish officer recognized by the government-in-exile in London, he was able to tour most of the war zones. His draftsman's record of the Battle of Britain, in which he was almost killed by a bomb blast in London during the blitz, was extensive, and he traveled to both European fronts, was with the British navy in the Arctic and the Mediterranean, and recorded campaigns in Africa, the Middle East, China, and Burma. Once, when emerging with his sketchbook from an air-raid shelter in Moscow in 1944, he was arrested as a

spy. Topolski's release was secured only when "a friend of mine came along and explained that I was a compulsive scribbler, not without friends in high British circles, and very *kulturny*."

Soon after the war Topolski completed *The East*, a large painting now in the National Collection of India, New Delhi. The work is characteristic of Topolski's manner—a loosely brushed bravura style which is very similar to his drawings and has overtones of caricature. An immense 60-by-20-foot mural entitled *Cavalcade of the Commonwealth*, commissioned in 1951 for the Festival of Britain, was later placed in the Victoria Memorial Hall, Singapore. When Singapore became a self-governing state in 1959, the mural was returned to the artist.

In 1953 Topolski began publishing *Topolski's Chronicle*, a broadsheet issued 24 times a year and consisting of butcher paper in sheets measuring 18 by 23 inches. Reproduced on these sheets were the pen, pencil, crayon, and wash sketches made at high speed by Topolski on his travels. Each issue had a theme; for instance, the "Hong Kong" and "English Theatre" numbers both appeared in 1954, "London International" and "U.S.A. Elects a President" in 1956, "English Upper and Other Classes" in 1958, and "Venezia" in 1960. The writer Joyce Cary described the *Chronicle* as "the most brilliant record we have of the contemporary scene as seized by a contemporary mind," and Andrew Ritchie of the Museum of Modern Art, New York City, declared, "Today Topolski has perhaps no equal as a reportorial draughtsman." The *Chronicle* was discontinued in the late '70s, in part because of rising production costs. How-

°tô pol´ skē, fā´ liks

ever, the large sheets, which could be assembled in portfolio form at the end of each year, may well become collector's items.

In 1958 Topolski was commissioned by Prince Philip, Duke of Edinburgh, to paint a mural 95 feet long and 4 feet high to commemorate the coronation of Queen Elizabeth II. In 1953, the year of the coronation, Topolski, as a government-commissioned artist, had made ink and watercolor sketches of coronation dress rehearsals and of the ceremony itself. Prince Philip decided to commission the mural after having seen some of the sketches during a visit to Topolski's studio in 1958. The mural was painted in tempera mixed according to a formula of the artist's own. The largest continuous section comprised eight panels and depicted the coronation procession. The painting was hung in a gallery in the royal family's private apartment in Buckingham Palace. *The New York Times* described Topolski's style in the mural as "reminiscent of a mixture of Daumier and Reginald Marsh."

There were additional mural commissions in the '60s—for the Carlton Tower Hotel, London, in 1960, and the St. Regis Hotel, New York City, in 1965. One of Topolski's most interesting assignments was the series of 20 portraits of contemporary English writers he executed for the University of Texas, Austin, in 1961–62.

A major exhibition of Topolski's drawings, including original sketches and enlarged reproductions, was held at the Hallmark Gallery, New York City, in 1965. Also shown were his wartime sketches and a group of portraits of such notables as Shaw, Nehru, and President Kennedy. Topolski attended the exhibition and, interested in current fashions, he made the scene at such trendy Manhattan nightclubs as Ondine's and Arthur's.

The "swinging '60s" brought colorful fashions before Topolski's observant eye and skillful pen and brush, but he recorded the decade's convulsive events as well. A world traveler, he arrived at locales when the action was hottest. He "just happened to be in West Berlin the day they closed the gate," and he witnessed the police riot at the 1968 Democratic Convention in Chicago. Although he feels that he is "always an observer and never a participant," Topolski instinctively sympathized with the counterculture in the '60s and struck lasting friendships with youthful dissidents—especially hippies and "flower children"—of that decade.

Topolski has published books—all copiously illustrated with his sketches—on a wide range of subjects. His *Shem, Ham and Japheth Inc.* (1971), a book about the multiethnic composition of America, was published in the US under the title *The American Chronicle. Paris Lost* (1973) was a nostalgic volume consisting of very appealing sketches of Paris that the young Topolski had made in the '30s. A handsome book with color illustrations, *Buckingham Palace Panoramas,* appeared in 1977, the year of Queen Elizabeth II's Silver Jubilee, with a foreword by Prince Philip. Topolski has been the subject of numerous films, including *Topolski's Moscow,* which was produced for the CBS television network in 1969, *Topolski,* which was aired on Polish television in 1976, and *South American Sketchbook,* which premièred on the BBC in 1982.

In 1944, before his wartime visit to Russia, Topolski had married Marion Everall, a former actress. They had two children—Daniel and Teresa—but the marriage was dissolved in 1975, the year Topolski married Caryl J. Stanley.

Topolski's studio is in a most unusual location—an arch under the railway bridge connecting Waterloo and Charing Cross Stations, directly opposite the artists' entrance to the Royal Festival Hall on the South Bank of the Thames. "It is slightly damp," the artist said, "and occasionally the rumble of trains passing overhead is mildly disconcerting, but to someone who has lived through the blitz it is a pleasure to hear minor civilized noises." In addition to this vast working space, which has a skylight, Topolski has the use of other rooms in the adjoining arches, but in these he must depend on artificial light. In 1977 he was completing an ambitious project requiring all available space: an immense 60-by-12-by-20-foot mural-environment entitled *Memoir of the Century,* commissioned in 1976 by the Greater London Council for the South Bank Art Center.

Feliks Topolski is an amiable, gregarious man of medium height, with brown eyes and gray hair. He is trim and has a dapper appearance, even when wearing the black turtleneck sweater and paint-spattered trousers which are his working costume. The walls of his studio are covered with enormous sheets of paper or canvas, on which, in 1977, were over-life-size figures of archetypal '60s hippies, painted in a bold, flowing, diffuse, almost expressionistic style. The tables are piled high with papers, books, sketches, and old copies of the *Chronicle.* For Topolski, the studio is his creative center, his workshop—"back to the Old Masters," as he has said—and he has no London gallery. His studio was an arena for "happenings" in the '60s and an art-world meeting place, it is still the scene of a constant ebb and flow of people. The very reverse of an unworldly artistic recluse, Topolski, a cosmopolite whose virtuoso draftsmanship has

captured so many aspects of the contemporary scene, likes to feel at all times "in the midst of life."

EXHIBITIONS INCLUDE: "Feliks Topolski's Chronicles," West End Gal., Washington D.C. 1960; Hallmark Gal., NYC 1965. Institute of Contemporary Art, London, 1980.

COLLECTIONS INCLUDE: British Mus., Victoria and Albert Mus., Imperial War Mus., and Tate Gal., London; Gals. in Edinburgh, Glasgow, Aberdeen, Nottingham, Brooklyn, Toronto, Tel Aviv, New Delhi, Melbourne, Lisbon, Warsaw.

ABOUT: Topolski, F. The London Spectacle, 1935, Britain in Peace and War, 1941, Russia in War, 1942, Three Continents, 1944, Portrait of G.B.S., 1946, and others, Holy China, 1968. *Periodicals*—Art or Artists, (London) August 1980; Art News (NY) November 1980; Guardian August 11, 1975; New York Herald Tribune May 3, 1965; New York Times May 25, 1959; New Yorker April 21, 1965; Washington Post and Times-Herald November 6, 1960; New York World-Telegram October 28, 1965.

TOYOFUKU, TOMONORI (February 18, 1925–), Japanese sculptor, writes: "I was born in Kurume, a country town in southwest Japan. My father was a small landowner, but, when I was a child, I was mainly under the influence of my mother. She was, and still is, a woman of genius, interested in a large range of arts—painting, singing, traditional theater, and architecture—but the care of the children, and we were six brothers, did not give her the possibility of getting a deeper knowledge of any art.

"My studies at Kokugakuin University, Tokyo, were devoted to Japanese classical literature, as I wanted to know the culture of my land. But after the tragic war which involved Japan and pulled down all traditional values my interest collapsed, so I turned to sculpture, as a more reliable and lasting value which would not betray me. My master was, and still is, an artist, faithful to traditional wood sculpture. From him I learned how to handle this noble and difficult material. My master's studio was not large, so I could not live and work with him, as I wished to do according to traditional custom. I found lodging in a Zen temple, near the studio, in the middle of a green wood. I spent seven years in the rarefied ambience of the temple, absorbing—but without realizing the fact—the ascetic atmosphere of Zen. I opened my first studio in Tokyo in 1952, when I was 27 years old. I soon took part in the artistic currents of the time, and started to exhibit my works and to receive some recognition. In 1960 I participated in the Venice Bien-

TOMONORI TOYOFUKU

nale as a representative of Japan. This was an occasion for my first journey to the West. I had a return ticket and luggage. Europe seemed to me more interesting than I had expected. I forgot my return ticket and answered the numerous invitations which came to me. The three large sculptures I exhibited in Venice were bought immediately, one by the Museum of Modern Art, New York City, another by Peggy Guggenheim, and the third by a private Italian collector. This unexpected amount of money opened the way to new experiences. I accepted the invitation of a Milan gallery a for a one-man show, and eventually I settled in Milan.

"At the beginning the artistic stimuli of Italy so strongly affected my art and my personality that I was on the point of giving up my original culture and adopting a new one. But within a few years I realized that it was impossible to give up a culture and take a new one. From a distance, the principles of Japanese culture became brighter and brighter to me, and at the same time I could also judge Western culture objectively, from the outside. Living in Italy eventually made me appreciate Japanese values more than if I had stayed in Japan.

"At the end of the '70s I was appointed a lecturer in a Japanese university. It was an occasion for me to renew the contact with my country after 20 years of absence. Also, this new meeting with my roots succeeded in showing me the importance of Western culture. The two cultures I share become more and more clear to me, owing to the opportunity I have of comparing them."

Toyofuku's native Kurume is a cultural center of southwestern Japan, famous for its woven fabrics and ceramics. In 1943, during World War II, with Japan cut off from outside contacts, Toyofuku was studying ancient Japanese literature at Kokugakuin University. Realizing that he must share the fate of his generation, he joined the Air Force. Fortunately, by the time young Toyofuku would have been assigned to the special kamikaze corps the war was almost over and there were no longer any planes or fuel.

The defeat of Japan brought about in Toyofuku, as in many other young Japanese, a combined sense of exhaustion and liberation. He decided to devote himself completely to sculpture, because "he was attracted by the solidity and credibility of simple material," to quote Ichiro Haryu. From 1946 to '48 he was a pupil of Chodo Tominaga, a wood sculptor in the classical tradition. Toyofuku was more impressed by his teacher's consummate craftsmanship than by the elderly sculptor's own work. The rigorous training he received from Tominaga included a method for sharpening chisels and learning to discern different types of wood simply through touch. Once he had mastered technique, Toyofuku felt free to absorb the influence of Western sculptors such as Aristide Maillol, Wilhelm Lehmbruck, Henry Moore, and Marino Marini.

In 1950, in a group show organized by the Japanese art group Shinseisaku-Kyokai (Association of New Painters), Toyofuku exhibited his work for the first time. In 1957 he became an active member of the group. At this time he was working on a series of sculptures in wood, using a motif based on Han dynasty figures of ladies and gentlemen found in Chinese tombs. He placed his figures in boats, emphasizing the horizontals and verticals. Other works, notably *Displaced Persons* and *Castaways*, reflected the melancholia of a defeated country. These sculptures were regarded by critics, and by the artist himself, as overly traditional. He gradually simplified his figures and made them more abstract, eliminating clothing and facial expressions. Haryu described these later works as "masses characterized by concavities mounted on horizontal bars." In 1959 this new series earned Toyofuku the Takamura Kotaro Prize as the most distinguished sculptor of the year. Three large Toyofuku sculptures were exhibited at the Venice Biennale of 1960; that same year his first solo show was held at the Tokyo Gallery.

In 1960, after traveling in Europe, Toyofuku settled in Milan. After arranging for a 1961 exhibition at the Grattacielo Gallery, Milan, he discovered that the fulcrum of his sculptures resided in the tense space between the holes and cavities of the wood. This brought about in his work a renewed emphasis on the two-dimensionality of the flat plane. Toyofuku was encouraged in this direction by Lucio Fontana and other Milanese artists, who also had been tackling, in various ways, the problem of limited space and the aggregation of simple units arranged in a regular sequence.

In the sculpture Toyofuku produced after 1960 the problem of negative space was resolved. He chiseled oval-shaped holes in the surface of simple slabs of woods; then, from the opposite side, he bored corresponding holes. Consequently, the sense of volume was, as Haryu pointed out, "realized negatively." The traces of the chisel remained on the surface and the skeletal structure was laid bare. In Haryu's words, " . . . The artist experiments with a sense of space that is based on concepts of life and death, existence and non-existence, that are fused into a unique totality."

Toyofuku's variations of this format were numerous. Sometimes he bored holes in joined vertical slabs to form screens, whereas other pieces were hollowed-out tree trunks in which openings cut from the surface produced a visual transparency. An example of the latter is *Sui (4 Elements)* (1964; Albright-Knox Gallery, Buffalo, New York), in wood on a metal base. Some of Toyofuku's hollow columns were made to be hung from the ceiling. The series of holes bored into the thin columnar compositions were often linked together, creating a mysterious "ant-eaten" effect. Although wood remained Toyofuku's favorite medium, he began to cast some of his pieces in bronze and to fashion a group of works in plastic whose series of holes were arranged in a line and mounted on a horseshoe-shaped base. In his works in metal and plastic the forms were simplified even more drastically than in the wood sculptures. Further exploring the possibilities of his plastic idiom, Toyofuku experimented with kinetic sculpture and made mobiles.

In 1961, together with the Japanese architect Ichiro Kawahara, Toyofuku participated in the international "Art and Architecture" exhibition in Copenhagen and was awarded third prize. His work was seen in a solo show at the Drian Gallery, London, and in 1962–63 he had solo exhibitions in Milan, Venice, and the George Lester Gallery, Rome. He showed at the Venice Biennale of 1964 and his work was included in the 1964 Carnegie International, Pittsburgh, where he won the Frew Memorial Prize. John Canaday, reviewing the Carnegie International exhibition in *The New York Times* (November 1, 1964), commented that Toyofuku's untitled abstract sculpture "might be an altar-screen for some unknown religion."

By the second half of the decade Toyofuku was internationally renowned, and in 1966 he received a commission for a monumental sculpture for a new concert hall in Rotterdam. Three years later he was commissioned to execute a monumental sculpture for the Kurume Citizens Hall.

Whereas European commentators tended to define Toyofuku's work as oriental, the Japanese called his sculpture international. According to Haryu, both are facile characterizations. Toyofuku's work was a fusion: the shapes he created show that he had abandoned all that was dead in his native tradition; yet, precisely because he was away from Japan, he retained a deep sense of the traditions he had learned in Japan before 1960.

At the time of the 1964 Venice Biennale Toyofuku remarked, "I have no intention of following new movements and, for the moment, I have nothing in mind other than continuing my present work." By the mid-1970s his sculptures were to be found in major museums in Europe, the US, and Japan, and in important international private collections.

Tomonori Toyofuku is married and has a daughter. A quiet, modest man, he lives and works in his adopted city of Milan, where his large studio, consisting of several rooms, is on the ground floor of an old building. He visits Japan at least twice a year and teaches there for months at a time. In 1979 he was appointed visiting professor at the Kyushu Sangyo University, Fukuoka, Japan.

Toyofuku thinks through problems of modern aesthetics by reflecting on the origins of the ancient plastic tradition in which he was trained. He collects ancient Japanese calligraphy and antique swords, and also practices fencing in his spare time. His work aspires "to a synthesis of the artistic traditions of East and West," as Haryu put it.

EXHIBITIONS INCLUDE: Tokyo Gal., 1960, '74; Grattacielo Gal., Milan 1961, '62; Drian Gal., London 1961; Cavallino Gal., Venice 1962; Naviglio Gal., Milan 1963, '66, '68, '71, '73, '74, '80; George Lester Gal., Rome 1963; Gal. Alice Pauli, Lausanne 1966, '73; Domenicani Gal., Bolzano, Italy 1973; Kitakyushu Municipal Mus. Kitakyushu 1978. GROUP EXHIBITIONS INCLUDE: Shinseisaku-Kyokai (Association of New Painters), Tokyo 1950; Venice Biennale 1960, '64; "Art and Architecture," Copenhagen 1961; International Sculpture Exhibition, Grattacielo Gal., Milan 1961; Carnegie International, Pittsburgh 1964, '67; São Paulo Bienal 1965; "Modern Art of Japan," Venice 1966; Tokyo Nat. Biennial 1968; "Prospect Exhibition," Kunsthalle, Düsseldorf 1968; "Japanese Artists in Europe," Nat. Mus. of Modern Art, Kyoto, Japan 1972; Nat. Mus. of Modern Art, Tokyo 1972; Biennial Exhi-

bition of International Sculpture, Carrara, Italy 1973; "Japanese Artists in Italy," Rome 1979.

COLLECTIONS INCLUDE: Nat. Mus. of Modern Art, Tokyo; Nat. Mus. of Modern Art, Kyoto, Japan; Hakone Open Air Mus., Hakone, Japan; Mus. of Contemporary Art, Nagaoka, Japan; Gal. d'Arte Moderna, Rome; Peggy Guggenheim Foundation, Venice; Mus. Civico, Padua, Italy; Mus. of Modern Art, Lausanne; Mus. of Modern Art, Helsinki, Finland; MOMA, NYC; Albright-Knox Art Gal., Buffalo, N.Y.; Mus. of Art, Carnegie Inst., Pittsburgh; Hirshhorn Mus. and Sculpture Garden, Washington, D.C.; George B. Lester Collection, Woodbridge, Conn.

ABOUT: Haryu, I. Tomonor; Toyofuku, 1974; Kaisserlian, G. I Ritmi Plastici di Toyofuku, 1962. *Periodicals*—Gazette des Beaux-Arts (Paris) April 1979; New York Times November 1, 1964.

***TROVA, ERNEST (TINO)** (February 19, 1927–), American sculptor and printmaker, is best known for his obsessively reiterated male figures in gleaming metal. In its many variations, Trova's "Study/Falling Man" series, which he developed in painting, sculpture, and graphics from 1961 to 1972 (largely in isolation from the art mainstreams in New York City, the West Coast, and Europe), attests to the artist's horror of and fascination with—even acceptance of—endemic spiritual anonymity and the intrusions of machines, both external and prosthetic, on human flesh. Like the best science fiction, these figures prepare us for what we may look like and be in some chilling technological future.

Ernest Trova was born in St. Louis, Missouri, where he has lived and worked most of his life. His father, Tino, was a tool designer. Trova never attended art school, but on his own began to paint, starting with watercolors and later moving to casein latex, lacquer, and oil. "Every kid draws but I became serious when I was about seventeen," he said. "Art study had nothing to do with it. I haven't studied, and I don't think it's even necessary today. To paint a picture you don't have to have anybody tell you what to do." In 1947, shortly after he began working as a decorator in a local department store, Trova exhibited his painting *Roman Boy* (1947) in the City Art Museum's St. Louis Annual (it was later reproduced as a full-page illustration in *Life*). *Roman Boy* is *art brut* in the manner of Jean Dubuffet, but by the time of *Abstraction* (1948), a colorful study rather like a well-laden table seen through bubbled glass, Trova had also absorbed the influence of Jackson Pollock and Mark Tobey, who had developed the technique of "all-over" composition. At this time he began

working in mixed media and made his first, co-lumnar, sculptures. In 1949 Trova met the poet Ezra Pound, then interned in St. Elizabeth's Hospital in Washington, D.C.; probably due to Pound's inspiration he spent much of the early 1950s writing poetry and editing the magazine *Mood*. He continued to paint intermittently while serving in the US Army (Special Services) at Ft. Benning, Georgia.

Willem de Kooning's "Women" of the early 1950s were the next important influences on Trova. His *Figure with Hat* (1953) and *Mother and Child* (1954) have de Kooning's unmistakable frontality and much of his seeming formlessness, but even at this stage are more volumetric and sculptural. More important, de Kooning's return to the figure against the tide of nonobjectivism reaffirmed Trova's own interest in the human body. An amateur jazz musician (he had started a band in the army), Trova also began to incorporate elements of performance into his art. "Trova Paints To Jazz Watch It Happen" ran one of the advertisements for his act at St. Louis's Crystal Palace in 1960. Other jazz and pop performers appeared in his paintings, as in *Ray Charles Brown* (1958, after the blues singers Ray Charles and Ray Brown).

By the late 1950s there could be discerned, under Trova's various experiments with style and medium, a logical development toward the "Study/Falling Man" series. His casein paintings of 1958, *Shaft #1* and *Shaft/Falling* (Trova was already carefully distinguishing and numbering his work in series) portrayed horrified, wormlike beings, on blank red or blue grounds, that obviously prefigure the later series; the figure in *Shaft #1* even has the same vertebral curve that characterizes the Falling Men. The "Shaft" paintings and others were exhibited in Trova's first solo show, at the Image Gallery, St. Louis. Shortly after, he began plundering good-will stores for found objects to use in a series of bizarre, Kienholzian tableaux—*Man in Chair, US Room*, and *Figure on Rack* (all 1961)—which reveal an obsession with prosthetic limbs and other medical technologies. Many of the Falling Men are also in complex assemblages/environments of found objects, in this case small mechanical or plastic parts.

Study/Falling Man Triptych (1961), one of a series, marks Trova's first conscious development of the theme that would occupy him for the next decade. Unlike his Bacon-like earlier paintings, with their air of squeamish horror, or his cluttered assemblages, this triptych was painted in a new, hard-edged style. The figure, armless, sexless, and bloated (as are all the Falling Men), seems robotic in its essential nature

(although Trova himself denies this) and is constructed from various imperfectly fitted parts. (This may reflect the artist's close familiarity with the construction of department-store mannequins; he was supporting himself as a commercial window display designer.) For the next three years Trova multiplied his Falling Men, now seamless and exclusively erect, or, at least, unbent, in dozens of combinations and patterns on canvas and in silkscreen. "The image of the figure in my works," the artist explained, "is fundamentally a *graphic symbol* of the 'individual' (I have a unique, particular individual in mind) whose posture is neutrally serene. . . . Personally, philosophically, the Falling Man accepts and meets his environment with rational detachment and anti-hysteria. . . . As man moves from one position to the next in an eventual fall to inevitable oblivion, what becomes most important to man (the Falling Man) is the *journey*, not the destination we have come to expect—death."

To most critics, however, the cyborglike Falling Man sculptures, begun in 1964, seemed already the death-in-life of technological dehumanization. After a number of important solo shows in Boston, New York City, and London in 1963–64, Trova, now probably the best-known artist in St. Louis, was offered the complete use of the design facilities of the Famous-Barr department store to create a new series of works for the city's bicentennial. Out of this collaboration came images of Falling Men merged with vehicles and cast in polished brass or chrome-plated bronze: *Falling Man/Study (Car Kit)* (1964), *Falling Man/Study (Wheelman)* (1965), and *Falling Man/Study (Carman)* (1966). A later permutation put the Falling Men, more burdened (or integrated) with mechanical prostheses than ever, in gleaming metallic landscapes or plexiglass gadget boxes: *Falling Man/ Study (Venice Landscape)* (1965–66), *Falling Man/Study (Two-Story Plexi-Box)* (1966), and *Falling Man/Study (U Landscape #56)* (1968) are examples. "Trova's groups of Falling Men, subtitled landscapes, accentuate the absence of human qualities, the object state of the noncommunicating figures," wrote Wayne Andersen in *American Sculpture in Process: 1930/1970*. " . . The human forms themselves are presented as objects, and the observer is brought into contact with them just as he is confronted by manufactured objects in his home, or objectified human situations in advertising and other forms of mass media."

Trova pursued the Falling Man theme through dozens of variations in cast bronze, silkscreen, and intaglio. The high level of craftsmanship sustained throughout the series, the artist's considerable ingenuity in spinning out

what would seem to be a limited idea over such a long period, and his canny use of sculptural multiples and large print runs kept his work popular and affordable for smaller institutions and collectors. Nonetheless, by 1972 Trova was ready to make a radical departure from his previous work. He did so in a surprising direction in the "Profile Cantos" (1972–76), monumental constructions in painted or rusted Cor-Ten steel plate. Although the "Cantos" resemble a host of similar works of the period by such artists as Anthony Caro, Tony Smith, Ellsworth Kelly, and even Alexander Calder (except for the tell-tale Falling Man profile half-hidden somewhere on the Canto, a vestigial reminder of Trova's past interests), the critic Udo Kultermann claims that they are fundamentally different, in reality "a synthesis of space interrelations and a complex adaptation of the Falling Man theme . . . the relationship of figure and the environment, of man and the world is incorporated into the image." Trova soon dropped any representational references in his "Abstract Variations" (begun in 1973), the flattened, relieflike "Gox" series (also begun in 1973), and the "Geometric Abstractions" (begun about 1976). Always prolific, the artist developed these works with the same thoroughness as the Falling Man series. In the late 1970s Trova returned to the figure in a different vein in his "Poet" and "Table" series. *3 Walking Poets (Women)* (1975), graceful silhouettes in pitted Cor-Ten, is unlike earlier Trova sculptures: it is gentle, evocative, and unmechanical. Perhaps, after nearly two decades of devotion to the male figure, Trova has found a new set of values to express through the female figure. Nonetheless, his major concern remains, as he wrote in 1972, "with the human figure . . . man as I see him . . . in his environment."

The artist, who wears the horn-rimmed glasses and neat mustache of a small-town store-owner of the 1950s, married Carla Clingman Rand in 1960. They have a son, Tino, and two daughters, Carla and Tristan. Trova's large brick studio in St. Louis is meticulously organized and crowded with scores of cast and welded studies for as yet undeveloped series. Another part of his studio houses his extensive collection of Americana and Disneyana. (According to Kultermann, Trova considers Walt Disney "the greatest artist of the surrealist period.") Trova is also a top-ranked badminton player.

EXHIBITIONS INCLUDE: Image Gal. St. Louis, Mo. 1959, '61; H. Balaban Carp Gal., St. Louis, Mo. 1963; Pace Gal., Boston 1963, '65; Pace Gal., NYC from 1963; Famous-Barr Co., St. Louis, Mo. 1964; Hanover Gal., London 1964, '66, '70; Pace Gal., Columbus, Ohio 1965, '70, '75; Hayden Gal., Massachusetts Inst. of Technology, Cambridge 1967; Gal. Gimpel-Hanover, Zürich 1970; Israel Mus., Jerusalem 1971; Gal. Charles Kriwin, Brussels 1972; Phoenix Mus. of Art, Ariz. 1974; Oklahoma Arts Center, Oklahoma City 1978. GROUP EXHIBITIONS INCLUDE: St. Louis Annual, City Art Mus. 1947–61; "Pop Art, U.S.A.," Mus. of Art, Oakland, Calif. 1963; American Exhibition, Art Inst. of Chicago 1964; "Word as Image," Solomon R. Guggenheim Mus., NYC 1966; "Art in the United States 1670–1966," Whitney Mus. of Am. Art, NYC 1966; "Eight Sculptors: The Ambiguous Image," Walker Art Center, Minneapolis 1966; Annual, Whitney Mus. of Am. Art, NYC 1966, '68; "Dada, Surrealism, and their Heritage," MOMA, NYC 1967; Documenta 4, Kassel, W. Ger. 1968; "Human Concern/ Personal Torment," Whitney Mus. of Am. Art, NYC 1969; "American Art Since 1960," Princeton Univ. Art Mus., N.J. 1970; "The Explosive Decade," Univ. of Wisconsin, Milwaukee School of Fine Arts 1973; "Sculpture in the Park," Van Saun Park, Paramus, N.J. 1974.

COLLECTIONS INCLUDE: MOMA, Whitney Mus. of Am. Art, and Solomon R. Guggenheim Mus., NYC; Aldrich Mus., Ridgefield, Conn.; Wadsworth Atheneum, Hartford, Conn.; Hirshhorn Mus. and Sculpture Garden, Washington D.C.; City Art Mus., St. Louis, Mo.; Worcester Art Mus., Mass.,; Nelson Art Gal., Atkins Mus. of Fine Arts, Kansas City, Mo.; Springfield Art Mus., Mo.; Des Moines Art Center, Iowa; Walker Art Center, Minneapolis; Indiana Univ. Art Mus., Bloomington; Phoenix Mus. of Art, Ariz.; Tate Gal., London.

ABOUT: Andersen, W. American Sculpture in Process: 1930/1970, 1975; Burnham, J. Beyond Modern Sculpture, 1968; Kultermann, U. Trova, 1978. *Periodicals*—Art and Artists April 1966; Art Digest December 1953; Art in America November/ December 1966; Art International September 1970; Artforum Summer 1980; Arts Magazine January 1969, March 1982; Arts Review April 1964; Esquire October 1973; Studio International April 1966.

TUCKER, WILLIAM (February 28, 1935–), British sculptor, writes: "I was born in Cairo, Egypt, on 28 February 1935. My father was in the British Army and subsequently served in France, northern Europe, Egypt again, Malaya, and Germany, during and after the war years; my childhood was spent largely in boarding schools, from the age of five, and in the homes of relatives. As a child I both read and drew continuously and compulsively. I aquired a reputation among my schoolfellows for my mastery of various genres—aircraft, knights in armour, apes, racing cars, prize-fighters. However, I never seriously considered art as a calling, being a successful classical scholar whose future plainly lay in a secure and respectable profession. I left school, was conscripted in the army for the years 1953–55, then worked for a while

WILLIAM TUCKER

as a journalist in Belfast. I did little drawing, and tried rather to express, in writing a novel, short stories, and articles, a growing sense of the futility and injustice of most human existence. Then I went to Oxford University to study history, and for the first time in my life met contemporaries whose interests and aspirations resembled my own—poets like Chris Salvesen and Mike Horowitz, and painters like Elemore Morgan and Neil Shevlin. These latter were among the group of Americans on their GI Bill after the Korean War, studying at the Ruskin School of Drawing in the Ashmolean Museum. I spent many hours drawing from the figure at the Ruskin. At the same time I became deeply interested in politics and was especially influenced by the writings of Gandhi and Kropotkin.

"I was one of a very small group of undergraduates immediately shocked and disgusted by the British invasion of Egypt in 1956 and who strongly protested against it; later I was one of the editors of the notorious anti-nuclear issue of *ISIS*. My new friends at Oxford had made me aware of a world of literature, art, and ideas with which I was quite unfamiliar; conscious of my late start and previous isolation, I devoured books, pictures, plays and films with an insatiable appetite. I visited London frequently, and on one of these visits more or less by accident came across an exhibition of contemporary sculpture organized by the LCC in Holland Park. It was the first time I had ever looked hard at sculpture, and my life was changed by the experience. In some way not quite clear to me now, I knew from that moment I was going to be a sculptor. There was nothing remarkable about the exhibi-

tion: I think I was rather impressed by the evident skill and professionalism of the single Henry Moore sculpture in contrast to the crudity and obviousness of most of the other work. In any case I have made sculpture from that day to the present. At first I modeled heads and figures in clay, taking as exemplars Moore, Marini, and Manzù. Working on my own, without guidance, I reached after perhaps two years an impasse, which was eventually resolved by the discovery, in London in 1959, that sculpture did not have to be made of clay or plaster or carved from wood or stone, but could be *constructed* out of any material: this being the case, sculpture was a *thing* before it was the image of a figure. This conclusion derived from work by Picasso, Duchamp, and David Smith, but it was powerfully reinforced by the experience of the painting of Clyfford Still and *The Human Condition* by Hannah Arendt. For a second time I was fortunate to find a group of like-minded contemporaries in the sculpture department of St. Martin's School of Art, and learned much from the inspired teaching of Anthony Caro there. Released at last, I worked with tremendous enthusiasm and produced in the course of a few months a great number of sculptures in welded steel and other materials, but all abstract and most placed directly on the ground.

"In the '60s it seemed as if sculpture had come into its own at last, was no longer painting's poor relation. In Britain and North America the sculptors were at the center of everyone's attention. I was part of this phenomenon—and I was suspicious of it. Almost all the work being produced at the time, including my own, seemed to me no more than artifacts, at best varied and vigorous articulations of space. None seemed to me to have the formal range, the intellectual depth, the intensity and seriousness of purpose that could equal either the poetry, novels or drama I most admired, nor the work of the sculptors of the early modern period—Rodin, Degas, Brancusi, Matisse, Picasso, whose heirs we were, but whom I felt we had in some way betrayed. The easy acceptance and success of the sculpture of the '60s in fact came about because its approach and ambition were derived from painting. From 1968 I started to publish critical articles on early modern sculpture (later collected into book form) in an attempt to point out what I felt to be the central tradition, and the only basis on which contemporary sculpture could transcend its innate physicality. In my sculpture (which I have always considered my primary commitment) of the last few years I have similarly attempted to make series of works or, more recently, individual works of a unique identity, separate from each other and from all

other objects: structured, whole, coherent *things*, whose meaning is essentially human, rather than a simple affirmation of their own form or material or space or cultural situation."

———

William Tucker was a key member of the new generation of British sculptors who came into prominence in the mid-1960s. His work has been described as a "sculpture of ideas." Reacting against the values of the previous generation, with its reliance on the human figure and its stress on dialogue and heroic struggle with the medium, Tucker wants his sculptures to function purely as formal structures, not as icons with a dramatic or evocative presence. As was pointed out in *Art and Artists* (May 1966), Tucker is "concerned with space, the space contained within volume, space on a two-dimensional plane, and the space without."

The revolution in modern British sculpture took place at St. Martin's School of Art, London, under the tutelage of Anthony Caro. Influenced by American abstract expressionism, Caro freed sculpture from dependence on the figure with his low-lying, horizontal, totally abstract compositions. Tucker and the other young British sculptors—Phillip King, David Annesley, and Tim Scott—who took part in the important "New Generation" show at the Whitechapel Art Gallery, London, in 1965 had studied with Caro. Tucker himself joined the faculty of St Martin's School in 1962.

There are parallels in Tucker's work to the creations of American Minimalists and Color-Field painters. He rejected heavy bulk and volume to create pieces that twist and sprawl along the floor. According to Edward Lucie-Smith, "Tucker . . . has experimented with a principle of extension which also appears in some of Frank Stella's linked canvases and . . . in the various versions of Brancusi's *Endless column*." Usually in polychrome metal or plastic, Tucker's sculptures are often carried out on an architectural scale, thus taking on an environmental character. Most of his pieces of the early and mid-1960s—*Florida* (1962), or *Memphis* (1965–66; Tate Gallery, London)—were solid forms which created a sense of extension in space. In the 1970s Tucker favored open structures in steel, as in the curvilinear *Beulah* (1971) and the four angular *Cat's Cradle* pieces, also of 1971.

Tucker exhibited at the Venice Biennale of 1972 and at the Arts Council, London, the next year. In the catalog to the 1973 exhibition, Andrew Forge wrote that the *Cat's Cradle* sculptures are "at first sight withdrawn and unemphatic," but that "they yield more and more as one explores." For example, from certain angles they seem to suggest a tent structure, but this form breaks up as the spectator's line of view changes. "Space is continuous and unbroken," Forge said, "and one's own maneuvers round the sculpture become one with one's perception of it."

A student of history at Oxford, Tucker has been an influential writer on 20th-century sculpture. His most important book, *Early Modern Sculpture: Rodin, Degas, Matisse, Brancusi, Picasso, González* (1974), was praised by Albert Elsen in the *Art Journal* (Winter 1975–76) for its splendidly "lucid, terse style" and by *Choice* (October 1974) for the author's "new insights into modern sculpture." "This book started as a series of lectures, on Picasso, Brancusi, Matisse, and David Smith, given at Leeds University during my period there [1968–70] as Gregory Fellow in Sculpture," Tucker explained.

Tucker selected the works for an important Arts Council exhibition, "The Condition of Sculpture," held in 1975 at London's Hayward Gallery. In 1976 he was appointed professor of sculpture at the University of Western Ontario. He is married and has five children.

EXHIBITIONS INCLUDE: Grabowski Gal., London 1962; Rowan Gal., London 1963, '66, '73; Richard Feigen Gal., NYC 1965; Kasim Gal., London, 1967; Elkin Gal., NYC 1968; Leslie Waddington Print Gal., London 1969; Venice Biennale 1972; Waddington Gal., London 1973; Serpentine Gal. (Arts Council Show), London 1973; Gal. Wintersberger, Cologne 1976; Robert Elkon Gal., NYC 1979. GROUP EXHIBITIONS INCLUDE: "New Generation 1965," Whitechapel Art Gal., London 1965; "Primary Structures," Jewish Mus., NYC 1966; "Eight Young British Sculptors," Stedelijk Mus., Amsterdam 1966–67; "Eight Young British Sculptors," Kunsthalle, Berne 1966–67; "Eight Young British Sculptors," Kunstverein, Düsseldorf 1966–67; Documenta 4, Kassel, W. Ger. 1968; "Contemporary British Painting and Sculpture," Mus. of Modern Art, Tokyo 1970; "British Painting and Sculpture 1960–70," Nat. Gal. of Art, Washington, D.C. 1971; "The Condition of Sculpture," Hayward Gal., London 1975; "New Acquisitions," British Mus., London 1975; The Biennale of Sydney, Australia 1976.

COLLECTIONS INCLUDE: Tate Gal., Victoria and Albert Mus., Arts Council, British Council, and Contemporary Art Society, London; Leicester Education Authority, England; MOMA, NYC; Walker Art Center, Minneapolis.

ABOUT: Bénézit, E. (ed.) Nouveau dictionnaire de la sculpture moderne, 1970; Forge, A. "Sculpture 1970–73" (cat.), Arts Council, London, 1973; Lucie-Smith, E. Late Modern: The Visual Arts Since 1945,

1969; Salvesen, C. "William Tucker" (cat.), Rowan Gal., London, 1963; Tucker, W. Early Modern Sculpture: Rodin, Degas, Matisse, Brancusi, Picasso, González, 1975. *Periodicals*—Art and Artists May 1966; Art in America October 1979; Art Journal Winter 1975–76; Choice October 1974.

TURNBULL, WILLIAM (January 11, 1922–) British sculptor and painter, was one of the first European artists to work in the color-field manner. He was born in Dundee, Scotland, where his father was an engineer in the shipyards. The family had no interest in art, but Turnbull was determined from boyhood to be an artist. In the '30s Dundee was in the throes of the Great Depression, and at the age of 15, Turnbull left school to earn a living. However, he attended evening classes at art school, and in 1939 his talent for drawing earned him a position in the illustration department of D.C. Thompson, a national periodical publishing company in Dundee. Effective magazine illustration required direct visual statement; thus Turnbull was already concerned with simplification and concentration. Through colleagues at work as well as through books and magazines, he became aware of modern European art and literature.

In 1941 Turnbull, who had never traveled beyond Edinburgh, left Scotland. He joined the RAF and flew wartime pilot missions in Canada, India, and Ceylon. While on leave he visited the National Gallery in London, but modern art, even in reproduction, affected him more than the old masters. In 1946 he entered the Slade School of Art, London, but was dismayed by the academicism of the teaching and by the parochialism of the English art scene. While studying at the Slade, he visited Italy, where he realized that sculpture, when placed in streets and squares for all to see and enjoy and not set apart in a museum, could be an integral part of life.

Turnbull visited Paris in 1947 and settled there the following year, having finished at the Slade. Paris in the late '40s was still regarded as the world center for new ideas in art, having not yet been supplanted by New York, and Turnbull met Jean Hélion, Léger, Giacometti, and the quasi-legendary Tristan Tzara, who in 1916 had been a founding member of the dada movement. A visit to Brancusi in his studio made a deep impression, and he particularly admired the great sculptor's *Endless Column*. Turnbull appreciated the fact that in Paris art was regarded not as the avocation of an eccentric but as a serious and respectable profession. Unknown to him, a young American artist, Ellsworth Kelly, whose later color-field paintings were to bear

Photo by Kim Lim

WILLIAM TURNBULL

striking affinities with Turnbull's work, was staying in the same Paris hotel.

Turnbull's closest friend in Paris was the sculptor Eduardo Paolozzi, also a native of Scotland and formerly a fellow student at the Slade, one of the very few there who had shared Turnbull's advanced ideas about art. Together they visited the Musée de l'Homme, with its fine collection of primitive art, and met the most provocative painter then working in Paris, Jean Dubuffet, who was inspired by graffiti on slum walls and by the drawings of psychotics, which he called *art brut* (raw art). Turnbull and Paolozzi shared Dubuffet's interest in rough texture and primitive forms of art.

Turnbull settled permanently in London in 1950, the year he and Paolozzi had a joint exhibition of sculpture at the Hanover Gallery. Despite their similarities, it was evident that Paolozzi favored a more complex, mutiple imagery, Lohereas Turnbull has a more abstract concern with pure form. The 12 sculptures Turnbull exhibited had all been made in Paris. Except for the mobile *Hanging Sculpture,* influenced by Calder's mobiles, Turnbull's works consisted of simple line or stick forms, mostly modeled in plaster for casting in bronze, rising from a flat plane and sometimes terminating in ambiguous blobs, giving them a vaguely anthropomorphic feeling. There was a suggestion of movement in space. Turnbull spoke of his fascination with "the random movement of pin-ball machines" and of his enjoyment of billiards and other ball games. He also loved aquariums with "fish in tanks hanging in space and moving in shoals." One piece in his 1950 exhibit was entitled

Aquarium, another *Game,* and yet another *Playground (Game).* "I wanted to make sculpture that would express implication of movement (not describe it), ambiguity of content, and simplicity," Turnbull wrote. He described his aim as "the opposite of the grand manner and means of the romantics. A sort of transistorized version of creation."

Besides primitive art, a major influence on Turnbull in the early 1950s was Paul Klee, especially in the stress on overall pictorial or sculptural organization, in which no one part was allowed to dominate.

Turnbull exhibited in the British Pavilion at the Venice Biennale of 1952 along with Robert Adams, Kenneth Armitage, Reg Butler, Lynn Chadwick, Geoffrey Clark, Bernard Meadows, Henry Moore, and Paolozzi. In his catalog introduction Herbert Read correctly said that "Henry Moore is in some sense . . . the parent of them all." Read claimed that "these new images belong to the iconography of despair or defiance"—but this statement hardly applied to the works by Turnbull, which were characterized, according to Richard Morphet, by a "sense of ordinariness and simplicity in combination with a numinous silence."

Turnbull's solo show at the Hanover Gallery in 1952 was of polychromatic sculpture, motivated by traces of the original coloring still visible on ancient sculptures. Many of the pieces were animal and human figures engaged in various activities—an expression of the artist's interest in balance and movement. The show also included large polychromatic paintings of groups of walking figures.

In 1954 Turnbull began to assemble contrasting materials and patinas in a single piece, as in *Horse,* in which the roughly textured horse's "head" in bronze rests on a wooden base supported in its turn by a stone block. By the mid-1950s Turnbull's work had moved from the representation of movement to an assertion of static qualities and an emphasis on surface. Stimulated by an architectural commission, he made, in the spirit of his earlier *Playground (Game),* plaster maquettes of a relief that was to cover the immense blank wall of a London building. These uncentered spread-out reliefs, though originally designed for a vertical surface, could also act as horizontals, providing a playground or some other environment for human activity. The project was never realized.

From 1950 to '57 Turnbull's principal motif was the human head. His striking series of "Mask" reliefs of 1953 were made by pressing the thumb into soft plaster. The faces have varied and grotesque expressions, and the circular forms, with their corrugated surfaces, are like enlargements, about 10 inches high, of archaic coins, time worn and dug out of the earth. In 1953 Turnbull began to make three-dimensional, free-standing "Heads," some based on skulls. By 1957 the human features had totally merged with the lacerated surface textures of the elementary "egg" or "drum" shapes. Indeed, one piece, made in 1955, was entitled *Drumhead.* Turnbull's paintings of "Heads" in these years recall Dubuffet in their flatness and symmetry, but there was a complete absence of psychological stress. The image as a sign, the artist's activity in making it, and the viewer's response were what counted.

In Turnbull's so-called totemic period, from 1954 to '62, his sculpture consisted mainly of upright forms of roughly human height standing directly on the floor. In their emotional neutrality and detachment, these motionless figures have been called "non-humanist sculptures of the human figure." In a series of "Idols" (1955–57) the human silhouette was progressively reduced to a shape of the utmost simplicity, like modern equivalents of neolithic or Cycladic fetishes.

Unlike the "Idols," which lacked any symbolic content, a series of figures including *War Goddess* (1956), *Aphrodite* (1958), and *Agamemnon* (1962) have mythic associations and evoke the bisexual imagery of primitive totems. *War Goddess,* 63½ inches high, occupies a corner in Turnbull's Camden Hill garden; the aggressive totemlike figure is constructed of forms suggesting a breastplate, shield, and spear. *Aphrodite* consists of a rough egglike shape balanced horizontally like an Indian lingam on a tall phallic form. *Agamemnon,* with its helmetlike head, is both regal and bellicose. Other totemic sculptures were named after explorers, *Columbus* and *Magellan* (1961). These and other figures made at this time were composed of two or more elements stacked on top of one another and usually made of different materials. These combinations as well as the solid yet ambiguous character of the forms reflected Turnbull's interest in permutation. In his view, the meaning of a form changes according to the context in which it appears.

Despite his growing reputation, Turnbull had minimal sales in these years. He depended on teaching for a livelihood, and from 1952 to '61 he conducted a class in experimental design at the Central School of Arts and Crafts, London, where he taught sculpture from 1964 to '72.

In his painting Turnbull also strove for neutrality and simplicity of statement, and in 1956 these tendencies were reinforced when he saw

the exhibition of American abstract expressionist painting at the Tate Gallery, London's first exposure to the new art. To Turnbull these immense canvases represented "pure painting," and now that he was occasionally selling his work he could afford to buy larger canvases and stretchers.

Early in 1957 he painted several near-monochromatic pictures and, later that year, visited New York City for the first time. There he saw the work of all the major Abstract Expressionists except for the near-monochromatic canvases of Barnett Newman. He was less drawn to the violent action painting of de Kooning and Franz Kline than to the concentration and inwardness of Mark Rothko and Clyfford Still. Turnbull himself soon arrived at what he called "totally silent" paintings, works conceived as a coloristic whole. Turnbull's paintings of the late '50s stressed large color areas and the rectangle of the canvas. He wrote in 1960, "I'd like to be able to make one saturated field of color so that you wouldn't feel you were short of all the others."

Turnbull had been a founding member of the Independent Group operating within London's Institute of Contemporary Arts, which had sponsored the earliest pop art, but he did not go in the direction of such colleagues as Paolozzi and Richard Hamilton. Though entertained by the popular imagery of the mass media, Turnbull was never concerned with the iconography or the flamboyance of pop art. Instead he followed the Rothko wing of the New York School and worked in the manner of American Color-Field painters like Jules Olitski and Ellsworth Kelly. Turnbull's painting was often criticized for being too cerebral, but in 1961 Lawrence Alloway wrote that his "fields of color" had "a tense, poised balance, a delicacy hardened in the direction of heraldic rigor, that is wholly personal."

In the 1960s Turnbull's sculpture became increasingly spare and clean-cut, stressing what he called "the factual rather than the expressive quality of the surface." His principal material in the years 1963–68 was steel. He began once again to paint his sculptures in order to reinforce their structural cohesion. He made tubular sculptures and flat zig-zag pieces such as *Double Red*, *3/4/5*, and *Echo* in which the negative spaces were as important as the solid forms.

In 1962 Turnbull traveled for the first time to Japan, Cambodia, and Malaysia. Flying near Singapore, he was struck by the view of the jungle from the air. The uniform texture of the luxuriant growth, broken by the winding course of the river, provided a motif for his abstract paintings of 1963–65.

Turnbull's clear, laconic, elementary forms in his sculpture had certain parallels with minimal art in the United States, but his approach was more relaxed and less programmatic. He wanted to use simple anonymous forms and materials taken from the everyday world and create autonomous sculptural units which could also form part of a group and relate to the environment. In *Sextet* (1966–67) each sculpture is made of $4\frac{1}{2}$ foot lengths of 5-by-5-inch angles. The concept underlying his earlier motionless standing figures was carried to its ultimate abstract conclusion in *9 x 1* (1966). Nine identical flat rectangular uprights in steel, each $85\frac{1}{2}$ inches high and painted a rich red, are arranged in rows of three. One such group occupies a large area of Turnbull's garden in Camden Town.

Turnbull's sculptures and paintings were exhibited at the São Paulo Bienal of 1967 and toured South America. In 1967 the Arts Council sponsored a major exhibition of his work at the Tate Gallery, and in July 1976 his recent paintings and prints were shown in the two separate exhibition areas of the Waddington Galleries, London. The only trace of figuration was in the prints, such as the 1967 lithograph *Black Leaf Form*, showing the influence of Matisse's late paper cutouts. The *Observer* critic, calling the paintings "near-monochrome eyefuls," wrote that "these minimals have been done so often already (by Turnbull among others) that I wonder whether more are needed"; but Robert Kudielka, in the catalog to Turnbull's 1974 exhibit of paintings at the Galerie Muller, Stuttgart, had praised the artist's cool intelligence, his consistency, his lack of dependence on changing fashions, his rejection of theatrics, and his complete disavowal of the neoromanticism which had characterized so much English art in the 1930s and '40s.

William Turnbull is a slender, dark-haired man with a friendly, pleasant, and matter-of-fact manner. He speaks with a light Scottish accent. He was married in 1950 to the Chinese-born sculptor and printmaker Kim Lim, whom he had met in London. They have two sons and live in Camden Town in northwest London in a small house that overlooks a large common. Kim Lim, who makes abstract sculptures in plastic and other materials, has her studio in their home; his is about a ten-minute drive from the house. On the walls alongside their own works are prints by Roy Lichtenstein, Ellsworth Kelly, and other American contemporaries whom Turnbull visited in New York in the early '60s and with whom he feels a strong affinity.

EXHIBITIONS INCLUDE: Hanover Gal., London 1952; ICA, London 1957; Marlborough-Gerson Gal., NYC

1963; Art Inst., Detroit 1963; Gal. Muller, Stuttgart, W. Ger. 1965, '74; Pavilion Gal., Balboa, Calif. 1966; São Paulo Bienal 1967; Waddington Gals., London, 1967, '76, '81; Tate Gal., London 1967, '73; Hayward Gal., London 1968; Scottish Arts Council Gal., Edinburgh 1974; Theo Waddington & Co. Inc., NYC, 1981–82. GROUP EXHIBITIONS INCLUDE: Hanover Gal., London 1950; Venice Biennale 1952; Carnegie International, Pittsburgh 1958; Situation Exhibition, R.B.A. Gals., London 1960; "Sculpture from the Hirshhorn Collection," Solomon R. Guggenheim Mus., NYC 1962; "New Shapes and Forms of Colour," Stedelijk Mus., Amsterdam 1966; Guggenheim International, NYC 1967; Documenta 4, Kassel, W. Ger. 1968.

COLLECTIONS INCLUDE: Tate Gal., Arts Council of Great Britain, and Victoria and Albert Mus., London; Albright-Knox Art Gal., Buffalo, N.Y.; Stadtisches Mus., Leverkusen, W. Ger.; Dundee Art Gal., Scotland; Opera House, Sydney, Australia.

JACK TWORKOV

ABOUT: Kudielka, R. "Bill Turnbull" (cat.), Gal. Muller, Stuttgart, W. Ger., 1974; Morphet, R. "William Turnbull" (cat.), Tate Gal., London, 1973; P-Orridge, G. and others (eds.) Contemporary Artists, 1977; Ritchie, A. C. "Sculpture of the Twentieth Century" (cat.), MOMA, NYC, 1952; Sylvester, D. "Eduardo Paolozzi and William Turnbull" (cat.), Hanover Gal., London, 1950. *Periodicals*—Architectural Design May 1967; Art in America March–April 1966; Art International (Lugano) vol. 5, no. 1 1961, September 1974; Art News and Review August 13, 1960; Gazette (London) no. 1 1961; Guardian March 25, 1970; Living Arts (London) no. 1 1963; Studio International (London) November 1968, July–August 1973.

TWORKOV, JACK (August 15, 1900– September 4, 1982), American painter, wrote: "I came to New York in 1913, a year or so before World War I. I was born in Biala, Poland. Neither my father nor mother were natives of that town. My father had a fairly affluent tailor shop that made uniforms for the officers of a Russian regiment. He moved with the regiment from Russia to Poland, which at that time was ruled by Russia. He was a widower with five children, the oldest of whom was already nearly 20 years old when I was born. After he settled in Biala he married a childless divorced woman from a neighboring village. My sister Janice (also a painter; she uses Biala as her painting name and is married to the painter Daniel Brustlein; they live and work in Paris) and myself were the children of this marriage.

"It was a frustrating marriage. My mother never quite forgot the man she loved but divorced after ten years of marriage because he could not give her a child. My father was to find his second wife a rather unhappy woman whose main role in the household was to shield her children from my father's brood. In return the hostility to their stepmother made our house a precarious place for me.

"My father was an affectionate person with much lust for life. I sought to escape my mother's care-sodden concern by turning my childhood love on him.

"Nevertheless, I remember my childhood as alienated within my home. My grandparents on both sides and their extensive families lived in other towns and I saw them rarely. My father's shop and home was near the officer's club in a non-Jewish neighborhood. I don't remember being at ease in either the Jewish or non-Jewish sections of the town.

"But I also remember pleasures. We lived on the edge of the town. I remember walks with my father in the woods and meadows around the town; swimming on sunny mornings in a clear placid pond; playing with my younger sister on the grounds of an old Polish castle reached through a breach in a fence bordering our yard.

"The first years in New York I remember as the most painful in my life. Everything I loved in my childhood I missed in New York; everything that had been painful in my childhood grew to distressing proportions as my father's situation deteriorated in the new land and as I had to face a new culture and adolescence at the same time. What saved me then, as soon as I

learned English, was reading, which provided me with the transition both to the new culture and to my adolescence. In the public library, with the help of a loving and sympathetic woman librarian, a window opened on the world. I read everything within reach in English, French, and Russian literature. I read all night at times and sat out my days in school listless and drowsy. By the time I was in my early 20s, I had become an avid reader of contemporary poetry and prose: Pound, Eliot, Frost, Cummings, Moore, Dos Passos, Joyce, and Proust.

"As soon as I could, I moved out of my parents' house and found refuge in Greenwich Village. It was in the early '20s in the Village that I was to experience for the first time in my life something like a sense of community. It was also in the early '20s that I saw for the first time the paintings of Cézanne, which became an important factor that led me out of college and into art school. Although I found a community in the Village, it was a community of alienated people—runaways from every part of America.

"Yet, New York was and remains as near as possible my home ground, since I can move around in Manhattan anywhere between Chinatown and Harlem and stop and be stopped by people I know or who know me. I have many acquaintances and some friends at every level of society. I have also visited and spent extended periods of time in nearly every part of the country. Nevertheless, I have not quite overcome the feeling that I have been an alien in the world to this day.

"I married my present wife, Rachel (always called Wally), in 1935. We have two daughters, Hermine and Helen. Helen, after some searching, has turned to writing. Hermine, a painter, is married to the painter Robert Moskowitz. They have a son, Erik.

"I'm afraid I'm not the most venturesome person. I suspect the most venturesome are likely to start from the most secure home base. They court the alien. But I have known alienation all my life. It holds no romance for me. My striving is not for the far-off or far-out landscape, but for the identification and naturalization of a home ground.

"My strivings as an artist are, then, in the direction of a continuing process, in spite of my age, of self-definition and toward the comprehension of the culture around me and my relation to it."

A leading first-generation Abstract Expres-sionist, Jack Tworkov immigrated with his parents to New York City in 1913. After attending Columbia College, New York City, as an English major from 1920 to '23 and the National Academy of Design from 1923 to '25, he studied at the Art Students League in 1925–26. He remembers Guy Pene du Bois as an excellent teacher "who taught me how to tell Renoir from Cézanne." He also took courses at Queens College and Brooklyn's Pratt Institute, and was already exhibiting his paintings in New York City in the early 1930s. From 1937 to '41 he worked in the easel-painting section of the Works Progress Administration's (WPA) Federal Arts Project. Tworkov produced canvases in the then prevalent style of social realism, though he admits he "wasn't very good at it." While working for the WPA, however, he was introduced to abstract painting by younger artists experimenting with the surrealist technique of automatic drawing. "At that time," Tworkov recalled in an *Art in America* (December 1982) interview, "I was also being exposed to Freudian thinking. I was in analysis for a short period and was showing automatic sketches to my analyst. I made quite a few paintings based on automatism."

For the three years during World War II that he worked as a tool designer for an engineering firm, Tworkov painted not at all. When he returned to the canvas, he found automatistic abstraction too weighted in psychic pain and for about two years painted a series of still lifes. But Tworkov came into his own in the late 1940s, those postwar years of creative ferment in New York City. He became part of abstract expressionism's first wave, which began with Willem de Kooning's first solo show, at Manhattan's Egan Gallery in 1948. De Kooning's repudiation of conventional "good style," his uninhibited brushwork, and his "open" imagery influenced Tworkov, and from 1948 to '53 the two artists had adjoining studios in Greenwich Village. Critics have suggested that he was one of de Kooning's epigones but Tworkov's "refined lyricism," to borrow Sam Hunter's phrase, was very different from the raw, aggressive violence of de Kooning.

From 1947 on, Tworkov exhibited regularly. His first postwar show was at the Egan Gallery, where he chose, perhaps unwisely, to exhibit his still lifes. "If I had shown my abstract paintings—as Egan initially wanted—I might have been counted among the first automatic, abstract painters," Tworkov said. "Instead I [was considered] a still-life painter who slowly got back into abstract painting." In 1951 he was represented in the Ninth Street Show, which was held in a Village store front and had been orga-

nized mainly by the Painters' Club, a group founded in the late fall of 1949 by Robert Motherwell and other avant-garde New York School artists.

As in much abstract expressionist painting, landscape provided an underlying motif in many of Tworkov's canvases of the 1950s. An outstanding example is *Pink Mississippi* (1954; Rockefeller University, New York City). In *Watergame* (1955) the flamelike brushstrokes dance in a flickering diagonal movement across the picture surface, creating an image that is both restless and controlled. But Tworkov rejected the idea of a totally nonobjective painting style; however abstract the treatment, there is, as Tworkov insisted, the suggestion of "the movement of a figure in space." "Every painter has a subject whether or not there are objects in his paintings," the artist declared, as quoted in *The New York Times* (September 6, 1982).

In the 1960s Tworkov's painting "developed towards a [gestural] expression of balanced and easy rhythm," to quote Aldo Pellegrini. A 1962 series of canvases entitled "Script" was done in that mode. Early in the decade the New York art scene was changing rapidly, and Tworkov's dealer, Leo Castelli, became increasingly involved with the new pop art. The market for abstract expressionism was declining, and in 1963 Tworkov accepted the post of chairman of the art department of the Yale School of Art and Architecture. Tworkov continued to live in Manhattan, paying weekly visits to New Haven, Connecticut. He enjoyed his first few years of teaching at Yale—his students included the painter Jennifer Bartlett, the sculptor Richard Serra, and the mixed-media artist Jonathan Borofsky—but found that it took too much of his time and energy and resigned in 1969.

Tworkov's work in the late '60s bore affinities with the style known as post-painterly abstraction, in which the use of thinned paint gave the canvas a flat look. His painting *North American* (1966) is large (80 by 64 inches), but Tworkov never worked on the immense mural-sized scale of Morris Louis or Kenneth Noland.

Tworkov was known for the fiery expressionism of his canvases, but in the mid-1970s his forms became geometrical and he abandoned the spontaneous gesture for a more structured approach. The new paintings had clean-cut geometrical shapes set off by a delicate framework of thin, straight white lines, and thus could be considered hard-edge works, but they retained the subtle color relationships and sensitive textures characteristic of Tworkov. Unlike his evocatively titled canvases of the '50s and '60s, the geometric compositions were identified simply by letters and numbers, as in *Q1–75–#4*, a large oil on canvas exhibited in his show at the Nancy Hoffman Gallery, New York City, in late 1975. The Gugggenheim Museum, New York City, held a major exhibition of the new paintings in 1982.

"I have had a complete change in point of view," Tworkov said of what he called his "diagonal grid" system of painting. "I wanted to get away from the extremely subjective focus of Abstract-Expressionist painting. I am tired of the artist's agonies, whether in painting or in poetry. . . . Now I surround my paintings with a system of limits—limits on the shapes that I use and the way in which I use them. . . . Working within (this system) is for me more creative than working in a completely nihilistic way. The limits impose a kind of order, yet the range of unexpected possibilities is infinite."

Jack Tworkov died in Provincetown, Massachusetts. He and his wife Wally had spent their summers in Provincetown and the winter months in New York City. They occupied the two top floors of a loft building in the Chelsea district of Manhattan. The living quarters were the upper floor and Tworkov's studio was on the floor below.

In *The New York Times* obituary for Tworkov, Clement Greenberg eulogized the artist: "He's a painter who has always had my respect. . . . He was exceptional among the artists of his generation for his decency, his sympathy, his modesty." Tworkov often spoke of his sense of being "an alien in this world." He told *Art in America* that he had encountered anti-Semitism, and lamented that art, though it is venerated in American society, has little influence on the culture. "I am bitterly aware that my life coincides with one of the most brutal centuries in history. I'm bitterly aware how helpless art has been in affecting a true civilization. What we call civilization today is more like a terminal disease."

EXHIBITIONS INCLUDE: A. C. A Gal., NYC 1940; Egan Gal., NYC 1947–54; Baltimore Mus. of Art 1948; Stable Gal., NYC 1954–58; Walker Art Center, Minneapolis 1957; Castelli Gal., NYC 1958–65; Yale Univ. Art Gal., New Haven, Conn. 1963; Whitney Mus. of Am. Art NYC 1964; Nancy Hoffman Gal., NYC from 1973; New Gal., Cleveland 1975; Arts Club of Chicago 1975; Mulvane Art Center, Washburn Univ., Topeka, Kans. 1976; Solomon R. Guggenheim Mus., NYC 1982. GROUP EXHIBITIONS INCLUDE: Dudensing Gal., NYC ca. 1931, '35; Ninth Street Show, NYC 1951; "New American Painting," MOMA, NYC 1958; Documenta 2, Kassel, W. Ger. 1959; "Abstract Expressionists and Imagists," Guggenheim Mus., NYC 1961; "Twelve American Artists," Virginia Mus. of Art,

Richmond 1974; "Contemporary American Painters," Cleveland Mus. of Art 1974; Hirshhorn Mus. and Sculpture Garden, Washington, D.C. 1976.

COLLECTIONS INCLUDE: Metropolitan Mus. of Art, MOMA, Whitney Mus. of Am. Art, and Rockefeller Univ., NYC; Wadsworth Atheneum, Hartford, Conn.; Walker Art Center, Minneapolis.

ABOUT: Bryant, E. "Jack Tworkov" (cat.), Whitney Mus. of Am. Art, NYC, 1964; Hess, T. B. Abstract Painting, 1951; Hunter, S. Modern American Painting and Sculpture, 1959; Lucie-Smith, E. Late Modern: The Visual Arts Since 1945, 1969; Pellegrini, A. New Tendencies in Art, 1966; Rose, B. American Art Since 1900, 2d ed. 1975;Sandler, I. The New York School: The Painters and Sculptors of the Fifties, 1978; Seuphor, M. Dictionnaire de la peinture abstraite, 1957. *Periodicals*—Artforum January 1971; Art in America September–October 1973, December 1982; Art International September–October 1974; Art Journal Spring 1982; Art News November 1950, May 1953; May 1954; It Is Spring 1958, Autumn 1958, Autumn 1959, Spring 1960; Leonardo Spring 1974; New York Times September 6, 1982; Partisan Review no. 4 1974.

*UHLMANN, HANS (November 27, 1900–November 1975), German sculptor who, after training as an engineer, turned to sculpture and became one of the first Germans to work directly in metal. Sculpting primarily in wire, bar stock, and sheet metal, he produced clean, inventive abstractions. Uhlmann was one of the few important links between pre–1933 German modernism and the younger artists who emerged in Germany after 1945.

Hans Uhlmann was born in Berlin. In his teens he studied music, concentrating on the violin. He pursued engineering and metallurgical studies at the Technische Hochschule, Berlin, from 1919 to 1924, when he received his engineering diploma. He began working as a sculptor, without any formal training, in 1925. Uhlmann visited Paris in 1929 and had his first solo show at the Gallery Gurlitt, Berlin, the following year. In 1932 he made a trip to Moscow, and in 1933 he exhibited in Berlin with the progressive November group. But that was the year the Nazis seized power, and Uhlmann was condemned by the new regime for "preparation for high treason"; he was imprisoned in the Berlin-Tegel prison for two years. After his release in 1935 he was forbidden to exhibit, and was forced

to earn his living as an engineer. In 1941 he married Hildegard Rohmann; their son, Hans Joachim, was born the following year.

During the war years the sculptor clandestinely made his first constructions in metal and wire, but he did not exhibit them until 1945. After the war Uhlmann rapidly won recognition in Germany. In 1950 he was given a chair at the Academy of Fine Arts, Berlin, received the German Critics' Prize in 1954, and in the same year participated in the Venice Biennale.

In the 1930s Uhlmann had sculpted many heads, both in stone and in metal. The stone and metal heads contrast sharply in style; the former are solid masses, the latter airy drawings in space. Like the Constructivists Naum Gabo and Antoine Pevsner, Uhlmann used space as a primary element of composition. These early metal heads led directly to his mature style, but he continued to work in stone until 1949, thus following two paths at once. A series of *Groups* made in the years 1945–48 comprise the most important of his stone works. The "Groups," all of which contain two figures, started rather traditionally, then became increasingly simplified, flattened, and relief-like, as in *Weibliche Gruppe* (Female Group). A *Group* of 1948 is yet more abstract and clearly shows the influence of cubism and futurism.

Meanwhile, Uhlmann was making constructivist metal sculptures. The wire heads, abstract and angular in the late '30s, became calligraphically curvilinear in the 1940s. Works like *Girl with Apple* (1945–46), though figurative in source, are almost completely nonrepresentational. The two works of 1946 entitled *Spielende Katze* (I and II; Playing Cats) record an abstract impression of the choreography of catlike movement.

In the late '40s and early '50s Uhlmann introduced flat shapes into his metal pieces, until then constructed mostly of bar stock and wire. By 1953 he was using cut and bent sheet metal almost exclusively. That year he took part in the competition held in London for a monument to "the unknown political prisoner," a theme which, given his past experience, must have had great personal significance for him.

For several years Uhlmann continued to give evocative titles to essentially nonrepresentational works—*Plant-like Form* (1952–53), *Bird* (1953), *Winged Insect* (1954)—but began calling others simply *Steel Sculpture. Symmetrical* (1955), *Form* (1956), and *Constellation* (1956) continued his investigation of curvilinear forms.

Uhlmann completed *Suspended Sculpture,* a complex web of straight steel bars, in 1957 for the library of the University of Freiberg, one of

°ool' män, häns

the first of his many public commissions. In 1958 he made *Stand Relief* and in 1959 the poly-chromed *Steel Relief* for the university's Physics Institute. He also continued to do complex planar sculpture in three dimensions, notably the huge arrow-shaped sculpture for the front of the Berlin Opera House (1961). Other commissioned works included pieces for a primary school in Hamburg (1950) and the library of the Polytechnic School in Stuttgart (1960). "In Germany, Hans Uhlmann is the strongest figure exploiting the abstract possibilities that exist spatially between architecture and sculpture," wrote A.M. Hammacher in 1969. "He develops an almost absolute force whose violence is accentuated by the choice of reflecting materials"—usually polished nickel-steel. In 1963 he created many works around triangular or tetrahedronal motifs, such as *Pyramid Sculpture* and *Small Pyramid Sculpture.* In the late 1960s and early '70s he abandoned the triangle for vertical boxes, including *Triangular Column* (1968), *Quadrilateral Column* (1970), and *Pentagonal Column* (1971).

Hans Uhlmann died in Berlin in 1975. He was given a memorial exhibition at the Berlin Academy of Fine Arts, where he had taught for 25 years. In the catalog to the exhibit held in 1955 at the Museum of Modern Art, New York City, titled "The New Decade: 22 European Painters and Sculptors," he had written: "The meaning of constructing and forming—the act of creation, this special way of life—is to me the greatest possible freedom." Although his works, with their element of mathematical calculation, may seem cerebral, Uhlmann also stressed the importance of intuition and spontaneous creation: "Important to me are the entirely spontaneous drawings which have to be jotted down, mostly without any thought of translation into sculptural terms. I want to create sculpture in a similarly spontaneous way. . . . I make spatial sculpture, which is more than merely three-dimensional sculpture, in which matter seems to have been overcome in much the same way that a dancer, flying across the stage, appears to deny the laws of gravity, and by his apparently effortless performance makes one forget his years of training."

EXHIBITIONS INCLUDE: Gal. Gurlitt, Berlin 1930; Kamillenstrasse, Berlin-Lichtenfeld 1945, '46; Gal. Gerd Rosen, Berlin 1947; Gal. Franz, Berlin 1950; Gal. Günther Francke, Munich 1950, '61, '65; Gal. Bremer, Berlin 1951, '55; Gal. Der Spiegel, Cologne 1956; Gal. Springer, Berlin 1957, '59; Kleeman Gals., NYC 1959; Kunsthalle, Bremen, W. Ger. 1960; Gal.Schuler, Berlin

1965; Gal. Strecker, Berlin 1967; Neue Nationalgal., Berlin 1975. GROUP EXHIBITIONS INCLUDE: November Group, Berlin 1933; Venice Biennale 1954; "The New Decade: 22 European Painters and Sculptors," MOMA, NYC 1955; World's Fair, Brussels 1958; Documenta 2, Kassel, W. Ger. 1959; "Modern Sculpture from the Joseph H. Hirshhorn Collection," Solomon R. Guggenheim Mus., NYC 1962.

COLLECTIONS INCLUDE: Opera House, Berlin; Technische Hochschule, Stuttgart; Beethovenhalle, W. Ger.; Inst. of Physics, Univ. of Freiburg, W. Ger.; City of Wolfsburg, W. Ger.; City of Leverkusen, W. Ger.; Städtische Kunstsammlung, Erlangen, W. Ger.; Kunstmus., Düsseldorf; Hirshhorn Mus. and Sculpture Garden, Washington, D.C.

ABOUT: Haftmann, W."Hans Uhlmann" (cat.), Berlin Academy, 1975; Hammacher, A.M. The Evolution of Modern Sculpture, 1969; Pellegrini, A. New Art Around the World, 1966; Read, H. A Concise History of Modern Sculpture, 1964; Schaefer-Simmern, H. Sculpture in Europe Today, 1955; Ritchie, A.C. "The New Decade: 22 European Painters and Sculptors" (cat.), MOMA, NYC, 1955. *Periodicals*—Das Kunstwerk (Stuttgart) nos. 8–9 1950, June 1964, November 1975; Life May 10, 1954.

VASARELY, VICTOR (April 9, 1908–), French painter, sculptor, designer, and graphic artist, is considered to be the originator of postwar optical painting. He was born in Pecs, Hungary, to gentleman-farmer Victor Vasarely and the former Anna Csiszar. The family's privileged background proved to be of little advantage during Vasarely's childhood, when warring communist and fascist factions displaced Hungary's traditional aristocracy.

Even as a child Vasarely was fascinated by "movement in a plane." He liked to draw trains and animals in motion and to experiment with the three-dimensional effects of tracing-paper transparencies and the "micro-universe" of changing lines and networks visible in gauze bandaging. In school he was keenly interested in the Isobar maps in geography class. He filled whole notebooks with linear designs which he called "births." His eye constantly led him to escape and to dream in the cross-hatchings of old engravings.

In 1925 Vasarely graduated from the state school in Budapest, the Lycée Isabelle, and entered the university to study medicine. Two years later political upheaval forced the curtail-

Courtesy of Vasarely Center, NYC

VICTOR VASARELY

ment of classes at the university and he dropped out, never to return. Abandoning medicine for art, he entered the Poldini-Volkmann Academy of Painting, Budapest, in 1927, supporting himself by working as a bookkeeper in a ball-bearing factory. His career in graphic art began when his employer asked him to design some posters for factory products. In 1929 he quit his job to enroll at the Mühely Academy, the so-called Budapest Bauhaus, founded by Alexander Bortnyik, who had been particularly influenced during his studies at Dessau by Albers and Moholy-Nagy. Bortnyik laid special stress on advertising techniques and the mechanics of mass production. Vasarely later wrote in his journal, which he calls his "rough notes" on his artistic development, that "the famous axonometric perspective, so dear to [François] Kupka, was our daily bread in Master Bortnyik's studio in Budapest. Before this, representing a cube in transparency was conceived only by means of six lozenges, a law well known to Italian perspective." The method taught by Bortnyik "gave us a cube, but its components were indeed two perfect squares and only two lozenges. The same procedure could likewise be followed with other figures of plane geometry." Vasarely has said that it was during this period at the Budapest Bauhaus that he began to understand "the functional character of plasticity."

Vasarely had some success as a graphic artist in the advertising field, but he felt "stifled" in Budapest and moved in 1930 to Paris. There he married the artist Claire Spinner on July 25, 1931. In collaboration with his wife he designed geometric prints for a fabric manufacturer in

1931 and 1932. Later he did graphic design for printing companies in and around Paris and worked for the Agence Havas and the Editions Draeger Frères. His affluence dates from 1935, when he began doing ads for a French company that specialized in publicity for the pharmaceuticals industry.

Optical kineticism, implicit in his drawings of 1931–32, became more explicit in the axonometric-perspective drawings of checkerboards, harlequins, zebras, tigers, prisoners, Martians, and so on, that he executed between 1933 and 1938. Vasarely later observed: "The ambiguity of these drawings did not result from the *trompe-l'oeil*, due to a given perspective, but from an as yet mysterious space that appeared in the plane." He made use of antecedents of his later colorforms in *Fille- Fleur*, a work of the early 1930s which he has called "an instinctive work that reassures me I have followed one fundamental path throughout my career." The meticulously painted *Chessboard* of 1935 created an illusion of space within which the surface seems to buckle and corrugate as the widths of the wavy lines contract and swell.

In the late 1930s Vasarely also worked a great deal on sheets of cellophane which he superimposed one on another to produce an effect of depth.

In 1938 he took what he considers a "wrong" turn into futurism, attempting to portray the movement of figures through simultaneity, or sequences of positions. This detour from optical kineticism led him to a real appreciation of painting, which, as a commercial artist, he had underestimated. He also discovered, as he has said, "in certain Futuristic canvases and in Paul Klee's pen-and-ink drawings . . . analogies with my networks. . . . "

Toward the end of World War II Vasarely helped Denise René establish her Paris gallery; he has exhibited regularly at the Galerie Denise René since 1944. In the immediate postwar years Vasarely was still on what he calls the "wrong track," turning out dozens of commercially successful symbolist and abstract expressionist paintings. The pictures he exhibited in 1946, for example, were still figurative, with symbolic simplifications. "I could have gone on," he said later, "but what I had learned from the Bauhaus made me rebel."

Two experiences rescued Vasarely from his "wrong course." One was the "oceanic feeling" he experienced while vacationing in the summer of 1947 on the island of Belle-Île off the coast of Brittany. It was here that he recognized "the inner geometry of nature" and the fact that "pure form-color could represent the world." This led

in his paintings to a greater emphasis on a purified ellipsoid form, which became for him "the synthesis of a whole world, engendering in me a unitary philosophy. . . . " "The languages of the spirit," he said, "are but the supervibrations of the great physical nature."

The second crucial experience came in the summer of 1948 and took place on his annual vacation at Gordes in the Midi. "Southern towns and villages devoured by an implacable sun have revealed to me a contradictory perspective," he wrote in his notebook. "Never can the eye identify to what a given shadow or strip of wall belongs; solids and voids merge into one another, forms and backgrounds alternate. . . . Identifiable things are transmuted into abstractions, and, passing over the threshold of the Gestalt, begin their independent life." At this time he was reading Teilhard de Chardin's *The Phenomenon of Man* and numerous works on relativity, wave mechanics, cybernetics, and astrophysics.

About 1950 Vasarely moved from what he calls his "crystal period," which still contained vestiges of figuration, to his "Denfort period," named for the Denfort-Rochereau métro station in Paris, where he had meditated on the crackle designs in the station's tile wall while he waited for the train to Auteuil. He recalled the experience in his journal: "I had the impression of curious landscapes when the crackles were horizontal, of bizarre cities or phantoms when they were vertical. . . . The incubation of the plactic theme was a lengthy one, and it was only in about 1948 that I made my first Denfort drawings from memory."

In 1951 Vasarely had these small linear drawings enlarged to wall scale and exhibited them under the title "photographisms." After transparencies of the networks were projected and used as settings for a ballet, the artist realized that "the intervention of the machine made it possible to go beyond the human scale." In *Sonata-T* (1953) and other "deep kinetic" works, he translated his drawings into large plexiglass constructions, transparent screens placed at varying angles so as to create different linear patterns. Later, in the pieces he called "refractions," he added deforming glass and mirror effects to produce constantly shifting images. One of the first projects on which Vasarely collaborated with architects was a ceramic mural and aluminum relief constructed for the University of Caracas, Venezuela, in 1954. Since then he has worked on similar collaborative projects in Paris and other cities.

In 1955 the Galerie Denise René held a group exhibition that brought together for the first time the works of artists in various kinetic fields, among them Agam, Calder, Duchamp, and Tinguely. By then Vasarely had concluded that painting was a thing of the past, that the modern world required a systematic exploration of forms and colors that could be scientifically controlled and that was directed primarily at sensation free of all psychological frames of reference. In the Yellow Manifesto he wrote for the 1955 group show he invented the term "plastique cinétique"; the term op art did not come into use until 1965, when the first American exhibition devoted exclusively to that branch of kinetic art was held at the Museum of Modern Art, New York City.

It was also in 1955 that Vasarely was first represented in major museums. He was awarded the Prix de la Critique in Brussels, a Gold Medal in Milan, and the International First Prize in Caracas.

In the mid-1950s Vasarely completed what he called his "planetary folklore," an alphabet of some 30 geometric forms and about the same number of colors that can be combined in innumerable ways to create a form-color whole, or "plastic unity." He has acknowledged a debt to the vocabulary of "color-forms" created in the 1930s by the French abstractionist Auguste Herbin. Vasarely patented his system of plastic unity in 1959, when he put together collages of single elements—round, oval, square, rhomboidal, and triangular—cut from squares of particular colors and placed on squares of different colors.

Vasarely's plastic alphabet did not reach full fruition until the 1960s, when he began to integrate color into his work. *Orion MC* (1963) features a checkerboard design made up of 420 squares, some containing circles of different sizes and others with ellipses that vary in size and spatial orientation. In the words of one critic, *Orion MC* "presents a quivering screen of light intensity established by the tonal strength and juxtaposition of subtly animated areas." *Cham* (1965), creates dazzling retinal vibrations with small color forms that expand and contract against grounds of contrasting colors.

Vasarely, who acquired French nationality in 1959, received many honors and awards during the 1960s, including an International Guggenheim Award in 1964; the Grand Prize of Engraving in Ljubljana, Yugoslavia; the Grand Prize at the São Paulo Bienal of 1965; and the Grand Prize at the Biennale of Tokyo and the Grand Prize for painting at the Carnegie Institute, Pittsburgh, in 1967. He was widely recognized as the originator of op art and he had a significant influence on such artists as Bridget Riley, although his own aesthetic was still based on con-

structive geometric abstraction. Such paintings of the late 1960s, as the "Ond" and "Vega" series presented the sensation of undulating hills and bulges, now convex, now concave. *Axo-77* and other works of 1969 express both volume and movement through the backward and forward shifts of two cubes.

Since 1948 Vasarely has divided his time between his villa in Annet-sur-Marne near Paris and his summer retreat in the Provençal village of Gordes. The Vasarely Didactic Museum was inaugurated at the artist's Renaissance château at Gordes in 1970 with a retrospective exhibition of more than one thousand works. Vasarely intended Gordes to be "the first stage of a sociological foundation. We still study and debate here one of the major problems of today: the integration of the arts with society. . . ." *Vasarely,* a film by Jean-Christophe Averly, was released in 1971.

By 1970 Vasarely was a millionaire several times over. He employed teams of assistants to execute his paintings, prints, and sculpture in large multiple editions, explaining that he rejected "the old egocentric philosophy" of such artists as Picasso and Dali.

In the spring of 1976 the Vasarely Foundation was opened near Aix-en-Provence to explore the application of Vasarely's theories to urban development. The exhibits in the Foundation building, a flat-roofed, pavilionlike structure, are intended to promote the idea of a "Polychrome City," in contrast to what the artist calls "the immense and dreary suburbias developing all over the world." In a sense the foundation represents a continuation of the Bauhaus ideals that inspired the young Vasarely in Budapest.

Now in his mid-70s, Vasarely is a tall and slender man, with a stiff carriage but an animated manner and the trace of a Hungarian accent. He has two sons, André, a physician, and Jean-Pierre, a painter who uses the name Yvaral and who shares his father's interest in kinetics. He is obviously an excellent organizer and businessman, and the scope of his achievement and of his influence are unquestioned. Some critics, however, have reproached him for sacrificing all other means of expression to the "icy exploitation of visual sensations." Vasarely himself views his concepts and practice as a necessary fusion of art and life. His paintings reflect his belief that "the 'star' artist and the 'solitary genius' have had their day." His works are, in effect, triumphs of mathematics and planning, executed by other hands and machines from his coded designs. John Canaday observed in *The New York Times Magazine* (February 21, 1965) that the motto of the op art movement, and of Vasarely

in particular, might well be, "From impersonality, universality."

As Vasarely wrote in the "Yellow Manifesto": "At a time when mankind has extended its knowledge to cover both macro- and microcosmos, how can an artist get excited about the same things that made up the day-to-day world of the painters of the past . . . his home, the people he knew, his garden. . . . Henceforth art will adequately express the cosmic age of atoms and stars."

EXHIBITIONS INCLUDE: Gal. Denise René, Paris from 1944; Palais des Beaux-Arts, Brussels 1954, '60; Rose Fried Gal., NYC 1958; Brook Street Gal., London 1964, '66; Kunsthalle, Bern 1964; Sidney Janis Gal., NYC 1966, '68, '69, '72; Mus. des Arts Décoratifs, Paris 1967; Palace of Fine Arts, Budapest 1969; Vasarely Didactic Mus., Gordes, France 1970; Denise René Gal., NYC 1972; Gal. Theo, Madrid 1975. GROUP EXHIBITIONS INCLUDE: Salon des Réalités Nouvelles, Paris 1947; "Younger European Painters," Solomon R. Guggenheim Mus., NYC 1953; Documenta 1–4, Kassel, W. Ger. 1955, '59, '64, '68; Pittsburgh International, Carnegie Inst. 1955, '61, '64, '67, '70; "Le Mouvement," Stedelijk Mus., Amsterdam 1961; "Painting and Sculpture of a Decade," Tate Gal., London 1964; São Paulo Bienal 1965; "The Responsive Eye," MOMA, NYC 1965; "Formen der Farbe," Kunsthalle, Bern 1967; "Painting in France 1900–1967," Mus. Nat. d'Art Moderne, Paris 1968; Collection Etzold, Kölnischer Kunstverein, Cologne 1970.

COLLECTIONS INCLUDE: Mus. d'Art Moderne, Paris; Mus. des Beaux-Arts, Nantes, France; Mus. Cantini, Marseilles, France; Tate Gal., London; Ulster Mus., Belfast; Mus. des Beaux-Arts, Brussels; Mus. de Liège, Belgium; Stedelijk Mus., Amsterdam; Boymans-Van Beuningen Mus., Rotterdam; Gemeente Mus., the Hague; Leverkusen Mus., W. Ger.; Mus. for Kunst, Copenhagen; MOMA, Solomon R. Guggenheim Mus., Vasarely Center, Jewish Mus., and Rockefeller Foundation, NYC; Albright-Knox Art Gal., Buffalo, N.Y.; Munson-Williams-Proctor Inst., Utica, N.Y.; Yale Univ. Art Gal., New Haven, Conn.; Mus. of Art, and Carnegie Inst., Pittsburgh; Hirshhorn Mus. and Sculpture Garden, Washington, D.C.; Art Inst., Chicago; St. Louis City Art Mus., Mo.; Delgado Mus., New Orleans; Dallas Mus.; Mus. of Contemporary Art, Montreal; São Paulo Mus.; Mus. of Buenos Aires; Jerusalem Mus., Israel; Tel Aviv Mus.; Vasarely Didactic Mus., Gordes, France; Vasarely Foundation, Aix-en-Provence, France.

ABOUT: Barnett, C. Op Art, 1970; Current Biography, 1971; Dewasne, J. Vasarely, 1952; Mahn, O. Vasarely, 1970; Lucie-Smith, E. Late Modern: The Visual Arts Since 1945, 1969; "Mouvement" (cat.), Gal. Denise René, Paris, 1955; Seuphor, M. "Vasarely" (cat.), Gal. Denise René, Paris, 1955; Spies, W. Vasarely, 1969; Vasarely, V. The Notebook of Victor Vasarely, 1964, Vasarely, 1965, Vasarely II, 1970. *Periodicals*—Architectes (Paris) December 1971; Art

and Artists June 1969; Arts (Paris) June 1948, March 1963; Arts Review October 1960; Les Beaux-Arts (Brussels) nos. 907–908 1960; Graphics (Geneva) vol. 27, no. 151 1972; New York Times Magazine February 21, 1965; Nouvel observateur (Paris) March 9, 1970; L'Oeil (Paris) no. 90 1962; Quadrum 3 (Brussels) 1957; Réalités (Paris) no. 176 1965; Studio International no. 889 1969; Yale Scientific November 1965.

MARIA ELENA VIEIRA DA SILVA

*VIEIRA DA SILVA, MARIA ELENA (June 13, 1908–), Brazilian-Portuguese-French painter, perfected a uniquely lyrical abstraction based on the forms and inner structure of architecture. Born in Lisbon, Vieira da Silva was the only child of wealthy Brazilian economist and diplomat Marco Vieira da Silva. After her father's death in 1911, her mother, María Graca, and her aunt and uncle guided her toward an art career. In 1919 she began drawing lessons and three years later took up painting with Armando Lucena at the Lisbon School of Fine Arts. At the age of 15 she was already searching for a poetic, associative style. "One afternoon I was looking at an extremely vast and beautiful landscape; I projected things I had read on what I saw, memories of music, pictures; I felt that a painting had to be an amalgam of this kind." Coming to Paris with her mother in 1928, she studied sculpture at the Académie de la Grande Chaumière with Bourdelle and at the Académie Scandinave with Charles Despiau, but not seriously—"I sculpted," she said, "to become freer in my painting." Abandoning sculpture after a year, she began painting again under Léger, Friesz, Bissière, and others; she also studied engraving and etching with Stanley William Hayter at Atelier 17. In 1930 she married the older Hungarian artist Arpad Szénes. Her first solo exhibition, at the Galerie Jeanne Bucher, Paris, was held in 1933.

Under the artistic influence of Léger, Hayter (whose gestural freedom and linear style was to crop up in her Composition of 1934 and again much later in her work), and the Cubists, Vieira de Silva moved from a fairly somber figurative impressionism (as in Villa des Camélias, 1932) to pattern-crammed interiors in muted colors. Le Chambre à carreaux (1935, The Checkerboard Room) and Les Yeux (1937, The Eyes), in which the room is covered with watching eyes, are obviously surrealistic and have affinities as well with Portuguese folk art and the work of M. C. Escher and even Vermeer. Her checkerboards, diamonds, and eyes are not merely decorative but are the essential fabric of her Riemannian rooms: in Les Arlequins (1939, The Harlequins), the jesters melt into the walls, their costume patterns matching the wallpaper perfectly.

At the outbreak of World War II she moved to Rio de Janeiro, where she stayed until 1947; there her work became increasingly labyrinthine. In such paintings as Le Couloir sans limites (1942–48, The Limitless Corridor) and Enigme (1947, Enigma) it is only the ubiquitous checkerboards that make her convoluted spaces at all readable. Traces of real objects—books, chairs, even people—are all but submerged while mosaic patterns obtrude everywhere: "I want to paint what is not there as if it were there," she said. One of her few public commissions, a ceramic-tile mural in this style for Rio's Agricultural University, was completed in 1945.

By 1950, three years after she returned to Paris, linear patterns, had begun to replace the checkboards and lozenge arrays; her ostensible subjects became increasingly hard to decipher until by the mid-1950s almost no comprehensible representation remained. At the same time she vastly expanded her vision to include all forms of exterior as well as interior architecture, especially cityscapes (The Town, 1953, Golden City, 1956, and New Amsterdam I and II, 1970), as well as details of every other kind. "My desire," she wrote, "is to make pictures with many different things, with every contradiction, with the unexpected. I would like to become so agile, so sure of my movements and my voice, that nothing could escape me, neither the buoyancy of the birds, the weight of the stones, nor the gloss of metal." Her tectonic linear webs, enclosing and defining blocks of color with a surprisingly gentle and equivocal geometry, are not only the intricate inner structure—the steel skeletons—of her cities, but also their exterior plan

°vē âr´ä dä sēl vä

and the direction and pulse of urban activity itself. "There are incredible depths in her paintings," wrote John Rewald, "and impenetrable spaces, shifting planes, delicate colors, and mysterious horizons, all empty, innocent of occupants, yet vibrant with shimmering light." Vieira da Silva, who lives with her husband in a villa outside Paris, has had some two dozen solo shows, including seven retrospectives. She was made a Commander of the Order of Arts and Letters in 1962 and awarded the Grand Prix National des Arts in 1966 by the French government. She is an accomplished printmaker and spent much of the 1970s, in addition to painting, illustrating the poems of her friend René Char and completing a set of stained-glass windows for the Church of St. Jacques at Reims. Her withdrawn personality, as mysterious as her paintings, caused John Rewald to asert that "in medieval times she might have been suspected of being a sorceress." Art for her has always been in the nature of a spiritual quest: "After forty years of always looking for the same thing, I have not found it. I don't have the right to say what I am looking for. This precious thing must form one body with my painting, and become visible."

EXHIBITIONS INCLUDE: Gal. Jeanne Bucher, Paris 1933, '37, '60, '63, '67, '76, '78; Gal. U.P., Lisbon 1935; Marian Willard Gal., NYC 1947; Gal. Pierre Loeb, Paris 1949; Gal. Blanche, Stockholm 1950; Redfern Gal., London 1952, '53; Birch Gal., NYC 1953; Saidenberg Gal., NYC 1956; Gal. d'Art Moderne, Basel 1956; Gal. du Perron, Geneva, Switzerland 1957; Hanover Gal., London 1957; Kestner Gesellschaft, Hanover, W. Ger. 1958; Knoedler Gal., NYC 1961, '63, '66; Phillips Art Gal., Washington, D.C. 1961; Kunsthalle, Mannheim, W. Ger. 1962; Gal. d'Arte Moderna, Turin, Italy 1964; Mus. d'Art Moderne, Paris 1969; Gal. Artel, Geneva, Switzerland 1974; Fondation Calouste Gulbenkian, Lisbon 1977; Mus. d'Art Moderne de la Ville de Paris 1977. GROUP EXHIBITIONS INCLUDE: Venice Biennale 1950, '54; "10 Painters from Paris," Stedelijk Mus., Amsterdam 1953; Documenta 1, Kassel, W. Ger. 1954; "The New Decade," MOMA, NYC 1954; "Vieira da Silva and Germaine Richter," Stedelijk Mus., Amsterdam 1955; "50 Ans d'Art Moderne," Palais des Beaux-Arts, Brussels 1958; "Painting Today," Mus. of Fine Arts, Tel-Aviv 1960; "French Art," Moscow 1961; "Premier salon," Gal.-Pilotes, Lausanne, Switzerland 1963; "50 Collage Artists," Mus. d'Art et d'Industrie, St. Etienne, France 1964; "Malerei des 20 Jahrunderts," Kunstsammlung Nordrhein-Westfalen, Düsseldorf 1965; "Dix ans d'art Francais 1945–1955," Fondation Maeght, St. Paul de Vence, France 1966; Pittsburgh International, Carnegie Inst. 1967; "L'Art vivant 1965–66," Fondation Maeght, St. Paul de Vence, France 1968; "Rose '71," Dublin 1971; "Kunstvan de 20° Eeuw," Mus. Boymans-Van Beuningen, Rotterdam 1972; "Europalia," Les Portes de Toiles, Brussels 1975.

COLLECTIONS INCLUDE: Stedelijk Mus., Amsterdam; Mus. Nat. d' Art Moderne, Pierre Granville Collection, and Louis Franck Collection, Paris; Tate Gal., London; MOMA, and Solomon R. Guggenheim Mus., NYC.

ABOUT: Descargues, P. Vieira da Silva, 1949; Franca, J. A. Vieira da Silva, 1958; Rewald, J. Vieira da Silva: Paintings 1967–1971, 1971; Ritchie, A. C. The New Decade, 1955; Sollier, R. de Vieira da Silva, 1956; Vallier, D. Vieira da Silva, 1973; Weelen, G. Vieira da Silva, 1974. *Periodicals*—Art News January 1968; Arts Yearbook No. 3 1959; XXe siècle (Paris) June 1977.

WARHOL, ANDY (August 6, 1928[?]–), American artist and filmmaker achieved international notoriety in the early 1960s as the paragon of American pop art and since then has become a cult figure, a legendary party-goer and scene-maker, a self-made "aristocrat" of the Manhattan beau monde. He still provokes paroxysms of praise and scorn from critics who cannot decide whether he is the quintessential, if affectless, distiller of the age or an artist manqué assiduously flattering the wealthy, powerful, and celebrated. Remote, wan, and deliberately bland, Warhol has with consummate skill made himself into a modern icon, as familiar to the public as his paintings of Brillo boxes, Campell Soup cans, arrays of Marilyn Monroes, and portraits of second-rank glitterati.

Warhol has consistently mystified interviewers about his early life. "I never give my background," he typically states, "and anyhow I make it all up different every time I'm asked." According to the Leo Castelli Gallery, he was born in Philadelphia in 1930; other sources name Pittsburgh as his birthplace. His date of birth has been variously given as 1927, 1928, 1929, 1931, and 1932. According to *Time* (August 27, 1965), he was "the son of a construction worker from McKeesport, Pa., named Warhola." His mother, Julia Warhol, told Bernard Weinraub of *Esquire* (November 1966) that Andy was one of three sons born to her and her husband (also named Andy) after the couple had emigrated from Mikova, Czechoslovakia, to Pennsylvania in 1921. His brothers are Paul and John.

In the late 1930s Warhol's father went from western Pennsylvania to northern West Virginia to work in the coal mines. There he contracted a prolonged illness, attributed by his wife to poisoned water, and died in 1942. In the *Esquire* interview Julia Warhol related that, unlike her other sons, Andy as a child was especially fond of pictures, cutting them out of dimestore comic books, and also drawing his own. In 1945, the summer before he entered Pittsburgh's Carnegie Institute of Technology to study art, he earned

ANDY WARHOL

money selling fruit from a truck, and he later worked as a window decorator at the Joseph Horne department store in Pittsburgh. Thus from 1945 to 1949 he not only acquired considerable formal training at Carnegie (where one of his classmates was Philip Pearlstein, later a renowned Realist painter), but gained practical experience as a commercial artist.

Warhol arrived in New York City in 1949 and for more than ten years earned his living as an advertising artist. Indeed, he was one of Manhattan's most gifted and successful commercial artists. In 1957 he received the Art Directors' Club Medal for a giant shoe ad, one of a series for I. Miller. In an early exhibition of his more "serious" work at the Bodley Gallery, New York City, in 1959, he showed a collection of his advertising drawings. Stuart Preston in *The New York Times* (December 5, 1959) described them as "clever frivolity in excelsis."

In 1960 Warhol began to paint, and in 1961 the Fifth Avenue department store Lord and Taylor used his blow-up paintings of the *Dick Tracy* comic strip in their window display. These works, produced in 1960, were among the earliest, and in a way most painterly, examples of what was soon to become known as pop art. Unlike Lichtenstein's comic-strip paintings, which in any case issued from a rather more sardonic, analytic intelligence, the captions in the speech balloons were blurred; Warhol pointedly had no thoughts of his own to contribute. According to Warhol, he began in 1961 to make stenciled pictures of money because an art dealer had advised him to paint whatever was most important to him. By the same token, because

soup was important to him, and because, as he said, "I used to have the same soup lunch every day for twenty years," he painted cans of Campbell Soup over and over again, row after row, fascinated by repetition and monotony. The first exhibition of his soup cans was held at the Ferus Gallery, Los Angeles, in 1962; after the initial controversy they aroused, the soup-can paintings proved to be his most successful commercial items. To Warhol they were as legitimate a subject for art as the apples of Cézanne. At the time he remarked, "I paint things I always thought beautiful—things you use every day and never think about." His silk-screen soup cans have been called by *New Yorker* writer Calvin Tomkins "perhaps the final apotheosis of the readymade." Although many people at first saw this approach as a deliberate put-on, others took Warhol's emphasis on the most commonplace visual phenomena endlessly repeated to be a shrewd and sophisticated comment on the depersonalization of modern American consumer society. His early work also included giant pictures of telephones and typewriters. *100 Cans* (1962; the Albright-Knox Art Gallery, Buffalo, New York) was one of the last of his works painted entirely by hand.

The soup cans were followed in 1962 by a series of green Coca Cola bottles which were later acquired by the Whitney Museum of American Art, New York City. Warhol had now adopted the technique of photo silkscreen which, with his calculatedly loose technique, paradoxically allowed considerable scope for accident or individual variation. Despite the fact that he later called each of his studios "factories," and once said, "I want to be a machine," his pictures all retain a studiedly hand-crafted look. In late 1962 Warhol was represented in the "New Realists" exhibition at the Sidney Janis Gallery, New York City, the show that launched the pop art phenomenon and which led to Warhol's recognition as a leader of the Pop painters. Critics were baffled or put off by Warhol's enigmatic, noncommittal attitude towards his subject matter. Irving Sandler, reviewing the show, asked: "In apeing commercial art does Warhol . . . satirize its vulgarity or does he accept its values complacently?"

From 1964 Warhol was represented by Leo Castelli. Always fascinated by the idea of celebrity, and the synthetic phenomena of stardom, in 1964 he produced an enormous diptych, executed in acrylic and silkscreen enamel on canvas, titled *Marilyn Monroe's Lips* (Hishhorn Museum and Sculpture Garden, Washington, D.C.). (His first multiple Monroe picture had been painted in 1962, and he returned to the Monroe theme again in 1967 in a silkscreen on paper, *Marilyn*

Monroe.) Warhol felt that the face of Monroe, a superstar destroyed by her inability to accept the image manufactured for her, was just as much a product, just as much as selling line, as a row of green Coke bottles or reproductions of the *Mona Lisa.* As always Warhol withheld any overt comment, but pretended to act as a neutral transmitter; the series' mechanical reproduction and garish color, however, emphasized the vacuous artificiality of the Monroe mask. As John Rublowsky pointed out in *Pop Art* (1965), the picture "tells the story of a human being transformed, of a women changed into a commercial property. She has been carefully manufactured, packaged, and sold like a can of soup."

However cool and outwardly detached his attitude, Warhol's activity, in his repetitive treatment (derived from newspaper photographs) of such celebrities as Elizabeth Taylor, Elvis Presley, and Troy Donahue (1962), could be regarded as the creation of social documents. This was particularly true of his portrait of the grief-stricken Jacqueline Kennedy after the assassination of President John F. Kennedy in 1963. Certainly his sharpest insights have always been into the self-destructive nature of stardom. Other works, using the same silkscreen process, dealt with the theme of violent death, reflecting in their own way the turmoil of the 1960s. In his four panels of 1967, *Electric Chair,* in acrylic and silkscreen on canvas, Warhol illustrated the point that a gruesome picture seen over and over again loses its effect, a thesis demonstrated every day on television. It has been argued that Warhol and other Pop artists, who in their emotional neutrality eagerly embraced the processes of commercialism, have made themselves part of the problem rather than probing the "disease" on a deeper level—and it would be hard to demonstrate that Warhol has ever had constructive social criticism as a motive, even in his most "violent" phase (which he soon abandoned). He did, however, show considerable skill in exploiting some of the more curious neuroses and anomalies of our time.

By 1964 Warhol had established his first "Factory," where he and his associates could, if necessary, carry out mass production assignments. Instead of painting his own pictures, or duplicating pictures by hand, Warhol would clip photographs out of newspapers and magazines and order silkscreens made from them. Any number of prints could be run off mechanically, with minor variations. "It's so boring painting the same picture over and over again," the artist guilelessly remarked in the late 1960s.

Warhol's first venture into three-dimensional art was no less controversial than his pop paintings. While browsing through a supermarket, Warhol was impressed by the design on Brillo-soap-pads shipping cartons. He hired a carpenter to construct over one hundred wooden boxes, printing each one with a silkscreen stencil of the Brillo design. These faithful replicas of the carton were exhibited for sale (about $300 each) at Warhol's widely publicized Stable Gallery show in Manhattan in the spring of 1964. When they were scheduled to be exhibited in a Toronto gallery in the spring of 1965, the director of the National Gallery of Canada ruled that they were not "original sculpture," and that therefore the Toronto art dealer who was to mount the show would have to pay a "merchandise duty" for them to be brought into Canada.

Later in 1965 Warhol exhibited several hundred silkscreen pictures, all of the same primroselike flower but varying in size and color, at the Ileana Sonnabend Gallery in Paris. At this exhibition he described himself as a "retired artist" and announced that in the future he planned to devote most of his time to making motion pictures. Just as "manufactured" paintings were easier to produce then handmade paintings, films—at least the sort he intended to make—were easier than manufactured paintings. Since 1963 he had been making experimental movies with an 8mm (later 16mm) home camera.

By this time Warhol had become a cult figure, with an extensive if shifting circle of friends, admirers, and hangers-on. In the *New York Review of Books* Robert Hughes described his coterie as being composed of "cultural space-debris, drifting fragments from a variety of Sixties subcultures (transvestite, drug, S & M, rock Poor Little Rich, criminal, street, and all the permutations) orbiting in smeary ellipses around their unmoved mover." He was also an international celebrity, and with him, to quote Barbara Rose, "the American avant-garde might presume to have its own Salvador Dali, a sign both of its maturity and its decadence." Dali was well-known, and scorned by some, for his obsessive self-promotion, but Warhol more than matched him in this. Hughes noted that Warhol "was the first American artist to whose career publicity was truly intrinsic."

Warhol really entered the popular consciousness as the director of scandalously boring underground films which exploited amateurism and the chance happening. Among his early movies were *Eat* (1964), showing Pop artist Robert Indiana eating a mushroom; *Haircut* (1963); *Sleep* (1964), a six-hour close-up of a man sleeping; *Kiss* (1963), which had some erotic interest because it featured a prolonged embrace be-

tween artists Marisol and Harold Stevenson; and *Empire* (1964), in which Warhol pointed his camera at one facade of the Empire State Building for eight straight hours, recording, at any rate, variations in light and shadow. As Warhol remarked, "I like boring things." His approach in these five films was sufficiently novel to win him the 1964 Independent Film Award of *Film Culture* magazine. He created his own "superstars," among them the fashion model Baby Jane Holzer, who appeared in his 1964 *Wee Love of Life* and in his gory spoof of *Dracula.* Another Warhol superstar was the doomed socialite Edie Sedgwick.

Warhol's most ambitious and original movie was *The Chelsea Girls,* released in New York City in December 1966 at the Cinema Rendezvous and then uptown at the Regency Theatre. It was the first underground movie to be shown in a conventional commercial theater, although the film itself was anything but conventional. A group of Warhol's friends and assorted superstars were filmed at New York's Chelsea Hotel, well known as a haunt for serious artists and writers as well as for many on the wilder fringes of the cultural scene, as "people doing different things." Seen on a single screen it ran for about seven hours, but the film was fortunately projected on a divided screen, simultaneously showing two different hotel rooms. Its unanticipated box-office success was due, according to *Current Biography,* to its being "a series of pseudo-documentary glimpses, of voyeuristic appeal, into the lives of a group of sex deviates, dope addicts, and other exponents of social pathology." The more erotic parts were widely spaced by arid stretches of cinéma vérité, and many found the overall impact of the film numbing rather than stimulating. Some Warhol admirers compared it to a Mahler symphony, but Dan Sullivan in *The New York Times* (December 2, 1968) called the movie "half Bosch and half bosh," and Richard L. Coe in *The Washington Post* (April 27, 1967) objected to its "self-engrossed posturings." *Chelsea Girls* and many of the late films were largely the work of Paul Morrisey, who more than anyone else ran the Warhol film operation.

Among the many other Warhol movies turned out by the Factory was °°°°, also known as *Four Stars* (1966–67); its full running time was 25 hours, and it used the technique of superimposition, with three projectors focused simultaneously on one screen. *My Hustler* (1965) was about male prostitution. *Bike Boy* and *Lonesome Cowboys* of 1967 had a strongly homosexual emphasis, while *I, a Man* starred Tom Baker in amorous episodes with several women.

In June 1968 Warhol nearly joined the ranks of the doomed celebrities that so fascinated him when he was shot by Valerie Solanis, a former Factory actress turned militant feminist. (Solanis later claimed that she shot him because he had too much control over her life.) Warhol was hospitalized but recovered, and, not one to miss an opportunity, had Alice Neel paint him in 1970 posing in bare torso, scars exposed and wearing a truss. Neel also painted the transvestites Jackie Curtis and Rita Red, who had been part of Warhol's circle.

Warhol has ironically observed that "in the future *everybody* will be famous for 15 minutes," and he himself has been irresistibly drawn to the transient glitter of the pop-rock world and the synthetic glamor of the rich, the beautiful, and the successful. He opened a nightclub for the "beautiful people" called *The Exploding Plastic Inevitable* and invented the projected light show for it. Its house band, The Velvet Underground, led by Lou Reed, was a forerunner of new wave and punk rock. Warhol's fascination with the upper classes found further expression in his gossip magazine, *Andy Warhol's Interview.* It has been pointed out that Warhol's move from painter to gossip-magazine publisher was a logical development, for "Warhol's subject is society, which he manipulates in actuality as a painter manipulates his paint, . . . to create, to comment upon and to illustrate."

After the shooting, the Factory scene dissolved and so, according to Robert Hughes, did Warhol's inspiration. "It is as though, after his near death in 1968, Warhol's lines of feeling were finally cut, he could not appropriate the world in such a way that the results meant much as art, although they became a focus of ever-increasing gossip, speculation, and promotional hoo-ha." In the late '70s, Warhol produced what Nina Ffrench-frazier in *Art News* (February 1978) called "pedestrian portraits of athletes," notably Chris Evert, Jack Nicklaus, and Muhammad Ali. The paintings (six versions of each athletic superstar) were apparently produced by laying down patches of acrylic, and then overlaying the photographic silkscreen image in black. The acrylic hues were described in *Art International* (January 1978) as "sweetly garish," and the series was seen by the critic as a paean to "celebrity as a leveling force," and as "a parody of American yearnings for democratic equality."

Warhol applied the same technique to his "Torso" series, exhibited at the Ace Gallery, Venice, California, in December 1978. Instead of repeating the image within a single canvas as in the past, separate canvases were joined later-

ally to form diptychs, triptychs, and in one instance, a five-panel painting. D. S. Rubin in *Arts Magazine* (December 1978) wrote that only in the five-panel work—the image being the back of a male body seen in three-quarters view—did Warhol even approach the vigor of his earlier repetitive imagery. Although in several of the other pictures the sexual imagery was highly explicit, Rubin felt that "many of the compositions are weak . . . and exceedingly lacking in any other sort of impact." He added that in an art which, like Warhol's, is partly conceptual, "careful control and forethought" were needed, instead of reliance on intuition alone. Warhol has also done numerous portraits of entertainment and political celebrities, from Mick Jagger to the Shah of Iran, and a number of unclassifiable series—"Ten Portraits of Jews of the Twentieth Century," for example. For all his many detractors, Warhol retains a loyal core of critical supporters; as late as 1982 Hans Gerd Tuchel wrote that Warhol is "a universal artist whose works show him to be thoroughly aware of the great European traditions and who is a particular admirer of the glorious French [19th century], which inspired him to experience and to apply the immanent qualities of 'pure' *peinture*."

Andy Warhol himself takes a "couldn't care less" attitude about adverse criticism, although he clearly cares about his own publicity. He lives in Manhattan, and is constantly photographed with celebrities. Pale, blue-eyed, with longish silver-dyed hair, he is casual in dress and maintains a deliberately expressionless face. Polite and relaxed, he speaks in a soft, almost inaudible voice, often with his hands covering his mouth. He is a Roman Catholic, and according to his mother, attends Mass every Sunday. John Rublowsky described his appearance and behavior as not so much a pose as "a carefully created mask." He is no way affronted by the term "commercial artist"—having nailed, as it were, the consumer society, he has become one of the embodiments.

Frederick Schruers of the *Toronto Globe and Mail* points out that Warhol "has been damned as America's greatest charlatan and praised as its greatest visionary." However he is assessed in the future, he will always be closely associated with the pop culture of the 1960s. As Calvin Tomkins said, "No one in the history of cool has ever been cooler than Andy," and Warhol's persona, no less than his work, tells us something about the leveling of values and fear of emotional commitment in contemporary society.

EXHIBITIONS INCLUDE: Bodley Gal., NYC 1956, '57, '58, '59; Ferus Gal., Los Angeles 1962, '63, '66, '68; Stable Gal., NYC 1962, '64; Gal. Ileanna Sonnabend, Paris 1964, '65, '67; Leo Castell Gal., NYC from 1964; Inst. of Contemporary Art, Univ. of Pennsylvania, Philadelphia 1965; Inst. of Contemporary Art, Boston 1966; Gal. Rudolf Zwemmer, Cologne 1967; '68; Moderna Mus., Stockholm 1968; Rowan Gal., London 1968; Stedelijk Mus., Amsterdam 1968; Mus. of Art, Rhode Island School of Design, Providence 1969–70; Pasadena Art Mus., Calif. 1970; Gotham Book Mart, NYC 1971; Mus. d'Art Moderne, Paris 1971; Inst. of Contemporary Arts, London 1971, '78; Mayor Gal., London 1974; Baltimore Mus. of Art 1974; Ace Gal., Venice, Calif. 1978; "Andy Warhol: Portraits of the 70s," Whitney Mus. of Am. Art, NYC 1979–80; "Andy Warhol: A Print Retrospective," Castelli Graphics, NYC 1981. GROUP EXHIBITIONS INCLUDE: "Recent Drawings, U.S.A.," MOMA, NYC 1956; "New Paintings of Common Objects," Pasadena Mus. of Art, Calif. 1962; "New Realists," Sidney Janis Gal., NYC 1962; "The Popular Image," Inst. of Contemporary Arts, London 1963; "American Pop Art," Stedelijk Mus., Amsterdam 1965; "The Arena of Love," Dwan Gal., Los Angeles 1965; "The Sixties," Whitney Mus. of Am. Art, NYC 1967; Documenta 4, Kassel, W. Ger. 1968; "New York Painting and Sculpture: 1940–1970," Metropolitan Mus. of Art, NYC 1969–70; "De Giotto à Warhol," Mus. d'Art Moderne de la Ville de Paris 1970; "Andy Warhol and Jamie Wyeth," Coe Kerr Gal., NYC 1976; "Andy Warhol and LeRoy Nieman," Los Angeles Inst. of Contemporary Art 1981.

COLLECTIONS INCLUDE: MOMA, Whitney Mus. of Am. Art, and Solomon R. Guggenheim Mus., NYC; Albright-Knox Art Gal., Buffalo, N.Y.; Brandeis Univ., Waltham, Mass.; Hirshhorn Mus. and Sculpture Garden, Washington, D.C.; Walker Art Center, Minneapolis; County Mus. of Art, Los Angeles; Pasadena Mus. of Art, Calif.; Art Gal. of Ontario, Toronto; Tate Gal., London; Moderna Mus., Stockholm.

ABOUT: Amaya, M. Pop Art . . . And After, 1965; Coplans, J. Andy Warhol, 1970; Crone, R. Andy Warhol, 1970; Current Biography, 1968; Gidal, P. Andy Warhol, 1971; Lippard, L. R. Pop Art, 1966; Lucie-Smith, E. Late Modern: The Visual Arts Since 1945, 1969; Rose, B. American Art Since 1900, 2d ed. 1975; Rublowsky, J. Pop Art, 1965; Stein, J. Edie, 1982; Warhol, A. Andy Warhol's Index Book, 1967, A: A Novel, 1968, The Philosophy of Andy Warhol, 1975, From A to B and Back Again, 1975, Andy Warhol's Exposures, 1979, POPism: The Warhol Sixties, 1980; Whitney, D. (ed.) "Andy Warhol: Portraits of the 70s" (cat.), Whitney Mus. of Am. Art, NYC, 1979. *Periodicals*—Art and Artists February 1973; Art International (Lugano) January 1978; Art News November 1963, February 1968, May 1974, Feburary 1978; Artforum March 1970; Arts Magazine February 1967, December 1978; Esquire November 1966; Films and Filming (London) August 1969; Guardian June 21, 1978; House & Garden July 1983; Interview November 1973; New York Review of Books February 18, 1982; New York Times December 5, 1959, December 2, 1968; Newsweek December 7, 1964; Studio International November 1972; Time August 27, 1965; Toronto Globe and Mail November 8, 1978; Washington Post April 27, 1967.

WEBER, MAX (April 18, 1881–October 4, 1961), American painter, was the dean of the modern movement in the United States. Born in Bialystok, in western Russia, the second son of Morris Weber, an impoverished tailor, and the former Julia Getz, the boy was brought up in a deeply religious atmosphere of Russian Judaism. He drew constantly, and, as an adult, remembered childhood impressions that influenced his painting: a Hasidic religious service, the colorful Russian folk art, the Byzantine icons in Russian churches, and the solemn pageantry of religious processions.

In 1891 Weber came with his family to America, and settled in the Williamsburg section of Brooklyn. At public school he was a diligent student and made such rapid progress in learning English that he was soon able to earn pocket money by giving language lessons to other foreign-born children. In 1897 he entered Boys High School, Brooklyn, but after one year was forced to choose between learning a profession or going to work. He made up his mind to study art, and in the fall of 1898 he entered Pratt Institute, Brooklyn, preparing to become a teacher of drawing and manual training.

During his first two years at Pratt Weber became an expert cabinet maker. He also took a course in composition with Arthur Wesley Dow, one of the most progressive art teachers of his time, who had been with Gauguin at Pont-Aven and had an intimate knowledge of Japanese and Chinese art. Weber was greatly influenced by Dow's principles of design and by his emphasis on the balance of line, mass, and color, rather than on the naturalistic study of plaster casts and models, which was customary in American art schools. In 1900 Weber received his diploma from Pratt and won a scholarship for another year. He continued to study with Dow and also copied paintings by Velázquez, Corot, and other artists in New York City's Metropolitan Museum of Art.

In 1901 Weber took a position as teacher of construction drawing and manual training at a public high school in Lynchburg, Virginia. He also taught summer school at the University of Virginia, Charlottesville. After two years he was appointed head of the department of art and manual training at the Minnesota State Normal School, Duluth.

In September 1905 Weber sailed for France, and in the winter of 1905 he enrolled at the Académie Julian, Paris. His teacher was the venerable academician Jean-Paul Laurens, and Weber's life drawings in Laurens's class, though highly academic, were marked by a painterly handling of light and shade. A cut in his right

Pach Bros., NYC

MAX WEBER

hand forced him to stop drawing for several weeks, during which time he visited the Louvre , the Oriental collections in the Musée Guimet, and the African and other primitive works in the old Trocadéro.

During the summer of 1906 Weber spent two months in Spain, chiefly in Madrid, where he discovered El Greco and admired the works of Velázquez and Goya. Back in Paris during the winter of 1906–07 he attended sketch classes at the Académie de la Grande Chaumière, in Montparnasse, and at the Académie Colarossi. In both these ateliers he painted directly from models without need of academic instruction. In March 1907 he went to Italy for five months, visiting Florence, Pisa, Rome, Naples, and Venice. He filled his notebooks with sketches of museum art work, and, in addition to the great Florentine and Venetian painters, he became interested in the sculpture of Donatello, Michelangelo, and the Greek and Roman works in Rome and Naples.

He returned to Paris in 1907 and came into contact with the most advanced art circles in the city. He spent days at the Cézanne memorial exhibition held in Aix on the first anniversary of Cézanne's death. Cézanne's influence on Weber's work remained steady. He resumed his studies at the Académie Colarossi, where he met Hans Purrmann, a German student who knew Matisse. Purrmann and Weber, with the help of Gertrude Stein's sister-in-law Sarah Stein, organized a Matisse class in the fall of 1907. Matisse was a strict teacher. He discouraged his students from painting fauvist pictures like his own and insisted on the rigorous study of nature; he advo-

cated simplification of form, bold color, and a sense of the unity of the whole picture. Weber remained with Matisse for one season, from 1907 to 1908, and then resumed his studies at the Colarossi. He worked in more subdued colors than those practiced in Matisse's class, and his work was not yet radical in style. Also in 1907, Weber met Picasso and other leaders of the modern movement, including Henri Rousseau.

The young Weber and the much older Rousseau became great friends. Weber, who as a youth had sung in synagogue, gave solo performances in his fine tenor voice at musical soirées at Rousseau's studio. The program was interspersed with violin solos performed by Rousseau, who gave lessons in music as well as art to his neighbors and their children. Weber bought a few small paintings by Rousseau. By the fall of 1908 Weber's funds were running low. Rousseau gave him a farewell soirée on the eve of his departure for America in December 1908, and he accompanied him to the Gare Saint-Lazare. "As the train began to move," Weber recalled, "I heard Rousseau say with great feeling in his voice, and an admonishing finger, 'N'oubliez pas la nature, Weber.'"

Weber spent the Christmas season in London, where he visited the National Gallery, and then sailed for America, arriving in New York City not long after New Year's 1909. In September 1910 he learned of Rousseau's death.

Weber found that the modern movement in Europe was practically unknown in provincial America where the art world was dominated by academicians. In 1908, however, the small liberal group of painters known as "the Eight" had exhibited at the Macbeth Gallery, New York City, and Alfred Stieglitz had begun to exhibit modern paintings at his Photo-Secession gallery at 291 Fifth Avenue.

Weber held his first solo show in 1909 at the Julius Haas Gallery, a frame store on Madison Avenue rented for the occasion. He did not sell enough work to finance a return trip to Paris, though Arthur B. Davies, a member of "the Eight," bought two paintings. Discouraged and lonely, the proud, sensitive, financially desperate Weber found consolation in studying American Indian art at the American Museum of Natural History. In the fall of 1909 he met Alfred Stieglitz, and for part of 1910 he lived at his gallery "291" and helped hang exhibitions. In March of that year he was included in "Younger American Moderns," an exhibit attacked by one conventional critic as "an insult to the public." Weber was the first in America to praise Henri Rousseau, and in November 1910, shortly after Rousseau's death, he arranged a small exhibition

of the artist's work at "291," which was also ridiculed by the critics.

Weber's work developed rapidly in 1910 and 1911. The contorted forms and sculptural weight of his figures were derived from the African, Mayan, and Aztec art he admired. He began to use bold rhythms, rich and sensuous color, and also semicubist stylizations, though the spirit of his pictures differed from those of the Parisian Cubists in their emotional expressionism and mystical elements. The peak of his work in 1911 was *The Geranium* (Museum of Modern Art, New York City). He later described this painting as "two crouching figures of women dwelling and brooding in a nether or unworldly realm. The conception and treatment sprung from a search [for] form in the crystal."

In January 1911 Weber had a solo show at "291." More radical than the work in his 1909 exhibit, his paintings were violently attacked by critics, one of whom wrote that "their ugliness is appalling." His next solo exhibition was held in February 1912 at the Murray Hill Gallery, New York City. The critics were still hostile, but Weber was encouraged by Robert Henri of the Ashcan School, who brought his students to see the show. In 1912 he painted a series of abstractions and semiabstractions, many based on New York. This new development in Weber's art combined fragmentation of form with opulent color. His pastel *An Automobile Ride on the Avenue* (1912) was inspired by an actual ride up Fifth Avenue. *Imaginary Portrait of a Woman* (1913) was more cubistic, with the face seen from several angles. Weber did not exhibit in the 1913 Armory Show, but he was impressed with Marcel Duchamp's much discussed painting *Nude Descending a Staircase*. Some of his own works that year were reminiscent of Duchamp's picture. In 1913 he was invited by Roger Fry to exhibit in London with the Grafton Group of English modernists, including Duncan Grant, Wyndham Lewis, and Vanessa Bell. Fry praised Weber's pictures for their "extraordinary power," but most of the London critics reacted negatively.

The rhythmic, near-abstract painting *New York* (1913) was followed in 1915 by two outstanding canvases, *Chinese Restaurant,* (Whitney Museum of American Art, New York City) and *Rush Hour, New York.* Weber said of *Chinese Restaurant* that "on entering a Chinese restaurant from the darkness of the night outside, a maze and blaze of light seemed to split into fragments the interior and its contents, the human and inanimate. . . . To express this, kaleidoscopic forms had to be found." In *Rush Hour, New York* there was an affinity with fu-

turism in the thrusting diagonals, forceful play of lines, and repetition of elements that suggested to one critic "the city's mechanical, multitudinous character."

Still financially hard-pressed, Weber held no more solo shows for seven years after 1915. In 1916 he married Frances Abrams, whom he had known when he was a student at Pratt. They lived in the Dyckman section of upper Manhattan and moved in 1921 to Garden City, Long Island. Their son Maynard Jay was born in 1923, and their daughter Judith Sarah (Joy) in 1927.

Though most of Weber's sculpture dates from before 1911, he produced small sculptures in 1915. Some were representational—*Crouching Woman*—others, like *Spiral Rhythm*, abstract. He completed other sculptures in 1917. Weber also had a strong feeling for words and ideas. He published *Cubist Poems* in 1914 and *Essays on Art* in 1916, which was based on lectures given at the White School of Photography, where he taught from 1914 to 1918. (For two seasons, 1920–21 and 1925–27, Weber taught at the Art Students League, New York City. His students remembered him as a dedicated teacher.)

Always conscious of his Jewishness, Weber turned to poetic and religious subjects in a more representational style. A series of colored woodcuts executed in 1918 bore affinities with African and Central American sculpture, and cubistic and semiabstract elements are evident in *Two Musicians* (1917; MOMA) and in *The Visit* (1919), but after 1919 these elements disappeared altogether. An echo of African primitivism is still present in the elongated heads, but in both *Two Musicians* and *The Visit* the figures are Jews.

There was a ritualistic, biblical and Oriental quality in *Gesture* (1921), in which the two women have a classic Semitic beauty. In some ways the work parallels Picasso's neoclassic phase of the early 1920s though the underlying spirit is very different. Weber's color was taking on a mellow, dusky richness. His still lifes and landscapes of the '20s, such as *Sugar Bowl* (1925) and *The Old Barn* (1926), were closer to Cézanne than to the Fauves or Cubists, and the same was true of his *Self-Portrait* (1928).

Weber held his first solo show since 1915 at the Montross Gallery, New York City, in February 1923. The critics were much less hostile than they had been, and his reputation was steadily growing. In 1924 J.B. Neumann became his dealer, giving him solo shows every few years at his gallery, the New Art Circle. In the same year, a retrospective of his work was held in Paris, at the Gallery Bernheim-Jeune. In 1925 one critic complained that "here is one of the best painters in the world practically going to waste among us." In 1928 Juliana Force bought *Chinese Restaurant,* later acquired by the Whitney Museum, and Weber received his first award. His second book of poems, *Primitives,* was published in 1926. He was included in MOMA's "Paintings by Nineteen Living Americans" show of 1929, the year he moved with his family to Great Neck, Long Island, his home for the rest of his life. In March 1930 Weber was given a retrospective at MOMA. The after-effects of the Depression, the rise of fascism in Europe, and the imminence of war in the late 1930s aroused Weber's social consciousness and affected his art. Always a radical in his political beliefs, he had every reason to be aware of the economic plight of the artist. He was elected first chairman of the left-wing American Artists' Congress, and in his 1937 address to the Congress he urged his younger colleagues to visit mills, shops, and construction sites. At this time he painted pictures of refugees fleeing with their possessions, and in other paintings, like *Whither Now?* (1939), Jewish patriarchal figures are discussing their plight. His series of labor subjects, including *On the Mill* (1938) and *The Builder* (1939), were sincere in intention, but, as one critic wrote, Weber's "fundamental romanticism, his fondness for the emotionally expressive gesture, prevented them from being convincing as realism. . . . " He was much more himself in *Hasidic Dance* (1940), marked by intensity of movement and mystical fervor. It was based on a childhood memory of a Hasidic service seen in Russia, when the men danced ecstatically in prayer. *Adoration of the Moon* (1944), with its four patriarchs, combines a visionary quality with a streak of fantastic humor.

Weber's greatest love next to painting was music, and many of his pictures from the mid-1940s on had musical themes. These include *Muses* (1944), *Guitar Player* (1944), and *Wind Orchestra* (1945).

United States entry into World War II and the country's subsequent economic recovery led to the demise of the American Artists' Congress and of social realism as an important art movement. The new American avant-garde of the late 1940s and '50s was unconcerned with politics. Weber withdrew to his studio in Great Neck, where he developed his final style of painting. His later works are fluid, graphic, almost cartoonlike drawings played against loosely brushed areas of rich, muted color. Often the heads of his figures bear a superficial resemblance to the double faced heads by Picaso, but whereas Picasso is harsh and aggressive, Weber is tender and lyrical. These paintings of the 1950s and early '60s are far removed from the

daring experimentalism of Weber's work of the 1910–1919 period.

Increasingly Weber suffered from arthritis and developing cataracts in his later years, and he returned to sculpture with renewed vitality. *Arts Magazine* (February 1980) reported that "his 'profile' heads vigorously exhibit the marks of hand and thumb often associated with Abstract Expressionist Sculpture."

Max Weber died at the age of 80. He had enjoyed a warm, affectionate, tightly knit home life with his family. He has been described as a "round-headed, bird-like little man," with a genial expression. He was modest in discussing his own work, but his early struggles had left their mark. He could be touchy and testy, and he resented the fact that his role as a pioneer of American modernism was often overlooked, though in recent years there has been a renewed interest in his work.

Weber eloquently stated his credo in a monograph published by the American Artists Group in 1945. He wrote: "Art dies when the natural dominates. I believe that the *expression* of an experience must go further than the experience that gave rise to the expression thereof. The expression of an experience whatever the art or the means should give rise to another, a newer and a still more inspiring experience."

EXHIBITIONS INCLUDE: Julius Haas Frame Shop, NYC 1909; Alfred Stieglitz's Photo-Secession Gal., "291," NYC 1909, '11; Murray Hill Gal., NYC 1912; Newark Mus., N.J. 1913, '59; Ehrlich Gal., NYC 1915; Print Gal., NYC 1915; Montross Gal., NYC 1915, '23; Gal. Bernheim-Jeune, Paris 1924; J.B. Neumann's New Art Circle, NYC 1924–37; MOMA, NYC 1930; Dayton Art Inst., Ohio 1938; Paul Rosenberg & Co., NYC 1942–45; Carnegie Inst., Pittsburgh 1943; Whitney Mus. of Am. Art, NYC 1949; Walker Art Gal., Minneapolis 1949; Jewish Mus., NYC 1956; Pratt Inst., Brooklyn 1959; Am. Academy of Arts and Letters, NYC 1962; Boston Univ. Art Gal. 1962; Rose Art Mus., Brandeis Univ., Waltham, Mass. 1966–67; Art Gal., Univ. of California, Santa Barbara 1968; Forum Gal., NYC 1976, '80, '81. GROUP EXHIBITIONS INCLUDE: "Younger American Moderns," "291," NYC 1910; Grafton Group, Alpine Club Gal., London 1913; Montross Gal., NYC 1917; Société Anonyme, Brooklyn Mus. of Art, N.Y. American Exhibition, Art Inst. of Chicago 1928, '41; "Paintings 1926; by Nineteen Living Americans," MOMA, NYC 1929.

COLLECTIONS INCLUDE: Metropolitan Mus. of Art, MOMA, and Whitney Mus. of Am. Art, NYC; Brooklyn Mus., N.Y.; Newark Mus., N.J.; Carnegie Inst., Pittsburgh; Nat. Gal. of Art, Phillips Collection, and Hirshhorn Mus. and Sculpture Garden, Washington, D.C.; Walker Art Center, Minneapolis; Wichita Art Mus., Kans.; Nebraska Mus. of Art, Lincoln; California Palace of the Legion of Honor, San Francisco; Santa Barbara Mus. of Art, Calif.; Mus. of Tel Aviv.

ABOUT: American Artists Group, Max Weber, 1945; Bénézit, E. (ed.) Dictionnaire des peintres, sculpteurs et graveurs, 1976; Cahill, H. Max Weber, 1930; Current Biography, 1941; Goodrich, L. Max Weber, 1949; "Max Weber Retrospective Exhibition" (cat.), MOMA, NYC, 1930; Meyers, B. S. and others (eds.) Dictionary of 20th Century Art, 1974; Rose, B. American Art Since 1900, 2d ed. 1975; Weber, M. Cubist Poems, 1914, Essays on Art, 1916, Primitives, 1926. *Periodicals*—American Magazine of Art January 1936; Art and Artists April 1971; Art Front May 1936; Art News February 15, 1942; Arts Magazine February 1980; Esquire November 1938; Life August 20, 1945; New York Times October 5, 1961.

WESSELMANN, TOM (February 23, 1931–), American painter, is one of the most inventive of the first-generation Pop artists. He is best known for the striking erotic imagery of his "Great American Nude" series.

He was born in Cincinnati, Ohio, the son of a business executive. Wesselmann came to painting late. He played basketball in high school and, as he told *Art News* (January 1982), "never had any artistic impulse as a kid. My goal was to own a sporting-goods store that had a real waterfall and a trout stream in the middle of it. My life revolved around sports, especially fishing." He attended Hiram College, Ohio, but in 1951 he studied psychology at the University of Cincinnati. His studies were interrupted when he was drafted into the US Army in 1952. In 1954 he returned to the University of Cincinnati and obtained his BA degree in psychology. Wesselmann had begun to draw, mostly cartoons, in the Army, and in 1955 he enrolled at the Art Academy, Cincinnati. He sold cartoons to *1000 Jokes,* a gag magazine, and in 1956 transferred to New York City's Cooper Union. Because Cooper Union charged no tuition he was able to live for three years on payments from the GI Bill.

In the late '50s abstract expressionism was dominant and Wesselmann, who admired de Kooning and Pollock, wanted to be part of the movement. But at Cooper Union he read extensively about art and art history, forming ideas which forced him to reconsider his artistic aims. After looking at de Kooning's *Easter Monday* painting in the Metropolitan Museum of Art, New York City, he decided de Kooning had "said it all." "I wanted my painting to be spatially and visually aggressive, like de Kooning," he told *Art News.* "But in order to be myself I knew I had to forget de Kooning. . . . "

When Wesselmann finished his studies at Cooper Union in 1959, he was 28 and married to the former Dot Irish, his college sweetheart.

Wide World Photos

TOM WESSELMANN

He made a meager living teaching at a school in deepest Brooklyn and, later, at Manhattan's High School of Art and Design; in the evenings he worked on collages.

Meanwhile, working in a style dubbed "neodada" by critics, Jasper Johns and Robert Rauschenberg were reacting against the "heroics" of abstract expressionism. Johns's flags and targets and Rauschenberg's fixing of three-dimensional objects to the surface of his paintings, expressed an ironic attitude which was indebted to Marcel Duchamp. Their work laid the basis for pop art imagery. Wesselmann was also impressed by the work of his friends Jim Dine and Claes Oldenburg, both of whom used images derived from discredited mass sources—advertisements, billboards, movies, and TV—although Dine and Oldenburg were closer to abstract expressionism than such "hard-core" New York Pop artists as Andy Warhol, Roy Lichtenstein, and James Rosenquist. Dine and Oldenburg were both progenitors of environments and happenings, and Wesselmann "performed" in some of their avant-garde theater pieces. However, he felt that his approach to art needed to be more orderly than theirs, less free-wheeling.

Abandoning the gestural brushstroke of action painting, Wesselmann reduced the size of his pictures and produced small works with collage and assemblage elements. He incorporated such "now" items as a whiskey bottle, a pack of cigarettes, and a coffee can; but these collages were somewhat tentative, lacking the startling impact of Rauschenberg's combine paintings or the outrageousness of Oldenburg's gigantic "soft" sculptures of sausages and hamburgers. However, as early as 1959 Wesselmann had experimented with the "portrait collages" that developed in 1961 into the ongoing series of paintings entitled "The Great American Nude." His variations of this erotic theme include "assemblage" still lifes and diverse compositional motifs.

In 1960 Wesselmann showed with Dine at the Judson Gallery in Greenwich Village, and his "Great American Nudes" were first shown at the Tanager Gallery, Greenwich Village, in 1961. In the "Nudes" he fused, to quote Lucy R. Lippard, "the arabesque and brilliant color of Matisse with the sinuous line of Modigliani and a more rigorous framework traceable to Mondrian." However, reviewing the "American Nude" series in *The New York Times* (February 11, 1968) Hilton Kramer pointed out: "His method was to treat the subject as a parody of the Renoir-Matisse-Modigliani tradition. . . . The hedonism that in Matisse was deeply felt and profoundly communicated as a personal emotion was, in Mr. Wesselmann, converted into something posterish, journalistic, campy and impersonal." Kramer noted that Wesselmann had substituted "the glossy vulgarities of the full-color magazine and of girlie magazine pin-ups for the felicities of French pictorial art." Of course the spirit of pop art was not that of the School of Paris, and Lippard observed that, unlike the other Pop artists, "Wesselmann did not paint *from* magazine advertisements, billboards and objects, but used them directly on the canvas, thus following conventional collage-assemblage methods." In the circular *Great American Nude No. 10* (1961) the truncated horizontal nude lying on a striped couch occupies most of the surface, while the uppermost segment is a collage of an aerial photograph of a city view.

In 1962, when New York pop art "arrived," Wesselmann showed in a group exhibit at the Sidney Janis Gallery, New York City, and had a solo show at the midtown Green Gallery, which became his dealer. Brian O'Doherty, in his *New York Times* (November 29, 1962) review called the latter "the best one-man Pop show I've seen"; he described Wesselmann's works as "wildly witty and madly hip. . . . All are put together with a blank, dead-pan air, and all of them traffic in double-takes in that everyman's land between illusion and reality."

By 1963, when he painted *Great American Nude No. 44,* Wesselmann was working on a much larger scale. That assemblage-painting, which was snapped up by Mr. and Mrs. Robert C. Skull, enthusiastic collectors of pop art in the '60s, presents the provocatively posed standing nude as a flat silhouette in an interior combining

decoratively flat areas of color with actual objects—a radiator, a wall telephone, a red door with a coat hanging on it, and a Renoir reproduction in a circular frame. An even more striking use of mixed media is the 84- by-102-by-40-inch *Great American Nude No. 54* (1964). This assemblage-painting is virtually an environment, with over three feet of carpeted floor projecting from the back "wall." A dark-skinned nude, again treated as a flat silhouette, sprawls erotically on a bed to the left; a radiator is in the center; an actual small table and chair are on the right; and red curtains frame a window, from which tape recorded street sounds emanate. In the center of the wall is a white telephone; in other, similar canvases, the phone occasionally rings. In the mid-'60s Wesselmann had often to point out that his three-dimensional paintings were not environments. "My rugs are not meant to be stepped on," he declared.

Other "Great American Nudes" of 1962–64 incorporated radios and working televisions, which, depending on the type of TV show that was on, dramatically altered the work's tone. The amusing *Bathtub Collage No. 3* (1963), with a blonde woman showering, included a plastic shower curtain, a towel on a red metal door rack, a bath mat, and a laundry basket, in a design almost as severe as a Mondrian. According to the artist, as quoted in John Rublowsky's *Pop Art*, when his paintings were enlarged "colors became flatter, cleaner, brighter; edges became harder, cleaner. . . . I felt the need to lock up my paintings so tightly that nothing could move. This way, by becoming static and somewhat anonymous, they also became more charged with energy."

Wesselmann's controversial brand of eroticism has not found favor among feminists, who would agree with Hilton Kramer that "Wesselmann's nudes suggested a kind of Pop-pornographic dream of the female as an ideal sexual appliance." But a *Time* (June 14, 1968) reviewer found that, "explicit though the images are, Wesselmann's nudes are not pornographic. They are too remote for that, too glazed, too impersonal."

Wesselmann depicts life-sized objects in a manner that questions the validity of tidy distinctions between art and life, as do Johns's targets and flags. His *Still Life No. 33* (1963), combining paint and collage, is of billboard dimensions (11 by 15 feet). Enormously blown-up photographs of a Pall Mall cigarette pack, a can of Budweiser beer, and part of a meat-and-cheese-crammed hero sandwich are superimposed on a flat decorative background. As always, the Wesselmann work is a tightly structured composition, and the background is enlivened by the artist's much-favored pattern of bold stripes. One enormous construction, *Landscape No. 5* (1964), features an almost life-sized Volkswagen cutout. These austere still lifes are, Lippard wrote, "belligerently simple" and have "the clarity and strong design of the 'Nudes' but [lack] the latter's *joie de vivre* and lively charm."

Although in the '60s he seemed the epitome of the Pop artist, Wesselmann himself disliked the label and the direction in which pop was going. "Some of the worst things about Pop Art have come from its admirers," he complained in 1963. "They begin to sound like some nostalgia cult—they really worship Marilyn Monroe or Coca-Cola." In 1982 he said, "As Pop art became linked with Coca-Cola and soup cans and road signs, I pulled back. It was becoming a subject-matter art, and the subject was very limiting. There was no esthetic content. . . . Long before the nostalgia cult I used a blunt Pop imagery and simple, clean colors to take on the traditional subjects of painting—the nude, the still life, the landscape."

Charlotte Willard, reviewing Wesselmann's 1966 show at the Janis Gallery in the *New York Post* (May 21, 1966) said of his nudes and sea-scapes, "The line that separates them from advertising is their brash, sterile treatment of his subject matter." Twenty-three of his "Great American Nude" pictures, many of them executed on shaped canvases, were exhibited at Chicago's Museum of Contemporary Art in 1968. To quote *Time* (June 14, 1968), the nudes "zero in on specific portions of the anatomy: feet that rise like mountains above the seashore, mouths dragging at enormous cigarettes, huge breasts." Despite the explicit imagery, Wesselmann's approach had become more abstract. But as the museum's director, Jan van der Marck, observed, the exhibit portrayed "woman as the consumer, both consuming and being consumed."

A series of "Bedroom Paintings" comprised most of Wesselmann's exhibit at the Sidney Janis in the spring of 1970. The general motif, to quote Peter Schjeldahl's *New York Times* (April 19, 1970) article, was "a close-up view of a bedside table-top decked with such objects, gorgeously rendered, as a Kleenex box, a rose in a vase, an electric clock, an orange, an ashtray with lit filter cigarette, a perfume bottle, and occasionally a framed photograph of the artist." The framed photograph is in *Bedroom Painting No. 12* (1969), a circular composition dominated by a huge fleshy female foot, its nails luridly polished. Schjeldahl applauded the artist's "extreme

erotic sensitivity" but added that these works "considered formally, merely as paintings, are obviously deft, but so busy and splashy that they give the eye nothing to do except admire their effect."

The shaped canvases Wesselmann exhibited at the Janis Gallery in 1972 were enormous constructions set, according to Emily Genauer of *Newsday*, "in juxtapositions that make for a whole environment." *Still Life No. 58*, for example, is composed of a huge rose in a vase, a bottle, and an ashtray with a smoking filter cigarette. Genauer described these works as "extremely vivid and thoroughly unsubtle in color, and so precisely realistic in detail that, paradoxically, identification is elusive. . . . The ambiguous results are interesting—as Wesselmann almost always is—but only if you like billboards."

Wesselmann's best paintings have a decorative quality owing much to Matisse, whose influence he acknowledged in the July 1975 issue of *Art in America*. In the late '70s Wesselmann began to paint close-ups of faces, their features rendered in a manner blending sweetness, innocence, and eroticism. He also began to execute painted sculptures as in *Dropped Bra* (1979–80), a 72-by-154-by-84-inch aluminum construction.

Wesselmann's marriage to Dot Irish ended in divorce, and in the early '60s he married Claire Selley, who modeled for the "American Nudes." They have two daughters, Jenny and Kate Ann, and a son, Lane. Wesselmann's Bowery studio is a 15-minute walk from his apartment in a Greenwich Village high-rise. He observes nine-to-five working hours so he can spend time with his family and share the responsibilities of parenthood with Claire.

In the early '60s Wesselmann's nudes sold for $500; now a seven-foot-square work commands about $60,000. Acquisitions by leading American museums enabled Wesselmann to purchase a rustic 400-acre home-away-from-home, complete with a lake, in upstate New York. In *Art News* Wesselmann was described as all-American. The characterization was only partly ironic: he has never been to Europe, considers chile a gourmand's feast, and works to the lachrymose strains of country music. "I suspect he's still sorting out the Midwestern values he grew up with and bending them to his own very individual life in New York," the art dealer Richard Bellamy observed.

EXHIBITIONS INCLUDE: Tanger Gal., NYC 1961; Green Gal., NYC 1962, '64, '65; Gal. Ileana Sonnabend, Paris 1966; Sidney Janis Gal., NYC from 1966; Dayton's Gal. 12, Minneapolis, Minn. 1968; Mus. of Contemporary Art, Chicago 1968; "Early Still Lifes: 1962–64," New-

port Harbor Art Mus., Balboa, Calif. 1970; "Wesselmann: The Early Years—Collages 1959–1962," Art Gals., California State Univ., Long Beach 1970–71; "Wesselmann: The Early Years—Collages 1959–1962;" Trisolini Gal. of Ohio Univ., Athens 1970–71; "Wesselmann: The Early Years—Collages 1959–1962," Nelson Atkins Mus. of Fine Arts, Kansas City, Mo. 1970–71; "Tom Wesselmann: Graphics 1964–1977," Inst. of Contemporary Art, Boston 1978. GROUP EXHIBITIONS INCLUDE: Judson Gal., NYC 1959, '60; "Pop Art," Pace Gal., Boston 1962; "Recent Painting USA: The Figure," MOMA, NYC 1962; Sidney Janis Gal., NYC 1962; Mixed Media and Pop Art," Albright-Knox Gal, Buffalo, N.Y. 1963; "Nouveaux Vulgarians," Gal. Saqqarah, Gstaad, Switzerland 1963; "The Popular Image," I.C.A., London 1964; "American Pop Art," Stedelijk Mus., Amsterdam 1964; "Pop Art and the American Tradition," Milwaukee Art Cntr. 1965; "The New American Realism," Worcester Art Mus., Mass. 1965; "Homage to Marilyn Monroe," Sidney Janis Gal., NYC 1967; Documenta 4, Kassel, W. Ger. 1968; ROSC, Dublin 1971; Whitney Biennial, NYC 1973; "The Nude in American Art," New York Cultural Cntr. NYC 1975; "'60's: American Pop Art and Culture of the Sixties," New Gal. of Contemporary Art, Cleveland 1976; "American Painting," Pushkin Mus., Moscow 1977; "American Art Since 1945," MOMA, NYC 1977; "Art about Art," Whitney Mus. of Am. Art, NYC 1978.

COLLECTIONS INCLUDE: MOMA, and Whitney Mus. of Am. Art, NYC; Albright-Knox Art Gal., Buffalo, N.Y.; Rose Art Gal., Brandeis Univ., Waltham, Mass.; Worcester Art Mus., Mass.; Hirshhorn Mus. and Sculpture Garden, Smithsonian Inst., Washington, D.C.; Princeton Univ. Art Mus., N.J.; Philadelphia Mus. of Art; Walker Art Cntr., and Minneapolis Inst. of Arts, Minneapolis; Cincinnati Art Museum; Atkins Mus. of Fine Arts, Kansas City, Mo.; Washington Univ., St. Louis, Mo.; Dallas Mus. of Fine Arts, Tex.; Wallraf-Richartz Mus., Cologne; Landesmus., Darmstadt, W. Ger.; Nasjonalgal., Oslo.

ABOUT: "Early Still Lifes 1962–1964," (cat.), Atkins Mus., Kans., 1970; Lippard, L. R. Pop Art, 1966; Lucie-Smith, E. Late Modern: The Visual Arts Since 1945, 1969; Rose, B. American Art Since 1900, 2d ed. 1975; Rublowsky, J. Pop Art, 1965. *Periodicals*—Art and Artist May 1966; Art in America July 1975; Art News January 1982; Arts Magazine March 1965; New York Magazine May 16, 1974, April 26, 1976; New York Post May 21, 1966; New York Times November 28, 1962, February 11, 1968, April 19, 1970, February 6, 1972; Newsday November 17, 1972; La Quinzaine (Paris) November 1–15, 1966; Time February 28, 1964, June 14, 1968; Village Voice January 31, 1963, May 10, 1976.

WINTER, FRITZ (September 22, 1905– October 1, 1976), German painter, was one of his country's leading abstractionists and was among the few modernists who, at the price of great

Courtesy of the Weintraub Gallery, NYC, and the Merbach Gallery, Bern

FRITZ WINTER

personal hardship, stayed in Germany during the period of Nazi rule.

He was born in Altenbögge, Westphalia, the eldest of eight children of Fritz Winter, a mining engineer, and his wife Berta. The family was poor, and as soon as he was of age Winter began working as a coal miner. He was, however, able to spend four weeks in Holland, where he was deeply impressed by the paintings of Vincent Van Gogh, especially the well-known painting of the yellow chair now in the Tate Gallery, London.

After six years down in the mines, in 1927 Winter submitted 15 of his drawings to the Bauhaus. Granted a scholarship, he studied at the Bauhaus for three years, working as an assistant to Kandinsky, Klee, and Oskar Schlemmer. He received much praise and encouragement, and at the end of his first year his grant was extended. In 1929 12 of his paintings were included in the important "Junge Bauhaus maler" exhibition, shown in Brunswick, Erfurt, Krefeld, and Berlin. Kandinsky and Klee, in particular, had a great influence on Winter; years later the artist said, "The [first] introduced me to ideas, the second to reflective thought."

Winter's early works were influenced by Van Gogh and expressionism. Two drawings from the late 1920s, *Self-Portrait* (1927) and *My Mother* (1928), reveal expressionistic distortions, especially in the drawing of his mother's hands. The depiction of her face appears to have been influenced by Klee's use of a continuous, string-like line to detail the features. Winter used a similar technique in *The Cow* (1929).

In 1930, after graduating from the Bauhaus,

Winter moved to Berlin, where he became friendly with the Constructivist sculptor Naum Gabo and worked in his studio. Later that year he traveled to Switzerland, where he renewed his contact with Klee, and stayed for several months near Davos with the Expressionist painter Ludwig Kirchner. Already, Winter's pictures were being acquired by museums, in Halle, Breslau, Hamburg, Mannheim, and Wuppertal.

Winter gave lectures on children's drawing and modern art in Halle, where he was appointed instructor at the Pädagogische Akademie in 1931. Later that year he had his first solo show in Berlin. In 1932–33 he made trips to Italy and Switzerland, and exhibited in a major show of contemporary German art held at the Zurich Kunsthaus in 1933. Also in 1933, he received his final degree from the Bauhaus, just before Hitler closed the school down.

When the Nazis came to power in 1933, Winter, like most German Modernists, was targeted for official harassment, which he partially avoided by frequently changing his residence. He moved to Munich, after going to Zurich to visit Klee, then in 1935 moved to Diessen-am-Ammersee in Bavaria. In Diessen he stayed at the house of Margerete Schreiber-Rüffer, who allowed him to pursue his painting, and whom he later married.

In the 1930s Winter experimented with many styles, which seemingly reflected the unsettled circumstances of the times and his own life. Sometimes, as in *Composition* (1933) and *Linear Composition* (1935), he imposed a black linear idiom on a loose geometry of colored areas. At other times he built up ambiguous architectonic elements related to cubism, as in *Light Breaking In II* (1933) and *Stairs* and *Rays of Light* (both 1934). Yet another type of work was a kind of abstract landscape, less geometric and often made up of strata that resembled strips of torn paper. In *Untitled* (1935) and *Light Falling* (1937), rays of light shine through the clouds in a mysterious landscape or seascape. In the late 1930s Winter also painted some heavily impastoed still lifes in which flowers and similar objects are almost completely lost within amorphous abstract shapes. Two pictures in this vein are *Leaf in Blossom* (1936) and *Fading Blossoms* (1937).

Winter's art was declared "degenerate" by the Nazis in 1937; his paintings were withdrawn from all German museums, and he was forbidden to paint. He moved from Diessen to the even more remote Bavarian town of Karlsfeld-Allach, where he bought a farmhouse in the hills. There he made and sold household utensils and knick-knacks as a front while working at night on his

paintings, which had to be stored away as soon as they were dry.

In 1939 Winter was inducted into the German Army, and sent to fight in the worst areas, Poland and Russia. But even this did not keep him from art. In 1940, while home on leave, and in 1944, during hospitalization for several serious wounds, he painted a few works which, more than any of his others, show the strong influence of Kandinsky. Among them were *Untitled, Composition About the First Blossoms in the Forest*, and *Vegetative Forces of the Earth,* the latter painted in 1944. Throughout the war Winter did postcard-sized drawings in a sketchbook.

Winter was released from the hospital in May 1945, but his ordeals were not yet over. He was sent to the Czechoslovakian border, where he was captured by the Russians just days before the war in Europe ended. For five years, Winter was interned in a prison camp in Siberia. With no paper or painting materials, he was forced to make paintings out of sand colored with crushed cough drops. He was the central figure in a group of about 30 men who maintained a constant and fruitful intellectual discourse among themselves even in the harsh conditions of the camp.

After his release in 1949, Winter returned to Germany and began painting furiously, still working in a variety of styles. With Willi Baumeister and other avant-garde painters he participated in the Zen 49 group. In some of his paintings of 1949, including *From the Atmosphere* and *The Wave*, Winter was developing a graceful, elegant abstraction. In other works of this period he continued his attempts to create an ambiguous depth by superimposing black linear elements—possibly inspired by the Hans Hartung paintings he saw on a trip to Paris in 1950–51—on both cloudy and clearly defined color areas. Examples of this style are *Summery* and *Silences* (both 1950), and *Tensions (1952). In Tensions* and *Red and Green Lighting Up* (also 1952), this style became increasingly complex, with color areas seen through a web of black lines; within a year, the black linear elements, sweepingly gestural in character, began to resemble the childish symbols of Miró. Meanwhile Winter was developing another style, composed of rectilinear arrangements of colors painted in a loose, almost abstract-expressionist manner, so that the brushstrokes were visible and the edges of the rectangles and the areas encroached on each other. This style was continued through the 1950s and 60s in such works as *Red Blue* (1953), *Black in Front of Blue* (1957), and *Breaking Through* (1965).

After 1949 Winter's paintings began to be in-cluded regularly in exhibitions in Germany, Japan, and the US. As the only painter then active in Germany who had studied at the Bauhaus, he was a vital link between the modernism of the pre-Hitler era and the younger German artists. In 1953 he married Margerete Schreiber-Rüffer, and two years later was appointed professor at the Hochschule für Bildende Künste, Kassel, West Germany, and had large retrospectives in Cologne and Munich.

Winter's health, never good since the war, worsened in 1959, and he was forced to work on a smaller scale with oils on board. In the late 1960s the shapes in his paintings became more irregular and the edges sharper, as in *Undisturbed Spaces* (1967) and *Black-Blue Vertical* (1969). Referring to Winter's 1964 painting *Broad Horizontals,* Will Grohmann praised the artist's "incomparable gamut of blacks and grays," and observes that in his work the "inward mystic construction," to borrow a phrase of Franz Marc's, "still wears its lifelike images, even when they are made up of rough blocks and are free from verifiable models."

Between 1965 and 1970 there were major retrospectives of Winter's work in West Germany (Kassel and Mannheim), Koblenz, Switzerland, Oslo, and Paris, and he was awarded the Grand Cross of Merit of the Federal Republic. In 1972 he made a poster for the Olympics in the style of his red, blue, black, and purple *Red Before Left* of 1970. Also in 1972 the Federal Republic named him to the Order of Merit and two years later he was given the Grand Cross of Merit with Star. The Fritz-Winter-Haus, a permanent installation of his work, was established in Ahlen, West Germany in 1975.

Fritz Winter died in Diessen at the age of 71. He had an expressive, sensitive, heavily-lined face which bespoke his illness and suffering during the war. However, the critic Herbert Baerlocher, who met him a few months before Winter's death, wrote of his cheerfulness, "inner serenity and self-contained demeanor."

Winter's endurance and dedication in the face of formidable obstacles—Nazi persecution, war, imprisonment, and ill-health—won him widespread respect and admiration. The German art historian Horst Keller called him "a heroic figure of art in the 20th century." Aldo Pellegrini saw Winter's painting as occupying an "intermediate zone" between postcubist informalism and formal abstraction. Winter was concerned with abstractly depicting the spirit of the age, asserting: "Nonobjective art has an incredibly big function. We can no longer perceive our world purely optically. Matter itself disintegrates into even smaller particles. Atoms are

smashed, time and space eliminated as barriers. The world has become transparent. . . . I must, therefore, try with color and form to give expression to this world, my world, just as Renaissance painters did to theirs." Elsewhere he stated: "Between the expanding microcosm of nucleonics and the macrocosm of astronomy we are learning to see anew."

EXHIBITIONS INCLUDE: Gal. Buchholz, Berlin 1930; "Variations on a Spatial Theme," Gal. Ferdinand Möller, Berlin 1931; Gal. Rusche, Cologne 1949–50; Gal. Otto Stangl, Munich 1950; Gal. Schüler, Berlin 1950, '53, '56, '58, '61, '64; Gal. Günther Franke, Munich 1951, '55; Gal. Mabarch, Bern 1951, '52, '56, '63, '68; Gal. Roque, Paris 1952, '61; Hacker Gal., NYC 1952; Lefevre Gal., London 1954; Kleeman Gal., NYC 1954, '55, '58; Gal. Ferdinand Möller, Cologne 1955; Gal. La Medusa, Rome 1959; Gal. Bussola, Turin, Italy 1960; Gal. Marbach, Paris 1964; Staatliches Mus., Kassel, W. Ger. 1965; Kunsthalle, Düsseldorf 1966; "The Graphic Work of Fritz Winter," Kunstkabinett, Frankfurt-am-Main, W. Ger. 1968; Staatliche Kunstsammlungen, Kassel, W. Ger. 1970–71; Weintraub Gal., NYC 1982. GROUP EXHIBITIONS INCLUDE: "Junge Bauhaus maler," Brunswick, Erfurt, Berlin and Krefeld, W. Ger. 1929; "Contemporary German Art in Private Collections," Kunsthaus, Zürich 1933; "German Art of the 20th Century," New Burlington Gals., London 1938; "Neue deutsche Kunst," Constance, W. Ger. 1946; "Extreme Malerei," Schaezler Palace, Augsburg, W. Ger. 1947; "Salon des Réalités Nouvelles," Paris 1948; "Gruppe Zen 49," Central Collecting Point, Munich 1949, '50; Venice Biennale 1950; Piitsburgh International, Carnegie Inst. 1952, '58; "Deutsche Kunst-Meisterwerke des 20 Jahrhunderts," Kunstmus., Lucerne, Switzerland 1953; Milan Triennale 1954; São Paulo Bienal 1955; "The New Decade: 22 European Painters and Sculptors," MOMA, NYC 1955; "One Hundred Years of German Painting," Tate Gal., London 1956; "German Art of the Twentieth Century," MOMA, NYC 1956; "German Art of the Twentieth Century," St. Louis Art Mus., Mo. 1956; International Graphics Exhibition, Tokyo 1957; "50 Ans d'art moderne," Brussels World's Fair 1958; Documenta 1 and 2, Kassel, W. Ger. 1958, '63; "Bauhaus," Stuttgart, W. Ger. 1969; "Bauhaus," Mus. Nat. d'Art Moderne, Paris 1969.

COLLECTIONS INCLUDE: Fritz-Winter-Haus, Ahlen, W. Ger.; Wallraf-Richartz Mus., Cologne; Kunsthalle, Hamburg, W. Ger.; Kunsthalle, Mannheim, W. Ger.; Staatliche Kunstsammlung, Kassel, W. Ger.; Solomon R. Guggenheim Mus., NYC; Albirght-Knox Art Gal., Buffalo, N.Y.

ABOUT: Baerlocher, H. "Fritz Winter 1924–38" (cat.), Gal. Marbach, Bern, 1963; "Bauhaus" (cat.), Mus. Nat. d'Art Moderne, Paris, 1969; Bénézit, E. (ed.) Dictionnaire des peintres, sculpteurs, et graveurs, 1976; Brion, M. Histoire de l' art abstrait, 1956; Domnick, O. Abstrakte Malerei, 1947; "Fritz Winter" (cat.), Staatliches Mus., Kassel, W. Ger., 1965; Fritz Winter" (cat.), Kunsthalle, Düsseldorf, 1966; "Fritz Winter-Zeichnungen" (cat.), Staatliche Kunstsammlungen, Kassel, W. Ger., 1970; Haftmann, W. Malerei im 20. Jahrhundert, 1954; Pellegrini, A. New Tendencies in Art, 1966; Ritchie, A. C. (ed.) "German Art of the Twentieth Century" (cat.), MOMA, NYC, 1957. Periodicals—Cashiers d'art (Paris) no. 1 1953; Kunstwerk (Stuttgart) November 1976; Weltwoche (Zürich) no. 874 1950.

WOTRUBA, FRITZ (April 23, 1907–August 25, 1975), Austrian sculptor, was best known for semiabstract stone carvings which combine premodern traditions and cubism, turning the human figure into monumental architecture. Although neglected for many years in the United States, in the 1950s and '60s Wotruba was considered one of Europe's leading sculptors.

He was born in Vienna, the son of a Czech father and a Hungarian mother. At the age of 16 he began to draw, using sculptures as models. He wrote in one of his notebooks, " . . . My earliest impressions were stimulated by figures in stone and bronze, and not by creations of flesh and blood. Movements were indifferent to me. . . . Solidity, rigidity, whatever did not yield to the pressure of the hand, attracted me."

From 1921 to 1924, Wotruba was apprenticed to an engraver. Every morning before work he would copy reproductions of the drawings of famous sculptors, in an attempt to overcome the awkwardness of his own draftsmanship. At night he studied life-drawing at the Vienna School of Fine Arts. In 1926 he studied briefly with sculptor Anton Hanak; it was here, in his teacher's studio, that he met the sculptor Marian Fleck, whom he was to marry in 1929.

The future husband and wife both studied for a short time in 1927 with a Professor Steinhof, but Wotruba later admitted that "attendance at his courses was only a pretext for obtaining a scholarship." Later in 1927, he made his first experiments with stone, in a rented shed without the guidance of teachers. In 1928 he carved his first Torso, a smooth work of classical beauty in which the stipple of small holes looked forward to the rough surfaces of his later sculpture. In the second Torso, carved in 1930, cuts in the smooth areas are larger and more numerous, like small gashes.

After the city of Vienna purchased his Young Giant in 1930, he and his wife were able to visit Germany, where Marian's parents lived, and Holland. During this trip, he first saw the works of Lehmbruck and Maillol. These made a strong impression on him. Ernst Gosebruch, director of the prestigious Folkwang Museum in Essen, took an interest in Wotruba, and a long friendship

Lucy Wotruba–Wien

FRITZ WOTRUBA

with Josef Hoffman, architect, designer, and one of the founders of the Wiener Werkstätte, also began in 1930. Wotruba's first solo show was held at the Folkwang Museum in 1931, and he was included in the first International Exhibition of Sculpture in Zürich. In 1932, and again in '34 and '36, he participated in the Venice Biennale. Among his friends in Vienna in these years were the art historian Meier-Gräfe, the writers Carl Moll and Hermann Brock, and the composer Alban Berg.

In 1934 Wotruba and his wife left Austria because of political disturbances arising from the violent measures taken by the government to suppress socialist and communist groups. They settled in briefly in Zürich, where Wotruba worked in a stonecutter's shed on the edge of the lake. Later that year, his friend Carl Moll arranged for his return to Vienna, and helped him obtain a commission for the tomb of the singer Selma Kurz. In 1936 the Wotrubas befriended Robert Musil, the celebrated author of *The Man Without Qualities*, and his wife. This was a time of growing tension in Austria. In July 1934 the Nazis had assassinated Chancellor Dollfuss; they failed to seize the government but by 1936 Nazi influence in Austria was strong. This was a difficult period for Wotruba and his friends, as they struggled to make a living from their art. "And yet," he wrote, "we were carried away by a frenzied joy of living. We were dancing against a background glowing with orange, red and black." Wotruba's *Kleiner Schläfer* (1937, Small Sleeper) shows that he had not yet discarded the classical influence. The stippled effect of the holes was no longer in opposition to the graceful-

ness of the pose, but had become part of a clean, overall surface.

In 1938, the year of German occupation in Austria, the Musils decided to flee to Switzerland. Wotruba noted: "In order to escape the immediate threat in our own country, we flung ourselves into the lion's mouth; a brief stay in Düsseldorf, then in Berlin." In September of that year Wotruba, carrying a false military passport and only ten marks, took a plane to Switzerland. His wife was Jewish, and after some difficulty—"She was on the point of being sent to Eritrea," Wotruba recalled—she managed to leave Germany for Switzerland, where the Wotrubas stayed for the duration of the war.

Wotruba's sculpture during the wartime years became less classical and more archaic and primitive. In the series of female figures carved between 1942 and 1946, one can see the surfaces growing progressively rougher. In 1945, Wotruba returned to Vienna to teach at the Akademie der Bildenden Künste. He wrote of this period: "What mattered to me was the figure, sculpture, statics, measure, balance, and unity."

While visiting Rome and Paris in 1947, Wotruba met Giacometti, Magnelli, Laurens, Ossip Zadkine, and Picasso's friend and dealer, D. H. Kahnweiler. In 1948, he was represented at the Venice Biennale and in a group exhibition at the Musée National d'Art Moderne, Paris.

There was a breakthrough in Wotruba's work in the late 1940s, when he turned to angular forms with rough surfaces, as in his *Seated Figure*. In *Two Forms*, a carved relief dating from 1949–50, Wotruba adorned the squared-off figures with symbolic body parts, such as flat circles for female breasts. These features disappeared in later works. In addition to his stone carvings, Wotruba in the late 1940s made a number of bronze sculptures. *Stehende*, a standing female figure of 1948, is more amorphous and less blocky than his works in stone, but the 18-inch-tall *Walking Figure*, a bronze he finished in 1949, is squared off like the stone carvings.

In 1951 Wotruba visited Munich, Brussels, London, and Switzerland before returning to Vienna. His wife's health was failing, and she died on the last day in August.

Wotruba's *Figural Composition* of 1951 anticipates the works of the late '50s and '60s in that the figure is almost totally lost. About 1954 Wotruba briefly left this chunky, blocklike style to create tubular figures and torsos. One of the best-known works of this period is *Figure with Raised Arms* of 1956–57, in bronze and 75¼ inches high. One of two casts of this sculpture is in the Hirshhorn Museum and Sculpture Garden, Washington, D.C.

Wotruba married Lucy Vorel in 1955, the year of his first solo show in the United States, held at the Institute of Contemporary Art, Boston. The exhibit toured the country in 1959.

Wotruba returned to his personal form of cubism in the late '50s and '60s. He continued to give his works names such as *Seated Figure* and *Reclining Figure,* and as Charles Spencer wrote in *Contemporary Artists:* "This insistence on a figurative connotation can be puzzling, for one wonders why a piece of sculpture, built up in square or oblong blocks, resembling towers or groups of buildings, should be called *Reclining Figure* or *Relief with Five Figures.* . . . Nothing in his work suggests the sexual or sensual involvement in the human form which other abstract sculptors, from Moore to Cascella, immediately express. . . . " Hilton Kramer, in an *Arts Magazine* piece, approached Wotruba's work from a different angle: "Wotruba seized on the Cubist matrix as a means of transmuting certain modes of monumental, architectural and iconographic sculpture of the past—particularly the columnar sculpture of the Gothic—into a more universalized, more modern statement of pure sculptural dynamics. . . . Stone is the perfect medium for this marriage of the past and present."

In his notebooks Wotruba expressed his love of cities, and some of his reclining and seated figures of the 1960s and later were piles of blocks resembling urban buildings. The standing figures increasingly in this period resembled rectangular pillars. In *Figure* (1961–62) one rectilinear leg comes forward in an Egyptian pose, and both feet are flat on the ground. Were it not for their stance and the title, the figural basis for this work could easily be overlooked.

Many of Wotruba's works from the late '50s were cast in bronze, some from the outset, others as casts taken from stone statues. One critic who found this procedure questionable wrote: "Strangely enough, the surface of the bronze is rougher and more in movement than that of the stone, as if the hand had been active during the casting." Even Wotruba's smallest sculptures are monumental, but in the mid-1960s he erected a true monument, a 33-meter-wide stone facade in the lecture hall at the University of Marburg, West Germany.

Fritz Wotruba, a serious, heavy-set man, lived and worked in Vienna, and continued to teach at the Academy of Fine Arts until his death. He has been described as "a humanist who vigorously avoided sentimentality." His belief that "great art is synonymous with anonymous art" links him with the medieval stone masons, and partly accounts for the elimination of detail in his work.

Although the architectonic basis of his sculpture bears some relationship to the aesthetic principles and social idealism of constructivism and de Stijl, Wotruba cannot be considered a member, or even fellow traveler, of those movements. As Spencer pointed out, "He [was] a private, romantic artist in the Central European tradition, inventing and using mysterious forms as an exploration of his own experience of his relationship to the outside world and his communication with the public." In his notebooks Wotruba wrote, "A good piece of sculpture must combine barbarism and culture."

EXHIBITIONS INCLUDE: Folkwang Mus., Essen, W. Ger. 1931; Kunsthaus, Zürich 1933, '42; Mus. Nat. d'Art Moderne, Paris 1948; Gal. Welz, Salzburg, Austria 1950; Palais des Beaux-Arts, Brussels 1951; Hanover Gal., London 1951; Gal. Gran Ferrari, Milan 1952; Gal. Wurthle, Vienna 1954, '59; Inst. of Contemporary Art, Boston 1959; Inst. of Contemporary Art, São Paulo 1957; Fine Arts Associates, Otto Gerson Gal., NYC 1960; Gal. Claude Bernard, Paris 1961; Marlborough-Gerson Gal., NYC from 1964; Haus der Kunst, Munich 1967–68; Nat. Gal., Prague 1969; Heidelberger Kunstverein, 1979. GROUP EXHIBITIONS INCLUDE: Venice Biennale 1932, '34, '36, '50, '52; Exhibition of Austrian Art, Mus. du Jeu de Paume, Paris 1937; "Marini, Richier, Wotruba," Kunsthalle, Bern 1945; "Work of Austrian Masters in Switzerland," Kunsthaus, Zürich 1947; Mus. Nat. d'Art Moderne, Paris 1948; "Moore, Marini, Wotruba," Gal. Welz, Salzburg, Austria 1952; Biennial of Sculpture, Middleheim Park, Antwerp, Belgium 1953; "50 Years of Modern Art," World Exposition, Brussels 1958; Pittsburgh International, Carnegie Inst. 1958; "New Images of Man," MOMA, NYC 1959; Documenta 2, Kassel, W. Ger. 1959; "Austrian Painting and Sculpture 1900–1960," Arts Council Gal., London 1960.

COLLECTIONS INCLUDE: City Mus., Oesterreichische Gal., Mus. des XX Jahrhunderts, and the Albertina, Vienna; Lehmbruck Mus., Duisberg, W. Ger.; Staatsgal., Stuttgart; Staatliche Kunsthalle, Baden-Baden, W. Ger.; MOMA, NYC; Albright-Knox Art Gal., Buffalo, N.Y.; Storm King Art Center, Mountainville, N.Y.; Larry Aldrich Mus., Conn.; Carnegie Inst., Pittsburgh; Hirshhorn Mus. and Sculpture Garden, Washington, D.C.; Mus. of Fine Art, San Francisco; Tate Gal., London; Mus. d'Art Moderne, Paris; Mus. Royal des Beaux-Arts, and Open-air Mus., Middelheim, Antwerp, Belgium; Stedelijk Mus., Amsterdam; Rijksmus. Kröller-Müller, Otterlo, Neth.; Mus. Internazionale d'Arte Contemporaneo, Florence; Kunsthaus, Zürich; Nat. Mus. of Israel, Jerusalem.

ABOUT: Arnason, H. H. History of Modern Art, 1968; Canetta, E. Fritz Wotruba, 1955; "Fritz Wotruba" (cat.), Gal. Welz, Salzburg, Austria, 1959; Heer, F. Fritz Wotruba: Humanity out of Stone, 1961; P- Orridge, G. and others (eds.) Contemporary Artists, 1977; Read, H. A. Concise History of Modern Sculpture, 1964; Salis, J.-R. de Fritz Wotruba, 1948; Selz, P.

(ed.) "New Images of Man" (cat.), MOMA, NYC, 1959;
Wotruba, F. Uberlegungen: Gedanken zur Kunst,
1945. *Periodicals*—Arts Magazine April 1964; Der Bau
(Vienna) no. 11/12 1954; Du (Zürich) February 1947;
Kontinents: Schöpferisches Osterreich (Vienna) April
1955; Studio International December 1965.

WYETH, ANDREW (NEWELL) (July 12,
1917–), American painter, is the master of a
meticulous, vaguely nostalgic brand of realism
that appeals mainly to those sections of the
American public opposed to modernism in art.
His painting appeals deeply to those who yearn
for a bygone state of supposedly rural simplicity
and innocence. Although Wyeth's work does not
propagandize in the manner of 1930s regional-
ism, it has had a distinctly polarizing effect. Wy-
eth has been hailed in some quarters as *the*
authentic American painter—he is certainly the
most popular—and has also aroused the antipa-
thy of many critics and supporters of modern
art. Actually, the undertones of his work are by
no means as reassuring as his admirers often be-
lieve, and he is a more complex figure than the
popular stereotype of the "homespun artist"
would indicate.

Andrew Wyeth was born in the sleepy village
of Chadds Ford, Pennsylvania, where he still
lives and works. This fact in itself is exceptional,
for very few 20th-century artists have made
their name by staying home. He was the youn-
gest of the five children of the successful illustra-
tor and muralist Newell Convers Wyeth, a pupil
of Howard Pyle, and the former Carolyn Bren-
neman Bockius. His sisters, Henriette (who mar-
ried the artist Peter Hurd) and Carolyn, are both
painters.

Because he was sickly during his childhood,
Wyeth never had formal schooling but was tu-
tored at home. At 14 he made accomplished
drawings in pen-and-ink of castles and medieval
soldiers. When he was about 15 he constructed
a miniature theater which greatly impressed his
father, who began to give him art lessons. Wyeth
recalled: "My father certainly came down upon
me, firmly pressing me on, but at the same time
he left me really very free. He made me get
down and approach the object, and work from
it rather than the images in my mind." In 1932
Wyeth contributed a watercolor to a show in
Wilmington, Delaware.

Summers at Port Clyde, Maine, provided
young Wyeth with the settings for the land-
scapes and seascapes he exhibited in October
1937 at the William Macbeth Gallery, New York
City. His father had shown the Maine watercol-
ors to Macbeth, whose gallery was the only one

Courtesy of Brandywine River Museum; Photo by Russ Kennedy

ANDREW WYETH

in New York to handle American paintings ex-
clusively. The show was a great success and Wy-
eth, to quote the artist, "achieved a sort of
renown for watercolor, gained considerable con-
fidence, and even made a little money. . . . "

Encouraged by this success but feeling the
need for more discipline, Wyeth returned to
Chadds Ford and continued to work in his fa-
ther's studio. He studied anatomy and hired
some models from the neighborhood to pose for
portraits. By this time he was working mostly on
his own, influenced not only by his father's train-
ing, there were other but also by the watercolors
of Winslow Homer and the watercolors, dry-
brush paintings, and prints of Albrecht Dürer.
When Wyeth was 13 his father had given him
an excellent facsimile publication of Dürer's
graphic work, and Wyeth was particularly im-
pressed by the microscopically detailed dry-
brush technique of Dürer's *Young Hare* (1502)
and *Large Piece of Turf* (1503). Some art histori-
ans have perceived the influence of the great
19th-century American realist Thomas Eakins,
but Wyeth has denied this: "Eakins is, in a real
sense, more European than American and was
less interesting for some reason to me."

In the late 1930s Wyeth was introduced to the
tempera technique by his brother-in-law, Peter
Hurd. Commenting on Wyeth's second show at
the Macbeth Gallery, held in 1939, one critic
wrote that "a deeper, richer color appears in the
latest works. . . . The artist's technique defies
formula."

On May 15, 1940, Wyeth married Betsy Merle
James, whom he had met the previous year dur-
ing his annual visit to Cushing, Maine. On the

day they met—it was his 22d birthday—Betsy drove him down to "a marvelous home" where the family of Christina Olson, who had been Betsy's friend since childhood, lived. Wyeth was struck by the contrast of that milieu with his favorite haunt nearer home, the Kuerners' farm in Pennsylvania. (Wyeth's father was French-Swiss with "a certain German element" and his mother was of Pennsylvania German descent; this, he feels, may explain his attraction to Karl Kuerner, who had fought in the German Army as a machine gunner at the Battle of the Marne in World War I, had been wounded, and had been decorated by the Crown Prince. Some viewers have sensed a Germanic quality in Wyeth's vision with its obsessive, if selective, attention to detail.) Since 1940 Wyeth has based his subject matter almost exclusively on these two locations, the one in Pennsylvania, the other in Maine. "Of the essential environments of my life," he said in 1976, "Kuerner's in Pennsylvania and Olson's in Maine are probably the most important. One has the colors of Pennsylvania and the surrounding area, the strength of the land, the enduring quality of it, the solidity of it; the other is spidery, light in color, windy perhaps, sometimes foggy, giving the impression sometimes of crackling skeletons rattling in the attic." It is evident from this statement that Wyeth's work, despite its specifically rural setting, is by no means bucolic; he is no Grandma Moses.

Wyeth's 1941 show at the Macbeth Gallery received enthusiastic notices, and in 1943 he was among the painters invited to participate in the "American Realists and Magic Realists" exhibition at the Museum of Modern Art in New York City. His work was included in the latter category. Of the works in Wyeth's 1943 show at the Macbeth Gallery, one critic noted a "certain hardness of effect" in the temperas, but another considered the drybrush drawings to be "something of a *tour de force.*"

The first tempera Wyeth painted at Olson's was *Oil Lamp* (1945; Museum of Fine Arts, Houston), a night scene in the kitchen, for which Christina's brother Alvaro reluctantly posed. While Wyeth was working on it he learned that his father, N.C. Wyeth, had died; the artist returned home to Chadds Ford and completed the picture there. Alvaro never sat for him again, but Wyeth did many drawings and paintings of Christina. *Christina Olson* (1947) is as much a portrait of the Olsons' environment as of Christina herself, a gaunt New England woman crippled by infantile paralysis, who sits on the kitchen doorstep gazing out to the sea and looking, in Wyeth's words, "like a wounded seagull." The haunting *Christina's World* (1948; MOMA), painted in tempera on a gesso panel, has become

an American classic. Here Wyeth transcends his customary idiom. The placing of the solitary woman against the minutely depicted expanse of grass, her face toward the horizon as she pulls herself slowly with her bony arms toward the house—all this creates an uneasy, otherworldly atmosphere akin to surrealism and well beyond the scope of American regionalism of the 1930s. (Christina Olson died in 1968.)

Karl, painted at the Kuerner farmhouse in 1948, is considered by the artist "the best portrait I ever did." Wyeth apparently feels an empathy with the solitary people he paints, but in *Karl,* as in many of his other portraits, a cold, hard, uncommunicative feeling emerges, heightened by the almost photographic technique and restricted palette. As Brian O'Doherty has observed, "Direct confrontation with the sitter . . . brings out an evasiveness in Wyeth, as if he didn't want to betray himself while thinking badly of anyone. In the famous *Karl,* the cruelty is displaced from the face to the hooks above." (The hooks were used for hanging salami.)

In the sense of human isolation and the so-called distilled reality Wyeth conveys, he has been compared to Edward Hopper, but as Mark Rothko remarked: "Hopper has a wholeness that Wyeth lacks."

Wyeth achieved a kind of poetry in some of his scenes without figures, as in *Wind from the Sea* (1947) and *Northern Point* (1950), both painted at the Olsons'. In *Wind from the Sea* the worn net curtains blown into the attic room, the cracked blind, and the empty landscape seen through the window, are images that remain in the mind. *Northern Point,* with its skillful selection of forms and the contrasts of scale between foreground and distant seacoast is arresting. Even his landscapes have an obliquely literary quality that the critic John Russell finds "manipulative."

Both the content of Wyeth's pictures and their great technical proficiency have contributed to his immense popularity in America, and he has received many awards and honors. The American Academy of Arts and Letters awarded him its Merit Medal in 1947 and he was made a member eight years later. He received a Gold Medal for Painting from the National Institute of Arts and Letters in 1965. A Wyeth Gallery was inaugurated in the Brandywine River Museum, Chadds Ford, in 1971.

There have been Wyeth retrospectives at the Fogg Art Museum in Cambridge, Massachusetts, in 1963, and at the Pennsylvania Academy of Fine Arts, Philadelphia, in 1966; both toured the United States. "Two Worlds of Andrew Wyeth: Kuerners and Olsons," a major exhibition held at

the Metropolitan Museum of Art, New York City, in 1976, aroused great interest. The museum's director, Thomas Hoving, organized the show and discussed in his catalog introduction the dispute between those who regard Wyeth as *the* truly American painter, a bulwark against "degenerate" abstraction, and those who see him as a "purposefully reactionary" and "coldly trite" anachronistic 19th-century realist. Some critics and viewers, while acknowledging the validity of Wyeth's obsession with his chosen subjects and his considerable technical skill, reacted against the drab tans and gray-browns of his palette (which Hilton Kramer of the *New York Times* found especially distasteful) and his retrogressive outlook. One chilling but curiously noncommittal image was provided by *The German,* a watercolor of 1975 for which the aging and stone-faced Karl Kuerner posed in his old World War I uniform and steel helmet against a stark winter background.

Andrew Wyeth still lives and works in Chadds Ford and spends his summers in Cushing, Maine. He and his wife Betsy have two sons, Nicholas and James Browning (Jamie), who has become a well-known artist in his own right. For many years Wyeth enjoyed boxing, fencing, and flying an airplane. His approach to painting has not changed appreciably since 1942, when he said, "I believe the artist should . . . be indigenous to the country which he paints. This, I know, is contrary to the practice of many present-day painters who dash about to sketch here and there." Of his familiar haunts he once said: "Maine to me is almost like going to the surface of the moon. I feel things are just hanging on the surface and that it's all going to blow away. . . . In Pennsylvania, there's a substantial foundation underneath, of depths of dirt and earth. Up in Maine I feel it's all bones and desiccated sinews. That's actually the difference between the two places to me."

EXHIBITIONS INCLUDE: William Macbeth Gal., NYC 1937–52; Doll and Richards Gal., Boston 1938–46; Currier Gal. of Art, Manchester, N.H.1951; M. Knoedler and Co., NYC 1953, '58; M.H. de Young Memorial Mus., San Francisco 1956; Santa Barbara Mus. of Art, Calif. 1956; Wilmington Society of the Fine Arts, Delaware Art Center 1957; Massachusetts Inst. of Technology, Cambridge, Mass. 1960; Albright-Knox Art Gal., Buffalo, N.Y.1962; Fogg Art Mus., Cambridge, Mass. 1963; Pennsylvania Academy of FineArts, Philadelphia 1966; Mus. of Fine Arts, Boston 1970; Lefevre Gal., London 1974; Nat. Mus. of Modern Art, Tokyo 1974; Nat. Mus. of Modern Art, Kyoto, Japan 1974; "Two Worlds of Andrew Wyeth: Kuerners and Olsons," Metropolitan Mus. of Art, NYC 1976. GROUP EXHIBITIONS INCLUDE: Annual Pennsylvania Academy of Fine Arts, Philadelphia 1938–65;

"American Realists and Magic Realists," MOMA, NYC 1943; Annual, Whitney Mus. of Am. Art, NYC 1946–67; Pittsburgh International, Carnegie Inst. 1950–64; "The Brandywine Heritage," Brandywine River Mus., Chadds River, Pa. 1971; "Ten Americans," Andrew Crispo Gal., NYC 1974.

COLLECTIONS INCLUDE: Metropolitan Mus. of Art, and MOMA, NYC; Munson-Williams-Proctor Inst., Utica, N.Y.; Wadsworth Atheneum, Hartford, Conn.; Currier Gal. of Art, Manchester, N.H.; Mus. of Fine Arts, Boston; Addison Gal. of Am. Art, Andover, Mass.; William A. Farnsworth Library and Art Mus., Rockland, Maine; Philadelphia Mus. of Art; Hirshhorn Mus. and Sculpture Garden, Washington, D.C.; Art Inst. of Chicago; Wilmington Society of the Fine Arts, Delaware Art Center; North Carolina Mus. of Art, Raleigh; Dallas Mus. of Fine Arts; Mus. of Fine Arts, Houston; Frye Art Mus., Seattle; California Palace of the Legion of Honor, San Francisco; Nat. Gal., Oslo.

ABOUT: Current Biography, 1981; Hoving, T. "Two Worlds of Andrew Wyeth: Kuerners and Olsons" (cat.), Metropolitan Mus. of Art, NYC, 1976; O'Doherty, B. American Masters: The Voice and the Myth, 1973; Watson, E. W. Color and Method in Painting, 1942. *Periodicals*—Art in America October 1955, May–June 1977; Art News November 1962; Atlantic June 1964; Horizon September 1961; Metropolitan Museum of Art Bulletin Autumn 1976; New York Times Magazine October 25, 1953; Studio December 1960; Time November 29, 1948, July 16, 1951.

***XCERON, JEAN** (February 24, 1890–March 29, 1967), Greek-American painter, embraced modernist aesthetics long before they became well known in the United States. Although he was one of the few nonobjectivists hired for the Federal Arts Project in the 1930s, his sensitive but undramatic work was later overshadowed by the emergence of abstract expressionism and other, more flamboyant movements. As a result he has not received the popular and critical recognition he deserves.

Born in 1890 in the Greek mountain town of Isari Likosouras, Xceron was the son of a blacksmith, Petros Xerocostas. As a boy he learned to paint and engrave, and constructed small sculptures from scraps of iron in his father's shop. The strongest early influence on him was not the ubiquitous (but ignored) classical remains, but rather was the equally omnipresent Greek Orthodox ikons and mosaics in the Byzantine tradition. In 1904, aged 14, he came to the US to stay with relatives in Washington, D.C., Pittsburgh, and Indianapolis; he finally settled in D.C. and enrolled in the Corcoran School of Art. Xceron trained there for seven years, drawing from plaster models of famous antiquities, and earning a meager living at odd jobs. His fellow students in-

°zcer ôN´, zhäN

cluded Abraham Rattner, George Lahr, and Charles Logasa; in 1916 the two last-mentioned artists organized Washington's Armory Show (modeling it after New York City's great Armory Show of 1913), which had a profound effect on Xceron's direction. The work of Georges Roualt, in particular, seems to have been important to him, as can be seen in *Crucifixion No. 6* (1917) and *Adam and Eve No. 9* (1919). Xceron combined Roualt's luminous primitivism with a spiritual directness derived from the religious ikons with which he was so familiar.

Xceron moved to New York City in 1920, where he met Max Weber, Abraham Walkowitz, Joseph Stella, and the Uruguayan painter Torres-Gracia. *Landscape No. 36* (1923), a view of a simple house in the woods, reveals his absorbing interest in Cézanne at this time. Inevitably, in 1927, he traveled to Paris, where he was befriended by the Greek-American artist Theodoros Dorros, whose sister he later married. Despite his contact with such notables as Piet Mondrian, Theo van Doesburg, Fernand Léger, and Jean Hélion, he painted clandestinely, supporting himself instead as a journalist and critic for the *Boston Evening Transcript* and the Paris edition of the *Chicago Tribune*. The paintings in his first solo exhibition, held in 1931, with their freely painted forms, half musical instrument and half player, recall Picasso's postcubist work, and, except for the grid he imposed on the side of *Violin 6F* (1932), in no way presage the cleanly rectilinear style that characterizes most of his later work.

Possibly under van Doesburg's and Hélion's influence, and sensitive to the constructivist experiments that had recently been imported out of Russia, Xceron by the mid-1930s developed a purified nonobjective style of pristine rectangles and curves; this was the style he brought back with him to the US in 1937. In the very earliest of his constructivist-neoplastic works Xceron shaded behind his forms to create the illusion of layered but shallow space, as in *Composition No. 242* (1937). By the time of *Painting No. 239* (1939), form and space were cut flat to the picture plane; within two years he began introducing irregular polygons to add tension to the static quadrilaterals he usually used (*Fragments No. 257,* 1941). As with many geometric painters (all ultimately taking their cue from Mondrian and van Doesburg), Xceron preferred the vertical canvas and arranged his forms on a strict up-and-down grid.

In 1938 Xceron joined the American Abstract Artists, the group of geometrical abstractionists formed some years earlier by George L.K. Morris and others. For a short period he worked for the Federal Arts Project. It may have been the work of Social Realist artists he came in contract with through the Project, or Hélion's radical conversion to figuration just at this time (they met occasionally in Hélion's Manhattan studio), or simply his underlying discomfort with dogmatic geometricity that influenced Xceron gradually to temper his former austerity with a more painterly approach. Beginning by rotating some of his forms off-axis (*White Form No. 271,* 1944), the artists began deliberately to subvert strict rectilinearity (*Composition No. 275,* 1945) until he found a temporary middle ground between geometry and a freer organicism, notable in *Beyond White* (1950), in which a web of black lines creates a complex, often contradictory sense of depth as it defines more frequent and various color areas.

In the later 1950s Xceron returned to the ikonic imagery of his youth—*Ikon No. 386* (1954) and *Figure No. 389A* (1955), for example—although his figures were still couched in the vocabulary of organic geometry he had developed in the past decade. It was now easy to see how important this folk-religious imagery was, in a formal sense, to his entire development, including the most abstract periods. In many of his late works, black forms are outlined in white, creating an effect both primitive and direct, as in *Painting 9, No. 435* (1961) and *Source No. 445* (1962). These somber paintings gave way, at the very end of his life, to a free and calligraphic series of "Caryatids" (ca. 1963).

Xceron died in New York City at the age of 77. The French critic Michel Seuphor wrote in 1957: "Xceron's style is absolutely his own. It is well-constructed, without excessive rigor. The compositional elements retain something lively and joyous." Reviewing a retrospective of Xceron's small works on paper at the André Zarre Gallery, New York City, in *Arts Magazine* (June 1979), Edgar Buonaguiro commented on the artist's "individual—often uncanny—feel for the intricacies and characteristics of specific materials. . . . Ultimately it is this acute sensitivity and sophistication that most clearly separates his humble works from the pack."

EXHIBITIONS INCLUDE: Gal. de France, Paris 1931; Gal. Percier, Paris 1933; Gal. Pierre, Paris 1934; Garland Gal., NYC 1938; Nierendorf Gal., NYC 1938; Univ. of New Mexico, Albuquerque 1948; Sidney Janis Gal., NYC 1950; Rose Fried Gal., NYC 1957; Solomon R. Guggenheim Mus., NYC 1965; André Zarre Gal., NYC 1979, '84. GROUP EXHIBITIONS INCLUDE: Barcelona Exhibition, Spain 1929; Salon des Surindépendents, Paris from 1931; "Art of Tomorrow," Mus. of Non-Objective Art, NYC 1939; American Abstract Artists Exhibition, NYC 1940–65; Pittsburgh International, Carnegie Inst. 1941–44, 1946–50; Salon des Réalités Nouvelle, Paris

1947–52; "The Classic Tradition in Contemporary Art," Walker Art Center, Minneapolis 1953; "Cezanne and Structure in Modern Painting," Solomon R. Guggenheim Mus., NYC 1963.

COLLECTIONS INCLUDE: MOMA, and Solomon R. Guggenheim Mus., NYC; Brooklyn Mus., N.Y.; Yale Univ. Art Gal., New Haven, Conn.; Hirshhorn Mus. and Sculpture Garden, Washington, D.C.

ABOUT: Cheney, S. the Story of Modern Art, 1958; "Jean Xceron" (cat.), Solomon R. Guggenheim Mus., NYC, 1965; Rose, B. American Art Since 1900, 2d ed. 1975, American Abstract Artists: The Early Years, 1980; Seuphor, M. (ed.) Dictionnaire de la peinture abstracte, 1957. *Periodicals*—Arts Magazine June 1979.

***YAMAGUCHI, TAKEO** (November 23, 1902–), Japanese painter, insists that he is not an abstractionist, although by any standards other than his own there is nothing representational in his massive black, red, and ocher canvases, which have the powerful simplicity of Japanese ideograms. Like many modern Japanese painters, he studied for a time in the West, absorbing the tenets and techniques of modernism before fully accepting the refined aesthetics of his own heritage. His later paintings perfectly embody the concept of *yūgen*—mystery and depth— while possessing *sabi*, the well-worn beauty of ordinary things.

Yamaguchi, who was born in Seoul, Korea, began as a farmer on a family estate under the supervision of his father, a successful businessman. This early experience left a strong impact on his subsequent development as an artist. The critic Tono Yoshiaki, discussing Yamaguchi in *New Art Around the World*, writes: "His work resembles the crude yet powerful prayer of a farmer—a farmer who loves to till the soil." In the 1920s Yamaguchi studied under Eisaku Wada at Tokyo University's Academy of Art and became interested in Western painting. His few pictures that survive from that period—*Landscape* (1923) and *Self-Portrait* (1927)—are neoimpressionist in style (an interesting reversal, since many of the Neoimpressionists used the elements of Japanese composition that they had absorbed during the "Japonisme" craze of the late 19th century). Already Yamaguchi shunned overly descriptive detail, aiming instead to represent the deep structure of things; thus his paintings became increasingly simplified through the 1930s.

While in Tokyo, Yamaguchi was deeply impressed by an exhibition of the work of Saeki Yūzō, a Japanese painter living in Paris. Shortly after his graduation from the academy in 1927,

Yamaguchi made his own pilgrimage to Paris. He soon met Saeki, who had a strong philosophical influence on him, but whose work was proceeding in an entirely different direction. On their sketching trips together, Saeki attempted to convey the fleeting qualities of the scene, while Yamaguchi was intent, he recalled, on "capturing the underlying forms of the subject in a rough sketch, drawing the form with black ink on a white painted canvas and then adding in a little color"—more the method of a Hokusai than of a Seurat. Yamaguchi also regularly attended gatherings at the atelier of the sculptor Ossip Zadkine; probably through Zadkine, then in a strongly cubistic phase himself, Yamaguchi was introduced to the work of Picasso, Léger, and Braque. *Two Figures, Man,* and *Head,* all of 1930, reveal the influence of postcubist Picasso.

Returning to Japan in 1931, Yamaguchi began to show his work in Tokyo in the exhibitions of the Nika artists' association. The titles of his paintings bear witness to a concern with both Western and Japanese subjects: *On a Table A* and *On a Table B,* both of 1933, indicated his interest in the traditional still life, while *Garden* (1934) and *Garden* (1935–36) are more Japanese in genesis. These works, however, although taken from nature, are not in any obvious sense representational; their amorphous spots of color and dark lines make up an essentially abstract symbolic idiom. A few years later Yamaguchi was experimenting with completely abstract shapes such as ovals and irregular organic masses (*Work B,* 1939, *Five Masses,* 1940), but then and since the artist has been adamant that "abstract" is the wrong term to apply to his work: "I deny the use of inorganic things as subject matter even though they easily become abstract configurations, and advocate taking as the foundation an expression of a sense of nature, an ordinary sense of beauty."

During World War II Yamaguchi lived in Korea, then under Japanese domination. Nearly all of his paintings of the early 1940s were lost or destroyed; after the war years he emerged as a mature painter. In the late '40s and early '50s his paintings usually incorporated two flat, simple shapes on a black field. After considerable experimentation with color, Yamaguchi reduced his palette to black, yellow-ocher, and Venetian red (the colors of earth and clay); he rarely used more than one color in a painting after 1952. Pigment was applied thickly with a palette knife or stiff brush on plywood panels. He used texture to subtly define his forms, which now resembled ideograms composed of intersecting strips and curves (as in *Crossing* and *Pattern,* both of 1954). Through the later 1950s Yamaguchi aggressively

°yä mä gōō´chē, tä kē ō

eliminated every unnecessary complication in the search for compositional purity; in *Ten (Turn)* (1961) the curves have vanished and the strips have become blocks separated by small areas of textured black. *Pattern* (1960) recalls such Japanese prehistoric artifacts as the perforated sandstone masks of the late Jōmon period.

Yamaguchi's canvases attained a monadic monumentality in the 1960s and '70s as he allowed the forms to move forward until they virtually blotted out the background. In *Mon (Crest)* (1972), a tiny triangle of black in the upper left corner defines the yellow-ocher form, while in the rusty-red *Go (Encounter)* (1975) all that separates the two compositional elements is a simple black line and contrasting textures. "My work," he said, " . . . is a natural result of my need for space. My motifs are drawn from nature, but they are not mere reproductions of nature. Actually, they are a record of my mental image. . . . The shapes I paint should move slowly as though living and breathing."

EXHIBITIONS INCLUDE: Seijusha, Tokyo 1939; Minami Gal., Tokyo 1961, '65, '68, '72; Nihonbashi Gal., NYC 1963; Musashino Art Col., Tokyo 1968. GROUP EXHIBITIONS INCLUDE: Nika Association Exhibition, Tokyo from 1931; Annual, Am. Artists Society, NYC 1954; "Contemporary Japanese Art," Tokyo 1954; São Paulo Bienal 1955, '63; Venice Biennale 1956; International Exhibition, Solomon R. Guggenheim Mus., NYC 1958; "Contemporary Japanese Painting," Zürich 1965; Expo '70, Osaka, Japan 1970.

ABOUT: Kung, D. The Contemporary Artist in Japan, 1966; Miller, D. C. and others The New Japanese Painting and Sculpture, 1966; Abrams, H. New Art Around the World, 1966.

YEATS, JACK BUTLER (August 29, 1871–March 28, 1957), Irish painter and illustrator, was the son of the renowned portraitist and illustrator John Butler Yeats and the younger brother of William Butler Yeats, Ireland's greatest poet. A fiercely independent spirit, Yeats was considered the leading Irish painter of his day, and was in turn the most devoted portrayer of his country.

Jack Butler Yeats was born in London, the youngest of five children; William was the oldest. His father encouraged Jack's career as an artist from the start. Yeats always maintained that he became a painter because his father was one before him. His childhood was spent with his maternal grandparents in Sligo, on the northwestern coast of Ireland. From a very early age he sketched and drew the local scenes and townspeople. He loved the ocean and the shore,

and even developed, according to his father, "a certain roll and lurch in his gait, that being the mark of the Sligo man."

In 1887 Yeats returned to live with his family in London. His father, excited by his sons's talent, insisted that he go to art school. Yeats attended the rigidly academic School of Art, South Kensington, and the Chiswick and Westminster schools, London, both known for chauvinistic emphasis on the British artistic tradition. He worked hard at his studies to please his father, but was essentially a loner who disliked the stuffiness of the academies. His greatest pleasures were attending boxing matches, circuses, and music halls, and walking along the docks. (Wherever he went, he could be seen sketching frantically.)

The family moved to Bedford Park, London, in 1888, where their house became a gathering place for his father's friends, mostly artists and intellectuals. His mother suffered a stroke during this time; she never completely recovered and died in 1900. In 1891 he met Mary Cottenham White (Cottie), a fellow art student, whom he was determined to marry. For three years he worked long hours as an illustrator for comic journals, sports sheets, and other publications, until in 1894 he had earned enough money to marry her and buy a house in Surrey. They had a long and happy, although childless, marriage.

Yeats's early work can be described as "pictorial journalism," that is, he illustrated sporting events and local news stories from sketches done on the spot. His first published drawings appeared in the *Vegetarian* magazine and in publications of his friends and siblings (such as William Butler Yeats's *Irish Fairy Tales*). By the mid-1890s his lively and humorous drawings, which contrasted with the heavily political cartoons of most of the artists of the day, were in wide demand. In 1896 *Punch* accepted one of his illustrations. He had been placing work in *Lika Joko*, a magazine similar to *Punch*, but more rowdy, including a series entitled "The Submarine Society" which poked fun at social conventions. Strongly realistic, with elements of parody and humor, these illustrations reveal nonetheless a sympathy and tenderness toward flawed humanity.

In 1897–98 Yeats and his wife moved to a home in Devon, which they dubbed "Snail's Castle" for the abundance of snails in the area. As photography began to supersede pictorial journalism, Yeats turned to other forms of art. He tried writing boys' stories, but considered painting and drawing superior forms of communication for their immediacy and directness. What he wanted out of art was to express the joy

and sadness of the life and people around him. He had little patience with abstraction: "The word 'art' I don't much care for because it doesn't mean anything much to me. . . . I believe that all fine pictures, and fine literature too, to be fine must have some of the living ginger of life in them."

Yeats began to experiment with watercolors, a medium with which he had had some experience in art school. He produced enough quality work during his first year in Devon to hold a well-received solo show at the Clifford Galleries in the Haymarket. Stylistically, the watercolors evolved directly from his black-and-white illustrations; they are evocations of the people and places he had seen in Ireland and England. *Memory Harbour* (1900), for example, is a pictures of the Irish coast, with cottages, horse and buggy, quaint ships, and a curious bearded traveler in the foreground. Many of the paintings are dominated by a picturesque, nostalgic quality. Watercolor was his main medium for nearly a decade, during which little changed in his work, save for a gradual deepening of color as he began to use a drier brush and paint with greater firmness.

As Yeats became increasingly interested in, and nostalgic for, the culture, people, and politics of Ireland, he grew restless in England and longed to return. This interest extended to folklore and oral history. In 1902 he helped design and publish *A Broadsheet*, a periodical collection of ballads and forgotten verse, rediscovered and in some cases translated from the Gaelic and accompanied by his illustrations. W.B. Yeats and a number of other well-known writers contributed to the magazine. *A Broadsheet* folded for a time, then resurfaced in 1908 as *A Broadside*, continuing until 1915. Yeats spent much time on the project, soliciting, editing, and illustrating.

Yeats was a playful man who indulged in youthful pastimes such as the construction and sailing of toy boats with his friend, the poet John Masefield. Both loved the sea and spent many hours staging mock sea battles. Yeats was also an enthusiastic puppeteer, and constructed a toy theater to entertain the neighborhood children. Two of the plays he wrote, which have been described as bloodthirsty and melodramatic (but were hardly more so than Punch and Judy), were later produced with human actors on the stage. The puppet theater seems to have held great significance for him, as he elaborated on it and played with it for nearly 30 years.

In 1902 Yeats met John Quinn, and Irish-American lawyer and collector who became his most important patron. Quinn purchased eight of Yeats's paintings, as well as a few of his father's works, and invited the younger man to exhibit in New York City the next year. Yeats enjoyed New York, spending most of his seven-week visit sketching at Coney Island, the Brooklyn Bridge, Chinatown, the vaudeville shows, the Bowery, and the docks, as well as watching the inspection of immigrants on Ellis Island. The exhibition itself was disappointing; only 12 paintings were sold, ten of them to Quinn.

In 1905 Yeats spent a month traveling through Ireland with the playwright J.M. Synge, who was writing a series of articles for the *Manchester Guardian* which Yeats was to illustrate. His drawings show a poor and downtrodden people, trying to salvage some nobility from a harsh life. These and many other works demonstrate Yeats's deep compassion. He refused to separate art from life, but believed that the former was meant to complement the latter: "There's too much old chat about the Beautiful: it's been something I've been turning over in my mind and I have a definition. The Beautiful is the Affection that one person or thing feels for another person or thing, either in life, or in the expression of the arts."

Though claiming to paint only for himself (and certainly not for critics or art historians), Yeats believed in art as communication, emphasizing affection over theory or technique. Regarding Sligo, for example, he wanted to record the beauty and the atmosphere of the place so that those seeing his paintings would feel what he had felt. "The finest picture in the world will give the finest moment finest felt by the finest soul with the finest memory." He remained aloof from the trends of modernism, claimed to dislike English painters on principle, and did not seek out the companionship of other artists. He admired Goya but was probably not influenced by him; in fact, he disliked the notion of being influenced by anyone at all. Critics, however, have seen in his paintings elements from the work of the Impressionists, Antoine Watteau, Honoré Daumier, Walter Sickert, George Cruikshank, and Oskar Kokoschka.

In 1910 Yeats and his wife moved to Greystones in County Wicklow, not far from Dublin. The move brought on a major change in his work; he began to paint almost exclusively in oil. He did few black-and-white illustrations (the sale of his art work having liberated him from money worries) and began to concentrate on landscapes and local scenes. Hilary Pyle, in her biography of Yeats, notes that his early oils give "an impression of watercolors carried out with oil instead of water." It was not until 1912, as shown in *The Circus Dwarf*, that Yeats availed himself of the greater range of expression of oils.

The eerie red-haired dwarf is a much stronger, more intriguing figure than the artist could create in watercolors. *The Circus Dwarf* was one of five paintings that Yeats, at Quinn's suggestion, entered in the epochal 1913 New York Armory Show.

In 1915 Yeats was elected a member of the Royal Hibernian Society, but this honor mattered less to him than the growing popular unrest in Ireland. In 1917 he and Cottie moved to Dublin and Yeats began studying Gaelic. His work increasingly reflected the tensions that were to lead to the Irish Civil War. The strike of 1913 and a series of other violent incidents had led him to paint *In Memory* (1915), sometimes called *Bachelor's Walk*, which depicts a boy and his mother in mourning on a lonely street. As the violence progressed, so did the protest element in his work. Although he was decidedly pro-Republican, he abhorred the loss of life on either side. Thus his work is devoid of "glorious" battle scenes, portraying instead the lonely and desolate aftermath of the conflict. *The Funeral of Harry Boland* (1922), in memory of an unarmed negotiator who was murdered, and *Communicating with Prisoners* (1924), showing a group of young girls shouting to converse with equally young prisoners in a towerlike jail, are painted in subdued colors, grays, blues, and browns. The First World War and the "troubles" affected Yeats to such an extent that his emotional and physical well-being was impaired: In 1916 he sank into a depression that was to last for five years and was to color his work for more than a decade.

The late 1920s and early '30s saw a drastic and unprecedented change in his life and art. Working the depression of the war years out of his system, he began experimenting with brighter colors and freer strokes; his subject matter became more lighthearted as well. His realism, as in *The Bus by the River* (1927), is no longer exact and detailed, but stylized in wide, thick strokes and swirls of blazing color, sometimes applied directly from the tube and spread with his fingers or a palette knife. A greater urgency animated his work, coupled with a reveling in humanity; he used bright colors to convey emotion rather than details of figures or scenery, so much so that one critic called him the "Irish Van Gogh." A late example of this style, which persisted until the end of his career, is *Freedom* (1947), a portrait of a horse in dashes of red, brown, blue, white, and orange, all of which give the clear impression of blazing sunlight reflecting off the back of a spirited animal.

Another important change in Yeats's life was his renewed dedication to literature. In the 1930s and '40's alone he wrote three plays, seven novels or volumes of memoirs, and numerous short stories, including *Sligo* (1930), a prolonged reminiscence of his boyhood. His novels included *Sailing, Swiftly Sailing* (1933), *The Amaranthers* (1936), and his final literary work, *The Careless Flower* (1947).

In the mid-1940s he redirected his attention toward painting. Nonetheless, his energy was flagging. Cottie died in 1947 and his sister Lily in 1949, making him the last surviving member of his immediate family (W.B. Yeats had died in 1939). His health failing, he spent several months of the year in a nursing home in Portobello, Scotland, from the early 1950s. He continued painting until 1955, and died two years later in Portobello.

EXHIBITIONS INCLUDE: Clifford Gals., London 1897; Clausen Gals., NYC 1904; Arthur Tooth and Sons, London 1926, '28; Ferrargil Gals., NYC 1932; Waddington Gals., London 1943–67; Nat. Col. of Art, Dublin 1945; Waddington and Co., London 1946; Temple Newsam Home, Leeds, England 1948; Inst. of Contemporary Arts, Boston 1951; Venice Biennale 1962; New Gal., Hayden Library, Massachusetts Inst. of Technology, Cambridge 1965; Nat. Gal. of Ireland, Dublin 1971. GROUP EXHIBITIONS INCLUDE: Royal Hibernian Academy of Arts Annual, Dublin 1885, 1911, 1915–50; Salon des Indépendants, Paris 1912; "Armory Show," NYC 1913; Society of Independent Artists Annual, NYC 1921–26; Pittsburgh International, Carnegie Inst. 1925, '31, 1934–39.

COLLECTIONS INCLUDE: Nat. Gal. of Ireland, Dublin; Sligo County Library and Mus., Ireland; Tate Gal., London; Hirshhorn Mus. and Sculpture Garden, Washington, D.C.

ABOUT: MacGreevy, T. Jack B. Yeats, 1945; Marriott, E. Jack B. Yeats: His Pictorial and Dramatic Art, 1911; Pyle, H. Jack B. Yeats: A Biography, 1970; Rosenthal, T. Jack B. Yeats, 1967; White, J. Jack B. Yeats: Drawings and Paintings, 1971; Yeats, J. B. Modern Aspects of Irish Art, 1922. *Periodicals*—New York Times March 8, 1962.

YOUNGERMAN, JACK (March 25, 1926–), American painter and sculptor, is best known for his broad, colorful abstractions which many critics have likened to the cutouts of Henri Matisse. Like Matisse, Youngerman is most adept at the generation of elegant organic shapes and has an unerring sense of composition. Unlike Matisse, however, his work makes regular and effective use of optical ambiguities and the huge, engulfing scale of the Abstract Expressionists and the Color-Field painters.

Youngerman was born in Webster Grove,

Missouri, and moved with his family in 1928 to Louisville, Kentucky. He studied at the University of North Carolina, Chapel Hill (in the US Navy training program), from 1944 to 1946 and then at the University of Missouri, Columbia, receiving his AB in 1947. After a brief hitch in the Navy, he went to Paris on the GI Bill to study at the Ecole des Beaux-Arts; he remained in Europe until 1956 and made three short trips to the Middle East. In 1950 he married the French film actress Delphine Seyrig, with whom he had a son, Duncan Pierre.

Youngerman had a brief career as a set designer, first in Paris for Jean-Louis Barrault's production of *Histoire de Vasco* by Georges Schehade in 1956, and after his return to the US for the 1958 New York City production of Jean Genet's *Deathwatch*. Youngerman settled in New York City in 1956 and began painting steadily; he was discovered by the perceptive Betty Parsons and had his first New York solo show in her avant-garde gallery in 1958.

Youngerman's early paintings, with their active brushstrokes and abstract color areas, appear to be a spontaneous fusion of abstract expressionism and color-field painting, but in fact his work is thoroughly preplanned, and although springing from preconscious motivations, is intellectual. "When I first started to work," he said in the early 1960s, "I painted abstractly for one primary reason: it seemed, and still seems to me the approach in which as a painter one can be freest." He had passed through a brief period of undogmatic geometric abstraction in Paris, influenced by Victor Vasarely, Auguste Herbin, and others of the Réalités Nouvelles group, as well as Sophie Taeuber-Arp. This style is preserved in such works as *Black, White, Blue, Aluminum* (1952) and a series of "Target" paintings (1952–53).

By the mid-1950s Youngerman had turned to the freely rendered organic forms that still characterize his work. These paintings—*Rose of Latakia* (1957), *Mevlana* (1957)—use just two or three colors or black and white; there is usually an optical shifting of the three or four positive and negative shapes. Youngerman will purposely make field and form roughly equal in area or will shape the field so that it is evocative of some known form, thus creating spatial confusion. "The ground in my paintings completes and forms a shape so that it is impossible to separate figure from ground. But most of [my paintings] go beyond being concerned with a figure floating on ground, and involve interconnected images. Forms are fashioned by other forms which intrude upon them." In such works as *Aquitaine* (1959), negative and positive forms vie for domi-

nance along edges jagged as those of torn paper, while in his "Aztec" series (1958–59) Youngerman breaks up his large, pure areas of color into an irregular pattern of clawlike shapes. Other paintings gain immense energy from the positive-negative interpenetration of knife-edged serrations, as in *Coenties Slip* (1959). Writes Michael Benedikt in *Art News* (September 1965): "Perhaps it would be most correct to see Youngerman's obliquely natural shapes as signs of abstracted activity—of growth or floating or flight. A feeling of plunging, perhaps even of abstract diagrams of air or waterway activity, is often implied, while the contained shapes so prominent in the work seem to be gripped, or even rather strenuously clenched."

For ten years (to the late 1960s) Youngerman's style changed little as he worked ingenious variations on his basic formula. Gradually the interfaces between color areas sharpened and became more baroque, resembling Rorschach blots in their curves and jags. At the same time, the artist switched from oils to flatter, more saturated acrylics and reduced the visibility of his brushstrokes. *Palma* (1964) and *Elegy to a Guerrilla* (1967) illustrate this slow evolution in his search for new forms.

The late 1960s brought more radical innovations, notably an experiment with symmetrical compositions. One of the first of these, *Totem Black* (1967), inspired by Northwest Coast Indian art, still preserves a dynamic tension between figure and ground; the orange that surrounds the dominant black form also penetrates it through narrow canals which collect in a central pool of color. Other large works—the asymmetrical, 108-by-87-inch *Yellow Rising* (1970), and *Opening* (1970), which measures 105 by 75 inches—evoke giant hothouse blooms. "Primacy of the form itself" is Youngerman's operating principal; "if it cannot evade associations neither is it lessened by them."

A logical extension of Youngerman's formal explorations was to shape the canvas, and he began to do so with works such as *Roundabout* (1970), a tondo, 96 inches in diameter, with bright colors languidly flowing and poking into a central field of white. Nor did he restrict himself to the traditional symmetrical shapes. The white-on-white *White Glide*, a multiple of lacquered plywood, is composed of curved organic shapes raised off the wall so that shadows become integral to the composition.

These pieces took on the character of sculptural reliefs, and in fact Youngerman began making free-standing sculpture in 1970. *Blade* and *Spreadeagle* (both of 1971), two polished stainless steel sculptures, show the typical painter's

preoccupation with surface. As investigations of volume they are rather ordinary, but the reflections on their immaculate and warped surfaces accurately transmute external objects into Youngermanish curves. His interest in the "colors of white," the subtler reflections of atmosphere and environment on matte-white surfaces, led to his well-known series of white sculptures. Laminated from square sheets of aluminum screen, fiberglass, and polyester resin, these pieces, such as *Orion* (1975) and *The Ohio* (1978), resemble folded, discarded napkins. Youngerman claims that they were inspired by an exhibition of *tsutsumu*, the traditional Japanese art of packaging. "In the polished pieces," he remarked, "images are reflected as if in a mirror, but the white ones mirror shadows; shadows are ghosts of forms just as reflections are. That light and transformation process is crucial to my sculpture. That is how I connect it with living things." Over the past decade, Youngerman has also produced a large number of lithographs and serigraphs.

The artist lives in downtown Manhattan, and since 1971 he has been represented by the Pace Gallery, New York City. In an interview with Barbara Rose in *Artforum* (January 1966), he declared: "For me shape is the central issue in painting. . . . People seem to have noticed my surfaces, edges, etc., but not my primary concern which is finding and inventing new shapes. I am working for something organic and lyrical. I like the expressiveness of locked, meshed or tension-provoking shapes in opposition, a union in combat."

EXHIBITIONS INCLUDE: Gal. Arnaud, Paris 1951; Betty Parsons Gal., NYC 1958–68; Gal. Lawrence, Paris 1962; Gal. dell'Ariete, Milan 1963; Worcester Art Mus., Mass. 1965; Massachusetts Inst. of Technology, Cambridge 1966; Gal. Maeght, Paris 1966; Phillips Collection, Washington, D.C. 1968; Pace Gal., NYC from 1971; Arts Club of Chicago 1973; Gal. Denise René, Paris 1973; Gal. Denise René/Hans Mayer, Düsseldorf 1973; Truman Gal., NYC 1978; Washburn Gal., NYC 1981. GROUP EXHIBITIONS INCLUDE: "Les Mains eblouies," Gal. Maeght, Paris 1950; Gal. Denise René, Paris 1952; Pittsburgh International, Carnegie Inst. 1958, '61, '67, '70; "Sixteen Americans," MOMA, NYC 1959; Biennial, Corcoran Gal., Washington, D.C. 1959, '61, '63, '67; "American Abstract Expressionists and Imagists," Solomon R. Guggenheim Mus., NYC 1961; "Recent American Painting and Sculpture," MOMA, NYC 1961; "Systemic Painting," Solomon R. Guggenheim Mus., NYC 1966; "Large Scale American Painting," Jewish Mus., NYC 1967; Whitney Mus. of Am. Art Annual, NYC 1967, '69; Pace Gal., NYC 1971; "Abstract Expressionists and Imagists," Univ. of Texas, Austin 1976.

ABOUT: Lucie-Smith, E. Late Modern: The Visual Arts Since 1945, 1969; Moore, E. (ed.) Contemporary Art 1942–72: Collection of the Albright-Knox Art Gallery, 1972; Rickey, G. Constructivism: Origins and Evolution, 1967. *Periodicals*—Art and Architecture March 1960; Art in America September 1968; Art News September 1965, September 1980; Artforum April 1971, January 1966; Arts Magazine December 1975.

***YUNKERS, ADJA** (July 15, 1900–December 24, 1983), Latvian–American painter, printmaker, and collagist, is known especially for his woodcuts, but he also did significant work in pastel, gouache, and collage. An important figure of the New York School (he came to the United States just after World War II), Yunkers was as innovative and technically accomplished as many New York artists with greater reputations, but his concentration on "secondary" media and his tendency to abandon a field before attaining international recognition has made his work much less well known than it deserves.

Yunkers was born in Riga, Latvia, to a well-to-do family. At the age of 14, with almost no formal education, he left home for St. Petersburg, lured by romantic visions of the bohemian life of the artist. In St. Petersburg he enrolled in art school (although he later claimed to be essentially self-taught) and live in the artists' quarter, museum-gazing, reading the great modern Russian poets, and "drinking tea and arguing in the old Russian tradition." At the end of World War I he traveled to Germany, but he had little money and was often forced to use discarded napkins and food wrappers as sketch paper. His paintings, which had been futurist in style, were strongly influenced by German expressionism and also by Edvard Munch. A 1922 review described the works in Yunkers's first solo show, in Hamburg, as "heavily painted" and "anxious" in mood.

From 1922 to 1923 Yunkers traveled in Italy (where he met Bernard Berenson and Emil Nolde), Spain, France, Belgium, and the Canary Islands. After taking on what proved to be an extremely unpleasant job as a stoker on a Danish freighter, he jumped ship and eventually settled in Havana, where for the next three years he worked as an interior decorator and magazine advertising manager. The great muralist Diego Rivera, whom he met in Mexico in 1927, taught him the art of fresco. For the next decade, Yunkers lived in Paris, painting in oil with great energy during the day and reading verse and works on Eastern philosophy and religion late into the night. Through an acquaintance with the writer Henri Burbusse, he was commissioned to paint a number of murals in a city hall outside

°yo͞on´kəs, äd´jə

Courtesy of Dore Ashton

ADJA YUNKERS

Paris; these works were later destroyed by the Nazis during the occupation.

Yunkers, who had visited Spain shortly before the Civil War and who was deeply disturbed by the rise of fascism in that country, tried to emigrate to the US in 1940 but was denied a visa. He spent World War II in Stockholm, editing two successful art journals and experimenting with woodcut; many of these early prints are anguished or disturbed images of women in the manner of Munch. In 1946 a fire in his studio destroyed much of his work; this was only the first of a series of disasters that were to some extent to define the future course of his career.

Sponsored by the New School for Social Research in Manhattan, Yunkers arrived in New York City in 1947. Inspired perhaps by the large scale of abstract expressionist work, he expanded the size and color ranges in his prints, exploiting, as he said, "the potential capacity of the print to emulate painting" and contributing his own brand of emotional intensity to the growth of printmaking as an individual art form. Two powerful woodcuts, *Crying Women* (1949) and the more abstract *The Birdlover* (1951), show the transition occurring in his work at this time. The next summer he moved to New Mexico to teach at the state university. Living on a Guggenheim Fellowship and enchanted with the landscape, he built a house and studio in Corrales, outside Albuquerque; unfortunately, the studio was twice flooded between 1950 and 1952, again destroying much of his work. Yunkers returned to New York, where he married the art critic Dore Ashton—they have two daughters—and became an American citizen.

The crowning achievement of Yunkers's printmaking career was undoubtedly *Polyptych* (1953), a five-panel monotype woodcut in 50 colors and measuring 3½ by 14 feet—one of the most complex and exacting prints ever attempted. The central panel, entitled *Magnificat*, is flanked by *Power of Circumstance, Personal Epiphany, Chaos of Unreason* (the most abstract), and *Graveyard of Cathedrals*. Yunkers's bad luck came to a head when the ceiling of his New York studio caved in, crushing the blocks for *Polyptych*. In part because of this, the next year Yunkers stopped making woodcuts; but he also had achieved his goals in the medium and wanted to experiment with new materials, despite the fact that his career as a printmaker was at its height. He had no desire to repeat himself, valuing personal satisfaction over outside opinion. "Perhaps I could no longer say what I wanted to do in prints . . . for me, the possibilities were exhausted, and I felt a need to do something else. I believe that there is no such thing as a minor medium—an artist seizes what is nearest him, instinctively grasps those materials which best cover his present experience." The last of his woodcuts, the "Ostia Antica" series (1954), completed during a visit to Rome while Yunkers was on a second Guggenheim grant, presage his forthcoming pastel work with their gleaming pinks, roses, golds, blues, and deep blacks.

From 1957 to 1962 Yunkers produced 23 major pastels, most of them the size of large paintings, which have been compared with the work of Mary Cassatt, Edgar Degas, Odilon Redon, and other great pastelists. His pastel style was unique. He used the chalk not as a stylus but as a brush, the flat of the piece creating wide, luxurious swaths of color in a so-called abstract impressionist manner; that is, with the forcefulness and freedom of abstract expressionism and the luminous, transparent colors of impressionism. While such works as *Bewitchers' Sabbath* (1958) and *The Jewish Bride* (1959) are somewhat abstract, they are not formalist. Even in his most abstract periods, Yunkers rejected pure formalism and maintained that great mastery of technique could combine with abstraction to produce an art concerned with both meaning and form.

Yunkers switched media again in 1962, abandoning pastel for gouache. In the gouaches, most of them miniatures only exhibited privately, the "brooding, melancholic spirit" and "mysterious and ominous forms" of his earlier work are replaced by calm arrangements of "subtle shapes in broad, pale tone," as Yunkers described them. He made the jump to complete abstraction in 1965, energetically turning away from gouache

to painted collage on canvas. His materials, "applied directly and with certainty," as one critic put it, now signaled the artist's "serene and lucid temper." Representative of this period is the "Aegean" series; executed in the late 1960s, these were optically active collages in white on white with flecks and patches of blue, gray, pink, and yellow. With *Folded Canvas I* (1970), he disrupted the flat surface of his works in an apparent attempt to create emotion purely through subtle juxtapositions of texture, color, and depth. "Such is his mastery of assembling a minimum of motives in telling relationships of outline and colour," wrote G.S. Whittet in *Contemporary Artists*, "he evokes a sense of classical economy and serene calm through such a simple means as the placing of what resembles a torn vertical strip laid across a roughly executed rectangular mass in the dark ground of the picture frame." *Between Two Parentheses* (1977) and *Immobile Sun* (1977) display Yunkers's unerring instinct for what is pleasing and intriguing to the eye. The abstractions are careful but not over-precise, appearing neither deliberate nor arbitrary.

Adja Yunkers, an intense, uncompromising man, was a resident of New York City at the time of his death. In the journal *It Is* he declared: "I abhor 'explaining' *post factum* what my intentions were, once the picture is a reality: to want to speak about one's conceptions and intentions is humanly understandable but to me a gruesome post mortem. If the painting does not 'explain itself' and convey the experience to be derived from it, surely no words will do it."

EXHIBITIONS INCLUDE: Gal. Marie Kunde, Hamburg, 1922; New School for Social Research, NYC 1946; Art Alliance, Philadelphia 1948; Corcoran Gal., Washington, D.C. 1950; Kleemann Gals., NYC 1950; Pasadena Art Inst., Calif., 1951; Borgenicht Gal., NYC 1952, '53, '55; Rose Fried Gal., NYC 1957, '58, '68; André Emmerich Gal., NYC 1959, '61, '63; Baltimore Mus. of Art 1960; Stedelijk Mus., Amsterdam 1962; Cleveland Mus. of Art 1966; Brooklyn Mus., N.Y. 1969; Whitney Mus. of Am. Art, NYC 1972; Zabriskie Gal., NYC 1974, '76; Fine Arts Mus., Hempstead, N.Y. 1984. GROUP EXHIBITIONS INCLUDE: "Master Prints of the MOMA Collection," MOMA, NYC 1949; Whitney Annual, NYC 1958, '59, '61, '63, '67; Pittsburgh International, Carnegie Inst. 1958, '61; "American Abstract Expressionists and Imagists," Solomon R. Guggenheim Mus., NYC 1961; "The First Generation," MOMA, NYC 1969; "L'Art vivant aux Etats-Unis," Maeght Foundation, Saint-Paul-de-Vence, France 1970.

COLLECTIONS INCLUDE: MOMA, Whitney Mus. of Am. Art, Solomon R. Guggenheim Mus., and Jewish Mus., NYC; Albright-Knox Art Gal., Buffalo, N.Y.; Syracuse Univ., N.Y.; Mus. of Fine Arts, Boston; Fogg Art Mus., and Hayden Gal., Massachusetts Inst. of Technology,

Cambridge, Mass.; Carnegie Inst., Pittsburgh; Nat. Gal., Corcoran Gal., Hirshhorn Mus. and Sculpture Garden, Library of Congress, and Nat. Collection of Fine Arts, Washington, D.C.; Walker Art Center, Minneapolis.

ABOUT: P-Orridge, G. and others (eds.) Contemporary Artist, 1977; Yunkers, A. Prints in the Desert, 1950, Blanco, 1957. *Periodicals*—Art and Architecture no. 5 1955, June 1958; Art in America January 1969; Art International (Lugano) January 1979; Arts Magazine February 1968; It Is (New York City) Autumn 1959; New York Times December 28, 1983.

***ZADKINE, OSSIP** (July 14, 1890–November 25, 1967), Russian-French sculptor, is considered in Europe one of the major sculptors of the century, and certainly the greatest woodcarver. Although best known as a successful translator of the cubist idiom into three dimensions, Zadkine's cubist period was only a digression in a large body of work essentially passionate, baroque, and lyrical, in keeping with his dramatic, willful, and sometimes abrasive personality. Few of his many American students—sculptors Sidney Geist, Gabriel Kohn, George Spaventa, and George Sugarman, among others—came back from his Paris atelier unmarked by his accurate but painfully sarcastic critical barbs (he described his teaching technique as "brutal, no doubt, but salutory"), and and all diverged radically from his style. Perhaps for this reason Zadkine has been rather neglected in the US, where he has not had a major exhibition for nearly 40 years.

This neglect is unfortunate, as Zadkine's technical ability was unmatched and his works still emotionally engaging, if only because the viewer is always in suspense as to whether the sculptor will pull off his ambitious schemes. "Zadkine's is a flashing, improvisatory talent," wrote Sidney Geist in his excellent memoir of the sculptor in *Artforum* (June 1970), "but the price of his invention is high. His noble aspirations are crowded by the less worthy ones; the work as a whole creates the impression of constant disruption, of a spiritual nervousness that accords ill with the ultimate stillness of the sculptural medium. Zadkine, to be sure, is never bland or neutral: he falls with a crash or soars to the highest poetry."

The artist was born in Smolensk, Russia. His father, Alexei, was a professor of ancient languages at the Smolensk Seminary (from him Zadkine may have gotten his lyrical gift and love of poetry); his mother, the former Sophie Lester, was descended from Scottish shipwrights. At the age of 15 he was sent to England—without

*tsäd´ kēn, us´ sēp

knowing a word of the language—to complete his education and to learn business and finance. Strong-willed and independent from the start, Zadkine was more interested in art than money, and while living in Sunderland in the northern country of Durham he took evening classes at the local art school. When he moved to London the next year to study art his parents were outraged and cut off his support. Zadkine worked as a woodcarver in a furniture shop until they agreed to put him through art school. In 1907–08 he attended the Regent Street Polytechnic and the Central School of Arts and Crafts, working mostly in modeled clay and carved wood. In his memoirs, *The Mallet and the Chisel* (1968), Zadkine recalls showing his work to the sculptor Jacob Epstein and enduring long minutes of stony silence before fleeing to throw his piece into the Thames.

In 1909 Zadkine moved to Paris, a city he came to love and revere, to study at the atelier of Jean-Antoine Injalbert at the École des Beaux-Arts. However, for him there was no longer much excitement in the academies; he dropped out in 1910 and rented a studio in La Ruche (the Beehive), meeting other young artists—Chaim Soutine, Marc Chagall, Amadeo Modigliani—as well as Picasso, Alexander Archipenko, Brancusi, and Jacques Lipschitz. Rodin and the Belgian sculptor George Minnes were the greatest early influences on him.

Initially, A. M. Hammacher commented in *The Evolution of Modern Sculpture*, Zadkine's creative drive sprang from "an innate feeling for the nature of wood and stone." Zadkine wrote in his memoirs of his early fascination with Romanesque, and other, more ancient, art: "The white woods of the Romanesque Middle Ages, the ordered excess of the Gothic, the genius of the Greeks—and even now I still recall vividly the deep and disturbing experience of discovering the Egyptians and Sumerians." Stylizations from the Byzantine and Egyptian appear in such early works as *Prophet* (1914) and *Job* (1914), the latter a group of five wood figures.

In 1915 he joined the French Army, working as a stretcher bearer and later as an ambulance driver. Severely gassed in the trenches at Rheims, he spent his convalescence sketching the series of war drawings now in the War Museum at Vincennes. Upon his recovery he served as an interpreter for the Russian brigades in France. After the war, he had his first solo show, in 1919 at the Galerie le Centaure, Brussels; the next year he married Valentine Prax.

Zadkine first turned to a cubism in the late 1910s. *Formes et lumières* (1918, Forms and Lights, in marble), *La Douce a l'éventail* (1924,

Lady with a Fan, in granite), and *Jouer d'accordéon* (1924, Accordion Player, in bronze) are among the best examples of this style. (Musicians, instruments, and musical imagery appear often in Zadkine's sculpture; he was himself an accomplished pianist and accordianist.) The move to cubism was to some extent an artificial one for him. The work, though lyrical and undogmatic, is occasionally broad and obvious to the point of bombast, which even he acknowledged. "One feels in these sculptures," he wrote in his journal, "the terror of a good student who wants his work to resemble his master's." But soon afterward Zadkine found an expression more natural to him: forms less blocky, more clearly defined and anatomical, though simplified.

The legacy of his experiment with cubism was a new formal freedom and a thorough grasp of the volumetric principles of concave and convex alternation, essential to cubistic sculpture, which he used in most of his later work. *Les Trois belles* (1927), in bronze and mirror, the lively *Niobe* (1929), in pear wood, and his series of alabaster carvings of fish and birds on crystal stands are sensuous and direct, with little discernible cubist influence. His great *Homo Sapiens* (1934), a virtuosic elmwood carving in which a man and a woman clutch symbols of all the arts, is a curious mixture of the classical, baroque, and cubist and attests to Zadkine's considerable powers of invention and composition. Wrote Geist: "Zadkine's thematic variations are accompanied by a stream of formal explorations: applied color, the evident chisel mark, the naturally convex form rendered by a convexity, anatomical dislocation, combination of materials; aerating of the sculptural mass." Large projects occupied him in the later 1930s: a massive elmwood *Homage to J. S. Bach* (1936) and a number of plaster monuments to French writers, including Alfred Jarry (writing *Ubu Roi* while riding on a bicycle), Guillaume Apollinaire, Arthur Rimbaud, and the Comte de Lautréamont.

Zadkine had first come to the United States in 1937 for the opening of his New York City show at the Brummer Gallery, but four years later he returned as a refugee from the Nazi invasion of France. Of his time in the US he wrote: "It was as if I had become young again . . . I started over." Indeed, he enjoyed considerable success, exhibiting regularly, teaching at the Art Students League, and doing some of his best work—*Clementius* (1941), in marble, with the outline of a hand incised on his thigh, *Maenads* (1943), and *Phénix* (1944). In later years, however, he faulted American art for not measuring up to the traditions of what he called "Old Europe"

in inspiration, sensibility, or craftsmanship.

In 1945 Zadkine returned to Paris and began taking students in his own atelier on rue Notre Dame des Champs and at the Colarossi studio at the Académie de la Grande Chaumière, Montparnasse. A number of young American artists followed him to France, among them the painters Kenneth Noland, Jules Olitski, and Richard Stankiewicz, as well as the sculptors already mentioned. In his view, however, it was not until his retrospective at the Musée d'Art Moderne, Paris, in 1949 that he received the recognition he deserved.

Mythological and classical themes occupied him through the late 1940s and '50s, and the myth of Orpheus, in particular, was paradigmatic for him. In most of his treatments the lyric musician is merged with his lyre, as is an elmwood *Prometheus* (1956) with the fire he brings. "I try to reorganize the objective form of a legendary figure so as to create an allegorical form that is complete in itself, no longer requiring an attribute." On *La Poète* (1953) he incised the poetry of Paul Eluard, as the Sumerians inscribed cuneiform verse on their figures. However, his most powerful work of the period is not mythological but painfully contemporary. *The Destroyed City* (1947–53), in Rotterdam, is a monumental bronze figure (40 feet high), "frighteningly exploded," in Geist's words, with arms upraised in a vain attempt to ward off the bombs dropped on the city in World War II. Zadkine's series, from the late 1950s, of emotional bronzes of Vincent Van Gogh were usually covered in marks resembling the great Postimpressionist's brushstrokes, and culminated in *Monument to Van Gogh* (1956–58) erected in Wasemes, Belgium.

A lean, white-haired figure, Zadkine smoked a pipe constantly and spiced his incisive talk with literary and historical allusions and strong opinions of his fellow artists. Despite his pronounced physical decline in the 1960s, his output remained prolific and various. Complex, dramatic abstractions—*La Force atomique* (1963, Atomic Energy), *Le Labyrinthe* (1966)—vied with simpler figures—*Le Repos* (1966, Rest), *Femme entendu* (1966, Listening Woman). Of the abstractions he saw his former students producing in America, he said, "A statue should not be a cold assembly of cold forms." Major retrospectives were held in 1958 at the Maison de la Pensée Française, Paris, the Tate Gallery, London, in 1961, and at the Knokke-le-Zoute, Belgium in 1963. Aged 77, Zadkine died in Paris. His wife has converted his studio on the rue d'Assas into the Musée Zadkine, where many of his drawings, sculptures, etchings, and gouaches are now housed.

EXHIBITIONS INCLUDE: Gal. le Centaure, Brussels 1919, '24, '27; Gal. La Licorne, Paris 1920; Gal. Barbazanges, Paris 1921, '26; Gal. Schwartzenberg, Brussels 1923, '24; Gal. Druet, Paris 1927; Tooth Gal., London 1928; Arts Club of Chicago 1931, '33, '36; Palais des Beaux-Arts, Brussels 1933, '48; Whitworth Art Gal., Univ. of Manchester, England 1935; Brummer Gal., NYC 1937; Wildenstein and Co., NYC 1941; Buchholz Gal., NYC 1943; Stedelijk Mus., Amsterdam 1948; Mus. d'Art Moderne, Paris 1949; Boysmans-Van Beuningen Mus., Rotterdam 1949; Leicester Gals., London 1952; Gemeentemus., Arnhem, Neth. 1954, '62; Nat. Gal. of Canada, Ottawa 1956; Maison de la Pensée Française, Paris 1958; Mus. des Beaux-Arts, Lyons, France 1959; Städtische Kunsthalle, Mannheim, W. Ger. 1960; Tate Gal., London 1961; Casino Municipal, Knokke-le-Zoute, Belgium 1963; Hirschl and Adler Gals., NYC 1971; Mus. Rodin, Paris 1972; Mus. d'Art Moderne de la Ville, Paris 1972; Gal. Artcurial, Paris 1979. GROUP EXHIBITIONS INCLUDE: Salon des Indépendants, Paris from 1911; Salon d'Automne, Paris from 1912; Neue Sezession, Berlin 1914; "Allied Artists Exhibition," London 1914; "Modigliani: Kisling: Zadkine," rue Huyghens, Paris 1918; Venice Biennale 1932, '38; "Artists in Exile," Pierre Matisse Gal., NYC 1942; Biennial Sculpture Exhibition, Middelheim Park, Antwerp, Belgium 1950; "50 ans d'art moderne, " World's Fair, Brussels 1958; International Exhibition, Ljubljana, Yugoslavia 1963.

COLLECTIONS INCLUDE: Stedelijk Mus., Amsterdam; Boysmans-Van Beuningen Mus., Rotterdam; Gemeentenmus., Arnhem, Neth.; Rijksmus. Kröller-Müller, Otterlo, Neth.; Stedlijk van Abbemus., Eindhoven, Neth.; Mus. Royaux des Beaux-Arts, and Open-Air Sculpture Park, Middelheim, Antwerp, Belgium; Mus. Royaux des Beaux-Arts, Brussels; Mus. Nat. d'Art Moderne, Mus. d'Art Moderne de la Ville, and Mus. Zadkine, Paris.

ABOUT: Chevalier, D. Zadkine, 1949; Cogniat, R. Zadkine, 1958; Gerz, U. Ossip Zadkine, 1963; Hammacher, A. M. Zadkine, 1954, The Evolution of Modern Sculpture, 1969; Marchal, G. I. Avec Zadkine, 1956; Ridder, A.H.P. de Zadkine, 1929; Zadkine, O. If I Were a Sculptor, 1951, Journey Through Greece, 1955, The Labors of Hercules, 1959, My Sculpture, 1963, Letters to Andre Ridder, 1962, Poems, 1963, The Mallet and the Chisel, 1968. *Periodicals*—Artforum June 1970; Canadian Art no. 1 1956; L'Oeil (Paris) May 1979.

ZORACH, WILLIAM (February 28, 1887– November 15, 1967), American figurative sculptor and painter, was the seventh child of a Jewish family who lived in the village of Euberick in Lithuania, at that time part of Russia. His father was a flax-maker, as was his father before him; his mother's family were farmers. In 1891, the family imigrated to America to join Zorach's father and oldest brother, who had already been in America three years. As Zorach explained in

his autobiography, *Art is My Life,* "We left because Jewish families had no rights and they dreaded having their sons drafted into the army." The Zorachs settled at first in Port Clinton, near Cleveland, and knew real hardship. The father drove about the country each day peddling notions, while his mother ran a boarding house in a slum section of Cleveland, a neighborhood with its share of anti-Semitic hooligans. Zorach had a hard time at school, but a seventh-grade teacher, Alice Sterling, took an interest in his obvious drawing ability. Early on, he took up woodcarving, practicing on back fences and barn walls.

Zorach's family, who knew nothing of art, were determined that he should learn a trade. Sterling persuaded the school supervisor of art to write him a letter of introduction to the Morgan lithograph shop in Cleveland, where he worked, first as an errand boy, then as an apprentice.

Between 1902 and 1905 Zorach attended night classes at the Cleveland Institute of Art. In the fall of 1905, at the age of 18, he went to New York City to study at the National Academy of Design, where his teachers were A. M. Ward and G. Maynard. Their instruction was academic and stiff, but Zorach worked hard, winning a prize in drawing in the Men's Day Class and an honorable mention in painting. After a winter at the academy he returned to Cleveland and the lithograph shop, and the following winter he went back to New York for a second, far more rewarding year at the National Academy. At the Metropolitan Museum of Art he copied Franz Hals, Rembrandt, and other Dutch masters, as well as Velázquez and Sir Henry Raeburn. In his last year at the academy, he also studied with George Bridgman at the Art Students League.

In the summer of 1909 Zorach returned again to Cleveland and the lithograph shop. By working 16 hours a day, Saturdays and Sundays included, he saved enough to go to Paris, and persuaded his best friend, Elmer Brubeck, to accompany him. On arriving in Paris that fall they took a room near the Luxembourg Gardens. Soon Brubeck, alarmed by the insecurity of an artist's life, returned home, but Zorach attended several art schools, eager to learn all he could. He ended up studying at the La Palette school, run by a Scottish artist, John Duncan Ferguson, where the criticism was in English. Twice a week the successful portraitist Jacques Emile Blanche, "an impressive, beautifully mannered Frenchman," as Zorach remembered him, came in to criticize the students' work, but Zorach did not find him very helpful.

Zorach later described himself as having been "very simple and naïve" as a young artist in Par-

is. The Modernist movement, unlike anything then existing in America, was in full swing, but cubism was a mystery to Zorach, who was more fascinated by the bold, brilliant use of color of the Postimpressionists and by Cézanne's new conception of form. At La Palette, Zorach met a talented and attractive art student from California, Marguerite Thomson, "who was to be my wife, companion, and fellow-artist for the rest of my life." Another fellow-student was Lee Simonson, later to become a leading Broadway stage designer.

The artist spent several months in the summer of 1910 in Avignon in southern France, painting mostly landscapes, four of which he sent to the Salon d'Automne after his return to Paris in the fall. All were accepted, and at the same time as this triumph there were obstacles to his relationship with Marguerite, created by her family. She was taken away by her aunt for a trip around the world on her way back to California, so Zorach left Paris and went to Munich, where he visited museums and galleries. On the return trip to Paris he stopped in Basel and Zurich, and found Switzerland "like a big park, so neat and well kept." Since he had no more money, he had to go back to America in 1911.

Thoroughly dejected, Zorach resumed his job at the lithographic studio in Cleveland. More than the lack of money and the absence of Marguerite, he was depressed by "the complete lack of interest in all those around me in the world outside," including the exciting work being done in Paris. He tried to paint on Sundays, and for a short period rented a studio with another young artist, Max Kalosh. Zorach had an exhibition in the winter of 1912 in a small gallery in a Cleveland department store. He exhibited his southern France landscapes and works done in Paris, and sold one canvas for $15.

Zorach and Marguerite arranged to meet in New York City just before Christmas 1912. They were married in City Hall and set up house on the top floor of a small building on 57th Street and Sixth Avenue. They had practically no money, but Marguerite insisted that her husband should take no jobs in lithograph shops. They both sketched and painted, and Marguerite made some textile designs, which she was only able to sell during World War I, when manufacturers could no longer get designs from Europe. Zorach's painting style at this time was eclectic, showing the influence of postimpressionism, fauvism, and German expressionism. He and Marguerite both had paintings in the historic New York Armory Show of 1913. In Paris he had not understood the Cubists, but after the Armory Show, Zorach recalled, "I began making my vi-

sual observations of nature into Cubist patterns." He also studied the stone carvings of the Eskimos, the Aztecs, and the Maya in the American Museum of Natural History.

Soon the Zorachs moved from their run-down studio to an apartment on 10th Street opposite the Jefferson Market Jail, where they lived for more than 20 years. In the summer of 1914 they vacationed in Chappaqua, in rural New York, where Zorach painted constantly.

From 1914 to 1916 Zorach was a member of the Society of Independent Artists. Because no gallery would show their work, the Zorachs held small exhibitions in their 10th Street studio. In March 1915 their son Tessim was born. The following year Zorach showed *Spring (No.1)*, a large canvas done in Chappaqua, with nude figures reclining in a vivid landscape, in the Forum Exhibition at a Manhattan gallery, where his wife also exhibited two pictures, *The Magnificent Squash* and *Maternity*. Zorach made another New York gallery contact in Charles Daniel, and in 1916 they had a show at the O'Brien Gallery in Chicago. The actor William Gillette bought two of Zorach's pictures, the artist's first real sale. The previous year, during a summer spent in Provincetown, Zorach had met and made a fine drawing of the playwright Eugene O'Neill which is now in the theater collection of the Museum of the City of New York.

In the summer of 1917, at Echo Farm in New Hampshire, Zorach made his first carving. Using a small butternut panel taken from the front of a bureau drawer, he carved an original bas-relief. In New York City, in November 1917, the Zorach's daughter, Dahlov, was born. She was the inspiration for Zorach's first sculpture in the round, *First Steps* (1918), modeled in clay and later cast in bronze.

Zorach's earliest sculptures, including a portrait of his sister, were more traditional than his paintings. He continued to paint until 1922, while at the same time producing a number of woodcarvings and several terra cottas. In 1922 he abandoned oil painting altogether, finding greater aesthetic fulfillment in sculpture; he said "I came to sculpture as a mature artist." As his work evolved, he was inspired by Egyptian, Persian, and archaic Greek art, as well as by African woodcarvings. Like José de Creeft, John Flanagan, Ossip Zadkine, and others, Zorach was a passionate advocate of direct carving in wood and stone, drastically simplifying the forms of nature into monumental, compressed masses. Although he owed something to cubism, Zorach was never a Cubist or Constructivist sculptor, but had greater affinity with the modern classicism of Aristide Maillol. A characteristic early

sculpture was *Floating Figure*, in African mahogany and carved in Provincetown in the summer of 1922 and now in the Albright-Knox Art Gallery, Buffalo, New York.

In 1924 Zorach had his first exhibition at the Kraushaar Gallery, New York City. Juliana Force, who ran the Whitney Club, bought two of his pieces, a wood carving called *Pegasus*, now owned by the Whitney Museum of American Art, New York City, and a small panel relief.

From 1923 on, the Zorachs spent part of each summer at their farm near the sea at Robinhood, Maine, a landscape that inspired many of his watercolors. Among Zorach's notable carvings of the mid-1920s were *The Artist's Wife* (1924) and *Child with Cat* (1926), both in Tennessee marble. In 1927 he bought a three-ton block of Spanish Florida Rosa marble in Astoria, Queens, had it shipped to Maine, and began carving *Mother and Child* (1930), considered one of his major works. When exhibited in Zorach's 1931 solo show at the Downtown Gallery, New York City, it was praised in *The New York Times* as an event marking a "prodigious advance" in the realm of sculpture. He was awarded the Logan Medal and a sculpture prize from the Chicago Art Institute. In 1956 *Mother and Child* was acquired by the Metropolitan Museum of Art, New York City.

In 1930 plans for constructing Radio City Music Hall were being drawn up, and Zorach, whose reputation had grown, was commissioned by the Rockefeller family to design a sculpture for the downstairs lounge. The result was *The Spirit of the Dance*, the kneeling figure of a graceful young woman dancer cast in aluminum. The piece aroused controversy when the manager of the Music Hall refused to exhibit it, finding it "too nude." Nelson Rockefeller and other art lovers came to its defense and the piece was eventually exhibited at Radio City.

From 1932 to 1935 Zorach lectured on the history of sculpture at summer sessions of Columbia University, and from 1929 to 1960 he was an instructor in sculpture at the Art Students League. During the administration of President Franklin Roosevelt he served as juror on the section for fine arts for the Treasury Department in Washington, D.C. Among his important public commissions was the over-life-sized marble figure of Benjamin Franklin (1936–37) for the Post Office building in the nation's capital, in which Zorach aimed to express Franklin's "great stature and extraordinary personality." Another monumental work was an ambitious group titled *Builders of the Future*, commissioned for the New York World's Fair of 1939.

In the 1940s and '50s Zorach's work developed

mainly along classical lines. He did not hire professional models but found his inspiration in family and friends. *Devotion,* a powerful mother-and-child group of 1946, carved in light gray granite, was given by the artist to Colby College in Maine. *The Family* (1957) was another example of his classicism. One of his most satisfying public commissions of the 1950s was a high relief, *Man and Work,* created in 1953 for the Mayo Clinic building in Rochester, Minnesota. The figures projected from a sheer slab of white Georgia marble, 16 stories high and a block wide. In 1961 Zorach carved a monumental high relief for the Municipal Court Building in New York City.

In addition to writing many articles for art periodicals, Zorach published a book, *Zorach Explains Sculpture,* in 1947. He received many honors and awards in the 1950s and '60s, and in 1959 was given a retrospective at the Whitney Museum. Attacked as a radical innovator in his early days, when he was an outspoken proponent of direct carving, he came to be regarded in his later years as a conservative, especially after sculptors such as Jacques Lipchitz accustomed artists and the public to a more open type of sculpture. But Zorach, unaffected by changing fashions, pursued his own humanistic vision with integrity and dedication. He frequently departed from classicism in the direction of the romantic and the primitive. He sometimes used field granite collected from farms in his animal compositions, "carving out the form," one writer observed, "with great economy and with resultant monumentality even when the physical scale was small." Another critic wrote that in his work "there is always a conviction that life is exalted and filled with dignity. His sculptures are never esoteric, although they may be mysterious."

William and Marguerite Zorach spent six months of each year in New York City, but were legal residents of Maine. Zorach died in Bath, Maine at the age of 80. A stocky, sturdily built man with attractive features, gray hair, he once described himself as "a simple person, close to the earth." Success did not affect his basic warmth, directness, and humor.

In his autobiography Zorach declared that he had "no artistic creed or formula." He summed up his work in the final chapter: "There are things one does for the pure love of form and color, in the eery abandonment to the moods and the fancies of the moment. These are my watercolors. Then there are the visions imprisoned in the rock and the visions deep in one's soul—the things one does in seeking for the inner rhythms of nature and life, in the journeys into an unknown region where one can grasp only mystic

fragments from the great subconscious that surrounds us. There is much of pain and exaltation in creative work. A . . . relentless power that makes one . . . create. This is my sculpture."

EXHIBITIONS INCLUDE: Taylor Gal., Cleveland 1912; Daniel Gal., NYC 1918; Dayton Art Inst., Ohio 1922; Kraushaar Gals., NYC 1924, '26; Downtown Gal., NYC from 1931; Ansel Adams Gals., San Francisco 1933, '41; Art Inst., Chicago 1938; Dallas Mus. of Fine Art 1945; Pasadena Art Mus., Calif. 1946; Art Students League, NYC 1950; Des Moines Art Center, Iowa 1954; Bowdoin Col., Brunswick, Maine 1958; Whitney Mus. of Am. Art, NYC 1959; Patten Free Library, Bath, Maine 1962; Nat. Collection of Fine Arts, Washington, D.C. 1967; Bernard Dannenberg Gals., NYC 1968, '70. GROUP EXHIBITIONS INCLUDE: Salon d'Automne, Paris 1910, '11; Armory Show, NYC 1913; Annual Exhibition, Society of Independent Artists, NYC 1914, '15, '16; Daniel Gal., NYC 1915, '16; O'Brien Gal., Chicago 1916; "Forum Exhibition of Modern American Painters," Artisan Gal., NYC 1916; Society of Independent Artists Annual, Whitney Studio, NYC 1917, '18, '22; "William Zorach, Marguerite Thomson," 10th Street Studio, NYC 1919; "Painting and Sculpture by Living Americans," MOMA, NYC 1930–31; "A Century of Progress," Chicago 1933; "Contemporary American Sculpture," Whitney Mus. of Am. Art, NYC 1950; Annual, Whitney Mus. of Am. Art, NYC 1955 '56; Pittsburgh International, Carnegie Inst. 1958, '61, '64; "American Painting and Sculpture," Tretyakov Gal., Moscow 1959; "Roots of Abstract Art in America 1910–1930," Nat. Collection of Fine Arts, Smithsonian Instn., Washington, D.C. 1965.

COLLECTIONS INCLUDE: Metropolitan Mus. of Art, MOMA, Whitney Mus. of Am. Art, and Columbia Univ., NYC; Brooklyn Mus., N.Y.; Albright-Knox Art Gal., Buffalo, N.Y.; Newark Mus., N.J.; Boston Mus. of Fine Arts; Addison Gal. of Am. Art, Andover, Mass.; Brandeis Univ., Waltham, Mass.; Colby Col., Waterville, Maine; Baltimore Mus. of Art; Cleveland Mus. of Art; Art Inst., Chicago; Milwaukee Art Center; Dallas Mus. of Fine Arts; Fort Worth Art Center, Tex.; Los Angeles County Mus.; Portland Art Mus., Oreg.; Hirshhorn Mus. and Sculpture Garden, and Corcoran Gal., Washington, D.C

ABOUT: Baur, J.I.H. William Zorach, 1959; Current Biography, 1963; Hooper, D. F. "William Zorach" (cat.), Dannenberg Gals., NYC, 1968; Myers, B. S. and others (eds.) Dictionary of 20th Century Art, 1974; Ritchie, A. C. Sculpture of the Twentieth Century, 1952; "William Zorach" (cat.), Art Students League, NYC, 1950; Wingert, P. S. The Sculpture of William Zorach, 1938; Zorach, W. Zorach Explains Sculpture: What it is, and How it is Made, 1947, Art is My Life: An Autobiography by William Zorach, 1967. *Periodicals*—American Magazine of Art March 1935; Artforum February 1969; College Art Journal Summer 1937; Creative Art June 1930; New York Times November 17, 1967.